THE OXFORD GUIDE TO
CLASSICAL MYTHOLOGY IN THE ARTS,
1300 – 1990s

We are all Greeks. Our laws, our literature, our religion, our arts, have their root in Greece.

—Percy Bysshe Shelley, Preface to *Hellas*

THE OXFORD GUIDE TO

Classical Mythology in the Arts, 1300–1990s

Jane Davidson Reid

with the assistance of
Chris Rohmann

VOLUME 1

New York Oxford
OXFORD UNIVERSITY PRESS
1993

To the memory of my teachers
Ernest Christopher Hassold
and Justus Bier

OXFORD UNIVERSITY PRESS

Oxford New York Toronto
Delhi Bombay Calcutta Madras Karachi
Kuala Lumpur Singapore Hong Kong Tokyo
Nairobi Dar es Salaam Cape Town
Melbourne Auckland Madrid
and associated companies in
Berlin Ibadan

Copyright © 1993 by Oxford University Press, Inc.

Published by Oxford University Press, Inc.,
200 Madison Avenue, New York, NY 10016

Oxford is a registered trademark of Oxford University Press

Library of Congress Cataloging-in-Publication Data

Reid, Jane Davidson, 1918–
The Oxford guide to classical mythology in the arts, 1300–1990s
Jane Davidson Reid; with the assistance of Chris Rohmann.
p. cm. Includes bibliographical references and index.
ISBN 0-19-504998-5
1. Mythology, Classical, in art—Catalogs. 2. Arts,
Modern—Catalogs. I. Rohmann, Chris. II. Title
NX650.M9R45 1993
700—dc20 92-35374 CIP

Printing (last digit): 9 8 7 6 5 4 3 2 1
PRINTED IN THE UNITED STATES OF AMERICA
on acid-free paper

CONTENTS

FOREWORD

These volumes, which have consumed many years of dedicated work by Jane Davidson Reid, represent much more than a bibliographical chronicle. They trace the paths followed by Greek and Roman mythological figures and stories through the human imagination in many countries and every medium of the arts, including music and dance, from the late Middle Ages to the present. There have been many books on the sweep of the tradition (for example, Gilbert Highet's *Classical Tradition*) and many monographs on the assimilation of it in a particular period and locality (for example, Richard Jenkyns's *The Victorians and Ancient Greece*), but I know of no other work like *The Oxford Guide to Classical Mythology in the Arts,* nothing that gives this kind of detailed record of the reimaginings of myth from age to age, with all the eye-opening metamorphoses from genre to genre and place to place. Historians of the arts and intellectual historians will be led by the lists of artworks to rich insights into local accents and obsessions, and they will find them either reinforced or subtly qualified as they move through the various media.

It is not possible in this space to parade any more than the smallest items of all this wealth, but a few examples may help to show the kind of curiosity that even a rapid survey provokes. Under "Aphrodite," we come upon the subentry "Venus Frigida" and find a host of listings of mostly Dutch and Flemish paintings, spanning from 1600 to about 1750, on the theme "Sine Cerere et Baccho friget Venus" (Venus is cold without bread and wine). How can we account for the surge and abrupt cessation of this theme? Was it perhaps the power of important pictures by painters like Rubens and Jan Brueghel the Elder that challenged the next few generations to try their hand at this *topos,* or were there larger social currents drawing artists to the popular display of Dutch abundance and prosperity through the seventeenth century? Later in the same entry, we are given another local variant in the subentry "Tannhauser and the Venusberg," the German story of the knight who is enfolded into the embrace of Venus on her numinous mountain and released only by prayers to the Virgin—a fine embodiment at the dawn of the Renaissance of the competing claims of two cultures, and resonant, like some deep-forested horn, with the stories of courtly love, and even further back, of Odysseus and Calypso.

Connections are made and questions raised from even casual browsing through these volumes. Under "Prometheus," for example, in the subentry "Prometheus the Creator," we duly note that Mary Wollstonecraft Shelley's *Frankenstein, or, The New Prometheus* appeared in 1817, three years before Percy Bysshe Shelley's dramatic poem *Prometheus Unbound* (listed in the subentry "Prometheus Freed"). The two versions of the god seem in many ways antipathetic, and we wonder what discussions of their views of the myth took place between the two writers. Throughout the long entry on Prometheus, we also note that the myth has apparently appealed more to sculptors, poets, and composers than to painters, and that in different countries it has been exploited for almost opposite ideological purposes in the same age: the Nazi propaganda play *Prometheus: Ein chorisches Spiel vom Licht* was produced in Leipzig by Klaus Bertling and Johannes Menge in 1933,

the same year that Paul Manship was creating his golden sculpture of Prometheus with his torch for Rockefeller Plaza in New York City.

The Oxford Guide to Classical Mythology in the Arts is a compilation of a great quantity of data, organized and presented in a uniquely useful way. It is the nature of all such collections that, once available, they can constantly be revised and expanded by fresh material. It is the herculean labor of assembling the first, vast core of information that will sustain the energies of future historians of artistic and intellectual traditions of the Western world. Generations of scholars in these rich fields will always be in Jane Reid's debt for having performed this work.

Peter R. Pouncey
Amherst College
October 1992

PREFACE

I did not set out to compile an index of classical mythology treated in the arts. I came to it by accident, propelled by concentration on one subject after another, often arising from my master's thesis (1948) on Rainer Maria Rilke. Focusing on the contrast between Rilke's way of seeing and those of other modern poets (e.g., W. B. Yeats, Edith Sitwell, Robert Lowell), I encountered, time and again, in the visionary world surrounding their poetic artifacts, works of painting and sculpture that had inspired them. So it was that in looking for comparable or contrasting treatments of one subject I would run into a throng of *other* subjects treated by my gathering fraternity of poets and artists.

My intention had been to add to four essays I had already published (on Leda, Eurydice, St. Sebastian, and Judith) another longer one on "Paolo and Francesca in the Nineteenth Century" and so to collect a book in honor of my two revered teachers, Ernest C. Hassold, chairman of English and Humanities at the University of Louisville and later head of the Division of Humanities, and Justus Bier, chairman of the Art History Department and subsequently director of the North Carolina Museum of Art in Raleigh, the great authority on Tilman Riemenschneider and Viet Stoss. Unfortunately, the "Paolo and Francesca" was already book length in rough draft and far from finished. My son, Colin Way Reid, a poet and an avid Greek student from his early days at St. John's in Annapolis, was attending Mount Holyoke College, again deeply absorbed in Greek. His advice was that I should collect my random notes on unexplored subjects in a way that would be useful to others as well as to myself in the future. Otherwise my end would predictably mean the emptying of drawers of notes into the trash bin. Ben L. Reid, my husband, agreed, and both father and son supported the idea of a working catalog that could be developed while I was teaching and trying to finish my book of essays.

As I began the process of accretion that eventually became this work, academic colleagues familiar with my inclusive bent started to request material on particular subjects. I then realized that no comprehensive, interdisciplinary reference work yet existed that gave access to works of art by subject—a suspicion confirmed by the exhaustive research that Nancy Devine at the Mount Holyoke College library conducted on my behalf. This guide to classical mythology in the arts was thus created, in its early stages, by evolution rather than plan, in response to a perceived need.

Later, on the very day I heard that Oxford University Press had agreed to publish this work, my husband and son persuaded me to telephone Drs. Hassold and Bier to ask if I might dedicate the work to them jointly. This I did, reaching them while they were still capable of savoring the idea; unfortunately completion of the *Guide* has come too late for them to enjoy the finished work.

Looking back, I am struck by the marvelous role of accident in my life, although I imagine it has worked in the same way for many: first, the accident of growing up in a time when Europe was expelling some of its best scholars because of the racial

paranoia of Hitler; second, the accident of being kept at home during the Great Depression, attending the University of Louisville rather than an Eastern women's college; and third, the accident of meeting at Louisville a man of the first rank in intelligence, vision, and exploration, who had begun as a son of a Norwegian-American Lutheran pastor in Indiana and of a German-American doctor's daughter.

Ernest Christopher Hassold, trained first as a candidate for the church, had added to the family German a solid grounding in Greek and an immersion in the classics. When he finally broke away from his theological training to enter the new world of the University of Chicago, he was free at last to read "frivolous," secular writers like Shakespeare. After study in England, he eventually wrote his dissertation on Milton, that Puritan lover of the classics. But his greatest devotion was always to Goethe and to Erasmus. I suppose these two most supported his rational cast of mind, shot through with engaging good humor, and his natural bent to explore both the literature of many countries rarely mentioned in college catalogs and later the visual arts. As a graduate fellow at Louisville, I was to help him explore these fields, which he had previously opened to me in independent study.

Now the accidents converged. Just as Ben Reid and I were callow undergraduates, Dr. Hassold undertook to travel to Germany where he extracted single-handedly two German-Jewish scholars, one in art history, Justus Bier, the other in music history, Gerhard Herz, later to become a foremost Bach scholar. These two, plucked from imminent danger, became guests of their rescuer and his wife while at the same time undertaking their university posts and learning U.S. citizenship and idiomatic English. And their rescuer learned deeply from them, turning, when well past fifty, much attention to a study of the baroque in art, music, and literature.

Without the foregoing accidents—depression, war, and the gift of refugee scholars guided by the vision and strength of purpose of our native mentor—my intellectual world might well have remained the narrow, back-watered, predominantly Anglo-Scottish heritage of which, by the way, I am still fiercely proud. All these accidents helped propel me through at least two other unrelated topics, to settle for my master's work on Rilke, who was so immersed in the arts and in classical subjects. My Latin teacher in high school, Mary Stewart Duerson, who had really been the first to open the ancient world to me and who so often interrupted a reading of Virgil or Ovid or Cicero to explain an historical reference or identify a Greek sculptor, would not have been surprised to learn that I had fallen into this *Guide to Classical Mythology in the Arts*.

Always, I have tried to do some justice to the legacy from my best teachers. As for more recent personal debts, I must declare that it has always been my great good fortune to be surrounded by a community of scholars, whose varied interests were often tapped in the friendliest workings of osmosis. I have enjoyed the camaraderie, sometimes quite deep, of the Mount Holyoke College community, including academic friends, college staff, and those devoted students who have served as assistants. I shall attempt to detail some of the most significant of these debts but must begin at a more central point.

Though working by necessity and inclination quite independent of any formal institutional support, I did approach the president of Mount Holyoke College, Elizabeth Topham Kennan, to tell her about the project. I was not requesting funds, nor was she in a position, during a mammoth fund drive, to offer any; but I must record gratefully that it took her fewer than eight minutes to grasp the potential of the *Guide* and to promise any support-in-kind that she could muster. My work became an officially sanctioned project of the college, I was given faculty status and the title Senior Research Associate (for which honor I am especially indebted to Joseph Ellis, dean of the faculty at that time, and a staunch supporter), and an office was made available for the project

in the college library through the generosity of its librarian, Anne Edmonds. Mrs. Kennan also gave me secretarial assistance from her own office as well as good advice on candidates who might serve as advisers to the project, whom she then solicited with personal letters describing in the kindest terms the project, its strengths, and its expected contribution to the academic library. To those advisers, too, my deep appreciation of the honor they have bestowed upon my work.

First among those who helped to make this work a reality was Matthew J. Bruccoli, a dear friend of my husband since Ph.D. days at Virginia. Years later, after a talk at Mount Holyoke, he politely inquired as to my doings and then insisted that the results would be publishable and, more encouraging still, that they *must* be published. This was all in the midst of his own distinguished teaching career and that publishing program without peer, the *Dictionary of Literary Biography,* which I have so often consulted. Matt took on the role of agent for the *Guide* and opened the doors to Oxford University Press in New York.

From the beginning Oxford University Press has proven to be not only the best of publishers but the most generous and patient, enduring one postponement after another on our part, delays perhaps inevitable with a work of such mammoth scope and made up entirely of details. We have enjoyed the energetic support of three editors. First was David Attwooll, who contracted for the book with a rare enthusiasm and faith in the future really remarkable when I recall the original typescript we had presented (which appears to me now as a skeleton of an embryo). Second, William Mitchell, who took over when David returned to England, also proved to be most loyal, encouraging our visit to the Warburg Institute in London and watching out for our interests in New York. When he left the press to return to England for personal reasons, the work was assigned to our third and present editor, Claude Conyers, whose involvement has immeasurably increased the value of the work and who has nurtured us in our times of need, which were practically perpetual. Always Claude has been there with his grace and personal "gentilesse," a quality that often seems to have departed this world; with Claude, I have always known we were in the firm, kind hands of a gentleman and a scholar.

Working just as staunchly and indefatigably have been Marion Britt, Mark Cummings, and lately Marion Osmun, whose hands-on editorial labors for the past two years in particular have been life-sustaining. Marcia Mogelonsky, Ph.D., gave us research time of inestimable value and helped to prepare the headnotes that introduce the entries in this work and that present the often complex stories of classical mythology that are at the heart of these volumes. Jeffrey Edelstein, in charge of production, is that even-tempered magician who must bring all our work to the light of day.

A special and crucial debt is owed to Dr. Jennifer Montagu, who invited me to visit the Photographic Library in the Warburg Institute, London, a visit that provided examples of fine art works that would otherwise have slipped our nets. An especial joy of the visit was encouragement from Ruth Rubinstein, engaged in her own fruitful research at the large table where we worked.

To Anne Edmonds, the Mount Holyoke College librarian, and her staff I am indebted for untold kindnesses and professional help over a period of at least ten years. Working diligently with us in Williston Library has been a corps remarkable in devotion: Marilyn A. Dunn, Head of Public Services, and Kathleen Egan Norton, Reference Librarian, in addition to countless other daily favors, have often gladly undertaken fact-checking for me; Irene Cronin and Cleopatra Gralenski both helped immeasurably with translations; and for myriad generous services I am equally thankful to Kuang-Tien Yao, Sue Fliss, Bryan Goodwin, Phyllis Joyce, Karen Fiegenbaum, AnnMarie Adams, Ruth Cooke, Margaret Lavallee, Aroxy Aykanian, Ajay Menon, Steven Barrett, Teresa Moffa, and Beverly Dowdy. I am especially grateful to Elaine Trehub and Patricia Albright for moral

support and encouragement; to my friend Beverly Galusha, who has done expert editing for us as well as computer entry; and to Irene Cronin, who helped me so often in Russian, Polish, and Spanish literature and who later undertook to edit my Lope de Vega file gratis.

I must also acknowledge the fine staff at the Hillyer Art Library at Smith College, Northampton, whose assistance to Chris Rohmann and other art history researchers was invaluable: Taeko Brooks, Mimi Lempart, Joanne Nadolny, and the director, Karen Harvey. Particularly helpful at Smith's Nielson Library was John Graife of the Interlibrary Loan Department.

On the technical end, Paul Dobosh and Michael A. Crowley of the Mount Holyoke College Academic Computing Department were more than helpful, as were their assistants, particularly Julie Temlak and Morgan Smith. Michael A. McAnulty, Ph.D., brought us his remarkable skills as a computer programming consultant at just the right time to complete the seemingly endless cross-checking required to finish the *Guide*.

To turn now to the informal contribution of the community of scholars I began by celebrating, I must acknowledge my lifelong friend, Dargan Jones, professor emeritus of English and classics, who supported me from the beginning. Next, her colleagues and my dearly esteemed friends, Betty Quinn, now professor emeritus of classics, and Philippa Goold, professor of classics, have been my constant strength and source of reference. Martha Leeb Hadzi, professor emeritus of classical art, has been a key adviser from the beginning. I wish also to salute friends at Smith College, particularly Patrick and Justina Gregory and George and Mary Dimock, for their friendly encouragement.

For help in the field of art history, I am especially beholden to John Varriano, professor of art at Mount Holyoke, who has also served as a formal adviser to the project. Craig Felton, at Smith, has also been constantly helpful, as were Karl Kilinski of Southern Methodist University and Mark Thistlethwaite of Texas Christian University. I also wish to acknowledge the assistance of Evelyn Samuels Welch, at the time a Ph.D. candidate at the Warburg Institute, who completed the research there after my return from London. Emily Harrison Weir did painstaking research in ancient art, and three Smith College students in particular, among many who contributed to the project, were indispensable for art history fact-checking: Vanessa Kraebber, Elizabeth Marlowe, and Kim Surkan.

In the literary disciplines I am indebted to countless scholars whose knowledge and generosity sustained the project. These include A. Kent Hieatt, once a fellow student at the University of Louisville, now professor emeritus of English, University of Western Ontario; my old friend Robert O. Preyer, professor emeritus of English, Brandeis University; and Robert Bagg and David Clark, both of the University of Massachusetts, who were helpful in the early preparation of this work. My old friends in the Mount Holyoke English Department have also been invaluable resources, particularly James D. Ellis, Anthony Farnham, John Lemly, Robert Shaw, Eugene D. Hill, and Frank Brownlow. My especial gratitude goes to Adaline Pates Potter, associate professor emeritus of English, accomplished editor, and friend of a lifetime, who has lately added to her benefactions the role of voluntary proofreader. For research and fact-checking, I am grateful to Elizabeth McAnulty, in Renaissance English poetry, and Sarah McAnulty, Sara Summers, and Rebecca Gunn, in modern poetry.

In foreign-language literatures, I wish to acknowledge the very substantial help of my Mount Holyoke faculty colleagues Peter and Susan Scotto, in Russian; Bonnie Catto and Robert Birkey, in modern Greek; Jeanne Brownlow, in Spanish; Angelo Mazzocco, in Spanish and Italian; Mario Moffa, in Italian; and particularly my friend Sidonie Cassirer, professor emeritus of German.

For the field of music I have relied heavily upon my old friend Irving Eisley, professor of music, and upon Louise Litterick, associate professor of music, both of Mount Holyoke. Miriam Jenkins, when she was a doctoral candidate in music, and Ann Maggs, Amherst College Music Librarian, were valued colleagues and researchers, as was Zoë McAnulty. Isaac Reid, my brother-in-law, modestly but tirelessly offered the fruits of his years as a professor of music; he opened to me his private library and persistently checked the research of others, becoming the focus of librarians' wonderment and admiration.

Marilyn Hunt, a past president of the Society of Dance History Scholars and an adviser to the project, did valuable research for us, early and late, at the New York Public Library for the Performing Arts, Lincoln Center.

Among other graduate researchers, I want to recognize David Vermette, who prepared the preliminary list of classical sources for each entry; Colette Speakman, who checked and revised that list; Erin Davis, who explored Chaucer, Skelton, Spenser, Shakespeare, and Milton for appropriate classical passages; Erica Behrens, who examined Mount Holyoke's unique Valentine Giamatti Dante Collection for illustrations of classical story in the *Commedia*; and David Morrell and David Powell, who ably performed a variety of research tasks. Above all, for her lively knowledge of current and historical playwrights, Heidi Holder, a Ph.D. candidate in modern drama, has been especially helpful.

Since practically everyone I know is a retired academic, it goes without saying that I am surrounded by experts, lavishly endowed by experience to contribute to the *Guide*. Informal vetters and proofreaders of the text in progress have also included my friend Kingman Grover; my sister-in-law, Eleanor Shaw Reid; and my sister, Ruth Davidson Malcolm. I cannot close the roster without recognizing the enormous debt I owe Jane Lawrence McAnulty, who has served in many capacities, most recently as the meticulous checker of the Index of Artists.

Our loyal secretarial staff—quite aside from battalions of intelligent and eager students to be reviewed later—form a long procession. In chronological order, then, march Celia Scott, our first invaluable, intelligent secretary; Joyce Schue, who added her modestly voiced contributions from prior experience as an editor, an advanced degree in French, and wide reading; and Helen Canney, my old friend and doyenne of academic secretaries at Mount Holyoke, who has sustained us almost throughout our history. In the same line came Phyllis Runnals, Beverly Lecca, and Hilary Shaw, along with Margo Klejna, Chrissie Bell, Susan Rainaud, Lois Christopher, Patricia Vincent, and Cynthia Morrell. Two particularly essential members of our initial staff were Cynthia Dearborn and Sharon De Fremery, both of whom brought not only technical skills but useful knowledge of musical works.

An even larger, equally dedicated cadre of student computer-typists accomplished that basic, ever-enlarging feat—putting the manuscript into machine-readable form—and I gratefully salute them all. From Mount Holyoke College: Maria Aguerra, Christiana Loh, Margaret Reiff, Morgan Smith, Julie Temlak, and Elyse Thorson. From Smith College: Elizabeth Berger, Elizabeth Carey, Sean Choi, Jenée Colton, Laura Forde, Gwyn Helverson, Theresa Hoyer, Christina Kay, Lisa Kipen, Mary Lex, Carolina Miranda, Rachel Rao, Susan Shell, Amy Shumaker, and Jobie Summer. Smith students Candace Decaire, Evaline Gamage, Miklyn Shankel, and Kate Wing also helped with fact-checking, as did Robin Morris and Pennie Ticen from the University of Massachusetts.

Much of the early research, beyond my own basic explorations and constant amplifications, was first undertaken by Carol Blakney (now Alvez). She was possessed of superhuman energy and devotion to the project; when it became inevitable that a computer must be purchased, she threw herself into the nightmare of mastering it. She

accompanied me on the month-long visit to the Warburg Institute and made a tremendous contribution to our early work, serving as its first project manager.

Lately, it has been my incredible good fortune to have as my associate Paula K. Hassett, a Mount Holyoke graduate in history and Frances Perkins Scholar, with boundless interest in research, facility in foreign languages, and the instincts of an editor. She has put in more woman-hours of work than one could dream possible and done it with grace, indefatigable drive, and resolve. Her impeccable standards have again proved invaluable in final proofreading, but it is for her untiring good nature in shouldering all her responsibilities that I chiefly prize her, the most reliable of mortals.

Chris Rohmann, who had already begun work as a superb editor of early research in fine art, became our project manager in 1986, and has seen our work through its many metamorphoses to final completion. To these executive functions he also added the completion of the fine art research and a careful review of my literary files to assure consistency of content and format. When research for this book was completed, his invaluable organizational skills made possible a thoroughgoing review and rationalization of the mass of material that constitutes the *Guide*. His devotion to detail, together with his overall mastery of the scope and substance of the work, have been the *sine qua non* of this project.

All involved have been responsible and faithful in their duties, and have much reason to be proud of the common endeavor. And so may this book fare well for its readers.

<div align="right">

Jane Davidson Reid
South Hadley, Massachusetts
October 1992

</div>

INTRODUCTION

The Oxford Guide to Classical Mythology in the Arts is an encyclopedic catalog of artworks dating from the early Renaissance to the present that treat subjects in Greek and Roman mythology. Organized into entries on mythological figures or themes, listings of artworks delineate the history of artistic interest in classical mythology as presented in the fine arts, music, dance, and literature of the past seven centuries. By presenting such information in one reference, thus bringing together material that heretofore has been segregated by discipline, nationality, time period, or other constraint, this work will, we trust, provide readers with a valuable tool for study of the history of the arts in the Western world.

BACKGROUND

Our selection of the entries in this work—that is, our decision to include some subjects and not others—has largely been determined by those figures and themes from classical mythology that have inspired an appreciable number of artistic treatments in the post-classical era. Subjects from classical history and the post-*Aeneid* legends of early Rome have not been included, nor have allegorical personifications, except as they apply to the mythological figures treated in these pages. Inclusion of these two categories, which was originally envisioned, would have overflowed an already bursting list of subjects. We do include some important subjects that have no classical origins but that revolve around mythological figures or derive from legends we do cover (e.g., the Statue of Venus, Telemachus and Calypso, Troilus and Cressida), and we have some entries on stories with a basis in classical literature but not in mythology (e.g., Daphnis and Chloe, Lysistrata). Minor myths for which we found a bare handful of postclassical treatments have been regretfully excluded.

As for treatments of the myths that we do include, we have sought to cover comprehensively both the work of the most important artists of the Western tradition, even those whose interest in classical subjects was minimal, and the work of lesser artists who treated mythological subjects extensively. Works listed are generally those in which our subject is central or at least occupies a prominent position or figures in an extended passage. (The "Masque of Cupid" and the figure of Cynthia/Diana are examples of the latter in Spenser's *The Faerie Queene,* as is the figure of Aurora in Rubens's "The Flight of Marie de' Medici.") Brief but famous literary passages, and those that have been seminal for other writers, are also included. (Milton's "Not that fair field / Of Enna, where Proserpine gathering flowers . . ." is a prime example of a famous quotation that could not be omitted.) Following a related principle, we have also included works (e.g., collections of poetry) in which a subject is evoked in the title but is not directly treated. For the most part, however, the *Guide* is intended as a catalog of actual treatments of classical themes, not as a concordance of classical allusion—an impossible goal even if it were a desired one.

Sources. When we began systematic research for the artworks to be included in these volumes, we first consulted dictionaries and encyclopedias in each discipline. These references not only yielded numerous items themselves and suggested further sources, but they also helped to establish a working list of several hundred creative artists to be investigated individually. In our effort to provide basic information on as many individual works of art as possible, we also investigated catalogs and concordances with an abundance of material, as well as major studies of artistic disciplines and classical themes in the arts. In choosing our sources, we applied the general criteria that they be respectable scholarly works written by acknowledged experts in their fields; that the data they provide about the works they cover include as much of the information we sought as possible; that they contain numerous examples of works that treat our subject matter; and that they be as up-to-date as possible (although we often chose older sources that better fulfilled the other criteria). When necessary, we made use of less extensive works, especially to account for lesser artists and less popular subjects. Occasionally, for modern works not yet covered in the scholarly literature, more ephemeral sources such as trade journals, correspondence with academics, and the *New York Times* arts pages had to suffice.

Anton Pigler's monumental *Barockthemen* (Budapest: Akadémiai Kiadó, 1974) was an early inspiration, but it has not been cited comprehensively because to do so would be to duplicate its coverage of mythological themes and because, in any event, its organization by subject and its exhaustive presentation of one field in one period make it a natural complement to the *Guide*. In general, it is cited herein only for works by prominent artists in major public collections not covered by other sources.

Another major source of information, the multivolume *Lexicon Iconographicum Mythologiae Classicae* (Zurich: Artemis, in progress), has not been cited because of its focus on antique artworks. It was originally envisioned that the introductory matter of appropriate entries would include a representative sampling of important examples of antique art—sculpture, vase-paintings, and wall-paintings—depicting the relevant subject. However, we felt that the detailed scholarship and exhaustive inventory of the *Lexicon* would provide our readers with a far more useful survey than our intended sampling could. Headnotes for some of our entries identify themes commonly treated in classical antiquity and briefly discuss some famous ancient artworks, especially those that have directly influenced postclassical representations, such as depictions of Aphrodite (Venus) based on antique statuary. But for the most part, iconographic parallels and divergences have not been emphasized in our work because of its skeletal structure, multidisciplinary coverage, and focus on subject matter. When completed, the *Lexicon* will detail all known antique visual representations of mythological scenes and figures, and interested readers are urged to consult it.

Works Cited. Of the visual arts, painting dominates the listings in this work, largely because of the much greater interest in this medium in the sources available to us. We have, however, covered as many of the important sculptors and sculpture collections as we could. An exhaustive review of the standard print catalogs, like Bartsch's, was considered but rejected as impossible to complete in time for publication; perhaps a later edition of the *Guide* will better serve such an important field. As it is, we examined the complete prints of several individual artists and included prints cited in other sources. We have also listed studies, replicas, and variants of works that constitute a complete rendering of the subject (as opposed to a figure study, for example), but only if they exist in a known location *or* are illustrated in our sources. We felt that information on subsidiary works that do not meet these criteria would be of limited use to the reader. Drawings for and prints after a work, however, are generally excluded unless they constitute our only record of a lost work. Copies by another hand after important works are

generally cited only when they appear in major collections or were made by artists famous in their own right. Lost and unlocated works have been included selectively, according to the importance of the artist and how recently the works have disappeared. We have also, largely for reasons of space, excluded most examples of applied art such as majolica, plate, coins, medals, and jewelry, although some exceptions have been made for works by important artists.

Among literary works listed in the *Guide,* translations of classical literature have been included if they were produced by translators who were important in their own right or whose work significantly influenced later writers. The modern reader tends to value "original" work much more highly than translation, but in earlier periods poets often sought publication as translators in order to achieve some standing in the world of letters. Not only have some of the best writers in all languages, places, and times been translators, but also some comparatively obscure writers must be credited with having kept an antique subject before the public. (In passing, I wish to record my own love of Horace Gregory's Ovid, wishing that we had had space to cite him throughout all our subjects derived from the *Metamorphoses* but realizing that many other splendid modern translations would also qualify. Truly, here is an embarrassment of riches.)

For works in the performing arts, including music and dance as well as drama, data on first performances are given when known; indeed, performance records are often the best indication of a work's date of composition. Subsequent performances are generally not cited unless the work was revised. However, incidental music written for performances of dramatic works (including classical dramas), additions to operatic scores, and ballets staged for operas or other entertainments are often cited separately. These listings illustrate later composers' and choreographers' interest in previous treatments of a mythological subject and often highlight a period of renewed interest in a particular work or theme.

ORGANIZATION

In total, the *Guide* lists more than 30,000 works of art, which in turn are organized into 205 main subject entries, arranged alphabetically from ACHILLES to ZEUS. In the larger entries (e.g., APHRODITE, APOLLO, HERACLES, ODYSSEUS, and others), the works are organized thematically into subentries of general and subsidiary listings. There are 131 of these subentries, for a total of 336 groups of listings that make up the body of the text.

Nomenclature. In the alphabetical order of the main entries, subjects are identified by the name of a central mythological figure or a commonly known theme (e.g., AGES OF THE WORLD, SEVEN AGAINST THEBES). Appropriate use of nomenclature of classical figures presented us with a difficult problem. Because the Greek and Roman pantheons include many functional counterparts, because so much of Roman mythology was derived from the Greek, and because, from the Renaissance onward, classical mythology was transmitted to European writers and artists (and to archivists, catalogers, and museum curators) via the Latin tradition, names of classical subjects in works of postclassical art are predominately Roman, even though the subject itself may be indisputably Greek. Until well into the nineteenth century, Roman names were used indiscriminately for mythological subjects, regardless of their cultural origin. Jupiter was thus equated with Zeus, Diana with Artemis or Selene, Neptune with Poseidon, and so on. Only relatively recently did poets, painters, dramatists, and historians of the arts begin to observe the scholarly practice of classicists in distinguishing between Greek and Roman deities and in using the names and epithets that reflect differences between functional counterparts in the two pantheons.

Realizing the impossibility of separating listings of artworks on Greek subjects from

those on Roman subjects, we faced a choice of using either Greek or Roman names, or both, as headwords for entries on the principal classical deities. In the end, we chose to use names of Greek gods and goddesses (in their commonly accepted romanized spellings) even when virtually all postclassical treatments of a subject are identified by a Roman name. Under APHRODITE, for example, a majority of the works listed use the Roman name Venus; under ARES most of the works identify the war-god as Mars. Headnotes explain differences between similar Greek and Roman deities and clarify confusing nomenclature wherever possible. Furthermore, names of Roman gods and goddesses appear throughout the alphabetical sequence of subjects, often as "blind entries" (i.e., cross-references) designed to guide readers to the information they seek. Under AURORA, for example, readers are directed to EOS; under MARS, to ARES. Thus the organization of the *Guide* acknowledges modern scholarly usage and the historical basis of the antique pantheons while reflecting the predominantly Roman heritage of European culture from the Renaissance through the nineteenth century.

Headnotes. Each entry and subentry begins with a headnote that briefly describes the subject and points out the most commonly depicted elements of the myth in postclassical treatments. The headnotes are not meant to be definitive accounts of the often complex and contradictory mythology of the subjects treated; rather, they are intended to serve the reader by providing a context for the listings of artworks that follow. After each headnote is a list of the major classical sources for the subject, except in the few cases where the subject did not derive from classical mythology or has no specific literary source. Some entries also contain, as appropriate, selective citations of books for further reference; a list of subentries; and a list of cross-references to other entries in which the subject also appears.

Listings. Following these introductory elements are the listings of artworks themselves. They are arranged in chronological order, usually by date of composition; all works by the same artist are grouped together, the earliest work first. In general, the chronology of listings begins in the fifteenth century, but in several entries, medieval works embracing classical themes (e.g., the *Roman de la rose,* romances on the Homeric and Virgilian epics, and others) have been selectively included, according to their importance as influences on later treatments of the subjects. Likewise, the most influential literary works of the fourteenth century, which form a bridge between the Middle Ages and the bulk of our items, are included; in this era, Dante, Petrarch, Boccaccio, Chaucer, Christine de Pizan, and the *Ovide moralisé* are comprehensively cited.

Each item provides (as known) the "who, what, when, and where" of a work: who created it, what it is (title and medium), when it was created (or first exhibited, performed, or published), and, as appropriate, where it was first performed or published, or (for works in the fine arts) where it is now. Performance, publication, and location data are provided as an aid to further investigation of the particular work and to avoid confusion among similar works. At the end of each listing is a citation for the source or sources of the information given about the work.

Although the search for appropriate themes in works in the visual arts proved to be relatively straightforward—in comparison to the chasing of literary allusion and musical evocation—the variety of media, the duplication of works, and the vagaries of provenance generated numerous problems for formatting the resultant listings. Throughout the *Guide* we have generally tried to provide the same *kinds* of data for each discipline, and to minimize technical and other field-specific information. Thus specific media and supports for works in the graphic arts are generally not given; "painting" is used to mean virtually all brush media, while "drawing" encompasses works in pen, pencil, charcoal, and so on. We do, however, specify frescoes, pastels, and watercolors and distinguish when we can among the various print and sculpture media.

The items below, with their elements subsequently described in order of appearance, are examples of the types of data to be found in the listings as a whole:

> **Peter Paul Rubens,** 1577-1640. "Battle of the Centaurs" (Hercules and Nessus?). 2 drawings, copies after Michelangelo (*c*.1492, Florence). **1600-08.** Museum Boymans-van Beuningen, Rotterdam; Fondation Custodia, Paris. [White 1987, pls. 18, 19]
> —— and **Jacob Jordaens,** 1593-1678. "Nessus Abducting Deianeira." Painting. *c*.**1635.** Niedersächsisches Landesmuseum, Hannover. [Jaffé 1989, no. 1112—ill.] Studio copy (also attributed to Rubens). Hermitage, Leningrad. [Ibid. / Rosenberg 1988, no. 217, fig. 2]

> **Pedro Calderón de la Barca,** 1600-1681. (Jason's search for the Golden Fleece in) *Los tres mayores prodigios* [The Three Greatest Marvels] act 1. Comedy. **1636.** First performed St. John's Night, 1636. Buen Retiro, Madrid. Published in *Comedias de Calderón,* part 2 (Madrid: 1637). [Valbuena Briones 1960-67, vol. 1 / Maraniss 1978, p. 104 / O'Connor 1988, pp. 186f.]

> **Christoph Willibald Gluck,** 1714-1787. *Orfeo ed Euridice.* Opera (azione teatrale). Libretto, Ranieri Calzabigi. First performed 5 Oct **1762,** Burgtheater, Vienna; décor, Giovanni Maria Quaglio. / Revised, performed 2 Aug 1774, Academie Royale, Paris. [Grove 1980, 1:426; 7:460f., 472 / Sternfeld 1966, pp. 114-22 / Kerman 1988, pp. 29-38, 212] Revived as a pastiche with 7 new arias by Johann Christian Bach. First performed 7 Apr 1770, King's Theatre, London. [Grove, 1:866, 873]

Each listing begins with the *artist's name* (in boldface type) and birth and death dates. Co-creators working in the same medium are cited together at the head of a listing. The "prime creator" of a musical work is considered the composer; of a dance, the choreographer. Collaborators who contributed other elements to the work (e.g., the libretto of an opera, the music for a ballet, the execution of a print after an artist's design) are cited separately in the body of the listing. When known, dramatic or musical works that were later adapted for other forms are cited both under the name of the original creator and separately in a listing for the later composer or choreographer, as a new work based on the original text.

Titles of works in the fine arts are given in English, with alternate and variant titles given parenthetically. Titles of literary, musical, and stage works are given in the original language, with English translations (in brackets) as necessary. When the title of a work does not reveal its relationship to the subject, or when the subject is only a part of the work and not the central focus, an explanation of the work's connection to the subject is given parenthetically. Locating numbers (book, stanza, line, act, etc.) immediately follow the title.

Identification of the work's *genre or medium* follows, with additional information as appropriate. When a work is related to another work that has been listed previously, the date (and, for fine arts, the location) of the original is given parenthetically.

The *date of composition*—or, if unknown, first performance, publication, or exhibition—is rendered in boldface type. If a work is undated, the artist's death date has been made bold and allowed to rule the chronological placement of the listing. In groups of works by the same artist, only the date of the earliest work is bold.

Performance data include, as known, exact date and place of first performance. Artistic contributions associated only with that production (scenery, costumes, etc.) follow the performance data.

Publication data include the city and date of publication and usually the publisher's name. In some cases, editors' names are also provided. When both performance and publication data for dramatic and musical works are known, both are given.

Locations of works in the visual arts are given as cited in our source(s). Unless a date is given (e.g., "Artist's collection in 1908"), the location can be considered current as of the date of the most recent source cited in the listing. Multiple locations are set off by semicolons. Locations of prints are given in parentheses; these repositories are those cited by a particular source and do not necessarily denote a unique impression.

Versions, revisions, translations, studies, copies, and other works related to the original are separated from the main work either by a slash or by bracketed source references for the first work. Only information that does not also apply to the original is given.

Source references are given in smaller type in square brackets and are cited by the author and date of publication; fuller bibliographical information is provided in the List of Sources at the end of the *Guide*. Multiple source references in a listing are separated by slashes. In further citations of a source in the same artist's listing, only the author's name, not the date, is repeated, and only new page or volume citations given.

For literary works, the bibliographical source is often an edition of the work itself and as such is cited in the listing as "Ipso" ("in itself"), without page numbers except when necessary to direct the reader to critical comments. Not duplicated in the List of Sources, nearly all "Ipso" citations are to modern editions, but occasionally the lack of such a text and access to an earlier edition has resulted in an "Ipso" citation for an antique book. Other publication data in the listings, when not derived from the source cited, were obtained from standard bibliographies and the National Union Catalog.

No one of the references in multiple-source citations may contain all the data given in the listing of a particular work. One source may contain only the brief mention that first introduced us to the work but that is now complemented by different sources; another may discuss the treatment of the myth in the work listed. In addition, many source citations refer the reader to useful information for further study—for example, to scholarly discussions of individual works.

In fine art listings, sources that provide little of the data given in the listing (often the case with illustration references) or that cite markedly different information from the source we have chosen to accept are preceded by "also" in the source references. Catalog, plate, or figure numbers are cited for fine arts sources, if appropriate.

By and large, we have presented the information about a particular artwork exactly as it appears in our sources, even if that information may now be out of date. For example, we have retained Leningrad as the location for the Hermitage Museum, in keeping with the citation given in sources published before the city's name was changed back to Saint Petersburg. We have, however, dropped "East" and "West" from Berlin when it was unnecessary to distinguish between them.

List of Sources. The List of Sources at the end of the *Guide* corresponds to, and provides full biographical information for, the author-date references cited in the listings of artworks. This list is not intended to constitute a comprehensive bibliography of the subjects or artists covered; nor should the source references cited for an individual work in the entries be considered exhaustive. Furthermore, in citing these sources we take no sides in scholarly disputes over interpretation, attribution, dating, and the like. Those selected are those that, in each case, best fulfill the criteria outlined above. Where data from two cited sources conflict, we either reflect the disagreement or cite the version given in the source that was our main text for that artist.

Index of Artists. Following the List of Sources is an extensive Index of Artists, providing the names, dates, nationalities, and disciplines of all the artists cited in the main

body of the text. With each artist is a list of the entries and subentries in which each appears, enabling readers to locate works by a given artist across numerous entries.

ENVOI

When our sources cite only the titles of works without discussing their content, we have occasionally included works that *seem* to belong to a subject but that, had we been able to investigate further, might prove to be unrelated. Our general principle has been to include rather than exclude, keeping open possibilities that may lead readers to fruitful research that might otherwise have been closed. We can only invite our readers to advise us of any errors we have unintentionally made in assigning a particular work to a certain subject.

In the same spirit, we invite our readers to help close the *lacunae* inevitable in a work of this sort. While we have included almost all of the works found in our sources, we cannot pretend to have listed every work of art—or even every important work—with a classical theme. The *Guide* is in many ways a "first draft," a preliminary attempt to organize a world of data in a new way, a work that by its very nature and its enormous compass can never really be considered complete.

THE OXFORD GUIDE TO
CLASSICAL MYTHOLOGY IN THE ARTS,
1300–1990s

A

ACHELOUS. See HERACLES, and Deianeira; THE-
SEUS, and Achelous.

ACHILLES. The central hero of Homer's *Iliad*,
Achilles was the strongest and swiftest of the Greeks
at Troy, as his epithet "swift-footed" suggests. His
strong emotions were responsible for many of the
important events in the Trojan saga, from his with-
drawal of support for Agamemnon in the opening
scene of the *Iliad* to his defilement of the Trojan
Hector's corpse in the epic's conclusion.

Achilles' godlike courage was that of a young man,
single-minded and valiant, but not balanced by fore-
thought (the image of the hero "sulking in his tent"
bespeaks this weakness). In his dispute with Aga-
memnon over the maiden Briseis, only Athena's
intervention prevented Achilles' impetuous attack on
his commander, which would have brought ruin to
all. Later, he foolishly allowed Patroclus to don his
armor and fight in his stead, when the Greek ships
were endangered by Achilles' stubborn refusal to
fight.

Nevertheless, Achilles was capable of acts of lead-
ership, compassion, and love. He loved and was
loved by Patroclus and Briseis, and he was esteemed
by his fellow leaders. He respected a gallant enemy,
such as the Amazon warrior Penthesilea, and treated
Hector's grieving father, Priam, with compassion.
And in post-Homeric accounts he loved Polyxena,
an innocent daughter of Priam; the liaison ultimately
brought death to them both.

The mutual devotion of Achilles and Patroclus
presented a paradigm of the Greek ideal, a concept
Homer treated realistically but ironically. It was
Patroclus's death that finally roused Achilles to re-
turn to battle, a furious onslaught in which he
fought the river Scamander itself. Achilles' return
changed the tide of battle back in favor of the
Greeks, but it also led to his death at Paris's hands.

Classical Sources. Homer, *Iliad*; *Odyssey* 11.465–540. Bion,
Achilleus. Ovid, *Metamorphoses* 12, 13. Apollodorus, *Biblio-
teca* 3.13.6–8, E3.18–E5.5. Statius, *Achilleid.* Hyginus, *Fab-
ulae* 96, 101, 106, 107, 112. Quintus of Smyrna, *Sequel to
Homer* 1–3.

Listings are arranged under the following headings:

> General List
> Infancy and Education
> Achilles at Scyros
> Wrath of Achilles
> Return to Battle
> Death of Achilles
> Afterlife

See also CHRYSEIS; HECTOR, Death; IPHIGENIA; MEM-
NON; ODYSSEUS, in Hades; PATROCLUS; PENTHESILEA;
POLYXENA; TROJAN WAR, General List.

General List

Benoît de Sainte-Maure, fl. 1150–70. (Achilles in) *Le
roman de Troie.* Verse romance, after Dares, *De excidio
Troiae historia,* and Dictys, *Ephemeris de historia belli
Troiani* (late Latin versions of lost Greek poems, pseudo-
classical forgeries). *c.*1165. [Baumgartner 1987]

Guido delle Colonne, *c.*1210–after 1287. (Achilles in) *His-
toria destructionis Troiae* [History of the Destruction of
Troy]. Latin prose chronicle, after Benoît de Sainte-
Maure. **1272–87.** Modern edition, edited by Nathaniel
E. Griffin (Cambridge, Mass.: Harvard University Press,
with Medieval Academy of America, 1936; reprinted New
York: Kraus, 1970). / Translated by M. E. Meek (Bloom-
ington: Indiana University Press, 1974). [Benson 1980,
p. 29 and passim]

Dante Alighieri, 1265–1321. (Achilles among the Lustful
in) *Inferno* 5.65f.; (allusion to Achilles in) *Purgatorio* 21.92.
Completed *c.*1314. In *The Divine Comedy.* Poem. Fo-
ligno: Neumeister & Angelini, 1472. [Singleton 1970–75,
vols. 1–2]

Anonymous English. (Achilles in) *The Destruction of Troy.*
Alliterative adaptation of Guido delle Colonne. *c.*1385–
1400? Modern edition by George A. Panton and David
Donaldson, *The "Gest Hystoriale" of the Destruction of
Troy* (London: Early English Text Society, 1869, 1874).
[Benson 1980, pp. 53, 102, 111]

Anonymous English. (Ulysses urges Achilles to return to
battle in) *The Laud Troy Book* lines 13047–126. Metrical
romance, after Guido delle Colonne. *c.*1400. Modern
edition by J. Ernst Wülfing (London: Early English Text
Society, 1902, 1903). [Benson 1980, pp. 69, 86, 90, 102, 112]

John Lydgate, 1370?–1449. (Achilles in) *Troy Book* 3.5332–
99, 4.1701–1805, 4.3251–61 and passim. Poem, elaboration
of Guido delle Colonne. **1412–20.** Modern edition by
Henry Bergen (London: Kegan Paul, Trench & Trüb-
ner, for Early English Text Society, 1906–35). [Benson
1980, p. 102, 112, 124–29]

Antonio Loschi, *c.*1365–**1441.** *Achilleis.* Tragedy in Latin
verse. In modern edition by Vittorio Zaccaria (with
Italian translation), *Il teatro umanistico veneto: La tragedia*
(Ravenna: Longo, 1981). [DELI 1966–70, 3:420]

Master of the Capture of Tarentum, fl. **1st half 15th
century.** "The Triumph of Venus, Worshiped by Six
Legendary Lovers" (Achilles, Paris, Troilus, Tristan,
Lancelot, Samson). Painting. Louvre, Paris, no. RF 2089.
[Louvre 1979–86, 2:201—ill.]

Raoul Lefèvre, fl. *c.*1454–67. (Achilles in) *Le recueil des
hystoires de Troyes* [Collection of the Stories of Troy].
Prose romance. **1464.** / English translation by William
Caxton as *The Recuyell of the Historyes of Troye* (Bruges:
Mansion, *c.*1474). / Modern edition (of original French)
by Marc Aeschbach (Bern & New York: Lang, 1987).
[Scherer 1963, pp. 82–89, 99, 102, 226]

Nicolas Filleul, 1537–*c.*1590. *Achilles.* Tragedy. **1563.** In *Les Théâtres de Gaillon, a la royne* (Rouen: Loyselet, 1566). [DLLF 1984, 1:808]

Thomas Heywood, 1573/74–1641. (Achilles in) *Troia Britanica: or, Great Britaines Troy* cantos 10–14. Epic poem. London: **1609.** [Heywood 1974]

——. (Achilles in) *The Iron Age.* Drama in 2 parts, derived from *Troia Britanica.* First performed *c.*1612–13, London. Published London: Okes, 1632. [Heywood 1874, vol. 3]

Vicente Carducho, 1576/78–1638. "The History of Achilles." Series of frescoes, for Palacio del Pardo, Madrid. **1609–12.** Lost. / 5 drawings. Biblioteca Nacional, Madrid; Academia de Bellas Artes de San Fernando, Madrid; Alcubierre coll., Madrid. [López Torrijos 1985, pp. 203ff., 409f. nos. 1–6—ill.]

Ben Jonson, 1572–1637, previously attributed (probably by Thomas Freeman). (Prince compared to Achilles in) "A Parallel of the Prince to the King." Poem, celebrating the birth of Prince Charles. **1630.** [Herford & Simpson 1932–50, vol. 8]

Peter Paul Rubens, 1577–1640. "The History of Achilles." Designs for series of 8 tapestries. *c.*1630–35? [Haverkamp Begemann 1975, passim / Jaffé 1989, pp. 323ff.] Oil sketches, 1630–32. Museum Boymans-van Beuningen, Rotterdam, nos. 1760–1760e, 2310; Detroit Institute of Arts, inv. 53–356. [Held 1980, nos. 120–28—ill. / Jaffé, nos. 1028, 1030, 1032, 1034, 1036, 1038, 1040, 1042—ill. / also Haverkamp Begemann, pp. 42ff., nos. 1a–8a—ill.] Modelli, by Rubens and assistant (Erasmus Quellinus? Theodoor van Thulden?). Ringling Museum, Sarasota, Fla., no. 221; Prado, Madrid, nos. 2454, 2455, 2566; Musée des Beaux-Arts, Pau, inv. 417, 418; Courtauld Institute, London (ex-Seilern coll.) (2). [Haverkamp Begemann, pp. 57ff., nos. 1b–3b, 4c, 5b–8b—ill. / Jaffé, nos. 1029, 1031, 1033, 1035, 1037, 1039, 1041, 1043—ill.] Numerous sets of tapestries woven, 1640s–60s. Partial sets in Musées Royaux d'Art et d'Histoire, Brussels; Staatliche Kunstsammlungen, Kassel; Paço Ducal, Vila Viçosa, Portugal; Cathedral, Santiago de Compostela; private coll., Jerez de la Frontera; Palazzo Reale, Turin; Nunnington Hall, Helmsley, Yorkshire; others unlocated. [Haverkamp Begemann, pp. 71ff., 81ff., nos. 1–8—ill.]

Cristóbal de Monroy y Silva, 1612–**1649.** *El Cavallero Dana, ó el Aquiles* [The Greek Knight, or Achilles]. Comedy. Valencia: Viuda of J. de Orga, 1768. [Barrera 1969, p. 264]

Luca Giordano, 1634–**1705.** "The Story of Achilles." Painting. Alte Pinakothek, Munich, no. 2256/1851, on deposit at Ministerium für Unterricht und Kultur in 1885. [Ferrari & Scavizzi 1966, 2:357]

Balthasar Huydecoper, 1695–1778. *Achilles.* Tragedy. **1719.** Amsterdam: Lescailje & Rank, 1728. Modern edition, Wolle: Willink, 1964. [Rijksmuseum 1976, p. 398 / Meijer 1971, p. 157]

Aimé-Joseph Furon, 1687–**1729.** Series of paintings on Achilles theme. Château, Lunéville. [Pigler 1974, p. 277]

Victor Honoré Janssens, 1658–1736. 13 or 14 compositions for a series of engravings, executed by Johann Balthasar Probst. [Pigler 1974, p. 277]

Jacobus Roore, 1686–**1747.** Cycle of 6 paintings depicting the story of Achilles. [Pigler 1974, p. 277]

Giovanni Battista Tiepolo, 1696–1770, with **Giovanni Domenico Tiepolo,** 1727–1804. "Achilles and Tiresias." Grisaille painting. *c.*1750–60. Formerly van Dirksen coll., Berlin, sold London, *c.* 1934, unlocated. [Morassi 1962, pp. 5, 48]

Lodovico Savioli, 1729–1804. *Achille.* Tragedy. Lucca: Biblioteca teatrale, **1761.** [DELI 1966–70, 5:59]

Johann Gottfried Schadow, 1764–1850. "Achilles." Clay statuette. **1786–87.** Nationalgalerie, Berlin, inv. G218. [Berlin 1965, no. 2—ill. / Cologne 1977, p. 161—ill.]

Marcello Leopardi, ?–**1795.** "The History of Achilles." Fresco cycle. Palazzo Conestabile della Staffa, Perugia. [Pigler 1974, p. 277]

Domenico Cimarosa, 1749–1801. *Achille all' assedio di Troja* [Achilles at the Siege of Troy]. Opera (dramma per musica). First performed Carnival **1797,** Teatro Argentina, Rome. [Grove 1980, 4:401]

Francesco Basili, 1767–1850. *Achille all' assedio di Troia.* Opera (dramma per musica). First performed 26 Dec **1798,** Teatro della Pergola, Florence. [Grove 1980, 2:239]

Johann Wolfgang von Goethe, 1749–1832. *Achilleis.* Epic, fragment of 651 lines. **1797–99.** Published 1808; collected in *Werke* (Stuttgart: Cotta, 1827–42). [Beutler 1948–71, vol. 3 / Butler 1958, pp. 130–34 / Reed 1980, pp. 189, 223 / Reed 1984, p. 83]

Sebastiano Nasolini, *c.*1768–1806/16. *Achille.* Opera seria. First performed **1811,** Florence. [Clément & Larousse 1969, 1:4]

Richard Westmacott, 1775–1856. "Achilles." Bronze statue, monument to Duke of Wellington. **1814–22.** Hyde Park, London. [Read 1982, pp. 91–93—ill. / Agard 1951, p. 116, fig. 63]

François Rude, 1784–1855. Series of bas-reliefs depicting the life of Achilles, for Château de Tervueren, Brussels. **1820–23.** Destroyed. / Drawings. Musée des Beaux-Arts, Dijon. [Bindman 1979, no. 231—ill.] Plaster models. Musée des Beaux-Arts, Dijon; Musée Rude, Dijon. [Ibid.—ill.]

Walter Savage Landor, 1775–1864. "The Garden of Epicurus" (Peleus and Thetis discuss the fate of Achilles). Prose dialogue. In *Imaginary Conversations,* 1st series (London: Taylor & Hessey, **1824**). / Recast as a poem, "Peleus and Thetis," in *Hellenics,* revised edition (Edinburgh: Nichol, 1859). [Wheeler 1937, vol. 2 / Bush 1937, p. 143 *n.*]

——. "Achilles and Helena on Ida." Poetic dialogue. In *Dry Sticks, Fagoted* (Edinburgh: Nichol, 1858). [Wheeler / Boswell 1982, p. 151]

William Blake, 1757–1827. "Achilles." Drawing. **1825.** Unlocated. [Butlin 1981, no. 707]

Louis Moritz, 1773–1850. "The Actor Andries Snoek in the Role of Achilles" (in Balthasar Huydecoper's *Achilles* of 1719). Painting. By **1827.** Rijksmuseum, Amsterdam, inv. A1512, on loan to Dienst Verspreide Rijkskollekties, The Hague. [Rijksmuseum 1976, p. 398—ill. / Wright 1980, p. 289]

Friedrich von Schlegel, 1772–**1829.** "Achilles." Poem. In "Entwürfe und Fragmente" in *Dichtungen,* edited by Hans Eichner (Zurich: Thomas, 1962). [NUC]

Richard Wagner, 1813–1883. *Achilleus.* Drama, fragment. **1849–50.** [Grove 1980, 20:140]

Jules-Isadore Lafrance, 1841–1881. "Achilles." Marble statue. Musées Nationaux, inv. RF 291, deposited in Musée, Niort, in 1881. [Orsay 1986, p. 274]

Max Bruch, 1838–1920. *Achilleus*. Composition for solo voices, chorus, and orchestra, opus 50. Text, H. Bulthaupt. Published Berlin: **1885**. [Grove 1980, 3:349]

Stanislaw Wyspiański, 1869–1907. *Achilleis*. Drama. Cracow: Odbito w Drukarni, University Jag sklad w Ksiegarni Gebethnera, **1903**. First performed 1916, Cracow. [Seymour-Smith 1985, p. 1013 / Miłosz 1983, p. 354]

Max Slevogt, 1868–1932. "Achilles." Series of 15 lithographs. **1908**. Metropolitan Museum, New York. [Scherer 1963, p. 253, pl. 68]

Ernst Rosmer, 1866–1949. *Achill*. Tragedy. Berlin: Fischer, **1910**. [Oxford 1986, p. 766]

Lascelles Abercrombie, 1881–1938. *Phoenix* (adviser to Achilles). Verse drama. London: Secker, **1923**. [Bush 1937, pp. 431f. / Boswell 1982, p. 4]

Lucio Fontana, 1899–1968. "Achilles." Bronze statue. **1946**. Unlocated. [Marck & Crispolti 1974, no. 46 SC 1—ill.]

Barnett Newman, 1905–1970. "Achilles." Abstract painting. **1952**. Annalee Newman coll., New York. [Rosenberg 1978, pl. 17]

Wilson Harris, 1921–. "Achilles" (as a Guianese). Dramatic poem, part of "Canje." In *Eternity to Season* (British Guiana: **1954**). Reprinted New Beacon Books, 1978. [CLC 1983, 25:212f.]

George Skibine, 1920–1981, choreography. *Achilles*. Ballet. First performed **1955**, Opéra-Comique, Paris. [DMB 1959, p. 317]

Marijan Matkovic, 1915–. *Ahilova bastina* [Achilles' Heritage]. Drama, part 3 of *I bogovi pati* [Even Gods Suffer]. **1961**. Zagreb: Zora, 1962. [McGraw-Hill 1984, 3:35]

Michael Tippett, 1905–. "Songs for Achilles." Composition for tenor and guitar. **1961**. [Grove 1980, 19:10]

Andrei Voznesénsky, 1933–. "Akhillesovo serdtse" [My Achilles Heart]. Poem. In *Antimiry* (Moscow: **1966**). / Translated by W. H. Auden in *Antiworlds: Andrei Voznesensky* (New York: Basic Books, 1966). [Terras 1985, p. 346]

Thuri (Arthur Müller), 1916–. *Achilles*. Collection of poetry. Lucerne: Harlekin, **1973–75**. [DLL 1968–90, 10:1438f.]

Infancy and Education. Achilles' mother was the sea goddess Thetis, who had been courted by Poseidon and by Zeus. Both abandoned her when they learned that her son would someday be more famous than his father. Thetis married Peleus, king of the Phthians, and from their union came Achilles, whom she tried to make immortal. In earlier tales, she accomplished this by anointing him with ambrosia during the day and dipping him in fire at night. In a later, more popular version of the legend, she dipped the infant in the river Styx, holding him by one heel. The parts of his body that touched the water were made invincible, but the heel remained vulnerable, and there he eventually received his fatal wound on the Trojan battlefield. As a boy, Achilles was placed by his mother in the care of the wise centaur Chiron, from whom he learned music and archery.

Classical Sources. Pindar, *Nemean Odes* 3.43–52. Ovid, *Metamorphoses* 11.256–65; *Fasti* 5.385–414. Apollodorus, *Biblioteca* 3.13.6. Statius, *Achilleid* 1.269, 2.381–452. Hyginus, *Fabulae* 107. Philostratus, *Imagines* 2.2.

Anonymous French. (Conception and birth of Achilles in) *Ovide moralisé* 11.44–1241, 2534–2545. Poem, allegorized translation/elaboration of Ovid's *Metamorphoses*. *c.*1316–28. [de Boer 1915–86, vol. 4]

John Gower, 1330?–1408. (Chiron teaches the young Achilles in) *Confessio amantis* 4.1963–2013. Poem. *c.*1390. Westminster: Caxton, 1483. [Macaulay 1899–1902, vol. 2]

Giovanni Gaspare Pedoni, 1499–1520. Marble relief, depicting Thetis dipping Achilles in the Styx, part of a mantel with 3 scenes from the life of Achilles. Metropolitan Museum, New York. [Agard 1951, p. 72—ill.]

Giulio Romano, *c.*1499–1546. "The Boy Achilles Presenting His First Slain Boar to Chiron." Painting, part of "Jupiter" cycle. *c.*1533? Hampton Court Palace. [Hartt 1958, p. 216—ill.]

———, school. "The Education of Achilles." Fresco. Palazzo Spada, Rome. [Warburg]

Rosso Fiorentino, 1494–1540, and assistants. "The Education of Achilles." Fresco. **1535–40**; repainted/restored 18th, 19th centuries and 1961–66. Galerie François I, Château de Fontainebleau. [Revue de l'Art 1972, p. 127 and passim—ill. / Panofsky 1958, pp. 150ff.—ill. / Barocchi 1950, pp. 131ff.—ill.]

Peter Paul Rubens, 1577–1640. "Achilles Dipped into the River Styx," "Achilles Instructed by Chiron" ("The Education of Achilles"). Designs for tapestries in "History of Achilles" series. *c.*1630–35? [Haverkamp Begemann 1975, nos. 1–2] Oil sketches, 1630–32. Museum Boymans-van Beuningen, Rotterdam, nos. 1760, 1760a. [Held 1980, nos. 120–21—ill. / Jaffé 1989, nos. 1030, 1031—ill. / also Haverkamp Begemann, pp. 42ff., nos. 1a–2a—ill.] Modelli, by Rubens and assistant (Erasmus Quellinus? Theodoor van Thulden?). Ringling Museum, Sarasota, Fla., no. 221; Prado, Madrid, no. 2454. [Haverkamp Begemann, pp. 57ff., nos. 1b, 2b—ill. / Jaffé, nos. 1029, 1031—ill.] Tapestries, 1640s/60s, in Musées Royaux d'Art et d'Histoire, Brussels; Cathedral, Santiago de Compostela; Nunnington Hall, Helmsley, Yorkshire. [Haverkamp Begemann—ill.]

Cavaliere d'Arpino, 1568–1640. "Thetis Receiving Achilles from Chiron." Painting. *c.*1620s–'30s. Sold Rome, 1968. [Rome 1973, no. 60 *n.*]

Jacob Jordaens, 1593–1678. "Thetis Leading the Young Achilles to the Oracle." Painting, modello for tapestry (addition to Rubens's "Achilles" series). *c.*1640. Allen Memorial Art Museum, Oberlin, Ohio. [d'Hulst 1982, pp. 304f. / Ottawa 1968, no. 73—ill.] 3 tapestries known. *c.*1640–65. Museum of Fine Arts, Boston; Young Memorial Museum, San Francisco; Palazzo Reale, Turin. [d'Hulst / Ottawa, no. 279—ill.]

———. "The Young Achilles [? or Jupiter?] and Pan." Cartoon for tapestry (addition to Rubens's "Achilles" series?). Tapestry, woven 1640s? Cathedral, Santiago de

Compostela. [d'Hulst, p. 305] Variant, painting. Formerly von Mallmann coll., Blaschkow, Czechoslovakia. [Ibid.]

Pietro Testa, 1611–1650. "Thetis Dips Achilles into the Styx." Painting. Formerly Galerie Liechtenstein (possibly identical with a work sold from H. O. Miethke coll., Vienna, 1918). [Pigler 1974, p. 277]

Jean-Baptiste de Champaigne, 1631–1681. "The Education of Achilles." Cycle of 4 ceiling paintings ("Shooting an Arrow," "Chariot Race," "The Lesson in Arms," "The Riding Lesson") for Château des Tuileries. 1666–71. 2 in Château Maisons-Laffitte, on deposit from Louvre, Paris (inv. 1172, 1173); 2 in Louvre, inv. 1174, 1175. [Louvre 1979–86, 3:117, 5:220—ill.]

Antonio Draghi, 1634/35–1700. *Achille in Tessaglia.* Opera. Anonymous libretto. First performed 26 July 1681, Mannersdorf. Music lost, libretto published. [Grove 1980, 5:604]

Pierre Mignard, 1612–1695. "The Marquise de Seignelay [as Thetis] and Two of Her Children as Achilles [?] and Cupid." Painting. 1691. National Gallery, London, no. 2967. [London 1986, p. 402—ill.]

Pierre Puget, 1620–1694. "Achilles and the Centaur Chiron." Painting. Musée des Beaux-Arts, Marseilles. / Variant, drawing with watercolor. Marseilles. [Metropolitan 1960, no. 109—ill.]

Bolognese School. "The Centaur Chiron Teaching Achilles to Play the Lute." Painting. 17th century. Szépművészeti Múzeum, Budapest, no. 54.1940. [Budapest 1968, p. 77]

Giuseppe Maria Crespi, 1665–1747. "The Centaur Chiron Teaches Archery to the Young Achilles." Painting. *c.*1700. Kunsthistorisches Museum, Vienna, inv. 270 (337). [Vienna 1973, p. 52—ill.]

Sebastiano Ricci, 1659–1734. "The Education of Achilles by the Centaur Chiron." Painting. Before 1710. Museo Civico, Padua, inv. 1727. [Daniels 1976, no. 289—ill.]

Sebastiano Conca, 1679–1764. "The Education of Achilles." Painting, study for decoration for Spanish Embassy, Rome, celebrating the birth of Infante Luis Antonio Jaime. 1727. Prado, Madrid, no. 2869. [Prado 1985, p. 159]

Hildebrand Jacob, 1693–1739. *Chiron to Achilles.* Poem. London: for J. Watts, 1732. [Bush 1937, pp. 30, 543]

———. *Achilles' Answer to Chiron.* Poem. Edinburgh: Ramsay, 1732. [Ibid.]

François Le Moyne, 1688–1737. "Young Achilles Entrusted to the Centaur Chiron." Painting. Lost. [Bordeaux 1984, p. 130]

Lady Mary Wortley Montagu, 1689–1762. *Achilles to Chiron.* Poem. London: for J. Robinson, 1738. [Bush 1937, p. 544]

Giovanni Antonio Pellegrini, 1675–1741. "Thetis Entrusting Achilles to Chiron." Painting. Narford Hall, Norfolk. [Pigler 1974, p. 278]

Pompeo Batoni, 1708–1787. "The Education of Achilles." Painting. 1746. Uffizi, Florence, no. 549. [Clark 1985, no. 103—ill. / Uffizi 1979, no. P168—ill. / also Pressly 1981, pl. 27]

———. "Thetis Entrusting Chiron with the Education of Achilles." Painting. 1760–61. Galleria Nazionale, Parma, no. 5. [Clark, no. 231—ill.]

———. "Thetis Entrusting Chiron with the Education of Achilles." Painting. 1770. Hermitage, Leningrad, no. 2608.

[Ibid., no. 340—ill. / also Hermitage 1981, pl. 217] Tapestry after, sold Monaco, 1984. [Clark, p. 320]

Nicola Bonifacio Logroscino, *c.*1698–1765/67. *Il natale di Achille.* Opera (azione drammatica). First performed 20 Jan 1760, Palermo. [Grove 1980, 11:134]

Nicolas-Bernard Lepicié, 1735–1784. "Achilles Instructed in Music by Chiron." Painting. 1769. Musée des Beaux Arts, Troyes. [Bénézit 1976, 6:594 / Pigler 1974, p. 279]

Alexander Runciman, 1736–1785. "Thetis Dipping the Infant Achilles into the River Styx." Drawing. *c.*1770. British Museum, London. [Pressly 1979, p. 9, pl. 6]

Giuseppe Marchesi, 1700–1771. "Chiron Instructing Achilles." Painting. Private coll., England. [*Paragone* 22 no. 261 (1971), pl. 27 / Pigler 1974, p. 279]

James Barry, 1741–1806. "The Education of Achilles." Painting. *c.*1772. Yale Center for British Art, New Haven. [Pressly 1981, no. 10—ill.; cf. no. D.3]

Jean-Baptiste Regnault, 1754–1829. "The Centaur Chiron Instructing Achilles." Painting. 1782. Louvre, Paris, inv. 7382. [Louvre 1979–86, 4:171—ill.] Reduced replicas/sketches. Hermitage, Leningrad; Musée Calvet, Avignon. [Hermitage 1983, no. 342—ill.]

Alessandro Alberganti. "Thetis Dips Achilles into the Styx." Painting. 1788. [Pigler 1974, p. 277]

Friedrich Hölderlin, 1770–1843. "Achill." Poem. Sep 1798. In *Sämmtliche Werke* (Stuttgart & Tübingen: 1846). [Beissner 1943–77, vol. I]

Thomas Banks, 1735–1805. "Thetis Dips Achilles into the Styx." Marble sculpture group. Victoria and Albert Museum, London. [Pigler 1974, p. 278]

Johan Tobias Sergel, 1740–1814. "Achilles and the Centaur Chiron." Terra-cotta sculpture. Nationalmuseum, Stockholm, no. 486. [Göthe 1921, no. 13—ill.]

Anne-Louis Girodet, 1767–1824. "The Education of Achilles." Drawing. École Nationale des Beaux-Arts, Paris. [Bernier 1975, p. 52—ill.]

Philippe-Auguste Hennequin, 1763–1833. "The Centaur Chiron Instructing Achilles in Archery." Painting. Musée d'Art, Saint-Étienne. [Bénézit 1976, 5:487]

Bertel Thorwaldsen, 1770–1844. "The Sea-Goddess Thetis Dipping Her Son Achilles in the River Styx," "The Centaur Chiron Teaching Achilles to Throw a Spear." Reliefs. Plaster originals, 1837, in Thorwaldsens Museum, Copenhagen, nos. A487–88. [Thorwaldsen 1985, p. 56 / also Hartmann 1979, pl. 99.1] Marble version of A488, executed by R. Andersen and T. Stein, 1888–90. Thorwaldsens Museum, no. A798. [Thorwaldsen, p. 78]

Honoré Daumier, 1808–1879. "The Baptism of Achilles." Comic lithograph, in "Ancient History" series. 1842. [Delteil 1906–30, 22: no. 946—ill.]

Eugène Delacroix, 1798–1863. "The Education of Achilles." Painting. 1844. Library, Chambre des Députés, Palais Bourbon, Paris. [Huyghe 1963, pp. 378f., 388, pl. 286 / Robaut 1885, no. 840] Replica. 1862. Private coll., Paris. [Johnson 1981–86, no. 341—ill. / also Huyghe, pl. 292]

Matthew Arnold, 1822–1888. (Callicles' song recounts Chiron's teaching of young Achilles and Peleus in) *Empedocles on Etna* 1.2.57ff. Dramatic poem. In *Empedocles on Etna, and Other Poems* (London: Fellowes, 1852). [Allott & Super 1986 / Bush 1971, pp. 56f.]

Frédéric-Étienne Barbier, 1829–1889. *Achille chez Chiron.* Opera. First performed **1864,** Paris. [Hunger 1959, p. 5]

Rinaldo Rinaldi, 1793–1873. "Achilles and Chiron." Sculpture. Accademia, Venice. [Hunger 1959, p. 76]

Pierce Francis Connelly, 1841–after 1902. "Thetis and Achilles" (as infant). Marble sculpture group. **1874.** Metropolitan Museum, New York. [Gerdts 1973, p. 79, fig. 52]

Pauline Thys, 1836–after 1881. *L'éducation d'Achille.* Operetta. Libretto, composer and G. Durval. **1881.** [Cohen 1987, 2:699]

Gustave Moreau, 1826–1898. "The Education of Achilles" ("The Centaur"). Painting. **1884.** Sold Paris, 1910, unlocated. [Mathieu 1976, no. 318—ill.]

Constantine Cavafy, 1868–1933. (Peleus prevents Thetis from immortalizing Achilles in) "Diakope" [Interruption]. Poem. **1900.** Published 1901; reprinted in *Poiemata* (Alexandria: 1910). / Translated by Edmund Keeley and Philip Sherrard in *Collected Poems* (Princeton: Princeton University Press, 1975). [Ipso / Keeley 1976, p. 34]

Émile-Antoine Bourdelle, 1861–1929. "Achilles and Chiron." Bronze bas-relief, study for (unexecuted?) fresco for Théâtre des Champs-Elysées, Paris. *c.*1912. 2 casts. [Jianou & Dufet 1975, no. 484]

Auguste Rodin, 1840–1917. "Achilles and Chiron." Drawing. Musée Rodin, Paris, inv. D.1897. [Rodin 1982, no. 9—ill.] Several related designs. Musée Rodin. [Ibid., pp. 24ff.—ill.]

Lovis Corinth, 1858–1925. "Education of Achilles." Etching, in "Antique Legends" series. **1919.** [Schwarz 1922, no. 351—ill.]

Edmund Dulac, 1882–1953. "The Good Chiron Taught His Pupils How to Play upon the Harp." Painting, illustration for Hawthorne's *Tanglewood Tales* (London: Hodder & Stoughton, **1919**). Original painting in Library of Congress, Washington, D.C. [Loizeaux 1986, p. 137, fig. 41]

Giorgio de Chirico, 1888–1978. "Achilles' Dream." Painting. **1927.** Private coll., Rome. [de Chirico 1971–83, 4.1: no. 286—ill.]

———. "Achilles and Chiron." Painting. 1939. Frisoli coll., Rome. [Ibid., 3.2: no. 233—ill.]

———. "Young Achilles." Painting. 1946. Di Mora coll., Palermo. [Ibid., 2.2: no. 149.—ill.]

———. "Achilles on Horseback." Painting. 1946. Giuliano Gemma coll., Rome. [Ibid., 1.2: no. 73—ill.] Variant ("Achilles on the Banks of the Aegean."). 1957. Baron coll., Milan. [Ibid., 2.3: no. 206—ill.]

———. "Achilles on the Bank of the River Peneus." Painting. 1951. F. Guenzani coll., Gallarate. [Ibid., 7.1: no. 1035—ill.]

———. "Achilles." Painting. 1952. Private coll., Rome. [Far 1968, no. 136—ill.]

———. "Achilles Descending Mount Pelion." Painting. 1954. Distillerie Ramazzotti coll., Milan. [de Chirico, 1.3: no. 19—ill.]

———. "Achilles at the Source of the River Peneus." Painting. 1961. Private coll., Rome. [Ibid., no. 93—ill.]

———. "Achilles Encounters the Peasants." Painting. 1963. Formerly Galleria Rotta, Genoa. [Ibid., 6.3: no. 877—ill.]

Robert Calverly Trevelyan, 1872–1951. *Cheiron.* Poetic drama. London: Leonard & Virginia Woolf, **1927.** [Boswell 1982, p. 304]

Yvor Winters, 1900–1968. "Chiron." Poem. In *Contact* new series 1 (**1932**); collected in *Before Disaster* (Tyron, N.C.: Tyron Pamphlets, 1934); reprinted in *Poems* (Los Altos, Calif.: Gyroscope, 1940). [Isaacs 1981, p. 87 / Powell 1980, pp. 75 *n.*, 116, 127, 145]

Pierre Traverse, b. 1892. "The Education of Achilles." Maquette for sculpture. By **1946.** [Baschet 1946, p. 181]

H. D. (Hilda Doolittle), 1886–1961. (Education of Achilles in) "Eidolon" 5.7. Part 3 of *Helen in Egypt.* Epic. **1952–56.** New York: New Directions, 1961. [Ipso]

Gerhard Marcks, 1889–1981. "Chiron" (teaching Achilles). Iron plaque. **1962.** 2,000 casts. [Busch & Rudloff 1977, no. 790—ill.]

Yannis Ritsos, 1909–1990. "The First Sensual Delight" [English title of work written in Greek]. Poem. **1964.** In *Poiemata* (Athens: Kedros, 1977). / Translated by Kimon Friar in *Modern Greek Poetry* (New York: Simon & Schuster, 1973). [Ipso]

Achilles at Scyros. During Achilles' education, his mother Thetis learned of an oracle that predicted that Troy could not be taken without the young hero and that he could either live for a long time and die in relative anonymity or go to Troy and die young but in glory. To protect her son, Thetis disguised him as a maiden and took him to the island of Scyros, where he was brought up with the daughters of King Lycomedes. There he grew to manhood, fathering the child Neoptolemus (also called Pyrrhus) by Deidamia, one of Lycomedes' daughters.

When the Trojan expedition was being organized, Achilles' whereabouts were discovered and an embassy of Greeks went to Scyros to search for him. He was identified by wily Odysseus (Ulysses), who came to the island as a merchant bearing a variety of goods, including dresses and weapons. When Achilles, still disguised as a maiden, reached for the weapons he was unmasked and taken to join the Greek forces at Aulis.

The episode on Scyros has been a great favorite in opera and drama. Treatments of the theme in the fine arts most commonly depict the discovery of Achilles among Lycomedes' daughters.

Classical Sources. Bion, *Epithalamion of Achilles and Deidamia.* Ovid, *Metamorphoses* 13.162–70. Apollodorus, *Biblioteca* 3.13.8, E1.24, 5.11. Statius, *Achilleid.* Plutarch, *Theseus* 35. Pausanias, *Description of Greece* 1.17.6, 10.26.4. Hyginus, *Fabulae* 96.

Anonymous French. (Ulysses discovers Achilles disguised in) *Ovide moralisé* 12.1101–1163. Poem, allegorized trans-

lation/elaboration of Ovid's *Metamorphoses. c.*1316–28. [de Boer 1915–86, vol. 4]

John Gower, 1330?–1408. (Tale of Achilles and Deidamia in) *Confessio amantis* 5.2961–3218. Poem. *c.*1390. Westminster: Caxton, 1483. [Macaulay 1899–1902, vol. 3]

Christine de Pizan, *c.*1364–*c.*1431. (Ulysses discovers Achilles at Scyros in) *L'epistre d'Othéa à Hector* . . . [The Epistle of Othéa to Hector] chapter 71. Didactic romance in prose. *c.*1400. MSS in British Library, London; Bibliothèque Nationale, Paris; elsewhere. / Translated by Stephen Scrope (London: *c.*1444–50). [Bühler 1970 / Hindman 1986, pp. 24, 200]

Baldassare Peruzzi, 1481–1536, attributed. "Lycomedes Summons His Daughters into the Palace," "Odysseus Recognizes Achilles among the Daughters of Lycomedes." Frescoes, for Villa Madama, Rome. **1521–23.** Later overpainted. [Frommel 1967–68, nos. 58c.1–2—ill. (drawings)]

Francesco Primaticcio, 1504–1570. "Achilles among the Daughters of Lycomedes." Fresco, part of cycle on prologue to Trojan War, for Chambre du Roi, Château de Fontainebleau. **1533–35.** Destroyed. / Copy, drawing. Albertina, Vienna, no. 9002. [Dimier 1900, pp. 256ff., no. 9]

Giulio Mazzoni, 1525–1618, studio. "Achilles among the Daughters of Lycomedes," "Achilles Recognized by Ulysses." Frescoes. *c.*1552. Stanza di Achille, Palazzo Capodeferro, Rome. [Pigliati 1984, figs. 281–84—ill.]

Niccolò Giolfino, 1476–1555, studio. "Achilles at Scyros." Painting. Museo del Castelvecchio, Verona, no. 189. [Berenson 1968, p. 171]

Niccolò dell' Abbate, 1509/12–1571? (formerly attributed to Cecchin Salviati). "Achilles on Scyros." Painting. Lord Pembrokee coll., Wilton House. [Pigler 1974, p. 279]

Edmund Spenser, 1552?–1599. "When stout Achilles heard of Helens rape. . . ." Commendatory verse to *The Faerie Queene.* Romance epic. London: Ponsonbie, **1590.** [Hamilton 1977]

Guidubaldo Bonarelli Della Rovere, 1563–1608. *Filli di Sciro* [Girls of Scyros]. Favola pastorale (drama in verse). Ferrara: Baldini, **1607.** [Clubb 1968, p. 47]

Thomas Heywood, 1573/74–1641. (Story of Achilles at Scyros in) *Troia Britanica: or, Great Britaines Troy* canto 11. Epic poem. London: **1609.** [Heywood 1974]

Vicente Carducho, 1576/78–1638. "Achilles among the Daughters of Lycomedes," "Achilles Bidding Farewell to Deidamia." Frescoes, in "History of Achilles" series, Palacio del Pardo, Madrid. **1609–12.** Lost. / Drawings. Biblioteca Nacional, Madrid; Academia de San Fernando, Madrid. [López Torrijos 1985, pp. 203ff., 409f. nos. 1, 3, 5—ill.]

Tirso de Molina, 1583–1648. *El Aquilés.* Comedy. **1611–12.** In *Quinta parte de comedias* (Madrid: Imprenta Real, Léon, 1636). [Wilson 1977, pp. 69–77 / McGraw-Hill 1984, 3:423]

Peter Paul Rubens, 1577–1640. "Achilles Discovered by Ulysses among the Daughters of Lycomedes." Painting. *c.*1616. Prado, Madrid, no. 1582. [Jaffé 1989, no. 370—ill.] Oil sketch. Fitzwilliam Museum, Cambridge, inv. P.D. 22–1964. [Ibid., no. 369—ill. / Held 1980, no. 228—ill.] Copies in Statens Museum for Kunst, Copenhagen; Wawel, Cracow. [Held]

———. "Achilles Discovered among the Daughters of Lycomedes." Design for tapestry in "History of Achilles" series. *c.*1630–35? [Haverkamp Begemann 1975, no. 3] Oil sketch, 1630–32. Museum Boymans-van Beuningen, Rotterdam, no. 2310. [Held, no. 122—ill. / Jaffé, no. 1032—ill. / also Haverkamp Begemann, pp. 42ff., no. 3a—ill. / White 1987, pl. 280] Modello, by Rubens and assistant (Erasmus Quellinus? Theodoor van Thulden?). Prado, Madrid, no. 2455. [Haverkamp Begemann, pp. 57ff., no. 3b—ill. / Jaffé, no. 1031—ill.] Tapestries, 1640s/60s, in Paço Ducal, Vila Viçosa, Portugal; Cathedral, Santiago de Compostela; private coll., Jerez de la Frontera; Nunnington Hall, Helmsley, Yorkshire. [Haverkamp Begemann—ill.]

———. *See also van Dyck, below.*

Anthony van Dyck, 1599–1641. "Achilles among the Daughters of Lycomedes" ("Achilles Discovered"). Painting (retouched by Peter Paul Rubens). **1618.** Prado, Madrid, no. 1661. [Larsen 1988, no. 287—ill. / Prado 1985, pp. 599f.]

———. "Achilles Recognized among the Daughters of Lycomedes." Painting, based on above, modello for several ceiling decorations. 1628–29. Graf von Schönborn coll., Pommersfelden. [Larsen, no. 734—ill.] Replicas/copies in Musée des Augustins, Toulouse; Alte Pinakothek, Munich; another in a private coll.; another unlocated. [Ibid., no. A172—ill.]

Simon Vouet, 1590–1649, attributed. "Achilles on the Isle of Scyros." Painting. Before **1627,** if by Vouet. Accademia Albertina, Turin. [Crelly 1962, no. 146]

Jusepe de Ribera, *c.*1590/91–1652. "(Odysseus Discovers) Achilles among the Daughters of Lycomedes." Drawing. **1634.** Teylers Museum, Haarlem, no. K.II.58. [López Torrijos 1985, p. 411 no. 46—ill. / Brown 1973, no. D.27—ill.]

Frans Francken II, 1581–1642. "Achilles among the Daughters of Lycomedes." Painting. *c.*1630–35. Sold Brussels, 1947, unlocated. [Härting 1983, no. A226]

———. "Achilles among the Daughters of Lycomedes." Painting. 1630s. Národní Galeri, Prague, inv. 10451. [Ibid., no. A224] Replica. Sold London, 1923, unlocated. [Ibid., no. A225a]

———, studio (formerly attributed to Francken). "Achilles among the Daughters of Lycomedes." Painting. Louvre, Paris, inv. RF 1535. [Ibid., no. A225 / Louvre 1979–86, 1:60—ill. / also de Bosque 1985, p. 74—ill.]

Francesco Sacrati, 1605–1650. *La finta pazza* [The Feigned Madwoman]. Opera. Libretto, Giulio Strozzi. First performed **1641,** Teatro Novissimo, Venice; machinery, G. Torelli. Lost. [Bianconi 1987, pp. 40, 188, 193ff. / Redlich 1952, pp. 29 n., 30 n. / Grove 1980, 16:377]

Erasmus Quellinus, 1607–1678. "Achilles Discovered among the Daughters of Lycomedes." Painting. **1643.** Liechtenstein Collection, Vaduz, inv. 580. [Pigler 1974, p. 281]

———. "Achilles among the Daughters of Lycomedes." Painting. Szépmüvészeti Múzeum, Budapest, no. 71.22. [Ibid.]

Pier Francesco Cavalli, 1602–1676, doubtfully attributed. *La Deidamia.* Opera. Libretto, Scipione Herrico. First performed 5 Jan **1644,** Teatro Novissimo, Venice. [Grove 1980, 4:32 / Clubb 1968, p. 109 / Glover 1978, p. 160]

Claude Lorrain, 1600–1682. "Coast View with Ulysses

Received by the Daughters of Lycomedes." Painting. Late **1640s**. Hermitage, Leningrad, no. 1784. [Röthlisberger 1961, no. 212—ill.]

Nicolas Poussin, 1594–1665. "Achilles and the Daughters of Lycomedes" ("Discovery of Achilles on Scyros"). Painting. *c.***1650**. Museum of Fine Arts, Boston, no. 463. [Wright 1985, no. 183—ill., pl. 199 / Blunt 1966, no. 126—ill. / also Thuillier 1974, no. 184—ill. / Boston 1985, p. 231—ill. / Wildenstein 1968, no. 31—ill.] Copy in Musée, Coustaces; 5 others recorded. [Blunt]

———. "Achilles and the Daughters of Lycomedes." Painting (damaged and overpainted original, or copy of lost original). *c.*1656. Virginia Museum of Fine Arts, Richmond. [Wright, no. A27 / also Blunt, no. 127—ill. / Thuillier, no. 199—ill. (print)] Copy in Musée d'Art et d'Histoire, Geneva. [Blunt]

———, formerly attributed. "Achilles among the Daughters of Lycomedes." Painting. Louvre, Paris, on deposit in Musée Saint-Denis, Rheims. [Thuillier, no. R51—ill. / also Blunt, no. R62]

Anonymous French choreographer. *La sortie d'Achille du palais de Lycomède.* Ballet-opera. First performed **1652**, Modena. Published Paris: 1682. (Documented in Claude-François Menestrier, *Des ballets anciens et modernes selon les règles du Théâtre,* otherwise unknown.) [Winter 1974, p. 10f.]

Pedro Calderón de la Barca, 1600–1681. (Achilles and Deidamia in) *El monstruo de los jardines* [The Monster of the Gardens]. Comedy. *c.***1650–53**. First performed Autumn 1667, Corral, Monteria, Seville. Published in *Comedias de Calderón,* part 4 (Madrid: 1672). [Valbuena Briones 1960–81, vol. 1 / O'Connor 1988, pp. 238–52 / McGraw-Hill 1984, 1:443]

Jean Lemaire, 1598–1659. "Achilles on Scyros." Painting. Sold London, 1947, unlocated. [Pigler 1974, p. 281]

Juan de la Corte, 1597–1660. "Achilles and the Daughters of Lycomedes." Painting, part of "Trojan War" cycle, for El Retiro, Torremolinos, Málaga. Palacio del Senado, Madrid. [López Torrijos 1985, pp. 206f., 410 no. 9—ill.]

Giovanni Legrenzi, 1626–1690. *L'Achille in Sciro.* Opera. Libretto, Ippolito Bentivoglio? First performed **1663**, Teatro S. Stefano, Ferrara. [Grove 1980, 10:618 / DELI 1966–70, 1:325]

Jan de Bray, *c.*1627–1697. "Achilles among the Daughters of Lycomedes." Painting. **1664**. Muzeum Narodowe, Warsaw, inv. 126175. [Warsaw 1969, no. 151—ill.]

Jan Boeckhorst, 1605–1668. "Achilles among the Daughters of Lycomedes." Painting. Muzeum Narodowe, Warsaw, inv. 129966. [Warsaw 1969, no. 112—ill.]

Antonio Draghi, 1634/35–1700. *Achille riconosciuto.* Opera. Libretto, Teofilo. First performed 12 June **1668**, Vienna. [Grove 1980, 5:604]

———. *Achille in Sciro.* Opera. Libretto, Ximenes. First performed 1669, Vienna. [Grove, 5:604]

Antonio Masini, 1639–1678. *Achille in Sciro.* Opera. First performed **1672**, Rome? [Palisca 1968, p. 186]

Willem van Herp, 1614–1677. "Achilles at the Court of Lycomedes." Painting. Felbrigg Hall, Norfolk. [Wright 1976, p. 89]

Pieter Thijs the Elder, 1624–1677. "Achilles Recognized at the Court of Lycomedes." Painting. Nationalmuseum,

Stockholm, no. 662. [Bénézit 1976, 10:174 / Pigler 1974, p. 281]

Jacob Jordaens, 1593–1678, attributed. "Achilles Discovered by Ulysses at the Court of Lycomedes." Painting. Recorded in 1715, untraced. [Rooses 1908, p. 257]

Pierre Lemaire, 1612–1688. "Achilles among the Daughters of Lycomedes." Painting. Los Angeles County Museum, inv. A.5141.49–670. [Warburg]

Gérard de Lairesse, 1641–1711 (active until *c.*1690). "Ulysses Recognizes Achilles among the Daughters of Lycomedes." Painting. Mauritshuis, The Hague, inv. 82. [Mauritshuis 1985, pp. 224, 389—ill.]

———. "Achilles among the Daughters of Lycomedes." Painting. Herzog Anton Ulrich-Museum, Braunschweig, no. 287. [Braunschweig 1969, p. 85] Further versions of the subject in Schilderijenzaal Prins Willem V, The Hague; Nationalmuseum, Stockholm; elsewhere? [Wright 1980, p. 229 / Pigler 1974, p. 281]

Philibert Vigier, 1636–1719. "Achilles at Scyros." Marble statue. **1695**. Tapis Vert, Gardens, Versailles. [Girard 1985, p. 284—ill.]

Alessandro Scarlatti, 1660–1725. *Achille e Deidamia.* Opera. Libretto, Francesco Maria Paglia. First performed **1698**, Naples? [Hunger 1959, p. 5]

Domenico Scarlatti, 1685–1757. *Tetide in Sciro* [Thetis in Scyros]. Opera (dramma per musica). Libretto, C. S. Capece. First performed 10 Jan **1712**, Teatro Domestico della Regina Maria Casimira di Pollonia, Rome. [Kirkpatrick 1953, p. 50, 52, 53, 415 / Grove 1980, 16:574]

Carlo Francesco Pollarolo, 1653–1723. *Tetide in Sciro.* Opera. Libretto, Capece. First performed **1715**, Vicenza. [Grove 1980, 15:47]

Giovanni Battista Tiepolo, 1696–1770. "Ulysses Discovering Achilles among the Daughters of Lycomedes." Painting, for Palazzo Sandi, Venice. *c.***1725–26**. Da Schio coll., Castelgomberto, Vicenza. [Pallucchini 1968, no. 33b—ill. / Levey 1986, p. 28—ill. / Morassi 1962, p. 8]

Giovanni Battista Pittoni, 1687–1767. "Achilles among the Daughters of Lycomedes." Painting. *c.***1730**. Formerly Wedewer coll., Wiesbaden. [Zava Boccazzi 1979, no. 287—ill.]

John Gay, 1685–1732. *Achilles.* Ballad opera (4 tunes attributed to Arcangelo Corelli). Libretto, composer. First performed 10 Feb **1733**, Theatre Royal, Covent Garden, London. [Fuller 1983, vol. 2 / Grove 1980, 7:203 / Fiske 1973, pp. 89, 107, 113f., 255, 598]

Gerard Hoet the Elder, 1648–1733. "Achilles on Scyros." Painting. Nationalmuseum, Stockholm, inv. 465. [Bénézit 1976, 5:571 / Pigler 1974, p. 281]

———. "Achilles on Scyros." Painting. Galerie, Schleissheim, inv. 3828. [Bénézit / Pigler]

———. "Achilles on Scyros." Painting. Bayerisches Staatsgalerie, Munich, inv. 1104/2199. [Warburg]

Ottmar Elliger the Younger, 1666–1735. "Achilles among the Daughters of Lycomedes." Painting. Musée, Tours (on deposit from Louvre, Paris, no. M.N.R. 344). [Louvre 1979–86, 2:48]

André Campra, 1660–1744. *Achille et Deidamie.* Opera (tragédie lyrique). Libretto, Antoine Danchet. First performed 24 Feb **1735**, L'Opéra, Paris. [Grove 1980, 3:665 / Girdlestone 1972, pp. 215f. / EDS 1954–66, 2:1609]

Pietro Metastasio, 1698–1782. *Achille in Sciro*. Libretto for opera. First set by Caldara, **1736** (below), and by at least 20 further composers to 1785. [Grove 1980, 12:217]

Antonio Caldara, c.1670–1736. *Achille in Sciro*. Opera (dramma per musica). Libretto, Metastasio. First performed 13 Feb **1736**, Burgtheater, Vienna. [Grove 1980, 3:616]

Domenico Sarro, 1679–1744 (also spuriously attributed to Giovanni Battista Pergolesi). *Achille in Sciro*. Opera. Libretto, Metastasio (1736). First performed 4 Nov **1737**, Teatro San Carlo, Naples. [Grove 1980, 12:217, 14:399, 16:501]

Giuseppe Arena, 1713–1784. *Achille in Sciro*. Opera. Libretto, Metastasio (1736). First performed 7 Jan **1738**, Theatro delle Dame, Rome. [Grove 1980, 1:560]

Michel Guyot de Merville, 1696–1755. *Achille à Scyros*. Comedy. **1738**. [Taylor 1893, p. 172]

Pietro Chiarini, 1717?–after 1765. *Achille in Sciro*. Opera (dramma per musica). Libretto, Metastasio (1736). First performed Carnival **1739**, San Angelo, Venice. [Grove 1980, 4:221 / Weaver 1978, p. 315]

Leonardo Leo, 1694–1744. *Achille in Sciro*. Opera seria. Libretto, Metastasio (1736). First performed Carnival **1740**, Regio, Turin. [Grove 1980, 10:668]

George Frideric Handel, 1685–1759. *Deidamia*. Opera. Libretto, Paolo Antonio Rolli. First performed 10 Jan **1741**, Lincoln's Inn Fields, London. [Lang 1966, pp. 321–326 / Hogwood 1984, pp. 164f., 287 / Keates 1985, pp. 236f.]

Francesco Corselli, c.1702–1778. *Achille in Sciro*. Opera seria. Libretto, Metastasio (1736). First performed 8 Dec **1744**, Buen Retiro. [Grove 1980, 4:805, 12:217]

Giovanni Verocai, c.1700–**1745**. *Achille in Sciro*. Opera. First performed Aug 1746, Braunschweig. [Grove 1980, 19:674]

Gennaro Manna, 1715–1779. *Achille in Sciro*. Opera seria. Libretto, Metastasio (1736). First performed 20 Jan **1745**, San Carlo, Naples. [Grove 1980, 11:622]

Pompeo Batoni, 1708–1787. "Achilles and the Daughters of Lycomedes." Painting. **1746**. Uffizi, Florence, no. 544. [Clark 1985, no. 104—ill. / Uffizi 1979, no. P167—ill.]

Anonymous Italian. *Il trionfo della Gloria*. Opera (dramma per musica). Libretto, Metastasio's *Achille in Sciro* (1736). First performed 24 Jan **1747**, Pergola, Florence. [Weaver 1978, p. 315]

Niccolò Jommelli, 1714–1774. *Achille in Sciro*. Opera seria. Libretto, Metastasio (1736). First performed 30 Aug **1749**, Burgtheater, Vienna. [Baker 1984, p. 1128 / Grove 1980, 9:690, 692f.; 12:217]

———. *Achille in Sciro*. Opera seria. Libretto, Metastasio (1736). First performed 26 Jan 1771, Delle Dame, Rome. [Baker, p. 1128 / Grove, 9:693; 12:217]

Gregorio Sciroli, 1722–after 1781. *Achille in Sciro*. Opera. Libretto, Metastasio (1736). First performed **1751**, Naples? [Grove 1980, 17:54]

Manuel Pereyra de Acosta, 1697–? *Achilles em Sciro*. Drama, based on Metastasio (1736). Lisbon: **1755**. [Barrera 1969, p. 300]

Antonio Mazzoni, 1717–1785. *Achille in Sciro*. Opera. First performed c.**1758**, Naples. [Clément & Larousse 1969, 1:5]

Hendrik van Limborch, 1681–1759. "Achilles and the Daughters of Lycomedes." Painting. Museum Boymans-van Beuningen, Rotterdam. [Wright 1980, p. 241]

Johann Adolf Hasse, 1699–1783. *Achille in Sciro*. Opera seria. Libretto, Metastasio (1736). First performed 4 Nov **1759**, San Carlo, Naples. [Grove 1980, 8:284, 288; 12:217]

Giuseppe Sarti, 1729–1802. *Achille in Sciro*. Opera (dramma per musica). Libretto, Metastasio (1736). First performed **1759**, Theatre on Kongens Nytorv, Copenhagen. [Grove 1980, 16:504]

Ferdinando Bertoni, 1725–1813. *Achille in Sciro*. Opera. Libretto, Metastasio (1736). First performed Carnival **1764**, San Cassiano, Venice. [Grove 1980, 2:647; 12:217]

Carlo Monza, c.1735–1801. *Achille in Sciro*. Opera seria. Libretto, Metastasio (1736). First performed 4 Feb **1764**, Regio Ducal, Milan. [Grove 1980, 12:544]

Johann Friedrich Agricola, 1720–1774. *Achille in Sciro*. Opera. Libretto, Metastasio (1736). First performed 16 Sep **1765**, Potsdam. [Grove 1980, 1:165; 12:217]

Florian Leopold Gassmann, 1729–1774. *Achille in Sciro*. Opera. Libretto, Metastasio (1736). First performed Spring **1766**, San Giovanni Grisostomo, Venice. [Baker 1984, p. 801 / Grove 1980, 7:178f., 12:217]

Étienne Lauchery, 1732–1820, choreography. *Achilles und Ulysses auf der Insel Scyros* [Achilles and Ulysses on the Island of Scyros]. Ballet. First performed **1766**, Kassel. [Cohen-Stratyner 1982, p. 528]

Johann Gottlieb Naumann, 1741–1801. *L'Achille in Sciro*. Opera seria. Libretto, Metastasio (1736). First performed 5 Sep **1767**, San Cecilia, Palermo. [Grove 1980, 13:79, 12:217]

Angelica Kauffmann, 1741–1807. "Ulysses Discovering Achilles. Painting. **1769**? Earl of Morley coll., Saltram Park, Plymouth. [Manners & Williamson 1924, pp. 37, 200 / Wright 1976, p. 110]

———. "Achilles Discovered in Feminine Attire." Painting. 1789. Formerly Hermitage, Leningrad. [Manners & Williamson, pp. 82, 157]

———. "A Homeric Legend." Painting in 4 "compartments," the 2 outside panels depicting Achilles dressed as a maiden and the entrance of Ulysses. Sir Herbert Cook coll., London. [Ibid., p. 183]

Thomas Augustine Arne, c.1710–1778. *Achilles in Petticoats*. Pantomime. Libretto, George Colman, after John Gay's *Achilles*. First performed 16 Dec **1773**, Covent Garden, London. [Grove 1980, 1:610 / Fiske 1973, pp. 255, 368, 399]

Christian Cannabich, 1731–1798, music. *Achille reconnu par Ulisse* [Achilles Recognized by Ulysses]. Ballet. First performed **1774**, Mannheim? [Hunger 1959, p. 5]

Pietro Pompeo Sales, c.1729–1797. *Achille in Sciro*. Opera. Libretto, Metastasio (1736). First performed **1774**, Munich. [Grove 1980, 12:217; 16:414]

Josef Mysliveček, 1737–1781. *Achille in Sciro*. Opera. Libretto, Metastasio (1736). First performed **1775**?, Naples? [Pečman 1970, p. 181]

Giovanni Paisiello, 1740–1816. *Achille in Sciro*. Opera (dramma per musica). Libretto, Metastasio (1736). First performed 6 Feb **1778**, Court, St. Petersburg. [Grove 1980, 12:217; 14:100]

Gaetano Pugnani, 1731–1798. *Achille in Sciro*. Opera (dramma per musica). Libretto, Metastasio (1736). First performed 15 Jan **1785**, Regio, Turin. [Grove 1980, 12:217; 15:447]

Marcello Bernardini, c.1740?–after 1799. *Achille in Sciro*.

Opera. Libretto, Metastasio (1736). First performed **1794,** Venice. [Grove 1980, 2:618]

Ludwig van Beethoven, 1770–1827. "Ah! Perfido." Scena, aria, recitative for solo soprano and orchestra, opus 65. Text, from Metastasio's *Achille in Sciro* (1736). **1795–96.** First performed 22 Dec 1808, Theater an der Wien, Vienna. [Kerman & Tyson 1983, pp. 46, 99, 178 / Grove 1980, 2:403]

Venetian School. "Achilles among the Daughters of Lycomedes." Painting. **18th century.** Walters Art Gallery, Baltimore, inv. 37.573. [Walters 1976, p. 579]

James Hervé D'Egville, c.1770–c.1836, choreography. *Achille et Déidamie.* Ballet. Music, Peter von Winter. First performed Jan **1804,** King's Theatre, Haymarket, London. [Winter 1974, pp. 11, 199f., pl. III]

Pierre Gardel, 1758–1840, choreography. *Achille à Scyros.* Ballet-pantomime. Music, Luigi Cherubini. Libretto, Metastasio (1736). First performed 18 Dec **1804,** L'Opéra, Paris. [Guest 1976, p. 304 / Grove 1980, 4:210]

Pietro Angiolini, 1746–1830, choreography. *Achille in Sciro.* Mime-ballet d'action. Music, A. Rolla and Baiglin. Scenario, Metastasio (1736). First performed May **1806,** La Scala, Milan; scenic design, Pasquale Canna. [Simon & Schuster 1979, p. 84]

Jean Charles Luce de Lancival, 1764–1810. *Achille à Scyros.* Poem. Paris: Gillé, **1805–07.** [DLF 1951–72, 5:141]

Pietro Antonio Coppola, 1793–1877. *Achille in Sciro.* Opera. First performed **c.1825,** Teatro del Fondo, Naples. [Clément & Larousse 1969, 1:5]

Rudolf Heinrich Klausen, 1807–1840. *Achilles auf Skyros.* Tragedy. Hamburg: Perthes & Besser **1831.** [DLL 1968–90, 8:1246]

Alfred de Musset, 1810–1857. (Achilles and Deidamia evoked in) *La coupe et les lèvres* [The Cup and the Lips]. Lyric drama. In *Un spectacle dans un fauteuil* (Paris: **1832**). [DLLF 1984, 2:1587]

Benjamin Robert Haydon, 1786–1846. "Achilles at the Court of Lycomedes." Painting. **1835.** [Olney 1952, pp. 204f.]

Laurent de Rillé. *Achille à Scyros.* Operetta. Libretto, Ernest Alley and Delmara. First performed Sep **1857,** Folies-Nouvelles, Paris. [Clément & Larousse 1969, 1:4]

Théodore de Banville, 1823–1891. *Déidamie.* Comedy. First performed Nov **1876,** L'Odéon, Paris. [DLLF 1984, 1:147 / Hunger 1959, p. 4]

Robert Bridges, 1844–1930. *Achilles in Scyros: A Drama in a Mixed Manner.* Pastoral. London: Bumpus, **1890.** First performed 27 June 1912, Cheltenham Ladies' College. [DLB 1983, 19:48, 50 / Bush 1937, p. 440–42]

Henri Maréchal, 1842–1924. *Déidamie.* Opera. Libretto, Edouard Noël. First performed 15 Sep **1893,** L'Opéra, Paris. [Grove 1980, 11:666]

François Rasse, 1873–1955. *Deidamia.* Opera. Libretto, L. Solvay, after de Musset's *La coupe et les lèvres* (1832). First performed **1905,** Brussels? [Grove 1980, 15:594 / DLLF 1984, 2:1587]

Wilhelm Schmidtbonn, 1876–1952. *Der junge Achilles.* Farce. In *Der spielende Eros* (Berlin: Fleischel, **1911**). [Wilpert 1963, p. 254]

Cyril Rootham, 1875–1938. "Achilles in Scyros." Choral composition for unaccompanied female voices. **1912.** [Grove 1980, 16:184]

E. Marti. *Achille chez Lycomède* [Achilles in the House of Lycomedes]. Operetta. Libretto, Brunel de Rieux. First performed **1913,** Paris? [Hunger 1959, p. 5]

Edward Shanks, 1892–1953. (Achilles and Deidamia on) "The Island of Youth." Poem. In *The Island of Youth and Other Poems* (London: Collins, **1921**). [Bush 1937, pp. 441, 572]

Hugo von Hofmannsthal, 1874–1929. *Achilles auf Skyros.* Comedy. **1925.** Published anonymously, Vienna: Universal-Edition, 1925. [Steiner 1946–58, *Dramen* vol. 4]

Egon Wellesz, 1885–1974, music. *Achilles auf Skyros.* Ballet. Scenario, Hofmannsthal (1925). First performed 4 Mar **1926,** Stuttgart (choreographer unknown). [Grove 1980, 20:336]

Marguerite Yourcenar, 1903–1987. "Achilles, ou, Le mensonge" [Achilles, or, The Lie], part of *Feux.* Prose poem. Paris: Grasset, **1936** / Translated by Dori Katz in *Fires* (New York: Farrar, Straus & Giroux, 1981) / Set to music by Donald Harris, performed Nov 1983, National Public Radio. [Horn 1985, p. 59 / DLLF 1984, 3:2519f.]

Hans Jüngst, 1888–1975. *Achill unter den Weibern* [Achilles among the Women]. Drama. Leipzig: Insel, **1940.** [DLL 1968–90, 8:715]

Karl Shapiro, 1913–. (Achilles evoked in) "Scyros." Poem. In *V. Letter* (New York: Random House, **1945**). [Boswell 1982, p. 219]

Wrath of Achilles. "Sing, goddess, the wrath of Peleus's son Achilles." Homer's *Iliad* opens with this invocation, and the event to which it refers—Achilles' quarrel with his commander Agamemnon—centers on the spoils they gained in the Trojan War before Homer's narrative begins.

Agamemnon received as part of his booty the woman Chryseis; Achilles was given Briseis. When Agamemnon was forced to relinquish his reward, he demanded that Achilles surrender Briseis to him as compensation. Stung by the insult and by the loss of someone he had come to love, Achilles retired to his tent and refused to lead his troops into battle. At the urging of Achilles' mother, Thetis, Zeus (Jupiter) punished Agamemnon by causing him to suffer great losses in subsequent battles with the Trojans. Only after the death of Patroclus did Achilles rejoin the war, at which time Agamemnon returned Briseis to him, along with costly gifts.

Classical Sources. Homer, *Iliad* passim. Ovid, *Heroides* 3. Apollodorus, *Biblioteca* E4.1–3. Hyginus, *Fabulae* 106.

See also CHRYSEIS; PATROCLUS.

Anonymous French. (The wrath of Achilles in) *Ovide moralisé* 12.3226–3321. Poem, allegorized translation/elaboration of Ovid's *Metamorphoses.* c.**1316–28.** [de Boer 1915–86, vol. 4]

Andrea Schiavone, 1522–**1563.** "The Departure of Bri-

seis." Painting. Hampton Court Palace, no. 132. [Berenson 1957, p. 160—ill.]

Juan Lopez de Oliveira. *Achiles i Thetis.* Comedy. First performed **1578**, Evora. [Barrera 1969, p. 221]

Cavaliere d'Arpino, 1568–1640. "Achilles and Briseis" (as love-pair). Fresco. **1594–95.** Loggia Orsini, Palazzo del Sodalizio dei Piceni, Rome. [Röttgen 1969, pp. 279ff.—ill.]

Thomas Heywood, 1573/74–1641. (Achilles in) *Troia Britannica, or Great Britaines Troy* cantos 10–14. Epic poem. London: **1609.** [Heywood 1974]

———. (Achilles in) *The Iron Age.* Drama in 2 parts, derived from *Troia Britanica.* First performed *c.*1612–13, London. Published London: Okes, 1632. [Heywood 1874, vol. 3]

Nicolas Poussin, 1594–1665. "Thetis and Achilles." Drawing (for G. B. Marino's unpublished edition of *Metamorphoses?*). *c.***1620–23.** Royal Library, Windsor Castle, no. 11934. [Friedlaender & Blunt 1953, no. 162—ill.]

Peter Paul Rubens, 1577–1640. "The Wrath of Achilles," "Briseis Restored to Achilles." Designs for tapestries in "History of Achilles" series. *c.***1630–35?** [Haverkamp Begemann 1975, nos. 5–6] Oil sketches, 1630–32. Museum Boymans-van Beuningen, Rotterdam, no. 1760b; Detroit Institute of Arts, inv. 53–356. [Held 1980, nos. 123, 125—ill. / Jaffé 1989, nos. 1034, 1036—ill. / also Haverkamp Begemann, pp. 42ff., nos. 5a, 6a—ill.] Modelli, by Rubens and assistant (Erasmus Quellinus? Theodoor van Thulden?). Courtauld Institute, London (ex-Seilern coll.); Prado, Madrid, no. 2566. [Haverkamp Begemann, pp. 57ff., nos. 5b, 6b / Jaffé, no. 1033, 1037—ill.] Studio replica of "Briseis." Szépmüvészeti Múzeum, Budapest, no. 51.2981. [Budapest 1968, p. 598] Tapestries, 1640s/60s, in Musées Royaux d'Art et d'Histoire, Brussels; elsewhere. [Haverkamp Begemann]

———. *See also van Dyck, below.*

Anthony van Dyck, 1599–1641, studio or follower, after design by van Dyck? (also attributed to Rubens). "The Horses of Achilles." Painting. Later 17th century? National Gallery, London. [Larsen 1988, no. A185—ill.]

Rembrandt van Rijn, 1606–1669, attributed. "Thetis Urges Achilles to Return to the Battle." Drawing. **Early 1640s?** Pierpont Morgan Library, New York. [Benesch 1973, no. A45—ill.]

Jacob Jordaens, 1593–1678, attributed. "Achilles Mourns the Death of Patroclus and Receives Briseis." Painting. Recorded in 1785, untraced. [Rooses 1908, p. 257]

Jean de La Fontaine, 1621–1695. *Achille.* Tragedy, fragment. Begun **1683,** unfinished. In *Oeuvres* (Paris: Petite Bibliothèque des Théâtres, 1785). [Clarac & Marmier 1965 / MacKay 1973, p. 150]

Pietro Torri, *c.*1650–1737, attributed (or possibly Agostino Steffani, 1654–1728). *La Briseida.* Opera. Libretto, F. Palmieri. First performed Carnival **1696,** Hanover. [Grove 1980, 18:94, 19:82]

Italian School. "Achilles Wounded at the Siege of Troy." Painting. **17th century.** Musée, Besançon on deposit from Louvre, Paris (no. M.I. 1422). [Louvre 1979–86, 2:305]

Sebastiano Ricci, 1659–1734. "The Rape of Briseis." Painting. *c.***1700.** Formerly with Colnaghi's, London, unlocated. [Daniels 1976 no. 186] Variant. Private coll., Nice. [Ibid., no. 279]

Antonio Lotti, *c.*1667–1740. *Achille placato* [Achilles Appeased]. Opera (tragedia per musica). Libretto, U. Rizzi. First performed Winter **1707,** Teatro San Cassiano, Venice. [Grove 1980, 11:250]

André Campra, 1660–1744. *Achille oisif* [Achilles Idle]. Cantata. In *Cantates françoises,* book 2 (Paris: **1714**). [Grove 1980, 3:665]

———. *La colère d'Achille* [The Anger of Achilles]. Cantata. In *Cantates françoises,* book 3 (Paris: 1728). [Ibid.]

Francesco Corradini, *c.*1700–after 1749. 3 new arias for production of Pietro Torri's *La Briseida* (1696). First performed 23 May **1746,** Madrid. [Grove 1980, 4:798]

Giovanni Battista Tiepolo, 1696–1770. "Minerva Prevents Achilles from Killing Agamemnon," "Briseis Led to Agamemnon (by Eurybates and Talthybius)," "Achilles Mourning on the Seashore (Consoled by Thetis)." Fresco cycle. **1757.** Stanza dell' Iliade, Villa Valmarana, Vicenza. [Levey 1986, pp. 233ff.—ill. / Pallucchini 1968, no. 240—ill. / Morassi 1962, pp. 64f.—ill.]

Louis Poinsinet de Sivry, 1733–1804. *Briséis, ou La colère d'Achille* [Briseis, or The Anger of Achilles]. Tragedy. First performed **1759,** Paris. [DLLF 1984, 3:1772]

Antonio Rodríguez de Hita, *c.*1724–1787, music. *La Briseida.* Zarzuela. Libretto, Ramon de la Cruz. First performed 10 July **1768,** Principe, Madrid. [Grove 1980, 16:94 / DLE 1972, p. 232]

Alexander Runciman, 1736–1785. "Achilles and Pallas." Drawing. *c.***1770.** National Gallery of Scotland, Edinburgh. [Pressly 1981, pl. 8]

Johann Heinrich Tischbein the Elder, 1722–1789. "Briseis Taken from the Tent of Achilles." Painting. **1773.** Kunsthalle, Hamburg, inv. 562. [Hamburg 1966, p. 162—ill.]

———. "The Dispute of Achilles and Agamemnon." Painting. 1776. Kunsthalle, Hamburg, inv. 561. [Ibid.—ill.]

Giuseppe Cades, *c.*1750–1799. "Achilles Playing the Lyre, with Patroclus, Surprised by Ulysses and Nestor." Painting. *c.***1775?** (exhibited 1789). Louvre, Paris, no. R.F. 1980–191. [Louvre 1979–86, 2:159—ill.]

George Romney, 1734–1802. "Thetis (Comforting Achilles)." Drawing. **1776–77.** Fitzwilliam Museum, Cambridge. [Jaffé 1977, no. 25]

———. "Jupiter and Thetis." Drawing. *c.*1779. Fitzwilliam Museum, Cambridge. [Bindman 1979, no. 207—ill.]

Francesco Bianchi, 1752–1810. *La Briseida.* Opera. First performed **1783,** Turin. [Grove 1980, 2:674]

Thomas Banks, 1735–1805. "Achilles, Enraged for the Loss of Briseis, Retires to the Seashore and Complains to Thetis." Stone relief. Exhibited **1784.** Tate Gallery, London, no. 1763. [Tate 1975, p. 2]

Antonio Canova, 1757–1822. "Achilles Returning Briseis (to Agamemnon's Messengers)." Plaster relief. **1787–90.** Gipsoteca Canoviana, Possagno, no. 39. [Pavanello 1976, no. 57—ill. / Licht 1983, p. 247—ill. / also Irwin 1979, fig. 90—ill.] Replicas in Museo Correr, Venice; Palazzo di San Bonifacio, Padua. [Pavanello]

[?] Robuschi. *Briseide.* Opera. First performed *c.***1790,** Naples. [Clément & Larousse 1969, 1:175]

The Prix de Rome painting competition subject for **1801**

was "Achilles Receiving the Ambassadors of Agamemnon." First prize: Jean-Auguste-Dominique Ingres *(see below)*. [Grunchec 1984, no. 39—ill. / Harding 1979, p. 9]

Jean-Auguste-Dominique Ingres, 1780–1867. "The Envoys from Agamemnon (Sent to Achilles to Urge Him to Fight, Find Him in His Tent with Patroclus, Singing of the Feats of the Heroes)." Painting (first prize, Prix de Rome). **1801.** École des Beaux-Arts, Paris. [Wildenstein 1954, no. 7—ill.] Sketch or reduced version, Nationalmuseum, Stockholm. [Ibid., no. 8—ill.]
———. "Jupiter and Thetis." Painting. 1811. Musée, Aix-en-Provence. [Ibid., no. 72—ill. / Bindman 1979, no. 208—ill.] Studies for head of Jupiter. Musée Ingres, Montauban; private colls. [Wildenstein, nos. 73–75—ill. / Montauban 1965, no. 156—ill.]

Bertel Thorwaldsen, 1770–1844. "Briseis Led Away from Achilles by Agamemnon's Heralds" ("Achilles and Briseis"). Relief. Plaster original, **1803.** Thorwaldsens Museum, Copenhagen, no. A490. / At least 4 marble versions, 1805–20. Art Museum, Kaunas, Lithuania; Woburn Abbey, Bedfordshire; Duke of Devonshire coll., Chatsworth; Thorwaldsens Museum, no. A489 (executed by C. Freund and H. W. Bissen, 1965). [Thorwaldsen 1985, pp. 56f., pl. 31 / Cologne 1977, no. 2, pp. 44, 96—ill. / Hartmann 1979, pp. 136ff., pl. 85.2] Plaster variant. 1837. Thorwaldsens Museum, no. A491. [Thorwaldsen, p. 57]

The Prix de Rome painting competition subject for **1810** was "The Wrath of Achilles." First prize: Michel-Martin Drölling, 1786–1851. École des Beaux-Arts, Paris. [Grunchec 1984, no. 47—ill. / Harding 1979, p. 92]

Francesco Basili, 1767–1850. *L'ira di Achille* [The Wrath of Achilles]. Opera (dramma serio). Libretto, P. Pola. First performed 30 Jan **1817,** La Fenice, Venice. [Grove 1980, 2:239]

Gaetano Donizetti, 1797–1848. *L'ira d'Achille* [The Wrath of Achilles]. Opera. **1817.** Unperformed. [Grove 1980, 5:564]

François Rude, 1784–1855. "Achilles Mourning the Abduction of Briseis." Bas-relief, part of series on life of Achilles for Château de Tervueren, Brussels. **1820–23.** Destroyed. / Drawing. Musée des Beaux-Arts, Dijon. [Bindman 1979, no. 231—ill.] Plaster model. Dijon. [Ibid.—ill.]

Salvatore Taglioni, 1789–1868, choreography. *L'ira d'Achille* [The Wrath of Achilles]. Ballet. Music, Gallenberg. First performed 6 July **1826,** San Carlo, Naples. [EDS 1954–66, 9:631]

Nicolas Gosse, 1787–1878, and **Auguste Vinchon**, 1789–1855. "Thetis Consoles Achilles." Grisaille painting, simulated bas-relief, part of series of 8 Homeric scenes. Commissioned **1827.** Louvre, Paris, inv. 8475. [Louvre 1979–86, 3:285—ill.]

Peter Cornelius, 1783–1867, and studio. "The Wrath of Achilles." Lunette fresco. **1826–30.** Trojanischer Saal, Glyptothek, Munich. [Glyptothek 1980, pp. 218ff.—ill.]

Horatio Greenough, 1805–1852. "Athena Interposing between Achilles and Agamemnon" and other scenes from the *Iliad.* Sculpture. c.**1832.** Wright coll., Maryville, Tenn.; elsewhere? [Wright 1963, p. 96—ill.]

Théodore Chassériau, 1819–1856. "Calchas and Agamem-

non before Achilles and the Greeks at the Siege of Troy" (? or "St. Paul Preaching to the Ephesians"?). Oil sketch. **1840.** Musée de Tessé, Le Mans, inv. 10266. [Sandoz 1974, no. 68—ill.]

Honoré Daumier, 1808–1879. "Achilles in His Tent," "The Wrath of Agamemnon." Comic lithographs, in "Ancient History" series. **1842.** [Delteil 1906–30, 22: nos. 927, 932—ill.]
———. "Achille Véron Retires to His Tent." Satirical lithograph. 1850. [Ibid., 25: no. 1991—ill.]
———. "Achilles and Agamemnon." Comic lithograph, in "Physionomies Tragiques" series. 1851. [Ibid., 26: no. 2175—ill.]

George Frederick Watts, 1817–1904. "Achilles and Briseis" (Achilles watching Briseis being led away). Fresco (detached), from Bowood House, Wiltshire. **1858.** Watts Gallery, Compton, Surrey. [Blunt 1975, pp. 100f. / Watts 1970, p. 10 / Wood 1983, p. 88]

Paul Cézanne, 1839–1906. Caricature of Ingres's "Jupiter and Thetis" (1811, Aix-en-Provence). Drawing. **1858–60.** Cabinet des Dessins, Louvre, no. R.F. 29949. [Chappuis 1973, no. 50—ill.]

William Rimmer, 1816–1879. "Achilles." Drawing, inscribed with lines from *Iliad* 2.770–79. **1867.** Museum of Fine Arts, Boston. [Whitney 1946, no. 44]

Pierce Francis Connelly, 1841–after 1902. "Thetis and Achilles" ("Thetis Thinking How She May Regain the Birthright of Her Son Achilles"). Marble sculpture. **1874.** Metropolitan Museum, New York, no. 77.2. [Metropolitan 1965, p. 38]

Jules Lemaître, 1853–1914. "Briseis." Story. In *Myrrha, vierge et martyre* (Paris: Lecène, Oudin, **1894**). [Ipso]

Karl Goldmark, 1830–1915. *Die Kriegsgefangene* [The Prisoner of War] (Briseis). Opera. Libretto, "A. Formey" (E. Schlict). First performed 17 Jan **1899,** Hofoper, Vienna. [Grove 1980, 7:501 / Young 1948, pp. 170f.]

Giovanni Pascoli, 1855–1912. "La cetra d'Achille" [The Cithara of Achilles]. Poem. In *Poemi conviviali* (Bologna: **1904;** reprinted Milan: 1964). [EW 1983–85, 7:1847]

Wilhelm Schmidtbonn, 1876–1952. *Der Zorn des Achilles* [The Wrath of Achilles]. Tragedy in verse. Berlin: Fleischel, **1909.** [Oxford 1986, p. 804]

August Bungert, 1845–1915. *Achilleus,* part 1 of *Die Ilias.* Opera, projected, unfinished. [Grove 1980, 3:455]

Paul Manship, 1885–1966. "Briseis." Bronze statuette. **1916–18.** 6 casts. Minnesota Museum of Art, St. Paul; elsewhere. [Murtha 1957, no. 88 / Minnesota 1985, no. 99—ill. / Minnesota 1972, no. 17] Large version. 3 casts. [Murtha, no. 89—ill.] Marble head and torso, 1950. St. Paul. [Ibid., no. 513—ill. / Minnesota 1985, no. 100—ill. / Minnesota 1972, no. 117—ill.]

Charles Williams, 1886–1945. "Briseis." Poem. In *A Miscellany of British Poetry,* edited by W. K. Seymour (London: Palmer & Hayward; New York: Harcourt, Brace & Howe, **1919**). [Ipso]

William Butler Yeats, 1865–1939. (Achilles' wrath evoked in) "The Phases of the Moon." Poem. In *The Wild Swans at Coole* (London & New York: Macmillan, **1919**). [Finneran 1983 / Feder 1971, p. 76]
———. (Achilles' wrath evoked in) "The Resurrection."

Poem. In *The Wild Swans at Coole* (1919). [Finneran / Feder]

André-Joseph Allar, 1845–**1926**. "Dispute between Achilles and Agamemnon." Sculpture. Musées Municipaux, Toulon. [Bénézit 1976, 1:119]

Francis Picabia, 1878–1953. "Briseis." Surrealistic painting. *c*.**1929**. Formerly Léonce Rosenberg coll., Paris. [Camfield 1979, p. 235, fig. 317 / also Borràs 1985, no. 522—ill.]

Paul Nivoix, 1889–1958. *Le bouillant Achille* [Angry Achilles]. Drama. **1949**. [McGraw-Hill 1984, 3:539]

Thom Gunn, 1929–. (Achilles in his tent evoked in) "My Sad Captains." Poem. In *My Sad Captains and Other Poems* (London: Faber & Faber; Chicago: University of Chicago Press, **1961**). [CLC 1981, 18:200]

Paul Wunderlich, 1927–. "Jupiter and Thetis." 2 gouache sketches, after Ingres (1811, Aix-en-Provence). **1973**. [Jensen 1979–80, 1:114f.; 2: nos. 501, 502—ill.] Variants, paintings ("Ideology and His Wife"). 7 versions. [Ibid., 1: nos. 525–31; 2:116ff.—ill.]

Return to Battle. After the death of Patroclus, the grief-stricken Achilles was spurred to revenge. Thetis obtained a new shield and armor for her son from Hephaestus (Vulcan) and Achilles returned to battle, his quarrel with Agamemnon ended. Protected by Athena's flaming aegis, he rushed into the fray and helped to rescue Patroclus's corpse. In a battle on the banks of the river Scamander (Xanthus), Achilles slaughtered so many Trojans that the river-god begged him to stop because the corpses were obstructing its passage to the sea. When Achilles refused, the river overflowed and pursued him back to the plain of Troy.

Classical Sources. Homer, *Iliad* 18–22. Ovid, *Metamorphoses* 13.288–95. Apollodorus, *Biblioteca* E6.7. Hyginus, *Fabulae* 106. Lucian, *Dialogues of the Sea Gods* 10, "Xanthus [Scamander] and Sea."

Anonymous French. (Thetis obtains new arms for Achilles, Achilles' fight at the river Xanthus, in) *Ovide moralisé* 12.3615–3837. Poem, allegorized translation/elaboration of Ovid's *Metamorphoses*. *c*.**1316–28**. [de Boer 1915–86, vol. 4]

Maerten van Heemskerck, 1498–1574. "Vulcan Giving Achilles' Shield to Thetis." Painting, part of a triptych, now dispersed. **1536**. Kunsthistorisches Museum, Vienna, inv. 6785. [Grosshans 1980, no. 23—ill. / Vienna 1973, p. 83—ill. / also de Bosque 1985, pp. 160–63—ill.]

Giulio Romano, *c*.1499–1546, assistants, after designs by Giulio. "Vulcan Making the Armor of Achilles," "Thetis Buckling on Achilles' Shield." Frescoes, part of cycle depicting scenes associated with the Trojan War. **1538–39**. Sala di Troia, Palazzo Ducale, Mantua. [Hartt 1958, pp. 179ff.—ill.]

Paris Bordone, 1500–1571. "Thetis and Hephaestus" (sometimes called "Minerva [or Venus] at the Forge of Vulcan"). Painting. *c*.**1555**. Kress coll. (K1112), Univer-

sity of Missouri, Columbia, no. 61.78. [Shapley 1966–73, 3:36—ill. / also Canova 1964, p. 103—ill. / Berenson 1957, p. 47]

Cristofano Gherardi, 1508–1556, under the direction of **Giorgio Vasari**, 1511–1574. "Daedalus Forging Weapons for Achilles." Fresco. **1555–56**. Sala degli Elementi, Palazzo Vecchio, Florence. [Sinibaldi 1950, pp. 13, 22 / also Lensi 1929, p. 157—ill.]

Luca Cambiaso, 1527–**1585** (previously attributed to Daniele da Volterra). "Thetis in Vulcan's Forge Receiving the Arms of Achilles." Painting. Bensa coll., Genoa. [Manning & Suida 1958, pp. 99f.—ill.]

Vincent Borée, fl. 1627–50. *Achille victorieux*. Tragedy. In *Les princes victorieux tragédies françaises* (Lyons: de Coeursilly, **1627**). [DLF 1951–72, 3:178 / Lancaster 1929–42, pt. 1:247–51]

Peter Paul Rubens, 1577–1640. "Thetis Receiving Armor for Achilles from Hephaestus." Design for tapestry in "History of Achilles" series. *c*.**1630–35**? [Haverkamp Begemann 1975, no. 4] Oil sketch, 1630–32. Museum Boymans-van Beuningen, Rotterdam, no. 1760c. [Held 1980, no. 124—ill. / Jaffé 1989, no. 1038—ill. / also Haverkamp Begemann, pp. 42ff., no. 4a—ill.] Modello, by Rubens and assistant (Erasmus Quellinus? Theodoor van Thulden?). Musée des Beaux-Arts, Pau, inv. 417. [Haverkamp Begemann, pp. 57ff., no. 4c—ill. / Jaffé, no. 1039—ill.] Studio sketch (also attributed to Rubens). Hyams coll., Mugswell, Surrey. [Haverkamp Begemann, no. 4b] Tapestries, 1640s/60s, in Paço Ducal, Vila Viçosa, Portugal; Cathedral, Santiago de Compostela. [Haverkamp Begemann—ill.]

Ferdinand Bol, 1616–1680. "Aeneas Receives a New Set of Armor at the Recommendation of Venus in Vulcan's Smithy" (formerly called "Achilles Receives from Thetis a New Set of Armor in Vulcan's Smithy"). Painting. *c*.**1660**. Vredespaleis, The Hague. [Blankert 1982, no. 18—ill.]

Jacob Jordaens, 1593–**1678**, attributed. (Vulcan with) "The Arms of Achilles." Painting. Recorded in 1734, untraced. [Rooses 1908, pp. 145, 257]

———, attributed. "Thetis Receiving the Arms of Achilles." Painting. Recorded in 1785, untraced. [Ibid.]

———, attributed. "Achilles Mourns the Death of Patroclus and Receives Briseis." Painting. Recorded in 1785, untraced. [Rooses 1908, p. 257]

Luca Giordano, 1634–**1705**. "Thetis Inspects the Arms of Achilles." Painting. Walter Chrysler, Jr. coll., New York. [Ferrari & Scavizzi 1966, 2:367]

Antonio Verrio, *c*.1639–**1707**, attributed. "The Arming of Achilles." Painting. City Art Gallery, Bristol. [Wright 1976, p. 214]

James Thornhill, 1675/76–1734. "Thetis Accepting the Shield of Achilles from Vulcan." Painting. *c*.**1710**. Tate Gallery, London, no. T.814. [Tate 1975, p. 78]

———. "Thetis in the Forge of Vulcan Watching the Making of Achilles' Armor." Drawing, study for presumed (lost) painting. *c*.**1710**. Tate Gallery, no. T.1551. [Ibid., p. 76]

Charles-Antoine Coypel, 1694–1752. "The Fury of Achilles." Painting. **1737**. Hermitage, Leningrad, inv. 5637. [Hermitage 1986, no. 34—ill.] Replica. Musée des Arts, Dijon. [Ibid.]

José Nebra, 1702–1768, music. *Antes que celos y amor la*

piedad llama al valor y Achilles en Troya [Before Jealousy and Love, Piety Calls Achilles at Troy to Valor]. Musical work for the theater. Libretto, González Martínez. First performed **1747**, Principe, Madrid. [Grove 1980, 13:89]

Henry Fuseli, 1741–1825. "Hephaestus" (hammering Achilles' shield). Drawing. **1759.** In Jugendalbum, Kunsthaus, Zurich. [Schiff 1973, no. 278—ill.]

———. "Thetis Asks Hephaestus for Arms for Achilles." Painting, design for engravings illustrating the *Iliad*. *c.*1803. Kunsthaus, Zurich (ex-Hürlimann coll.). Engraved by Edward Smith for illustrations to Alexander Pope's *The Iliad and Odyssey of Homer* (London: F. J. du Roveray, 1806) and William Cowper's *The Iliad [and the Odyssee] of Homer* (London: Johnson, 1810). [Ibid., nos. 1191, 1247—ill.]

———. "Scamander Seeks to End Achilles' Slaying of the Trojans." Drawing. 1800–05. Crane coll., New York. [Ibid., no. 1357—ill.]

———. "Achilles, Athena's Aegis on His Shoulders and a Fiery Cloud around His Head, Stands by the Trench and Raises the War Cry." 2 drawings. 1815. Staatliche Kunstsammlungen, Weimar, inv. KK 1168; City of Auckland Art Gallery, New Zealand, inv. 1965–71. [Ibid., nos. 1511, 1817—ill.]

Esprit-Antoine Gibelin, 1739–1813. "Achilles Fighting the River Scamander." Painting. **1770.** [Pressly 1979, pp. 10f.]

Philipp Otto Runge, 1777–1810. "Achilles and Scamander" ("Achilles Fighting with the Rivers"). Series of drawings illustrating Homer. **1801.** Kunsthalle, Hamburg. [Bindman 1979, nos. 219, 220—ill. / Hamburg 1977, nos. 46–50—ill.]

Benjamin West, 1738–1820. "Thetis Bringing the Armor to Achilles." Painting. Several versions, **1804–05.** Lost or in private colls. [von Erffa & Staley 1986, nos. 170, 173–74—ill.] Studies in Royal Academy, London; New York Historical Society, New York. [Ibid., nos. 171–72—ill.] Variant. 1806? New Britain Museum of American Art, Conn. [Ibid., no. 175—ill.]

The *Propyläen* prize competitions in the years **1799–1805** included "Achilles' Battle with the Rivers." (The negligible response to this subject disappointed Goethe.) [Viëtor 1949, p. 145]

John Flaxman, 1755–1826. "The Shield of Achilles." Design for relief on silver-gilt shield, after the description in *Iliad* 18.478–607. *c.*1810–18. 4 examples executed by Rundell & Co., 1821–23. Royal Collection, England; Anglesey Abbey, Cambridgeshire; Huntington Art Gallery, San Marino, Calif.; another sold London, 1984. [Jackson-Stops 1985, no. 529—ill. / also Irwin 1979, pp. 194ff., figs. 270, 273–75 / Bindman 1979, no. 187—ill.] Several bronze and plaster casts known; 1 bronze in Royal Academy, London; others unlocated. [Jackson-Stops]

Auguste Couder, 1789–1873. "[Allegory of] Water: Achilles Nearly Engulfed by the Xanthus and the Simois, Maddened by the Carnage He Has Dealt the Trojans." Ceiling painting. **1819.** Vestibule, Galerie d'Apollon, Louvre, Paris (inv. 3379). [Louvre 1979–86, 3:163—ill.]

Nicolas Gosse, 1787–1878 and **Auguste Vinchon,** 1789–1855. "Thetis Giving Arms to Achilles." Painting (simulated grisaille bas-relief), part of series of 8 Homeric

scenes. Commissioned **1827.** Louvre, Paris, inv. 8475. [Louvre 1979–86, 3:285—ill.]

The Prix de Rome painting competition subject for **1831** was "Achilles Pursued by the Xanthus." First prize: Henri-Frédéric Schopin. École des Beaux-Arts, Paris. [Grunchec 1984, no. 69—ill. / Harding 1979, p. 94]

Augustin Franquelin, 1798–**1839.** "Achilles Fighting." Painting. Louvre, Paris, no. R.F. 2966. [Louvre 1979–86, 3:261—ill.]

Alfred, Lord Tennyson, 1809–1892. "Achilles Over the Trench." Poem, translation of *Iliad* 18.202–230. **1863–64?** In *Ballads and Other Poems* (London: Kegan Paul; Boston: Osgood, 1880). [Ricks 1969]

Henri Regnault, 1843–1871. "Automedon Bringing Achilles' Horses Back from the Banks of Scamander." Painting. **1868.** Museum of Fine Arts, Boston. [Boime 1971, p. 107, pl. 75 / Tellyard 1948, pl. 5] 2 sketches. Boston; Musée d'Orsay, Paris, no. R.F. 2380. [Boime, pls. 74, 76 / Louvre 1979–86, 4:170—ill.]

André Suarès, 1868–1948. *Achille vengeur* [Achilles the Avenger]. Tragedy. Paris: **1922.** [Frenzel 1962, p. 5]

C. Day Lewis, 1904–1972. (Achilles fights the Scamander in) "Transitional Poem" part 3, section 18. Poem. In *Transitional Poem* (London: Hogarth Press, **1929**). [Ipso]

Mark Van Doren, 1894–1972. "Achilles." Poem. In *New Poems* (New York: Sloane, **1948**). [Boswell 1982, p. 305]

———. (Achilles and Thetis evoked in) "And So It Was." Poem. In *Morning Worship and Other Poems* (New York: Harcourt, Brace, 1960). [Ibid.]

W. H. Auden, 1907–1973. "The Shield of Achilles." Poem. In *The Shield of Achilles and Other Poems* (New York: Random House; London: Faber & Faber, **1955**). [Mendelson 1976 / Johnson 1973, pp. 168–71 / Replogle 1969, p. 163]

Christopher Logue, 1926–. "Achilles Fights the River." Poem. In *Songs* (London: Hutchinson, **1959**). [DLB 1984, 27:220]

Richard Wilbur, 1921–. (Allusion to Achilles and Xanthus in) *Advice to a Prophet*. Poem. New York: Harcourt Brace, **1961.** [Boswell 1982, p. 308]

Bryan Kelly, 1934–. *The Shield of Achilles.* Vocal composition. **1967.** [Grove 1980, 9:854]

Robert Lowell, 1917–1977. "Achilles to the Dying Lykaon." Poem. In *History* (London: Faber & Faber; New York: Farrar, Straus & Giroux, **1973**). [Ipso]

Henry Moore, 1898–1986. "Multitude II," "Thin Lipped Armourer II." Lithographs, illustrating W. H. Auden's "The Shield of Achilles" (1955) **1973.** Published in *Auden Poems, Moore Lithographs* (London: Petersburg, 1974). [Cramer et al. 1973–76, nos. 253–54—ill.] Alternate versions ("Multitude I," "Thin Lipped Armourer I") in hand-printed portfolio edition. [Ibid., nos. 267–68—ill.]

Jay Macpherson, 1931–. "Scamander." Poem. In *Welcoming Disaster* (Toronto: Saannes, **1974**). [Ipso]

C. H. Sisson, 1914–. "In the Trojan Ditch." Poem. In *In the Trojan Ditch: Collected Poems and Translations* (Cheadle: Carcanet New Press, **1974**). [DLB 1984, 27:329]

Giuseppe Spagnulo, 1936–. "The Arms of Achilles" (shield and spear). Mixed-media sculpture. **1980.** M. Wandel coll., Stuttgart. [Munich 1984, p. 177—ill.]

Louise Glück, 1943–. "The Triumph of Achilles." Poem.

In *The Triumph of Achilles* (New York: Ecco, **1985**). [Ipso]

Death of Achilles. The Trojan prince Paris lay in ambush for Achilles as the hero fought before the Scaean gate, the main northwest entry into the city of Troy. The dying Hector had prophesied that Achilles would be slain by a god and a hero, and now Paris, with Apollo's aid, shot an arrow into the hero's vulnerable heel, killing him. Achilles' corpse was retrieved by Ajax after a fierce battle. He was given an elaborate funeral, mourned by the Grecian host and by his mother, Thetis.

In some medieval versions of the story, Achilles was ambushed while sacrificing to Apollo or while meeting with his beloved, Polyxena.

Classical Sources. Homer, *Odyssey* 24.15–97. Arctinus of Miletus, *Aethiopis*. Ovid, *Metamorphoses* 12.580–611. Apollodorus, *Biblioteca* E5.3–5. Hyginus, *Fabulae* 107, 110. Lucian, *Dialogues of the Dead* 26, "Achilles and Antilochus."

See also POLYXENA.

Anonymous French. (Death of Achilles in) *Ovide moralisé* 12.3226–3346, 4516–4579, 4611–4702. Poem, allegorized translation/elaboration of Ovid's *Metamorphoses*. *c.***1316–28.** [de Boer 1915–86, vol. 4]

Christine de Pizan, *c.*1364–*c.*1431. (Death of Achilles in) *L'epistre d'Othéa à Hector* . . . [The Epistle of Othéa to Hector] chapters 40, 93. Didactic romance in prose. *c.***1400.** MSS in British Library, London; Bibliothèque Nationale, Paris; elsewhere. / Translated by Stephen Scrope (London: *c.*1444–50). [Bühler 1970 / Hindman 1986, pp. 24, 122, 198; pl. 35]

French School. "Death of Achilles at the Hand of Paris." Tapestry, part of series depicting the fall of Troy. **15th century.** Cathedral, Zamora. [Scherer 1963, pp. 241ff.]

Andrea Schiavone, 1522–1563. "The Death of Achilles." Painting. *c.***1555?** Wellesley College Museum, Mass. [Richardson 1980, no. 330—ill.]

Thomas Powell, 1572?–1635? (Achilles' death in) *Loves Leprosie.* Poem, after Caxton or Lydgate? London: **1598.** Reprinted in *Ancient Poetical Tracts,* edited by E. F. Rimbault (London: Percy Society, 1842). [Bush 1963, p. 325]

Thomas Heywood, 1573/74–1641. (Death of Achilles in) *Troia Britanica: or, Great Britaines Troy* canto 14. Epic poem. London: **1609.** [Heywood 1974]

———. (Episode, as above, in) *The Iron Age* Part 1. Drama, partially derived from *Troia Britanica*. First performed *c.*1612–13, London. Published London: Okes, 1632. [Heywood 1874, vol. 3 / DLB 1987, 62:101, 122ff. / also Boas 1950, pp. 83ff. / Clark 1931, pp. 62ff.]

Alexandre Hardy, *c.*1570–1632. *La mort d'Achille.* Tragedy. Before **1610.** In *Théâtre* (Paris: Quesnel, 1624–28). [Stone 1974, p. 133 / Deierkauf-Holsboer 1972, pp. 155, 210]

Isaac de Bensérade, 1613–1691. *La mort d'Achille et la dispute de ses armes* [The Death of Achilles and the Contention over His Arms]. Tragedy. First performed **1635,** Paris. Published Paris: Sommaville, 1636. [Stone 1974, pp. 196f. / Lancaster 1929–42, pt. 2, 2:777]

Peter Paul Rubens, 1577–1640. "The Death of Achilles." Design for tapestry in "History of Achilles" series. *c.***1630–35?** [Haverkamp Begemann 1975, no. 8] Oil sketches, 1630–32. Museum Boymans-van Beuningen, Rotterdam, no. 1760e. [Held 1980, no. 128—ill. / Jaffé 1989, no. 1042—ill. / also Haverkamp Begemann, pp. 42ff., no. 8a—ill.] Modello, by Rubens and assistant (Erasmus Quellinus? Theodoor van Thulden?). Courtauld Institute, London (ex-Seilern coll.). [Haverkamp Begemann, pp. 57ff., no. 8b—ill. / Jaffé, no. 1043—ill.] Tapestries, 1640s/60s, in Musées Royaux d'Art et d'Histoire, Brussels; Staatliche Kunstsammlungen, Kassel; Paço Ducal, Vila Viçosa, Portugal; Cathedral, Santiago de Compostela; private coll., Jerez de la Frontera. [Haverkamp Begemann—ill.]

Thomas Corneille, 1625–1709. *La mort d'Achille.* Tragedy. First performed Dec **1673,** Théâtre Guénégaud, Paris. Published Paris: Barbin, 1674. [Girdlestone 1972, pp. 137, 239, 269 / Collins 1966, pp. 157–61, 190]

Bertholet Flémal the Elder, 1614–1675. "Achilles Wounded by Paris." Painting. Nationalmuseum, Stockholm, inv. 428. [Pigler 1974, p. 283]

Christophe Veyrier, 1637–1689. "Dying Achilles." Marble sculpture. **1682.** Victoria and Albert Museum, London. [John Pope-Hennessy, *Burlington Magazine* 89 (Jan 1947)— ill.]

Jean-Baptiste Lully, 1632–1687 (overture and Act 1) and **Pascal Collasse,** 1649–1709 (Acts 2–5). *Achille et Polyxène.* Opera (tragédie en musique). Libretto, Jean-Galbert de Campistron, after de Bensérade's *La mort d'Achille* (1635). First performed 7 Nov **1687,** Académie Royale de Musique, Paris. [Grove 1980, 11:327, 4:535 / Girdlestone 1972, pp. 137f., 269]

Reinhard Keiser, 1674–1739. *Das zerstörte Troja, oder Der durch den Tod Helenen versöhnte Achilles* [The Destruction of Troy, or Achilles Reconciled to Helen through Death]. Opera. Libretto, J. J. Hoe. First performed Nov **1716,** Hamburg. [Zelm 1975, p. 65 / Grove 1980, 9:848]

William Hatchett, fl. 1730–41. *The Rival Father: or, The Death of Achilles.* Tragedy. Based on Corneille's *Mort d'Achille* and Racine's *Andromaque.* First performed 8 Apr **1730,** Little or French Theatre, Haymarket, London. [Stratman 1966, p. 233 / Nicoll 1959–66, 2:95, 334]

Antonio Balestra, 1666–1740. "Death of Achilles." Fresco. **1738.** Villa Pompei-Carlotti, Illasi. [Pigler 1974, p. 283]

Henry Fuseli, 1741–1825. "Thetis Mourning the Body of Achilles." Drawing. **1780.** Art Institute of Chicago, inv. 2221/54. [Schiff 1973, no. 799a—ill.]

———. "By Achilles' Corpse, Nestor Stops the Frightened Achaeans as Thetis and her Nymphs Rise From the Sea." Drawing, illustrating *Odyssey* 24.47f. 1813. City Museum and Art Gallery, Birmingham, England, inv. P.31–60. [Ibid., no. 1520—ill.]

Gavin Hamilton, 1723–1798. "Death of Achilles." Painting. Museo di Roma, Rome. [Pigler 1974, p. 283]

Johann Wolfgang von Goethe, 1749–1832. *Achilleis.* Epic, fragment of 651 lines. **1797–99.** Published 1808. Collected in *Werke* (Stuttgart: Cotta, 1827–42). [Beutler 1948–71, vol. 3 / Butler 1958, pp. 130–34 / Reed 1980, pp. 189, 223 / Reed 1984, p. 83]

Friedrich von Schiller, 1759–1805. "Kassandra" (prophe-

sying Achilles' and Polyxena's deaths). Ballad. **1802.**
[Oellers 1983 / Butler 1958, p. 195]

The Prix de Rome sculpture competition subject for **1850** was "Achilles Wounded in the Heel." First prize, Charles-Alphonse-Achille Guméry (1827–1871). [Wagner 1986, pp. 63f.—ill. (print)]

Jean-Baptiste Carpeaux, 1827–1875. "Achilles Wounded in the Heel." Painted plaster sculpture, for Prix de Rome competition. **1850.** Musée des Beaux-Arts, Valenciennes. [Wagner 1986, pp. 63f., fig. 47]

Innocenzo Fraccaroli, 1805–1882. "Wounded Achilles." Marble sculpture. **1851** or earlier. Victoria and Albert Museum, London; Galleria d'Arte Moderna, Milan. [Clapp 1970, 1:312 / Bénézit 1976, 4:470]

Luigi Cicconi, 1804–1856. *La morte d'Achille.* Tragedy. [DELI 1966–70, 2:46]

Johann Ludwig Uhland, 1787–1862. *Tod des Achill* [Death of Achilles]. Tragedy. In *Werke,* edited by Hans Rüdiger-Schwab (Frankfurt: Insel, 1983). [Strich 1970, 2:288]

Alfred Christlieb Kalischer, 1842–1909. *Der Untergang des Achilleus* [The Downfall of Achilles]. Tragedy. Berlin: Stern & Ollendorff, **1893.** [DLL 1968–90, 8:855]

George Santayana, 1863–1952. (Achilles' destined death evoked in) "Before a Statue of Achilles." Poem. In *Harvard Monthly* 25 no. 1 (**1897**); collected in *A Hermit of Carmel and Other Poems* (New York: Scribner, 1901). [Boswell 1982, p. 218 / Bush 1937, p. 583]

Henri-Charles Maniglier, 1826–1901. "Wounded Achilles." Bronze sculpture. Musée, Castres. [Bénézit 1976, 7:142]

Constantine Cavafy, 1868–1933. (Thetis blames death of Achilles on Apollo in) "Apisria" [Unfaithfulness]. Poem. **1903.** First published 1904; reprinted in *Poiemata* (Athens: Kedros, 1963). / Translated by Edmund Keeley and Philip Sherrard in *Collected Poems* (Princeton: Princeton University Press, 1975). [Ipso / Bowra 1948, p. 41]

Valéry Bryúsov, 1873–1924. "Akhilles u altaria" [Achilles at the Altar]. Poem, part of cycle "Pravda vechnaia kumirov" [Eternal Truth of Idols]. **1904.** In *Stephanos (Venok)* [Wreath] (Moscow: Skorpion, 1906). [Bryúsov 1982 / Poggioli 1960, p. 103f. / Grossman 1985, pp. 275, 291, 350–53]

Rupert Brooke, 1887–1915. "They Say Achilles in the Darkness Stirred." Poem, fragment. In *Collected Poems* (London: Lane, 1918). [Jenkyns 1980, p. 339 / Keynes 1954, p. 120]

Willy Seidel, 1887–1934. "Der Tod des Achilleus." Story. In *Der Tod des Achilleus und andere erzählungen* (Stuttgart: Deutsche Verlags-anstalt, 1936). [Hunger 1959, p. 4]

John Peale Bishop, 1892–1944. "Whom the Gods Love." Poem. In *Collected Poems* (New York: Scribner, 1948). [Boswell 1982, p. 43]

André Roussin, 1911–. *Le tombeau d'Achille* [The Tomb of Achilles]. Comedy. Paris: Librairie Théatrale, Éditions Billaudot, **1956.** [DLLF 1984, 3:2038]

Richard Selig, 1929–1957. (Thetis mourning Achilles in) "On the Verge of Summer." Poem. In *Poems* (Dublin: Dolmen, 1962). [Ipso]

Arman, 1928–1974. "Achilles' Skeleton." *Accumulation* (shoe trees in wooden box, representing Achilles' heel). **1960.** Schwartz Galleria d'Arte, Milan. [Martin 1973, p. 34—ill.]

Randall Jarrell, 1914–1965. "When Achilles Fought and Fell." Poem. In *Complete Poems* (New York: Farrar, Straus & Giroux, 1969). [Wright 1986, p. 118]

Robert Duncan, 1919–1988. "Achilles' Song." Poem. First published in folio, New York: Phoenix Book Shop, **1969**; collected in *Ground Work: Before the War* (New York: New Directions, 1984). [Ipso]

Oskar Kokoschka, 1886–1980. "The Fall of Achilles" (from his chariot). Lithograph. **1969.** [Wingler & Welz 1975–81, no. 453—ill.]

Gerhard Marcks, 1889–1981. "Wounded Achilles, Kneeling." Bronze sculpture. **1969.** Unique (?) cast in private coll., Hamburg. [Busch & Rudloff 1977, no. 936—ill.]

Robert Lowell, 1917–1977. (Deaths of Achilles and Polyxena prophesied in) "Cassandra." Poem. In *History* (London: Faber & Faber; New York: Farrar, Straus & Giroux, **1973**). [Ipso]

Afterlife. According to Homer, Achilles was sent after his death to the Underworld, where his shade met Odysseus (Ulysses), who told him of the prowess of his son Neoptolemus (Pyrrhus). In a later, more common version of the myth, Achilles was taken by his mother, Thetis, to the Black Sea island of Leuce—called the Island of the Blest or White Island—where she restored him to life and immortality. Achilles was then united with Helen of Troy.

Goethe's *Faust* popularized the identification of Faust, who also desired to possess the most beautiful of women, with Achilles in afterlife. This theme has enjoyed great prominence in poetry, music, and dance.

Classical Sources. Homer, *Odyssey* 11. Pindar, *Nemean Odes* 4.49; *Olympian Odes* 2.68ff. Pausanias, *Description of Greece* 3.19.11–13. Philostratus, *Heroicus* 20.32–40.

See also ODYSSEUS, in Hades.

Christopher Marlowe, 1564–1593. (Helen's union with Achilles evoked in) *The Tragicall History of Doctor Faustus* 5.1. Tragedy. Licensed **1592.** First recorded performance 2 Oct 1594, by the Lord Admiral's Men, Rose Theatre. London. Published London: Bushell, 1604. [Bowers 1973, vol. 2 / Levin 1952, pp. 108–35 / Leech 1986, pp. 16–20, 83–121]

Reinhard Keiser, 1674–1739. *Das zerstörte Troja, oder Der durch den Tod Helenen versöhnte Achilles* [The Destruction of Troy, or Achilles Reconciled to Helen through Death]. Opera. Libretto, J. J. Hoe. First performed Nov **1716,** Hamburg. [Zelm 1975, p. 65 / Grove 1980, 9:848]

Johann Wolfgang von Goethe, 1749–1832. (Faust as Achilles-figure, with Helen, in) *Faust* Part 2, Act 3. Tragedy. This episode written **1825–27,** first published as "Helena: Klassisch-romantische Phantasmogorie" (1827). Incorporated into *Faust,* published posthumously, Heidelberg: 1832. [Beutler 1948–71, vol. 5 / Suhrkamp 1983–88, vol. 2 / Poggioli 1975, pp. 228–40 / Hamburger 1969, p. 94 / Fairley 1961, p. 192 / Highet 1967, pp. 387–89 / Viëtor 1949, p. 306]

Heinrich Heine, 1797–1856. (Faust as Achilles-figure in) *Der Doktor Faust.* Ballet scenario. **1847.** Hamburg: Hoffman & Campe, 1851. [Windfuhr 1975–82, vol. 9 / Butler 1958, pp. 287f.]

Edward Bulwer Lytton, 1803–1873. (Achilles and Helen on the White Island in) "Bridals in the Spirit Land." Story. In *The Lost Tales of Miletus* (London: Chapman & Hall, **1866**). [Boswell 1982, p. 171]

John Addington Symonds, 1840–1893. "Leuké." Poem. In *New and Old: A Volume of Verse* (London: Smith, Elder, **1880**). [Boswell 1982, p. 227]

Edmund Gosse, 1849–1928. "The Island of the Blest." Poem. In *Firdausi in Exile and Other Poems* (London: Kegan Paul, Trench, **1885**). [Bush 1937, p. 561]

Robert Bridges, 1844–1930. "The Isle of Achilles." Poem. In *Poetical Works,* vol. 2 (London: Smith, Elder, **1899**). [Bush 1937, p. 441 *n.*]

Arthur Symons, 1865–1945. (Faust as Achilles-figure in) "Helen and Faustus." Poem. In *Poems* (New York: Lane, **1911**). [Beckson 1987, p. 298 / Boswell 1982, p. 229]

Lili Boulanger, 1893–1918. (Faust as Achilles-figure in) *Faust et Hélène.* Cantata. Prix de Rome, **1913.** [Grove 1980, 3:99]

Archibald MacLeish, 1892–1982. (Faust as Achilles-figure in) "Our Lady of Troy." Dramatic scene in blank verse. In *Tower of Ivory* (New Haven: Yale University Press, **1917**). [Falk 1965, p. 26]

William Gerard. "Achilles and Helen in Elysium." Poem. In *Dramatic Vistas* (London: Mathews, **1919**). [Boswell 1982, p. 113]

Rudolf Pannwitz, 1881–1969. (Afterlife of Achilles and Helen evoked in) *Faustus und Helena.* Poem. Munich-Feldafing: Carl, **1920.** [Kunisch 1965, p. 453]

Isolde Kurz, 1853–1944. *Leuke: Ein Geisterspiel* [Leuke: A Ghost Play]. Drama. Munich: Müller, **1926.** [DLB 1988, 66:280]

Herbert Read, 1893–1968. "The White Isle of Leuce." Poem. In *Lyrical Poems,* **1919–1934**; reprinted in *Collected Poems* (London: Faber & Faber, 1966). [Boswell 1982, p. 208]

Robinson Jeffers, 1887–1962. "The Resurrection of Achilles." Poem. In *Four Poems and a Fragment* (Carmel, Calif.: for Alberts, **1936**). [Ipso]

Gottfried Benn, 1886–1956. (Achilles and Helen on Leuce evoked in) "V. Jahrhundert" part 3. **1945.** In *Statische Gedichte* (Zürich: Arche, 1948). [Wellershof 1960 / Wodtke 1963, pp. 92–95 / Wood 1961, pp. 305–07]

Marcel Luipart, 1912–, choreography. (Faust as Achilles-figure in) *Abraxas.* Ballet. Music and scenario, Werner Egk, based on Heine's *Der Doktor Faust.* First performed 6 June **1948,** Bayerische Staatsoper, Munich; décor, Wolfgang Znamenacek. [Sharp 1972, pp. 1, 247 / Oxford 1982, p. 264 / DMB 1959, p. 1 / Grove 1980, 6:68]

Janine Charrat, 1924–, choreography. (Faust as Achilles-figure in) *Abraxas.* Ballet. Music and scenario, Egk. First performed 21 Oct **1949,** Stadtische Oper, Berlin; décor, Joseph Fenneker. [Oxford 1982, p. 91 / DMB 1959, p. 1]

André Jolivet, 1905–1974. *Hélène et Faust.* Incidental music for a production of Alexandre Arnoux's adaptation of Goethe. First performed **1949.** [Grove 1980, 9:689]

Helge Pawlinin, choreography. (Faust as Achilles-figure in) *Abraxas.* Ballet. Music and scenario, Egk. First performed **1951,** Deutsche Ballett Theater, Hamburg. [Sharp 1972, pp. 1, 247 / Oxford 1982, p. 1]

H. D. (Hilda Doolittle), 1886–1961. (Achilles with Helen in) "Pallinode," "Leuké." Parts 1 and 2 of *Helen in Egypt.* Epic. **1952–56.** New York: New Directions, 1961. [Ipso / Ostriker 1986, pp. 5, 7, 222–28, 231f., 237 / DLB 1986, 45:140f. / Friedman 1981, pp. 61, 268, 289ff., 294 / Peck 1975, pp. 64–66, 68]

Robert Duncan, 1919–1988. "Achilles' Song." Poem. First published in folio, New York: Phoenix Book Shop, **1969**; collected in *Ground Work: Before the War* (New York: New Directions, 1984). [Ipso]

Maurice Béjart, 1924/27–, choreography and scenario. (Faust as Achilles-figure in) *Notre Faust,* part 2. Balletic play. Music, J. S. Bach and Argentine tangos. First performed 12 Dec **1975,** Théâtre de la Monnaie, Brussels; sets and costumes, Thierry Bousquet. [Simon & Schuster 1979, pp. 302f.]

ACIS. *See* GALATEA.

ACONTIUS AND CYDIPPE. A young man from the island of Keos, Acontius fell in love with the maiden Cydippe, who was of higher social standing than he. In order to win her, he inscribed the words "I swear before Artemis to marry only Acontius" on an apple (or orange) and threw it in front of her. Cydippe picked up the fruit and read the inscription aloud, which bound her to the vow. Thereafter, whenever her parents found a suitable prospective husband, Cydippe fell so ill that the marriage had to be called off. Eventually, her parents consulted an oracle, which revealed the truth, and Cydippe was allowed to marry Acontius.

Classical Sources. Callimachus, *Aitia* 3.1.26ff. Ovid, *Heroides* 20–21; *Ars amatoria* 1.457ff.

John Skelton, 1460?–1529. (Acontius and Cydippe in) "The Garlande or Chapelet of Laurell" lines 885–91. Poem. *c.*1495. London: Fakes, 1523. [Scattergood 1983 / Brownlow 1990]

Edmund Spenser, 1552?–1599. (Allusion to Acontius and Cydippe in) *The Faerie Queene* 2.7.55. Romance epic. London: Ponsonbie, **1590,** 1596. [Hamilton 1977 / Hieatt 1975, pp. 204, 235f.]

Monsieur le Chevalier de Baussays. *La Cydippe.* Pastoral poem. Paris: Martin, **1633.** [Taylor 1893, p. 103 / DLF 1951–72, 3:141]

Antonio Draghi, 1634/35–1700. *Cidippe.* Opera. Libretto, N. Minato. First performed 18 Nov **1671,** Vienna. [Grove 1980, 5:604]

John Dryden, 1631–1700. (Cydippe and Acontius in)

Ovid's Art of Love 1.518–27. Translation. London: Tonson, 1709. [Dryden 1956–87, vol. 4]

Melchior Hoffmann, *c.*1685–1715. *Acontius und Cydippe.* Opera. First performed **1709,** Leipzig. [Grove 1980, 8:627]

François-Joseph Giraud, ?–*c.*1790. *Acanthe et Cydippe.* Opera (pastorale héroique). Libretto, Maximilian-Jean Boutillier, parody of Rameau's *Acanthe et Céphise.* First performed **1764,** Théâtre de Nicolet, Paris. [Grove 1980, 7:406]

Carl Christian Agthe, 1762–1797. *Acontius und Cydippe.* Opera (singspiel). Libretto based on Ovid. First performed possibly **1780,** Reval, Estonia (or *c.*1784, Ballenstedt?). Music lost. [Grove 1980, 1:167 / Clément & Larousse 1969, 1:6]

[?] Froment. *Cydippe.* Comic opera. Libretto, Boutillier. First performed 20 July **1785,** Théâtre des Beaujolais, Paris. [Clément & Larousse 1969, 1:283]

Erik Johan Stagnelius, 1793–**1823.** *Cydippe.* Opera libretto, fragment. Published Stockholm: Bonnier, 1825. [Gustafson 1961, p. 191]

Charles Kent, 1823–1902. "The Golden Apple." Poem. **1850.** In *Poems* (London: Tucker, 1870). [Bush 1937, p. 553]

Edward Bulwer Lytton, 1803–1873. "Cydippe, or the Apple." Poem. In *The Lost Tales of Miletus* (London: Murray, **1866**). [Bush 1937, p. 556 / Boswell 1982, p. 11]

William Morris, 1834–1896. "The Story of Acontius and Cydippe." Poem. **1868.** In *The Earthly Paradise,* vol. 4 (London: Ellis, 1870). [Morris 1910–15, vol. 5 / Calhoun 1975, pp. 178, 183 / Bush 1963, p. 314 *n.*]

ACRISIUS. *See* DANAË; PERSEUS, General List.

ACTAEON. The son of Aristaeus and Autonoe and the grandson of Cadmus, Actaeon had the misfortune of discovering Artemis (Diana) as she bathed with her nymphs in the nude. The chaste goddess, embarrassed and startled, splashed Actaeon with water and transformed him into a stag. As he stumbled through the woods, his hunting dogs attacked him and tore him to pieces. In the *Metamorphoses,* Ovid states that the gods disagreed about the punishment Artemis handed the unfortunate hunter: some thought she was merciless; others felt that she was justified in defending her chastity.

Classical Sources. Diodorus Siculus, *Bibliotheca* 4.81.3–5. Ovid, *Metamorphoses* 3.138–252. Apollodorus, *Bibliotheca* 3.4.4. Pausanias, *Description of Greece* 9.2.3–4. Hyginus, *Fabulae* 180, 181. Lucian, *Dialogues of the Gods* 18, "Hero and Leto."

Anonymous French. (Story of Actaeon and Diana in) *Ovide moralisé* 3.336–675. Poem, allegorized translation/elaboration of Ovid's *Metamorphoses.* *c.*1316–28. [de Boer 1915–86, vol. 1 / also de Bosque 1985, pp. 35f.—ill.]

Giovanni Boccaccio, 1313–1375. (Transformation of Actaeon evoked, reversed, in) *La caccia di Diana* [Hunt of Diana] 18.11ff. Poem. **1334–38?** [Branca 1964–83, vol. 1 / Havely 1980, p. 193]

————. (Diana in) *Il ninfale fiesolano* [The Nymph of Fiesole]. Pastoral romance. *c.*1344–46? [Branca, vol. 3 / Hollander 1977, pp. 66ff.]

Francesco Petrarca, 1304–1374. (Actaeon evoked in) "Non al suo amante più Diana piacque" [Diana Never Pleased Her Lover More], madrigal, no. 52, and in canzone, no. 23 of *Canzoniere (Rime sparse).* Collection of sonnets, madrigals, and *canzone.* Begun *c.*1336, completed by 1373; nos. 23 and 52 composed by 1348. [Contini 1974 / Armi 1946 / Cottino-Jones 1975, pp. 161, 164f. / Sturm-Maddox 1985, pp. 23f. / . / Barkan 1980, pp. 335–39]

John Gower, 1330?–1408. (Tale of Actaeon in) *Confessio amantis* 1.333–88. Poem. *c.*1390. Westminster: Caxton, 1483. [Macaulay 1899–1902, vol. 2 / Beidler 1982, pp. 7ff.]

Christine de Pizan, *c.*1364–*c.*1431. (Diana and Actaeon in) *L'epistre d'Othéa à Hector* . . . [The Epistle of Othéa to Hector] chapter 69. Didactic romance in prose. *c.*1400. MSS in British Library, London; Bibliothèque Nationale, Paris; elsewhere. / Translated by Stephen Scrope (London: *c.*1444–50). [Bühler 1970 / Hindman 1986, pp. 93, 200]

Paolo Schiavo, 1397–? "Story of Diana and Actaeon." Painting (bridal plate). *c.*1440. Williams College Museum of Art, Williamstown, Mass., inv. 62.3. [Seen by author, 1988]

Filarete, *c.*1400–1469? "Actaeon." Relief, on bronze door of St. Peter's, Rome. **1433–45.** In place. [Pope-Hennessy 1985b, 2:318]

Italian School (Florentine? studio of Mariotto di Nardo?). (Actaeon in) "Results of Diana's Wrath." Painting, fragment of a bridal cassone. **1400/50.** Muzeum Narodowe, Warsaw, inv. 158656. [Warsaw 1969, no. 1617—ill.]

Italian School. "The Story of Actaeon." Painting. **1425/50.** Metropolitan Museum, New York, no. 41.190.129. [Metropolitan 1980, p. 92—ill.]

Domenico Veneziano, *c.*1400?–**1461/62,** studio. "Diana and Actaeon." Painting. Peter Fuld coll., London. [Berenson 1963, p. 61]

Jacopo del Sellajo, *c.*1441–1493, attributed (formerly attributed to Piero di Cosimo, *c.*1462–1521). "Death of Actaeon," "Story of Actaeon." Paintings (fragments). Yale University Art Gallery, New Haven, Conn., nos. 1871.44, 1952.37.1. [Berenson 1963, p. 198 / also Bacci 1966, p. 123]

Venetian School. "Diana and Actaeon." Painting. **15th century.** Kunsthistorisches Museum, Vienna. [Berenson 1957, p. 206]

Floriano Ferramola, *c.*1480–1528. "Diana and Actaeon." Fresco (detached), for Casa Borgondio della Corte, Brescia. *c.*1511. Formerly Sir Humphrey Noble coll., sold Christie's, London, 1960, to J. Weitzner. [Kauffmann 1973, pp. 102f.]

Baldassare Peruzzi, 1481–1536 (formerly attributed to Giulio Romano). "Diana and Actaeon." Fresco, part of a frieze. **1511–12.** Sala del Fregio, Villa Farnesina, Rome. [d'Ancona 1955, pp. 91f. / Gerlini 1949, pp. 21ff.—ill. / Frommel 1967–68, no. 18a / also Berenson 1968, p. 334—ill.]

————. "Diana and Actaeon." Fresco. *c.*1535. Villa Belcaro, near Siena. [Frommel 1967–68, no. 107b, pl. 84]

Italian School. "Diana and Actaeon." Ceiling fresco. **1508–13?** Sala delle Nozze di Alessandro con Rossana, Villa Farnesina, Rome. [Gerlini 1949, pp. 34ff.]

Parmigianino, 1503–1540. "Diana and Actaeon." Frescoes. **1534–36** or earlier? Gozague coll., Castello Sanvitale, Fontanellato, Parma. [Berenson 1968, p. 319—ill. / Barkan 1980, p. 350, fig. 7]

Lucas Cranach, 1472–1553, studio (probably Lucas Cranach the Younger, 1515–1586). "Diana and Actaeon." Painting. *c.***1540.** Wadsworth Atheneum, Hartford, no. 1946.629. [Friedlaender & Rosenberg 1978, no. 410—ill.] At least 3 other versions. P. de Boer Gallery, Amsterdam, cat. 1968 no. 88; Count Segré-Sartorio coll., Trieste; Hessisches Landesmuseum, Darmstadt, cat. 1914 no. 74. [Ibid., nos. 409c–e]

Hans Holbein the Younger, 1497–1543. "Diana and Actaeon." Drawing. Duke of Devonshire coll., Chatsworth. [Pigler 1974, p. 69]

Maurice Scève, *c.*1510–*c.*1564. (Actaeon, subject of several dixains in) *Délie.* Poem. Lyons: Sabon, **1544.** Modern edition by I. D. McFarlane (Cambridge: Cambridge University Press, 1966). [Barkan 1980, p. 341]

Pernette Du Guillet, *c.*1520–**1545.** (Diana and Actaeon evoked in) *Rymes* second elegy. Modern edition, Geneva: Droz, 1968. [Dellaneva 1988, pp. 48, 50f.]

Luca Penni, *c.*1500/04–1556. "The Metamorphosis of Actaeon." Drawing, composition for print. **1537–45?** / Etching by Jean Mignard (Bartsch 16, anon. no. 73). [Paris 1972, no. 418 / Hofmann 1987, no. 5.10—ill. / also Lévêque 1984, p. 203—ill. / Barkan 1980, p. 350, fig. 8]

Giulio Romano, *c.*1499–**1546,** school. "Diana and Actaeon." Painting. Formerly Earl of Ellesmere coll.; sold Sotheby's, 1972. [Warburg] *See also Peruzzi, above.*

School of Fontainebleau. "Diana and Actaeon." Painting, sketch for unknown work. *c.***1540–50.** Louvre, Paris, no. R.F. 1952–28. [Louvre 1979–86, 4:293—ill. / Paris 1972, no. 233—ill. / also Lévêque 1984, p. 39—ill.]

————. "Diana and Actaeon." Fresco. 1578. Chambre de Diane, Château d'Ancy-le-Franc. [Paris, p. 483]

Lambert Sustris, 1515/20–after 1568. "Diana and Actaeon." Painting. *c.***1550.** Christ Church, Oxford. [Byam Shaw 1967, no. 91—ill. / Berenson 1957, p. 168 / Wright 1976, p. 196]

————. "Diana and Actaeon." Painting. Hampton Court Palace, no. 73. [Berenson—ill.]

————. "Diana and Actaeon." Painting. Castello Sforzesco, Milan, no. 74. [Ibid.]

Matteo Balducci, ?–**1555?** "Diana and Actaeon." Painting. Earl of Crawford and Balcarres coll., Fife. [Berenson 1968, p. 24]

Giacomo Francia, *c.*1486–**1557,** attributed. "Diana and Actaeon." Drawing. Musée Wicar, Lille. [Pigler 1974, p. 68]

Bernard Salomon, 1506/10–*c.*1561. "Actaeon Transformed into a Stag by Diana." Woodcut, part of cycle illustrating Ovid. In *Les Metamorphoses d'Ovide figurée* (Lyons: Tivornes, **1557**). [Barkan 1986, p. 187, fig. 18]

Titian, 1488/90–1576. "Diana and Actaeon." Painting. **1556–59.** National Gallery of Scotland, Edinburgh. [Wethey 1975, no. 9—ill. / Barkan 1980, pp. 345–48] / also Mauritshuis 1985, p. 39—ill. / Berenson 1957, p. 184—ill.]

Copies in Prado, Madrid, no. 423; Museum Boymans-van Beuningen, Rotterdam; Ham House, Richmond, Petersham; Musée, La Rochelle (French, 17th century, on deposit from Louvre, Paris, inv. 8616); others known, unlocated. [Wethey / also Louvre 1979–86, 2:300] *See also Andrea Schiavone, below.*

————. "The Death of Actaeon." Painting. *c.*1570–75. National Gallery, London. [Wethey, no. 8—ill. / London 1986, p. 621—ill. / Barkan, pp. 348f., fig. 6 / also Berenson 1957, p. 186—ill.]

————, formerly attributed. "Death of Actaeon." Painting. *c.*1600. Raleigh Museum of Art, N.C. [Wethey, no. X–14—ill.]

Andrea Schiavone, 1522–1563. "Diana and Actaeon." Painting, variant after Titian (Edinburgh). *c.*1559. 4 versions. Hampton Court Palace (attributed to school of Veronese); Kunsthistorisches Museum, Vienna, no. 168; 2 others unlocated. [Richardson 1980, nos. 262, 327–28, 333—ill. / also Vienna 1973, p. 157]

Paolo Veronese, 1528–1588. "Actaeon and Diana" ("Actaeon Watching Diana and Her Nymphs"). Painting. *c.*1561–63. Museum of Fine Arts, Boston, inv. 59.260. [Pallucchini 1984, no. 78—ill. / Pignatti 1976, no. 148—ill. / Boston 1985, p. 292—ill.]

————, questionably attributed. "The Metamorphosis of Actaeon." Painting. *c.*1560? Philadelphia Museum of Art, inv. 225. [Pignatti, no. A251—ill. / also Berenson 1957, p. 135—ill. / Barkan 1980, fig. 9]

William Adlington. (Actaeon "hounded" by his own emotions, evoked in) Dedicatory poem to the author's translation of *The Golden Asse of Apuleius* (London: Wykes, **1566**). [Bush 1963, p. 72 n.]

Anonymous English. "History of Diana and Actaeon, (sung) to the Quarter Braules." Ballad lyric. In *A Handefull of Pleasant Delights* (London: **1566**). / Enlarged, published London: Ihones, 1584. Modern edition by H. E. Rollins (Cambridge, Mass: Harvard University Press, 1924). [Bush 1963, pp. 58, 314]

Frans Floris, 1516/20–**1570.** "Diana and Actaeon." Painting. Christ Church College Picture Gallery, Oxford. [Byam Shaw 1967, no. 238—ill.]

Luís Vaz de Camões, 1524?–1580. (Diana and Actaeon evoked in) *Os Lusiades* [The Sons of Lusus] 2.35, 9.26. Epic. Lisbon: Gonçalvez, **1572.** / Translated by Sir Richard Fanshawe (Cambridge, Mass.: Harvard University Press, 1940). [Barkan 1980, pp. 331f.]

Joos de Beer, ?–1591. "Diana and Actaeon." Painting. **1573.** Kunsthistorisches Museum, Vienna, no. 775, in 1941. [Pigler 1974, p. 69]

————, attributed. "Diana and Actaeon." Painting. 1579. Centraal Museum, Utrecht, cat. 1952 no. 10. [Wright 1980, p. 24]

Leandro Bassano, 1557–1622, tentatively attributed (also attributed to Jacopo Bassano, Francesco Bassano). "Diana and Actaeon" ("Actaeon and the Nymphs"). Painting, sketch. Early work if by Leandro. Art Institute of Chicago, no. 39.2239. [Arslan 1960, p. 259 / also Berenson 1957, p. 17]

————. "Diana and Actaeon." Painting. Private coll., Vienna, in 1932, unlocated. [Arslan / Berenson, p. 251]

Hans Speckaert, ?–*c.*1577, attributed. "Diana and Ac-

taeon." Drawing. Lugt coll., Fondation Custodia, Paris. [de Bosque 1985, pp. 62, 189f.—ill.]

———. "Diana and Actaeon." Drawing. Szépmüvészeti Múzeum, Budapest. [Ibid.—ill.]

———. "Diana and Actaeon." Painting. Palazzo Patrizzi, Rome. [Ibid.]

Francesco Mosca, ?–**1578.** "Diana and Actaeon." Marble bas-relief. Museo Nazionale, Florence. [Bénézit 1976, 7:560]

Bernaert de Ryckere, c.1535–1590. "Diana Turns Actaeon into a Stag." Painting. **1582.** Szépmüvészeti Múzeum, Budapest, no. 378 (652). [Budapest 1968, p. 609—ill.]

Luca Marenzio, 1553/54–1599. "Non al suo amante più Diana piacque" [Diana Never Pleased Her Lover More]. Madrigal. Text, Petrarca. Published Venice: **1584.** [Grove 1980, 11:672]

Giordano Bruno, 1548–1600. (Actaeon evoked in) *De gl'eroici furori* [On the Heroic Frenzies] part 1, dialogue 4. Collection of dialogues and sonnets. London: Charlewood, **1585.** Modern edition, translated by P. E. Memmo, Jr. (Chapel Hill: University of North Carolina Press, 1964). [Barkan 1980, pp. 342–45 / Davies 1986, pp. 215, 260]

Hendrik Goltzius, 1558–1617. "Diana and Actaeon." Drawing. c.**1589.** Hermitage, Leningrad, inv. 25594. [Reznicek 1961, no. 109—ill.]

Samuel Daniel, 1562–1619. (Actaeon story in) *Delia,* sonnet 5. In *Contayning certayne sonnets: with the Complaint of Rosamond* (London: Waterson, 1592). [Bush 1963, p. 72 n. / Barkan 1980, p. 340]

Abraham Fraunce, fl. 1587–1633. (Actaeon evoked in) *The Countess of Pembrokes Ivychurch* part 3. Poem. London: Woodcocke, **1592.** [Bush 1963, p. 71 n.]

Barnabe Barnes, c.1569–1609. (Actaeon attacked by his own emotions in) Elegy 3 of *Parthenophil and Parthenophe: Sonnettes, Madrigals, Elegies, and Odes* (London: Wolfe, **1593**). In modern edition by Sir Sidney Lee, *Elizabethan Sonnets,* vol. 1 (Westminster: Constable, 1904). [Bush 1963, p. 72 n. / Barkan 1980, p. 339]

Luis Barahona de Soto, 1548–**1595.** *Fábula de Actéon.* Poem, adaptation of Ovid. [DLE 1972, p. 88]

Paolo Fiammingo, 1540–**1596.** "Diana and Actaeon." Painting. / Engraved by Aegidius Sadeler (1570–1629). [Pigler 1974, p. 71]

William Shakespeare, 1564–1616. (Titania and Bottom, comic equivalents of Diana and Actaeon, in) *A Midsummer Night's Dream.* Comedy. c.**1595–96?** Published London: 1600; collected in First Folio, London: Jaggard, 1623. [Riverside 1974 / Barkan 1980, pp. 352–59]

———. (Orsino likens himself to Actaeon in) *Twelfth Night, or What You Will* 1.1.18–22. Comedy. 1600–02. First (?) performed Feb 2 1602, Middle Temple, London. Published London: Jaggard, 1623 (First Folio). [Riverside / Barkan, pp. 340f. / Davies 1986, p. 111]

Bartholomew Griffin, ?–1602. (Actaeon prey to his own emotions in) *Fidessa,* sonnet 8. London: Lownes, **1596.** In modern edition by Sidney Lee, *Elizabethan Sonnets,* vol. 2 (Westminster: Constable, 1904). [Bush 1963, p. 72 n. / Barkan 1980, pp. 339f.]

Anonymous. Cycle of 5 tapestries depicting the myth of Actaeon. Kunsthistorisches Museum, Vienna. **16th century.** [Warburg]

French School, after a work of school of Frans Floris (previously attributed to Anthonie van Blocklandt). "Diana and Actaeon." Painting. **Late 16th century.** Louvre, no. R.F. 1941–9. [Louvre 1979–86, 1:159—ill.]

Joseph Heintz the Elder, 1564–1609. "Diana and Actaeon." Painting. c.**1590–1600.** Kunsthistorisches Museum, Vienna, inv. 1115 (1521). [Zimmer 1971, no. A16—ill. / Vienna 1973, p. 84—ill. / Hofmann 1987, no. 3.23—ill.] Copies (after print by Egidius Sadeler, by 1619) in Accademia, Venice, inv. 159; Galleria Nazionale (Palazzo Barberini), Rome, no. 1252; Germanisches Nationalmuseum, Nuremberg, inv. 1296; Szépmüvészeti Múzeum, Budapest; others in private colls. *See also Nicolas Poussin, 1614, below.* [Zimmer, no. A16.0.2.1–10—ill.] Terra-cotta relief, after Sadeler's print, by Andrea Fantoni, in Accademia Carrara, Bergamo. [Ibid., no. A16.0.4—ill.]

Adriaen de Vries, c.1550–1626. "Actaeon" (?). Bronze statuette. c.**1600.** Victoria and Albert Museum, London, inv. A119–1910. [Warburg]

English School. Diana and Actaeon Fountain. **Late 16th/ early 17th century.** Park, Nonsuch House. [Barkan 1980, pp. 332f.]

Ben Jonson, 1572–1637. (Earl of Essex as Actaeon in) *Cynthia's Revels, or The Fountaine of Selfe-Love* 1.1, 5.2 and passim. Satirical comedy. First performed Blackfriar's Theatre, London, **1600–01.** Published London: 1601. [Herford & Simpson 1932–50, vol. 4 / Barkan 1980, pp. 333ff. / Barton 1984, pp. 73–81 / Le Comte 1944, pp. 69f.]

Cavaliere d'Arpino, 1568–1640. "Diana and Actaeon" ("Diana Turns Actaeon into a Stag"). Painting. c.**1601.** Louvre, Paris, inv. 250. [Louvre 1979–86, 2:166—ill. / Rome 1973, no. 29—ill.] Replica. c.1603–06. Szépmüvészeti Múzeum, Budapest, no. 508 (210). [Budapest 1968, p. 135 / Rome, no. 30—ill.] Copies in Galleria Borghese, Rome, inv. 414 (Bernardino Cesari, d. 1614); Musée des Beaux-Arts, Valenciennes (anonymous, c.1700); Museo Sforzesco, Milan; Uffizi, Florence; Museo Civico, Padua. [Pergola 1955–59, 2: no. 124—ill. / also Rome, no. 151—ill.]

Agostino Carracci, 1557–**1602,** studio. "Diana and Actaeon." Painting. Wildenstein coll., New York. [Marafarina 1976, no. 193—ill.]

Johann Rottenhammer, 1564–1625. "Diana and Actaeon." Painting. **1602.** Alte Pinakothek, Munich, inv. 1588. [Munich 1983, p. 430—ill. / Lowenthal 1986, fig. 39]

———. "Diana Turns Actaeon into a Stag." Painting. Szépmüvészeti Múzeum, Budapest, no. 552. [Budapest 1968, p. 592]

———. "Diana and Actaeon." Painting. Nostitz coll., Národní Galeri, Prague. [Pigler 1974, p. 72]

———, questionably attributed. "Diana and Actaeon." Painting. c.1597? Christ Church College Picture Gallery, Oxford. [Byam Shaw 1967, no. 258—ill.]

Paulus Moreelse, 1571–1638, composition. "Diana and Actaeon." Engraving, executed by Jacob Matham, **1606?** (Rijksprentenkabinet, Amsterdam.) [de Jonge 1938, no. 12—ill.]

John Day, 1574–1640. (Actaeon evoked in) *The Parliament of Bees.* 12 short dialogues in verse. **1607.** Earliest extant copy published London: Lee, 1641. [Cambridge 1983, p. 223]

Joachim Wtewael, 1566–1638. "Diana and Actaeon."

Painting. **1607.** Kunsthistorisches Museum, Vienna, inv. 1052 (798). [Lowenthal 1986, no. A-46—ill. / Vienna 1973, p. 206—ill. / de Bosque 1985, p. 188—ill.]

————. "Diana and Actaeon." Painting. *c.*1606–10. Unlocated. [Lowenthal, no. A-51—ill.]

————. "Diana and Actaeon." Lost painting, *c.*1607–10, presumed from copy in Musée de la Chartreuse, Douai. [Ibid., no. C-35]

————. "Diana and Actaeon." Painting. 1612. Museum of Fine Arts, Boston, inv. 57.119. [Ibid., no. A-60—ill. / Boston 1985, p. 304—ill. / de Bosque, pp. 188, 191—ill.]

————, attributed, figures (landscape by unknown master in circle of Gillis van Coninxloo?). "Diana and Actaeon." Painting. *c.*1610? Upton House, Warwickshire, inv. 152. [Lowenthal, no. B-2—ill.]

Hendrik van Balen, 1575–1632. "Diana and Actaeon." Painting. *c.***1605–08.** Staatliche Gemäldegalerie, Kassel, no. G.K. 63. [d'Hulst 1982, fig. 27 / de Bosque 1985, pp. 189f.—ill.]

————. "Diana and Actaeon." Painting. 1616. Kassel, no. G.K. 64. [de Bosque, pp. 189f.—ill.]

———— and **Abraham Govaerts,** 1589–1626, attributed (previously attributed to David Vinckeboons, 1576–1629). "Diana and Actaeon." Painting. Moscow Museum, inv. 350. [Warburg]

————. Further versions of the subject in Musée des Beaux-Arts, Nantes; Stedelijk Prentenkabinet, Antwerp (drawing). [de Bosque,—ill. / Bénézit 1976, 1:401]

————. *See also Jan Brueghel the Younger, below.*

Jan Brueghel the Elder, 1568–1625, landscape, and **Hendrik de Clerck,** *c.*1570–1629, figures. "Diana and Actaeon." Painting. **1606–09.** Národní Galeri, Prague, inv. DO–4130. [Ertz 1979, no. 146—ill.]

————. Painting; figures depicting the story of Diana and Actaeon added later by François Le Moyne (1688–1737). Hermitage, Leningrad, no. 514. [Pigler 1974, p. 71]

Annibale Carracci, 1560–**1609,** attributed, or **Agostino Carracci,** 1557–1602, attributed. "Diana Bathing, Surprised by Actaeon." Painting. Musées Royaux des Beaux-Arts (Musée d'Art Ancien), Brussels, inv. 732 (90). [Brussels 1984a, p. 48—ill. / Malafarina 1976, no. 147—ill. / Ostrow 1966, no. II/3]

Francis Bacon, 1561–1626. "Actaeon et Pentheus, sive curiosus." Chapter 10 of *De sapientia veterum.* Mythological compendium. London: Barker, **1609.** / Translated as "Actaeon and Pentheus, or a Curious Man" by Arthur Gorges in *The Wisdome of the Ancients* (London: Bill, 1619). Modern facsimile edition (bilingual), New York & London: Garland, 1976. [Ipso / Bush 1963, p. 252]

Michelangelo da Caravaggio, 1571–1610, attributed. "Diana and Her Nymphs Surprised by Actaeon." Painting. *c.***1609.** Smith Art Gallery and Museum, Stirling, Scotland. [Wright 1976, p. 32]

Domenichino, 1581–1641. "Diana and Actaeon." Ceiling fresco, part of "Life of Diana" cycle. **1609.** Palazzo Giustiniani-Odelscalchi, Bassano di Sutri. [Spear 1982, no. 34.iii—ill.]

Nicolas Poussin, 1594–1665, questionably attributed. "Diana and Actaeon." Painting, copy after engraving by Aegidius Sadeler (1570–1629) after the painting by Joseph

Heintz (*c.*1590–1600, Vienna). **1614?** Louvre Paris, no. R.F. 1979–58. [Wright 1985, no. A23 / Louvre 1979–86, 4:309—ill. / Blunt 1966, no. 148—ill. / Thuillier 1974, no. R63—ill.]

Bartolomeo Schidone, *c.*1570–**1615.** "Diana and Actaeon." Painting. Hermitage, Leningrad, inv. 271. [Pigler 1974, p. 69] Another version of the subject known, painting or drawing, formerly in coll. of the poet G. B. Marino (1569–1625). [Ibid.]

Johann Liss, *c.*1595–1629. "Diana and Actaeon." *c.***1618–19.** Painting. Private coll., England. [Augsburg 1975, no. A8—ill.]

Karel van Mander the Younger, *c.*1579–1623. "Diana and Actaeon." Drawing. **1619.** Landesmuseum Johanneum, Graz. [Bénézit 1976, 7:131]

————. "Diana and Actaeon." Drawing. Kunsthalle, Bremen. [Ibid.]

Giovanni Battista Marino, 1569–1625. "Atteone." Idyll. No. 1 in *La sampogna* (Paris: Pacardo, **1620**). [Getto 1962]

————. (Mercury relates the story of Diana and Actaeon in) *L'Adone* canto 5. Poem. Paris: Varano, 1623. [Ibid. / Bondanella 1979, p. 320]

Jan Brueghel the Younger, 1601–1678, landscape, and **Hendrik van Balen,** 1575–1632, figures, attributed. "Diana and Actaeon." Painting. *c.***1620–21.** Szépművészeti Múzeum, Budapest, inv. 53.459 (as Flemish School). [Ertz 1984, no. 241—ill. / Budapest 1968, p. 233]

Francesco Albani, 1578–1660. "Actaeon Surprising Diana and Her Nymphs." Painting. *c.***1620–22.** Louvre, Paris, inv. 15. [Louvre 1979–86, 2:141—ill.] Copy (studio?). Kress Foundation, New York (K1405). [Shapley 1966–73, 3:77—ill.]

————. "Diana, with Nine Nymphs and the Fleeing Actaeon." Painting. Louvre, Paris, inv. 16. [Louvre—ill.] Reversed variant. Gemäldegalerie, Dresden, no. 339. [Dresden 1976, p. 21]

————. Further versions of the subject in Musée, Rennes (on deposit from Louvre, inv. 17); Herzog Anton Ulrich-Museum, Braunschweig, no. 486 (doubtfully attributed); private coll., Vienna, in 1932, unlocated. [Louvre, 2:283 / Braunschweig 1969, p. 26 / Arslan 1960, p. 275—ill.]

Cornelis de Vos, 1584–1651. "Diana and Actaeon." Painting. **1623.** Landesmuseum Johanneum, Graz, inv. 134. [Bénézit 1976, 10:573 / Pigler 1974, p. 71]

Andreas Goetting, *c.*1570–**1625.** "Diana and Her Nymphs with Actaeon." Painting. Museum Boymans-van Beuningen, Rotterdam, cat. 1962 no. 1243. [Wright 1980, p. 142]

Denis van Alsloot, 1570–**1628,** and **Hendrik de Clerck,** *c.*1570–1629. "Diana and Actaeon." Painting. Prado, Madrid. [Ertz 1979, fig. 627]

Camillo Gavasetti, ?–**1628.** "Diana and Actaeon." Painting. Galleria Pallavicini, Rome. [Pigler 1974, p. 69]

Otto van Veen, 1556–**1629.** "Diana and Actaeon." Painting. Formerly Boyer d'Aguilles coll., Aix. / Engraving, Jacob Coelemans, 1700. [Pigler 1974, p. 71]

David Vinckeboons, 1576–**1629,** attributed. "Diana and Actaeon." Painting. Musée des Beaux-Arts, Valenciennes, inv. 252. [Pigler 1974, p. 71]

————. *See also Hendrik van Balen, above.*

Peter Paul Rubens, 1577–1640. "Diana and Actaeon"

("Diana Bathing"). Painting, right part of a canvas (left part lost) which originally also showed Actaeon. **1630–32** or *c*.1635. Museum Boymans-van Beuningen, Rotterdam. [Jaffé 1989, no. 1078—ill. / Mauritshuis 1985, pp. 38f.—ill.] Engraved (entire composition) by P. Spruyt, 1787. / Copy (entire composition) in Rotterdam. [Jaffé, no. 1078a—ill.] Related drawing. Count A. Seilern coll., London. [Burchard & d'Hulst 1963, no. 159—ill.]

———. "Cyparissus" (formerly called "Adonis" or "Actaeon Transformed into a Stag"). Painting, oil sketch (for unknown work for Torre de la Parada?). **1636–38?** Musée Bonnat, Bayonne, no. 1001. [Alpers, p. 273—ill. / Held, no. 181—ill. / Jaffé, no. 1255—ill.]

———. "Diana and Actaeon." Painting, for Torre de la Parada, El Pardo, executed by Jacob Jordaens from Rubens's design. **1636–38.** Lost. [Alpers 1971, no. 18]

———. "The Death of Actaeon." Painting (executed by assistants from Rubens's design), part of series of hunts for Philip IV of Spain. **1639–40.** Lost. / Oil sketch. Formerly Nieuwenhuys coll., Brussels, sold 1985. [Jaffé, no. 1397—ill. / also Held 1980, no. 221—ill.] Studio version in Musée des Beaux-Arts, Nîmes, inv. IP-295. [Held, fig. 41 / White 1987, pl. 309]

Kerstiaen de Coninck, *c*.1560–**1635.** "Landscape with Diana and Actaeon." Painting. Koninklijk Museum voor Schone Kunsten, Antwerp, no. 876. [Antwerp 1970, p. 53]

Rembrandt van Rijn, 1606–1669. "The Goddess Diana Bathing, with the Stories of Actaeon and Callisto." Painting. **1635.** Prince of Salm-Salm coll., Anholt. [Gerson 1968, no. 61—ill.]

———. "Diana at the Bath (Surprised by Actaeon)." 2 drawings, derived from engraving by Antonio Tempesta (Bartsch no. 823). 1 (attributed to Rembrandt), early 1640s, in Louvre, Paris; another (by Rembrandt), *c*.1662–65, in Kupferstichkabinett, Dresden. [Benesch 1973, nos. A50, 1210—ill.]

———, follower. "Diana Bathing Surprised by a Satyr" (?). Painting. *c*.1640? National Gallery, London, inv. 2538. [London 1986, p. 518—ill.]

Bartholomäus Dietterlin, *c*.1590–after **1638.** "Woody Landscape with Diana and Actaeon." Painting. Gemäldegalerie, Dresden, no. 862. [Dresden 1976, p. 44]

Jacob Jordaens, 1593–1678. "Diana and Actaeon." Painting, for Torre de la Parada, El Pardo. *See Rubens, above.*

———. "Diana and Actaeon." Painting. *c*.**1640.** Gemäldegalerie, Dresden. [d'Hulst 1982, fig. 146]

Claude Lorrain, 1600–1682. "Landscape with Diana and Actaeon." Painting. *c*.**1641.** Lost. / Drawing after, in the artist's *Liber veritatis*. British Museum, London. [Röthlisberger 1961, no. LV 57—ill.]

John Denham, 1615–1669. (Actaeon as stag evoked in) *Cooper's Hill.* Topographical poem. London: Walkley, **1642.** Modern edition by Brendan O'Hehir (Berkeley & Los Angeles: University of California Press, 1969). [Barkan 1980, pp. 332 *n*.29]

Antonio Mira de Amescua, 1574?–**1644.** "Acteón y Diana." Poem. In *Poesías varias de grandes ingenios* (Zaragoza: 1654). Reprinted in *Floresta de rimas antiguas castellanas* part 3a (Hamburg: Perthes & Besser, 1821–25). [DLE 1972, p. 598 / Barrera 1969, pp. 257f.]

Agostino Tassi, *c*.1580–**1644.** "Diana and Actaeon." Painting. Palazzo Pitti, Florence. [Pigler 1974, p. 70]

Cristóbal de Monroy y Silva, 1612–**1649.** *Acteon y Diana.* Comedy. [Barrera 1969, p. 264]

Alessandro Turchi, 1578–**1649.** "Diana and Actaeon." Painting. Museo di Castelvecchio, Verona, no. 987. [Pigler 1974, p. 70]

———, style. "Diana and Actaeon." Painting. Museo Correr, Venice. [Ibid.]

Artemisia Gentileschi, 1593–1652/53. "The Bath of Diana, with Five Nymphs, Actaeon, and Two Dogs." Painting. **1650.** Lost. [Garrard 1989, p. 128]

Eustache Le Sueur, 1616–**1655.** "Diana and Actaeon." Painting. / Engraved by Claude Duflos (1665–1727). [Pigler 1974, p. 73]

Francis Kirkman, 1632?–**1674,** or **Robert Cox,** ?–**1655.** *Acteon and Diana.* Comedy, with songs. Published with *The Pastorall Story of the Nymph Oenone* (London: Newcomb, **1655**). / Revised by Kirkman, published in *The Wits, or Sport upon Sport* part 1 (London: Johnson & Marsh, **1662**). Modern edition by J. J. Elson (London: Oxford University Press; Ithaca: Cornell University Press, 1932). [Nicoll 1959–66, 1:251, 417]

Abraham van Cuylenburgh, before 1620–**1658.** "Diana and Her Nymphs Surprised by Actaeon." Painting. Centraal Museum, Utrecht, cat. 1952 no. 73. [Wright 1980, p. 89]

Giovanni Francesco Romanelli, 1610–1662. "Diana and Actaeon." Fresco, part of cycle depicting scenes from the lives of Apollo and Diana. **1655–58.** Salle des Saisons, Apartement d'Été (Galerie du Bord de l'Eau), Louvre, Paris, inv. 20348. [Louvre 1979–86, 2:228—ill.]

Guercino, 1591–**1666.** "Diana and Actaeon." Painting. / Engraved by Giovanni Ottaviani (*c*.1735–1808). [Pigler 1974, p. 70]

———. "Diana and Actaeon." Drawing. Albertina, Vienna. [Ibid.]

Cornelis van Poelenburgh, *c*.1586–**1667.** "Diana and Actaeon." Painting. Maidstone Museum and Art Gallery, inv. 00.1865–67. [Wright 1976, p. 162]

———. "Diana and Actaeon." Painting. Musée des Beaux-Arts, Nancy. [Bénézit 1976, 8:392]

———. "Diana and Actaeon." Painting. Prado, Madrid. [Pigler 1974, p. 71]

Dirck van der Lisse, ?–**1669.** "Landscape with Diana and Actaeon." Painting. Fitzwilliam Museum, Cambridge, no. 407. [Fitzwilliam 1960–77, 1:73—ill.]

———. "Diana and Actaeon." Painting. Staatliche Museen, Berlin, no. 463. [Pigler 1974, p. 72]

———. "Diana and Actaeon." Painting. Nationalmuseum, Stockholm. [Ibid.]

Jan van Bijlert, 1603–**1671.** "Diana and Actaeon and Her Nymphs in a Grotto." Painting. Centraal Museum, Utrecht, cat. 1971 no. 22. [Wright 1980, p. 69]

Anonymous English. (Actaeon evoked in) *Chaucer's Ghost: or, A Piece of Antiquity.* Poem. London: **1672.** [Bush 1963, p. 339]

Luca Giordano, 1634–1705. "Diana and Actaeon." Painting. Recorded in Rosso coll., Florence, in **1677,** untraced. [Ferrari & Scavizzi 1966, 2:330f.]

————. "Diana and Actaeon," detail in "Allegory of Human Life and the Medici Dynasty." Fresco. 1682–83. Palazzo Medici Riccardi, Florence. [Ferrari & Scavizzi, 2:112ff.—ill.] Study. C. Phillimore coll., London. [Ibid., p. 114]

————. "Diana and Actaeon." Painting. c.1683–84. Lord Exeter coll., Burghley House, Northamptonshire. [Ferrari & Scavizzi, 2:121—ill.]

————. "Diana and Actaeon." Drawing. British Museum, London, no. 1950.11.11.46. [Ferrari & Scavizzi, 2:257]

————. Another version of the subject (painting?) sold 1832, untraced. [Ibid., 2:374]

Arie de Vois, 1632–**1680.** "Diana and Actaeon." Painting. Muzeum Narodowe, Warsaw, inv. 129017. [Warsaw 1969, no. 1400—ill.]

Daniel Vertangen, 1598–**1681/84.** "Diana and Actaeon." Painting. University of Göttingen, inv. 182. [Bénézit 1976, 10:479 / Pigler 1974, p. 72]

Marc-Antoine Charpentier, 1645/50–1704. "Actaeon Changed into a Stag." Musical pastorale. **1683–85.** [Grove 1980, 4:174]

Pietro Liberi, 1614–**1687.** "Diana and Actaeon." Painting. Staatliche Museen, Berlin, no. 455. [Pigler 1974, p. 70]

————. "Diana and Actaeon." Painting. Palazzo Reale, Venice. [Ibid.]

Jonathan Swift, 1667–1745, formerly attributed. "Actaeon; or the Original of Horn Fair." Poem. In *Gentleman's Journal* Feb **1691–92.** [Williams 1958, 3:1073]

Filippo Lauri, 1623–**1694.** "Diana and Actaeon." Painting. England. [Pigler 1974, p. 70]

North Netherlandish School. "Diana and Actaeon." Painting. Late 17th century. Museum Bredius, The Hague, inv. C681. [Wright 1980, p. 313]

Pierre-César Abeille, 1674–after 1733. *Actéon.* Burlesque cantata. c.**1700.** [Grove 1980, 1:10]

Sebastiano Ricci, 1659–1734. "Diana and Actaeon." Fresco. **1703** or later. Palazzo Fulcis-Bertoldi, Belluno. [Daniels 1976, no. 25c—ill.]

———— (with Giuseppe Tonelli and Marco Ricci?). "Diana and Actaeon." Fresco. 1707–08. Palazzo Pitti, Florence. [Ibid., no. 92b]

Guy-Louis Vernansal, 1648–1729. "Diana and Actaeon." Painting, for Ménagerie, Versailles (now largely ruined). **1703.** Louvre, Paris, inv. 8617. [Louvre 1979–86, 4:266—ill.]

Michel Corneille the Younger, 1642–1708. "Diana and Actaeon." Drawing. Louvre, Paris. [Pigler 1974, p. 73]

Benedetto Riccio, c.1678–after 1710. *L'Ateone.* Opera. Libretto, I. Romani. First performed **1708,** Teatro dei Fiorentini, Naples? [Grove 1980, 15:833]

Carlo Maratti, 1625–**1713,** studio. "Diana and Actaeon." Painting. Christ Church College Picture Gallery, Oxford. [Byam Shaw 1967, no. 152—ill.] Variant, attributed to Maratti and Gaspard Dughet. Duke of Devonshire coll., Chatsworth. [Ibid.]

Johann Brokoff, 1652–**1718.** Fountain with figures of Actaeon and Polyphemus. Courtyard, Cerveny Hradek, Czechoslavakia. [Clapp 1970, 1:115]

Louis Néron, fl. early 18th century. *Diane et Actéon.* Cantata. **1720.** [Grove 1980, 13:112]

Giovanni Battista Tiepolo, 1696–1770. "Diana and Ac-

taeon." Painting. c.**1720–22.** Accademia, Venice. [Pallucchini 1968, no. 19b—ill. / Morassi 1962, p. 53—ill.]

————. "Diana and Actaeon." Painting (sketch). c.1720–22. Private coll., Bergamo. [Pallucchini, no. 15—ill. / Morassi, p. 4—ill.]

————. "Diana and Actaeon" ("Bath of Diana"). Painting. Mid-1740s or c.1750–60. Bührle coll., Zurich (formerly Rothschild coll., New York). [Pallucchini, no. 210—ill. / Morassi, p. 36—ill. / Levey 1986, p. 132—ill.]

————. Another version of the subject, in Algarotti coll., Venice in 1779, untraced. [Pallucchini, p. 136]

Antoine Coypel, 1661–**1722.** "Diana and Actaeon." Painting. Musée, Lyon. [Pigler 1974, p. 73]

Antonio Bellucci, 1654–**1726.** "Diana and Actaeon." Painting. / Engraved by Joseph Wagner (1706–1780). [Pigler 1974, p. 70]

Marcantonio Franceschini, 1648–**1729.** "Diana and Actaeon." Painting. Liechtenstein coll., Vaduz, no. A101. [Pigler 1974, p. 70]

Louis Boulogne the Younger, 1654–**1733.** "Actaeon and Diana." Painting. / Engraved by Dominique Sornique (d. 1756). [Pigler 1974, p. 73] A drawing of the same subject in Louvre, Paris. [Ibid.]

Gerard Hoet the Elder, 1648–**1733.** "Diana and Actaeon." Painting. [Bénézit 1976, 5:571]

Jean-François de Troy, 1679–1752. "Diana Surprised by Actaeon." Painting. **1734.** Fondation Gottfried Keller, Berne. [Royal Academy 1968, no. 679]

Antoine Rivalz, 1667–**1735.** "Diana and Actaeon." Painting. Musée d'Art et d'Histoire, Narbonne. [Bénézit 1976, 8:782]

Charles-Joseph Natoire, 1700–1777. "Diana and Actaeon." Painting. **1735** or earlier. Lost. / Engraved by Desplaces. [Boyer 1949, no. 207—ill.]

————. Another version of the same subject sold Paris (?), 1821, untraced. [Boyer, no. 100]

Andrea Locatelli, 1695–**1741.** "Diana and Actaeon." Painting. Formerly Palazzo Barberini, Rome. [Voss 1924, p. 386]

Giovanni Battista Piazzetta, 1683–1754. "Diana and Actaeon." Drawing, illustration for Torquato Tasso's *La Gerusalemme liberata* (1575). Published Venice: Albrizzi, **1745.** Original drawing in Biblioteca Reale, Turin. [Pallucchini 1982, no. D80—ill.]

Johann Friedrich Lampe, c.1703–1751, music. *Diana and Actaeon.* Pantomime. Librettist unknown. First performed 23 Apr **1746,** Theatre Royal, Drury Lane, London. [Nicoll 1959–66, 2:370]

Jacopo Amigoni, 1675–**1752.** "Diana and Actaeon." Painting. Museum Bisdom van Vliet, Haastrecht. [Wright 1980, p. 8]

Richard Wilson, 1714–1782. "Diana and Actaeon." Painting. **1753–54.** Lord Wharton coll. [Constable 1953, pp. 159f., pl. 17a] Variant. H. T. Watlington coll., Bermuda. [Ibid.]

Franz Anton Maulbertsch, 1724–1796. "Diana and Actaeon." Ceiling painting. **1754.** Schloss Suttner, Ebenfurth, Austria. [Garas 1960, no. 48—ill.]

Joseph Bodin de Boismortier, 1689–**1755** (formerly attributed to Jean-Philippe Rameau, 1683–1764). *Diane et Actéon.* Cantata for soprano, violin, basso continuo. Pub-

lished in Rameau's *Oeuvres complètes,* edited by Saint-Saëns et al. (Paris: Duranc, 1895–1924, vol. 3). [Grove 1980, 2:862, 15:571 / Girdlestone 1983, p. 77]

Johannes Buma, 1694–1756. "Artemis and Actaeon." Painting. Hannemahuis, Harlingen, inv. 6. [Wright 1980, p. 66]

Louis de Silvestre the Younger, 1675–1760, studio. "Diana and Actaeon." Painting. Muzeum Narodowe, Warsaw, inv. Wil. 1133 (527)., on display at Wilanów Palace. [Warsaw 1969, no. 1205—ill.]

Giovanni Paolo Panini, 1691–1765, school. "Diana and Actaeon in an Architectural Setting." Painting. Musée, Niort, on deposit from Louvre, Paris (no. R.F. 1956–12) since 1958. [Louvre 1979–86, 2:295]

Giovanni Battista Pittoni, 1687–1767. "Diana and Actaeon." Painting. Museo Civico, Vicenza. [Bénézit 1976, 8:369]

Johann Konrad Seekatz, 1719–1768. "Diana and Actaeon." Painting. Schloss, Darmstadt. [Bénézit 1976, 9:496]

Giuseppe Banti, fl. 1767–93, choreography. *Diane e Atteone.* Ballet. First performed 1769, San Moisè, Venice. [EDS 1954–66, 1:1437]

Luigi Vanvitelli, 1700–1773. "Diana and Actaeon." Marble fountain figures. *c.*1770. Great Cascade, Royal Park, Caserta, near Naples. [Molesworth 1965, p. 194, fig. 204]

Onorato Viganò, 1739–1811, choreography. *Diana sorpresa* [Diana Surprised]. Ballet. First performed 1774, Venice. [Oxford 1982, p. 125]

John Abraham Fisher, 1744–1806. *Diana and Acteon.* Cantata. *c.*1780. [Grove 1980, 6:617]

Friedrich von Schiller, 1759–1805. "Aktäon." Poem. In *Anthologie auf das Jahr 1782* (Stuttgart: Metzler, 1782). [Petersen & Beissner 1943]

Thomas Gainsborough, 1727–1788. "Diana and Nymphs Surprised by Actaeon." Painting, unfinished. *c.*1784–85. Royal Collection, Buckingham Palace, London. [Ellis K. Waterhouse, *Gainsborough* (London: Hulton, 1958)]

Francesco Zuccarelli, 1702–1788. "Landscape with Diana and Actaeon." Painting. Art Gallery and Museum, Glasgow, cat. 1970 no. 148. [Wright 1976, p. 226]

——. "The Death of Actaeon." Painting. Hunterian coll., University of Glasgow. [Ibid.]

Paolo Persico, *c.*1729–1780, **Pietro Solari,** ?–1790 and **Angelo Brunelli,** 1740–1806. "Diana and Actaeon." Marble fountain. 1790. Palazzo Reale, Caserta. [Clapp 1970, 1:692]

José Antonio Porcel y Salamanca, 1715–1794. "Acteón y Diana." Burlesque fable. In modern edition, *Biblioteca de autores españoles,* vol. 61 (Madrid: 1869). [Oxford 1978, p. 471]

Italian School. "Diana and Actaeon." Drawing on a fan. 18th century. Metropolitan Museum, New York, no. 88.3.37. [Kilinski 1985, no. 31—ill.]

James Byrne, 1756–1845, libretto. *Acteon and Diana.* Pantomime ballet. First performed 1800, Theatre Royal, Drury Lane, London. [Nicoll 1959–66, 4:423, 619]

Mme. Rossi, choreography. *La surprise de Diane.* Ballet. Music, Joseph Woelfl. First performed 21 Dec 1805, King's Theatre, London. [Oxford 1982, p. 125 / Guest 1972, p. 153]

Jacques-Antoine Vallin, 1760–after 1831. "Diana and Her Nymphs Bathing, Surprised by Actaeon: Effect of Sunset." Painting. 1810. Louvre, Paris, no. M.N.R. 149. [Louvre 1979–86, 4:258—ill.]

Eugène Delacroix, 1798–1863. "Head of Actaeon." Painting. 1817–18. Musée, Melun. [Johnson 1981–86, no. 60—ill. / also Robaut 1885, no. 1509—ill. (copy drawing)]

——. "Summer: Diana and Actaeon." Painting, part of "Four Seasons" series. Begun 1856, unfinished. Museu de Arte, Sao Paulo. [Johnson, no. 249—ill. / Huyghe 1963, p. 416—ill. / also Robaut 1885, no. 1428—ill. (copy drawing)] Oil sketch. Mahmoud Khalil Museum, Cairo. [Ibid., no. 245—ill.] Copy (attributed to Pierre Andrieu, d. 1892) in Museum of Fine Arts, Boston, no. 21.1454. [Boston 1985, p. 78—ill.]

Franz Schubert, 1797–1828. "Der zürnenden Diana" [Diana Angered]. Lied. Text, Mayrhofer. 2 versions. Dec 1820. [Grove 1980, 16:798 / Brown 1958, pp. 173, 258]

Percy Bysshe Shelley, 1792–1822. (Allusion to Actaeon in) *Adonais* stanza 31. Elegy. Pisa: Didot, 1821. [Knerr 1984 / Bush 1937, p. 134, pp. 83f.]

——. (Allusion to Actaeon in) *Prometheus Unbound* lines 454ff. Dramatic poem. London: Ollier, 1820. [Zillman 1968]

Andries Cornelis Lens, 1739–1822. "Actaeon Surprising Diana and Her Nymphs Bathing." Painting. Koninklijk Museum voor Schone Kunsten, Antwerp, no. 837. [Antwerp 1970, p. 122]

William Blake, 1757–1827. "Diana and Actaeon" (?). Drawing. *c.*1825. Princeton University Library, N.J. [Butlin 1981, no. 781—ill.]

Peter Cornelius, 1783–1867, and studio. "Diana and Actaeon." Ceiling fresco. 1820/26. Göttersaal, Glyptothek, Munich. [Glyptothek 1980, pp. 214ff.]

Ivan Prokofievtch Prokofieff, 1758–1828. "Actaeon." Bronze statue. Hermitage, Leningrad. [Bénézit 1976, 8:502]

Francesco Hayez, 1791–1882. "Nymphs Bathing" ("Diana Surprised by Actaeon"?). Painting. 1831. Private coll., Lugo, Vicenza. [Coradeschi 1971, no. 143a—ill.] Replica. Lost. [Ibid., no. 143b]

Jean-Baptiste Camille Corot, 1796–1875. "Diana Surprised at the Bath." Oil sketch. *c.*1835. Paul Jumot coll. in 1936. [Lyons 1936, no. 22 / also Robaut 1905, no. 364—ill.]

——. "Diana and Actaeon (Diana Bathing, Surprised by Actaeon)." Painting. 1836. Metropolitan Museum, New York, no. 1975.1.162. [Metropolitan 1980, p. 31—ill. / Metropolitan 1983, p. 328—ill. / Robaut, no. 363—ill.]

——. "Diana and Actaeon." Oil sketch. 1855–65. Alfred Robaut coll. in 1905. [Robaut, no. 1178—ill.]

Daniel-François-Esprit Auber, 1782–1871. *Actéon.* Comic opera. Libretto, Eugène Scribe. First performed 23 Jan 1836, Théâtre de l'Opéra-comique, Paris. [McGraw-Hill 1984, 4:357 / Grove 1980, 1:681, 17:89]

Bertel Thorwaldsen, 1770–1844. "Diana Surprised by Actaeon." "Actaeon Torn by His Dogs." Reliefs, part of "Metamorphoses of Ovid" series. Executed by Pietro Galli from Thorwaldsen's designs, 1838. Formerly Palazzo Torlonia, Rome, destroyed. / Plaster casts. Thorwaldsens Museum, Copenhagen, nos. 460–61, A779. [Thorwaldsen 1985, pp. 5f., 76 / Hartmann 1979, p. 103, pl. 103.6]

Joseph Mallord William Turner, 1775–1851. "Mountain Glen" (with Diana and Actaeon?). Painting. *c.*1835–

40. Tate Gallery, London, no. 561. [Butlin & Joll 1977, no. 439—ill.]

Théodore Chassériau, 1819–1856. "Diana Surprised by Actaeon" ("Diana in the Bath, Surrounded by Her Nymphs"). Painting. **1840.** Private coll., Paris. [Sandoz 1974, no. 62—ill.]

William Edward Frost, 1810–1877. "Diana and Her Nymphs Surprised by Actaeon." Painting. **1846.** [Kestner 1989, p. 72]

Hermann Steinfurth, 1823–1880. "Diana in the Bath, Surprised by Actaeon." Painting. **1847.** Kunsthalle, Hamburg, inv. 2321. [Hamburg 1969, p. 398]

Arthur Hugh Clough, 1819–**1861.** "Actaeon." Poem. In *Poems,* edited by Lowry, Norrington, and Mulhauser (Oxford: Clarendon Press, 1951). [Boswell 1982, p. 75]

Joseph Noel Paton, 1821–1901. "Actaeon in Hades." Poem. In *Spindrift* (Edinburgh: Blackwood, **1867**). [Bush 1937, p. 555]

Henri Fantin-Latour, 1836–1904. "Diana and Actaeon" ("Bathers Surprised"). Painting. **1871.** [Fantin-Latour 1911, no. 468]

———. "Diana and Actaeon" (Actaeon behind a tree, Diana calling to him). Painting. 1904, unfinished. Victoria Fantin-Latour coll. in 1911. [Fantin-Latour, no. 2167]

Gustave Moreau, 1826–1898. "Diana the Huntress" (riding on the back of a hunter whom she has turned into a stag). Painting. *c.*1872. Sold Paris, Drouot, 1918. [Mathieu 1976, no. 136—ill.]

Friedrich Preller, 1804–**1878.** "Diana and Actaeon in a Landscape." Painting. Museum, Breslau. [Bénézit 1976, 8:479]

M. F. Chassaigne. *Actéon.* Operetta. Libretto after a vaudeville by Duvert, Théaulon, and de Leuven. First performed Jan **1878,** Palais-Royal, Paris. [Clément & Larousse 1969, 1:6]

John La Farge, 1835–1910. "Actaeon." Marble and wood relief, for Vanderbilt mansion, New York. **1881–82.** [Weinberg 1977, pp. 256ff., 261f.—ill.]

Briton Riviere, 1840–1920. "Actaeon and the Hounds." Painting. **1884.** [Kestner 1989, p. 235]

Marius Petipa, 1818–1910, choreography. "Diana and Actaeon." Pas de deux. Music, Riccardo Drigo (1846–1930). Added to Jules Perrot's ballet *La Esmeralda.* First performed **1886,** Drigo Company, St. Petersburg. [Oxford 1982, p. 145]

Charles G. D. Roberts, 1860–1943. "Actaeon." Poem. In *In Divers Tones* (Boston: Houghton Mifflin, **1886**). [Boswell 1982, p. 285]

José-Maria de Heredia, 1842–1905. "Actéon." Sonnet, fragment. **1890–93.** [Delaty 1984, vol. 2]

Jean-Léon Gérôme, 1824–1904. "Diana and Actaeon" ("Hallali"). Painting. **1895.** Lost. [Ackerman 1986, no. 428—ill.]

Max Klinger, 1857–1920. "Diana Spied upon by Actaeon" (figure of Diana only). Marble sculpture. **1906.** Ny Carlsberg Glyptotek, Copenhagen. [Hildesheim 1984, no. 12—ill.]

John Erskine, 1879–1951. "Actaeon." Poem. In *Actaeon and Other Poems* (New York & London: Lane, **1907**). [Boswell 1982, p. 101]

John Davidson, 1857–1909. (Actaeon and Diana in) The *Testament of John Davidson.* Poem. London: Richards, **1908.** [Bush 1937, p. 467]

Edith Wharton, 1862–1937. "Artemis to Actaeon." Poem. In *Artemis to Actaeon and Other Poems* (New York: Scribner, **1909**). [Bush 1937, p. 586]

Ker-Xavier Roussel, 1867–1944. "Diana and Actaeon." Painting. **1911.** Private coll., Munich. [Georgel 1968, p. 355, no. 247—ill.]

Valentin Serov, 1865–1911. "Diana and Actaeon," "Diana." Drawing and watercolor, sketches for an unexecuted mural. **1911.** "Diana and Actaeon" in Tretyakov Gallery, Moscow, inv. 30182; "Diana" unlocated. [Sarabyanov & Arbuzov 1982, nos. 651, 653—ill.]

Nikolay Stephanovich Gumilyev, 1886–1921. *Akteon.* Drama. **1913.** In *Gondla: Dramaticheska i a poema* (Shanghai: Izdatelsí va Drakon, 1946). [EWL 1981–84, 2:305]

Alfred Noyes, 1880–1958. "Actaeon." Poem. In *Collected Poems* (New York: Stokes, **1913**). [Boswell 1982, p. 197]

Ezra Pound, 1885–1972. "The Coming of War: Actaeon." Poem. In *Poetry* 5 no. 6 (Mar **1915**); collected in *Personae,* revised, expanded edition (New York: New Directions; London: Faber & Faber, 1926). [Ruthven 1969, pp. 27, 53f.]

———. (Actaeon evoked in) Canto 4, in *A Draft of XXX Cantos* (Paris: Hours; Norfolk, Conn.: New Directions, [1930?]), and Canto 80, in *The Pisan Cantos* (New York: New Directions, 1948). [Kearns 1980, pp. 28–30 / Surette 1979, pp. 28, 64, 203, 208]

Felix Braun, 1885–1973. *Aktaion.* Tragedy. Vienna: Wiener literarische Anstalt, **1921.** [DLL 1968–90, 1:907]

T. S. Eliot, 1888–1965. (Ironic allusion to Actaeon's encounter with Diana in Sweeney's visit to Mrs. Porter in) *The Waste Land* lines 196–201. Poem. In *Criterion* Oct **1922** and *The Dial* Nov 1922; first published in book form, New York: Boni & Liveright, [Dec] 1922. [Eliot 1964 / Feder 1971, p. 225 / Matthiessen 1958, p. 51]

Paul Manship, 1885–1966. "Diana" (running with hound) and "Actaeon" (running from 2 hounds). Sculptures. Various versions. Bronze statuettes, 1921 (Diana) and **1923** (Actaeon). Carnegie Institute, Pittsburgh; Minnesota Museum of Art, St. Paul, nos. 66.14.103a, b. [Murtha 1957, nos. 138, 155 / Minnesota 1972, nos. 26, 27—ill.] Bronze sketch for "Actaeon," 1922. [Murtha, no. 147] Heroic-size gilded bronze replicas, 1924. Brookgreen Gardens, Georgetown, South Carolina. / Nickel bronze casts, 1939. Norton Gallery and School of Art, West Palm Beach, Florida. [Ibid., nos. 166, 167] Life-size replicas, 1925, 5 casts of each. Ball State Teachers College, Muncie, Indiana; Art Gallery of Toronto; Hudson River Museum, Yonkers, N. Y.; elsewhere. [Ibid., nos. 182, 183 / Kilinski 1985, no. 32—ill.]

Robinson Jeffers, 1887–1962. (Actaeon evoked in) "Science." Poem. In *Roan Stallion, Tamar, and Other Poems* (New York: Random House, **1925**). [Bush 1937, p. 522]

Sacheverell Sitwell, 1897–1988. "Actaeon." Poem. In *Poor Young People* by Edith, Osbert, and Sacheverell Sitwell (London: Fleuron, **1925**). [Ipso]

Franz von Stuck, 1863–1928. "Diana and Actaeon." Painting. **1926.** Unlocated. [Voss 1973, no. 587—ill.]

Francis Poulenc, 1899–1963. (Diana and Actaeon evoked

in) *Aubade.* "Choreographic concerto" for piano and 18 instruments. First performed 18 June **1929**. [Grove 1980, 15:167]

Bronislava Nijinska, 1891–1972, choreography. (Diana's passion over Actaeon danced in) *Aubade.* Ballet. Music and scenario, Francis Poulenc (1929). First performed 29 June **1929**, soirée at the Vicomte de Noailles', Paris; scenery and costumes, J. M. Frank. [Oxford 1982, pp. 125, 302 / DMB 1959, p. 14]

Armand Point, 1860/61–1932. "Diana and Actaeon." Pastel. By **1929**. [Bénézit 1976, 8:397]

Louis Alexandre Aubin, 1907–. *Actéon.* Cantata for soprano, tenor, bass, and orchestra. Text, P. Arosa. **1930**. [Grove 1980, 1:684]

George Balanchine, 1904–1983, choreography and libretto. (Actaeon evoked in) *Aubade.* Ballet. Music, Poulenc (1929). First performed 21 Jan **1930**, Ballets Russes, Théâtre des Champs-Elysées, Paris; décor, Angeles Ortiz. [Taper 1984, p. 401] Revived, with new décor by A. M. Cassandre, 11 April 1936, Ballets de Monte-Carlo, Monte Carlo. [DMB 1959, p. 14]

H. D. (Hilda Doolittle, 1886–1961). "Actaeon." Poem. In *Red Roses for Bronze* (London: Chatto & Windus; Boston: Houghton Mifflin, **1931**). [Martz 1983]

Libero Andreotti, 1877–**1933**. "Actaeon." Bronze sculpture. [Clapp 1970, 1:28]

William Rose Benét, 1886–1950. "Ghost Actaeon," "Fastidious Artemis." Poems. In *Starry Harness* (New York: Duffield & Green, **1933**). [Boswell 1982, p. 37]

Harald Lander, 1905–1971, choreography. (Actaeon evoked in) *Diana.* Ballet. Music by F. Poulenc (1929). First performed **1933**, Royal Danish Ballet, Copenhagen. [EDS 1954–66, 6:1197]

———, choreography. (Actaeon evoked in) *Aubade.* Ballet. **1951**. [Chujoy & Manchester 1967, p. 552]

André Masson, 1896–1987. "Actaeon." Painting. **1934**. [Rubin & Lanchner 1976, p. 169]

———. "Actaeon" (eaten by his dogs). Painting. 1945. Städtische Kunsthalle, Mannheim. [Clébert 1971, pl. 160]

Agrippina Jacovlevna Vaganova, 1879–1951, choreography. (Pas de deux of Diana and Actaeon in) *Esmeralda.* Ballet. First performed **1935**, Leningrad. [Oxford 1982, pp. 145, 430]

Alexis Dolinoff, c.1900–, choreography. (Actaeon evoked in) *Aubade.* Ballet. Music, Poulenc (1929). First performed **1936**, Catherine Littlefield Ballet, Philadelphia; décor, R. Deshays; costumes, J. Pascal. [Sharp 1972, p. 250 / Amberg 1949, p. 208]

Simon Vestdijk, 1898–1971. *Aktaion onder de sterren* [Actaeon among the Stars]. Novel. Rotterdam: Nijgh & Van Ditmar, **1941**. [EWL 1981–84, 4:556 / Meijer 1971, p. 336]

John Peale Bishop, 1892–**1944**. "Another Actaeon." Poem. In *Collected Poems* (New York: Scribner, 1948). [Boswell 1982, p. 41]

Rayner Heppenstall, 1911–. "Actaeon." Poem. **1933–45**. In *Poems, 1933–1945* (London: Secker & Warburg, 1946). [Boswell 1982, p. 261]

Serge Lifar, 1905–1986, choreography. (Actaeon evoked in) *Aubade.* Ballet. Music, Poulenc (1929). First performed Dec **1946**, Nouveaux Ballets de Monte Carlo,

Monte Carlo; décor, Constantin Nepo. [Oxford 1982, p. 255 / Sharp 1972, p. 250 / DMB 1959, p. 14]

Vernon Watkins, 1906–1967. "Actaeon." Poem. In *Lady and the Unicorn and Other Poems* (London: Faber & Faber, **1948**). [Ipso]

Adrian Cruft, 1921–. *Actaeon.* Overture, opus 9. **1951**. [Grove 1980, 5:69]

Graham Hough, 1908–. "Diana and Actaeon." Poem. In *Legends and Pastorals* (London: Duckworth, **1961**). [Boswell 1982, p. 138]

C. H. Sisson, 1914–. (Actaeon evoked in) "Metamorphoses." Poem. **1961**. In *In the Trojan Ditch* (Cheadle: Carcanet, 1974). [Ipso]

Rudolph Nureyev, 1938–, choreography. *Diana and Actaeon.* Ballet, after Vaganova's pas de deux for *Esmeralda* (1935). First performed **1963**, Royal Academy of Dancing. [EDS 1954–66, suppl. p. 802]

Yannis Ritsos, 1909–1990. "O Aktaíon." Poem. **1969**. In *Epanalepseis* (Athens: Kedros, 1972). [Ipso]

Gloria Contreras, 1934–, choreography. *Diana and Actaeon.* Ballet. First performed **1970**, by Taller Coregráfico de la Universidad Nacional Autónoma de México, Mexico City. [Cohen-Stratyner 1982, p. 201]

Elizabeth Brewster, 1922–. (Actaeon's story evoked in) "Moon." Poem. In *In Search of Eros* (Toronto & Vancouver: Clarke, Irwin, **1974**). [Ipso]

Earl Staley, 1938–. "Story of Actaeon" (I and II). Pair of paintings. **1977**. Chase Manhattan Bank coll., New York. [Houston 1984, p. 48—ill.]

Ted Hughes, 1930–. "Actaeon." Poem. In "Earth-numb" section of *Moortown* (London: Faber & Faber, **1979**). [Ipso / Scigaj 1986, pp. 274, 345]

Kate Waring, 1953–, music. *Acteon.* Ballet. **1982**. [Cohen 1987, 2:740]

Bruno Civitico. "Actaeon." Painting. **1983**. Robert Schoelkopf Gallery, New York. [Personal communication to author from Prof. Mark Thistlethwaite, Texas Christian University, 1984]

Jeanne Ebner, 1918–. *Aktäon.* Novella. Graz: Styria, **1983**. [Daviau 1987, p. 145]

Peter Porter, 1929–. "Diana and Actaeon." Poem. In *Collected Poems* (London & New York: Oxford University Press, **1983**). [CLC 1985, 33:324]

ADMETUS. *See* ALCESTIS; APOLLO, as Shepherd.

ADONIS. The offspring of an incestuous relationship between King Cinyras of Cyprus and his daughter, Myrrha, Adonis was a young hunter of great beauty. His comeliness attracted the attention of the goddess Aphrodite (Venus) and they became lovers; Aphrodite bore him two children.

One day, despite Aphrodite's constant fears for his safety, Adonis went out hunting and was killed by a wild boar. (In some versions of the myth, the boar was either a jealous Hephaestus or Ares in disguise.)

Aphrodite sprinkled nectar on Adonis's blood, causing a flower to spring up: the anemone, which matures and dies quickly. It is also said that as Aphrodite hastened to the side of dying Adonis, her foot was pierced by the thorn of a rose; her blood, staining the white flower's petals, turned them henceforth red.

A variant of the myth cites Adonis as the son of Theias and Smyrna. In this tale, Aphrodite hid the infant in a box and left him for safekeeping with Persephone, who then refused to return the child to Aphrodite. Finally Zeus interceded, ruling that Adonis would spend half of each year on earth with Aphrodite and the other half in the underworld with Persephone.

Adonis is thought of as a vegetation and fertility god, similar to the Babylonian Tammuz, from whom his cult of death and resurrection may have developed. His name probably stemmed from the semitic "Adon" ("Lord"). Adonis was probably brought to Greece in the fifth century BCE through Cyprus, where he was worshiped at the site of Amathus. The cult functioned only in association with Aphrodite, although Adonis was also linked with Eros (Cupid).

Artistic representations commonly depict Aphrodite and Adonis as lovers, the goddess trying to restrain the youth from the hunt, Adonis's death, and Aphrodite mourning.

Classical Sources. Orphic Hymns 56, "To Adonis." Theocritus, *Idylls* 15, 30. Bion, "Lament for Adonis." Ovid, *Metamorphoses* 10.519–59, 708–39. Apollodorus, *Biblioteca* 3.14.3–4. Hyginus, *Fabulae* 58, 248, 251; *Poetica astronomica* 2.7. *Anacreontea* 50.

See also ASTARTE; MYRRHA.

Jean de Meun, 1250?–1305? (Story of Venus and Adonis recounted in) *Le roman de la rose* lines 15675–750. Verse romance, completion of unfinished work begun by Guillaume de Lorris (c.1230–35). c.1275. Lyon: Ortuin & Schenck, c.1481. [Dahlberg 1971 / Poirion 1974]

Anonymous French. (Story of Venus and Adonis in) *Ovide moralisé* 10.1960–2093, 2438–2493 (narrative); 3711–3953 (allegory). Allegorized translation/elaboration of Ovid's *Metamorphoses.* c.1316–28. [de Boer 1915–86, vol. 4 / also de Bosque 1985, p. 36—ill.]

Christine de Pizan, c.1364–c.1431. (Death of Adonis in) *L'epistre d'Othéa à Hector* . . . [The Epistle of Othéa to Hector] chapter 65. Didactic romance in prose. c.1400. MSS in British Library, London; Bibliothèque Nationale, Paris; elsewhere. / Translated by Stephen Scrope (London c.1444–50). [Bühler 1970 / Hindman 1986, p. 200]

John Lydgate, 1370?–1449. (Venus and Adonis evoked in) *Reson and Sensuallyte* lines 3685ff. Poem, partial translation of *Les échecs amoureux* [Love's Game of Chess] (1370–80). Probably before **1412.** Modern edition by E. Sieper (London: Early English Text Society, 1901). [Pearsall 1970, p. 117 / Ebin 1985, p. 37]

John Skelton, 1460?–1529. (Poet as Adonis, conceit in Latin prefatory verse to) "The Garlande or Chapelet of

Laurell." Poem. **c.1495.** London: Fakes, 1523. [Scattergood 1983 / Brownlow 1990]

Tommaso (hypothetical artist of **15th/16th century,** circle of Lorenzo di Credi or Piero di Cosimo; possibly Giovanni Cianfanini, 1462–1542). "Venus Asks Cupid to Wound Adonis with Arrow of Love," "Death of Adonis." Pendant paintings. Werner coll., Edenbridge, Kent; Earl of Wemyss and March coll., Gosford House, Longniddry. [Berenson 1963, p. 207—ill.]

Giorgione, c.1477–**1510.** "Venus and Adonis," "Death of Adonis." Paintings. Formerly Palazzo Widman, Venice. [Pigler 1974, pp. 254, 261]

———, style (follower of Titian?). "Venus and Adonis" (? with scenes from the life of Adonis? in background). Painting. National Gallery, London, no. 1123 (as possibly "Atalanta and Hippomenes"). [Berenson 1957, p. 86 / London 1986, p. 623—ill.]

———, circle. "Venus and Mars" ("Venus and Adonis"). Painting. Brooklyn Museum, New York, inv. 37–529. [Pignatti 1978, no. A35—ill.]

Baldassare Peruzzi, 1481–1536, circle, questionably attributed (also attributed to school of Giulio Romano or Raphael). "Venus and Adonis" (Adonis dead, Venus pricked by thorn). Fresco. **1511–12.** (or c.1517–18). Sala delle Prospettive, Villa Farnesina, Rome. [d'Ancona 1955, pp. 27f., 93f. / Gerlini 1949, pp. 31ff. / also Frommel 1967–68, no. 51]

Giulio Romano, c.1499–1546, school, questionably attributed. Frescoes in Villa Farnesina, Rome, **1511–12.** *See Peruzzi, above.*

———, attributed. Frescoes, for Stufetta del Cardinal Bibbiena. 1516. *See Raphael, above.*

———, assistant, after design by Giulio. "Adonis Escaping from Mars" ("Mars Driving Adonis from Venus's Bower"). Fresco. 1528. Sala di Psiche, Palazzo del Tè, Mantua. [Hartt 1958, pp. 129, 132—ill. / Verheyen 1977, p. 117, fig. 42] Venus and Adonis also depicted in stucco relief, Sala delle Stucchi, and possibly (Bacchus and Ariadne?) in fresco, Sala di Ovidio (Metamorfosi). [Verheyen, pp. 110, 123f. / Hartt, p. 111—ill.]

———. "The Wedding of Venus and Adonis." Drawing, design for fresco, for Chambre de la Reine, Château de Fontainebleau. 1534–37. Louvre, Paris, no. 3485. [Dimier 1900, [Ibid., pp. 265ff.] Fresco executed by Primaticcio. *See below.*

Raphael, 1483–1520, school, questionably attributed. Frescoes in Villa Farnesina, Rome, **1511–12.** *See Peruzzi, above.*

———, assistant (probably Giulio Romano), after Raphael's designs. "Venus and Adonis," "Venus Extracting a Thorn from Her Foot." Frescoes, for Stufetta del Cardinal Bibbiena, Vatican, Rome. 1516. "Venus and Adonis" in place; "Thorn" destroyed, known from a print (Bartsch 14:241 no. 321) by Marco Dente da Ravenna (after a copy by Marcantonio Raimondi?). [Vecchi 1987, no. 125—ill. / Hartt 1958, pp. 31f.—ill. / Jones & Penny 1983, p. 193 / also Bartsch 1978, 27:11ff.—ill.]

———, school. "Venus and the Rose." Painting. 1525/50. Hermitage, Leningrad, no. 49. [Pigler 1974, p. 264]

Sebastiano del Piombo, c.1485–1547, attributed. "Death of Adonis." Painting. **c.1511–12.** Uffizi, Florence, inv. 916. [Uffizi 1979, no. P1592—ill. / Berenson 1957, p. 163—ill.]

Antonio da Correggio, *c.*1489/94–1534. "Adonis" (?). Fresco. *c.***1519.** Camera di San Paolo, Parma. [Gould 1976, pp. 51ff., 244f.—ill.]

Francesco Primaticcio, 1504–1570. "The Death of Adonis." Fresco, for Chambre du Roi, Château de Fontainebleau. **1533–35.** Destroyed. [Dimier 1900, pp. 256ff.]

————. "The Wedding of Venus and Adonis." Fresco, after design by Giulio Romano (Louvre, above), for Chambre de la Reine (Salon François I), Fontainebleau. 1534–37. Destroyed. [Ibid., pp. 265ff.]

————, design. "Venus and Adonis [?], with Cupid Asleep," "Adonis Asleep." Frescoes, for Salle de Bal, Fontainebleau, executed by Niccolò dell' Abbate under Primaticcio's direction. 1551–56. Repainted 19th century. / Drawing for "Venus and Adonis." Louvre, Paris, no. 8541. [Dimier, pp. 160ff., 284ff., no. 28 / also Paris 1972, no. 169—ill. / Lévêque 1984, p. 97—ill.]

———— (or Luca Penni? 1500/04–1556), composition. "Adonis [?] and His Hunters Pursuing a Boar." Etching (Bartsch 16, anon. no. 48), executed by Master L. D., fl. 1540–56. (Bibliothèque Nationale, Paris.) [Paris 1972, no. 386—ill.]

Rosso Fiorentino, 1494–1540, and assistants. "The Death of Adonis." Fresco. **1535–40;** repainted/restored 18th, 19th centuries and 1961–66. Galerie François I, Château de Fontainebleau. [Revue de l'art 1972, pp. 130f. and passim—ill. / Panofsky 1958, pp. 139ff.—ill. / Barocchi 1950, pp. 146ff.—ill. / Berenson 1963, p. 195—ill. / de Bosque 1985, pp. 105–07—ill.] Tapestry after, 1540–50. Kunsthistorisches Museum, Vienna, no. 159. [Carroll 1987, no. 77—ill. / Revue de l'art, pp. 106ff.—ill. / also Hofmann 1987, no. 1.1—ill. / Barocchi, fig. 140 / Panofsky, fig. 34 / Lévêque, p. 251—ill. / Berenson]

Parmigianino, 1503–**1540,** attributed. "Venus and the Rose." Painting. [Pigler 1974, p. 264]

Jacopo Tintoretto, 1518–1594. "Venus and Adonis" (formerly called "Diana and Endymion"). Painting. **1543–44.** Uffizi, Florence, Contini-Bonacolsi coll. no. 34, on deposit at Palazzo Pitti. [Rossi 1982, no. 66—ill. / also Uffizi 1979, no. P1709—ill. / also Berenson 1957, p. 173]

————. "Venus and Adonis," "Lament for the Dead Adonis." Paintings. 1543–44. Museo Civico, Padua, nos. 2810, 2812. [Rossi, nos. 73, 75—ill.]

————, previously attributed (now attributed to Domenico Tintoretto). "Venus Lamenting the Death of Adonis." Painting. *c.*1590. University of Arizona, Tucson, no. K2135. [Ibid., no. A98—ill.]

————, formerly attributed (Flemish or Dutch School; Lambert Sustris?). "Venus Fainting at the Sight of the Dead Adonis." Painting. 1550–1600. Louvre, Paris (as Sustris), inv. 1759 (2732). [Ibid., no. A80—ill. / Louvre 1979–86, 1:134—ill. / also Berenson, p. 177 (as Tintoretto and assistants)]

Perino del Vaga, 1501–**1547,** attributed. "Venus Finds Adonis Dead." Painting. Uffizi, Florence, inv. SMeC 118. [Uffizi 1979, no. P1154—ill.]

Diego Hurtado de Mendoza, 1503–1575. "Fábula de Adonis." Verse fable. **1553.** In *Obras,* edited by Juan Díaz Hidalgo (Madrid: J. de Cuesta, 1610). Modern edition by P. Bohigas, in *Epístolas y otras poesías* (Barcelona: 1944). [Oxford 1978, p. 284]

Titian, 1488/90–1576. "Venus and Adonis" (Venus trying to prevent Adonis's departure). Painting. **1553–54.**

Prado, Madrid, no. 422. [Wethey 1975, no. 40—ill. / also Vermeule 1964, pp. 90, 175f. / Berenson 1957, p. 187] Variants, by Titian and studio. *c.*1555, *c.*1560–65. National Gallery, London; Earl of Normanton coll., Ringwood, Hampshire (*c.*1555); Metropolitan Museum, New York, no. 49.7.16 (*c.*1560); National Gallery, Washington, D.C., no. 680. [Wethey, nos. 41–44—ill. / also Hulse 1981, pp. 143–46, 159–64 / London 1986, p. 621—ill. / Metropolitan 1983, p. 125—ill. / Sienkewicz 1983, p. 9—ill. / Walker 1984, p. 212—ill. / Berenson 1957, p. 192] Numerous copies and variant copies, in Galleria Nazionale, Palazzo Barberini, no. 922, Rome; Duke of Northumberland coll., Alnwick Castle; Dulwich College Picture Gallery, Dulwich, London, cat. 1953 no. 209; City Art Gallery, York, cat. 1974 no. 358; others in private colls. or unlocated. [Wethey, nos. X-39–40—ill. / Wright 1976, p. 202]

————, follower. "Mythological Scene" (Atalanta and Hippomenes? with story of Adonis? in background). Painting. National Gallery, London, inv. 1123. [London, p. 623—ill.]

————. *See also Giorgione, above.*

Luca Penni, 1500/04–1556. "The Death of Adonis." Drawing. Teylers Museum, Haarlem. / Etching (Bartsch 16, anon. no. 58) by Jean Mignard (fl. *c.*1535–55). (École des Beaux-Arts, Paris.) [Paris 1972, no. 416 / also Lévêque 1984, p. 236—ill.]

————, composition. "The Death of Adonis." Engraving, executed by Étienne Delaune. (Bibliothèque Nationale, Paris.) [Lévêque, p. 147—ill.]

Niccolò dell' Abbate, 1509/12–1571? Frescoes for Salle de Bal, Fontainebleau. 1551–56. *See Primaticcio, above.*

————, attributed (or studio?). "The Boar Responsible for the Death of Adonis Brought before Venus." Painting. Late work. Private coll. [Paris 1972, no. 4—ill.]

Giorgio Vasari, 1511–1574, design (or direction). "Adonis and Venus." Fresco. **1555–56.** Executed by Cristofano Gherardi. Sala degli Elementi, Palazzo Vecchio, Florence. [Sinibaldi 1950, pp. 13, 22 / Voss 1920, 1:283]

————. "Death of Adonis." Painting. Lost. [Voss, 1:276]

Girolamo Parabosco, *c.*1524–**1557.** "Favola di Adone." Short narrative poem. [DELI 1966–70, 4:247]

Paolo Veronese, 1528–1588. "Venus and Adonis." Painting. *c.***1561–63.** Städtische Kunstsammlungen, Augusta. [Pallucchini 1984, no. 75—ill. / Pignatti 1976, no. 116—ill.]

————, attributed. "Venus and Adonis with Cupid and Dogs." Painting. *c.*1561–63. Unlocated. [Pallucchini, no. 76—ill. / Pignatti, no. A421—ill.]

————. "Venus and Adonis Asleep." Painting. *c.*1580–82. Prado, Madrid, inv. 482. [Pallucchini, no. 179—ill. / Pignatti, no. 250—ill. / Prado 1985, p. 753] Copy in Christ Church College Picture Gallery, Oxford. [Byam Shaw 1967, no. 111]

————. "Venus with the Dying Adonis and Amorini." Painting. *c.*1580–82. Nationalmuseum, Stockholm, inv. 4414. [Pallucchini, no. 181—ill. / Pignatti, no. 252—ill.]

————. "Venus and Adonis with Cupid and Dogs." Painting. *c.*1578–82. Kress coll. (K1552), Seattle Art Museum, no. It37/V5994.1. [Pallucchini, no. 182—ill. / Pignatti, no. 249—ill. / Shapley 1966–73, 3:41f.—ill.]

————. "Venus and Adonis with Amorino and Dogs." Painting. *c.*1582–84. Kunsthistorisches Museum, Vienna, inv. 1527 (400). [Pallucchini, no. 234—ill. / Pignatti, no. 259—ill. / Vienna 1973, p. 198—ill.]

————, studio. "Venus and Adonis with Cupid and Dogs." Painting. University Museum, Edinburgh. [Pignatti, no. A77—ill.]

————, circle. "Venus and Adonis" (with Cupid and dogs). Painting. Gemäldegalerie, Dresden, inv. 244. [Pignatti, no. A70—ill.]

————, style. "The Death of Adonis." Painting, part of "Eight Scenes from the Metamorphoses of Ovid" series. Gardner Museum, Boston, no. P17w32-s-1. [Hendy 1974, p. 286—ill.]

Andrea Schiavone, 1522–1563. "Venus and Adonis." Painting. Pinacoteca, Padua, no. 150. [Berenson 1957, p. 161]

————. "Venus and Adonis." Painting. Conte Vittorio Cini coll., Venice. [Ibid.]

Pierre de Ronsard, 1524–1585. "L'Adonis." Poem. In *Les trois livres du recueil des nouvelles poésies* book 1 (Paris: Buon, **1563**). [Laumonier 1914–75, vol. 12 / Cave 1973, pp. 37f., 202f. / McFarlane 1973, pp. 37f.]

Luca Cambiaso, 1527–1585. "Venus and Adonis" (as lovers). Painting. *c.*1565. Private coll., Genoa. [Manning & Suida 1958, p. 102—ill.] (Studio?) variant. Museo Civico, Padua. [Ibid., pp. 143f.]

————. "Venus and Adonis" (as lovers). Painting. 1565–68. Galleria Borghese, Rome, inv. 317. [Ibid., p. 147—ill. / Pergola 1955–59, 1: no. 126—ill.]

————. "Venus and Adonis." Drawing. *c.*1565–70. Poole coll., Cincinnati. [Manning & Suida, p. 189—ill.]

————. "Venus and the Dying Adonis." Painting. 1570–75. Palazzo Barberini, Rome. [Ibid., p. 146—ill.] Studio copy. Pinacoteca Nazionale, Naples. [Ibid., p. 142]

————. "Venus and Adonis" (Venus trying to keep Adonis from the hunt). Painting. Palazzo Bianco, Genoa. [Ibid., p. 70—ill.] Variant. Formerly Monotti coll., Rome. [Ibid., p. 149—ill.]

————. "The Death of Adonis." Painting (copy after lost original?). Italian Embassy, Moscow (on loan from Pinacoteca Nazionale, Naples). [Ibid., p. 158—ill.]

————. "The Death of Adonis." Drawings. Courtauld Institute, London; Louvre, Paris, inv. 9331, 9334; Prado, Madrid, no. 562. [Ibid., pp. 89, 147, 176—ill.]

————. "Venus and Adonis." Painting. Hermitage, Leningrad, inv. 2774. [Hermitage 1981, pl. 93]

————. Numerous other versions of this subject, known from prints and documents, untraced. [Manning & Suida, pp. 89, 165, 166, 171—ill.]

Taddeo Zuccari, 1529–1566. "Venus Wounded on the Foot and Cared for by Cupids." Fresco. Villa Giulia, Rome. [de Bosque 1985, p. 41—ill.]

Arthur Golding, 1536?–1605. (Story of Venus and Adonis in) *Ovids Metamorphosis* book 10 (London: **1567**). [Rouse 1961]

Frans Floris, 1516/20–1570. "Venus and Adonis." Painting. Museum, Breslau. [Pigler 1974, p. 255]

————. "Venus and Adonis." Painting. Mauritshuis, The Hague. [Ibid.]

Giorgio Ghisi, 1520/21–1582. "Venus and Adonis." Engraving, after composition by Teodora Ghisi. *c.*1570. (Kunsthalle, Hamburg, inv. 1/724). [Hofmann 1987, no. 5.48—ill.]

Paris Bordone, 1500–1571. "Venus and Adonis." Painting. Formerly Crespi coll., Milan. [Canova 1964, p. 126]

————. "Venus and Adonis." Painting. Lost. / Replica (or copy?). Kunsthistorisches Museum, Vienna, no. 253, on deposit in Residenzgalerie, Salzburg. [Ibid., p. 132 / Berenson 1957, p. 49]

————. "The Death of Adonis." Painting. Unlocated. [Canova, p. 133 / Berenson 1957, p. 49—ill.]

————. "Venus and Adonis." Painting. Palazzo dei Rettori Dubrovnik. [Berenson, p. 46]

M. Philone (Louis Des Masures), *c.*1515–**1574**. *Adonis.* Tragedy. Lausanne: 1586. [Stone 1974, pp. 95, 119, 121, 214]

Hans Speckaert, ?–*c.***1577**. "The Death of Adonis." Drawing. Szépmüvészeti Múzeum, Budapest. [de Bosque 1985, p. 62—ill.]

Battista Zelotti, *c.*1526–**1578**. "Venus and Adonis." Painting, after Titian. Gemäldegalerie, Dresden, no. 182. [Berenson 1957, p. 204]

Netherlandish School (previously attributed to Gillis III van Coninxloo, 1544–1607). "Venus and Adonis in a Wooded Landscape in Front of the Beersel Castle." Painting. *c.*1570s? Kunstmuseum, Basel, inv. 673. [Cleveland 1982, p. 10]

Christoph Schwarz, 1545–1592. "The Death of Adonis." Painting. **1570s.** Kunsthistorisches Museum, Vienna, inv. 3827 (1541). [Vienna 1973, p. 160—ill.]

Flemish School. "Venus and Adonis." Drawing. *c.***1580.** Uffizi, Florence, no. 8534. [Warburg]

Juan de la Cueva de Garoza, 1550?–1610. "El llanto de Venus en la muerte de Adonis" [The Lament of Venus at the Death of Adonis]. Poem. In *Obras* (Seville: A. Pescioni for F. Rodriquez, **1582**). [Oxford 1978, p. 143]

Anthonie van Blocklandt, 1532/34–**1583**. "Venus Mourns the Dead Adonis." Drawing. Szépmüvészeti Muzeum, Budapest. [Warburg]

————. "Venus and Adonis." Drawing. Perman coll., Stockholm. [Ibid.]

Vincenzo de' Rossi, 1525–**1587**, attributed (formerly attributed to Michelangelo). "Dying Adonis." Marble fountain ornament, from Villa di Poggio Imperiale, Florence. Museo del Bargello, Florence. [Baldini 1982, no. 77—ill.]

Annibale Carracci, 1560–1609. "Venus and Adonis." Painting. *c.***1588–89.** Prado, Madrid. [Malafarina 1976, no. 44—ill.] Reduced copy (previously considered autograph) in Kunsthistorisches Museum, Vienna. [Ibid.—ill.]

————. "Venus, Adonis, and Cupid." Painting. *c.*1590. Prado, Madrid, no. 2631. [Prado 1985, p. 129] Copy (previously considered autograph) in Kunsthistorisches Museum, Vienna. [Ibid.]

————. "Venus Wounded by Cupid as She Sees Adonis." Painting. Replica. Prado, Madrid.

————. "Adonis Discovering Venus." Painting. *c.*1588–89. Kunsthistorisches Museum, Vienna, inv. 234 (470). [Vienna 1973, p. 39—ill.]

Hans Bol, 1534–1593. "Venus and Adonis." Drawing. **1590.** Sold Vienna, 1933 (as "Atalanta and Meleager"). [Pigler 1974, p. 255]

————. "Venus and Adonis." Painting (with ovals depicting Adonis's birth and death on the frame). M. Knoedler Gallery, New York, in 1962. [Warburg]

————. "Landscape with Venus and Adonis." Drawing.

Museum Mayer van den Bergh, Anvers. [de Bosque 1985, p. 183—ill.]

Edmund Spenser, 1552?–1599. (Story of Venus and Adonis illustrated on a tapestry in the Castle Joyous, description of the Garden of Adonis, in) *The Faerie Queene* 3.1.34–38, 3.6.29–52. Romance epic. London: Ponsonbie, **1590,** 1596. [Hamilton 1977 / Freeman 1970, 207–09 / Davies 1986, pp. 69ff., 81f., 86ff. / Nohrnberg 1976, pp. 514–20, 525f., 548ff. / Lewis 1958, pp. 324ff. / MacCaffrey 1976, pp. 259–63 / Hieatt 1975, pp. 86f.]

William Shakespeare, 1564–1616. *Venus and Adonis.* Narrative poem. **1592–93.** London: Field, 1593. [Riverside 1974 / Edwards 1986, pp. 41, 55f. / Root 1903, pp. 9, 31 / Hulse 1981, pp. 143–75 / Barkan 1986, pp. 271, 273]

————, formerly attributed. (Venus and Adonis in) *The Passionate Pilgrim* sonnets 4, 6, 9, 11. (No. 11 written by Bartholomew Griffin, first published in his *Fidessa,* London: 1596; authorship of others unknown.) Date of first publication unknown; 2d edition, London: Jaggard, 1599. [Riverside / Edwards]

Cavaliere d'Arpino, 1568–1640. "Adonis." Fresco. **1594–95.** Loggia Orsini, Palazzo del Sodalizio dei Piceni, Rome. [Röttgen 1969, pp. 279ff.—ill.]

Bartholomeus Spranger, 1546–1611. "Venus and Adonis" (as lovers). Painting. **Mid-1590s.** Kunsthistorisches Museum, Vienna, inv. 2526 (1496A). [Vienna 1973, p. 166—ill. / also de Bosque 1985, p. 180—ill.]

————. "Venus and Adonis." Painting. Duchcov, Czechoslovakia. [de Bosque, p. 169]

————. "Venus and Adonis." Painting. Národní Galeri, Prague. [Ibid., pp. 180f.—ill.]

————. "Venus and Adonis." Painting. Rijksmuseum, Amsterdam, inv. A3888. [Rijksmuseum 1976, p. 520—ill.]

Gabriel Le Breton. *Adonis.* Tragedy. First performed **1597,** Paris. Published Rouen: Petit-Val, 1597. [Stone 1974, pp. 95, 213]

Gillis III van Coninxloo, 1544–1607. "Landscape with Venus and Adonis." Painting. **1588–98.** Cleveland Museum of Art, Ohio, no. 62.293. [Cleveland 1982, no. 4—ill.] 2 further versions of the subject. Biblioteca Ambrosiana, Milan. [Ibid.]

————, previously attributed (Netherlandish School). "Venus and Adonis in a Wooded Landscape in Front of the Beersel Castle." Painting. *c.*1570s? Kunstmuseum, Basel, inv. 673. [Ibid., p. 10]

Giovanni Bandini, 1540–1599. "Adonis," "Venus." Related bronze statuettes. Victoria and Albert Museum, London (both); Metropolitan Museum, New York (Adonis only); Frick Collection, New York, no. 16.2.29 (Adonis only); elsewhere (separately and as a pair). [Frick 1968–70, 3:212f.—ill.]

Italian School. "Venus and Adonis." Painting. **16th century.** William Morris Gallery, Walthamstow, London, inv. Br.O.57. [Wright 1976, p. 99]

School of Fontainebleau. "Venus Mourning the Death of Adonis." Painting. **1550/1600.** Musée National des Beaux-Arts, Algiers, on deposit in Louvre, Paris (no. D.L. 1970–18). [Louvre 1979–86, 5:11—ill.]

Henry Chettle, 1565–1607 (formerly attributed to Henry Constable). "The Sheepheards Song of Venus and Adonis." Poem. In *England's Helicon* (London: Ling & Bodenham, **1600**). [Bush 1963, p. 326]

Netherlandish School. "Venus and Adonis." Painting. *c.***1600.** Lacock Abbey, Wiltshire. [Wright 1976, p. 148]

German School. "Venus and Adonis." Painting. **Early 17th century.** Herzog Anton Ulrich-Museum, Braunschweig, no. 1643. [Braunschweig 1976, p. 18]

Peter Paul Rubens, 1577–1640. "Lamentation over the Dead Adonis." Painting. *c.***1602.** Private coll., Paris. [Jaffé 1989, no. 25—ill. / also Baudouin 1977, fig. 26]

————. "Venus Pricked by a Thorn." Painting. 1607–08. University Galleries, University of Southern California, Los Angeles. [Jaffé, no. 72—ill.]

————, figures, and **Paul Bril,** 1554–1626, landscape. "Venus and Adonis" (Venus attempting to keep Adonis from the hunt). Painting. 1610–11. Kunstakademie, Düsseldorf. [Ibid., no. 141—ill.] Studio variants. Hermitage, Leningrad (Frans Snyders? and Jan Wildens); formerly Kaiser Friedrich-Museum, Berlin, destroyed 1945. [Ibid.] Copy in Mauritshuis, The Hague, inv. 254. [Mauritshuis 1985, pp. 434f.—ill.]

———— (Rubens). "Lamentation over the Dead Adonis" ("Venus Lamenting Adonis"). Painting. *c.*1614. Saul Steinberg coll., New York. [Jaffé, no. 254—ill.] Oil sketch. Dulwich College Picture Gallery, London, no. 451. [Ibid., no. 253—ill. / Held 1980, no. 267—ill.]

————. "Cyparissus" (formerly called "Adonis" or "Actaeon Transformed into a Stag"). Painting, oil sketch (for unknown work for Torre de la Parada?). 1636–38? Musée Bonnat, Bayonne, no. 1001. [Alpers 1971, p. 273—ill. / Held, no. 181—ill. / Jaffé, no. 1255—ill.]

————. "Venus and Adonis" (Venus trying to keep Adonis from the hunt). Painting. 1635–38. Metropolitan Museum, New York, no. 37.162. [Jaffé, no. 1204—ill. / Metropolitan 1983, p. 147—ill. / Metropolitan 1980, p. 160—ill.]

————. "The Death of Adonis." Painting, part of series of hunts for Philip IV of Spain. 1639–40. Lost. / Oil sketch. Art Museum, Princeton University, N.J., inv. 30–458. [Held, no. 222—ill. / Jaffé, no. 1399—ill.] Copy in Lord Brooke coll., Warwick Castle; 4 others known, unlocated. / Tapestry, woven by Daniel Eggermans, Brussels, in Kunsthistorisches Museum, Vienna. [Held]

————. "Adonis Dying in the Arms of Venus." 3 drawings. British Museum, London, inv. 1895.9.15; L. Burchard coll., London; Prentenkabinet, Antwerp. [Burchard & d'Hulst 1963, no. 66—ill.]

————. *See also Frans Wouters, and Flemish School, 17th century, below.*

Lope de Vega, 1562–1635. *Adonis y Venus.* Tragedy. **1597–1603.** Madrid: Alonso Perez, 1621. [Sainz de Robles 1952–55, vol. 3 / McGraw-Hill 1984, 5:89, 94 / DLE 1972, p. 924]

Cornelis Cornelisz van Haarlem, 1562–1638. "Venus and Adonis." Painting. **1603.** Nationalmuseum, Stockholm, cat. 1928 no. 348. [de Bosque 1985, pp. 180, 184—ill.] Variant. Národní Galeri, Prague. [Ibid., p. 185—ill.] Copy in Herzog Anton Ulrich-Museum, Braunschweig, no. 167. [Braunschweig 1969, p. 45—ill.]

————. "Venus and Adonis." Painting. 1610. Musée, Caën, cat. 1928 no. 131. [Pigler 1974, p. 257]

————. "Venus and Adonis." Painting. 1619. Baltimore Museum of Art, no. 66.1. [Warburg]

———. "Venus, Adonis and Cupid." Painting. 1625. Kasteel Het Nijenhuis, Heino, cat. 1967 no. 53. [Pigler / Wright 1980, p. 82]

———. "Venus and Adonis." Painting. Galerie Brukenthal, Hermannstadt, no. 193. [Pigler]

———. Several further versions of the subject known, unlocated. [Pigler, pp. 257f. / Warburg]

Hendrik Goltzius, 1558–1617. "Dying Adonis." Painting. **1603**. Rijksmuseum, Amsterdam, inv. A1284. [Rijksmuseum 1976, p. 244—ill.]

———. "Venus and Adonis" ("Venus Trying to Keep Adonis from the Hunt"). Painting. 1614. Alte Pinakothek, Munich, inv. 5613. [Munich 1983, p. 222—ill. / de Bosque 1985, pp. 180, 182—ill.]

———. "Venus Mourning over the Dead Adonis." Painting. Musée d'Art Ancien, Blois, no. 183. [Warburg]

Joseph Heintz the Elder, 1564–1609. "Venus and Adonis." Painting. **Shortly after 1603**. Kunsthistorisches Museum, Vienna, inv. 1105 (1520). [Zimmer 1971, no. A24—ill. / Vienna 1973, p. 85—ill.]

Domenichino, 1581–1641. "The Death of Adonis." Fresco. **1603–04**. Loggia del Giardino, Palazzo Farnese, Rome. [Spear 1982, no. 10.i—ill.]

———. "Venus and Adonis." Painting. Lost. [Ibid., p. 311]

Alessandro Allori, 1535–**1607**. "Venus and Adonis." Painting. Galleria Palatina, Palazzo Pitti, Florence, no. 6266. [Pitti 1966, p. 125—ill.]

Andrea Boscoli, 1550–**1607**. "Venus and Adonis." 2 drawings. Uffizi, Florence. [Pigler 1974, p. 256]

Dirck de Quade van Ravesteyn, fl. c.1589–1608, attributed. "Venus, Adonis, and Cupid." Painting. Louvre, no. M.N.R. 19. [Louvre 1979–86, 2:34—ill.]

Joachim Wtewael, 1566–1638. "Venus and Adonis." Painting. c.**1607–10**. Kunstgalerie Hohenbuchau K.G., Schlangenbad. [Lowenthal 1986, no. A-47—ill.] Replica (or copy?). Rijksdienst Beeldende Kunst, The Hague, inv. NK 3424. [Ibid., no. B-1—ill.]

———. "The Death of Adonis." Drawing (study for lost painting?). c.1610. Albertina, Vienna. [Ibid., no. A-47 n.—ill. / de Bosque 1985, pp. 180f.—ill.]

Paulus Moreelse, 1571–1638. "Venus and Adonis" (Venus discovering Adonis dead). Drawing. c.**1610**. Welcker coll., Amsterdam. [de Jonge 1938, no. 15—ill.]

———, figures, and **Roelandt Savery**, 1576–1639, landscape. "Venus and Adonis" (as lovers). Painting. 1622. Staatsgalerie, Stuttgart, no. 1093. [Ibid., no. 267—ill. / Müllenmeister 1988, no. 183—ill.]

———. "Venus and Adonis." Painting. Sold 1773, untraced. [de Jonge, no. 299]

Jacopo Peri, 1561–1633. *Adone*. Opera. Libretto, J. Cicognini. Completed May **1611**. Planned for May 1620, Mantua, unperformed. [Grove 1980, 14:404]

Thomas Heywood, 1573/74–1641. (Venus and Adonis in) *The Brazen Age*. Drama, partially derived from Heywood's *Troia Britanica* (1609). First performed c.**1610–13**, London. Published London: Okes, 1613. [Heywood 1874, vol. 3 / DLB 1987, 62:101, 122ff. / also Boas 1950, pp. 83ff. / Clark 1931, pp. 62ff.]

Giulio Angolo dal Moro, documented 1573–**1615**. "The Death of Adonis." Drawing. Louvre, Paris. [Pigler 1974, p. 261]

Palma Giovane, c.1548–1628. "Adonis Killed by the Boar and Venus Mourning." Painting (sketch). c.**1615**. G. B. Marino coll., in 1636, untraced. [Mason Rinaldi 1984, p. 186]

Anthony van Dyck, 1599–1641. "Venus and Adonis." Painting. c.**1615–16**. Private coll., Locarno. [Larsen 1988, no. 478—ill.]

———. "Venus with Adonis Departing for the Hunt," "The Death of Adonis." Drawings. British Museum, London, Hind cat. 1923 nos. 33–34. [Warburg]

———, imitator. "Venus Lamenting the Death of Adonis." Painting. 17th century. Szépművészeti Múzeum, Budapest, no. 744. [Budapest 1968, p. 206]

———. *See also Thomas Willeboirts, below.*

William Browne, c.1590–c.1645. (Death of Adonis in) *Britannia's Pastorals* 2.2.95ff. Pastoral poem. London: Norton, **1616**. [Bush 1963, p. 176]

Scarsellino, 1551–**1620**. "Venus Mourning Adonis." Painting. Galleria Borghese, Rome, no. 212. [Berenson 1968, p. 391 / Pergola 1955–59, 1: no. 115—ill] Another version of the subject, formerly Platky coll., Leipzig. [Berenson, p. 390]

Abraham Janssens, c.1575–1632, figures, and **Jan Wildens**, 1586–1653, landscape. "Venus and Adonis." Painting. c.**1620**. Kunsthistorisches Museum, Vienna, inv. 728 (888). [Vienna 1973, p. 93—ill.]

Giovanni Battista Marino, 1569–1625. "Venere e Adone." Poem, in *La galeria* (Venice: Ciotti, **1620**). [Getto 1962]

———. *L'Adone*. Poem. Paris: Varano, 1623. [Ibid. / Bondanella 1979, p. 320 / Vinge 1967, pp. 207–11 / Panofsky 1956, pp. 139ff.]

Francesco Albani, 1578–1660. "Adonis Led to Venus by Cupids." Painting, representing "Water," part of a series depicting the Elements. c.**1621**. Louvre, Paris, inv. 12. [Louvre 1979–86, 2:140—ill.]

———. "Venus and Adonis." Painting, part of a series depicting the Elements. 1622. Galleria Borghese, Rome, inv. 44. [Pergola 1955–59, 1: no. 3—ill.]

———. "Venus and Adonis." Painting. Louvre, inv. 20. [Louvre, 2:141—ill.]

———, attributed. "Venus and Adonis." Painting. Tatton Park, Cheshire. [Wright 1976, p. 2]

———, follower. "Venus and Adonis." Painting, copy after Albani. Herzog Anton Ulrich-Museum, Braunschweig, no. 484. [Braunschweig 1969, p. 25]

Adriaen de Vries, 1550–1626. "Venus and Adonis." Bronze sculpture group. **1621**. [Pigler 1974, p. 257]

———. "Venus and Adonis." Bronze sculpture group. 1624. Park, Drottningholm. [Ibid.]

———. "Venus and Adonis." Bronze sculpture group. Castlepark, Bückeburg. [Ibid.]

Juan de Tassis y Peralta, 1582–**1622**. "La fábula de Venus y Adonis." Poem. In *Obras* (Zaragoza: Bonilla, 1629). [DLE 1972, p. 937]

Johann Liss, c.1595–1629. "Venus and Adonis." Painting. **Early 1620s**. Staatliche Kunsthalle, Karlsruhe. [Augsburg 1975, no. A25—ill.]

Nicolas Poussin, 1594–1665. "Venus and Adonis" (Venus mourning dead Adonis). Painting. **Mid-1620s**. Musée des Beaux-Arts, Caen. [Wright 1985, no. 13, pl. 10 / Blunt 1966, no. 186—ill. / Thuillier 1974, no. 19—ill. / Metropolitan 1960, no. 62—ill.]

———. "Venus and Adonis." Painting. Mid-1620s. Rhode Island School of Design, Providence. [Wright, no. 21, pl. 116 / also Blunt, no. 185—ill. / Thuillier, no. 29—ill.]

———. "Venus and Adonis." Painting. c.1625. Lost. / Copy in Uffizi, Florence, inv. 1014. [Uffizi 1979, no. P1279—ill. / Thuillier, no. B6—ill.]

———, attributed. "Landscape, Grottaferrata, with Venus and Adonis." Painting (fragment). c.1627. Musée Fabre, Montpellier. [Wright, no. 31, pl. 12 / also Thuillier, no. B9 (as circle)—ill. / Blunt, no. R105 (as circle of Testa)]

———. "Venus and Adonis." Painting. c.1628. Manchester City Art Gallery (Cook coll.) until 1983. [Wright, no. 35, pl. 14 / also Thuillier, no. 16a—ill. / Blunt, no. R107 (attribution rejected)] Another version in Smith College Art Museum, Northampton, Mass. [Blunt / Thuillier]

———. "Death of Adonis" (Venus pours nectar into Adonis's wound, producing the scarlet anemone). Painting. c.1629–30. Musée des Beaux-Arts, Caën. [Blunt, p. 132, no. 186 / Vermeule 1964, pp. 112, 174]

———. "Venus and the Rose." Drawing. Royal Library, Windsor Castle. [Blunt, p. 164, no. L73]

———, circle (formerly attributed to Poussin). "Venus and Adonis." Painting. Duke of Devonshire coll., Chatsworth. [Thuillier, no. R95—ill.]

———, formerly attributed. "Venus and Adonis." Painting, lost, known from engraving by M. Pool. [Thuillier, no. R96—ill.]

Paul Bril, 1554–1626. "Venus Watching Adonis Being Attacked by the Boar." Painting. Musée des Augustins, Toulouse. [Warburg]

Jean Puget de La Serre, 1594–1665. "Venus et Adonis." Poem. In *Les amours des déesses* (Paris: Courbé, **1626**). [DLF 1951–72, 3:821]

Domenico Mazzocchi, c.1592–1665. *La catena d'Adone* [The Chain of Adonis]. Opera. Libretto, Ottavio Tronsarelli, after G. B. Marino's *L'Adone* (1623). First performed Feb **1626**, Rome. [Grove 1980, 11:869f. / Palisca 1968, p. 105 / Bukofzer 1947, p. 61 / Pirrotta & Povoledo 1982, pp. 168, 271, 273]

Jan Muller, 1571–**1628**. "Death of Adonis." Painting. V. Ivask coll., Riga. [Warburg]

Ivan Gundulić, 1589–1638. *Adona*. Tragedy. Dubrovnik: **1628**. [Hunger 1959, p. 6]

Hendrik de Clerck, 1570–**1629**. "Venus and Adonis." Painting. M. H. de Young Memorial Museum, San Francisco. [Warburg]

Joos de Paepe, ?–1646. "Venus and Adonis." Painting. **1629**. Rijksmuseum, Amsterdam, inv. A2961. [Rijksmuseum 1976, p. 434—ill.]

Jan Brueghel the Younger, 1601–1678, landscape, and **Hendrik van Balen**, 1575–1632, figures (previously attributed to Jan Brueghel the Elder and Abraham Govaerts). "Venus and Adonis." Painting. **1626–32**. Sold Christie's, London, 1982. [Ertz 1984, no. 259—ill.]

——— (Brueghel), landscape, and unknown collaborator, figures. "Wooded Landscape with [Venus and] Adonis." Painting. c.1650. Private coll., Madrid (as Roelandt Savery and Cornelis Cornelisz van Harlem). [Ibid., no. 262—ill.]

Abraham Bloemaert, 1564–1651. "Venus and Adonis on Mount Libanus." Painting. **1632**. Statens Museum for Kunst, Copenhagen, on loan to Foreign Ministry. [Delbanco 1928, no. I.39 / Copenhagen 1951, no. 68]

———. "Venus and Adonis." Painting. 1632. Statens Museum for Kunst, Copenhagen. [de Bosque 1985, p. 97—ill.]

———. "Venus and Adonis." Drawing. Herzog Anton Ulrich-Museum, Braunschweig. [Ibid., pp. 180, 184—ill.]

———. "Venus and Adonis." Drawing. Rijks-Universiteit, Leyden. [Ibid.]

Giulio Antonio Ridolfi. *La corona d'Adone* [The Crown of Adonis]. Heroic drama in verse. Viterbo: Diotallevi, **1633**. [Clubb 1968, p. 196]

Giovanni da San Giovanni, 1592–1636. "Venus and Cupid Mourning the Dead Adonis." Fresco. c.1634. Formerly Palazzo Amerighi (Piazza Santo Spirito 15), Florence. [Banti 1977, no. 47—ill.]

John Milton, 1608–1674. (Death of Adonis in) *Comus* lines 998–1002. Masque. Music, Henry Lawes. First performed Michaelmas Day **1634**, Ludlow Castle. Published London: Robinson, 1637. [Carey & Fowler 1968 / Brown 1985, pp. 149f.]

———. (Adonis evoked as Thammuz, also Garden of Adonis, death of Adonis, evoked in) *Paradise Lost* 1.446–52, 4.246–87, 9.440. Epic. London: Parker, Boulter & Walker, 1667. [Carey & Fowler / Du Rocher 1985, pp. 214f.]

Simon Vouet, 1590–1649. (Venus and Adonis representing Spring and Winter in) "The Four Seasons." Painting. **c.1635?** National Gallery of Ireland, Dublin, no. 1982. [Dublin 1985, no. 41—ill. / also Dublin 1981, p. 175—ill.]

——— (or studio replica of lost original?). "Venus and Adonis." Painting. Before 1638. Hermitage, Leningrad. [Crelly 1962, nos. 50, 230—ill.]

———. "The Story of Venus and Adonis." Series of paintings for house of President Perault, Paris. Lost. [Ibid., no. 253]

———, attributed. "Venus and Adonis." Painting. Chatsworth, Derbyshire. [Warburg]

———, or studio. "Venus and Adonis." Painting, cartoon for "Loves of the Gods" tapestry series. [Crelly, no. 270t]

———. At least 3 further treatments of this subject known. F. Baron coll., Paris; others unlocated. [Ibid., nos. 113, 118, 231]

Jusepe de Ribera, c.1590/91–1652. "Venus Discovering the Dead Adonis." Painting. **1637**. Galleria Corsini, Rome, no. 248. [López Torrijos 1985, p. 419 no. 31—ill. / Spinosa 1978, no. 105—ill. / Fort Worth 1982, no. 23—ill.] Numerous other versions of the subject recorded, lost. [López Torrijos, pp. 283f., 419 nos. 32–35 / Spinosa, nos. 105a–c / Fort Worth, pp. 178f.]

——— attributed (circle?). "Venus and the Dead Adonis." 1630s. Cleveland Museum of Art, Ohio, no. 65.19 (as Ribera). [Spinosa, no. 386—ill. / Fort Worth, p. 178—ill. / Cleveland 1982, no. 222—ill. / López Torrijos, p. 420 no. 37—ill.]

Francesco Manelli, 1594–1667 (previously attributed to Claudio Monteverdi). *L'Adone*. Opera (tragedia). Libretto, Paul Vendramin, after Marino (1623). First performed Carnival **1639–40**, Teatro SS Giovanni e Paolo, Venice. [Grove 1980, 11:613 / Bianconi 1987, p. 187 / See also Redlich 1952, pp. 109–111, who suggests the possibility that Manelli collaborated with Monteverdi]

Gerrit van Honthorst, 1590–1656. "Venus with Adonis

Departing for the Hunt." Painting. **1641.** Formerly Viscount Maugham coll., with Spink & Son, London, in 1955. [Judson 1959, no. 95]

Reynier van der Laeck, ?–*c.*1658. "Venus Mourning the Dead Adonis." Painting. **1641.** Gemeentemuseum, The Hague, cat. 1935 no. 292. [Wright 1980, p. 228]

Guido Reni, 1575–**1642.** "Venus and Adonis." Painting. Museo Cospiano, Bologna, in 1677, untraced. [Pepper 1984, p. 307 no. E13]

Christiaen van Couwenbergh, 1604–1667. "Venus and Adonis." Painting. **1642.** Szépművészeti Muzeum, Budapest, no. 66.19. [Pigler 1974, p. 258]

Alessandro Algardi, 1598–1654. "Adonis Dead in the Arms of Venus." Bronze sculpture group. By **1643.** Formerly Villa Sasso, near Bologna, lost. [Montagu 1985, no. L.124] 2 bronze casts, after original. Marquis Georges de Lastic coll., Paris; Musée des Arts Décoratifs, Paris. [Ibid., pp. 403f.—ill.]

Scipione della Staffa. "Venere con Adone in braccia" [Venus with Adonis in her arms]. Poem, on Algardi's sculpture (above). In *Poesie dedicate alle glorie del sig Alessandro Algardi, ottimo degli scultori,* edited by della Staffa (Perugia: **1643**). The volume also contained poems on the same theme by Francesco Maria Calidonij, Giovanni Battista Lazzarini, Camillo de Mari and Ottaviano Platoni. [Montagu 1985, 2:403]

Stefano Della Bella, 1610–1664. "Venus and Adonis." Etching, design for a set of playing cards. **1644.** Gabinetto Disegni e Stampe, Uffizi, no. 102406. [Florence 1986, no. 3.22—ill.]

Francesco Furini, 1604–**1646.** "Venus Lamenting Adonis." Painting. Szépművészeti Múzeum, Budapest, no. 493. [Budapest 1968, p. 251—ill.]

Bartholomeus Breenbergh, 1599–1657. "Venus Mourning Adonis." Painting. **1646.** B. Meissner coll., Zürich. [Röthlisberger 1981, no. 219—ill.]

Robert Baron, fl. 1630–58. (Story of Venus and Adonis in) *Erotopaignion, or The Cyprian Academy.* Romance in prose and verse (plagiary). London: **1647.** [Bush 1963, p. 337]

Charles-Alphonse Dufresnoy, 1611–1668. "Venus and the Rose." Painting. **1647.** Neues Palais, Potsdam. [Pigler 1974, p. 264]

Guercino, 1591–1666. "Venus and Adonis (and Cupid)" (Venus discovering dead Adonis). Painting. **1647.** Formerly Gemäldegalerie, Dresden, destroyed 1945. [Salerno 1988, no. 237—ill.]

———. "Venus, Adonis, and Cupid" (Venus and Adonis as lovers). 2 drawings, presumed studies for lost painting Denis Mahon coll., London; Duke of Devonshire coll., Chatsworth. [Bologna 1968, 2: nos. 36–37—ill.]

———. "Venus Mourning the Death of Adonis." Drawing. Schloss, Aschaffenburg. [Pigler 1974, p. 262]

Padovanino, 1588–**1648.** "Venus and Adonis." Painting. Museo di Capodimonte, Naples. [Pigler 1974, p. 256]

———, attributed. "Venus and Adonis." Painting. Warschaw coll., Los Angeles. [Ibid.]

———, attributed. "Venus and Adonis." Painting. Herzog Anton Ulrich-Museum, Braunschweig, no. 693. [Braunschweig 1969, p. 138]

Andrew Marvell, 1621–1678. (Adonis evoked in) "An El-egy upon the Death of My Lord Francis Villiers" lines 105–114. Elegy. London: Boulter, **1648.** [Margoliouth 1971 / Craze 1979, pp. 62f.]

Alessandro Turchi, 1578–**1649.** "Venus and Adonis." Painting. Galleria Corsini, Florence. [Pigler 1974, p. 256]

———. "Venus with the Dead Body of Adonis." Painting. Gemäldegalerie, Dresden, no. 521. [Dresden 1976, p. 105]

———, style. "Venus and Adonis." Painting. Staatsgalerie, Stuttgart, no. 594. [Pigler]

Richard Lovelace, 1618–1658. (Venus and Adonis evoked in) "Princess Louisa Drawing." Poem. In *Lucasta: Epodes, Odes, Sonnets, and Songs* (London: Ewster, **1649**). [Wilkinson 1930]

Frans Wouters, 1612–1659 (previously attributed to Rubens). "Venus and Adonis." Painting. *c.***1640–50.** Uffizi, Florence, inv. 1131. [Uffizi 1979, no. P1900—ill.]

———. "Venus Bewailing the Slain Adonis." Painting. Statens Museum for Kunst, Copenhagen. [Copenhagen 1951, no. 1637—ill.]

Pietro Testa, 1611–**1650.** "Venus and Adonis." 2 paintings. Akademie der Bildenden Künste, Vienna. [Pigler 1974, p. 256]

French School. Painting of unknown subject, formerly called "Death of Adonis." **1650.** Louvre, Paris, inv. 20407. [Louvre 1979–86, 4:302—ill.]

Jacob Backer, 1608–**1651.** "Venus and Adonis." Painting. Schloss Fasanerie, Eichenzell bei Fulda. [Mauritshuis 1985, p. 34—ill.]

Alexander Keirincx, *c.*1600–**1652.** "Landscape with Venus and Adonis." Painting. E. J. Otto coll., Celle, Germany, in 1941. [Warburg]

Pedro Soto de Rojas, 1584–1658. "Los fragmentos de Adonis" [The Fragments of Adonis]. Poem. In *Parayso cerrado para muchos* (Granada: Baltasar de Bolibar, **1652**). [DLE 1972, p. 854]

Thomas Willeboirts, *c.*1614–**1654.** "The Death of Adonis." Painting. 2 versions: Gemäldegalerie, Berlin; National Gallery of Canada, Ottawa, no. 4269 (previously attributed to Anthony van Dyck). [Larsen 1988, no. A40—ill.] Copy in Nationalmuseum, Stockholm. [Ibid.]

———. "Venus and Adonis." Painting. Formerly Mauritshuis, The Hague, no. 452, destroyed in World War II. [Warburg]

———. "Venus Mourning the Death of Adonis." Painting. Jagdschloss Grunewald, Berlin, no. 5172. [Warburg]

———. "Venus Mourning Adonis." Painting. Sold Christie's, London, 1974. [Warburg]

———, questionably attributed (previously attributed to van Dyck). "Venus and Adonis." Painting. Herzog Anton Ulrich-Museum, Braunschweig, no. 687. [Braunschweig 1969, p. 150]

Herman van Swanevelt, *c.*1600–1655. "The Life of Adonis." Etching cycle. **1654.** [Pigler 1974, pp. 258, 263]

———. "The Rape of Adonis." Painting. Palazzo Doria-Pamphili, Rome, cat. 1942 no. 68. [Warburg]

Francesco Cirillo, 1623–after 1667. *Adone.* Opera. Libretto, Gennaro Paolella. First performed **1656,** Naples. [Hunger 1959, p. 7]

Samuel Holland, fl. 1656–80. "Venus and Adonis." Masque. In *Wit and Fancy in a Maze* (London: Vere, **1656**). [Greg 1939–59, 2:768f.]

Luigi Primo, 1606–1667. "Venus Lamenting the Dead Adonis." Painting. *c.*1655–57. Kunsthistorisches Museum, Vienna, inv. 1705 (1213). [Vienna 1973, p. 137—ill.]

Jacques Stella, 1596–1657. "Venus and Adonis." Painting. Hermitage, Leningrad. [Bénézit 1976, 9:815]

Ferdinand Bol, 1616–1680. "Venus and Adonis." Painting. *c.*1656–58? Landesmuseum Johanneum, Graz, cat. 1923 no. 151. [Blankert 1982, no. 30—ill.]

———. "Venus and Adonis." Painting. *c.*1658. Musée des Beaux-Arts, Orléans. [Ibid., no. 27—ill.] Replica. Private coll., Germany. [Ibid., no. 26—ill.]

———. "Venus and Adonis." Painting. *c.*1658. Art market, Amsterdam, in 1982. [Ibid., no. 29—ill.]

———. "Venus and Adonis." Painting. 1661. Bass Museum of Art, Miami Beach, no. 131. [Ibid., no. 31—ill.]

Cornelis Holsteijn, 1618–1658. "Venus Mourning the Death of Adonis." Painting. Frans Hals Museum, Haarlem, cat. 1969 no. 172. [Wright 1980, p. 179]

Jean de La Fontaine, 1621–1695. "Adonis." Poem. By **1658**. Published with *Les amours de Psyché et Cupidon* (Paris: 1669). [Clarac & Marmier 1965 / MacKay 1973, pp. 42, 46, 173 / DLLF 1984, 2:1175ff.]

Pedro Calderón de la Barca, 1600–1681. (Adonis and Venus in) *La púrpura de la rosa* [The Blush of the Rose]. Zarzuela. Music, Juan Hidalgo. **1659**. First performed 5 Dec 1660, Buen Retiro, Madrid. Libretto published in *Comedias de Calderón,* part 3 (Madrid: 1664). [Valbuena Briones 1960–67, vol. 1 / O'Connor 1988, pp. 304–15 / Bianconi 1987, pp. 260f.]

Diego Velázquez, 1599–1660. "Venus and Adonis." Painting. *c.*1659. Formerly Alcázar de Madrid, destroyed 1734. [López-Rey 1963, no. 67]

Giovanni Francesco Romanelli, 1610–1662. "Venus with Adonis Departing for the Hunt." Painting. Louvre, Paris, no. M.I. 882. [Louvre 1979–86, 2:232—ill.]

———. "Venus and Adonis." Painting. Formerly Musée, Morlaix (on deposit from Louvre, Paris, inv. 580), stolen in 1981. [Ibid., 2:298]

Luca Giordano, 1634–1705. "Venus, Adonis, and Cupid." Painting. *c.*1663–65. Szépmüvészeti Múzeum, Budapest, no. 534 (189). [Ferrari & Scavizzi 1966, 2:61 / Budapest 1968, p. 263]

———. "Adonis and Venus." Painting. 1663? Recorded in Andrea d'Avalos coll., Naples, in 1743, untraced. [Ferrari & Scavizzi, 2:361]

———. "Death of Adonis." Fresco. 1682. Galleria Riccardiana, Palazzo Medici, Florence. [Kempter 1980, pp. 76f., no. 85—ill.]

———. "Venus and Adonis." Painting. Musée, Toulouse, in 1899. [Ferrari & Scavizzi, 2:386]

Juan Bautista del Mazo, *c.*1612–1667, attributed. "Venus and the Dead Adonis." Painting. Prado, Madrid, no. 899a. [Prado 1985, p. 399 / López Torrijos 1985, p. 420 no. 38—ill.]

Cornelis van Poelenburgh, *c.*1586–1667. "Adonis Departing" (for the hunt). Painting. Earl of Wemyss and March coll., on loan to National Gallery of Scotland, Edinburgh. [Warburg]

Joris van Son, 1623–1667, and **Erasmus Quellinus,** 1607–1678. "Venus Mourning Adonis." Painting. Mrs. T. Sanger coll., England, in 1955. [Warburg]

Nicolaes van Helt, called Stockade, 1614–**1669**. "Venus with Adonis." Painting. Munchen-Alexandre coll., Luxemburg, 1955. [Warburg]

———. "Venus and Adonis." Painting. Nijmeegs Museum Commanderie van St. Jan, Nijmegen. [Wright 1980, p. 169]

Andrea Vaccaro, 1598–**1670**, attributed. "Venus and Adonis." Painting. Musée, Aix-en-Provence. [Pigler 1974, p. 256]

Jean Donneau de Visé, 1638–1710. *Les amours de Vénus et d'Adonis.* Tragedy. First performed **1670**, Théâtre Marais, Paris. Published Paris: Barbin, 1670. [Lancaster 1929–42, pt. 3, 2:524–27, 868 / Arnott 1977, p. 22 / DLLF 1984, 1:661]

Jan van Bijlert, 1603–**1671**. "Venus and Adonis." Painting. Centraal Museum, Utrecht, cat. 1952 no. 59. [Wright 1980, p. 69]

Georges Biset, fl. from 1634, d. **1671**. "Venus Mourning." Painting. Herzog Anton Ulrich-Museum, Braunschweig, no. 288. [Braunschweig 1969, p. 33]

Francis Kirkman, 1632?–1674. *Venus and Adonis, or the Maid's Philosophy.* Comedy. In *The Wits; or Sport upon Sport* (London: **1673**). [Nicoll 1959–66, 1:418]

Jean Jouvenet, 1644–1717. "Venus and Adonis." Painting. **1674**. Unlocated. [Schnapper 1974, no. 4]

Giovanni Legrenzi, 1626–1690. *Adone in Cipro.* Opera. Libretto, G. M. Giannini or I. Teomagnini. First performed **1676**, Teatro S. Salvatore, Venice. [Grove 1980, 10:618]

Karel Dujardin, 1622–**1678**. "Venus and Adonis." Painting. Schilderijenzaal Prins Willem V, The Hague. [Wright 1980, p. 106]

Jacob Jordaens, 1593–**1678**, attributed. "Venus and Adonis." Painting. Musées Royaux des Beaux-Arts (Musée d'Art Ancien), Brussels, inv. 8732. [Brussels 1984a, p. 160—ill.]

———, attributed. "Adonis Embraces Venus." Painting. 2 versions of the subject known, recorded in sales of 1763, 1777, untraced. [Rooses 1908, p. 257]

———, attributed. "The Death of Adonis." Painting. 2 versions of the subject known, recorded in sales of 1886, 1903, untraced. [Ibid.]

Paul de Vos, 1596–**1678**. "Venus Mourning Over the Dead Adonis." Painting. Academia de Bellas Artes de San Fernando, Madrid. [Warburg]

Arie de Vois, *c.*1632–1680. "Venus and Adonis." Painting. **1678**. Neues Palais, Potsdam. [Warburg]

Daniel Vertangen, 1598–**1681/84**. "Venus with Departing Adonis." Painting. Art market, London, in 1937. [Warburg]

John Blow, 1649–1708, music. *Venus and Adonis.* Masque. First performed *c.***1685**, for the King, Hampton Court. [Baker 1984, p. 281 / Grove 1980, 2:806, 810 / Bukofzer 1947, pp. 189f.]

Marc-Antoine Charpentier, 1645/50–1704. "Vénus et Adonis." Musical interlude. Text, De Visé. **1685**. Autograph MS in Bibliothèque Nationale, Paris (Charpentier vol. 22). [Grove 1980, 4:174]

Angelo Michele Colonna, 1600–**1687**. "Venus and the Rose." Fresco. Palazzo Albergati, Bologna. [Pigler 1974, p. 264]

Pietro Liberi, 1614–**1687**, questionably attributed (variously attributed to Liberi, P. Testa, B. Guidobono,

Tylman van Gameren). "Venus and Adonis." Painting. Muzeum Narodowe, Warsaw, inv. 130850, on display at Wilanów Palace. [Warsaw 1969, no. 1731—ill.]

———. "The Death of Adonis." Painting. Palazzo Conti, Padua. [Pigler 1974, p. 262]

Philip Ayres, 1638–1712. "Death of Adonis." Poem, after Theocritus. In *Lyric Poems* (London: **1687**). [Praz, *Modern Language Review* 20 (1925): 283, 426]

Louis Lecomte, 1639–1694. "Venus and Adonis." Monumental sculpture group. **1680s.** Orangerie, Gardens, Versailles. [Girard 1985, p. 277]

Gérard de Lairesse, 1641–1711 (active until *c.*1690), questionably attributed. "Venus and Adonis." Painting. Muzeum Narodowe, Warsaw, inv. 231553. [Warsaw 1969, no. 610—ill.]

François Verwilt, *c.*1620–1691. "The Death of Adonis." Painting. Museum, Mainz. [Bénézit 1976, 10:481]

Christian Kirchner, ?–1732, attributed. "Adonis, Venus, and Cupid." Sandstone sculpture group. *c.*1680–90. Grosser Garten, Dresden. [Asche 1966, p. 335]

Abraham Hondius, *c.*1625–1695. "Venus with Adonis Departing for the Hunt." Painting. Van Riemsdijk coll., Amsterdam, in 1943. [Warburg]

Michel-Richard de Lalande, 1657–1726, music. *Adonis.* Ballet divertissement. First performed **1696** (or 1698?) Versailles. [Grove 1980, 10:384 / Baker 1984, p. 561]

Alessandro Scarlatti, 1660–1725. *Venere, Adone e Amore (dal giardin del piacere)* [Venus, Adonis, and Cupid (in the Pleasure Garden)]. Serenata for 3 voices and instruments. Libretto, F. M. Paglia. First performed 15 July **1696,** Casino del Vicerè a Posillipo, Naples. / Revised, performed 1706, Rome. [Grove 1980, 16:560]

———. *Venere e Adone: Il giardino d'amore* [Venus and Adonis: The Garden of Love]. Serenata for 2 voices and instrument. First performed *c.*1700–05. [Ibid.]

Hendrik Anders, 1657–1714/20. *Venus en Adonis.* Opera. Libretto, Dirck Buysero. *c.*1697. [Grove 1980, 1:398]

Henry Desmarets, 1661–1741. *Vénus et Adonis.* Opera (tragédie lyrique). Libretto, Jean-Baptiste Rousseau. First performed 17 Mar **1697,** L'Opéra, Paris. [Grove 1980, 5:391 / Girdlestone 1972, pp. 162 *n.*, 148]

Reinhard Keiser, 1674–1739. *Der geliebte Adonis* [Adonis Beloved]. Opera. Libretto, C. Heinrich Postel. First performed **1697,** Hamburg. [Grove 1980, 9:847]

Johann Carl Loth, 1632–1698. "Venus and Adonis." Painting. Musée, Poitiers (on deposit from Louvre, Paris, no. M.I. 1197). [Louvre 1979–86, 2:292]

Nicolaus Adam Strungk, 1640–1700, questionably attributed. *Der geliebte Adonis* [Adonis Beloved]. Opera. Libretto, C. H. Postel. First performed **1694–99,** Leipzig. [Grove 1980, 18:299]

Flemish School (school of Rubens?). "Death of Adonis." Painting. **17th century.** Bowes Museum, Barnard Castle, County Durham, list 1934 no. 831. [Wright 1976, p. 64]

Italian School. "Venus and Adonis." Painting. **17th century.** Herzog Anton Ulrich-Museum, Braunschweig, no. 1108. [Braunschweig 1976, p. 35]

Italian School. "Venus and Adonis." Painting. **17th century.** Muzeum Narodowe, Warsaw, inv. 76459. [Warsaw 1969, no. 1654—ill.]

Italian School. "Venus and Adonis." Painting. **17th cen-**

tury. Musée, Périgueux (on deposit from Louvre, Paris, inv. 852). [Louvre 1979–86, 2:306]

Italian School. "Venus Lamenting Adonis." Painting. **17th century.** Private coll., Scotland. [Warburg]

Madrilenian School. "Venus and the Dead Adonis." Painting. **17th century.** Private coll., Madrid. [López Torrijos 1985, p. 420 no. 39—ill.]

Netherlandish School (?). "Adonis." Painting. **17th century.** Rijksmuseum, Amsterdam, inv. A512. [Rijksmuseum 1976, p. 649—ill.]

Tomás de Torrejón y Velasco, 1644–1728. *La púrpura de la rosa.* Opera. Libretto, Calderón (1659). First performed 19 Oct **1701,** Viceregal Palace, Lima, Peru. [Grove 1980, 19:80 / O'Connor 1988, p. 314, *n.*4 / Bianconi 1987, p. 261]

Eglon Hendrick van der Neer, 1634?–1703. "Venus and Adonis." Painting. Art Gallery and Museum, Glasgow, cat. 1961 no. 59. [Wright 1976, p. 146]

Robert Le Lorrain, 1666–1743. "Venus Attempting to Keep Adonis from the Hunt." Bronze sculpture. **1704.** 2 casts extant. Palais de L'Elysée, Paris; Wallace Collection, London. [Beaulieu 1982, p. 54—ill.]

Daniel Seiter, 1649–1705. "Venus Mourning the Dead Adonis." Painting. Städtliche Kunstsammlung, Düsseldorf. [Bénézit 1976, 9:511]

———. "Venus and Adonis." Painting. Schönborn coll., Pommersfelden. [Ibid.]

Philip Tidemann, 1657–1705. "Venus Mourns the Death of Adonis." Painting. Hopetown House, Scotland. [Warburg]

Sebastiano Ricci, 1659–1734 (with Giuseppe Tonelli and Marco Ricci?). "Venus Bidding Farewell to Adonis." Fresco. *c.*1707–08. Palazzo Pitti, Florence. [Daniels 1976, no. 92a—ill.] Oil sketch. Musée des Beaux-Arts, Orléans. [Ibid., no. 282—ill.]

———. "The Death of Adonis." Painting. *c.*1707–08. Sold Christie's, London, 1975. [Ibid., no. 182]

———. "Venus and Adonis." Painting. Landesmuseum, Hannover. [Ibid., no. 119a]

Jean Cotelle the Younger, 1642–1708, attributed. "Venus and Adonis." Painting. Hermitage, Leningrad, inv. 2228. [Hermitage 1986, no. 27—ill.]

Georg Philipp Telemann, 1681–1767. *Adonis.* Opera. **1708.** 1 aria extant. [Grove 1980, 18:656]

Giuseppe Mazzuola, 1644–1725. "The Death of Adonis." Marble sculpture. **1709.** Hermitage, Leningrad, inv. 1113. [Hermitage 1984, no. 376—ill./ Hermitage 1975, pls. 50–51]

Nicolas Coustou, 1658–1733. "Adonis Resting from the Hunt." Marble statue, for Château de Marly. **1710.** Louvre, Paris. [Chappuis 1973, p. 269—ill.] Copy, alabaster statuette (Flemish or German school), 18th century. Schleswig-Holsteinisches Landesmuseum, Schleswig, no. 1965–307. [Düsseldorf 1971, no. 302—ill.]

Antonio Caldara, *c.*1670–1736. *Mercurio, Adone, Venere.* Serenata. First performed **1711,** Milan. [Grove 1980, 3:615]

George Frideric Handel, 1685–1759. *Venus and Adonis.* Cantata. Libretto, John Hughes. **1711.** 2 surviving arias: "Behold, where Venus weeping stands" and another. [Keates 1985, p. 60 / Hogwood 1984, pp. 66, 74 / Grove 1980, 8:122]

Carlo Maratti, 1625–1713, studio. "Venus Creating the

Red Rose." Painting. Statens Museum for Kunst, Copenhagen, inv. 4551. [Copenhagen 1976, p. 7]

Johan van Neck, 1635–**1714.** "Venus and Adonis." Painting. Noordbrabants Museum, 's Hertogenbosch, Netherlands, inv. 7496. [Wright 1980, p. 296]

Colley Cibber, 1671–1757. *Venus and Adonis.* Masque. Incidental music, Johann Christoph Pepusch. First performed 12 Mar **1715**, Theatre Royal, Drury Lane, London. [McGraw-Hill 1984, 1:518 / Fiske 1973, pp. 56–58 / Nicoll 1959–66, 2:133, 259 / Grove 1980, 14:359]

Gottfried Heinrich Stölzel, 1690–1749. *Venus and Adonis* (also called *Adonis*). Musical drama. Libretto, composer. First performed **1715–17**, Prague. / Revised, performed 1728–30, Altenburg. [Grove 1980, 18:175]

Carlo Cignani, 1628–**1719.** "Venus and Adonis." Painting. Wellington Museum, London, list 1964 no. 1612. [Wright 1976, p. 37]

———. "Bacchus and Ariadne" ("Venus and Adonis"). Painting. Schönborn coll., Pommersfelden (as Venus and Adonis). [Pigler 1974, p. 47]

Christoph Graupner, 1683–1760. *Adone.* Opera. First performed **1719**, Darmstadt. [McCredie 1966, p. 116]

Antoine Coypel, 1661–**1722.** "The Parting of Venus and Adonis." Dienst Vorspreide Rijkskollekties, The Hague. [Wright 1980, p. 1]

Benjamin Thomae, 1682–1751. "Adonis" (?), "Venus and Cupid." Sandstone statues. **1721–23.** Schlosspark, Neschwitz. [Asche 1966, nos. T29c–d, pls. 146, 147]

Constantijn Netscher, 1668–**1723.** "Venus Mourning Adonis Transformed into an Anemone." Painting. Louvre, Paris, inv. 1608. [Louvre 1979–86, 1:97—ill.]

Bolognese School. "Venus and the Sleeping Adonis." Painting. **1700/25.** Szépmüvészeti Múzeum, Budapest, no. 7745. [Budapest 1968, p. 77]

Giovanni Battista Foggini, 1652–**1725.** "The Death of Adonis." Bronze sculpture group. Bayerische National Museum, Munich. [Pigler 1974, p. 262]

Marco Liberi, 1640–*c.***1725.** "Venus and Adonis." Painting. Schönborn coll., Pommersfelden. [Pigler 1974, p. 257]

———, attributed. Painting. Citton coll., Pordenone. [Ibid.]

Johannes Glauber, 1646–**1726.** "Adonis Leaving Venus." Painting. Formerly Middelburg, Holland, destroyed 1943. [Warburg]

———, attributed. "Landscape (with Venus Finding the Dead Adonis)." Painting. Felbrigg Hall, Norfolk. [Warburg / Wright 1976, p. 79]

Marcantonio Franceschini, 1648–**1729.** "Venus and Adonis." Painting. Liechtenstein coll., Vaduz. [Pigler 1974, p. 257]

———, attributed. "Venus and Adonis." Painting. Private coll., Madrid. [Ibid.]

François Le Moyne, 1688–1737. "Venus and Adonis." Painting. **1729.** Nationalmuseum, Stockholm, inv. 854. [Bordeaux 1984, no. 78—ill.]

———, rejected attribution (manner of Jean-Baptise Van Loo?). "Venus and Adonis." Painting. A. Loewy coll., Montreal. [Bordeaux, no. X20—ill.]

Benedetto Marcello, 1686–1739. *La morte di Adone.* Serenata. First performed **1729**, Rome. [Grove 1980, 11:649]

François Boucher, 1703–1770. "The Death of Adonis."

Painting. *c.***1730.** Goudchaux coll., Paris. [Ananoff 1976, no. 39—ill.]

———. "Venus and Adonis" (as lovers, seated on a cloud; also called "Aurora and Cephalus"). Painting. 1732–33. Musée des Beaux-Arts, Nancy (as "Aurora and Cephalus"). [Louvre 1979–86, 3:79—ill. / also Ananoff, no. 86—ill.]

———. "Venus Finding the Body of Adonis." Painting. *c.*1733. Lost. [Ananoff, no. 87—ill.] Prints ("Death of Adonis") by LeVasseur and Surugue. [Ibid.—ill.]

———. "Venus, Adonis, and Two Cupids." Painting. 1741. Los Angeles County Museum of Art, no. 47.29.19. [Ibid., no. 152—ill.]

François de Troy, 1645–1730. "Venus and Adonis." Painting. *c.***1730.** Private coll. [Bordeaux 1984, fig. 396 *bis*]

Antonio Bioni, 1698–after 1739. *Adone.* Opera. First performed Carnival **1731**, private theatre of Count Sporck, Prague. [Grove 1980, 2:726]

Giuseppe Chiari, 1654–1727/33. "Adonis Leaving Venus." Painting. Marquess of Exeter coll., Burghley. [Warburg]

James Thornhill, 1675/76–**1734.** "Venus and Adonis." Drawing. Colnaghi Ltd., London, in 1971. [Pigler 1974, p. 261]

Andrew Carpenter (Andries Charpentière), ?–**1737.** "Adonis" (with dog). Lead sculpture. Victoria and Albert Museum, London. [Warburg]

Massimiliano Soldani-Benzi, 1658–**1740.** "Venus and Adonis." Bronze sculpture group. Walters Art Gallery, Baltimore. [Clapp 1970, 1:818]

———. "Venus and the Dying Adonis." Terra-cotta sculpture group. Landesmuseum, Schwerin. [Pigler 1974, p. 262]

Giovanni Antonio Pellegrini, 1675–**1741.** "Venus Mourning the Death of Adonis." Painting. Formerly I. Brass coll., Venice. [Pigler 1974, p. 262]

Jacob de Wit, 1695–1754. "Departure of Adonis." Painting. **1749.** Huis ten Bosch, The Hague. [Staring 1958, p. 155, pl. 55]

Michele Rocca, *c.*1670/75–**1751** or later. "Venus and the Rose" (with Cupid). Painting. Neues Palais, Potsdam. [Voss 1924, p. 624]

Jacopo Amigoni, 1675–**1752.** "Venus and Adonis." Accademia, Venice. [Pigler 1974, p. 257]

———. "Venus and Adonis." Painting. Galerie, Schleissheim. [Ibid.]

———, follower. "Venus and Adonis" (Venus entreating Adonis). Painting. Museum of Fine Arts, Boston, res. 21.79. [Boston 1985, p. 4—ill.]

Jean-Joseph Cassanéa de Mondonville, 1711–1772, music. *Vénus et Adonis.* Ballet-héroïque. Scenario, C. de Messine. First performed **1752**, Paris. [Grove 1980, 12:481]

Nicolo Pasquali, *c.*1718–1757, music. *Venus and Adonis.* Masque. Only overture survives, published in *Twelve Overtures* (*c.***1755**). [Grove 1980, 14:263 / Fiske 1973, p. 595]

Jean-Philippe Rameau, 1683–1764. "L'enlèvement d'Adonis" [The Abduction of Adonis], movement in *Les surprises de l'amour.* Divertissement. Libretto, Pierre-Joseph Bernard, called Gentil-Bernard. First performed 10 Oct **1758**, L'Opéra, Paris. [Grove 1980, 15:571]

Hendrik van Limborch, 1681–1759. "Venus and Adonis." Painting. Neues Palais, Potsdam. [Pigler 1974, p. 259]

————. "Venus Mourning the Death of Adonis." Painting. In artist's estate, untraced. [Ibid., p. 263]

————. "Venus Trying to Prevent Adonis's Departure." Painting. Vuyk-Gaillard coll., The Hague, in 1965. [Warburg]

Jean-Baptiste-François De Hesse (Deshayes), 1705–1779, choreography. *Vénus et Adonis*. Ballet. Music, R. Debrosses. First performed 19 Nov **1759**, Paris. [EDS 1954–66, 4:534]

Antoine Bonaventura Pitrot, 1720s–after 1792, choreography. *Venus et Adonis*. Heroic pantomime-ballet. First performed **1759**, Comédie-Italienne, Paris. [EDS 1954–66, 8:203]

Louis Galloche, 1670–**1761.** "Venus and Adonis." Painting. Château, Fontainebleau. [Bénézit 1976, 4:597]

Benjamin West, 1738–1820. "Venus Lamenting the Death of Adonis." Painting. *c.***1763–67.** Private coll. [von Erffa & Staley 1985, no. 117—ill.]

————. "Venus Relating to Adonis the Story of Hippomenes and Atalanta." Painting. *c.*1767. Private coll. [Ibid., no. 112—ill.]

————. "Venus Lamenting the Death of Adonis." Painting. 1768, retouched 1819. Carnegie Institute Museum of Art, Pittsburgh. [Ibid., no. 116—ill.]

————. "Venus and Adonis, with Cupids Bathing" ("The Bath of Venus"). Painting. *c.*1799. Alexander Gallery, New York. [Ibid., no. 113—ill.]

————. "Adonis and His Dogs." Painting. 1800, retouched 1806. Dayton Art Institute, Ohio. [Ibid., no. 114—ill.] Variant ("Adonis and His Dog"). 1804–08? Unlocated. [Ibid., no. 115—ill.]

————. "Venus Lamenting the Death of Adonis." Painting. 1803. Rutgers University Art Gallery, New Brunswick. [Ibid., no. 118—ill.]

Nicolas-Bernard Lepicié, 1735–1784. "Venus Mourning the Death of Adonis." Painting. **1769.** Petit-Trianon, Versailles. [Bénézit 1976, 6:594 / Pigler 1974, p. 264]

Johann Christian Bock, 1724?–1785. "Adonis." Poem. In *Erstlinge meiner Muse* (Leipzig: **1770**). [Strich 1970, 1:225 *n.*]

Francisco Goya, 1746–1828. "Venus Mourning Adonis." Painting. *c.***1771.** Private coll., Zurich. [Gassier & Wilson 1981, no. 21—ill. / Gudiol 1971, no. 13—ill.]

Charles [Karl?] Wagner. *Adonis*. Opera (monodrama). First performed **1772**, Darmstadt. [Clément & Larousse 1969, 1:10]

Jean-Georges Noverre, 1727–1810, choreography. *Vénus et Adonis*. Ballet. First performed 3 Jan **1773**, Burgtheater, Vienna. [Guest 1972, pp. 22, 151 / Lynham 1950, pp. 111, 171 *n.* / Grove 1980, 13:443]

————, choreography. *Venus and Adonis*. Heroic pantomime ballet. Music, Stephen Storace the Younger. First performed 26 Feb 1793, King's Theatre, London. [Fiske 1973, p. 524 / Grove, 18:181]

Antoine François Callet, 1741–1823. "Adonis Leaving for the Hunt," "The Procession of Adonis." Paintings, part of ceiling decoration for Palais-Bourbon, Paris. **1774.** Louvre, Paris, inv. 572. [Louvre 1979–86, 3:95—ill.]

James Barry, 1741–1806. "The Death of Adonis." Painting. *c.*1775. National Gallery of Ireland, Dublin, no. 1393. [Dublin 1981, p. 193—ill. / Pressly 1981, no. 17—ill.]

Elie Catherine Fréron, 1719–1776, with **Colbert d'Estouteville,** ?–1780. *Adonis*. Novel. Paris: Musier fils, **1775.** [NUC]

George Romney, 1734–1802. "Venus and Adonis." Drawing, in Roman sketchbook. *c.*1775. Fitzwilliam Museum, Cambridge. [Jaffé 1977, no. 6—ill.]

Balthazar Beschey, 1708–**1776.** "Venus and Adonis." Painting. Bayerische Staatsgemaldesammlungen, Munich, no. 6680. [Warburg]

Charles-Joseph Natoire, 1700–**1777.** "Venus Crowning Adonis." Painting. Rasquinot-Lenan coll., Cointe-lez-Liège. [Boyer 1949, no. 114]

Laurent Delvaux, 1696–**1778,** and **Pieter Scheemakers,** 1691–1781. "Venus and Adonis." Marble (?) sculpture group. Loveday coll., Ware, Hertfordshire. [Whinney 1964, p. 257, *n.*12]

Jean-Baptiste Huet, 1745–1811. "Venus and Adonis." Painting. **1778.** Rothschild coll., Waddesdon Manor. [Pigler 1974, p. 260]

Alexander Runciman, 1736–1785. "The Departure of Adonis." Painting. **1770s.** Private coll., Scotland. [Warburg]

Francesco Bianchi, 1752–1810. *Venere e Adone*. Opera (azione teatrale). Libretto, F. Casori. First performed 14 Sep **1781,** Pergola, Florence. [Grove 1980, 2:674]

Stefano Torelli, 1712–**1784.** "The Death of Adonis." Painting. Arkangelskoie, near Moscow. [*Arte Veneta* 24 (1970), p. 183]

Alphonse-Toussaint Fortia de Piles, 1758–1826. *Venus et Adonis*. Opera. Libretto, Collet de Messine? First performed **1784,** Nancy. [Grove 1980, 6:722]

Gaetano Pugnani, 1731–1798. *Adone e Venere*. Opera seria. Libretto, G. Boltri. First performed Nov·**1784,** San Carlo, Naples. [Grove 1980, 15:447]

Antonio Canova, 1757–1822. "Adonis [or Endymion?] Sleeping." Painting. *c.***1784–85.** Formerly Casa Canova, Possagno, destroyed in World War I. [Pavanello 1976, no. D2]

————. "Venus Mourning Over the Body of Adonis." 2 terra-cotta bozzetti. 1787. Gipsoteca Canoviana, Possagno, nos. 22, 93. [Ibid., nos. 35–36—ill. / Licht 1983, p. 231—ill.]

————. "Adonis Crowned by Venus." Plaster sculpture group. 1789. Possagno, no. 23. [Pavanello, no. 37—ill. / Licht, pp. 162, 163—ill.]

————. "(The Farewell of) Venus and Adonis." Marble sculpture group. 1789. Villa La Grange, Geneva. [Pavanello, no. 69—ill.] Plaster model. Possagno. [Licht, pp. 171, 172—ill.]

————. "The Death of Adonis." Plaster relief. 1797. Possagno, no. 94. [Pavanello, no. 103—ill. / Licht, p. 256—ill.]

————. "Venus and Adonis." Statue. 1793–95. [Vermeule 1964, pp. 138, 169]

Franz Anton Maulbertsch, 1724–1796. "Venus and Adonis." Grisaille painting. *c.***1785–86.** Albertina, Vienna. [Garas 1960, no. 340]

Angelica Kauffmann, 1741–1807. "Venus and Adonis" (Venus trying to keep Adonis from the hunt). Painting. At least 2 versions: **1786,** for Duc de Chaulnes, Paris; 1788, for Duke Peter of Courland. [Manners & Williamson 1924, pp. 151, 155]

————. (Bas-reliefs on temple walls depict scenes from the story of Venus and Adonis in) "Hero and Leander" (meeting in the temple of Venus). Painting, for Prince of Waldeck. 1791. [Ibid., pp. 160, 170]

————. "The Bath of Adonis." Painting. Colonel Bramston-Newman coll., Vichy. [Ibid., p. 179]

————. "The Death of Adonis." Drawing. British Museum, London. [Ibid., p. 195]

————. "Venus with the Body of Adonis on Her Knees." Etching. 1770. [Ibid., p. 220]

Joseph Starzer, 1726/27–**1787,** music. *Venere e Adone.* Ballet. [Grove 1980, 18:82]

Michele Mortellari, *c.*1750–1807. *Venus and Adonis.* Opera. First performed 8 May **1787,** Hanover Square Rooms, London. [Grove 1980, 12:593]

Teresa Bandettini-Landucci, 1763–1837. *La morte d'Adone* [The Death of Adonis]. Epic poem. Modena: Società Tipografica, **1790.** [DELI 1966–70, 1:241]

Joseph Weigl the Younger, 1766–1846. *Venere ed Adone.* Cantata. Libretto, G. B. Casti. First performed **1791,** Eszterházy Palace. [Landon 1988, pp. 85ff. / Grove 1980, 20:298]

José Antonio Porcel y Salamanca, 1715–**1794.** "El Adónis." Hunting eclogue, written for the Academia del Tripode in Granada. Modern edition, in *Biblioteca de autores españoles,* no. 61 (Madrid: Rivadeneyra, 1861). [Oxford 1978, p. 471 / HLE 1981–83, 4:15]

French School. "Adonis and Dogs," "Venus and Cupid." Pair of statues. **18th century.** Brinsley Ford coll., London. [Warburg]

German School. "Venus and Adonis." Bronze group. **18th century.** California Palace of Legion of Honor, San Francisco. [Clapp 1970, 1:397]

Charles Monnet, 1732–after 1808. "Venus and Adonis." Drawing, design for an engraving, executed by G. Vidal (1742–**1801**). [Pigler 1974, p. 260]

Joseph Mallord William Turner, 1775–1851. "Venus and Adonis" ("Adonis Departing for the Chase"). Painting. *c.*1803–05. Christopher Gibbs, Ltd., London, in 1977. [Butlin & Joll 1977, no. 150]

————. "Venus and the Dead Adonis." Painting. *c.*1805? Tate Gallery, London, no. 5493. [Ibid., no. 151—ill.]

André Jean-Jacques Deshayes, 1777–1846, choreography. *L'enlèvement d'Adonis* [The Abduction of Adonis]. Ballet. Music, Venua. First performed 7 May **1807,** King's Theatre, London. [Guest 1972, p. 154]

Anonymous choreographer. *Les amours de Vénus et Adonis.* Ballet. Composer unknown. First performed **1808,** St. Petersburg. [Sharp 1972, p. 286]

Pierre Gardel, 1758–1840, choreography. *Venus and Adonis.* Ballet. Music, Lefebvre. First performed **1808,** L'Opéra, Paris. [Guest 1976, p. 304]

Bertel Thorwaldsen, 1770–1844. "Adonis." Statue. Plaster original, **1808.** Thorwaldsens Museum, Copenhagen, no. A53. / 2 marble versions. Staatsgemäldesammlungen, Munich, inv. WAF B29; Thorwaldsens Museum, no. A790 (executed by A. Saabye, 1887). [Thorwaldsen 1985, pp. 24, 77 / Cologne 1977, no. 35, pp. 101, 163—ill. / Hartmann 1979, p. 58—ill.]

————. "Adonis." Relief, part of "Metamorphoses of Ovid" series. Executed by Pietro Galli from Thorwaldsen's de-

signs. 1838. Formerly Palazzo Torlonia, Rome, destroyed. / Plaster cast. Thorwaldsens Museum, no. A476. [Thorwaldsen, p. 56]

Gottlieb Christian Schick, 1776–**1812?** "The Birth of the Red Rose." Painting. Castle Museum, Mannheim. [Pigler 1974, p. 264]

Pierre-Paul Prud'hon, 1758–1823. "Venus and Adonis." Painting. Exhibited **1812.** Wallace Collection, London, no. 347. [Guiffrey 1924, no. 162—ill.] 6 studies known. Musée Condé, Chantilly; Musée de Cluny; others in private colls. or unlocated. [Ibid., nos. 163–68]

————, doubtfully attributed. "Venus and Adonis." Painting. Sold 1898, unlocated. [Ibid., no. 176]

Jean-Baptiste Regnault, 1754–1829. "The Death of Adonis." Painting. **1812.** Formerly Christiani coll., sold 1913. [Louvre 1979–86, 4:171—ill.] Sketch. Louvre, Paris, no. R.F. 1972–3. [Ibid.—ill.]

Percy Bysshe Shelley, 1792–1822. "Fragment of the Elegy on the Death of Adonis." Translation of Bion 1.1–49. **1816.** In *Poetical Works,* edited by H. Buxton Forman (London: Reeves & Turner, 1876). [Hutchinson 1932 / Webb 1976, pp. 44, 69 *n.,* 88 *n.,* 121f.]

————. *Adonais: An Elegy on the Death of John Keats.* Poem. Pisa: Didot, 1821. [Knerr 1984 / Cameron 1974, pp. 431–44 / Wasserman 1971, pp. 462–502]

Andrea Appiani the Elder, 1754–1817. "Venus and Adonis." Painting. Château, Compiègne. [Bénézit 1976, 1:236]

Désiré-Alexandre Batton, 1798–1855. *La mort d'Adonis* [The Death of Adonis]. Cantata. Prix de Rome, **1817.** [Grove 1980, 2:295]

John Keats, 1795–1821. (Story of Venus and Adonis in) *Endymion* 2.390–572. Poem. **1817.** London: Taylor & Hessey, 1818. [Stillinger 1978 / Aske 1985, p. 57 / Gradman 1980, pp. 21ff.]

Pietro Tenerani, 1789–1869. "Cupid Removes Thorn from Foot of Venus." Marble sculpture. **1822.** Duke of Devonshire coll., Chatsworth. [Warburg]

Anne-Louis Girodet, 1767–**1824,** composition. "The Death of Adonis." Lithograph, part of "Loves of the Gods" cycle. Published Paris: Engelmann, 1825–26. [Boutet-Loyer 1983, no. 87 *n.*]

John Edward Carew, 1785–1868. "Adonis and the Boar." Sculpture. **1825–26.** Lord Leconfield coll., Petworth, Sussex. [Clapp 1970, 1:146]

Anonymous. *Venus and Adonis; or, The Bower of Bliss.* Ballet. First performed **1828,** Sadler's Wells, London. [Nicoll 1959–66, 4:549]

The Prix de Rome landscape painting competition subject for **1829** was "The Death of Adonis." First prize: Jean-Baptiste Gibert (1803–1889). École des Beaux-Arts, Paris. [Grunchec 1984, no. 110—ill.]

John Barnett, 1802–1890. *The Paphian Bower, or Venus and Adonis.* Burletta. Libretto, James Robinson Planché and Charles Dance. First performed 26 Dec **1832,** Olympic Theatre, London. [Grove 1980, 2:169 / Nicoll 1959–66, 4:379 / Planché 1986, p. 234]

Louis-Pierre Baltard, 1764–1846. "Death of Adonis." Painting. **1833.** [Bénézit 1976, 1:411]

Carlo Blasis, 1797–1878, choreography. *Gli amori di Adone*

e Venere. Ballet. First performed **1835**, La Scala, Milan. [EDS 1954–66, 2:607]

Eduard Mörike, 1804–1875. "Der todte Adonis" [The Dead Adonis]. Translation of Theocritus, Idyll 30. In *Classische Blumenlese* (Stuttgart: Schweizerbart, **1840**). [Hötzer 1967]

———. *Die syrakuserinnen am Adonisfest* [The Syracusan Women at the Festival of Adonis]. Translation of Theocritus's 15th Idyll. In *Theokritos, Bion und Moschos* (Stuttgart: Hoffman, 1855). [Ibid.]

———. "Der todte Adonis" [The Dead Adonis]. Translation of Anacreontic songs no. 50. In *Anakreon und die sogenannten anakreontischen Lieder* (Stuttgart: Krais & Hoffmann, 1864). [Ibid.]

William Wordsworth, 1770–1850. "Love Lies Bleeding" (Venus finding Adonis mortally wounded), "Companion to the Foregoing." Sonnets. **1833–42**. In *Poems Chiefly of Early and Late Years* (London: Moxon, 1842). [De Selincourt 1940–66, vol. 2]

Bernardo Vestris, choreography. *Venere ed Adone.* Ballet. First performed 21 Mar **1844**, La Scala, Milan. [Guest 1970, p. 208]

Elizabeth Barrett Browning, 1806–1861. "Lament for Adonis, from the Greek of Bion." Translation. **1845**. In *Poems,* new edition, vol. 1 (London: Chapman & Hall, 1850). [Browning 1932 / Taplin 1957, p. 154, 228]

Charles Marie René Leconte de Lisle, 1818–1894. "Le retour d'Adonis" [The Return of Adonis]. Poem. In *Oeuvres: Poèmes antiques* (Paris: Lemerre, **1852**). [Pich 1976–81, vol. 1]

———. "Parfum d'Adonis, l'anémone et la rose" [Perfume of Adonis, the Anemone, and the Rose]. Poem, no. 8 of "Hymnes orphiques," verse translation from Orphic Hymns. In *Oeuvres: Derniers poèmes* (Paris: Lemerre, 1895). [Ibid., vol. 4]

———. "La résurrection d'Adonis" [The Resurrection of Adonis]. Poem. In *Oeuvres: Poèmes tragiques* (Paris: Lemerre, 1884). [Ibid., vol. 3]

Louis Antoine Duport, 1781/83–**1853**, choreography. *L'amour d'Adonis, ou la vengeance de Mars* [The Love of Adonis, or the Vengeance of Mars]. Ballet. Libretto, Duport. First performed St. Petersburg. [Lifar 1938, p. 279]

Johannes Riepenhausen, 1788/89–**1860**. "Venus and Adonis." Painting. Thorwaldsens Museum, Copenhagen, no. B152. [Thorwaldsen 1985, p. 111]

Matthew Arnold, 1822–1888. "Hymn to Adonis." Translation of Theocritus's 15th Idyll. In "Pagan and Christian Religious Sentiment," essay in *Cornhill Magazine* Apr **1864**. [Tinker & Lowry 1940, p. 218 / Bush 1971, p. 100]

Francis Cowley Burnand, 1836–1917. *Venus and Adonis: or, The Two Rivals and the Small Boar.* Burlesque. First performed **1864**, Haymarket, London. [Nicoll 1959–66, 5:288]

Vincent Amcotts. *Adonis Vanquished.* Comedy. First performed **1867**, St. James Theatre, London. / Revised by T. W. Robertson as *A Rapid Thaw.* [Nicoll 1959–66, 5:240]

Giovanni Casati, 1811–1895, choreography. *Adone all' isola di Ciprigna* [Adonis on the Isle of Cypris]. Ballet. First performed **1868**, Florence. [EDS 1954–66, 3:164]

José-Maria de Heredia, 1842–1905. (Rebirth of Adonis evoked in) "Le réveil d'un Dieu" [The Awakening of a

God]. Sonnet. In *Le livre des Sonnets* (Paris: Lemerre, **1874**); collected in *Les trophées* (Paris: Lemerre, 1893). [Delaty 1984, vol. 1; cf. 2:74]

Frederik Paludan-Müller, 1809–1876. *Adonis.* Poem. Copenhagen: Reitzel, **1874**. Modern edition Copenhagen: Kunstog Kultur, 1950. [CEWL 1973, 3:284]

Adolf Jensen, 1837–**1879**. *Adonis-Klage* [Lament for Adonis]. Choral composition. Text, A. Wolf. / Part 1 revised by Gustav Jensen as *Adonis feier* [Festival of Adonis], for solo voices, chorus, and piano. Published Berlin: 1881. [Grove 1980, 9:601]

Max Zenger, 1837–1911, music. *Venus und Adonis.* Ballet. First performed **1881**, Neuschwanstein, for Ludwig II of Bavaria. [Baker 1984, p. 2563]

Charles S. Calverly, 1831–**1884**. "Death of Adonis," "The Festival of Adonis." Poems, based on Theocritus's 15th Idyll. In *Complete Works* (London: Bell, 1901). [Boswell 1982, p. 64]

Edward Everett Rice, 1848–1924, compiler. *Adonis* (statue of Adonis comes to life). Musical comedy. Music from Beethoven, Sullivan, Offenbach, Mozart, Haydn, and others. Libretto, William Gill and H. E. Dixey. First performed 6 July **1884**, Hooley's Theater, Chicago; New York opening 4 Sep. [Bordman 1978, pp. 78f. / Grove 1986, 4:37] Performed 1886, Gaiety Theatre, London. [Nicoll 1959–66, 5:381]

William Barnes, 1801–**1886**. "Death of Adonis." Poem. In *Poems* (Carbondale: Southern Illinois University Press, 1962). [Boswell 1982, p. 33]

Briton Riviere, 1840–1920. "Adonis Wounded." Painting. **1887**. [Kestner 1989, p. 235, pl. 4.25]

———. "Adonis's Farewell." Painting. 1888. [Ibid., pl. 4.24]

Mark Melford, libretto. *Venus and Adonis.* Comedietta. First performed **1888**, Wolverhampton. [Nicoll 1959–66, 5:484]

Auguste Rodin, 1840–1917. "The Resurrection of Adonis." Marble sculpture. **1889**. Private coll., Israel. [Tancock 1976, p. 279] Plaster study. Musée Rodin, Paris. [Rodin 1944, no. 227—ill.]

———. "The Death of Adonis" ("Venus Kissing Adonis"). Marble sculpture. 1891. Walters Art Gallery, Baltimore. [Tancock, pp. 276ff.—ill.] Plaster studies. c.1888. Rodin Museum, Philadelphia; Ny Carlsberg Glyptotek, Copenhagen. [Ibid.—ill.] Bronze casts: Musée Rodin, Paris (2 versions); private colls.; elsewhere? [Ibid.—ill. / Rodin, no. 226—ill.]

Anonymous English. *Venus and Adonis.* Dramatic extravaganza. First performed **1890**, Theatre Royal, Drury Lane, London. [Nicoll 1959–66, 5:763]

Isabella T. Aitken. "Adonis." Poem. In *Bohemia and Other Poems* (Philadelphia: Lippincott, **1891**). [Boswell 1982, p. 6]

Gabriele D'Annunzio, 1863–1938. "La morte del dio" [The Death of the God] (Adonis). Sonnet, part of "Animal Triste." **1893**. In *Intermezzo* (Naples: 1894). [Palmieri 1953–59, vol. 1]

John Byrne Leicester Warren, Lord de Tabley, 1835–1895. "Lament for Adonis." Poem. In *Poems: Dramatic and Lyrical,* 1st series (London: Mathews & Lane, **1893**). [Boswell 1982, p. 250]

Leopold von Sacher-Masoch, 1835–**1895**. "Venus und

Adonis." Tale. Berlin: Newfeld & Henius, 1900. / Translated in *Venus and Adonis and Other Tales of the Court of Catherine II* (London: Methuen, 1929). [NUC]

Xavier Leroux, 1863–1919. "Vénus et Adonis." Lyric scene. Text, L. de Gramont. First performed **1897,** Concerts de L'Opéra, Paris. [Grove 1980, 10:686]

George Whitefield Chadwick, 1854–1931. *Adonais.* Orchestral overture, opus 13. **1899.** First performed 2 Feb 1900, by Boston Symphony, Boston. [Grove 1986, 1:385, 388]

———. "Adonais." Elegiac overture, based on Shelley. First performed 3 Feb 1900, Boston Symphony Orchestra. MS in New England Conservatory of Music, Boston. [Grove 1980, 4:106]

John William Waterhouse, 1849–1917. "The Awakening of Adonis." Painting. *c.*1900. Formerly Yates coll., Britain. [Hobson 1980, no. 126, pl. 91] Replica or variant. K. Losch coll., Britain. [Ibid., no. 127]

Robert Williams Buchanan, 1841–1901. "Venus on the Sun-Car" (death of Adonis). Poem. In *Complete Poetical Works* (London: Chatto and Windus, 1901). [Boswell 1982, p. 59]

Théodore Dubois, 1837–1924. *Adonis.* Symphonic poem. Paris: **1907.** [Grove 1980, 5:665]

Francis Thomé, 1850–1909. *Vénus et Adonis.* Symphonic ode. [Baker 1984, p. 2303]

Constantine Cavafy, 1868–1933. (Adonis evoked in) "Meres tou 1903" [Days of 1903]. Poem. **1909.** Published 1917. / Translated by Edmund Keeley and Philip Sherrard in *Collected Poems* (Princeton, N.J.: Princeton University Press, 1975, bilingual edition). [Ipso / Keeley 1976, pp. 56f.]

———. (Adonis evoked in) "Gkriza" [Gray]. Poem. 1917. / Translated by Keeley and Sherrard in *Collected Poems* (1975). [Ipso / Keeley, p. 57]

———. (Adonis evoked in contemporary Alexandria in) "Meres tou 1909, 10, Kai '11" [Days of 1909, '10, and '11]. Poem. Published 1928. / Translated by Keeley and Sherrard in *Collected Poems* (1975). [Ipso / Keeley, pp. 72f.]

———. (Dead Adonis evoked in) "Myres: Alexandreia tou 340.M.X." [Myris: Alexandria, A.D. 340]. Poem. Published 1929. / Translated by Keeley and Sherrard in *Collected Poems* (1975). [Ipso / Keeley, pp. 136–39]

———. (Adonis reflected in) "O kathreptes sten eisodo" [The Mirror in the Front Hall]. Poem. Published 1930. / Translated by Keeley and Sherrard in *Collected Poems* (1975). [Ipso / Keeley, pp. 140f.]

Rupert Brooke, 1887–1915. "Venus in the Wood" (original MS titled "The Goddess in the Wood"). Poem. In *Nation* (**1911**); collected in *Poems* (London: Sidgwick & Jackson, 1911). [Keynes 1954, pp. 32, 116 / Boswell 1982, p. 53]

Christian Rohlfs, 1849–1938. "Venus and Adonis." Watercolor. **1913.** Private coll. [Vogt 1958, no. 13/4]

Wilfred Scawen Blunt, 1840–1922. "Adonis." Poem. In *Poetical Works* (London: MacMillan, **1914**). [Boswell 1982, p. 47]

Zinaida Hippius, 1869–1945. "Adonai." Poem. **1914.** In *Poslednie stikhi: 1914–1918* [Last Poems] (St. Petersburg: 1918, bilingual edition). [Pachmuss 1971, pp. 184–85, 435]

H. D. (Hilda Doolittle), 1886–1961. "Adonis" (dead). Poem. In *Some Imagist Poets: An Anthology,* edited by

Amy Lowell (Boston: Houghton Mifflin, **1917**). [Martz 1983 / DLB 1986, p. 117]

Mikhail Fabianovich Gnesin, 1883–1957. *Traurnïye plyaski iz "Pesen ob Adonise"* [Mourning Dances from "Elegy to Adonis"]. Orchestral composition, opus 20, after Shelley. **1917.** [Grove 1980, 7:479]

Duncan Grant, 1885–1978. "Venus and Adonis." Painting. *c.*1919. Tate Gallery, London, no. T.1514. [Tate 1975, p. 144]

Paul Paray, 1886–1979. *Adonis troublé.* Symphonic poem. **1921.** First performed as music for *Artemis troublée,* ballet by N. Guerra, 1922, L'Opéra, Paris. [Grove 1980, 14:180]

Frederick William MacMonnies, 1863–1937. "Venus and Adonis." Colored marble sculpture group. Exhibited **1923.** [Clapp 1970, 2 pt. 2: 722]

Ted Shawn, 1891–1972, choreography. *Adagio pathétique (Death of Adonis).* Modern dance, solo for Shawn. Music, Benjamin Godard. **1923.** First performed 6 Oct 1924, Academy of Music, Newburgh, N.Y. [McDonagh 1976, pp. 35f.]

Pierre Louÿs, 1870–1925. "Le retour d'Adonis." Poem. In *Poësies* (Paris: Crès, 1927). [Ipso]

Louis Fourestier, 1892–1976. *La mort d'Adonis.* Cantata. Grand Prix de Rome, **1925.** [Baker 1984, p. 752 / Grove 1980, 6:734]

Archibald MacLeish, 1892–1982. "The Pot of Earth" (garden of Adonis). Poem. In *The Pot of Earth* (Boston: Houghton Mifflin, **1925**). [CLC 1978, 8:360 / Boswell 1982, pp. 175f.]

Francis Picabia, 1878–1953. "Venus and Adonis" ("Faun"). Painting, based on figures in Titian's "Venus and Adonis" (1553–54, Prado). **1925–26.** Schwarz coll., Milan, in 1979. [Borràs 1985, no. 406, p. 293—ill. / Camfield 1979, fig. 278]

———. "Idyll." Painting, based on Veronese's "Venus and Adonis" (*c.*1580–82, Prado). Private coll., Paris. [Camfield, pp. 223–24, fig. 280 / Borràs, p. 293, no. 444—ill.]

Cale Young Rice, 1872–1943. "A Vision of Venus and Adonis" (death of Adonis). Poem. In *Selected Plays and Poems* (London: Hodder & Stoughton, **1926**). [Boswell 1982, p. 211]

Abrasha Lozoff, 1887–1936. "Venus and Adonis." Wood sculpture. *c.*1925–30. Tate Gallery, London, no. T.255. [Tate 1975, p. 168]

Ezra Pound, 1885–1972. (Death of Adonis evoked in) Canto 1, in *A Draft of XXX Cantos* (Paris: Hours, **1930;** Norfolk, Conn.: New Directions, 193[3?]). [Feder 1971, pp. 203–05]

———. (Odysseus comes upon a ritual to Adonis in) Canto 47, in *The Fifth Decad of Cantos, XLII–LI* (London: Faber & Faber, 1937). [Ibid., p. 204 / Surette 1979, p. 64 / Quinn 1972, pp. 122f.]

Fritz Brügel, 1897–1955. *Klage um Adonis* [Lament for Adonis]. Poem. Zürich: **1931.** [DLL 1968–90, 2:144]

George Dillon, 1906–1968. "Weep, Aphrodite, for Adonis is Dead." Poem. In *The Flowering Stone and Other Poems* (New York: Viking, **1931**). [Bush 1937, p. 591]

Carl Paul Jennewein, 1890–1978. "Adonis." Polychrome terra-cotta figure. **1932.** Pediment of north wing, Philadelphia Museum of Art. [Agard 1951, p. 159, fig. 86]

André Obey, 1892–1975. *Vénus et Adonis.* Dramatic adap-

tation of Shakespeare's poem. First performed 5 Dec **1932**, Théâtre de l'Atelier, Paris. Published Paris: 1948. [McGraw-Hill 1984, 4:5f.]

William Butler Yeats, 1865–1939. "Her Vision in the Wood" (Venus finding Adonis dead). Poem. In *The Winding Stair and Other Poems* (London & New York: Macmillan, **1933**). [Finneran 1983 / Feder 1971, pp. 86f., 198f.]

Caroline Gordon, 1895–1981. *The Garden of Adonis.* Novel. New York: Scribner, **1937**. [EWL 1981–84, 2:260]

Vittorio Giannini, 1903–1966. *Lament for Adonis.* Cantata. **1940**. [Grove 1980, 7:349]

John Heath-Stubbs, 1918–. *Wounded Thammuz.* Collection of poetry. London: Routledge, **1942**. [DLEL 1970–78, 2:138]

Katherine Ruth Willoughby Heyman, 1877–**1944**. "Lament for Adonis." Song. [Cohen 1987, 1:318]

Ker-Xavier Roussel, 1867–**1944**. "Venus and Adonis." Print. [Alain 1968, no. 109—ill.]

Ruth Page, 1905–, choreography. *Adonis.* Ballet. Music, Lehman Engel. First performed **1944**, Chicago. [EDS 1954–66, 7:1480]

Pierre Traverse, b. 1892. "Venus and Adonis." Sculpture group. By **1946**. [Baschet 1946, p. 181]

Louis MacNeice, 1907–1963. (Death of Adonis likened to Byron's in) "Cock of the North" 3 and 4. Poem. *c.*1950–51. [Dodds 1966]

———. "Adonis." Poem. In *Blind Fireworks* (London: Gollancz, 1929). Excluded by MacNeice from his collected poems. [Dodds, p. 560]

W. H. Auden, 1907–1973, libretto. *The Rake's Progress.* Opera. *See Stravinsky, below.*

Igor Stravinsky, 1882–1971. (Anne and Tom modeled on Venus and Adonis in) *The Rake's Progress.* Opera. Libretto, W. H. Auden and Chester Kallman, after Hogarth's series of engravings. First performed 11 Sep **1951**, La Fenice, Venice. [Grove 1980, 18:255ff., 262 / Spears 1963, pp. 270ff.]

Daryl Hine, 1936–. (The wound of Adonis evoked in) "Avernus," (Venus tends Adonis in) "The Wound." Poems. In *The Carnal and the Crane* (Toronto: Contact Press, **1957**). [CLC 1980, 15:280]

Reuben Nakian, 1897–1986. "Venus and Adonis." Terracotta sculpture. **1958**. Egan Gallery, New York. [O'Hara 1966, no. 33]

———. "Venus and Adonis." 2 drawings. 1966. Egan Gallery. [Ibid., nos. 138–39]

Paul Goodman, 1911–1972. "Reading *Adonais*." Sonnet. In *The Lordly Hudson: Collected Poems* (New York: Macmillan, **1962**). [Ipso]

Kenneth Rexroth, 1905–1982. "Adonis in Summer," "Adonis in Winter." Poems. In *Collected Shorter Poems* (New York: New Directions, **1966**). [Boswell 1982, p. 285]

Constantine Trypanis, 1909–. *The Elegies of a Glass Adonis.* Poetry cycle. New York: Chilmark, **1967**. [Vinson 1985, p. 869 / DLEL 1970–78, 2:309]

Alan Hovhaness, 1911–. *The Garden of Adonis.* Chamber composition for flute, harp, and piano, opus 245. **1971**. [Grove 1986, 2:433 / Grove 1980, 8:742]

Kathleen Louise Saint John, 1942–, music. *Where Young Adonis Reposes.* Multimedia composition. **1979**. [Cohen 1987, 2:609]

Hugo Weisgall, 1912–. *The Gardens of Adonis.* Opera. **1980**. [Baker 1984, p. 2473]

Earl Staley, 1938–. "Venus and Adonis." Painting cycle: "Adonis Leaves Venus to Hunt," "Adonis Gored by the Boar," "Venus Mourns Adonis." **1982**. Downe coll., New York. [Houston 1984, pp. 76ff.—ill.]

Carol Orlock, 1947–. (Persephone writes to Demeter of her attachment to Adonis, and Venus's part in his education, in) *The Goddess Letters* chapter 16. Novel. New York: St. Martin, **1987**. [Ipso]

ADRASTUS. *See* ERIPHYLE; SEVEN AGAINST THEBES.

AEËTES. *See* JASON, Golden Fleece.

AEGEUS. *See* THESEUS, General List, at Athens.

AEGINA. *See* ZEUS, Loves.

AEGISTHUS. *See* AGAMEMNON; ATREUS AND THYESTES; ORESTES.

AENEAS. The legendary founder of the Roman race, Aeneas was the son of the Trojan prince Anchises and the goddess Aphrodite (Venus). As a child, he was cared for by a nymph of Mount Ida and was educated by the centaur Chiron. He fought valiantly during the Trojan War, but fled the devastated city when it burned. After many adventures, the most famous of which was his infatuation with Queen Dido at Carthage, Aeneas finally settled in Latium in Italy, where he married Lavinia, daughter of King Latinus of Latium.

Aeneas appears as a secondary character in the *Iliad,* but he becomes an epic hero in Virgil's *Aeneid,* written to inspire Augustus and the Romans under his empire. Much of Virgil's narrative closely parallels Homer's *Odyssey.* While the *Aeneid* ends with Aeneas's slaying of his rival, Turnus, other Roman works continue the hero's saga, detailing his later meeting with Dido's sister, Anna, and his eventual apotheosis.

Classical Sources. Homer, *Iliad* 2.819ff, 5.166ff., 541ff., and books 12–13, 15–17, 20 passim. Arctinus, *Sack of Ilium. Homeric Hymns* 5, "To Aphrodite." Lesches (?), *The Little Iliad.* Sophocles, *Laocoön* (fragment). Timaeus, *History of*

Sicily 1. Naevius, *History of the Punic War*. Ennius, *Annals*. Virgil, *Aeneid*. Dionysius of Halicarnassus, *Roman Antiquities*. Ovid, *Metamorphoses* 13.623–724, 14.72–157, 14.445–608. Pausanias, *Description of Greece* 2.23.5, 3.22.11, 8.12.8, 10.17.6.

Further Reference. Charles Martindale, editor, *Virgil and His Influence: Bimillennial Studies* (Bristol: Bristol Classical Press, 1984).

Listings are arranged under the following headings:

> General List
> Flight from Troy
> Wanderings
> Storm at Sea
> Shipwreck
> Aeneas and Dido
> Aeneas in Sicily
> Aeneas in the Underworld
> Aeneas in Latium
> Apotheosis

See also TROJAN WAR.

General List

Anonymous Norman. *Roman d'Eneas*. Verse romance, adaptation of the *Aeneid*. *c.***1158–60**. Modern edition by J. J. Salverda de Grave, *Énéas, roman du XIIe siècle* (Paris: Champion, 1925–31). [Yunck 1974 / Cormier 1973, p. 21 and passim / DMA 1982–89, 4:451 / Singerman 1986, pp. 32–98, 353]

Benoît de Sainte-Maure, fl. 1150–70. (Aeneas's travels in) *Le roman de Troie*. Verse romance, after Dares, *De excidio Troiae historia*, and Dictys, *Ephemeris de historia belli Troiani* (late Latin versions of lost Greek poems, pseudo-classical forgeries). *c.***1165**. [Baumgartner 1987 / Singerman 1986, pp. 137, 139–47, 352]

Heinrich von Veldeke, *c.*1140/50–before 1210. *Die Eneide (Die Eneit)*. Verse romance, expanded translation/free adaptation of the *Roman d'Eneas*. *c.***1170–89**. Modern edition of Gotha MS, by G. Schieb and T. Frings (Berlin: Akademie, 1964–70). / English translation by J. W. Thomas, *Eneit, Eneide* (New York: Garland, 1985). [Oxford 1986, p. 383 / see also M. L. Dittrich, *Die 'Eneide' Heinrichs von Veldeke: Quellenkritischer Vergleich mit dem Roman d'Eneas und Virgils Aeneis* (Wiesbaden: 1966)]

Anonymous French. (Aeneas's career treated in) *L'histoire ancienne jusqu'à César* [Ancient History to Caesar] folios 148c–178 (Paris MS). Prose history. Dictated to Roger de Lille, **1208–30**. MSS in Bibliothèque Nationale, Paris, f. fr. 20125; Morgan Library, New York, MS 212; elsewhere. [Singerman 1986, p. 155]

Guido delle Colonne, *c.*1210–after 1287. (Aeneas's adventures recounted in) *Historia destructionis Troiae* [History of the Destruction of Troy], end of book 12. Latin prose chronicle, after Benoît de Sainte-Maure. **1272–87**. Modern edition by Nathaniel E. Griffin (Cambridge, Mass.: Harvard University Press, with Mediæval Academy of America, 1936; reprinted New York: Kraus, 1970). / Translated by M. E. Meek (Bloomington: Indiana University Press, 1974). [Benson 1980, p. 156 *n*.12]

Dante Alighieri, 1265–1321. (Aeneas among the heroes of antiquity in Limbo, in) *Inferno* 4.122. *c.*1307–*c.***1314?** In *The Divine Comedy*. Poem. Foligno: Neumeister & Angelini, 1472. [Singleton 1970–75, vol. 1 / Hardie 1984, p. 56]

Anonymous French. (Story of Aeneas in) *Ovide moralisé* books 13, 14. Poem, allegorized translation/elaboration of Ovid's *Metamorphoses*. *c.***1316–28**. [de Boer 1915–86, vols. 4–5]

Jean de Courcy, 1360–1431. (Story of Aeneas in) *Chronique universelle* books 2–3. Verse history. *c.***1416**. MS in Morgan Library, New York, MS 214 folr. [Singerman 1986, pp. 183–93, 331f.]

Apollonio di Giovanni, *c.*1415–**1465**, and **Marco del Buono Giamberti,** ?–**1489**. 2 paintings (panels on the "Jarves Cassone"), depicting scenes from the *Aeneid*. Yale University Art Gallery, New Haven, nos. 1871.34–35. [Berenson 1963, p. 18—ill.] Variants (by Apollonio), miniatures in MS of the *Aeneid*. Biblioteca Riccardiana, Florence, codex 492. [Ibid., pls. 740–42]

Anonymous French. *Le livre des Eneydos*. Romance, after Virgil. Lyons: LeRoy, **1483**. [Singerman 1986, pp. 198ff.]

William Caxton, *c.*1422–1491. *Eneydos*. English translation of *Livre des Eneydos* (1483). Westminster: Caxton, **1490**. [Singerman 1986, pp. 197ff., 202–12, 223, 225f., 242–56, 259–61]

Gavin Douglas, *c.*1474–1522. *Eneados*. Scots translation of the *Aeneid* (written as refutation of Caxton's *Eneydos*). **1513**. London: Copland, 1553. [Singerman 1986, pp. 217–230, 239, 242ff., 267–70, 276–85]

Dosso Dossi, *c.*1479–1542. Series of 10 paintings depicting scenes from the *Aeneid*. **1523–30**. Only 2 extant: "The Sicilian Games," "Aeneas in the Elysian Fields" ("Aeneas and the Cumean Sybil"). Barber Institute of Fine Arts, Birmingham, England; National Gallery of Canada, Ottawa. [Gibbons 1968, nos. 6, 50—ill. / cf. Berenson 1968, pp. 110ff.—ill.]

——— and **Bastista Dossi,** *c.*1474–1548, attributed. "The Story of Aeneas." Painting, from Castello Estense, Ferrara. Lost. [Gibbons, p. 269]

Benedictus Ducis, *c.*1490–**1544**. "Arma virumque cano" [Arms and the Man I Sing]. Vocal composition. Text, Virgil (*Aeneid* 1.1). 2 versions. Published Wittemberg: 1551. [Grove 1980, 5:671]

Niccolò dell' Abbate, 1509/12–1571. 12 frescoes illustrating the *Aeneid*, for castle at Scandiano, near Modena. Early work, before **1546?** Detached, now in Galleria Estense, Modena. [Erika Langmuir, "Armavirumque . . . Niccolò dell' Abbate's Aeneid Gabinetto for Scandiano," *Journal of the Warburg and Courtauld Institutes* 39 (1976): 151–70, 271—ill.]

Perino del Vaga, 1501–**1547**. Frescoed frieze, depicting scenes from the *Aeneid*. Palazzo Massimo alle Colonne, Rome. [Berenson 1968, p. 324—ill.]

Noël Jallier. Series of murals depicting scenes from the *Aeneid*. *c.***1552**. Château d'Oiron, France. [McGowan 1985, pp. 63, 124f., 271, pls. 33, 34]

Anonymous English. "The Wandering Prince of Troy." Ballad. Published London: **1564**. Modern edition (text of 1624), in *The Roxburghe Ballads* (Hertford: for the Ballad Society, 1871–99, vol. 6). [Bush 1963, p. 59]

Jean de Cartigny, *c.*1520–1578. *Le voyage du chevalier errant* [The Voyage of the Wandering Knight]. Poem. Anvers: Bellére, **1572**. / Translated by William Goodyear (London: East, 1581). [Bush 1963, p. 317]

Edmund Spenser, 1552?–1599. (Story of Aeneas and the

Trojan race told in Britomart's genealogy, in) *The Faerie Queene* 3.9.38–46. Romance epic. London: Ponsonbie, **1590**, 1596. [Hamilton 1977]

Marco Scacchi, c.1600–1681/87. *L'Enea*. Opera. Libretto, Virgilio Puccitelli. First performed **1641**, Warsaw. [Grove 1980, 15:440]

François Perrier, c.1590–1650, **Fabrizio Chiaro**, 1621–1695, **Giovanni Francesco Romanelli**, 1610–1662, **Juste d'Egmont**, 1601–1674 (attributed), **Eustache Le Sueur**, 1616–1655, and other(s)? Series of paintings depicting the story of Aeneas, for Cabinet de l'Amour, Hôtel Lambert, Paris. **1646–47**. "Aeneas and the Harpies" (Perrier), Louvre, Paris, inv. 7160; "Aeneas and Dido" (Chiaro), unlocated; "Venus Pouring Balm on Aeneas's Wound" (Romanelli), Louvre, inv. 579; "Venus Arming Aeneas" (d'Egmont?), Louvre, inv. 2901; "Venus Asking Jupiter for the Deification of Aeneas" (Le Sueur), in place. [Louvre 1972, pp. 9f., 29ff., 44ff.—ill. / Louvre 1979–86, 1:55, 2:228, 4:129—ill]

Agustín Moreto y Cabaña, 1618–1669, doubtfully attributed. *El Eneas de Dios, o El caballero del sacramento* [The Aeneas of God, or The Knight of the Sacrament]. Comedy (Act 1 based on Lope de Vega's *El caballero del sacramento*). Before **1651**. Published 1661. [McGraw-Hill 1984, 3:440]

Pietro da Cortona, 1596–1669. Series of 13 frescoes depicting scenes from the *Aeneid*. **1651–54**. Palazzo Doria Pamphili, Rome. [Briganti 1962, no. 117—ill.]

Marco Uccellini, c.1603–1680, music. *Le navi d'Enea* [The Ships of Aeneas]. Ballet. Libretto, Alessandro Guidi. First performed **1673**, Parma. [Grove 1980, 19:306]

John Dryden, 1631–1700. *Virgil's Aeneis*. Free translation of the *Aeneid* (James I allegorized as Aeneas). In *The Works of Virgil* (London: Tonson, **1697**). [Dryden 1956–87, vols. 5, 6 / Winn 1987, pp. 110f., 487ff.]

Antoine Coypel, 1661–1722. Cycle of 7 paintings illustrating the adventures of Aeneas. **1716–17**. Placed in Galerie d'Énée, Palais-Royal. 3 ("The Descent of Aeneas into Hades," "Evander Mourning the Death of His Son Pallas," "Turnus Slain by Aeneas") in Louvre, Paris, inv. 3546, 3551, 8724; 2 ("Aeneas Carrying Anchises," "The Death of Dido") in Musée, Montpellier; 1 ("Aeneas Appearing to Dido") in Musée, Arras, on deposit from Louvre (inv. 3514); 1 ("Jupiter Appearing to Aeneas") formerly Louvre, (inv. 8644), lost. [Louvre 1979–86, 3:170f.—ill.]

————. Tapestries after designs by Antoine and Charles Coypel. 1717–30. French National Collection, Paris. [Scherer 1963, pp. 249f.]

Corrado Giaquinto, 1703–1765. Series of 6 paintings depicting scenes from the *Aeneid*, for Royal Palace, Turin. **Early 1730s**. Palazzo Quirinale, Rome. [Llewellyn 1984, pp. 126–28]

Claudio Francesco Beaumont, 1694–1766. Cycle of paintings based on the *Aeneid*. c.**1740**. Armory, Royal Palace, Turin. [Llewellyn 1984, p. 121]

John Cheere, 1709–1787, **Henry Flitcroft**, 1697–1769, and others. Travels of Aeneas allegorized in sculptural decorations for gardens of Stourhead, Wiltshire. **1750s**. [Woodbridge 1965, pp. 83–116—ill.]

Giovanni Battista Tiepolo, 1696–1/70. Fresco cycle illus-

trating scenes from the *Aeneid*: "Venus Departing from Aeneas (on the coast of Libya)," "Aeneas Presenting Amor with the Features of Ascanius to Dido," "The Dream of Aeneas" ("Mercury Appears to Aeneas at Carthage"), "Venus Asking Vulcan for the Arms for Aeneas," "Triumph of Venus." **1757**. Sala dell' Eneide, Villa Valmarana, Vicenza. [Pallucchini 1968, no. 240—ill. / Morassi 1962, p. 65 / Llewellyn 1984, pp. 121–25]

————. "Allegory of Venus Entrusting an Infant [Cupid? Aeneas?] to Time." Ceiling painting, for Ca' Contarini, Venice. Before 1758. National Gallery, London, inv. 6387. [Levey 1986, pp. 267f. / London 1986, p. 612—ill. / also Morassi, pp. 18, 71]

Christoph Willibald Gluck, 1714–1787, doubtfully attributed. *Enea e Ascanio*. Opera (componimento per musica). First performed Apr **1764**, Frankfurt. Music lost. [Grove 1980, 7:473]

Johan Henrik Kellgren, 1751–1795, with **King Gustavus III of Sweden**, 1746–1792. *Aeneas*. Verse drama. **1780–82**. In *Samlade Skrifter* (Stockholm: 1796). [Sharp 1933, p. 144]

Nikolay Petrovich Osipov, 1751–1799. *Virgilleva Eneida, vyvorochennaia na iznanku* [Virgil's *Aeneid*, Turned Inside Out]. Verse travesty. **1791–96**. St. Petersburg: Glazunova, 1796–1808. [Terras 1985, p. 345]

Ivan Petrovich Kotlyarevsky, 1769–1838. *Eneida*. Verse travesty of *Aeneid* 1–3. St. Petersburg: **1798**. Modern edition, Moscow: 1961. [GSE 1973–83, 13:449]

Anne-Louis Girodet, 1767–1824. At least 200 illustrations to the *Aeneid*. **1811–24**. 72 published Paris: 1825. Original drawings in Musée, Montargis; Louvre, Paris; elsewhere. [Boutet-Loyer 1983, nos. 53–85—ill. / Bernier 1975, pp. 170ff. / also Bindman 1979, nos. 228–29—ill.]

Edward Burne-Jones, 1833–1898. 12 drawings for illuminated manuscript of the *Aeneid*. **1874**. Fitzwilliam Museum, Cambridge. [Harrison & Waters 1973, pp. 117, 121f., 191—ill. / Arts Council 1975, no. 272] MS (completed by Fairfax Murray and others) in Camarillo Monastery, Calif. [Harrison & Waters, p. 117 / Arts Council]

William Morris, 1834–1896. *The Aeneids of Virgil Done into English Verse*. Translation. London: Ellis & White; Boston: Roberts, **1876**. [Morris 1910–15, vol. 11 / Henderson 1967, pp. 160f.]

Harry Bates, 1850–1899. "The Aeneid." Bronze low-relief triptych, illustrating scenes from the *Aeneid*. Exhibited **1885**. Private coll. [London 1968, no. 2—ill.]

Aubrey Beardsley, 1872–1898. "Aeneas on the Links" (playing golf). Satirical drawing. In *Pall Mall Budget* **1893**. [Weintraub 1976, p. 8—ill. / Beardsley 1967, pl. 54]

Ildebrando Pizzetti, 1880–1968. *Aeneas*. Opera. **1903–07**, unfinished. [Oxford 1972, p. 312]

Valéry Bryúsov, 1873–1924. "Enej" [Aeneas]. Poem. **1908**. In *Vse napevy* [All Melodies] (Moscow: [Skorpion?], 1909). [Bryúsov 1982]

Mykola Vytal'yevych Lysenko, 1842–1912. *Aeneid*. Opera. Libretto, Sodovsky, after Kotlyarevsky's travesty (1798). **1910**. First performed 1911, Kiev. [Grove 1980, 11:403]

Albert Roussel, 1869–1937. *Aeneas*. Ballet score for chorus and orchestra. Libretto, Joseph Weterings. First performed (in concert) July **1935**, Palais des Beaux-Arts, Brussels. [Baker 1984, p. 1,44 / Grove 1980, 16:275]

Aurel Milloss, 1906–, choreography. *Aenéas.* Ballet. Music, Roussel (1935). First performed **1936**, Naples. [Chujoy & Manchester 1967, p. 629]

Luigi Chiarelli, 1884–1947. *Enea come oggi* [Aeneas as Today]. Travesty. Naples: Rispoli, **1938.** [McGraw-Hill 1984, 1:501]

Serge Lifar, 1905–1986, choreography. *Aeneas.* Ballet. Music, Roussel (1935). Scenario, Wetterings. First performed 7 Apr **1938**, L'Opéra, Paris. [Lifar 1938, 249, 254–57 / Grove 1980, 16:275 / Chujoy & Manchester 1967, p. 576 / Guest 1976, p. 316]

Takis Papatsonis, b. 1895. (Aeneas's rescue of Anchises, founding of Rome, evoked in) "I Sing the Wrath" [English title of work written in Greek]. Poem. **1941.** In *Ursa Minor* (Athens: Ikaros, 1944). Translated by Kimon Friar in *Ursa Minor and Other Poems* (Minneapolis: Nostos, 1988). [Ipso / Friar 1973, pp. 265ff., 728f.]

Gian Francesco Malipiero, 1882–1973. *Vergilii Aeneis* [The *Aeneid* of Virgil]. Heroic symphony for orchestra, chorus, and 7 soli. **1943–44.** Libretto, composer, after A. Caro's translation of Virgil. First performed 21 June 1946, Radio Audizioni Italiane, Turin. First staged 6 Jan 1958, Fenice, Venice. [Baker 1984, p. 1436 / Grove 1980, 11:582]

Georgios Thémelis, 1900–. "The King of Voyages" [English title of work written in Greek]. Poem. **1948.** In *Ode gia na thymomaste tous heroes* (Thessaloniki: 1949). [Friar 1973]

W. H. Auden, 1907–1973. (Aeneas recalled in) "Memorial for the City." Poem. In *Horizon* Nov **1949**; collected in *Collected Shorter Poems, 1927–1957* (New York: Random House, 1967). [Mendelson 1976 / Carpenter 1981, p. 337 / Johnson 1973, pp. 60f. / Feder 1971, pp. 334–36 / Fuller 1970, pp. 226–28, 237]

———. "Secondary Epic." Poem. In *Homage to Clio* (London: Faber & Faber; New York: Random House, 1960). [Mendelson / Feder, pp. 339f.]

Anthony Burgess, 1917–. *A Vision of Battlements.* Novel, after the *Aeneid.* **1949.** London: Sidgwick & Jackson, 1965. [EWL 1981–84, 1:365]

Elaine Feinstein, 1930–. (Aeneas's wanderings recalled in *Poems in Exile,* written by the fictional Hans Wendler, hero of) *The Border.* Novel. London: Hutchinson; New York: St. Martin's Press, 1984. [Vinson 1985, p. 253 / CLC 1986, 36:172]

Flight from Troy. During the sack of Troy by the Greek forces, Hector's shade appeared to Aeneas, warning him to flee the doomed city. In the final battle Aeneas saw Priam killed and encountered Helen of Troy hiding in the palace. He would have killed her, but his mother, Venus, appeared and stopped him, imploring him to save his family.

Aeneas fled the burning city with his son Ascanius (later called Iulus or Ilus) and his father Anchises, whom he carried on his shoulders. He also took the *penates* (household gods). His wife, Creusa, following behind, was lost; Aeneas later met her shade, which revealed to him his destiny as the founder of the Roman race.

Classical Sources. Virgil, *Aeneid* 2.268–804. Ovid, *Metamorphoses* 13.623–29. Apollodorus, *Biblioteca* E5.21.

See also TROJAN WAR, Fall of Troy.

Geoffrey Chaucer, 1340?–1400. (Aeneas and Ascanius [Iulo] part from Creusa in) "The Hous of Fame" lines 174–88. Poem. **1378–80.** Westminster: Caxton, 1483. [Riverside 1987]

Girolamo Genga, 1476–1551. "The Flight of Aeneas from Troy." Fresco (detached) from Palazzo Petrucci. **1509–10.** Pinacoteca, Siena, no. 334. [Berenson 1968, p. 164—ill.]

Raphael, 1483–1520, and assistants. (Figures representing Aeneas, Anchises, and Ascanius, in) "The Fire in the Borgo." Fresco. **1514.** Stanza dell' Incendio di Borgo, Vatican, Rome. [Vecchi 1987, no. 115a—ill. / also Jones & Penny 1983, pp. 148ff.—ill. / Joannides 1983, no. 367—ill. (drawing)]

Jan van Scorel, 1495–1562, circle. "Aeneas Rescues Anchises and Ascanius." **1523.** Painting. Centraal Museum, Utrecht, cat. 1952 no. 265. [Wright 1980, p. 422]

Domenico Beccafumi, 1486–1551. "Aeneas Rescues Anchises." Fresco. *c.*1530? Palazzo Bindi Sergardi, Siena. [Sanminiatelli 1967, pp. 93f., pl. 31s]

Bernardo Parentino, 1437–1531. "The Flight from Troy." Painting. Museo del Bargello, Florence, no. 2022. [Berenson 1968, p. 318]

Giulio Romano, *c.*1499–1546, assistants, after designs by Giulio. "Aeneas Rescued by Venus," "Venus Swoons in the Arms of Jupiter" (in fear for Aeneas's safety). Frescoes, part of a cycle depicting scenes associated with the Trojan War. **1538–39.** Sala di Troia, Palazzo Ducale, Mantua. [Hartt 1958, pp. 179ff.]

Henry Howard, Earl of Surrey, 1517?–1547. Blank verse translation of *Aeneid* 2. *c.*1540? In *Certain Bokes of Virgiles Aenæis* (London: Toitel, 1557). Modern edition by Florence H. Ridley, in *The "Aeneid" of Henry Howard, Earl of Surrey* (Berkeley & Los Angeles: University of California Press, 1963). [Ipso / Brower 1971, pp. 109–11 / BW 1979–87, 1:116–19]

Giorgio Ghisi, 1520/21–1582, after a composition by G. B. Scultori. "The Fall of Troy and Aeneas's Flight." Engraving (Bartsch no. 29), part of a cycle on the Fall of Troy. After **1543.** (Kunsthalle, Hamburg, inv. 2/721a.) [Hofmann 1987, no. 4.11—ill.]

Andrea Schiavone, *c.*1522–1563. "Aeneas's Departure from Troy." Painting. *c.*1553–60. Formerly Landesmuseum Johanneum, Graz, no. 211. [Richardson 1980, no. 258 / Berenson 1957, p. 160—ill.]

Luca Cambiaso, 1527–1585. "The Flight of Aeneas from Troy." Drawing. *c.*1555–60. Louvre, Paris. [Manning & Suida 1958, p. 177—ill.]

Annibale Carracci, 1560–1609, **Agostino Carracci,** 1557–1602, or **Ludovico Carracci,** 1555–1619, variously attributed. "Venus Saves Aeneas," "Aeneas Leaving the Palace," "The Flight of Aeneas," "Aeneas and the Shade of Creusa." Frescoes, part of a cycle depicting the scenes from *Aeneid* 2 and 3. *c.*1586. Palazzo Fava (now Hotel Majestic-Baglioni), Bologna. [Malafarina 1976, no. 16—ill.]

Federico Barocci, c.1535–1612. "Aeneas Fleeing Troy with His Family." Painting. **1586–89.** Formerly Národní Galeri, Prague, lost. / Variant. 1598. Galleria Borghese, Rome, inv. 68. [DeGrazia 1984, pp. 184f.—ill. / Pergola 1955–59, 2: no. 99—ill.]

Bartolomeo Passarotti, 1529–**1592.** "Aeneas Rescues Anchises and Ascanius from Troy." Drawing. Princeton University Art Museum, inv. 48–590. [Warburg]

Jacopo Tintoretto, 1518–**1594,** attributed. "Aeneas Rescues Anchises." Painting. Duke of Devonshire coll., Chatsworth. [Pigler 1974, p. 286]

Jan Brueghel the Elder, 1568–1625. "Aeneas Carrying Anchises from Burning Troy." Painting. c.1595. Alte Pinakothek, Munich, no. 832. [Ertz 1979, no. 26—ill. / Munich 1983, p. 107—ill.]

Adam Elsheimer, 1578–1610. "The Burning of Troy" (Aeneas fleeing with his family). Painting. c.**1600–01.** Alte Pinakothek, Munich, inv. 205. [Andrews 1977, no. 11—ill. / Munich 1983, p. 193—ill.]

Peter Paul Rubens, 1577–1640. "Aeneas Prepares to Lead the Surviving Trojans into Exile." Painting. **1602–03.** Louvre, Paris, on deposit in Château de Fontainebleau. [Jaffé 1989, no. 28—ill.]

Frederic van Valckenborch, c.1565/66–1623. "Aeneas Rescues Anchises." Grisaille painting. **1607.** Private coll., Stockholm. [Pigler 1974, p. 288]

Guercino, 1591–1666. "The Flight of Aeneas." Fresco (detached), derived from print by Antonio Tempesta, from Casa Pannini, Cento. **1615–17.** Pinacoteca Civica, Cento. [Bagni 1984, p. 117—ill.]

Gian Lorenzo Bernini, 1598–1680. "Aeneas, Anchises, and Ascanius." Marble sculpture group. c.**1618–19.** Galleria Borghese, Rome, inv. 182. [Wittkower 1981, no. 8—ill. / Pope-Hennessy 1985b, 3:107, 427, 466—ill. / Faldi 1954, no. 32—ill.]

Gerrit van Honthorst, 1590–1656. "Aeneas Fleeing from the Sack of Troy." Painting. **1621** or earlier. Formerly Arundel coll., unlocated. [Judson 1959, no. 71]

Lionello Spada, 1576–**1622.** "Aeneas and Anchises" (with Creusa and Ascanius). Painting. Louvre, Paris, inv. 680. [Louvre 1979–86, 2:240—ill.]

Giovanni da San Giovanni, 1592–1636. "The Flight of Aeneas from Troy with His Father, Anchises." Fresco. **1623–24.** Palazzo Pallavicini Rospigliosi (Bentivoglio), Rome. [Banti 1977, no. 28—ill.]

———. "Aeneas and Creusa" (?). Monochrome fresco, artificial bas-relief. 1635–36. Salone degli Argenti, Palazzo Pitti, Florence. [Ibid., no. 64, pl. 143]

Kerstiaen de Coninck, c.1560–**1635.** "Aeneas Rescues Anchises." Painting. Musée, Courtrai, no. 36. [Pigler 1974, p. 288]

———. "Aeneas Rescues Anchises." Painting. Hermitage, Leningrad. [Ibid.]

———. "Aeneas Rescues Anchises." Painting. Donnet coll., Brussels. [Ibid.]

Guido Reni, 1575–**1642.** "The Flight of Aeneas." Painting (sketch). Lost. [Pepper 1984, p. 305 no. A26]

Richard Crashaw, 1612–1649. "Aeneas Patris" [Father Aeneas]. Latin poem. In *The Delights of the Muses . . .* (London: Moseley, **1648**). [Martin 1966]

Hendrick van Steenwijck the Younger, 1580–**1649.**

"Aeneas Rescuing Anchises from Burning Troy." Painting. After 1620. Art Institute of Chicago, no. 62.817. [Chicago 1965]

Veronese School (previously attributed to Alessandro Allori, 1535–1607). "Aeneas Flees from Burning Troy." Painting. **1600/50.** Uffizi, Florence, inv. SMeC 107. [Uffizi 1979, no. P1591—ill.]

Francisco Collantes, 1599–c.1656. (Aeneas in) "The Burning of Troy." Painting. Prado, Madrid, no. 3086. [Prado 1985, p. 157]

Juan de la Corte, 1597–1660. (Aeneas in) "The Burning of Troy." Painting, part of "Trojan War" cycle. El Retiro, Torremolinos, Málaga. [López Torrijos 1985, pp. 206f., 410 no. 12, pl. 6] At least 5 replicas. Prado, Madrid, nos. 3103, 4728; Universidad de Murcia, Spain; private coll., Madrid; Palacio de Riofrío, Segovia; other(s) unlocated. [Ibid., pp. 410f. nos. 27, 28, 31, 34–36—ill.]

Francisque Millet, 1642–**1679/80,** attributed. "Landscape with a Burning City" (Aeneas's flight from Troy?). Painting. Hatton Gallery, Newcastle-upon-Tyne. [Wright 1976, p. 137]

Domenico Maria Canuti, 1620–**1684,** attributed. "Aeneas Rescues Anchises." Drawing. Albertina, Vienna, inv. 25267. [Pigler 1974, p. 286]

Francisco Rizi, 1608–**1685.** "Aeneas Carrying His Father Anchises." Drawing. Private coll., Madrid. [López Torrijos 1985, p. 412 no. 67—ill.]

Sebastiano Ricci, 1659–1734. "Aeneas, Anchises, and Ascanius Escaping from Troy." Painting. **1691–94.** Museo de Arte, Ponce, Puerto Rico. [Daniels 1976, no. 355—ill.]

Mattia Preti, 1613–**1699,** attributed (previously attributed to Simon Vouet, 1590–1649). "Aeneas and Anchises." Painting. Galleria Nazionale d'Arte Antica (Palazzo Barberini), Rome. [Crelly 1962, no. 219 / Cannata 1978, pl. 4]

German School. "Aeneas and Anchises in Their Flight from Troy." Bronze statuette. **17th century.** John G. Johnson coll., Philadelphia. [Agard 1951, fig. 52]

Luca Giordano, 1634–1705. "Aeneas Fleeing from Troy." Painting. c.**1699–1700.** Prado, Madrid, no. 196. [Ferrari & Scavizzi 1966, 2:223—ill. / Prado 1985, p. 253]

North Italian School. "Aeneas Saving His Father Anchises from the Burning City of Troy." Painting. c.**1700.** Szépművészeti Múzeum, Budapest, no. 5581. [Budapest 1968, p. 504]

Michel Corneille the Younger, 1642–**1708.** "Aeneas Rescues Anchises." Painting. / Engraved by Pierre-Étienne Moitte (1722–1780). [Pigler 1974, p. 289] Another version of the subject, drawing, in Louvre, Paris. [Ibid.]

François Girardon, 1628–**1715.** "Aeneas and Anchises." Marble sculpture group. Musée, Troyes. [Pigler 1974, p. 289]

Pierre Lepautre, 1660–1744. "Aeneas and Anchises." Marble sculpture. **1716.** Jardin des Tuileries, Paris. [Hunisak 1977, fig. 75] Bronze replicas. Hermitage, Leningrad; Pushkin Museum, Moscow. [Pigler 1974, p. 289]

Antoine Coypel, 1661–1722. "Aeneas Carrying Anchises." Painting, part of cycle illustrating the adventures of Aeneas. **1716–17.** Placed in Galerie d'Énée, Palais-Royal. Now in Louvre, Paris, inv. 8724. [Louvre 1979–86, 3:170f.—ill.] Another version of the subject in Musée Fabre, Montpellier. [Pigler 1974, p. 289]

Carle van Loo, 1705–1765. "Aeneas Carrying Anchises."

Painting. **1729.** Louvre, Paris, inv. 6278. [Louvre 1979–86, 4:262—ill.] Another version of the subject in Musée des Beaux-Arts, Angers. [Bénézit 1976, 6:729f.]

Georg Philipp Telemann 1681–1767. *Die Flucht des Aeneas* [The Flight of Aeneas]. Opera. First performed 19 Nov **1731,** Hofoper, Hamburg. [Baker 1984, p. 2290]

Pompeo Batoni, 1708–1787. "Aeneas's Flight from Troy." Painting. **1748.** Marchese Gianpaolo Poschi-Meuron coll., Lucca. [Clark 1985, no. 121—ill.] Variant. Early 1750s. Galleria Sabauda, Turin, no. 484. [Ibid., no. 172—ill.]

Giulio Quaglio, 1668–**1751.** "Aeneas Rescues Anchises and Ascanius from Troy." Fresco. Palazzo Braida, Udine. [Warburg]

Jacopo Amigoni, 1675–1752. "Aeneas Rescues Anchises." Painting. Formerly Cortinovis coll., Bologna. [Pigler 1974, p. 287]

Johann Heinrich Keller, *c.*1692–1765. "Aeneas Saving His Father Anchises." Painting. **1753.** Formerly Rijksmuseum, Amsterdam, destroyed. [Rijksmuseum 1976, p. 314]

Francesco Algarotti, 1712–1764. *Enea in Troia.* Sketch for libretto for "the ideal opera," in *Saggio sopra l'opera in musica.* **1755.** [Grove 1980, 1:256]

Gaspare Diziani, 1689–**1767.** "Aeneas Rescues Anchises." Drawing. Szépmüvészeti Múzeum, Budapest, no. 2651. [Pigler 1974, p. 287]

Francesco Fontebasso, 1709–**1768/69.** "Aeneas Rescues Anchises." Drawing. Ashmolean Museum, Oxford. [Pigler 1974, p. 288]

Johann Georg Trautmann, 1713–**1769.** "Aeneas Rescues Anchises." Painting. Goethe-Museum, Frankfurt. [Pigler 1974, p. 288]

John Bacon, 1740–1799. "Aeneas and Anchises." Gesso relief. Before **1770.** Royal Society of Medicine, London. [Whinney 1964, pp. 166, 270 *n.5*]

Benjamin West, 1738–1820. "Aeneas and Creusa." Painting. *c.***1771.** New York Historical Society, New York. [von Erffa & Staley 1986, no. 179—ill.]

Joseph-Benoît Suvée, 1743–1807. "Aeneas at Burning Troy, Wishing to Return to the Battle, Is Restrained by His Wife, Creusa." Painting. **1784–85.** Louvre, Paris, inv. 8072. [Louvre 1979–86, 4:228—ill.]

Martin Johann Kremser-Schmidt, 1718–1801. "The Flight of Aeneas and Anchises from the Burning City of Troy." Painting. **1785.** Schreiner coll., Voitsberg, Steiermark, Austria. / Replica. Szépmüvészeti Múzeum, Budapest, no. 63.8. [Budapest 1968, p. 630]

Jacques-Louis David, 1748–1825. "Aeneas Rescues Anchises and Ascanius from Burning Troy." Engraving, illustration for Pierre Didot's *Publii Virgilii Maronis Bucolica, Georgica, et Aeneis* (Paris: **1798**). Portfolio of proofs in Lessing J. Rosenwald coll., Library of Congress, Washington, D.C. [Patterson 1987, p. 247, fig. 24]

The Prix de Rome painting competition subject for **1803** was "Aeneas Carrying Anchises." First prize: Merry-Joseph Blondel (1781–1853). École des Beaux-Arts, Paris. [Grunchec 1984, no. 41—ill. / Harding 1979, p. 91]

Francesco Hayez, 1791–1882. "Aeneas and Creusa." Painting. **1809.** Lost. [Coradeschi 1971, no. 5]

———. "Aeneas and Anchises." Painting. *c.*1811–13. Lost. [Ibid., no. 13]

Peter Cornelius, 1783–1867, and studio. "Aeneas Carrying Anchises from the Ruins of Troy." Lunette fresco. **1826–30.** Trojanischer Saal, Glyptothek, Munich. [Glyptothek 1980, pp. 218ff.]

Alfred Stevens, 1817–1875. "Aeneas Bearing Anchises on His Shoulders." Painting, for Dorchester House, London. *c.*1860. / Study, drawing. Tate Gallery, London, no. 3778. [Tate 1975, p. 75]

Allen Tate, 1899–1979. "Aeneas at Washington" (contemporary Washington, D.C. seen as Troy at its fall). Poem. In *Hound and Horn* 6 (**1932–33**); collected in *The Mediterranean and Other Poems* (New York: Alcestis, 1936). [Ipso / Boswell 1982, p. 229 / DLB 1986, 45:388f. / Davie 1978, pp. 70–72 / Squires 1972, pp. 153f. / Feder 1971, pp. 175–79, 397–99]

Takis Papatsonis, 1895–. (Aeneas's rescue of Anchises evoked in) "I Sing the Wrath" [English title of work written in Greek]. Poem. **1941.** In *Ursa Minor* (Athens: Ikaros, 1944). / Translated by Kimon Friar in *Ursa Minor and Other Poems* (Minneapolis: Nostos, 1988). [Ipso / Friar 1973, pp. 265, 728f.]

John Peale Bishop, 1892–**1944.** (Aeneas's rescue of Anchises evoked in) "Experience of the West." Poem. In *Collected Poems,* edited by Allen Tate (New York: Scribner, 1948). [Ipso]

Stanley Kunitz, 1905–. "Open the Gates." Poem. In *Selected Poems: 1928–1958* (Boston & Toronto: Little, Brown, **1958**). [Ipso]

Allen Grossman, 1932–. "Creusa." Poem. In *A Harlot's Hire* (Cambridge, Mass.: Walker-de Berry, **1961**). [Ipso]

Leonard Baskin, 1922–. "Aeneas Carrying His Father from Burning Troy." Bronze sculpture group. **1971.** A. Richards coll., New York. [Jaffe 1980, pp. 184, 216—ill.]

———. "Aeneas Carrying His Father from the Ruins of Troy." Lithograph. 1971. [Fern & O'Sullivan 1984, no. 599—ill.]

C. H. Sisson, 1914–. (Flight from Troy recalled in) "Anchises." Poem. In *Anchises* (Manchester: Carcanet, **1976**). [Ipso / DLB 1984, 27:329 / Seymour-Smith 1985, p. 339]

Wanderings. After fleeing from the ruins of Troy, Aeneas and his companions wandered for seven years. Beginning with twenty ships, the Trojans intended to found a colony in Thrace, but were warned against it by the ghost of the Trojan prince Polydorus and sailed on. At Delos, the oracle of Apollo told Aeneas to seek the land of his ancestors. At Crete, he was told in a dream that the oracle had meant Hesperia (Italy), where Dardanus, the founder of Troy, had been born. Tossed by a storm onto the Strophades, the travelers battled the Harpies, whose leader prophesied a famine that would make them eat their tables.

At Buthrotum, in Chaonia, a peaceful interlude was provided by Helenus, Hector's friend and now the husband of Hector's widow, Andromache. Helenus told Aeneas that he would establish his city where he found a white sow and thirty piglets, but

prophesied wars and troubles before that came to pass. He told Aeneas to consult the Sibyl at Cumae, and the Trojans proceeded around the coast of Italy as far as Sicily, where Anchises died.

Classical Sources. Virgil, *Aeneid* 3. Ovid, *Metamorphoses* 13.629–739.

See also POLYDORUS.

Annibale Carracci, 1560–1609, **Agostino Carracci,** 1557–1602 and **Ludovico Carracci,** 1555–1619, variously attributed. "The Sacrifice of Aeneas," "The Offering to Neptune," "The Banquet Attacked by Harpies," "Polyphemus Attacks the Trojan Fleet." Frescoes, part of a cycle depicting the scenes from *Aeneid* 2 and 3. *c.***1586.** Palazzo Fava (now Hotel Majestic-Baglioni), Bologna. [Malafarina 1976, no. 16—ill.]

Hendrik Goltzius, 1558–**1617,** attributed. "The Penates Appear to Aeneas in a Dream." Drawing. Fogg Art Museum, Harvard University, Cambridge. [de Bosque 1985, pp. 286, 290—ill.]

François Perrier, *c.*1590–1650. "Aeneas and His Companions Fighting the Harpies." Painting, part of series depicting the story of Aeneas, for Cabinet de l'Amour, Hôtel Lambert, Paris. *c.***1646–47.** Louvre Paris, inv. 7160. [Louvre 1979–86, 4:129—ill. / Louvre 1972, pp. 29ff., no. 50—ill.]

Pietro da Cortona, 1596–1669. "The Sacrifice to Juno." Fresco, part of *Aeneid* cycle. **1651–54.** Palazzo Doria Pamphili, Rome. [Briganti 1962, no. 117—ill.]

Claude Lorrain, 1600–1682. "Coast View of Delos with Aeneas" (Anius, Anchises, Ascanius). Painting. *c.***1669–72.** National Gallery, London, no. 1018. [Röthlisberger 1961, no. LV 179—ill.] Drawing after, in the artist's *Liber veritatis.* British Museum, London. [Ibid. / London 1986, p. 113—ill / Llewellyn 1984, pp. 130f.]

Johann Adolf Hasse, 1699–1783. *Enea in Caonia* [Aeneas in Chaonia]. Serenata. Libretto, L. M. Stampiglia. First performed **1727,** Naples. [Grove 1980, 8:287]

Jeronymo Francisco de Lima, 1743–1822. *Enea in Tracia* [Aeneas in Thrace]. Opera. **1781.** [Grove 1980, 10:863]

Allen Tate, 1899–1979. (Prophecy that Aeneas's men would eat their tables evoked in) "The Mediterranean." Poem. **1933.** In *The Mediterranean and Other Poems* (New York: Alcestis, 1936). [Ipso / DLB 1986, 45:388f. / Squires 1972, pp. 153, 168, 179, 183, 310 / Feder 1971, pp. 175f., 192 / Axelrod 1978, p. 25]

C. H. Sisson, 1914–. (Death of Anchises evoked in) "Anchises." Poem. In *Anchises* (Manchester: Carcanet, **1976**). [Ipso]

Storm at Sea. When Aeneas was sailing away from Sicily, Juno—who had never forgiven Paris for his judgment against her and who remained Troy's enemy—commanded Aeolus to raise a dreadful storm, promising the nymph Deiopea to the wind god as a reward. The storm threatened to destroy all of Aeneas's fleet, but Neptune confronted Aeolus and calmed the waves with the command "Quos ego!" ("I am he who commands the waves"). But now blown off course, the Trojans were forced to land on the coast of Libya in northern Africa.

The storm and Neptune's intervention have been very popular subjects in the fine arts.

Classical Source. Virgil, *Aeneid* 1, 3.

Apollonio di Giovanni, *c.*1415–**1465,** and **Marco del Buono Giamberti,** ?–1489. "Juno Asks Aeolus to Start a Tempest." Painting, detail in "Jarves Cassone" decoration depicting scenes from the *Aeneid.* Yale University Art Gallery, New Haven, no. 1871.34. [Berenson 1963, p. 18—ill.] Variant (by Apollonio), miniature in MS of the *Aeneid.* Biblioteca Riccardiana, Florence, codex 492. [Ibid., pl. 740]

Marcantonio Raimondi, *c.*1480–1527/34. "Quos ego." Engraving (Bartsch no. 352), after (lost) design by Raphael. *c.***1518.** [Jones & Penny 1983, pp. 180ff.—ill. / Shoemaker 1981, no. 32—ill. / also Bartsch 1978, 27:49—ill.]

Taddeo Zuccari, 1529–**1566.** "Aeolus Raises the Winds." Fresco. Stanza dell' Inverno, Villa Farnese, Caprarola. [Warburg]

Luca Cambiaso, 1527–1585. "Neptune with the Quadriga" ("Quos ego"). Stucco relief, after a composition by Raphael. **1567.** Villa Battista Grimaldi, Genoa. [Manning & Suida 1958, p. 87—ill.]

Francesco Primaticcio, 1504–**1570,** school. "Aeolus Looses the Winds." Drawing. Kunsthalle, Hamburg, inv. no. 21374. [Warburg]

Hans Bol, 1534–**1593,** attributed. "Aeolus Looses the Winds, Neptune Calms the Waves." Painting (2 scenes in 1 composition). Nationalmuseum, Stockholm, no. 730. [Pigler 1974, pp. 191, 284]

François Perrier, *c.*1590–1650. "Juno and Aeolus." Fresco. **1624–29.** Palazzo Peretti-Almagia, Rome. [Eisler 1977, p. 264]

———. "Venus Imploring Neptune." Painting. 1625–29. Musée Départemental des Vosges, Epinal. [Ibid.]

———. "Neptune and Aeolus." Painting. Art market, Rome, 1977. [Ibid.]

Peter Paul Rubens, 1577–1640. "The (Happy) Voyage of Prince Ferdinand (from Barcelona to Genoa)" ("Neptune Calming the Tempest"). Design for part of the Stage of Welcome, decoration for "Pompa Introitus Fernandi," triumphal entry of Cardinal-Infante Ferdinand of Spain into Antwerp, 17 Apr **1635.** Original decoration destroyed. / Oil sketch. Fogg Art Museum, Harvard University, Cambridge. [Martin 1972, no. 3a—ill. / Held 1980, no. 146—ill. / Jaffé 1989, no. 1117—ill. / Harvard 1985, no. 187—ill. / White 1987, pl. 283 / Baudouin 1977, fig. 176] Cartoon, by Rubens and assistants. Gemäldegalerie, Dresden, no. 464b. [Martin, no. 3—ill. / Held, 1:227f. / Jaffé, no. 1120—ill. / Harvard, no. 187—ill.] Oil sketch, study for whole stage. Hermitage, Leningrad, inv. 498 (562). [Held, no. 145—ill.] Copies in Accademia Carrara, Bergamo (as Jacob Jordaens); Koninklijk Museum voor Schone Kunsten, Antwerp. [Martin]

Pietro da Cortona, 1596–1669. "Juno Asks Aeolus to Loose the Winds," "Neptune Calms the Winds." Fres-

coes, part of *Aeneid* cycle. **1651–54.** Palazzo Doria Pamphili, Rome. [Briganti 1962, no. 117—ill.]

Francesco Albani, 1578–**1660.** "Aeolus Looses the Winds." Painting. Galleria Sabauda, Turin. [Pigler 1974, pp. 284, 191]

Charles Cotton, 1630–1686/87. *Scarronides, or Le Virgile travestie: A Mock-poem, being the first book of Virgil's Anaeis in English.* Burlesque. London: **1664–65.** [Bush 1963, pp. 303f., 338]

Domenico Canuti, 1620–**1684.** "Aeneas in the Storm." Drawing. Albertina, Vienna, inv. no. 25368. [Warburg]

Raymond de La Fage, *c.*1650–**1684.** "Aeolus Looses the Winds." Drawing. Louvre, Paris. [Pigler 1974, p. 285]

Johann Heinrich Schönfeld, 1609–**1684.** "Neptune Calms the Waves." Drawing. Albertina, Vienna, cat. 1933 no. 654. [Pigler 1974, p. 191]

Pierre Mignard, 1612–**1695.** "Aeolus Looses the Winds." Drawing. Musée, Lille. [Warburg]

Amsterdam School. "Neptune Calms the Waves." Painted lid of an ivory box. **1696.** Rijksmuseum, Amsterdam, inv. NG 1974 R30. [Rijksmuseum 1976, p. 786—ill.]

Flemish School. "Aeolus Looses the Winds." Drawing. **17th century.** National Gallery of Scotland, Edinburgh, inv. D2962. [Warburg]

Michel Corneille the Younger, 1642–**1708.** "Neptune Calms the Waves." Drawing. Louvre, Paris. [Pigler 1974, p. 191]

Charles de La Fosse, 1636–**1716.** "Neptune Chasing the Winds." Painting. Musée, Alger. [Bénézit 1952, 5:354]

Antoine Coypel, 1661–1722. "Neptune Calms the Waves." Painting. Formerly Palais Royal, Paris. / Engraved by Bernard Picart, 1717. [Pigler 1974, p. 191]

———. "Aeolus Looses the Winds." Painting. Formerly Palais Royal, Paris. / Engraved by N. H. Tardieu (1674–1749). [Ibid., p. 285]

Jean Restout the Younger, 1692–1768. "Juno and Aeolus." Painting, after Louis Boullogne (1699, engraved 1718 by Ch. Dupuis as "The Air"). **1727.** Hermitage, Leningrad, inv. 5629. [Hermitage 1986, no. 187—ill.] Copy by Dodenare, 1735 or 1775, in Ringling Museum of Art, Sarasota, Fla. [Ibid.]

Lambert-Sigisbert Adam, 1700–1759. "Neptune Calming the Waves." Marble sculpture group. *c.*1737. Louvre, Paris. [Thirion 1885, p. 74—ill.]

William Hogarth, 1697–1764, attributed (or Gerard Vandergucht?). "Aeneas in a Storm." Satirical engraving. **1736–37.** [Paulson 1965, no. 284—ill.]

Gabriel-François Doyen, 1726–1806. "On Juno's Command, Aeolus Releases the Winds from His Cave." Painting, part of a "Four Elements" cycle. **1753.** Szépművészeti Múzeum, Budapest, no. 60.8. [Budapest 1968, p. 196]

Hendrik van Limborch, 1681–1759. "Aeolus Looses the Winds." Painting. [Pigler 1974, p. 285]

Giovanni Battista Tiepolo, 1696–1770. "Neptune and the Zephyrs (Winds)." Painting, sketch for an unknown ceiling decoration. *c.*1762–66. Metropolitan Museum, New York, no. 37.165.4. [Pallucchini 1968, no. 287—ill. / Morassi 1962, p. 33—ill. / Columbia 1967, no. 44—ill. / Metropolitan 1980, p. 183—ill.]

François Boucher, 1703–1770. "Juno Orders Aeolus to Loose the Winds." Painting. **1769.** Kimbell Art Museum, Fort Worth, Texas. [Ananoff 1976, no. 674—ill.]

Maria Cosway, 1759–1838. "Aeolus Looses the Winds." Painting. / Mezzotint by Valentine Green, **1783.** [Pigler 1974, p. 285]

Nicolas Bernard Lepicié, 1735–**1784.** "The Wrath of Neptune." Painting. Musée des Beaux-Arts, Troyes. [Bénézit 1976, 6:594]

Stefano Torelli, 1712–**1784.** "Neptune Calms the Waves." Drawing. Albertina, Vienna, cat. VI (1941) no. 325. [Warburg]

Merry-Joseph Blondel, 1781–1853. "Air: Aeolus Looses the Winds against the Trojan Fleet." Ceiling painting, part of a cycle by Blondel and Auguste Couder representing the Four Elements. **1819.** Vestibule, Galerie d'Apollon, Louvre, Paris (inv. 2625). [Louvre 1979–86, 3:64—ill.]

Eugène Delacroix, 1798–1863. "Neptune Calming the Waves." Painting, for Salon de la Paix, Hôtel de Ville, Paris. **1849–53.** Destroyed 1871. [Robaut 1885, no. 1149]

———. "Winter: Juno Beseeching Aeolus to Destroy the Fleet of Aeneas." Painting, part of "Four Seasons" cycle. Begun 1856, unfinished. Museu de Arte, Sao Paulo. [Johnson 1981–86, no. 251—ill. / Huyghe 1963, p. 416 / also Robaut, no. 1432—ill. (copy drawing)] Oil sketch. Reemstsma coll., Hamburg. [Johnson, no. 247—ill.] Copy, attributed to Pierre Andrieu (d. 1892), in Museum of Fine Arts, Boston, no. 21.1452. [Boston 1985, p. 78—ill.]

Thomas Ashe, 1836–1889. "The Gift of Hera" (of Deiopea to Aeolus). Poem. In *Poems* (London: Bell, **1886**). [Boswell 1982, p. 22]

Welland Lathrop, 1906–1981, choreography. *Quos ego.* Ballet. First performed **1933,** Seattle. [Cohen-Stratyner 1982, p. 527]

Shipwreck. Only seven of Aeneas's ships survived the storm called up by Juno and landed on the Libyan coast. Venus, Aeneas's mother, implored Jupiter to explain what her son and his followers—now shipwrecked in a strange land far off course from their destination—had done to deserve such a cruel fate. Jupiter reassured her that not only would Aeneas reach Italy and found the Roman race, but his descendants would rule an eternal empire.

Aeneas and his closest companion, Achates, set out to explore the Libyan countryside. There they encountered Venus, in the guise of a huntress, who told them the story of the Carthaginian queen Dido (known also as Elissa). Venus then revealed her identity and told Aeneas to go to Dido, assuring him that the queen would grant the Trojans safe haven in her country or safe passage to Italy.

Most fine art treatments of this episode depict Aeneas and Achates meeting Venus.

Classical Source. Virgil, *Aeneid* 1.

Apollonio di Giovanni, *c.*1415–**1465,** and **Marco del Buono Giamberti,** ?–1489. "Venus Summons Aeneas and Achates." Painting, detail in Jarves Cassone decoration depicting scenes from the *Aeneid*. Yale University Art Gallery, New Haven, no. 1871.34. [Berenson 1963, p. 18—ill.] Variant (by Apollonio), miniature in *Aeneid* MS. Biblioteca Riccardiana, Florence, codex 492. [Ibid., pl. 740]

Dosso Dossi, *c.*1479–1542. "Aeneas Landing in Africa" (traditional title, now identified as "The Sicilian Games"). Painting, one of 10 (8 lost) in *Aeneid* series, from Camerino d'Alabastro of Alfonso I d'Este, Ferrara. *c.*1520. Barber Institute of Fine Arts, Birmingham, England. [Gibbons 1968, no. 6—ill. / also Berenson 1968, p. 110—ill.]

———. "Scene from a Legend" (traditionally called "Departure of the Argonauts," now questionably identified as "The Building of the Argo" or "Aeneas and Achates on the Libyan Coast"). Painting. Mid-1520s? Kress coll. (K448), National Gallery, Washington, D.C., no. 361. [Gibbons, no. 79—ill. / Shapley 1966–73, 2:73f. (as "Aeneas and Achates")—ill.]

Marcantonio Raimondi, *c.*1480–**1527/34.** "Venus Appearing to Aeneas." Engraving (Bartsch no. 288). [Bartsch 1978, 26:276—ill.]

Peter Paul Rubens, 1577–1640. "The Shipwreck of Aeneas" (?). Painting. **1604–05.** Gemäldegalerie, Berlin-Dahlem, no. 776E (as "The Shipwreck of St. Paul"). [Jaffé 1989, no. 40—ill. / also Berlin 1986, p. 66—ill.]

———, or studio. "Jupiter Reassuring Venus" (that the Trojans will be spared to found Rome; formerly called "Thetis Supplicating Jupiter," "Jupiter Committing to Woman the Government of the Universe"). Painting. *c.*1618–20. Lost or partially destroyed; fragment (of original?) on Swiss art market in 1989. [Jaffé, no. 659—ill.] Oil sketch. Beit coll., Russborough, Blessington, Ireland. [Ibid., no. 658—ill. / Held 1980, no. 247—ill.]

Frederic van Valckenborch, *c.*1565/66–**1623.** "Landscape with the Shipwreck of Aeneas." Painting. Museum Boymans-van Beuningen, Rotterdam, cat. 1962 no. 2644. [Wright 1980, p. 461]

Pietro da Cortona, 1596–1669 (and Giovanni Francesco Romanelli? 1610–1662). "Venus as a Huntress Appearing to Aeneas" (formerly called "Aeneas and Dido Hunting"). Painting. *c.*1630–35. Louvre, Paris, inv. 112. [Briganti 1962, no. 57—ill. / Louvre 1979–86, 2:152—ill.]

Joos de Momper, 1564–**1635.** "Aeneas Lands in Libya." Painting. Nationalmuseum, Stockholm, cat. 1958 no. 730. [Warburg]

Charles Cotton, 1630–1686/87. *Scarronides, or Le Virgile travestie: A Mock-poem, being the first book of Virgil's Anaeis in English.* Burlesque. London: **1664–65.** [Bush 1963, pp. 303f., 338]

Pieter Mulier, 1615–1670. "Shipwreck of Aeneas's Fleet on the Shore of Africa." Painting. New York Historical Society, New York. [Warburg]

Claude Lorrain, 1600–1682. "Coast of Libya with Aeneas Hunting (the Stag)." Painting. **1672.** Musées Royaux des Beaux-Arts (Musée d'Art Ancien), Brussels, inv. 1480 (276). [Röthlisberger 1961, no. LV 180—ill. / Brussels 1984a, p. 119—ill.] Drawing after, in the artist's *Liber veritatis.* British Museum, London. [Röthlisberger] Copy ("Land-

ing of Aeneas") in Shipley Art Gallery, Gateshead, cat. 1951 no. 376. [Wright 1976, p. 39]

Corrado Giaquinto, 1703–1765. "Venus Appearing before Aeneas and Achates." Painting, part of series depicting scenes from the *Aeneid,* for Royal Palace, Turin. **Early 1730s.** Palazzo Quirinale, Rome. [Llewellyn 1984, pp. 126–28]

Charles-Joseph Natoire, 1700–1777, questionably attributed. "Venus and Aeneas." Painting. **1750s?** Musée, Bordeaux. [Boyer 1949, no. 81]

Washington Allston, 1779–1843. "Landscape" ("Aeneas and Achates Come Ashore"?). Painting. *c.*1800. Fruitlands Museum, Harvard, Mass. [Gerdts & Stebbins 1979, p. 20—ill. / also Richardson 1948, no. 17]

Angelica Kauffmann, 1741–**1807.** "Venus Directing Aeneas and Achates to Carthage." Painting. Saltram Park, Devon, cat. 1967 no. 87T. [Wright 1976, p. 110]

François-Edouard Picot, 1786–1868. "The Meeting of Aeneas and Venus." Painting. **1813.** Musées Royaux des Beaux-Arts (Musée d'Art Moderne), Brussels, inv. 433. [Brussels 1984b, p. 503—ill.]

Sacheverell Sitwell, 1897–1988. "Aeneas Hunting Stags upon the Coast of Libya." Poem. In *Canons of Giant Art: Twenty Torsos in Heroic Landscapes* (London: Faber & Faber, **1933**). [Boswell 1982, p. 294]

Aeneas and Dido. When Aeneas arrived at Carthage in Libya, he was greeted by Queen Dido, who held a sumptuous banquet to honor the Trojans. Aeneas told her the story of the fall of Troy, his ensuing travels, and his prophesied destiny. During the banquet, Cupid—disguised by Venus as Aeneas's son Ascanius—was fondled by Dido, who was thus stricken with love for Aeneas.

Dido's sister, Anna, encouraged the match, urging Dido to end her mourning for her murdered husband, Sychaeus, and ally with Aeneas against her enemies. Venus and Juno, each for her own reason, then arranged to bring Aeneas and Dido together. During a royal hunt, a storm arose and the couple took shelter in a cave, there consummating their union.

While Aeneas tarried in Carthage, Jupiter sent Mercury, his messenger, to remind Aeneas of his destiny and urge him on to Italy. Dido tried in vain to prevent Aeneas's departure; as his fleet sailed away she threw herself on a funeral pyre, cursing Aeneas and his descendants.

Perhaps the best-known part of the *Aeneid,* the liaison between Aeneas and Dido is an especially popular subject in music, drama, and literature. In the visual arts the most frequently depicted scenes are the welcoming banquet, the royal hunt and the storm, and Dido's suicide.

Classical Sources. Virgil, *Aeneid* 1, 4. Ovid, *Heroides* 7; *Metamorphoses* 14.74–81.

See also AENEAS, in the Underworld.

Jean de Meun, 1250?–1305? (Aeneas's betrayal of Dido recounted in) *Le roman de la rose* lines 13173–210. Verse romance, completion of unfinished work begun by Guillaume de Lorris (*c.*1230–35). *c.***1275.** Lyon: Ortuin & Schenck, *c.*1481. [Dahlberg 1971 / Poirion 1974]

Dante Alighieri, 1265–1321. (Dido among the Lustful in) *Inferno* 5.61f. *c.*1307–*c.***1314?** In *The Divine Comedy.* Poem. Foligno: Neumeister & Angelini, 1472. [Singleton 1970–75. vol. 1 / Bono 1984, pp. 52f.]

Anonymous French. (Story of Aeneas and Dido in) *Ovide moralisé* 14.302–526. Poem, allegorized translation/elaboration of Ovid's *Metamorphoses* and other works. *c.***1316–28.** [de Boer 1915–86, vol. 5]

Francesco Petrarca, 1304–1374. (Dido celebrated in) *Il trionfo della Pudicizia* [The Triumph of Chastity] lines 154ff. Poem. **1340–44.** In *Trionfi* (Bologna: Malpiglius, 1475). [Wilkins 1962 / Bezzola 1984]

Giovanni Boccaccio, 1313–1375. "De Didone seu Elissa Cartaginensium regine" [Dido, or Elissa, Queen of Carthage]. In *De mulieribus claris* [Concerning Famous Women]. Latin verse compendium of myth and legend. **1361–75.** Ulm: Zainer, 1473. [Branca 1964–83, vol. 10 / Guarino 1963 / Bergin 1981, p. 250]

Italian School. "Dido at Aeneas's Departure." Painted ceiling, from "Lo Steri." **1377–80.** Palazzo Chiaramonte, Palermo. [Scherer 1963, p. 239]

Geoffrey Chaucer, 1340?–1400. "The Legend of Dido." In *The Legend of Good Women.* Poem. **1385–86.** Westminster: Caxton, *c.*1495. [Riverside 1987 / Hieatt 1975, p. 122]

John Gower, 1330?–1408. (Story of Aeneas and Dido in) *Confessio amantis* 4.77–146. Poem. *c.***1390.** Westminster: Caxton, 1483. [Macaulay 1899–1902, vol. 2]

Christine de Pizan, *c.*1364–*c.*1431. (Dido in) *Le livre de la Cité des Dames* [The Book of the City of Ladies] part 1 no. 46, part 2 no. 55. Didactic compendium in prose, reworking of Boccaccio's *De mulieribus claris.* **1405.** [Hicks & Moreau 1986] Translated by Brian Anslay (London: Pepwell, 1521). [Richards 1982]

Apollonio di Giovanni, *c.*1415–1465. "Work on the Walls of Carthage." Painting, detail in "Jarves Cassone" decoration depicting scenes from the *Aeneid.* Yale University Art Gallery, New Haven, no. 1871.35. [Berenson 1963, p. 18—ill.] Variant, by Apollonio ("Meeting of Dido and Aeneas while the Walls of Carthage are Being Built"), miniature in MS of the *Aeneid.* Biblioteca Riccardiana, Florence, codex 492. [Ibid., pl. 742]

———. "Story of Dido and Aeneas." 2 paintings. Kestner-Museum, Hannover, nos. 186–87. [Ibid., p. 18]

Francesco di Giorgio, 1439–1502, studio (previously attributed to Francesco). "The Meeting of Dido and Aeneas." Painting. *c.***1480?** Kress coll. (K530), Portland Art Museum, Ore., no. 61.36. [Shapley 1966–73, 1:154—ill. / Berenson 1968, p. 141]

Sienese School. "The Story of Dido." **15th century.** Painting cycle. Musée du Petit Palais, Avignon (on deposit from Louvre, Paris, nos. M.I. 439–42). [Louvre 1979–86, 2:302]

Marcantonio Raimondi, *c.*1480–1527/34. "Dido" (committing suicide). Engraving (Bartsch no. 187), after de-sign by Raphael (?). *c.***1510.** [Shoemaker 1981, no. 18—ill. / also Bartsch 1978, 26:187ff.—ill. / see also D. H. Thomas, "Note on Marcantonio's 'Death of Dido,' " *Journal of the Warburg and Courtauld Institutes* 32 (1969): 394–96]

Dosso Dossi, *c.*1479–1542. "Dido." Painting. **Early 1520s.** Galleria Doria-Pamphili, Rome, no. 202. [Gibbons 1968, no. 65—ill. / also Berenson 1968, p. 113]

Anonymous English. "The Letter of Dydo to Aeneas." Free, abridged paraphrase of epistle in Ovid's *Heroides.* Printed in Pynson's edition of Chaucer, London: **1526.** [Bush 1963, p. 312]

Alessandro Pazzi de' Medici, 1483–1530. *La Dido in Cartagine* [Dido in Carthage]. Tragedy. **1527–28.** In modern edition, *Le tragedie metriche,* edited by Angelo Solerti (Bologna: Romagnoli dall' Acqua, 1887). [Bono 1984, pp. 87f., 129]

Liberale da Verona, *c.*1445–1526/29. "Dido's Suicide." Painting. National Gallery, London, inv. 1336. [London 1986, p. 319—ill. / Berenson 1968, p. 210]

Albrecht Altdorfer, *c.*1480–1538. "(The Suicide of) Dido." Engraving (Bartsch no. 42). *c.***1520–30.** [Winzinger 1963, no. 159—ill.]

Giampietrino, fl. **1500–40.** "Dido." Painting. Palazzo Borromeo, Isolabella. [Berenson 1968, p. 168]

Henry Howard, Earl of Surrey, 1517?–1547. *The Fourth Boke of Virgill.* Blank verse translation from the *Aeneid. c.***1540?** London: 1554. Modern facsimile edition by H. Hartman, *Surrey's Fourth Boke of Virgill* (London: Oxford University Press, 1933). [Brower 1971, pp. 112f. / BW 1979–87, 1:116–19]

Giovanni Battista Giraldi Cinthio, 1504–1573. *La Didone.* Tragedy. **1541–43.** In *Tragedie nove* (Nice: Cagnacini, 1583). [Bono 1984, pp. 91–97, 137, 227]

Lodovico Dolce, 1508–1568. *La Didone.* Tragedy. Venice: Aldus, **1547.** [Bono 1984, pp. 88f., 226]

Joachim Du Bellay, 1522–1560. *Le quatriesme livre de "l'Éneide"* [The Fourth Book of the *Aeneid*]. Translation. Paris: **1552.** [DLLF 1984, 1:226 / Highet 1967, p. 115]

Daniele da Volterra, 1509–1566. "The Embassy of Mercury to Aeneas." Painting. **1555–56.** Lost. / Drawings in Rijksmuseum, Amsterdam; British Museum, London; Albertina, Vienna. / Copy, painting, formerly private coll., Sweden. [Barolsky 1979, no. 19—ill.]

Étienne Jodelle, 1532–1573. *La Didon se sacrifiant* [Dido Sacrificing Herself]. Tragedy. First performed **1558,** Paris. Published in *Les oeuvres et meslanges poétiques* (Paris: Chesneau, 1574). In modern edition, *Four Renaissance Tragedies* (Cambridge: Harvard University Press, 1966). [DLLF 1984, 1:1125 / Lancaster 1929–42, pt. 2, 1:47 / Stone 1974, pp. 94–104 / McGraw-Hill 1984, 3:101 / Bono 1984, pp. 107–16, 137f.]

Hans Kels the Elder, 1480/85–*c.*1559. "Dido on the Funeral Pyre." Ivory carving. Kunsthistorisches Museum, Vienna. [Pigler 1974, p. 315]

Andrea Schiavone, 1522–1563. "Aeneas Taking Leave of Dido," "Aeneas Recalled from Dido." Pendant paintings. *c.***1553–60.** Kunsthistorisches Museum, Vienna, nos. 190a, 190b. [Richardson 1980, nos. 318–19—ill.]

———, attributed. "The Death of Dido." Drawing. Louvre, Paris, no. 6495. [Ibid., no. 193—ill.]

Matteo Bandello, 1480?–1561. "Dido." Novella. In *Le*

novelle del Bandello (Lucca: Buadrago, 1554–73). [Stone 1974, pp. 26f.]

Alessandro Striggio the Elder, c.1540–1592. "Il cicalmento delle donne al bucato et la caccia . . . con un lamento di Didone ad Enea. . . ." [The Chattering of Ladies at the Washing and the Chase . . . with a Lament of Dido to Aeneas]. Vocal composition. Published Venice: Scotto, **1567.** [Grove 1980, 18:272]

Lambert Sustris, 1515/20–after **1568.** "Dido Asleep." Painting. Staatliche Kunstsammlungen, Kassel. [Bénézit 1976, 10:19]

Pierre de Ronsard, 1524–1585. (Story of Aeneas and Dido retold in) *La Françiade* 3. Epic poem, unfinished. Paris: Buon **1572.** [Laumonier 1914–75, vol. 16 / Stone 1974, p. 153 n.7]

Guillaume de la Grange. *La Didon.* Tragedy. First performed **1576,** Théâtre Français, Paris. Published Lyon: Rigaud, 1582. [Turner 1926, pp. 7, 122–29, 132]

Orazio Samacchini, 1532–**1577.** "Mercury Ordering Aeneas to Leave Dido." Painting. Louvre, Paris, inv. 4637. [Louvre 1979–86, 2:234—ill.]

Edmund Spenser, 1552?–1599. (Colin Clout's pastoral elegy to Dido in) "November," in *The Shepheardes Calender.* Cycle of eclogues. London: **1579.** [Oram et al. 1989 / Bono 1984, pp. 67f.]

William Gager, 1555–1632 (previously attributed to Christopher Marlowe). *Dido.* Tragedy. First performed **1583,** London. Published in *Works of Christopher Marlowe,* edited by A. Dyce (London: 1853). [Cambridge 1969–77, 1:1767]

Jehan Baptista Houwaert, 1533–1599. "Aeneas and Dido." Drama, part of *Den Handel der amoreusheyt* [The Commerce of Amorosity]. **1583.** [Gosse 1910, p. 721]

Gabriel Lobo Lasso de la Vega, 1559–1610/15? *La honra de Dido restaurada* [The Honor of Dido Restored]. Tragedy. In *Primera parte del romancero y tragedias* (Alcalá: **1587**). In modern edition by H. E. Isar, *The Tragedies of Gabriel Lobo Lasso de la Vega* (Ann Arbor: University Microfilms, 1955). [Oxford 1978, p. 334]

Christopher Marlowe, 1564–1593, and **Thomas Nashe,** 1567–1601. *The Tragedie of Dido, Queen of Carthage.* Tragedy. First performed **1587–88,** by the Children of Her Majestie's Chappell, London. Published London: Woodcocke, 1594. [Bowers 1973, vol. 1 / Bono 1984, pp. 127–37, 228 / Leech 1986, pp. 15, 26, 35, 41 / Friedenreich et al. 1988, pp. 83–97 / Levin 1952, pp. 13–17 / Brower 1971, p. 174f. / Leech 1986, pp. 15, 35–41]

———— (Marlowe), formerly attributed. *Dido.* 1583. *See William Gager, above.*

Philipp Nicodemus Frischlin, 1547–**1590.** *Dido.* Tragedy. In *Operum poeticorum* (Argentor: Jobin, 1596). [Taylor 1893, p. 27]

Annibale Carracci, 1560–1609. "The Death of Dido." Fresco. c.1592. Palazzo Francia, Bologna. [Malafarina 1976, no. 63—ill.]

William Shakespeare, 1564–1616. (Aemilius compares Lucius's tale to Aeneas relating the fall of Troy to Dido, in) *Titus Andronicus* 5.3.80ff. Tragedy. **1593–94.** First performed 24 Jan 1594, Rose Theatre, London. Published London: 1594; collected in First Folio, London, Jaggard, 1623. [Riverside 1974 / Root 1903, pp. 33f.]

————. (Allusion to Dido at Aeneas's departure in) *The Merchant of Venice* 5.1.9–12. Comedy. 1596–97? Stationers' Register 22 July 1598. Published London: 1600; collected in First Folio, London: Jaggard, 1623. [Riverside / Root, p. 4]

Jacopo Tintoretto, 1518–**1594,** attributed. "The Feast of Dido." Painting. Private coll. [Pigler 1974, p. 286]

Maerten de Vos, 1532–**1603.** "Aeneas and Dido Seek Shelter from the Storm." Drawing. Louvre, Paris, inv. 20.594. [Warburg]

Cristóbal de Morales, fl. **1600–06.** *Amores de Dido y Eneas* [The Loves of Dido and Aeneas]. Tragedy. [Barrera 1969, p. 274]

Cristóbal de Virués, 1550?–1614. *Elisa Dido.* Tragedy. In *Obras trágicas y líricas del capitán Christóbal de Virués* (Madrid: Martin, **1609**). [DLE 1972, p. 940]

Alexandre Hardy, c.1570–1632. *Dido se sacrifiant* [Dido Sacrificing Herself]. Tragedy. **1605–15.** Paris: 1624. [McGraw-Hill 1984, 2:446]

Guillén de Castro y Bellvis, 1569–1631. *Los amores de Dido y Eneas.* Drama. First performed **1613–16?** Published Madrid: 1625. Modern edition by E. Julia (Madrid: Revista de Archivos, Bibliotecas y Museos, 1925). [McGraw-Hill 1984, 1:477 / DLE 1972, p. 168 / Oxford 1978, p. 110]

Thomas Campion, 1567–1619, music and lyric. "Dido Was the Carthage Queen." Ballad. No. 5 in *Ayres That Were Sung and Playd at Brougham Castle* . . . (London: printed by Thomas Snodham, **1618**). [Vivian 1966, p. 231]

Sigismondo d'India, c.1582–before c.1629, music and text. "Infelice Didone." Song. **1623.** [Grove 1980, 9:67]

Arthur Gorges, 1557–**1625.** "Dido to Aeneas," "Dido's True Complainte." Poems. Nos. 90, 91 in *The Vannetyes and Toyes of Youth.* MS in British Museum, London, MS Egerton 3165. [Sandison 1953, pp. 87ff., 106ff., 215ff., 218]

Peter Paul Rubens, 1577–1640. "Aeneas Assisting Dido to Dismount." Painting. c.1628. Städelsche Kunstinstitut, Frankfurt, inv. 2097. [Jaffé 1989, no. 921—ill.] Oil sketch. Formerly private coll., Germany, unlocated. [Ibid., no. 920—ill. / Held 1980, no. 229—ill.]

————. "Dido and Aeneas Escaping from the Storm." Painting. Lost. / Sketch, art market, London, in 1911, unlocated. / Fragmentary copy in University of Granada. [Alpers 1971, p. 272]

————. "The Death of Dido." Painting. c.1635–38. Louvre, Paris, no. R.F. 1942–33. [Jaffé, no. 1214—ill. / also Louvre 1979–86, 1:120—ill.]

Guercino, 1591–1666. "The Death of Dido." Painting. **1630–31.** Galleria Spada, Rome. [Bagni 1984, p. 141 / Salerno 1988, no. 135—ill. / also Garrard 1989, fig. 176] Drawing, early pensée. Denis Mahon coll., London. [Bagni—ill. / Bologna 1968, 2: no. 123—ill.]

Hendrik van Balen, 1575–**1632.** "Aeneas and Dido (Seek Shelter from the Storm)." Painting. [Bénézit 1976, 1:701 / Pigler 1974, p. 289]

Georges de Scudéry, 1601–1667. *Didon.* Tragedy. First performed **1636,** Paris. Published Paris: Courbé, 1637. [Lancaster 1929–42, pt. 2, 1:47–49, 2:777]

Nicolas Poussin, 1594–1665, attributed. "Dido and Aeneas" (? also conjecturally titled "Mars and Venus," "Rinaldo and Armida"). Painting. **Late 1630s.** Toledo Museum

of Art, Ohio. [Wright 1985, no. 94, pl. 43 / Thuillier 1974, no. R64—ill. / also Blunt 1966, no. R74 (attribution rejected)]
————, circle (formerly attributed to Poussin). "Dido and Aeneas." Painting. Musée des Beaux-Arts, Besançon. [Thuillier, no. R65—ill.]

George Rivers. "Dido." Prose piece, part of *The Heroinae* (London: Bishop, for John Colby, **1639**). [Bush 1963, p. 335]

Giovanni Francesco Romanelli, 1610–1662. 8 cartoons for tapestry cycle illustrating the story of Aeneas and Dido: "Venus Appearing to Aeneas," "Dido's Banquet," "Dido's Sacrifice to Juno," "Dido Showing Aeneas Her Plans for Carthage," "The Royal Hunt and Storm," "Mercury Appearing to Aeneas," "Aeneas Leaving Dido," "The Death of Dido." **1630s?** 6 sold Sotheby's, London, 1969; others unlocated. / Tapestries woven by Michel Wauters and workshop, Antwerp. Complete sets in Cleveland Museum of Art, Ohio; Museo del Collegio Alberoni, Piacenza; Swedish Royal Collection, Drottninghom; Town Hall, Nijmegen; formerly Kunsthistorisches Museum, Vienna. 3 partial sets known: Museo Civico, Castello Sforzesco, Milan; others unlocated. [Ruth Rubenstein, "G. F. Romanelli's Dido and Aeneas Tapestry Cartoons," in *Art at Auction: The Year at Sotheby's and Parke-Bernet, 1968–69* (New York: Viking, 1969)—ill.]

Pier Francesco Cavalli, 1602–1676. *La Didone.* Opera. Libretto, Giovanni Francesco Busenello. First performed **1641**, Teatro San Cassiano, Venice. [Grove 1980, 4:29, 32 / Worsthorne 1954, pp. 54f., 71, 81f., 113, 115, 125, 152 / Pirrotta & Povoledo 1982, pp. 266f. / Bianconi 1987, pp. 187, 194, 215 / Glover 1978, pp. 18, 42, 43ff.]

Simon Vouet, 1590–1649. "The Death of Dido." Painting. **1641** or earlier. Musée de Peinture, Dôle, Jura. [Crelly 1962, pp. 125ff., no. 29—ill.]

Guido Reni, 1575–1642, studio. "Dido and Aeneas." Painting. 3 versions. Gemäldegalerie, Kassel, inv. 1749; Musée des Beaux-Arts, Béziers, no. 16; Palacio Real, Madrid. [Pepper 1984, p. 301 no. C10]

Sidney Godolphin, 1610–1643. *The Passion of Dido for Aeneas as it is incomparably expresst in the fourth book of Virgil.* Poem, translation. London: Moseley, 1658. [Dryden 1956–87, p. 959, notes on pp. 1001–05, 1007–10]

Ferdinand Bol, 1616–1680. "Aeneas Hunting," "Dido Hunting." Paintings. **1647.** Ranger's House, Blackheath, London; Bergsten coll., Stockholm. [Blankert 1982, nos. 22, 23—ill.]

Antoine Furetière, 1619–1688. *L'Aeneide travestie: Libre quatriesme contenant les amours d'Aenée et de Didon* [The *Aeneid* Travestied: Fourth Book, Containing the Loves of Aeneas and Dido]. Burlesque. **1649.** Paris: Courbé, 1649. [DLLF 1984, 1:856ff.]

Pietro Testa, 1611–1650. "The Death of Dido." Painting. *c.***1645–50.** Uffizi, Florence, inv. 8294. [Uffizi 1979, no. P1691—ill.]

Marco Marazzoli, *c.*1602/08–1662. *Già l'infelice Dido da Troiano tradito* [Unhappy Dido Betrayed by the Trojan]. Cantata. **1645–53.** [Grove 1980, 11:645]

Thomas Willeboirts, *c.*1614–**1654.** "Aeneas and Dido Seek Shelter from the Storm." Painting. Sanssouci, Potsdam, cat. 1962 no. 95. [Warburg]

Andrea Mattioli, *c.*1620–1679. *La Didone.* Opera. Li-

bretto, P. Moscardini. First performed 25 Apr **1656,** Bologna. [Grove 1980, 11:838]

Juan de la Corte, 1597–**1660.** "Soldiers before the Throne of Dido," "Banquet of Dido and Aeneas." Paintings, in "Trojan War" cycle. El Retiro, Torremolinos, Málaga. [López Torrijos 1985, pp. 206, 410 nos. 13–14—ill.]

Gaspard Dughet, 1615–1675, and **Carlo Maratti,** 1625–1713, attributed (formerly attributed to Nicolas Poussin, 1594–1665). "Landscape with the Union of Dido and Aeneas (Taking Refuge in the Cave)." Painting. **Late 1650s/early 1660s.** National Gallery, London, inv. 95. [London 1986, p. 173—ill. / Thuillier 1974, no. R115—ill. / Blunt 1966, no. R76]

Francesco Allegrini, 1587–1663. "Aeneas and Dido Seek Shelter from the Storm," "Dido on the Funeral Pyre." Ceiling frescoes. Palazzo Pamphili, Rome. [Voss 1924, p. 273—ill.]

Charles Cotton, 1630–1686/87. *Scarronides, or Le Virgile travestie: A Mock-poem, being the first book of Virgil's Anaeis in English.* Burlesque. London: **1664.** / Travesty of Book 4 added in 1665. [Bush 1963, pp. 303f., 338]

Carlo Francesco Nuvoloni, 1608–*c.***1665.** "The Death of Dido." Painting. Gemäldegalerie, Dresden, no. 381. [Dresden 1976, p. 75]

John Denham, 1615–1669. "The Passion of Dido for Aeneas." Poem, paraphrase of *Aeneid* book 4. In *Poems and Translations* (London: **1668**). [Banks 1928, pp. 181f. / Dryden 1956–87, p. 959]

Theodoor van Thulden, 1606–**1669.** "Aeneas and Dido Seek Shelter from the Storm." Painting. Kunstmuseum, Hannover, inv. 407. [Pigler 1974, p. 289] Another version of the subject recorded 1852, unlocated. [Bénézit 1976, 10:171]

Benito Manuel de Agüero, 1626?–**1670,** attributed. "Landscape with Aeneas Helping Dido to Dismount," "Landscape with Aeneas Departing from Dido." Paintings. Prado, Madrid, nos. 895, 896. [López Torrijos 1985, p. 411 nos. 38–39—ill. / Prado 1985, pp. 3f.]

Sébastien Bourdon, 1616–**1671.** "The Death of Dido." Painting. Hermitage, Leningrad. [Hermitage 1974, pl. 36] Another version of the subject in Musée, Béziers. [Pigler 1974, p. 316]

Antoine Jacob de Montfleury, 1640–1685. *Les amours de Didon et d'Aenée.* Tragedy. Paris: Promé, **1673.** [Taylor 1893, p. 133]

Claude Lorrain, 1600–1682. "View of Carthage with Dido, Aeneas, and Their Suite Leaving for the Hunt" ("Dido Showing Aeneas Carthage"). Painting. **1676.** Kunsthalle, Hamburg (ex-Heywood-Lonsdale), inv. 783 (as "Aeneas's Departure from Dido"). [Röthlisberger 1961, no. LV 186—ill. / Hamburg 1985, no. 32—ill./ Hamburg 1966, p. 94—ill.] Drawing after, in the artist's *Liber veritatis.* British Museum, London. [Röthlisberger]

Arie de Vois, 1632–1680. "Mars and Diana" (or "Dido and Aeneas"?). Painting. Centraal Museum, Utrecht, cat. 1952 no. 334. [Wright 1980, p. 480]

Pietro Andrea Ziani, 1616–1684. *L'Enea in Cartagine* [Aeneas in Carthage]. Opera. Libretto, M. A. Catania. Palermo, **1680.** [Grove 1980, 20:676]

Giovanni Coli, 1636–**1681,** and **Filippo Gherardi,** 1643–

1704. "The Death of Dido." Painting. Los Angeles County Museum. [Pigler 1974, p. 315]

Andries Pels, 1631–**1681.** *Didoos Dood* [Dido's Death]. Tragedy. Amsterdam: Lescailje, 1701. [Gosse 1910, p. 725]

Nicolaes Berchem, 1620–**1683.** "Dido on the Funeral Pyre." Painting. Liechtenstein coll., Vaduz. [Pigler 1974, p. 316]

Pierre Beauchamps, 1631–1705, choreography and music. Ballet, for the tragedy *Didon.* First performed **1687,** Collège d'Harcourt, Paris. [Astier 1983, pp. 153, 162]

Sebastiano Moratelli, 1640–1706. *Didone.* Opera. Libretto, Rapparini. Overture and dance music, Georg Andreas Kraft. First performed **1688,** Düsseldorf. [Grove 1980, 10:231, 12:561]

Thomas Blanchet, *c.*1614–**1689.** "The Death of Dido." Painting. Musée, Semur-en-Auxois. [Dublin 1985, p. 7]

Henry Purcell, *c.*1658–**1695.** *Dido and Aeneas.* Opera. Libretto, Nahum Tate. First performed **1689,** Chelsea Girls School, London. First professional performance, Lincoln's Inn Fields, London; choreography, Josias Priest. [Grove 1980, 15:461, 469 / Fiske 1973, pp. 6, 14, 19, 540 / Spink 1974, pp. 223–26 / Robinson 1985, pp. 109f., 151–54 / Kerman 1988, pp. 43, 47]

Gérard de Lairesse, 1641–1711 (active until *c.*1690). "Aeneas at Dido's Feast: The Queen Welcomes Cupid in the Guise of Ascanius." Painting. Galerie, Schleissheim, no. 4050. [Pigler 1974, p. 286]

———. "Dido on the Funeral Pyre." Painting. Museum, Lübeck, no. 45. [Ibid., p. 316]

Spanish School. "Dido Coming out to Receive Aeneas" (?), "Aeneas Feasted by Dido" (?). Paintings. **1690.** Private coll., Barcelona. [López Torrijos 1985, pp. 227, 413 nos. 71–72—ill.]

Louise-Geneviève, Mme Gillot de Sainctonge, 1650–1718. *Didon.* Tragedy. Paris: Ballard, **1693.** [Girdlestone 1972, p. 128]

Henry Desmarets, 1661–1741. *Didon.* Opera (tragédie lyrique). Libretto, Mme. Gillot de Sainctonge. First performed 5 June or 11 Sep **1693,** L'Opéra, Paris. [Clément & Larousse 1969, 1:329 / Grove 1980, 5:391]

Jean Poulletier, 1653–1719. "Dido on the Pyre." Marble statue. By **1694.** Tapis Vert, Gardens, Versailles. [Girard 1985, p. 284—ill.]

Agostino Steffani, 1654–1728. *Il trionfo di Fato* (*Le glorie d'Enea*) [The Triumph of Fate (The Glories of Aeneas)]. Opera. Libretto, Ortenzio Mauro. First performed **1695,** Hannover. [McCredie 1966, p. 90 / Grove 1980, 18:96]

Alessandro Scarlatti, 1660–1725. *La Didone delirante* [Dido Delirious]. Opera. Libretto, F. M. Paglia, after A. Franceschi. First performed 28 May **1696,** Teatro San Bartolomeo, Naples. [Grove 1980, 16:559]

Mattia Preti, 1613–**1699.** "Dido on the Funeral Pyre." Painting. Musée des Beaux-Arts, Chambéry. [Bénézit 1976, 8:483]

Anonymous English. "Staye, Staye, Aeneas," "Dido to Eneas." Songs. **17th century.** Published in *Seventeenth Century Songs and Lyrics,* edited by J. P. Cutts (Columbia: University of Missouri Press, 1959). [Ipso]

Giovanni Gioseffo del Sole, 1654–1719. "Dido's Dream." Painting. *c.***1700.** Kunsthistorisches Museum, Vienna, inv. 247 (565). [Vienna 1973, p. 164—ill.]

Johann Heiss, 1640–**1704.** "The Death of Dido." Painting. Museum of Fine Arts, Boston, no. Res. 22.304. [Boston 1985, p. 130—ill.]

———, attributed. "The Death of Dido." Painting. Herzog Anton Ulrich-Museum, Braunschweig, no. 1140. [Braunschweig 1969, p. 72]

Christoph Graupner, 1683–1760. *Dido, Königin von Carthago* [Dido, Queen of Carthage]. Opera. Libretto, Hinrich Hinsch. First performed **1707,** Hamburg. [McCredie 1966, pp. 78, 81]

André Campra, 1660–1744. *Didon.* Cantata. Published in *Cantates françoises,* book 1 (Paris: **1708**). [Grove 1980, 3:665]

———. *Enée et Didon.* Cantata. Published in *Cantates françoises,* book 2 (Paris: 1714). [Ibid.]

———. *Enée et Didon.* Divertissement. First performed 29 Oct 1714, Marseilles. [Ibid.]

Michel Pignolet de Montéclair, 1667–1737. *La mort de Didon.* Cantata. Published Paris: *c.*1709. [Grove 1980, 12:509f.]

Augustin Caylot, 1667–1722. "Dido on the Funeral Pyre." Small marble sculpture group. **1711.** Louvre, Paris, inv. 1083; Hermitage, Leningrad. [Pigler 1974, p. 316]

Daniel Haringhs, 1636–*c.*1715. "The Death of Dido." Painting. Ferens Art Gallery, Hull. [Wright 1976, p. 87]

Pieter Langendijk, 1683–1756. *Eneas in zijn zondags pak* [Aeneas in His Sunday Suit]. Comedy in the manner of Scarron, imitation of *Aeneid* 4. First performed **1715,** Haarlem. [McGraw-Hill 1984, 3:207]

Johann Christoph Pepusch, 1667–1752, music. *The Death of Dido.* Masque. Libretto, Barton Booth. First performed 17 Apr **1716,** Theatre Royal, Drury Lane, London. [Grove 1980, 14:359 / Fiske 1973, pp. 58f., 179 / Nicoll 1959–66, 2:299]

Antoine Coypel, 1661–1722. "Aeneas Appearing to Dido," "The Death of Dido." Paintings, part of cycle illustrating the adventures of Aeneas. **1716–17.** Placed in Galerie d'Énée, Palais-Royal. Now in Musée, Arras, on deposit from Louvre (inv. 3514); Musée, Montpellier. [Louvre 1979–86, 3:170f.—ill.]

Gian Pietro Zanotti, 1674–1765. *Didone.* Tragedy. Bologna: Pisarri, **1718.** [DELI 1966–70, 5:513]

Arnold Houbraken, 1660–**1719.** "Dido Conducting Aeneas into Carthage." Painting. Ringling Museum, Sarasota, Fla., no. SN273. [Sarasota 1980, no. 88—ill.] Variant, attributed to Gerard Hoet (1648–1733). Sold London, 1978. [Ibid.—ill.] Copy (early 18th century) in Victoria and Albert Museum, London, no. 1362–1869. [Kauffmann 1973, no. 176—ill.] At least 3 other treatments of Aeneas and Dido theme by Houbraken known, unlocated. [Ibid.]

Adriaen van der Werff, 1659–**1722.** "Dido Mourning." Painting. Herzog Anton Ulrich-Museum, Braunschweig, no. 333. [Braunschweig 1976, p. 62]

François Collin de Blamont, 1690–1760. *Didon.* Solo cantata. Published in *Cantates françoises à voix seule, avec simphonie et sans simphonie,* book 1 (Paris: **1723**). [Grove 1980, 4:563]

Pietro Metastasio, 1698–1782. *Didone abbandonata* [Dido Abandoned]. Libretto for opera, first set by Sarro, **1724,** and in at least 50 further settings between 1724 and 1824. *See below.* [Grove 1980, 12:216]

Domenico Sarro, 1679–1744. *Didone abbandonata.* Opera. Libretto, Pietro Metastasio. First performed 1 Feb **1724,** San Bartolomeo, Naples. / Revised, performed Autumn 1730, San Giovanni Grisostomo. [Grove 1980, 16:500f. / Weaver 1978, p. 245]

Tomaso Giovanni Albinoni, 1671–1751. *Didone abbandonata.* Opera. Libretto, Metastasio (1724). First performed **1725,** Venice. Music lost. [Grove 1980, 1:219]

Nicola Porpora, 1686–1768. *Didone abbandonata.* Heroic opera. Libretto, Metastasio (1724). First performed Ascension **1725,** Teatro Pubblico, Reggio Emilia. [Grove 1980, 15:126]

Leonardo Vinci, c.1690–1730. *Didone abbandonata.* Opera. Libretto, Metastasio (1724). First performed 14 Jan **1726,** Alibert, Rome. [Grove 1980, 19:787]

Jean-Marie Leclair the Elder, 1697–1764. Music for ballets for production of Sarro/Metastasio opera *Didone abbandonata.* First performed Carnival **1727,** Teatro Regio, Turin. [Grove 1980, 10:591]

Francesco Solimena, 1657–1747. "Dido Receiving Aeneas and Cupid Disguised as Ascanius." Painting. **1720s.** National Gallery, London, inv. 6397. [London 1986, p. 589—ill.]

Giovanni Battista Tiepolo, 1696–1770. "Mercury Appearing to Aeneas." Painting. **1731.** Formerly Palazzo Archinto, Milan, destroyed 1943. [Morassi 1962, p. 25]

———. "Aeneas Presenting Amor with the Features of Ascanius to Dido," "Mercury Exhorts Aeneas to Depart" ("The Dream of Aeneas"). Frescoes, part of cycle illustrating scenes from the *Aeneid.* **1757.** Sala dell' Eneide, Villa Valmarana, Vicenza. [Pallucchini 1968, no. 240—ill. / Morassi, p. 65 / Llewellyn 1984, pp. 122ff.]

———, attributed. "The Death of Dido." Painting. c.1750–60? Pushkin Museum, Moscow. [Morassi, p. 30—ill.] Studio copy in Gemäldegalerie, Berlin, no. 2065. [Ibid., p. 5 / Berlin 1986, p. 74—ill.]

Corrado Giaquinto, 1703–1765. "Aeneas and Dido Seek Shelter from the Storm," "Mercury Warning Aeneas That He Must Leave Dido." Painting, part of series depicting scenes from the *Aeneid,* for Royal Palace, Turin. **Early 1730s.** Palazzo Quirinale, Rome. [Llewellyn 1984, pp. 126–28]

Jonathan Swift, 1667–1745. (Aeneas, dressed by the clouds to meet Dido, recalled in) "An Answer to a Scandalous Poem" (Thomas Sheridan's "A New Simile for the Ladies," comparing them to clouds). Poem. **1732.** First printed as a pamphlet, 1733; collected in *Works,* revised edition (Dublin: Faulkner, 1738). [Williams 1958, vol. 2]

Michelangelo Faggioli, 1666–1733. *Didone abbandonata da Enea* [Dido Abandoned by Aeneas]. Cantata for solo voice. [Grove 1980, 6:360]

Thomas Augustine Arne, 1710–1778, music. *Dido and Aeneas.* Masque. Libretto, Barton Booth's *Death of Dido* (1716). First performed 12 Jan **1734,** Little or New Theatre, Haymarket, London. [Baker 1984, p. 77 / Grove 1980, 1:608]

Jean-Jacques Le Franc, Marquis de Pompignan, 1709–1784. *Didon.* Tragedy. First performed **1734,** Paris. Published Paris: Chaubert, 1734. [Girdlestone 1972, p. 296 *n.*]

Ottmar Elliger the Younger, 1666–1735. "Dido on the Funeral Pyre." Painting. Herzog Anton Ulrich-Museum, Braunschweig, no. 1038. [Braunschweig 1969, p. 56]

———. "Dido on the Funeral Pyre." Painting. Bayerisches Staatsgalerie, Munich, inv. 19410. [Warburg]

Giovanni Andrea Fioroni, 1704?–1778. *La Didone abbandonata.* Opera. Libretto, Metastasio (1724). First performed 18 Jan **1735,** Ducale, Milan. [Grove 1980, 6:602]

Gaetano Maria Schiassi, 1698–1754. *Didone abbandonata.* Opera. Libretto, Metastasio (1724). First performed Spring **1735,** Formagliari, Bologna. [Grove 1980, 16:638]

Antoni Elliger, 1701–1781. 2 paintings depicting scenes from the story of Dido and Aeneas. **1736.** Keizersgracht 269, Amsterdam. [Staring 1958, pl. 5]

Baldassare Galuppi, 1706–1785. *Elisa, regina di Tiro* [Elisa (Dido), Queen of Tyre]. Opera seria. Libretto, A. Zeno & P. Pariati. First performed 27 Jan **1736,** San Angelo, Venice. [Grove 1980, 7:136]

———. *Didone abbandonata.* Opera seria. Libretto, Metastasio (1724). First performed Carnival 1741, Molzo, Modena. [Ibid.]

François Le Moyne, 1688–1737. "Dido Expiring." Painting. Lost. [Bordeaux 1984, p. 129]

Louis Galloche, 1670–1761. "Aeneas, Landing at Carthage, Presents Himself to Dido," "Dido Caressing Cupid in the Guise of Ascanius" ("The Banquet of Aeneas and Dido"). Pendant paintings. **1737.** Louvre, Paris, inv. 4658; Musée, Château de Compiègne, on deposit from Louvre (inv. 4559). [Louvre 1979–86, 3:264, 5:259—ill.]

Giovanni Alberto Ristori, 1692–1753. *Didone abbandonata.* Pasticcio. Libretto, Metastasio (1724). First performed 13 Apr **1737,** Covent Garden, London. [Grove 1980, 16:56]

———. *Didone abbandonata.* Cantata for soprano and orchestra. Libretto, Princess Maria Antonia. First performed 1748, Dresden. [Ibid.]

Andrea Bernasconi, 1706?–1784. *Didone abbandonata.* Opera seria. Libretto, Metastasio (1724). First performed 26 Dec **1738,** Milan. [Grove 1980, 2:620]

Benedetto Marcello, 1686–1739. *Didone.* Cantata. [Grove 1980, 11:649]

Egidio Duni, 1708–1775. *La Didone abbandonata.* Opera seria. Libretto, Metastasio (1724). First performed Jan **1739,** Regio Ducal, Milan. [Grove 1980, 5:718]

Giovanni Battista Lampugnani, 1706–c.1786. *Didone abbandonata.* Opera. Libretto, Metastasio (1724). First performed June **1739,** Obizzi, Padua. [Grove 1980, 10:422]

———, arias. *Didone.* Pasticcio. Text, Metastasio (1724). First performed 26 Mar 1748, King's Theatre, London. [Ibid.]

Francesco Corradini, c.1700–after 1749. *La Elisa.* Opera seria. Libretto, José de Cañizares. First performed Nov **1739,** de la Cruz, Madrid. [Grove 1980, 4:798]

Johann Elias Schlegel, 1719–1749. *Dido.* Tragedy. **1739.** In *Werke* (Copenhagen & Leipzig: Mumme, 1761–70). Modern edition, Frankfurt: Athenäum, 1977. [McGraw-Hill 1984, 4:342]

Rinaldo di Capua, c.1705–c.1780. *Didone abbandonata.* Opera. Libretto, Metastasio (1724). First performed **1741,** Rua dos Condes, Lisbon. [Grove 1980, 16:43]

Johann Adolf Hasse, 1699–1783. *Didone abbandonata.* Opera seria. Libretto, Francesco Algarotti, after Metastasio (1724). First performed 7 Oct **1742,** Hubertusburg. / Revised by Nicola Logroscino, performed 1744, San

Carlo, Naples. / Several other revisions known. [Grove 1980, 8:288]

———. *Dunque il perfido Enea* [Then the Perfidious Aeneas]. Cantata. Lost. [Ibid., 8:290]

Guillaume Coustou the Elder, 1677–**1746.** "Dido on the Funeral Pyre." Bronze statuette. Löwenburg, Kassel-Wilhelmshöhe. [Pigler 1974, p. 316]

Niccolò Jommelli, 1714–1774. *Didone abbandonata.* Opera seria. Libretto, Metastasio (1724). First performed 28 Jan **1747,** Argentina, Rome. [Grove 1980, 9:693]

———. *Didone abbandonata* (second setting). Opera seria. Libretto, Metastasio. First performed 8 Dec 1749, Burg, Vienna. [Ibid., 9:693]

———. *Didone abbandonata* (third setting). Opera seria. Libretto, Metastasio. First performed 11 Feb 1763, Opera House, Stuttgart. [Ibid., 9:693]

———. *Giusti numi* [Just Powers]. Cantata. [Grove, 9:694]

Andrea Adolfati, 1721/22–1760. *Didone abbandonata.* Opera. Libretto, Metastasio (1724). First performed Carnival **1747,** Teatro San Girolamo, Venice. Music lost. [Grove 1980, 1:111]

Pompeo Batoni, 1708–1787. "Aeneas Abandoning Dido." Painting. **1747.** Brinsley Ford coll., London. [Clark 1985, no. 115—ill.]

Johann Leopold von Ghelen, 1700–1760. *Didone abbandonata, oder Die verlassene Dido* [Dido Abandoned, or The Forsaken Dido]. Tragedy, libretto for opera. Vienna: J. Peter von Ghelen, **1747** (Italian and German text). [Hunger 1959, p. 90]

Domingo Terradellas, 1713–1751. *Didone abbandonata.* Opera. Libretto, Metastasio (1724). First performed Carnival **1750,** Teatro Regio, Turin. [Grove 1980, 18:697]

Ignazio Fiorillo, 1715–1787. *Didone abbandonata.* Opera seria. Libretto, Metastasio (1724). First performed **1751,** Braunschweig. [Grove 1980, 6:601]

Pierre de La Garde, 1717–*c.*1792. *Enée et Didon.* Cantata. Published Paris: *c.***1751.** [Grove 1980, 10:359f.]

Gennaro Manna, 1715–1779. *Didone abbandonata.* Opera seria. Libretto, Metastasio (1724). First performed Carnival **1751,** San Giovanni Grisostomo, Venice. [Grove 1980, 11:622]

Davide Perez, 1711–1778. *La Didone.* Opera. Libretto, Metastasio (1724). First performed **1751,** Genoa. [Grove 1980, 14:367]

Jean Restout, 1692–1768. "Dido Showing Aeneas the Battlements of Carthage" ("Architecture"). Painting, model for tapestry in Gobelins set "The Arts." *c.***1751.** Préfecture du Rhône, Lyons, on deposit from Louvre, Paris (inv. 7452). [Louvre 1979–86, 5:325 (cf. 4:181)]

Jacopo Amigoni, 1675–**1752.** "Aeneas at Dido's Feast: The Queen Welcomes Cupid in the Guise of Ascanius." Ceiling fresco. Dining room, Schloss Schleissheim. [Pigler 1974, p. 286]

Giuseppe Scolari, *c.*1720–after 1774. *Dido abbandonata.* Opera (dramma per musica). Libretto, Metastasio (1724). First performed 30 May **1752,** Santa Cruz, Barcelona. / Revised with new music, performed Carnival 1763, Ferrara. [Grove 1980, 17:55]

Antonio Mazzoni, 1717–1785. *La Didone abbandonata.* Opera. Libretto, Metastasio (1724). First performed **1753,** Teatro Formagliari, Bologna. [Grove 1980, 11:872]

Vincenzo Ciampi, 1719?–1762. *Didone.* Opera (dramma per musica). Libretto, Metastasio (1724). First performed 5 Jan **1754,** King's Theatre, London. [Grove 1980, 4:387]

Francesco Antonio Baldassare Uttini, 1723–1795. *Enée à Carthage.* Opera. First performed *c.***1756,** Stockholm. [Clément & Larousse 1696, 1:389]

Pietro Auletta, *c.*1698–1771. *Didone.* Heroic opera. Libretto, Metastasio (1724). First performed **1759,** Teatro della Pergola, Florence. [Grove 1980, 1:698]

Antonio Ferradini, 1718?–1779. *Didone.* Opera. First performed **1760,** Lucca. [Grove 1980, 6:485]

Giuseppe Sarti, 1729–1802. *Didone abbandonata.* Opera (dramma per musica). Libretto, Metastasio (1724). First performed Winter **1762,** Theater on Kongens Nytorv, Copenhagen. [Grove 1980, 16:504]

———. *Didone abbandonata* (second setting). Opera (dramma per musica). Libretto, Metastasio (1724). First performed June 1782, Teatro Obizzi, Padua. [Ibid., 16:505]

Johann Gottfried Schwanenberger, *c.*1740–1804. *La Didone abbandonata.* Opera. Libretto, Metastasio (1724). First performed Aug **1765.** [Grove 1980, 17:40]

Gaspare Angiolini, 1731–1803, choreography, music, and scenario. *Le départ d'Enée, ou La Didon abandonée* [Aeneas's Departure, or Dido Abandoned]. Heroic ballet, after Metastasio (1724). First performed 26 Sep **1766,** Court Theater, St. Petersburg. [Simon & Schuster 1979, p. 71 / Winter 1974, p. 136]

Francesco Zannetti, 1737–1788. *La Didone abbandonata.* Opera. Libretto, Metastasio (1724). First performed **1766,** Livorno. [Grove 1980, 20:643]

James Barry, 1741–1806. "Dido and Aeneas." Painting. *c.***1766–67,** unfinished. Lost. [Pressly 1981, no. 2]

Joseph Reed, 1723–1787. *Dido.* Tragedy. First performed 28 Mar **1767,** Theatre Royal, Drury Lane, London. Published London: Egerton, 1792. [Stratman 1966, p. 535]

Giuseppe Colla, 1731–1806. *Enea in Cartagine.* Opera seria. Libretto, G. M. Orengo. First performed **1769,** Teatro Regio, Turin. [Grove 1980, 4:533]

———. *Didone.* Opera seria. Libretto, Metastasio (1724). First performed Carnival 1773, Teatro Regio, Turin. [Grove 1980, 4:533]

Thomas Jones, 1743–1803, landscape, and **John Hamilton Mortimer,** 1740–1779, figures. "Landscape with Dido and Aeneas" (seeking shelter from the storm). Painting. **1769.** Hermitage, Leningrad, inv. 1343. [Hermitage 1979, pl. 123]

Angelica Kauffmann, 1741–1807. "Venus Meeting Aeneas" ("Venus Showing Aeneas and Achates the Way to Carthage"). Painting. Exhibited **1769.** Earl of Morley coll., Saltram Park, Plymouth. [Manners & Williamson 1924, pp. 37, 200]

———. "Dido." Painting. Exhibited 1777. [Ibid., pp. 45, 237] Print by Delattre and Bartollozzi, 1780. [Ibid., p. 224]

———, attributed. "Dido before Aeneas." Ceiling painting. Ballroom, 20 Portman Square, London. [Ibid., p. 132—ill.]

Gian Francesco de Majo, 1732–1770. *Didone abbandonata.* Opera. Libretto, Metastasio (1724). First performed 26 Dec **1769,** San Benedetto, Venice. [Grove 1980, 11:544]

Ignazio Celoniati, before 1740–1784. *Didone abbandonata.*

Opera. Libretto, Metastasio (1724). First performed Carnival **1769–70**, Milan. [Grove 1980, 4:52]

Niccolò Piccinni, 1728–1800. *Didone abbandonata*. Opera seria. Libretto, Metastasio (1724). First performed 8 Jan **1770**, Argentina, Rome. [Grove 1980, 14:727]

———. *Didon*. Opera (tragédie lyrique). Libretto, Jean-François Marmontel. First performed 6 Dec 1783, Fontainebleau. [Ibid., 11:694, 14:728]

Giacomo Insanquine, 1728–1795. *La Didone abbandonata*. Opera. Libretto, Metastasio (1724). First performed 20 Jan **1770**, San Carlo, Naples. [Grove 1980, 9:236]

James Hook, 1746–1827. *Dido and Aeneas*. Burlesque. Libretto attributed to Thomas Brydges. First performed 24 July **1771**, Little Theatre, Haymarket, London. [Grove 1980, 8:685 / Fiske 1973, p. 321]

Paul Weidmann, 1744–1801. *Dido*. Tragedy. In *Sämmtliche Werke* vol. 3 (Vienna: Wallishausser, **1771**). First performed 21 Oct 1776, Kärntnertor Theatre, Vienna. [Oxford 1986, p. 963]

Gerard Hoet the Elder, 1648–1773. Cycle of paintings depicting the story of Aeneas and Dido: "Aeneas before Dido," "Aeneas and Achates See the Building of Carthage," "The Hunting Party of Dido and Aeneas," "Dido and Aeneas Encounter a Storm," "Dido on Funeral Pyre." De Slangenberg castle, Doetinchem. [Warburg]

———. "Aeneas at Dido's Feast: The Queen Welcomes Cupid in the Guise of Ascanius." Painting. Galerie, Schleissheim, no. 3827. [Pigler 1974, p. 286]

———. "The Death of Dido." Painting. Statens Museum for Kunst, Copenhagen. [Copenhagen 1951, no. 313]

Jean-Georges Noverre, 1727–1810, choreography. *Les amours d'Énee et Didon, ou Didon abandonée* [The Loves of Aeneas and Dido, or Dido Abandoned]. Heroic ballet. First performed **1768–73**, Vienna. [Lynham 1950, p. 169]

Christian Wilhelm Dietrich, 1712–1774. "Dido on the Funeral Pyre." Drawing. Albertina, Vienna. [Pigler 1974, p. 316]

Rowland Rugeley, 1735?–1776. *The Story of Aeneas and Dido Burlesqued*. Burlesque. Charleston, S.C.: Wells, **1774**. [Bush 1937, p. 546]

Pasquale Anfossi, 1727–1797. *Didone abbandonata*. Opera (dramma per musica). Libretto, Metastasio (1724). First performed Ascension **1775**, Teatro San Moise, Venice. [Grove 1980, 1:422]

Domenico Mombelli, 1751–1835. *Dido abbandonata*. Opera. Libretto, Metastasio (1724). First performed **1775**, Crescentino. [Clément & Larousse 1969, 1:331]

Antonio Sacchini, 1730–1786. *Didone abbandonata*. Opera. Libretto, Prince Hoare, after Metastasio (1724). First performed **1775**, King's Theatre, London. [Fiske 1973, p. 513]

Franz Joseph Haydn, 1732–1809. *Dido*. Singspiel for marionettes. Libretto, Bader. First performed Mar **1776**, Esterháza. Music lost. [Grove 1980, 8:365]

[?] Schirer. *Didone abbandonata*. Opera. Libretto, Metastasio (1724). First performed **1776**, Naples. [Clément & Larousse 1969, 1:331]

Joseph Schuster, 1748–1812. *La Didone abbandonata*. Opera. Libretto, Metastasio (1724). First performed **1776**, San Carlo, Naples. [Grove 1980, 16:876]

Maximilien Gardel, 1741–1787, choreography. *La mort de*

Didon. Ballet. Music, L. J. Saint-Amans. First performed **1776–77**, Théâtre de la Cour, Paris. [Grove 1980, 16:385]

Gottfried August Bürger, 1747–1794. *Dido*. Epic, adaptation from Virgil. In *Deutsches Museum* (Leipzig periodical) **1777**. [DLL 1968–90, 2:298]

Vincenzo Galeotti, 1733–1816, choreography. *Dido Abandoned*. Ballet. Composer unknown. First performed **1777**, Royal Danish Ballet, Danish Royal Theatre, Copenhagen. [Oxford 1982, p. 168]

Anton Raphael Mengs, 1728–1779. "Dido on the Funeral Pyre." Drawing. Crocker Art Gallery, Sacramento, Calif. [Pigler 1974, p. 317]

Ignaz Holzbauer, 1711–1783. *La morte di Didone*. Opera (melodrama). First performed **1779**, Mannheim. [Grove 1980, 8:670]

Bernardo Ottani, 1736–1827. *La Didone*. Opera. Libretto, Metastasio (1724). First performed Spring **1779**, Teatro Pubblico, Forlì. [Grove 1980, 14:23]

Gennaro Astarita, c.1745/49–after 1803. *La Didone abbandonata*. Opera. First performed **1780**, Pressburg. [Grove 1980, 1:661]

Francesco Piticchio, fl. 1760–1800. *Didone abbandonata*. Opera. Libretto, after Metastasio (1724). First performed Carnival **1780**, San Cecilia, Palermo. / Revised, performed Winter 1784, Braunschweig. [Grove 1980, 14:790]

Joshua Reynolds, 1723–1792. "The Death of Dido." Painting. Exhibited **1781**. Royal Collection, Buckingham Palace, London. [Royal Academy 1986, no. 123—ill. / Waterhouse 1941, p. 72—ill.] Replica. Philadelphia Museum of Art. [Waterhouse]

Johann Gottlieb Naumann, 1741–1801. *Elisa*. Opera. Libretto, C. Mazzolà. First performed 21 Apr **1781**, Kleines Kurfürstliches Theater, Dresden. [Grove 1980, 13:79]

———. *La Didone abbandonata*. Cantata. Libretto, Maria Antonia Walpurgis. [Ibid.]

Nicolau Luíz da Silva, 1723–1787. *Dido desamparada, destruí, cas de Cartago* [Dido Forsaken, Destroyed, the Fall of Carthage]. Comedy. Lisbon: Santos, **1782**. [NUC]

Carlo Monza, c.1735–1801. *Enea in Cartagine* [Aeneas in Carthage]. Opera. Libretto, G. M. D'Orengo. First performed Oct **1784**, Città, Alessandria. [Grove 1980, 12:544]

Gaetano Andreozzi, 1755–1826. *Didone abbandonata*. Opera. Libretto, Metastasio (1724). First performed **1785**, Pisa. [Grove 1980, 1:411]

Pietro Alessandro Guglielmi, 1728–1804, doubtfully attributed. *Didone*. Opera. First performed **1785**, Venice. [Grove 1980, 7:797]

Franz Anton Maulbertsch, 1724–1796. "The Death of Dido." Painting. c.**1785–86**. Österreichische Galerie, Vienna. [Garas 1960, no. 349—ill.]

Giuseppe Gazzaniga, 1743–1818. *La Didone*. Opera. Libretto, Metastasio (1724). First performed **1787**, Teatro Eretenio, Vicenza. [Grove 1980, 7:206, 12:215]

Anonymous English. *Queen Dido, or The Trojan Ramblers*. Comic extravaganza. First performed 9 Apr **1792**, Sadler's Wells, London. [Nicoll 1959–66, 3:341]

Friedrich Heinrich Füger, 1751–1818. "The Death of Dido." Painting. **1792**. Hermitage, Leningrad, inv. 6635. [Hermitage 1987b, no. 381—ill.] Study. Hermitage, no. 9796. [Ibid., no. 382—ill.]

Charles Le Picq, 1744–1806, choreography. *Didon abban-*

donée. Ballet. Music, Vicente Martín y Soler. First performed **1792**, St. Petersburg. [Oxford 1982, p. 253 / Grove 1980, 11:736]

————, choreography. *Dido, or the Destruction of Carthage.* Grand tragic ballet. Music, Martín y Soler and others, compiled by C. Cavos. First performed 24 Oct 1828, St. Petersburg; staged by Charles Didelot and M. Auguste; scenery, Canoppi; machines, Thibeault. [Swift 1974, p. 203]

Stephen Storace, 1762–1796. *Dido, Queen of Carthage.* Opera. Libretto, Prince Hoare (1775), after Metastasio (1724). First performed 23 May **1792**, King's Theatre, London. [Fiske 1973, pp. 315, 513 / Nicoll 1959–66, 3:269]

Vincenzo Federici, 1764–1826. *Didone abbandonata.* Opera. Libretto, Metastasio (1724). First performed *c.***1794,** King's Theatre (?), London. [Clément & Larousse 1969, 1:331]

Giovanni Paisiello, 1740–1816. *Didone abbandonata.* Opera. Libretto, Metastasio (1724). First performed 4 Nov **1794,** San Carlo, Naples. [Grove 1980, 14:101]

William Blake, 1757–1827. "Aeneas Aroused by Mercury." Drawing. *c.***1790–95.** British Museum, London. [Butlin 1981, no. 254—ill.]

Vicente Rodriquez de Arellano, ?–*c.*1806. *Dido abandonada.* Comedy. First performed Summer **1795.** Published Barcelona: Piferrer [n.d.]. [NUC]

Giovanni Liverati, 1772–1846. *Enea in Cartagine* [Aeneas in Carthage]. Opera. First performed (?) **1796,** Potsdam. [Grove 1980, 11:92 / Baker 1984, p. 1374 (performed 1809)]

Sébastien Gallet, 1753–1807, choreography. *Énée et Didon.* Ballet. First performed 19 Apr **1798,** King's Theatre, London. [Guest 1972, p. 152]

Josef Martin Kraus, 1756–1792. *Aeneas i Carthago (Dido och Aeneas)* [Aeneas in Carthage (Dido and Aeneas)]. Opera. Libretto, J. H. Kellgren. First performed 18 Nov **1799,** Royal Opera, Stockholm; choreography, F. N. Terrade. [Grove 1980, 10:242]

Domenico Cimarosa, 1749–**1801,** doubtfully attributed. "Didone abbandonata." Aria. [Grove 1980, 4:402]

Giovanni Domenico Tiepolo, 1727–**1804,** attributed. "Dido on the Funeral Pyre." Drawing. Louvre, Paris. [Pigler 1974, p. 315]

L. Capotorti. *Enea in Cartagine* [Aeneas in Carthage]. Opera. First performed **1805,** San Carlo, Naples. [Clément & Larousse 1969, 1:388 / Hunger 1959, p. 10 (as a ballet, 1800]

Ferdinando Paer, 1771–1839. *La Didone.* Opera (melodramma serio). Libretto, Metastasio (1724). First performed **1810,** Tuileries, Paris. [Grove 1980, 14:83]

Franz Danzi, 1763–1826. *Dido.* Opera (melodrama). First performed **1811,** Stuttgart. Lost. [Grove 1980, 5:235]

Gioacchino Rossini, 1792–1868. *La morte di Didone.* Cantata for soprano, chorus, and orchestra. **1811.** First performed 2 May 1818, San Benedetto, Venice. [Grove 1980, 16:245]

Joseph Mallord William Turner, 1775–1851. "Dido and Aeneas Leaving Carthage on the Morning of the Chase." Painting. Exhibited **1814.** Tate Gallery, London, no. 494. [Butlin & Joll 1977, no. 129—ill.]

————. "Mercury Sent to Admonish Aeneas," "Aeneas Relating His Story to Dido," "A Visit to the Tomb" (of Sychaeus?), "The Departure of the Fleet." Painting cycle.

Exhibited 1850. Tate Gallery, London, nos. 553–55; "Mercury" formerly Tate Gallery, unlocated. [Ibid., nos. 429–32—ill. / Schulz 1985, pp. 208–10]

Washington Allston, 1779–1843. "Dido and Anna" (Anna consoles Dido as Aeneas slips away). Painting. **1813–15,** unfinished. Dana coll., Cambridge, Mass. in 1948. [Richardson 1948, no. 46] Oil study. Lowe Art Museum, University of Miami, Fla. [Gerdts & Stebbins 1979, pp. 45, 93f.—ill. / also Richardson, no. 45—ill.]

Pierre-Narcisse Guérin, 1774–1833. "Dido" (with Aeneas recounting the misfortunes of Troy). Painting. **1815.** Louvre, Paris, inv. 5184. [Louvre 1979–86, 3:295—ill. / Harding 1979, pp. 10, 132—ill.] Sketch ("Aeneas and Dido"). Louvre, no. R.F. 762. [Louvre—ill.] Further versions of the subject in Musée des Beaux-Arts, Bordeaux; Galeria Moderna, Madrid. [Borowitz 1985, pp. 82–83—ill. / Bénézit 1976, 5:272]

Eduard Heinrich Gehe, 1793–1850. *Dido.* Tragedy. Leipzig: Göschen, **1821.** [DLL 1968–90, 6:131 / Frenzel 1962, p. 128]

Salvatore Viganò, 1769–1821, choreography, completed by Giulio Viganò. *Didone.* Heroic ballet. Music, G. Ayblinger. First performed Autumn **1821,** La Scala, Milan. [Oxford 1982, p. 438]

Karl Weichselbaumer, 1791–1871. *Dido.* Tragedy. Bamberg: Goebhardt, **1821.** [Frenzel 1962, p. 128]

Juan de la Cruz Varela, 1794–1839. *Dido.* Tragedy. Buenos Aires: Expositos, **1823.** [NUC / Oxford 1978, p. 594 (as 1836) / DLE 1972, p. 232 (as 1836)]

Bernhard Klein, 1793–1832. *Dido.* Opera. First performed **1823,** Berlin. [Grove 1980, 10:101]

Saverio Mercadante, 1795–1870. *Didone abbandonata.* Opera (dramma per musica). Libretto, Metastasio (1724). First performed 18 Jan **1823,** Teatro Regio, Turin. [Grove 1980, 12:174]

Karl Gottlieb Reissiger, 1798–1859. *Didone abbandonata.* Opera. Libretto, Metastasio (1724). First performed 31 Jan **1824,** Hofoper, Dresden. [Grove 1980, 15:730]

Henry Fuseli, 1741–**1825.** "Dido on the Funeral Pyre." Painting. Graham Galleries, New York, in 1973. [Schiff 1973, no. 713—ill.]

Charlotte von Stein, 1742–**1827.** *Dido.* Tragedy. Modern edition by A. von Gleichen-Russwurm (Berlin: Collignon, 1920). [Hunger 1959, p. 90]

Manuel Bretón de los Herreros, 1796–1873. *Dido.* Tragedy. Madrid: Burgos, **1827.** [Flynn 1978, p. 18]

Adolf Schöll, 1805–1882. *Dido.* Tragedy. Stuttgart: Cotta, **1827.** [Frenzel 1962, p. 128]

Charles Edward Horn, 1786–1849. *Dido.* Musical work for the theater, after various Rossini operas. First performed 9 Apr **1828,** Park Theater, New York. [Grove 1980, 8:713]

Alberto Lista y Aragón, 1775–1848. "Dido." Dramatic monologue. *c.***1836.** In *Poesías inéditas* (Santander: Biblioteca de Autores Españoles, 1927). [DLE 1972, p. 529]

Niccolò Zingarelli. 1752–**1837.** *Didone.* Cantata. [Grove 1980, 20:694]

Paul Taglioni, 1808–1884, choreography. *Aeneas in Carthago* [Aeneas in Carthage]. Ballet. Music, Michael Umlauf. Before **1842.** Unperformed? [Grove 1980, 19:330]

Honoré Daumier, 1808–1879. "Aeneas and Dido." Comic

lithograph, part of "Ancient History" series. **1842.** [Delteil 1906–30, 22: no. 939—ill.]

[?] Lambert. *Didon.* Opera. First performed Apr **1845,** Gotha. [Clément & Larousse 1969, 1:329]

Hector Berlioz, 1803–1869. *Les troyens à Carthage.* Opera, part 2 of *Les troyens.* Libretto, composer, after the *Aeneid.* **1856–58**; revised and enlarged 1859–60. Part 2 divided from part 1 in 1863, first performed 4 Nov 1863, Théatre-Lyrique, Paris. [Grove 1980, 2:590, 602 / Robinson 1985, pp. 102–51 passim]

Francis Cowley Burnand, 1836–1917. *Dido, the Celebrated Widow.* Burlesque. First performed **1860,** St. James Theatre, London. Performed as *The Widow Dido* 20 Nov 1865, Royalty Theatre, London. [Nicoll 1959–66, 5:288]

Edward Burne-Jones, 1833–1898. "Dido." 2 decorative tiles, based on Chaucer's *Legend of Good Women* (1385–86). **1861.** Ashmolean Museum, Oxford. [Harrison & Waters 1973, p. 69—ill.]

———. "Dido." Drawing with watercolor. 1861. Tate Gallery, London, no. 4354. [Tate 1975, p. 16]

———. "Dido." Stained-glass panel, part of "Chaucer's Good Women" series. Designed 1864, executed by William Morris & Co. Peterhouse College, Oxford. [Harrison & Waters , p. 187f.]

Franz Nissel, 1831–1897. *Dido.* Tragedy. **1863.** In *Ausgewählte dramatische Werke,* vol. 2 (Stuttgart: Cotta, 1892–96). [DLL 1968–90, 11:375–76 / Frenzel 1962, p. 128]

Felice Blangini the Younger. *Didon.* Opera buffa. Libretto, Adolphe Belot. First performed 5 Apr **1866,** Bouffes-Parisiens, Paris. [Clément & Larousse 1969, 1:329]

H. S. Granville. *Aeneas; or Dido Done.* Burlesque. First performed 2 Mar **1868,** Cork. [Nicoll 1959–66, 5:388]

William H. Mallock, 1849–1923. *Aeneas and Dido.* Drama, unfinished. **1866–69.** / Poem from the play, "Aeneas to Dido," published in *Poems* (London: 1880). [Bush 1937, p. 557]

Wilhelm Jensen, 1837–1911. *Dido.* Tragedy. Berlin: Duncker, **1870.** [Oxford 1986, p. 452]

John Atkinson Grimshaw, 1836–1893. "Dido." Painting. By **early 1870s.** [Kestner 1989, p. 304]

Paolo Falciano, c.1780–**1872.** "Aeneas in the Presence of Dido." Painting. Galleria dell' 800 di Capodimonte, Naples, no. 6580. [Capodimonte 1964, p. 62]

Joseph Stallaert, 1825–1903. "The Death of Dido." Painting. By **1872.** Musées Royaux des Beaux-Arts (Musée d'Art Moderne), Brussels, inv. 2522. [Brussels 1984b, p. 580—ill.]

Paul Cézanne, 1839–1906. "Aeneas Meeting Dido in Carthage." Watercolor. c.**1875.** Pearlman coll., New York. [Rewald 1983, no. 43—ill. / Chappuis 1973, no. 324—ill.]

Henri Fantin-Latour, 1836–1904. "Duet from *The Trojans*" (Dido and Aeneas). Painting, illustrating a scene from Berlioz's opera. **1876.** Musée Berlioz, Côte Saint-André, Isère. [Fantin-Latour 1911, no. 778 / Hédiard 1906, no. 10—ill. (print)] Replica. Painting (exhibited 1878 as a pastel, later painted over in oil). Sold 1903 (Alexandre coll.). [Fantin-Latour, no. 869] Oil sketch for pastel. [Ibid., no. 870] Variant, lithograph. 1879. [Hédiard, no. 22—ill. / also Fantin-Latour, no. 979] Variant, lithograph ("The Trojans at Carthage, Act III: Love Duet"), illustration for A. Jullien's *Hector Berlioz* (Paris: Librarie de l'Art, 1888).

[Hédiard, no. 88—ill.] Other lithograph versions, 1889 (?), 1894 (2), 1903. [Hédiard 1906, nos. 90, 116–17, 177—ill.] Variant, painting. Sold 1910 (Dolent coll.). [Fantin-Latour, no. 2181]

———. "Dances" (6 dancers in Dido's gardens). Painting. 1891. Musée, Pau. [Ibid., no. 1433 / also Lucie-Smith 1977, p. 161] Lithograph ("Ballet from *The Trojans*"). 1893. [Hédiard, no. 114—ill. / also Fantin-Latour, no. 1523] Replica, painting. 1895. Esnault-Pelterie coll. in 1911. [Fantin-Latour, no. 1582]

———. "The Trojans at Carthage" (Dido receiving gifts from Ascanius, Aeneas looking on). Painting. 1894. C. E. Haviland coll. in 1911. [Ibid., no. 1526] Oil sketch. [Ibid., no. 1527]

Hans Makart, 1840–1884. "The Death of Dido." Painting. Sold Vienna, 1924, unlocated. [Frodl 1974, no. 556]

Harry Bates, 1850–1899. 3 bronze reliefs with scenes from the *Aeneid*: "Whither Does He Fly?" (Dido and Anna), "Then Indeed Aeneas Wept," "The Form of the God . . ." (Mercury and sleeping Aeneas). **1884.** Glasgow Art Gallery. [Beattie 1983, pp. 52f.—ill.]

Edward Samhaber, 1846–1927. *Dido.* Tragedy. **1886.** In *Gesammelte Werke,* vol. 3, *Dramen* (Munich & Leipzig: G. Müller, 1909–10). [Hunger 1959, p. 90 / Frenzel 1962, p. 128]

Gustave Charpentier, 1860–1956. "Didon." Lyric scene. Text, A. de Lassus. First performed **1887,** Paris. Published Paris: 1887. [Grove 1980, 4:162]

Otto Neitzel, 1852–1920. *Dido.* Opera. First performed **1889** [Berlin?]. [Frenzel 1962. p. 128]

Franz Wichmann. 1859–1923. *Die Königin von Carthago* [The Queen of Carthage]. Drama. Leipzig: Mutze, **1891.** [Frenzel 1962, p. 128]

Déodat de Séverac, 1872–1921. *Didon et Enée.* Symphonic suite. **1903.** [Grove 1980, 17:202]

Dionyssios Lavrangas, 1860/64–1941. *Dido.* Opera. Libretto, P. Dimitrakopoulos. c.**1906.** First performed Apr 1909, Athens. [Grove 1980, 10:555 / Baker 1984, p. 1315]

Gotthold Hildebrand, 1873–. *Dido.* Tragedy. **1909.** [Frenzel 1962, p. 128]

Maurice Baring, 1874–1945. "Pious Aeneas" (leaving Dido). Drama. In *Diminutive Dramas* (London: Constable, **1911**). [Boswell 1982, p. 32]

Alois Ausserer, 1876–1950. *Dido, die Gründerin von Karthago* [Dido, Founder of Carthage]. Tragedy. Innsbruck: Wagner, **1912.** [DLL 1968–90, 1:191]

Wilhelm Becker, b. 1887. *Dido.* Tragedy. Augsburg: Lampart, **1920.** [DLL 1968–90, 1:351]

Léo Staats, 1877–1952. Choreography for dances from Berlioz's *Les troyens* (1856–60). First performed **1921** (dances only), L'Opéra, Paris. [Beaumont 1938, p. 545]

Kurt Jooss, 1901–1979, choreography. *Dido and Aeneas.* Ballet. Music, Purcell. First performed **1926,** Staats Theater, Münster. [Beaumont 1938, p. 771]

———. Choreography for production of Purcell's *Dido and Aeneas* (1689), 1966, Schwetzingen Festival. [Oxford 1982, p. 224]

Rudolf Borchardt, 1877–1945. "Die neue Dido" [The New Dido]. Short story. In *Das hoffnungslose Geschlect: Vier zeitgenössische Erzählungen* (Berlin: Horen Press, **1929**). [DLB 1988, 66:57]

Sacheverell Sitwell, 1897–1988. "The Royal Hunt and Storm in the Forest: Aeneas and Dido." Poem. In *Canons of Giant Art: Twenty Torsos in Heroic Landscapes* (London: Faber & Faber, **1933**). [Boswell 1982, p. 294]

Artur Müller, 1909–. *Didos Tod* [Dido's Death]. Tragedy. **1941.** [Hunger 1959, p. 90]

Frederic Prokosch, 1908–1989. *Among the Caves* (Dido and Aeneas shelter in cave during storm). Poem. Lisbon: privately printed, **1941.** [Vinson 1985, p. 679]

J. V. Cunningham, 1911–1985. "Agnosco veteris vestigia flammae" [I recognize the vestiges of the ancient flame] (Dido listening to Aeneas at the banquet). Poem. In *The Judge Is Fury* (New York: Swallow/Morrow, **1947**). [Ipso]

César Klein, 1876–1954. "Dido." Painting. **1947.** [Pfefferkorn 1962, p. 31]

Edith Sitwell, 1887–1964. "Dido's Song." Poem. In *The Song of the Cold* (New York: Vanguard, **1948**). [Sitwell 1968]

Giuseppe Ungaretti, 1888–1970. (Dido evoked in) *La terra promessa: Frammenti* [The Promised Land: Fragments]. Poem. Verona: Mondadori, **1950.** [Kilmer 1977, p. 177]

Benjamin Britten, 1913–1976, and **Imogen Holst,** 1907–1984. *Dido and Aeneas.* Opera, revision of Purcell (1689). First performed 1 May **1951,** Lyric Theatre, Hammersmith, London. [Palmer 1984, pp. 360–65, 439]

Luigi Nono, 1924–. "Cori di Didone" [Choruses of Dido]. Composition for chorus and percussion. Text, Ungaretti. **1958.** First performed 11 June 1960, 34th Festival of the International Society for Contemporary Music, Cologne. [Grove 1980, 13:272 / Slonimsky 1971, p. 1087]

Mary Skeaping, 1902–, choreography. *Les troyens.* Ballet. Music, Berlioz. First performed **1958,** Royal Swedish Opera, Stockholm. [Oxford 1982, p. 56]

Harald Lander, 1905–1971. Choreography for a performance of Berlioz's opera *Les troyens.* First performed *c.***1960** (?), Paris. [Chujoy & Manchester 1967, p. 553]

Alan Dugan, 1923–. "On Lines 69–70, Book IV, of Virgil's *Aeneid.*" Poem. In *Poems 3* (New Haven: Yale University Press, **1967**). [Howard 1969, pp. 103, 588]

Jan Novák, 1921–. *Dido.* Oratorio for mezzo-soprano, speaker, male chorus, and orchestra. Text, after *Aeneid* 4. First performed **1967,** Prague. [Grove 1980, 13:434]

Kenneth Burke, b. 1897. "Of Rome and Carthage." Poem. In *Collected Poems* (Los Angeles: University of California Press, **1968**). [Boswell 1982, p. 60]

Joseph Brodsky, 1940–. "Enei i Didona" [Aeneas and Dido]. Poem. **1969.** / Translated by George Kline in *Selected Poems* (Harmondsworth: Penguin, 1973; Baltimore: Penguin, 1974). [Ipso / CLC 1988, 50:121ff.]

Iain Crichton Smith, 1928–. "Dido and Aeneas." Poem. In *From Bourgeois Land* (London: Gollancz, **1969**). [DLB 1985, 40 pt. 2: 537]

John Taras, 1919–, and **Margarethe Wallman,** 1904–, choreography. *Les troyens.* Ballet. Music, Berlioz. First performed **1969,** L'Opéra, Paris. [Oxford 1982, p. 56]

Todd Bolender, 1914–, choreography. *Les troyens.* Ballet. Music, Berlioz. First performed **1973,** Metropolitan Opera House, New York. [Oxford 1982, p. 56]

Rachel Hadas, 1948–. "After the Cave" (Dido and Aeneas after the storm). Poem. In *Starting from Troy* (Boston: Godine, **1975**). [Ipso]

Barry Moser, 1940–. "Dido." Drawing, illustration for edition of Dante's *Inferno* (Berkeley & Los Angeles: University of California Press, **1980**). [Ipso]

Charles Martin. "Dido and Aeneas." Poem. In *Poetry* 144 no. 3 (June **1984**). [Ipso]

Aeneas in Sicily. After leaving Libyan Carthage, the Trojans returned to Sicily, where Aeneas's father, Anchises, had died the year before. In his honor they held funeral games both on land and on the water. While the men were competing, the women of the group, tired after years of wandering, set fire to the ships. Aeneas prayed to Jupiter for rain, which extinguished the flames and enabled the Trojans to continue their voyage to Italy.

The footrace during the funeral games between the Trojans Nisus and Euryalus has been a popular subject in art.

Classical Sources. Virgil, *Aeneid* 3, 5. Ovid, *Metamorphoses* 14.82–85.

Apollonio di Giovanni, *c.*1415–**1465,** and **Marco del Buono Giamberti,** ?–**1489.** "Tournament Honoring Aeneas." Painting. Museum of Fine Arts, Boston, no. 06.2441a. [Boston 1985, p. 7—ill.]

Dosso Dossi, *c.*1479–1542. "The Sicilian Games." Painting, one of 10 in *Aeneid* series (8 lost), from Camerino d'Alabastro of Alfonso I d'Este, Ferrara. *c.***1520.** Barber Institute of Fine Arts, Birmingham, England. [Gibbons 1968, no. 6—ill. / also Berenson 1968, p. 110 (as "Aeneas Landing in Africa")—ill.]

Thomas Heywood, 1573/74–1641. "Troades" (the women of Troy, setting fire to their ships). Passage in *Gynaikeion: or, Nine Books of Various History Concerning Women* book 3. Compendium of history and mythology. London: printed by Adam Islip, **1624.** [Ipso]

Arthur Gorges, 1557–**1625.** (Nisus and Euryalus evoked in) Sonnet 50 of *The Vannetyes and Toyes of Youth.* MS in British Museum, Egerton 3165. First published by H. E. Sandison in *The Poems of Sir Arthur Gorges* (Oxford: Clarendon Press, 1953). [Ipso]

Claude Lorrain, 1600–1682. "(Coast View with) The Trojan Women Setting Fire to Their Fleet." Painting. *c.***1643.** Metropolitan Museum, New York, no. 55.119. [Röthlisberger 1961, no. LV 71—ill. / Metropolitan 1980, p. 28—ill. / Metropolitan 1983, p. 169—ill. / also Llewellyn 1984, pp. 129f.] Drawing after, in the artist's *Liber veritatis.* British Museum, London. [Röthlisberger]

Pietro da Cortona, 1596–1669. "The Archery Contest." Fresco, part of *Aeneid* cycle. **1651–54.** Palazzo Doria Pamphili, Rome. [Briganti 1962, no. 117—ill.]

Ferdinand Bol, 1616–1680. "Aeneas Awarding Prizes after the Race at Sea." Painting. *c.***1661–63.** Scheepvaart Museum, Amsterdam. [Blankert 1982, no. 58—ill.] Study. Herzog Anton Ulrich-Museum, Braunschweig, no. 249. [Ibid., no. 57—ill. / Braunschweig 1969, p. 36]

John Dryden, 1631–1700. "The Entire Episode of Nisus and Euryalus." Translation from *Aeneid* 5 and 9. In *Sylvae,* part 2 of Tonson's *Miscellany* (London: Tonson, **1685**). [Dryden 1956–87, vol. 3 / Van Doren 1946, pp. 212f.]

Théodore Chassériau, 1819–1856. "On a Deserted Beach the Trojan Women Mourn the Death of Anchises. . . ." Painting. **1841.** Formerly Baron Hatvany coll., Budapest, destroyed. [Sandoz 1974, no. 90—ill.]

Leigh Hunt, 1784–**1859.** "Nisus and Euryalus." Tale. In *Tales,* edited by William Knight (London: Paterson, 1891). [Bush 1937, pp. 175, 548]

Alfred Williams, 1877–1930. "Aeneas in Sicily." Poem. In *Aeneas in Sicily and Other Poems* (London: MacDonald, *c.***1905**). [Boswell 1982, p. 309]

———. "The Story of Acestes." Poem. In *Nature and Other Poems* (London: MacDonald, 1912). [Ibid.]

Humbert Wolfe, 1885–1940. "The Sicilian Expedition." Poem. In *Shylock Reasons with Mr. Chesterton and Other Poems* (Oxford: Blackwell, **1920**). [Bush 1937, p. 572]

Aeneas in the Underworld. After leaving Sicily for the second time, Aeneas visited the Cumaean Sibyl, who told him of his future in the Italian kingdom of Latium. At his request to visit the Underworld, the Sibyl directed him to the Golden Bough, his passport across the river Styx.

At the river's edge, he met the ghost of Palinurus; his faithful helmsman had fallen asleep at the tiller and been washed overboard as a sacrifice to Neptune, ensuring the safety of the rest of the fleet. Unburied, Palinurus could not cross over the Styx, and he begged Aeneas for burial; a tomb was later erected for him.

After being ferried across the Styx by Charon, Aeneas and the Sibyl traveled through the Underworld, seeing many of its terrible denizens. The shade of Dido was also there, but she remained Aeneas's enemy even in death and refused to recognize him. In the Fields of the Blessed he encountered the shade of his father, Anchises, who predicted the future of the Roman race and then led him back through the Underworld to the land of the living.

Classical Sources. Virgil, *Aeneid* 5.813–71, 6. Ovid, *Metamorphoses* 14.100–60. Decius Magnus Ausonius, *Epigrammata* 118.

Dante Alighieri, 1265–1321. (Aeneas entering the Underworld evoked in) *Inferno* 3.94–96, *Purgatorio* 1.134–36. *c.*1307–*c.*1314? In *The Divine Comedy.* Poem. Foligno: Neumeister & Angelini, 1472. [Singleton 1970–75, vols. 1–2 / Hardie 1984, pp. 58f.]

Anonymous French. (Aeneas in the Underworld in) *Ovide moralisé* 14.790–972 (narrative), 973–1066 (allegories). Poem, allegorized translation/elaboration of Ovid's *Metamorphoses. c.***1316–28**. [de Boer 1915–86, vol. 5]

Sebastian Brant, 1458?–1521. Translation of the *Aeneid* by Virgil. Poem. Strassburg: **1502**. / The sixth book, with 14 anonymous woodcuts, reproduced in Anna Cox Brinton, *Descensus Averno: Fourteen Woodcuts Reproduced from Sebastian Brant's Virgil* (Palo Alto: Stanford University Press; London: Oxford University Press, 1930). [Ipso]

Biernat z Lublina, *c.*1465–*c.*1529. *Dyalog Palinura z Karonem* [Dialogue of Palinurus with Charon]. Poem, unfinished. *c.***1519–21**? / Modern edition, Warsaw: Druk Rubieszewskiego i Wrotnowskiego, 1909. [Miłosz 1983, pp. 50f. / Krzyżanowski 1978, p. 40]

Dosso Dossi, *c.*1479–1542. "Aeneas in the Elysian Fields" ("Aeneas and the Cumaean Sybil"). Painting, from *Aeneid* series. **1525–30**. National Gallery of Canada, Ottawa. [Gibbons 1968, no. 50—ill. / also Berenson 1968, p. 113—ill.]

Joachim Du Bellay, 1522–**1560**. Translation of the *Aeneid* book 6. In *Deux livres de l'Eneide de Virgile* (Paris: Sertenas, 1560). [Highet 1967, p. 115]

Thomas Sackville, 1536–1608. (Aeneas in the Underworld evoked in) "Induction." Poem. In *A Myrroure for Magistrates* (London: Marsh, **1563**). Modern edition by Lily B. Campbell, *The Mirror for Magistrates* (Cambridge: Cambridge University Press, 1938). [Bush 1963, pp. 60–64, 313]

Jan Brueghel the Elder, 1568–1625. "Aeneas with the Sibyl in the Underworld." Painting. **1600**. Szépművészeti Múzeum, Budapest, inv. 551 (640). [Ertz 1979, no. 65—ill.] Variant or study. Budapest, inv. 553 (645). [Ibid., no. 66—ill. / also Budapest 1968, p. 105—ill.]

———. "Aeneas with the Sibyl in the Underworld." Painting. Shortly after 1600. Kunsthistorisches Museum, Vienna, inv. 817 (912). [Ertz, no. 67—ill. / Vienna 1973, p. 33—ill.] Variant, attributed to Jan Brueghel the Younger (1601–1678). Musées Royaux des Beaux-Arts (Musée d'Art Ancien), Brussels, inv. 6249. [Brussels 1984a, p. 40—ill. / Ertz 1984, no. 130—ill. / also Ertz 1979, fig. 134] Further versions of the variant, in F. Hardy coll., Bendorf; Baron Kronacker coll., Antwerp. [Ertz 1984, nos. 131–32—ill.]

———, attributed. "Aeneas and the Cumaean Sibyl in the Underworld" ("Hell"). Painting. Thorwaldsens Museum, Copenhagen, no. B44. [Thorwaldsen 1985, p. 91]

Walter Ralegh, 1552?–1618. "I am that Dido which Thou here do'st see." Poem, translation of Ausonius's *Epigrammata* 118. [Hammond 1984]

Peter Paul Rubens, 1577–1640. "Aeneas in the Underworld." Painting, oil sketch (study for an unknown/ unexecuted Aeneas cycle?). *c.***1635–37**. National Museum of Wales, Cardiff. [Jaffé 1989, no. 1027—ill. / also Held 1980, no. 230—ill.]

Pietro da Cortona, 1596–1669. "Aeneas Seeking the Golden Bough," "Aeneas's Descent into the Underworld." Frescoes, part of *Aeneid* cycle. **1651–54**. Palazzo Doria Pamphili, Rome. [Briganti 1962, no. 117—ill.]

Giovanni Francesco Busenello, 1598–1659. *La discesa d'Enea all' inferno* [Aeneas's Descent into Hades]. Drama, intended as a libretto, but never set to music. Unpublished. [Grove 1980, 3:501]

Francesco Allegrini, 1587–1663, attributed. "Aeneas Seeing Dido's Shade in the Underworld." Painted ceiling. Palazzo Doria Pamphili, Rome. [Scherer 1963, p. 247]

Maurice Atkins, attributed. *Cataplus, or Aeneas His De-*

scent into Hell. Travesty. London: Heinchman, **1672**.
[Bush 1963, p. 339]

Claude Lorrain, 1600–1682. "Coast View with Aeneas and the Cumaean Sibyl." Painting. **1673**. Lost. / Drawing after, in the artist's *Liber veritatis*. British Museum, London. [Röthlisberger 1961, no. LV 183—ill. / also Llewellyn 1984, pp. 131f.]

Giuseppe Maria Crespi, 1665–1747. "Aeneas, the Sibyl, and Charon." Painting. *c*.**1700**. Kunsthistorisches Museum, Vienna, inv. 306 (338). [Vienna 1973, p. 52—ill.]

Carlo Agostino Badia, 1672–1738. *Enea negli Elisi* [Aeneas in Elysium]. Opera (poemetto drammatico). Libretto, Bernardoni. First performed 26 July **1702**, Vienna. [Grove 1980, 2:9]

Giovanni Paolo Panini, 1691–1765, attributed. "Aeneas Consulting the Cumaean Sybil." Painting. **1710–15**. Galleria Sabauda, Turin, no. 544. [Arisi 1961, no. 9, pl. 31]

Antoine Coypel, 1661–1722. "The Descent of Aeneas into Hades." Painting, part of cycle illustrating the adventures of Aeneas. **1716–17**. Placed in Galerie d'Énée, Palais-Royal. Now in Louvre, Paris, inv. 3546. [Louvre 1979–86, 3:170f.—ill.]

Johann Joseph Fux, 1660–1741. *Enea negli Elisi, ovvero Il tempio dell' Eternita* [Aeneas in Elysium, or The Temple of Eternity]. Opera (festa teatrale). Libretto, Pietro Metastasio. First performed 28 Aug **1731**, Hoftheater, Vienna. [Grove 1980, 7:46]

Laurent Gervais, fl. 1725–45. *Didon aux Champs-Elysées* [Dido in the Elysian Fields]. Cantata. **1732**? [Grove 1980, 7:309]

Corrado Giaquinto, 1703–1765. "Aeneas Offering Sacrifice at the Shrine of Apollo." Painting, part of series depicting scenes from the *Aeneid*, for Royal Palace, Turin. **Early 1730s**. Palazzo Quirinale, Rome. [Llewellyn 1984, pp. 126–28]

———. "Aeneas and the Sibyl." Painting. Galleria di Capodimonte, Naples, no. 233. [Capodimonte 1964, p. 58]

Sebastiano Conca, 1679–1764. "(The Vision of) Aeneas in the Elysian Fields." Painting. *c*.**1735–40**. Several versions. Uffizi, Florence, inv. SMeC 20 (displayed in Cenacolo di Foligno); Ringling Museum, Sarasota, Fla., inv. SN168.; Holkham Hall, Norfolk; another known, unlocated (Turin art market in 1976). [Uffizi 1979, no. P447—ill. / Sarasota 1976, no. 151—ill.]

Giovanni Battista Costanzi, 1704–1778. "Enea in Cuma" [Aeneas in Cumae]. Opera/cantata. First performed 21 Jan **1746**, Rome. [Grove 1980, 4:822]

Niccolò Piccinni, 1728–1800. *Enea in Cuma* [Aeneas in Cumae]. Parody opera. Libretto, Mililotti. First performed **1775**, Teatro Fiorentini, Naples. [Grove 1980, 14:727]

George Romney, 1734–1802. "Aeneas and the Cumaean Sibyl." 2 drawings, in Roman sketchbook. *c*.**1775**. Fitzwilliam Museum, Cambridge. [Jaffé 1977, no. 49 n.]

———. "Aeneas before the Cumaean Sibyl" (?). Drawing. 1782–83? [Ibid., no. 49]

Joseph Mallord William Turner, 1775–1851. "Aeneas and the Sibyl, Lake Avernus." Painting. *c*.**1798**. Tate Gallery, London, no. 463. [Butlin & Joll 1977, no. 34—ill.] Variant.

1814–15. Yale Center for British Art, New Haven. [Ibid., no. 226—ill.]

———. "(Lake Avernus, the Fates, and) The Golden Bough." Painting. Exhibited 1834. Tate Gallery, London, no. 371. [Ibid., no. 355—ill. / also Schulz 1985, p. 201]

Eugène Delacroix, 1798–1863. "The Cumaean Sibyl" (pointing to the Golden Bough). Painting. **1838**. Wildenstein & Co., New York. [Johnson 1981–86, no. 263—ill.]

Honoré Daumier, 1808–1879. "Aeneas in the Underworld." Comic lithograph, part of "Ancient History" series. **1842**. [Delteil 1906–30, 22: no. 941—ill.]

Aubrey De Vere, 1814–1902. "The Sibyl's Cave at Cuma." Poem. In *The Search after Proserpine, Recollections of Greece, and Other Poems* (Oxford: Parker, **1843**). [Boswell 1982, p. 86]

Edward Burne-Jones, 1833–1898. "Souls on the Bank of the River Styx." Painting, derived from passage in Virgil. **1871–72**. P. Nahum coll., London. [Kestner 1989, p. 96, pl. 2.24]

David Scott. *The Golden Bough*. Comedy. Incidental music, J. Pelzer. First performed 27 Jan **1897** (by amateurs), Broughton Ferry, London. [Nicoll 1959–1966, 5:558]

Thomas Sturge Moore, 1870–1944. "The Sibyl." Poem. In *The Vine Dresser and Other Poems* (London: At the Sign of the Unicorn, **1899**). [Bush 1937, p. 565]

Thomas Mann, 1875–1955. (Leverkühn makes Aeneas's trip to the Underworld in) *Doktor Faustus*. Novel. Stockholm: Bermann-Fischer, **1947**. / Translated by H. T. Lowe-Porter as *Doctor Faustus* (New York: Knopf, 1948). [Newman 1986, p. 487]

Sydney Goodsir Smith, 1915–1975. (Aeneas meets Dido in Hades in) *Under the Eildon Tree*. Poem. Edinburgh: Serif, **1948**. [DLB 1984, 27:343]

Giuseppe Ungaretti, 1888–1970. (Palinurus evoked in) *La terra promessa: Frammenti* [The Promised Land: Fragments]. Poem. Verona: Mondadori, **1950**. [Kilmer 1977, p. 176]

W. S. Merwin, 1927–. "The Bones of Palinurus Pray to the North Star." Poem. In *A Mask for Janus* (New Haven: Yale University Press, **1952**). [Ipso]

Enzio Cetràngolo, 1919–. "Il sonno di Palinuro" [The Sleep of Palinurus]. Poem, translation from Virgil. Florence: **1955**. [DELI 1966–70, 2:24]

Daryl Hine, 1936–. "Avernus." Poem. In *The Carnal and the Crane* (Montreal: McGill University Press; Toronto: Contact, **1957**). [Howard 1969, pp. 179f., 589 / CLC 1980, 15:280]

Geoffrey Hill, 1932–. "After Cumae." Poem. **1952–58**. In *For the Unfallen* (London: Deutsch, 1959). [Ipso]

Rolfe Humphries, 1894–1969. "Episode in Elysium." Poem. In *Collected Poems* (Bloomington: Indiana University Press, **1966**). [Boswell 1982, p. 140]

Vernon Watkins, 1906–**1967**. "The Sibyl." Poem. In *Fidelities* (London: Faber & Faber, 1968). [Ipso]

Brewster Ghiselin, 1903–. (Palinurus in) "The Wheel" part 4. Poem. In *Country of the Minotaur* (Salt Lake City: University of Utah Press, **1970**). [Ipso]

Reynolds Price, 1933–. "Cumaean Song." Poem, after Virgil. In *Vital Provisions* (New York: Atheneum, **1982**). [Ipso]

Aeneas in Latium. The second half of the *Aeneid* relates Aeneas's adventures in Latium and the war by which the Trojan hero finally secured the future home of the Romans.

Arriving at the mouth of the Tiber River, Aeneas made camp and the hungry travelers devoured the flat hardtack on which their food was served. Thus, the Harpy's prophecy that they would eat their "tables" was fulfilled.

The land was ruled by King Latinus, whose daughter, Lavinia, was betrothed to Turnus, ruler of the Rutuli. But Latinus, having learned from an oracle that Lavinia was fated to marry a foreigner and to become the mother of a race that would make the world its empire, agreed to an alliance with the Trojans and promised Aeneas his daughter's hand in marriage.

Juno, Aeneas's implacable enemy, now sent the Fury Allecto to meddle, first by poisoning the Latin queen, Amata, against Aeneas, then by taunting Turnus into declaring war on the Latins and Trojans. She also caused strife between the Latins and the Trojans themselves by setting the hounds of Aeneas's son, Ascanius, to track a stag that was the pet of Sylvia, daughter of Latinus's huntsman. Not knowing the stag's provenance, Ascanius shot it; outraged, the people rose against him and the Trojans and war began.

While Turnus prepared for battle, the god of the Tiber appeared to Aeneas in a dream, urging him to form an alliance with King Evander of Pallanteum. On the way to Pallanteum (now the Palatine Hill) Aeneas saw on a bank of the Tiber a white sow with thirty piglets; this would be the site of his future city, according to Helenus's prophecy. Aeneas secured the alliance with Evander, who also advised him to seek the support of the Etruscans. They had banished their former leader, Mezentius, for cruelty, and he had joined Turnus's forces.

Meanwhile, Venus asked her husband, Vulcan (who had once provided armor for Achilles), to make a set of arms, which she presented to Aeneas. The shield was elaborately decorated with scenes of the future history of Rome.

While Aeneas journeyed to seek an alliance with the Etruscan king, Tarchon, Juno's messenger, Iris, instructed Turnus to attack the poorly defended Trojans. The Rutuli set fire to the Trojan ships, but Cybele changed the burning ships into sea nymphs that swam away. That night the Trojans Nisus and Euryalus tried to slip through the enemy camp to summon Aeneas. They killed many of the sleeping soldiers, but were themselves discovered and slain. In a fierce battle the next day, Turnus managed to infiltrate the Trojan camp. Stranded, he escaped by jumping into the Tiber.

Jupiter then called a council of the gods to demand an end to Olympian intervention in the battle, decreeing that every man's future should be decided by his own actions. Meanwhile, Aeneas returned to the Trojan camp with his Etruscan allies, including Evander's son Pallas. In hand-to-hand combat, Pallas was killed by Turnus, who then insulted the corpse by taking its armor. This incited Aeneas to such fury that Juno, with Jupiter's permission, lured Turnus away from the battle to safety. Mezentius assumed the leadership and was wounded by Aeneas, who also killed Mezentius's son, Lausus. Unlike Turnus, however, Aeneas returned the young warrior's body to his comrades. The grief-stricken Mezentius faced Aeneas in battle again and was killed.

A truce was called to allow both sides to bury their dead, and the Latins decided to sue for peace. Saying his quarrel was only with Turnus, not the Latin people, Aeneas proposed that he and the Rutulian leader settle the war in single combat. Turnus spurned the offer and returned to action. A cavalry battle ensued, in which the warrior-maiden Camilla (a parallel of the Amazon Penthesilea in the *Iliad*) led a squadron from the Volscian nation. She fought bravely, but was felled by an Etruscan spear.

Again, a truce was declared and Turnus agreed to meet Aeneas in single combat. Instead, Turnus's immortal sister, Juturna, persuaded the Rutuli to a surprise attack, in which Aeneas was wounded. This caused the fighting to resume at full pitch. With the help of the healer Iapis, Venus cured her son's wound and sent him back into the fray, urging him to attack the Latin capital. As the city burned, Queen Amata, thinking Turnus was dead, committed suicide.

Turnus and Aeneas finally confronted each other. When, in the first round, Turnus's sword broke and Aeneas's became impaled in a tree trunk, Juturna gave her brother her own sword while Venus freed her son's weapon. Jupiter again called a halt to heavenly interference. Juno agreed, but begged Jupiter to preserve the Latin race. With his reassurance, she reluctantly persuaded Juturna to leave the scene. The duel recommenced; Aeneas wounded Turnus, who pledged Lavinia to his rival and declared defeat. But when Aeneas saw that Turnus wore the swordbelt of the murdered Pallas, he avenged the youth's death by killing his enemy.

Aeneas thus established the Trojans in Latium, naming their settlement Lavinium after his bride. Through his son, Ascanius, he became the ancestral founder of the Roman race. Ascanius (later called Iulus or Ilus) moved the capital from Lavinium to

Alba Longa, near the present site of Rome, and became the legendary progenitor of the Julian line that spawned Caesar and Augustus.

The most commonly treated episodes from this section of the *Aeneid* are Aeneas's arrival in Latium, Venus securing armor for Aeneas, the death of Sylvia's stag, the combat of Aeneas and Turnus, the love of Aeneas and Lavinia, and the stories of Camilla, Turnus, and Nisus and Euryalus. Venus in Vulcan's forge is commonly depicted as an allegory of the element Fire.

Classical Sources. Virgil, *Aeneid* 7–12. Ovid, *Metamorphoses* 14.445–580.

See also HEPHAESTUS.

Dante Alighieri, 1265–1321. (Aeneas, Camilla, Latinus, and Lavinia among the heroes and heroines of antiquity in Limbo, in) *Inferno* 4.122–26; (Lavinia appears in a vision in) *Purgatorio* 17.31–39. *c.*1307–*c.*1314? In *The Divine Comedy*. Poem. Foligno: Neumeister & Angelini, 1472. [Singleton 1970–75, vols. 1–2 / Hardie 1984, p. 56]
———. (Turnus's prayer to Aeneas for life, Turnus's death, evoked in) *De monarchia* 2.3.16, 2.10.2–3. Treatise. 1312–13? Basel: Operinus, 1559. [Hardie / Toynbee 1968, p. 623]
Anonymous French. (Aeneas in Latium in) *Ovide moralisé* 14.3551–4590. Poem, allegorized translation/elaboration of Ovid's *Metamorphoses*. *c.*1316–28. [de Boer 1915–86, vol. 5]
Giovanni Boccaccio, 1313–1375. "De Lavinia Laurentum regina" [Lavinia, Queen of Latium], "De Camilla Volscorum regina" [Camilla, Queen of the Volscians]. In *De mulieribus claris* [Concerning Famous Women]. Latin verse compendium of myth and legend. 1361–75. Ulm: Zainer, 1473. [Branca 1964–83, vol. 10 / Guarino 1963 / Bergin 1981, p. 251]
Christine de Pizan, *c.*1364–*c.*1431. (Camilla, Lavinia in) *Le livre de la Cité des Dames* [The Book of the City of Ladies] part 1 nos. 24, 48. Didactic compendium in prose, reworking of Boccaccio's *De mulieribus claris*. 1405. [Hicks & Moreau 1986] Translated by Brian Anslay (London: Pepwell, 1521). [Richards 1982]
Maffeo Vegio (Mapheus Vegius), 1407–1458. *Il canto XIII dell' Eneide* [Canto Thirteen of the *Aeneid*]. Poem, continuation of the *Aeneid*. *c.*1430. Published in Latin as *Aeneis Vergiliana cum liber addititius per Mapheus Vegius* (Lugduni: 1517). Modern edition by Anna Cox Brinton, *Mapheus Vegius and his Thirteenth Book of the Aeneid* (Berkeley: University of California Press, 1930). [Ipso / DELI 1966–70, 5:407]
Apollonio di Giovanni, *c.*1415–1465. "Duel between Turnus and Aeneas and Wedding of Lavinia and Aeneas." Painting. Musée de Cluny, Paris, no. 1710. [Berenson 1963, p. 18]
———. "Battle between the Latins and the Trojans." Painting. Museum of Fine Arts, Springfield, Mass., inv. 63.01. [Scherer 1963, p. 243]
Guidoccio Cozzarelli, fl. 1450–87, d. 1516. "Camilla and Aeneas." Painting. Johnson coll., Philadelphia Museum of Art, no. 111. [Berenson 1968, p. 99]

———. "Camilla Engaged in Battle." Painting. Formerly Woodward coll., London. [Ibid., p. 98]
Maerten van Heemskerck, 1498–1574. "(Venus and Cupid in) The Forge of Vulcan." Painting, part of triptych, now dispersed. 1536. Národní Galeri, Prague, inv. DO4290. [Grosshans 1980, no. 21—ill. / de Bosque 1985, p. 160—ill. / also Eisler 1977, p. 34]
Perino del Vaga, 1501–1547, composition. "Venus in Vulcan's Forge." Engraving, executed by Giorgio Ghisi (1520–1582). [Pigler 1974, p. 291]
Luca Cambiaso, 1527–1585. "The Battle between Aeneas and Turnus." Fresco. *c.*1565? Palazzo della Meridiana, Genoa. [Manning & Suida 1958, pp. 92f.—ill.]
Luíz Vaz de Camões, 1524?–1580. (Death of Euryalus evoked in) *Os Lusiades* [The Sons of Lusus]. Epic. Lisbon: Gonçalvez, 1572. / Translated by Sir Richard Fanshawe (Cambridge: Harvard University Press, 1940). [Bowra 1945, pp. 107f.]
Giovanni Maria Butteri, *c.*1550–1606. "Aeneas Landing in Italy." Painting. 1570–73. Studiolo di Francesco I, Palazzo Vecchio, Florence. [Sinibaldi 1950, pp. 11f., 19]
Francesco Bracciolini dall' Api, 1566–1645. *L'Evandro* [Evander]. Tragedy. Florence: Giunti, 1612. [DELI 1966–70, 1:463f.]
Jean Prévost, *c.*1580–1622. *Turne* [Turnus]. Tragedy. First performed 1614, Paris. Published in *Les secondes oeuvres poétiques et tragiques* (Poitiers: Thoreau, 1614). [DLF 1951–72, 3:817 / Stone 1974, pp. 98–1–1 / Lancaster 1929–42, pt. 1, 1:94f., 2:760]
Thomas Heywood, 1573/74–1641. "Camilla." Passage in *Gynaikeion: or, Nine Books of Various History Concerning Women* book 5. Compendium of history and mythology. London: pr. Adam Islip, 1624. [Ipso]
Arthur Gorges, 1557–1625. (Nisus and Euryalus evoked in) Sonnet 50 of *The Vannetyes and Toyes of Youth*. MS in British Museum, Egerton 3165. First published by H. E. Sandison in *The Poems of Sir Arthur Gorges* (Oxford: Clarendon Press, 1953). [Ipso]
Hendrik de Clerck, *c.*1570–1629. "Venus in Vulcan's Forge." Painting. Museum, Aachen. [Pigler 1974, p. 293]
Anthony van Dyck, 1599–1641. "Venus in the Forge of Vulcan." Painting. *c.*1626–32. Kunsthistorisches Museum, Vienna, inv. 498 (1035). [Larsen 1988, no. 747—ill. / Vienna 1973, p. 61—ill.] Studio replica, Sanssouci, Potsdam; copy, Liechtenstein coll., Vaduz. [Larsen, no. A179—ill.]
———. "Venus in the Forge of Vulcan (Asking Vulcan for Arms for Aeneas)." Painting. *c.*1626–32. Louvre, Paris, inv. 1234. [Larsen, no. 748—ill. / Louvre 1979–86, 1:51—ill.] Copy (previously attributed to van Dyck), Musée des Beaux-Arts, Strasbourg. [Larsen, no. A180—ill.]
Nicolas Poussin, 1594–1665. "Venus Presenting Arms to Aeneas." Painting. Mid-1630s. Art Gallery of Ontario, Toronto. [Wright 1985, no. 93, pl. 45 / Blunt 1966, no. 190—ill. / also Thuillier 1974, no. 98—ill.]
———. "Venus Presenting Arms to Aeneas." Painting. 1639. Musée des Beaux-Arts, Rouen. [Wright, no. 112, pl. 55 / Blunt, no. 191—ill. / also Thuillier, no. 119—ill.] Contemporary copy, Victoria and Albert Museum, London, no. CAI.21. [Kauffmann 1973, no. 287—ill.]
———. "The Death of Camilla." Drawing. Royal Library, Windsor, no. 11936. [Friedlaender 1949, no. 113—ill.]

————, follower(s). "Venus in the Forge of Vulcan." 2 drawings, copies after presumed lost original of 1630s. École des Beaux-Arts, Paris, nos. 2862–63. [Friedlaender & Blunt 1953, nos. A52–53—ill.]

Domenico Mazzocchi, c.1592–1665. "Nisus et Euryalis." Musical dialogue, after the *Aeneid*. In *Dialoghi e sonetti* (Rome: Zannetti, **1638**). [Grove 1980, 11:869]

Peter Paul Rubens, 1577–1640. "The Death of Sylvia's Stag" ("The Wounded Stag"). Painting (executed by assistants from Rubens's design), part of series of hunts for Philip IV of Spain. c.**1639**. Lost (but see below). / Oil sketch. Philadelphia Museum of Art. [Held 1980, no. 224—ill. / Jaffé 1989, no. 1377—ill.] Studio version (possibly the original?) in Museu d'Art, Gerona. [Jaffé, no. 1376—ill. / Held, fig. 38]

Claudio Monteverdi 1567–1643. *Le nozze d'Enea con Lavinia*. [The Wedding of Aeneas and Lavinia]. Opera. Libretto, Giacomo Badoaro. First performed **1641**, Teatro SS Giovanni e Paolo, Venice. Music and libretto lost; scenario extant. [Redlich 1952, pp. 37, 109, 187 / Grove 1980, 12:525, 530 / Palisca 1968, p. 120 / Worsthorne 1954, p. 119 / Bianconi 1987, p. 187]

Juste d'Egmont, 1601–1674, attributed (previously called French School, 17th century, also previously attributed to Charles Le Brun). "Venus Arming Aeneas." Painting, part of series (see also Romanelli, below) depicting the story of Aeneas, for Cabinet de l'Amour, Hôtel Lambert, Paris. c.**1646–47.** Louvre, Paris, inv. 2901. [Louvre 1979–86, 1:55—ill. / also Louvre 1972, pp. 29ff., no. 49—ill.]

Giovanni Francesco Romanelli, 1610–1662. "Venus Pouring Balm on Aeneas's Wound" ("Iapis Cures Aeneas of His Wound"). Painting, part of series (see also d'Egmont, above) depicting the story of Aeneas, for Cabinet de l'Amour, Hôtel Lambert, Paris. c.**1646–47.** Louvre, Paris, inv. 579. [Louvre 1979–86, 2:228—ill. / also Louvre 1972, pp. 29ff., no. 51—ill.]

[?] Brosse. *Le Turne de Virgile* [The Turnus of Virgil]. Tragedy. First performed **1647**, Paris. Published Paris: de Sercy, 1647. [Girdlestone 1972, p. 137 / DLF 1951–72, 3:213]

Claude Lorrain, 1600–1682. "Seacoast with the Landing of Aeneas in Latium." Painting. **1650.** Earl of Radnor coll., Longford Castle. [Röthlisberger 1961, no. LV 122—ill.] Drawing after, in the artist's *Liber veritatis*, British Museum, London. [Ibid.] Variant, by imitator (based in part on a drawing in École des Beaux-Arts, Paris, no. 937). 18th century? Earl of Plymouth coll., England. [Ibid., pp. 301, 529—ill.]

————. "Landscape with the Landing of Aeneas in Latium (Palantium)." Painting. 1675. Anglesey Abbey, Cambridgeshire. [Ibid., no. LV 185—ill. / Llewellyn 1984, pp. 128ff.—ill. / Jackson-Stops 1985, no. 309—ill.] Drawing after, in *Liber veritatis*. [Röthlisberger]

————. "Landscape with Ascanius Shooting the Stag of Sylvia." Painting. 1682. Ashmolean Museum, Oxford. [Ibid., no. 222—ill. / Llewellyn, p. 134—ill.]

Georges de Brebeuf, 1616–1661. *Énéide: Chant 7* [*Aeneid*: Canto 7]. Burlesque. First performed **1651**, Paris. [DLLF 1984, 1:322]

Pietro da Cortona, 1596–1669. "Aeneas Arriving at the Mouth of the Tiber," "Aeneas Arriving in Evander's Realm," "Aeneas's Meeting with Pallas," "Venus at Vul-

can's Forge," "Venus Appears [with Aeneas's arms] in the Caerean Grove," "The Death of Turnus." Frescoes, part of *Aeneid* cycle. **1651–54.** Palazzo Doria Pamphili, Rome. [Briganti 1962, no. 117—ill.]

Valerio Castello, 1625–**1659,** attributed (formerly attributed to Ludovico Carracci, 1555–1619). "The Forge of Vulcan." Herzog Anton Ulrich-Museum, Braunschweig, no. 478. [Braunschweig 1969, p. 42 / also Pigler 1974, p. 292]

Ferdinand Bol, 1616–1680. "Aeneas Receives a New Set of Armor at the Recommendation of Venus in Vulcan's Smithy" (formerly called "Achilles Receives from Thetis a New Set of Armor in Vulcan's Smithy"). Painting. c.**1660.** Vredespaleis, The Hague. [Blankert 1982, no. 18—ill.]

Salvator Rosa, 1615–1673. "The Dream of Aeneas." Painting. c.**1663.** Metropolitan Museum, New York, no. 65.118. [Salerno 1975, no. 183—ill. / Wallace 1979, no. 117a—ill. / Metropolitan 1980, p. 159—ill.] Replica, etching (Bartsch no. 23). c.1663–64. [Wallace, no. 117—ill. / Salerno, no. 183a—ill.]

Jacopo Melani, 1623–1676. *Enea in Italia*. Opera. Libretto, G. A. Moniglia. First performed Winter **1670**, Medici Court, Pisa. [Grove 1980, 12:97]

Sébastien Bourdon, 1616–**1671.** "Venus and Aeneas." Painting. Hermitage, Leningrad. [Hermitage 1974, pl. 38]

Pier Francesco Cavalli, 1602–1676. *Massenzio*. Opera. Libretto, Giacomo Francesco Bussani. Rehearsed early **1673** for Teatro San Salvatore, Venice, abandoned. Music lost. [Glover 1978, pp. 29, 158]

Antonio Sartorio, 1630–1680. *Massenzio*. Opera, new setting for Cavalli's rejected work (above). Libretto, G. F. Bussani. First performed 25 Jan **1673**, San Salvatore, Venice. [Grove 1980, 16:509]

Carlo Pallavicino, c.1630/40?–1688. *Enea in Italia*. Opera. Libretto, Giacomo Francesco Bussani. First performed **1675**, Teatro SS Giovanni e Paolo, Venice. [Grove 1980, 14:142]

Antonio Draghi, 1634/35–1700. *Enea in Italia*. Opera. Libretto, Nicolò Minato. First performed 29 Oct **1678**, Wiener Neustadt. [Grove 1980, 5:604]

Giuseppe Antonio Bernabei, 1649?–1732. *Enea in Italia*. Opera. Libretto, V. Terzago. First performed **1679**, Munich. [Clément & Larousse 1969, 1:389 / Grove 1980, 2:612]

————. *L'Ascanio* [Ascanius]. Opera. Libretto, V. Terzago. First performed 1686. [Grove 1980, 2:612]

Johann Wolfgang Franck, 1644–c.1710. *Aeneas des trojanischen Fürsten Ankunft in Italien* [The Trojan Prince Aeneas Arrives in Italy]. Opera. Libretto, Johann Philipp Förtsch. First performed **1680**, Theater in Gansemarkt, Hamburg. [Grove 1980, 6:786]

Luca Giordano, 1634–1705. "Aeneas Healed by Venus." Painting. **1680–83.** Galleria Corsini, Florence. [Ferrari & Scavizzi 1966, 2:117] Replica. Alte Pinakothek, Munich. [Ibid., 2:157—ill.] Contemporary copy ("Aeneas Comforted by the Nymphs") in Pinacoteca Civica, Vicenza, no. A-208. [Ibid.]

————. "Aeneas Defeats Turnus." Painting. 1680–83. Galleria Corsini, Florence. / Replica. Alte Pinakothek, Munich; Museu d'Art, Gerona (dated 1688). [Ibid.—ill.] Another version of the subject at Squerryes Court, Westerham, Kent. [Jacobs & Stirton 1984b, p. 30] Another, formerly Musée, Lille (on deposit from Louvre, Paris,

inv. 307), destroyed in World War I. [Louvre 1979–86, 2:290]

———. "Venus Giving Arms to Aeneas." Painting. Museum of Fine Arts, Boston, no. 1984.409. [Boston 1985, p. 118—ill.]

John Dryden, 1631–1700. "The Entire Episode of Nisus and Euryalus." Translation from *Aeneid* 5 and 9. In *Sylvae,* part 2 of Tonson's *Miscellany* (London: Tonson, **1685**). [Dryden 1956–87, vol. 3 / Van Doren 1946, pp. 212f.]

———. (Aeneas's proposal to Latinus recalled and ridiculed in) *The Hind and the Panther* 3.766–80. Poem. London: Tonson, 1687. [Dryden]

Paolo Magni, *c.*1650–1737, **Carlo Ambrogio Lonati,** *c.*1645–*c.*1710/15, and **Francesco Ballarotti,** *c.*1660–1712. *Enea in Italia.* Opera. Libretto, Bussani (1675). First performed **1686,** Teatro Regio Nuovo, Milan. [Grove 1980, 11:141, 495]

Carlo Francesco Pollarolo, *c.*1653–1723. *Enea in Italia.* Opera. Libretto, Bussani (1675). First performed **1686,** Milan. [Grove 1980, 15:46]

———. *Ascanio.* Opera. Libretto, d'Averara. First performed 1702, Milan. [Grove, 15:47]

Pascal Collasse, 1649–1709. *Enée et Lavinie.* Opera (tragédie lyrique). Libretto, Bernard Le Bovier de Fontenelle. First performed 16 Dec **1690,** L'Opéra, Paris. [DLLF 1984, 1:831 / Grove 1980, 4:535 / Girdlestone 1972, pp. 136ff.]

Agostino Steffani, 1654–1728. *I trionfi del fato (Le glorie d'Enea)* [The Triumphs of Fate (The Glories of Aeneas)]. Opera. Libretto, O. Mauro. First performed **1695,** Hanover. [Grove 1980, 18:96]

Giovanni Bononcini, 1670–1747. *Il trionfo di Camilla, regina de Volsci* [The Triumph of Camilla, Queen of the Voscians]. Opera (dramma per musica). Libretto, Silvio Stampiglia. First performed 27 Dec **1696,** Teatro di San Bartolomeo, Naples. [Grove 1980, 3:32 / Bianconi 1987, p. 203]

Italian School. "Aeneas Landing in Italy." Painting. **17th century.** New York Historical Society, New York, inv. D–49. [Warburg]

António Palomino, 1655–1726. "Venus at the Forge of Vulcan Asking Arms for Aeneas" ("Fire"). Painting, part of "Elements" series, for Palacio Buen Retiro, Madrid. By **1700.** Lost. / Replica (or copy?) in Prado, Madrid, no. 3186. [López Torrijos 1985, pp. 413 nos. 75–76, 419 nos. 26–27—ill. / Prado 1985, pp. 483f.]

Jean Jouvenet, 1644–1717. "Venus in Vulcan's Forge." Painting. **1703.** Lost. / Engraving by Louis Desplaces (1682–1739). [Schnapper 1974, no. 95—ill.]

Alessandro Scarlatti, 1660–1725. *Turno Aricino* [Turnus Aricinus]. Opera (dramma per musica). Libretto, Stampiglia. First performed Sep **1704,** Villa Medicea, Pratolino. [Grove 1980, 16:559]

Samuel Massé, 1672–1753. "Venus Asks Arms for Aeneas from Vulcan." Painting. **1705.** École des Beaux-Arts, Paris. [Bénézit 1976, 7:243]

Lucas Rotgans, 1654–1710. *Eneas en Turnus* [Aeneas and Turnus]. Tragedy. **1705.** Amsterdam: Rotterdam, 1710. Modern edition, Zwolle: Willink, 1959. [McGraw-Hill 1984, 2:68]

Nicola Haym, 1678–1729. *Camilla.* Opera, revision of Bononcini (1696). Libretto, Owen Swiney, translation

of Stampiglia. First performed 30 Mar **1706,** Theatre Royal, Drury Lane, London. [Keates 1985, p. 55 / Baker 1984, p. 300 / Hogwood 1984, pp. 51, 86 / Grove, 8:415f. / Fiske 1973, pp. 44f., 589]

Johann Joseph Fux, 1660–1741. *Julo Ascanio, re d'Alba* [Iulus Ascanius, King of Alba]. Opera (poemetto drammatico). Libretto, Bernardoni. First performed 19 Mar **1708.** Hoftheater, Vienna. [Grove 1980, 7:45]

Paolo de Matteis, 1662–1728. "Venus at the Forge of Vulcan." Painting. *c.*1712. Palazzo Bonacorsi, Macerata. [Shapley 1966–73, 3:99] Variant. London art market in 1963. [Ibid.]

Andrea Stefano Fiorè, 1686–1732. *Il trionfo di Camilla.* Opera seria. Libretto, Stampiglia (1696). First performed **1713,** Publico, Reggio Emilia. [Grove 1980, 6:599]

Charles de La Fosse, 1636–**1716.** "Venus Asks Vulcan for Arms for Aeneas." Painting. Musée, Nantes. [Bénézit 1976, 6:374]

Italian School. "Venus in Vulcan's Forge." Marble chimney-piece relief. *c.*1716. Hall of Marble, Unteres Belvedere, Vienna. [Pigler 1974, p. 292]

Antoine Coypel, 1661–1722. "Evander Mourning the Death of His Son Pallas," "Turnus Slain by Aeneas," "Venus in Vulcan's Forge." Paintings, part of cycle depicting the adventures of Aeneas. **1716–17.** Formerly Galerie d'Énée, Palais-Royal, 2 ("Evander," "Turnus") now in Louvre, Paris, inv. 3551, 8724. [Louvre 1979–86, 3:170f.—ill. / Pigler 1974, p. 293] Another version of the "Venus in Vulcan's Forge" subject in Musée, Angers. [Pigler]

———. "Venus and Aeneas." Painting. Hermitage, Leningrad, inv. 5715. [Hermitage 1986, no. 32—ill.] Variant in Musée des Beaux-Arts, Rennes (as "Jupiter and Juno on Mount Ida"). [Ibid.]

Louis Boulogne the Younger, 1654–1733. "Venus in Vulcan's Forge." Drawing. By **1717.** Louvre, Paris. [Pigler 1974, p. 293]

André Campra, 1660–1744. *Camille, reine de Volsques* [Camilla, Queen of the Volscians]. Opera (tradédie lyrique). Libretto, Antoine Danchet. First performed 9 Nov **1717,** L'Opéra, Paris. [Grove 1980, 3:665 / Girdlestone 1972, pp. 209–12, 341]

Jean Restout, 1692–1768. "Venus in Vulcan's Forge." Painting. Prix de Rome, **1717.** Private coll. [Pigler 1974, p. 294]

Antonio Lotti, *c.*1667–1740. *Ascanio, ovvero Gli odi delusi dal sangue* [Ascanius, or The Deluded Hatreds of Race]. Opera seria. Libretto, A. M. Luchini. First performed Feb **1718,** Redoutensaal, Dresden. [Grove 1980, 11:250]

Leonardo Leo, 1694–1744. *Il trionfo di Camilla, regina dei Volsci.* Opera. Libretto, Stampiglia (1696). First performed 8 Jan **1726,** Capranica, Rome. [Grove 1980, 10:667]

Giovanni Battista Pittoni, 1687–1767. "Venus in Vulcan's Forge." Painting. **1720s.** Unlocated. [Zava Boccazzi 1979, no. 288—ill.]

Giovanni Battista Tiepolo, 1696–1770. "Vulcan [making arms for Aeneas?] and Venus." Painting, sketch for an unknown fresco. *c.*1725–30. Private coll., Zurich. [Morassi 1962, p. 69—ill. / Pallucchini 1968, p. 136 (as uncertain attribution)]

———. "Venus at Vulcan's Forge (Asking for the Arms for Aeneas)." Monochrome fresco, part of cycle illus-

trating scenes from the the *Aeneid*. 1757. Sala dell' Eneide, Villa Valmarana, Vicenza. [Pallucchini, no. 240 / Morassi, p. 65]

————. "Venus and Vulcan" (making arms for Aeneas?). Painting. *c.*1755–60. Johnson coll., Philadelphia Museum of Art. [Pallucchini, no. 254—ill. / Morassi, p. 44—ill.]

Bartolomeo Cordans, *c.*1700–1757 (also attributed to M. Fino). *Sponsali d'Enea* [The Betrothal of Aeneas]. Opera seria. Libretto, F. Passarini. First performed Spring **1731**, S. Angelo, Venice. [Grove 1980, 4:764]

François Boucher, 1703–1770. "Venus Asks Vulcan for Weapons for Aeneas." Painting. **1732**. Louvre, Paris, inv. 2709 (M.R. 1221). [Ananoff 1976, no. 85—ill. / Louvre 1979–86, 3:79—ill.]

————. "Venus Presents the Weapons Forged by Vulcan to Aeneas." Painting. *c.*1747. Lost. / Drawing for. Ashmolean Museum, Oxford (as "Mars and Venus"). [Ananoff, no. 304—ill.]

————. "Venus Asking Vulcan to Forge Weapons for Aeneas." Painting. 1747. Lost. / Related painting. Formerly private coll., Switzerland, *c.*1946–48, unlocated. [Ibid., no. 306—ill.]

————. "Venus in Vulcan's Forge." Painting, model for tapestry in "Loves of the Gods" series. *c.*1750. Louvre, Paris, no. M.I. 1025. [Ibid., no. 351—ill. / Louvre 1979–86, 3:80—ill.] 15 tapestries woven by Beauvais, 1752. Metropolitan Museum of Art, New York, no. 22.16.1; Daniel Wildenstein coll., New York; Council Presidency, Budapest; others unlocated. [Ananoff]

————. "Venus Asks Vulcan for Weapons for Aeneas." Painting, early version of Louvre painting, below. 1756. Private coll., New York. [Ibid., no. 479—ill.] Monochrome sketch. Musée des Arts Décoratifs, Paris, inv. 36.231. [Ibid.—ill.]

————. "Vulcan Giving Venus the Weapons for Aeneas" ("The Forge of Vulcan"). Painting. 1757. Louvre, Paris, inv. 2707 *bis*. [Ibid., no. 478—ill. / Louvre, 3:79—ill.] Copy after detail (2 nymphs) by Berthe Morisot (1841–1895). Rouart coll. in 1938. [Ananoff—ill.]

————. "Venus Asks Vulcan for Weapons for Aeneas." Painting. 1769. Kimbell Art Museum, Fort Worth, Texas. [Ibid., no. 675—ill.] Grisaille sketch. Estate of Paul Leroi in 1907. [Ibid., no. 673—ill.]

Carlo Innocenzo Frugoni, 1692–1768. *La venuta d'Ascanio in Italia* [The Arrival of Ascanius in Italy]. Scenario for horse-ballet. Published Parma: Rosati, [**1732**]. [NUC]

Corrado Giaquinto, 1703–1765. "Venus Asking Vulcan for Arms for Aeneas." Painting, part of series depicting scenes from the *Aeneid,* for Royal Palace, Turin. **Early 1730s.** Palazzo Quirinale, Rome. [Llewellyn 1984, pp. 126–28] Another version of the subject in De Luca coll., Molfetta. [Pigler 1974, p. 292]

————. "Venus Presenting Arms to Aeneas." Painting. Palazzo del Quirinale, Rome. [Pigler, p. 295] Another version in Bowes Museum, Barnard Castle, cat. 1970 no. 568. [Wright 1976, p. 76]

Charles-Joseph Natoire, 1700–1777. "Venus Asking Vulcan for Weapons for Aeneas." Painting. **1734**. Musée Fabre, Montpellier. [Troyes 1977, no. 17—ill. / Boyer 1949, no. 43] Study or replica. Fine Arts Museum, Moscow. [Boyer, no. 45]

————. "Venus Asking Vulcan for Arms for Aeneas" ("Fire"). Painting, one of a pair representing Fire and Air. 1741. Louvre, Paris, inv. 6848, on loan to Sénat, Assemblée Nationale, Paris. [Louvre 1979–86, 5:309 / Troyes, no. 22—ill.]

————, doubtfully attributed. "Venus Asks Vulcan for Arms for Aeneas." Painting. Musée, Bordeaux, no. 525. [Boyer, no. 44]

Nicola Porpora, 1686–1768. *Enea nel Lazio* [Aeneas in Latium]. Heroic opera. Libretto, Paolo Antonio Rolli. First performed 11 May **1734**, Lincoln's Inn Fields, London. [Grove 1980, 15:126 / DELI 1966–70, 4:580]

————. *Il trionfo di Camilla*. Heroic opera. Libretto, Stampiglia (1696). First performed 20 Jan 1740, San Carlo, Naples. / Revised, with libretto by G. Lorenzi, after Stampiglia. First performed 30 May 1760, San Carlo, Naples. [Grove 1980, 15:126]

Victor Honoré Janssens, 1658–**1736**. "The Prediction of the Fate of Lavinia, Wife of Aeneas." Painting. Musées Royaux des Beaux-Arts (Musée d'Art Ancien), Brussels, inv. 116. [Brussels 1984a, p. 154—ill.]

Bartolomé de Sousa Mejia, 1723–? *Amores de Lavinia (Las guerras de Turno e Eneas)* [The Loves of Lavinia (The Battles of Turnus and Aeneas)]. Drama. Unpublished. [Barrera 1969, p. 378]

Rinaldo di Capua, *c.*1705–*c.*1780. *Turno Heredonio Aricino* [Turnus Heredonius Aricinus]. Opera (dramma per musica). Libretto, S. Stampiglia. First performed 11 Dec **1743**, Capranica, Rome. [Grove 1980, 16:43]

Lorenzo Gibelli, *c.*1719–1812. *Gli sponsali di Enea* [The Betrothal of Aeneas]. Pasticcio. **1744**. [Grove 1980, 7:361]

Pompeo Batoni, 1708–1787. "Venus Delivering the Arms of Vulcan to Aeneas." Painting. **1748**. Liechtenstein coll., Vaduz, no. 163. [Clark 1985, no. 122—ill.]

Giovanni Alberto Ristori, 1692–1753. *Lavinia e Turno*. Cantata for soprano and orchestra. Libretto, Princess Maria Antonia of Saxony. First performed **1748**, Dresden. [Grove 1980, 16:56]

Vincenzo Ciampi, 1719?–1762. *Il trionfo di Camilla* [The Triumph of Camilla]. Opera (dramma per musica). Libretto, Metastasio. First performed 31 Mar **1750**, King's Theatre, London. [Grove 1980, 4:387]

Charles-Antoine Coypel, 1694–1752. "Venus Requesting Arms for Aeneas." Painting. [Bénézit 1976, 3:248]

Niccolò Jommelli, 1714–1774. *Enea nel Lazio* [Aeneas in Latium]. Opera seria. Libretto, Verazi. First performed 30 Aug **1755**, Ducal, Stuttgart. Lost. [Grove 1980, 9:693]

————. *Enea nel Lazio* (second setting). Opera seria. Libretto, Mattia Verazi. First performed 6 Jan 1766, Ducal, Ludwigsburg. [Ibid.]

Giovanni Marco Rutini, 1723–1797. *Lavinia e Turno*. Cantata. Libretto, Princess Maria Antonia of Saxony (1748). Published Leipzig: **1756**. [Grove 1980, 16:351]

François-Gaspard Adam, 1710–1761. "Vulcan Forging Arms for Venus." Statue, part of a mythological cycle. **1755–1758**. Gardens, Sanssouci, Potsdam. [Thirion 1885, pp. 161f.—ill.]

Antoine Dauvergne, 1713–1797. *Enée et Lavinie*. Opera (tragédie lyrique). Libretto, B. de Fontenelle. First performed 14 Feb **1758**, L'Opéra, Paris. [Grove 1980, 5:257]

Egidio Duni, 1708–1775, doubtfully attributed. *L'embarras du choix* [The Embarrasment of Choosing]. Opéra comique, parody of Dauvergne's *Enée et Lavine*. First performed **1758.** [Grove 1980, 5:718]

Carl Heinrich Graun, 1703/04–**1759.** *Lavinia e Turno.* Cantata for soprano, 2 violins, viola, bass. Published Leipzig: Breitkopf, 1762. [Grove 1980, 7:646]

Davide Perez, 1711–1778. *Enea in Italia.* Opera. First performed **1759,** Salvaterra, Lisbon. [Grove 1980, 14:367]

Tomasso Traetta, 1727–1779. *Enea nel Lazio.* Opera (dramma per musica). Libretto, Vittorio Amedeo Cigna-Santi. First performed Carnival **1760,** Teatro Regio, Turin. [Grove 1980, 19:113]

————. *Enea e Lavinia.* Opera (dramma per musica). Libretto, B. de Fontenelle. First performed 1761, Teatro Ducale, Parma. [Grove 1980, 19:113]

Carlo Goldoni, 1707–1793. *Enea nel Lazio* [Aeneas in Latium]. Tragicomedy. First performed Oct **1760.** Teatro San Luca, Venice. [McGraw-Hill 1984, 2:356]

Giovanni Battista Lampugnani, 1706–c.1786. *Enea in Italia.* Opera. Libretto, after Bussani (1675). First performed **1763,** Palermo. [Grove 1980, 10:422]

Felice de Giardini, 1716–1796. *Enea e Lavinia.* Opera. Libretto, G. Sertor. First performed 5 May **1764,** King's Theatre, London. [Grove 1980, 7:351]

Franz Anton Hilverding, 1710–1768, choreography. *Enea in Italia.* Ballet. Music, Florian Gassmann. First performed Aug **1765,** Kärntnertor, Vienna, for betrothal of Archduke Leopold. [Winter 1974, p. 98 / Hunger 1959, p. 10]

Baldassare Galuppi, 1706–1785. *L'arrivo di Enea nel Lazio* [The Arrival of Aeneas in Latium]. Opera (componimento drammatico). Libretto, Alamanni. First performed 15 Nov **1765,** Teatro della Pergola, Florence. [Grove 1980, 7:137]

Jean-Georges Noverre, 1727–1810, choreography. *Énée et Lavine.* Ballet. Music, Florian Deller. First performed *c.*1760–66, Hoftheater, Stuttgart. [Grove 1980, 13:443]

Gaspare Diziani, 1689–**1767.** "Venus Asks Vulcan for Arms for Aeneas." Painting. Chiomenti coll., Rome. [Pigler 1974, p. 292]

Wolfgang Amadeus Mozart, 1756–1791. *Ascanio in Alba.* Opera (festa teatrale). Libretto, Giuseppe Parini. First performed 17 Oct **1771,** Teatro Regio Ducal, Milan; choreography, Jean-Georges Noverre. [Einstein 1945, pp. 398f. / Baker 1984, p. 1600 / Grove 1980, 12:689, 728 / Mann 1977, pp. 108–123 / Lynham 1950, p. 172]

F. G. Regnaud, choreography. *Énée et Lavine.* Ballet. Music, Florian Deller (*c.*1760–66), with additional music by Johann Baptist Toeschi. First performed **1773,** Kassel. [Grove 1980, 5:350]

Flaminio Scarselli, 1705–**1776.** *Enea nel Lazio* [Aeneas in Latium]. Tragedy. In *Teatro italiano del secolo XVIII* (Florence: 1784). [DELI 1966–70, 5:75]

Angelica Kauffmann, 1741–1807. "Sylvia Lamenting over Her Favorite Stag Wounded by Ascanius." Painting. Exhibited **1777.** [Manners & Williamson 1924, pp. 45, 237]

————. "The Funeral of Pallas." Painting. 1786. Kunsthistorisches Museum, Vienna, no. 1611. [Manners & Williamson, pp. 70, 151f.]

Antonio Sacchini, 1730–1786. *Enea e Lavinia.* Opera. Libretto, Botarelli. First performed 25 Mar **1779,** King's Theatre, London. [Grove 1980, 16:372]

Luigi Cherubini, 1760–1842. *Il Mesenzio, re d'Etruria* [Mezentius, King of Etruria]. Opera. Libretto, F. Casori. First performed 6 Sep **1782,** Pergola, Florence. [Grove 1980, 4:210]

Pietro Alessandro Guglielmi, 1728–1804. *Enea e Lavinia.* Opera seria. Libretto, V. de Stefano or G. Sertor. First performed 4 Nov **1785,** San Carlo, Naples. [Grove 1980, 7:796]

————. *Il trionfo di Camilla.* Opera seria. Libretto, after Stampiglia (1696)? First performed 30 May 1795, San Carlo, Naples. [Ibid., 7:796]

António Leal Moreira, 1758–1819. *Ascanio in Alba.* Serenata. Libretto, G. Parini. First performed **1785,** Queluz, Portugal. [Grove 1980, 12:567]

Francesco Gardi, 1760/65–c.1810. *Enea nel Lazio* [Aeneas in Latium]. Opera seria. Libretto, V. A. Cigna-Santi (1760). First performed Carnival **1786,** Rangoni, Modena. [Grove 1980, 7:162]

Francesco Bianchi, 1752–1810. *Mesenzio, re d'Etruria* [Mezentius, King of Etruria]. Opera. Libretto, F. Casori (1782). First performed 4 Nov **1786,** San Carlo, Naples. [Grove 1980, 2:674]

Lorenzo Da Ponte, 1749–1838. *Il Mezenzio* [Mezentius]. Tragedy. **1791.** [Grove 1980, 5:238]

Vincenzo Righini, 1756–1812. *Enea nel Lazio.* Opera (dramma eroi-tragico). Libretto, A. Filistri de Caramandani. First performed **1793,** Berlin. [Grove 1980, 16:21]

Friedrich Hölderlin, 1770–1843. "Nisus und Euryalus." Translation of *Aeneid* 9.176–318. *c.*1794–95. First published in *Sämtliche Werke und Briefe,* vol. 3 (Leipzig: Insel, 1915). [Beissner 1943–77, vol. 5]

Michelangelo Monti, 1751–1822, libretto. *Il sogno di Enea* [The Dream of Aeneas]. Cantata. First performed **1795,** Palermo. Libretto published in *Poesie scelte* (Palermo: Lao, 1839). [DELI 1966–70, 4:51]

Giuseppe Sarti, 1729–1802. *Enea nel Lazio.* Opera (dramma per musica). Libretto, Moretti. First performed 26 Oct **1799,** Kamennig Theatre, St. Petersburg. [Grove 1980, 16:505]

French School. "Venus Asks Vulcan for Arms for Aeneas." Painting. **18th century.** Bowes Museum, Barnard Castle. [Wright 1976, p. 69]

Roman School. "Venus and Aeneas." Painting. **18th century.** Art Gallery and Museum, Glasgow, cat. 1970 no. 3233. [Wright 1976, p. 106]

Lord Byron, 1788–1824. "Nisus and Euryalus." Poem, paraphrase from *Aeneid* 9. In *Hours of Idleness* (London: Murray, **1807**). [McGann 1980–86, vol. 1 / Bush 1937, p. 72 *n.*]

F. Rossi, choreography. *Énée et Lavine.* Ballet. First performed 23 July **1807,** King's Theatre, London. [Guest 1972, p. 154]

Bernhard Severin Ingemann, 1789–1862. *Turnus.* Tragedy. In *Procne* (Copenhagen: Brünnich, **1813**). [Sharp 1933, p. 136]

Auguste Couder, 1789–1873. "Fire: Venus Receives from Vulcan the Arms He Has Forged for Aeneas." Ceiling

painting, part of cycle depicting the Elements. **1819.** Vestibule, Galerie d'Apollon, Louvre, Paris, inv. 3380. [Louvre 1979–86, 3:163—ill.]

Augustin Dumont, 1701–1781. "Evander Mourning (the Corpse of Pallas)." Plaster bas-relief. **1823.** École des Beaux-Arts, Paris. [Wagner 1986, fig. 81]

Francisque-Joseph Duret, 1804–1865. "Evander Mourning (the Corpse of Pallas)." Plaster bas-relief. **1823.** École des Beaux-Arts, Paris. [Wagner 1986, fig. 79]

Giovanni Galzerani, 1790–1853, choreography. *Enea nel Lazio* [Aeneas in Latium]. Ballet. First performed **1823,** La Scala, Milan. [EDS 1954–66, 5:878]

Anne-Louis Girodet, 1767–**1824,** circle. "Venus Curing Aeneas." Painting. Prado, Madrid, no. 6075. [Prado 1985, p. 825]

Franciszek Wincenty Mirecki, 1791–1862. *Evandro in Pergamo* [Evander in Pergamo]. Opera. First performed **1824,** Genoa. [Grove 1980, 12:359]

Henri-Frédéric Schopin, 1804–1881. "The Dream of Aeneas." Painting (sketch). **1829.** École des Beaux-Arts, Paris. [Grunchec 1984, no. 25—ill.]

Andrew Becket, 1749–1843. *Lavinia.* Tragedy. Unperformed. In *Dramatic and Prose Miscellanies,* vol. 1, edited by W. Beattie (London: Virtue, **1838**). [Stratman 1966, p. 46]

John Smyth. *Evander.* Tragedy. Unperformed. London: Johnson, **1847.** [Stratman 1966, p. 610]

Leigh Hunt, 1784–1859. "Nisus and Euryalus." Tale. In *Tales,* edited by William Knight (London: Paterson, 1891). [Bush 1937, pp. 175, 548]

The Prix de Rome bas-relief sculpture competition subject for **1859** was "The Wounded Mezentius." 2 first prizes were awarded, to Alexandre Falguière (1831–1900) and Léon Cugnot (1835–1894). Both works lost. [Wagner 1986, p. 100—ill. (prints)]

Christopher Pearse Cranch, 1813–1892. "Iapis." Poem. In *The Bird and the Bell* (Boston: Osgood, **1875**). [Boswell 1982, p. 79]

Eden Phillpotts, 1862–1960. *Evander.* Prose fable. London: Richards, **1917.** [Bush 1937, p. 569]

Allen Tate, 1899–1979. (Fulfillment of the prophecy that Aeneas's men would eat their tables evoked in) "The Mediterranean." Poem. **1933.** In *The Mediterranean and Other Poems* (New York: Alcestis, 1936). [Ipso / DLB 1986, 45:388f. / Squires 1972, pp. 153, 168, 179, 183, 310 / Feder 1971, pp. 175f., 192 / Axelrod 1978, p. 25]

Giuseppe Ungaretti, 1888–1970. *La terra promessa: Frammenti* [The Promised Land: Fragments]. Poem. Verona: Mondadori, **1950.** [EWL 1981–84, 4:509 / Kilmer 1977, pp. 175f.]

Robert Lowell, 1917–1977. (Poet dreams of Aeneas, Turnus, Pallas, in) "Falling Asleep over the Aeneid." Poem. In *The Mills of the Kavanaughs* (New York: Harcourt Brace, **1951**). [Bell 1983, pp. 36f.]

Apotheosis. Venus, seeing her son Aeneas well established in Latium and the house of Iulus (Ascanius) flourishing around him, asked her father, Jupiter, to make Aeneas immortal. Jupiter agreed and had Numicus, the horned river-god, wash away all mortality from the hero. Venus then touched Aeneas's lips with nectar and he took his place among the gods on Olympus.

This subject is not treated by Virgil. Representations in the visual arts depict Aeneas welcomed by the Olympian gods.

Classical Sources. Livy, *Ab urbe condita* 1. Ovid, *Metamorphoses* 14.581–609.

Anonymous French. (Apotheosis of Aeneas in) *Ovide moralisé* 14.4591–4742. Poem, allegorized translation/ elaboration of Ovid's *Metamorphoses.* *c.*1316–28. [de Boer 1915–86, vol. 5]

Jacob Jordaens, 1593–1678. "The Apotheosis of Aeneas." Painting. *c.*1617. Statens Museum for Kunst, Copenhagen. [d'Hulst 1982, fig. 43]

Elia Candido, 1548–1628. "The Apotheosis of Aeneas." Painting. Staatliche Museen, Berlin. [Pigler 1974, p. 295]

Abraham Janssens, *c.*1575–**1632.** "The Apotheosis of Aeneas." Painting. Alte Pinakothek, Munich. [Bénézit 1976, 6:38]

———. "The Apotheosis of Aeneas" (Venus crowns Aeneas). Painting. Museum, Würzburg. [Ibid.]

Charles Le Brun, 1619–1690. "The Apotheosis of Aeneas." Painting. **Early 1640s.** Montreal Museum of Fine Arts, cat. 1960 no. 1082. [Versailles 1963, no. 5—ill.]

Eustache Le Sueur, 1616–1655. "Venus Asking Jupiter for the Deification of Aeneas." Ceiling painting, part of cycle depicting the story of Aeneas, for Hôtel Lambert, Paris. **1646–47.** In place. [Louvre 1972, pp. 9f., 44ff.—ill.]

Pietro da Cortona, 1596–1669. "Venus and Cupid Conducting Aeneas to Olympus." Fresco, part of *Aeneid* cycle. **1651–54.** Palazzo Doria Pamphili, Rome. [Briganti 1962, no. 117—ill.]

Johan van Neck, 1635–1714. "The Apotheosis of Aeneas." Painting. **1683.** W. F. Fruin coll., The Hague, in 1957. [Warburg]

Luca Giordano, 1634–**1705,** attributed. "The Apotheosis of Aeneas." Painting. Museo, Vicenza, no. 208. [Pigler 1974, p. 295]

Charles de La Fosse, 1636–1716. "The Deification of Aeneas." Painting. Musée, Nantes. [Pigler 1974, p. 296]

François Boucher, 1703–1770. "The Apotheosis of Aeneas." Painting. **1747.** Lost. [Ananoff 1976, no. 307] Monochrome sketch ("Venus Presents Aeneas to the Gods of Olympus"). Private coll. [Ibid., no. 305—ill.]

Ignaz Stern, 1680–1748. "Aeneas on Olympus." Painting. Palazzo Albicini, Forlì. [Pigler 1974, p. 296] Oil sketch. Reuschel coll., Munich, in 1963. [Ibid.]

Jacob de Wit, 1695–1754. "The Apotheosis of Aeneas" (3 panels: Aeneas declared immortal, the Fates, Cassandra). Ceiling painting, for Herengracht 458, Amsterdam. N. J. van Aalst coll., Hoevelaken, Holland. [Staring 1958, pl. 86]

Giovanni Battista Tiepolo, 1696–1770, and studio. "The Apotheosis of Aeneas" ("Aeneas Conducted to the Temple of Venus"). Fresco. **1762–66.** Guard-room, Palacio

Real, Madrid. [Levey 1986, p. pp. 265ff.—ill. / Pallucchini 1968, no. 279—ill. / Morassi 1962, p. 21—ill.] 2 studies. Museum of Fine Arts, Boston; Fogg Art Museum, Harvard University, Cambridge. [Pallucchini—ill. / Levey—ill. / Morassi, pp. 6, 8 / Columbia 1967, nos. 43, 58—ill. / also Boston 1985, p. 277—ill. / Harvard 1985, no. 182—ill.]

Jean Restout, 1692–1768. "The Apotheosis of Aeneas." Painting. Private coll., France. [Pigler 1974, p. 296]

AEOLUS. The mortal son of the god Hippotes, Aeolus lived on the island of Aeolia with his intermarried sons and daughters. According to Homer, he had the power to control the winds by tying them up. In the *Odyssey,* Aeolus tried unsuccessfully to ensure a calm voyage for Odysseus by giving him the storm winds tied up in a goatskin bag, which Odysseus's men unwittingly unleashed. Virgil describes Aeolus as a minor deity who imprisoned the winds in a cave on Aeolia; at Juno's behest, he loosed them, creating the storm that drove Aeneas to the coast of Libya.

Aeolus is often seen in the visual arts as a personification of the element Air or of Winter. His daughters, the Aeolides, became the islands that bear their name. The aeolian harp, an instrument played by the wind, takes its name from Aeolus.

Classical Sources. Homer, *Odyssey* 10.1–77. Virgil, *Aeneid* 1.50–86. Ovid, *Metamorphoses* 1.268ff., 11.748ff., 14.223ff. Apollodorus, *Biblioteca* E.7.10–11.

See also AENEAS, Storm; GODS, as Elements, as Seasons; ODYSSEUS.

Geoffrey Chaucer, 1340?–1400. (Aeolus summoned as trumpeter for Fame in) "The Hous of Fame" lines 1567ff. Poem. 1378–80. Westminster: Caxton, 1483. [Riverside 1987]

John Gower, 1330?–1408. (Aeolus described in) *Confessio amantis* 5.966–80. Poem. *c.*1390. Westminster: Caxton, 1483. [Macaulay 1899–1902, vol. 2]

Piero di Cosimo, *c.*1462–1521. "Vulcan and Aeolus" ("Vulcan as Teacher of Mankind"). Painting. National Gallery of Canada, Ottawa. [Bacci 1966, pl. 16 / Warburg]

Francesco Primaticcio, 1504–1570, and assistants. "Aeolus." Ceiling fresco, in Galerie d'Ulysse, Château de Fontainebleau. 1541–47. Destroyed 1738–39. / Drawing for. Uffizi, Florence, no. 471F. [Béguin et al. 1985, pp. 135f.—ill. / also Dimier 1900, pp. 295ff.]

Elia Candido, 1548–1628. "Aeolus" ("Zephyrus"). Bronze statuette. 1573. Studiolo di Francesco I, Palazzo Vecchio, Florence. [Pope-Hennessy 1985b, 3:100, 380 / also Sinibaldi 1950, pp. 12, 18 / Lensi 1929, pp. 236f., 262 (as Giovanni Bandini)—ill.]

Maerten de Vos, 1532–1603. Aeolus, representing Winter, in a design for "The Seasons" tapestry series. Unique set woven by Sheldon workshop, Barcheston, *c.*1611. Marquess of Salisbury coll., Hatfield House, Hatfield. [Jackson-Stops 1985, no. 33—ill.]

Spanish School. "Aeolus." Ceiling painting. **Early 1600s.** Casa de Pilatos, Seville. [López Torrijos 1985, pp. 112ff., 405 no. 3, pl. 8]

Abraham Janssens, *c.*1575–**1632.** "Aeolus." Painting. Residenz, Würzburg. [Bénézit 1976, 6:38]

Peter Paul Rubens, 1577–**1640,** school. "Aeolus, or Air." Painting, part of a set representing the Elements. Prado, Madrid, no. 1716. [Prado 1985, pp. 603f. / also Alpers 1971, p. 113, fig. 9]

Simon Vouet, 1590–1649. "Jupiter and Aeolus" ("Fire"). Painting, part of "The Four Elements" cycle for Vestibule of the Queen, Fontainebleau. Lost. / Engraved by Michel Dorigny, **1644.** [Crelly 1962, no. 251]

Pietro da Cortona, 1596–**1669,** attributed. "Aeolus." Drawing. Art Institute of Chicago, inv. 1922.494. [Warburg]

Pierre Beauchamps, 1631–1705, music. "Eole." Entrée in *Ballet des arts.* First performed **1685,** Collège Louis-le-Grand, Paris. [Astier 1983, p. 161]

François Le Moyne, 1688–1737. (Aeolus in) "Allegory of Trade and Good Government." Painting, study for unexecuted decoration ceiling for Banque Royale. **1719.** Musée des Arts Décoratifs, Paris, inv. 18096. [Bordeaux 1984, no. 21—ill.]

Johann Sebastian Bach, 1685–1750. "Der zufriedengestellte Äolus: Zerreisset, zerspringet, zertrümmert die Gruft" [Aeolus Calmed: The Cave Rent, Split, Shattered]. Cantata (dramma per musica). Libretto, C. F. Picander. First performed 3 Aug **1725,** University, Leipzig. [Wolff et al. 1983, pp. 133, 190 / Grove 1980, 1:824]

Giovanni Battista Tiepolo, 1696–1770. "The Winds" (Aeolus and 2 young Winds). Ceiling fresco, part of scenes illustrating the story of Antony and Cleopatra. *c.*1740–50. Palazzo Labia, Venice. [Levey 1986, p. 144—ill.]

——. "Diana and Aeolus." Fresco, part of a cycle depicting the Sacrifice of Iphigenia. Sala d'Ifigenia, Villa Valmarana, Vicenza. [Pallucchini 1968, no. 240—ill. / Morassi 1962, pp. 64f.—ill. / Levey, pp. 231f.—ill.]

Jean-Jacques Lagrenée the Younger, 1739–1821. "Winter" ("Aeolus Loosing the Winds Which Cover the Mountains with Snow"). Painting. **1775.** Ceiling, Galerie d'Apollon, Louvre, Paris, inv. 5568. [Louvre 1979–86, 4:24—ill.]

Victor Hugo, 1802–1885. "Éole allait criant: Bacchus m'a pris mon outre" [Aeolus Went Crying: Bacchus Has Taken My Skin-sack]. Poem. 28 Oct **1852.** No. 18 in *Toute la lyre* part 1, in *Oeuvres inédites* (Paris: Hetzel, 1888). [Hugo 1985–86, vol. 7 / Py 1963, p. 85]

Charles Marie René Leconte de Lisle, 1818–1894. (Aeolus evoked in) "Les Éolides" (Aeolides islands). Poem. In *Oeuvres: Poèmes antiques* (Paris: Lemerre, **1852**). [Pich 1976–81, vol. 1]

William Allingham, 1824–1889. (Aeolus evoked in) "Aeolian Harp." 4 separate poems with same title, numbered II, VI, XI, and XXIV. In *Poems* (Boston: Tickenor & Fields, **1861**). [Ipso]

César Franck, 1822–1890. *Les Éolides.* Symphonic poem, after Leconte de Lisle (1852). First performed 13 May **1877,** Paris. [Grove 1980, 6:780, 783 / Baker 1984, p. 756]

Algernon Charles Swinburne, 1837–1909. "Aeolus." Poem.

In *Universal Review* **1888.** Retitled "A Word with the Wind" in *Poems and Ballads,* 3d series (London: Chatto & Windus, 1889). [Gosse & Wise 1925–27, vol. 3]

Julia Parker Dabney, b. 1850. "Aeolus." Poem. In *Songs of Destiny and Others* (New York: Dutton, **1898**). [Boswell 1982, p. 81]

Arthur B. Davies, 1862–**1928.** "Iris and Aeolus Bandying Showers." Painting. Artist's estate in 1931. [Cortissoz 1931, p. 27]

Rolfe Humphries, 1894–1969. "Aeolus." Poem. In *Europa and Other Poems and Sonnets* (New York: Gaige, **1928**). [Boswell 1982, p. 140 / Bush 1937, p. 590]

Emil Cimiotti, 1927–. "Aeolus I." Bronze sculpture. **1960.** Galerie Lutz & Meyer, Stuttgart. [Clapp 1970, 1:172]

Manuel Rosenthal, 1904–. "Aeolus." Composition for wind quintet and orchestra. **1970.** [Grove 1980, 16:205]

Dimitri Hadzi, 1921–. "Aeolus." Bronze sculpture. **1971–72.** Exhibited Richard Gray Gallery, Chicago, 1972. [Gallery exhibition catalogue]

Kathleen Louise Saint John, 1942–. "The Winds of Aeolus." Woodwind quintet. **1980.** [Cohen 1987, 2:609]

AESCULAPIUS. *See* ASCLEPIUS AND HYGIEIA.

AESON. *See* MEDEA.

AETHRA. *See* DEMOPHON; THESEUS, General List, Coming of Age, and Helen.

AGAMEMNON. Son of Atreus, brother of Menelaus, and husband of Clytemnestra, Agamemnon was the king of Mycenae (or Argos) and commander-in-chief of the Greek forces against Troy. He had great valor, but lacked decisiveness. His quarrel with Achilles over the Trojan woman Briseis precipitated the so-called "wrath of Achilles" and much of the action in Homer's *Iliad.*

Agamemnon returned from the Trojan War with a captive concubine, Cassandra, daughter of King Priam of Troy. In his absence his wife, Clytemnestra, had taken his cousin Aegisthus as her lover. Shortly after his arrival Agamemnon and Cassandra were murdered by Aegisthus, with the connivance or active participation of Clytemnestra. Clytemnestra's motives for her part in the crime vary according to the sources; for example, Aeschylus cites Agamemnon's sacrifice of their daughter Iphigenia at the outset of the war as well as Agamemnon's own infidelities as the causes of her wrath. The murders were later avenged by Agamemnon's son, Orestes.

The legend of Agamemnon was given new life in the nineteenth century when Heinrich Schliemann, a dedicated amateur archaeologist, excavated the shaft graves and "palace" at Mycenae, one of the major late Helladic administrative centers. Among the objects he discovered was a carefully wrought gold funerary mask, regarding which he proclaimed, "I have gazed upon the face of Agamemnon." Modern scholars are more cautious about the identity of the tomb's occupant, but the tomb and mask of "Agamemnon" have nonetheless become a subject for poets and painters.

Classical Sources. Homer, *Iliad* passim; *Odyssey* 3.193f., 303f.; 4.529ff.; 11.404ff. Aeschylus, *Agamemnon*; *Eumenides* 631ff. Euripides, *Iphigenia in Aulis*; *Hecuba.* Accius, *Aegisthus*; *Agamemnonidae*; *Clytaemnestra*; *Erigona.* Ovid, *Metamorphoses* 12.25–38. Seneca, *Agamemnon.* Pausanias, *Description of Greece,* 2.16.6, 9.40.11. Hyginus, *Fabulae* 98, 117, 122.

See also ACHILLES; CASSANDRA; CHRYSEIS; IPHIGENIA, at Aulis; ODYSSEUS, in Hades; ORESTES; PALAMEDES; PHILOCTETES; TROJAN WAR.

Giovanni Boccaccio, 1313–1375. "De Agamenone Micenarum rege," "Paupertati applaudet" [About Agamemnon, King of Mycenae; Poverty Applauded]. In *De casibus virorum illustrium* [The Fates of Illustrious Men] 1.15–16. Didactic poem in Latin. **1355–73?** [Branca 1964–83, vol. 9 / Hall 1965]

———. "De Clitemestra Micenarum regina" [Clytemnestra, Queen of Mycenae]. In *De mulieribus claris* [Concerning Famous Women]. Latin verse compendium of myth and legend. 1361–75. Ulm: Zainer, 1473. [Branca vol. 10 / Guarino 1963]

Francesco Primaticcio, 1504–1570. "Agamemnon Elected King of the Kings." Fresco, part of cycle on prologue to Trojan War, for Chambre du Roi, Château de Fontainebleau. **1533–35.** Destroyed. [Dimier 1900, pp. 256ff.]

———. "The Return of Agamemnon," "The Murder of Agamemnon and Cassandra." Frescoes, part of cycle in Galerie d'Ulysse, Château de Fontainebleau. 1555–59. Destroyed. / Drawings for "Murder" in Nationalmuseum, Stockholm; Fitzwilliam Museum, Cambridge. Original designs for "Return" lost; known from copies. [Béguin et al. 1985, pp. 214ff.—ill. / also Dimier 1900, no. 174] Copies, drawings, by Theodoor van Thulden, design for set of prints. Albertina, Vienna. [Béguin—ill.] Several further copies known. Stockholm; Louvre, Paris; British Museum, London. [Ibid.—ill.]

Hans Sachs, 1494–1576. *Clitemnestra, die möderische Königen (Klytämnestra, die blutdürstige Königen)* [Clytemnestra, the Murderous (Bloodthirsty) Queen]. Tragedy. Published **1554.** Modern edition in *Werke* (Stuttgart: 1870–1908; Hildesheim: Olms, 1964). [McGraw-Hill 1984, 4:301]

Pierre Matthieu, 1563–1621. *Clytemnestre.* Tragedy. Lyons: Rigaud, **1589.** Modern edition by Gilles Ernst (Geneva: Droz, 1984). [Stone 1974, pp. 87, 122f., 206, 213 / DLLF 1984, 2:1437]

Thomas Heywood, 1573/74–1641. (Agamemnon at Troy,

and his homecoming and death, in) *Troia Britanica: or, Great Britaines Troy*. Epic poem. London: **1609**. [Heywood 1974 / also Boas 1950, p. 59]

————. (Episodes, as above, in) *The Iron Age*. Drama in 2 parts, partially derived from *Troia Britanica*. First performed *c*.1612–13, London. Published London: Okes, 1632. [Heywood 1874, vol. 3 / DLB 62:101, 122ff. / also Boas 1950, pp. 83ff. / Clark 1931, pp. 62ff.]

Eugenio Cajés. "The Story of Agamemnon" (in the Greek camp). Painting, for Palacio del Pardo, Madrid. Before **1626**. Lost. / Drawing. Uffizi, Florence. [López Torrijos 1985, pp. 217f., 411 nos. 48–49—ill.]

Sieur Arnauld of Provence. *Agamemnon*. Tragedy in verse, imitation of Seneca. Avignon: Bramereau, **1642**. [Taylor 1893, p. 116 / DLF 1951–72, 3:97]

Pier Francesco Cavalli, 1602–1676. *L'Egisto* [Aegisthus]. Opera (favola dramatica musicale). Libretto, Giovanni Faustini. First performed **1643**, Teatro S. Cassiano, Vienna. [Grove 1980, 4:25, 32 / Glover 1978, pp. 75–76, 112 / Palisca 1968, pp. 123f. / Worsthorne 1954, pp. 15, 110–13, 137]

Benedetto Ferrari, 1597/1604–1681. *Egisto*. Opera (dramma per musica). Libretto, G. B. Faustini [not named on surviving MS]. First performed 22 Jan **1651**, Piacenza. [Grove 1980, 6:491, 492]

Claude Boyer, 1618?–1698. *Agamemnon*. Tragedy. First performed 12 Mar **1680**, Théâtre Guénégaud, Paris. [Lancaster 1929–42, pt. 4, 1:155–59, 2:941f., 952 / DLLF 1984, 1:317 / Girdlestone 1972, pp. 161ff.]

François-Joseph de Lagrange-Chancel, 1677–1758. *Cassandre*. Tragedy, after Boyer's *Agamemnon* (1680). First performed **1702**, Paris. [Girdlestone 1972, pp. 160–63, 201]

Thomas Bertin de La Doué, *c*.1680–1745, and **François Bouvard,** *c*.1683–1760. *Cassandre*. Opera (tragédie en lyrique). Libretto, Lagrange-Chancel (1702). First performed 22 June **1706**, Académie Royale de Musique, Paris. [Grove 1980, 2:638, 3:120 / Girdlestone 1972, pp. 160ff.]

Bartolomeo Cordans, *c*.1700–1757. *Attanaganamenone*. Opera buffa. Libretto, G. B. Buini. First performed Spring **1731**, S. Moisè, Venice. [Grove 1980, 4:764]

James Thomson, 1700–1748. *Agamemnon*. Tragedy, after Aeschylus. First performed 6 Apr **1737**, Theatre-Royal, Drury Lane, London. [Stratman 1966, pp. 65sf.]

Louis Léon Felicité, duc de Brancas, Comte de Lauraguais, 1733–1824. *Clitemnestre*. Tragedy. Paris: Lambert, **1761**. [Brunel 1971, p. 381]

Henry Fuseli, 1741–1825. "Agamemnon, Pursuing a Trojan, in the Tomb of Ilos." Drawing. **1768–70**. Fogg Art Museum, Harvard University, Cambridge, no. 1943.706. [Schiff 1973, no. 323—ill.]

Jean-Georges Noverre, 1727–1810, choreography. *Agamemnon (Der Tod Agamemnons)*. Ballet. Music, Joseph Starzer. First performed **1771**, Vienna. [Grove 1980, 18:82]

Juan Crisóstomo Faría Cordero, 1732–? *Agamenon e Clitemnestra*. Comedy. *c*.1772? [Barrera 1969, p. 149]

Vittorio Alfieri, 1749–1803. *Agamemnone*. Tragedy. **1776–78**. First performed 1842, Teatro Re, Milan. [McGraw-Hill 1984, 1:47ff. / Hamburger 1969, pp. 16, 21 / Brunel 1971, p. 382]

————. (Murder of Agamemnon in) *Oreste*. Tragedy. 1778. First performed 1781, Teatro di Foligno, Rome. [McGraw-Hill]

Matteo Borsa, 1752–1798. *Agamemnone e Clitemnestra*. Tragedy. Venice: Zatta, **1786**. [DELI 1966–70, 1:449]

Francesco Mario Pagano, 1748–1799. *Agamemnone*. Lyric monodrama. First performed **1787**, Naples. [DELI 1966–70, 4:214f.]

Niccolò Piccinni, 1728–1800. *Clytemnestre*. Opera (tragédie lyrique). Libretto, L. G. Pitra? Rehearsed **1787**, Paris, unperformed. [Grove 1980, 14:728]

Francesco Clerico, *c*.1755–after 1833, choreography. *Il ritorno di Agamemnone*. Tragic ballet. First performed Carnival **1789**, San Benedetto, Venice. Revived, as *Agamemnone*, 1801, La Scala, Milan. [Simon & Schuster 1979, p. 76]

John Flaxman, 1755–1826. 4 drawings illustrating the *Agamemnon* of Aeschylus, part of a cycle illustrating the *Oresteia*. **1793–94**. Various collections. [Irwin 1979, pp. 85ff.] Engraved by Tomasso Piroli, published London and Rome: 1795. [Flaxman 1872, 3: pls. 15–18]

Luigi Cherubini, 1760–1842. *Clytemnestre*. Cantata for solo voice. **1794**. [Grove 1980, 4:211]

Gerhard Anton von Halem, 1752–1819. *Agamemnon*. Tragedy. **1794**. In *Schriften* (Münster: Waldek, 1803). [Hunger 1959, p. 12]

Alessandro Pèpoli, 1757–**1796**. *Agamemnone*. Tragedy. [DELI 1966–70, 4:311]

Louis Jean Népomucène Lemercier, 1771–1840. *Agamemnon*. Verse tragedy. First performed **1797**, Théâtre de la République, Paris. [DLLF 1984, 2:1276]

Niccolò Zingarelli, 1752–1837. *Clitemnestre*. Opera. Libretto, F. Salfi. First performed 26 Dec **1800**, La Scala, Milan. [Grove 1980, 20:694]

François-Georges Fougues Desfontaines, 1733–1825. *Cassandra Agamemnon et Colombine Cassandre*. Parody of Lemercier's *Agamemnon* (1797). First performed 3 Dec **1803**, Paris. [EDS 1954–66, 4:529]

John Galt, 1779–1839. *Agamemnon, Clytemnestra*. Tragedies. In *The Tragedies of Maddalen, Agamemnon, Lady Macbeth, Antonia, and Clytemnestra* (London: Cadell & Davies, **1812**). [Stratman 1966, p. 205 / Nicoll 1959–66, 4:585]

A. Gondeville de Mont-Riché. *Egisthe et Clitemnestre*. Tragedy. Paris: **1813**. [Taylor 1893, p. 217]

Pierre-Narcisse Guérin, 1774–1833. "Clytemnestra" (with Aegisthus, hesitating before killing the sleeping Agamemnon). Painting. **1817**. Louvre, Paris, inv. 5185. [Louvre 1979–86, 3:295—ill.]

Michael Beer, 1800–1833. *Klytämnestra*. First performed **1820**, Hofbühne. [Brunel 197: 382]

Giovanni Galzerani, 1790–1853, choreography. *Agamemnone*. Ballet. First performed Carnival **1821**, Pergola, Florence. [EDS 1954–66, 5:879, 882] New version, with music by Cesare Pugni. First performed 1 Sep 1828, La Scala, Milan. [Grove 1980, 15:448]

Alexandre Soumet, 1788–1845. *Clytemnestre*. Tragedy. First performed 7 Nov **1822**, L'Odéon, Paris. [Brunel 1971, pp. 208ff. / DLLF 1984, 3:2192]

Thomas Stothard, 1755–**1834**. "Orestes and Agamemnon." Painting. Victoria and Albert Museum, London. [Bénézit 1976, 9:855]

Benjamin Robert Haydon, 1786–1846. "Cassandra Predicting the Murder of Agamemnon on His Arrival after Ten Years Absence at Mycenae." Painting. **1834**. [Olney 1952, p. 202]

Walter Savage Landor, 1775–1864. "The Shades of Agamemnon and of Iphigeneia." Poetic dialogue, incorporated into *Pericles and Aspasia* (London: Saunders & Otley, **1836**). Reprinted as a separate piece, 1847. [Wheeler 1937, vol. 2 / Boswell 1982, p. 55 / Pinsky 1968, pp. 44, 63, 76, 144–45, 151–61]

Juliusz Slowacki, 1809–1849. "Grab Agamemnona" [The Grave of Agamemnon]. Poem. *c.*1836. Warsaw: Drukarnia S. Sirorskiego, [1898]. [Miłosz 1983, p. 258]

G. Treves. *Agamennone.* Opera. Libretto, Perrane (Perone). First performed 10 Nov **1847**, La Scala, Milan. [Clément & Larousse 1969, 1:15]

George Meredith, 1828–1909. (Deaths of Agammemnon and Cassandra prophesied in) "Cassandra." Poem. **1850–51**. In *Modern Love and Poems of the English Roadside* (London: Chapman & Hall, 1862). [Bartlett 1978, vol. 1 / Boswell 1982, pp. 181f. / Bush 1937, p. 386]

Owen Meredith (Edward Robert Bulwer Lytton), 1831–1891. "Clytemnestra." Verse drama. In *Clytemnestra, The Earl's Return, The Artist, and Other Poems* (London: Chapman & Hall, **1855**). [Boswell 1982, p. 173 / Bush 1937, pp. 291, 554]

Alexandre Dumas *père*, 1802–1870. *L'Orestie* [The Oresteia]. 3-act tragedy. Paris: Librairie Théatrale, **1856**. [DLLF 1984, 1:694]

Hervé, 1825–1892. *Agamemnon.* Burlesque opera. Libretto, composer. First performed May **1856**, Folies-Nouvelles, Paris. [Clément & Larousse 1969, 1:15]

Eduard von Tempeltey, 1832–1919. *Klytämnestra.* Tragedy. Berlin: Schroeder, **1857**. [Brunel 1971, p. 382]

José-Maria de Heredia, 1842–1905. "La mort d'Agamemnon." Sonnet. In *La conférence La Bruyère* (**1861–62**). [Delaty 1984, vol. 2]

Honoré Daumier, 1808–1879. "History Reviewed and Corrected by Operetta—Chilperic and Agamemnon in the Leads." Satirical lithograph. **1868**. [Delteil 1906–30, 28: no. 3679—ill.]

Robert Reece, 1838–1891, writing as E. G. Lankester. *Agamemnon and Cassandra, or the Prophet and Loss of Troy.* Burlesque. First performed 13 Apr **1868**, Prince of Wales Theatre, Liverpool. [Nicoll 1959–66, 5:537]

Georg Siegert, 1836–1921. *Klytämnestra.* Tragedy. Munich: Ackermann, **1871**. [Brunel 1971, p. 382]

Frederic, Lord Leighton, 1830–1896. "Clytemnestra from the Battlements of Argos Watches for the Beacon Fires Which Are to Announce the Return of Agamemnon." Painting. *c.*1874. Leighton House, London, no. 372. [Ormond 1975, no. 227—ill. / also Wood 1983, p. 52—ill. / Kestner 1989, p. 1, pl. 3.10]

André Wormser, 1851–1926. *Clytemnestre.* Cantata. Grand Prix de Rome, **1875**. [Baker 1984, p. 2529]

Edward Fitzgerald, 1809–1883. *Agamemnon.* Tragedy, after Aeschylus. London: privately printed, **1876**. [Nicoll 1959–66, 5:368]

Louise-Angelique Bertin, 1805–**1877**. *Retour d'Agamemnon.* Choral composition. [Cohen 1987, 1:78]

Robert Browning, 1812–1889. *The Agamemnon of Aeschylus.* Translation. London: Smith Elder, **1877**. [Scudder 1895 / Ryals 1975, pp. 143–46 / Ward 1969, pp. 92ff., 106f., 239]

Victor Hugo, 1802–1885. "Cassandre" (and Clytemnestra). Dialogue poem, part of "Après les dieux, les rois" part

1. In *La légende des siècles,* new series (Paris: Hetzel, **1877**). [Hugo 1985–86, vol. 6]

Arthur Coquard, 1846–1910. *Cassandre.* Opera (drame lyrique). Libretto, H. de Bornier, after Seneca's *Agamemnon.* First performed 13 May **1881**, Société Chorale d'Amateurs, Paris. [Grove 1980, 4:760]

Gustav Kastropp, 1844–1925. *Agamemnon.* Tragedy. Hannover: Wasserkampf, **1890**. [DLL 1968–90, 8:950 / Frenzel 1962, p. 14]

Arrigo Boito, 1842–1918. *Orestiade.* Opera (dramma per musica). Begun **1892**, unfinished. [Kunitz & Colby 1967, p. 112]

Richard Garnett, 1835–1906. "Aegisthus." Poem. In *Poems* (London: Mathews & Lane, **1893**). [Boswell 1982, p. 109]

Sergey Ivanovich Taneyev, 1856–1915. *Oresteya.* 3–act opera (called trilogy). Libretto, Venkstern, after Aeschylus. **1887–94**. First performed 29 Oct 1895, Maryinsky Theatre, St. Petersburg. [Grove 1980, 18:559f. / Montagu-Nathan 1914, p. 276 / Zinar 1971, pp. 86, 93]

Paul Claudel, 1868–1955. *Agamemnon.* Tragedy, part of *L'Orestie* trilogy, after Aeschylus. **1892–94**. Paris: Heugel, 1947; reprinted in *Théâtre* (Paris: Pléiade, 1967–71). [Ipso / Popkin 1977, 1:285]

Rudolf Prochazka, 1864–1936. *Klytämnestra.* Tragedy. Prague: **1896**. [Hunger 1959, p. 12]

Lewis Morris, 1833–1907. "Clytemnestra in Paris" (modern story of a woman who has killed her husband). Narrative poem. In *Works* (London: Kegan Paul, Trench, & Trübner, **1898**). [Boswell 1982, p. 189]

John Collier, 1850–1939. "Clytemnestra." Painting. *c.*1890s. City Museum and Art Gallery, Worcester. [Dijkstra 1986, p. 375 / Jacobs & Stirton 1984b, p. 167] Another version of the subject in Guildhall Art Gallery, London. [Wood 1983, p. 212—ill.]

Constantine Cavafy, 1868–1933. (Agamemnon's murder evoked in) "Otan o phulas eide to phos" [When the Watchman Saw the Light]. Poem. Jan **1900**. In *Poiemata* (Athens: Ikaros, 1963). / Translated by Edmund Keeley and Philip Sherrard in *Collected Poems* (Princeton: Princeton University Press, 1975; bilingual edition). [Keeley 1976, pp. 35f. / Ipso]

C. Hubert Parry, 1848–1918. Incidental music for Aeschylus's *Agamemnon.* First performed 16 Nov **1900**, Cambridge University. [Grove 1980, 14:244]

Arnold Graves, 1844–1914. *Clytaemnestra.* Tragedy. London: Longmans, Green, **1903**. [Hunger 1959, p. 12]

Eberhard König, 1871–1949. *Klytaimnestra.* Tragedy. Berlin: Costenoble, **1903**. [DLL 1968–90, 9:89 / Brunel 1971, p. 382]

Valéry Bryúsov, 1873–1924. "Klitemnestra." Poem. **1911**. In *Zerkalo tenej* [Mirror of Shadows] (Moscow: Skorpion, 1912). [Bryúsov 1982]

Darius Milhaud, 1892–1974. *Agamemnon.* Opera, opus 14, part of *Orestia* trilogy. Libretto, Claudel (1892–94). **1913–14**. First performed 16 Apr 1927, Paris. [Baker 1984, p. 1549 / Burbank 1984, pp. 126f., 167 / Grove 1980, 12:305, 308]

August Bungert, 1845–1915. *Klytämnestra,* part 2 of *Die Ilias.* Opera, projected, unfinished. [Grove 1980, 3:455]

Hermann Hagedorn, 1882–1964. (Clytemnestra in) "The Great Maze." Poem. In *The Great Maze and the Heart of Youth* (New York: Macmillan, **1916**). [Bush 1937, p. 587]

T. S. Eliot, 1888–1965. (Agamemnon's fate contrasted with Sweeney's in) "Sweeney among the Nightingales." Poem. In *Ara vos prec* (London: Ovid Press, **1920**), *Poems* (New York: Knopf, 1920). [Eliot 1964 / Feder 1971, pp. 126–28 / Williamson 1966, pp. 97–99 / Matthiessen 1958, pp. 53, 129]

Fritz Brügel, 1897–1955. *Agamemnon*. Tragedy, free adaptation of Aeschylus. **1923**. [DLL 1968–90, 2:144]

Rudolf von Laban, 1879–1958, choreography, after Noverre. *Agamemnons Tod*. Ballet. First performed **1924**, Hamburg. [Oxford 1982, p. 4]

George Frederick Linstead, 1908–. *Agamemnon*. Opera. **1924**. [Baker 1984, p. 1364]

Ninette de Valois, b. 1898, choreography. *Oresteiad*. Trilogy of ballets, after Aeschylus. First performed Oct **1926**, Festival Theatre, Cambridge. [Clarke 1955, pp. 44f.]

Hilding Rosenberg, b. 1892. Incidental music for Aeschylus's *Agamemnon*. First performed **1928**, Stockholm. [Grove 1980, 16:200]

Louise Bogan, 1897–1970. "Cassandra." Poem. In *Dark Summer* (New York: Scribner, **1929**). [Frank 1985, p. 113]

Ildebrando Pizzetti, 1880–1968. Incidental music for Aeschylus's *Agamemnon*. First performed 26 Apr **1930**, Teatro Greco, Syracuse. [Grove 1980, 14:797]

Eugene O'Neill, 1888–1953. *Homecoming*. Tragedy, part 1 of *Mourning Becomes Electra*, modern adaptation of Aeschylus's *Oresteia* and Euripides' *Orestes*. First performed 26 Oct **1931**, Guild Theatre, New York. [Oxford 1984, p. 491 / Bogard 1972, pp. 341–48, 468 / Hamburger 1969, pp. 58, 62 / Long 1968, pp. 117–32 / Stamm 1949, pp. 244–46]

Mario Varvoglis, 1885–1967. Incidental music for Aeschylus's *Agamemnon*. **1932**. [Baker 1984, p. 2374]

Sacheverell Sitwell, 1897–1988. "Agamemnon's Tomb." Poem. In *Canons of Giant Art: Twenty Torsos in Heroic Landscapes* (London: Faber & Faber, **1933**). [Vinson 1985, p. 790 / Bush 1937, p. 576]

Otto Stoessl, 1875–1936. "Aegisth." Poem. In *Arcadia*, vol. 1 of *Gesammelte Werke* (Vienna: Saturn, **1933**). [DULC 1959–63, 4:672]

George Seferis, 1900–1971. "Memneso loutron hois enosphistheis" [Remember the Baths Where You Were Slain] (Orestes speaks to Agamemnon's ghost). Poem. In *Mythistorema* (Athens: Ikaros, **1935**). / Translated by Rex Warner in *Poems* (Boston & Toronto: Little, Brown, 1960). [Ipso]

Marguerite Yourcenar, 1903–1987. "Clytemnestre, ou Le crime" [Clytemnestra, or The Crime], part of *Feux*. Prose poem. Paris: Grasset, **1935**. / Translated by Dori Katz in *Fires* (New York: Farrar, Straus & Giroux, 1981). / Set to music by Donald Harris, performed Nov 1983, National Public Radio, U.S.A. [Horn 1985, pp. 60f. / DLLF 1984, 3:2519f.]

Ilse Langner, 1899–. *Der Mord in Mykene* [The Murder in Mycenae]. Tragedy. Berlin: **1936**. Reissued as *Klytämnestra* (Hamburg: Mölich, 1947). [DLL 1968–90, 9:939]

Louis MacNeice, 1907–1963. *The Agamemnon of Aeschylus*. Translation. Published London: Faber & Faber, **1936**. First performed 4 Nov 1937, Westminster Theatre, London. [DLB 1983, 20:233]

Alexandros Mátsas, 1911–1969. *Klytaimnestra*. Verse tragedy. **1936**. Athens: 1945. First performed 1955, National Theatre, Athens. [Friar 1973, p. 720 / Trypanis 1981, p. 699]

Victor Eftimiu, b. 1888. *Atrizii* [Descendants of Atreus]. Tragedy. Bucharest: **1939**. [McGraw-Hill 1984, 2:77]

Isolde Kurz, 1853–1944. *Das Haus des Atreus*. Collection of tales. Tübingen: Wunderlich, **1939**. [DLB 1988, 66:281]

Gerhart Hauptmann, 1862–1946. *Agamemnons Tod*. Tragedy, part 2 of *Die Atriden* tetralogy. **1942**. First performed 28 July 1946, Berlin Radio; complete tetralogy first performed 10 Sep 1947, Max Reinhardts Deutsches Theater, Berlin. Published Berlin: Suhrkamp, 1949. [McGraw-Hill 1984, 2:462 / Hamburger 1969, p. 21 / Seidlin 1961, pp. 238, 241 / Voight 1965, pp. 158–62]

Mark Rothko, 1903–1970. "The Omen of the Eagle." Painting, evocation of the *Oresteia*. **1942**. Mark Rothko Foundation, New York. [Ashton 1983, p. 45, fig. 8 / Waldman 1978, p. 40, no. 26—ill.]

Willi Baumeister, 1889–1955. "Agamemnon in Mycenae." Painting. **1943**. [Hannover 1950, no. 9]

———. "Shield of Agamemnon." Abstract painting. 1948. Unlocated. [Grohmann 1965, no. 736—ill.]

Lawrence Durrell, 1912–1990. (Agamemnon's tomb evoked in) "To Argos." Poem. In *A Private Country* (London: Faber & Faber, **1943**). [Boswell 1982, pp. 98]

Rudolf Bayr, 1919–. *Agamemnon*. Tragedy. First performed **1948**, Vienna. [DLL 1968–90, 1:330]

Herwig Hensen, 1917–. *Agamemnoon*. Tragedy. Brussels: Manteau, **1948**. [DULC 1959–63, 2:706]

Rabbe Enckell, 1903–1974. *Agamemnon*. Verse drama. Helsingfors: Söderström, **1949**. [Algulin 1989, p. 222]

Norman Demuth, 1898–1968. *The Oresteia*. Musical dramatic work. **1950**. Libretto, D. Clarke, after Aeschylus. [Grove 1980, 5:363]

William Alfred, 1922–. *Agamemnon*. Blank verse adaptation of Aeschylus. First performed **1953**, Cambridge, Mass. [Vinson 1982, p. 30]

Richmond Lattimore, 1906–1984. *Agamemnon*. Translation of Aeschylus. Published as part of the *Oresteia* (Chicago: Chicago University Press, **1953**). [Ipso]

Paul Angerer, 1927–. *Agamemnon musz sterben* [Agamemnon Must Die]. Cantata. Libretto, Bayr (1948). First performed **1955**, Vienna. [Kunisch 1965, p. 76]

H. D. (Hilda Doolittle), 1886–1961. (Clytemnestra in) *Helen in Egypt*. Epic. **1952–56**. New York: New Directions, 1961. [Ipso / Friedman 1981, pp. 261–65, 288f.]

Richard Selig, 1929–1957. (Agamemnon's death evoked in) "Ruins: Mycenae." Poem. In *Poems* (Dublin: Dolmen Press, 1962). [Ipso]

Havergal Brian, 1876–1972. *Agamemnon*. Opera. Libretto, J. S. Blackie's translation of Aeschylus, with additions by the composer. **1957**. First performed 28 Jan 1971, St. John's, London. [Grove 1980, 3:275]

Martha Graham, 1894–1991, choreography. *Clytemnestra*. Modern dance. Music, Halim El-Dabh. First performed 1 Apr **1958**, Adelphi Theatre, New York; décor, Isamu Noguchi; costumes, Martha Graham and Helen McGehee; lighting, Jean Rosenthal. [Stodelle 1984, pp. 183–94 / Noguchi 1987, p. 128—ill.]

Tatjana Gsovsky, 1901–, choreography. (Clytemnestra in) *Black Sun*. Ballet. Music, H. F. Harting. First performed **1959**, Municipal Opera, Berlin. [Oxford 1982, p. 98]

Yannis Ritsos, 1909–1990. "To nekro spi" [The Dead House] (Electra in old age, or as modern survivor, recalls

Agamemnon's return and murder). Dramatic monologue. **1959.** Athens: Kedros, 1962. / Translated by Nikos Stangos in *Yannis Ritsos: Selected Poems* (Harmondsworth: Penguin, 1974). [Ipso / Myrsiades 1978, pp. 455–57 / CLC 1985; 31:325f.]

————. (Murder of Agamemnon in) "Hē pragmatike aitia" [The Real Reason]. Poem. 7 June 1969. In *Epanalepseis* (Athens: Kedros, 1972). / Translated by Edmund Keeley in *Yannis Ritsos, Exile and Return: Selected Poems 1967–1974* (New York: Ecco, 1985). [Ipso / Myrsiades, p. 452]

————. "Agamemnon." Dramatic monologue. Athens: Kedros, 1972. [Myrsiades, p. 451]

Josep Soler, 1935–. *Agamemnon.* Opera. **1960.** [Baker 1984, p. 2160 / also Grove 1980, 17:451 (as 1968)]

Robert Lowell, 1917–1977. *Agamemnon.* Tragedy, adaptation after other English translations of Aeschylus, particularly Richmond Lattimore's. **Early 1960s,** unfinished. In *The Oresteia of Aeschylus* (New York: Farrar, Straus & Giroux, 1978). [Ipso]

————. "Agamemnon," "The House of Argos," parts 2 and 3 of "Five Dreams." Poem. In *Notebook: 1967–68* (New York: Farrar, Straus & Giroux, 1969). [Ipso]

————. "Clytemnestra 1," "Clytemnestra 2," "Clytemnestra 3." Poems. In *History* (London: Faber & Faber; New York: Farrar, Straus & Giroux, 1973). [Ipso]

Nicos Mamangakis, 1929–. "Monologue of Cassandra." Vocal composition. Text, Aeschylus. **1963.** [Grove 1980, 11:592]

Grant Strate, 1927–, choreography. *The House of Atreus.* Ballet. Music, Alberto Ginastera's String Quartet no. 2. First performed 5 Apr **1963,** Julliard Dance Ensemble, New York. [Chujoy & Manchester 1967, p. 866] Revised, with music by Harry Somers, performed 13 Jan 1964, National Ballet of Canada, Toronto. [Oxford 1982, p. 394 / Baker 1984, p. 2163 / Grove 1980, 17:474]

Monic Cecconi-Botella, 1936–. *Les Visions prophétiques de Cassandre.* Cantata. Libretto, Aeschylus. **1965.** [Cohen 1987, 1:141]

Jani Christou, 1926–1970. Incidental music for Aeschylus's *Agamemnon.* First performed 27 June **1965,** Epidaurus. [Grove 1980, 4:376]

André Masson, 1896–1987. Ceiling painting, depicting the murder of Agamemnon. **1965.** L'Odéon, Paris. [Clébert 1971, pp. 87f.]

Peter Russell, 1921–. *Agamemnon in Hades.* Poem. Aylesford, Kent: Saint Albert's Press, **1965.** [Vinson 1985, p. 733]

Dominick Argento, 1927–. Incidental music for Aeschylus's *Oresteia.* First performed **1967,** Guthrie Theatre, Minneapolis. [Grove 1986, 1:64]

Eric Bentley, 1916–. "A Time to Die." Short play, based on the *Oresteia.* First performed **1967,** New York. Published New York: Grove, 1970. [Vinson 1982, p. 86]

Thomas Merton, 1915–1968. (Clytemnestra in) "The Greek Women." Poem. In *Collected Poems* (New York: New Directions, 1977). [Labrie 1979, pp. 117f.]

Theodore Antoniou, 1935–. *Clytaemnestra.* "Sound-action" for actress, dancers, instruments, and tape. Libretto, T. Roussos. First performed 4 June **1968,** Kassel. [Baker 1984, p. 64 / Grove 1980, 1:494]

Iain Hamilton, 1920–1986. *Agamemnon.* Opera. Libretto, composer, after Aeschylus. **1967–69.** [Grove 1980, 8:72]

Ralph Gustafson, 1909–. (Agamemnon evoked in) "Agamemnon's Palace at Mykenai," "At the Odeum of Herodes Atticus: Athens," "Agamemnon's Mask: Archeological Museum, Athens." Poems. In *Ixion's Wheel* (Toronto & Montreal: McClelland & Stewart, **1969**). [Ipso]

Nikita Dolgushin, 1938–, choreography. *Clytemnestra.* Ballet. Music, Gluck. First performed **1972,** Maly Theater, Leningrad. [Oxford 1982, p. 127]

Zbigniew Herbert, 1924–. (Clytemnestra, Agamemnon, and Aegisthus in modern setting in) "The Missing Knot" [English title of a work written in Polish]. Poem. In *Poezje wybrane* (Warsaw: Spoldzielnia Wydawnicza, **1973**). / Translated by John and Bogdana Carpenter in *Selected Poems* (London & New York: Oxford University Press, 1977). [Ipso]

Ivana Loudova, 1941–. *Agamemnon Suite.* Instrumental composition. **1973.** [Cohen 1987, 1:427]

Elizabeth Swados, 1951–. Incidental music for *Agamemnon.* **1976.** [Cohen 1987, 2:679 / Grove 1986, 4:336]

Colin Way Reid, 1952–1983. "Remains" (Agamemnon's burial mask). Poem. **1978.** Unpublished, MS in author's estate, South Hadley, Mass. [Ipso]

————. (Agamemnon's mask in) "Looking East." Poem. In *Open Secret* (Gerrards Cross, Buckinghamshire: Colin Smythe, 1986). [Ipso]

Tony Harrison, 1937–. *The Oresteia.* Adaptation of Aeschylus. First performed 28 Nov **1981,** National Theatre, London. Music, Harrison Birtwistle. Published London: Collings, 1981. [Vinson 1985, p. 354 / DLB 1985, 40 pt. 1: 158, 163, 165]

AGAVE. *See* PENTHEUS.

AGES OF THE WORLD. In his *Works and Days,* the early Greek poet Hesiod enumerates five ages of man: the Age of Gold, of Silver, of Bronze, of Heroes, and of Iron. The Roman writer Ovid speaks of only four ages, discounting the Age of Heroes.

The Golden Age was the period when Cronus (Saturn) ruled the sky and men were as gods, without toil or troubles. During the Silver Age, the immortal gods of Olympus were the rulers of the heavens; in this period men became impious and arrogant and were destroyed by Zeus (Jupiter). Zeus then created the Bronze Age, in which men became violent and warlike, destroyed themselves, and disappeared into Hades. After that came the Heroic Age, according to Hesiod, when Zeus created a race of men who were more godlike and just; this was the age of the Trojan and Theban wars. The poet describes these men as demigods, the forerunners of the human race. Finally, there was the Iron Age, the era in which Hesiod places himself and his fellows. Characterizing it as an age when men toil ceaselessly,

dishonor their parents, and fight among themselves, the poet predicts that Zeus will destroy this race as well.

These subjects are favorite postclassical themes, especially in the fine arts of the fifteenth and sixteenth centuries. Illustrations of the Golden Age have been by far the most popular, often equated with an Eden-like state of nature.

Classical Sources. Hesiod, *Works and Days* 106–201. Virgil, *Eclogue* 4; *Georgics* 2.532–40. Ovid, *Metamorphoses* 1.89–150. Statius, *Silvae.*

Further Reference. Harry Levin, *The Myth of the Golden Age in the Renaissance* (Bloomington: Indiana University Press, 1969). E. H. Gombrich, "Renaissance and the Golden Age," in *Norm and Form: Studies in the Art of the Renaissance* (London, 1966). Roy Walker, *The Golden Feast: A Perennial Theme in Poetry* (New York: Macmillan, 1952). H. C. Baldry, "Who Invented the Golden Age?" *Classical Quarterly* 46 (1952): 83–92.

See also ARCADIA; CRONUS; DEUCALION AND PYRRHA.

Anicius Manlius Severinus Boethius, *c.*480–524. "Felix nimium prior aetas" [Happy was the first age]. Passage in *De consolatione philosophiae* book 2 metrum 5. Dialogue. **524.** [Stewart 1968] Translated into Anglo-Saxon by Alfred the Great (*c.*900), and into Middle English by Geoffrey Chaucer as *Boece* (1381–85). *See Chaucer, below.* [Ibid.]

Jean de Meun, 1250?–1305? (Golden Age described in) *Le roman de la rose* lines 8355–8454. Verse romance, completion of unfinished work begun by Guillaume de Lorris (*c.*1230–35). *c.*1275. Lyon: Ortuin & Schenck, *c.*1481. [Dahlberg 1971 / Poirion 1974]

Dante Alighieri, 1265–1321. (Golden Age symbolized by "Old Man of Crete" in) *Inferno* 14.94–120; (Golden Age evoked in) *Purgatorio* 22.148f., 28.139–42. *c.*1307–*c.*1314? In *The Divine Comedy.* Poem. Foligno: Neumeister & Angelini, 1472. [Singleton 1970–75, vol. 1 / Giamatti 1966, p. 33 n. / 105f. / Schless 1984, pp. 230ff.]

Anonymous French. (Golden Age described in) *Ovide moralisé* 1.454–512. Poem, allegorized translation/elaboration of Ovid's *Metamorphoses.* *c.*1316–28. [de Boer 1915–86, vol. 1]

Ch. (French poet, hypothetical, fl. *c.*1357–67). "Balade." MS at University of Pennsylvania, Ch. VI, MS 242, MS French 15. / Translated as "A New Golden Age" in *Chaucer and the Poems of "Ch"* (Cambridge: Brewer; Totowa, N.J.: Rowman & Littlefield, 1982). [Ipso]

Giovanni Boccaccio, 1313–1375. (Age of Gold described in) "De Cerere dea frugum et Syculorum regina" [Ceres, Goddess of Fertility and Queen of Sicily]. In *De mulieribus claris* [Concerning Famous Women]. Latin verse compendium of myth and legend. **1361–75.** Ulm: Zainer, 1473. [Branca 1964–83, vol. 10 / Guarino 1963 / Bergin 1981, pp. 253f.]

Geoffrey Chaucer, 1340?–1400. "Blisful was the first age of men." Passage in *Boece* book 4 metrum 7. Prose translation of Boethius's *De consolatione philosophiae* (524). **1381–85.** Westminster: Caxton, 1478. [Riverside 1987]

———. "The Former Age" (the Golden Age). Poem, derived from Boethius, Ovid, and Jean de Meun's translation of Boethius. 1381–85? [Ibid. / Levin 1969, pp. 23, 203]

Angelo Poliziano, 1454–1494. (Golden Age evoked in) *Sylvae.* Cycle of Latin poems, after Statius. / Translated as *Selve d'amore* [Forest of Love] (Florence: **1483**). [Levin 1969, p. 42]

Lorenzo de' Medici, 1449–1492. (Revery on the Golden Age in) *Selve d'amore* [Forest of Love] part 2. Poem, after *Sylvae* of Statius and of Poliziano. Florence: **1486;** corrected edition, Pistoia: Fortunati, 1674. [Levin 1969, pp. 42, 206 / DDLI 1977, 2:641]

Clément Marot, 1496–1544. (Golden Age evoked in) "De l'amour du siècle antique" [Love in the Olden Time]. Poem (rondeau). *c.*1530. Collected in *Oeuvres* (Lyon: Dolet, 1538). [Levin 1969, p. 70]

———. (Ages of the world described in) *La Metamorphose d'Ovide* books 1 and 2. Translation. 1533. *Oeuvres* (1538). [DLLF 1984, 2:1425]

Lucas Cranach, 1472–1553. "The Age of Silver." Painting. Several versions, *c.*1527–35. National Gallery, London, no. 3922 (questionably called "The Close of the Silver Age"); Schlossmuseum, Weimar, no. G398; Louvre, Paris, no. R.F. 1184 (alternately called "The Effects of Jealousy"); private colls., Berlin (1932) & Paris (1931). [Friedlaender & Rosenberg, nos. 263–65—ill. / also London 1986, p. 135—ill. / Louvre 1979–86, 2:24—ill.]

———. "The Golden Age." Painting. *c.*1530. 2 versions. Alte Pinakothek, Munich, no. 13175; Nasjonalgalleriet, Oslo. [Friedlaender & Rosenberg, nos. 261–62 / Munich 1983, p. 153—ill.]

Jean-Antoine de Baïf, 1532–1589. "Que le siècle revinst de celle gent dorée. . . ." [That the Age of Gold may return]. Sonnet. 1555. Paris: 1574. In modern edition, *Oeuvres* (Geneva: Slatkine, 1972). [Armstrong 1968, p. 98]

Cristofano Gherardi, 1508–1556, under the direction of **Giorgio Vasari,** 1511–1574. "The First Fruits of the Earth Being Given to Saturn" (allegory of Earth). Fresco. **1555–56.** Sala degli Elementi, Palazzo Vecchio, Florence. [Sinibaldi 1950, pp. 13, 22 / Lensi 1929, pp. 154ff., 159—ill.]

Bernard Salomon, 1506/10–*c.*1561, attributed. Woodcuts depicting Ages of Gold, Silver, Iron, part of cycle illustrating Ovid. In *Les Metamorphoses d'Ovide figurée* (Lyons: Tivornes, **1557**). [Levin 1969, p. 195]

Arthur Golding, 1536?–1605. "The Four Ages." Translation from Ovid. In *Ovids Metamorphosis* 1.103–70 (London: **1565**, 1567). [Rouse 1961 / Levin 1969, p. 36, 205]

Giorgio Vasari, 1511–1574, design. "The Golden Age." Painting, executed by Francesco Morandini (called Il Poppi). **1567.** National Gallery of Scotland, Edinburgh, inv. 2268. [Arezzo 1981, no. 5.50c] Drawing by Vasari (previously attributed to Bronzino, Allori), in Louvre, Paris, inv. 2170. [Ibid., no. 5.50b / Hofmann 1987, no. 5.21—ill. / Barocchi 1964, pl. 92]

———. "The Ages of Man." Fresco cycle. Palazzo Vecchio, Florence. [Levin 1969, p. 196]

Jacopo Zucchi, *c.*1541–1589/90 (previously attributed to Federico Zuccari, 1540/43–1609). "The Golden Age," "The Silver Age," "The Iron Age." Paintings. *c.*1570. Uffizi, Florence, inv. 1548, 1506, 1509. [Uffizi 1979, nos. P1915–17—ill. / de Bosque 1985, p. 40]

Torquato Tasso, 1544–1595. (Golden Age evoked in) "O

bella età de l'oro." Chorus, in *Aminta* 1.2. Pastoral play (favola boschereccia). First performed **1573**, Ferrara. Published Venice: Aldo, 1583. / Translated by Frederic Whitmore as *Amyntas: A Sylvan Fable* (Springfield, Mass.: 1900). [Poggioli 1975, pp. 43f. (chorus reproduced) / Giamatti 1966, p. 33 *n.*]

————. (False Golden Age reported from the Fortunate Isles in) *Gerusalemme liberata* [Jerusalem Delivered]. Epic. Authorized version published 1581. / Translated by R. Carew (London: 1594) and by Edward Fairfax (London: 1600). [Walker 1952, pp. 94–96]

Agostino Carracci, 1557–1602, attributed (also attributed to Paolo Fiammingo, 1540–1596). "(Love in) The Golden Age." Painting. **Late 1580s.** Kunsthistorisches Museum, Vienna, inv. 2361. [Vienna 1973, p. 39—ill. / Ostrow 1966, no. III/7 (attribution rejected)]

Hendrik Goltzius, 1558–1617, composition. "The Age of Gold," "The Age of Silver," "The Age of Bronze," "The Age of Iron." Engravings, part of set illustrating Ovid's *Metamorphoses* (1st series, nos. 1–4), executed by assistant(s). *c.*1589. (Unique impressions in British Museum, London.) [Bartsch 1980–82, nos. 0302.33–36—ill.]

————. "The Golden Age." Painting. 1598. Musée des Beaux-Arts, Arras. [de Bosque 1985, p. 87]

Edmund Spenser, 1552?–1599. (Golden Age evoked in) *The Faerie Queene* 2.7.16–17; 4.8.30–31; 5.Proem.9. Romance epic. London: Ponsonbie, **1590**, 1596. [Hamilton 1977 / Freeman 1970, p. 82 / MacCaffrey 1976, p. 346]

Maerten de Vos, 1532–1603. "Four Ages." Drawings. *c.*1594. Musée Plantin Moretus, Antwerp. [Pigler 1974, p. 270]

Joachim Wtewael, 1566–1638. "The Golden Age." Drawing (for lost painting?). **1595.** Kupferstichkabinett, Dresden. / Copy, painting, in Galerie Füssl & Jakob, Munich, in 1981. [Lowenthal 1986, no. C-38]

Joseph Hall, 1574–1656. "The Olden Days." Verse satire. In *Virgidemiarum*, vol. 1 (London: for Dexter, **1597**). [Walker 1952, pp. 113f.]

Samuel Daniel, 1562–1619. ("O Happy Golden Age," chorus in) "A Pastorall." Poem, translation from Tasso's *Aminta* (1573). In *Works* (London: Waterson, **1601**). [Smith 1952, p. 15]

Johann Rottenhammer, 1564–1625. "The Golden Age." Drawing. **1604.** Kupferstichkabinett, Staatliche Museen, Berlin. [Pigler 1974, p. 99]

————. "The Golden Age." Painting. Kunsthalle, Hamburg, inv. 151. [Ibid.]

Miguel de Cervantes Saavedra, 1547–1616. (Don Quixote contrasts the Golden Age of the past with the Iron Age of the present in) *Don Quixote* 1.11. Novel. Madrid: **1605.** [Poggioli 1975, pp. 202–04 / Giamatti 1966, p. 33 *n.*]

Frans Francken II, 1581–1642. "The Golden Age." Painting. **1608.** Estate of Matthew Prior (1664–1721), untraced. [*Art Bulletin* 27 (1945): 199, no. 32]

Thomas Heywood, 1573/74–1641. (Golden Age in) *Troia Britanica: or, Great Britaines Troy* canto 1. Epic poem. London: **1609**. [Heywood 1974]

————. *The Golden Age, The Silver Age, The Brazen Age, The Iron Age* (in 2 parts). Dramas, partially derived from *Troia Britanica*. First performed *c.*1610–13, London. Published London: Okes, 1611, 1613, 1613, 1632. [Heywood 1874,

vol. 3 / DLB 1987, 62:101, 122ff. / Boas 1950, pp. 83ff. / Clark 1931, pp. 62ff.]

William Shakespeare, 1564–1616. (Gonzalo envisions a golden age in) *The Tempest* 2.1.147–68. Drama (romance). **1611.** First performed 1 Nov 1611, Whitehall, London. Published London: Jaggard, 1623 (First Folio). [Riverside 1974]

Cornelis Cornelisz van Haarlem, 1562–1638. "The Golden Age." Painting. **1614.** Szépmüvészeti Múzeum, Budapest, no. 2062 (as "Bacchanale"). [Lowenthal 1986, fig. 36 / Budapest 1968, p. 152—ill.]

————. "The Golden Age." Painting. 1627. Formerly Esterházy collection, Nordkirchen, Westfalen. [Pigler 1974, p. 98]

————. "Corruption of Men before the Flood." Painting. Musée des Augustus, Toulouse. [Jacobs & Stirton 1984a, p. 208]

————, follower. "The Golden Age." Painting, after composition by Cornelis (or Joachim Wtewael?). 17th century. Ringling Museum, Sarasota, Fla., no. SN209. [Sarasota 1980, no. 82—ill.]

Walter Ralegh, 1552?–1618. (Golden Age evoked in) *The Historie of the World* chapter 9.3. London: for Burre, **1614.** [Hammond 1984]

Abraham van der Houve, 1575/76–1621. "The Golden Age." Painting. **1615.** Herzog Anton Ulrich-Museum, Braunschweig, no. 166. [Braunschweig 1969, p. 77—ill.]

Ben Jonson, 1572–1637. (Golden Age and Iron Age personified in) "The Golden Age Restored." Masque. Music, A. Ferrabosco. Performed Jan **1615**, Whitehall, London. Published London: 1616. [Herford & Simpson 1932–50, vol. 7 / Hunger 1959, p. 373]

————. (Golden Age evoked in) "To the Same [Benjamin Rudyerd]." Poem. By 1612. No. 122 of *Epigrammes*, in *Works* (London: 1616). [Ibid.]

William Browne, *c.*1590–*c.*1645. (The Golden Age evoked in) *Britannia's Pastorals* book 2. Poem. London: Norton, **1616**. [Bush 1963, pp. 178]

William Drummond of Hawthornden, 1585–1649. (James I described as destined to bring in the new Golden Age in) "Forth Feasting: A Panegyricke to the King's Most Excellent Majestie." In *Poetical Works* (Edinburgh: Hart, **1617**). [Levin 1969, p. 112]

Anonymous English. "The Silver Age, or the World Turned Backward." Ballad. Stationers' Register, 16 Nov **1621**. In modern edition by Hyder E. Rollins, *The Pepys Ballads* (Cambridge, Mass.: Harvard University Press, 1929–31, vol. 1). [Clark 1931, p. 67]

Jan Brueghel the Elder, 1568–**1625**, attributed. "The Golden Age." Painting. Musée des Beaux-Arts, Troyes. [de Bosque 1985, p. 123—ill.]

Palma Giovane, *c.*1548–**1628**. "The Iron Age." Painting (part of a set with Sante Peranda's, below). Palazzo Ducale, Mantua. [Paccagnini 1974, p. 54]

John Milton, 1608–1674. (Earth awaits return of the Golden Age, in) "Elegia quinta: In adventus veris" [Elegy Five: On the Coming of Spring]. Poem. **1629.** In *Poems* (London: Moseley, 1645). [Carey & Fowler 1968 / Woodhouse 1972, pp. 29f.]

————. (Golden Age evoked and transformed in) "On the Morning of Christ's Nativity." Ode. 25 Dec 1629. In

Poems (London: Moseley, 1645). [Carey & Fowler / Poggioli 1975, pp. 124–34]

———. (Golden Age recreated in Paradise in) *Paradise Lost* book 4. Epic. London: Parker, Boulter & Walker, 1667. [Carey & Fowler / Levin 1969, pp. 136–38]

Michael Drayton, 1563–1631. (Threnody for Golden Age of the Virgin Queen in) *The Muses Elizium.* Pastoral poem. London: Waterson, 1630. [Hebel 1931–32, vol. 3 / Barton 1984, pp. 35of.]

Lope de Vega, 1562–1635. "El siglo de oro" [The Golden Age]. Poem. In *La Vega del Parnaso* (Madrid: Imprenta del Reyno, 1637). [Sainz de Robles 1952–55, vol. 2]

Sante Peranda, 1566–1638. "The Stone Age," "The Bronze Age," "The Gold Age." Paintings (part of a set with Palma Giovane's, above). Palazzo Ducale, Mantua. [Paccagnini 1974, p. 54]

Pietro da Cortona, 1596–1669. "The Age of Gold," "The Age of Silver," "The Age of Bronze," "The Age of Iron." Frescoes. 1637, 1640–41. Sala della Stuffa, Palazzo Pitti, Florence. [Campbell 1977, pp. 26ff.—ill. / Briganti 1962, no. 69–70, 77–78.—ill. / Pitti 1966, pp. 252ff.-ill.] Copy after "The Age of Bronze," in National Museum of Wales, Cardiff, cat. 1955 no. 292. [Wright 1976, p. 43]

Andrew Marvell, 1621–1678. (Golden Age evoked in) "The Garden." Poem. *c.*1652. In *Miscellaneous Poems* (London: Boulter, 1681). [Margoliouth 1971 / Poggioli 1975, pp. 174–81]

Charles Le Brun, 1619–1690. "The Four Ages of the World." Drawing, design for (unexecuted) decoration of Chambre du Conseil, Paris. 1653. Louvre, Paris, inv. 27.653. [Versailles 1963, no. 85—ill.]

Johann Heinrich Schönfeld, 1609–1684. "The Golden Age." Drawing. Uffizi, Florence. [Pigler 1974, p. 99]

John Dryden, 1631–1700. "The Golden Age," "The Silver Age," "The Brazen Age," "The Iron Age," sections of "The First Book of Ovid's *Metamorphoses*." Translation. In *Examen poeticum,* part 3 of Tonson's *Miscellany* (London: Tonson, 1693). [Dryden 1956–87, vol. 4]

Luca Giordano, 1634–1705. "The Four Ages of the World," detail in "The Story of Hercules Related to the Origin of the Order of the Golden Fleece." Ceiling fresco. 1697. Casón del Buen Retiro, Madrid. [López Torrijos 1985, pp. 161ff., 407.—ill.]

———. "The Golden Age." Painting. Atheneum, Boston. [Ferrari & Scavizzi 1966, 2:320]

Reinhard Keiser, 1674–1739. *Die Wiederkehr der güldenen Zeit* [The Return of the Golden Age]. Opera. Libretto, Friedrich Christian Bressand. First performed 1699, Hamburg or Lüneburg, for wedding of Joseph and Wilhelmine Amalia of Braunschweig. [Grove 1980, 9:847 / Zelm 1975, p. 47 / DLL 1968–90, 2:39]

Johann Mattheson, 1681–1764. *Le retour du siècle d'or* [The Return of the Golden Age]. Opera. Libretto, Countess Löwenhaupt. First performed 1705, Holstein, near Plön. [Grove 1980, 11:835]

Sebastiano Ricci, 1659–1734. "The Golden Age." Fresco. *c.*1695–1707? Palazzo Marucelli-Fenzi, Florence. [Daniels 1976, no. 101—ill.]

Anne Finch, Lady Winchilsea, 1661–1720. "Part of the Description of the Golden Age." Poem. In *Miscellany Poems on Several Occasions* (London: Taylor & Browne, 1713). [Fausset 1930, p. 58]

Bernard de Mandeville, 1670?–1733. (The Age of Gold expounded in) "Preface" to *Fable of the Bees; or, Private Vices, Publicke Benefits* (London: Roberts, 1714). [Walker 1952, pp. 166ff.]

Jonathan Swift, 1667–1745. (Golden Age evoked in) "A Panegyrick on the Reverend Dean Swift." Poem. Dublin: 1729–30; London: Roberts, 1730. [Williams 1958, vol. 3 / Walker 1952, pp. 174f.]

James Thomson, 1700–1748. (The Golden Age evoked in) "Spring," "Summer." Poems, part of *The Seasons* (London: 1730). [Walker 1952, pp. 178–83]

Alexander Pope, 1688–1744. (The Golden Age as the "state of nature" and "reign of God" in) *An Essay on Man* 3.147–68, 4.361–72. Poem. London: Wilford, 1732–33. [Twickenham 1938–68, vol. 3 pt. 1 / Walker 1952, pp. 171f.]

Michel Corrette, 1709–1795, music. *Les âges.* Ballet, opus 10. Score published Paris: 1733. [Grove 1980, 4:801]

Pierre-Charles Trémollière, 1703–1739. "The Age of Gold." Painting. Musée, Cholet. [Bénézit 1976, 10:266] Another work on the same subject, in Musée des Beaux-Arts, Niort. [Ibid.]

Joseph Warton, 1722–1800. "Happy the First of Men!" Poem. In *The Enthusiast; or, The Lover of Nature* (London: Dodsley, 1744). [Walker 1952, pp. 188f.]

Jean-Jacques Rousseau, 1712–1778. (State of Nature as Golden Age in) *Discours sur l'origine et les fondemens de l'inegalité parmi les hommes* (Amsterdam: 1754). [Walker 1952, pp. 193f.]

Pierre-Montan Berton, 1727–1780, with **François-Joseph Giraud,** ?–*c.*1790, music. "L'âge d'or" [The Golden Age]. Musette, in *Deucalion et Pyrrha.* Opera-ballet. Libretto, G.-F. Poullain de Saint-Foix and P. Morand. First performed 30 Sep 1755, Paris. [Grove 1980, 2:642]

Hendrik van Limborch, 1681–1759. "The Pleasures of the Golden Age." Painting. Louvre, Paris, inv. 1433. [Louvre 1979–86, 1:82—ill.]

Edmé Bouchardon, 1698–1762. "The Four Ages." Set of drawings. Louvre, Paris, nos. 764–69. [Pigler 1974, p. 271]

Johann Wolfgang von Goethe, 1749–1832. (Tasso nostalgic for the Golden Age in) *Torquato Tasso* 2.1. Tragedy in verse. 1788–90 (2 acts written 1780–81 in poetic prose?). First performed 16 Feb 1807, Weimar. Published in *Schriften,* vol. 6 (Stuttgart: Cotta, 1790). [Beutler 1948–71, vol. 1 / Suhrkamp 1983–88, vol. 8 / Poggioli 1975, pp. 222ff. / Reed 1980, pp. 123ff.]

John Flaxman, 1755–1826. "The Golden Age" (family group). Drawing. *c.*1787–94. John Murray coll., London. [Irwin 1979, p. 33, fig. 39—ill.]

———. 6 drawings, illustrating Hesiod's *Works and Days* 108–201: "Golden Age," "Good Daemons," "Silver Age," "Bronze Age," "Modesty and Justice Returning to Heaven," "Iron Age." 1807–14. Engraved by William Blake, published London: Longman & Co., 1817. [Ibid., pp. 90f.—ill. / Flaxman 1872, 7: pl. 9–14]

Joseph Anton Koch, 1768–1839. "The Golden Age." Painting. 1797. [Hunger 1959, p. 371]

Asmus Jakob Carstens, 1754–1798. "The Golden Age." Painting, cartoon (final version never completed). Unlocated. / Drawing (related?) in Albertina, Vienna. [Maisak 1981, pp. 227, 355 nn.1006–07] Painting, copy after drawing, by Franz Catel and John James Rubby. 1812.

Thorwaldsens Museum, Copenhagen, no. B299. [Thorwaldsen 1985, p. 93]

Friedrich von Schiller, 1759–1805. "Die vier Weltalter" [The Four Ages of the World]. Poem. In *Gedichte* (Leipzig: Crusius, **1800–03**). [Oellers 1983 / Butler 1958, p. 186]

William Wordsworth, 1770–1850. (Golden Age evoked in) *The Excursion* 3.756–60. Poem. Begun by 1806. London: Longman & Co., **1814**. [De Selincourt 1940–66, vol. 5 / Sheats 1973, p. 71]

———. ("Golden Years" evoked in) "Vernal Ode" lines 124–35. Poem. 1817. In *Miscellaneous Poems* (London: Longman & Co., 1820). [De Selincourt, vol. 2]

Salvatore Viganò, 1769–1821, choreography and scenario. (The Golden Age in) Act 1 of *I titani.* Epic ballet. Music, Ayblinger and Viganò. First performed **1819**, La Scala, Milan; scenery, Alessandro Sanquirico. [Beaumont 1938, pp. 39, 43 / Simon & Schuster 1979, pp. 90f.]

Leigh Hunt, 1784–1859. "Ode to the Golden Age." Translation of chorus from Tasso's *Aminta* (1573). In *Amyntas, a Tale of the Woods* (London: Allman, **1820**). [Walker 1952, p. 96]

Percy Bysshe Shelley, 1792–1822. (Asia interprets first 3 Ages of the World in) *Prometheus Unbound* 2.4.32–58. Dramatic poem. London: Ollier, **1820**. [Zillman 1968 / Wasserman 1971, pp. 359f.]

———. (The Golden Age evoked in) *Hellas* lines 1060ff., and lines 31–37 of Prologue. Dramatic poem. London: Ollier, 1822. [Hutchinson 1932 / Cameron 1974, pp. 375–93 / Wasserman, pp. 407, 409 / Webb 1976, p. 63]

Giacomo Leopardi, 1798–1837. (Lament for the Golden Age in) "Alla primavera" [To Spring]. Poem. **1822**. In *Canzoni* (Bologna: Brighenti, 1824). [Casale 1981 / Origo 1953, pp. 109f., 278]

———. (Ages of Man in) "Storia del genere umano" [History of Mankind]. Tale. 1824. In *Operette morali* (Milan: Stella, 1827). [Cecchetti 1982]

Lord Byron, 1788–1824. *The Age of Bronze, or Carmen Seculare et annus haud mirabilis.* Poem, satire on the Congress of Vienna. 1st published anonymously, London: Hunt, **1823**. [Byron 1905 / Oxford 1985, p. 154]

Friedrich von Schlegel, 1772–**1829**. "Die Weltalter" [The Ages of the World]. Poem. In modern edition by Hans Eichner, *Dichtungen* (Zurich: Thomas, 1962). [Ipso]

Thomas Stothard, 1755–**1834**. "The Golden Age: A Frieze." Watercolor. Victoria and Albert Museum, London, no. A.L.8777. [Lambourne & Hamilton 1980, p. 368]

George Frederick Watts, 1817–1904. "The Golden Age." Painting. c.**1840**. Tate Gallery, London, no. 4556. [Tate 1975, p. 91]

Antoine Wiertz, 1806–1865. "The Golden Age." Painting. **1842**. Musées Royaux des Beaux-Arts (Musée d'Art Moderne), Brussels, inv. 1992. [Brussels 1984b, p. 685—ill.]

Jean Auguste Dominique Ingres, 1780–1867. "The Golden Age." Fresco. **1843–50**, unfinished. Château de Dampierre, Seine-et-Oise. [Wildenstein 1954, no. 251—ill.] Completed smaller replica (on canvas), 1862. Fogg Art Museum, Harvard University, Cambridge. [Ibid., no. 301—ill. / Levin 1969, pp. 198f.]

Charles Marie René Leconte de Lisle, 1818–1894. (Golden Age evoked in) "Niobé" lines 1–130. Poem. In *Oeuvres: Poèmes antiques* (Paris: Lemerre, **1852**). [Pich 1976–81, vol. 1]

William Bouguereau, 1825–1905. "The Golden Age." Painting. **1866**. [Montreal 1984, pp. 63, 164] Drawing for, c.1863. Private coll. [Ibid., no. 32—ill.]

Arthur Rimbaud, 1854–1891. "Âge d'or" [Golden Age], part 4 of "Fêtes de la patience" [Festivals of Patience]. Poem. **1872**. In *Oeuvres de Rimbaud: Vers nouveaux et chansons* (1898). [Adam 1972; cf. pp. 924ff. / Fowlie 1966 / Starkie 1947, p. 172]

Adolf von Hildebrand, 1847–1921. "The Golden Age." Painting. c.**1872–75**. Brewster-Peploe coll., Florence. [Fiesole 1980, no. 54—ill.]

Edward John Poynter, 1836–1919. "The Golden Age." Pair of paintings. **1875**. [Wood 1983, p. 143]

Auguste Rodin, 1840–1917. "The Age of Bronze" ("Waking Man," "Man of the First Ages"). Bronze sculpture. **1875–76**. Numerous casts. [Tancock 1976, no. 64—ill. / Rodin 1944, no. 36—ill. / Elsen 1981, no. 21, figs. 1.6, 1.32 / also Orsay 1986, p. 232—ill.] Plaster model. Hermitage, Leningrad. [Hermitage 1975, pls. 152–53]

———. "The Golden Age." Drawing. c.1875–80. Metropolitan Museum, New York. [Elsen, no. 231, fig. 7.17]

Hans Thoma, 1839–1924. "The Golden Age." Painting. **1876**. Küchler coll., Frankfurt. [Thode 1909, p. 88—ill.]

Hans von Marées, 1837–1887. "Golden Age I," "Golden Age II." Paintings. **1879–80** and 1882–83. Neue Pinakothek, Munich, inv. 7860, 7861. [Gerlach-Laxner 1980, nos. 146, 147—ill. / Munich 1982, pp. 214f.—ill.]

Victor Hugo, 1802–1885. (The Golden Age in) "Le titan." Poem. In *La légende des siècles*, last series (Paris: Hetzel & Lévy, **1883**). [Hugo 1985–86, vol. 6 / Py 1963, p. 231f.]

Gustave Moreau, 1826–1898. "The Dream," "The Song," "The Tears," 3 panels of "The Life of Mankind" polyptych, depicting "The Silver Age." Painting. **1879–86**. Musée Gustave Moreau, Paris. [Mathieu 1976, pp. 167ff., 197—ill.]

Alfred-Désiré Lanson, 1851–**1898**. "The Iron Age." Marble statue. Musées Nationaux, inv. R.F. 568, deposited in Musée, Commentry, after 1926. [Orsay 1986, p. 274]

Léon Frédéric, 1856–1940. "The Golden Age." Painting, triptych. **1900–01**. Musée d'Orsay, Paris, nos. R.F. 1492–94. [Louvre 1979–86, 1:61—ill.]

André Derain, 1880–1954. "The Golden Age." Painting. **1905**. Walter P. Chrysler, Jr., coll., New York. [Sutton 1958, pp. 15, 147—ill.]

Henri Matisse, 1869–1954. "The Joy of Life" (landscape with figures representing the Golden Age). Painting. **1905–06**. Barnes Foundation, Merion, Pa. [Schneider 1984, pp. 241ff.—ill. / Barr 1951, pp. 88ff., 320—ill.] Oil study. Hass coll., San Francisco. [Ibid., p. 321—ill.] Crayon study. Hart coll., U.S.A. [Schneider, p. 245—ill.] Several other paintings of this period are considered studies for "The Joy of Life": "Landscape at Collioure" (Statens Museum for Kunst, Copenhagen); "Nude with Pipes"; "Pastoral" (private coll., Paris); "Nude in a Wood" (Or coll., New York). [Barr, pp. 71, 89, 319–21—ill.]

———. "The Dance." Painting, based on figures in "The Joy of Life." 2 versions: 1909, 1909–10. Museum of Modern Art, New York; Hermitage, Leningrad. [Schneider, pp. 282ff.—ill. / also Barr, pp. 132ff., 361ff.—ill.] Watercolor. 1910–11. Sembat coll., Paris? [Ibid., p. 363—ill.]

———. "The Dance." Mural painting. 1931–32. first version: Musée d'Art Moderne, Paris. second version: Barnes

Foundation, Merion, Pa. [Schneider, pp. 614ff.—ill. / also Barr, pp. 135ff., 462ff.—ill.]

Emile-René Ménard, 1862–1930. "The Golden Age." Painting, diptych, for Société Nationale des Beaux-Arts. **1908**. Musée d'Orsay, Paris, nos. 20742–43. [Louvre 1979–86, 4:83—ill.]

Wilhelm Lehmbruck, 1881–1919. "Plaque for a Golden Age." Bronze and silver relief. **1911**. Städtliche Kunstsammlung, Duisburg. [Hoff 1961, p. 161]

Ezra Pound, 1885–1972. "Pax Saturni" [The Peace of Saturn]. Poem. First published with the title "Reflection and Advice" in *Poetry* 2 no. 1 (April **1913**); collected as "Pax Saturni" in *Collected Shorter Poems* (London: Faber & Faber, 1968). [Ruthven 1969, pp. 265, 267]

Franz Werfel, 1890–1945. (Regression to a Golden Age evoked in) *Die Mittagsgöttin* [The Noon Goddess]. Drama ("magic play"). Munich: Wolff, [*c*.1919]. [Ritchie 1976, p. 146]

William Hamo Thornycroft, 1850–**1925**. "The Age of Iron." Bronze sculpture. [Bénézit 1976, 10:167]

E. I. Kaplan, V. I. Vainonen, and **L. Yacobson**, choreography. *The Golden Age*. Ballet (satire, contemporary industrial setting). Music, Dmitry Shostakovich. Scenario, A. V. Ivanovsky. First performed **1931**, Bolshoi Theatre, Moscow; scenery and costumes, V. M. Khodasevich. [Beaumont 1938, pp. 840ff.]

Æ (George William Russell), 1867–1935. "The Iron Age Departs." Poem. In *The House of the Titans and Other Poems* (New York: Macmillan, **1934**). [Ipso]

Paul Nord, 1901–1981. *O chrysos aeonas* [The Golden Age]. Satire. **1939**. [Gassner & Quinn 1969, p. 395]

Maurice Denis, 1870–**1943**. "The Age of Gold." 7 ceiling and staircase murals. Musée Départemental de L'Oise, near Paris. [Jacobs & Stirton 1984a, p. 166]

W. H. Auden, 1907–1973. "The Golden Age." Poem, part I of "Two Don Quixote Lyrics." **1964?** [Mendelson 1976]

Howard Nemerov, 1920–. "The Four Ages." Poem. In *The Western Approaches: Poems* **1973–75** (Chicago: University of Chicago Press, 1975). [Ipso]

John Ashbery, 1927–. (Ages of the World recalled in) "Litany." Poem. In *As We Know* (New York: Viking, **1979**). [DLB Yearbook 1981, p. 21]

AGLAURUS. *See* ERICHTHONIUS; HERSE AND AGLAURUS.

AJAX. Son of King Telamon of Salamis, Ajax (Greek, Aias) brought twelve ships to support the Greeks in the Trojan War. A courageous warrior, called the "bulwark of the Achaeans," Ajax entered into single combat with the Trojan leader, Hector, but before either emerged victorious, the heralds of Zeus (Jupiter) stopped the fight and the rivals exchanged gifts on the battlefield. When the Greek ships were in imminent danger, Ajax defended them staunchly. He was one of the three emissaries sent to persuade Achilles to rejoin the battle. It was he who defended the corpse of Patroclus and later carried the body of the slain Achilles from the field.

Ajax and Odysseus (Ulysses) were rivals off the battlefield, first in a wrestling match that ended in a draw, and later in a dispute over which of them should be given the armor of the dead Achilles. When the Greek leaders awarded the arms to Odysseus, Ajax was so humiliated that he fell into a madness and slaughtered a flock of sheep he took for the Greek leaders. Not even his loyal concubine, Tecmessa, could dispel his sense of shame over this act; after giving his shield to his son, Eurysaces, Ajax fell on the sword he had received as a gift from Hector. In the *Odyssey*, Odysseus encounters Ajax's shade in Hades and attempts a reconciliation, but the hero will not speak to him.

Classical Sources. Homer, *Iliad* 7.66–219, 17.114ff., 17.715ff. and passim; *Odyssey* 2.541–67. Aeschylus, *Ajax* (fragments). Pindar, *Isthmian Odes* 6.41–54. Sophocles, *Ajax*. Ovid, *Metamorphoses* 12.624–13.398. Apollodorus, *Biblioteca* 3.10.8, 3.12.7, 5.4, E5.6–7. Hyginus, *Fabulae* 107, 116. Lucian, *Dialogues of the Dead* 23, "Ajax and Agamemnon."

See also ACHILLES; ODYSSEUS, in Hades; PATROCLUS; TROJAN WAR.

Guido delle Colonne, *c*.1210–after 1287. (Encounter of Hector and Ajax in) *Historia destructionis Troiae* [History of the Destruction of Troy] 15.681–88. Latin prose chronicle, adaptation of Benoît de Sainte-Maure's *Roman de Troie* (*c*.1165). **1272–87**. Modern edition by Nathaniel E. Griffin (Cambridge, Mass.: Harvard University Press, with Mediæval Academy of America, 1936; reprinted New York: Kraus, 1970). / Translated by M. E. Meek (Bloomington: Indiana University Press, 1974). [Benson 1980, pp. 66, 69]

Anonymous French. (Contest of Ajax and Ulysses over the arms of Achilles, death of Ajax, in) *Ovide moralisé* 12.4795–4876; 13.1–930, 1255–1303 (narrative); 13.931–1254, 1304–35 (allegories). Poem, allegorized translation/elaboration of Ovid's *Metamorphoses*. *c*.**1316–28**. [de Boer 1915–86, vol. 4]

Anonymous English. (Encounter of Hector and Ajax in) *The Laud Troy Book* lines 5973–84. Metrical romance, after Guido delle Colonne. *c*.**1400**. Modern edition by J. Ernst Wülfing (London: Early English Text Society, 1902, 1903). [Benson 1980, p. 69]

Christine de Pizan, *c*.1364–*c*.1431. (Death of Ajax in) *L'epistre d'Othéa à Hector* . . . [The Epistle of Othéa to Hector] chapter 94. Didactic romance in prose. *c*.**1400**. MSS in British Library, London; Bibliothèque Nationale, Paris; elsewhere. / Translated by Stephen Scrope (London: *c*.1444–50). [Bühler 1970 / Hindman 1986, p. 202]

John Lydgate, 1370?–1449. (Encounter of Hector and Ajax in) *Troy Book* 3.2078–2121. Poem, elaboration of Guido delle Colonne. **1412–20**. Modern edition by Henry Bergen (London: Kegan Paul, Trench & Trübner, for Early English Text Society, 1906–35). [Benson 1980, p. 69]

Giulio Romano, *c.*1499–1546, assistants, after designs by Giulio. "The Death of Ajax." Fresco, part of cycle depicting scenes associated with the Trojan War. **1538–39.** Sala di Troia, Palazzo Ducale, Mantua. [Hartt 1958, pp. 179ff.]

Pierre de Ronsard, 1524–1585. (Story of Ajax in) "Epistre . . . à très illustre prince Charles Cardinal de Lorraine" [Letter to the Most Illustrious Prince Charles, Cardinal of Lorraine]. Poem. In *Le second livre des hymnes* (Paris: Wechel, **1556**). [Laumonier 1914–75, vol. 8 / Silver 1985, pp. 262f.]

Antonio de Villegas, 1512–**1561.** *Disputa . . . Ajax Telamon y Ulixes sobre las armas de Achiles* [Dispute of Telemonian Ajax and Ulysses over the Arms of Achilles]. Poem. Medina: Francesco del Canto, 1577. [DLE 1972, p. 938]

Giovanni Battista Castello, *c.*1509–**1579.** "Ajax Runs on His Sword." Fresco. Giovanelli Castle, Gorlago. [Pigler 1974, p. 11]

Hernando de Acuña, 1520–**1580.** *La contienda de Ayax Telamonio y de Ulises sobre las armas de Aquiles* [The Contention of Telemonian Ajax and Ulysses over the Arms of Achilles]. Poem. In *Varias poesías* (Madrid: Madrigal, 1591). Modern edition by Antonio Vilanova, *Varias poesías* (Barcelona: 1954). [DLE 1972, p. 9]

Juan de la Cueva, 1550?–1610? *Tragedia de Ayax Telemón.* Tragedy, after Sophocles. In *Obras* (Seville: printed by A. Pescioni for F. Rodriquez, **1582**). In modern edition, *Comedias y tragedias* (Madrid: Maestre, for Sociedad de Bibliófilos Españoles, 1917). [DLE 1972, p. 238 / Cook 1959, p. 109]

John Harington, *c.*1561–1612. *A New Discourse . . . Called the Metamorphosis of Ajax: An Anatomie of the Metamorphosed Aiax. . . .* Poem. London: Field, **1596.** Modern edition by "Peter Warlock" and Jack Lindsay, *The Metamorphosis of Aiax . . .* (London: Fanfrolico, 1927). [Bush 1937, p. 71]

Wolfhart Spangenberg, *c.*1570–*c.*1636. *Ajax.* Translation of Sophocles. **1608.** In modern edition, *Sämtliche Werke*, vol. 7, *Dramenübersetzungen*, edited by A. Tarnai and A. Vizkelety (Berlin & New York: De Gruyter, 1979). [Hunger 1959, p. 14]

Thomas Heywood, 1573/74–1641. (Ajax in) *Troia Britanica: or, Great Britaines Troy.* Epic poem. London: **1609.** [Heywood 1974 / also Boas 1950, p. 58ff. / Clark 1931, pp. 50ff.]
———. "Aiax and Ulisses contend for the Armour of Achilles," "The Death of Aiax." Episodes in *The Iron Age* part 1. Drama, derived from *Troia Britanica.* First performed *c.*1612–13, London. Published London: Okes, 1632. [Heywood 1874, vol. 3 / Clark, p. 64]

Pieter Corneliszoon Hooft, 1581–1647. *Ayax en Ulisses.* Tragedy. Published with *Achilles en de Polyxena* (Rotterdam: **1614**). [CEWL 1973, 2:705]

Isaac de Bensérade, 1613–1691. *La mort d'Achille et la dispute de ses armes* [The Death of Achilles and the Contention over His Arms]. Tragedy. First performed **1635,** Paris. Published Paris: A. de Sommaville, 1637. [DLLF 1984, 1:235 / Stone 1974, pp. 196f. / Girdlestone 1972, pp. 137f., 269]

Thomas Hall, 1610–1665. *Wisdoms conquest, or, an explanation of the thirteenth book of Ovids Metamorphoses, con-*

taining that curious and rhetoricall contest between Ajax and Ulysses, for Achilles armour. . . . Poem. London: **1651.** [Bush 1937, p. 337]

James Shirley, 1596–1666. *The Contention of Ajax and Ulysses for the Armor of Achilles.* Entertainment. *c.***1645–58.** First performed before 1659 [at Shirley's grammar school?], London. Published in *Honoria and Mammon* (London: Crook, 1659). [DLB 1987, 58:249, 251, 254 / Logan & Smith 1978, p. 160, 166]

Samuel Butler, 1613–1680. (The contest over arms and Ajax's suicide recalled in) *Hudibras* 1.2.299ff. Satirical poem. London: Marriott, **1663.** Modern edition by John Wilders (Oxford University Press, 1967). [Ipso]

Salvator Rosa, 1615–**1673,** attributed. "Ajax." Painting. Musée, Bordeaux. [Bénézit 1976, 9:85]

Jean de La Chapelle, 1655–1723. *Ajax.* Tragedy. First performed 27 Dec **1684,** Comédie-Française, Paris. [Lancaster 1929–42, pt. 4, 2:953]

Pascal Collasse, 1649–1709. (Ajax's story retold in) *Achille et Polyxène* act 5. Opera (tragédie en musique). (Collasse composed acts 2–5; overture and act 1 by Jean-Baptiste Lully). Libretto, Jean-Galbert de Campistron, after de Bensérade's *La mort d'Achille* (1635). First performed 7 Nov **1687,** Académie Royale de Musique, Paris. [Grove 1980, 11:327, 4:535 / Girdlestone 1972, pp. 137f., 269]

Francesco Ballarotti, *c.*1660–1712, Carlo Ambrogio Lonati, *c.*1645–1710/15, and Paolo Magni, *c.*1650–1737. *L'Aiace.* Opera. Libretto, P. d'Averara. First performed **1694,** Teatro Ducale, Milan. [Grove 1980, 2:86; 11:141, 495]

Francesco Gasparini, 1668–1727. *L'Ajace.* Opera seria. First performed **1697,** Rome. [Grove 1980, 7:174f.]

Bernardo Sabadini, ?–1718, with additions from Lonati, Magni, and Ballarotti (1694). *L'Aiace.* Opera seria. Libretto, d'Averara. First performed **1697,** Teatro Capranica, Rome. [Grove 1980, 16:363]

Alessandro Scarlatti, 1660–1725. *Ajace.* Opera. Libretto, d'Averara. **1697.** [Hunger 1959, p. 14]

Spanish School. "The Suicide of Ajax." Painting. **Late 17th century.** Private coll., Madrid. [López Torrijos 1985, pp. 219f., 411 no. 51—ill.]

John Dryden, 1631–1700. "The Speeches of Ajax and Ulysses." Poem, translation from Ovid's *Metamorphoses* 13. In *Fables, Ancient and Modern* (London: Tonson, **1700**). [Dryden 1700 / Van Doren 1946, pp. 219f. / Miner 1967, pp. 291, 299 / Winn 1987, p. 499]

Nicholas Rowe, 1674–1718 and [?] Jackson. *Ajax.* Tragedy, after Sophocles. London: **1714.** [Nicoll 1959–66, 2:338]

Lewis Theobald, 1688–1744. *Ajax.* Tragedy, after Sophocles. London: Lintott, **1714.** [Nicoll 1959–66, 2:359]

Antoine Rivalz, 1667–**1735.** "Ajax Leading His Horse from the Temple." Painting. Musée des Augustins, Toulouse. [Bénézit 1976, 8:782]

Jean-Georges Noverre, 1727–1810, choreography. *La mort d'Ajax.* Ballet. First performed **1758–60** (?), L'Opéra, Lyons. [Grove 1980, 13:443]

François Francoeur, 1698–1787. *Ajax.* Opera. Libretto, Poinsinet de Sivry. First performed **1762,** Paris. [DLLF 1984, 3:1772 / Grove 1980, 6:793]

Henry Fuseli, 1741–1825. "The Mad Ajax, after Slaying the Lambs, Recovers Himself and Is Surprised by His

Comrades." Drawing. **1768.** Kunsthaus, Zurich, inv. 1940/128. [Schiff 1973, no. 325]

———. "The Mad Ajax, Turned toward His Son Eurysakes." Drawing. 1770–72. Zurich, inv. 1940/189. [Ibid., no. 389—ill.] Copy ("Ajax, Free Illustration to the Tragedy of Sophocles"). *c.*1772. British Museum, London (Roman Album) inv. 1885–3–14–283. [Ibid., no. 390—ill.] Variant. *c.*1772. Victoria and Albert Museum, London, no.1095.87. [Ibid., no. 391]

———. "In the Underworld, the Shade of Ajax Refuses a Reconciliation with Odysseus." Painting, design for engraving, part of a series illustrating the *Odyssey*. Exhibited Royal Academy, London, 1812, lost. / Engraved by Isaac Taylor for Alexander Pope's *The Iliad and Odyssey of Homer* (London: F. J. du Roveray, 1806) and William Cowper's *The Iliad* [*and the Odyssee*] *of Homer* (London: Johnson, 1810). [Ibid., no. 1253—ill.]

———. "Tekmessa and Eurysakes." Painting, fragment of a "Mad Ajax" or "Ajax Committing Suicide." 1800–10. Mellon coll., Upperville, Va. [Ibid., no. 1196—ill.]

August K. Borheck, 1751–1816. *Ajax und Tekmessa.* Drama. **1789.** [Hunger 1959, p. 14]

Friedrich Hölderlin, 1770–1843. "Aus dem Ajax des Sophokles" [From Sophocles' *Ajax*]. Translation, fragment. *c.*1803. First published in *Sämtliche Werke*, vol. 5 (Munich & Leipzig: Muller, 1913). [Beissner 1943–77, vol. 5 / Steiner 1984, pp. 68, 70]

Ugo Foscolo, 1778–1827. (Tomb of Ajax evoked in) *Dei sepolcri* [On Sepulchres]. Ode, to Ippolito Pindemonte. **1806.** Brescia: 1807. / Translated by Thomas G. Bergin (Bethany, Conn.: Bethany Press, 1971). [Ipso]

———. *Aiace* (contention of Ajax and Ulysses in which Ulysses represents General Fouché). Satirical tragedy. First performed Dec 1811, La Scala, Milan. [EW 1983–85, 5:339 / Cambon 1980, pp. 73, 253ff. / DELI 1966–70, 2:513–24 / Stanford 1974, p. 214]

Antonio Canova, 1757–1822. "Ajax." Marble statue. **1811–12.** Palazzo Treves, Venice. [Pavanello 1976, no. 219—ill.] Plaster model. Gipsoteca Canoviana, Possagno, no. 207. [Ibid., no. 220—ill.]

Bertel Thorwaldsen, 1770–1844. "Minerva Awarding Ulysses the Arms of Achilles." Marble relief. *c.*1832–33. Thorwaldsens Museum, Copenhagen, no. A497. / Plaster original. Thorwaldsens Museum, no. A498. [Thorwaldsen 1985, p. 57 / Hartmann 1979, pl. 99.3]

William Sterndale Bennett, 1816–1875. Musical prelude to Sophocles' *Ajax*. First performed 8 July **1872**, Philharmonic Society, London. [Grove 1980, 2:501, 503]

———. March for Sophocles' *Ajax*. First performed 18 Mar 1875, Philharmonic Society, London. [Ibid.]

Otto Franz Gensichen, 1847–1933. *Ajas.* Tragedy in verse. **1873.** Berlin: Grosser, 1874. [DLL 1968–90, 6:197]

C. Hubert Parry, 1848–1918. Choral ode for Shirley's *Contention of Ajax and Ulysses* (*c.*1645–58). First performed **1883**, Gloucester Festival. [Grove 1980, 14:244]

Johanna Niemann, 1844–1917. *Ajax.* Novel. Dresden: Reissner, **1905.** [Hunger 1959, p. 14]

André Gide, 1869–1951. *Ajax.* I scene of an unfinished drama (conference of Minerva and Ulysses). **1907.** Paris: Gallimard, 1921. [Martin-Chauffier 1932–39, vol. 4 / Watson-Williams 1967, pp. 86–88, 92f.]

Hans José Rehfisch, 1891–1960. *Die goldenen Waffen* [The

Golden Arms] (of Achilles). Tragedy. Berlin: Reiss, **1913.** [Kunisch 1965, p. 471]

Bertus van Lier, 1906–1972, translation and incidental music. *Aias.* Version of Sophocles' *Ajax*. **1933.** [Grove 1980, 10:850f.]

Riccardo Zandonai, 1883–1944. Incidental music for Sophocles' *Ajax*. First performed **1939**, Syracuse. [Grove 1980, 20:638]

———. *Ajax.* Orchestral suite. 1940. [Ibid.]

Hilding Rosenberg, b. 1892. Incidental music for Sophocles' *Ajax*. First performed **1950**, Stockholm. [Grove 1980, 16:200]

Georges Braque, 1882–1963. "Ajax." Painting. **1949–54.** Private coll. [Cogniat 1980, fig. 68—ill.]

Joseph Brodsky, 1940–. (At the moment of death Hector recalls his combat with Ajax in) "Velikii Gektor strelami ubit." Sonnet. *c.*1959–60. / Translated by George Kline as "Great-hearted Hector" in *Selected Poems* (Harmondsworth, Middlesex: Penguin, 1973; Baltimore: Penguin, 1974). [Ipso]

Betty Jolas, 1926–. Incidental music for Sophocles' *Ajax*. **1960.** [Cohen 1987, 1:353]

Ilse Aichinger, 1921–. "Ajax." Short story. **1968.** In *Meine sprache und ich* [My Language and I] (Frankfurt: Fischer, 1978). [Daviau 1987, p. 35]

Yannis Ritsos, 1909–1990. "Aias." Dramatic monologue. **1967–69.** In *Tetarti dhiastasi* [Fourth Dimension] (Athens: Kedros, 1972). [Myrsiades 1978, pp. 452–55]

Giorgio de Chirico, 1888–1978. "Ajax" (mannequin figure). Bronze sculpture. **1970.** 9 casts, 2 artist's proofs. [de Chirico 1971–83, 2.3: no. 300—ill. / cf. de Chirico 1972, no. 145—ill.]

Hartmut Lange, 1937–. *Die Ermordung des Aias* [The Suicide of Ajax]. Drama. Berlin: Wagenbach, **1971.** [DLL 1968–90, 9:900]

John Eaton, 1935–. *Ajax.* Composition for baritone and orchestra. Text, after Sophocles. First performed **1972.** [Baker 1984, p. 639 / Grove 1980, 5:809]

ALCESTIS. Daughter of Peleus, Alcestis was the wife of Admetus, king of Pherae in Thessaly. When she had come of age to marry, her father would give her only to a suitor who could harness wild beasts (according to Boeotian legend, a lion and a boar) to a chariot. Admetus performed this amazing feat with the help of Apollo, who had been acting as the king's herdsman while in exile from Olympus.

According to Apollodorus, at the wedding feast, Admetus forgot to sacrifice to Artemis and was therefore destined to live only a short time. Apollo again intervened and persuaded the Fates to prolong Admetus's life if someone else would die on his behalf. According to Euripides, no one, not even his mother or father, would undertake such a sacrifice except Alcestis. She left her children and sorrowing husband and departed for Hades. However, she was rescued from Thanatos (Death) by Heracles and

restored to her husband; Apollodorus says that Persephone released her from Hades.

The subject is popular in postclassical drama and opera, but rarely depicted in art; when it is, the scene is often Heracles wrestling Thanatos for possession of Alcestis.

Classical Sources. Euripides, *Alcestis.* Plato, *Symposium* 179b5–179d1. Apollodorus, *Biblioteca* 1.9.14–15. Hyginus, *Fabulae* 50–51.

Further Reference. E. M. Butler, "Alkestis in Modern Dress," *Journal of the Warburg Institute* 1 (1937–38): 46–60.

Geoffrey Chaucer, 1340?–1400. (Alcestis evoked in) *The Legende of Goode Women* prologue, passim. Poem. 1385–86. Westminster: Caxton, c.1495. [Riverside 1987 / Howard 1987, pp. 394, 509]
———. (Cassandra recounts Alcestis's story, poet praises Alcestis's loyalty, in) *Troilus and Criseyde* 3.1527–33, 1772–85. Poem. 1381–85. Westminster: Caxton, 1475. [Riverside / Howard]
Bernardo Parentino, c.1437–1531. "Hercules in Hades." Painting. Museo Correr, Venice, no. 624. [Berenson 1968, p. 319]
Hans Sachs, 1494–1576. *Alcestis, die getreue Fürstin (Die getreue Fürstin Alcestis mit ihrem getreuen Mann Admetus)* [Alcestis, the Faithful Princess (and Her Faithful Husband Admetus)]. Tragedy. Published 1555. In modern edition, *Werke* (Stuttgart: 1870–1908; Hildesheim: Olms, 1964). [McGraw-Hill 1984, 4:301]
George Buchanan, 1506–1582. *Euripidis poetae tragici Alcestis Georgio Buchanano Scoto interprete* [The *Alcestis* of the Poetic Tragedian Euripides, Interpreted by George Buchanan, Scot]. Translation. Paris: 1556. [Stone 1974, p. 68 / Cambridge 1969–77, 1:2441]
George Pettie, 1548–1589. "Admetus and Alcest." Tale. In *A Petite Pallace of Pettie His Pleasure* (London: W[atkins], 1576). Modern facsimile edition by Herbert Hartman (London & New York: Oxford University Press). [Ipso]
Wolfhart Spangenberg, c.1570–c.1636. *Alkestis.* Drama, translation of Euripides. 1604. In modern edition by A. Tarnai and A. Vizkelety, in *Sämtliche Werke*, vol. 7, *Dramenübersetzungen* (Berlin & New York: De Gruyter, 1979). [Frenzel 1962, p. 32]
Alexandre Hardy, c.1570–1632. *Alceste.* Tragi-comedy. Before 1615. In *Théâtre* (Paris: Quesnel, 1624–[28]). [McGraw-Hill 1984, 2:446 / Deierkauf-Holsboer 1972, pp. 149, 154]
Thomas Heywood, 1573/74–1641. (Story of Alcestis in) *Gynaikeion: or, Nine Books of Various History Concerning Women* book 3. Compendium of history and mythology. London: printed by Adam Islip, 1624. [Ipso]
Francesco Bracciolini dall' Api, 1566–1645. *Tragedie of Alceste.* Translation of Euripides. London: Waterson, 1638. [DELI 1966–70, 1:464.]
Prospero Bonarelli Della Rovere, 1582–1659. *L'Alceste.* Melodrama in verse. 1647. In *Melodrami cioè opere da rappresentarsi in musica* (Ancona: Salvioni, 1647). [Clubb 1968, p. 49]
John Milton, 1608–1674. (Milton's dead wife likened to Alcestis in) "Methought I saw my late espousèd Saint."

Sonnet 23. **c.1658?** In *Poems, etc. upon Several Occasions* (London: Dring, 1673). [Carey & Fowler 1968 / Segal 1989, pp. 161f.]
Pietro Andrea Ziani, 1616–1684. *L'Antigona delusa da Alceste* [Antigona Tricked by Alcestis]. Opera. Libretto, Aurelio Aureli. First performed 15 Jan **1660**, SS. Giovanni e Paolo, Venice. [Keates 1985, p. 127 / Grove 1980, 20:675 / Butler 1937–38, p. 48]
Girolamo Bartolommei, 1584–1662. *La fedeltà d'Alceste* [The Faithfulness of Alcestis]. Opera (dramma musicale). Florence: Onofri, **1661.** [Weaver 1978, pp. 134f.]
Jean-Baptiste Lully, 1632–1687. *Alceste, ou Le triomphe d'Alcide* [Alcestis, or The Triumph of Alcides (Hercules)]. Opera (tragédie lyrique). Libretto, Philippe Quinault. First performed 19 Jan **1674**, Palais Royal, then at Saint-Germain, finally in Paris. [Grove 1980, 11:321f., 326 / Girdlestone 1972, pp. 60–69 / Bianconi 1987, pp. 243ff., 248ff. / Clément & Larousse 1969, 1:27 / Butler 1937–38, p. 48]
Jean Racine, 1639–1699. *Alceste.* Drama. Begun *c.*1674, unfinished, lost. [Pocock 1973, pp. 235f., 280, 306]
Johann Wolfgang Franck, 1644–*c.*1710. *Alceste.* Opera. Libretto, Franck, after Matsen. First performed **1680**, Hamburg. Music lost. [Grove 1980, 6:786]
Anonymous German. *Alkestis.* Singspiel. **1680.** [Frenzel 1962, p. 33]
———. *Der siegende Alcides* [Hercules Triumphant]. Singspiel. **1696.** [Ibid.]
Nicolaus Adam Strungk, 1640–1700. *Alceste.* Opera. Libretto, J. P. Förtsch, after Quinault (1674). First performed **1680**, Hamburg. [Grove 1980, 18:298]
———. *Alceste.* Opera. Libretto, P. Thymach, after Aureli's *L'Antigona delusa d'Alceste* (1660). First performed 18 May **1693**, Leipzig. [Ibid., 18:298f.]
Luca Giordano, 1634–1705. "Hercules Entering the Underworld in Search of Alcestis," "Hercules Restoring Alcestis to Her Husband Admetus." Frescoes, part of "Hercules" cycle, for Buen Retiro, Madrid. *c.*1697. Destroyed. / Engraved by Giuseppe Castillo and Juan Barcelon, 1779. [López Torrijos 1985, p. 407 nos. 47–48 / Ferrari & Scavizzi 1966, 1:155, 2:278]
Antonio Draghi, 1634/35–1700. *L'Alceste.* Opera. Libretto, D. Cupeda. First performed 28 Jan **1700**, Vienna. [Grove 1980, 5:605]
Paolo Magni, *c.*1650–1737. *Admeto, re di Tessaglia* [Admetus, King of Thessaly]. Opera. Libretto, d'Averara. **1702.** [Grove 1980, 11:495]
Thomas Bertin de La Doué, *c.*1680–1745, and **François Bouvard,** *c.*1683–1760. *Alceste.* Opera (tragédie en musique). Libretto, François-Joseph de Lagrange-Chancel. First performed Dec **1703**, L'Opéra, Paris. [Girdlestone 1972, p. 158 / Lancaster 1929–42, pt. 4, 1:119, 228, 368, 378, 383]
Noël Coypel, 1628–1707. "Hercules Leading Alcestis from the Underworld to Admetus." Painting. Musée, Grenoble no. 437. [Pigler 1974, p. 111]
Pier Jacopo Martello, 1665–1727. *Alceste.* Tragedy. First performed **1709**, Rome. Published in *Della tragedia antica e moderna* (Rome: 1715). [DELI 1966–70, 3:530]
Louis Galloche, 1670–1761. "Hercules Returning Alcestis to Admetus." Painting. **1711.** École des Beaux-Arts, Paris. [Bordeaux 1984, fig. 379]
Sebastiano Ricci, 1659–1734. "Hercules Struggling with Death for the Body of Alcestis" (? or fighting a Cen-

taur?). Ceiling painting, part of "Hercules" cycle, for Portland House, London. **1712–13**. Lost. [Daniels 1976, no. 208—ill.]

Giuseppe Porsile, 1680–1750. *Alceste*. Opera (festa teatrale). Libretto, Pietro Pariati. First performed 19 Nov **1718**, Vienna. [Grove 1980, 15:128]

Georg Caspar Schürmann, 1672–1751. *Die getreue Alceste* [Faithful Alcestis]. Opera. Libretto, König, after Quinault (1674). First performed **1719**, Braunschweig. [Grove 1980, 16:874 / Butler 1937–38, p. 48]

George Frideric Handel, 1685–1759. *Admeto, re di Tessaglia* [Admetus, King of Thessaly]. Opera. Libretto, probably N. Haym, after Ortenzio Mauro's Hannover version of Aureli's *L'Antigona delusa da Alceste* (1660). First performed 31 Jan **1727**, King's Theatre, London; new scenery by Goupy. [Grove 1980, 8:92 / Lang 1966, pp. 185f. / Keates 1985, pp. 127–30 / Hogwood 1984, p. 86 / Tovey 1934, p. 84]

Pierre François Biancolelli, called Dominique, 1680–1734, and **Jean Antoine Romagnesi**, 1690–1742. *Alceste*. Comedy, parody. First performed 21 Dec **1728**, Théâtre de l'Hôtel de Bourgogne, Paris. [NUC]

Gerard Hoet the Elder, 1648–1733. "Alcestis and Admetus." Painting. Statens Museum for Kunst, Copenhagen. [Copenhagen 1951, no. 314]

Louis de Boissy, 1694–1758. *Admete et Alceste*. Tragedy. The Hague: Waast, **1735**. [Taylor 1893, p. 167]

Giovanni Battista Lampugnani, 1706–c.1786. *Alceste*. Opera. Libretto, Paolo Antonio Rolli, after Pietro Metastasio. First performed 28 Apr **1744**, King's Theatre, London. [Grove 1980, 10:422]

Tobias Smollett, 1721–1771. *Alceste*. Masque or "semiopera." Incidental music, George Frideric Handel (airs and dances and the scene in Hades survive in score). Projected for **1750**, unperformed, lost. [Lang 1966, pp. 501–505 / Keates 1985, pp. 291, 298 / Hogwood 1984, p. 219]

Charles-Guillaume Alexandre, c.1735–1787/88. *Le triomphe de l'amour conjugal, ou L'histoire d'Admète et d'Alceste*. Opera/spectacle. Libretto, G. N. Servandoni. First performed 16 Mar **1755**, Théâtre Palais des Tuileries, Paris. [Grove 1980, 1:248]

Hermann Friedrich Raupach, 1728–1778. *Alceste*. Opera. Libretto, Aleksandr Petrovich Sumarokov. First performed **1758**, St. Petersburg. [Grove 15:605]

Giuseppe Ponzo, fl. 1759–91, doubtfully attributed. *Alceste*. Opera. First performed **1760**, Reggio Emilia. [Grove 1980, 15:83]

Jean-Georges Noverre, 1727–1810, choreography. *Admète et Alceste*. Tragic ballet. Music, J. J. Rodolphe or F. Deller. First performed 11 Feb **1761**, Hoftheater, Wurtenburg-Teck, Stuttgart. [Swift 1974, p. 22 / Winter 1974, pp. 5, 153 / Lynham 1950, p. 166]

————, choreography. *Admète*. Ballet. Music, Joseph Mazzinghi. First performed 31 Mar 1789, King's Theatre, London. [Grove 1980, 11:868 / Lynham, pp. 59, 166]

Georg Philipp Telemann, 1681–1767. *Hercules und Alceste*. Opera. 4 fragments survive. [Grove 1980, 18:657]

Jacques-Louis David, 1748–1825. "Hercules Brings Alcestis Out of Hades." Painting. **1767**. Sold 1929. [Cantinelli 1930, no. 1]

Claude Joseph Dorat, 1734–1780. *Alceste*. Tragedy, frag-

ment. *c.***1767**. In *Théâtre* (Paris: Jorry, 1765–80). [Taylor 1893, p. 185]

Christoph Willibald Gluck, 1714–1787, with **François-Joseph Gossec**, 1734–1829 (act 3, Hercules' rescue). *Alceste*. Opera. Libretto, Ranieri Calzabigi, after Euripides. First performed 26 Dec **1767**, Burgtheater, Vienna; ballet by Jean-Georges Noverre at close of opera. [Grove 1980, 3:636; 7:462f., 468, 472f. / Sternfeld 1966, pp. 123–29 / Cooper 1935, pp. 125ff. / Tovey 1934, pp. 81f., 92–94, 96f., 115] French version, libretto, F. L. G. Leblanc du Roullet, after original. First performed 23 Apr **1776**, Académie Royale, Paris. [Grove / Sternfeld / Cooper, p. 285 / Clément & Larousse 1969, 1:26f.]

Pietro Alessandro Guglielmi, 1728–1804. *Alceste*. Opera. Libretto, Calzabigi (1767). First performed 26 Dec **1768**, Teatro Ducale, Milan. [Grove 1980, 7:796]

————. *Admeto*. Opera. Libretto, Palomba. First performed 5 Oct **1794**, Fondo, Naples. [Ibid.]

Christian Cannabich, 1731–1798. *Admette et Alceste*. Opera. First performed **1770**, Mannheim. [Grove 1980, 3:687]

Christoph Martin Wieland, 1733–1813, libretto. *Alkeste*. Singspiel, after Euripides. Leipzig: Weidmanns, Erben & Reich, **1773**. [Radspieler 1984, vol. 8 / Galinsky 1972, pp. 214f., 229 n.55 / Butler 1937–38, pp. 49–52]

Johann Wolfgang von Goethe, 1749–1832. *Götter, Helden und Wieland* [Gods, Heroes, and Wieland]. Satirical farce, lampoon of Wieland's *Alkeste*. **1773**. Leipzig: Kehl, 1774. [Beutler 1948–71, vol. 4 / Butler 1937–38, pp. 49–53 / Reed 1980, pp. 56, 60]

Anton Schweitzer, 1735–1787. *Alkeste*. Singspiel. Libretto, Wieland. First performed 28 May **1773**, Hoftheater, Weimar. [Grove 1980, 17:46]

Carlo d'Ordoñez, 1734–1786. *Alceste*. Marionette opera. Libretto, J. K. von Pauersbach, parody, after Gluck (1767). First performed 30 Aug **1775**, Castle Theatre, Esterháza, conducted by Haydn. [Baker 1984, p. 1686 / Grove 1980, 13:702]

Étienne Lauchery, 1732–1820, choreography. *La descente d'Hercule aux Enfers*. Ballet. Music, Christian Cannabich. First performed 20 Jan **1780**, Mannheim. [Grove 1980, 3:687 / EDS 1954–66, 2:1643] [Cohen-Stratyner 1982, p. 528]

Étienne-Joseph Floquet, 1748–1785. *Alceste, ou Le triomphe d'Alcide*. Opera (tragédie lyrique). Libretto, J.-P.-A. Razins de Saint-Marc, after Quinault (1674). **1783**. Unperformed. [Grove 1980, 6:644]

Louis Adrien Masreliez, 1748–1810. "The Death of Alcestis." Painting. **1784**. Nationalmuseum, Stockholm. [Hunger 1959, p. 20]

Pierre Peyron, 1744–1814. "The Death of Alcestis" ("The Heroism of Conjugal Love"). Painting. **1785**. Louvre, Paris, inv. 7175. [Louvre 1979–86, 4:130—ill.]

Friedrich Benda, 1745–1814. *Alceste*. Singspiel. Libretto, Wieland (1773). First performed (in concert) 15 Jan **1786**, Berlin. [Grove 1980, 2:465]

Antoine-Frédéric Gresnick, 1755–1799. *Alceste*. Opera. Libretto, C. F. Badini, after Metastasio. First performed 23 Dec **1786**, King's Theatre, London. [Grove 1980, 7:704]

Johann Gottfried Herder, 1744–1803. *Admetus Haus*. Dramatic poem. *c.***1789**. In *Adrastea* (journal published by Herder and his wife Caroline), 1804; collected in *Dramatische Stücke* vol. of *Sämmtliche Werke* (Tübingen:

Cotta, 1805–20). [Herder 1852–54, vol. 15 / Clark 1955, pp. 428f. / Strich 1970, 1:260 / Butler 1958, p. 79]

Niccolò Zingarelli, 1752–1837. *La morte di Alceste.* Cantata. **1789.** [Grove 1980, 20:694]

Angelica Kauffmann, 1741–1807. "The Death of Alcestis" (recommending her sons to Admetus). **1790.** [Manners & Williamson 1924, p. 157]

Vittorio Alfieri, 1749–1803. *Alceste Seconda* [Alcestis the Second]. Tragedy. **1798.** Brescia: Bettoni, 1804. First performed 1831, Teatro Carignano, Turin. [McGraw-Hill 1984, 1:46, 50 / DELI 1966–70, 1:73 / Butler 1937–38, pp. 53f.]

Marcos Antonio Portugal, 1762–1830. *Alceste.* Opera. Libretto, Simeone Antonio Sografi. First performed **1798,** La Fenice, Venice. [Grove 1980, 15:148 / Zinar 1971, p. 90]

Gaetano Gioia, 1764/68–1826, choreography. *Alceste.* Ballet. Music, J. Weigl? First performed **1800,** Vienna. [Oxford 1982, p. 175 / Hunger 1959, p. 21]

Wenzel Müller, 1767–1835. *Die neue Alceste* [The New Alceste]. Parody opera. Libretto, J. Perinet, after Pauersbach (1775) and Richer. First performed 12 June **1806,** Leopoldstädten-Theater, Vienna. [Grove 1980, 12:773]

Giuseppe Antonio Capuzzi, 1755–1818, music. *Admeto ed Alceste.* Ballet. First performed **1807,** Bergamo. [Hunger 1959, p. 21]

William Wordsworth, 1770–1850. (Alcestis evoked in) "Laodamia" lines 79–84. Poem. **1814.** In *Poems, Including Lyrical Ballads* (London: Longman & Co., 1815). / Radically revised, 1827. [De Selincourt 1940–66, vol. 2]

Issachar Styrke. *Euripides' Alcestis Burlesqued.* Burlesque. London: **1816.** [Nicoll 1959–66, 4:409]

Samuel Iperuszoon Wiselius, 1769–1845. *Alkestis.* Tragedy in verse, adaptation and translation of Euripides. **1817.** Amsterdam: 1819. [McGraw-Hill 1984, 2:69]

Charles-Louis Didelot, 1767–1837, choreography. *Alceste, ou La déscente d'Hercule aux Enfers* [Alcestis, or The Descent of Hercules into Hades]. Heroic ballet. Music, F. Antonolini. First performed 7 Feb **1821,** St. Petersburg; scenery, Canoppi and Gonzaga; costumes, Babini. [Swift 1974, pp. 160, 199]

Antonio Cortesi, 1796–1879, choreography. *Alceste.* Ballet. First performed **1827,** La Scala, Milan. [Oxford 1982, p. 7]

Pietro Benvenuti, 1769–1844. "Hercules Restoring Alcestis to Admetus." Painting, part of "Stories of Hercules" cycle. **1828.** Saloncino d'Ercole, Palazzo Pitti, Florence. [Pitti 1966, p. 141—ill.]

Felicia Dorothea Hemans, 1793–**1835.** "The Alcestis of Alfieri." Dramatic poem, adaptation of act 1, scene 2 of Alfieri's *Alceste Seconda* (1798). In *Poetical Works* (Philadelphia: Porter & Coates, 1853). [Boswell 1982, p. 128]

Hippolite Lucas, 1807–1878. *Alceste.* Drama, after Euripides. First performed **1847,** Odéon, Paris; incidental music and chorus, Antoine Elwart. [Grove 1980, 6:148]

Francis Talfourd, 1828–1862. *Alcestis, the Original Strong-Minded Woman.* Burlesque. First performed **1850,** Strand Theatre, London. [Nicoll 1959–66, 5:590]

Eugène Delacroix, 1798–1863. "Hercules Bringing Alcestis Back from Hades." Ceiling painting, in "Life of Hercules" cycle, for Salon de la Paix, Hôtel de Ville, Paris. **1851–52.** Destroyed by fire, 1871. [Robaut 1885, no. 1161—ill. (copy drawing) / Huyghe 1963, pp. 289, 423, 474]

———. "Hercules Bringing Alcestis Back from the Un-

derworld." Painting. 1862. Phillips Gallery, Washington, D.C. [Johnson 1981–86, no. 342—ill. / Huyghe, pl. 358—ill. / also Robaut, no. 1140]

Giuseppe Staffa, 1807–1877. *Alceste.* Opera (lyric drama). Libretto, Sesto Giannini. First performed **1852,** San Carlo, Naples. [Clément & Larousse 1969, 1:27]

Henry Spicer, d. 1891. *Alcestis.* Lyrical drama, after Euripides and Hippolite Lucas (1847). First performed 15 Jan **1855,** St. James Theatre, London. [Nicoll 1959–66, 5:576]

Walter Savage Landor, 1775–1864. "Hercules, Pluto, Alcestis, Admetus." Dramatic dialogue. In *Hellenics,* revised edition (Edinburgh: Nichol, **1859**). [Wheeler 1937, vol. 2]

Ludovic de Vauzelles, 1828–1888. *Alceste.* Tragedy. Paris: Hachette, **1860.** [Taylor 1893, p. 217]

Julius Leopold Klein, 1810–1876. *Alceste.* Drama. **1862.** In *Dramatische Werke* (Leipzig: Weigel, 1871–72). [Oxford 1986, p. 494]

Edward Burne-Jones, 1833–1898. "Love Leading Alcestis." Watercolor cartoon for (unfinished) tapestry, "Legend of Good Women." **1863.** Ashmolean Museum, Oxford. [Arts Council 1975, no. 83] Sketch. Birmingham City Museum & Art Gallery, England, no. 13'04. [Ibid., no. 82]

Edward Hodges Baily, 1788–**1867.** "Hercules Restores Alcestis to Admetus." Sculpture group. [Bénézit 1976, 1:384]

William Morris, 1834–1896. "The Love of Alcestis." Poem. In *The Earthly Paradise,* vol. 2 (London: Ellis, **1868**). [Morris 1910–15, vol. 4 / Calhoun 1975, pp. 146, 161–68]

Frederic, Lord Leighton, 1830–1896. "Hercules Wrestling with Death for the Body of Alcestis." Painting. **1869–71.** Wadsworth Atheneum, Hartford. [Wood 1983, pp. 51–53—ill. / also Ormond 1975, no. 193—ill. / Maas 1969, p. 180—ill. / Kestner 1989, pl. 3.9]

Robert Browning, 1812–1889. (Story of Alcestis retold in) *Balaustion's Adventure, Including a Transcript from Euripides* lines 517–3495. Poem, containing a translation of Euripides' *Alcestis.* London: Smith, Elder, **1871.** [Scudder 1895 / Ryals 1975, pp. 28–40 / Ward 1969, pp. 85–89 / Bush 1937, pp. 366–75 / Galinsky 1972, pp. 260–64]

———. "Apollo and the Fates: A Prologue" (Apollo appeals to the Fates on behalf of Admetus). Monologue. 1871. In *Parleyings with Certain People of Importance in Their Day* (London: Smith, Elder, 1887). [Scudder / Ryals, pp. 206–08 / Ward, p. 282]

Emma Lazarus, 1849–1887. "Admetus." Poem. In *Admetus and Other Poems* (New York: Hurd & Houghton, **1871**). [Bush 1937, p. 372 / Ostriker 1986, p. 285]

Francis Turner Palgrave, 1824–1897. "Alcestis." Poem. In *Lyrical Poems* (London: Macmillan, **1871**). [Boswell 1982, p. 277]

Wathen Mark Wilks Call, 1817–1890. "Alcestis," "Admetus" (a sequel). Poems. In *Reverberations* (London: Trübner, **1876**). [Boswell 1982, p. 63]

John Todhunter, 1839–1916. *Alcestis.* Dramatic poem. London: Kegan Paul, **1879.** [Bush 1937, pp. 372, 560]

M. A. Gambaro. *Alceste.* Opera. Libretto, Sesto Giannini. First performed **1882,** Teatro des Avvalorati, Livorno. [Clément & Larousse 1969, 5:27]

Hugo von Hofmannsthal, 1874–1929. *Alkestis.* Tragedy, after Euripides. **1893.** In *Hesperus* 1909 (Leipzig: Insel).

First performed 14 Apr 1916, Kammerspiele, Munich. [Steiner 1946–58, *Dramen* vol. 1 / McGraw-Hill 1984, 2:509 / Galinsky 1972, pp. 235f. / Hamburger 1969, pp. 105–07]

William Wetmore Story, 1819–**1895**. "Alcestis." Marble sculpture. After 1874. Wadsworth Atheneum, Hartford. [Gerdts 1973, p. 114, fig. 122]

T. Sturge Moore, 1870–1944. "Alkestis Speaks," "Alkestis Is Spoken Of." Poems. In *The Vinedresser and Other Poems* (London: At the Sign of the Unicorn, **1899**); reprinted in *Poems: Collected Edition* (London & New York: Macmillan, 1931–33). [Boswell 1982, p. 274]

Auguste Rodin, 1840–1917. "The Death of Alcestis." Marble sculpture. **1899**. Thyssen-Bornemisza coll., Lugano-Castagnola. [Tancock 1976, pl. 21] Bronze variant. Museum of Fine Arts, Boston. [Ibid., pl. 20] Plaster study. Musée Rodin, Paris. [Rodin 1944, no. 305—ill.]

Per Hallström, 1866–1960. (Alcestis in) *Thanatos*. Novella. In *Thanatos-noveller* (Stockholm: Gernandt, **1900**). [Hunger 1959, p. 20]
———. *Alkestis*. Drama. In *Alkestis, Ahasuerus: Två legenddramer* (Stockholm: Bonnier, **1908**). [Oxford 1983b, p. 367]

Edwin Arlington Robinson, 1869–1935. (Alcestis in) "As a World Would Have It." Poem. In *Captain Craig: A Book of Poems* (Boston & New York: Houghton, Mifflin, **1902**). [Bush 1937, p. 584]

Fernand Khnopff, 1858–1921. Costume designs for a production of Gluck's *Alceste*, Théâtre de la Monnaie, Brussels, **1904**. Designs lost. [Delevoy et al. 1979, no. 391—ill.]

Rainer Maria Rilke, 1875–1926. "Alkestis." Poem. *c.*1904. In *Neue Gedichte* (Leipzig: Insel, 1907). [Zinn 1955–66, vol. 1 / Leishman 1960 / Strauss 1971, pp. 173f. / Hamburger 1969, pp. 112f. / Butler 1937–38, pp. 57–60]

Eva Gore-Booth, 1870–1926. "The Three Resurrections: Lazarus, the Return of Alcestis, and Psyche in Hades." Poem. In *The Three Resurrections and the Triumph of Maeve* (London: Longmans, Green, **1905**). [Bush 1937, pp. 460f., 567]

Sara King Wiley, 1871–1909. "Alcestis." Poem. In *Alcestis and Other Poems* (New York: Macmillan, **1905**). [Boswell 1982, p. 309]

Mary Elizabeth Coleridge, 1861–**1907**. "Alcestis to Admetus." Poem. In *Poems* (London: Mathews, 1908). [Boswell 1982, p. 78]

Robert Prechtl, b. 1874. *Alkestis: Die Tragödie vom Leben* [Alcestis: The Tragedy of Life]. Tragedy. **1908**. Charlottenburg: Lehmann, 1917. [Hamburger 1969, p. 173 *n.*]

Carlota Maria Montenegro, 1876–after 1956? *Alcestis*. Drama. Poet-lore, **1909**. [Hunger 1959, p. 20]

Gustav Renner, 1866–1945. *Alkestis*. Drama. Stuttgart: Bonz, **1911**. [Frenzel 1962, p. 33]

Sir Reed Gooch Baggorre (George Shoobridge Carr), 1837–1912. "Alcestis." Poem. In *Mythological Rhymes* (London: Hodgson, **1912**). [Boswell 1982, p. 26]

Eberhard König, 1871–1949. *Alkestis*. Comedy. Berlin: Borongraeber, **1912**. [DLL 1968–90, 9:89]

Albert A. Stanley, 1851–1932. Incidental music for Euripides' *Alcestis*. First performed 24 June **1912**, Alumni Memorial, University of Michigan, Ann Arbor. [Stanley 1924, pp. 71ff.]

Franklin Simmons, 1839–**1913**. "Hercules and Alcestis." Marble sculpture group. [Gerdts 1973, p. 114]

Benito Pérez Galdós, 1843–1920. *Alceste*. Tragicomedy. First performed 21 Apr **1914**, Teatro de la Princesa, Madrid. [McGraw-Hill 1984, 4:91]

Laurence Housman, 1865–1959. *The Return of Alcestis*. Poetic drama. New York: French, **1916**. Reprinted as *The Death of Alcestis; The Doom of Admetus* in *The Wheel: Three Poetic Plays on Greek Subjects* (New York: French, 1920). [Bush 1937, p. 572]

Gustav Holst, 1874–1934. *Alcestis*. Composition for women's chorus, harp, and flutes. **1920**. [Baker 1984, p. 1044]

Rutland Boughton, 1878–1960. *Alkestis*. Music drama. Libretto, Gilbert Murray's translation of Euripides. **1920–22**. First performed 26 Aug 1922, Glastonbury. [Baker 1984, p. 314 / Grove 1980, 3:98]

Egon Wellesz, 1885–1974. *Alkestis*. Opera, opus 35. Libretto, von Hofmannsthal (1893). Vienna & New York: Universal-edition, 1923. First performed 20 Mar **1924**, Mannheim. [Grove 1980, 20:335f. / Butler 1937–38, p. 57]

Emil Zegadlowicz, 1888–1941. *Alcesta*. Tragedy. **1925**. In *Dramaty* (Szamotulach: Kawalera, 1932). [DULC 1959–63, 4:1232]

André-Joseph Allar, 1845–**1926**. "The Death of Alcestis." Marble sculpture group. Musées Nationaux, inv. R.F. 3871, deposited in Musée, Lisieux, in 1942. [Orsay 1986, p. 265]

Theodore Morrison, 1901–. *The Dream of Alcestis*. Narrative poem. By **1926**. New York: Viking, 1950. [Oxford 1983a, p. 509 / Galinsky 1972, pp. 187, 285f., 293 *n.*44]

Martha Graham, 1894–1991, choreography. *Prelude from "Alceste"*. Modern dance for solo and trio. Music, from Gluck's *Alceste* (1767). Scenario, Theodore Morrison. First performed 27 May **1926**, Kilbourn Hall, Rochester, N.Y.; costumes, Norman Edwards; lighting, Graham. [Stodelle 1984, pp. 221, 300]
———, choreography and costumes. *Alcestis*. Modern dance. Music, Vivian Fine. Scenario, Theodore Morrison. First performed 29 Apr 1960, 54th Street Theatre, New York; décor, Isamu Noguchi, from *Night Journey*; lighting, Jean Rosenthal. [Stodelle, pp. 201, 218–24, 313 / Grove 1980, 6:564 / Cohen 1987, 1:236 / also Noguchi 1968, p. 129—ill.]

Alexander Lernet-Holenia, 1897–1976. *Alkestis*. One-act drama. First performed **1926**, Vienna. Published in *Zwei Einakter: Saul, Alkestis* (Zürich: Pegasus, 1946). [Hamburger 1969, pp. 114f., 173 *n.* / McGraw-Hill 1984, 3:266]

Hilding Rosenberg, b. 1892. Incidental music for Euripides' *Alcestis*. First performed **1933**, Stockholm. [Grove 1980, 16:200]

Giovanni Salviucci, 1907–1937. *Alcesti*. Composition for chorus and orchestra. Text, after Euripides. **1937**. [Baker 1984, p. 1978]

Charles Koechlin, 1867–1950. *Alceste*. Choral composition, opus 169. Text, H. Marchand's translation of Euripides. **1938**. [Grove 1980, 10:146]

Elsa Respighi, b. 1894. *Alcesti*. Opera. Libretto, C. Guastalla. **1941**. [Cohen 1987, 1:579]

Carlo Felice Boghen, 1869–**1945**. *Alceste*. Opera. Libretto, U. Fleres. Unperformed. [Grove 1980, 2:848]

T. S. Eliot, 1888–1965. *The Cocktail Party* (modern treatment of Alcestis theme). Verse drama. First performed **1949**, Edinburgh Festival. Published New York: Harcourt, Brace; London: French, 1950. [Eliot 1962 / Smith

1974, pp. 218–20 / Kenner 1964, pp. 335, 338f. / Maxwell 1966, pp. 191f. / Barber 1958, pp. 226–242]

Nicholas Moore, 1918–. "Alcestis in Ely" (modern Alcestis, finding no Hercules). Poem. In *The New British Poets,* edited by Kenneth Rexroth (Norfolk, Conn: New Directions, **1949**). [Ipso]

Edna St. Vincent Millay, 1892–**1950.** "Alcestis to Her Husband." Sonnet. In *Collected Poems* (New York: Harper & Row, 1956). [Boswell 1982, p. 186]

Ernst Wilhelm Eschmann, 1904–. *Alkestis.* Drama. Tübingen: Heliopolis, **1950.** [DLL 1968–90, 4:526 / Hamburger 1969, pp. 115f., 173 *n.*]

Herwig Hensen, 1917–. *Alkestis.* Tragedy. In *Alkestis, Agamemnon, Tarquinius* (Brussels: Manteau, **1953**). [DULC 1959–63, 2:706]

José Antonio Novais Tome, 1925–. *Admeto.* Drama. **1953.** [DLE 1972, p. 640]

Thornton Wilder, 1897–1975. *The Alcestiad, or A Life in the Sun.* Drama. First performed **1955,** Edinburgh Festival. Published New York: Harper & Row, 1977. {Galinsky 1972, pp. 219f., 230 / Burbank 1978, pp. 128f. / Hamburger 1969, pp. 102, 108–12]

Lars Forssell, 1928–. (Admetus in) *Kröningen* [Coronation]. Drama. Stockholm: Bonnier, **1956.** / Translated in *Players Magazine* 40 no. 2 (1963). [EWL 1981–84, 2:120]

Louise Talma, 1906–. *Die Alkestiade.* Opera. Libretto, Thornton Wilder (1955), translated by H. Herlitschka. **1955–58.** First performed 1 Mar 1962, Frankfurt Opera, Frankfurt. [Cohen 1987, 2:687 / Baker 1984, p. 2270 / Grove 1980, 18:548]

Hugo Vernon Anson, 1894–**1958.** Incidental music for Euripides' *Alcestis,* for chorus and orchestra. Text, Gilbert Murray's translation of Euripides. [Grove 1980, 1:450]

Mary Wigman, 1886–1973. Choreography for a performance of Gluck's *Alceste.* First performed Dec **1958,** Mannheim. [Sorell 1975, pp. 189f. / Oxford 1982, p. 449]

Erwin Wickert, 1915–. *Der Klassenaufsatz-Alkestis* [Alcestis the Unique]. Radio play. Stuttgart: Reclam, **1960.** [Wilpert 1963, p. 629]

Paul Goodman, 1911–1972. "Alcestis's Speech." Poem. In *The Lordly Hudson: Collected Poems* (New York: Macmillan, **1962**). [Ipso]

Ton de Leeuw, 1926–. *Alceste.* Opera. First performed 13 Mar **1963,** Dutch television. [Baker 1984, p. 1325 / Grove 1980, 10:604]

Marguerite Yourcenar, 1903–1987. *Le mystère d'Alceste.* Drama. Paris: Plon, **1963.** [Horn 1985, pp. 81f. / DLLF 1984, 3:2519 / EWL 1981–84, 4:690]

Daryl Hine, 1936–. *Alcestis.* Radio play. First performed **1972,** London. [Vinson 1985, p. 385]

Erica Jong, 1942–. "Alcestis on the Poetry Circuit." Poem. In *Halflives* (New York: Holt, Rinehart & Winston, **1973**). [Ostriker 1986, p. 287]

Jules Olitski, 1922–. "Alcestis." Abstract steel sculpture. **1973.** Artist's coll. in 1981. [Moffett 1981, pl. 169]

Katha Pollitt, 1949–. "Alcestis." Poem. In *Poetry* July **1976;** collected in *Antarctic Traveller* (New York: Knopf, 1982). [Ipso]

Donald Justice, 1925–. "The Return of Alcestis." Poem. In *Selected Poems* (New York: Atheneum, **1979**). [Ipso]

Peter Porter, 1929–. "Alcestis and the Poet." Poem. In

English Subtitles (Oxford & New York: Oxford University Press, **1981**). [CLC 1985, 33:321]

Maura Stanton, 1946–. "Alcestis." Poem. In *Cries of Swimmers* (Salt Lake City: University of Utah Press, **1984**). [Ipso]

ALCINOUS. *See* ODYSSEUS, Nausicaä.

ALCMAEON. *See* ERIPHYLE; SEVEN AGAINST THEBES.

ALCMENE. *See* AMPHITRYON AND ALCMENE; HERACLES, Birth.

ALCYONE AND CEYX. According to Apollodorus, Alcyone, daughter of Aeolus, and her husband Ceyx, son of the morning star, ruled in Trachis and impiously called each other Hera and Zeus. For that reason, Zeus turned them into birds, she an alcyon (kingfisher) and he a ceyx (tern).

In the *Metamorphoses,* Ovid gives another account. Ceyx was distinguished for his great love of Alcyone. When he was drowned on his way to consult an oracle, Alcyone learned of his death in a dream. She went down to the sea and there found his body. In her grief, she was transformed into a kingfisher. As she flew by the body of her dead husband, she touched it, and it, too, was transformed into a kingfisher.

The Ovidian story of Alcyone and Ceyx has been especially popular in poetry and music, but only rarely a subject of the visual arts.

Classical Sources. Ovid, *Metamorphoses* 11.384–748. Apollodorus, *Biblioteca* 1.7.3–4.

Anonymous French. (Story of Alcyone and Ceyx in) *Ovide moralisé* 11.2546–2705, 2996–3787. Poem, allegorized translation/elaboration of Ovid's *Metamorphoses.* *c.*1316–28. [de Boer 1915–86, vol. 4]

Guillaume de Machaut, *c.*1300–1377. (Alcyone's dream evoked in) "The Complainte," part of *Livre de la Fonteinne amoureuse.* Allegorical poem. **1360.** MS in Bibliothèque Nationale, Paris, MS français 22545–46, folio 119r0–137r0. [Huot 1987, p. 307 / DLLF 1984, 2:996]

Geoffrey Chaucer, 1340?–1400. (Story of Alcyone and Ceyx related in) *The Boke of the Duchesse* lines 62–220. Poem. **1368–69.** Probably performed in memorial to Blanche of Gaunt, 1374, London. London: Thynne, 1532. [Riverside 1987 / Howard 1987, pp. 154f., 159 / Minnis 1982, pp. 17f.]

John Gower, 1330?–1408. (Tale of Ceyx and Alcyone in) *Confessio amantis* 4.2927–3123. Poem. *c.*1390. Westmin-

ster: Caxton, 1483. [Macaulay 1899–1902, vol. 2 / Ito 1976, p. 39]

Christine de Pizan, *c.*1364–*c.*1431. (Alcyone, representing devotion and wisdom, in) *L'epistre d'Othéa à Hector* . . . [The Epistle of Othéa to Hector] chapter 79. Didactic romance in prose. *c.***1400.** MSS in British Library, London; Bibliothèque Nationale, Paris; elsewhere. / Translated by Stephen Scrope (London *c.*1444–50). [Bühler 1970 / Hindman 1986, pp. 130, 200]

Vittore Carpaccio, *c.*1465–**1525/26.** "The Story of Alcyone." Painting. Johnson coll., Philadelphia Museum of Art, no. 173. [Berenson 1957, p. 58]

W. Hubbard. *The Tragicall and Lamentable Historie of Two Faithful Mates, Ceyx, Kynge of Trachine and Alcione His Wife.* Poem. London: W. How for R. Johnes, **1569.** [Bush 1963, p. 315]

John Dryden, 1631–1700. "Ceyx and Alcyone." Poem, translation from Ovid's *Metamorphoses* book 10. In *Fables, Ancient and Modern* (London: Tonson, **1700**). [Dryden 1700 / Van Doren 1946, p. 219]

Marin Marais, 1656–1728. *Alcione.* Opera. Libretto, Antoine Houdar de La Motte. First performed 18 Feb **1706,** L'Opéra, Paris. Libretto published Paris: Ribon, 1719. [Baker 1984, p. 1447 / Grove 1980, 11:641 / Girdlestone 1972, p. 189 / DLLF 1984, 2:1040]

Louis Marchand, 1669–1732. *Alcione.* Cantata. [Grove 1980, 11:657]

Louis Fuzelier, 1674–1752. *La rupture du Carnaval et de la folie.* Parody of La Motte and Marais's *Alcione* (1706). In *Le théâtre de la foire, ou L'opéra comique* . . . (Paris: Ganeau, **1721–37**). [Grove 1980, 7:47]

Adolfe Benoît Blaïse, ?–1772. *Alcyone.* Opera. Libretto, Romagnesi. 1741. [Hunger 1959, p. 187]

Étienne Lauchery, 1732–1820, choreography. *Ceyx und Alcyone.* Ballet. Music, Christian Cannabich. First performed **1763,** Mannheim. [Hunger 1959, p. 187]

Richard Wilson, 1714–1782. "(A Storm at Daybreak, with the Story of) Ceyx and Alcyone." Painting. Exhibited **1768.** Baccolini coll., Buenos Aires. [Constable 1953, p. 166, pl. 25a]

George Romney, 1734–1802. "Ceyx and Alcyone." Drawing, in Roman sketchbook. *c.***1775.** Fitzwilliam Museum, Cambridge. [Jaffé 1977, no. 9]

Georg Christoph Lichtenberg, 1742–1799. *Alcyone.* Drama. Before **1779.** [Strich 1970, 1:225 *n.*]

João de Sousa Carvalho, 1745–1798. *Alcione.* Opera. Libretto, Martinelli. First performed 25 July **1787,** palace of Ajuda or Queluz. [Grove 1980, 3:842]

Louis Joseph Saint-Amans, 1749–*c.*1820. "Scène d'Alcyone." Lyric scene. 1789. Unperformed. [Grove 1980, 16:385]

Nicolas-Joseph Chartrain, *c.*1740–**1793.** *Alcione.* Opera (tragédie lyrique). Libretto, La Motte (1706). Unperformed. [Grove 1980, 4:177]

Samuel Taylor Coleridge, 1772–1834. "Domestic Peace" (Alcyone as bird of domestic peace). Sonnet. **1794.** First published in *The Fall of Robespierre* (1795); reprinted as "Song" in 1796 and later editions. [Yarlott 1967, p. 80]

Victor-Charles-Paul Dourlen, 1780–1864. *Alcyone.* Cantata. Libretto, Arnault. **1804.** [Grove 1980, 5:592]

Christian Gottlieb Kratzenstein Stub, 1783–1816. "Alcyone Looking Out over the Sea." Painting. 1810. Sta-

tens Museum for Kunst, Copenhagen. [Bindman 1979, p. 199]

———. "Alcyone's Dream" (of Ceyx shipwrecked). Drawing. 1810. Kobberstiksamling, Statens Museum for Kunst, Copenhagen. [Bindman, no. 250—ill.]

Christoffer Wilhelm Eckersberg, 1783–1853. "Alcyone by the Sea." Painting. **1813.** Statens Museum for Kunst, Copenhagen. [Bindman 1979, p. 199]

———. "Alcyone's Dream." Painting, fragment (showing only a figure known as "Alcyone's nurse"). 1813. Thorwaldsens Museum, Copenhagen, no. B210. [Ibid. / Thorwaldsen 1985, p. 95]

Felicia Dorothea Hemans, 1793–**1835.** "Lament of Alcyone" (later retitled "Antique Greek Lament"). Poem. In *Poetical Works* (Philadelphia: Porter & Coates, 1853). [Boswell 1982, pp. 128f.]

William George Caldcleugh. "Alcyon." Poem. In *The Branch and Other Poems* (Philadelphia: Challen, **1862**). [Bush 1937, p. 579]

Margaret Junkin Preston, 1820–1897. "Alcyone." Poem. In *Old Song and New* (Philadelphia: Lippincott, **1870**). [Boswell 1982, p. 205.]

Frederick Tennyson, 1807–1898. *Halcyone.* Poem. London: privately printed, **1888;** collected in *Daphne and Other Poems* (London & New York: Macmillan, 1891). [Boswell 1982, p. 300 / DLB 1984, p. 285.]

Edmund Gosse, 1849–1928. "Alcyone." Poem. In *On Viol and Flute* (London: Kegan Paul, **1890**). [Boswell 1982, p. 119 / Bush 1937 p. 414]

Georges Palicot. *Alcyone.* Opera. Libretto, Charles L. A. Guérin. First performed 18 Aug **1891,** Boulogne-sur-Mer. [Clément & Larousse 1969, 1:28]

Archibald Lampman, 1861–1899. "Alcyone." Poem. **1899.** In *Poems* (Toronto: Morang, 1900). [DULC 1959–63, 3:30]

Maurice Ravel, 1875–1937. *Alcyone.* Cantata for 3 solo voices and orchestra. Libretto, E. and E. Adénis. **1902.** [Baker 1984, p. 1859 / Grove 1980, 15:620]

Jean-Jules Roger-Ducasse, 1873–1954. *Alcyone.* Cantata. **1909.** [Baker 1984, p. 1916]

William Rose Benét, 1886–1950. "The Halcyon Birds." Poem. In *Merchants from Cathay* (New York: Appleton-Century, **1913**). [Bush 1937, p. 586 / Boswell 1982, p. 37]

Eden Phillpotts, 1862–1960. "Alcyone." Fairy story. London: Benn, **1930.** [Kunitz 1961, p. 1103]

I. M. Panayotopoulos, 1901–. *Alkyone.* Collection of poems. Athens: **1950.** [EWL 1981–84, 3:468]

ALPHEUS AND ARETHUSA. The Alpheus is the largest river of the Peloponnesus, originating in Arcadia and flowing past the city of Olympia. The river-god Alpheus fell in love with Arethusa, a nymph of Artemis. In escaping his pursuit, Arethusa beseeched the goddess for help and Artemis covered her with a cloud. The cloud and the nymph were transformed into a stream that flowed underground until it was united with the waters of the Alpheus in the sea. The stream is said to have come out at Syracuse, in Sicily, where there is a spring called the fountain of Arethusa.

The story of Alpheus and Arethusa has been a popular subject in poetry and literature; it became a favorite theme of works in the visual arts only around the seventeenth century.

Classical Sources. Hesiod, *Theogony* 338. Virgil, *Eclogues* 10.1; *Aeneid* 3.694ff. Ovid, *Metamorphoses* 5.572–641. Pausanias, *Description of Greece* 5.6.2–3, 5.7.2. Lucian, *Dialogues of the Sea-Gods* 3, "Poseidon and Alpheus."

Anonymous French. (Arethusa and Alpheus in) *Ovide moralisé* 5.3256–3746. Poem, allegorized translation/elaboration of Ovid's *Metamorphoses*. *c.*1316–28. [de Boer 1915–86, vol. 2]

Rosso Fiorentino, 1494–1540. "The Crowning of Arethusa." Drawing. E. B. Crocker Gallery, Sacramento. [Warburg]

Battista Dossi, *c.*1474–1548. "Arethusa." Cartoon for tapestry. **1543–45.** / Tapestry woven by Hans Karcher, 1545. Private coll., Ferrara. [Gibbons 1968, no. 196—ill.]

Bernardino Martirano, *c.*1490–**1548.** "Aretusa." Poem. In *Stanze di diversi autori* (Venice: 1564, 1580). [DELI 1966–1970, 3:535]

Alberto Lóllio, 1508–1568. *Aretusa.* Pastoral comedy. Ferrara: Mantoano, **1564.** Modern edition by A. F. Pavanello (Ferrara: 1901). [DELI 1966–1970, 3:405]

Battista Lorenzi, 1527/28–1594. "Alpheus and Arethusa." Marble statue. *c.*1570–80. Metropolitan Museum, New York, no. 40.33. [Metropolitan 1983, p. 205—ill.]

Alexandre Hardy, *c.*1570–1632. *Alphée, ou La justice d'amour* [Alpheus, or The Justice of Love]. Pastoral drama. **1610–20.** In *Théâtre* (Paris: Quesnel, 1624–[28]). [McGraw-Hill 1984, 2:446 / Deierkauf-Holsboer 1972, pp. 152–155]

Filippo Vitali, *c.*1590–after 1653. *L'Aretusa.* Opera (favola in musica). First performed **1621,** Rome. [Pirrotta & Povoledo 1982, p. 273 / Grove 1980, 20:20]

Nicolas Poussin, 1594–1665, studio. "Alpheus and Arethusa." Drawing, copy after presumed lost original by Poussin of late **1620s.** Royal Library, Windsor, no. 11977. [Friedlaender & Blunt 1953, no. A55—ill.]

John Milton, 1608–1674. (Alpheus and Arethusa evoked in) "Lycidas" lines 85f., 132f. Pastoral elegy. Nov **1637.** In *Justa Eduardo King . . .* (Cambridge: 1638). [Carey & Fowler 1968; cf. p. 246 *n.*]

———. (Alpheus and Arethusa evoked in) *Arcades* lines 30ff. Masque. First performed 1632 (?) for Dowager Countess of Derby, Harefield. / Revised version published in *Poems* (London: Moseley, 1645). [Ibid.; cf. pp. 158 *n.*, 246 *n.*]

Juan Bautista Diamante, 1625–1687. *Alfeo y Aretusa.* Comedy. In *Comedias,* part 2 (Madrid: Rico de Miranda for Garcia de la Iglesia, 1670). [Barrera 1969, p. 124]

Juan Hidalgo, 1612/16–1685. *Alfeo y Aretusa.* Opera. Libretto, Diamante (1670). First performed **1672,** Madrid? [Grove 1980, 8:548]

Abraham van Diepenbeeck, 1596–1675. "Alpheus and Arethusa." Drawing. Graphische Sammlung, Munich. [Pigler 1974, p. 12]

Jean-Baptiste Boësset, 1614–**1685.** *Alphée et Aréthuse.* Opera (tragédie en musique). Libretto, Boucher. First performed Oct 1686, Fontainebleau. [Girdlestone 1972, p. 135]

Willem Doudijns, 1630–**1697.** "Alpheus and Arethusa." Painting. University Museum, Göttingen. [Warburg]

André Campra, 1660–1744. *Aréthuse ou La vengence de l'amour* [Arethusa, or The Vengeance of Love]. Opera (tragédie lyrique). Libretto, Antoine Danchet. First performed 14 July **1701,** L'Opéra, Paris. [Grove 1980, 3:665]

Alexander Pope, 1688–1744, doubtfully attributed. "The Story of Arethusa." Verse translation from Ovid's *Metamorphoses*. *c.*1702 (?). In *Miscellaneous Poems and Translations, by Several Hands* (London: Lintot, 1712). [Twickenham 1938–68, vol. 6, p. 409]

Clemente Monari, *c.*1660?–*c.*1729. *L'Aretusa.* Opera. Libretto, P. d'Averara. First performed 1703, Milan. [Grove 1980, 12:477]

Michel Corneille the Younger, 1642–1708. "Alpheus and Arethusa" Drawing. Louvre, Paris. [Pigler 1974, p. 12]

Luis Calixto de Acosta y Faría, 1679–*c.*1738. *Fábula de Alfeo y Aretusa.* Fiesta with music. Published Lisbon: Manescal, **1712.** [Barrera 1969, p. 5]

Charles-Hubert Gervais, 1671–1744. *Aréthuse.* Cantata. In *Cantates françoises,* book 1 (Paris: **1712**). [Grove 1980, 7:309]

Louis-Nicolas Clérambault, 1676–1749. *Alphée et Aréthuse.* Cantata. In *Cantates françoises,* book 2 (Paris: **1713**). [Grove 1980, 4:492]

Nicola Fago, 1677–1745. "D'Aretusa in su lito" [Of Arethusa on her Shore]. Vocal composition. **1715.** [Grove 1980, 6:361]

Jean Restout, 1692–1768. "Alpheus and Arethusa" Painting. **1720.** Musée, Rouen. [Warburg]

Nicolas-Antoine Bergiron de Briou, 1690–1768. *Aréthuse.* Opera. First performed **1722–23,** Paris. [Grove 1980, 2:548]

François Le Moyne, 1688–1737. "Alpheus and Arethusa." Painting, for Hôtel Peyrenc de Moras (Hôtel Biron), Paris. **1729–30.** Lost. [Bordeaux 1984, no. 84]

———, rejected attribution. "Alpheus and Arethusa." Drawing. Yale University Art Gallery, New Haven. [Ibid., no. X48—ill.]

Lorenzo Mattielli, 1682/88–1748. "Alpheus and Arethusa." Stucco sculpture group. **1731.** Schloss Eckartsau, Switzerland. [Pigler 1974, p. 12]

Pierre-Charles Trémollière, 1703–1739. "Alpheus and Arethusa." Painting. Musée, Cholet. [Bénézit 1976, 10:266]

Andrea Locatelli, 1695–1741. "Landscape with Alpheus and Arethusa." Painting. Hermitage, Leningrad. [Hermitage 1981, pl. 211]

François Boucher, 1703–1770. "Alpheus and Arethusa." Painting. **1761.** Lost. [Ananoff 1976, no. 549]

Edmé Bouchardon, 1698–1762. "Alpheus and Arethusa." Drawing. Louvre, Paris. [Pigler 1974, p. 12]

Antoine Dauvergne, 1713–1797, music. *Alphée et Aréthuse.* Ballet. Scenario, Antoine Danchet. Choreographer unknown. First performed 15 Dec **1762,** Choisy-le-roi. [Grove 1980, 5:257]

José Antonio Porcel y Salamanca, 1715–**1794.** *Fabula de Alfeo y Aretusa.* Poem. Modern edition, *Biblioteca des autores españoles,* vol. 69 (Madrid: Rivadeneyra, 1869). [DLE 1982, 4:15 / Oxford 1978, p. 471]

Michelangelo Monti, 1751–1822. *Aretusa ed Alfeo.* Cantata. First performed **1794,** Palermo. [DELI 1966–1970, 4:51]

Samuel Taylor Coleridge, 1772–1834. ("River Alph" in)

"Kubla Khan; A Vision in a Dream." Poem. **1797–99.** In *Christabel; Kubla Khan; The Pains of Sleep* (Boston: Wells & Lilly, 1816). [Jordan 1972, p. 185 / Lowes 1959, pp. 327–29, 336f.]

Benjamin West, 1738–1820. "Arethusa." Painting. *c.*1802. Lost. [von Erffa & Staley 1986, no. 119 (cf. 120, 154)]

John Keats, 1795–1821. (Arethusa and Alpheus in) *Endymion* 2.933–1018. Poem. **1817.** London: Taylor & Hessey, 1818. [Stillinger 1978 / Aske 1985, pp. 40, 57 / Bush 1937, pp. 91, 97]

Percy Bysshe Shelley, 1792–1822. "Arethusa." Poem. **1820.** In *Posthumous Poems,* edited by Mary Shelley (London: Hunt, 1824). [Hutchinson 1932 / Bush 1937, pp. 135f. / Chernaik 1972, p. 135]

———. "From Vergil's Tenth Eclogue." Translation, fragment. In *Poetical Works* (London: 1870). [Hutchinson]

William Blake, 1757–1827. "Return Alpheus." Drawing, after Milton's "Lycidas" line 132. *c.*1825–27. British Museum, no. 1874–12–12–116. [Butlin 1981, no. 800—ill.]

John Martin, 1789–1854. "Alpheus and Arethusa." Painting. **1832.** Earl Howick of Glendale coll. [Feaver 1975, pp. 23, 218 *n.*]

Thales Fielding, 1793–1837. "Alpheus and Arethusa" Watercolor. **1837.** Fine Arts Society, London. [Warburg]

Robert Eyres Landor, 1781–1869. *The Fountain of Arethusa.* Collection of dialogues. London: Longman & Co., **1848.** [Oxford 1985, p. 547]

Elihu Vedder, 1836–1923. "Arethusa" ("The Water Nymph," "The Birth of Spring"). Painting. **1876–78.** Formerly Shillaber coll., San Francisco, unlocated. [Soria 1970, no. 311]

Alan Gray, 1855–1935. *Arethusa.* Cantata. First performed **1892,** Leeds. [Grove 1980, 7:650]

Mme. de Montgoméry. *Aréthuse.* Opera. First performed May **1894,** Monte Carlo. [Clément & Larousse 1969, 1:70 / Cohen 1987, 1:486]

Henri de Régnier, 1864–1936. *Aréthuse.* Collection of poems. Paris: Librairie de l'Art Indépendant, **1895.** [DLLF 1984, 3: 1885]

Enrico Castelnuovo, 1839–1915. *Il ritorno dell' Aretusa.* Novel. Milan: Castoldi, **1901.** [DELI 1966–1970, 1:627]

Samuel Coleridge-Taylor, 1875–1912. ("River Alph" in) *Kubla Khan.* Rhapsody for solo voice, chorus, and orchestra, opus 61. Text, Coleridge's poem (1797–99). First performed **1906,** Queen's Hall, London. [Grove 1980, 4:529]

Arthur B. Davies, 1862–1928. "Arethusa." Painting. **1910.** C. J. Sullivan coll., New York. [Cortissoz 1931, p. 20]

———. "Daughters of Arethusa." Watercolor. Private coll. [Metropolitan 1930, no. 142]

Karol Szymanowski, 1882–1937. "La fontaine d'Aréthuse." Musical "poem" for violin and piano, part of *Mity* [Mythes], opus 30. First performed **1915.** [Baker 1984, p. 2262]

Aristide Maillol, 1861–1944. "Arethusa." Woodcut, illustrating Virgil's Tenth Eclogue. Leipzig: Insel, **1926.** [Guérin 1965, no. 55—ill.]

Ettore Romagnoli, 1871–1938, with **Giuseppe Lipparini,** 1877–1951. *Aretusa.* Collection of poems. Bologna: Zanichelli, **1926.** [DELI 1966–1970, 4:582]

Ludwig Kasper, 1893–1945. "Arethusa." Stucco sculpture. **1940.** [Clapp 1970, 1:511]

Benjamin Britten, 1913–1976. "Arethusa." Composition for solo oboe, part of *Six Metamorphoses after Ovid,* opus 49. First performed 14 June **1951,** Thorpeness, The Meare. [Grove 1980, 3:296, 306]

Peter Viereck, 1916–. "Arethusa." Poem. In *The First Morning: New Poems* (New York: Scribner, **1952**). [DLB 1980, 5 pt. 2: 345]

Ezra Pound, 1885–1972. (Allusion to Fountain of Arethusa in) Canto 90 lines 607ff., in *Section: Rock-Drill, 85–95 De Los Cantares* (New York: New Directions, **1955**). [Flory 1980, pp. 96f., 244]

Toni Stadler, b. 1888. "Arethusa." Bronze sculpture. **1955.** Hessisches Landesmuseum, Darmstadt. [Berlin 1963, no. 85]

Maurice Zermatten, 1910–. *La fontaine d'Aréthuse.* Novel. [Bruges?]: Desclée, De Brouwer, **1958.** [EWL 1981–1984, 4:386]

Anne Ridler, 1912–. "Evenlode, a Fable of Rivers." Poem. In *A Matter of Life and Death* (London: Faber & Faber, **1959**). [Ipso]

Pierre Benoit, 1886–1962. *Aréthuse.* Novel, unfinished. [DLLF 1984, 1:233]

Robert Duncan, 1919–1988. "Shelley's 'Arethusa' Set to New Measures." Poem. **1961–63.** In *Roots and Branches* (New York: Scribner, 1964). [Ipso]

Donald Davie, 1922–. "The Fountain of Arethusa." Poem. In *Three for Water-Music and The Shires* (Manchester: Carcanet, **1981**). [CLC 1985, 31:119]

AMARYLLIS. *See* SHEPHERDS AND SHEPHERDESSES.

AMAZONS. A legendary (or, as some maintain, wholly mythical) race of warrior women, the Amazons were said to live at the boundaries of the known world. Their realm was usually placed in the east, particularly on the Thermodon River, which empties into the Black Sea. Amazons' primary activities were hunting and fighting from horseback; their weapons were bow, ax, and javelin. To perpetuate their race, they would from time to time mate with men of another race and afterward keep only their female children. The Amazons' name is said to mean "breastless," deriving from their custom of destroying their daughters' right breasts to enable them to use their weapons without interference. Diodorus Siculus writes of an earlier race of Amazons from Libya, who shared many of the attributes of their more famous counterparts in Asia; for example, both were led by fierce queens.

Amazons are mentioned in Greek literature as early as Homer's *Iliad* and other poems of the epic cycle. In the *Iliad* they are said to have battled Bellerophon in Lycia and King Priam of Troy. In Arctinus's *Aethiopis* they come to Priam's aid after the death of

Hector and in the fray lose their queen, Penthesilea, at the hands of Achilles. One Hellenistic legend suggests that an Amazon queen met Alexander the Great on the border of India.

Another queen, Hippolyta, figures prominently in one of the twelve labors of Heracles, who was sent to capture her girdle. It is said that the hero Theseus either joined Heracles in this expedition or launched his own campaign against the Amazons, taking Hippolyta or her sister Antiope as his wife. In response, the Amazons attacked him in Athens, but were defeated in a great battle.

A popular theme in archaic and classical art from the end of the seventh century BCE, Amazons are usually depicted in battle scenes, wearing short tunics; from the fifth century BCE, they are shown with one breast exposed, sometimes wearing trousers, and bearing light arms. In postclassical art, numerous "Battles of the Amazons" that follow this tradition are sometimes said to depict Heracles' or Theseus's combats with Amazons, although in most cases they are nonspecific frays. The idea of warrior women has long entranced poets as well, and many authors have invented their own so-called Amazon heroines out of whole cloth. The term has also become generalized, referring in some cases to any independent, bellicose, or even equestrian woman.

Classical Sources. Homer, *Iliad* 3.184–90, 6.186. Arctinus, *Aethiopis* 1.2. Aeschylus, *Eumenides* 685–90. Herodotus, *History* 4.110–17. Diodorus Siculus, *Biblioteca* 3.52–72, 4.16, 17.77.1–3. Virgil, *Aeneid* 1.693–97. Apollodorus, *Biblioteca* 2.3.2, 2.5.9, E1.16f., E5.1–2. Plutarch, *Parallel Lives,* "Theseus" 26–28. Pausanias, *Description of Greece* 1.21.1, 1.41.7, 2.32.9, 7.2.7–8. Hyginus, *Fabulae* 163. Quintus of Smyrna, *Sequel to Homer* 1.538–810.

Further Reference. Abby W. Kleinbaum, *The War against the Amazons* (New York: McGraw-Hill, 1983).

See also HERACLES, Girdle of Hippolyta; PENTHESILEA; THESEUS, and the Amazons.

Benoît de Sainte-Maure, fl. 1150–70. (Account of Amazons in) *Le roman de Troie* lines 23127–356. Verse romance, after Dares, *De excidio Troiae historia,* and Dictys, *Ephemeris de historia belli Troiani* (6th century Latin versions of lost Greek poems, pseudo-classical forgeries). *c.*1165. [Baumgartner 1987]

Anonymous French. (Amazons treated in) *L'histoire ancienne jusqu'à César* [Ancient History to Caesar] folios between 1170 & 1230 (Paris MS). Prose history. Dictated to Roger de Lille, 1208–30. MSS in Bibliothèque Nationale, Paris, f. fr. 20125; Morgan Library, New York, MS 212; elsewhere. [Singerman 1986, p. 155]

Guido delle Colonne, *c.*1210–after 1287. (Account of Amazons in) *Historia destructionis Troiae* [History of the Destruction of Troy]. Latin prose chronicle, after Benoît de Sainte-Maure. 1272–87. Modern edition by Nathaniel E. Griffin (Cambridge, Mass.: Harvard University Press, with Mediæval Academy of America, 1936; reprinted New York: Kraus, 1970). / Translated by M. E.

Meek (Bloomington: Indiana University Press, 1974). [Benson 1980, p. 68]

Giovanni Boccaccio, 1313–1375. "De Martesia et Lampedone reginis Amazonum" [Marthesia [Marpessa] and Lampedo, Queens of the Amazons], "De Orythi et Anthiope reginis Amazonum" [Orithyia and Antiope, Queens of the Amazons]. In *De mulieribus claris* [Concerning Famous Women]. Latin verse compendium of myth and legend. 1361–75. Ulm: Zainer, 1473. [Branca 1964–83, vol. 10 / Guarino 1963]

Anonymous English. (Amazon's exploits recounted in) *The Laud Troy Book* lines 15963–16036. Metrical romance, after Guido delle Colonne. *c.*1400. Modern edition by J. Ernst Wülfing (London: Early English Text Society, 1902, 1903). [Benson 1980, p. 68]

Christine de Pizan, *c.*1364–*c.*1431. (Lampedo, Marpessa, and Thamiris, leaders of the Amazons, in) *Le livre de la Cité des Dames* [The Book of the City of Ladies] part 1 no. 17. Didactic compendium in prose, reworking of Boccaccio's *De mulieribus claris.* 1405. [Hicks & Moreau 1986] Translated by Brian Anslay (London: Pepwell, 1521). [Richards 1982]

Garci Rodríquez de Montalvo, fl. *c.*1490–1500. (Amazons in) *Los quatro libros del virtuoso cavallero Amadís de Gaula* [The Four Books of the Most Virtuous Knight, Amadis of Gaul]. Romance. *c.*1492. Saragossa: 1508. [Kleinbaum 1983, pp. 77–86 / Oxford 1978, p. 21f. / DLE 1972, p. 611]

Garci Ordóñez de Montalvo. *Las sergas de Esplandian* [The Exploits of Esplandian]. Romance, sequel (fifth book) to Garci Rodriquez de Montalvo's *Los quatro libros del virtuoso cavallero Amadis de Gaula* (*c.*1492). Seville: 1510. [Kleinbaum 1983, pp. 77–86]

Domenico Morone, 1442–after 1517. "Battle of Amazons" (?). Painting. Art Museum, Princeton University, N.J., no. 35.54. [Berenson 1968, p. 280]

Giulio Romano, *c.*1499–1546, assistant, after design by Giulio. "Battle of Greeks and Amazons." Fresco frieze. 1527–28. Sala delle Aquile, Palazzo del Tè, Mantua. [Hartt 1958, p. 125 / Verheyen 1977, p. 121]

Luca Cambiaso, 1527–1585. "Amazon on Horseback." Drawing. *c.*1544. Albertina, Vienna. [Manning & Suida 1958, p. 175–ill.]

———. "Battle of the Amazons." Fresco. Palazzo Spinola, Genoa. [Pigler 1974, p. 297]

Perino del Vaga, 1501–1547. "Amazons." Drawing. Louvre, Paris. [Warburg]

Giovanni Bernardi, 1496–1553, and **Manno di Bastiano,** design. (Battle of Amazons depicted on) "The Farnese Coffer." Silver gilt coffer. 1548–61. Museo di Capodimonte, Naples, no. 10507. [Capodimonte 1964, p. 129]

William Painter, *c.*1540–1594. "Amazons." Short tale, translation of Gruget's French version of Pedro Mexia's *Silva.* In *The Palace of Pleasure* (London: Tottell & Jones, 1566). [Bush 1963, pp. 34 *n.,* 314]

Lope de Vega, 1562–1635. *Las justas de Tebas y reina de las Amazonas* [The Jousts of Thebes and the Amazon Queen]. Comedy. Before 1596. [McGraw-Hill 1984, 5:96, 98]

Edmund Spenser, 1552?–1599. (Radigund, an evil Amazon queen, conquered finally by Britomart, the virtuous Amazon in) *The Faerie Queene* 5.4, 5.5, 5.7. Romance epic. London: Ponsonbie, 1596. [Hamilton 1977 / Nohrnberg

Peter Paul Rubens, 1577–1640, attributed. "Battle of the Amazons." Painting. *c.***1598.** Sanssouci, Potsdam. [Jaffé 1989, no. 7—ill.]

———. "Battle of the Amazons." Painting. *c.*1615. Alte Pinakothek, Munich, inv. 324. [Ibid., no. 295—ill. / Munich 1983, pp. 459f.—ill. / also White 1987, pl. 96 / Huyghe 1963, pl. 246 / Baudouin 1977, pl. 78] 3 further versions of the subject known. Painting, private collection, England; drawing, copy of lost painting, Statens Museum for Kunst, Copenhagen, inv. IV/3i; drawing, British Museum, London, inv. 1895.9.15. [Burchard & d'Hulst 1963, no. 50—ill.]

Roman School. "Amazons." Drawing. **16th century.** Kunsthalle, Hamburg, no. 21345. [Warburg]

Pieter Schoubroeck, *c.*1570–1607. "Battle of the Amazons." Painting. **1603.** Gemäldegalerie, Dresden. [Pigler 1974, p. 297]

William Shakespeare, 1564–1616. (Ladies appear as Amazons in a masque in) *Timon of Athens* 1.2.131ff. Tragedy, unfinished. **1607–08?** London: Jaggard, 1623 (First Folio). [Riverside 1974 / Kleinbaum 1983, p. 98]

John Fletcher, 1579–1625. (Amazons discovered on) *The Sea Voyage.* Comedy. Licensed 22 June **1622.** First performed Globe Theatre, London. / Possibly revised by Philip Massinger and published London: 1647. [McGraw-Hill 1984, 2:179]

Thomas Heywood, 1573/74–1641. "Of the Amazons." Passage in *Gynaikeion: or, Nine Books of Various History Concerning Women* book 5. Compendium of history and mythology. London: Adam Islip, **1624.** [Ipso]

Bartolomeo Tortoletti, "L'Amazoni." Verse fable. In *La scena reale* (Rome: Grignani, **1645**). [Herrick 1966, p. 65]

Tirso de Molina, 1583–1648. *Amazonas en la India.* Comedy. Madrid: Theresa de Guzman, 17–? [DLE 1972, p. 878]

Pier Francesco Cavalli, 1602–1676. *Veremonda l'Amazzone di Aragona* [Veremonda, the Amazon of Aragon]. Opera. Libretto, Giulio Strozzi, as "L. Zorzisto," after Cicognini's *Celio.* First performed 21 Dec **1652,** Teatro del Palazzo Reale, Naples. [Grove 1980, 4:32 / Bianconi 1987, p. 197]

Claude Deruet, 1588–1662. "Departure of the Amazons," "Battle of the Amazons and Greeks." Paintings. Metropolitan Museum, New York, nos. 1976.100.6–7. [Metropolitan 1980, p. 46—ill.]

Frans Francken III, 1607–1667, attributed. "Battle of the Amazons." Painting. Art Gallery and Museum, Glasgow. [Wright 1976, p. 68]

Cornelis van Poelenburgh, *c.*1586–1667. "Amazon Sleeping." Painting. Musée Crozatier, Le Puy. [Bénézit 1976, 8:392]

Edward Howard, 1624–? *The Woman's Conquest.* Tragicomedy. First performed *c.*Nov **1670,** Lincoln's Inn Fields, London. [Nicoll 1959–66, 1:414 / Kleinbaum 1983, p. 160]

———. (Amazons in) *The Six Days Adventure, or New Utopia.* Comedy. First performed *c.*Mar 1671, Lincoln's Inn Fields, London. [Ibid.]

Paul de Vos, 1595–1678. "Amazon Chasing a Deer." Painting. Musée d'Art et d'Histoire, Narbonne. [Bénézit 1976, 10:575]

Bernardo Pasquini, 1637–1710. *La caduta del regno dell' Amazzoni* [The Fall of the Amazons' Realm]. Opera. Libretto, G. de Totis. First performed as *L'Artide* (?), **1678,** Palazzo Colonna, Rome. [Grove 1980, 14:266]

Carlo Pallavicino, *c.*1630–1688. Scene in *Le Amazoni nell' isole fortunate* [The Amazons of the Fortunate Isles]. Opera. Libretto, F. M. Piccioli. First performed Nov **1679,** Teatro Contarini, Poazzola sul Brenta, near Padua. [Baker 1984, p. 1713 / Grove 1980, 14:142]

Thomas D'Urfey, 1653–1723. *A Commonwealth of Women.* Comedy, after John Fletcher's *The Sea Voyage* (1622). **1685.** London: Bentley & Hindmarsh, 1686. [Kleinbaum 1983, p. 160 / Nicoll 1959–66, 1:408]

Antonio de Solís y Rivadeneira, 1610–1686. *Las Amazonas de Escitia* [The Amazons of Scythia]. Comedy. Seville: Imprenta Real. [Barrera 1969, p. 375]

Alessandro Scarlatti, 1660–1725. *L'Amazone corsara [guerriera] overo L'Alvilda* [The Amazon Corsair (Warrior), or Alvilda]. Opera (dramma per musica). Libretto, G. C. Corradi. First performed 6 Nov **1689,** Palazzo Reale, Naples. [Grove 1980, 16:558]

Charles Le Brun, 1619–1690, or **François Verdier,** 1651–1730, attributed. "Battle of the Amazons." Painting. Musée, Courtrai, no. 38. [Pigler 1974, p. 297]

Carlo Agostino Badia, 1672–1738. *L'Amazone corsara, ovvero L'Alvilda, regina de'Goti* [The Amazon Corsair, or Alvilda, Queen of the Goths]. Opera (dramma per musica). Libretto, Corradi (1689). Autograph MS dated **1692.** [Grove 1980, 2:9]

André Cardinal Destouches, 1672–1749. *Marthésie, reine des Amazones.* Opera (tragédie lyrique). Libretto, Antoine Houdar de La Motte. First performed Oct **1699,** Fontainebleau. [Grove 1980, 5:402 / Girdlestone 1972, pp. 190f.]

Clemente Monari, *c.*1660?–*c.*1729. *L'Amazzone corsara.* Opera. Libretto, Corradi (1689). First performed **1704,** Milan. [Grove 1980, 12:477]

Giacomo Farelli, 1624–1706. "The Battle of the Amazons." Painting. Art Gallery and Museum, Perth. [Wright 1976, p. 62]

Johann Philipp Käfer, 1672–*c.*1730. *Der erste Königen derer Amazonen Marthesia* [The First Queen of the Amazons, Marthesia]. Opera. First performed **1717,** Durlach. [Grove 1980, 9:766]

Jean-Claude Gillier, 1667–1737. *L'île des Amazones.* Opéra comique. Libretto, Alain-René Lesage, with D'Orneval, 1718. First performed **1720,** Théâtre de la Foire Saint-Laurent, Paris. [Grove 1980, 7:381 / McGraw-Hill 1984, 3:268]

Louis Le Maingre de Bouciqault. *Les Amazones révoltées.* Novel, parody. Rotterdam: **1730.** [Taylor 1893, pp. 169f.]

Niccola de'Marini, 1704–1790. *L'impero delle Amazoni* [The Empire of the Amazons]. Serenata. Palermo: **1744.** [DELI 1966–70, 3:511]

Marie Anne Fiquet du Boccage, 1710–1802. *Tragédie des Amazones.* Verse drama. First performed July **1749,** by Comédiens Ordinaire du Roi, Paris. [Kleinbaum 1983, pp. 158–64]

José de Cañizares, 1676–1750. *Las Amazonas de España.* Comedy. [Barrera 1969, p. 69]

Christian Felix Weisse, 1726–1804. *Amazonenlieder* [Songs of the Amazons]. Collection of poetry. Leipzig: Weidmen, **1760–62.** [Oxford 1986, p. 968]

Johann Nikolaus Götz, 1721–1781. *Die Mädchen-Insel* [Is-

land of the Maidens]. Elegiac poem. **1773**. In *Gedichte* (Aachen: 1817). [DLL 1968–90, 6:546 / Closs 1957, p. 209]

Mathias Stabinger, 1750–*c*.1815, music. *La sconfitta delle Amazone* [Defeat of the Amazons]. Ballet. First performed **1779**, Canobbiana, Milan. [Grove 1980, 18:39]

João de Sousa Carvalho, 1745–1798. *Tomiri Amazzone guerriera* [Tomyris the Amazon Warrior]. Opera seria. Libretto, Martinelli. First performed 17 Dec **1783**, Ajuda or Queluz, Portugal. [Grove 1980, 3:842]

Agostino Accorimboni, 1739–1818. *Il regno delle Amazzoni* [The Realm of the Amazons]. Comic opera. Libretto, Giuseppe Petrosellini. First performed 27 Dec **1783**, Teatro Ducale, Parma. [Grove 1980, 1:41]

Bernardo Ottani, 1736–1827, doubtfully attributed. *Le Amazzoni.* Opera. Libretto, Bertati. First performed Carnival **1784**, Carignano, Turin. [Grove 1980, 14:24]

Wolfgang Amadeus Mozart, 1756–**1791**. *Il regno delle Amazzoni.* Opera. Libretto, Giuseppe Petrosellini. Abandoned after introduction, unfinished. [Einstein 1945, pp. 384, 424]

Józef Antoni Franciszek Elsner, 1769–1854. *Amazonki czyli Herminia* [Amazons, or Herminia]. Heroic-comic opera. Libretto, Stanislaw Boguslawski. First performed 26 July **1797**, Lwów (Lemberg), Poland. [Abraham 1985, pp. 131f. / Grove 1980, 6:144]

Franz Holbein von Holbeinsberg, 1779–1855. *Mirina, Königen der Amazonen* [Mirina, Queen of the Amazons]. Drama. By **1806**. In *Theater* (Rudolstadt: Hof-Buch und Kunsthandlung, 1811). [DLL 1968–90, 8:24]

Adalbert Gyrowetz, 1763–1850. *Mirana, die Königen der Amazonen* [Mirana, Queen of the Amazons]. Opera (melodrama). Libretto, Holbein von Holbeinsberg. First performed **1806**, Hoftheater, Vienna. [Grove 1980, 7:871]

Étienne Méhul, 1763–1817. *Les Amazones, ou La fondation de Thèbes* [The Amazons, or The Founding of Thebes] (originally titled *Amphion, ou Les Amazones*). Opera. Libretto, Victor Joseph Étienne de Jouy. First performed 17 Dec **1811**, L'Opéra, Paris. [Grove 1980, 12:66 / DLLF 1984, 2:1137]

Louis Henry, 1784–1836, choreography. *Les Amazones.* Ballet. First performed Aug **1823**, Kärntnerthor, Vienna. [Winter 1974, p. 252]

Théodore Géricault, 1791–**1824**. "Amazon." Painting. [Bénézit 1976, 4:685]

———. "Amazon." Watercolor. [Ibid.]

Anne-Louis Girodet, 1767–**1824**. "Amazon." Painting. Formerly Duchesse de Berry coll. / Replica. Private coll. [Montargis 1967, no. 41—ill.]

Filippo Taglioni, 1777–1871, choreography. (Amazons battle Greeks in) *Schwerdt und Lanze* [Sword and Lance]. Ballet. First performed *c*.**1826–27** (?), Stuttgart. [Winter 1974, p. 259]

Amédée de Beauplan. *L'Amazone.* Comic opera. Libretto, after Scribe, Delestre-Poirson, and Melesville's vaudeville *Le petit dragon.* First performed 15 Nov **1830**, L'Opéra-Comique, Paris. [Clément & Larousse 1969, 1:42]

Ludwig Joachim von Arnim, 1781–**1831**. *Die neuen Amazonen* [The New Amazons]. Novella. In *Sämmtliche Werke* (Berlin: Veit, 1839). [DLL 1968–90, 1:153]

Paolo Taglioni, 1808–1884, choreography. *La nouvelle Amazone.* Ballet. First performed **1831**, Hofoper, Berlin. [EDS 1954–66, 9:637 / Beaumont 1938, p. 296]

———, choreography. *L'île des Amazones.* Ballet. First performed 1851, Her Majesty's Theatre, London. [Cohen-Stratyner 1982, p. 857]

August Kiss, 1802–1865. "Amazon on Horseback Attacked by a Tiger." Bronze sculpture. **1839**. Altes Museum, Berlin. [Read 1982, pp. 29, 31—ill. / also Janson 1985, fig. 92] Zinc and bronze replica. Victoria and Albert Museum, London. [Clapp 1970, 1:516]

Karl Immermann, 1796–**1840**. "Das Land der Weiber" [The Land of Women]. Comic poem. In *Schriften*, vol. 1 of *Gedichte* (Leipzig: Klemm, [184?]). [Closs 1957, p. 209]

John Gibson, 1790–1866. "Wounded Amazon." Sculpture. **1840**. Chesterfield House, Richmond, Surrey. [Hunger 1959, p. 25]

Honoré Daumier, 1808–1879. "The Amazons." Comic lithograph, in "Ancient History" series. **1842**. [Delteil 1906–30, 22: no. 929—ill.]

Alfred, Lord Tennyson, 1809–1892. (Princess Ida instills Amazonian virtues at her school for young ladies in) *The Princess: A Medley.* Poem. London: Moxon, **1847**. [Ricks 1969 / Lefkowitz 1986, pp. 15ff.]

Emil Wolff, 1802–1879. "Amazons." Marble sculpture group. **1847**. Hermitage, Leningrad, inv. 107. [Hermitage 1984, no. 405—ill.]

Thomas Egerton Wilks, 1812–1854. *Battle of the Amazons.* Spectacle. First performed 12 Feb **1848**, London. [Nicoll 1959–66, 4:421]

Jean-Baptiste Barrez, choreography. *The Amazons.* Ballet, after Auguste Mabille. Music, François Benoist. First performed 9 Oct **1848**, Covent Garden, London. [Guest 1972, p. 166]

William Etty, 1787–**1849**. "Queen of the Amazons." Painting. [Bénézit 1976, 4:211]

Josef Engel, 1815–1891. "The Amazons and the Argonaut." Marble sculpture group. *c*.**1851**. Royal Collection, Osborne House, Isle of Wight. [Read 1982, p. 132, pl. 161]

Jules Perrot, 1810–1882, choreography. *The War of the Women, or the Amazons of the Ninth Century.* Grand ballet. Music, Cesare Pugni. First performed 23 Nov **1852**, Bolshoi Theatre, St. Petersburg. [Guest 1984, pp. 261–68, 356, 365]

Anselm Feuerbach, 1829–1880. "Battle of the Amazons." Painting. **1856–57**. Landesmuseum, Oldenburg. [Karlsruhe 1976, no. 27—ill.]

———. "Battle of the Amazons." Painting. 1873. Museen der Stadt, Nürnberg. [Ibid., no. 62—ill.]

———. "Amazons Hunting Wolves." Painting. *c*.1874. Hessisches Landesmuseum, Darmstadt. [Ibid., no. 63—ill.]

Théodore de Banville, 1823–1891. "Amazone nue" [Nude Amazon]. Poem. In *Le sang de la coupe* (Paris: Lemerre, **1857**). [Ipso]

Anonymous. *The Amazon's Oath; or, The Hour of One.* Drama. First performed 25 Oct **1858**, Queen's Theatre, London. [Nicoll 1959–66, 5:641]

Anonymous. *Amazonian Warriors.* Spectacle. First performed 30 Sep **1861**, Amphitheatre, Leeds. [Nicoll 1959–66, 5:826]

W. S. Gilbert, 1836–1911. *The Princess: A Whimsical Allegory, Being a Respectful Perversion of Mr. Tennyson's Poem.* Comedy. London: Lacy, **1870**. [Lefkowitz 1986, pp. 15f. / Ellis 1985, p. 106 / Jefferson 1984, p. 160]

———, libretto. *Princess Ida, or Castle Adamant.* Operetta,

adapted from *The Princess*. Music by Arthur Sullivan. First performed 5 Jan 1884, Savoy Theatre, London. [Jefferson, pp. 160ff. / Lefkowitz, pp. 15f. / Ellis, p. 106 / Grove 1980, 18:362]

Charles Samuel Bovy-Lysberg, 1821–**1873**. "L'Amazone." Caprice for piano, opus 57. [Grove 1980, 3:124]

William Rimmer, 1816–1879. "Battle of the Amazons." Painting. *c.*1873–74. Gunn coll., Newtonville, Mass. [Whitney 1946, no. 21]

Walter Crane, 1845–1915. "Amor vincit omnia" [Love Conquers All] (surrender of the Amazons to love). Painting. **1875**. [Kestner 1989, p. 238, pl. 4.29]

Wilhelm Trübner, 1851–1917. "Battle of the Amazons." Painting. **1879**. [Dijkstra 1986, p. 214—ill.]

Hans von Marées, 1837–1887. "Battle of the Amazons." Painting. Before **1880**. Unlocated. [Gerlach-Laxner 1980, no. 154—ill.]

Hans Makart, 1840–**1884**. "Amazons Hunting." Painting. [Frodl 1974, no. 497—ill.]

Stéphane Mallarmé, 1842–1898. (Antique Amazon evoked in) "Mes bouquins refermés sur le nom de Paphos" [My Books Closed on the Name of Paphos]. Sonnet. In *Poésies* (Paris: La Révue Indépendante, **1887**). / Translated by Roger Fry in *Poems by Mallarmé* (London: Chatto & Windus, 1936). [Mondor & Jean-Aubry 1974 / Fowlie 1970, pp. 54–56]

Adolf von Hildebrand, 1847–1921. "Amazons." Relief. **1887–88**. S. Francesco, Florence. [Heilmeyer 1922, p. 31 / also Fiesole 1980, no. 70—ill. (drawing)]

Bolossy Kiralfy, 1847–1932, libretto. *Antiope*. Extravaganza. Composer unknown. First performed 17 Aug **1889**, Niblo's Theater, New York. [Bordman 1978, pp. 99f.]

Cécile Chaminade, 1857–1944. *Les Amazones*. Choral symphony, opus 26. Text, Charles Grandmougin. Published Paris: Enoch & Costallat, **1890**. [Cohen 1987, 1:144 / Grove 1980, 4:125]

Arthur Wing Pinero, 1855–1934. *The Amazons*. Farce. First performed 7 Mar **1893**, Court Theatre, London. [McGraw-Hill 1984, 4:99 / Nicoll 1959–66, 5:525]

Charles Rochussen, 1814–**1894**, attributed. "Amazon, Standing in a Landscape, before Her a Dog." Painting. Museum Boymans-van Beuningen, Rotterdam, cat. 1963 no. 2246. [Wright 1980, p. 389]

Louis Tuaillon, 1862–1919. "Amazon." Bronze sculpture. *c.*1895. Neue Pinakothek, Munich, inv. L.1414. [Munich 1982, p. 345—ill.]

Charles Shannon, 1863–1937. "The Wounded Amazon." Painting. Exhibited 1897. [Gwynn 1951, p. 24]

Franz von Stuck, 1863–1928. "Fighting Amazon." Painting. **1897**. Sezessionsgalerie, Munich. [Voss 1973, no. 169—ill.]

———. "Fighting Amazon." Painting. 1902. Artist's coll., Munich, in 1909. [Ibid., no. 243—ill.]

———. "Amazon, Mounted." Bronze statue. Before 1903. Art Institute of Chicago. [Clapp 1970, 1:837 / Agard 1951, fig. 72]

———. "Wounded Amazon." Painting. 1904. H. Tauscher coll., Munich. [Voss, no. 264—ill.] Study. Unlocated. [Ibid., no. 263—ill.] Variant. 1905. Private coll., Rio de Janeiro. [Ibid., no. 276—ill.]

———. "Amazon and Centaur" (fighting). Painting, study

for figures in Wittelsbach Fountains of Adolf von Hildebrand, Munich. 1912. Unlocated. [Voss, no. 404—ill.]

Edward Burne-Jones, 1833–**1898**. "An Amazon." Pastel, unfinished. In artist's estate, 1898, sold Christie's, London, 1898. [Bell 1901, p. 132]

T. Sturge Moore, 1870–1944. *The Rout of the Amazons*. Collection of poetry. London: Duckworth, **1903**. [Boswell 1982, p. 275]

José-Maria de Heredia, 1842–**1905**. "Les Amazons." Plan for cycle of 4 sonnets. 3 fragmentary, 1 ("L'enlèvement d'Antiope") completed. **1903–05**. [Delaty 1984, vol. 2]

Marie Felice Clemence de Reiset Grandval, 1830–**1907**. *Amazones*. Symphony. [Cohen 1987, 1:282]

Anatol Konstantinovich Lyadov, 1855–1914. *Danse de l'Amazone*. Orchestral composition, opus 65. Published **1910**. [Grove 1980, 11:384]

Marina Tsvetaeva, 1892–1941. (Amazons evoked in) *Vechernii al'bom* [The Evening Album]. Collection of poetry. Moscow: **1910**. [Karlinsky 1985, pp. 41, 208–11]

Max Beckmann, 1884–1950. "Battle of the Amazons." Painting. **1911**. May coll., St. Louis. [Gopel 1976, no. 146—ill. / Dijkstra 1986, p. 213f.—ill.]

Wyndham Lewis, 1884–1957. "Amazons." Drawing. **1912**. Unlocated. [Michel 1971, no. 30]

———. "Eighteenth-Century Amazons" ("The Dance of Women"). Drawing. Leicester Galleries in 1960. [Ibid, no. 55—ill.]

———. "Pool of the Amazons." Drawing with watercolor. 1942. W. F. McLean coll. [Ibid., no. 1003]

Remy de Gourmont, 1858–1915. *Lettres à l'Amazone* [Letters to the Amazon]. Essays. In *Mercure de France* **1912–13**; published in book form, Paris: Crès, 1914. / Translated by Richard Aldington (London: Chatto & Windus, 1931). [DLLF 1984, 2:969]

Henri Bataille, 1872–1922. *L'Amazone*. Drama. Paris: Flammarion, **1917**. [DLLF 1984, 1:179 / Sharp 1933, p. 18]

Romaine Brooks, 1874–1970. "The Amazon." Painting, portrait of Natalie Barney. **1920**. Barney coll., Musée du Petit Palais, Paris. [Kleinbaum 1983, p. 216 / Breeskin 1971, no. 19, p. 22—ill.]

Carl Burckhardt, 1878–1923. "Amazon." Bronze sculpture. **1923**. Stadt Seite der Mittleren-Rheinbrucke, Basel. [Clapp 1970, 1:120]

Paul Valéry, 1871–1945. "Amazon." Prose sketch, part of *Petits textes*. Collection first published as *Modes et manières d'aujourd'hui* (Paris: Carrard, **1923**); reprinted as *Petits textes* in *Nouvelle revue française* 1 Jan. 1928. [Mathews 1956–71, vol. 2]

Gerhart Hauptmann, 1862–1946. *Die Insel der grossen Mutter oder das Wunder von Ile des Dames* [The Island of the Great Mother, or The Wonder of the Isle of Women] (contemporary shipwreck recasts Amazon state). Novel. Berlin: Fischer, **1924**. [Oxford 1986, p. 440 / Closs 1957, p. 209]

Pierre Louÿs, 1870–**1925**. "L'Amazone." Poem. In *Poësies* (Paris: Crès, 1927). [Ipso]

Carl Milles, 1875–1955. (Amazons pursuing a Centaur in) "Fountain of Industry." Bronze fountain relief. **1926**. Institute of Technology, Stockholm. [Rogers 1940, pp. 51f.—ill.]

D. H. Lawrence, 1885–1930. "Fight with an Amazon."

Painting. **1926–27.** Saki Karavas coll. [Levy 1964, no. 15—ill.]

Giorgio de Chirico, 1888–1978. "Battle of Amazons." Painting. **1927.** Formerly Galerie Krugier, Geneva. [de Chirico 1971–83, 3.1: no. 231—ill.]

———. "Amazon." Drawing. 1949–50. Private coll., Rome. [Ibid., 7.2: no. 663—ill.]

———. "School of the Amazons." Painting. 1967. Max Perl coll., New York. [Ibid., 1.3: no. 131—ill.]

Helen Tamiris, 1905–1966, choreography. *Amazon.* Ballet. Music, Louis Gruenberg. First performed 9 Oct **1927,** Little Theater, New York. [McDonagh 1976, p. 108 / Borzoi 1949, pp. 134f.]

Oscar Miestchaninoff, 1884–1956. "The Amazon." Stone statuette. **1928.** Metropolitan Museum, New York, no. 58.162.1. [Metropolitan 1965, p. 149]

Émile-Antoine Bourdelle, 1861–1929. "Wounded Amazon." Bronze sculpture. **1929.** 2 casts. [Jianou & Dufet 1975, no. 714]

Max Ernst, 1891–1976. ". . . or down there, the indecent Amazon in her small private desert. . . ." Collage, illustration for the artist's collage-book *Rêve d'une petite fille qui voulut entrer au Carmel* (Paris: 1930). **1929–30.** Timothy Baum coll., New York. [Spies & Metken 1975–79, no. 1595—ill.]

Ilse Langner, b. 1899. *Amazonen.* Farce. Berlin: **1932.** Revised 1936. [DLL 1968–90, 9:939]

Albert H. Hussman, 1874–c.1933. "Dying Amazon." Bronze sculpture. [Clapp 1970, 1:457]

George Barker, 1913–. "The Amazons." Poem. In *Poems* (London: Faber & Faber, **1935**). [CLC 1988, 48:9, 12, 20]

Christian Rohlfs, 1849–1938. "Amazon." Painting. Museum Folkwang, Essen, inv. G219. [Vogt 1978, no. 525—ill.]

Hjalmar Gullberg, 1898–1961. "Död amazon" [Dead Amazon]. Poem, in memory of Karen Boye. c.1941? In *Samlade dikter* (Stockholm: Norstedt, 1955). [DSL 1990, p. 80]

Nina Fonaroff, 1914–, choreography. *Theodolina, Queen of the Amazons, or, Little Theodolina.* Dance. First performed **1942,** New York. [Clark & Vaughan 1977, p. 144]

César Klein, 1876–1954. "Amazon." Painting. **1946.** [Pfefferkorn 1962, p. 31]

Gerhard Marcks, 1889–1981. "Amazon." Bronze statuette. **1948.** At least 8 casts. Museum of Modern Art, New York; Landesmuseum, Oldenburg; Museum am Ostwall, Dortmund; private colls., Germany and U.S.A. [Busch & Rudloff 1977, no. 516—ill. / also Barr 1977, p. 565—ill.]

———. "Amazon." Bronze sculpture. 1969. 2 versions. Unique cast of first version, unlocated; 6 casts of second, unlocated. [Busch & Rudloff, nos. 938, 943—ill.] Variant ("Small Amazon"). 1970. At least 11 casts. [Ibid., no. 953—ill.]

———. "Wounded Amazon." Bronze sculpture. 1970. Unique (?) cast. Private coll. [Ibid., p. 477]

Janine Charrat, 1924–, choreography. *Le massacre des Amazones.* Ballet. Music, Ivan K. Semenoff. Scenario, Charrat and Maurice Sarrazin. First performed 24 Dec **1951,** Théâtre Municipal, Grenôble; scenery and costumes, Jean Bazaine. [Sharp 1972, p. 288 / Simon & Schuster 1979, p. 258]

Lew Christensen, 1909–1984, choreography. (Amazons,

in love with a heroic bandit who will not love them, in) *Con amore,* first and third episodes. Ballet. Music, Gioacchino Rossini. Scenario, J. Graham-Lujan. First performed 10 Mar **1953,** San Francisco Ballet; scenery and costumes, James Bodrero. [Terry 1976, pp. 88f.]

Marino Marini, 1901–1980. "Amazon." Painting. **1955.** Abrams family coll., New York. [Hammacher 1969, pl. 221—ill.]

Helga Nogueira, choreography and scenario. *Amazon Symphony.* Ballet. Music, Walter Portoalegre. First performed **1961,** Teatro Municipal, Rio de Janeiro; décor, Arlindo Rodriques. [Chujoy & Manchester 1967, p. 17]

Salvador Dalí, 1904–1989. "Amazon" (on horseback). Drawing. c.1962? Galleria Sanluca, Bologna. [Rotterdam 1970, no. 148—ill.]

Robert Graves, 1895–1985. (Amazon in) "The Alabaster Throne." Poem. In *New Poems* (London: Cassell, **1962**). [Ipso]

William Carlos Williams, 1883–1963. "Mounted as an Amazon." Poem. In *Pictures from Brueghel* (New York: New Directions, **1962**). [MacGowan 1988]

Ezio Martinelli, 1913–. "Amazon." Steel sculpture. Exhibited **1963,** Sculpture Guild, New York. [Clapp 1970, 2 pt. 2: 736]

Andrei Voznesénsky, 1933–. (Amazon fighting on) "The Wall of Death" [English title of work written in Russian]. Poem. In *Antimiry* (Moscow: **1966**). / Translated by William Jay Smith in *Antiworlds* (New York: Basic Books, 1966). [Ipso]

André Masson, 1896–1987. "Amazons." Etching. **1969.** [Passeron 1973, p. 178]

Monique Wittig, 1935–. *Les guérillères* [The Women Warriors]. Fantasy novel. Paris: Éditions de Minuit, **1969.** / Translated by David Le Vay. New York: Viking, 1971. [Kleinbaum 1983, pp. 217, 224]

Olga Broumas, 1949–, poem, and **Sandra McKee,** painting. "Amazon Twins." Part of 2–media piece "Twelve Aspects of God." Exhibited Sep **1975,** Maude Kerns Gallery, Eugene, Ore. Broumas's poem in *Beginning with O* (New Haven: Yale University Press, 1977). [Ipso]

Dorothy Quita Buchanan, 1946–. *Amazon Grace, or The Truth about the Amazons.* Opera. **1975.** [Cohen 1987, 1:119]

Paul Wunderlich, 1927–. "Amazon." Painting. **1976.** 9 versions. [Jensen 1979–80, 1:132ff., 2: nos. 662–70—ill.]

Joan Tower, 1938–. *Amazon I.* Composition for quintet. **1977.** [Cohen 1987, 2:702 / Baker 1984, p. 2329]

———. *Amazon II.* Composition for chamber orchestra. 1979. [Cohen / Baker]

AMPHIARAUS. *See* ERIPHYLE; SEVEN AGAINST THEBES.

AMPHION. The sons of Antiope and Zeus, Amphion and his twin brother Zethus were abandoned at birth and raised by a shepherd. Given a lyre by the god Hermes, Amphion became a great musician,

while Zethus became a herdsman. As adults, they were reunited with their mother when they saved her from the torments of Lycus, king of Cadmeia, and his cruel wife, Dirce.

The two brothers became the rulers of Cadmeia and set about to fortify the city. By the power of his music, Amphion charmed the stones needed to build the city walls and moved them into place. Zethus married the nymph Thebe, for whom the city was renamed Thebes.

Amphion married Niobe, and when their children were slain by Apollo and Artemis, he committed suicide. Others say that Amphion assaulted the temple at Delphi in revenge and was killed by Apollo.

Most postclassical treatments of the myth in the arts celebrate the power of Amphion's music.

Classical Sources. Homer, *Odyssey* 11.260–64. Ovid, *Metamorphoses* 6.146–312. Apollodorus, *Biblioteca* 3.5.5–6. Pausanias, *Description of Greece* 9.5.6–9. Hyginus, *Fabulae* 7, 8, 9.

See also ANTIOPE, and Dirce; NIOBE.

John Lydgate, 1370?–1449. (Amphion raises the walls of Thebes in) *The Siege of Thebes* 1.202f., 231–91. Verse narrative, after a French prose redaction of the *Roman de Thèbes* and other sources. **1420–22**. Included in *The Canterbury Tales* in Stour's edition of Chaucer, 1561. Modern edition, London: Oxford University Press, for Early English Text Society, 1960. [Pearsall 1970, pp. 60, 202, 225, 227f., 230 / Ebin 1985, pp. 53f.]

———. (Amphion celebrated in) *The Fall of Princes* 6.335–91, 3491–96. Poem, adaptation of Boccaccio's *De casibus virorum illustrium* (c.1358), after Laurent de Premierfait's French translation (1409). c.1433–39. Modern edition by Henry Bergen, London: Early English Text Society, 1918–19. [Pearsall 1970, p. 239]

Francesco Primaticcio, 1504–1570, design. "Amphion." Fresco, for Salle de Bal, Château de Fontainebleau, executed by Niccolò dell' Abbate under Primaticcio's direction. **1551–56**. Repainted 19th century. [Dimier 1900, pp. 160ff., 284ff.]

Philip Sidney, 1554–1586. (Amphion in) Sonnet 68 and third song of *Astrophel and Stella*. Sonnet sequence. London: Newman, **1591** (pirated). [Ringler 1962]

John Davies, 1569–1626. (Amphion in) *Orchestra, or A Poeme of Dauncing* lines 133–40. Poem. London: Ling, **1596**. [Tillyard 1970, pp. 30–48]

Edmund Waller, 1606–1687. (Amphion at Thebes evoked in) "Upon his Majesties repairing of Paul's." Poem. In *Workes* (London: Walkley, **1645**). [Patterson 1978, pp. 74f.]

Robert Herrick, 1591–1674. (Power of Amphion's harp evoked in) "To his Friend, on the untuneable Times" lines 3–8. Poem. In *Hesperides* (London: Williams & Eglesfield, **1648**). [Martin 1956]

——— and **Robert Ramsey**. (Power of Amphion's harp evoked in) "Orpheus and Pluto" lines 23ff. Poetic dialogue. MS in Bodleian Library, MS Don c57, f. 53v. [Ibid.]

Andrew Marvell, 1621–1678. (Amphion evoked in) "The First Anniversary of the Government under His Highness the Lord Protector" lines 49–66. Poem. London: Newcomb, **1655**. [Margoliouth 1971 / Patterson 1978, pp. 74f.]

Richard Lovelace, 1618–1658. (Amphion evoked in) "To My Noble Kinsman T[homas] S[tanley] Esquire, on His Lyric Poems, Composed by Mr. J[ohn] G[amble]" stanza 3. Poem. In *Lucasta: Posthume Poems* (London: Darby, 1659). [Wilkinson 1930]

Carlo Grossi, c.1634–1688. *L'Anfione*. Chamber composition, opus 7. First performed **1675**, Venice. [Grove 1980, 7:743]

Luca Giordano, 1634–1705. (Amphion [or Orpheus?] in) "Allegory of Human Life and the Medici Dynasty." Fresco. **1682–83**. Palazzo Medici Riccardi, Florence. [Ferrari & Scavezzi 1966, 2:112ff.—ill.] Study. Denis Mahon coll., London. [Ibid.—ill.]

Jean-Claude Gillier, 1667–1737. *Amphion*. Opera. First performed **1696**, Paris. [Grove 1980, 7:381]

Paolo Magni, c.1650–1737. *L'Amfione*. Opera. First performed **1698**, Teatro Ducale, Milan. [Grove 1980, 11:495]

Italian (or French?) School. "Four Musician-Gods: Pan, Amphion, Musaeus, Marsyas." Painting (4 panels joined together), from Hôtel Pimodan, Paris. **17th century**. Louvre, Paris, no. R.F. 998. [Louvre 1979–86, 2:265—ill.]

Alexander Pope, 1688–1744. (Amphion evoked in) "The Temple of Fame: A Vision" lines 85–92. Poem. c.1711, later revised. London: Lintott, 1715. [Twickenham 1938–68, vol. 2]

———. (Amphion celebrated in) "Ode for Musick on St. Cecilia's Day" lines 35ff. Poem. 1713; this passage added to revision in *Quaestiones* (London: 1730). [Twickenham, vol. 6]

Giovanni Battista Tiepolo, 1696–1770. "Amphion, by the Power of His Music, Causes the Walls of Thebes to Build Themselves," part of "Allegory of Eloquence." Ceiling fresco. c.1725. Palazzo Sandi, Venice. [Levey 1986, pp. 23ff.—ill. / Morassi 1962, p. 60 / Pallucchini 1968, no. 32—ill.] Modello. Courtauld Institute, London. [Levey—ill. / also Pallucchini, no. 32a—ill.]

François Lupien Grenet, c.1700–1753. "Amphion." Entrée in *Le triomphe de l'harmonie*. Ballet-heroïque. Libretto, Jean-Jacques Le Franc de Pompignan. First performed 9 May **1737**, L'Opéra, Paris. [Grove 1980, 7:702]

Jean-Benjamin de La Borde, 1734–1794, music. *Amphion*. Ballet. Libretto, Antoine L. Thomas. First performed 13 Oct **1767**, L'Opéra, Paris. [Grove 1980, 10:343]

Johann Gottlieb Naumann, 1741–1801. *Amphion*. Opera-ballet. Scenario G. G. Adlerbeth, after Thomas (1767). First performed 1 Jan **1778**, Royal Opera, Stockholm. [Grove 1980, 13:79 / Edler 1970, p. 40]

Baldassare Galuppi, 1706–1785. *L'Anfione*. Cantata. Text, G. da Ponte. First performed **1780**, Venice. [Grove 1980, 7:137]

Jean Dauberval, 1742–1806, choreography. *Amphion et Thalie*. Ballet. First performed 19 Feb **1791**, Pantheon, London. [Guest 1972, p. 165]

Johann Gottfried Herder, 1744–1803. "Amphion an die Thebaner, bei Erbauung der Stadt" [Amphion to the

Thebans at the Building of the City]. Poem. In *Gedichte* book 7, *Sämmtliche Werke* (Tübingen: Cotta, 1805–20). [Herder 1852–54, vol. 13]

Friedrich Weis, 1744–1826, music. *Amphion.* Ballet. First performed **1806**, Göttingen? [Hunger 1959, p. 320]

Étienne Méhul, 1763–1817. *Les Amazones, ou La fondation de Thèbes* (originally titled *Amphion, ou Les Amazones*). Opera. Libretto, Victor Joseph Étienne de Jouy. First performed 17 Dec **1811**, L'Opéra, Paris. [Grove 1980, 12:66 / DLLF 1984, 2:1137]

William Wordsworth, 1770–1850. (Amphion evoked in) "The Power of Sound" stanza 9, lines 129–44. Poem. **1828–29.** In *Yarrow Revisited and Other Poems* (London: Longman & Co., 1835). [De Selincourt 1940–66, vol. 2]

Alfred, Lord Tennyson, 1809–1892. "Amphion." Poem. *c.*1837–38. In *Poems* (London: Moxon, 1842). [Ricks 1969 / Hughes 1987, pp. 116–18 / Albright 1986, pp. 88–90 / Nicolson 1962, pp. 55, 154]

Edward Calvert, 1799–1883. "Amphion with the Herds of Zethus." Painting. British Museum, London. [Bénézit 1976, 2:469]

Claude Debussy, 1862–1918. *Amphion.* Projected ballet score. Libretto, Paul Valéry. *c.*1894, unfinished. [Grove 1980, 5:311]

Arthur Somervell, 1863–1937. "The Power of Sound." Choral composition. Text, Wordsworth (1828–29). **1895.** [Grove 1980, 17:475]

Charles Ives, 1874–1954. "Amphion." Song, no. 27b. Text, Tennyson (*c.*1837–38). **1896.** [Grove 1980, 9:425]

Pascual de Rogatis, 1881–1980. *Anfión y Zeto.* Opera. First performed 18 Aug. **1915**, Colón, Argentina. [Baker 1984, p. 576]

Ernst Penzoldt, 1892–1955. *Der Schatten Amphion* [The Phantom Amphion]. Collection of idylls. Munich: Heimeran, **1924.** [Wilpert 1963, p. 451 / DULC 1959–63, 3:1019]

Paul Valéry, 1871–1945. *Amphion.* Libretto for opera (melodrama). In *Poésies* (Paris: Gallimard, **1929**). [Hytier 1957–60, vol. 1 / Mathews 1956–71, vol. 3 / DLLF 1984, 3:2365–69 / Myers 1971, p. 121 / Strauss 1971, p. 237]

Arthur Honegger, 1892–1955. *Amphion.* Opera (melodrama). Libretto, Valéry. First performance 23 June **1931**, Rubenstein company, L'Opéra, Paris; choreography, Léonide Massine; décor, Alexander Benois. [Oxford 1982, p. 14 / Grove 1980, 8:680]

Henri Laurens, 1885–1954. "Small Amphion," "Great Amphion." Bronze sculptures. **1937.** [Hofmann 1970, pp. 26, 218—ill.] Monumental variant, 1952. University of Caracas, Venezuela. [Ibid., pp. 44, 218—ill.]

Aurel Milloss, 1906–1988, choreography. *Amphion.* Ballet. Music, Honegger? First performed **1944**, Rome; décor, Giorgio de Chirico. [Oxford 1982, p. 93]

W. H. Auden, 1907–1973. (Amphion's power evoked in) "Ode to Gaea." Poem. In *The Shield of Achilles and Other Poems* (New York: Random House; London: Faber & Faber, **1955**). [Mendelson 1976 / Feder 1971, pp. 174—76]

Ezra Pound, 1885–1972. (Power of Amphion's music associated with building of the temple of Baucis and Philemon in) Canto 90 lines 605–39 passim. In *Section: Rock Drill, 85–95 De Los Cantares* (New York: New Directions, **1955**). [Flory 1980, p. 242]

Thomas Merton, 1915–1968. (Amphion's music evoked in) "The New Song." Poem. In *Collected Poems* (New York: New Directions, 1977). [Boswell 1982, p. 185]

Iain Hamilton, 1922–1986. *Amphion.* Violin concerto, no. 2. **1971.** [Grove 1980, 8:72]

AMPHITRITE. One of the fifty Nereids (daughters of Nereus and Doris), Amphitrite was the consort of Poseidon (Neptune). The sea-god had fallen in love with her after seeing her dancing on Naxos. Their union produced the merman Triton and the nymphs Rhode and Benthesicyme.

A minor mythological figure, Amphitrite is sometimes credited with turning the sea-nymph Scylla into a monster capable of seizing sailors from passing ships. She occasionally personifies the sea or the element Water. Amphitrite is often depicted in the visual arts in the company of Poseidon, usually in stylized sea-triumphs (similar to, and sometimes interchangeably identified as, triumphs of Venus or the sea-nymph Galatea).

Classical Sources. Homer, *Odyssey* 3.91, 5.422, 12.60. Hesiod, *Theogony* 243, 254, 930ff. Apollodorus, *Biblioteca* 1.2.2, 1.2.7, 1.4.5. Pausanias, *Description of Greece* 1.17.3. Hyginus, *Poetica astronomica* 2.17.

See also GODS AND GODDESSES, as Elements; POSEIDON.

Baldassare Peruzzi, 1481–1536 (formerly attributed to Giulio Romano). "Neptune and Amphitrite." Fresco, part of a frieze. **1511–12.** Sala del Fregio, Villa Farnesina, Rome. [d'Ancona 1955, pp. 91f. / Gerlini 1949, pp. 21ff. / Frommel 1967–68, no. 18a / Berenson 1968, p. 334]

Pinturicchio, 1454–1513, and studio. "Triumph of Amphitrite." Ceiling fresco (detached), from Palazzo Pandolfo Petrucci ("Il Magnifico"), Siena. Metropolitan Museum, New York, no. 114.11. [Metropolitan 1980, p. 142—ill. / Berenson 1968, p. 345—ill.]

Jan Gossaert, called Mabuse, *c.*1478–1533/36. "Neptune and Amphitrite." Painting. **1516–17.** Staatliche Museen, Berlin. [Mauritshuis 1985, p. 106—ill. / Grosshans 1980, p. 34—ill.]

Andrea Schiavone, *c.*1522–1563. "Neptune and Amphitrite." Painting. *c.*1559. Musée des Beaux Arts, Chambéry. [Richardson 1980, no. 252—ill.]

Stoldo di Lorenzi, 1534–1583. "Marine Nymph" (variously identified as Galatea, Amphitrite, Venus). Bronze statuette. **1573.** Studiolo, Palazzo Vecchio, Florence. [Sinibaldi 1950, pp. 12, 18 / also Pope-Hennessy 1985b, 3:100—ill. / Lensi 1929, pp. 236f., 265 (as Vincenzo de'Rossi)—ill.] Variant copies. Frick Collection, New York, no. 16.2.48 (mid-18th century?); Victoria and Albert Museum, London (stucco, late 18th/19th century). [Frick 1968–70, 3:208f.—ill.]

Bartolommeo Ammannati, 1511–1592, follower. "Amphitrite." Bronze sculpture. *c.*1563–75. Sold Sotheby's, London, 1969. [Warburg]

Luca Cambiaso, 1527–1585. "Triumph of Amphitrite."

Print. (Louvre, Paris, no. 9316.) [Manning & Suida 1958, p. 171]

Jacopo Zucchi, c.1541–**1589/90**. "Neptune and Amphitrite." Fresco. Palazzo di Firenze, Rome. [de Bosque 1985, p. 40]

Edmund Spenser, 1552?–1599. (Amphitrite and Neptune attend the marriage of the rivers Medway and Thames, in) *The Faerie Queene* 4.11.11–12. Romance epic. London: Ponsonbie, **1596**. [Hamilton 1977]

Florentine School? "Amphitrite." Marble statuette. **16th century**. Waddesdon Bequest, British Museum. [Warburg]

Frans Francken II, 1581–1642. "Triumph of Neptune and Amphitrite." Painting. **1607**. Currier Gallery of Art, Manchester, N.H. [Sarasota 1980, no. 23 *n.*—ill. / cf. Härting 1983, no. A206]

————. "Triumph of (Neptune and) Amphitrite." Painting. Dated variously c.1610–20. Galleria Palatina, Palazzo Pitti, Florence, no. 1068. [Uffizi 1979, no. P633—ill. / Pitti 1966, p. 193—ill. / Härting, no. A213 / also de Bosque 1985, pp. 275f.—ill.] Variant. Konstmuseum, Göteborg, inv. 327. [Härting, no. A213b]

————. "Triumph of (Neptune and) Amphitrite." Painting. Late 1620s. Herzog Anton Ulrich-Museum, Braunschweig, no. 100. [Härting, no. A214—ill. / Braunschweig 1969, p. 61]

————. "Triumph of Amphitrite." Painting. 1631. Ringling Museum, Sarasota, Fla., no. SN230. [Härting, no. A207 / Sarasota 1980, no. 23—ill.]

————. "Triumph of Amphitrite." Painting. 1630s? Prado, Madrid, inv. 1523. [Härting, no. A215 / Prado 1985, p. 227]

————, attributed. "Triumph of Amphitrite, with Bacchus." Painting. Nationalmuseum, Stockholm, inv. 609. [Härting, no. B223 / de Bosque, pp. 275–77—ill.]

————. Numerous other versions of the subject: Castle, Kroměříž, Czechoslovakia, inv. 031; Musée Curtius, Liège; Galleria Nazionale, Rome, inv. 448; Dorotheum, Vienna (as Frans I); Gemäldegalerie, Berlin, inv. 703-A (by Hieronymus III); others in private colls. or unlocated. [Härting, nos. A207–18, A355–56, B206, B214–15, C212–14]

————, style. "Neptune and Amphitrite." Painting. Gemäldegalerie, Berlin-Dahlem, no. 703. [Berlin 1986, p. 32—ill.]

Bartholomeus Spranger, 1546–**1611**. "The Abduction of Amphitrite." Drawing. Stedelijk Prentenkabinet, Antwerp. [de Bosque 1985, p. 275—ill.]

————. Drawing. "Amphitrite." Albertina, Vienna, inv. 7993. [Warburg]

Peter Paul Rubens, 1577–1640. "Neptune and Amphitrite." Painting. c.1615. Formerly Kaiser-Friedrich-Museum, Berlin, destroyed 1945. [Jaffé 1989, no. 302—ill.] Oil sketch. Dulière coll., Brussels. [Ibid., no. 301—ill. / also Held 1980, no. 254—ill.]

————. "Neptune and Amphitrite." Painted cut-out, part of Stage of Mercury, decoration for "Pompa Introitus Fernandi," triumphal entry of Cardinal-Infante Ferdinand of Spain into Antwerp, 17 Apr 1635. Original decoration destroyed. [Martin 1972, pp. 178ff.—ill. (print)] Oil sketch. Hermitage, Leningrad, inv. 501 (565). [Ibid., no. 46a—ill. / Held 1980, no. 162—ill. / Jaffé, no. 1156—ill.]

Thomas Heywood, 1573/74–1641. "Amphitrite." Passage in *Gynaikeion: or, Nine Books of Various History Concerning Women* book 1. Compendium of history and mythology. London: Adam Islip, **1624**. [Ipso]

Jean Puget de La Serre, 1594–1665. "Neptune et Amphitrite." Poem. In *Les amours des dieux* (Paris: d'Aubin, **1624**). [NUC]

Giovanni da San Giovanni, 1592–1636. "The Rape of Amphitrite." Ceiling fresco. **1627**. Palazzo Pallavicini Rospigliosi (Bentivoglio), Rome. [Banti 1977, no. 29—ill.]

Jacob de Gheyn II, 1565–**1629**. "Poseidon and Amphitrite." Painting. Wallraf-Richartz-Museum, Cologne, no. 1792. [Cologne 1965, p. 61]

[?] Monléon. *L'Amphytrite*. Pastoral poem. Paris: Guillemot, **1630**. [DLF 1951–72, 3:725 / Lancaster 1929–42, pt. 1, 1:352–4, 2:761]

Ben Jonson, 1572–1637. (Amphitrite in) *Love's Triumph through Callipolis*. Masque. Performed 9 Jan **1631**, at Court, London. [Herford & Simpson 1932–50, vol. 7]

Nicolas Poussin, 1594–1665. "Triumph of Neptune (and Amphitrite)." Painting (part of "Bacchanals" series for Château de Richelieu?). **Mid-1630s?** Philadelphia Museum of Art. [Wright 1985, no. 80, pl. 35 / Blunt 1966, no. 167—ill. / also Thuillier 1974, no. 93—ill.]

Giovanni Carlo Coppola, 1599–1652, libretto. (Marriage of Neptune and Amphitrite in) *Le nozze degli dei* [The Weddings of the Gods]. Opera (favola in musica). First performed **1637**, Palazzo Pitti, Florence, for wedding of Ferdinand, Duke of Tuscany, and Vittoria of Urbino. Published Florence: Massi & Landi, 1637. [Bianconi 1987, p. 172 / Taylor 1893, p. 370]

Jacob Jordaens, 1593–1678. "Neptune and Amphitrite" ("Neptune Abducts Amphitrite"). Painting. **1640s**. Rubenshuis, Antwerp, no. S3.94. [d'Hulst 1982, p. 220, fig. 178 / Ottawa 1968, no. 80—ill.]

————. "The Abduction of Amphitrite." Painting. c.1645? Formerly Duke of Arenberg coll., Brussels. [d'Hulst, p. 220 / also Rooses 1908, pp. 48f., 58—ill.]

———— with **Adriaan van Utrecht**. "The Gifts of the Sea" (Neptune, Amphitrite, Cupid, and Mercury fishing). Painting. c.1637. 2 versions known. Musées Royaux des Beaux-Arts, Brussels; Schönborn Galerie, Vienna. [Rooses, pp. 96f.]

————, attributed. "The Elopement of Amphitrite." Painting. Exhibited 1877, untraced. [Rooses, p. 257]

Artemisia Gentileschi, 1593–1652/53, and **Bernardo Cavallino**, 1616–1656, attributed (previously attributed to Cavallino). "Triumph of Galatea" (also called Triumph of Amphitrite"). Painting. c.**1645–50**. Private coll., New York. [Garrard 1989, pp. 123ff.—ill. / also Percy & Lurie 1984, no. 68—ill.]

François Perrier, c.1590–**1650**. "Triumph of Amphitrite." Painting. Musée des Beaux-Arts, Carcassonne. [Eisler 1977, p. 264]

Abraham Bloemaert, 1564–**1651**. "Neptune and Amphitrite." Painting. Nationalmuseum, Stockholm. [Delbanco 1928, no. I.37]

————. "Neptune and Amphitrite." Painting. Wadsworth Atheneum, Hartford, Conn. [de Bosque 1985, pp. 274f.—ill.]

Gerard Seghers, 1591–**1651**. "Neptune and Amphitrite."

Painting. Herzog Anton Ulrich-Museum, Braunschweig. [Pigler 1974, p. 189]

Dutch School. "Amphitrite." Marble sculpture. **Mid-17th century.** Victoria and Albert Museum, London. [Warburg]

Francesco Albani, 1578–**1660.** "Triumph of Amphitrite." Drawing. Duke of Devonshire coll., Chatsworth, no. 553. [Warburg]

————. "Triumph of Amphitrite." Painting. Getty Museum, Malibu? [Warburg]

Ferdinand Bol, 1616–1680. "Neptune and Amphitrite." Painting. **Early 1660s.** Staatliche Museen, Berlin. [Blankert 1982, no. 25—ill.]

Crispin de Passe the Younger, 1589/93–c.**1667.** "Amphitrite." Painting. Centraal Museum, Utrecht, inv. 11267. [Warburg]

Abraham van Diepenbeeck, 1596–**1675.** "Neptune and Amphitrite." Painting. Gemäldegalerie Dresden, cat. 1920 no. 1016. [Warburg]

Luca Giordano, 1634–1705. "Neptune and Amphitrite." Painting. c.**1675–80?** Musée des Beaux-Arts, Douai, no. 1145, in 1919. [Ferrari & Scavizzi 1966, 2:325]

————. "Neptune and Amphitrite." Painting. Recorded as formerly at El Escorial, untraced. [Ibid., 2:327]

————, school (previously attributed to Giordano). "Triumph of Amphitrite." Painting. Château de Fontainebleau (on deposit from Louvre, Paris, inv. 302). [Louvre 1979–86, 2:290]

Michel Anguier, 1612–1686. "Neptune and Amphitrite." Marble sculpture. c.**1680.** Louvre, Paris. [Agard 1951, p. 97—ill.]

————. "Amphitrite with a Dolphin." Bronze statuette. After 1652 (cast early 18th century?). Musée des Arts Décoratifs, Paris, inv. D.25.199. [Düsseldorf 1971, no. 319—ill.]

Livio Mehus, c.1630–1691. "Neptune and Amphitrite." Painting. c.**1680?** Prefettura, Massa. [Florence 1986, no. I.268—ill.]

François Girardon, 1628–1715. "Triumph of Amphitrite" ("Triumph of Venus"). Relief on marble vase, for Versailles. **1683.** Louvre, Paris (as "Triumph of Amphitrite"). [Francastel 1928, no. 55—ill.]

Raymond de La Fage, c.1650–**1684.** "Apollo and Amphitrite" (? or "Apollo and Thetis"?). Drawing. Holkham Hall, portfolio no. 32. [Warburg]

————. "Triumph of Amphitrite." 2 drawings. Nationalmuseum, Stockholm. [Pigler 1974, p. 21]

Johann Heinrich Schönfeld, 1609–**1684.** "The Wedding of Amphitrite and Neptune." Painting. Szépmüveszeti Múzeum, Budapest. [Pigler 1974, pp. 189f.]

————. "The Wedding of Amphitrite and Neptune." Painting. Castle Museum, Vizovice. [Ibid.]

Charles Le Brun, 1619–**1690.** "Triumph of the Waters" ("Neptune and Amphitrite"). Ceiling painting. Galerie d'Apollon, Louvre, Paris, inv. 2902. [Louvre 1979–86, 4:41—ill.]

David Teniers the Younger, 1610–**1690.** "Neptune and Amphitrite." Painting. Gemäldegalerie, Berlin-Dahlem, no. 866E. [Berlin 1986, p. 73—ill.]

French School. "Neptune and Amphitrite." Painting. **17th century.** Muzeum Narodowe, Warsaw, inv. 191238;

on display at Lazienki Palace. [Warsaw 1969, no. 1550—ill.]

Corneille van Clève, 1644/45–1735. "Neptune and Amphitrite." Lead sculpture group, part of Cascade de Trianon, Versailles. **1702–04.** In place. [Beaulieu 1982, p. 29—ill.]

Johann Heiss, 1640–**1704.** "Neptune and Amphitrite." Painting. Herzog Anton Ulrich-Museum, Braunschweig, no. 1095. [Braunschweig 1969, p. 72]

Willem van Mieris, 1662–1747. "Triumph of Amphitrite." Painting, frieze in a portrait tablet with the portraits of a man and woman (portraits by Pieter Cornelisz van Slingeland). **1705.** Rijksmuseum, Amsterdam, inv. A1983. [Rijksmuseum 1976, p. 515—ill.]

Antoine Coysevox, 1640–1720. "Triumph of Amphitrite." Marble sculpture. **1703–07.** Musée Municipal, Brest. [Bénézit 1976, 3:250]

Noël Coypel, 1628–**1707,** attributed. "Triumph of Amphitrite." Painting. National Gallery of Ireland, Dublin, no. 1656. [Dublin 1981, p. 30—ill.]

Sebastiano Ricci, 1659–1734. "Neptune and Amphitrite." Painting. c.**1700–10.** Wax coll., Genoa. [Daniels 1976, no. 114]

Andreas Schlüter, 1660/64–1714. "Amphitrite." Sculptural detail from decoration of Kamecke House (destroyed). **1711–12.** Staatliche Museen, Berlin. [Clapp 1970, 1:793]

Ignatius van Logteren, circle. "Amphitrite." Terra-cotta bust, pendant to "Neptune." c.**1712.** Rijksmuseum, Amsterdam, inv. NM3324. [Düsseldorf 1971, no. 236—ill.]

Jacques Prou the Younger, 1655–1706. "Amphitrite." Marble fountain. **1705–13.** Château, Courances. [Warburg]

Jean-Louis Lemoyne, 1665–1755. "Amphitrite." Statue, for garden of Palais-Royal, Paris. **1715–23.** [Réau 1927, p. 18, no. 16]

Christian Kirchner, ?–1732. "Neptune and Amphitrite." Sandstone sculpture group. c.**1725.** Nymphaeum, Zwinger, Dresden. [Asche 1966, no. K127, pl. 224—ill.]

Alessandro Gherardini, 1655–1726. Painting. Newhouse Galleries, London, in 1972. [Pigler 1974, p. 189]

Carlo Innocenzo Frugoni, 1692–1768. *Le nozze di Nettune l'equestre con Anfitrite* [The Wedding of Neptune the Horseman and Amphitrite]. Drama. Parma: Ser, **1728.** [NUC]

Jan Baptist Xavery, 1697–1742. "Amphitrite." Wooden statuette. **1728.** Gementemuseum, The Hague, inv. OH 256b. [Düsseldorf 1971, no. 291—ill.]

Nöel-Nicolas Coypel, 1690–**1734.** "Triumph of Amphitrite." Painting. Bowes Museum, Barnard Castle, list 1971.266. [Wright 1976, p. 44] At least 3 further versions of the subject known. Musée du Berry, Bourges; Musée de Peinture et Sculpture, Grenoble; Musée des Beaux-Arts, Marseille. [Hermitage 1986, no. 36 *n.*]

Lambert-Sigisbert Adam, 1700–1759. "Triumph of Neptune and Amphitrite." Bronze sculpture group, part of Neptune Fountain, Versailles. **1733–40.** In place. [Thirion 1885, p. 113—ill.]

————. "Amphitrite." Marble bust, pendant to "Neptune." Sanssouci, Potsdam, in 1885. [Thirion, pp. 39, 45—ill.]

Charles-Joseph Natoire, 1700–1777. "Water" ("Triumph

of Amphitrite"). Painting, part of "Elements" series. **1741.** Lost. [Troyes 1977, no. 22 *n.*]

————. "Neptune and Amphitrite." Painting. Sold Amsterdam, 1912. [Boyer 1949, no. III]

————. "Triumph of Amphitrite." Painting. Muzeum Narodowe, Warsaw, inv. 127907. [Warsaw 1969, no. 877—ill.]

————. Numerous further versions of the same subject ("Amphitrite," "Triumph of Amphitrite"). Unlocated. [Boyer, nos. 87–93]

French School. "Amphitrite." Painting, for mirror head. *c.*1745. Waddesdon Manor, Buckinghamshire, cat. 1967 no. 140. [Wright 1976, p. 70]

Thomas Augustine Arne, 1710–1778, music. *Neptune and Amphitrite.* Masque, interpolated into Shakespeare's *The Tempest.* First performed 31 Jan **1746,** Theatre Royal, Drury Lane, London. [Grove 1980, 1:609]

Louis de Silvestre the Younger, 1675–**1760,** studio. "Triumph of Amphitrite." Painting. Muzeum Narodowe, Warsaw, inv. Wil. 1121 (formerly 511), on display at Wilanów Palace. [Warsaw 1969, no. 1210—ill.]

Jean-Marc Nattier, 1685–**1766.** "Triumph of Amphitrite." Painting. Musée, Amiens. [Bénézit 1976, 7:660]

Gaspare Diziani, 1689–**1767.** "Triumph of Amphitrite." Painting. Private coll., Como. [Pigler 1974, p. 21]

————. "Neptune and Amphitrite." 2 frescoes. Palazzo Azzoni degli Avogadro, Castelfranco. [Ibid., p. 189]

François Boucher, 1703–**1770.** "The Abduction of Proserpine" (formerly called "Neptune and Amphitrite"). Grisaille sketch, study for lost or unexecuted tapestry. 1769. Musée Municipal des Beaux-Arts, Quimper. [Columbia 1967, no. 62—ill. / Ananoff, no. 669—ill.]

————, studio? "The Triumph of Amphitrite." Painting, variant of Boucher's "Birth of Venus" (1743). Wallace Collection, London, no. P.433 (as Boucher). [Ananoff, no. 243.14 / Wright 1976, p. 23]

————, attributed. "Amphitrite." Painting. Major R. T. A. Hog coll., Newliston. [Warburg]

Hinrich Philip Johnson, 1717–1779, music. *Neptun och Amphitrite.* Ballet. First performed **1775,** Stockholm. [Grove 1980, 9:675]

Jean-Hugues Taraval, 1729–1785. "Triumph of Amphitrite." Painting, design for Gobelins tapestry, part of "Loves of the Gods" cycle. **1777.** Louvre, Paris, inv. 8088. [Louvre, 4:229—ill.]

Anton Raphael Mengs, 1728–**1779.** "Triumph of Amphitrite." Painting. Schloss Hohenstadt, Donaueschingen. [Honisch 1965, no. 406]

Venetian School. "Amphitrite." Painting. **18th century.** Dade County Art Museum, Miami. [Warburg]

Luigi Pampaloni, 1791–1847. "Triumph of Amphitrite." Stucco bas-relief. **Early 19th century.** Saletta da Bagno, Palazzo Pitti, Florence. [Pitti 1966, p. 237—ill.]

Gabriel-François Doyen, 1726–**1806.** "Neptune and Amphitrite." Painting. Petit Trianon, Versailles. [Pigler 1974, p. 189]

Peter Cornelius, 1783–1867, and studio. "The Kingdom of Neptune" ("The World of Water," chariot of Neptune and Amphitrite, with Cupid, Arion, Tethys, Tritons, and Nereids). Fresco. **1820–26.** Göttersaal, Glyptothek, Munich. [Glyptothek 1980, pp. 214ff., no. 265—ill.]

Luigi Catani, 1762–**1840.** "Neptune and Amphitrite."

Fresco. Sala dell' Educazione di Giove, Palazzo Pitti, Florence. [Pitti 1966, p. 241]

Marie Paul Taglioni, 1833–1891, choreographer and dancer of the role of Amphitrite, in Paul Taglioni's *Flik und Flok.* Fantastic ballet. Music, Wilhelm Hertel. First performed **1858,** Hofoper, Berlin. [Oxford 1982, pp. 158, 406]

Eugène Delacroix, 1798–1863. "Triumph of Amphitrite." Painting. *c.***1861–63,** unfinished. Emil Bührle Foundation, Zurich. [Johnson 1981–86, no. 252—ill. / also Robaut 1885, no. 1420]

Émile Gilliot. "Triumph of Amphitrite." Painting (sketch). **1868.** École des Beaux-Arts, Paris. [Boime 1971, p. 109, pl. 81]

Paul Baudry, 1828–**1886.** "Amphitrite." Painting. [Bénézit 1976, 1:520]

Antonin Mercié, 1845–1916. "Amphitrite." Ivory, gold, and silver sculpture. Exhibited **1889.** Walters Art Gallery, Baltimore. [Beattie 1983, pl. 149]

Augustin-Jean Moreau-Vauthier, 1831–1893. "Amphitrite." Marble statue. Musées Nationaux, inv. Ch. M. 31, deposited in Musée, Sèvres, in 1922. [Orsay 1986, p. 278]

Marius Petipa, 1818–1910, choreography. (Amphitrite in) *La perle* [The Beautiful Pearl]. Ballet. Music, Riccardo Drigo. First performed 17 May **1896,** Bolshoi Theatre, Moscow; settings, M. I. Bocharov and P. B. Lambini. [Sharp 1972, p. 253]

Max Klinger, 1857–1920. "Amphitrite." Marble sculpture. **1894–98.** Nationalgalerie, East Berlin, inv. 7149. [Dückers 1976, pp. 129, 163—ill.]

Albert Samain, 1858–1900. "Le cortège d'Amphitrite." Poem. In *Aux flancs du vase* (Paris: **1898;** 1947). [Ipso]

John Knowles Paine, 1839–1906. *Poseidon and Amphitrite: An Ocean Fantasy.* Symphonic poem. *c.***1903.** First performed 1907, Leipzig. [Grove 1980, 14:95]

Henri Fantin-Latour, 1836–**1904.** "Amphitrite." Drawing (incorporating several poses). [Fantin-Latour 1911, no. 2312]

Charles Koechlin, 1867–1950. "Le cortège d'Amphitrite." Song, part of *6 mélodies,* opus 31. Text, Samain (1898). **1902–08.** [Grove 1980, 10:146]

Lovis Corinth, 1858–1925. "The Sea God and Amphitrite." Etching, illustration for edition of Arno Holz's "Daphnislieder" (Berlin: Fritz Gurlitt, **1923**). [Müller 1960, no. 743—ill.]

Georges Migot, 1891–1976. "Le cortège d'Amphitrite." Choral composition. Text, Samain (1898). **1923.** [Grove 1980, 12:284]

Raoul Dufy, 1877–1953. "Amphitrite." Gouache. *c.***1925.** [Guillon-Laffaille 1981, no. 1827—ill.]

————. "Amphitrite and Seahorses." Watercolor. *c.*1925. [Ibid., no. 1876—ill.] 2 variants, *c.*1925. Formerly Helena Rubenstein coll.; elsewhere. [Ibid., nos. 1877–78—ill.]

————. "Amphitrite." Watercolor. *c.*1927. Evergreen House Foundation, Baltimore. [Ibid., no. 1848—ill.]

————. "Amphitrite with a Seashell" (in a fanciful seascape). Gouache. *c.*1927. Sold Parke Bernet, New York, 1977. [Ibid., no. 1849—ill.] Variant. Galerie Louis Carré, Paris. [Ibid., no. 1850—ill.]

————. "Amphitrite" (holding a seashell, in a fanciful seascape). Painting. 1936. Formerly David Thompson coll., Pittsburgh. [Lafaille 1977, no. 1632—ill.] Tapestry, based

on, 1936. Röhsska Konstslöjdmuseet, Gothenborg. [Arts Council 1983, no. 407—ill., p. 100] Painting, variant, c.1945, formerly Laffaille coll. [Laffaille, no. 1634, p. 338—ill.] Variant, c.1950, Musée de l'Art Moderne, Paris. [Laffaille, no. 1633, p. 338—ill.]

———. "Amphitrite" (standing on a seashell, in a fanciful seascape). 5 similar paintings. 1945 and c.1945. [Laffaille, nos. 1635–38—ill. / Laffaille 1985, no. 2037—ill.]

———. "Amphitrite." Painting (similar to above), design for tapestry. 1948. [Laffaille 1977, no. 1658—ill.]

———. "Amphitrite." Painting. [Laffaille 1985, no. 1958—ill.]

Francis Picabia, 1878–1953. "Amphitrite." Painting. *c.*1935. [Borràs 1985, no. 629—ill.]

Henri Matisse, 1869–1954. "Amphitrite." Painted paper cut-out. **1947.** Private coll., France. [St. Louis 1977, no. 61—ill.]

AMPHITRYON AND ALCMENE.

AMPHITRYON AND ALCMENE. When the eight sons of Electryon, king of Mycenae, were killed by the Taphians in a raid on the king's cattle, Electryon went off to seek revenge, leaving his dominion in the care of his nephew, Amphitryon, with the promise that Amphitryon could wed his daughter Alcmene if he ruled well. Amphitryon fulfilled the charge and even recovered the king's cattle, but accidentally killed Electryon in an ensuing dispute. Amphitryon was banished to Thebes, where Alcmene refused him his conjugal rights until he had avenged the death of her brothers.

Amphitryon launched a successful campaign against the Taphians, but before he returned from battle, Zeus (Jupiter) visited Alcmene in her husband's guise and seduced her. The next day Amphitryon returned victoriously and consummated the marriage. Alcmene gave birth to twin sons, Heracles and Iphicles, one day apart; Iphicles was Amphitryon's child and Heracles was the son of Zeus.

Treatments of this story are rare in the visual arts, but it is popular in opera and drama. Most postclassical versions are based on the Roman playwright Plautus's comedy *Amphitruo,* in which Mercury and his servant Sosia are involved in the complex plot.

Classical Sources. Homer, *Iliad* 19.96–133. Hesiod, *Theogony* 943f.; *Shield of Heracles* 1–56. Euripides, *Heracles.* Plautus, *Amphitruo.* Ovid, *Metamorphoses* 6.112, 9.273–323. Apollodorus, *Biblioteca* 2.4.5–11. Pausanias, *Description of Greece* 9.11.1–3. Lucian, *Dialogues of the Dead* 11, "Diogenes and Heracles"; *Dialogues of the Gods* 14, "Hermes and Helios."

Further Reference. Charles E. Passage and James H. Mantinband, *Amphitryon: Three Plays in New Verse Translations . . . Together with a Comprehensive Account of the Evolution of the Legend and Its Subsequent History on the Stage* (Chapel Hill: University of North Carolina Press, 1974). L. R. Shero, "Alcmena and Amphitryon in Ancient and Modern Drama," *Transactions and Proceedings of the American Philological Association* 87 (1956): 192–238.

See also HERACLES, Birth.

Anonymous French. (Story of Alcmene and Zeus, birth of Hercules, in) *Ovide moralisé* 9.1060–1179. Poem, allegorized translation/elaboration of Ovid's *Metamorphoses.* *c.***1316–28.** [de Boer 1915–86, vol. 3]

Pandolfo Collenuccio, 1444–1504. *Anfitrione.* Comedy, after Plautus. First performed Jan **1487,** Court of Ferrara. In modern edition, *Biblioteca rara,* vol. 55 (Milan: Daelli, 1864). [DELI 1966–70, 2:81 / Passage & Mantinband 1974, p. 115]

Francisco Lopez de Villalobos, 1473?–1549. *La comedia del Plauto llamada Amphytriõ* [The Comedy of Plautus Called Amphytrion]. Prose drama, translation of Plautus. Zaragoza: **1515?** [DLE 1972, p. 539]

Fernán Pérez de Oliva, 1494?–1533. *El nascimiento de Hércules, ó, Comedia de Anfitrion* [The Birth of Hercules, or, Comedy of Amphitryon]. Comedy, adapted from Plautus. **1525.** Probably unperformed. In *Obras,* edited by Ambrosio de Morales (Cordova: Bejarano, 1586). [Oxford 1978, pp. 458f. / Passage & Mantinband 1974, p. 116]

Lodovico Dolce, 1508–1568. *Il marito è* [The Husband]. Comedy. Venice: **1545.** [Passage & Mantinband 1974, p. 115]

Luíz Vaz de Camões, 1524?–1580. *Comédia dos Anphitriões* (or *Enfatrões*). Verse comedy. **1544–49.** Lisbon: Alvarez, 1587. [EW 1983–85, 2:754ff. / Passage & Mantinband 1974, pp. 116f. / Lindberger 1956, pp. 52–55, 60–62, 177ff.]

Nicholas Udall, 1505–1556, attributed. *A New Interlued for Chyldren to Playe, Named Jacke Jugeler.* Stage interlude, based on Plautus's *Amphitruo.* First performed *c.*1547–57. Published London: Copland, 1562? [DLB 1987, 62: 354, 357, 358]

Juan de Timoneda, *c.*1520–1583. *Amfitrión.* Pastoral comedy, after Lopez de Villalobos (1515?). In *Tres comedias* (Valencia: **1559**). [Oxford 1978, p. 569 / Passage & Mantinband 1974, p. 116 / Lindberger 1956, p. 52]

Anonymous English. *Jack Juggler.* Stage interlude, after Plautus's *Amphitruo.* First performed *c.***1560,** London. Published London: Allde, *c.*1561. (Perhaps identical to Udall, above?) [Highet 1967, p. 138]

Giorgio Vasari, 1511–1574. "Jupiter and Alcmene." Fresco, part of "Labors of Hercules" cycle. Sala di Ercole, Palazzo Vecchio, Florence. [Warburg / cf. Barocchi 1964, pp. 38ff., 147, 316]

Edmund Spenser, 1552?–1599. (Jove's conquest of Alcmene depicted in tapestry of "Cupid's Wars," in) *The Faerie Queene* 3.11.331. Romance epic. London: Ponsonbie, **1590,** 1596. [Hamilton 1977 / MacCaffrey 1976, pp. 105–09 / Barkan 1986, pp. 237f.]

———. (Jove and Alcmene evoked in) "Prosopopoia; or, Mother Hubberds Tale" lines 1292–99. In *Complaints* (London: Ponsonbie, 1591). [Oram et al. 1989]

William Shakespeare, 1564–1616. (The two Dromios based on the two Sosias in Plautus's *Amphitruo* and *Menaechmi* in) *The Comedy of Errors.* Comedy. First recorded performance 28 Dec **1594** (Christmas Revels), Gray's Inn, London. [Riverside 1974 / Highet 1967, pp. 214, 624 / Barber & Wheeler 1986, pp. 68, 74f. / Barkan 1986, pp. 274ff.]

Thomas Heywood, 1573/74–1641. (Story of Alcmene and

Amphitryon, and the birth of Hercules, in) *The Silver Age*. Drama. First performed *c*.**1610–12**, London. Published London: Okes, 1613. [Heywood 1874, vol. 3 / DLB 1987, 62:101, 122ff. / Boas 1950, pp. 85ff. / also Clark 1931, pp. 62ff. / Passage & Mantinband 1974, pp. 118–20]

———. (Scenes, as above, in) *The Escapes of Jupiter (Callisto)*. Comedy, compilation of scenes from Heywood's *The Golden Age* and *The Silver Age*. First performed *c*.1625, London. [Heywood 1978 / DLB 1987, 62:101, 126]

———. "Mercury and Apollo" (discuss Jupiter's seduction of Alcmene). Poetic dialogue, translation from Lucian. No. 9 in *Pleasant Dialogues and Dramma's, Selected Out of Lucian, Erasmus, Textor, Ovid, etc* (London: 1637). [Heywood 1874, vol. 6]

Anonymous English. *The Birthe of Hercules*. Comedy, after Plautus's *Amphitruo* and perhaps Heywood's *The Silver Age*. First performed 4 June **1626**, Court Theatre, Dresden? [Passage & Mantinband 1974, p. 117 / Shero 1956, pp. 192ff. / Clark 1931, p. 67 *n*.]

Wolfhart Spangenberg, *c*.1570–*c*.1636. *Amphitruo*. Comedy, translation of Plautus. In modern edition by A. Tarnai and A. Vizkelety **Sämtliche Werke**, vol. 7, **Dramenübersetzangen** (Berlin & New York: De Gruyter, 1979). [NUC]

Jean Rotrou, 1609–1650. *Les deux Sosies* [The Two Sosias]. Comedy, after Plautus. First performed *c*.1637, Paris. Published Paris: 1638. [DLLF 1984, 3:2019 / Passage & Mantinband 1974, pp. 122–25, 302 / Lindberger 1956, pp. 57–67, 71–76]

Pierre Beauchamps, 1631–1705, choreography, with assistance of Jean-Baptiste Lully, 1632–1687, and others. (Story of Alcmene and Amphitryon in) *Ballet royal de la nuit*. Court ballet in pantomime. Music, Jean de Camberfort and Lully. Subject, Clément. Verses, Isaac de Bensérade. First performed **1653**, Salle du Petit Bourbon, Paris; scenery and machines, Giacomo Torelli. [Simon & Schuster 1979, pp. 5f. / Passage & Mantinband 1974, p. 125]

Charles-Alphonse Dufresnoy, 1611–**1668**. "The Vision of Alcmena." Painting. Galerie Gzernin, Vienna. [Bénézit 1976, 3:723]

Molière, 1622–1673. *Amphitryon*. Comedy. First performed 13 Jan **1668**, Palais-Royal, Paris. Published Paris: Ribou, 1668. [Passage & Mantinband 1974 / McGraw-Hill 1984, 3:417 / Lindberger 1956, pp. 68ff.]

Dirck van Delen, 1605/07–**1671/73**. "Jupiter and Alcmene." Painting. Bowes Museum, Barnard Castle. [Wright 1976, p. 49]

Antonio Draghi, 1634/35–1700. Prologue and intermezzos for *Anfitrione*. Opera. Libretto, Nicolò Minato, after Plautus? First performed 1 Mar **1685**, Vienna. [Grove 1980, 5:604]

John Dryden, 1631–1700. *Amphitryon; or, The Two Sosias*. Comedy. Music, Henry Purcell. First performed 21 Oct **1690**, Theatre Royal, London. [Dryden 1956–87, vol. 15 / Winn 1987, pp. 442–48, 618f. / Passage & Mantinband 1974, pp. 193–96 / Van Doren 1946, pp. 89f., 136, 177]

Nicolaus Adam Strungk, 1640–1700, questionably attributed. *Jupiter und Alkmene*. Opera. First performed **1694–99**, Leipzig. [Grove 1980, 18:299]

Andrea Stefano Fiorè, 1686–1732, doubtfully attributed.

L'Anfitrione. Opera. Libretto, Pietro Pariati. First performed Carnival **1707**, Ducal, Milan. [Grove 1980, 6:599 / DELI 1966–70, 4:254 / Shero 1956, pp. 192ff.]

Francesco Gasparini, 1668–1727. *Anfitrione*. Opera (tragicommedia). First performed Autumn **1707**, San Cassiano, Venice). [Grove 1980, 7:175, 14:183 / DELI 1966–70, 4:254 / Shero 1956, pp. 192ff.]

François Raguenet, *c*.1660–1722. *Amphitryon*. Parody-vaudeville. First performed **1713**, Lille. [Shero 1956, pp. 192ff.]

Simon-Joseph Pellegrin, 1663–1745. *Amphitryon*. Vaudeville. First performed **1714**, Foire Saint-Germain, Paris. [Shero 1956, pp. 192ff.]

António José da Silva, 1705–1739. *Amphitryão, o Jupiter e Alcmena*. Spectacle play in prose and verse. First performed **1736**, Teatro do Bairro Alto, Lisbon. [Passage & Mantinband 1974, p. 198 / Lindberger 1956, p. 103]

José de Cañizares, 1676–1750. *Amor es todo invención: Jupiter, y Añfitrion* [Love is Wholly Invention]. Melodrama in verse. First performed *c*.**1740**, Madrid, for Philip V of Spain. [Passage & Mantinband 1974, p. 198 / Barrera 1969, p. 69]

Anonymous English. *Jupiter and Alcmena*. Dramatic entertainment. First performed 16 Apr **1750**, London. [Nicoll 1959–66, 3:333]

John Hawkesworth, 1715–1773. *Amphitryon; or, The Two Sosias*. Comedy, after Dryden (1690). First performed 15 Dec **1756**, Theatre Royal, Drury Lane, London. [Nicoll 1959–66, 3:113, 267] Revised version, by Henry Woodward, published as *A Comedy, Altered from Dryden, by Mr. Woodward* (London: 1777). [Passage & Mantinband 1974, p. 196]

William Shirley, fl. 1739–80. *The Birth of Hercules*. Masque. Music, Thomas Arne. In rehearsal Jan **1763**, for Covent Garden, London, but performance postponed because of Half Price Riots. Published London: 1765. [Nicoll 1959–66, 3:306 / Fiske 1973, p. 316]

Michael Arne, *c*.1740–1786, and **Jonathan Battishill,** 1738–1801. *Almena*. Opera. Libretto, Richard Rolt. First performance 2 Nov **1764**, Theatre Royal, Drury Lane, London. Published London: Becket & De Hondt, 1764. [Fiske 1973, p. 311 / Nicoll 1959–66, 3:303]

Charles Dibdin, 1745–1814. *Amphitryon*. Opera. Libretto, Hawkesworth (1756). First performed 23 Nov **1769**, Theatre Royal, Drury Lane, London. [Grove 1980, 5:426]

———. *Jupiter and Alcmena*. Ballad opera. Libretto, composer, after Dryden (1690). First performed 27 Oct **1781**, Covent Garden, London. [Ibid., 5:425, 427 / Nicoll 1959–66, 3:113, 255]

André Grétry, 1741–1813. *Amphitryon*. Opéra comique. Libretto, Michel-Jean Sédaine, after Molière (1668). First performed 15 Mar **1786**, Versailles. [Grove 1980, 7:710 / Lindberger 1956, p. 104]

Josef Martin Kraus, 1756–1792. Entr'acte and ballet music for a performance of Molière's *Amphitryon*. Text adapted by Gustav III of Sweden. Commissioned 1784, first performed Summer **1787**, Drottningholm Court Theatre, Sweden. [Grove 1980, 10:242f. / Lindberger 1956, pp. 104f., 107]

Heinrich von Kleist, 1777–1811. *Amphitryon*. Tragicomedy

("after Molière," but quite different from Molière's 1668 original). **1803**. Published Dresden: Arnold, 1807. First performed 8 Apr 1899, Neues Theater, Berlin. [Passage & Mantinband 1974 / McGraw-Hill 1984, 3:165f. / Strich 1970, 2:369 / Lindberger 1956, pp. 121ff.]

Johannes Daniel Falk, 1768–1826. *Amphitruon*. Comedy. Halle: Ruffschen, **1804**. [Oxford 1986, p. 225 / Lindberger 1956, pp. 118–20 / Passage & Mantinband 1974, pp. 199f.]

James Robinson Planché, 1795–1880. *A Burletta of Errors; or, Jupiter and Alcmena*. Extravaganza. First performed 6 Nov **1820**, Adelphi, London. [Planché 1986, p. 232]

John Oxenford, 1813–1877. *Amphitryon*. Comedy. **1872**. [Passage & Mantinband 1974, pp. 196f. / cf. Nicoll 1959–66, 5:641 (anonymous)]

Paul-Jean-Jacques Lacôme d'Estaleux, 1838–1920. *Amphitryon*. Opera. Libretto, Beaumont and Nuitter. First performed 5 Apr **1875**, Paris. [Passage & Mantinband 1974, p. 283]

Julian Edwards, 1855–1910. *Jupiter*. Musical comedy. Book and lyrics, Harry B. Smith. First performed 14 Apr (or 2 May) **1892**, Palmer's Theatre, New York. [Baker 1984, p. 644 / Bordman 1978, p. 116]

Valéry Bryúsov, 1873–1924. *Amphitryon*. Comedy, translation of Molière (1668). First performed **1912**. Published in *Polnoye sobranie socinenij* (St. Petersburg: 1913–14). [Passage & Mantinband 1974, p. 294]

Svend Borberg, 1888–1947. (Amphitryon as) *Ingen* [Nobody]. Drama. Copenhagen: Hasselbach, **1920**. [Mitchell 1958, p. 256]

Lovis Corinth, 1858–1925. "Alcmene with Zeus-Amphitryon and Hermes." Color lithograph, part of "Loves of Zeus" cycle. **1920**. [Schwarz 1922, no. L401]

Jean Giraudoux, 1882–1944. *Amphitryon 38*. Comedy. First performed 8 Nov **1929**, Comédie des Champs-Élysées, Paris. [Mauron 1971, pp. 55–78, 82–89, 91–93, 239–41 / Inskip 1958, pp. 60–64 / Lindberger 1956, pp. 167ff., 227ff. / Fass 1974, pp. 140, 243–45 / McGraw-Hill 1984, 2:324 / Passage & Mantinband 1974, pp. 283–88]

Giorgio de Chirico, 1888–1978. "The Repose of Alcmene." Painting. **1933**. Private collection, Rome. [Far 1968, no. 131–ill.]

Yvor Winters, 1900–1968. "Alcmena." Poem. In *Rocking Horse* 2 (**1935**); collected in *Poems* (Los Altos, Calif: Gyroscope, 1940). [Boswell 1982, p. 236 / Isaacs 1981, p. 87 / Powell 1980, pp. 133f., 145, 157]

Maurice Emmanuel, 1862–1938. *Amphitryon*. Incidental music and choruses, opus 28. Libretto, A. Ernout's translation of Plautus. **1936**. [Grove 1980, 6:155]

———. *Amphitryon*. Opéra-bouffe. First performed 20 Feb 1937, Paris. [Baker 1984, p. 661]

Samuel Barlow, 1892–1982. 12 orchestral pieces, incidental music to Giraudoux's *Amphitryon 38* (1929). **1937**. [Grove 1980, 2:165]

S. N. Behrman, 1893–1973. *Amphitryon 38*. Comedy, free adaptation of Giraudoux (1929). First performed **1937**, New York. Published New York: Random House, 1938. [Passage & Mantinband 1974, pp. 288f.]

Luigi Chiarelli, 1884–1947. *Anfitrione*. Comedy, after Plautus. Naples: Rispolianonima, **1939**. [DULC 1959–63, 1:782]

W. J. Turner, 1889–1946. *Jupiter Translated*. Comedy, after Molière (1668). First performed **1930s**, Mercury Theatre, London. [McGraw-Hill 1984, 3:409]

Boris Papandopulo, 1906–. *Amfitrion*. Opera. Libretto, after Molière (1668). First performed 17 Feb **1940**, Zagreb. [Grove 1980, 14:168]

Daniel Ruyneman, 1886–1963. *Amphitryon*. Overture. **1943**. [Grove 1980, 16:352]

Ermanno Wolf-Ferrari, 1876–1948. (Amphitryon as) *Der Kuckuck in Theben* [The Cuckoo in Thebes]. Opera. Libretto, L. Andersen and M. Ghisalberti. First performed as *Gli dei a Tebe* [The Gods in Thebes], 5 Jun **1943**, Hannover. [Baker 1984, p. 2520 / Grove 1980, 20:507.]

Georg Kaiser, 1878–1945. *Zweimal Amphitryon* [Amphitryon Doubled]. Verse drama, part 2 of *Griechische Dramen* [Hellenic Trilogy]. First performed 29 Apr **1944**, Schauspielhaus, Zürich. Published Zürich: Artemis, 1948. [McGraw-Hill 1984, 3:120, 122 / Passage & Mantinband 1974, pp. 289–93 / Paulsen 1960, pp. 172f.]

Friedrich Michael, b. 1892. (Amphitryon in) *Ausflug mit Damen* [Excursion with Ladies]. Comedy. Wiesbaden: Steyer, **1944**. [Frenzel 1962, p. 42]

Bernard Rogers, 1893–1968. *Amphitryon*. Overture. **1946**. [Grove 1980, 16:103]

Francis Poulenc, 1899–1963. Incidental music for Molière's *Amphitryon* (1668). First performed 5 Dec **1947**, Théâtre, Marigny Paris. [Grove 1980, 15:167]

Guilherme Figueiredo, 1915–. *Um deus dromiu lá em casa* [A God Slept in the House]. Comedy. First performed **1949**, Teatro Copacabana, Rio de Janeiro. Published Rio de Janeiro: Ministerio da Educaçao i Cultura, 1957. [McGraw-Hill 1984, 2:159] Adapted by Lloyd F. George and John Fostini as *A God Slept There*. First performed 20 Feb 1957, New York. [Passage & Mantinband 1974, p. 296]

Robert Oboussier, 1900–1957. *Amphitryon*. Opera. Libretto, Oboussier, after Molière (1668) and Kleist (1803). **1950**. First performed 13 Mar 1951, Berlin. [Baker 1984, p. 1672 / Grove 1980, 13:476]

Cole Porter, 1891–1964, music and lyrics. *Out of This World*. Musical comedy. Book, Dwight Taylor and Reginald Lawrence, after Giraudoux's *Amphitryon 38* (1929). First performed 21 Dec **1950**, New Century Theater, New York. [Bordman 1978, p. 577 / Sharp 1969, 1:538, 2:1209]

Eckart Peterich, 1900–. *Alkmene*. Comedy. Cologne: Hegner, **1959**. [Wilpert 1963, p. 453]

George Sklavos, 1888–1976. *Amphitryon*. Opera. Libretto, Sperantzas. **1955–60**. First performed 1960. [Grove 1980, 17:366 / Baker 1984, p. 2143]

Thomas Hugh Eastwood, 1922–. *Amphitryon II*. Radio score. First performed **1961**. [Grove 1980, 5:808]

Giselher Klebe, 1925–. *Alkmene*. Opera. Libretto, composer, after Kleist (1803). First performed **1961**, West Berlin. [Grove 1980, 10:98]

Peter Hacks, 1928–. *Amphitryon*. Comedy in verse, after Molière (1668) and Kleist (1803). First performed **1968**, Deutsches-Theater, Göttingen. Published Berlin: Eulenspiegel, 1969. [Oxford 1986, p. 339 / Buddecke & Fuhrmann 1981, pp. 291–93]

Yannis Ritsos, 1909–1990. "Alkmene." Poem. 23 March **1968**. In *Epanalepseis* (Athens: Kedros, 1972). / Trans-

lated by Edmund Keeley in *Yannis Ritsos, Exile and Return: Selected Poems 1967–1974* (New York: Ecco Press, 1985). [Ipso]

AMYMONE. *See* POSEIDON, Loves.

AMYNTAS. *See* SHEPHERDS AND SHEPHERDESSES.

ANCHISES. *See* AENEAS; APHRODITE, and Anchises.

ANDROMACHE. Daughter of the Theban king Eëtion and wife of the Trojan prince Hector, Andromache is known as a paragon of virtue and loyalty. After Hector's death and the murder of her infant son Astyanax at the fall of Troy, Andromache was given as captive and concubine to Achilles' son Neoptolemus (Pyrrhus).

After Menelaus gave his daughter Hermione in marriage to Neoptolemus instead of her betrothed, Orestes, Neoptolemus brought her to live in his household with Andromache. The jealous and childless Hermione bitterly hated the older woman, particularly in envy of her children by Neoptolemus. While Neoptolemus was gone to Delphi to consult the oracle about Hermione's infertility, she plotted unsuccessfully to murder Andromache and one of her sons. Meanwhile Neoptolemus was killed at Delphi by Orestes, who then reclaimed Hermione.

Upon the death of Neoptolemus (or after his marriage to Hermione, according to Virgil's *Aeneid*), Andromache was given to Helenus, king of Epirus, who married her. There Aeneas visited them on his voyage.

The story of Andromache, like that of Hermione, has been enormously popular in opera and drama, stemming from Euripides and, in postclassical literature, from Racine's seminal tragedy.

Classical Sources. Homer, *Iliad* 6.390–502, 24.723–45; *Little Iliad* fr. 19.3. Euripides, *Andromache*; *The Trojan Women*. Sappho, *The Wedding of Andromache*. Virgil, *Aeneid* 3.294–348. Apollodorus, *Biblioteca* E5.23, E6.12–13. Pausanias, *Description of Greece* 1.11.1–2, 10.25.9.

See also AENEAS, Wanderings; HECTOR; TROJAN WAR, Fall of Troy.

Guido delle Colonne, *c.*1210–after 1287. (Andromache's life with Pyrrhus, Pyrrhus's murder by Orestes, in) *Historia destructionis Troiae* [History of the Destruction of Troy] 34.188ff., 205ff. Latin prose chronicle, adaptation of Benoît de Sainte-Maure's *Roman de Troie* (*c.*1165).

1272–87. Modern edition by Nathaniel E. Griffin (Cambridge: Harvard University Press, with Mediæval Academy of America, 1936; reprinted New York: Kraus, 1970). / Translated by M. E. Meek (Bloomington: Indiana University Press, 1974). [Benson 1980, pp. 30f., 154, *n.*52]

Anonymous French. (Andromache in) *Ovide moralisé* 13.3060–3088. Poem, allegorized translation/elaboration of Ovid's *Metamorphoses* and other works. *c.*1316–28. [de Boer 1915–86, vol. 4]

Raphael, 1483–1520. "Neoptolemus Carrying Off Andromache after the Fall of Troy." Drawing. *c.*1516. Duke of Devonshire coll., Chatsworth, no. 903. [Joannides 1983, no. 380r—ill.]

Luc Percheron. *Pyrrhe* [Pyrrhus]. Tragedy. First performed **1592**, Paris. Modern edition Geneva: Slatkine, 1970. [Stone 1974, pp. 122–127, 214]

Giovanni Felice Sances, *c.*1600–1679. *L'Ermiona.* Opera. Libretto, Pio Enea degli Obizzi. First performed 11 Apr **1636**, Padua. [Grove 1980, 16:462 / Clubb 1968, p. 170]

Jean Racine, 1639–1699. *Andromaque.* Tragedy. First performed 7 Nov **1667**, Hôtel de Bourgogne, Paris. [Rat 1974 / Pocock 1973, pp. 178–90 / Turnell 1972, pp. 53–88 / Vinaver 1963, pp. 47–50, 118–25, 139–44, 158–63, 243 / Barnwell 1982, pp. 7–24 passim, 76–80, 107–10, 147f., 195ff., 232–36 and passim]

Anonymous. (Andromache in) *L'incostanza del fato* [The Inconstancy of Fate]. Opera (drama musicale). Librettist unknown. First performed 25 Jan **1672**, Cocomero, Florence. [Weaver 1978, pp. 142f.]

John Crowne, 1640?–1703?. *Andromache.* Tragedy. First performed *c.*Dec **1674**, Duke's Theatre, Dorset Garden, London. Published London: Bentley, 1675. [Nicoll 1959–66, 1:357 / Stratman 1966, p. 137]

Antonio Draghi, 1634/35–1700. *Pirro.* Opera. Libretto, N. Minato. First performed 30 May **1675**, Vienna. [Grove 1980, 5:604]

Giuseppe Antonio Bernabei, 1649?–1732. *L'Ermione* [Hermione]. Opera. Libretto, Terzago. First performed **1683**, Munich. [Grove 1980, 2:612]

Gérard de Lairesse, 1641–1711 (active until *c.*1690). "The Death of Pyrrhus." Painting. Musées Royaux des Beaux-Arts (Musée d'Art Ancien), Brussels, inv. 127. [Brussels 1984a, p. 170—ill.]

Christian Heinrich Postel, 1658–1705. *Die glücklich wiedererlangete Hermione.* [The Happily Rescued Hermione]. Opera. First performed **1695**. [Hunger 1959, p. 232]

Carlo Francesco Pollarolo, *c.*1653–1723. *L'Oreste in Sparta.* Opera. Libretto, P. Luchesi. First performed **1697**, Reggio Emilia. [Grove 1980, 15:47]

William Congreve, 1670–1729. "Lamentations of Hecuba, Andromache, and Helen." Poem. In *Poems upon Several Occasions* (London: Tonson, **1710**). [Dryden 1956–87, 4:703]

Ambrose Philips, 1675?–1749. *The Distrest Mother* (Andromache). Tragedy. First performed Mar **1712**, Theatre Royal, Drury Lane, London. [Nicoll 1959–66, 2:348]

Jean-Joseph Mouret, 1682–1738, music. (Andromache in) "La ceinture de Vénus." Ballet-opera, first interlude for *Les grandes nuits de sceaux*. Libretto, Antoine Houdar de La Motte. First performed **1715**, for Duc and Duchesse du Maine, Château de Sceaux. [Winter 1974, p. 48]

Anonymous. *The French Andromache.* Burlesque of Ra-

cine's *Andromaque* (1667). First performed **1716**, Lincoln's Inn Fields, London. [Winter 1974, p. 66]

Antonio Salvi. *L'Andromaca.* Libretto for opera. First set by Orlandini in **1723** or by Chiocchetti in 1726, and thereafter by at least 9 other composers to 1797.

Apostolo Zeno, 1668–1750. *L'Andromaca.* Libretto for opera. First set by Orlandini in **1723** (?) or by Caldara in 1724 and thereafter by at least 4 other composers.

Giuseppe Maria Orlandini, 1675–1760. *L'Andromaca.* Opera. Libretto, Antonio Salvi (or Apostolo Zeno?). First performed **1723**, Ferrara. [Weaver 1978, p. 253]

Antonio Caldara, c.1670–1736. *L'Andromaca.* Opera. Libretto, Apostolo Zeno. First performed **1724**, Vienna. [Clément & Larousse 1969, 1:58 / Weaver 1978, p. 253]

Pietro Vincenzo Chiocchetti. *L'Andromaca.* Opera. Libretto, Antonio Salvi. First performed **1726**, Modena. [Weaver 1978, p. 253]

Gregorio Redi, 1676–1748. *Andromaca.* Tragedy, translation of Racine (1667). Florence: **1726**; reprinted in *Opere varie* (Venice: Recurti, 1751). [DELI 1966–70, 4:522]

Antonio Bioni, 1698–after 1739. *Andromaca.* Opera. Libretto, Zeno (1723–24). First performed **1729–30**, Ballhaus Theater, Breslau. [Grove 1980, 2:726]

Francesco Feo, 1691–1761. *Andromaca.* Opera. Libretto, Zeno (1723–24). First performed 5 Feb **1730**, Teatro Della Valle, Rome. [Grove 1980, 6:466]

Charles-Antoine Coypel, 1694–1752. "Andromache and Pyrrhus." Painting. c.**1730s**? [Bénézit 1976, 3:248]

Leonardo Leo, 1694–1744. *Andromaca.* Opera (dramma per musica). Libretto, Salvi (1723–26). First performed 4 Nov **1742**, Teatro San Carlo, Naples. [Grove 1980, 10:668 / Weaver 1978, p. 297]

Giovanni Battista Lampugnani, 1706–c.1786. *Andromaca.* Libretto, Salvi (1723–26). First performed **1748**, Teatro Regio, Turin (or Carnival 1749, Turin). [Grove 1980, 10:422]

———. Arias in *Andromaca.* Pasticcio. Text, after Salvi (1723–26). First performed 11 Nov 1755, King's Theatre, London. [Ibid., 10:422]

Davide Perez, 1711–1778. *Andromaca.* Opera. First performed **1750**, Imperial Theatre, Vienna. [Grove 1980, 14:367]

Antonio Gaetano Pampani, c.1705–1775 (arias), with **Antonio Aurisicchio,** c.1710–1781. *Andromaca.* Pasticcio. Libretto, Salvi (1723–26). First performed Carnival **1753**, Teatro Argentina, Rome. [Grove 1980, 1:706, 14:149, 16:436]

Christoph Willibald Gluck, 1714–1787. "Andromache before Pyrrhus," scene in *Le cinesi* [The Chinese]. Opera (azione teatrale). Libretto, Metastasio. First performed 24 Sep **1754**, for Prince of Saxe-Hildburghausen, Schlosshof, Vienna. [Grove 1980, 7:459, 472]

Giuseppe Scolari, c.1720–after 1774. *L'Andromaca.* Opera (dramma per musica). Libretto, G. M. Viganò. First performed 20 Jan **1757**, Sociale, Lodi. [Grove 1980, 17:55]

Giuseppe Sarti, 1729–1802. *Andromaca.* Opera (dramma per musica). Libretto, Zeno (1723–24). First performed Autumn **1759–60**, Theatre on Kongens Nytorv, Copenhagen. [Grove 1980, 16:504]

Antonio Sacchini, 1730–1786. *Andromaca.* Opera. Libretto, Salvi (1723–26). First performed 30 May **1761**, Teatro San Carlo, Naples. [Grove 1980, 16:372]

Antonio Tozzi, c.1736–after 1812. *Andromaca.* Opera (dramma serio). Libretto, Salvi (1723–26). First performed Spring **1765**, Hoftheater, Braunschweig. [Grove 1980, 19:105]

Michelangelo Valentini, c.1720–after **1768.** *Andromaca.* Opera. Libretto, Zeno (1723–24), with additions from Salvi (1723–26). First performed Teatro Ducale, Milan. [Grove 1980, 19:497]

Ferdinando Bertoni, 1725–1813. *Andromaca.* Opera. Libretto, Salvi (1723–26). First performed 26 Dec **1771**, San Benedetto, Venice. [Grove 1980, 2:647]

Angelica Kauffmann, 1741–1807. "Andromache Fainting at the Unexpected Sight of Aeneas on His Arrival in Epirus." Painting. Exhibited **1775.** [Manners & Williamson 1924, p. 237]

———. "Andromache." Painting. Lord Glenconner estate. [Ibid., p. 190]

Luigi de Baillou, c.1735–c.1809, music. *Andromaca e Pirro.* Ballet/pantomime. Libretto, Ricciardi. First performed 1 Jan **1777**, Teatro Interinale, Milan. [Grove 1980, 2:38]

Karl Wilhelm Dassdorf, 1750–1812. *Andromache.* Drama with music. First performed **1777**, Dresden? [DLL 1968–90, 2:997]

Johann Friedrich Brömel, 1743–1819. *Hermione.* Singspiel. **1778.** [DLL 1968–90, 2:106]

André Grétry, 1741–1813. *Andromaque.* Opera (tragédie lyrique). Libretto, Louis-Guillaume Pitra, after Racine (1667). First performed 6 June **1780**, Académie royale de musique, Paris. Published Paris: Lormel, 1780. [Grove 1980, 7:710 / DLF 1951–72, 2:376]

Vicente Martín y Soler, 1754–1806. *Andromaca.* Opera seria. Libretto, Salvi (1723–26). First performed 26 Dec **1780**, Teatro Regio, Turin. [Grove 1980, 11:736]

Carlo Canobbio, 1741–1822, music. *Andromacca e Pirro.* Ballet. First performed **1784**, Imperial Theatre, St. Petersburg. [Hunger 1959, p. 31 / Grove 1980, 3:688]

Onorato Viganò, 1739–1811, choreography. *Andromaca in Epiro.* Ballet. Music, Luigi Marescalchi. First performed Carnival **1784**, Teatro Argentina, Rome. [Grove 1980, 11:675]

F. G. Steidele. *Orest und Hermione.* Drama. **1788.** [Hunger 1959, p. 232]

Luciano Francisco Comella, 1751–1812. *La Andrómaca.* Drama. [Madrid?]: Libreria de Cerro; Barcelona: Piferrer, **1790**? [DLE 1972, p. 202]

Sebastiano Nasolini, c.1768–1806/16. *Andromaca.* Opera. Libretto, Salvi (1723–26). First performed Feb **1790**, San Samuele, Venice. [Grove 1980, 13:43]

Giovanni Paisiello, 1740–1816. *Andromaca.* Opera. Libretto, Lorenzi, after Salvi (1723–26). First performed 4 Nov **1797**, San Carlo, Naples. [Grove 1980, 14:101]

Anne-Louis Girodet, 1767–1824. Series of illustrations to Racine's *Andromaque* (1667). Published in *Oeuvres de Jean Racine* (Paris: Didot, **1801**). Original drawings in Musée des Beaux-Arts, Orléans; Musée, Montargis; elsewhere? [Montargis 1967, nos. 69–71 / Boutet-Loyer 1983, no. 34—ill.]

Stefano Pavesi, 1779–1850. *Andromaca.* Opera. Libretto, Artusi. First performed **1804** (or 1822?), Milan. [Hunger 1959, p. 31 / Clément & Larousse 1969, 1:59]

Pierre-Paul Prud'hon, 1758–1823. "Andromache and Pyr-

rhus." 2 drawings, illustrating Racine's *Andromaque* (1667). Engraved by Marais for edition of Racine's *Oeuvres complets* (Paris: Didot, **1801–05**). Original drawings in private colls. or unlocated. [Guiffrey 1924, nos. 252, 1065–66, pp. 407f.]

————. "Andromache (and Pyrrhus)." Painting. Begun 1815, unfinished; completed by Charles Boulanger de Boisfrémont (d. 1838). Metropolitan Museum, New York, no. 25.110.14. [Metropolitan 1980, p. 145—ill. / also Guiffrey, no. 249; cf. nos. 251–58 (drawings)—ill.]

Vincenzo Puccita, 1778–1861. *Andromaca.* Opera. First performed **1806**, Lisbon. [Grove 1980, 15:440]

Giacomo Tritto, 1733–1824. *Andromacca e Pirro.* Opera. First performed **1807** (San Carlo, Naples?). [Hunger 1959, p. 31]

Jean Bardin, 1732–1809. "Andromache." Painting. [Bénézit 1976, 1:439]

Pierre-Narcisse Guérin, 1774–1833. "Andromache and Pyrrhus." Painting. **1810.** Louvre, Paris, inv. 5183. [Louvre 1979–86, 3:295—ill.] Another version of the subject in Musée, Bordeaux. [Bénézit 1976, 5:272]

Robert Treat Paine, Jr., 1773–1811. *Andromache; or, The Fall of Troy.* Tragedy. Unperformed. London: privately printed, 1820. [Stratman 1966, p. 515]

Francesco Bernardino Cicala, 1765–1816. *Ermione.* Tragedy. In *Opere* (Lecce: Agianese, **1814**). [DELI 1966–70, 2:45]

Ignazio Raimondi, *c.*1735–1813. *Andromaca.* Opera. First performed *c.***1815**, Palermo. [Clément & Larousse 1969, 1:59]

Gioacchino Rossini, 1792–1868. *Ermione.* Opera (azione tragica). Libretto, Tottola, after Racine's *Andromaque* (1667). First performed 27 Mar **1819**, San Carlo, Naples. [Grove 1980, 16:244]

Giuseppe Maria Cambini, 1746–1825. "Andromaque." Lyric scene, for solo voice and orchestra. MS in Bibliothèque Nationale, Paris. [Grove 1980, 3:640]

John Lodge Ellerton, 1801–1873. *Andromaca.* Opera. First performed *c.***1830**, Prussia. [Clément & Larousse 1969, 1:59]

E. Seidelmann. *Pyrrhus in Delphi.* Opera. Libretto, Perglass. **1834.** [Hunger 1959, p. 233]

Honoré Daumier, 1808–1879. "Yes! Since I have found such a true friend, my fortune will take a new turn." Lithograph, caricature after Racine's *Andromaque* (1667), part of "La tragédie" series. **1848.** [Delteil 1906–30, 25: no. 1742—ill.]

————. "Andromache." Comic lithograph, in "Physionomies tragiques" series. 1851. [Ibid., 26: no. 2180—ill.]

Charles Baudelaire, 1821–1867. (Andromache evoked in) "Le cygne" [The Swan]. Poem, dedicated to Victor Hugo. **1859.** In *Les fleurs du mal,* 2d edition (Paris: Poulet-Malassis & de Broise, 1861). [Pichois 1975 / EW 1983–85, 7:1339, 1341f.]

Max Bruch, 1838–1920. *Hermione.* Opera. First performed **1872.** [Hunger 1959, p. 233]

Frederic, Lord Leighton, 1830–1896. "Captive Andromache." Painting. *c.***1888.** City Art Gallery, Manchester, England, no.1889.2. [Minneapolis 1978, no. 55—ill. / Kestner 1989, pp. 157ff., pl. 3.13 / Ormond 1975, no. 334—ill. / Wood 1983, pp. 61–62—ill.] Color sketch. Private coll. [Ormond, no. 335—ill.]

Eugène Guillaume, 1822–1905. "Andromache and As-

tyanax." Marble sculpture group. *c.***1889.** / Plaster studies. Musée d'Orsay, Paris, inv. R. F. 1728; another formerly Musée Fabre, Montpelier. [Orsay 1986, p. 1970—ill.]

William Entriken Baily. "Andromache in Captivity." Poem. In *Dramatic Poems* (Philadelphia: privately printed, **1894**). [Hunger 1959, p. 31]

French (?) School. "Andromache." Terra-cotta sketch. **19th–20th century.** Musée d'Orsay, Paris, inv. RF 4088 (acquired 1974). [Orsay 1986, p. 260—ill.]

Gilbert Murray, 1866–1957. *Andromache.* Tragedy in modern prose. First performed 24 Feb **1901**, Stage Society, Strand Theatre, London. [DLB 1982, 10:61–63]

Camille Saint-Saëns, 1835–1921. Incidental music to Racine's *Andromaque* (1667). First performed 7 Feb **1903**, Théâtre Sarah Bernhardt, Paris. [Grove 1980, 16:404]

Gabriele D'Annunzio, 1863–1938. (Hermione evoked in) "O tristezza" [Sadness], "Le ore marine" [Sea Shore], "Litorea dea" [Goddess of the Shore]. Poems. In *Alcyone* (Milan: Treves, **1904**). [Roncoroni 1982 / Bàrberi Squarotti 1982, p. 157 / Mutterle 1982, p. 140]

John La Farge, 1835–1910. "Andromache." Watercolor. Syracuse Museum of Fine Arts, N.Y. [Weinberg 1977, fig. 174]

Cecil Roberts, 1892–1976. "Andromache." Poem. **1915.** In *Poems* (New York: Stokes, 1920). [Bush 1937, p. 572 / Boswell 1982, p. 285]

Charles Williams, 1886–1945. "Troy: Sonnets on Andromache, Helen, Hecuba, and Cassandra." Sonnet cycle. In *Poems of Conformity* (London: Oxford University Press, **1917**). [Bush 1937, p. 571]

Herbert Windt, 1894–1965. *Andromache.* Opera. Libretto, composer. First performed 16 Mar **1932**, Berlin. [Baker 1984, p. 2510]

George Seferis, 1900–1971. "Andromáche." Poem. No. 17 in *Mythistorema* (Athens: Ikaros, **1935**). [Keeley & Sherrard 1967 / Keeley 1983, pp. 56, 103]

Giuseppe Lipparini, 1877–1951. *Ermione.* Tragedy. Bologna: Zanichelli, **1937.** [DELI 1966–70, 3:397]

Georges Rochegrosse, 1859–1938. "Andromache and Astyanax." Painting. Musée des Beaux-Arts, Rouen. [Jacobs & Stirton 1984a, p. 37]

Ferdinand Bruckner, 1891–1958. *Pyrrhus und Andromache.* Tragedy. **1951.** First performed 16 Feb 1952, Schauspielhaus, Zürich. [McGraw-Hill 1984, 1:419f.]

Michele Saponaro, 1885–1959. *Andromaca.* Tragedy/romance. Milan: Ceschina, **1955.** [DELI 1966–70, 5:48f.]

Robert Lowell, 1917–1977. "The Swan." Poem, after Baudelaire (1859). In *Imitations* (New York: Farrar, Straus & Giroux, **1961**). [CLC 1974, 2:249]

Eric Bentley, 1916–. *A Time to Live.* Drama, adaptation of Euripides. First performed **1967**, New York. Published New York: Grove, 1967. [Vinson 1982, p. 88]

Mirko, 1910–1969. "Andromache." Bronze sculpture. *c.***1968.** [Trieste 1976, p. 98—ill.]

Leonard Baskin, 1922–. "Andromache." Bronze relief. **1969.** Virginia Museum of Fine Arts, Richmond; private colls. [Jaffe 1980, p. 215]

————. "Andromache" (in mourning). Bronze sculpture. 1971. Kennedy Galleries, New York, in 1978. [Ibid., pp. 101–06, 216—ill.]

Linda Gregg, 1942–. "Andromache Afterwards." Poem.

In *The Ardis Anthology of New American Poetry* (Ann Arbor: Ardis, **1977**). [Ipso]

Clive Wilmer, 1945–. "Andromache." Poem. In *The Dwelling-Place* (Manchester: Carcanet, **1977**). [DLB 1985, 40 pt. 2: 642]

Martha Graham, 1894–1991, choreography. *Andromache's Lament*. Modern dance. Music, Samuel Barber. First performed 23 June **1982**, City Center, New York; costumes, Halston; lighting, Beverly Emmons. [Stodelle 1984, p. 317]

Richard Wilbur, 1921–. *Andromache*. Translation of Racine (1667). New York: Harcourt, Brace & Jovanovich, **1982**; illustrations by Igor Tulipanov. [Ipso]

ANDROMEDA. *See* PERSEUS, and Andromeda.

ANTAEUS. *See* HERACLES, and Antaeus; TITANS AND GIANTS.

ANTEROS. *See* EROS AND ANTEROS.

ANTIGONE. One of the four children born of the incestuous union of Jocasta and her son Oedipus, Antigone accompanied her blind father to Colonus after his exile from Thebes.

When her brothers Eteocles and Polyneices killed each other in their struggle for Theban rule, her uncle Creon seized the throne and, in violation of divine law, decreed that Polyneices should remain unburied. Defying this order, Antigone buried Polyneices and as punishment was entombed alive by Creon, even though she was betrothed to his son Haemon. Her sister Ismene, who had refused to help bury Polyneices, later tried to claim some of Antigone's guilt but was dismissed by Creon as insane.

Only after the seer Tiresias warned him that his impious actions would bring dire consequences did Creon relent. He set out to rescue Antigone from the tomb, but she had already hanged herself. Haemon committed suicide beside her corpse.

Representing the triumphant voice of individual conscience in defiance of the state, Antigone's story has enjoyed a renaissance in this century—particularly in theater, dance, and music—as a response to dictatorship in Europe.

Classical Sources. Aeschylus, *Seven against Thebes*. Sophocles, *Oedipus at Colonus; Antigone*. Euripides, *The Phoenician Maidens*. Accius, *Antigone*. Apollodorus, *Biblioteca* 3.7.1. Seneca, *The Phoenician Maidens*. Statius, *Thebaid* 12. Hyginus, *Fabulae* 72.

Further Reference. George Steiner, *Antigones* (Oxford & New York: Oxford University Press, 1984).

See also OEDIPUS, at Colonus; SEVEN AGAINST THEBES.

Dante Alighieri, 1265–1321. (Antigone and Ismene cited as among the women of antiquity in Limbo in) *Purgatorio* 22.109–14. Completed *c.*1314? In *The Divine Comedy*. Poem. Foligno: Neumeister & Angelini, 1472. [Singleton 1970–75, vol. 2]

Luigi Alamanni, 1495–1556. *Tragedia di Antigone*. Tragedy. In *Opere Toscane* (Lyons: Gryphius, 1533). [Clubb 1968, p. 16]

Jean-Antoine de Baïf, 1532–1589. *Antigone*. Tragedy, after Sophocles. In *Les jeux* (Paris: Breyer, 1572). [Taylor 1893, p. 66 / Steiner 1984, p. 139 (as 1573)]

Robert Garnier, 1545–1590. *Antigone*. Tragedy, after Sophocles and Seneca, with a duel based on Statius's *Thebaid*. In *Tragédiès* (Paris: Patisson, 1580). [Steiner 1984, pp. 139f., 143, 170, 195f. / Stone 1974, pp. 93f., 133 / Jondorf 1969, pp. 39–41, 48f., 66f., 76f., 86f., 102–08, 143 / Yarrow 1954, p. 142]

Giovanni Paolo Trapolini, ?–1599. *Antigone*. Allegorical drama. Padua: Pasquati, 1581. [Steiner 1984, p. 195 / Yarrow 1954, p. 142]

William Bosworth, 1607–1650? (A story involving Antigone and Haemon told in) *The Chast and Lost Lovers, Arcadius and Sepha*. Poem. *c.*1626. London: Blaiklock, 1651. [Bush 1963, p. 199]

Thomas May, 1595–1650. *The Tragedy of Antigone, the Theban Princesse*. Tragedy, after Garnier, Sophocles, Seneca, Statius, and Lucian. Unperformed. London: printed by T. Harper for B. Fisher, 1631. [DLB 1987, 58:190, 192 / Steiner 1984, p. 196 / Stratman 1966, pp. 420f.]

Jean Rotrou, 1609–1650. *Antigone*. Tragedy. First performed 1637, Hôtel de Bourgogne, Paris. [DLLF 1984, 3:2018ff. / Yarrow 1954, p. 142ff.]

Claude Boyer, 1618?–1698, writing as "Pader d'Assézan." *Antigone*. Tragedy. First performed 14 Mar 1686, Comédie-Française, Paris. Published Paris: 1687. [Steiner 1984, p. 196 / Lancaster 1929–42, pt. 4, 2:953]

————, questionably attributed. *Antigone*. Tragedy. In MS, 1672. First performed 1673. [Lancaster, pt. 4, 2:951]

Marc' Antonio Ziani, *c.*1653–1715. *Creonte*. Opera. Libretto, Ciallis. First performed 1690, Teatro San Angelo, Venice. [Grove 1980, 20:674]

Giuseppe Maria Orlandini, 1675–1760. *Antigona*. Opera. Libretto, B. Pasqualigo. First performed Carnival 1718, San Cassiano, Venice. [Steiner 1984, p. 154 / Grove 1980, 13:824]

Jean-Marie Leclair the Elder, 1697–1764. Ballet music for performance of Orlandini's opera, *Antigona*, Carnival 1727, Teatro Regio, Turin. [Grove 1980, 10:591]

Baldassare Galuppi, 1706–1785. *Antigona*. Opera seria. Libretto, Gaetano Roccaforte. First performed 9 Jan 1751, Teatro delle Dame, Rome. [Grove 1980, 7:137]

Giovanni Battista Casali, *c.*1715–1792. *Antigone*. Opera. First performed 1752, Rome? [Steiner 1984, p. 155]

Pietro Gugliantini, choreography. *Antigona*. Ballet. First performed Carnival 1752, Florence. [Weaver 1978, p. 332]

Gaetano Latilla, 1711–1788. *Antigone*. Heroic opera. Li-

bretto, Roccaforte (1751). First performed **1753**, Court, Modena. [Grove 1980, 10:504]

Ferdinando Bertoni, 1725–1813. *Antigona.* Opera. Libretto, Roccaforte (1751). First performed Carnival **1756**, Teatro Falcone, Genoa. [Grove 1980, 2:647]

———. *Creonte.* Opera. Libretto, G. Roccaforte. First performed 1776, Teatro Ducale, Modena. [Ibid., 2:647]

Giuseppe Scarlatti, c.1718/23–1777. *Antigona.* Opera. Libretto, Roccaforte (1751). First performed Carnival **1756**, Ducale, Milan. [Steiner 1984, p. 155 / Grove 1980, 16:579]

José Durán, ?–after 1791. *Antigona.* Opera. Libretto, Metastasio. First performed **1760**, Barcelona. [Grove 1980, 5:738]

Vincenzo Ciampi, 1719?–1762. *Antigona.* Opera seria. Libretto, Roccaforte (1751). First performed Apr **1762**, San Samuele, Venice. [Grove 1980, 4:387]

Pietro Pompeo Sales, c.1729–1797. *Antigona in Tebe.* Opera. First performed **1767**, Padua. [Grove 1980, 16:414]

Gian Francesco de Majo, 1732–1770. *Antigona.* Opera seria. Libretto, Roccaforte (1751). First performed Carnival **1768**, Teatro della Dame, Rome. [Grove 1980, 11:544]

Jean-Baptiste Vivien de Chateaubrun, 1686–1775. *Antigone.* Tragedy. First performed c.**1770**? [DLF 1951–72, 4 pt. 1: 313]

Henry Fuseli, 1741–1825. "By the Corpse of Antigone, Haimon Draws His Sword against His Father Creon." Drawing. **1770**. Staatliche Kunstsammlungen, Dresden, inv. c.1914–64. [Schiff 1973, no. 388—ill.]

———. "Antigone Buries Polyneices." Drawing. 1800. Huntington Library and Art Gallery, San Marino, Calif. [Ibid., no. 1368—ill.]

Tommaso Traetta, 1727–1779. *Antigona.* Opera. Libretto, Marco Coltellini. First performed Nov **1772**, Imperial Theatre, St. Petersburg. [Yarrow 1954, p. 143]

Josef Mysliveček, 1737–1781. *Antigona.* Opera. Libretto, Roccaforte (1751). First performed Carnival **1774**, Teatro Regio, Turin. [Grove 1980, 13:8 / Pečman 1970, p. 181]

Dmitri Bortnyansky, 1751–1825. *Creonte.* Opera (dramma per musica). Libretto, M. Coltellani. First performed **1776**, San Benedetto, Venice. [Grove 1980, 3:70]

Michele Mortellari, c.1750–1807. *Antigona.* Opera. First performed **1776**. [Steiner 1984, p. 155]

D'Oigny du Ponceau, c.1750–1830. *Antigone, ou la piété fraternelle.* Tragedy. **1787**. In *Théâtre* (Paris: Delaforest, 1826). [Jones 1950, p. 93 / Taylor 1893, p. 222]

Pierre Dutillieu, 1754–1798. *Antigone.* Opera. First performed **1788**, Paris. [Grove 1980, 5:761]

Gaetano Gioia, 1764/68–1826, choreography. *Antigone.* Ballet. First performed **1790**, Venice. [Oxford 1982, p. 17]

Niccolò Zingarelli, 1752–1837. *Antigone.* Opera. Libretto, Jean-François Marmontel. First performed 30 Apr **1790**, L'Opéra, Paris. [Steiner 1984, p. 155 / Grove 1980, 20:694 / Yarrow 1954, p. 143 *n.*]

Peter von Winter, 1754–1825. *Antigona.* Opera seria. Libretto, M. Coltellini. First performed **1791**, San Carlo, Naples. [Grove 1980, 20:456]

Francesco Bianchi, 1752–1810. *Antigona.* Opera. Libretto, Lorenzo Da Ponte. First performed 24 May **1796**, King's Theatre, London. [Grove 1980, 2:674]

Antonio Canova, 1757–1822. "Lament for Eteocles and Polyneices" (dead, Antigone mourning, an old tutor kneeling beside). Terra-cotta sculpture group. c.**1798**–

99. Museo Correr, Venice. [Pavanello 1976, no. 108—ill. / Licht 1983, pp. 232–38—ill.]

Francesco Basili, 1767–1850. *Antigona.* Opera (dramma seria). Libretto, G. Rossi. First performed 5 Dec **1799**, La Fenice, Venice. [Grove 1980, 2:239]

Joseph Anton Koch, 1768–1839. "Landscape with Antigone Disinterring Her Brother Polyneices." Drawing. **1799**. Schafer coll, Schweinfurt. [Steiner 1984, pl. 14]

Johann Nepomuk Poissl, 1783–1865. *Antigone.* Opera. First performed **1803**, Bavaria. [Clément & Larousse 1969, 1:64]

Friedrich Hölderlin, 1770–1843. *Antigonae.* Translation of Sophocles. **1799–1804**. Frankfurt: Wilmans, 1804. [Beissner 1943–77, vol. 5 / Steiner 1984, pp. 66ff., 84–106, 196f.]

Pierre-Simon Ballanche, 1776–1847. *Antigone.* Prose epic. Paris: Didot, **1814**. [Steiner 1984, p. 142]

Edward Fitzball, 1793–1873. *Antigone, or, The Theban Sister.* Tragedy. First performed **1821**, Norwich. [Nicoll 1959–66, 4:312, 427, 584]

Alexis-Jacques de Serre, comte de Saint-Roman, 1770–1843. *Antigone.* Tragedy. In *Poésies dramatiques d'un emigré* (Paris: Pillet, **1823**). [Taylor 1893, p. 210]

The Prix de Rome painting competition subject for **1825** was "Antigone Burying Polyneices." First prize, Sébastien-Louis-Wilhelm Norblin de La Gourdaine; École des Beaux-Arts, Paris. Second prize, Jean-Louis Bézard. [Grunchec 1984, no. 63—ill. / Harding 1979, p. 93]

Giovanni Galzerani, 1790–1853, choreography. *Antigone.* Ballet. First performed **1825**, La Scala, Milan. [Oxford 1982, p. 17]

John Smith, 1776–1833. *Creon, the Patriot.* Drama. First performed **1828**, Norwich. [Nicoll 1959–66, 4:446, 623]

W. Frohne. *Antigone.* Tragedy. First performed **1833**. [Steiner 1984, p. 196]

A. Duhamel. *Antigone.* Tragedy. Paris: Barba, **1834**. [Daemmrich 1987, p. 35]

Gotthard Oswald Marbach, 1810–1890. *Antigone.* Tragedy. Leipzig: Hinrichs, **1839**. [DLL 1968–90, 10:390]

Felix Mendelssohn, 1809–1847. Incidental music for Ludwig Tieck's production of Sophocles' *Antigone.* Opus 55. First performed 28 Oct **1841**, Potsdam. [Grove 1980, 12:152 / Jones 1950, p. 94]

Jean Reboul, 1796–1864. *Antigone.* Tragedy. First performed **1844**, Paris. Published Paris: Chapentier, 1846. [Steiner 1984, p. 196]

B. Bartholomew, libretto. *Antigone.* Opera. Libretto adapted from the German, with Mendelssohn's incidental music. First performed 2 Jan **1845**, Covent Garden, London. [Nicoll 1959–66, 4:262]

Edward Leman Blanchard, 1820–1899. *Antigone.* Burlesque. First performed **1845**, Strand Theatre, London. [Nicoll 1959–66, 4:268]

Matthew Arnold, 1822–1888. "Fragment of an *Antigone.*" Dramatic poem. In *The Strayed Reveller, and Other Poems* (London: Fellowes, **1849**). [Allott & Super 1986 / Tinker & Lowry 1940, pp. 161f. / Bush 1971, pp. 46f. / Joseph 1981, pp. 22, 31f.]

Camille Saint-Saëns, 1835–1921. *Antigone.* Composition for solo voices and orchestra. c.**1850**. [Grove 1980, 16:404]

———. *Antigone.* Incidental music for P. Meurice and A. Vacquerie's adaptation of Sophocles. First performed 21 Nov **1894**, Comédie Française, Paris. [Ibid.]

Friedrich Hebbel, 1813–1863. (Antigone evoked in) *Agnes Bernauer: Ein deutsches Trauerspiel* [Agnes Bernauer: A German Tragedy]. Prose tragedy. **1851.** First performed Mar 1852, Hoftheater, Munich. [Oxford 1986, p. 9 / Steiner 1984, p. 4]

George Meredith, 1828–1909. "Antigone." Poem. In *Poems* (London: Parker, **1851**). [Bartlett 1978, vol. 1]

George Eliot, 1819–1880. (Antigone's example influences Romola in) *Romola* book 1, chapter 17. Novel. London: Smith, Elder, **1862–63**; Edinburgh: Blackwood, 1863. [Joseph 1981, pp. 25–27]

————. (Antigone evoked in) *Daniel Deronda* chapter 32. Novel. Edinburgh & London: Blackwood, 1876. [Ibid.]

Adolf von Wilbrandt, 1837–1911. *Antigone.* Tragedy. First performed **1866**, Munich. [Steiner 1984, p. 170]

William Henry Rinehart, 1825–1874. "Antigone Pouring a Libation over the Corpse of Her Brother Polyneices." Marble statue. **1867–70.** Metropolitan Museum, New York, no. 91.4. [Ross & Rutledge 1948, no. 2—ill. / Metropolitan 1965, p. 24 / also Agard 1951, fig. 75] Reduced marble replica. 1871. Peabody Institute, Baltimore. [Metropolitan / Ross & Rutledge—ill.] Original plaster. Peabody Institute. [Ross & Rutledge]

Algernon Charles Swinburne, 1837–1909. (Antigone mourned in) "Tiresias." Poem. In *Songs before Sunrise* (London: Ellis; Boston: Roberts, **1871**). [Gosse & Wise 1925–27, vol. 2 / Bush 1937, p. 348]

Eugen Reichel, 1853–1916. *Antigone.* Tragedy. Leipzig: Reclam, **1877.** [Frenzel 1962, p. 46]

Frederic, Lord Leighton, 1830–1896. "Antigone." Painting. *c.***1882.** Unlocated. [Ormond 1975, no. 296]

Robert Herdman, 1830–1887. "Antigone." Painting. **1883.** Sold Sotheby's, London, 1972. [Warburg]

Aubrey De Vere, 1814–1902. "The *Antigone* of Sophocles." Poem. In *Poetical Works* (London: Kegan Paul, Trench, **1884**). [Boswell 1982, p. 84]

Edward German, 1862–1936. *Antigone.* Incidental music. *c.***1885.** Unpublished. [Grove 1980, 7:261]

Roberto Jorge Payro, 1867–1928. *Antígona.* Drama. Buenos Aires: Impr. de Sud-América, **1885.** [EWL 1981–84, 3:493]

William Francis Barry, 1849–1930. *The New Antigone.* Romance. London: Macmillan, **1887.** [Joseph 1981, p. 28]

Franz Matsch, 1861–? "Scenes from the Greek Theatre" (Antigone). Ceiling painting. *c.***1886–88.** Burgtheater, Vienna. [Novotny & Dobai 1968, p. 288]

Robert Whitelaw, 1854–1937. *Antigone.* Tragedy. First performed **1890**, Crystal Palace, London. [Nicoll 1959–66, 5:621]

Marguerite Elizabeth Easter, 1839–1894. "Antigone's Farewell to Haemon." Poem. In *Clytie and Other Poems* (Boston: Philpott, **1891**). [Boswell 1982, p. 99]

Carlo Pedrotti, 1817–1893. *Antigone.* Opera seria. Libretto, M. M. Marcello. Unperformed. [Grove 1980, 14:333]

William Entriken Baily. "The Daughters of Oedipus." Poem. In *Dramatic Poems* (Philadelphia: privately printed, **1894**). [Bush 1937, p. 582]

Albert Samain, 1858–1900. "Antigone." Poem, part of *Symphonie héroïque.* In *Le chariot d'or* (Paris: Société du Mercure de France, 1901). [Ipso]

Wojciech Gawronski, 1868–1910. *Antygona.* Choral composition. *c.***1900.** [Grove 1980, 7:202]

Hugo von Hofmannsthal, 1874–1929. "Vorspiel zur *Antigone* des Sophokles." Verse prologue to production of Sophocles' *Antigone,* Berlin, **1900.** Published in *Vorspiele von Hugo von Hoffmannsthal* (Leipzig: Insel, 1908). [Steiner 1946–58, *Dramen* vol. 1 / Steiner 1984, pp. 5f.]

Houston Stewart Chamberlain, 1855–1927. *Der Tod der Antigone* [The Death of Antigone]. Tragedy. In *Drei Bühnendichtungen* (Munich: Bruckmann, **1902**). [Steiner 1984, p. 155]

Alfred Poizat, 1863–1936. *Antigone.* Tragedy. Paris: Grasset, **1911.** [NUC]

Gerhard Schultze, b. 1891. *Antigone.* Drama. First performed **1911.** [Steiner 1984, p. 170]

Mikhail Fabianovich Gnesin, 1883–1957. *Antigona.* Incidental music for D. Merezhkovsky's translation of Sophocles, opus 13. First performed **1912–13.** [Grove 1980, 7:479]

Virginia Woolf, 1882–1941. (Antigone evoked in) *The Voyage Out.* Novel. London: Duckworth, **1915.** [Joseph 1981, p. 28]

————. (Antigone as model for heroine's endurance in) *The Years.* Novel. London: Hogarth Press, 1937. [Ibid.]

Walter Hasenclever, 1890–1940. *Antigone.* Tragedy (a modern Antigone attacks tyranny of Wilhelm II). **1916.** First performed 15 Dec 1917, Schauspielhaus, Stadttheater, Leipzig. [McGraw-Hill 1984, 2:450–52 / Ritchie 1976, pp. 96–100]

Eduard Caudella, 1841–1924. Incidental music for Sophocles' *Antigone.* First performed **1920**, Bucharest? [Grove 1980, 4:16]

Väinö Raitio, 1891–1945. *Antigone.* Symphonic trilogy, opus 23. **1921–22.** [Grove 1980, 15:548]

Willem Pijper, 1894–1947. Incidental music to Sophocles. Performed **1922.** [Grove 1980, 14:747]

Jean Cocteau, 1889–1963. *Antigone.* Tragedy, adaptation of Sophocles. First performed Dec **1923**, Théâtre de l'Atelier, Paris; incidental music, Arthur Honegger; décor, Pablo Picasso. Published Paris: Gallimard, 1927. [Sprigge & Kihm 1968, pp. 86f., 262 / Fowlie 1966, pp. 59, 121, 174 / Steegmuller 1970, pp. 292f., 297–301, 383f.]

Victor Eftimiu, b. 1888. *Thebaida.* Drama, after Sophocles' *Antigone* and *Oedipus at Colonus.* Bucharest: Ancora, **1924.** [McGraw-Hill 1984, 2:77]

Frank Fleetwood, 1902–. "Antigone." Poem. In *The Threshold* (London: Selwyn & Blount, **1926**). [Bush 1937, p. 574]

Lauro De Bosis, 1901–1931. *Antigone.* Tragedy, after Sophocles. Rome: Convivio, **1927.** [DDLI 1977, 1:158]

Arthur Honegger, 1892–1955. *Antigone.* Opera. Libretto, Cocteau (1923). First performed 28 Dec **1927**, Théâtre de la Monnaie, Brussels. [Steiner 1984, pp. 169f., 293f. / Grove 1980, 8:679–80]

William Butler Yeats, 1865–1939. "From the *Antigone*" (originally titled "Oedipus' Child"). Poem. **1927.** In *The Winding Stair* (New York: Fountain Press, 1929). / Revised by Ezra Pound, published in *The Winding Stair and Other Poems* (London & New York: Macmillan, 1933). [Finneran 1983 / Clark 1983, pp. 216–42]

Carlos Chávez, 1899–1978. Incidental music for Cocteau's *Antigone,* for piccolo, flute, oboe, English horn, clarinet, trumpet, harp, 2 percussion. First performed **1932**, Paris. [Grove 1980, 4:187]

———. *Sinfonía de Antígona*. Symphony, no. 1. First performed 15 Dec 1933, Mexico City. [Ibid.]

Giorgio Federico Ghedini, 1892–1965. *Antigone*. Symphonic cantata. Text, G. Debenedetti. **1933**. [Grove 1980, 7:334]

Isa Krejci, 1904–1968. *Antigona*. Opera. Libretto, after Sophocles. **1933–34**. / Revised 1963. [Grove 1980, 10:251]

Hilding Rosenberg, 1892–. Incidental music for Sophocles' *Antigone*. First performed **1934**, Stockholm. [Grove 1980, 16:200]

Pierre Froidebise, 1914–1962. Incidental music for Sophocles' *Antigone*. **1936**. [Grove 1980, 6:865]

Marguerite Yourcenar, 1903–1987. "Antigone, ou, Le choix" [Antigone, or, The Choice], part of *Feux* [Fires]. Prose poem. Paris: Grasset, **1936**. / Translated by Dori Katz in *Fires* (New York: Farrar, Straus & Giroux, 1981). / Set to music by Donald Harris, performed Nov 1983, National Public Radio, U.S.A.; directed by Jordan Pecile. [Horn 1985, p. 60 / Steiner 1984, p. 142]

Mark Rothko, 1903–1970. "Antigone." Painting. **1938**. Mark Rothko Foundation, New York. [Ashton 1983, fig. 3 / Waldman 1978, no. 23—ill.]

Robert Oboussier, 1900–1957. *Antigone*. Cantata for voice and orchestra. Libretto, after Sophocles. **1939**. [Grove 1980, 13:476]

Anna Sokolow, 1912–, choreography. *Antigone*. Ballet. Music, Carlos Chavez. First performed **1940** (?), Mexico City. [Oxford 1982, p. 17]

Jean Anouilh, 1910–1987. *Antigone*. Drama. **1942**. First performed Feb 1944, Paris. Published Paris: La Table Ronde, 1944. [Oxford 1983b, p. 29 / Steiner 1984, pp. 170f., 192–94 / Hamburger 1969, pp. 139, 150, 156–61, 175 *n*. / Jones 1950, pp. 91–100]

Menelaos Pallandios, 1914–. *Antigone*. Opera. Libretto, composer, after Sophocles. First performed **1942**. [Grove 1980, 14:140]

Paul Zumthor, 1915–. *Antigone; ou l'espérance* [Antigone, or Hope]. Drama. Neuchâtel: Baconnière, **1945**. [Daemmrich 1987, p. 34]

José Maria Pemán y Pemartín, 1898–1981. *Antigona*. Tragedy, after Sophocles. Madrid: Escelicer, **1946**. [DULC 1959–63, 3:1017 / Labanyi 1989, p. 40]

Elisabeth Langgässer, 1899–1950. "Die getreue Antigone" [The Faithful Antigone]. Story. In *Der Torso* (Hamburg: Claassen & Goverts, **1947**). [DLL 1968–90, 9:919]

Henry Reed, 1914–1986. "Antigone." Poem. In *New Writing Thirty* (Harmondsworth: Penguin Books, **1947**). [Ipso]

Kazimierz Brandys, 1916–. *Antigone*, part 2 of *Miedzy wojnami* [Between the Wars]. Novel. Warsaw: Czytelnik, **1948**. [Miłosz 1983, p. 498]

Bertolt Brecht, 1898–1956. *Die Antigone des Sophokles*. Tragedy (modern setting, Berlin 1942), after Hölderlin's translation. First performed **1948**, Chur, Switzerland. [Steiner 1984, pp. 171–73 / Oxford 1986, p. 31 / Hamburger 1969, p. 175] Variant, *Antigone-Legende*, epic in hexameters. [Oxford]

Luiz Cosme, 1908–1965. Incidental music for Sophocles' *Antigone*, for chorus and orchestra. **1948**. [Grove 1980, 4:814]

Charles Maurras, 1868–1952. *Antigone, vierge-mère de l'ordre*

[Antigone, Virgin Mother of the Order]. Verse and prose. Geneva: Aeschlimann, **1948**. [Steiner 1984, pp. 186f.]

Linke Poot (Alfred Döblin), 1878–1957. (A modern Antigone in) *November 1918: Eine deutsche Revolution*. Novel. Munich: Alber, **1948–49**. [Oxford 1986, p. 171 / Steiner 1984, pp. 188–90]

Carl Orff, 1895–1982. *Antigonae, ein Trauerspiel des Sophokles* [Antigone, a Tragedy of Sophocles]. Piano and vocal score, for a musical play based on Hölderlin's translation. First performed 9 Aug **1949**, Salzburg. Published Mainz: Schott, 1949. [Baker 1984, p. 1697 / Grove 13:709 / Steiner 1984, pp. 169f., 215]

Werner Scholz, b. 1898. "Antigone." Painting. 2 versions. **1949**. [Hannover 1950, nos. 124–25]

Howard Nemerov, 1920–. "Antigone." Poem. In *Guide to the Ruins* (New York: Random House, **1950**). [Boswell 1982, p. 275]

André Jolivet, 1905–1974. Incidental music for performances of Sophocles' *Antigone*, **1951** and 1960, Paris. [Steiner 1984, p. 170 *n*. / Grove 1980, 9:689]

Bernard Kops, 1926–. *An Anemone for Antigone*. Collection of poems. **1951**. Northwood, Middlesex: Scorpion, 1959. [DLEL 1970–78, 2:178]

José Limón, 1908–1972, choreography. *Antigona*. Modern dance. First performed **1951**, Paris. [McDonagh 1976, p. 209]

Leopoldo Marechal, 1900–1970. *Antígona vélez*. Lyric monologue, modern treatment of Antigone theme set in Argentina. First performed **1951**, Buenos Aires. Published Buenos Aires: Aterea, 1965. [LAW 1989, 2:894]

Aloijs-Henri-Gérard Fornerod, 1890–1965. Incidental music for Sophocles' *Antigone*. Opus 5b. **1952**. [Grove 1980, 6:713]

Bertus van Lier, 1906–1972, music. Incidental music for the composer's translation of Sophocles' *Antigone*. **1952**. [Grove 1980, 10:850f.]

David Harries, 1933–. *Two Comments on the Tragedy of Antigone*. Orchestral composition, opus 3. **1953**. [Grove 1980, 8:248]

John Joubert, 1927–. *Antigone*. Opera for radio, opus 11. Libretto, R. Trickett, after Sophocles. First performed **1954**, BBC, London. [Grove 1980, 9:739]

Donald Davie, 1922–. "Creon's Mouse." Poem. In *Brides of Reason* (Swinford, Eynsham, Oxford: Fantasy Press, **1955**). [Steiner 1984, pp. 108, 191]

Salvador Espriu, 1913–. *Antígona*. Drama, modern treatment of Antigone theme set in Spanish Civil War. Palma de Mallorca: Moll, **1955**. First performed 1958, Barcelona. [McGraw-Hill 1984, 1:482]

Michele Saponaro, 1885–1959. *Antigone*. Tragedy. Milan: Ceschina, **1955**. [DELI 1966–70, 5:48f.]

Shigeishi Kure, b. 1897. *Antigone*. Drama. First performed **1956**, Tokyo. [Steiner 1984, p. 196]

Wladimir Vogel, 1896–1984. *Antigone*. Incidental music for performance of Hölderlin's translation of Sophocles, for male speaking chorus and percussion. First performed **1956**, Zurich. [Grove 1980, 20:57]

Vladimir Sommer, 1921–. *Antigona*. Prelude. **1956–57**. [Grove 1980, 17:478]

Robert Fitzgerald, 1910–1985, and **Dudley Fitts**, 1903–1968. *Antigone*. Adaptation of Sophocles, part of a trans-

lation of the Oedipus cycle. New York: Harcourt, Brace, **1958.** [Ipso]

John Cranko, 1927–1973, choreography and scenario. *Antigone.* Ballet. Music, Mikis Theodorakis. First performed 19 Oct **1959,** Royal Ballet, Royal Opera House, Covent Garden, London; décor, Rufino Tamayo. [Oxford 1982, pp. 17, 107 / Sharp 1972, p. 249]

Peter Tranchell, 1922–. *Antigone.* Cantata for male voice and taped orchestra. Text, after Sophocles. 1959. [Grove 1980, 19:116]

Klaus Hubalek, 1926–. *Die Stunde der Antigone* [The Hour of Antigone]. Tragedy. First performed **1960,** Berlin. [Moore 1967, p. 155]

Jacques Leduc, 1932–. *Antigone.* Symphonic poem, opus 5. **1960.** [Grove 1980, 10:599]

Pavle Merkù, 1929–. Incidental music for Anouilh's *Antigone* (1942). 1960. [Grove 1980, 12:185]

Notis Pergialis, 1920–. *Antigone tis Katochis* [Antigone of the Occupation]. Drama. **1960.** [Gassner & Quinn 1969, p. 400]

Dominik Smolé, 1929–. *Antígona.* Tragedy. First performed **1960.** Published Lublin: Drzavna Zalozba Slovenije, 1961. [McGraw-Hill 1984, 5:199 / Steiner 1984, p. 170]

Svend Westergaard, 1922–. Incidental music for Sophocles' *Antigone.* **1960.** [Grove 1980, 20:374]

Rolf Hochhuth, 1931–. *Die Berliner Antigone.* Novella. **1958–61.** First published 1964; reprinted Reinbek: Rowohlt, 1975. [Oxford 1986, p. 408 / Steiner 1984, pp. 122, 143 / EWL 1981–84, 2:381]

Peter Karvas, 1920–. *Antigona a tí druhí* [Antigone and the Others]. Tragedy (concentration camp setting). Bratislava: Slovensky spisovatel, **1961.** [McGraw-Hill 1984, 1:598; 3:133 / Steiner 1984, pp. 196f. / Goetz-Stankiewicz 1979, p. 296 *n.*]

Lyubomir Pipkov, 1904–1974. *Antigona 43.* Opera, opus 63. **1961.** First performed 23 Dec 1963, Ruse, Bulgaria. [Grove 1980, 14:765 / Baker 1984, p. 1778]

Mirko, 1910–1969. "Antigone." Bronze sculpture. *c.*1963. [Trieste 1976, no. 63, p. 117—ill.]

———. "Antigone." Bronze sculpture. 1969. [Ibid., no. 91, p. 140—ill.]

Gábor Jodál, 1913–. Incidental music for Sophocles' *Antigone.* **1964.** [Grove 1980, 9:658]

Claire Polin, 1926–. "Antigone." Song. **1964.** [Cohen 1987, 1:554]

Roger Wybot, 1912–. *Antigone.* Tragedy. Published with *Pourquoi Barrabas* (Paris: Denoël, **1965**). [Daemmrich 1987, p. 35]

Jan Maegaard, 1926–. Incidental music for a television production of Sophocles' *Antigone,* for male chorus, orchestra, and tape. First performed **1966.** [Grove 1980, 11:484]

Julian Beck, 1925–1985, **Judith Malina,** 1926–, and The Living Theater company. *Antigone.* Tragedy, after Sophocles, Hölderlin, and Brecht. First performed **1967,** Berlin. [Steiner 1984, p. 150 / McGraw-Hill 1984, 1:130]

Eric Bentley, 1916–. *A Time to Die.* Tragedy, after Sophocles' *Antigone.* First performed **1967,** New York. [Vinson 1982, p. 88]

Milan Uhde, 1936–. *Děvka z města Théby* [The Wench from the Town of Thebes]. Anti-tragedy. **1967.** First performed 1968, Brno. [McGraw-Hill 1984, 5:67f. / Goetz-Stankiewicz 1979, pp. 197, 202f.]

María Zambrano de Rodriguez Aldave, 1907–. *La tumba de Antígona* [The Tomb of Antigone]. Mexico: Siglo veintiuno, **1967.** [Galerstein 1986, p. 334]

Talley Beatty, *c.*1923–, choreography. *Antigone.* Modern dance. First performed **1969,** New York. [Cohen-Stratyner 1982, p. 72]

Reginald Smith Brindle, 1917–. *Death of Antigone.* Chamber opera for voices, winds, and percussion. **1969.** First performed 1978, London. [Steiner 1984, p. 170]

Yannis Ritsos, 1909–1990. "Ho Apollon sto metallio tou Antigone" [Apollo at the Cave of Antigone]. Poem. 10 June **1969.** In *Epanalepseis* (Athens: Kedros, 1972). [Ipso]

———. "Ismini." Dramatic monologue. 1966–71. Athens: Kedros, 1972. / Translated by Rae Dalven in *Yannis Ritsos: The Fourth Dimension* (Boston: Godine, 1977). [Ipso / CLC 1985, 31:326]

Sally Lutyens, 1927–. "Antigone." Electronic tape. **1970.** [Cohen 1987, 1:434]

Piet Drescher. *Antigone.* Drama. First performed **1972,** Leipzig. [Steiner 1984, p. 198]

József Soproni, 1930–. *Antigone.* Opera. **1968–73.** [Grove 1980, 17:533]

Kemal Demirel, 1926–. *Antigone.* Drama. First performed **1973,** Istanbul. [Steiner 1984, pp. 107, 156]

Athol Fugard, 1932–. *The Island.* Drama (Antigone theme translated to South Africa). First performed **1973,** South Africa. [Steiner 1984, pp. 143f.]

Joseph A. Walker, 1935–. *Antigone Africanus.* Drama. First performed **1975,** New York. [Vinson 1982, p. 812]

Margaret Drabble, 1939–. (Antigone, central metaphor in) *The Ice Age.* Novel. London: Weidenfeld & Nicolson; New York: Knopf, **1977.** [Joseph 1981, p. 30]

John Spurling, 1936–. *Antigone through the Looking Glass.* Drama. First performed **1979,** London. [Vinson 1982, p. 746]

Stephen Spender, 1909–. *Antigone.* Adaptation of Sophocles, part 3 of Spender's translation of the Oedipus trilogy. First performed **1983,** Oxford. Published New York: Random House, *c.*1985. [Vinson 1985, p. 820] A passage published as a separate poem ("From *Antigone*") in *Collected Poems 1928–1985* (New York: Random House, 1986). [Ipso]

A. R. Gurney, 1930–. *Another Antigone.* Drama. First performed **1987,** Old Globe Theater, San Diego, Calif. [*The New York Times,* 10 Jan 1988, Section H, p. 5]

ANTINOUS. *See* ODYSSEUS, Return; PENELOPE.

ANTIOPE. (1) The daughter of the king of Thebes, seduced by Zeus. *See* ANTIOPE. (2) An Amazon, sister of Hippolyta. *See* AMAZONS; HERACLES, LABORS OF, Girdle of Hippolyta; THESEUS, and the Amazons.

ANTIOPE. The daughter of Nycteus, king of Thebes, Antiope was seduced by Zeus (Jupiter), who came to her in the form of a satyr. Fearing her father's wrath, she fled to the protection of the king of Sicyon. Nycteus committed suicide in shame, after charging his brother Lycus (sometimes called Antiope's first husband) to punish Antiope. Lycus attacked Sicyon and killed the king, bringing Antiope home a captive. She bore twin sons, Amphion and Zethus, whom Lycus exposed on Mount Cythaeron to die, but they were discovered and reared by a herdsman.

The theme of Antiope (often found sleeping) approached by Zeus as a satyr is popular in postclassical art. This scene has often been confused or conflated with images of Venus (or a nymph) and satyr.

Classical Sources. Ovid, *Metamorphoses* 6.110–11. Apollodorus, *Biblioteca* 3.5.5. Hyginus, *Fabulae* 8.

Listings are arranged under the following headings:
General List
Antiope and Dirce

See also APHRODITE, and Satyrs; SATYRS, and Nymphs.

General List

Sandro Botticelli, 1445–1510. (Jupiter and Antiope depicted in relief in setting of) "The Calumny of Apelles." Painting. *c.*1494–95. Uffizi, Florence, no. 1496. [Lightbown 1978, no. B79—ill. / Uffizi 1979, no. P269]

Pinturicchio, 1454–**1513**, and studio. "Jupiter and Antiope." Fresco (detached), from Palazzo Pandolfo Petrucci ("Il Magnifico"), Siena. Metropolitan Museum, New York, no. 114.20. [Metropolitan 1980, p. 142—ill. / Berenson 1968, p. 345—ill.]

Dosso Dossi, *c.*1479–1542, attributed (previously attributed to Giorgione, Titian, followers). "Nymph and Satyr" ("Jupiter and Antiope"?). Painting. *c.*1520. Galleria Palatina, Palazzo Pitti, Florence, no. 147. [Gibbons 1968, no. 18—ill. / Pitti 1966, p. 86—ill.] Copy in Corsini coll., Florence, no. 34 [Ibid.]

————, and/or **Battista Dossi**, *c.*1474–1548. "Pan and Echo" (previously called "Jupiter and Antiope"). Painting. Early 1520s. Marquess of Northampton coll., Castle Ashby. [Ibid., p. 113, no. 11—ill. / also Berenson 1968, p. 111 (as "Sleeping Antiope")]

Antonio da Correggio, *c.*1489/94–**1534**. "Venus, Cupid, and a Satyr" (previously called "Antiope Sleeping," "Jupiter and Antiope," erroneously). Painting. Louvre, Paris, inv. 42 (1118). [Gould 1976, p. 238—ill. / Louvre 1979–86, 2:168—ill.]

Titian, *c.*1488/90–1576. "Jupiter and Antiope" ("The Pardo Venus"). Painting. *c.*1535–40, retouched *c.*1560. Louvre, Paris, inv. 752 (1487). [Wethey 1975, no. 21—ill. / Louvre 1979–86, 2:246—ill.] Copy in Ham House, Richmond. [Wethey]

Jacopo Tintoretto, 1518–1594. "Antiope and Jupiter." Painting. *c.*1541. Galleria Estense, Modena. [Rossi 1982, no. 31—ill.]

Jean Cousin the Elder, *c.*1490–*c.*1560, composition. "Jupiter and Antiope." Etching, by "Master N. H." (fl. mid-16th century). (Bibliothèque National, Paris.) [Paris 1972, no. 402—ill.]

Giovanni Francesco Bezzi, ?–**1571**. "Jupiter and Antiope." Drawing. Duke of Devonshire coll., Chatsworth, no. 394. [Warburg]

Michiel Coxie the Elder, 1499–**1592**. "Jupiter and Antiope." Drawing. British Museum, London. [de Bosque 1985, p. 58]

Bartholomeus Spranger, 1546–1611. "Jupiter and Antiope." Painting. **1590s**. Kunsthistorisches Museum, Vienna, inv. 5752. [Vienna 1973, p. 166 / de Bosque 1985, p. 110—ill.]

Abraham Janssens, *c.*1575–1632, questionably attributed (also attributed to Abraham van Bloemaert, 1564–1651). "Jupiter and Antiope." Painting. **1607**. Statens Museum for Kunst, Copenhagen, no. 2435. [Copenhagen 1951, no. 347 / also Delbanco 1928, no. II.8 (as "Hercules and Omphale," unattributed)]

Hans von Aachen, 1552–**1616**. "Jupiter, Antiope, and Cupid." Painting. Kunsthistorisches Museum, Vienna, inv. 1110 (1515). [Vienna 1973, p. 2—ill.]

Hendrik Goltzius, 1558–1617. "Jupiter and Antiope." Painting. **1616**. Louvre, Paris, no. R.F. 2125. [Louvre 1979–86, 1:63—ill.] Another version of the subject in Dienst Verspreide Rijkskollekties, The Hague, inv. NK2425. [Wright 1980, p. 145]

Anthony van Dyck, 1599–1641. "Jupiter and Antiope." Painting. *c.*1616–17. 4 versions. Museum voor Schone Kunsten, Ghent; Wallraf-Richartz-Museum, Cologne; Riemsdijk coll., Amsterdam, on loan to Rijksmuseum (fragment); J. O'Connor Lynch coll., New York. [Larsen 1988, nos. 296–99—ill.]

————. "Jupiter and Antiope." Painting. 1632–41. Lost. / Copy (formerly considered original), by follower (Thomas Willeboirts?). Alte Pinakothek, Munich, no. 1808 (864). [Larsen, no. A42—ill.]

————, follower (formerly attributed to van Dyck). "Jupiter and Antiope." Painting. 1632–41. Lord Wemyss and March coll., Gosford, East Lothian, Scotland. [Larsen, no. A41—ill.]

Peter Paul Rubens, 1577–1640 (with dead birds by Frans Snyders). "Sleeping Nymphs and Satyrs" ("Jupiter and Antiope"). Painting. *c.*1617. Royal Collection, Buckingham Palace. [Jaffé 1989, no. 447—ill.]

Cavaliere d'Arpino, 1568–1640. "A Nymph Surprised by a Satyr ("Jupiter and Antiope"?). Painting. Late **1620s?** Lodi coll., Munich. [Rome 1973, no. 60—ill.]

Nicolas Poussin, 1594–1665. "Jupiter and Antiope." Drawing. **1624**–30. École des Beaux-Arts, Paris, no. 2865. [Friedlaender & Blunt 1953, no. 170—ill.]

————. "Jupiter and Antiope." Painting. 1630s. Lost. / Engraving by Picart, 1693. / Copy, painting, after engraving. Zornmuseet, Mora, Sweden. [Thuillier 1974, no. B39—ill. / Wright 1985, no. L25 / cf. Blunt 1966, no. R82] Another copy in Dulwich College Picture Gallery, cat. 1953 no. 482. [Wright 1976, p. 165]

Jusepe de Ribera, *c.*1590/91–1652. "Sleeping Nude [Antiope? Venus?] with Cupids and a Satyr." Drawing. **1626**–30. Fitzwilliam Museum, Cambridge, no. 113-1961. [Brown 1973, no. D.15—ill. / Fort Worth 1982, pp. 79f.—ill. / López Torrijos 1985, p. 417 no. 22—ill.]

Rembrandt van Rijn, 1606–1669. "Jupiter and Antiope" (formerly called "Venus and Satyr," "Danaë"). Etching (Bartsch no. 204). *c.***1631.** 2 states. [White & Boon 1970, no. 204—ill. / Guillaud 1986, p. 156, fig. 215]

————. "Jupiter and Antiope." Etching (Bartsch no. 203). 1659. 2 states. [White & Boon, no. 203 p. 156, fig. 216 / Guillaud, fig. 216]

Jacob Jordaens, 1593–1678. "The Sleep of Antiope." Painting. **1650.** Musée de Peinture et de Sculpture, Grenoble, no. 609. [d'Hulst 1982, fig. 194 / Ottawa 1968, no. 99—ill.] 2 further versions recorded in 18th and 19th century, untraced. [Rooses 1908, p. 145]

Alonso Cano, 1601–**1667.** "Jupiter and Antiope" (?). Drawing. Uffizi, Florence, no. 10260. [López Torrijos 1985, p. 417 no. 21—ill.]

Benito Manuel de Agüero, 1626?–**1670.** "Jupiter and Antiope" (?). Painting. Prado, Madrid, no. 893. [López Torrijos 1985, p. 417 no. 17—ill.]

Bartolomé Esteban Murillo, 1617–**1682,** attributed. "Jupiter and Antiope" ("Jupiter and Sleeping Young Woman"). Painting. Sold Paris, 1810, untraced. [López Torrijos 1985, pp. 268, 417 no. 20]

François Verwilt, *c.*1620–**1691.** "Jupiter and Antiope." Painting. Dulwich College Picture Gallery, London, Cat. 1953.485. [Wright 1976, p. 215]

Ignaz Elhafen, 1658–1715. "Jupiter and Antiope." Wood relief. Probably **1697.** Baron Guido von Conrad coll., Luxembourg. [Zimmer 1971, no. A12.0.4.2]

Luca Giordano, 1634–**1705.** "Jupiter and Antiope." Painting. Formerly Sanssouci, Potsdam, destroyed. [Ferrari & Scavizzi 1966, 2:284] 2 further versions of the subject known, sold 1810, 1823, untraced. [Ibid., 2:371, 375]

————, imitator. "Jupiter and Antiope." Painting. Early 18th century. Szépművészeti Múzeum, Budapest, no. 7742. [Budapest 1968, p. 263]

Antoine Watteau, 1684–1721. "Jupiter and Antiope" ("Nymph and Satyr"). Painting. *c.***1715.** Louvre, Paris, no. M.I. 1129 (as "Nymph and Satyr"). [Camesasca 1982, no. 104—ill. / Grasselli & Rosenberg 1984, no. P.36—ill. / Louvre 1979–86, 4:286—ill. / Posner 1984, pp. 79f., fig. 68]

————, rejected attribution. "Jupiter and Antiope." Painting. Wildenstein coll., Paris. [Camesasca, no. 6*d—ill.]

Arnold Verbuys, *c.*1645–**1729.** "Jupiter and Antiope." Painting. Museum Bredius, The Hague, inv. 123–1946. [Wright 1980, p. 467]

Christian Wilhelm Dietrich, 1712–1774. "Jupiter and Antiope." Painting. **1745.** Hermitage, Leningrad, inv. 8572. [Hermitage 1987b, no. 162—ill.]

Jean-Baptiste-Marie Pierre, 1713–1789. "Jupiter and Antiope." Painting. Shortly before **1750.** Prado, Madrid, no. 3218. [Prado 1985, p. 507]

Carle van Loo, 1705–1765. "Jupiter and Antiope." Painting. *c.***1753.** Hermitage, Leningrad, inv. 5639. [Hermitage 1986, no. 268—ill.]

Francesco Fontebasso, 1709–1768/69. "Jupiter and Antiope." Painting, for Palazzo Bernardi, Venice. **1750s?** Szépművészeti Múzeum, Budapest. [Budapest 1968, pp. 237f.]

Louis de Silvestre the Younger, 1675–1760, studio. "Jupiter and Antiope." Painting. Muzeum Narodowe, War-

saw, inv. Wil. 1689 (534), on display at Wilanów Palace. [Warsaw 1969, no. 1206—ill.]

Jacques-Louis David, 1748–1825. "Jupiter and Antiope." Painting. **1768.** Musée, Sens. [Cantinelli 1930, no. 2]

Nicolas-Guy Brenet, 1728–1792. "Jupiter and Antiope." Painting. **1771.** [Bénézit 1976, 2:297]

Charles Monnet, 1732–after 1808. "Antiope." Drawing, design for an engraving, executed by G. Vidal (1742–**1801**). [Pigler 1974, p. 144]

Théodore Géricault, 1791–1824. "Jupiter and Antiope" (? "Satyr and Nymph," "Satyr and Bacchante"). Stone sculpture. *c.***1815–16.** Musée des Beaux-Arts, Rouen. [Eitner 1983, pp. 82–84, 333, no. 115—ill.] Bronze casts, unlocated. [Ibid.] Drawing, variant. 1816. Private coll., Paris. [Ibid.]

Jean-Auguste-Dominique Ingres, 1780–1867. "Jupiter and Antiope." Painting. **1851.** Louvre, Paris, no. R.F. 2521. [Wildenstein 1954, 3:325—ill. / Louvre 1979–86, 3:325—ill.]

Théophile Gautier, 1811–1872. (Correggio's "Antiope" alluded to in) "La nue." Poem. In *Revue du XIXe siècle* 1 Jun **1866**; collected in *Émaux et camées*, 5th edition (Paris: Charpentier, 1866). Modern edition by C. Gothot-Mersch (Paris: Gallimard, 1981). [Ipso]

Georg Jakoby, 1840–1906, music. *Antiope.* Ballet. First performed **1888,** Alhambra Theatre, London. [Hunger 1959, p. 35]

Gaston de Meaupou. *L'amour vengé* [Cupid Revenged (on Jupiter and Antiope)]. Comic opera. Libretto, poem by Lucien Auge de Lassus. First performed 31 Dec **1890,** Opéra-comique, Paris. [Clément & Larousse 1969, 1:54f.]

Lovis Corinth, 1858–1925. "Antiope and the Faun." Color lithograph, part of "Loves of Zeus" cycle. **1920.** [Schwarz 1922, no. L401]

Antiope and Dirce. After being returned to Thebes by Lycus, Antiope was imprisoned and tormented by Lycus's wife, Dirce. According to differing accounts, Antiope either escaped or was rescued by her sons, Amphion and Zethus, now grown. When Dirce tried to have Antiope tied to the horns of a raging bull, to be dragged to her death, the twins rescued her and visited that punishment on Dirce instead. Dirce was transformed into the stream (or spring) in Thebes that bears her name.

After killing or dethroning Lycus, Amphion and Zethus ruled Thebes in his stead. Later, Antiope was driven mad by Dionysus and wandered through Greece until she was purified by Phocus, who married her.

This part of Antiope's story has been more popular on the stage than in the visual arts.

Classical Sources. Euripides, *Antiope* (lost). Pacuvius, *Antiopa.* Propertius, *Elegies* 3.15.11ff. Apollodorus, *Biblioteca* 3.5.5. Pausanias, *Description of Greece* 2.6.1–4, 9.17.6, 9.25.3. Hyginus, *Fabulae* 7, 8.

Apollonio and Taurisco di Tralle. "The Farnese Bull" (supplication of Dirce). Marble sculpture. Before **1546.** Formerly Palazzo Farnese, Rome, now in Museo Nazionale, Naples. / Numerous bronze reductions copies. Galleria Borghese, Rome, inv. 249 (by Antonio Susini, 1613); Museo Nazionale, Florence, inv. 2564; elsewhere. [Faldi 1954, no. 59—ill.]

Francesco Pona, 1594–1654. (Dirce in) *La galeria delle donne celebri* [The Gallery of Famous Women] part 1. Poetic catalogue. Bologna: Cavalieri, **1633.** [DDLI 1977, 2:425]

Andrea Mattioli, c.1620–1679. *L'Antiopa.* Opera. Libretto, Francesco Berni. First performed **1653,** Teatro di Sala, Ferrara. [Grove 1980, 11:838]

Johann Kaspar Kerll, 1627–1693. *Antiopa giustificata* [Antiope Vindicated]. Opera. Libretto, Pietro Paolo Bissari. First performed 26 Sep **1662,** Munich. Libretto published Munich: Jeklino, 1662. [Baker 1984, p. 1184]

Carlo Pallavicino, c.1630–1688. *L'Antiope.* Opera. Unfinished, completed by Nicolaus Adam Strungk. Libretto, S. P. Pallavicino. First performed **1689,** Dresden. [Grove 1980, 18:298]

Cornelius Hermann von Ayrenhoff, 1733–1819. *Antiope.* Tragedy in verse. Vienna: **1772.** [EDS 1954–66, 1:1185]

Gaspare Angiolini, 1731–1803, choreography. *Il sacrificio di Dircea* [The Sacrifice of Dirce]. Ballet. First performed **1773,** St. Petersburg. [EDS 1954–66, 1:619]

Charles Edward Horn, 1786–1849. *Dirce, or the Fatal Urn.* Opera. Libretto, in English, after Metastasio's *Demofoonte.* First performed 2 June **1821,** Theatre Royal, Drury Lane, London. [Grove 1980, 8:713]

Antonio Canova, 1757–1822. "Dirce." Marble sculpture. Modeled 1819, completed **1822.** Royal Collection, Buckingham Palace, London. [Pavanello 1976, no. 322—ill. / Licht 1983, p. 217—ill.] Plaster model (headless). Gipsoteca Canoviana, Possagno, no. 281. [Pavanello, no. 323—ill.]

Walter Savage Landor, 1775–1864. "Dirce" (ferried across the Styx by Charon). Poem. First published **1831.** Incorporated into *Pericles and Aspasia* (London: Saunders & Otley, 1836). [Wheeler 1937, vol. 3 / Pinsky 1968, p. 9 / Bush 1937, p. 242]

Achille Peri, 1812–1880. *Dirce.* Opera (tragedia lirica). Libretto, P. Martini. First performed May **1843,** Teatro Comunale, Reggio Emilia. [Grove 1980, 14:400]

Charles Lawes-Wittewronge, 1843–1911. "Dirce." Bronze statue. **1906.** Tate Gallery, London, no. 2871. [Tate 1975, p. 49]

Pascual de Rogatis, 1881–1980. *Anfión y Zeto.* Opera. First performed 18 Aug **1915,** Colón, Argentina. [Baker 1984, p. 576]

Edith M. Thomas, 1854–1925. "The Water of Dirce." Poem. In *The Flower from the Ashes and Other Verse* (Portland, Maine: Mosher, **1915**). [Boswell 1982, p. 302]

Ezra Pound, 1885–1972. (Dirce's story evoked in) Cantos 76, 82, in *The Pisan Cantos* (New York: New Directions, **1948**). [Flory 1980, pp. 197f., 216, 219f.]

APHRODITE. The Greek goddess of erotic love, beauty, and fertility, Aphrodite arose, according to Hesiod, from the foam (Greek, *aphros*) of the sea; Homer calls her the daughter of Zeus (Jupiter) and Dione. Her attributes suggest an Asiatic origin and roots in common with the Phoenician deity Astarte. Other evidence of her Eastern lineage includes her point of origin at Paphos, on the west coast of Cyprus, or at Cythera, an island south of the Peloponnesus. Her epithets "Cytherea" and Paphian or Cyprian Aphrodite evoke her connection to these locations. Aphrodite's beloved Adonis, who was also introduced to Greece from Cyprus, may have derived from Near Eastern mythology as well. Parallels for this pair of deities include the Assyrio-Babylonian Ishtar and Tammuz and the Phrygian Cybele and Attis. Aphrodite was later identified by the Romans with Venus.

According to Homer, Aphrodite was married to the crippled god Hephaestus (Vulcan), but this did not restrict her amorous activities. She mated with Ares (Mars) and by him gave birth to Harmonia (Concord), Deimos (Fear), and Phobos (Panic). According to some legends, she also bore him Eros (Cupid, Amor), who in other myths was only her closest attendant. By Hermes (Mercury) she bore Hermaphroditus; by Dionysus (Bacchus), the fertility god Priapus and the god of marriage Hymen; and by the mortal Anchises, the Trojan hero Aeneas. She bested Athena (Minerva) and Hera (Juno) in the Judgment of Paris, and was an ardent supporter of Troy during the Trojan War.

Indeed, in places such as Sparta, Aphrodite was considered a goddess of war, but when, as recounted in the *Iliad,* she was wounded by Diomedes, she was reminded by Zeus that love rather than war was her primary domain. She was also identified as a goddess of marriage (although this role belonged largely to Hera) and as a deity of the sea and seafaring. Her identification as a goddess of vegetation derived from her association with Adonis. Two common epithets for her were "Urania" ("heavenly") and "Pandemos" ("popular"), a duality that Plato described, perhaps inaccurately, as symbolizing both intellectual and sensual love. The term Urania was often used to identify Asian deities, while Pandemos described the political stature attained by the goddess at Athens and other city states.

The Roman goddess Venus was originally an Italian deity whose name meant "charm" or "beauty." She may have presided over the fertility of herb or vegetable gardens. By the Roman period, however, she was linked to the cult of Aphrodite as the mother of Aeneas, Rome's greatest hero. There was a temple to Venus Erycina (Aphrodite of Eryx) on the Capitoline hill in 217 BCE, and by the Imperial period

Venus had taken on all the attributes of the Greek goddess.

Aphrodite is the subject of some of the most famous sculptures of the Classical period. The best-known include the relief on the Ludovisi throne that depicts Aphrodite rising from the foam; the relief of her with Eros in the Parthenon frieze; Praxiteles' Aphrodite of Cnidos, showing a modest goddess about to enter the bath, a pose repeated in the famous "Capitoline" and "Medici" Venuses; the Aphrodite of Cyrene; the crouching Aphrodite by the Bithynian Doidalsas; and the Aphrodite of Melos, called Venus de Milo, probably the most celebrated statue in the history of the nude.

All of these themes and poses became popular subjects for postclassical artists as well. In the fine arts the goddess is often accompanied by Eros, the three Graces, and doves, her sacred birds. She is also frequently shown with Hephaestus at his forge, sometimes asking for arms for Aeneas. The postclassical theme of sacred and profane love—derived from Plato's interpretation of Aphrodite's duality and prominent in work inspired by fifteenth-century Florentine humanists—presents the goddess in celestial (nude) and earthly (richly attired) form. Portrayals of the sleeping goddess, sometimes watched by satyrs, are also popular. Aphrodite is often seen at her toilet, admiring her own beauty in a mirror held by Eros, while in the many reclining representations she is like a self-admiring odalisque.

Classical Sources. Homer, *Iliad* 3.373–425, 5.311–430, 14.187–224, 21.416–33, 23.185–91; *Odyssey* 8.266–366. Hesiod, *Theogony* 188–206. *Homeric Hymns,* "To Aphrodite" (3). Sappho, "Hymn to Aphrodite." Herodotus, *History* 1.105, 1.131, 1.199, 3.8, 4.59, 4.67. *Orphic Hymns* 55, "To Aphrodite." Plato, *Symposium* 180D, 203B. Apollonius Rhodius, *Argonautica* 2.25–155. Lucretius, *De rerum natura* 1.30–41. Virgil, *Aeneid* 1.223–417, 1.656–96, 2.588–633, 4.90–128, 5.779–826, 8.370–406, 8.608–731, 10.1–117, 12.383–467. Horace, *Odes* 4.1. Ovid, "Invocation to Venus," in *Odes* 4.15; *Metamorphoses* 10.534. *Pervigilium Veneris* (anonymous late Latin poem). Lucian, *Dialogues of the Gods* 19, "Aphrodite and Selene," 20, 23, "Aphrodite and Eros."

Listings are arranged under the following headings:

> General List
> Birth of Aphrodite
> Cythera, Isle of Aphrodite
> Aphrodite and Anchises
> Girdle of Aphrodite
> Worship of Venus
> Venus Frigida
> Venus and Satyrs
> Statue of Venus
> Tannhäuser and the Venusberg

See also ADONIS; ARES AND APHRODITE; ASTARTE; ATALANTA; DIOMEDES; EROS; GODS AND GODDESSES; HEPHAESTUS; HERACLES, Choice; MYRRHA; PARIS; PHAEDRA AND HIPPOLYTUS; PSYCHE; PYGMALION; TROJAN WAR.

General List

Alain de Lille, 1128?–1203. (Venus in) *Liber de planctu natural* [The Plaint of Nature]. Latin poem. Before 1176, probably **1160–70.** Modern edition, edited by T. Wright, translation and commentary by James J. Sheridan, in *Satirical Poets of the Twelfth Century* (Toronto: Pontifical Institute of Mediaeval Studies, 1980). [Fleming 1969, pp. 190–92, 196ff. 205, 208]

Ulrich von Lichtenstein, c.1200–c.1275. "Venusfahrt [Journey of Venus]." Minnelied, in Middle High German. **1255.** In modern edition, *Frauendienst* (Leipzig: Bruckner, 1885). [Goldin 1967, pp. 175–78]

Guillaume de Lorris, 1215?–1240? and **Jean de Meun,** 1250?–1305? (Venus, active throughout) *Le roman de la rose.* Verse romance. Begun by Guillaume, c.1230–35, completed by Jean, c.1275. Lyon: Ortuin & Schenck, c.1481. [Dahlberg 1971 / Poirion 1974 / Fleming 1969, pp. 191f.]

Giovanni Boccaccio, 1313–1375. (Venus in) *La caccia di Diana* [The Hunt of Diana] canto 17. Poem. **1334–38?** [Branca 1964–83, vol. 1 / Hollander 1977, pp. 16f. / Bergin 1981, pp. 67f.]

———. (Venus sends Cupid to Florio and Biancifiore, later rescues the lovers, in) *Filocolo.* Prose romance. 1336–39? [Branca / Bergin, pp. 75ff. / Hollander, pp. 31ff.]

———. ("Lady" sent to the poet in a vision, identified with celestial Venus, in) *L'amorosa visione.* Poem, allegorical dream-vision. 1342. First published Venice: Zoppinol, 1531. [Branca, vol. 3 / Hollander, pp. 77ff.]

———. (Venus in) *Elegia di Madonna fiammetta.* Prose elegy. 1343–44? [Branca / Hollander, pp. 44ff.]

———. (Power of Venus active in) *Il ninfale fiesolano* [The Nymph of Fiesole]. Pastoral romance. c.1344–46? [Branca / Hollander, pp. 66ff.]

———. "De Venere Cypriorum regina" [Venus, Queen of Cyprus]. In *De mulieribus claris* [Concerning Famous Women]. Latin verse compendium of myth and legend. 1361–75. Ulm: Zainer, 1473. [Branca, vol. 10 / Guarino 1963 / Bergin, p. 250]

Francesco Petrarca, 1304–1374. (Venus's isle of Cyprus, destination of "captives" in) *Il trionfo dell' amore* [The Triumph of Love] part 4. Poem. **1340–44.** In *Trionfi* (Bologna: Malpiglius, 1475). [Bezzola 1984 / Wilkins 1962 / Wilkins 1978, p. 251]

Geoffrey Chaucer, 1340?–1400. (Venus in) *The Romaunt of the Rose* lines 3697ff. and passim. Poem, fragments, translation of *Roman de la rose.* **1370** and later. London: Thynne, 1532. [Riverside 1987]

———. (Dream of the "two Venuses," good and sinful love, in) "The Parlement of Foules." Poem. 1380–82. Westminster: Caxton, 1477. [Ibid. / Howard 1987, pp. 309f., 508]

———. (Scenes associated with Venus painted in Temple of Venus; Venus takes Palamon's part in battle to win Emelye, in) "The Knight's Tale" lines 1918–54, 2209–60, 2664ff. Poem, after Boccaccio's *Teseida.* Early 1380s (as "Palamon and Arcite"); revised and incorporated in *The Canterbury Tales,* 1388–95 (Westminster: Caxton, 1478).

[Riverside / Havely 1980, pp. 130ff. / Miller 1977, pp. 336–43 / Minnis 1982, p. 21 / Gaylord 1974, pp. 171–90]

———. (Venus invoked in) *Troilus and Criseyde* 3.1–49, 705–21. Poem. 1381–85. Westminster: Caxton, 1475. [Riverside]

John Gower, 1330?–1408. (Venus in) *Confessio amantis* 1.123–190, 8.2301–2439, 8.2900–2970. Poem. *c.*1390. Westminster: Caxton, 1483. [Macaulay 1899–1902, vol. 2]

Christine de Pizan, *c.*1364–*c.*1431. (Venus in) *L'epistre d'Othéa à Hector* . . . [The Epistle of Othéa to Hector] chapter 7 and passim. Didactic romance in prose. *c.*1400. MSS in British Library, London; Bibliothèque Nationale, Paris; elsewhere. / Translated by Stephen Scrope (London: *c.*1444–50). [Bühler 1970 / Hindman 1986, pp. 80, 85ff., 91, 194, pls. 11, 75]

John Lydgate, 1370?–1449. (Venus encourages lovers in) *The Temple of Glas.* Poem. *c.*1403. Westminster: Caxton, *c.*1477–78. Modern edition, Millwood, N.Y.: Kraus Reprint, 1987. [Kratzmann 1980, pp. 57–59 / Pearsall 1970, pp. 104–15 / Ebin 1985, pp. 30–34 / Renoir 1967, pp. 50, 152 *n.*14 / Lewis 1958, pp. 241f. / Pearsall 1977, pp. 214f., 217]

———. (Venus in) *Reson and Sensuallyte* lines 4778ff., 4818ff. Poem, partial translation of *Les échecs amoureux* [Love's Game of Chess] (1370–80). Probably before 1412. Modern edition by E. Sieper (London: Early English Text Society, 1901). [Pearsall 1970, p. 116]

Master of the Capture of Tarentum, fl. 1st half 15th century. "The Triumph of Venus, Worshiped by Six Legendary Lovers" (Achilles, Tristan, Lancelot, Samson, Paris, Troilus). Painting. Louvre, Paris, no. R.F. 2089. [Louvre 1979–86, 2:201—ill.]

Agostino di Duccio, 1418–1481, or studio (Matteo de-'Pasti? *c.*1420–1467/68). "Venus." Marble relief. 1450s. Chapel of the Planets, Tempio Malatestiano, Rimini. [Pope-Hennessy 1985b, 2:311ff., 361—ill. / Agard 1951, pp. 68f.—ill.]

Francesco del Cossa, *c.*1435–1477, and followers. "Triumph of Venus." Fresco, representing the month of April. 1470. Sala dei Mesi, Palazzo Schifanoia, Ferrara. [Berenson 1968, pp. 94, 131]

Angelo Poliziano, 1454–1494. (Venus bemuses Giuliano de' Medici in) *Stanze . . . per la giostra di Giuliano de' Medici* books 1 and 2. Poem. 1475–78. [Tateo 1972, pp. 107–112 / Bondanella 1979, p. 409]

———. "In Venerem armatum." Epigram. [Wind 1968, pp. 93, 127 *n.*, 132, 136f.]

Sandro Botticelli, 1445–1510. "The Primavera" (Venus in garden of Hesperides, with Graces, Cupid, Mercury, Flora, Cloris, and Zephyr). Painting. *c.*1478. Uffizi, Florence, inv. 8360. [Lightbown 1978, 1:73ff., no. B39—ill. / Berenson 1963, p. 34—ill.] Free copy of Venus, attributed to Piero di Cosimo (*c.*1462–1521), property of Staatliche Museen, Berlin. [Bacci 1966, p. 115 (as circle of Piero]

———. "Giovanna degli Albizzi Receiving a Gift of Flowers from Venus" ("Venus and the Graces Offering Gifts to a Young Woman"). Fresco, detached. Louvre, Paris, no. R.F. 321. [Lightbown, no. B44—ill. / Louvre 1979–86, 2:156—ill.]

———, school (previously attributed to Jacopo del Sellaio). "Clothed, Reclining Venus in Landscape with Three Cupids" ("An Allegory"). Painting. National Gallery, London, no. 916. [Warburg / London 1986, p. 63—ill.]

———, school (also attributed to Jacopo del Sellaio, Bartolomeo di Giovanni). "Venus with Three Putti." Painting. Louvre, Paris, no. M.I. 546. [Warburg / Louvre 1979–86, 2:157—ill.]

Lorenzo di Credi, 1459?–1537. "Venus." Painting. *c.*1490 (or *c.*1478?). Uffizi, Florence, inv. 3094. [Uffizi 1979, no. P908—ill. / Berenson 1963, p. 115]

Jacopo del Sellajo, *c.*1441–1493. "Venus and Three Putti." Painting. Louvre, Paris, no. 1299. [Berenson 1963, p. 199]

Hans Memling, *c.*1430/40–1494. "Venus Standing in Landscape Holding a Mirror." Painting. Gemäldegalerie, Strasburg. [Warburg]

Antico, *c.*1460–1528. "Venus ("Atropos")." Bronze statuette. **Late 15th century.** Victoria and Albert Museum, London, no. A.16-1931. [Clapp 1970, 1:39] 2 further versions of the subject (one a copy) in Museo di Capodimonte, Naples, nos. 10638, 10933. [Capodimonte 1964, p. 111]

———. "Venus Felix." Bronze statuette, derived from the antique (Vatican). Kunsthistorisches Museum, Vienna. [Pope-Hennessy 1985b, 2:84, 334—ill.] 2 further, inferior, versions known, 1 in Museo di Capodimonte, Naples, no. 10645. [Ibid. / Capodimonte]

Francesco Colonna, *c.*1433–1527. (Venus in) *Hypnerotomachia Poliphili* [The Dream of Poliphilo]. Romance. Venice: **1499;** illustrated with woodcuts by anonymous engraver. [Appell 1893, passim—ill.]

Girolamo di Benvenuto, 1470–1524 (previously attributed to Matteo Balducci). "Venus and Cupid." Painted wood birth salver. *c.*1500. Kress coll. (K222), Denver Art Museum, no. E-It–18–XV–943. [Shapley 1966–73, 1:162—ill. / Berenson 1968, p. 186]

———. "Venus and Cupid in a Landscape." Painting. Museo Horne, Florence, no. 33. [Berenson]

Lorenzo Lotto, 1480–1556. "Venus in Landscape." Painting. *c.*1500. Unlocated. [Berenson 1957, p. 107—ill.]

———. "Venus and Cupid." Painting. Grasset Bequest, Louvre, Paris. [Ibid., p. 104]

———. "The Triumph of Chastity" (over Venus and Cupid). Painting. Pallavicini coll., Palazzo Rospigliosi, Rome. [Ibid., p. 105—ill.]

Gavin Douglas, *c.*1474–1522. (Poet stands trial before Venus in) *The Palice of Honoure.* Poem. **1501.** London: Copland, *c.*1553–58; Edinburgh: Charteris, 1579. [Bawcutt 1967, pp. viiff., xlv / Kratzmann 1980, pp. 104–27]

Pietro Perugino, 1446/47–1523. (Diana and Minerva battle Venus in) "The Battle of Love and Chastity" (sometimes mistakenly called "Triumph of Chastity"). Painting, for studiolo of Isabella d'Este, Corte Vecchia, Mantua. *c.* **1503.** Louvre, Paris, inv. 722. [Louvre 1975, no. 121—ill. / Louvre 1979–86, 2:217—ill. / Wind 1948, p. 19, fig. 62]

Giorgione, *c.*1477–1510. "Venus and Cupid in a Landscape." Painting. *c.*1505. Kress coll. (K284), National Gallery, Washington, D.C., no. 253. [Shapley 1966–73, 2:152—ill. / Pignatti 1978, no. A69—ill. / Walker 1984, fig. 234]

——— and **Titian,** *c.*1488/90–1576. "(Sleeping) Venus." Painting. Begun by Giorgione *c.*1508, unfinished, completed by Titian *c.*1510–11. Gemäldegalerie, Dresden, no. 185. [Wethey 1975, no. 38—ill. / also Pignatti, no. 23—ill. / Dresden 1976, p. 55—ill. / Berenson 1957, p. 84—ill.] Numerous

variant copies, in Fitzwilliam Museum, Cambridge; Academia de San Fernando, Madrid (in storage); Landesmuseum, Darmstadt; Dulwich Picture Gallery, London; Alte Pinakothek, Munich (in storage in 1971); Uffizi, Florence, inv. 5050; elsewhere. [Wethey; cf. no. X-36—ill. / also Fitzwilliam 1960–77, 2:64 / Uffizi 1979, no. P1221—ill.] *See also separate Titian listings below.*

Andrea Mantegna, 1430/31–**1506,** and **Lorenzo Costa,** 1460–1535 (begun by Mantegna, completed by Costa after Mantegna's death). (Earthly and celestial Venus in) "The Reign of Comus" ("The Gate of Comus"). Painting. Louvre, Paris, inv. 256 (1262). [Louvre 1979–86, 2:169—ill. / Lightbown 1986, no. 41—ill. / Louvre 1975, no. 128—ill. / Wind 1948, pp. 46f., fig. 59]

Albrecht Dürer, 1471–1528. "Venus, Cupid, and Hercules." Drawing. **1506?** British Museum, no. 5218/130. [Strauss 1974, no. 1506–58—ill.]

Raphael, 1483–1520. "Bust of Venus." Drawing. *c.*1507–08. Fogg Art Museum, Harvard University, Cambridge, no. 1932–354. [Joannides 1983, no. 194v—ill. (cf. no. 195v)]

———. "Standing Nude Venus." Drawing, part of a sheet of studies (for lost or unexecuted painting?). *c.*1508–09. Uffizi, Florence, no. 496E. [Ibid., no. 202r—ill.]

———, school? (also attributed to circle of Peruzzi or Giulio Romano). Frescoes in Villa Farnesina, Rome, 1510–11. *See Peruzzi, below.*

———. "Female Nude Posed as [Cnidian] Venus." Drawing. *c.*1512. Szépművészeti Múzeum, Budapest, no. 1934. [Ibid., no. 285—ill.]

———. "Venus." Drawing (related to early pensée for "School of Athens"?). *c.*1512. British Museum, London, no. 1895–9–15–629. [Ibid., no. 286—ill.]

———, studio (probably Giulio Romano), after Raphael's design. Cycle of frescoes depicting Venus and Adonis, Venus and Cupid, and other scenes, for Stufetta del Cardinal Bibbiena, Vatican, Rome. 1516. In place. [Vecchi 1987, no. 125—ill. / also Hartt 1958, pp. 31f.]

———. "Venus Supported by Putti in Clouds." Drawing. Dukes of Devonshire coll., Chatsworth. [Warburg]

———, attributed. Drawing (back of Venus putting on a robe). Academia de Bellas Artes San Fernando, Madrid. [Warburg]

———. *See also Marcantonio Raimondi, below.*

Albrecht Altdorfer, *c.*1480–1538. "Venus and Cupid." Engraving. **1508.** 2 states. [Winzinger 1963, no. 107—ill.]

———. "Standing Venus with Two Putti." Engraving (Bartsch no. 32). *c.*1512–15? [Ibid., no. 114—ill.]

———. "Reclining Venus with Putti." Engraving (Bartsch no. 35). *c.*1520–30. [Ibid., no. 161—ill.]

Lucas Cranach, 1472–1553. "Venus and Cupid." Painting. **1509.** Hermitage, Leningrad, no. 680 (302). [Friedlaender & Rosenberg 1978, no. 22—ill. / Hermitage 1987b, no. 14]

———. "Venus." Painting. *c.*1518. National Gallery of Canada, Ottawa, no. 6087. [Friedlaender & Rosenberg, no. 115—ill.]

———. "Venus and Cupid." Painting. *c.*1520. Princeton University Art Museum, N.J. [Ibid., no. 116—ill.]

———. "Venus Outdoors" ("Standing Venus in a Landscape"). Painting. 1529. Louvre, Paris, inv. 1180. [Ibid., no. 242—ill. / Louvre 1979–86, 2:23—ill.]

——— and studio. "Venus and Cupid." Painting. *c.*1530.

Gemäldegalerie, Berlin-Dahlem, no. 594. [Friedlaender & Rosenberg, no. 241—ill. / Berlin 1986, p. 25—ill.]

———, attributed. "Venus" (and Cupid). Painting. *c.*1530. Fragment, "Cupid," in Kunsthistorisches Museum, Vienna, inv. 3530 (1464a). [Vienna 1973, p. 50]

———. "Venus." Painting. *c.*1530. Herzog Anton Ulrich-Museum, Braunschweig, no. 26. [Friedlaender & Rosenberg, no. 243 / Braunschweig 1969, p. 47—ill. / also Braunschweig 1976, p. 15—ill.]

———. "Venus." Painting. 1532. Städelsches Kunstinstitut, Frankfurt, no. 1125. [Friedlaender & Rosenberg, no. 246—ill. / Yale 1981, fig. 20] 2 related (?) versions. Formerly Schlossmuseum, Weimar, lost; Hallwylska Museet, Stockholm (fragment). [Friedlaender & Rosenberg, nos. 246p-q]

———, attributed. "Venus and Cupid." Painting. Burrell coll., Glasgow City Art Gallery, inv. 9. [Wright 1976, p. 44]

———. Numerous other versions of "Venus and Cupid" subject, 1526–40. Herzog Anton Ulrich-Museum, Braunschweig, no. 26 ("Venus"—Cupid now missing); Staatliches Museum, Schwerin, cat. 1882 no. 160; Römer und Pelizäus Museum, Hildesheim; Pennsylvania Museum, Philadelphia (fragment, Cupid only); National Gallery of Scotland, Edinburgh; others in private colls. or unlocated. [Ibid., nos. 243, 246a-s, 249, 399—ill.; and cf. nos. 244–48 / also Braunschweig 1969, p. 47—ill. / Braunschweig 1976, p. 15—ill.]

———, school. "Venus and Amor." Painting. Dienst Vorspreide Rijkskollekties, The Hague, no. NK 1421. [Wright 1980, p. 86]

Girolamo Savoldo, *c.*1480–after 1548. "Sleeping Venus." Painting. *c.*1510. Galleria Borghese, Rome, inv. 30. [Pergola 1955–59, 1: no. 229—ill.]

Pinturicchio, 1454–**1513,** and studio. "Venus and Cupid." Fresco (detached), from Palazzo Pandolfo Petrucci ("Il Magnifico"), Siena. Metropolitan Museum, New York, no. 114.22. [Metropolitan 1980, p. 142—ill. / Berenson 1968, p. 345—ill.]

Titian, *c.*1488/90–1576. "Sacred and Profane Love" (Venus and Cupid with contemporary woman). Painting. *c.*1514. Galleria Borghese, Rome, no. 147. [Wethey 1975, no. 33—ill. / Pergola 1955–59, 1: no. 233—ill. / also Berenson 1957, p. 190—ill. / Vermeule 1964, pp. 86, 175f.]

———. "Venus of Urbino" ("Reclining Venus"). Painting. 1538. Uffizi, Florence, inv. 1437. [Wethey, no. 54 / Uffizi 1979, no. P1725—ill. / Berenson, p. 186—ill.] Copies in Walters Art Gallery, Baltimore (by J-A-D Ingres, 1822); Uffizi, Florence (in storage); Hampton Court (2, in storage); Louvre, Paris, no. R.F. 2269 (variant copy, style of Ferdinand Bol, previously attributed to G. van den Eeckhout); Musée des Beaux-Arts, Nantes; Rijksmuseum, Amsterdam, inv. A3479 (variant, by Lambert Sustris, formerly in Galleria Borghese); Galleria Borghese, Rome, inv. 50 (copy after Sustris, preceding, in storage); National Gallery of Ireland, Dublin; Victoria and Albert Museum, London (by Alfred Stevens, 1843–44); elsewhere. [Wethey / also Berenson, pp. 167—ill. / Louvre 1979–86, 1:29—ill. / Rijksmuseum 1976, p. 529—ill. / Pergola, 1: no. 248—ill. / Dublin 1981, p. 164—ill. / Towndrow 1939, pp. 62f.] Edouard Manet's "Olympia" is another famous derivation of Titian's work. [Cachin & Moffett 1983, no. 64—ill.]

———. "Venus at Her Toilet with Two Cupids" ("Venus

with a Mirror"). Painting. *c.*1552–55. National Gallery, Washington, D.C., no. 34. [Wethey, no. 51—ill. / Sienkewicz 1983, p. 8—ill. / also Walker 1984, p. 208—ill.] Studio replica. *c.*1555. Wallraf-Richartz Museum, Cologne. [Wethey, no. 52—ill.] Studio variants ("Venus at Her Toilet with One Cupid," "Venus and Cupid with a Mirror"). Bergsten coll., Stockholm; Gemäldegalerie, Berlin-Dahlem (on loan to Staatliche Museum, Wiesbaden). [Ibid., no. 53—ill. / Berlin 1986, p. 75—ill.] Copies in Gemäldegalerie, Dresden; Gemäldegalerie, Magdeburg; Musée, Toulouse (on deposit from Louvre, Paris, inv. 764 *bis*); elsewhere? [Wethey, no. 52 *n.* / also Louvre, 2:300] School variants: "Venus Dressed at Her Toilet with One Cupid" (school of Veronese), *c.*1575, Courtauld Institute, London; "Venus Alone at Her Toilet," 16th century, Ca' d'Oro, Venice. [Wethey, nos. X-37, X-38-ill.]

———. "Venus (and Cupid) with an Organist." Painting. Numerous versions, *c.*1548–1560s, some with a lutenist or other variation. Prado, Madrid, nos. 420, 421; Gemäldegalerie, Berlin-Dahlem; Uffizi, Florence, inv. 1431; Fitzwilliam Museum, Cambridge, no. 129; Metropolitan Museum, New York, no. 36.29. [Wethey, nos. 45–50 / also Berenson, pp. 184–89 / Prado 1985, p. 709 / Uffizi, no. P1730—ill. / Fitzwilliam 1960–77, 2:167—ill. / Metropolitan 1980, p. 185—ill. / Metropolitan 1983, p. 124—ill. / de Bosque 1985, p. 43—ill.] Copies in Holyrood House, Edinburgh; Hampton Court Palace (in storage); Lady Lever Gallery, Port Sunlight; Ham House, Richmond; Mauritshuis, The Hague; Altarriba coll., Paris (Émile Bernard, 1920); Document archives Mouradian, Paris (Raoul Dufy, 1926; also 2 gouaches and 2 watercolors, 1949, unlocated); elsewhere. [Wethey / also Mauritshuis 1985, p. 449—ill. / Luthi 1982, no. 987—ill. / Guillon-Lafaille 1981, nos. 1977–81—ill.]

———, formerly attributed. "Venus and Wounded Cupid" ("L'Amour piqué"). Painting. *c.*1520. Wallace Collection, London. [Wethey, no. X-44-ill.]

———, formerly attributed (Bolognese School). "Omnia Vanitas—Venus Reclining before a Landscape." Painting. Mid-17th century. Unlocated. / Engraved by Valentin Lefebvre (*c.*1642–1680/82). / Numerous paintings after engraving. Louvre, Paris, no. M.N.R. 760; Glasgow Art Gallery; Accademia di San Luca, Rome; elsewhere. [Louvre 1979–86, 2:263—ill. / also Wethey, no. X–30]

———, formerly attributed (actually by Lambert Sustris). "Venus and Cupid." Painting. *c.*1565. Formerly Wendland coll., Lugano. [Ibid., no. X–41]

Giovanni Bellini, *c.*1430–1516. "Venus with a Mirror." Painting. 1515. Kunsthistorisches Museum, Vienna, no. 13. [Pigler 1974, p. 246]

Jacopo de' Barbari, *c.*1440/50–1516. "Venus" ("Vanity"). Engraving (Bartsch no. 12). [Borenius 1923, no. 19-ill.]

Antonio Lombardo, *c.*1458–1516? "Venus." Relief, for Camerini di Alabastro, Castello d'Este, Ferrara. Museo del Bargello, Florence. [Pope-Hennessy 1985b, 2:343]

Giulio Romano, *c.*1499–1546, attributed, after designs by Raphael. Frescoes for Stufetta del Cardinal Bibbiena, 1516. *See Raphael, above.*

———, assistants, after designs by Giulio. Venus depicted in frescoes and stuccoes in Sala dei Venti, Sala di Psiche, and Sala delle Aquile, Palazzo del Tè, Mantua. 1527–30. [Verheyen 1977, pp. 25f., 119–22]

———. (Venus and amorini in) "The Erotes of Philostratus." Drawing, study for unexecuted painting (for Palazzo del Tè?). *c.*1532? Duke of Devonshire coll., Chatsworth. [Hartt 1958, p. 300 no. 217—ill.]

———. "Venus." Fresco (simulated statue). 1540–44. Casa Giulio Romano, Milan. [Hartt, p. 239, figs. 489, 491]

———. "Venus, Cupid, and the Three Graces." Drawing. Earl of Ellesmere coll., Mertoun House, Roxburghshire, Scotland, no. 119. [Hartt 1958, p. 304 no. 295—ill.]

———, composition. "Venus and Eros." Engraving (Bartsch no. 318), executed by Marcantonio Raimondi (*c.*1480–1527/34). [Bartsch 1978, 26:320—ill.]

———, circle? (also attributed to circle of Peruzzi or Raphael). Frescoes in Villa Farnesina, Rome. *See Peruzzi, below.*

Hans Sachs, 1494–1576. *Der Frau Venus Hofgesinde (Das Hofgesinde der Venus)* [The Court of Lady Venus]. Comedy. Published 1517. In modern edition, *Werke* (Stuttgart: 1870–1908; Hildesheim: Olms, 1964). [McGraw-Hill 1984, 4:302f.]

Girolamo di Tommaso da Treviso the Younger, 1497–1544. "Venus Asleep in a Landscape." Painting. *c.***1517.** Galleria Borghese, Rome, no. 130. [Berenson 1957, p. 90—ill.]

Baldassare Peruzzi, 1481–1536. "Venus (and Cupid) with Four Muses" (Poetry, Drama, Dance, Music). Fresco (detached), from Villa Stati, Rome. **1519–20?** Metropolitan Museum, New York, no. 48.17.14. [Frommel 1967–68, no. 56—ill. / Metropolitan 1980, p. 141—ill.]

———. "Venus." Painting. Galleria Borghese, Rome, inv. 92. [Pergola 1955–59, 1: no. 60—ill. / Berenson 1968, p. 334]

———, circle? (also attributed to school of Giulio Romano or Raphael). "Venus," "The Triumph of Venus," "The Adornment of Venus." Frescoes. 1511–12 (or *c.*1517-18). Sala delle Prospettive, Villa Farnesina, Rome. [d'Ancona 1955, pp. 27ff., 93f. / Gerlini 1949, pp. 31ff. / also Frommel, no. 51]

Palma Vecchio, 1480–1528. "Venus and Cupid." Painting. Dated variously *c.*1520 (or earlier), *c.*1525. Fitzwilliam Museum, Cambridge, no. 109. [Fitzwilliam 1960–77, 2:115—ill. / Mariacher 1968, pl. 54] Copy (or replica?) in Muzeul de Arta, Bucharest. Another, without Cupid, formerly Viscount Lee of Fareham coll., sold London 1966. [Mariacher, pp. 95, 101]

———. "Reclining Venus." Painting. 1520–25. Gemäldegalerie, Dresden, no. 190, on loan to Národní Galeri, Prague. [Ibid., pl. 53 / Dresden 1976, p. 78] Further versions of the subject in Museum, Bucharest; Count Antoine Seilern coll., London. [Bénézit 1976, 8:95 / Warburg]

———, rejected attribution (actually by Francesco Rizzo da Santacroce?). "Venus and Cupid." Painting. Formerly Böhler coll., Munich. [Mariacher, p. 103]

———, school? "Venus in a Landscape." Painting. Akerblom coll., Göteborg. [Mariacher, pl. 83]

Jan Gossaert, called Mabuse, *c.*1478–1533/36. "Venus and Cupid." Painting. 1521. Musées Royaux des Beaux-Arts (Musée d'Art Ancien), Brussels, inv. 6611. [Brussels 1984a, p. 122—ill. / Rotterdam 1965, no. 15—ill. / de Bosque 1985, p. 54—ill.]

Hans Baldung Grien, 1484/85–1545. "Venus and Cupid."

APHRODITE General List

Painting. *c.*1524. Rijksmuseum Kröller-Müller, Otterlo, no. 8.13. [Osten 1983, no. 55, pl. 124]

———. "Nude Young Woman Holding an Apple" ("Venus"). Drawing. *c.*1525. Kupferstichkabinett, Staatliche Museen, Berlin. [Yale 1981, no. 76—ill.]

———, rejected attribution. "Venus and Cupid." Painting. Minneapolis Institute of Arts, no. 56.13. [Osten, no. X135, pl. 207]

Venetian School. "Venus." Painting. *c.*1500–25. Rijksmuseum, Amsterdam, inv. C1354. [Rijksmuseum 1976, p. 646—ill.]

Brescianino, fl. 1507–25. "Venus with Two Amorini." Galleria Borghese, Rome, inv. 324. [Pergola 1955–59, 2: no. 17—ill. / Berenson 1968, p. 66—ill.]

———. "Reclining Venus with Cupids." Painting. Formerly Le Roy coll., Paris. [Berenson]

Hans Holbein the Younger, 1497–1543. "Dorothea Offenburg as Venus with Cupid." Painting. Before 1526. Öffentliche Kunstsammlung, Basel. [Warburg]

Giovanni lo Spagna, *c.*1450–1528, attributed. "Venus in a Chariot, with Cupid." Painting, derived from figures in Perugino's "Combat of Love and Chastity" (*c.*1503, Louvre). Uffizi, Florence. [Louvre 1975, no. 125]

Lucas van Leyden, 1494–1533. "Venus and Amor." Engraving (Bartsch no. 138). 1528. / Copy, painting, in Muzeum Narodowe, Warsaw, inv. 180693. [Warsaw 1969, no. 1589—ill.] Further copies in private coll., Netherlands (Jan van Scorel); Hoblitzelle coll., Dallas, Texas. [Ibid. / Warburg]

Georg Pencz, *c.*1500–1550. "Venus and Cupid." Painting. *c.*1528–29. Gemäldegalerie, Berlin-Dahlem, no. 1905. [Berlin 1986, p. 59—ill.]

Marbrianus de Orto, *c.*1460–1529. "Venus tu m'a pris" [Venus Thou Hast Captured Me]. Rondeau for 3 voices. Published in *O. Petrucci: Harmonice musices odhecaton A,* edited by H. Hewitt. [Grove 1980, 13:878]

Domenico Beccafumi, 1486–1551, questionably attributed (or Girolamo Genga?). "Venus and Cupid (with Vulcan)." Painting. *c.*1530. Kress coll. (K1932), Isaac Delgado Museum of Art, New Orleans, no. 61.73. [Shapley 1966–73, 3:4—ill. / Sanminiatelli 1967, p. 172]

Maerten van Heemskerck, 1498–1574, composition. "The Children of Venus" (Venus in a chariot, with Cupid, above scenes of play and lovemaking). Woodcut, in "Planets" series, executed by G. Pencz, 1531. [Grosshans 1980, p. 248, pl. 247]

———, composition. "The Children of Venus" (similar, but unrelated, scene). Engraving, executed by H. Muller, 1568. [Ibid., pl. 246]

———. "Venus and Cupid" (with Vulcan's forge in background). Painting. 1545. Wallraf-Richartz-Museum, Cologne, inv. 875. [Ibid., no. 48—ill. / de Bosque 1985, pp. 158f.—ill. / Cologne 1965, p. 68—ill.]

———. "Venus and Cupid." Painting, executed by C. J. Visscher after drawing by Heemskerck. Lost. / Engraved by B. Dolendo. [Grosshans, no. V52—ill.]

Girolamo Romanino, *c.*1484/87–*c.*1562 "Venus and Cupid." 2 frescoes. 1531–32. Loggia, Castello del Buonconsiglio, Trento. [Berenson 1968, p. 369]

Bernardino Luini, 1480/85–1532, attributed. "Venus" ("Spring Nymph"). Painting. Kress coll. (K249), National Gallery, Washington, D.C. [Luino 1975, p. 94, pl. 42 / Shapley 1966–73, 2:143f.—ill. / Sienkewicz 1983, p. 2—ill. / also Walker 1984, fig. 283]

———, attributed. "Venus." Painting. Gerli coll., Milan. [Luino, pp. 94f., pl. 60]

Michelangelo, 1475–1564. "Venus and Cupid." Painting and cartoon. *c.*1532. Both lost. / Copies in Uffizi, Florence, inv. 1570 (Jacopo Pontormo [? or copy after?], 1532–34); Galleria Colonna, Rome (Michele di Ridolfo); Galleria di Capodimonte, Naples, no. 748 (attributed to Hendrik van der Broecke, Angolo Bronzino, Alessandro Allori); Ringling Museum of Art, Sarasota, Fla., inv. SN29 (figures only, 17th-century Flemish?). [Uffizi 1979, no. P1258—ill. / Berenson 1963, p. 150 / Capodimonte 1964, p. 38 / Sarasota 1976, no. 198]

———, questionably attributed (also attributed to Vincenzo Danti, 1530–1576). "Venus with Two Cupids." Marble statue. Casa Buonarroti, Florence. [Baldini 1982, no. 56—ill.]

Giorgio Vasari, 1511–1574. "The Toilet of Venus." Painting. *c.*1532. Staatsgalerie, Stuttgart, inv. 2777. [Arezzo 1981, no. 4.8, pl. 280]

Marcantonio Raimondi, *c.*1480–1527/34. "Venus Attended by Two Small Cupids." Engraving (Bartsch no. 251), after design by Raphael? [Bartsch 1978, 26:250—ill.]

———. "Venus and Eros." Engraving (Bartsch no. 260). [Bartsch 1978, 26:253—ill.]

———. "Venus [with Cupid] after Her Bath." Engraving (Bartsch no. 297), after design by Raphael. [Ibid., pp. 287ff.—ill.]

———. "Venus and Eros" (statues in a niche). Engraving (Bartsch no. 311), after design by Raphael. [Ibid., p. 311—ill.]

———. "Crouching Venus." Engraving (Bartsch no. 313), after design by Francesco Francia? [Ibid., p. 314—ill.]

———. "Venus and Eros." Engraving (Bartsch no. 318), after design by Giulio Romano. [Ibid., p. 320—ill.]

Antonio da Correggio, *c.*1489/94–1534, attributed. "Venus." Isabella Stewart Gardner Museum, Boston. [Gould 1976, p. 288]

———, attributed. "Sleeping Venus." Painting. Formerly G. M. Fiammingo coll., Rome. [Ibid., p. 289]

Lorenzo Costa, 1460–1535, attributed. "Nude Woman" (Venus?). Painting. Szépművészeti Múzeum, Budapest, no. 1257. [Budapest 1968, p. 156—ill. / Berenson 1968, p. 96]

———. "Venus." Painting. Scarselli coll., Bologna. [Berenson—ill.]

Girolamo del Pacchia, 1477–1535. "Reclining Venus with Three Cupids." Painting. Lady Freyberg coll., London. [Berenson 1968, p. 307]

Dosso Dossi, *c.*1479–1542, and **Battista Dossi,** *c.*1474–1548, attributed. "Venus and Cupid." Drawing. *c.*1525–35? Uffizi, Florence, no. 1475F (as Biagio Pupini). [Gibbons 1968, no. 189—ill.]

——— (Battista), attributed. "Venus." Painting. Römer und Pelizäus Museum, Hildesheim, no. 350. [Berenson 1968, p. 115]

——— (Dosso), rejected attribution (Italian School, late 16th century?). "Allegory of Venus." Painting. New York art market in 1968. [Gibbons, no. 169—ill.]

Anonymous English. "The Courte of Venus." Poem.

*c.***1536.** London: Copland, 1547–49. In modern edition, *The Renaissance in England: Non-dramatic Prose and Verse of the Sixteenth Century,* edited by Hyder E. Rollins and Herschel Baker (Lexington, Mass.: Heath, 1954). [Smith 1952, p. 229 / Bush 1963, p. 60 *n.*]

Danese Cattaneo, *c.*1509–1573. "Negro Venus." Bronze statuette. *c.***1537–39.** Metropolitan Museum, New York; elsewhere. [Pope-Hennessy 1985b, 3:411] Related work (Italian School, 1550/1600). Liebieghaus, Frankfurt, inv. 1568. [Hofmann 1987, no. 3.1—ill.]

———. "Venus." Bronze statue. *c.*1560. Cleveland Museum of Art, Ohio, no. 50.578; Victoria and Albert Museum, London, no. A.80–195; elsewhere? [Warburg / also Clapp 1970, 1:153]

Jacopo Sansovino, 1486–1570, and assistants (Tiziano Minio, Danese Cattaneo). 4 marble reliefs depicting Venus with river gods and Venus on Cyprus. **1537–39.** Loggetta, Piazza San Marco, Venice. [Pope-Hennessy 1985b, 3:404f.]

Lambert Sustris, 1515/20–after 1568. "Venus and Cupid." Painting. *c.***1539.** Gemäldegalerie, Dresden. [Gnudi & Cavalli 1955, no. 98—ill.]

———, attributed (also questionably attributed to Friedrich Sustris). "(Reclining) Venus and Cupid" (with Mars in background). Painting. Louvre, Paris, inv. 1978 (2640). [Louvre 1979–86, 1:134—ill. / Berenson 1957, p. 168—ill.]

——— (formerly attributed to Titian). "Venus and Cupid." Painting. *c.*1565. Formerly Wendland coll., Lugano. [Wethey 1975, no. X–41]

Giampietrino, fl. **1500–40.** "Venus and Cupid." Painting. Formerly Baron Lazzaroni coll., Paris. [Pigler 1974, p. 249]

Andrea Schiavone, *c.*1522–1563. "The Toilet of Venus," "Homage to Venus." Pendant paintings. *c.***1539–40.** Private coll., Venice. [Richardson 1980, nos. 312–13]

———. "Venus and Cupid" ("Venus Leaving the Bath"). Print (after lost drawing by Parmigianino?). *c.*1540–43. [Ibid., no. 75]

———. "Jupiter, Juno [or Venus?], and Cupid." Drawing, sketch for (unexecuted?) work. Several versions. Museo Civico, Bassano, nos. 8.226.531–536. [Ibid., no. 151—ill.]

———. "Venus and Cupid." Drawing. Szépmüvészeti Múzeum, Budapest, no. 1891. [Ibid., no. 158—ill.]

———. "Venus and the Graces." Painting. Unlocated. [Ibid., no. 334]

———, rejected attribution (attributed to Battista del Moro). "Venus and Cupid." Painting. Kunsthistorisches Museum, Vienna, no. 185. [Ibid., no. D380—ill.]

Parmigianino, 1503–**1540.** "Venus and Nymphs Bathing." Drawing. Uffizi, Florence. / Etching by Antonio Fantuzzi, 1543. (Bibliothèque Nationale, Paris.) [Paris 1972, no. 320—ill. / also Lévêque 1984, p. 104—ill.]

Agnolo Bronzino, 1503–1572. "Allegory of Venus and Cupid" ("Allegory of the Triumph of Venus," "Venus, Cupid, Folly, and Time"). Painting. *c.*1540–45? National Gallery, London, inv. 651. [McCorquodale 1981, pp. 87ff., pl. 8 / Baccheschi 1973, no. 50—ill. / London 1986, p. 73—ill. / Berenson 1963, p. 43]

———. "Venus, Cupid, and Jealousy." Painting. *c.*1550. Szépmüvészeti Múzeum, Budapest, no. 163. [Budapest

1968, p. 99—ill. / Baccheschi, no. 93—ill. / McCorquodale, fig. 80 / Berenson, p. 41—ill.]

———. "Allegory of Hymen with Venus Crowned by the Muses," part of "Stories of Hymen," decorations for wedding festival of Francesco I de' Medici and Joanna of Austria. 1565. Lost. / Drawing. Christ Church Gallery, Oxford. [McCorquodale, p. 149, fig. 105]

[?] Delafont, fl. *c.*1545–59. "Venus avoit son filz Amour perdu" [Venus has lost her son, Amor]. Song. 1545. [Grove 1980, 5:330]

Robert Meigret, 1508–1568. "Venus un jour en veneur se déguise" [Venus One Day Appeared in Disguise]. Chanson. 1546. [Grove 1980, 12:70]

Francesco Primaticcio, 1504–1570, and assistants. "Venus and the Fates." Ceiling fresco, in Galerie d'Ulysse, Château de Fontainebleau. **1541–47.** Destroyed 1738–39. / Drawing. Louvre, Paris, inv. R.F. 1470. [Béguin et al. 1985, pp. 147ff.—ill. / also Dimier 1900, pp. 295ff., no. 115]

———, design. "Venus and Cupid." Fresco, for Salle de Bal, Château de Fontainebleau, executed by Niccolò dell' Abbate under Primaticcio's direction. 1551–56. Repainted 19th century. [Dimier, pp. 160ff., 284ff.]

[?] L'Huyllier, fl. 1539–50. "O ma Venus." Chanson. 1547. [Grove 1980, 10:713]

Giovanni Busi, called Cariani, 1485–**1547/48.** "Venus Lying in Landscape." Painting. Hampton Court Palace, no. 1103. [Berenson 1957, p. 54]

Luca Penni, 1500/04–1556, composition. (Venus and Cupid representing) "Lust." Etching, by "Master L. D." *c.*1547–**48.** (Private coll., Paris.) [Paris 1972, no. 391—ill.]

———, composition. "Venus Pricked by a Rose Bush." Engraving (Bartsch [1813] 15:40), by Giorgio Ghisi. 1556. (Bibliothèque Nationale, Paris.) [Ibid., no. 348—ill. / also Lévêque 1984, p. 130—ill.]

———, doubtfully attributed, composition. "Venus Bathing, Served by Nymphs." Etching (Bartsch 16, anon. no. 60), by Jean Mignard (fl. *c.*1535–55). (British Museum, London.) [Paris, no. 411]

Decapella. "Héllas Vénus, trop tu me fuz contraire" [Alas Venus, you work too much against me]. Chanson for 4 voices. First performed 1549. [Grove 1980, 5:314]

Master of the Female Half-figures, fl. 1525–50. "Venus and Cupid." Painting. *c.*1550. Gemäldegalerie, Berlin-Dahlem, no. 386. [Berlin 1986, p. 52—ill.]

Battista Zelotti, *c.*1526–1578. "Venus between Mars and Neptune." Painting, ceiling panel. **1553–54.** Sala dei Dieci, Palazzo Ducale, Venice. [Berenson 1957, p. 204—ill.]

Giuliano Bugiardini, 1475–**1554.** "Sleeping Venus." Painting. Ca' d'Oro, Venice. [Berenson 1963, p. 46—ill.]

Pierre de Ronsard, 1524–1585. "La belle Venus un jour." Ode. In *Les meslanges* (Paris: **1555**). [Laumonier 1914–75, vol. 6]

———. (Venus and her cestus evoked in) *La franciade.* Epic poem, unfinished. Paris: Buon, 1572. [Ibid., vol. 16 / Cave 1973, p. 76 / McFarlane 1973, p. 76]

———. "Veu à Venus: Belle déesse" [Vow to Venus, Beautiful Goddess]. Poem. In *Le second livre des amours* (Paris: Buon, 1571–72). [Laumonier, vol. 15]

Frans Floris, 1516/20–1570. "Venus Playing with Cupids." Drawing. **1556.** Staatliche Kunstsammlungen, Dresden. [de Bosque 1985, pp. 55f.—ill.]

————— and studio. "Venus and Cupid." Painting. Louvre, Paris, no. M.N.R. 396. [Louvre 1979–86, 1:59—ill.]

—————. *See also Willem Key, below.*

Paolo Veronese, 1528–1588. "Venus and Amorini." Fresco. *c.*1557. Palazzo Trevisan, Murano. [Pallucchini 1984, no. 36a—ill. / Pignatti 1976, no. 64—ill.]

—————. "Apollo and Venus with Cupid." Fresco, part of cycle celebrating Bacchus and wine. *c.*1560–61. Stanza di Bacco, Villa Barbaro-Volpi, Maser (Treviso). [Pallucchini, no. 60—ill. / Pignatti, no. 98—ill.]

—————. "Venus and Mercury before Jupiter" (with an infant—Cupid? Aeneas?). Painting. *c.*1560–62. Formerly Contini-Bonacossi coll., Florence. [Pallucchini, no. 74—ill. / Pignatti, no. 117—ill.]

—————. "Hymen between Juno and Venus with a Bride and Groom before Him" ("Tribunal of Love"). Fresco. *c.*1560–61. Stanza dell' Amore Coniugale, Villa Barbaro-Volpi, Maser (Treviso). [Pallucchini, no. 61a—ill. / also Pignatti, no. 99—ill.]

—————. "Venus and Jupiter" (as lovers). Painting. *c.*1561–63. Museum of Fine Arts, Boston, inv. 60.125. [Pallucchini, no. 80—ill. / Pignatti, no. 150—ill.]

—————. "Venus with Cupid at the Mirror." Painting. Early 1580s. Joslyn Art Museum, Omaha. [Pallucchini, no. 213—ill. / Pignatti, no. 275—ill.] Variant, attributed to Veronese. Courtauld Institute, London; another version (previously attributed to Veronese), unlocated. [Pignatti, nos. A158, A420—ill. / also Berenson 1957, p. 133]

—————, questionably attributed (probably Benedetto Caliari, 1538–1598). "Venus and Cupid." Painting. Rijksmuseum, Amsterdam, inv. A3010 (2529 B1). [Pignatti, no. A4—ill. / also Rijksmuseum 1976, p. 574—ill.] Copy in Musée, Bordeaux (on deposit from Louvre, Paris, inv. 152). [Louvre 1979–86, 2:301]

Jean Goujon, *c.*1510–*c.*1565/68, traditionally attributed. "Venus and Cupid." Marble relief. **1550s.** Hermitage, Leningrad, inv. 907. [Hermitage 1984, no. 355—ill. / also Hermitage 1975, pl. 92]

Bartolommeo Ammannati, 1511–1592. "Venus." Bronze sculpture. **1559.** Prado, Madrid. [Pope-Hennessy 1985b, 3:373]

Niccolò dell' Abbate, 1509/12–1571? attributed. "Venus Seated, Holding a Golden Apple." Painting. *c.*1560? Christ Church, Oxford. [Byam Shaw 1967, no. 167—ill.]

—————. "Venus and Cupid" ("Eros and Psyche"). Painting, after Primaticcio's "Ulysses and Penelope" (lost painting from Galerie d'Ulysse, Fontainebleau). 1552–71. Detroit Institute of Arts, inv. 65331. [Béguin et al. 1985, p. 307 / Paris 1972, no. 2—ill. / Hofmann 1987, no. 3.8—ill. / also Lévêque 1984, p. 222—ill.]

—————, previously attributed (School of Fontainebleau). "Venus at Her Toilet." Painting. Mid-16th century. Louvre, Paris, no. R.F. 658. [Louvre 1979–86, 4:293—ill.]

—————. *See also Primaticcio, above.*

Giambologna, 1529–1608. "Little Venus Drying Herself" ("Woman Bathing"). Bronze figurine. *c.*1560. Museo del Bargello, Florence, no. 71. [Avery 1987, no. 51—ill. / Avery & Radcliffe 1978, no. 6—ill.] 7 further versions known. [Avery & Radcliffe]

—————. "Venus Kneeling on a Stool" ("Venus and Cupid"). Bronze figurine, cast after model by Giambologna. *c.*1560?

Numerous versions, with and without figure of Cupid. Metropolitan Museum, New York; Musée des Beaux-Arts, Dijon; Staatliche Museen, Berlin-Dahlem; Herzog Anton Ulrich-Museum, Braunschweig; elsewhere. [Avery, nos. 53–54—ill. / Avery & Radcliffe, nos. 8, 10–11—ill.]

—————. "Venus Drying Herself" ("Woman Bathing"). Bronze statuette. *c.*1565. Kunsthistorisches Museum, Vienna, no. 5874. [Avery, no. 52—ill. / Avery & Radcliffe, no. 1] Lifesize marble replica. *c.*1583. American Embassy, Rome. [Avery, no. 14—ill.] Numerous replicas, variants, reductions, by Giambologna (?), studio, some with added figure of Cupid. [Avery & Radcliffe, nos. 2–5, 9—ill. / Avery, no. 54—ill.]

—————. "Kneeling Venus" ("Woman Bathing"). Bronze statuette. *c.*1565. Museo del Bargello, Florence, no. 62, elsewhere. [Avery, no. 61—ill. (cf. no. 171) / Avery & Radcliffe, nos. 19–20—ill.]

—————. "Venus of the Grotticella." Marble fountain figure. *c.*1570. Boboli Gardens, Florence. [Avery, no. 7—ill.]

—————. "Venus Kallipygos." Bronze figurine, after antique statue, cast by A. Susini after Giambologna model. Victoria and Albert Museum, London, no. A.141–1910. [Avery, no. 59 / Avery & Radcliffe, no. 7—ill.]

Luca Cambiaso, 1527–1585. "Venus on the Sea with Cupid." Painting. *c.*1561. Galleria Borghese, Rome, inv. 123. [Manning & Suida 1958, p. 147—ill. / Pergola 1955–59, 1: no. 128—ill.]

—————. "Venus Blindfolding Cupid." Painting. *c.*1565–70. Private coll., Vienna, in 1930. [Manning & Suida, p. 152—ill.] Variant, drawing. Louvre, Paris. [Ibid.—ill.]

—————. "Venus and Cupid." Painting. *c.*1570. Barone Lazzaroni coll., Rome. [Ibid., p. 148—ill.]

—————. "Venus and Cupid." Painting. *c.*1570. Art Institute of Chicago, no. 42.290. [Ibid., p. 159—ill. / Chicago 1961, p. 64—ill.]

—————. "Venus and Cupid." Painting. Private coll., Genoa. [Manning & Suida, p. 103—ill.] 2 replicas (or copies?). Accademia, Venice; Dulwich Picture Gallery, London. [Ibid.]

—————. "Venus and Cupid Sleeping under a Tree." Engraving. [Ibid., p. 172—ill.]

—————, studio (Orazio Cambiaso?). "Venus and Cupid." Painting. Formerly C. Franze coll., Tetschen, Czechoslovakia. [Ibid., p. 152—ill.]

Jan Massys, 1509–1575. "Resting Venus." Painting. **1561.** Nationalmuseum, Stockholm, cat. 1958 no. 507. [Warburg]

Alessandro Vittoria, 1525–1608, tentatively attributed. "Venus" (with water jug). Bronze statuette. **Early 1560s.** Formerly Palazzo Ducale, Venice. [Cessi 1960, p. 49, pl. 23] Studio variant, figure on bronze andiron. Formerly Estensiche Kunstsammlung, Vienna, unlocated. [Ibid., pl. 24]

—————, attributed. "Venus." Bronze statuette. *c.*1575–77. Formerly Hofmuseum, Vienna, unlocated. [Cessi 1960, p. 49, pl. 26]

Anonymous English (once attributed to Chaucer). *The Courte of Venus.* Allegorical poem, surviving in 3 printed fragments (contains poems by Sir Thomas Wyatt, 1503?–1542, and others). *c.*1535–64. Modern edition, Durham, N.C.: Duke University Press, 1955. [Lewis 1958, pp. 256f. / Pearsall 1977, p. 272]

Daniele da Volterra, 1509–**1566,** attributed. "Venus and

Cupid." Drawing. Szépmüvészeti Múzeum, Budapest. [Barolsky 1979, p. 120]

Willem Key, *c.*1520–**1568,** attributed (previously attributed to Frans Floris, 1516/20–1570). "Venus and Cupid Resting." Painting. Herzog Anton Ulrich-Museum, Braunschweig, no. 42. [Braunschweig 1976, p. 36 / also Braunschweig 1969, p. 60]

Paris Bordone, 1500–**1571.** "Sleeping Venus with Cupid." Painting. Accademia, Venice (deposited in Ca' d'Oro). [Canova 1964, p. 95—ill.] Variant ("Venus, Cupid, and a Satyr"). Galleria Borghese, Rome, inv. 119. [Ibid., p. 111—ill. / Pergola 1955–59, 1: no. 193—ill.]

———. "Venus and Cupid." Painting. Muzeum Narodowe, Warsaw, inv. 187158. [Canova, p. 114—ill. / Warsaw 1969, no. 128—ill.]

———. "Venus, Cupid, Bacchus, and Diana." Painting. Formerly Chiesa coll., Milan, sold New York, 1927. [Canova, pp. 119f.—ill.]

Luís Vaz de Camões, 1524?–1580. (Venus in) *Os Lusiades* [The Sons of Lusus] 10.3–74. Epic. Lisbon: Gonçalvez, **1572.** / Translated by Sir Richard Fanshawe (Cambridge: Harvard University Press, 1940). [Giamatti 1966, pp. 216ff.]

Vincenzo Danti, 1530–1576. "Venus." Marble statue. *c.*1570–**73.** Palazzo Pitti, Florence. [Pope-Hennessy 1985b, 3:377]

———, attributed (also attributed to Michelangelo). "Venus with Two Cupids." Marble statue. Casa Buonarroti, Florence. [Baldini 1982, no. 56—ill.]

John Rolland, fl. 1560–75. *The Court of Venus.* Allegorical poem. Dalkeith: **1575.** Modern edition, Edinburgh & London: Blackwood, 1884. [Lewis 1958, pp. 292–96]

Michele Tosini, 1503–**1577.** "Venus and Cupid." Painting. National Gallery of Ireland, Dublin, no. 77. [Dublin 1981, p. 165—ill.]

John Grange, *c.*1557–1611. *The Golden Aphroditis.* Romance. London: Bynneman, **1577.** Modern edition, New York: Scholar's Facsimiles, 1937. [Oxford 1985, p. 410]

Parrasio Micheli, before 1516–**1578.** "Venus Playing a Guitar, with Cupid." Painting. After 1550. Szépmüvészeti Múzeum, Budapest, no. 85. [Budapest 1968, p. 444] Variant copies in Galleria Colonna, Rome, no. 108 (Carletto Caliari); Galerie Schwerin; Chicago Art Institute (Domenico Brusacorci). [Ibid.]

Jacopo Tintoretto, 1518–1594. "Venus with a Mirror" ("Allegory of Vanity"). Painting. *c.*1578. Getty Museum, Malibu, no. A54 P.–6. [Rossi 1982, no. 383—ill.]

Adriano Valerini da Verona. *Afrodite.* Tragedy in verse. Verona: **1578.** [DELI 1966–70, 5:378 / Herrick 1966, p. 66 / Praz 1956, p. 459]

John Lyly, *c.*1554–1606. (Venus in) *Sapho and Phao.* Comedy. **1581–82.** First performed at Court, London, Shrove Tuesday 1582. Published London: 1584. [Bond 1902, vol. 2]

———. (Venus in) *Gallathea.* Comedy. By 1585. First performed 1584–85? or at Court, London, 1 Jan 1588. Published London: 1591. [Ibid.]

Anthonie van Blocklandt, 1532/34–**1583** (formerly attributed to Abraham Bloemaert). "Venus and Cupid." Painting. Národní Galeri, Prague. [Lowenthal 1986, fig. 17 / Delbanco 1928, no. II.13—ill.]

Hendrik Goltzius, 1558–1617. "Venus and Cupid." En-

graving. **1583.** [Strauss 1977a, no. 171—ill. / Bartsch 1980–82, no. 160—ill.]

———. "Venus." Drawing, composition for print in "Seven Planets" series. 1595–96. Lost. (Engraved by Jan Saenredam, Bartsch no. 77.) [Reznicek 1961, nos. 143–46 *n.*] Variant, for second ("small") series, 1597. Unlocated. / Engraved by Jacob Matham (Bartsch no. 153). [Ibid., no. 151]

———, composition. "Venus in Half-length." Engraving, part of "Three Deities in Half-length" series. Executed by Jan Saenredam (Bartsch no. 66). *c.*1596. [Strauss, no. 337—ill. / Bartsch, no. 160e—ill.]

———, composition. "Venus" (with Cupid). Engraving, in "Four Deities" series. Executed by Jan Saenredam (Bartsch no. 63). 1596. [Strauss, no. 329—ill. / Bartsch, no. 160b—ill. / also de Bosque 1985, p. 159—ill.]

———. "Venus." Drawing, composition for print. *c.*1596. Staatliche Kunstakademie, Düsseldorf. (Engraved by Jan Saenredam, Bartsch no. 57). [Reznicek, no. 138—ill.]

———. "Venus with Cupid." Drawing. 1597. Formerly Kupferstichkabinett, Berlin. [Reznicek, no. 120—ill.]

———, attributed, composition. "Venus and Cupid." Engraving, anonymous, 1630. (Unique impression in British Museum, London.) [Bartsch, no. 0302.26 (102)—ill.]

———, rejected attribution. "Athena and Aphrodite." Drawing. Teylers Museum, Haarlem. [Reznicek, 1:486 / also de Bosque, p. 159—ill.]

Tobias Stimmer, 1539–**1584.** "Venus and Cupid." Drawing. Szépmüveszeti Museum, Budapest. [Pigler 1974, p. 250]

Angelo Ingegneri, 1550–1613. *Danza di Venere* [Dance of Venus]. Pastorale in verse. Vicenza: Nella Stamperia Nova, **1584.** [Clubb 1968, p. 138]

Bartholomeus Spranger, 1546–1611. "Venus and Mercury." Painting. *c.*1580s. Kunsthistorisches Museum, Vienna, inv. 1100 (1501). [Vienna 1973, p. 166]

———. "Bacchus and Venus." Painting. 1597? Niedersächsische Landesgalerie, Hannover. [de Bosque 1985, pp. 169, 171—ill.]

———. "Juno, Venus, and Ceres." Drawing. 2 versions. Hessisches Landesmuseum, Darmstadt; Albertina, Vienna. [Ibid., p. 134—ill.]

Philipp Nicodemus Frischlin, 1547–**1590.** *Venus.* Tragedy. In *Operum poeticorum* (Argentor: Jobin, 1596). [Taylor 1893, p. 27]

Edmund Spenser, 1552?–1599. (Story of Venus turning Astery into a butterfly related in) "Muiopotmos; or the Fate of the Butterfly" lines 113–144. Poem. London: Ponsonbie, **1590;** reprinted in *Complaints* (London: Ponsonbie, 1591). [Oram et al. 1989]

———. "An Hymne in Honour of Beautie." Poem. In *Fowre Hymnes* (London: Ponsonbie, 1596). [Oram et al.]

William Vallans, fl. 1578–90. (Venus in) *A Tale of Two Swannes.* Poem with prose. London: for J. Sheldrake, **1590.** [Bush 1963, p. 320]

Giovan Battista Naldini, 1537–**1591,** style (earlier attributed to Cavaliere d'Arpino, Scarsellino). "Venus and Cupid." Painting. Galleria Borghese, Rome, inv. 206. [Pergola 1955–59, 2: no. 56—ill.]

Jo M. (unknown author). *Philippes Venus: Wherein is pleasantly discoursed sundrye fine and wittie arguments in a senode of the gods and goddesses assembled for the expelling*

of wanton Venus from among their sacred societie. Poem.
London: **1591.** [Bush 1963, p. 320]

Joachim Wtewael, 1566–1638. "The Apotheosis of Venus
[with Cupid] and Diana" (honored by a putto repre-
senting Victory). Painting. *c.*1590–92. Private coll.
[Lowenthal 1986, no. A–1—ill.]

———. "Venus and Cupid." Painting. *c.*1618. Muzeul Bru-
kenthal, Sibiu, inv. 1277. [Ibid., no. A–75—ill.]

———. "Venus and Cupid." Painting. 1628. City Art Gal-
lery, York, inv. 902. [Ibid., no. A–95—ill.]

———. "Venus and Cupid." Drawing. Sold Sotheby's,
London, 1978. [Ibid., no. A–45 *n.*—ill.]

Annibale Carracci, 1560–1609. "Venus and Cupid." Paint-
ing. *c.*1592. Galleria Estense, Modena. [Malafarina 1976,
no. 61—ill.]

———. "Toilet of Venus" ("Venus Adorned by the Graces").
Painting. *c.*1594–95. Kress coll. (K1622), National Gallery,
Washington, D.C., no. 1366. [Ibid., no. 79—ill. / Shapley
1966–73, 3:73f.—ill. / Sienkewicz 1983, p. 16—ill. / also Walker
1984, fig. 411 / Augsburg 1975, no. E32—ill.]

——— (previously attributed to Domenichino). "Sleeping
Venus." Painting. *c.*1602. Musée Condé, Chantilly. [Ma-
lafarina, no. 126—ill.]

———. "Toilet of Venus." Painting. *c.*1605. Pinacoteca
Nazionale, Bologna. [Ibid., no. 140—ill.]

Cornelis Cornelisz van Haarlem, 1562–1638. "Venus and
Cupid." Painting. **1592.** Unlocated. [Lowenthal 1986, fig.
26]

———. "Venus and Cupid." Painting. 1610. Herzog Anton
Ulrich-Museum, Braunschweig, no. 168. [Braunschweig
1969, p. 45—ill.]

———. "Venus and Cupid." Painting. 1622. Williams-
Drummond coll., Hawthornden Castle, Lasswade, Mid-
lothian. [Warburg]

Cavaliere d'Arpino, 1568–1640. "Sunset/Venus." Fresco.
1594–95. Loggia Orsini, Palazzo del Sodalizio dei Pi-
ceni, Rome. [Röttgen 1969, pp. 279ff.—ill.]

———. "Venus and Cupid." Painting. *c.*1601. Private coll.,
Italy. [Rome 1973, no. 31—ill.]

———. "Venus Crowned by Cupid." Painting. By 1607.
Galleria Borghese, Rome, inv. 138. [Pergola 1955–59, 2: no.
90—ill.]

———. *See also Naldini, above.*

Anonymous. "Venus and Cupid." Painting. **16th cen-
tury.** Gemäldegalerie, Berlin-Dahlem, no. 1598. [Berlin
1986, p. 76—ill.]

School of Fontainebleau. "Venus Caressed by Cupid."
Painting. **16th century.** Musée du Berry, Bourges. [Paris
1972, no. 236—ill. / also Lévêque 1984, p. 143—ill.]

Paduan School. "Venus Standing, with Mirror." Bronze
statue. **16th century.** Historisches Museum, Basel. [War-
burg]

Venetian School. "Venus and Amor." Bronze sculpture
group. **16th century?** Bowes Museum, Barnard Castle.
[Warburg]

Venetian School. "Venus and Cupid." Painting. **16th
century.** Dulwich College Picture Gallery, London.
[Warburg]

Venetian School (?). "Venus and Cupid." Painting. **1550/
1600.** Musée, Strasbourg (on deposit from Louvre,
Paris, no. M.N.R. 16). [Louvre 1979–86, 2:305]

Veronese School. "Venus Playing a Guitar, with Cupid."
Painting. **1575/1600.** Szépművészeti Múzeum, Buda-
pest, no. 1272. [Budapest 1968, p. 750]

German School. "Venus Resting, with Cupid." Painting.
Late 16th century. Herzog Anton Ulrich-Museum,
Braunschweig, no. 1154. [Braunschweig 1976, p. 17]

Venetian School (Flemish artist under Italian influence,
formerly attributed to Pordenone, 1483/84–1538). "Venus
and Cupid." Painting. **Late 16th century.** Fitzwilliam
Museum, Cambridge, no. 128. [Fitzwilliam 1960–77, 2:181]

Venetian School. "Standing Venus." Bronze statuette.
Late 16th century. Victoria and Albert Museum, Lon-
don, no. A.168–1929. [Warburg]

North Italian or Netherlandish School. "Venus and
Cupid." Painting. *c.*1600. Szépművészeti Múzeum, Bu-
dapest, no. 50.756. [Budapest 1968, p. 503]

Joseph Heintz the Elder, 1564–1609. "Reclining Woman"
("Venus Resting"). Painting. 2 versions. *c.*1600? Kunst-
historisches Museum, Vienna, inv. 1104 (1516); Musée
des Beaux-Arts, Dijon, inv. 134. [Zimmer 1971, nos. A19–
20—ill. / also Vienna 1973, p. 85—ill.]

———. "Venus, Cupid, and Apollo." Painting. 1590s or
later. Gemäldegalerie Alter Meister, Dresden, inv. 646,
in 1930. [Zimmer, no. A25—ill.]

———. "Venus and Cupid with Amoretti." Painting. 1604–
07. Lost. / Engraving, by Lucas Kilian, 1607. [Ibid., no.
B10—ill.] Painting, anonymous copy after the print. Na-
tionalmuseum, Stockholm, inv. 664. [Ibid., no. B.10.0.2—
ill.]

Jerónimo de Heredia. *Guirlanda de Venus casta, y Amor
enamorado* [Garland of the Chaste Venus and Amor in
Love]. Poem. In *Prosas y versos* (Barcelona: Cendrat,
1603). [Bonilla y San Martín 1908, pp. 73f.]

Lope de Vega, 1562–1635. "De Venus y Palas" [On Venus
and Pallas]. Sonnet, no. 139 of *Rimas humanas* part I.
1602–04. Madrid: Martin, for Alonso Perez, 1609. [Sainz
de Robles 1952–55, vol. 2]

———. "A Venus divina" [To Divine Venus]. Lyric, in *El
cardenal de Belén* act I. Comedy. In *Comedias,* part 13
(Madrid: Martin, for Alonso Perez, 1620). [Ibid.]

Eckbert Wolff. "Venus," figure in "Portal of the Gods."
Sculpture. **1605.** Golden Hall, Buckeburg. [Clapp 1970,
1:913]

Guillaume Costeley, *c.*1530–**1606.** "Venus est par cent
mille noms" [Venus is (Called) by a Hundred Thousand
Names]. 4 voice chanson. Text, Ronsard. [Grove 1980,
4:826]

Alessandro Allori, 1535–**1607.** "Venus and Cupid." Paint-
ing. Musée, Montpellier. / Replica. Uffizi, Florence, inv.
1512. [Uffizi 1979, no. P30—ill.]

Tiziano Aspetti, 1565–**1607,** attributed. (also attributed
to Girolamo Campagna). "Venus." Bronze statuette,
pendant to "Vulcan." *c.*1585–95. Hermitage, Leningrad,
inv. 1312; elsewhere. [Hermitage 1984, no. 366—ill. / also
Hermitage 1975, pl. 27]

Thomas Campion, 1567–1619. (Venus in) *The Lord Hay's
Masque.* Masque. First performed 6 Jan **1607,** Whitehall
Palace, London. Published London: Brown, 1607. [Viv-
ian 1966 / DLB 1987, 58: 37, 38f.]

Adam Elsheimer, 1578–1610. "The Realm of Venus" ("Ve-
nus and Cupid"). Painting, part of "Three Realms of the

World" (Venus, Minerva, Juno) series. *c.*1607–08. Fitz-william Museum, Cambridge, inv. 532. [Andrews 1977, no. 22a—ill. / Fitzwilliam 1960–77, 1:201—ill. / Röthlisberger 1981, no. 70—ill.] Variant. Akademie der Bildungen Künst, Vienna. [Fitzwilliam]

Ben Jonson, 1572–1637. (Venus in) *The Haddington Masque (The Hue and Cry after Cupid).* Masque, for marriage of Lord Haddington, 9 Feb **1608**, at Court, London. Published London: 1608. [Herford & Simpson 1932–50, vol. 7 / McGraw-Hill 1984, 3:111, 113]

———. (Venus, as a deaf tire-woman, in) *The Masque of Christmas.* Masque. Performed Christmastime 1616, at Court, London. Published London: 1640. [Herford & Simpson]

———. (Venus in) "Time Vindicated to Himself and to His Honours." Masque. Performed 19 Jan 1623, at Court, London. Published London: 1623. [Ibid.]

———. (Venus in) "Love's Triumph through Callipolis." Masque. Performed 9 Jan 1631, at Court, London. [Ibid.]

Johann Hermann Schein, 1586–1630. "Venus Kräntzlein" [Little Garland for Venus]. Song. Published Wittenberg: **1609.** [Grove 1980, 16:619]

———. "Cupido blind, das Venuskind" [Blind Cupid, Venus's Child]. Song. Published Leipzig: 1622. [Ibid.]

———. "Frau Venus und ihr blinder Sohn" [Lady Venus and Her Blind Son]. Song. 1626. [Ibid.]

Second School of Fontainebleau. "Venus." Marble bas-relief. *c.*1594–1610. Musée de Cluny, Paris. [Paris 1972, no. 562]

Palma Giovane, *c.*1548–1628. "Venus and Cupid in the Forge of Vulcan." Painting. *c.*1600–10. Gemäldegalerie, Kassel, inv. GK502. [Mason Rinaldi 1984, no. 119—ill.]

———. "Venus at the Mirror with Amorino (Cupid)." Painting. *c.*1605–10. Formerly Gemäldegalerie, Kassel, no. 499. [Ibid., no. 121—ill.]

———. "Venus and the Graces." Painting. Recorded in Lechi coll., Brescia, in 18th century, untraced. [Ibid., p. 177] A painting of the same subject (possibly identical) cited in Fondaco dei Tedeschi, Venice, in 17th century, untraced. [Ibid., p. 185]

Johann Staden, 1581–1634. *Venus Kräntzlein: Neuer musicalischen Gesäng und Lieder* [Little Garland for Venus: New Musical Songs and Lieder]. Collection of songs. Published Nuremberg: **1610.** [Grove 1980, 18:43]

Bartholomeus Spranger, 1546–**1611.** "Venus." Painting. Musée des Beaux-Arts, Troyes. [de Bosque 1985, p. 169]

William Shakespeare, 1564–1616. (Iris recounts Miranda and Ferdinand's resistance to the temptations of Venus and Cupid in) *The Tempest* 4.1.86–100. Drama (romance). **1611.** First performed 1 Nov 1611, Whitehall, London. Published London: Jaggard, 1623 (First Folio). [Riverside 1974 / Brownlow 1977, p. 177]

———, and **John Fletcher,** 1579–1625. (Palamon prays for Venus's patronage in) *The Two Noble Kinsmen* 5.1.77–136 (this passage attributed to Shakespeare). Drama (romance), adaptation of Chaucer's "The Knight's Tale" (1380s–90s). *c.*1613. No recorded performance in Shakespeare's lifetime. Published London: Waterson, 1634. [Riverside 1974 / Brownlow 1977, pp. 202, 213f., 219 / Muir 1985, p. 74]

Peter Paul Rubens, 1577–1640. "The Toilet of Venus." Painting. *c.*1613–14. Liechtenstein Collection, Vaduz. [Jaffé 1989, no. 213—ill. / also Baudouin 1977, pl. 19]

———. "Toilet of Venus." Painting, copy after Titian (*c.*1552–55, Washington, etc.). *c.*1615. Thyssen-Bornemisza coll., Lugano. [Jaffé, no. 305—ill.]

———, figures, and **Jan Brueghel the Elder,** 1568–1625. (Venus [?] and Cupid in) "Allegory of Sight," "Allegory of Touch," "Allegory of Hearing," "Allegory of Smell." Paintings, in "The Five Senses" cycle. 1617–18. Prado, Madrid, inv. 1394, 1395, 1396, 1398. [Ibid., nos. 465–67, 469, pp. 28f.—ill. / Ertz 1979, nos. 327–29, 331—ill.] Copies by Jan Brueghel the Younger and unknown artist in Rubens's circle. *c.*1626. Private coll., U.S.A. [Ertz 1984, nos. 178–81, 182—ill.]

——— (Rubens). "Helena Fourment (as Aphrodite) in Furs." Painting. 1630s. Kunsthistorisches Museum, Vienna. [Jaffé, no. 1364—ill. / White 1987, p. 243, pl. 264 / also Baudouin, pl. 91]

———, school. "Venus and Cupid." Painting. Dulwich College Picture Gallery, London. [Wright 1976, p. 177]

———. *See also Johann Liss, below.*

Lavinia Fontana, 1552–**1614.** "Venus and Cupid." Painting (copy after Primaticcio?). Musée, Rouen (on deposit from Louvre, Paris, inv. 446). [Louvre 1979–86, 2:289]

Giovanni Battista Marino, 1569–1625. "Venere ignuda, di Fidia" [The Lost "Venus" of Phidias]. Sonnet. By **1614.** In *La galeria* (Venice: Ciotti, 1620). [Getto 1962]

William Drummond of Hawthornden, 1585–1649. "Sonnet upon a Sonnet." Sonnet, after G. B. Marino's "Venere ignuda" (above). In *Poems* (Edinburgh: Hart, **1614**). [MacDonald 1976, p. 29 / Bush 1963, p. 228]

———. "Like the Idalian Queene." Poem (madrigal). No. 3 in "Madrigals and Epigrammes" section of *Poems* (Edinburgh: Hart, 1616). [Bush]

Guercino, 1591–1666. "Venus Nursing Cupid." Fresco, for Casa Pannini, Cento. **1615.** Pinacoteca Civica, Cento. [Salerno 1988, no. 24I—ill. / Bagni 1984, p. 141—ill. / also Bologna 1968, 2: nos. 13–14—ill. (drawing)] Variant, painting ("Christian Charity"), lost; copy in Rijksmuseum, Amsterdam. [Salerno, no. 25—ill.]

———. "The Toilet of Venus." Painting. *c.*1622–23. Goethe Academy, Renaissance, Calif. [Ibid., no. 93—ill.] Copy in Kunstmuseum, Dusseldorf. [Ibid.] Another version of the subject in Pinacoteca Ambrosiana, Milan. [Warburg]

———. "Venus and Cupid." Fresco (detached), from Villa Giovannina, Cento. 1632. Accademia di San Luca, Rome. [Ibid., no. 144—ill.]

———. "Venus and Cupid." Painting, pendant to "Mars." Wellington Museum, London. [Ibid., no. 130—ill.]

Hans von Aachen, 1552–**1616.** "Bacchus, Venus, and Cupid." Painting. Kunsthistorisches Museum, Vienna, inv. 1132 (1512). [Hofmann 1987, no. 3.25—ill. / Vienna 1973, p. 3—ill.]

———. "Amor Fucatus" (Cupid, with Venus with attributes of the arts). Painting? / Engraving by Raphael Sadeler (*c.*1560/61–*c.*1628). [Hofmann, no. 7.36—ill.]

Scarsellino, 1551–**1620.** "The Bath of Venus" (earlier called "The Bath of Diana"). Painting. Galleria Borghese, Rome, inv. 219. [Pergola 1955–59, 1: no. 118—ill. / Berenson 1968, p. 391]

————. "Venus." Painting (ruined). Galleria Nazionale, Parma, no. 998. [Berenson, p. 390]

Francesco Albani, 1578–1660. Cycle of 4 paintings, depicting the rivalry of Venus and Diana: "Venus in Vulcan's Forge," "The Toilet of Venus," "Venus and Adonis," "Triumph of Diana." **1622.** Borghese Gallery, Rome, inv. 35, 40, 44, 49. [Pergola 1955–59, 1: nos. 1–4—ill. / also Shapley 1966–73, 3:73 / Augsburg 1975, no. E33—ill.] Variants of "Toilet of Venus." Prado, Madrid, no. 1; Louvre, Paris, inv. 9 (1623, retouched 1633, part of a series of Elements, representing Air). [Shapley / Prado 1985, p. 5 / Louvre 1979–86, 2:140—ill.] Copies of "Toilet of Venus" in Herzog Anton Ulrich-Museum, Braunschweig, no. 483; Musée, Saumur (on deposit from Louvre, Paris, no. 29). [Braunschweig 1969, p. 25 / Louvre, p. 283]

————. "Venus Resting." Painting. Uffizi, Florence, inv. 1414. [Uffizi 1979, no. P18—ill.]

————, or school. "Venus and Cupid in a Landscape." Painting. Fitzwilliam Museum, Cambridge, no. 168. [Fitzwilliam 1960–77, 2:1]

————, copy after. "Venus Caressing Cupids." Painting. Château de Fontainebleau (on deposit from Louvre, Paris, inv. 31). [Louvre 1979–86, 2:283]

————, copy after. "Venus in the Bath Surrounded by Cupids." Painting. Musée, Blois (on deposit from Louvre, Paris, inv. 32). [Ibid.]

Guido Reni, 1575–1642, and studio. "The Toilet of Venus." Painting, for Duke of Mantua, executed by Reni and/or studio after Reni's design. **1622.** National Gallery, London, inv. 90. [Pepper 1984, no. 83—ill. / London 1986, p. 522—ill.] Copies in Stourhead, Wiltshire; Alte Pinakothek, Munich, inv. 5232 (on loan to Stadtsgalerie, Augsburg); National Gallery, Malta, inv. 1699; 4 others unlocated. [Pepper]

————. "Venus (Reposing) with Cupid." Painting. 1639. Gemäldegalerie, Dresden, no. 324. [Pepper, no. 98—ill. / Dresden 1976, p. 86—ill.]

————, previously attributed. "Venus and Cupid." Painting. Earl of Portsmouth coll. [Pepper, p. 304 no. C15]

————, previously attributed. "Venus and Cupid" (old identification, now called "Ariadne Abandoned," attributed to Giacinto Gimignani). Painting. 1650–60. Uffizi, Florence, inv. 579. [Uffizi 1979, no. P709—ill.]

Thomas Heywood, 1573/74–1641. "Of Venus," passage in *Gynaikeion: or, Nine Books of Various History Concerning Women* book 1. Compendium of history and mythology. London: printed by Adam Islip, **1624.** [Ipso]

Johann Rottenhammer, 1564–**1625.** "Venus and Cupid." Painting. Szépmüvészeti Múzeum, Budapest, no. 57.1. [Budapest 1968, p. 592]

————. "Venus and Cupid" (? "Woman with a Little Cupid," "Allegory of Summer"). Painting. Hermitage, Leningrad, inv. 693. [Hermitage 1987b, no. 81—ill.]

————, style. "Venus and Minerva." Painting. Rijksmuseum, Amsterdam, inv. A3952. [Rijksmuseum 1976, p. 483—ill.]

Girolamo Campagna, 1549/50–**1625?** "Venus." Sculpture. / Copy, bronze statuette, in Museo di Capodimonte, Naples, no. 10649. [Capodimonte 1964, p. 111]

Nicolas Poussin, 1594–1665. "Venus and Mercury." Painting (allegory of the sovereignty of beauty and spiritual love in the arts?). **Mid-1620s.** Dulwich College Picture Gallery, London, no. 481. [Thuillier 1974, no. 32—ill. / Blunt 1966, no. 184—ill. / Wright 1985, no. 12, pl. 6] A fragment ("Concert of Love" [Cupids playing music]) in the Louvre, Paris, inv. 7299. [Thuillier—ill. / Blunt—ill. / Wright—ill. / Louvre 1979–86, 4:145—ill.] Copies in Musée de Lille; Museo Communale, Prato; 2 others known. [Blunt]

————, attributed. "Venus and the Shepherds" ("Venus Reposing, and Cupids"). Painting. Late 1620s. Staatliche Gemäldegalerie, Dresden, 721. [Wright, no. 34, pl. 121 / Dresden 1976, p. 82 / also Blunt, no. 189—ill. / Thuillier, no. B12—ill.] Copy in Kunstakademie, Vienna. [Blunt]

————, attributed. "Venus and Cupid." Painting. 1630s. Lost. / Engraving by Étienne Baudet, 1665. [Wright 1985, no. L29 / Blunt 1966, no. 187—ill. / Thuillier 1974, no. 122—ill.]

————. "Venus" ("Flora"). Design and wax model for marble term. 1655–56. Lost. / Marble executed by Jean-Baptiste Théodon, by 1661. Quinconce du Midi, Gardens, Versailles. [Girard 1985, pp. 273f. / Blunt, no. 227—ill.]

————. "Venus, Cupid, and Pan" ("Omnia vincit amor"). 2 drawings. Royal Library, Windsor Castle, nos. 11980, 11915. [Friedlaender & Blunt 1953, nos. 209–10—ill.]

————. "Venus at the Fountain." Drawing. 1662–65. Louvre, Paris, no. R.F. 762. [Ibid., no. 212—ill.]

————, questionably attributed. "Venus and Cupid" ("Amor vincit omnia"). Painting (copy after lost original?). c.1630? Hermitage, Leningrad. [Thuillier, no. 38—ill. / Wright, no. A15 / also Blunt, no. R59 (as "Hovingham Master")]

————, circle (formerly attributed to Poussin). "The Toilet of Venus." Painting. Worsley coll., Hovingham Hall, Yorkshire. [Blunt, no. R102 / Thuillier, no. R92—ill.]

————, formerly attributed (Pierre Mignard?). "The Triumph of Venus." Painting. Duke of Devonshire coll., Chatsworth. [Thuillier, no. R94 / also Blunt, no. R103]

Johann Liss, c.1595–1629 (previously attributed to Peter Paul Rubens, Jacob Jordaens). "Venus at the Mirror." Painting. **1624–26.** 2 versions. Uffizi, Florence, inv. 2179; Schönborn-Wiesentheid coll., Pommersfelden. [Augsburg 1975, nos. A28, D4—ill. / also Uffizi 1979, no. P883—ill.]

————. "The Toilet of Venus." Painting. Lost. / Copy, drawing. British Museum. [Augsburg, no. C59—ill.]

Jacob de Gheyn II, 1565–**1629.** "Venus and Amor." Painting. After 1600. Rijksmuseum, Amsterdam, inv. A2395. [Rijksmuseum 1976, p. 242—ill.]

Giovanni da San Giovanni, 1592–1636. "Venus Combing Cupid's Hair" ("Maternal Care"). Painting. c.1630. Palazzo Pitti, Florence, inv. 2123. [Uffizi 1979, no. P732—ill. / Pitti 1966, p. 129—ill. / also Banti 1977, no. 51—ill.]

————. "Juno, Venus, and the Three Fates: Allegory of the Union between the Houses of de' Medici and della Rovere." Ceiling fresco. 1635–36. Salone degli Argenti, Palazzo Pitti, Florence. [Banti, no. 64—ill.]

————. "Venus and Cupid." Fresco. Formerly Lanckoronsky coll., Vienna. [Ibid., no. 61]

Paulus Moreelse, 1571–1638. "Portrait of a Young Mother [Maria de Rohan, Duchess of Chevreuse] and Child as Venus and Amor." Painting. **1630.** Hermitage, Leningrad, cat. 1895 no. 744. [de Jonge 1938, no. 278—ill.]

————. "Venus with Two Doves." Painting. c.1633. 3 versions known. Léon Seijffers coll., Brussels, on loan to Centraal Museum, Utrecht; Centraal Museum, Utrecht, cat. 1933 no. 136 (fragment); another sold 1738, untraced. [Ibid., nos. 303, 334, 335—ill.]

————, formerly attributed. "The Grotto of Venus." Painting. 1602. Hermitage, Leningrad, cat. 1869. [Ibid., p. 135, no. 46]

Alessandro Turchi, 1578–1649. "Venus," "Cupid." Pendant paintings. *c.*1630. Art Institute of Chicago, nos. 64, 65. [Chicago 1965]

————. (Venus and Cupid in) "Allegorical Representation" (probably "The Power of Venus"). Painting. Mauritshuis, The Hague, inv. 342. [Mauritshuis 1985, p. 453—ill.]

John Donne, 1572–**1631.** (Complaint to Venus in) "The Indifferent." Poem. In *Poems* (London: Marriot, 1635). [Patrides 1985 / Pinka 1982, pp. 84, 87f.]

Jan Brueghel the Younger, 1601–1678, landscape, and **Hendrik van Balen,** 1575–**1632,** figures. "Allegory of Abundance" ("Nymphs Bringing Offerings to Venus"). Painting. Glasgow Art Gallery, Scotland, inv. 43. [Ertz 1979, pp. 389f.—ill. / Ertz 1984, no. 219—ill.]

———— (Brueghel). (Mercury in Venus's chariot in) "Allegory of the Topsy-Turvy World." Painting. Late 1640s? 3 versions known, unlocated. [Ertz 1984, nos. 224–26—ill.]

———— (Brueghel) and unidentified collaborator. (Venus in her chariot, in) "Allegory of Love." Painting. After 1648. Sold Amsterdam, 1971. [Ertz 1984, no. 236—ill.] Variant, by Brueghel. Galerie Brandt, Amsterdam, in 1976. [Ibid., no. 237—ill.]

———— (van Balen). "Fertility" (represented by Venus, with Cupid). Painting. Musées Royaux des Beaux-Arts (Musée d'Art Ancien), Brussels, inv. 16. [Brussels 1984a, p. 13—ill.]

Artemisia Gentileschi, 1593–1652/53, attributed. "Sleeping Venus." Painting. **Early 1630s.** Johnson coll., Princeton, N.J. [Garrard 1989, pp. 108f.—ill.]

Georg Petel, c.1590/93–**1634.** "Venus and Cupid." Ivory sculpture group. Ashmolean Museum, Oxford. [Clapp 1970, 1:693]

Simon Vouet, 1590–1649. "Allegory of Love and Abundance" (Bacchus, Venus, and Cupid). Ceiling decoration, for Château de Colombes. Lost. / Engraved by J. Boulanger, **1634.** [Crelly 1962, no. 237—ill.]

————. "The Toilet of Venus." Painting. c.1640? Carnegie Institute, Pittsburgh. [Ibid., p. 126ff., no. 125—ill.]

————. "Venus Threatened by Cupid," "Venus Testing the Arrows of Love." Paintings. Musée des Beaux Arts, Nancy. [Ibid., p. 87, nos. 71a, 71b—ill.]

————, attributed. "Venus (in the Clouds)." Painting. Szépmüvészeti Múzeum, Budapest, no. 704. [Ibid., no. 18 / Budapest 1968, p. 762 (as imitator)]

————, or studio. "The Toilet of Venus," "Venus and Cupid." Paintings, cartoons for "Loves of the Gods" tapestry series. [Crelly, nos. 270c, 2700]

————, circle. "Venus as Vanitas" ("The Toilet of Venus"). Painting. Gemäldegalerie, Berlin-Dahlem, no. 5/60. [Berlin 1986, p. 79—ill. / also Crelly, no. 117—ill. (questionably attributed to Vouet)]

Niccolo Roccatagliata, fl. 1593–**1636.** "Venus." Bronze statuette. Hermitage, Leningrad. [Hermitage 1975, pl. 32]

Jacques Blanchard, 1600–**1638.** "Venus and the Graces, Surprised by a Mortal" (earlier called "Cimon and Iphigenia"). Painting. Louvre, Paris, no. R.F. 2317. [Louvre 1979–86, 3:62—ill.]

Giovanni Biliverti, 1576–**1644.** "Venus Chained by Cupid." Painting. **1638.** Recorded in Cremer coll., Dortmund, before 1914, untraced. / Variant copy in Louvre, Paris, inv. 20225. [Louvre 1979–86, 2:153—ill.]

————. "Venus and Sleeping Cupid." Painting. 1641. Szépmüvészeti Múzeum, Budapest, no. 474. [Budapest 1968, p. 65]

Pietro da Cortona, 1596–1669. (Venus awakening in) "The Triumph of Divine Providence. . . ." Fresco. **1633–39.** Palazzo Barberini, Rome. [Briganti 1962, no. 45—ill.]

Orazio Gentileschi, 1563–**1639,** questionably attributed (also hesitantly attributed to Carlo Saraceni, 1579–1620, or Adam Elsheimer, 1578–1610). "Woman at Her Toilette" ("Venus"). Painting. Formerly Aldo Briganti coll., Rome. [Bissell 1981, no. X–26—ill.]

Francesco Manelli, 1594–1667, music. (Venus in) *La Delia, o sia La sera sposa del sole* [Delia, or the Evening Bride of the Sun]. Opera. Libretto, G. Strozzi. First performed **1639,** Teatro SS Giovanni e Paolo, Venice. [Grove 1980, 11:612f.]

Philippe de Buyster, 1595–1688. "Venus." Stone sculpture. **1635–40.** Château de Wideville, near Paris. [Chaleix 1967, pp. 32ff., pl. 5.3]

Anthony van Dyck, 1599–1641. "A Lady as Venus [with armor of Mars] with Cupid" (? also interpreted as Herminia putting on Corinda's armor). Painting. *c.*1636–40. Duke of Marlborough coll., England. [Larsen 1988, no. 1042—ill.]

Marin Le Roy de Gomberville, 1599–1674. *La Cythérée.* Romance. 1640. Paris: Courbé, 1642 (2d edition). [DLLF 1984, 2:958]

Domenichino, 1581–**1641,** attributed. "Reclining Venus." Painting. City Art Gallery, York, cat. 1961 no. 813. [Wright 1976, p. 51]

————, previously attributed. "Sleeping Venus." Painting. c.1602. Musée Condé, Chantilly. [Malafarina 1976, no. 126 (as Annibale Carracci)—ill.]

Jacob Jordaens, 1593–1678. (Venus and Cupid in) "February" ("Pisces"), "May" ("Gemini"). Ceiling paintings, part of "Signs of the Zodiac" series for artist's house in Antwerp. **Early 1640s.** Senate Library, Palais du Luxembourg, Paris. [Rooses 1908, pp. 124f. / also d'Hulst 1982, p. 230, fig. 156]

————. 8 cartoons for "The Riding School" tapestry series: "Levade Performed under the Auspices of Mars and in the Presence of Mercury," "Levade Performed under the Auspices of Mars and in the Presence of Mercury, Venus, and a Riding-master," "Mars and Mercury Leading Horses to Venus," 5 others (4 lost). c.1645. National Gallery of Canada, Ottawa; Marquess of Bath coll., Longleat, Wiltshire (2). [d'Hulst, pp. 232, 303, fig. 184] Tapestries woven by Leyniers & Rydams, Brussels, 1651. Kunsthistorisches Museum, Vienna. [Ibid., pp. 303f., fig. 185 / Ottawa 1968, no. 281—ill.]

————. "Venus Asleep" ("Cupid Observes Venus and Her Nymphs Asleep"). Painting. c.1645–50. Koninklijk Mu-

seum voor Schone Kunsten, Antwerp, no. 5023. [d'Hulst, p. 216, fig. 192 / Ottawa 1968, no. 98—ill. / Antwerp 1970, p. 117] Another version of theme, in West European Museum, Kiev. [d'Hulst]

——. *See also Johann Liss, above.*

Francesco Sacrati, 1605–1650, attributed. *Venere gelosa* [Venus Jealous]. Opera. Libretto, N. E. Bartolini. First performed **1643**, Teatro Novissimo, Venice. [Grove 1980, 16:377]

Johann Heinrich Schönfeld, 1609–1684. "The Triumph of Venus." Painting. *c.***1640–45.** Gemäldegalerie, Berlin-Dahlem, no. KFMV 1947. [Berlin 1986, p. 69—ill.]

Giovanni Lanfranco, 1582–**1647.** "Sleeping Venus." Painting. Suida coll., New York. [Pigler 1974, p. 245]

Padovanino, 1588–**1648.** "Venus [sleeping] and Cupid." Painting. Louvre, Paris, inv. 730. [Louvre 1979–86, 2:210—ill.] Another version of the subject in Musée, Grenoble. [Benezit 1976, 10:401]

——. "Triumph of Venus." Painting. Accademia Carrara, Bergamo. [Ibid.]

Govaert Flinck, 1615–1660. "Portrait of a Lady with a Child as Venus and Cupid." Painting. **1648**? Tel Aviv Museum. [von Moltke 1965, no. 102a—ill.] Replicas in Statens Museum for Kunst, Copenhagen, inv. 301; another unlocated. [Ibid., nos. 102b, 102c—ill. / Copenhagen 1951, no. 223—ill.]

——. "Venus and Amor." Drawing. Houthakker coll., Amsterdam. [von Moltke, no. D32—ill.]

——. "Venus and Amor." Drawing. Welcker coll., Prentenkabinet Rijksuniversiteit, Leiden, no. 514. [Ibid., no. D33—ill.]

——. Several further versions of the subject known, unlocated. [Ibid., nos. 103–06—ill.]

Robert Herrick, 1591–1674. "A Vow to Venus," "A Short Hymne to Venus." Poems. In *Hesperides* (London: Williams & Eglesfield, **1648**). [Martin 1956]

Thomas Stanley, 1625–1678. "Venus vigils." Poem, translation of the "Pervigilium Veneris." In *Europa, Cupid crucified, and Venus vigils* (London: Moseley, **1648**, bilingual edition). [Bush 1963, p. 247]

Franco-Flemish School (previously attributed to Francavilla). "Venus." Bronze statue. **1600/50.** Huntington Art Gallery, San Marino, Calif. [Frick 1968–70, 4:46]

Rombout Verhulst, 1624–1698. "Venus." Marble sculpture. *c.***1650.** Koninklijk Paleis, Amsterdam. [Clapp 1970, 1:885]

Volterrano, 1611–1689. "Venus Caressing Cupid." Painting. *c.***1650** or later. Staatsgalerie, Stuttgart. [Florence 1986, no. 1.227—ill.]

Diego Velázquez, 1599–1660. "Venus at Her Mirror" ("Toilet of Venus," "The Rokeby Venus"). Painting. *c.***1648–51.** National Gallery, London, no. 2057. [López-Rey 1963, no. 64—ill. / London 1986, p. 644—ill. / López Torrijos 1985, pp. 278ff.—ill.] 2 further representations of Venus listed in inventory of artist's estate, 1661, untraced. [López-Rey, nos. 65, 66]

Abraham Bloemaert, 1564–1651. "Venus and Cupid." Painting. Gemäldegalerie, Berlin-Dahlem, no. B135. [Berlin 1986, p. 15—ill.]

——, attributed. "Toilet of Venus." Painting. Tschuppik coll., Vienna, in 1934. [Warburg]

——. *See also Antonie van Blocklandt, above.*

Jean-Baptiste Lully, 1632–1687. Music for 4 entrées in *Ballet de la nuit*. Ballet. Libretto, Isaac de Bensérade. First performed 23 Feb **1653**, Palais, Petit Bourbon, Paris. [Grove 1980, 11:314, 327]

Samuel Twardowski, 1600–1660. "Cupid's Suicide" (caused by Lisbon lady's defeat of Venus). Poem, in *Nadobna Paskwalina* [The Comely Pasqualina] part 3. Pastoral romance (based on anonymous Spanish poem?). **1655.** In modern edition, *Five Centuries of Polish Poetry: 1450–1970* by J. Pietrkiewicz & Burns Singer (London: Oxford University Press, 1970). [Ipso]

Abraham van Cuylenburgh, before 1620–**1658.** "Venus and Cupid." 2 paintings. Centraal Museum, Utrecht, cat. 1952 nos. 71–72. [Wright 1980, p. 89]

Pedro Calderón de la Barca, 1600–1681. (Venus in) *La púrpura de la rosa* [The Blush of the Rose]. Zarzuela. Music, Juan Hidalgo. **1659.** First performed 5 Dec 1660, Buen Retiro, Madrid. Libretto published in *Comedias de Calderón*, part 3 (Madrid: 1664). [Valbuena Briones 1960–67, vol. 1 / O'Connor 1988, pp. 304–15]

Ferdinand Bol, 1616–1680. "Venus and Cupid." Painting. *c.***1661.** Staatliche Museen, Berlin. [Blankert 1982, no. 32—ill.]

Rembrandt van Rijn, 1606–1669. "Woman with the Arrow" ("Cleopatra"?—traditional title "Venus and Cupid" now rejected). Etching (Bartsch no. 202). **1661.** [White & Boon 1970, p. 98—ill.]

Leonhard Kern, 1588–**1662.** "Sleeping Venus." Soapstone or plaster statuette. Staatliche Kunstsammlungen, Kassel. [Pigler 1974, p. 245]

Gerhard van Bronckhorst, 1637–1673. "Venus with Cupid." Painting. **1662.** Szépművészeti Múzeum, Budapest, no. 5099. [Budapest 1968, p. 98]

Augustin Terwesten, 1649–1711/17. "Minerva Incites Pictura to Paint Venus." Painting. **1663.** Castle Grunewald, inv. I 1552. [Warburg]

Antonio del Castillo, 1616–1668. "Venus and Cupid." Drawing. **1664.** Courtauld Institute, London. [López Torrijos 1985, p. 419 no. 19—ill.]

Carel van Savoy, *c.*1621–**1665.** "Venus and Cupid." Painting. Musée, Bordeaux. [Pigler 1974, p. 252]

Cornelis van Poelenburgh, *c.*1586–**1667.** "Venus in a Landscape." Painting. City Art Gallery, Bristol, cat. 1970 no. K1345. [Wright 1976, p. 161]

Wybrand Symonsz de Geest, 1592–**after 1667**, attributed. "Venus and Cupid." Painting. Hofje van Aerden, Leerdam, cat. 1978 no. 8. [Wright 1980, p. 135]

Charles-Alphonse Dufresnoy, 1611–**1668.** "Venus Sleeping." Painting. Formerly Dabrovska coll., Warsaw. [Bénézit 1976, 3:723]

——. "Toilet of Venus." Painting. Sold Paris, 1899, unlocated. [Ibid.]

Sebastián de Herrera Barnuevo, 1619–1671. "Venus and Cupid." Drawing. *c.***1660–70.** Courtauld Institute, London. [López Torrijos 1985, p. 418 no. 18—ill.]

Bartholomeus van der Helst, 1613–1670, "Venus with the Apple." Painting. Museé des Beaux-Arts, Lille. [Warburg]

——, questionably attributed. "Venus and Cupid."

Painting. Statens Museum for Kunst, Copenhagen, inv. 3213. [Copenhagen 1951, no. 307—ill.]

René-Antoine Houasse, c.1645–1710. "Venus in a Chariot Pulled by Doves." Ceiling painting. **Early 1670s.** Salon de Vénus II, Appartement du Roi, Château de Versailles. [Berger 1985, pp. 41ff., 70] Decorations in the first Salon de Vénus (by Charles Nocret and/or Pierre de Sève) and the Salon de Vénus in l'Appartement de la Reine (by Nocret) were destroyed in renovation, c.1678–79. [Ibid.]

Jean de La Fontaine, 1621–1695. (Venus in) *Daphné.* Libretto for opera-ballet. **1674.** Commissioned for Jean-Baptiste Lully, but rejected, unperformed. Published in *Poème du quinquina et autres ouvrages en vers* (Paris: Thierry & Barbin, 1682). [Clarac & Marmier 1965]

————. (Venus and Cupid in) "L'Amour et la Folie" [Love and Folly]. Verse fable (book 12 no. 14). In *Ouvrages de prose et de poésie des sieurs de Maucroix et de La Fontaine* (Paris: Garnier, 1685); reprinted in *Fables choisies* (Paris: 1693). [Ibid. / Spector 1988 / Moore 1954]

Luca Giordano, 1634–1705. "Venus and Cupid." Painting. **c.1670–75?** Duke of Devonshire coll., Chatsworth, Derbyshire. [Ferrari & Scavizzi 1966, 2:323—ill.]

————. "The Triumph of Venus," detail in "Allegory of Human Life and the Medici Dynasty." Fresco. 1682–83. Palazzo Medici Riccardi, Florence. [Ibid., 2:112f.]

————. "Venus and Cupid with a Maidservant," "Venus and Cupid" (with a woman holding doves). Paintings. Recorded in Rosso coll., Florence, in 1677, untraced. [Ibid., 2:330f.]

————. "Bacchanal of Venus and Diana." Painting. Recorded in 1688, untraced. [Ibid., 2:363]

————, attributed. "The Triumph of Venus." Painting. Musée des Beaux-Arts, Douai, no. 159, in 1919. [Ibid., 2:325]

————, attributed (also attributed to Corrado Giaquinto, 1699–1765). "Venus and Cupid." Painting. Walker Art Gallery, Liverpool. [Ibid., 2:293]

————. *See also Sebastiano Ricci, below.*

Jan de Duyts, 1629–**1676.** "Venus and Cupid." Painting. Musées Royaux des Beaux-Arts (Musée d'Art Ancien), Brussels, inv. 7109. [Brussels 1984a, p. 94—ill.]

————. "Venus and Cupid." Painting. Herzog Anton Ulrich-Museum, Braunschweig, no. 150. [Braunschweig 1969, p. 54]

Jan van Noort, 1620–c.1676. "Venus and the Three Graces." Painting. Dienst Verspreide Rijkskollekties, The Hague, inv. NK1697. [Wright 1980, p. 347]

John Smith. *Cytherea, or The Enamouring Girdle.* Comedy. **1677.** Unperformed. [Harbage 1964, pp. 176f.]

Cesar Boetius van Everdingen, c.1617?–**1678.** "Venus and Amor." Painting. Stedelijk Museum, Alkmaar, cat. 1932 no. 24. [Wright 1980, p. 119]

————, attributed. "Venus and Amor." Painting. Bisschoppelijk Museum, Haarlem, inv. 95. [Ibid.]

Onorio Marinari, 1627–1715. "Venus Victorious." Painting. c.1670–80? Uffizi, Florence, inv. SMeC 110. [Uffizi 1979, no. P1000—ill.]

Frans van Mieris the Elder, 1635–**1681.** "Venus and Cupid with Two Amorini." Painting. Wallace Collection, London, no. P639. [Wright 1976, p. 136]

Daniel Vertangen, c.1598–**1681/84.** "Venus and Cupid in

a Landscape." Painting. Museum Bredius, The Hague, inv. 17–1892. [Wright 1980, p. 473]

Charles Le Brun, 1619–1690, design. "Venus" ("Noon"). Marble statue. Executed by Gaspard Marsy, **1675–84.** Parterre du Nord, Gardens, Versailles. [Girard 1985, p. 272—ill.]

Jean Jouvenet, 1644–1717. "Venus on a Cloud, Visited by Zephyr [or Flora]." Ceiling painting, for Hôtel de Saint-Poulange, Paris. c.1681–84. [Schnapper 1974, no. 17] Drawing (for?). Nationalmuseum, Stockholm, no. THC4594. [Ibid., no. 152—ill.]

Raymond de La Fage, c.1650–**1684.** "Toilet of Venus." Drawing. Duke of Devonshire coll., Chatsworth, no. 702. [Warburg]

John Dryden, 1631–1700. (Venus as nature goddess in) "Lucretius: The Beginning of the First Book." Translation from *De rerum natura* 1.1–40. In *Sylvae,* part 2 of Tonson's *Miscellany* (London: Tonson, **1685**). [Dryden 1956–87, vol. 3 / Winn 1987, pp. 402f., 511f.]

————. (Venus as nature goddess in) "The Secular Masque." Masque. Music, Daniel Purcell. First performed as part of Vanbrugh's *The Pilgrim,* 29 Apr 1700, Theatre Royal, Drury Lane, London. [Kinsley 1958, vol. 4 / Winn, p. 511 / Grove 1980, 15:475]

Antoine Coysevox, 1640–1720. "Venus Crouching." Marble sculpture. **1686.** Louvre, Paris. [Chappuis 1973, p. 149—ill.]

Pietro Liberi, 1614–**1687.** "Venus and Cupid." Painting. Kunsthistorisches Museum, Vienna, inv. 1642 (441). [Vienna 1973, p. 99—ill.]

David Teniers the Younger, 1610–**1690.** "Venus and Cupid." Painting. Stedelijk Museum 'De Lakenhal,' Leiden, cat. 1949 no. 673. [Wright 1980, p. 448]

Godfried Schalcken, 1643–1706. "Sleeping Venus and Cupid." Painting. **1690?** Národní Galeri, Prague, no. 193. [Warburg]

Georg Bronner, 1667–1720. *Venus, oder Die siegende Liebe* [Venus, or The Conquering Love]. Opera. First performed **1694,** Hamburg. [Grove 1980, 3:331]

Vicente Salvador Gomez, 1645?–**1698?** "Venus Embracing Cupid," "Venus and Cupid" (with other studies). Drawings. Prado, Madrid, nos. F.D. 351, F.D. 850. [López Torrijos 1985, p. 419 nos. 20, 21—ill.]

Johann Carl Loth, 1632–**1698.** "Venus and Sleeping Amor." Painting. Wallace Collection, London, cat. 1920 no. 181. [Warburg]

Sebastiano Ricci, 1659–1734. "Venus and Cupid." Ceiling fresco (detached), part of "The Olympian Gods" cycle, from Palazzo Mocenigo-Robilant, Venice. **1697–99.** Gemäldegalerie, Berlin-Dahlem, on loan from German government. [Daniels 1976, no. 45—ill. / Berlin 1986, p. 64—ill.]

————. "Venus, Cupid, and Vulcan." Painting. c.1697–99? Hermitage, Leningrad, no. 9517. [Daniels, no. 132—ill.]

————. "Venus and Cupid." Painting. c.1713. Chiswick House, London. [Daniels, no. 171—ill.]

————. "Venus (Surrounded by Nymphs [or Graces?]) Watching a Dance of Cupids." Painting. After 1716. Louvre, no. M.I. 866. [Daniels, no. 298 / Louvre 1979–86, 2:227—ill.]

————, attributed. "Venus and Cupids." Painting. E. Viancini coll., Venice, in 1973. [Daniels, no. 489]

———— (previously attributed to G. B. Tiepolo). "The Toilet of Bathsheba" ("The Toilet of Venus"). Painting. *c.*1725. Gemäldegalerie, Berlin, no. 454. [Ibid., no. 41—ill. / Morassi 1962, p. 5 / Berlin 1986, p. 62—ill.]

————, attributed. "Sleeping Venus and Two Cupids." Painting. Duke of Devonshire coll., Chatsworth, Derbyshire. [Warburg]

Adriaen van der Werff, 1659–1722. "Venus Seated with a Bowl of Fruit, Cupid at Her Feet." Painting. **1699.** Gemäldegalerie, Dresden. [Warburg]

————. "Amor Kissing Venus." Painting. Rijksmuseum, Amsterdam, inv. A466. [Rijksmuseum 1976, p. 600—ill.]

————. "Venus and Cupid." Painting. Wallace Collection, London, no. P151. [Wright 1976, p. 220]

————. "Venus and Cupid." Painting. Castle Museum and Art Gallery, Nottingham, inv. 33.245. [Ibid.]

Italian School. "Venus and Two Cupids." Painting. **17th century.** Musée, Libourne (on deposit from Louvre, Paris, inv. 861 *bis*). [Louvre 1979–86, 2:306]

Netherlandish School. "Venus" ("Eve"). Bronze statuette. **17th century.** Frick Collection, New York, no. 16.2.62. [Frick 1968–70, 4:46—ill.]

North Netherlandish School. "Portrait Bust of Venus." Painting. **17th century.** Academie voor Hoger Bouwkundig Onderwijs, Amsterdam, cat. 1976 no. A2519c. [Wright 1980, p. 309]

Alessandro Scarlatti, 1660–1725. *Venere ed Amore.* Serenata for 2 voices, instruments. First performed *c.*1695–**1700,** Casino del Vicerè a Posillipo (?), Naples. [Grove 1980, 16:560]

————. *Venere, Amore e Ragione: Il ballo delle ninfe* [Venus, Cupid, and Reason: The Dance of the Nymphs]. Serenata for 3 voices and instruments. Text, S. Stampiglia. First performed 1706, Rome. [Ibid.]

Italian School. "Sleeping Venus, and Angel Musicians." Painting, decoration on harpsichord lid. **17th century or later.** Metropolitan Museum, New York, no. 89.4.1231. [Metropolitan 1980, p. 95—ill.]

John Nost, fl. 1678–1729. "The Car of Venus" (drawn by Cupids). Chimney-piece relief. *c.*1700. Cartoon Gallery, Hampton Court Palace. [Whinney 1964, p. 61, pl. 47]

Florentine School? (previously attributed to Volterrano). "Venus and Cupid." Painting. **Late 17th/early 18th century.** Uffizi, Florence, inv. SMeC 86. [Uffizi 1979, no. P1509—ill.]

Noël Coypel, 1628–1707, attributed, design. "The Triumph of Venus." Tapestry, part of "Triumphs of the Gods" series. Woven by Gobelins, 1705–13. Examples in Mobilier National, Paris; Palazzo Pitti, Florence; French Academy, Rome. [Warburg]

Antoine Watteau, 1684–1721. "Allegory of Spring" (Venus or Flora, with playing infants). Drawing. *c.*1708–09 or *c.*1713. Art Institute of Chicago. [Grasselli & Rosenberg 1984, no. D.13—ill.]

————. "The Triumph of Venus." Painting. 1712–15? Lost. / Print by P. Mercier. [Camesasca 1982, no. 54—ill.]

Matthew Prior, 1664–1721. "Venus Mistaken," "Cupid Mistaken." Poems. In *Poems on Several Occasions* (Lon-

don: Tonson, **1709**). Modern edition by A. R. Waller (Cambridge: Cambridge University Press, 1905). [Ipso]

Johannes Voorhout, 1647–1723. "Venus and Cupid in the Clouds." Painting. By **1710.** Herzog Anton Ulrich-Museum, Braunschweig, no. 293. [Braunschweig 1969, p. 144]

Jonathan Swift, 1667–1745. (Venus in) "Cadenus and Vanessa." Poem. **1712–13.** Dublin: 1726; collected in *Works* (Dublin: Faulkner, 1735). [Williams 1958, vol. 2]

————. (Venus in) "The Storm; Minerva's Petition" (to Neptune). Satirical poem. 1722. In *Poems on Several Occasions* (London: for J. Bromage, 1749). [Ibid., vol. 1]

Augustin Terwesten, 1649–**1711/17.** "Venus and Cupid." Painting. Herzog Anton Ulrich-Museum, Braunschweig, no. 295. [Braunschweig 1969, p. 133]

Benedetto Luti, 1666–1724. "Venus Reclining with Cupid." Painting. *c.***1717.** Ringling Museum of Art, Sarasota, Fla., inv. SN164. [Sarasota 1976, no. 140—ill.]

Jakob Kremberg, *c.*1650–*c.***1718?** *Venus, oder Die siegende Liebe* [Venus, or Triumphant Love]. Opera. Libretto lost. [Grove 1980, 10:252]

François Le Moyne, 1688–1737. "Triumph of Venus" (? or "Olympus"). Painting, sketch for an unexecuted ceiling decoration. *c.***1718–19.** Louvre, Paris, inv. 6718. [Bordeaux 1984, no. 22—ill. / also Louvre 1979–86, 4:47 (as "Olympus")—ill.] Replica. Rochelmayer coll., Mainz. [Bordeaux, fig. 18a]

————. "Venus Showing Cupid the Zeal of Her Arrows." Painting, for Hôtel Peyrenc de Moras (Hôtel Biron, now Musée Rodin), Paris. 1729–30. Lost. [Ibid., no. 81] Drawing in Louvre, Paris. [Ibid., no. D.119—ill.]

————. "Venus and Cupid." Painting. Lost. [Ibid., p. 130]

————. "Venus with Putti." Painting. Lost. [Ibid., p. 129]

————, tentatively attributed. "The Toilet of Venus." Painting. Palais de Monaco. [Ibid., no. 104—ill.]

————, formerly attributed (style of Cazes). "The Toilet of Venus." Painting. Musée des Beaux-Arts, Le Havre. [Ibid., no. X1—ill.]

————, rejected attribution. "Venus and Cupid with Diana." Painting. University of Notre Dame Art Gallery, Indiana. [Ibid., no. X4—ill.]

Carlo Cignani, 1628–1719. "Triumph of Venus." Fresco. Palazzo del Giardino, Parma. [Pigler 1974, p. 265]

Paul Heermann, 1673–1732. "Reclining Venus." Marble sculpture. *c.***1720?** Albertinum, Dresden. [Asche 1966, no. H26, pl. 94]

————. "Venus and Cupid." Sandstone sculpture. *c.*1720–25. Pheasant-preserve, Moritzburg. [Ibid., no. H22, pl. 101]

Herman Collenius, 1650–**1720/21.** "Venus Caressing Amor," "Venus Punishing Amor." Paintings. Nationaal Rijtuigmuseum, Leek, inv. P2, P3. [Wright 1980, p. 80]

Benjamin Thomae, 1682–1751. "Venus and Cupid." Sandstone statue. **1721–23.** Schlosspark, Neschwitz. [Asche 1966, no. T29d, pl. 147]

François Collin de Blamont, 1690–1760. *La toilette de Vénus.* Cantata. Published in *Cantates françoises à voix seule, avec simphonie et sans simphonie,* book 1 (Paris: **1723**). [Grove 1980, 4:563]

Daniel Gran, 1694–1757. "Venus and Cupid." Fresco. **1723–24.** Kuppelsaal, Gartenpalais Schwarzenberg, Vienna. [Knab 1977, pp. 42ff., no. F5—ill.]

————. "Evening" (Ceres, or Venus?). Fresco. 1726–30. Nationalbibliothek, Vienna. [Ibid., pp. 50ff., no. F20—ill.]

Giovanni Battista Foggini, 1652–**1725,** attributed. "Venus and Cupid." Bronze statuette. Sold Christie's, London, 1899, untraced. [Montagu 1968, p. 173—ill.]

Giovanni Battista Tiepolo, 1696–1770. "Venus with a Mirror." Painting. *c.*1725–26. Gerli coll., Milan. [Pallucchini 1968, no. 39—ill. / Morassi 1962, p. 27] Another version of the subject ("Toilet of Venus"), attributed to Tiepolo, in City Museum and Art Gallery, Plymouth. [Wright 1976, p. 200]

————. "Juno with Fortuna and Venus." Fresco. 1731. Formerly Palazzo Archinto, Milan, destroyed 1943. [Pallucchini, no. 61—ill. / Morassi, p. 25—ill.]

————. "Allegory of Venus Entrusting an Infant [Cupid? Aeneas?] to Time." Ceiling painting, for Ca' Contarini, Venice. Before 1758. National Gallery, London, inv. 6387. [Levey 1986, pp. 267f. / London 1986, p. 612—ill. / also Morassi, pp. 18, 71]

————. "(Allegory with) Venus and Apollo." Painting, presumed study for unknown ceiling fresco. *c.*1762–66. Heinemann coll., New York. [Pallucchini, no. 282—ill. / Morassi, p. 35—ill.]

————. "Triumph of Venus" ("Olympus") (Venus in her chariot, surrounded by gods). Fresco, for Imperial Court, St. Petersburg. *c.*1762–70. Lost. / Sketch. Prado, Madrid, no. 365. [Pallucchini, no. 281—ill. / Morassi, p. 21—ill. / Prado 1985, p. 680]

————. "Chronos (Time) Entrusting Cupid to Venus." Painting. *c.*1762–70. Pinto-Basto coll., Lisbon. [Morassi, p. 16—ill. / Pallucchini, no. 297—ill. / also Levey, pp. 268f.—ill.]

————, previously attributed (now attributed to Francesco Chiaruttini, 1748–1796). "Triumph of Venus." Fresco (detached), from Villa Steffaneo, Crauglio. Bardini coll., Florence. [Morassi, p. 12—ill.]

————, previously attributed (now attributed to Sebastiano Ricci, 1659–1734). "The Toilet of Bathsheba" ("The Toilet of Venus"). Painting. *c.*1725. Gemäldegalerie, Berlin, no. 454. [Ibid., p. 5 / Berlin 1986, p. 62—ill.]

————, follower. "Triumph of Venus." Ceiling painting. Château de la Princesse Faucigny-Lucinge, Vaux-de-Penil, Melun. [Morassi, p. 53—ill.]

Antonio Bellucci, 1654–**1726.** "Venus Resting, with Cupid Feeding Doves." Painting. Gemäldegalerie, Dresden. [Bénézit 1976, 1:609]

Noël-Nicolas Coypel, 1690–1734. "Venus, Bacchus, and Cupid." Painting. **1727.** Louvre, Paris, inv. 3527. [Louvre 1979–86, 3:175—ill.]

Marcantonio Franceschini, 1648–**1729.** "Sleeping Venus, with Cupid." Painting. Liechtenstein coll., Vaduz. / Copy in Szépmüvészeti Múzeum, Budapest, no. 842. [Budapest 1968, p. 240]

Johann Franz Michael Rottmayr, 1654–**1730.** "Venus with Doves and the Anvil (Forge) of Vulcan." Art Institute of Chicago, no. 61.40. [Chicago 1965]

James Thomson, 1700–1748. "The Venus de' Medici." Poem. In *The Seasons* (London: Millan, **1730**). [Larrabee 1943, p. 159]

————. "The Venus de Medici," part 4 of *Liberty.* Poem. London: Millar, 1735–36. [Ibid., p. 81]

Louis Fabritius Dubourg, 1693–1775. "Venus, Cupid, and Time [Cronus]." Painting. **1731.** Gemäldegalerie, Wiesbaden, no. 68. [Warburg / Bénézit 1976, 3:692]

François Boucher, 1703–1770. "Venus and Cupid." Painting. **1732.** Lost. / Prints by Boucher and others. [Ananoff 1976, no. 84—ill.]

————. "Venus Sleeping on a Couch." Painting. *c.*1734. Lost. / Prints by Michel Aubert and Nicolas Dufour ("Cupid Sleeping"). [Ibid., no. 97—ill.] Copy in Metropolitan Museum, New York, no. 07.225.260, in 1976. [Ibid.]

————. "The Sleep of Venus," "Venus and Cupid." Pendant paintings. *c.*1735. Musée Jacquemart-André, Paris, nos. 14, 15. [Ibid., nos. 121–22—ill.]

————. "Sleeping Venus." Painting. *c.*1735–36. Pushkin Museum, Moscow, no. 732. [Ibid., no. 124—ill.]

————. "Venus Entering the Bath." Painting. *c.*1738. Lost. / Print by Michel. [Ibid., no. 155—ill.]

————. "Venus Descending from Her Chariot to Enter the Bath." Overdoor painting. Exhibited 1738. Archives Nationales, Paris. [Ibid., no. 163—ill.]

————. "Cupid Bathing" (entering a pool, guided by Venus). Painting. 1739. Lost. / Print by Dugy. [Ibid., no. 172—ill.]

————. "The Sleep of Venus." Painting. *c.*1739. Baron Maurice de Rothschild coll., Paris. [Ibid., no. 173—ill.]

————. "Cupid Caresses His Mother." Painting. *c.*1739. Private coll., New York. [Ibid., no. 242—ill.] Gouache replica, for theater décor. Hermitage, Leningrad, no. 39595. [Ibid., no. 242.1—ill.]

————. "The Toilet of Venus." Painting. *c.*1740. Count Alfred Potocki coll. [Ibid., no. 174—ill.]

————. "The Triumph of Venus." Painting. 1740. Lost. [Ibid., no. 180—ill.]

————. "Venus, Cupid, and Two Followers." Painting. *c.*1741? Private coll., New York. [Ibid., no. 153—ill.]

————. "The Bath of Venus" (Venus and a companion splashed by 2 amorini). Oil sketch. *c.*1742. Private coll., New York. [Ibid., no. 198—ill.]

————. "The Toilet of Venus." Painting. 1742. Rothschild coll., Paris. [Ibid., no. 237—ill.]

————. "Venus and Cupid" ("Venus Resting"). Painting. *c.*1742. Gemäldegalerie, Berlin-Dahlem, no. KFMV272. [Berlin 1986, p. 17—ill. / also Ananoff, no. 217—ill.]

————. "The Toilet of Venus." Painting. 1743. Private coll., New York. [Ibid., no. 244—ill.] Replica, by Boucher and studio. Hermitage, Leningrad, inv. 7656. [Ibid. / Hermitage 1986, no. 11—ill.]

————. "Venus and Cupid." Painting. *c.*1743. Private coll., Paris. [Ibid., no. 250—ill.]

————. "Venus Intoxicating Cupid." Painting. *c.*1743. Lost. Prints by M. Dupont, F. Basin? ("Cupid Drunk on Nectar"). [Ibid., no. 251—ill.] Drawing. Nationalmuseum, Stockholm, no. 2947/1862. [Ibid.—ill.]

————. "Cupid Offering an Apple to Venus." Painting, pendant to a "Judgment of Paris." 1744. Lost. / Copy, by Jacques Chartier, in private coll., Paris. [Ibid., no. 269—ill.]

————. "The Toilet of Venus." Painting. 1746. Nationalmuseum, Stockholm. [Ibid., no. 299—ill.]

————. "The Toilet of Venus." Painting. 1749. Louvre, Paris, inv. no. R.F. 288. [Ibid., no. 330—ill. / Louvre 1979–86, 3:81—ill.]

————. "The Chariot of Venus." Painting. c.1750. Gardner Museum, Boston, no. P18w5. [Ibid., no. 356—ill. / Hendy 1974, p. 45—ill.]

————. "The Toilet of Venus." Painting. 1751. Metropolitan Museum, New York, no. 20.155.9. [Ananoff, no. 376—ill. / also Metropolitan 1980, p. 16—ill. / Metropolitan 1983, p. 172—ill.]

————. "Venus Consoling Cupid." Painting. 1751. National Gallery of Art, Washington, D.C., no. 739. [Ibid., no. 377—ill. / Sienkewicz 1983, p. 26—ill. / Walker 1984, p. 332—ill.]

————, design. "Venus and Cupids." Tapestry, part of "Fragments from Opera" series. Woven by Beauvais, 1752. Unlocated. [Ananoff, no. 387—ill.]

————. "Cupid Offering an Apple to Venus." Painting. 1754. Wallace Collection, no. P.411. [Ibid., no. 433—ill.]

————. "Fountain of Venus" (Venus receiving the apple from Cupid). Painting. 1756. Cleveland Museum of Art, Ohio, no. 79.55. [Cleveland 1982, no. 23 (first publication)—ill.]

————. "The Triumph of Venus." Painting (cartoon for tapestry?). c.1758. Musée de Picardie, Amiens. [Ibid., no. 485—ill.] 2 maquettes (medallions by Boucher on background by Maurice Jacques). Musée des Gobelins, no. GOB 28–29. [Ibid.]

————. "Venus Sleeping." Painting. c.1765. Private coll. [Ibid., no. 610—ill.]

————. Cycle of paintings depicting Cupid, amorini, and attributes of Venus and Cupid (doves, arrows, torch, quiver), decorations for salon of Gilles Demarteau, Paris. c.1765. Musée Carnalet. [Ibid., nos. 620–25—ill.]

————. "Venus and Cupids." Painting. 1767. Cole coll., Harrison, N.Y. [Ibid., no. 646—ill.]

————. "Venus and Cupid." Painting. 1769. Lucius P. Green coll., Los Angeles. [Ibid., no. 678—ill.]

————, attributed. "Venus and Cupid in the Clouds." Painting. Lady Lever Art Gallery, Port Sunlight, Cheshire. [Wright 1976, p. 23]

————, circle. "Triumph of Venus." Painting. Muzeum Narodowe, Warsaw, inv. 127679, on display at Myslewicki Palace. [Warsaw 1969, no. 137—ill.]

Gerard Hoet the Elder, 1648–1733. "Triumph of Venus in a Chariot Drawn by Swans." Painting. Bayerische Staatsgemaldesammlungen, Munich, inv. 6617. [Warburg]

Seedo, c.1700–c.1754, music. *Venus, Cupid, and Hymen.* All-sung masque. First performed 21 May 1733, Theatre Royal, Drury Lane, London. [Grove 1980, 17:101 / Fiske 1973, p. 124]

Karl Gustav Klingstedt, 1657–1734. "Venus." Painting. Wallace Collection, London. [Bénézit 1976, 6:246]

Michiel van der Voort, 1667–1737. "Venus and Cupid." Stone sculpture. Koninklijk Museum voor Schone Kunsten, Antwerp, no. 5029. [Antwerp 1970, p. 253]

Alexander Pope, 1688–1744. "Horace His Ode to Venus." Poem, imitation of Horace. Poem. First published in folio, 1737; collected in *Works*, vol. 2 (London: 1938). [Twickenham 1938–68, vol. 4 / Mack 1985, pp. 672–74]

Elizabeth Singer Rowe, 1674–1737. "On Love" (prayer to Venus Genetrix). Poem. In *Poems by Mrs. Elizabeth Singer* (London: Curll, 1737). [Marshall 1987, pp. 35f., 188]

Davide Perez, 1711–1778. *Il trionfo di Venere.* Serenata. First performed 1738, Palermo. [Grove 1980, 14:367]

Pierre-Charles Trémollière, 1703–1739. "Venus and Cupid." Painting. Szépmüvészeti Múzeum, Budapest, no. 664. [Budapest 1968, p. 708]

Georg Raphael Donner, 1693–1741. "Venus." Lead statue. c.1739. Österreichisches Barockmuseum, Vienna, inv. 2430; Szépmüvészeti Múzeum, Budapest; Kunsthistorisches Museum, Vienna; Hermitage, Leningrad; Herzog Anton Ulrich-Museum, Braunschweig. [Schwarz 1968, no. 15]

Antonio Balestra, 1666–1740, questionably attributed. "Venus and Cupid." Painting. Herzog Anton Ulrich-Museum, Braunschweig, no. 657. [Braunschweig 1969, p. 30]

Henry Desmarets, 1661–1741. *La toilette de Vénus.* Cantata. Text, Henault. Published in *Oèuvres inédités de M. le président Henault* (Paris: 1806). [Grove 1980, 5:392]

Herman van der Myn, 1684–1741. "Venus and Cupid." 2 paintings. Art Gallery and Christchurch Mansion, Ipswich. [Wright 1976, p. 144]

Giovanni Antonio Pellegrini, 1675–1741. "Sleeping Venus." Painting. Private coll., U.S.A., in 1964. [Pigler 1974, p. 245]

Charles-Joseph Natoire, 1700–1777. "Venus Awakening." Painting. 1741. Kleinberger coll., Paris, in 1904. [Boyer 1949, no. 58]

————. "Venus at Her Toilet," "Venus at the Fountain." Pendant paintings. 1742. "Toilet" in Musée des Beaux-Arts, Bordeaux, inv. 1971.2.14; "Fountain" sold Paris, 1942, unlocated. [Ibid., nos. 61, 62 / also Troyes 1977, no. 32—ill.] 2 further "Toilets of Venus" known, sold 19th century, untraced. [Boyer, nos. 66, 115]

————. "Goddess with the Attributes of Venus, Flora, and Leda." Painting. Musée, Valenciennes, no. 99. [Ibid., no. 112]

————. "Venus and Cupid." Painting. Sold Paris, 1913, unlocated. [Ibid., no. 117]

Gilles-Marie Oppenord, 1672–1742, circle (formerly attributed to Pierre Puget). "Sleeping Venus." Bronze sculpture. Museum of Fine Arts, Houston. [Herding 1970, no. 122]

Carl Heinrich Graun, 1703/04–1759. *Venere e Cupido.* Opera. Libretto, G. G. Botarelli. First performed 6 Jan 1742, Schlosstheater, Potsdam. [Grove 1980, 7:646]

Nicholas Lancret, 1690–1743, rejected attribution. "The Toilet of Venus." Painting. Musée, Clamecy, in 1924. [Wildenstein 1924, no. 727]

————. "Venus, Accompanied by Cupids, on the Clouds." Painting. Sold 1776, untraced. [Ibid., no. 726]

Pierre Gobert, 1662–1744. "Portrait of a Woman as Venus." Painting. Museum of Fine Arts, Boston, no. 17.3220. [Boston 1985, p. 119—ill.]

Charles-Michel-Ange Challe, 1718–1778. "Sleeping Venus." Painting. 1744. Herzog Anton Ulrich-Museum, Braunschweig, no. 538. [Braunschweig 1969, p. 43]

Jean-Baptiste Lemoyne, 1704–1778. "Venus and Cupid." Marble fountain figures. 1744. Princesse de Poix coll., Paris. [Réau 1927, no. 14—ill.]

———. "Venus" (leaving the bath). Bronzed plaster sculpture. Before 1761. Formerly Louvre, Paris. [Réau 1927, no. 19; cf. p. 154 no. 21]

Willem van Mieris, 1662–**1747.** "Venus and Cupid." Painting. Koninklijk Museum voor Schone Kunsten, Antwerp, no. 738. [Antwerp 1970, p. 165]

———. "Venus with the Apple and Cupid." Wallace Collection, London, no. P181. [Wright 1976, p. 136]

Francesco Solimena, 1657–**1747.** "Venus and Cupid." Painting. Galleria di Capodimonte, Naples, no. 837. [Capodimonte 1964, p. 59]

Jean-Baptiste Pigalle, 1714–1785. "Venus (Giving a Message to Mercury)." Marble statue, pendant to "Mercury Fastening His Talaria." **1748.** Kaiser Friedrich Museum, Berlin. [Réau 1950, no. 2, pl. 5] Stone replica. Paul Gouvert coll., Paris. [Ibid., pl. 4]

Pierre de La Garde, 1717–*c.*1792, music. "La toilette de Vénus," act 1 of *La journée galante.* Opéra-ballet. Libretto, Pierre Laujon. First performed 25 Feb **1750,** Versailles. [Grove 1980, 10:359f.]

———. *Vénus retrouvée.* Cantata. Published Paris: 1757? [Ibid.]

French School. "Venus and Cupid." Painting. **Mid-18th century.** Louvre, Paris, no. M.I. 1427. [Louvre 1979–86, 4:312—ill.]

Corrado Giaquinto, 1703–1765. (Venus and Cupid in) "Apotheosis of the Spanish Monarchy" (?). Ceiling painting, for Palazzo Santa Croce, Palermo. Now in Palazzo Rondinini-Sanseverino, Rome. *c.*1751? / Study. National Gallery, London, inv. 6229. National Gallery, London, inv. 6229. [London 1986, p. 232—ill.]

———. (Venus in) "Triumph of the Sun God Apollo and Bacchus." Ceiling painting. Mid-1700s. Salón de Columnas, Palacio Real, Madrid. [Honisch 1965, pp. 39f.]

———. (Venus in) "The Birth of the Sun and the Triumph of Bacchus." Painting. Prado, Madrid, inv. 103. [Prado 1985, p. 243]

———, attributed (also attributed to Luca Giordano). "Venus and Cupid." Painting. Walker Art Gallery, Liverpool, no. 3419 (as Giaquinto). [Wright 1976, p. 105 / Ferrari & Scavizzi 1966, 2:293]

Michele Rocca, *c.*1670/75–**1751** or later. "Venus Pulling a Thorn from Cupid's Foot." Painting. Herzog Anton Ulrich-Museum, Braunschweig, no. 1123. [Braunschweig 1969, p. 115]

Jean-Honoré Fragonard, 1732–1806. "Venus Awakening" ("Dawn"). Painting. **1748–52.** Private coll. [Wildenstein 1960, no. 25—ill.]

———. "The Triumph of Venus" ("Toilet of Venus"). Oil sketch, study for a ceiling. 1748–52. Musée des Beaux-Arts, Besançon. [Ibid., no. 84—ill. / also Rosenberg 1988, p. 224—ill.]

———. "Venus and Cupid ("Day," "Venus Offering Crowns"). Painting, for Pavillion de Louveciennes. Dated variously before 1756, 1765–70. National Gallery of Ireland, Dublin, no. 4313. [Rosenberg, p. 328—ill. / Wildenstein, no. 295—ill. / Dublin 1981, p. 54—ill.]

———. "The Toilet of Venus." Painting. 1765–72. Private coll. [Wildenstein, no. 314—ill.]

———. "Marie-Catherine Colombe as Victorious Venus." 2 paintings. 1773–76. Los Angeles County Museum of Art; private coll., United States. [Ibid., nos. 416, 418—ill.]

———. "Venus Refusing Cupid a Kiss" ("Sappho Entreated by Cupid," "Mlle Colombe as Cupid"). Painting. 1773–76. Private coll., New York. [Ibid., no. 429—ill.]

———. "Venus Receiving the Apple." Painting. 1773–76. Lost. [Ibid., no. 431]

———. "Anacreon Crowned by Venus." Drawing with watercolor. C. Groult coll., Paris. [Réau 1956, p. 191—ill.]

———. "The Toilet of Venus." Drawing with watercolor. Cabinet des Dessins, Louvre, Paris. [Ibid.]

Jacopo Amigoni, 1675–**1752.** "Venus and Cupid." Painting. Molinari-Pradelli coll., Bologna. [Martini 1964, pl. 56]

———. "Sleeping Venus in a Landscape with Amoretti." Painting. Sold London, 1978. [Warburg]

Jacob de Wit, 1695–**1754.** "Mercury Bringing a Hero Before Venus." Painting. Rijksmuseum, Amsterdam, inv. A4659. [Rijksmuseum 1976, p. 609—ill.]

———. "Venus Refusing Cupid a Kiss" ("Sappho Entreated by Cupid," **Jean-Georges Noverre,** 1727–1810, choreography. *La toilette de Vénus.* Ballet. Music, Joseph Starzer (or François Granier). First performed before Sep 1758 (?), L'Opéra, Lyons. [Grove 1980, 7:636, 18:82 / Oxford 1982, p. 306 / Lynham 1950, p. 165]

Louis-Claude Vassé, 1716–1772. "Venus Directing Cupid's Darts." Sculpture group. **1758.** Château de Versailles. [Versailles 1949, p. 84]

Hendrik van Limborch, 1681–**1759.** "Venus and Cupid." Painting. Gemäldegalerie, Dresden, no. 1357. [Pigler 1974, p. 252]

Antonio Guardi, 1698–**1760.** "The Triumph of Venus." Cycle of 4 paintings: "Venus Looking in the Mirror" (seated in her chariot), "Cupids Carrying Venus's Carriage," "Cupids with Flowers," "Cupids Making Arrows" (in Vulcan's forge). **1750–60.** Italian Embassy, Paris. [Morassi 1984, nos. 79–82—ill.]

———. "Venus and Cupid." Fresco. Ca' Rezzonico, Venice. [Ibid., no. 87—ill.]

Louis de Silvestre the Younger, 1675–**1760,** studio. "Venus at Her Toilet." Painting. Muzeum Narodowe, Warsaw, inv. Wil. 1131 (524), on display at Wilanów Palace. [Warsaw 1969, no. 1209—ill.]

Carle van Loo, 1705–**1765.** "Venus and Cupid." Painting. Musée Municipal, Alençon. [Bénézit 1976, 6:729f.]

———. "Venus and Cupids." Painting. Öffentliche Kunstsammlung, Basel. [Ibid.]

———. "The Bath of Venus." Painting. Hermitage, Leningrad. [Ibid.]

———. "Venus and Cupid." Painting. Heylshof, Worms. [Ibid.]

Benjamin West, 1738–1820. "Venus and Cupid." Painting. *c.***1765.** The Parthenon, Nashville, Tenn. [von Erffa & Staley 1986, no. 128—ill.] Another version of this subject recorded; lost. [Ibid., no. 129]

Christophe-Gabriel Allegrain, 1710–1795. "Venus Entering the Bath." Marble statue. **1766.** Louvre, Paris, no. 884. / Bronze reduction. After 1767. Hirshhorn Museum and Sculpture Garden, Washington, D.C. [Hirshhorn 1974, p. 658, pl. 11 / also Royal Academy 1968, no. 793]

Nicolas-Guy Brenet, 1728–1792. "Cupid Caressing Venus." Painting. **1766.** [Bénézit 1976, 2:297]

Augustin Pajou, 1730–1809. "Venus, Surrounded by Cu-

pids." Wood sculpture group. **1769–70.** Foyer, Salle de l'Opéra, Versailles. [Stein 1912, pp. 182ff., 402f.—ill.]

Joshua Reynolds, 1723–1792. "Venus Chiding Cupid for Learning to Cast Accompts." Painting. Exhibited **1771.** Kenwood House, London. [Waterhouse 1941, p. 61 / Pressly 1981, pl. 23] Variant. 1776. Lady Lever Art Gallery, Port Sunlight, Cheshire. [Waterhouse, p. 67]

————. "Venus and Cupid." Painting. Exhibited 1785. Formerly Lord Castletown coll., sold 1924. [Waterhouse, p. 76] 2 replicas. Unlocated. [Ibid.]

————. "Nymph [or Venus] and Cupid" ("Snake in the Grass"). Painting. Exhibited 1784. Tate Gallery, London, no. 885. [Waterhouse, p. 75—ill.] Replica ("Cupid Untying the Zone of Venus"). 1788–89. Hermitage, Leningrad, inv. 1320; others in Sir John Soane's Museum, London; private colls. [Hermitage 1984, no. 110—ill. / also Hermitage 1979, pls. 126–27]

————. "Venus and Piping Boy." Painting. Polesden Lacey, near Dorking, Surrey. [Jacobs & Stirton 1984b, p. 25]

Gottfried August Bürger, 1747–1794. "Die Nachtfeier der Venus" [The Vigil of Venus]. Poem, translation of the "Pervigilium Veneris." In *Der teutsche Merkur* **1773.** [Oxford 1986, p. 649 / Butler 1958, pp. 161f.]

Niccolò Jommelli, 1714–**1774.** *Oh come oltre l'osato (Venere ed Amore)* [Oh, How Far Beyond the Dared (Venus and Amor)]. Cantata. [Grove 1980, 9:694]

Pompeo Batoni, 1708–1787. "Venus Caressing Cupid." Painting. **1774.** Unlocated. [Clark 1985, no. 370—ill.] Variant, 1784. Museum of Western and Oriental Art, Odessa. [Ibid., no. 451]

————. "Venus and Cupid." Painting. National Gallery of Ireland, Dublin, no. 704. [Dublin 1981, p. 7—ill.]

Antoine François Callet, 1741–1823. "The Toilet of Venus," "Night Strewing Flowers and Genii Harnessing Doves to the Chariot of Venus." Paintings, part of ceiling decoration for Palais-Bourbon, Paris. **1774.** Louvre, Paris, inv. 572. [Louvre 1979–86, 3:95—ill.]

Louis Simon Boizot, 1743–1809. "Triumph of Beauty." Sculpture. **1776.** [Warburg]

Giuseppe Canziani, choreography. *Venere in Cipro* [Venus in Cyprus]. Ballet. Music, Felice Alessandri. First performed 30 Jan **1779,** La Scala, Milan. [Grove 1980, 1:244]

John Singleton Copley, 1738–1815. "Venus and Cupid." Painting. *c.*1779. Museum of Fine Arts, Boston. [Prown 1966, 2:458—ill.]

Étienne-Maurice Falconet, 1716–1791, attributed. "Venus and Cupid." Series of marble statuettes depicting Venus nursing, chastising, consoling, instructing Cupid, other poses. **1770–80.** Wallace Collection, London; private colls. [Levitine 1972, pp. 44f.—ill. / also Réau 1922, pp. 505ff., pls. 15–19 / Agard 1951, fig. 9]

————. "Venus in the Bath." Marble sculpture. Louvre, Paris. [Kocks 1981, no. 215—ill.]

————. "Venus." Sculpture. Formerly Pierpont Morgan coll., New York. [Réau 1922, pl. 17—ill.]

————, attributed. "Venus with a Dove." Sculpture. Formerly Pierpont Morgan coll. [Ibid., pl. 18—ill.]

Louis-Jean-François Lagrenée, 1725–1805. "Venus Worshiping Love." Painting. *c.*1770–80. Wadsworth Atheneum, Hartford, inv. 1983.1. [Seen by author, 1987]

Friedrich von Schiller, 1759–1805. "Der Venuswagen" [The

Chariot of Venus]. Poem. **1776–80.** First published anonymously in *Os magna sonaturum* (Stuttgart: Metzler, 1781), later suppressed by the author. In *Gedichte* (Leipzig: Crusius, 1800–03). [Petersen & Beissner 1943 / Oxford 1986, p. 926]

Angelica Kauffmann, 1741–1807. "Venus Attended (Attired) by the Graces." Painting. Exhibited Royal Academy, **1781.** [Manners & Williamson 1924, p. 238] Other versions of the subject in Earl of Rosebery coll., London (possibly identical with 1781 work); 12 Grosvenor Sq., London. [Ibid., pp. 48, 134]

————. "The Mirror of Venus." Painting. / Engraved by Trotter, 1787. [Ibid., p. 226]

————. "Venus and Cupid, Who Has Wounded Euphrosyne with an Arrow." Painting, for Lord Barwick. 1793. [Ibid., pp. 164, 173]

————. "The Triumph of Venus." Painting. Unlocated. [Ibid., pp. 180, 219—ill.]

————. "The Marchioness Townsend [as Venus?] and Her Son as Cupid." Painting. Marquis of Exeter coll., Burghley House, Stamford. [Ibid., p. 188] Reduced replica or variant. Countess of Yarborough coll., Brocklesby Park, Lincolnshire. [Ibid., p. 214—ill.]

————. "Venus." Ceiling painting, from Ashburton House. Formerly Litchfield Gallery, London. [Ibid., p. 195]

Charles Monnet, 1732–after 1808. "Venus Leaving the Bath." Drawing. **1781.** [Bénézit 1976, 7:487]

————. "Venus Leaving the Bath." Drawing. [Ibid.]

Giovanni Battista Cipriani, 1727–1785. "Venus Binding Her Hair with a Garland, Attended by Cupids." Watercolor, design for a benefit ticket. Victoria and Albert Museum, London, no. 97–1892. [Lambourne & Hamilton 1980, p. 64]

————. "Venus Reclining on a Cloud, Embracing Cupid and Holding His Bow in Her Left Hand." Drawing. Victoria and Albert Museum, London, no. E.152–1948. [Ibid., p. 65]

Antonio Canova, 1757–1822. "Venus with a Mirror." Painting. *c.*1785. Gipsoteca Canoviana, Possagno, no. 7. [Pavanello 1976, no. D3—ill.]

————. "Venus and Infant Cupid(s)." Painting. 1789. Gipsoteca Canoviana, Possagno, no. 43. [Ibid., no. D4—ill.]

————. "Venus Playing with Cupid." Wax sculpture (sketch). *c.*1789. Gipsoteca Canoviana, no. 45. [Licht 1983, p. 232—ill. / Pavanello, no. 38—ill.]

————. "The Graces and Two Amorini Dancing befoe an Image of Venus." Painting. *c.*1797. Museo Civico, Bassano del Grappa, no. 7. [Pavanello, no. D75—ill. (cf. nos. 105, D68)] Related relief and painting ("Venus and the Graces Dancing before Mars"). 1797. Gipsoteca Canoviana, Possagno, nos. 98–99. [Ibid., nos. 105, D68—ill. / also Licht, pp. 256–62—ill.]

————. "Cupid, Having Wounded a Nymph, Flies to Venus." Painting. 1790s. Museo Civico, Bassano del Grappa, no. 107. [Pavanello, no. D42—ill.]

————. "Venus with Cupid." Painting. 1798–99. 2 versions. Gipsoteca Canoviana, Possagno, nos. 44, 46. [Ibid., nos. D23–24—ill.]

————. "Paolina Borghese Bonaparte as Venus Victorius." Marble sculpture. 1804/08. Galleria Borghese, Rome, inv. 54. [Ibid., no. 165—ill. / Licht, pp. 130–43—ill. / Faldi 1954,

no. 44—ill.] Plaster model (headless). Gipsoteca Canoviana, Possagno, no. 191. [Pavanello, no. 166—ill.]

———. "Venus Italica." Marble statue. 1804–12. Galleria Palatina, Palazzo Pitti, Florence. [Ibid., no. 168—ill. / Licht, pp. 191ff.—ill. / also Pitti 1966, p. 217—ill. / Janson 1985, fig. 47] Variant ("Venus"). 1807–10. Residenzmuseum, Munich. [Pavanello, no. 170—ill. / Licht—ill.]

———. "(The Lansdowne) Venus." Marble statue, variant of "Venus Italica." 1811–14. L. Berkman coll., New York. [Licht, pp. 191–93—ill. / also Pavanello, no. 171—ill.]

———. "(The Hope) Venus." Marble statue, variant of "Venus Italica." 1817–20. City Art Gallery, Leeds. [Pavanello, no. 309—ill. / Licht, pp. 191–93—ill.] Plaster model. Possagno, no. 210. [Pavanello, no. 310—ill.]

Johan Tobias Sergel, 1740–1814. "Venus Leaving the Bath." Marble statue. **1785?** Nationalmuseum, Stockholm, no. 694. [Göthe 1921, no. 35—ill.] Terra-cotta sketch. Stockholm, no. 493. [Ibid., no. 34—ill.]

John Deare, 1759–1798. "Venus." Sculpture. **1787.** Parkham Park, Sussex. [Clapp 1970, 1:204]

Carl Michael Bellmann, 1740–1795. (Triumph of Venus evoked in) "Blåsen mi alla" [Sound the Horns]. Poem, in rococo pastoral style. In *Fredman's såner* [Fredman's Songs] (Stockholm: Zetterberg, **1791**). [Algulin 1989, p. 60]

Fedosii Shchedrin, 1751–1825. "Venus." Marble statue. **1792.** [Kennedy 1983, pp. 198, 205, pl. 10.3]

François Guérin, ?–1791/93? "Venus [and Cupid] and Nymphs." Painting. Hermitage, Leningrad, inv. 8419. [Hermitage 1986, no. 72—ill.]

William Wordsworth, 1770–1850. (Venus in) "The Birth of Love." Poem. *c.*1794. In Juvenilia MS, with Vale of Esthwaite. [De Selincourt 1940–66, vol. 1]

Francesco Chiaruttini, 1748–**1796** (previously attributed to G. B. Tiepolo, 1696–1770). "Triumph of Venus." Fresco (detached), from Villa Steffaneo, Crauglio. Bardini coll., Florence. [Morassi 1962, p. 12—ill.]

Bernhard Rode, 1725–**1797.** "Venus and Cupid." Painting. Szépmüvészeti Múzeum, Budapest, no. 62.11. [Budapest 1968, p. 582]

Johann Gottfried Herder, 1744–1803. (Venus speaks in) "Huld und Liebe" [Homage and Love]. Poem. In *Zerstreuter Blätter* no. 6 (Gotha: Ettinger, **1797**). [Herder 1852–54, vol. 13]

Gavin Hamilton, 1723–**1798.** "Toilet of Venus with Three Graces and Three Cupids." Painting. Private coll., Scotland. [Warburg]

Pierre-Paul Prud'hon, 1758–1823. (Venus representing) "Pleasure." Painting, for Hôtel Lanois, Paris. **1796–99.** Rothschild coll., Schloss Schlechsdorf, Austria. [Guiffrey 1924, pp. 294ff., no. 802] Sketch. Musée, Montpellier. [Ibid., no. 806]

——— and **Constance Mayer,** 1775–1821. "Sleeping Venus and Cupid Awakened by Loves" ("The Sleep of Psyche"). Painting, executed by Mayer under Prud'hon's direction. Exhibited 1806 (as by Mayer, as "The Sleep of Psyche"). Wallace Collection, London, no. 348 (as Prud'hon, "The Sleep of Psyche"). / Studies, by Prud'hon. Musée Condé, Chantilly, no. 422; elsewhere. [Ibid., nos. 197–201]

——— and Mayer. "The Torch of Venus." Painting, exe-

cuted by Mayer under Prud'hon's direction. Exhibited 1808 (as by Mayer). / Study, by Prud'hon. Musée Condé, Chantilly, no. 421. [Ibid., no. 202]

——— (Prud'hon). "Venus Bathing" ("Innocence"). Painting. Louvre, Paris, no. R.F. 3696. [Louvre 1979–86, 4:151—ill. / Guiffrey, no. 178—ill.] Sketch. D. Weill coll. [Guiffrey, no. 179] Numerous drawings of the subject known. Musée Bonnat, Bayonne; others in private colls. or unlocated. [Guiffrey, nos. 180–88]

———. "Venus, Hymen, and Cupid." Painting, grisaille sketch, unfinished. Musée National des Beaux-Arts, Algiers, on deposit in Louvre, Paris (no. D.L. 1970–18). [Louvre, 5:10—ill. / also Guiffrey, no. 190] Another version of the subject known, unlocated. [Guiffrey, no. 189]

———. "The Triumph of Venus." Painting, unfinished sketch. Sold 1919, unlocated. [Ibid., no. 196; cf. nos. 194–95]

German School. "Venus and Cupid." Painting. **18th century.** Herzog Anton Ulrich-Museum, Braunschweig, no. 1204. [Braunschweig 1976, p. 21]

Italian School. "Venus with Putti." Painting. **18th century.** Bowes Museum, Barnard Castle, cat. 1970 no. 440. [Wright 1976, p. 105]

French School. "Venus and Cupid." Terra-cotta sculpture. **Late 18th century.** Brinsley Ford coll., London. [Royal Academy 1968, no. 823]

Italian School. "Venus Gathering Apples in the Gardens of Hesperides." Painting. Before **1800.** Duwich College Picture Gallery, cat. 1953 no. 260. [Wright 1976, p. 107]

Bertel Thorwaldsen, 1770–1844. "Venus and Cupid." Statuette. Plaster original, *c.*1800. Thorwaldsens Museum, Copenhagen, no. A13. [Thorwaldsen 1985, p. 22 / also Cologne 1977, p. 155—ill. / Hartmann 1979, pl. 61.3]

———. "Venus." Marble statue. 3 versions, 1805–17. Art Museum, Kaunas, Lithuania; Statens Museum for Kunst, Copenhagen; 1 unlocated. [Cologne, no. 16]

———. "Venus with the Apple Awarded by Paris." Marble statue, variant of above. 5 versions, *c.*1816–28. Thorwaldsens Museum, Copenhagen, no. A853 (A11); Hearst Castle, San Simeon, Calif.; Duke of Devonshire coll., Chatsworth; private coll.; unlocated. [Cologne, no. 66, p. 103—ill. / also Thorwaldsen 1985, p. 82, pl. 18 / Hartmann, pp. 63—ill.] Plaster original. 1813/16. Thorwaldsens Museum, no. A12. [Thorwaldsen, p. 21 / Hartmann, pl. 60]

———. "Venus and Cupid." Sculptural sketch. 1827? Hirschsprungske Samling, Copenhagen. / Plaster cast. Thorwaldsens Museum, no. Dep. 23. [Thorwaldsen, p. 88 / Hartmann, pp. 164f.—ill. / also Cologne, p. 160—ill.]

Luigi Pampaloni, 1791–1847. "The Toilet of Venus." Stucco bas-relief. **Early 19th century.** Saletta da Bagno, Palazzo Pitti, Florence. [Pitti 1966, p. 240—ill.]

Antonio Tozzi, *c.*1736–after 1812. *El triunfo de Venus.* Cantata. First performed Oct **1802,** Barcelona. [Grove 1980, 19:105]

Ugo Foscolo, 1778–1827. (Venus celebrated in) "Ode all' amica risanata" [Ode to the Smiling Friend]. Ode. In *Poesie* (Milan: **1803**). In modern edition by Mario Puppo, *Opere* (Milan: Mursia, 1966). [Cambon 1980, pp. 122–29]

———. (Venus as mother of the Graces in) *Le Grazie* part 1. Poem, unfinished. 1814. Florence: 1848. Modern edition by Saverio Orlando, *Le Grazie, carme ad Antonio*

Canova (Brescia: Paideia, 1974). [Cambon, pp. 193–99, 224ff., 346]

Louis-Joseph Francoeur, 1738–**1804.** "Le bouquet de Vénus." Cantatille. [Grove 1980, 6:794]

Henry Fuseli, 1741–1825. "Venus and Cupid." Drawing. **1800–05.** Huntington Library and Art Gallery, San Marino, California. [Schiff 1973, no. 1374]

————. "Venus Sleeping, and Cupid." Drawing. 1808. City of Auckland Art Gallery, New Zealand, inv. 1965–63. [Ibid., no. 1812—ill.]

Lord Byron, 1788–1824. (Venus evoked, "Venus de' Medici" praised, in) *Childe Harold's Pilgrimage* 1.66, 4.49–53. Poem. London: Murray, **1812.** [McGann 1980–86, vol. 2 / Larrabee 1943, pp. 158–63]

Louis La Chapelle, choreography. *Venus Revenged by Her Son, or A Day of Love.* Ballet pantomime. First performed 7 Oct **1812,** Schouwberg, Amsterdam. [Winter 1974, pp. 203f.]

John Flaxman, 1755–1826. "Venus Presents Cupid to Jupiter." Drawing, part of series illustrating Hesiod's *Theogony.* **1807–14.** / Engraved by William Blake, published London: Longman & Co., 1817. [Irwin 1979, p. 90 / Flaxman 1872, 7: pl. 27]

Francesco Bartolozzi, 1727–**1815.** "Venus Reclining on a Bank Strewn with Drapery." Watercolor. Victoria and Albert Museum, London, no. D.764. [Lambourne & Hamilton 1980, p. 22—ill.]

Andrea Appiani the Elder, 1754–**1817.** "Venus and Cupid," "Hercules and Venus." Paintings. Château, Compiègne. [Bénézit 1976, 1:236]

Piat Joseph Sauvage, 1744–**1818.** "Venus and Cupid." Painting. Metropolitan Museum, New York, no. 07.225.265. [Metropolitan 1980, p. 168—ill.]

Percy Bysshe Shelley, 1792–1822. "Homer's Hymn to Venus." Translation of first Homeric Hymn to Aphrodite, lines 1–55, with omissions. Early **1818.** In *Relics of Shelley,* edited by Richard Garnett (London: Moxon, 1862). [Hutchinson 1932 / Webb 1976, pp. 10f., 70, 107–08]

————. (Asia takes on qualities of Aphrodite in) *Prometheus Unbound* 2.20–28. Dramatic poem. London: Ollier, 1820. [Zillman 1968 / Wassermann 1971, pp. 276–78]

João Baptista da Silva Leitão Almeida Garret, 1799–1854 *O retrato de Venus* [Portrait of Venus]. Poem. Coimbra: Universidade, **1821.** [Sharp 1933, p. 94]

Jean-Auguste-Dominique Ingres, 1780–1867. "Recumbent Venus." Painting, copy of Titian's "Venus of Urbino" (Uffizi). **1822.** Walters Art Gallery, Baltimore, inv. 37.2392. [Walters 1982, no. 5—ill. / also Wildenstein 1954, no. 149]

————, figures, and **Alexandre Desgoffe,** landscape. "Venus at Paphos." Painting, unfinished. Louvre, Paris, no. R.F. 1981–39. [Louvre 1979–86, 3:326—ill.]

Heinrich Heine, 1797–1856. (Venus, statue of Venus de' Medici, evoked in) *Die Harzreise* [Journey through the Harz]. Satiric idyll in prose. Halle: Hendel, [**1824**]. [Windfuhr 1975–82, vol. 6 / Butler 1958, pp. 254, 260]

Francisco Goya, 1746–1828. "Nude Reclining against Rocks" ("Venus"). Miniature painting. **1824–25.** Museum of Fine Arts, Boston, no. 63.1081. [Gassier & Wilson 1981, no. 1688—ill. / Gudiol 1971, no. 739—ill.]

————. *Note:* Goya's "Naked Maja" and "Clothed Maja"

(1897, Prado, Madrid) were called "Venus" by several observers in the early 1800s. [Gassier & Wilson, p. 165, nos. 743–44 *n.*]

Charles Paul Landon, 1760–**1826.** "Venus Aphrodite and Eros." Painting. Musée des Beaux-Arts Jules Chéret, Nice. [Bénézit 1976, 6:419]

Joseph Mallord William Turner, 1775–1851. "Reclining Venus." Painting. **1828.** Tate Gallery, London, no. 5498. [Butlin & Joll 1977, no. 296—ill.]

Johann Wolfgang von Goethe, 1749–1832. "An Venus." Poem. In *Gedichte der Ausgabe letzter Hand* (Stuttgart: Cotta, **1827–30**). [Beutler 1948–71, vol. 2]

Francesco Hayez, 1791–1882. (The ballerina Carlotta Chabert as) "Venus Playing with Two Doves." Painting. **1830.** Museo Nazionale, Trento. [Coradeschi 1971, no. 131—ill.]

————. "Venus and Cupid." Painting. 1832. Private coll., Pavia. [Ibid., no. 155]

Nicolas de Courteille, 1768–after 1830. "Venus and Cupids." Painting. Hermitage, Leningrad, inv. 8314. [Hermitage 1983, no. 90—ill.]

José María de Heredia y Campuzano, 1803–1839. "A la estrella de Venus" [To the Star of Venus]. Poem. In *Poesías,* 2d revised edition (Toluca, Mexico: **1832**). [LAW 1989, 1:137]

John Gibson, 1790–1866. "Venus Verticordia." Sculpture. Several versions, **1833** and later. Formerly Grittleton House, Wiltshire; City Art Gallery, Manchester; elsewhere? [Read 1982, pp. 140f. / Bénézit 1976, 4:714]

————. "The Tinted Venus." Painted marble statue, based on above. 1851–56. Walker Art Gallery, Liverpool. [Read, pp. 25f., 141—ill. / also Beattie 1983, pl. 1 / also Minneapolis 1978, fig. 2]

Erwin Speckter, 1806–**1835.** "The Singing Contest" ("Minerva, the Muses, Venus and Cupid"). Wax-painting on plaster. Kunsthalle, Hamburg, inv. 2592. [Hamburg 1969, p. 397]

Carl Loewe, 1796–1869. "Eis Aproditen" [Ice Aphrodite]. Song, in *6 Lieder,* opus 9.9. Text, C. von Blankensee's translation of Sappho. **1835.** Leipzig: 1836. [Grove 1980, 11:128]

William Dyce, 1806–1864. "The Descent of Venus." Painting. **1835–36?** 2 versions. Aberdeen Art Gallery, Scotland; Ella Dyce coll. in 1940. [Pointon 1979, p. 198]

Johann Baptist Lampi the Younger, 1775–**1837.** "Venus." Painting. Szépművészeti Múzeum, Budapest, no. 453. [Budapest 1968, p. 370]

Charles Boulanger de Boisfremont, 1773–**1838.** "Venus and Cupid." Painting. Museum der Bildenden Künste, Leipzig. [Bénézit 1976, 2:124]

William Hilton the Younger, 1786–**1839.** "Venus, Diana, and Nymphs." Painting. Wallace Collection, London. [Bénézit 1976, 5:547]

John Sterling, 1806–1844. "Aphrodite." Poem. In *Poems* (London: Moxon, **1839**). [Boswell 1982, p. 297]

Thomas Crawford, 1813–1857. "Venus as Shepherdess." Marble relief. *c.*1840. Museum of Fine Arts, Boston. [Gerdts 1973, p. 80, fig. 54]

Eduard Mörike, 1804–1875. "Auf Aphrodite." Translation of second Homeric Hymn to Aphrodite. In *Classische Blumenlese* (Stuttgart: Schweizerbart, **1840**). [Hötzer 1967]

Horatio Greenough, 1805–1852. "Venus." Marble sculpture. **1837–41.** Boston Athenaeum. [Gerdts 1973, pp. 23, 80, fig. 57]

Frederik Paludan-Müller, 1809–1876. *Venus.* Dramatic poem. Copenhagen: Reitzel, **1841.** [CEWL 1973, 3:284]

François-Joseph Bosio, 1769–1845. "Venus in Her Chariot." Sculpture. [Bénézit 1976, 2:194]

Antoine-Louis Barye, 1796–1875. (Venus, with Minerva and Juno, in) "Candelabrum of Nine Lights." Bronze candlestick. *c.*1847. Walters Art Gallery, Baltimore. [Benge 1984, pp. 150f.—ill.] Variant of Venus figure ("Nereid"), in edition of bronze statuettes. Baltimore; elsewhere. [Ibid., fig. 147]

Narcisse-Virgile Diaz de la Peña, 1808–1876. "Venus and Two Cupids" ("The Offspring of Love"). Painting. **1847.** National Gallery, London, inv. 3246. [London 1986, p. 157—ill.]

———. "Venus and Cupid (I)," "Venus and Cupid (II)." Paintings. *c.*1847. Museum of Fine Arts, Boston, nos. 03.738–39. [Boston 1985, p. 83—ill.]

———. "Venus and Cupid." Painting. 1857. Hermitage, Leningrad, inv. 3861. [Hermitage 1983, no. 136—ill.]

———. "Venus and Cupid." Painting. 1850s. Hermitage, inv. 9962. [Ibid., no. 137—ill.]

———. "Venus and Cupid." Painting. 1850s. Hermitage, inv. 8141. [Ibid., no. 138—ill.]

William Etty, 1787–1849. "The Toilet of Venus," "Venus and Cupid." Paintings. City Art Gallery, York. [Jacobs & Stirton 1984b, p. 223]

———, attributed. "Venus Reclining." Painting. [Bénézit 1976, 4:211]

Charles Marie René Leconte de Lisle, 1818–1894. "Vénus de Milo." Poem, after Théodore de Banville's poem, "A la Muse grecque." In *Oeuvres: Poèmes antiques* (Paris: Lemerre, **1852**). [Pich 1976–81, vol. 1 / Denommé 1973, pp. 32f., 83]

———. "Parfum d'Aphrodite, la myrrhe" [Myrrh, the Perfume of Aphrodite]. Poem, no. 5 of "Hymnes orphiques," verse translation from Orphic Hymns. In *Oeuvres: Derniers poèmes* (Paris: Lemerre, 1895). [Pich, vol. 4 / Hurtado Chamorro 1967, p. 53]

Eugène Delacroix, 1798–1863. "Venus." Painting, for Salon de la Paix, Hôtel de Ville, Paris. **1849–53.** Destroyed 1871. [Robaut 1885, no. 1144—ill. (copy drawing)]

Ivan Vitali, 1794–1855. "Venus." Marble statue. **1852–53.** Russian Museum, Leningrad. [Kennedy 1983, pp. 205, 259, pl. 10.11]

Honoré Daumier, 1808–1879. "Cupid and His Mother." Comic lithograph. **1853.** [Delteil 1906–30, 26: no. 2432—ill.]

Henri Fantin-Latour, 1836–1904. "Venus and Cupid." Painting. **1854.** Ottin coll. in 1911. [Fantin-Latour 1911, no. 26]

———. "The Toilet of Venus," "Venus and Cupid." Drawings. 1869. Musée, Grenoble. [Ibid., nos. 339, 341]

———. "Venus and Cupid." Painting. 1871. Manchester City Art Gallery, England. [Lucie-Smith 1977, p. 159 / Fantin-Latour, no. 481] Replica ("Venus Embraced by Cupid"), 1894. [Fantin-Latour, no. 1539]

———. "Venus and Two Cupids." Painting. 1871. [Ibid., no. 489]

———. "The Toilet of Venus." Painting. 1891. [Ibid., no. 1436]

———. "Venus Sleeping, and Cupids." Painting. 1894. [Ibid., no. 1541]

———. "Venus and Cupids." Painting. 1896. DuLois coll. in 1911. [Ibid., no. 1613]

———. "Venus and Her Court." Painting. 1903. [Ibid., no. 1993]

———. "The Toilet of Venus." Painting. 1904. Several versions. Private colls. or unlocated in 1911. [Ibid., nos. 2031, 2038, 2106, 2159, 2209]

———. Numerous further versions of the "Venus and Cupid" subject, 1871–1904. All unlocated in 1911. [Ibid., nos. 517, 583, 1578, 1502, 1694, 1740, 1750, 1757, 1810, 1869, 1913, 1921, 1987, 2155, 2199, 2260] Lithographs, 1892–96. [Hédiard 1906, nos. 101, 124, 131—ill.]

Victor Hugo, 1802–1885. "Vénus rit toute nue au-dessus de mon lit" [Venus, Naked, Smiles at the Foot of My Bed]. Poem. *c.*1856. No. 9 in *Toute la lyre* part 5. In *Oeuvres inédites* (Paris: Hetzel, 1888). [Hugo 1985–86, vol. 7]

Frederic, Lord Leighton, 1830–1896. "Venus and Cupid." Painting. *c.*1856. Unlocated. [Ormond 1975, no. 31]

———. "Venus Disrobing (for the Bath)." Painting. 1866–67. Private coll. [Ibid., no. 124—ill. / Minneapolis 1978, p. 97 / also Wood 1983, p. 49—ill.]

William Bouguereau, 1825–1905. "The Triumph of Venus." Painting, wall decoration for home of Émile Pereire. **1857.** [Montreal 1984, p. 215—ill.]

———. "Venus and Cupid." Painting, sketch. *c.*1879. Vincens-Bouguereau coll., Paris. [Boime 1971, pl. 44]

———. "The Wasp's Nest" (Venus in a swarm of Cupids). Painting. 1892. [Montreal, pp. 110–12—ill.]

Robert Hamerling, 1830–1889. *Venus im Exil* [Venus in Exile]. Poem. Prague: Kober, **1858.** [Oxford 1986, p. 346]

Thomas Kibble Hervey, 1799–1859. "Venus." Poem. In *Poems* (Boston: Ticknor & Fields, 1866). [Boswell 1982, p. 262]

Charles-Auguste Arnaud, 1825–1883. "Venus with Golden Hair." Marble statue. Exhibited **1859.** Musées Nationaux, inv. R.F. 424, deposited in Château, Compiègne. [Montreal 1984, p. 120—ill. / Orsay 1986, p. 265]

Paul Baudry, 1828–1886. "The Toilet of Venus." Painting. **1859.** Musée des Beaux-Arts, Bordeaux. [Harding 1979, pp. 20, 132—ill.]

———. "Venus Playing with Cupid." Overdoor painting, for Hôtel Achille Fould, Paris. *c.*1859. Musée Condé, Chantilly. [Walters 1982, no. 113 *n.*]

Arnold Böcklin, 1827–1901. "Venus Abandoned." 2 paintings. **1860.** Kunstmuseum, Basel, inv. 1594; the other lost. [Andree 1977, nos. 116–17—ill. / also Fiesole 1980, no. 5—ill.]

———. "Venus and Cupid." Painting. 1861. Landesmuseum, Münster, inv. 1226BRD (68–303). [Andree, no. 135—ill.] Oil sketch. 1860. Kunstmuseum, Basel, inv. 1962.43. [Fiesole, no. 33—ill.]

———. "Venus Genitrix." Painting, triptych (Venus with triangle; Cupid sharpening his arrows, 2 lovers above; harvest scene with father, child, and nursing mother). 1895. Kunsthaus, Zurich, inv. 1167. [Andree, no. 446—ill.]

Pierre-Auguste Renoir, 1841–1919. "Venus and Love"

("Allegory"). Painting. **1860**. Private coll. [White 1984, p. 14—ill.]

————. 3 drawings of Venus, illustrating Mallarmé's poem "Le phénomène futur" (1864). **1888**. [Ibid., pp. 178, 185—ill.] Etching. **1889**. [Ibid.—ill.]

————. "(Small) Standing Venus" ("Venus Victorious"). Bronze statuette, with the Judgment of Paris in relief on the base. **1913–14**. Executed by Richard Guino from Renoir's design. Baltimore Museum of Art; Hirshhorn Museum and Sculpture Garden, Washington, D.C.; Kunsthalle, Hamburg, no. 1957/15; elsewhere. [White, pp. 258, 261—ill. / Haesaerts 1947, no. 3—ill. / also Hirschhorn 1974, p. 278 / Hamburg 1985, no. 509—ill.] Watercolor study. Petit Palais, Paris. [White, p. 244—ill.] Smaller variant (plaster?). [Haesaerts, no. 4—ill.] Over-lifesize bronze replica ("Venus Victorious"), executed by Guino. **1914–16**. Tate Gallery, London; elsewhere? [White, p. 259—ill. / Haesaerts, no. 6—ill.]

Edward Burne-Jones, 1833–1898. "The Passing of Venus." Drawing, design for tiles. **1861**. Joanna Matthews coll. [Harrison & Waters 1983, p. 52—ill.]

————. "Venus Epithalamia." Gouache painting. **1871**. Fogg Art Museum, Harvard University, Cambridge. [Ibid., p. 96—ill. / Wood 1983, p. 181—ill.]

————. "The Passing of Venus." Painting. *c*.**1875**. Tate Gallery, London. [Harrison & Waters, p. 138 / also Tate 1975, p. 13 (as 1881)] Tapestry. **1898**. Exeter College, Oxford. [Harrison & Waters, pl. 26]

————. "The Mirror of Venus." Painting. **1866–77**. [Ibid., pp. 64, 84 / Bell 1901, p. 130] Larger version, **1873–77**. Gulbenkian Foundation, Lisbon. [Harrison & Waters, p. 84 / Bell, p. 130—ill. / Cecil 1969, pl. 87—ill.]

————. "Venus Concordia." Painting, part of "Troy" polyptych. Begun **1870s**, unfinished. City Museum and Art Gallery, Plymouth, England. [Harrison & Waters, pp. 154, 191f.]

————. "Venus Discordia." Painting, part of "Troy" polyptich, unfinished. National Museum of Wales, Cardiff. [Ibid. / Arts Council, no. 123—ill.]

————. "The Mirror of Venus." Gouache painting, design for "The Flower Book." *c*.**1885**. British Museum, London. [Harrison & Waters, p. 36—ill.]

————. "The Bath of Venus." Painting. **1873–88**. Gulbenkian Foundation. [Ibid., pp. 84, 193 / also Bell, pp. 15, 65—ill.]

————. "The Court of Venus." Painting, based on illustration to Morris's "Cupid and Psyche" (1868), unfinished. Maas Gallery in 1972. [Harrison & Waters, p. 80—ill. (drawing)]

Théophile Gautier, 1811–1872. (Allusions to Venus and Cupid in) "Le château du souvenir" strophes 36–37. Poem. In *Le moniteur universal* 30 Dec **1861**; collected in *Émaux et camées,* 4th edition (Paris: Charpentier, 1863). Modern edition, Paris: Gallimard, 1981. [Ipso]

————. (Aphrodite evoked in) "La nue" [The Nude]. Poem. In *Revue du XIXe siècle* 1 June 1866; collected in *Émaux et camées,* 5th edition (Paris: Charpentier, 1866). Modern edition, as above. [Ipso]

Joseph Noel Paton, 1821–1901. "Hymn to Aphrodite." Poem. In *Poems by a Painter* (Edinburgh & London: Blackwood, **1861**). [Bush 1937, p. 555]

Charles Baudelaire, 1821–1867. "Le Fou et la Vénus" [The Fool and Venus]. Prose poem. In *La presse* 26 Aug **1862**; collected in *Petits poëmes en prose* (later called *Le spleen de Paris*), vol. 4 of *Oeuvres complètes* (Paris: Lévy, 1869). [Pichois 1975 / Ruff 1966, p. 187] Translated by Louise Varèse as "Venus and the Motley Fool" in *Paris spleen* (New York: New Directions, 1947; 1970). [Ipso]

Johann Eduard Müller, 1828–1895. "Venus and Cupid" ("Innocence in Danger"). Marble sculpture group. **1862**. Osborne House, Isle of Wight. [Read 1982, pp. 64, 132, pls. 62, 164]

Ernest Reyer, 1823–1909. *Erostrate* (story of how Venus de Milo lost her arms). Opera. Libretto, Méry, E. Pacini. First performed 12 Aug **1862**, Baden-Baden. [Grove 1980, 15:783]

Edouard Manet, 1832–1883. "Olympia." Painting, derived in part from Titian's "Venus of Urbino" (1538, Uffizi). **1863**. Musée d'Orsay, Paris, no. R.F.644. [Cachin & Moffett 1983, no. 64—ill. / also Louvre 1979–86, 4:68—ill.] Watercolor sketch, after (or for?). Private coll. [Cachin & Moffett, no. 67—ill.]

Stéphane Mallarmé, 1842–1898. (Venus evoked in) "Le phénomène futur" [The Future Phenomenon]. Prose poem. Nov **1864**. In *La république des lettres* 20 Dec 1875; collected in *Pages* (Brussels: Deman, 1891). [Mondor & Jean-Aubry 1974]

————. "Mes bouquins refermés sur le nom de Paphos" [My Books Closed on the Name of Paphos]. Sonnet. In *Poésies* (Paris: La Révue Indépendante, 1887). Translated by Roger Fry in *Poems by Mallarmé* (London: Chatto & Windus, 1936). [Mondor & Jean-Aubry / Fowlie 1970, pp. 54–56]

Hans Makart, 1840–1884. "Venus with Two Amoretti." Painting, sketch for a ceiling decoration. *c*.**1866–67**. Private coll., Vienna. [Frodl 1974, no. 80—ill.]

————. "Venus and Cupid" (Cupid crying, Venus holding his bow). Painting. **1870**. Berlin art market in 1925, unlocated. [Ibid., no. 125—ill.]

————. "Venus and Cupid, with Their Playmates in the Air above Them" (? or "Allegory of Fertility," "Victory of Light over Darkness"?). Oil sketch, for an unexecuted ceiling painting. *c*.**1883–84**. Sold Vienna, 1968, unlocated. [Ibid., no. 425—ill.]

————. "The Love Secret" (Venus and Cupid?). Painting. **1880–81**. Unlocated. [Ibid., no. 367—ill.]

————. "Venus and Cupid." Painting, study. Private coll., Salzburg, in 1940. [Ibid., no. 588]

Emma Lazarus, 1849–1887. "Aphrodite." Poem. In *Poems and Translations* (Boston: Hurd & Houghton, **1867**). [Boswell 1982, p. 267]

————. "Venus of the Louvre." Poem. In *Poems* (Cambridge, Mass: Riverside, 1889). [Ostriker 1986, p. 285]

James McNeill Whistler, 1834–1903. "Venus." Oil sketch, study for unexecuted decoration project. *c*.**1868**. Freer Gallery of Art, Washington, D.C. [Curry 1984, pl. 7]

————. "Venus and Cupid." Watercolor. **1890s**. Freer Gallery. [Ibid., pl. 138]

————. "Venus Astarte." Drawing. **1890s**. Freer Gallery of Art, Washington, D.C. [Ibid., pl. 281 / Maas 1969, p. 170—ill.]

Pietro Tenerani, 1789–**1869**. "Venus and Cupid." Sculp-

ture group. Ny Carlsberg Glyptothek, Copenhagen. [Bénézit 1976, 10:110] Another version in Prado, Madrid. [Ibid.]

Albert Moore, 1841–1893. "A Venus" (pose after Venus de Milo). Painting. **1869.** City Art Gallery, York, England. [Minneapolis 1978, no. 73—ill. / Wood 1983, pls. 61–64—ill. / Ormond 1975, pl. 110—ill. / Kestner 1989, p. 181, pl. 3.41]

Arthur Rimbaud, 1854–1891. "Invocation à Vénus." Poem, based on Sully-Prudhomme's translation of Lucretius's *De rerum natura.* **1869.** In *Bulletin de l'Academie de Douai* 11 Apr 1870. [Adam 1972]

———. (Venus evoked in) "Villes I" [Cities I]. Prose poem, part of *Les illuminations. c.*1874. In *La vogue* 1886; reprinted Paris: Vanier, 1895. [Adam / Fowlie 1966]

William Rimmer, 1816–1879. "Morning" ("Venus and Cupid"). Drawing. **1869.** Fogg Art Museum, Harvard University, Cambridge. [Whitney 1946, no. 77]

Gustave Moreau, 1826–1898. "Aphrodite." Drawing with watercolor. *c.*1870. Fogg Art Museum, Harvard University, Cambridge. [Mathieu 1976, no. 121—ill.]

Arthur W. E. O'Shaughnessy, 1844–1881. "The Wife of Hephaestus." Poem. In *An Epic of Women and Other Poems* (London: Hotten, **1870**). [Bush 1937, p. 558]

———. (Venus evoked in) "Black Marble." Poem. In *Music and Moonlight* (London: Chatto & Windus, 1874). [Ipso]

Leopold von Sacher-Masoch, 1835–1895. *Venus im Pelz* [Venus in Furs]. Novel. Leipzig: Wigand, **1870.** [Dijkstra 1986, pp. 372–75, 394f.]

Peter Cornelius, 1824–1874. "O Venus!" Composition for male chorus. Text, Horace. **1872.** Arranged for piano by M. Hasse. [Grove 1980, 4:783]

Paul Cézanne, 1839–1906. "Venus and Cupid" (Venus reclining, Cupid overhead aiming bow). Painting. **1870–73.** Private coll. [Orienti 1972, no. 245—ill.]

———. "Reclining Venus" ("Nude in a Landscape"). Watercolor. *c.*1875. National Museum of Western Art, Tokyo. [Rewald 1983, no. 58—ill.]

———. "Venus and Cupid." Watercolor. *c.*1875. Rosengart coll., Lucerne. [Ibid., no. 59—ill.]

Edward Carpenter, 1844–1929. "Sleeping Venus." Poem. In *Narcissus and Other Poems* (London: King, **1873**). [Boswell 1982, p. 67]

Auguste Rodin, 1840–1917. "Venus and Cupid." Terracotta sculpture. *c.*1873. Musée Rodin, Paris. [Rodin 1944, no. 25—ill.] Variant ("The Spring"). Musée Rodin. [Ibid., no. 26—ill.]

———. "Iris Waking a Nymph" ("Iris Waking Aurora," "Venus and Cupid"). Bronze sculpture. 1885. Musée Rodin. [Ibid., no. 145—ill.]

———. "The Toilet of Venus." Marble sculpture. Before 1886. National Gallery of Art, Washington, D.C. [Tancock 1976, p. 172] Limestone replica (or variant). John G. Johnson coll., Philadelphia. [Ibid.—ill.] 12 (?) bronze casts: Musée Rodin, Paris; National Museum of Western Art, Tokyo; private colls., U.S.A.; elsewhere? [Ibid. / Rodin, no. 159—ill.]

———. "Aphrodite." Plaster sculpture, based on a figure in "The Gates of Hell." Before 1889. Musée Rodin, Paris. [Rodin, no. 215—ill.]

———. "Venus Climbing the Mountain of Fame." Plaster study for uncompleted "Monument to Whistler." 1903. Unlocated. [Tancock, p. 81—ill.]

Jean-Baptiste Camille Corot, 1796–1875. "Bath of Venus." Painting. **1873–74.** Jean Dupuy coll. in 1905. [Robaut 1905, no. 2179—ill.]

Charles Gleyre, 1806–**1874.** "Venus Pandemos." Painting. With Kurt Meissner, Zurich, in 1974. [Winterthur 1974, no. 106 / Clément 1878, no. 70] Sketch. Wall coll. in 1878, unlocated. [Clément, no. 71—ill.]

Anselm Feuerbach, 1829–1880. "Aphrodite." Ceiling painting. **1875.** Akademie, Vienna. [Karlsruhe 1976, p. 103, no. Z47—ill.]

Dante Gabriel Rossetti, 1828–1882. "Astarte Syriaca" ("Venus Astarte"). Painting. **1875–77.** City Art Gallery, Manchester, England, no. 1891.5. [Surtees 1971, no. 249—ill. / also Maas 1969, p. 143—ill. / Wood 1981, p. 102—ill.]

———. "Astarte Syriaca." Sonnet, to accompany above painting. 1877. In *Ballads and Sonnets* (London: Ellis & White, 1881). [Doughty 1965 / Rees 1981, p. 124 / also Surtees, p. 146 (reproduced)]

Lawrence Alma-Tadema, 1836–1912. "The Sculptor's Model" ("Venus Esquilina"). Painting. **1877.** Lost. [Swanson 1977, pp. 22, 138—ill. / also Kestner 1989, p. 275]

———. "Aphrodite's Cradle" (symbolic title; group of women looking out to sea). Painting. 1908. [Ibid.—ill.]

Henry Augustin Beers, 1847–1926. "The Rise of Aphrodite." Poem. In *Odds and Ends* (Boston: Houghton, Osgood, **1878**). [Bush 1937, p. 580]

Anonymous. *The Loves of Venus.* Comedietta. First performed 23 Mar **1880,** L. C. Caste Travelling Company. [Nicoll 1959–66, 5:713]

Edward John Poynter, 1836–1919. "A Visit to Aesculapius" (Venus showing Aesculapius a thorn in her foot). Painting. **1880.** Tate Gallery, London. [Wood 1983, pp. 142–44—ill. / Hutchinson 1986, p. 124, p. 43 / Kestner 1989, p. 218, pl. 4.7]

Wilfred Scawen Blunt, 1840–1922. "The Venus de Milo." Sonnet. In *The Love Sonnets of Proteus* (London: Kegan Paul, **1881**). [DLB 1983, 19:29 / Boswell 1982, p. 47]

John La Farge, 1835–1910. "Venus." Painting, for ceiling of reception hall, Vanderbilt mansion, New York. **1881–82.** [Weinberg 1977, pp. 256ff., 265f.—ill.]

George Henry Boughton, 1833–1905. "Venus and Neptune" (satirical title: Dutch milkmaid and seaman). Painting. *c.*1882. Walters Art Gallery, Baltimore, inv. 37.198. [Walters 1982, no. 263—ill.]

Antonio Nicolau, 1858–1933. *El triomf de Venus.* Symphonic poem. First performed **1882,** Paris. [Grove 1980, 13:216]

Gabriele D'Annunzio, 1863–1938. (Venus evoked in) "Studii di nudo" [Studies of the Nude]. Poem. In *Intermezzo di rime* (Rome: Sommaruga, **1883**). [Palmieri 1953–59, vol. 1 / Mutterle 1982, pp. 41f. / Bàrberi Squarotti 1982, pp. 52, 57]

Théodore Aubanel, 1829–1886. "La Vénus d'Avignoun," "La Vénus d'Arles." Poems, in Provençal. In *Li Fiho d'Avignoun* (Mont-Pélie: Empremarié Centralo dóu Miejour, **1885**). [DLLF 1984, 1:91f.]

George Harrison Van Zandt. "Venus and Luna." Poem. In *Poems* (Philadelphia: Jay, **1886**). [Boswell 1982, p. 306]

Thomas Woolner, 1825–1892. "Cytherea." Poem. In *Ti-*

resias and Other Poems (London: Bell, **1886**). [Boswell 1982, p. 310]

James Russell Lowell, 1819–1891. "Endymion, A Mystical Comment on Titian's *Sacred and Profane Love*." Poem. In *Heartsease and Rue* (Boston: Houghton, Mifflin, **1888**). [Bush 1937, pp. 485, 582 / Le Comte 1944, p. 124 / Boswell 1982, p. 168]

Nicolas Milan. *Aphrodite*. Operetta. First performed Jan **1888**, Agram. [Clément & Larousse 1969, 1:66]

Paul Gauguin, 1848–1903. "Black Venus." Stoneware statue. *c*.**1888–89**. Harry Guggenheim coll., New York. [Gray 1963, no. 91—ill.]

Pierre de Bréville, 1861–1949. "Hymne à Vénus." Song. Text, Philippe Auguste Villiers de l'Isle-Adam. **1889**. [Grove 1980, 3:272]

Rubén Darío, 1867–1916. (Ideal Venus evoked in) "El salmo de la pluma" [Psalm of the Feather]. Poem. In *El eco nacional* (Léon, Nicaragua) 14 Mar **1889**. [Méndez Plancarte 1967 / Jrade 1983, pp. 99ff.]

———. "Venus." Sonnet. 1889. / Revised, published in *Azul*, 2d edition (Buenos Aires: Bilioteca de 'La Nación,' 1905). [Méndez Plancarte / Ellis 1974, pp. 59, 90–95 / Paz 1976, p. 34]

———. (Venus de Milo evoked in) "Yo persigo una forma . . ." [I Importune a Figure]. Poem, part of "Las ánforas de Epicuro" [Amphoras of Epicurus]. In *Prosas profanas y otros poemas* (Buenos Aires: Coni, 1896). [Méndez Plancarte / Jrade, p. 21 / Hurtado Chamorro 1967, p. 55]

———. ("Queen Venus" in) "Dezir." Poem. In *Prosas profanas y otros poemas*, 2d edition (Paris: Bouret, 1901). [Méndez Plancarte / Hurtado Chamorro, pp. 50, 52]

Hector Le Roux, 1829–1900. "Ode to Venus." Ceiling painting. **1889**. Cabinet de Marie Antoinette, Louvre, Paris (inv. 20089). [Louvre 1979–86, 4:53—ill.] Sketch after. Louvre, inv. 20535. [Ibid.—ill.]

Arthur Symons, 1865–1945. "Venus of Melos." Poem. In *Days and Nights* (London & New York: Macmillan, **1889**). [Beckson 1987, p. 21]

Paul Cézanne, 1839–1906. "Venus and Cupids." Sketchbook drawing. **1887–90**. Chappuis coll., Tresserve. [Chappuis 1973, no. 967—ill.]

Émile-Antoine Bourdelle, 1861–1929. "Crouching Aphrodite." Terre-sèche sculpture. **1890**. Musée Bourdelle, Paris. / 2 bronze casts. [Jianou & Dufet 1975, no. 116]

———. "Aphrodite." Bronze sculpture. 1900. 4 casts. Private coll(s). [Ibid., no. 262] Plaster, terra-cotta, and sandstone studies/replicas. [Ibid.] Marble version. Petit Palais, Paris. [Ibid.] Ceramic version, edition of 3. Musée Haviland, Limoges; Musée Bourdelle; elsewhere. [Ibid.]

———. "Venus the Bather" (head on a pedestal). Sculpture. 1905. Bronze and terre-sèche versions. [Ibid., no. 314]

Gustav Klimt, 1862–1918. "Early Italian Art, Florentine Cinquecento, with the figure of Venus in the style of Botticelli." Painted spandrel. **1890–91**. Staircase, Kunsthistorisches Museum, Vienna. [Novotny & Dobai 1968, no. 50—ill.]

Grant Allen, 1848–**1891**. "The Return of Aphrodite." Poem. In *The Lower Slopes* (London: Mathew & Lane, 1894). [Boswell 1982, p. 13 / Bush 1937, pp. 462 *n*., 564]

William Blake Richmond, 1842–1921. "The Bath of Ve-

nus." Painting. Exhibited **1891**. Aberdeen Art Gallery. [Kestner 1989, pp. 176f., pl. 3.37]

Richard Le Gallienne, 1866–1947. "The House of Venus." Poem. In *English Poems* (London: Mathews & Lane; New York: Cassell, **1892**). [Boswell 1982, p. 268]

———. "Alma Venus." Poem. In *The Lonely Dancers and Other Poems* (London: Lane, 1914). [Ibid.]

James Maurice Thompson, 1844–1901. "Garden Statues: Eros, Aphrodite, Psyche, and Persephone." Poem. In *Poems* (Boston: Houghton, Mifflin, **1892**). [Boswell 1982, p. 303]

Arthur Hacker, 1858–1919. (Venus and Cupid in) "The Sleep of the Gods: 'Evohe! ah! evohe! ah! Pan is dead.'" Painting, inspired by Elizabeth Barrett Browning's "The Dead Pan." Exhibited **1893**. [Kestner 1989, p. 232, pl. 4.18]

Christina Rossetti, 1830–**1894**. "Venus's Looking Glass." Sonnet. In *New Poems*, edited by W. M. Rossetti (London and New York: Macmillan, 1895). [Bush 1937, p. 279 / Boswell 1982, p. 287]

Madison Cawein, 1865–1914. "The Paphian Venus." Poem. In *Intimations of the Beautiful* (New York: Putnam, **1894**). [Boswell 1982, p. 72]

Augusta Holmès, 1847–1903. *Hymne à Vénus*. Orchestral composition. **1894**. [Grove 1980, 8:656]

Margaret Ruthven Lang, 1867–1972. "Sappho's Prayer to Aphrodite." Song. **1895**. [Cohen 1987, 1:397]

Pierre Louÿs, 1870–1925. *Aphrodite: Moeurs antiques* [Aphrodite: Antique Customs]. Novel. Paris: Fasquelle, **1895**. [DLLF 1984, 2:1339]

———. "Aphrodite." Poem. In *Poësies* (Paris: Crès, 1927). [Ipso]

John Byrne Leicester Warren, Lord de Tabley, 1835–1895. "Hymn to Aphrodite." Poem. In *Poems: Dramatic and Lyrical* second series (London: Lane, **1895**). [Boswell 1982, p. 250]

Coventry Patmore, 1823–**1896**. "Venus and Death." Poem. In *Poems* (London: Oxford University Press, 1949). [Boswell 1982, p. 201]

Karl Johan Gustav Snoilsky, 1841–1903. "Afrodite och sliparen" [Aphrodite and the Knife Grinder]. Poem. In *Dikter, tredje samlingen* (Stockholm: Seligmann, **1881–97**). [Gustafson 1961, p. 241]

Claude Debussy, 1862–1918. *Aphrodite*. Projected ballet score. Scenario, after Louÿs's novel (1895). **1896–97**, unfinished. [Grove 1980, 5:311]

Paul Lincke, 1866–1946. *Venus auf Erden* [Venus of the Earth]. Operetta. Libretto, H. Bolten-Baeckers. First performed 6 June **1897**, Apollo Theatre, Berlin. [Grove 1980, 10:864]

Adolf Hirémy-Hirschl, 1860–1933. "Aphrodite." Painting. *c*.**1898**. [Dijkstra 1986, p. 104—ill.]

Philip Wilson Steer, 1860–1942. "The Toilet of Venus." Painting. *c*.**1898**. Tate Gallery, London, no. 4272. [Maas 1969, p. 169 / Tate 1975, p. 210] Oil study. Williamson Art Gallery and Museum, Birkenhead. [Maas—ill.]

Ernest Dowson, 1867–1900. (Venus evoked in) "Libera me." Poem. In *Decorations in Verse and Prose* (London: Smithers, **1899**). [Bush 1937, pp. 460, 565]

Giuseppe Baruffi (**19th century**). "Sleeping Venus." Marble sculpture. Galleria dell' 800 di Capodimonte, Naples, no. 362. [Capodimonte 1964, p. 64]

T. Sturge Moore, 1870–1944. *Aphrodite against Artemis*. Tragedy. London: Unicorn, **1901**. [DLB 1983, 19:333, 335, 350]

———. (Venus evoked in) "To Slow Music." Poem. In *Selected Poems* (London: Macmillan, **1934**). [DLB 1983, 19:342]

Henrietta Rae, 1859–1928. "Venus Enthroned." Painting. **1902**. [Kestner 1989, p. 285]

Heinrich Mann, 1871–1950. *Venus*. Novel, third of trilogy *Die Göttinnen* [The Goddesses] (Munich: Langen, **1903**). [DLB 1988, 66:315, 323f. / Seymour-Smith 1985, p. 565]

Charles Shannon, 1863–1937. "The Bath of Venus." Painting. **1898–1904**. Tate Gallery, London, no. 5160. [Tate 1975, p. 204]

Eugen d'Albert, 1864–1932. "Mittelalterliche Venusshymne" [Medieval Hymn to Venus]. Composition for tenor, male chorus, and orchestra, opus 26. **1904**. [Grove 1980, 1:209]

Æ (George William Russell), 1867–1935. "Aphrodite." Poem. In *The Divine Vision and Other Poems* (London: Macmillan, **1904**). [Boswell 1982, p. 216]

Lucien Schnegg, 1864–1909. "Aphrodite Leaning Forward." Bronze statuette. *c*.**1905**. Musée d'Orsay, Paris, inv. R.F. 3300; elsewhere. [Orsay 1986, p. 247—ill.]

———. "Torso of Aphrodite." Bronze sculpture. Musée d'Orsay, inv. R.F. 3299. [Ibid.—ill.] Plaster model, with arms completed, exhib. 1906, unlocated. [Ibid.]

———. "Small Head of Aphrodite." Gilded bronze sculpture. Musée d'Orsay, inv. R.F. 3297. [Ibid., p. 246—ill.]

Lovis Corinth, 1858–1925. "Venus" (holding helmet and cape). Painting. **1906**. Unlocated. [Berend-Corinth 1958, no. 323—ill.]

———. "Toilet of Venus." Etching. 1910. [Schwarz 1922, no. 42—ill.]

———. "Venus and Cupid before the Mirror." Painting. 1916. Formerly Kunstsammlung, Königsberg. [Berend-Corinth, no. 675—ill.]

———. "Venus with the Mirror." 2 etchings. 1916. [Schwarz, nos. 223, 224]

———. 10 lithographs illustrating Schiller's "Der Venuswagen" (1776–80). Berlin: Gurlitt, 1919. [Ibid., no. L383.IV—ill.]

Bruno Eelbo, 1853–1917. *Aphrodite: Ein Dämmerungstraum* [Aphrodite: A Twilight Dream]. Epic. Leipzig: **1906**. [DLL 1968–90, 3:923]

Tullio Cestero, 1877–1955. *Citerea*. Fantasy. Madrid: **1907**. [DULC 1959–63, 1:762]

Arthur Davison Ficke, 1883–1945. "Cytherea." Poem. In *From the Isles: A Series of Songs Out of Greece* (Norwich, England: Samurai, **1907**). [Boswell 1982, p. 254]

Richard Dehmel, 1863–1920. *Die Verwandlungen der Venus* [The Metamorphoses of Venus]. Poem cycle. Berlin: Fischer, **1907**. [Oxford 1986, p. 153 / Moore 1967, p. 10]

Laurent Tailhade, 1854–1919. "Hymne à Aphrodite." Poem. In *Poèmes élégiaques* (Paris: Société du Mercure de France, **1907**). [Ipso]

Hans Thoma, 1839–1924. "Venus." Painting. **1907**. Kunsthalle, Karlsruhe. [Thode 1909, p. 493—ill.]

Francis William Bourdillon, 1852–1921. "The Debate of the Lady Venus and the Virgin Mary." Poem. In *Preludes*

and Romances (London: Allen, **1908**). [Boswell 1982, p. 244 / Bush 1937, p. 460]

John Payne, 1842–1916. "The Wrath of Venus." Poem. In *Carol and Cadence* (London: printed for the Villon Society, **1908**). [Boswell 1982, p. 279]

Christian Rohlfs, 1849–1938. "Venus and Cupid." Watercolor. **1908**. Private coll. [Vogt 1958, no. 08/6]

———. "Venus and Cupid." Painting. *c*.1919. Universitätsmuseum für Kunst und Kulturgeschichte, Marburg, inv. 3094. [Ibid., no. 641—ill.]

Wilhelm Weigand, 1862–1949. *Der Gürtel der Venus* [The Girdle of Venus]. Tragedy. Munich: Müller, **1908**. [Wilpert 1963, p. 617]

———. *Venus in Kümmelburg*. Novel. Halle: 1942. [DULC 1959–63, 4:1139]

Albert Anker, 1831–**1910**. "Venus and Cupid." Drawing. Private coll. [Winterthur 1974, p. 130—ill.]

Theodor Däubler, 1876–1934. (Venus as goddess of Venice in) "Venedig, dankbar bringen dir" [Venice, Thankful, We Bring You]. Poem, part of *Das Nordlicht*. Epic. Florence: **1910**; Leipzig: 1921. [Ipso] English translation, *The Northern Lights* (Geneva: 1922).

George Whitefield Chadwick, 1854–1931. *Aphrodite*. Symphonic fantasy, opus 21. **1910–11**. First performed 4 June 1912, Norfolk Festival. [Grove 1986, 1:385f.]

Émile Bernard, 1868–1941. "Venus and Cupid." Painting. **1911**. Pozarnik coll., Paris. [Luthi 1982, no. 750—ill.]

———. "The Toilet of Venus." Painting. 1911. Musée de l'Orangerie, Paris, in 1982. [Luthi 1982, no. 821]

———. "Mulatto Venus." Painting. 1914. Private coll. [Ibid., no. 875—ill.]

———. "Venus and the Organist." Painting, copy after Titian (Prado). 1920. Altarriba coll., Paris. [Ibid., no. 987—ill.]

Elisarion, b. 1872. *Die gefesselte Afrodite* [Aphrodite Bound]. Dramatic poem. Munich: Akropolis, **1911**. [DLL 1968–90, 9:730 / Hunger 1959, p. 38]

Ossip Zadkine, 1890–1967. "Venus." Wood sculpture. **1912**. Marval coll., Paris. [Jianou 1979, no. 23]

———. "Venus." Wood sculpture. 1921. Private coll., Netherlands. [Ibid., no. 90]

———. "Venus." Wood sculpture. *c*.1923. Tate Gallery, London, no. 6226. [Ibid., no. 106—ill. / Alley 1981, p. 768—ill.]

———. "Venus." Wood sculpture. 1923. Walker coll. [Jianou, no. 109]

———. "Venus Fountain." Stone sculpture. 1925. Villa Hope Nelson, Leno, Italy. [Ibid., no. 124—ill.]

———. "The Small Venus." Wood sculpture. 1928. Van der Wal coll., Amsterdam. [Ibid., no. 166]

———. "Venus." Stone sculpture. 1937. Hessisches Landesmuseum, Darmstadt. [Ibid., no. 242]

———. "Venus." Brass sculpture. 1938. 3 versions. Van der Wal coll., Amsterdam; Inocente Palacios coll.; Palais des Beaux-Arts, Charleroi. [Ibid., no. 260—ill.]

Michel Larionov, 1881–1964. "Promenade, Venus of the Boulevard." Painting. **1912–13**? Musée National d'Art Moderne, Paris, no. AM 1982–436. [Pompidou 1987, p. 344—ill.]

Ronald Ross, 1857–1932. "To Aphrodite in Cyprus." Poem.

1913. In *Poems* (London: Mathews & Marrot, 1928). [Bush 1937, p. 561]

Lady Margaret Sackville, 1881–1963. *Songs of Aphrodite.* Poem cycle. In *Songs of Aphrodite and Other Poems* (London: Mathews, **1913**). [Bush 1937, p. 570]

Jacob Epstein, 1880–1959. "Venus." Marble statue. **1913–14.** 2 versions, large and small. Yale University Art Gallery, New Haven; elsewhere. [Buckle 1963, p. 70—ill.]

Ghrighorios Xenopoulos, 1867–1951. *I Afrodhiti.* Novel. **1913–14.** Athens: Kollaros, 1922. [EWL 1981–84, 4:668]

Michael Field (**Katherine Harris Bradley,** 1848–**1914**, and **Edith Cooper,** 1862–1943). "Not Aphrodite." Poem. In *A Selection from the Poems of Michael Field* (Boston: Houghton Mifflin, 1925). [Boswell 1982, p. 245]

Pierre Frondaie, b. 1884. *Aphrodite.* Verse drama, based on Pierre Louÿs's novel (1895). Music, Henri Février. First performed **1914**, Théâtre Renaissance, Paris. [Horwitz 1985, p. 41]

Rupert Brooke, 1887–**1915.** "Ante Aram" [Before the Altar (of Venus)]. Poem. In *Collected Poems* (New York: Dodd, Mead, 1915). [Boswell 1982, p. 52]

Paul Klee, 1879–1940. "Anatomy of Aphrodite." Abstract watercolor. **1915.** Felix Klee coll., Bern. [San Lazzaro 1957, p. 288—ill.]

———. "Ceramic-Erotic-Religious" ("The Vessels of Aphrodite"). Abstract watercolor. 1921. Klee Foundation, Bern. [Grohmann 1954, no. 153—ill. / also San Lazzaro, p. 290—ill.]

Lidia Testore. *Il bagno di Venere* [The Bath of Venus]. Operetta. Libretto, A. Franci. First performed **1915,** Milan. [Cohen 1987, 2:693]

Gottfried Benn, 1886–1956. (Venus evoked in) "Karyatide" [Caryatids]. Poem. In *Die Weissen Blätter* III.3 (Mar **1916**). [Wellershof 1960] Translated by Michael Hamburger in *Modern German Poetry, 1910–1960* (New York: Grove, 1962). [Ipso]

Kaikhosru Shapurji Sorabji, b. 1892. "Hymne à Aphrodite." Song. Text, Tailhade. **1916.** [Grove 1980, 17:535]

Romaine Brooks, 1874–1970. "Weeping Venus." Painting. **1916–18.** Unlocated. [Breeskin 1971, p. 25—ill.]

Charles Koechlin, 1867–1950. "Hymne à Vénus." Song, in *2 mélodies,* opus 68. Text, Villiers de l'Isle Adam. **1918.** [Grove 1980, 10:147]

Henri Matisse, 1869–1954. "Crouching Venus." Bronze statuette. **1918.** Edition of 10. Hermitage, Leningrad; elsewhere. [Monod-Fontaine 1984, no. 53—ill. / Hermitage 1975, pl. 167]

———. "Venus." Painted paper cut-out. 1952. National Gallery of Art, Washington, D.C. [St. Louis 1977, no. 181—ill. / Schneider 1984, p. 379—ill.]

Henri Février, 1875–1957, and **Anselm Goetzel,** 1878–1923. *Aphrodite.* Musical. Libretto, G. C. Hazelton and P. Frondaie, after Louÿs's novel (1895) and Frondaie's drama (1914). First performed 24 Nov **1919,** Century Theater, New York; choreography, Michel Fokine; costumes, J. and P. Harker, Léon Bakst. [Horwitz 1985, pp. 41–46 / Bordman 1978, p. 345]

Michel Fokine, 1880–1942, choreography. Ballets for *Aphrodite.* Musical comedy. **1919.** See *Février and Goetze, above.*

Harry Kemp, b. 1883. "The Mirrored Venus." Poem. In *The Passing God and Other Poems* (New York: Brentano, 1919). [Boswell 1982, p. 266]

Edith Sitwell, 1887–1964. "Queen Venus and the Choir-Boy." Poem. In *Saturday Westminster Gazette* 5 Jan **1919**; collected in *Wheels, Fourth Cycle* (Oxford: Blackwell, 1919). / Revised, published in *The Wooden Pegasus* (Oxford: Blackwell, 1920). [Ipso]

———. " 'Lo, This Is She That Was the World's Desire.' " Poem. In *Green Song and Other Poems* (London: Macmillan, 1944). [Sitwell 1968]

———. "A Hymn to Venus." Poem. In *Poetry London* 11 (1947); collected in *The Song of the Cold* (New York: Vanguard, 1948). [Sitwell / Brophy 1968, p. 147]

Willa Cather, 1873–1947. "Coming, Aphrodite!" Story. In *Youth and the Bright Medusa* (New York: Knopf, **1920**). [DLB 1981, 9:147]

Paul Ernst, 1866–1933. *Die Venus.* Novella. Heidelberg: Meister, **1920.** [DLB 1988, 66:107]

Valdemar Rørdam, 1872–1946. *Afrodites boldspil* [Aphrodite's Ballgame]. Poem. Copenhagen: Aschehoug, **1920.** [Mitchell 1958, p. 207]

Arthur B. Davies, 1862–1928. "Mirror of Venus." Bronze relief. **Early 1920s.** Hirshhorn Museum and Sculpture Garden, Washington, D.C. [Hirshhorn 1974, p. 679, pl. 283]

———. "Venus." Mezzotint. 1927. [Davies 1975, no. 80—ill. / also Price 1929, no. 182—ill.]

———. "Aphrodite." Tapestry. Artist's estate in 1930. [Metropolitan 1930, no. 186]

———. "Heavenly Aphrodite." Painting. Artist's estate in 1931. [Cortissoz 1931, p. 26]

Hippolyte Petitjean, 1854–1929. "Bather" ("Venus"). Painting. **1921.** Musée d'Orsay, Paris, no. R.F. 1977–284. [Louvre 1979–86, 4:130—ill.]

Eden Phillpotts, 1862–1960. *The Bronze Venus.* Novel. London: Richards, **1921.** [Kunitz & Haycraft 1942, p. 1103]

Velimir Khlébnikov, 1885–**1922.** "Shaman i Venera" [The Shaman and Venus] (Venus offers herself to a Mongol sorcerer). Poem. In *Stikhotvoreniia i poemy* (Leningrad: Sovetskii pisatel, 1960). [Poggioli 1960, p. 258]

Thomas Lowinsky, 1892–1947. "The Dawn of Venus." Painting. **1922.** Tate Gallery, London, no. 5226. [Tate 1975, p. 168]

John Drinkwater, 1882–1937. "Venus in Arden." Poem. In *Collected Poems* (London: Sidgwick & Jackson, **1923**). [Boswell 1982, p. 253]

Aristide Maillol, 1861–1944. "Venus Holding a Palm." Limestone statue. **1923.** Vieux Port, Port-Vendres. [Linnenkamp 1960, pp. 35–41—ill.]

———. "Torso of Venus." Bronze sculpture. 1925. [Waldemar-George 1965, pp. 57, 233—ill.]

———. "Venus." Lifesize bronze statue. 2 versions. Without a necklace, 1918–28: National Gallery of Art, Washington, D.C.; Kunsthalle, Bremen; Musée Toulouse-Lautrec, Albi; Jardin des Tuileries, Paris; elsewhere. With a necklace, 1928–29: Tate Gallery, London; Kunsthaus, Zürich; St. Louis Art Museum; Musée des Beaux-Arts, Lyons (necklace removed by museum); elsewhere. [Linnenkamp, p. 119, figs. 110, 112 / also Guggenheim 1977, no. 72—ill. / Alley 1981, p. 466—ill. / Waldemar-George, p. 187—ill.]

Bust, based on above (study for "Venus with a Necklace"?). 1928. [Waldemar-George, pp. 191, 233—ill.]

Marina Tsvetaeva, 1892–1941. "Xvala Afrodite" [Eulogy of Aphrodite]. Poem cycle. In *Remeslo: Kniga stikhov* (Moscow: Gelikon, **1923**). [Karlinsky 1985, p. 109 / TCLC 1978–89, 7:560]

H. D. (Hilda Doolittle), 1886–1961. (Aphrodite addressed in) "Amaranth." Poem. In *Heliodora and Other Poems* (London: Cape; Boston: Houghton Mifflin, **1924**). / Revised version in *Contemporary Literature* 10 (Autumn 1969). [Martz 1983]

———. "Triplex" (Aphrodite, Artemis, Athene). Poem. In *Red Roses for Bronze* (London: Chatto & Windus; Boston: Houghton Mifflin, 1931). [Martz / DLB 1986, 45:131]

———. (Venus evoked in) "Tribute to the Angels" stanzas 10–12, 19. Poem, part 2 of *Trilogy* (London & New York: Oxford University Press, 1946). [Martz / Friedman 1981, pp. 248ff.]

Eric Gill, 1882–1940. "Venus." Wood-engraving. **1924**. (Victoria and Albert Museum, London.) [Physick 1963, no. 290—ill.]

———. "Venus instructrix artis amoris." Woodcut, decoration for edition of Chaucer's *Troilus and Creseyde* (Waltham St. Lawrence, Berkshire: Golden Cockerell, 1927). (Victoria and Albert Museum, London.) [Ibid., no. 453]

———. "Venus and Cupid with a Golden Cockerell." Wood-engraving, decoration for edition of Chaucer's *Canterbury Tales* (Waltham St. Lawrence: Golden Cockerell, 1929). (Victoria and Albert Museum, London.) [Ibid., no. 535]

Sacheverell Sitwell, 1897–1988. "The Venus of Bolsover Castle." Poem. In *The Thirteenth Caesar* (London: Duckworth, **1924**). [Boswell 1982, p. 295]

Jules Pascin, 1885–1930. "Back View of Venus." Painting. **1924–25**. Petit Palais, Paris. [Werner 1959, pl. 23]

Salvador Dalí, 1904–1989. "Venus and Cupids." Painting. **1925**. Private coll. [Pompidou 1979, pl. 22]

———. "Venus and the Sailor." Painting. 1926. Ikeda Museum of 20th Century Art, Shizuoka. [Ibid., pl. 21 / also New York 1965, no. 17—ill.]

———. "Venus de Milo with Drawers." Patinated bronze statuette. Modeled 1936, cast 1965. [Pompidou, pl. 175 / Tate 1980, no. 120—ill. / Rotterdam 1970, no. 188—ill.]

———. "Rhinocerotic Goose-flesh" (Venus of Praxiteles as logarhythmic shape of rhinoceros horn). Painting. 1956. Pagliani coll., Mexico City. [Ibid., no. 84—ill.]

———. "Otorhinological Head of Venus" (nose and ears exchanged). Plaster bust. 1964. Private coll. [Pompidou, pl. 176 / also Rotterdam, no. 191—ill.]

———. "Aphrodite." Painting. 1965. M. Knoedler & Co., New York, in 1965. [New York, suppl. p. 6]

———. 3 illustrations for Sacher-Masoch's *Venus im Pelz* (1870). 1968. [Rotterdam, no. 183—ill.]

———. (Figure of Venus de Milo incorporated into) "Hallucinogenic Toreador." Painting. 1969–70. [Pompidou, p. 371—ill.]

———. "Giraffe-Venus." Bronze sculpture. 1973. Kunsthalle, Hamburg, inv. 1985/87. [Hofmann 1987, no. 16.36—ill.]

Ferencz Herczeg, 1863–1954. *A milói Vénusz karja* [The Arms of Venus de Milo]. Novel. Budapest: Singer & Wolfne, **1925**. [DULC 1959–63, 2:708]

R. P. Blackmur, 1904–1965. "Alma Venus." Poem. **1926**. In *A Funeral for a Few Sticks* (Lynn, Mass.: Lone Gull, 1927). [Boswell 1982, p. 46]

———. "Venus as Evening Star," part 9 of "From Jordan's Delight." Poem. In *From Jordan's Delight* (New York: Arrow, 1937). [Ipso]

———. "Indubitable Venus," part 12 of "A Labyrinth of Being." Poem. In *From Jordan's Delight* (1937). [Ipso]

Raoul Dufy, 1877–1953. "Souvenir of the Prado." Gouache painting, copy of Titian's "Venus and the Organist" (Prado). **1926**. Document archives Mouradian, Paris. [Guillon-Lafaille 1981, no. 1977—ill.]

———. "Venus, Boats, Birds." Watercolor. *c*.1930. [Ibid., no. 1841—ill.]

———. 4 further copies of Titian's "Venus and the Organist." 1949. 2 gouaches: "The Prado Titian," Galerie Louis Carré, Paris, in 1981; "Venus Recreated by Music," sold New York, 1976, unlocated. / 2 watercolors ("Venus and the Organist"). Unlocated. [Ibid., nos. 1978–81—ill.]

Michel de Ghelderode, 1898–1962. *Vénus*. Tragi-farce. **1926**. Ostende-Bruges: La Flandre Littéraire, 1927. [EWL 1981–84, 2:228]

Basil Bunting, 1900–1985. "Darling of Gods and Men." Poem, translation of invocation to Alma Venus from Lucretius's *De rerum natura*. **1927**. In *Collected Poems* (Oxford: Oxford University Press, 1978). [Ipso]

Rachel Crothers, 1878–1958. *Venus*. Comedy. First performed 26 Dec **1927**, Masque Theatre, New York. [Oxford 1984, p. 175 / McGraw-Hill 1984, 1:570]

Julio Gonzalez, 1876–1942. "Venus." Wrought-iron sculpture. **1927**. [Clapp 1970, 1:416]

———. "Little Venus." Bronze sculpture. 1935. Open-air Museum, Middelheim, Antwerp. [Ibid.]

Nathalia Crane, 1913–. "Venus Invisible." Poem. In *Venus Invisible and Other Poems* (New York: Coward-McCann, **1928**). [DULC 1959–63, 1:895]

Wallace Gould. "Aphrodite." Poem. In *Aphrodite and Other Poems* (New York: Macaulay, **1928**). [Boswell 1982, p. 260]

Pavel Tchelitchew, 1898–1957. "Green Venus." Painting. **1928**. Private coll. [Tchelitchew 1964, no. 31, fig. 5]

Aldous Huxley, 1894–1963. (Orion ambushed by huntress-Venus in) "Mythological Incident." Poem. In *Arabia Infelix and Other Poems*. New York: Fountain; London: Chatto & Windus, **1929**. [Watt 1971]

D. H. Lawrence, 1885–1930. "Volcanic Venus." Poem. In *Pansies* (London: Secker, **1929**). [Pinto & Roberts 1964, vol. 1]

———. (Venus evoked as a dolphin in) "Whales Weep Not!" Poem. In *Last Poems* (Florence: Orioli; London: Heinemann, 1932). [Ibid., vol. 2]

———. (Sacrifice of living things to Venus and Hermes scorned in) "Self-Sacrifice" (1). Poem. In *Last Poems* (1932). [Ibid.]

———. "Venus in the Kitchen." Painting. Unlocated. [Levy 1964, no. 31—ill.]

Timothy Spelman, 1891–1970. *Pervigilium veneris*. Cantata for soprano, baritone, chorus, and orchestra. **1929**. [Grove 1980, 17:823]

George Havard Thomas, 1893–1933. "Aphrodite." Stone sculpture. c.1928–30. Tate Gallery, London, no. 4767. [Tate 1975, p. 214]

Arturo Dazzi, 1881–. "A Modern Venus." Marble sculpture. Before **1930.** [Clapp 1970, 1:204]

W. H. Auden, 1907–1973. "Venus Will Now Say a Few Words." Poem. In *Poems 1930* (London: Faber & Faber, **1930**). / Revised version in *Collected Poetry* (New York: Random House, 1945). [Mendelson 1976 / Johnson 1973, p. 129 / Feder 1971, p. 139 / Fuller 1970, pp. 40f., 56 / Spears 1963, p. 32]

Gerhard Marcks, 1889–1981. "Thüringen Venus." Bronze sculpture. **1930.** Unique cast. Gerhard-Marcks-Stiftung, Bremen, inv. 16/71. [Busch & Rudloff 1977, no. 204—ill.] Numerous studies, some holding a mirror, some an apple. [Ibid.] Variant, "Seated Thüringen Venus," based on a study for above. 1975. At least 10 casts. [Ibid., no. 1053—ill.]

———. "Venus and Cupid" (Venus teaching Cupid archery). Bronze sculpture. 1952. At least 3 casts. Gerhard-Marcks-Stiftung, Bremen, inv. 95/71; Stadtverwaltung, Herne; another on art market in 1977. [Ibid., no. 594—ill.] Bronze "Head of Venus," derived from above. Unique cast in Gerhard-Marcks-Stiftung, inv. 96/71. [Ibid.]

———. "Venus Tying Up Her Hair." Bronze sculpture. 1960. At least 6 casts. [Ibid., no. 748—ill.]

Alan Durst, b. 1883 "Venus and Cupid." Stone sculpture. Before **1931.** [Clapp 1970, 1:238]

Lucio Fontana, 1899–1968. "Venus." Terra-cotta sculpture. **1931.** Veronesi coll., Milan. [Marck & Crispolti 1974, no. 31 SC 6—ill.]

Paul Delvaux, b. 1897. "Sleeping Venus." Painting. **1932.** Destroyed. [Delvaux 1975, no. 53—ill.]

———. "Sleeping Venus." Painting. 1943. Vanthournout coll. [Ibid., no. 131—ill.]

———. "Sleeping Venus." Painting. 1944. Van Geluwe coll., Brussels. [Ibid., no. 136—ill.]

———. "Sleeping Venus." Painting. 1944. Tate Gallery, London, inv. T.134. [Ibid., no. 149—ill. / Alley 1981, p. 165—ill.]

———. "Nude with a Mirror" ("Venus with a Mirror"). Painting. 1945. Private coll. [Delvaux, no. 155—ill.]

———. "Venus with a Mirror" ("The Mirror"). Painting. 1946. Galleria del Naviglio, Milan. [Ibid., no. 175—ill.]

———. "Reclining Venus" ("The Chandelier," "The Gynaeceum"). Painting. 1952. Private coll., Brussels. [Ibid., no. 211—ill.]

———. "Aphrodite." Painting. 1969. Private coll., Brussels. [Ibid., no. 312—ill.]

Carl Paul Jennewein, 1890–1978. "Venus and Cupid." Polychrome terra-cotta figures. **1932.** Pediment of north wing, Philadelphia Museum of Art. [Agard 1951, p. 159, fig. 86]

Elisabeth Langgässer, 1899–1950. "Venus" (represented by prostitutes). Short story. In *Triptychon des Teufels* (Dresden: Jess, **1932**). [DLB 1988, 69:220]

———. "Venus." Short story. Published 1973. [Ibid.]

Edwin Markham, 1852–1940. "Divine Aphrodite." Poem. In *New Poems: Eighty Songs at Eighty* (Garden City, N.Y.: Doubleday Doran, **1932**). [Boswell 1982, p. 272]

William Rose Benét, 1886–1950. "Young Apollo" (and Aphrodite). Poem. In *Starry Harness and Other Poems* (New York: Duffield & Green, **1933**). [Bush 1937, p. 591]

James Laver, 1899–1975. *Background for Venus.* Novel. London: Heinemann, **1934.** [Ipso]

Francis Picabia, 1878–1953. "Venus." Painting. **1925–35.** Galerie Jacques Benador, Geneva, in 1979. [Borràs 1985, no. 406—ill. / Camfield 1979, fig. 281]

———. "Venus." Abstract painting. 1946. [Borràs, no. 839—ill.]

Owen Seaman, 1861–**1936.** "To Venus Shot in Her Tracks." Poem. In *Owen Seaman: A Selection* (London: Methuen, 1937). [Boswell 1982, p. 291]

Man Ray, 1890–1976. "Venus Restored" (Venus de Milo tied with rope). Sculpture-assemblage. **1936.** A. Schwarz coll., Milan. [Schwarz 1977, pl. 288 / Munich 1984, p. 10—ill.]

———. "Venus" (head covered with a net). Sculpture-assemblage. 1937. Schwarz coll. [Schwarz, pl. 289 / Munich, p. 10—ill.]

Jaroslav Seifert, 1901–1986. "Ruce Venusiny" [The Hands of Venus]. Poem. In *Ruce Venusiny* (Prague: Melantrich, **1936**). / Translated by Ewald Osers in *Selected Poetry* (New York: Macmillan, 1986). [EWL 1981–84, 4:186 / CLC 1985, 34:255f.]

Hermann Hubacher, b. 1885. "Aphrodite." Bronze sculpture. Exhibited Venice Biennale, **1938.** [Clapp 1970, 1:455]

———. "Torso of Aphrodite." Bronze sculpture. By 1959. [Ibid.]

John Brooks Wheelwright, 1897–1940. *Mirrors of Venus.* Novel in sonnets. 1914–38. Boston: Humphries, **1938.** [Gregory & Zaturenska 1946, p. 348]

Granville Bantock, 1868–1946. *Aphrodite in Cyprus.* Orchestral composition. **1938–39.** [Grove 1980, 2:125]

Leoníd Nicolaevich Martýnov, 1905–. "Homespun Venus" [English title of work written in Russian]. Novella in verse. **1930s.** In *Stikhi* (Moscow: Pravda, 1964). [GSE 1973–83, 15:512]

Louis MacNeice, 1907–1963. "Venus' Speech." Poem. In *Poems 1925–1940* (New York: Random House, **1940**). [Boswell 1982, p. 271]

David Jones, 1895–1974. "Aphrodite in Aulis" (as Iphigenia). Painting. **1941.** Private coll. [Blamires 1972, pp. 4, 67–69]

Marino Marini, 1901–1980. "Venus" (torso and legs). Bronze statue. **1942.** 3 casts. Tannahill coll., Detroit; elsewhere. [Hammacher 1970, pl. 72—ill. / Apollonio 1958, p. 37—ill.] Terra-cotta variant. 1945. Mattioli coll., Milan. [Apollonio, p. 38—ill.]

———. "Dream of Venus" (Venus sleeping). Plaster sculpture. 1942. / Variant, 1943. Both in artist's coll. in 1958. [Ibid., pp. 37f.—ill.]

František Zavřel, 1885–1947. *Hora Venusina.* Novel. Prague: **1942.** [NUC]

Benjamin Jarnés Millán, 1888–1949. *Venus dinámica* [Dynamic Venus]. Novella. Mexico: "Proa," **1943.** [EWL 1981–84, 2:500]

Allen Tate, 1899–1979. "The Vigil of Venus." Poem, translation of the "Pervigilium Veneris." **1943.** In *Poems, 1922–1947* (New York: Scribner, 1948). [Squires 1972, pp. 188f. / Gregory & Zaturenska 1946, p. 377]

———. (Venus evoked in) "Winter," part 3 of "Seasons

of the Soul." Poem. In *The Winter Sea* (Cummington, Mass.: Cummington Press, 1944). [DLB 1986, 45:391]

Charles Wheeler, b. 1892. "Aphrodite." Alabaster torso. By **1943.** Burlington House, London. [Agard 1951, fig. 11] Another version, "Aphrodite II." Tate Gallery, London, no. 5559. [Tate 1975, p. 223]

Ker-Xavier Roussel, 1867–**1944.** "Venus and Cupid by the Sea." Painting. Musée d'Orsay, Paris, no. R.F. 1941–55. [Louvre 1979–86, 4:201—ill.]

———. "The Sleep of Venus." Painting. Formerly private coll., Paris, sold Versailles, 1973. [Bénézit 1976, 9:141 / also Georgel 1968, p. 350, no. 244—ill.]

Felix von Woyrsch, 1860–**1944.** "Sapphische ode an Aphrodite" [Sapphic Ode to Aphrodite]. Song. [Baker 1984, p. 2531]

Enrique Asunsolo. *Venus analgésica* [Analgesic Venus]. Farce. In *Revista literaria* (Mexico City) 4 no. 15 (15 Oct **1944**). [Allen 1987, p. 309]

Rune Wahlberg, 1910–. *Afrodite.* Suite for orchestra. **1944.** [Baker 1984, p. 2439]

Roger Bissière, 1886–1964. "Black Venus." Painting. **1945.** Musée National d'Art Moderne, Paris, no. AM 1983–463. [Pompidou 1987, p. 75—ill.]

Dana Suesse, 1911–. "Ode to Aphrodite." Song. Text, Sappho. **1945.** [Cohen 1987, 2:676]

Alfred-Auguste Janniot, b. 1889. "Venus." Marble relief. Before **1946.** Palais des Colonies, Paris. [Clapp 1970, 1:480]

Xavier Montsalvatge, 1912–, music. *La Venus de Elna.* Ballet. **1946.** [Grove 1980, 12:543]

Sydney Goodsir Smith, 1915–1975. "Venus." Poem, part 1 of *The Deevil's Waltz* (Glasgow: William MacLellan, **1946**). [DLB 1984, 27:342]

Ezra Pound, 1885–1972. (Aphrodite, as Cythera, moves under the earth in) Canto 77, in *The Pisan Cantos* (New York: New Directions, **1948**). [Surette 1979, p. 207]

Otto Vrieslander, 1880–1950. "Grosse Venus, mächt'ge Göttin" [Great Venus, Mighty Goddess]. Lied. Text, Goethe's "An Venus" [To Venus]. By **1949.** Published in *Goethe-Lieder.* [Moser 1949, p. 144]

Robert Duncan, 1919–1988. (The Venus of Lespuges in) "The Venice Poem." Poem. In *Poems, 1948–49* (Berkeley, Calif.: Berkeley Miscellany, **1949**). [DLB 1983, 16:172]

John Erskine, 1879–1951. *Venus the Lonely Goddess.* Novella. New York: Morrow, **1949**; illustrated by Warren Chappell. [Boswell 1982, p. 102]

Christopher Fry, 1907–. *Venus Observed.* Comedy in verse. First performed 1950, London. Published London & New York: Oxford University Press, **1949.** [Oxford 1983b, p. 308]

Pablo Picasso, 1881–1973. "Venus and Cupid." Lithograph. **1949.** Several versions. [Bloch 1971–79, nos. 613–14, 1835—ill.]

———. "Venus and Cupid." Aquatint. 1965. [Ibid., no. 1214—ill.]

———. "Vénus du gaz." Found-object sculpture (valve and burner from gas stove). *c.*1952. Claude Picasso coll., Paris. [Rubin 1980, p. 412—ill.]

———. "Venus at the Fairground" (Venus twirling a baton [?], with Cupid and musicians). Etching and drypoint. 1966. [Bloch, no. 1232—ill.]

Fritz Fleer. "Small Aphrodite." Bronze sculpture. **1950.** [Clapp 1970, 1:299]

Horst Wolfram Geissler, b. 1893. *Sie kennen Aphrodite nicht!* [They Don't Know Aphrodite]. Novella. Zürich: Arche, **1950.** [DLL 1968–90, 6:164]

Carlo Sergio Signori, 1906–. "Venus." Marble sculpture. **1950.** [Clapp 1970, 1:810]

———. "Venus." Marble sculpture. 1955. [Ibid.]

———. "Venus." Marble sculpture. 1957. Albright-Knox Art Gallery, Buffalo, N.Y. [Ibid.]

———. "Reclining Venus." Marble sculpture. 1959. [Ibid.]

Hans Studer, 1911–. *Pan kai Aphrodite* [Pan and Aphrodite]. Cantata for alto, female chorus, and orchestra. **1950.** [Grove 1980, 18:304]

Kurt Ziesel, 1911–. *Aphrodite lächelt* [Aphrodite Smiled]. Novel. Vienna: Deutsche Buchgemeinschaft, **1950**; reprinted as *Die goldenen Tage: Roman der Insel Rhodos* [The Golden Days: Novel of the Isle of Rhodes] (Freiburg: Dikreiter Verlagsgesellschaft, 1953). [Wilpert 1963, p. 649]

Aquiles Certad, 1914–. *Cuando Venus tuvo brazos* [When Venus Had Arms]. Farce. In *Tres obras de teatro* (Buenos Aires: Editorial Interamérica, **1951**). [Allen 1987, p. 545]

Horace Gregory, 1898–1982. "Venus and the Lute Player." Poem. In *Selected Poems* (New York: Viking, **1951**). [DLB 1986, 48:216 / Boswell 1982, p. 127]

Reuben Nakian, 1897–1986. "Venus." Plaster statue. **1952.** Destroyed. [O'Hara 1966, p. 42—ill.]

———. "Venus." Terra-cotta sculpture. 1963. Egan Gallery, New York, in 1966. [Ibid., no. 90] 2 terra-cotta studies. 1962. Egan Gallery. [Ibid., nos. 78–79]

Tatjana Gsovsky, 1901–, choreography. *Trionfo di Aphrodite.* Modern dance. Music, Carl Orff. Text, Orff, after Catullus, Sappho, and Euripides. First performed **1953,** La Scala, Milan. [Oxford 1982, pp. 188, 311]

Wesley Trimpi, 1928–. "Venus." Poem. In *The Glass of Perseus* (Denver: Swallow, **1953**). [Ipso]

Mark Brunswick, 1902–1971. "Hymn to Venus." Hymn (text after Lucretius) in *Eros and Death.* Choral symphony. **1932–54.** [Grove 1986, 1:315]

Stanley Spencer, 1891–1959. "Love on the Moor" (a man embracing a statue of Venus: apotheosis of the painter's wife as Venus). Painting. **1949–54.** Fitzwilliam Museum, Cambridge, no. PD.968–1963. [Fitzwilliam 1960–77, 3:242]

George Antheil, 1900–1959. *Venus in Africa.* Opera. Libretto, M. Dyne. **1954.** First performed 24 May 1957, Denver. [Grove 1980, 1:454]

Alexander Archipenko, 1887–1964. "Venus." Abstract relief construction. **1954.** [Archipenko 1960, pl. 73]

W. S. Merwin, 1927–. "December of Aphrodite." Poem. In *The Dancing Bears* (New Haven: Yale University Press, **1954**). [Boswell 1982, p. 273]

Wallace Stevens, 1879–**1955.** (Venus evoked in) "The Dove in Spring." Poem. In *Opus Posthumous,* edited by Samuel French Morse (New York: Knopf, 1957). [Vendler 1980, pp. 56–58]

Robert Conquest, 1917–. "The Rokeby Venus." Poem, on Velázquez's painting (*c.*1648–51, London). In *Poems* (London: Macmillan, **1955**). [Ipso]

Robert Creeley, 1926–. "The Death of Venus." Poem. In

All That Is Lovely in Men (Asheville, N.C.: Williams, **1955**). [Novick 1973, p. 5 / Boswell 1982, p. 80]

Daryl Hine, 1936–. "Venus Big with Time" (clock figure of Venus de Milo). Poem. In *Five Poems* (Toronto: Emblem, **1955**). [CLC 1980, 15:281]

Gian Francesco Malipiero, 1882–1973. *Venere prigioniera* [Venus Prisoner]. Opera. Libretto, Malipiero, after story by Emmanuel Gonzales. **1955**. First performed 14 May 1957, Pergola, Florence. [Grove 1980, 11:581f.]

Max Weiss, 1921–. "Venus barbare" [Barbaric Venus]. Sculpture. **1955**. Switzerland. [Clapp 1970, 1:904]

William King, 1925–. "Venus" (pudica). Bronze statue. **1956**. Hirshhorn Museum and Sculpture Garden, Washington, D.C. [Hirshhorn 1974, p. 706, pl. 623]

Jean Arp, 1887–1966. "Venus of Meudon." Abstract bronze sculpture. **1957**. Edition of 5. Hirshhorn Museum and Sculpture Garden, Washington, D.C.; elsewhere. [Clapp 1970, 1:53 / Giedion-Welcker 1957, no. 145 / Arp 1968, p. 104 / Read 1968, p. 206—ill.] Variant ("Small Venus of Meudon"). 1957. Edition of 5. [Arp, no. 159—ill.]

Octavio Paz, 1914–. (Aphrodite evoked as restorer of life to fragmented man in) *Piedra de sol* [Sun Stone]. Poem. Mexico City: Tezontle, **1957**. [Wilson 1986, pp. 90, 95f.]

John Hollander, 1929–. (Venus pudica evoked in) "The Lady of the Castle." Poem. In *A Crackling of Thorns* (New Haven: Yale University Press, **1958**). [Ipso]

William Turnbull, 1922–. "Aphrodite." Sculpture. **1958**. Bronze and bronze, wood, and stone versions. [Clapp 1970, 1:873]

Karl Springenschmid, b. 1897. *Die sizilianische Venus* [The Sicilian Venus]. Novel. Graz: Stocker, **1959**. [Wilpert 1963, p. 555]

César, 1921–. "Venus of Villetaneuse." Bronze statue. **1960**. Hirshhorn Museum and Sculpture Garden, Washington, D.C. [Hirshhorn 1974, p. 673, pl. 809]

Heinz Rosen, 1908–1972, choreography. *Trionfo di Afrodite*. Ballet. Music and text, Carl Orff (1953). First performed **1960**, Staatsoper, Munich. [Oxford 1982, p. 353]

Peter Viereck, 1916–. "The Aphrodite Trilogy." Poem. In *The Tree Witch, a Poem and a Play* (New York: Scribner, **1961**). [Ipso]

Babette Deutsch, 1895–1982. (Venus evoked in) "Love's a Fever the Moon Died Of." Poem. By **1962**. In *Collected Poems, 1919–1962* (Bloomington: Indiana University Press, 1963). [Ipso]

Paul Goodman, 1911–1972. "Ballade to Venus." Poem. In *The Lordly Hudson: Collected Poems* (New York: Macmillan, **1962**). [Ipso]

Wilhelm Loth, 1920–. "Great Venus Torso." Bronze sculpture. **1962**. Galerie Gunar, Düsseldorf. [Gertz 1964, pl. 74]

Isamu Noguchi, 1904–. "Aphrodite." Abstract bronze sculpture. **1962**. 2 casts. Artist's coll.; Martha Graham coll. [Grove & Botnick 1980, no. 518—ill.]

Gustav Seitz, 1908–. "Flensburg Venus." Bronze sculpture. **1963**. [Grohn 1980, no. 160—ill.] Reduced variant. 4 casts. Atelier Gustav Seitz, Hamburg; private colls., Germany. [Ibid., no. 161—ill.]

Juan Corelli, 1934–, choreography. *De bronzen Venus* [The Bronze Venus]. Ballet. Music, H. Cliques-Pleyel. First performed **1964**, Opera, Amsterdam. [EDS 1954–66, suppl. p. 240]

Ibram Lassaw, 1913–. "Cytherea." Welded metal sculpture. **1964**. Albright-Knox Gallery, Buffalo, N.Y. [Clapp 1970, 2 pt. 2: 686]

Louis Le Brocquy, 1916–. "Willendorf Venus." Abstract painting. **1964**. Hirshhorn Museum and Sculpture Garden, Washington, D.C. [Hirshhorn 1974, p. 712, pl. 808]

Robert Rauschenberg, 1925–. "Persimmon." Painting, incorporating Rubens's "Toilet of Venus" (c.1613–14, Vaduz). **1964**. Castelli coll., New York. [Smithsonian 1976, no. 102—ill. / also Berlin 1980, p. 316—ill.]

Tomonori Toyofuku, 1925–. "Venus." Wood sculpture. **1964**. Sarnoff coll., New York. [Clapp 1970, 1:869]

Norman Walker, 1934–, choreography. *Trionfo di Afrodite*. Modern dance. Music and scenario, Carl Orff (1953). First performed Summer **1964**, Utah State University. [McDonagh 1976, p. 271 / Chujoy & Manchester 1967, p. 957]

H. P. Alvermann, 1931–. "Aphrodite." Sculpture. **1965**. [Clapp 1970, 1:25]

Mario Ceroli, 1938–. "Venus." Wood sculpture. **1965**. [Clapp 1970, 1:159]

David Gascoyne, 1916–. "Venus Androgyne." Poem. In *Collected Poems* (London: Oxford University Press, **1965**). [Ipso / CLC 1987, 45:157]

Jaime Gil de Biedma, 1929–. *En favor de Venus*. Collection of poetry. Barcelona: Literatura, **1965**. [DLE 1972, p. 391]

Elio Marchegiani, 1929–. "Venus." Sculpture. **1965**. [Clapp 1970, 1:573]

Paul Blackburn, 1926–1971. "Venus, the Lark. . . ." Poem. **1949–66**. In *Early Selected Y Mas: Poems, 1949–1966* (Los Angeles, Calif.: Black Sparrow, 1972). [CLC 1987, 43:63]

Leopoldo Marechal, 1900–1970. *Las tres caras de Venus* [The Three Faces of Venus]. Drama. Buenos-Aires: Ediciones Citerea, **1966**. [EWL 1981–84, 3:25]

John Butler, 1920–, choreography. *Aphrodite*. Modern dance. First performed **1967**, New York. [McDonagh 1976, p. 147]

Michelangelo Pistoletto, 1933–. "Venus of the Rags." Assemblage (cement statue and pile of rags). **1967–68**. Galerie Tanit, Munich. [Munich 1984, pp. 16ff.—ill.]

Giacomo Manzù, 1908–. "Apollo, Venus, and Minerva." Bronze bozzetto for sculpture. **1968**. Meadows coll., Dallas, Texas. [Micheli 1971, fig. 89—ill.]

Kathleen Raine, 1908–. "Venus." Poem. In *Collected Poems* (London: Hamilton, **1968**). [Boswell 1982, p. 283]

Riccardo Bacchelli, 1891–1985. *L*ˣ*Afrodite*" (symbolic evocation of myth in title and central character). Novel. Milan: Mondador, **1969**. [Seymour-Smith 1985, p. 749]

Robert Bagg, 1935–. "Aphrodite." Poem, from Euripides' *Hippolytus*. By **1969**. In *The Scrawny Sonnets and Other Narratives* (Urbana: University of Illinois Press, 1973). [Ipso]

Leonard Baskin, 1922–. "Venus." Etching, illustration for edition of Euripides' *Hippolytus,* translated by Robert Bagg (Northampton, Mass.: Gehenna, **1969**). [Fern & O'Sullivan 1984, no. 526—ill.]

———. "Venus." Etching, illustration for edition of Tennyson's *Tiresias* (Northampton: Gehenna, 1971). [Ibid., no. 607—ill.]

Arman, 1928–1974. "Venu$." *Accumulation* (money in a

polyester form). 20 examples. **1970.** Artist's coll. in 1973. [Martin 1973, 183—ill.]

Daniel Hoffman, 1923–. "Aphrodite." Poem. In *Broken Laws* (New York: Oxford University Press, **1970**). [DLB 1980, 5 pt. 1: 338]

Ulysses Kay, 1917–. *The Capitoline Venus.* Opera. Libretto, composer (or J. Dvorkin), after Mark Twain. **1970.** First performed 12 Mar 1971, University of Illinois, Urbana. [Slonimsky 1986, p. 21 / Grove 1986, 2:615]

Maureen Duffy, 1933–. *The Venus Touch.* Collection of poems. London: Wiedenfeld & Nicholson, **1971.** [Seymour-Smith 1985, p. 317 / DLEL 1970–78, 2:92]

Carolyn Kizer, 1925–. "The Dying Goddess." Poem. In *Midnight Was My Cry: New and Selected Poems* (Garden City, N.Y.: Doubleday, **1971**). [CLC 1980, 15:309]

Richmond Lattimore, 1906–1984. "Remember Aphrodite." Poem. In *Poems from Three Decades* (New York: Scribner, **1972**). [Ipso]

Olga Broumas, 1949–, poem, and **Sandra McKee,** painting. "Aphrodite." Part of 2–media piece "Twelve Aspects of God." Exhibited Sep **1975,** Maude Kerns Gallery, Eugene, Ore. Broumas's poem in *Beginning with O* (New Haven: Yale University Press, 1977). [Ipso]

Kay Gardner, 1941–. "Prayer to Aphrodite." Instrumental composition. **1975.** [Cohen 1987, 1:258]

Giulio Paolini, 1940–. "Mimesis." Sculpture (2 plaster copies of Venus de' Medici facing each other). **1975– 76.** [Bandini et al. 1985, pl. 25 / Munich 1984, p. 72—ill. / Villeurbanne 1983, pp. 70f.—ill.]

George Barker, 1913–. "Even Venus Turns Over." Poem. In *Dialogues etc.* (London: Faber & Faber, **1976**). [CLC 1978, 8:47]

Robert Francis, 1901–1987. "Aphrodite as History." Poem. In *Collected Poems: 1936–1976* (Amherst: University of Massachusetts Press, **1976**). [Ipso]

Ruth Zechlin, 1926–. *Aphrodite.* "Scenic" chamber music piece, for alto, baritone, 2 pantomimists, and 7 instrumentalists. **1976.** [Baker 1984, p. 2558]

Anthony Hecht, 1922–. (Venus genetrix evoked in) "Goliardic Song." Poem. In *Millions of Strange Shadows* (New York: Atheneum, **1977**). [Ipso]

Jules Olitski, 1922–. "Cythera–4." Abstract painting. **1977.** Artist's coll. [Moffett 1981, pl. 132]

Murray Louis, 1926–, choreography. *The Canarsie Venus.* Ballet. First performed **1978,** New York. [Cohen-Stratyner 1982, p. 563]

Humberto Costantini, 1924?–1987. (Athena, Aphrodite, and Hermes fight Hades on behalf of mortals in) *De dioses, hombrecitos y policías* [The Gods, the Little Guys, and the Police]. Novel. [Havana?]: Casa de las Américas, **1979.** / Translated by Tony Talbott (New York: Harper & Row, 1984). [Ipso]

Claudio Parmiggiani, 1943–. "Porta Veneris." Assemblage (drawings on 2 canvases, marble egg). **1979.** [Reggio Emilia 1985, pp. 79f.—ill.]

Louise Glück, 1943–. "Aphrodite." Poem. In *Descending Figure* (New York: Ecco, **1980**). [Ipso]

George Lloyd, 1913–. *The Vigil of Venus.* Choral composition for tenor and soprano. **1980.** [Grove 1980, 11:99]

Peter Taylor, 1917–. "Venus, Cupid, Folly, and Time." Short story. By **1983.** [Marilyn Malina, "An Analysis of Peter Taylor's 'Venus, Cupid, Folly, and Time,' *Studies in Short Fiction* 20 (Fall 1983), pp. 249–54]

Medbh McGuckian, 1950–. *Venus and the Rain.* Collection of poems. Oxford & New York: Oxford University Press, **1984.** [Johnston 1985, p. 261 / CLC 1988, 48:277f. / DLB 1985, 40 pt. 2: 354]

Maura Stanton, 1946–. "Venus." Poem. In *Cries of Swimmers* (Salt Lake City: University of Utah Press, **1984**). [Ipso]

Alfred Corn, 1943–. "Prayer to Aphrodite." Poem, after Sappho. In *The West Door* (New York: Viking/Penguin, **1988**). [Ipso]

Michael Pritchett, 1961–. "The Venus Tree." Short story. In *The Venus Tree* (Iowa City: University of Iowa Press, **1988**). [Ipso]

Laurie Sheck. "Poem Beginning with a Line from Sappho." Poem. In *Io at Night* (New York: Knopf, **1990**). [Ipso]

Birth of Aphrodite. According to Homer, Aphrodite was the fruit of a union between Zeus (Jupiter) and Dione. But in Hesiod's far more popular version, Aphrodite sprang from the foam (Greek, *aphros*) of the sea that gathered around the severed genitals of the Titan Uranus when he was castrated by his son Cronus. Borne by the sea on a scallop shell, the goddess landed either at Cythera or at Paphos in Cyprus (hence her epithets "Cytherea" and Paphian or Cyprian Aphrodite).

A painting by Apelles of Cos (fl. *c.*332–329 BCE), described by Pliny but now lost, depicts the goddess rising from the sea. This theme, commonly called Venus Anadyomene, is a favorite subject in postclassical art. She is also commonly depicted wringing out her hair on the beach. Aphrodite's marine origin is evoked in sea-triumphs in which she is pulled by dolphins and accompanied by Eros (Cupid) and Nereids (sea nymphs) and sometimes by Poseidon (Neptune). These triumphs are similar to, and sometimes interchangeably identified as, triumphs of the Nereids Amphitrite or Galatea.

Classical Sources. Hesiod, *Theogony* 188–206. *Homeric Hymns,* second hymn "To Aphrodite." Pliny, *Naturalis historia* 35.91.

See also AMPHITRITE; GALATEA.

Jean de Meun, 1250?–1305? (Birth of Venus evoked in) *Le roman de la rose* lines 5535–48. Romance. *c.***1275–80.** [Oxford 1976, p. 547 / Hill 1974, pp. 418ff.]

Angelo Poliziano, 1454–1494. (Birth of Venus evoked in) *Stanze . . . per la giostra di Giuliano de' Medici* 1.94. Poem. **1475–78.** [Wind 1968, pp. 113ff., 131ff., 136ff.]

———. Epigram on the "Venus Anadyomene" of Apelles. [Ibid.]

Sandro Botticelli, 1445–1510. "The Birth of Venus" ("Venus Landing on the Shore"). Painting. *c.***1486.** Uffizi,

Florence, no. 878. [Lightbown 1978, no. B46—ill. / Uffizi 1979, no. P256—ill.] School copies of figure of Venus ("Venus Pudica"), 1480s–90s, in Gemäldegalerie, Berlin-Dahlem, no. 1124; Bodmer coll., Geneva; Galleria Sebauda, Turin, no. 656. [Lightbown, nos. C10–12—ill. / also Berlin 1986, p. 17—ill.]

Lorenzo de' Medici, 1449–**1492.** "Nascita di Venere." Poem. MS handwritten, with drawings. [Warburg]

Albrecht Dürer, 1471–1528. "Pupila Augusta" (Venus arriving [in Nuremberg?] on a dolphin). Drawing. *c.*1495–96. Royal Library, Windsor, no. 12175. [Strauss 1974, no. 1496/17—ill.]

———. "Venus Riding on a Dolphin." Drawing. 1503. Albertina, Vienna, no. 3074. [Ibid., no. 1503/1—ill. / Strauss 1977b, p. 298—ill.]

Filippino Lippi, *c.*1457–1504. "The Birth of Venus" (?). Painting, unfinished sketch on one side of a double-sided panel. *c.*1500 or earlier. Christ Church, Oxford. [Byam Shaw 1967, no. 41—ill.]

Antonio Lombardo, *c.*1458–1516. "Venus Anadyomene." Marble high-relief sculpture. **Early 16th century.** Victoria and Albert Museum, London. [Pressly 1981, pl. 25]

Marcantonio Raimondi, *c.*1480–1527/34. "Venus Wringing Her Hair." Engraving (Bartsch no. 312). **1506.** [Shoemaker 1981, no. 9—ill. / Bartsch 1978, 26:313—ill.]

Baldassare Peruzzi, 1481–1536. (Venus on a shell, with doves and a ram, Venus and Cupid with Saturn, in) Ceiling frescoes, representing the constellations Capricorn and Pisces. **1510–11.** Sala di Galatea, Villa Farnesina, Rome. [d'Ancona 1955, pp. 25f., 87f. / Gerlini 1949, pp. 10ff. / also Frommel 1967–68, no. 18c]

Raphael, 1483–1520, studio (probably Giulio Romano), after Raphael's design. "The Birth of Venus," "Venus and Cupid Led by Dolphins." Frescoes, part of cycle for Stufetta del Cardinal Bibbiena, Vatican, Rome. **1516.** In place. [Vecchi 1987, no. 125 / cf. Hartt 1958, pp. 31f.]

———, composition. "Venus Reclining on a Dolphin." Engraving, by Agostino Veneziano (Bartsch 14:192 no. 239). [Bartsch 1978, 26:236—ill.]

———, composition. "The Birth of Venus" ("Venus on the Sea"). Engraving, by Marco Dente da Ravenna (Bartsch 14:243 no. 323). [Ibid., 27:15—ill.]

Giulio Romano, *c.*1499–1546, attributed, after design by Raphael. "The Birth of Venus," "Venus and Cupid Led by Dolphins." Frescoes, part of cycle for Stufetta del Cardinal Bibbiena, **1516.** *See Raphael, above.*

———. "The Birth of Venus." Painting, part of "Jupiter" cycle. *c.*1533? Lost. / Drawing. Louvre, Paris, no. 3483 [Hartt 1958, pp. 214, 305 no. 306—ill.]

Titian, *c.*1488/90–1576. "Venus Anadyomene." Painting. *c.*1525. National Gallery of Scotland, Edinburgh (on loan from Duke of Sutherland coll.). [Wethey 1975, no. 39—ill. / Berenson 1957, p. 184]

Jacopo Sansovino, 1486–1570. "Venus Anadyomene." Bronze statue. *c.*1527. National Gallery, Washington, D.C., no. A–21. [Sienkewicz 1983, p. 32 / also Walker 1984, fig. 991] *See also Cattaneo, below.*

Danese Cattaneo, *c.*1509–1573, under direction of **Jacopo Sansovino**, 1486–1570. "Venus Cyprica" (with Cupid). Marble relief. *c.*1537–39. Loggetta, Piazza San Marco, Venice. [Pope-Hennessy 1985b, 3:84f., 404f.—ill.]

———. "Fortune" (also called "Marine Venus"). Bronze statue. Bargello, Florence. [Pope-Hennessy 1985b, 3:411 / Cessi 1960, p. 51—ill.]

———, studio. "Venus Marina." Bronze sculpture. Complete version, with flying drapery, Kunsthistorisches Museum. / Variant (without drapery), sold Sotheby's, London, 1968. [Warburg]

Perino del Vaga, 1501–1547. "Aphrodite Anadyomene" (? or Galatea?). Painting. *c.*1540. Palazzo Doria, Rome. [Warburg]

Battista Dossi, *c.*1474–1548, and **Girolamo da Carpi**, 1501–1556 (previously attributed to Girolamo only). "Venus on the Eridanus" ("Venus in a Shell, Drawn by Swans with Amor and Nymphs"). Painting. *c.*1541. Gemäldegalerie, Dresden, no. 143. [Gibbons 1968, no. 93—ill. / Dresden 1976, p. 55]

Andrea Schiavone, *c.*1522–1563, rejected attribution (questionably attributed to Lambert Sustris). "Venus Carried by a Dolphin to Cythera." Painting. *c.*1548–54? Castello Sforzesco, Milan, no. 195 (as Venetian school). [Richardson 1980, no. D357, p. 35 / also Berenson 1957, p. 160 (as Schiavone, inv. 55)—ill.]

Pierre de Ronsard, 1524–1585. (Venus Anadyomene evoked in) Poem 9 of *Les amours . . . nouvellement augmentées* (Paris: La Porte, **1554**). [Laumonier 1914–75, vol. 7 / McGowan 1985, pp. 199–204]

Giorgio Vasari, 1511–1574, and **Cristofano Gherardi**, 1508–1556. "Venus Born from the Sea" (allegory of Water). Fresco. **1555–56.** Sala degli Elementi, Palazzo Vecchio, Florence. [Sinibaldi 1950, pp. 13, 22, 49—ill. / Lensi 1929, pp. 154ff., 160—ill.]

Girolamo da Carpi, 1501–**1556.** "Venus on the Seashell." Painting. Gemäldegalerie, Dresden. [Warburg]

Giambologna, 1529–1608, attributed. "Kneeling Venus Wringing Out Her Hair." Alabaster statue. *c.*1556–58? Muncaster Castle, Cumbria. [Avery 1987, no. 164—ill. / also Avery & Radcliffe 1978, no. 23—ill.]

——— (traditionally attributed to Michelangelo). "Venus and a Dolphin." Terra-cotta relief. *c.*1560? Brinsley Ford coll., London. [Avery, no. 160—ill.]

———. "The Birth of Venus." Marble relief on pedestal of "Fountain of Ocean." 1570/75. Boboli Gardens, Florence. [Ibid., no. 149—ill.]

———, attributed. "Venus with a Dolphin." Marble statue. *c.*1560? Villa Fabbricotti, Florence. [Ibid., no. 25—ill.]

Luca Cambiaso, 1527–1585. "Venus on the Sea with Cupid." Painting. *c.*1561. Galleria Borghese, Rome, inv. 123. [Manning & Suida 1958, p. 147—ill. / Pergola 1955–59, 1: no. 128—ill.]

———. "Venus [or Galatea] Carried by a Dolphin." Woodcut. (Uffizi, Florence, no. 6942.) [Manning & Suida, p. 171—ill.]

———. "Venus on the Sea." Drawing. Uffizi, Florence, inv. 13835. [Ibid., p. 186—ill.]

Michelangelo, 1475–**1564**, formerly attributed (now given to Giambologna). "Venus and a Dolphin." Terra-cotta relief. *See Giambologna, above.*

Vincenzo Danti, 1530–1576, attributed (also attributed to Bartolommeo Ammannati, Elia Candido). "Venus (Anadyomene)." Bronze statuette. **1570–73.** Studiolo di Francesco I, Palazzo Vecchio, Florence. [Pope-Hennessy

1985b, 3:100, 379f. / also Sinibaldi 1950, pp. 12, 18, 38—ill. / Lensi 1929, pp. 236f., 265—ill.]

Stoldo di Lorenzi, 1534–1583. "Marine Nymph" (variously identified as Galatea, Amphitrite, Venus). Bronze statuette. **1573.** Studiolo di Francesco I, Palazzo Vecchio, Florence. [Sinibaldi 1950, pp. 12, 18 / also Pope-Hennessy 1985b, 3:100—ill. / Lensi 1929, pp. 236f., 265 (as Vincenzo de'Rossi)—ill.] Variant copies in Frick Collection, New York, no. 16.2.48 (mid-18th century?); Victoria and Albert Museum, London (stucco, late 18th/19th century). [Frick 1968–70, 3:208f.—ill.]

Hendrik Goltzius, 1558–1617. "Venus Marina." Woodcut, in "Children of Demogorgon" series; executed by studio after Goltzius's composition (Bartsch no. 235, as "Galatea"; also previously called "Amphitrite"). *c.*1594. [Strauss 1977a, no. 422—ill. / Bartsch 1980–82, no. 235—ill.]

Agostino Carracci, 1557–1602. "Venus [or Galatea] Carried by Dolphins." Engraving (Bartsch no. 129), in *"lascivie"* series. *c.*1590–95. [DeGrazia 1984, no. 181—ill.]

Edmund Spenser, 1552?–1599. (Birth of Venus evoked in) *The Faerie Queene* 4.12.2. Romance epic. London: Ponsonbie, **1596.** [Hamilton 1977 / MacCaffrey 1976, p. 293]

Peter Paul Rubens, 1577–1640. "The Birth of Venus." Painting. *c.*1615. Formerly Sanssouci, Potsdam, lost in 1945. [Jaffé 1989, no. 323—ill.]

———. (Marie depicted as Venus Marina in) "The Disembarkation of Marie de' Medici at the Port of Marseilles;" (Venus in) "The Meeting of Marie de' Medici and Henri IV at Lyons," "The Apotheosis of Henri IV and the Assumption of the Regency by Marie de' Medici," "The Council of the Gods" ("The Government of the Queen"). Paintings, part of "Life of Marie de' Medici" cycle. 1622–25. Louvre, Paris, inv. 1774, 1775, 1779, 1780. [Saward 1982, pp. 64, 67ff., 98ff., 114ff.—ill. / also Jaffé, nos. 723, 725, 735, 737—ill. / Louvre 1979–86, 1:116f.—ill. / Baudouin 1977, pl. 42] Oil sketches. Alte Pinakothek, Munich, inv. 95, 102, 103 ("Disembarkation," "Apotheosis," "Council"); Hermitage, Leningrad ("Apotheosis"). [Jaffé, nos. 722, 733, 734, 736—ill. / Held 1980, nos. 63–64, 60–71 / also Munich 1983, pp. 463ff.—ill. / Baudouin, fig. 97]

———. "The Triumph of the Sea-born Venus." Painting, oil sketch, design for (or copy after?) ivory salt-cellar. 1627–28. Lady Bentinck coll., Welbeck Woodhouse, Notts. [Jaffé, no. 897—ill. / Held 1980, no. 266—ill. / White 1987, pp. 203f.—ill.] Salt cellar, carved by Jörg Petel, in Kungl-Husgerådskammeren, Copenhagen. [Jaffé / White, pl. 228]

———. "The Birth of Venus." Painting, grisaille sketch, probably modello for a silver basin decoration. *c.*1630–33. National Gallery, London, inv. 1195. [Jaffé, no. 1000—ill. / Held 1980, no. 265—ill. / London 1986, p. 547—ill. / also Baudouin 1977, fig. 119] Copies in Musée Bonnat, Bayonne, inv. 35; private coll., Zurich (partial). [Held]

———. "The Birth of Venus." Painting, for Torre de la Parada, El Pardo, executed by Cornelis de Vos from Rubens's design. 1636–38. Prado, Madrid, no. 1862. [Alpers 1971, no. 58—ill. / Jaffé, no. 1330—ill. / Prado 1985, pp. 766f.] Oil sketch. Musées Royaux des Beaux-Arts (Musée d'Art Ancien), Brussels, inv. 4106 (815). [Held 1980, no. 217—ill. / Alpers, no. 58a—ill. / Brussels 1984a, p. 251—ill. / Jaffé, no. 1329—ill.]

Nicolas Poussin, 1594–1665. "The Birth of Venus." 3 drawings. **1630s.** Galleria Corsini, Rome, no. 127422; Musée Condé, Chantilly, no. 183b; Nationalmuseum, Stockholm, no. Wengstrom XIV verso. [Friedlaender & Blunt 1953, nos. 202–04—ill.]

———. "Venus Landing on Cythera." Drawing. 1645–47. Musée Bonnat, Bayonne, no. 1668. [Ibid., no. 205—ill.] Variant copy, painting, by Charles-Alphonse Dufresnoy. 1647. Neues Palais, Potsdam. [Ibid.]

Adriaen van Nieulandt, 1587–1658, attributed. "Venus and Neptune" (sea-triumph of Venus, Neptune on the shore). Painting. Formerly Rijksmuseum, Amsterdam, destroyed. [Rijksmuseum 1976, pp. 417f.]

Francesco Albani, 1578–1660, questionably attributed. "Venus on the Sea." Painting. Herzog Anton Ulrich Museum, Braunschweig, no. 1103. [Braunschweig 1969, p. 26]

Jean-Baptiste Lully, 1632–1687, music. 12 entrées for *La naissance de Vénus.* Ballet. Scenario, Isaac de Bensérade. First performed 26 Jan **1665,** Palais Royale, Paris. [Oxford 1982, p. 264 / Grove 1980, 11:318, 327] *See also* Colasse, *below.*

François Girardon, 1628–1715. "Triumph of Venus." Relief on marble vase, for Versailles. **1683.** Louvre, Paris (as "Triumph of Amphitrite"). [Francastel 1928, no. 55—ill.]

Raymond de La Fage, *c.*1650–1684. "Birth of Venus and Sea-borne Triumph to Cyprus." Drawing. Nationalmuseum, Stockholm. [Warburg]

Gabriel Grupello, 1644–1730. "Venus." Marble fountain figure. *c.*1689–91. Formerly Slot Het Loo, Holland, lost. [Kultermann 1968, no. 21 / Düsseldorf 1971, nos. 57–60—ill. (prints)]

———. "Venus with a Mussel-shell." Marble statue (related to above?). Musées Royaux des Beaux-Arts, Brussels. [Kultermann, figs. 117–18]

Jacques Sarrazin, 1588/92–1660, **Étienne Le Hongre,** 1628–1690, and **Pierre Le Gros,** 1629–1714. "Venus Rising from the Sea" ("The Richelieu Venus"). Marble statue, begun by Sarrazin, continued by Le Hongre, completed by Le Gros, **1685–96.** Tapis Vert, Gardens, Versailles. [Girard 1985, pp. 264, 279—ill.]

Pascal Collasse, 1649–1709, with additions by **Jean-Baptiste Lully,** 1632–1687. *La naissance de Vénus.* Musical pastorale. Libretto, Jean Pic. First performed 1 May **1696,** L'Opéra, Paris. [Grove 1980, 4:534f. / Girdlestone 1972, pp. 126–28]

Jacob de Wet the Younger, 1640–1697. "The Birth of Venus." Painting. Holyrood House, Edinburgh. [Pigler 1974, p. 243]

Antoine Watteau, 1684–1721. "The Birth of Venus." Drawing, design for (unexecuted) decorative panel. *c.*1708–09. Hermitage, Leningrad. [Grasselli & Rosenberg 1984, no. D.40—ill.]

Sebastiano Ricci, 1659–1734. "Triumph of the Marine Venus." Painting. **1713.** Getty Museum, Malibu, Calif., inv. A.72,P–20. [Daniels 1976, no. 220—ill.]

Antoine Coypel, 1661–1722. "Venus on the Waters." Painting. Louvre, Paris, inv. 3524. [Louvre 1979–86, 3:170—ill.]

Benedetto Luti, 1666–1724. "The Birth of Venus." Painting. Národní Galeri, Prague. [Pigler 1974, p. 243]

Balthasar Permoser, 1651–1732. "Venus Anadyomene and Cupid" ("Spring"). Sandstone statue. **1724.** Kronentor, Zwinger, Dresden. [Asche 1966, no. P74, pl. 67]

Antonio Bellucci, 1654–1726. "Venus on the Waves, Cupid Tending the Sails." Painting. Alte Pinakothek, Munich. [Bénézit 1976, 1:609]

Paolo de Matteis, 1662–1728. "Triumph of Venus" (pulled by dolphins, surrounded by gods and sea deities). Painting. Weinmiller, Munich. [Warburg]

Noël-Nicolas Coypel, 1690–1734. "The Birth of Venus." Painting. **1732.** Hermitage, Leningrad, inv. 1176. [Hermitage 1986, no. 37—ill.] 2 other versions of the subject known, unlocated. [Ibid.]

George Frideric Handel, 1685–1759. "Venus Now Leaves Her Paphian Dwelling." Song. Published in *British Musical Miscellany*, vol. 1 (**1734**). [Grove 1980, 8:126]

François Boucher, 1703–1770. "The Birth (Triumph) of Venus." Painting. **1743.** Private coll., New York. [Ananoff 1976, no. 243—ill.] Replica, by Boucher and studio. Hermitage, Leningrad, inv. 7655. [Ibid. / Hermitage 1986, no. 10—ill.] Studio variant. Wallace Collection, London, no. P.433 (as Boucher, "Triumph of Amphitrite"). [Ibid., no. 243.14 / Wright 1976, p. 23]

———. "Venus Reclining [on the waves] beside Two Amorini." Painting. **1754.** Wallace Collection, London, no. P.423. [Ibid., no. 434—ill.]

———. "The Triumph of Venus and Neptune." Grisaille painting. *c.*1760. Lost. [Ibid., no. 528—ill.]

———. "The Birth of Venus." Painting. 1764? Lost. [Ibid., no. 577] Drawing. Armand Hammer coll. / Maquettes for tapestries, by Boucher and Maurice Jacques. Musée des Gobelins, nos. GOB/28,29. [Ibid.—ill.]

———. "The Birth of Venus." Painting, sketch. 1765. Detroit Institute of Art, no. 29445. [Ibid., no. 619—ill.]

———. "Venus on the Water." Painting. 1766. David M. Koester Gallery, Zurich, in 1976. [Ibid., no. 636—ill.] Studio replica. *c.*1766. North Carolina Museum of Art, Raleigh, no. G.55.8.2. [Ibid., no. 637—ill.]

———. "Venus Rising from the Waters." Painting, design for tapestry, based on above. 1766. Lost. [Ibid., no. 638] Modellos ("Venus on the Water"). Musée des Gobelins; Louvre, Paris, no. 2731 (studio replica). [Ibid. / Louvre 1979–86, 3:83—ill.] Tapestry medallions, several sets. Musée des Gobelins; others unlocated. [Ananoff—ill.]

———. "Venus on the Water" ("Venus Crowned by Cupids"). Painting (similar to above). 1769. Getty Museum, Malibu, Calif. [Ibid., no. 671—ill.]

Charles-Joseph Natoire, 1700–1777. "Venus Received on the Sea by Neptune." Painting, decoration for Château de Marly. 1743. Sold Paris, 1868. [Boyer 1949, no. 66]

Jean-Joseph Cassanéa de Mondonville, 1711–1772, music. *Les fêtes de Paphos*. Ballet-héroïque. Libretto, Charles Collé, La Bruère, and Voisenon. First performed 9 May **1758**, L'Opéra, Paris. [Grove 1980, 12:481]

Michel Corrette, 1709–1795. "Paphos." Cantatille. Published Paris: **1762.** [Grove 1980, 4:801]

Corrado Giaquinto, 1703–**1765.** (Venus Marina in) "The Birth of the Sun and the Triumph of Bacchus." Painting. Prado, Madrid, inv. 103. [Prado 1985, p. 243]

James Barry, 1741–1806. "Venus Rising from the Sea" ("Venus Anadyomene"). Painting. *c.***1772.** National Gallery of Ireland (on loan from Municipal Gallery), Dublin. [Pressly 1981, no. 7—ill.] Oil sketch. Ulster Museum, Belfast. [Ibid., no. 8—ill.]

———. "The Birth of Venus." Etching. 7 states, 1776–91. [Ibid., no. P.7—ill.]

François Guichard, 1745–1807. *Les soirées de Paphos*. Song collection. **1776.** [Grove 1980, 7:800]

Franz Anton Maulbertsch, 1724–1796, composition. "[Sea] Triumph of Venus" ("Neptune and Ariadne"). **1792.** Engraving, executed by Samuel Czetter, 1792–93. [Garas 1960, no. 368, p. 145—ill.]

Benjamin West, 1738–1820. "Venus at Her Birth Attired by the Graces." Painting. **1799** (?), retouched 1806. Private coll. [von Erffa & Staley 1986, no. 157—ill. (cf. 158)]

Italian School. "Venus on the Sea." Painting. **17th/18th century.** Szépművészeti Múzeum, Budapest, no. 53.456. [Budapest 1968, p. 337]

Philipp Otto Runge, 1777–1810. (Figure of "Venus-Aurora" in) "The Morning" (small version). Painting. **1808.** Kunsthalle, Hamburg, inv. 1016. [Hamburg 1969, p. 284—ill. / Hamburg 1977, pp. 204ff., no. 189—ill. / Hamburg 1985, no. 79—ill.; cf. no. 454] Large version. 1809. Kunsthalle, Hamburg, inv. 1022. [Hamburg 1969, p. 285—ill. / Hamburg 1977, no. 200—ill.]

Bertel Thorwaldsen, 1770–1844. "Venus Rising from the Foam" ("The Birth of Venus"). Marble relief. Formerly Fürst Malthe coll., Putbus, destroyed. [Cologne 1977, no. 40] Plaster original. **1809.** Thorwaldsens Museum, Copenhagen, no. A348. [Thorwaldsen 1985, p. 47 / Hartmann 1979, pp. 162f.—ill. (drawing)]

John Flaxman, 1755–1826. "The Birth of Venus," "Venus Aphrodite Brings Happiness to Men." Drawings, part of series illustrating Hesiod's *Theogony* (lines 188–206). **1807–14.** / Engraved by William Blake, published London: Longman & Co., 1817. [Irwin 1979, p. 90 / Flaxman 1872, 7: pls. 25–26]

Ugo Foscolo, 1778–1827. (Venus on her shell evoked in) *Le Grazie* part I. Poem, unfinished. **1814.** Florence: 1848. Modern edition by Saverio Orlando, *Le Grazie, carme ad Antonio Canova* (Brescia: Paideia, 1974). [Cambon 1980, pp. 192–200, 209, 346 / Circeo 1974, p. 65]

William Etty, 1787–1849. "The Coral Finder" (Aphrodite arriving at Paphos). Painting. **1820.** [Kestner 1989, p. 70]

Salvatore Taglioni, 1789–1868, choreography. *Il natale di Venere*. Ballet. Music, Luigi Carlini. First performed Summer **1822**, San Carlo, Naples. [EDS 1954–66, 9:631]

Anne-Louis Girodet, 1767–**1824.** "The Birth of Aphrodite." Painting. Private coll. [Montargis 1967, no. 28—ill.]

James Hervé D'Egville, *c.*1770–*c.*1836, choreography. *La naissance de Vénus*. Ballet. Music, Nicolas Bochsa. First performed 8 Apr **1826**, King's Theatre, London. [Nicoll 1959–66, 4:579 / Guest 1972, pp. 36, 157]

Valentine Sonnenschein, 1749–**1828.** "Venus Anadyomene with Cupid." Terra-cotta sculpture. Victoria and Albert Museum, London, no. A.19.1955. [Warburg]

Joseph-François Ducq, 1762–1829. "Venus Rising from the Sea." Painting. Musées Royaux des Beaux-Arts (Musée d'Art Moderne), Brussels, inv. 87. [Brussels 1984b, p. 186—ill.]

Victor Hugo, 1802–1885. "Écrit sur la plinthe d'un bas-relief antique" [Written on the plinth of an antique bas-relief] (on the Ludovisi Throne, depicting the birth of Venus). Poem. June **1833.** No. 21 in *Les contemplations,* book 3 (Paris: Hetzel, 1856). [Hugo 1985–86, vol. 5 / Py 1963, pp. 146f.]

Théodore Chassériau, 1819–1856. "Venus Marine" ("Venus Anadyomene"). Painting. **1838.** Louvre, Paris, inv. R.F. 2262. [Sandoz 1974, no. 44—ill. / Louvre 1979–86, 3:130—ill.] Lithograph. 1842. [Sandoz, no. 266—ill.]

Francesco Hayez, 1791–1882. "The Birth of Venus." Painting. **1838.** Formerly Villa Sola Busca, Agliate, on art market in 1946, unlocated. [Coradeschi 1971, no. 200]

Francisque-Joseph Duret, 1804–1865. "Venus among the Reeds." Bronze sculpture, after designs by Jacques Hittorf. **1840.** Fontaine des Ambassadeurs, Champs-Elysées, Paris. [Wagner 1986, p. 80, fig. 59]

Jean-Auguste-Dominique Ingres, 1780–1867. "Venus Anadyomene." Painting (early version of "La source"). **1848.** Musée Condé, Chantilly. [Wildenstein 1954, no. 257—ill.] Reduced replica (or studio copy?). Louvre, Paris, no. M.I. 726. [Ibid., no. 259—ill. / Louvre 1979–86, 3:326—ill.] Variant (or study?), "Head of Venus Anadyomene." Unlocated. [Wildenstein, no. 258—ill.]

Heinrich Keller, 1778–1862. "The Birth of Venus." Bronze sculpture. After 1796. Kunsthaus, Zurich. [Hartmann 1979, pl. 113.3]

Francisco Martínez de la Rosa, 1787–1862. "El nacimiento de Venus." Poem. Modern edition, *Obras,* edited by Carlos Seco Serrano (Madrid: Ediciones Atlas, 1962–63). [Hurtado Chamorro 1967, p. 214]

Eugène-Emmanuel Amaury-Duval, 1808–1885. "The Birth of Venus." Painting. **1862.** Musée des Beaux-Arts, Lille. [Ormond 1975, pl. 179—ill.]

John La Farge, 1835–1910. "Venus Anadyomene." Painting. **1862.** Private coll. in 1966. [Weinberg 1977, fig. 27]

Alexandre Cabanel, 1823–1889. "The Birth of Venus." Painting. *c.***1863.** Musée d'Orsay, Paris, no. R.F. 273. [Louvre 1979–86, 3:93—ill. / Harding 1979, pp. 48, 132—ill. / also Ormond 1975, pl. 108—ill.] Replica. Metropolitan Museum, New York, no. 94.24.1. [Metropolitan 1980, p. 230—ill.]

Gustave Moreau, 1826–1898. "Venus Rising from the Sea." Painting. **1866.** Sold Sotheby's, London, 1971. [Mathieu 1976, no. 85—ill.]

———. "The Birth of Venus" ("Venus with Sailors [or Fishermen]"). Painting. *c.*1866. Sold Drouot, Paris, 1895. [Ibid., no. 86—ill.]

———. "Venus (Appearing to the First Men)." Painting. 1867. Private coll., Paris. [Ibid., no. 87—ill.]

Algernon Charles Swinburne, 1837–1909. (Birth of Venus evoked in) "Hymn to Proserpine." Poem. In *Poems and Ballads,* 1st series (London: Moxon, **1866**). [Gosse & Wise 1925–27, vol. 1]

Arnold Böcklin, 1827–1901. "The Birth of Venus." Painting. **1868–69.** Hessische Landesmuseum, Darmstadt, inv. 8767. [Andree 1977, no. 227—ill.]

———. "Venus Anadyomene." Painting. 1872. Eduard Arnhold family coll. [Ibid., no. 280—ill.] Oil sketch, Kunsthaus Heylshof, Worms, inv. Swarzenski 95. [Ibid., no. 279—ill.]

———. "Venus Anadyomene." Painting, fragment. 1891. Museum, Wiesbaden, inv. M834. [Ibid., no. 428—ill.]

James McNeill Whistler, 1834–1903. "Venus Rising from the Sea." Oil sketch. *c.***1869–70.** Freer Gallery of Art, Washington, D.C. [Curry 1984, pl. 13]

Arthur Rimbaud, 1854–1891. (Marine Venus evoked in) "Soleil et chair" [Sun and Flesh] parts 1 and 2. Poem. May **1870.** Published with *Le reliquaire* (Paris: Genonceaux, 1891). [Adam 1972 / Fowlie 1966]

———. "Venus Anadyomène." Sonnet. Poem. 1871. [Adam / Fowlie / Starkie 1947, pp. 47, 52, 160]

Edward Carpenter, 1844–1929. (Birth of) "Venus Aphrodite." Poem. In *Narcissus and Other Poems* (London: King, **1873**). [Boswell 1982, p. 68]

Hans Makart, 1840–1884, questionably attributed. "The Birth of Venus." Painting. *c.***1870–75.** George Schäfer coll., Schweinfurt, inv. 49551163. [Frodl 1974, no. 641—ill.]

Thomas Gordon Hake, 1809–1895. "The Birth of Venus." Poem. In *New Symbols* (London: Chatto & Windus, **1876**). [Boswell 1982, p. 128]

———. "Venus Anadyomene." Poem, based on sculpture of Praxiteles (4th century BCE). In *Legends of the Morrow* (London: Chatto & Windus, 1879). [Ibid.]

Walter Crane, 1845–1915. "The Renaissance of Venus" (Venus coming ashore). Painting. **1877.** Tate Gallery, London. [Wood 1983, pp. 193f.—ill. / Spalding 78, pp. 16, 25—ill. / Kestner 1989, pp. 237f., pl. 4.28]

Albert Moore, 1841–1893. "Sea Shells" (Aphrodite on the seashore). Painting. **1878.** Walker Art Gallery, Liverpool. [Kestner 1989, pl. 3.42]

Hans Thoma, 1839–1924. "Foam-sprung." Painting. **1878.** Simon Ravenstein coll., Frankfurt. [Thode 1909, p. 115—ill.]

———. "Venus on the Seas." Painting. *c.*1880 or 1898. Cossack coll., Bonn. [Ibid., p. 407—ill.]

———. "Venus on the Dolphin" (with blindfolded Cupid). Painting. 1887. Max Freiherr von Waldberg coll., Heidelberg. [Ibid., p. 276—ill.] Variant, "Through the Floods." 1889. Thode coll., Heidelberg. [Ibid., p. 307—ill.]

William Bouguereau, 1825–1905. "The Birth of Venus." Painting. **1879.** Musée d'Orsay, Paris, no. R.F. 253. [Montreal 1984, no. 89—ill. / Louvre 1979–86, 3:86—ill.] Oil sketch, exhibited Galerie Breteau, Paris, 1965–6. [Montreal, p. 216] Variant. Private coll., California. [Ibid.]

Anselm Feuerbach, 1829–1880. (Venus and Cupid on a seashell drawn by dolphins in) "Fall of the Titans." Ceiling painting. **1879.** Akademie, Vienna. [Karlsruhe 1976, p. 101, no. Z52—ill.]

Paul Gauguin, 1848–1903. "The Birth of Venus." Oak sculpture, originally polychromed, now worn off. By **1880.** Private coll., Paris. [Gray 1963, no. A–1—ill.]

Gabriele D'Annunzio, 1863–1938. "Venere d'acqua dolce" [Venus of Sweet Water]. Idyll. **1883.** In *Intermezzo di rime* (Rome: Sommaruga, 1883; 1894). [Palmieri 1953–59, vol. 1]

Philip Calderon, 1833–1898. "Aphrodite." Painting. **1884.** [Kestner 1989, p. 179]

Max Klinger, 1857–1920. "Venus in a Shell-chariot." Painting. **1884–85.** Staatliche Museen Preussicher Kulturbesitz, National-Galerie, Berlin, inv. AI706. [Dückers 1976, p. 165—ill.]

————. Venus on a seashell, beside a nereid, reacting to an accusing gesture from John the Baptist (depicting conflict between Christendom and the antique world). Bronze relief, on back of throne in "Beethoven" sculpture. Completed 1902. Museum der Bildenden Kunste, Leipzig, inv. 28. [Rotterdam 1978, no. 6—ill. / also Leipzig 1970, no. 10—ill. / Dückers, p. 50—ill. / Hildesheim 1984, pl. 277—ill.]

————. "Beauty" ("Aphrodite"). Etching, no. 31 in "Brahms-fantasy" cycle, opus 12. Before 1894. [Hildesheim, no. 266—ill. / also Dückers, pp. 56, 78f.—ill. / Rotterdam, no. 76.31]

Gabriel Fauré, 1845–1924. *La naissance de Vénus.* Cantata, for solo voices, chorus, and orchestra, opus 29. Text, R. Collin. First performed 3 Apr **1886,** Paris. [Grove 1980: 6:427 / Baker 1984, p. 695]

Madison Cawein, 1865–1914. "Aphrodite." Poem. In *Blooms of the Berry* (Louisville: Morton, **1887**). [Boswell 1982, p. 69]

————. "The Paphian Venus." Poem. In *Intimations of the Beautiful* (New York: Putnam, 1894). [Ibid., p. 72]

William Stott of Oldham, 1857–1900. "Venus Born of the Sea Foam." Painting. **1887.** Oldham Art Gallery, England. [Jacobs & Stirton 1984b, p. 214]

Paul Valéry, 1871–1945. "Naissance de Vénus." Sonnet. **1891.** In *Album de vers anciens, 1890–1900* (Paris: Monnier, 1920). [Hytier 1957–60, vol. 1 / Mathews 1956–71, vol. 1 / Nash 1983, pp. 149–57]

Jean-Léon Gérôme, 1824–1904. "Venus Rising" ("The Star"). Painting. 1890. Private coll. [Ackerman 1986, no. 389—ill.] Reduced replica. **1890–92.** Lost. [Ibid., no. 390]

Alfred Woolmer, 1805–**1892.** "The Birth of Venus." Painting. Maas Gallery, London. [Maas 1969, p. 166—ill.]

William Entriken Baily. "The Birth of Venus." Poem. In *Classical Poems* (Cincinnati: Clarke, **1892**). [Boswell 1982, p. 30]

Charles D. Bell, 1818–1898. "The Birth of Venus." Poem. In *Poems Old and New* (London: Arnold, **1893**). [Bush 1937, p. 564]

José-Maria de Heredia, 1842–1905. "La naissance d'Aphrodite." Sonnet. In *Les trophées* (Paris: Lemerre, **1893**). [Delaty 1984, vol. 1]

Pierre Louÿs, 1870–1925. (Birth of Aphrodite evoked in) "La mer de Kypris" [The Sea of Cyprus]. Poem. In *Chansons de Bilitis* (Paris: Crès, **1894**; 1913). [Ipso]

Rubén Darío, 1867–1916. (Venus Anadyomene in) "Coloquio de los centauros" [Colloquy of Centaurs]. Poem. **1895.** In *Prosas profanas y otros poemas* (Buenos Aires: Coni, 1896). [Méndez Plancarte 1967 / Jrade 1983, pp. 35–37 / Paz 1976, p. 39]

————. (Venus Anadyomene evoked in) "Carne, celeste carne de la mujer!" [Flesh, divine flesh of woman!]. Poem. In *Cantos de vida y esperanza: Los Cisnes y otros poemas* (Madrid: Tipografía de la Revista de Archivos, Bibliotecas y Museos, 1905). [Méndez Plancarte / Jrade, p. 97]

Lovis Corinth, 1858–1925. "The Birth of Venus." Painting. **1896.** Formerly Richter coll., Berlin, unlocated. [Berend-Corinth 1958, no. 132—ill.] Oil sketch. 1894. Formerly Lenzner coll., Stettin, unlocated. [Ibid., no. 120—ill.] Etching. 1920–21. [Müller 1960, no. 553—ill.]

————. "The Birth of Venus." Lithograph. 1914. [Schwarz 1922, no. L159]

————. "The Birth of Venus II," "The Birth of Venus III." Etchings. 1916. [Ibid., nos. 272–73]

————. "Venus" (on a seashell, Neptune looking on). Letter "V" from "ABC" lithograph series. 1917. [Ibid., no. 315]

————. "The Birth of Venus." Painting. 1923. Kallier coll., New York. [Berend-Corinth, no. 920—ill.]

Solomon J. Solomon, 1860–1927. "The Birth of Love." Painting. **1896.** [Kestner 1989, pp. 245, pl. 4.43]

Henri Fantin-Latour, 1836–1904. "Venus Anadyomene." Lithograph. **1898.** [Hédiard 1906, no. 144—ill.]

————. "The Birth of Venus," "Venus Rising from the Sea." Paintings. 1902. [Fantin-Latour 1911, nos. 1904–05].

————. "Venus Anadyomene." Painting. 1904, unfinished. F. Tempelaere coll. in 1911. [Ibid., no. 2148]

Laurence Binyon, 1869–1943. "Queen Venus." Poem. In *The Death of Adam and Other Poems* (London: Methuen, **1904**). [Boswell 1982, p. 40.]

Rainer Maria Rilke, 1875–1926. "Geburt der Venus." Poem. Jan **1904.** In *Neue Gedichte* (Leipzig: Insel, 1907). [Zinn 1955–66, vol. 1 / Leishman 1960 / Leppmann 1984, p. 193 / Peters 1960, p. 83 / see also Christopher Middleton, "Rilke's Birth of Venus," *Arion* 7 no. 3 (Autumn 1968): 372–91]

Arthur Davison Ficke, 1883–1945. "Foam Around Delos." Poem. In *From the Isles: A Series of Songs Out of Greece* (Norwich: Samurai, **1907**). [Boswell 1982, p. 255]

Lawrence Alma-Tadema, 1836–1912. "Aphrodite's Cradle" (symbolic title; group of women looking out to sea). Painting. **1908.** [Kestner 1989, p. 279—ill.]

Odilon Redon, 1840–1916. "The Birth of Venus." Painting. **1908.** Galerie Druet, Paris, in 1964. [Berger 1964, no. 174]

————. "The Birth of Venus." Series of paintings. 1912. Private colls. [Ibid., nos. 175, 177–79—ill.]

————. "The Birth of Venus." Pastel. 1912. Petit Palais, Paris. [Ibid., no. 382 / Hobbs 1977, fig. C.9]

Paul Heyse, 1830–1914. *Die Geburt der Venus.* Novel. Stuttgart & Berlin: Cotta, **1909.** [Oxford 1986, p. 403]

Ezra Pound, 1885–1972. (Birth of Venus evoked in) "Hugh Selwyn Mauberley." Poem. In *Personae* (London: Mathews, **1909**). Revised, published in *Personae,* expanded edition (New York: New Directions; London: Faber & Faber, 1926). [Feder 1971, p. 104 / Ruthven 1969, pp. 144, 146f.]

————. (Botticelli's "Birth of Venus" evoked in) Canto 1, in *A Draft of XXX Cantos* (Paris: Hours, 1930; Norfolk, Conn.: New Directions, 193[3?]). [Surette 1979, p. 44]

————. (Sea-born Aphrodite evoked in) Cantos 74, 76, in *The Pisan Cantos* (New York: New Directions, 1948). [Ibid., pp. 205–07 / Quinn 1972, p. 135 / Flory 1980, pp. 192f.]

Osip Mandel'shtam, 1891–1939/42. (Birth of Venus evoked in) Untitled poem. **1910.** In *Kamen* [Stone] (Peterburg: Akme, 1913). [Raffel & Burago 1973, no. 14 / Terras 1966, p. 257]

Sara Teasdale, 1884–1933. "Anadyomene." Poem. In *Helen of Troy and Other Poems* (New York: Putnam, **1911**). [Boswell 1982, p. 300]

Émile Bernard, 1868–1941. "The Birth of Venus." Painting. c.**1912.** Private coll. [Luthi 1982, no. 841—ill.]

Angelos Sikelianos, 1884–1951. "Anadyomene" [Aphro-

dite Rising]. Poem. **1915**. [Savidis 1981, vol. 2 / Keeley & Sherrard 1979 / Keeley 1983, pp. 45f. / Friar 1973, pp. 211, 749]

Herbert James Draper, 1864–1920. "The Pearls of Aphrodite" (Aphrodite in the foam, with sea-nymphs). Painting. *c*.**1917**. [Kestner 1989, p. 292]

Amy Lowell, 1874–1925. "Venus Transiens." Poem. In *Pictures of the Floating World* (New York: Macmillan, **1919**). [Buttel 1967, pp. 126f.]

Wallace Stevens, 1879–1955. "A Paltry Nude Starts on a Spring Voyage." Poem. **1919**. In *Harmonium* (New York: Knopf, 1923). [Lensing 1986, pp. 257f., 283 / Buttel 1967, pp. 126–28]

Conrad Aiken, 1889–1973. "Venus Anadyomene," part 4 of "John Deth: A Metaphysical Legend." Poem. **1922**. In *John Deth and Other Poems* (New York: Scribner, 1930). [Boswell 1982, p. 6]

Giorgio de Chirico, 1888–1978. "The God Neptune Riding [in a cart] through a Mediterranean City" (with Aphrodite). Drawing. *c*.**1922?** Galleria Jolas, Milan. Wadsworth Atheneum, Hartford. [de Chirico 1971–83, 1.1: no. 50—ill.]

Émile-Antoine Bourdelle, 1861–1929. "Aphrodite" ("The Birth of Beauty") (with the Muses). Polychrome stucco relief. **1924**. Proscenium, Opéra, Marseille. [Jianou & Dufet 1975, no. 656—ill. / Cannon-Brookes 1983, pp. 108ff.—ill.] Colored plaster model. Musée Bourdelle, Paris. [Jianou & Dufet / Cannon-Brookes] Variant ("The Birth of Aphrodite: Tragic Art and Comedy"). Bronze and colored plaster versions. Private colls. [Jianou & Dufet, no. 657]

———. "The Birth of Venus." Bronze sculpture. 1927. 7 casts. Art Museum, Princeton University, New Jersey; elsewhere. [Ibid., no. 681] *Terre-sèche* study/variant. Musée Bourdelle. [Ibid.]

Paul Manship, 1885–1966. "Venus Anadyomene." Marble fountain figure. **1924**. Phillips Academy, Andover, Mass. [Rand 1989, pp. 59f.—ill. / Murtha 1957, no. 230—ill.] Bronze reduction. 20 casts. Minnesota Museum of Art, St. Paul; National Museum of American Art, Washington, D.C.; elsewhere. [Murtha, no. 171 / Minnesota 1985, no. 62—ill. / Rand, fig. 48] Bronze sketch, large marble version known. [Murtha, nos. 170–71]

———. "Nude Female with Putto and Dolphin" (Aphrodite and Eros?). Drawing. Mr. and Mrs. Thomond R. O'Brien coll. [Minnesota, no. 17—ill.]

Merle St. Croix Wright, 1859–**1925**. "Venus Anadyomene." Poem. In *Ignis Ardens* (New York: Vinal, 1926). [Boswell 1982, p. 311]

Raoul Dufy, 1877–1953. "Venus and Shell." 2 watercolors. **1925**. [Guillon-Lafaille 1981, nos. 1830–31—ill.] 2 variants (figure only): "Venus on the Seashore," watercolor; "Venus," gouache. 1925. [Ibid., nos. 1832–33—ill.]

———. "Venus and Seahorses." Gouache painting. *c*.1925. [Ibid., no. 1875—ill.]

———. "Venus with a Shell." Watercolor. 1925–30. Dalzell Hatfield Galleries, Los Angeles. [Ibid., no. 1835—ill.]

———. "Venus with a Net." Painting. 1928–30. Jungmeyer coll., Los Angeles. [Laffaille 1977, no. 1652—ill.]

———. "The Birth of Venus." Gouache. *c*.1930. Formerly Roudinesco coll., Paris. [Guillon-Lafaille, no. 1834—ill.]

———. "Venus, Boats, Birds." Watercolor. *c*.1930. [Ibid., no. 1841—ill.]

———. "Venus with a Shell" (wringing out her hair). Painting. *c*.1935. Sold Hôtel Drouot, Paris, 1985. [Laffaille 1985, no. 2034—ill.]

———. "The Birth of Venus." 2 similar paintings. 1937. [Laffaille 1977, nos. 1639–40—ill.]

———. "The Birth of Venus." Painting, after Botticelli. 1938. Sold Sotheby's, London, 1975. [Ibid., no. 1606—ill.] 5 variants. Evergreen House Foundation, Baltimore; Musée de l'Art Moderne, Paris; 3 others unlocated. [Laffaille 1977, nos. 1607–11—ill.]

———. "The Birth of Venus." Painting. *c*.1940. Sold Motte, Geneva, 1963. [Ibid., no. 1641, p. 338—ill.]

———. "Venus on a Seashell." Painting (related to "Amphitrite" of 1945). Formerly Galerie Louis Carré, Paris. [Laffaille 1985, no. 2035—ill.]

D. H. Lawrence, 1885–1930. (Kate sees her sexuality as "Aphrodite of the foam" in) *The Plumed Serpent* chapter 26. Novel. London: Secker; New York, Knopf, **1926**. [DLB 1985, 36:139]

———. (Birth of Aphrodite evoked in) "Spiral Flame." Poem. In *Pansies* (London: Secker, 1929). [Pinto & Roberts 1964, vol. 1]

———. (Venus evoked as a dolphin in) "Whales Weep Not!" Poem. In *Last Poems* (Florence: Orioli; London: Heinemann, 1932). [Ibid., vol. 2]

Henri Matisse, 1869–1954. "Venus in a Shell I." Bronze sculpture. **1930**. Edition of 10. Museum of Modern Art, New York; Hermitage, Leningrad, inv. 2413; elsewhere. [Monod-Fontaine 1984, no. 65—ill. / also Barr 1977, p. 567—ill. / Schneider 1984, p. 562—ill. / Barr 1951, p. 461—ill. / Hermitage 1984, no. 428—ill. / Hermitage 1975, pl. 169] Variant, "Venus in a Shell II." 1932. Edition of 10, cast 1958–59. Hirshhorn Museum and Sculpture Garden, Washington, D.C.; elsewhere. [Monod-Fontaine, no. 67—ill. / Schneider, p. 563—ill.]

Ossip Zadkine, 1890–1967. "The Birth of Venus." Bronze sculpture. **1930**. / Plaster original. Private coll. [Jianou 1979, no. 186]

William MacMillan, b. 1887. "The Birth of Venus." Stone sculpture. Exhibited **1931**. Tate Gallery, London, no. 4602. [Tate 1975, p. 170 / Clapp 1970, 1:561]

T. Sturge Moore, 1870–1944. "To Aphrodite." Poem. In *Poems*, vol. 3 (London: Macmillan, **1932**). [Ipso]

John Galsworthy, 1867–**1933**. "Botticelli's *The Birth of Venus*." Poem. In *Collected Poems* (New York: Scribner, 1934). [Boswell 1982, p. 257]

Philippe Besnard, b. 1885. "The Birth of Aphrodite." Plaster sculpture. **1934**. [Clapp 1970, 1:87]

Basil Bunting, 1900–1985. (Paphian Venus in modern guise in) "The Well of Lycopolis." Poem. **1935**. In *Collected Poems* (Oxford: Oxford University Press, 1978). [Ipso]

Maurice Carpenter, 1911–. "Venus on a Sea Horse." Poem. In *IX Poems* (London: Phoenix, **1935**). [Boswell 1982, p. 247]

John Hall Wheelock, 1886–1978. "Aphrodite, 1906." Poem. In *Collected Poems, 1911–1936* (New York: Scribner, **1936**). [Boswell 1982, p. 234]

Paul Delvaux, b. 1897. "Composition" ("Birth of Venus/Women in a Bath"). Surrealist painting. **1937**. Sold Sotheby's, London, 1981. [Warburg / Delvaux 1975, no. 82—ill.]

————. "The Birth of Venus." Painting. 1947. Private coll. [Delvaux, no. 184—ill.]

Man Ray, 1890–1976. "Venus" (head covered with a net). Sculpture-assemblage. **1937.** Schwarz coll. [Schwarz 1977, pl. 289 / Munich 1984, p. 10—ill.]

Ronald Bottrall, 1906–. (Birth of Venus evoked in) "New Birth." Poem. In *The Turning Path* (London: Barker, **1939**). [DLB 1983, 20:80]

Cesare Pavese, 1908–1950. (Aphrodite's birth evoked in) "Schiuma d'onda" [Sea Foam]. Dialogue. In *Dialoghi con Leucò* (Turin: Einaudi, **1947**). / Translated by William Arrowsmith and D. S. Carne-Ross in *Dialogues with Leucò,* bilingual edition (Ann Arbor: University of Michigan, 1965). [Ipso / Biasin 1968, pp. 201, 312]

————. (Aphrodite addressed in) "Sempre vieni dal mare" [Always You Come from the Sea]. Poem. In *La terra e la morte* (Turin: Einaudi, 1947). [Ipso / Thompson 1982, pp. 250, 256 / Biasin, p. 25]

William Carlos Williams, 1883–1963. "The Birth of Venus." Poem. **1948.** In *Collected Later Poems* (New York: New Directions, 1950). [MacGowan 1988]

Darius Milhaud, 1892–1974. *Naissance de Vénus.* Cantata, opus 292. Libretto, Supervielle. **1949.** [Grove 1980, 12:309]

Randall Jarrell, 1914–1965. "The Birth of Venus." Poem. **1952.** In *Complete Poems* (New York: Farrar, Straus & Giroux, 1969). [Wright 1986, p. 119]

Alexander Archipenko, 1887–1964. "The Birth of Venus." Abstract bronze, marble, and turquoise sculpture. **1954.** Private colls., New York and Connecticut. [Archipenko 1960, pl. 12—ill.]

Alan Davie, 1920–. "The Birth of Venus." Painting. **1955.** Tate Gallery, London, no. T.203. [Tate 1975, p. 123]

Henrikas Radauskas, 1910–1970. "Veneros gimimas" [Birth of Venus]. Poem. **1955.** / Translated by Jonas Zdanys in *Chimeras in the Tower: Selected Poems* (Middletown: Wesleyan University Press, 1986). [Ipso / EWL 1981–84, 4:2]

Walter De La Mare, 1873–**1956.** "The Birth of Venus." Poem. In *Collected Poems* (London: Faber & Faber, 1979). [Boswell 1982, p. 249]

Lawrence Durrell, 1912–1990. "Near Paphos." Poem. **1956.** In *The Ikons and Other Poems* (London: Faber & Faber, 1966; New York: Dutton, 1967). [Ipso]

————. "Aphrodite." Poem. In *The Ikons and Other Poems* (1966–67). [Ipso / Boswell 1982, p. 97]

————. "Aphros Meaning Spume." Poem. 1971. In *Vega and Other Poems* (Woodstock, N.Y.: Overlook, 1973). [Ipso]

Constance Urdang, 1922–. "The Birth of Venus." Poem. *c.*1956. In *The Poetry Anthology, 1912–1977,* edited by Daryl Hine and Joseph Parisi (Boston: Houghton Mifflin, 1978). [Ipso]

Geoffrey Hill, 1932–. "The Rebirth of Venus." Poem. **1952–58.** In *For the Unfallen: Poems 1952–1958* (London: Deutsch, 1959). [Boswell 1982, p. 262]

Muriel Rukeyser, 1913–1980. "The Birth of Venus." Poem. In *Body of Waking* (New York: Harper, **1958**). [Ostriker 1986, p. 285 / Ipso]

David Wright, 1920–. "An Invocation to the Goddess" (Venus Anadyomene). Poem. In *Monologues of a Deaf Man* (London: Peters, **1958**). [Vinson 1985, p. 949]

Hayden Carruth, 1921–. "The Birth of Venus." Poem. **1946–59.** In *The Crow and the Heart* (New York: Macmillan, 1959). [Boswell 1982, p. 247]

Denis Devlin, 1908–**1959.** "Venus of the Salty Shell." Poem. In *Collected Poems* (Dublin: Dolmen, 1964). [Boswell 1982, p. 252]

Cecil Bødker, 1927–. "Anadyomene." Poem. In *Anadyomene* (Fredensborg: Digte, **1959**). [Jansen 1977, p. 218]

Uli Nimptsch, b. 1897. "The Birth of Venus." Bronze fountain. **1959.** [Clapp 1970, 1:667]

Robert Laurent, 1890–1970. "The Birth of Venus." Bronze sculpture. Exhibited **1961.** [Clapp 1970, 2 pt. 2: 689]

Mirko, 1910–1969. "Anadyomene." Bronze sculpture. **1961.** [Trieste 1976, no. 46, p. 149—ill.]

Salvador Dalí, 1904–1989. "The Birth of Venus." Etching, in "Mythology" series. **1963.** [Rotterdam 1970, no. 173—ill.]

————. "Dalí Lifts the Skin Off the Mediterranean Sea to Show Gala the Birth of Venus." Stereoscopic painting in 2 sections. 1977. Private coll. [Pompidou 1979, pl. 340]

Peter D. Thomas, 1928–. "Belle Aphrodite—A Conundrum," "Venus at Evening." Poems, evoking Botticelli's "Birth of Venus" (*c.*1486, Uffizi). **1964.** In *Poems from Nigeria* (New York: Vantage, 1967). [Ipso]

Reuben Nakian, 1897–1986. "The Birth of Venus." Plaster sculpture. **1963–66.** Egan Gallery, New York, in 1966. [O'Hara 1966, no. 92—ill. / also Parry 1978, p. 193]

Vernon Watkins, 1906–**1967.** (Venus evoked in) "Sea Chant (Taliesin to Venus)." Poem. In *Fidelities* (London: Faber & Faber, 1968). [Ipso]

José Emilio Pacheco, 1926–. "*Venus Anadiomena* por Ingres." Poem, on Ingres's "Venus Anadyomene" (1864). **1964–68.** In *No me preguntes cómo pasa el tiempo: Poemas 1964–1968* (Mexico: Mortiz, 1969). / Translated by George McWhirter in *Selected Poems,* bilingual edition (New York: New Directions, 1987). [Ipso]

Einojuhani Rautavaara, 1928–. "Anadyomene." Song, opus 33. Text, Rilke's "Geburt der Venus" (1904). **1968.** [Grove 1980, 15:606]

Ralph Gustafson, 1909–. (Aphrodite's birth evoked in) "A Conviction: Not Far Off Salamis." Poem. In *Ixion's Wheel* (Toronto & Montreal: McClelland & Stewart, **1969**). [Ipso]

Brewster Ghiselin, 1903–. "Aphrodite of the Return." Poem. In *Country of the Minotaur* (Salt Lake City: University of Utah Press, **1970**). [Ipso]

Gene Fowler, 1931–. "Venus Returns to the Sea." Poem. In *Fires* (Berkeley, Calif.: Thorp Springs, **1971**). [Vinson 1985, p. 275]

Richmond Lattimore, 1906–1984. "Remember Aphrodite." Poem. In *Poems from Three Decades* (New York: Scribner, **1972**). [Boswell 1982, p. 164]

Erica Jong, 1942–. (Birth of Venus evoked in) "This Element." Poem. In *Ordinary Miracles* (New York: New American Library, **1983**). [Ipso]

Eva Noel Harvey, 1900–**1984.** "The Birth of Venus." Song, 1 of "Three Songs from Venus Legends." [Cohen 1987, 1:306]

Maura Stanton, 1946–. "Venus." Poem. In *Cries of Swimmers* (Salt Lake City: University of Utah Press, **1984**). [Ipso]

Mary Jo Salter, 1954–. "The Rebirth of Venus." Poem. In *Unfinished Painting* (New York: Knopf, **1989**). [Ipso]

Cythera, Isle of Aphrodite. According to Hesiod, when Aphrodite (Venus) was born from the foam of the sea, she first landed on the island of Cythera; thus her epithet "Cytherea." Because of this association with the goddess of love, Cythera became identified as a place of pilgrimage for lovers and was a popular setting for *fêtes galantes* of the eighteenth century. The most famous treatment of this subject is Antoine Watteau's 1717 painting, which inspired numerous later treatments in literature and music as well as the fine arts.

Classical Source. Hesiod, *Theogony* 191–98.

See also APHRODITE, Birth.

Francesco Colonna, c.1433–1527. (Cythera, setting of part of) *Hypnerotomachia Poliphili* [The Dream of Poliphilo]. Romance. Venice: **1499,** illustrated with woodcuts by anonymous engraver. [Appell 1893, pp. 5f., 11f., pls. 113–51]

Giovanni Francesco Penni, 1488–1528 (previously attributed to Perino del Vaga, 1501–1547). "Departure for Cythera." Drawing. Nationalmuseum, Stockholm, inv. NMH 350/1863. [Zimmer 1971, p. 99, pl. 50]

Giulio Romano, c.1499–1546. Isle of Venus depicted in frescos in Sala di Psiche, Palazzo del Tè, Mantua. **1528.** In place. [Verheyen 1977, pp. 25f.]

Karel van Mander, 1548–1606 (also attributed to Paulus Moreelse, 1571–1638). "The Feast of Venus at Cythera." Painting. **1602.** Hermitage, Leningrad. [de Bosque 1985, p. 85 / Warburg]

Marin Le Roy de Gomberville, 1599–1674. *La Cythérée.* Romance. **1640.** Paris: Courbé, 1642 (2d edition). [DLLF 1984, 2:958]

Florent Dancourt, 1661–1725. (Voyage to Cythera in) *Les trois cousines.* Comedy. **1700.** [Grasselli & Rosenberg 1984, p. 263]

Bernard Picart, 1673–1733. "Pilgrimage to the Island of Cythera" (*galant* couple). Drawing. **1708.** Victoria and Albert Museum, London. [Grasselli & Rosenberg 1984, p. 497—ill.]

————, composition. "On the Island of Cythera." Engraving, by Claude Duflos (?). (Bibliothèque Nationale, Paris). [Ibid.—ill. (as anonymous) / Posner 1984, p. 187—ill.]

Antoine Watteau, 1684–1721. "The Island of Cythera." Painting, illustrating a scene in a play (probably Dancourt's *Trois cousines,* 1700, revived 1709). c.**1709–10.** Städelsches Kunstinstitut, Frankfurt. [Grasselli & Rosenberg 1984, no. P.9—ill. / Posner 1984, pp. 187ff.—ill. / also Camesasca 1982, no. 14—ill.]

————. "The Amusements of Cythera." Painting. 1715. Lost. / Print by S. Surugue, 1730. [Camesasca, no. 99—ill.]

————. "Pilgrimage to the Island of Cythera" ("Embarkation for the Island of Cythera"). Painting. 1717. Louvre, Paris, inv. 8525. [Grasselli & Rosenberg, no. P.61, pp. 460ff.—ill. / Camesasca, no. 168—ill. / Posner, pp. 182ff.—ill. / Louvre

1979–86, 4:285—ill.] Variant. 1718–19. Schloss Charlottenburg, Berlin. [Grasselli & Rosenberg, no. P.62—ill. / Camesasca, no. 185—ill. / also Posner, fig. 155]

————, rejected attribution (actually by Pater?). "The Island of Cythera" ("Bathing Women"). Painting. Lost. / Print by V. Picot, 1787. [Camesasca, no. 2.0]

————, rejected attribution. "Pilgrim on the Island of Cythera." Print by L. Desplaces, mistakenly attributed to nonexistent Watteau original. [Ibid., no. 2.u—ill.]

François Bouvard, c.1683–1760. "L'isle de Cythère." Cantatille. c.**1740.** [Grove 1980, 3:120]

Nicholas Lancret, 1690–**1743.** "The Departure for Cythera" ("Voyage to Cythera"). Painting. Sanssouci, Potsdam. [Wildenstein 1924, no. 296]

Charles-Simon Favart, 1710–1792, libretto. *Le pouvoir de l'amour, ou Le siège de Cythère* [The Power of Love, or the Siege of Cythera]. Ballet. First performed June/July **1748,** Paris. [Grove 1980, 6:438f.]

Charles Amédée Philippe van Loo, 1719–1795. "Embarkation for Cythera." Painting. c.**1750.** Schloss Charlottenburg, Berlin. [Grasselli & Rosenberg 1984, pp. 551f.—ill.]

Jean-Georges Noverre, 1727–1810, choreography. *Cythère assiégée* [Cythera Besieged]. Ballet. Scenario, Favart (1748). First performed 12 Aug **1754,** L'Opéra-comique, Paris. [Grove 1980, 13:443]

————, choreography. *L'amour corsaire, ou L'embarquement pour Cythère* [Love the Corsair, or The Embarkation for Cythera]. Ballet. Music, François Granier. First performed c.1758–60, L'Opéra, Lyons. [Ibid., 7:636; 13:443]

François Martin II, 1727–1757. *Douze recueils de nouveautés, ou Avantures de Cythère* [Twelve Collections of Novelties, or Adventures of Cythera]. Instrumental music. Published Paris: **1757.** [Grove 1980, 11:714f.]

Christoph Willibald Gluck, 1714–1787. *La Cythère assiégée* (*La Citera assediata*) [Cythera Besieged]. Comic opera. Libretto, Favart (1748). First performed Spring **1759,** Burgtheater, Vienna. / Revised as opera-ballet, performed 1 Aug 1775, Académie Royale, Paris. [Grove 1980, 6:439; 7:460, 472ff. / Cooper 1935, pp. 56, 285]

Gaspare Angiolini, 1731–1803. Choreography for ballet-pantomime performance of Gluck's *La Citera assediata* (1759), 15 Sep **1762,** Burgtheater, Vienna. [Grove 1980, 1:426; 7:460, 465, 472]

Carlo Innocenzo Frugoni, 1692–1768. "L'imbarcamento per Citera, l'isola amorosa" [The Embarkation for Cythera, the Isle of Love]. Poem. In *Opere poetiche* (Parma: 1779). [DELI 1966–70, 2:551]

Étienne Lauchery, 1732–1820, choreography. *L'embarquement pour Cythère, ou Le triomphe de Venus* [The Embarkation for Cythera, or The Triumph of Venus]. Ballet. Music, Florian Johann Deller. First performed **1770,** Kassel. [Grove 1980, 5:350]

André Grétry, 1741–1813. "Le marché de Cythère" [The Course of Cythera]. Musical anacréontic ode. Paris: **1783.** [Grove 1980, 7:711]

————. "L'île de Cythère." Musical romance. Text, Grécour. [Ibid.]

Charles-Louis Didelot, 1767–1837, choreography. *L'embarquement pour Cythère* [The Embarkation for Cythera]. Ballet. First performed 10 Jan **1789,** King's Theatre, London. [Swift 1974, pp. 19, 23, 194]

Jean Dauberval, 1742–1806, choreography. *Le siège de Cythère* [The Siege of Cythera]. Ballet. First performed 9 May **1791**, Pantheon, London. [Guest 1972, p. 165]

Antoine-Frédéric Gresnick, 1755–1799. *L'Amour exilé de Cythère* [Amor Exiled from Cythera]. Opera. First performed **1793**, Opéra, Lyons. [Baker 1984, p. 888 / Grove 1980, 7:704 (as "spurious")]

Louis Henry, 1784–1836, choreography. *L'Amour à Cythère*. Ballet. First performed **1805**, L'Opéra, Paris. [Lifar 1938, p. 105]

————, choreography. *L'Amour à Cythère*. Ballet-pantomime. Music, Pierre Gaveaux. First performed 29 Oct 1805, L'Opéra, Paris. [Grove 1980, 7:198 / Guest 1976, p. 304]

Ignaz Vitzthumb, 1720–1816. *La cohorte d'Amour, ou Le siège de Cythère* [Love's Cohort, or The Siege of Cythera]. Ballet-pantomime. First performed **1813**, Grand Théâtre, Brussels. [Grove 1980, 20:31]

James Hervé D'Egville, c.1770–c.1836, choreography. *Le siège de Cythère*. Ballet. Music, Nicolas Bochsa. First performed 6 Mar **1827**, King's Theatre, London. [Guest 1972, p. 157 / Nicoll 1959–66, 4:579]

Charles Baudelaire, 1821–1867. "Un voyage à Cythère." Poem, dedicated to Gérard de Nerval. In *Les fleurs du mal* (Paris: Poulet-Malassis & de Broise, 1857). [Pichois 1975 / EW 1983–85, 7:1327–30] Translated by George Dillon in *Flowers of Evil* (New York: Washington Square Press, 1936; 1962). [Ipso]

Alfred Glatigny, 1839–1873. "Cythère." Poem. In *Les vignes folles* (Paris: Lemerre, **1860**). [DLLF 1984, 2:944]

Andrew Lang, 1844–1912. "Ballade of the Voyage to Cythera." Poem. In *XXII Ballades in Blue China* (London: Kegan Paul, **1880**). [Boswell 1982, p. 158]

Thomas Woolner, 1825–1892. "Cytherea." Poem. In *Tiresias and Other Poems* (London: Bell, **1886**). [Boswell 1982, p. 310]

Jules Laforgue, 1860–**1887**. "Cythère." Poem. In *Des fleurs de bonne volonté* (Paris: Vanier, 1894). [Ipso]

Rubén Darío, 1867–1916. (Cythera evoked in) "Marina" [Sea]. Poem, part of "Las ánforas de Epicuro" [Amphoras of Epicurus]. In *Prosas profanas y otros poemas*, 2d edition (Paris: Bouret, **1901**). [Méndez Plancarte 1967 / Hurtado Chamorro 1967, p. 59]

Claude Debussy, 1862–1918. "L'isle joyeuse" [The Joyous Isle]. Piano composition, inspired by Watteau's painting "Embarkation for Cythera" (c.1709–10, Frankfurt). **1904**. [Grove 1980, 5:305]

Tullio Cestero, 1877–1955. *Citerea*. Fantasy. Madrid: **1907**. [DULC 1959–63, 1:762]

Arthur Davison Ficke, 1883–1945. "Cytherea." Poem. In *From the Isles: A Series of Songs Out of Greece* (Norwich, England: Samurai, **1907**). [Boswell 1982, p. 254]

Georgy Ivánov, 1894–1958. "Otplytie na ostrov Tsiteru" [Embarkation for the Island of Cythera]. Poem. **1912**. In *Isbrannye stikhi 1916–1936* (Berlin: "Petropolis," 1937). [Seymour-Smith 1985, p. 1086 / Poggioli 1960, p. 236]

Alméry Lobel-Riche. Etching, illustration for edition of Baudelaire's "Un voyage à Cythère" (Paris: Cercle Grolier, **1923**). [DLLF 1984, 2:pl. following p. 1100]

W. J. Turner, 1889–1946. *Landscape of Cytherea*. Collection of poems. London: Chatto & Windus, **1923**. [Ipso]

André Derain, 1880–1954. "Embarkation for Cythera." Painting. c.1945. Lévy coll., Troyes. [Sutton 1958, p. 157]

Jean Françaix, 1912–. *Les bosquets de Cythère* [The Groves of Cythera]. Orchestral composition. **1946**. [Grove 1980, 6:741]

Louis Simpson, 1923–. "The Flight to Cytherea." Poem. In *A Dream of Governors* (Middletown: Wesleyan University Press, **1959**). [Ipso]

Daniel Hoffman, 1923–. "In Cytherea." Poem. In *A Little Geste and Other Poems* (New York: Oxford University Press, **1960**). [CLC 1976, 6:243]

Alexis Parnés. *Nisi tis Aphroditis* [Isle of Aphrodite]. Drama. First performed **1960**, Soviet Union. [Gassner & Quinn 1969, p. 400]

Paul Goodman, 1911–1972. "Voyage à Cythère." Poem. In *The Lordly Hudson: Collected Poems* (New York: Macmillan, **1962**). [Ipso]

Peter Davison, 1928–. "The Embarkation for Cythera," "The Return," parts 1 and 2 of "North Shore." Poem. In *The Breaking of the Day and Other Poems* (New Haven: Yale University Press, **1964**). [Ipso]

Jiří Dvořáček, 1928–. *Ostrov Afrodity* [The Island of Aphrodite]. Opera. Libretto, composer, after A. Parnis. **1967**. First performed 1971, Dresden. [Grove 1980, 5:764]

David Wright, 1920–. "A Voyage to Cythera." Poem, after Baudelaire (1857). In *To the Gods the Shades: New and Collected Poems* (Manchester: Carcanet, **1976**). [Ipso]

Jules Olitski, 1922–. "Cythera–4." Abstract painting. **1977**. Artist's coll. [Moffett 1981, pl. 132]

Aphrodite and Anchises. According to the first Homeric Hymn to Aphrodite, the goddess boasted that while she had the power to force other deities to fall in love with mortals, she herself would not do so. To show his power, Zeus caused her to fall in love with the Trojan prince Anchises as he tended cattle on Mount Ida. Their union produced the child Aeneas. Although forbidden to reveal the name of the child's mother, Anchises drunkenly bragged about his affair with the goddess and as punishment was blinded or crippled by Zeus's lightning bolt.

Classical Sources. *Homeric Hymns,* first hymn "To Aphrodite" lines 45–201. Theocritus, *Idylls* 1.105–07. Virgil, *Aeneid* 1.866ff. Hyginus, *Fabulae* 94.

Annibale Carracci, 1560–1609. "Venus and Anchises." Fresco. **1597–1600**. Galleria, Palazzo Farnese, Rome. [Malafarina 1976, no. 104d—ill. / Martin 1965, pp. 91ff.—ill.]

Phineas Fletcher, 1582–1650. *Venus and Anchises, or Brittain's Ida*. Epyllion. c.**1605–15**. London: Walkley, 1628. Modern edition by E. S. Seaton, *Venus and Anchises and Other Poems* (London: Oxford University Press, 1926). [Hulse 1981, pp. 76–81, / Bush 1963, pp. 169–73, 180]

Johan Tobias Sergel, 1740–1814. "Venus and Anchises." Terra-cotta statue. **1769–70**. Nationalmuseum, Stockholm, no. 491. [Cologne 1977, p. 156—ill. / Göthe 1921, no. 14—ill.]

Benjamin Robert Haydon, 1786–1846. "Venus Appearing to Anchises." Painting. *c.*1826? [Olney 1952, p. 165]
————. "Venus and Anchises Quarrelling." Painting. 1830? [Ibid., p. 187]
William Blake Richmond, 1842–1921. "Venus and Anchises." Painting. Exhibited **1890.** Walker Art Gallery, Liverpool. [Spalding 1978, p. 33—ill. / Wood 1983, p. 207—ill. / Kestner 1989, p. 176, pl. 3.36]
John Byrne Leicester Warren, Lord de Tabley, 1835–1895. "Hymn to Aphrodite." Poem, after Homeric Hymn. In *Poems: Dramatic and Lyrical,* 2d series (London: Lane, **1895**). [Bush 1937, p. 427]
————. "Anchises." Poem. In *Collected Poems* (New York & London: Macmillan, 1903). [Boswell 1982, p. 249]
John Payne, 1842–1916. "Anchises." Poem. In *Poetical Works* (London: for the Villon Society, **1902**). [Boswell 1982, p. 278]
Ezra Pound, 1885–1972. (Anchises' union with Venus evoked in) Canto 23, in *A Draft of XXX Cantos* (Paris: Hours, **1930**; Norfolk, Conn.: New Directions, 193[3?]); and Cantos 74, 76 in *The Pisan Cantos* (New York: New Directions, 1948). [Surette 1979, pp. 48, 59, 64, 201, 240, 272 *n.* / Flory 1980, pp. 200f.]
Robert Graves, 1895–1985. "Anchises to Aphrodite." Poem. In *More Poems* (London: Cassell, **1961**). [Boswell 1982, p. 122]
C. H. Sisson, 1914–. (Anchises' romance with Venus recalled in) "Anchises." Poem. In *Anchises* (Manchester: Carcanet, **1976**). [Ipso]

Girdle of Aphrodite. As the goddess of love, Aphrodite (Venus) possessed a magic girdle or belt *(cestus)* that held all the secrets of love. She is often depicted wearing it, especially in scenes of the Judgment of Paris, which she won by promising Paris possession of the beautiful Helen.

The best-known story involving the girdle is from the *Iliad.* During the great Battle of the Ships, Hera (Juno) wanted to distract her husband while the sea god Poseidon (Neptune) aided the Trojan side, despite the dictum of Zeus (Jupiter) that the gods remain neutral. Using a ruse, she borrowed the girdle from Aphrodite and wore it to seduce Zeus, who then fell into a deep sleep. He awoke to discover the battle raging below to the disadvantage of the Trojans. Zeus berated Hera for meddling and sent her back to Mount Olympus, after which Aphrodite reclaimed the girdle.

Many postclassical works treat this episode or the Judgment of Paris; others focus on the girdle as a general attribute of the goddess of love.

Classical Source. Homer, *Iliad* 14.153–360, 15.4–220.

See also PARIS, Judgment; TROJAN WAR, General List.

Pierre de Ronsard, 1524–1585. (Juno wearing the girdle of Venus in) "Des peintures contenues dedans un ta-bleau" [On Paintings in a Panel]. Ode. In *Les quatre premiers livres des odes* book 2 (Paris: Cauellat, **1550**). [Laumonier 1914–75, vol. 1 / McGowan 1985, p. 81 / Cave 1973, pp. 164f.]
Francesco Coscia, fl. 1568–76. "Venus Retrieving Her Girdle from Juno in Order to Appear Before Paris." Painting. **1570–73.** Studiolo di Francesco I, Palazzo Vecchio, Florence. [Sinibaldi 1950, pp. 11f., 19]
John Smith. *Cytherea; or The Enamouring Girdle.* Comedy. Licensed 30 May **1677**, London. Unperformed. [Nicoll 1959–66, 1:432 / Harbage 1964, pp. 176f.]
Jean-Baptiste Rousseau, 1671–1741. *La ceinture enchantée* [The Magic Girdle]. Comedy. First performed **1701**, Versailles. [Nicoll 1959–66, 3:242, 378]
Elisabeth-Claude Jacquet de la Guerre, 1659/67–1729. "La ceinture de Venus" [The Girdle of Venus]. Comic musical duet. 1713. [Cohen 1987, 1:391]
Jean-Joseph Mouret, 1682–1738, music. "La ceinture de Vénus." First interlude in *Les grandes nuits de sceaux.* Ballet-opera. Scenario, A. Houdart de La Motte. Choreographer unknown. First performed Apr/May **1714** or 4 May 1715, Château de Sceaux. [Winter 1974, p. 48 / DLF 1951–72, 2:99]
Jean-Claude Gillier, 1667–1737. *Le ceinture de Venus.* Opéra comique. Libretto, Alain René Lesage. First performed **1715**, Foire St. Germain, Paris. [Grove 1980, 7:381]
Arnold Houbraken, 1660–**1719**. "Juno, Wearing Venus's Girdle, Seduces Jupiter." Painting. [Pigler 1974, p. 145]
Jacob de Wit, 1695–1754. "Mercury Steals Venus's Girdle." Ceiling painting, for N. Keizersgracht 58, Amsterdam. **1726.** Sold 1897. [Staring 1958, p. 146] Drawing. Rijksprentenkabinet, Amsterdam. [Ibid., pl. 72]
Jean-Baptiste-Marie Pierre, 1713–1789. "Juno Asks Venus for Her Girdle," "Juno, Wearing Venus's Girdle, Seduces Jupiter." Paintings, for appartement du Dauphin, Château de Versailles. **1748.** Louvre, Paris, no. 701B, on deposit at Versailles since 1946. [Pigler 1974, p. 145]
François-Hippolyte Barthélemon, 1741–1808. *La ceinture enchantée* [The Magic Girdle]. Comic opera. Libretto, J.-B. Rousseau (1701). First performed **1769**, Théâtre de Bordeaux, Bordeaux. / Translated by George Saville Carey. First performed 4 July 1770, Marylebone Gardens, London. [Grove 1980, 2:195]
Benjamin West, 1738–1820. "Juno Receiving the Cestus from Venus." Painting. **1771.** University of Virginia Art Museum, Charlottesville. [von Erffa & Staley 1986, no. 169—ill.]
Angelica Kauffmann, 1741–1807. "Juno Borrowing the Cestus of Venus." Painting. / Engraved by Ryland, **1777.** [Manners & Williamson 1924, p. 226]
Charles Dibdin, 1745–1814. "The Cestus" (Trojan War story). Serenata afterpiece. Text, composer. First performed **1783**, Royal Circus, St. George's Field, London. [Grove 1980, 5:427 / Fiske 1973, p. 482 / Nicoll 1959–66, 3:256]
Mark Lonsdale. *Venus's Girdle; or The World Bewitched.* Entertainment. First performed **1796**, Sadler's Wells, London. [Nicoll 1959–66, 3:347]
James Barry, 1741–**1806.** "Juno Receiving the Cestus from Venus." Drawing. Ashmolean Museum, Oxford. [Pressly 1981, no. D.18]
Jean-Pierre Franque, 1774–1860. "Jupiter Sleeping in the

Arms of Juno on Mount Ida" (Juno holding a thunder-bolt, about to strike the Trojans). Painting. Exhibited **1822.** Musée Ingres, Montauban. [Montauban 1965, no. 131—ill.]

Wilhelm Weigand, 1862–1949. *Der Gürtel der Venus* [The Girdle of Venus]. Tragedy. Munich: Müller, **1908.** [Wilpert 1963, p. 617]

Worship of Venus. Although Aphrodite did not have a strong cult following in classical Greek religion, Venus was a prominent deity in imperial Rome. As Venus Genetrix (mother of the *gens Iulia*), she was honored with a temple in 46 BCE by Julius Caesar, who traced his heritage to Iulus, son of Aeneas, and thus to Aeneas's mother, Venus.

In the postclassical arts, various aspects of the traditional worship of Venus are treated, ranging from depictions of sacrifices to or statues of the goddess to descriptions of temples, fountains, or gardens sacred to her. The subject is popular not only in painting, but also in poetry; the theme of the Temple of Venus was borrowed by Chaucer from Boccaccio, and taken up later by Spenser and Marlowe, among others. Feasts of Venus show her worshipers in worldly devotion, and the Garden of Love became, through Rubens, a set piece of decorous amorousness.

Classical Source. Philostratus, *Imagines* 1.6, 2.1.

Giovanni Boccaccio, 1313–1375. (Palemone's prayer to Venus, Temple of Venus, in) *Teseida* 7.42–69; Venus evoked passim. Poem. *c.*1340–42. [Branca 1964–83, vol. 2 / McCoy 1974 / Hollander 1977, pp. 55ff. / Havely 1980, pp. 128–33]
———. (Feast of Venus in) *Comedia delle ninfe fiorentine* [Comedy of the Florentine Nymphs]. Pastoral romance. 1341–42. [Branca / Hollander, p. 74]
Geoffrey Chaucer, 1340?–1400. (Temple of Venus in) "The Hous of Fame" lines 119ff. Poem. **1378–80.** Westminster: Caxton, 1483. [Riverside 1987]
———. (Scenes associated with Venus painted in Temple of Venus, in) "The Knight's Tale" lines 2209–60, 2664ff. Poem, after Boccaccio's *Teseida.* Early 1380s (as "Palamon and Arcite"); revised and incorporated in *The Canterbury Tales,* 1388–95 (Westminster: Caxton, 1478). [Riverside / Havely 1980, pp. 130ff. / Miller 1977, pp. 336–43 / Minnis 1982, p. 21 / Gaylord 1974, pp. 171–90]
King James I of Scotland, 1394–1437. (Poet worships Venus, enters Venus's dream-palace, in) *The Kingis Quair* stanzas 77–93 and passim. Poem, in Middle Scots. *c.*1424. Modern edition, Oxford: Clarendon Press, 1971. [Kratzmann 1980, pp. 43–45, 50–60 / Royle 1983, p. 165 / Pearsall 1977, pp. 216f.]
Francesco Colonna, *c.*1433–1527. (Temple of Venus in) *Hypnerotomachia Poliphili* [The Dream of Poliphilo]. Romance. Venice: **1499;** illustrated with woodcuts by anonymous engraver. [Appell 1893, passim—ill.]

Fra Bartolommeo, 1472–1517. "The Feast of Venus." Drawing. Uffizi, Florence. [Wind 1948, p. 59, fig. 65]
Titian, *c.*1488/90–1576. "The Worship of Venus" ("Feast of Venus") (nymphs and putti before a statue of Venus). Painting. **1518–19.** Prado, Madrid, no. 419. [Wethey 1975, no. 13—ill. / Wind 1948, pp. 56ff., pl. 68 / Berenson 1957, p. 187—ill.] Copies in Nationalmuseum, Stockholm (Peter Paul Rubens, *c.*1628); Accademia Carrara, Bergamo (Padovanino, 1588–1648); 2 others in private colls., Dortmund and Venice. [Wethey / also White 1987, pl. 244]
Baldassare Peruzzi, 1481–1536. "Feast of Venus." Fresco, for Villa Madama, Rome. **1521–23.** Later overpainted. [Frommel 1967–68, no. 58a.4—ill. (drawing)]
Giulio Romano, *c.*1499–1546. (Venus and amorini in) "The Erotes of Philostratus." Drawing, study for unexecuted painting (for Palazzo del Tè?). *c.*1532? Duke of Devonshire coll., Chatsworth. [Hartt 1958, p. 300 no. 217—ill.]
Andrea Schiavone, 1522–1563. "Homage to Venus." Painting. *c.*1539–40. Private coll., Venice. [Richardson 1980, no. 313]
Cristofano Gherardi, 1508–1556. "Offerings to Venus." Fresco. **1555–56.** Sala degli Elementi, Palazzo Vecchio, Florence. [Sinibaldi 1950, pp. 13, 22]
Clément Janequin, *c.*1485–1558. "Petit jardin à Vénus consacré" [Little Garden Consecrated to Venus]. Chanson. [Grove 1980, 9:493]
Louis de Caullery, 1555/60–after 1620. "Feast of Venus." Painting. **1555–60.** Wildenstein, New York. [Warburg]
———, circle? "Feast of Venus." Painting. Statens Museum for Kunst, Copenhagen. [Warburg / Pigler 1974, p. 266 (as Caullery)]
Edmund Spenser, 1552?–1599. (Venus evoked in) *The Faerie Queene* dedicatory sonnet ("The Chian Peincter"), 1.1.48, 3.6.11ff., 4.5.3–5, 4.10 (Temple of Venus), 6.10.9. Romance epic. London: Ponsonbie, **1590,** 1596. [Hamilton 1977]
Christopher Marlowe, 1564–1593. (Temple of Venus in) *Hero and Leander* 1.131ff. Poem, after Musaeus (Temple of Venus passage is original with Marlowe), unfinished. Licensed **1593.** London: Blunt, 1598. [Bowers 1973, vol. 2 / Friedenreich et al. 1988, p. 303 / Leech 1986, p. 181]
Netherlandish School (Pieter Isaacz or Louis van Brüssel?). "Venus Worshipers." Painting. **Early 17th century.** Statens Museum for Kunst, Copenhagen, inv. 1978. [Copenhagen 1951, no. 873—ill.]
Valentin Haussmann, *c.*1565/70–*c.*1614. "Venusgarten." Instrumental composition. **1602.** [Grove 1980, 8:315]
Peter Paul Rubens, 1577–1640. (Statue of Venus Victrix, fountain figure, in) "The Garden of Love" ("Conversation à la Mode"). Painting. *c.*1632–33. Prado, Madrid. [Jaffé 1989, no. 1080, p. 74—ill.]
———. "The Worship of Venus." Painting, copy after Titian (1518–19, Prado). 1636–38. Nationalmuseum, Stockholm. [Jaffé, no. 1339—ill. / also White 1987, pl. 244]
———. "The Feast of Venus (Verticordia)." Painting. Mid-1630s or later. Kunsthistorisches Museum, Vienna, inv. 684 (830). [Vienna 1973, p. 148—ill. / Jaffé, no. 1341—ill. / White, p. 296 / also Baudouin 1977, fig. 175]
Padovanino, 1588–1648. "The Worship of Venus." Painting, copy after Titian (1518–19, Prado). Accademia Car-

rara, Bergamo. [Wethey 1975, no. 13 *n.* / also Bénézit 1976, 10:401]

Jacob Jordaens, 1593–1678. "Homage to Venus" (by bacchantes) ("Festival of Venus"). Painting. **1640s?** 2 versions known. Gemäldegalerie, Dresden; Herzog Anton Ulrich-Museum, Braunschweig. [d'Hulst 1982, pp. 212, 336 *n.*26 / also Braunschweig 1969, p. 80 (as copy after Dresden version) / Rooses 1908, pp. 94, 99—ill.]

Caspar Netscher, 1639–1684. "Offering to [statue of] Venus." Painting. *c.*1665–68. Uffizi, Florence, inv. 1271. [Uffizi 1979, no. P1113—ill.]

———. "Feast of Venus." Painting. 1670. Corporation Art Gallery, Glasgow, no. 80. [Warburg]

Claude Boyer, 1618?–1698. *La feste de Vénus* [The Feast of Venus]. Pastoral comedy. First performed Feb **1669,** Théâtre Marais, Paris. [Lancaster 1929–42, pt. 3, 2:867]

Giulio Carpioni, 1613–**1679.** "Feast of Venus." Painting. Miazzo coll., Genoa. [Pigler 1974, p. 265]

Gérard de Lairesse, 1641–1711 (active until *c.*1690). "Floral Tribute to Venus." Painting. Glynn Vivian Art Gallery, Swansea, cat. 1913 no. 32. [Wright 1976, p. 113]

———. "Homage to Venus." Painting. Formerly Graf v. Bruhl coll., Dresden. / Engraved by Lorenzo Zucchi (1704–1779). [Pigler 1974, p. 266]

Giovanni Bononcini, 1670–1747. *Sacrificio a Venere.* Serenata. Libretto, P. A. Rolli. First performed 28 Aug **1714,** Piazza de' SS Apostoli, Rome. [Grove 1980, 3:32]

Jean-Baptiste-François Pater, 1695–**1736.** "Fête in a Park by a Statue of Venus." Painting. Museum Boymans-van Beuningen, Rotterdam, cat. 1962 no. 2585. [Wright 1980, p. 360]

Jean-Joseph Cassanéa de Mondonville, 1711–1772, music. *Les fêtes de Paphos.* Ballet-héroïque. Libretto, Collé, La Bruère, and Voisenon. First performed 9 May **1758,** L'Opéra, Paris. [Grove 1980, 12:481]

Sebastiano Conca, 1679–**1764.** "Homage to Venus." Painting. Musée, Marseilles. [Voss 1924, p. 621]

Norbert Grund, 1717–**1767.** "Offering to a Statue of Venus." Painting. City Art Museum, Prague. [Pigler 1974, p. 266]

Sébastien Gallet, 1753–1807, choreography. *La fête de Vénus.* Ballet. First performed 4 Dec **1802,** King's Theatre, London. [Guest 1972, p. 153]

Lawrence Alma-Tadema, 1836–1912. "The Shrine of Venus" (symbolic title; group of indolent women). Painting. **1889.** [Kestner 1989, p. 279]

Émile Bernard, 1868–1941. "The Fountain of Venus" (allegory of love, fountain of youth: statue of Venus with water spouting from her breasts, worshipers drinking). Painting. **1925.** Private coll. [Luthi 1982, no. 1128—ill.]

August Enna, 1859–1939. *Afrodites praestinde* [Priestess of Aphrodite]. Opera. First performed **1925,** Copenhagen. [Grove 1980, 6:207]

Alexandre Sakharoff, 1886–1963, and **Clothilde von Derp,** 1892–1974, choreography. *Invocation à Aphrodite.* Modern dance. First performed **1933.** [EDS 1954–66, 8:1410]

T. Sturge Moore, 1870–1944. "Tempio di Venere." Poem. In *Selected Poems* (London: Macmillan, **1934**). [DLB 1983, 19:342]

Doris Humphrey, 1895–1958, choreography. *With My Red Fires.* Modern dance (hymn to Aphrodite). Music, Wall-ingford Riegger. First performed 13 Aug **1936,** Armory, Bennington, Vt.; costumes, Pauline Lawrence. [Siegel 1987, pp. 157–71, 161—ill., 228–30 / Cohen 1972, pp. 141–43, 281]

George Santayana, 1863–**1952.** "Aphrodite's Temple." Poem. In *Complete Poems,* edited by W. G. Holzberger (Lewisburg: Bucknell University Press, 1979). [Boswell 1982, p. 218]

Venus Frigida. Terence, in a famous quotation, said, "Sine Cerere et Baccho friget Venus" ("Without Ceres and Bacchus, Venus freezes," that is, "Without food and drink, love grows cold"). The "frigid" Venus theme became a popular allegory for painters, especially in the Low Countries, France, and Germany of the seventeenth century.

Classical Source. Terence, *Eunuch* 732.

Geoffrey Chaucer, 1340?–1400. (Venus with Bacchus and Ceres in) "The Parlement of Foules" lines 274–79. Poem. **1380–82.** Westminster: Caxton, 1477. [Riverside 1987 / Kratzmann 1980, p. 43]

Hendrik Goltzius, 1558–1617. "Venus and Cupid" (with symbols of Bacchus and Ceres and inscription "Venus friget"). Engraving. *c.*1590. 3 states. [Strauss 1977a, no. 284—ill.]

———. "Sine Cerere et Baccho friget Venus." Drawing. 1593. British Museum, London. [de Bosque 1985, pp. 87, 176f.—ill.]

———. "Bacchus, Ceres, and Venus." Engraving. 1595. [Strauss, no. 325—ill. / Bartsch 1980–82, no. 155—ill.]

———. "Bacchus," "Venus," "Ceres." Engraving series (Bartsch nos. 65–67, as Jan Saenredam), "Three Deities in Half-length." *c.*1596. [Strauss, nos. 336–38—ill. / Bartsch 1980–82, nos. 160d–f—ill.]

———. "Sine Cerere et Baccho friget Venus." Grisaille painting. 1599. British Musuem, London. [de Bosque, p. 177—ill. / also Reznicek 1961, no. 130—ill.] Watercolor sketch ("Venus, Ceres, and Bacchus"). Musée Royaux des Beaux-Arts, Brussels. [de Bosque—ill. / Reznicek, no. 127—ill.]

———. "Venus, Bacchus, Ceres, and Cupid." Drawing. 1604. Hermitage, Leningrad, inv. 18983. [Reznicek, no. 128—ill.]

Bartholomeus Spranger, 1546–1611. "Sine Cerere et Bacchus friget Venus" ("Bacchus and Ceres Leaving Venus"), "Venus Warmed by Ceres and Bacchus's Return." Pendant paintings. **1590.** "Leaving" in Kunsthistorisches Museum, Vienna, inv. 2435. [Vienna 1973, p. 166 / also de Bosque 1985, pp. 170, 177f.—ill. / Hofmann 1987, no. 3.17 *n.*—ill. (print)] Related drawing ("Bacchus and Ceres"). Národní Galeri, Prague. [de Bosque, pp. 169f.—ill.]

Gillis Congnet the Elder, *c.*1538–**1599.** "Sine Cerere et Baccho friget Venus." Painting. Nationalmuseum, Stockholm, cat. 1958 no. 385 (attributed to M. J. van Mierevelt). [Warburg]

Karel van Mander, 1548–**1606.** "Venus, Ceres, and Bacchus." Drawing. Museum Boymans-van Beuningen, Rotterdam. [de Bosque 1985, pp. 177, 179—ill.]

Andrea Boscoli, c.1560–**1607.** "Venus frigida." Drawing. Lyon, Musée des Beaux-Arts. [Warburg]

Abraham Bloemaert, 1564–1651, composition. "Sine Cerere et Baccho friget Venus." Engraving (Bartsch no. 28), executed by Jan Saenredam (1565–**1607**). [Pigler 1974, p. 51]

————. "Venus, Ceres, Bacchus." Drawing. Sold Sotheby's, London, 1972. [Warburg]

Anton Möller the Elder, 1563–**1611.** "The Power of Love and Music" ("Sine Cerere et Baccho friget Venus"). Drawing. Kupferstichkabinett, Berlin, cat. Bock 1921 no. 5577. [Warburg]

Peter Paul Rubens, 1577–1640. "Venus, Cupid, Bacchus, and Ceres" ("Sine Cerere et Baccho friget Venus"). Painting. 1612–13. Staatliche Kunstsammlungen, Kassel. [Jaffé 1989, no. 191—ill.]

————. "Venus Frigida" ("Sine Cerere et Baccho friget Venus"). Painting. c.1614. Koninklijk Museum voor Schone Kunsten, Antwerp, no. 709. [Jaffé, no. 234, p. 117—ill. / Antwerp 1970, p. 196 / Baudouin 1977, pl. 20]

————. "Sine Cerere et Baccho friget Venus." Painting. c.1616–17. Cut in half in 17th century, left side replaced by scene of Vulcan's forge. Musées Royaux des Beaux-Arts, Brussels, inv. 1372 (as "Venus in Vulcan's Forge"). [Jaffé, no. 429A—ill. / Brussels 1984, p. 253—ill. / also Baudouin 1977, fig. 54] Original left side ("Woman with a Brazier") now in Gemäldegalerie, Dresden. [Jaffé, no. 429B—ill.] Copy after complete original composition, in Mauritshuis, The Hague, inv. 247. [Mauritshuis 1985, p. 434—ill.]

Cornelis Cornelisz van Haarlem, 1562–1638. "Venus, Ceres, and Bacchus" ("Sine Cerere et Baccho friget Venus"). Painting. **1614.** Staatliche Kunstsammlungen, Dresden, no. 851. [de Bosque, pp. 177, 179—ill. / Pigler 1974, p. 51]

————. "Ceres, Bacchus, Venus, and Cupid" ("Sine Cerere et Baccho friget Venus"). Painting. 1624. Musée des Beaux-Arts, Lille. [de Bosque, p. 92—ill. / Pigler, p. 51]

————. "Ceres, Bacchus, Venus, and Cupid" ("Sine Cerere et Baccho friget Venus"). Painting. Nationalmuseum, Stockholm, no. 385. [Pigler]

————. "Ceres and Bacchus." Painting. Koninklijk Museum voor Schone Kunsten, Antwerp, no. 5017. [Antwerp 1970, p. 54]

Jan Brueghel the Elder, 1568–1625, landscape, and **Hendrik van Balen,** 1575–1632, figures. "Allegory of Abundance" ("Venus [Flora?], Bacchus, and Ceres," "Worship of Ceres"). Painting. c.1615. Private coll., France; another version sold Sotheby's, London, 1957. [Ertz 1979, nos. 303–04, pp. 389f.—ill.] Variant ("Festival of Bacchus"). *See Jan Brueghel the Younger, below.*

Jan Brueghel the Younger, 1601–1678, landscape, and **Hendrik van Balen,** 1575–1632, (or Johann Rottenhammer?) figures. "Festival of Bacchus." Painting, variant of Jan Brueghel the Elder and van Balen's "Allegory of Abundance" (c.1615, above). Gemäldegalerie, Berlin. [Ertz 1984, no. 213—ill.]

———— (both). "Festival of Bacchus" ("Sine Cerere et Baccho friget Venus"). Painting. Late 1620s. Several versions. Galerie Müllenmeister, Solingen; Národní Galeri, Prague, inv. DO4930; 3 (copies?) unlocated. [Ibid., nos. 211, 214–15—ill.]

Jacob Jordaens, 1593–1678. "Sine Baccho et Cerere friget Venus." Painting. c.1616. Museum voor Schone Kunsten, Ghent, no. 1903–F. [Ottawa 1968, no. 15—ill. / also Rooses 1908, p. 48 (as "Bacchanalian Scene")]

Joachim Wtewael, 1566–1638. "Ceres," "Bacchus," "Venus and Cupid." Painting cycle. c.1618. Muzeum Brukenthal, Sibiu, nos. 1275–77. [Lowenthal 1986, nos. A–74–76—ill.]

Louis de Caullery, 1555/60–after 1620. "Venus, Bacchus, and Ceres with Mortals in a Garden of Love." Painting. Rijksmuseum, Amsterdam, inv. A1956. [Rijksmuseum 1976, p. 165—ill.]

Gerrit van Honthorst, 1590–1656. "Sine Baccho." Painting. c.1623. Schonborn coll., Pommersfelden. [Judson 1959, no. 79]

Abraham Janssens, c.1575–1632. "Venus, Bacchus, and Ceres." Painting. Galerie Brukenthal, Hermannstadt, inv. 597. [Bénézit 1976, 6:38 / Pigler 1974, p. 52]

Simon de Vos, 1603–1676. "Sine Cerere et Baccho friget Venus." Painting. **1635.** Národní Galeri, Prague. [Pigler 1974, p. 52]

Thomas Nabbes, c.1605–1641. (Ceres and Bacchus vs. Venus and Cupid in) *The Springs Glorie: Vindicating Love.* . . . Masque. First performed **1636**–37 (?) privately, London (?). Published London: Greene, 1638. [DLB 1987, 58:223, 227f.]

Paulus Moreelse, 1571–1638. "The Three Delights, Venus, Bacchus, and Ceres." Painting. Documented 1768, untraced. [de Jonge 1938, no. 306]

Jacob Backer, 1608–1651, attributed. "Bacchus, Ceres, and Venus." Painting. Recuperation Française, Paris, no. M.N.R. 919 (as Frans Floris). [Warburg]

Nicolas Poussin, 1594–1665, attributed (also attributed to J. van Haensbergen). "Sine Cerere et Baccho friget Venus." Gabritschesky coll., Munich, in 1929, sold Munich 1933 (as Cornelis van Poelenburgh). [Warburg]

Cornelis van Poelenburgh, c.1586–**1667.** "Pomona, Bacchus, and Venus" (in clouds with 2 cupids). Painting. Akademie der Bildenden Künste, Vienna, no. 666. [Warburg]

————. "Sine Cerere et Baccho friget Venus." Painting. A. Lehmann coll., Paris, c.1920, unlocated. [Warburg] Another version of the subject in Galerie, Kassel, no. 193. [Pigler 1974, p. 52]

Theodoor van Thulden, 1606–1669, attributed. "Sine Cerere et Baccho friget Venus." Painting. Noordbrabants Museum, 's Hertogenbosch, inv. 865. [Wright 1980, p. 452]

Abraham Hondius, c.1625–1695. "Sine Cerere et Baccho friget Venus." **1676.** Art dealer, London, 1955. [Warburg]

Cesar Boetius van Everdingen, c.1617?–**1678.** "Sine Cerere et Baccho friget Venus." Painting. Gemäldegalerie, Dresden, no. 1834. [Pigler 1974, p. 52]

Flemish School. "Ceres, Bacchus, and Venus." Drawing. 17th century. Formerly Earl Beauchamp coll., sold Sotheby's, London 1973. [Warburg]

Flemish School. "Sine Cerere et Baccho friget Venus, with Minerva Bringing Temperance, and Cronus." Painting. **17th century.** E. L. Cats coll., The Hague, in 1960. [Warburg]

Bon Boulogne, 1649–1717. "Venus, Bacchus, and Ceres." Painting, part of series for Château de Meudon. **1700.** Louvre, Paris, inv. 8608. [Louvre 1979–86, 3:88—ill.]

Daniel Seiter, 1649–**1705.** "Bacchus, Ceres, and Venus." Painting. Schloss, Pommersfelden. [Voss 1924, p. 591]

Godfried Schalcken, 1643–**1706.** "Sine Cerere et Baccho friget Venus." Painting. Národní Galeri, Prague, cat. 1905 no. 194. [Warburg]

Carlo Maratti, 1625–**1713.** "Venus, Bacchus, and Ceres." Drawing. Sold Sotheby's, London, 1980. [Warburg] Another version of the subject is in the Louvre. [Pigler 1974, p. 52]

Jacob de Wit, 1695–1754. "Sine Baccho et Cerere friget Amor" ("Venus, Bacchus, and Ceres with Amor Sleeping"). Painting for chimney-piece. **1720.** Dienst Verspreide Rijkskollekties, The Hague, on loan to Kunsthistorisches Institut, Utrecht. [Staring 1958, p. 144 / Wright 1980, p. 500]

Noël-Nicolas Coypel, 1690–**1734.** "Sine Cerere et Baccho friget Venus." Painting. Museum voor Schone Kunsten, Ghent. [Pigler 1974, p. 52]

Michele Rocca, c.1670/75–**1751 or later.** "Sine Cerere et Baccho friget Venus." Painting. Earl of Bradford coll., Weston Park. [Warburg]

Lawrence Alma-Tadema, 1836–1912. "Between Venus and Bacchus." Watercolor. **1882.** Walters Art Gallery, Baltimore. [Swanson 1977, p. 139]

Venus and Satyrs. Although not derived from any specific classical myth, the image of Venus watched by a satyr (or satyrs) is a common theme in paintings of the Renaissance and later. In these works, the goddess is frequently depicted asleep and often accompanied by Eros (Cupid, Amor). The theme is a variation of that in which a nymph is watched lustfully by a satyr, and it is often confused or conflated with the story in which Zeus (Jupiter) disguised himself as a satyr in order to seduce Antiope.

Giulio Romano, c.1499–1546, and assistant. "Venus, Satyr, and Maenad" ("Satyr Tormented by Two Nymphs"). Fresco. **1527–28.** Sala di Ovidio (Metamorfosi), Palazzo del Tè, Mantua. [Verheyen 1977, p. 110 / Hartt 1958, p. 111—ill.]

———. (Venus and satyr in) "The Erotes of Philostratus." Drawing, study for unexecuted painting (for Palazzo del Tè?). c.1532? Duke of Devonshire coll., Chatsworth. [Hartt, p. 300 no. 217—ill.]

Antonio da Correggio, c.1489/94–**1534.** "Venus, Cupid, and a Satyr" (previously also called "Antiope Sleeping," "Jupiter and Antiope"). Painting. Louvre, Paris, inv. 42 (1118). [Gould 1976, p. 238—ill. / Louvre 1979–86, 2:168—ill.] Copy at Saltram Park, Devon. [Gould] Copy by F. Stiémart (1680–1740) in Musée Lambinet, Versailles (on deposit from Louvre, Paris, inv. 47). [Louvre, 2:288]

Titian, c.1488/90–1576. "The Pardo Venus" ("Jupiter and Antiope"). Painting. c.**1535–40,** retouched c.1560. Louvre, Paris, inv. 752 (1487). [Wethey 1975, no. 21—ill. / Louvre 1979–86, 2:246—ill.] Copy in Ham House, Richmond. [Wethey]

———, formerly attributed (Venetian School). "Venus with Satyr and Cupid." Painting. c.1600–25. Villa Borghese, Rome. [Ibid., no. X–42]

Brescian School. "Venus, Cupid, and a Satyr." Painting. **Mid-16th century.** Szépművészeti Múzeum, Budapest, no. 1409. [Budapest 1968, p. 95]

Agnolo Bronzino, 1503–1572. "Venus, Cupid, and a Satyr." Painting. c.**1550–55.** Galleria Colonna, Rome, no. 56. [Baccheschi 1973, no. 94—ill. / McCorquodale 1981, fig. 81 / Berenson 1963, p. 44 / Voss 1920, p. 214—ill.]

Luca Cambiaso, 1527–1585. "Venus and Cupid, with a Satyr." Painting. c.1565. Palazzo dei Marchesi Negrotto Cambiaso, Genoa. [Manning & Suida 1958, p. 80—ill.]

———. "Satyr Mocked by Cupid (and Derided by Venus and the Graces [?])." Ceiling fresco. c.1565. Formerly Palazzo della Meridiana, Genoa, destroyed. / Drawing (for?). Art Museum, Princeton University, N.J. [Ibid., p. 92—ill.]

Paolo Veronese, 1528–1588. "Venus, Satyr, and Cupid." Painting. c.**1570–71.** Koetser coll., Zurich. [Pallucchini 1984, no. 119—ill. / Pignatti 1976, no. 139—ill.] Variant, attributed to Veronese. Galleria Palatina, Palazzo Pitti, Florence. [Pallucchini, no. 120—ill. / also Pignatti, no. A107—ill.] Another version of the subject, attributed to Veronese (or copy after lost or generic work). Galleria Borghese, Rome, inv. 124. [Pignatti, no. A272 / Pergola 1955–59, 1: no. 244—ill.]

Paris Bordone, 1500–**1571.** "Venus, Cupid, and a Satyr." Painting, variant after his "Sleeping Venus with Cupid" (Ca' d'Oro, Venice). Galleria Borghese, Rome, inv. 119. [Canova 1964, pp. 95, 111—ill. / Pergola 1955–59, 1: no. 193—ill.]

Annibale Carracci, 1560–1609. "Venus, Satyr, and Two Amorini" ("Bacchantes"). Painting. c.1588. Uffizi, Florence, inv. 1452 (1133). [Malafarina 1976, no. 43—ill. / Uffizi 1979, no. P372—ill.] Copy ("Nymph and Satyr") in Galleria Palatina, Palazzo Pitti, Florence, no. 480. [Pitti 1966, p. 134]

———. "Sleeping Venus and a Satyr." Etching/engraving (Bartsch no. 17), after composition by Agostino Carracci? 1592. [DeGrazia 1984, no. 17—ill.]

Vincent Sellaer, 1539–**1589,** attributed (previously attributed to Frans Floris, others). "Resting Venus with Cupid, Amoretti, and Satyrs." Painting. Herzog Anton Ulrich-Museum, Braunschweig, no. 41. [Braunschweig 1969, p. 124 / de Bosque 1985, p. 60—ill.]

Agostino Carracci, 1557–1602 (or school/studio of Ludovico Carracci?). "Venus and Cupid with a Satyr." Painting. c.1600. Kunsthistorisches Museum, Vienna, inv. 257 (468). [Vienna 1973, p. 39—ill. / Ostrow 1966, no. II/12] *See also Annibale Carracci, above.*

Joseph Heintz the Elder, 1564–1609. "Venus and Satyr." Painting. c.1600. Lost. / Engraving by Lucas Kilian. [Zimmer 1971, no. 107—ill.] Copy, wood relief, by Ignaz Elhafen, 1709. Bayerisches Nationalmuseum, Munich, no. 425. [Ibid., no. B12.0.4.1—ill.]

———. "Venus, Cupid, and a Satyr." Painting. Lost. / Engraving by Franz Aspruck, 1601. [Ibid., no. B11—ill.]

Pietro Francavilla, 1546/53–**1615.** "Venus Attended by Nymph and Satyr." Fountain figure. Wadsworth Atheneum, Hartford, Conn. [Clapp 1970, 1:314]

Johann Rottenhammer, 1564–1625. "Sleeping Venus, with Amor, Admired by Satyrs." Painting. / Engraving

(Bartsch 3:180 no. 193) by Jacob Matham (1571–1631). [Pigler 1974, p. 254]

Palma Giovane, c.1548–1628. "Venus and Satyr." Painting, known from engraving by Wolfgang Kilian (1581–1662). [Pigler 1974, p. 253]

Bartholomeus Breenbergh, 1599–c.1657, imitator (Italian? formerly attributed to Domenichino). "(Wooded Scene with) Venus, Cupid, and Satyrs." Painting. c.1628? Palazzo Pitti, Florence, no. 461. [Röthlisberger 1981, no. 348 / Spear 1982, p. 315]

Jusepe de Ribera, 1590/91–1652. "Sleeping Nude [Antiope? Venus?] with Cupids and a Satyr." Drawing. 1626–30. Fitzwilliam Museum, Cambridge, no. 113–1961. [Brown 1973, no. D.15—ill. / Fort Worth 1982, pp. 79f.—ill. / López Torrijos 1985, p. 417 no. 22—ill.]

Rembrandt van Rijn, 1606–1669. "Jupiter and Antiope" (formerly called "Venus and Satyr," "Danaë"). Etching (Bartsch no. 204). c.1631. 2 states. [White & Boon 1970, no. 204—ill. / Guillaud 1986, p. 156, fig. 215]

Nicolas Poussin, 1594–1665, attributed. "Venus [or Nymph] Surprised by the Satyrs." Painting. Early 1630s? Kunsthaus, Zurich. [Wright 1985, no. A34, pl. 217 / also Thuillier 1974, no. B14—ill.] Replica. Thalberg coll., Zurich. [Blunt 1966, no. R113 (attribution rejected for both versions)] Variant, "Sleeping Nymph Surprised by Satyrs." National Gallery, London, inv. 91 (as copy after a lost original). [London 1986, p. 494—ill. / Wright / Thuillier, no. B15—ill. / Blunt (attribution rejected)]

———, questionably attributed. "Venus and Satyrs." Painting. Dally coll., Amersham. [Wright, no. A1—ill.]

———, doubtfully attributed. "Venus and Cupid with a Satyr" ("Venus and Cupid with a Man Holding Fruit"). Painting. Mid-1620s? Wildenstein Gallery, New York, in 1983. [Wright 1985, no. A21 / also Blunt 1966, no. 188—ill. / Thuillier 1974, no. B16—ill.]

———, formerly attributed (Karel Philips Spierincks?). "Venus Surprised by Satyrs." Painting. Royal Collection, Hampton Court. [Thuillier, no. R93—ill.]

Domenichino, 1581–1641, formerly attributed (Netherlandish School?). "Venus Watched by Satyrs." Painting. c.1700. Herzog Anton Ulrich-Museum, Braunschweig, no. 488. [Braunschweig 1976, p. 45 / also Braunschweig 1969, p. 53] *See also Bartholomeus Breenbergh, above.*

Giovanni Biliverti, 1576–1644. "Venus, Cupid, and Satyr." Painting. 1644. Sold Sotheby's, London, 1974. [Warburg]

Luca Giordano, 1634–1705. "(Sleeping) Venus, with Cupid and a Satyr." Painting. c.1663. Central Picture Galleries, New York, c.1966. [Ferrari & Scavizzi 1966, 1:56, 2:60—ill.] Replica. Museo di Capodimonte, Naples, no. 452. [Ibid.—ill.] Variant. Painting. c.1663. Museo di Capodimonte, on deposit in Palazzo di Montecitorio, Rome. [Ibid., 2:59—ill.]

———. "Venus, Satyr, and Amorini." Painting. c.1683–84. Lord Exeter coll., Burghley House, Northamptonshire. [Ibid., 2:121—ill.] Another version of the subject recorded in Rosso coll., Florence, in 1677, untraced. [Ibid., 2:330f.—ill.]

Jacob Jordaens, 1593–1678, attributed. "Venus and Satyrs," "Venus and Cupid with a Satyr," "Venus with Cupid and Satyrs." Paintings, recorded in 18th-century sales, untraced. [Rooses 1908, p. 261]

Netherlandish School? (previously attributed to Domen-

ichino). "Venus Watched by Satyrs." Painting. c.1700. Herzog Anton Ulrich-Museum, Braunschweig, no. 488. [Braunschweig 1976, p. 45 / also Braunschweig 1969, p. 53]

Sebastiano Ricci, 1659–1734. "Venus and a Satyr." Painting. c.1702–03 or later. Rino Alessi coll., Trieste. [Daniels 1976, no. 429]

———. "Venus, Cupid, and a Satyr." Painting. c.1705. Sold Christie's, London, 1974. [Ibid., no. 184—ill.]

———. "Venus and Cupid Surprised by a Satyr." Painting. 1710 or after 1720. Staatsgalerie, Stuttgart, inv. 2754. [Ibid., no. 417—ill.]

———. "Venus and a Satyr" ("An Old Satyr Approaching the Sleeping Venus"). Painting. Szépművészeti Múzeum, Budapest, no. 58.43. [Ibid., no. 69—ill. / Budapest 1968, p. 579]

Adriaen van der Werff, 1659–1722. "Venus and Faun." Painting. [Warburg]

Jan Baptist Govaerts. 1701?–1746. "Venus, Amor, and Satyrs." Painting. 1726. Muzeum Narodowe, Warsaw, inv. 293. [Warsaw 1969, no. 432—ill.]

Richard Wilson, 1714–1782. "Venus and Satyr." Painting. 1752. D. J. Lucie coll., Britain. [Constable 1953, pl. 16b]

Giovanni Battista Tiepolo, 1696–1770. "Venus and a Satyr." Painting. Lost. [Morassi 1962, p. 62]

Antonio Canova, 1757–1822. "Venus and a Satyr." Painting. c.1792. Gipsoteca Canoviana, Possagno, no. 8. [Pavanello 1976, no. D13—ill. / Licht 1983, p. 134—ill. / also Vermeule 1964, pl. 117]

Statue of Venus. Stories about young men's infatuation with statues of Venus did not originate in classical mythology, but a work ascribed to "Pseudo-Lucian" (fourth century CE?) tells of a young man of good family who spent his days in the Temple of Venus gazing on her statue and whispering to her. Inflamed by desire, he managed one night to lock himself in the temple, where he embraced the statue with such passion that a "bruise" showed on the marble. Alarmed, he dove into the sea.

In the early Middle Ages a similar story was told by William of Malmesbury. In this version a young Roman, engaged in games at his wedding, temporarily placed his ring on the finger of a Venus statue. The goddess later came to his bridal bed and suffocated him in her embrace. This story, and variants on it in which the young man actually falls in love with the statue, emphasize the magical and malign powers of the goddess of love and the unholy influence of paganism. It became a favorite theme of Romantic literature, particularly German and French.

Classical Source. Pseudo-Lucian, *Erotes* 15.
Further Reference. Paull F. Baum, "The Young Man Betrothed to a Statue," *Publications of the Modern Language Association* 34 (1919): 523–79; 35 (1920): 60–62. Robert Mühler, "Der Venusring: Zur Geschichte eines romantischen Motivs," *Aurora* 17 (1957): 50–62. Barbara Fass, *La*

Belle Dame sans Merci and the Aesthetics of Romanticism (Detroit: Wayne State University Press, 1974).

William of Malmesbury, 1090/96–1143. (Story of Roman who put his ring on the finger of a statue in) *Gesta regum anglorum.* Verse chronicle. **1125.** / Translated as *Chronicle of Kings of England,* edited by J. A. Giles (London: Bohn, 1847; reprinted New York: AMS, 1968). [Praz 1956, p. 454]

Robert Burton, 1577–1640. (Legend of the Ring of Venus explored in) *The Anatomy of Melancholy* part 3, sec. 2, mem. 1, subs. 1. Treatise. Oxford: Printed for Henry Gripps **1621.** Modern edition, edited by Floyd Dell and Paul Jordan-Smith (New York: Tudor, 1927). [Ipso / Fass 1974, p. 276]

Joseph von Eichendorff, 1788–1857. (Statue of Venus frightens the poet in) *Das Marmorbild* [The Marble Statue]. Novella. In *Das Frauentaschenbuch für das Jahr 1819,* edited by Friedrich de la Motte Fouqué (Nürnberg: Schrag, **1819**). [Oxford 1986, pp. 196, 598 / Sandor 1967, pp. 28f. / Fass 1974, pp. 123–33, 161, 284f.]

Jean Coralli, 1779–1854, choreography. *La statua di Venere* [The Statue of Venus]. Ballet. First performed **1825,** La Scala, Milan. [Winter 1974, pl. 211 / Chujoy & Manchester 1967, p. 227]

Prosper Mérimée, 1803–1870. "La Vénus d'Ille." Story. In *Révue des deux mondes* 15 May **1837**; collected in *Oeuvres* (Paris: 1842). [Praz 1956, p. 208, DULC 1959–63, 3:516 / Fass 1974, pp. 140–44]

Richard Monckton Milnes, 1809–1885. (Ring of Venus story in) "The Northern Knight in Italy." Narrative poem. In *Poems Legendary and Historical* (London: Moxon, **1844**). [Fass 1974, pp. 135f.]

William Morris, 1834–1896. "The Ring Given to Venus." Poem. By **1868.** In *The Earthly Paradise,* vol. 4 (London: Ellis, 1870). [Morris 1910–15, vol. 6 / Calhoun 1975, pp. 210–14 / Fass 1974, p. 136]

Edward Burne-Jones, 1833–1898. 2 engravings illustrating William Morris's "The Ring Given to Venus." **1865–68.** [Harrison & Waters 1973, pp. 79, 83f.—ill. / Arts Council 1975, no. 270—ill.]

Oscar Wilde, 1854–1900. "Charmides." Poem, variation of Ring of Venus story, after Pseudo-Lucian. In *Poems* (London: Bogue, **1881**). [Ellmann 1988, pp. 115, 141 / Bush 1937, pp. 420f.]

Frank Anstey, 1856–1934. "The Tinted Venus: A Farcical Romance." Short story. London: Lovell, **1885.** [Read 1982, pp. 25f.]

James Dryden Hosken. "The Betrothal of Venus." Poem. In *The Betrothal of Venus and Other Poems* (London: Methuen, **1903**). [Bush 1937, p. 563]

Henry James, 1843–**1916.** "The Last of the Valerii" (contemporary variant of ring of Venus story). Short story. In modern edition, *Complete Tales,* vol. 3 (Philadelphia: Lippincott, 1962). [Fass 1974, pp. 145ff.]

Othmar Schoeck, 1886–1957. *Venus.* Opera, opus 32. Libretto, C. F. Rüeger, after Mérimée's "La Vénus d'Ille" (1837). **1919–20.** First performed 10 May 1922, Zurich. [Grove 1980, 16:699]

Hermann Hans Wetzler, 1870–1943. *Die baskische Venus* [The Basque Venus]. Opera, opus 14. Libretto, Lini Wetzler, after Mérimée's "La Vénus d'Ille" (1837). First performed 18 Nov **1928,** Leipzig. [Grove 1980, 20:378f.]

Kurt Weill, 1900–1950. *One Touch of Venus.* Musical comedy. Libretto, S. J. Perelman and Ogden Nash, after Anstey's "The Tinted Venus" (1885). First performed 7 Oct **1943,** Imperial Theatre, New York; choreography, Agnes de Mille. [Oxford 1984, p. 524 / Grove 1980, 20:309 / Bordman 1978, p. 538]

Anthony Burgess, 1917–. *The Eve of Saint Venus.* Novel. London: Sidgwick & Jackson, **1964;** New York: Norton, 1970. [Fass 1974, pp. 146–48]

Henri Büsser, 1872–1973. *La Vénus d'Ille.* Opera (lyric drama). Libretto, composer, after Mérimée (1837). First performed **1964,** Lille. [Grove 1980, 3:512]

Charles Olson, 1910–1970. "The Ring of." Poem (ode to Aphrodite). In *Selected Writings,* edited by Robert Creeley (New York: New Directions, **1966**). [CLC 1976, 5:328]

Tannhäuser and the Venusberg. Tannhäuser was a thirteenth-century lyric poet whose travels around Germany and participation in one of the Crusades became legend. He was later identified with a knight in a sixteenth-century ballad who, on passing the Venusberg (hill of Venus), found himself enchanted by a vision of the goddess. After living a life of sensual pleasure with her, the knight was at length seized by a longing to return to his mundane existence and invoked the name of the Virgin to help him escape. Having fled the Venusberg, he asked the Pope's absolution but received only a decree stating that his sins would be forgiven when the papal staff bore flowers. Three days later, the staff did bloom, but by that time Tannhäuser had returned to the Venusberg.

The legend of Tannhäuser has no true classical source, but it is a persistent theme in the postclassical arts. It has been given rich treatment not only in German and English literature, but also in art, music, and dance, particularly of the Romantic period. The Venusberg scene in Richard Wagner's opera *Tannhäuser* remains the most famous and influential version of the theme.

The Swedish tale of "The Mines of Falun," stemming from an actual incident, is an offshoot of the Tannhäuser subject. In 1670 a miner was killed underground; fifty years later his preserved body was discovered and identified by his still-faithful betrothed. Because this strange story was set underground and included a "Queen of the Mines," it was identified, and eventually merged, with the hill of Venus theme. Popularized by E. T. A. Hoffmann's retelling, the tale still receives attention.

Further Reference. Barbara Fass, *La Belle Dame sans Merci and the Aesthetics of Romanticism* (Detroit: Wayne State University Press, 1974). Philip S. Barto, *Tannhäuser*

and the Mountain of Venus: A Study in the Legend of the Germanic Paradise (New York: Oxford University Press, 1916). "The German Venusberg," *Journal of English and German Philology* 12 (1913): 295–303. Arthur F. J. Remy, "The Origin of the Tannhäuser Legend," *Journal of English and German Philology* 12 (1913): 32–77.

Der Tannhäuser, *c*.1200–*c*.1270. "Tannhäuserlied." Lied. Modern edition, as *Der Tannhäuser,* in *Des Knaben Wunderhorn: Alte deutsche Lieder,* edited by L. J. von Arnim and C. Brentano (Berlin: Deutsche Bibliothek, 1805–08). [Oxford 1986, p. 881]

Hermann von Sachsenheim, 1366/69–1458. (Tannhäuser [or Danheuser] mentioned as husband of "Dame Venus") in "Die Mörin." Allegorical poem. **1453.** In modern edition by E. Martin, *Bibliothek des literarischen Vereins zu Stuttgart* (Tübingen: 1878). [Remy 1913, pp. 37, 48]

Hans Sachs, 1494–1576. (Tannhäuser in) *Der Frau Venus Hofgesinde (Das Hofgesinde der Venus)* [The Court of Lady Venus]. Comedy. Published **1517.** In modern edition, *Werke* (Stuttgart: 1870–1908; Hildesheim: Olms, 1964). [Remy 1913, p. 39 / McGraw-Hill 1984, 4:302f.]

Joseph Heintz the Elder, 1564–1609. "(Venus and Cupid before) The Venusberg." Painting. *c*.**1603.** Kunsthistorisches Museum, Vienna, inv. 6953 (1523). [Zimmer 1971, no. A15—ill. / Vienna 1973, p. 85—ill.]

Ludwig Tieck, 1773–1853. "Der Getreue Eckart und der Tannenhäuser" [Trusty Eckhart and Tannhäuser]. In *Phantasus.* **1799.** [Ibid., pp. 122, 284]

———. (Christian relives Tannhäuser's story in) "Der Runenberg." Tale. 1802. Munich: Hyperion [n.d.]; collected in *Phantasus* (Berlin: Realschulbuchhandlung, 1812–16). [Fass 1974, pp. 81–91, 281]

E. T. A. Hoffmann, 1776–1822. (Tannhäuser/Venusberg theme woven into) "Die Bergwerke zu Falun" [The Mines at Falun]. Tale. **1818.** In *Die Serapionsbrüder,* vol. 1 (1819). Modern edition, Stuttgart: Reclam, 1966. / Translated by L. J. Kent and E. C. Knight in *Selected Writings* (Chicago: University of Chicago Press, 1969). [Oxford 1986, p. 76 / Fass 1974, pp. 15, 91ff., 172, 251, 255 / Grove 1980, 20:128]

Johann Peter Hebel, 1760–1826. (Evocation of Venusberg and the lost miner of Falun in) "Unverhofftes Wiedersehen" [Unhoped-for Reunion]. Short story. In *Poetische Werke* (Munich: Winkler, 1961). [Fass 1974, pp. 91f., 281 n.16]

Heinrich Heine, 1797–1856. "Tannhäuser: Eine Legende." Poem, based on Willibald Alexis's tale "Mons Veneris." In *Elementargeister* part 2 (Hamburg: Hoffmann & Campe, **1836**). [Windfuhr 1975–82, vol. 2 / Draper 1982 / Sammons 1979, pp. 216f., 277 / Sandor 1967, p. 28 / Butler 1958, pp. 275–77]

———. (Venus dances a pas de deux with Tannhäuser in the Venusberg in) *Die Göttin Diana.* "Dance-poem," scenario for ballet/pantomime. 1846. In *Vermischte Schriften* (Hamburg: Hoffmann & Campe, 1854). [Windfuhr, vol. 9 / Butler, p. 287 / Fass 1974, pp. 121ff.]

Richard Monckton Milnes, 1809–1885. (Tannhäuser legend in) "Venus and the Christian Knight," ballad, and "The Northern Knight in Italy," poem. In *Poetry for the*

People and Other Poems (London: Moxon, **1840**). [DLB 1984, 32:221]

Richard Wagner, 1813–1883. (Tannhäuser/Venusberg theme woven into) *Die Bergwerke zu Falun* [The Mines at Falun]. Scenario for opera, unwritten. **1841–42.** [Grove 1980, 20:140 / Fass 1974, pp. 101, 282 n.27]

———. *Tannhäuser und der Sängerkrieg auf Wartburg.* Opera. 1843–45. First performed 19 Oct 1845, Königliches Hoftheater, Dresden. / Venusberg scene revised ("Paris version") 1860–61. First performed 13 Mar 1861, Paris, L'Opéra. / Revised, first performed 5 Mar 1865, Königliches Hof- und Nationaltheater, Munich. / Final revision, first performed 22 Nov 1875, Hofoper, Vienna. [Grove, 20:128, 136f. / Fass, pp. 155f., 160–69]

Paul Hamilton Hayne, 1830–1886. (Version of Tannhäuser legend in) "The Temptation of Venus: A Monkish Legend." Poem. In *Poems* (Boston: Ticknor & Fields, **1855**). [Bush 1937, p. 578]

Algernon Charles Swinburne, 1837–1909. (Legend of the Venusberg in) "Laus Veneris" ("Praise of Venus"). Poem. By **1861.** In *Poems and Ballads,* 1st series (London: Moxon, 1866). [Gosse & Wise 1925–27, vol. 1 / Fletcher 1973, pp. 23–25 / Bush 1937, p. 350 / Praz 1956, pp. 228f. / McGann 1972, pp. 254–58 / Hyder 1970, pp. 69f.]

———. (Hill of Venus evoked in) "Ave atque vale." Ode on Baudelaire's death. In *Poems and Ballads,* 2d series (London: Chatto & Windus, 1878). [Gosse & Wise, vol. 3 / Praz, pp. 228f.]

Edward Burne-Jones, 1833–1898. "Laus Veneris." Watercolor, based on Swinburne's poem. **1861.** [Harrison & Waters 1973, pp. 110–14. Variant, painting. 1873–78. Formerly Laing Art Gallery, Newcastle-upon-Tyne, sold Sotheby's, London, 1971. [Harrison & Waters 1973, pp. 110–114, pl. 30—ill. / Arts Council 1975, no. 135]

———. 12 drawings for William Morris's "The Hill of Venus" (below). 1864–68. [Harrison & Waters, p. 84]

Henri Fantin-Latour, 1836–1904. "Tannhäuser: Venusberg" (Venus and Tannhäuser with 4 dancing nymphs). Lithograph, illustrating Act 1 scene 2 of Wagner's opera. **1862.** [Hédiard 1906, no. 1—ill. / Lucie-Smith 1977, pl. 129 / Fantin-Latour 1911, no. 204] 2 variants, 1876, 1878. [Hédiard, nos. 9, 22 / also Fantin-Latour, nos. 822, 979] Variant, painting. 1864. Los Angeles County Museum of Art. [Lucie-Smith, p. 159, pl. 90 / Fantin-Latour, no. 233] Several further variants and sketches. [Fantin-Latour, nos. 234–35, 1254, 1627, 1663, 2210, 2229]

———. "Tannhäuser: Act III" (Tannhäuser watching Elizabeth's funeral cortege, Venus in the clouds). Lithograph, illustrating Act 3 scene 3 of Wagner's opera. *c*.1877. [Hédiard, no. 15—ill. / Fantin-Latour, no. 863]

William Morris, 1834–1896. "The Hill of Venus." Poem. **1864–68.** In *The Earthly Paradise,* vol. 3 (London: Ellis, 1870). [Morris 1910–15, vol. 6 / Rees 1981, pp. 187f. / Calhoun 1975, pp. 209–14 / Marshall 1979, pp. 71–74, 134–38 / Henderson 1967, p. 112 / Fass 1974, pp. 15, 161, 202, 204–12]

Pierre-Auguste Renoir, 1841–1919. Series of 4 overdoor paintings, depicting scenes from Wagner's *Tannhäuser.* **1879.** Private colls. [Daulte 1971, nos. 315–18—ill. / also White 1984, pp. 95f.—ill.] Study for scene from Act 3. Clark Institute, Williamstown, Mass. [White—ill.]

Eugene Lee-Hamilton, 1845–1907. "Tannhäuser." Poem.

In *Gods, Saints, and Men* (London: Satchell, **1880**). [Bush 1937, p. 561]

Thomas Hardy, 1840–1928. (Hill of Venus theme, in) *The Woodlanders*. Novel. London: Macmillan, **1887**. [Fass 1974, pp. 136f.]

————. (Venus appears to bridegroom, Hill of Venus theme, in) *The Well-Beloved: A Sketch of a Temperament*. Novel. Published 1892; revised 1897. [Ibid., pp. 136, 138ff.]

————. "The Well-Beloved." Ballad. In *Collected Poems* (London: Macmillan, 1962). [Ibid., p. 138]

Aubrey Beardsley, 1872–1898. *The Story of Venus and Tannhäuser*. Novel. *c.*1895, unfinished. Expurgated excerpts published as *Under the Hill* in *The Savoy* 1 and 2 (1896). [Reade 1967, pp. 19, 350, no. 387 / Weintraub 1976, pp. 168–76] Drawings for, *c.*1895. Fogg Art Museum, Harvard University, Cambridge. [Reade, nos. 387–90, 424—ill. / also Weintraub, pp. 145, 149, 170–72—ill. / Fass 1974, pp. 197–99]

Herbert E. Clarke. "Tannhäuser." Poem. In *Tannhäuser and Other Poems* (London: Dobell, **1896**). [Fletcher 1973, p. 23 *n.*]

Laurence Koe, d. 1913. "Venus and Tannhäuser." Painting. **1896**. [Dijkstra 1986, pp. 228f.—ill.]

John Davidson, 1857–1909. "A New Ballad of Tannhäuser." Ballad. In *New Ballads* (London: Lane, **1897**). [Fass 1974, pp. 220–23 / Fletcher 1973, p. 23 *n.*]

Hugo von Hofmannsthal, 1874–1929. (Tannhäuser/Venusberg theme woven into) *Die Bergwerke zu Falun* [The Mines of Falun]. Tragedy, adaptation of Hoffmann's tale. Only Act 1 published, **1899**; other acts came out over 10 years in mixed order, not published as whole until 1933. [Steiner 1946–58, *Dramen*, vol. 4 / Fass 1974, pp. 15, 91f., 171f., 287 *n.*4]

John Collier, 1850–1939. "In the Venusberg" ("Tannhäuser"). Painting. **1901**. [Kestner 1989, p. 293]

George Cabot Lodge, 1873–1909. "Tannhauser to Venus." Poem. **1899–1902**. In *Poems* (Boston & New York: Houghton Mifflin, 1903). [Bush 1937, p. 585]

Michel Fokine, 1880–1942, scenario and choreography. *Grotto of Venus*. Ballet, based on the Venusberg scene from *Tannhäuser*. Music, Wagner. First performed 6 Apr **1910**, Maryinsky, St. Petersburg; décor, Fokine. [Fokine 1961, p. 302]

Alexander Gorsky, 1871–1924, choreography. *The Venusberg Grotto*. Ballet. Music, Wagner. First performed **1923**, Moscow. [Oxford 1982, p. 181]

Charles Stanford, 1852–**1924**. (Venus and Tannhäuser theme in) *The Miner of Falun*. Opera. Libretto, W. Barclay Squire and H. F. Wilson. Only Act 1 completed, unperformed. In MS. [*Music Review* 37 (1976): 114]

Thomas Mann, 1875–1955. (Hans Castorp relives the Tannhäuser legend in) *Der Zauberberg* [The Magic Mountain]. Novel. Berlin: Volksverband der Bücherfreunde Wegweiser-verlag, **1924**. / Translated by H. T. Lowe-Porter (London: Secker, 1927). [Fass 1974, pp. 15, 247–67]

Anthony Powell, 1905–. *Venusberg*. Novel. London: Duckworth, **1932**. [EWL 1981–84, 3:581]

Frederick Ashton, 1904–1988. *Venusberg Scene*. Ballet. First performed 2 Nov **1938**, Vic-Wells Opera, Sadler's Wells, London. [Vaughan 1977, p. 471]

Salvador Dalí, 1904–1989. Costume designs for "Venus-

berg" scene in *Tannheuser*. **1939**. Anfusco coll., Rome. [Rotterdam 1970, no. 125—ill.]

Merrill Moore, 1903–1957. *The Hill of Venus*. Collection of poems. New York: Twayne, **1957**. [Ipso]

Donald Finkel, 1929–. "The Bush on Mount Venus." Poem. In *Simeon* (New York: Atheneum, **1964**). [Ipso]

Maurice Béjart, 1924/27–, choreography. *Venusberg*. Ballet. Music, Wagner. First performed **1965**, Théâtre de la Monnaie, Brussels. [Oxford 1982, pp. 28, 51]

Pina Bausch, 1940–, choreography. "Tannhäuser-Bacchanal." Ballet. First performed **1972**, Essen? [Oxford 1982, p. 48]

APOLLO. The son of Zeus (Jupiter) and Leto (Latona) and the twin of the goddess Artemis (Diana), Apollo personifies the Greek love of beauty, balance, clarity, and music. One of the twelve Olympian deities and the lord of Parnassus, he is the sun god as well as the patron of fine arts, medicine, music, poetry, eloquence, and prophecy. He is also associated with the tending of flocks and herds. His attributes include the bow and arrow (whence the epithet "far shooting") and the lyre, since the god was famous both for his ability as an archer and his musical skills. The Romans also knew him as Apollo.

Apollo is credited with the foundation of the oracle at Delphi in mainland Greece, which was established on the site where he slew the dragon (or serpent) Python. The epithet "Pythian" Apollo commemorates this triumph. His origins and the development of his power in different aspects of Greek religion are obscure. In the fifth century BCE Apollo became a sun god, with the epithet "Phoebus" ("bright, shining"), assuming the power and attributes of Helios.

Representations of Apollo in ancient art often portray him with the lyre or flute, or bow and arrow, attributes that have persisted in later images of the god.

Classical Sources. Homer, *Iliad* 1.9, 7.17–41, 21.436–68, 22.6–20 and passim; *Odyssey* 8.226ff., 15.243–53. Hesiod, *Theogony* 94–95, 346ff., 918–20. Homeric Hymns, "To Apollo." Pindar, *Pythian Odes* 1, 3.1–67, 4.176ff., 8.12ff., 9.1–70. Orphic Hymns 34, "To Apollo." Callimachus, *Hymns*, "To Apollo" (2). Virgil, *Aeneid* 3–73, 6.41–83; *Eclogues* 3, 4, 5, 6, 10. Horace, *Odes* 1.31. Ovid, *Metamorphoses* 1.416ff., 452ff., 3.534ff., 6.204–66, 6.382–400, 10.106ff., 11.153–71; *Fasti* 6.703ff. Apollodorus, *Biblioteca* 1.3.2–4, 1.4.1–2, 3.10.2–3. Pausanias, *Description of Greece* 9.10.5–6. Hyginus, *Fabulae* 49–51, 53. Lucian, *Dialogues of the Gods*, "Apollo and Dionysus," 11, "Hephaestus and Apollo," 16–17, "Hermes and Apollo," 21, 25, "Apollo and Hermes."

Listings are arranged under the following headings:
General List
Apollo as Sun God
Apollo and Python

Apollo as Shepherd and Herdsman
Apollo and the Cumaean Sibyl
Loves of Apollo

See also ALCESTIS; ARES AND APHRODITE; ARTEMIS; CASSANDRA; CLYTIE; CYPARISSUS; DAPHNE; GODS AND GODDESSES; HERMES, Infancy; HYACINTH; LAOMEDON; LETO; MARSYAS; MUSES; PARNASSUS; PHAETHON; TITANS AND GIANTS; TROJAN WAR.

General List

Dante Alighieri, 1265–1321. (Apollo invoked in) *Paradiso* 1.13–27, 2.9. Completed *c.*1321. in *The Divine Comedy*. Poem. Foligno: Neumeister & Angelini, 1472. [Singleton 1970–75. vol. 3 / Schless 1984, pp. 68f., 80f.]

Francesco Petrarca, 1304–1374. "Apollo, s'ancor vive il bel desïo" [Apollo, if the sweet desire still lives]. Sonnet, no. 34 of *Canzoniere (Rime sparse)*. Collection of sonnets, madrigals, and *canzone*. Begun *c.*1336, completed by 1373; no. 23 composed *c.*1341? [Contini 1974 / Armi 1946]

Christine de Pizan, *c.*1364–*c.*1431. (Apollo in) *L'epistre d'Othéa à Hector* . . . [The Epistle of Othéa to Hector] chapter 9. Didactic romance in prose. *c.*1400. MSS in British Library, London; Bibliothèque Nationale, Paris; elsewhere. / Translated by Stephen Scrope (London: *c.*1444–50). [Bühler 1970 / Hindman 1986, pp. 79f., 87f., 194, pl. 13]

Taddeo di Bartolo, 1362–1422. "Apollo." Fresco. *c.*1414. Anticappella, Palazzo Pubblico, Siena. [Berenson 1968, p. 423—ill.]

Agostino di Duccio, 1418–1481. "Apollo." Marble relief. **1454–57.** Cappella S. Francesco, Rimini. [Agard 1951, pp. 68f.—ill. / Clapp 1970, 1:18]

Francesco del Cossa, *c.*1435–1477, school. "Triumph of Apollo." Fresco, representing month of May. **1470.** Sala dei Mesi, Palazzo Schifanoia, Ferrara. [Berenson 1968, pp. 94, 131]

Master of the Apollini Sacrum. "A Tribute to Apollo" ("Apollini sacrum"). Painting. *c.*1485. Kress coll. (K77), Atlanta Art Association Galleries, no. 58.47. [Shapley 1966–73, 1:128—ill.]

Bertoldo di Giovanni, *c.*1420–**1491.** "Apollo" (or Orpheus?). Bronze statuette. Museo del Bargello, Florence. [Pope-Hennessy 1985b, 2:304—ill. / Vermeule 1964, p. 57]

Albrecht Dürer, 1471–1528. "Apollo." Drawing, copy after engraving for set of Tarot cards (known as the "Tarocchi," attributed to Parrasio Michele da Ferrara, *c.*1470s). *c.***1494–95.** Formerly Museum Boymans-van Beuningen, Rotterdam, lost in World War II. [Strauss 1974, no. 1495–61—ill.]

———. "Apollo" (and Diana?). Drawing. *c.*1501. British Museum, London. [Ibid., no. 1501/7—ill. / Strauss 1977b, p. 298—ill.] Variant ("Apollo with Bow and Solar Disk," known as "Apollo Poynter"). Metropolitan Museum, New York. [Strauss 1974, no. 1501/8—ill.]

———. "Apollo and Diana." Engraving (Bartsch no. 38). 1502. [Strauss 1977b, no. 38—ill.]

———, formerly attributed (possibly by Hans von Kulmbach, *c.*1480–*c.*1522). "Apollo." Drawing. *c.*1500–05. Kunsthaus, Zürich, no. N.40. [Strauss 1974, no. XW.264—ill.]

———, or follower. "Apollo Playing the Violin." Drawing (copy after lost original?). 1507. British Museum, London. [Ibid., no. 1507/9—ill.]

Michelangelo, 1475–1564. "Apollo" (or Cupid?). Lifesize marble statue. *c.***1497.** Lost. [Baldini 1982, no. 12 / also Goldscheider 1964, pp. 5, 223] Related (?) marble statue ("Apollo"). Unlocated. [Baldini, no. 60—ill.]

———. "Apollo" (formerly called "David"). Marble statue. *c.*1525–30. Museo del Bargello, Florence. [Baldini, no. 40—ill. / Goldscheider, p. 18—ill. / Pope-Hennessy 1985b, 3:324f.—ill.]

———, previously attributed. "Apollo." Marble statuette. Staatliche Museen, Berlin. [Baldini, no. 65—ill.]

Jacopo de' Barbari, *c.*1440/50–1516. "Apollo and Diana" ("Seated Apollo"). Engraving (Bartsch no. 16). Before **1505.** [Borenius 1923, no. 8—ill. / Servolini 1944, no. 16—ill.]

Raphael, 1483–1520. (Statue of Apollo in niche, in) "The School of Athens." Fresco. **1509–10.** Stanza della Segnatura, Vatican, Rome. [Vecchi 1987, no. 85J—ill. / Jones & Penny 1983, pp. 74ff.—ill.]

Baldassare Peruzzi, 1481–1536. "Apollo." Fresco. **1511–12** (or *c.*1517–18). Sala delle Prospettive, Villa Farnesina, Rome. [d'Ancona 1955, pp. 27ff., 93f. / Gerlini 1949, pp. 31ff. / also Frommel 1967–68, no. 51]

———. "Apollo." Fresco (detached), from Villa Stati-Mattei, Palatine Hill, Rome. 1519–20? Metropolitan Museum, New York, no. 48.17.15. [Frommel, no. 56—ill. / Metropolitan 1980, p. 141—ill.]

———. "Apollo." Drawing, design for (lost) fresco for Villa Madama, Rome. 1521–23. Louvre, Paris, no. 10386. [Frommel, no. 69—ill.]

Antonio Lombardo, *c.*1458–**1516.** "Apollo." Relief, for Camerini di Alabastro, Castello d'Este, Ferrara. Museo del Bargello, Florence. [Pope-Hennessy 1985b, 2:343]

Andrea Riccio, *c.*1470–1532. "Della Torre Teaching at the Foot of a Statue of Minerva, with Apollo and Hygieia Looking On." Bronze relief. *c.*1516–21? Tomb of Girolamo della Torre, S. Fermo Maggiore, Verona. Original removed to Louvre, Paris, 1796, replaced by copy. [Pope-Hennessy 1985b, 2:333]

Bernardino Luini, 1480/85–1532. "Horseman" ("Apollo and Pegasus," with Pan and Syrinx in the background). Fresco (detached), in "Apollo and Pan" cycle, from Villa Pelucca, Sesto San Giovanni. **1520–23.** Pinacoteca di Brera, Milan. [Luino 1975, pp. 35f., 87f., pls. 26–27]

Timoteo Viti da Urbino, 1469/70–**1523.** "Apollo." Painting. Galleria Corsini, Florence, no. 407. [Berenson 1968, p. 450]

Dosso Dossi, *c.*1479–1542. "Apollo" (Daphne in background) (sometimes called "Orpheus"). Painting. **1520–25.** Galleria Borghese, Rome, no. 1. [Gibbons 1968, no. 55—ill. / Berenson 1968, p. 113 / Pergola 1955–59, 1: no. 35 (as "Apollo and Daphne")—ill.]

———. "Apollo in a Landscape." Painting, from Bevilacqua coll., Ferrara. Lost. [Gibbons, p. 270]

Gil Vicente, *c.*1465–*c.*1539. *Templo de Apolo* [Shrine of Apollo]. Entertainment, in Spanish and Portuguese. First performed Jan **1526,** Almeirim, Portugal. [McGraw-Hill 1984, 5:105]

Giulio Romano, *c.*1499–1546. Apollo depicted in frescoes and stuccoes in Sala dei Venti, Sala delle Aquile, and

Salla delle Stucchi of Palazzo del Tè, Mantua. **1527–30**. [Verheyen 1977, pp. 114, 119–124 / also Hartt 1958, pp. 108, 115ff., 225, 304 (no. 290)—ill.]

————. "Apollo." Fresco (simulated statue). 1540–44. Casa Giulio Romano, Milan. [Hartt, p. 240—ill.] *See also Raphael, above.*

Lucas Cranach, 1472–1553. "Apollo and Diana." Painting. *c.***1530.** 3 versions. Musées Royaux des Beaux-Arts, Brussels, no. 779; Gemäldegalerie, Berlin-Dahlem, no. 564; Royal Collection, Buckingham Palace, London. [Friedlaender & Rosenberg 1978, nos. 270–71—ill. / also Brussels 1984a, p. 76—ill. / Berlin 1986, p. 24—ill.]

Marcantonio Raimondi, *c.*1480–**1527/34.** "Apollo" (simulated statue in a niche). Engraving (Bartsch no. 263), after design by Raphael. [Bartsch 1978, 26:257—ill.]

————. "Apollo" (simulated statue in a niche). Engraving (Bartsch no. 332). [Ibid., 27:26ff.—ill.]

————, questionably attributed. "Apollo" (simulated statue in a niche). Engraving (Bartsch no. 334), after detail in Raphael's "School of Athens" (1509/10, Vatican). [Ibid., pp. 29f.—ill.]

Rosso Fiorentino, 1494–1540. "Apollo Holding a Lyre." Fresco detail, in Salle Haut, Pavillon des Poêles, Château de Fontainebleau. **1537–38**. Destroyed 1738. / Drawing. Louvre, Paris, inv. 8632. [Carroll 1987, no. 104—ill.]

Benvenuto Cellini, 1500–1571. "Apollo." Life-size silver statue. **1540**–*c.***1545.** Lost. [Pope-Hennessy 1985a, pp. 102f.]

————. "Apollo." Drawing, rejected design for seal of Accademia del Disegno, Florence. Before 1568. Staatliche Graphische Sammlung, Munich. [Ibid., pp. 278f.—ill.]

Jacopo Sansovino, 1486–1570. "Apollo." Bronze statuette. **1540–45**. Loggetta, Piazza San Marco, Venice. [Pope-Hennessy 1985b, 3:79f., 404f.—ill.]

Francesco Primaticcio, 1504–1570, and assistants. "Apollo in the Sign of the Lion." Ceiling fresco, in Galerie d'Ulysse, Château de Fontainebleau. **1541–47**. Destroyed 1738–39. / Drawing for. Albertina, Vienna, inv. 1967. [Béguin et al. 1985, pp. 157ff.—ill. / also Dimier 1900, pp. 295ff., no. 144.]

Andrea Schiavone, *c.*1522–1563, attributed. "Apollo," "Apollo and a Nymph" (?). Paintings. *c.***1549**? National Gallery, London, nos. 1883, 1884 (as "Mythological Figures," the first formerly catalogued as "Apollo Killing the Python"). [Richardson 1980, nos. 272–73 (as autograph)—ill. / London 1986, p. 571—ill. / Berenson 1957, p. 160—ill.]

————, attributed. "Apollo" (?). Drawing. National Gallery of Scotland, Edinburgh, no. D1764. [Richardson, no. 166—ill.]

————, attributed. "Apollo." Drawing. Louvre, Paris, no. 5458. [Ibid., no. 192—ill.]

Giorgio Vasari, 1511–1574. Cycle of 10 ceiling paintings, depicting Apollo surrounded by the Muses. **1548–50**; restored 1827. Camera di Apollo e delle Muse, Casa Vasari, Arezzo. [Arezzo 1981, no. 1.6—ill.]

Bartolommeo Ammannati, 1511–1592. "Apollo." Statue (now much damaged). Before **1550**. Palazzo Mantova Benavides, Padua. [Pope-Hennessy 1985b, 3:372]

Hans Sachs, 1494–1576. *Gott Apollo mit Fabius (Fastnachtspiel zwischen dem Gott Apollo und dem Römer Fabius)* [(Shrovetide Play between) The God Apollo and (the Roman) Fabius]. Comedy. Published **1551**. In modern edition, in *Werke* (Stuttgart: 1870–1908; Hildesheim: Olms, 1964). [McGraw-Hill 1984, 4:303]

Pierre de Ronsard, 1524–1585. (Lyre of Apollo evoked in) "Ode au seigneur de Carnavalet." Ode. In *Les quatre premiers livres des odes* book 1 (Paris: La Porte, **1555**). [Laumonier 1914–75, vol. 6 / Cave 1973, pp. 220f.]

————. (Apollo's history decorates) "La Lyre." Poem. In *Le sixième livre des poèmes* (Paris: Buon, 1569). [Laumonier, vol. 15 / Cave, pp. 161, 190–92]

Paolo Veronese, 1528–1588. "Bacchus and Apollo." Fresco. *c.***1557**. Palazzo Trevisan, Murano. [Pallucchini 1984, no. 36c—ill. / Pignatti 1976, no. 66—ill.]

————. "Apollo and Venus with Cupid." Fresco, part of cycle celebrating Bacchus and wine. *c.*1560–61. Stanza di Bacco, Villa Barbaro-Volpi, Maser (Treviso). [Pallucchini, no. 60—ill. / Pignatti, no. 98—ill.]

————. "Juno and Apollo." Painting, part of series glorifying Germany, for Fondaco dei Tedeschi, Venice. *c.*1578–80. Formerly Kaiser Friedrich Museum, Berlin, destroyed. [Pallucchini, no. 168b—ill. / Pignatti, no. 210—ill.]

Giambologna, 1529–1608. "Little Apollo." Bronze statuette. *c.***1560**. Museo del Bargello, Florence, no. 71; elsewhere. [Avery 1987, no. 65—ill. / also Avery & Radcliffe 1978, nos. 37–38] Variant ("Apollo"). 1573–75. Palazzo Vecchio, Florence. [Avery, no. 71—ill. / Pope-Hennessy 1985, 3:101, 379ff., 461—ill. / also Avery & Radcliffe, no. 36—ill. / Lensi 1929, pp. 236f., 263—ill. / Jones & Penny 1983, pl. 85]

Daniele da Volterra, 1509–**1566**, rejected attribution. "Apollo." Painting, pendant to "Diana." Springfield Museum. [Barolsky 1979, pp. 139ff.]

Domenico Brusasorci, *c.*1516–**1567**. "Apollo and Diana." Ceiling fresco (detached), from Palazzo Chericati. Museo Civico, Vicenza. [Berenson 1968, p. 69]

Alessandro Vittoria, 1525–1608. "Apollo." Bronze statuette. *c.***1575–77**. Formerly Staatliche Museen, Berlin. [Cessi 1960, p. 50, pl. 29] Terra-cotta model. Formerly Estensische Kunstsammlung, Vienna. [Ibid., pl. 30]

Philip Sidney, 1554–1586. (Basilius and his family pray to Apollo in) *The Countess of Pembroke's Arcadia (The Old Arcadia)* book 2. Prose romance with poems, pastoral eclogues. Completed *c.*1580. [Robertson 1973] Revised 1582–84 *(The New Arcadia)*; this passage included. London: Ponsonbie, 1590. [Skretkowicz 1987]

Luca Marenzio, 1553/54–1599. "Apollo s'ancor vive il bel desïo" Madrigal. Text, Petrarca (*c.*1341). Venice: **1585**. [Grove 1980, 11:671]

Domenico Tintoretto, 1562–1635 (previously attributed to Jacopo Tintoretto). "Apollo and Minerva." Painting. Late **1580s**. Formerly Thyssen-Bornemisza coll., Lugano. [Rossi 1982, no. A55 / also Berenson 1957, p. 173 (as Jacopo)]

Ludovico Carracci, 1555–1619. "Apollo." Fresco. *c.***1591–92**. Palazzo Masetti (now Associazione Commerciante), Bologna. [Ostrow 1966, no. I/10 *n.*]

Cornelis Cornelisz van Haarlem, 1562–1638. "Apollo before the Tribunal of the Gods." Painting. **1594**. Prado, Madrid, no. 2088. [Prado 1985, p. 326]

Cavaliere d'Arpino, 1568–1640. "Apollo." Fresco. **1594–95**. Loggia Orsini, Palazzo del Sodalizio dei Piceni, Rome. [Röttgen 1969, pp. 279ff.—ill.]

Federico Zuccari, 1540/43–1609. (Apollo, with Minerva,

in) "Apotheosis of the Artist." Ceiling painting. **1598.** Palazzo Zuccari, Rome. [Garrard 1989, fig. 302]

Antoine Caron, 1520/21–**1599.** (Apollo and other gods in) "Triumph of Winter." Painting. Private coll., Paris. [Paris 1972, no. 35—ill.]

John Lyly, c.1554–1606, and/or **John Day,** 1574–1640, questionably attributed. (Apollo in) *The Maydes Metamorphosis.* Comedy. **1590s?** Published London: 1600. [Bond 1902, vol. 3]

Joseph Heintz the Elder, 1564–1609. "Venus, Cupid, and Apollo." Painting. **1590s** or later. Gemäldegalerie Alter Meister, Dresden, inv. 646, in 1930. [Zimmer 1971, no. A25—ill.]

Girolamo Campagna, 1549/50–1625? "Apollo." Bronze statuette. **Early 17th century.** Numerous versions. Hermitage, Leningrad, inv. 977; Staatliche Museum, Berlin-Dahlem; Kestner Museum, Hannover; elsewhere. [Hermitage 1984, no. 364—ill.]

Jan van der Straet, 1523–**1605.** "Apollo at the Foot of a Tree." Drawing. Teylers Museum, Haarlem. [de Bosque 1985, p. 148—ill.]

Thomas Campion, 1567–1619. (Apollo in) *The Lord Hay's Masque.* Masque. First performed 6 Jan **1607,** Whitehall Palace, London. Published London: Brown, 1607. [Vivian 1966 / DLB 1987, 58: 37, 38f.]

Bartholomeus Spranger, 1546–**1611.** "Apollo." Drawing. Österreichische Nationalbibliothek, Vienna. [de Bosque 1985, p. 149—ill.]

Domenichino, 1581–1641. "Scenes from the Life of Apollo." 10 frescoes, for Villa Aldobrandini (Belevedere), Frascati. **1616–18.** 2 and a fragment in place; others (detached) National Gallery, London, nos. 6284–91. [Spear 1982, no. 55—ill. / London 1986, pp. 160–63—ill.]

Hendrik van Balen, figures, 1575–1632, and **Jan Brueghel the Elder,** landscape, 1568–1625. (Apollo in) "Allegory of the Five Senses." Painting. c.**1617–18.** Private coll., Germany. [Ertz 1979, no. 334, p. 362—ill.]

Michael Drayton, 1563–1631. "The Sacrifice to Apollo." Poem. In *Odes with Other Lyrick Poesies* (London: Smethwicke, **1619**). [Hebel 1931–32, vol. 2]

Ben Jonson, 1572–1637, libretto. (Apollo in) *The Masque of Augurs.* Masque. Performed Twelfth Night **1622,** at Court, London. Published London: 1622. [Herford & Simpson 1932–50, vol. 7]

————. (Apollo and the Delphic Oracle satirized in) "Over the Door at the Entrance into the Apollo." Poem, part of "Leges convivales." First published by Jacob Frey in *Oratio panegyrica in obitum Reverendi & Clarissimi Viri* (Basel: 1636); reprinted in *Works* (London: 1692). [Ibid., vol. 8]

Peter Paul Rubens, 1577–1640. (Apollo in) "The Education of Marie de' Medici," "The Council of the Gods" ("The Government of the Queen"). Paintings, part of "Life of Marie de' Medici" cycle. **1622–25.** Louvre, Paris, inv. 1771, 1780. [Saward 1982, pp. 40ff., 114ff.—ill. / Jaffé 1989, nos. 716, 737—ill. / Louvre 1979–86, 1:115–17—ill. / also Baudouin 1977, pl. 45] Oil sketches. Alte Pinakothek, Munich, inv. 92, 103 (both); Simson coll., Freiburg ("Education"). [Jaffé, nos. 714–15, 736—ill. / Munich 1983, pp. 463–67—ill. / Held 1980, nos. 58–59, 71—ill.] Copy (formerly attributed to Delacroix), detail depicting Apollo and

Mars dispelling Discord and Envy. Walters Art Gallery, Baltimore, inv. 37.1. [Walters 1982, p. 49]

Johann Rottenhammer, 1564–**1625.** "Apollo and a Nymph." Painting. Musées Royaux des Beaux-Arts (Musée d'Art Ancien), Brussels, inv. 3742. [Brussels 1984a, p. 246—ill.]

Nicolas Poussin, 1594–1665. "Bacchus/Apollo" (originally painted as "Bacchus and Erigone"?). Painting. c.**1626–27.** Nationalmuseum, Stockholm. [Wright 1985, no. 20, pl. 115 / Blunt 1966, no. 135—ill. / also Thuillier 1974, no. 33—ill.]

————. "Apollo" ("A Reaper"). Design and wax model for marble term. 1655–56. Poussin's originals lost. / Marble executed by Jean-Baptiste Théodon, by 1661. Quinconce du Midi, Gardens, Versailles. [Girard 1985, pp. 273f. / Blunt, no. 229—ill.]

————, circle (formerly attributed to Poussin). "Apollo and Diana [or Bacchus and Bacchantes] Hunting." Painting. Herzog Anton Ulrich-Museum, Braunschweig, no. 514. [Blunt, no. R62 / Thuillier, no. R53—ill. / Braunschweig 1969, p. 109]

————, formerly attributed. (Venus, Bacchus, Mercury, and Cupid, representing) "The Four Seasons Dancing to the Music of Apollo's Lute." Presumed painting, known from engraving by J. Avril, 1779. [Blunt, no. R56 / also Thuillier, no. R54—ill.]

Elia Candido, 1548–**1628.** "Apollo of Lycia." Bronze statue. National Gallery, Washington, D.C., no. A–1618. [Sienkewicz 1983, p. 33—ill.]

Gerrit van Honthorst, 1590–1656. (King Charles I and Queen Henrietta Maria as) "Apollo and Diana." Painting. **1628.** Hampton Court Palace. [Judson 1959, no. 73—ill.]

Frans Francken II, 1581–1642. "The World Pays Homage to Apollo." Painting. **1629.** Landesmuseum, Oldenburg. [Härting 1983, no. A286]

Lope de Vega, 1562–1635. *Laurel de Apolo.* Poem of literary criticism. Madrid: Gonçalez, **1630.** [Oxford 1978, p. 598]

Simon Vouet, 1590–1649. "Apollo and Diana Attacking the Furies." Painting. Lost. / Engraved by François Perrier, **1632.** [Crelly 1962, p. 95, no. 220]

———— or studio. "Apollo." Painting, cartoon for "Loves of the Gods" tapestry series. [Ibid., no. 270e]

Francesco Furini, 1604–1646. "Archer" ("Apollo"). Painting. c.**1636.** Columbia University, New York. [Florence 1986, no. 1.135—ill.]

Thomas Heywood, 1573/74–1641. "Vulcan and Apollo" (discuss Cillenius, son of Maia). Poetic dialogue, translation from Lucian. No. 8 in *Pleasant Dialogues and Drammas* (London: **1637**). [Heywood 1874, vol. 6]

Angelo Cecchini, fl. c.1635–39. *L'intemperie d'Apollo, o Il prencipe indisposto* [The Intemperance of Apollo, or The Unfit Prince]. Opera (dramma boscareccio). Libretto, Ottaviano Castelli. First performed Feb **1638,** by Accademici Transcurati, at the house of the Marquis Patrizi, Rome. [Grove 1980, 4:44]

Charles Le Brun, 1619–1690. Drawing, for unexecuted print (Mars and Apollo flanking the bow of a ship). c.**1642.** Anthony Blunt coll., London, in 1963. [Versailles 1963, no. 59—ill.]

————. Decorations for Galerie d'Apollon, Louvre, Paris. 1661. [Dublin 1985, p. 32]

————. Series of drawings, designs for projected (unexecuted) painting cycle depicting the deeds of Apollo, for Galerie des Glaces, Château de Versailles. c.1678. Cabinet des Dessins, Louvre, Paris. [Berger 1985, p. 52—ill.]

Pietro da Cortona, 1596–1669. "Apollo (Awakens the Love of the Arts in Mankind)." Fresco. **1642–44.** Sala di Giove, Palazzo Pitti, Florence. [Campbell 1977, pp. 127, 133—ill. / also Briganti 1962, no. 95—ill. / Pitti 1966, p. 48—ill.]

————. Ceiling fresco, depicting a Medici prince [Cosimo I de' Medici?] being instructed by Apollo; series of high-relief stuccoes, depicting stories of Apollo and Python, Daphne, Marsyas, and Hyacinthus. Begun 1645–47, unfinished, completed 1659–61 by Ciro Ferri. Sala di Apollo, Palazzo Pitti. [Campbell, pp. 108ff.—ill. / also Pitti, pp. 79f.—ill. / Briganti, no. 97—ill.]

Alessandro Algardi, 1598–1654. "Apollo with His Lyre and Bow." Stucco relief, for Galleria dei Costumi dei Romani, Villa Belrespiro (now Villa Doria Pamphili), executed by R. Bolla and G. M. Sorisi from Algardi's designs. **1646.** In place. [Montagu 1985, no. A.199—ill.]

Robert Herrick, 1591–1674. "A Canticle to Apollo," "To Apollo: A Short Hymn," "To Apollo." Poems. In *Hesperides* (London: Williams & Eglesfield, **1648**). [Martin 1956]

Gerbrandt van den Eeckhout, 1621–1674. "Apollo." Painting. **1653.** Neues Palais, Potsdam, no. 3131. [Warburg]

Giovanni Francesco Romanelli, 1610–1662. Fresco cycle depicting scenes from the lives of Apollo and Diana. **1655–58.** Salle des Saisons, Apartement d'Été (Galerie du Bord de l'Eau), Louvre, Paris (inv. 20348). [Louvre 1979–86, 2:228—ill.]

————. "Apollo Wearing a Laurel Wreath." Painting. Thorwaldsens Museum, Copenhagen, no. B28. [Thorwaldsen 1985, p. 111]

Andrea Sacchi, 1599–1661. "Marcantonio Pasqualini Crowned by Apollo." Painting. Metropolitan Museum, New York, no. 1981.317. [Metropolitan 1983, p. 122—ill.]

Alonso Cano, 1601–1667. "Apollo Surrounded by Cupids." Drawing. Biblioteca Nacional, Madrid. [López Torrijos 1985, p. 420 no. 3—ill.]

Noël Coypel, 1628–1707. "Apollo Crowned by Victory," "Apollo Crowned by Minerva." Paintings, for Château des Tuileries. **1667–68.** Louvre, Paris, inv. 3460, 3461. [Louvre 1979–86, 3:173—ill.]

————. "The Triumph of Apollo." Painting (fragments), cartoon for Gobelins tapestry, for "Triumphs of the Gods" series. Louvre, Paris, inv. 3489. [Louvre, 3:174—ill.]

Leopold I of Austria, 1640–1705, with **Giovanni Felice Sances,** c.1600–1679. *Apollo deluso* [Apollo Deceived]. Opera (dramma per musica). Libretto, Antonio Draghi. First performed 9 June **1669,** Vienna. [Grove 1980, 10:680, 16:462]

Jean Nocret, 1615–1672. (Louis XIV as Apollo in) "Allegorical Portrait of the Royal Family." Painting. **1670.** Salle de l'Oeil de Boeuf, Château de Versailles. [Versailles 1949, pp. 12ff.—ill.]

Zacharias Webber, c.1644/45–1696. "A Sacrifice to Apollo." Painting. **1672.** Statens Museum for Kunst, Copenhagen. [Copenhagen 1951, no. 797]

Carlo Grossi, c.1634–1688. *Le cetra d'Apollo* [The Lyre of Apollo]. Set of 62 cantatas, opus 6. First performed **1673,** Venice. [Grove 1980, 7:743]

Juste d'Egmont, 1601–1674. "Apollo." Painting. Galerie, Pommersfelden, cat. 1894 no. 599 (as P. Thys). [Warburg]

Balthasar Permoser, 1651–1732. "Apollo." Sandstone statue. Before **1675.** Schloss Mirabell, Salzburg. [Asche 1966, no. P1, pl. 9]

————. "Apollo." Marble statue. 1715. Albertinum, Dresden. [Asche, no. P58, pl. 46]

Agustín de Salazar y Torres, 1642–1675. *Cythara de Apolo* [Lyre of Apollo]. Collection of poems. Madrid: Gonçalez de Reyes, 1694. [Oxford 1978, p. 521]

Claude Ballin, 1615–1678, and others. Series of vases with Apollonian motifs. North and South Parterres, Gardens, Versailles. [Girard 1985, pp. 270, 285—ill.]

Pietro della Vecchia, 1605–1678, attributed. "Apollo." Painting. Muzeum Narodowe, Warsaw, inv. 131449, on display at Lazienki Palace. [Warsaw 1969, no. 1341—ill.]

Jean Jouvenet, 1644–1717. Cycle of paintings depicting scenes from the life of Apollo, for Hôtel de Saint-Poulange, Paris. c.1681–84. Destroyed. [Schnapper 1974, no. 18]

Jacob Potma, 1610–1684. "Apollo." Painting. Bayerische Staatsgemäldesammlungen, Munich, no. 3506. [Warburg]

Matthias Maria Bartolommei, music. "Apollo, l'inganno, e'l giovane" [Apollo, the Fraud, and the Youth], prologue to *L'inganno vince l'inganno* [Fraud Conquers Fraud]. Comedy. Text of prologue, G. B. Faginoli. First performed 23 Jan **1684,** Accademia de'Sorgenti, Florence. [Weaver 1978, p. 155]

Gillis Nyts, 1647–1690. "Landscape with Apollo." Painting. City Art Gallery, York, cat. 1961 no. 55. [Wright 1976, p. 151]

Giuseppe Antonio Bernabei, 1649?–1732. *Vaticinio di Apollo e Diana* [Prophesy of Apollo and Diana]. Opera. Ballet music, Melchior d'Ardespin. First performed **1690.** [Grove 1980, 1:559, 2:612]

Carlo Agostino Badia, 1672–1738. "La ninfa Apollo." Musical scene (pastorale). Libretto, Francesco de Lemene. First performed **1692,** Rome and Milan. [Grove 1980, 2:9, 16:213]

Sebastiano Ricci, 1659–1734. "Apollo." Ceiling fresco (detached), part of "Olympian Gods" cycle, from Palazzo Mocenigo-Robilant, Venice. **1697–99.** Gemäldegalerie, Berlin-Dahlem, on loan from German government. [Daniels 1976, no. 50—ill. / Berlin 1986, p. 64—ill.]

Brussels School. "Apollo, Surrounded by the Four Seasons, Embraces the Poet." Tapestry, 1 in a series of 3 tapestries (with the Horae and the Graces). **17th century.** Kunsthistorisches Museum, Vienna. [Warburg]

French School (circle of Valentin). "Apollo Crowned by Accaro." Painting. **17th century.** Museo Civico d'Arte Antica, Turin. [Augsburg 1975, no. E37—ill]

Augustin Stom (**17th century**). "Apollo." Painting. Muzeum Narodowe, Warsaw, inv. Wil. 1583. [Warsaw 1969, no. 1247—ill.]

Johann Christoph Pez, 1664–1716. *Il riso d'Apolline* [The Smile of Apollo]. Serenata. **1701.** [Grove 1980, 14:607]

Jean Raon, 1630–1707. "Apollo." Marble sculpture. Musée de Versailles. [Bénézit 1976, 8:604]

Antonio Lotti, c.1667–1740, with **Francesco Gasparini,**

1668–1727. "La ninfa Apollo" ("La musa d'Apollo"?). Musical scene (pastorale). Libretto, Lemene (1692). First performed 12 Feb **1709**, Teatro San Cassiano, Venice. [Grove 1980, 11:250, 7:175]

Matthew Prior, 1664–1721. "The Second Hymn of Callimachus to Apollo." Translation. In *Poems on Several Occasions* (London: Tonson, **1709**). Modern edition by A. R. Waller (Cambridge: Cambridge University Press, 1905). [Ipso]

Jonathan Swift, 1667–1745. "Apollo Outwitted." Poem. **1709**. In *Miscellanies in Prose and Verse* (London: Morphew, 1711). [Williams 1958, vol. 1]

———. "Apollo: or, A Problem Solved." Poem. 1731. In *Works* (Dublin: Faulkner, 1735). [Ibid., vol. 2]

——— and **Patrick Delany.** "Verses on the Deanery Window" (by Delany); "Apollo, to Dean Swift" (by Swift), "News from Parnassus" (Delany), "Apollo's Edict" (attributed to Swift). Exchange of poems. 1721. In *Miscellaneous Poems . . . by Several Hands* (London: Concanen for Peele, 1724). [Ibid., vol. 1]

———, attributed. (Apollo tricks the Muses in) "The First of April." Poem. 1723? First published as a broadside. [Ibid.]

———. References to Apollo as the author's patron occur frequently in Swift's poetry. See the exchange with Dr. Delany, above; also "A Letter from D. S——t to D. S——y" (1725), line 10; "Verses on the Death of Dr. Swift" (1731), line 249; "Stella's Birth-Day" (1723), lines 13–30. [Ibid.]

Anne Finch, Countess of Winchilsea, 1661–1720. "The Circuit of Apollo." Poem. In *Miscellany Poems on Several Occasions* (London: **1713**). [Fausset 1930, p. 49]

Benjamin Thomae, 1682–1751. "Apollo with Lyre and a Companion" (nymph?). Sandstone statue. *c.***1714–15.** Französischer Pavillon, Zwinger, Dresden. [Asche 1966, no. T13, pl. 156]

François Girardon, 1628–**1715**, attributed. "Apollo." Marble bust. Formerly (1798) Louvre, Paris, lost. [Francastel 1928, no. 94]

Charles de La Fosse, 1636–**1716**. "Time, Apollo, and the Four Seasons." Painting. Manchester City Art Gallery, England. [Rosenberg 1988, p. 295—ill.]

Louis-Nicolas Clérambault, 1676–1749. *Apollon.* Cantata. Published in *Cantates françoises,* book 3 (Paris: **1716**). [Grove 1980, 4:492]

Sebastiano Ricci, 1659–1734. "Sacrifice to [a statue of] Apollo." Painting. *c.***1716**. Hovingham Hall, Yorkshire. [Daniels 1976, no. 535—ill.]

Paul Heermann, 1673–1732. "Apollo." Sandstone statue. *c.***1716–17.** Mathematischer Pavillon (F), Zwinger, Dresden. [Asche 1966, no. H15, pl. 97]

———. "Apollo" (?). Sandstone statue. *c.*1720–25. Pheasant-preserve, Mortizburg. [Ibid., no. H23]

———. "Apollo" (torso). Marble sculpture. *c.*1725. Skulpturen-Sammlung, Dresden. [Ibid., no. H31]

———. "Mercury and Apollo." Marble sculpture. 1729. Museum für Geschichte, Leipzig. [Asche, no. H30]

Giovanni Antonio Pellegrini, 1675–1741. "Apollo." Ceiling painting. By **1718**. Mauritshuis, The Hague, inv. 834a. [Mauritshuis 1985, pp. 415f.—ill.]

Carlo Innocenzo Carlone, 1686–1775. "Apollo and the Four Seasons." Fresco. *c.*1722. Schloss Hetzendorf, Vienna. [Knab 1977, p. 212, fig. 4]

Gottfried Heinrich Stölzel, 1690–1749. *Die beschütze Irene* [Eirene the Protectress]. Cantata. First performed **1722**, Altenburg. Lost. / Revised as *Irene und Apollo.* Cantata. First performed 1733, at Court, Gotha (or Sondershausen)? [Grove 1980, 18:175]

Louis Chéron, 1660–**1725**. "Apollo." Painting. Tate Gallery, London, no. T.894. [Tate 1975, p. 19 / Wright 1976, p. 37]

Francesco Rossi, *c.*1650–**1725**, attributed. "La ninfa Apollo." Musical scene. Libretto, after Lemene (1692). First performed 1726, Accademici Liberali Teatro San Michiel, Murano. [Grove 1980, 16:213]

Daniel Gran, 1694–1757. "Apollo Surrounded by Virtues and Sciences [or Vices]" (with Minerva and the Graces). Fresco. **1726.** Marmorsaal, Gartenpalais Schwarzenberg, Vienna. [Knab 1977, pp. 48f., no. F12—ill.]

William Hogarth, 1697–1764. "Music Introduced to Apollo by Minerva." Etching and engraving. 3 states. **1727?** [Paulson 1965, no. 110—ill.]

Pierre Carlet de Chamblain de Marivaux, 1688–1763. *Le triomphe de Plutus* [The Triumph of Plutus] (Plutus steals Apollo's love). Comedy. First performed 22 Apr **1728,** Comédie-Italienne, Paris. [McGraw-Hill 1984, 3:326,331 / Arnott 1977, p. 147]

Louis-Antoine Dornel, *c.*1680–*c.*1757. *Les élèves d'Apollon* [The Pupils of Apollo]. Divertissement. First performed **1729,** Concert Français. [Grove 1980, 5:578]

Johann Franz Michael Rottmayr, 1654–1730. "Apollo in Laurel Wreath and with Lyre, with the Mares of Admetus, the Muses, and Hercules" (?). Painting. Art Institute of Chicago, no. 61.39. [Chicago 1965]

Giovanni Battista Tiepolo, 1696–1770. Cycle of 8 ceiling frescoes depicting scenes related to Apollo. **1731.** Formerly Palazzo Archinto, Milan, destroyed 1943. [Morassi 1962, p. 25—ill. / Levey 1986, pp. 59ff.—ill.]

———. "Apollo Bringing the Bride" ("Apollo Conducting to Barbarossa His Bride, Beatrice of Burgundy"). Fresco. 1751–53. Kaisersaal, Residenz, Würzburg. [Levey, pp. 178ff.—ill. / Pallucchini 1968, no. 199—ill. / Morassi, p. 68—ill.] Study. Staatsgalerie, Stuttgart. [Levey, p. 179—ill. / Pallucchini—ill. / Morassi, p. 50] Variant or study (attributed to Tiepolo). Mainfränkisches Museum, Würzburg. [Morassi, p. 68]

———. "Apollo and Diana." Fresco. 1757. Sala dell' Olimpo, Villa Valmarana, Vicenza. [Pallucchini, no. 240—ill. / Morassi, p. 65]

———. "(Allegory with) Venus and Apollo." Painting, presumed study for unknown ceiling fresco. *c.*1762–66. Heinemann coll., New York. [Pallucchini, no. 282—ill. / Morassi, p. 35—ill.]

Johann Joachim Kretzschmar, ?–1740. "The Lycian Apollo." Sandstone statue. *c.***1732.** Schlosspark, Hermsdorf. [Asche 1966, no. K20, pl. 104, 106]

Pieter Scheemaeckers the Younger, 1691–1781. "Apollo." Ivory statuette. **1732.** Musées Royaux d'Art et d'Histoire, Brussels, inv. 8857. [Düsseldorf 1971, no. 265—ill.]

Baldassare Galuppi, 1706–1785. *La ninfa Apollo.* Opera (favola pastorale). Libretto, Lemene (1692), with additions by Boldini. First performed 30 May **1734,** S. Samuele, Venice. [Grove 1980, 7:136]

———. *Flora, Apollo, Medoaco*. Cantata. 1769. [Ibid., 7:137]

Jacques Bergé, 1693–1756. "Apollo." Terra-cotta sculpture. **1735**. Musées des Beaux-Arts, Brussels. [Bénézit 1976, 1:651]

James Thomson, 1700–1748. (The Apollo Belvedere evoked in) *Liberty* 4.141ff. Poem. London: Millar, **1735–36**. [Larrabee 1943, p. 81]

Henry Fielding, 1707–1754. "An Interlude between Jupiter, Juno, Apollo, and Mercury." Comic interlude. *c.***1736–37**. In *Miscellanies*, vol. 1 (London: Millar, 1743). Modern edition by H. K. Miller (Middletown: Wesleyan University Press, 1972). [Nicoll 1959–66, 2:328]

Paul Egell, 1691–1752. "The Lycian Apollo." Marble statue. *c.***1740**. Schlosspark, Schwetzingen. [Asche 1966, no. E16]

Giuseppe Mazza, 1653–**1741**. "Apollo." Marble bust. Galerie Liechtenstein, Vienna. [Bénézit 1976, 7:294]

Lambert-Sigisbert Adam, 1700–1759. "Apollo" (portrait of Louis XV?). Marble bust. *c.***1741?** Baron Edmond de Rothschild coll., Paris, in 1885. [Thirion 1885, p. 127—ill.]

Pompeo Batoni, 1708–1787. "Apollo, Music, and Metre." Painting. **1741**. Private coll., Turin. [Clark 1985, no. 45] Replica, Louvre, Paris, inv. R.F. 1983–47. [Ibid., no. 48—ill.]

Andrea Bernasconi, 1706?–1784. "La ninfa Apollo." Comic-pastoral scherzo. Libretto, Lemene (1692). First performed Carnival **1743**, Venice. [Grove 1980, 2:620]

Nicolas de Largillière, 1656–**1746**. "Portrait of a Man as Apollo." Painting. Louvre, Paris, no. M.I. 1083. [Louvre 1979–86, 4:31—ill.]

———. "Apollo." Painting. Vicomtesse de Bonneval coll. [Warburg]

Francesco Trevisani, 1656–**1746**. "Apollo" (head). Painting. Lost. [DiFederico 1977, p. 77]

François-Gaspard Adam, 1710–1761. "Apollo." Marble sculpture. **1749**. Sanssouci, Potsdam, in 1885. [Thirion 1885, p. 160]

François Boucher, 1703–1770. "Apollo Crowning the Arts." Painting. **1750**. Musée des Beaux-Arts, Tours. [Ananoff 1976, no. 354—ill.] Grisaille sketch ("Apollo and the Muses"). Ferault coll., Paris. [Ibid.]

Franz Anton Maulbertsch, 1724–1796. "(Mythological Scene with) Diana and Apollo" (and other gods). Painting. *c.***1750**. Muzeum Narodowe, Warsaw, inv. 130543. [Garas 1960, no. 28, p. 15—ill. / Warsaw 1969, no. 767—ill.] Another version in Barockmuseum, Vienna. [Hunger 1959, p. 41]

———. "The Reward of Chastity" ("Allegory with Diana and Apollo") (Diana bestows a medal on a lady and cavalier, with other gods). Drawing. *c.*1750. Albertina, Vienna. [Garas, no. 33, p. 16—ill.]

Jacob de Wit, 1695–1754. "Apollo and the Four Seasons." Ceiling painting. **1750**. Herengracht 440, Amsterdam. [Staring 1958, p. 155, pl. 69]

François Martin II, 1727–1757. *Six recueils des étrennes d'Apollon* [Six Collections of the Gifts of Apollo]. Instrumental music. Published Paris: 1757. [Grove 1980, 11:714f.]

Antonio Guardi, 1698–**1760**. "Apollo." Fresco. Ca' Rezzonico, Venice. [Morassi 1984, no. 8—ill.]

Gaspare Angiolini, 1731–1803, choreography. *Apollon et Diane*. Ballet. Music, Joseph Starzer. First performed **1763**, Vienna. [Grove 1980, 18:82]

Jean-Baptiste Lemoyne, 1704–1778. "Apollo with the Attributes of the Arts" (accompanied by Cupid). Terra-cotta model for unexecuted marble sculpture. **1751–65**. Musée, Saint-Germain-en-Laye. [Réau 1927, no. 17—ill.]

———. "Apollo." Marble statue. 1771. Sanssouci, Potsdam. [Ibid., no. 23—ill.]

———. "Apollo, God of the Arts and Poetry. . . ." Sculpture. Lost. [Ibid., no. 24]

John Potter, *c.*1734–after 1813. *The Choice of Apollo*. Masque. Music, William Yates. First performed 11 Mar **1765**, Little Theatre, Haymarket, London. [Fiske 1973, pp. 316, 408, 588]

Nicola Sala, 1713–1801. *Il guidizio d'Apollo* [The Judgment of Apollo]. Serenata. Text, G. Fenizia. First performed **1768**, San Carlo, Naples. [Grove 1980, 16:409]

Christoph Willibald Gluck, 1714–1787. *Le feste d'Apollo* [The Feasts of Apollo]. Opera (festspiel). Scenario, C. I. Frugoni and R. Calzabigi; libretto by various poets for individual acts. First performed 24 Aug **1769**, Corte, Parma. [Grove 1980, 7:463f., 472 / Cooper 1935, pp. 123, 141, 227, 285]

Augustin Pajou, 1730–1809. "Apollo, or the Fine Arts." Stone statue. **1767–69**. Façade, Palais-Royal, Paris. [Stein 1912, pp. 198, 401]

———. "Apollo, Accompanied by Two Groups of Cupids Symbolizing the Arts." Wood sculpture group. 1769–70. Foyer, Salle de l'Opéra, Versailles. [Ibid., pp. 179–81, 402f.—ill.]

Johan Tobias Sergel, 1740–1814. "Apollino." Marble statue, after antique statue from Villa Medici, Rome (now in Uffizi, Florence). **1770**. Nationalmuseum, Stockholm, no. 358. [Göthe 1921, no. 21—ill.]

Richard Wilson, 1714–1782. "Apollo and the Seasons." Painting. Early **1770s?** Viscount Allendale coll. in 1953. [Fitzwilliam 1960–77, 3:287 / Constable 1953, p. 167, pl. 26a]

———. "Apollo and the Seasons." Painting. Mid-late 1770s. Fitzwilliam Museum, Cambridge, no. PD.27–1952. [Fitzwilliam 1960–77, 3:287—ill. / Constable 1953, pl. 26b]

———. "Apollo and the Seasons." Painting. Tate Gallery, London, no. 5551. [Tate 1975, p. 94]

Antonio Canova, 1757–1822. "Apollo." Terra-cotta statue. **1778**. Accademia, Venice. [Pavanello 1976, no. 12—ill.]

———. "Apollo Crowning Himself." Marble statue. 1781–82. Sold Paris, 1951. [Ibid., no. 19—ill.] Plaster model (headless). Gipsoteca Canoviana, Possagno. [Ibid., no. 20—ill. / also Vermeule 1964, pp. 135, 169—ill.]

———. "Apollo." Marble statue, variant of "Amorino" (1787–89, Angelsey Abbey). 1797. Lost. [Pavanello, no. 107—ill. (print)]

———. "Apollo Citharaeus Crowned by Putti, with Athena." Painting, sketch. Museo Civico, Bassano del Grappa. [Ibid., no. D94—ill.]

François Guichard, 1745–1807. *Les loisirs d'Apollon* [Apollo's Leisure] (new collection). Song collection, opus 7. **1778**. [Grove 1980, 7:800]

Nicolas Roze, 1745–1819. "Hymne à Apollon." Vocal work. **1784**. [Grove 1980, 16:286]

Giovanni Battista Cipriani, 1727–**1785**. "Apollo with His Lyre, with Mercury and a Muse." Watercolor, design for a benefit ticket. Victoria and Albert Museum, London, no. 97b–1892. [Lambourne & Hamilton 1980, p. 64]

Jean-Antoine Houdon, 1741–1828. "Apollo." Bronze sculpture. **1788.** Gulbenkian Foundation, Lisbon. [Réau 1964, no. 4—ill.]

Gottfried August Bürger, 1747–1794. "An den Apollo" [To Apollo]. Poem. In *Gedichte* (Frankfurt or Göttingen: **1789**). [DLL 1968–90, 2:297]

Nicolas-Guy Brenet, 1728–1792. "Apollo and the Arts." Painting. *c.*1780s? [Bénézit 1976, 2:297]

Joseph Chinard, 1756–1813. "Apollo Trampling Superstition [a woman representing Faith] Underfoot." Terracotta statuette. **1792.** Musée Carnavalet, Paris. [Janson 1985, p. 46—ill.]

William Wordsworth, 1770–1850. "Ode to Apollo." Ode, translation of Horace. *c.*1792. [De Selincourt 1940–66, vol. 1 / Sheats 1973, p. 273 *n*.11]

Francesco Gardi, 1760/65–*c.*1810. *Apollo esule, ossia L'amore alla prova* [Apollo Exiled, or Love Put to the Test]. Opera (favola). Libretto, Alessandro Pèpoli. First performed **1793**, private theatre of Count Pèpoli, Venice. [Grove 1980, 7:162]

Luigi Cherubini, 1760–1842. *Cantata for Inauguration of Statue of Apollo.* Cantata. **1796,** incomplete. [Grove 1980, 4:211]

James Hook, 1746–1827. *The Monthly Banquet of Apollo.* Song collection. **1796.** [Grove 1980, 8:685]

Pierre-Paul Prud'hon, 1758–1823. "Apollo." Painting, part of series of imitation bronze bas-reliefs for Hôtel Lanois, Paris. **1796–99.** Louvre, Paris, no. R.F. 1983–12. [Louvre 1979–86, 4:152—ill. / also Guiffrey 1924, pp. 294ff.]

François-Marie Poncet (18th century). "Apollo." Marble sculpture. National Gallery of Ireland, Dublin. [Bénézit 1976, 8:420]

Philipp Otto Runge, 1777–1810. "Triumph of Apollo." Drawing. **1801.** Kunsthalle, Hamburg, inv. 34251. [Hamburg 1977, no. 128—ill.]

Nicolas Isouard, 1775–1818. "Air d'Apollon." Song. **1802.** [Grove 1980, 9:355]

Johann Gottfried Schwanenberger, *c.*1740–**1804.** "Das Gericht Apollos" [The Judgment of Apollo]. Dramatic prologue. [Grove 1980, 17:40]

Friedrich Hölderlin, 1770–1843. "Pythische Ode I" [First Pythian Ode]. Translation from Pindar, lines 1–28. **1804.** In *Sämmtliche Werke,* vol. 2 (Stuttgart & Tübingen: 1846). [Beissner 1943–77, vol. 5]

Bertel Thorwaldsen, 1770–1844. "Apollo." Marble statue. **1805.** Unlocated. [Cologne 1977, no. 15] Plaster original. Thorwaldsens Museum, Copenhagen, no. A3. [Thorwaldsen 1985, p. 21 / Hartmann 1979, pp. 57f., pl. 15.4]

————. "Apollo." Relief. Plaster original. *c.*1836. Thorwaldsens Museum, no. A326. [Thorwaldsen, p. 46.]

Giuseppe Castagnoli, 1754–1832. "Apollo Surrounded by the Signs of the Zodiac." Ceiling fresco. **Early 19th century.** Sala del Castagnoli, Palazzo Pitti, Florence. [Pitti 1966, pp. 112—ill.]

Charles-Louis Didelot, 1767–1837. "Apollo and Diana." Pas de deux in ballet-divertissement. First performed Dec **1806,** St. Petersburg. [Beaumont 1938, p.17]

Anne-Louis Girodet, 1767–1824. "Apollo" ("Autumn"). Painting. *c.*1814. Chambre de l'Impératrice, Palais, Compiègne. [Bernier 1975, pp. 167, 174—ill.]

Jean Paul, 1763–1825. *Mars und Phöbus Thronwechsel: Eine scherzhafte Flugschrift* [Mars and Apollo Exchange Thrones: A Joking Pamphlet]. Satire. Tübingen: Cotta, **1814.** [DLL 1968–90, 8:533]

John Keats, 1795–1821. "Ode to Apollo." Poem. Feb **1815.** First published in *Life, Letters, and Literary Remains of John Keats,* edited by Richard Monckton Milnes (London: Moxon, 1848). [Stillinger 1978 / Gittings 1968, p. 44 / Bate 1963, pp. 40f., 289 / Bush 1937, p. 82]

————. "God of the golden bow" ("Hymn to Apollo"). Poem. Late 1816/early 1817. In *The Western Messenger* 1 June 1836 as "Ode to Apollo"; collected in *Life, Letters, and Literary Remains* (1848). [Stillinger / De Selincourt 1951, pp. 350, 556, 563 / Bate, pp. 138–40, 148, 289]

————. (Apollo in) *Hyperion: A Fragment,* book 3. Poem. *c.*Oct 1818–*c.*Apr 1819. London: Taylor & Hessey, 1820. [Stillinger / Aske 1985, p. 96 / Gradman 1980, pp. 22f., 47f., 58f., 60f.]

Samuel Woodforde, 1763–**1817.** "Pan Teaching Apollo to Play on the Pipes." Watercolor. Victoria and Albert Museum, London, no. F.A.555. [Lambourne & Hamilton 1980, p. 424—ill.]

Percy Bysshe Shelley, 1792–1822. (Apollo in) *Prometheus Unbound.* Dramatic poem. London: Ollier, 1820. [Zillman 1968 / Curran 1975, p. 59 / Wasserman 1971, pp. 284f.]

Charles Meynier, 1768–1832. (Apollo in) "The Triumph of French Painting: Apotheosis of Poussin, Le Sueur, and Le Brun." Ceiling painting. **1822.** Salle Duchatel, Louvre, Paris (inv. 6626). [Louvre 1979–86, 4:86—ill.]

Giuseppe Maria Cambini, 1746–**1825.** "Apollon prends pitié" [Apollo Takes Pity]. Lyric scene for solo voice and orchestra. Paris. [Grove 1980, 3:640]

Peter Cornelius, 1783–1867, and studio. Cycle of ceiling frescoes, depicting Helios on the sun-chariot, Apollo and Daphne, Hyacinth, Clytie, and Leucothea. **1820–26.** Göttersaal, Glyptothek, Munich. [Glyptothek 1980, pp. 214ff., 219f.—ill.]

Henri-Jean Rigel, 1772–1852. *Invocation à Apollon.* Cantata for 3 soli, chorus, and orchestra. First performed 4 May **1826,** Société Académique des Enfants d'Apollon, Paris. [Grove 1980, 16:19]

Robert Browning, 1812–1889. (Sordello wishes to be Apollo in) *Sordello* 1.895–935. Poem. London: Moxon, **1840.** [Jack & Smith 1983, vol. 2]

Eduard Mörike, 1804–1875. "Hymnus auf den Delischen Apollon" [Hymn to Delian Apollo]. Translation from first Homeric Hymn to Apollo. In *Classische Blumenlese* (Stuttgart: Schweizerbart, **1840**). [Hötzer 1967]

Thomas Crawford, 1813–1857. "Apollo and Diana." Marble sculpture group. **1848.** Rollins College, Winter Park, Fla. [Gerdts 1973, pp. 20, 34f., fig. 165]

Conradin Kreutzer, 1780–**1849.** *Der Apollosaal* [The Hall of Apollo]. Singspiel. [Grove 1980, 10:264]

Gaspare Martellini, 1785–1857. "Apollo." Painting. *c.*1850. Sala di Ulisse, Palazzo Pitti, Florence. [Pitti 1966, p. 131]

Heinrich Heine, 1797–1856. "Der Apollogott" [The God Apollo]. Poem. In *Romanzero* (Hamburg: Campe, **1851**). [Atkins & Boeck, 1973–78, vol. 2 / Draper 1982]

Matthew Arnold, 1822–1888. (Tales of Apollo recounted in) *Empedocles on Etna* 2.1. Dramatic poem. In *Empedocles on Etna, and Other Poems* (London: Fellowes, **1852**). [Allott & Super 1986 / Bush 1971, p. 59]

Pierre-Auguste Renoir, 1841–1919. "Apollo." Painting, copy after detail in Rubens's "Council of the Gods" ("Coronation of Marie de' Medici") (1622–25, Louvre). **1861**. Private coll., New York. [Daulte 1971, no. 7—ill. / also White 1984, p. 15—ill.]

Edward Hodges Baily, 1788–**1867**. "Apollo." Sculpture. [Bénézit 1976, 1:384]

Aimé Millet, 1819–1891. "Apollo, Dance and Music." Bronze sculpture group. **1866–69**. Gable of stage proscenium, l'Opéra, Paris. / Plaster models. Musée d'Orsay, Paris, inv. DO 1983–205; Musée de l'Opéra, Paris. [Orsay 1986, p. 200—ill.] Bronze cast of Orsay model known. [Ibid.]

Arthur Sullivan, 1842–1900. (Aged Apollo in) *Thespis; or, The Gods Grown Old*. Comic operetta. Libretto, W. S. Gilbert. First performed 26 Dec **1871**, Gaiety Theatre, London. Music lost. [Jefferson 1984, pp. 23ff.]

Augusta Holmès, 1847–1903. *Hymne à Apollon*. Symphonic poem. **1872**. [Grove 1980, 8:656]

Briton Riviere, 1840–1920. "Apollo" (charming wild beasts with his lyre). Painting. **1874**. Bury Art Gallery, England. [Wood 1983, pp. 216–18—ill.]

———. "Phoebus Apollo." Painting. 1895–98. Birmingham City Art Gallery. [Wood 1983, p. 218—ill.]

Antoine-Louis Barye, 1796–**1875**. "Apollo." Sculpture. [Pivar 1974, no. F43—ill.]

———. "Enthroned Apollo-Napoleon." Drawing. Walters Art Gallery, Baltimore, no. 37.2207. [Benge 1984, pl. 168—ill.]

Louise-Angelique Bertin, 1805–**1877**. *Hymne à Apollon*. Cantata. [Cohen 1987, 1:78 / Grove 1980, 2:638]

Josephine Lang, 1815–**1880**. *Apollo March*. Instrumental work. [Cohen 1987, 1:396]

Gabriele D'Annunzio, 1863–1938. "Ad Apollo." Poem, translation of first Homeric Hymn to Apollo, part of "Dal Greco." In *Primo vere*, 2d edition (Lanciano: Carabba, **1880**). [Palmieri 1953–59, vol. I]

John La Farge, 1835–1910. 4 bronze reliefs with heads of Apollo, for Vanderbilt mansion, New York. **1881–82**. Private coll.; elsewhere? [Adams et al. 1987, fig. 138 / also Weinberg 1977, pp. 256ff., 259—ill.]

Augustus Saint-Gaudens, 1848–1907. "Apollo." Wood panel relief, for dining room, Vanderbilt mansion, New York. **1881–83**. Lost. / Plaster model. J. B. Speed Art Museum, Louisville. [Dryfhout 1982, no. 104—ill.]

Hans Thoma, 1839–1924. "Apollo and Diana." Painting. **1887**. Unlocated. [Thode 1909, p. 262—ill.]

Gustav Klimt, 1862–1918 (or Franz Matsch? b. 1861). "Altar of Apollo." Painting. **1886–88**. Burgtheater, Vienna. [Novotny & Dobai 1968, no. 42 / Strobl 1980, 1:55] Oil sketch, unlocated. [Novotny & Dobai, no. 37]

Richard Garnett, 1835–1906. (Apollo instructs a young priest in) "The Dumb Oracle." Prose fantasy. In *The Twilight of the Gods and Other Tales* (London: Unwin, **1888**). [Bush 1937, pp. 401, 563]

Randal Roberts. *Apollo M. D.* Farce. First performed 26 Dec **1888**, Jodrell Theatre, London. [Nicoll 1959–66, 5:545]

Walter Pater, 1839–**1894**. "Apollo in Picardy" (in the Middle Ages). Story. In *Miscellaneous Studies* (London & New York: Macmillan, 1895). [Jenkyns 1980, pp. 186f., 364]

Gabriel Fauré, 1845–1924. "Hymne à Apollon." Vocal

composition, opus 63 *bis*. Text, Homeric Hymn to Pythian Apollo. **1894**; revised 1914. [Grove 1980, 6:427]

Marco Praga, 1862–1929. *Il bell' Apollo* [The Beautiful Apollo]. Comedy. First performed 3 Dec **1894**, Teatro Goldoni, Venice. [McGraw-Hill 1984, 4:168]

Émile-Antoine Bourdelle, 1861–1929. "Head of Apollo." Bronze sculpture. **1900**. 10 casts. Musée Bourdelle, Paris; Musée Fabre, Montpellier; private colls. [Jianou & Dufet 1975, no. 258—ill. / Cannon-Brookes 1983, pp. 28f.—ill.] Variant (mask). 5 versions, 1900, 1909, 1925. Numerous casts. [Jianou & Dufet, no. 259]

Wallace Stevens, 1879–1955. (Apollo evoked in) "Street Songs." Poem. In *Harvard Advocate* 3 Apr **1900**. [Buttel 1967, pp. 32, 34]

Robert Williams Buchanan, 1841–**1901**. "The Swan Song of Apollo." Poem. In *Complete Poetical Works* (London: Chatto & Windus, 1901). [Boswell 1982, p. 59]

Æ (George William Russell), 1867–1935. "The Childhood of Apollo," "The Mask of Apollo." Short stories. In *The Mask of Apollo and Other Stories* (London: Macmillan, **1904**). [Bush 1937, p. 567]

Carl Spitteler, 1845–1924. *Hera die Braut* [Hera the Bride] (Hera, in love with Apollo, marries Zeus), part 2 of *Olympischer Frühling* [Olympian Spring]. Epic poem. **1900–06**. / Revised, published Jena: Diedericks, 1910. [Butler 1958, p. 321]

Rainer Maria Rilke, 1875–1926. "Früher Apoll" [Early Apollo]. Poem. In *Neue Gedichte* (Leipzig: Insel, **1907**). [Zinn 1955–66, vol. I / Leishman 1960 / Brodsky 1984, pp. 186–91]

———. "Archäischer Torso Apollos" [Archaic Torso of Apollo]. Poem. In *Neuen Gedichte: Anderer Teil* (Leipzig: Insel, 1908). [Zinn / Leishman / Brodsky / Strauss 1971, pp. 146f., 149]

———. (Reader erects his own temple to Apollo in) Sonnet 3 of *Die Sonette an Orpheus* part I. 1922. Leipzig: Insel, 1923. [Zinn / Leishman]

Herbert Trench, 1865–1923. "Apollo and the Seaman." Poem. In *New Poems* (London: Methuen, **1907**). [Bush 1937, p. 568]

John Davidson, 1857–1909. (The poet battles Diana, Apollo, and Thor in) *The Testament of John Davidson*. Poem. London: Richards, **1908**. [DLB 1983, 19:100]

Ford Madox Ford, 1873–1939. *Mr. Apollo: A Just Possible Story*. Novel. London: Methuen, **1908**. [Ipso]

Monsita Monserrate Ferrer Otero, 1882–1966, music. *Apolo*. Dance. **1910**. [Cohen 1987, 1:234]

Manuel Machado y Ruiz, 1874–1947. "Apolo." Poem. In *Teatro pictorico* (Madrid: Prieto, **1911**). [Schneider & Stern 1988, p. 245]

John Gould Fletcher, 1886–1950. "Dionysus and Apollo." Poem. In *Fire and Wine* (London: Richards, **1913**). [Boswell 1982, p. 106]

Witter Bynner, 1881–1968. "Apollo Troubadour." Poem. In *Grenstone Poems* (New York: Stokes, **1917**). [Ipso]

Henry Benrath, 1882–1949. *Dank an Apollon: Gedichte 1902–1920* [Thanks to Apollo: Poems **1902–1920**]. Collection of poems. Stuttgart & Berlin: Deutsche Verlagsanstalt, 1937. [Kunisch 1965, p. 94]

Giorgio de Chirico, 1888–1978. "Dancing Apollo." Draw-

ing. **1920.** Formerly Galleria Odyssia, Rome. [de Chirico 1971–83, 4.1: no. 270—ill.]

————. "Apollo with Pegasus." Painting. 1958. Private coll., Ravenna. [Ibid., 1.3: no. 57—ill.]

————. "Apollo and Tulips." Drawing. 1970. Artist's coll., Rome, in 1972. [de Chirico 1972, no. 116—ill.]

Max Ernst, 1891–1976. "Apollo steadfastly refuses to marry the archeologist's only daughter. . . ." Collage-painting with title inscription. **1920.** Kolodny coll., N.J. [Spies & Metken 1975–79, no. 371—ill.]

Laurence Housman, 1865–1959. "Apollo in Hades." Verse drama. In *The Wheel: Three Poetic Plays on Greek Subjects* (New York: French, **1920**). [Bush 1937, p. 572]

John Singer Sargent, 1856–1925. (Figures representing) "Classical and Romantic Art" (attended by Pan and Minerva, with Apollo), "Apollo and the Muses." Murals. **1916–21.** Museum of Fine Arts, Boston. [Ratcliff 1982, pp. 145–47—ill.]

Willi Baumeister, 1889–1955. "Apollo" series of abstract paintings. **1919–22.** "Apollo on a Blue Ground," 1919, formerly T. van Portvliet coll.; "Apollo with Diagonal Figure," 1919–20, lost; "Apollo with Circle," 1919–20, formerly Schwitters coll., Hannover; "Apollo" ("Green Figure"), 1920, Schleicher coll., Stuttgart; "Apollo and the Painter," 1921, unlocated; "Representation of Apollo," 1921, 2 versions, unlocated; "Apollo and Sitting Figure," 1921–22, lost; "Apollo," 1922, Müller coll., Tübingen. [Grohmann 1954, p. 46, nos. 168–70, 173, 175–76, 181, 183, 1670—ill.; cf. p. 6 (lithograph)]

————. "The Painter (Apollonian) I." Abstract painting. 1920. Unlocated. [Ibid., no. 188—ill.]

————. "The Painter (Apollonian) II." Abstract painting. 1921. Destroyed. [Ibid., no. 189]

————. "Line-figure" ("Apollo"). Abstract painting. 1932. Lost. [Ibid., no. 307—ill.]

————. "Figure" ("Apollo"). Abstract painting. 1933. Borst coll., Stuttgart. [Ibid., no. 238—ill.]

Theodor Däubler, 1876–1934. (Apollo, as god of music, leads Amphion, Orpheus, and the Muses in) *Päan und Dithyrambos: Eine Phantasmagorie* [Paean and Dithyramb: A Phantasmagoria] part 4. Poem. Leipzig: Insel, **1924.** [Ipso / DULC 1959–63, 1:964]

Aristide Maillol, 1861–1944. "Pan, Sylvanus, and Apollo." Woodcut, illustrating Virgil's Tenth Eclogue. Leipzig: Insel, **1926.** [Guérin 1965, no. 56—ill.]

Robert David Fitzgerald, 1902–. *The Greater Apollo.* Poem. Sydney: privately printed, **1927.** [Vinson 1985, p. 269 / EWL 1981–84, 1:147]

Igor Stravinsky, 1882–1971, music. *Apollon musagète (Apollo).* Ballet with string orchestra (commissioned by Elizabeth Sprague Coolidge). First performed 27 Apr **1928,** Library of Congress, Washington, D.C.; choreography, Adolph Bolm; décor, Nicolai Remesoff. [Grove 1980, 18:252, 262 / Oxford 1982, p. 18 / Simon & Schuster 1979, p. 208 / Vlad 1967, pp. 91–93, 98f.]

George Balanchine, 1904–1983, choreography. *Apollon musagète.* Ballet. Music, Stravinsky. First performed 12 June **1928,** Diaghilev's Ballets Russes, Théâtre Sarah Bernhardt, Paris; sets and costumes, André Bauchant. [Taper 1984, pp. 98–104—ill. / Sorley Walker 1983, p. 20 / Oxford 1982, p. 18 / Kirstein 1978, pp. 62–66] Revived/revised 27 Apr

1937, American Ballet Ensemble, Metropolitan Opera, New York; 1947, L'Opéra, Paris; 1951; 1960. [Taper, pp. 173, 216, 358–61 / Kirstein, pp. 62–66, 353 / Reynolds 1977, pp. 46–50 / Guest 1976, p. 318]

Edwin Arlington Robinson, 1869–1935. (Apollo evoked in) "Many are Called." Poem. In *Collected Poems* (New York: Macmillan, **1929**). [Ipso]

Carl Milles, 1875–1955. "Apollo with His Lyre." Stucco bas-relief, pediment over orchestra platform. Before **1930.** Concert House, Stockholm. [Clapp 1970, 1:625]

Pavel Tchelitchew, 1898–1957. "The Hands of Apollo." Drawing. **1931.** Dix coll., New York. [Tchelitchew 1964, no. 89]

Jean Binet, 1893–1960. "Ode à Diana et Apollo." Composition for chorus and orchestra. **1932.** [Grove 1980, 2:723]

François Sicard, 1862–1934. "Apollo." Marble sculpture, detail in Archibald Fountain, Sydney. Before **1933.** [Clapp 1970, 1:808]

————. "Apollo." Colossal bronze statue. Musées Nationaux, inv. AM 504, deposited in Musée, Maubeuge, in 1956. [Orsay 1986, p. 282]

William Rose Benét, 1886–1950. "Young Apollo" (and Aphrodite). Poem. In *Starry Harness and Other Poems* (New York: Duffield & Green, **1933**). [Bush 1937, p. 591]

Marianne Moore, 1887–1972. "Apollo in the Days of Prismatic Color." Poem. In *Selected Poems* (New York: Macmillan; London: Faber, **1935**). [Ipso]

Federico García Lorca, 1898–**1936.** (Apollo evoked as symbol of masculine beauty in) "Tu infancia en Menton," "Oda a Walt Whitman." Poems. In *Poeta en Nueva York,* edited by J. Bergamín (Mexico City: Séneca, 1940). [Predmore 1980, pp. viii, 73 / Harris 1978, pp. 16, 29] Translated by Rolfe Humphries in *The Poet in New York and Other Poems,* bilingual edition (New York: Norton, 1940).

Bronislava Nijinska, 1891–1972, choreography. *Apollon et la belle* [Apollo and the Beauty]. Ballet. First performed **1937,** Paris. [Oxford 1982, p. 18]

Benjamin Britten, 1913–1976. *Young Apollo.* Orchestral work for piano and strings, opus 16. Text, last lines of Keats's *Hyperion* (1818–19). First performed Aug **1939,** Toronto. Withdrawn. [Grove 1980, 3:306 / Palmer 1984, pp. 111–13]

Raoul Dufy, 1877–1953. "Venetian Apollo." Painting. **1939.** Jean Mouraille coll. [Laffaille 1977, no. 1578—ill.]

Ignace Lilien, 1897–1964. "Sonatine apollonique" [Apollonian Sonatina]. Instrumental composition. **1939.** [Grove 1980, 10:858]

Jean Giraudoux, 1882–1944. *L'Apollon de Bellac* (originally titled *L'Apollon de Marsac*). Comedy. First performed 16 June **1942,** Teatro Municipal, Rio de Janeiro. [McGraw-Hill 1984, 2:317, 323f. / Inskip 1958, pp. 147–49]

Robert Graves, 1895–1985. "Apollo of the Physiologists." Poem. In *Poems: 1938–1945* (London: Cassell, **1945;** New York: Creative Age, 1946). [Graves 1975 / Boswell 1982, pp. 122f.]

Alfred-Auguste Janniot, b. 1889. "Apollo." Fountain figure, in Fontaine de Nice. By **1946.** / Study, torso. Musée Nationale d'Art Moderne, Paris. [Clapp 1970, 1:480]

W. H. Auden, 1907–1973. (Apollo evoked in) "Under Which Lyre: A Reactionary Tract for the Times." Poem.

1946. In *Harper's Magazine* June 1947; collected in *Nones* (New York: Random House, 1951). [Mendelson 1976 / Carpenter 1981, p. 341 / Fuller 1970, pp. 184f., 237 / Spears 1963, pp. 186f.]

Peter Mieg, 1906–. "An die Leier Apollons" [To Apollo's Lyre]. Song. Text, Hölderlin (1804). **1946.** [Grove 1980, 12:280]

Luis Cernuda, 1902–1963. "Escultura inacabada (David-Apolo, de Miguel Angel)" [Unfinished Statue (Michelangelo's David-Apollo)]. Poem, part of *Vivir sin estar viviendo* [Living without Being Alive]. **1944–49.** [Capote 1984] Translated by Reginald Gibbons in *Selected Poems of Luis Cernuda,* bilingual edition (Berkeley & Los Angeles: University of California Press, 1977). [Ipso]

Françoise Adret, 1920–, choreography. *Apollon musagète.* Ballet. Music, Stravinsky (1928). First performed **1951,** Strasbourg. [Cohen-Stratyner 1982, p. 6]

Tatjana Gsovsky, 1901–, choreography. *Apollon musagète.* Ballet. Music, Stravinsky (1928). First performed **1951,** Berlin. [Oxford 1982, p. 18]

Barbara Hepworth, 1903–1975. "Apollo." Abstract steel rod sculpture, part of a set for Sophocles' *Elektra.* 2 versions. **1951.** 1 in estate of Mrs. E. M. MacDonald in 1961; the other in artist's coll. in 1961. [Hodin 1962, no. 167]

Aurel Milloss, 1906–1988, choreography. *Apollon musagète.* Ballet. Music, Stravinsky (1928). First performed **1951,** Rome. [Oxford 1982, p. 18]

Simon Vestdijk, 1898–1971. *De verminkte Apollo* [Apollo Diminished]. Novel. Rotterdam: Nijgh & Van Ditmar, **1952.** [EWL 1981–84, 4:556 / Meijer 1971, p. 336]

Henri Matisse, 1869–1954. "Apollo." Painted paper cut-out. **1953.** Moderna Museet, Stockholm. [St. Louis 1977, no. 205—ill.]

Richard Selig, 1929–1957. "Poem, 1953" (Apollo and Eros). Poem. **1953.** In *Poems* (Dublin: Dolmen, 1962). [Ipso]

Yvonne Georgi, 1903–1975, choreography. *Apollon musagète.* Ballet. Music, Stravinsky (1928). First performed **1955,** Hannover. [Oxford 1982, p. 18]

Ezra Pound, 1885–1972. (Poet seeks Apollo at Delphi in) Canto 90, in *Section: Rock-Drill, 85–95 De Los Cantares* (New York: New Directions, **1955**). [Feder 1971, p. 119]

John Holloway, 1920–. "Apollonian Poem." Poem. In *The Minute and Longer Poems* (East Yorkshire: Marvell, **1956**). [DLB 1984, 27:157 / Boswell 1982, p. 263]

Delmore Schwartz, 1913–1966. (Apollo evoked in) "Once and For All." Poem. By **1958.** In *Summer Knowledge: New and Selected Poems, 1938–1958* (Garden City, N.Y.: Doubleday, 1959). [Boswell 1982, p. 289]

Hayden Carruth, 1921–. "A Word for Apollo in the Spring." Poem. In *The Crow and the Heart: 1946–59* (New York: Macmillan, **1959**). [Boswell 1982, p. 247]

William Plomer, 1903–1973. "Archaic Apollo." Poem. In *Collected Poems* (London: Cape, **1960**). [Boswell 1982, p. 281]

Richard Lippold, 1915–. "Orpheus and Apollo." Space sculpture. **1962.** Avery Fisher Hall, Lincoln Center, New York. [Marks 1984, p. 503]

André Masson, 1896–1987. "Apollo and Dionysus." Etching. **1967.** [Passeron 1973, p. 177]

Matthew Mead, 1924–. "227 Idle Words against Apollo." Poem. In *Identities and Other Poems* (London: Rapp & Carroll, **1967**). [DLB 1985, 40(Pt. 2):358]

Zbigniew Herbert, 1924–. (Apollo as healer of war in) "Fragment" [English title of work written in Polish]. Poem. / Translated by Czeslaw Miłosz and Peter Dale Scott in *Selected Poems* (Harmondsworth: Penguin, **1968**). [Ipso]

———. "On the Road to Delphi" [English title of work written in Polish] (Apollo with Medusa's head). Poem. In *Poezje wybrane* (Warsaw: Spoldzielnia Wydawnicza, 1973). / Translated by John and Bogdana Carpenter in *Selected Poems* (Oxford & New York: Oxford University Press, 1977). [Ipso]

Giacomo Manzù, 1908–. "Apollo, Venus, and Minerva." Bronze bozzetto for sculpture. **1968.** Meadows coll., Dallas. [Micheli 1971, fig. 89—ill.]

William DeWitt Snodgrass, 1926–. "An Archaic Torso of Apollo." Poem, after Rilke (1908). In *After Experience: Poems and Translations* (New York: Harper & Row, **1968**). [Boswell 1982, p. 295]

Leonard Baskin, 1922–. "Apollo." Bronze relief sculpture. **1969.** Virginia Museum of Fine Arts, Richmond; 4 private colls. [Jaffe 1980, p. 215]

Yannis Ritsos, 1909–1990. "Hē Apollon sto metallio tou Antigone" [Apollo at the Cave of Antigone]. Poem. 10 June **1969.** In *Epanalepseis* (Athens: Kedros, 1972). [Ipso]

Henrikas Radauskas, 1910–**1970.** "Apollo." Poem. / Translated by Jonas Zdanys in *Chimeras in the Tower* (Middletown: Wesleyan University Press, 1986). [Ipso]

Hans Holewa, 1905–. *Apollons förvandling* [Apollo's Transformation]. Opera. **1967–71.** Libretto, Holewa. Published Pesaro: 1967. [Grove 1980, 8:645]

Daryl Hine, 1936–. "To Apollo." Poem, as preface to Hine's translation of *The Homeric Hymns and the Battle of the Frogs and the Mice* (New York: Atheneum, **1972**). [Vinson 1985, p. 385]

Andor Kovách, 1915–. *L'Apollon de Bellac.* Opera. Libretto, composer, after Giraudoux (1942). **1972.** [Grove 1980, 10:221]

James Cunningham, 1938–, and **Lauren Persichetti,** 1944–, choreography. *Apollo and Dionysus: Cheek to Cheek.* Ballet. First performed **1974,** New York. [McDonagh 1976, p. 358]

Ruth Zechlin, 1926–. *Dionysos und Apollo.* Composition for flute, strings, and percussion. **1976.** [Baker 1984, p. 2558]

Ursule Molinaro. "Letter to Apollo." Poem. In *Contemporary Quarterly* 2 no. 3 (**1977**). [Ipso]

Robert Natkin, 1930–. "Apollo Series." Painting. **1980.** Gimpel & Weitzenhoffer Gallery, New York, in 1982. [DCAA 1982, pp. 4, 415—ill.]

Claudio Parmiggiani, 1943–. "Apollo." Assemblage (plaster, metal, 2 canvases). **1980.** [Reggio Emilia 1985, p. 82—ill.]

Alfred Corn, 1943–. "Archaic Torso of Apollo." Poem, after Rilke (1908). In *The West Door* (New York: Viking, Penguin, **1988**). [Ipso]

Apollo as Sun God. In the Homeric Hymn, Apollo is given the epithet "Phoebus" ("bright, shin-

ing"), but it was not until the classical period (fifth century BCE) that he assumed the attributes of a sun god. In this guise he took over the powers of Helios, son of the Titans Thea and Hyperion and brother of the dawn-goddess Eos and the moon-goddess Selene.

Postclassical representations of Phoebus Apollo (also called Sol by the Romans) often depict him driving the sun chariot across the sky, sometimes led by Eos (Aurora). Other representations show him in the company of his sister Artemis (Diana), as goddess of the moon, or rising from the couch of the sea deity Tethys, wife of Oceanus, to begin his journey across the heavens.

Classical Sources. Homer, *Odyssey* 1.8–9, 12.260–419 (Helios). Hesiod, *Theogony* 371–74, 956–62. *Homeric Hymns,* "To Apollo," "To Helios," first hymn "To Demeter" lines 62–89. Pindar, *Olympian Odes* 7.54–76. *Orphic Hymns* 8, "To the Sun." Ovid, *Metamorphoses* 1.750–2.400, 4.194–270.

See also APOLLO, Loves; CLYTIE; EOS; HYPERION; PERSEPHONE, Demeter's Search; PHAETHON; SELENE.

Geoffrey Chaucer, 1340?–1400. (Phoebus Apollo evoked in) "The Franklin's Tale" lines 1031–79; "The Squire's Tale" lines 48–51, 263–67; Prologue to "The Man of Law's Tale" lines 7–15; "The Merchant's Tale" lines 2220ff. Poems, in *The Canterbury Tales.* 1388–95. Westminster: Caxton, 1478. [Riverside 1987]

Baldassare Peruzzi, 1481–1536. "Apollo and the Centaur." Ceiling fresco, representing the Sun in the constellation Sagittarius. 1510–11. Sala di Galatea, Villa Farnesina, Rome. [d'Ancona 1955, pp. 25f., 87—ill. / Gerlini 1949, pp. 10ff.—ill. / also Frommel 1967–68, no. 18c]

———. "Helios, with the Hours." Fresco. 1511–12 (or *c.*1517–18). Sala delle Prospettive, Villa Farnesina, Rome. [d'Ancona, pp. 27ff., 93f. / Gerlini, pp. 31ff. / also Frommel, no. 51]

Pinturicchio, 1454–1513, and studio. "The Chariot of Apollo." Fresco (detached), from Palazzo Pandolfo Petrucci ("Il Magnifico"), Siena. Metropolitan Museum, New York, no. 114.6. [Metropolitan 1980, p. 142—ill.]

Giulio Romano, *c.*1499–1546, studio, after design by Giulio. "Chariots of the Sun and Moon" ("Sol and Luna"). Fresco. 1527. Sala del Sole, Palazzo del Tè, Mantua. [Hartt 1958, pp. 108f.—ill.; cf. pp. 159, 300 (no. 214)—ill. / Verheyen 1977, p. 113]

Girolamo Romanino, *c.*1484/87–*c.*1562. "Apollo in His Chariot." Fresco. 1531–32. Loggia, Castello del Buonconsiglio, Trento. [Berenson 1968, p. 369—ill.]

Parmigianino, 1503–1540. "Apollo Helios." Drawing, from Duke of Alba coll. D. L. Munby coll., Oxford. [Warburg]

Francesco Primaticcio, 1504–1570, and assistants. "The Hours Surrounding the Chariot of the Sun." Ceiling fresco, in Galerie d'Ulysse, Château de Fontainebleau. 1541–47. Destroyed 1738–39. / Drawing for. Louvre, Paris, inv. 8519. [Béguin et al. 1985, pp. 173ff.—ill. / also Dimier 1900, pp. 295ff., no. 10]

Battista Dossi, *c.*1474–1548 (with Girolamo da Carpi?).

"An Hour [or Aurora?] Leading Forth the Horses of Apollo." Painting. *c.*1540s. Gemäldegalerie, Dresden, no. 130. [Gibbons 1968, no. 91—ill.]

Giorgio Vasari, 1511–1574, and Cristofano Gherdardi, 1508–1556. "Chariot of the Sun," "Chariot of the Moon." Ceiling paintings. 1555–56. Sala degli Elementi, Palazzo Vecchio, Florence. [Sinibaldi 1950, pp. 13, 22—ill.]

Cecchin Salviati, 1510–1563. "Apollo Driving the Sun Chariot." Fresco. Palazzo Grimani, Venice. [de Bosque 1985, p. 47]

Derick Gerarde, fl. 1540–80. "Yf Phebus stormes." Madrigal. [Grove 1980, 7:246]

Johann Gregor van der Schardt, *c.*1530–1581. "Sol." Bronze sculpture. Rijksmuseum, Amsterdam, inv. R.B.K. 1977–24. [Hofmann 1987, no. 1.9—ill.]

Luca Marenzio, 1553/54–1599. "Già Febo il tuo splendor rendeva chiaro" [Once Phoebus Displayed His Splendor]. Madrigal. Published Venice: 1581. [Grove 1980, 11:671]

Philip Sidney, 1554–1586. (Apollo, as sun god, in) Sonnet 22 of *Astrophil and Stella.* Sonnet sequence. 1581–83. London: Newman, 1591 (pirated). [Ringler 1962]

Hendrik Goltzius, 1558–1617. "Apollo" ("The Sun God"). Engraving. 1588. [Strauss 1977a, no. 263—ill. / Bartsch 1980–82, no. 141—ill.]

———. "Sol." Engraving, in "Eight Deities" series, after (lost) chiaroscuro frescoes by Polidoro da Caravaggio (*c.*1498–1543). 1592. 4 states. [Strauss, no. 293—ill. / Bartsch 1980–82, no. 253—ill.]

———. "Helios." Chiaroscuro woodcut, in "Children of Demogorgon" series. *c.*1594. [Strauss 1977a, no. 41—ill. / Bartsch 1980–82, no. 234—ill.]

———. "Apollo." Drawing, composition for print in "Seven Planets" series. 1595–96. Original drawing lost. Engraved by Jan Saenredam (Bartsch no. 76). [Reznicek 1961, nos. 143–46 *n.*] Variant, for second ("small") series, 1597. Original drawing unlocated. Engraved by Jacob Matham (Bartsch no. 152). [Ibid., no. 150]

Antonio Maria Viani, 1555/60–1629, assistant(s). "The Chariots of the Sun and the Moon Driven by Apollo and Diana." Ceiling fresco. Late 16th century. Galleria degli Specchi, Palazzo Ducale, Mantua. [Paccagnini 1974, p. 46]

Bastianino, 1532–1602 (or Cesare Filippi?). "The Day" (Apollo in his chariot). Fresco. Sala dell' Aurora, Castello Estense, Ferrara. [Arcangeli 1963, pp. 29f., 64—ill.]

Tiziano Aspetti, 1565–1607, studio. "Apollo Helios." Bronze sculpture. Galleria Nazionale, Perugia. [Warburg]

Guido Reni, 1575–1642. "The Dawn" (Apollo's chariot led by Aurora). Fresco. 1613–14. Casino Rospigliosi-Pallavicini, Rome. [Gnudi & Cavalli 1955, no. 33—ill.]

———. (Apollo in his chariot, preceded by) "Aurora." Fresco. 1614. Casino dell' Aurora, Palazzo Rospigliosi-Pallavicini, Rome. [Pepper 1984, no. 40—ill. / Gnudi & Cavalli 1955, no. 33—ill.]

William Drummond of Hawthornden, 1585–1649. "Phoebus Arise." Poem. In *Poems: Amorous, Funerall, Divine, Pastorall* (Edinburgh: Hart, 1616). [MacDonald 1976, p. 36]

Guercino, 1591–1666. "Apollo." Fresco, for Casa Pannini,

Cento. **1615–17**. Detached, unlocated. [Bagni 1984, p. 165—ill.]

Domenichino, 1581–1641, with **Agostino Tassi**, *c.*1580–1644. (Apollo in his chariot in) "Truth Disclosed by Time." Ceiling fresco. *c.***1622**. Palazzo Costaguti, Rome. [Spear 1982, no. 81—ill.]

William Byrd, 1543–**1623**. "Where Phoebus Us'd to Dwell." Consort song for soli and violins. [Grove 1980, 3:550]

Peter Paul Rubens, 1577–1640. (Apollo in the sun chariot in) "The Birth of Louis XIII." Painting, part of "Life of Marie de' Medici" cycle. **1622–25**. Louvre, Paris, inv. 1776. [Saward 1982, pp. 79ff.—ill. / Jaffé 1989, no. 727—ill. / also Louvre 1979–86, 1:116—ill.]

————. "The Chariot of Apollo." Painting, after design by Primaticcio for Fontainebleau. Formerly Neuerburg coll., Hamburg, unlocated. [Jaffé, no. 796 / Held 1980, p. 3, fig. 71] Replica/copy in Staatliche Museen, Berlin. [Jaffé]

————, follower. "Sol on the Sun Chariot." Painting. Gemäldegalerie, Berlin-Dahlem, no. 798D. [Berlin 1986, p. 66—ill.]

Pietro da Cortona, 1596–1669. "The Chariot of the Sun." Fresco, for Villa Chigi (Sacchetti), Castel Fusano. **1626–29**. Destroyed, replaced by a copy. [Briganti 1962, no. 23—ill.]

John Milton, 1608–1674. (Allusion to Apollo as sun god in) "On the Morning of Christ's Nativity" stanza 7. Ode. 25 Dec **1629**. In *Poems* (London: Moseley, 1645). [Carey & Fowler 1968; cf. pp. 97f.]

————. (Phoebus assures poet of "Lycidas" enduring fame, in) "Lycidas" lines 76–84. Pastoral elegy. Nov 1637. In *Justa Eduardo King naufrago . . .* (Cambridge: 1638). [Carey & Fowler / Blessington 1979, p. 40]

George Jeffreys, *c.*1610–1685, music. "Drowsy Phoebus." Dialogue, in Peter Hausted's *The Rivall Friends*. **1631**. [Grove 1980, 9:585]

Simon Vouet, 1590–1649. "Jupiter Giving the Reins of the Sun Chariot to Apollo." Decoration for gallery of Hôtel Séguier, Paris. **1633–38**. Lost. / Engraved by Michel Dorigny, 1651. [Crelly 1962, pp. 112ff., no. 248b—ill.]

————, attributed. "Apollo in His Chariot Accompanying Time." Painting. City Art Gallery, Manchester. [Wright 1976, p. 218]

Francesco Manelli, 1594–1667, music. (Cupid in) *La Delia, ossia La sera sposa del sole* [Delia, or The Evening Bride of the Sun]. Opera. Libretto, G. Strozzi. First performed **1639**, Teatro SS Giovanni e Paolo, Venice. [Grove 1980, 11:612f.]

Nicolas Poussin, 1594–1665. (Apollo in the sun chariot, in) "The Dance to the Music of Time." Painting. *c.***1640** or earlier. Wallace Collection, London. [Wright 1985, no. 115, pl. 59 / Blunt 1966, no. 121—ill. / also Thuillier 1974, no. 123—ill.] Copies in Musée Réattu, Arles; Accademia, Venice; private colls.; elsewhere. [Blunt]

Italian School. "The Chariot of the Sun." Tapestry. **1643**. Sala di Ester, Palazzo Vecchio, Florence. [Sinibaldi 1950, p. 25]

Giovanni Baglione, 1571–**1644**. "Apollo in His Sun Chariot." Drawing. Kunstmuseum, Dusseldorf. [Pigler 1974, p. 26]

Edmund Waller, 1606–1687. "Stay, Phoebus." Poem. In

Poems (London: Mosley, **1645**). Modern facsimile edition, Menston: Scolar Press, 1971. [Ipso]

François Perrier, *c.*1590–1650. "Apollo on His Chariot." Ceiling painting, for Hôtel la Vrillière, Paris. **After 1645**. Destroyed, replaced by copy. [Dublin 1985, p. 50]

Jan van den Hoecke, 1611–1651. (Apollo in) "Allegory of Day." Painting. *c.***1650**. Kunsthistorisches Museum, Vienna, inv. 1679 (1122). [Vienna 1973, p. 88—ill.]

Charles Le Brun, 1619–1690. "Apollo Taking Leave of Tethys" (wife of Oceanus, to begin his skyward journey). Ceiling painting, for Hôtel Jérôme de Nouveau, Paris. **1650–51**. Lost. / Study. National Gallery of Ireland, Dublin, cat. 4197. [Dublin 1985, no. 20—ill.]

————. "The Chariot of Apollo." Design for sculpture group in Fountain of Apollo. Executed in gilded lead by Jean-Baptiste Tubi, by 1671. Gardens, Versailles. [Girard 1985, pp. 288f.—ill.]

Henry Lawes, 1596–1662, attributed (also attributed to William Lawes, *c.*1602–1645). "Stay, Phoebus, Stay." Song. Text, E. Waller. Published in *Ayres and Dialogues* (London: Playford, **1653**). [Grove 1980, 10:558]

Jean de La Fontaine, 1621–1695. "Phoebus et Boréas." Verse fable (book 6 no. 3). In *Fables choisies* (Paris: **1668**). [Clarac & Marmier 1965 / Spector 1988 / Moore 1954]

Gérard de Lairesse, 1641–1711. "Apollo and Aurora." Painting. **1671**. Metropolitan Museum, New York, no. 43.118. [Metropolitan 1980, p. 103—ill.]

Richard Fleckno, ?–*c.*1678. "Go Phoebus Go." Canzonet. **1672**. [Grove 1980, 6:633]

Charles de La Fosse, 1636–1716. "Apollo in a Chariot Pulled by Horses" ("The Rising of the Sun"). Ceiling painting. **Early 1670s**. Salon d'Apollon, Appartement du Roi, Château de Versailles. [Berger 1985, pp. 41ff., 69, fig. 76 / also Girard 1985, pp. 189, 288—ill.] Oil sketches. Musée des Beaux-Arts, Rouen; Musée Cantini, Marseilles, no. 647. [Columbia 1967, nos. 57, 81—ill.] Another work on this subject, "Apollo with the Hours and the Four Parts of the World," by Gilbert de Sève, in Salon d'Apollon, Appartement de la Reine, was destroyed in renovation, *c.*1678–79. [Berger, p. 70]

François Girardon, 1628–1715, with **Thomas Regnaudin**, 1622–1706. "Apollo Tended by the Nymphs" (after returning from his circuit of the sky). Marble sculpture. **1666–75**. Bains d'Apollon, Gardens, Versailles. [Girard 1985, pp. 288f.—ill. / also Francastel 1928, no. 19—ill. / Vermeule 1964, pp. 117, 171—ill.]

————. "Daybreak" (Apollo with torch). Model for marble statue. Executed by Pierre Le Gros, 1693. Gardens, Versailles. [Francastel 1928, no. 58—ill.]

Balthazar Marsy, 1628–1674, and **Gaspard Marsy**, 1629–1681. "The Horses of the Sun." Marble sculpture. **1668–75**. Bains d'Apollon, Gardens, Versailles. [Girard 1985, p. 289—ill.]

Jean Jouvenet, 1644–1717. "Dawn." Drawing, study for ceiling painting. *c.***1675–80**. Kunstbibliothek, Berlin, no. Hdz 6630. [Schnapper 1974, no. 151—ill.]

————. "Dawn." Ceiling painting, for Hôtel de Saint-Poulange, Paris. *c.*1681–84. Destroyed. / Drawing. Schnapper coll., Paris. [Ibid., nos. 19, 153—ill.]

————. "Apollo and Tethys" (wife of Oceanus, from whom Apollo departs to begin his skyward journey).

Painting. 1695. Lost. / Print by C. DuBosc. [Ibid., no. 69—ill.] Anonymous copy in Musée, Rennes. [Ibid.]
———. "Apollo and Tethys." Painting. *c.*1700. Grand Trianon, Versailles. [Ibid., no. 88—ill.]

Luca Giordano, 1634–1705. "Apollo in the Sun Chariot." Painting. *c.*1682–83. Museum of Fine Arts, Boston, no. 46.1566. [Ferrari & Scavizzi 1966, 2:125—ill. / Boston 1985, p. 118—ill.]
———. "Sacrifice to the Sun." Fresco. 1692–1702. Formerly Casón del Buen Retiro, Madrid, lost. / Drawing (for?). British Museum, London, no. 1950.11.11.59. [Ferrari & Scavezzi, 2:256—ill.]

Johann Philipp Krieger, 1649–1725. *Der wiederkehrenden Phöbus* [Phoebus Returning]. Singspiel. First performed **1692,** Weissenfels? [Grove 1980, 10:269]

Mattia Preti, 1613–**1699.** (Apollo in the sun chariot, in) "Allegory of Fortune." Ceiling fresco. Sala dell' Aria, Villa Pamphili, Rome. [Cannata 1978, pl. 9]

Michel Corneille the Younger, 1642–1708. "Apollo and Tethys and Cybele." Painting. Nationalmuseum, Stockholm. [Warburg]

Anne Finch, Countess of Winchilsea, 1661–1720. (Phoebus's course evoked in) "The Consolation." Poem. In *Miscellany Poems on Several Occasions* (London: Taylor & Browne, **1713**). [Fausset 1930, p. 9]

Antonio Caldara, *c.*1670–1736. *Apollo in cielo* [Apollo in the Sky]. Chamber composition. Text, Pariati. First performed **1720,** Vienna. [Grove 1980, 3:615]

Antoine Coypel, 1661–1722 (also attributed to François Perrier, *c.*1590–1650). "Apollo Helios." Drawing. Perce Ward-Jackson coll. [Warburg]

Carlo Innocenzo Carlone, 1686–1775. "Apollo and the Four Seasons." Fresco. **1721–23.** Schloss Hetzendorf, Vienna. [Knab 1977, p. 45, fig. 4]

Jacob de Wit, 1695–1754. "Apollo as Sun God, Making the Plants Thrive." Drawing, study for lost ceiling painting. *c.*1724. [Staring 1958, p. 145, pl. 85]
———. "Apollo and Thetis [Tethys]." Painting. Sold London, 1964. [Warburg]

Giovanni Paolo Panini, 1691–1765. "The Chariot of Apollo." Ceiling fresco. *c.*1725. Galleria Nobile, Palazzo del Senato (formerly Alberoni), Rome. [Arisi 1961, no. 55, pls. 89–90]

Daniel Gran, 1694–1757. "Noon" ("Apollo"). Fresco. **1726–30.** Nationalbibliothek, Vienna. [Knab 1977, pp. 50ff., no. F20—ill.]

Johann Michael Rottmayr, 1654–1730. "Apollo in His Sun Chariot." Ceiling fresco. Sommerpalais Liechtenstein, Vienna. [Pigler 1974, p. 26]

Giuseppe Chiari, 1654–1727/33. "The Chariot of Apollo." Ceiling painting. Palazzo Barberini, Rome. [Warburg]

Robert Le Lorrain, 1666–1743. "The Horses of Apollo." Stone bas-relief, on stable doors, Hôtel de Rohan, Paris. *c.*1740. In place. [Beaulieu 1982, p. 71—ill.]

Giovanni Battista Tiepolo, 1696–1770. "The Course of the (Chariot of the) Sun (on Olympus)." Fresco. **1740.** Palazzo Clerici, Milan. [Levey 1986, pp. 91ff.—ill. / Pallucchini 1968, no. 132—ill. / Morassi 1962, p. 25] Related sketch ("Olympus"). Hausammann coll., Zurich. [Morassi, p. 69—ill.]
———. "Apollo and the Continents" ("Olympus, with the

Quarters of the Earth," "Allegory of the Planets and Continents"). Fresco. 1753. Grand Staircase, Residenz, Würzburg. [Levey, pp. 191ff. / Pallucchini, no. 199—ill. / Morassi, p. 68] Oil sketch, 1752. Metropolitan Museum, New York, no. 1977.1.3. [Levey, pl. 176 / Metropolitan 1983, p. 129—ill. / also Pallucchini—ill.]
———. (Apollo's chariot in) "Allegory of Marriage." Ceiling fresco. *c.*1758. Ca' Rezzonico, Venice. [Pallucchini, no. 245—ill.]
———, attributed (or F. A. Krauss?). "The Chariot of Apollo." Painting. Early work if by Tiepolo. Musée des Beaux-Arts, Troyes. [Morassi, p. 51]

Edward Young, 1683–1765. (Eclipse of the sun god, who covers his eyes so as not to see the crucifixion, in) *The Complaint, or Night Thoughts on Life, Death, and Immortality* Night Four, lines 246–57. Poem. London: Dodsley, **1742–45;** London: Tegg, 1812. [Ipso]

Giuseppe Bazzani, 1690/1701–1769. "Phoebus." Painting. *c.*1750. Kress coll. (K1270), Mead Art Gallery, Amherst College, Mass. [Shapley 1966–73, 3:115—ill.]

Franz Anton Maulbertsch, 1724–1796. "Allegory of Time and Truth" (chariot of Apollo, led by Hermes and Veritas, driving away night-demons). Painting, sketch for a ceiling. *c.*1750. Wallraf-Richartz-Museum, Cologne. [Garas 1960, no. 23, p. 13—ill.]
———. "Triumph of Apollo: Allegory." Drawing, study for a ceiling painting. *c.*1754. Albertina, Vienna. [Ibid., no. 58, p. 32]
———. "Triumph of Apollo" (allegory of the hours of the day?). Ceiling painting. 1765. Schloss, Halbturn, Austria. [Ibid., no. 175—ill.]

Corrado Giaquinto, 1703–1765. "Triumph of the Sun God Apollo and Bacchus" (with Aurora, Ceres, Venus, Diana, Pan, and others). Ceiling painting. **Mid-1700s.** Salón de Columnas, Palacio Real, Madrid. [Honisch 1965, pp. 39f.]
———. "The Birth of the Sun and the Triumph of Bacchus." Painting. Prado, Madrid, inv. 103. [Prado 1985, p. 243]

Jacopo Amigoni, 1675–1752. "Apollo in His Sun Chariot." Ceiling fresco. Schloss Nymphenburg, near Munich. [Pigler 1974, p. 26]

François Boucher, 1703–1770. "The Chariot of Apollo." Ceiling painting. 1753. Salle de Conseil, Palais de Fontainebleau. [Ananoff 1976, no. 417—ill.]
———. "The Rising of the Sun," "The Setting of the Sun" (Apollo rising from, returning to Tethys's couch). Pendant paintings, models for tapestries. 1753. Wallace Collection, London, nos. P.485, P.486. [Ibid., nos. 422–23—ill.] Tapestries, executed 1758, 1759 by Cozette, for Marquise de Pompadour. Lost. [Ibid.]

Ferdinand Dietz, ?–*c.*1780. "Apollo Helios." Marble bust. **1764.** Schloss Seehof, near Bamberg. [Warburg]

Corrado Giaquinto, 1700–**1765.** "The Birth of the Sun and the Triumph of Bacchus." Painting. Prado, Madrid, inv. 103. [Prado 1985, p. 243]

Thomas Gray, 1716–1771. "Phoebus." Poem. In *Poems* (Dublin: Sleater, 1775). [Bush 1937, p. 53]

Louis-Jean-Jacques Durameau, 1733–1796. "Summer" ("Ceres and Her Companions Imploring the Sun [Apollo]"). Painting. **1774.** Galerie d'Apollon, Louvre,

Paris, inv. 4326. [Louvre 1979–86, 3:242—ill. / Rosenberg 1988, p. 225—ill.]

Jean-Antoine Houdon, 1741–1828. "Apollo" (head, as sun god). Plaster bas-relief. Exhibited Salon of **1781.** [Réau 1964, no. 257] Replica? 1792. Léopold Gouvy coll. [Ibid., no. 274]

William Blake, 1757–1827. Drawing, illustrating Edward Young's *Night Thoughts* 4.247–53 (1742–45). *c.*1795–97. British Museum, London, no. 1929–7–13–63v. [Butlin 1981, no. 330.125] Variant drawing, illustrating Blake's *Vala, or the Four Zoas,* Night IV. *c.*1797–1807. British Library, London, MS 39764. [Ibid., no. 337.47]

―――. "The Overthrow of Apollo and the Pagan Gods." Watercolor, illustrating Milton's "On the Morning of Christ's Nativity" (1629). 2 versions: 1809, Whitworth Art Gallery, University of Manchester; *c.*1815, Huntingdon Library and Art Gallery, San Marino, Calif. [Butlin, nos. 538.4, 542.4—ill.]

―――. "When the Morning Stars Sang Together" (Helios and Selene representing Time in God's description of the creation). Drawing, after the Bible, *Job* 38:4–7. *c.*1805–26. Pierpont Morgan Library, New York. [Butlin, no. 550.14—ill.]

William Wordsworth, 1770–1850. (Apollo in his chariot evoked in) *The Waggoner* 4.108–15. Poem. **1805.** London: Longman & Co., 1819. [De Selincourt 1940–66, vol. 2]

―――. (Apollo as sun god evoked in) *The Excursion* 4.847–60. Poem. Begun by 1806. London: Longman & Co., 1814. [Ibid., vol. 5]

John Flaxman, 1755–1826. (Apollo in the sun chariot in) "Ancient Drama" (Muses, Pegasus, Orestes and Furies, Apollo's chariot, and others, flanking Aristophanes, Menander, and Aeschylus). Frieze, for façade of Covent Garden Theatre, London. **1809.** Royal Opera House, London. [Irwin 1979, pp. 172–74—ill.]

―――. (Apollo's sun chariot depicted on) "The Shield of Achilles." Design for relief on silver-gilt shield, after the description in *Iliad* 18.478–607. *c.*1810–18. 4 examples executed by Rundell, Bridge & Rundell Co., 1821–23. Royal Collection, England; Anglesey Abbey, Cambridgeshire; Huntington Art Gallery, San Marino, Calif.; 1 unlocated. [Jackson-Stops 1985, no. 529—ill. / Irwin, pp. 194ff., figs. 270, 273–75 / Bindman 1979, no. 187—ill.]

Andrea Appiani the Elder, 1754–1817. "The Chariot of Apollo." Fresco. **1811.** Villa Reale, Milan. [Bénézit 1976, 1:236]

John Keats, 1795–1821. "God of the Meridian." Poem, in a letter to John Hamilton Reynolds, 31 Jan **1818.** First published in *Life, Letters, and Literary Remains of John Keats,* edited by Richard Monckton Milnes (London: Moxon, 1848). [Stillinger 1978 / Vendler 1983, pp. 79f.]

―――. "Apollo to the Graces" (Apollo invites the Graces to ride in the sun chariot). Poem. 1818. First published in *Times Literary Supplement* 16 Apr 1914. [Stillinger 1978 / De Selincourt 1951, pp. 385, 563 / Vendler, p. 249]

Percy Bysshe Shelley, 1792–1822. "Hymn of Apollo." Poem. **1820.** In *Posthumous Poems,* edited by Mary Shelley (London: Hunt, 1824). [Hutchinson 1932 / Webb 1976, pp. 105, 156]

―――. "Homer's Hymn to the Sun." Translation of Homeric Hymn to Helios. 1818. In *Poetical Works,* edited by Mary Shelley (London: Moxon, 1839). [Hutchinson]

Peter Cornelius 1783–1867, and studio. "Noon" (Helios on the sun chariot). Fresco. **1820–26.** Ceiling, Göttersaal, Glyptothek, Munich. [Glyptothek 1980, pp. 214ff., no. 254—ill.]

César Franck, 1822–1890, doubtfully attributed. "Blond Phébus." Song. **1835.** [Grove 1980, 6:783]

Leigh Hunt, 1784–1859. "Apollo and the Sunbeams." Poem. **1836.** In *Poetical Works* (London: Oxford University Press, 1923). [Bush 1937, p. 176 *n.*]

Horatio Greenough, 1805–1852. Relief depicting Apollo's chariot, on side of chair in "Washington." Marble sculpture. **1832–41.** National Collection of Fine Arts, Washington, D.C. [Wright 1963, p. 133—ill.]

Aubrey De Vere, 1814–1902. "Sunrise" ("The Sun God"). Poem. In *The Search after Proserpine, Recollections of Greece, and Other Poems* (Oxford: Parker, **1843**); reprinted as "The Sun God" in *Poetical Works* (London: Kegan Paul, Trench, 1884). [Bush 1937, p. 273]

Jean-François Millet, 1814–1875. "Phoebus and Boreas" (evocative title: windy land- and sea-scape). Drawing. *c.*1851. [Lepoittevin 1973, fig. 75]

Charles Marie René Leconte de Lisle, 1818–1894. "Le réveil d'Hélios" [Phoebus Awakes]. Poem. In *Oeuvres: Poèmes antiques* (Paris: Lemerre, **1852**). [Pich 1976–81, vol. 1]

Charles Baudelaire, 1821–1867. "Le soleil" [The Sun]. Poem. In *Les fleurs du mal* (Paris: Poulet-Malassis & de Broise, **1857**). [Pichois 1975] Translated by Edna St. Vincent Millay in *The Flowers of Evil* (New York: Washington Square Press, 1936; 1962). [Ipso]

José-Maria de Heredia, 1842–1905. "Au soleil" [To the Sun]. 2 poem fragments. **1859–63.** [Delaty 1984, vol. 2]

Frederic, Lord Leighton, 1830–1896. "Helios and Rhodos" (embracing, symbolizing the creation of Rhodes). Painting. *c.*1869. Formerly Tate Gallery, London, destroyed. [Ormond 1975, no. 190]

Arnold Böcklin, 1827–1901. "Apollo." Wall fresco. **1869–70.** Museum an der Augustine-gasse, Basel. [Andree 1977, no. 220—ill.]

Antoine-Louis Barye, 1796–1875. "Apollo Driving the Chariot of the Sun." Bronze clock. [Pivar 1974, no. F44]

Gustave Moreau, 1826–1898. "Phoebus and Boreas." Watercolor, illustrating La Fontaine's fable. **1879.** Private coll. [Mathieu 1976, no. 202—ill.] Painting, variant ("Phoebus-Apollo"). *c.*1880. Sold Paris, 1964. [Ibid., no. 265—ill.]

Hans Makart, 1840–1884. "The Victory of Light over Darkness" ("Apollo Driving Ignorance over the Abyss"). Painting, sketch for unexecuted ceiling painting for Kunsthistorisches Museum, Vienna. **1883–84.** Österreichische Galerie, Vienna, inv. 3756. [Frodl 1974, no. 444—ill.] Earlier version. *c.*1882–84. Österreichische Galerie, inv. Lg.12. [Ibid., no. 424—ill.]

Valentin Serov, 1865–1911. "Phoebus Effulgent." Ceiling painting. **1887.** Art Museum, Tula, Russia. [Sarabyanov & Arbuzov 1982, no. 127]

Gabriele D'Annunzio, 1863–1938. (Helios evoked in) "Donna Francesca" lines 9–17. Poem. **1885–88.** In *La chimera* (Milan: Treves, 1890). [Palmieri 1953–59, vol. 2]

Francis Thompson, 1859–1907. "Ode to the Setting Sun." Poem. **1889**. In *New Poems* (London: Burns & Oates, 1897). [Bush 1937, p. 563 / Boswell 1982, p. 303]

Auguste Rodin, 1840–1917. Apollo in the sun chariot, relief in pedestal of "Monument to Claude Lorrain." Bronze sculpture with stone pedestal. **1889–92**. Jardin de la Pépinière, Nancy. [Tancock 1976, p. 410—ill.] Bronze proofs. 1889. Musée Rodin, Paris; Rodin Museum, Philadelphia. [Ibid., no. 70—ill. / Rodin 1944, no. 228—ill.]

Odilon Redon, 1840–1916. "He falls into the abyss, head downwards" (Apollo falling from his chariot). Lithograph, illustration to Flaubert's *La tentation de Saint-Antoine* V, third series, no. XVII (Paris: **1896**). [Mellerio 1913, no. 151—ill.]

———. "Apollo's Sun Chariot." Painting. At least 12 versions, 1905–10. Petit Palais, Paris; Metropolitan Museum, New York; Musée des Beaux-Arts, Bordeaux; Yale University Art Gallery, New Haven; private colls. [Ibid., nos. 153–64—ill. / also Metropolitan 1980, p. 148—ill. / Hobbs 1977, fig. 92—ill.]

Briton Riviere, 1840–1920. "Phoebus Apollo" (in chariot drawn by lions). Painting. **1895–98**. Birmingham City Art Gallery, England. [Wood 1983, p. 218—ill. / Kestner 1989, p. 234, pl. 4.22]

Stéphane Mallarmé, 1842–**1898**. "To Apollo" [English title of work written in French]. Poem. / Translated by Arthur Ellis in *Stéphane Mallarmé in English Verse* (London: Cape, 1977). [Ipso]

Gerhart Hauptmann, 1862–1946. "Helios." Dramatic fragment. **1899**. / Translated by Ludwig Lewisohn in *Dramatic Works*, vol. 7 (New York: Huebsch, 1917). [DLB 1988, 66:156 / DLL 1968–90, 7:521]

Carl Nielsen, 1865–1931. *Helios*. Overture, opus 17. **1903**. [Grove 1980, 13:229]

Rubén Darío, 1867–1916. "Helios." Poem. In *Cantos de vida y esperanza: Los Cisnes y otros poemas* (Madrid: Tipografía de la Revista de Archivos, Biliotecas y Museos, **1905**). [Méndez Plancarte 1967 / Jrade 1983, pp. 116–26]

———. (Phoebus-Apollo celebrated in) "El canto a la Argentina." Poem. In *Canto a la Argentina y otros poemas* (Madrid: Biblioteca Corona, 1914). [Méndez Plancarte / Hurtado Chamorro 1967, pp. 128–30]

———. (Apollo as sun god in) "Lirica." Poem. 1902. In *El canto errante* (Madrid: Perez Villavicencio, 1907). [Méndez Plancarte / Jrade, p. 48 / Ellis 1974, p. 59]

Alexander Mackenzie, 1847–1935. *The Sun God's Return*. Cantata, opus 69. Libretto, J. Bennett. First performed **1910**, Cardiff Festival. [Grove 1980, 11:442]

Michael Field (**Katherine Harris Bradley**, 1848–**1914**, and **Edith Cooper**, 1862–1943). "Gold is the Sun of Zeus." Poem. In *A Selection from the Poems of Michael Field* (Boston: Houghton Mifflin, [Boswell 1982, p. 245]

Friedrich Gernsheim, 1839–**1916**. "Phoebus Apollon." Vocal composition, opus 58. Text, H. Allmers. [Grove 1980, 7:300]

Lovis Corinth, 1858–1925. "Apollo and the Rosy-fingered Eos." Etching, in "Antique Legends" series. **1919**. [Schwarz 1922, no. 351.II]

H. D. (Hilda Doolittle), 1886–1961. "Helios and Athene." Set of 4 prose epigrams. **1920**. In *Iowa Review* 12 (Spring/Summer 1981). [Martz 1983]

———. "Helios." Poem. In *Collected Poems* (New York: Boni & Liveright, 1925). [Ibid. / Boswell 1982, p. 92]

Alfred Noyes, 1880–1958. "The Inn of Apollo." Poem. In *The Elfin Artist and Other Poems* (New York: Stokes, **1920**). [Boswell 1982, p. 198]

John Peale Bishop, 1892–1944. "Epilogue" (prayer to Phoebus Apollo). Poem. In *The Undertaker's Garland and Other Poems* (New York: Knopf, **1922**). [Boswell 1982, p. 42]

Raoul Dufy, 1877–1953. "The Horses of Apollo." Gouaches (9 color variations), design for fabric. *c*.**1918–24**. Maison Bianchini-Férier, Lyons. [Arts Council 1983, no. 350]

Theodor Däubler, 1876–1934. (Apollo as sun god invoked in) *Päan und Dithyrambos: Eine Phantasmagorie* [Paean and Dithyramb: A Phantasmagoria] part 1. Poem. Leipzig: Insel, **1924**. [Ipso / DULC 1959–63, 1:964]

John Singer Sargent, 1856–1925. "Apollo in His Chariot with the Hours." Painting, part of mural series. **1921–25**. Museum of Fine Arts, Boston. [Ratcliff 1982, p. 148—ill.]

Francis Picabia, 1878–1953. "Phoebus" ("Punishment of Kore"?). Painting. *c*.**1927**. Private coll. [Camfield 1979, p. 225 *n*. 34, fig. 286 / also Borràs 1985, no. 436—ill.]

———. "Phoebus." Surrealistic painting. *c*.1930. [Borràs, no. 563—ill.]

———. "Apollo and His Steeds" ("Hercules and His Coursers"). Painting. 1935. [Ibid., no. 650—ill. / Camfield, fig. 371]

Franz von Stuck, 1863–1928. "Helios." Painting. *c*.**1927**. Clemens-Sels-Museum, Neuss. [Voss 1973, no. 607—ill.]

Georges Braque, 1882–1963. "Helios" ("The Chariot"). Painting. **1930**. Buchheim Galerie, Feldafing. [Hannover 1950, no. 16—ill.]

———. "Helios." Etched-plaster relief, after Hesiod. 1931. [Fumet 1951, intro., cf. nos. 21–28—ill.]

———. "Helios." 6 color lithographs (no. 6 also called "Hera"). 1946–48. [Braque 1961, nos. 21–24, 28–29—ill.]

———. "The Chariot of the Sun." Plaster relief. 1952. [Cogniat 1980, fig. 29]

Cesare Pavese, 1908–1950. (Apollo, god of summer, in) "Mito" [Myth]. Poem. In *Lavorare stanca* (Florence: Solaria, **1936**). / Translated by William Arrowsmith in *Hard Labor* (New York: Grossman, 1976). [Biasin 1968, pp. 13f.]

Edwin Scharff, 1877/87–1955. "Helios." Painting. **1947**. [Hannover 1950, no. 122]

Ezra Pound, 1885–1972. (Apollo as sun god evoked in) Cantos 76, 83, in *The Pisan Cantos* (New York: New Directions, **1948**). [Terrell 1980–84, 2:390 / Quinn 1972, p. 139]

Henri Matisse, 1869–1954. "Apollo." Ceramic sculpture. **1953**. Sold Sotheby's, London, 1968. [Warburg]

Ulysses Kay, 1917–. *Phoebus, Arise*. Cantata. Text from Thomas Hood, Lord Herbert of Cherbury, William Drummond, Thomas Middleton, William Rowley, Abraham Cowley. **1958**. [Grove 1980, 9:834]

Robert Rauschenberg, 1925–. "Gift for Apollo" (wooden "chariot" anchored by a bucket). Assemblage. **1959**. Panza coll., Milan. [Smithsonian 1976, no. 73—ill.]

Elsa Marianne von Rosen, 1927–, choreography. *Helios*.

Ballet. Music, Nielsen. First performed **1960**, Stockholm. [Oxford 1982, p. 353]

Marianne Moore, 1887–1972. "Sun." Poem. In *A Marianne Moore Reader* (New York: Viking, **1961**). [Ipso]

John Hall Wheelock, 1886–1978. "Helios-Apollo." Poem. In *The Gardener and Other Poems* (New York: Scribner, **1961**). [Boswell 1982, p. 235]

———. "Helios." Poem. In *Dear Men and Women* (New York: Scribner, 1966). [Ibid.]

Giorgio de Chirico, 1888–1978. "The Chariot of the Sun." Drawing. **1970.** Artist's coll., Rome, in 1972. [de Chirico 1972, no. 117—ill.]

Margaret Ruthven Lang, 1867–1972. *Phoebus.* Cantata. [Cohen 1987, 1:397]

William Mathias, 1934–. *Helios.* Composition for orchestra, opus 76. **1977.** [Grove 1980, 11:822]

Stanley Kunitz, 1905–. "The Flight of Apollo." Poem. By **1978.** In *Poems 1928–1978* (Boston: Little, Brown, 1979). [Boswell 1982, p. 266]

Claudio Parmiggiani, 1943–. "Phoebus." Assemblage (plaster head, mussel-shell, butterflies, palette, canvas). **1979.** [Reggio Emilia 1985, p. 131—ill.]

Apollo and Python.

According to the Homeric Hymn, Apollo descended from Mount Olympus and chose the site of Delphi for the location of his oracle. He laid out the foundations of his temple, and at the spring nearby he slew a female dragon. The spot was called Pytho (from the ancient Greek *pytho,* "to rot") because the sun's rays caused the carcass to rot, and the god was given the epithet "Pythian" Apollo.

Other versions of the story credit Apollo with killing a male dragon, or serpent, called Pytho or Python. According to Ovid, Apollo killed a serpent that sprang from the stagnant water remaining after a deluge sent by Zeus. In some accounts the serpent was a son of Gaia. In others it was sent by Hera to persecute Leto while she was pregnant with Apollo and Artemis; as soon as Apollo was born, he killed the serpent.

Apollo slaying Python, who is usually represented as a serpent rather than a dragon, is a popular theme in the visual arts of all periods. The story in which the infant Apollo kills the serpent is often shown in classical vase painting.

Classical Sources. *Homeric Hymns,* "To Pythian Apollo" 281–374. Pindar, *Pythian Odes* 3.1–67, 9.1–70. Ovid, *Metamorphoses* 1.437–49. Pausanias, *Description of Greece* 2.7.7, 2.30.3–33.2

Anonymous French. (Apollo's defeat of Python in) *Ovide moralisé* 1.2647–2678. Poem, allegorized translation/elaboration of Ovid's *Metamorphoses.* *c.*1316–28. [de Boer 1915–86, vol. 1]

Giorgione, *c.*1477–**1510,** questionably attributed. "Apollo

and Python." Painting. Seminario Patriarcale, Venice. [Warburg]

Baldassare Peruzzi, 1481–**1536,** composition. Apollo slaying Python, depicted in first of "Apollo and Daphne" series of engravings, executed by "Maestro del Dado" (Bartsch 15:196ff., no. 19). [Frommel 1967–68, no. 37—ill.]

Luca Cambiaso, 1527–1585. "Apollo Killing Python." Fresco. **1544.** Palazzo della Prefettura, Genoa. [Manning & Suida 1958, pp. 74f.]

Francesco Primaticcio, 1504–1570, and assistants. "Apollo Slaying the Serpent Python." Ceiling fresco, in Galerie d'Ulysse, Château de Fontainebleau. **1541–47.** Destroyed 1738–39. [Béguin et al. 1985, p. 158 / Dimier 1900, pp. 295ff.] Related (?) engraving, by Étienne Delaune. [Béguin, fig. 48]

Giovanni Francesco Rustici, 1474–**1554,** doubtfully attributed. "Apollo and the Secret Python." Bronze statue. Louvre, Paris. [Pope-Hennessy 1985b, 3:340]

Bernard Salomon, 1506/10–*c.*1561. "Apollo and Python." Woodcut, part of a cycle illustrating Ovid. In *Les Metamorphoses d'Ovide figurée* (Lyons: Tivornes, **1557**). [Warburg]

Roman School. "Apollo and Python." Carved wood relief. **1570.** Victoria and Albert Museum, London. [Pigler 1974, p. 37]

Bernardo Buontalenti, 1536–1608. "Apollo Slaying Python." Drawing. **1589.** Uffizi, Florence. [Warburg]

Emilio de' Cavalieri, *c.*1550–1602, **Giovanni dei Bardi,** 1534–1612, and others, choreography. "Apollo's Pythian Combat." Third interlude in *La pellegrina.* Ballet. Music, Cavalieri, Luca Marenzio, Jacopo Peri, Giulio Caccini, and others. First performed 2 May **1589,** Florence; settings and machines by Bernardo Buontalenti. [Simon & Schuster 1979, pp. 45f. / Grove 1980, 2:150f.; 4:20ff.]

Hendrik Goltzius, 1558–1617, composition. "Apollo Killing Python." Engraving, part of a set illustrating Ovid's *Metamorphoses* (1st series, no. 13), executed by assistant(s). *c.***1589.** (Unique impression in British Museum, London.) [Bartsch 1980–82, no. 0302.43—ill.]

Agostino Carracci, 1557–1602. "Apollo and the Dragon." Etching/engraving (Bartsch no. 122) after composition by Andrea Boscoli (?) after B. Buontalenti. **1589–95.** [DeGrazia 1984, no. 154—ill.]

Domenichino, 1581–1641, and assistant. "Apollo and Python." Fresco, part of "Life of Apollo" cycle. **1616–18.** Villa Aldobrandini (Belvedere), Frascati. [Spear 1982, no. 55.ii—ill.]

Anonymous French. *La Victoire du Phébus françois contre le Python de ce temps* [Victory of the French Phoebus against the Modern Python]. Tragedy (political satire on the assassination of Maréchal d'Ancre). Rouen: Mallart, [*c.*1618]. [Taylor 1893, pp. 296f.]

Giovanni da San Giovanni, 1592–1636. "Apollo Slaying Python, with Cupid." Monochrome fresco, simulated bas-relief. **1635–36.** Salone degli Argenti, Palazzo Pitti, Florence. [Banti 1977, no. 64, pl. 144]

Simon Vouet, 1590–1649. "Apollo Slaying Python." Decoration for Gallery of Hôtel Séguier, Paris. **1633–38.** Lost. Engraved by Michel Dorigny, 1651. [Crelly 1962, pp. 112ff., no. 248F—ill.]

Peter Paul Rubens, 1577–1640. "Apollo and Python."

("Apollo Bested by Cupid"). Painting, for Torre de la Parada, El Pardo, executed by Cornelis de Vos from Rubens's design. **1636–38.** Prado, Madrid, no. 1861. [Alpers 1971, no. 2—ill. / Jaffé 1989, no. 1233—ill. / Prado 1985, p. 593] Oil sketch, by Rubens. Prado, Madrid, no. 2040. [Alpers, no. 2a—ill. / Held 1980, no. 167—ill. / Jaffé, no. 1232—ill. / Prado, p. 766]

Jan Boeckhorst, 1605–1668, attributed (previously attributed to Anthony van Dyck, 1599–1641). "Apollo and Python." Painting (sketch for "History of Apollo" tapestry series?). **1630s.** Museum voor Schone Kunsten, Ghent. [Larsen 1988, no. A184—ill.]

Pietro da Cortona, 1596–1669. "Apollo and Python." High-relief stucco, part of series depicting stories of Apollo. Begun **1645–47,** unfinished, completed 1659–61 by Ciro Ferri. Sala di Apollo, Palazzo Pitti. [Campbell 1977, pp. 108ff.—ill. / also Pitti 1966, pp. 79f.—ill.]

François Girardon, 1628–1715. "Louis XIV as Apollo, Conqueror of Python." Marble statue. *c.*1653? Lost. [Francastel 1928, no. 93]

Joachim von Sandrart, 1606–1688. "Apollo and the Serpent Python." Painting. *c.*1650–60? Uffizi, Florence, inv. 1097. [Uffizi 1979, no. P1415—ill.]

Nicolas Poussin, 1594–1665. "Apollo Sauroctonos" (previously known as "Apollo and Daphne"). Drawing, depicting scene from Pliny, *Historia naturalis* 34.70. **1664–65.** Louvre, Paris, no. 761. [Friedlaender & Blunt 1953, no. 177—ill.]

John Milton, 1608–1674. (Serpent in Eden compared to Python in) *Paradise Lost* 10.528–32. Epic. London: Parker, Boulter & Walker, **1667.** [Carey & Fowler 1968 / Du Rocher 1985, pp. 119–121]

Charles Le Brun, 1619–1690. (Apollo standing over slain Python in) Design for ceiling decoration of Escalier des Ambassadeurs, Château de Versailles. Executed by assistants by **1679,** demolished 1752. [Berger 1985, pp. 29ff., 38—ill.]

———. (Apollo and Python in) Design for a fountain. [Pigler 1974, p. 38]

Willem van Mieris, 1662–1747. "Apollo Slaying Python." Drawing. **1690.** Pierpont Morgan Library, New York. [Warburg]

Jean Raon, 1630–1707. "Apollo Trampling Python Underfoot." *c.*1699. Marble sculpture group. Waddesdon Manor, Buckinghamshire. [Warburg]

French School. "Apollo Slaying Python." Drawing. **Late 17th century.** Bibliothèque Nationale, Paris. [Warburg]

Italian School. "Apollo Slaying Python." Overdoor relief. *c.*1716. Great Marble Hall, Unteres Belvedere, Vienna. [Pigler 1974. p. 37]

François-Gaspard Adam, 1710–1761. "Apollo Seated on Python." Statue, part of mythological cycle. **1755–58.** Gardens, Sanssouci, Potsdam. [Thirion 1885, pp. 161f.—ill.]

Prosper-Didier Deshayes, *c.*1750–1815. "Défaite du serpent Python par Apollon" [Defeat of the Serpent Python by Apollo]. Lyric scene. First performed **1786.** [Grove 1980, 5:389]

Joseph Mallord William Turner, 1775–1851. "Apollo and Python." Painting. Exhibited **1811.** Tate Gallery, London, no. 488. [Butlin & Joll 1977, no. 115—ill.].

———. "Apollo and Python," "The Monstrous Python."

Poems. In *The Sunset Ship,* edited by Jack Lindsay (Lowestoft, Suffolk: Scorpion, 1966). [Boswell 1982, p. 305]

Eugène Delacroix, 1798–1863. "Apollo Destroying the Serpent Python." Ceiling painting. **1850–51.** Gallerie d'Apollon, Louvre, Paris (inv. 3818). [Huyghe 1963, pl. 304 / Louvre 1979–86, 3:199—ill. / also Harding 1979, pp. 12, 132—ill. / Robaut 1885, no. 1118] Sketch. Musées Royaux des Beaux-Arts (Musée d'Art Moderne), Brussels, inv. 1727. [Brussels 1984b, p. 162—ill.]

Matthew Arnold, 1822–1888. (Apollo's defeat of Python recalled in) *Empedocles on Etna* 2.1.191–207. Dramatic poem. In *Empedocles on Etna, and Other Poems* (London: Fellowes, **1852**). [Allott & Super 1986 / Tinker & Lowry 1940, p. 287]

Herman Melville, 1819–1891. (Apollo and Python evoked in) "On the Slain Collegians" stanza 3. Poem. In *Battle Pieces and Aspects of the War* (New York: Harper, **1866**). [Ipso]

Richard Watson Dixon, 1833–1900. "Apollo Pythius." Poem. In *Odes and Eclogues* (London: Daniel, **1884**). [Boswell 1982, p. 86 / also Bush 1937, pp. 413, 561]

Gustave Moreau, 1826–1898. "Apollo Victorious over the Serpent Python." Painting. *c.*1885. National Gallery of Canada, Ottawa. [Mathieu 1976, no. 333—ill.] Oil sketch. Musée Gustave Moreau, Paris. [Ibid.]

Elihu Vedder, 1836–1923. "Apollo and Python." Painting. *c.*1886? University of Virginia Museum of Fine Arts, Charlottesville. [Soria 1970, no. 423] Oil sketch. Fleischman coll. [Ibid., no. 424]

Auguste Rodin, 1840–1917. "Apollo Crushing the Serpent Python" (symbolizing the victory of enlightenment over ignorance). Stone pedestal figure for monument to President Sarmiento. **1894–96.** Park of the Third of February, Buenos Aires. [Tancock 1976, 460ff.—ill. / also Agard 1951, fig. 6] Plaster study. Musée Rodin, Paris. [Ibid.—ill.] Plaster cast. *c.*1922? Musée Rodin, Paris. [Rodin 1944, no. 274—ill.]

Apollo as Shepherd and Herdsman. As god of herdsmen and shepherds, Apollo is known by the epithet "Nomius" ("of the pastures"). In this role he is most often portrayed in his service as the shepherd of Admetus, the king of Pherae in Thessaly.

Furious with Zeus (Jupiter) for killing his son Asclepius (Aesculapius), Apollo took revenge by slaying the Cyclopes who manufactured Zeus's thunderbolts. As punishment, he was banished from Mount Olympus for a year and obliged to tend the herds of Admetus as the king's mortal servant. A pious man, Admetus treated the god with respect and benevolence and won his friendship. Because of their amity, Apollo interceded when he learned that Admetus's life was about to end, persuading the Fates to spare him in exchange for someone else. The bargain resulted in the sacrifice of Admetus's

wife, Alcestis, who willingly gave up her life for her husband.

In a popular postclassical confabulation of two myths, the tale of Apollo's service to Admetus is combined with a legend told in the Homeric Hymn to Hermes, in which the infant Hermes (Mercury) steals fifty head of cattle from Apollo's own herd. This conflation is common in fine art treatments depicting Hermes stealing off with the cattle while Apollo guards them.

Classical Sources. Homeric Hymns, first hymn "To Hermes." Euripides, *Alcestis* 1ff. Ovid, *Metamorphoses* 2.677ff., 6.122. Apollodorus, *Biblioteca* 1.8.2, 1.9.14–16, 3.10.2–4.

See also ALCESTIS; HERMES, Infancy.

Cornelis Cornelisz van Haarlem, 1562–1638. "Apollo before the Tribunal of the Gods" (answering to the killings of the Cyclopes?). Painting. **1594.** Prado, Madrid, no. 2088. [Prado 1985, p. 326]

Francis Bacon, 1561–1626. "Cyclopes, sive ministri terroris" (slain by Apollo in revenge for the death of Aesculapius). Chapter 3 of *De sapientia veterum.* Mythological compendium. London: Barker, **1609.** / Translated as "Cyclopes, or the Ministers of Terror" by Arthur Gorges in *The Wisdome of the Ancients* (London: Bill, 1619). Modern facsimile edition (bilingual), New York & London: Garland, 1976. [Ipso]

Domenichino, 1581–1641, and assistant(s). "Apollo Killing the Cyclopes." Fresco (detached), part of "Life of Apollo" cycle, from Villa Aldobrandini, Frascati. **1616–18.** National Gallery, London, inv. 6290. [Spear 1982, no. 55.iii—ill. / London 1986, p. 163—ill.]

Adam Elsheimer, 1578–1610, school (also attributed to Bartholomeus Breenbergh, Cornelis van Poelenburgh). "Apollo and the Flocks of Admetus." Painting. *c.*1620. Uffizi, Florence, inv. 1080. [Uffizi 1979, no. P574—ill. / also Röthlisberger 1981, no. 27 (attributed to van Poelenburgh)—ill.]

Nicolas Poussin, 1594–1665. "Apollo Guarding the Herds of Admetus." Drawing, illustrating Ovid, for G. B. Marino (for unpublished edition of *Metamorphoses?*). *c.*1620–23. Royal Library, Windsor Castle, no. 11947. [Friedlaender & Blunt 1953, no. 159—ill.]

———. "Apollo Guarding the Herds of Admetus." 2 drawings. École des Beaux-Arts, Paris, no. 2866; Royal Library, Turin, no. 16295. [Ibid., nos. 178–79—ill.]

Lorenzo Ratti, *c.*1590–1630. *Il Ciclope, overo della vendetta d'Apolline* [The Cyclops, or the Vendetta of Apollo]. Opera (dramma harmonico). First performed **1628,** Collegio Germanico e Ungarico, Rome. [Grove 1980, 15:600]

Joachim Wtewael, 1566–1638. "Apollo [as a shepherd] Playing the Flute." Drawing. Rijksmuseum, Amsterdam. [de Bosque 1985, p. 156—ill.]

Antonio Maria Vassallo, fl. 1637–48. "Apollo as a Shepherd." Painting. Museum of Fine Arts, Boston, no. 36.893. [Boston 1985, p. 289—ill.]

Francesco Albani, 1578–1660. "Apollo Guarding the Herds of Admetus." Painting. Château de Fontainebleau, (on deposit from Louvre, Paris, inv. 13). [Louvre 1979–86, 2:283]

Petronio Franceschini, 1650–1680. *Apollo in Tessaglia* [Apollo in Thessaly]. Opera (dramma per musica). Libretto, T. Stanzani. First performed 27 May **1679,** Teatro Formagliari, Bologna. [Grove 1980, 6:771]

[?] Boucher, libretto. *Apollon berger chez Admète* [Apollo. Shepherd of Admetus]. Pastorale. Composer unknown. Mentioned in **1682,** otherwise unknown. [DLF 1951–72, 3:193 / Lancaster 1929–42, pt. 4, 2:924]

Italian School. "Apollo as a Shepherd." Painting. **17th century.** Staffordshire County Museum, Shugborough. [Wright 1976, p. 103]

Johann Franz Michael Rottmayr, 1654–1730. "Apollo in Laurel Wreath and with Lyre, with the Mares of Admetus, the Muses, and Hercules" (?). Painting. Art Institute of Chicago, no. 61.39. [Chicago 1965]

Giovanni Verocai, *c.*1700–1745. *Apollo fra pastori* [Apollo among the Shepherds]. Opera. First performed 1746, Braunschweig. [Grove 1980, 19:674]

François Lupien Grenet, *c.*1700–1753, music. "Apollon, berger d'Admète" [Apollo, Shepherd of Admetus]. New act for *Le triomphe de l'harmonie.* Ballet héroïque. First performed **1745,** Paris. [Grove 1980, 7:702]

———. "Apollon, berger d'Admète." Musical fragment, part of *Les fragments héroïques.* Text, Louis Fuzelier. First performed 20 July 1759, Paris. [Ibid., 7:47]

Giovanni Porta, *c.*1690–1755. *Apollo in Tempe.* Cantata. [Grove 1980, 15:133]

Hyacinthe Colin de Vermont, 1693–1761. "Apollo as Herdsman of Admetus." Drawing. Louvre, Paris. [Pigler 1974, p. 34]

Alessandro Felici, 1742–1772. *Apollo in Tessaglia* [Apollo in Thessaly]. Cantata. Text, L. Semplici. First performed 12 Mar **1769,** Corso de'Tintori, Florence. [Grove 1980, 6:457]

Anton Schweitzer, 1735–1787. *Apollo unter den Hirten* [Apollo among the Shepherds]. Prelude with songs. Text, Johann Georg Jacobi. First performed 4 June **1770,** Halberstadt, for birthday of King George III of England. [DLL 1968–90, 8:428 / Grove 1980, 17:46]

Carl David Stegmann, 1751–1826. *Apollo unter den Hirten.* Prelude with songs. First performed **1776,** Königsberg. [Grove 1980, 18:101]

Sébastien Gallet, 1753–1807, choreography. *Apollon berger* [Shepherd Apollo]. Ballet-divertissement. First performed 27 Dec **1796,** King's Theatre, London. [Swift 1974, p. 64 / Guest 1972, p. 152]

Johann Christian Klengel, 1751–1824. "Apollo with the Herds of Admetus." Painting. **1802.** Formerly Gemäldegalerie, Dresden. [Hunger 1959, p. 41]

Gottlieb Christian Schick, 1776–1812. "Apollo among the Shepherds." Painting. **1808.** Staatsgalerie, Stuttgart. [Bénézit 1976, 9:370]

Stephan Ivanovich Davídov, 1777–1825. *Apollon u Admeta.* Cantata. **1817.** [Grove 1980, 5:271]

John Keats, 1795–1821. (Apollo as shepherd to Admetus evoked in) *Endymion* 1.139–44. Poem. London: Taylor & Hessey, **1818.** [Stillinger 1978 / De Selincourt 1951, p. 420]

John Flaxman, 1755–1826. "Pastoral Apollo" (with dog and staff). Marble statue. **1813–24.** Petworth House, Sussex. [Irwin 1979, pp. 178–80, fig. 248—ill.]

Joseph Anton Koch, 1768–1839. "Apollo among the Thes-

salian Shepherds." Painting. **1834–35.** Thorwaldsens Museum, Copenhagen, no. B125. [Thorwaldsen 1985, p. 103]

The Prix de Rome landscape painting competition subject for **1837** was "Apollo Tending the Flocks of Admetus." First prize, Eugène-Ferdinand Buttura. École des Beaux-Arts, Paris. [Grunchec 1984, no. 112—ill. / Boime 1971, p. 147, pl. 121]

Bertel Thorwaldsen, 1770–1844. "Apollo among the Shepherds." Marble relief. Modeled **1837.** Executed from Thorwaldsen's model by Pietro Galli, for pediment of Villa Carolina, Castel Gandolfo. / Plaster original. Thorwaldsens Museum, Copenhagen, no. A344. [Thorwaldsen 1985, p. 47]

James Russell Lowell, 1819–1891. "The Shepherd of King Admetus." Poem. **1842.** In *Poems* (Cambridge: Owen, 1843). [Boswell 1982, p. 168 / Cooke 1906, p. 56]

Théophile Gautier, 1811–1872. (Allusion to Apollo as herdsman of Admetus in) "Le château du souvenir" strophe 20. Poem. In *Le moniteur universel* 30 Dec **1861;** collected in *Émaux et camées,* 4th edition (Paris: Charpentier, 1863). Modern edition by C. Gothot-Mersch (Paris: Gallimard, 1981). [Ipso]

William Morris, 1834–1896. (Apollo as shepherd to Admetus in) "The Love of Alcestis." Poem. In *The Earthly Paradise,* vol. 2 (London: Ellis, **1868**). [Morris 1910–15, vol. 4 / Calhoun 1975, pp. 162, 166f.]

Briton Riviere, 1840–1920. "Apollo with the Herds of Admetus." Painting. **1874.** [Kestner 1989, pp. 234ff.]

George Meredith, 1828–1909. "Phoebus with Admetus." Poem. **1880.** In *Poems and Lyrics of the Joy of Earth* (London: Macmillan, 1883). [Bartlett 1978, vol. 1 / Boswell 1982, p. 183]

Gustave Moreau, 1826–1898. "Apollo Receiving the Shepherds' Offerings" ("Apollo and the Shepherds"). Painting. *c.***1885.** Richard L. Feigen & Co., New York, in 1974. [Mathieu 1976, no. 320—ill.]

Edith M. Thomas, 1854–1925. "Apollo the Shepherd." Poem. In *Lyrics and Sonnets* (Boston & New York: Houghton, Mifflin, **1887**). [Bush 1937, p. 581]

Stopford Brooke, 1832–1916. "Phoebus the Herdsman." Poem. In *Poems* (London: MacMillan, **1888**). [Boswell 1982, p. 54]

Richard Garnett, 1835–1906. "Apollo in Tempe." Poem. In *Poems* (London: Matthews & Lane, Boston: Copeland & Day, **1893**). [Boswell 1982, p. 109]

Alice Brown, 1857–1948. (Apollo and Admetus in) "The Shepherds." Poem. In *The Road to Castaly* (New York: Macmillan, **1896**). [Boswell 1982, p. 246 / Bush 1937, p. 587]

Innokénty Ánnensky, 1856–1909. (Apollo as herdsman to Admetus in) Entr'act to *Melanippe-filosof.* Tragedy. First performed **1901,** St. Petersburg. [Setschkareff 1963, p. 166]

Eleanor Farjeon, 1881–1965. "Apollo in Pherae." Poem. In *Pan-Worship and Other Poems* (London: Mathews, **1908**). [Bush 1937, p. 568]

Michael Field (**Katherine Harris Bradley,** 1848–**1914,** and **Edith Cooper,** 1862–1943). "Shepherd Apollo." Poem. In *A Selection from the Poems of Michael Field* (Boston: Houghton, Mifflin, 1925). [Boswell 1982, p. 245]

Edgar Lee Masters, 1869–1950. "Apollo at Pherae." Poem. In *The Great Valley* (New York: Macmillan, **1917**). [Boswell 1982, p. 178]

Richard Rowley, 1877–1947. *Apollo in Mourne.* Comedy. London: Duckworth, **1926.** [Hogan 1979, p. 577]

Apollo and the Cumaean Sibyl. The Sibyl of Cumae was one of the most famous prophetesses in Greek mythology. Apollo desired her and promised to grant her any wish if she yielded to him. The Sibyl asked for as many years of life as there were grains in a pile of sand, but she forgot to ask for eternal youth as well. According to Ovid, had the Sibyl become the god's lover, he would have kept her eternally young, but she would not succumb. She lived for a thousand years in her cave at Cumae, delivering prophecies to Aeneas, among others. It is in Ovid's version of the Aeneas saga that she relates her story of Apollo.

In Petronius's *Satyricon,* the Sibyl, now centuries old and still denied death by Apollo, becomes a tiny entity suspended in a bottle. When youths ask her what she desires, she requests only death.

Most postclassical treatments of the subject depict Apollo and the Sibyl in romantic landscapes. The Sibyl's cruel fate is also alluded to in later poetry.

Classical Sources. Ovid, *Metamorphoses* 14.129–53. Petronius Arbiter, *Satyricon,* 48.4.

Claude Lorrain, 1600–1682. "Coast View with Apollo and the Cumaean Sibyl" ("The Bay of Baiae"). Painting. *c.***1646–47.** Hermitage, Leningrad, no. 1228. [Röthlisberger 1961, no. LV 99—ill. / Hermitage 1984, no. 94—ill.] Drawing after, in the artist's *Liber veritatis.* British Museum, London. [Röthlisberger]

———. "Coast View with Apollo and the Cumaean Sibyl." Painting. 1665. Bührle coll., Zurich. [Ibid., no. LV 164—ill.] Drawing after, in *Liber veritatis.* [Ibid.]

Salvator Rosa, 1615–1673. "Landscape with Apollo and the Cumaean Sibyl." Painting. **Mid-1650s.** Wallace Collection, London. [Wallace 1979, no. 102a—ill. / Salerno 1975, no. 128—ill.] Variant, print (Bartsch no. 17). *c.***1661.** 2 states. [Wallace, no. 102—ill. / Salerno, no. 128a—ill.] Copy (?) in National Gallery, Dublin. [Pigler 1974, p. 38]

Jean Jouvenet, 1644–1717. "Apollo and the Cumaean Sibyl." Ceiling painting, for Hôtel de Saint-Poulange, Paris. *c.***1681–84.** Schnapper coll., Paris. [Schnapper 1974, no. 20—ill.]

Richard van Orley, 1663–**1732.** "Apollo and the Cumaean Sibyl." Painting. Národní Galeri, Prague. [Pigler 1974, p. 38]

Louis Boulogne the Younger, 1654–**1733.** "Apollo and the Sibyl." Painting. Château de Fontainebleau. [Bénézit 1976, 2:229] A drawing of the same subject, Louvre, Paris. [Pigler 1974, p. 38]

Joseph Mallord William Turner, 1775–1851. "The Bay of Baiae, with Apollo and the Sibyl." Painting. Exhibited **1823.** Tate Gallery, London, no. 505. [Butlin & Joll 1977, no. 230—ill.]

Rainer Maria Rilke, 1875–1926. "Eine Sibylle" [A Sibyl].

Poem. In *Neuen Gedichte: Anderer Teil* (Leipzig: Insel, **1908**). [Zinn 1955–66, vol. 1]

T. S. Eliot, 1888–1965. (Quotation from the Cumaean Sibyl, "I want to die," in Petronius Arbiter's *Satyricon*, used as epigraph for) *The Waste Land*. Poem. In *Criterion* Oct **1922**; *The Dial* Nov 1922. First published in book form New York: Boni & Liveright, [Dec] 1922. [Eliot 1964 / Smith 1974, pp. 69, 303 / Kenner 1964, pp. 147, 158f.]

Jay Macpherson, 1931–. (Apollo and the Cumaean Sibyl in) "Sibylla." Poem. In *The Boatman* (Toronto & Oxford: Oxford University Press, **1957**). [Ipso]

Margaret Atwood, 1939–. "A Sibyl." Poem. In *The Circle Game* (Toronto: Contact, **1966**). [CLC 1983, 25:66]

F. T. Prince, 1912–. "Apollo and the Sibyl." Poem. In *Collected Poems* (London: Menard, Anvil; New York: Sheep Meadow, **1979**). [DLB 1983, 20:286]

Loves of Apollo. Apollo's amorous conquests were rarely successful, frequently bringing rebuff to himself or ruin to those he pursued. The objects of his attentions, both male and female, included Clytie, Creusa, Cassandra, Cyparissus, Daphne, and Hyacinth. Among Apollo's lesser-known loves, treated together in this entry, were Chione, Clymene, Coronis, Dryope, Evadne, Isse, Leucothoë (Leucothea), and Marpessa.

Chione, daughter of Daedalion, was visited by Apollo and Hermes on the same night. She gave birth to twin sons: the notorious thief Autolycus, by Hermes, and the famous musician Philammon, by Apollo. Later, she dared to declare her own beauty greater than that of Artemis (Diana), and for this the goddess killed her and transformed her into a hawk.

As Phoebus, Apollo seduced the nymph Clymene, who bore him a son, Phaethon, and daughters, known as the Heliades (daughters of Helios). After Phaethon's tragic fall from the sun chariot, Clymene traveled the earth seeking his remains. She found them at last on the banks of the Eridanus River, where his sisters, weeping for him, were turned into poplar trees by their tears.

Coronis, a maiden of Thessaly, was seduced by Apollo and bore him the child Asclepius (Aesculapius). While pregnant, Coronis was discovered by Apollo's bird, the raven, in an amorous tryst with a Thessalian youth. The bird reported her infidelity to the god who, in anger, slew Coronis. Then, regretting what he had done, he tried unsuccessfully to revive her, but managed to save only the infant Asclepius, whom he gave to the centaur Chiron to rear. He also punished the raven by changing its feathers from white to black.

Apollo took the form of a tortoise to ravish Dryope, daughter of the king of Oechalia. As the girl played with him in her lap he became a serpent and coupled with her. Keeping her secret, Dryope married the mortal Andraemon, but bore Apollo's son, Amphissus. According to Ovid, while nursing the infant by a lake, Dryope saw some water lotuses in bloom. Unaware that the blossoms were the transformed body of the naiad Lotis, Dryope picked them. The flowers trembled and bled, and she herself was turned into a lotus tree.

A Peloponnesian legend relates that Evadne, a daughter of Poseidon, bore Apollo's son Iamus by the banks of the Alpheus river and left him there. Apollo and Poseidon brought the child to Olympia, where he was eventually given the gift of prophecy.

Another victim of Apollo's disguises was Isse, a shepherdess. According to Ovid, the god appeared to her as a shepherd, seduced her, and left her pregnant.

Phoebus was stricken with love for Leucothoë (Leucothea) by Aphrodite (Venus), in revenge for his betrayal of her affair with Ares (Mars) to her husband. The jealous Clytie, resentful of the attention Apollo was paying to the girl, reported it to Leucothoë's father, King Orchamus, who had his daughter buried alive. Apollo tried fruitlessly to save her, and the tears he shed on her corpse caused it to grow into a frankincense tree.

Marpessa, daughter of Evenus and granddaughter of Ares, was wooed by both Apollo and Idas, one of the Argonauts. When Idas carried her off in his chariot, Evenus committed suicide in grief and anger. Apollo pursued Idas until Zeus intervened and forced Marpessa to choose between her two lovers. She chose the mortal Idas, fearing that Apollo would abandon her when she grew old.

Classical Sources. Homer, *Iliad* 9.557ff. Antoninus Liberalis, *Metamorphoses* 32. Pindar, *Pythian Odes* 3.14ff. Ovid, *Metamorphoses* 1.750–75, 2.542–636, 4.194–252, 6.122ff., 9.323–93, 11.290–348. Apollodorus, *Biblioteca* 1.7.8–9, 3.10.3. Plutarch, *Lives* 40.315e. Pausanias, *Description of Greece* 2.26.7, 4.2.7. Hyginus, *Fabulae* 200, 202.

See also APOLLO, and the Cumaean Sibyl; CASSANDRA; CLYTIE; CREUSA; CYPARISSUS; DAPHNE; HYACINTH; PHAETHON.

Anonymous French. (Stories of Coronis, Leucothoë, Dryope, and Chione in) *Ovide moralisé* 2.2121–2735; 4.1172–1453, 1756–1923; 9.1180–1381; 11.2616–2705, 2706–2797. Poem, allegorized translation/elaboration of Ovid's *Metamorphoses*. c.**1316–28**. [de Boer 1915–86, vols. 1, 3, 4]

Guillaume de Machaut, c.**1300**–1377. (Apollo and Coronis story retold in) *Le livre du voir-dit*. Poem. c.**1364**. Modern edition by Paulin-Paris (Paris: Société des Bibliophiles Français, 1875). [Huot 1987, p. 306 / Oxford 1985, p. 167 / DLLF 1984, 2:996]

John Gower, 1330?–1408. (Stories of of Coronis, Leucothoë in) *Confessio amantis* 3.783–817, 5.6713–6801. Poem.

c.**1390**. Westminster: Caxton, 1483. [Macaulay 1899–1902, vols. 2, 3 / Beidler 1982, p. 75]

Geoffrey Chaucer, 1340?–1400. (Story of Coronis in) "The Manciple's Tale." Poem, part of *The Canterbury Tales*. **1388–95.** Westminster: Caxton, 1478. [Riverside 1987]

Christine de Pizan, *c*.1364–*c*.1431. (Apollo and Coronis in) *L'epistre d'Othéa à Hector . . .* [The Epistle of Othéa to Hector] chapter 48. Didactic romance in prose. *c*.**1400.** MSS in British Library, London; Bibliothèque Nationale, Paris; elsewhere. / Translated by Stephen Scrope (London: *c*.1444–50). [Bühler 1970 / Hindman 1986, p. 198]

Hendrik Goltzius, 1558–1617, composition. 3 engravings, depicting the story of Coronis, part of a set illustrating Ovid's *Metamorphoses* (2d series, nos. 11, 13, 14), executed by assistant(s). *c*.**1590.** Unique impressions in British Museum, London. [Bartsch 1980–82, nos. 0302.61, 63, 64—ill.]

————, composition. "Apollo and Leucothoë." Engraving, part of set illustrating Ovid's *Metamorphoses* (3d series, no. 11). 1590–91, engraved by assistant(s), *c*.1615. Unique impression in British Museum, London. [Ibid., no. 0302.81—ill.] Original drawing in Kunsthalle, Hamburg, inv. 1926–229. [Reznicek 1961, no. 104—ill.]

Edmund Spenser, 1552?–1599. (Loves of Apollo—Daphne, Hyacinth, Coronis, Isse—depicted in tapestry of "Cupid's Wars," in) *The Faerie Queene* 3.11.36–39. Romance epic. London: Ponsonbie, **1590**, 1596. [Hamilton 1977 / MacCaffrey 1976, pp. 104ff.]

Jean Cousin the Younger, 1522–**1594.** "Landscape with Apollo" (unidentified amorous adventure). Drawing. Hermitage, Leningrad, inv. 5604. [Hermitage 1984, no. 280—ill.]

Toussaint Dubreuil, *c*.1561–1602. "The Death of Chione." Design for tapestry, in "History of Diana" series. *c*.**1597.** 5 sets woven. Mobilier National, Paris; Prado, Madrid; Kunsthistorisches Museum, Vienna; partial sets elsewhere. [Paris 1972, no. 464]

Adam Elsheimer, 1578–1610. "Apollo and Coronis" (formerly called "Death of Procris"). Painting. *c*.**1607–08.** Lord Methuen coll., Corsham Court, England. [Andrews 1977, no. 21—ill. / also Augsburg 1975, no. E30—ill. / Lavin 1954, p. 286—ill.; cf. pls. 42b-c]

Bartholomeus Spranger, 1546–**1611.** "The Vengeance of Venus" (on Apollo, for betraying her liaison with Mars to Vulcan, by sending Cupid to strike him with love for Leucothoë). Painting. Musée des Beaux-Arts, Troyes. [de Bosque 1985, p. 185—ill.]

Domenichino, 1581–1641, and assistant(s). "Apollo Slaying Coronis." Fresco (detached), part of "Life of Apollo" cycle from Villa Aldobrandini (Belevedere), Frascati. **1616–18.** National Gallery, London, inv. 6284. [Spear 1982, no. 55.x—ill. / London 1986, p. 160—ill.]

Nicolas Poussin, 1594–1665. "Diana Slaying Chione," "Dryope." Drawings, illustrating Ovid, for G. B. Marino (for unpublished edition of *Metamorphoses*?). *c*.**1620–23.** Royal Library, Windsor Castle, nos. 11935, 11941. [Friedlaender & Blunt 1953, nos. 156–57—ill.]

Pieter Lastman, *c*.1583–**1633.** "Apollo and Coronis." Painting. Armonk, New York. [Warburg]

Richard Lovelace, 1618–1658. (Apollo and Leucothoë evoked in) "Princess Louisa Drawing" lines 28–33. Poem. In *Lucasta: Epodes, Odes, Sonnets, and Songs* (London: Ewster, **1649**). [Wilkinson 1930]

Juan de Matos Fragoso, 1608–1689. *Fábula burlesca de Apolo y Leucotoe.* Burlesque poem. Madrid: **1652.** [Oxford 1978, p. 373]

Jean de La Fontaine, 1621–1695. "Clymène." Comedy. Date uncertain; probably before **1659**, possibly *c*.1668. In *Contes et nouvelles en vers* (Paris: Barbin, 1671). [Clarac & Marmier 1965 / MacKay 1973, p. 147]

Pedro Calderón de la Barca, 1600–1681. *Apolo y Climene.* Comedy, part 1 of *El hijo del Sol, Faetón* [Son of the Sun, Phaethon]. **1661.** First performed 1 Mar 1661, Buen Retiro, Madrid. Published in *Comedias de Calderón*, part 4 (Madrid: 1672). [Valbuena Briones 1960–67, vol. 1 / O'Connor 1988, pp. 267f., 270–85, 298–301 / McGraw-Hill 1984, 1:442 / Honig 1972, p. 184]

Giovanni Battista Volpe, *c*.1620–1691. *Gli amori di Apollo e di Leucote* [The Loves of Apollo and Leucothoë]. Opera. Libretto, Aurelio Aureli. First performed **1663**, Teatro SS Giovanni e Paolo, Venice. [Grove 1980, 20:74]

Jean Donneau de Visé, 1638–1710. *Les amours du Soleil* [Love of the Sun] (for Leucothoë). Tragedy. First performed early 1671, Théâtre Marais, Paris. Published Paris: Barbin 1671. [Lancaster 1929–42, pt. 3, 2:527–29, 868]

Louis de Mollier, *c*.1615–1688, attributed. *Les amours du Soleil.* Opera. Libretto, Donneau de Visé. 1671. Lost. [Grove 1980, 12:471.]

Anonymous English. (Apollo and Coronis evoked in) *Chaucer's Ghoast; or, A Piece of Antiquity.* Poem. (London: Ratcliff & Thompson for Richard Mills, **1672**). [Bush 1963, p. 339]

Johann Wolfgang Franck, 1644–*c*.1710. *Der verliebte Phöbus* [The Lovesick Phoebus]. Opera. First performed **1678**, Ansbach. [Grove 1980, 6:786]

Juan Hidalgo, 1612/16–1685. *Apolo y Leucotea.* Opera. Libretto, Pedro Scotti de Agoiz. (First performed?) **1684**, Madrid? [Grove 1980, 8:548f. / Barrera 1969, p. 367 / Palau y Dulcet 1948–77, 20:213]

André Cardinal Destouches, 1672–1749. *Issé.* Opera (pastorale-héroïque). Libretto, Antoine Houdar de la Motte. First performed 7 Oct **1697**, directed by Grimaldi, Fontainebleau. Revised and augmented by 2 acts, 1708. [Grove 1980, 5:400–402 / Winter 1974, p. 110 / Girdlestone 1972, pp. 189, 319]

Giacomo Antonio Perti, 1661–1756. *Apollo geloso* [Jealous Apollo]. Opera. Libretto, Pier Jacopo Martelli. First performed 16 Aug **1698**, Bologna. [Grove 1980, 14:556]

Alexander Pope, 1688–1744. "The Fable of Dryope." Verse translation from Ovid's *Metamorphoses* 9. *c*.**1702**, revised before 1711. In *Works* (London: 1717). [Twickenham 1938–68, vol. 1]

Jonathan Swift, 1667–1745. "Apollo Outwitted" (in seducing a friend of the poet). Poem. **1709.** In *Miscellanies in Prose and Verse* (London: Morphew, 1711). [Williams 1958, vol. 1]

Georg Caspar Schürmann, 1672–1751. *Issé, oder die vergnügende Liebe* [Isse, or the Contented Love]. Opera (pastorale), adaptation of Destouches. Libretto, Antoine Houdar de la Motte. First performed **1710**, Wolfenbüttel. [Grove 1980, 16:874]

Antonio Bioni, 1698–after 1739. *Climene.* Opera. Libretto, V. Cassani. First performed Carnival **1721,** Teatro Beregan, Chioggia. [Grove 1980, 2:726]

Giovanni Battista Foggini, 1652–**1725.** "Apollo and Coronis." Drawing. Metropolitan Museum, New York. [Warburg]

Jean-Joseph Mouret, 1682–1738. "Apollon et Coronis." Entrée in *Les amours des dieux.* Opera-ballet. Libretto, Louis Fuzelier. First performed 14 Sep **1727,** L'Opéra, Paris; choreography, Françoise Prévost. [Baker 1984, p. 1595 / Grove 1980, 12:655 / Winter 1974, p. 51]

José de Cañizares, 1676–**1750.** *Apolo y Climene.* Zarzuela. [Barrera 1969, p. 69]

François Boucher, 1703–1770. "Apollo Revealing His Divinity to the Shepherdess Isse." Painting. **1750.** Musée des Beaux-Arts, Tours, no. 794–1–1. [Ananoff 1976, no. 355—ill.] Copy after detail (2 nymphs), oil sketch, by Berthe Morisot (1841–1895). [Ibid.—ill.]

———. "The Sleep of Isse." Painting, model for tapestry, part of "Fragments from Opera" series. 1758. Woven by Beauvais. 3 examples known, unlocated. [Ibid., no. 386]

Jean-Marie Leclair the Elder, 1697–1764, music. "Apollon et Climène." Second entrée of *Amusements lyriques.* Ballet. First performed Feb **1750,** Théâtre de Puteaux, Paris. [Grove 1980, 10:591]

Isaac Bickerstaff, 1733–1808? *Leucothoë.* Dramatic poem. London: Dodsley, **1756.** [Tasch 1971, pp. 25, 27–30 / Nicoll 1959–66, 3:197, 237]

Rowland Rugeley, 1735?–1776. (Story of Apollo and Leucothoë burlesqued in) *Miscellaneous Poems and Translations from La Fontaine and Others* (Cambridge: Fletcher & Hodson, **1763**). [Bush 1937, p. 545]

Gaetano Pugnani, 1731–1798. *Issea.* Opera (favola pastorale). Libretto, Vittorio Amedeo Cigna Santi. First performed **1771,** Teatro Regio, Turin. [Grove 1980, 15:447]

———. *Apollo e Issea.* Opera. First performed 30 Mar 1773, London. [Ibid.]

Louis-Charles-Joseph Rey, 1738–1811, with **Jean-Baptiste Rey the Elder,** 1734–1810. *Apollon et Coronis.* Opera. Libretto, after Fuzelier's *Les amours des dieux* (1727). First performed 3 May **1781,** L'Opéra, Paris. [Grove 1980, 15:782]

John Flaxman, 1755–1826. "Apollo and Marpessa." Marble relief. *c.*1790–**94.** Royal Academy, London. [Irwin 1979, pp. 169f., fig. 233 / Bindman 1979, no. 114—ill.]

———. "Apollo Carrying Off Marpessa from Idas." Drawing. Fitzwilliam Museum, Cambridge. [Irwin, pp. 169f., fig. 234]

Ignaz von Seyfried, 1776–1841. *Idas und Marpissa.* Opera. Libretto, Mathäus Stegmayer. First performed 10 Oct **1807,** Theater an der Wien, Vienna. [Grove 1980, 17:208; 18:101]

Vincenc Tucek, 1773–*c.*1821. *Idas und Marpissa.* Opera, parody of Seyfried and Stegmayer (above). Libretto, J. Perinet. First performed 19 Dec **1807,** Leopoldstädtertheater, Vienna. [Grove 1980, 19:245]

Charles Monnet, 1732–after **1808.** "Apollo and Leucothea." Drawing, design for an engraving, executed by Jean-Baptiste Simonet (1742–*c.*1810). [Pigler 1974, p. 30]

Vittorio Trento, *c.*1761–1833. *La Climène.* Opera. Libretto,

G. Caravita. First performed **1811,** King's Theatre, London. [Grove 1980, 19:133]

John Keats, 1795–1821. (Allusion to Dryope lulling her child in) *Endymion* 1.493f. Poem. **1817.** London: Taylor & Hessey, 1818. [Stillinger 1978 / De Selincourt 1951, p. 426 n.495 / Bush 1937, p. 103]

———. (Clymene in) *Hyperion: A Fragment* 2.248ff. *c.*Oct 1818–*c.*April 1819. London: Taylor & Hessey, 1820. [Stillinger 1978 / Aske 1985, pp. 94, 96]

Peter Cornelius, 1783–1867, and studio. "Leucothea." Ceiling fresco. **1820–26.** Göttersaal, Glyptothek, Munich. [Glyptothek 1980, pp. 214ff., 219f.—ill.]

Bertel Thorwaldsen, 1770–1844. "Chione and Daedalion." Relief, part of "Metamorphoses of Ovid" series. Executed by Pietro Galli from Thorwaldsen's designs. **1838.** Formerly Palazzo Torlonia, Rome, destroyed. / Plaster cast. Thorwaldsens Museum, Copenhagen, no. 464. [Thorwaldsen 1985, p. 55]

Walter Savage Landor, 1775–1864. "Dryope." Poem. In *Hellenics* (London: Moxon, **1847**). / Revised in 1859 edition (Edinburgh: Nichol). [Wheeler 1937, vol. 2 / Pinsky 1968, pp. 58f., 63–71]

Thomas Ashe, 1836–1889. "Dryope." Poem. In *Dryope and Other Poems* (London: Bell & Daldy, **1861**). [Boswell 1982, p. 21]

Robert Browning, 1812–1889. (Allusion to Dryope in) "Parleying with Gerard de Lairesse" stanza 5. Monologue. In *Parleyings with Certain People of Importance in Their Day* (London: Smith, Elder, **1887**). [Scudder 1895 / Langbaum 1979, p. 160 / Ward 1969, p. 274]

Gabriele D'Annunzio, 1863–1938. "Climene." Poem. **1891–92.** In *Poema paradisaco* (Milan: Treves, 1893). [Palmieri 1953–59, vol. 3]

Stephen Phillips, 1868–1915. "Marpessa." Poem. In *Poems* (London & New York: Lane, **1897**). [Bush 1937, pp. 473f., 565]

Arthur Knowles Sabin, 1879–1959. "Clymene." Poem. In *Typhon and Other Poems* (London: Stock, **1902**). [Boswell 1982, p. 288]

Howard Sutherland, b. 1868. "Idas and Marpessa." Poem. In *Idylls of Greece,* 3d series (Boston: Sherman, French & Co., **1908**). [Boswell 1982, p. 298]

Edgar Lee Masters, 1869–1950. (Apollo loves and abandons Chione in) "Apollo at Pherae." Poem. In *The Great Valley* (New York: Macmillan, **1917**). [Boswell 1982, p. 178]

H. D. (Hilda Doolittle), 1886–1961. "Evadne." Poem. In *Collected Poems* (New York: Boni & Liveright, **1925**). [Martz 1983]

Roselle Mercier Montgomery, d. 1933. "Marpessa." Poem. In *Many Devices* (New York: Appleton-Century, **1929**). [Bush 1937, p. 590]

Francis Picabia, 1878–1953. "Apollo." Surrealistic painting (faces of 4 women, with leaves). *c.*1930. [Borràs 1985, no. 561—ill.]

Ludomir Rózycki, 1884–1953, music. *Apollo i dziewczyna* [Apollo and the Maiden]. Ballet. First performed **1937,** Warsaw. [Grove 1980, 16:291]

Keith Douglas, 1920–**1944.** "Leukothea." Poem. In *The New British Poets,* edited by Kenneth Rexroth (Norfolk, Conn.: New Directions, 1949). [Ipso]

Cesare Pavese, 1908–1950. (Hermes and Chiron discuss Coronis in) "Le cavalle" [The Mares]. Dialogue. In *Dialoghi con Leucò* (Turin: Einaudi, **1947**). / Translated by William Arrowsmith and D. S. Carne-Ross in *Dialogues with Leucò*, bilingual edition (Ann Arbor: University of Michigan, 1965). [Ipso / Biasin 1968, pp. 195, 309]

Ezra Pound, 1885–1972. (Apollo and Leucothoë evoked in) Cantos 98, 102, in *Thrones, 96–109 De Los Cantares* (New York: New Directions, **1959**). [Surette 1979, p. 251 / Feder 1971, pp. 213f.]

Yannis Ritsos, 1909–1990. "Hē eklogē tes Marpessas" [Marpessa's Choice]. Poem. 28 Oct **1968**. In *Epanalepseis* (Athens: Kedros, 1972). / Translated by Edmund Keeley in *Yannis Ritsos, Exile and Return: Selected Poems 1967–1974* (New York: Ecco, 1985). [Ipso]

Robert Graves, 1895–1985. "Confess Marpessa." Poem. **1970–72**. In *Poems, 1970–72* (Garden City, N.Y.: Doubleday, 1973). [Graves 1975]

AQUILO. *See* BOREAS.

ARACHNE. Ovid tells of the Lydian woman Arachne, a daughter of Idmon of Colophon, whose skill in weaving was legendary. She was so boastful of her ability that she challenged her own teacher, Athena (Minerva), goddess of household and womanly skills, to a weaving contest. The goddess, in disguise, warned her of her folly, but Arachne persisted. Both of them wove beautiful tapestries that portrayed themes from mythology: Athena, her contest with Poseidon for the possession of Athens; Arachne, the romantic conquests of Zeus, Poseidon, Apollo, and other gods. Furious at Arachne's work, Athena beat the girl with her weaving shuttle and Arachne, in shame, hanged herself. Athena took pity and spared her life, but transformed her into a spider, who would weave forever.

Artistic representations, often allegories of the punishment of presumption and pride, depict the weaving competition as well as the transformation of Arachne from mortal to spider.

Classical Source. Ovid, *Metamorphoses* 6.1–145.

Dante Alighieri, 1265–1321. (Arachne metamorphosing into a spider, sculpted on pathway as an example of pride defeated, in) *Purgatorio* 12.16–24, 43–45. Completed *c.*1314? In *The Divine Comedy*. Poem. Foligno: Neumeister & Angelini, 1472. [Singleton 1970–75, vol. 2]

Giovanni Boccaccio, 1313–1375. "De Aragne colophonia muliere" [Arachne, Woman of Colophon]. In *De mulieribus claris* [Concerning Famous Women]. Latin verse compendium of myth and legend. **1361–75**. Ulm: Zainer, 1473. [Branca 1964–83, vol. 10 / Guarino 1963]

Christine de Pizan, *c.*1364–*c.*1431. (Story of Arachne in) *L'epistre d'Othéa à Hector* . . . [The Epistle of Othéa to Hector] chapter 64. Didactic romance in prose. *c.***1400**. MSS in British Library, London; Bibliothèque Nationale, Paris; elsewhere. / Translated by Stephen Scrope (London: *c.*1444–50). [Bühler 1970 / Hindman 1986, p. 200]

———. (Arachne in) *Le livre de la Cité des Dames* [The Book of the City of Ladies] part 1 no. 39. Didactic compendium in prose, reworking of Boccaccio's *De mulieribus claris*. 1405. [Hicks & Moreau 1986] Translated by Brian Anslay (London: Pepwell, 1521). [Richards 1982]

Jacopo Tintoretto, 1518–1594. "Athena and Arachne." Painting. **1543–44**. Uffizi, Florence, Contini-Bonacossi coll. no. 35, on deposit at Palazzo Pitti (Meridiana). [Rossi 1982, no. 67—ill.]

Battista Franco, *c.*1498–**1561**. "Arachne." Ceiling painting. Palazzo Reale, Venice. [Pigler 1974, p. 39]

Taddeo Zuccari, 1529–1566, and assistants. "The Contest," "The Transformation." Ceiling frescoes. **1560–66**. Villa Farnese, Caprarola. [Warburg / Pigler 1974, p. 39]

Arthur Golding, 1536?–1605. (Story of Arachne in) *Ovids Metamorphosis* book 6. Translation. London: **1567**. [Rouse 1961]

Giuseppe Porta, called Salviati, *c.*1520–*c.*1575. "Arachne." Drawing. Albertina, Vienna. [Pigler 1974, p. 39]

Luca Cambiaso, 1527–**1585**. "The Transformation of Arachne." Fresco, part of series illustrating the gods' punishment of presumptuous mortals. Palazzo Marchese Ambrogio Doria, Genoa. [Manning & Suida 1958, pp. 82f.—ill.]

Edmund Spenser, 1552?–1599. (Tapestry in the house of Busyrane, modeled on Arachne's tapestry, described in) *The Faerie Queene* 3.11.28–46. Romance epic. London: Ponsonbie, **1590**, 1596. [Hamilton 1977 / Barkan 1986, chapter 5 / MacCaffrey 1976, pp. 105–09]

———. (Story of Minerva and Arachne related in) "Muiopotmos; or the Fate of the Butterfly" lines 257–352. Poem. London: Ponsonbie, 1590; collected in *Complaints* (London: Ponsonbie, 1591). [Oram et al. 1989 / Miller 1986, p. 293 / Nohrnberg 1976, p. 98 / Dundas 1985, pp. 51f.]

Friedrich Sustris, *c.*1540–**1599**, and studio. "Arachne." Painting. Schloss Trausnitz, Landshut. [Pigler 1974, p. 39]

John Donne, 1572–1631. (Arachne evoked in) "Twicknam Garden." Poem. In *Poems* (London: Marriot, 1635). [Patrides 1985 / Pinka 1982, pp. 99f.]

Peter Paul Rubens, 1577–1640. "Arachne and Minerva" ("Arachne Punished by Pallas"). Painting, for Torre de la Parada, El Pardo (executed by assistant from Rubens's design?). **1636–38**. Lost. [Alpers 1971, no. 3] Oil sketch. Virginia Museum of Fine Arts, Richmond, inv. 58.18. [Ibid., no. 3a—ill. / Held 1980, no. 170—ill. / Jaffé 1989, no. 1238—ill. / Baudouin 1977, fig. 178] Copied in background of Velázquez's "Las Meninas" (1656, Prado, Madrid). [Alpers]

Diego Velázquez, 1599–1660. "The Fable of Arachne" ("The Spinners," "The Tapestry Weavers"). Painting. Dated variously *c.*1644–48, *c.*1657. Prado, Madrid, no. 1173. [López-Rey 1963, no. 56—ill. / López Torrijos 1985, pp. 319ff.—ill. / also Barkan 1986, pp. 5–8, 290 n.5, 291 n.9] Another version of the subject documented in 1664, lost. [Barkan, p. 290 n.6]

Luca Giordano, 1634–1705. "Minerva and Arachne" ("Penelope"). Painting. *c.***1695–96?** Monastero, El Escorial. [Ferrari & Scavizzi 1966, 2:190—ill.]

Barend Graat, 1628–1709. "Minerva Turns Arachne into a Spider." Painting. Hartveld coll., Antwerp, in 1939. [Warburg]

René-Antoine Houasse, *c.*1645–1710. "Arachne." Painting. Cabinet de Travail, Grand Trianon, Versailles. [Pigler 1974, p. 39]

John Gay, 1685–1732. "The Story of Arachne." Poem, after Ovid's *Metamorphoses*. In *Lintot's Miscellany* (London: Lintot, **1712**). [Dearing & Beckwith 1974, vol. 1]

Anne Finch, Countess of Winchilsea, 1661–1720. (Arachne's weaving evoked in) "A Description of One of the Pieces of Tapestry at Long-leat." Poem. In *Miscellany Poems on Several Occasions, Written by a Lady* (London: **1713**, 1714.) [Miller 1986, p. 288]

William Wordsworth, 1770–1850. (Allusion to Arachne's challenge to Athena in) "On Seeing a Needlecase in the Form of a Harp" lines 7–16. Poem. **1827**. In *Poetical Works* (London: Longman & Co., 1827). [De Selincourt 1940–66, vol. 2]

Marcel Schwob, 1867–1905. "Arachné." Story. In *Coeur double* (Paris: Charpentier, **1891**). [TCLC 1978–89, 20:323]

George Meredith, 1828–1909. (Arachne evoked in) "A Garden Idyl." Poem. In *Scribner's Magazine* Feb **1900**; collected in *A Reading of Life and Other Poems* (Westminster: Constable, 1901). [Bartlett 1978, vol. 1]

Conrad Aiken, 1889–1973. (Tithonus, as a grasshopper, sings of Arachne in) "The Wedding." Poem. **1925**. In *The London Mercury* 14 no. 81 (July 1926); collected in *Collected Poems* (New York: Oxford University Press, 1953). [Boswell 1982, p. 6]

Eden Phillpotts, 1862–1960. *Arachne*. Novel. London: Faber & Gwyer, **1927–28**. [Kunitz & Haycraft 1961, p. 1103]

William Empson, 1906–1984. "Arachne." Poem. In *Poems* (London: Chatto & Windus, **1935**). [CLC 1973–89, 3:147, 19:155, 33:141]

Andrée Howard, 1910–1968, choreography. *Le festin del' Araignée* [Arachne's Feast] (later called *The Spider's Banquet*). Ballet. Music, Albert Roussel. First performed **1944**, London; décor, Michael Ayrton. [Clark 1955, pp. 182–84]

A. D. Hope, 1907–. (Arachne evoked in) "The Muse." Poem. **1945**. In *Wandering Islands* (Sydney: Edwards & Shaw, 1955). [Ipso]

Richard Hunt, 1935–. "Arachne." Steel sculpture. **1956**. Museum of Modern Art, New York, no. 5.57. [Barr 1977, p. 551—ill.]

Alfred Koerppen, 1926–, music. *Arachne*. Ballet. **1968**. [Grove 1980, 10:151]

Rolfe Humphries, 1894–1969. "Arachne, Penelope." Poem. In *Coat on a Stick* (Bloomington: Indiana University Press, **1969**). [Boswell 1982, p. 140]

Colin Way Reid, 1952–1983. "Arachne." Poem. **1976**. Unpublished. [Author's collection]

Pamela White Hadas, 1946–. "Arachne." Poem. In *Designing Women* (New York: Knopf, **1979**). [Miller 1986, p. 288]

Josephine Jacobsen, 1908–. "Arachne, Astonished." Poem.

In *The Chinese Insomniacs* (Philadelphia: University of Pennsylvania Press, **1981**). [CLC 1988, 48:194]

ARCADIA. A province in the central Peloponnesus, Arcadia is mountainous and sparsely populated even today. In mythology, it was known as the birthplace of Hermes and the realm of Pan. It was also considered a haunt of Zeus (Jupiter), especially in his adventures with Lycaon and Callisto (the name Arcadia derives from Callisto's son Arcas). Three of Heracles' labors—the Ceryneian Hind (also known as the Arcadian Stag), the Erymanthian Boar, and the Stymphalian Birds—were undertaken in Arcadia.

Theocritus and Virgil describe Arcadia as a simple, rustic land inhabited by shepherds and nymphs, demigods and satyrs. Their poems were the fountainhead of the pastoral ideal that has become such a popular subject in the arts, especially poetry and painting. In postclassical treatments Arcadia has been commonly portrayed as a lush land supporting an Eden-like existence similar to the Golden Age, as in the late sixteenth-century works of Philip Sidney in England and of Tasso and Guarini in Italy.

The idyllic perfection that Arcadia came to symbolize also had a poignant side, a recognition of its unreality, embodied in the phrase "Et in Arcadia ego," meaning "Even in Arcadia there am I [Death]" (sometimes misinterpreted as "I too have lived in Arcady"). The earliest known depiction, Guercino's painting of *c.*1618, shows a pair of shepherds gazing on a skull at a ruined tomb that bears the now-famous Latin inscription as a grim reminder of mortality.

Classical Sources. Homeric Hymns, "To Pan." Theocritus, *Idylls*. Virgil, *Eclogues*. Pausanias, *Description of Greece* 8.1–2, 4.

Further Reference. Petra Maisak, *Arcadien: Genese und Typologie einer idyllischen Wunschwelt* (Frankfurt & Bern: Peter Lang, 1981). Renato Poggioli, *The Oaten Flute: Essays on Pastoral Poetry and the Pastoral Ideal* (Cambridge: Harvard University Press, 1975). Erwin Panofsky, "Et in Arcadia Ego," in *Philosophy and History: Essays Presented to Ernst Cassirer*, edited by Raymond Klibansky (Oxford: Clarendon Press, 1936).

See also PAN; SATYRS; SHEPHERDS AND SHEPHERDESSES.

Dante Alighieri, 1265–1321. (Arcadia evoked in) *Eclogae latinae* eclogue 2. Cycle of Latin eclogues. **1319–21**. First printed in *Carmina illustrium poetarum italorum* (Florence: 1719–26). / Modern edition by P. H. Wicksteed and E. O. Gardner, in *Dante and Giovanni del Virgilio* (Westminster: Constable 1902). [Toynbee 1968, pp. 51, 240f.]

Jacopo Sannazaro, 1458?–1530. *Arcadia*. Pastoral poem,

linked by prose passages. MS dated **1489.** Pirated edition, Venice: Vercelli, 1502. [Bondanella 1979, pp. 461f. / Poggioli 1975, pp. 99f. / Levin 1969, pp. 43–45]

Giorgione, c.1477–1510, circle (previously attributed to Titian). "Mythological Arcadian Scene" (traditionally known as "Moses and the Burning Bush"). Painting. **c.1510.** Courtauld Institute, London. [Wethey 1975, no. X–25]

Torquato Tasso, 1544–1595. *Aminta.* Pastoral play (favola boschereccia). First performed 31 July **1573,** Ferrara. Published Venice: Aldo, 1583. / Translated by Frederic Whitmore as *Amyntas: A Sylvan Fable* (Springfield, Mass.: 1900). [Poggioli 1975, pp. 42ff., 53f. and passim / Giamatti 1966, p. 33 *n.* / Palisca 1968, p. 37 / Highet 1967, p. 140]

Philip Sidney, 1554–1586. *The Countess of Pembroke's Arcadia (The Old Arcadia).* Prose romance with poems, pastoral eclogues. Completed *c.*1580. [Robertson 1973] Revised 1582–84 (*The New Arcadia*). London: Ponsonbie, 1590. [Skretkowicz 1987 / see also Dennis Kay, ed., *Sir Philip Sidney: An Anthology of Modern Criticism* (Oxford: Clarendon Press, 1987) / Michael McCanles, *The Text of Sidney's Arcadian World* (Durham: Duke University Press, 1989)]

Gian Battista Guarini, 1538–1612. *Il pastor fido.* Pastoral tragicomedy. Conceived 1569, composed **1580–83;** revised 1585. Published Venice: 1589 (dated 1590). First performed 1595, Crema. [McGraw-Hill 1984, 2:429ff. / Kettering 1983, pp. 107ff.]

Hendrik Goltzius, 1558–1617. "Arcadian Landscape." Woodcut. Before **1588.** 3 states. [Strauss 1977a, no. 407—ill.]

Robert Greene, 1558–1592. (Arcadian setting in) *Menaphon.* Prose romance, with interludes of verse. London: **1589;** reprinted as *Greene's Arcadia* (London: 1599). [Oxford 1985, p. 415]

Anonymous. Ceiling painting, illustrating Sidney's *Arcadia,* for Single Cube Room, Wilton House, Wiltshire. [Jacobs & Sirton 1984b, p. 139]

Lope de Vega, 1562–1635. *La Arcadia.* Pastoral novel. Madrid: Luis Sanchez, 1598. [Sainz de Robles 1952–55, vol. 2 / DLE 1972, pp. 923f. / Oxford 1978, p. 599]

———. *La Arcadia.* Pastoral comedy. 1610–15. Madrid: 1620. [Sainz de Robles / McGraw-Hill 1984, 5:94]

Samuel Daniel, 1562–1619. *The Queenes Arcadia.* Pastoral drama. First performed Aug **1605,** before the Queen and her ladies, University of Oxford, Christ's Church. Published London: for S. Waterson, 1606. [Levin 1969, p. 120]

John Day, 1574–1640. (Arcadia, setting for) *The Isle of Gulls.* Drama. First performed **1606,** London. [Oxford 1985, p. 259]

Gervase Markham, c.1568–1637. *The English Arcadia.* Collection of poetry (?). London: **1607.** [Oxford 1985, p. 620]

Thomas Heywood, 1573/74–1641. (Founding of Arcadia by Archas in) *Troia Britanica: or, Great Britaines Troy* canto 3. Epic poem. London: **1609.** [Heywood 1974]

———. (Archas in) *The Golden Age.* Drama, based on *Troia Britanica.* First performed c.1610–12, London. Published London: Okes, 1611. [Heywood 1874, vol. 3 / DLB 1987, 62:101, 122ff. / also Boas 1950, pp. 83ff. / Clark 1931, pp. 62ff.]

Guercino, 1591–1666. "Et in Arcadia ego" (Shepherds contemplating skull). Painting. *c.1618.* Galleria Nazionale d'Arte Antica, Rome, no. 1440. [Salerno 1988, no. 48—ill. / Bologna 1968, 1: no. 30—ill.]

Tirso de Molina, 1583–1648. *La fingida Arcadia* [The False Arcadia]. Play. **1622.** [Wilson 1977, pp. 42, 53–56, 63, 83, 140]

Aegidius Sadeler, 1570–**1629.** "Arcadia." Drawing. Louvre, Paris. [Augsburg 1975, no. E89—ill.]

Nicolas Poussin, 1594–1665. "The Arcadian Shepherds: 'Et in Arcadia Ego.'" Painting. *c.1630.* Duke of Devonshire coll., Chatsworth, Derbyshire. [Wright 1985, no. 54, pl. 23 / also Blunt 1966, no. 119—ill. / Thuillier 1974, no. 55—ill. / Jackson-Stops 1985, no. 315—ill.]

———. "Et in Arcadia ego." Painting. Late 1630s. Louvre, Paris, no. 734. [Wright, no. 104, pl. 57 / Louvre 1979–86, 4:145—ill. / also Blunt, no. 120—ill. / Thuillier, no. 116—ill. / Poggioli 1975, pp. 80–82] Copies in Musée des Beaux-Arts, Bordeaux (by A. Girault, 1865); Musée National de Céramique, Sèvres; Kunstakademie, Vienna, no. 940; private colls.; elsewhere. [Blunt]

———, formerly attributed (Pier Francesco Mola?). "Landscape with Arcadian Shepherds." Painting. Walker Art Gallery, Liverpool. [Ibid., no. R119]

John Milton, 1608–1674. *Arcades.* Masque. Music, Henry Lawes. First performed **1632** (?) for Dowager Countess of Derby, Harefield. / Revised, published in *Poems* (London, Moseley, 1645). [Carey & Fowler 1968 / Brown 1985, pp. 12–26, 47–52 / Grove 1980, 10:557 / Spink 1974, p. 94]

James Shirley, 1596–1666, attributed. *The Arcadia.* Dramatic version of Sidney's pastoral. Performed by Her Majesties Servants, Phoenix, Drury Lane, **1632**? Published London: Williams & Eglesfield, 1640. [DLB 1987, 58:249ff. / Logan & Smith 1978, p. 167]

Johan van Heemskerck, 1597–1656. *Batavische Arcadia* [Batavian Arcadia]. Novel (courtly pastoral romance). **1637.** Amsterdam: Bouman, 1678. [Kettering 1983, p. 25]

Herman Saftleven, 1609–1685, landscape, and **Cornelis van Poelenburgh,** c.1586–1667, figures. "Arcadian Landscape." Painting. **1643.** Herzog Anton Ulrich-Museum, Braunschweig, no. 343. [Braunschweig 1969, p. 122]

Joost van den Vondel, 1587–1679. (Leeuwendaal as Arcadia in) *De Leeuwendalers.* Pastoral play. **1647.** First performed 7 May 1648, Amsterdam, for festivities commemorating the Peace of Münster. [Kettering 1983, pp. 25–28 / McGraw-Hill 1984, 5:119]

Moyses van Uyttenbroeck, c.1590–**1648.** "Arcadian Landscape." Painting. Gemeentemuseum, The Hague. [Wright 1980, p. 460]

———. "Arcadian Landscape." Painting. Schilderijenzaal Prins Willem V, The Hague. [Ibid.]

Anonymous Spanish (Agustin Aoreto y Cabaña, 1618–1669, Act 3? contribution by Calderón?). *La fingida Arcadia* [The False Arcadia]. Comedy. **1664**? Published 1666. [McGraw-Hill 1984, 3:440]

Adriaen van de Velde, 1636–1672. "Arcadian Landscape with Resting Herdsmen and Cattle." Painting. Rijksmuseum, Amsterdam, inv. A2343. [Rijksmuseum 1976, p. 557—ill.]

Johannes Glauber, 1646–1726, landscape, and **Gérard de Lairesse,** 1641–1711 (active until *c.*1690), attributed, figures. "Arcadian Scenery." 2 pendant paintings. Statens

Museum for Kunst, Copenhagen. [Copenhagen 1951, nos. 261–62]

———. "Arcadian Landscape." 2 pendant paintings (related to above?). Rijksmuseum, Amsterdam, nos. A1201–02 (as Glauber). [Rijksmuseum 1976, p. 244—ill. / also Kettering 1983, p. 91—ill. (as Glauber and Lairesse)]

———. "Arcadian Landscape." Painting. Kunsthistorisches Museum, Vienna, inv. 6781 (1222A). [Vienna 1973, p. 79]

Reinhard Keiser, 1674–1739. *Der königliche Schäfer, oder Basilius in Arcadien* [The Royal Shepherd, or Basilius in Arcadia]. Opera. Libretto, Friedrich Christian Bressand, after material by F. Parisetti. First performed *c.*1693, Braunschweig. [Grove 1980, 9:847 / DLL 1968–90, 2:39]

Aalbert Meijeringh, 1645–1714. "Arcadian Scenery." Painting. 1696. Statens Museum for Kunst, Copenhagen. [Copenhagen 1951, no. 438]

Alessandro Magnasco, 1667–1749. "Arcadian Landscape." Painting. *c.*1700. Art Institute of Chicago, no. 29.915. [Chicago 1961, p. 265]

Adriaen van Diest, 1655–1704. "Arcadian Landscape." Painting. Herzog Anton Ulrich-Museum, Braunschweig, no. 409. [Braunschweig 1969, p. 52]

Pier-Giovanni Balestrieri. *L'Arcade.* Pastoral drama. Parma: Rosati, 1713. [Taylor 1893, p. 355]

Giovanni Alberto Ristori, 1692–1753. *Pallide trionfante in Arcadia* [Pallas Triumphant in Arcadia]. Opera (dramma pastorale). Libretto, O. Mandelli. First performed Summer 1713, Teatro Obizzi, Padua. [Grove 1980, 16:55f.]

Francesco Bartolomeo Conti, 1681–1732. *I sattiri in Arcadia* [The Satyrs in Arcadia]. Opera. Libretto, P. Pariati. First performed 1714, Vienna. [Grove 1980, 4:681]

Floriano Arresti, *c.*1660–1719. *Il trionfo di Pallade in Arcadia.* Opera. First performed 1716, Marsigli-Rossi, Bologna. [Grove 1980, 1:634]

Georg Philipp Telemann, 1681–1767. *Die Satyren in Arcadien* [The Satyrs in Arcadia]. Opera. First performed 1719, Leipzig. / Revised as an operetta, *Der neu-modische Liebhaber Damon* [The New-fashioned Gallant Damon], performed 1724. [Grove 1980, 18:656]

Maria Teresa Agnesi, 1720–1795. *Il ristoro d'Arcadia* [The Solace of Arcadia]. Cantata. Libretto, G. Riviera. First performed 1747, Teatro Ducale, Milan. [Grove 1980, 1:157]

Jan Frans van Bloemen, 1662–1749. "Arcadian Landscape." 2 pendant paintings. Statens Museum for Kunst, Copenhagen, inv. 707, 708. [Copenhagen 1951, nos. 69–70]

Jan van Huysum, 1682–1749. "Arcadian Landscape." Painting. Rijksmuseum, Amsterdam, inv. A185. [Rijksmuseum 1976, p. 294—ill.]

Baldassare Galuppi, 1706–1785. *L'Arcadia in Brenta* [Arcadia on the Brenta]. Opera (dramma giocoso). Libretto, Carlo Goldoni. First performed 14 May 1749, S. Angelo, Venice. Published Barcelona: 1751? [Grove 1980, 7:137, 503] At least 3 further settings of Goldoni's libretto: Meneghetti, 1757, Vicenza; Silva, 1764, Lisbon; Bosi, 1780, Ferrara. [Ibid.]

John Stanley, 1712–1786. *Arcadia, or the Shepherd's Wedding.* Opera. Libretto, Robert Lloyd. First performed 26 Oct 1761, Theatre Royal, Drury Lane, London. [Grove 1980, 18:77 / Fiske 1973, pp. 135, 247, 588]

Jan van Gool, 1685–1763. "Arcadian Landscape with Shepherds and Cattle." Painting. Rijksmuseum, Amsterdam, inv. C133. [Rijksmuseum 1976, p. 245—ill.]

Angelica Kauffmann, 1741–1807. "A Shepherd and Shepherdess in Arcadia. . . ." Painting. Exhibited 1766. [Manners & Williamson 1924, p. 21]

———. Painting of an Arcadian scene (an old man reunited with his daughter whom he had believed dead), after a poem by George Keate. 1790. [Ibid., p. 158]

Joshua Reynolds, 1723–1792. "Mrs. Bouverie and Mrs. Crewe" ("Et in Arcadia ego"). Painting. Exhibited 1769. Marquess of Crewe coll., London. [Waterhouse 1941, p. 60—ill.]

Balthasar Beschey, 1708–1776. "Arcadian Landscape." Painting. Frans Hals Museum, Haarlem, inv. no. 504. [Wright 1980, p. 32]

Joseph Aloys Schmittbaur, 1718–1809. *Ein Grab in Arkadian* [A Tomb in Arcadia]. Opera. First performed 1779, Karlsruhe. [Grove 1980, 16:679]

Richard Wilson, 1714–1782. "Shepherds in Arcadia: 'Et in Arcadia Ego.'" Painting. Lady Byng coll., Wrotham Park. [Pigler 1974, p. 479]

William Beckford, 1760–1844. *The Arcadian Pastoral.* Opera. Libretto, Lady Craven. First performed 1782, Queensbury House, London. [Fiske 1973, pp. 439f., 585]

Johann Adam Hiller, 1728–1804. *Das Denkmal in Arkadien* [The Monument in Arcadia]. Singspiel. *c.*1782. Libretto, Christian Felix Weisse. Unperformed. Lost. [Grove 1980, 20:328]

C. Hunt. *Das Denkmal in Arkadien* [The Monument in Arcadia]. Opera. Libretto, C. F. Weisse. First performed 1785, Dresden. [Clément & Larousse 1969, 1:307]

Joseph-Charles Marin, 1759–1834. "Arcadian Family." Terra-cotta sculpture. *c.*1790. [Clapp 1970, 1:575]

Franz Xaver Süssmayr, 1766–1803. *Der Spiegel von Arkadien* [The Mirror of Arcadia]. Comic opera. Libretto, Emanuel Schikaneder. First performed 14 Nov 1794, Theater auf der Wienen, Vienna. Performed as *Die neuen Arkadier* [The New Arcadians] 2 Feb 1796, Hoftheater, Weimar. [Landon 1988, p. 139 / Grove 1980, 18:381]

William Wordsworth, 1770–1850. (Arcadia evoked in) *The Prelude* 8.312–24. Poem. 1799–1805. London: Moxon, 1850. [Owen 1985 / Patterson 1987, pp. 279f. / Zwerdling 1964, pp. 345–47]

Joseph Anton Koch, 1768–1839. "(Heroic) Landscape with Rainbow" ("Greek Landscape"). Painting. 1805. Kunsthalle, Karlsruhe. / Further versions in Neue Pinakothek, Munich (dated 1815); Märkisches Museum, Berlin (1824). [Munich 1982, pp. 177f.—ill.]

Jean-Honoré Fragonard, 1732–1806. "Et in Arcadia ego." Drawing. National Gallery of Scotland, Edinburgh. [Royal Academy 1968, no. 251]

Johann Christian Klengel, 1751–1824. "Arcadian Landscape." Painting. Gemäldegalerie, Dresden, no. 2186. [Dresden 1976, p. 65]

Johann Wolfgang von Goethe, 1749–1832. (Faust enjoys a new Arcadia with Helen in) *Faust* Part 2, 3.9506ff. Tragedy. This episode written 1825–27, first published as "Helena: Klassisch-romantische Phantasmogorie" (1827). Incorporated into *Faust*, published posthumously, Heidelberg: 1832. [Beutler 1948–71, vol. 5 / Suhrkamp 1983–88, vol. 2 / Poggioli 1975, pp. 221, 225f., 232f.]

Thomas Cole, 1801–1848. "The Course of Empire: The Arcadian or Pastoral." Painting, first of a series of 5. **1833–36.** New York Historical Society, New York. [Hartford 1949, no. 153]

————. "A Dream of Arcadia." Painting. 1838. Denver Art Museum, Colorado. [Rochester 1969, no. 36—ill. / also Hartford, no. 28—ill.] Oil study. New York Historical Society, New York. [Hartford, no. 29—ill.]

————. "An Evening in Arcady." Painting. 1843. Wadsworth Atheneum, Hartford, Conn. [Ibid., no. 39—ill.]

Francis Oliver Finch, 1802–1862. "Arcadia." Watercolor. *c.*1840? Ashmolean Museum, Oxford. [Lister 1984, p. 88, pl. 128]

Jan Willem Pieneman, 1779–1853. "Arcadian Landscape." Painting. Rijksmuseum, Amsterdam, inv. A1110. [Rijksmuseum 1976, p. 440—ill.]

William Bouguereau, 1825–1905. "Arcadia." Painting. 1860. Wadsworth Atheneum, Hartford, Conn., inv. 1913–1. [Seen by author]

Mary Elizabeth Maxwell Braddon, 1835–1915. *The Loves of Arcadia.* Comedietta. First performed **1860,** Strand Theatre, London. [Nicoll 1959–66, 5:273]

W. S. Gilbert, 1836–1911, libretto. *Happy Arcadia.* Operetta. Music, Frederic Clay. First performed 28 Oct **1872,** Royal Gallery of Illustration, London. [McGraw-Hill 1984, 2:308]

Richard Stoddard, 1825–1903. "Arcadian Idyl." Poem. In *Poems* (New York: Scribner, **1880**). [Boswell 1982, p. 222]

Samuel Palmer, 1805–1881. Illustrations to Milton's *Arcades,* in *The Shorter Poems of John Milton* (London: Seeley, 1889). [NUC]

Robert Louis Stevenson, 1850–1894. "Et tu in Arcadia." Poem. In *Cornhill Magazine,* Feb **1881**; collected in *Underwoods* (London: Chatto & Windus, 1887). [Ipso]

————. "You Know the Way to Arcady." Poem. In *Underwoods* (1887). [Ipso]

Pierre Puvis de Chavannes, 1824–1898. "Pleasant Land." Painting. **1882.** Musée Bonnat, Bayonne. [Ottawa 1977, p. 172] Reduced replica. Yale University Art Gallery, New Haven, no. 1958–64. [Ibid., no. 155—ill. / Wattenmaker 1975, no. 23—ill.] Study ("The Sacred Grove"). Clemens-Sels-Museum, Neuss, no. MA54. [Ottawa, no. 156—ill.]

Edward Calvert, 1799–1883. "Simple Life: Arcadia." Painting. H.R.H. the Princess Royal coll., England. [Lister 1962, pl. LVII—ill.]

Thomas Eakins, 1844–1916. Series of photographs, plaster reliefs and oil sketches on the theme of Arcadia. **1883.** Hirshhorn Museum and Sculpture Garden, Washington, D.C. (relief); Metropolitan Museum, New York, no. 67.187.125. (painting); Lloyd Goodrich coll., New York (painting); elsewhere. [Hirshhorn 1974, pp. 69, 687, pls. 55–56 / Metropolitan 1965–85, 3:608–12—ill. / Hendricks 1974, nos. 64–65, 186—ill.]

Alexander Harrison, 1853–1930. "In Arcadia." Painting. **1886.** Musée d'Orsay, Paris, no. R.F. 1316. [Louvre 1979–86, 2:67—ill.]

Karl Gjellerup, 1857–1919. *En arkadisk Legende* [An Arcadian Legend]. Novel. Copenhagen: Schou, **1887.** [DLL 1968–90, 6:357]

Philipp Scharwenka, 1847–1917. *Arkadische Suite.* Orches-tral composition, opus 76. Leipzig: **1887.** [Grove 1980, 16:595]

William Butler Yeats, 1865–1939. "Song of the Last Arcadian." Poem. In *The Wanderings of Oisin and Other Poems* (London: Kegan Paul, Trench, **1889**). [Ipso / Bush 1937, p. 463]

Hippolyte Petitjean, 1854–1929. "Mythological Scene" ("In Arcadia"). Painting. **1895.** M. Knoedler & Co., in 1975. [Wattenmaker 1975, no. 68—ill.]

Aubrey Beardsley, 1872–1898. "Et in Arcadia ego" (middle-aged dandy reading inscription on a monument). Satirical drawing. **1896.** Princeton University Library, N.J. [Reade 1967, no. 452—ill. / also Weintraub 1976, p. 258—ill.]

Charles Ricketts, 1866–1931. Series of woodcuts illustrating Milton's *Arcades,* in *John Milton: Early Poems* (London: Hacon & Ricketts, **1896**). [NUC]

Arthur B. Davies, 1862–1928. "Fleecy Arcadia." Painting. **1900.** Mary Austin coll., New York. [Cortissoz 1931, p. 25]

————. "Arcadian Scene." Painting. Private coll., New York. [Davies 1975, no. 5—ill.]

Alice Pike Barney, 1857–1931. "Arcady." Pastel sketch. *c.*1903. Barney coll. no. 180, National Collection of Fine Arts, Washington, D.C. [Barney 1965, p. 62—ill.]

George Frederick Watts, 1817–1904. "Arcadia." Painting. After 1843. [Phythian 1907, pp. 80f., 90]

Henri de Régnier, 1864–1936. "En Arcadie." Poem. **1903–05.** In *La sandale ailée: 1903–1905* (Paris: Société du Mercure de France, 1906). [DLLF 1984, 3:1885]

Albert Pinkham Ryder, 1847–1917. "Arcadia." Painting. Julia M. Sherman coll., New York. [Price 1932, no. 3]

————. "Maid of Arcady." Painting. Frank L. Babbot coll., New York. [Ibid., no. 92]

Gottfried Benn, 1886–1956. (Arcadia evoked in) "Prolog 1920." Poem. *c.*1920. In *Gesammelten Schriften* (Berlin: 1922). [Wellershof 1960]

George Sklavos, 1888–1976. *Arcadian Suite.* Orchestral composition. **1922.** [Grove 1980, 17:366]

P. H. van Moerkerken, 1877–1951. *In de lusthof Arkadië* [In the Pleasure-palace of Arcadia]. Novel, third volume in the cycle *Die Gedachte der tijden* [The Reflection of the Seasons]. **1918–24.** Amsterdam: van Oorschot, 1948. [Meijer 1971, p. 281]

Gunnar Silfverstolpe, 1893–1942. "Arkadia." Poem. / Translated by C. D. Locock in *A Selection from Modern Swedish Poetry* (New York: Macmillan, **1929**). [Ipso]

Erik Axel Karlfeldt, 1864–1931. (Arcadian themes reflected in) *Arcadia Borealis: Selected Poems.* Collection of poetry. Translated by Charles W. Stork. Minneapolis: University of Minnesota Press, [1938]. [Gustafson 1961, p. 656 / Columbia 1980, p. 423]

Otto Stoessl, 1875–1936. *Arkadia.* Collection of poetry. Vienna: Saturn, **1933.** [EWL 1981–84, 4:342 / DULC 1959–63, 4:672]

Wilhelm Kempff, b. 1895. *Arkadische Suite.* Composition for chamber orchestra. **1939.** [Baker 1984, p. 1182]

Ker-Xavier Roussel, 1867–1944. "The Fountain of Youth." Painting, part of triptych. Private coll., Paris. [Georgel 1968, p. 367, no. 257—ill.]

————. "The Fountain of Youth." Painting. Private coll., Paris. [Ibid., p. 376, no. 288—ill.]

P. Mustapää (Martti Haavio), 1899–1973. *Jäähyväiset Ar-*

kadialle [A Farewell to Arcadia]. Collection of poems. Helsinki: Söderström, **1945**. [DSL 1990, p. 426]

August Baeyens, 1895–1966. *Arkadia*. Chamber symphony for 19 soloists. **1951**. [Baker 1984, p. 127]

Charles Gullans, 1929–. "First Death: Et in Arcadia Ego." Poem. In *The Hudson Review* 9 no. 3 (Autumn **1956**); collected in *Arrivals and Departures* (Minneapolis: University of Minnesota Press, 1962). [Ipso]

Lawrence Durrell, 1912–1990. "In Arcadia." Poem. In *Collected Poems* (New York: Dutton, **1960**). [Ipso]

Tadeusz Różewicz, 1921–. "Et in Arcadia ego." Poem. In *Zielona róza* (Warsaw: Panstwowy Instytut, **1961**). [Różewicz 1976, p. xiv]

Luis Cernuda, 1902–1963. (Et in Arcadia ego, theme of) "Luna llena en Semana Santa" [Full Moon in Semana Santa]. Poem. **1956–62**. In *Desolación de la quimera* (Mexico City: Mortiz, 1962). [Capote 1984]

W. H. Auden, 1907–1973. "Et in Arcadia ego." Poem. **1964**. In *About the House* (New York: Random House, 1965). [Mendelson 1976 / EWL 1981–84, 1:138 / Johnson 1973, pp. 164f. / Feder 1971, p. 176]

Vincent Buckley, 1925–. "Arcady." Poem. In *Arcady and Other Places* (Melbourne: Melbourne University Press; Cambridge: Cambridge University Press, **1966**). [Vinson 1985, p. 108 / DLEL 1970–78, 2:47]

Horia Lovinescu, 1917–. *Si eu am fost in Arcadia* [I Have Been in Arcadia]. Drama. Unperformed. Published in *Coperta colectiei* (Bucharest: "Cartea romanesca," **1971**). [McGraw-Hill 1984, 3:285]

Richmond Lattimore, 1906–1984. "Et in Arcadia ego." Poem. In *Poems from Three Decades* (New York: Scribner, **1972**). [Ipso]

Ian Hamilton Finlay, 1925–, with **George Oliver**. "Arcadia." Color print. **1973**. (Tate Gallery, London, no. PR344.) [Tate 1975, p. 131]

————(Finlay). "Et in Arcadia ego." Painting. Scottish National Gallery of Modern Art, Edinburgh. [Jacobs & Stirton 1984b, p. 236]

I. A. Richards, 1893–1979. "Et ego in Arcadia." Poem. In *New and Selected Poems* (Manchester: Carcanet, **1978**). [Ipso]

Christopher Reid, 1949–. (City as anti-Arcadia, theme running through) *Arcadia*. Collection of poetry. Oxford: Oxford University Press, **1979**. [CLC 1985, 33:348–57]

ARES. The only son of Zeus and Hera, Ares is the god of war and warlike spirit. He was unpopular among many of the ancient Greeks, his worship limited to Thebes (Boeotia), perhaps Attica, and to communities in the north such as Thessaly and Aetolia. Some scholars posit a northern or Thracian origin for the god.

As the personification of strife, Ares' companions are Fear and Panic (sometimes called his children). Athena, as goddess of forethought in battle, regularly bested Ares' brute force. In mythology, Ares often supported foreign powers in battles: he took the side of the Trojans during the Trojan War and supported the Amazons on a number of occasions, although he fought with some success for the Olympians against the Giants. Even among the Olympian deities, however, his behavior in battle was not praised. In Book 5 of the *Iliad*, for example, when Ares is wounded by the mortal Diomedes, Zeus condemns him as the most hateful of all the gods.

Ares' amorous liaisons included Eos (Aurora) and, most notably, Aphrodite (Venus). With Aphrodite he is said to have fathered Harmonia (also called Hermione, later the wife of Cadmus), Eros and Anteros, and Deimos (Fear) and Phobos (Panic).

The Roman god Mars derived almost entirely from Ares, but unlike him, Mars was second in importance, after Jupiter, in the Roman pantheon. Months were named after him in the city of Rome and other areas, and two festivals were celebrated annually in his honor. Originally an agricultural god, Mars was worshiped by many Italian tribes and associated with spring, regeneration, and growth. He was also identified with two animals, the wolf and the woodpecker.

As the Romans became more warlike, Mars changed as well. Offerings were made to him before and after battle; under the Emperor Augustus, he was given the epithet "Ultor" ("Avenger") and had a temple dedicated in his honor in 42 BCE. He was closely associated with the Sabine war deity Quirinus and a number of lesser deities, including the goddess Bellona, who was sometimes called his wife or sister.

In classical art Ares is frequently depicted among groups of gods but rarely shown alone. In later periods as well he is usually seen alongside other deities, most commonly Bellona and Athena (Minerva). In postclassical art he is often used as an allegory for war; conversely, the image of the sleeping Mars—a metaphor for fragile peace—is also a popular theme.

Classical Sources. Homer, *Iliad* 2.512ff., 5 passim, 15.110ff., 20.32ff., 21.391ff. and passim. Hesiod, *Theogony* 921–23, 934–37. *Homeric Hymns*, "To Ares." *Orphic Hymns* 65, "To Ares." Virgil, *Aeneid* passim; *Eclogues* 10, 18. Ovid, *Fasti* 5.229ff. Hyginus, *Fabulae* 159. Quintus of Smyrna, *Sequel to Homer* 1.675ff., 8.340ff., 14.47ff. Lucian, *Dialogues of the Gods* 1, "Ares and Hermes."

See also ADONIS; ARES AND APHRODITE; ARES AND ATHENA; DIOMEDES; GODS AND GODDESSES; TITANS AND GIANTS; TROJAN WAR.

Anonymous French. (Birth of Mars in) *Ovide moralisé* 14.56–64. Poem, allegorized translation/elaboration of Ovid's *Metamorphoses* and other works. *c*.**1316–28**. [de Boer 1915–86, vol. 5]

Giovanni Boccaccio, 1313–1375. (Temple of Mars, Arcita's prayer to Mars, description of the house of Mars, in)

Teseida 7.23–41, 96–102; Mars evoked and invoked passim. Poem. *c.*1340–42. [Branca 1964–83, vol. 2 / McCoy 1974 / Hollander 1977, pp. 55ff. / Havely 1980, pp. 125–28]

Geoffrey Chaucer, 1340?–1400. (Scenes associated with Mars painted in Temple of Mars; Arcite prays to Mars for victory, in) "The Knight's Tale" lines 1967–2050, 2367–2437, and Mars evoked passim. Poem, after Boccaccio's *Teseida*. **Early 1380s** (as "Palamon and Arcite"); revised and incorporated in *The Canterbury Tales,* 1388–95. Westminster: Caxton, 1478. [Riverside 1987 / Minnis 1982, p. 20 / Havely 1980, pp. 125ff.]

Christine de Pizan, *c.*1364–*c.*1431. (Mars in) *L'epistre d'Othéa à Hector* . . . [The Epistle of Othéa to Hector] chapter 11, 56. Didactic romance in prose. *c.*1400. MSS in British Library, London; Bibliothèque Nationale, Paris; elsewhere. / Translated by Stephen Scrope (London: *c.*1444–50). [Bühler 1970 / Hindman 1986, pp. 80, 87f., 103f., 106, 112, 194, 198, pls. 14, 15]

Taddeo di Bartolo, 1362–1422. "Mars on a Chariot." Fresco. *c.*1414. Anticapella, Palazzo Pubblico, Siena. [Berenson 1968, p. 423—ill.]

Giovanni d'Ambrogio, fl. 1384–1418, and workshop. "Mars." Marble sculpture. Porta della Mandorla Cathedral, Florence. [Warburg]

John Lydgate, 1370?–1449. (Apostrophe to Mars, Mars denounced in) *Troy Book* Prologue, 4.4440–537. Poem, elaboration of Guido delle Colonne's *Historia destructionis Troiae* (1272–87); these passages original with Lydgate. **1412–20.** Modern edition by Henry Bergen (London: Kegan Paul, Trench & Trübner, for Early English Text Society, 1906–35). [Benson 1980, p. 118 / Pearsall 1970, p. 126]

Agostino di Duccio, 1418–1481. "Mars." Marble relief. **1454–57.** Cappella S. Francesco, Rimini. [Clapp 1970, 1:18 / Agard 1951, pp. 68f.—ill.]

Andrea Mantegna, 1430/31–1506, attributed. Grisaille painting with "four figures" (Mars, Neptune, Amymone, 1 other), for Studiolo of Isabella d'Este, Corte Vecchia, Mantua. Lost. / Figure of Mars reproduced in a drawing by Mantegna. British Museum, London. [Louvre 1975, nos. 93, 131—ill.]

Albrecht Altdorfer, *c.*1480–1538. "Mars with Spear and Shield." Engraving. **1506.** [Winzinger 1963, no. 95—ill.]

———, circle (previously attributed to Altdorfer). "The Rule of Mars." Painting, part of triptych "The Fall of Man." *c.*1520s? Kress coll. (K1849C), National Gallery, Washington, D.C., no. 1110 (as Altdorfer). [Eisler 1977, pp. 33–35—ill. / Sienkewicz 1983, p. 19—ill.]

Raphael, 1483–1520. "Sculptural (?) Ensemble with a Standing Figure of Mars." Drawing, sketch for unknown work. *c.*1508–09 or later. Szépművészeti Múzeum, Budapest, no. 1935. [Joannides 1983, no. 215v—ill.]

Giorgione, *c.*1477–1510, formerly attributed (probably by Palma Vecchio). (Mars in) "The Forge of Vulcan." Painting. Pozzi coll., Novara. [Pignatti 1978, no. V25]

Baldassare Peruzzi, 1481–1536. "Mars." Ceiling fresco. **1510–11.** Sala di Galatea, Villa Farnesina, Rome. [d'Ancona 1955, pp. 25f., 86 / Gerlini 1949, pp. 10ff. / also Frommel 1967–68, no. 18c]

———. "Mars." Fresco. 1511–12 (or *c.*1517–18). Sala delle Prospettive, Villa Farnesina, Rome. [d'Ancona, pp. 27ff., 93f. / Gerlini, pp. 31ff. / also Frommel, no. 51]

Pinturicchio, 1454–1513, and studio. "The Triumph of Mars." Fresco (detached), from Palazzo Pandolfo Petrucci ("Il Magnifico"), Siena. Metropolitan Museum, New York, no. 114.7. [Metropolitan 1980, p. 142—ill. / Berenson 1968, p. 345—ill.]

Giulio Romano, *c.*1499–1546, assistant, after design by Giulio. "Mars." Stucco relief. *c.*1529–30. Sala degli Stucchi, Palazzo del Tè, Mantua. [Hartt 1958, p. 148, fig. 307 / Verheyen 1977, p. 123, fig. 65] Mars also depicted in frescoes in Sala dei Venti and Sala di Psiche, and stucco relief in Sala delle Stucchi. 1527–30. [Verheyen, pp. 117, 119f., 123f.—ill. / also Hartt, pp. 115ff., 129, 132—ill.]

———. "Mars." Drawing (modello for unknown or unexecuted fresco?). British Museum, London, Ff.1–40. [Hartt, p. 308 (no. 356)—ill.]

Agnolo Bronzino, 1503–1572, attributed (with others?). "Mars." Fresco. **1530–32.** Sala dei Semibusti, Villa Imperiale, Pesaro. [Baccheschi 1973, no. 13]

Marcantonio Raimondi, *c.*1480–1527/34. "Mars." Engraving (Bartsch no. 254), after design by Francesco Francia? [Bartsch 1978, 26:251—ill.]

Andrea Schiavone, *c.*1522–1563. "Mars." Etching. *c.*1536–38? [Richardson 1980, no. 97]

———. "Mars and Cupid." Etching (Bartsch no. 73). *c.*1542–46. [Ibid., no. 73]

———. "Mars." Etching. *c.*1546–52? [Ibid., no. 78 / Hofmann 1987, no. 7.10—ill.]

Battista Zelotti, *c.*1526–1578. "Venus between Mars and Neptune." Painting, ceiling panel. **1553–54.** Sala dei Dieci, Palazzo Ducale, Venice. [Berenson 1957, p. 204—ill.]

Francesco Primaticcio, 1504–1570, design. "Mars Sleeping." Fresco, for Salle de Bal, Château de Fontainebleau, executed by Niccolò dell' Abbate under Primaticcio's direction. **1551–56.** Repainted 19th century / Drawing. Louvre, Paris, no. 8603. [Dimier 1900, pp. 160ff., 284ff., no. 90]

Bartolommeo Ammannati, 1511–1592. "Mars." Bronze figure. **1559.** Uffizi, Florence. [Pope-Hennessy 1985b, 3:373]

Giovanni Bernardi, 1496–1553, and **Manno di Bastiano**, design. (Statuette of Mars at corner of) "The Farnese Coffer." Silver gilt coffer. **1548–61.** Museo di Capodimonte, Naples, no. 10507. [Capodimonte 1964, p. 129]

Thomas Sackville, 1536–1608. (Shield of Mars in) "Induction." Poem. In *A Myrroure for Magistrates* (London: Marsh, **1563**). Modern edition by Lily B. Campbell, *The Mirror for Magistrates* (Cambridge: Cambridge University Press, 1938). [Bush 1963, pp. 62, 313]

Jacopo Sansovino, 1486–1570. "Mars." Colossal marble statue. Commissioned 1554, completed **1567.** Scala dei Giganti, Palazzo Ducale, Venice. [Pope-Hennessy 1985b, 3:408—ill.]

———. "Mars." Bronze statue. Detroit Institute of Arts. [Clapp 1970, 1:786]

———, style. "Mars." Bronze statuette. Victoria & Albert Museum, London, no. A.113–1910. [Warburg]

Giambologna, 1529–1608. "Mars." Gilt bronze statuette. Modeled **early 1570s** or before. Several versions, nu-

merous examples, by Giambologna and workshop, 1586/87–early 17th century. [Avery & Radcliffe 1978, p. 93, nos. 42–47—ill. / also Avery 1987, no. 69—ill. / Florence 1986, p. 66—ill.]

———. "Mars" (or Francesco I de' Medici?). Polychrome terra-cotta bust. c.1580? Private coll. [Avery, no. 200 / also Avery & Radcliffe, no. 234—ill.]

Luis Vaz de Camões, 1524?–1580. (Mars defends the Portuguese on Olympus in) *Os Lusiadas.* Epic poem. Royal license, Lisbon, **1572.** [Bowra 1945, p. 10]

Jacopo Bertoia, 1544–1574. "Mars." Painting. Christ Church, Oxford. [Byam Shaw 1967, no. 168—ill.]

Maerten van Heemskerck, 1498–1574. "Mars in the Smithy." Painting. Dienst Verspreide Rijkskollekties, The Hague, inv. NK2869. [Wright 1980, p. 166]

Torquato Tasso, 1544–1595. (Mars evoked in) *Gerusalemme liberata* 6.55, 10.72. Epic. **1575.** Venice: Perchacino, 1581 (authorized edition). [Kates 1983, p. 69]

Paolo Veronese, 1528–1588. "Mars and Neptune." Ceiling painting, part of decoration glorifying Venice. **1575–78.** Sala del Collegio, Palazzo Ducale, Venice. [Pallucchini 1984, no. 143b—ill. / Pignatti 1976, no. 192—ill. / also Berenson 1957, p. 136—ill.]

Hendrik Goltzius, 1558–1617. "Mars in Half-length." Woodcut. c.1588. 5 states. [Strauss 1977a, no. 406—ill. / Bartsch 1980–82, no. 230—ill.]

———. "Mars." Drawing, composition for print. c.1590. Musée des Beaux-Arts, Besançon, inv. 2745. / Print by Jacob Matham, Bartsch no. 298. [Reznicek 1961, no. 118—ill.]

———. "Mars in Full-length." Woodcut. c.1594. 2 states. [Strauss, no. 416—ill. / Bartsch, no. 229—ill.]

———. "[Statue of] Mars as Protector of War." Drawing, composition for print in "Seven Planets" series. 1595–96. Rijksprentenkabinet, Amsterdam, inv. 1905–A62. (Engraved by Jan Saenredam, Bartsch no. 75.) [Reznicek, no. 145—ill.] Variant, for second ("small") series, 1597. Unlocated. (Engraved by Jacob Matham, Bartsch no. 151.) [Ibid., no. 149]

Juan de la Cueva, 1550?–1610? *Los amores de Marte* [The Loves of Mars]. Poem. In *Parnaso español,* vol. 8 (Madrid: Ibarra, 1774). [DLE 1972, p. 238]

Jan Brueghel the Elder, 1568–1625. "Mars Receiving His Armor" (from Vulcan). Painting. **1613?** Alte Pinakothek, Munich, inv. 1881. [Ertz 1979, no. 276—ill.]

William Shakespeare, 1564–1616, and **John Fletcher,** 1579–1625. (Arcite prays for Mars's patronage in) *The Two Noble Kinsmen* 5.1.34–68 (this passage attributed to Shakespeare). Drama (romance), adaptation of Chaucer's "The Knight's Tale" (1388–95). c.1613. No recorded performance in Shakespeare's lifetime. Published London: Waterson, 1634. [Riverside 1974 / Brownlow 1977, pp. 202f., 212f., 219 / Muir 1985, pp. 73f.]

Jacopo Peri, 1561–1633. *Marte e Amore* [Mars and Cupid]. Dramatic music (cantata?). Libretto, F. Saracinelli. First performed 9 Feb **1614,** Salone grande, Palazzo Pitti, Florence. [Grove 1980, 14:404]

Peter Paul Rubens, 1577–1640. "Portrait of a Man as Mars." Painting. c.1616–17. Miami Savings Bank, Fla. (ex-Kress coll.). [Jaffé 1989, no. 415—ill. / also Eisler 1977, pp. 109f.—ill.]

———. (Mars in) "The Council of the Gods" ("The Government of the Queen"). Painting, part of "Life of Marie de' Medici" cycle. 1622–25. Louvre, Paris, inv. 1780. [Saward 1982, pp. 114ff.—ill. / Jaffé, no. 737—ill. / also Louvre 1979–86, 1:117—ill.] Oil sketch. Alte Pinakothek, Munich, inv. 103. [Jaffé, no. 736—ill. / Munich 1983, pp. 463, 467—ill. / Held 1980, no. 71—ill.] Copy (formerly attributed to Delacroix), detail depicting Apollo and Mars dispelling Discord and Envy. Walters Art Gallery, Baltimore, inv. 37.1. [Walters 1982, p. 49]

———. (Mars in) "The Advent of the Prince." Design for part of the Stage of Welcome, decoration for "Pompa Introitus Fernandi," triumphal entry of Cardinal-Infante Ferdinand of Spain into Antwerp, 17 Apr 1635. Original decoration destroyed. / Etching (copy after lost painting by Cornelis Schut) by Theodoor van Thulden. [Martin 1972, no. 2—ill.]

———. (Mars in) 2 oil sketches, designs for title pages of books commemorating "Pompa Introitus Fernandi" (above). c.1635. Victoria and Albert Museum, London, inv. D. 1399–1891; Fitzwilliam Museum, Cambridge, inv. F.M. 240. [Held, nos. 305–06—ill. / Jaffé, no. 1182—ill.]

———. "Venus Trying to Restrain Mars." Painting, oil sketch. c.1634–36. Louvre, Paris. [Jaffé, no. 1172—ill. / Held, no. 268—ill. / also Baudouin 1977, fig. 122] Final version, by Paul de Vos and Rubens's studio, in Neue Palais, Potsdam. [Held / Jaffé, no. 1173—ill.]

———. "Venus [and Cupid] Trying to Restrain Mars" ("The Consequences (Horrors) of War"). Painting. 1637–38. Sala di Marte, Palazzo Pitti, Florence, no. 86. [Jaffé, no. 1353—ill. / Pitti 1966, p. 72—ill. / White 1987, p. 230—ill. / Baudouin 1977, fig. 130]

Robert Herrick, 1591–1674. "A Vow to Mars." Poem. c.1627. In *Hesperides* (London: Williams & Eglesfield, 1648). [Martin 1956 / Scott 1974, p. 55]

Guercino, 1591–1666. "Mars." Painting. c.1628. Tatton Park, Knutsford, Cheshire. [Salerno 1988, no. 123 bis.—ill.] Copy (previously considered autograph) in Uffizi, Florence, inv. 522. [Uffizi 1979, no. P790—ill.]

———. "Mars with an Amorino." Painting. 1649. Cincinnati Art Museum, Ohio. [Salerno, no. 257—ill.]

———. "Mars." Painting. Wellington Museum, London. [Ibid., no. 130—ill.]

———. "Mars Furious, Restrained by an Amorino." Presumed painting, lost, known from an engraving by Giacomo Giovannini. [Ibid., no. 364—ill.]

Claudio Monteverdi, 1567–1643. *Mercurio e Marte* [Mercury and Mars]. Torneo [tournament]. Text, C. Achillini. First performed **1628,** Parma. Music lost. [Grove 1980, 12:530 / Redlich 1952, p. 105]

Hendrik Terbrugghen, 1588–1629. "Sleeping Mars." Painting. **1629.** Centraal Museum, Utrecht, cat. 1952 no. 52. [Wright 1980, p. 65]

Joachim von Sandrart, 1606–1688, attributed. "Mars, Venus, and Cupid" ("Allegory of Wrath") (Venus and Cupid restraining Mars from departing for war). Painting. c.1630. Hermitage, Leningrad, inv. 7621. [Hermitage 1987b, no. 93—ill.]

Anthony van Dyck, 1599–1641. "Mars Going to War" (or returning, to Venus). Painting (sketch). c.1630–32. Christ

Church, Oxford. [Larsen 1988, no. 739—ill. / Byam Shaw 1967, no. 248—ill.]

———, follower. "Mars Returning from War." Drawing (possibly related to above). Kupferstichkabinett, Berlin. [Byam Shaw, no. 248—ill.]

Giovanni da San Giovanni, 1592–1636. "Cupid Presenting to Mars the Marzocco [heraldic lion], Symbol of the City of Florence." Ceiling fresco. **1635–36.** Salone degli Argenti, Palazzo Pitti, Florence. [Banti 1977, no. 64—ill.]

Gerrit van Honthorst, 1590–1656, attributed. "Sleeping Mars." Painting. **1636.** Cranford Manor. / Several other versions, unlocated. [Judson 1959, no. 85]

——— (or Jan van Bylertt?). "Mars Overpowered by Cupids." Painting. Unlocated. [Ibid., no. 86]

Paulus Moreelse, 1571–1638. "Mars." Painting. Documented 1659, untraced. [de Jonge 1938, no. 310]

Diego Velázquez, 1599–1660. "Mars." Painting. *c.*1639–42. Prado, Madrid, no. 1208. [López-Rey 1963, no. 61—ill. / López Torrijos 1985, pp. 331ff., pl. 143 / Prado 1985, pp. 743f.]

Charles Le Brun, 1619–1690. Drawing, depicting Mars and Apollo flanking the bow of a ship, design for unexecuted print *c.*1642. Anthony Blunt coll., London. [Versailles 1963, no. 59—ill.]

Jacob Jordaens, 1593–1678. 8 cartoons for "The Riding School" tapestry series: "Levade Performed under the Auspices of Mars and in the Presence of Mercury," "Levade Performed under the Auspices of Mars and in the Presence of Mercury, Venus, and a Riding-master," "Mars and Mercury Leading Horses to Venus," 5 others (4 lost). *c.*1645. National Gallery of Canada, Ottawa; Marquess of Bath coll., Longleat, Wiltshire (2). [d'Hulst 1982, pp. 232, 303, fig. 184] Tapestries woven by Leyniers & Rydams, Brussels, 1651. Kunsthistorisches Museum, Vienna. [Ibid., pp. 303f., fig. 185 / Ottawa 1968, no. 281—ill.]

———. "Mars" ("March"). Ceiling painting, part of "Signs of the Zodiac" series for artist's house in Antwerp. Early 1640s. Senate Library, Palais du Luxembourg, Paris. [Rooses 1908, pp. 124f.]

———, attributed. "Mars and Bellona." Painting. Sold Antwerp, 1856, unlocated. [Ibid., p. 259]

Pietro da Cortona, 1596–1669. "Mars Flies from Earth on Pegasus" (or Bellerophon and Pegasus?). Fresco. **1642–46.** Sala di Giove, Palazzo Pitti, Florence. [Pitti 1966, p. 49—ill. / also Campbell 1977, pp. 127, 133—ill.]

———. Ceiling fresco, depicting a Medici prince aided in war by Mars, Hercules, and the Dioscuri. 1644–47. Sala di Marte, Palazzo Pitti, Florence. [Campbell, pp. 121ff.—ill. / Pitti, p. 66—ill. / also Briganti 1962, no. 96—ill.]

Michelangelo Brunerio. *Mars ed Amore* [Mars and Amor]. Opera (dramma per musica). First performed **1646** (?), Warsaw? [Abraham 1985, p. 124]

Cornelis de Vos, 1585–1651. "Mars Crowned by Victory." Painting. Herzog Anton Ulrich-Museum, Braunschweig. [Bénézit 1976, 10:573]

Pierre Puget, 1620–1694, or circle. "Mars Resting." Terracotta sculpture. *c.*1660. Musée des Arts Décoratifs, Paris. [Herding 1970, no. 60—ill.]

Nicolas Poussin, 1594–1665, formerly attributed. "Mars and Rhea Silvia." Painting (copy or forgery after lost original?). Louvre, Paris. [Thuillier 1974, no. R76—ill. / also Blunt 1966, no. R86]

Claude II Audran, 1639–84. "Mars in a Chariot Pulled by Wolves." Ceiling painting. **Early 1670s.** Salon de Mars, Appartement du Roi, Château de Versailles. [Berger 1985, pp. 41ff., 69, fig. 70] A Salon de Mars, originally part of the Appartement de la Reine, decorated by Claude François Vignon, *c.*1678–79. [Ibid.]

Paul de Vos, 1595–1678. "Mars Crowned by Victory." Painting. Musée des Beaux-Arts, Tours. [Bénézit 1976, 10:575]

Arie de Vois, 1632–1680. "Mars and Diana" ("Dido and Aeneas"?). Painting. Centraal Museum, Utrecht, cat. 1952 no. 334. [Wright 1980, p. 480]

Pierre Beauchamps, 1631–1705, and **Louis Pécourt,** 1653–1729, choreography. (Mars in) Entrée in *Le triomphe de l'amour.* Music, Jean-Baptiste Lully. Scenario, Isaac de Bensérade and Philippe Quinault. First performed 21 Jan **1681,** St. Germain-en-Laye, Paris; scenery and machines, Vigarani; costumes, Jean Bérain. [Simon & Schuster 1979, pp. 6off.]

——— (Beauchamps), music. "Mars." Entrée in *Ballet des arts.* First performed 1685, Collège Louis-le-Grand, Paris. [Astier 1983, p. 161]

François Girardon, 1628–1715. "Mars and Hercules." Sculpture relief. **1680–82.** Façade, Château de Versailles. [Vermeule 1964, p. 119]

———. "Mars and Bellona." Sculpture. Model known, lost. / Print by Charpentier. [Francastel 1928, no. 82]

Luca Giordano, 1634–1705. (Mars in) "Allegory of Human Life and the Medici Dynasty." Fresco. **1682–83.** Palazzo Medici Riccardi, Florence. [Ferrari & Scavizzi 1966, 2:112ff.—ill.] Study. Denis Mahon coll., London. [Ibid.—ill.]

———. "Hercules Fighting with Mars." Painting. Walter Chrysler, Jr., coll., New York. [Ibid., 2:367]

Jules Hardouin-Mansart, 1646–1708. "The Childhood of Mars." Design for bas-reliefs on a pair of vases. Executed in marble by Jacques Prou and Jean Hardy, **1684–88.** Parterre de Latone, Gardens, Versailles. [Girard 1985, pp. 275f.—ill.]

Johann Philipp Krieger, 1649–1725. *Mars und Irene* [Mars and Eirene] (War and Peace). Tafelmusik (music played at a banquet). 1692. [Grove 1980, 10:269]

Gabriel Grupello, 1644–1730. "Mars." Marble statue. Before **1695?** Lost. [Kultermann 1968, no. 20]

Italian School. "Mars." Painting. **17th century.** Szépművészeti Múzeum, Budapest, no. 1504. [Budapest 1968, p. 334]

John Dryden, 1631–1700. (Mars, representing the English Civil Wars, in) *The Secular Masque.* Masque. Music, Daniel Purcell. First performed as part of Vanbrugh's *The Pilgrim,* 29 Apr **1700,** Theatre Royal, Drury Lane, London. [Kinsley 1958, vol. 4 / Winn 1987, p. 511 / Van Doren 1946, pp. 188f. / Grove 1980, 15:475]

Attilio Ariosti, 1666–1729. *Mars und Irene* [Mars and Eirene]. Singspiel. Libretto, C. Reuter. First performed 12 July **1703,** Lietzenburg, Berlin. [Grove 1980, 1:584]

German or Austrian School. "Kurfürst Johann Wilhelm as Mars." Gilded silver statuette. **1704.** Residenz, Munich. [Düsseldorf 1971, no. 129—ill.]

Noël Coypel, 1628–1707. "The Triumph of Mars." Paint-

ing (fragments), cartoon for Gobelins tapestry, part of "Triumphs of the Gods" series. Louvre, Paris, inv. 3484. [Louvre 1979–86, 3:174—ill.]

Antoine Watteau, 1684–1721. "The Monkeys of Mars" (Mars enthroned, surrounded by monkeys). Painting. *c.***1710.** Lost. / Print by J. Moyreau, 1729. [Camesasca 1982, no. 68—ill.]

François Le Moyne, 1688–1737 (previously attributed to Watteau). "Putti Playing with the Accoutrements of Mars." Painting, sketch. *c.***1721–24?** Fogg Art Museum, Harvard University, Cambridge. [Bordeaux 1984, no. 40—ill.]

————. "Mars and Rhea." Painting, for Hôtel de Brissac. Lost. [Ibid., p. 130]

Daniel Gran, 1694–1757. "Bellona and Mars." Fresco. **1726–30.** Nationalbibliothek, Vienna. [Knab 1977, pp. 50ff., no. F24—ill.]

Giovanni Battista Tiepolo, 1696–1770. "Mars." Fresco. **1734.** Villa Loschi, Biron, Vicenza. [Pallucchini 1968, no. 90—ill. / Morassi 1962, p. 65—ill.]

————. "Mars and the Graces." Painting. *c.*1762–70. Formerly Oranienbaum Castle, near Leningrad, unlocated. [Morassi, p. 37]

Jean-Jacques Le Franc, Marquis de Pompignan, 1709–1784. *Adieux de Mars.* Comedy. First performed **1735,** Paris. Published Paris: Chaubert, 1735. [DLLF 1984, 3:1773]

Nicolas Chédeville, 1705–1782. *Amusements de Bellone, ou Les plaisirs de Mars* [Amusements of Bellona, or The Pleasures of Mars]. Composition for 2 musettes, hurdy-gurdies, flute, oboe, basso continuo, opus 6. Published Paris: **1737.** [Grove 1980, 4:190]

Giovanni Battista Pittoni, 1687–1767. "Homage to [statue of] Mars." Painting. **Late 1730s.** Pardo coll., Paris. [Zava Boccazzi 1979, no. 150—ill.]

Jean-Baptiste Dupuits, fl. 1741–57. *Le retour de Mars.* Cantata, opus 9. Published **1742–51.** [Grove 1980, 5:737]

Claude Guimond de La Touche, 1723–1760. *Mars au berceau* [Mars at the Cradle]. Comedy. First performed **1751,** Paris? [DLF 1951–72, 4:539]

François-Gaspard Adam, 1710–1761. "Mars" (in a rage). Statue, part of mythological cycle. **1755–58.** Gardens, Sanssouci, Potsdam. [Thirion 1885, pp. 161f.—ill.]

Laurent Guyard, 1723–1788. "Mars in Repose." Marble sculpture. **1767.** [Bénézit 1976, 5:320]

Christian Joseph Lidarti, 1730–*c.*1793. *La tutela contrastata fra Giunone, Marte e Mercurio, col giudizio di Giove* [The Guardianship Contested between Juno, Mars, and Mercury, with the Judgment of Jove]. Dramatic musical composition. **1767.** [Grove 1980, 10:827]

Augustin Pajou, 1730–1809. "Mars, or the Military Arts." Stone statue. **1767–69.** Façade, Palais-Royal, Paris. [Stein 1912, pp. 198, 401]

Francesco Zugno, 1709–**1787.** "Mars Sleeping." Painting. Rijksmuseum, Amsterdam, inv. A3435. [Rijksmuseum 1976, p. 622—ill.]

John Flaxman, 1755–1826. "Peace Preventing Mars from Opening the Gates of (the Temple of) Janus." Relief on commemorative plaque, for Wedgwood. Designed 1786, produced **1787.** / Wax and biscuit models. Wedgwood Museum, Barlaston, Staffs. [Irwin 1979, p. 26 / also Bindman 1979, no. 51—ill.]

Johann Gottfried Schadow, 1764–1850. "Mars." Sand-stone statue, executed by Carl Wichmann. **1793.** Brandenburger Tor, Berlin. / Plaster model. 1792. National-galerie, Berlin, inv. G287. [Berlin 1965, no. 7—ill.]

Karl Ditters von Dittersdorf, 1739–1799, music and libretto. *Gott Mars und der Hauptmann von Bärenzahn (Gott Mars oder Der eiserne Mann)* [The God Mars, and the Captain of Bärenzahn (or The Iron Man)]. Singspiel. First performed 30 May **1795,** Oels. [Grove 1980, 5:502]

Michael Ivanovich Kozlovski, 1753–**1802.** "General Suvorov as Mars." Bronze monument. Leningrad. [Clapp 1970, 1:523]

Giuseppe Sarti, 1729–**1802.** *Giove, la Gloria, Marte* [Jove, Gloria, Mars]. Cantata for 3 solo voices, chorus, 2 orchestras, Russian horns, and cannons. [Grove 1980, 16:505]

Antonio Canova, 1757–1822. "Napoleon Bonaparte as Mars (the Peacemaker)." Marble statue. **1803–06.** Wellington Museum, Apsley House, London. [Pavanello 1976, no. 143—ill. / Licht 1983, pp. 100–02—ill.] Plaster study. 1802. Civico Museo Revoltella, Trieste. [Pavanello, no. 144—ill.] Bronze replica. 1809. Palazzo di Brera, Milan. [Pavanello, no. 145—ill. / Licht., pp. 101f.—ill.]

Daniel Gottlieb Steibelt, 1765–1823. *La fête de Mars* [The Feast of Mars]. Intermezzo, composed to celebrate the Austerlitz campaign. Libretto, d'Esmenard. First performed 4 Mar **1806,** L'Opéra, Paris. [Grove 1980, 18:103]

Bertel Thorwaldsen, 1770–1844. "Mars (the Peace-bringer)." Sketch model for a statue. **1808.** Lost. / Drawing. Statens Museum for Kunst, Copenhagen, inv. Td 566.6. [Hartmann 1979, pl. 116.1]

————. "Mars and Cupid." Marble sculpture group. Modeled *c.*1810. Marble begun 1824–25, completed 1868 by B. L. Bergslien & H. W. Bissen. Thorwaldsens Museum, Copenhagen, no. A6. [Thorwaldsen 1985, p. 21 / Cologne 1977, no. 52, p. 100—ill. / Hartmann 1979, p. 165, pl. 116.2] Plaster original. Thorwaldsens Museum, no. A7. [Thorwaldsen]

————. "(Mars and Cupid in) Vulcan's Forge" ("Cupid's Arrows Forged in Vulcan's Smithy"). Marble relief. Modeled *c.*1810. 2 versions, both unlocated. [Cologne, no. 53, p. 164] Plaster original. Thorwaldsens Museum, Copenhagen, no. A419. [Ibid.—ill. / Thorwaldsen, p. 53 / Hartmann, p. 166, pl. 117.1] Plaster variant ("Venus, Mars, and Cupid in the Smithy of Vulcan"). Thorwaldsens Museum, no. A420. [Thorwaldsen, p. 53]

Pierre Gardel, 1758–1840, choreography. *La fête de Mars* [The Feast of Mars]. Ballet. Music, Rodolphe Kreutzer. First performed 26 Dec **1809,** L'Opéra, Paris. [Guest 1976, p. 304 / Grove 1980, 7:160, 10:261]

Jean Paul, 1763–1825. *Mars und Phöbus Thronwechsel: Eine scherzhafte Flugschrift* [Mars and Apollo Exchange Thrones: A Joking Pamphlet]. Satire. Tübingen: Cotta, **1814.** [DLL 1968–90, 8:533]

Armand Vestris, 1786–1825, choreography, after Pierre Gardel. *Mars et l'Amour.* Ballet. First performed 29 Apr **1815,** King's Theatre, London. [Guest 1972, pp. 29, 155]

John Gibson, 1790–1866. "Mars and Cupid." Marble sculpture group. **1819.** Duke of Devonshire coll., Chatsworth. [Bénézit 1976, 4:713 / Clapp 1970, 1:405]

Karol Kazimierz Kurpinski, 1785–1857, music. *Mars i Flora.* Ballet. First performed 3 Aug **1820,** Warsaw; choreography, L. Thierry. [Grove 1980, 10:319]

Eugène Delacroix, 1798–1863. "The God Mars Accompanied by Fame, Fear, and Death." Drawing. *c.***1820–**

23. Cabinet des Dessins, Louvre, Paris. [Huyghe 1963, p. 452, pl. 328]

———. "Mars Chained." Painting, for Salon de la Paix, Hôtel de Ville, Paris. 1849–53. Destroyed 1871. [Robaut 1885, no. 1146—ill. (copy drawing)]

Antoine-Jean Gros, 1771–1835. "Mars, Crowned by Victory, Listening to Moderation, Halts His Steeds and Lowers His Spears." Ceiling painting. Exhibited **1827**. Salle E des Antiquités Égyptiennes, Louvre, Paris (inv. 5059). [Louvre 1979–86, 3:291—ill.]

Laurent Pécheux, 1729–**1829**. "Sacrifice to Mars." Painting. Musée des Beaux-Arts, Chambéry. [Bénézit 1976, 8:181]

Luigi Catani, 1762–**1840**. "Mars." Fresco. Sala dell' Educazione di Giove, Palazzo Pitti, Florence. [Pitti 1966, p. 241]

Honoré Daumier, 1808–1879. "Mars and M. Prud'homme." Satirical lithograph, part of "Ces bons autrichiens" series. **1859**. [Delteil 1906–30, 27: no. 3161—ill.]

———. Mars depicted as the spirit of war in a series of political cartoons (lithographs) commenting on the situation prior to the Franco-Prussian war: "Bah! I will make the Grand Tour!"; "My Poor Mars! I Have Done All I Can"; (Cupid speaking:) "This Year Papa Mars Doesn't Seem to Want Me to Cut the Grass under His Feet!" and "Why Does Papa Mars Always Stand at Attention?"; "Mars Without Lent" (eating his fill); "Using the Leisure-time Made by the Elections" (to sharpen his sword); (Liberty, pushing Mars aside:) "Pardon, my dear—let's test my powers before yours". 1867–69. [Ibid., 28: nos. 3553, 3573; 29, nos. 3629, 3630, 3698, 3716, 3724—ill.]

Jean-Auguste-Dominique Ingres, 1780–**1867**. "Mars." Painting. Museum, Basel. [Wildenstein 1954, no. 263—ill.]

Léon Roques. *Le retour de Mars*. Comic operetta. Libretto, Alfred Poullion. Published Paris: Bathlot, **1868**. [NUC]

Hans Makart, 1840–1884. "A Putto Cleaning the Weapons of Mars." Painting. **1869–70**. Österreichische Galerie, Vienna, inv. 5860. [Frodl 1974, no. 120—ill.]

Arthur Sullivan, 1842–1900. (Aged Mars in) *Thespis; or, The Gods Grown Old*. Comic operetta. Libretto, W. S. Gilbert. First performed 26 Dec **1871**, Gaiety Theatre, London. Music lost. [Jefferson 1984, pp. 23ff.]

Antoine-Louis Barye, 1796–**1875**. "Standing Mars." Drawing. Louvre, Paris, no. R.F. 4661. [Benge 1984, pl. 170]

———. "Napoleon as Mars." Drawing. Louvre, no. R.F. 6073. [Ibid., pl. 171]

Edward Burne-Jones, 1833–**1898**. "Mars." Watercolor, unfinished. Sold 1898, from artist's estate. [Bell 1901, pp. 132f.]

George Meredith, 1828–1909. "The Caging of Ares" (by the giants Ephialtes and Otus). Poem. **1899**. In *A Reading of Life, with Other Poems*. London: Murray, 1901. [Bartlett 1978, vol. 1 / Boswell 1982, p. 181]

Hans Thoma, 1839–1924. "Mars." Painting. **1903**. Artist's coll., Karlsruhe, in 1909. [Thode 1909, p. 444—ill.]

———. "Mars." Painting. 1907. Kunsthalle, Karlsruhe. [Ibid., p. 492—ill.]

Dmitri Tiomkin, 1894–1979, music. *Mars Ballet*. Ballet. First performed **1925**, U.S.A. [Grove 1980, 19:1]

Arthur B. Davies, 1862–**1928**. "Girdle of Ares" (evocative title: a group of fighting men). Painting. Metropolitan Museum, New York, no. 14.17. [Metropolitan 1965–85, 2:426f.—ill. / Cortissoz 1931, p. 25]

Elisabeth Langgässer, 1899–1950. "Mars." Short story (modern setting; Mars personified by soldiers and officers). In *Triptychon des Teufels: Ein Buch von dem Hass, den Börsenspiel und der Unzucht* (Dresden: Jess, **1932**). [DLB 1988, 69:219]

Richard Anthony, 1917–. *The War God*. Cantata, opus 36. **1944**. [Grove 1980, 1:612]

Sydney Goodsir Smith, 1915–1975. "Mars." Poem, part 3 of *The Deevil's Waltz* (Glasgow: William Maclellan, **1946**). [DLB 1984, 27:342]

Rodney Ackland, 1908–, with **Robert G. Newton**, 1903–. *Cupid and Mars*. Comedy. First performed 1 Oct **1947**, Arts Theatre, London. [DLEL 1970–78, 1:1]

Jean Françaix, 1912–, music. *Les zigues de Mars*. Ballet. **1950**. [Grove 1980, 6:741]

Howard Nemerov, 1920–. "Mars." Poem. In *Guide to the Ruins* (New York: Random House, **1950**). [Boswell 1982, p. 275]

Rudolf Meerbergen, 1908–. "Krishna/Mars." Abstract painting. **1962**. Musées Royaux des Beaux-Arts (Musée d'Art Moderne), Brussels, inv. 7026. [Brussels 1984b, p. 414—ill.]

Yannis Ritsos, 1909–1990. (Ares belittled in) "Exagnismos" [Expiation]. Poem. 19 June **1969**. In *Epanalepseis* (Athens: Kedros, 1972). / Translated by Edmund Keeley in *Yannis Ritsos, Exile and Return: Selected Poems 1967–1974* (New York: Ecco, 1985). [Ipso]

ARES AND APHRODITE.

The goddess Aphrodite (Venus), married to the crippled god Hephaestus (Vulcan), carried on an illicit love affair with his half-brother Ares (Mars). Hephaestus learned of his wife's deceit from Apollo, and plotted his revenge. He forged a net of unbreakable chains and ensnared the lovers, trapping them in his own bed. He then called the other gods to observe and ridicule them in their embarrassing position. All the gods found the situation amusing except Poseidon (Neptune), who begged Hephaestus to free the lovers. They were released and fled, Ares to Thrace and Aphrodite to Paphos on Cyprus.

Ares' five children by Aphrodite were Deimos (Fear) and Phobos (Panic), Harmonia (also called Hermione), and, some say, Eros and Anteros.

In postclassical representations the lovers are commonly seen as a love-pair (usually accompanied by Eros/Cupid) or ensnared in Hephaestus's net. Renaissance artists sometimes used them in allegories of beauty and valor, or as strife overcome by love, with Venus disarming Mars.

Classical Sources. Homer, *Odyssey* 8.266–366. Ovid, *Ars amatoria* 2.561ff.; *Metamorphoses* 4.169–257. Lucian, *Dialogues of the Gods* 17, "Hermes and Apollo," 21, "Apollo and Hermes."

See also APHRODITE; ARES; HEPHAESTUS.

Anonymous Norman. (Story of Mars and Venus in the net, related in) *Roman d'Eneas*. Verse romance, adaptation of the *Aeneid*. *c.*1158–60. Modern edition by J. J. Salverda de Grave, *Enéas: Roman du XIIe siècle* (Paris: Champion, 1925–31). [Yunck 1974, pp. 141–43 / Singerman 1986, p. 48 / Cormier 1973, p. 103]

Jean de Meun, 1250?–1305? (Love of Mars and Venus evoked in) *Le roman de la rose* lines 13835–68, 14159–86, 18061–89. Verse romance, completion of unfinished work begun by Guillaume de Lorris (*c.*1230–35). *c.*1275. Lyon: Ortuin & Schenck, *c.*1481. [Dahlberg 1971 / Poirion 1974]

Anonymous French. (Story of Venus and Mars caught in Vulcan's net in) *Ovide moralisé* 4.1268–1362, 1488–1755. Poem, allegorized translation/elaboration of Ovid's *Metamorphoses*. *c.*1316–28. [de Boer 1915–86, vol. 2 / Bush 1963, p. 299 *n.*2]

Geoffrey Chaucer, 1340?–1400. "The Compleynt of Mars," "The Compleynt of Venus." Pair of poems. *c.*1385. [Riverside 1987 / Lewis 1958, pp. 165, 170, 177 / also Melvin Storm, "The Mythological Tradition in Chaucer's Complaint of Mars," *Philological Quarterly* 57 (1978): 323–35]

John Gower, 1330?–1408. (Tale of Mars and Venus discovered by Vulcan in) *Confessio amantis* 5.635–728. Poem. *c.*1390. Westminster: Caxton, 1483. [Macaulay 1899–1902, vol. 2 / Ito 1976, p. 15]

Christine de Pizan, *c.*1364–*c.*1431. (Vulcan's discovery of Mars and Venus in) *L'epistre d'Othéa à Hector . . .* [The Epistle of Othéa to Hector] chapter 56. Didactic romance in prose. *c.*1400. MSS in British Library, London; Bibliothèque Nationale, Paris; elsewhere. / Translated by Stephen Scrope (London: *c.*1444–50). [Bühler 1970 / Hindman 1986, p. 198]

John Lydgate, 1370?–1449. (Venus, Mars, and Vulcan evoked in) *The Temple of Glas* lines 353–59. Poem. *c.*1403. Westminster: Caxton, 1477. Modern edition, Millwood, N.Y.: Kraus Reprint, 1987. [Pearsall 1970, p. 108]

———. (Venus and Mars evoked in) *Reson and Sensuallyte* lines 3760ff. Poem, partial translation of *Les échecs amoureux* [Love's Game of Chess] (1370–80). Probably before 1412. Modern edition by E. Sieper (London: Early English Text Society, 1901). [Pearsall 1970, p. 117 / Ebin 1985, p. 37]

———. (Vulcan's jealousy evoked in) *Troy Book*, 2.5803–25. Poem, elaboration of Guido delle Colonne's *Historia destructionis Troiae*. 1412–20. Modern edition by Henry Bergen (London: Kegan Paul, Trench & Trübner, for Early English Text Society, 1906–35). [Benson 1980, p. 104]

Francesco del Cossa, *c.*1435–1477. "Mars and Venus." Fresco detail. 1472. Schifanoia Palace, Ferrara. [Wind 1968, p. 89]

Sandro Botticelli, 1445–1510 (previous attributed to Piero di Cosimo). "Mars and Venus." Painting. *c.*1485? National Gallery, London, no. 915. [Lightbown 1978, no. B41—ill. / London 1986, p. 60—ill. / Bacci, p. 120 / Berenson 1963, p. 36]

———. (Mars and Venus [?] depicted in frieze in setting of) "The Calumny of Apelles." Painting. *c.*1494–95. Uffizi, Florence, no. 1496. [Lightbown, no. B79—ill.]

Lorenzo de' Medici, 1449–1492. "Gli amori di Venere e Marte." Poem. In modern edition, *Poemi* (Lanciano: Carabba, 1934). [Bondanella 1979, p. 327]

Andrea Mantegna, 1430/31–1506. (Mars and Venus in) "Parnassus" ("Mars and Venus"). Painting, for Studiolo of Isabella d'Este, Corte Vecchia, Mantua. 1497. Louvre, Paris, inv. INV 370. [Lightbown 1986, p. 189, no. 39—ill. / Louvre 1979–86, 2:203—ill. / Wind 1948, pp. 9ff.—ill. / Paris 1975, no. 96—ill.] *See also Marcantonio Raimondi, below.*

Francesco Colonna, *c.*1433–1527. (Mars, Venus, and Cupid depicted in relief on triumphal car in) *Hypnerotomachia Poliphili* [The Dream of Poliphilo]. Romance. Venice: 1499, illustrated with woodcuts by anonymous engraver. [Appell 1893, p. 9, pl. 56]

Piero di Cosimo, *c.*1462–1521. "Venus, Mars (and Cupid)." Painting. *c.*1505. Gemäldegalerie, Berlin-Dahlem, no. 107. [Bacci 1966, pl. 28 / Berlin 1986, p. 60—ill. / Berenson 1963, p. 175—ill.] *See also Botticelli, above.*

Marcantonio Raimondi, *c.*1480–1527/34. "Mars, Venus, and Cupid." Engraving (Bartsch no. 345), derived from a drawing by Mantegna and other sources. 1508. [Shoemaker 1981, no. 13—ill. / also Bartsch 1978, 27:40f.—ill.]

Giorgione, *c.*1477–1510, circle. "Venus and Mars" ("Venus and Adonis"). Painting. Brooklyn Museum, New York, inv. 37–529. [Pignatti 1978, no. A35—ill.]

Palma Vecchio, 1480–1528. "Venus and Mars." Painting. *c.*1510. Brooklyn Museum, New York. [Mariacher 1968, pl. 1]

——— and studio. "Mars, Venus, and Cupid." Painting. Formerly, Bulkeley Gavin coll., London. [Ibid., p. 101]

———, rejected attribution. "Venus and Mars." Painting. Polli coll., Milan. [Ibid., p. 102]

Sodoma, 1477?–1549. "Mars and Venus in the Net of Vulcan." Painting, 1 of series depicting scenes from Ovid. *c.*1511. Greitzer coll., New York. [Hayum 1976, no. 12—ill.] *See also Veronese, below.*

Jacopo de' Barbari, *c.*1440/50–1516. "Mars and Venus." Engraving (Bartsch no. 20). [Borenius 1923, no. 26—ill. / Servolini 1944, no. 23—ill.]

Jan Smeken, *c.*1450–1517. *Hue Mars en Venus tsamen bueleerden* [How Mars and Venus Had a Love Affair]. Comedy. [Gassner & Quinn 1969, p. 194]

Giulio Romano, *c.*1499–1546, assistant, after design by Giulio. "Bath of Mars and Venus," "Adonis Escaping from Mars" ("Mars Driving Adonis from Venus's Bower"). Frescoes. 1528. Sala di Psiche, Palazzo del Tè, Mantua. [Hartt 1958, pp. 129, 132—ill. / Verheyen 1977, p. 117, fig. 42]

Rosso Fiorentino, 1494–1540, attributed. "Mars and Venus Served by Nymphs and Cupids." Drawing, composition for engraving. 1530. Louvre, Paris, inv. 1575. [Carroll 1987, nos. 57–58—ill. / Paris 1972, no. 204—ill. / also Lévêque 1984, p. 105—ill. / Barocchi 1950, fig. 46 (print)] Variant copy, painting ("Mars and Venus Undressed by Cupids"), by Marin le Bourgeoys. Musée de Cluny, Paris. [Paris, no. 595]

———, and assistants. "Venus (Scolding Cupid)" ("Venus Frustrated" [by departure of Mars?]). Fresco. 1535–40; repainted/restored 18th, 19th centuries and 1961–66. Galerie François I, Château de Fontainebleau. [*Revue de l'art* 1972, p. 126 and passim—ill. / Barocchi, pp. 140f.—ill. / Panofsky 1958, pp. 157f.—ill.]

———. "The Sun-God [and Vulcan?] Discovering Mars and Venus" (?). Fresco, for Chambre sur la Porte Dorée, Château de Fontainebleau. 1536–40. Destroyed. / Drawing (for?). Albertina, Vienna. [Dimier 1900, pp. 262ff., no. 21]

————. "Mars and Venus in the Bath." Fresco, in Appartement des Bains, Fontainebleau. 1541–47. Destroyed 1697. / Drawing for. Louvre, Paris. / Etching by Antonio Fantuzzi, 1543 (Bartsch no. 19). [Paris, p. 479, no. 323—ill. / also Lévêque, p. 93—ill.]

————, design. "Mars and Venus." Fresco, for Salle de Bal, Château de Fontainebleau, executed by Niccolò dell' Abbate under Primaticcio's direction. 1551–56. Repainted 19th century. [Dimier, pp. 160ff., 284ff.]

Titian, c.1488/90–1576. "Allegory of the Marchese del Vasto" (so-called, an allegory of marriage: man and woman as Mars and Venus, with Vesta? and Cupid; conjectural interpretation). Painting. c.1530–35. Louvre, Paris, inv. 754. [Wethey 1975, no. 1—ill. / Louvre 1979–86, 2:247—ill.] 17th-century copies in Hampton Court (2, 1 in storage); Marquess of Bath coll., Longleat; Ham House, Richmond; Royal Library, Windsor Castle (by Peter Oliver). / 17th-century variants (by Padovanino and studio, others?), with elements from Titian's "Cupid Blindfolded" (c.1565, Villa Borghese, Rome), in Palazzo Durazzo-Pallavicini, Genoa; Alte Pinakothek, Munich (2, in storage); Kunsthistorisches Museum, Vienna (in reserves); Chicago Art Institute ("Allegory of Venus and Cupid," attributed to Damiano Mazza or Lambert Sustris); another known, unlocated. [Wethey—ill.; cf. no. X–3]

————. "Mars and Venus." Painting. c.1560? Lost. / Copy, drawing, by Van Dyck (in "Italian sketchbook"), c.1622–27. / Copy (painting) in Kunsthistorisches Museum, Vienna, inv. 13 (153), as Titian and studio. [Ibid., no. L–9—ill. / also Vienna 1973, p. 183—ill. / Berenson 1957, p. 191]

Maerten van Heemskerck, 1498–1574. "Venus and Mars." Painting. 1536. Gavazzi coll., Milan. [Grosshans 1980, no. 20—ill.]

————. "Vulcan Showing the Gods Mars and Venus in the Net." Painting, part of triptych, now dispersed. 1536. Kunsthistorisches Museum, Vienna, inv. 6395 (795A). [Ibid., no. 22—ill. / Vienna 1973, p. 83—ill. / de Bosque 1985, pp. 160–62—ill.]

————. At least 3 further paintings of the subject recorded ("The Adultery of Venus and Mars," "Mars and Venus [in the net] before the Olympian Gods," "Mars and Venus Captive in Vulcan's Net"), untraced. [Grosshans, nos. V15, V22, V47—ill. (print)]

Dosso Dossi, c.1479–1542. "Landscape with Venus, Mars, Cupid, and Vulcan." Painting, from Cesare Ignazio d'Este coll., Ferrara. Lost. [Gibbons 1968, p. 270]

———— and **Battista Dossi,** c.1474–1548. Painting(s) depicting the story of Mars and Venus, from Castello Estense, Ferrara. Lost. [Ibid., p. 269]

Frans Floris, 1516/20–1570. "Mars and Venus Surprised by Vulcan." Painting. 1547. Staatliche Museen, Berlin, inv. 698. [Pigler 1974, p. 169 / de Bosque 1985, p. 55] Variant (attributed to Willem Key, previously to Floris). Herzog Anton Ulrich-Museum, Braunschweig, no. 40. [Braunschweig 1976, p. 36 / also Braunschweig 1969, p. 60] Another version of the subject, in Galerie Brukenthal, Hermannstadt, inv. 1241. [Pigler, p. 169]

————. "Vulcan Denouncing His Wife's Infidelity to the Assembly of Gods." Painting. Formerly Kaiser-Friedrich Museum, Berlin, inv. 698, lost. / Copy (or replica?). Musées Royaux des Beaux-Arts (Musée d'Art Ancien), Brussels, inv. 182. [Brussels 1984a, p. 109—ill.]

Luca Penni, 1500/04–1556, attributed, composition. "Mars and Venus Served [by adolescent Cupid] at Table." Etching, by "Master L. D." c.1547 (Bartsch 1818, 16:52). [Paris 1972, no. 385—ill. / also Lévêque 1984, p. 253—ill.]

Paris Bordone, 1500–1571. "Mars and Venus Surprised by Vulcan." Painting. c.1548–50. Gemäldegalerie, Berlin-Dahlem. [Berlin 1986, p. 16—ill. / also Canova 1964, p. 84—ill. / Berenson 1957, p. 47]

————. "Mars, Venus, Flora, and Cupid." Painting. c.1550–60. Kunsthistorisches Museum, Vienna, inv. 69. [Canova, p. 116—ill. / Vienna 1973, p. 26—ill.]

————. "Allegory" ("Two Lovers as Mars and Venus Crowned by Victory"). Painting. c.1560. Vienna, inv. 120 (233). [Canova, p. 115—ill. / Vienna, p. 26—ill.]

————. "Flora and Venus, with Mars and Cupid." Painting. Hermitage, Leningrad, no. 1846. [Canova, p. 80—ill. / Berenson 1957, p. 46—ill.]

————. "Mars, Venus, and Cupid." Painting. Late work. Galleria Doria Pamphili, Rome, no. 277. [Canova, p. 86—ill. / also Berenson, p. 48] Replica. Hermitage, Leningrad. [Canova, p. 104—ill.]

————, rejected attribution. "Mars and Venus with Cupid." Painting. Hampton Court Palace. [Canova, p. 125]

Anonymous. "The Story of Venus and Vulcan." Series of 7 tapestries. First woven Brussels, **1525–50;** further sets woven Mortlake, 1620s. Partial sets in Victoria & Albert Museum, London; St. James's Palace, London; Drayton House; Haddon Hall, Derbyshire. [Jackson-Stops 1985, no. 128—ill.]

Pierre de Ronsard, 1524–1585. (Mars and Venus evoked in) "A son lict" [To His Bed]. Burlesque poem. In *Les quatre premiers livres des odes* book 2 (Paris: Cauellat, **1550**). [Laumonier 1914–75, vol. 2 / McGowan 1985, p. 83 / Cave 1973, pp. 201, 203]

Flemish School. "The History of Vulcan." Series of 8 or 9 tapestries depicting Vulcan's discovery of the love of Mars and Venus. **Mid-16th century.** 5 in Biltmore House, Asheville. N.C.; others unlocated. / At least 8 copy sets woven, including at least 1 at Mortlake works (England), 1630s. Formerly Château de Vaux-le-Vicomte, Mainsy (17th century), now Mobilier National, Paris (5); others unlocated. [Titcomb 1967, pp. 214ff., pls. 11–17]

Jacopo Tintoretto, 1518–1594. "Mars, Venus, and Vulcan" (Venus and Mars Surprised by Vulcan). Painting. **1551–52.** Alte Pinakothek, Munich, no. 9257. [Rossi 1982, no. 155—ill. / Munich 1983, p. 527—ill.]

————. "Cupid, Venus, and Mars." Painting. c.1555. Formerly O. Burchard coll., New York. [Rossi, no. 189—ill.]

————, formerly attributed. "Venus, Mars, and the Three Graces in a Landscape." Painting. *See Domenico Tintoretto, below.*

Cristofano Gherardi, 1508–1556, under direction of **Giorgio Vasari,** 1511–1574. "Vulcan Surprises Mars and Venus." Fresco. **1555–56.** Sala degli Elementi, Palazzo Vecchio, Florence. [Sinibaldi 1950, pp. 13, 22]

Garofalo, c.1481–**1559.** "Mars, Venus, and Cupid." Painting. Lanckoronski coll., Vienna. [Berenson 1968, p. 158]

Joachim Du Bellay, 1522–**1560.** *Les amours de Mars et de Vénus.* Poem. Paris: Morel, 1571. [DLLF 1984, 1:226]

Michelangelo, 1475–**1564,** attributed. "Venus, Mars, and Cupid" (traditionally called "Zenobia"). Drawing. Uffizi, Florence, no. 598E. [Goldscheider 1951, no. 50—ill.]

Willem Key, *c.*1520–**1568,** attributed (previously questionably attributed to Frans Floris). "Mars and Venus Surprised by Vulcan." Painting. Herzog Anton Ulrich-Museum, Braunschweig, no. 40. [Braunschweig 1976, p. 36 / also Braunschweig 1969, p. 60]

———, attributed. "Mars, Venus, and Cupid." Painting. Louvre, Paris, inv. 2004. [Louvre 1979–86, 1:80—ill.]

Lambert Sustris, 1515/20–**after 1568,** attributed (also questionably attributed to Friedrich Sustris). "(Reclining) Venus and Cupid (with Mars in Background)." Painting. Louvre, Paris, inv. 1978 (2640). [Louvre 1979–86, 1:134—ill. / Berenson 1957, p. 168—ill.]

———. "Mars and Venus on Clouds" (?). Painting. Chrysler coll., New York. [Berenson, p. 168]

George Whetstone, 1544?–1587? "Venus and Vulcan." Poem. In *The Rocke of Regard* (London: Waley, **1576**). [Bush 1963, p. 299, 316]

Francesco Mosca, called Moschino, ?–**1578.** "Mars and Venus." Marble group. Palazzo Niccolini, Rome. [Pigler 1974, p. 167]

Paolo Veronese, 1528–1588. "Mars and Venus with Cupid." Painting. *c.***1575–78.** Galleria Sabauda, Turin, inv. 683. [Pallucchini 1984, no. 145—ill. / Pignatti 1976, no. 237—ill. / also Berenson 1957, p. 136—ill.]

——— (formerly attributed to Sodoma). "Venus and Mars United by Love [Cupid]." Painting. *c.*1578–80. Metropolitan Museum, New York, inv. 10.189. [Pallucchini, no. 174—ill. / Pignatti, no. 248—ill. / Metropolitan 1980, p. 191—ill. / Metropolitan 1983, p. 127—ill.]

———. "Mars and Venus." Painting. *c.*1578–82. National Gallery of Scotland, Edinburgh. inv. 339. [Pallucchini, no. 184—ill. / Pignatti, no. 253—ill. / Berenson, p. 131] Variant. Musée Condé, Chantilly. [Pignatti, no. 254—ill.]

———. "Mars and Venus with Amorini and a Horse." Painting. Lost. / Anonymous copy in private coll., Florence. [Ibid., no. A82—ill.] Possible fragment ("Bust of Mars"), attributed to Veronese. Private coll., Rome. [Ibid., no. A266—ill.]

———, attributed. "Venus with Mars and Cupid." Painting. Private coll., Milan. [Ibid., no. A190—ill.]

Stoldo di Lorenzi, 1534–**1583.** "Mars and Venus." Marble relief. Walker Art Gallery, Liverpool, inv. 6528. [Warburg]

Jehan Baptista Houwaert, 1533–1599. "Mars and Venus." Drama, part of *Den Handel der amoreusheyt* [The Commerce of Amorosity]. **1583.** [Gosse 1910, p. 721]

Hendrik Goltzius, 1558–1617. "Mars and Venus Surprised by Vulcan." Engraving (Bartsch no. 139). **1585.** 3 states. [Strauss 1977a, no. 216—ill. / Bartsch 1980–82, no. 139—ill. / Reznicek 1961, no. 105—ill.] Variant copy, painting, by Marin le Bourgeoys. Musée de Cluny, Paris. [Paris 1972, no. 595]

———, after composition by Bartholomeus Spranger. "Mars and Venus." Engraving. 1588. 4 states. [Strauss, no. 262—ill. / Bartsch, no. 276—ill. / Hofmann 1987, no. 3.15—ill.]

———, composition. "Phoebus Exposing Mars and Venus to the Ridicule of the Olympians." Engraving, part of set illustrating Ovid's *Metamorphoses* (3d series, no. 10), executed by assistant(s). *c.*1615. (Unique impression in British Museum, London.) [Bartsch, no. 0302.80—ill. / also de Bosque 1985, pp. 161, 168—ill.]

Bartholomeus Spranger, 1546–1611. "Venus and Mars, Warned by Mercury." Painting. **1580s.** Kunsthisto-

risches Museum, Vienna, inv. 1097 (1496). [Vienna 1973, p. 166]

———, composition. "Mars and Venus." Engraving, by Hendrik Goltzius. 1588. [Strauss 1977a, no. 262—ill. / Bartsch 1980–82, no. 276—ill. / Hofmann 1987, no. 3.15—ill.]

———. "Mars, Venus, and Cupid." Painting. *c.*1595. Landesmuseum Joanneum, Graz, inv. 67. [Hofmann, no. 1.33—ill. / de Bosque 1985, pp. 161, 165—ill.]

———, questionably attributed. "Mars, Venus, and Cupid." Painting. Kunsthistorisches Museum, Vienna, inv. 1162 (1499). [Vienna, p. 167]

———. "Mars and Venus." 2 drawings. Städelsches Kunstinstitut, Frankfurt. [de Bosque, pp. 67, 167—ill.]

Hubert Gerhard, *c.*1540/50–1620 (previously attributed to Adriaen de Vries). "Mars, Venus, and Amor." Bronze sculpture. **1590.** Bayerisches Nationalmuseum, Munich. [Pigler 1974, p. 167] Another version in Kunsthistorisches Museum, Vienna. [Ibid. / Frick 1968–70, 4:38]

Palma Giovane, *c.*1548–1628. "Venus and Mars." Painting. *c.***1590.** National Gallery, London, no. 1866. [Mason Rinaldi 1984, no. 132—ill. / London 1986, p. 462—ill.]

———. "Venus and Mars." Painting. *c.*1605–09. Getty Museum, Malibu, Calif., inv. A71.P–50. [Mason Rinaldi, no. 141—ill.]

———. "Venus and Mars." Painting. *c.*1615. G. B. Marino coll. in 1636, untraced. [Ibid., p. 186]

Edmund Spenser, 1552?–1599. (Mars's love for Venus and "other nymphs" evoked in) *The Faerie Queene* 3.11.44. Romance epic. London: Ponsonbie, **1590,** 1596. [Hamilton 1977]

Joseph Heintz the Elder, 1564–1609. "Mars, Venus, and Cupid." Painting. Lost. / Copy drawing (by Lucas Kilian?), **1597.** Formerly Geiger coll., Leipzig (?), unlocated. [Zimmer 1971, no. B14—ill.]

Domenico Tintoretto, 1562–1635 (previously attributed to Jacopo Tintoretto). "Venus, Mars, and the Three Graces in a Landscape." Painting. **1590s.** Art Institute of Chicago, no. 29.914. [Rossi 1982, no. A22—ill. / also Chicago 1961, p. 450 (as studio of Jacopo); cf. supplement, 1965 (as "Venus and Adonis and the Three Graces. . . .")]

Italian School. "Mercury Presenting Venus to Mars." Painting. **16th century.** City Art Gallery and Temple Newsam, Leeds, cat. 1954 no. 682. [Wright 1976, p. 107]

French School. "Mars and Venus." Bronze sculpture. *c.***1600.** Herzog Anton Ulrich-Museum, Braunschweig, inv. Bro 352. [Hofmann 1987, no. 3.4—ill.]

Joachim Wtewael, 1566–1638. "Mars and Venus Surprised by Vulcan." Painting (after Goltzius engravings of 1585, 1588). **1601.** Mauritshuis, The Hague, inv. 223. [Lowenthal 1986, no. A-18—ill. / Mauritshuis 1985, pp. 326, 467—ill. / cf. Wright 1980, p. 506]

———. "Mars, Venus, and Cupid." Painting. *c.*1600–05. Private coll. [Lowenthal, no. A-19—ill.]

———. "Mars and Venus Surprised by Vulcan." Painting. *c.*1606–10. Getty Museum, Malibu, inv. 83.PC.274. [Ibid., no. A-44—ill.]

———. "Mars, Venus, and Cupid." Painting. *c.*1610. Stichting Peter en Nelly de Boer, Amsterdam. [Ibid., no. A-52—ill.] Replica or copy. Private coll. [Ibid., no. B–3—ill.]

Agostino Carracci, 1557–1602. "Mars and Venus." Fresco,

in "Allegories of Love" cycle. *c.*1600–02. Palazzo del Giardino, Parma. [Ostrow 1966, no. I/22–D]

Johann Rottenhammer, 1564–1625. "Venus and Mars." Painting. **1604.** Rijksmuseum, Amsterdam, inv. A343. [Rijksmuseum 1976, p. 483—ill.]

William Shakespeare, 1564–1616. (Antony and Cleopatra parallel Mars and Venus in) *Antony and Cleopatra,* passim and 4.8.16–18 (allusion to Vulcan's net). Tragedy. **1606–07?** Stationers' Register 20 May 1608. No recorded performance in Shakespeare's lifetime. Published London: Jaggard, 1623 (First Folio). [Riverside 1974 / Bono 1984, pp. 167–76, 180, 184f.]

Tiziano Aspetti, 1565–1607. "Mars," "Venus." Pair of bronze statuettes. Several versions. Frick Collection, New York, no. 16.2.56 (Mars only, Venus lost); P. Harris coll., London; 2 others known (Mars only), unlocated. [Frick 1968–70, 3:183f.—ill.] Variants, as andiron figures. Kress coll., National Gallery, Washington, D.C.; Bode Museum, Berlin, inv. 524 (Venus only). [Ibid.]

Paulus Moreelse, 1571–1638, composition. "Mars and Venus." Engraving, by Jacob Matham, **1607.** (Rijksprentenkabinet, Amsterdam.) [de Jonge 1938, no. 13—ill.]

Jan Brueghel the Elder, 1568–1625, landscape, and **Hendrik van Balen,** 1575–1632, figures. "Venus Arming Mars." Painting. **1608?** Formerly Sanssouci, Potsdam, lost. [Ertz 1979, no. 191—ill.]

Cornelis Cornelisz van Haarlem, 1562–1638. "Venus and Mars." Painting. **1609.** Muzeum Narodowe, Warsaw, inv. 137. [Warsaw 1969, no. 471—ill.]

———. "Venus and Mars." Painting. 1623. Rijksmuseum, Amsterdam, inv. A3016. [Rijksmuseum 1976, p. 175—ill. / de Bosque 1985, pp. 161, 166—ill.]

———. "Venus and Mars." Painting. Niedersächsische Landesgalerie, Hannover. [de Bosque, pp. 161, 166—ill.]

———. "Venus and Mars." Drawing. Uffizi, Florence. [de Bosque, p. 168—ill.]

Thomas Heywood, 1573/74–1641. (Story of Mars and Venus in) *Troia Britanica: or, Great Britaines Troy* canto 5. Epic poem. London: **1609.** [Heywood 1974]

———. (Episode, as above, in) *The Brazen Age.* Drama, partially derived from *Troia Britanica.* First performed *c.*1610–13, London. Published London: Okes, 1613. [Heywood 1874, vol. 3 / DLB 62:101, 122ff. / also Boas 1950, pp. 83ff. / Clark 1931, pp. 62ff.]

Carlo Saraceni, 1579–1620. "Venus and Mars with a Circle of Cupids." Painting. **1605–10?** Museu de Arte, Sao Paulo, Brazil. [Ottani Cavina 1968, no. 74—ill.]

———. "The Bath of Venus and Mars." Painting. Private coll., Minneapolis. [Ibid., no. 32—ill.]

Juan de la Cueva, 1550?–1610? (Mars and Venus in) *Los amores de Marte* [The Loves of Mars]. Poem. In *Parnaso español,* vol. 8 (Madrid: Ibarra, 1774). [DLE 1972, p. 238]

Peter Paul Rubens, 1577–1640. "Mars Disarmed by Venus." Painting. *c.*1615–17. Formerly Schloss Königsberg, East Prussia, lost. [Held 1980, p. 102]

———. (Marriage of Mars and Venus allegorized in) "The Presentation of the Portrait of Marie de' Medici to Henri IV;" (Mars and Venus in) "The Council of the Gods" ("The Government of the Queen") Paintings, part of "Life of Marie de' Medici" cycle. 1622–25. Louvre, Paris, inv. 1772, 1780. [Saward 1982, pp. 51ff., 114ff.—ill. / Jaffé 1989,

nos. 718, 737, pp. 61f.—ill. / also Louvre 1979–86, 1:116f.—ill.] Oil sketches. Alte Pinakothek, Munich, inv. 93, 103. [Jaffé, no. 717, 736—ill. / Munich 1983, pp. 463ff.—ill. / Held, no. 60—ill.]

———. "Mars, Venus, and Cupid." Painting. *c.*1630. Dulwich College Picture Gallery, London. [Jaffé, no. 974—ill.]

———. "Mars, Venus, Bacchus, Cupid, and the Fury." Painting. 1632–35. Palazzo Bianco, Genoa. [Jaffé, no. 1091—ill.]

———. "Venus Trying to Restrain Mars." Painting, oil sketch. *c.*1634–36. Louvre, Paris. [Jaffé, no. 1172—ill. / Held, no. 268—ill. / also Baudouin 1977, fig. 122] Final version, by Paul de Vos and Rubens's studio, in Neue Palais, Potsdam. [Held / Jaffé, no. 1173—ill.]

———. "Venus [and Cupid] Trying to Restrain Mars" ("The Consequences [Horrors] of War"). Painting. 1637–38. Sala di Marte, Palazzo Pitti, Florence, no. 86. [Jaffé, no. 1353—ill. / Pitti 1966, p. 72—ill. / White 1987, p. 230—ill. / Baudouin, fig. 130]

———, doubtfully attributed. "Mars, Venus and Cupid." Painting, oil sketch. *c.*1628–30. Gemäldegalerie, Berlin-Dahlem, inv. 798B. [Held, no. A5—ill. / Berlin 1986, p. 66—ill.]

———, school. "Mars and Venus." Painting. Gemeentemuseum, Helmond, Netherlands. [Wright 1980, p. 396]

———, school. "Mars and Venus." Painted cabinet panel. Rijksmuseum, Amsterdam, inv. NM11906–1. [Rijksmuseum 1976, p. 484—ill.]

Francesco Bracciolini dall' Api, 1566–1645. *Lo scherno de gli dei* [The Derision of the Gods] (at Mars and Venus in Vulcan's net). Poem. Florence: Giunti, **1618.** [DELI 1966–70, 1:463]

Michael Drayton, 1563–1631. (Cupid, Mars, and Venus in) Sonnet 48 of *Idea.* Cycle of 63 sonnets. London: Smethwicke, **1619.** [Hebel 1931–32, vol. 2]

Hubert Gerhard, *c.*1540/50–**1620** (previously attributed to Adriaen de Vries). "Mars, Venus, and Amor." Bronze sculpture group. Kunsthistorisches Museum, Vienna. [Frick 1968–70, 4:38]

Gerrit van Honthorst, 1590–1656. "Mars and Venus." Drawing. *c.*1621. Staatliche Graphische Sammlung, Munich. [Judson 1959, no. 223]

Guercino, 1591–1666. "Venus, Mars, Cupid, and Time." Painting. *c.*1624–26. National Trust coll., Dunham Marsy, Cheshire. [Salerno 1988, no. 109—ill.] Copy in Hermitage, Leningrad; 4 others known, 1 in private coll., others unlocated. [Ibid.]

———. "Mars," "Venus and Cupid." Pendant paintings. Wellington Museum, London. [Ibid., nos. 130–31—ill.]

———. "Venus, Mars, and Cupid." Painting. 1633. Pinacoteca Estense, Modena. [Ibid., no. 151—ill.]

Hendrik de Clerck, *c.*1570–**1629.** "Mars, Venus, and Vulcan." Drawing. Louvre, Paris. [Warburg]

Nicolas Poussin, 1594–1665, attributed. "Venus and Mars." Drawing. **1628–30.** Musée Condé, Chantilly, no. 174. [Friedlaender & Blunt 1953, no. 207—ill.]

———. "Venus and Mars." Painting. *c.*1630? Museum of Fine Arts, Boston, no. 40.89. [Wright 1985, no. 44, pl. 125 / Blunt 1966, no. 183—ill. / Boston 1985, p. 231—ill. / also Thuillier 1974, no. 45—ill. (cf. no. B29)]

————, attributed. "Mars and Venus" (? also conjecturally titled "Dido and Aeneas," "Rinaldo and Armida"). Painting. Late 1630s. Toledo Museum of Art, Ohio. [Wright, no. 94, pl. 43 / Thuillier, no. R64—ill. / also Blunt, no. R74 (attribution rejected)]

————, formerly attributed (now considered contemporary forgery or school copy after lost original). "Venus and Mars." Painting. Louvre, Paris, no. 7293 (727). [Blunt, no. R104 / Thuillier, no. R97—ill. / Louvre 1979–86, 4:146—ill.]

Joachim von Sandrart, 1606–1688, attributed. "Mars, Venus, and Cupid" ("Allegory of Wrath") (Venus and Cupid restraining Mars from departing for war). Painting. *c.*1630. Hermitage, Leningrad, inv. 7621. [Hermitage 1987b, no. 93—ill.]

Diego Velázquez, 1599–1660. "The Forge of Vulcan" (Apollo and Vulcan). Painting. 1630. Prado, Madrid, no. 1171. [López-Rey 1963, no. 68—ill. / López Torrijos 1985, p. 426 no. 2—ill. / Prado 1985, pp. 727f.] Study for head of Apollo. New York art market in 1963. [López-Rey, no. 69—ill.]

Anthony van Dyck, 1599–1641. "Mars Going to War" (or returning, to Venus). Painting (sketch). *c.*1630–32. Christ Church, Oxford. [Larsen 1988, no. 739—ill. / Byam Shaw 1967, no. 248—ill.]

————. "A Lady as Venus [with armor of Mars] with Cupid" (? also interpreted as Herminia putting on Corinda's armor). Painting. *c.*1636–40. Duke of Marlborough coll., England. [Larsen, no. 1042—ill.]

————, follower. "Mars Returning from War." Drawing (possibly related to "Mars Going to War," above). Kupferstichkabinett, Berlin. [Byam Shaw, no. 248—ill.]

Hendrik van Balen, 1575–**1632.** "Venus and Mars." Painting. [Bénézit 1976, 1:401] *See also Brueghel, above.*

Gotthard Ringgli, 1575–**1635.** "Venus and Mars Surprised by Vulcan." Painting. Landesmuseum, Zürich. [Schiff 1973, no. 118]

Sebastiano Mazzoni, *c.*1611–1678. "Venus and Mars Surprised by Vulcan." Painting. 1638. Private coll., Florence. [Florence 1986, no. 1.203—ill.]

Simon Vouet, 1590–1649. "Venus and Mars." Painting. Lost. / Engraved by Michel Dorigny, 1638. [Crelly 1962, no. 229—ill.]

———— (or studio?). "Venus and Mars with Cupid and Cronus." Painting. Ringling Museum, Sarasota, Fla. [Ibid., no. 139]

————, or studio. "Mars and Venus." Painting, cartoon for "Loves of the Gods" tapestry series. [Ibid., no. 270s]

Rembrandt van Rijn, 1606–1669. "Mars and Venus Caught in Vulcan's Net." Drawing. *c.*1643. Rijksprentenkabinet, Amsterdam. [Benesch 1973, no. 540—ill.]

Padovanino, 1588–**1648.** "Mars, Venus, and Cupid." Painting. Roumianzeff coll., Moscow. [Bénézit 1976, 8:479]

William Drummond of Hawthornden, 1585–**1649.** "Pourtrait of Mars and Venus." Poem (madrigal). In *Poems,* edited by Edward Phillips (London: Tomlins, 1656). [MacDonald 1976]

Thomas Willeboirts, *c.*1614–**1654.** "Allegorical Depiction of Mars [Friedrich Wilhelm, elector of Brandenburg?] Receiving the Weapons of Venus [Louisa Henrietta, Countess of Nassau?] and Vulcan." Painting. Rijksmu-

seum, Amsterdam, inv. C400. [Rijksmuseum 1976, p. 606—ill.]

Pier Francesco Valentini, *c.*1570–1654. "La cattività di Venere e di Marte" [The Captivity of Venus and Mars]. Musical intermedio, added to the opera *La trasformazione di Dafne.* 1654. [Grove 1980, 19:498]

Pedro Calderón de la Barca, 1600–1681. (Mars and Venus in) *La púrpura de la rosa* [The Blush of the Rose]. Zarzuela. Music, Juan Hidalgo. 1659. First performed 5 Dec 1660, Buen Retiro, Madrid. Libretto published in *Comedias de Calderón,* part 3 (Madrid: 1664). [Valbuena Briones 1960–67, vol. 1 / O'Connor 1988, pp. 304–15]

Luca Giordano, 1634–1705. "Venus, Mars, and the Forge of Vulcan." Painting. *c.*1657–60. Denis Mahon coll., London. [Ferrari & Scavizzi 1966, 2:38—ill.]

————. "Mars and Venus with Cupid." Painting. *c.*1660–70? Ringling Museum of Art, Sarasota, Fla., no. SN160. [Ferrari & Scavizzi, 2:82—ill. / Sarasota 1976, no. 159—ill.] Variant. Denis Mahon coll., London. [Sarasota]

————. "Venus, Mars, and Vulcan." Painting. *c.*1670. Akademie der Bildenden Künste, Vienna, no. 310. [Ferrari & Scavizzi, 1:73, 2:81—ill.]

————. "Mars and Venus." *c.*1670. Painting. Museo di Capodimonte, Naples, no. 1194. [Ferrari & Scavizzi, 1:73, 2:82—ill.]

————. "Mars and Venus (in Vulcan's Forge)." Painting. Mid-1670s. Louvre, Paris, inv. 306 (1305). [Ferrari & Scavizzi, 2:82 / Louvre 1979–86, 2:179—ill.] Variant or study ("Mars, Venus, and Vulcan"). Private coll., Florence. [Ferrari & Scavizzi, 2:83—ill.] Variant. R. Manning coll., New York. [Ibid., 2:367f.]

————. "Venus and Mars." Painting. *c.*1675–80? Musée des Beaux-Arts, Douai, no. 1142, in 1919. [Ibid., 2:325]

————, attributed. "The Surprise of the God Vulcan." Painting. Perez coll., Jerez de la Frontera. [Ibid., 2:293]

————. "Mars, Venus, and Vulcan." Painting. Sold 1767, untraced. [Ibid., 2:339]

————, school. "Venus, Mars, and Two Amorini." Painting. Recorded in Rosso coll., Florence, in 1677, untraced. [Ibid., 2:330f.]

Jean de La Fontaine, 1621–1695. "Les amours de Mars et de Vénus" (description of Flemish "History of Vulcan" tapestries, mid-16th century, see above). Part 9 of *Le songe de Vaux* [The Dream of Vaux]. *c.*1659–60? In *Contes et nouvelles en vers* (Paris: Barbin, 1665); collected with other fragments of *Le songe* in *Fables nouvelles et autres poësies* (Paris: Barbin, 1671). [Titcomb 1967 / Clarac & Marmier 1965 / DLLF 1984, 2:1176]

Francesco Albani, 1578–**1660.** "Mars and Venus." Painting. Chiswick House, London. [Warburg]

————, studio. "Venus and Mars." Painting. Alte Pinakothek, Munich, no. 530. [Pigler 1974, p. 167]

Ferdinand Bol, 1616–1680. "Venus and Sleeping Mars." Painting. *c.*1661–63. Herzog Anton Ulrich-Museum, Braunschweig, no. 247. [Blankert 1982, no. 33—ill. / Braunschweig 1969, p. 35—ill.] Replica. Unlocated. [Blankert, no. 34]

István Gyöngyösi, 1629–1704. *Murányi Vénus* [Venus of Murány (United to Mars)]. Poem. **1664.** Modern edition, Budapest: Franklin, 1906. [Czigány 1984, p. 61]

Jacob Jordaens, 1593–**1678,** attributed. "Venus and Mars,"

"A Sacrifice to Venus and Mars," "Venus, Mars, and Vulcan." Paintings, recorded in 18th and 19th century sales, untraced. [Rooses 1908, p. 261]

Gérard de Lairesse, 1641–1711 (active until *c.*1690). "Mars and Venus." Painting. Rijksmuseum, Amsterdam. [Pigler 1974, p. 168]

Jean-François Regnard, 1655–1709, and **Charles Rivière Dufresny,** 1648–1724. *La baguette de Vulcain* [Vulcan's Tongs]. Comedy. First performed 10 Jan **1693,** Théâtre-Italien, Paris. [Lancaster 1929–42, pt. 4, 2:786]

[?] Bordelon. *La baguette de Vulcain* [Vulcan's Tongs]. Comedy. Paris: **1693.** [Lancaster 1929–42, pt. 4, 2:956]

Louis Chéron, 1660–1725. "Vulcan Catching Mars and Venus in His Net." Painting. *c.*1695. Tate Gallery, London, no. T.578. [Tate 1975, p. 19]

Peter Motteux, 1660–1718. *The Loves of Mars and Venus.* Masque. Music, Daniel Purcell, with John Eccles and Gottfried Finger. First performed Nov **1696,** Lincoln's Inn Fields, London, with Edward Ravenscroft's *The Anatomist.* [Grove 1980, 5:820; 6:566 / Spink 1974, p. 253 / Fiske 1973, p. 13]

Severo di Luca, fl. 1684–1701. *Venere, Cupido, Marte* [Venus, Cupid, Mars]. Serenata. First performed **1700,** Rome. [Grove 1980, 11:296]

Luise Hollandine, 1622–1709. "Portrait of a Lady with Mars and Cupid." Painting. Herzog Anton Ulrich-Museum, Braunschweig, no. 673. [Braunschweig 1976, p. 40]

André Campra, 1660–1744, music. *Les amours de Vénus et de Mars.* Ballet. Scenario, Antoine Danchet. First performed 6 Sep **1712,** L'Opéra, Paris. [Grove 1980, 3:665]

John Weaver, 1673–1760, choreography. *The Loves of Mars and Venus.* Pantomime ballet. Music, Symonds and Charles Fairbank. First performed 2 Mar **1717,** Theatre Royal, Drury Lane, London. [Ralph 1985, pp. 25, 43 *n.*, 55, 126, 153, 1017 / Fiske 1973, pp. 70–72]

Giovanni Battista Piazzetta, 1683–1754. "Venus and Mars." Painting. *c.*1720. Private coll., Pordenone. [Mariuz 1982, no. 35—ill.]

Giovanni Battista Pittoni, 1687–1767. "Venus and Mars." Painting. *c.*1723. Private coll., Milan. [Zava Boccazzi 1979, no. 114—ill.]

———. "Venus and Mars." Painting. *c.*1723. Mobilier National (on deposit from Louvre, Paris, no. M.N.R. 668). [Ibid., no. 141—ill. / Louvre 1979–86, 2:295 (as style of Pittoni)] Variant (reversed). *c.*1723–25. Lord Iliffe coll., London. [Zava Boccazzi, no. 90—ill.]

Antonio Bellucci, 1654–1726. "Mars and Venus." Painting. Steffanoni coll., Bergamo. [Bénézit 1976, 1:609 / Pigler 1974, p. 167]

Arnold Verbuys, *c.*1645–1729. "Mars and Venus." Painting. Musée des Beaux-Arts, Angers (as Jan Verbuys). [Bénézit 1976, 10:444]

Nicolas Renier, ?–*c.*1731. *Mars et Vénus.* Cantata (parody). [Grove 1980, 15:743]

Louis Boulogne the Younger, 1654–1733. "Mars and Venus." Drawing. Louvre, Paris. [Pigler 1974, p. 168]

François Le Moyne, 1688–1737, rejected attribution (Italian school, style of Balestra). "Mars and Venus." Painting. Muzeum Narodowe, Warsaw, inv. 47099 (as Le Moyne), on deposit at Muzeum Sytuki, Lódz. [Bordeaux 1984, no. XII—ill. / Warsaw 1969, no. 662—ill.]

Pierre Février, 1696–1762/79. *Vulcain dupé par l'amour* [Vulcan Duped by Love]. Cantatille for bass, violin, basso continuo. Paris: **1741.** [Grove 1980, 6:518]

Giovanni Battista Tiepolo, 1696–1770. "(Allegory with) Mars and Venus." Fresco. *c.*1742. Palazzo Giusti del Giardino, Venice. [Pallucchini 1968, no. 143—ill. / Morassi 1962, p. 60—ill.] Study. Formerly Flameng coll., Paris. [Pallucchini—ill. / Morassi, p. 40—ill.]

———. "Mars, Venus, and Cupid." Fresco. 1757. Sala dell' Olimpo, Villa Valmarana, Vicenza. [Pallucchini, no. 240—ill. / Morassi, p. 65]

French School. "Mars Embracing Venus." Painting. **1700/ 50.** Louvre, Paris, no. R.F. 1939–4. [Louvre 1979–86, 4:311—ill.]

François Boucher, 1703–1770. "Mars and Venus." Painting, model for tapestry in "Loves of the Gods" series. *c.***1750.** Lost. / 12 tapestries woven by Beauvais, 1750. Council Presidency, Budapest; others unlocated. [Ananoff 1976, no. 348—ill.]

———. "Mars and Venus Surprised by Vulcan." Painting. 1754. Wallace Collection, London, no. P.438. [Ibid., no. 430—ill. / also Vermeule 1964, p. 128]

John Singleton Copley, 1738–1815. "Mars, Venus, and Vulcan." Painting (after an unidentified 18th-century print?). **1754.** Chapman coll., Pueblo, Colo. [Prown 1966, 1:17, 236—ill.]

Louis de Silvestre the Younger, 1675–1760, studio. "Venus and Mars." Painting. Muzeum Narodowe, Warsaw, inv. Wil. 1687 (formerly 523), on display at Wilanów Palace. [Warsaw 1969, no. 1211—ill.]

Johann Georg Platzer, 1704–1761. "Feast of Mars and Venus." Painting. Hermitage, Leningrad, inv. 1321. [Hermitage 1987b, no. 424—ill.]

Rowland Rugeley, 1735?–1776. "Venus and Mars Taken in Adultery." Burlesque poem. In *Miscellaneous Poems and Translations from La Fontaine and Others* (Cambridge: Fletcher & Hodson, **1763**). [Bush 1937, p. 545]

Louis-Jean-François Lagrenée, 1725–1805. "Mars and Venus Surprised by Vulcan." Painting. 1768. Louvre, Paris, no. R.F. 1983–77 (on loan from Kaufmann/Schlageter coll.). [Louvre 1979–86, 5:12]

Joseph-Marie Vien, 1716–1809. "Mars and Venus." Painting. 1768. Hermitage, Leningrad, inv. 2249. [Hermitage 1986, no. 313—ill.]

John Bacon, 1740–1799. "Mars," "Venus." Marble statues. "Mars" exhibited **1771,** Royal Academy, London. "Venus" added 1778. [Whinney 1964, pp. 166, 270 *n.*6] Copy of "Mars" in Yarborough coll. [Ibid.]

Jean-Georges Noverre, 1727–1810, choreography. *Les amours de Vénus, ou La vengeance de Vulcain* [The Loves of Venus, or The Vengeance of Vulcan]. Ballet. First performed 13 Dec **1773,** Burgtheater, Vienna. [Grove 1980, 13:443]

———, choreography. *Gli amori di Venere, ossia La vendetta di Vulcano.* Ballet (possibly identical with the above). Music, Étienne-Joseph Floquet. First performed 1775, Milan. [Lynham 1950, p. 170]

Charles Dibdin, 1745–1814, music and libretto. *Poor Vulcan.* Burletta, after Motteux's *Loves of Mars and Venus* (1696). Additional music, Thomas Arne; 1 song by Dr. Samuel Arnold. First performed 4 Feb **1778,** Covent

Garden, London. [Grove 1980, 5:427; 1:618 / Nicoll 1959–66, 3:116f., 195, 255]

Paul Ignaz Kürzinger, 1750–c.1820, music. *Der von der Liebe gebändigte Kriegsgott* [The God of War Bound by Love]. Ballet. First performed **1783**, Regensberg. [Grove 1980, 10:324]

Franz Anton Maulbertsch, 1724–1796. "Mars, Venus, and Vulcan." Etching. *c.*1780–84. [Garas 1960, no. 323]

Alexandre Trippel, 1744–1793. "Mars and Venus." Terracotta sculpture group. **1785.** Kunsthaus, Zürich. [Cologne 1977, pp. 133, 159—ill.]

Philip Freneau, 1752–1832. "Mars and Venus." Poem. **1768–94.** In *Poems Written between 1768 and 1794* (Monmouth, N.J.: privately printed, 1795). In modern edition by Fred Louis Pattee, *Poems* (Princeton: Princeton University Library, 1902–07; New York: Russell & Russell, 1963). [Boswell 1982, p. 256]

Jean-Baptiste Regnault, 1754–1829. "Mars and Venus." Painting. *c.*1796. Lost. [Hermitage 1983, no. 342 *n.*]

Antonio Canova, 1757–1822. "Venus and the Graces Dancing before Mars." Plaster relief. **1797.** Gipsoteca Canoviana, Possagno, no. 99. [Pavanello 1976, no. 105—ill. / Licht 1983, pp. 256—ill.] Replica, painting. Gipsoteca Canoviana, Possagno, no. 98. [Pavanello, no. D68—ill.] Related painting ("The Graces and Two Amorini Dancing before an Image of Venus"). Museo Civico, Bassano del Grappa, no. 7. [Ibid., no. D75—ill.]

———. "Venus and Mars." Marble sculpture group. Modeled 1816, completed 1822. Buckingham Palace, London. [Pavanello, no. 307—ill. / Licht, p. 219—ill.] Plaster model. Possagno, no. 246. [Pavanello, no. 308—ill.]

Johann Tobias Sergel, 1740–1814. "Mars and [swooning] Venus." Marble sculpture. **1804.** Nationalmuseum, Stockholm, no. 1113. [Göthe 1921, no. 29—ill. / Hartmann 1979, pl. 69] Plaster model, *c.*1775. Stockholm, no. 453. [Cologne 1977, p. 158—ill. / Göthe, no. 26—ill.] Variant, terracotta relief. 2 examples. Stockholm, no. 430; Thielska Galleriet, Djurgården, nr. Stockholm. [Göthe, no. 27—ill.]

Jean Bardin, 1732–1809. "Mars and Venus." Painting. Musée des Beaux-Arts, Orléans. [Bénézit 1976, 1:439]

[Mimi?] Favier, choreography. *Les amours de Mars et Vénus.* Ballet. Composer unknown. First performed 30 Apr **1811**, King's Theatre, London. [Guest 1972, p. 154 / Nicoll 1959–66, 4:426]

Fortunato Bernadelli, *c.*1795–after 1830, choreography. *L'amour de Mars et Vénus ou L'antre de Vulcain* [The Love of Mars and Venus, or Vulcan's Lair]. Ballet. Music, Lengard. First performed **1818**, St. Petersburg. [Winter 1974, p. 211]

Jean-Baptiste Blache, 1765–1834, choreography. *Les filets de Vulcain, ou Mars et Vénus* [The Nets of Vulcan, or Mars and Venus]. Ballet. Music, Jean-Madeleine Schneitzhoeffer. First performed **1820**, L'Opéra, Paris. [Oxford 1982, p. 60 / Guest 1976, p. 306]

Anne-Louis Girodet, 1767–1824, composition. "Mars and Venus." Lithograph, part of "Loves of the Gods" cycle. Published Paris: Engelmann, 1825–26. [Boutet-Loyer 1983, no. 87 *n.*—ill.]

Jacques-Louis David, 1748–1825. "Mars Disarmed by Venus (and the Graces)." Painting. **1824.** Musées Royaux des Beaux-Arts (Musée d'Art Moderne), Brussels, inv.

3261. [Schnapper 1982, p. 298—ill. / Brussels 1984b, p. 153—ill. / also Cantinelli 1930, no. 159—ill.]

Jean-Antoine Houdon, 1741–**1828.** "Venus and Mars." Miniature wax sculpture. Lost. [Réau 1964, no. 52]

Honoré Daumier, 1808–1879. "Vulcan's Net," "Mars and Venus." Comic lithographs, in "Ancient History" series. **1842.** [Delteil 1906–30, 22: nos. 962, 958—ill.]

Anonymous. *Venus and Mars, or The Golden Net.* Burletta. First performed **1844**, Strand, London. [Nicoll 1959–66, 4:549]

Léon Roques. *Vénus infidèle.* Operette-bouffe. Libretto, Alfred Poullion. Published Paris: Bathlot, **1868.** [NUC]

Max Klinger, 1857–1920. "Venus and Mars" (sea-triumph). Pair of paintings, door panels for Villa Albers, Berlin. **1883–85.** Museum der Bildenden Künste, Berlin. [Hildesheim 1984, no. 16]

Lawrence Alma-Tadema, 1836–1912. "Venus and Mars." Painting. **1888.** Unlocated. [Swanson 1977, p. 140]

John Cowper Powys, 1872–1963. "Ares and Aphrodite." Poem. In *Poems* (London: Rider, **1899**). [Bush 1937, p. 565]

Alfred Noyes, 1880–1958. "The Net of Vulcan." Poem. In *Forty Singing Seamen* (Edinburgh & London: Blackwood, **1907**). [Bush 1937, p. 567]

Max Beckmann, 1884–1950. "Mars and Venus." Painting. **1908.** Bilger coll., Neu-Ulm. [Göpel 1976, no. 91—ill.]

———. "Mars and Venus." Painting. 1939. Private coll., New York. [Ibid., no. 525—ill.]

Lovis Corinth, 1858–1925. "Homeric Laughter" (Mars and Venus discovered by Vulcan, other gods looking on). Painting. **1909.** Neue Pinakothek, Munich, inv. 9559. [Berend-Corinth 1958, no. 390—ill. / Munich 1982, p. 54—ill.] 2d version, 1919. Private coll. [Berend-Corinth 1958, no. 752—ill.] Etching, 1920. [Schwarz 1922, no. 395]

———. "Mars in Vulcan's Forge" (Venus looking on). Painting. 1910. Unlocated. [Berend-Corinth, no. 412—ill.]

———. "The Weapons of Mars" (Venus using Mars's shield as a mirror) Painting. 1910. Kunsthistorisches Museum, Vienna. [Ibid., no. 413—ill. / also Cologne 1976, no. 36—ill.] Lithograph, 1914. [Schwarz, no. L169]

Kostas Varnalis, 1884–1974. "Aphrodite" (escapes from Hephaestus's net). Poem. **1913.** In *Poietika* (Athens: Kedros, 1959). / Translated by Kimon Friar in *Modern Greek Poetry* (New York: Simon & Schuster, 1973). [Ipso / Colby 1985, p. 761]

Marie Rambert, 1888–1982, choreography. *The Ballet of Mars and Venus.* Ballet. Music, sonatas of Domenico Scarlatti, orchestrated by Constant Lambert. First performed 29 July **1929**, Opera House, Blackpool. / Revised as *Mars and Venus.* First performed 25 Feb 1930, Lyric Theatre, Hammersmith, London. [Vaughan 1977, p. 454]

John Peale Bishop, 1892–1944. "And When the Net Was Unwound Venus Was Found Ravelled with Mars." Poem. In *Now with His Love* (New York: Scribner, **1933**). [Boswell 1982, p. 41]

Sydney Meteyard, 1868–**1947.** "Venus and Mars." Painting. [Wood 1983, p. 201—ill. / Kestner 1989, p. 111]

Anthony Hecht, 1922–. (Allusion to Mars and Venus in the net in) "The Gardens of Villa D'Este." Poem. In *A Summoning of Stones* (New York: Macmillan, **1954**). [Vinson 1985, p. 368]

Iris Murdoch, 1919–. *Under the Net* (theme underscored by imagery of Mars and Venus). Novel. London: Chatto & Windus, **1954.** [BW 1979–87, suppl. 1, pp. 220ff., 225, 228f.]

Richard Selig, 1929–1957. "Horoscope" (Mars and Venus). Poem. In *Poems* (Dublin: Dolmen, 1962). [Ipso]

David Garnett, 1892–1981. *A Net for Venus.* Novel. London: Longmans, Green, **1959.** [Heilbrun 1961, p. 209]

Reuben Nakian, 1897–1986. "Mars and Venus." Abstract steel sculpture. **1959–60.** Albright-Knox Art Gallery, Buffalo, N.Y. [Marks 1984, p. 595 / cf. O'Hara 1966, no. 47—ill.]

————. "Mars and Venus Series." Incised terra-cotta plaque(s). 1959–60. Egan Gallery, New York; elsewhere? [O'Hara, no. 48—ill.]

————. "Mars and Venus Series." Abstract drawings. 1959–60. Museum of Modern Art, New York; Egan Gallery, New York; elsewhere? [Ibid., nos. 121–24—ill.]

Paul Goodman, 1911–1972. "Venus and Mars." Sonnet. In *The Lordly Hudson* (New York: Macmillan, 1962). [Ipso]

Sylvia Sleigh. "Maureen Connor and Paul Rosano: Mars and Venus." Painting. **1974.** Artist's coll.? [Personal communication to author from Professor Mark Thistlethwaite, Texas Christian University, 1984]

Franz Fühmann, 1922–1984. (Mars and Venus betray Vulcan, in one of the stories in) *Der Geliebte der Morgenröte* [The Lovers in their Prime]. Story cycle. Rostock: Hinstorff, **1978.** [Oxford 1986, p. 271]

ARES AND ATHENA. In the Trojan War, Athena (Minerva) supported the Greeks while Ares (Mars) defended the Trojans. Although both deities bore the epithet "warlike," Athena was also recognized as a champion of civic virtues and above all wisdom. Ares, on the other hand, was primarily a war god who was characterized by violence and strife. Their rivalry in the *Iliad* was the fountainhead of later allegorical representations in which the two Olympians embody the conflict between rationality and mindless violence—between peace and war. In other metaphorical treatments they are found together in harmony, representing the twin virtues of warlike valor and civic wisdom, especially in paeans to cities, nations, or patrons.

Classical Source. Homer, *Iliad* 5.30–35, 5.825–909, 21.391–414 and passim.

See also ARES; ATHENA; DIOMEDES.

Jacopo Tintoretto, 1518–1594. "Peace, Concord, and Minerva Driving out Mars." Painting. **1577–78.** Palazzo Ducale, Venice. [Rossi 1982, no. 375—ill. / also Berenson 1957, p. 179]

Paolo Veronese, 1528–1588. "Minerva and Mars." Painting, part of series glorifying Germany, for Fondaco dei Tedeschi, Venice. *c.*1578–80. Formerly Kaiser Friedrich Museum, Berlin, destroyed. [Pallucchini 1984, no. 168c—ill. / Pignatti 1976, no. 211—ill.]

Bartholomeus Spranger, 1546–1611. "Athena, Minerva, [*sic*] and Mars." Drawing. Nationalmuseum, Stockholm. [de Bosque 1985, p. 146—ill.]

————, composition. "Athena Led into the Temple of Wisdom by Hercules [strength] and Mars [valor]." Engraving, executed by Jan Muller. [Warburg]

Peter Paul Rubens, 1577–1640. "Minerva Protects Pax from Mars" ("Peace and War"). Painting. **1629–30.** National Gallery, London, inv. 46. [Jaffé 1989, no. 969—ill. / London 1986, p. 543—ill. / White 1987, pp. 228f.—ill. / also Baudouin 1977, pl. 63] Studio variant. *c.*1630. Alte Pinakothek, Munich, no. 343. [Jaffé, no. 993—ill. / Munich 1983, p. 455—ill. / Baudouin, fig. 132]

————. "Wisdom [Minerva] Keeping Armed Rebellion [Mars] from the Throne of King James," detail in "The Peaceful Reign of King James I." Ceiling painting, for Banqueting House, Whitehall, London. 1633–34. In place. [Jaffé, no. 1010, p. 71—ill.] Oil sketch for entire composition. Akademie der Bildenden Künste, Vienna, inv. 628. [Ibid., no. 1007—ill. / Held 1980, no. 130—ill. / White, pl. 275 / Baudouin, fig. 124] Oil sketch for detail. Musées Royaux des Beaux-Arts, Brussels, inv. 3283 (392). [Held, no. 132—ill. / Jaffé, no. 1009—ill. / Baudouin, fig. 123]

————. "Hercules and Minerva Fighting Mars." 2 oil sketches and a gouache, early pensées for "The Horrors of War" (*c.*1637–38, Pitti, Florence). *c.*1634–35. Speelman & Co., London; Museum Boymans-van Beuningen, Rotterdam, no. 253, on loan to Dienst voor 's Rijks Verspreide Kunstvoorwerpen (without Hercules); Louvre, Paris (gouache). [Held, nos. 244, 253—ill. / Jaffé, nos. 1113–14—ill. / White, pl. 255 / also Baudouin, fig. 121, pl. 62 / Burchard & d'Hulst 1963, no. 169—ill.]

Charles Le Brun, 1619–1690. (Minerva, Mars, and other Olympian deities represent king's virtues in) "The King Governs by Himself." Ceiling painting. **1678–79.** Galerie des Glaces, Château de Versailles. [Berger 1985, p. 54, figs. 94–95]

————. (Mars and Minerva in) "The Decision Taken to Make War on Holland, 1671," "The King Armed on Land and Sea, 1672," "The Taking of the City and Citadel of Ghent in 6 Days, 1678," "The Conquest of La Franche-Comté, 1674." Paintings, sketches for decoration of Grand Galerie, Versailles, celebrating the Treaty of Nejmegen in 1678. 1679–84. Musée des Beaux-Arts, Auxerre (2); Musée des Beaux-Arts, Troyes; Musée National de Versailles. [Versailles 1963, nos. 36–38, 40—ill.]

Dutch School. "The Apotheosis of a Ruler Being Brought by Mars and Minerva to Jupiter." Painting. *c.*1700. Rijksmuseum, Amsterdam, inv. A4655. [Rijksmuseum 1976, p. 680—ill.]

Antonio Giannettini, 1648–1721. *La gara di Minerva e Marte* [The Contest of Minerva and Mars]. Cantata. First performed **1716,** Modena. Music lost. [Grove 1980, 7:348]

French (or German?) School. "Mars, Janus, and Minerva—Allegory of War and Peace." Bronze sculpture. *c.*1700–30. Museum für Kunst und Gewerbe, Hamburg, inv. 1961.207. [Düsseldorf 1971, no. 187—ill.]

Jacques-Louis David, 1748–1825. "Combat of Minerva against Mars (Saved by Venus)" Painting. **1771.** Louvre, Paris, inv. 3695. [Schnapper 1982, p. 23—ill. / Cantinelli 1930,

203

no. 6—ill. / Louvre 1979–86, 3:184—ill. / Vermeule 1964, pp. 144, 170—ill. / also Rosenberg 1988, p. 314—ill.]

Jean-Honoré Fragonard, 1732–1806. "The Battle of Minerva and Mars" (Venus intervening). Painting, sketch. **1771.** Musée des Beaux-Arts, Quimper, inv. 873–1–387. [Rosenberg 1988, no. 149—ill.] *See also Suvée, below.*

Maria Margherita Grimani (18th century). *Pallade e Marte* [Pallas and Mars]. Dramatic cantata. [Cohen 1987, 1:288]

Joseph-Benoît Suvée, 1743–1807. "The Battle of Minerva and Mars." Painting. Musée des Beaux-Arts, Lille. [Rosenberg 1988, p. 314—ill.] Sketch (previously attributed to Fragonard). Musée des Beaux-Arts, Rouen. [Ibid.—ill.]

Pierre-Paul Prud'hon, 1758–1823. "Hymen Uniting Mars and Minerva" (representing Napoleon and Marie-Louise). Drawing, design for entablature above "Psyche," sculpture decoration for apartments of Empress Marie-Louise, Paris. *c.*1810. Marcille-Jahan-Chévrier coll. [Guiffrey 1924, no. 980, pp. 365f.—ill.]

Antonio Canova, 1757–1822. "Minerva, Neptune, and Mars Consigning the Infant Hero [Horatio Nelson] to England." Relief, for monument to Lord Nelson, final version never executed. Plaster, wax and terra-cotta models, Gipsoteca Canoviana, Possagno, nos. 181–84. [Pavanello 1976, no. 192—ill.] Monochrome painting ("Birth of Horatio Nelson"). Museo Civico, Bassano del Grappa, no. 15. [Ibid., no. D85—ill.]

Robert Bagg, 1935–. "War and Grey Eyes" (Mars and Minerva). Poem. In *Madonna of the Cello* (Middletown, Conn.: Wesleyan University Press, **1956**). [Ipso]

ARETHUSA. *See* ALPHEUS AND ARETHUSA.

ARGONAUTS. *See* JASON, and the Argonauts.

ARGUS. (1) The shipwright who built the ship, the *Argo,* on which Jason sailed in quest of the Golden Fleece. *See* JASON, and the Argonauts. (2) The many-eyed herdsman who guarded Io for Hera. *See* Io.

ARIADNE. The daughter of King Minos of Crete and his wife Pasiphaë, Ariadne fell in love with Theseus when he came to Crete to kill the Minotaur. The beast, offspring of a union between Pasiphaë and a bull, was kept in a labyrinth built by Daedalus. Every nine years a tribute of fourteen young Athenians was brought to Crete and sacrificed to it. When Theseus arrived in Crete as part of this group, Ariadne told him she could help him negotiate the labyrinth successfully if he would take her with him when he left. She gave him a ball of golden thread, which he unwound along his path as he penetrated the maze. After encountering and slaying the Minotaur, he retraced his steps by following the thread.

Having succeeded in his mission, Theseus left Crete, taking Ariadne with him. On the way back to Athens they stopped on the island of Naxos (Dia), where Theseus abandoned Ariadne. According to one legend, he simply forgot her and sailed away; others say that he left her in favor of her sister Phaedra. Ariadne was discovered on the island by Dionysus (Bacchus), who married her. In Homer's version, Artemis killed Ariadne for eloping with Theseus while already engaged to Dionysus. According to Hesiod, Ariadne became immortal through her marriage to the god. In yet another legend, Ariadne died giving birth to Theseus's child.

Ariadne abandoned has been a favorite theme in the fine arts. She is depicted woefully watching Theseus's ships sail into the distance, or sleeping; sometimes Dionysus and his train can be seen approaching.

Classical Sources. Homer, *Iliad* 18.590ff.; *Odyssey* 11.321–25. Bacchylides, "Theseus." Catullus, *Carmina* 64.50–201. Ovid, *Heroides* 20; *Metamorphoses* 8.170–82. Apollodorus, *Biblioteca* 3.1.2, E1.7–10. Plutarch, *Parallel Lives,* "Theseus." Pausanias, *Description of Greece* 1.17.3, 2.23.8, 10.29.3–4. Hyginus, *Fabulae* 42, 43.

See also DIONYSUS, and Ariadne; MINOS; THESEUS, General List.

Anonymous French. (Story of Theseus and Ariadne in) *Ovide moralisé* 7.2171–2204, 8.1083–1578. Poem, allegorized translation/elaboration of Ovid's *Metamorphoses*. *c.*1316–28. [de Boer 1915–86, vol. 3]

Giovanni Boccaccio, 1313–1375. "De Theseo, rege Athenarum" [About Theseus, King of Athens]. In *De casibus virorum illustrium* [The Fates of Illustrious Men] 1.10; and Theseus in Crete discussed in 1.11. Didactic poem in Latin. **1355–73?** [Branca 1964–83, vol. 9 / Hall 1965]

Geoffrey Chaucer, 1340?–1400. "The Legend of Ariadne." Part of *The Legende of Goode Women* lines 1922ff., 2136–50. Poem. **1385–86.** Westminster: Caxton, *c.*1495. [Riverside 1987]

John Gower, 1330?–1408. (Tale of Theseus and Ariadne in) *Confessio amantis* 5.5231–5495. Poem. *c.*1390. Westminster: Caxton, 1483. [Macaulay 1899–1902, vol. 3 / Ito 1976, p. 39]

Filarete, *c.*1400–1469? "Theseus and Minotaur." Relief, on bronze door of St. Peter's, Rome. **1433–45.** In place. [Pope-Hennessy 1985b, 2:318]

Bergonzio di Botta, choreography. (Story of Theseus and Ariadne introduced in) Ballet-spectacle for marriage of Duke of Milan to Isabella of Aragon. **1459.** [Chujoy & Manchester 1967, p. 150 / Sharp 1972, pp. 219, 310]

Maso da Finiguerra, 1426–1464. "Theseus and Ariadne."

*c.*1460. Drawing. British Museum, London. [Pigler 1974, p. 240 / Warburg]

Cima da Conegliano, *c.*1459–1517/18. "Theseus and the Minotaur," "Theseus at the Court of Minos." Paintings, part of a cycle (3rd panel presumed lost). *c.*1495–97. Pinacoteca di Brera, no. 1013, on loan to Museo Poldi Pezzoli, Milan; private coll., Zurich. [Humfrey 1983, nos. 90, 167—ill.]

North Italian School. "Theseus and the Minotaur." Painting. *c.*1500. Szépművészeti Múzeum, Budapest, no. 1411. [Budapest 1968, p. 497]

Bartolomeo di Giovanni, fl. *c.*1483–1511. "Theseus Following Ariadne's Thread." Painting. Musée de Longchamp, Marseille. [Pigler 1974, p. 240]

Giovanni Bellini, *c.*1430–1516. "Theseus and the Minotaur." Painting. Formerly Gnecchi coll., Milan. [Berenson 1957, p. 32]

Josaphat Araldi, fl. *c.*1520, attributed. "Ariadne on Naxos." Painting. Rijksmuseum, Amsterdam, inv. A3967. [Rijksmuseum 1976, p. 86—ill.]

Piero di Cosimo, *c.*1462–1521, previously attributed. "Theseus and Ariadne." Painting. Musée des Beaux-Arts, Marseilles. [Bacci 1966, p. 122]

Battista Dossi, *c.*1474–1548, attributed (formerly attributed to Dosso Dossi). "Ariadne" (?). Painting (fragment of larger work?). Late 1520s? Private coll., London. [Gibbons 1968, no. 99—ill.]

Hans Sachs, 1494–1576. *Theseus mit dem Minotaurus (im Irrgarten)* [Theseus and the Minotaur (in the Labyrinth)]. Tragedy. *c.*1564. In *Werke* (Nuremberg: Heussler, 1558–91). In modern edition, *Werke* (Stuttgart: 1870–1908; Hildesheim: Olms, 1964). [McGraw-Hill 1984, 4:301]

Thomas Underdowne, fl. 1566–87. *The Excellent Historye of Theseus and Ariadne.* Poem. London: R. Johnes, 1566. Modern edition, London: Routledge, [1923]. [Bush 1963, p. 314]

Giovanni Andrea dell' Anguillara, *c.*1517–1572. "Lamento d'Ariana abandonata da Teseo" [Lament of Ariadne Abandoned by Theseus]. Translation from Ovid's *Metamorphoses* (Bologna: 1640). [Bianconi 1987, p. 218f.]

Titian, *c.*1488/90–1576, copy after. "Ariadne in Naxos." Painting. National Gallery of Scotland, Edinburgh, cat. 1970 no. 103. [Wright 1976, p. 202]

Edmund Spenser, 1552?–1599. (Ariadne evoked in) *The Faerie Queene* 6.10.13. Romance epic. London: Ponsonbie, 1596. [Hamilton 1977 / MacCaffrey 1976, pp. 394–96]

Pieter Corneliszoon Hooft, 1581–1647. *Het spel van Theseus ende Ariadne* [The Play of Theseus and Ariadne]. Tragedy. First performed 1602, Amsterdam. [CEWL 1973, p. 683]

Carlo Saraceni, 1579–1620. "(Landscape with) Ariadne Abandoned." Painting. Probably before 1608. Gallerie di Capodimonte, Naples, no. 156. [Ottani Cavina 1968, no. 45—ill. / Capodimonte 1964, p. 51]

Ottavio Rinuccini, 1562–1621. *L'Arianna.* Tragedy. Venice: Giunti, Ciotti, 1608. [Taylor 1893, p. 369]

Claudio Monteverdi 1567–1643. *L'Arianna.* Opera (dramma per musica). Libretto, Ottavio Rinuccini. First performed 28 May 1608, Gonzaga court, Mantua. Music lost, except for "Lamento"; libretto extant. [Grove 1980,

12:516, 524 / Bianconi 1987, pp. 22, 209–13, 216, 218 / Palisca 1968, p. 33 / Kerman 1956, pp. 250–67 / Redlich 1952, pp. 16ff., 100ff. / Bukofzer 1947, pp. 30f., 36, 59f. / Pirrotta & Povoledo 1982, pp. 206, 257 *n.*, 271 *n.*, 276f.]

Scipione Herrico, 1592–1670. *Arianna.* Idyl. Messina: Bianco? 1611. [DELI 1966–70, 2:382]

Lope de Vega, 1562–1635. *El laberinto de Creta* [The Cretan Labyrinth]. Comedy. 1612?–15. In *Comedias* part 16 (Madrid: 1621). [Menéndez y Pelayo 1890–1913, vol. 6 / McGraw-Hill 1984, 5:96]

Alexandre Hardy, *c.*1570–1632. *Ariane ravie* [Ariadne Seduced]. Tragicomedy. Before 1615. First performed *c.*1624, Paris. [Girdlestone 1972, p. 229 *n.* / Deierkauf-Holsboer 1972, pp. 149, 155]

Claudio Pari, fl. 1611–19. "Il lamento d'Arianna." Madrigal. Published with 12 others, Palermo: 1619. [Grove 1980, 14:183]

Antonio Il Verso, *c.*1560?–1621. "Lamento d'Arianna." Madrigal. Published Palermo [?]: 1619. [Grove 1980, 14:183]

Scarsellino, 1551–1620. "Ariadne." Painting. Formerly Galerie St. Lukas, Vienna. [Berenson 1968, p. 391]

Giambattista Marino, 1569–1625. "Arianna." Idyll. No. 2 in *La sampogna* (Paris: Pacardo, 1620). [Getto 1962]

Pellegrino Possenti, fl. 1623–28. "Lamento d'Ariana." Song. Text, Marino (1620). Published Venice: 1623. [Grove 1980, 15:153]

José García de Salcedo Coronel, 1592?–1651. *Ariadna.* Poem. Madrid: 1624. [DLE 1972, p. 817]

Ivan Gundulić, 1589–1638. *Ariadna.* Tragedy. Dubrovnik: 1632. In modern edition, *Works* (Zagreb: Izdavko Knjizarska radna organicija, 1980). [CEWL 1973, 2:604]

Pedro Calderón de la Barca, 1600–1681. (Theseus and Ariadne and the Minotaur in) *Los tres mayores prodigios* [The Three Greatest Marvels] act 2. Comedy. 1636. First performed St. John's Night, 1636, Buen Retiro, Madrid. Published in *Comedias de Calderón*, part 2 (Madrid: 1637). [Valbuena Briones 1960–67, vol. 1 / O'Connor 1988, pp. 136, 140–52, 174f. / Maraniss 1978, p. 104]

——. "El laberinto del mundo; El Teseo in Creta" [The Labyrinth of the World: Theseus in Crete]. Auto sacramental. Published in *Autos sacramentales*, part 1 (Madrid: de Buendia, 1677). [McGraw-Hill 1984, 1:444 / Léon 1982, p. 183]

Joachim Wtewael, 1566–1638, formerly attributed. "Ariadne on Naxos." Painting, fragmentary copy after Wtewael's "Lot and His Daughters" (lost). Grzimek coll., Friedrichshaven. [Lowenthal 1986, no. C–33]

Tirso de Molina, 1583–1648. *El laberinto de Creta* [The Cretan Labyrinth]. Auto sacramentale. MS dated 1638. [Wilson 1977, p. 126 / Barrera 1969, pp. 390, 597]

Henry Lawes, 1596–1662. "Theseus, O Theseus, hark!" (Ariadne's lament). Song. 1636–43? Text, William Cartwright. Published in *First Book of Ayres and Dialogues* (London: Playford, 1653–58). [Grove 1980, 10:557 / Spink 1974, pp. 96, 104f. / Bush 1963, p. 229]

Richard Lovelace, 1618–1658. (Theseus and Ariadne evoked in) "Princess Louisa Drawing." Poem. In *Lucasta: Epodes, Odes, Sonnets, and Songs* (London: Ewster, 1649). [Wilkinson 1930]

French School. "Ariadne Abandoned," "Ariadne Sleeping." Pendant paintings. **1600/50.** Louvre, Paris, inv. 8604, 8854. [Louvre 1979–86, 4:300—ill.]

Jacob van Loo, *c.*1614–1670. "Ariadne." Painting. **1652.** Muzeum Narodowe, Warsaw, inv. Wil. 1590, on display at Wilanów Palace. [Warsaw 1969, no. 690—ill.]

Richard Fleckno, ?–*c.*1678. *Ariadne Deserted by Theseus and Found and Courted by Bacchus.* Opera. Libretto, composer. Published London: **1654.** [Grove 1980, 6:633 / Greg 1939–59, 2:845, no. 734]

Jacques Stella, 1596–**1657.** "Ariadne." Painting. Museé d'Art et d'Histoire, Geneva. [Bénézit 1976, 9:815]

Pietro Andrea Ziani, 1616–1684. *L'incostanza trionfante, overo Il Theseo* [Inconstancy Triumphant, or Theseus]. Opera. Libretto, F. Piccioli. First performed 16 Jan **1658,** San Cassiano, Venice. [Grove 1980, 20:675]

Giacinto Gimignani, 1611–1681 (formerly attributed to Guido Reni, as "Venus and Cupid"). "Ariadne Abandoned." Painting. **1650–60.** Uffizi, Florence, inv. 579. [Uffizi 1979, no. P709—ill.]

Francesco Rossi, fl. *c.*1660–92. *L'Arianna.* Opera. Libretto, Carlo Torre. First performed Summer **1660,** Pavia. [Grove 1980, 16:213]

Marco Marazzoli, *c.*1602/08–**1662,** doubtfully attributed, listed among the composer's effects at his death. May be related to Rossi. *L'Arianna.* Opera (comedia in musica). [Grove 1980, 11:643]

Cornelis van Poelenburgh, *c.*1586–**1667.** "Ariadne." Painting. Musée d'Art et d'Histoire, Geneva. [Bénézit 1976, 8:392]

Juan Bautista Diamante, 1625–1687. *El labyrinto de Creta.* Comedy. In *Comedias nuevas escogidas,* vol. 27 (Madrid: **1667**). [Barrera 1969, p. 124]

Thomas Corneille, 1625–1709. *Ariane.* Tragedy. First performed Feb **1672,** Hôtel de Bourgogne, Paris. Published Paris: de Luyne, Barbin & Trabouillet, 1672. [DLLF 1984, 1:550 / Pocock 1973, pp. 242–48, 260, 304 / Collins 1966, pp. 142–51, 190]

Urbano Romanelli, 1652–1682. "Theseus and Ariadne by the Labyrinth." Ceiling fresco, for Palazzo Barberini, Rome. **1678.** In place; restored 1960s. [Montagu 1971, pp. 366ff.—ill.]

Jean de La Fontaine, 1621–1695. "Les filles de Minée" [The Daughters of Minos] (Ariadne and Phaedra). Poem. **c.1683.** In *Ouvrages de prose et de poésie des sieurs de Maucroix et de La Fontaine* (Paris: Barbin, 1685) and *Fables choisies* (Paris: 1693). [Clarac & Marmier 1965 / MacKay 1973, p. 173]

Cristóbal Galán, *c.*1630–**1684.** Incidental music for Diamante's *El labyrinto de Creta* (1667). [Grove 1980, 7:92]

Bernardo Pasquini, 1637–1710. *L'Arianna.* Opera. First performed **1685,** Rome. [Grove 1980, 14:266]

Antonio Draghi, 1634/35–1700. *Il ritorno di Teseo dal laberinto di Creta* [The Return of Theseus from the Cretan Labyrinth]. Opera. Libretto, Nicolò Minato. First performed **1686,** Vienna. [Grove 1980, 5:604]

Johann Georg Conradi, ?–1699. *Die schöne und getreue Ariadne* [The Beautiful and True Ariadne]. Opera. Libretto, Christian Heinrich Postel. First performed **1691,** Opera House, Hamburg. [Grove 1980, 4:664f.]

Johann Sigismund Küsser, *c.*1660–1727. *Ariadne.* Opera.

Libretto, Friedrich Christian Bressand. First performed 15 Feb **1692,** Braunschweig. [Baker 1984, p. 1279 / Grove 1980, 10:325 / DLL 1968–90, 2:38]

Francesco Redi, 1626–**1698.** *Arianna inferma* [Weak Ariadne]. Poem (ditirambo seguirono). In *Opere* (Venice: Ertz, 1712–30). [DELI 1966–70, 4:520]

Carlo Agostino Badia, 1672–1738. *L'Arianna.* Opera (poemetto drammatico). Text, Bernardoni. First performed 21 Feb **1702,** Vienna. [Grove 1980, 2:9]

Johann Caspar Ferdinand Fischer, *c.*1670–1746. *Ariadne.* Organ music. First performed **1702,** Schlackenwerth. [Grove 1980, 6:609]

Thomas-Louis Bourgeois, 1676–1750/51. *Ariane.* Cantata. Published Paris: **1708.** [Grove 1980, 3:113]

Philippe Courbois, fl. 1705–30. *Arianne.* Cantata. Text, Louis Fuzelier. Published Paris: **1710.** [Grove 1980, 5:1]

Pietro Pariati, 1655–1733. *Arianna e Teseo.* Drama. Used as libretto for opera by Porpora, **1714** (below), and by at least 16 further composers to 1792. [Grove 1980, 14:183] Drama first performed without music 1727, San Grisostomo, Venice. Published Venice: Rossetti, 1727. [Ibid.]

Nicola Porpora, 1686–1768. *Arianna e Teseo.* Heroic opera. Libretto, Pietro Pariati. First performed 1 Oct **1714,** Hoftheater, Vienna. [Grove 1980, 15:124, 126]

————. *Arianna in Nasso.* Heroic opera. Libretto, Paolo Antonio Rolli. First performed 29 Dec 1733, Lincoln's Inn Fields, London. [Keates 1985, p. 176 / Hogwood 1984, p. 119 / Grove, 15:126]

Francesco Bartolomeo Conti, 1681–1732. *Teseo in Creta.* Opera. Libretto, Pariati (1714). First performed **1715,** Vienna. [Grove 1980, 4:681]

Jean-Joseph Mouret, 1682–1738. *Ariane.* Opera (tragédie lyrique). Libretto, Pierre-Charles Roy and François-Joseph de Lagrange-Chancel. First performed 6 Apr **1717,** L'Opéra, Paris. [Grove 1980, 12:655 / Girdlestone 1972, pp. 229–232]

Leonardo Leo, 1694–1744. *Arianna e Teseo.* Opera seria. Libretto, Pariati (1714). First performed 26 Nov **1721,** Teatro San Bartolomeo, Naples. [Grove 1980, 10:667 / Hogwood 1984, pp. 119f., 125]

Reinhard Keiser, 1674–1739. *Die betrogene und nochmahls vergötterte Ariadne* [Ariadne Betrayed and Later Deified]. Opera, adaptation of Conradi's *Die schöne und getreue Ariadne* (1691). Libretto, C. H. Postel. First performed **1722,** Hamburg. [Grove 1980, 9:846, 848 / Zelm 1975, p. 73]

Giovanni Porta, *c.*1690–1755. *L'Arianna nell' isola di Nasso* [Ariadne on the Island of Naxos]. Opera seria. Libretto, N. Stampa. First performed 28 Aug **1723,** Teatro Ducale, Milan. [Grove 1980, 15:133]

Tomaso Giovanni Albinoni, 1671–1751, doubtfully attributed. *Teseo in Creta.* Opera. **1725.** [Grove 1980, 1:219]

Benedetto Marcello, 1686–1739. "Arianna." Musical scene. Text, Vincenzo Cassini. First performed **1727,** Florence. [Grove 1980, 11:649]

Francesco Feo, 1691–1761. *Arianna.* Opera seria. Libretto, Pariati (1714). First performed Carnival **1728,** Teatro Regio, Turin. [Grove 1980, 6:466]

Giovanni Benedetto Platti, 1700–1763. *Arianna.* Opera. First performed **1729,** Würzburg. [Grove 1980, 14:858]

George Frideric Handel, 1685–1759. *Ariadne in Crete.* Opera. Libretto, Pariati (1714), translated by Francis

Colman. First performed 26 Jan **1734,** King's Theatre, Haymarket, London. [Dean & Knapp 1987, p. 231 / Keates 1985, pp. 176f. / Lang 1966, p. 249 / Hogwood 1984, pp. 119f., 125, 284 / Fiske 1973, p. 253 *n.*]

Alain René Lesage, 1668–1747, scenario and verses. "Ariadne et Thésée," part of musical entertainment *L'histoire de l'Opéra-comique ou les metamorphoses de la foire.* First performed **1736,** Paris. [DLF 1951–72, 2:99]

Giovanni Alberto Ristori, 1692–1753. *Arianna.* Opera (azione scenica). Libretto, Pallavicini. First performed 7 Oct **1736,** for birthday of the Elector of Hubertusburg. [Grove 1980, 16:56]

Giuseppe Maria Orlandini, 1675–1760. *Arianna.* Opera. Libretto, Pariati (1714). First performed **1739,** Pergola, Florence. [Grove 1980, 13:824]

Giuseppe de Majo, 1697–1771. *Arianna e Teseo.* Opera seria. First performed 20 Jan **1747,** San Carlo, Naples. [Grove 1980, 11:544]

Girolamo Abos, 1715–1760. *Arianna e Teseo.* Opera seria. Libretto, Pariati (1714). First performed Spring **1748,** Teatro delle Dame, Rome. [Grove 1980, 1:20]

Viennese School. "Ariadne Abandoned" (or "Magdalene in the Desert"?). Painted wood sculpture. *c.***1740–50.** Busch-Reisinger Museum, Cambridge, Mass., inv. 1961.3. [Houser 1979, no. 56—ill.]

Giovanni Battista Pescetti, 1704–1766. *Arianna e Teseo.* Opera (dramma per musica). Libretto, Pariati (1714). First performed 20 Jan **1750,** Pergola, Florence. [Grove 1980, 14:570 / Weaver 1978, pp. 327f.]

Andrea Adolfati, 1720/21–1760. *Arianna.* Opera. Libretto, Pariati (1714). First performed Winter **1750,** Teatro Falcone, Genoa. [Grove 1980, 1:111]

Giuseppe Sarti, 1729–1802. *Arianna e Teseo.* Opera (dramma per musica). Libretto, Pariati (1714). First performed Carnival **1756,** Theatre on Kongens Nytorv, Copenhagen. [Grove 1980, 16:504]

Antonio Mazzoni, 1717–1785. *Arianna e Teseo.* Opera. Libretto, Pariati (1714). First performed **1758,** Teatro San Carlo, Naples. [Grove 1980, 11:872]

Giuseppe Carcani, 1703–1779, music. *Arianna e Teseo.* Dramatic musical scenes. Text, Pariati (1714). First performed **1759,** Filarmonica Carnival, Verona. [Grove 1980, 3:772]

Giuseppe Ponzo, fl. 1759–91. *Arianna e Teseo.* Opera seria. Libretto, Pariati (1714). First performed Jan **1762,** Teatro Ducale, Milan. [Grove 1980, 15:83]

Baldassarre Galuppi, 1706–1785. *Arianna e Teseo.* Opera seria. Libretto, Pariati (1714). First performed 12 June **1763,** Nuovo, Padua. [Grove 1980, 7:137]

Jean-Honoré Fragonard, 1732–1806. "The Sacrifice to the Minotaur." Painting, sketch. *c.***1765?** Private coll., Paris. [Rosenberg 1988, p. 220—ill. / also Wildenstein 1960, no. 217—ill.] Watercolor version. Private coll. [Rosenberg, no. 107—ill.] Further oil sketch of the subject (or "Sacrifice of Iphigenia"?). Unlocated. [Ibid.—ill. / Wildenstein, no. 218—ill.]

Pasquale Cafaro, 1716?–1787. *Arianna e Teseo.* Opera. Libretto, Pariati (1714). First performed 20 Jan **1766,** San Carlo, Naples. [Grove 1980, 3:595]

Heinrich Wilhelm von Gerstenberg, 1737–1823. *Ariadne auf Naxos.* Tragedy. **1767.** In *Tragischen Kantaten* (Co-

penhagen & Leipzig: Mumme, 1767). Set as opera or cantata by at least 4 composers beginning with Benda 1775 (below) to *c.*1820. [DLL 1968–90, 6:273 / Oxford 1986, p. 289] [Grove 1980, 7:306]

Daniel Schiebeler, 1741–1771. "Theseus und Ariadne." Poem. **1767.** [Frenzel 1962, p. 51]

Felice Alessandri, 1747–1798. *Arianna e Teseo.* Opera (pasticcio). First performed 11 Oct **1768,** King's Theatre, London. [Grove 1980, 1:244]

Brizio Petrucci, 1737–1828. *Teseo in Creta.* Opera (azione teatrale). Libretto, G. F. Fattiboni. First performed **1771,** Cesena. [Grove 1980, 14:595]

Anton Schweitzer, 1735–1787. *Ariadne auf Naxos.* Opera (melodrama), including music also used for composer's *Alkeste* (1773). Libretto, Johann Christian Brandes. **1772.** [Grove 1980, 17:46]

Angelica Kauffmann, 1741–1807. "Ariadne Abandoned by Theseus." Painting. Exhibited **1774.** Capt. Spencer Churchill coll., Northwick Park. [Manners & Williamson 1924, p. 181]

————. "Ariadne Deserted" ("Ariadne and Theseus"). Painting. Gemäldegalerie, Dresden, no. 2183. [Ibid., p. 215 / Dresden 1976, p. 64]

Gaspare Angiolini, 1731–1803, choreography. *Teseo in Creta.* Ballet. Music, Joseph Starzer. First performed **1775,** Vienna. [Grove 1980, 18:82]

————, choreography and music. *Thésée et Ariadne.* Ballet. First performed 1776–79 (?), Imperial Theatre, St. Petersburg. [Oxford 1982, p. 16]

Georg Benda, 1722–1795. *Ariadne auf Naxos.* Opera (melodrama, spoken text with music). Libretto, Johann Christian Brandes after von Gerstenberg (1767). First performed 27 Jan **1775,** Gotha. [Grove 1980, 2:463 / DLL 1968–90, 1:874]

Voltaire, 1694–1778, writing as M. De La Visclede. "Le dimanche, ou Les filles de Minée" [Sunday, or The Daughters of Minos]. Tale in verse. Amsterdam: **1775.** [Moland 1877–85, vol. 10 / DLF 1951–72, 4 pt. 2: 659]

Benjamin West, 1738–1820. "Ariadne on the Seashore." Painting. *c.***1763–76?** Lost. [von Erffa & Staley 1986, no. 121]

Johann Adolf Scheibe, 1708–**1776.** *Ariadne auf Naxos.* Cantata. Libretto, von Gerstenberg (1767). Music lost. [Grove 1980, 16:600]

Domenico Fischietti, *c.*1725–*c.*1810. *Arianne e Teseo.* Opera. Libretto, Pariati (1714). First performed 4 Jan **1777,** San Carlo, Naples. [Grove 1980, 6:616]

Pierre Peyron, 1744–1814. "Athenian Girls Drawing Lots to Determine Which Seven among Them Shall Be Sent to Crete for Sacrifice to the Minotaur." Painting. **1778.** Apsley House, London. [Royal Academy 1968, no. 557—ill.]

Johann Friedrich Reichardt, 1752–1814. *Ariadne auf Naxos.* Choral composition. Text, von Gerstenberg (1767). Published Leipzig: **1780.** [Grove 1980, 15:707]

Jean-Frédéric Edelmann, 1749–1794. *Ariane dans l'isle de Naxos.* Opera (drame lyrique). Libretto, P. L. Moline. First performed 24 Sep **1782,** L'Opéra, Paris. [Grove 1980, 5:835]

Onorato Viganò, 1739–1811, choreography. *Minosse re di Creta, ossia La fuga d'Arianna e di Fedra* [Minos, King of Crete, or The Flight of Ariadne and Phaedra]. Ballet.

Music, Luigi Marescalchi. First performed Autumn **1782**, Teatro San Samuele, Venice. [Grove 1980, 11:675]

Georg Joseph Vogler, 1749–1814. *Ariadne auf Naxos.* Cantata. **1782.** [Grove 1980, 20:62]

Antonio Canova, 1757–1822. "Theseus and the Minotaur." Marble sculpture. **1781–83.** Victoria and Albert Museum, London. [Pavanello 1976, no. 21—ill. / Licht 1983, pp. 159–62—ill. / also Janson 1985, fig. 40 / Vermeule 1964, pp. 135, 169] Copy of (lost) plaster model in Gipsoteca Canoviana, Possagno, no. 3. [Pavanello, no. 22—ill.]

———. "Theseus Fighting the Minotaur." Terracotta sculpture (sketch). *c.*1800? Tadolini coll., Rome. [Pavanello, no. 23—ill.]

Adolf Ulrik Wertmüller, 1751–1811. "Ariadne on Naxos." Painting. **1783.** Nationalmuseum, Stockholm. [Hunger 1959, p. 50]

Francesco Basili, 1767–1850. *Arianna e Teseo.* Cantata. **1787.** [Grove 1980, 2:239]

Henry Fuseli, 1741–1825. "Theseus Receiving the Thread from Ariadne." Painting. **1788.** Kunsthaus, Zürich. [Schiff 1973, no. 714—ill.]

———. "Ariadne Watches Theseus Battling the Minotaur." Painting. 1815–20. Richard Dreyfuss coll., Basel. [Ibid., no. 1488—ill.]

Jean Baptiste Rochefort, 1746–1819. "Ariane." Lyric scene. First performed **1788,** Paris. [Grove 1980, 16:82]

Franz Joseph Haydn, 1732–1809. *Arianna a Naxos.* Cantata, for soprano and harpsichord or pianoforte. First performed 9 Feb **1790,** Vienna? [Landon 1988, pp. 39f., 217 *n.* / Grove 1980, 8:369 / Martin 1979, p. 199]

August Wilhelm von Schlegel, 1767–1845. *Ariadne.* Poem. **1790.** Frankfurt: [Wentz], 1847. [Hunger 1959, p. 50]

Friedrich Eberhard Rambach, 1767–1826. *Theseus auf Kreta.* Drama. Leipzig: Barth, **1791.** [Strich 1970, 1:225 *n.* / Hunger 1959, p. 352]

Peter von Winter, 1754–1825. *Il sacrifizio di Creta, ossia Arianna e Teseo* [The Cretan Sacrifice, or Ariadne and Theseus]. Opera (dramma giocoso). Libretto, Pariati (1714). First performed 13 Feb **1792,** San Benedetto, Venice. [Grove 1980, 20:456]

———. *Das Labyrinth.* Opera. First performed 1798, Vienna. [Ibid.]

Victor Pelissier, 1740/50–1820. *Ariadne Abandoned by Theseus on the Isle of Naxos.* Opera (melodrama). First performed **1797,** New York. [Grove 1980, 14:343]

Johann Gottfried Herder, 1744–1803. *Ariadne libera.* Dramatic poem. In *Adrastea* (journal published by Herder and his wife Caroline), **1802.** [Herder 1852–54, vol. 15 / Clark 1955, pp. 427]

Jean-Baptiste Greuze, 1725–1805. "Ariadne on the Isle of Naxos." Painting. Exhibited **1804.** Wallace Collection, London. [Brookner 1972, p. 87]

August von Kotzebue, 1761–1819. *Ariadne auf Naxos.* Tragicomedy. First performed **1804,** Burgtheater, Vienna. [DLL 1968–90, 9:318]

Bertel Thorwaldsen, 1770–1844. "Theseus Battling the Minotaur." 3 drawings. *c.*1805 or later. 2 in Thorwaldsen Museum, Copenhagen, nos. Sch. C1, Sch. 10a. [Hartmann 1979, p. 155, pls. 102.1–3]

Luigi Marescalchi, 1745–after **1805,** music. *Arianna abbandonata.* Ballet. [Grove 1980, 11:675]

The Prix de Rome painting competition subject for **1807** was "Theseus Conqueror of the Minotaur" (Athenian youths and maidens thanking Theseus). First prize, François-Joseph Heim. École des Beaux-Arts, Paris. [Grunchec 1984, no. 44—ill. / Harding 1979, p. 91]

Anton Fischer, 1778?–**1808.** *Theseus und Ariadne.* Singspiel. Libretto, Stegmayer. First performed 11 Mar 1809, Theater an der Wein, Vienna. [Grove 1980, 6:605]

John Vanderlyn, 1776–1852. "Ariadne" (asleep on Naxos). Painting. **1812.** Pennsylvania Academy of Fine Arts, Philadelphia. / Reduced copy, and an engraving, by Asher Brown Durand. Early 1830s. Metropolitan Museum, New York. [Metropolitan 1965–85, 1:208—ill.]

Ludwig Guttenbrunn, before 1750–*c.*1816. "Portrait of a Young Woman in the Guise of Ariadne." Painting. Hermitage, Leningrad, inv. 5240. [Hermitage 1987b, no. 390—ill.]

Louis Gianella, 1778?–**1817.** *Arianna a Nasso.* Cantata. Libretto, P. A. Cratisto Jamejo. [Grove 1980, 7:347]

Charles-Louis Didelot, 1767–1837, choreography. *Theseus and Ariadne, or the Defeat of the Minotaur.* Grand tragic-heroic ballet. Music, Antonolini. First performed **1817,** St. Petersburg; combats, Valville; scenery, Condratiev; machines, Dranché; costumes, Babini. [Swift 1974, pp. 145, 197]

Johann Baptist Schenk, 1753–1836. *Ariadne auf Naxos.* Cantata. Libretto, von Gerstenberg (1767). *c.*1820. [Grove 1980, 16:626]

Edward Thurlow, 1781–1829. "Ariadne." Narrative poem. In *Poems on Several Occasions* (London: Booth, **1822**). [Boswell 1982, p. 303]

Bernhard Klein, 1793–1832. *Ariadne.* Opera. First performed **1823,** Berlin. [Grove 1980, 10:101]

Anne-Louis Girodet, 1767–**1824.** "Ariadne Abandoned." Painting. Exhibited 1936, unlocated. / Drawing ("Ariadne Sleeping"). Musée, Montargis. [Montargis 1967, no. 90]

Maria Theresia von Paradis, 1759–**1824.** *Ariadne auf Naxos.* Opera. Libretto, composer. [Cohen 1987, 1:531]

Adolphe Adam, 1803–1856. *Ariane à Naxos.* Cantata. Text, Vinaty. First performed 1825, Paris. [Grove 1980, 1:93]

Thomas Stothard, 1755–**1834.** "Theseus and Ariadne." Painting. Kunsthaus, Zurich. [Hunger 1959, p. 351]

Letitia Elizabeth Landon, 1802–1838. "The Head of Ariadne." Poem. In *The Vow of the Peacock* (London: Saunders & Otley, **1835**). [Boswell 1982, p. 150]

Anonymous. *Theseus and Ariadne, or, The Labyrinth of Crete.* Burlesque. First performed 11 July **1836,** English Opera House, London. [Nicoll 1959–66, 4:541]

Honoré Daumier, 1808–1879. "Ariadne's Thread," "Ariadne Abandoned." Comic lithographs, in "Ancient History" series. **1842.** [Delteil 1906–30, 22: nos. 940, 949—ill.]

Antoine-Louis Barye, 1796–1875. "Theseus Fighting the Minotaur." Bronze statuette. **1846.** Walters Art Gallery, Baltimore, no. 27.64; Ny Carlsberg Glyptotek, Copenhagen; elsewhere. [Benge 1984, pp. 116–18, pl. 107—ill. / Janson 1985, fig. 122 / also Kilinski 1985, no. 17—ill. / Pivar 1974, no. F20—ill.]

Romain Cazes, 1810–1881. "Ariadne Abandoned." Painting. **1847.** Musée Ingres, Montauban. [Montauban 1965, no. 74—ill.]

Sara Jane Clarke, 1823–1904. "Ariadne." Poem. In *The American Female Poets,* edited by Caroline May (Philadelphia: Lindsay & Blakiston, **1848**). [Ostriker 1986, p. 285]

James Robinson Planché, 1795–1880. *Theseus and Ariadne; or, The Marriage of Bacchus.* Burlesque. Music, R. Hughes. First performed 24 Apr **1848,** Lyceum, London. [Nicoll 1959–66, 4:383]

William Etty, 1787–**1849.** "Ariadne Abandoned." Painting. [Bénézit 1976, 4:211]

John Oxenford, 1813–1877. *Ariadne.* Tragedy. First performed Feb **1849,** Marylebone Theatre, London. [Nicoll 1959–66, 5:826]

Anonymous. *Ariadne.* Tragedy. First performed 28 Jan **1850,** Olympic Theatre, London. [Nicoll 1959–66, 5:642]

Théodore Chassériau, 1819–1856. "Ariadne Abandoned (on a Beach on Naxos, Lying on the Shore)." Painting. **1849–51.** Louvre, Paris, inv. R.F. 3884. [Louvre 1979–86, 3:133—ill. / Sandoz 1974, no. 152—ill.]

———. "Ariadne Abandoned and Lamenting." Painting. 1849–56. Private coll., Nice, in 1960. [Sandoz, no. 133—ill.]

Eugène Delacroix, 1798–1863. "Ariadne Abandoned." Painting. **1849–52.** Private coll., Switzerland. [Johnson 1981–86, no. 301—ill. / Robaut 1885, no. 1163—ill. (copy drawing)]

Gustave Moreau, 1826–1898. "Athenians Delivered to the Minotaur in the Cretan Labyrinth." Painting. **1855.** Musée de l'Ain, Bourg-en-Bresse, inv. 856.1. [Mathieu 1976, no. 29—ill.] Variant. Sold Paris, Drouot, 1928. [Ibid., no. 30—ill.]

William Cox Bennett, 1820–1895. "Ariadne." Poem. In *Queen Eleanor's Vengeance and Other Poems* (London: Chapman & Hall, **1857**). [Boswell 1982, p. 242]

John Stuart Blackie, 1809–1895. "Ariadne." Poem. In *Lays and Legends of Ancient Greece with Other Poems* (Edinburgh: Sutherland, Knox, **1857**). [Boswell 1982, p. 45]

Aimé Millet, 1819–1891. "Ariadne." Marble statue. **1857.** Musées Nationaux, inv. R.F. 50, deposited at Les Invalides, Paris, in 1898. [Orsay 1986, p. 277]

William Caldwell Roscoe, 1823–**1859.** "Ariadne." Poem. In *Poems and Essays,* edited by Richard Holt Hutton (London: Chapman & Hall, 1860). [Boswell 1982, p. 287]

Anonymous. *Ariadne.* Ballet. First performed 25 Apr **1859,** Theatre Royal, Drury Lane, London. [Nicoll 1959–66, 5:642]

Elizabeth Barrett Browning, 1806–1861. "Ariadne in Naxos." Poem. In *Cornhill Magazine* Dec **1860.** [Browning 1932]

John Byrne Leicester Warren, Lord de Tabley, 1835–1895. "Ariadne." Poem. In *Ballads and Metrical Sketches* (London: Kent, **1860**). [Boswell 1982, p. 250]

Joseph Noel Paton, 1821–1901. "Ariadne." Poem. In *Poems by a Painter* (Edinburgh & London: Blackwood, **1861**). [Boswell 1982, p. 278]

Edward Burne-Jones, 1833–1898. "Theseus in the Labyrinth." Drawing (design for a tile). **1862.** Birmingham City Museum and Art Gallery, England. [Harrison & Waters 1973, p. 68—ill. / also Arts Council 1975, no. 69]

———. "Theseus and Ariadne" (Ariadne giving spear and thread to Theseus). Gouache. 1861–62. Private coll. [Arts Council, no. 36]

———. "The Golden Thread." Watercolor roundel, in "The Flower Book." 1882–98. British Museum, London. [Cecil 1969, pl. 95—ill.]

Frederic, Lord Leighton, 1830–1896. "Ariadne Aban-

doned by Theseus; Ariadne Watches for His Return; Artemis Releases Her by Death." Painting. *c.*1868. Salar Jung Museum, Hyderabad. [Ormond 1975, no. 180—ill.]

———. "Ariadne." Illustration to E. B. Browning's "Ariadne in Naxos" (1860). [Ibid., pp. 58, 160]

Arthur Rimbaud, 1854–1891. (Ariadne abandoned in) "Soleil et chair" [Sun and Flesh] part 4. Poem. May **1870.** Published with *Le reliquaire* (Paris: Genonceaux, 1891). [Adam 1972 / Fowlie 1966]

Wathen Mark Wilks Call, 1817–1890. "The Legend of Ariadne." Poem. In *Golden Histories* (London: Smith, Elder, **1871**). [Boswell 1982, p. 63]

Henri Fantin-Latour, 1836–1904. "Ariadne Abandoned." Painting. **1872.** [Fantin-Latour 1911, no. 592]

———. "Ariadne Abandoned." Painting. 1882. [Ibid., no. 1060]. Replica. Sold 1900. [Ibid., no. 1064]. Variant, pastel. 1887. [Ibid., no. 1293]

———. "Ariadne." Painting. 1882. [Ibid., no. 1067].

———. "Ariadne Abandoned." Painting. 1890. [Ibid., no. 1393]

———. "Ariadne Abandoned." Drawing. 1898. Alf Beurdelay coll. in 1911. [Ibid., no. 1716]

———. "Ariadne Abandoned" ("The Despair of Ariadne"). Painting. 1899. Sold 1909 (Darrasse coll.). [Ibid., no. 1741]

———. "Ariadne (Abandoned)." Painting. 1899. Musée des Beaux-Arts, Lyon. [Ibid., no. 1746 / Lucie-Smith 1977, p. 159]

———. "Ariadne" (watching Theseus's ship disappear). Lithograph. 1900. [Hédiard 1906, no. 154—ill.]

———. "Ariadne." Painting. 1901. [Fantin-Latour, no. 1877]

———. "Ariadne." Painting. *c.*1904, unfinished. Kröller-Müller Museum, Otterlo. [Lucie-Smith, pl. 95, p. 160 / Fantin-Latour, no. 2103]

———. "Ariadne." Painting. Dubourg coll. in 1911. [Fantin-Latour, no. 2270]

William Blake Richmond, 1842–1921. "Ariadne Lamenting the Desertion of Theseus." Painting. **1872.** [Kestner 1989, p. 173, pl. 3.29]

Julius Wenzel Reisinger, *c.*1827–1892, choreography. *Ariadne.* Ballet. First performed **1875,** Bolshoi Theatre, Moscow. [Oxford 1982, p. 20]

George Frederick Watts, 1817–1904. "Ariadne on Naxos" (looking seaward, her maid indicating Bacchus's approach). Painting. Completed **1875.** Guildhall Art Gallery, London. [London 1974, no. 29—ill. / Kestner 1989, pp. 73, 75; pl. 2.13 / Wood 1983, pp. 100ff.—ill. / Spalding 1978, pp. 71f.—ill. / Maas 1969, p. 17—ill.] Replicas in Walker Art Gallery, 1863, Liverpool; Fogg Art Museum, Harvard University, Cambridge. [London / also Houser 1979, no. 70—ill.]

———. "Ariadne in Naxos." Painting. 1894. Metropolitan Museum, New York, no. 05.39.1. [Metropolitan 1980, p. 195—ill.]

José-Maria de Heredia, 1842–1905. "Ariane." Sonnet. In *Le siècle littéraire* 1 Jan **1876;** collected in *Les trophées* (Paris: Lemerre, 1893). [Delaty 1984, vol. 1]

John Atkinson Grimshaw, 1836–1893. "Ariadne at Naxos." Painting. **1877.** [Kestner 1989, p. 304]

Evelyn Pickering de Morgan, 1855–1919. "Ariadne in Naxos." Painting. **1877.** De Morgan Foundation, London. [Kestner 1989, p. 110, pl. 2.43]

Paul Kuczynski, 1846–1897. *Ariadne.* Oratorio. Text, Herrig, after Herder's *Ariadne libera* (1802). **1880.** [Hunger 1959, p. 50]

Charles G. D. Roberts, 1860–1943. "Ariadne." Poem. In *Orion and Other Poems* (Philadelphia: Lippincott, **1880**). [Bush 1937, p. 560]

Arthur Symons, 1865–1945. "Ariadne in Naxos." Poem. **1880.** Unpublished. [Beckson 1987, p. 10]

Helen Hunt Jackson, 1831–**1885.** "Ariadne's Farewell." Poem. In *Poems* (Boston: Roberts, 1892; New York: Arno, 1972). [Boswell 1982, p. 143]

Lawrence Alma-Tadema, 1836–1912. "Ariadne." Painting. **1885.** Unlocated. [Swanson 1977, p. 139]

Henrietta Rae, 1859–1928. "Ariadne Deserted by Theseus." Painting. **1885.** [Kestner 1989, p. 285]

Friedrich Nietzsche, 1844–1900. *Klage der Ariadne* [Ariadne's Lament]. Poem, unfinished. **1884–88.** [Frenzel 1962, p. 51]

———. *Ariadne.* Poem, unfinished. [Highet 1967, p. 689]

Auguste Rodin, 1840–1917. "Ariadne" (reclining). Marble sculpture. **After 1889;** reworked *c.*1894; unfinished. Musée Rodin, Paris. [Rodin 1944, no. 238—ill.] Variant. 1908. Musée Rodin. [Ibid., no. 375]

Jean-Antoine Injalbert, 1845–1933. "Ariadne Sleeping." Terra-cotta statuette. **1891.** Musée d'Orsay, Paris, inv. R.F. 2270. [Orsay 1986, p. 179—ill.]

Frederick Tennyson, 1807–1898. "Ariadne" (abandoned). Poem. In *Daphne and Other Poems* (London & New York: MacMillan, **1891**). [DLB 1984, 32:285]

Chauncey Ives, 1810–**1894.** "Ariadne." Marble sculpture. [Gerdts 1973, p. 41]

Christina Rossetti, 1830–**1894.** "Ariadne's Farewell to Theseus." Poem. In *Poems* (London: Blackie, 1923). [Boswell 1982, p. 287]

Philip Calderon, 1833–1898. "Ariadne." Painting. **1895.** [Kestner 1989, p. 179, pl. 3.38]

Maurice Hewlett, 1861–1923. "Ariadne Forsaken." Poem. In *Songs and Meditations* (Westminster: Constable, **1896**). [Boswell 1982, p. 130]

———. "Ariadne in Naxos." Drama. In *The Agonists: A Trilogy of God and Man* (New York: Scribner, 1911). [Ibid., p. 131]

André Gide, 1869–1951. (Theseus abandons Ariadne in) *Les nourritures terrestres.* Prose and verse. Paris: Société du Mercure de France, **1897.** [DLLF 1984, 2:912 / Watson-Williams 1967, p. 127]

———. (Theseus in Crete in) *Thésée.* Novella. Paris: Gallimard, 1946. / Translated by John Russell in *Two Legends: Oedipus and Theseus* (New York: Knopf, 1950). [Martin-Chauffier 1932–39, vol. 2 / Fowlie 1965, pp. 107–18 / Starkie 1954, p. 53]

Gustav Klimt, 1862–1918. "Theseus and the Minotaur." Drawing, poster design for First Secession Exhibition, Vienna. **1898.** Kunsthistorisches Museum, Vienna, inv. 116.210. [Hofmann 1987, no. 13.57—ill.]

John William Waterhouse, 1849–1917. "Ariadne." Painting. **1898.** J. Henderson coll., Britain. [Hobson 1980, no. 123, p. 104—ill. / Wood 1983, pp. 235f.—ill.]

May Ostiere (**19th century**). *Ariadne.* Composition for piano. [Cohen 1987, 1:525]

Valéry Bryúsov, 1873–1924. "Nit' Ariadny" [Ariadne's Thread]. Poem. **1902.** In *Urbi et orbi* [To the City and the World] (Moscow: Skorpion, 1903). [Bryúsov 1982]

———. "Tezej Ariadne" [Theseus to Ariadne]. Poem, part of cycle "Pravda vechnaia kumirov" [Eternal Truth of Idols]. 1904. In *Stephanos (Venok)* [Wreath] (Moscow: Skorpion, 1906). [Ibid., p. 164]

Herbert James Draper, 1864–1920. "Ariadne Deserted by Theseus." Painting. **1905.** [Kestner 1989, p. 291, pl. 5.25]

Jules Massenet, 1842–1912. *Ariane.* Opera. Libretto, Catulle Mendès. First performed 31 Oct **1906,** L'Opéra, Paris. [Grove 1980, 11:808]

Harold Monro, 1879–1932. "Ariadne in Naxos." Poem. In *Collected Poems* (London: Duckworth, **1906**). [Boswell 1982, p. 273]

Harold Parker, b. 1873. "Ariadne." Stone sculpture. Exhibited **1908.** Tate Gallery, London, no. 2265. [Tate 1975, p. 187]

Hugo von Hofmannsthal, 1874–1929. *Ariadne auf Naxos.* Comedy, libretto for opera. **1910.** Published Berlin: Fürstner, 1912. / Revised, published Berlin: Fürstner, 1916. [Steiner 1946–58, *Lustspiele* vol. 3; *Prosa* vol. 3 / McGraw-Hill 1984, 2:508 / DLL 1968–90, 7:1428]

Giuseppe Lipparini, 1877–1951. *Il filo d'Arianna* [The Thread of Ariadne]. Novella. Milan: Treves, **1910.** [DELI 1966–70, 3:397]

Alexandre Guilmant, 1837–**1911.** *Ariane.* Symphonic cantata. [Grove 1980, 7:819]

Maurice Baring, 1874–1945. "Ariadne in Naxos." Drama. In *Diminutive Dramas* (London: Constable, **1911**). [Boswell 1982, p. 31]

Giorgio de Chirico, 1888–1978. "The Enigma of the Arrival and the Afternoon" (city square with reclining Ariadne, figure after antique "Ariadne of the Vatican"). Painting. **1912.** Dal Cin coll., Milan. [de Chirico 1971–83, 5.1: no. 298—ill.] Variant ("The Lassitude of the Infinite"). 1912. Franklin coll., Greenwich (Conn.?). [Ibid., 3.1: no. 166—ill.] Variants ("The Silent Statue, or Ariadne," "Ariadne's Afternoon"). 1913. Kunstsammlung Nordrhein-Westfalen, Düsseldorf. Galleria Nazionale d'Arte Moderna, Rome. [Ibid., 1.1: no. 10, 2.1: no. 97—ill.] Variant ("The Soothsayer's Recompense"). 1913. Philadelphia Museum of Art. [Ibid., 1.1: no 11—ill.] Variant ("Italian Square"). Numerous versions, 1913, 1939–69. Private colls., Italy and elsewhere. [Ibid., 1.1: no. 11; 1.3: nos. 63, 93, 103, 123, 132; 2.2: no. 156; 2.3: nos. 141, 174, 201–2, 246–47, 252, 271; 3.3: nos. 325, 372, 389, 391–94, 405, 408, 422, 435–37; 4.2: no. 336; 4.3: nos. 463, 472, 519, 521, 552, 558, 567–68, 575, 583, 589; 5.2: nos. 441–42; 5.3: nos. 669–71, 698, 708–9; 6.2: nos. 459, 461, 519–20, 523; 6.3: nos. 870–71, 886, 927–28, 947, 999, 1001, 1007; 7.2: nos. 591, 553–54; 7.3: nos. 1022–24, 1026, 1066–67, 1085, 1107, 1117–20, 1129—ill.] Variants ("Melancholy in Turin"). *c.*1958–59, *c.*1965. Luppi coll., Modena; Galleria Marescalchi, Bologna. [Ibid., 7.3: nos. 1104, 1128—ill.] Variants ("Ariadne's Repose," "Hot Summer Afternoon," "Ariadne's Dream," "Ariadne's Afternoon"). 1972. Artist's coll., Rome, in 1975. [Ibid., 5.3: nos. 795, 800–801, 808—ill.] Variant ("Ariadne's Solitude"). 1973. Artist's coll., Rome, in 1975. [Ibid., 5.3: no. 831—ill.]

———. "Ariadne Adorned." Drawing. 1916. Marlborough Fine Art, London, in 1972. [Ibid., 2.1: no. 110—ill.]

————. "Ariadne." Painting. 1931. Galleria Gissi, Turin. [Ibid., 2.2: no. 102—ill.]

————. "The Thread of Ariadne." Painting. c.1939–40. Alfano coll., Milan. [de Chirico, 7.2: no. 613—ill.]

————. "Ariadne" (sleeping). Painted terra-cotta sculpture. 1940. Artist's coll., Rome, in 1973. [de Chirico, 3.2: no. 248—ill. / cf. Far 1968, no. 60—ill.]

————. "Roses and Ariadne." Watercolor. 1971. Artist's coll., Rome, in 1975. [de Chirico, 5.3: no. 765—ill.]

Paul Ernst, 1866–1933. *Ariadne auf Naxos.* Drama in verse. Leipzig: Poeschel & Trepte; Weimar: Gesellschaft der Bibliophilen, **1912.** [DLB 1988, 66:106, 110 / DULC 1959–63, 2:66]

Richard Strauss, 1864–1949. *Ariadne auf Naxos.* Opera, opus 60. Libretto, von Hofmannsthal (1910). First performed 25 Oct **1912,** Hoftheater, Stuttgart. [Grove 1980, 18:234 / Martin 1979, pp. 194–203] Second version, performed 4 Oct 1916, Hofoper, Vienna. [Grove / Martin]

Lovis Corinth, 1858–1925. "Ariadne in Naxos" (Theseus and sleeping Ariadne; Bacchus and retinue approaching). Painting. **1913.** Unlocated. [Berend-Corinth 1958, no. 569—ill.]

————. "Theseus and Ariadne." 2 etchings. 1914. [Schwarz 1922, nos. 177, 178—ill.]

Lady Margaret Sackville, 1881–1963. "Ariadne by the Sea." Poem. **1913.** In *Ariadne by the Sea* (London: Red Lion, 1932). [Bush 1937, p. 570]

Joseph Southall, 1861–1944. "Ariadne in Naxos." Painting. c.**1915.** Unlocated. [Harrison & Waters 1973, pp. 183f.—ill.]

Walter Conrad Arensberg, 1878–1954. "The Night of Ariadne." Poem. In *Idols and Other Poems* (Boston: Houghton, Mifflin, **1916**). [Boswell 1982, p. 241]

T. S. Eliot, 1888–1965. (Allusion to Ariadne abandoned by Theseus in) "Sweeney Erect." Poem. c.**1919.** In *Ara vos prec* (London: Ovid, 1920); *Poems* (New York: Knopf, 1920). [Eliot 1964 / DLB 1986, 45:150, 160 / Smith 1974, p. 47 / Maxwell 1966, pp. 80f.]

Franz von Stuck, 1863–1928. "Minotaur" (Theseus fighting Minotaur). Painting. c.**1921.** Unlocated. [Voss 1973, no. 542—ill.] Study. Private coll. [Ibid., no. 541—ill.]

Marguerite Yourcenar, 1903–1987. "Paroles d'Ariane" [Words of Ariadne]. Poem. In *Les dieux ne sont pas morts* (Paris: Chiberre, **1922**). [Horn 1985, p. 85]

————. (Theseus and Ariadne in) *Qui n'a pas son Minotaure?* [Who Doesn't Have His Own Minotaure?]. Drama. Published with *Le mystère d'Alceste* (Paris: Plon, 1963). First performed 1980, Théâtre Marie-Stuart, Paris. [Horn, pp. 82f. / EWL 1981–84, 1:690]

Marina Tsvetaeva, 1892–1941. *Tezej* [Theseus]. Verse tragedy. **1923–24.** In *Versty,* book 2 (Paris: 1927). Title changed to *Ariadna* in *Izbrannye proizvedenija* (Leningrad: 1965). / Translated in *Three Plays* (Letchworth: Prideaux, 1978). [Karlinsky 1985, pp. 181–85 / Venclova 1985, pp. 100–04]

Pierre Louÿs, 1870–1925. "Ariane, ou Le chemin de la paix éternelle" [Ariadne, or The Way of Eternal Peace]. Short story. In *Le crépuscule des nymphes* (Paris: Montaigne, **1925,** with 5 woodcuts by Jean Saint-Paul. 2d edition, Paris: Briant-Robert, 1926, with 10 lithographs by Bosshard. 3d edition, Paris: Tisné, 1946, with 24 lithographs by Pierre Bonnard. [NUC / also Bouvet 1981, no. 128—ill.]

Frank Morgan. "Theseus and Ariadne." Poem. In *The Quest of Beauty* (London: Parsons, **1926**). [Boswell 1982, p. 275]

Darius Milhaud, 1892–1974. *L'abandon d'Ariane.* Opera, opus 98. Libretto, Henri Hoppenot. First performed **1927,** Wiesbaden. [Grove 1980, 12:308]

————. *La délivrance de Thésée.* Opera, opus 99. 1927. Libretto, Henri Hoppenot. First performed 1928, Wiesbaden. [Ibid., 12:305, 308]

Elinor Wylie, 1885–**1928.** "Minotaur." Poem. In *Trivial Breath* (New York: Knopf, 1928). [Gould 1980, p. 145]

Paul Manship, 1885–1966. "Theseus and Ariadne" (Theseus kneeling over the sleeping Ariadne). Stone sculpture, for garden of Clarence H. Mackay, Roslyn, N.Y. **1928.** [Murtha 1957, no. 244—ill. / Rand 1989, pp. 85f.—ill.] Bronze variant. National Museum of American Art, Washington, D.C. [Rand—ill.]

————. "Ariadne." Gilded bronze statuette. 1956. Unique cast. Minnesota Museum of Art, St. Paul, no. 66.14.95. [Minnesota 1972, no. 138]

Darius Milhaud, 1892–1974. *L'abandon d'Ariane.* Satirical opera, opus 98. Libretto, Henri Hoppenot. First performed 20 Apr **1928,** Wiesbaden. [Burbank 1984, p. 131 / Grove 1980, 12:308]

Émile-Antoine Bourdelle, 1861–**1929.** "Ariadne." Bronze sculpture. 1929. 7 casts. Private colls. [Jianou & Dufet 1975, no. 699]

Conrad Aiken, 1889–1973. (Cretan labyrinth evoked in) "Prelude III," "Prelude XIII," "Prelude XXXIV." Poems. In *Preludes for Memnon* (New York: Scribner, **1931**). [Ipso / Feder 1971, pp. 387–89]

Carl Paul Jennewein, 1890–1978. "Theseus Slaying the Minotaur," "Ariadne." Polychrome terra-cotta figures. **1932.** Pediment of north wing, Philadelphia Museum of Art. [Agard 1951, p. 159, fig. 86]

Georg Kolbe, 1877–1947. "Ariadne." Sculpture. **1932.** / Statuette (model?). Hermitage, Leningrad, inv. 2361. [Hermitage 1984, no. 429—ill. / also Hermitage 1975, pl. 89 / cf. Agard 1951, pp. 168f.—ill.]

Yvor Winters, 1900–1968. "Theseus and Ariadne." Poem, part 2 of "Theseus, A Trilogy." In *Hound and Horn* 6 (**1933**); collected in *Poems* (Los Altos, Calif.: Gyroscope, 1940). [Powell 1980, pp. 136–42]

Salvador Espriu, 1913–1985. *Ariadna al laberint grotesc* [Ariadne in the Grotesque Labyrinth]. Collection of tales. **1935.** New edition, Barcelona: Edicions del Mall, 1987. [Schneider & Stern 1988, pp. 169, 558]

Grace Williams, 1906–1977, music. *Theseus and Ariadne.* Ballet. **1935.** [Baker 1984, p. 2503]

Gabriel Marcel, 1889–1964. *Le chemin de Crète* [The Road from Crete]. Drama. Paris: Grasset, **1936.** / Translated as *Ariadne* in *Three Plays* (London: Secker & Warburg, 1952). [CLC 1980, 15:361 / DLLF 1984, 2:1401]

W. H. Auden, 1907–1973. (Ariadne's thread evoked in) "Casino." Poem. In *On This Island* (New York: Random House, **1937**). [Mendelson 1976 / Johnson 1973, p. 29 n. / Feder 1971, pp. 146, 247f. / Fuller 1970, p. 112]

Irwin Fischer, 1903–. "Ariadne Abandoned." Composition for solo piano. **1938.** [Grove 1980, 6:606]

André Masson, 1896–1987. "Ariadne's Thread." Painting. **1938.** Lacan coll., Paris. [Benincasa 1981, p. 47—ill. / Rubin & Lanchner 1976, pp. 55, 150—ill.]

————. "The Labyrinth." Surrealist painting. 1938. Musée National d'Art Moderne, Paris, no. AM 1982–46. [Pompidou 1987, p. 404f.—ill. / also Rubin & Lanchner, pp. 48f., 53—ill. / Benincasa 1981, p. 89—ill.] Variant, for cover of the journal *Minotaure* no. 12–13 (1938). [Rubin & Lanchner, pp. 48f.—ill.]

————. "Ariadne." Painting. 1945. [Clébert 1971—ill.]

————. "The Lady in the Labyrinth" ("Ariadne's Dream"). Etching. 1962. [Passeron 1973, no. 42—ill.]

Ernst Wilhelm Eschmann, 1904–. *Ariadne.* Tragedy. Jena: Diederichs, **1939.** [DLL 1968–90, 4:526]

Adrienne Rich, 1929–. *Ariadne.* Drama (juvenilia). Baltimore: Furst, **1939.** [DLB 1980, 5 pt. 2: 184]

Boris Lovet-Lorski, 1894–1972. "Ariadne." Marble sculpture. Before **1940.** Metropolitan Museum, New York, no. 52.151. [Metropolitan 1965, p. 167—ill] Black marble replica. Exhibited New York, 1945, unlocated. [Ibid.]

Thomas Merton, 1915–1968. "Ariadne at the Labyrinth." Poem. *c.*1940–41. In *A Man in the Divided Sea* (Norfolk, Conn.: New Directions, 1946); collected as "Ariadne" in *Collected Poems* (New York: New Directions, 1977). [Boswell 1982, p. 184 / Labrie 1979, pp. 111, 117]

Léonide Massine, 1895–1979, choreography. *Labyrinth.* Surrealist ballet. Music, Schubert's 7th symphony. First performed 8 Oct **1941,** by Ballet Russe de Monte Carlo, Metropolitan Opera House, New York; scenario, scenery and costumes, Salvador Dalí. [Oxford 1982, pp. 242, 276 / Sharp 1972, pp. 219, 284 / Soby 1968, p. 96 / Marks 1984, p. 177]

Marya Zaturenska, 1902–1982. "The Thread of Ariadne." Poem. In *Listening Landscape* (New York: Macmillan, **1941**). [Ipso]

Adolph Gottlieb, 1903–1974. "Minotaur." Abstract painting ("pictograph"). **1942.** [Alloway & MacNaughton 1981, p. 44]

————. "Threads of Theseus." Abstract painting ("pictograph"). 1948. [Ibid.]

Rolfe Humphries, 1894–1969. "Theseus." Poem. In *Out of the Jewel* (New York: Scribner, **1942**). [Boswell 1982, p. 141]

————. "The Labyrinth." Poem. In *Collected Poems* (Bloomington: Indiana University Press, 1946). [Ibid.]

Jacques Lipchitz, 1891–1973. "Theseus and the Minotaur" (allegory of de Gaulle defeating Hitler). Bronze sculpture. **1942.** Edition of 7? Walker Art Center, Minneapolis; Milwaukee Art Institute; List coll., New York; elsewhere? [Lipchitz 1972, pp. 159, 197] Bronze sketches. Artist's coll. in 1972; elsewhere? [Ibid.—ill.] Gouache and other sketches. Artist's coll. in 1972; elsewhere? [Ibid.—ill.]

Robert Morse, 1907–1947. "Ariadne: A Poem for Ranting." Poem. In *The Two Persephones* (New York: Creative Age, **1942**). [Merrill 1986, p. 171]

Maurice Denis, 1870–**1943.** "Ariadne on Naxos." Painting. [Bénézit 1976, 3:494]

Georges Neveux, 1900–1983. *Le voyage de Thésée* (to Crete). Drama. In *Théâtre* (Paris: Éditions littéraires de Monaco, R. Julliard, **1943**). [DLLF 1984, 2:1640]

Dorothy Barret, *c.*1918–, choreography. *Ariadne Leads the Way.* Ballet. First performed **1944,** New York. [Cohen-Stratyner 1982, p. 64]

Eleanor Farjeon, 1881–1965. *Ariadne and the Bull.* Poem. London: Joseph, **1945.** [Boswell 1982, p. 254]

Robert Graves, 1895–1985. "Theseus and Ariadne." Poem. In *Poems, 1938–45* (London: Cassell, **1945**). [Graves 1975 / DLB 1983, 20:175 / Cohen 1960, pp. 105f.]

A. D. Hope, 1907–. (Ariadne recalled in) "The Muse." Poem. **1945.** In *Wandering Islands* (Sydney: Edwards & Shaw, 1955). [Ipso]

David Diamond, 1915–, music. *Labyrinth.* Ballet. First performed **1946.** [Grove 1980, 5:421]

Patric Thomas Dickinson, 1914–. *Theseus and the Minotaur.* Collection of poems. London: Cape, **1946.** [DLEL 1970–78, 2:88]

Martha Graham, 1894–1991, choreography. *Errand into the Maze.* Modern dance. Music, Gian Carlo Menotti. First performed 27 Feb **1947,** Ziegfield Theater, New York; settings, Isamu Noguchi; costumes, Martha Graham; lighting, Jean Rosenthal. [Stodelle 1984, pp. 134–36, 151, 311 / Noguchi 1968, p. 126—ill.]

Cesare Pavese, 1908–1950. (Theseus speaks of abandoning Ariadne in) "Il toro" [The Bull]. Dialogue. In *Dialoghi con Leucò* (Turin: Einaudi, **1947**). / Translated by William Arrowsmith and D. S. Carne-Ross in *Dialogues with Leucò,* bilingual edition (Ann Arbor: University of Michigan Press, 1965). [Ipso / Biasin 1968, p. 206]

John Taras, 1919–, choreography. *The Minotaur.* Ballet. Music, Elliott Carter. Scenario, Lincoln Kirstein & Joan Junger. First performed 26 Mar **1947,** Central High School of Needle Trades, New York; décor and costumes, Joan Junger. [Reynolds 1977, pp. 78f. / Sharp 1972, p. 289 / Chujoy & Manchester 1967, p.373]

Jack Lindsay, 1900–1990. (Ariadne abandoned in) *Clue of Darkness.* Poem. London: Dakers, **1949.** [Herbert 1960, pp. 178f., 184]

Edwin Muir, 1887–1959. "The Labyrinth." Poem. In *The Labyrinth* (London: Faber & Faber, **1949**). [DLB 1983, 20:244 / Huberman 1971, pp. 162–68 / Boswell 1982, p. 195]

Hans Werner Henze, 1926–, music. "Labyrinth." Choreographic fantasy. **1951.** [Grove 1980, 8:495]

John Ashbery, 1927–. (Theseus recounts his adventure in the labyrinth in) *The Heroes.* One-act play. First performed **1952,** by the Living Theater, New York. Published in *Artist's Theatre* (New York: Grove, 1960). [Howard 1969, pp. 20–22, 587 / DLB 1980, 5 pt. 1: 19]

Nikos Kazantzakis, 1883–1957. (Theseus in Crete in) *Theseos (Kouros).* Tragedy. Athens: **1953.** Daemmrich 1987, p. 184]

Louis MacNeice, 1907–1963. (Theseus and the Minotaur in) *Autumn Sequel: A Rhetorical Poem* canto 26. **1953.** London: Faber & Faber, 1954. [Dodds 1966]

Robert Penn Warren, 1905–1989. (Theseus and the Minotaur evoked in) *A Brother to Dragons.* Novel in verse. New York: Random House; London: Eyre & Spottiswoode, **1953.** [Feder 1971, pp. 402ff. / DLB 1986, 48:433]

Ramon José Sender, 1901/02–1982. *Los cinco libros de Ariadna.* Novel. Mexico City: Aquelarre, **1955.** [EWL 1981–84, 4:191]

H. D. (Hilda Doolittle), 1886–1961. (Theseus tells Helen his story of the Minotaur and Ariadne in) "Leuké" 5.3–4. Part 2 of *Helen in Egypt*. Epic. **1952–56**. New York: New Directions, 1961. [Ipso / Robinson 1982, p. 396]

————. [Martz 1983 (previously unpublished, from a typescript in Beinecke Library, Yale University)]

C. Day Lewis, 1904–1972. "Ariadne on Naxos." Dramatic monologue. In *Pegasus and Other Poems* (London: Cape, **1957**). [Ipso / Parsons 1977, pp. 208ff.]

Jay Macpherson, 1931–. "The Thread" (of Ariadne). Poem. In *The Boatman* (Toronto: Oxford University Press, **1957**). [Ipso]

Ossip Zadkine, 1890–1967. "Ariadne." Bronze sculpture. **1957**. 10 casts. Private colls. [Jianou 1979, no. 417]

Birgit Aakesson, 1908–, choreography. *The Minotaur*. Ballet. Music, Karl-Birger Blomdahl. Scenario, Erik Lindegren. First performed 5 Apr **1958**, Royal Swedish Ballet, Royal Opera Theater, Stockholm; décor, Tor Hörlin. [Sharp 1972, pp. 219, 289 / Oxford 1982, p. 6]

Bohuslav Martinů, 1890–1959. *Ariadne*. Opera. Libretto, composer, after Georges Neveux's *Voyage de Thésée* (1948). **1958**. First performed 1961, Gelsenkirchen. [Grove 1980, 11:734]

Mary Renault, 1905–1983. (Story of Theseus and Ariadne in) *The King Must Die*. Novel. London: Longmans, Green; New York: Pantheon, **1958**. [Boswell 1982, p. 209 / Daemmrich 1987, p. 184 / CLC 1981, 17:389, 393f.]

Inez Wiesinger-Maggi, 1914–. *Theseus auf Kreta* [Theseus on Crete]. Poem. Zürich: Origo, **1958**. [Hunger 1959, p. 127]

Alain Robbe-Grillet, 1922–. *Dans le labyrinthe* [In the Labyrinth] (a modern Theseus). Novel. Paris: Éditions de Minuit, **1959**. [Popkin 1977, 2:280, 283]

Dieter Wellershoff, 1925–. *Der Minotaurus*. Radio play. In *Das Schreien der Katze im Sack* (Wiesbaden: Limes, **1960**). [Oxford 1986, p. 969 / CLC 1988, 46:435]

Rosemary Thomas, 1901–1961. "Crete." Poem. In *Selected Poems* (New York: Twayne, 1968). [Ipso]

Daryl Hine, 1936–. (Ariadne evoked in) "Osiris Remembered." Poem. In *The Devil's Picture-Book* (New York: Abelard-Schumans, **1961**). [Ipso]

Paul Goodman, 1911–1972. "Theseus," (Theseus, Ariadne, and the Minotaur evoked in) "Woman eternal my muse, lean toward me." Sonnets. In *The Lordly Hudson: Collected Poems* (New York: Macmillan, **1962**). [Ipso]

Sylvia Plath, 1932–1963. "To Ariadne (Deserted by Theseus)." Poem. Unpublished. [Lane & Stevens 1978, p. 51, no. 529]

André Jolivet, 1905–1974. *Ariadne*. Orchestral suite. By **1963**. [Grove 1980, 9:688 (as 1964)]

Alvin Ailey, 1931–1989, choreography. *Labyrinth*. Ballet. Music, André Jolivet's *Ariadne*. First performed **1963**, Robert Joffrey Ballet for Harkness Ballet. Performed as *Ariadne* 12 Mar 1965, L'Opéra-comique, Paris. [Baker 1984, p. 1127 / Oxford 1982, p. 5 / Grove 1980, 9:688]

Anthony Burgess, 1917–, writing as Joseph Kell. (Evocation of Theseus and Minotaur, symbolizing original sin, in) *Inside Mr. Enderby*. Novel. London: Heinemann, **1963**. [DLB 1983, 14:185]

Donald Finkel, 1929–. "Scrawl at the Entrance of the Labyrinth" (Ariadne as priestess of Minos). Poem. In *Simeon* (New York: Atheneum, **1964**). [Ipso]

Max Aub, 1903–1972. *El laberinto mágico* [The Magic Labyrinth] (Spanish Civil War seen as labyrinth claiming its tribute of youth). Cycle of epic novels. **1943–65**. Madrid: Alfaguara, 1981–. [EWL 1981–84, 1:135]

Walentin Chorell, 1912–1983. *Ariadne*. Comedy. Stockholm: Bonnier, **1965**. [DSL 1990, p. 105]

Marcel Aymé, 1902–1967. *Le Minotaure*. Play. First performed 20 Nov **1966**, Théâtre de l'Athénée, Paris. [Oxford 1976, p. 33 / Daemmrich 1987, p. 184]

Kenneth Pitchford, 1931–. "Ariadne with Child." Poem. In *A Suite of Angels and Other Poems* (Chapel Hill: University of North Carolina Press, **1967**). [Ipso]

John Butler, 1920–, choreography. *The Minotaur*. Modern dance. **1970**. [McDonagh 1976, p. 147 / Cohen-Stratyner 1982, p. 140]

Elizabeth Maconchy, 1907–. "Ariadne." Song for soprano and chamber orchestra. Text, Day Lewis's "Ariadne on Naxos" (1957). **1970**. [Grove 1980, 11:448 / Cohen 1987, 1:439]

Boris Blacher, 1903–1975. *Ariadne*. Duodrama for 2 speakers and electronic music. Text, Friedrich Wilhelm Gotter. **1971**. [Grove 1980, 2:768]

Jitka Snizkova-Skrhova, 1924–. "Ariadne." Dramatic aria with movement. **1971**. [Cohen 1987, 2:655]

Gordon Crosse, 1937–. "Ariadne." Composition for oboe and chamber ensemble. **1971–72**. [Grove 1980, 5:62]

Thea Musgrave, 1928–. *The Voice of Ariadne*. Chamber opera. Libretto, A. Elguera, after Henry James's *The Last of the Valerii*. **1972–73**. First performed 11 June 1974, English Opera Group, Maltings, Aldeburgh. [Grove 1980, 12:799 / Cohen 1987, 1:499]

Howard Nemerov, 1920–. (Theseus leaving the labyrinth evoked in) "On Getting Out of Vietnam." Poem. In *Gnomes and Occasions* (Chicago: University of Chicago Press, **1973**). [Ipso]

Jules Olitski, 1922–. "Ariadne." Abstract steel sculpture. **1973**. Artist's coll. [Moffett 1981, pl. 171]

Zbigniew Herbert, 1924–. "Historia Minotaura" [History of the Minotaur] (satirical retelling of Theseus and Minotaur story). Prose poem. In *Pan cogito* (Warsaw: Czytelnik, **1974**). / Translated by John and Bogdana Carpenter in *Selected Poems* (Oxford & New York: Oxford University Press, 1977). [Ipso / CLC 1987, 43:187 / Pilling 1982, p. 421]

Radcliffe Squires, 1917–. "The Garden of Ariadne." Poem. In *Sewanee Review* 83 no. 3 (Summer **1975**); collected in *Gardens of the World* (Baton Rouge: Louisiana State University Press, 1981). [Ipso]

Arne Nordheim, 1931–, music. *Ariadne*. Ballet. **1977**. [Grove 1980, 13:276]

Elzbieta Sikora, 1943–. *Ariadna*. Chamber opera. **1977**. [Cohen 1987, 2:642]

Jorge de Sena, 1919–1978. "In Crete, with the Minotaur." Poem. In *In Crete, with the Minotaur and Other Poems* (Providence: Gávea-Brown, 1980). [EWL 1981–84, 4:190]

Charles Simic, 1938–. "Ariadne." Poem. **1967–82**. In *Weather Forecast for Utopia and Vicinity: Poems 1967–1982* (Barrytown, N.Y.: Station Hill, 1983). [Ipso]

Reynolds Price, 1933–. "For Leontyne Price after *Ari-*

adne." Poem. In *Vital Provisions* (New York: Atheneum, **1982**). [Ipso]

ARION. A semilegendary figure, the son of Cycleus, Arion (fl. 628–625 BCE) was a gifted musician and poet from the island of Lesbos. He is reputed to have been the originator of the dithyramb. He spent most of his life in Corinth but visited Magna Graecia, where he gained great wealth from his singing and playing of the lyre.

When Arion was on his homeward journey to Corinth, the sailors giving him passage robbed him and threw him overboard to drown. But, according to Herodotus, he was rescued and carried to shore by a dolphin. In the Renaissance the theme of Arion on the dolphin was a favorite of artists and poets, often as an allegory of music.

Classical Sources. Herodotus, *Histories* 1.23–24. Ovid, *Fasti* 2.79ff. Hyginus, *Fabulae* 194; *Poetica astronomica* 2.17. Lucian, *Dialogues of the Sea-Gods* 8, "Poseidon and the Dolphins."

Andrea Mantegna, 1430/31–1506. 3 ceiling frescoes, depicting the story of Arion. **1468–74.** Camera Picta (Camera degli Sposi), Palazzo Ducale, Mantua. [Lightbown 1986, no. 20, pls. 72–74]

———— and **Lorenzo Costa,** 1460–1535 (begun by Mantegna, completed by Costa after Mantegna's death). (Arion in) "The Reign of Comus" ("The Gate of Comus"). Painting. Louvre, Paris, inv. 256. [Ibid., no. 41—ill. / Louvre 1979–86, 2:169—ill. / Louvre 1975, no. 128—ill. / Wind 1948, pp. 46f., fig. 59]

Bertoldo di Giovanni, c.1420–1491. "Arion." Bronze statue. **c.1470–90.** Museo del Bargello, Florence. [Clapp 1970, 1:86]

Francesco Bianchi Ferrari, c.1460?–1510, attributed. "Arion." Painting. Ashmolean Museum, Oxford, inv. A733. [Warburg]

Andrea Riccio, c.1470–1532. "Arion." Bronze statuette. **c.1510.** Louvre, Paris. [Pope-Hennessy 1985b, 2:304 / Clapp 1970, 1:742]

Baldassare Peruzzi, 1481–1536, circle (? also attributed to school of Giulio Romano or Raphael). "Arion." Fresco. **1511–12** (or c.1517–18). Sala delle Prospettive, Villa Farnesina, Rome. [d'Ancona 1955, pp. 27ff., 93f. / Gerlini 1949, pp. 31ff. / Frommel 1967–68, no. 51—ill.]

Albrecht Dürer, 1471–1528. "Arion Riding the Dolphin." Drawing. **1514.** Ambras Album, Kunsthistorisches Museum, Vienna. [Strauss 1974, no. 1514–34—ill.]

Albrecht Altdorfer, c.1480–1538. "Arion [or Triton] and Nereid." Engraving (Bartsch no. 39). **c.1520–25.** [Winzinger 1963, no. 165—ill.]

Girolamo Mocetto, c.1458–c.1531, attributed. "Arion on a Dolphin." Painting. Ashmolean Museum, Oxford (as questionably Bianchi Ferrari). [Wright 1976, p. 137]

Tobias Stimmer, 1539–1584. "Arion Thrown into the Sea."

Design for glass painting. **1562.** Victoria and Albert Museum, London. [Warburg]

Edmund Spenser, 1552?–1599. (Arion's music evoked in) Sonnet 38 of *Amoretti.* In *Amoretti and Epithalamion* (London: Ponsonbie, **1595**). [Oram et al. 1989]

————. (Arion evoked in) *The Faerie Queene* 4.11.23–24. Romance epic. London: Ponsonbie, 1596. [Hamilton 1977 / Freeman 1970, p. 255 / MacCaffrey 1976, pp. 329f., 340]

Annibale Carracci, 1560–1609, design. "Arion and the Dolphin." Fresco, executed by studio under direction of Domenichino. **c.1603–04** (or c.1608?). Galleria, Palazzo Farnese, Rome. [Malafarina 1976, no. 104h—ill. / Martin 1965, pp. 138f.—ill.]

Marc-Antoine Gérard, Sieur de Saint-Amant, 1594–1661. "L'Arion." Poem. **1623.** In *Oeuvres du sieur de Saint-Amant* (Paris: Toussainct Quinet, 1642–49). [DLLF 1984, 3:2065]

Peter Paul Rubens, 1577–1640. "Arion Saved by the Dolphins." Painting. **1625–28.** Formerly Mackey coll., Petersfield, Hampshire, sold London, 1958, unlocated. [Jaffé 1989, no. 868—ill.] Another version (formerly considered the original), formerly Schloss coll., Paris. [Ibid.]

Cornelis Cornelisz van Haarlem, 1562–1638, composition. "Arion on the Dolphin." Engraving, executed by Jan Muller (1571–**1628**). [Lowenthal 1986, fig. 76]

Richard Crashaw, 1612–1649. "Arion." Poem. In *The Delights of the Muses . . .* (London: Moseley, **1648**). [Martin 1966]

Salvator Rosa, 1615–1673. "Arion on the Dolphin." Painting. By **1650.** J. Winter coll., Florence. [Florence 1986, no. 1.220—ill.]

Alessandro Algardi, 1598–**1654.** "Arion on the Dolphin." Sculpture. Formerly Villa Ludovisi, Rome. [Pigler 1974, p. 40]

Johann Lauremberg, 1590–1658. "Die Geschichte Arions" [The Story of Arion]. Poem. **1655.** In *Scherzgedichte,* edited by J. M. Lappenberg (Stuttgart: Litterarischer Verein, 1861). [CEWL 1973, 3:20]

Giovanni Francesco Romanelli, 1610–1662. "Arion on the Dolphin." Fresco. Palazzo Costaguti, Rome. [Voss 1924, p. 266]

Carlo Ambrogio Lonati, c.1645–c.1710/15, with **Alessandro Scarlatti,** 1660–1725, **Dionigi Erba, C. Valtolina,** and others. *Arione.* Opera (dramma per musica). Libretto, O. d'Arles. First performed 9 June **1694,** Milan. [Grove 1980, 6:223, 11:141, 16:560]

François Girardon, 1628–1715. "Arion." Model for marble statue, executed by Jean Raon, **1695.** Bosquet des Dômes, Gardens, Versailles. [Girard 1985, p. 288—ill. / also Francastel 1928, no. 58—ill.]

Louis de Silvestre the Younger, 1675–1760. "Arion Playing His Lyre." Painting, for Ménagerie, Versailles. **1701.** Formerly Louvre, Paris (inv. 7954), lost. / Copy (?), before 1737, in Louvre, inv. 3529. [Louvre 1979–86, 4:216—ill.]

André Campra, 1660–1744. *Arion.* Cantata. Published in *Cantates françoises,* book 1 (Paris: **1708**). [Grove 1980, 3:665]

Antoine-Louis Le Brun, 1680–1743. *Arion.* Tragedy. Probably before **1712.** [Girdlestone 1972, pp. 173ff., 180]

Jean-Baptiste Matho, c.1660–1746. *Arion*. Opera (tragédie lyrique). Libretto, Louis Fuzélier. First performed 10 Apr **1714**, L'Opéra, Paris. [Grove 1980, 11:824 / Girdlestone 1972, pp. 177ff.]

Noël-Nicolas Coypel, 1690–1734. "Arion Carried by a Dolphin." Painting, for Hôtel du Grand Maître (now Hôtel de Ville), Versailles. *c*.**1724**. In place. [Bordeaux 1984, no. 50 *n*.—ill.]

François Boucher, 1703–1770. "Arion Carried on a Dolphin." Overdoor painting. **1749**. Private coll., London. [Ananoff 1976, no. 328—ill.] Variant, maquette for tapestry (medallions by Boucher on background by Maurice Jacques), Musée des Gobelins, no. GOB 28–9. [Ibid.—ill.]

Vicente García de la Huerta, 1734–1787. (Arion evoked in) *Endimión*. Poem. In *Obras poéticas* (Madrid: **1778–79**). [DLE 1972, p. 369]

August Wilhelm von Schlegel, 1767–1845. "Arion." Ballad and prose poem. *c*.**1797**. In *Sämtliche Werke*, edited by E. Böcking, vol. 1 (Leipzig: 1846). [Edler 1970, pp. 41f.]

Ludwig Tieck, 1773–1853. "Gesang des Arion" [Song of Arion]. Ballad. *c*.**1797**. In *Gedichte*, part 1 (Dresden: Hilscher, 1821). [Edler 1970, pp. 41f.]

Novalis (Friedrich Leopold von Hardenberg), 1772–**1801**. (Arion myth retold in) *Heinrich von Ofterdingen* part 1, first *märchen*. Novel, unfinished. In *Schriften*, edited by F. Schlegel and L. Tieck (Berlin: Buchhandlung der Realschule, 1802). [EW 1983–85, 5:226 / Strauss 1971, p. 43]

Benjamin West, 1738–1820. "Arion." Painting. *c*.**1802**. Lost. [von Erffa & Staley 1986, no. 122]

Philipp Otto Runge, 1777–1810. "Arion's Sea-journey." Watercolor, study for a theater curtain. **1809**. Kunsthalle, Hamburg, inv. 1027. [Hamburg 1969, p. 288—ill. / Hamburg 1977, no. 143—ill.]

Peter Cornelius, 1783–1867, and studio. (Arion in) "The Kingdom of Neptune" ("The World of Water"). Fresco. **1820–26**. Göttersaal, Glyptothek, Munich. [Glyptothek 1980, pp. 214ff., no. 265—ill.]

Aleksandr Pushkin, 1799–1837. "Arion." Poem. **1827**. In *Mednyi vsadnik*. / Translated by D. M. Thomas in *The Bronze Horseman* (New York: Viking, 1982). [Arndt 1984 / Bayley 1971, pp. 146–48]

William Wordsworth, 1770–1850. (Arion riding the dolphin, evoked in) "On the Power of Sound" stanza 9. Poem. **1828**. In *Yarrow Revisited and Other Poems* (London: Longman & Co., 1835). [De Selincourt 1940–66, vol. 2]

Friedrich von Schlegel, 1772–**1829**. "Arion." Poem. Modern edition, in *Friedrich Schlegel: Dichtungen*, edited by Hans Eichner (Zürich: Thomas-Verlag, 1962). [Ipso]

Letitia Elizabeth Landon, 1802–**1838**. "Arion." Poem. In *Complete Works* (Boston: Phillips Sampson; New York: Derby, 1854). [Boswell 1982, p. 149]

Honoré Daumier, 1808–1879. "Arion Rescued." Comic lithograph, in "Ancient History" series. **1842**. [Delteil 1906–30, 22: no. 957—ill.]

William Bouguereau, 1825–1905. "Arion on a Seahorse." Painting. **1855**. [Montreal 1984, p. 62]

Carl Rahl, 1812–**1865**. "Arion." Painting. Provincial Museum, Breslau. [Bénézit 1976, 8:584]

Ernest-Eugène Hiolle, 1834–1886. "Arion Seated on the Dolphin." Marble sculpture group. 1870. Musée d'Orsay, Paris, inv. RF 181. [Orsay 1986, p. 174—ill.] Plaster study. **1865–66**. Formerly Musée des Beaux-Arts, Valenciennes. [Ibid.]

Thomas Forder Plowman, 1844–1919. *Arion, or, A Leap for Life*. Burlesque. Oxford: Shrimpton, **1870**. [NUC]

Francis Cowley Burnand, 1836–1917. *Arion, or, The Story of a Lyre*. Burlesque. First performed 20 Dec **1871**, Strand Theatre, London. [Nicoll 1959–66, 5:290]

George Eliot, 1819–1880. "Arion." Poem. In *The Legend of Jubal* (**1874**). [Bush 1937, p. 559 / Boswell 1982, p. 254]

Georg, Prince of Prussia, 1826–1902. *Arion*. Tragedy. Berlin: **1877**. [DLL 1968–90, 6:205]

John Ruskin, 1819–1900. "The Last Song of Arion." Poem. In *Poems*, edited by J. G. Wright (New York: Wiley, **1882**). [Boswell 1982, p. 215]

Max Klinger, 1857–1920. "Arion." Lithograph, title-page illustration to edition of 4 Brahms *Lieder* (opus 96). **1886**. Berlin: Simrock. [Hildesheim 1984, no. 337, fig. 211]

Peter Erasmus Lange-Müller, 1850–1926. *Arion*. Choral composition, opus 62. Text, E. von der Recke. First performed **1899**. [Grove 1980, 10:449]

Gian Francesco Malipiero, 1882–1973. *Arione*. Composition for violin, cello, and orchestra. **1912**. Unpublished. Destroyed? [Grove 1980, 11:582]

Ronald Bottrall, 1906–. "Arion Anadyomenos." Poem sequence. In *The Loosening and Other Poems* (Cambridge: Fraser, Minority Press, **1931**). [DLB 1983, 20:78]

Anne Ridler, 1912–. "On a Picture by Michele da Verona, of Arion, as a Boy Riding upon a Dolphin." Poem. In *The Golden Bird and Other Poems* (London: Faber & Faber, **1951**). [Ipso]

Robert Francis, 1901–1987. (Arion evoked in) "Dolphin." Poem. In *Massachusetts Review* Spring **1962**; collected in *Collected Poems: 1936–1976* (Amherst: University of Massachusetts Press, 1976). [Ipso]

Thomas Merton, 1915–**1968**. (Arion evoked in) "The New Song." Poem. In *Collected Poems* (New York: New Directions, 1977). [Boswell 1982, p. 185]

Zbigniew Herbert, 1924–. "Arijon." Poem. In *Wiersze zebrane* (Warsaw: Czytelnik, 1971). / Translated by Czeslaw Milosz and Peter Dale Scott in *Selected Poems* (Harmondsworth & Baltimore: Penguin, **1968**). [CLC 1987, 43:183 / Mihailovich et al. 1972–76, 2:300]

Robert Lowell, 1917–1977. (The poet as Arion in) "The Dolphin." Poem. In *The Dolphin* (New York: Farrar, Straus & Giroux; London: Faber & Faber, **1973**). [Bell 1983, pp. 195–204, 225 / Axelrod 1978, pp. 231f.]

ARISTAEUS. *See* ORPHEUS, and Eurydice.

ARTEMIS. Daughter of Zeus (Jupiter) and Leto (Latona) and twin sister of Apollo, Artemis is the virgin goddess, patroness of the hunt and defender of chastity.

Worshiped during the Classical period, Artemis appears earlier on a Linear B tablet as a slaveowner, and her origins may have been Minoan. She is said to have been born at Ortygia (Quail Island), which may be another name for Delos, the accepted birthplace of Apollo. (Artemis is sometimes called Cynthia, a name derived from the island's Mount Cynthos; she is also called Phoebe, after her grandmother, the Titan Phoebe.) Born before Apollo, she helped to deliver him, an act that reflects her role as a goddess of childbirth, along with Hera and Eileithyia.

As a goddess of the hunt she is often depicted carrying a bow and arrow, wearing animal skins, or accompanied by animals. Her band of chaste maidens is often pursued by satyrs. She is also the goddess of chastity; a number of legends, among them her intervention against the sacrifice of Iphigenia and her punishment of the nymph Callisto, reflect her role as protectress of maidens and enforcer of purity.

As a goddess of the night, Artemis became identified with the moon goddess, Selene (Luna). In this guise she is said to have fallen in love with Endymion.

The Roman goddess Diana, who shares many traits with Artemis, was established even before Rome's predominance in ancient Italy; she was worshiped especially by women and slaves. The center of her cult was at Aricia, near Lake Nemi, which was also known as "Diana's mirror," perhaps a suggestion of her power as moon goddess, since the moon was reflected in the waters of the lake. She had a temple on the Aventine hill, just outside the early Roman walls, and was also worshiped in Campania at Mount Tifata near Capua, an area with strong Greek influence; it is perhaps at this site that the two traditions combined.

Like Artemis, Diana is a virgin huntress and a goddess of childbirth. She is also associated with the underworld and was said to preside over all places where three roads meet, functions also shared by Hecate. In the latter role she was given the epithet "Trivia" ("of the crossroads").

In postclassical treatments, Artemis is often depicted with her brother, Apollo, or in her role as goddess of the hunt. Images of her bathing—often derived from the story of her punishment of Actaeon—or resting after the hunt, with or without her companion nymphs and sometimes spied upon by satyrs, are also popular. She is also seen as a personification of virtue triumphing over vice (often represented by Aphrodite, Eros, or satyrs).

Classical Sources. Homer, *Iliad* 21.468–513; *Odyssey* 5.121ff., 6.102–9. Hesiod, *Theogony* 918–20. *Homeric Hymns,* first and second hymns "To Artemis," first hymn "To Aphrodite" lines 16–20. Pindar, *Pythian Odes* 2.7–12, 3.9–11, 3.31–37. Euripides, *Hippolytus* 1283–1429; *Iphigenia in Tauris.* *Orphic Hymns* 36, "To Artemis." Callimachus, *Hymns,* "To Zeus," "To Artemis." Catullus, *Carmina* no. 34. Diodorus Siculus, *Biblioteca* 5.73.5. Ovid, *Metamorphoses* 2.441–65, 6.204–312, 8.271–839, 11.321–27, 12.24–38, 15.487–551. Apollodorus, *Biblioteca* 1.4.1, 1.6.2, 1.7.3–5 1.9.15, 2.5.3, 3.5.6, 3.8.2, E3.21, 22. Statius, *Silvae* 2.3.8–61. Hyginus, *Fabulae* 9, 53, 98, 122, 150, 189, 200; *Poetica astronomica* 2.7, 2.16, 2.18.

See also ACTAEON; ARTEMIS OF EPHESUS; CALLISTO; ENDYMION; EROS, Punishment; GODS AND GODDESSES; HECATE; IPHIGENIA; LETO; MELEAGER; NIOBE; ORION; PAN, Loves; PHAEDRA AND HIPPOLYTUS; SELENE.

Giovanni Boccaccio, 1313–1375. *La caccia di Diana* [The Hunt of Diana]. Poem. **1334–38?** [Branca 1964–83, vol. 1 / Hollander 1977, pp. 12ff. / Bergin 1981, pp. 67f. / DELI 1966–70, 1:389–402]

———. (Diana tries to break off the love affair of Florio and Biancifiore in) *Filocolo.* Prose romance. 1336–39? [Branca / Bergin, pp. 76f.]

———. (Emilia's prayer to Diana in) *Teseida* 7.70–93. Poem. *c.*1340–42. [Branca, vol. 2 / McCoy 1974 / Havely 1980, pp. 133–36]

Geoffrey Chaucer, 1340?–1400. (Scenes associated with Diana painted in Temple of Diana; Emelye seeks Diana's intercession to remain a maiden, in) "The Knight's Tale" lines 2051–88, 2296–2365. Poem, after Boccaccio's *Teseida* (*c.*1340–42). **Early 1380s** (as "Palamon and Arcite"); revised and incorporated in *The Canterbury Tales,* 1388–95. Westminster: Caxton, 1478. [Riverside 1987 / Bryan & Dempster 1958, pp. 88ff. / Minnis 1982, pp. 21, 108 / Havely 1980, pp. 133f.]

———, formerly attributed (until end of 19th century; now called anonymous, 15th century). *The Floure and the Leafe* (Diana, "Queen of the Leaf," contests with Flora, "Queen of the Flower"). Poem. Modern edition by D. A. Pearsall (London: Nelson, 1962; Manchester: University Press, 1980). [Lewis 1958, pp. 247f.]

Francesco Landini, *c.*1325–1397. "Selvagia, fera di Diana" [The Bloodthirsty Huntress Diana]. Madrigal. [Grove 1980, 10:433]

Christine de Pizan, *c.*1364–*c.*1431. (Diana in) *L'epistre d'Othéa à Hector* . . . [The Epistle of Othéa to Hector] chapters 23, 63, 69. Didactic romance in prose. *c.*1400. MSS in British Library, London; Bibliothèque Nationale, Paris; elsewhere. / Translated by Stephen Scrope (London: *c.*1444–50). [Bühler 1970 / Hindman 1986, pp. 93, 130, 194, 200, pl. 23]

John Lydgate, 1370?–1449. (Diana in) *Reson and Sensuallyte* lines 4778ff. Poem, partial translation of *Les échecs amoureux* [Love's Game of Chess] (1370–80). Probably before **1412.** Modern edition by E. Sieper (London: Early English Text Society, 1901). [Pearsall 1970, p. 116 / Ebin 1985, p. 36]

Master of the Griggs Crucifixion (first half 15th century), circle. "Scenes from a Legend" (of Diana: Callisto, Endymion, others). Painting. *c.*1430. Kress coll. (K275), Walker Art Museum, Bowdoin College, Brunswick, Me., no. 1961.100.1. [Shapley 1966–73, 1:100—ill.]

Filarete, *c.*1400–1469? "The Bath of Diana." Relief, on bronze door of St. Peter's, Rome. **1433–45**. [Warburg]

Francesco Colonna, *c.*1433–1527. (Vision of the "Triumph of Love," Venus's defeat of Diana, in) *Hypnerotomachia Poliphili* [The Dream of Poliphilo]. Romance. Venice: **1499**; illustrated with woodcuts by anonymous engraver. [Appell 1893, p. 12, pl. 160]

Konrad Celtis, 1459–1508. *Ludus Dianae in modum comedie* [The Play of Diana in the Comic Mode]. Comedy. Nuremberg: Holzel, **1501**. [Wilpert 1963, p. 92]

Gavin Douglas, *c.*1474–1522. (Poet's vision of Diana's court in) *The Palice of Honoure*. Poem. **1501**. London: Copland, *c.*1553–58; variant text, Edinburgh: Charteris, 1579. [Bawcutt 1967]

Francesco di Giorgio 1439–**1502**. "Triumph of Diana." Painting (fragment). Metropolitan Museum, New York, no. 20.182. [Berenson 1968, p. 140]

Albrecht Dürer, 1471–1528. "Apollo and Diana." Engraving (Bartsch no. 38). **1502**. [Strauss 1977b, no. 38—ill.]

Lorenzo Costa, 1460–1535. (Diana [or a nymph?] in) "Allegory of the Court of Isabella d'Este"). Painting. *c.*1504. Louvre, Paris, inv. INV 255. [Louvre 1979–86, 2:169—ill. / Wind 1948, p. 49, fig. 61 / Paris 1975, no. 136—ill.]

Jacopo de' Barbari, *c.*1440/50–1516. "Apollo and Diana" ("Seated Apollo"). Engraving (Bartsch no. 16). Before **1505**. [Borenius 1923, no. 8—ill. / Servolini 1944, no. 16—ill.]

Baldassare Peruzzi, 1481–1536. (Diana as huntress in) Ceiling fresco, representing the Moon in Virgo. **1510–11**. Sala di Galatea, Villa Farnesina, Rome. [d'Ancona 1955, pp. 25f., 86 / Gerlini 1949, pp. 10ff. / also Frommel 1967–68, no. 18c]

———. "Diana." Fresco. 1511–12 (or *c.*1517–18). Sala delle Prospettive, Villa Farnesina, Rome. [d'Ancona, pp. 27ff., 93f. / Gerlini, pp. 31ff. / also Frommel, no. 51]

Antonio da Correggio, *c.*1489/94–1534. "Diana in Her Chariot." Fresco. *c.*1519. Camera di San Paolo, Parma. [Gould 1976, pp. 51ff., 243—ill.]

South German School. "Diana Huntress." Bronze sculpture. *c.*1525. Deutschesmuseum, Berlin. [Warburg]

Palma Vecchio, 1480–1528, attributed. "Diana and Her Nymphs in the Bath." Painting. Kunsthistorisches Museum, Vienna, no. 142A. [Pigler 1974, p. 74]

Giulio Romano, *c.*1499–1546, assistants, after designs by Giulio. Diana depicted in frescoes and stuccoes in Sala dei Venti, Sala delle Aquile, Salla delle Stucchi and Grotta, Palazzo del Tè, Mantua. **1527–30**. [Verheyen 1977, pp. 119–130 passim / also Hartt 1958, pp. 115ff.—ill.]

———. Drawing, depicting Cupid, Diana, Cronus, and Boreas as the Four Elements. Earl of Ellesmere coll., Mertoun House, Roxburghshire, Scotland, no. 123. [Hartt, p. 295 (no. 141)—ill.]

Lucas Cranach, 1472–1553. "Apollo and Diana." Painting. *c.*1530. 3 versions. Musées Royaux des Beaux-Arts, Brussels, no. 779; Gemäldegalerie, Berlin-Dahlem, no. 564; Royal Collection, Buckingham Palace, London. [Friedlaender & Rosenberg 1978, nos. 270–71—ill. / also Brussels 1984a, p. 76—ill. / Berlin 1986, p. 24—ill.]

Girolamo Romanino, 1484/87–*c.*1562. "Diana Hunting." Fresco. **1531–32**. Castello del Buonconsiglio, Trento. [Berenson 1968, p. 369]

Marcantonio Raimondi, *c.*1480–**1527/34**. "Diana." En-

graving (Bartsch no. 255), after design by Francesco Francia? [Bartsch 1978, 26:251—ill.]

Andrea Schiavone, 1522–1563. "Diana." Etching. *c.*1536–38? [Richardson 1980, no. 112]

———. "Diana." Etching. *c.*1538–40? [Ibid., no. 69]

———, attributed. "Diana and the Fisherman." Painting. Asquith coll., Mells, Somerset. [Ibid., p. 144]

Marguerite de Navarre, 1492–1549. *L'histoire des satyres et nimphes de Diane* [The Story of the Satyrs and Diana's Nymphs]. Poem. Lyon: Saulnier, **1543**. [Giraud 1968, pp. 206–11]

Jacopo Tintoretto, 1518–1594. "Diana and a Cupid." Painting. **1543–44**. Private coll. [Rossi 1982, no. 77—ill.]

———, previously attributed (now attributed to Domenico Tintoretto). "Allegory of Chastity" (Diana?). Painting. Fogg Art Museum, Harvard University, Cambridge, no. 1942.165. [Berenson 1957, p. 171 (as Jacopo) / Rossi, no. A18 (as Domenico)—ill.]

Maurice Scève, *c.*1510–*c.*1564. (Diana, Luna, and Hecate in) *Délie: Objet de plus haute vertue*. Poem. Lyon: Sabou, **1544**. Modern edition, Paris: Gallimard, *c.*1984. [Dellaneva 1988, p. 47]

School of Fontainebleau (previously attributed to Primaticcio, Niccolò dell' Abbate, circle of Jean Cousin, circle of Penni). "Diana Huntress." Painting. **Mid-16th century?** Louvre, Paris, inv. 445. [Paris 1972, no. 234—ill. / Louvre 1979–86, 4:293—ill. / also Lévêque 1984, p. 37—ill.]

School of Fontainebleau. "The History of Diana." Set of 8 tapestries (designs attributed to Jean Cousin the Elder or Luca Penni), for Château d'Anet. **1549–52**. Château d'Anet (4); Musée des Antiquités, Rouen (1); Metropolitan Museum, New York (2); private coll. (1). [Paris 1972, nos. 455–61—ill. / also Lévêque 1984, pp. 247, 249—ill.]

Giuliano Bugiardini, 1475–**1554**. "The Rape of Diana." Painting. Kunsthistorisches Museum, Vienna. [Bénézit 1976, 2:383]

Taddeo Zuccari, 1529–1566. "Diana Huntress." Painting. *c.*1555. Uffizi, Florence, inv. 1551. [Uffizi 1979, no. P1913—ill.]

———. "Mercury Attending a Concert with Dancing Nymphs, Led by Diana, at Sunrise." Fresco. Villa Giulia, Rome. [de Bosque 1985, p. 41—ill.]

———. "The Bath of Diana." Drawing. Metropolitan Museum. [Pigler 1974, p. 74]

Francesco Primaticcio, 1504–1570. "Diana Reclining among Dogs and Savage Beasts." Fresco, known from engraving (Bartsch no. 39) by Master L. D. fl. **1540–56**. (Bibliothèque Nationale, Paris.) [Dimier 1900, p. 314, no. 31 / Paris, no. 373—ill. / also Lévêque 1984, p. 29—ill.]

———, or Luca Penni, 1500/04–1556, composition. Diana and Her Nymphs Hunting a Stag. Etching, by Master L. D., fl. 1540–56 (Bartsch no. 43). (Bibliothèque Nationale, Paris.) [Paris 1972, no. 387—ill. / also Lévêque 1984, p. 62—ill.]

School of Fontainebleau. "Diane of Poitiers as Diana." Painting, copy after lost original (fragment of original, "Diana Spencer," in Earl Spencer coll., Althorp). Before **1556**. Musée de la Vénerie, Senlis. [Paris 1972, no. 237—ill.]

Girolamo da Carpi, 1501–**1556**. "Diana with Nymphs

Bathing." Painting. Bowes Museum, Barnard Castle, cat. 1970 no. 822. [Wright 1976, p. 78]

Luca Penni, 1500/04–**1556,** attributed. "The Hunt of Diana." Drawing. Musée des Beaux-Arts, Rennes. [Paris 1972, no. 139—ill. / also Lévêque 1984, p. 35—ill.] *See also School of Fontainebleau, Primaticcio, above.*

Claude Roillet, *c.*1520–after 1578. *Diana sive satyri* [Diana, or The Satyrs]. Tragedy. **1556.** [EDS 1954–66, 8:1085]

François Clouet, *c.*1510?–1572, attributed (or a copy after lost original?). "The Bath of Diana" (with nymphs, satyrs, and passing horseman; Diana and horseman depicted as Diana de Poitiers and Henri II). Painting. *c.***1550–60**? 2 versions. Museo de Arte, Sao Paolo; Musée des Beaux-Arts, Rouen. [Paris 1972, no. 54—ill. / also Lévêque 1984, p. 153—ill.] Anonymous copy (depicting Gabrielle d'Estrée and Henri IV). Musée des Beaux-Arts, Tours. [Paris, no. 55—ill. / Levêque, p. 151—ill.]

Giovanni Bernardi, 1496–1553, and **Manno di Bastiano,** design. (Statuette of Diana at corner of) "The Farnese Coffer." Silver gilt coffer. **1548–61.** Museo di Capodimonte, Naples, no. 10507. [Capodimonte 1964, p. 129]

Daniele da Volterra, 1509–**1566,** rejected attribution. "Diana." Painting, pendant to "Apollo." Springfield Museum. [Barolsky 1979, pp. 139ff.]

Domenico Brusasorci, *c.*1516–**1567.** "Apollo and Diana." Ceiling fresco, from Palazzo Chericati. Museo Civico, Vicenza. [Berenson 1968, p. 69]

School of Fontainebleau (Jean Goujon? *c.*1510–*c.***1565/ 68**). "Diana Caressing a Stag." Marble bas-relief sculpture, reduced variant of Cellini's "Nymph of Fontainebleau" (1542–43). Musée de Cluny, Paris. [Paris 1972, no. 506]

Lambert Sustris, 1515/20–after **1568.** "Diana and Her Nymphs." Painting. Italico Brass coll., Venice. [Berenson 1957, p. 168]

Paolo Veronese, 1528–1588. "Diana Huntress." Painting. *c.***1565–70.** Hermitage, Leningrad, inv. 167. [Pallucchini 1984, no. 109—ill. / Pignatti 1976, no. 155—ill. / Hermitage 1984, no. 21—ill. / also Hermitage 1981, pl. 73]

Niccolò dell' Abbate, 1509/12–**1571**? "Diana." Drawing. Musée des Beaux-Arts, Besançon, inv. 1745. [Warburg]

Paris Bordone, 1500–**1571.** "Diana the Huntress with a Nymph." Painting. Kress coll. (K127), Alexander City Public Library, Ala. [Shapley 1966–73, 3:37—ill. / Canova 1964, p. 108—ill. / Berenson 1957, p. 47]

————. "Diana the Huntress with Two Nymphs." Painting. Formerly Gemäldegalerie, Dresden, no. 204, destroyed. [Canova, p. 118—ill. / Berenson, p. 45—ill.]

————. "Venus, Cupid, Bacchus, and Diana," "Satyr, Cupid, Flora, and Diana." Paintings. Formerly Chiesa coll., Milan, sold New York, 1927. [Canova, pp. 119f.—ill.]

Jacopo Zucchi, *c.*1541–1589/90. "Diana and Nymphs." Ceiling painting. *c.***1572.** Sala delle Carte Geografiche, Uffizi, Florence. [Uffizi 1979, no. S102—ill.]

————. "Diana." Fresco. *c.*1586–87. Palazzo Ruspoli, Rome. [Hunger 1959, p. 54]

Torquato Tasso, 1544–1595. (Sylvia, a nymph and niece of Diana, in) *Aminta.* Pastoral play (favola boschereccia). First performed 31 July **1573,** Ferrara. Published Venice: Aldo, 1583. / Translated by Frederic Whitmore as *Amyntas: A Sylvan Fable* (Springfield, Mass.: 1900). [Poggioli

1975, pp. 42ff., 53f. and passim / Giamatti 1966, p. 33 *n.* / Palisca 1968, p. 37 / Highet 1967, p. 140]

————. *Gerusalemme liberata* 9.28. Epic. 1575. Venice: Perchacino, 1581 (authorized edition). [Kates 1983, p. 69]

Alessandro Vittoria, 1525–1608. "Diana." Bronze statuette. **1575–77.** Schlossmuseum, Berlin. [Cessi 1960, p. 50, pl. 28]

John Lyly, *c.*1554–1606. (Diana and nymphs in) *Gallathea.* Comedy. By **1585.** First performed 1584–85? or at Court, London, 1 Jan 1588. Published London: 1591. [Bond 1902, vol. 2]

————. "A Nymphs Disdaine of Love." Poem. In *England's Helicon* (London: 1600). [Ibid., vol. 3]

Walter Ralegh, 1552?–1618. "The Ocean to Scinthia." Poem, fragmentary, unfinished. *c.*1589. [Hammond 1984]

Edmund Spenser, 1552?–1599. (Diana curses the Nymph's waters; Britomart characterized as Diana; "Arlo-hill" described as Diana's haunt, story of Diana and her nymphs punishing Faunus for watching her bathe related, in) *The Faerie Queene* 1.7.5; 3–4 passim; 7.6.36–55. Romance epic. London: Ponsonbie, **1590,** 1596, 1609. [Hamilton 1977 / MacCaffrey 1976, pp. 424–26]

Jacopo Bassano, *c.*1517/18–**1592,** rejected attribution. "Diana and Hounds." Painting. Late 16th-early 17th century. Palazzo Ducale, Mantua. [Arslan 1960, p. 352]

————, rejected attribution. "Diana and Nymphs." Painting. Goetz coll., Paris, in 1937. [Arslan, p. 362]

Bartolomeo Passarotti, 1529–**1592,** and studio. "Diana Huntress." Painting. Louvre, no. R.F. 1941–10. [Louvre 1979–86, 2:215—ill.]

Joachim Wtewael, 1566–1638. "The Apotheosis of Venus [with Cupid] and Diana" (honored by a putto representing Victory). Painting. *c.*1590–92. Private coll. [Lowenthal 1986, no. A-1—ill.]

George Chapman, *c.*1559–*c.*1634. "Hymnus in Cynthiam" [Hymn to Cynthia]. Poem. **1594.** In *The Shadow of Night* (London: Ponsonby, 1594). [Bush 1963, pp. 207, 209f. / Le Comte 1944, pp. 86ff.]

Paolo Fiammingo, 1540–1596. "Wooded Landscape with Diana and Her Nymphs." Painting. *c.*1590–95. Gemäldegalerie, Berlin-Dahlem, no. 182B. [Berlin 1986, p. 59—ill.]

————. "Diana Hunting." Painting. 1592–96. Musée des Beaux-Arts, Nancy, inv. LA 23836. [Hofmann 1987, no. 3.13—ill.]

School of Fontainebleau. "The History of Diana." Set of 8 tapestries, after designs by Toussaint Dubreuil (6) and F. Bardon (2). *c.***1597.** 5 sets woven. Mobilier National, Paris; Prado, Madrid; Kunsthistorisches Museum, Vienna; partial sets at Ashmolean Museum, Oxford (2); isolated examples at Berlin, Milan, Baroda, Prague (Sylva-Taroucca Palace), private colls. [Paris 1972, nos. 463–66—ill.]

Emilion (**16th century**). "Diana Huntress." Drawing. Princeton Art Museum, Princeton, N.J. [Warburg]

Bolognese School. "Diana." Drawing. **Late 16th century.** Lord Methuen coll., Corsham Court. [Warburg]

Bolognese School (formerly attributed to Titian). "Diana with Hunting Dog." Painting. *c.***1600.** Unlocated. [Wethey 1975, no. X–15]

Ambrose Dubois, 1543–1614. Fresco cycle, for Galerie de

Diane, Château de Fontainebleau. *c.*1600. Partially destroyed, 1738–39; partially remounted in Galerie des Assiettes, 1840. [Paris 1972, p. 481]

Anonymous English. Queen Elizabeth celebrated as Diana in inscription at entrance to Whitehall Park, London. **Late 16th-early 17th century.** [Barkan 1980, pp. 332f.]

Cavaliere d'Arpino, 1568–1640. "Diana Huntress." *c.*1600–01. Pinacoteca Capitolina, Rome. [Rome 1973, no. 33—ill.]

Ben Jonson, 1572–1637. *Cynthia's Revels, or The Fountaine of Selfe-Love.* Satirical comedy. First performed **1600–01,** Blackfriar's Theatre, London. Published London: 1601. [Herford & Simpson 1932–50, vol. 4 / McGraw-Hill 1984, 3:109, 112 / Barton 1984, pp. 73–81 (includes the famous "Hymn" (5.6) "Queen and Huntress, Chaste and Fair")]

————. (Diana in) *Time Vindicated to Himself and to His Honours.* Masque. Performed 19 Jan 1623, at Court, London. Published London: 1623. [Herford & Simpson, vol. 7]

Joost van Winghe, 1544–**1603,** questionably attributed. "Diana Resting after the Hunt." Painting. Szépművészeti Múzeum, Budapest, no. 351. [Budapest 1968, p. 774]

Thomas Campion, 1567–1619. (Diana punishes the knights of Apollo for trying to seduce her nymphs, in) *The Lord Hay's Masque.* Masque. First performed 6 Jan **1607,** Whitehall Palace, London. Published London: Brown, 1607. [Vivian 1966 / DLB 1987, 58:37, 39]

William Shakespeare, 1564–1616, attributed, with unknown collaborator? (Thaisa vows to serve at Temple of Diana for a year, Diana appears to Pericles in a vision, in) *Pericles, Prince of Tyre* 2.5.11–12, 3.4, 5.1.240–49. Drama (romance). **1607–08.** Published in quarto (corrupt), London: 1609. [Riverside 1974 / Muir 1985, p. 68 / Thompson 1978, pp. 213ff.]

———— and **John Fletcher,** 1579–1625. (Emilia prays to Diana in) *The Two Noble Kinsmen* 5.1.137–73 (this passage attributed to Shakespeare). Drama (romance), adaptation of Chaucer's "The Knight's Tale." *c.*1613. No recorded performance in Shakespeare's lifetime. Published London: Waterson, 1634. [Riverside / Brownlow 1977, pp. 212, 219 / Muir, p. 74 / Thompson]

Annibale Carracci, 1560–**1609,** attributed. "The Bath of Diana." Drawing. Kunstakademie, Düsseldorf. [Pigler 1974, p. 74]

Joseph Heintz the Elder, 1564–**1609.** "Diana in Her Bath." Painting. Palazzo Ducale, Venice. [Bénézit 1976, 5:468]

————. "The Bath of Diana." Painting. Galleria Reale, Venice. [Ibid.]

Domenichino, 1581–1641, and assistant. "Scenes from the Life of Diana." Ceiling fresco, depicting Latona nursing Apollo and Diana, the Sacrifice of Iphigenia, and Diana and Actaeon, Endymion and Pan. **1609.** Palazzo Giustiniani-Odelscalchi, Bassano di Sutri. [Spear 1982, no. 34—ill.]

————. "Diana with Nymphs at Play" ("The Hunt of Diana"). Painting. 1616–17. Galleria Borghese, Rome, inv. 53. [Spear 1982, no. 52—ill. / Pergola 1955–59, 1: no. 31—ill. / Chappuis 1973, p. 97—ill.] Copies in private coll., England; municipal coll., Lyon; Academia de San Fernando, Madrid (José del Castille); another unlocated. [Spear] Another version of the subject, by Domenichino, recorded 1712, untraced. [Ibid., p. 311]

————. "The Bath of Diana." Painting. Recorded 1664, untraced. [Ibid., p. 311]

Guercino, 1591–1666. "Diana." Fresco (detached), for Casa Pannini, Cento. **1615–17.** Private coll., Venice. [Salerno 1988, no. 24L—ill. / also Bagni 1984, p. 165—ill.]

————. "Diana." Painting. 1645. Formerly Gemäldegalerie, Dresden, lost in World War II. [Salerno, no. 219—ill.]

————. "Diana." Painting. 1658. Private coll. [Ibid., no. 329 bis.—ill.]

————. "Diana." Painting. 1658–59. Pantucci coll., London. [Ibid., no. 335—ill.]

Peter Paul Rubens, 1577–1640. "Diana and Her Nymphs Departing for the Chase." Painting. *c.*1617. Cleveland Museum of Art, Ohio, no. 59.190. [Jaffé 1989, no. 436—ill. / Cleveland 1982, no. 11—ill.] Studio replica (also considered autograph, or the original). Getty Museum, Malibu, Calif. [Jaffé] Another version (by Rubens's studio, or begun by Rubens, completed by studio) in Staatliche Kunstsammlungen, Kassel. / Studio sketch in Secondo Pozzi coll., Novara. / Copies in Lady Exeter coll., Burghley House, Stamford; Ludwig Meyer coll., Munich, in 1963, unlocated. [Cleveland—ill.]

————. "Diana (and Nymphs) Returning from the Hunt." Painting. *c.*1617. Hessisches Landesmuseum, Darmstadt. [Jaffé, no. 450—ill.] Oil sketch. Earl of Radnor coll., Longford Castle, Wiltshire. [Ibid., no. 449—ill. / Held 1980, no. A2] Variant (three-quarter-length figures). Gemäldegalerie, Dresden. [Jaffé, no. 451—ill.]

————, studio, after Rubens's design. "The Hunt of Diana." Painting. 1627–28. Lost. [Ibid., no. 930] Oil sketch. Private coll., Switzerland. [Ibid., no. 929—ill. / Held 1980, no. 237—ill.] Numerous studio variants and later copies known. [Held]

———— (Rubens). "Diana Bathing." Painting, right part of a canvas (left part lost) which originally also showed Actaeon. 1630–32 or *c.*1635. Museum Boymans-van Beuningen, Rotterdam. [Ibid., no. 1078—ill. / Mauritshuis 1985, pp. 38f.—ill.] Engraved (entire composition) by P. Spruyt, 1787. / Copy (entire composition) in Rotterdam. [Jaffé, no. 1078a—ill.] Related drawing. Count A. Seilern coll., London. [Burchard & d'Hulst 1963, no. 159—ill.]

———— (also attributed to Paul de Vos). "Diana Huntress." Painting. *c.*1636. Prado, Madrid, no. 1727. [Prado 1985, p. 592] Variant copy, by Juan Bautista del Mazo (*c.*1612–1667), in Prado, no. 1725. [Ibid., p. 403]

————. "Diana and Nymphs Hunting." Painting, for Torre de la Parada, El Pardo, executed by Rubens and assistant (?). 1636–38. Private coll., London (?). [Alpers 1971, no. 20—ill. / Jaffé, no. 1264 (as studio work)—ill.] Oil sketch. Wernher coll., Luton Hoo, Bedfordshire. [Alpers, no. 20a—ill. / Held 1980, no. 186—ill. / Jaffé, no. 1263—ill.]

————. "Diana and Her Nymphs Surprised by Satyrs (Fauns)." Painting, part of series of hunts for Philip IV of Spain. 1639. Prado, Madrid, no. 1665. [Jaffé, no. 1347—ill. / Held, pp. 305f. / Prado, pp. 580f.]

————. "The Hunt of Diana." Painting (executed by assistants from Rubens's design), part of hunt series for Philip IV. 1639–40. Lost. / Oil sketch, by Rubens or studio. Formerly Nieuwenhuys coll., Brussels, with Bruno Meissner, Zurich, in 1988. [Jaffé, no. 1398—ill. / Held, no. 223—ill.] Studio version (? or possibly the original?) in

Musée des Beaux-Arts, Nîmes, inv. IP–294. [Held, fig. 40] Copy in Städelsches Kunstinstitut, Frankfurt. / Tapestry, woven by Daniel Eggermans, Brussels, in Kunsthistorisches Museum, Vienna. [Ibid.]

———, with **Paul de Vos**, c.1596–1678, attributed. "Diana Hunting." Painting. Art Gallery, Brighton. [Wright 1976, p. 177]

———, studio (? previously attributed to Rubens). "Diana and Nymphs Returning from the Hunt." Painting. 2 versions. Hessiches Landesmuseum, Darmstadt; Gemäldegalerie, Dresden. / Oil sketch, previously attributed to Rubens. Earl of Radnor coll., Longford Castle, Wilts. [Held, no. A2]

———, studio (previously attributed to Rubens, also to van Dyck). "Diana Hunting the Stag." Painting. Museum Boymans-van Beuningen, Rotterdam. [Larsen 1988, no. A310—ill.]

———, school. "Diana Hunting," "Diana Returning from the Hunt." Painted cabinet panels. Rijksmuseum, Amsterdam, inv. NM11906–1. [Rijksmuseum 1976, p. 484—ill.]

———. See also Jan Brueghel the Elder, below.

Artemisia Gentileschi, 1593–1652/53. "The Bath of Diana." Painting. By **1618–19.** Documented in Medici collection, Florence, in 1681, lost. [Garrard 1989, p. 51]

Jan Brueghel the Elder, 1568–1625, landscape, and **Peter Paul Rubens,** figures. "Diana and Her Nymphs Preparing to Depart for the Hunt," "(Diana and Her) Nymphs Sleeping, Watched by Satyrs." Pendant paintings. c.**1620–21** (or 1623–24). Musée de la Chasse et de la Nature, Paris, inv. 68–3–1, 68–3–2. [Ertz 1979, nos. 354–55—ill. / Jaffé 1989, nos. 771–72—ill.] Variant of "Nymphs Sleeping." Alte Pinakothek, Munich, inv. 344/3884. [Ertz, no. 358—ill.] Copies in Museu Nacional de Arte Frei, Lisbon; Dayton Art Institute, Ohio. [Ibid., no. 355n.]

———, Rubens, and **Frans Snyders,** 1579–1657. "Diana's Return from the Hunt." Painting. c.1620–21. Alte Pinakothek, Munich, inv. 842. [Ibid., no. 356—ill.] 2 copies by Jan Brueghel the Younger and Hendrik van Balen. Musée de la Chasse et de la Nature, Paris, inv. MR1003 INV1799; the other sold Sotheby's, London, 1979 (possibly anonymous). [Ertz 1984, no. 244–45—ill. / also de Bosque 1985, p. 71—ill.]

———, **Hendrik van Balen,** 1575–1632, and Snyders. "Diana's Nymphs after the Hunt." Painting. c.1621. Alte Pinakothek, Munich, inv. 850. [Ertz 1979, no. 373—ill.] Variant by Jan the Younger and van Balen. c.1621–22. Private coll., Germany. [Ertz 1984, no. 243—ill.]

———, van Balen, and Snyders. "Diana's Nymphs with a Fishnet." Painting. 2 versions. c.1621. Galerie Kurt Müllenmeister, Solingen; Alte Pinakothek, Munich, inv. 1950. [Ertz 1979, nos. 374–75—ill.]

———, van Balen, and Snyders. "Diana after the Hunt." Painting. 2 versions. c.1621. Lord Spencer coll. in 1923; Mrs. Rush Kress coll. (K143), New York (as Brueghel and van Balen). [Ertz 1979, nos. 376–77—ill. / Eisler 1977, p. 100—ill.]

——— and follower of Rubens. "Diana Resting after the Hunt." Painting. Alte Pinakothek, Munich. [Ertz 1979, fig. 476]

———. See also Jan Brueghel the Younger, below.

Ivan Gundulíc, 1589–1638. *Diana.* Tragedy. Dubrovnik:

1621. Modern edition, in *Diana i Armida: Pjesanzi* (Dubrovnik: 1837). [CEWL 1973, 2:604 / EDS 1954–66, 6:73]

Jan Brueghel the Younger, 1601–1678, landscape, and **Hendrik van Balen,** 1575–1632, figures. "Diana and Her Nymphs, Watched by Satyrs." Painting. c.1621–22. Gemäldegalerie, Dresden, inv. 925. [Ertz 1984, no. 240—ill.]

——— and an artist in circle of Peter Paul Rubens. "Sleeping Nymphs [of Diana] Watched by Satyrs." Painting. c.1620–21. Galerie Waterman, Amsterdam, in 1982. [Ertz 1984, no. 242—ill.; cf. Ertz 1979, no. 357 (attributed to Rubens and Jan the Elder)—ill.]

———, van Balen, and **Frans Snyders,** 1579–1657. (Nymphs of Diana) "Plucking a Heron." Painting. 1627. Private coll., Germany. [Ertz 1984, no. 246—ill.]

——— and studio of van Balen. "Diana and Her Nymphs Bathing." Painting. Late 1620s. Private coll., France. [Ibid., no. 247—ill.]

——— and circle of van Balen. "Diana's Kill." Painting. 1630s. Staatliche Kunsthalle, Karlsruhe, inv. 1890. [Ibid., no. 248—ill.]

———. See also Jan Brueghel the Elder, above.

Francesco Albani, 1578–1660. Rivalry of Venus and Diana depicted in a cycle of 4 paintings: "Venus in Vulcan's Forge," "The Toilet of Venus," "Venus and Adonis," "The Triumph of Diana." **1622.** Borghese Gallery, Rome, inv. 35, 40, 44, 49. [Pergola 1955–59, 1: nos. 1–4—ill.]

———. "Diana Resting after the Hunt." Painting. / Old copy (formerly attributed to Albani) in Herzog Anton Ulrich-Museum, Braunschweig, no. 485. [Braunschweig 1969, p. 26]

Karel van Mander the Younger, c.1579–1623. "Diana with Her Companions." Painting. Landesmuseum Johanneum, Graz. [Bénézit 1976, 7:131]

Thomas Heywood, 1573/74–1641. "Diana," passage in *Gynaikeion: or, Nine Books of Various History Concerning Women* book 1. Compendium of history and mythology. London: pr. Adam Islip, **1624.** [Ipso]

Paul Bril, 1554–1626. "Diana and Her Nymphs Hunting." Painting. Louvre, Paris, inv. 1114. [Louvre 1979–86, 1:34—ill.]

Frans Francken II, 1581–1642, and **Abraham Govaerts,** 1589–1626. "Landscape with Diana and Her Nymphs." Painting. Abrams coll., Boston. [Härting 1983, no. A250—ill.]

Abraham Govaerts, 1589–1626. "Diana Resting." Painting. Musée Royal des Beaux-Arts, Antwerp. [Bénézit 1976, 5:138]

Michael Drayton, 1563–1631. "The Quest of Cynthia." Poem. Published with *The Battle of Agincourt* (London: **1627**). [Hebel 1931–32, vol. 3]

Gerrit van Honthorst, 1590–1656. "Diana on the Hunt." Painting. **1627.** Formerly Schloss Grünewald, Berlin. [Judson 1959, no. 81—ill.]

———. (King Charles I and Queen Henrietta Maria as) "Apollo and Diana." Painting. 1628. Hampton Court Palace. [Ibid., no. 73—ill.]

———. "Diana with Her Nymphs." Drawing. c.1635. Rijksmuseum, Amsterdam. [Judson, no. 221]

———. "Diana's Toilet." Painting. 1650. Statens Museum

for Kunst, Copenhagen, inv. 1690. [Copenhagen 1951, no. 322 / cf. Judson, no. 82]

Palma Giovane, *c*.1548–**1628.** "Bath of Diana with Nymphs." Painting. Formerly Pico coll., Mirandola, Modena, lost. [Mason Rinaldi 1984, p. 178]

Nicolas Poussin, 1594–1665. "Diana Hunting." Drawing. **Late 1620s.** Royal Library, Windsor Castle, no. 11985. [Friedlaender & Blunt 1953, no. 200—ill.]

———, formerly attributed. "Landscape with Diana Asleep." Painting. Prado, Madrid, no. 2319. [Blunt 1966, no. R72]

———, circle (formerly attributed to Poussin). "Apollo and Diana (Bacchus and Bacchantes) Hunting." Painting. Herzog Anton Ulrich-Museum, Braunschweig, no. 514. [Blunt, no. R62 / Thuillier 1974, no. R53—ill. / Braunschweig 1969, p. 109]

David Vinckeboons, 1576–**1629.** "Diana and Nymphs Hunting." Painting. Musées Royaux des Beaux-Arts, Brussels. [Warburg]

Giacinto Cornacchioli, 1590–1653. *Diana schernita* [Diana Derided]. Opera. Published Rome: **1629.** [EDS 1954–66, 3:1459]

Jacob Jordaens, 1593–1678. "Goddesses [Juno (or Venus?) and others] and Nymphs in the Bath" (formerly known as "The Bath of Diana and Her Nymphs"). Painting. ***c*.1630.** Prado, Madrid, no. 1548. [Prado 1985, p. 343 / Rooses 1908, pp. 50, 258]

———. "Diana Resting with Nymphs, Satyrs, and Booty." Painting. *c*.1645. 2 versions known. Petit Palais, Paris; another formerly T. Dreyfus coll., Paris. [d'Hulst 1982, p. 216, fig. 179 / also Rooses, p. 93] 3 further versions known, unlocated. / Copy in Hermitage, Leningrad. [Rooses, p. 258]

Rembrandt van Rijn, 1606–1669. "Diana at the Bath." Etching (Bartsch no. 201). *c*.**1631.** [White & Boon 1970, no. 201—ill. / Guillaud 1986, p. 151, fig. 205] School copy, painting, in Kleiweg de Zwaan coll., Amsterdam. [Benesch 1973, no. 21 *n*.]

———. "The Goddess Diana Bathing, with the Stories of Actaeon and Callisto." Painting. 1635. Prince of Salm-Salm coll., Anholt. [Gerson 1968, no. 61—ill.]

———. "Diana with Two Greyhounds." Drawing. *c*.1635–36. Private coll., Basel. [Ibid., no. 116—ill.]

———, follower. "Diana Bathing Surprised by a Satyr" (?). Painting. *c*.1640? National Gallery, London, inv. 2538. [London 1986, p. 518—ill.]

Hendrik van Balen, 1575–**1632.** "Bacchus and Diana" (bacchanal, Diana looking on). Painting. Rijksmuseum, Amsterdam, inv. A17. [Rijksmuseum 1976, p. 99—ill.]

———. "Diana Setting Out for the Hunt." Painting. Bonnefantenmuseum, Maastricht, inv. NK1921. [Wright 1980, p. 19]

———. "Diana and Two Nymphs." Painting. Musée, Épinal. [Bénézit 1976, 1:401]

———. "Diana and Her Nymphs." Painting. Gemälde-galerie, Dresden. [Ibid.]

———. "Diana and Her Nymphs." Painting. National-museum, Stockholm. [Ibid.]

———. "Diana in a Landscape." Painting. [Ibid.]

———. *See also Jan Brueghel the Elder, Jan Brueghel the Younger, above.*

Abraham Janssens, *c*.1575–**1632.** "Diana Surrounded by Nymphs (and Watched by Satyrs)." Painting. Late work. Alte Pinakothek, Munich, inv. 13111. [Munich 1983, p. 261—ill. / de Bosque 1985, p. 73]

———. "Diana Asleep, Surrounded by Nymphs and Watched by Satyrs." Painting. Staatliche Kunstsammlungen, Kassel. [de Bosque, p. 73—ill.]

———. "Diana and Her Companions." Painting. Shipley Art Gallery, Gateshead, Tyne-on-Wear. [Jacobs & Stirton 1984b, p. 200]

Simon Vouet, 1590–1649. "Apollo and Diana Attacking the Furies." Painting. Lost. / Engraved by François Perrier, **1632.** [Crelly 1962, p. 95, no. 220]

———. "Diana." Painting. 1637. Royal Collection, Hampton Court. [Ibid., p. 125, no. 41—ill.]

——— or studio. "The Bath of Diana," "Diana Reclining with Two Hounds." Paintings, cartoons for "Loves of the Gods" tapestry series. [Crelly 1962, nos. 270a, n]

Ivan Gundulić, 1589–1638. *Diana*. Drama. Published **1633.** Modern edition, *Works* (Zagreb: Izdavko Knjizarska Radna Organicija, 1980). [CEWL 1973, 2:604]

Pieter Feddes, 1586–**1634.** "Diana and Her Nymphs Surprised by Satyrs." Painting. Westfries Museum, Hoorn, cat. 1924 no. 19. [Wright 1980, p. 122]

Anthony van Dyck, 1599–**1641.** "Sleeping Diana" (with nymphs, watched by satyr). Painting. *c*.**1632–34.** Private coll. [Larsen 1988, no. 1044—ill.] *See also Rubens, above.*

John Milton, 1608–1674. (Diana's power of chastity celebrated in) *Comus* lines 435f. Masque. Music, Henry Lawes. First performed Michaelmas Day **1634,** Ludlow Castle. Published London: Robinson, 1637. [Carey & Fowler 1968]

Orazio Gentileschi, 1563–1639. "Diana Huntress." Painting. **Mid-1630s.** Musée des Beaux-Arts, Nantes. [Bissell 1981, no. 69—ill.]

Nicholas Stone, *c*.1587–1647. "Diana Taking Her Repose Having Bereaved Cupid of His Bow and Arrow. . . ." Sculpture, for Gate at Windsor Castle. **1636.** [Whinney 1964, pp. 29f.]

Francesco Fanelli. Diana Fountain. Before **1640.** Bushey Park, Middlesex. [Whinney 1964, p. 37, pl. 26B]

Adriaen van Nieulandt, 1587–1658. "Landscape with Diana and Nymphs." Painting. **1641.** Herzog Anton Ulrich-Museum, Braunschweig, no. 214. [Braunschweig 1969, p. 103]

———. "Diana with Nymphs." Painting. Ham House, Richmond, England. [Wright 1976, p. 150]

Eustache Le Sueur, 1616–1655. "Sacrifice to Diana." Painting. **Early 1640s?** Museum of Fine Arts, Boston, no. 48.16. [Boston 1985, p. 167—ill. / Wildenstein 1968, no. 23—ill.]

Andrea Camassei, 1601–1648. "Diana and Her Nymphs." Painting. *c*.**1630–44.** Museo Nazionale, Rome, inv. 2425. [Warburg]

Pietro da Cortona, 1596–1669. "Diana (Suspends the Hunt)." Fresco. **1642–44.** Sala di Giove, Palazzo Pitti, Florence. [Campbell 1977, pp. 127, 133—ill. / Briganti 1962, no. 95—ill. / also Pitti 1966, p. 48—ill.] Copy, by Jacob Ennis (1728–1770), in National Gallery of Ireland, Dublin, no. 4126. [Dublin 1981, p. 204—ill.]

Willem de Heusch, 1618?–1699/1712. "Landscape with

Diana and Nymphs." Painting. *c*.**1645.** Mount Holyoke College Art Museum, South Hadley, Mass. [Seen by author]

Abraham van Cuylenburgh, before 1620–1658. "The Bath of Diana." Painting. **1646.** Galleria Borghese, Rome, inv. 279. [Pergola 1955–59, 2: no. 230—ill.]

——. "Diana and Her Companions." Painting. Mauritshuis, The Hague, inv. 24. [Mauritshuis 1985, p. 355—ill.]

——. "Diana and Nymph in a Grotto." Painting. Szépművészeti Múzeum, Budapest, no. 60.13. [Budapest 1968, p. 173]

Bartholomeus Breenbergh, 1599–*c*.1657. "Landscape with Diana and Her Nymphs." Painting. **1647.** Musée, Grenoble. [Röthlisberger 1981, no. 226—ill.]

——. "Diana and Her Nymphs Surprised." Painting. Dienst Verspreide Rijkskollekties, The Hague, inv. NK2300. [Wright 1980, p. 58]

Govaert Flinck, 1615–1660. "Diana." Painting. **1647.** William Humphreys Art Gallery, Kimberley, in 1962. [von Moltke 1965, no. 87—ill.]

——. "Diana." Painting. 1640s. Private coll., Hiversum. [Ibid., no. 88—ill.]

David Teniers the Elder, 1582–1649. "The Bath of Diana." Painting. In private coll., Amsterdam, in 1668, lost. [Duverger & Vlieghe 1971, p. 79]

Bolognese School (previously attributed to Furini). "Bath of Diana." Painting. **1600/50?** Uffizi, Florence, inv. SMeC 99. [Uffizi 1979, no. P1449—ill.]

French School. "Diana Hunting." Painting. *c*.**1650.** Louvre, Paris, inv. 8623. [Louvre 1979–86, 4:302—ill.]

Jan Fyt, 1611–1661, landscape, and **Thomas Willeboirts,** called Bosschaert, *c*.1614–1654, figures. "Diana's Booty of the Hunt." Painting. **1650.** Kunsthistorisches Museum, Vienna, inv. 706 (1212). [Vienna 1973, p. 72—ill.]

—— (Fyt), figures, and **Willem van Herp,** 1614–1677, or **Erasmus Quellinus II,** 1607–1678, landscape. "Diana and Her Dogs, with Game." Painting. Gemäldegalerie, Berlin-Dahlem, no. 967. [Berlin 1986, p. 33—ill.]

Leonhard Kern, 1588–1662. "Diana." Boxwood sculpture. **Mid-17th century.** Victoria and Albert Museum, London. [Molesworth 1965, fig. 226]

Ignatius van der Stock, fl. mid-17th century, attributed. "Landscape with Diana and Her Huntresses." Painting. Museum of Fine Arts, Boston, Res. 21.91. [Boston 1985, p. 271—ill.]

Abraham Bloemaert, 1564–1651. "Diana." Painting. Shipley Art Gallery, England, cat. 1951 no. 486. [Wright 1976, p. 18]

Jan van den Hoecke, 1611–1651, questionably attributed (manner of J. Duyts). "Diana and Nymphs Hunting." Painting. Schönborn coll., Pommersfelden. [Warburg]

Artus Quellinus the Elder, 1609–1668. "Diana (with a Deer and Sea-bulls)." Terra-cotta relief sculpture. **1651–53.** Rijksmuseum, Amsterdam, inv. Am 51–12. [Düsseldorf 1971, no. 240—ill.]

Jacob van Loo, *c*.1614–1670. "Diana and Her Nymphs." Painting. **1654.** Statens Museum for Kunst, Copenhagen, cat. 1951, no. 397—ill.] Several other versions of the subject known. Herzog Anton Ulrich-Museum, Braunschweig, no. 274; Musée des Beaux-Arts, Liège (formerly attributed to Govaert Flinck); Staatliche

Museen, Berlin. [Braunschweig 1969, p. 90 / von Moltke 1965, no. W42—ill. / Bénézit 1976, 6:730]

Claes Cornelisz Moeyaert, 1590/91–**1655,** and **Jan Pynas,** 1583/84–1631. "Diana Hunting." Painting. Gemäldegalerie, Dresden. [Warburg]

Jan Vermeer, 1632–1675, attributed (previously attributed to Nicolaes Maes). "Diana and Her Companions." Painting. *c*.**1655.** Mauritshuis, The Hague, inv. 406. [Mauritshuis 1985, pp. 310, 457—ill.]

Laurent de La Hyre, 1606–1656. "Countess de Beauvais as Diana." Painting. Musée, Châlons-sur-Marne. [Bénézit 1976, 6:386]

Pacecco de Rosa, 1607–1656. "The Bath of Diana." Painting. Galleria di Capodimonte, Naples, no. 491. [Capodimonte 1964, p. 52, pl. 71]

Jacques Stella, 1596–**1657.** "Diana with Her Nymphs." Painting. Museum, Oldenbourg. [Bénézit 1976, 9:815]

Giovanni Francesco Romanelli, 1610–1662. Fresco cycle depicting scenes from the lives of Apollo and Diana. **1655–58.** Salle des Saisons, Apartement d'Été (Galerie du Bord de l'Eau), Louvre, Paris (inv. 20348). [Louvre 1979–86, 2:228—ill.]

Ferdinand Bol, 1616–1680. "Diana Hunting." Painting. *c*.**1656–58.** Centraal Museum, Utrecht, cat. 1952 no. 1039. [Blankert 1982, no. 21—ill.]

——, formerly attributed. "Diana." Painting (copy after composition by Govaert Flinck). *c*.1647? Los Angeles County Museum of Art, Calif. [Ibid., no R39]

——, formerly attributed (circle of J. Victors). "Diana." Painting. Unlocated. [Ibid., no. R40]

Frans Wouters, 1612–**1659.** "Landscape with Diana Resting." Painting. Kunsthistorisches Museum, Vienna, inv. 3863 (1101). [Vienna 1973, p. 204]

——. "Diana Leaving for the Hunt." Painting. Museum, Augsburg. [Bénézit 1976, 10:799]

——. "The Sleep of Diana." Painting." Galerie, Schleissheim. [Ibid.]

Cornelis van Poelenburgh, *c*.1586–1667. "Diana and Her Nymphs." Painting. **1659.** Statens Museum for Kunst, Copenhagen. [Copenhagen 1951, no. 549]

——. "The Bath of Diana." Painting. Prado, Madrid, no. 2129. [Prado 1985, p. 511]

——. "Diana in the Bath." Painting. Städelsches Kunstinstitut und Städtische Galerie, Frankfurt-am-Main. [Bénézit 1976, 8:392]

Nicolaus Knupfer, *c*.1603–*c*.1660. "Diana and Nymphs Hunting." Painting. Carraciola di Brienza Renesse coll. [Warburg]

——. "Diana and Nymphs in the Bath." Painting. Národní Galeri, Prague. [Pigler 1974, p. 76]

Johannes Spruyt, 1627/28–1671. "Diana and Her Followers." Painting. **1661.** Gemäldegalerie, Berlin-Dahlem, on loan from German government. [Berlin 1986, p. 71—ill.]

Bolognese School? "Diana Sleeping." Painting. **1665.** Uffizi, Florence, inv. SMeC 16. [Uffizi, no. P1450—ill.]

Jan Boeckhorst, 1605–1668. "Repose of Diana." Painting. Kunsthistorisches Museum, Vienna, inv. 1707 (1074). [Vienna 1973, p. 25]

Dirck van der Lisse, ?–1669 (previously attributed to Cornelis van Poelenburg, Jan van der Lys). "Landscape

with Diana and Nymphs." Painting. Statens Museum for Kunst, Copenhagen. [Copenhagen 1951, no. 394]

—— (previously attributed to Jan van der Lys). "Diana and Her Nymphs." Painting. Statens Museum for Kunst, Copenhagen, inv. 1984. [Copenhagen 1951, no. 396]

——. "Diana Bathing." Painting. Staatliche Museen, Berlin. [Bénézit 1976, 6:694]

——. "Diana and Nymphs." Painting. Gemäldegalerie, Dresden. [Ibid.]

——. "Diana and Nymphs." Painting. Städtische Kunsthalle, Mannheim. [Ibid.]

——. "Diana in a Landscape." Painting. Nationalmuseum, Stockholm. [Ibid.]

François Girardon, 1628–1715. "Diana's Bathing Nymphs." Lead bas-relief on fountain cascade. **1668–70.** Bain de Diane, Gardens, Versailles. [Girard 1985, p. 290—ill.]

Gabriel Grupello, 1644–1730. "Diana" (with dog). Marble statue. **1670–71.** Musée Royaux des Beaux-Arts, Brussels, no. 372. [Kultermann 1968, no. 7—ill.] Clay model. Brussels, no. 1426. [Ibid., no. 6—ill. / Düsseldorf 1971, no. 34—ill.]

Jacob van Oost the Elder, 1601–1671. "Diana Huntress." Painting. Town Hall, Chester. [Warburg]

Gabriel Blanchard, 1630–1704. "Diana in a Chariot Pulled by Hinds." Ceiling painting. **Early 1670s.** Salon de Diane, Appartement du Roi, Château de Versailles. [Berger 1985, pp. 41ff., 69, fig. 69] Decorations in another Salon de Diane, originally part of the Appartement de la Reine, were destroyed in renovation, c.1678–79. [Ibid.]

Jacob Huysmans, c.1633–1696. "Portrait of a Lady [Margaret Blagg?] in Masque Costume as Diana." Painting. **c.1674?** Tate Gallery, London, no. T.901. [Tate 1975, p. 45]

Jean de La Fontaine, 1621–1695. (Diana in) *Daphné.* Libretto for opera-ballet. **1674.** Commissioned for Jean-Baptiste Lully, but rejected, unperformed. Published in *Poème du quinquina et autres ouvrages en vers* (Paris: Thierry & Barbin, 1682). [Clarac & Marmier 1965]

Jan Thomas van Yperen, 1617–1678. "The Sleep of Diana." Painting. Louvre, Paris, no. M.I. 973. [Louvre 1979–86, 1:140—ill.]

Paul de Vos, c.1596–1678. "Diana on the Hunt." Painting. Groninger Museum, Groningen, inv. 1948/126. [Wright 1980, p. 483]

Onorio Marinari, 1627–1715. "Diana the Huntress." Painting. c.1670–80? Uffizi, Florence, inv. SMeC 116. [Uffizi 1979, no. P999—ill.]

Arie de Vois, 1632–1680. "Mars and Diana" ("Dido and Aeneas"?). Painting. Centraal Museum, Utrecht, cat. 1952 no. 334. [Wright 1980, p. 480]

Daniel Vertangen, c.1598–1681/84. "Diana and Her Nymphs." Painting. Statens Museum for Kunst, Copenhagen. [Copenhagen 1951, no. 760] Several other versions of the subject known. Museum of Fine Arts, Boston; Museum, Hannover; Centraal Museum, Utrecht, cat. 1952 no. 1335 (attributed). [Bénézit 1976, 10:479 / Wright 1980, p. 473]

Pierre Beauchamps, 1631–1705, music. "Diane," entrée in *Ballet des arts.* First performed **1685,** Collège Louis-le-Grand, Paris. [Astier 1983, p. 161]

Henry Desmarets, 1661–1741. *La Diane de Fontainebleau.*

Divertissement. Libretto, Maurel. First performed Nov **1686,** Fontainebleau. [Grove 1980, 5:391]

Philip Ayres, 1638–1712. "Revenge against Cynthia." Poem, imitation of Petrarca. In *Lyric Poems, Made in Imitation of the Italians* (London: For Knight & Saunders, **1687**). [Praz 1925, p. 423]

Charles de La Fosse, 1636–1716. "Diana and Nymphs" (bathing). Painting. **1688–90.** Several versions. Hermitage, Leningrad, inv. 1120; Art Gallery of Ontario, Toronto ("Diana and Three Nymphs," enlargement of central group of Hermitage work; acquired 1955 as by Antoine Coypel; may be earliest version of the composition); Musée des Beaux-Arts, Rennes; another (executed for Grand Trianon, Versailles) in residence of Governor of Paris in 19th century; another in Sanssouci, Potsdam, in 19th century. [Hermitage 1986, no. 85—ill. / also Bordeaux 1984, fig. 355]

Gérard de Lairesse, 1641–1711 (active until c.1690). "Diana and Her Companions." Ceiling painting. Rijksmuseum, Amsterdam, inv. A1233. [Rijksmuseum 1976, p. 336—ill.]

Giuseppe Antonio Bernabei, 1649?–1732. *Vaticinio di Apollo e Diana* [Prophesy of Apollo and Diana]. Opera. Ballet music, Melchior d'Ardespin. First performed **1690.** [Grove 1980, 1:559, 2:612]

Martin Desjardins, 1637–1694. "Diana." Marble fountain figure. Parterre d'Eau, Gardens, Versailles. [Girard 1985, pp. 150, 281—ill.]

Johann Carl Loth, called Carlotto, 1632–1698. "The Bath of Diana." Painting. Formerly Czernin coll., Prague. [Pigler 1974, p. 76]

Sebastiano Ricci, 1659–1734. "Diana." Ceiling fresco (detached), part of "The Olympian Gods" cycle, from Palazzo Mocenigo-Robilant, Venice. **1697–99.** Gemäldegalerie, Berlin-Dahlem, on loan from German government. [Daniels 1976, no. 49—ill. / Berlin 1986, p. 64—ill.]

——. "Diana and Her Nymphs Bathing." Painting. 1712–16. Royal Academy, London. [Daniels, no. 169—ill.]

——. "Diana." Painting. Getty coll., Sutton Place, Guildford, Surrey. [Ibid., no. 117—ill.]

Antonio Verrio, c.1639–1707. "Diana Huntress." Painting. c.1699. William III's State Bedroom, Hampton Court. [Warburg]

Bolognese School. "Diana and Putti in a Landscape." Painting. **17th century.** Walters Art Gallery, Baltimore, inv. 37.1811. [Walters 1976, p. 580]

Flemish School. "Diana and the Nymphs." Painting. **17th century.** Bowes Museum, Barnard Castle, list 1934 no. 847. [Wright 1976, p. 64]

Flemish School (false signature "P. P. R." [Rubens]). "Landscape with Diana's Hunt." Painting. **17th century.** Herzog Anton Ulrich-Museum, Braunschweig, no. 1126. [Braunschweig 1976, p. 26]

French School. "Diana Resting." Painting. **17th century.** Musées Royaux des Beaux-Arts (Musée d'Art Ancien), Brussels, inv. 293. [Brussels 1984a, p. 370—ill.]

French School. "Marie de Rohan, Duchess of Chevreuse, as Diana." Painting. **17th century.** Château de Versailles. [Versailles 1949, p. 7f.—ill.]

Italian School. "Diana's Bath." Painting. **17th century.** Muzeum Narodowe, Warsaw, inv. Wil. 1673, on display at Wilanów Palace. [Warsaw 1969, no. 1664—ill.]

North Italian School. "Diana and Cupid." Painting. **17th century.** Chiswick House, London. [Wright 1976, p. 104]

Netherlandish School. "Mary Killigrew as Diana." 2 paintings. **1650/1700.** Museum Bredius, The Hague, inv. C282, C283. [Wright 1980, p. 313]

Genoese School. "Diana." Painting (fragment). **1675/ 1700.** Museum of Fine Arts, Boston, Res. 11.6. [Boston 1985, p. 143—ill.]

Antoine Coypel, 1661–1722. "Diana Resting." Painting. *c.*1700? Hermitage, Leningrad, inv. 3693. [Hermitage 1986, no. 30—ill.] Variants. Musée des Vosges, Épinal; Musée Hyacinthe Rigaud, Perpignan; enlarged replica sold Berlin, 1918. [Ibid. / Metropolitan 1960, no. 146—ill. / Bordeaux 1984, fig. 356]

John Dryden, 1631–1700. (Diana, representing Court of James I, in) *The Secular Masque.* Masque. Music, Daniel Purcell. First performed as part of Vanbrugh's *The Pilgrim,* 29 Apr **1700,** Theatre Royal, Drury Lane, London. [Kinsley 1958, vol. 4 / Winn 1987, pp. 510–12 / Van Doren 1946, p. 188 / Grove 1980, 15:475 / Nicoll 1959–66, 1:407]

———. "The Flower and the Leaf." Poem, after 15th-century poem formerly attributed to Chaucer (see above). In *Fables, Ancient and Modern* (London: Tonson, 1700). [Dryden 1700 / Van Doren, pp. 56, 227, 244 / Miner 1967, pp. 289, 296ff., 320]

Giovanni Gioseffo dal Sole, 1654–1719. "The Bath of Diana." Painting. *c.*1700. Kunsthistorisches Museum, Vienna, inv. 7052. [Vienna 1973, p. 164]

Flemish School. "Diana." Tapestry. **Early 18th century.** Musée, Lille. [Warburg]

Balthasar Permoser, 1651–1732. "Diana and Putto." Ivory sculpture. **1704.** Grünes Gewölbe, Dresden. [Asche 1966, no. P35, pl. 38]

Luca Giordano, 1634–**1705,** attributed. "Diana and Her Nymphs." Painting. Museo Cerralbo, Madrid, in 1955. [Ferrari & Scavizzi 1966, 2:345]

———, attributed. "Diana." Painting. Iriarte coll., Madrid, in 1954. [Ibid., 2:352]

———. "Bacchanal of Venus and Diana." Painting. Recorded in 1688, untraced. [Ferrari & Scavizzi 1966, 2:363]

———, attributed. "The Hunt of Diana," "Diana with a Hound." Paintings. Palacio Real, Riofrio, in 1884. [Ibid., 2:379—ill.]

———. "Diana Bathing." Painting. Sold 1850, untraced. [Ibid., 2:375]

———, studio (Paolo de Matteis?) "The Hunt of Diana." Painting. Louvre, no. M.I. 867 (1307). [Louvre 1979–86, 2:180—ill. / Ferrari & Scavezzi 1966, 2:307 (as Matteis)]

Louis de Boullogne the Younger, 1654–1733. "Diana Resting," "The Hunt of Diana." Pendant paintings. **1707.** Musée des Beaux-Arts, Tours. [Metropolitan 1960, no. 151—ill. / also Bordeaux 1984, fig. 358 / Posner 1984, fig. 65]

George Frideric Handel, 1685–1759. *Alla caccia (Diana cacciatrice)* [To the Hunt (Diana the Huntress)]. Cantata, for soprano, trumpet, basso continuo. First performed May or June **1707,** for Marchese Francesco Maria Ruspoli, Castello, Vignanello. [Hogwood 1984, p. 37 / Grove 1980, 8:122]

Pietro Locatelli, *c.*1634–**1710** (previously attributed to Filippo Lauri). "The Hunt of Diana." Painting. Galleria Borghese, Rome, inv. 531. [Pergola 1955–59, 2: no. 141—ill.]

Jean-Louis Lemoyne, 1665–1755. "Companion of Diana" ("Diana"). Marble statue, for gardens of Château, Marly. **1710.** [Réau 1927, no. 9] Marble replica for Château de La Muette. 1724. Widener coll., National Gallery, Washington, D.C., no. A–127. [Ibid., no. 17—ill. / Sienkewicz 1983, p. 36—ill. / Walker 1984, fig. 1010]

Antoine Watteau, 1684–1721. "Diana Bathing." Painting. *c.*1715. Louvre, Paris. [Grasselli & Rosenberg 1984, no. P.28—ill. / Camesasca 1982, no. 113—ill. / Louvre 1979–86, 4:286—ill. / also Posner 1984, fig. 64]

———. "The Temple of Diana." Drawing. *c.*1716. Pierpont Morgan Library, New York. [Grasselli & Rosenberg 1984, no. D.72—ill. / Posner 1984, p. 61, pl. 11 (cf. fig. 55)]

———. *See also Le Moyne, below.*

Georg Werle, 1668–1727. "The Glorification of Diana." Fresco. **1715.** Oradada Castle, Hluboka, Czechoslovakia. [Knab 1977, fig. 2a]

Pietro de' Pietris, *c.*1671–**1716.** "Diana Bathing in a Landscape." Painting. Saltram Park, Devon, cat. 1967 no. 29. [Wright 1976, p. 160]

Johann Joseph Fux, 1660–1741. *Diane placata* [Diana Appeased]. Opera. First performed 19 Nov **1717,** Vienna. [EDS 1954–66, 5:791]

Jan Griffier, 1645–**1718.** "Classical Ruins with Diana and Nymphs." Painting. Sudbury Hall, Derbyshire, cat. 1973 no. 29. [Wright 1976, p. 83]

Johann David Heinichen, 1683–1729. *Diana sull' Elba* [Diana on Elba]. Serenata. First performed 18 Sep **1719,** Elba. [Grove 1980, 8:439]

Bernardino Cametti, 1669/70–1736. "Diana." Marble sculpture. Orsini Palace, Rome. *c.*1720. [Clapp 1970, 1:138]

Jacques Aubert, 1689–1753, with **Thomas-Louis Bourgeois,** 1676–1750/51 (vocal music). *Diane.* Symphonic divertissement. Text, Antoine Danchet. First performed 8 Sep **1721,** Chantilly. [Grove 1980, 1:683]

Adriaen van der Werff, 1659–**1722.** "Diana." Painting. Staatliche Museen, Berlin. [Bénézit 1976, 10:697]

François Boucher, 1703–1770. "Diana Resting" (watched by a satyr). Painting. *c.*1722. Lost. / Engraving by Pelletier. [Ananoff 1976, no. 6—ill.]

———. "Diana Resting." Painting. *c.*1742. Lost. [Ibid., no. 216]

———. "The Sleep of Diana." Painting. *c.*1742. Edouard Jonas coll. *c.*1932. [Ibid., no. 214—ill.]

———. "Diana Leaving the Bath." Painting. 1742. Louvre, Paris, inv. 2712. [Ibid., no. 215—ill. / Louvre 1979–86, 3:79—ill. / Vermeule 1964, p. 128—ill.] Copy by Edouard Manet, 1852. Lost. / Copy by Henri Fantin-Latour, 1854. Lost. [Ananoff]

———. "Diana and Her Companions" (huntresses meeting at a statue of Diana). Painting. *c.*1742. Maurice Fenaille coll., Paris. [Ibid., no. 218—ill.]

———. "Diana Returning from the Hunt." Painting. 1745. Musée Cognac-Jay, Paris, no. 10. [Ibid., no. 279—ill.]

Abraham Genoels, 1640–1723. "Landscape with Diana Hunting." Painting. Rijksmuseum, Amsterdam, inv. A1838. [Rijksmuseum 1976, p. 241—ill.]

Giovanni Battista Pittoni, 1687–1767. "Diana and Her Nymphs." Painting. *c.*1723. Museo Civico, Vicenza. [Zava Boccazzi 1979, no. 242—ill.]

———. "Diana the Huntress," "Diana." Frescoes. 1727.

Palazzetto Widman, Bagnoli di Sopra, Padua. [Ibid., nos. 6, 8—ill.] 2 modelloes, paintings. Sabin Gallery, London, in 1938. [Ibid., nos. 258–59—ill.]

François Le Moyne, 1688–1737, attributed (previously attributed to Watteau). "Putti Playing with the Accoutrements of Diana." Painting, sketch. *c.*1721–24? Christie-Miller coll., Salisbury, England. [Bordeaux 1984, no. 39—ill.]

―――. "Diana Returning from the Hunt." Painting, for Hôtel Peyrenc de Moras (Hôtel Biron, now Musée Rodin), Paris. 1729–30. Lost. [Ibid., no. 82]

―――, rejected attribution. "Venus and Cupid with Diana." Painting. University of Notre Dame Art Gallery, Ind. [Ibid., no. X4—ill.]

―――, rejected attribution. "Diana Asleep" (watched by satyr). Painting. Sold Palais Galleria, Paris, 1976 (as attributed to Le Moyne). [Ibid., no. X6—ill.]

Daniel Gran, 1694–1757. "Diana Lucina, Diana Luna, Diana Venatrix" (Diana as goddess of childbirth, the moon, the hunt). Fresco. **1723–24.** Formerly Gartenpalais Schwarzenberg, Vienna, destroyed. [Knab 1977, pp. 42ff., no. F10—ill.] Drawings. Albertina, Vienna. [Ibid., no. Z15—ill.]

―――. "Diana Received into Olympus." Fresco. 1732. Schloss Eckartsau, Austria. [Ibid., no. F47—ill.] Oil sketch. Barockmuseum, Österreichische Galerie, inv. 4178. [Ibid., no. Ö22—ill.]

Louis de Silvestre the Younger, 1675–1760. "History of Diana." Series of paintings. *c.*1725. Moritzburg Castle. [Hunger 1959, p. 54]

Francesco Trevisani, 1656–1746. "A Lady as Diana." Painting. *c.*1725? Earl of Mansfield coll., Scone Palace, Perthshire. [DiFederico 1977, no. P17—ill.] Variant. Campbell coll., Crarae, Scotland. [Ibid.]

Antonio Bellucci, 1654–1726. "Diana." Painting. Central Museum and Art Gallery, Northampton, inv. P.59.1974. [Wright 1976, p. 14]

Anton Domenico Gabbiani, 1652–1726. "Diana." Painting. Musée des Beaux-Arts, Chambéry. [Bénézit 1976, 4:569]

Alessandro Gherardini, 1655–1726 (previously attributed to Giovanni da San Giovanni, Baldassare Franceschini). "Diana Sleeping, with Boy and Hounds." Fresco. Victoria and Albert Museum, London, no. 680–1864. [Kauffmann 1973, no. 148—ill.]

Johannes Glauber, 1646–1726. "Arcadian Landscape with Diana Bathing." Painting. Rijksmuseum, Amsterdam, inv. A119. [Rijksmuseum 1976, p. 243—ill.]

François de Troy, 1645–1730. "Diana Resting." Painting. **1727.** Musée des Beaux-Arts, Nancy. [Bordeaux 1984, fig. 385]

Noël-Nicolas Coypel, 1690–1734. "Diana Bathing." Painting. **1728.** Hermitage, Leningrad, inv. 2757. [Hermitage 1986, no. 36—ill.]

Marcantonio Franceschini, 1648–1729. "Diana Hunting." Painting. Statens Museum for Kunst, Copenhagen. [Copenhagen 1951, no. 225]

François Bouvard, *c.*1683–1760. *Diane et l'amour.* Opera. First performed **1730**, France. [EDS 1954–66, 2:935]

Carle van Loo, 1705–1765. "Diana Resting." Ceiling painting, for Villa Stupinigi, Piedmont. **1732–33.** / Study.

Hermitage, Leningrad, inv. 1140. [Hermitage 1986, no. 265—ill.]

―――. "Diana's Kiss." Painting. Muzeum Narodowe, Warsaw, inv. 72818. [Warsaw 1969, no. 689—ill.]

―――. "Artemis." Painting. Musée Municipal, Alençon. [Bénézit 1976, 6:729]

François Collin de Blamont, 1690–1760. "La feste de Diane" [Festival of Diana]. Entrée added to *Les festes grecques et romaines.* Ballet héroïque. Libretto, Louis Fuzelier. First performed 9 Feb **1734**, l'Opéra, Paris. [Grove 1980, 4:562, 563; 7:47]

Giovanni Battista Tiepolo, 1696–1770. "Triumph of Diana." Fresco, part of "Iphigenia" cycle. **1736.** Palazzo Cornaro di S. Maurizio, Merlengo. [Pallucchini 1968, no. 112 / also Morassi 1962, p. 23] Sketches ("Diana," "Apollo and a Goddess [Diana?]"). Dulwich College Picture Gallery, London. [Pallucchini—ill. / Morassi, p. 17—ill.]

―――. "Apollo and Diana." Fresco. 1757. Sala dell' Olimpo, Villa Valmarana, Vicenza. [Pallucchini 1968, no. 240—ill. / Morassi 1962, p. 65]

John Cheere, 1709–1787. "Diana." Lead garden statue, for Stourhead, Wiltshire. **1743.** [Woodbridge 1965, p. 95]

―――. "Diana." Lead garden statue. Major Simon Whitbread coll., Southill. [Warburg]

Charles-Joseph Natoire, 1700–1777. "The Repose of Diana." Painting, decoration for Château de Marly. **1743.** Petit-Trianon, Versailles. [Troyes 1977, no. 33 *n.* / Boyer 1949, no. 64]

―――. "The Toilet of Diana." Oil sketch. Musée, Carcasonne, no. 132. [Boyer, no. 99]

―――. "Diana Hunting" (resting after the hunt). Painting. Sold Paris, 1862. [Ibid., no. 102]

―――. "Diana and Her Nymphs, Surrounded by Cupids." Painting. Sold Paris, 1920. [Ibid., no. 103]

Giovanni Battista Piazzetta, 1683–1754. "Diana." Drawing. **1743.** National Gallery of Victoria, Melbourne. [Mariuz 1982, no. D14—ill.]

Charles-Michel-Ange Challe, 1718–1778. "Sleeping Diana." Painting. **1744.** Herzog Anton Ulrich-Museum, Braunschweig, no. 538. [Braunschweig 1969, p. 44]

Jean-Marc Nattier, 1685–1766. "Marie Adélaïde of France as Diana." Painting, for Louis XV. *c.*1745. Château de Versailles. / Replicas. Uffizi, Florence, dep. 21; Rothschild coll., Ferrières. [Royal Academy 1968, no. 497 / also Uffizi 1979, no. P1101—ill.]

―――. "Portrait of a Lady as Diana." Painting. 1756. Metropolitan Museum of Art, New York, no. 03.37.3. [Metropolitan 1980, p. 133—ill.]

José Nebra, 1702–1768, music. *La colonia de Diana* [The Colony of Diana]. Theatrical work. First performed 7 Sep **1745**, Madrid. / Revised, performed 29 Apr 1746. [Grove 1980, 13:89]

Nicolas de Largillière, 1656–1746. "Portrait of a Woman as Diana." Painting. Louvre, Paris, no. M.I. 1079, on deposit at Musée, Pau. [Louvre 1979–86, 4:31]

―――, follower. "A Lady as Diana." Painting. Bowes Museum, Barnard Castle, County Durham, list 1971.383. [Wright 1976, p. 114]

Nicolaes Verkolje, 1653–1746. "Diana Huntress with Nymphs." Painting. Count von Moltke coll., Bielefeld. [Warburg]

Giovanni Alberto Ristori, 1692–1753. *Diana vendicata* [Diana Vindicated]. Opera (festa per musica). Libretto, G. C. Pasquini. First performed 8 Dec **1746,** Dresden. [Grove 1980, 16:56]

Franz Anton Maulbertsch, 1724–1796. (Diana in) "Allegory of the Four Seasons." 2 variant oil sketches for a ceiling painting. *c.*1750. Städelsches Kunstinstitut, Frankfurt; Österreichische Galerie, Vienna. [Garas 1960, nos. 24–25, p. 14—ill.]

——. (Diana in) "Allegory of the Four Seasons" ("Allegory of Time and Truth"). Ceiling painting. *c.*1750. Schloss Suttner, Kirchstetten, Austria. [Ibid., no. 26, pp. 13f.—ill.]

——. "Mythological Scene with Diana and Apollo" (and other gods). Painting. *c.*1750. Muzeum Narodowe, Warsaw, inv. 130543. [Ibid., no. 28, p. 15—ill. / Warsaw 1969, no. 767—ill.] Another version in Barockmuseum, Vienna. [Hunger 1959, p. 41]

——. "The Reward of Chastity" ("Allegory with Diana and Apollo") (Diana bestows a medal on a lady and cavalier, with other gods). Drawing. *c.*1750. Albertina, Vienna. [Garas, no. 33, p. 16—ill.]

——. "Diana and Mercury." Drawing, sketch for a ceiling painting. *c.*1754. Philipp Hermann coll., Karlsruhe. [Ibid., no. 59—ill.]

——. Diana and Bacchus, representing Spring, in "Allegory of the Seasons and Elements." Painting, study for a ceiling decoration. *c.*1754. Germanisches Nationalmuseum, Nuremberg. [Ibid., no. 61, p. 33—ill.]

——. "The Bath of Diana." Painting (study for a ceiling decoration?). *c.*1759. Österreichische Galerie, Vienna. [Ibid., no. 117—ill. / Augsburg 1975, no. E91—ill.]

Jean-Philippe Rameau, 1683–1764, music. *Zéphyre* (first called *Les nymphes de Diane*). Acte de ballet. **1748–51.** Unperformed. [Girdlestone 1983, pp. 481f., 623 / Grove 1980, 15:571]

Pompeo Batoni, 1708–1787. "Portrait of a Lady of the Milltown Family (Lady Leeson) as Diana." Painting. **1751.** National Gallery of Ireland, Dublin, no. 703. [Clark 1985, no. 148—ill. / Dublin 1981, p. 7—ill.] Copy in National Gallery of Ireland, Dublin, no. 1650. [Dublin—ill.]

——. "Sarah, Lady Fetherstonhaugh" (as Diana). Painting. 1751. National Trust coll., Uppark, Sussex. [Clark, no. 155—ill.]

——. "Carlotta Ondedci Caetani, Duchess of Sermoneta" (as Diana). Painting. *c.*1750–52, unfinished? Palazzo Caetani, Rome. [Ibid., no. 166—ill.]

——. "Diana Awakened by a Nymph." Painting. *c.*1761, unfinished. Private coll., Milan. [Ibid., no. 234—ill.]

Jean-Honoré Fragonard, 1732–1806. "Diana Resting." Painting. **1748–52.** Private coll. [Wildenstein 1960, no. 26—ill.]

——. "Diana and Cupids Sprinkling Flowers on the World and Setting it Ablaze" ("Night"). Painting. 1748–52. Musée de l'Ile de France, Cap Ferrat. [Ibid., no. 82—ill.]

Jacopo Amigoni, 1675–1752. "Portrait of a Lady as Diana." Painting. Gemäldegalerie, Berlin-Dahlem, no. 1659. [Berlin 1986, p. 11—ill.]

Henry Fuseli, 1741–1825. "Naked Figure of Diana with a Spear. . . ." Drawing. **1752.** Kunsthaus, Zürich (*Jugendalbum*). [Schiff 1973, no. 116]

——. "Diana Leaving the Bath." Drawing. 1800–05. Oskar Reinhart Estate, Winterthur. [Ibid., no. 1458—ill.]

Ferdinand Dietz, ?–*c.*1780. "Diana." Garden sculpture, from Schloss Seehof. **1754–55.** Bayerisches Museum, Munich. [Warburg]

——. "Diana." Garden sculpture. Liebighaus, Frankfurt. [Warburg]

Giovanni Battista Ferrandini, *c.*1710–1791. "Diana placata" [Diana Appeased]. Serenata. First performed 17 Aug **1755.** / Revised, performed 1758, Munich. [Grove 1980, 6:485]

Rosalba Carriera, 1675–1757. "A Lady in the Character of Diana." Watercolor and gouache miniature. Gemäldegalerie, Dresden, no. M18. [Dresden 1976, p. 116] Copy ("Diana with a Greyhound"), watercolor and gouache miniature, by Felicita Sartori Hoffmann (?–1760). Dresden, no. M31. [Ibid., p. 117]

François-Gaspard Adam, 1710–1761. "Diana Bathing." Statue, part of mythological cycle. **1755–58.** Gardens, Sanssouci, Potsdam. [Thirion 1885, pp. 161f.—ill.]

Antonio Guardi, 1698–1760. "Triumph of Diana." Fresco. Ca' Rezzonico, Venice. [Morassi 1984, no. 86—ill.]

Louis Galloche, 1670–1761, attributed (previously attributed to anonymous French School or Louis Chalon). "Diana and Actaeon." Painting. Hermitage, Leningrad, inv. 1163. [Hermitage 1986, no. 50—ill.]

Franz-Christoph Janneck, 1703–1761. "The Repose of Diana." Painting. [Bénézit 1976, 6:34]

Edmé Bouchardon, 1698–1762. "The Bath of Diana." Drawing. Louvre, Paris. [Pigler 1974, p. 76]

Italian School (copy after Pietro Rotari? 1707–1762). "Diana." Painting. Gemäldegalerie, Berlin-Dahlem, no. 3/84. [Berlin 1986, p. 65]

Hendrick Frans van Lint, 1684–1763. "Diana and Nymphs Bathing." Painting. Art Gallery and Christ Church Mansion, Ipswich. [Wright 1976, p. 118]

Gaspare Angiolini, 1731–1803, choreography. *Apollon et Diane.* Ballet. Music, Joseph Starzer. First performed **1763,** Vienna. [Grove 1980, 18:82]

Louis de Moni, 1698–1771. "Diana and Her Nymphs." Painting. Museum Bisdom van Vliet, Haastrecht. [Wright 1980, p. 282]

Nicolas-Guy Brenet, 1728–1792. "Diana." Painting. Exhibited Salon of **1771,** Paris. [Bénézit 1976, 2:297]

William Taverner, 1703–1772. "The Bath of Diana." Painting. / Engraving by Thomas Gaugain, 1780. [Pigler 1974, p. 76]

Jean-Antoine Houdon, 1741–1828. "Diana (the Huntress)." Statue. Plaster model (replica of original plaster, lost?), *c.*1776. Schlossmuseum, Gotha. [Frick 1968–70, 4:127ff.] / Marble busts, 1778. National Gallery, Washington, D.C.; Musée des Arts Décoratifs, Paris. [Réau, no. 5F—ill. / also Walker 1984, fig. 1016] Life-size terra-cotta replica. *c.*1778–82. Frick Collection, New York, no. 39.2.79. [Frick—ill. / Janson 1985, pp. 43f.—ill. / Réau 1964, no. 5A—ill.] Marble replica, 1780. Gulbenkian coll., Palàcio Pombal, Oeiras. [Frick / Réau, no. 5C—ill.] 3 bronze casts. Huntington Art Gallery, San Marino, Calif. (1782); Louvre, Paris (1790); Musée de Tours (1839). [Frick] 2 plaster reduc-

tions. Musée Houdon, Versailles; the other lost. [Réau, nos. 5B, 5D]

James Hook, 1746–1827. *Diana.* Cantata. First performed 29 June **1777**, Covent Garden, London. [Grove 1980, 8:685]

Joseph Nollekens, 1737–1823. "Diana." Marble sculpture. *c.***1773–78.** Wentworth Woodhouse, Yorkshire. [Whinney 1964, p. 159]

[?] Simonet, choreography. *Les nymphes de Diane.* Ballet. First performed 24 Nov **1778**, King's Theatre, London. [Guest 1972, p. 149]

Angelica Kauffmann, 1741–1807. "Diana with One of Her Nymphs." Painting. Exhibited **1779**. [Manners & Williamson 1924, pp. 46, 238]

———, attributed. "Diana with Her Nymphs and Hounds." Ceiling painting. 20 Queen Anne's Gate, London. [Ibid., p. 133—ill.]

———, attributed. "Diana." Ceiling painting, from Ashburton House. Formerly Litchfield Gallery, London. [Ibid., p. 195]

———, attributed. "Homage to Diana." Painting. Unlocated. [Ibid., p. 219]

Pieter Scheemakers, 1691–1781. "Artemis." Sculpture. Louvre, Paris, no. 462. [Whinney 1964, p. 257 *n.*10]

Jean-Hugues Taraval, 1729–1785. "Diana Surprised in Her Bath." Painting. [Bénézit 1976, 10:76]

Vicente Martín y Soler, 1754–1806. *L'arbore di Diana* [The Tree of Diana]. Opera buffa. Libretto, Lorenzo Da Ponte. First performed 1 Oct **1787**, Burgtheater, Vienna. [Grove 1980, 11:736] Revived 1797, King's Theatre, London, with added aria by Joseph Mazzinghi. [Ibid., 11:868]

William Blake, 1757–1827. "Diana." Drawing, illustrating Edward Young's *Night Thoughts* 10.1641–43. *c.***1795–97.** British Museum, London, no. 1929-7-13-251V. [Butlin 1981, no. 330.500]

French School. "Diana and Time." Painting. **18th century.** Galleria Palatina, Palazzo Pitti, Florence, no. 3879. [Pitti 1966, p. 240—ill.]

Jean-Frédéric Edelmann, 1749–1794. *Diane et l'amour.* Opera-ballet. Libretto, P. J. Moline. Choreographer unknown. First performed **1802**, Théâtre de Jeunes-Élèves, Paris. [Grove 1980, 5:835]

Gaspar Gabrielli, fl. 1803–30. "A Landscape with Diana and Attendants." Painting. **1803**. National Gallery of Ireland, Dublin, no. 4202. [Dublin 1981, p. 59—ill.]

Pierre-Paul Prud'hon, 1758–1823. "Diana Begs Jupiter Not to Subject Her to Hymen's Laws." Ceiling painting. **1803.** Ceiling, Salle d'Olympie (grecque archaïque), Louvre, Paris (inv. 20115). [Louvre 1979–86, 4:149—ill. / Guiffrey 1924, no. 872—ill.] Sketch. Louvre, no. R.F. 209. [Louvre, p. 150—ill. / Guiffrey, no. 873]

Washington Allston, 1779–1843. "Diana (and Her Nymphs) in the Chase" ("Swiss Scenery"). Painting. **1805**. Fogg Art Museum, Harvard University, Cambridge, inv. 1956.62. [Gerdts & Stebbins 1979, pp. 36, 43–46—ill. / Richardson 1948, no. 37—ill. / Harvard 1985, no. 209—ill.]

———. "Diana (Bathing)." Painting. *c.*1812. Lost. [Gerdts & Stebbins, p. 76 / Richardson, no. 73]

Charles-Louis Didelot, 1767–1837. "Apollo and Diana."

Pas de deux in ballet-divertissement. First performed Dec **1806**, St. Petersburg. [Beaumont 1938, p.17]

Francisco Goya, 1746–1828. "Artemis." Drawing. **1806–12.** Unlocated. [Gassier & Wilson 1981, no. 1423—ill.]

Johann Ernst Heinsius, 1740–**1812.** "Portrait of Baroness de Villequier as Diana." Painting. Louvre, no. M.N.R. 157. [Louvre 1979–86, 2:27—ill.]

Philipp Jakob Loutherbourg the Younger, 1740–**1812.** "Diana Reposing." Painting. Hermitage, Leningrad, inv. 8190. [Hermitage 1986, no. 127—ill.]

Thomas Stothard, 1755–1834. "Diana and Her Nymphs Bathing." Painting. Exhibited **1816**. Tate Gallery, London, no. 320. [Tate 1975, p. 76]

Piat Joseph Sauvage, 1744–**1818.** "Diana and Nymphs." Painting. Glynn Vivian Art Gallery, Swansea, cat. 1913 no. 89. [Wright 1976, p. 183]

Francesco Hayez, 1791–1882. "Diana" (portrait of Virginia Martini). Painting. **1820.** Private coll., Asti. [Coradeschi 1971, no. 42—ill.]

Fedosii Shchedrin, 1751–**1825.** "Diana." Marble statue. Russian Museum, Leningrad. [Kennedy 1983, p. 199]

Peter Cornelius, 1783–1867, and studio. "Evening" (Luna, with Hesperus and a maiden as Twilight), with pendants "Diana and Actaeon," "Diana and Endymion" in adjacent gussets. Ceiling frescoes. **1820–26.** Göttersaal, Glyptothek, Munich. [Glyptothek 1980, pp. 214ff., fig. 5]

Gaetano Grazzini, 1786–1858. "Diana the Huntress." Marble sculpture. *c.***1820–30.** Uffizi, Florence. [Uffizi 1979, no. P778—ill.]

Johann Baptist Lampi the Elder, 1751–**1830.** "Diana." Painting. Szépművészeti Múzeum, Budapest, no. 462. [Budapest 1968, p. 370]

Daniel-François-Esprit Auber, 1782–1871. "Pas de Diane" [Diana's Dance]. Orchestral composition, for the dancer Marie Taglioni. **1837.** [Grove 1980, 1:682]

Charles Gleyre, 1806–1874. "Diana." Painting. **1838.** Musée Cantonal des Beaux-Arts, Lausanne, inv. 1391. [Winterthur 1974, no. 4—ill.]

———. "Diana the Huntress." Alexandre Denuelle coll. in 1878. [Clément 1878, no. 33]

Bertel Thorwaldsen, 1770–1844. "Diana with Her Hind." Relief, part of "Metamorphoses of Ovid" series. Executed by Pietro Galli from Thorwaldsen's designs, **1838.** Formerly Palazzo Torlonia, Rome, destroyed. / Plaster cast. Thorwaldsens Museum, Copenhagen, no. 459. [Thorwaldsen 1985, p. 55]

———. "Diana Beseeches Jupiter for Permission to Devote Herself to Hunting." Relief sculpture. Plaster original, 1840. Thorwaldsens Museum, no. A345. [Ibid., p. 47]

William Hilton the Younger, 1786–**1839.** "Venus, Diana, and Nymphs." Painting. Wallace Collection, London. [Bénézit 1976, 5:547]

Robert Browning, 1812–1889. "Artemis Prologizes." Dramatic monologue. In *Bells and Pomegranates no. III: Dramatic Lyrics* (London: Moxon, **1843**). [King et al. 1969–88, vol. 3 / Ward 1969, pp. 85, 113]

———. (Artemis described in) "With Gerard de Lairesse" stanza 9. Monologue. In *Parleyings with Certain People of Importance in Their Day* (London: Smith, Elder, 1887). [Scudder 1895]

Jules Perrot, 1810–1882, choreography. *Pas de Diane chas-*

seresse [Dance of Diana Huntress]. Ballet movement. First performed 20 Apr **1843**, Her Majesty's Theatre, London. [Guest 1984, pp. 96, 353]

Heinrich Heine, 1797–1856. "Diana." Poem. In *Neue Gedichte* (Hamburg: Hoffmann & Campe, **1844**). [Windfuhr 1975–82, vol. 2 / Draper 1982]

————. *Die Göttin Diana* [The Goddess Diana]. "Dance-poem," scenario for ballet/pantomime. 1846. In *Vermischte Schriften* (Hamburg: Hoffmann & Campe, 1854). [Windfuhr, vol. 9 / Sammons 1979, pp. 289, 317 / Sandor 1967, pp. 37–41 / Butler 1958, pp. 244, 286]

————. (Diana, turned lustful, in) *Atta Troll: Ein Sommernachtstraum* [Atta Troll: A Summer Night's Dream]. Satirical epic poem. 1841–47. Hamburg: Hoffmann & Campe, 1847. [Windfuhr, vol. 4 / Draper]

George Frederick Watts, 1817–1904. "Diana's Nymphs." Painting. *c.***1846**. Watts Gallery, Compton. [Watts 1970, no. 95]

Thomas Crawford, 1813–1857. "Apollo and Diana." Marble sculpture group. **1848**. Rollins College, Winter Park, Fla. [Gerdts 1973, pp. 20, 34f., fig. 165]

Narcisse-Virgile Diaz de la Peña, 1808–1876. "Diana." Painting. **1849**. Metropolitan Museum, New York, no. 25.110.30. [Metropolitan 1980, p. 47—ill.]

Richard James Wyatt, 1795–**1850**. "Diana Huntress." Marble statue. Galleria dell' 800 di Capodimonte, Naples, no. 5051. [Capodimonte 1964, p. 63]

George Washington Smith, 1820–1899, choreography. *Diana and Her Nymphs*. Ballet. **1851**. [EDS 1954–66, 9:56]

Karl-Joseph-Aloys Agricola, 1779–**1852**. "Diana." Painting. Harrach coll., Vienna. [Bénézit 1976, 1:60]

Anselm Feuerbach, 1829–1880. "Diana Emerging from the Bath, Surrounded by Nymphs." Painting. **1854–55**. Bayerische Staatsgemäldesammlungen, Munich. [Karlsruhe 1976, no. 23—ill.]

Arnold Böcklin, 1827–1901. "Hilly Countryside with Diana's Hunting Party." Painting. *c.***1855**. Städtische Kunsthalle, Mannheim, inv. 745. [Andree 1977, no. 84—ill.]

————. "Diana's Hunt." Painting. 1862. Kunstmuseum, Basel, inv. 99. [Ibid., no. 143—ill.]

————. "Sleeping Diana, Observed by Two Fauns." Painting. 1877. Kunstmuseum, Düsseldorf, inv. 5561. [Ibid., no. 314—ill.]

————. "(Landscape with) Diana's Hunt." 1895–96. Painting. Louvre, Paris, inv. R.F. 1977–1. [Ibid., no. 456 / Louvre 1979–86, 2:356—ill.] Oil sketch, 1894. Private coll. [Andree, no. 455—ill.]

Jean-Baptiste Camille Corot, 1796–1875. "Diana and Her Attendants" ("Diana's Bath"). Painting. **1855**. Musée des Beaux-Arts, Bordeaux. [Orangerie 1975, no. 75—ill. / also Robaut 1905, no. 1065—ill. / Arts Council 1965, no. 72—ill.]

————. "The Sleep of Diana." Painting. 1865. Metropolitan Museum, New York, no. 08.236. [Metropolitan 1980, p. 32—ill. / Lyons 1936, no. 87 / also Robaut, no. 1633—ill.] Oil sketch. [Robaut, no. 1631] Variant drawing. Louvre, Paris, inv. R.F. 23334. [Orangerie, no. 165—ill. / also Hours 1972, p. 65—ill. / Robaut, no. 2979—ill.]

————. "Diana Bathing." Painting. 1869–70. Sarlin coll. in 1903. [Robaut, no. 1515—ill.]

————. "Diana Bathing." Painting. 1873–74. [Ibid., no. 2178—ill.]

Paul Baudry, 1828–1886. "Diana Reposing." Overdoor painting, for Hôtel Achille Fould, Paris. *c.***1859**. Château de Chantilly. / Variant sketch. Walters Art Gallery, Baltimore, inv. 37.12. [Walters 1982, no. 113—ill.]

Armand Cambon, 1819–1885. "Diana at the Bath." Painting. Exhibited Salon of **1861**. Lost. / Drawing. Musée Ingres, Montauban. [Montauban 1965, no. 45—ill.]

Hans von Marées, 1837–1887. "Diana Resting." Painting. **1863**. Neue Pinakothek, Munich, inv. 7866. [Gerlach-Laxner 1980, no. 61—ill. / Munich 1982, p. 210—ill.] Oil study ("The Bath of Diana"). Kunsthalle, Hamburg, inv. 1468. [Gerlach-Laxner, no. 60—ill. / Hamburg 1969, p. 206—ill.]

Théodore de Banville, 1823–1891. *Diane au bois* [Diana in the Woods]. Comedy in verse. Paris: Lévy, **1864**. [NUC]

————. "Artémis partant pour la chasse" [Diana Leaving for the Hunt]. Poem. In *Le sang de la coupe* (Paris: Lemerre, 1874). [DLLF 1984, 1:146f.]

Aimé-Jules Dalou, 1838–1902. "Diana Reclining on a Kneeling Stag." Painted plaster relief. **1864**. Hôtel Pavïa, Paris. [Hunisak 1977, p. 41, fig. 16 / Caillaux 1935, p. 124]

————. "Diana with Quiver." Bronze sculpture. Edition of 10. / Terra-cotta model. Petit Palais, Paris, no. 232. [Caillaux, p. 155]

Dante Gabriel Rossetti, 1828–1882. "Diana." Drawing or painting (known only from hearsay). *c.***1865**. Lost. [Surtees 1971, no. 188]

José-Maria de Heredia, 1842–1905. "Artemis et les Nymphes." Cycle of 5 sonnets. "Artémis," "La dhasse" [The Hunt] first published in *Le Parnasse contemporain* **1866**; "Nymphée" in *La muse orientale* 15 Oct 1877; "Pan" in *Revue française* May-Aug 1863; "Le bain des Nymphes" ("Nymphée") in *Revue des deux mondes* 15 May 1890. Collected in *Les trophées* (Paris: Lemerre, 1893). [Delaty 1984, vol. 1; cf. 2:89 / Hill 1962]

Pierre-Auguste Renoir, 1841–1919. "Diana (the Huntress)." Painting. **1867**. National Gallery of Art, Washington, D.C. [White 1984, p. 23—ill. / Daulte 1971, no. 30—ill. / Winterthur 1974, p. 119—ill. / Sienkewicz 1983, p. 28—ill. / also Walker 1984, fig. 684]

Henri Fantin-Latour, 1836–1904. "Diana" (mounting her chariot). Painting. **1871**. [Fantin-Latour 1911, no. 466]

————. "Vision of Diana." Painting. 1871. [Ibid., no. 515]

————. "Diana in Repose." Painting. 1879. [Ibid., no. 926]

————. "Bath of Diana." Painting. 1884. [Ibid., no. 1158]. Replica ("Bather"). 1895. Picard coll. in 1911. [Ibid., no. 1586]

————. "Diana and Her Followers." Painting. 1892. [Ibid., no. 1470]

————. "Diana Sleeping." Painting. 1895. Formerly Kerchner coll., sold 1902. [Ibid., no. 1574]

————. "Diana Reclining in the Moonlight." Painting. 1896. Sold Paris, 1909. [Ibid., no. 1632]

————. "Diana" (reclining). Painting. 1898. Henri Rouart coll. in 1911. [Ibid., no. 1697]

————. "Diana" (seated). Painting. 1899. [Ibid., no. 1762]

————. "Diana and a Cupid." Painting. 1900. [Ibid., no. 1802]

————. "Diana" (mounting her chariot). Painting. 1900. National Gallery of South Australia, Adelaide. [Lucie-Smith 1977, p. 157 / Fantin-Latour, no. 1832]

————. "Diana" (bathing). Lithograph, illustrating André Chénier's poem "Diane." 1903. [Hédiard 1906, no. 172—ill. / Fantin-Latour, no. 2025]

———. "Diana and Her Court." Painting. 1904, unfinished. Victoria Fantin-Latour coll. in 1911. [Fantin-Latour, no. 2166]

———. "Diana the Huntress." Painting. [Fantin-Latour, no. 2242]

Arthur Sullivan, 1842–1900. (Aged Diana in) *Thespis; or, The Gods Grown Old.* Comic operetta. Libretto, W. S. Gilbert. First performed 26 Dec **1871,** Gaiety Theatre, London. Music lost. [Jefferson 1984, pp. 23ff.]

Hans Makart, 1840–1884. "Nymph and Faun Hunting" ("Hunt of Diana"). Painting, part of decoration for Palais Helfert, Vienna. **1871–72.** Unlocated. [Frodl 1974, no. 163.4—ill.]

———. "The Hunt of Diana." Painting. 1880. Ringling Museum of Art, Sarasota, Fla., inv. 451. [Ibid., no. 341—ill.] 2 oil sketches. Bayerische Staatsgemäldesammlungen, Munich, inv. 13294; another unlocated. [Ibid., nos. 340, 334—ill.]

———. "The Young Diana." Painting. Bizományi Aruház Vállalat, Budapest, in 1960. [Ibid., no. 608]

Edmund-Louis-Auguste Lévêque, 1814–1875. "Diana." Marble statue. Before **1872.** Jardin des Tuileries, Paris (Musées Nationaux, inv. 141). [Orsay 1986, p. 175]

Walter Crane, 1845–1915. "Diana at the Bath." Watercolor. **1872.** [Kestner 1989, p. 238]

———. "Diana." Painting. 1881. [Ibid., p. 239]

Jules-Élie Delaunay, 1828–1891. "Diana" (bathing). Painting. **1872.** Musée d'Orsay, Paris, no. R.F. 2712. [Louvre 1979–86, 3:213—ill.]

Gustave Moreau, 1826–1898. "Diana the Huntress" (riding on the back of a hunter whom she has turned into a stag). Painting. *c.*1872. Sold Paris, Drouot, 1918. [Mathieu 1976, no. 136—ill.]

Hiram Powers, 1805–1873. "Diana." Marble sculpture. After 1863. Glasgow Art Gallery and Museum. [Gerdts 1973, p. 79, fig. 50]

Paul Lindau, 1839–1919. *Diana.* Drama. In *Theater* (Berlin: **1874).** [EDS 1954–66, 6:1508]

Arthur Rimbaud, 1854–1891. (Diana evoked in) "Villes I" [Cities I]. Prose poem, part of *Les illuminations. c.*1874. In *La vogue* 1886; reprinted Paris: Vanier, 1895. [Adam 1972 / Fowlie 1966]

C. Hubert Parry, 1848–1918. "To Diana." Song for 3 female voices, setting of "Queen and Huntress, Chaste and Fair," from Ben Jonson's *Cynthia's Revels* (1600–01). **1875.** [Grove 1980, 14:244]

Louis Mérante, 1828–1887, choreography. *Sylvia, ou La nymphe de Diane.* Ballet. Music, Léo Delibes. Libretto, Jules Barbier and Baron de Reinach, after Tasso's *Aminta* (1573). First performed 14 June **1876,** L'Opéra, Paris; scenery, Jules Chéret, Alfred Rubé, and Philippe Chaperon; costumes, Eugène Lacoste. [Grove 1980, 5:337 / Simon & Schuster 1979, pp. 136f. / DMB 1959, p. 330]

Edmund Gosse, 1849–1928. "The Praise of Artemis." Poem. In *New Poems* (London: Kegan Paul, **1879).** [Bush 1937, p. 560]

Gabriele D'Annunzio, 1863–1938. "Ad Artemide." Poem, translation of Homeric Hymn to Artemis, part of "Dal Greco." In *Primo vere,* 2d edition (Lanciano: Carabba, **1880).** [Palmieri 1953–59, vol. 1]

———. "A Diana (da Orazio)." Poem. In *Primo vere* (1880). [Ibid.]

———. "Diana inerme" [Diana Unarmed]. Poem. In *Fanfulla della domenica* 8 Nov 1885 (with illustrations by Alesandro Moreni and Giuseppe Cellini); collected in *La chimera* (Milan: Treves, 1890). [Ibid., vol. 2]

Adolphe Dennery (D'Ennery), 1811–1899, and **Jules Henri Brésil,** 1818–1899. *Diana.* Drama. First performed 15 Oct **1880** (?), Paris. [EDS 1954–66, 2:1080, 4:477]

William Hamo Thornycroft, 1850–1925. "Artemis." Sculpture. Several versions. *c.***1880–82.** Marble, formerly Eaton Hall, Cheshire. Original plaster, Town Hall, Macclesfield. [Read 1982, pp. 291f., 341, pl. 38 / also Beattie 1983, p. 147, pl. 139] Sketch. Tate Gallery, London, no. 4215. [Tate 1975, p. 215]

Alexandre Falguière, 1831–1900. "Head of Diana." Bronze bust. *c.***1882.** Hirshhorn Museum and Sculpture Garden, Washington, D.C. [Hirshhorn 1974, p. 692, pl. 45]

Gustave Doré, 1832–**1883.** "Diana the Huntress." Painting. [Bénézit 1976, 3:641]

Albert-Ernest Carrier-Belleuse, 1824–1887. "Diana Victorious." Marble statue. *c.***1885.** / Terra-cotta reduction. Private coll. [Beattie 1983, p. 173, pl. 168]

Claude Debussy, 1862–1918. Choral music for Act 2 scenes 3 and 4 of de Banville's *Diane au bois* (1864). **1883–86.** Unpublished. [Grove 1980, 5:294f., 311]

Giacomo Puccini, 1858–1924. "Inno a Diana" [Hymn to Diana]. Song. Text, C. Abeniacar (F. Salvatori). **1887.** [Grove 1980, 15:439]

Hans Thoma, 1839–1924. "Apollo and Diana." Painting. **1887.** Unlocated. [Thode 1909, p. 262—ill.]

———. "Diana under a Tree." Painting. Muzeum Narodowe, Warsaw, inv. 186363. [Warsaw 1969, no. 1286—ill.]

Olin Levi Warner, 1844–1896. "Diana." Bronze statuette. **1887.** Metropolitan Museum, New York, no. 98.9.5. [Metropolitan 1965, p. 42] Marble replica. New York art market in 1903. [Ibid.]

Madison Cawein, 1865–1914. "Artemis." Poem. In *The Triumph of Music and Other Lyrics* (Louisville, Ky.: Morton, **1888).** [Boswell 1982, p. 70]

Katti Lanner, 1829–1908, choreography. *Diana.* Ballet. First performed 31 Oct **1888,** Empire Theatre, London. [EDS 1954–66, 6:1226]

Raimundo de Madrazo y Garreta, 1841–1920. "The Marquise d'Hervey Saint-Denys as Diana." Painting. **1888.** Louvre, Paris, inv. 20417. [Louvre 1979–86, 2:118—ill.]

Frederick William MacMonnies, 1863–1937. "Diana." Bronze statuette. **1890.** Metropolitan Museum, New York, no. 27.21.9; Minneapolis Institute of Arts, no. 64–62; elsewhere? [Metropolitan 1965, p. 83 / Minnesota 1985, pp. 74f.—ill.]

Augustus Saint-Gaudens, 1848–1907. "Diana." Colossal bronze statue, weathervane for Madison Square Garden, New York. First version, **1886–91,** installed 1891, moved to Columbian exposition grounds 1892, partially destroyed by fire 1894, lost. [Dryfout 1982, no. 144—ill.] Second version, 1892–94, installed 1894, removed 1925, in storage 1925–32, given to Philadelphia Museum of Art. [Ibid., no. 154—ill. / Janson 1985, pp. 253f.] Numerous bronze models and reduced replicas (some called "Diana of the Tower"); also bronze head (1908) and bronze bust ("Diana of the Tower"). Saint-Gaudens National Historic Site, Cornish, N.H. (plaster model and bronze cast, 1972); Metropolitan Museum, New York; National Gallery,

Washington, D.C.; elsewhere. [Dryfhout / also Metropolitan 1965, p. 52—ill. / Walker 1984, fig. 1028]

Elihu Vedder, 1836–1923. "Diana Passes." Drawing. **1892.** Georgia Museum of Art, University of Georgia, Athens. [Soria et al. 1979, fig. 247]

———. "Diana at the Hunt." Drawing, study for (unexecuted?) decoration for home of Collis P. Huntington, New York. 1892–93. Love family coll. [Ibid., pp. 209f.—ill.]

———. "Diana." Painting. 1895? Unlocated. [Soria 1970, no. 519]

Richard Garnett, 1835–1906. "Dian's Ways." Poem. In *Poems* (London: Mathews & Lane, **1893**). [Boswell 1982, p. 109]

Charles Marie René Leconte de Lisle, 1818–**1894.** "Parfum d'Artémis, la verviene." Poem, no. 4 of "Hymnes orphiques," verse translation from Orphic Hymns. In *Oeuvres: Derniers poèmes* (Paris: Lemerre, **1895**). [Pich 1976–81, vol. 4]

William Rockstro, 1823–**1895.** "Queen and Huntress." Song. Text, from Ben Jonson's *Cynthia's Revels* (1600–01). [Grove 1980, 16:85]

Maurice Boutet de Monvel, 1850–1913. "Rachel Boyer as Diana." Painting. **1896.** Louvre, Paris, no. R.F. 1974–14. [Louvre 1979–86, 3:91—ill.]

Daniel Chester French, 1850–1931. "Diana." Plaster sculpture. **1896.** Chesterwood, Stockbridge, Mass. [Richman 1976, p. 20—ill.]

Maurice Hewlett, 1861–1923. "A Hymn to Artemis." Poem. In *Songs and Meditations* (Westminster: Constable, **1896**). [Bush 1937, p. 564]

———. "Leto's Child." Poem. In *Artemision: Idylls and Songs* (New York: Scribner, 1899). [Boswell 1982, p. 133]

———. (Diana evoked in) "Arkadia." Poem. In *Gai Saber: Tales and Songs* (London: Mathews, 1916). [Ibid., p. 131]

Eugène Smits, 1826–1912. "Diana." Painting. By **1897.** Musées Royaux des Beaux-Arts (Musée d'Art Moderne), Brussels, inv. 3393. [Brussels 1984b, p. 566—ill.]

Emmanuel Fremiet, 1824–1910. "Chariot of Diana." Plaster model, for part of set of figurines. *c.***1897.** Musée d'Orsay, Paris, inv. R.F. 3429. [Orsay 1986, p. 157—ill.] Biscuit edition, by Manufacture de Sèvres, 1897–1942. / Bronze edition, by G. Leblanc-Barbedienne, from 1906. Musée des Beaux-Arts, Dijon (2 examples); elsewhere. [Ibid.]

Aubrey Beardsley, 1872–1898. "Atalanta in Calydon" ("Diana"). Drawing. In *The Idler* Mar **1897.** Unlocated. [Weintraub 1976, p. 223—ill. / also Reade 1967, no. 482—ill.]

Arthur Wardle, 1864–1949. "Diana." Painting. **1897.** [Kestner 1989, p. 335, pl. C.6]

Théodore Dubois, 1837–1924. "Diana." In *Poèmes virgiliens . . . pour piano.* Composition for piano. **1898.** Paris: Heugel, 1926. [Grove 1980, 5:665]

Alberto Nepomuceno, 1864–1920. *Artemis.* Opera. First performed **1898,** Rio de Janeiro. [Grove 1980, 13:110]

John Cowper Powys, 1872–1963. "To Diana" (triple-throned Diana). Poem. In *Poems* (London: Rider, **1899**). [Boswell 1982, p. 204]

Wallace Stevens, 1879–1955. (Diana evoked in) "Street Songs." Poem. In *Harvard Advocate* 3 Apr **1900.** [Buttel 1967, pp. 32, 34]

Paul de Vigne, 1843–**1901.** "Diana." Bronze sculpture.

Musées Royaux des Beaux-Arts, Brussels. [Hunger 1959, p. 54]

T. Sturge Moore, 1870–1944. *Aphrodite against Artemis.* Tragedy. London: Unicorn Press, **1901.** [DLB 1983, 19:333, 335, 350]

Marcellin-Gilbert Desboutin, 1823–**1902.** "Diana and Nymphs." Painting, sketch (for unknown work). Hermitage, Leningrad, inv. 8341. [Hermitage 1983, no. 126—ill.]

Ernst Barlach, 1870–1938. "The Goddess of the Hunt and a Youth in Woodland Scenery." Drawing. **1903.** Barlach Estate, Güstrow, inv. A.6. [Schult 1958–72, 3: no. 210—ill.]

Adolf Brütt, b. 1855. "Diana." Marble sculpture. **1903.** Staatliche Museen, Berlin. [Bénézit 1976, 2:367]

Enrique Rodriguez Larreta, 1875–1961. "Artemis." Poem. **1903.** In *Le novele semanal* (Buenos Aires) 1 no. 3 (1917). [DULC 1959–63, 3:50]

Heinrich Mann, 1871–1950. *Diana.* Novel, first in the trilogy *Die Göttinnen* [The Goddesses]. (Munich: Langen, **1903**). [DLB 1988, 66:315, 323f. / Seymour-Smith 1985, p. 565]

Charles Wellington Furse, 1868–1904. "Diana of the Uplands." Painting. **1903–04.** Tate Gallery, London, no. 2059. [Tate 1975, p. 134 / Hobson 1980, p. 65]

Feodora Gleichen, 1861–1922. Diana Fountain. Before **1906.** Hyde Park, London. [Read 1982, p. 355]

Arthur Dillon, b. 1873. *The Maid of Artemis.* Play. London: Mathews, **1906.** [Ellis 1985, p. 77]

Bertram MacKennal, 1863–1931. "Diana Wounded." Stone sculpture. *c.***1907.** Tate Gallery, London, no. 2266. [Tate 1975, p. 170]

John Davidson, 1857–1909. (The poet battles Diana, Apollo, and Thor in) *The Testament of John Davidson.* Poem. London: Richards, **1908.** [DLB 1983, 19:100]

Marie Laurencin, 1885–1956. "Artemis." Painting. *c.***1908.** Hermitage, Leningrad, inv. 9000. [Hermitage 1987a, pl. 264—ill.]

Rainer Maria Rilke, 1875–1926. "Kretische Artemis" [Cretan Artemis]. Poem. In *Neuen Gedichte: Anderer Teil* (Leipzig: Insel, **1908**). [Zinn 1955–66, vol. 1 / Leishman 1960]

Arthur B. Davies, 1862–1928. "Artemis." Painting. **1909.** Metropolitan Museum, New York, no. 1976.201.5. [Metropolitan 1965–85, 2:428ff.—ill.]

———. "Artemis—Mistress of the Months and Stars." Painting. 1916. Estate of Miss L. P. Bliss in 1931. [Cortissoz 1931, p. 20]

———. "Diana, Preserver." Painting. Artist's estate in 1931. [Cortissoz, p. 23]

Loie Fuller, 1862–1928, choreography. *Diana the Huntress.* Modern dance. First performed **1909,** Paris. [McDonagh 1976, p. 24]

Karl Bitter, 1867–1915. "Diana." Bronze statuette. **1910.** Metropolitan Museum, New York, no. 12.50. [Metropolitan 1965, p. 99]

Rembrandt Bugatti, 1884–1916. "Diana." Bronze statue. Exhibited Venice-Biennale, **1910.** [Clapp 1970, 1:119]

Émile-Antoine Bourdelle, 1861–1929. "Diana's Hunt at Night." Fresco. **1912.** Grand Galerie, Théâtre des Champs-Elysées, Paris. [Basdevant 1982, pp. 114f.—ill.] Watercolor and gouache studies. Musée Bourdelle, Paris. [Ibid.—ill.]

Eduardo Dalbono, 1841–**1915.** "Diana Huntress." Paint-

ing. Galleria dell' 800 di Capodimonte, Naples, no. 13667. [Capodimonte 1964, p. 73]

Serafín Alvarez Quintero, 1871–1938, and **Joaquín Alvarez Quintero,** 1873–1944, libretto. *Diana cazadora, o Pena de muerte al amor* [Diana the Huntress, or Death, Penalty for Love]. Musical comedy. First performed 19 Nov **1915,** Teatro de Apolo, Madrid. [McGraw-Hill 1984, 1:55]

Louis Glass, 1864–1936. *Artemis.* Music for ballet, opus 50. **1915.** Published as a suite, Copenhagen: 1939. [Grove 1980, 7:427]

Paul Manship, 1885–1966. "Diana" (running with hound). Relief in bronze ashtray, for National Sculpture Society. **1915.** [Murtha 1957, no. 68]

———. "Diana," (running with hound). Sculpture, pendant to "Actaeon" (running from 2 hounds). Various versions. Bronze statuette, 1921 (Actaeon added 1923). Carnegie Institute, Pittsburgh; Minnesota Museum of Art, St. Paul, nos. 66.14.103a, b. [Murtha 1957, nos. 138, 155 / Minnesota 1972, no. 26—ill.] Heroic-size gilded bronze replicas, 1924. Brookgreen Gardens, Georgetown, S.C. / Nickel bronze casts, 1939. Norton Gallery and School of Art, West Palm Beach, Fla. [Ibid., no. 166] Life-size replica, 1925, 5 casts. Ball State Teachers College, Muncie, Ind.; Art Gallery of Toronto; Hudson River Museum, Yonkers, N.Y.; elsewhere. [Ibid., no. 182 / Kilinski 1985, no. 32—ill.]

John Todhunter, 1839–**1916.** "The Wooing of Artemis." Poem. In *Trivium amoris.* (London: Dent, 1927.) [Boswell 1982, p. 304]

H. D. (Hilda Doolittle), 1886–1961. "The Huntress." Poem. In *Sea Garden* (London: Constable; Boston: Houghton, Mifflin, **1916**). [Martz 1983 / DLB 1986, 45:125]

———. "Triplex" (Artemis, Athene, Aphrodite). Poem. In *Red Roses for Bronze* (London: Chatto & Windus; Boston: Houghton Mifflin, 1931). [Martz / DLB 45:131]

Percy MacKaye, 1875–1956. (Diana evoked in) *The Chase.* Poem, 3 dance motives imagined for dances of Isadora Duncan. In *Poems and Plays* (New York: Macmillan, **1916**). [Boswell 1982, p. 270 / Bush 1937, p. 587]

Albert Pinkham Ryder, 1847–**1917.** "Diana." Painting. After 1880? John Mayers coll. [Goodrich 1959, fig. 53]

———. "Diana's Hunt." Painting. Cudney coll., Chicago. [Price 1932, no. 32—ill.]

Witter Bynner, 1881–1968. "Diana, Captive." Poem, to Saint-Gaudens's statue (1886–94). In *Grenstone Poems: A Sequence* (New York: Stokes, **1917**). [Ipso]

———. "O Hunted Huntress." Poem. In *Caravan* (New York: Knopf, 1925); *Selected Poems* (New York: Knopf, 1936). [Ipso]

Evelyn Pickering de Morgan, 1855–**1919.** "Diana and Her Hounds." Wash drawing. Sold Sotheby's, 1972. [Warburg]

Richard Aldington, 1892–1943. (Artemis worshiped in) "At Mitylene." Poem. In *Images* (London: Egoist, **1919**). [Boswell 1982, p. 9]

Romain Coolus, 1868–1952, and **Charles Maurice Hennequin,** 1863–1926. *Diane au bain* [Diana in the Bath]. Drama. First performed 3 Mar **1922,** Nouveautés, Paris. [EDS 1954–66, 3:1376, 6:274]

Nicola Guerra, 1865–1942, choreography. *Artemis troublée.* Ballet. Music, Paul Paray's symphonic poem, *Adonis*

troublé (1921). First performed 28 Apr **1922,** L'Opéra, Paris; scenery and costumes, Léon Bakst. [Oxford 1982, p. 189 / Grove 1980, 14:180] Bakst's original designs in Lobanov-Rostovsky coll., New York; elsewhere? [Spencer 1973, p. 236, pls. 142–44]

Anna Vaughn Hyatt Huntington, 1876–1973. "Diana of the Chase." Bronze sculpture. **1922.** Brookgreen Gardens, Georgetown, S.C. [Clapp 1970, 2 pt. 2: 554]

———. "Youthful Diana." Bronze sculpture. Fine Arts Gallery, San Diego. [Ibid.]

Edward McCartan, 1879–1947. "Diana." Bronze statue. **1920–23.** Private coll., Greenwich, Conn. / Reductions. Metropolitan Museum, New York, no. 23.106.1; Brookgreen Gardens, S.C.; Fogg Art Museum, Harvard University, Cambridge; Canajoharie Art Gallery, N.Y. [Metropolitan 1965, pp. 138f. / also Agard 1951, fig. 89]

Ker-Xavier Roussel, 1867–1944. "Diana Resting." Painting. **1923.** Musée Nationale d'Art Moderne, Paris. [Bénézit 1976, 9:141]

———. "The Sleep of Diana." Print. [Alain 1968, no. 119—ill.]

Jenö Zádor, 1894–1977. *Diana.* Opera. Libretto, J. Mohacsi. First performed 22 Dec **1923,** Budapest. [Baker 1984, p. 2550 / Grove 1980, 20:617]

Irénée Berge, 1867–**1926.** "Les nymphes d'Artémis." Song. Text, Baudoux. [Cohen 1987, 1:76]

Henri Weigele, 1858–**1927.** "Diana." Marble bust. Musées Nationaux, deposited in Musée, Bagnères-de-Bigorre, in 1934. [Orsay 1986, p. 283] Another version, marble and bronze (inv. Ch. M. 20) known, unlocated. [Ibid.]

Francis Jammes, 1868–1938. *Diane.* Drama. Paris: Éditions de l'Ermitage, **1928.** [Hunger 1959, p. 55]

Carl Milles, 1875–1955. "Diana Fountain." Bronze sculpture in marble basin. **1928.** Match Palace, Stockholm. [Cornell 1957, pp. 22–24—ill. / Rogers 1940, p. 54—ill.]

———. "Diana Fountain." Bronze sculpture in marble basin. 1930. Michigan Square Building, Chicago. [Rogers, p. 55—ill. / also Cornell, p. 24]

Ruth Page, 1905–, choreography. *Diana.* Ballet. First performed **1928,** Chicago. [EDS 1954–66, 7:1480]

———. *Modern Diana.* Ballet. First performed 1930, Chicago. [Ibid.]

Francis Picabia, 1878–1953. "Artemis." Surrealistic painting. *c.*1929. Ehrman coll., San Francisco. [Camfield 1979, p. 237, fig. 332 / also Borràs 1985, no. 546—ill.]

Frane Krsinic, b. 1897. "Diana." Bronze sculpture. **1930.** Moderna Gelerija, Zagreb. [Clapp 1970, 1:525]

Ezra Pound, 1885–1972. (Artemis evoked in) Canto 30, in *A Draft of XXX Cantos* (Paris: Hours, **1930;** Norfolk, Conn.: New Directions, 193[3?]); cantos 76, 80, in *The Pisan Cantos* (New York: New Directions, 1948); cantos 106, 109, in *Thrones, 96–109 De Los Cantares* (New York: New Directions, 1959); canto 110, in *Drafts and Fragments of Cantos CX–CXVII* (New York: New Directions, 1968). [Surette 1979, pp. 203–09 / Flory 1980, pp. 139, 265f., 274 / Quinn 1972, pp. 158–60]

Paul Véra, 1882–1957. "Diane" (on horseback). Gilded and lacquered wood panel. *c.***1930.** Sold Christie's, London, 1984. [Warburg]

Paul Klee, 1879–1940. "Diana." Abstract painting. **1931.** Curt Valentin coll., New York. [Grohmann 1954, p. 286, no. 316—ill.]

―――. "Diana in the Autumn Wind." Abstract watercolor. 1934. Klee Foundation, Bern. [San Lazzaro 1957, p. 297—ill.]

Jean Binet, 1893–1960. "Ode à Diana et Apollo." Composition for chorus and orchestra. **1932.** [Grove 1980, 2:723]

Georges Braque, 1882–1963. "Artemis." Etching, from series illustrating Hesiod's *Theogony*. **1932.** [Braque 1961, p. 76—ill.]

―――. "Diana." Drawing. 1932. [Cogniat 1980, fig. 37—ill.]

René Schickele, 1883–1940. "Verwandlung der Diana" [Transformation of Diana]. Prose poem. In *Die Grenze* (Berlin: Rowohlt, **1932**). [Wilpert 1963, p. 514]

William Rose Benét, 1886–1950. "Fastidious Artemis." Poem. In *Starry Harness and Other Poems* (New York: Duffield & Green, **1933**). [Bush 1937, p. 591]

Giorgio de Chirico, 1888–1978. "Draped Diana in the Woods." Painting. **1933.** Private coll., Rome. [de Chirico 1971–83, 1.2: no. 7—ill.]

―――. Diana." Painting. 1954. W. B. coll., Rome. [Ibid., 3.3: no. 332—ill.]

―――. "Diana the Huntress." Painting. 1955. Verrando coll., Florence. [Ibid., 4.3: no. 482—ill.]

Harald Lander, 1905–1971, choreography. *Diana*. Ballet. Music, Francis Poulenc. First performed 23 Nov **1933**, Royal Danish Ballet, Copenhagen. [EDS 1954–66, 6:1197]

Ossip Zadkine, 1890–1967. "Diana." Bronze sculpture. **1934.** City of Manchester Art Gallery; private colls. [Jianou 1979, no. 224—ill.]

―――. "Diana." Wood sculpture. 1939. 2 versions. Hannema de Stuers Foundation, Heino; Musée Royal des Beaux-Arts, Brussels. / Bronze replica. 5 casts. Private colls. [Ibid., no. 267]

Michel Fokine, 1880–1942, choreography. *Diane*. Ballet. Music, Jacques Ibert. Scenario, Gramont. First performed **1935**, by de Basil Ballet Russe de Monte Carlo, Paris. [Fokine 1961, p. 310]

Marianne Moore, 1887–1972. (Statue of "black obsidian Diana" evoked in) "Marriage." Poem. In *Selected Poems* (New York: Macmillan; London: Faber & Faber, **1935**). [Ipso]

Yvonne Georgi, 1903–1975, choreography. *Diana*. Ballet. Music, Alexander Voormolen. First performed **1936**, Amsterdam. [Koegler 1963, p. 55 / Grove 1980, 20:62]

Werner von der Schulenburg, 1881–1958. *Diana im Bade* [Diana in the Bath]. Comedy. [Munich?]: **1936.** [Wilpert 1963, p. 537]

―――. "Artemis und Ruth." Short story. Munich: Piper, 1936. [Ibid.]

Benjamin Britten, 1913–1976. "Hymn to Diana." Song for tenor, horn, and strings. Text, from Ben Jonson's *Cynthia's Revels* (1600–01). In *Serenade,* opus 31. First performed 15 Oct **1943**, Wigmore Hall, London. [Grove 1980, 3:297, 307]

Paul Gasq, 1860–**1944.** "Diana." Bronze sculpture. Mount Holyoke College Art Gallery, South Hadley, Mass. [Seen by author]

Cesare Pavese, 1908–1950. (Diana speaks with Hippolytus in) "Il lago" [The Lake], (Artemis evoked in) "In famiglia" [In the Family]. Dialogues. In *Dialoghi con Leucò* (Turin: Einaudi, **1947**). Translated by William Arrow-smith and D. S. Carne-Ross in *Dialogues with Leucò,* bilingual edition (Ann Arbor: University of Michigan, 1965). [Ipso / Biasin 1968, pp. 200, 205, 313]

Angelos Sikelianos, 1884–**1951.** "Hymnos sten Orthia Artemida" [Hymn to Artemis Orthia]. Poem. [Savidis 1981, vol. 3 / Keeley & Sherrard 1979 / Keeley 1983, p. 34]

Horace Gregory, 1898–1982. (Artemis in) "The Night Walker." Poem. In *Selected Poems* (New York: Viking, **1951**). [Ipso]

Frederick Ashton, 1904–1988, choreography. *Sylvia*. Ballet. Music, Léo Delibes. Libretto, Jules Barbier and Baron Reinach, after Tasso's *Aminta*. First performed 3 Sep **1952**, Sadler's Wells Ballet, Covent Garden, London; décor, Robin and Christopher Ironside. [Vaughan 1977, pp. 265–68, 480]

Cesare Meano, 1899–1957. *Diana non vuole amore* [Diana Disdains Love]. Drama. First performed **1953**, Teatro Goldoni, Rome. [EDS 1954–66, 7:349]

Robert Graves, 1895–1985. "Return of the Goddess." Poem. In *Collected Poems, 1955* (New York: Doubleday, **1955**). [Graves 1975]

Dominique Rolin, 1913–. *Artémis*. Novel. Paris: Denoël, **1958.** [DLLF 1984, 3:1957]

Maxwell Anderson, 1888–**1959.** "For Anna Huntington's Diana." Poem, after Anna Vaughn Hyatt Huntington's "Diana of the Chase" (1922, Brookgreen Gardens, S.C.). Unpublished. MS at University of Texas, Austin. [Shivers 1985, item 159]

Gerhard Marcks, 1889–1981. "Diana." Bronze sculpture. **1959.** 10? casts. Gerhard-Marcks-Stiftung, Bremen, inv. 148/71; private colls. [Busch & Rudloff 1977, no. 717—ill.]

Margaret Atwood, 1939–. "Temple of Artemis." Poem. In *Acta victoriana* 84 no. 2 (Mar **1960**; reprinted in *Canadian Forum* 40 (Aug **1960**). [Davidson 1981, p. 248]

Günter Grass, 1927–. "Diana, oder Die Gegenstände" [Diana, or The Difficulty]. Poem. In *Gleisdreieck* (Darmstadt: Luchterhand, **1960,** with a drawing by the author). [Ipso]

Marya Zaturenska, 1902–1982. "Hymn to Artemis, the Destroyer." Poem. In *Terraces of Light* (New York: Grove Press, **1960**). [Ipso]

Peter Davison, 1928–. "Artemis." Poem. In *Poetry* 98 (July **1961**); collected in *The Breaking of the Day and Other Poems* (New Haven: Yale University Press, 1964). [DLB 1980, 5 pt. 1, p. 168]

Priska von Martin, 1912–. "Artemis." Bronze sculpture. **1962.** Artist's studio in 1964. [Gertz 1964, pl. 45]

Eduardo Paolozzi, 1924–. "Diana as an Engine I." Abstract aluminum sculpture. **1962.** Artist's coll. [Konnertz 1984, fig. 242] Variant ("Diana as an Engine II"). 1963, painted 1966. Artist's coll. [Ibid., fig. 243 / Kirkpatrick 1970, fig. 45]

Vernon Watkins, 1906–1967. "Words to Artemis." Poem. In *Affinities* (Norfolk, Conn.: New Directions, **1962**). [Ipso]

Joseph Brodsky, 1940–. "Orpheus i Artemis." Poem. **1964.** In *Ostanovka u pustyne* [A Stop in the Desert] (New York: Chekhov, 1970). [Ipso]

Paul Wunderlich, 1927–. "Diana." Painting. **1964.** [Jensen 1979–80, 1:30f.—ill., 2:no. 140—ill.]

Roy Lichtenstein, 1923–. "Diana." Drawing. **1965.** Castelli coll., New York. [Lichtenstein 1970, no. 65.1—ill.]

Peter D. Thomas, 1928–. "Song for Diana." Poem. In *Poems from Nigeria* (New York: Vantage, **1967**). [Ipso]

Leonard Baskin, 1922–. "Artemis." Etching, illustration for Robert Bagg's translation of Euripides' *Hippolytus* (Northampton, Mass.: Gehenna, **1969**). [Fern & O'Sullivan 1984, no. 528—ill.]

Yannis Ritsos, 1909–1990. "Hē Artemis." Poem. **1969.** In *Epanalepseis* (Athens: Kedros, 1972). [Ipso]

Olga Broumas, 1949–, poem, and **Sandra McKee,** painting. "Artemis." Part of 2–media piece "Twelve Aspects of God." Exhibited Sep **1975,** Maude Kerns Gallery, Eugene, Ore. Broumas's poem in *Beginning with O* (New Haven: Yale University Press, 1977). [Ipso]

Erica Jong, 1942–. "The Deaths of the Goddesses" (Diana and Proserpine). Poem. In *At the Edge of the Body* (New York: Holt, Rinehart & Winston, **1979**). [Ipso]

Sharon Thesen, 1946–. *Artemis Hates Romance.* Collection of poems. Toronto: Coach House, **1980.** [CLC 1989, 56:414f.]

Reynolds Price, 1933–. (Artemis evoked in) "Pure Boys and Girls." Poem, after Catullus. In *Vital Provisions* (New York: Atheneum, **1982**). [Ipso]

ARTEMIS OF EPHESUS. The temple of Artemis at Ephesus, on the coast of Asia Minor, was founded in about 550 BCE and was rebuilt in the fourth century BCE. A wonder of the ancient world, famous for its double row of Ionic columns, the fourth-century temple was also distinguished by its cult statue of Artemis. The gold statue depicted the goddess in a robe of animal heads, open at the top to reveal a row of multiple breasts. Xenophon built a small model of the great temple, with a cypress-wood image of the goddess. The Aventine temple of Diana also had a statue modeled on this type.

This representation of Artemis suggests her role as a fertility goddess, her association with woodlands and wild animals depicted in the trunklike rendering of her lower body and the numerous animals surrounding her. She also wore a crown that represented the city of Ephesus; although this role as a city goddess was not one of her primary functions, it became more common as her power increased. Representations are chiefly bound up in the cult of the Ephesian goddess; in art they are often fanciful reproductions of the statue itself.

Classical Sources. *Acts of the Apostles* 19:39. Strabo, *Geography* 4.1.5. Pausanias, *Description of Greece* 7.

See also ARTEMIS.

Benvenuto Cellini, 1500–1571. "Natura" (Diana of Ephesus). 4 caryatids on pedestal of "Perseus" statue. **1546–53.** Museo Nazionale, Florence. [Pope-Hennessy 1985a, p. 176, pls. 85–86]

J. D. *The Ungodlinesse of the Hethnicke Goddes, or the Downfall of Diana of the Ephesians.* Poem. London: **1554.** [Bush 1963, p. 72 *n.*]

Maerten van Heemskerck, 1498–1574. (Statue of Diana of Ephesus in) "Allegory of Nature." Painting. **1567.** Sold London, 1973. [Grosshans 1980, no. 101—ill.]

Hugues Sambin, *c.*1520–1602. "Ephesian Diana." Drawings, studies for a sculptural caryatid. Published Lyons: **1572.** [G. W. Elderkin, "Sambin's Ephesian Diana," *Art in America* 27 (January 1939): 22–28]

William Shakespeare, 1564–1616, attributed, with unknown collaborator? (Temple of Diana at Ephesus, setting for) *Pericles, Prince of Tyre* 5.2, 5.3. Drama (romance). **1607–08.** Published in quarto (corrupt), London: 1609. [Riverside 1974 / Brownlow 1977, p. 131 / Muir 1985, p. 68 / Barber & Wheeler 1986, pp. 321–27]

Peter Paul Rubens, 1577–1640, with **Jan Brueghel the Elder,** 1568–1625, fruits and flowers. "Nature [Diana of Ephesus] Adorned by the Graces." *c.*1615. Glasgow Museum and Art Galleries. [Jaffé 1989, no. 322—ill.]

———— (Rubens). (Diana of Ephesus, fountain-figure, in) "The Daughters of Cecrops Discovering Erichthonius." Painting. *c.*1615. Liechtenstein Collection, Vaduz. [Ibid., no. 320—ill. / also d'Hulst 1982, fig. 50] Oil sketch. Courtauld Institute, London. [Jaffé, no. 319—ill. / Held 1980, no. 231—ill.]

Jacob Jordaens, 1593–1678. "Allegory" (of choice between vice and virtue, Diana of Ephesus representing Nature). Drawing, possibly design for a tapestry. Hermitage, Leningrad, inv. 4211. [Hermitage 1984, no. 290—ill.]

Benjamin West, 1738–1820. "The Graces Unveiling Nature [Diana of Ephesus]." Ceiling painting. *c.*1780. Royal Academy of Arts, London. [Erffa & Staley 1986, no. 426—ill.] Sketch. Private coll. [Ibid., no. 427—ill.]

Johann Wolfgang von Goethe, 1749–1832. "Gross ist die Diana der Epheser" [Great is Diana of Ephesus]. Gnomic poem, parody of Acts of the Apostles 19:39. 23 Aug **1812.** In *Gedichte der Ausgabe letzter Hand* (Stuttgart: Cotta, 1827–30). [Beutler 1948–71, vol. 1]

Sebastiano Nasolini, *c.*1768–1806/16, doubtfully attributed. "I riti d'Efeso" [The Rites of Ephesus]. Serenata. Text, Rossi. First performed Carnival **1812–13,** Turin. [Grove 1980, 13:43]

Gustave Flaubert, 1821–1880. (Artemis of Ephesus described in) *La tentation de Saint Antoine* [The Temptation of Saint Anthony]. Dramatic prose poem. **1848–72.** Paris: Charpentier, 1874. [Praz 1956, p. 391]

Aristide Sartorio, 1860–1932. "Diana of Ephesus and Her Slaves." Painting. *c.*1899. Galleria Nazionale d'Arte Moderna, Rome. [Praz 1956, p. 392 *n.*15 / Dijkstra 1986, pp. 239f.—ill.]

Fernand Khnopff, 1858–1921. "The Idol" (Diana of Ephesus?). Drawing and pastel. **1909.** Private coll., Brussels. [Delevoy et al. 1979, no. 459—ill.]

————. "Orpheus" (with Ephesian Diana and Venus Astarte). Artwork, medium unknown. 1913. Unlocated. [Ibid., no. 519]

Ezra Pound, 1885–1972. (Diana of Ephesus evoked in) Canto 80, in *The Pisan Cantos* (New York: New Directions, **1948**). [Surette 1979, p. 208 / Terrell 1980–84, 2:435]

John Squire, 1884–1958. "Artemis Altera." Poem. In *Collected Poems* (London: Macmillan; New York: St. Martin, 1959). [Boswell 1982, p. 296]

James Merrill, 1926–. (Diana of Ephesus described as palm tree in childhood vision in) "From the Cupola." Poem. In *Nights and Days* (New York: Atheneum, 1966). [Yenser 1987, p. 146]

———. (Diana of Ephesus appears to the shade of the architect of her temple in) *Scripts for the Pageant.* Poem. New York: Atheneum, 1980. [Ibid., p. 286]

Harry Martinson, 1904–1978. (Diana of Ephesus in) "Durga." Poem. In *Dikter om ljus och mörker* [Poems about Light and Dark] (Stockholm: Bonnier, 1971). [Ipso]

ASCLEPIUS AND HYGIEIA.

The mortal son of Apollo and Coronis, Asclepius became deified as the god of healing and medicine. As an unborn child, he was rescued from his mother's funeral pyre by Apollo (or Hermes, according to Pausanias) and given to the centaur Chiron, who taught him medicine. Asclepius married Epione and they had several children, among them the Greek goddess of health, Hygieia.

When Theseus's son Hippolytus died, Artemis begged Asclepius to restore him to life. Asclepius did so but was himself killed by Zeus for disrupting the course of nature. Apollo avenged his son's death by killing the Cyclopes who made Zeus's thunderbolts.

The healing cult of Asclepius, centered in Epidaurus, was especially important in the fourth century BCE. His worship was brought to Rome—where he was called Aesculapius—after a plague in 293 BCE. The Roman cult followed the Greek version almost completely, but of the minor deities worshiped with Asclepius, only his daughter Hygieia made the transition.

Asclepius is usually shown in ancient art with his attributes, a staff with a snake coiled above it. In postclassical treatments he often appears as an allegory of healing or in pseudohistorical renderings of the temple of Aesculapius in Rome.

Classical Sources. Homeric Hymns, "To Asclepius." Pindar, *Pythian Odes* 3.1–45. *Orphic Hymns* 67, "To Asclepius," 68, "To Hygieia." Virgil, *Aeneid* 7.760–83. Ovid, *Metamorphoses* 2.600–34, 15.533–46, 15.626–744; *Fasti* 6.746–54. Apollodorus, *Biblioteca* 3.10.3–4. Pausanias, *Description of Greece* 2.26.3–10, 8.25.11. Hyginus, *Fabulae* 49; *Poetica astronomica* 2.23. Lucian, *Dialogues of the Gods* 15, "Zeus, Asclepius, and Heracles."

See also APOLLO, Loves; PHAEDRA.

Anonymous French. (Aesculapius in) *Ovide moralisé* 2.3145–3222. Poem, allegorized translation/elaboration of Ovid's *Metamorphoses. c.*1316–28. [de Boer 1915–86, vol. 1]

John Gower, 1330?–1408. (Aesculapius described in) *Confessio amantis* 5.1059–1082. Poem. *c.*1390. Westminster: Caxton, 1483. [Macaulay 1899–1902, vol. 2]

Christine de Pizan, *c.*1364–*c.*1431. (Aesculapius, representing the virtues of medicine in contrast to sorcery, in) *L'epistre d'Othéa à Hector* . . . [The Epistle of Othéa to Hector] chapter 39. Didactic romance in prose. *c.*1400. MSS in British Library, London; Bibliothèque Nationale, Paris; elsewhere. / Translated by Stephen Scrope (London *c.*1444–50). [Bühler 1970 / Hindman 1986, pp. 117f., pl. 34]

Francesco di Giorgio, 1439–1502, attributed. "Aesculapius." Bronze statuette. Albertinum, Dresden. [Pope-Hennessy 1985b, 2:308 / Berenson 1968, p. 141]

Andrea Riccio, *c.*1470–1532. "Della Torre Teaching at the Foot of a Statue of Minerva, with Apollo and Hygieia Looking On." Bronze relief. *c.*1516–21? Tomb of Girolamo della Torre, S. Fermo Maggiore, Verona. Original removed to Louvre, Paris, 1796, replaced by copy. [Pope-Hennessy 1985b, 2:333]

Domenico Beccafumi, 1486–1551, rejected attribution (actually by G. B. Sozzini?). "Aesculapius" (formerly called "Orpheus"). Marble intarsia, in floor of Capella di S. Caterina, Chiesa di S. Domenico, Siena. [Sanminiatelli 1967, p. 174 / Berenson 1968, p. 37 (as Beccafumi, "Orpheus")]

Girolamo Genga, 1476–1551, attributed. "Hygieia." Painting. Art Museum, Princeton University, N.J., inv. 62–61. [Warburg]

Francesco Primaticcio, 1504–1570, design. "Aesculapius." Fresco, for Salle de Bal, Château de Fontainebleau, executed by Niccolò dell' Abbate under Primaticcio's direction. 1551–56. Repainted 19th century. [Dimier 1900, pp. 160ff., 284ff.]

———. "Aesculapius." Ceiling fresco, in Galerie d'Ulysse, Château de Fontainebleau. 1541–47. Destroyed 1738–39. [Béguin et al. 1985, p. 158 / Dimier, pp. 295ff.]

Hendrik Goltzius, 1558–1617, composition. "Apollo Entrusting Chiron with the Education of Aesculapius." Engraving, part of set illustrating Ovid's *Metamorphoses* (2d series, no. 15), executed by assistant(s). *c.*1590. Unique impression in British Museum, London. [Bartsch 1980–82, no. 0302.65—ill.]

Francis Bacon, 1561–1626. "Cyclopes, sive ministri terroris" (slayers of Aesculapius). Chapter 3 of *De sapientia veterum.* Mythological compendium. London: Barker, 1609. / Translated as "Cyclopes, or the Ministers of Terror" by Arthur Gorges in *The Wisdome of the Ancients* (London: Bill, 1619). Modern facsimile edition (bilingual), New York & London: Garland, 1976. [Ipso]

Thomas Heywood, 1573/74–1641. (Death of Aesculapius in) *Troia Britanica: or, Great Britaines Troy* 4.6–18. Epic poem. London: 1609. [Heywood 1974]

Peter Paul Rubens, 1577–1640. "Hygieia Feeding the Sacred Serpent" (formerly called "Cleopatra"). Painting. *c.*1614. 2 versions. Národní Galeri, Prague; Detroit Institute of Arts. [Jaffé 1989, no. 264—ill.]

Robert Herrick, 1591–1674. (Aesculapius evoked in) "Upon Prudence Baldwin her sicknesse." Poem. In *Hesperides* (London: Williams & Eglesfield, 1648). [Martin 1956]

Luca Giordano, 1634–1705. "Aesculapius Receives the Roman Messengers." Painting. *c.*1652–55. Herzog Anton

Ulrich-Museum, Braunschweig. [Ferrari & Scavizzi 1966, 1:60, 2:64—ill. / Braunschweig 1976, p. 28]

John Milton, 1608–1674. (Serpent in Eden compared to that of Aesculapius in) *Paradise Lost* 10.503–07. Epic. London: Parker, Boulter & Walker, **1667.** [Carey & Fowler 1968 / Du Rocher 1985, pp. 144–46]

Pierre Beauchamps, 1631–1705, music. "Esculape." Entrée in *Ballet des arts.* First performed **1685,** Collège Louis-le-Grand, Paris. [Astier 1983, p. 161]

Sebastiano Ricci, 1659–1734. "The Dream of Aesculapius." Painting. Late **1720s.** Accademia, Venice, inv. 1090. [Daniels 1976, no. 465—ill.]

Edward Young, 1683–1765. (Aesculapius evoked in) *The Complaint, or, Night Thoughts on Life, Death, and Immortality* Night Two. Poem. London: Dodsley, **1742–45;** London: Tegg, 1812. [Ipso]

Jean-Baptiste Lemoyne, 1704–1778. (Hygieia in) "Louis XV Monument." Bronze sculpture group. **1746–49.** Musée, Rennes. [Réau 1927, no. 48—ill.] Bronze reduction of figure of Hygieia. Louvre, Paris. [Ibid.—ill.]

Antonio Canova, 1757–1822. "Alvise Valaresso as Aesculapius." Marble statue. **1778.** Museo Civico, Padua. [Pavanello 1976, no. 13—ill. / Licht 1983, pp. 96–97—ill.]

Angelica Kauffmann, 1741–1807. "Hygieia." Painting. **1796.** [Manners & Williamson 1924, p. 158]

Pierre-Narcisse Guérin, 1774–1833. "Offering to Aesculapius." Painting. **1803.** Louvre, Paris, inv. 5181, deposited in Musée, Arras, in 1926. [Louvre 1979–86, 5:270]

Pierre-Paul Prud'hon, 1758–1823. "Aesculapius, Hygieia, the Three Fates, and Charity." Design for (unexecuted) decoration for façade of Hôtel-Dieu, Paris. **1804.** Several drawings, in private colls. or unlocated. [Guiffrey 1924, pp. 338f.]

Bertel Thorwaldsen, 1770–1844. "Hygieia Feeding the Snake of Aesculapius" ("An Allegory of Health"). Marble relief. 4 versions. Kongeporten, Christiansborg Palace, Copenhagen; Thorwaldsens Museum, Copenhagen, no. A322 (reduction); others unlocated. [Thorwaldsen 1985, p. 45 / Cologne 1977, no. 32] Plaster original. **1808.** Thorwaldsens Museum, no. A318. [Thorwaldsen]

———. "Cupid Feeding Hygieia's Snake." Marble relief. Thorwaldsens Museum, no. A371. / Plaster original, 1837. Thorwaldsens Museum, no. A372. [Ibid., p. 49]

———. "Aesculapius" ("Allegory of Health"). Statue. Plaster models, 1839 and 1843. Thorwaldsens Museum, nos. A20–21 (cf. A784). / Bronze cast of over-lifesize version, executed by H. W. Bissen. Prinz Jørgens Gaard, Christiansborg Palace, Copenhagen. [Ibid., p. 22 / Cologne, no. 46]

John Flaxman, 1755–1826, design. Hygieia offering a libation at an altar, depicted on reverse of London Medical Society prize medal. **1824.** British Museum, London. [Bindman 1979, no. 187—ill.]

Luigi Canina, 1795–1856. "Aesculapius" Fountain figure. Villa Borghese, Rome. [Clapp 1970, 1:141]

John William Waterhouse, 1849–1917. "A Sick Child Brought into the Temple of Aesculapius." Painting. **1877.** [Kestner 1989, p. 296]

Edward John Poynter, 1836–1919. "A Visit to Aesculapius" (Venus showing Aesculapius a thorn in her foot). Painting. **1880.** Tate Gallery, London. [Wood 1983, pp.

142–44—ill. / Hutchison 1986, p. 124, p. 43 / Kestner 1989, p. 218, pl. 4.7]

William Canton, 1845–1926. "The God and the Schoolboy." Poem. In *A Lost Epic and Other Poems* (Edinburgh: Blackwood, **1887**). [Bush 1937, p. 562]

Gustav Klimt, 1862–1918. (Hygieia representing) "Medicine." Ceiling painting, for Great Hall, University of Vienna. 1900–07. Destroyed. [Novotny & Dobai 1968, no. 112—ill.] Oil study. **1897–98.** Private coll., Vienna. [Ibid., no. 88—ill.]

Auguste Rodin, 1840–1917. "Aesculapius" (with a child). Bronze sculpture. *c.*1903. Musée Rodin, Paris; elsewhere. [Rodin 1944, no. 326—ill. / Tancock 1976, p. 409—ill.]

Lawrence Alma-Tadema, 1836–1912. "Thalia's Homage to Aesculapius." Painting. **1904.** Musée National d'Art Moderne, Paris. [Swanson 1977, p. 545—ill.]

Émile-Antoine Bourdelle, 1861–1929. "Asclepius." Bronze sculpture. **1929.** 5 casts. Art Museum, Princeton University, N.J.; private colls. [Jianou & Dufet 1975, no. 700]

Robert Turney, 1900–. (Aesculapius in) *Daughters of Atreus.* Tragedy. First performed **1936.** Published New York: Knopf, 1936. [Boswell 1982, p. 305]

Miklós Hubay, 1918–. *The Cock of Aesculapius* [English title of a work written in Hungarian]. Tragedy. / Translated by the author and André Prudhommeaux as *Le coq d'Esculape* (Paris: Editions des Portes de France, **1946**). [NUC]

Cesare Pavese, 1908–1950. (Chiron speaks of Asclepius in) "Le cavalle" [The Mares]. Dialogue. In *Dialoghi con Leucò* (Turin: Einaudi, **1947**). / Translated by William Arrowsmith and D. S. Carne-Ross in *Dialogues with Leucò,* bilingual edition (Ann Arbor: University of Michigan, 1965). [Ipso / Biasin 1968, pp. 193, 195]

Angelos Sikelianos, 1884–**1951.** *Ho thanatos Asklepios* [The Death of Asclepius]. Poetic tragedy, unfinished. In *Thymelē* (Athens: Collection de l'Institut Français d'Athènes, 1950–55). [Trypanis 1981, p. 676 / Friar 1973, p. 748]

Marianne Moore, 1887–1972. "The Staff of Aesculapius." Poem. In *Abbott Laboratories What's New* Dec **1954;** collected in *Like a Bulwark* (New York: Viking, 1956). [Phillips 1982, pp. 210–12 / Hadas 1977, p. 26]

Robert Bagg, 1935–. "The Cult of Asklepios," part 4 of "Epidauros." Poem. In *The Scrawny Sonnets* (Middletown: Wesleyan University Press, **1956**). [Ipso]

Giorgio de Chirico, 1888–1978. "Metaphysical Interior with Bust of Aesculapius." Painting. **1969.** Artist's coll., Rome, in 1974. [de Chirico 1971–83, 4.3: no. 627—ill.]

Claudio Parmiggiani, 1943–. "The Book of Aesculapius." Sculpture (snakeskin folio). **1971.** [Reggio Emilia 1985, p. 31—ill.]

Ralph Gustafson, 1909–. "To Old Asclepius—Lyric at Epidaurus." Poem. In *Fire on Stone* (Toronto: McClelland & Stewart, **1974**). [Ipso / CLC 1986, 36:218]

Oskar Kokoschka, 1886–1980. "The Death of Asclepius." Lithograph. **1976.** [Wingler & Welz 1975–81, no. 563—ill.]

Peter Redgrove, 1932–. "Aesculapian Notes." Poem. In *From Every Chink of the Ark and Other New Poems* (London: Routledge & Kegan Paul, **1977**). [CLC 1987, 41:355]

ASPHODEL. *See* HADES [2].

ASTARTE. A Canaanite fertility goddess with variant cults throughout the Near East, Astarte is mentioned in the Old Testament as Ashtoreth. In the Tel Amarna letters she is called Ashtart, while in Akkadian (Babylonian) she is Ishtar and in Ugaritic, Asherah. Her association with the planet Venus also links her with the Greek Aphrodite and the Roman Venus; the Romans called her Dea Syria. The female counterpart of Baal, she was accorded first place in the Phoenician pantheon. She was identified with the moon and often represented under the symbol of the crescent; her other attributes included the pomegranate and the dove. She was worshiped in sacred groves, usually under specific trees. According to an Assyrian epic that parallels the Greek myth of Aphrodite and Adonis, Ishtar was the lover of Tammuz, who was killed by a boar and thereafter spent half the year in the Underworld and the other half with Ishtar.

Classical Sources. Ishtar's Descent to the Nether World (Assyrian epic, *c.*1850–1650 BCE). Herodotus, *History* 1.105. Pausanias, *Description of Greece* 1.14.7. Lucian, *Of the Syrian Goddess.*

Further Reference. James George Frazer, *The Golden Bough: The Scapegoat* (New York: Macmillan, 1935), pp. 369ff.

Davide Perez, 1711–1778. *Astartea.* Opera. First performed **1743,** Palermo. [Grove 1980, 14:367]

Vicente Martín y Soler, 1754–1806. *Astartea.* Opera seria. Libretto, Pietro Metastasio. First performed Carnival **1781,** Lucca. [Grove 1980, 11:736]

Lord Byron, 1788–1824. (Phantom of Astarte in) *Manfred* 2.4. Dramatic poem. **1816–17.** London: Murray, 1817. [McGann 1980–86, vol. 4 / Cox 1987, p. 99 / Gleckner 1967, pp. 254, 262f.]

Robert Schumann, 1810–1856. Incidental music for Byron's *Manfred* (1816–17). **1848–49.** Performed 13 June 1852, Leipzig. [Grove 1980, 16:854]

Thomas Holley Chivers, 1809–1858. "Astarte's Song to Endymion." Poem. In *Viginalia; or Songs of My Summer Nights* (Philadelphia: Lippincott, **1853**). [Boswell 1982, p. 248]

Dante Gabriel Rossetti, 1828–1882. "Astarte Syriaca" ("Venus Astarte"). Painting. **1875–77.** City Art Gallery, Manchester, England, no. 1891.5. [Surtees 1971, no. 249—ill. / also Maas 1969, p. 143—ill. / Wood 1981, p. 102—ill.]

———. "Astarte Syriaca." Sonnet, to accompany above painting. 1877. In *Ballads and Sonnets* (London: Ellis & White, 1881). [Doughty 1965 / Rees 1981, p. 124 / also Surtees, p. 146 (reproduced)]

Henri Fantin-Latour, 1836–1904. "Manfred and Astarte." Lithograph, illustrating Byron/Schumann *Manfred.* **1879.** [Hédiard 1906, no. 29—ill. / also Fantin-Latour 1911, no. 978]. 2

variants, 1881, 1892. [Hédiard, nos. 34, 107—ill. / also Fantin-Latour, no. 1051, 1499]. 3 variants, paintings. [Fantin-Latour, nos. 2221–22, 2256]

Pierre Louÿs, 1870–1925. "Astarté." Poem. In *Astarté* (Annonay: Royer, **1891**). [DLLF 1984, 2:1339]

———. "Les prêtresses de l'Astarté" [The Priestesses of Astarte], "Hymne à Astarté" [Hymn to Astarte]. Poems. In *Chansons de Bilitis* (Paris: Crès, 1894; 1913). [Ipso]

George Meredith, 1828–1909. (Astarte evoked in) "Ode to the Comic Spirit." Poem. In *Poems* (London: Macmillan, **1892**). [Ipso]

John Byrne Leicester Warren, Lord de Tabley, 1835–1895. "A Hymn to Astarte." Poem. In *Poems: Dramatic and Lyrical* first series (London: Mathews & Lane, **1893**). [Boswell 1982, p. 250]

Madison Cawein, 1865–1914. (Astarte as goddess of temple prostitutes in) "The Paphian Venus." Poem. In *Intimations of the Beautiful* (New York: Putnam, **1894**). [Boswell 1982, p. 72]

Vincent d'Indy, 1851–1931. *Istar.* Symphonic poem, variations, opus 42. **1896.** First performed 10 Jan 1897, Brussels. [Grove 1980, 9:222, 223 / Baker 1984, p. 1083]

James McNeill Whistler, 1834–1903. "Venus Astarte." Drawing. **1890s.** Freer Gallery of Art, Washington, D.C. [Curry 1984, pl. 281 / Maas 1969, p. 170—ill.]

Xavier Leroux, 1863–1919. *Astarté.* Opera. Libretto, Louis de Gramont. First performed 15 Feb **1901,** L'Opéra, Paris. [Grove 1980, 10:686]

Augusta Holmès, 1847–**1903.** *Astarté.* Opera. Libretto, composer. Unperformed. [Grove 1980, 8:656]

Aleksandr Blok, 1880–1921. (Astarte evoked in) *Stixi o prekrasnoj dame* [Poems about the Beautiful Lady] (Moscow: **1904**). [Grossman 1985, pp. 239, 253]

Charles Koechlin, 1867–1950. "Hymne à Astarté." Song. In *5 chansons de Bilitis* opus 39. Text, P. Louÿs. **1898– 1908.** [Grove 1980, 10:147]

Ivan Klustin, 1862–1941, choreography. *Istar.* Ballet. Music and scenario, Vincent d'Indy (1896). Scenario, d'Indy. First performed **1912,** Paris; décor, G. Desvalière. [Oxford 1982, p. 214 / DMB 1959, pp. 184f.]

Fernand Khnopff, 1858–1921. "Orpheus" (with Ephesian Diana and Venus Astarte). Artwork, medium unknown. **1913.** Unlocated. [Delevoy et al. 1979, no. 519]

John Singer Sargent, 1856–1925. (Astarte in) "Pagan Deities." Ceiling painting. **1895–1916.** Boston Public Library. [Ratcliff 1982, pp. 142–46—ill.] Studies for Astarte. Gardner Museum, Boston; Metropolitan Museum, New York, no. 50.130.3. [Ibid.—ill. / Hendy 1974, p. 224—ill. / Metropolitan 1965–85, 2:242ff.—ill.] Studies for entire composition. Museum of Fine Arts, Boston; Boston Public Library. [Metropolitan]

Ruth St. Denis, 1879–1968, choreography. *Ishtar of the Seven Gates.* Modern dance. Music, Charles T. Griffes. First performed **1915–16,** New York; décor, Robert Law Studio. [Sharp 1972, pp. 108f. / Cohen-Stratyner 1982, p. 784 (as 1923)]

Marguerite Yourcenar, 1903–1987. "Astarte Syrica." Poem. In *Les dieux ne sont pas morts* (Paris: Chiberre, **1922**). [Horn 1985, p. 85]

R. Remislawsky, choreography. *Istar.* Ballet. Music, Bo-

huslav Martinů, 1918–22. Libretto, J. Zeyer. First performed 11 Sep **1924**, Prague. [Oxford 1982, p. 274 / Grove 1980, 11:734]

Léo Staats, 1877–1952, choreography. *Istar.* First performed **1924**, Diaghilev's Ballets Russes, L'Opéra, Paris; décor, Léon Bakst. [DMB 1959, pp. 19, 184, 252f.]

Karin Boye, 1900–1941. *Astarte.* Novel. Stockholm: Bonnier, **1931**. [EWL 1981–84, 1:312 / DULC 1959–63, 1:530]

Serge Lifar, 1905–1986, choreography. *Ishtar.* Ballet. Music, d'Indy (1896). First performed 31 Dec **1941**, L'Opéra, Paris; décor, Léon Bakst. [Oxford 1982, p. 214]

Felix Harold White, 1884–**1945.** *Astarte Syriaca.* Tone poem, after Rossetti (1875–77). [Baker 1984, p. 2487]

Angelos Sikelianos, 1884–**1951.** (Astarte prepares herself to enter Hades with her beloved in) "Melete thanatou" [Rehearsing for Death]. Poem. [Savidis 1981, vol. 5 / Keeley & Sherrard 1979]

Ossip Zadkine, 1890–1967. "Astarte." Bronze sculpture. **1959.** 6 casts. Private colls. [Jianou 1979, no. 434]

Robert Joffrey, 1930–1988, choreography. *Astarte.* Ballet/mixed media spectacle. Music, Crome Syrcus. First performed 20 Sep **1967**, Joffrey Ballet, City Center, New York; décor and lighting, Thomas Skelton; costumes, Hugh Sherer; film, Gardner Compton. [Anderson 1986, p. 144 / Oxford 1982, p. 23 / Clarke & Vaughan 1977, pp. 30, 188]

ASTERIA. *See* ZEUS, Loves.

ASTYANAX. *See* HECTOR, General List; TROJAN WAR, Fall of Troy.

ATALANTA. A fleet-footed huntress, Atalanta was the daughter of either Iasus of Arcadia and Clymene or King Schoeneus of Boeotia: the ancient sources are not clear whether there were, in fact, two different figures with this name or if they were one and the same person. One Atalanta was famous for her part in the Calydonian boar hunt, the other associated with the legend covered in this entry.

Atalanta was determined to keep her virginity and, known as a swift runner, refused to marry any man who could not best her in a footrace. Those who lost the race were killed. After a number of suitors had perished, Hippomenes (Melanion) agreed to race with her. Aphrodite (Venus) gave him three golden apples—said to be the apples of the Hesperides—and these he dropped along the way to delay Atalanta. The ruse worked and he won the race (some say because Atalanta wished him to). But the successful suitor was so eager to consummate the marriage that he made love to Atalanta in a sacred shrine. For this impiety they were changed into lions. In Propertius's version, the couple fell in love while hunting.

Classical Sources. Hesiod, *Catalogue of Women* 14 (fragment). Propertius, *Elegies* 1.1.9. Ovid, *Metamorphoses* 10.560–704. Apollodorus, *Biblioteca* 1.8.2–3, 3.9.2. Pausanias, *Description of Greece* 8.35.10. Hyginus, *Fabulae* 185.

See also MELEAGER, Boar Hunt.

Anonymous French. (Venus tells Adonis the story of Atalanta and Hippomenes in) *Ovide moralisé* 10.2094–2437 (narrative), 3954–4127 (allegory). Poem, allegorized translation/elaboration of Ovid's *Metamorphoses*. *c.***1316–28.** [de Boer 1915–86, vol. 4]

Christine de Pizan, *c.*1364–*c.*1431. (Atalanta's race in) *L'epistre d'Othéa à Hector* . . . [The Epistle of Othéa to Hector] chapter 72. Didactic romance in prose. *c.***1400.** MSS in British Library, London; Bibliothèque Nationale, Paris; elsewhere. / Translated by Stephen Scrope (London: *c.*1444–50). [Bühler 1970 / Hindman 1986, p. 200]

Veronese School. "Atalanta's Race with Hippomenes." Painting. *c.***1460.** Musée Jacquemart-André, Paris. [Pigler 1974, p. 133]

Siennese School (circle of Francesco di Giorgio, 1439–1502, and Neroccio di Landi, 1447–1500). "The Race of Atalanta and Hippomenes." 3 paintings. *c.***1470.** Central Museum and Art Gallery, Northampton, England. [Jacobs & Stirton 1984b, p. 156]

Francesco del Cossa, *c.*1435–1477. "Atalanta's Race." Painting. Staatliche Museem, Berlin, no. 113a. [Pigler 1974, p. 133]

Ercole de' Roberti, *c.*1448/55–**1496**, circle. "Atalanta, Beaten in the Race with Hippomenes." Painting. Gemäldegalerie, Berlin-Dahlem, no. 113A. [Berlin 1986, p. 65—ill. / Berenson 1968, p. 120]

Andrea Mantegna, 1430/31–**1506.** "Atalanta and Hippomenes." Painting. Lost. [Lightbown 1986, no. 90]

Giulio Romano, *c.*1499–1546. "Atalanta and Hippomenes." Ceiling fresco. **1527–28.** Sala dei Venti, Palazzo del Tè, Mantua. [Hartt 1958, pp. 115ff., 118—ill. / Verheyen 1977, p. 119]

Niccolò Giolfino, 1476–1555. "Atalanta's Race." Painting. Fitzwilliam Museum, Cambridge, no. 210. [Fitzwilliam 1960–77, 2:63—ill.; cf. no. 208 / Berenson 1968, p. 171]

Andrea Schiavone, *c.*1522–**1563.** "Atalanta's Race." Painting. Cook coll., Richmond, Surrey, no. 170. [Berenson 1957, p. 161]

Arthur Golding, 1536?–1605. (Atalanta's race in) *Ovids Metamorphosis* book 10. Translation. London: **1567.** [Rouse 1961 / Braden 1978, p. 13]

Sebastiano Marsili. "The Race of Atalanta." Painting. **1570–73.** Studiolo di Francesco I, Palazzo Vecchio, Florence. [Sinibaldi 1950, pp. 11f., 19]

James Sanford. "Atalanta." Poem. In *The Garden of Pleasure* (London: **1573**). [Bush 1963, p. 315]

Diego Hurtado de Mendoza, 1503–1575. "Fábula de Hipómenes y Atalanta." Fable. In *Obras,* edited by Juan Díaz Hidalgo (1610). / Modern edition, *Epistolas y otras poesías* (Barcelona: 1944). [Oxford 1978, p. 284]

Titian, *c.*1488/90–**1576,** follower. "Mythological Scene" (Atalanta and Hippomenes? with story of Adonis? in background). Painting. National Gallery, London, inv. 1123. [London 1986, p. 623—ill. / also Berenson 1957, p. 86 (as Venus and Adonis, style of Giorgione)]

Luca Cambiaso, 1527–**1585.** "Atalanta." Frescoes, part of series for Palazzo Giovanni Battista Grimaldi, Genoa, representing mythological and historical figures (some now destroyed). Palazzo Bianco, Genoa. [Manning & Suida 1958, pp. 71f.]

Edmund Spenser, 1552?–**1599.** (Allusion to Atalanta's race in) *The Faerie Queene* 2.7.54. Romance epic. London: Ponsonbie, **1590,** 1596. [Hamilton 1977 / Hieatt 1975, pp. 204, 236]

Benedetto Caliari, 1538–**1598.** "Atalanta's Race." Grisaille fresco. Formerly Cà Mocenigo, Venice. [Pigler 1974, p. 134]

Hendrik Goltzius, 1558–**1617.** "Atalanta." Drawing. **1595–1600.** Staatliche Graphische Sammlung, Munich, inv. 21085. [Reznicek 1961, no. 112—ill.]

Francis Bacon, 1561–**1626.** "Atalanta, sive Lucrum." Chapter 25 of *De sapientia veterum.* Mythological compendium. London: Barker, **1609.** / Translated as "Atalanta, or Gaine" by Arthur Gorges in *The Wisdome of the Ancients* (London: Bill, 1619). Modern facsimile edition (bilingual), New York & London: Garland, 1976. [Ipso]

Guido Reni, 1575–**1642.** "Atalanta and Hippomenes." Painting. **1618–19.** 2 versions. Prado, Madrid; Museo di Capodimonte, Naples, no. 349. [Pepper 1984, no. 59—ill. / also Gnudi & Cavalli 1955, no. 46—ill. / Capodimonte 1964, p. 50, pl. 61 / Prado 1985, p. 541 / Ormond 1975, pl. 117] 2 other treatments of the subject known, both unlocated. [Pepper]

Thomas Heywood, 1573/74–**1641.** (Story of Atalanta in) "Of Amazons and Warlike Women." Passage in *Gynaikeion: or, Nine Books of Various History Concerning Women* book 5. Compendium of history and mythology. London: printed by Adam Islip, **1624.** [Ipso]

Bartholomeus Breenbergh, 1599–*c.*1657. "Landscape with Atalanta and Hippomenes." Painting. **1630.** Staatliche Kunstsammlungen, Kassel, no. 207. [Röthlisberger 1981, no. 133—ill.]

John Donne, 1572–**1631.** (Atalanta in) "To His Mistress Going to Bed" lines 35–38. Elegy no. 19 in *Poems* (London: Herringman, 1669). [Patrides 1985]

Jan Tengnagel, 1584/85–**1635.** "The Race between Atalanta and Hippomenes." Painting. Historisch Museum, Amsterdam, inv. A27278. [Wright 1980, p. 447]

Peter Paul Rubens, 1577–**1640.** "Atalanta and Hippomenes." Painting, for Torre de la Parada, El Pardo, executed by Jacob Peter Gowy from Rubens's design. **1636–38.** Prado, Madrid, no. 1538. [Alpers 1971, no. 4—ill. / Jaffé 1989, no. 1240—ill. / Prado 1985, p. 262] Oil sketch. Kunsthaus Heylshof, Worms, inv. 19. [Held 1980, no. 171—ill. / Jaffé, no. 1239—ill.] Copy (or autograph replica?) in Heugel coll., Paris. [Held / Alpers, no. 4a—ill. (as autograph)]

Jacob Jordaens, 1593–**1678.** "Atalanta and Hippomenes." Painting. *c.*1646. 3 versions known, unlocated. [Rooses 1908, pp. 153f., 257 / also d'Hulst 1982, p. 220]

Simone Cantarini, called Il Pesarese, 1612–**1648.** "Atalanta and Hippomenes." Painting. Dell' Acqua coll., Ferrara. [Warburg]

Frans Wouters, 1612–**1659,** attributed (or Van den Hoecke? Boeckhorst?). "Figures in a Landscape" (Atalanta and Hippomenes? Hero and Leander?). Painting. Ringling Museum, Sarasota, Fla., no. SN238. [Sarasota 1980, no. 57—ill.]

Francesco Albani, 1578–**1660.** "Hippomenes and Atalanta." Painting. Earl of Bradford coll. [Warburg]

Antonio Draghi, 1634/35–**1700.** *Atalanta.* Opera. Libretto, N. Minato. First performed 18 Nov **1669.** [Grove 1980, 5:604]

Claude Boyer, 1618?–**1698.** *Atalante.* Drama with songs. First performed May **1671,** Hôtel de Bourgogne, Paris. Lost. [Lancaster 1929–42, pt. 3, 2:533, 572; pt. 4, 1:155]

Ivan Sibencanin, *c.*1640–**1705.** *L'Atalanta.* Opera. Libretto, Bianca. First performed 6 Dec **1673,** Teatrino della Venaria Reale, Turin. [Grove 1980, 17:98]

Willem van Herp, 1614–**1677.** "Atalanta and Hippomenes." Painting. Muzeum Narodowe, Warsaw, inv. 129890. [Warsaw 1969, no. 508—ill.]

John Dryden, 1631–**1700.** (Hippomenes ridiculed in) "Amaryllis, or the Third Idyllium of Theocritus Paraphras'd" lines 91–101. Poem. In Tonson's *Miscellany Poems* (London: Tonson, **1684).** [Dryden 1956–87, vol. 2]

Ciro Ferri, 1634–**1689.** "Hippomenes and Atalanta." Painting. / Engraved by B. Farjat. (British Museum, London.) [Warburg]

Friedrich Christian Bressand, *c.*1670–**1699.** *Atalanta, oder Die verirrten Liebhaber* [Atalanta, or The Lover Led Astray]. Singspiel. First performed **1698,** Braunschweig? [DLL 1968–90, 2:39.]

Pierre Lepautre, 1660–**1744.** "Atalanta." Marble sculpture. **1702.** Jardin des Tuileries, Paris. [Pigler 1974, p. 134]

Bon Boulogne, 1649–**1717.** "The Race of Atlanta and Hippomenes." Painting. Exhibited **1704,** untraced. [Hermitage 1986, no. 21 n.] *See also Louis Boulogne the Younger, below.*

Thomas-Louis Bourgeois, 1676–1750/51. *Hippomène.* Cantata. In *Cantates* book 1 (Paris: **1708).** [Grove 1980, 3:113]

Clemente Monari, *c.*1660?–*c.*1729. *L'Atalanta.* Opera. Libretto, Apostolo Zeno. First performed **1710,** Modena. [Grove 1980, 12:477]

Guillaume Coustou the Elder, 1677–**1746.** "Hippomenes." Marble sculpture. **1712.** Jardin des Tuileries, Paris. [Pigler 1974, p. 134]

Giovanni Battista Foggini, 1652–**1725.** "Atalanta's Race." Bronze sculpture. Skulpturen Sammlungen, Dresden. [Pigler 1974, p. 134]

Louis Boulogne the Younger, 1654–**1733,** attributed (previously attributed to Bon Boulogne). "The Marriage of Hippomenes and Atalanta." Painting. **1720s.** Hermitage, Leningrad, inv. 1210. [Hermitage 1986, no. 21—ill.]

Johann Adolf Hasse, 1699–**1783.** *Atalanta.* Opera seria. Libretto, Stefano Pallavicino. First performed 26 July **1737,** Court, Dresden. [Grove 1980, 8:288 / DELI 1966–70, 4:223]

Davide Perez, 1711–**1778.** *L'Atlanta.* Serenata. First performed **1739,** Palermo. [Grove 1980, 14:367]

Georg Raphael Donner, 1693–**1741.** "Atalanta" Lead

sculpture. *c.*1740. Szépművészeti Múzeum, Budapest, inv. 52/57. [Schwarz 1968, no. 18—ill.]

Johann Christoph Gottsched, 1700–1766. *Atalanta (Atlanta, oder Die bezwungene sprödigkeit* [Atalanta, or Coyness Conquered]). Pastoral comedy. **1741.** In *Der Deutsche Schaubühne* (Leipzig: Breitkopf, 1746). [Gassner & Quinn 1969, p. 329]

Louis Antoine Lefebvre, ?–1763. *Atalante et Hippomène.* Cantata. Paris: **1759.** [Grove 1980, 10:606]

Benjamin West, 1738–1820. "Venus Relating to Adonis the Story of Hippomenes and Atalanta." Painting. *c.*1767. Private coll. [von Erffa & Staley 1985, no. 112—ill.]

Pierre Nicolas Brunet, 1733/34–1771, scenario. *Hippomène et Atalante.* Ballet. First performed **1769,** Paris. [DLF 1951–72, 4.1:233]

Joseph Starzer, 1726/27–1787. *Atlante.* Ballet. First performed **1771,** Vienna. [Grove 1980, 18:82]

Anonymous choreographer. *Hippomene e Atalante.* Ballet. First performed 23 Mar **1779,** King's Theatre, London. [Guest 1972, p. 149]

Giuseppe Sarti, 1729–1802. *Il trionfo d'Atalanta.* Musical composition. **1791.** No performance known. [Grove 1980, 16:505]

Giuseppe Giordani, *c.*1753–1798. *Atalanta.* Opera. First performed **1792,** Turin. [Grove 1980, 7:393]

Niccolò Zingarelli, 1752–1837. *Atalanta.* Opera. Libretto, C. Olivieri. First performed Carnival **1792,** Regio, Turin. [Grove 1980, 20:694]

James Hervé D'Egville, *c.*1770–*c.*1836, choreography. *Hyppomène et Atalante.* Ballet. First performed **1800,** London. [EDS 1954–66, 4:343]

Filippo Taglioni, 1777–1871, choreography. *Atalante und Hippomenes.* Ballet. First performed **1805,** Vienna. [Oxford 1982, p. 405]

Luigi Piccinni, 1764–1827. *Hippomène et Atalante.* Opera. First performed **1810,** Paris. [Grove 1980, 14:728]

Salvatore Taglioni, 1789–1868, choreography. *Atalanta ed Ippomene.* Ballet. Music, Gallenberg. First performed 30 May **1817,** San Carlo, Naples. [EDS 1954–66, 9:630]

[?] Baudry, choreography. *Atalante vaincue par Hippomène* [Atalanta Vanquished by Hippomenes]. Ballet. First performed **1824,** Moscow. [Winter 1974, p. 212]

James Pradier, 1792–1852. "Atalanta at Her Toilet." **1830.** Marble sculpture. Louvre, Paris. [Clapp 1970, 1:719]

Jules Perrot, 1810–1882, choreography. *Atalante.* Solo (?) dance. First performed *c.*1843, London? [Guest 1984, p. 96]

Francis Talfourd, 1828–1862. *Atalanta; or, The Three Golden Apples.* Burletta. First performed 13 Apr **1857,** Theatre Royal, Haymarket, London. [Nicoll 1959–66, 5:590]

Walter Savage Landor, 1775–1864. "Hippomenes and Atalanta." Poem. In *Heroic Idylls* (London: Newby, **1863**). [Wheeler 1937, vol. 2 / Boswell 1982, p. 155]

William Morris, 1834–1896. "Atalanta's Race." Poem. By **1864.** In *The Earthly Paradise,* vol. 1 (London: Ellis, 1868). [Morris 1910–15, vol. 3 / Calhoun 1975, pp. 128–33 / Bush 1937, p. 314]

Edward Burne-Jones, 1833–1898. 8 drawings for William Morris's "Atalanta's Race." **1864–68.** [Harrison & Waters 1973, p. 84]

William Henry Rinehart, 1825–1874. "Atalanta." Marble

statuette. **1874.** Public Library, Troy, N.Y. [Ross & Routledge 1948, no. 3—ill.] Reduction, unfinished; completed by studio, 1875. Baltimore Museum of Art. [Ibid.]

Christopher Pearse Cranch, 1813–1892. "Atalanta" (race with Hippomenes). Poem. In *The Bird and the Bell* (Boston: Osgood, **1875**). [Boswell 1982, p. 79]

Edward Dowden, 1843–1913. "Atalanta's Race." Poem. In *The Heroines* (London: King, **1876**). [Boswell 1982, p. 252]

Edward John Poynter, 1836–1919. "Atalanta's Race." Painting. Exhibited **1876.** Lost. [Wood 1983, pp. 140f. / Kestner 1989, pp. 217f., pl. 4.5]

Richard Dadd, 1817–1886. "Atalanta's Race." Painting. *c.*1877. Unlocated. [Allderidge 1974, no. 210]

Edwin Arnold, 1832–1904. "Atalanta" (race with Hippomenes). Poem. In *Lotus and Jewel with Other Poems* (Boston: Robert Brothers, **1887**). [Boswell 1982, p. 17]

George P. Hawtrey, 1846?–1910. *Atalanta.* Burlesque. Music, A. E. Dyer. First performed 17 Nov **1888,** Strand Theatre, London. [Nicoll 1959–66, 5:410]

Frederic, Lord Leighton, 1830–1896. "Atalanta." Painting. *c.*1893. Unlocated. [Ormond 1975, no. 375]

Rubén Darío, 1867–1916. (A modern Atalanta in) "Diálogo de una mañana de Año Nuevo" [Dialogue of New Year's Morning]. Poem. **1897.** [Méndez Plancarte 1967 / Jrade 1983, pp. 110f.]

———. (Atalanta evoked in) "Envio de Atalanta" [Remittance of Atalanta]. Poem. 1899. [Méndez Plancarte]

———. (Atalanta evoked in) "Otro dézir." Poem. 1901. In *Prosas profanas y otros poemas* (Buenos Aires: 1896). [Ibid. / Hurtado Chamorro 1967, pp. 102f.]

Gustav Wied, 1858–1914, with **Jens Petersen.** *Atalanta.* Comedy. Copenhagen: Glydendal, **1901.** [NUC] Performed 19 Dec 1901, Copenhagen; incidental music, Carl Nielsen. [Grove 1980, 13:229]

Emil Ludwig, 1881–1948. *Atalanta.* Tragic poem. Berlin: Oesterheld, **1909.** [DLL 1968–90, 10:33 (1911)]

Walter Conrad Arensberg, 1878–1954. "Atalanta." Poem. In *Poems* (Boston: Houghton, Mifflin, **1914**). [Boswell 1982, p. 241]

Paul Manship, 1885–1966. "Atalanta." Bronze statuette. **1921.** 15 casts. National Museum of American Art, Washington, D.C.; elsewhere. [Murtha 1957, no. 129 / Rand 1989, p. 56—ill. / Minnesota 1985, no. 67—ill. / also DCAA 1982, p. 379—ill.] Gilded bronze version, unique cast, 1939. Minnesota Museum of Art, St. Paul. [Minnesota 1972, no. 93]

Dorothy Dow, 1903–. "To Atalanta." Poem. In *Black Babylon* (New York: Boni & Liveright, **1924**). [Boswell 1982, p. 252]

Alfred Gilbert, 1854–1934. "Atalanta" (stooping to pick up apple). Drawing. **1931.** National Museum of Wales, Cardiff. [Minneapolis 1978, no. 113—ill.]

Jean-Antoine Injalbert, 1845–**1933.** "Hippomenes." Bronze bust. Musées Nationaux, inv. RF 2354, deposited in Musée, Béziers, in 1961. [Orsay 1986, p. 273]

Antony Tudor, 1908–1987, choreography. *Atalanta of the East.* Ballet. Music, Seelig. First performed **1933,** Marie Rambert's Ballet Club, London. [Amberg 1949, p. 103 / Beaumont 1938, p. 828]

Nicola Guerra, 1865–1942, choreography. *Atalanta.* Ballet. Music, Gnecchi. [EDS 1954–66, 6:23]

Roger Vercel, 1894–1957. *L'Atalante.* Novel. Paris: Michel, **1951.** [DLLF 1984, 3:2397]

ATHAMAS AND INO.

The king of Boeotia and the son of Aeolus, Athamas married the cloud goddess Nephele, with whom he had two children, Phrixus and Helle. After giving birth, Nephele returned to the sky. Athamas then married Ino, a daughter of Cadmus. She bore him two sons, Learchus and Melicertes. She was so jealous of her stepchildren, however, that she plotted their death. She first caused a famine, then, when envoys were sent to the oracle at Delphi for advice, she persuaded them to say that the famine would end only if Phrixus was sacrificed.

As Athamas was about to sacrifice his son, Nephele saved him and took him and his sister Helle to the sky on a golden-fleeced ram, given to her by Hermes. As they flew, Helle fell into the sea at the place now called the Hellespont. Phrixus continued the journey to Colchis, at the eastern end of the Black Sea, where he was welcomed by its king, Aeëtes. The ram was sacrificed to Zeus and its golden fleece remained in Colchis, guarded by a dragon, until Jason and the Argonauts arrived and stole it away.

Ino had nursed Dionysus, son of Semele by Zeus, thus incurring the wrath of Hera (Juno). The goddess journeyed to Hades and enlisted the Fury Tisiphone who, as a serpent, attacked Athamas and Ino, driving them mad. Athamas, convinced that Ino and her babies were a lioness with two cubs, tore Learchus from Ino's arms and flung him against a wall. Ino, still holding Melicertes, climbed a cliff near the water and leapt into the sea. But Aphrodite called on Poseidon to change the mother and son into sea creatures. Transformed and renamed Palaemon and Leucothea, they often came to the aid of sailors; Leucothea protected Odysseus when he was shipwrecked by Poseidon.

Treatments of this subject touch on all aspects of the narrative, from the sacrifice and rescue of Phrixus and Helle to the fury of Athamas and Ino's suicide. There are representations in the visual arts, but the story is principally represented in narrative poetry, drama, and opera.

Classical Sources. Hesiod, *Theogony* 975ff. Sophocles, *Athamas* (fragments). *Orphic Hymns* 74, "To Leucothea." Ovid, *Metamorphoses* 4.474–559. Apollodorus, *Biblioteca* 1.9.1–2, 3.4.2–3. Pausanias, *Description of Greece* 1.44.7–8, 9.23.6, 9.34.5–9. Hyginus, *Fabulae* 2, 3, 4.

Dante Alighieri, 1265–1321. (Athamas's madness evoked in) *Inferno* 30.1ff. *c.*1307–*c.*1314? In *The Divine Comedy*. Poem. Foligno: Neumeister & Angelini, 1472. [Singleton 1970–75, vol. 1]

Anonymous French. (Story of Phrixus and Helle, Athamas and Ino, in) *Ovide moralisé* 4.2786–3149, 3732–5115. Poem, allegorized translation/elaboration of Ovid's *Metamorphoses* and other texts. *c.*1316–28. [de Boer 1915–86, vol. 2]

John Gower, 1330?–1408. (Tale of Phrixus and Helle in) *Confessio amantis* 5.4243–4382. Poem. *c.*1390. Westminster: Caxton, 1483. [Macaulay 1899–1902, vol. 3]

Christine de Pizan, *c.*1364–*c.*1431. (Story of Athamas in) *L'epistre d'Othéa à Hector* . . . [The Epistle of Othéa to Hector] chapter 17; Ino in chapter 99. Didactic romance in prose. *c.*1400. MSS in British Library, London; Bibliothèque Nationale, Paris; elsewhere. / Translated by Stephen Scrope (London: *c.*1444–50). [Bühler 1970 / Hindman 1986, pp. 58, 136, 194, 202, pls. 22, 49]

Filarete, *c.*1400–1469? "Helle." Relief, on bronze door of St. Peter's, Rome. **1433–45.** In place. [Pope-Hennessy 1985b, 2:318]

Pinturicchio, 1454–**1513,** and studio. "Helle on a Ram." Ceiling fresco (detached), from Palazzo Pandolfo Petrucci ("Il Magnifico"), Siena. Metropolitan Museum, New York, no. 114.16. [Metropolitan 1980, p. 142—ill. / Berenson 1968, p. 345—ill.]

Tiziano Minio, 1517–1552/53, under direction of Jacopo Sansovino. "The Fall of Helle." Marble relief. **1537–39.** Loggetta, Piazza San Marco, Venice. [Pope-Hennessy 1985b, 3:404f.]

Léonard Thiry, 1500–**1550.** "Phrixus Received by King Aeëtes." Drawing, 1 of 2 extant from "Conquest of the Golden Fleece" cycle. / Engraved by René Boyvin, published in French and Latin editions, with text by Jacques Gohory, dedicated to Charles IX of France, 1563. [Paris 1972, no. 225, 283—ill.]

Jan Brueghel the Elder, 1568–1625. "Juno in the Underworld." Painting. **1596?** Gemäldegalerie, Dresden, inv. 877. [Ertz 1979, no. 32—ill.] Variants by Jan the Younger (and/or studio). *c.*1640s. Gemäldegalerie, Dresden, inv. 913; private coll., Germany; Galerie Finck, Brussels, in 1963. [Ertz 1984, nos. 133–35—ill.]

Antonio Cavallerino, 1511–**1598,** questionably attributed. *Ino.* Tragedy. First performed Venice. [DELI 1966–70, 1:653f.]

Anonymous French. "Athamas foudroyé" [Athamas Frenzied]. Dramatic interlude. Paris: **1624.** [Lancaster 1929–42, pt. 1, 1:192f., 2:761]

Thomas Heywood, 1573/74–1641. (Ino in) "Of the Daughters of Triton." Passage in *Gynaikeion: or, Nine Books of Various History Concerning Women* book 1. Compendium of history and mythology. London: printed Adam Islip, **1624.** [Ipso]

Frans Wouters, 1612–1659. "Juno in the Underworld." Painting. Szépművészeti Múzeum, Budapest, no. 549. [Budapest 1968, p. 777]

Molière, 1622–1673. *Mélicerte.* Comedy. Unfinished. First performed **1666,** Saint Germain, Paris. In *Les oeuvres posthumes* (Amsterdam: Jacques le Jeune [H. Wetstein], 1684). [DLLF 1984, 2:1527]

Charles Le Brun, 1619–1690. "Phrixus and Helle." Drawing, design for unexecuted fountain. **1675–80.** Musée des Beaux-Arts, Besançon, no. inv. C.2716. [Versailles 1963, no. 154—ill.]

Joseph Rayol, 1655–1718. "Ino." Marble statue. **1685–88.** Bosquet des Dômes, Gardens, Versailles. [Girard 1985, p. 288—ill.]

François Girardon, 1628–1715, design. "Ino and Melicertes" (leaping into the sea). Marble statue, executed by Pierre Granier, **1686–91.** Gardens, Versailles. [Girard 1985, p. 279—ill. / also Francastel 1928, no. 58—ill.]

William Congreve, 1670–1729. (Ino and Athamas in) *Semele.* Tragedy. **1707.** In *Works* (London: 1710). [Nicoll 1959–66, 2:315]

François-Joseph de Lagrange-Chancel, 1677–1758. *Ino et Mélicerte.* Tragedy. First performed **1713,** Paris. Published Paris: Pierre Ribou, 1715. [DLLF 1984, 2:1184 / Girdlestone 1972, p. 152]

George Frideric Handel, 1685–1759. (Ino and Athamas in) *Semele.* Opera (oratorio). Libretto, after Congreve (1707) and Pope's "Summer," revised by Newburgh Hamilton. First performed 10 Feb **1744,** Covent Garden, London. [Grove 1980, 8:118 / Keates 1985, pp. 251–53 / Hogwood 1984, pp. 184, 288]

Georg Philipp Telemann 1681–1767. *Ino.* Cantata. Text, Ramler. Published in *Denkmäler deutscher Tonkunst,* vol. 28 (Leipzig: 1907). [Grove 1980, 15:574, 18:657]

Karl Wilhelm Ramler, 1725–1798. "Ino." Poem. By **1767.** Modern edition, in *Poetische Werke,* edited by A. Anger (Stuttgart: Metzler, 1965). [Strich 1970, 1:220]

Étienne-Joseph Floquet, 1748–1785. *Hellé.* Opera (tragédie lyrique). Libretto, P. R. Lemonnier and La Boullaye, 1777. First performed 5 Jan **1779,** L'Opéra, Paris. [Grove 1980, 6:644]

Johann Friedrich Reichardt, 1752–1814. *Ino.* Melodrama. Libretto, Johann Christian Brandes. First performed **1779,** Leipzig. [Grove 1980, 15:706 / DLL 1968–90, 1:874]

Georg Joseph Vogler, 1749–1814. *Ino.* Cantata. Text, Karl Wilhelm Ramler. **1779.** [Grove 1980, 20:62]

Johann Christoph Friedrich Bach, 1732–1795. "Ino." Cantata for soprano and instruments. Libretto, K. W. Ramler. Vocal score published Leipzig: **1780.** [Wolff et al. 1983, p. 314]

John Flaxman, 1755–1826. "The Fury of Athamas." Marble sculpture group. **1790–94.** Ickworth House, Suffolk. [Irwin 1979, pp. 57f., fig. 69—ill. / also Bindman 1979, fig. 8]

Franz Grillparzer, 1791–1872. *Der Gastfreund* [The Intimate Friend] (Phrixus). Tragedy, first of the trilogy *Das Goldene Vlies* [The Golden Fleece]. **1820.** First performed 26 Mar 1821, Burgtheater, Vienna. Vienna: Wallishausser, 1822. [McGraw-Hill 1984, 2:414 / DLL 1968–90, 6:800–802]

Giovanni Battista Niccolini, 1782–1861. *Ino e Temisto* [Ino and Themisto (Athamas's third wife)]. Tragedy. *c.*1858. In *Opere,* edited by A. Gargiolli (Milan: 1860–80). [DELI 1966–70, 4:133]

Frederick Tennyson, 1807–1898. "King Athamas." Poem. London: privately printed, **1888;** collected in *Daphne and Other Poems* (London & New York: Macmillan, 1891). [DLB 1984, 32:285]

Pio Fedi, 1816–1892. "The Fury of Athamas." Sculpture. *c.*1890. Florence. [Hunger 1959, p. 163]

Algernon Charles Swinburne, 1837–1909. "The Ballad of Melicertes." Poem, in memory of Théodore de Banville. In *Conque* (**1891**); reprinted in *Astrophel and Other*

Poems (London: Chatto & Windus, 1911). [Gosse & Wise 1925–27, vol. 6 / Hyder 1970, p. xxix]

Jules Lemaître, 1853–1914. "Hellé." Short story. In *Myrrha, vierge et martyre* (Paris: Lecène, Oudin, **1894**). [NUC]

Victor Alphonse Duvernoy, 1842–1907. *Hellé.* Opera. Libretto, DuLocle and Nuitter. First performed **1896,** L'Opéra, Paris. [Grove 1980, 5:763]

Henri de Régnier, 1864–1936. "Phrixus." Poem. **1903–05.** In *La sandale ailée: 1903–1905* (Paris: Société du Mercure de France, 1906). [DLLF 1984, 3:1885]

Richard Edwin Day, b. 1852. "Ino." Poem. In *New Poems* (New York: Grafton, **1909**). [Boswell 1982, p. 83]

Francis Picabia, 1878–1953. "Ino." Surrealistic painting. *c.***1929–30.** Formerly Mme. Dubose coll., Paris. [Camfield 1979, pp. 235–37, fig. 322 / also Borràs 1985, no. 551—ill.]
——. "Ino." Painting. *c.*1934. [Borràs, no. 618—ill.]

Gerhard Marcks, 1889–1981. "Ino." Bronze sculpture. **1934.** At least 2 casts. Detroit Institute of Arts; elsewhere. [Busch & Rudloff 1977, no. 289—ill.]

Robert Graves, 1895–1985. (Story of Athamas, Phrixus, and Helle in) *Hercules, My Shipmate* chapter 2. Novel. First published as *The Golden Fleece* (London: Cassell, **1944**). Retitled, published New York: Creative Age Press, 1945. [Ipso / DLB 1983, 20:155 / Seymour-Smith 1982, pp. 383–86, 389]

ATHENA. Daughter of Zeus and Metis, Athena (Athene) is the warrior-goddess of wisdom and reason. She is also called "Pallas" ("brandisher of arms"); among her many other epithets are "goddess of the city," "counselor," "worker," "nurturer of children," "maiden," "champion," "mighty," and "warlike." She is identified with Minerva, the Roman goddess of handicrafts, with whom she shares common attributes as protector of intellectual and manual skills and as patron of warlike gods and heroes.

A virgin goddess, Athena stands against licence and vice; she is a stern exemplar of control and the pursuit of excellence. As protectress of the arts, she is often in the Parnassian company of Apollo and the Muses. She invented the flute and is particularly allied to the handicrafts of spinning and weaving as well as to skills such as the taming of horses and the building of chariots and ships. Of all the Olympians she is the chief proponent of *nous* and *sophia* ("mind" and "wisdom").

Athena's mastery of women's domestic arts is reflected in the myth of Arachne, whom she bested in a weaving and spinning competition. The goddess also plays a part in many other myths, including the Judgment of Paris, the birth of Erichthonius, and the labors of Heracles. She is associated not only with other gods, but also with mortal heroes.

In the Trojan War, Athena was the protectress of

the Achaians, particularly of Achilles, Diomedes, and Odysseus. She was ill-disposed toward Paris and the Trojans, for having been passed over by Paris in his judgment in favor of Aphrodite. However, when the lesser Ajax raped Cassandra at Athena's own shrine, the goddess joined Poseidon in destroying much of the Greek fleet in punishment for this double blasphemy.

The Palladium, a small wooden statue of Athena that late commentators say commemorated a childhood playmate of hers called Pallas, was worshiped by the Trojans as a divine protector of Troy. To make the city vulnerable, Odysseus and Diomedes stole it by night. Later, the Romans claimed that only a copy had been stolen and that Aeneas had brought the real object across the seas, later to be enshrined in Rome's Temple of Vesta.

Athena is also the patron of Athens, giving her name to the city when she won the contest with Poseidon for control of Attica. It was in Athena's honor that the fifth-century Athenians built the Parthenon, in which a great gold and ivory cult statue of Athena Parthenos stood. Athenian coinage of the period bore a helmeted Athena on the obverse and an owl, one of her emblems as goddess of wisdom, on the reverse—attributes that also appear in the postclassical arts. She is usually depicted with the aegis on her breast and a Gorgon's head on her shield. She is present in allegories of the triumph of knowledge over ignorance or war, or of virtue combating vice, and is often paired with Heracles as wisdom crowning might.

Classical Sources. Homer, *Iliad,* 1.193–218, 5.733ff., 875, 9.390, 14.178ff.; *Odyssey* 7.110ff., 20.72ff. and passim. *Homeric Hymns,* first and second hymns "To Athena," first hymn "To Aphrodite" lines 8–15. Aeschylus, *The Eumenides* 397–1047. Sophocles, *Ajax* 1–133. Euripides, *The Suppliants* 1183–1226; *The Trojan Women* 48–97; *Iphigenia in Tauris* 1135–1499; *Ion* 1548–1622; *Rhesus* 595–674. *Orphic Hymns* 32, "To Pallas." Apollonius Rhodius, *Argonautica,* passim. Diodorus Siculus, *Biblioteca* 3.70.1–6. Ovid, *Metamorphoses* 4.790–803, 6.1–145, 8.251ff. Pausanias, *Description of Greece* 1.24.1–7. Hyginus, *Fabulae* 142, 165, 168.

Further Reference. Rudolf Wittkower, "Transformations of Minerva in Renaissance Imagery," *Journal of the Warburg and Courtauld Institutes* 2 (1938–39).

Listings are arranged under the following headings:
General List
Birth of Athena
Contest with Poseidon

See also ACHILLES; AJAX; ARACHNE; ARES AND ATHENA; BELLEROPHON; CADMUS; CASSANDRA; DANAÏDS; DIOMEDES; ERICHTHONIUS; EROS, Punishment; GODS AND GODDESSES; HERACLES; JASON, General List; MARSYAS; MUSES; ODYSSEUS; ORESTES; PARIS, Judgment; PARNASSUS; PERSEUS, and Medusa; PROMETHEUS; TELEMACHUS; TIRESIAS; TITANS AND GIANTS; TROJAN WAR.

General List

Giovanni Boccaccio, 1313–1375. "De Minerva." In *De mulieribus claris* [Concerning Famous Women]. Latin verse compendium of myth and legend. **1361–75.** Ulm: Zainer, 1473. [Branca 1964–83, vol. 10 / Guarino 1963]

John Gower, 1330?–1408. (Minerva as goddess of wisdom, Pallas as goddess of war, described in) *Confessio amantis* 5.1189–1220. Poem. *c.*1390. Westminster: Caxton, 1483. [Macaulay 1899–1902, vol. 2]

Christine de Pizan, *c.*1364–*c.*1431. (Minerva as warrior-goddess, Pallas Athena as goddess of wisdom, in) *L'epistre d'Othéa à Hector* . . . [The Epistle of Othéa to Hector] chapters 13–14. Didactic romance in prose. *c.*1400. MSS in British Library, London; Bibliothèque Nationale, Paris; elsewhere. / Translated by Stephen Scrope (London: *c.*1444–50). [Bühler 1970 / Hindman 1986, pp. 90, 93, 103, 106–08, 112f., 129f., 194, pls. 17–19, 94]

————. (Minerva in) *Le livre de la Cité des Dames* [The Book of the City of Ladies] part 1 no. 34. Didactic compendium in prose, reworking of Boccaccio's *De mulieribus claris.* 1405. [Hicks & Moreau 1986] Translated by Brian Anslay (London: Pepwell, 1521). [Richards 1982 / Hindman, p. 90, pl. 76]

Taddeo di Bartolo, 1362–1422. "Pallas." Fresco. *c.*1407–14? Anticapella, Palazzo Pubblico, Siena. [Berenson 1968, p. 423—ill.]

King James I of Scotland, 1394–1437. (Minerva joins Venus in rescue of the poet from Fortune's imprisonment in) *The Kingis Quair* stanza 145 and elsewhere. Poem, in Middle Scots. *c.*1424. Published by William Tytler, 1783. Modern edition, Oxford: Clarendon Press, 1971. [Kratzmann 1980, pp. 44f., 59f. / Royle 1983, p. 165]

Francesco del Cossa, *c.*1435–1477, and followers. "Triumph of Minerva." Fresco, representing the month of March. **1470.** Sala dei Mesi, Palazzo Schifanoia, Ferrara. [Berenson 1968, pp. 94, 131—ill.]

Sandro Botticelli, 1445–1510. "Pallas [?] and the Centaur" (also identified as Camilla or nymph of Diana; allegory of victory of reason over sensuality?). Painting. *c.*1482–83. Uffizi, Florence. [Lightbown 1978, 1:82ff., no. B43—ill. / Uffizi 1979, no. P257—ill. / Berenson 1963, p. 34—ill.]

————. ("Pallas with the Head of Medusa" depicted in relief in setting of) "The Calumny of Apelles." Painting. *c.*1494–95. Uffizi, Florence, no. 1496. [Lightbown, no. B79—ill. / also Uffizi, no. P269—ill.]

————. (Minerva in) Drawings, design for tapestry. *c.*1498–1502? Uffizi, Florence, no. 201E.BB 575; Ashmolean Museum, Oxford, no. BB 581. [Lightbown, nos. D14–15—ill.] Tapestry in Vicomte de Baudreuil coll., Château de Favelles. [Ibid.]

————, attributed. "Pallas." Drawing. 1490s? Biblioteca Ambrosiana, Milan, no. f.14.BB 568. [Ibid., no. D13—ill.]

————, formerly attributed (now attributed to Baccio Pontelli). "Pallas." Intarsia panel. Designed *c.*1476. Door of Sala Segli Angeli, Palazzo Ducale, Urbino. [Warburg]

John Skelton, 1460?–1529. (Conversation between "Dame

Pallas" and the Queen of Fame, in) "The Garlande or Chapelet of Laurell." Poem. *c.*1495. London: Fakes, 1523. [Scattergood 1983 / Brownlow 1990]

Raphael, 1483–1520. (Statue of Minerva in niche, in) "The School of Athens." Fresco. **1509–10.** Stanza della Segnatura, Vatican, Rome. [Vecchi 1987, no. 85J—ill. / Jones & Penny 1983, pp. 74ff.—ill.]

Baldassare Peruzzi, 1481–1536. "Minerva (Athena)." Fresco. **1511–12** (or *c.*1517–18). Sala delle Prospettive, Villa Farnesina, Rome. [d'Ancona 1955, pp. 27ff., 93f. / Gerlini 1949, pp. 31ff. / also Frommel 1967–68, no. 51—ill.]

———. "Minerva." Fresco (detached), from Villa Stati, Rome. 1519–20? Metropolitan Museum, New York, no. 48.17.15. [Frommel 1967–68, no. 56—ill. / Metropolitan 1980, p. 141—ill.]

Antonio da Correggio, *c.*1489/94–1534. "Minerva" (? or Bellona?). Fresco. *c.*1519. Camera di San Paolo, Parma. [Gould 1976, pp. 51ff., 244—ill.]

———. "Allegory of Virtues" (Minerva [?] surrounded by women representing Virtues). Painting, for Studiolo of Isabella d'Este, Corte Vecchia, Mantua. 1529. Louvre, Paris, inv. 5926. [Ibid., pp. 128, 239f.—ill. / Louvre 1975, no. 144—ill. / also Louvre 1979–86, 2:168—ill.]

Andrea Riccio, *c.*1470–1532. "Della Torre Teaching at the Foot of a Statue of Minerva, with Apollo and Hygeia Looking On." Bronze relief, on tomb of Girolamo della Torre, S. Fermo Maggiore, Verona. *c.*1516–21? Original removed to Louvre, Paris, 1796, replaced by copy. [Pope-Hennessy 1985b, 2:333]

Giulio Romano, *c.*1499–1546, assistants, after designs by Giulio. "Minerva." Ceiling fresco. **1527–28.** Sala dei Venti, Palazzo del Tè, Mantua. [Hartt 1958, pp. 115ff.]

———. "Minerva." Fresco (simulated statue). 1540–44. Casa Giulio Romano, Milan. [Ibid., p. 240, fig. 492]

Parmigianino, 1503–1540. "Minerva." Drawing. *c.*1533. Louvre, Paris. [Warburg]

———. "Bust of Minerva" (?). Painting. Hampton Court Palace, inv. 1138. [Berenson 1968, p. 319]

Marcantonio Raimondi, *c.*1480–1527/34. "Minerva" (simulated statue in niche). Engraving (Bartsch no. 264), after design by Raphael. [Bartsch 1978, 26:257—ill.]

———. "Athena" ("Pallas"). Engraving (Bartsch no. 337), after design by Giulio Romano or Raphael. [Ibid., 27:32—ill.]

Rosso Fiorentino, 1494–1540. (Minerva in) "Allegory to the Glory of François I." Fresco. **1535–40.** Galerie François I, Château de Fontainebleau. [Lévêque 1984, p. 79—ill.]

Francesco Primaticcio, 1504–1570. "Minerva under a Trellis." Painting. *c.*1543. Grotte du Jardin des Pins, Château de Fontainebleau. Effaced. / Drawing for. Louvre, Paris, no. 8552. [Dimier 1900, pp. 309ff., no. 39 / Paris 1972, no. 149—ill.]

———, design. "Saturn and Minerva," "Minerva." Frescoes, for Salle de Bal, Château de Fontainebleau, executed by Niccolò dell' Abbate under Primaticcio's direction. 1551–56. Repainted 19th century. [Dimier, pp. 160ff., 284ff.]

———. "Minerva," "The Triumph of Minerva," "Minerva

Carried to the Heavens," "Minerva Visiting Jupiter and Juno." Ceiling frescoes, in Galerie d'Ulysse, Château de Fontainebleau. 1541–47. Destroyed 1738–39. / "Triumph" known only from descriptions. Drawings for others: Louvre, Paris, inv. 8525; British Museum, London, no. 1865–9–15–677; Uffizi, Florence, no. 1502E. [Béguin et al. 1985, pp. 135f., 169ff., 183ff., 188f.—ill. / Dimier, pp. 295ff.]

Jacopo Tintoretto, 1518–1594. "Minerva." **1543–44.** Painting. Private coll. [Rossi 1982, no. 76—ill.]

———, rejected attribution (attributed to Domenico Tintoretto). "Apollo and Minerva." Painting. Late 1580s. Formerly Thyssen-Bornemisza coll., Lugano. [Ibid., no. A55 / also Berenson 1957, p. 173 (as Jacopo)]

Jacopo Sansovino, 1486–1570. "Pallas." Bronze statuette. **1540–45.** Loggetta, Piazza San Marco, Venice. [Pope-Hennessy 1985b, 3:79f., 404f.]

Perino del Vaga, 1501–**1547.** "Pallas with Silenus." Drawing. Uffizi, Florence. [Warburg]

Florentine School. "Minerva" (statue in a niche). Painting. **1500/50.** Louvre, Paris, no. R.F. 1945–9. [Louvre 1979–86, 2:257—ill.]

Léonard Thiry, 1500–**1550,** composition. "Pallas." Engraved by René Boyvin. [Lévêque 1984, p. 34—ill.] Drawing (for?) in Metropolitan Museum, New York. [Warburg]

Benvenuto Cellini, 1500–1571. "Minerva." Bronze statuette. **1546–53.** Formerly in base of "Perseus" statue, Loggia dei Lanzi, Florence, now in Museo Nazionale, Florence. [Pope-Hennessy 1985a, pp. 174f.—ill.]

Bastianino, 1532–1602. "Minerva." Painting, part of decoration for Stanzino della Duchesse. *c.*1555–60. Municipio, Ferrara. [Arcangeli 1963, pp. 19, 64—ill.]

Paris Bordone, 1500–1571. "Thetis and Hephaestus" (sometimes called "Minerva [or Venus] at the Forge of Vulcan"). Painting. *c.*1555–60. Kress coll. (K1112), University of Missouri, Columbia, no. 61.78. [Shapley 1966–73, 3:36—ill. / also Canova 1964, p. 103—ill. / also Berenson 1957, p. 47 (as "Venus and Vulcan")]

Giovanni Bernardi, 1496–1553, and **Manno di Bastiano,** design. (Statuette of Minerva on) "The Farnese Coffer." Silver gilt coffer. **1548–61.** Museo di Capodimonte, Naples, no. 10507. [Capodimonte 1964, p. 129]

Paolo Veronese, 1528–1588. "Minerva." Painting. *c.*1565–70. Pushkin Museum, Moscow, inv. 2666. [Pallucchini 1984, no. 110—ill. / Pignatti 1976, no. 156—ill.]

Giambologna, 1529–1608. "Minerva." Bronze figurine. **1578.** Unique cast, executed by A. Susini. Museo del Bargello, Florence, no. 420. [Avery 1987, no. 58 / also Avery & Radcliffe 1978, no. 30—ill.]

Balthasar de Beaujoyeulx, ?–*c.*1587, choreography. (Minerva in) *Ballet comique de la reine* act 3. Ballet. Music, Lambert de Beaulieu, Jacques Salmon, Beaujoyeulx, others. Libretto, La Chesnaye. First performed 15 Oct **1581,** Palais Bourbon, Paris; scenery and costumes, Jacques Patin. [Simon & Schuster 1979, p. 43 / Arnott 1977, p. 105 / Clarke & Vaughan 1977, p. 42 / Terry 1976, p. 4]

Hendrik Goltzius, 1558–1617. "Mercury and Minerva." Drawing, composition for print. **1588.** Landolt coll., Chur. [Reznicek 1961, no. 134—ill.] Print by Jacob Matham (Bartsch no. 281). [Ibid.]

———. "Minerva." Engraving, in "Four Deities" series

(Bartsch no. 62, Jan Saenredam). 1596. [Strauss 1977a, no. 328—ill./ Bartsch 1980–82, no. 160a—ill.]

———. "Minerva." Drawing, composition for print. *c.*1596. Staatliche Kunstakademie, Düsseldorf. [Reznicek, no. 137—ill.] Engraving by Jan Saenredam (Bartsch no. 56). [Ibid.]

———, composition. "Athena Seated in a Pavilion (Surrounded by Soldiers)." Engraving, executed by Jacob Goltzius. 1597. [Bartsch, p. 393—ill.]

———. "Minerva" (as personification of the theory of painting). Painting. *c.*1611. Mauritshuis, The Hague, inv. 42, on loan to Frans Hals Museum, Haarlem, no. 470. [Mauritshuis 1985, p. 366—ill. / de Bosque 1985, pp. 143, 145—ill.]

———. "Minerva." Painting. Hermitage, Leningrad. [Bénézit 1976, 5:96]

———. "Athena." Drawing. Graphische Sammlung, Munich. [de Bosque—ill.]

———, rejected attribution. "Athena and Aphrodite." Drawing. Teylers Museum, Haarlem. [Reznicek, 1:486 / also de Bosque—ill.]

Edmund Spenser, 1552?–1599. (Britomart compared to Minerva dressed for battle in) *The Faerie Queene* 3.9.22. Romance epic. London: Ponsonbie, **1590**, 1596. [Hamilton 1977 / MacCaffrey 1976, p. 311]

Bartholomeus Spranger, 1546–1611. "Minerva as Conqueror of Ignorance" ("The Triumph of Wisdom"). Painting. *c.*1591. Kunsthistorisches Museum, Vienna, inv. 1133 (1503). [Vienna 1973, p. 166—ill. / Hofmann 1987, no. 7.1—ill. / also de Bosque 1985, p. 146—ill.]

———. "Athena as Warrior." Drawing. Österreichische Nationalbibliothek, Vienna. [de Bosque—ill.]

———. "Mercury and Minerva." Painting. Národní Galeri, Prague. [Ibid., p. 115—ill.]

———. "Pallas Athena and Cybele." Drawing. University Library, Erlangen, cat. 1929 no. 912. [Warburg]

———, composition. "Athena Led into the Temple of Wisdom by Hercules [strength] and Mars [valor]." Engraving, executed by Jan Muller. [Warburg]

Federico Zuccari, 1540/43–1609. (Apollo, with Minerva, in) "Apotheosis of the Artist." Ceiling painting. **1598.** Palazzo Zuccari, Rome. [Garrard 1989, fig. 302]

Antoine Caron, 1520/21–**1599.** (Minerva and other gods in) "The Triumph of Winter." Painting. Private coll., Paris. [Paris 1972, no. 35—ill.]

School of Fountainebleau. "Pallas Athena" (?). Painting. **16th century.** Private coll., Basel. [Hofmann 1987, no. 3.10—ill.]

Hubert Gerhard, *c.*1540/50–1620, attributed. "Minerva." Bronze sculpture. Before **1600.** [Warburg]

Hans von Aachen, 1552–1616. "Athena Introducing [female figure representing] Painting to the Liberal Arts." Painting. *c.*1600. Sonia Gilbert coll., Brussels. [Garrard 1989, fig. 303 / also Hofmann 1987, no. 7.35—ill. (print)]

Emilio de'Cavalieri, *c.*1550–1602, music and choreography. *La contesa fra Giunone e Minerva* [The Contest between Juno and Minerva]. Musical pastorale. Libretto, Gian Battista Guarini. First performed 5 Oct **1600,** Florence, for the wedding of Henry IV of France and Maria de' Medici. [Grove 1980, 4:21ff., 7:771]

Lope de Vega, 1562–1635. "De Venus y Palas" [On Venus and Pallas]. Sonnet, no. 139 of *Rimas humanas* part 1.

1602–04. Madrid: Martin, for Alonso Perez, 1609. [Sainz de Robles 1952–55, vol. 2]

Girolamo Campagna, 1549/50–1625? "Minerva." Bronze statuette. **Early 17th century.** Hermitage, Leningrad, inv. 978. [Hermitage 1984, no. 365—ill.]

Adam Elsheimer, 1578–1610. "The Realm of Minerva" ("Minerva as Patroness of the Arts and Sciences"). Painting, part of "Three Realms of the World" (Venus, Minerva, Juno) series. *c.*1607–08. Fitzwilliam Museum, Cambridge, inv. 539. [Andrews 1977, no. 22b—ill. / Fitzwilliam 1960–77, 1:202—ill.]

Joseph Heintz the Elder, 1564–**1609.** "Allegorical Representation with Minerva." Painting. Lost. / Drawing after, by Anton Gasser, 1610. Stiftung Preussischer Kulturbesitz, Berlin, no. K.d.Z. 7212. [Zimmer 1971, no. B13—ill.]

Lavinia Fontana, 1552–1614. "Minerva Dressing." Painting. 1613. Borghese Gallery, Rome, inv. 7. [Pergola 1955–59, 1: no. 44—ill.]

Ambrose Dubois, 1543–**1614**, attributed. "Marie de' Medici as Minerva." Painting (from Chambre du Roi, Château de Fontainebleau?). Private coll., Paris. [Paris 1972, no. 86—ill.]

Artemisia Gentileschi, 1593–1652/53. "Minerva" (portrait of Anne of Austria?). Painting. *c.*1615. Uffizi, Florence, inv. 8557. [Garrard 1989, pp. 48ff., 160–64—ill. / Uffizi 1979, no. P689—ill.]

Pierre Guédron, *c.*1570/75–1619/20, music. *Ballet du triomphe de Minerve.* Ballet. First performed **1615**, Paris. [Grove 1980, 7:784]

Ben Jonson, 1572–1637. (Pallas in) *The Golden Age Restored.* Masque. First performed Jan **1615**, Whitehall, London. Published London: 1616. [Herford & Simpson 1932–50, vol. 7]

Jacob Jordaens, 1593–1678. (Minerva in) "Allegory of Knowledge." Painting. *c.*1617. Unlocated. [d'Hulst 1982, p. 74—ill.]

———. "The Triumph of Minerva." Drawing. *c.*1655–60. Private coll., Belgium. [Ibid., fig. 219]

Thomas Heywood, 1573/74–1641. "Minerva," "Of Minerva, and Others." Passages in *Gynaikeion: or, Nine Books of Various History Concerning Women* books 1, 8. Compendium of history and mythology. London: printed by Adam Islip, **1624.** [Ipso]

Johann Rottenhammer, 1564–**1625,** manner. "Venus and Minerva." Painting. Rijksmuseum, Amsterdam, inv. A3952. [Rijksmuseum 1976, p. 483—ill.]

Peter Paul Rubens, 1577–1640. (Minerva in) "The Education of Marie de' Medici," "The Apotheosis of Henri IV and the Assumption of the Regency by Marie de' Medici," "The Council of the Gods" ("The Government of the Queen"), "Marie de' Medici as Patroness of the Fine Arts" ("The Felicity of the Regency"); (the Queen depicted with attributes of Minerva in) "The Triumph of Juliers," "The Meeting of the Queen with Louis XIII at Angoulême" ("The Treaty of Angoulême"). Paintings, part of "Life of Marie de' Medici" cycle. **1622–25.** Louvre, Paris, inv. 1771, 1779–81, 1783, 1786. [Saward 1982, pp. 40ff., 98ff., 114ff., 133ff., 142ff.—ill. / Jaffé 1989, nos. 716, 735, 737, 739, 745, 750—ill. / also Louvre 1979–86, 1:115–17—ill. / White 1987, pl. 186 / also Baudouin 1977, pl. 45] Oil sketches

(for all but "Angoulême"). Alte Pinakothek, Munich, inv. 92, 99, 100, 102, 103 (all); Simson coll., Freiburg ("Education"); Hermitage, Leningrad ("Apotheosis"). [Jaffé, nos. 714, 715, 733, 734, 736, 744, 738—ill. / Held 1980, nos. 58–59, 69–72, 74—ill. / also Munich 1983, pp. 463ff.—ill.]

————. "The Glorification of the Duke of Buckingham" ("Minerva and Mercury Conduct the Duke to the Temple of Virtue"). Ceiling painting, for George Villiers, Duke of Buckingham. c.1625–27. Formerly Osterley Park, destroyed 1949. [Jaffé, no. 795—ill.] Oil sketch. National Gallery, London, inv. 187. [Ibid., no. 794—ill. / Held 1980, no. 291—ill. / also London 1986, p. 545—ill.] Copy of lost early sketch, formerly Reyve coll., London, unlocated. [Jaffé, no. 793 / Held, no. 290—ill.]

————. (Minerva in) "The Victorious Hero Takes Occasion to Conclude Peace." Drawing with watercolor, possible study for unexecuted painting in unfinished "Life of Henry IV" series. 1627–31? Staatliche Kunstsammlungen, Weimar. [Burchard & d'Hulst 1963, no. 168—ill.]

————. "Prudence (Minerva) Conquering Sedition." Ceiling painting, for Banqueting House, Whitehall. 1633–34. In place. [Jaffé, no. 1021—ill. / White, pl. 276] Oil sketch. Koninklijk Museum voor Schone Kunsten, Antwerp, inv. 802. [Held 1980, no. 142—ill. / Jaffé, no. 1019—ill. / Antwerp 1970, p. 200]

————. (Minerva as counselor to Philip in) "Philip IV Appoints Prince Ferdinand Governor of the Netherlands" ("The Apotheosis of Isabella Clara Eugenia"). Painting, executed by Gerard Seghers from Rubens's design, part of Stage of Isabella, decoration for "Pompa Introitus Fernandi," triumphal entry of Cardinal-Infante Ferdinand of Spain into Antwerp, 17 Apr 1635. Largely destroyed; fragment in Rubenshuis, Antwerp. [Martin 1972, no. 35—ill. / Jaffé, no. 1142—ill.] Oil sketch, by Rubens. Pushkin Museum, Moscow, inv. 2626. [Martin, no. 34a—ill. / also Held, no. 158—ill. / Jaffé, no. 1141—ill.]

————, composition. (Minerva in) Frontispiece for *Justus Lipsius, opera omnia* (Antwerp: 1637). Engraved by Cornelis Galle. [Baudouin 1977, fig. 160]

Philip Massinger, 1583–1640. *Minerva's Sacrifice*. Drama. First performed **1629**, Blackfriar's Theatre, London. Lost? [DLB 1987, 58:169 / Logan & Smith 1978, p. 109]

Rembrandt van Rijn, 1606–1669. "Minerva." Painting. **1632**. Gemäldegalerie, Berlin-Dahlem, no. 828C. [Gerson 1968, no. 90—ill. / Berlin 1986, p. 63—ill.]

————. "Minerva." Painting. 1635. J. Weitzner coll., London. [Gerson, no. 94—ill.]

————. "Anna Wijmer, Jan Six's Mother (as Pallas in Her Study)." Drawing. 1652. Six coll., Amsterdam. [Benesch 1973, no. 914—ill.]

————, attributed (or pupil, corrected by Rembrandt?). "Minerva with a Helmet and Lance (Meeting Homer)." Drawing. Formerly de Robiano coll., Brussels. [Ibid., no. A79—ill.]

————, circle (Hendrick Pot? earlier attributed to Rembrandt). "Minerva." Painting. Mauritshuis, The Hague, inv. 626. [Mauritshuis 1985, p. 474—ill.]

Pieter Lastman, c.1583–1633. "Hercules and Minerva." Painting. Dienst Verspreide Rijkskollekties, The Hague, inv. NK1830. [Pigler 1974, p. 118 / Wright 1980, p. 232]

Niccolò Roccatagliata, fl. 1593–**1636**. "Minerva." Bronze statuette. Museo di Capodimonte, Naples, no. 10546. [Capodimonte 1964, p. 111]

Francis Kynaston, 1587–1642. *Corona Minervae* [The Crown of Minerva]. Masque. First performed 27 Feb **1636**, before the Princes of Wales and York and Princess Mary. College of the Museum Minervae, London. Published London: 1635. [Greg 1939–59, 2:647, no. 503]

Simon Vouet, 1590–1649. "Minerva and Bellona." Painting, ceiling decoration for Hôtel Séguier, Paris. **1633**–38. Destroyed. [Crelly 1962, pp. 112ff., no. 249]

————. "Minerva." Painting. Hermitage, Leningrad, inv. 7523. [Hermitage 1984, no. 91—ill. / also Hermitage 1974, pl. 10]

Cornelis Cornelisz van Haarlem, 1562–**1638**. "Minerva." Painting. Formerly Stenger coll., The Hague, sold London, 1962. [Warburg]

Pietro da Cortona, 1596–1669. (Minerva, symbolizing victory of intelligence over brute force, in) "The Triumph of Divine Providence." Fresco. **1633**–39. Palazzo Barberini, Rome. [Briganti 1962, no. 45—ill.]

Philippe de Buyster, 1595–1688. "Minerva." Stone sculpture. **1635**–40. Château de Wideville. [Chaleix 1967, pp. 32ff., pl. 4.3]

Bernardo Strozzi, 1581–1644. "Minerva" (or Bellona?). Painting. **1631**–44. Cleveland Museum of Art, Ohio, no. 29.133. [Cleveland 1982, no. 184—ill.]

Alessandro Algardi, 1598–1654. "Minerva with the Cross of Malta." Stucco relief, for Galleria dei Costumi dei Romani, Villa Belrespiro (now Villa Doria Pamphili). Executed by R. Bolla and G. M. Sorisi from Algardi's designs. **1646**. In place. [Montagu 1985, no. A.199—ill.]

Robert Herrick, 1591–1674. "A Vow to Minerva." Poem. In *Hesperides* (London: Williams & Eglesfield, **1648**). [Martin 1972]

Abraham Bloemaert, 1564–**1651**. "Athena as Warrior." Drawing. Kunstmuseum, Dusseldorf. [de Bosque 1985, p. 142—ill.]

Sophie Elisabeth, Duchess of Brunswick-Lüneburg, 1613–1676. *Der Minervae Banquet*. Operetta. Libretto, composer. **1655**. [Grove 1980, 17:530 / Cohen 1987, 2:658]

Nicolas Poussin, 1594–1665. "Minerva." Design and wax model for marble term. **1655**–56. Lost. / Marble executed by Domenico Guidi, by 1661. Quinconce du Nord, Gardens, Versailles. [Girard 1985, pp. 273f. / also Blunt 1966, no. 225—ill.]

Ferdinand Bol, 1616–1680. "Allegory on Education" (Minerva teaching a group of children). Painting. c.**1656**. Sold London, 1976. [Blankert 1982, no. 42—ill.]

————. "Allegory on Education" (Minerva teaching classics to young woman, putti bringing Bible to her). Painting. 1663. Rijksmuseum, Amsterdam, inv. A46. [Ibid., no. 43—ill. / Rijksmuseum 1976, p. 124—ill.]

Govaert Flinck, 1615–**1660**. "Painting of a Lady as Athena" ("Face of a Laughing Woman with an Owl"). Painting. Unlocated. [von Moltke 1965, no. 80—ill.]

————, formerly attributed. "Athena." Painting. Formerly Tritsch-Wien coll., Berlin, sold 1929. [Ibid., no. W34—ill.]

Augustin Terwesten, 1649–1711/17. "Minerva Incites Pictura to Paint Venus." Painting. **1663**. Castle Grunewald. [Warburg]

Giovanni Coli, 1636–1681, and **Filippo Gherardi**, 1643–1704. "Triumph of Minerva." Cycle of 5 paintings, comprising ceiling decoration for Monasterio, Isola di San Giorgio. **1663–65.** Destroyed? / Study. Uffizi, Florence, inv. 609. [Uffizi 1979, no. P444—ill.]

Cornelis van Ryssen, called Cornelio Satiro, documented **1667.** "Landscape with Pallas among Shepherds." Galleria Borghese, Rome, inv. 283. [Pergola 1955–59, 2: no. 276—ill.]

Claude-François Vignon, 1633–1703. "Hercules Overcoming Vice and Ignorance in the Presence of Minerva." Painting (largely ruined). **1667.** Louvre, Paris, inv. 8442. [Louvre 1979–86, 4:273—ill.]

Noël Coypel, 1628–1707. "Apollo Crowned by Minerva." Painting, for Château des Tuileries. **1667–68.** Louvre, Paris, inv. 3461. [Louvre 1979–86, 3:173—ill.]

———. "The Triumph of Minerva." Painting (fragments), cartoon for Gobelins tapestry in "Triumphs of the Gods" series. Louvre, Paris, inv. 3482. [Louvre 1979–86, 3:174—ill.]

Jakob Balde, 1604–1668. (Pallas, representing War, in) Neo-Latin poem. / Translated by Johann Gottfried Herder as "Zwo Göttinnen" [Two Goddesses] (1795). *See Herder, below.*

Sebastián de Herrera Barnuevo, 1619–1671. "Allegory with the Goddess Minerva." Drawing. *c.*1650–70. Uffizi, Florence, no. 105425. [López Torrijos 1985, p. 424 no. 6]

Jan Lievens, 1607–1674. "Justice Receiving the Corpus Juris from the Hands of Time, Accompanied by Pallas Athena." Painting. Hoogheemraadschap Rijnland, Leiden. [Wright 1980, p. 240]

Juan Hidalgo, 1612/16–1685. *El templo de Palas* [The Shrine of Pallas]. Musical work for the stage. Libretto, Avellaneda. **1675.** Music lost. [Grove 1980, 8:548]

François Girardon, 1628–1715. "Pallas" ("Wisdom"). Stone statue. **1679.** Cour de Marbre, Château de Versailles. [Francastel 1928, no. 45—ill.]

———, attributed. "Pallas." Marble bust. Formerly (1798) Louvre, Paris, lost. [Ibid., no. 94]

Luca Giordano, 1634–1705. (Athena in) "Allegory of Human Life and the Medici Dynasty." Fresco. **1682–83.** Palazzo Medici Riccardi, Florence. [Ferrari & Scavizzi 1966, 2:112ff.—ill.] Study. Denis Mahon coll., London. [Ibid.—ill.]

———. (Jupiter and Minerva in) "Allegory of Peace between Florence and Fiesole." Painting, study for unexecuted fresco. Early 1680s. Palazzo Pitti, Florence. [Ibid., 2:111f.—ill.]

———, attributed (or Nicolas Loir? 1624–1679). Painting. Louvre, Paris, inv. 308, on deposit at Musée des Beaux-Arts, Perpignan. [Ferrari & Scavizzi, 2:308]

Antoine Coysevox, 1640–1720. (Minerva representing France in relief on) "The War Vase." Marble vase. **1684–85.** Terrasse, Château de Versailles. [Girard 1985, p. 286—ill.]

Pierre Beauchamps, 1631–1705, music. "Minerve." Entrée in *Ballet des arts.* First performed **1685,** Collège Louis-le-Grand, Paris. [Astier 1983, p. 161]

Joachim von Sandrart, 1606–1688. "Minerva and Saturn Protecting Art and Science." Painting. Kunsthistorisches Museum, Vienna, inv. 1136 (1538). [Vienna 1973, p. 153—ill.]

Volterrano, 1611–1689. (Minerva appears in 2 of) Cycle of ceiling frescoes comprising an allegory of Vittoria della Rovere. Sala delle Allegorie, Palazzo Pitti, Florence. [Pitti 1966, pp. 63f.]

Pietro Torri, *c.*1650–1737. *Gli oracoli di Pallade e di Nemesi* [The Oracles of Pallas and Nemesis]. Serenata. First performed 6 Feb **1690,** Munich. [Grove 1980, 19:82]

Marianna Rasschenau. *Il consiglio di Pallade* [The Counsel of Pallas]. Cantata? **1697.** [Cohen 1987, 1:573]

Gabriel Grupello, 1644–1730. "Minerva as Allegory of Sagacity and Honesty." Bronze sculpture. *c.*1697–98. Staatliche Kunstsammlungen, Kassel, inv. B VIII.193. [Düsseldorf 1971, no. 40—ill.]

———. "Minerva." Bronze statuette. *c.*1695–1700? Kunstmuseum, Düsseldorf, inv. 1938–30. [Kultermann 1968, no. 40—ill. / Düsseldorf, no. 44—ill.] Studio (?) replica, wood. Bayerisches Nationalmuseum, Munich. [Kultermann, no. 41—ill. / Düsseldorf, no. 45—ill.] Bronze variant (circle of Grupello). Before 1711? Kassel, inv. B VIII.191. [Düsseldorf, no. 46—ill.]

———, circle. "Minerva." Wood statuette. 1700–25. Kassel, inv. U/63a III. [Düsseldorf, no. 47 / Kultermann, fig. 125]

———. "Minerva-Pictura." Life-size marble statue. 1700–09. Park, Schloss Schwetzingen. [Kultermann, no. 133—ill.]

———. "Minerva." Life-size marble statue. 1715–16. Garden, Schloss Schwetzingen. [Ibid., no. 176—ill.]

———. "Pallas." Statue. Before 1716. Several versions, all lost. [Ibid., nos. 134–36]

Sebastiano Ricci, 1659–1734. "Minerva." Fresco (detached), part of "The Olympian Gods" ceiling decoration, from Palazzo Mocenigo-Robilant, Venice. **1697–99.** Gemäldegalerie, Berlin-Dahlem, on loan from German government. [Daniels 1976, no. 48—ill. / Berlin 1986, p. 64—ill.]

———. "The Triumph of Wisdom and the Arts over Ignorance" (female figure representing the Medicis accepting the homage of Minerva). Painting. 1703. Palazzo Marucelli-Fenzi, Florence. [Daniels, no. 109—ill.]

———. "The Triumph of Learning over Ignorance" ("Allegory of France: Minerva [Wisdom], Trampling Ignorance and Crowning Warlike Virtue"). Painting. 1717–18. Louvre, Paris, inv. 562. [Ibid., no. 297—ill. / Louvre 1979–86, 2:227—ill.]

———. (Minerva presiding over) "The Glorification of the Arts and Sciences." Painting. 1720. Seminario Patriarcale, Venice. [Daniels, no. 462—ill.] Study. Private coll., Rome. [Ibid., no. 394—ill.]

Flemish School. "Sine Cerere et Baccho friget Venus, with Minerva Bringing Temperance, and Cronus." Painting. **17th century.** E. L. Cats coll., The Hague, in 1960. [Warburg]

Italian School. "Minerva." Marble bust. **17th century.** Galleria Borghese, Rome, inv. 231. [Faldi 1954, no. 9—ill.]

Spanish School. "Allegory with Minerva, Virtue, Time, and Other Figures." Painting. **17th century.** Formerly Torrecilla coll., Madrid. [López Torrijos 1985, p. 323, pl. 140]

Caius Gabriel Cibber, 1630–1700. "Minerva." Bronze sculpture. Duke of Devonshire coll., Chatsworth. [Warburg]

Jean-Baptiste Morin, 1677–1754. *Junon et Pallas* [Juno and Pallas]. Cantata. Published in *Cantates françoises,* book 2 (Paris: **1707**). [Grove 1980, 12:576]

Jonathan Swift, 1667–1745. (Venus and Minerva vie in) "Cadenus and Vanessa." Poem. **1712–13**. Dublin: 1726; collected in *Works* (Dublin: Faulkner, 1735). [Williams 1958, vol. 2]

———. "The Storm; Minerva's Petition" (to Neptune). Satirical poem. 1722. In *Poems on Several Occasions* (London: for J. Bromage, 1749). [Ibid., vol. 1]

Giovanni Alberto Ristori, 1692–1753. *Pallide trionfante in Arcadia* [Pallas Triumphant in Arcadia]. Opera (dramma pastorale). Libretto, O. Mandelli. First performed Summer **1713**, Teatro Obizzi, Padua. [Grove 1980, 16:55f.]

Louis-Nicolas Clérambault, 1676–1749. *Le bouclier de Minerve* [The Shield of Minerva]. Cantata. Published Paris: **1714**. [Grove 1980, 4:492]

Floriano Arresti, *c.*1660–1719. *Il trionfo di Pallade in Arcadia.* Opera. First performed **1716**, Marsigli-Rossi, Bologna. [Grove 1980, 1:634]

Balthasar Permoser, 1651–1732. "Minerva." Marble statue. **1716**. Albertinum, Dresden. [Asche 1966, no. P59, pl. 47]

Herman Collenius, 1650–1720/21. "Minerva Gives the Mask of Treason to the Town Patroness of Groningen, Who Is Listening to Good Counsel." Painting. Museum, Groningen. [Wright 1980, p. 80]

French School. "Portrait of Cornélie-Brigitte-Cécile de Witte 1701–1730, Wife of Colonel François Collin, as Minerva." Painting. **1700/25**. Musées Royaux des Beaux-Arts (Musée d'Art Ancien), Brussels, inv. 6283. [Brussels 1984a, p. 371—ill.]

Daniel Gran, 1694–1757. "Apollo Surrounded by Virtues and Sciences [or Vices]" (with Minerva and the Graces), "A Youth (Led by Pallas Athena) Receiving the Lamp of Knowledge from the Graces." Frescoes. **1726**. Marmorsaal, Gartenpalais Schwarzenberg, Vienna. [Knab 1977, pp. 48f., nos. F12, F13—ill.]

William Hogarth, 1697–1764. "Music Introduced to Apollo by Minerva." Etching and engraving. 3 states. **1727?** [Paulson 1965, no. 110—ill.]

Paul Egell, 1691–1752. "Minerva." Sandstone statue. *c.***1725–30**. Museum, Speyer. [Asche 1966, no. E14, pl. 299]

Giovanni Battista Pittoni, 1687–1767. "Justice and Peace with Minerva and Jupiter." Painting. *c.***1727–30**. Palazzo Pesaro, Venice. [Zava Boccazzi 1979, no. 218—ill.]

Louis Boulogne the Younger, 1654–1733. "Minerva and the Arts." Painting. Musée, Fontainebleau. [*Revue de l'art* 1972, p. 16—ill.]

James Thornhill, 1675/76–1734. "Minerva as Patron of the Arts." Ceiling painting. Queen's House, Greenwich. [Jacobs & Stirton 1984b, p. 56]

François Le Moyne, 1688–1737. "Allegory with Minerva as Protectress of the Arts." Painting, sketch. Lost. [Bordeaux 1984, p. 130] Related drawing, falsely attributed to Le Moyne (actually by Charles Parrocel?). Albertina, Vienna, inv. 23615 (as Le Moyne). [Ibid., no. X35—ill.]

———, rejected attribution (manner of Jean-Jacques Lagrenée). "Minerva, Protectress of the Arts." Painting. Unlocated. [Bordeaux 1984, no. X26—ill.]

Pompeo Batoni, 1708–1787. (Minerva in) "The Triumph of Venice." Painting. **1737**. North Carolina Museum of Art, Raleigh. [Clark 1985, no. 13—ill.]

Pierre-Charles Trémollière, 1703–**1739**. "Minerva." Painting. Hôtel de Soubise, Paris. [Bénézit 1976, 10:266]

Massimiliano Soldani-Benzi, 1658–1740. "Athena." Bronze statue. Louvre, Paris. [Warburg]

Francesco Solimena, 1657–1747. "Minerva and Hercules." Painting. Museo di Capodimonte, Naples. [Pigler 1974, p. 119]

Giuseppe Bazzani, 1690/1701–1769. "Erminia" (? or Minerva?). Painting. *c.***1750**. Kress coll. (K1271), Walker Art Museum, Bowdoin College, Brunswick, Me. [Shapley 1966–73, 3:115—ill.]

Franz Anton Maulbertsch, 1724–1796. "(Allegory of) The Academy, with Its Attributes, at the Feet of Minerva." Painting, academy competition piece. **1750**. Formerly Akademie der Bildenden Kunste, Vienna, lost. [Garas 1960, no. 18] Grisaille sketch. Wilhelm Reuschel coll., Munich. [Ibid., no. 17—ill.]

———. "Allegory with Minerva." Painting. *c.*1750. Szépmüvészeti Múzeum, Budapest. [Ibid., no. 19—ill.]

———. "Triumph of Minerva." Drawing. *c.*1750. Morauské Muzeum, Brno, Czechoslovakia. [Ibid., no. 36—ill.]

German School. "Minerva with Personifications of the Arts and Sciences." Painting. **1753**. Museum of Fine Arts, Boston, Res. 17.102. [Boston 1985, p. 114—ill.]

Jacob de Wit, 1695–1754. "Allegory of Minerva and Three Putti." Painting. Museum Boymans-van Beuningen, Rotterdam. [Wright 1980, p. 500]

Joseph-Marie Vien, 1716–1809. "Minerva." Painting. *c.*1754. Hermitage, Leningrad, inv. 3688. [Hermitage 1986, no. 315—ill.]

Giovanni Battista Tiepolo, 1696–1770. "Minerva with Putti on Clouds," "Minerva Prevents Achilles from Killing Agamemnon." Frescoes. **1757**. Stanza dell' Iliade, Villa Valmarana, Vicenza. [Pallucchini 1968, no. 240—ill. / Morassi 1962, pp. 64f.—ill.]

———. "Minerva as Protectress of the Arts and Sciences." Fresco. Formerly Palazzo Giovannelli, Venice, untraced. [Morassi, p. 59 / Pallucchini, p. 136]

François-Gaspard Adam, 1710–1761. "Minerva Armed." Statue, part of mythological cycle. **1755–58**. Gardens, Sanssouci, Potsdam. [Thirion 1885, pp. 165f.—ill.]

Henry Fuseli, 1741–1825. "Minerva." Drawing. **1759**. Kunsthaus, Zürich (*Jugendalbum*). [Schiff 1973, no. 280—ill.]

Antonio Guardi, 1698–1760. "Minerva." Painting. **1750–60**. Musée de Picardie, Amiens. [Morassi 1984, no. 90—ill.]

———. "Minerva." Fresco. Ca' Rezzonico, Venice. [Ibid., no. 89—ill.]

Jean-Marc Nattier, 1685–1766. "Mme. de Fremicourt as Minerva." Painting. *c.***1760**. Birmingham Museum of Art, Ala. [Seen by author, 1986]

Augustin Pajou, 1730–1809. "The Princess of Hesse-Homburg as Minerva." Marble bas-relief. **1761**. Academy of Fine Arts, St. Petersburg, in 1912. [Stein 1912, pp. 12f.—ill.]

Ferdinand Dietz, ?–*c.*1780. "Minerva." Sculpture. **1760–65**. Seehof, Bamberg, Park. [Warburg]

Clodion, 1738–1814. "Minerva." Terra-cotta statuette. **1766.** Private coll., France, in 1911. [Frick 1968–70, 4:100]

Jean-Pierre-Antoine Tassard, 1727–1788. "Portrait of Catherine II as Minerva." Marble bust. **1774.** Hermitage, Leningrad, inv. 1653. [Hermitage 1984, no. 385—ill. / also Hermitage 1975, pl. 104–05]

Jean-Honoré Fragonard, 1732–1806. "Bust of Minerva." Painting. **1773–76.** Detroit Institute of Art. [Wildenstein 1960, no. 407—ill.]

Charles-Joseph Natoire, 1700–**1777.** "Allegory" (History writing under the protection of Minerva?). Painting, sketch. Louvre, Paris, no. R.F. 2223. [Louvre 1979–86, 4:120—ill.]

Jean-Antoine Houdon, 1741–1828. "Minerva." Marble medallion. Exhibited **1777.** [Réau 1927, no. 258—ill.]

———. "Minerva." Plaster sculpture. 1779. Destroyed. [Ibid., no. 7]

———. "Minerva." Stone bust. Fountain, Palais de l'Institut, Paris. [Ibid., no. 162]

———. "Ceres and Minerva." Bronze statuette, model for Palais-Bourbon decorations (unexecuted). Lost. [Réau 1964, no. 53]

Jean-Baptiste Lemoyne, 1704–**1778.** "Mme. Adélaïde as Minerva." Terra-cotta bust. Sorel coll., Paris. [Réau 1927, no. 69—ill.]

Antoine Légat de Furcy, c.1740–after 1790. *Les leçons de Minerve.* Set of instrumental compositions. Published Paris: **1779,** 1785. [Grove 1980, 10:610]

Wilhelm von Kaulbach, 1804–1874. "Pedantry Attacked by Artists and Students under the Protection of Minerva." Painting, part of a cycle of 6 frescoes on allegories of art. **1760–80.** Neue Pinakothek, Munich, inv. WAF.409. [Munich 1982, p. 152—ill.]

Karl Siegmund Seckendorff, 1744–1785. *Minervens Geburt, Leben, und Taten* [Minerva's Birth, Life, and Deeds]. Shadow play. First performed 28 Aug **1781,** for Goethe's birthday, Weimar. [Grove 1980, 17:99]

William Blake, 1757–1827. "The Awards of Athena (to the Arts)." Drawing. *c.***1780–85.** Clarke coll., Caterham, Surrey. [Butlin 1981, no. 96—ill.]

Johann Gottfried Herder, 1744–1803. "Minerva, die Schuzgöttin der Frauen" [Patron Goddess of Women]. Prose poem, part of *Paramythien.* In *Zerstreuter Blätter* no. 1 (Gotha: Ettinger, **1785).** [Herder 1852–54, vol. 15 / Clark 1955, p. 348f.]

———. (Pallas, representing War, in) "Zwo Göttinnen" [Two Goddesses]. Poem, translation from Jakob Balde (1604–1668). In *Terpsichore* part 1, book 4 (Lübeck: Bohn, 1795). [Herder, vol. 17]

Pietro Alessandro Guglielmi, 1728–1804. *Pallade* [Pallas]. Cantata. Libretto, C. G. Lanfranchi-Rossi. First performed 30 May **1786,** San Carlo, Naples. [Grove 1980, 7:797]

John Cheere, 1709–1787. "Minerva." Lead sculpture. Whitbread coll., Southill, Bedfordshire. [Warburg]

Joseph Weigl, 1766–1846. *Flora e Minerva.* Cantata. Text, Lorenzo da Ponte. First performed **1791,** Vienna. [Grove 1980, 5:238, 20:298]

Johann Gottfried Schadow, 1764–1850. "Minerva." Sandstone statue, executed by Carl Wichmann from Schadow's design. **1793.** Brandenburger Tor, Berlin. [Berlin 1963, no. 7 *n.*]

Philip Freneau, 1752–1832. "Minerva's Advice." Poem. **1768–94.** In *Poems Written between 1768–1794* (Monmouth, N.J.: privately printed, 1795). [Bush 1937, p. 577]

Pierre-Paul Prud'hon, 1758–1823. "Wisdom [Minerva] and Truth Descend to Earth, Dispelling Darkness as They Come." Painting. Commissioned 1796–98, exhibited **1799.** Louvre, Paris, inv. 7341. [Louvre 1979–86, 4:149—ill. / Guiffrey 1924, no. 123] Oil sketch. Neue Pinakothek, Munich, inv. 0031. [Munich 1982, p. 257—ill.]

———. "Minerva." Painting, part of series of simulated bronze bas-reliefs for Hôtel Lanois, Paris. 1796–99. Louvre, Paris, no. R.F. 1983–16. [Louvre, 4:152—ill. / also Guiffrey, pp. 294ff.]

———. "Minerva Leading the Genius of the Arts to Immortality." Design for unexecuted ceiling decoration for Louvre, Paris. Early 1800s. Several oil sketches and drawings known, in private colls. or unlocated. [Guiffrey, nos. 875–79]

———. "Minerva Enlightening the Sciences and the Arts." Painting, unfinished sketch. 2 versions. Louvre, Paris, no. R.F. 208; Borthon coll., Dijon. [Louvre 1979–86, 4:150—ill. / Guiffrey, nos. 128–29]

John Flaxman, 1755–1826. Minerva and Victory depicted hanging a plaque to the deceased in relief on monument to Captain Willet Miller. **After 1799.** St. Paul's Cathedral, London. [Irwin 1979, p. 162, fig. 226—ill.]

———, design. Jugate heads of Minerva and Mercury depicted on obverse of gold medal for Royal Society of Arts. 1805. [Ibid., p. 203—ill. / also Bindman 1979, no. 186—ill.]

———. Minerva, with 2 midshipmen, depicted in monument to Horatio Nelson. 1807–18. St. Paul's Cathedral, London. [Irwin, pp. 158–60—ill.]

James Barry, 1741–1806. "Minerva Instructing Her Rural Companions." Drawing, study for unexecuted ceiling decoration. *c.***1801.** Ashmolean Museum, Oxford. [Pressly 1981, no. D.44—ill.; cf. no. D.44]

———. "Minerva Turning from Scenes of Destruction and Violence to Religion and the Arts." Etching. *c.*1805. 2 states. [Ibid., no. P.42—ill.]

Vincenzo Righini, 1756–1812, music. *Minerva belebet die Statue des Dädalus* [Minerva Animates the Statue of Daedalus]. Pantomime-dance. Libretto, Telle. First performed **1802,** Berlin. [Grove 1980, 16:21]

François Lemot, 1771–1827. Relief, depicting Minerva accompanied by Victory and the Muses, crowning a bust of Napoleon (Napoleon's face later changed to Louis XIV). **1808.** Façade, Louvre, Paris. [Janson 1985, p. 96]

Étienne d'Antoine, 1737–**1809.** "Minerva Seated." Sculpture. [Bénézit 1976, 1:214]

Jean Guillaume Moitte, 1746–**1810.** "Minerva." Marble statuette. Louvre, Paris. [Bénézit 1976, 7:457]

Lord Byron, 1788–1824. "The Curse of Minerva" (on the English for removing the Elgin Marbles). Satirical poem. **1811.** London: Davison, 1812. [McGann 1980–86, vol. 1 / Gleckner 1967, pp. 35ff.]

Edward Smyth, 1746–**1812.** "Minerva." Sculpture. Palace of Justice, Dublin. [Bénézit 1976, 9:659]

Guillaume Boichot, 1735–**1814.** 3 wash drawings, studies of Minerva. Musée des Beaux-Arts, Chartres. [Bénézit 1976, 2:121]

Ugo Foscolo, 1778–1827. (Pallas in) *Le Grazie* part 3.

Poem, unfinished. **1814.** Florence: 1848. Modern edition by Saverio Orlando (Brescia: Paideia, 1974). [Cambon 1980, pp. 184, 237, 278–85, 346 / Circeo 1974, pp. 96ff.]

Domenico Podestà, ?–1862. "Jupiter Sending Iris and Minerva to the Arts." Ceiling fresco. **1817.** Sala delle Belle Arti, Palazzo Pitti, Florence. [Pitti 1966, p. 131—ill.]

Percy Bysshe Shelley, 1792–1822. "Homer's Hymn to Minerva." Translation of second Homeric Hymn to Athena. **1818.** In *Poetical Works,* edited by Mary Shelley (London: Moxon, 1839). [Hutchinson 1932 / Webb 1976, pp. 63, 118]

————. (Minerva evoked in) *Hellas* lines 733–37. Dramatic poem. Late 1821. London: Ollier, 1822. [Hutchinson / Webb 1977, p. 150f.]

Charles Meynier, 1768–1832. "France, with the Attributes of Minerva, Protecting the Arts." Painting. **1819.** Ceiling, Salle Percier, Louvre, Paris (inv. 20091). [Louvre 1979–86, 4:87—ill.] Oil sketch. Louvre, no. R.F. 1980-50. [Ibid.—ill.]

Vincenzo Monti, 1754–1828, libretto. *L'invito a Pallade* [Invitation to Pallas]. Opera. First performed (?) **1819,** Milan. [DELI 1966–70, 4:53]

Antonio Canova, 1757–1822. "Ferdinand IV of Naples (King of the Two Sicilies) in the Guise of Minerva." Marble statue. Modeled 1800, completed **1820.** Museo Nazionale, Naples. [Pavanello 1976, no. 137—ill. / Licht 1983, p. 107—ill.] Plaster model. Gipsoteca Canoviana, Possagno, no. 88. [Pavanello, no. 138—ill.]

————. "Apollo Citharaeus Crowned by Putti, with Athena." Painting, sketch. Museo Civico, Bassano del Grappa. [Ibid., no. D94—ill.]

————, previously attributed (now attributed to B. Brunelli). "Minerva." Terra-cotta bust. Palazzo Papafava, Padua. [Ibid., no. 371—ill.]

Andries Cornelis Lens, 1739–1822. "Minerva." Pastel. Kunsthistorisches Museum, Vienna. [Bénézit 1976, 6:581]

Johann Nepomuk Haller, 1792–1826. "Minerva Ergane." Model for stone statue, after sketch by Martin von Wagner. **1822.** Executed by Johann Leeb, c.1829. In tympanum of pediment, façade, Glyptothek, Munich. [Glyptothek 1980, no. 220.6—ill.]

Bertel Thorwaldsen, 1770–1844. "Jupiter Enthroned between Minerva and Nemesis." Statue. Plaster sketch, **c.1822,** in Thorwaldsens Museum, Copenhagen, no. A316. / Over-lifesize terra-cotta version, executed by G. Borup, before 1847. Formerly Christiansborg Palace, Copenhagen, destroyed. [Thorwaldsen 1985, p. 45]

————. "Minerva." Plaster relief. c.1836. Thorwaldsens Museum, no. A325. [Thorwaldsen 1985, p. 46]

————. "Minerva" ("Allegory of Wisdom"). Bronze statue, executed by H. W. Bissen from Thorwaldsen's model. Prinz Jørgens Gaard, Christiansborg Palace, Copenhagen. [Ibid., p. 22 / Cologne 1977, no. 46] 2 plaster sketches. 1839, 1843. Thorwaldsens Museum, nos. A18–19. [Thorwaldsen]

Antoine-Jean Gros, 1771–1835. "Time [Saturn] Raising Truth to the Steps of the Throne, Wisdom [Minerva] Receiving Her." Ceiling painting. Exhibited **1827.** Salle E des Antiquités Égyptiennes, Louvre, Paris (inv. 5059). [Louvre 1979–86, 3:291—ill.]

William Wordsworth, 1770–1850. ("Owl of Athena" in) *Evening Voluntaries* 7.26–34. Poem. **1834.** In *Poetical*

Works (London: Moxon, 1835). [De Selincourt 1940–66, vol. 4]

Thomas Hood, 1799–**1845.** "To Minerva." Poem. In *Poetical Works* (Boston: Little, Brown, 1854–66). [Ipso]

Antoine-Louis Barye, 1796–1875. (Minerva, with Juno and Venus, in) "Candelabrum of Nine Lights." Bronze candlestick. **c.1847.** Walters Art Gallery, Baltimore. [Benge 1984, pp. 150f.—ill.] Bronze edition of the 3 figures, by 1855. / Bronze edition of separate figures, by 1855. Baltimore; elsewhere. [Ibid., fig. 146 / also Pivar 1974, no. F19—ill.]

Eugène Delacroix, 1798–1863. "Minerva, Goddess of the Arts." Painting, for Salon de la Paix, Hôtel de Ville, Paris. **1849–53.** Destroyed 1871. [Robaut 1885, no. 1151—ill. (copy drawing)]

Honoré Daumier, 1808–1879. "Minerva." 2 caricature drawings. **1853.** Private coll., Paris; second unlocated. [Maison 1968, nos. 464–65—ill.]

Matthew Arnold, 1822–1888. (Soul likened to Minerva's shrine in) "Palladium." Poem. **1864–65?** In *New Poems* (London: Macmillan, 1867). [Allott & Super 1986 / Tinker & Lowry 1940, pp. 189–91]

Charles Gleyre, 1806–1874. "Minerva and the Graces." Painting. **1866.** Musée Cantonal des Beaux-Arts, Lausanne, inv. 1388. [Harding 1979, pp. 43, 132—ill. / Winterthur 1974, no. 74—ill.]

Jean-Auguste-Dominique Ingres, 1780–**1867.** "Minerva." Painting. Wallraf-Richartz Museum, Cologne. [Wildenstein 1954, no. 264—ill.]

James Russell Lowell, 1819–1891. "Invita Minerva" [Minerva Unwilling (i.e., contrary to the bent of one's genius)]. Poem. In *Under the Willows and Other Poems* (Boston: Fields, Osgood, 1868). [Boswell 1982, p. 168 / Cooke 1906, p. 115]

John Ruskin, 1819–1900. (Athena evoked as) *The Queen of the Air: Being a Study of the Greek Myths of Cloud and Storm.* Reinterpretation of myth in prose. London: Smith, Elder, **1869.** [Jenkyns 1980, pp. 183–85]

Oscar Wilde, 1854–1900. (Charmides embraces Athena's statue in) "Charmides." Poem. In *Poems* (London: Bogue, **1881**). [Ellmann 1988, pp. 115, 141 / Bush 1937, pp. 420f.]

Aubrey De Vere, 1814–1902. (Athena addressed in) "The Acropolis of Athens" sonnet 2. Poem. In *Poetical Works* (London: Kegan Paul, Trench, **1884**). [Boswell 1982, p. 84]

Thomas Woolner, 1825–1892. "Pallas Athene." Poem. In *Tiresias and Other Poems* (London: Bell, **1886**). [Boswell 1982, p. 310]

Gabriele D'Annunzio, 1863–1938. (Pallas Athena evoked in) "Agli olivi." Sonnet, inspired by *Georgics* I.18. **1885–88.** In *La chimera* (Milan: Treves, 1890). [Palmieri 1953–59, vol. 2]

Émile-Antoine Bourdelle, 1861–1929. "Pallas." Bronze bust. **1889.** 10 casts. [Jianou & Dufet 1975, no. 105] Sandstone and plaster studies/variants. [Ibid., nos. 104–05]

————. "Pallas Draped." Bronze sculpture. 1889. 3 casts. Private coll(s). [Ibid., no. 106] Marble version, 1905. Musée Bourdelle, Paris. [Ibid.]

————. "Mask of Pallas." Bronze sculpture, based on above. 1889. 7 casts. Musée Bourdelle; elsewhere. [Ibid., no. 107—ill.] Plaster and bronze studies/variants. Private colls. [Ibid.]

————. "Torso of Pallas." Bronze sculpture, based on

above. 1901. 3 casts. Arts Club of Chicago; elsewhere. [Ibid., no. 108] Bronze and plaster studies/variants. / Marble version, 1905. Musée Bourdelle. [Ibid.] Bronze variant ("Torso of the Warrior Pallas"). 1911. 2 casts. Private coll(s). [Ibid., no. 109]

————. "Pallas the Warrior." Fresco. 1913. Loge, Théâtre des Champs-Elysées, Paris. [Basdevant 1982, pp. 74ff.—ill.] Bronze relief (study). Private coll. [Ibid.—ill. / Jianou & Dufet, no. 492]

Aimé-Jules Dalou, 1838–1902. "Wisdom [Minerva?] Supporting Freedom." Bronze statuette. **1889.** Hirshhorn Museum and Sculpture Garden, Washington, D.C. [Hirshhorn 1974, p. 676, pl. 76]

Kostis Palamas, 1859–1943. *Imnos is tin Athenán* [Hymn to Athena]. Collection of poetry. **1889.** Athens: Palamas, 1900. [CLC 1981, 5:376, 386 / Trypanis 1981, p. 655]

Gustav Klimt, 1862–1918. "Art of Ancient Greece I" (Athena with gorgoneion and figurine of Nike). Painted spandrel. **1890–91.** Staircase, Kunsthistorisches Museum, Vienna. [Novotny & Dobai 1968, no. 48—ill. / also Strobl 1980, 1:83f.]

————. "Pallas Athena." Painting. 1898. Historisches Museum der Stadt Wien, Vienna, inv. 100.686. [Novotny & Dobai, no. 93—ill. / Hofmann 1987, no. 13.29—ill.]

Franz von Stuck, 1863–1928. "Pallas Athena." Painting. **1891.** Private coll. in 1924. [Voss 1973, no. 55—ill.]

————. "Pallas Athena." Painting. 1898. Schäfer coll., Schweinfurt. [Ibid., no. 183—ill. / Hofmann 1987, no. 13.13—ill.]

Emmanuel Fremiet, 1824–1910. "Chariot of Minerva." Plaster figurine, model for porcelain edition (Manufacture de Sèvres, 1899–1942). **1896.** Musée d'Orsay, Paris, inv. R.F. 3430. [Orsay 1986, p. 157—ill.] Bronze edition, by G. Leblanc-Barbedienne, from 1903. Musée des Beaux-Arts, Dijon (2 examples); elsewhere. [Ibid.]

————. "Athena Leading a Three-Horse Chariot." Gilded bronze sculpture group. Musées Nationaux, inv. Ch. B. 127, deposited to government of Alsace-Lorraine (?). [Ibid., p. 272]

T. Sturge Moore, 1870–1944. "Pallas and the Centaur." Poem, after Botticelli's painting (c.1482–83, Uffizi). In *Pageant* 1 **(1896).** [Gwynn 1951, p. 123]

Auguste Rodin, 1840–1917. "Minerva." Marble bust. **1896?** Rodin Museum, Philadelphia. [Tancock 1976, no. 109—ill.] Variants ("Pallas Wearing a Helmet," "Pallas with the Parthenon [on her head]," "Minerva without a Helmet"). Musée des Beaux-Arts, Lyons; Walker Art Gallery, Liverpool; National Gallery of Victoria, Melbourne; Musée Rodin, Paris (plasters). [Ibid.—ill. / also Rodin 1944, no. 285—ill.]

Elihu Vedder, 1836–1923. "Minerva." Mosaic. **1897.** Library of Congress, Washington, D.C. [Soria et al. 1979, pp. 225ff., fig. 290] Oil study. J. B. Speed Art Museum, Louisville, Ky. [Ibid., fig. 289]

John La Farge, 1835–1910. (Minerva in) "Athens." Mural painting. **1893–98.** Walker Art Building, Bowdoin College, Brunswick, Me. [Adams et al. 1987, p. 188—ill. / Weinberg 1977, pp. 280f. 287—ill.]

Heinrich Mann, 1871–1950. *Minerva.* Novel, second in trilogy *Die Göttinnen* [The Goddesses] (Munich: Langen, **1903**). [DLB 1988, 66:315, 323f. / Seymour-Smith 1985, p. 565 / Oxford 1986, p. 588]

Stanislaw Wyspiánski, 1869–1907. (Pallas Athena's statue brought to life in) *Noc listopadowa* [November Night]. Drama. Cracow: Sklad w Ksiegarni Gebethnera, **1904.** [Klein et al. 1986, 2:516]

Fernand Khnopff, 1858–1921. "Minerva." Drawing, illustration for Henry Carton de Wiart's *L'idée de justice* (Brussels: **1909**). Private coll., Brussels. [Delevoy et al. 1979, no. 419.8—ill.]

Paul Manship, 1885–1966. "Marietta" ("Young Minerva"). Bronze statuette. **1911.** 6 casts. [Murtha 1957, no. 17]

Fernand Mazade, 1863–1939. *Athéna.* Collection of poetry. Paris: **1912.** [DULC 1959–63, 3:466f.]

Rubén Darío, 1867–1916. "Palas Athenea." Poem. **1915.** [Méndez Plancarte 1967 / Hurtado Chamorro 1967, pp. 227f.]

Osip Mandel'shtam, 1891–1939/42. (Farewell to Athena in) Untitled poem. **1916.** In *Tristia* (Peterburg: 1922). [Raffel & Burago 1973, no. 89]

Edgar Lee Masters, 1869–1950. "Pallas Athene." Poem. In *Starved Rock* (New York: Macmillan, **1919**). [Bush 1937, p. 588]

H. D. (Hilda Doolittle), 1886–1961. "Helios and Athene." Set of 4 prose epigrams. **1920.** First published in *Iowa Review* 12 (Spring/Summer 1981). [Martz 1983]

————. "Pallas." Poem. In *Collected Poems* (New York: Boni & Liveright, 1925). [Boswell 1982, p. 93 / Robinson 1982, p. 431 / Peck 1975, pp. 56, 71]

————. "Triplex" (Athena, Artemis, Aphrodite). Poem. In *Red Roses for Bronze* (London: Chatto & Windus; Boston: Houghton Mifflin, 1931). [Martz / DLB 1986, 45:131]

William Butler Yeats, 1865–1939. (Athena in) "Michael Robartes and the Dancer." Poem. In *Michael Robartes and the Dancer* (Churchtown, Dundrum: Cuala, **1920**). [Finneran 1983 / Reid 1961, p. 129]

————. (Athena rescues the heart of Dionysus after his death, in a song in) *The Resurrection.* Play. Dublin: Cuala, 1927. Song reprinted as stanza 1 of "Two Songs from a Play" in *The Tower* (London & New York: Macmillan, 1928). [Finneran / Reid]

————. "Colonus' Praise" stanza 2 (called "the Athene stanza"). Poem, version of first stasimon of Yeats's *Oedipus at Colonus.* In *The Tower* (London & New York: Macmillan, 1928). [Finneran / Clark 1983, pp. 148–50, 153]

John Singer Sargent, 1856–1925. "Painting and Sculpture Protected from the Ravages of Time by Minerva," "[Figures representing] Classical and Romantic Art" (attended by Pan and Minerva, with Apollo). Murals. **1916–21.** Museum of Fine Arts, Boston. [Ratcliff 1982, pp. 145–47—ill.]

Georges Braque, 1882–1963. "Athena" (in her chariot). Painting. **1931.** Private coll., France. [Braque 1961, p. 80—ill. / Cogniat 1980, fig. 24—ill.] Color lithograph. 1932. [Braque, no. 15—ill.]

————. "Athena." Polychrome plaster relief. 1938. [Fumet 1951, no. 3—ill.]

Pablo Picasso, 1881–1973. "Minerva." Drawing. **1933.** [Zervos 1932–78, 8: no. 158—ill.]

Eden Phillpotts, 1862–1960. *The Owl of Athene.* Novel. London: Hutchinson, **1936.** [Kunitz & Haycraft 1961, p. 1103]

Paul Klee, 1879–1940. "Mephistopheles as Pallas." Painting. **1939.** Cooper coll., Argilliers. [Grohmann 1954, no. 432—ill.]

Ezra Pound, 1885–1972. (Allusion to Athena in) Canto 79,

in *The Pisan Cantos* (New York: New Directions, **1948**). [Terrell 1980–84, 2:425f.]

Ernst Krenek, 1900–1974. "Pallas Athene weint" [Pallas Athena Wept]. Opera prelude. Libretto, composer. **1952–55.** First performed 17 Oct 1955, Hamburg. [Baker 1984, p. 1256 / Grove 1980, 10:255]

Donald Davie, 1922–. "The Owl Minerva." Poem. In *Brides of Reason* (**1955**); collected in *Collected Poems, 1950–1970* (New York: Oxford University Press, 1972). [Ipso]

Giorgio de Chirico, 1888–1978. "Bust of Minerva." Painting. **1962.** Private coll., Rome. [de Chirico 1971–83, 3.3: no. 396—ill.]

Salvador Dalí, 1904–1989. "Dionysus and Pallas Athena." Silver medallion (face). **1966.** Club Français de la Médaille, Paris. [Rotterdam 1970, no. 198—ill.]

Giacomo Manzù, 1908–. "Apollo, Venus, and Minerva." Bronze bozzetto for sculpture. **1968.** Meadows coll., Dallas, Texas. [Micheli 1971, fig. 89—ill.]

Leonard Baskin, 1922–. "Athena's Shield." Bronze relief. **1969.** Virginia Museum of Fine Arts, Richmond; 3 others in private colls. [Jaffe 1980, p. 215]

W. S. Merwin, 1927–. (Athena worshiped as Wisdom by Odysseus in) "Memory." Prose poem. In *The Miner's Pale Children* (New York: Atheneum, **1970**). [CLC 1981, 18:333]

Henry Leland Clarke, 1907–. *The Bounty of Athena.* Choral composition for soprano and alto. **1978.** [Grove 1986, 1:451]

Robert Small, 1949–, choreography. *Minerva.* Modern dance. First performed **1978,** New York. [Cohen-Stratyner 1982, p. 822]

Humberto Costantini, 1924?–1987. (Athena, Aphrodite, and Hermes fight Hades on behalf of mortals in) *De dioses, hombrecitos y policías* [The Gods, the Little Guys, and the Police]. Novel. [Havana?]: Casa de las Américas, **1979.** / Translated by Tony Talbott (New York: Harper & Row, 1984). [Ipso]

Claudio Parmiggiani, 1943–. "Athena Hermetica." Painted plaster bust, cut in half. **1980.** [Reggio Emilia 1985, p. 130—ill.]

Ronald Bottrall, 1906–. "Athenian Owls." Poem. In *Against a Setting Sun* (London & New York: Allison & Busby, **1984**). [Ipso]

Amy Clampitt, 1920–. "Athene." Poem. In *Poetry* 145 no. 6 (Mar **1985**); collected in *Archaic Figure* (New York: Knopf, 1987). [Ipso]

Birth of Athena. In the most common versions of this myth, Athena (Minerva) sprang, fully grown and fully armed, from the head of Zeus (Jupiter). Early sources, such as Homer, make no mention of Athena's mother, but later mythographers identify Metis, the consort of Zeus and wisest of all the gods, as her mother. According to Hesiod, when Metis was pregnant by Zeus, he took the advice of Gaia and Uranus and swallowed the expectant mother so that his offspring would not usurp his power. In time Hephaestus (Vulcan)—in some versions Pro-

metheus—split Zeus's forehead open with an ax and Athena was born.

The birth of Athena is a theme commonly shown on Athenian black-figure vases of the sixth century BCE. One of the best-known depictions of the myth, only fragments of which survive today, was on the east pediment of the Parthenon.

Classical Sources. Hesiod, *Theogony* 886–91, 924–29. Pindar, *Olympian Odes* 7.35–38. Apollodorus, *Biblioteca* 1.3.6. Lucian, *Dialogues of the Gods* 12, "Poseidon and Hermes," 13, "Hephaestus and Zeus." Philostratus, *Imagines* 27.

Antonio Lombardo, c.1458–**1516.** "The Birth of Athena." Marble relief. Hermitage, Leningrad. [Hermitage 1975, pls. 10–11]

Pierre de Ronsard, 1524–1585. (Birth of Athena evoked in) "La lyre." Poem. In *Le sixième livre des poèmes* (Paris: Buon, **1569**). [Laumonier 1914–75, vol. 15 / McGowan 1985, p. 115 / Cave 1973, p. 185 n.]

Thomas Heywood, 1573/74–1641. "Vulcan and Jupiter" (reënact birth of Minerva). Poetic dialogue, translated from Lucian. No. 11 in *Pleasant Dialogues and Drammas* (London: **1637**). [Heywood 1874, vol. 6]

Antonio Draghi, 1634/35–1700. *La nascità di Minerva.* Opera. Libretto, N. Minato. First performed 18 Nov **1674,** Vienna. [Grove 1980, 5:604]

Reinhard Keiser, 1674–1739. *Die Geburt der Minerva.* Opera. Libretto, H. Hinsch. First performed **1703,** Hamburg. [Grove 1980, 9:847 / Zelm 1975, p. 51]

Antonio Caldara, c.1670–1736. *Il natale di Minerva* [The Birth of Minerva]. Serenata. First performed **1729,** Vienna. [Grove 1980, 3:615]

———. *Il natale di Minerva Tritonia.* Opera (festa). Libretto, Pasquini. First performed 1735, Vienna. [Ibid., 3:616]

Karl Siegmund Seckendorff, 1744–1785. *Minervens Geburt, Leben, und Taten* [Minerva's Birth, Life, and Deeds]. Shadow play. First performed 28 Aug **1781,** for Goethe's birthday, Weimar. [Grove 1980, 17:99]

Anselm Feuerbach, 1829–1880. "The Birth of Athena." Drawing, study for abandoned ceiling design. **1874.** Staatliche Graphische Sammlung, Karlsruhe. [Karlsruhe 1976, no. Z46—ill.]

Contest with Poseidon. Athena (Minerva) competed with Poseidon (Neptune) for control of Attica and the devotion of its people. When challenged to produce the most useful gift for these mortals, Poseidon struck a rock with his trident and created a salt spring (some say a horse), while Athena touched the soil with her spear and brought forth an olive tree. Her gift, representing peace (persisting in the phrase "bearing the olive branch"), was deemed to be the more useful, and it was her name that was given to the major city of the region, Athens. The contest was judged by the mythical first king of Athens, Cecrops (sometimes confused with his descendant Erichthonius), with the twelve Olympians

sitting on the Areopagus (Hill of Ares) to oversee the outcome. In her later contest with Arachne, Athena wove this episode into her tapestry.

The most important antique representation of this episode, of which only two or three fragmentary figures survive today, was on the west pediment of the Parthenon.

Classical Sources. Herodotus, *History* 8.55. Virgil, *Georgics* 1.12–18. Ovid, *Metamorphoses* 6.70–82. Apollodorus, *Biblioteca* 3.14.1. Pausanias, *Description of Greece* 1.27.2.

Garofalo, c.1481–1559. "Poseidon and Athena." Painting. **1512.** Gemäldegalerie, Dresden, no. 132. [Dresden 1976, p. 54 / also Berenson 1968, p. 153 / Wind 1948, fig. 29]

Antonio Lombardo, c.1458–1516. "Athena's Contention with Poseidon" ("Neptune and Minerva before Erichthonius"). Marble high-relief, part of series for Alfonso d'Este, Ferrara. **1507–16.** Hermitage, Leningrad, inv. 1770. [Hermitage 1984, no. 360—ill. / Pope-Hennessy 1985b, 2:95 / also Hermitage 1975, pls. 12–13]

Domenico Beccafumi, 1486–1551. "The Rivalry of Minerva and Neptune." Fresco. *c.*1530? Palazzo Bindi Sergardi, Siena. [Sanminiatelli 1967, pp. 93f., pl. 31i]

Rosso Fiorentino, 1494–1540, attributed. "The Dispute of Minerva and Neptune." Fresco, for Galerie François I, Château de Fontainebleau. **1534–37.** Lost (replaced by a copy after the etching, 19th century). / Etching by Antonio Fantuzzi (Bartsch 16:402, no. 68). c.1510–after 1550. [Paris 1972, no. 312—ill. / Lévêque 1984, p. 245—ill. / also Panofsky 1958, fig. 55]

Pierre de Ronsard, 1524–1585. (Muses sing of the contest for Attica in) "Ode à Michel de l'Hospital." Ode. In *Le cinquiesme livre des odes* (Paris: **1553**). [Laumonier 1914–75, vol. 3 / Silver 1985, p. 245]

———. (Apollo makes peace between Athena and Poseidon in) "La Lyre." Poem. In *Le sixième livre des poèmes* (Paris: Buon, 1569). [Laumonier, vol. 15 / Cave 1973, pp. 189f.]

Frans Floris, 1516/20–1570. "Minerva's Contest with Neptune." Painting. City Hall, Condé-sur-Escaut. [Warburg]

Edmund Spenser, 1552?–1599. (Story of Minerva and Neptune's contest woven into tapestry in) "Muiopotmos; or, The Fate of the Butterfly" lines 305–320. Poem. London: Ponsonbie, **1590;** collected in *Complaints* (London: Ponsonbie, 1591). [Oram et al. 1989 / Dundas 1985, p. 52]

Jacopo Tintoretto, 1518–1594, studio. "The Contest of Minerva and Neptune." Ceiling painting. Musée Jacquemart-André, Paris. [Pigler 1974, p. 184]

Hendrik de Clerck, c.1570–1629. "Minerva's Contest with Neptune." Painting. Staatliche Museum, Berlin. [Warburg]

Johann König, c.1586–1632/35. "Minerva's Contest with Neptune." Painting. Julius Bohler coll., Munich. [Warburg]

Pietro da Cortona, 1596–1669. "Minerva and Cecrops" ("Minerva Planting the Olive, Symbol of Peace"). Fresco. **1642–46.** Sala di Giove, Palazzo Pitti, Florence. [Campbell 1977, pp. 127, 133—ill. / Pitti 1966, p. 48—ill. / also Briganti 1962, no. 95—ill.]

Simon Vouet, 1590–1649, attributed. "The Contest of Neptune and Minerva." Painting. Manning coll., New York. [Pigler 1974, p. 184]

Nicolas Mignard, 1606–1668. "The Contest of Minerva and Neptune." Drawing. Louvre, Paris. [Pigler 1974, p. 184]

Pieter Jacobsz Codde, 1599–1678. "Minerva's Contest with Neptune." Painting. Kunsthalle, Bremen. [Warburg]

Thomas Parnell, 1679–1718. "The Horse and the Olive; or War and Peace." Poem. London: for John Morphew [**1712**]. [Fausset 1930, pp. 179ff.]

François Verdier, 1651–1730. "The Contest of Minerva and Neptune." Drawing. Paignon-Dijonval coll., Paris. [Pigler 1974, p. 184]

Jean Restout, 1692–1768. "The Contest of Minerva and Neptune." Painting. **1738.** Archives Nationales, Paris. [Pigler 1974, p. 184]

Noël Hallé, 1711–1781. "The Dispute of Minerva and Neptune over the Naming of Athens." Painting. **1748.** Louvre, Paris, inv. 5269. [Louvre 1979–86, 3:301—ill.]

Jean-Baptiste Lemoyne, 1704–1778. "Minerva, Goddess of Wisdom, Strikes the Earth with Her Lance and Brings Forth the Olive Tree." Sculpture. Lost. [Réau 1927, no. 25]

Merry-Joseph Blondel, 1781–1853. "The Dispute of Minerva and Neptune over Athens." Painting. **1822.** Louvre, Paris, inv. 2626 (originally in ceiling, Salle Henri II, moved 1938). [Louvre 1979–86, 3:64—ill.] Oil sketch. 1821. Louvre, no. R.F. 1939–15. [Ibid., 66—ill.]

Edward Augustus Freeman, 1823–1892. "Poseidon and Athena." Poem. In *Poems, Legendary and Historical* (London: Longman & Co., **1850**). [Boswell 1982, p. 108]

ATLANTIS. In Greek legend, Atlantis was a large island beyond the Pillars of Hercules (Straits of Gibraltar). Its name derives from its supposed position, facing Mount Atlas. The kings of Atlantis, supported by Poseidon, controlled southwest Europe and northwest Africa. In an attempt to conquer more territory they waged war against the prehistoric Athenians, but were soundly defeated. The inhabitants of Atlantis then became savage and impious; the gods punished them by destroying the island in one day, causing it to sink into the ocean.

A very popular theme in literature since Plato's account, Atlantis is often seen as a lost paradise. Its existence has also become a favorite subject of parascientific theory, with events surrounding it placed at c.9500 BCE. Some scholars speculate that the cataclysmic eruption of the volcanic island Thera (Santorini), in the Aegean Sea, inspired the myth.

Classical Sources. Plato, *Critias* 108E–109A, 113B–121B; *Timaeus* 24E–25D. Strabo, *Geography* 2.3.6.

Francis Bacon, 1561–1626. *The New Atlantis: A Worke Unfinished.* Utopian fable of political philosophy. London: **1626.** [Levin 1969, p. 109]

Thomas Heyrick, 1650?–1694. *The New Atlantis.* Poem. London: **1687.** [Winn 1987, p. 614 *n.*]

Olof Rudbeck, 1630–1702. *Atland, eller Manhem* [Atlantis, or Manheim]. Allegorical poem (Scandinavia as Atlantis). Published in 4 parts, Upsala: **1679–1702**. / Translated into Latin as *Atlantica illustrata* (Upsala: Curio, Werner, 1732). Modern edition, Stockholm: Almquist & Wiksell, 1937. [Algulin 1989, pp. 30f. / Gustafson 1961, pp. 91ff.]

Daniel Defoe, 1660?–1731. *Atalantis Major*. Political tract. Edinburgh: **1711**. [Todd 1985, p. 210]

Mary de la Rivière Manley, 1663–1724. *Court Intrigues in a Collection of Original Letters from the Island of New Atlantis*. Novel. London: for John Morphew & James Woodward, **1711**. [Todd 1985, pp. 208–11]

Novalis (Friedrich Leopold von Hardenberg), 1772–**1801**. (Atlantis evoked in second fairy tale, part of) *Heinrich von Ofterdingen* part 1. Novel, unfinished. In *Schriften*, edited by F. Schlegel and L. Tieck (Berlin: Buchhandlung der Realschule, 1802). [Strauss 1971, p. 44]

Louis Jean Népomucène Lemercier, 1771–1840. *L'Atlantiade*. Epic poem. Paris: Pichard, **1812**. [DLLF 1984, 2:1276]

E. T. A. Hoffmann, 1776–1822. (Anselmus carried off to Atlantis in) "Der goldne Topf" [The Golden Pot]. Fairy tale. **1813**. In *Fantasiestücke in Callots Manier* (Bamberg: Kunz, 1814–15). / Translated by Thomas Carlyle in *German Romance*, vol. 2 (Edinburgh: Tait, 1827). [Oxford 1986a, pp. 307f.]

John Galt, 1779–1839. *The Apostate, or Atlantis Destroyed*. Tragedy. Unperformed. Published in *The New British Theatre*, edited by J. Galt (London: Valpy, **1814–15**). [Ellis 1985, p. 102 / De Camp 1970, pp. 253f. / Stratman 1966, p. 749 / Nicoll 1959–66, 4:318]

Percy Bysshe Shelley, 1792–1822. (Atlantis, setting of) *Prometheus Unbound* 3.2. Dramatic poem. London: Ollier, **1820**. [Zillman 1968 / Webb 1976, p. 334]

———. (America evoked as the Atlantis, in) *Hellas* lines 65–71, and semichorus II. Dramatic poem. 1821. London: Ollier, 1822. [Hutchinson 1932 / Wasserman 1971, pp. 408f.]

Giacomo Leopardi, 1798–1837. (Atlantis myth retold in) "Storia del genere umano" [History of Mankind]. Tale. **1824**. In *Operette morali* (Milan: Stella, 1827). [Cecchetti 1982]

Edgar Allan Poe, 1809–1849. "The Doomed City." Poem. In *Poems* (New York: Bliss, **1831**). / Revised as "The City in the Sea." In *The American Review* (New York) Apr 1845. [Tate 1968, 76:214–25 / Gregory & Zaturenska 1946, p. 475]

Jules Verne, 1828–1905. (Atlantis rediscovered in) *Vingt mille lieues sous les mers* [Twenty Thousand Leagues under the Sea]. Novel. Paris: Hetzel, **1869**. / First English edition, Boston: Osgood, 1871. [De Camp 1970, pp. 256ff.]

Wilhelm Fischer-Graz, 1846–1932. *Atlantis*. Epic poem. Leipzig: Friedrich, **1880**. [DLL 1968–90, 5:153 / Oxford 1986, p. 237]

Olegario Victor Andrade, 1841–1882. *Atlántida*. Lyric poem. **1881**. In *Obras poéticas* (Buenos Aires: Peuser, 1887). [DLE 1972, p. 38]

Maurice Dalton and **Ernest Genet**. *Atlantis, or the Lost Land*. Comic opera. Music, T. M. Haddow. First performed 17 Mar **1886**, Gaiety Theatre, London. [Nicoll 1959–66, 5:333]

Frederick Tennyson, 1807–1898. "Atlantis." Poem. In *Daphne and Other Poems* (London & New York: Macmillan, **1891**). [DLB 1984, 32:285]

Enrique Morera, 1865–1942. *Introducció a l'Atlántida*. Symphonic poem. **1893**. [Grove 1980, 12:572]

Gustaf Fröding, 1860–1911. "Atlantis." Poem. In *Nya dikter* (Stockholm: Bonnier, **1894**). [Algulin 1989, pp. 145f.]

Mario Rapisardi, 1844–1912. *Atlantide*. Poem, political satire. Cantania: Giannotta, **1894**. [DELI 1966–70, 4:507]

Gordon Bottomley, 1874–1948. "Atlantis." Poem. **1912**. In *Poems of Thirty Years* (London: Constable, 1925). [Boswell 1982, p. 244]

Gerhart Hauptmann, 1862–1946. *Atlantis*. Novel. Berlin: Fischer, **1912**. [Oxford 1986, p. 361]

Velimir Khlébnikov, 1885–1922. *Gibel Atlantidy* [The Destruction of Atlantis]. Poem. **1912**. In *Stikhotvoreniia i poemy* (Leningrad: Sovetskii pisatel, 1960). [EWL 1981–84, 2:582]

John Masefield, 1878–1967. "In Some Green Island of the Sea." Poem. In *Story of a Roundhouse* (London: Macmillan, **1912**). [De Camp 1970, pp. 76, 256]

Bertil Malmberg, 1889–1958. *Atlantis*. Poetry collection. Stockholm: Bonnier, **1916**. [CEWL 1973, 3:106]

Pierre Benoit, 1886–1962. *L'Atlantide*. Novel. Paris: Michel, **1919**. (Grand Prix du Roman de l'Académie Française.) [DLLF 1984, 1:233] Translated as *The Queen of Atlantis* (1920). [Columbia 1980, p. 76]

Conrad Aiken, 1889–1973. "Atlantis." Poem. In *Priapus and the Pool* (Cambridge, Mass.: Dunster House, **1922**). [Gregory & Zaturenska 1946, p. 219 / DLB 1986, 45:4]

Joseph Auslander, 1897–1965. "After Atlantis." Poem. In *Cyclops' Eye* (New York & London: Harper, **1926**). [Boswell 1982, p. 25]

Hart Crane, 1899–**1932**. "Atlantis," section of "The Bridge." Poem. In *Collected Poems* (New York: Liveright, 1933). [Boswell 1982, p. 79 / Gregory & Zaturenska 1946, pp. 475, 477]

Bjarne Brustad, b. 1895. *Atlantis*. Symphonic poem. **1932**. [Grove 1980, 3:399]

———. *Atlantis*. Opera. 1945. [Ibid.]

Alexander Lernet-Holenia, 1897–1976. "Atlantis." Tale. In *Die neue Atlantis, Erzählungen* (Berlin: Fischer, **1935**). [Ungar 1973, p. 172]

Osip Mandel'shtam, 1891–1939/42. (Vision of Atlantis in) "Birth of a Smile." Poem. **1936–37**. In *Sobranie sochinenii*, edited by Gleb Struve and Boris Filipoff (Washington, D.C.: Inter-Language Literary Associates, 1967). [Raffel & Burago 1973, no. 342]

Louis MacNeice, 1907–1963. (Atlantis evoked in) "Leaving Barra." Poem. **1937**. [Dodds 1966]

Jānis Ivanovs, 1906–. *Atlantida*. Symphony, no. 4. **1941**. [Grove 1980, 9:414]

Riccardo Bacchelli, 1891–1985. "La fine d'Atlantide" [The End of Atlantis]. Short story. In *La fine d'Atlantide, ed altre favole lunatiche* (Milan: Garzanti, **1942**). [EWL 1981–84, 1:174]

Alfonso Reyes, 1889–1959. (Atlantis evoked in) *Última Tule*. Poetry collection. Mexico City: Imprenta universitaria, **1942**. [LAW 1989, 3:698]

Adolph Gottlieb, 1903–1974. "Nostalgia for Atlantis."

Abstract painting ("pictograph"). **1944.** Private coll. [Alloway & MacNaughton 1981, no. 43—ill.]

Paul Valéry, 1871–**1945.** "Le dernier Atlante" [The Last Atlantis], part of "L'île de Xiphos" [The Island of Xiphos]. Prose poem. In *Histoires brisées* (Paris: Gallimard, 1950). [Hytier 1957–60, vol.2 / Mathews 1956–71, vol. 2]

H. D. (Hilda Doolittle), 1886–1961. (Atlantis, setting of) "The Flowering of the Rod" stanza 31. Poem. Collected as part 3 of *Trilogy* (London & New York: Oxford University Press, **1946**). [Martz 1983 / Friedman 1981, pp. 113–15, 274f.]

Willi Baumeister, 1889–1955. "Atlantis." Abstract painting. **1947.** Städtische Kunstmuseum, Duisburg. [Grohmann 1965, no. 637]

———. "Pre-Atlantis." Abstract painting. 1950. Louise Richter coll., Caracas. [Ibid., no. 864]

Richard Church, 1893–1972. "Atlantis." Poem. In *Collected Poems* (London: Dent, **1948**). [Boswell 1982, p. 74]

Hubert Lampo, 1920–. *Terugkeer naar Atlantis* [Return to Atlantis]. Novel. The Hague: Stols, **1953.** [EWL 1981–84, 1:220]

John Cowper Powys, 1872–1963. *Atlantis.* Novel. London: Macdonald, **1954.** [CLC 1977, 7:348–49]

Henri Tomasi, 1901–1971. *L'Atlantide.* Opera. Libretto, P. Benoit. First performed 26 Feb **1954**, Mulhouse. [Grove 1980, 19:35f. / Baker 1984, p. 2321]

W. H. Auden, 1907–1973. "Atlantis." Poem. **1927–57.** In *Collected Shorter Poems 1927–1957* (London: Faber & Faber, 1966). [Mendelson 1976 / Fuller 1970, p. 180]

Morton Feldman, 1926–. *Atlantis.* Orchestral composition. **1958.** [Grove 1980, 6:455]

Serge Lifar, 1905–1986, with **Georges Skibine,** 1920–1981, choreography. *L'Atlantide.* Ballet. First performed **1958**, Paris. [Chujoy & Manchester 1967, p. 835]

Henry Brant, 1913–. *Atlantis.* Antiphonal symphony for mezzo-soprano, speaker, chorus, orchestra, band, and percussion. First performed 31 Jan **1960**, Poughkeepsie, N.Y. [Baker 1984, p. 335 / Grove 1980, 3:206]

Robert Duncan, 1919–1988. "Atlantis." Poem. In *The Opening of the Field* (New York: Grove, **1960**). [DLB 1983, 16:174]

Marya Zaturenska, 1902–1982. "Time and Atlantis." Poem. In *Terraces of Light* (New York: Grove, **1960**). [Ipso]

Dieter Waldmann, 1926–. *Atlantis.* Comedy. Frankfurt: Suhrkamp, *c.***1962.** [Wilpert 1963, p. 609]

Kenneth Burke, b. 1897. "Atlantis." Poem. **1915–67.** In *Collected Poems, 1915–1967* (Berkeley & Los Angeles: University of California Press, **1968**). [Ipso]

Louis Dudek, 1918–. *Atlantis.* Epic poem. Montreal: Delta Canada, **1967.** [Oxford 1983c, p. 662 / CLC 1973–1989, 11:159–61, 19:138]

———. "Reflections after Atlantis." Poem. [CLC]

Robert Lowell, 1917–1977. (Atlantis evoked in) "Near the Ocean." Poem. In *Near the Ocean* (New York: Farrar, Straus & Giroux; London: Faber & Faber, **1967**). [Bell 1983, pp. 109f.]

Richmond Lattimore, 1906–1984. "Atlantic," "Atlantis Now." Poems. In *Poems from Three Decades* (New York: Scribner, **1972**). [Ipso]

David Earle, 1939–, choreography. *Atlantis.* Ballet. First

performed **1974**, Toronto Dance Theatre, Toronto. [Cohen-Stratyner 1982, p. 291]

Ralph Gustafson, 1909–. "Atlantis." Poem. In *Fire on Stone* (Toronto: McClelland & Stewart, **1974**). [Ipso]

Kay Gardner, 1941–. *Atlantis Rising.* Electronic composition. **1975.** [Cohen 1987, 1:258]

Viktor Ullmann, 1898–1944? *Der Kaiser von Atlantis* [The Emperor of Atlantis]. Opera. First performed 16 Dec **1975.** [Baker 1984, p. 2349]

James Merrill, 1926–. "Atlantis and After." Poem. No. 4 in *Mirabell: Books of Number* (New York: Atheneum, **1978**). [Ipso]

Slavko Mihalić, 1928–. "Atlantis." Poem. **1953–82.** / Translated by Charles Simic in *Atlantis: Selected Poems 1953–1982* (Greenfield Center, N.Y.: Greenfield Review Press, 1983). [Ipso]

Maura Stanton, 1946–. "Atlantis." Poem. In *Cries of Swimmers* (Salt Lake City: University of Utah Press, **1984**). [Ipso]

ATLAS. Son of the Titan Iapetus and the Oceanid Clymene, Atlas opposed Zeus in the Titans' revolt against the Olympians. As punishment he was forced to guard the pillars of heaven or to hold up the sky itself. He is variously named as the father of Calypso, the Hesperides, the Pleiades, and others.

Atlas helped Heracles to obtain the golden apples of the Hesperides, offering to fetch the apples if Heracles would assume the mantle of the sky in his stead; he had to be tricked by Heracles into resuming his burden. When Perseus, after beheading the Gorgon Medusa, was refused hospitality by Atlas, the hero showed him the Gorgon's head, which turned him into stone. This was said to be the origin of Mount Atlas, the highest peak in the Atlas range of northwest Africa.

Classical Sources. Homer, *Odyssey* 1.51, 7.245. Hesiod, *Theogony* 507–17. Virgil, *Aeneid* 4.246–50, 481. Ovid, *Metamorphoses* 4.630–662. Apollodorus, *Biblioteca* 1.2.3, 2.5.11, 3.10.1. Hyginus, *Fabulae* 150, 192. Philostratus, *Imagines* 20.

See also HERACLES, LABORS OF, Apples of the Hesperides; HESPERIDES; PERSEUS, and Medusa; TITANS AND GIANTS.

Adam Kraft, 1455–1509. "Self-portrait as Atlas, Kneeling." Stone sculpture. **1490–92.** Sebald Schreyer tomb, Sebaldskirche, Nuremberg. [Molesworth 1965, p. 12—ill.]

Bartolommeo Bellano, *c.*1440–**1496/97.** "Atlas." Bronze statue. Formerly Kaiser Friedrich Museum, Berlin. [Pope-Hennessy 1985b, 2:85, 373]

———. "Atlas." Bronze statue. Louvre, Paris. [Ibid., 2:331]

Benvenuto Cellini, 1500–1571. "Atlas." Jeweled medal. **1528–29.** Lost. [Pope-Hennessy 1985a, p. 46]

Andrea Riccio, *c.*1470–**1532,** attributed (probably designed by the artist, produced by studio). "Atlas Sup-

porting the Globe of Heaven." Bronze inkstand. Frick Collection, New York, no. 15.2.24. [Frick 1968–70, 3:106ff.—ill.] Further versions (inferior, incomplete) in Staatliche Museen, Berlin; Musée des Arts Décoratifs, Paris; British Museum, London; Herzog-Anton-Ulrich Museum, Braunschweig; Museo Civico, Bologna; Castello Sforzesco, Milan; Bayerisches Nationalmuseum, Munich; private colls. [Ibid.] Variants in Musée Jacquemart-André, Paris; Palazzo Venezia, Rome; Hermitage, Leningrad. [Ibid. / Hermitage 1975, pl. 8]

Luigi Alamanni, 1495–1556. "Favola di Atlante" [Fable of Atlas]. Poem. In *Opere Toscane* (Lyons: Gryphius, **1532**). [DELI 1966–70, 1:38f.]

Ben Jonson, 1572–1637. (Mount Atlas, setting of) *Pleasure Reconciled to Virtue*. Masque. Performed 6 Jan **1618**, at Court, London. Published London: 1640. [Herford & Simpson 1932–50, vol. 7 / McGraw-Hill 1984, 3:112f.]

Diego Velázquez, 1599–1660. "Atlas" (?). Painting. *c.*1623–25. Lost. / Anonymous copy in private coll., Madrid. [López-Rey 1963, no. 75]

Thomas Carew, 1594/95–1639/40. (Atlas in) *Coelum Britannicum*. Satirical masque. First performed **1634**, London; stage designs, Inigo Jones. [Saslow 1986, pp. 194f., fig. 5.15]

Peter Paul Rubens, 1577–1640. "Atlas." Painting, for Torre de la Parada, El Pardo (executed by assistant from Rubens's design?). **1636–38**. Lost. [Alpers 1971, no. 5] Oil sketch. Count A. Seilern coll., London. [Ibid., no. 5a—ill. / Held 1980, no. 172—ill.] Copy in Prado, Madrid, no. 2039. [Alpers / Prado 1985, p. 606]

Tommaso Tomasi, 1608–1658. *Il giardino d'Atlante* [The Garden of Atlas]. Poem. Venice: Bertani, **1641**. [DELI 1966–70, 5:290]

Guercino, 1591–1666. "Atlas." Painting. **1646**. Museo Bardini, Florence. [Salerno 1988, no. 230—ill.]

Jerónimo Ferrer, fl. 1649–54. "Atlas Holding the World on His Shoulders." Drawing (study for a sculpture?). **1654**. Biblioteca Nacional, Madrid. [López Torrijos 1985, p. 428 no. 8—ill.]

Artus Quellinus the Elder, 1609–1668. "Atlas." Bronze figure surmounting pediment of Koninklijk Institut voor de Tropen, Town Hall, Amsterdam. **1655**. In place. [Clapp 1970, 1:728]

Josse de Corte, 1627–1679. "Atlas." Sculpture, on Morosini monument. **1676**. San Clemente all' Isola, Venice. [Clapp 1970, 1:186]

Georg Christoph Strattner, *c.*1644–1704. *Atlas, oder Die vier Theil der Welt* [Atlas, or The Four Parts of the World]. Sing ballett. **1681**. Lost. [Grove 1980, 18:203]

Pierre Puget, 1620–1694. "Atlas." Two sculptures, flanking doorway of Hôtel de Ville, Toulon. [Chappuis 1973, pp. 130, 259—ill.] Plaster casts, Musée de Sculpture Comparée, Paris. [Ibid.]

Jonathan Swift, 1667–1745. "Atlas; or the Minister of State." Satirical poem, to the Earl of Oxford. *c.*1712. In *Miscellanies: The Last Volume* (London: for B. Motte, 1727). [Williams 1958, vol. 1]

François Girardon, 1628–1715. "Atlas." Terra-cotta sculpture model. Sold 1833, untraced. [Francastel 1928, no. 83]

Leonardo Leo, 1694–1744. *Il castello d'Atlante* [The Castle of Atlas]. Opera seria. Libretto, T. Mariani. First performed 4 July **1734**, Teatro S. Bartolomeo, Naples. [Grove 1980, 10:667]

Matthias Bernard Braun, 1684–1738. "Atlas." Supporting figures. Clam-Gallas Palace, Prague. [Clapp 1970, 1:111]

Vicente Martín y Soler, 1754–1806. *Il castello d'Atlante* [The Castle of Atlas]. Opera buffa. Libretto, A. Amelli. First performed Carnival **1791**, Teatro Communale, Desenzano. [Grove 1980, 11:736]

Percy Bysshe Shelley, 1792–1822. (Mount Atlas, home of) "The Witch of Atlas." Poem. **1820**. In *Posthumous Poems*, edited by Mary Shelley (London: Hunt, 1824). [Hutchinson 1932 / Cameron 1974, pp. 273–75 / Bush 1937, pp. 139–43]

Heinrich Heine, 1797–1856. "Der Atlas." Poem, no. 24 in "Die Heimkehr" cycle. **1823–24**. In *Reisebilder* (Hamburg: Hoffmann & Campe, 1826). [Windfuhr 1975–82, vol. 1, pts. 1 and 2 / Draper 1982 (as "I, unfortunate Atlas") / Miller 1973, p. 96]

Giacomo Leopardi, 1798–1837. "Dialogo d'Ercole e di Atlante" [Dialogue between Hercules and Atlas]. Dialogue. **1824**. In *Operette morali* (Milan: Stella, 1827). [Cecchetti 1982 / Casale 1981; cf. p. 16]

Franz Schubert, 1797–1828. "Der Atlas." Lied. Text, Heine (1823–24). **1828**. No. 8 in *Schwanengesang* (Vienna: Haslinger, 1829). [Grove 1980, 16:804 / Brown 1958, pp. 288, 305]

Victor Hugo, 1802–1885. (Atlas in) "Un jour au mont Atlas" [One Day on Mount Atlas]. Poem. Apr **1830**. No. 10 in *Les feuilles d'automne* (Paris: Renduel, 1831). [Hugo 1985–86]

Honoré Daumier, 1808–1879. "The New Atlas." Satirical lithograph. **1851**. [Delteil 1906–30, 25: no. 2108—ill.] vol. 4]

Elihu Vedder, 1836–1923. "Atlas, the Deep-thinking—The Endurer." Drawing. **1868**. L. Fleischman coll., New York. [Soria et al. 1979, pp. 120f., 183—ill.]

Francis Derwent Wood, 1871–1926. "Atlas." Stone sculpture (column capital). *c.*1899. British Linen Bank, Glasgow. [Read 1982, pp. 366, 368—ill.]

Maxfield Parrish, 1870–1966. "Atlas Holding Up the Sky." Painting, for *Collier's* magazine "Mythology" series. **1907**. Published 16 May 1908. [Ludwig 1973, pp. 35, 209]

George Meredith, 1828–**1909**. "Atlas." Poem. [Bartlett 1978, vol. 2]

Marina Tsvetaeva, 1892–1941. (Atlas evoked in) *Poèma gory* [Poem of the Mountain]. Poem. Prague: **1923**; reprinted Paris: 1926. / Translated by Elaine Feinstein in *Selected Poems* (London: Hutchinson, 1986). [Ipso]

John Singer Sargent, 1856–1925. "Atlas and the Hesperides." Painting, part of mural series. **1921–25**. Museum of Fine Arts, Boston. [Ratcliff 1982, p. 155—ill.] Study. Boston. [Ibid.—ill.]

William Jeffrey, 1896–1946. "The Doom of Atlas." Poem. In *The Doom of Atlas and Other Poems* (London: Gowans & Gray, **1926**). [Royle 1983, p. 156 / Bush 1937, p. 574]

André Suarès, 1868–1948. *Atlas.* Poem. Paris: Hecht, **1928**. [Ipso]

Lee Lawrie, 1877–1963. "Atlas." Colossal bronze sculpture.

*c.*1943? Rockefeller Center, New York. [Agard 1951, pp. 166f., fig. 94]

John Cage, 1912–1992. "Atlas eclipticalis." Composition for random-instrument ensemble of 86 or more. **1961.** First performed Feb 1964, New York Philharmonic, Lincoln Center, New York. [Grove 1980, 3:600, 602]

Thomas Merton, 1915–1968. "Atlas and the Fat Man." Essay. In *The Behavior of Titans* (New York: New Directions, **1961**). [Labrie 1979, p. 101]

Alfred Aschauer, 1931–. "Atlas." Bronze sculpture. **1963.** Artist's coll. [Gertz 1964, pl. 169]

ATREUS AND THYESTES. Sons of Pelops, Atreus and Thyestes engaged in a bitter and endless struggle for control of Mycenae, promised by an oracle to an unspecified son. The right of dominion was conferred by a golden-fleeced ram, given to Atreus by Hermes, but Thyestes gained possession of the ram through his adulterous affair with Atreus's wife, Aërope. With the help of Zeus and Eris, Atreus regained Mycenae and banished Thyestes.

In an extraordinary act of revenge, Atreus then invited his brother to a banquet, ostensibly as a gesture of reconciliation. Included on the menu was the flesh of Thyestes' sons, which Thyestes unsuspectingly consumed. When he learned what he had done, he went again into exile (or was banished), cursing Atreus's name for eternity. This curse on the House of Atreus was borne out in the fates of his descendants, especially that of his son Agamemnon.

According to Apollodorus and Hyginus, Thyestes later had an incestuous affair with his own daughter, Pelopia, on the advice of an oracle. Pregnant, she married Atreus and subsequently gave birth to a son, Aegisthus. As a child, Aegisthus was ordered by Atreus to kill Thyestes, but learning that Thyestes was his father, the boy helped to slay Atreus.

The story of Atreus and Thyestes was popular in ancient literature and has remained so in postclassical tragedies and tragic operas.

Classical Sources. Aeschylus, *Agamemnon* 1583–1602. Euripides, *Thyestes.* Ennius, *Thyestes.* Accius, *Atreus.* Varius Rufus, *Thyestes.* Apollodorus, *Biblioteca* 2.4.6, E2.10–15. Seneca, *Thyestes.* Hyginus, *Fabulae* 83, 86, 88.

Giovanni Boccaccio, 1313–1375. "Thiestis et Atrei iurgium" [The Quarrel of Thyestes and Atreus]. In *De casibus virorum illustrium* [The Fates of Illustrious Men] 1.9. Didactic poem in Latin. **1355–73?** [Branca 1964–83, vol. 9 / Hall 1965]

Lodovico Dolce, 1508–1568. *Thyeste.* Tragedy. Venice: Gioli di Ferrarij, **1553.** [DELI 1966–70, 2:313]

Thomas Newton, 1542?–1607. *Thyestes.* Tragedy. Published with *Hercules furens* (London: **1581**). Modern edition, *The Tenne Tragedies of Seneca Translated into English* (Manchester: Spenser Society, 1887). [NUC]

John Wright. *Mock-Thyestes.* Burlesque. Published with Wright's translation of Seneca, London: Banks, **1674.** [Nicoll 1959–66, 1:438]

John Crowne, 1640?–1703? *Thyestes.* Tragedy. First performed Mar **1680,** Theatre Royal, London. Published London: Bentley & Magnes, 1681. [Nicoll 1959–66, 1:357 / Stratman 1966, p. 139]

Prosper Jolyot de Crébillon, 1674–1762. *Atrée et Thyeste.* Tragedy. First performed **1707,** Paris. Published Paris: Pierre Ribou, 1709. [Girdlestone 1972, pp. 181 *n.*, 219 *n.* / DLLF 1984, 1:566]

Simon-Joseph Pellegrin, 1663–1745. *Pélopée* [Pelopeia]. Tragedy. First performed 2 Feb **1710,** Versailles. / Revised 1733. [Girdlestone 1972, pp. 181 *n.*, 219 *n.*, 245f.]

Petros Katsaitis, fl. 1715–20. *Thyestes.* Tragedy. **1720.** Modern edition by Emmanuel Kriaras (Athens: 1950). [Trypanis 1981, p. 575]

Christian Felix Weisse, 1726–1804. *Atreus und Thyest.* Verse tragedy. Published **1767.** Modern edition, in *Das Drama des gegeneinander in den sechziger Jahren,* vol. 12 of *Deutsche Literatur* (1938). [Oxford 1986, p. 968]

Johann Jakob Bodmer, 1698–1783. *Atreus und Thyest.* Tragedy, after Weisse (1767). In *Neue theatralische Werke,* vol. 1 (Lindau im Bodensee: Otto, **1768**). [DLL 1968–90, 1:649]

Voltaire, 1694–1778. *Les Pélopides, ou Atrée et Thieste* [The Sons of Pelops, or Atreus and Thyestes]. Tragedy. **1771.** Unperformed in author's lifetime. Published Geneva & Paris: Valade, 1772. [Moland 1877–85, vol. 7 / Besterman 1969, p. 502 / McGraw-Hill 1984, 5:117]

Ugo Foscolo, 1778–1827. *Tieste.* Tragedy. First performed Jan **1797,** Teatro Sant'Angelo, Venice. [DELI 1966–70, 2:515]

Edward Sinnet, d. 1845. *Atreus and Thyestes.* Tragedy, after Crébillon (1707). London: Baldwyn, **1822.** [Stratman 1966, pp. 605f.]

José María de Heredia y Campuzano, 1803–1839. *Atreo.* Tragedy. In *Poésias* (New York: **1825;** revised edition, Toluca, Cuba: Matute, 1832). [DLE 1972, p. 433]

Tommaso Sgricci, 1788–1836. *Tieste.* Tragedy, improvised. First performed 10 Nov **1827,** Arezzo. Published Arezzo: Loddi e Bellotti, 1828. [DELI 1966–70, 5:127]

John Byrne Leicester Warren, Lord de Tabley, 1835–1895, writing as "George Preston." *The Threshold of Atrides.* Poem. London: Kent, **1861.** [Bush 1937, p. 424]

Isolde Kurz, 1853–1944. *Das Haus des Atreus.* Collection of tales. Tübingen: Wunderlich, **1939.** [DLB 1988, 66:281]

Louis MacNeice, 1907–1963. "Thyestes." Poem. **1943.** [Dodds 1966]

Cesare Pavese, 1908–1950. (Castor and Pollux discuss Atreus and Thyestes in) "In famiglia" [In the Family]. Dialogue. In *Dialoghi con Leucò* (Turin: Einaudi, **1947**). / Translated by William Arrowsmith and D. S. Carne-Ross in *Dialogues with Leucò,* bilingual edition (Ann Arbor: University of Michigan, 1965). [Ipso]

Donald Davie, 1922–. "Thyestes." Poem. In *Brides of Reason* (Oxford: Fantasy Press, **1955**). [Ipso]

José Maria Pemán y Pemartín, 1898–1981. *Tyestes, la*

tragedia de la venganza [Thyestes, the Tragedy of Vengeance]. Tragedy. Madrid: Alfil, **1955**. [Holt 1975, p. 84]

Hugo Claus, 1929–. *Thyestes.* Tragedy, after Seneca. Amsterdam: De Bezige Bij; Antwerp: Contact, **1966**. [McGraw-Hill 1984, p. 529]

ATTIS. A mythical Phrygian youth whose legend became associated with the worship of the fertility goddess Cybele, Attis (Atys) was said to be the son of Nana, daughter of the river-god Sangarios. He was born from the nut of an almond tree, which his mother had eaten or placed in her womb or on her breast. In the most popular accounts, Attis grew to be a beautiful youth and was beloved of Cybele. When he fell in love with the wood nymph Sagaritis, Cybele, in a jealous rage, killed the nymph by cutting down the tree in which she lived. Attis went mad with grief, castrated himself, and died at the foot of a pine tree; from his blood violets grew. Some say that Attis was conjoined with the pine tree or was transformed into a pine. The myth of Attis as sacrificial vegetation deity is often considered a counterpart to that of Adonis.

The figure of Attis is rare in the Greek tradition, but he gained importance in Rome during the reign of Claudius, and after about 150 CE became equal to Cybele herself in the organization of her cult. Cybele's priests castrated themselves and feigned madness in ritual commemorations of his death. During the late Empire, he was given the status of a solar deity.

Classical Sources. Catullus, *Carmina* 63, "Attis." Diodorus Siculus, *Biblioteca* 3.58.4ff. Virgil, *Aeneid* 6.785–90. Ovid, *Fasti* 4.183ff., 6.321f.; *Metamorphoses* 10.104, 560ff., 686–702. Pausanias, *Description of Greece* 7.17.9–12. Lucian, *Dialogues of the Gods* 20, "Aphrodite and Eros."

See also CYBELE.

Donatello, c.1386–**1466**. "Amor-Atys." Bronze statuette. Museo del Bargello, Florence. [Pope-Hennessy 1985b, 2:11, 82—ill.]

Pierre de Ronsard, 1524–1585. "Le pin" [The Pine]. Poem. In *Le septiesme livre des poèmes* (Paris: Buon, **1569**). [Laumonier 1914–75, vol. 15 / Cave 1973, pp. 56, 200 / McFarlane 1973, p. 56]

Jean Regnauld de Segrais, 1624–1701. *Athys.* Pastoral poem. Paris: **1653**. [DLLF 1984, 3:2160]

Simon Rettenpacher, 1634–1706. *Ineluctabilis vis fatorum seu Atys* [The Ineluctible Force of the Fates, or Attis]. Tragedy. **1673**. In *Selecta dramata* (Salisbury: Mayr, 1683). [Wilpert 1963, p. 479]

Pierre Patel the Elder c.1605–**1676**. "Cybele Turning Atys into a Pine Tree." Painting. Dinton Park, Wiltshire. [Wright 1976, p. 157]

Jean-Baptiste Lully, 1632–1687. *Atys.* Opera (tragédie lyrique). Libretto, Philippe Quinault. First performed 10 Jan **1676**, Saint-Germain, Paris. [Grove 1980, 11:321–24, 326 / Girdlestone 1972, pp. 73–77]

Attilio Ariosti, 1666–1729. *Atys, o L'inganno vinto della costanza* [Atys, or Deceit Conquered by Constancy]. Musical pastorale. Libretto, Mauro. First performed 6 June **1700**, Lietzenburg, Berlin. [Grove 1980, 1:583f.]

Louis Fuzelier, 1674–1752, with Le Sage and D'Orneval, libretto. *La grand-mère amoureuse* [The Amorous Grandmother]. Comic opera, parody of Lully and Quinault's *Atys* (1676). First performed **1726**, Paris. [Grove 1980, 7:47]

Niccolò Piccinni, 1728–1800. *Atys.* Opera (tragédie lyrique). Libretto, Jean-François Marmontel, after Quinault (1676). First performed 22 Feb **1780**, L'Opéra, Paris. [Grove 1980, 14:726, 728 / also Winter 1974, 157]

Alessandro Pèpoli, 1757–1796. *Ati e Cibele.* Tragedy. By **1789**. [DELI 1966–70, 4:311]

Giambattista Cimador, 1761–1805. *Ati e Cibele.* Opera (favola per musica). Libretto, A. Pèpoli. First performed Spring **1789**, Accademia dei Rinnovati, Venice. Music lost. [Grove 1980, 4:398]

Leigh Hunt, 1784–1859. *Attis.* Poem, based on Catullus. **1810**. In *Works* (London: Smith, Elder, 1876–89). [Bush 1937, p. 174]

Franz Schubert, 1797–1828. "Atys." Lied. Text, Mayrhofer. Sep **1817**. Published 1833. [Grove 1980, 16:797]

Grant Allen, 1848–**1891**. "The Attis." Poem, adaptation of Catullus. London: Nutt, 1892. [Boswell 1982, p. 12]

George Meredith, 1828–1909. (Attis evoked in) "The Empty Purse." Poem. In *Poems* (London: Macmillan, **1892**). [Bartlett 1978, vol. 1]

Albert Augustus Stanley, 1851–1932. *Attis.* Symphonic poem, after Catullus. First performed **1898**. [Baker 1984, p. 2190]

Harry Kemp, b. 1883. "To Atthis." Poem. In *The Passing God and Other Poems* (New York: Brentano, **1919**). [Bush 1937, 588]

Basil Bunting, 1900–1985. "Attis: Or, Something Missing." Poem ("sonata"). **1931**. In *Poems 1950* (Galveston, Texas: Cleaner's Press, 1950). [DLB 1983, 20:86f. / EWL 1981–84, 1:364]

William Butler Yeats, 1865–1939. (Allusion to Attis as a pine in) "Vacillation" part 2. Poem. In *The Winding Stair and Other Poems* (London & New York: Macmillan, **1933**). [Finneran 1983 / Feder 1971, 196f.]

Robert Moevs, 1920–. "Attis." Choral composition. Libretto, from Catullus. **1958–63**. [Grove 1980, 12:459]

Robert Duncan, 1919–1988. (Allusion to Attis in reworking of Emperor Julian's "Hymn to the Mother of the Gods," in) "Passages." Poem. In *Bending the Bow* (New York: New Directions, **1968**). [Ipso / DLB 1983, 16:177]

Reynolds Price, 1933–. "Attis." Poem. In *Vital Provisions* (New York: Atheneum, **1982**). [Ipso]

AURORA. *See* EOS.

B

BACCHANALIA. The Latinized form of the Dionysiac orgies that accompanied worship of the god Dionysus (Bacchus), the Bacchanalia were especially notorious in Rome, where their celebration was banned in 186 BCE. They incorporated rites of the Greek Dionysiac mysteries, but some scholars suggest that Eastern traditions were involved as well. The ceremonies, characterized by ecstatic abandon, included drunkenness, wild dancing, and the dismembering of live animals.

Ancient Dionysiac rituals were conducted by maenads (bacchantes), mortal young women who became possessed with the wanton spirit of the god. In antique representations they are often accompanied by satyrs; together they sang, danced, played music, drank wine, and existed in an almost perpetual state of sexual excitement. Traditional attributes of the bacchic revelers include animal skins and garlands (although satyrs are usually nude); maenads carry the thyrsus, a pole wreathed with ivy and topped with a pine cone, which served as both a magic wand and a weapon.

An enormously popular theme in the postclassical visual arts, especially painting, bacchanalia are usually depicted as woodland revels, with figures associated with Dionysus as celebrants: satyrs and fauns, nymphs and maenads, centaurs, and sometimes the god himself. Dionysus's marriage to Ariadne is often depicted as a bacchanal.

Classical Sources. Herodotus, *Histories* 2.48–49. Euripides, *The Bacchae. Orphic Hymns* 54, "To Silenus, Satyrus, and the Priestesses of Dionysus." Terence, *The Self-Tormentor* (translation of a lost work of Menander). Diodorus Siculus, *Biblioteca* 4.3. Virgil, *Georgics* 2.380–96. Ovid, *Metamorphoses* 3.528ff., 4.1–41; *Fasti* 1.353ff., 392ff., 6.319ff., 489ff. Philostratus, *Imagines* 1.18.

See also CENTAURS; CYBELE; DIONYSUS; ORPHEUS, Death; PAN; PENTHEUS; PRIAPUS; SATYRS AND FAUNS; SILENUS.

Andrea Mantegna, 1430/31–1506. "Bacchanal with Silenus," "Bacchanal with a Wine Vat." Engravings, probably two sides of a single composition. By **1494.** [Lightbown 1986, nos. 208–09—ill. / Borenius 1923, nos. 2–3—ill.]

Francesco Colonna, c.1433–1527. (Festival of Bacchus represented on triumphal car in) *Hypnerotomachia Poliphili* [The Dream of Poliphilo]. Romance. Venice: Aldus, **1499;** illustrated with woodcuts by anonymous engraver. [Appell 1893, p. 9, pls. 58, 60–65]

Dosso Dossi, c.1479–1542. "Bacchanal." Painting. **c.1515.** Castel Sant' Angelo, Rome. [Gibbons 1968, no. 64—ill.]

——— (with **Battista Dossi?**, c.1474–1548. "Bacchanal" ("The Feast of Cybele"). Painting, after Giovanni Bellini's "Feast of the Gods" (1514, Washington). c.1519.

National Gallery, London, no. 5279. [Gibbons, no. 127 (as Dosso and Battista)—ill. / also London 1986, p. 166—ill. / Wind 1948, p. 62 *n.*, fig. 70]

——— (Dosso). "Bacchanal." Painting (known only from documentary evidence; cited as in Castello, Mantua). Lost. [Gibbons, p. 270]

——— (Dosso). "Portrait of Alfonso d'Este (as a Bacchic Votary)." Painting. Private coll., Venice. [Ibid., no. 183—ill. / Wind 1948, fig. 69]

Titian, c.1488/90–1576. Series of paintings for Alfonso d'Este, called "Ferrara Bacchanals." "The Worship of Venus" ("Feast of Venus"), **1518–19** (?), Prado, Madrid; "Bacchus and Ariadne," 1520–23, National Gallery, London, inv. 35; "The Andrians" ("Bacchanal"), c.1523–25, Prado, no. 418. [Wethey 1975, nos. 13–15—ill.] Giovanni Bellini's "Feast of the Gods," 1514 (landscape repainted by Titian c.1529), in National Gallery, Washington, D.C., is also considered part of this series. [Ibid., no. 12—ill.]

Raphael, 1483–1520, questionably attributed, composition. "Dance of Fauns and Bacchantes." Engraving, by Agostino Veneziano (Bartsch 14:203 no. 250). [Bartsch 1978, 26:248—ill.]

Giulio Romano, c.1499–1546, and assistant. "Venus, Satyr, and Maenad" ("Satyr Tormented by Two Nymphs"), "Three Maenads [or nymphs] Dance to Pipes Played by a Satyr [or Pan?]." Frescoes. **1527–28.** Sala di Ovidio (Metamorfosi), Palazzo del Tè, Mantua. [Hartt 1958, p. 111—ill. / also Verheyen 1977, p. 110]

Michelangelo, 1475–1564. "A Bacchanal with Children." Drawing. **1532–33.** Royal Library, Windsor, no. 12777. [Goldscheider 1951, no. 92—ill. / Saslow 1986, pp. 17ff., fig. 1.12]

Lorenzo Leonbruno, 1489–c.1537. "Bacchanal." Drawing. Gabinetto Designi e Stampe, Uffizi, Florence. [Bénézit 1976, 6:586]

Giorgio Vasari, 1511–1574. "Bacchanal." Painting. **1530s?** Lost. / Engraving by Ferdinando Gregori after a drawing by R. Allegranti. [Arezzo 1981, no. 4.8, pl. 360]

———. "Bacchanal." 2 drawings, studies for frescoes (lost or unexecuted) in Villa Giulia, Rome. 1553. Gabinetto Disegni e Stampe, Uffizi, no. 620F; the other unlocated. [Ibid., nos. 5.24a, f.—ill.]

Andrea Schiavone, c.1522–1563. "Bacchic Revel." Print (after design by Giulio Romano? or antique relief?). **c.1540–43?** [Richardson 1980, no. 123—ill.]

Pierre de Ronsard, 1524–1585. "Les Bacchanales, ou le folastrissime voyage d'Hercueil" [The Bacchanales, or the Frolicsome Voyage of Hercules]. Ode. **1549.** In *Les amours* (Paris: Buon, 1552). [Laumonier 1914–75, vol. 3 / DLLF 1984, 3:2013 / Cave 1973, p. 77, 347]

———. "Dithyrambes." Poem, part of *Livret de folastries* (Paris: La Porte, 1553). [Laumonier, vol. 5 / Cave, pp. 69f., 173 *n.*, 196 / McFarlane 1973, p. 70]

Taddeo Zuccari, 1529–1566. "Bacchanal." Fresco. **1551.** Palazzo Farnese, Caprarola. [Pigler 1974, p. 45]

Bastianino, 1532–1602, and circle. "The Vintage," "Bacchic Scene." Frescoes. **c.1555.** Camerino dei Baccanali, Cas-

tello Estense, Ferrara. [Arcangeli 1963, pp. 9f., nos. 28, 30—ill.]

Francesco Primaticcio, 1504–1570, design. "Bacchanal" (Bacchus, Hebe, fauns, and satyrs). Fresco, for Salle de Bal, Château de Fontainebleau, executed by Niccolò dell' Abbate under Primaticcio's direction. **1551–56.** Repainted 19th century. / Drawing for. Château de Chantilly. [Dimier 1900, pp. 160ff., 284ff., no. 125]

———. "The Daughters of Minyas" (scorning the feast of Bacchus and weaving a work dedicated to Minerva, turned into bats). Drawing, after Ovid's *Metamorphoses* 4. Lost. / Etching by Antonio Fantuzzi. (Bibliothèque Nationale, Paris.) [Paris 1972, no. 328 / also Lévêque 1984, p. 145—ill.] Copies of drawing in Albertina, Vienna; Hessisches Landesmuseum, Darmstadt; elsewhere. [Paris]

Garofalo, c.1481–**1559.** "Bacchanal." Painting. Late work. Gemäldegalerie, Dresden, no. 138. [Berenson 1968, p. 154]

Annibale Carracci, 1560–1609. "Venus, Satyr, and Two Amorini" ("Bacchantes"). Painting. *c.***1588.** Uffizi, Florence, inv. 1452. [Malafarina 1976, no. 43—ill. / Uffizi 1979, no. P372—ill.] Copy ("Nymph and Satyr") in Galleria Palatina, Palazzo Pitti, Florence, no. 480. [Pitti 1966, p. 134]

Friedrich Sustris, c.1540–**1599.** "The Procession of Bacchus." Drawing. Louvre, Paris. [de Bosque 1985, pp. 170, 173—ill.]

Italian School. "Bacchanal." Painting. **16th century.** Musée, Sens (on deposit from Louvre, Paris, inv. 851). [Louvre 1979–86, 2:305]

William Shakespeare, 1564–1616. ("Egyptian bacchanals" celebrated in) *Antony and Cleopatra* 2.7.103ff. Tragedy. **1606–07?** Stationers' Register 20 May 1608. No recorded performance in Shakespeare's lifetime. Published London: Jaggard, 1623 (First Folio). [Riverside 1974 / Root 1903, p. 44]

Adam Elsheimer, 1578–**1610** (? or Willem Basse?). "Nymph Dancing with Tambourine and Satyrs." Print. [Andrews 1977, no. 59—ill.]

Peter Paul Rubens, 1577–1640. "Bacchanal" (satyr and nymph with a young man). Painting. **1612–14.** Palazzo Durazzo Pallavicini, Genoa. [Jaffé 1989, no. 216—ill.]

———. "Bacchanal." Painting. 1614–15. Pushkin Museum, Moscow. [Ibid., no. 279—ill.]

———. "Leopards (with Satyr and Nymph)." Painting. *c.*1615. Musée des Beaux-Arts, Montreal. [Ibid., no. 289 *bis*—ill. / Held 1980, pp. 353ff.]

———. "Satyr and Bacchante (Nymph)." Painting. 1616–17. Numerous versions by Rubens and studio/school. Walbors coll., Tampa; Gemäldegalerie, Dresden; Mauritshuis, The Hague ("parody" copy); Museo Provincial, San Sebastian, on deposit from Prado, Madrid; elsewhere. [Jaffé, no. 427—ill.]

———. Painting, copy after Titian's "The Andrians" (*c.*1523–25, Prado). 1636–38. Nationalmuseum, Stockholm. [Ibid., no. 1340—ill.]

Cornelis Cornelisz van Haarlem, 1562–1638. "Bacchanal." Painting. **1614.** Szépművészeti Múzeum, Budapest, no. 2062. [Budapest 1968, p. 152—ill. / de Bosque 1985, pp. 210, 215—ill.]

Polidoro da Caravaggio, c.1498–1543, composition. "Bacchanal." Print, executed by Cherubino Alberti (1553–

1615). (British Museum, London.) [Saslow 1986, pp. 54f., fig. 1.16]

Jacob Jordaens, 1593–1678. "Bacchanal" (nymphs and satyrs). Painting. *c.***1615–16.** Formerly Nardus coll., sold Paris, 1953. [d'Hulst 1982, fig. 21]

———. "Bacchanalian Scene" ("Sine Baccho et Cerere friget Venus"). Painting. *c.*1616. Museum voor Schone Kunsten, Ghent, no. 1903–F. [Rooses 1908, p. 48 / Ottawa 1968, no. 15—ill.]

———. "A Bacchic Festival" ("October"). Ceiling painting, part of "Signs of the Zodiac" series for the artist's house in Antwerp. Early 1640s. Senate Library, Palais du Luxembourg, Paris. [Rooses, p. 124]

———. "Homage to Venus" (by bacchantes). Painting. 1640s? 2 versions known. Gemäldegalerie, Dresden; Herzog Anton Ulrich-Museum, Braunschweig. [d'Hulst, pp. 212, 336 n.26 / also Rooses 1908, pp. 94, 99—ill.]

———. Numerous further bacchanals known, unlocated. [Rooses, p. 258]

———, school. "Bacchanalian Scene." Painting. Royal Institution of Cornwall, Truro, cat. 1936 no. 23. [Wright 1976, p. 109]

Gian Lorenzo Bernini, 1598–1680. "Bacchanal: Faun [?] Teased by Children." Marble statue. Early work. Metropolitan Museum, New York, no. 1876.92. [Metropolitan 1983, p. 206—ill.]

Nicolas Poussin, 1594–1665. "Bacchanal of Putti." Pair of paintings. *c.***1626** or later. Galleria Nazionale, Rome. [Wright 1985, nos. 47, 48, pls. 128–29 / Thuillier 1974, nos. 27–28—ill.]

———. "Nymph (Bacchante) and Satyr Drinking" ("Bacchic Scene"). Painting. Mid-1620s. 3 versions (disputed attribs.; 1 or 2 may be copies). National Gallery of Ireland, Dublin; Prado, Madrid; Pushkin Museum, Moscow. [Wright, no. 19, pls. 112–14 / Blunt 1966, no. 200—ill. / Thuillier, no. 39—ill. / Dublin 1985, no. 32—ill. / also Prado 1985, pp. 517f.] Copy in Musée de Besançon. [Blunt]

———. "Bacchanal with a Guitar Player" ("The Andrians," "The Great Bacchanal"). Painting. *c.*1630. Louvre, Paris, inv. 7296 (730). [Wright, no. 43—ill. / Blunt, no. 139—ill. / Louvre 1979–86, 4:144—ill. / also Thuillier, no. 47—ill.] Copy by Eugène Isabey (1803–1889). Louvre, Paris, no. R.F. 1974–12. [Louvre, 3:327—ill.]

———. "Bacchanalian Revel before a Term (of Pan)." Painting. Early/mid-1630s. National Gallery, London, no. 62. [Wright, no. 79, pl. 33 / Blunt, no. 141—ill. / London 1986, p. 491—ill. / also Thuillier, no. 71—ill.] Copies in Musée de Lyons; Musée de Vire. [Blunt] Drawing ("Bacchanalian Dance"), early *pensée*. Late 1620s. Royal Library, Windsor Castle, no. 11979. [Friedlaender & Blunt 1953, no. 196—ill.]

———. Series of "Bacchanals," for Château de Richelieu. Paintings. Mid-1630s. "Triumph of Bacchus," Nelson Gallery of Art, Kansas City; "Triumph of Pan," National Gallery, London; "Triumph of Silenus," original lost, copies in National Gallery, London, elsewhere. ("Triumph of Neptune and Amphitrite," Philadelphia Museum of Art, is also possibly part of the series.) [Wright, nos. 80–83—ill. / Blunt, nos. 136–38—ill. / Thuillier, nos. 90–93—ill.]

———. "Bacchanal before a Temple." Painting. *c.*1650.

Lost or unidentified. / 20 copies known. DeYoung Museum, San Francisco; Musée de Besançon; Musée de Caen; Musée d'Orléans; elsewhere. [Blunt, no. 140—ill. / Wright, no. A2—ill. / also Thuillier, no. 167—ill.]

————. "Bacchante." Design and wax model for marble term. 1655–56. Lost. / Marble executed by Jean-Baptiste Théodon, by 1661. Quinconce du Nord, Gardens, Versailles. [Girard 1985, pp. 273f., 185—ill. / also Blunt, p. 157—ill.]

————. "Bacchanal." Drawing. Louvre, Paris, no. 32427. [Friedlaender & Blunt, no. 199—ill.]

————, follower (formerly attributed to Poussin). "Bacchanal." Painting. Herzog Anton Ulrich-Museum, Braunschweig, no. 512. [Braunschweig 1969, p. 109 / Blunt, no. R70 (as "Hovingham Master") / Thuillier, no. R60—ill.]

————, circle (formerly attributed to Poussin). "Apollo, Diana, Bacchus, and Bacchantes." Painting. Braunschweig, no. 514. [Braunschweig / also Blunt, no. R62 / Thuillier, no. R53—ill.]

————, formerly attributed. "Festival in Honor of Bacchus." Presumed painting, untraced. / Engraved 1817. [Thuillier, no. R62—ill.]

————. See also French School, 17th century, below.

Massimo Stanzione, 1585–1656. "Bacchanal" ("Sacrifice to Bacchus"). Painting. c.1630. Prado, Madrid, no. 259. [Fort Worth 1982, fig. 131 / Prado 1985, p. 655]

Hendrik van Balen, 1575–**1632.** "Bacchic Procession." Painting. Art Gallery and Museum, Glasgow, cat. 1961 no. 57. [Wright 1976, p. 8]

————. "Bacchanal." Painting. Musée, Liège. [Bénézit 1976, 1:401]

Jacques Blanchard, 1600–1638. "Bacchanal." Painting (1 of a series of 4?). **1636?** Musée des Beaux-Arts, Nancy, cat. 1909 no. 325. [Dublin 1985, no. 4—ill. / Metropolitan 1960, no. 48—ill.]

Hieronimus van Kessel, 1578–**after 1636,** figures, and **Alexander Keirincx,** c.1600–1652, landscape. "Bacchanal in a Landscape." Painting. Herzog Anton Ulrich-Museum, Braunschweig, no. 89. [Braunschweig 1969, p. 82]

Joachim Wtewael, 1566–**1638,** previously attributed. "Bacchanal." Painting. Private coll., New York. [Lowenthal 1986, no. C–87] Another "Bacchanal" by Wtewael known, unlocated. [Ibid.]

Giulio Carpioni, 1613–1679. "A Bacchanal." Painting. c.1638. Kress coll. (K1639), Columbia Museum of Art, S.C., no. 54–402/21. [Shapley 1966–73, 3:124f.—ill.]

————. "Feast of Bacchus." Painting. 1640s. Kunsthistorisches Museum, Vienna, inv. 339 (445). [Vienna 1973, p. 39]

————. "Bacchanal." Painting. Schilderijenzaal Prins Willem V, The Hague, cat. 1977 no. 77. [Wright 1980, p. 72]

————. "Bacchanal." Painting. Szépművéseti Múzeum, Budapest, no. 623. [Budapest 1968, p. 126]

————. "Bacchanal." Painting. Muzeum Narodowe, Warsaw, inv. Wil. 392. [Warsaw 1969, no. 196—ill.]

Antoine de Boësset, 1586–**1643,** music. *Les bacchanales.* Ballet. First performed 1683, Paris. [Grove 1980, 2:843]

François Duquesnoy, 1594–**1643,** and **Giovanni Campi,** fl. mid-17th century. "Bacchanal of Putti." Bronze relief. Galleria Borghese, Rome, inv. 276 (508). [Faldi 1954, no. 50—ill.]

Eustache Le Sueur, 1616–1655. "Poliphilo and Polia Assisting at the Triumph of Bacchus." Painting, after Francesco Colonna's *Hypnerotomachia Poliphili* (1499). **1635–45.** Musée de Tessé, Le Mans, inv. 18.20. [Dublin 1985, no. 22—ill.]

Salvator Rosa, 1615–1673 (also attributed to Niccolò da Simone). "Bacchanal." Painting. **1645–46.** Formerly Lord Pembroke coll., sold Christie's, London, 1960. [Salerno 1975, no. 83—ill.]

Moyses van Uyttenbroeck, c.1590–**1648,** questionably attributed. "Peasant's Bacchanal." Painting. Muzeum Narodowe, Warsaw, inv. 128572. [Warsaw 1969, no. 1327—ill.]

Robert Herrick, 1591–1674. "A Bacchanalian Verse." 2 poems (with the same title). In *Hesperides* (London: Williams & Eglesfield, **1648**). [Martin 1956]

Simon Vouet, 1590–**1649** (previously attributed to Charles Le Brun). "Bacchanal." Drawing. Musée de Besançon. [Metropolitan 1960, no. 16—ill.]

Flemish School. "Bacchic Feast." Painting (largely ruined). **1600/50?** Louvre, Paris, inv. 2005. [Louvre 1979–86, 1:160—ill.]

Michel Mazuel, 1603–1676, music. *Les festes de Bacchus.* Ballet. **1651.** [Grove 1980, 11:865]

Louis de Mollier, c.1615–1688, music. *Ballet du roy des festes de Bacchus* [King's Ballet of the Feasts of Bacchus]. Ballet. May **1651.** [Grove 1980, 12:471]

Jacob van Loo, c.1614–1670. "Bacchic Scene." Painting. **1653.** Rijksmuseum, Amsterdam, inv. A3483. [Rijksmuseum 1976, pp. 352f.—ill.]

Gerrit van Honthorst, 1590–**1656.** "Bacchanal." Painting. Sold 1796, unlocated. [Judson 1959, no. 76]

————. "Bacchanal." Painting. Sold 1806, untraced. [Judson, no. 77]

Adriaen van Nieulandt, 1587–**1658.** "Landscape with Bacchanal." Painting. Staatliche Museen, Berlin. [Bénézit 1976, 7:722]

Frans Wouters, 1612–**1659.** "Procession of Bacchantes." Painting. Kunsthistorisches Museum, Vienna. [Bénézit 1976, 10:799]

David Teniers the Younger, 1610–1690, attributed (previously attributed to the school of Rubens). "Bacchanal." Painting. c.**1640–60.** Uffizi, Florence, inv. 1040. [Uffizi 1979, no. P1681—ill.]

Thomas Jordan. *Bacchus Festival: or, A New Medley, etc.* Musical entertainment. First performed **1660,** London. [Nicoll 1959–66, 1:415]

Luca Giordano, 1634–1705. "Bacchanals" (of infants). Pair of paintings. c.**1663.** Villa Albani-Torlonia, Rome. [Ferrari & Scavizzi 1966, 2:61—ill.] Studio copies in Museo Civico, Vicenza, nos. 305, 308. [Ibid., 2:313]

————. "Bacchanal." Painting. Mid-1680s? Hermitage, Leningrad, no. 197. [Ferrari & Scavizzi, 2:337]

————. "Bacchanal of Venus and Diana." Painting. Recorded in 1688, untraced. [Ferrari & Scavizzi, 2:363]

————, studio (previously considered original). "Bacchanal." Painting. Ringling Museum, Sarasota, Fla., no. SN161. [Ferrari & Scavizzi, 2:311 / Sarasota 1976, no. 185]

————. "Bacchanal." Painting. Recorded in 1710, untraced. [Ferrari & Scavizzi, 2:317]

————. "Bacchanal." Painting. Sold 1843, untraced. [Ferrari & Scavizzi, 2:3473]

———. "Bacchanal." Painting. Sold Galleri Slatner, Prague, 1927, untraced. [Ferrari & Scavizzi, 2:378]

———. "Bacchanal." Painting. Sold Sotheby's, London, 1955, untraced. [Ferrari & Scavizzi, 2:341]

———. "Bacchanal." Painting. Musée, Ajaccio (on deposit from Louvre, Paris, inv. 305). [Louvre 1979–86, 2:290]

Cornelis van Poelenburgh, c.1586–1667. "Landscape with Bacchantes and Fauns." Painting. Landesmuseum Joanneum Alte Galerie, Graz. [Bénézit 1976, 8:392]

Abraham van Diepenbeeck, 1596–1675. "Children's Bacchanal." Painting. Herzog Anton Ulrich-Museum, Braunschweig, no. 123. [Braunschweig 1969, p. 51]

Simon de Vos, 1603–1676. "Bacchanalia." Painting (after a drawing by Johann Liss in Freiburg?). Muzeum Narodowe, Warsaw, inv. 128519. [Warsaw 1969, no. 1410—ill.]

Bartolomé Esteban Murillo, 1617–1682, attributed. "Head of a Bacchante." Painting. Lord Wells of Holmewood coll. in 1883, untraced. [López Torrijos 1985, pp. 349, 428 no. 21]

Daniel Vertangen, c.1598–1681/84. "Maenads and Satyrs." Painting. Szépművéseti Múzeum, Budapest, no. 386. [Budapest 1968, p. 753] 2 variants. Herzog Anton Ulrich-Museum, Braunschweig; the other sold Stuttgart, 1966. [Ibid., p. 753]

———. "Maenads and Satyrs." Painting. Musées Royaux des Beaux Arts, Brussels. [Bénézit 1976, 10:479]

———. "Bacchanal." Painting. Muzeum Narodowe, Gdansk. [Ibid.]

———. "Feast of Bacchus." Painting. Municipal Museum, The Hague. [Ibid.]

Johann Heinrich Schönfeld, 1609–1684 (formerly attributed to Bernardo Cavallino). "Bacchanal" ("Bacchic Procession"). Painting. Museo di Capodimonte, Naples, no. 305. [Percy & Lurie 1984, no. 66 / Capodimonte 1964, p. 54]

Jean Dedieu, 1646–1727. "Bacchante" ("Maenad"). Marble term. 1684–85. Parterre de Latone, Gardens, Versailles. [Girard 1985, p. 287—ill.]

Johan Danckerts, c.1615–1681/87. "Bacchanalia." Painting. Metropolitan Museum, New York, no. 27.146. [Metropolitan 1980, p. 41—ill.]

Eberhard Keil, called "Monsu Bernardo," 1624–1687. "Infants' Bacchanal." Painting. Prado, Madrid, no. 3127. [Prado 1985, p. 355]

Philips Koninck, 1619–1688. "Bacchus Feast." Painting. Museum Bredius, The Hague, inv. 62–1946. [Wright 1980, p. 219]

Gérard de Lairesse, 1641–1711 (active until c.1690). "Bacchanal in a Landscape." Painting. Herzog Anton Ulrich-Museum, Braunschweig, no. 1069. [Braunschweig 1969, p. 85] *See also French School, 17th century, below.*

Filippo Lauri, 1623–1694. "Bacchanal." Painting. Musée, Mayence. [Bénézit 1976, 6:485]

Agostino Steffani, 1654–1728. *Baccanali.* Favola pastorale. Libretto, Ortenzio Mauro. First performed 1695, Hannover. [Grove 1980, 18:296]

Mattia Preti, 1613–1699. "Bacchanal." Painting. Raggi coll., Rome. [Cannata 1978, pl. 11]

French School (previously attributed to Poussin, Gérard de Lairesse). "Bacchanal." Painting. 17th century. Prado, Madrid, no. 2359. [Prado 1985, pp. 823f.]

French School. "A Festival in Honor of Bacchus." Painting. 17th century. Art Gallery, Brighton. [Wright 1976, p. 69]

Neapolitan School. "Bacchanalian Boys." Painting. 17th century. National Gallery of Ireland, Dublin, no. 1074. [Dublin 1981, p. 116—ill.]

Jean Mansel, fl. late 17th century. "Putti Bacchanal." Ivory relief. Bayerisches Nationalmuseum, Munich, inv. R.4681. [Düsseldorf 1971, no. 237]

French School. "Bacchante." Bronze statuette. Early 18th century. Staatliche Museen, Berlin, inv. 358. [Düsseldorf 1971, no. 360—ill.]

Sebastiano Ricci, 1659–1734. "Bacchanal." Fresco. 1703 or later. Palazzo Fulcis-Bertoldi, Belluno. [Daniels 1976, no. 25b]

———. "Bacchanal." Painting. c.1710? Hermitage, Leningrad, cat. 5367. [Ibid., no. 133—ill.]

———, with **Marco Ricco**. "Bacchanal" ("Festival in Honor of Pan"). Painting. c.1715 or later. Formerly H. Voss coll., Wiesbaden. [Ibid., no. 532—ill.]

——— (Ricci). "Bacchanal in Honor of Pan." Painting. 1731–33. Private coll., Italy. [Ibid., no. 122] 2 variants. Anacleto Frezzati coll., Venice; the other (studio?) sold Sotheby's, London, 1964. [Ibid., nos. 542a, 197a—ill.]

———, studio (?). "Bacchanal." Painting. Early 1720s. Palazzo Taverna, Rome. [Ibid., no. 388]

Robert Le Lorrain, 1666–1743. "Bacchante." Bronze statuette. 1704. Staatliche Kunstsammlungen, Dresden. [Beaulieu 1982, pp. 52f.—ill.]

———. "Bacchante with a Little Satyr." Bronze statuette. Before 1715. Musée de Rennes. [Beaulieu, p. 53, pl. 58] Variant. Metropolitan Museum, New York. [Ibid.]

Arnold Verbuys, c.1645–1729. "Bacchanal." Painting. Before 1708. [Bénézit 1976, 10:444]

Ignaz Elhafen, 1658–1715. "Bacchic Scene." Ivory highrelief. 1708. Bayerisches Nationalmuseum, Munich, inv. R.4666. [Düsseldorf 1971, no. 111—ill.]

Antoine Watteau, 1684–1721. "Bacchic Festival." Painting, decoration for Hôtel Chauvelin. 1710. Lost. / Print by F. Moyreau, 1731. [Camesasca 1982, no. 47a—ill.]

———. "The Children of Silenus," "Children of Bacchus." Paintings. c.1710? Lost. / Prints by P. Dupin, E. Fessard (1734). [Camesasca, nos. 73, 74—ill.] Old copy of "Bacchus" in Louvre, Paris, inv. R.F. 1950–20. [Louvre 1979–86, 4:286 (as original)—ill.]

———, rejected attribution. "Children's Bacchanal." Painting, after original of 1709. Schwabe Heerliberg coll., Zurich. [Camesasca, no. 1.b—ill.]

Niccolo Cassana, 1659–1713. "Bacchanalian Scene." Painting. Hermitage, Leningrad. [Hermitage 1981, pl. 174]

Benjamin Thomae, 1682–1751. "Bacchant." Sandstone statue. c.1716–18. Kronentor, Zwinger, Dresden. [Asche 1966, no. T23]

Michel-Ange Houasse, 1680–1730. "Bacchanal," "Sacrifice to Bacchus." Pair of paintings. 1719, 1720. Prado, Madrid, nos. 2267–68. [Prado 1985, p. 333]

Alessandro Magnasco, 1667–1749 (architectural background by Clemente Spera). "Bacchanalian Scene." 2 paintings. 1710–20. Hermitage, Leningrad; Pushkin Museum, Moscow. [Hermitage 1981, pls. 203–04]

———. "Bacchanal." Painting. 1711–35. Pellosi coll., Milan.

[Sarasota 1976, pp. 6of.] Sketch. Ringling Museum of Art, Sarasota, Fla., inv. SN745. [Ibid., no. 53—ill.]

Jacob de Wit, 1695–1754. "Bacchantes, Amoretti, and Satyrs" ("The Maturing of the Wine"). Ceiling painting. **1719–20.** Lange Vijverberg, The Hague. [Staring 1958, pl. 51]

——. "Children's Bacchanal." Painting. 1748. Hermitage, Leningrad. [Ibid., pl. 101]

Adriaen van der Werff, 1659–**1722.** "Bacchantes." Painting. Musée Ariana, Geneva. [Bénézit 1976, 10:697]

Girolamo Baruffaldi, 1675–1755. *I baccanali.* Poem. Venice: Buonarrigo, **1722.** [DELI 1966–70, 1:279]

Daniel Gran, 1694–1757. "Bacchanal." Fresco. **1726.** Marmorsaal, Gartenpalais Schwarzenberg, Vienna. [Knab 1977, pp. 48f., no. F14—ill.]

François Couperin, 1668–1733. "Les baccanales." Fourth suite of "Ordres." Instrumental composition. **1713–30.** Paris. [Grove 1980, 4:871 / Edler 1970, p. 200]

Noël-Nicolas Coypel, 1690–**1734.** "Bacchanal." Painting. Muzeum Narodowe, Warsaw, inv. 129769. [Warsaw 1969, no. 256—ill.]

John James, ?–*c.*1745. "Ye Thirsty Drinkers: A Bacchanalian Song." Song. London: *c.*1735. [Grove 1980, 9:472]

Pompeo Batoni, 1708–1787, figures, and **Hendrik Frans van Lint,** 1684–1763, landscape. "Ideal Landscape with Bacchanalian Figures." Painting. *c.***1735–37.** Private coll., U.S.A. [Clark 1985, no. 10—ill.]

—— (Batoni) and **Jan Frans van Bloemen,** 1662–1749. "Imaginary View of Rome with a Bacchanal," "Ideal Landscape with a Bacchanal." 2 paintings. 1739. Private coll., Rome. [Ibid., nos. 20–21—ill.]

François Le Moyne, 1688–**1737.** "Bacchanal." Painting. Sold Brussels, 1934, untraced. [Bordeaux 1984, p. 129]

——, questionably attributed. "A Bacchante." Painting. 1700/50? Louvre, Paris, no. R.F. 3924 (as French School). [Louvre 1979–86, 4:311—ill.]

——. *See also Natoire, below.*

Andrea Locatelli, 1695–**1741.** "Bacchantes and Fauns in a Landscape." Painting. Nasjonalgalleriet, Oslo. [Bénézit 1976, 6:709]

François Boucher, 1703–1770. "Bacchantes" (with flute and tambourine). Painting. **1745.** Private coll., New York. [Ananoff 1976, no. 288—ill.]

——. "Sleeping Bacchantes" (watched by satyrs). Painting. 1758. Private coll., New York. [Ibid., no. 515—ill.]

——. "Bacchantes and Satyrs" (2 sleeping bacchantes, observed by satyrs, cupids overhead). Painting, similar to above. 1760. Feather coll., London. [Ibid., no. 534—ill.]

Georg Raphael Donner, 1693–1741, follower. "Bacchante" (?). Lead statue. *c.***1745.** Mestské Múzeum, Bratislava, inv. B343. [Schwarz 1968, no. 64]

Louis de Silvestre the Younger, 1675–**1760,** studio. "Bacchanalia." Painting. Muzeum Narodowe, Warsaw, inv. Wil. 1148 (formerly 554), on display at Wilanów Palace. [Warsaw 1969, no. 1204—ill.]

Jacques de Lajoue, 1687–**1761.** "Bacchantes and Satyrs." Painting. Hessisches Landesmuseum, Darmstadt. [Bénézit 1976, 6:391]

Johann Georg Platzer, 1704–**1761.** "Bacchic Revels." Pair of paintings. Art Institute of Chicago. [Lowenthal 1986, figs. 55–56]

Jean-Honoré Fragonard, 1732–1806, design. "Bacchanal" ("Satyrs' Games"). Cycle of 4 etchings. *c.***1763.** 2 states for each. [Rosenberg 1988, nos. 67–70—ill. / Réau 1956, p. 234]

——. "Sleeping Bacchante." Painting. 1765–72. Louvre, Paris, no. M.I. 1056. [Louvre 1979–86, 3:269—ill. / Wildenstein 1960, no. 275—ill.]

——. *See also Natoire, below.*

Carle van Loo, 1705–**1765.** "Bacchante." Painting. Musée, Épinal. [Bénézit 1976, 6:730]

Clodion, 1738–1814. "Satyr with Two Bacchantes." Terracotta statuette. **1766.** Frick Collection, New York, no. 16.2.75. [Frick 1968–70, 4:98f.—ill.] Similar group, Rothschild coll., Waddesdon Manor, Buckinghamshire. [Kocks 1981, p. 443—ill. / also Thirion 1885, p. 206—ill.] Another, in Baron Rothschild coll. in 1885. [Thirion, p. 288]

——. 3 stucco reliefs with bacchanalian scenes, for Hôtel de Bourbon-Condé, Paris. *c.*1781–87. Metropolitan Museum, New York, no. 59.24. [Metropolitan 1983, p. 211—ill.]

——. "A Bacchante," "A Bacchante with a Cluster of Grapes in Her Left Hand." Pair of marble statues. National Gallery, Washington, D.C., nos. A–1621, 120A (only A–1621 on display). [Sienkewicz 1983, p. 40—ill.]

——. "Bacchant, Bacchante, and Little Satyr." Terracotta sculpture model. Barbedienne coll., France, in 1885. [Thirion, p. 196—ill.]

——. "Bacchante Carrying a Baby Satyr." Marble sculpture group. Louvre, Paris, in 1885. [Ibid., p. 245—ill.] A similar group, in Musée, Orléans, in 1885. [Ibid., p. 220—ill.]

——. "Bacchante and Bacchantes," "Bacchantes and Satyrs." Wax etchings. San-Donato coll. in 1885. [Ibid., pp. 331, 357—ill.]

——. "Reclining Bacchante Playing with an Infant," "Reclining Bacchante," "Bacchante with Grapes," others. Terra-cotta sculpture group. Unlocated. [Ibid., pp. 191, 215, 229—ill. (drawings)]

——. "Bacchic Games." Pair of wax reliefs. Hermitage, Leningrad. [Hermitage 1975, pls. 130–31]

——, attributed. "Reclining Bacchante Holding a Vase." Drawing. Fogg Art Museum, Harvard University, Cambridge, inv. 1965.243. [Houser 1979, no. 55—ill.]

Henry Fuseli, 1741–1825. "Triumph of Death: Three Cloaked Skeletons Break in upon an Antique Bacchanal." Drawing. *c.***1768–70.** Somerville coll., London. [Schiff 1973, no. 1729—ill.]

——. "Bacchanal." Drawing. 1770–78. Museo Horne, Florence, inv. 225. [Ibid., no. 544—ill.]

——. "Bacchanal." Drawing. *c.*1790–1800. Kunsthaus, Zurich, no. 1914/20. [Ibid., no. 999—ill.]

——. "Bacchanalian Pair: Bust of a Man and Woman with Vineleaves in Her Hair." Drawing. 1822. Kunsthaus, Zurich, inv. 1938/721. [Ibid., no. 1697—ill.; see also no. 1530]

Augustin Pajou, 1730–1809. "Bacchante." Plaster statue. **1774.** Louvre, Paris. [Stein 1912, pp. 207–11—ill.] Terracotta sketch. Caroline Morgan coll., New York. [Ibid., p. 406]

Charles-Joseph Natoire, 1700–1777 (formerly attributed to François Le Moyne, Jean-Honoré Fragonard). "Bac-

chantes and Satyrs." Painting. Glasgow Art Gallery and Museum. [Bordeaux 1984, no. X17—ill.]

———. "Bacchante." Painting. Sold Paris, 1907. [Boyer 1949, no. 98]

———. "Maenads Surrounded by Satyrs and Infants." Drawing. Fogg Art Museum, Harvard University, Cambridge, inv. no. 1957.51. [Houser 1979, no. 63—ill.]

Angelica Kauffmann, 1741–1807. "Two Nymphs [or Bacchantes] Decorating the Bust of Pan." Painting, design for porcelain group, modeled by J. J. Spängler. By **1777.** [Manners & Williamson 1924, pp. 5f.—ill.]

———. "The Bacchantes." Painting. Formerly Charles Boddam coll., unlocated. / Colored etching by Francesco Bartolozzi, 1786. (Hermitage, Leningrad, inv. 355178.) [Hermitage 1979, pl. 263]

———. "A Bacchante." Drawing. British Museum, London. [Manners & Williamson, p. 196]

Jean-Baptiste Lemoyne, 1704–**1778.** "Satyr, Bacchante, and Children." Bas-relief. Sold 1795, unlocated. [Réau 1927, no. 32]

Anna Dorothea Therbusch-Lisiewska, 1721–1782. "Bacchante." Painting. Hermitage, Leningrad, inv. 8357. [Hermitage 1987b, no. 321—ill.]

Joshua Reynolds, 1723–1792. "Lady Hamilton as a Bacchante." Painting. Exhibited **1784.** Tankerville-Chamberlayne coll. in 1904. [Waterhouse 1941, p. 75]

George Romney, 1734–1802. "Initiation of a Rustic Nymph" (by bacchantes). Painting. c.**1784?** Unfinished, lost. / Numerous drawings for. Fitzwilliam Museum, Cambridge; elsewhere? [Jaffé 1977, nos. 64–67—ill.]

———. "Lady Hamilton as a Bacchante." Painting. c.1786. Tate Gallery, London, no. 1312. [Tate 1975, p. 68]

Johann Gottfried Schadow, 1764–1850. "Bacchanal by a Statue of Pan." Drawing. c.**1784.** Deutsche Akademie der Künste, Berlin, inv. Schadow 806. [Berlin 1965, no. 60]

Bernhard Rode, 1725–1797. "Allegorical Female Figure" (Bacchante?). Painting. c.**1785.** Hermitage, Leningrad, inv. 7630. [Hermitage 1987b, no. 290—ill. Cf. no. 295]

Philip Freneau, 1752–1832. "A Bacchanalian Dialogue." Poem. In *Poems* (Philadelphia: **1786**); reprinted in *Poems Written and Published During the American Revolutionary War and Now Republished* (Philadelphia: Bailey, 1809). Modern edition, in *Poems,* edited by F. L. Pattee (Princeton: Princeton University Press, 1902–07). [Boswell 1982, p. 256]

André Chénier, 1762–1794. "Bacchus." Poem, part of *Les bucoliques.* c.**1778–87.** In *Oeuvres complètes* (Paris: Foulon, Baudouin, 1819). [DLLF 1984, 1:447]

Laurent Guyard, 1723–**1788.** "Bacchante." Sculpture. Galleria Nazionale, Parma. [Bénézit 1976, 5:320]

Francesco Zuccarelli, 1702–**1788.** "Bacchanals." Painting. Dulwich College Picture Gallery, cat. 1953 no. 452. [Wright 1976, p. 226]

Giovanni Pindemonte, 1751–1812. *I baccanali.* Drama (satire, attack on secret societies). **1788.** In *Componimenti teatrali,* vol. 1 (Milan: Sonzogno, 1804–05). [McGraw-Hill 1984, 4:95 / DELI 1966–70, 4:375]

Franz Anton Maulbertsch, 1724–1796. Bacchantes, centaurs, and fauns, representing primitive instincts, in "Allegory of the Sciences." Ceiling painting. **1794.** Strahov Foundation, Prague. [Garas 1960, no. 383, p. 155—ill.] Oil

sketches, Národní Galeri, Prague; Stoner coll., London. [Ibid., nos. 381–82—ill.]

Benjamin West, 1738–1820. "A Bacchante." Painting. **1797.** Berman coll., Allentown, Pa. [von Erffa & Staley 1986, no. 123—ill.]

———. "Bacchanté Boys" ("Boys and Grapes"). Painting. 1819. Chastain coll. [Ibid., no. 124—ill.]

Italian School. "Bacchanal." 2 paintings (with the same title). Before **1800.** Glynn Vivian Art Gallery, Swansea, cat. 1913 nos. 30, 66. [Wright 1976, p. 107]

Piat Joseph Sauvage, 1744–1818, style. Series of 6 overdoor paintings, depicting infant bacchanals and nymphs with putti. **Late 18th century.** Metropolitan Museum, New York, nos. 07.225.252, 272, 306a-b, 314a-b. [Metropolitan 1980, pp. 168f.—ill.]

Martin Claude Monnot, 1733–**1803.** "Bacchante." Marble sculpture. Huntington Library and Art Gallery, San Marino, Calif. [Clapp 1970, 1:635]

Didier Boguet, 1755–1839. "Feast of Bacchus." Painting. **1803.** Galleria dell' 800 di Capodimonte, Naples, no. 113. [Capodimonte 1964, p. 63]

Philipp Otto Runge, 1777–1810. "Bacchanal." Drawing. **1803.** Kunsthalle, Hamburg, inv. 34271. [Hamburg 1977, no. 138—ill.]

Jean-Baptiste Greuze, 1725–**1805.** "Bacchante," "Bacchante with an Amphora." Paintings. Waddesdon Manor, Buckinghamshire, cat. 1967 nos. 106, 107. [Wright 1976, p. 82]

———. "Bacchante." Painting. Wallace Collection, London, no. P.407. [Ibid.]

James Barry, 1741–1806. "Bacchanal." Drawing. Royal Academy, London. [Pressly 1981, no. D.19]

Johannes van Drecht, 1737–**1807,** attributed. "Bacchic Scene." Painting. Rijksmuseum, Amsterdam, inv. A3463. [Rijksmuseum 1976, p. 199—ill.]

Friedrich Rauscher, 1754–**1808.** "Children's Bacchanal." Painting. Muzeum Narodowe, Warsaw, inv. 129296. [Warsaw 1969, no. 1028—ill.] Replica. Museum, Weimar. [Ibid.]

Jean-Joseph Taillasson, 1746–**1809.** "Bacchante and Faun." Drawing. [Bénézit 1976, 10:56]

Traugott Maximilian Eberwein, 1775–1831. *14 Canons für Bachanalien.* Cycle of canons. Leipzig: Breitkopf & Härtel, **1811.** [NUC]

Pietro Generali, 1773–1832. *I baccanali di Roma.* Opera. Libretto, G. Rossi. First performed 14 Jan **1816,** La Fenice, Venice. [Grove 1980, 7:232 / Baker 1984, p. 811]

Andrea Appiani the Elder, 1754–**1817.** "Bacchante." Painting. Château de Compiègne. [Bénézit 1976, 1:236]

Gasparo Luigi Spontini, 1774–1851. "Grand Bacchanale." Orchestral interlude, for Antonio Salieri's opera *Les danaïdes.* First performed 22 Oct **1817,** Paris. [Grove 1980, 18:23 / Edler 1970, pp. 106f. (as 1822)]

Thomas Love Peacock, 1785–1866. (Bacchanalian revels in) *Rhododaphne.* Poem. London: **1818.** Modern edition, in *Works* (New York: AMS, 1967). [Bush 1937, p. 184 n. / Boswell 1982, p. 279]

Percy Bysshe Shelley, 1792–1822. (Maenads evoked in) "Ode to the West Wind" lines 15–23. Poem. Oct **1819.** In *Prometheus Unbound and Other Poems* (London: Ol-

lier, 1820). [Hutchinson 1932 / Curran 1975, p. 157 / Webb 1977, pp. 27, 213f.]

Andries Cornelis Lens, 1739–1822. "Offering to Bacchus." Painting. Musées Royaux des Beaux-Arts (Musée d'Art Ancien), Brussels, inv. 591. [Brussels 1984a, p. 174—ill.]

Pierre-Paul Prud'hon, 1758–1823. "Bacchante." Painting. Several versions of the subject known, unlocated. [Guiffrey 1924 nos. 216–17]

Daniel Gottlieb Steibelt, 1765–1823. Cycle of 36 "Bacchanals" for pianoforte and harp. [Grove 1980, 18:103 / Edler 1970, p. 199]

Robert Sievier, 1794–1865. "Sleeping Bacchante." Bronze (?) sculpture. **1824.** Formerly Grittleton House, England. [Read 1982, pl. 171]

Jacques-Louis David, 1748–1825. "Bacchante and Bacchic Spirits." Painting. Musée, Narbonne, in 1930. [Cantinelli 1930, no. 165]

Aleksandr Pushkin, 1799–1837. "Bakx'b" ["Bacchus" ("Bacchic Song")]. Poem. **1825.** [Arndt 1984 / EW 1983–85, 5:674]

Edward Calvert, 1799–1883. "The Bacchante." Woodcut. Before **1827.** [Lister 1962, pp. 57, 61–63—ill.]

Hector Berlioz, 1803–1869. ("Bacchanal" at close of) *La mort d'Orphée* [The Death of Orpheus]. Choral composition for tenor, soprano, and orchestra. Libretto, Berton. First written for Prix de Rome cantata competition, **1827.** Rescored for orchestra, for Paris Institute, 1828 (rejected as "unplayable"). Published Paris: 1930. [Grove 1980, 2:603 / Barzun 1950, 1:73ff., 103, 283 *n.*; 2:338 *n.*]

Jean-Antoine Houdon, 1741–1828. "A Sleeping Bacchante." Terra-cotta relief. Lost. [Réau 1964, no. 57]

William Wordsworth, 1770–1850. (Bacchic procession in) "On the Power of Sound" stanza 10. Poem. **1828.** In *Yarrow Revisited, and Other Poems* (London: Longman & Co., 1835). [De Selincourt 1940–66, vol. 2 / Bush 1937, p. 69]

Frédéric Chopin, 1809–1849. "Bacchanal." Lied, opus 74 no. 4. Text, Witwicki. **1830.** Published Berlin: 1857. [Grove 1980, 4:309]

Bertel Thorwaldsen, 1770–1844. "Bacchante and a Child Satyr." Marble relief. Modeled **1833.** Thorwaldsens Museum, Copenhagen, no. A354. [Thorwaldsen 1985, p. 48 / also Hartmann 1979, pl. 112.1] Original plaster. Thorwaldsens Museum, no. A355. [Thorwaldsen]

———. "Bacchante with a Bird." Relief. Plaster original, 1834. Thorwaldsens Museum, Copenhagen, no. A648. [Ibid., p. 69]

———. "Satyr Dancing with a Bacchante." 2 reliefs. Plaster originals, 1840–41. Thorwaldsens Museum, Copenhagen, nos. A357–58 (cf. A814). [Thorwaldsen, p. 48]

———. Drawing of a bacchic procession, study for an unexecuted frieze. 1841. Thorwaldsens Museum, Stampe coll. no. 8. [Hartmann, pp. 151f., pl. 100.3] 2 related drawings. Thorwaldsens Museum. [Ibid., pls. 100.1–2]

Joseph-Charles Marin, 1759–1834. "Bacchante." Terra-cotta bust. Brinsley Ford coll., London. [Royal Academy 1968, no. 810]

———. "A Bacchante Reclining." Terra-cotta sculpture. Kenneth Clark coll. [Ibid., no. 811—ill.]

James Pradier, 1792–1852. "Satyr and Bacchante." Marble

sculpture group. Exhibited Salon of **1834.** Louvre, Paris. [Montreal 1984, p. 117—ill. / Janson 1985, fig. 111]

Théodore Chassériau, 1819–1856. "Bacchante and Faun Holding Leashed Tigers," "Sleeping Bacchante with Two Putti." Paintings, for Church of St. Thomas du Louvre. **1833–35.** Private colls., Paris. [Sandoz 1974, no. 4—ill.]

———. "Bacchante with a Satyr." Painting, oil study. 1849. Musée, Orléans. [Ibid., no. 132—ill.]

Jean-Baptiste Mallet, 1759–1835. "Bacchante in a Landscape." Painting. Louvre, Paris, no. R.F. 3843. [Louvre 1979–86, 4:67—ill.]

Friedrich Rehberg, 1758–1835. "Bacchic Scene." Painting. Residenz Museum, Munich. [Bénézit 1976, 8:656]

Désiré Beaulieu, 1791–1863. "Fête bacchique." Musical scene. **1835.** [Grove 1980, 2:325]

Maurice de Guérin, 1810–1839. *La bacchante.* Prose poem. In *Journal, lettres et poèmes* (Paris: Didier, 1844, 1862; reprinted Paris: Haumont, 1944). [Oxford 1959, p. 324]

Ferdinando Paer, 1771–1839. *Sinfonia baccante.* Orchestral composition. [Grove 1980, 14:84 / Edler 1970, p. 195]

Marie-Louise Elizabeth Vigée-Lebrun, 1755–1842. "Lady Hamilton as a Bacchante." Painting. Lady Lever Art Gallery, Port Sunlight, Cheshire. [Wright 1976, p. 215]

Elizabeth Barrett Browning, 1806–1861. "Wine of Cyprus." Poem. In *Poems* (London: Moxon, **1844**). [Browning 1932]

Gustave Courbet, 1819–1877. "La bacchante." Painting. **1844.** Private coll. [Léger 1948, fig. 5—ill.]

———. "Sleeping Woman" ("The Bacchante"). Painting. *c.*1844–47. Lefevre Gallery, London. [Fernier 1977–78, no. 55—ill.]

Jules Perrot, 1810–1882, choreography. *La bacchante.* Divertissement. Music, Cesare Pugni. First performed 1 May **1845,** Her Majesty's Theatre, London. [Guest 1984, pp. 147f., 174, 354]

Eugène Delacroix, 1798–1863. "Sleeping Nymph" ("Sleeping Bacchante"). Painting. **1847?** Louvre, Paris, no. M.N.R. 953 (as questionably attributed). [Johnson 1981–86, no. 167—ill. / Robaut 1885, no. 789—ill. (copy drawing) / Louvre 1979–86, 3:208—ill.]

Theodor Kalide, 1801–1864. "Bacchante with a Panther." Marble sculpture. **1844–48.** Formerly Nationalgalerie, Berlin, destroyed. [Janson 1985, fig. 93]

Charles Gleyre, 1806–1874. "The Dance of the Bacchantes." Painting. **1846–48.** Musée Cantonal des Beaux-Arts, Lausanne, inv. 1326. [Winterthur 1974, no. 19]

———. "Bacchante with a Donkey." Painting. *c.*1860. Lausanne, inv. 01056. [Ibid., no. 68]

William Etty, 1787–1849. "Bacchante with Tambourine." Painting. Louvre, no. R.F. 1970–49. [Louvre 1979–86, 2:83—ill.]

Honoré Daumier, 1808–1879. "Two Nymphs Pursued by Satyrs" ("Bacchantes"). Painting. **1850.** Museum of Fine Arts, Montreal. [Maison 1968, no. I–32—ill.]

———. "The Procession of Silenus" ("Bacchanal: Bringing in the Grape-harvest"). Painting. Unlocated. [Ibid., no. II–2—ill.]

Horatio Greenough, 1805–1852. "Bacchante and Young Faun." Bas-relief. *c.*1850. Lost, presumed destroyed. [Wright 1963, p. 251—ill.]

Jean-Léon Gérôme, 1824–1904. "The Bacchante." Paint-

ing. **1853.** Musée des Beaux-Arts, Nantes. [Ackerman 1986, no. 53—ill.]

————. "A Bacchante" ("A Wood Nymph"). Painting. 1873. Unlocated. [Ibid., no. 231—ill.] Bronze variant. 1892. Cast in 3 (?) sizes. Swihart coll., Santa Monica, Calif.; others unlocated. [Ibid., no. S.26—ill.]

Valerio Villareale, 1773–**1854.** "Bacchante." Marble sculpture. Museu de Arte, Sao Paulo. [Clapp 1970, 1:892]

William Bouguereau, 1825–1905. "Head of a Bacchante." Painting. **1854.** Musée des Beaux-Arts, Moulins. [Montreal 1984, pp. 48, 61]

————. "Bacchante on a Panther." Painting. 1855. [Ibid., p. 62]

————. "Faun and Bacchante." Painting. 1860. Metropolitan Museum, New York. [Ibid., pp. 62, 117—ill.]

————. "Bacchante Teasing a Goat." Painting. 1862. [Ibid., p. 62]

Carlo Romani. *I baccanali di Roma.* Opera. First performed **1854,** Pergola, Florence. [Clément & Larousse 1969, 1:107]

Jean-Antoine Cubisole, 1811–1877. "Bacchante." Marble statue. Musées Nationaux, inv. MI 22, deposited in Musée, Le Puy, in **1855.** [Orsay 1986, p. 270]

Arnold Böcklin, 1827–1901. "Bacchanal." Painting. *c.*1856. Oskar Reinhart coll., Winterthur. [Andree 1977, no. 99—ill.]

————. "Bacchanal" (in ancient Rome). Painting. 1885. Küsnacht coll., Zurich. [Ibid., no. 390—ill.]

————. "Procession to the Temple of Bacchus." Painting. 1891. Briganti coll., Rome. [Ibid., no. 426—ill. / also Fiesole 1980, no. 24—ill.]

Eugène Gautier, 1822–1878. *La bacchante.* Opéra-comique. First performed **1858,** Théâtre-Lyrique, Paris. [Clément & Larousse 1969, 1:107]

Jean-Baptiste Camille Corot, 1796–1875. "Hide-and-seek" ("Idyll," "Antique Feast") (bacchantes and satyrs in a glade). Painting. **1859.** Musée des Beaux-Arts, Lille. [Orangerie 1975, no. 77—ill. / also Robaut 1905, no. 1110—ill. (copy drawing)]

————. "Bacchante with a Panther." Painting. 1855–60. Payne coll., Binghamton, N.Y. [Hours 1972, p. 126 / Robaut, no. 1276—ill.]

————. "Bacchante with Tambourine." Painting. 1860. Corcoran Gallery, Washington, D.C. [Chicago 1960, no. 89 / also Robaut, no. 1277—ill. (copy drawing)]

————. "(Reclining) Bacchante by the Sea." Painting. 1865. Metropolitan Museum, New York, no. 29.100.19. [Metropolitan 1980, p. 32—ill. / Chicago, no. 96 / also Robaut, no. 1376—ill. / Lyons 1936, no. 82—ill.]

————. "The Feast of Bacchus" ("Evening"). Painting. 1866. [Robaut 1905, no. 1637—ill. (copy drawing)]

————. "Bacchante in a Landscape." Painting. 1865–70. Metropolitan Museum, New York, no. 29.100.598. [Metropolitan, p. 32—ill. / also Robaut, no. 1377—ill.]

————. "Bacchanal at the Spring" ("Souvenir of Marly-le-Roy"). Painting. *c.*1872. Museum of Fine Arts, Boston, no. 17.3234. [Boston 1985, p. 59—ill. / also Robaut, no. 2201—ill. (copy drawing) / Chicago, no. 135—ill.]

————. Several further treatments of the subject, lost or unlocated in 1905. "Reclining Bacchante in the Countryside," 1865–70; "Bacchante Holding Cupid" ("Morn-

ing"), 1865; "A Bacchanal" ("Souvenir of Saint-Cucuphat"), 1872; "Little Bacchanal," 1874. [Robaut, nos. 1377, 1635, 2258, 2434—ill. (copy drawings)]

Richard Wagner, 1813–1883, music. "Bacchanal." Ballet, added to Act I in revised version of *Tannhäuser.* Opera. Libretto, Wagner and C. L. E. Nuitter. Choreography, Lucien Petipa. Revised version first performed 13 Mar **1861,** Opéra, Paris. [Grove 1980, 20:136 / Oxford 1982, pp. 28, 323]

Richard Dadd, 1817–1886. "Bacchanalian Scene." Painting. **1862.** Private coll. [Alldridge 1974, no. 184—ill.]

José-Maria de Heredia, 1842–1905. 4 "Bacchanal" sonnet fragments. **1859–63** (and later?). [Delaty 1984, 2:64ff.]

————. (Bacchanalia evoked in) "Le triomphe d'Iacchos" [The Triumph of Iacchus]. Sonnet. In *Revue française* 1 May 1863. [Ibid., vol. 2]

————. (Bacchantes depicted on ivory vase in) "Le vase." Sonnet. In *L'artiste* 1 Feb 1868; collected in *Les trophées* (Paris: Lemerre, 1893). [Ibid.]

————. "Bacchanale." Sonnet. In *Le Parnasse contemporain* 1876; collected in *Les trophées* (1893). [Ibid.]

Albert-Ernest Carrier-Belleuse, 1824–1887. "Bacchante with a Herm of Dionysus." Marble sculpture. Modeled 1860, completed **1863.** Originally in Jardins des Tuileries, Paris; now in Musée d'Orsay, Paris, inv. R.F. 143. [Orsay 1986, p. 91—ill. / Janson 1985, pp. 137f.—ill.] Bronze and terra-cotta reductions. [Orsay]

————. "Satyr and Bacchante." Terra-cotta sculpture group. Late 1870s. Hermitage, Leningrad, inv. 946. [Hermitage 1984, no. 408 / also Hermitage 1975, pls. 144–45]

————. "Satyr and Nymph" ("Bacchante"). Terra-cotta sculpture group. Musée d'Orsay, Paris, inv. R.F. 2335. [Orsay, p. 92—ill.] Marble replica, by Louis Carrier-Belleuse, in Petit Palais, Paris. [Ibid.]

————. "Bacchante." Marble bust. / Copy (French School, second half 19th century), in Museum of Fine Arts, Boston, no. 40.18. [Boston 1985, p. 106—ill.]

Hans Makart, 1840–1884. "Bacchanal." Painting. *c.*1863. Kunstmuseum, Dusseldorf, inv. 4561. [Frodl 1974, no. 30—ill.]

————. "Love-pair Surrounded by Bacchantes." Painting. *c.*1863–64. Residenzgalerie, Salzburg, inv. 396. [Ibid., no. 35—ill.]

————. "Bacchanal." Painting. *c.*1865. Historisches Museum der Stadt Wien, Vienna, inv. 100.993. [Ibid., no. 50—ill.]

————. "Family of Bacchantes" (satyr and nymph with children). Painting. 1880. Bayerische Staatsgemäldesammlungen, Munich, inv. 13292. [Ibid., no. 344—ill.]

————. "Bacchanal." Painting. Bizományi Aruház Vállalat, Budapest, in 1970. [Ibid., no. 616]

Aimé-Jules Dalou, 1838–1902. 2 stone figures of fauns and a marble "Young Woman with Grapes." Fireplace sculptures. **1864.** Hôtel Pavïa, Paris. [Hunisak 1977, pp. 42f., figs. 17, 18]

————. "Bacchanal." Painted plaster high-relief. 1879. Bethnal Green Museum (Victoria and Albert Museum), London. [Ibid., fig. 76 / also Caillaux 1935, p. 131, pl. 13] Replica. Jardin Fleuriste d'Auteuil, Paris. / Plaster models, reductions, and sketches for replica. Musée d'Orsay,

Paris, inv. R.F. 1692; elsewhere. [Caillaux, p. 140 / also Orsay 1986, p. 106—ill.]

————. "Laughing Bacchante." Terra-cotta mask, study for "The Triumph of Silenus" of 1884. Musée d'Orsay, Paris, inv. R.F. 3769. [Orsay 1986, p. 114—ill.] Patinated plaster version. Petit Palais, Paris. [Ibid.]

————. "Nymph and Faun" ("The Kiss"). Bronze statue. 1890–94. Unique cast. Unlocated. / Original plaster model. Petit Palais, Paris. [Caillaux, p. 141]

Matthew Arnold, 1822–1888. "Bacchanalia, or The New Age." Poem. **1860–67?** In *New Poems* (London: Macmillan, 1867). / Revised in 2d edition, 1868. [Allott & Super 1986 / Tinker & Lowry 1940, pp. 183f. / Bush 1971, p. 37]

Adamo Tadolini, 1788–**1868.** "Bacchante." Marble (?) sculpture. Galleria Borghese, Rome. [Bénézit 1976, 10:52]

Jean-Baptiste Carpeaux, 1827–1875. (Bacchantes, representing dance, poetry, music, and drama, in) "The Dance." High-relief stone sculpture, for façade of Opéra, Paris. **1865–69.** Original removed 1964, replaced by a copy, by Belmondo; original now in Musée d'Orsay, Paris, inv. R.F. 2884. [Orsay 1986, p. 84—ill. / Wagner 1986, pp. 209ff.—ill. / Beyer 1975, nos. 284–329—ill. / Kocks 1981, pp. 88ff., pl. 382] Plaster models. Musée d'Orsay, Musée de l'Opéra, Paris. [Wagner, fig. 249 / Janson 1985, fig 152] Terra-cotta version. Ny Carlsberg-Glypotek, Copenhagen. [Kocks, p. 441—ill.] Painting after. Private coll., Paris. [Beyer, no. 320—ill.]

————. "Bacchante with Laurels." Plaster bust, derived from a figure in "The Dance." Versions by Carpeaux in Musée d'Orsay, inv. R.F. 2922; Musée des Beaux-Arts, Valenciennes. [Orsay, p. 86 / Beyer, appendix] Terra-cotta edition by studio, 1873. [Orsay—ill.] Edition in marble by studio, 1873–75. Edition in biscuit, by Manufacture de Sèvres, before 1905 and after 1919. [Ibid.]

Henri Justament, fl. 1861–82, choreography. "Bacchanale." Ballet, added for performance of Gounod's *Faust,* 3 Mar **1869,** L'Opéra, Paris. [Oxford 1982, p. 28 / Grove 1980, 7:582; 587]

Marcello, 1836–1879. "Tired Bacchante." Marble bust. **1869.** Musée d'Art et d'Histoire, Fribourg. [Janson 1985, fig. 162]

William Blake Richmond, 1842–1921. "Procession in Honor of Bacchus." Painting. **1869.** [Kestner 1989, p. 173]

Auguste Rodin, 1840–1917. "Head of a Bacchante." Plaster sculpture. **1865–70.** Musée Rodin, Meudon. [Tancock 1976, pp. 576ff.] Terra-cotta version. Unlocated. [Ibid.—ill.]

————. "Entwined Bacchantes." Marble sculpture. Before 1910. Leona Cantor coll., Beverly Hills, Calif. [Ibid., p. 334—ill.] Bronze casts (3 sizes). Musée Rodin, Paris; National Museum of Western Art, Tokyo; Aage Fersing coll., Paris; Fitzwilliam Museum, Cambridge (as "La nature"); elsewhere? [Ibid. / Rodin 1944, no. 408—ill.] Plaster models. Fersing coll; elsewhere? [Tancock, p. 334]

————. "Bacchantes." Marble sculpture. Before 1910. Musée Rodin, Paris. [Rodin, no. 405—ill.]

————. "Bacchante" (Rose Beuret). Terra-cotta bust. Metropolitan Museum, New York. [Kocks 1981, p. 377—ill.]

————. Series of aquarelles illustrating Maurice de Guérin's *La bacchante.* Published with *Le centaure* (Lausanne: Mermod, 1947). [NUC]

Charles-Alphonse-Achille Guméry, 1827–1871. "The Dance." Marble sculpture group (commissioned to replace Carpeaux's, see above). **1870.** Musée des Beaux-Arts, Angers. [Wagner 1986, p. 246, fig. 242]

Lawrence Alma-Tadema, 1836–1912. "Bacchic Dance." Painting. **1871.** Unlocated. [Swanson 1977, p. 136]

————. "Autumn: A Vintage Festival" (bacchante with torch and leopard skin). Painting. 1873. Birmingham City Art Gallery, England. [Kestner 1989, p. 277, pl. 5.6]

————. "There He Is!" ("A Bacchante"). Painting. 1875. Sudley Art Gallery, Liverpool. [Kestner, p. 277, pl. 5.7 / Jacobs & Stirton 1984b, p. 206]

————. "Exhausted Maenades/After the Dance." Painting. 1875. Vosmaer coll. [Swanson, pp. 55f.—ill.]

————. "After the Dance" (sleeping bacchante). Painting. 1875. Private coll., Japan. [Ibid., pp. 50, 137—ill.]

————. "A Bacchante Dancing Before the Thymele." Watercolor. 1881. Unlocated. [Ibid., p. 138]

————. "The Women of Amphissa" (awakening after a night of revels). Painting. 1880s. Clark Institute, Williamstown, Mass. [Wood 1983, pp. 48, 119—ill. / Kestner, pl. 5.5 / also Swanson, p. 130—ill.]

————. "A Dedication (Consecration) [of a child] to (the Priestess of) Bacchus." Painting. 1889. 2 versions. Kunsthalle, Hamburg, inv. 1905; Richard Proby coll., Northamptonshire. [Swanson, pp. 53, 130, 140—ill. / Hamburg 1985, no. 207—ill. / Hamburg 1969, p. 9—ill. / also Jackson-Stops 1985, no. 555—ill. / Wood, pp. 119, 123—ill.]

————. "Bacchante." Painting. 1907. Private coll., England. [Swanson, pp. 131, 141—ill.]

————. Dionysian themes occur in other works by the artist, e.g. "The Torch Dance" (1881), "On the Way to the Temple" (1883). [Kestner, pp. 276ff.]

Briton Riviere, 1840–1920. "Bacchantes." Painting. **1871.** [Kestner 1989, p. 234]

Adolf Jensen, 1837–1879. "Dionysosfeier" [Feast of Dionysus], part of "Idyllen." Piano composition, opus 43. **1872.** Breslau: 1873. [Grove 1980, 9:601 / Edler 1970, p. 204]

Arthur Rimbaud, 1854–1891. (Bacchantes evoked in) "Villes I" [Cities I]. Prose poem, part of *Les illuminations.* **c.1874.** In *La vogue* 1886. Reprinted Paris: Vanier, 1895. [Adam 1972 / Fowlie 1966]

George Frederick Watts, 1817–1904. "A Bacchante." Painting. Completed *c.*1875. Watts Gallery, Compton. [Watts 1970, no. 42]

————. "A Bacchanal." Painting. Watts Gallery. [Ibid., no. 133]

Paul Cézanne, 1839–1906. "The Struggle of Love" ("Love Play"). 2 paintings. **1875–76.** Harriman coll., New York; private coll. [Orienti 1972, nos. 270, 271—ill.] Watercolor. 1875–76. Feichenfield coll., Zurich. [Rewald 1983, no. 60—ill. / also Dijkstra 1986, p. 277—ill.]

Gustave Crauk, 1827–1905. "Bacchante and Satyr." Marble sculpture group. Musées Nationaux, inv. R.F. 167, deposited in Château de Fontainebleau in **1876.** [Orsay 1986, p. 269]

George Cruikshank, 1782–1878. "The Worship of Bacchus." Watercolor. Victoria and Albert Museum, London, no. 71.1880. [Lambourne & Hamilton 1980, p. 95]

Tommaso Solari, 1820–**1878.** "A Bacchante." Marble statue. Galleria dell' 800 di Capodimonte, Naples, no. 360. [Capodimonte 1964, p. 63]

Anton Rubinstein, 1830–1894. "Bacchanal." Composition for bass and male chorus. First performed **1879,** St. Petersburg. [Grove 1980, 16:299]

Gabriele D'Annunzio, 1863–1938. "Bacchanalia." Idyl, part of "Idillii selvaggi." In *Primo vere,* 2d edition (Lanciano: Carabba, **1880**). [Palmieri 1953–59, vol. 1]

———. "Baccha" [Bacchante]. Sonnet, in "La corona di Glauco" [The Crown of Glaucus]. Sonnet sequence. 1903. In *Alcyone* (Milan: Treves, 1904). [Roncoroni 1982]

Joseph-Michel Caillé, 1836–**1881.** "Bacchant Playing with a Panther." Marble sculpture group. Musées Nationaux, inv. R.F. 1270, deposited in Musée, Amiens, in 1899. [Orsay 1986, p. 267]

Jean-Baptiste Clésinger, 1814–**1883.** "Bacchante." Plaster bust. 2 versions. Musées Nationaux, inv. R.F. 1918, 1919, deposited in Musée, Compiègne, in 1928. [Orsay 1986, p. 269]

Gustave Doré, 1832–**1883.** "Bacchante with a Group of Little Fauns." Plaster sculpture model. Sold 1885, untraced. [Leblanc 1931, p. 543]

Charles S. Calverly, 1831–**1884.** "The Bacchanals." Poem. In *Complete Works* (London: Bell, 1901). [Boswell 1982, p. 63]

Jean-Esprit Marcellin, 1821–**1884.** "Bacchante Making Sacrifice on Mount Citheron." Marble sculpture group. Musées Nationaux, deposited at Ministère de la Guerre, Paris. [Orsay 1986, p. 275]

Robert Bridges, 1844–1930. *The Feast of Bacchus.* Comedy, based in part on Terence. **1885.** Oxford: privately printed, 1889. [DLB 1983, 19:48]

Henrietta Rae, 1859–1928. "A Bacchante." Painting. **1885.** [Kestner 1989, p. 284f., pl. 5.11]

Solomon J. Solomon, 1860–1927. "Bacchante." Painting. **1885.** [Bénézit 1976, 9:692]

Paul Baudry, 1828–**1886.** "Bacchantes." Watercolor. [Bénézit 1976, 1:520]

Adolphe-Joseph Monticelli, 1824–**1886.** "Les bacchantes." Painting. Kasteel Het Nijenhuis, Heine. [Wright 1980, p. 286]

John Collier, 1850–1939. "Maenads." Painting. Exhibited **1886.** [Kestner 1989, p. 293, pl. 5.29]

———. "A Priestess of Bacchus." Painting. 1888. [Ibid.]

Eugène-Louis Lequesne, 1815–**1887.** "Priestess of Bacchus." Sculpture. Musée Municipal, Cambrai. [Bénézit 1976, 6:601]

Gustav Klimt, 1862–1918. "Altar of Dionysos." Painting (lunette). **1886–88.** Burgtheater, Vienna. [Novotny & Dobai 1968, no. 40—ill. / also Strobl 1980, 1:55–57—ill.] Oil study. 1886. Private coll., Vienna. [Novotny & Dobai, no. 35—ill.]

Friedrich Nietzsche, 1844–1900. *Dionysus-Dithyramben.* Poetry. **1888.** Leipzig: Naumann, 1891. [Wilpert 1963, p. 436].

Louis Auvray, 1810–**1891.** "Bacchante." Marble bust. By 1892. Musées Nationaux, deposited in Musée, Valenciennes, in 1892. [Orsay 1986, p. 265]

Hervé, 1825–1892. *Bacchanale.* Musical work for the stage. Libretto, H. Raymond and P. Burani. First performed 22 Oct **1892,** Menus-Plaisirs, Paris. [Grove 1980, 8:526]

Frederic, Lord Leighton, 1830–1896. "Bacchante." Paint-

ing. *c.*1892. Forbes Magazine coll., U.S.A. [Ormond 1975, no. 366 / Minneapolis 1978, no. 60—ill.]

———. "A Bacchante." Painting. *c.*1895–96, unfinished. George Christie coll. [Ormond, no. 402]

Augustin-Jean Moreau-Vauthier, 1831–1893. "Sleeping Bacchante." Marble statue. **1892.** Musée d'Orsay, Paris, inv. R.F. 2225. [Orsay 1986, p. 201—ill.]

Frederick William MacMonnies, 1863–1937. "Bacchante and Infant Faun." Bronze statue. **1893.** Metropolitan Museum, New York, no. 97.19; Whitney Museum, New York (reduction); Musée du Luxembourg, Paris; Museum of Fine Arts, Boston; Cleveland Museum of Art, Ohio. [Metropolitan 1965, p. 83—ill. Metropolitan 1983, p. 33—ill. / Janson 1985, fig. 313]

Pierre Louÿs, 1870–1925. "Les ménades." Poem. In *Chansons de Bilitis* (Paris: Crès, **1894;** 1913). [Ipso]

Lovis Corinth, 1858–1925. "Procession of Bacchantes." Color lithograph. **1895.** [Schwarz 1922, no. L14]

———. "Procession of Bacchantes." Painting. 1896. Unlocated. [Berend-Corinth 1958, no. 130—ill.]

———. "Bacchanal." Painting. 1896. Städtliche Kunstsammlung, Gelsenkirchen. [Berend-Corinth, no. 131—ill. / also Dijkstra 1986, pp. 278f.—ill]

———. "Homecoming Bacchantes." Painting. 1898. Städtliche Museum, Wuppertal. [Berend-Corinth, no. 154—ill.] Etching. 1920–21. [Müller 1960, no. 555—ill.]

———. "Self-portrait as Bawling Bacchant." Painting. 1905. Private coll. [Berend-Corinth, no. 304—ill.]

———. "Bacchante." Painting. 1913. Private coll. [Berend-Corinth, no. 567—ill.] Lithograph and etching. [Schwarz, nos. L120, 121—ill.]

———. "Bacchant" (with panther). Painting. 1913. Private coll. [Berend-Corinth, no. 568—ill.]

———. "Bacchantin." Lithograph. 1913. [Schwarz, no. L120]

———. "Bacchanal." Etching. 1914. [Ibid., no. 150]

———. "Bacchant." Etching. 1916. [Ibid., no. 225]

———. "Bacchantes" (drunken Silenus with Bacchantes). Lithograph, letter "B" from "ABC" series. 1917. [Schwarz, no. L315]

———. "Bacchanal." Painting. 1921. Kulturkreis im Bundesverband der dt. Industrie, Cologne. [Berend-Corinth, no. 814—ill.]

Alexander Sergeyevich Famintsïn, 1841–**1896.** *Shestviye Dionisa* [The Train of Dionysus]. "Symphonic picture." [Grove 1980, 6:378]

Arthur B. Davies, 1862–1928. "Bacchanals." Painting. **1896.** Maxwell coll., Rockville, Conn. [Cortissoz 1931, p. 21]

———. "A Mighty Forest, Maenads." Painting. 1905. Dickey coll., Pasadena, Calif. [Ibid., p. 29]

———. "Maenads." Aquatint. 4 states. 1921. [Price 1929, no. 31—ill.]

———. "Maenad." Bronze relief sculpture. Early 1920s. Hirshhorn Museum and Sculpture Garden, Washington, D.C. [Hirshhorn 1974, p. 679, pl. 284]

———. "Bacchantes." Lithograph and lithotint. 1922. [Price, no. 66—ill.]

———. "Bacchante Spring." Painting. Warner coll., Cleveland. [Cortissoz, p. 21 / also Metropolitan 1930, no. 24]

———. "Dionysians." Painting. Artist's estate in 1931. [Cortissoz, p. 23]

———. "Bacchanal." Tapestry. Artist's estate in 1930. [Metropolitan 1930, no. 177]

Franz von Stuck, 1863–1928. "Procession of Bacchantes." Painting. **1897.** Schäfer coll., Schweinfurt. [Voss 1973, no. 159—ill.]

———. "Bacchanal." Painting. 1905. Private coll. [Ibid., no. 278—ill.] Study. Unlocated. [Ibid., no. 277—ill.]

———. "Feast of Dionysus." Painting. c.1920. Unlocated. [Ibid., no. 512—ill.]

Siegmund von Hausegger, 1872–1948. *Dionysische Phantasie.* Orchestral work. **1896–99.** [Baker 1984, p. 969 / Edler 1970, p. 208]

Alexander Glazunov, 1865–1936, music. "Bacchanale," section of "L'automne," in *Les saisons.* Ballet, opus 67. Choreographer unknown. First performed **1899,** St. Petersburg. [Edler 1970, pp. 207f.]

Alexandre Falguière, 1831–**1900.** "Bacchantes" ("Huntresses"). Painting. Musée d'Orsay, Paris, no. R.F. 1341. [Louvre 1979–86, 3:245—ill.]

T. Sturge Moore, 1870–1944. "Lines on Titian's *Bacchanal* in the Prado at Madrid." Poem, after Titian (c.1523–25). **1900.** In *The Gazelles and Other Poems* (London: Duckworth, 1904). [Gwynn 1951, pp. 44, 124 / DLB 1983, 19:334, 347]

Albert Samain, 1858–**1900.** "Bacchante." Poem. In *Symphonie héroïque, évocations,* bound with *Le chariot d'or* (Paris: Société du Mercure de France, 1901). [Ipso]

Evelyn Beatrice Longman, 1874–1954. "Bacchante Head" ("Peggy"). Bronze bust. c.1901. National Museum of Women in the Arts, Washington, D.C. [Washington 1987, p. 59—ill.]

Gustave Vanaise, 1854–**1902.** "The Bacchante." Painting. Musées Royaux des Beaux-Arts (Musée d'Art Moderne), Brussels, inv. 3697. [Brussels 1984b, p. 624—ill.]

Émile-Antoine Bourdelle, 1861–1929. "Old Bacchante." Bronze sculpture. **1903.** 5 casts. [Jianou & Dufet 1975, no. 290 / Cannon-Brookes 1983, fig. 52]

———. "Bacchante with Crossed Legs." Bronze sculpture. 1906. 10 casts. [Jianou & Dufet, no. 340] Terra-cotta and bronze replicas/studies. [Ibid.]

———. "Bacchante," "Bacchante," "Young Bacchante." Bronze sculptures. 1907. Numerous casts of each. [Jianou & Dufet, nos. 358–60] Plaster casts of no. 358. Musée Bourdelle, Paris; elsewhere. [Ibid.] Plaster, terra-cotta, and bronze replicas, studies, variants. [Ibid., nos. 358–62, 729–30]

———. "Bacchante Carrying Eros." Bronze sculpture. 1923. 3 versions. Fujikawa Galleries, Osaka; elsewhere. [Jianou & Dufet, no. 651]

Constantine Cavafy, 1868–1933. "He synodeia tos Dionysos" [The Retinue of Dionysus]. Poem. **1903.** Published 15 Apr 1907. Collected in *Poiemata* (Athens: Ikaros, 1963). / Translated by Edmund Keeley and Philip Sherrard in *Collected Poems,* bilingual edition (Princeton: Princeton University Press, 1975). [Ipso / Keeley 1976, p. 34]

Henri Fantin-Latour, 1836–1904. Lithograph depicting dancing maenads, illustration to Chénier's "Bacchus" (c.1778–87). **1903.** [Hédiard 1906, no. 166—ill. / Fantin-Latour 1911, no. 2019]

———. "Bacchanal." Painting. 1904. Sabourdin coll. in 1911. [Fantin-Latour, no. 2035]. Drawing. Musée du Luxembourg, Paris. [Fantin-Latour, no. 2062]

———. "Bacchus and Bacchante." Painting. Haviland coll. in 1911. [Fantin-Latour, no. 2263]

Jean-Antoine Injalbert, 1845–1933. "Bacchante with Bagpipe." Marble statue. By **1903.** Musée d'Orsay, Paris, inv. RF 1360. [Orsay 1986, p. 178—ill.] Sketches in Musée des Beaux-Arts, Béziers. [Ibid.]

Isadora Duncan, 1877–1927, choreography. "Bacchanal." Ballet, for Bayreuth production of Wagner's *Tannhäuser,* **1904.** [Oxford 1982, p. 28 / also McDonagh 1976, p. 18]

André Derain, 1880–1954. "Bacchic Dance." Watercolor. **1906.** Museum of Modern Art, New York, no. 61.35. [Barr 1977, p. 536]

———. "Bacchantes." Painting. c.1945. Pierre Lévy coll., Troyes. [Sutton 1958, p. 157—ill.]

Jef Lambeaux, 1852–1908. "The Bitten Faun" (with bacchante). Marble sculpture group. c.1906. [Dijkstra 1986, pp. 278f.—ill.]

Michel Fokine, 1880–1942, choreography. "Bacchanale," movement from *Le pavillon d'Armide.* Ballet. Music, Victor Alphonse Duvernoy, ballet suite, opus 29. First performed 25 Nov **1907,** St. Petersburg. [Baker 1984, p. 2287]

———, choreography. "Bacchanale." Ballet, in *Aphrodite.* Musical, based on Pierre Louÿs's *Aphrodite: Moeurs antiques* (1895). First performed **1919,** New York. [Fokine 1961, p. 243]

Hans Lerche, 1867–1920. "Bacchanal Vase." Bronze sculpture. Exhibited Venice Biennale, 1907. [Clapp 1970, 1:546]

Vincenzo Davico, 1889–1969. "Baccanale," part of *Impressioni liriche.* Orchestral composition. Published **1908.** [Grove 1980, 5:261]

Arthur Wardle, 1864–1949. "A Bacchante." Painting. c.**1907–09.** [Kestner 1989, p. 335, pl. C.8 / cf. Dijkstra 1986, p. 293—ill. / Wood 1983, p. 218—ill.]

Loie Fuller, 1862–1928, choreography. *Bacchanal.* Modern dance. First performed **1909.** [McDonaugh 1976, p. 24]

Theodore Kosloff, c.1881–1956, choreography. *L'automne bacchanale* [Autumn Bacchanale]. Ballet. First performed **1910,** Paris. [Cohen-Stratyner 1982, p. 504]

Ker-Xavier Roussel, 1867–1944. Series of prints illustrating Maurice de Guérin's *La bacchante.* c.**1910.** [Alain 1968, nos. 32n, 51–56—ill.]

———. Bacchic scene, design for curtain of Théatre des Champs Elysées. Painting. 1913. / 3 oil studies. Private colls., Paris and Washington, D.C. [Georgel 1968, no. 253—ill.]

———. "Bacchanal." Painting, part of "The Four Seasons" series, for residence of Lucien Rosengard, Paris. c.1925–26. Private coll., Paris? / Oil study. Private coll., Paris. [Georgel, pp. 308, 365—ill.]

———. "Bacchante" ("Variations"). Print. Before 1934. [Alain, no. 57—ill.]

———. "Pan and Bacchante." Print. [Ibid., no. 58—ill.]

———. "Pan [or a Faun] Carrying a Bacchante on His Back." Print. [Georgel 1968, p. 380, no. 296—ill. / Alain, no. 88—ill.]

Léon Bakst, 1866–1924. "Bacchantes." Costume designs for Michel Fokine's *Narcisse,* first performed Monte Carlo, **1911.** Private coll(s). [Spencer 1973, p. 229, pls. XIV–XV]

———. "Bacchante." Costume design for ballet *La légende*

de Joseph (*Joseph and Potiphar*) (libretto, Kessler and Hoffmannsthal; music, R. Strauss; choreography, Fokine; Paris, 1914). Private coll. [Spencer, p. 232—ill.]

Marie Laurencin, 1885–1956. "Bacchante." Painting. **1911.** Hermitage, Leningrad, inv. 9069. [Hermitage 1987a, pls. 265–66—ill.]

Tamara De Swirska, b. *c.*1890, choreography. "Bacchanal," in *Tanagra Suite*. Ballet. First performed **1911,** London. [Cohen-Stratyner 1982, p. 254]

John Gould Fletcher, 1886–1950. "The Bacchanal." Poem. **1910–12.** In *The Book of Nature* (London: Constable, 1913). [Boswell 1982, p. 106]

Raoul Dufy, 1877–1953. "The Feast of Bacchus." Watercolor. **1912.** Paul Poiret coll. [Guillon-Laffaille 1981, no. 70—ill.]

Malvina Hoffman, 1887–1966. "Bacchanal Russe." Bronze statuette, based on Pavlova and Mordkin in Kosloff's *L'automne bacchanale* (1910). **1912.** Metropolitan Museum, New York, no. 50.145.40. [Metropolitan 1965, pp. 160f.—ill.] Several further versions known (3 lifesize, 6 statuettes), unlocated; 1 colossal version, formerly Luxembourg Gardens, destroyed 1941. [Ibid.]

Ivan Khlustin, 1862–1941, choreography. *Les bacchantes.* Ballet. Music, Alfred Bruneau. First performed **1912,** L'Opéra, Paris. Opéra Ballet Company. [Guest 1976, p. 312]

Paul Manship, 1885–1966. Low relief depicting satyrs and maenads, on pedestal of "Centaur and Dryad." Bronze statuette. **1913.** 5 casts. Fogg Art Museum, Harvard University, Cambridge; Detroit Institute of Arts; Metropolitan Museum, New York; Smith College Museum of Art, Northampton, Mass.; City Art Museum, St. Louis. [Murtha 1957, no. 28—ill. / also Minnesota 1985, no. 42—ill. / Metropolitan 1965, pp. 150f.—ill. / Rand 1989, pp. 29ff.—ill.]

———. "Maenad" (with 4 dolphins). Bronze fountain figure. 1953. [Murtha, no. 548—ill.]

Max Reger, 1873–1916. "Bacchanal," in finale of *Vier tondichtungen nach Böcklin* [Four Tone Poems after Böcklin]. Cycle of tone poems, opus 128. First performed 12 Oct **1913.** [Baker 1984, p. 1869 / Edler 1970, p. 210]

Alfred Drury, 1859–1944. "Young Bacchante." Bronze statuette. Before **1914.** Ashmolean Museum, Oxford. [London 1968, no. 31]

Carl Milles, 1875–1955. "Dancing Maenad." Stone sculpture study. **1914.** Millesgården, Lidingö, Sweden. [Rogers 1940, p. 64]

Jeanne Itasse-Broquet, 1867–**after 1914.** "Bacchante." Marble statue. Musées Nationaux, inv. RF 1276, deposited in Musée, Dol-de-Bretagne, in 1924. [Orsay 1986, p. 274]

Heinrich Schulz-Beuthen, 1838–**1915.** *Bacchantenzug des Dionysos* [The Bacchante-procession of Dionysus]. Symphonic poem. [Edler 1970, p. 208]

Heinrich Kröller, 1880–1930, choreography. *Bacchusfest* [Festival of Bacchus]. Ballet. First performed **1915,** Frankfort. [Beaumont 1938, p. 615]

Arthur Schnitzler, 1862–1931. *Das Bacchusfest.* Drama. First performed 12 Oct **1915,** Burgtheater, Vienna. In *Komödie der Worte; drei Einakter* (Berlin: Fischer, 1915). [McGraw-Hill 1984, 4:346 / Ungar 1973, pp. 238f.]

Gottfried Benn, 1886–1956. "Kretische Vase" [Cretan Vase] (depicting a bacchanal). Poem. **1916.** In *Die Aktion* VI.31/32 (5 Aug 1916). [Wellershof 1960 / Wodtke 1963, p. 159]

Leo Friedlander, b. 1890. "A Bacchante." Bronze statuette. **1916.** Metropolitan Museum, New York, no. 24.50. [Metropolitan 1965, p. 164—ill.]

Andreas Pavley, 1892–1931, choreography (with Serge Oukrainsky? 1886–1972). *Bacchanal.* Ballet. First performed **1917,** Chicago? [Cohen-Stratyner 1982, p. 698]

Lidia Testore. *Baccante.* Operetta. Libretto, Zimar Baldo. First performed **1917,** Milan. [Cohen 1987, 2:693]

Wilfrid Gibson, 1878–1962. "Bacchanal." Poem. **1918.** In *Collected Poems: 1905–1925* (London: Macmillan, 1929). [Boswell, 1982, p. 114]

D. H. Lawrence, 1885–1930. (Nighttime shadows seen as bacchantes in) "Late at Night." Poem. In *New Poems* (London: Martin Secker, **1918**). [Pinto & Roberts 1964, vol. 1]

Wyndham Lewis, 1884–1957. "Bacchic Festival." Drawing. **1918** (or earlier?). Formerly Sacheverell Sitwell coll., lost. [Michel 1971, no. 261]

Babette Deutsch, 1895–1982. "Bacchanal," "The New Dionysiac." Poems. In *Banners* (New York: Doran, **1919**). [Ipso]

Charles T. Griffes, 1884–1920. *Bacchanal.* Orchestral composition. First performed 19 Dec **1919,** Philadelphia. [Grove 1980, 7:729]

Tamara Nikolayevna Vakhvakhishvili, b. 1893, music. *The Festival of Bacchus.* Ballet. **1919.** [Cohen 1987, 2:713]

Margaret Severn, 1901–, choreography. *Bacchanal.* Ballet. First performed **1920,** Greenwich Village Follies, New York. [Cohen-Stratyner 1982, p. 807]

Ted Shawn, 1891–1972, choreography. *Les mystères dionysiaques* [Dionysiac Mysteries]. Modern dance. First performed **1920,** New York. [McDonagh 1976, p. 40]

Auguste Léveque, 1864–**1921.** "Bacchanal." Painting. Koninklijk Museum voor schone Kunsten, Antwerp. [Bénézit 1976, 6:628]

William Blake Richmond, 1842–**1921.** "Dionysus and the Maenads." Painting. [Kestner 1989, p. 173]

Jaroslaw Iwaszkiewicz, 1894–1980. *Dionizje* [Dionysiacs]. Collection of poems. Warsaw: Ignis, **1922.** [Mihailovich et al. 1972–76, 2:314]

Margaret Petit, *c.*1904–before 1982, choreography. *The Masked Bacchantes.* Ballet. First performed **1922,** New York. [Cohen-Stratyner 1982, p. 711]

Osbert Sitwell, 1892–1969. "Bacchanalia." Poem. In *Out of the Flame* (London: Richards, **1923**). [Boswell 1982, p. 293]

Rudolf Borchardt, 1877–1945. *Bacchische epiphanie* [Bacchic Epiphanies]. Collection of poems. [Berlin: Rowohlt], **1924.** [Kunisch 1965, p. 117]

Theodor Däubler, 1876–1934. (Bacchanal in) *Päan und Dithyrambos: Eine Phantasmagorie* [Paean and Dithyramb: A Phantasmagoria] part 1. Poem. Leipzig: Insel, **1924.** [Ipso / DULC 1959–63, 1:964]

Francis Derwent Wood, 1871–1926. "Bacchante." Sculpture. Before **1925.** City Art Gallery, Leeds, in 1925. [Read 1982, p. 341]

Joseph Bernard, 1866–1931. "Bacchante." Bronze sculpture. Exhibited Venice Biennale, **1926.** [Clapp 1970, 1:81]

————. "Boy Bacchant." Bronze sculpture. Exhibited Venice Biennale, 1932. [Ibid.]

Karl Hofer, 1878–1955. "Drunken Bacchante." Painting. *c.***1926.** [Rigby 1976, pp. 150, 289]

Aristide Maillol, 1861–1944. "Bacchante." Etching. **1926.** [Guérin 1965, no. 325—ill.]

————. 6 etchings, illustrating Ronsard's "Dithyrambes" (*c.*1553), for edition of *Livret de folastries,* 1940. [Ibid., nos. 361–66—ill.]

Ebbe Hamerik, 1898–1951, music. *Dionysia.* Ballet. First performed **1927,** Antwerp. [Grove 1980, 8:71]

Pablo Gargallo, 1881–1934. "Bacchante." Copper sculpture. By **1928.** [Clapp 1970, 1:367]

Francisco Broch y Llop. "Bacchante." Bronze sculpture. Exhibited Venice Biennale, **1928.** [Clapp 1970, 1:115]

Émile Aubry, 1880–1964. "Bacchanal" ("The Education of Bacchus"). Painting. Before **1929.** Musée d'Orsay, Paris, no. RF 1978–41. [Louvre 1979–86, 3:38—ill.]

Doris Humphrey, 1895–1958, choreography. "Bacchanal." Dance, in a production of Aristophanes' *Lysistrata.* Music, Leo Ornstein. First performed 28 Apr **1930,** Walnut Street Theatre, Philadelphia. [Cohen 1972, pp. 93, 287]

————, choreography. *Dionysiaques.* Modern dance. Scenario, after Nietzsche (1888). Music, Florent Schmitt. First performed 13 Mar **1932,** Guild Theatre, New York; costumes, Pauline Lawrence. [Siegel 1987, pp. 132, 134f., 161 / Cohen 1972, pp. 106, 114, 132, 279, 287]

Rudolf von Laban, 1879–1958, and **Kurt Jooss,** 1901–1979, choreography. "Bacchanal." Ballet, in Bayreuth production of Wagner's *Tannhäuser,* 1930. [Oxford 1982, p. 28]

Alice Pike Barney, 1857–**1931.** "Bacchante," "Bacchante Triste." Pastels. Barney coll. nos. 12, 254, National Collection of Fine Arts, Washington, D.C. [Barney 1965, p. 117]

Charles Ricketts, 1866–**1931.** "Centaurs and the Bacchante." Bronze statuette group. Private coll. [London 1968, no. 131]

Martha Graham, 1894–1991, choreography. *Bacchanal.* Modern dance. Music, Wallingford Riegger. First performed 2 Feb **1931,** Craig Theatre, New York; costumes and lighting, Martha Graham. [Stodelle 1984, pp. 161, 305]

————. *Dithyrambic.* Solo dance. Music, Aaron Copland. First performed 6 Dec 1931, Martin Beck Theatre, New York; costumes & lighting, Martha Graham. [Ibid., pp. 161, 306]

————. *Bacchanal, no. 2.* Modern dance. First performed 2 June 1932. Lydia Mendelssohn Theater, Ann Arbor, Mich. [McDonagh 1973, p. 313]

Gertrud Bodenwieser, 1886–1959, choreography. *Bacchanal.* Ballet. First performed *c.*1933, Vienna. [Cohen-Stratyner 1982, p. 106]

Giorgio Federico Ghedini, 1892–1965. *Marinaresca e baccanale* [Sailors' Dance and Bacchanale]. Orchestral composition. **1933.** [Grove 1980, 7:334]

André Masson, 1896–1987. "Bacchanal." Painting. **1933.** [Clébert 1971, pl. 76—ill.]

————. "Bacchantes." Bronze sculpture. 1964. [Benincasa 1981, p. 139—ill.]

————. "Classical Bacchanal." Abstract painting. 1965. [Clébert, pl. 225]

Pablo Picasso, 1881–1973. "The Sculptor at Rest before a Bacchanal with a Bull." Etching. **1933.** [Bloch 1971–79, no. 165—ill; cf. nos. 166–74, 190–92]

————. "Bacchanal, after Poussin." Painting, after Poussin's "Bacchanal: The Triumph of Pan" (1630s, London). 1944. Artist's coll. in 1973. [Penrose & Golding 1973, fig. 331 / Zervos 1932–78, 14: pl. 35] Watercolor. [Zervos, 14: pl. 34]

————. "La joie de vivre" (naked bacchante dancing with centaurs and fauns). Painting. 1946. Musée Grimaldi, Antibes. [Penrose & Golding, fig. 332 / Zervos, 14: pl. 289 (as "Pastorale")]

————. "Bacchanal: Seated Silenus and Standing Drinker." Ceramic tile. 1956. Musée Picasso, Paris, no. 3726. [Picasso 1986, no. 495—ill.]

————. "Bacchanal: Musician, Dancer, and Drinker." Ceramic floor tile. 1957. Musée Picasso, no. 3734. [Picasso, no. 501—ill.] Variant ("Dancer and Musician"). Musée Picasso, no. 3735. [Ibid., no. 502—ill.]

————. "Bacchante." Gold sculpture. 1960–67. Artist's coll. in 1971. [Spies 1971, no. 562]

————. Bacchanalian scenes occur frequently in Picasso's work. See Bloch 416f., 831, 901f., 927, 930–36, 938f., 1006, 1020—ill. / Zervos 3: pls. 221–26; 16: pls. 427–29, 157, 460–71; 17: pls. 92, 96, 154–56, 309; 18: pls. 369; 19: pls. 82, 103, 105, 114f; 24: pls. 18–21; 31: pls. 69, 230—ill. / Penrose & Golding, figs. 334, 353. *See also* SATYRS AND FAUNS; CENTAURS.

Harilaos Perpessas, 1907– . *Dionysos Dithyramben.* Composition for pianoforte and orchestra. Before **1934.** Destroyed? [Grove 1980, 14:543]

Ossip Zadkine, 1890–1967. "The Maenads." Bronze sculpture. **1935.** 6 casts and 1 artist's proof. Musée National d'Art Moderne, Paris; Gemeentemuseum, The Hague; private colls. [Jianou 1979, no. 225—ill.]

————. "The Maenads." Bronze bas-relief. 1936. Private colls. [Jianou, no. 239]

Mikhail Mordkin, 1880–1944, choreography. "Bacchanal II," in *The Goldfish.* Ballet. Music, Tchérepnin. First performed **1936;** costumes, S. Soudeikine. [EDS 1954–66, 7:826]

Georges Rouault, 1871–1958. "Bacchanal." Painting. **1937.** Formerly Ambrose Vollard coll. [Courthion 1962, p. 465, no. 320—ill.]

John Cage, 1912–1992. "Bacchanal." Composition for prepared piano, written for Syvilla Fort. **1938.** Danced by Syvilla Fort, 1940, Seattle. [Grove 1980, 3:598, 601 / Grove 1986, 1:335]

Gerhard Marcks, 1889–1981. "Maenad." Bronze sculpture. **1939.** At least 2 casts. Private colls., Bruchsal and Plön. [Busch & Rudloff 1977, no. 366—ill.]

Léonide Massine, 1895–1979, choreography. *Bacchanal.* Surrealist ballet. Music, Wagner, "Venusberg" episode from *Tannhäuser.* Scenario, Salvador Dalí. First performed 9 Nov **1939,** Ballet Russe de Monte Carlo, Metropolitan Opera House, New York; scenery and costumes, Dalí. [Terry 1976, p. 44 / Soby 1968, p. 96—ill. / Beaumont 1944, pp. 57–60 / Oxford 1982, pp. 28, 112, 276]

Giorgio de Chirico, 1888–1978. "Bacchante." Painting. *c.***1943.** Private coll., Rome. [de Chirico 1971–83, 7.2: no. 636—ill.]

———. "Bacchante." Painting. 1952. Artist's coll., Rome, in 1975. [Ibid., 5.3: no. 654—ill.]

———. "Bacchante." Painting. 1954. Ceci coll., San Severino Marche. [Ibid., 2.3: no. 171—ill.]

Charles Despiau, 1874–1946. "Bacchante." Bronze sculpture. Musée d'Art Moderne de la Ville de Paris. [Agard 1951, p. 167]

Hans Hofmann, 1880–1966. "Bacchanal." Abstract painting. 1946. Artist's estate. [Bannard 1976, no. 12—ill. / also Hofmann 1963, no. 15—ill.]

Alois Stettner. "Maenads." Print. 1950. [Hannover 1950, no. 132]

Henri Laurens, 1885–1954. "Woman with Grapes" ("Bacchante"). Bronze sculpture. 1952. Sprengel coll., Hannover. [Clapp 1970, 1:534]

Mary Wigman, 1886–1973, choreography. *Maenad's Rhythm.* Dance. First performed 1953, West Berlin? [Cohen-Stratyner 1982, p. 944]

Irving Layton, 1912–. "Bacchanal." Poem. In *Cold Green Element* (Toronto: Contact, 1955). [CLC 1980, 15:319]

Marion Scott, 1922–, choreography. *Bacchanal.* Modern dance. First performed 1955, New York. [Cohen-Stratyner 1982, pp. 801f.]

Jacques Ibert, 1890–1962. *Bacchanal.* Orchestral composition. 1956. [Grove 1980, 9:2]

Max Ernst, 1891–1976. "Three Young Dionysaphrodites." Abstract painting. 1957. Anne Doll coll., Paris. [Quinn 1977, fig. 367—ill.]

Maxwell Anderson, 1888–1959. "Bacchanal." Poem. Unpublished, MS in University of Texas, Austin. [Shivers 1985, item 143]

Denis Devlin, 1908–1959. "Bacchanal." Poem. In *Collected Poems* (Dublin: Dolmen, 1964). [Boswell 1982, p. 252]

Boris Pasternak, 1890–1960. "Bakhanaliya." Poem. In *Kogda razguliaetsia* (Paris: 1959). / Translated by Michael Harari in *When Skies Clear,* bilingual edition (London: Collins & Harvill, 1960). [Ipso]

Paul Swan, 1883–1972, choreography. *Bacchanal in the Desert.* Ballet. First performed 1959, New York. [Cohen-Stratyner 1982, p. 853]

Maurice Béjart, 1924/27–, choreography. "Bacchanal." Dance, for a performance of Wagner's *Tannhäuser,* 1961, Bayreuth. [Oxford 1982, p. 28]

Henry Barraud, 1900–1980. *Rapsodie Dionysienne.* Orchestral composition. 1962. [Grove 1980, 2:180]

Jens Bjerre, 1903–. "Dionysisk Suite." Composition for oboe. 1962. [Grove 1980, 2:764]

Sylvia Plath, 1932–1963. "Maenad." Poem. In *Crossing the Water* (New York: Harper & Row; London: Faber & Faber, 1971). [CLC 1979, 11:448]

James Waring, 1922–1975, choreography. *Bacchanal.* Dance. Music, Richard Maxfield. First performed 1963, Hunter College, New York. [Cohen-Stratyner 1982, p. 926]

Nicos Mamangakis, 1929–, music. *The Bacchantes.* Ballet. 1969. [Grove 1980, 11:592]

Robert Barnett, 1925–, choreography. *Bacchic.* Ballet. First performed 1970, Atlanta. [Cohen-Stratyner 1982, p. 62]

Ethel Glen Hier, 1889–1971. "Bacchanal." Song. [Cohen 1987, 1:319]

Pina Bausch, 1940–, choreography. "Tannhäuser-Bacchanal." Ballet. First performed 1972, Essen? [Oxford 1982, p. 48]

Jules Olitski, 1922–. "Maenads." Abstract steel sculpture. 1973. Artist's coll. [Moffett 1981, pl. 170]

Olga Broumas, 1949–, poem, and **Sandra McKee**, painting. "Maenad." Part of 2–media piece "Twelve Aspects of God." Exhibited Sep 1975, Maude Kerns Gallery, Eugene, Ore. Broumas's poem in *Beginning with O* (New Haven: Yale University Press, 1977). [Ipso]

Claudio Bravo, 1936–. "Bacchanal." Painting, reinterpretation of Titian's "The Andrians" (*c.*1523–25, Madrid). 1981. Marlborough Gallery, New York. [Personal communication from Prof. Mark Thistlethwaite, Texas Christian University, 1984]

Siegrid Ernst, 1929–. *Bacchanal und Huldigung* [Bacchanal and Homage]. Orchestral composition. 1981. [Cohen 1987, 1:222]

Sandra Gilbert, 1936–. "Bas Relief: Bacchante." Poem. In *Emily's Bread* (New York: Norton, 1984). [Ostriker 1986, pp. 216, 286]

BACCHUS. Another name for the god Dionysus, used in both Greek and Roman mythology. *See* DIONYSUS.

BANQUET OF THE GODS. *See* GODS AND GODDESSES.

BATTUS. *See* HERMES, Infancy.

BAUCIS AND PHILEMON. According to a Greek story adopted by Ovid, when Zeus (Jupiter) and his son Hermes (Mercury) came to earth in disguise, Baucis and Philemon, an old Phrygian couple, were the only ones willing to receive them. They freely shared their meal, during which their table and wine bowl were constantly replenished by the gods. In return for the couple's hospitality and piety, the gods saved them from a storm and deluge and further rewarded them by transforming their cottage into a temple, of which they became priest and priestess. The couple prayed to die together and at their death were turned into an oak and linden tree with intertwining boughs.

The popularity of this subject in seventeenth-century Netherlandish painting may have been partly owing to an allegorical interpretation of Zeus and Hermes as counterparts to God the Father and Christ. In

contrast, English poets of the eighteenth century told the story in broadly humorous, mundane terms.

Classical Source. Ovid, *Metamorphoses* 8.616–724.

Further Reference. Manfred Beller, *Philemon und Baucis in der europäischen Literatur, Stoffgeschichte und Analyse* (Heidelberg: Winter-Universitätsverlag, 1967). Wolfgang Stechow, "The Myth of Philemon and Baucis in Art," *Journal of the Warburg and Courtauld Institutes* 4.1–2 (1940–41): 103–113.

Anonymous French. (Story of Philemon and Baucis in) *Ovide moralisé* 8.2915–3184. Poem, allegorized translation/elaboration of Ovid's *Metamorphoses*. *c.*1316–28. [de Boer 1915–86, vol. 3]

Bramantino, 1450/55–1536. "Jupiter Visiting Philemon and Baucis." Painting. *c.*1500. Wallraf-Richartz-Museum, Cologne, no. 527. [Cologne 1965, p. 34—ill. / also Berenson 1968, p. 60—ill. / Stechow 1940–41, fig. 24a / Luino 1975, p. 91, pl. 55]

Francesco Primaticcio, 1504–1570, design. "Philemon and Baucis." Fresco, for Salle de Bal, Château de Fontainebleau, executed by Niccolò dell' Abbate under Primaticcio's direction. 1551–56. Repainted 19th century. [Dimier 1900, pp. 160ff., 284ff.]

Bernard Salomon, 1506/10–*c.*1561. "Philemon and Baucis." 2 woodcuts, part of cycle illustrating Ovid. In *Les Metamorphoses d'Ovide figurée* (Lyons: Tivornes, 1557). [Stechow 1940–41 p. 106—ill.] Several copies and variants, by V. Solis, P. van der Borcht, and others, in subsequent publications (Frankfort: 1563; Leipzig: 1582; Antwerp: 1591; etc.). [Ibid.—ill.]

Taddeo Zuccari, 1529–1566. Story of Baucis and Philemon, part of a series of frescoes depicting scenes from the "Life of Mercury," on façade of Casa Mattiuolo, Rome. Destroyed. / Drawing. Albertina, Vienna. [Stechow 1940–41, p. 105—ill.]

Adam Elsheimer, 1578–1610. "Jupiter and Mercury in the House of Philemon and Baucis." Painting. *c.*1608–09. Gemäldegalerie, Dresden, inv. 1977. [Andrews 1977, no. 24—ill. / Dresden 1976, p. 49—ill. / Stechow 1940–41 pp. 109—ill.]

————. "Jupiter and Mercury with Philemon." Drawing. Staatliche Museen, Berlin-Dahlem, inv. Kdz 5642. [Andrews, no. 46—ill.]

Peter Paul Rubens, 1577–1640. "[Stormy] Landscape with Philemon and Baucis." Painting. *c.*1625. Kunsthistorisches Museum, Vienna. [Jaffé 1989, no. 804, p. 99—ill.]

————, studio, after Rubens's design. "Jupiter and Mercury with Philemon and Baucis." Painting. Dated variously *c.*1615–late 1620s. Kunsthistorisches Museum, Vienna, inv. 806 (870). [Ibid., no. 877—ill. / Vienna 1973, p. 149 / White 1987, pl. 242 / Stechow 1940, pp. 107f.—ill. / Beller 1967, p. 61—ill.] Copy (after lost original oil sketch) in de Végvár coll., Greenwich, Conn. [Held 1980, no. 246—ill.]

Sinibaldo Scorza, 1589–1631. "Philemon and Baucis." Painting. National Gallery of Scotland, Edinburgh. [Wright 1976, p. 186]

Philipp Gyselaer, fl. 1625–50. "Jupiter and Mercury with Philemon and Baucis." Painting. Kunsthistorisches Museum, Vienna, inv. 1697 (1132). [Vienna 1973, p. 81]

Jacob Jordaens, 1593–1678. "Jupiter and Mercury in the House of Philemon and Baucis." Paintings; several versions of the subject known, including studio versions, *c.*1642–51. Atheneum, Helsinki, no. 405 (*c.*1645); North Carolina Museum of Art, Raleigh, inv. 52.9.99; elsewhere. [d'Hulst 1982, p. 220 / Ottawa 1968, no. 87—ill. / also Rooses 1908, pp. 181, 260] Copy (after a version formerly in Dresden?) in Victoria and Albert Museum, London, no. CAI.93. [Kauffmann 1973, no. 198]

Jan van den Hoecke, 1611–1651. "Jupiter and Mercury with Philemon and Baucis." Painting. Národní Galeri, Prague. [Stechow 1940–41, pp. 108f.—ill.]

Rembrandt van Rijn, 1606–1669. "Jupiter with Philemon and Baucis." Drawing. *c.*1655. Kupferstichkabinett, Berlin. [Benesch 1973, no. 960—ill.]

————. "Philemon and Baucis." Painting. 1658. National Gallery, Washington, D.C., no. 661. [Gerson 1968, no. 278—ill. / Stechow 1940–41, pp. 111f.—ill. / Sienkewicz 1983, p. 22—ill. / also Walker 1984, fig. 370]

Johann Carl Loth, 1632–1698. "Jupiter and Mercury with Philemon and Baucis." Painting. Before 1659. Kunsthistorisches Museum, Vienna, inv. 109 (1550). [Vienna 1973, p. 101—ill.]

Jean de La Fontaine, 1621–1695. "Philémon et Baucis." Poem. In *Ouvrages de prose et de poésie des sieurs de Maucroix et de La Fontaine* (Paris: Barbin, 1685) and *Fables choisies* (Paris: 1693). [Clarac & Marmier 1965 / DLLF 1984, 2:1170ff. / Oxford 1976, p. 323 / Beller 1967, pp. 63–74 / MacKay 1973, pp. 174, 211]

John Dryden, 1631–1700. "Baucis and Philemon." Poem. In *Fables, Ancient and Modern* (London: Tonson, 1700). [Dryden 1700 / Van Doren 1946, pp. 217–19 / Miner 1967, p. 297 / Martindale 1986, pp. 184ff.]

Matthew Prior, 1664–1721. "The Ladle." Poem. 1704. In *Poems on Several Occasions* (London: Tonson, 1709). Modern edition by A. R. Waller (Cambridge: Cambridge University Press, 1905). [Ipso / Beller 1967, pp. 78–83]

Jonathan Swift, 1667–1745. "The Story of Baucis and Philemon." Poem, travesty of Ovid. 1706. Unpublished. / Revised version in *Miscellanies . . . the Sixth Part* (London: Tonson, 1709). [Williams 1958, vol. 1 / Beller 1967, pp. 83–93]

Friedrich von Hagedorn, 1708–1754. "Philemon und Baucis." Verse tale. In *Versuch in poetischen Fabeln und Erzählungen* (Hamburg: 1738). [Beller 1967, pp. 94–100]

François Rebel, 1701–1775, and **François Francoeur,** 1698–1787, music. (Baucis and Philemon in) *Le ballet de la paix,* third entrée. Ballet. Libretto, Pierre-Charles Roy. First performed 29 May 1738, L'Opéra, Paris. Choreographer unknown. [Grove 1980, 6:793 / Beller 1967, pp. 104–6]

Voltaire, 1694–1778. (Story of Baucis and Philemon recalled in) "Ce qui plaît aux dames" [What Pleases the Ladies] lines 254ff. Verse tale. 1738. Paris: Robert dit Marton, 1764. [Moland 1877–85, vol. 10 / Besterman 1969, p. 430 *n.*58]

Peter Prelleur, fl. *c.*1728–55. *Baucis and Philemon.* Opera. First performed 1740, New Wells, Goodman's Fields, London. [Fiske 1973, p. 125]

Pierre-Charles Roy, 1683–1764, libretto. *Philemon et Baucis.* Opera (pastorale en musique). First performed 30

Dec **1762**, Court, Versailles. Libretto published Paris: Christophe Ballard, 1763. [NUC]

Gottlieb Konrad Pfeffel, 1736–1809. *Philemon und Baucis*. Drama. **1763**. [Wilpert 1963, p. 454]

Carlo Innocenzo Frugoni, 1692–1768. "Bauci e Filemone." Poem. In *Versi sciolti* (Venice: Pasquale, **1766**). [Beller 1967, p. 111]

Pierre-Alexandre Monsigny, 1729–1817. *Philemon et Baucis*. Comic opera. Libretto, M.-J. Sedaine. First performed **1766**, Theatre of Duke of Orléans, Bagnolet. [Grove 1980, 12:501]

Gerard Jan Palthe, 1681–1767, or **Jan Palthe**, 1717–1769. "Hermes and Zeus in the Hut of Philemon and Baucis." Painting. Gemeentemusea, Deventer. [Wright 1980, pp. 358, 359]

Anton Cajetan Adlgasser, 1729–1777. *Philemon und Baucis* (*Der Besuch Jupiters* [Jupiter's Visit]). Oratorio. First performed **1768**, Salzburg. [Grove 1980, 1:110]

Marco Coltellini, 1719–1777. *La favola di Filemone e Bauci*. Drama. First performed **1769**, Parma. [DELI 1966–70, 2:90]

Christoph Willibald Gluck, 1714–1787. "Bauci e Filemone," act 1 of *Le feste d'Apollo*. Opera (festspiel). Libretto, G. M. Pagnini, after scenario by Frugoni and Calzabigi. First performed 24 Aug **1769**, Parma. [Grove 1980, 7:463, 472 / Beller 1967, p. 110]

Isaac Bickerstaff, 1733–1808? *Baucis and Philemon*. Burletta, based on a scenario by John Hoadly, after anonymous work of 1740 (?). In rehearsal at Drury Lane Theatre, London, **1772**, abandoned. [Tasch 1971, pp. 25, 243]

Anton Schweitzer, 1735–1787. *Philemon and Baucis*. Opera. Libretto, Pfeffel (1763). First performed **1772**, at Court, Weimar? [Grove 1980, 17:46]

Charles Dibdin, 1745–1814. "The Ladle." Musical dialogue. Text after Matthew Prior (1704). First performed 12 Apr **1773**, Sadler's Wells, London. [Grove 1980, 5:427]

Franz Joseph Haydn, 1732–1809. *Philemon und Baucis, oder Jupiters Reise auf die Erde* [Philemon and Baucis, or Jupiter's Journey to Earth]. Singspiel and marionette opera. Libretto, Pfeffel (1763). First performed 2 Sep **1773**, Eszterházy. [Grove 1980, 8:365]

Ludwig Christoph Heinrich Hölty, 1748–1776. (Philemon and Baucis evoked in) "Töffel und Käthe." Ballad. In *Almanach der deutschen Musen auf das Jahr 1773* (Leipzig: Weygandschen Buchhandlung, **1773**). [Beller 1967, pp. 100–03]

François-Joseph Gossec, 1734–1829. *Philémon et Baucis*. Opera (pastorale héroïque). Libretto, N. J. Chabanon de Maugris. First performed 26 Sep **1775**, L'Opéra, Paris. [Grove 1980, 7:562]

Carl David Stegmann, 1751–1826. *Philemon und Baucis*. Singspiel. First performed **1777**, Gotha. [Grove 1980, 18:101]

Onno Zwier van Haren, 1711–1779. (Story of Philemon and Baucis in) *Pietje en Agnietje of De Doos van Pandora* [Peter and Annette, or Pandora's Box]. Play with music. Utrecht: **1779**. [Beller 1967, pp. 111f.]

Lorenzo Da Ponte, 1749–1838. *Favola di Filemone e Bauci*. Drama. Vienna: **1781**. [Grove 1980, 5:237]

Johann Heinrich Voss, 1751–1826. "Philemon and Baucis." Idyll, after Callimachus and Ovid. **1785** (or 1795). In *Idyllen* (Königsberg: Nicolovius, 1801–02). [Daemmrich 1987, p. 181 / Beller 1967, pp. 121, 123, 128 / Frenzel 1962, p. 518]

João Cordeiro da Silva, c.1735–1808? *Bauce e Philemone*. Opera. Libretto, G. Martinelli. First performed 25 Apr **1789**, Teatro d'Ajuda (or Queluz), Lisbon. [Grove 1980, 17:318]

Johann Christoph Kaffka, ?–1815. *Philemon und Baucis, oder Gastfreyheit und Armuth* [Philemon and Baucis, or Hospitality and Poverty]. Singspiel. Libretto, Johann Christoph von Zubuesnig. Published Augsburg: **1792**. [Beller 1967, pp. 112–16]

Carl Christian Agthe, 1762–1797. "Philemon und Baucis." Musical divertissement. [Grove 1980, 1:168]

Jean-Joseph Verellen, 1788–1856. "Jupiter and Mercury in the House of Philemon and Baucis." Painting. c.**1815**. Musées Royaux des Beaux-Arts (Musée d'Art Moderne), Brussels, inv. 437. [Brussels 1984b, p. 634—ill.]

The Prix de Rome painting competition subject for **1818** was "Philemon and Baucis." First prize, Nicolas-Auguste Hesse. École des Beaux-Arts, Paris. [Grunchec 1984, no. 55—ill. / Harding 1979, p. 92]

Johann Wolfgang von Goethe, 1749–1832. (Baucis and Philemon, in their grove and temple, consumed by Mephistopheles' fire, as reported by Lynkeus, the watchman in the tower, in) *Faust* Part 2, 5.235–383 Tragedy. This episode written **1831–32**. Heidelberg: 1832. [Beutler 1948–71, vol. / Suhrkamp 1983–88, vol. 2 / Poggioli 1975, pp. 204–14, 225, 238, 327f. / Beller 1967, pp. 134–37]

Pierre-Narcisse Guérin, 1774–**1833**. "Philemon and Baucis Receiving a Visit from Jupiter and Mercury." Painting. [Bénézit 1976, 5:272]

Carl Loewe, 1796–1869. (3 songs of Lynkeus, relating to Baucis and Philemon, in) *5 Gedichte*, opus 9.8. Song cycle. Text from Goethe's *Faust* (1831–32). **1833**. Published Leipzig: 1834. [Grove 1980, 11:128]

Nikolai Gogol, 1809–1852. (Philemon and Baucis recalled, as Little Russians, in) "Starosvetskiye pooneschchiki" [Old-fashioned Landowners]. Story. In *Mirgorod*, vol. 1 (Moscow: **1835**). [Poggioli 1975, pp. 241ff.]

August Bournonville, 1805–1879, choreography. (Baucis and Philemon in) *Gamle minder eller En lanterna magica* [Ancient Memories, or A Magic Lantern]. Ballet. Music arranged by E. Helsted. First performed **1848**, Royal Ballet, Copenhagen. [EDS 1954–66, 2:926]

Robert Schumann, 1810–1856. "Lied Lynceus der Türmer" [Song of Lynceus the Tower-watchman] (evoking Baucis and Philemon). Lied, no. 27 of *Lieder-Album für die Jugend*, opus 79. Text, Goethe's *Faust* (1832–33). Published Leipzig: Brietkopf & Härtel, **1849**. [Grove 1980, 16:861]

Nathaniel Hawthorne, 1804–1864. "The Miraculous Pitcher." Tale. In *A Wonder-Book for Girls and Boys* (London: Bohn, **1851**). [Beller 1967, pp. 142ff.]

Charles Gounod, 1818–1893. *Philémon et Baucis*. Comic opera. Libretto, Jules Barbier and Michel Carré. First performed 18 Feb **1860**, Théâtre-Lyrique, Paris. / Revised version performed 16 May 1876, Opéra-comique, Paris. [Grove 1980, 7:586f.]

Emil von Schönaich-Carolath, 1852–1908. "Philemon und

Baucis." Verse tale. **1894.** In *Gesammelte Werke*, vol. 3 (Leipzig: 1907). [Beller 1967, p. 150]

Maryan Gawalewicz, 1852–1919. *Philemon i Baucis*. Fantasy drama. Warsaw: Wydawnpolskie/Gebethner & Woeff, **1897.** [Beller 1967, p. 154 / Hunger 1959, p. 285]

Ezra Pound, 1885–1972. (Baucis and Philemon memorialized in) "The Tree." Poem. In *Hilda's Book*, **1907,** handbound, presented to Hilda Doolittle (now in Houghton Library, Harvard University). Reprinted in *A lume spento* (Venice: All' insegna del Pesce d'Oro; Norfolk, Conn.: New Directions, 1908). [Ipso / DLB 1986, 45:310 / Ruthven 1969, p. 242]

―――. (Allusion to Baucis and Philemon in) Canto 90 lines 605–39, in *Section: Rock Drill, 85–95 De Los Cantares* (New York: New Directions, 1955). [Ipso / Flory 1980, p. 242 / Kenner 1971, pp. 529f. / Ruthven, p. 242]

Wilhelm Becker, b. 1887. *Lynkeus der Türmer* [Lynkeus the Tower-watchman] (Faust's watchman, who reports the fire consuming Baucis and Philemon, their cottage, grove, and temple). Collection of poems. Augsburg: Lampart, **1913.** [DLL 1968–90, 1:351]

Lucien Descaves, 1861–1949. *Philémon, vieux de la vieille* [Philemon, the Old Lady's Old Man]. Novel. Paris: Ollendorff, **1913.** [DLLF 1984, 1:622]

Robert Graves, 1895–1985. "An Idyll of Old Age." Poem. In *Whipperginny* (London: Heinemann, **1923**). [Beller 1967, p. 151 / Bush 1937, p. 574 / Cohen 1960, p. 35]

Ruth Pitter, b.1897. (Baucis and Philemon evoked in) "On a Passage from the *Metamorphoses*." Poem. **1926– 35.** In *A Trophy of Arms* (New York: Macmillan, 1936). [Ipso]

Hermann Kasack, 1896–1966. (Story of Baucis evoked in) *Die Stadt hinter dem Strom* [The City beyond the River]. Novel. Berlin: Bermann-Fischer, **1947.** [Beller 1967, pp. 147ff.]

Fritz Diettrich, 1902–. *Philemon und Baucis: Sechs Gesänge* [Philemon and Baucis: Six Songs]. Cycle of poems. Basel: Bärenreiter, **1950.** [DLL 1968–90, 3:247]

Karl Wache, b. 1887. *Baucis und Philemon*. Comedy. Vienna: Europäischer Verlag, **1954.** [Beller 1967, p. 154 / Hunger 1956, p. 285]

Leopold Ahlsen, 1927–. *Philemon und Baukis* (also called *Die Bäume stehen Draussen* [The Trees Stand Without]). Drama. First performed **1956,** Kammerspielen, Munich. Published Hamburg: Hans Bredow-Institut, 1956. [Buddeke & Fuhrmann 1981, pp. 73f. / Beller 1967, pp. 154–56 / Moore 1967, p. 155]

C. Day Lewis, 1904–1972. "Baucis and Philemon." Poem. In *Pegasus and Other Poems* (London: Cape, **1957**). [Parsons 1977]

Isamu Noguchi, 1904–. "Man with Woman" ("Philemon and Baucis"). Abstract stone sculpture. **1959.** [Grove & Botnick 1980, no. 494—ill.]

Tibor Déry, 1884/94–1977. *Philemon und Baucis*. Novella. **1961.** / Translated into French by Georges Kassaï and Agnès Kahane in *Jeu de bascule* (Paris: Éditions du Seuil, 1969). [Beller 1967, p. 148]

Graham Hough, 1908–. "The Heavenly Visitors." Poem. In *Legends and Pastorals* (London: Duckworth, **1961**). [Ipso]

Czeslaw Miłosz, 1911–. (Philemon and Baucis evoked in) "Gucio zaczarowany." Poem. In *Gucio zaczarowany* (Parygz: Instytut Literacki). **1962.** / Translated as "Bobo's Metamorphosis" in *Collected Poems 1931–1987* (New York: Ecco, 1988). [Ipso].

Mark Van Doren, 1894–1972. "The Dinner." Poem. In *Collected and New Poems, 1924–1963* (New York: Hill & Wang, **1963**). [Boswell 1982, p. 306]

Max Frisch, 1911–. (Baucis and Philemon evoked in) *Mein Name sei Gantenbein* [My Name is Gantenbein]. Novel. Frankfurt: Suhrkamp, **1964.** / Translated by Michael Bullock as *A Wilderness of Mirrors* (New York: Random House; London: Methuen, 1965). [EWL 1981–84, 2:168]

W. S. Merwin, 1927–. "The Hosts." Poem. In *The Compass Flower* (New York: Atheneum, **1977**). [Ipso]

Rachel Hadas, 1948–. "Philemon and Baucis." Poem. In *A Son from Sleep* (Middletown, Conn.: Wesleyan University Press, **1987**). [Ipso]

BELLEROPHON. The grandson of Sisyphus and son of Glaucus and Eurymede, Bellerophon was sometimes also known as the son of Poseidon. After accidentally killing a man in his native Corinth, Bellerophon went to the palace of Proetus, king of Argos, where Queen Anteia (or Stheneboea) fell in love with him. When Bellerophon rejected her advances, she accused him of having tried to violate her and demanded that Proetus kill the youth. Unwilling to do so, Proetus sent the hapless hero to his father-in-law, Iobates, king of Lycia, with a letter recounting the incident and asking him to put Bellerophon to death. Iobates dispatched Bellerophon on several dangerous missions, certain he could not survive. According to Homer, he successfully killed the fire-breathing Chimaera, a monster combining parts of a lion, a goat, and a snake; defeated the Solymians and the Amazons in battle; and evaded an ambush by Lycian warriors. Recognizing that these feats betokened divine descent, Iobates made peace with Bellerophon and gave him his daughter Anticlea in marriage.

In Pindar's recasting of the tale, Bellerophon was helped in his battles by the winged horse Pegasus, introduced to him by Athena, who gave him a bridle of gold. Later, he offended the gods by attempting to ride Pegasus to Olympus, but the horse, stung by a gadfly sent by Zeus, threw him back to earth. He spent the rest of his life as an outcast, blind and crippled.

Classical Sources. Homer, *Iliad* 6.154–202. Hesiod, *Theogony* 319–25. Pindar, *Olympian Ode* 13.60–92; *Isthmian Ode* 7.45–47. Horace, *Odes* 4.11.26ff. Strabo, *Geography* 8.6.21. Apollodorus, *Biblioteca* 1.9.3, 2.3. Pausanias, *Description of Greece* 2.2.3ff, 2.4.1–2, 2.27.2, 2.31.9, 3.18.13. Hyginus, *Fabulae* 56, 57, 157, 243, 273.

Anonymous French. (Bellerophon's defeat of the Chimaera in) *Ovide moralisé* 4.5892–6209. Poem, allegorized translation/elaboration of Ovid's *Metamorphoses*. *c.*1316–28. [de Boer 1915–86, vol. 2]

Christine de Pizan, *c.*1364–*c.*1431. (Bellerophon in) *L'epistre d'Othéa à Hector* . . . [The Epistle of Othéa to Hector] chapter 35. Didactic romance in prose. *c.*1400. MSS in British Library, London; Bibliothèque Nationale, Paris; elsewhere. / Translated by Stephen Scrope (London: *c.*1444–50). [Bühler 1970 / Hindman 1986, pp. 25, 196]

Bertoldo di Giovanni, *c.*1420–1491. "Bellerophon and Pegasus." Bronze statuette. Before **1486.** Kunsthistorisches Museum, Vienna. [Pope-Hennessy 1985b, 2:302f.—ill. / also Vermeule 1964, p. 58]

Francesco di Giorgio, 1439–**1502.** "Bellerophon." Bronze plaquette. Victoria and Albert Museum, London, inv. A410–1910. [Warburg]

Thomas Heywood, 1573/74–1641. (Story of Bellerophon in) *Troia Britanica: or, Great Britaines Troy* canto 6. Epic poem. London: **1609.** [Heywood 1974]

———. (Bellerophon in) *The Silver Age.* Drama, partially derived from *Troia Britanica.* First performed *c.*1610–12, London. Published London: Okes, 1613. [Heywood 1874, vol. 3 / DLB 62:101, 122ff. / also Boas 1950, pp. 83ff. / Clark 1931, pp. 62ff.]

Peter Paul Rubens, 1577–1640. "Bellerophon Slaying the Chimaera." Painting, executed by Jan van Eyck from Rubens's sketch, part of Arch of St. Michael's Abbey, decoration for "Pompa Introitus Fernandi," triumphal entry of Cardinal-Infante Ferdinand of Spain into Antwerp, 17 Apr **1635.** Formerly Royal Palace, Brussels, destroyed 1731. [Martin 1972, pp. 203ff., no. 55—ill. (print) / Jaffé 1989, no. 1165] Oil sketch. Musée Bonnat, Bayonne, inv. 458. [Martin, no. 55a—ill. / Held 1980, no. 166—ill. / Jaffé, no. 1164—ill. / Baudouin 1977, fig. 177]

Frans Franken II, 1581–**1642.** "The Xanthian Women Testing Bellerophon." Painting. Schloss Grünewald, Germany. [Warburg]

Francesco Sacrati, 1605–1650. *Il Bellerofonte.* Opera (drama musicale). Libretto, Vincenzo Nolfi. First performed **1642,** Teatro Novissimo, Venice; settings and machines, G. Torelli. [Grove 1980, 16:377 / Worsthorne 1954, pp. 32, 41, 51, 154, appendix 5; pls. 12–17 / Bianconi 1987, pp. 187, 238]

Pietro da Cortona, 1596–1669. "Bellerophon [?] and Pegasus" ("Mars Flies from Earth on Pegasus"). Fresco. **1642–44.** Sala di Giove, Palazzo Pitti, Florence (as "Mars . . ."). [Campbell 1977, pp. 127, 133—ill. / Pitti 1966, p. 49—ill.]

Philippe Quinault, 1635–1688. *Bellérophon.* Tragedy. First performed **1671,** Paris. [Girdlestone 1972, pp. 38 n., 72, 129]

Giuseppe Passeri, 1654–1714. "Bellerophon Overcomes the Chimaera." Fresco. **1678.** Palazzo Barberini, Rome. [Montagu 1968, pl. 64b]

Jean-Baptiste Lully, 1632–1687. *Bellérophon.* Opera. Libretto, Thomas Corneille and Bernard de Fontenelle. First performed 31 Jan **1679,** Académie de Musique, Paris. Published Paris: Ballard & Beaujeu, 1679. [Grove 1980, 11:322, 327 / Girdlestone 1972, pp. 130f. / Collins 1966, pp. 17, 191]

Antonio Draghi, *c.*1634/35–1700. *La Chimera.* Opera. Libretto, Nicolò Minato. First performed 7 Feb **1682,** Vienna. [Grove 1980, 5:604]

Pietro Antonio Fiocco, *c.*1650–1714. Prologue to Lully's *Bellérophon.* After **1694?** Lost. [Grove 1980, 6:597]

Christoph Graupner, 1683–1760. *Bellerophon.* Opera. Libretto, Barthold Feind, after Corneille, Fontenelle, and Boileau. First performed 28 Nov **1708,** Hamburg. [Grove 1980, 7:648 / McCredie 1966, pp. 79f., 84]

Reinhard Keiser, 1674–1739. *Das bey seiner Ruh und Gebuhrt eines Printzen frolockende Lycien unter der Regierung des Königs Jacobates und Bellerophon.* Opera. Libretto, Johann Joachim Hoë. First performed **1717,** Hamburg. [Grove 1980, 9:848]

Antoine Coysevox, 1640–**1720.** "Mercury with Bellerophon." Sculpture. / Copy, bronze statuette (cast 1875?), in Kunsthalle, Hamburg, inv. 1939/87. [Düsseldorf 1971, no. 325—ill.]

Johann Augustin Kobelius, 1674–1731. *Die vom Himmel geschützte Unschuld und Tugend, oder, Bellerophon* [Innocence and Courage Shot from Heaven, or, Bellerophon]. Opera. First performed **1720,** Neumeister. [Grove 1980, 10:129]

Giovanni Battista Tiepolo, 1696–1770. "Bellerophon on Pegasus Slays the Chimaera," part of "Allegory of Eloquence." Ceiling fresco. *c.*1725. Palazzo Sandi, Venice. [Levey 1986, pp. 23ff.—ill. / Morassi 1962, p. 60 / Pallucchini 1968, no. 32—ill.] Modello. Courtauld Institute, London. [Levey—ill. / also Pallucchini, no. 32a—ill.]

———. "Bellerophon [?] on Pegasus" ("Genius on Pegasus Putting Time to Flight"). Ceiling fresco. *c.*1745–50. Palazzo Labia, Venice. [Levey, p. 144—ill. / Morassi, p. 59—ill. / Pallucchini, no. 187—ill.]

Pierre François Biancolelli, called Dominique, 1680–1734, and **Jean Antoine Romagnesi,** 1690–1742. *Arlequin Bellerophon.* Comedy. Published in *Les parodies du nouveau théâtre italien* (Paris: **1738**). [NUC]

Domingo Terradellas, 1713–1751. *Bellerofonte.* Opera. Libretto, Vanneschi. First performed 24 Mar **1747,** King's Theatre, London. [Grove 1980, 18:697]

Francesco Araia, 1709–1770. *Bellerofonte.* Opera. Libretto, Bonecchi. First performed 9 Dec **1750,** St Petersburg. [Grove 1980, 1:540]

Josef Mysliveček, 1737–1781. *Il Bellerofonte.* Opera. Libretto, G. Bonecchi. First performed 20 Jan **1767,** Teatro S. Carlo, Naples. [Pečman 1970, p. 181 / Grove 1980, 13:7]

German School (follower of Anton Raphael Mengs?). "Bellerophon with Pegasus." Painting. **18th century.** Hermitage, Leningrad, inv. 8750. [Hermitage 1987b, no. 355—ill.]

Johann Nepomuk Schaller, 1777–**1842.** "Bellerophon Fighting the Chimera." Sculpture. Galerie Belvedere, Österreichische Galerie des 19. und 20. Jahrhunderts, Vienna. [Bénézit 1976, 9:344]

John Stuart Blackie, 1809–1895. "Bellerophon." Poem. In *Lays and Legends of Ancient Greece* (Edinburgh: Sutherland & Knox, **1857**). [Boswell 1982, p. 45]

William Morris, 1834–1896. "Bellerophon at Argos," "Bellerophon in Lycia." Poems. In *The Earthly Paradise*, vol. 4 (London: Ellis, **1870**). [Morris 1910–15, vol. 6 / Rees 1981, p. 188 / Calhoun 1975, pp. 200, 206–09 / Marshall 1979, pp. 154ff.]

Arran and Isla Leigh (**Katherine Harris Bradley,** 1848–

1914, and **Edith Cooper,** 1862–1943). *Bellerophon.* Drama. London: Bell, **1881.** [Bush 1937, p. 560]

George Meredith, 1828–1909. "Bellerophon." Poem. In *Ballads and Poems of Tragic Life* (London & New York: Macmillan, **1887**). [Bartlett 1978, vol. 1 / Boswell 1982, p. 181]

Odilon Redon, 1840–1916. "Captive Pegasus." Lithograph. **1889.** [Mellerio 1913, no. 102—ill. / Hobbs 1977, fig. 9]
———. "Pegasus and Bellerophon." Drawing. 1889. Robert Lehman coll., New York. [Berger 1964, no. 662]
———. "Pegasus and Bellerophon." Painting. *c.*1900? National Gallery of Victoria, Melbourne. [Ibid., no. 139]

Ettore Sanfelice, 1862–1923. *La Chimera.* Drama. In *Nuovi drammi* (Parma: Pellegrini, **1899**). [DELI 1966–70, 5:36 / DDLI 1977, 2:487]

Emilia Pardo Bazán, 1852–1921. *La Quimera* (modern painter confronts and slays his own Chimaera). Novel. Madrid: Administracion, **1905.** [Galerstein 1986, p. 252]

Rubén Darío, 1867–1916. "Pegaso" (and Bellerophon). Poem. In *Cantos de vida y esperanza: Los cisnes y otros poemas* (Madrid: Tipografía de la Revista de Archivos, Bibliotecas y Museos, **1905**). [Méndez Plancarte 1967 / Jrade 1983, pp. 8of.]

Maxfield Parrish, 1870–1966. 2 paintings, for *Collier's* magazine "Mythology" series: "The Chimaera: Bellerophon Watching the Fountain," published 15 May **1908;** "The Fountain of Pirene," unpublished. [Ludwig 1973, pp. 35, 209]

Eino Leino, 1878–1926. "Bellerophon." Story in verse. Helsinki: Otava, **1919.** [EWL 1981–84, 3:41]

Hilaire Belloc, 1870–1953. (Bellerophon evoked in) "The Winged Horse." Sonnet. In *Sonnets and Verse* (London: Duckworth, **1923**). [Boswell 1982, p. 35]

Paul Manship, 1885–1966. "Bellerophon and Pegasus." Gilded bronze sculpture (sketch). **1930.** Unique cast. [Murtha 1957, no. 268—ill.]
———. "Bellerophon Taming Pegasus." Obverse of bronze Carnegie Corporation medal. 1934. Minnesota Museum of Art, St. Paul, no. 66.14.204; National Museum of American Art, Washington, D.C.; elsewhere. [Murtha, no. 335—ill. / Minnesota 1985, no. 109—ill. / Rand 1989, p. 137—ill.]

Luigi Antonelli, 1882–1942. *Bellerofonte.* Comedy. First performed **1936.** [DULC 1959–63, 1:147]

Georg Kaiser, 1878–1945. *Bellerophon.* Verse drama. **1944.** In *Griechische Dramen* (Zürich: Artemis-Verlag, 1948). First performed 25 Nov 1953, Stadttheater, Saarbrücken. [McGraw-Hill 1984, 3:120–23 / Paulsen 1960, p. 170]

Werner Gilles, 1894–1961. "Pegasus and the Dragon." Drawing. 1947. Seel coll., Berlin. [Berlin 1962, no. 259—ill.]

Cesare Pavese, 1908–1950. (Bellerophon discussed in) "La chimera." Dialogue. In *Dialoghi con Leucò* (Turin: Einaudi, **1947**). / Translated by William Arrowsmith and D. S. Carne-Ross in *Dialogues with Leucò,* bilingual edition (Ann Arbor: University of Michigan, 1965). [Ipso]

Michael Hamburger, 1924–. (Bellerophon and the Chimaera evoked in) "Palinode." Poem. In *The Dual Site: Poems* (London: Routledge & Kegan Paul, **1958**). [Ipso]

C. Day Lewis, 1904–1972. (Bellerophon evoked in) "Hero and Saint." Poem. In *The Whispering Roots and Some Later Poems* (London: Cape, **1970**). [Parsons 1977]

John Barth, 1930–. "Bellerophoniad." Novella. In *Chi-*

mera, trilogy of retold myths. New York: Random House, **1972.** [EWL 1981–84, 1:200 / CLC 1980, 14:53f.]

Jacques Lipchitz, 1891–1973. "Bellerophon Taming Pegasus." Bronze sculpture. **1964–73.** Columbia University Law School, New York. [Hammacher 1975, pp. 88, 215 / also Lipchitz 1972, pp. 214–19] At least 4 bronze sketches, 1964–65. Artist's coll. and Marlborough Galleries in 1972–75. [Lipchitz—ill. / Hammacher, pl. 157] Bronze maquette, 1966. On loan to Smithsonian Institution in 1975. [Lipchitz—ill. / also Hammacher, pl. 158]

John Manifold, 1915–. "Bellerophon." Poem. In *Collected Verse* (Brisbane: University of Queensland Press, **1978**). [Boswell 1982, p. 271]

Adrien Stoutenberg, 1916–. (Bellerophon evoked in) *Land of Superior Mirages: New and Selected Poems* (Baltimore: Johns Hopkins University Press, **1987**). [Ipso]

BOREAS. Son of Eos and Astraeus, Boreas (Aquilo) was the north wind, often associated with winter. He is best known for his abduction of Orithyia, daughter of King Erechtheus of Athens, while she was playing by the river Ilissus. He took her to his native land of Thrace, where she bore him winged twin sons, Zetes and Calais (the Boreadae), who later participated in the Argonautic expedition.

Classical Sources. Homer, *Iliad* 20.221–29. Hesiod, *Theogony* 378–80. *Orphic Hymns* 80, "To Boreas." Plato, *Phaedrus* 229B. Apollonius Rhodius, *Argonautica* 1.211–23, 1.1302–08. Ovid, *Metamorphoses* 6.675–722, 14.223ff. Apollodorus, *Biblioteca* 3.15.1–4; *Epitome* 7.10. Pausanias, *Description of Greece* 1.19.5, 5.19.1, 8.27.14, 8.36.6.

See also PAN, Loves.

Anonymous French. (Boreas and Orithyia in) *Ovide moralisé* 6.3841–3930. Poem, allegorized translation/elaboration of Ovid's *Metamorphoses. c.*1316–28. [de Boer 1915–86, vol. 2]

Sebastiano del Piombo, *c.*1485–1547. "Boreas and Orithyia." Fresco. *c.*1511. Sala di Galatea, Villa Farnesina, Rome. [d'Ancona 1955, pp. 39ff., 88 / Gerlini 1949, pp. 15f.]

Giulio Romano, *c.*1499–1546. Drawing, depicting Cupid, Diana, Cronus, and Boreas as the Four Elements. Earl of Ellesmere coll., Mertoun House, Roxburghshire, Scotland, no. 123. [Hartt 1958, p. 295 (no. 141)—ill.]

Taddeo Zuccari, 1529–1566. "Vulcan Chaining Boreas." Ceiling fresco. **1560–61.** Stanza dell' Inverno, Caprarola. [Warburg]

John Donne, 1572–1631. (Boreas's "rough shivering" of Orithyia evoked in) "On his Mistris" lines 20–25. Poem. *c.*1595? In *Poems* (London: Marriot, 1635). [Patrides 1985]

Annibale Carracci, 1560–1609. "Boreas and Orithyia." Grisaille fresco. **1597–1600.** Galleria, Palazzo Farnese, Rome. [Malafarina 1976, no. 104f.—ill. / Martin 1965, pp. 96f.—ill.]

Ben Jonson, 1572–1637. (Boreas in) *The Masque of Beauty.* Masque. Performed 10 Jan **1608,** at Court, London. Published London: 1608. [Herford & Simpson 1932–50, vol. 7]

Peter Paul Rubens, 1577–1640. "Boreas and Orithyia."

Painting. *c.*1615. Akademie der Bildenden Künste, Vienna. [Jaffé 1989, no. 298—ill.]

———. (Boreas in) "The (Happy) Voyage of Prince Ferdinand (from Barcelona to Genoa)" ("Neptune Calming the Tempest"). Design for part of the Stage of Welcome, decoration for "Pompa Introitus Fernandi," triumphal entry of Cardinal-Infante Ferdinand of Spain into Antwerp, 17 Apr 1635. Original decoration destroyed. / Oil sketch. Fogg Art Museum, Harvard University, Cambridge. [Martin 1972, no. 3a—ill. / Held 1980, no. 146—ill. / Jaffé, no. 1117—ill. / also White 1987, pl. 283] Cartoon, by Rubens and assistants. Gemäldegalerie, Dresden, no. 464b. [Martin, no. 3—ill. / Jaffé, no. 1120—ill.] Oil sketch, study for whole stage. Hermitage, Leningrad, inv. 498 (562). [Held, no. 145—ill.] Copies in Accademia Carrara, Bergamo (as Jacob Jordaens); Koninklijk Museum voor Schone Kunsten, Antwerp. [Martin]

John Milton, 1608–1674. (Infant carried off by Aquilo, parallel to abduction of Orithyia, in) "On the Death of a Fair Infant Dying of a Cough" stanzas 1–3. Poem. Winter **1625–26.** In *Poems, etc. upon Several Occasions* (London: Dring, 1673). [Carey & Fowler 1968 / Woodhouse 1972, p. 33]

Gasparo Sartorio, 1625/26–1680, or **Antonio Sartorio,** 1630–1680. *Orithia.* Opera. Libretto, Maiolino Bisaccioni. First performed **1650,** Teatro S. Apostoli, Venice. [Grove 1980, 16:510 (as Gasparo) / Clément & Larousse 1969, 2:819 (as Antonio)]

Andrea Mattioli, *c.*1620–1679. *Oritia.* Opera. Libretto, A. Passarelli. First performed **1655,** Ferrara. [Grove 1980, 11:838]

Giovanni Francesco Romanelli, 1610–**1662.** "Boreas Abducting Orithyia." Painting. Galleria Spada, Rome. [Pigler 1974, p. 54]

Jean de La Fontaine, 1621–1695. "Phoebus et Boréas." Verse fable (book 6 no. 3). In *Fables choisies* (Paris: **1668**). [Clarac & Marmier 1965 / Spector 1988 / Moore 1954]

Gaspard Marsy, 1629–1681. "Boreas Carrying Off Orithyia." Colossal marble sculpture group, representing "Air," for Parterre d'Eau, Versailles, after design by Charles Le Brun. Modeled *c.*1675, unfinished at Marsy's death, completed by Anselme Flamen (1647–1717). Jardins des Tuileries, Paris. / Bronze reductions, 17th/18th century. Wallace Collection, London; Fogg Art Museum, Harvard University, Cambridge; elsewhere. [Wildenstein 1968, no. 24—ill. / cf. Düsseldorf 1971, no. 349—ill.]

Ignaz Elhafen, 1658–1715. "Abduction of Orithyia by Boreas." Relief. *c.*1688–97. Kunsthistorisches Museum, Vienna, inv. 4177. [Zimmer 1971, no. A21.0.4.4]

South Netherlands School. "Boreas Abducting Orithyia." Drawing. *c.*1666–1700. Kunsthistorische Museum, Antwerp, inv. 624. [Düsseldorf 1971, no. 314]

Francesco Solimena, 1657–1747. "The Abduction of Orithyia." Painting. **1701.** Galleria Spada, Rome. / Replica. *c.*1730? Kunsthistorisches Museum, Vienna, no. 518. / Copy, by follower, in Walters Art Gallery, Baltimore, inv. 37.1695. [Walters 1976, no. 431—ill.]

Michel Corneille the Younger, 1642–**1708.** "Boreas Abducting Orithyia." Drawing. Louvre, Paris, no. 2427. [Pigler 1974, p. 55]

Thomas-Louis Bourgeois, 1676–1750/51. *Borée.* Cantata. Published Paris: **1709.** [Grove 1980, 3:113]

Jan Claudius de Cock, *c.*1668–1736. "Boreas Abducting Orithyia." Drawing. **1709.** Albertina, Vienna. [Pigler 1974, p. 54]

Christian Kirchner, ?–1732. (Boreas and Orithyia in) "The Four Winds." Group of sandstone sculptures. *c.*1718. Wallpavillon, Zwinger, Dresden. [Asche 1966, no. K110, pl. 227]

Giovanni Gioseffo del Sole, 1654–**1719.** "Boreas Abducting Orithyia." Drawing. Kunstmuseum, Düsseldorf. [Pigler 1974, p. 54]

Giovanni Battista Foggini, 1652–**1725.** "Boreas and Orithyia." Bronze sculpture group. Corsini Gallery, Rome. [Montagu 1968, p. 172]

Jean-Philippe Rameau, 1683–1764. "L'enlèvement d'Orithie." Cantata. **1727** (or 1719?). / Revised as *Aquilon et Orithie,* for bass, violin, basso continuo. Published in *Oeuvres complètes* (Paris: 1731–36). [Girdlestone 1983, pp. 21, 77f., 80 / Grove 1980, 15:570f.]

Giovanni Antonio Pellegrini, 1675–**1741.** "Boreas Abducting Orithyia." Painting. Louvre, Paris, no. R.F. 1964–3. [Louvre 1979–86, 2:215—ill.]

Lorenzo Mattielli, 1682/88–**1748.** "Boreas Abducting Orithyia." Stone sculpture group. Schwarzenberggarten, Vienna. [Pigler 1974, p. 54]

François Boucher, 1703–1770. "The Abduction of Orithyia." Painting, model for tapestry in "Loves of the Gods" series. *c.*1750. Lost. [Ananoff 1976, no. 352] 6 tapestries woven by Beauvais, from 1750. Palazzo Quirinale, Rome; others in private colls. or unlocated. [Ibid.]

———. "Boreas Abducts Orithia in the Presence of Her Sisters." Painting. 1769. Kimbell Art Museum, Fort Worth, Texas, no. AP72.10 (as "Abduction of Psyche"). [Ibid., no. 677—ill.]

Antoine Bailleux, *c.*1720–*c.*1798. *Borée et Orithié.* Cantatille. Published Paris: Bayard, *c.*1760. [Grove 1980, 2:36]

Franz Anton Hilverding, 1710–1768, choreography. *La victoire de Flore sur Borée* [The Victory of Flora over Boreas]. Ballet. Music, Joseph Starzer. First performed 29 Apr 1760, Court Theater, St. Petersburg. [Grove 1980, 8:570 / Winter 1974, p. 94]

Sebastiano Conca, 1679–**1764** (previously attributed to Luca Giordano, Paolo de Matteis). "Boreas Abducting Orithea." Painting. Louvre, Paris, inv. 303. [Louvre 1979–86, 2:168—ill. / Ferrari & Scavizzi 1966, 2:288]

Stefano Pozzi, *c.*1707–**1768** (previously attributed to Ciro Feni). "Boreas and Orithyia." Drawing. Art Institute of Chicago. [Warburg]

Giovanni Domenico Ferretti, 1692–**1766/69.** "Boreas Abducting Orithyia." Drawing. Hermitage, Leningrad, no. 19822. [Pigler 1974, p. 54]

Charles Monnet, 1732–after 1808. "Boreas and Orithyia." Painting. *c.*1773. Trianon, Versailles. [Bénézit 1976, 7:487]

François-André Vincent, 1746–1816. "Boreas Abducting Orithyia." Painting. 1782. Préfecture, Chambéry. [Pigler 1974, p. 55]

Giovanni Battista Cipriani, 1727–**1785.** "Boreas Abducting Orithyia." Drawing. / Engraved by Richard Earlom (1742/43–1822). [Pigler 1974, p. 54]

Constantin Michel Telle, fl. 1802–30, choreography. *Boreas und Orithyia.* Tableau vivant, based on engravings by Aloys Ludwig Hirt. First performed **1802,** Court, Berlin. [Winter 1974, p. 199]

Louis-Joseph Francoeur, 1738–**1804.** *Borée et Orithie.* Cantata. [Grove 1980, 6:793]

F. Rossi, choreography. *Borea e Zeffiro.* Ballet. Music, Ferrari. First performed 14 Dec **1809,** King's Theatre, London. [Guest 1972, p. 154]

Walter Savage Landor, 1775–1864. (Boreas in) "Pan and Pitys" [English title of work written in Latin]. Idyll. In *Idyllia heroica* (Oxford: Munday & Slatter, **1815**). / Translated by the author in *Hellenics* (London: Moxon, 1847). [Wheeler 1937, vol. 2 / Pinsky 1968, pp. 56f., 134–40]

Anne-Louis Girodet, 1767–**1824,** composition. "The Rape of Orithyia." Lithograph, part of "Loves of the Gods" cycle. Published Paris: Engelmann, 1825–26. [Boutet-Loyer 1983, no. 87 *n.*]

Jean-Baptiste Regnault, 1754–**1829.** "Boreas Abducting Orithyia." Painting. Musée des Beaux-Arts, Tours. [Pigler 1974, p. 55]

Jean-Baptiste Blache, 1765–**1834,** choreography. *Zephire et Borée.* Ballet. [EDS 1954–66, 2:581]

Paul Taglioni, 1808–1884, choreography. *Orithia.* Ballet. Music, Cesare Pugni. First performed 15 Apr **1847,** Her Majesty's Theatre, London. [Guest 1984, p. 207 / Guest 1972, p. 159]

Jean-François Millet, 1814–1875. "Phoebus and Boreas" (evocative title: windy land- and seascape). Drawing. *c.***1851.** [Lepoittevin 1973, fig. 75]

George Francis Armstrong, 1845–1906. "Orithyia." Poem. In *A Garland from Greece* (London: Longmans, Green, **1882**). [Boswell 1982, p. 16]

Ernst Barlach, 1870–1938. "Boreas." Drawing. **1891–92.** Barlach Estate, Güstrow, inv. VII.1. [Schult 1958–72, 3: no. 16]

John William Waterhouse, 1849–1917. "Boreas." Painting. **1904.** Lost. [Hobson 1980, no. 147]

Maurice Hewlett, 1861–1923. "Oreithyia." Poem. In *Helen Redeemed and Other Poems* (New York: Scribner; London: Macmillan, **1913**). [Boswell 1982, p. 134]

Alan Hovhaness, 1911–. "Boreas and Mount Wildcat." Orchestral composition, opus 2a. **1931;** revised 1936. [Grove 1986, 2:432]

Leonid Lavrosky, 1905–1967, choreography and scenario. (Boreas in) *Katerina.* Ballet. Music, Anton Rubinstein, arranged by E. A. Doubrovsky. First performed 25 May **1935,** Kirov Theater, Leningrad; décor, B. Ebstein. [Sharp 1972, p. 283]

BRISEIS. *See* ACHILLES, General List, Wrath; TROJAN WAR, General List.

BRITOMARTIS. *See* MINOS.

BYBLIS AND CAUNUS. Daughter and son of Miletus and great-grandchildren of the Cretan king Minos. Byblis was passionately attracted to her twin brother, Caunus; when she confessed her love to him, he fled in horror to Lycia. Byblis went in search of him, wandering through many lands, until at last she was turned by nymphs into a fountain of her own tears. In another account, Caunus returned Byblis's love but then left her, whereupon she hanged herself with her girdle.

The Phoenician city of Byblos (Jubayl) was said to have been named for Byblis. This minor mythological tale is more commonly a theme of literature and the stage than of the visual arts.

Classical Sources. Ovid, *Metamorphoses* 9.451–665. Hyginus, *Fabulae* 243.

Anonymous French. (Story of Byblis and Caunus in) *Ovide moralisé* 9.1997–2767. Poem, allegorized translation/elaboration of Ovid's *Metamorphoses. c.***1316–28.** [de Boer 1915–86, vol. 3]

Netherlandish (Antwerp?) School. "Byblis Writing to Caunus." Painting. **1538?** Art Gallery and Museum, Glasgow, cat. 1961 no. 1592. [Wright 1976, p. 148]

Edmund Spenser, 1552?–1599. (Byblis's incestuous love for Caunus evoked in) *The Faerie Queene* 3.2.40–41. Romance epic. London: Ponsonbie, **1590,** 1596. [Hamilton 1977 / Nohrnberg 1976, p. 442]

Phineas Fletcher, 1582–1650. (Byblis evoked in) *The Purple Island, or the Isle of Man* 5.19. Allegorical poem. *c.***1610.** Cambridge: University of Cambridge, 1633. [Smith 1984, p. 277]

John Oldham, 1653–1683. *The Passion of Byblis in Ovid's Metamorphosis Imitated in English.* Poem. London: printed for J. Hindmarsh, **1682.** [Bush 1937, p. 540]

John Dennis, 1657–1734. *The Passion of Byblis, Made English.* Translation from Ovid. London: for R. Parker, **1692.** [Paul 1966, pp. 19–20 / Bush 1937, p. 541]

Louis de Lacoste, *c.*1675–mid 1750s. *Biblis.* Opera (tragédie lyrique). Libretto, Fleury de Lyon. First performed 6 Nov **1732,** Paris. [Girdlestone 1972, p. 272 / Grove 1980, 10:352]

Martin Gottlieb Klauer, 1742–1801. "Caunus and Byblis." Sculpture group. Landesbibliothek, Weimar. [Hartmann 1979, pl. 62.2]

William Drummond, 1770?–1820. *Byblis.* Tragedy. London: Bulmer, **1802.** [Bush 1937, p. 547]

Algernon Charles Swinburne, 1837–1909. "Byblis." Poem. *c.***1849–50.** In *Juvenilia* (privately printed by T. J. Wise, 1912). [Bush 1937, p. 329]

Jean-Baptiste Camille Corot, 1796–1875. "Byblis." Painting. Exhibited **1875.** Unlocated. [Robaut 1905, no. 2197—ill.]

Jules Massenet, 1842–1912. *Biblis.* Choral composition (scène païenne). Libretto, Claude Boyer, after Ovid. First performed **1886,** Société Chorale des Amateurs, Paris. [Baker 1984, p. 1478 / Grove 1980, 11:808]

William Bouguereau, 1825–**1905.** "Byblis" (lying on the ground). Painting. Hyderabad Museum, India. [Montreal 1984, p. 121—ill.]

Pierre Louÿs, 1870–1925. "Byblis, ou L'enchantement des larmes" [Byblis, or the Enchantment of Tears]. Short story. In *Le crépuscule des nymphes* (Paris: Montaigne,

1925; illustrated with 5 woodcuts by Jean Saint-Paul). [NUC] / 2d edition, Paris: Briant-Robert, 1926, illustrated with 10 lithographs by Bosshard. / 3d edition, Paris: Tisné, 1946, illustrated with 24 lithographs by Pierre Bonnard. [NUC / also Bouvet 1981, no. 128—ill.]

C

CACUS. *See* HERACLES, and Cacus.

CADMUS. Son of Agenor, king of Tyre, Cadmus was sent to seek his sister, Europa, after she was abducted by Zeus. He consulted the oracle at Delphi, which led him to settle at the site of Thebes, where he built a citadel. In order to supply the town with water, he sent his companions to a nearby spring, where they were devoured by the dragon that guarded it. Cadmus killed the dragon and then, on the advice of Athena (Minerva), planted its teeth on the plain. From the teeth sprang up a crop of armed men, ready for battle. Cadmus enticed them to fight each other, and in the ensuing melee all but five were killed. These "Spartoi" ("sown men") became his allies and the ancestors of the Theban nobility.

Cadmus married Harmonia (also called Hermione), daughter of Ares and Aphrodite, and gave her many gifts. (One of these was a necklace that would bring disaster to its later owner, Eriphyle.) Cadmus and Harmonia had five children—a son, Polydorus, and four daughters, Agave, Autonoë, Ino, and Semele—all of whom met tragic fates. In old age, sick with loss and grief, Cadmus and Harmonia went to Illyria, where they were transformed into serpents; they were finally sent to Elysium.

Cadmus was honored in Thebes as its founder. He was also credited with introducing the Phoenician alphabet to the Greeks.

Classical Sources. Hesiod, *Theogony* 937ff. Herodotus, *History* 1.166ff., 2.49, 4.147. Euripides, *The Bacchae; The Phoenician Maidens* 939ff. Diodorus Siculus, *Biblioteca* 5.49.1–6, 58.2. Ovid, *Metamorphoses* 3.1–136, 4.561–603. Strabo, *Geography* 9.2.3. Apollodorus, *Biblioteca* 3.4.1–2, 5.2–4. Pausanias, *Description of Greece* 3.24–3, 9.5.1–3, 12.1–3. Hyginus, *Fabulae* 6.

Anonymous French. (Story of Cadmus in) *Le roman de Thèbes* lines 9125–240. Verse romance. *c.*1150–55. [Raynaud De Lage 1966–67, vol. 2]

Jean de Meun, 1250?–1305? (Cadmus's building of Thebes evoked in) *Le roman de la Rose* lines 19736–54. Verse romance, completion of unfinished work begun by Guillaume de Lorris (*c.*1230–35). *c.*1275. Lyon: Ortuin & Schenck, *c.*1481. [Dahlberg 1971 / Poirion 1974]

Dante Alighieri, 1265–1321. (Allusion to Cadmus's transformation into a serpent in) *Inferno* 25.97–102. *c.*1307– *c.*1314? In *The Divine Comedy.* Poem. Foligno: Neumeister & Angelini, 1472. [Singleton 1970–75, vol. 1 / Samuel 1966, pp. 111f. / Toynbee 1968, pp. 124f. / Barkan 1986, p. 156]

Anonymous French. (Story of Cadmus and Harmonia in) *Ovide moralisé* 4.5116–5381. Poem, allegorized translation/elaboration of Ovid's *Metamorphoses. c.*1316–28. [de Boer 1915–86, vol. 2]

Giovanni Boccaccio, 1313–1375. "De Cadmo Thebanorum rege" [About Cadmus, King of Thebes], in *De casibus virorum illustrium* [The Fates of Illustrious Men] 1.6. Didactic poem in Latin. 1355–73? [Branca 1964–83, vol. 9 / Hall 1965]

Christine de Pizan, *c.*1364–*c.*1431. (Cadmus in) *L'epistre d'Othéa à Hector* . . . [The Epistle of Othéa to Hector] chapter 28. Didactic romance in prose. *c.*1400. MSS in British Library, London; Bibliothèque Nationale, Paris; elsewhere. / Translated by Stephen Scrope (London: *c.*1444–50). [Bühler 1970 / Hindman 1986, pl. 25]

Pierre de Ronsard, 1524–1585. (Cadmus as victim of fortune in) "Ode de la paix" [Ode of Peace] 3.27ff. Ode. Paris: Cauellat, 1550. [Laumonier 1914–75, vol. 3 / Silver 1985, p. 263]

Francesco Primaticcio, 1504–1570, composition. "Cadmus Kills the Dragon." Etching, by Monogrammist L. D. **Mid-16th century.** [Pigler 1974, p. 150]

Cornelis Cornelisz van Haarlem, 1562–1638. "Two Followers of Cadmus Devoured by the Dragon." Painting. **1588.** National Gallery, London, inv. 1893. [London 1986, p. 121—ill. / de Bosque 1985, p. 255—ill.] Replica or copy. Staatliche Kunstsammlungen, Dresden. [de Bosque, p. 257—ill.] Engraving, by Hendrik Goltzius, 1588. [Strauss 1977a, no. 261—ill. / Bartsch 1980–82, no. 262—ill. / Hofmann 1987, no. 4.13—ill.]

Hendrik Goltzius, 1558–1617. "The Dragon Devouring the Companions of Cadmus." Engraving (Bartsch no. 261), after Cornelisz van Haarlem (above). **1588.** 4 states. [Strauss 1977, no. 261—ill. / Hofmann 1987, no. 4.13—ill.]

————. Series of drawings depicting the story of Cadmus, part of a set illustrating Ovid (2d series, no. 1): "Cadmus Asks the Oracle in Delphi (for the Whereabouts of His Sister Europa)," "Cadmus's Companions Killed by the Dragon," "Cadmus Kills the Dragon," others. 1590. Drawings in Kunsthalle, Hamburg, inv. 1926/226–228. [Reznicek 1961, nos. 101–03—ill. / also Hofmann, no. 4.12—ill. / de Bosque 1985, pp. 256, 259—ill.]

————, composition. 4 engravings depicting the story of Cadmus, part of a set illustrating Ovid's *Metamorphoses* (3d series, nos. 1–4), executed by assistant(s). *c.*1615. (Unique impressions in British Museum, London.) [Bartsch 1980–82, nos. 0302.71–74—ill.]

Maerten de Vos, 1532–**1603**. "Cadmus and Harmonia Changed into Serpents." Drawing. Cabinet des Estampes, Musée Plantin-Moretus, Antwerp. [Warburg]

Annibale Carracci, 1560–**1609**. "Cadmus Kills the Dragon." Drawing. Formerly Metz coll., unlocated. / Engraved by Conrad Martin Metz (1749–1827). [Pigler 1974, p. 150]

Paul Bril, 1554–**1626**. "Cadmus Kills the Serpent." Painting. Earl of Bradford coll., Weston. [Warburg]

Giovanni Felice Sances, c.1600–1679. *Ermiona* [Harmonia]. Opera. Libretto, P. E. degli Obizzi. First performed 11 Apr **1636**, Padua. [Grove 1980, 16:462]

Peter Paul Rubens, 1577–1640. "Cadmus and Minerva" ("Cadmus Sowing the Dragon's Teeth"). Painting, for Torre de la Parada, El Pardo, executed by Jacob Jordaens from Rubens's design. **1636–38**. Prado, Madrid, no. 1713. [Alpers 1971, no. 9—ill. / Jaffé 1989, no. 1246—ill. / Prado 1985, p. 345] Oil sketch, by Rubens. Bacon coll., Raveningham Hall, Norfolk. [Alpers, no. 9a—ill. / Held 1980, no. 176—ill. / Jaffé, no. 1245—ill.] Copy in Rijksmuseum, Amsterdam, inv. A4051. [Rijksmuseum 1976, p. 484—ill.]

Pedro Orrente, 1570/80–**1644/45**. "Cadmus Arrives at the Place Designated by the Oracle." Painting. Private coll., Madrid. [López Torrijos 1985, p. 414, pl. 95]

Salvator Rosa, 1615–1673. "The Legend of the Founding of Thebes by Cadmus." Painting. Late 1650s? Statens Museum for Kunst, Copenhagen. [Copenhagen 1951, no. 600—ill. / Salerno 1975, no. 152—ill.] *See also* de Jong, below.

Kaspar Förster, 1616–1673. *Der lobwürdige Cadmus* [Praiseworthy Cadmus]. Opera. Libretto, A. F. Werner. First performed 25 Sep **1663**, Copenhagen. [Grove 1980, 6:720]

John Milton, 1608–1674. (Cadmus and Hermione as serpents, compared to the serpent in Eden, in) *Paradise Lost* 9.503–07. Epic. London: Parker, Boulter & Walker, **1667**. [Carey & Fowler 1968 / Martindale 1986, p. 20 / Du Rocher 1985, pp. 144–46]

Jean-Baptiste Lully, 1632–1687. *Cadmus et Hermione*. Opera (tragédie en musique, balletic tragedy). Libretto, Philippe Quinault. First performed 27 Apr **1673**, Académie Royale de Musique, Jeu de Paume de Bel-Air, Paris; choreography, Pierre Beauchamps; machines, Carlo Vigarani. [Simon & Schuster 1979, p. 60 / Grove 1980, 2:322, 11:326 / Girdlestone 1972, pp. 55ff. / Palisca 1968, pp. 160–66, 183]

Leonard Bramer, 1596–**1674**. "The Dragon Attacks Cadmus's Companions," "Cadmus Kills the Dragon." Drawings. Staatliche Museen, Berlin. [Warburg]

Thomas Blanchet, 1614?–1689. "Cadmus and Minerva." Painting. **1681**. Musée, Semur-en-Auxois. [Dublin 1985, p. 7]

Johann Heinrich Schönfeld, 1609–**1684**. "Cadmus Kills the Dragon." Painting. Private coll., Dresden. [Warburg]

Frans de Jong, ?–**1705** (previously attributed to Salvator Rosa). "Cadmus and the Dead Dragon." Painting. Statens Museum for Kunst, Copenhagen. [Copenhagen 1951, no. 349—ill.]

Georg Caspar Schürmann, 1672–1751. *Cadmus*. Singspiel. Libretto, Johann Ulrich von König. **1720**. [Grove 1980, 16:875]

Johann Paul Kunzen, 1696–1757. *Cadmus*. Opera. Libretto, J. U. König. First performed **1725**, Hamburg? [Grove 1980, 10:311]

Daniel Gran, 1694–1757. "Cadmus Sowing the Dragon's Teeth." Fresco. **1726–30**. Nationalbibliothek, Vienna. [Knab 1977, pp. 50ff., no. F27—ill.] Oil sketch. Stift Wilten, Innsbruck. [Ibid., no. Ö10—ill.]

Johann Andreas Thelott, 1655–**1734**. "Cadmus Slaying the Dragon," "Cadmus Sowing the Dragon's Teeth." Drawings. Albertina, Vienna. [Pigler 1974, p. 151]

Georg Raphael Donner, 1693–1741, follower. "Cadmus and Harmonia." Lead statuette. **c.1745**. Mestské Múzeum, Bratislava, inv. B342. [Schwarz 1968, no. 63]

Elizabeth Montagu, 1720–1800. Hercules and Cadmus discuss the uses of wisdom, in a dialogue included in George Lyttelton's *Dialogues of the Dead* (London: Sandby, **1760**). [Todd 1985, p. 221]

João Cordeiro da Silva, c.1735–1808? *Il Cadmo*. Opera. Libretto, Martinelli. First performed **1784**, Ajuda or Quelaz, Portugal. [Hunger 1959, p. 177]

Anonymous. "Soldiers Born of Serpent's Teeth Fighting Each Other." Gobelins tapestry. **1789**. Wadsworth Atheneum, Hartford, no. 1946.147. [Seen by author, 1986]

Marc-Antoine Désaugiers, 1742–**1793**. *Cadmus et Hermione*. Opera. [Grove 1980, 5:386]

John Martin, 1789–1854. "Cadmus (and the Dragon)." Painting. **1813**. Allen Memorial Art Museum, Oberlin College, Ohio. [Warburg / also Feaver 1975, pp. 21f., pl. 8—ill.]

Vincenzo Monti, 1754–1828. *L'idillio delle nozze di Cadmo e di Ermione* [Idyll of the Wedding of Cadmus and Hermione]. Dramatic idyll. First performed **1825**, for wedding of Princess Trivalzio, Milan. [DELI 1966–70, 4:51, 53, 56]

Matthew Arnold, 1822–1888. (Story of Cadmus and Harmonia, idyll in) *Empedocles on Etna* 1.2.425–60. Dramatic poem. In *Empedocles on Etna, and Other Poems* (London: Fellowes, **1852**). Published separately as "Cadmus and Harmonia" in *Poems* (1853, 1854, 1857). [Allott & Super 1986 / Tinker & Lowry 1940, p. 286 / Bush 1971, p. 58]

Walter Savage Landor, 1775–1864. "Cadmus." Poem. In *Dry Sticks, Fagoted* (Edinburgh: Nichol, **1858**). [Wheeler 1937, vol. 4]

Maxfield Parrish, 1870–1966. "Cadmus Sowing the Dragon's Teeth." Painting, for *Collier's* magazine "Mythology" series. **1907**. Published 31 Oct 1908. Original painting in Vose Galleries, Boston. [Ludwig 1973, pp. 35, 209, pl. 4—ill.]

Sir Reed Gooch Baggorre (George Shoobridge Carr), 1837–1912. "Cadmus." Poem. In *Mythological Rhymes* (London: Hodgson, **1912**). [Boswell 1982, p. 27]

Ezra Pound, 1885–1972. (Allusion to Cadmus sowing the earth with the dragon's teeth in) Canto 27, in *A Draft of XXX Cantos* (Paris: Hours, **1930**; Norfolk, Conn.: New Directions, 193[3?]). [Surette 1979, pp. 134, 207]

Rudolf Pannwitz, 1881–1969. *Kadmos: Erste Teil der Dichtung Thebais* [Cadmus: First Part of the Poem of Thebes]. Poem. **1959**. Olten, Switzerland: Oltner Bücher-freunden, 1960. [Kunisch 1965, p. 454]

CAENIS. *See* POSEIDON, Loves.

CALAIS. *See* BOREAS; JASON, and the Argonauts, Phineus and the Harpies.

CALCHAS. *See* ACHILLES; CHRYSEIS; IPHIGENIA, at Aulis; TROILUS AND CRESSIDA; TROJAN WAR, General List.

CALLIOPE. *See* MUSES, Poetry and Music.

CALLISTO. Daughter of Lycaon, Callisto (also called Helice) was one of the nymphs of Artemis (Diana). She was seduced and impregnated by Zeus (Jupiter), who came to her disguised as Artemis. The maiden tried to hide her pregnancy from the goddess of chastity, but as they bathed together her transformed figure gave away her secret. In fury Artemis banished the girl, who soon gave birth to a son, Arcas.

According to Ovid, Hera (Juno), Zeus's jealous wife, changed Callisto into a bear. When Arcas, grown to manhood, was hunting, he tried to kill the bear, not recognizing her as his mother. In Apollodorus's account, Zeus himself changed Callisto into a bear and she was killed unknowingly by Artemis. Ultimately, Zeus transformed Callisto into the constellation Ursa Major (the Great Bear) and Arcas into the star Arctophylax (the Bear Guardian).

Treatments of the theme in painting most commonly depict the seduction by Zeus and the discovery of Callisto's pregnancy in the bath. Literary and stage works often emphasize Callisto's transformation into a bear.

Classical Sources. Ovid, *Metamorphoses* 2.409–531; *Fasti* 2.155–92. Apollodorus, *Biblioteca* 3.8.2–9.1. Pausanias, *Description of Greece* 1.25.1, 8.3.6–7, 8.4.1, 10.9.5. Hyginus, *Fabulae* 177; *Poetica astronomica* 2.1; *Astronomy* 4.

Further Reference. Kathleen Wall, *The Callisto Myth from Ovid to Atwood: Initiation and Rape in Literature* (Montreal: McGill–Queen's University Press, 1988).

Dante Alighieri, 1265–1321. (Story of Helice [Callisto] alluded to in) *Purgatorio* 25.131; *Paradiso* 31.32. In *The Divine Comedy.* Poem. *Purgatorio* completed *c.*1314 (?), *Paradiso* completed *c.*1321. Foligno: Neumeister & Angelini, 1472. [Singleton 1970–75, vols. 2–3]

Anonymous French. (Story of Callisto in) *Ovide moralisé* 2.1365–2006. Poem, allegorized translation/elaboration of Ovid's *Metamorphoses. c.*1316–28. [de Boer 1915–86, vol. 1]

John Gower, 1330?–1408. (Callisto's story told in) *Confessio amantis* 5.6225–6359. Poem. *c.*1390. Westminster: Caxton, 1483. [Macaulay 1899–1902, vol. 3]

Master of the Griggs Crucifixion (first half 15th century),

circle. "Scenes from a Legend" (of Diana: Callisto, Endymion, others). Painting. *c.*1430. Kress coll. (K275), Walker Art Museum, Bowdoin College, Brunswick, Me., no. 1961.100.1. [Shapley 1966–73, 1:100—ill.]

Raoul Lefèvre, fl. *c.*1454–67. (Story of Callisto in) *Le recueil des hystoires de Troyes* [Collection of the Stories of Troy]. Prose romance. 1464. / English translation by William Caxton as *The Recuyell of the Historyes of Troye* (Bruges: Mansion, *c.*1474). / Modern edition (of original French) by Marc Aeschbach (Bern & New York: Lang, 1987). [Wall 1988, pp. 29–33, 76f., 102]

Guidoccio Cozzarelli, fl. 1450–87, d. 1516. "Callisto." Painting. Marchesa Chigi Zondadari Bonelli coll., Vicobello, Siena. [Berenson 1968, p. 100]

Venetian School. "Diana Discovers Callisto," "Diana Punishes Callisto." 2 paintings. 15th century. Kunsthistorisches Museum, Vienna. [Berenson 1957, p. 206]

Giorgione, *c.*1477–1510 (formerly attributed to Titian). "Jupiter and Callisto." Drawing. Hessisches Landesmuseum, Darmstadt, inv. 1328. [Pignatti 1978, no. A11—ill.] *See also Sebastiano del Piombo, below.*

Palma Vecchio, 1480–1528. "Two Nymphs" (seduction of Callisto?). Painting. *c.*1510. Städelsches Kunstinstitut, Frankfurt, no. 1417. [Mariacher 1968, pl. 6]

———. "The Bath of Diana" ("Diana Discovers Callisto's Lapse"). Painting. *c.*1525. Kunsthistorisches Museum, Vienna, inv. 6803. [Ibid., pl. 55 / Vienna 1973, p. 129—ill.]

Baldassare Peruzzi, 1481–1536. "The Myth of Callisto." Ceiling fresco. 1510–11. Sala di Galatea, Villa Farnesina, Rome. [d'Ancona 1955, pp. 25f., 85—ill. / Gerlini 1949, pp. 10ff.—ill. / also Frommel 1967–68, no. 18c]

Sebastiano del Piombo, *c.*1485–1547, attributed (previously attributed to Giorgione). "Callisto and the Nymphs." Drawing. 1511. Louvre, Paris, inv. 4649. [Pignatti 1978, no. A43—ill.]

Dosso Dossi, *c.*1479–1542, with **Battista Dossi,** *c.*1474–1548. "Diana and Callisto" (traditional title; subject unknown, possibly "Transformation of Syrinx"?). Painting. Late 1520s. Galleria Borghese, Rome, no. 304 (as "Callisto"). [Gibbons 1968, no. 132—ill. / Pergola 1955–59, 1: no. 37—ill.]

Luca Cambiaso, 1527–1585. 2 frescoes depicting the story of Callisto. 1544. Palazzo della Prefettura, Genoa. [Manning & Suida 1958, pp. 74f.—ill.]

———. "Diana and Callisto." Drawing. *c.*1569. Fogg Art Museum, Harvard University, Cambridge, inv. 265–1920. [Ibid., p. 189, fig. 117]

———. "Diana Discovering Callisto's Offense." Painting. Galleria Sabauda, Rome. [Manning & Suida, p. 150—ill.] Variant (previously attributed to Primaticcio). *c.*1570. Staatliche Kunstsammlungen, Kassel, inv. G.K.948. [Ibid., p. 155—ill. / Hofmann 1987, no. 5.4—ill.] Variant, drawing. Royal Scottish Academy, Edinburgh. [Manning & Suida—ill.]

Francesco Primaticcio, 1504–1570. Fresco cycle, depicting the story of Callisto, for Appartement des Bains, Château de Fontainebleau. 1541–47. Destroyed 1697. / Drawings. Louvre, Paris, nos. 8521, 8682. [Dimier 1900, pp. 279ff., nos. 11, 114 / Paris 1972, p. 479, no. 157—ill.; cf. no. 422 / also Lévêque 1984, p. 148—ill. / de Bosque 1985, p. 106] Another fresco ("Callisto Placed among the Stars") known from a drawing in Louvre (no. 8536), and engraving by Mono-

CALLISTO

281

grammist F. G. [Dimier, p. 314, no. 23, no. 72] *See also Cambiaso, above.*

Léonard Thiry, 1500–1550, composition. "The Story of Callisto." Etching cycle, by Master L. D. *c.*1548. (Bibliothèque Nationale, Paris.) [Paris 1972, nos. 393–95—ill. / also Lévêque 1984, p. 73—ill.]

Andrea Schiavone, *c.*1522–1563. "Diana and Callisto." Painting. *c.*1549. Musée de Picardie, Amiens, no. 248. [Richardson 1980, no. 244—ill.]

Bonifazio de' Pitati, *c.*1487–1553. "Diana and Callisto." Painting. William Suida coll., New York. [Berenson 1957, p. 43—ill.]

Giorgio Vasari, 1511–1574, and **Cristofano Gherardi,** 1508–1556. "Callisto." Painting (executed by Gherardi under Vasari's direction?). 1555–59. Terrazzo di Giunone, Palazzo Vecchio, Florence. [Barocchi 1964, p. 135—ill.]

Titian, *c.*1488/90–1576. "Diana and Callisto." Painting. 1556–59. National Gallery of Scotland, Edinburgh (on loan from Duke of Sutherland). [Wethey 1975, no. 10—ill. / Berenson 1957, p. 184] Variant. *c.*1566–68. Kunsthistorisches Museum, Vienna, inv. 71 (169). [Wethey, no. 11—ill. / Vienna 1973, p. 182—ill.] Copies of no. 10 in Accademia di San Luca, Rome; Knole House, Sevenoaks, Kent; Museo de Bellas Artes, Seville; private colls. Copy of no. 11 in Akademie der Bildenden Künste, Vienna; another unlocated. [Wethey] *See also Giorgione, above.*

Arthur Golding, 1536?–1605. (Story of Callisto in) *Ovids Metamorphosis* book 2 (London: 1565, 1567). [Rouse 1961]

Luigi Groto, 1541–1585. *La Calisto.* Pastoral fable. Venice: Zopini, 1583. [DELI 1966–70, 3:205]

William Warner, 1558?–1609. (Jupiter and Callisto, an insert-tale, in) *Albions England.* Epic. London: Cadman, 1586–89. [Wall 1988, pp. 33ff., 41, 63, 76f.]

Hendrik Goltzius, 1558–1617, composition. 5 engravings depicting the story of Callisto, part of set illustrating Ovid's *Metamorphoses* (2d series, nos. 6–10), executed by assistant(s). *c.*1590. Unique impressions in British Museum, London. [Bartsch 1980–82, nos. 0302.56–60—ill.]

———. "Diana and Callisto." Painting. Dienst Verspreide Rijkskollekties, The Hague, inv. NK1910. [Wright 1980, p. 145]

———, questionably attributed. "Diana and Callisto." Painting. Muzeum Narodowe, Warsaw, inv. 72665. [Warsaw 1969, no. 426—ill.]

Annibale Carracci, 1560–1609. "Landscape with Diana and Callisto." Painting. *c.*1598–99. Duke of Sutherland coll., St. Boswell, Scotland. [Malafarina 1976, no. 106—ill.]

——— (or Domenichino?), design. "Diana and Callisto," "The Transformation of Callisto." Frescoes, executed by studio of Carracci under direction of Domenichino. *c.*1603–04 (or *c.*1608?). Galleria, Palazzo Farnese, Rome. [Malafarina 1976, nos. 105e, 105f.—ill. / Martin 1965, p. 137—ill. / Spear 1982, no. 12.iv (as Domenichino)—ill.]

Joseph Heintz the Elder, 1564–1609. "Diana and Callisto." Painting. *c.*1600. Paris market in 1939, unlocated. [Zimmer 1971, no. A17—ill.]

Netherlandish School. "Diana Discovers Callisto's Secret." Painting. *c.*1600. Szépmüvészeti Múzeum, Budapest, no. 59.2. [Budapest 1968, p. 490]

Abraham Janssens, *c.*1575–1632. "Diana Discovers Callisto's Secret." Painting. 1601. Szépmüvészeti Múzeum,

Budapest, no. 51.797. [Budapest 1968, p. 342—ill. / de Bosque 1985, pp. 186f.—ill.]

Paulus Moreelse, 1571–1638. "Diana Discovers Callisto's Pregnancy." Grisaille sketch, design for a print. 1606. Unlocated. [de Jonge 1938, no. 11a—ill.] Engraved by Jan Saenredam, 1606. [Ibid., no. 11b—ill.]

Andrea Boscoli, *c.*1560–1607. "Callisto and Jupiter." 3 drawings, part of a series illustrating Ovid. Gabinetto Nazionale delle Stampe, Rome, nos. F.C. 130575–76, 130578. [Florence 1986, nos. 2.45–47—ill.]

W. N. (sometimes attributed to Nicholas Breton). (Seduction of Callisto in an insert-tale in) *The Barley-breake, or, A Warning for Wantons.* Pastoral. London: 1607. Modern edition by A. B. Grosart (Blackburn, England: for Simms, Manchester, 1877). [Bush 1963, pp. 327f. / Wall 1988, pp. 41ff., 47, 123]

Thomas Heywood, 1573/74–1641. (Story of Callisto in) *Troia Britanica: or, Great Britaines Troy* cantos 2–3. Epic poem. London: 1609. [Heywood 1974]

———. (Episodes, as above, in) *The Golden Age.* Drama, based on *Troia Britanica.* First performed *c.*1609–11, London. Published London: Okes, 1611. [Heywood 1874, vol. 3 / DLB 1987, 62:101, 122ff. / also Boas 1950, pp. 83ff. / Clark 1931, pp. 62ff. / Wall 1988, pp. 37f., 47, 55]

———. (Scenes, as above, in) *The Escapes of Jupiter (Callisto).* Comedy, compilation of scenes from Heywood's *The Golden Age* and *The Silver Age.* First performed *c.*1625, London. [Heywood 1978 / DLB / also Clark, p. 67 *n.*1]

Peter Paul Rubens, 1577–1640. "Jupiter and Callisto." Painting. 1613. Staatliche Kunstsammlungen, Kassel. [Jaffé 1989, no. 196—ill. / Baudouin 1977, fig. 47]

———. "Diana and Callisto." Painting, copy after Titian (1556–59, Edinburgh). *c.*1630. Earl of Derby coll., Knowsley, Lancashire. [Jaffé, no. 978—ill. / Held 1980, 1:324]

———. "Diana and Callisto." Painting. 1637–38. Prado, Madrid, no. 1671. [Jaffé, no. 1352—ill. / Baudouin, fig. 181 / Prado 1985, p. 583] Copies in Museum Boymans-van Beuningen, Rotterdam, inv. 2298 (on loan from Dienst voor 's Rijks Verspreide Kunstvoorwerpen, no. N.K. 2674); Leclercq coll., Hem-lez-Lille; 2 others known, unlocated. [Held, no. 236 (as copies after lost original sketch)—ill. / Jaffé]

———. "The Discovery of Callisto's Shame." Drawing. Staatliche Museen, Berlin, no. 3239. [Burchard & d'Hulst 1963, no. 49—ill.] Another version, in L. Burchard coll., London. [Ibid., no. 122—ill.]

———. "Juno's Vengeance on Callisto." Drawing. Count A. Seilern coll., London. [Ibid., no. 82—ill.]

Jean Puget de La Serre, 1594–1665. "Jupiter et Calisto." Poem. In *Les amours des dieux* (Paris: d'Aubin, 1624). [NUC]

Guido Reni, 1575–1642. "The Story of Callisto." Cycle of paintings. Before 1625. Lost, recorded in a poem by Giovanni Battista Marino (1569–1625). [Pepper 1984, p. 305 no. A8]

Johann Rottenhammer, 1564–1625, follower. "Diana and Callisto." Painting. Musées Royaux des Beaux-Arts (Musée d'Art Ancien), Brussels, inv. 6602. [Brussels 1984a, p. 246—ill.] *See also de Clerck and van Alsloot, below.*

Paul Bril, 1554–1626, landscape, and unknown Italian artist, figures. "Diana Discovers Callisto's Pregnancy."

Painting. Louvre, Paris, inv. 207. [Louvre 1979–86, 1:34—ill.] *See also Tassi, and de Clerck and van Alsloot, below.*

Agostino Tassi, *c.*1580–1644, attributed (previously attributed to Paul Bril). "Diana and Callisto." Painting. *c.***1626?** National Gallery, London, inv. 4029. [London 1986, p. 605—ill.]

Palma Giovane, *c.*1548–**1628.** "Diana and Callisto." Painting. Formerly collection of Emperor Rodolf II, Prague, lost. [Mason Rinaldi 1984, p. 179]

Hendrik de Clerck, *c.*1570–**1629,** figures, and **Denis van Alsloot,** 1570–1628, landscape (previously attributed to Johann Rottenhammer and school of Paul Bril). "Diana Discovers Callisto's Pregnancy." Painting. Louvre, Paris, no. M.I. 960. [Louvre 1979–86, 1:39—ill.]

Cavaliere d'Arpino, 1568–1640. "Diana and Callisto" (discovery of Callisto's pregnancy). Painting. **1620s.** L. Grassi coll., Rome. [Rome 1973, no. 64—ill.]

Pier Paolo Bonzi, called Gobbo dei Carracci, *c.*1576–1636. "Diana and Callisto." Painting. *c.***1620–30.** Uffizi, Florence, inv. SMeC 148 (displayed in Cenacolo di Foligno). [Uffizi 1979, no. P228—ill.]

Hendrik van Balen, 1575–**1632.** "Diana and Callisto." Drawing. Musée Fabre, Montpellier. [de Bosque 1985, pp. 186, 188—ill.]

Simon Vouet, 1590–1649. attributed. "Diana and Callisto." Painting. **Early 1630s?** Musée Magnin, Dijon. [Crelly 1962, no. 27]

Rembrandt van Rijn, 1606–1669. "The Goddess Diana Bathing, with the Stories of Actaeon and Callisto." Painting. **1635.** Prince of Salm-Salm coll., Anholt. [Gerson 1968, no. 61—ill.]

————. "Diana and Callisto." Drawing. *c.*1642–43. Formerly W. R. Valentiner coll. [Benesch 1973, no. 521—ill.]

Cornelis Cornelisz van Haarlem, 1562–**1638.** "Diana Discovers Callisto's Offense." Painting. Gemäldegalerie, Berlin-Dahlem, no. 1988. [Berlin 1986, p. 24—ill.]

Joachim Wtewael, 1566–**1638,** figures (landscape by another hand). "Diana and Callisto." Painting (lost, presumed from copies). / Copies in Cleveland Museum of Art, Ohio, inv. 74.106 (attributed to Wtewael); Kilham Roberts coll., London. [Lowenthal 1986, nos. C–36, C–37 / also Cleveland 1982, no. 131—ill.]

————. "Diana and Callisto." Drawing. Rijksmuseum, Amsterdam. [de Bosque 1985, p. 186—ill.]

————, circle (formerly attributed to Wtewael). "Diana and Callisto." Painting. Musée Déchelette, Roanne. [Lowenthal, no. C–94]

Jacob Jordaens, 1593–1678. "Diana and Callisto." Painting. *c.***1640.** Formerly R. Palitz coll., New York, sold Sotheby's, London, 1973. [d'Hulst 1982, p. 176, fig. 144 / also Ottawa 1968, no. 77—ill. / also Rooses 1908, pp. 152ff.—ill.] Smaller version. Private coll., Courtrai. [d'Hulst, p. 335 n.56] 4 further versions of the subject recorded, untraced. [Rooses, p. 258]

Frans Francken II, 1581–**1642.** "Diana Sending Callisto Away." Drawing. Louvre, Paris. [de Bosque 1985, pp. 186f.—ill.]

Govaert Flinck, 1615–1660. "Jupiter, Disguised as Diana, and Callisto." Painting. *c.***1643.** Art market, Amsterdam, in 1965. [von Moltke 1965, p. 275—ill.]

Claude Lorrain, 1600–1682. "Landscape with Jupiter and

Callisto." Painting. *c.***1643–44.** Lost. / Drawing after, in the artist's *Liber veritatis.* British Museum, London. [Röthlisberger 1961, no. LV 76—ill.]

Pier Francesco Cavalli, 1602–1676. *La Calisto.* Opera. Libretto, G. Faustini. First performed **1651–52,** Teatro San Apollinaire, Venice. [Grove 1980, 4:32 / Glover 1978, pp. 77, 158, 170]

Adriaen van Nieulandt, 1587–1658. "The Discovery of Callisto's Lapse." Painting. **1654.** Herzog Anton Ulrich-Museum, Braunschweig, no. 215. [Braunschweig 1969, p. 103]

Gerrit van Honthorst, 1590–**1656.** "Callisto and Jupiter." Painting. Sold 1764, untraced. [Judson 1959, no. 78]

Frans Wouters, 1612–**1659.** "Diana and Callisto." Painting. Museum, Olmutz. [Bénézit 1976, 10:799]

Anonymous German. *Die Verwandlung der Calisto* [The Transformation of Callisto]. Singspiel. First performed **1660,** Braunschweig-Wolfenbüttel. [Grove 1980, 17:348]

Nicolas Poussin, 1594–**1665,** formerly attributed (Karel Philips Spierincks?). "Jupiter and Callisto." Painting. Philadelphia Museum of Art. [Blunt 1966, no. R83 / Thuillier 1974, no. R73—ill.]

————, formerly attributed (now attributed to Jean-François Millet). "Arcas and Callisto." Painting. Dukes of Westminster Estates. [Blunt, no. R63]

Cornelis van Poelenburgh, *c.*1586–**1667.** "Diana and Callisto." Painting. Bayerisches Staatsgemäldesammlungen, Munich. [Bénézit 1976, 8:392]

————. "Diana Discovering Callisto's Pregnancy." Painting. Musée Granet, Aix-en-Provence. [Ibid.]

————. "Diana and Callisto." Painting. Hermitage, Leningrad, inv. 761. [Pigler 1974, p. 78]

————. "Diana and Callisto." Painting. Hampton Court Palace. [Ibid.]

————. "Diana and Callisto." Painting. Städelsches Kunstinstitut, Frankfurt, inv. 625. [Ibid.]

————. "Diana and Callisto." Painting. Schönborn coll., Pommersfelden. [Ibid.]

Dirck van der Lisse, ?–**1669.** "Diana and Callisto." Painting. City Art Gallery and Temple Newsam, Leeds, cat. 1954 no. 7136. [Wright 1976, p. 119]

Jacob van Loo, *c.*1614–**1670.** "Diana and Callisto." Painting. [Bénézit 1976, 6:730]

Pietro Liberi, 1614–**1687.** "Diana and Callisto." 2 paintings. **1650/75.** Hermitage, Leningrad, inv. 217, 7796. / Sketch for no. 7796. Uffizi, Florence, inv. 9462. [Uffizi 1979, no. P858—ill.]

————. "Jupiter, Disguised as Diana, Seduces Callisto." Painting. Ringling Museum of Art, Sarasota, Fla., inv. SN143. [Sarasota 1976, no. 93]

————. "Jupiter and the Nymph Callisto." Painting. Muzeum Narodowe, Warsaw, inv. 130865, on display at Belweder Palace. [Warsaw 1969, no. 668—ill.]

John Crowne, 1640?–1703? *Calisto: or, The Chaste Nymph.* Masque. Music, Nicholas Staggins. First performed **1675,** at Court, London; choreography, Josias Priest. [Nicoll 1959–66, 1:399 / Grove 1980, 18:55 / Winter 1974, p. 12]

Daniel Vertangen, *c.*1598–**1681/84.** "Diana and Callisto." Painting. Museum of Fine Arts, Boston, no. 16.66. [Boston 1985, p. 293—ill.]

————. "Callisto's Pregnancy Discovered." Painting. Musée Jeanne, La Fère d'Aboville. [Bénézit 1976, 10:479]

Pieter van Halen, 1612–**1687.** "The Bath of Diana and Callisto." Painting. Koninklijk Museum voor Schone Kunsten, Antwerp, no. 5086. [Antwerp 1970, p. 102]

Gérard de Lairesse, 1641–1711 (active until *c.*1690). "Diana and Callisto." Painting. Provinciaal Museum van Drenthe, Assen. [Wright 1980, p. 229]

Adriaen van der Werff, 1659–1722. "The Guilt of Callisto." Painting. **1704.** Formerly Gemäldegalerie, Dresden. [Hunger 1959, p. 178]

———. "Diana and Callisto." Painting. Museum Boymans-van Beuningen, Rotterdam, cat. 1962 no. 1535. [Wright 1980, p. 493]

———. "Diana and Callisto." Painting. Museum, Bamberg. [Bénézit 1976, 10:697]

———. "Diana Discovers Callisto's Pregnancy." Painting. Bayerisches Staatsgemäldesammlungen, Munich. [Ibid.]

———. "Diana Discovers Callisto's Pregnancy." Painting. Museum, Speyer. [Ibid.]

Luca Giordano, 1634–**1705,** school. "Diana and Callisto." Painting. Château de Fontainebleau (on deposit from Louvre, Paris, inv. 304). [Louvre 1979–86, 2:290]

Sebastiano Ricci, 1659–1734 (with Giuseppe Tonelli and Marco Ricci?). "Diana and Callisto." Fresco. *c.*1707–08. Palazzo Pitti, Florence. [Daniels 1976, no. 92c]

———. "Diana and Callisto." Painting. 1712–16. Palazzo Vecchio, Florence. [Ibid., no. 93—ill.]

Georg Werle, 1668–1727. "Diana Shoots Callisto." Fresco. **1715.** Schloss Orada, Hluboka, Czechoslovakia. [Knab 1977, fig. 2b]

Antonio Lotti, *c.*1667–1740, with **Alessandro Scarlatti,** 1660–1725. *Giove in Argo* [Jupiter in Argos]. Opera (melodramma pastorale). Libretto, A. M. Luchini. First performed 25 Oct **1717,** Redoutensaal, Dresden. [Grove 1980, 11:250, 16:560 / Grout 1979, p. 82]

François Marot, 1666–**1719.** "Jupiter Disguised as Diana, with Callisto." Painting. Louvre, Paris, inv. 3525. [Louvre 1979–86, 4:72—ill.]

Giovanni Gioseffo del Sole, 1654–**1719.** "Diana Telling Nymphs about Callisto." Painting. Muzeum Narodowe, Warsaw, inv. 130435. [Warsaw 1969, no. 1223—ill.]

Giovanni Battista Tiepolo, 1696–1770. "Diana and Callisto." Painting. *c.***1720–22.** Accademia, Venice. [Pallucchini 1968, no. 19c—ill. / Morassi 1962, p. 53—ill.]

Giuseppe Maria Crespi, 1665–1747. "The Birth of Arcas" ("The Birth of Adonis"?). Painting. *c.***1720–25.** Gemäldegalerie, Berlin-Dahlem, no. 1/68. [Berlin 1986, p. 26—ill.]

Benedetto Marcello, 1686–1739, doubtfully attributed. *Calisto in Orsa.* Pastorale. **1725.** Libretto, G. B. Carminati. [Grove 1980, 11:649]

Jacob de Wit, 1695–1754. "Jupiter Disguised as Diana Seducing the Nymph Callisto." Ceiling painting (detached). **1727.** Rijksmuseum, Amsterdam, inv. A3885. [Rijksmuseum 1976, pp. 607f.—ill. / Staring 1958, pl. 94] Variant, watercolor. 1733. [Staring, pl. 95]

———. "The Reception of Callisto" (in the heavens). Ceiling painting. 1731. Herengracht 475, Amsterdam. [Staring, p. 131, pl. 66] Oil study. Frits Lugt coll., Paris. [Ibid., pl. 65]

———. "Mercury Guiding Callisto to the Heavens" (?). Painting, study for (lost? unexecuted?) ceiling painting. 1753. A. Staring coll., Vorden. [Ibid., pl. 76]

———. "Callisto Taken Up to the Heavens." Painting, study for (lost? unexecuted?) ceiling painting. Formerly Hubert de Steurs coll. [Ibid., pl. 74]

François Le Moyne, 1688–1737. "Diana and Callisto." Painting. **1725–28.** A. Wengraf coll., London. [Bordeaux 1984, no. 60—ill.] Copy ("The Guilt of Callisto") in Art Gallery and Museum, Glasgow, cat. 1967 no. 48. [Wright 1976, p. 116]

Christian Wilhelm Dietrich, 1712–1774. "Diana Discovering Callisto's Shame." Painting. **1731** or earlier. Gemäldegalerie, Dresden, no. 2133. [Dresden 1976, p. 43]

Gerard Hoet the Elder, 1648–**1733.** "Callisto and Diana." Painting. Art Gallery and Museum, Glasgow. [Bénézit 1976, 5:571]

Jean-François de Troy, 1679–1752. "Jupiter and Callisto." Painting. **1734.** Schloss Charlottenburg, Berlin. [Royal Academy 1968, no. 677]

Nicolas Vleughels, 1668–**1737.** "Diana Discovers Callisto's Pregnancy." Drawing. [Bénézit 1976, 10:550]

George Frideric Handel, 1685–1759. *Giove in Argo* [Jupiter in Argos]. Musical pasticcio. Libretto adapted from Luchini (1717). First performed 1 May **1739,** King's Theatre, Haymarket, London. [Hogwood 1984, pp. 158, 269, 286 / Keates 1985, pp. 226f. / Grove 1980, 8:96, 116]

Andrea Locatelli, 1695–**1741.** "Diana and Callisto." Painting. Palazzo Barberini, Rome. [Bénézit 1976, 6:709]

Nicholas Lancret, 1690–**1743.** "Diana and Callisto." Painting. Unlocated. [Wildenstein 1924, no. 721—ill.]

François Boucher, 1703–1770. "Jupiter and Callisto" (Jupiter disguised as Diana). Painting. **1744.** Pushkin Museum, Moscow, no. 733. [Ananoff 1976, no. 267—ill.]

———. "Diana and Callisto" (Jupiter as Diana). Painting. 1759. Nelson Gallery of Art, Kansas City, no. 32.29. [Ibid., no. 518—ill.]

———. "Jupiter and Callisto." Painting. 1760. Dr. MacDonald coll. [Ibid., no. 533] Studio copy in North Carolina Museum of Art, Raleigh, no. 637. [Ibid.]

———. "Diana and Callisto" (Diana discovering Callisto's pregnancy). Painting, monochrome sketch. 1760. Private coll. [Ibid., no. 535—ill.]

———. "Jupiter and Callisto." Painting, similar to above. 1763. Private coll., New York. [Ibid., no. 576—ill.]

———. "Jupiter and Callisto." Painting. *c.*1767. Lost. [Ibid., no. 639—ill.] Oil sketch. Private coll., Geneva. [Ibid.—ill.] Studio copy (modello for tapestry). Louvre, Paris, no. M. R. 1220. [Ibid]

———. "Jupiter and Callisto." Painting. 1769. Wallace Collection, London, no. P.446. [Ibid., no. 668]

Charles-Joseph Natoire, 1700–1777. "Jupiter and Juno [or Callisto?]." Painting. **1745.** Nationalmuseum, Stockholm. [Boyer 1949, no. 70]

———. "Jupiter and Callisto." Painting. Exhibited 1745. Musée, Périgueux, no. 405. [Ibid., no. 71] Another version of the subject, sold Amsterdam, 1912, unlocated. [Ibid., no. 110]

Jean-Baptiste-Marie Pierre, 1713–1789. "Diana and Callisto." Painting. Shortly before **1750.** Prado, Madrid, no. 3217. [Prado 1985, p. 507]

Jean-Honoré Fragonard, 1732–1806. "Jupiter, Disguised as Diana, Tries to Seduce Callisto." Painting. **1748–52.** Musée des Beaux-Arts, Angers. [Wildenstein 1960, no. 50—ill.] Oil sketch. Private coll. [Ibid., no. 49—ill.]

Nicola Maria Rossi, *c.*1699–*c.*1755, attributed (previously attributed to Francesco Solimena, Sebastiano Conca). "Diana and Callisto." Painting. Uffizi, Florence, inv. 1395. [Uffizi 1979, no. P1371—ill.]

Johann Heinrich Tischbein the Elder, 1722–1789. "Jupiter and Callisto." Painting. **1756.** Gemäldegalerie, Kassel. [Hunger 1959, p. 178]

Franz Anton Maulbertsch, 1724–1796. "Diana and Callisto." Painting. *c.*1759. Muzeum Moravské, Brno. [Garas 1960, no. 121—ill.]

Louis Galloche, 1670–1761. "Diana Discovering the Pregnant Callisto." Painting. [Bénézit 1976, 4:597]

Richard Wilson, 1714–1782. "Diana and Callisto." Painting. **1763–67.** Mrs. G. Parsons coll., England. [Constable 1953, pp. 164f., pl. 23b] Variants. Mrs. R. W. West coll., England; Lady Lever Art Gallery, Port Sunlight, Cheshire, no. 641; estate of G. Leon, England. [Ibid., pls. 23a, 23c] Copy (or variant) by Joseph Mallord William Turner. *c.*1796. Tate Gallery, London, no. 5490. [Butlin & Joll 1977, no. 43—ill.]

Angelica Kauffmann, 1741–1807. "Jupiter and Callisto." Painting. Before **1782.** [Manners & Williamson 1924, p. 231; cf. pl. 11]

Jean-Hugues Taraval, 1729–1785. "Jupiter Disguised as Diana Seduces Callisto." Painting. [Bénézit 1976, 10:76]

Jean-Baptiste Greuze, 1725–1805. "Portrait of a Woman as Callisto." Painting. *c.*1790? Delacorte coll., New York. [Munhall 1976, no. 104—ill.]

Jean-Baptiste Regnault, 1754–1829. "Jupiter and Callisto." Painting. Exhibited Salon of **1799,** Paris. [Pigler 1974, p. 147] Engraved by Maurice Blot (1754–1818). [Bénézit 1976, 1:94]

Stefan Paluselli, 1748–1805. *Diana und Ursus* [Diana and the Bear]. Singspiel. First performed **1802,** Stams Oberinntal, Austria. [Grove 1980, 14:148]

François-Joseph Gossec, 1734–1829, music. *Calisto.* Ballet. [Grove 1980, 7:562]

Bertel Thorwaldsen, 1770–1844. "Callisto." Relief, part of "Metamorphoses of Ovid" series, executed by Pietro Galli from Thorwaldsen's designs. **1838.** Formerly Palazzo Torlonia, Rome, destroyed. / Plaster cast. Thorwaldsens Museum, Copenhagen, no. 472. [Thorwaldsen 1985, pp. 55f.]

Pierre Massot, choreography. *Calisto.* Ballet. First performed 15 Apr **1858,** Her Majesty's Theatre, London. [Guest 1972, p. 159]

Maurice Hewlett, 1861–1923. (Callisto evoked in) "Leto's Child." In *Artemision: Idylls and Songs* (New York: Scribner, **1899**). [Boswell 1982, p. 133]

Henrietta Rae, 1859–1928. "Diana and Callisto." Painting. Exhibited **1899.** [Kestner 1989, p. 286]

Lovis Corinth, 1858–1925. "Calisto and Zeus-Artemis." Color lithograph, part of "Loves of Zeus" cycle. **1920.** [Schwarz 1922, no. L401]

John Hollander, 1929–. "The Great Bear." Poem. In *A Crackling of Thorns* (New Haven: Yale University Press, **1958**). [Boswell 1982, p. 263]

CALYDONIAN BOAR HUNT. *See* MELEAGER, Boar Hunt.

CALYPSO. *See* ODYSSEUS, Calypso; TELEMACHUS.

CAMILLA. *See* AENEAS, in Latium.

CASSANDRA. Daughter of King Priam and Queen Hecuba of Troy, Cassandra (also called Alexandra) is best known for her prophetic powers, although they are not mentioned by Homer. Instead, it is according to a later tradition that Apollo granted her these powers as a token of his love for her and that, when she refused him, he punished her by assuring that her predictions, while always true, would never be believed.

During the sack of Troy, Cassandra fled for safety to the temple of Athena (Pallas; Minerva). There, Ajax, the son of Oileus of Locris (also known as Ajax the Lesser to distinguish him from Ajax the son of Telemon), found her embracing a statue of the goddess. He dragged her by her hair from the temple and raped her. In expiation, Ajax's people, the Locrians, had to send a yearly tribute of maidens to the temple as slaves.

After the fall of Troy, Cassandra was awarded to the Greek king, Agamemnon, as war booty, but on the journey to Mycenae (or after arriving there), both were murdered by Agamemnon's wife, Clytemnestra, and her lover Aegisthus.

A common image in archaic and classical art is that of Cassandra clutching at the statue of Athena or being dragged out of the temple by Ajax. Her prognostications were used as a literary device by a number of ancient authors, especially in tragedy and other writing, in which she vainly foretold numerous events, most notably the fall of Troy.

Classical Sources. Homer, *Iliad* 6.252, 13.361–82, 24.699; *Odyssey* 11.421ff. Aeschylus, *Agamemnon.* Pindar, *Pythian Odes* 11.19ff. Euripides, *Trojan Women.* Virgil, *Aeneid* 2.245ff., 2.343, 3.183. Apollodorus, *Biblioteca* 3.12.5, E5.22–23. Seneca, *Agamemnon.* Pausanias, *Description of Greece* 2.16.6–7, 3.26.5, 10.26.3ff., 10.27.1. Hyginus, *Fabulae* 90, 108, 116, 117, 128, 193. Philostratus, *Imagines* 2.10.

See also AGAMEMNON; TROJAN WAR.

Benoît de Sainte-Maure, fl. 1150–70. (Cassandra in) *Le roman de Troie* lines 4155–63, 4848–84, 10417–54. Verse romance, after Dares, *De excidio Troiae historia,* and Dictys, *Ephemeris de historia belli Troiani* (late Latin versions of lost Greek poems, pseudo-classical forgeries). *c.*1165. [Baumgartner 1987 / Scherer 1963, pp. 128f., pl. 105]

Guido delle Colonne, *c.*1210–after 1287. (Cassandra in) *Historia destructionis Troiae* [History of the Destruction of Troy] 7.465–85, 31.189–99. Latin prose chronicle, after Benoît de Sainte-Maure. **1272–87.** Modern edition by Nathaniel E. Griffin (Cambridge, Mass.: Harvard Uni-

versity Press, with Mediæval Academy of America, 1936; reprinted New York: Kraus, 1970). / Translated by M. E. Meek (Bloomington: Indiana University Press, 1974). [Benson 1980, pp. 26, 101]

Giovanni Boccaccio, 1313–1375. "De Cassandra, Priami Troianorum regis filia" [Cassandra, Daughter of Priam, King of Troy]. In *De mulieribus claris* [Concerning Famous Women]. Latin verse compendium of myth and legend. **1361–75**. Ulm: Zainer, 1473. [Branca 1964–83, vol. 10 / Guarino 1963]

Anonymous English. (Cassandra in) *The Destruction of Troy.* Alliterative adaptation of Guido delle Colonne. *c.***1385–1400?** Modern edition by George A. Panton and David Donaldson, *The "Gest Hystoriale" of the Destruction of Troy* (London: Early English Text Society, 1869, 1874). [Benson 1980, p. 52]

Christine de Pizan, *c.*1364–*c.*1431. (Cassandra in) *L'epistre d'Othéa à Hector . . .* [The Epistle of Othéa to Hector] chapter 32. Didactic romance in prose. *c.***1400**. MSS in British Library, London; Bibliothèque Nationale, Paris; elsewhere. / Translated by Stephen Scrope (London: *c.*1444–50). [Bühler 1970 / Hindman 1986, pp. 130, 196, pl. 29]

Raoul Lefèvre, fl. *c.*1454–67. (Cassandra prophesying in) *Recueil des hystoires de Troyes* [Collection of the Stories of Troy]. Prose romance. **1464**. / English translation by William Caxton as *The Recuyell of the Historyes of Troye* (Bruges: Mansion, *c.* 1474). Modern edition (of original French) by Marc Aeschbach (Bern & New York: Lang, 1987). [Benson 1980, p. 165]

Pierre de Ronsard, 1524–1585. (Cassandra evoked in) Sonnet 79 of *Les amours . . . nouvellement augmentées* (Paris: La Porte, **1553**). [Laumonier 1914–75, vol. 5]

Jan Swart van Groningen, *c.*1500?–**1535/60.** "Cassandra Foretelling the Fall of Troy." Drawing. Rijksmuseum, Amsterdam. [Pigler 1974, p. 328]

Thomas Sackville, 1536–1608. (Cassandra captured at Troy in) "Induction." Poem. In *A Myrroure for Magistrates* (London: Marsh, **1563**). Modern edition by Lily B. Campbell, *The Mirror for Magistrates* (Cambridge: Cambridge University Press, 1938). [Bush 1963, pp. 62, 313]

Annibale Carracci, 1560–1609, **Agostino Carracci,** 1557–1602, and **Ludovico Carracci,** 1555–1619, variously attributed. "The Battle around Cassandra." Fresco, part of a cycle depicting the scenes from *Aeneid* 2 and 3. *c.***1586**. Palazzo Fava (now Hotel Majestic-Baglioni), Bologna. [Malafarina 1976, no. 16—ill.]

Richard Barnfield, 1574–1627. "The Legend of Cassandra." Poem. In *Cynthia, with Certaine Sonnets and the Legend of Cassandra* (London: Humfrey Lownes, **1595**). [Bush 1963, p. 322]

Francis Bacon, 1561–1626. "Cassandra, sive parresia." Chapter 1 of *De sapientia veterum.* Mythological compendium. London: Barker, **1609**. / Translated as "Cassandra, or Divination" by Arthur Gorges in *The Wisdome of the Ancients* (London: Bill, 1619). Modern facsimile edition (bilingual), New York & London: Garland, 1976. [Ipso]

Thomas Heywood, 1573/74–1641. (Cassandra in) *Troia Britanica: or, Great Britaines Troy.* Epic poem. London: **1609**. [Heywood 1974]

———. (Cassandra in) *The Iron Age.* Drama in 2 parts, partially derived from *Troia Britanica.* First performed *c.*1612–13, London. Published London: Okes, 1632. [Heywood 1874, vol. 3]

Cristóbal de Virués, 1550?–1614. *La cruel Cassandra.* Tragedy. In *Obras trágicas y líricas* (Madrid: Martin, **1609**). [DLE 1972, p. 940 / Cook 1959, pp. 110f.]

Juan de Arguijo, 1567–1623. "A Casandra" [To Cassandra]. Sonnet. [DLE 1972, p. 58]

Pier Francesco Cavalli, 1602–1676. (Cassandra's lament recalled in) *La Didone.* Opera. Libretto, Giovanni Francesco Busenello. First performed **1641**, Teatro San Cassiano, Venice. [Rosand 1976, pp. 98–102]

Guido Reni, 1575–1642. "The Rape of Cassandra." Painting, chimney decoration in the Palmieri Palace. Lost. [Pepper 1984, p. 305 no. A16]

Anonymous choreographer. *Cassandre.* Ballet. Libretto, Isaac de Bensérade. First performed **1651**, Paris. [Sharp 1972, p. 257]

François le Metel de Boisrobert, 1592–1662. *Cassandre.* Tragicomedy. First performed Oct **1653**, Paris. Published Paris: 1654. [Lancaster 1929–42, pt. 3, 2:863]

Gautier des Costes de La Calprenède, 1614–1663. *Cassandre.* Tragedy. [DLLF 1984, 2:1158]

Gottfried Finger, fl. 1685–1723? *The Virgin Prophetess; or, The Fate of Troy.* Opera. Libretto, Elkanah Settle. First performed May **1701**, Theatre Royal, Drury Lane, London. Libretto published London: 1701; reissued anonymously London: 1701; and as *Cassandra; or, The Virgin Prophetesse* (London: 1702). [Nicoll 1959–66, 2:233f., 353 / Grove 1980, 6:566 / Fiske 1973, pp. 8–10f., 24, 586]

Nicola Fago, 1677–1745, music. *Cassandra indovina* [Cassandra Prophesying]. Opera. Libretto, N. Giuvo. First performed **1711**, Teatro, Piedimonte. [Grove 1980, 6:361]

Benedetto Gennari, 1633–1715. "Cassandra." Painting. Charlecote Park, Warwickshire. [Wright 1976, p. 73]

Jean-Baptiste Stuck, 1680–1755, and **Thomas Bertin de La Doué,** *c.*1680–1745. (Cassandra in) *Ajax.* Opera-ballet. Libretto, A. Mennesson. First performed Apr **1716**, L'Opéra, Paris. [Girdlestone 1972, pp. 181f. / Grove 1980, 2:638]

William Hogarth, 1697–1764. 5 etchings, illustrations for Cotterell's translation of La Calprenède's *Cassandre* (above), 3d edition (London: John Darby et al., **1725**). [Paulson 1965, nos. 49–53—ill.]

Louis Fuzelier, 1674–1752, libretto. *L'amant brutal.* Comic opera, parody of Bertin de La Doué and Stuck's *Ajax* (1716). First performed 3 July **1726**, L'Opéra-comique, Paris. [Grove 1980, 2:638 / Girdlestone 1972, pp. 181f.]

Antoine Rivalz, 1667–1735. "Cassandra Dragged by Her Hair Out of the Temple of Pallas." Painting. Musée des Beaux-Arts, Rouen. / Oil sketch. Musée des Beaux-Arts, Dijon, cat. 1968 no. 197. [Dublin 1985, no. 38—ill.]

———. "Cassandra." Painting. Musée des Augustins, Toulouse. [Bénézit 1976, 8:782]

Jacob de Wit, 1695–1754. (Cassandra in) "The Apotheosis of Aeneas." Ceiling painting, for Herengracht 458, Amsterdam. N. J. van Aalst coll., Hoevelaken, Holland. [Staring 1958, pl. 86]

Louis Poinsinet de Sivry, 1733–1804. *Cassandre.* Parody. Paris: Cailleau, **1761**? [DLLF 1984, 3:1772]

Karl Hanke, 1750–1803. "Cassandra abbandonata." Intermezzo. First performed **before 1781**, Rosswald. [Grove 1980, 8:145]

George Romney, 1734–1802. "Lady Hamilton as Cassan-

dra." Painting. *c.*1785–86. Tate Gallery, London, no. 1668. [Tate 1975, p. 68]

Johann Christoph Friedrich Bach, 1732–**1795.** *Cassandra.* Cantata for alto and instruments. Published in *Music of the Bach Family,* edited by Karl Geiringer (Cambridge, Mass.: 1955). [Grove 1980, 1:864]

Richard Westall, 1765–1836. "Cassandra in the Temple of Minerva Prophesying the Death of Hector and the Fall of Troy." Watercolor. **1797.** Victoria and Albert Museum, London, no. 1060–1873. [Lambourne & Hamilton 1980, p. 412—ill.]

Friedrich von Schiller, 1759–1805. "Kassandra" (prophesying Achilles' and Polyxena's deaths). Ballad. **1802.** [Oellers 1983 / Butler 1958, p. 195]

Ugo Foscolo, 1778–1827. (Cassandra's prophecy of the fall of Troy evoked in) *Dei sepolcri* [On Sepulchres]. Ode, to Ippolito Pindemonte. **1806.** Brescia: 1807. / Translated by Thomas G. Bergin (Bethany, Conn.: Bethany Press, 1971). [Ipso]

Winthrop Mackworth Praed, 1802–1839. "Cassandra." Poem. **1830.** In *Poems,* vol. 1 (London: Moxon, 1864). [Bush 1937, pp. 386 n., 550]

Benjamin Robert Haydon, 1786–1846. "Cassandra Predicting the Murder of Agamemnon on His Arrival after Ten Years Absence at Mycenae." Painting. **1834.** [Olney 1952, p. 202]

———. "Cassandra Prophesying the Death of Hector." Painting. 1836. Lost. [Ibid., p. 202]

George Meredith, 1828–1909. "Cassandra." Poem. **1850–51.** In *Modern Love and Poems of the English Roadside* (London: Chapman & Hall, 1862). [Bartlett 1978, vol. 1 / Boswell 1982, pp. 181f. / Bush 1937, p. 386]

Heinrich Zirndorf, 1829–1893. *Kassandra.* Tragedy. Vienna: Keck, **1856.** [Frenzel 1962, p. 358]

William Cox Bennett, 1820–1895. "Cassandra Speaks." Poem. In *Queen Eleanor's Vengeance and Other Poems* (London: Chapman & Hall, **1857**). [Bush 1937, p. 554]

Antonio Somma, 1809–1864. *Cassandra.* Tragedy. First performed **1859,** Théâtre-Italien, Paris. [DELI 1966–70, 5:163]

Dante Gabriel Rossetti, 1828–1882. "Cassandra" (prophesying Hector's death as he departs for battle). Drawing. **1861.** British Museum, London, no. 1910–12–10–4. [Surtees 1971, no. 127—ill.]

———. "Cassandra." 2 sonnets, one to accompany above drawing. In *Poems* (London: Ellis, 1870). [Doughty 1965 / Rees 1981, p. 112 / Bush 1937, pp. 410]

Frederick Sandys, 1829–1904. "Cassandra." Painting. *c.*1864. Exhibited 1865. [Kestner 1989, p. 170]

———. "Helen and Cassandra." Drawing. 1866. [Ibid.]

———. "Cassandra." *c.*1895–96. [Ibid. / Dijkstra 1986, p. 48—ill.]

Robert Reece, 1838–1891, writing as "E. G. Lankester." *Agamemnon and Cassandra, or, The Prophet and Loss of Troy.* Burlesque. First performed 13 Apr **1868,** Prince of Wales Theatre, Liverpool. [Nicoll 1959–66, 5:537]

Friedrich Gessler, 1844–1891. *Kassandra.* Tragedy. Lahr: Moritz Schauenburg, **1877.** [DLL 1968–90, 6:296]

Adolf Jensen, 1837–**1879.** "Cassandra." Composition for piano, part of *Erotikon,* group of 7 pianoforte pieces. Published New York: Schirmer, *c.*1889. [Grove 1980, 9:601]

Solomon J. Solomon, 1860–1927. "Ajax and Cassandra" (Ajax the Lesser carrying Cassandra from the temple of Athena). Painting. **1886.** Ballarat Art Gallery, Australia. [Wood 1983, p. 208—ill. / Kestner 1989, pp. 243f.—ill.]

Aimé Millet, 1819–**1891.** "Cassandra Places Herself under the Protection of Pallas." Marble statue. Jardin des Tuileries, Paris (Musées Nationaux, inv. LUX 77). [Orsay 1986, p. 277]

Max Klinger, 1857–1920. "Cassandra." Painted marble statue (half-length). **1886–95.** Museum der Bildenden Künste, Leipzig, inv. 26. [Hildesheim 1984, no. 2—ill. / Leipzig 1970, no. 3—ill. / also Dückers 1976, pp. 129–33, 163—ill. / Rotterdam 1978, no. 2—ill.] Reduced bronze cast, after 1895. Von-der-Heydt-Museum, Wuppertal. [Hildesheim, no. 3] Variant, bust. Kunsthalle, Hamburg, no. 1980/10. [Hamburg 1985, no. 504—ill.]

William Wetmore Story, 1819–**1895.** "Cassandra." Poem. In *Poems* (Boston: Houghton Mifflin, 1896). [Boswell 1982, p. 297]

Edward Burne-Jones, 1833–**1898.** "Head of Cassandra." Watercolor. National Gallery, London. [Bénézit 1976, 2:406]

Valéry Bryúsov, 1873–1924. "Cassandra" (in Hades). Poem. **1898.** In *Tertia vigilia* [Third Vigil] (Moscow: Skorpion, 1900). [Grossman 1985, p. 202 / Bryúsov 1980, p. 182]

Gordon Bottomley, 1874–1948. "Kassandra Prophesies." Poem. In *Poems at White-Nights* (London: At the Sign of the Unicorn, **1899**). [Bush 1937, pp. 430, 566]

Herbert Eulenberg, 1876–1949. *Kassandra.* Drama. Berlin: Fleischel, **1903.** First performed 26 Apr 1905, Altes Theater, Cologne. [DLL 1968–90, 4:577 / EDS 1954–66, 4:1688]

Hans Pischinger. *Kassandra.* Tragedy. Vienna: Weiss, **1903.** [Frenzel 1962, p. 358]

José-Maria de Heredia, 1842–1905. "La vision d'Ajax" [The Vision of Ajax] (stalked by Pallas for desecrating her altar). Sonnet. **1905.** Added to 1914 edition of *Les trophées* (Paris: Ferroud). [Delaty 1984, vol. 2]

Benito Pérez Galdós, 1843–1920. *Casandra: Novela en cinco jornadas* [Cassandra: A Novel in Five Days]. Novel. **1905.** Madrid: Perlado, Paez y, *c.*1906. / Performed as a drama, 1910, Teatro Español, Madrid. [DLE 1972, p. 697]

Vittorio Gnecchi, 1876–1954. *Cassandra.* Opera. Libretto, Luigi Illica. First performed **1905,** Bologna. [Grove 1980, 7:478]

Bernard Drew, b. 1885. "Cassandra." Poem. In *Cassandra and Other Poems* (London: Nutt, **1906**). [Boswell 1982, p. 94]

Francesco Santoliquido, 1883–1971. *L'ultima visione di Cassandra* [The Last Vision of Cassandra]. Cantata for soprano, chorus, and orchestra. **1908.** [Grove 1980, 16:483]

Lesya Ukrayinka, 1871–1913. *Kassandra.* Tragedy. **1908.** Berlin: 1928. [EWL 1981–84, 4:499]

John Mavrogordato, b. 1882. *Cassandra in Troy.* Prose drama. London: Secker, **1914.** [Boswell 1982, p. 272]

Paul Ernst, 1866–1933. *Kassandra.* Tragedy in verse. **1915.** First performed 11 Apr 1931, Deutsches Nationaltheater, Weimar. Published in *Dramen,* vol. 3 (Munich: Langen/Müller, 1932–33). [McGraw-Hill 1984, 2:114 / EDS 1954–66, 4:1568]

Edwin Arlington Robinson, 1869–1935. "Cassandra." Poem. In *The Man against the Sky* (New York: Macmillan, **1916**). [DLB 1987, 54 pt. 2: 378]

Osip Mandel'shtam, 1891–1939/42. "To Cassandra" [English title of a work written in Russian]. **1917.** In *Tristia* (Peterburg: 1922). [Raffel & Burago 1973, no. 95 / Terras 1966, p. 255]

Charles Williams, 1886–1945. "Troy: Sonnets on Andromache, Helen, Hecuba, and Cassandra." Sonnet cycle. In *Poems of Conformity* (London: Oxford University Press, **1917**). [Bush 1937, p. 571]

James Havard Thomas, 1854–1921. "Cassandra." Bronze sculpture. *c.***1912–21.** Tate Gallery, London, no. 6082. [Tate 1975, p. 214] Plaster model. Tate Gallery, no. 6031. [Ibid.]

Giovanni Alfredo Cesàreo, 1860–1937. *Cassandra*. Poem. Rome: **1921.** [DELI 1966–70, 2:19]

H. D. (Hilda Doolittle), 1886–1961. "Cassandra." Poem. In *Rhythmus* June/July **1923**; revised in *Heliodora and Other Poems* (London: Cape; Boston: Houghton Mifflin, 1924). [Martz 1983 / DLB 1986, 45:130 / Peck 1975, p. 70]

Yvonne Georgi, 1903–1975, choreography. *Kassandra*. Modern dance. First performed **1928,** Hannover? [Cohen-Stratyner 1982, p. 361]

Louise Bogan, 1897–1970. "Cassandra." Poem. In *Dark Summer* (New York: Scribner, **1929**). [Frank 1985, p. 113 / Boswell 1982, p. 47]

Horace Gregory, 1898–1982. "New York, Cassandra." Poem. In *No Retreat* (New York: Harcourt, Brace, **1933**). [Boswell 1982, p. 126]

Witter Bynner, 1881–1968. (Cassandra prophesying on the Titanic in) "Captain's Table." Poem. In *Guest Book* (New York: Knopf, **1935**). [Boswell 1982, p. 61]

Hans Hofmann, 1880–1966. "Cassandra." Painting. **1936.** Hofer coll., Berlin. [Rigby 1976, p. 291]

Hans Schwarz, 1890–1967. *Kassandra*. Tragedy. **1941.** [Frenzel 1962, p. 358 / Kürschner 1963, p. 600]

Gerhard Marcks, 1889–1981. "Cassandra." Terra-cotta sculpture. **1947.** 7 examples. Gerhard-Marcks-Stiftung, Bremen, inv. 66/71; Hetjensmuseum-Museum, Düsseldorf, inv. 1951/99; private coll.; 4 on art market in 1977. [Busch & Rudloff 1977, no. 505—ill.] Variant. 1947. 5 examples. Gerhard-Marcks-Stiftung, Bremen, inv. 72/71; façade, Katharinekirche, Lübeck; Behnhaus, Lübeck (mask); others on art market in 1977. [Ibid., no. 512—ill.]

Robinson Jeffers, 1887–1962. "Cassandra." Poem. In *The Double Axe and Other Poems* (New York: Random House, **1948**). [Boswell 1982, p. 145]

César Klein, 1876–1954. "Cassandra." Painting. **1948.** [Hannover 1950, no. 44]

Hans Erich Nossack, 1901–1978. "Kassandra." Story. In *Dorothea: Berichte* (Hamburg: Krüger, **1948**). [DLL 1968–90, 11:448]

Siegfried Borris, 1906–. *Cassandra*. Opera. **1949.** Unperformed. [EDS 1954–66, 2:859]

Pauline Koner, 1912–, choreography. *Cassandra*. Solo ballet. First performed **1953,** New York. [Clarke & Vaughan 1977, p. 199]

Zoë Karélli, 1901–1973. "Kassandra." Poem. In *Kassandra xai alla poimata* [Cassandra and Other Poems] (Athens: **1955**). [Friar 1973, p. 710]

Marianne Moore, 1887–1972. "Cassandra." Poem. In *Complete Poems* (New York: Viking, **1959**). [Boswell 1982, p. 187]

Eva-Liisa Manner, 1921–. "Kassandra." Poem. In *Orfiset laulut* [Orphic Songs] (Helsinki: Tammi, **1960**). [Ahokas 1973, p. 61]

Karel Kupka, 1927–, music. *Cassandra*. Ballet. Choreography, R. Rücker. **1961.** [Grove 1980, 10:313]

Richard Wilbur, 1921–. (Cassandra evoked in) "Advice to a Prophet." Poem. In *Advice to a Prophet and Other Poems* (New York: Harcourt Brace & World, **1961**). [Ipso]

Johann Gunert, 1903–. *Kassandra lacht* [Cassandra Laughs]. Collection of poetry. Graz: Stiasny Verlag, **1962.** [DLL 1968–90, 6:1059]

Nicos Mamangakis, 1929–. "Monologue of Cassandra." Vocal composition. Text, Aeschylus. **1963.** [Grove 1980, 11:592]

Wolfgang Bauer, 1941–. *Cassandra*. Drama ("microdrama"). In *Manuskripte* 10 (**1964**). [McGraw-Hill 1984, 1:276]

Monic Cecconi-Botella, 1936–. *Les visions prophétiques de Cassandre*. Cantata. Libretto, Aeschylus. **1965.** [Cohen 1987, 1:141]

Georg Johannessen, 1931–. *Kassandra*. Comedy. Oslo: Gyldendal, **1967.** [McGraw-Hill 1984, 3:555]

Theodore Antoniou, 1935–. *Cassandra*. "Sound action" for television with mixed media, for dancers, actors, chorus, orchestra and tapes, lights, and projections. Taped **1969.** First performed 14 Nov 1970, Barcelona. [Baker 1984, p. 64 / Grove 1980, 1:494]

Joan Franks-Williams, 1930–. *Cassandra Monodrama*. Instrumental composition. **1969.** [Grove 1980, 6:803]

Yannis Ritsos, 1909–1990. (Cassandra in) "Hē pragmatike aitia" [The Real Reason]. Poem. 7 June **1969.** In *Epanalepseis* (Athens: Kedros, 1972). / Translated by Edmund Keeley in *Yannis Ritsos, Exile and Return: Selected Poems 1967–1974* (New York: Ecco, 1985). [Ipso / Myrsiades 1978, p. 452]

Brian Ferneyhough, 1943–. *Cassandra's Dream Song*. Composition for flute. **1971.** London. [Grove 1980, 6:475]

Jules Olitski, 1922–. "Chinese Cassandra." Abstract steel sculpture. **1972.** Artist's coll. [Moffett 1981, pl. 166]

Robert Lowell, 1917–1977. "Cassandra." 2 poems. In *History* (London: Faber & Faber; New York: Farrar, Straus & Giroux, **1973**). [Ipso]

Ursule Molinaro. *The Autobiography of Cassandra, Princess and Prophetess of Troy*. Novel. Danbury, Conn.: Archer, **1979.** [Ipso]

Elisabeth Meyer-Runge, 1929–. *Wenn Kassandra wiederkehrte* [When Cassandra Returned]. Collection of poetry. **1981.** [Ipso] [Location?]

Christa Wolf, 1929–. *Kassandra*. Novel, with 4 essays. Darmstadt & Neuwied: Luchterhand, **1983.** / Translated by Jan van Heurck as *Cassandra* (New York: Farrar, Straus & Giroux, 1984). [Oxford 1986, pp. 481, 998]

Eleanor Heller, 1918–. "Cassandra's Crucible." Painting. By **1985.** National Museum of Women in the Arts, Washington, D.C. [Washington 1987, p. 248]

CASTOR. *See* DIOSCURI.

CAUNUS. *See* BYBLIS AND CAUNUS.

CECROPS. *See* ATHENA, Contest with Poseidon; ERICHTHONIUS.

CENTAURS. Descendants of Ixion and Nephele (the *eidolon* of Hera as a cloud), centaurs were half human (head, torso, arms) and half horse (body, legs). Living in wild nature in woods and mountains, this race was bestial in behavior but capable of thought.

Two centaurs were famous for their wisdom and humanity. Chiron was the teacher of many heroes, including Heracles (Hercules), Achilles, and Jason. Pholus, son of Silenus and a hamadryad, was the unwitting author of an unfortunate incident with Heracles. When the hero visited Pholus's cave he was welcomed with food and wine. The other centaurs became drunk and involved Heracles in a fight, during which Chiron was accidentally wounded. In another episode from the legend of Heracles, the centaur Nessus tried to rape Heracles' wife, Deianeira, and was killed by the hero. At the wedding of the Lapith king Pirithous, centaurs instigated another drunken brawl when one of their number, Eurytion, molested the bride, Hippodamia.

In postclassical art, centaurs are often seen abducting or playing with nymphs and participating in Bacchanalia, as well as in peaceful family scenes. They are also sometimes depicted as sea creatures.

Classical Sources. Homer, *Iliad* 1.262–68; *Odyssey* 21.295ff. Hesiod, *Shield of Achilles* 178ff. Pindar, *Pythian Odes* 2.42–48. Theocritus, *Idylls* 7.149ff. Ovid, *Metamorphoses* 9.123, 12.210–536. Apollodorus, *Biblioteca* 1.2.3, 2.5.4ff., 3.13.3, 3.4.4, 3.10.3, E1.20–22. Pausanias, *Description of Greece* 5.5.10, 5.19.9. Hyginus, *Fabulae* 33, 34, 62. Philostratus, *Imagines* 2.3.

See also BACCHANALIA; CHIRON; HERACLES, General List, and Deianeira; PIRITHOUS, Wedding.

Dante Alighieri, 1265–1321. (The centaurs Chiron, Nessus, and Pholus guard the Murderers in) *Inferno* 12.52–139; (Cacus, as a centaur, among the Thieves in) *Inferno* 25.17–33; (centaurs among the Gluttons in) *Purgatorio* 24.121f. *c.*1307–*c.*1314? In *The Divine Comedy.* Poem. Foligno: Neumeister & Angelini, 1472. [Singleton 1970–75, vols. 1–2 / Toynbee 1968, p. 165 / Barkan 1986, pp. 150, 154]

Jacopo della Quercia, 1374–**1438,** attributed. "Centaur." Bas-relief. Baptismal font, Chapel of San Giovanni, Cathedral, Siena. [Warburg]

Paduan School. "Battling Centaurs." Drawing. *c.*1465. British Museum, London, inv. 1420–2–14–1. [Warburg]

Francesco Squarcione, 1397–**1468,** school. "Satyrs and Centaurs." Drawing. Bayerische Staatsgemäldesammlungen, Munich. [Warburg]

Sandro Botticelli, 1445–1510. "Pallas [?] and the Centaur" (allegory of victory of reason over sensuality?). Painting. *c.*1482–83. Uffizi, Florence. [Lightbown 1978, 1:82ff., no. B43—ill. / Uffizi 1979, no. P257—ill. / Berenson 1963, p. 34—ill.]

———. (Nessus, Chiron, and Pholos in) Drawings illustrating *Inferno* 12 and 13, part of series of illustrations to Dante's *Divine Comedy.* 1480s/early 1490s. Biblioteca Vaticana, Rome. [Lightbown, 1:147ff., 2:172f., nos. E26–27—ill.]

———. (Centaurs depicted in reliefs in setting of) "The Calumny of Apelles." Painting. c.1494–95. Uffizi, Florence, no. 1496. [Ibid., no. B79—ill. / also Uffizi 1979, no. P269]

Michelangelo, 1475–1564. "Battle of the Centaurs" (subject disputed; battle of Hercules and centaurs, with rape of Deianeira? battle of centaurs and lapiths?). Marble relief. *c.*1492. Casa Buonarroti, Florence. [Baldini 1982, no. 4—ill. / Goldscheider 1964, p. 9—ill. / Pope-Hennessy 1985, 3:302—ill.] 2 chalk copies by Peter Paul Rubens, 1600–08. [White 1987, pls. 18, 19]

Albrecht Dürer, 1471–1528. "Sea Centaurs Embracing." Drawing. **1494.** Louvre, Paris, no. 4299. [Strauss 1974, no. 1494/14—ill.]

———. "Centauress Feeding Her Young," "Centaur Family." Drawings. *c.*1505. Kuntsammlungen Veste Coburg, Coburg; T. Christ coll., Basel. [Strauss 1974, nos. 1505/16–17—ill. / Strauss 1977b, pp. 300f.—ill.]

Paduan School. "A Naiad" (with a sea-centaur). Painting. **15th century.** Muzeum Narodowe, Warsaw, inv. 186509. [Warsaw 1969, no. 1621—ill.]

Filippino Lippi, *c.*1457–1504. "The Wounded Centaur." Painting. *c.*1500 or earlier. Christ Church, Oxford. [Byam Shaw 1967, no. 41—ill.]

Baldassare Peruzzi, 1481–1536. "Apollo and the Centaur." Ceiling fresco, representing the Sun in the constellation Sagittarius. **1510–11.** Sala di Galatea, Villa Farnesina, Rome. [d'Ancona 1955, pp. 2sf., 87—ill. / Gerlini 1949, pp. 10ff.—ill. / also Frommel 1967–68, no. 18c]

Hans Baldung Grien, 1484/85–1545. "The Centaur." Drawing. **1515.** Kupferstichkabinett, Basel. [Warburg]

Jacopo de' Barbari, *c.*1440/50–**1516.** "A Centaur Pursued by Dragons." Engraving. (British Museum, London—only known impression.) [Borenius 1923, no. 23—ill. / Servolini 1944, no. 26—ill.]

Albrecht Altdorfer, *c.*1480–1538. "A Centaur." Engraving (Bartsch no. 37). *c.*1515–25. [Winzinger 1963, no. 154—ill.]

Hans Vischer the Elder, 1489–1550. "Centaur Battle." Bronze escutcheon. **1540.** Rathaus door, Nuremberg. [Clapp 1970, 1:893]

Andrea Schiavone, *c.*1522–1563, attributed (also attributed to Lambert Sustris). "Centaur Carrying Off a Nymph" ("Nessus and Deianeira"). Painting. *c.*1540–45? Rijksmuseum, Amsterdam, inv. A3374 (as Schiavone, "Nessus and Deianeira"). [Rijksmuseum 1976, p. 504—ill. / Richardson 1980, no. D339—ill.]

Giovanni Bernardi, 1496–1553, **Manno di Bastiano,** design. (Battle of centaurs depicted on) "The Farnese Coffer." Silver gilt coffer. **1548–61.** Museo di Capodimonte, Naples, no. 10507. [Capodimonte 1964, p 129]

Florentine School. "Centaur." Bronze statuette. **16th century.** Victoria and Albert Museum, London, inv. A.6866—1860. [Warburg]

Peter Paul Rubens, 1577–1640. 2 drawings, copies of Michelangelo's "Battle of the Centaurs" (*c*.1492, Florence). **1600–08.** Museum Boymans-van Beuningen, Rotterdam; Fondation Custodia, Paris. [White 1987, pls. 18, 19]

————. "The Loves of the Centaurs." Painting. Lost. / Drawings, several studies on 1 sheet. Count Anton Seilern coll., London. [Burchard & d'Hulst 1963, no. 197—ill.] 2 variant copy paintings, in A. Einstein coll., London, and Gulbenkian Foundation, Lisbon. [Ibid.]

Anonymous Italian. *La centaura.* Spectacle play. **1622.** [Oxford 1983b, p. 27]

Adriaen de Vries, *c*.1550–1626. "Battle with Centaur." Garden sculpture. **1624–26.** Wallenstein (Waldstein) Palace, Prague. [Clapp 1970, 1:898]

Nicolas Poussin, 1594–1665. "Centaurs." 5 drawings on 1 sheet. **Early 1630s?** Royal Library, Windsor Castle, no. 11915 verso. [Friedlaender & Blunt 1953, no. 239—ill.]

————. "A Centaur Carrying Off a Nymph." Drawing. Late 1630s. Musée Bonnat, Bayonne, no. 1669. [Ibid., no. 240—ill.]

Jusepe de Ribera, *c*.1590/91–**1652,** formerly attributed. "Battle between a Centaur and a Triton." Print (Bartsch no. 11). [Brown 1973, no. P.19—ill.]

Charles Le Brun, 1619–1690. "Centaur with a Bow." Painting, decoration for Pavillon de l'Aurore, Sceaux. *c*.1670. / Drawing. Louvre, Paris, no. 27.722. [Versailles 1963, no. 141—ill.]

Antonio Draghi, 1634/35–1700. *Il trionfatore de' centauri* [The Triumph of the Centaurs]. Opera. Libretto, N. Minato. First performed 13 Aug **1674.** [Grove 1980, 5:604]

Luca Giordano, 1634–1705. "Centaur and Nymph." Drawing. *c*.**1682–85.** Museo di Capodimonte, Naples, no. 60. [Ferrari & Scavizzi 1966, 2:262]

————. "School of the Centaur." Painting. Recorded in 1801, untraced. [Ibid., 2:361]

Antoine Coysevox, 1640–1720. "Two Centaurs." Sculpture. **1709.** Château de Plessis-Pâté, Monthléry. [Bénézit 1976, 3:250]

Sebastiano Ricci, 1659–1734. "A Centaur Family." Painting. **Early 1720s.** Palazzo Taverna, Rome. [Daniels 1976, no. 387—ill.] Variant (by studio?). Private coll., Italy. [Ibid., no. 123a]

————. "Centaurs." Painting. Formerly Accademia Carrara, Bergamo. [Ibid., no. 35a]

Antonio Guardi, 1698–**1760.** "The Family of Centaurs." Drawing. Fogg Art Museum, Harvard University, Cambridge, inv. 1949.96. [Morassi 1984, no. D38—ill.]

Louis de Silvestre the Younger, 1675–**1760.** "Family of Centaurs." Painting. Muzeum Narodowe, Warsaw, inv. 128023, on deposit at Palace of the Board of Ministers. [Warsaw 1969, no. 1198—ill.]

————, studio. "Fighting Centaurs." Painting. Muzeum Narodowe, Warsaw, inv. Wil. 1561 (formerly 444), on display at Wilanów Palace. [Ibid., no. 1213—ill.]

Giovanni Domenico Tiepolo, 1727–1804. Pair of overdoor frescoes ("Centaurs and Satyresses") and 8 fresco tondi ("Centaur and Nymph," "Centaur and Satyrs" (6), "A Centaur Battling the Hydra"). *c*.**1771?** Camerino dei Centauri, Ca' Rezzonico, Venice. [Mariuz 1979, p. 141—ill.]

John Flaxman, 1755–1826. "As Dante and Virgil Watch, Three Centaurs Separate Themselves from the Group, Armed with Bows and Javelins," "Cacus, in the Form of a Centaur, Bitten by Serpents." Drawings, illustrating Dante's *Inferno* 12.59–60, 25.17–24, part of series of illustrations for *The Divine Comedy*. *c*.1792. Houghton Library, Harvard University, Cambridge. / Engraved by Tomasso Piroli, published privately, Rome: 1793; London: Longman & Co., 1807. [Irwin 1979, pp. 94, 226 *n*. / Flaxman 1872, 4: pls. 13, 27]

Franz Anton Maulbertsch, 1724–1796. Centaurs, with bacchantes and fauns, representing primitive instincts, in "Allegory of the Sciences." Ceiling painting. **1794.** Strahov Foundation, Prague. [Garas 1960, no. 383, p. 155—ill.] Oil sketches, Národní Galeri, Prague; Stoner coll., London. [Ibid., nos. 381–82—ill.]

Henry Fuseli, 1741–1825. "Leaping Centaur." Drawing (illustration to Dante's *Inferno* 12?). *c*.**1790–1800.** Kunsthaus, Zürich, inv. 1940/127. [Schiff 1973, no. 1003]

Théodore Géricault, 1791–1824. Drawings of a centaur carrying off a woman (Nessus and Deianeira?). **1816–17.** Louvre, Paris (single drawings, no. 26737–8; sheet of sketches, no. R.F.5176); private coll., London. [Eitner 1983, figs. 88–90, 335 *n*., pp. 35f.]

Jean-Antoine Houdon, 1741–1828. "A Centaur." Marble sculpture, after an antique statue. Exhibited **1818.** Lost. [Reau 1964, no. 1]

Thomas Hood, 1799–1845. "Lycus, the Centaur." Narrative poem. In *London Magazine* 6 (**1822**). [Bush 1937, pp. 190, 548f.]

William Blake, 1757–1827. "The Centaurs and the River of Blood," "The Centaur Cacus." Watercolors, illustrating *Inferno* 12.46–57, 73–75, 15.16–34, part of a series of illustrations for Dante's *Divine Comedy*. **1824–27.** Fogg Art Museum, Harvard University, Cambridge; British Museum, London. [Butlin 1981, nos. 812.23, 812.50]

Honoré Daumier, 1808–1879. "The Centaur Grammont." Satirical lithograph, in "Parliamentary Idylls" series. **1850–51.** [Delteil 1906–30, 25: no. 2066—ill.]

————. "A Man on a Centaur, Drawing a Bow." Drawing. Marcy coll., Beverly Hills, Calif. [Maison 1968, no. 746—ill.]

————. "Centaur Carrying Off a Woman." Drawing. National Gallery of Art, Washington, D.C. [Ibid., no. 747—ill.]

————. "Love of the Centaurs." Watercolor. Pierre Dubant coll., Paris. [Ibid., no. 748—ill.]

————. "Centaur Carrying Off a Woman." Drawing. Claude Roger-Marx coll., Paris. [Ibid., no. 750—ill.]

Arnold Böcklin, 1827–1901. "Forest's Edge with Centaur and Nymph." Painting. **1855.** Staatliche Museen, Berlin, inv. AI 781. [Andree 1977, no. 97—ill.]

————. (Sea centaurs in) "Magna Mater" (sea triumph of Cybele). Mural. **1869.** Museum an der Augustinergasse, Basel. [Ibid., no. 218—ill.]

————. "Battle of the Centaurs." Unfinished painting. 1872. Private coll. [Ibid., no. 265—ill.] Oil sketches. Kunstmuseum, Bern; Georg Schäfer coll., Schweinfurt. [Ibid., nos. 263, 264—ill.]

————. "Battle of the Centaurs." Painting. 1872–73. Kunstmuseum, Basel, inv. 107. [Ibid., no. 266—ill. / also Fiesole 1980, no. 12—ill.]

————. "Battle of the Centaurs." Painting. 1878. Lost. [Andree, no. 322—ill.]

———. "Centaur by the Water" ("Centaur Watching Fish"). Painting. 1878. Kunsthaus, Zurich, inv. 1966/68. [Ibid., no. 323—ill. / Fiesole, no. 14—ill.]

———. "Centaur Couple Leaping over an Abyss." Painting. 1882. Lost. [Ibid., no. 368—ill.]

———. "Playing in the Waves" (nymphs and centaurs). Painting. 1883. Neue Pinakothek, Munich, inv. 7754. [Ibid., no. 375—ill. / Munich 1982, p. 34—ill.]

———. "In the Sea" (sea nymph with a centaur harpist). Painting. 1883? Albert Vorster-Burckhardt coll., Basel. [Andree, no. 376—ill.]

———. (Centaur in) "The Elysian Fields." Painting. 1877–88. Lost. [Ibid., no. 320—ill.] Oil sketch, 1877. Stiftung Oskar Reinhart, Winterthur. [Ibid., no. 319—ill.]

———. "Centaur at the Blacksmith's." Painting. 1888. Szépművészeti Múzeum, Budapest. [Ibid., no. 408—ill.]

Charles Gleyre, 1806–1874. "The Centaurs." Drawing. c.1858. Musée Cantonal des Beaux-Arts, Lausanne, inv. D1044. [Winterthur 1974, no. 53—ill.]

John La Farge, 1835–1910. "Centaur." Painting. 1864. Private coll., Washington, D.C. [Adams et al. 1987, fig. 60]

———. "The Centauress." Painting. 1887. Brooklyn Museum, N.Y. [Adams et al., fig. 75]

Louis-Fréderic Schützenberger, 1825–1903. "Centaurs Hunting a Boar." Painting. 1864. Musée d'Orsay, Paris, no. R.F. 1980–164. [Louvre 1979–86, 4:208—ill.]

Hans Makart, 1840–1884. "Centaurs in the Wood." Painting. c.1865–67. Unlocated. [Frodl 1974, no. 76—ill.]

———. "Battle between Nymphs and Centaurs in a Wood." Painting. [Ibid., no. 494]

Eugène Fromentin, 1820–1876. "Centaurs and Centauresses Practicing Archery." Painting. 1868. Petit Palais, Paris. [Hobbs 1977, fig. 3]

William Rimmer, 1816–1879. "The Dying Centaur." Bronze statuette. Modeled c.1871. Metropolitan Museum, New York, no. 06.146. [Metropolitan 1965, pp. 14f.—ill. / Whitney 1946, no. 5—ill.] Plaster original. Museum of Fine Arts, Boston. [Metropolitan / Janson 1985, fig. 191] Plaster replica. Avery Library, Columbia University, New York. [Metropolitan]

Odilon Redon, 1840–1916. "Centaur with Cello." Drawing. c.1875. J. Dubourg coll., Paris. [Berger 1964, no. 571]

———. "Centaur." Drawing. Early 1880s? N. Nakagawa coll., Tokyo. [Ibid., no. 737a]

———. "Centaurs with Dragons." Drawing. Before 1883. Roger-Marx coll., Paris. [Ibid., no. 606]

———. "There were battles and vain victories" (centauress about to spear a dragon). Lithograph, no. VI in *Origins* album (Paris: 1883). [Mellerio 1913, no. 50—ill.]

———. "Centaur Aiming [his bow] at the Clouds." Lithograph, designed for *Origins* (see above), unused. [Ibid., no. 53—ill.] Variant. 1895. [Ibid., no. 133—ill.]

———. "Battle of the Centaurs." Drawing. 1880–89. A. Redon coll., Paris. [Berger, no. 738]

———. "Centaur." Pastel. c.1895 (or 1910). Museum of Fine Arts, Boston, no. 64.2206 (ex-Bacou coll.). [Ibid., no. 344 / Boston 1985, p. 237—ill.]

———. "Battle of the Centaurs." Painting. c.1905. Jacques Dubourg coll., Paris. [Berger, no. 137]

———. "Centaur and Dragon." Painting. c.1908. Rijksmuseum Kröller-Müller, Otterlo. [Ibid., no. 138]

Austin Dobson, 1840–1921. "Eros Riding a Centaur." Poem, part of "A Case of Cameos." In *Proverbs in Porcelain and Other Verses* (London: King, **1877**); reprinted in *Complete Poetical Works* (London: Oxford University Press, 1923). [Boswell 1982, p. 88]

Friedrich Preller, 1804–**1878.** "Landscape with Nymphs and Centaurs." Painting. Gemäldegalerie, Dresden. [Bénézit 1976, 8:479]

Auguste Rodin, 1840–1917. "Night" (centaur family). Porcelain vase. **1880.** Musée Rodin, Paris, inv. Co.203. [Rodin 1982, no. 14—ill.]

———. "The Centauress." Marble sculpture. Before 1888. Musée Rodin, Paris. [Tancock 1976, fig. 20.5 / Rodin 1944, no. 239—ill.] Plaster. Musée Rodin, Paris, inv. S.65. [Rodin 1982, no. 5—ill.] Bronzes: Rodin Museum, Philadelphia; Los Angeles County Museum of Art, Stanford University Art Gallery and Museum, Calif.; private colls. [Tancock, no. 20—ill. / also Elsen 1981, fig. 6.52] Variant, bronze torso. Dickson coll., Beverly Hills, Calif. [Tancock, p. 204]

———. Numerous drawings depicting centaurs. Musée Rodin; elsewhere. [Rodin 1982, passim—ill. / also Elsen, no. 252, fig. 7.39]

———. "Centaur." Watercolor. Rodin Museum, Philadelphia. [Tancock, fig. 20.2]

Max Klinger, 1857–1920. "Centaur Pursued," "Battling Centaurs," (centaurs in) "Moonlit Night," "Avalanche." Etchings, nos. 3–6 in "Intermezzos" cycle, opus 4. **1879–81.** [Hildesheim 1984, nos. 121–24—ill. / also Rotterdam 1978, nos. 69.1–2—ill.]

———. "The Centaur with the Washerwomen." Drawing. 1881. Kupferstichkabinett, Berlin, cat. 35. [Leipzig 1970, no. 87—ill.]

———. "Sea-frieze" (2 sea-centaurs and a nymph). Painting. 1912. Galerie Brockstedt, Hamburg. [Hildesheim, no. 33—ill.]

Elihu Vedder, 1836–1923. "A Young Centaur in a Landscape." Painting. **1883,** repainted 1911. Wadsworth Atheneum, Hartford, Conn. [Soria 1970, p. 418] Variant (or study?). c.1883 or earlier? H. Love coll. [Ibid., no. 419]

Hans Thoma, 1839–1924. "Scene of Centaurs." Painting. **1887?** Hirth coll., Munich. [Thode 1909, p. 265—ill.]

José-Maria de Heredia, 1842–1905. "Hercule et les centaures." Cycle of 6 sonnets: "Némée," "Stymphale," "Nessus," "La centauresse," "Centaures et lapithes," "Fuite des centaures." In *Revue des deux mondes* 15 Jan **1888;** collected in *Les trophées* (Paris: Lemerre, 1893). [Delaty 1984, vol. 1; cf. 2:42, 51 / Hill 1962]

Gustave Moreau, 1826–1898. "Dead Poet Borne by a Centaur." Watercolor. *c.*1890. Narodni Muzej, Belgrade (as "The Weary Centaur"). [Mathieu 1976, no. 362—ill.] Related painting. Lost. [Ibid., no. 363] Watercolor sketch. Musée Gustave Moreau, Paris, no. 481. [Ibid.]

———. "Centaurs Carrying Off a Dead Poet." Watercolor. *c.*1890. Musée Gustave Moreau, Paris. [Mathieu 1985, pl. 30]

———. "Battle of the Centaurs." Watercolor. Musée Gustave Moreau, Paris. [Mathieu 1985, pl. 44]

Franz von Stuck, 1863–1928. "(Dead) Orpheus" (head, discovered by a centaur). Painting. *c.*1891. Neef coll., Cologne. [Voss 1973, no. 44—ill. / Kosinski 1989, p. 198, fig. 6.22]

———. "Battle of Centaurs" (over a centauress). Painting.

1894. Städelsches Kunstinstitut, Frankfurt. [Voss, no. 100—ill.]

————. "Jesting Centaur (and Nymph)." Painting. c.1895. 3 versions. Private coll., Paris; formerly Staatliche Kunstsammlungen, Dresden, lost; another unlocated. [Ibid., nos. 108–10—ill. / also Dijkstra 1986, pp. 280f.—ill.]

————. "Wounded Centaur." Bronze sculpture. c.1895–1900. Neue Pinakothek, Munich, inv. B.25. [Munich 1982, p. 332—ill. / cf. Hermitage 1975, pl. 87]

————. "Going for a Ride" (3 nymphs on a centaur's back). Painting. 1903. Schäfer coll., Schweinfurt. [Voss, no. 250—ill.]

————. "Amazon and Centaur" (fighting). Painting, study for figures in Wittelsbach Fountains of Adolf von Hildebrand, Munich. 1912. Unlocated. [Ibid., no. 404—ill.]

————. "Nymph-abduction" (centaur abducting a nymph, with Cupid). Painting. c.1920. 3 versions. Unlocated. [Ibid., nos. 518–20—ill.] 2 variants. c.1925, c.1927. Städische Kunstsammlung, Nuremburg; the other unlocated. [Ibid., nos. 574, 602—ill.]

————. "Meeting" (centaur and minotaur). Painting. 1921. Bayerische Staatsgemäldesammlungen, Munich. [Ibid., no. 540—ill.]

————. Numerous other works depicting centaurs, in private colls. or unlocated. [Ibid., nos. 26–28, 36, 45–47, 62, 94–95, 108–10, 213, 248, 251, 300, 375, 404, 516, p. 314 no. 10—ill.]

Rubén Darío, 1867–1916. "Coloquio de los centauros" [Colloquy of Centaurs]. Poem. In *Prosas profanas y otros poemas* (Buenos Aires: Coni, **1896**). [Méndez Plancarte 1967 / Hurtado Chamorro 1967, pp. 195–201]

T. Sturge Moore, 1870–1944. "Pallas and the Centaur." Poem, after Botticelli's painting (c.1482–83, Uffizi). In *Pageant* 1 (**1896**). [Gwynn 1951, p. 123]

————. *The Centaur's Booty* (Pholus and Medon, the last centaurs, embodiments of wisdom and piety). Poem. London: Duckworth, 1903. [Ibid., pp. 31, 123 / DLB 1983, 19:333, 345 / Bush 1937, p. 566]

Aimé-Jules Dalou, 1838–1902. "Centaur Carrying Off a Nymph." Terra-cotta statuette, study for unexecuted (?) marble. c.**1898**. Private coll., Paris, in 1935. [Caillaux 1935, p. 155] Terra-cotta sketch. Petit Palais, Paris, no. 212. [Ibid. / Hunisak 1977, fig. 73] Patinated plaster model. Petit Palais, no. 211. [Caillaux, p. 155] Bronze cast (unique). Musée d'Orsay, Paris, inv. R.F. 2820. [Orsay 1986, p. 112—ill.]

————. "Centaur Stoning a Man." Bronze statuette. Edition of 10. Petit Palais, Paris; elsewhere. [Caillaux, p. 155] Terra-cotta original and terra-cotta study ("Torso of Centaur"). Petit Palais, nos. 207, 208. [Ibid.] / Bronze casts of study, edition of 10. [Ibid.]

Guillermo Valencia, 1873–1943. "San Antonio y el centaur" [Saint Anthony and the Centaur]. Poem. In *Ritos* (Bogotá: Papeleria de Samper Matiz, **1899**). [LAW 1989, 2:479f.]

Andrei Bely, 1880–1934. (Centaur[s?] in) *Severnaya simfoniya* [Northern Symphony]. Poem. Moscow: Skorpion, **1900**. [Mochulsky 1977, p. 29]

————. 4 poems on centaurs in *Zoloto v lazuri* [Gold in Azure] (Moscow: Skorpion, 1904). [Ibid.]

Gabriele D'Annunzio, 1863–1938. "Il cervo" [The Deer]

(killed by a centaur). Poem. **1902.** In *Alcyone* (Milan: Treves, 1904). [Roncoroni 1982 / Bàrberi Squarotti 1982, p. 154 / Mutterle 1982, p. 142]

Gustav Vigeland, 1869–1943. "Centaur Carrying Three Children." Plaster relief, design for the artist's Fountain project, unused. **1904.** Vigeland-Museet, Oslo, no. 196. [Oslo 1952, no. 307]

Ernst Barlach, 1870–1938. "Two Centaurs" (standing in their droppings, surrounded by flies, inscribed, "Nothing is better for rheumatism than your own warm dung"). Satirical drawing. **1906.** Ernst Barlach Haus, Hamburg, inv. 1937/43. [Schult 1958–72, 3: no. 298—ill.]

Georg Kaiser, 1878–1945. *Der Zentaur.* Comedy. **1906**; revised 1916. Berlin: Fischer, 1916. Retitled *Konstantin Strobel,* performed 23 Oct 1917, Schauspielhaus, Frankfurt-am-Main. [McGraw-Hill 1984, 3:122 / DLL 1968–90, 8:835]

Lidiya Zinovyeva-Annibal, 1866–**1907**. "Tsarevna Kentavr" [The Tsarevna Centaur]. Short story. In *Tragichesky zverinets* [*The Tragic Menagerie*] ([Moscow:] 1907). [Pachmuss 1978, p. 199]

Giorgio de Chirico, 1888–1978. "Battle of the Centaurs." Painting. **1908–09.** Private coll. [Fiesole 1980, pp. 180f.—ill.]

————. "Dying Centaur." Painting. 1909. Formerly Galleria Annunciata, Milan. [de Chirico 1971–83, 3.1: no. 162—ill.]

————. "Demoniacal Personages" (stick-horses with human heads). Drawing. 1929. Ugo Mulas coll., Milan. [Ibid., 1.1: no. 81—ill.] Watercolor variant ("Demoniacal Antiquity"). 1963. Formerly Gallerie Ile de France, Paris. [Ibid., 4.3: no. 562—ill.] (Similar figures in) "Mediterranean Composition." Painting. 1964. Schreiber coll., Turin. [Ibid., no. 564—ill.]

————. "Centaur with a Cupid." Watercolor. 1960. Barbarosa coll., Rome. [Ibid., 1.3: no. 86—ill.]

————. "Cupid and the Minotaur" [*sic*] (Cupid riding on the back of a centaur). Painting. 1961. M. M. coll., Trani. [Ibid., 3.3: no. 397—ill.]

Paul Manship, 1885–1966. "Centaur and Mermaid." Plaster sculpture (sketch). **1909.** Minnesota Museum of Art, St. Paul, no. 66.14.77. [Minnesota 1972, no. 2—ill. / also Murtha 1957, no. 9]

————. "Wood Nymph's Dance" (with a centaur). Plaster high-relief. 1909–10. Destroyed. [Murtha, no. 14 / Minnesota 1985, p. 64—ill.]

————. "Centaur and Dryad" (centaur seizes struggling dryad; satyrs and maenads in low-relief on pedestal). Bronze statuette. 1913. 5 casts. Fogg Art Museum, Harvard University, Cambridge; Detroit Institute of Arts; Metropolitan Museum, New York; Smith College Museum of Art, Northampton, Mass.; City Art Museum, St. Louis. [Ibid., no. 28—ill. / also Minnesota 1985, no. 42—ill. / Metropolitan 1965, pp. 150f.—ill. / Rand 1989, pp. 29ff.—ill.]

————. "Male Centaur and Female Satyr," "Female Satyr Riding on a Centaur," "Male Centaur Holding a Baby Satyr." Drawings, designs for engravings on crystal vase. 1938–39. Minnesota Museum of Art, St. Paul, nos. 66.14.140a-c. [Minnesota 1985, nos. 91–93—ill.] Vase executed by Steuben Glass, 1939. Art Institute of Chicago, no. 1964.248; elsewhere. [Ibid., no. 94—ill.]

T. S. Eliot, 1888–1965. (Centaur symbolizes crossing of human and animal in) "Mr. Apollinax." Poem. **1910–11.** In *Prufrock and Other Observations* (London: Egoist, 1917). [Eliot 1964 / Feder 1971, p. 126]

Algernon Blackwood, 1869–1951. *The Centaur.* Novel. London: Macmillan, **1911.** [Robinson 1982, pp. 294f. / Merivale 1969, pp. 192f.]

Émile Antoine Bourdelle, 1861–1929. "Winged Centaur Carrying a Lyre." Plaster sculpture, study for the relief "Apollo and the Muses" (Théâtre des Champs-Elysées, Paris), unused. **1911.** Musée Bourdelle, Paris. [Jianou & Dufet 1975, no. 447]

————. "Centaur." 1911. Bronze sculpture. [Clapp 1970, 1:104]

————. "The Death of the Last Centaur." Fresco. 1912–13. Grand Galerie, Théâtre des Champs-Elysées, Paris. [Basdevant 1982, pp. 110f.—ill.] Gouache study. Musée Bourdelle, Paris. [Ibid.—ill.]

————. "The Dying Centaur." Bronze sculpture. Several versions, 1911–14. Numerous casts. [Jianou & Dufet, nos. 526–27—ill. / Cannon-Brookes 1983, pp. 75ff.—ill. / Clapp]

Hugo von Hofmannsthal, 1874–1929. "Idylle, nach einem antiken Vasenbild: Zentaur mit verwundeter Frau am Rand eines Flusses" [Idyll, after an Antique Vase-painting: Centaur with Wounded Woman on the Edge of a River]. Dramatic poem. **1911.** In *Gedichte und Kleinen Dramen* (Leipzig: Insel, 1911). [Steiner 1946–58, *Gedichte*]

Ricardo de Léon y Román, 1877–1943. *Los centauros.* Novel of provincial life. Madrid: Renacimiento, **1912**; collected in *Obras completas* (1944). [HLE 1981–83, 5:207 / Oxford 1978, p. 323]

Wyndham Lewis, 1884–1957. "Centauress." Drawing. **1912.** Higgins Art Gallery, Bedford, England. [Michel 1971, no. 41—ill.]

————. "Centauress No. Two" ("Study of a Female Nude, Half-Length"). Drawing. 1912. Anthony d'Offay coll. [Ibid., no. 42—ill.]

————. "Centaur Observing a Group of Girls." Drawing with watercolor. 1942. [Ibid., no. 993—ill.]

Sem Benelli, 1877–1949. *Le nozze dei centauri* [Wedding of the Centaurs]. Dramatic poem in verse. First performed 17 Apr **1915,** Teatro Carignano, Turin. [McGraw-Hill 1984, 1:325]

Camilo Pessanha, 1867–1926. *The Centaur.* Collection of poems. Lisbon: **1916.** [Seymour-Smith 1985, p. 1030]

Enea Biafora, 1892–1953? "The Little Centauress." Bronze statuette. *c.*1917. Metropolitan Museum, New York, no. 25.88. [Metropolitan 1965, p. 166]

Lovis Corinth, 1858–1925. "Centaur and Nymph." Painting. **1918.** Formerly in collection of city of Berlin. [Berend-Corinth 1958, no. 729—ill.]

Hellmuth Unger, 1891–1956. *Die Kentaurin* [The Centauress]. Drama. Leipzig: Weicher, **1919.** [Oxford 1986, p. 916]

Pablo Picasso, 1881–1973. "The Rape" (centaur carrying off a woman). Painting. 2 versions, **1920** and 1920–23. [Zervos 1932–78, 4: pl. 187; 30: pl. 104]

————. "Combat of Faun and Centaur." Cycle of 21 drawings. 1946. [Ibid., 14: pls. 203–05, 207–24]

————. "Triptych" (satyr, faun, and centaur). Painting. 1946. Musée Grimaldi, Antibes. [Penrose & Golding 1973, fig. 1 / also Zervos, 14: pls. 242–44]

————. "The Centaur and the Ship." Painting. 1946. [Zervos, 16: pl. 18]

————. 4 etchings, illustrating Ramón Reventós's "El centaur picador" (see below). 2 published in Spanish edition, 2 in French edition (Paris & Barcelona: 1947). [Goeppert et al. 1983, nos. 44, 45—ill. / Bloch 1971–79, nos. 468, 469, 472, 473—ill.]

————. "The Centaur." Bronze sculpture from ceramic original. 1948. Artist's coll. in 1971. [Spies 1971, no. 336—ill.] 4 more bronze centaurs, dated 1949–52, were in the artist's coll. in 1971. [Ibid., nos. 343, 380, 430, 446]

————. "Combat of Centaurs." Painted ceramic plate. 1948. [Boecke & Sabartes, p. 498 no. 480—ill.]

————. "Winged Centaur with Owl." Bronze sculpture. 1950. 2 versions. Artist's coll. in 1971. [Ibid., nos. 382, 383—ill.]

————. "Centaur." Ceramic sculpture. 1950. Artist's coll. in 1971. [Ibid., no. C2—ill.]

————. "Centaur in Profile." Ceramic medallion. 1950. 50 examples. [Bloch, no. C.8—ill.]

————. "Centaur." Ceramic plate. 1956. 2 versions, 100 examples of each. [Bloch, no. C.108—ill.]

————. "Centaur." Gold sculpture. 1960–67. Artist's coll. in 1971. [Spies, no. 563 / Boecke & Sabartes 1955, pp. 497f. nos. 437–38, 440, 442, 449, 452, 459—ill.]

————. *Note:* Centaurs, centaur battles, and centaur families are depicted in numerous drawings and prints. [Bloch, nos. 167, 413, 416, 417, 573, 903, 904—ill. / Zervos, 6: pls. 1394, 1395, 1402; 15: pl. 18]

William Butler Yeats, 1865–1939. "On a Picture of a Black Centaur by Edmund Dulac." Poem. **1920.** In *The Tower* (London & New York: Macmillan, 1928). [Finneran 1983 / Loizeaux 1986, pp. 137, 141f., 150f. / Feder 1971, pp. 8of., 367]

Auguste Léveque, 1864–**1921.** "Combat of Centaurs." Painting. Musée des Beaux-Arts, Liége. [Bénézit 1976, 6:628]

Pop Hart, 1868–1933. "Centaurs and Nymphs." Watercolor. **1921.** Hirshhorn Museum and Sculpture Garden, Washington, D.C. [Hirshhorn 1974, p. 700, pl. 364]

John Peale Bishop, 1892–1944. "The Death of the Last Centaur" (Eurytion). Poem. In *The Undertaker's Garland and Other Poems* (New York: Knopf, **1922,** with illustrations by Boris Artzybaskeff). [Ipso / Boswell 1982, p. 41]

Ramón Reventós, 1881–**1924.** "El centaur picador." Short story. In *Dos contes* (Paris & Barcelona: Albor, 1947, with 2 etchings by Picasso). / French edition, *Deux contes,* translated by Jaume Canyameres, with 2 different etchings by Picasso (Paris: Albor, 1947). [Goeppert et al. 1983, pp. 124–26]

Vojtěch Bořivoj Aim, 1886–1972. "The Centaurs." Choral composition. **1924.** [Grove 1980, 1:179]

H. D. (Hilda Doolittle), 1886–1961. "Centaur Song." Poem. In *Collected Poems* (New York: Boni & Liveright, **1925**). [Martz 1983 / Boswell 1982, p. 91]

D. H. Lawrence, 1885–1930. (Lewis, a centaur-figure, in) *St. Mawr.* Novel. London: Secker, **1925.** [Merivale 1969, p. 212]

Mihály Babits, 1883–1941. *Battle of the Centaurs* [English title of a work written in Hungarian]. Collection of short stories. / Translated into German as *Kentaurenschlacht* by Stefan J. Klein (Berlin: Spaeth, *c.* **1926**). [NUC]

Carl Milles, 1875–1955. (Amazons pursuing a centaur in) "Fountain of Industry." Bronze fountain relief. **1926.** Institute of Technology, Stockholm. [Rogers 1940, pp. 51f.—ill.]

———. "Centaur." Bronze figure in "Aganippe Fountain." 1949–54. Metropolitan Museum, New York, no. 54.198.7. [Metropolitan 1965, pp. 120f.—ill. / also Cornell 1957, p. 40f.—ill.]

Thornton Wilder, 1897–1975. *Centaurs.* Play. Published **1928.** [McGraw-Hill 1984, 5:148]

Charles Ricketts, 1866–1931. "Centaurs and the Bacchante." Bronze statuette. Private coll. [London 1968, no. 131]

Joseph Todd Gordon Macleod, 1903–1984. *Foray of Centaurs.* Poem. **1931.** [Royle 1983, p. 200]

Sacheverell Sitwell, 1897–1988. "Battle of the Centaurs." Poem. In *Canons of Giant Art: Twenty Torsos in Heroic Landscapes* (London: Faber & Faber, **1933**). [Boswell 1982, p. 294]

Alexander Báras, 1906–1973. "Kentauros" [Centaur]. Poem. **1935.** In *Ta poiemata: 1933–53* (Athens: Ikaros, 1954). [Friar 1973, pp. 438f.]

Jean de La Varende, 1887–1959. *Le centaure de Dieu* [The Centaur of God]. Novel (Grand Prix du Roman de l'Académie Française). Paris: Grasset, **1938.** [DLLF 1984, 2:1252]

Leopoldo Marechal, 1900–1970. *El centauro.* Allegorical dialogue (centaur symbolizing pagan past to be redeemed by Christ). **1939.** Buenos Aires: Sol y Luna, 1940. [EWL 1981–84, 3:225 / LAW 1989, 2:890]

James Stephens, 1880–1950. "The Centaurs." Poem. In *Anthology for the Enjoyment of Poetry,* edited by Max Eastman (New York: Scribner, **1939**). [Ipso]

Salvador Dalí, 1904–1989. "Centaur." Drawing. **1940.** Private coll., New York. [New York 1965, no. 191—ill.]

———. "Family of Marsupial Centaurs." Painting. 1941. Alfonso Gonzales coll. [Soby 1968, p. 76—ill.]

Ion Jalea. "Centaur." Stone sculpture. Exhibited Venice Biennale, **1942.** [Clapp 1970, 1:479]

Ker-Xavier Roussel, 1867–**1944.** "Centaur Fighting a Bear," "Centaur and Nymph by the Sea," "Old Centaur in a Landscape." Prints. [Alain 1968, nos. 86, 96, 99—ill.]

Jean Garrigue, 1914–1972. "The Ego and the Centaur." Poem. In *The Ego and the Centaur* (New York: New Directions, **1947**). [Gould 1984, p. 104 / CLC 1974, 2:153]

André Masson, 1896–1987. "Centaur-turnkey." Painting. **1947.** [Clébert 1971, pl. 174]

———. "The Meeting of the Rider with the Centauress." Color woodcut. 1960. [Passeron 1973, p. 177]

Oskar Kokoschka, 1886–1980. "Still Life with Centaur." Painting. **1949.** Private coll., Bari. [Wingler 1958, no. 356—ill.]

Gerhard Marcks, 1889–1981. "Centaur." Bronze sculpture. **1949.** 14 (?) casts. Private colls. [Busch & Rudloff 1977, no. 538—ill.]

Jean Arp, 1887–1966. "Cobra-Centaur." Abstract marble sculpture. **1952.** Kunstmuseum, Winterthur. / Plaster original. Artist's coll. in 1957. / 3 bronze casts, 1952. Art Institute of Chicago; private colls. [Giedion-Welcker 1957, no. 118]

Jacques Lipchitz, 1891–1973. "Centaur Enmeshed." Bronze sculpture. **1952.** Artist's coll. in 1972. [Lipchitz 1972, fig. 171—ill.]

Ossip Zadkine, 1890–1967. "The Centaur." Bronze sculpture. **1952.** 5 casts. Private colls. [Jianou 1979, no. 374—ill.]

Henri Laurens, 1885–1954. "Female Centaur." Bronze sculpture. **1953.** [Marks 1984, p. 474]

Sebastiano Madia. *Il centauro.* Tragedy. Messina: D'Anna, **1953.** [Hunger 1959, p. 184]

Albert Ciamberlani, 1864–**1956.** (Battle of centaurs in background of) "Demeter." Painting. Musées Royaux des Beaux-Arts (Musée d'Art Moderne), Brussels, inv. 9729. [Brussels 1984b, p. 105—ill.]

Louis Conne, 1905–. "Centauress Playing the Lyre." Sculpture. **1956.** [Clapp 1970, 1:182]

Dimitri Hadzi, 1921–. "Centaur with Flutes." Polychrome wood sculpture. Galleria Schneider, Rome, in 1958. [Gallery exhibition catalogue, 1958, no. 1] Bronze versions, **1956–57.** Galleria Schneider; Sigra Hadzi coll. [Ibid., nos. 5, 6—ill.]

———. "Centaur(s) with Woman." Bronze sculpture. Several versions, 1955–58. Galleria Schneider in 1958. [Ibid., nos. 2–4, 7]

———. "Centaur." Bronze sculpture. 1958. Galleria Schneider in 1958. [Ibid., no. 8] Gesso model. Galleria Schneider in 1958. [Ibid., no. 9—ill.]

———. "Centaurs with Shields." Bronze sculpture. 1958. Galleria Schneider in 1958. [Ibid., no. 11—ill.]

Jean Vincent De Crozals, 1922–. "Centauress." Sculpture. Exhibited Venice Biennale, **1957.** [Clapp 1970, 1:205]

May Swenson, 1919–. "The Centaur." Poem. In *A Cage of Spines* (New York: Holt & Rinehart, **1958**). [Gould 1984, pp. 77, 363]

Lars Forssell, 1928–. *Kentaur.* Stockholm: Bonnier, **1959.** [EWL 1981–84, 2:120]

David Hare, 1917–. "Centaur." Sculpture cycle. *c.*1960. [Marks 1984, p. 356]

Reuben Nakian, 1897–1986. "Nymph and Centaur." Terracotta sculpture. **1960.** Egan Gallery, New York, in 1966. [O'Hara 1966, no. 53—ill.]

Roy Fuller, 1912–. "The Centaurs." Poem. **1936–61.** In *Collected Poems 1936–1961* (Philadelphia: Dufour, 1962). [Boswell 1982, p. 257]

Theodore Roethke, 1908–1963. "The Centaur." Poem. In *Collected Poems* (Garden City, N.Y.: Doubleday; London: Faber & Faber, 1966). [Ipso]

Jorge Luis Borges, 1899–1986, with **Margarita Guerrero.** "El centauro." Poem. In *El libro de los seres imaginarios* (Buenos Aires: Kier, **1967**). / Translated by N. T. di Giovanni, with Borges, in *The Book of Imaginary Beings* (New York: Dutton, 1969). [Ipso]

Anthony Hecht, 1922–. "Origin of Centaurs." Poem. In *The Hard Hours* (New York: Atheneum; London: Oxford University Press, **1967**). [CLC 1978, 8:268]

Michael Longley, 1939–. "The Centaurs." Poem. **1963–68.** In *No Continuing City: Poems 1963–1968* (London: Gill & Macmillan; Chester Springs, Pa.: Dufour, 1969). [Ipso / CLC 1984, 29:295]

Edgar Bowers, 1924–. "The Centaur Overheard." Poem.

In *Living Together: New and Selected Poems* (Boston: Godine, **1973**). [Ipso / CLC 1978, 9:122]

CEPHALUS AND PROCRIS. Cephalus, a grandson of Aeolus, was loved by Eos (Aurora), goddess of the dawn. According to Ovid, the young hunter was tempted by the goddess to test the faithfulness of his wife, Procris. He did so by attempting to seduce her while in disguise, revealing himself when he had almost succeeded. Procris fled in shame to Artemis (Diana), who gave her two gifts: a spear that never missed its mark and a hunting dog, Laelaps, which always caught its quarry. Procris and Cephalus were later reconciled, and she gave the magical gifts to him.

Thereafter, Cephalus would take the spear and dog to go hunting. On these expeditions he often called the breeze, Aura, to cool him. Hearing from gossip that Aura was a young woman with whom her husband was having a liaison, Procris one day followed him into the forest. Mistaking her movements in the undergrowth for those of a wild animal, Cephalus killed his wife with the unerring spear.

Several versions of the myth exist—Ovid himself conflated this story with that of an Athenian Cephalus, son of Hermes and Herse. Variants disagree on the fate of Procris, but in all of them Cephalus is carried off by the amorous Eos, whose role is given prominence by Ovid and other later mythographers. Depictions in postclassical art commonly show Eos gazing on the sleeping Cephalus or abducting him in her chariot, or Cephalus mourning over the body of Procris.

Classical Sources. Hesiod, *Theogony* 986–991. *Orphic Hymns* 78, "To Eos." Ovid, *Ars amatoria* 3; *Metamorphoses* 7.668–862. Apollodorus, *Biblioteca* 1.9.4, 2.4.7, 3.15.1. Pausanias, *Description of Greece* 1.3.1, 1.37.6, 10.29.6. Hyginus, *Fabulae* 48, 160, 189.

Further Reference. Irving Lavin, "Cephalus and Procris: Transformations of an Ovidian Myth," *Journal of the Warburg and Courtauld Institutes* 17 (1954): 260–87; cf. pp. 366–72.

Anonymous French. (Tale of Cephalus and Procris in) *Ovide moralisé* 7.2759–3678. Poem, allegorized translation/elaboration of Ovid's *Metamorphoses*. *c.*1316–28. [de Boer 1915–86, vol. 3 / also Lavin 1954, pl. 43c]

Francesco Petrarca, 1304–1374. (Cephalus and Procris led captive in) *Il trionfo dell' Amore* [The Triumph of Love] part 3. Poem. **1340–44.** In *Trionfi* (Bologna: Malpiglius, 1475). [Bezzola 1984 / Wilkins 1962]

Giovanni Boccaccio, 1313–1375. "De Pocri [*sic*] Cephali coniuge" [Procris, Wife of Cephalus]. In *De mulieribus claris* [Concerning Famous Women]. Latin verse compendium of myth and legend. **1361–75.** Ulm: Zainer, 1473. [Branca 1964–83, vol. 10 / Guarino 1963]

John Gower, 1330?–1408. ("Prayer of Cephalus" to Apollo, in) *Confessio amantis* 4.3187–3316. Poem. *c.***1390.** Westminster: Caxton, 1483. [Macaulay 1899–1902, vol. 2]

Christine de Pizan, *c.*1364–*c.*1431. (Cephalus and Procris in) *L'epistre d'Othéa à Hector* . . . [The Epistle of Othéa to Hector] chapter 76. Didactic romance in prose. *c.***1400.** MSS in British Library, London; Bibliothèque Nationale, Paris; elsewhere. / Translated by Stephen Scrope (London: *c.*1444–50). [Bühler 1970 / Hindman 1986, p. 200 / also Lavin 1954, pp. 264f.—ill.]

Niccolò da Correggio, 1450–1508. *Fabula di Cephalo.* Tragedy. First performed 21 Jan **1487,** Court, Ferrara. Published Venice: 1510. Modern edition, in *Opere,* edited by A. T. Benvenuti (Bari: Laterza, 1969). [Lavin 1954, pp. 266ff. / DELI 1966–70, 2:132]

Florentine School. "Story of Cephalus and Procris." Pendant paintings. **15th century.** Musée du Petit Palais, Avignon (on deposit from Louvre, Paris, inv. 20256, 20257). [Louvre 1979–86, 2:302 / also Lavin 1954, p. 271, pl. 38c]

Piero di Cosimo, *c.*1462–1521. "The Death of Procris" (?). Painting. *c.***1506.** National Gallery, London, no. 698 (as "Mythological Subject"). [Bacci 1966, pl. 22 / Lavin 1954, pp. 271f.—ill. / London 1986, p. 477—ill.]

Sodoma, 1477?–1549. "Cephalus and Procris." Painting, one of a series depicting scenes from Ovid. *c.***1511.** Unlocated. [Hayum 1976, no. 12—ill.]

Baldassare Peruzzi, 1481–1536, circle (? also attributed to school of Giulio Romano or Raphael). "Aurora [with Tithonus], Cephalus, and Procris." Fresco. **1511–12** (or *c.*1517–18). Sala delle Prospettive, Villa Farnesina, Rome. [d'Ancona 1955, pp. 27ff., 93f. / Gerlini 1949, pp. 31ff.—ill. / also Frommel 1967–68, no. 51—ill. / Lavin 1954, pl. 39e]

Bernardino Luini, 1480/85–1532. "The Myth of Cephalus and Procris." Series of 9 frescoes (detached), from Casa Rabia, Milan. **1520–23.** National Gallery, Washington, D.C., nos. K1314–22. [Luino 1975, pp. 89f., pls. 35–44 / Lavin 1954, pp. 260f., 272ff.—ill. / Shapley 1966–73, 2:141f.—ill. / Walker 1984, figs. 223–31 / Berenson 1968, p. 235—ill.]

Giulio Romano, *c.*1499–1546. "The Death of Procris." Drawing, composition for engraving, executed by Giorgio Ghisi (Bartsch 15:409 no. 61). *c.***1530.** Original drawing in Städelsches Kunstinstitut, Frankfurt. [Hartt 1958, pp. 225, 305 (no. 292)—ill.] *See also* Peruzzi, *above.*

Rosso Fiorentino, 1494–1540, composition. "Cephalus and Procris in Two Niches." *c.***1538–40.** Engraving, attributed to René Boyvin. [Carroll 1987, no. 106—ill.]

Pierre de Ronsard, 1524–1585. "Le ravissement de Cephale" [The Rape of Cephalus]. Poem. In *Le quatrième livre des odes* (Paris: Cauellat, **1550**). [Laumonier 1914–75, vol. 2 / McGowan 1985, p. 100 / Cave 1973, pp. 100, 165]

Thomas Howell, fl. 1560–81. (Death of Procris in) "The lover praieth his service to be accepted." Poem. In Tottel's *Miscellany* (London: **1557**). Modern edition by Hyder E. Rollins (Cambridge, Mass.: Harvard University Press, 1962). [Bush 1963, pp. 55, 58 *n.,* 59]

———. "The lamentable historie of Sephalus with the Unfortunat end of Procris." Ballad. In *The Arbor of Amitie* (London: Denham, 1568). Modern edition, in *Poems,* edited by A. B. Grosart (Manchester: Simms, 1879). [Ibid.]

Andrea Schiavone, c.1522–**1563,** formerly attributed (questionably attributed to Stefano Cernoto). "Cephalus and Procris." Painting. Paul Drey Galleries, New York, in 1980. [Richardson 1980, no. D358—ill.]

Arthur Golding, 1536?–1605. (Story of Cephalus and Procris in) *Ovids Metamorphosis* book 7 (London: **1567**). [Rouse 1961]

Paris Bordone, 1500–**1571.** "Cephalus and Procris" (?). Painting. Unlocated. [Berenson 1957, p. 49—ill.]

Paolo Veronese, 1528–1588, attributed. "The Death of Procris." Painting. c.**1568**–74. Private coll., London. [Pallucchini 1984, no. 118—ill. / also Pignatti 1976, no. A207—ill. / Berenson 1957, p. 139—ill.]

———. "The Death of Procris." Painting. Before 1584. Musée des Beaux-Arts, Strasbourg, inv. 634. [Pallucchini, no. 180—ill. / Pignatti, no. 251—ill.]

———, style. "The Death of Procris." Painting, part of a series of "Eight Scenes from the Metamorphoses of Ovid." Gardner Museum, Boston, no. P17w32–s–3. [Hendy 1974, p. 286—ill.]

George Pettie, 1548–1589. "Cephalus and Procris." Tale. In *A Pettie Pallace of Pettie His Pleasure* (London: R. W[atkins], **1576**). Modern facsimile edition by Herbert Hartman (London & New York: Oxford University Press). [Ipso]

Thomas Edwards. *Cephalus and Procris.* Poem. Licensed 22 Oct **1593.** London: Wolfe, 1595. Modern edition, London: Roxburghe Club, 1882. [Bush 1963, pp. 123, 322f. / Smith 1952, pp. 90f.]

Francesco Primaticcio, 1504–1570, circle ("Master of Flora"). "Procris and Cephalus." Drawing. **1550/1600.** G. Seligman coll., New York. [Paris 1972, no. 132—ill.]

Joachim Wtewael, 1566–1638. "The Death of Procris." Painting. c.**1595**–1600. City Art Museum, St. Louis, inv. 198.57. [Lowenthal 1986, no. A–11—ill. / also de Bosque 1985, pp. 206f.—ill.]

Agostino Carracci, 1557–1602. "Aurora and Cephalus." Fresco. **1597**–1600. Galleria, Palazzo Farnese, Rome. [Malafarina 1976, no. 104q—ill. / Martin 1965, pp. 59ff.—ill.]

Gabriello Chiabrera, 1552–1638. *Il rapimento de Cefalo* [The Rape of Cephalus]. Pastoral melodrama. Incidental music, Giulio Caccini, with S. Venturi del Nibbio, Luca Bati, Petro Strozzi. First performed 9 Oct **1600,** for marriage of Marie de' Medici to Henri IV, Gran Sala delle Commedie, Uffizi, Florence. [Bondanella 1979, p. 120 / Grove 1980, 3:579 / Weaver 1978, p. 90 / Lavin 1954, p. 279 / Pirotta & Povoledo 1982]

Hendrik de Clerck, c.1570–1629, figures, and **Denis van Alsloot,** 1570–1628, landscape. "Woodland Scene with Cephalus and Procris." Painting. **1608.** Kunsthistorisches Museum, Vienna, inv. 1077 (988). [Vienna 1973, p. 5—ill.]

——— (de Clerck), figures, and **David Vinckeboons** (?), 1576–1629, landscape. "Cephalus and Procris." Painting. Národní Galeri, Prague. [Ertz 1979, fig. 628]

Nicolas Chrestien des Croix. *Le ravissement de Céfale.* Tragedy, translation of Chiabrera (1600). Rouen: Petit Val, **1608.** [DLLF 1984, 1:453]

Thomas Heywood, 1573/74–1641. (Story of Cephalus and Procris in) *Troia Britanica: or, Great Britaines Troy* canto 11, passage translated from Ovid's *Ars amatoria.* Epic poem. London: **1609.** [Heywood 1974]

Adam Elsheimer, 1578–**1610.** "The Death of Procris." Painting. Corsham Court, England. [Hunger 1959, p. 185]

William Browne, c.1590–1643. (Cephalus and Procris evoked in) *Britannia's Pastorals* book 1, song 4. Collection of poetry. London: Snodham for Norton, **1613.** [Bush 1963, pp. 175 n.]

Ridolfo Campeggi, 1565–1624. "La morte di Procri." Idyll. In *Idilli del molto* (Vinegia: **1614**). [DELI 1966–70, 1:548]

Alexandre Hardy, c.1570–1632. *Procris, ou, La jalousie infortunée* [Procris, or, Unfortunate Jealousy]. Tragicomedy. Before **1615.** In *La théâtre* (Paris: Quesnel, 1624). [Deierkauf-Holsboer 1972, pp. 149 / McGraw-Hill 1984, 2:446]

Hans von Aachen, 1552–**1616.** "Cephalus and Procris." Drawing. Städelsches Kunstinstitut, Frankfurt. [Pigler 1974, p. 58]

Paulus Moreelse, 1571–1638. "Cephalus and Procris." Grisaille sketch, design for a print. **1616.** Louvre, Paris, no. 22765. [de Jonge 1938, no. 19a—ill.] Engraved by Crispin de Passe the Elder, 1616. [Ibid., no. 19b—ill.]

Johann Liss, c.1595–1629. "Cephalus and Procris." Print. Early **1620s.** [Augsburg 1975, no. B51—ill.]

Paul Bril, 1554–1626. "Landscape with Cephalus and Procris." Painting. **1621.** Palazzo Corsini, Rome. [Budapest 1968, p. 356] Variant copy, by Johann König, in Szépmüvészeti Múzeum, Budapest, no. 60.1. [Ibid.]

Anonymous choreographer. *Aurore et Céphale.* Ballet. First (?) performed by Ballet Royal, Lyon. Published Paris: **1622.** [Taylor 1893, p. 253]

Lope de Vega, 1562–1635. *La bella Aurora* [The Beautiful Aurora] (in love with Cephalus). Drama. **1612**–25. Madrid: 1635. [Sainz de Robles 1952–55, vol. 1 / McGraw-Hill 1984, 5:95]

Nicolas Poussin, 1594–1665. "Cephalus and Aurora." Painting. c.**1624**–25. Worsley coll., Hovingham Hall, Yorkshire. [Wright 1985, no. 6, pl. 103 / Blunt 1966, no. 145—ill. / also Thuillier 1974, no. 15—ill.]

———. "Cephalus and Aurora." Painting. Mid/late-1620s. National Gallery, London, no. 65. [Wright, no. 24, pl. 7 / London 1986, p. 491—ill. / also Blunt, no. 144—ill. / Thuillier, no. 30—ill.]

Jan Brueghel the Elder, 1568–**1625.** "Cephalus and Procris." Painting. Národní Galeri, Prague. [Warburg]

Jan Linsen, 1602/03–1635. "Landscape with Cephalus and Procris." Painting. **1626** (additions by Cornelis van Poelenburg, 1641?). Städelsches Kunstinstitut, Frankfurt, no. 1616. [Röthlisberger 1981, no. 278—ill.]

Jean Puget de la Serre, 1594–1665. "Aurore et Cephale." Poem. In *Les amours des déesses* (Paris: d'Aubin, **1627**). [NUC]

Francesco Furini, 1604–1646, attributed. "Cephalus and Aurora." Painting. **1628**? Museo de Arte, Ponce, Puerto Rico. [Florence 1986, no. 1.130—ill.]

John Milton, 1608–1674. (Cephalus as the "Attic Boy" in) "Il penseroso" lines 124ff. Poem. Summer **1631**? In *Poems* (London: Moseley, 1645). [Carey & Fowler 1968]

Cesare Gonzaga the Younger, 1592–**1632.** *Procri.* Pastoral drama. First published by M. Pellegri (Parma: 1958). [DELI 1966–70, 3:164]

Claude Lorrain, 1600–1682. "Landscape with Cephalus and Procris Reunited by Diana." Painting. **Mid-1630s.** Formerly Gemäldegalerie, Berlin, destroyed 1945. [Röthlisberger 1961, no. 243—ill.]

————. "Landscape with Cephalus and Procris Reunited by Diana." Painting. 1645. National Gallery, London, no. 2. [Ibid., no. LV 91—ill. / also London 1986, p. 110—ill.] Variant. 1664. Earl of Plymouth coll. [Ibid., no. LV 163—ill.] Drawings, in *Liber veritatis.* British Museum, London. [Ibid.]

————. "Landscape with Cephalus and Procris Reunited by Diana." Painting. c.1645–46. Galleria Doria Pamphilj, Rome. [Ibid., no. 233—ill.]

————. "Landscape with the Death of Procris." Painting. c.1646–47. Lost. / Drawing after, in *Liber veritatis.* [Ibid., no. LV 100—ill.] Copy, painting, in National Gallery, London, inv. 55. [London, p. 114—ill.]

Peter Paul Rubens, 1577–1640. "Aurora and Cephalus." Painting, for Torre de la Parada, El Pardo (executed by assistant from Rubens's design?). **1636–38.** Lost. [Alpers 1971 no. 6] Oil sketch, by Rubens. National Gallery, London, no. 2598. [Ibid., no. 6a—ill. / Held 1980, no. 173—ill. / Jaffé 1989, no. 1247—ill. / London 1986, p. 547—ill.]

————. "Cephalus and Procris." Painting, for Torre de la Parada, executed by Peeter Symons from Rubens's design. 1636–38. Prado, Madrid, no. 1971. [Alpers, no. 10—ill. / Jaffé, no. 1249—ill.] Oil sketch. Prado, no. 2459. [Alpers, no. 10a—ill. / Held, no. 177—ill. / Jaffé, no. 1248—ill. / Prado 1985, pp. 596, 661 / White 1987, pl. 298] School variant, painted cabinet panel. Rijksmuseum, Amsterdam, inv. NM11906-I. [Rijksmuseum 1976, p. 484—ill.]

————, attributed (also attributed to Anthony van Dyck). "Cephalus Lamenting the Death of Procris." Drawing. Art Museum, Princeton University, N.J. [Burchard & d'Hulst 1963, no. 84—ill.]

Guido Reni, 1575–1642 (? or follower). "The Death of Procris." Painting. Herzog Anton Ulrich-Museum, Braunschweig. [Lavin 1954, p. 285—ill.]

Simon Vouet, 1590–1649. "Aurora and Cephalus." Painting. Lost. Engraved by Michel Dorigny, 1642. [Crelly 1962, no. 221]

———— or studio. "Aurora and Cephalus," "Cephalus and Procris." Paintings, cartoons for "Loves of the Gods" tapestry series. Lost. / Tapestry of "Aurora and Cephalus." Hôtel de Sully, Paris. [Ibid., noa. 270m, w—ill.]

Guercino, 1591–1666. "Cephalus and Procris." Painting. **1644.** Formerly Gemäldegalerie, Dresden, destroyed 1945. [Hunger 1959, p. 185 / Salerno 1988, no. 212—ill. / also Lavin 1954, pl. 41d]

Pedro Orrente, 1570/80–1644/45. "Cephalus and Procris." Painting. Private coll., Valencia. [López Torrijos 1985, p. 438 no. 51—ill.]

Orazio Fidani, 1606–1656. "Cephalus and Procris" (Cephalus, having shot Procris, breaking his arrows). Painting. c.1645. Private coll., Florence. [Florence 1986, no. 1.206—ill.]

Andrea Mattioli, c.1620–1679. *Il ratto di Cefalo* [The Rape of Cephalus]. Opera. Libretto, Francesco Berni. First performed **1650,** Teatro di Sala, Ferrara. [Grove 1980, 11:838 / Clubb 1968, p. 43]

Guidubaldo Bonarelli Della Rovere, 1563–1608. *Cefalo e Procri.* Melodramma per intramezzi in verse. In *Poesie drammatiche* (Ancona: Beltrano, **1651**). [Clubb 1968, p. 48]

Alexander Keirincx, c.1600–**1652.** "Cephalus and Procris." Painting. Wilton House, Wiltshire. [Pigler 1974, p. 57]

Laurent de La Hyre, 1606–**1656.** "Cephalus and Procris." Design for tapestry. Executed by Gobelins, 17th century. Sala dello Zodiaco, Palazzo Ducale, Mantua. [Paccagnini 1974, p. 42]

Willem Verschoor, ?–1678. "Cephalus and Procris." Painting. **1657.** Centraal Museum, Utrecht. [Wright 1980, p. 471 / Warburg]

Agostino Mitelli, 1609–1660, and **Angelo Michele Colonna,** 1600–1687. Story of Cephalus and Procris depicted in a cycle of ceiling paintings, Buen Retiro, Madrid. **1658.** Lost. / Modello. Prado, Madrid. [López Torrijos 1985, pp. 354f., 429 nos. 13–18, pls. 159–63]

Francesco Albani, 1578–**1660,** school. "Aurora Raping Cephalus." Painting. Galleria Estense, Modena. [Lavin 1954, p. 281—ill.]

Juan Hidalgo, 1612/16–1685. (Tale of Procris in) *Celos aún del aire matan* [Even Jealousy of the Air Kills]. Opera (the oldest surviving Spanish opera). Libretto, Pedro Calderón de la Barca. First performed 5 Dec **1660,** Buen Retiro, Madrid. Music lost. Calderón's libretto published in *Comedias nuevas y escogidas,* part 2 (Madrid: 1663). [Valbuena Briones 1960–67, vol. 1 / O'Connor 1988, pp. 316–32 / McGraw-Hill 1984, 1:442 / also Grove 1980, 8:548]

Antonio Draghi, 1634/35–1700. *Gl'amori di Cefalo e Procri.* Opera. Libretto, Draghi or P. Bonarelli. First performed 9 June **1668,** Vienna. [Grove 1980, 5:604]

Agustin de Salazar y Torres, 1642–**1675.** *Zefalo y Procris.* Comedy. Barcelona: Suria y Burgados [178?]. [NUC]

Louis de Mollier, c.1615–1688. *Les amours de Céphale e d'Aurore.* Opera. **1677.** [Grove 1980, 12:471]

Toussaint Gelton, c.1630–**1680.** "The Dying Procris." Painting. Statens Museum for Kunst, Copenhagen. [Copenhagen 1951, no. 236]

Guido Canlassi, 1601–**1681,** questionably attributed. "Cephalus and Procris." Painting. Herzog Anton Ulrich-Museum, Braunschweig, no. 480. [Braunschweig 1969, p. 42—ill. / Braunschweig 1976, p. 13—ill.]

Jean de La Fontaine, 1621–1695. (Aurora's love for Cephalus evoked in) "Les filles de Minée" [The Daughters of Minos]. Poem. c.1683. In *Ouvrages de prose et de poésie des sieurs de Maucroix et de La Fontaine* (Paris: Garnier, 1685). [Clarac & Marmier 1965]

Daniel Vertangen, c.1598–**1681/84.** "Cephalus and Procris." Painting. Statens Museum for Kunst, Copenhagen. [Copenhagen 1951, no. 762] Another version of the subject in Muzeum Narodowe, Gdansk. [Bénézit 1976, 10:479]

Carlo Francesco Pollarolo, c.1653–1723. *La costanza gelosa negl' amori di Cefalo e Procri* [Jealous Constancy in the Loves of Cephalus and Procris]. Opera. First performed **1688,** Verona. Lost. [Grove 1980, 15:45f.]

Pietro Montanini, 1626–**1689,** attributed. "Cephalus and Procris." Painting. Hatton Gallery, Newcastle-upon-Tyne. [Wright 1976, p. 140]

Johann Philipp Krieger, 1649–1725. *Die ausgesöhnte Eifer-*

sucht, oder, Cephalus und Procris [Jealousy Reconciled, or, Cephalus and Procris]. Opera. **1689**. [Grove 1980, 10:269]

Pierre Le Gros, 1629–1714. "Aurora and Cephalus." Monumental sculpture group. *c.***1680s**. Orangerie, Gardens, Versailles. [Girard 1985, p. 277]

Elisabeth-Claude Jacquet de la Guerre, 1659/67–1729. *Céphale et Procris*. Opera (tragédie lyrique). Libretto, J.-F. Duché de Vancy. First performed 15 Mar **1694**, Académie Royale de Musique, Paris. [Grove 1980, 9:456 / Girdlestone 1972, pp. 149ff.]

Reinhard Keiser, 1674–1739. *Procris und Cephalus*. Singspiel. Libretto, Friedrich Christian Bressand. First performed **1694**, Braunschweig. [Zelm 1975, p. 41 / DLL 1968–90, 2:38]

Romagna School. "The Death of Procris." Painting. **17th century**. National Gallery of Ireland, Dublin, no. 4090. [Dublin 1981, p. 140—ill.]

Georg Bronner, 1667–1720. *Procris und Cephalus*. Opera. Libretto, Bressand (1694). First performed **1701**, Hamburg. [Grove 1980, 3:331 / DLL 1968–90, 2:38]

Giovanni Bononcini, 1670–1747. *Cefalo*. Pastorella. Libretto, A. Guidi. First performed Spring **1702**, Teatro di Litzenbourg (now Charlottenburg), Berlin. [Grove 1980, 3:32]

Willem van Mieris, 1662–1747. "Cephalus and Procris." Painting. **1702**. Gemäldegalerie, Dresden, no. 1970. [Pigler 1974, p. 57]

———. "Cephalus and Procris." Painting. Centraal Museum, Utrecht. [Wright 1980, p. 278]

Jean-Louis Lemoyne, 1665–1755. "Cephalus and Procris." Marble sculpture. *c.***1704**. [Réau 1927, no. 1]

Luca Giordano, 1634–1705. "Cephalus and Procris." Painting. Formerly Castle, Gatchina, sold Berlin, 1929. [Ferrari & Scavizzi 1966, 2:333]

Godfried Schalken, 1643–1706. "Cephalus and Procris." Painting. Metropolitan Museum, New York, no. 1974.109. [Metropolitan 1980, p. 169—ill.]

Jean Baptiste Stuck, 1680–1755. *Céphale et Procris*. Opera-ballet. First performed **1710**, Versailles. [Clément & Larousse 1969, 1:215]

Jean-Claude Gillier, 1667–1737. *Céphale et Procris*. Opera (comédie en musique). Libretto, Florent Dancourt. First performed 27 Oct **1711**, Comédie Française, Paris. [Grove 1980, 7:381 / Lancaster 1929–42, pt. 4, 2:771]

Jean Raoux, 1677–1734. "Cephalus and Procris." Painting. *c.***1710–12**. Sold Paris, 1985. / Reduced replica. Gemäldegalerie, Berlin-Dahlem, no. 498. [Berlin 1986, p. 63—ill.]

Alexander Pope, 1688–1744. "On a Fan of the Author's design, in which was painted the story of Cephalus and Procris, with the Motto, Aura Veni." Sonnet, imitation of Edmund Waller. In the *Spectator* no. 527, 4 Nov **1712**; collected in *Works* (London: 1717). [Twickenham 1938–68, vol. 6]

Daniel Gran, 1694–1757. "Aurora and Cephalus." Fresco. **1723–24**. Kuppelsaal, Gartenpalais Schwarzenberg, Vienna. [Knab 1977, pp. 42ff., no. F9—ill.]

Honoré-Claude Guédon de Presles, ?–*c.*1730. *Céfale*. Cantata. *c.***1724**. [Grove 1980, 7:783]

François Le Moyne, 1688–1737. "Aurora and Cephalus." Painting, for Hôtel du Grand Maître (now Hôtel de

Ville), Versailles. **1724**. In place. [Bordeaux 1984, no. 50—ill.]

———. "Aurora and Cephalus." Painting, for Hôtel Peyrenc de Moras (Hôtel Biron, now Musée Rodin), Paris. **1729–30**. Lost. [Ibid., no. 80]

Francesco Solimena, 1657–1747. "Aurora and Cephalus." Ceiling painting. Before **1726**. Formerly Oberes Belvedere, Vienna, destroyed. [Knab 1977, p. 51, fig. 6]

Jean-Baptiste-Maurice Quinault, 1687–1745, music. "L'Aurore et Céphale." Entrée in *Les amours des déesses*. Ballet-héroïque. Libretto, Louis Fuzelier. First performed 25 Aug **1729**, L'Opéra, Paris. [Grove 1980, 7:47, 15:507]

Henry Carey, *c.*1689–1743, music and libretto. *Cephalus and Procris*. Pantomime masque, possibly all sung. First performed 28 Oct **1730**, Theatre Royal, Drury Lane, London. [Grove 1980, 3:781]

François Boucher, 1703–1770. "Aurora and Cephalus" (also called "Venus and Adonis"). Painting. **1733**. Musée des Beaux-Arts, Nancy. [Louvre 1979–86, 3:79 / also Ananoff 1976, no. 86—ill.]

———. "Aurora and Cephalus." Painting. **1736–39**. Archives Nationales, Paris. [Ananoff, no. 161—ill.]

———. "Aurora and Cephalus." Painting. *c.***1745**. Private coll., New York. [Ibid., no. 291—ill.]

———. "Aurora and Cephalus." Painting, model for Gobelins tapestry. **1764**. Louvre, Paris, inv. 2710. [Ibid., no. 481—ill. / Louvre—ill.] Modello, after Boucher, 1765. Musée des Gobelins. / Tapestry in Mobilier National; 2 others known, formerly Daniel Wildenstein coll., formerly Kress coll., unlocated. [Ananoff—ill.]

Henri-Charles Guillon, fl. *c.*1700–50. *Céphale et l'Aurore*. Cantata. Published Paris: **1737**. [Grove 1980, 1980, 7:818]

Nicholas Lancret, 1690–**1743**, formerly attributed. "Cephalus and Procris." Painting. Musée, Clamecy. [Wildenstein 1924, no. 720]

Johann Elias Schlegel, 1719–**1749**, libretto. *Prokris und Cephalus*. Cantata. Published in *Werke* (Copenhagen & Leipzig: Mummischen Buchhandlung, 1761–70). [Strich 1970, 1:220]

Jean-Honoré Fragonard, 1732–1806. "Cephalus and Procris." Overdoor painting. **1748–52**. Musée des Beaux-Arts, Angers. [Wildenstein 1960, no. 51—ill.]

Francesco Araia, 1709–1770. *Cephal i Prokris*. Opera. Libretto, Aleksandr Petrovich Sumarokov. First performed 9 Mar **1755**, St. Petersburg. [Grove 1980, 1:539f.]

Christoph Martin Wieland, 1733–1813. "Aurora und Cephalus." Verse tale. In *Komische Erzählungen* (Munich: Parcus, **1762**). [Radspieler 1984, vol. 3 / Frenzel 1953, p. 116]

Diego Antonio Rejón de Silva y Lucas, 1740–1796. *Fábula de Céfalo y Procris*. Poem. **1763**. [DLE 1972, p. 769]

Johann Adolf Scheibe, 1708–1776. *Prokris und Cephalus*. Cantata. Libretto, Schlegel. Published in *Tragischen Kantaten* (Copenhagen: Mummischen Buchhandlung, **1765**). [Grove 1980, 16:600]

Louis-Joseph Francoeur, 1738–1804, music. *L'Aurore et Céphale*. Ballet héroïque. Choreographer unknown. First performed 7 May **1766**, Magasin de Musique de l'Académie, Paris. [Grove 1980, 6:793]

Johann Friedrich Reichardt, 1752–1814. *Cephalus und*

Prokris. Opera. Libretto, Karl Wilhelm Ramler. Published Stuttgart: **1766**. First performed 1777, Hamburg. [Grove 1980, 15:704–06 / Strich 1970, 1:223]

Benjamin West, 1738–1820. "The Death of Procris." Painting. **1770**. Art Institute of Chicago, no. 00.445. [von Erffa & Staley 1986, no. 150—ill. / Chicago 1961, p. 481]

Ludwig Wilhelm Busch, 1703–1772. "Cephalus and Procris." Painting. Herzog Anton Ulrich-Museum, Braunschweig, no. 1081. [Braunschweig 1969, p. 40]

André Grétry, 1741–1813. *Céphale et Procris, ou, L'amour conjugal*. Opéra-ballet. Libretto, Jean-François Marmontel, after Ovid. First performed 30 Dec **1773**, Versailles. [Grove 1980, 7:709; 11:694]

Johann Christian Bach, 1735–1782. *Cefalo e Procri*. Cantata for 2 sopranos, alto, orchestra. Libretto, G. G. Bottarelli? First performed 26 Apr **1776**, Hanover Square Rooms, London. Published as *Aurora: A Favorite Cantata*, c.1819. [Grove 1980, 1:873]

Hinrich Philip Johnson, 1717–1779, with **L. Lalin**. *Procris och Cephal*. Opera. **1778**. [Grove 1980, 9:675]

Anton Raphael Mengs, 1728–1779, questionably attributed. "Procris." Painting. Castle, Fredensborg, Denmark. [Honisch 1965, no. 401]

Angelica Kauffmann, 1741–1807. "The Death of Procris." Painting. Exhibited **1779**. [Manners & Williamson 1924, pp. 46, 238]

———. "Cephalus and Procris with Cupid." Painting. Sold 1859. [Ibid., p. 182]

———. Pair of paintings depicting Procris receiving a hunting hound and arrow from Diana, and Cephalus drawing out the arrow from Procris's bosom. For Prince Youssoupoff of Russia. 1784. [Ibid., p. 146]

Jean Antoine Julien de Parme, 1736–1799. "Aurora's Rape of Cephalus." Painting. **1779**. Prado, Madrid, no. 6773. [Prado 1985, pp. 351f.]

Hugo Franz Karl Alexander von Kerpen, 1749–1802. *Cephalus und Procris*. Opera (melodrama), after Ovid. **1781**. [Grove 1980, 10:3]

Georg Anton Benda, 1722–1795. *Cephalus und Aurore*. Cantata for soprano and orchestra. Published Leipzig: **1789**. [Grove 1980, 2:465]

———, doubtfully attributed. *Cephalus und Procris*. Opera (melodrama). Libretto, Karl Wilhelm Ramler. First performed 25 Nov 1805, Berlin. [Ibid., 2:464]

John Flaxman, 1755–1826. "Cephalus and Aurora." Marble sculpture. **1787–94**. [Janson 1985, p. 24]

———. "Aurora Visiting Cephalus on Mount Ida." Marble sculpture. 1789–90. Lady Lever Art Gallery, Port Sunlight, Cheshire. [Irwin 1979, p. 54, fig. 65 / also Bindman 1979, fig. 9]

Jonas Akerström, 1759–1795. "Cephalus and Procris." Painting. Exhibited **1794**. Private coll. [Bénézit 1976, 1:73]

Antonio Canova, 1757–1822. "Cephalus and Procris." Painting. **1796**. Gipsoteca Canoviana, Possagno, no. 63. [Pavanello 1976, no. D20—ill.] Terra-cotta study (also considered possible study for "Cupid and Psyche" or "Venus and Adonis"). Possagno, no. 37. [Ibid., no. 91—ill.]

Daniel-François-Esprit Auber, 1782–1871. "Procris." Composition for soprano and string orchestra. *c.***1800**. MS in Bibliothèque Nationale, Paris. [Grove 1980, 1:682]

Pierre-Narcisse Guérin, 1774–1833. "Aurora and Cephalus." Painting. **1810**. Louvre, Paris, no. R.F. 513. [Louvre 1979–86, 3:295—ill.] Variant. 1811. Museum of Fine Arts, Moscow, inv. 1808. / Study. Hermitage, Leningrad, inv. 10310. [Hermitage 1983, no. 227—ill.]

Jean-Baptiste Hullin, fl. 1809–20, choreography. *Céphale et Procris*. Ballet. First performed 6 June **1820**, King's Theatre, London. [Guest 1972, p. 156]

Anne-Louis Girodet, 1767–**1824**, composition. "Cephalus and Aurora." Lithograph, part of "Loves of the Gods" cycle. Published Paris: Engelmann, 1825–26. [Boutet-Loyer 1983, no. 87 *n*.]

Thomas Moore, 1779–1852. "Cephalus and Procris." Poem. In *Legendary Ballads* (London: Power, **1828**). [Boswell 1982, p. 188 / Bush 1937, p. 550]

Luigi Astolfi, fl. 1817–51, choreography. *Cefalo e Procri*. Ballet. Music, Giovanni Bignani. First performed Autumn **1831**, Pergola, Florence. [EDS 1954–66, 1:1033]

Jean Bruno Gassies, 1786–1832. "Aurora and Cephalus." Painting, for Château de Saint-Cloud. Louvre, Paris, inv. 8619. [Louvre 1979–86, 3:266—ill.]

Patrick MacDowell, 1799–1870. "Cephalus and Procris." Marble sculpture group. **1834**. Cooper coll., Markree Castle, County Sligo, Ireland. [Strickland 1968, 2:60, 62]

Austin Dobson, 1840–1921. "The Death of Procris." Poem. **1869**. In *Vignettes in Rhyme* (London: King, 1873); in *Complete Poetical Works* (London: Oxford University Press, 1923). [Bush 1937, p. 559 / Boswell 1982, p. 88]

Francis Reginald Statham. "Cephalus and Procris." Poem. In *Glaphyra* (London: **1870**). [Bush 1937, p. 558]

John Spencer Stanhope, 1829–1908. "Procris and Cephalus." Painting. **1872**. Barry Friedman Gallery, New York, in 1983. [Wood 1983, pp. 198, 201—ill. / also Kestner 1989, p. 109]

Bernard-Prosper Debia, 1791–1876. "Cephalus and Procris." Painting. Musée Ingres, Montauban, inv. 881.5. [Montauban 1965, no. 105—ill.]

Richard Watson Dixon, 1833–1900. "Cephalus and Procris." Poem. In *Odes and Eclogues* (London: Daniel, **1884**). [Boswell 1982, p. 86]

W. G. Hole. "Procris." Poem. In *Procris and Other Poems* (London: Kegan Paul, **1886**). [Boswell 1982, p. 263 / Bush 1937, p. 562]

Henrietta Rae, 1859–1928. "Cephalus and Procris." Painting. **1889**. [Kestner 1989, p. 285]

Edmund Gosse, 1849–1928. "The Death of Procris." Poem. In *In Russet and Silver* (London: Heinemann, **1894**). [Bush 1937, p. 561]

Charles Smith Cheltnam, b. 1823. *Procris: An Idyllic Comedy*. Comedy. London & Edinburgh: Ballantyne, Hanson, **1895**. [Ellis 1985, p. 53]

Ezra Pound, 1885–1972. (Reference to Cephalus in) "Hugh Selwyn Mauberley" part 2. Poem. In *Personae* (London: Mathews, **1909**; revised, expanded edition, New York: New Directions; London: Faber & Faber, 1926). [Ruthven 1969, p. 141 / Bush 1937, p. 507]

Jean Escoula, 1851–**1911**. "The Death of Procris." Marble sculpture group. Musées Nationaux, inv. R.F. 1263, deposited in Musée de Rambouillet in 1921. [Orsay 1986, p. 271]

Ernest Dame, 1845–1920. "Cephalus and Procris." Sculpture group. Musée Archéologique Muncipal, Laon. [Bénézit 1976, 3:337]

Pablo Picasso, 1881–1973. "Cephalus and Procris, His Wife, Whom He Has Killed by Accident." Etching, illustrating Ovid. **1930.** Published in an edition of Ovid's *Metamorphoses* (Lausanne: Albert Skira, 1931). [Goeppert et al. 1983, no. 19—ill. / Bloch 1971–79, no. 112—ill.]

Ninette de Valois, b. 1898, choreography. *Cephalus and Procris.* Ballet. Music, André Grétry. First performed 25 Jan **1931,** Camargo Society, London; designs, William Chappell. [Clarke 1955, pp. 75, 321]

Ranald Newson. "Procris and the Faun." Poem. In *For Saxophone and Harpsichord* (London: New Temple, 1932). [Boswell 1982, p. 276]

Sacheverell Sitwell, 1897–1988. "Cephalus and Procris." Poem. In *Canons of Giant Art: Twenty Torsos in Heroic Landscapes* (London: Faber & Faber, **1933**). [Bush 1937, p. 576]

Ernst Krenek, 1900–1974. *Cefalo e Procri.* Opera, opus 77. Libretto, R. Küfferle. **1933–34.** First performed 15 Sep 1934, Venice. [Baker 1984, p. 1256 / Grove 1980, 10:255]

Horst Lange, 1904–1971. *Kephalos und Prokris.* Poem. **1940.** Munich: Piper, 1948. [DLL 1968–90, 9:903]

Edwin Scharff, 1877/87–1955. "Cephalus and Procris." Drawing with watercolor. **1946.** [Hannover 1950, no. 118]

Ralph Vaughan Williams, 1872–1958. "Procris." Song. In *Four Last Songs.* Text, Ursula Vaughan Williams. **1954–58.** [Grove 1980, 19:579]

Paul Mills, 1948– . "Procris." Poem. In *Third Person* (Manchester: Carcanet, **1978**). [Ipso / Jones & Schmidt 1980, p. 227]

CERBERUS. *See* HADES [2]; *also* GODS AND GODDESSES, as Elements; HADES [1]; HERACLES, LABORS OF, Cerberus; ORPHEUS, and Eurydice.

CERES. The Roman corn goddess, associated with the Greek Demeter, the Egyptian Isis, and the Phrygian Cybele. *See* DEMETER.

CEYX. *See* ALCYONE AND CEYX.

CHARICLEA. *See* THEAGENES AND CHARICLEA.

CHARON. *See* HADES [2].

CHARYBDIS. *See* JASON, and the Argonauts; ODYSSEUS, Scylla and Charybdis.

CHIMAERA. A fire-breathing monster, the Chimaera was said to be the offspring of Echidna and Typhon. According to Homer, she had the head of a lion, the body of a goat, and the tail of a serpent, but in Hesiod she is lion-, goat-, and serpent-headed. Hesiod also says that the Chimaera was the mother of the Sphinx by her brother Orthus, although other sources suggest that Orthus was the Chimaera's father. Because of her semidivine origin, the Chimaera was reputed to be invulnerable, but she was finally slain by Bellerophon.

Postclassical treatments of the myth have come to incorporate the modern meaning of the word "chimaera"—a fleeting illusion, particularly dangerous because it cannot be dismissed.

Classical Sources. Homer, *Iliad* 6.178–83. Hesiod, *Theogony* 319–25. Ovid, *Metamorphoses* 6.339, 9.647. Apollodorus, *Biblioteca* 1.9.3, 2.3.1. Hyginus, *Fabulae* 57, 151.

See also BELLEROPHON.

Edmund Spenser, 1552?–1599. (Chimaera mentioned as mother of the Blatant Beast in) *The Faerie Queene* 6.1.7–8. Romance epic. London: Ponsonbie, **1596.** [Hamilton 1977 / Nohrnberg 1976, p. 692]

Antonio Draghi, 1634/35–1700. *La Chimera.* Opera. Libretto, Nicolò Minato. First performed 7 Feb **1682,** Vienna. [Grove 1980, 5:604]

Thomas Odell, 1691–1749. *The Chimaera, or, A Hue and Cry to Change Alley.* Comedy. First performed Jan **1721,** Lincoln's Inn Fields, London. [Nicoll 1959–1966, 2:347]

Gérard de Nerval, 1808–1855. *Les Chimères.* Collection of sonnets. **1843–54.** In *Les filles du feu* (Paris: Calman-Lévy, 1855). / Translated by Peter Jay in *The Chimeras: Essays by Richard Holmes and Peter Jay* (Redding Ridge, Conn.: Black Swan, 1984). [DLLF 1984, 2:1637f.]

Charles Baudelaire, 1821–1867. "Chacun sa chimère" [Each His Own Chimaera]. Prose poem. In *La presse* 26 Aug **1862,** as "Chacun la sienne" [Each His Own]; collected in *Petits poëmes en prose* (later called *Le spleen de Paris*), vol. 4 of *Oeuvres complètes* (Paris: Lévy, 1869). [Pichois 1975] Translated by Louise Varèse in *Paris Spleen* (New York: New Directions, 1947; 1970). [Ipso]

Gustave Moreau, 1826–1898. "The Chimaera" (as a winged centaur). Painting. **1867.** D. Wildenstein coll. [Mathieu 1976, no. 88—ill.] Variant. Fogg Art Museum, Harvard University, Cambridge. [Ibid., no. 89—ill.; cf. no. 90]

———. "The Chimaera." Painting. *c.*1879. Rheims coll., Paris. [Ibid., no. 186—ill.]

———. "The Chimaeras." Painting. Begun 1884, unfinished. Musée Gustave Moreau, Paris. [Mathieu, pp. 158f., 186—ill.]

———. "The Chimaeras." Watercolor. *c.*1884. Musée Gustave Moreau, Paris. [Mathieu 1985, pl. 42]

Gustave Flaubert, 1821–1880. (Chimaera evoked in) *La*

tentation de Saint Antoine 7. Poetic drama. Begun 1845. Paris: Charpentier, **1874.** [DLLF 1984, 2:817f.]

Antoine-Louis Barye, 1796–**1875.** Bronze incense burner, decorated with Chimaeras. Walters Art Gallery, Baltimore. [Pivar 1974, no. D4—ill.]

——. "Chimaera." Bronze sculpture. [Ibid., no. A98—ill.]

Stéphane Mallarmé, 1842–1898. (Chimaera evoked in) "Quelle soie aux baumes de temps" [What silk in the balms of time]. Sonnet. **1885.** In *Poésies* (Paris: Éditions de la Revue Indépendante, 1887). [Mondor & Jean-Aubry 1974 / Fowlie 1970, pp. 38f.]

Odilon Redon, 1840–1916. "The Chimaera looked at everything with terror." Lithograph, no. 4 in *Night* album (Paris: **1886**). [Mellerio 1913, no. 65—ill. / also Hobbs 1977, fig. 33]

——. Illustrations to Flaubert's *La tentation de Saint-Antoine* 7 (1874). "The green-eyed Chimaera turns, barks," lithograph, no. 7 of first series (Brussels: 1888). "Sphinx: . . . My gaze that nothing can deflect, passing through objects, remains fixed on an inaccessible horizon. Chimaera: As for me, I am light and joyful," lithograph, no. 5 of second series (Paris: 1889). [Mellerio, nos. 90, 99—ill. / also Hobbs, figs. 49, 63]

——. Lithograph, depicting flying Chimaera, frontispiece illustration to Edmond Picard's *El moghreb al Aksa* (Brussels: Larcier, 1889). [Mellerio, no. 103—ill.]

——. Lithograph, depicting Chimaera in shadows, frontispiece illustration to Jules Destrée's *Les Chimères* (Brussels: Monnom, 1889). [Ibid., no. 105—ill.]

——. "Chimaera." Drawing. 1902. Louvre, Paris. [Hobbs, fig. 81]

——. "Chimaera." Drawing. After 1886. Private coll., London. [Berger 1964, no. 647]

Gabriele D'Annunzio, 1863–1938. "La Chimera." Sonnet. 1885–88. In *La Chimera* (Milan: Treves, 1890). [Palmieri 1953–59, vol. 2]

Kees van Dongen, 1877–1968. "The Pied Chimaera" (as a dappled horse). Painting. **1895.** Private coll., Monaco. [Chaumeil 1967, p. 315, no. 1—ill.] Small replica. 1952. Monaco. [Ibid.]

Ettore Sanfelice, 1862–1923. *La Chimera.* Drama. In *Nuovi drammi* (Parma: Pellegrini, **1899**). [DELI 1966–70, 5:36 / DDLI 1977, 2:487]

Albert Samain, 1858–**1900.** "La Chimère." Poem. In *Symphonie héroïque, evocations,* bound in *Le chariot d'or* (Paris: Société du Mercure de France, 1901). [Ipso]

Paul Gauguin, 1848–**1903.** "The Gorilla and the Chimaera." Wood relief. Lost. / Print (after?), also called "Siren and Sea-God." [Gray 1963, no. 124—ill.]

Emilia Pardo Bazán, 1852–1921. *La Quimera* (modern painter confronts and slays his own Chimaera). Novel. Madrid: Administracion, **1905.** [Galerstein 1986, p. 252]

Louis-Welden Hawkins, 1849–1910. "The Sphinx and the Chimaera." Painting. **1906.** Musée d'Orsay, Paris, no. R.F. 1973–52. [Louvre 1979–86, 3:303—ill.]

Rainer Maria Rilke, 1875–1926. "Der Ursprung der Chimäre" [The Birth of the Chimaera]. Poem. **1908.** [Zinn 1955–66, vol. 2 / Leishman 1960]

Fernand Khnopff, 1858–1921. "Chimaera." Painting. *c.*1910, unfinished. Mabille coll., Brussels. [Delevoy et al. 1979, no. 470—ill.]

Arthur Symons, 1865–1945. "The Chimaera." Poem. In *Poems* (New York: Lane, **1911**). [Boswell 1982, p. 229]

Dino Campana, 1885–1932. "La Chimera," (Chimaera evoked in) "Genoa," "La notte," "La verna." Poems. In *Canti orfici* (Florence: Vallecchi Editore, **1914**). / Translated by I. L. Salomon in *Orphic Songs* (New York: October House, 1968). [Ipso / Pilling 1982, pp. 152–54]

Constantin Brancusi, 1876–1957. "Chimaera." Abstract wood sculpture. **1915–18.** Philadelphia Museum of Art. [Geist 1975, no. 116—ill. / Geist 1969, p. 85—ill. / also Giedion-Welcker 1959, pls. 76–77—ill.]

Luigi Chiarelli, 1884–1947. *Chimere.* Comedy of the grotesque. First performed 6 Feb **1920,** Teatro Carignano, Turin. Published Milan & Rome: Mondadori, 1922. [McGraw-Hill 1984, 1:500f.]

John Singer Sargent, 1856–1925. "The Sphinx and Chimaera." Painting, part of a mural cycle. **1916–21.** Museum of Fine Arts, Boston. [Ratcliff 1982, p. 149—ill.]

Max Ernst, 1891–1976. "Young Chimaera" (figure with leg-braces). Painting-collage. *c.*1921. Simone Breton-Collinet coll., Paris. [Spies & Metken 1975–79, no. 417—ill. / also Quinn 1977, fig. 86—ill.]

——. "Red Chimaera" (figure similar to above). Painting. 1925. Galerie Jan Krugier, Genf. [Ibid., no. 669—ill.]

——. "Two Young Nude Chimaeras." Painting. 1927. Aram Mouradian coll., Paris. [Ibid., no. 1133—ill.]

——. "Chimaera." Painting. 1928. Musée National d'Art Moderne, Paris, no. AM 1983–47. [Pompidou 1987, p. 202—ill. / also Spies & Metken, no. 1300—ill.]

——. "Loplop Presents Loplop" ("Chimaera"). Painting. 1930. Alexander Iolas Gallery, New York. [Spies & Metken, no. 1710—ill.]

——. "Chimaera." Illustration for *This Quarter* (Paris), Surrealist number, Sep 1932. [Ibid., no. 1757—ill. (study)] Variant, "Loplop Presents Chimaera" (same figure in another composition), drawing with collage. 1932. Julien Levy coll., Bridgewater, Conn. [Ibid., no. 1758—ill.; cf. no. 1759]

——. "Two Sexless Figures" ("Chimaeras"). Painting. 1933. Private coll., Paris. [Ibid., no. 2128—ill.]

——. "Chimaera." Plaster sculpture. 1935. Destroyed. [Ibid., no. 2162—ill.]

Loïe Fuller, 1862–1928, choreography. *Chimères.* Modern dance. First performed **1921,** Paris. [McDonagh 1976, p. 25]

Marguerite Yourcenar, 1903–1987. *Le jardin des chimères* [The Garden of the Chimaeras]. Verse drama. Paris: Perrin, **1921.** [Horn 1985, pp. 84f.]

Armande de Polignac, Comtesse de Chabannes, 1876–1962, music. *Chimères.* Ballet. **1923.** [Cohen 1987, 1:554]

Countee Cullen, 1903–1946. "That Bright Chimeric Beast." Poem. In *Copper Sun* (New York & London: Harper, **1927**). [Webster 1947, p. 223]

Elinor Wylie, 1885–**1928.** "Chimaera Sleeping." Poem. In *Collected Poems* (New York: Knopf, 1932). [Gregory & Zaturenska 1946, pp. 290f.]

D. H. Lawrence, 1885–**1930.** "Chimaera." Poem. In *Last Poems* (Florence: Orioli; London: Heinemann, 1932). [Pinto & Roberts 1964, vol. 2]

Jacob Epstein, 1880–1959. "Chimaera." Stone sculpture.

1932. Edward P. Schinman coll., Wayne, N.J. [Schinman 1970, p. 91—ill. / also Buckle 1963, p. 191—ill.]

Pablo Picasso, 1881–1973. "Four Girls with Chimaera." Etching. **1934.** [Penrose & Golding 1973, fig. 319 / also Bloch 1971–79, no. 229 (as "Winged Bull Observed by Four Children")—ill. / Rubin 1980, p. 316—ill.]

Federico García Lorca, 1898–**1936.** "Quimera." Poem. 1928. / Translated by William T. Oliver in *New Directions* 8 (Norfolk, Conn.: 1944). [Schneider & Stern 1988, p. 559 / EWL 1981–84, 2:197]

Henri Martin, 1860–**1943.** "To Each His Own Chimaera." Painting. Musée et Galerie des Beaux-Arts, Bordeaux. [Bénézit 1976, 7:212]

Merce Cunningham, 1919–, choreography. *Shimmera.* Modern dance. Music, John Cage. First performed **1943.** [McDonagh 1976, p. 294]

Jean Arp, 1887–1966. "Cup with Small Chimaera." Abstract bronze sculpture. **1947.** 3 casts: Warren coll., New York; Galleria Nazionale d'Arte Moderna, Rome; artist's coll. in 1957. [Giedion-Welcker 1957, no. 86—ill.] Plaster. Kunsthalle, Hamburg, no. 1976/4. [Hamburg 1985, no. 537—ill.]

Cesare Pavese, 1908–1950. "La chimera." Dialogue. In *Dialoghi con Leucò* (Turin: Einaudi, **1947**). / Translated by William Arrowsmith and D. S. Carne-Ross in *Dialogues with Leucò,* bilingual edition (Ann Arbor: University of Michigan, 1965). [Ipso]

W. H. Auden, 1907–1973. "The Chimeras." Poem. In *Times Literary Supplement* 9 Mar **1951**; collected in *Collected Shorter Poems* (London: Faber & Faber, 1966). [Mendelson 1976 / Fuller 1970, p. 232]

Oskar Kokoschka, 1886–1980. "Chimaera and Kneeling Figure." Lithograph, illustrating the artist's narrative *Ann Eliza Reed* (**1952**). [Wingler & Welz 1975–81, no. 188—ill.]

————. Border design for "Amor and Psyche" tapestry, depicting male Chimaera with a sun and female Chimaera with a moon. 1955. [Ibid., no. D16—ill.]

Michalis Karagatses (Demetrios Rodopoulos), 1908–1960. *He megale Chimaira mythhistorema* [The Great Chimaera Mythhistory]. Novel. 1936. [Athens]: Kollacos & Sias, **1953** (2d edition). [Seymour-Smith 1985, p. 694]

Tadeusz Jarecki, 1889–**1955.** *Chimera.* Symphonic poem. [Grove 1980, 9:557]

Mirko, 1910–1969. "Chimaera." Bronze sculpture. **1955.** [Trieste 1976, no. 17, p. 116—ill.]

Janine Charrat, 1924–, choreography. *La Chimère.* Ballet. Music, Jacques Thiérac. First performed **1958,** Paris. [Cohen-Stratyner 1982, p. 173]

Hans Hofmann, 1880–1966. "Chimaera." Abstract painting. **1959.** Futter coll., Northampton, Mass. [Bannard 1976, no. 41—ill. / also Hofmann 1963, no. 101—ill.]

Léonor Fini, 1918–. "Chimère." Painting. **1961.** [Lauter 1984, p. 120]

Luis Cernuda, 1902–1963. "Desolación de la Quimera" [The Disconsolate Chimaera]. Poem. **1956–62.** In *Desolación de la Quimera* (Mexico City: Mortiz, 1962). [Capote 1984 / Jimenez-Fajardo 1978, p. 141]

Georg von Kováts, 1912–. "Chimaera." Bronze sculpture. **c.1963.** [Gertz 1964, pl. 115 (plaster model)]

Janet Mansfield Soares, choreography. *Chimera.* Ballet. First performed **1964,** New York. [Cohen-Stratyner 1982, p. 826]

Leonard Baskin, 1922–. "Chimaera." Drypoint print. **1966.** [Fern & O'Sullivan 1984, no. 729—ill.]

————. "Chimaera." Bronze sculpture. 1973. Kennedy Galleries, New York, in 1978. [Jaffe 1980, p. 217]

Andrew Hoyem, 1935–. *Chimeras: Transformations of "Les Chimères" by Gérard de Nerval.* Poems. San Francisco: Dave Haselwood, **1966.** [Vinson 1985, p. 412]

Murray Louis, 1926–, choreography. *Chimera (Charade).* Modern dance. Music, Alwin Nikolais. First performed 25 Feb **1966,** Henry Street Settlement House, New York; scenery and costumes, Margo Hoff. [Sorell 1986, p. 190 / McDonagh 1976, pp. 405f.]

Jorge Luis Borges, 1899–1986. "La Quimera" [The Chimaera]. Poem. In *El libro de los seres imaginarios* (Buenos Aires: Kier, **1967**). / Translated by N. T. di Giovanni, with Borges, in *The Book of Imaginary Beings* (New York: Dutton, 1969). [Ipso]

Helen Gifford, 1935–. *Chimaera.* Orchestral work. **1967.** [Cohen 1987, 1:268 / Grove 1980, 7:365]

Robert Duncan, 1919–1988. "The Chimeras of Gérard de Nerval." Translation. In *Bending the Bow* (New York: New Directions, **1968**). [Boswell 1982, p. 253]

Pierre Gascar, 1916–. *Les Chimères.* Collection of 3 stories. Paris: Gallimard, **1969.** [DLLF 1984, 2:872 / Popkin 1977, p. 431]

Brewster Ghiselin, 1903–. "Pursuits of a Chimera (Homocanis concolor)." Poem. In *Country of the Minotaur* (Salt Lake City: University of Utah Press, **1970**). [Ipso]

John Barth, 1930–. *Chimera.* Collection of 3 novellas. New York: Random House, **1972.** [DLB 1978, 2:30f. / CLC 1974, 2:37f.; 1980, 14:52–55 / EWL 1981–84, 1:200]

Robert Yohn, 1905–, choreography. *Chimera.* Ballet. First performed **1974,** New York. [Cohen-Stratyner 1982, p. 960]

Derek Mahon, 1941–. *The Chimeras.* Collection of poems, after Nerval. Dublin: Gallery Books, **1982.** [DLB 1985, 40 pt. 2: 338]

CHIONE. See APOLLO, Loves.

CHIRON. A wise and gentle centaur, Chiron nurtured and educated many heroes, including Achilles, Aeneas, Asclepius, Heracles, Jason, Peleus, and even Apollo. He was versed in archery, music, and the use of medicinal plants and herbs.

Born immortal, Chiron was most often called the son of the Titan Cronus (who had taken the shape of a horse to trick his jealous spouse Rhea) and Philyra. He was also sometimes identified as the offspring of Zeus, or as a descendant of Ixion and the cloud Nephele.

When Heracles battled Pholus and other centaurs,

Chiron was accidentally wounded in the knee by a poisoned arrow. In terrible pain, he begged to die rather than to endure eternal suffering. He was finally released by Prometheus, who took on Chiron's immortality and allowed him to die. In Ovid, Chiron's daughter Ocyrhoë foretells his eventual death.

Classical Sources. Homer, *Iliad* 11.829–35 Hesiod, *Theogony* 1000ff. Pindar *Pythian Odes* 3.1ff., 9.29ff. Apollonius Rhodius, *Argonautica* 1.1231. Ovid, *Metamorphoses* 2.630–54. *Fasti* 5.384, 413; Apollodorus, *Biblioteca* 1.2.3–4, 2.5.4, 3.4.4, 3.13.3–5. Pliny, *Naturalis historia* 7.196. Pausanias, *Description of Greece* 5.5.10, 5.19.9. Hyginus, *Poetica astronomica* 2.38.

See also ACHILLES, Education; ASCLEPIUS; CENTAURS; HERACLES, General List; JASON, General List.

Dante Alighieri, 1265–1321. (Chiron among the centaurs guarding the Murderers in) *Inferno* 12.52–99. *c.*1307–*c.*1314? In *The Divine Comedy.* Poem. Foligno: Neumeister & Angelini, 1472. [Singleton 1970–75, vols. 1–2 / Toynbee 1968, p. 165 / Barkan 1986, pp. 150, 154]

Sandro Botticelli, 1445–1510. Chiron depicted in drawing illustrating *Inferno* 12, part of a series of illustrations to Dante's *Divine Comedy.* **1480s/early 1490s.** Biblioteca Vaticana, Rome. [Lightbown 1978, 1:147ff., 2:172f., nos. E26—ill.]

Pierre de Ronsard, 1524–1585. (Orpheus visits Chiron in) "L'Orphée." Poem, hymn. In *Les trois livres du recueil des nouvelles poésies* book 1 (Paris: Buon, 1563). [Laumonier 1914–75, vol. 12 / Cave 1973, pp. 166, 227f.]

Carlo Francesco Pollarolo, *c.*1653–1723. *L'inganno di Chirone* [The Deceit of Chiron]. Opera. Libretto, D. P. d'Averara. First performed **1700,** Milan. [Grove 1980, 15:47]

Friedrich Hölderlin, 1770–1843. "Chiron." Ode. **1802–03.** In *Nachtgesänge* (Stuttgart: Cotta, 1804). [Beissner 1943–77, vol. 2 / Hamburger 1980]

Johann Wolfgang von Goethe, 1749–1832. (Chiron, symbolizing knight-errantry, in the "Classical Walpurgisnight" in) *Faust* Part 2, 2.7320–7494. Tragedy. This episode written **1830.** Heidelberg: 1832. [Beutler 1948–71, vol. 5 / Suhrkamp 1983–88, vol. 2 / Galinsky 1972, pp. 216f.]

Maurice de Guérin, 1810–1839. *Le centaure* (Chiron's life story). Prose poem. *c.*1835. Published by George Sand in *Revue des deux mondes* 15 May 1840. Modern edition, Paris: Haumont, 1944. [DLLF 1984, 2:989f. / Oxford 1976, p. 272]

Charles Marie René Leconte de Lisle, 1818–1894. "Khirôn." Poem. In *Oeuvres: Poèmes antiques* (Paris: Lemerre, 1852). [Pich 1976–81, vol. 1 / DLLF 1984, 2:1261]

William Canton, 1845–1926. (Chiron evoked in) "Comfort on Pelion." Poem. In *A Lost Epic and Other Poems* (Edinburgh: Blackwood, 1887). [Bush 1937, p. 562]

Ernst Barlach, 1870–1938. "The Centaur Chiron." Satirical drawing. **1895.** Private coll., Hamburg. [Schult 1958–72, 3: no. 39—ill.]

Rubén Darío, 1867–1916. (Chiron takes part in) "Coloquio de los centauros" [Conversation of the Centaurs].

Poem. In *Prosas profanas y otros poemas* (Buenos Aires: Coni, 1896). [Méndez Plancarte 1967 / Ellis 1974, pp. 78, 83 / Jrade 1983, pp. 27–45]

T. Sturge Moore, 1870–1944. Print, illustration to Guérin's *The Centaur* (*c.*1835). Published London: Vale, 1899. [Lister 1962, pl. 55 / Gwyn 1951, pp. 23, 123]

———. "The Song of Cheiron." Monologue poem. In *The Sea Is Kind* (London: Richards, 1914; Boston: Houghton Mifflin, 1914). [DLB 1983, 19:333, 341f. / Bush 1937, p. 570]

Ker-Xavier Roussel, 1867–1944. Series of prints illustrating Guérin's *Le centaure* (*c.*1835). *c.*1910. [Alain 1968, nos. 32–50—ill. / Georgel 1968, pp. 309ff.]

William Rose Benét, 1886–1950. "The Centaur's Farewell" (Chiron bids farewell to the Argonauts). Poem. In *Merchants from Cathay* (New York: Century, 1913). [Boswell 1982, p. 36]

Auguste Rodin, 1840–1917. Series of aquarelles illustrating Maurice de Guérin's *Le centaure* (*c.*1835). Published with *La bacchante* (Lausanne: Mermod, 1947). [NUC]

Rainer Maria Rilke, 1875–1926. *Der Kentaur.* Free translation of Maurice de Guérin (*c.*1835). Leipzig: Insel, 1919. [Zinn 1955–66, vol. 2 / Prater 1985, pp. 187f., 361 / Leppmann 1984, pp. 282f.]

John Peale Bishop, 1892–1944. (Euryton nursed by Chiron in) "The Death of the Last Centaur." Poem. In *The Undertaker's Garland and Other Poems* (New York: Knopf, 1922). [Boswell 1982, pp. 41f.]

Robert Calverly Trevelyan, 1872–1951. *Chieron.* Poetic drama. London: Leonard and Virginia Woolf, 1927. [Boswell 1982, p. 304]

Anna Vaughn Hyatt Huntington, 1876–1973. "The Centaur Cheiron." Brass sculpture. Exhibited New York World's Fair, 1939. [Clapp 1970, 2 pt. 2: 554]

Cesare Pavese, 1908–1950. (Chiron speaks with Dionysus in) "Le cavalle" [The Mares]. Dialogue. In *Dialoghi con Leucò* (Turin: Einaudi, 1947). / Translated by William Arrowsmith and D. S. Carne-Ross in *Dialogues with Leucò,* bilingual edition (Ann Arbor: University of Michigan, 1965). [Ipso / Biasin 1965, p. 193]

Rabbe Enckell, 1903–1974. *Mordet på Kiron* [The Murder of Chiron]. Tragedy. Helsingfors: Söderström; Stockholm: Wahlström & Widstrand, 1954. [DSL 1990, p. 142]

Gerhard Marcks, 1889–1981. "Chiron." Bronze sculpture. 1955. Unique (?) cast. Hohe Landesschule, Hanau. [Busch & Rudloff, no. 630—ill.]

Camilo José Cela, 1916–. "La pitonista" [The Pythia] (abduction of the priestess Jezebel by Chiron). Tale, part 5 of "La historia troyana." In *Gavilla de fábulas sin amor* [Bundle of Tales without Love] (Palma de Mallorca: Papeles de San Armadans, 1962). [Goeppert et al. 1983, p. 286]

Pablo Picasso, 1881–1973. "The Rape of Jezebel by the Centaur Chiron." Print, illustration to Cela's "La pitonista" (above). 1962. [Bloch 1971–79, nos. 1842, 1842a—ill. / Goeppert et al. 1983, no. 116—ill.; cf. no. 143]

John Updike, 1932–. *The Centaur* (Chiron, symbol for father). Novel. New York: Knopf, 1963. [CLC 1973, 1:344; 1975, 3:485–86; 1976, 5:451–52]

Yvor Winters, 1900–**1968.** "Chiron" (at the end of his life). Poem. In *Collected Poems* (Manchester: Carcanet, 1978). [Boswell 1982, p. 236]

CHLOE. *See* DAPHNIS AND CHLOE.

CHLORIS. *See* FLORA.

CHRYSAOR. *See* MEDUSA; PERSEUS, and Medusa.

CHRYSEIS. The daughter of Chryses, a Trojan priest of Apollo, Chryseis was abducted by the Greek forces at Troy and given to Agamemnon as a concubine. She prayed to Apollo for release, and he set a plague upon the Greeks. The seer Calchas announced that the pestilence would be cured only if Agamemnon surrendered the captive maiden to her father. Agamemnon complied, but demanded that he receive the captive Briseis, who had been awarded to Achilles, in exhange. This demand provoked the episode known as the Wrath of Achilles, the subject of Homer's *Iliad.* Chryseis was later called Criseyde or Cressida, and became the beloved of Troilus in some tales.

Classical Sources. Homer, *Iliad* 1.8–474. Hyginus, *Fabulae* 120–21.

See also ACHILLES, Wrath; TROJAN WAR, General List.

Luca Cambiaso, 1527–1585. "Apollo, at the Urging of Chryses, Attacks the Camp of the Greeks before Troy." Ceiling fresco. **1544.** Palazzo della Prefettura, Genoa. [Manning & Suida 1958, pp. 74f.—ill.]

Claude Lorrain, 1600–1682. "Seaport with Ulysses Restoring Chryseis to Her Father Chryses." Painting. *c.*1644. Louvre, Paris, inv. 4718. [Röthlisberger 1961, no. LV 80—ill. / Louvre 1979–86, 3:271—ill.] Drawing after, in the artist's *Liber veritatis.* British Museum, London. [Röthlisberger]

Benjamin West, 1738–1820. "Chryseis Returned to Her Father." Painting. **1771?** New York Historical Society, New York. [von Erffa & Staley 1986, no. 160—ill.]

———. "Chryses Invoking the Vengeance of Apollo against the Greeks." Painting. 1773. Mount Holyoke College Art Museum, South Hadley, Mass. [Ibid., no. 159—ill.]

———. "Chryseis Returned to Her Father." Painting (retouched by another?). Lyman Allyn Museum, New London, Conn. [Ibid., no. 161—ill.]

James Sherwood Westmacott, 1823–1900. "Chryseis." Bronze statue. **1867.** Laing Art Gallery, Newcastle-upon-Tyne. [Read 1982, pl. 264]

Francis William Bourdillon, 1852–1921. "Chryseis." Poem. In *Preludes and Romances* (London: Allen, **1908**). [Boswell 1982, p. 244]

Charles Tournemire, 1870–1939. (Chryseis evoked in) *Les dieux sont morts* [The Gods Are Dead]. Opera (drame antique), opus 42. Libretto, E. Berteaux. **1910/12.** First performed 19 Mar 1924, L'Opéra, Paris. [Baker 1984, p. 2328 / Grove 1980, 19:95]

Walter Conrad Arensberg, 1878–1954. "Chryseis." Poem. In *Poems* (Boston: Houghton Mifflin, **1914**). [Bush 1937, p. 587]

CINYRAS. *See* MYRRHA.

CIRCE. The daughter of Helios and Perse, Circe was a sorceress (or a goddess) living on the island of Aeaea, off the western coast of Italy. A powerful magician, she offered visitors wine with a potion that turned them into beasts. When Odysseus landed on her island, she turned half his men into swine, then restored them after he promised to become her lover. He remained with Circe for a year, after which she allowed him to resume his homeward journey.

Circe is primarily associated with this episode from the *Odyssey,* but she figures in other myths as well. In some legends, she married Odysseus's son Telemachus after his father's death. According to the Argonautic tradition, after Jason and Medea killed Medea's brother Apsyrtus in their flight from Colchis, they went to Circe to be purified of the crime. In still another story, Glaucus, a sea-god who was unsuccessfully pursuing the nymph Scylla, came to Circe to ask for a love potion. When Glaucus rejected her own advances, Circe poisoned the waters where Scylla bathed, turning her into a hideous monster. Circe also once loved Picus, son of Saturn, whom she transformed into a woodpecker for resisting her advances.

Classical Sources. Hesiod, *Theogony* 956f., 1011–14. Apollonius Rhodius, *Argonautica* 4.559–91, 659–752. Ovid, *Metamorphoses* 13.966–14.71, 14.246–440; *Telegony* 1. Apollodorus, *Bibliotheca* E7.10–18.

See also GLAUCUS; JASON, Golden Fleece; ODYSSEUS, Circe; TELEMACHUS.

Anonymous French. (Story of Picus in) *Ovide moralisé* 14.2675–2895 (narrative), 2957–3266 (allegory). Poem, allegorized translation/elaboration of Ovid's *Metamorphoses. c.*1316–28. [de Boer 1915–86, vol. 5]

Giovanni Boccaccio, 1313–1375. "De Circe Solis filia" [Circe, Daughter of the Sun]. In *De mulieribus claris* [Concerning Famous Women]. Latin verse compendium of myth and legend. **1361–75.** Ulm: Zainer, 1473. [Branca 1964–83, vol. 10 / Guarino 1963]

Filarete, *c.*1400–1469? "Circe and Picus." Relief, on bronze door of St. Peter's, Rome. **1433–45.** In place. [Pope-Hennessy 1985b, 2:318]

Dosso Dossi, c.1479–1542. "Circe (and Her Lovers in a Landscape)" (? or Alcina in *Orlando Furioso*?). Painting. Dated variously **c.1515–30.** Kress coll. (K1323), National Gallery, Washington, D.C., no. 716. [Shapley 1966–73, 2:73f.—ill. / Gibbons 1968, no. 80—ill. / Sienkewicz 1983, p. 12—ill. / Walker 1984, fig. 222]

————. "Circe" (traditional title; subject uncertain, possibly "Melissa"?). Painting. c.1530. Galleria Borghese, Rome, inv. 217. [Pergola 1955–59, 1: no. 36—ill. / Gibbons, no. 59—ill.]

Parmigianino, 1503–**1540.** "Circe." Drawing. / Etching by Andrea Schiavone. / Aquatint by Stefano Mulinari. [Pigler 1974, p. 308]

Garofalo, c.1481–**1559.** "Picus Transformed into a Bird." Painting. Galleria Nazionale, Rome. [Berenson 1968, p. 157]

Hans Kels the Elder, 1480/85–**c.1559.** "Circe." Carved spielstone sculpture. Kunsthistorisches Museum, Vienna. [Pigler 1974, p. 308]

Torquato Tasso, 1544–1595. (Armida likened to Circe in) *Gerusalemme liberata* 4.86, 10.65ff. Epic. **1575.** Venice: Perchacino, 1581 (authorized edition). [Kates 1983, p. 69]

Giordano Bruno, 1548–1600. *Cantus Circaeus* [Incantation of Circe]. Poem. Paris: **1582.** [Bondanella 1979, p. 80]

Thomas Heywood, 1573/74–1641. (Circe in) "Of Witches." Passage in *Gynaikeion: or, Nine Books of Various History Concerning Women* book 8. Compendium of history and mythology. London: Adam Islip, **1624.** [Ipso]

Jan Roos the Elder, 1591–**1638.** "Picus Turned into a Woodpecker by Circe." Painting. Ravasco coll., Genoa. [Pigler 1974, p. 221]

Antonio Maria Vassallo, fl. **1637–48** (previously attributed to Castiglione). "Circe." Painting. Uffizi, Florence, inv. 1363. [Uffizi 1979, no. P1858—ill.]

Luca Giordano, 1634–1705. "Circe and Picus." Painting. c.**1652–55.** Herzog Anton Ulrich-Museum, Braunschweig, no. 500. [Ferrari & Scavizzi 1966, 1:60, 2:64—ill. / Braunschweig 1969, p. 64 / Braunschweig 1976, p. 28—ill.]

Thomas Corneille, 1625–1709, with **Jean Donneau de Visé,** 1638–1710. *Circé.* Tragedy (spectacle with machines). Music, Marc-Antoine Charpentier. First performed **1673,** Théâtre Le Marais, Paris. Published Paris: Bessin, 1675. [Girdlestone 1972, pp. 292, 316, 420 / Arnott 1977, p. 22]

Marc-Antoine Charpentier, 1645/50–1704. *Circé.* Intermède for voices, strings, and basso continuo. Text, Corneille and de Visé (above). **1675.** [Grove 1980, 4:174 / Girdlestone 1972, pp. 292, 316, 420]

Giovanni Domenico Cerrini, 1609–**1681.** "Circe." Painting. Musée, Brive (on deposit from Louvre, Paris, no. M.N.R. 811). [Louvre 1979–86, 2:287]

Laurent Magnier, c.1619–1700. "Circe." Marble term. **1684.** Gardens, Versailles. [Girard 1985, p. 284—ill.]

Carlo Antonio Monza, ?–1736. *La Circe in Italia.* Opera. First performed Carnival **1717,** Teatro della Pace, Rome. [Grove 1980, 12:545]

Francesco Solimena, 1657–1747. "Study for Circe." Painting. Ulster Museum, Belfast, inv. 150. [Wright 1976, p. 190]

Jacopo Amigoni, 1675–**1752.** "Circe" (?). Painting. Museum Bisdom van Vliet, Haastrecht. [Wright 1980, p. 8]

Joshua Reynolds, 1723–1792. "Mrs. Nisbett as Circe." Painting. **1781.** Lord Stanley of Alderley coll., Penrhos, in 1925. [Waterhouse 1941, p. 73]

George Romney, 1734–1802. "Lady Hamilton as Circe." Painting. **c.1782.** Tate Gallery, London, no. 5591. [Tate 1975, p. 68]

Antoine Reicha, 1770–**1836.** *Circé.* Cantata for soprano and pianoforte. [Grove 1980, 15:700]

John Byrne Leicester Warren, Lord de Tabley, 1835–1895. "Circe." Poem. In *Ballads and Metrical Sketches* (London: Kent, **1860**). [Boswell 1982, p. 250]

————. "The Island of Circe." Poem. In *Poems: Dramatic and Lyrical,* 1st series (London: Mathews & Lane, 1893). [Boswell / Bush 1937, pp. 427, 564]

————. "Circe." Poem. In *Poems: Dramatic and Lyrical,* 2d series (London: Lane, 1895). [Boswell]

————. "A Daughter of Circe." Poem. In *Orpheus in Thrace and Other Poems* (London: Smith Elder, 1901). [Boswell]

Joseph Noel Paton, 1821–1901. "Circe." Poem. In *Poems by a Painter* (Edinburgh & London: Blackwood, **1861**). [Bush 1937, p. 555]

Thomas Love Peacock, 1785–1866. *Gryll Grange* (Gryllus, a victim of Circe who preferred to retain his swinish nature). Novel. London: Parker & Bourn, **1861.** [Bush 1937, p. 181]

Dante Gabriel Rossetti, 1828–1882. "Circe." Drawing (or painting?), known only from contemporary reports. c.**1865.** [Surtees 1971, no. 187]

————. "For 'The Wine of Circe' by Edward Burne-Jones." Sonnet. 1869. In "Sonnets for Pictures" section of *Poems* (London: Ellis, 1870). [Doughty 1965 / Rees 1981, p. 112]

Edward Burne-Jones, 1833–1898. "The Wine of Circe." Watercolor. **1863–69.** Private coll., England. [Cecil 1969, pl. 66—ill. / Arts Council 1975, no. 105 / also Bell 1901, 39, 115—ill.]

Philippe Auguste Villiers de l'Isle-Adam, 1838–1889. (Susannah Jackson, the "Scottish Circe," in) "Le convive inconnu" [The Unknown Guest]. Short story. In *Revue du monde nouveau* 15 Feb **1874;** collected as "Le convive des dernières fêtes" [The Eleventh-Hour Guest] in *Contes cruels* (Paris: Calmann-Levy, 1883). [Dijkstra 1986, p. 322]

Richard Greenough, 1819–1904. "Circe." Marble sculpture. **1882.** Metropolitan Museum, New York. [Gerdts 1973, p. 114, fig. 121]

Henry Marriot Paget, 1857–1936. "Circe." Painting. Exhibited **1884.** [Kestner 1989, p. 352]

John Collier, 1850–1939. "Circe." Painting. **1885.** [Kestner 1989, p. 293]

John Godfrey Saxe, 1816–**1887.** "The Spell of Circe." Poem. In *Poetical Works* (Boston & New York: Houghton Mifflin, 1900). [Boswell 1982, p. 289]

Louis Chalon, b. 1866. "Circe." Painting, inspired by Villiers de l'Isle-Adam's "Le convive inconnu" (1874). Exhibited **1888.** [DLLF 1984, 1:2461 / Dijkstra 1986, p. 322—ill.]

Bertram MacKennal, 1863–1931. "Circe." Bronze (?) statue. Exhibited **1893.** / Bronze reduction. Exhibited 1894. Private coll. [London 1968, no. 106]

Alfred Drury, 1859–1944. "Circe." Bronze statue. **1893–94.** City Art Gallery, Leeds, England. [Beattie 1983, pls. 86, 167]

Arthur Symons, 1865–1945. "The Wine of Circe." Poem. In *London Nights* (London: Smithers, **1895**). [Beckson 1987, p. 117]

Gabriele D'Annunzio, 1863–1938. "L'incanto circio" [The Magic of Circe]. Poem (madrigal), part of "Madrigale dell' estate." **1903.** In *Alcyone* (Milan: Treves, 1904). [Roncoroni 1982]

Lee Wilson Dodd, 1879–1933. "Circe." Poem. In *A Modern Alchemist and Other Poems* (Boston: Badger, **1906**). [Bush 1937, p. 584]

Arthur Wardle, 1864–1949. "Circe" (surrounded by leopards). Painting. **1908.** [Kestner 1989, p. 335, pl. C7]

George Storey, 1834–1919. "Circe." Painting. **1909.** [Kestner 1989, p. 336, pl. C–10]

Alfred Gilbert, 1854–1934. "Circe." Plaster sculpture. *c.*1909–11. Lost, presumed destroyed. [Minneapolis 1978, fig. 35]

Franz von Stuck, 1863–1928. "Tilla Durieux as Circe." Painting. *c.*1913. 5 versions. Nationalgalerie, Berlin; others in private colls. or unlocated. [Voss 1973, nos. 418–21, suppl. no. 11—ill.]

Eleanore Plaisted Abbott, 1875–1935. "Circe." Painting. *c.*1918. [Dijkstra 1986, p. 324—ill.]

Annie Vivanti, 1868–1942. *La Circe.* Romance. Milan: **1918.** [DELI 1966–70, 5:483]

George Sterling, 1869–1926. "The Death of Circe." Poem. In *Sails and Mirage and Other Poems* (San Francisco: Robertson, **1921.** [Bush 1937, p. 588]

George Grosz, 1893–1959. "Circe." Watercolor. *c.*1925. Hirshhorn Museum and Sculpture Garden, Washington, D.C., no. 1966.2263. [Hirshhorn 1974, p. 699, pl. 355 / Kilinski 1985, no. 23]

Henry Miller, 1891–1980. "Circe." Short story. By Dec **1925.** [CLC 1980, 14:373]

Robert Neumann, 1897–1975. *Hochstapler* [Swindler]. Novella. Stuttgart: Engelhorns Nachfolger, **1930.** Reprinted as *Die Insel der Circe* (Munich: Desch, 1952). / Translated as *Circe's Island* (London: Hutchinson, 1954). [Domandi 1972, 2:176]

Alice Pike Barney, 1857–**1931.** "Circe." Pastel. Barney coll. no. 14, National Collection of Fine Arts, Washington, D.C. [Barney 1965, p. 112—ill. / also Dijkstra 1986, pp. 322f.—ill.]

Bertram MacKennal, 1863–**1931.** "Circe." Bronze sculpture. [*Apollo* new series no. 112 (Sep 1983): 215]

Witter Bynner, 1881–1968. "Circe." Poem. Before **1947.** In *Selected Poems,* edited by Richard Wilbur (New York: Farrar, Straus & Giroux, 1977–1978). [Ipso]

A. D. Hope, 1907–. "Circe: After The Painting by Dosso Dossi." Poem, after Dossi's "Circe and Her Lovers" (1515–30, Washington). **1948.** In *The Wandering Islands* (Sydney: Angus & Robertson, 1955). [Ipso / Boswell 1982, p. 135 / Hooton 1979, p. 2]

William Gibson, 1914–. "Circe." Poem. In *Poetry* **1949**; collected in *The Poetry Anthology: 1912–1977,* edited by Daryl Hine and Joseph Parisi (Boston: Houghton Mifflin, 1978). [Ipso]

Katherine Anne Porter, 1894–1980. *A Defense of Circe.* Essay. New York: Harcourt, Brace & Co., **1954.** [Lauter 1984, pp. 66f.]

Mario Castelnuovo-Tedesco, 1895–1968. "3 preludi al Circeo" [3 Preludes to Circe]. Composition for guitar, opus 194. **1961.** [Grove 1980, 3:869]

Geoffrey Grigson, 1905–1985. "Circe." Poem. **1961.** In *Collected Poems, 1924–1962* (London: Phoenix House, 1963). [Ipso]

Emilio Belaval, 1903–. *Circe, o, El amor* [Circe, or Love]. Platonic farce. Barcelona: Rumbos, **1963.** [Allen 1987, pp. 460, 469]

Peter Russell, 1921–. *Complaints to Circe* (evocative use of myth in title, a man transformed by magic to love hopelessly). Poem. London: privately printed, **1963.** [Vinson 1985, p. 733]

Joseph Cornell, 1903–1972. "Rapport de Contreras." Collage, incorporating a reproduction of part of Dosso Dossi's "Circe and Her Lovers" (1515–30, Washington). *c.*1965. Hirshhorn Museum and Sculpture Garden, Washington, D.C. [Hirshhorn 1974, p. 675, pl. 989]

Irving Layton, 1912–. "Circe." Poem. In *Collected Poems* (Toronto: McClelland & Stewart, **1965**). [Ipso]

Stuart Montgomery, 1940–. *Circe.* Poem. London: Fulcrum, **1969.** [Ipso]

Olga Broumas, 1949–, poem, and **Sandra McKee,** painting. "Circe." Part of 2–media piece "Twelve Aspects of God." Exhibited Sep **1975,** Maude Kerns Gallery, Eugene, Ore. Broumas's poem in *Beginning with O* (New Haven: Yale University Press, 1977). [Ipso]

Cecilie Ore, 1954–. "Circe." Electronic musical composition. **1982.** [Cohen 1987, 1:523]

CLIO. *See* MUSES, History.

CLYMENE. *See* APOLLO, Loves; PHAETHON.

CLYTEMNESTRA. *See* AGAMEMNON; IPHIGENIA, at Aulis; ORESTES.

CLYTIE. Daughter of the Titans Oceanus and Tethys, Clytie loved Apollo and spent each day watching his sun chariot traverse the sky. But Apollo preferred Leucothea (sometimes called Clytie's sister). The jealous Clytie told Leucothea's father, King Orchamus, of his daughter's liaison with the god. In his anger, Orchamus had Leucothea buried alive. As Apollo grieved for the girl, his tears changed her body into a frankincense tree. Clytie herself wasted

away until she was transformed into a heliotrope (sunflower), a flower that constantly faces the sun.
Classical Source. Ovid, *Metamorphoses* 4.169–270.

Anonymous French. (Story of Clytie in) *Ovide moralisé* 4.1454–1487, 1756–1923. Poem, allegorized translation/elaboration of Ovid's *Metamorphoses*. *c.*1316–28. [de Boer 1915–86, vol. 2]

Lorenzo de' Medici, 1449–**1492.** (Clytie evoked in) Sonnet 2. In *Poesie volgari* (Vinegia: Aldo, 1554). [Lipari 1936, pp. 158ff.]

Annibale Carracci, 1560–**1609,** attributed. "Clytie Transformed into a Sunflower." Painting. Art Museum, Cincinnati, Ohio. [Pigler 1974, p. 61]

Jean Puget de La Serre, 1594–1665. "Soleil et Clytie," [The Sun and Clytie]. Poem. In *Les amours des dieux* (Paris: d'Aubin, **1624**). [NUC]

Peter Paul Rubens, 1577–1640. "Clytie (Grieving)" (previously called "Ariadne Abandoned"). Painting, for Torre de la Parada, El Pardo (executed by assistant from Rubens's design?). **1636–38.** Lost. [Alpers 1971, no. 11] Oil sketch. Formerly Suhr coll., New York, sold New York 1984. [Jaffé 1989, no. 1250—ill. / also Alpers, no. 11a—ill. / Held 1980, no. 178—ill.]

Marc-Antoine Bonet. *Les larmes de Clytie* [The Tears of Clytie]. Allegorical poem. Toulouse: **1648.** [Giraud 1968, p. 297]

Laurent de La Hyre, 1606–1656. "Clytie." Etching. [Pigler 1974, p. 61]

Antonio Bertali, 1605–1669. *Gli amori di Apollo con Clizia* [The Loves of Apollo and Clytie]. Opera. First performed **1661,** Vienna. [Grove 1980, 2:633]

José de Cañizares, 1676–1750, music. *Clicie y el sol* [Clytie and the Sun]. Zarzuela. [Barcelona:] **1700.** [Barrera 1969, p. 70]

Charles de La Fosse, 1636–1716. "Clytie." Painting. Musée, Versailles. [*Apollo* 88 (Nov 1968), p. 341 / Pigler 1974, p. 61]

Charles-Antoine Coypel, 1694–1752. "Clytie." Painting. / Engraved by Louis Surugue, **1720.** [Pigler 1974, p. 61]

Antoine Watteau, 1684–**1721,** attributed. "Clytie." Painting. Maurice de Rothschild coll., Paris. [Pigler 1974, p. 61]

Henry Desmarets, 1661–1741. "Clytie." Cantata. First performed **1724.** Music lost. [Grove 1980, 5:392]

Louis-Nicolas Clérambault, 1676–1749. "Clytie." Cantata. Published in *Cantates françoises à I. et II. voix avec simphonie et sans simphonie,* book 5 (Paris: **1726**). [Grove 1980, 4:492]

Francesco Corrodini, *c.*1700–after 1749. *La Clicie.* Opera. Libretto, José de Cañizares. First performed Carnival **1739,** Principe. [Grove 1980, 4:798]

Pierre Lepautre, 1660–**1744.** "Clytie." Marble statue. Hôtel Édouard Kann, Paris. [Pigler 1974, p. 61] Another version in Castle Park, La Muette. [Ibid.]

Charles-Joseph Natoire, 1700–1777. "Apollo and Clytie." Painting. **1745.** Nationalmuseum, Stockholm. [Boyer 1949, no. 69]

François Boucher, 1703–1770. "Apollo and Clytie." Painting, model for tapestry in "Loves of the Gods" series. *c.***1750.** Lost. / 7 tapestries woven by Beauvais, 1750; unlocated. [Ananoff 1976, no. 352—ill.]

Giovanni Battista Crosato, *c.*1685–**1758.** "Clytie." Painting. Palazzo Madama, Turin. [*Paragone* 12 no. 135 (1961), pl. 52a / Pigler 1974, p. 61]

Anton Raphael Mengs, 1728–**1779.** "Clytie." Painting. Castle, Fredensborg, Denmark. [Honisch 1965, no. 402]

Maria Cosway, 1759–1838. "Clytie." Painting. **1785.** / Mezzotint by Valentine Green (1739–1813). [Pigler 1974, p. 61]

André Chénier, 1762–1794. "Clytie." Poem, part of *Les bucoliques* (unpublished MS). *c.***1778–87.** First published in *Oeuvres complètes* (Paris: Foulon, Baudouin, 1819). [Oxford 1959, p. 129 / DLLF 1984, 1:447]

John Martin, 1789–1854. "Clytie." Painting. Several versions: **1810,** unlocated; 1814, damaged and painted over as "Alpheus and Arethusa" (q.v.); reduced variant of 1814 version, formerly Mrs. C. Frank coll. [Feaver 1975, pp. 13, 23, pl. 10]

Washington Allston, 1779–1843. "Clytie." Painting (?). **1817.** Lost. [Richardson 1948, no. 98]

Anne-Louis Girodet, 1767–**1824,** composition. "Clytie Changed into a Sunflower." Lithograph, part of "Loves of the Gods" cycle. Published Paris: Engelmann, 1825–26. [Boutet-Loyer 1983, no. 87 n.]

Peter Cornelius, 1783–1867, and studio. "Clytie." Ceiling fresco. **1820–26.** Göttersaal, Glyptothek, Munich. [Glyptothek 1980, pp. 214ff., 219f.—ill.]

William Wetmore Story, 1819–1895. "Clytie." Poem. In *Poems* (Boston: Little, Brown, **1847**). [Boswell 1982, p. 297]

Algernon Charles Swinburne, 1837–1909. "Clytie." Poem. *c.***1849–50.** In *Juvenilia* (privately printed by T. J. Wise, 1912). [Bush 1937, p. 329]

Charles Marie René Leconte de Lisle, 1818–1894. "Klytie." Poem. In *Oeuvres: Poèmes antiques* (Paris: Lemerre, **1852**). [Pich 1976–81, vol. 4]

———. "Parfum de Hélios-Apollons, l'heliotrope." Poem, no. 2 of "Hymnes orphiques," verse translation from Orphic Hymns. In *Oeuvres: Derniers poèmes* (Paris: Lemerre, 1895). [Ibid.]

Mary E. Hewitt, 1808–after 1856. "Clytia." Poem. In *Poems: Sacred, Passionate, and Legendary* (New York: Lamport, Blakeman & Law, **1853**). [Ostriker 1986, p. 285]

George Frederick Watts, 1817–1904. "Clytie." Marble bust. *c.***1868.** Guildhall Art Gallery, London. [Wood 1983, pp. 92, 95—ill. / Minneapolis 1978, no. 16—ill.] Bronze version. Watts Gallery, Compton, Surrey; Tate Gallery, London; Leighton House, London; elsewhere. [Beattie 1983, p. 147, pl. 138 / Blunt 1975, pp. 190f.—ill. / London 1968, no. 187—ill. / Kestner 1989, p. 74, pl. 2.12]

William Henry Rinehart, 1825–1874. "Clytie." Marble statue. 5 examples, **1872–74.** Peabody Institute, Baltimore; Metropolitan Museum, New York; Hospitalfield coll., Arbroath, Angus, Scotland; 2 others known, unlocated. [Ross & Rutledge 1948, no. 8—ill. / Metropolitan 1965, p. 24 / also Gerdts 1973, pp. 39f., 54, fig. 7]

Evelyn Pickering de Morgan, 1855–1919. "Clytie." Painting. **1886–87.** Hartnoll & Eyre, London, in 1973. [Harrison & Waters 1973, p. 181—ill.]

Henri Chapu, 1833–**1891.** "Clytie." Marble sculpture. Musée, Dijon. [Pigler 1974, p. 61]

Frederic, Lord Leighton, 1830–1896. "Clytie." Painting.

*c.*1892. Fitzwilliam Museum, Cambridge, no. M.84. [Ormond 1975, p. 127, no. 368 / Fitzwilliam 1960–77, 3:153 / Minneapolis 1978, no. 52—ill.]

——. "Clytie." Painting. *c.*1895–96. Private coll., India. [Ormond, no. 396—ill. / Wood 1983, pp. 62, 75—ill.] Color sketch, Lady Lever Art Gallery, Port Sunlight, Cheshire, no. 1427. [Ormond, no. 397]

Maurice Hewlett, 1861–1923. "The Ballad of Clytie." Poem. In *Songs and Meditations* (Westminster: Constable, **1896**). [Bush 1937, p. 564]

Sara King Wiley, 1871–1909. "Clytie." Poem. In *Poems Lyrical and Dramatic* (London: Chapman & Hall, **1900**). [Boswell 1982, p. 309]

Harold Monro, 1879–1932. "Clytie." Poem. In *Collected Poems* (London: Duckworth, **1906**). [Boswell 1982, 273]

Wilfred Owen, 1893–1918. "I Am to Thee a Sunflower to the Sun." Poem. **1915?** In *Poems,* edited by Siegfried Sasson (London: Chatto & Windus, 1920). [Ipso]

Bernard Spencer, 1909–**1963**. (Clytie evoked in) "Bring me the sunflower so that I can transplant it." Poem. In *Collected Poems* (Oxford & New York: Oxford University Press, 1981). [Ipso]

Ron Sequoio, choreography. *Clytie.* Ballet. First performed **1964**, New York. [Cohen-Stratyner 1982, p. 804]

COMUS. An obscure Greek deity, Comus was a winged god of mirth and feasting who led processions of Dionysus and was associated with the early history of comedy. He gained prominence under the Romans, still in his role as leader of singing and dancing, revelry, and drunkenness. He was often depicted wearing roses and carrying a torch.

In John Milton's masque *Comus,* the seminal postclassical treatment of the figure, Comus is said to have descended from Bacchus and Circe. Milton took a puritanical stance against the god's dissolute behavior, which has nevertheless remained his greatest attraction.

Classical Source. Philostratus, *Imagines* 1.2.

Giovanni Bellini, *c.*1430–1516. "Comes virtutis." Painting. Before **1506?** Accademia, Venice. [Wind 1948, p. 48—ill.]

Andrea Mantegna, 1430/31–**1506**, and **Lorenzo Costa,** 1460–1535 (begun by Mantegna, completed by Costa after Mantegna's death). "The Reign of Comus" ("The Gate of Comus") (Comus, Janus, and Mercury chasing away the Vices, with other figures representing virtue and vice). Painting. Louvre, Paris, inv. 256. [Louvre 1979–86, 2:169—ill. / Lightbown 1986, no. 41—ill. / Louvre 1975, no. 128—ill. / Wind 1948, pp. 46f., fig. 59]

Erycius Puteanus (Hendrik van der Putten), 1574–1646. *Comus.* Neo-Latin prose fantasy, with some verse. Louvain: Rivius, **1608**. Reprinted in Oxford, 1634. [Crown 1985, pp. 65, 91/ CEWL 1973, 3:366 / Bush 1963, p. 278]

Ben Jonson, 1572–1637. (Comus as personification of Komos in) *Pleasure Reconciled to Virtue.* Masque. Performed 6 Jan **1618,** at Court, London. Published London: 1640.

[Herford & Simpson 1932–50, vol. 7 / McGraw-Hill 1984, 3:112f. / Levin 1969, pp. 133f., 136]

John Milton, 1608–1674. *Comus.* Masque. Music, Henry Lawes. First performed Michaelmas Day **1634,** Ludlow Castle. Published (as *A Masque Presented at Ludlow Castle*) London: Robinson, 1637. [Carey & Fowler 1968 / Brown 1985, / Spink 1974, pp. 94f. / Brown 1985, chapters 3–6]

Peter Paul Rubens, 1577–1640. (Comus in) "The Stage of Mercury." Painted stage, decoration for "Pompa Introitus Fernandi," triumphal entry of Cardinal-Infante Ferdinand of Spain into Antwerp, 17 Apr **1635**. Original decoration destroyed. [Martin 1972, pp. 178ff.—ill. (print)]

Pierre Beauchamps, 1631–1705, music. "Comus." Entrée in *Ballet des arts.* First performed **1685,** Collège Louis-le-Grand, Paris. [Astier 1983, p. 161]

Paolo Antonio Rolli, 1687–1765. *Sabrina.* Opera, after Milton's *Comus* (1634). Libretto, composer. First performed **1737,** Covent Garden, London. [Hogwood 1984, p. 138]

Thomas Augustine Arne, 1710–1778, music. *Comus.* Masque. Libretto, John Dalton, after Milton (1634). First performed 4 Mar **1738,** Theatre Royal, Drury Lane, London. [Keates 1985, pp. 233, 267 / Hogwood 1984, p. 202 / Grove 1980, 1:605, 609 / Fiske 1973, pp. 179–89, 197f., 211f., 294f. / Nicoll 1959–66, 2:317, 435]

George Frideric Handel, 1685–1759. 3 songs and trio for a private arrangement of *Comus.* Text, John Dalton's revision of Milton. First performed **1745,** house party at Lord Gainsborough's, Exton, Rutland. [Keates 1985, p. 267 / Hogwood 1984, p. 202 / Grove 1980, 8:117]

François Bouvard, *c.*1683–1760. *Les délices de Comus* [The Delights of Comus]. Composition for 10 voices. Paris: **1750**. [Grove 1980, 3:120]

George Colman the Elder, 1732–1794. *Comus.* Masque, after Milton (1634). Music, Thomas Arne (1738). First performed 16 Oct **1773,** Theatre Royal, Covent Garden, London. [Nicoll 1959–66, 3:246]

Henry Fuseli, 1741–1825. "Comus." Illustration to Milton's *Comus* (1634). **1791**. Published in *Bell's British Theatre.* / Sketch. Victoria and Albert Museum, London, inv. Dyce 1199/1887. [Schiff 1973, no. 1033—ill.]

——. "The Palace and the Revelers of Comus." Painting, for Milton Gallery (no. 35). 1796–99. Lost. / Drawing. Unlocated. [Ibid., no. 1030—ill.]

William Blake, 1757–1827. Drawing, illustration to Thomas Gray's "Ode for Music" (a genius driving away "Comus and his midnight crew" at dawn). *c.***1797–98.** Mellon coll., Upperville, Va. [Butlin 1981, no. 335.95]

——. 8 watercolor illustrations to Milton's *Comus* (1634). 2 sets: *c.*1801, Huntington Library and Art Gallery, San Marino, Calif.; *c.*1815, Museum of Fine Arts, Boston, Mass. [Ibid., nos. 527–28—ill. / also Bindman 1982, no. 92—ill.]

Anonymous. *Comus.* Masque. First performed **1815,** London. [Nicoll 1959–1966, 4:443]

Johann Heinrich Ramberg, 1763–1840. (Comus tickling the Muse's feet in title-page illustration to) *Homer's Iliad, Serious and Comic* (**1828**). [Bindman 1979, no. 260—ill.]

John Graham Lough, 1798–1842. "Comus." Marble sculpture. *c.***1833?** Mansion House, London. [Boase 1960, p. 287, pl. 37a]

Edwin Landseer, 1802–1873. "The Defeat of Comus." Painting. **1843**. Tate Gallery, London, no. 605. [Tate 1975, p. 48]

William Dyce, 1806–1864. "Comus." Fresco, illustrating scenes from Milton's *Comus* (1634). **1844**. Formerly Buckingham Palace Pavilion, London, destroyed. / Print by L. Gruner, c.1846. [Pointon 1979, pp. 85, 200—ill.]

Charles Robert Leslie, 1794–1859. "A Scene from Milton's *Comus*." Painting. Exhibited **1844**. Tate Gallery, London, no. 1182. [Tate 1975, p. 52]

George Richmond, 1809–1896. (Comus in) "The Measure." Painting. **1864**. Walker Art Gallery, Liverpool. [Lister 1984, p. 78, pl. 109]

Charles Edward Horsley, 1822–1876. "Comus." Song (ode). Published New York: **1874**. [Grove 1980, 8:724]

Madison Cawein, 1865–1914. *The Cup of Comus: Fact and Fancy*. Collection of poems. New York: Cameo, 1915. [NUC]

Frederick Ashton, 1904–1988, choreography. Concluding dance in "Comus, a Masque by John Milton," part of *A Masque of Poetry and Music*. Music, Henry Purcell, arranged by Constant Lambert. First performed 10 Dec **1930**, Arts Theatre Club, London. [Vaughan 1977, pp. 47, 455]

Robert Helpmann, 1909–1986, choreography. *Comus*. Masque, after Milton (1634). Music, Henry Purcell, arranged by Constant Lambert. First performed 14 Jan **1942**, New Theatre, Sadler's Wells, London; sets, costumes, Oliver Messel. [Clarke 1955, pp. 167f., 182, 326 / Grove 1980, 10:397]

Mona Inglesby, 1918–, choreography. *The Masque of Comus*. Ballet. Music, original songs of Henry Lawes, additional music from Handel, arranged by Irving, with Milton's text (1634) spoken by actors. First performed by International Ballet, London Coliseum, London, **1946**. [Oxford 1982, pp. 101, 211 / DMB 1959, p. 184]

Hugh Wood, 1932–1984. *Scenes from Comus*. Composition for soprano, tenor, and orchestra, opus 6. Text, Milton (1634). **1962–65**. First performed 2 Aug 1965, London. [Baker 1984, p. 2526 / Grove 1980, 20:518]

CORONIS. The name of two related figures associated with the loves of Apollo and Poseidon. *See* APOLLO, Loves; POSEIDON, Loves.

CORYDON. *See* SHEPHERDS AND SHEPHERDESSES.

CREON. *See* ANTIGONE; OEDIPUS; SEVEN AGAINST THEBES.

CRESPHONTES. *See* MEROPE.

CRESSIDA. *See* Troilus and Cressida.

CREUSA. (1) A daughter of the king of Athens who was raped by Apollo and gave birth to Ion. *See* CREUSA. (2) The wife of Jason, killed by Medea; also called Glauce. *See* JASON, General List *and* MEDEA. (3) The wife of Aeneas. *See* AENEAS, Flight from Troy.

CREUSA. According to Attic legend, Creusa was the third daughter of Erechtheus, king of Athens. As a maiden she was ravished by Apollo and bore a son, Ion. Fearing her father's wrath, she left the infant to die in a grotto on the Acropolis. At Apollo's request, Ion was rescued by Hermes, who brought him to Delphi, where the child became a temple servant.

Creusa was later married to Xuthus as a reward for his aid to Erechtheus in battle, but she was barren. According to Euripides, she and her husband visited the oracle at Delphi, where Xuthus was told to accept as his son the first boy he saw on leaving the temple. He saw Ion, now a priest of Apollo, and laid claim to him. Jealously imagining that the boy was Xuthus's child by a previous union, Creusa planned to poison Ion, but he discovered the plot and took refuge in the temple. With the intervention of Athena, mother and son were reconciled.

Classical Source. Euripides, *Ion*.

Louis de Lacoste, c.1675–mid-1750s. *Créuse l'Athènienne*. Opera (tragédie lyrique). Libretto, Pierre-Charles Roy, after Euripides' *Ion*. First performed 5 May **1712**, L'Opéra, Paris. [Grove 1980, 10:352 / Girdlestone 1972, p. 224 *n*.]

William Whitehead, 1715–1785. *Creusa, Queen of Athens*. Tragedy, based on Euripides' *Ion*. First performed 20 Apr **1754**, Theatre Royal, Drury Lane, London. Published London: Dodsley, 1754. [Stratman 1966, p. 685 / Nicoll 1959–66, 3:71, 80, 315, 398]

Davide Perez, 1711–1778. *Creusa in Delfo*. Opera. Libretto, G. Martinelli. First performed Carnival **1774**, Salvaterra, Lisbon. [Grove 1980, 14:367]

Johann Jakob Bodmer, 1698–1783. *Kreusa*. Epic. **1777**. In *Evadne und Kreusa: Zwei griechische Gedichte* (Zurich: Burgklischen Drukerey, 1777). [DLL 1968–90, 1:650 / Hunger 1959, p. 165]

Venanzio Rauzzini, 1746–1810. *Creusa in Delfo*. Opera. Libretto, G. Martinelli. First performed 29 Apr **1783**, King's Theatre, London. [Grove 1980, 15:608]

August Wilhelm von Schlegel, 1767–1845. *Ion*. Tragedy, after Euripides. First performed **1803**, Weimar, directed by Goethe. [Oxford 1986, p. 797]

Samuel Iperuszoon Wiselius, 1769–1845. *Ion*. Tragedy,

adaptation and translation of Euripides. Amsterdam: **1818.** [McGraw-Hill 1984, 2:69]

Thomas Talfourd, 1795–1854. *Ion.* Tragedy. **1835.** First performed 25 Apr 1836, Covent Garden, London. Published in *Tragedies* (London: Moxon, 1840). [Nicoll 1959–66, 4:177, 410]

Frederick Fox Cooper, 1806–1879. *Ion.* Burlesque. First performed 9 Oct **1836,** Garrick Theatre, London. [Nicoll 1959–66, 4:283]

Charles Marie René Leconte de Lisle, 1818–**1894.** "L'Apollonide" (Ion, son of Apollo). Verse drama. In *Oeuvres: Derniers poèmes* (Paris: Lemerre, 1895). [Pich 1976–81, vol. 3]

François Mathieu Servais, 1846–1901. *L'Apollonide* (later titled *Iôn*). Opera. Libretto, Leconte de Lisle. First performed **1899,** Karlsruhe. [Grove 1980, 17:188 / Pich 1976–81, 3:294f. / Baker 1984, p. 2105]

H. D. (Hilda Doolittle), 1886–1961. *Euripides' Ion.* Translation. Begun **1927.** Boston: Houghton Mifflin, 1937. [Robinson 1982, pp. 106, 229, 254, 370, 469 / Gregory 1961, p. ix]

Theodore Karyotakis, 1903–1978. Incidental music for Euripides' *Ion.* First performed **1937,** Athens. [Grove 1980, 9:814]

T. S. Eliot, 1888–1965. *The Confidential Clerk.* Verse drama, based on theme from Euripides' *Ion.* First performed **1953,** Edinburgh Festival. [Eliot 1962 / Barber 1958, pp. 213–26 / Smith 1974, p. 219]

CRONUS. The youngest of the Titans, Cronus was said by Hesiod to be the most terrible. When his father, Uranus, tried to prevent the birth of the Titans, Cronus castrated him with a sickle and released his brothers and sisters from inside their mother, Gaia. Now ruler of the world, he married his sister Rhea and fathered the Olympian deities Hestia, Demeter, Hera, Hades, Poseidon, and Zeus. Seeking to avert the prophecy that one of his children would dethrone him, Cronus swallowed each of them at birth. Only Zeus (Jupiter) escaped; when he reached maturity he forced Cronus to disgorge the other Olympians and subsequently led them in a victorious revolt against the Titans.

In other myths, after the overthrow of Uranus, Cronus ruled the earth in a peaceful, idyllic period known as the Golden Age. One tale tells of his love of the Oceanid Philyra and of how, upon being surprised by Rhea, he turned himself and the nymph into horses. The centaur Chiron was their offspring.

In Roman mythology, Cronus was identified with Saturn, an ancient Italian deity who may have been a seed god. Saturn was the husband of Ops, the Roman goddess of abundance associated with the Greek Rhea and perhaps with the Phrygian fertility goddess Cybele. According to Virgil, King Latinus

of Latium was descended from Saturn and kept statues of Saturn and Janus in his palace hall. The Saturnalia, a mid-December festival celebrated in Saturn's honor, was a time of goodwill and gift-giving, during which sacrifices were made at the temple of Saturn and a public feast was held; Saturn is thus sometimes depicted as a personification of winter in postclassical art.

According to the Roman author Varro (as quoted by Augustine in *City of God*), "Saturn is called Cronus, indicating as a Greek word the extent of time, without which the seed cannot be fertile." The association of Cronus with time (Greek, *chronos*) may be a deliberate pun by Varro and may also explain the popular postclassical image of Saturn as Father Time, an old man carrying his scythe.

Classical Sources. Homer, *Iliad* 14.203f., 14.271ff., 15.221ff. Hesiod, *Theogony* 137–210, 168–82, 453–91; *Works and Days* 169ff. Pindar, *Olympian Odes* 2.70ff. *Orphic Hymns* 13, "To Cronus." Plato, *Politicus* 269A, 276A. Apollonius Rhodius, *Argonautica* 2.1231–41. Virgil, *Aeneid* 7.180f. Horace, *Epodes* 16.63. Ovid, *Metamorphoses* 1.89–116, 2.676, 6.126; *Fasti* 4.197ff. Apollodorus, *Biblioteca* 1.1.1–2.1. Pausanias, *Description of Greece* 5.7.6ff., 8.36.2ff. Lucian, *Dialogues of the Gods* 14, "Hermes and Helios." Augustine, *City of God* 7.19.

Further Reference. Erwin Panofsky, "Saturn," in *Studies in Iconology: Humanistic Themes in the Art of the Renaissance* (New York: Oxford University Press, 1939). Raymond Klibansky, Erwin Panofsky and Fritz Saxl, *Saturn and Melancholy: Studies in the History of Natural Philosophy, Religion, and Art* (New York: Basic Books, 1964).

Listings are arranged under the following headings:
General List
Birth of the Olympians

See also GODS AND GODDESSES, as Seasons; TITANS AND GIANTS; URANUS.

General List

Anonymous French. (Saturn in) *Ovide moralisé* 1.513–718. Poem, allegorized translation/elaboration of Ovid's *Metamorphoses.* **c.1316–28.** [de Boer 1915–86, vol. 1]

Giovanni Boccaccio, 1313–1375. "De Saturno." In *De casibus virorum illustrium* [The Fates of Illustrious Men] 1.5. Didactic poem in Latin. **1355–73?** [Branca 1964–83, vol. 9]

Geoffrey Chaucer, 1340?–1400. (Saturn intercedes for Venus and Palamon against Mars and Arcite in) "The Knight's Tale" lines 2438–78, 2664ff. Poem, adaptation of Boccaccio's *Teseida* (this passage original with Chaucer). **Early 1380s** (as "Palamon and Arcite"); revised and incorporated in *The Canterbury Tales,* 1388–95. Westminster: Caxton, 1478. [Riverside 1987 / Gaylord 1974, 171–90]

Christine de Pizan, c.1364–c.1431. (Saturn in) *L'epistre d'Othéa à Hector* [The Epistle of Othéa to Hector] chapters 8, 51. Didactic romance in prose. **c.1400.** MSS in British Library, London; Bibliothèque Nationale, Paris;

elsewhere. / Translated by Stephen Scrope (London: *c.*1444–50). [Bühler 1970 / Hindman 1986, pp. 80, 87f., 194, 198, pl. 12]

Maso da Finiguerra, 1426–1464. "Saturn." Drawing. *c.***1460.** British Museum, London. [Warburg]

Baldassare Peruzzi, 1481–1536. Saturn, with Venus and Cupid, depicted in a ceiling fresco, representing the constellation Pisces. **1510–11.** Sala di Galatea, Villa Farnesina, Rome. [d'Ancona 1955, pp. 25f., 88 / Gerlini 1949, pp. 10ff. / also Frommel 1967–68, no. 18c]

———. "Saturn." Fresco. 1511–12 (or *c.*1517–18). Sala delle Prospettive, Villa Farnesina. [d'Ancona, pp. 27ff., 93f. / Gerlini, pp. 31ff. / also Frommel, no. 51]

Giulio Campagnola, 1481/82–1516. "Saturn." Engraving (Bartsch no. 4). [Borenius 1923, no. 3—ill.]

Rosso Fiorentino, 1494–1540, composition. "Saturn and Philyra." Engraving, part of "Loves of the Gods" series, executed by Gian Jacopo Caraglio, **1527** (Bartsch no. 23). [Carroll 1987, no. 43—ill. / also Barocchi 1950, fig. 41] Variant, fresco, in Galerie François I, Château de Fontainebleau. 1534–37. Repainted 18th/19th century. [Barocchi, p. 136 / Carroll 1987, no. 85—ill. (print)]

Pordenone, 1483/84–**1539.** "Saturn." Fresco, on façade of Palazzo d'Anna, Venice. Lost. / Engraved by Andrea Andreani (Bartsch 12.1215.127), 1604. [Warburg]

Parmigianino, 1503–**1540.** "Saturn." Chiaroscuro woodcut. (Museum of Fine Arts, Boston.) [Vermeule 1964, pp. 80, 173]

Giulio Romano, *c.*1499–**1546.** Drawing, depicting Cupid, Diana, Cronus, and Boreas as the Four Elements. Earl of Ellesmere coll., Mertoun House, Rosburghshire, Scotland, no. 123. [Hartt 1958, p. 295 (no. 141)—ill.]

Francesco Primaticcio, 1504–1570, design. "Saturn and Minerva," "Saturn." Frescoes, for Salle de Bal, Château de Fontainebleau, executed by Niccolò dell' Abbate under Primaticcio's direction. **1551–56.** Repainted 19th century / Drawing for "Saturn." Louvre, Paris, no. 8602. [Dimier 1900, pp. 160ff., 284ff., no. 89]

———. "Saturn." Drawing. *c.*1555–62. Nationalmuseum, Stockholm. [Paris 1972, no. 189—ill. / also Lévêque 1984, pp. 2, 5—ill.]

Cristofano Gherardi, 1508–1556, under direction of **Giorgio Vasari,** 1511–1574. "The First Fruits of the Earth Being Given to Saturn" (Allegory of Earth). Fresco. **1555–56.** Sala degli Elementi, Palazzo Vecchio, Florence. [Sinibaldi 1950, pp. 13, 22 / Lensi 1929, pp. 154ff., 159—ill.] *See also Vasari, below.*

Giorgio Vasari, 1511–1574, and assistant(s). Fresco cycle, ceiling of Terrazzo di Saturno, Palazzo Vecchio, Florence. "Saturn Devouring His Male Children," "Saturn Landing in Italy, Received by Janus," "Saturn and Janus Building Saturnia." *c.*1558. Damaged by fire in 1600. In place. [Sinibaldi 1950, pp. 13, 22 / also Barocchi 1964, pp. 50, 316]

Paolo Veronese, 1528–1588. "Saturn and History" ("Time and Meditation"). Fresco. *c.*1560–61. Stanza del Cane, Villa Barbaro-Volpi, Maser (Treviso). [Pallucchini 1984, no. 62—ill. / Pignatti 1976, no. 100—ill.]

———. "Time (Saturn) Helping Religion to Defeat Heresy." Painting, part of series glorifying Germany, for

Fondaco dei Tedeschi, Venice. *c.*1578–80. Formerly Kaiser Friedrich Museum, Berlin, destroyed. [Pallucchini, no. 168d—ill. / Pignatti, no. 212—ill.]

Jacopo Zucchi, *c.*1541–1589/90. "Saturn." Fresco. *c.***1586–87.** Palazzo Ruspoli, Rome. [Hunger 1959, p. 192]

Edmund Spenser, 1552?–1599. (Story of Saturn and Philyra depicted in tapestry of "Cupid's Wars," in) *The Faerie Queene* 3.11.43. Romance epic. London: Ponsonbie, **1590,** 1596. [Hamilton 1977]

Hendrik Goltzius, 1558–1617. "Saturn." Engraving, in "Eight Deities" series, after (lost) chiaroscuro frescoes by Polidoro da Caravaggio (*c.*1498–1543). **1592.** 4 states. [Strauss 1977a, no. 256—ill. / Bartsch 1980–82, no. 256—ill.]

———. "[Statue of] Saturn as Protector of Agriculture." Drawing, composition for print in "Seven Planets" series. 1596. Rijksprentenkabinet, Amsterdam, inv. 1905-A62. (Engraved by Jan Saenredam, Bartsch no. 73.) [Reznicek 1961, no. 143—ill.] Variant, for second ("small") series, 1597. Original drawing unlocated. / Engraved by Jacob Matham (Bartsch no. 149). [Ibid., no. 147]

Cavaliere d'Arpino, 1568–1640. "Cronus." Fresco. **1594–95.** Loggia Orsini, Palazzo del Sodalizio dei Piceni, Rome. [Röttgen 1969, p. 285]

Thomas Heywood, 1573/74–1641. (Saturn battles [his brother] Titan [*sic*] and Jupiter for mastery of the earth in) *Troia Britanica: or, Great Britaines Troy* cantos 1–5. Epic poem. London: **1609.** [Heywood 1974 / also Boas 1950, pp. 58ff. / Clark 1931, pp. 50ff.]

———. (Saturn, Titan, and Jupiter in) *The Golden Age.* Drama, based on *Troia Britanica.* First performed *c.*1609–11, London. Published London: Okes, 1611. [Heywood 1874, vol. 3 / DLB 1987, 62:101, 122ff. / Boas, pp. 83ff. / Clark, pp. 62ff.]

Gherardo Silvani, 1579–1673. "Saturn." Marble statue. *c.***1610?** Giardino di Boboli, Florence. [Florence 1986, no. 4.23—ill.]

Walter Ralegh, 1552?–1618. (Saturn in) *The Historie of the World* chapter 2.5. London: Burre, **1614.** [Hammond 1984]

Ben Jonson, 1572–1637. (Saturn in) *Time Vindicated to Himself and to His Honours.* Masque. Performed 19 Jan **1623,** at Court, London. Published London: 1623. [Herford & Simpson 1932–50, vol. 7 / Levin 1969, p. 133]

Peter Paul Rubens, 1577–1640. (Saturn in) "The Apotheosis of Henri IV and the Assumption of the Regency by Marie de' Medici," "Marie de' Medici as Patroness of the Fine Arts" ("The Felicity of the Regency"). Paintings, part of "Life of Marie de' Medici" cycle. **1622–25.** Louvre, Paris, inv. 1779, 1783. [Saward 1982, pp. 98ff., 142ff.—ill. / Jaffé 1989, nos. 735, 745—ill. / also Louvre 1979–86, 1:117—ill. / White 1987, pls. 185–86] Oil sketches. Hermitage, Leningrad ("Apotheosis"); Alte Pinakothek, Munich, inv. 100, 102 (both). [Jaffé, nos. 733–34, 744—ill. / Held 1980, nos. 69–70, 74—ill. / also Munich 1983, pp. 463, 467, 470—ill.]

Anthony van Dyck, 1599–1641. "Time [Saturn] Clipping the Wings of Love [infant Cupid]." Painting. *c.***1628–32.** Musée Jacquemart-André, Paris. [Larsen 1988, no. 737—ill.] Copies in Staatliche Kunstsammlung, Kassel; Nationalmuseum, Stockholm. [Ibid., no. A174—ill.]

Simon Vouet, 1590–1649. "Time [Saturn] Overcome by Love [Cupid], Venus, and Hope." Painting. **1640–43?**

Musée du Berry, Bourges, no. D.959.2.1. [Dublin 1985, no. 42—ill.]

Jan Brueghel the Younger, 1601–1678. "Children of the Planet Saturn" (Saturn in chariot drawn by dragons, above peasant scene). Painting. **Late 1640s?** Sold Christie's, London, 1978. [Ertz 1984, no. 231—ill.]

Thomas Willeboirts, *c.*1614–**1654.** "Saturn." Painting. Neues Palais, Potsdam, no. 299. [Warburg]

Gerrit van Honthorst, 1590–**1656.** "Saturn Disguised as an Old Man." Painting. Sold 1823, unlocated. [Judson 1959, no. 92]

Ciro Ferri, 1634–1689. Ceiling fresco, depicting an old man led before Saturn by Prudence and Mars, and 3 oval pendants depicting Saturn. **1663–66.** Sala di Saturno, Palazzo Pitti, Florence. [Pitti 1966, pp. 30f.—ill.]

Theodoor van Thulden, 1606–**1669,** attributed. "The Three Fates with Cronus." Painting. Musée de Peinture et de Sculpture, Grenoble. [Bénézit 1976, 10:171]

Nicolas Loir, 1624–1679. Decorations for Salon de Saturne, Appartement de la Reine, Château de Versailles. **Early 1670s,** destroyed. [Berger 1985, pp. 41ff., 70f.]

Charles Nocret, 1615–1672, and/or **Pierre de Sève,** 1623–1695. Decorations for Salon de Saturne, Appartement du Roi, Château de Versailles. **Early 1670s,** destroyed. [Berger 1985, pp. 41ff., 70f.]

Charles Le Brun, 1619–1690. "Saturn Abducting Cybele." Drawing. Before **1674.** Louvre, Paris, inv. 29.851. [Düsseldorf 1971, no. 343—ill.]

François Girardon, 1628–1715. "Fountain of Saturn." Lead fountain figure (one of 4 representing the Seasons, others destroyed), from a design by Charles Le Brun, after an idea by Poussin. **1673–75.** Gardens, Versailles. [Girard 1985, p. 280—ill. / also Francastel 1928, no. 33—ill.] Marble reduction. Sold Paris, 1914. [Francastel]

Gérard de Lairesse, 1641–1711. "Saturn." Ceiling painting. *c.*1675. Rijksmuseum, Amsterdam, inv. C382–B. [Rijksmuseum 1976, p. 335—ill.]

Pierre Beauchamps, 1631–1705, music. "Saturne." Entrée in *Ballet des arts.* First performed **1685,** Collège Louis-le-Grand, Paris. [Astier 1983, p. 161]

Joachim von Sandrart, 1606–**1688.** "Minerva and Saturn Protecting Art and Science." Painting. Kunsthistorisches Museum, Vienna, inv. 1136 (1538). [Vienna 1973, p. 153—ill.]

Balthasar Permoser, 1651–1732. "Cronus." Sandstone statue. *c.***1690–95.** Unlocated. [Asche 1966, no. P23]

———. "Cronus." Sandstone statue. *c.*1695. Formerly Dresden, unlocated. [Ibid., no. P24]

Sebastiano Ricci, 1659–1734. "Saturn." Ceiling fresco (detached), part of "The Olympian Gods" cycle, from Palazzo Mocenigo-Robilant, Venice. **1697–99.** Gemäldegalerie, Berlin-Dahlem, on loan from German government. [Daniels 1976, no. 46—ill. / Berlin 1986, p. 64—ill.]

Flemish School. "Sine Cerere et Baccho friget Venus, with Minerva Bringing Temperance, and Cronus." Painting. **17th century.** E. L. Cats coll., The Hague, in 1960. [Warburg]

South Netherlands School. "Cronus [Time] Abducting Youth." Terra-cotta sculpture. **Late 17th/early 18th century.** Musées Royaux des Beaux-Arts, Brussels, inv. 1534. [Düsseldorf 1971, no. 300—ill.]

Ferdinand Maximilian Brokoff, 1687–1731. "Cronus."

Sculpture, in tomb of Vratislav Mitrovice, St. James Church, Prague. **1716.** [Clapp 1970, 1:115]

Matthias Bernard Braun, 1684–1738. "Cronus," detail in "Allegory of Time." Sculpture. *c.***1717.** Citoliby, Czechoslavakia. [Clapp 1970, 1:111]

Louis Fabritius Dubourg, 1693–1775. "Venus, Cupid, and Time [Cronus]." Painting. **1731.** Gemäldegalerie, Wiesbaden, no. 68. [Warburg / Bénézit 1976, 3:692]

Franz Anton Maulbertsch, 1724–1796. "Saturn, with Female Figure." Drawing. *c.***1750.** Moravské Muzeum, Brno, Czechoslovakia. [Garas 1960, no. 35—ill.]

Giovanni Battista Tiepolo, 1696–1770. "Cronus" ("Time"). Fresco. **1757.** Sala dell' Olimpo, Villa Valmarana, Vicenza. [Morassi 1962, p. 65 / Pallucchini 1968, no. 240—ill.]

———. "Cronus (Time) Entrusting Cupid to Venus." Painting. *c.*1762–70. Pinto-Basto coll., Lisbon. [Morassi, p. 16—ill. / Pallucchini, no. 297—ill. / also Levey 1986, pp. 268f.—ill.]

Anton Raphael Mengs, 1728–1779. (Figure of Time [Cronus/Saturn] in) "Allegory of History." Fresco. **1772–73.** Camera dei Papiri, Vatican, Rome. [Honisch 1965, no. 3—ill.]

Friedrich Hölderlin, 1770–1843. "Natur und Kunst, oder, Saturn und Jupiter" [Nature and Art, or, Saturn and Jupiter]. Ode. *c.***1801.** In *Gedichte* (Stuttgart & Tübingen: Cotta, 1826). [Beissner 1943–77, vol. 2 / Hamburger 1980 / Steiner 1984, pp. 66–75, 80f., 84–106, 196f.]

John Keats, 1795–1821. (Saturn in) *Hyperion: A Fragment.* Poem. *c.*Oct 1818–*c.*April **1819.** London: Taylor & Hessey, 1820. [Stillinger 1978 / Aske 1985, pp. 85–89 / Gradman 1980, pp. 48–51, 54]

Salvatore Viganò, 1769–1821, choreography and scenario. (Golden Age in) *I Titani* [The Titans] act 1. Epic ballet. Music, Gioacchino Rossini, with Viganò and Ayblinger. First performed 11 Oct **1819,** La Scala, Milan; scenery, Alessandro Sanquirico. [Oxford 1982, pp. 353, 438 / Simon & Schuster 1979, p. 90]

Antoine-Jean Gros, 1771–1835. "Time [Saturn] Raising Truth to the Steps of the Throne, Wisdom [Minerva] Receiving Her. . . ." Ceiling painting. Exhibited **1827.** Salle E des Antiquités Égyptiennes, Louvre, Paris (inv. 5059). [Louvre 1979–86, 3:291—ill.]

Hans Thoma, 1839–1924. "Cronus Sharpening His Scythe." Painting. **1873.** Artist's coll., Karlsruhe, in 1909. [Thode 1909, 50—ill.]

———. "Saturn." Mural. 1875. Albert Ullmann coll., Frankfurt. [Ibid., 73—ill.]

———. "Saturn." Painting. 1907. Kunsthalle, Karlsruhe. [Ibid., 494—ill.]

Rudolf Borchardt, 1877–1945. *Saturnische Elegie* [Saturnian Elegies]. Collection of elegies. Göttingen: privately printed, **1901.** [DLB 1988, 66, pt. 1: 50 / DLL 1968–90, 1:784]

Gustav Klimt, 1862–1918. "Saturn" (holding an hourglass). Design for a calendar. **1901.** Original drawing, Georg Schäfer coll., Schweinfurt, inv. 310845A. [Strobl 1980, 2: no. 719—ill.]

Frank Edwin Elwell, 1858–1922. "Cronus." Sculpture. Before **1918.** [Clapp 1970, 2, pt. 1: 341]

Federico García Lorca, 1898–1936. (Saturn as god of seed time in) "Tu infancia en Mentón" [Your Childhood in Menton], (Saturn stops trains in Edem [*sic*] in) "Poema

doble del lago Eden" [Double Poem of Lake Eden (sic)] stanza II. Poems. **1929.** In *Poeta en Nueva York,* edited by José Bergamin (México, D.F.: Seneca, 1940). [Predmore 1980, pp. 80, 84 / Harris 1978, p. 17]

Jan Jacob Slauerhoff, 1898–1936. *Saturnus.* Collection of poems. Rotterdam: Nijgh & Van Ditmar, **1930.** [Meijer 1971, p. 324]

Giuseppe Ungaretti, 1888–1970. "La fine di Crono" [The End of Cronus]. Poem. In *Sentimento dal tempo* (Florence: Vallecchi, **1933**). [Ipso]

Ruth Pitter, b. 1897. "Saturn's Counsel." Poem. **1926–35.** In *A Trophy of Arms* (New York: Macmillan, 1936). [Ipso]

Robert Graves, 1895–1985. "The Sirens' Welcome to Cronos." Poem. **1938–45.** In *Poems, 1938–1945* (London: Cassell, 1946). [CLC 1974 2:175]

Juan Nickford, 1926–. "Cronus." Bronze and chrome-nickel steel sculpture. Exhibited **1956.** [Clapp 1970, 2 pt. 2: 828]

Günter Grass, 1927–. "Saturn." Poem. In *Gleisdreieck* (Darmstadt: Luchterhand, **1960**). [Moore 1967, p. 134]

Nicolas Schöffer, 1912–. "Chronos I." Mobile sculpture. Exhibited **1961.** [Clapp 1970, 1:794]

———. "Chronos 5." Aluminum, cast steel, and plastic sculpture. 1962. Schöffer, Paris. [Ibid.]

Arthur Vincent Lourié, 1892–1966. "Funeral Games in Honor of Chronos." Instrumental composition. **1964.** [Grove 1980, 11:258]

André Masson, 1896–1987. "Saturn." Bronze sculpture. **1964.** [Benincasa 1981, p. 138—ill.]

Jorge Luis Borges, 1899–1986, with **Margarita Guerrero.** "Cronos o Hércules" [Cronus or Hercules]. Prose sketch. In *El libro de los seres imaginarios* (Buenos Aires: Kier, **1967**). / Translated by N. T. di Giovanni, with Borges, in *The Book of Imaginary Beings* (New York: Dutton, 1969). [Ipso]

David Hare, 1917–. "Cronus." Series of paintings and drawings. *c.***1966–75.** Exhibited 1977, Guggenheim Museum, New York. [Marks 1984, pp. 356f.]

Birth of the Olympians. Told that he would be overthrown by one of his Olympian offspring, Cronus (Saturn) swallowed each of his children (or only his sons) at birth. When Zeus (Jupiter), the last child, was born, his mother Rhea (Ops) hid the infant on Crete and tricked Cronus into swallowing a stone. At maturity, Zeus returned to force his father to disgorge the other Olympians, thus setting the stage for their ten-year-long revolt against the Titans.

Classical Sources. Hesiod, *Theogony* 453–506. Ovid, *Fasti* 4.197–200. Apollodorus, *Biblioteca* 1.2.1. Pausanias, *Description of Greece* 8.8.2, 8.36.3.

Jean de Meun, 1250?–1305? (Castration of Saturn evoked in) *Le roman de la rose* lines 5537–42, 20034–36. Verse romance, completion of unfinished work begun by Guillaume de Lorris (*c.*1230–35). *c.***1275.** Lyon: Ortuin &

Schenck, *c.*1481. [Dahlberg 1971 / Poirion 1974 / Hill 1974, pp. 404f., 417f. / Fleming 1969, pp. 130, 220f.]

Anonymous French. (Story of Saturn and his children in) *Ovide moralisé* 1.513–718. Poem, allegorized translation/elaboration of Ovid's *Metamorphoses* and other works. *c.***1316–28.** [de Boer 1915–86, vol. 1]

Giovanni Boccaccio, 1313–1375. (Ops [Rhea] saves her children from their father Saturn in) "De Opi, Saturni coniuge" [Ops, Wife of Saturn]. In *De mulieribus claris* [Concerning Famous Women]. Latin verse compendium of myth and legend. **1361–75.** Ulm: Zainer, 1473. [Branca 1964–83, vol. 10 / Guarino 1963]

Jan Gossaert, called Mabuse, *c.*1478–**1533/36,** attributed. "Cybele Beseeching Saturn to Spare Her Child." Painting. Bowes Museum, Barnard Castle, list 1934 no. 62. [Wright 1976, p. 80]

Giulio Romano, *c.*1499–1546, design. "Cronus Devouring His Children." Clock figure. **1538–39.** Loggia, Appartemento di Troia, Palazzo Ducale, Mantua. [Hartt 1958, p. 301 (no. 237)—ill.]

Maerten van Heemskerck, 1498–1574. "Saturn Swallowing a Child." Painting, in "Gods and Heroes from Mythology and the Old Testament" cycle. *c.*1545. Yale University Art Gallery, New Haven, inv. 60.50a. [Grosshans 1980, no. 30g—ill.]

Domenico Beccafumi, 1486–1551. "Saturn Devouring His Children." Drawing. Victoria and Albert Museum, London. [Pigler 1974, p. 236]

Giorgio Vasari, 1511–1574, and assistant(s). "Saturn Devouring His Male Children." Fresco, part of "Saturn" cycle, ceiling of Terrazzo di Saturno, Palazzo Vecchio, Florence. *c.*1558. Damaged by fire in 1600. In place. [Sinibaldi 1950, pp. 13, 22 / also Barocchi 1964, pp. 50, 316]

Francesco Primaticcio, 1504–1570. "Saturn Devouring His Children." Drawing, study for unexecuted or lost decoration for Château de Fontainebleau. Cabinet des Dessins, Louvre, Paris. [Paris 1972, no. 182—ill. / also Lévêque 1984, p. 173—ill.]

Francis Bacon, 1561–1626. "Coelum, sive origines" (Saturn dethroned by Jupiter). Chapter 12 of *De sapientia veterum.* Mythological compendium. London: Barker, **1609.** / Translated as "Coelum, or Beginnings" by Arthur Gorges in *The Wisdome of the Ancients* (London: Bill, 1619). Modern facsimile edition (bilingual), New York & London: Garland, 1976. [Ipso / Nohrnberg 1976, p. 747]

Thomas Heywood, 1573/74–1641. (Birth of the Olympians in) *Troia Britanica: or, Great Britaines Troy* cantos 1–5. Epic poem. London: **1609.** [Heywood 1974 / also Boas 1950, pp. 58ff. / Clark 1931, pp. 50ff.]

———. (Saturn and Jupiter in) *The Golden Age.* Drama, based on *Troia Britanica.* First performed *c.*1609–11, London. Published London: Okes, 1611. [Heywood 1874, vol. 3 / DLB 1987, 62:101, 122ff. / Boas, pp. 83ff. / Clark, pp. 62ff.]

Peter Paul Rubens, 1577–1640. "Saturn (Devouring One of His Sons)." Painting, for Torre de la Parada, El Pardo. **1636–38.** Prado, Madrid, no. 1678. [Alpers 1971, no. 55—ill. / Jaffé 1989, no. 1324—ill.] Oil sketch. Formerly Galerie St. Lukas, Vienna (1932–38), unlocated. [Alpers, no. 55a—ill. / Held 1980, no. 215—ill. / Jaffé, no. 1323—ill.]

Jacob Jordaens, 1593–1678, attributed. "Saturn Devouring

His Children." Etching. **1652?** / Drawing for, sold Brussels, 1797, untraced. [Rooses 1908, pp. 176, 261]

———, attributed. "Saturn Devouring One of His Sons." Painting. Sold Antwerp, 1865, untraced. [Ibid., p. 261]

Luca Giordano, 1634–**1705**, questionably attributed. "Saturn Devouring His Children." Drawing. Albertina, Vienna, no. 34205. [Ferrari & Scavizzi 1966, 2:314]

Giuseppe Bonno, 1711–1788. *Il natale di Giove* [The Birth of Jupiter]. Opera (azione teatrale). Libretto, Pietro Metastasio. First performed 1 Oct **1740**, Favorita, Vienna. [Grove 1980, 3:27, 28]

Johann Adolf Hasse, 1699–1783. *Il natale di Giove*. Serenata. Libretto, Metastasio (1740). First performed 7 Oct **1749**, at Court, Hubertusburg. [Grove 1980, 8:288].

Joseph Friebert, 1724–1799. *Il natale di Giove*. Opera. Libretto, Metastasio (1740). First performed *c.*1764, Passau. [Grove 1980, 6:848]

Andrea Lucchesi, 1741–1801. *Il natale di Giove*. Cantata. Text, Metastasio (1740). First performed 13 May **1772**, Hoftheater, Bonn. [Grove 1980, 11:300]

Francis Olivari. *The Birth of Jupiter*. Drama, translation of Metastasio's *Il natale di Giove* (1740). In *Three Dramatic Pieces of Metastasio* (Dublin: **1797**). [Nicoll 1959–66, 3:295]

Francisco Goya, 1746–1828. "Saturn Devouring His Sons." Drawing. **1797–98**. Prado, Madrid, no. 85. [Gassier & Wilson 1981, no. 635—ill.]

———. "Saturn (Devouring One of His Children)." Painting. 1821–22. Prado, no. 763. [Ibid., no. 1624—ill. / Gudiol 1971, no. 702—ill. / Prado 1985, p. 283]

John Flaxman, 1755–1826. "Saturn and His Children" (Saturn devouring his children), "The Brothers of Saturn Delivered." Drawings, part of a series illustrating Hesiod's *Theogony*. **1807–14**. / Engraved by William Blake, published London: Longman & Co., 1817. [Irwin 1979, p. 90, fig. 117 / Flaxman 1872, 7: pls. 31, 33]

Johann Wolfgang von Goethe, 1749–1832. "Kronos als Kunstrichter" [Cronus as Art Critic]. Poem. **1820**. In *Gedichte der Ausgabe letzter Hand* (Stuttgart: Cotta, 1827–30). [Beutler 1948–71, vol. 1 / Suhrkamp 1983–88, vol. 1]

Ramón Ledesma Miranda, 1901–1963. *Saturno y sus hijos* [Saturn and His Children]. Collection of short stories. Madrid: **1934**. [DLE 1972, p. 514]

Isamu Noguchi, 1904–. "Cronus." Balsawood sculpture. **1947**. Walker Art Center, Minneapolis. [Noguchi 1968, pp. 29, 92—ill. / Grove & Botnick 1980, no. 256a—ill.] 3 bronze casts. Private colls. [Grove & Botnick, no. 2566]

Jens Rehn, 1918–1983. *Die Kinder des Saturn* [The Children of Saturn]. Novel. Darmstadt: Luchterland, **1959**. [DLL 1968–88, 12:759]

CUMAEAN SIBYL. *See* AENEAS, in the Underworld; APOLLO, and the Cumaean Sibyl.

CUPID. *See* EROS.

CYBELE. Goddess of fertility and mountains, Cybele was also the ruler of wild nature and protector of her people, especially in times of war. A mothergoddess originating in Anatolia, her main cult was in Phrygia. Called "Great Mother," Cybele and her cult were transferred to Greece, where she was identified with Rhea, wife of the Titan Cronus and mother of the gods. The Romans identified her with the nature goddess Ops, wife of Saturn, and also called her "Magna Mater." She was also associated with Demeter (Ceres).

Cybele's cult stone image was brought to Rome in 204 BCE during the second Punic War, but it gained major status under the emperor Claudius. During this time it also embraced the cult of Attis, the youth beloved of Cybele, who was driven to self-emasculation and suicide when the goddess slew the nymph he loved; the priests of Cybele castrated themselves and feigned Attis's delirium in rituals honoring him.

In ancient art Cybele was often shown wearing a turreted crown, seated on a throne, and flanked by lions. A popular theme in later visual arts as well, she is usually depicted in her role as goddess of vegetation (sometimes symbolizing the element Earth), or riding in her lion-drawn chariot, accompanied by Corybantes and maenads.

Classical Sources. Hesiod, *Theogony* 453ff. *Homeric Hymns*, "To the Mother of the Gods." Apollonius Rhodius, *Argonautica* 1.1092–1152. Lucretius, *De rerum natura* 2.594–670. Diodorus Siculus, *Biblioteca* 3.58.1–3, 3.58.4ff. Pausanias, *Description of Greece* 7.17.9–12. Virgil, *Aeneid* 3.150–55, 6.785–90, 10.156f., 10.252–55. Ovid, *Fasti* 4.179–85, 6.321ff.; *Metamorphoses* 10.102–05, 10.686–704, 14.535–55. Apollodorus, *Biblioteca* 1.1.5–7, 3.5.1. 3.12.6. Hyginus, *Fabulae* 139, 191. Emperor Julian the Apostate, "Hymn to the Mother of the Gods."

Further Reference. Pamela Berger, *The Goddess Obscured: Transformation of the Grain Protectress from Goddess to Saint* (Boston: Beacon Hill, 1985), pp. 27–29; 33–37. M. Renee Salzman, "Magna Mater: Great Mother of the Roman Empire," in *The Book of the Goddess Past and Present: An Introduction to Her Religion*, edited by Carl Olson (New York: Crossroad, 1983).

See also AENEAS, in Latium; ATTIS; CRONUS, Birth of the Olympians; GODS, as Elements.

Giovanni Boccaccio, 1313–1375. "De Opi, Saturni coniuge" [Ops, Wife of Saturn]. In *De mulieribus claris* [Concerning Famous Women]. Latin verse compendium of myth and legend. **1361–75**. Ulm: Zainer, 1473. [Branca 1964–83, vol. 10 / Guarino 1963]

John Gower, 1330?–1408. (Cybele described in) *Confessio amantis* 5.1132–1154. Poem. *c.***1390**. Westminster: Caxton, 1483. [Macaulay 1899–1902, vol. 2]

Andrea Mantegna, 1430/31–1506. "Introduction of the Cult of Cybele at Rome" ("The Triumph of Scipio").

Painting. *c.*1504–06. National Gallery, London, no. 902. [Lightbown 1986, no. 57—ill. / London 1986, p. 348—ill.]

Pinturicchio, 1454–1513, and studio. "The Triumph of Cybele." Fresco (detached), from Palazzo Pandolfo Petrucci ("Il Magnifico"), Siena. Metropolitan Museum, New York, no. 114.9. [Metropolitan 1980, p. 142—ill. / Berenson 1968, p. 345—ill.]

Baldassare Peruzzi, 1481–1536. "Cybele." Drawing, design for engraving by "Maestro del Dado" (Bartsch 15:195, no. 18). 1518–19. Drawing in British Museum, London, no. 1880–5–8–82. [Frommel 1967–68, no. 37—ill.]

Dosso Dossi, *c.*1479–1542, and **Battista Dossi,** *c.*1474–1548. "Bacchanal" ("The Feast of Cybele"). Painting. *c.*1519. National Gallery, London, no. 5279. [Gibbons 1968, no. 127—ill. / London 1986, p. 166—ill.]

Giulio Romano, *c.*1499–1546. "The Birth of a Child, Attended by Cybele." Fresco. 1527–30. Loggia della Grotta, Palazzo del Tè, Mantua. [Hartt 1958, pp. 143f.—ill.]

Rosso Fiorentino, 1494–1540, assistants, after Rosso's designs. "Cybele in Her Chariot," "Orgy of Votaries of Cybele." Stucco reliefs. 1535–40. Galerie François I, Château de Fontainebleau. [Panofsky 1958, pp. 139ff.—ill. / also Barocchi 1950, fig. 144]

———, composition. "The Goddess Ops" (as old woman). Engraving (Bartsch 15 no. 9), executed by Gian Jacopo Caraglio. / Variant print by René Boyvin (*c.*1525–1610). [Hofmann 1987, no. 3.21—ill.]

Francesco Primaticcio, 1504–1570, design. "Cybele." Fresco, for Salle de Bal, Château de Fontainebleau, executed by Niccolò dell' Abbate under Primaticcio's direction. 1551–56. Repainted 19th century. [Dimier 1900, pp. 160ff., 284ff.]

———, design. "Cybele." Tapestry fragment, part of "The Gods' Arabesques." 1547–59. Musée des Gobelins. [Ibid., pp. 384ff.]

———. *See also Toussaint Dubreuil, below.*

Giorgio Vasari, 1511–1574, with **Cristofano Gherardi,** 1508–1556. "Sacrifice to Cybele." Fresco, executed by Gherardi under Vasari's direction. 1555–56. Sala degli Elementi, Palazzo Vecchio, Florence. [Sinibaldi 1950, pp. 13, 22]

——— with Gherardi. "Ops in a Chariot Drawn by Four Lions." Ceiling painting. 1556–57. Sala di Opi, Palazzo Vecchio. [Ibid., pp. 13, 23 / Lensi 1929, pp. 154ff., 173—ill. / Barocchi 1964, pp. 41, 316]

Girolamo da Carpi, 1501–1556. "The Legend of the Gran Dea." Painting. Galleria Corsini, Rome. [Warburg]

Paolo Veronese, 1528–1588. "Cybele." Fresco. *c.*1557. Palazzo Trevisan, Murano. [Pallucchini 1984, no. 36c—ill. / Pignatti 1976, no. 66—ill. / cf. Byam Shaw 1967, no. 110—ill.]

School of Fontainebleau. "Cybele." Tapestry, for Château de Fontainebleau. 1551–59. Mobilier National, Paris. [Paris 1972, no. 449—ill.]

Giambologna, 1529–1608. "Allegory of Prince Francesco de' Medici" ("The Child of Cybele") (led by Mercury to Ceres/Abundance/Cybele). Alabaster relief. *c.*1560–61. Prado, Madrid, no. 296E. [Avery 1987, no. 145—ill. / Avery & Radcliffe 1978, no. 121—ill.] Bronze and silver versions. Kunsthistorisches Museum, Vienna, nos. 5814, 1195; Museo del Bargello, Florence, no. 128. [Avery & Radcliffe, nos. 118–20—ill. / also Avery, nos. 146–47—ill.]

Andrea Schiavone, *c.*1522–1563, attributed. "Woman on a Chariot Drawn by Winged Dragons" (Cybele?). Drawing. Princeton University Art Museum, N.J., no. 48–822. [Richardson 1980, no. 198—ill.]

Bartolommeo Ammannati, 1511–1592, attributed. "Ops." Bronze statuette. 1572–73. Studiolo di Francesco I, Palazzo Vecchio, Florence. [Pope-Hennessy 1985a, 3:100—ill. / Lensi 1929, pp. 236f., 262—ill. / Sinibaldi 1950, pp. 12, 18, 38 (attributed to Andrea Calamech)—ill.]

Jacopo Tintoretto, 1518–1594. "Cybele in Her Chariot Drawn by Lions." Fresco, for Casa Marcello, San Trovaso, Venice. *c.*1580–81? Lost. / Engraving by A. M. Zanetti, 1771. [Rossi 1982, p. 261, fig. 16a]

Edmund Spenser, 1552?–1599. (Cybele attends the marriage of the rivers Medway and Thames in) *The Faerie Queene* 4.11.28. Romance epic. London: Ponsonbie, 1596. [Hamilton 1977 / Nohrnberg 1976, pp. 648ff.]

Toussaint Dubreuil, *c.*1561–1602, questionably attributed (or circle; previously attributed to Primaticcio). "Cybele Awakening Morpheus." Painting. Château de Fontainebleau. [Paris 1972, no. 94—ill. / also Lévêque 1984, p. 44—ill.]

Bartholomeus Spranger, 1546–1611. "Pallas Athena and Cybele." Drawing. University Library, Erlangen, cat. 1929 no. 912. [Warburg]

Peter Paul Rubens, 1577–1640. "The Union of Earth and Air" ("Neptune and Cybele"). Painting. *c.*1615. Hermitage, Leningrad. [Jaffé 1989, no. 304—ill.] Oil study. Fitzwilliam Museum, Cambridge. [Ibid., no. 303—ill.]

———. "River God with Cybele and Pomona" ("Allegory of Earth, Water, and Air," "Two Nymphs and a River God"). Painting, sketch for unexecuted or lost work. *c.*1615. Art Museum, Academy of Sciences, Kiev. [Ibid., no. 306—ill. / also Held 1980, no. 256—ill.]

———, figures, and **Jan Brueghel the Elder,** 1568–1625, fruits and flowers. "Garland with Cybele." Painting. *c.*1619. Glasgow Art Gallery, inv. 609. [Ertz 1979, no. 349—ill.]

——— (Rubens). (Cybele in) "The Birth of Louis XIII," "The Apotheosis of Henri IV and the Assumption of the Regency by Marie de' Medici." Paintings, part of "Life of Marie de' Medici" cycle. 1622–25. Louvre, Paris, inv. 1776, 1779. [Saward 1982, pp. 79ff., 98ff.—ill. / Jaffé, nos. 727, 735—ill. / also Louvre 1979–86, 1:116f.—ill. / White 1987, pl. 186] Monochrome oil sketch for "Birth." 1622. Hermitage, Leningrad. [Jaffé, no. 726—ill.] Oil sketches for "Apotheosis." Hermitage, Leningrad; Alte Pinakothek, Munich, inv. 102. [Ibid., nos. 733–34—ill. / also Munich 1983, pp. 463, 467—ill. / Held, nos. 69–70—ill.]

Jan Brueghel the Elder, 1568–1625, flowers and background, and **Hendrik van Balen,** *c.*1570–1629, figures. "Cybele in a Garland of Fruits" (honored by Flora, Ceres, Bacchus, and Hiems as the seasons). Painting. *c.*1617–18. Mauritshuis, The Hague, inv. 233. [Ertz 1979, no. 340—ill. / Mauritshuis 1985, p. 18f.—ill.] Replica. Banque de Paris et des Pays-Bas, Antwerp. [Ertz, no. 341—ill. / also de Bosque 1985, p. 51—ill.] Variant ("Cybele and the Seasons in a Garland of Fruits"). Late 1630s. Prado, Madrid, inv. 1414. [Prado 1985, p. 97 / Ertz 1984, no. 305 (as Jan Brueghel the Younger and follower of van Balen)—ill.]

——— (Brueghel, landscape), and **Hendrik de Clerck,**

c.1570–1629, attributed, figures. "Abundance [Cybele] and the Four Elements." Painting. Prado, Madrid, inv. 1401. [Prado, p. 146]

——— (Brueghel, landscape), and follower of van Balen, figures. (Cybele in) "Allegory of Abundance." Painting. c.1626? Prado, Madrid, inv. 1402 (as "Abundance with Children," by Brueghel and van Balen). [Ertz 1984, no. 212—ill. / Prado]

———. See also Rubens, above.

Thomas Heywood, 1573/74–1641. "Cybele," "Rhea." Passages in *Gynaikeion: or, Nine Books of Various History Concerning Women* book 1. Compendium of history and mythology. London: printed by Adam Islip, **1624.** [Ipso]

Philippe de Buyster, 1595–1688. "Cybele." Stone sculpture (damaged). **1635–40.** Château de Wideville, near Paris. [Chaleix 1967, pp. 32ff., pl. 3.4]

Simon Vouet, 1590–**1649.** "Cybele." Drawing. Musée, Rennes. [Warburg]

Alessandro Algardi, 1598–**1654,** design. "Cybele in Her Lion-Drawn Chariot." Andiron figure. / Bronze fountain figure, executed by Domenico Guidi (?) after Algardi's model for the andiron figure. Jardin de la Isla, Aranjuez. [Montagu 1985, no. 126—ill.]

Francesco Albani, 1578–**1660.** "Triumph of Cybele." Painting. Château de Fontainebleau (on deposit from Louvre, Paris, inv. 14). [Louvre 1979–86, 2:283]

Charles Le Brun, 1619–1690. "Saturn Abducting Cybele." Drawing. Before **1674.** Louvre, Paris, inv. 29.851. [Düsseldorf 1971, no. 343—ill.]

———, design. "Earth" (Cybele). Marble statue, executed by Benoît Massou, 1681. Parterre du Nord, Gardens, Versailles. [Girard 1985, pp. 33, 271—ill.]

———. "The Awakening of the Earth" (represented by Cybele). Drawing. Louvre, Paris. / Ceiling painting ("Triumph of Earth"), after Le Brun's drawing, by Joseph-Benoît Guichard, 1850. Galerie d'Apollon, Louvre (inv. 2954). [Louvre 1979–86, 3:296—ill.]

Michel Corneille the Younger, 1642–**1708.** "Apollo, Tethys, and Cybele." Painting. Nationalmuseum, Stockholm. [Warburg]

José Nebra, 1702–1768, music. *La mágica Cibeles* [The Magician Cybele]. Theatrical work. First performed 19 Oct **1748,** Madrid. [Grove 1980, 13:89]

Antonio Guardi, 1698–1760. "Cybele." Painting. **1750–60.** V. Cini coll., Venice. [Morassi 1984, no. 78—ill.]

Antoine François Callet, 1741–1823. "Spring" (Zephyr and Flora Crowning Cybele with Flowers). Ceiling painting. **1780.** Galerie d'Apollon, Louvre, Paris, inv. 3097. [Louvre 1979–86, 3:94—ill.]

John C. Cross, fl. 1794–1812. *Cybele; or, Harlequin's Hour.* Pantomime. First performed 2 Apr **1808,** Royal Circus, London. [Nicoll 1959–66, 4:286]

Lord Byron, 1788–1824. (Venice seen as "sea-Cybele" in) *Childe Harold's Pilgrimage* 4.2. Poem. London: Murray, **1812.** [McGann 1980–86, vol. 2 / Bush 1937, p. 73]

John Keats, 1795–1821. (Vision of Cybele in her chariot in) *Endymion* 2.639–49. Poem. **1817.** London: Taylor & Hessey, 1818. [Stillinger 1978 / Aske 1985, p. 91 / De Selincourt 1951, pp. 433f.]

———. (Cybele described in) *Hyperion: A Fragment.* Poem.

Oct 1818–Apr 1819 (London: Taylor & Hessey, 1820). [Stillinger / Aske, p. 91]

Luigi Catani, 1762–**1840.** "Cybele." Fresco. Sala dell' Educazione di Giove, Palazzo Pitti, Florence. [Pitti 1966, p. 241]

Charles Marie René Leconte de Lisle, 1818–1894. "Kybèle." Poem. In *Oeuvres: Poèmes antiques* (Paris: Lemerre, **1852**). [Pich 1976–81, vol. 1]

Eugène Delacroix, 1798–1863. (Cybele surrounded by Olympian gods in) "The Triumph of Peace." Ceiling painting, Salon de la Paix, Hôtel de Ville, Paris. **1852–54.** Destroyed by fire 1871. [Huyghe 1963, pp. 406f., 423 / Robaut 1885, no. 1143—ill. (copy drawing)]

Gérard de Nerval, 1808–1855. (Isis identified with Cybele and Aphrodite in) "Horus." Sonnet, in *Les Chimères.* Published as appendix to *Les filles du feu* (Paris: Giraud, **1854**). [Strauss 1971, p. 70]

Victor Hugo, 1802–1885. (Cybele evoked in) "L'océan d'en haut" part 4. Poem. **1855.** In *Dieu* (Paris: Hetzel & Quantin, 1891). [Hugo 1985–86, vol. 7]

Arnold Böcklin, 1827–1901. "Magna mater" (sea triumph). Mural. **1869.** Museum an der Augustinergasse, Basel. [Andree 1977, no. 218—ill.]

Arthur Rimbaud, 1854–1891. (Cybele evoked in) "Soleil et chair" [Sun and Flesh] part 1. Poem. May **1870.** Published with *Le reliquaire* (Paris: Genonceaux, 1891). [Adam 1972 / Fowlie 1966]

Miguel Nieto, 1844–1915, music. *Cibeles y Neptune.* Zarzuela. First performed **1880,** Buen Retiro, Madrid. [Clément & Larousse 1969, 1:236]

Paul Baudry, 1828–**1886.** "Cybele." Painting. [Bénézit 1976, 1:520]

Auguste Rodin, 1840–1917. "Study of a Seated Woman" ("Cybele"). Plaster sculpture. **1889.** Musée des Beaux-Arts, Bordeaux. [Tancock 1976, fig. 25.3]

———. "Cybele." Bronze sculpture. c.1904–05. Tate Gallery, London, no. 6048. [Tate 1975, p. 197]

Odilon Redon, 1840–1916. "Here Is the Good Goddess, the Idean of the Mountains" Lithograph, illustration to Flaubert's *La tentation de Saint-Antoine,* V, third series, no. XV (Paris: **1896**). [Mellerio 1913, no. 148—ill.]

Théodore Dubois, 1837–1924. "Kybèle." Musical scene. Text, Leconte de Lisle (1852). Published Paris: Heugel, **1906.** [Grove 1980, 5:665]

D. H. Lawrence, 1885–1930. (Birkin stones reflection of the moon as if to destroy Cybele in) *Women in Love* chapter 19. Novel. London: Secker, **1921.** [DLB 1985, 36:116, 131]

Eugene O'Neill, 1888–1953. (Cybel, Earth-mother figure, in) *The Great God Brown.* Drama. **1925.** First performed 23 Jan 1926, Greenwich Village Theatre, New York. [McGraw-Hill 1984, 4:31, 39]

Richard Aldington, 1892–**1943.** "An Earth Goddess." Poem. In *Complete Poems* (London: Wingate, 1948). [Boswell 1982, p. 10]

Antony Tudor, 1908–1987, choreography and scenario. (Cybele evoked in) *Undertow.* Ballet. Music, William Schuman. First performed **1945,** New York. [Terry 1976, p. 351]

Robert Graves, 1895–1985. "Rhea." Poem. In *Poems, 1953* (London: Cassell, **1953**). [Graves 1975]

————. "The White Goddess." Poem. In *Collected Poems* (Garden City, N.Y.: Doubleday, Doran, 1955). [Ibid.]

Ed Wilson, 1925–. "Cybele." Marble sculpture. Before **1960.** [Clapp 1970, 2 pt. 2: 1118]

Babette Deutsch, 1895–1982. "Cybele." Poem. In *Collected Poems* (Bloomington: Indiana University Press, **1963**). [Ipso]

Robert Duncan, 1919–1988. A version of the Emperor Julian's "Hymn to the Mother of the Gods," included in "Passages." Poem. In *Bending the Bow* (New York: New Directions, **1968**). [Ipso / DLB 1983, 16:177]

Joyce Carol Oates, 1938–. *Cybele.* Novel. Santa Barbara, Calif.: Black Sparrow, **1979.** [EWL 1981–84, 3:409 / CLC 1985, 33:289]

CYCLOPES. Giant, one-eyed monsters, the Cyclopes were said by Hesiod to be three offspring of Uranus and Gaia and named Brontes, Steropes, and Arges. Hated by their father, they were imprisoned in Tartarus until Zeus released them. Thereafter, they worked in the forge of Hephaestus making Zeus's thunderbolts.

According to Homer, however, the Cyclopes were cannibalistic shepherds who lived in anarchy in a faraway land. When Odysseus landed on their island, he and his men were taken prisoner by the Cyclops Polyphemus. Polyphemus was said to be the son of Poseidon, who, after Odysseus managed to escape from the island, thwarted his homecoming in as many ways as possible.

In another story, Theocritus relates that Polyphemus lived in Sicily and wooed the sea nymph Galatea.

Classical Sources. Homer, *Odyssey* 9.104–115. Hesiod, *Theogony* 139–46. Theocritus, *Idylls* 11. Virgil, *Aeneid* 3.616–81, 8.424–54; Georgics 4.170ff. Apollodorus, *Biblioteca* 1.1.2, 1.1.4–5, 1.2.1. Pausanias, *Description of Greece* 2.2.1, 2.25.8, 7.25.6. Hyginus, *Fabulae* 49.

See also GALATEA; HEPHAESTUS; ODYSSEUS, Polyphemus.

Giulio Romano, *c.*1499–1546, and assistant(s). "Polyphemus." Fresco. **1528.** Sala di Psiche, Palazzo del Tè, Mantua. [Hartt 1958, pp. 129, 132—ill. / Verheyen 1977, p. 117, fig. 39]

————. "Polyphemus." Fresco. Sala delle Aguile, Palazzo del Tè. [Verheyen, p. 121]

Bernardino Martirano, *c.*1490–**1548.** *Polifemo.* Poem. Printed as appendix n Francesco Fiorentino's *Bernardino Telesio* (Florence: 1872–74). [DELI 1966–70, 3:535]

Michelangelo, 1475–**1564,** rejected attribution. "Head of a Cyclops." Sculpture. Museo del Bargello, Florence. [Goldscheider 1964, p. 225]

Francis Bacon, 1561–1626. "Cyclopes, sive ministri terroris." Chapter 3 of *De sapientia veterum.* Mythological compendium. London: Barker, **1609.** / Translated as "Cyclopes, or the Ministers of Terror" by Arthur Gorges in *The Wisdome of the Ancients* (London: Bill, 1619).

Modern facsimile edition (bilingual), New York & London: Garland, 1976. [Ipso]

Nicolas Poussin, 1594–1665. "Landscape with Polyphemus." Painting. **1649** (? or later). Hermitage, Leningrad, no. 1186. [Blunt 1966, no. 175—ill. / Thuillier 1974, no. 166—ill. / Wright 1985, no. 166 (as "Ulysses Deriding Polyphemus")—ill. / Hermitage 1984, no. 93—ill. / Hermitage 1974, pl. 28] Copy ("Landscape: Polyphemus and Galatea") in Prado, Madrid, no. 2322. [Prado 1985, p. 519]

Pierre Puget, 1620–1694, questionably attributed. "Polyphemus" (?). Sandstone sculpture. *c.*1660? Discovered 1920, lost since 1924. [Herding 1970, no. 88] *See also Falconet, below.*

Johann Brokoff, 1652–1718. Fountain with figures of Polyphemus and Actaeon. Courtyard, Cerveny Hradek, Czechoslavakia. [Clapp 1970, 1:115]

Jean-Philippe Rameau, 1683–1764. *Les cyclopes.* Composition for harpsicord. Published in *Pièces de clavecin avec une méthode sur la méchanique des doigts* (Paris: **1724**). / Revised 1731. [Grove 1980, 15:561, 562, 572 / Girdlestone 1982, pp. 21, 35f.]

Corneille van Clève, 1644/45–**1735.** "Polyphemus." Sculpture. Louvre, Paris, inv. 1517. [Clapp 1970, 1:175]

Nicola Porpora, 1686–1768. *Polifemo.* Opera. Libretto, Paolo Antonio Rolli. First performed 1 Feb **1735,** King's Theatre, London. [Grove 1980, 15:126]

Étienne-Maurice Falconet, 1716–1791, questionably attributed (previously attributed to Pierre Puget). "Polyphemus." Terra-cotta statue. *c.*1745? Minneapolis Institute of Arts, no. 69.80. [Herding 1970, no. 123]

Isabelle de Charriere, called "Zélide," 1740–**1805.** *Le Cyclope.* Opera. Libretto, composer. Unperformed. [Cohen 1987, 1:153]

Victor Hugo, 1802–1885, writing as V. d'Auvernay. "L'antre des Cyclopes" [The Cave of the Cyclops]. Translation of *Aeneid* 8.416–53, extract from an unpublished translation of the entire *Aeneid.* In *Le conservateur littéraire* 1 Apr 1820. [Hugo 1985–86, vol. 4]

Richard Dadd, 1817–1886. "Polyphemus Discovered Asleep by the Shepherds of Sicily." Watercolor. **1852.** Forbes Magazine Collection, New York. [Allderidge 1974, no. 107—ill.]

Odilon Redon, 1840–1916. "Cyclops." Drawing. Before **1883.** P. Bacou coll., Paris. [Berger 1964, no. 607]

————. "The Deformed Polyp Floats on the Strand, a Kind of Smiling and Hideous Cyclops." Lithograph, no. III in *Origins* album (Paris: 1883). [Mellerio 1913, no. 47—ill.]

————. "The Cyclops" (observing a sleeping nymph). Painting. 1898–1900. Rijksmuseum Kröller-Müller, Otterlo. [Hobbs 1977, fig. 90 / also Berger, no. 65—ill.]

Gustave Moreau, 1826–1898. "Polyphemus." Drawing, study for an unexecuted sculpture. Before **1885.** Musée Gustave Moreau, Paris. [Mathieu 1976, p. 190 n.665]

Henry Gadsby, 1842–1907. *The Cyclops.* Cantata. **1890.** [Grove 1980, 7:75]

Adolf Schafheitlin, 1852–1917. *Das Zeitalter der Cyklopen* [The Age of the Cyclopes]. Dramatic poem. Berlin: Rosenbaun & Hart, **1899.** [Trousson 1976, 2:397f., 510]

Henri de Régnier, 1864–1936. "La Plainte du Cyclope"

[The Cyclops's Complaint]. Poem. In *La cité des eaux* (Paris: Mercure de France, **1902**). [NUC]

Alfred Williams, 1877–1930. "The Cyclops." Poem. In *Aeneas in Sicily and Other Poems* (London: MacDonald, **1905**). [Boswell 1982, p. 309]

Ker-Xavier Roussel, 1867–1944. "The Cyclops." Painting. **1908**. Musée Nationale d'Art Moderne, Paris. [Bénézit 1976, 9:141]

Vincenzo Davico, 1889–1969. *Polifemo*. Orchestral composition. First performed **1910**. [Grove 1980, 5:261]

Alfred Poizat, 1863–1936. *Le Cyclope*. Tragedy. Paris: Grasset, **1911**. [NUC]

Oscar Esplá y Triay, 1886–1976, music. *Ciclopes de Ifach*. Ballet. *c*.**1920**. / Arranged as concert suite, 1926. [Grove 1980, 6:251]

August Baeyens, 1895–1966. *De Cyclopen*. Symphony. **1925**. [Grove 1980, 2:16]

Francis Picabia, 1878–1953. "Cyclops." Painting. *c*.**1926**. Paride Accetti coll., Milan. [Camfield 1979, fig. 283 / Borràs 1985, no. 443—ill.]

Max Ernst, 1891–1976. "Cyclops." Assemblage (stone, iron, and clothespins). *c*.**1934**. Zahnd coll., Paris. [Spies & Metken 1975–79, no. 2125—ill.]

William Baziotes, 1912–1963. "Cyclops." Painting. **1947**. Art Institute of Chicago, no. 47.468. [Chicago 1961, p. 19]

Eduardo Paolozzi, 1924–. "Cyclops." Abstract bronze sculpture. **1957**. Tate Gallery, London, no. T.225. [Konnertz 1984, fig. 181 / Tate 1975, p. 185]

Ilse Langner, b. 1899. *Die Zyklopen*. Novel. Hamburg: Wegner, **1960**. [DLL 1968–90, 9:939]

Willy Kyrklund, 1921–. *Polyfem förvandlad* [Polyphemus Transformed]. Novel. Stockholm: Bonnier, **1964**. [DSL 1990, p. 347]

Clearchos Loucopoulos, 1908–. "Ciclopico." Iron sculpture. Exhibited Venice Biennale, **1966**. [Clapp 1970, 1:555]

Bernhard Luginbühl, 1929– . "Cyclops." Steel sculpture. **1967**. Small and large versions. Kunsthalle, Hamburg; Winterthur. [Hamburg 1985, no. 563—ill.]

Salvador Dalí, 1904–1989. "Cyclops." Glass sculpture. **1968**. Museum für Kunst und Gewerbe, Hamburg, inv. 1969.162. [Hofmann 1987, no. 16.32—ill.]

Margaret Atwood, 1939–. "Cyclops." Poem. In *Procedures for Underground* (Toronto: Oxford University Press; Boston: Little, Brown, **1970**). [Ipso]

Hans Carl Artmann, 1921–. *Die Zyklopin, oder Die Zerstörung einer Schneiderpuppe* [The Lady Cyclops, or The Destruction of a Tailor's Dummy]. Drama/pantomime, in "Chirico-antique" style. By **1981**. [Buddecke & Fuhrmann 1981, p. 190]

CYDIPPE. *See* ACONTIUS AND CYDIPPE.

CYNTHIA. *See* ARTEMIS; SELENE.

CYPARISSUS. A boy loved by Apollo, Cyparissus lived on the Aegean island of Keos. While hunting, he accidentally killed a favorite stag, and grieved so deeply that the gods turned him into a cypress tree. The cypress has since been a symbol of mourning.

Classical Source. Ovid, *Metamorphoses* 10.106–42.

Anonymous French. (Story of Cyparissus in) *Ovide moralisé* 10.620–707. Poem, allegorized translation/elaboration of Ovid's *Metamorphoses*. *c*.**1316–28**. [de Boer 1915–86, vol. 4]

Giulio Romano, *c*.1499–1546. "Apollo and Cyparissus" (?). Drawing. Nationalmuseum, Stockholm, no. 347. [Hartt 1958, p. 305 no. 298—ill. / Saslow 1986, pp. 113, 241 *n*., 242 *n*., fig. 3.15]

Domenichino, 1581–1641. "The Transformation of Cyparissus." Fresco, part of "Life of Apollo" cycle, for Villa Aldobrandini (Belevedere), Frascati. **1616–18**. Upper portion (Apollo) in place; lower fragment (Cyparissus) detached, in National Gallery, London, inv. 6286. [Spear 1982, no. 55.vi—ill. / London 1986, p. 161—ill.]

Jacopo Vignali, 1592–1664, attributed. "Cyparissus" (with dead stag). Painting. **1623–25**. J. Plaskie coll., Meise. [Florence 1986, no. 1.119—ill.]

Theodoor van Thulden, 1606–1669. "Cyparissus." Drawing, copy after lost decoration for Château de Fontainebleau. **1631–33**. Bibliothèque Royale Albert I, Brussels. [Paris 1972, no. 227—ill. / also Lévêque 1984, p. 234—ill.]

Peter Paul Rubens, 1577–1640. "Cyparissus" (formerly called "Adonis" or "Actaeon Transformed into a Stag"). Painting, oil sketch (for unknown work for Torre de la Parada?). **1636–38**? Musée Bonnat, Bayonne, no. 1001. [Alpers 1971, p. 273—ill. / Held 1980, no. 181—ill. / Jaffé 1989, no. 1255—ill.]

Anselme Flamen, 1647–1717. "Cyparissus and His Deer." Marble statue (after a model by François Girardon?). **1687–88**. Tapis Vert, Gardens, Versailles. [Girard 1985, p. 284—ill.]

Antoine Denis Chaudet, 1763–1810. "Cypress" (Cyparissus mourning his stag). Marble sculpture. **1794–98**. Hermitage, Leningrad, inv. 1107. [Hermitage 1984, no. 391—ill. / also Hermitage 1975, pl. 134]

Innocenzo Fraccaroli, 1805–1882. "Cyparissus Mourning the Death of His Stag." Sculpture. Galleria d'Arte Moderna, Milan. [Bènèzit 1976, 4:470]

Robert Duncan, 1919–1988. "Cyparissus." Poem. In *Roots and Branches* (New York: Scribner, **1964**). [DLB 1983, 16:176]

Marya Zaturenska, 1902–1982. (Cyparissus evoked in) "The Scythe, the Spindle, and the Cypress Tree." Poem. In *Thresholds and Hearth: Collected Poems* (New York: Viking, **1977**). [Ipso]

CYTHERA. *See* APHRODITE, Cythera.

D

DAEDALUS. *See* ICARUS AND DAEDALUS; MINOS; PASIPHAË.

DAMON. *See* SHEPHERDS AND SHEPHERDESSES.

DANAË. The chaste daughter of Acrisius, king of Argos, Danaë was confined by her father in a bronze chamber (or tower) because he had learned from an oracle that the child she bore would kill him. During her confinement, however, Zeus (Jupiter) appeared to her in a shower of gold and impregnated her. Danaë gave birth to a son, Perseus. When Acrisius discovered the child, he put both him and his mother in a chest and cast them into the sea. They drifted onto the island of Seriphos, where they were sheltered by Dictys, brother of King Polydectes. Polydectes proposed marriage to Danaë, but she refused and was persecuted for it. When Perseus was grown he rescued her and took her back to Argos.

The theme was particularly popular in Renaissance treatments of the nude. In medieval interpretations Danaë became a symbol of chastity and a prefiguration of the Annunciation.

Classical Sources. Homer, *Iliad* 14.319ff. Pindar, *Pythian Odes* 12. Diodorus Siculus, *Biblioteca* 4.9. Virgil, *Aeneid* 7.371ff., 406–13. Horace, *Odes* 3.16. Ovid, *Metamorphoses* 4.605–11. Apollodorus, *Biblioteca* 2.2–4. Pliny, *Naturalis historia* 3.9.56. Hyginus, *Fabulae* 63, 155, 224. Lucian, *Dialogues of the Sea Gods* 12, "Doris and Thetis," 14, "Triton and Nereids."

Anonymous French. (Story of Danaë in) *Ovide moralisé* 4.5382–5636. Poem, allegorized translation/elaboration of Ovid's *Metamorphoses*. *c.*1316–28. [de Boer 1915–86, vol. 2]

Francesco Petrarca, 1304–1374. (Love of Jupiter for Danaë evoked in) Canzone, no. 23 of *Canzoniere* (*Rime sparse*). Collection of sonnets, madrigals, and *canzoni*. Begun *c.*1336, completed by 1373; no. 23 composed *c.*1341? [Contini 1974 / Armi 1946 / Sturm-Maddox 1985, pp. 25f., 30f.]

Francesco Colonna, *c.*1433–1527. (Triumph of Danaë represented in) *Hypnerotomachia Poliphili* [The Dream of Poliphilo]. Romance. Venice: **1499**; illustrated with woodcuts by anonymous engraver. [Appell 1893, pp. 5, 9, pls. 54–57, 59 / Barkan 1986, p. 227]

Lorenzo Lotto, 1480–1556. "Plutus and the Nymph Rhodos" (also called "Danaë," "A Maiden's Dream"). Painting. *c.*1505. Kress coll. (K291), National Gallery, Washington, D.C., no. 258. [Shapley 1966–73, 2:158f.—ill./ also Berenson 1957, p. 107—ill.]

Baldassare Peruzzi, 1481–1536 (formerly attributed to Giulio Romano). "Danaë" (in the shower of gold). Fresco, part of a frieze. **1511–12.** Sala del Fregio, Villa Farnesina, Rome. [d'Ancona 1955, pp. 91f. / Gerlini 1949, pp. 21ff. / Frommel 1967–68, no. 18a / Berenson 1968, p. 334]

Jan Gossaert, called Mabuse, *c.*1478–1533/36. "Danaë." Painting. **1527.** Alte Pinakothek, Munich, inv. 38. [Munich 1983, p. 223—ill.]

Antonio da Correggio, *c.*1489/94–1534. "(Rape of) Danaë." Painting. **1530–32**? Villa Borghese, Rome, no. 125. [Gould 1976, pp. 130f., 270—ill. / Pergola 1955–59, 1: no. 24—ill. / Saslow 1986, pp. 63f., fig. 2.5 / Berenson 1968, p. 93] Copies in Hôtel de Ville, Versailles (by F. Stiémart, 1680–1740) and Musée, Chartres; both on deposit from Louvre, Paris, nos. 45, 46. [Louvre 1979–86, 2:288]

Francesco Primaticcio, 1504–1570, attributed (traditionally attributed to Rosso Fiorentino). "Danaë." Fresco. *c.*1542. Galerie François I, Fontainebleau. [Barocchi 1950, pp. 167ff.—ill. / Dimier 1900, pp. 300ff. / Revue de l'Art 1972, pp. 131f., 166f., and passim—ill. / de Bosque 1985, pp. 104f.—ill. / Berenson 1963, p. 195—ill.] Tapestry after. Kunsthistorisches Museum, Vienna, no. 160. [Revue de l'Art, pp. 106ff.—ill. / Barocchi, fig. 151 / Paris 1972, p. 251—ill. / Berenson]

Titian, *c.*1488/90–1576. "Danaë with Cupid." Painting. **1545–46.** Galleria di Capodimonte, Naples, no. 134. [Wethey 1975, no. 5—ill. / Capodimonte 1964, p. 46, pl. 47] 2 variants ("Danaë with a Nursemaid"). 1553–54, *c.*1555–60. Prado, Madrid, no. 425 (as "Danaë Receiving the Shower of Gold"); Kunsthistorisches Museum, Vienna, inv. 90 (174). [Wethey, nos. 6, 7—ill. / also Prado 1985, p. 701 / Vienna 1973, p. 181—ill. / de Bosque 1985, p. 44—ill.] Copies of Naples version in Prince of Wales Museum, Bombay; Wallace Collection, London; at least 3 others known, in private colls. or unlocated. [Wethey / Wright 1976, p. 202] Copies of Madrid and Vienna versions (falsely attributed to Titian) in Art Institute of Chicago; Hermitage, Leningrad, inv. 121; Duke of Wellington coll., London. [Wethey, nos. X10–13—ill. / Hermitage 1984, no. 18—ill.]

Marcello Fogolino, 1480–**1548**. "Danaë." Painting. Accademia dei Concordi, Rovigo, no. 169. [Berenson 1957, p. 77]

Benvenuto Cellini, 1500–1571. "Danaë with the Child Perseus." Bronze statuette. **1546–53.** Formerly in base of "Perseus" statue, Loggia dei Lanzi, Florence, now in Museo Nazionale, Florence. [Pope-Hennessy 1985a, pp. 174f.—ill.]

Florentine School. "Danaë." Painting. *c.*1560. Kunsthistorisches Museum, Vienna, inv. 2608. [Vienna 1973, p. 67]

Andrea Schiavone, 1522–1563. "Danaë." Painting. *c.*1560. Museo di Capodimonte, Naples, no. 863. [Richardson 1980, no. 278—ill.]

————, rejected attribution (Andrea Vicentino? d. 1614). "Danaë." Painting. Private coll., Venice. [Ibid., no. D379]

Bartolommeo Traballesi, ?–1585. "Danaë." Painting. **1570–73.** Studiolo di Francesco I, Palazzo Vecchio, Florence. [Sinibaldi 1950, pp. 11f., 19]

Pompeo Leoni, 1535?–1610, attributed. "Danaë and the

Shower of Gold." Gilt bronze plaquette. *c.*1550–75. Metropolitan Museum, New York, no. 36.110.18. [Kilinski 1985, no. 6—ill.]

Giuseppe Porta, called Salviati, *c.*1520–*c.*1575. "Danaë." Painting. Nationalmuseum, Stockholm, no. 1568. [Pigler 1974, p. 62]

Jacopo Tintoretto, 1518–1594. "Danaë." Painting. **1577–78.** Musée des Beaux-Arts, Lyons, no. 45. [Rossi 1982, no. 378—ill. / de Bosque 1985, p. 45—ill. / Berenson 1957, p. 174]

Hieronymus Wierix, 1551–1619. "Jupiter and Danaë." Engraving. *c.*1580. (Metropolitan Museum, New York, no. 51.501.6165.) [Kilinski 1985, no. 7—ill.]

Edmund Spenser, 1552?–1599. (Jove and Danaë depicted in tapestry of "Cupid's Wars," in) *The Faerie Queene* 3.11.33. Romance epic. London: Ponsonbie, **1590,** 1596. [Hamilton 1977]

Palma Giovane, *c.*1548–1628. "Danaë." Painting. *c.***1595–1600.** Formerly private coll., Paris, unlocated. [Mason Rinaldi 1984, no. 205—ill.] *See also Padovanino, below.*

Annibale Carracci, 1560–1609, or follower (Domenichino? 1581–1641, or Francesco Albani? 1578–1660). "Danaë." Painting. *c.*1605. Formerly Bridgewater House, London, destroyed. [Malafarina 1976, no. 141—ill.]

Thomas Heywood, 1573/74–1641. (Story of Danaë in) *Troia Britanica: or, Great Britaines Troy* cantos 4–5. Epic poem. London: **1609.** [Heywood 1974]

———. (Danaë in) *The Golden Age.* Drama, based on *Troia Britanica.* First performed *c.*1609–11, London. Published London: Okes, 1611. [Heywood 1874, vol. 3 / DLB 1987, 62:101, 122ff. / also Boas 1950, pp. 83ff. / Clark 1931, pp. 62ff.]

———. (Scenes, as above, in) *The Escapes of Jupiter (Callisto).* Comedy, compilation and revision of scenes from Heywood's *The Golden Age* and *The Silver Age.* First performed *c.*1625, London. [Heywood 1978 / DLB]

Joachim Wtewael, 1566–1638, attributed (also attributed to Johann Rottenhammer). "Jupiter and Danaë." Painting. *c.***1606–10.** Louvre, Paris, no. R.F. 1979–23. [Lowenthal 1986, no. A–45—ill. / Louvre 1979–86, 1:154, 2:381—ill. / de Bosque 1985, p. 197—ill.]

———. "Jupiter and Danaë." Drawing (early *pensée* for above?). *c.*1606–08. Staatliche Graphische Sammlung, Munich, inv. 1011. [Lowenthal, no. A–45 *n.*—ill. / de Bosque, pp. 94, 197f.—ill.]

Hendrik Goltzius, 1558–1617. "Danaë." Painting. Musée des Beaux-Arts, Cognac. [de Bosque 1985, pp. 197f.—ill.]

Denys Calvaert, 1540–1619. "Danaë." Painting. Pinacoteca, Lucca. [de Bosque 1985, pp. 197f.—ill.]

———. "Danaë." Painting. Ferens Art Gallery, Hull. [Wright 1976, p. 29]

Orazio Gentileschi, 1563–1639. "Danaë and the Shower of Gold." Painting. *c.*1621. Feigen & Co., New York, in 1981. [Bissell 1981, no. 49—ill.] Replica. *c.*1621–22. Cleveland Museum of Art, Ohio. [Bissell, no. 50—ill. / also Cleveland 1982, no. 154—ill. / Garrard 1989, fig. 208]

Jean Puget de La Serre, 1594–1665. "Jupiter et Danaë." Poem. In *Les amours des dieux* (Paris: d'Aubin, **1624).** [NUC]

Johann Rottenhammer, 1564–1625. "Danaë." Painting. Nationalmuseum, Stockholm, no. 237. [Pigler 1974, p.65] *See also Wtewael, above.*

Rembrandt van Rijn, 1606–1669. "Jupiter and Antiope" (formerly called "Danaë," "Venus and Satyr"). Etching (Bartsch no. 204). *c.*1631. 2 states. [White & Boon 1970, no. 204—ill. / Guillaud 1986, p. 156, fig. 215]

———. "Danaë." Painting. 1636, reworked *c.*1645–50. Hermitage, Leningrad, inv. 723. [Gerson 1968, no. 270—ill. / Hermitage 1984, no. 70—ill. / also Guillaud 1986, fig. 387]

Peter Paul Rubens, 1577–1640. "Danaë and the Golden Rain" ("Jupiter and Danaë"). Painting, for Torre de la Parada, El Pardo, executed by assistant (Cornelis de Vos?) from Rubens's design. **1636–38.** Lost. [Alpers 1971, no. 15] Oil sketch. Pauline Green coll., Boston (ex-Shaw). [Ibid., no. 15a / Jaffé 1989, no. 1294—ill.]

———, studio. "Danaë and the Shower of Gold." Painting. *c.*1616–18? Ringling Museum, Sarasota, Fla., no. SN220. [Sarasota 1980, no. 43—ill.]

Jacques Blanchard, 1600–1638. "Danaë." Painting. Tsarkoié Sélo. [Dublin 1985, p. 4]

Anthony van Dyck, 1599–1641, follower (previously attributed to van Dyck). "Danaë." Painting. Formerly Gemäldegalerie, Dresden, destroyed. [Larsen 1988, no. A43—ill.]

Emanuel de Witte, *c.*1616/18–1692. "Jupiter and Danaë." Painting. **1641.** W. M. J. Russel coll., Amsterdam. [Warburg]

Padovanino, 1588–1648, attributed. "Danaë." Painting. Galleria Sabauda, Turin, no. 564 (as follower of Palma Giovane). [Pigler 1974, p.63]

Simon Vouet, 1590–1649. "Danaë." Painting. W. P. Chrysler, Jr. coll., New York (possibly now in Chrysler coll., Norfolk, Va.). [Pigler 1974, p.65]

Nicolas Poussin, 1594–1665. "Danaë." Painting. Documented in 1797, untraced. [Blunt 1966, no. L61 / also Thuillier 1974, no. 224]

———, rejected attribution. "Jupiter and Danaë." Drawing. Accademia, Venice (as Poussin). [Friedlaender & Blunt 1953, no. 170 *n.*]

Michiel Coxie the Younger, after 1650–after 1689. "Jupiter and Danaë." Painting. **1669.** Bayerisches Staatsgemäldesammlungen, Munich, no. 3293. [Warburg]

Jacob van Loo, *c.*1614–1670. "Danaë in the Shower of Gold." Painting. [Bénézit 1976, 6:730]

Jacob Jordaens, 1593–1678, attributed. "Danaë and Jupiter." Painting. Recorded in 1754, untraced. [Rooses 1908, p. 258]

Francesco Alfonso Donnoli, 1636–1724. *La Danae.* Drama, dedicated to Francesco Maria de' Medici. **1680.** Unperformed; unpublished. [Weaver 1978, p. 150]

François Verwilt, *c.*1620–1691. "Danaë." Painting. Hermitage, Leningrad, Reserves, no. 2951. [Bénézit 1976, 10:481 / Pigler 1974, p. 64]

North Netherlandish School. "Danaë." Painting. *c.***1700.** Museum Bredius, The Hague, inv. C680. [Wright 1980, p. 313]

Paolo de Matteis, 1662–1728. "Danaë." Painting. **1702–05.** Detroit Institute of Arts, no. 79.140. [Kilinski 1985, no. 8—ill.]

Luca Giordano, 1634–1705, previously attributed. "Danaë and the Golden Shower." Painting. Hunterian coll., University of Glasgow, cat. 1937 no. 10. [Wright 1976, p. 76]

Joseph de La Font, 1686–1725. *Danaë, ou, Jupiter Crispin.* Comedy in verse. In *Théâtre* (Paris: **1707**). [Taylor 1893, p. 160]

Charles Emmanuel Biset, 1633–c.**1710.** "Danaë and an Old Woman." Painting. Museum der Bildenden Künste, Leipzig. [Bénézit 1976, 2:49]

Carlo Cignani, 1628–**1719.** "Jupiter and Danaë." Painting. Louvre, Paris, inv. 252, deposited in Ministère de la Guerre, Paris, before 1879. [Louvre 1979–86, 2:287]

Antonio Bellucci, 1654–**1726.** "Danaë and the Shower of Gold." Painting. Szépmüvéseti Múzeum, Budapest, no. 53.482. [Budapest 1968, p. 57]

———. "Danaë." Painting. Gemäldegalerie, Augsburg, inv. 2388. [Pigler 1974, p. 63]

Jean-Baptiste Lemoyne I, 1679/81–**1731.** "Danaë, Semi-Reclining." Terra-cotta sculpture. Hermitage, Leningrad? [Réau 1927, no. 4]

Charles-Joseph Natoire, 1700–1777. "Danaë." Painting, part of "Story of the Gods" series, for Château de La Chapelle-Godefroy, Champagne. c.**1731.** Musée des Beaux-Arts, Troyes, no. 206. [Boyer 1949, no. 38 / Troyes 1977, pp. 54f.] Replica. Musée, Périgueux, no. 789. [Boyer, no. 47]

Francesco Guardi, 1712–1793. "Danaë in the Shower of Gold." Drawing. Early work. Kupferstichkabinett, Berlin, inv. 13670. [Morassi 1984, no. D184—ill.]

Giovanni Battista Tiepolo, 1696–1770. "Danaë (and Jupiter)." Painting. c.**1736.** Universitet Konsthistoriska Institutionen, Stockholm. [Pallucchini 1968, no. 111—ill. / Levey 1986, pp. 72f.—ill. / Morassi 1962, p. 49—ill.]

François Boucher, 1703–1770. "Danaë Receiving the Golden Shower." Painting, oil sketch. c.**1740.** Atheneum, Helsinki. [Eisler 1977, p. 319]

———. "Danaë Receiving the Golden Shower." Painting, oil sketch. c.1755–60. Nationalmuseum, Stockholm, inv. NM5761. [Ibid., p. 319—ill. / Columbia 1967, no. 63—ill.] Related drawing. 1757. Kress coll. (dK506), National Gallery, Washington, D.C., no. B–22.370. [Eisler, p. 318—ill. / Walker 1984, fig. 1081]

———, studio. "Danaë." Painting. Musée Cognacq-Jay, Paris. [Columbia, no. 88]

———, school. "Danaë and the Golden Rain." Painting. Wallace Collection, London, no. P.766. [Wright 1976, p. 23]

Tomás de Añorbe y Corregel, 1686?–**1741.** *Júpiter y Danaë.* Zarzuela. [Barrera 1969, p. 14 / Cook 1959, p. 152]

Herman van der Myn, 1684–**1741.** "Danaë." Painting. Art Gallery and Christchurch Mansion, Ipswich. [Wright 1976, p. 144]

Francesco Trevisani, 1656–**1746.** "Danaë and Jove in a Shower of Gold." Painting. Lost. [DiFederico 1977, p. 78]

Antonio Literes, 1673–**1747,** music. *Júpiter y Danae.* Zarzuela. [Grove 1980, 11:79]

Jean-Honoré Fragonard, 1732–1806. "Danaë." Painting, after Rembrandt (1636, Hermitage). **1748–52.** Lost. [Wildenstein 1960, no. 3]

———. "A Metamorphosis of Jupiter" (with Danaë?). Drawing. 3 versions, c.1765–70. Musée "Ile de France," Saint-Jean-Cap Ferrat; Kimbell Art Museum, Fort Worth, Texas (ex-Seligmann coll.); another unlocated. [Rosenberg 1988, nos. 111–112—ill. / also Kilinski 1985, no. 9—ill.]

Louis-Maurice de La Pierre, 1697–1753. *Danaé.* Vocal composition. Published Paris. [Grove 1980, 10:466]

William Hogarth, 1697–1764. "Danaë." Painting. Lost. [Paulson 1971, 1:388]

Jean-Baptiste Deshayes, 1729–1765. "Danaë." Drawing. Louvre, Paris. [Rosenberg 1988, p. 236—ill.]

Jean-Baptiste Greuze, 1725–1805. "Aegina (Visited by Jupiter)" (formerly called "Danaë"). Painting. **Late 1760s?** Metropolitan Museum, New York, no. 1970.295. [Munhall 1976, no. 65—ill. / Metropolitan 1980, 1:80—ill. / Rosenberg 1988, p. 236—ill. / also Wildenstein 1968, no. 17—ill.]

———. "Aegina" (or "Danaë"). Painting, sketch. Louvre, Paris, no. M.I. 1068. [Louvre 1979–86, 3:288—ill. / Brookner 1972, pl. 5 / also Rosenberg—ill.]

Gianbettino Cignaroli, 1706–1770. "Danaë." Painting. Muzeum Narodowe, Warsaw, inv. 131950. [Warsaw 1969, no. 214—ill.]

William Boyce, c.1710–**1779.** *Danaë.* Cantata. [Grove 1980, 3:143]

Antonio Canova, 1757–1822, attributed. "Danaë." Terra-cotta relief, after painting by Correggio (1530–32, Rome). c.**1780.** Staatliche Museen, Berlin. [Pavanello 1976, no. 15—ill.]

Adolf Ulrik Wertmuller, 1751–1811. "Danaë." Painting. **1787.** Nationalmuseum, Stockholm. [Pigler 1974, p. 66]

Henry Fuseli, 1741–1825. "Danaë in the Boat with the Infant Perseus." Drawing. **1780–90.** Kupferstichkabinett, Berlin, cat. 20. [Schiff 1973, no. 801—ill.]

Joshua Reynolds, 1723–1792. "(The Actress) Kitty Fisher (as Danaë)." Painting (sketch). Gemäldegalerie, Berlin-Dahlem, no. 1637A. [Waterhouse 1941, p. 115 / also Berlin 1986, p. 64—ill.]

Pierre Joseph Candeille, 1744–1827. *Danaé.* Opera. First performed c.**1796,** Paris. [Grove 1980, 3:683]

Anne-Louis Girodet, 1767–1824. "Danaë." Painting. **1798.** Museum, Leipzig. [Bernier 1975, p. 40—ill. (print)]

———. "Mlle. Lange as Danaë." Painting. 1799. Minneapolis Institute of Arts. [Ibid., p. 43—ill. / also Montargis 1967—ill.] Oil study. Private coll. [Bernier, p. 49—ill.]

Christoph Martin Wieland, 1733–1813. "An Danae," prologue to "Die Grazien." Poem. In *Sämmtliche Werke* (Leipzig: Göschen, 1794–**1811**). [Radspieler 1984, vol. 3]

Heinrich Heine, 1797–1856. (Danaë in) "Mythologie." Poem. In *Lamentationen, Romanzero* book 2 (Hamburg: Hoffmann & Campe, **1851**). [Atkins & Boeck 1973–78, vol. 2 / Draper 1982]

Sylvain Mangeant. *Danaé et sa bonne* [Danaë and Her Nurse]. Operetta. Libretto, Hyppolyte Lefebvre. First performed July **1862,** Palais-Royal, Paris. [Clément & Larousse 1969, 1:294]

Edward Burne-Jones, 1833–1898. "Danäe and the Brazen Tower" (Danaë watching its construction). Painting, after a drawing for "Perseus" series. 1863 or c.**1866.** [Arts Council 1975, no. 41; cf. no. 42—ill. / Harrison & Waters 1973, pp. 84, 91] Replica, contemporary or 1872. Fogg Art Museum, Harvard University, Cambridge. [Harrison & Waters, pp. 91, 193] Replica, 1872. Ashmolean Museum, Oxford. [Harrison & Waters, p. 192 / Cecil 1969, pl. 85] Large replica, 1888. Glasgow Art Gallery. [Arts Council, no. 177—ill. / also Kestner 1989, p. 99, pl. 2.28]

Frederick Sandys, 1829–1904. "Danaë in the Brazen Chamber." Drawing. **1867.** Bradford Art Galleries and Museums. [Kestner 1989, p. 170, pl. 3.27]

William Morris, 1834–1896. (Story of Danaë in) "The Doom of King Acrisius." Poem. In *The Earthly Paradise,* vol. 1 (London: Ellis, **1868**). [Morris 1910–15, vol. 3 / Calhoun 1975, pp. 133ff.]

Charles-Alphonse-Achille Guméry, 1827–**1871.** "Danaë." Terra-cotta sketch. Musée d'Orsay, Paris, inv. R.F. 3416. [Orsay 1986, p. 173—ill.]

Hans Makart, 1840–1884. "Danaë." Painting, study for a ceiling decoration (unexecuted?). *c.***1875–79.** Sold Vienna, 1916, unlocated. [Frodl 1974, no. 233—ill.] Oil sketch. Rossacher coll., Salzburg. [Ibid., no. 232—ill.]

John William Waterhouse, 1849–1917. "Danaë" (emerging from chest holding infant Perseus). Painting. **1892.** Formerly Ford coll., New York, stolen. [Hobson 1980, no. 95, pl. 59 / also Kestner 1989, p. 298, pl. 5.37]

T. Sturge Moore, 1870–1944. "Danaë." Poem. In *The Dial* **1893.** / Expanded, published London: Hacon, Roberts; New York: Lane, 1903. / Revised versions in *Danaë, Aforetime, Blind Thamyris* (London: Richards, 1920) and *Poems of T. Sturge Moore* (London: Macmillan, 1931–33). [DLB 1983, 19:333, 335, 344f. / Gwynn 1951, pp. 112, 128]

Max Slevogt, 1868–1932. "Danaë." Painting. **1895.** Städtische Galerie im Lenbachhaus, Munich. [Munich 1984, p. 9—ill. / Dijkstra 1986, pp. 369f.]

Antoine-Auguste Thivet, 1822–after 1900. "Danaë." Painting. **1896.** [Dijkstra 1986, p. 370—ill.]

Henri Fantin-Latour, 1836–1904. "Danaë." Painting. **1898.** [Fantin-Latour 1911, no. 1505]

———. "Danaë." Painting. 1900. [Ibid., no. 1809]

———. "Danaë." Painting. 1902. [Ibid., no. 1920]

Paul Désiré Trouillebert, 1829–**1900.** "Danaë." Painting. [Dijkstra 1986, p. 370]

Carl Strathmann, 1866–1939. "Danaë." Painting. *c.***1905.** [Dijkstra 1986, p. 370—ill.]

Gustav Klimt, 1862–1918. "Danaë." Painting. *c.***1907–08.** Galerie Würthle, Vienna. [Strobl 1980, 1:287–90—ill. / also Novotny & Dobai 1968, no. 151—ill.]

Franz von Stuck, 1863–1928. "Danaë." Painting. **1909.** Unlocated. [Voss 1973, no. 345—ill.] Variant. 1923. Unlocated. [Ibid., no. 558—ill.] Study (for variant). Private coll. [Ibid., no. 557—ill.]

Robert Nichols, 1893–1944. "Danaë: Mystery in Eight Poems." Poem cycle. **1912–13.** In *Ardours and Endurances* (London: Stokes, 1917). [Bush 1937, p. 571]

Frederic Manning, 1887–1935. "Danaë." Poem. In *Eidola* (London: Murray, **1917**). [Boswell 1982, p. 272]

D. H. Lawrence, 1885–1930. (Sunshine seen as golden coins falling on Danaë to) "Tommies in the Train" lines 1–12. Poem. In *Poetry* Feb **1919**; collected in *Bay* (London: Beaumont, 1919). [Pinto & Roberts 1964, vol. 1]

Lovis Corinth, 1858–1925. "Danaë and the Shower of Gold." Color lithograph, part of "Loves of Zeus" cycle. **1920.** [Schwarz 1922, no. L401]

Hugo von Hofmannsthal, 1874–1929. *Danae, oder, Die Vernunftheirat* [Danae, or, The Marriage of Convenience]. Opera libretto. **1920.** [Steiner 1946–58, *Lustspiele* vol. 3]

Paul Manship, 1885–1966. "Danaë." Bronze statuette. **1920–21.** National Museum of American Art, Washington, D.C.; elsewhere. [Rand 1989, p. 61—ill. / Murtha 1957, no. 127]

Émile Bernard, 1868–1941. "Danaë." Painting. **1924.** Private coll. [Luthi 1982, no. 1102—ill.]

Pierre Louÿs, 1870–1925. "Danaë, ou, Le malheur" [Danaë, or, Misfortune]. Short story. In *Le crépuscule des nymphes* (Paris: Montaigne, **1925,** with 5 woodcuts by Jean Saint-Paul). / 2d edition, Paris: Briant-Robert, 1926, with 10 lithographs by Bosshard. / 3d edition, Paris: Tisné, 1946, with 24 lithographs by Pierre Bonnard. [NUC / also Bouvet 1981, no. 128—ill.]

Gustav Seitz, 1908– "Danaë." Terra-cotta sculpture. **1926.** Lost. / Bronze variant. 1955. 11 casts. Kunsthalle, Bremen, inv. 561–1976/12; Atelier Gustav Seitz, Hamburg (2); private colls., Germany. [Grohn 1980, no. 101 (cf. no. 37—ill.)] Terra-cotta model. Atelier Seitz. [Ibid.—ill.] Variant ("Large Danaë"). 1967–68. Atelier Seitz; Universitätsklinik, Hamburg-Eppendorf. [Ibid., no. 175—ill.] Bronze and plaster models. Atelier Seitz; private colls.; lost. [Ibid., nos. 174–75—ill.]

Gerhard Marcks, 1889–1981. "Danaë." Bronze sculpture. **1933.** Unique (?) cast. Private coll., Germany. [Busch & Rudloff 1977, no. 277—ill.]

———. "Small Danaë." Bronze sculpture. 1937. At least 16 casts. Museum of Modern Art, New York; Hirschhorn Museum and Sculpture Garden, Washington, D.C.; Senat, Hamburg; St. Louis Art Museum; Gerhard-Marcks-Stiftung, Bremen; elsewhere. [Ibid., no. 341—ill.]

Richard Strauss, 1864–1949. *Die Liebe der Danaë* [The Love of Danaë]. Opera, opus 83. Libretto, Joseph Gregor, after von Hofmannsthal's *Danae* (1920). **1938–40.** Scheduled for Aug 1944, cancelled; first performed 14 Aug 1952, Festspielhaus, Salzburg. [Baker 1984, p. 2227 / Grove 1980, 18:232–34 / Martin 1979, pp. 255–59]

Eudora Welty, 1909–. "The Shower of Gold." Short story. In *The Golden Apples* (New York: Harcourt, Brace, **1947**). [CLC 1982, 22:459 / DLB 1978, 2:530]

Willi Baumeister, 1889–1955. "Dänae." Abstract painting. **1955.** Schätz coll., Stuttgart. [Grohmann 1965, no. 1321—ill.]

Stanley Kunitz, 1905–. (Zeus and Danaë in) "Among the Gods." Poem. In *Selected Poems, 1928–1958* (Boston & Toronto: Little, Brown, **1958**). [Ipso]

Barbara Howes, 1914–. "Danaë." Poem. In *Light and Dark* (Middletown, Conn.: Wesleyan University Press, **1959**). [Vinson 1985, p. 412 / CLC 1978, 15:289]

Josep Soler, 1935–. *Danaë.* Composition for string orchestra. **1959;** revised 1969. First performed 23 Jun 1977, Lisbon. [Baker 1984, p. 2160]

———, music. *Danaë.* Ballet. 1960. [Grove 1980, 17:451]

Paul Goodman, 1911–1972. "Danaë (after Titian)." Poem. In *The Lordly Hudson: Collected Poems* (New York: Macmillan, **1962**). [Ipso]

Pablo Picasso, 1881–1973. "Danaë." Color lino-cut. **1962.** [Bloch 1971–79, no. 1084—ill.]

François-Bernard Mâche, 1935–. "Danaé." Vocal composition. **1970.** [Grove 1980, 11:437]

Jack Beal, 1931–. "Danaë II." Painting. **1972.** Whitney

Museum of American Art, New York, no. 74.82. [Kilinski 1985, no. 10—ill.]

Ann Stanford, 1916–. (Danaë, one of) "The Women of Perseus." Poem. In *In Mediterranean Air* (New York: Viking, **1977**). [Ostriker 1986, pp. 221, 288]

Ursula Le Guin, 1929–. "Danaë." Poem. In *Hard Words, and Other Poems* (New York: Harper & Row, **1981**). [CLC 1987, 45:212]

Amy Clampitt, 1920–. (Perseus rescues Danaë from Polydectes in) "The Nereids of Seriphos." Poem. In *Archaic Figure* (New York: Knopf, **1987**). [Ipso]

DANAÏDS. The fifty daughters of Danaus, known as Danaïds, were given in marriage to the fifty sons of Aegyptus, Danaus's brother, with whom Danaus had a long-standing quarrel. Danaus ordered his daughters to kill their husbands on their wedding night, supplying them with knives for the deed. All but one did so; Hypermnestra spared her husband, Lynceus, and they founded a line that produced Perseus and other Argive kings. The remaining forty-nine daughters were purified of their sins by Athena and Hermes, but as punishment for the murders they were condemned in Hades to carry water in sieves or jars (amphorae) with holes in the bottom.

Aeschylus's tragedy *The Suppliants* relates an early episode in the tale, when the Danaïds have fled to Argos to escape marriage to the sons of Aegyptus. In the postclassical period the subject has been particularly manifest in opera. Treatments of the theme in the fine arts most commonly depict the Danaïds carrying their porous water jars.

Classical Sources. Aeschylus, *The Suppliants.* Pindar, *Pythian Odes* 9.112–25., 193ff. Horace, *Odes* 3.2. Ovid, *Heroides* 14. Apollodorus, *Biblioteca* 2.1–20. Pausanias, *Description of Greece* 2.16–20, 25. Hyginus, *Fabulae* 168, 170, 255.

Anonymous French. (Danaïds in) *Ovide moralisé* 2.4587ff. Poem, allegorized translation/elaboration of Ovid's *Metamorphoses* and other works. c.**1316–28.** [de Boer 1915–86, vol. 1]

Giovanni Boccaccio, 1313–1375. "De Ypermestra, Argivorum regina et sacerdote Iunonis [Hypermnestra, Queen of the Argives and Priestess of Juno]. In *De mulieribus claris* [Concerning Famous Women]. Latin verse compendium of myth and legend. **1361–75.** Ulm: Zainer, 1473. [Branca 1964–83, vol. 10 / Guarino 1963]

Geoffrey Chaucer, 1340?–1400. "The Legend of Hypermnestra," in *The Legende of Goode Women.* Poem. **1385–86.** Westminster: Caxton, c.1495. [Riverside 1987 / Howard 1987, p. 396 / Frank 1966, pp. 126, 131f.]

Thomas Heywood, 1573/74–1641. "The daughters of Danaus, and the sons of Aegyptus." Passage in *Gynaikeion: or, Nine Books of Various History Concerning Women* book 5. Compendium of history and mythology. London: Adam Islip, **1624.** [Ipso]

Jean Ogier de Gombauld, 1570?–1666. *Les Danaïdes.*

Tragedy. First performed late **1644,** Paris. Published Paris: Courbé, 1658. [Lancaster 1929–42, pt. 2, 2:616–18, 780; pt. 4, 1:177 / Girdlestone 1972, pp. 182f.]

Pier Francesco Cavalli, 1602–1676. *Ipermestra.* Opera. **1654.** Libretto, G. A. Moniglia. First performed 12 June 1658, Teatro degli Immobili, Florence. [Grove 1980, 4:25, 32 / Bianconi 1987, p. 198 / Glover 1978, pp. 22, 120 n. 159]

Antonio Draghi, 1634/35–1700 (Act 3 only), and others. *Ipermestra.* Musical pasticcio. Libretto, N. Minato. First performed Spring **1671,** Venice. Lost. [Grove 1980, 5:604]

Abraham van Diepenbeeck, 1596–**1675.** "The Danaïds." Drawing. / Engraved by Cornelis Bloemaert. [Pigler 1974, p. 66]

Gaspard Abeille, 1648–1718. *Lyncée* [Lynceus] (also called *Danaüs*). Tragedy. First performed 25 Feb **1678,** Hôtel de Bourgogne, Paris. Published Paris: 1681. [Lancaster 1929–42, pt. 4, 1:172 n.3, 177ff., 2:952 / Girdlestone 1972, p. 183]

Ciro Ferri, 1634–**1689.** "The Danaïds." Drawing. Rijksmuseum, Amsterdam. [Pigler 1974, p. 66]

Charles Le Brun, 1619–**1690.** "The Danaïds." Drawing. Städelsches Kunstinstitut, Frankfurt. [Pigler 1974, p. 66]

Robert Owen. *Hypermnestra; or, Love in Tears.* Tragedy. Unperformed. London: Lintott, **1703.** [Stratman 1966, p. 515]

Théodore de Riupeirous, 1664–1706. *Hypermnestre.* Tragedy. First performed **1704,** Paris. [Girdlestone 1972, pp. 183, 219 n.]

Charles-Hubert Gervais, 1671–1744 (with Philippe d'Orléans?). *Hypermnèstre.* Opera. Libretto, J. de Lafond and perhaps d'Orléans. First performed 3 Nov **1716,** L'Opéra, Paris. / Act 5 revised by Pellegrin, 1717. [Grove 1980, 7:309]

Geminiano Giacomelli, c.1692–1740. *Ipermestra.* Opera. Libretto, Antonio Salvi. First performed **1724,** Teatro Grimani, Venice, and Palazzo Ducale, Parma. [Grove 1980, 7:344f.]

Antonio Vivaldi, 1678–1741. *Ipermestra.* Opera (dramma per musica). Libretto, Salvi (1724). First performed 26 Jan **1727,** Teatro della Pergola, Florence. [Grove 1980, 20:44 / Weaver 1978, pp. 251f.]

Francesco Feo, 1691–1761. *Ipermestra.* Opera. Libretto, Salvi (1724). First performed Jan **1728,** Teatro delle Dame, Rome. [Grove 1980, 6:466]

Gerard Hoet the Elder, 1648–1733. "The Danaïds." Painting. [Pigler 1974, p. 66]

Pierre François Biancolelli, called Dominique, 1680–**1734,** and **Jean Antoine Romagnesi,** 1690–1742. *La bonne femme.* Comedy, parody. In *Les parodies du nouveau théâtre italien* (Paris: 1738). [NUC]

Pietro Metastasio, 1698–1782. *Ipermestra.* Libretto for opera, first set in **1741** by Rinaldo di Capua, and thereafter by at least 16 other composers to 1843 (see below). [DELI 1966–70, 3:592 / Grove 1980, 12:217]

Rinaldo di Capua, c.1705–c.1780. *Ipermestra.* Opera seria. Libretto, Metastasio. First performed **1741,** Rua dos Condes, Lisbon. [Grove 1980, 16:43]

Johann Adolf Hasse, 1699–1783. *L'Ipermestra.* Opera seria. Ballet music, Ignaz Holzbauer. Libretto, Metastasio (1741). First performed 8 Jan **1744,** Burgtheater, Vienna. [Grove 1980, 8:282, 288, 670]

Christoph Willibald Gluck, 1714–1787. *Ipermestra.* Opera

(dramma per musica). Libretto, Metastasio (1741). First performed 21 Nov **1744**, San Giovanni Grisostomo, Venice. [Grove 1980, 7:472 / Cooper 1935, pp. 44, 59, 62, 284]

Ferdinando Bertoni, 1725–1813. *Ipermestra*. Opera. Libretto, Metastasio (1741). First performed Carnival **1748**, Teatro Falcone, Genoa. [Grove 1980, 2:647]

Egidio Duni, 1708–1775. *Ipermestra*. Opera. Libretto, Metastasio (1741). First performed Carnival **1748**, Teatro Falcone, Genoa. [Grove 1980, 5:718]

Anonymous composer (Giovanni Battista Pescetti or Giuseppe Bertoni?). *Ipermestra*. Opera (dramma per musica). Libretto, Metastasio (1741). First performed 20 Aug **1749**, Teatro della Pergola, Florence. [Weaver 1978, p. 326]

Niccolò Jommelli, 1714–1774. *Ipermestra*. Opera seria. Libretto, Metastasio (1741). First performed Oct **1751**, Teatro Comunale, Spoleto. [Grove 1980, 9:693]

Pasquale Cafaro, 1716?–1787. *Ipermestra*. Opera. Libretto, Metastasio (1741). First performed 26 Dec **1751**, Naples. [Grove 1980, 3:595]

Andrea Adolfati, 1720/21–1760. *Ipermestra*. Opera. Libretto, Metastasio (1741). First performed Carnival **1752**, Teatro Rangoni, Modena. [Grove 1980, 1:111]

Giovanni Battista Lampugnani, 1706–c.1786. Arias in *Ipermestra*. Pasticcio. Text, after Metastasio (1741). First performed 9 Nov **1754**, King's Theatre, London. [Grove 1980, 10:422]

Davide Perez, 1711–1778. *L'Ipermestra*. Opera. Libretto, Metastasio (1741). First performed **1754**, Lisbon. [Grove 1980, 14:367]

Baldassare Galuppi, 1706–1785. *Ipermestra*. Opera seria. Libretto, Metastasio (1741). First performed 14 Jan **1758**, Regio Ducal, Milan. [Grove 1980, 7:137]

Antoine-Marin Lemierre, 1723–1793. *Hypermnestre*. Tragedy. First performed **1758**, Paris. [DLLF 1984, 2:1276]

Ignazio Fiorillo, 1715–1787. *Ipermestra*. Opera seria. Libretto, Metastasio (1741). First performed **1759**, Braunschweig. [Grove 1980, 6:601]

Johann Ernst Eberlin, 1702–1762. *Ipermnestra*. Opera. Libretto, Metastasio (1741). **1761**. Lost. [Grove 1980, 5:814]

Jean-Georges Noverre, 1727–1810, choreography. *Ipermestra* (*Hypermestre*). Ballet. Music, Jean-Joseph Rodolphe. First performed 11 Feb **1764**, Hoftheater, Stuttgart. [Grove 1980, 13:443]

Giuseppe Sarti, 1729–1802. *Ipermestra*. Opera (dramma per musica). Libretto, Metastasio (1741). First performed Carnival **1766**, Teatro Argentina, Rome. [Grove 1980, 16:505]

Gerolamo Pompei, 1731–1788. *L'Ipermestra*. Tragedy. Verona: Ramanzini, **1767**. [DELI 1966–70, 4:424]

Nicolas-Antoine Bergiron de Briou, 1690–**1768**. *Hipermenestre* [*sic*]. Divertissement. Lost. [Grove 1980, 2:549]

Gian Francesco de Majo, 1732–1770. *Ipermestra*. Opera. Libretto, Metastasio (1741). First performed 13 Aug **1768**, San Carlo, Naples. [Grove 1980, 11:544]

Josef Mysliveček, 1737–1781. *L'Ipermestra*. Opera. Libretto, Metastasio (1741). First performed 28 Mar **1769**, Teatro della Pergola, Florence. [Pečman 1970, p. 181 / Grove 1980, 13:7]

Niccolò Piccinni, 1728–1800. *Ipermestra*. Opera (dramma

lyrica). Libretto, Metastasio (1741). First performed 4 Nov **1772**, San Carlo, Naples. [Grove 1980, 14:727]

Gian Francesco Fortunati, 1746–1821. *Ipermestra*. Opera seria. Libretto, Metastasio (1741). First performed **1773**, Teatro di Corte, Modena. Music lost. [Grove 1980, 6:725]

Johann Gottlieb Naumann, 1741–1801. *Ipermestra*. Opera seria. Libretto, after Metastasio (1741). First performed 1 Feb **1774**, San Benedetto, Venice. [Grove 1980, 13:79]

Vicente Martín y Soler, 1754–1806. *Ipermestra*. Opera. Libretto, Metastasio (1741). First performed 12 Jan **1780**, San Carlo, Naples. [Grove 1980, 11:736]

Antonio Salieri, 1750–1825 (advertised as by Salieri and Christoph Willibald Gluck, but attributed entirely to Salieri by Gluck). *Les Danaïdes*. Opera (tragédie lyrique). Libretto, Du Roullet and Tschudi, after Calzabigi's *Ipermestra*. First performed 26 (or 19) Apr **1784**, L'Opéra, Paris. [Baker 1984, p. 1975 / Grove 1980, 16:416–18 / Landon 1988, pp. 172f.]

Martin Johann Kremser-Schmidt, 1718–1801. "The Danaïds." Painting. **1785**. Museum, Ljubljana. [Pigler 1974, p. 66]

Salvatore Rispoli, c.1736/45–1812. *Ipermestra*. Opera (dramma per musica). Libretto, Metastasio (1741). First performed 26 Dec **1785**, La Scala, Milan. [Grove 1980, 16:54]

John Flaxman, 1755–1826. 4 drawings, illustrating Aeschylus's *The Suppliants*. **1792–94**. Engraved by Tommaso Piroli, published London: 1795. 1 additional illustration, engraved by Frank Howard, published 1831. [Irwin 1979, pp. 69, 88–90—ill. / also Flaxman 1872, 3: pls. 7–10]

Angelo Tarchi, c.1760–1814. *Le Danaidi*. Opera (dramma per musica). Libretto, G. Sertor. First performed 26 Dec **1794**, La Scala, Milan. [Grove 1980, 18:577]

Johann Diederich Gries, 1775–1842. "Die Danaiden." Poem. In *Die Horen* (**1797**). [Oellers 1983, p. 470]

Francesco Morlacchi, 1784–1841. *Le Danaidi*. Opera seria. Libretto, S. Scatizzi, after Metastasio's *Ipermestra* (1741). First performed 11 Feb **1810**, Teatro Argentina, Rome. [Grove 1980, 12:578]

Stefano Pavesi, 1779–1850. *Le Danaidi romane* [The Roman Danaïdes]. Opera. Libretto, Simeone Antonio Sografi. Libretto published Venice: **1816**. [DELI 1966–70, 5:155]

Eugène Scribe, 1791–1861, with **Jean-Henri Dupin**, 1787–1887. *Les nouvelles Danaïdes*. Vaudeville. First performed 3 Dec **1817**, Théâtre des Variétés, Paris. [McGraw-Hill 1984, 4:353]

Simon Mayr, 1763–1845. *Le Danaide*. Opera (melodramma serio). Libretto, Felice Romani. First performed Carnival **1819**, Teatro Argentina, Rome. [Grove 1980, 11:860]

Thomas Frognall Dibdin, 1776–1847. *The Daughters of Danaus and the Sons of Aegyptus, or, Fifty Weddings and Nine and Forty Murders*. Burlesque. First performed **1821**, London. [Hunger 1959, p. 81]

Saverio Mercadante, 1795–1870. *Ipermestra*. Opera (dramma tragico). Libretto, L. Ricciuti, after Metastasio (1741). First performed Carnival **1824–25** (?), San Carlo, Naples. [Grove 1980, 12:174]

Antonio Cortesi, 1796–1879, choreography. *Le piccole Danaidi* [The Little Danaïds]. Ballet. First performed **1834**, Teatro Regio, Turin. [EDS 1954–66, 3:1538]

Baltasar Saldoni, 1807–1889. *Ipermestra*. Opera. Libretto, Metastasio (1741). First performed 20 Jan **1838**, Teatro Cruz, Madrid. [Grove 1980, 16:413]

Ramon Carnicer y Batlle, 1789–1855. *Ipermestra*. Opera (dramma per musica). Libretto, Metastasio (1741). First performed early **1843**, Liceo, Zaragoza. [Grove 1980, 3:801]

Michael-François Hoguet, 1793–1871, choreography. *Les Danaïdes*. Ballet. Music, Schmidt. First performed 4 Feb **1845**, Theatre Royal, Drury Lane, London. [Guest 1972, p. 166]

Honoré Daumier, 1808–1879. "The New Barrel of the Danaïds" (artillery cannon). Satirical lithograph. **1869**. [Delteil 1906–30, 29: no. 3719—ill.]

Frank Sikes. *Hypermnestra, the Girl of the Period.* Comedy. First performed 27 Mar **1869**, Lyceum Theatre, London. [Nicoll 1959–66, 5:566]

John Reinhard Weguelin, 1849–1927. "The Labor of the Danaïds." Painting. Exhibited **1878**. [Kestner 1989, p. 333]

Ernst von Wildenbruch, 1845–1909. "Die Danaïde." Tale. In *Neue Novellen* (Berlin: Freund & Jeckel, **1885**). [Grove 1980, 20:706]

Auguste Rodin, 1840–1917. "The Danaïd." Sculpture. **1885** (–88?). Numerous versions. Marble: Musée Rodin, Paris; Musée d'Orsay, Paris; Ny-Carlsberg Glyptotek, Copenhagen; Kunstmuseum Athenaeum, Helsinki; Brooklyn Museum, N.Y.; Pennsylvania Academy of Fine Arts, Philadelphia; Princeton University Art Museum, N.J. Stone: Museu Nacional de Arte Antiga, Lisbon. Terracotta: Nationalmuseum, Stockholm. Plaster: Musée, Bagnols-sur-Cèze, France. Bronze: Baltimore Museum of Art; Cummer Gallery of Art, Jacksonville, Fla.; Maryhill Museum of Fine Arts, Wash.; Los Angeles County Museum of Art; Stanford University Art Gallery, Calif.; Musée d'Art et d'Industrie, St.-Etienne; Nasjonalgalleriet, Oslo; private colls. [Tancock 1976, 254f.—ill. / Rodin 1944, no. 138—ill. / Elsen 1981, figs. 4.18–19]

———. "Danaïd Overcome." Bronze sculpture. *c.*1889. Musée Rodin, Paris. [Rodin, no. 221—ill.]

Fernand Khnopff, 1858–1921. "Danaïds." Drawing. **1892**. [Delevoy et al. 1979, no. 202—ill.]

Heinrich Zöllner, 1854–1941. *Der Überfall* [The Surprise Attack]. Opera, opus 65. Libretto, composer, after Wildenbruch's *Die Danaïde* (1885). First performed 7 Sep **1895**, Hofoper, Dresden. [Grove 1980, 20:706]

Arturo Graf, 1848–1913. *Le Danaidi*. Dramatic poem. Turin: Loescher, **1897**. [DELI 1966–70, 3:182 / DULC 1959–63, 2:549]

Ernst Barlach, 1870–1938. "Danaïd." Plaster (?) sculpture. *c.***1904**. Lost. [Schult 1958–72, 1: no. 52]

———. "Danaïd Fountain-figure." Drawing (for above?). 1904. Barlach Estate, Güstrow, inv. D.31. [Ibid., no. 226—ill.]

John William Waterhouse, 1849–1917. "The Danaïds." Painting. **1906**. Aberdeen Art Gallery, Scotland. [Hobson 1980, no. 151, pl. 118 / Wood 1983, pp. 239ff.—ill. / Kestner 1989, p. 300, pl. 5.44]

Constantin Brancusi, 1876–1957. "Danaïd." Stone sculpture. **1907–09**. Rîmniceanu coll., Bucharest. [Geist 1975, no. 63—ill.]

———. "Danaïd." Marble sculpture, study. 1910. Recarved

1925. Norton Simon Museum, Fullerton, Calif. [Ibid., nos. 73, 176—ill. / also Geist 1969, p. 99—ill.] 4 bronze casts, *c.*1913. Musée Nationale d'Art Moderne, Paris; Kunstverein, Winterthur, Switzerland; Philadelphia Museum of Art; private coll., Baltimore. [Geist 1975, no. 87—ill. / also Geist 1969, p. 98—ill.] 2 casts, *c.*1918. Tate Gallery, London;, private coll., New York. [Geist 1975, nos. 87e-f / Alley 1981, p. 73—ill. / also Geist 1969, p. 98—ill.]

Mihály Babits, 1883–1941. "A Danaidák" [The Danaïds]. Poem. In *Herceg, Látha megjön a tél is* (Budapest: Nyugat Kiadasa, *c.***1911**). [Reményi 1964, p. 312]

Pierre Benoit, 1886–1962. *Les suppliantes*. Collection of poems. Paris: Albin Michel, **1920**. [DLLF 1984, 1:234]

John Singer Sargent, 1856–1925. "The Danaïds." Painting, part of mural series. **1921–25**. Museum of Fine Arts, Boston. [Ratcliff 1982, p. 149—ill.]

Philippe Wolfers, 1858–1929. "Woman with a Jug" ("Danaïd"). Bronze statuette. By **1927**. Unique cast in Musée d'Orsay, Paris, inv. RF 3323. [Orsay 1986, p. 258—ill.]

T. Sturge Moore, 1870–1944. (Story of the Danaïds in) *Daimonassa*. Drama. In *Mystery and Tragedy* (London: Cayme, **1930**). [Gwynn 1951, p. 109 / Bush 1937, pp. 451, 575]

Joseph-Jules-Emmanuel Descomps, called Cormier, 1869–**1950**. "Danaïd" ("Woman with Amphora"). Stone statuette. Musée d'Orsay, Paris, inv. RF 3187; Musée d'Art Moderne de la Ville de Paris. [Orsay 1986, p. 102—ill.]

DAPHNE. The daughter of the river-god Peneus, Daphne was ardently desired by Apollo because he had been smitten by Eros (Cupid). According to Ovid, when Apollo mocked Eros's bow and arrows as unsuitable weapons for a child, the love-god responded by loosing two arrows. One, which inflamed love, struck Apollo; the other, which repelled it, pierced Daphne. Apollo relentlessly pursued the girl, who ran away from him at every opportunity. She implored her father to help her, and he did so by changing her into a laurel tree. Even this did not deter the amorous Apollo, who embraced the tree and made it his sacred symbol; he was thereafter wreathed in laurel.

The story of Daphne is enormously popular in the fine arts. The nymph is usually depicted in flight, metamorphosing into a laurel as Apollo reaches for her in vain.

In another tale, rarely treated by postclassical artists, Leucippus, son of Oenomaus, loved Daphne and disguised himself as a woman so that he could bathe with her. Apollo, however, revealed the secret, and the young man was killed by Daphne and her nymphs.

Classical Sources. Ovid, *Metamorphoses* 1.452–567. Pausanias, *Description of Greece* 10.7.8. Hyginus, *Fabulae* 203.
Further Reference. Yves F.-A. Giraud, *La fable de Daphne: Essai sur un type de métamorphose végétale dans la littérature et dans les arts jusqu'à la fin du XVIIe siècle* (Geneva: Droz,

1968). Wolfgang Stechow, *Apollo und Daphne,* 2d revised edition (Darmstadt: Wissenschaftliche Buchgesellschaft, 1965).

Benoît de Sainte-Maure, fl. 1150–70. (Story of Apollo and Daphne in) *Le roman de Troie* lines 17489–18128, 26241–590. Verse romance, after Dares, *De excidio Troiae historia,* and Dictys, *Ephemeris de historia belli Troiani* (6th century Latin versions of lost Greek poems, pseudo-classical forgeries). *c.*1165. [Baumgartner 1987]

Guido delle Colonne, *c.*1210–after 1287. (Story of Apollo and Daphne in) *Historia Destructionis Troiae.* Latin prose chronicle, after Benoît de Sainte-Maure. **1272–87.** Modern edition by Nathaniel E. Griffin (Cambridge, Mass.: Harvard University Press, with Medieval Academy of America, 1936; reprinted New York: Kraus, 1970). / Translated by M. E. Meek (Bloomington: Indiana University Press, 1974). [Benson 1980, passim]

Dante Alighieri, 1265–1321. (Daphne alluded to in) *Paradiso* 1.32f. Completed *c.*1321. In *The Divine Comedy.* Poem. Foligno: Neumeister & Angelini, 1472. [Singleton 1970–75, vol. 3 / Toynbee 1968, p. 211]

Anonymous French. (Story of Apollo and Daphne in) *Ovide moralisé* 1.2737–3260. Poem, allegorized translation/elaboration of Ovid's *Metamorphoses. c.*1316–28. [de Boer 1915–86, vol. 1 / DLLF 1984, 2:1678f. / Cottino-Jones 1975, pp. 155f.]

Francesco Petrarca, 1304–1374. (Evocations of Apollo and Daphne story in) Sonnets, nos. 5, 6, 34, 41, 43, 51, 188, 197; *canzoni,* nos. 23, 30; madrigal, no. 52, of *Canzoniere (Rime sparse).* Collection of sonnets, madrigals, and *canzoni.* Begun *c.*1336, completed by 1373; nos. 1–263 composed by **1348.** [Contini 1974 / Armi 1946 / Sturm-Maddox 1985, pp. 9ff., 13ff., 21–38 / Cottino-Jones 1975, pp. 157–69 / Giraud 1968, pp. 142–47]

Jean Froissart, 1337?–*c.*1410. (Apollo and Daphne evoked in) *L'espinette amoureuse* strophes 1–13. Verse novel. *c.*1370. Modern edition by Anthime Fourrier (Paris: Klincksieck, 1972). [Giraud 1968, pp. 129–34]

———. (Apollo and Daphne evoked in) *La prison amoureuse* lines 1760ff. Poem. *c.*1372–73. Modern edition by Anthime Fourrier (Paris: Klincksieck, 1974). [Huot 1987, pp. 307–09]

———. (Apollo and Daphne evoked in) *Le joli buisson de jonece* lines 3154–63. Poem. Modern edition by Anthime Fourrier (Geneva: Droz, 1975). [Ibid.]

———. (Apollo and Daphne evoked in complaint of) *Le paradis d'amour.* Poem. Modern edition by P. Dembowski (Geneva: Droz, 1986). [Ibid.]

John Gower, 1330?–1408. (Story of "Phebus and Daphne" in) *Confessio amantis* 3.1685–1720. Poem. *c.*1390. Westminster: Caxton, 1483. [Macaulay 1899–1902, vol. 2 / Giraud 1968, pp. 139f. / Beidler 1982, p. 25]

Christine de Pizan, *c.*1364–*c.*1431. (Story of "Phoebus and Daphne" in) *L'epistre d'Othéa à Hector* . . . [The Epistle of Othéa to Hector] chapter 87. Didactic romance in prose. *c.*1400. MSS in British Library, London; Bibliothèque Nationale, Paris; elsewhere. / Translated by Stephen Scrope (London: *c.*1444–50). [Bühler 1970 / Hindman 1986, pp. 24, 202 / Giraud 1968, pp. 135f.]

Filarete, *c.*1400–1469? "Apollo and Daphne." Relief, on bronze door of St. Peter's, Rome. **1433–45.** In place. [Pope-Hennessy 1985b, 2:318]

Antonio del Pollaiuolo, 1432/33–1498, attributed. "Apollo and Daphne." Painting. Early work. National Gallery, London, inv. 928. [London 1986, p. 486—ill. / Ettlinger 1978, no. 9—ill. / also Berenson 1968, p. 179—ill. / Harrison & Waters 1973, p. 99—ill. / Stechow 1965, pp. 21ff.]

Sandro Botticelli, 1445–1510. (Apollo and Daphne depicted in relief in setting of) "The Calumny of Apelles." Painting. *c.*1494–95. Uffizi, Florence, no. 1496. [Lightbown 1978, no. B79—ill. / also Uffizi 1979, no. P269—ill.]

John Skelton, 1460?–1529. (Story of "Phoebus and Daphne" related in) "The Garlande or Chapelet of Laurell" lines 287–322. Poem. *c.*1495. London: Fakes, 1523. [Scattergood 1983 / Brownlow 1990]

Master of the Apollo and Daphne Legend (previously attributed to Bartolomeo di Giovanni). "Daphne Found Asleep by Apollo," "Daphne Fleeing from Apollo." Paintings. *c.*1500. Kress Foundation, New York, nos. K1721A, K1721B. [Shapley 1966–73, 1:129f.—ill.]

Albrecht Dürer, 1471–1528, attributed, or studio (Hans von Kulmbach?). "Apollo and Daphne." Woodcut, illustrating Conrad Celtis's *Quatuor libri amorum* (Nuremburg: **1502**). [Strauss 1980, pp. 612f.—ill. / Stechow 1965, p. 23 (as studio of Dürer)]

Andrea del Sarto, 1486–1530. "Apollo and Daphne, and Narcissus." Painting. Early work? Galleria Corsini, Florence, no. 241. [Berenson 1963, p. 9] Variant copy, by Domenico Puligo (1492–1527). Pollen coll., Norton Hall, Gloucestershire. [Ibid., p. 184 / Stechow 1965, pp. 25, 37—ill.] *See also Pontormo, below.*

Giorgione, *c.*1477–**1510,** follower (questionably attributed to Paris Bordone, 1500–1571; also previously attributed to Titian). "Apollo and Daphne." Painting. Seminario Patriarcale, Venice. [Pignatti 1978, no. A60—ill. / Wethey 1975, no. X–4—ill. / Canova 1964, p. 114—ill. / also Berenson 1957, p. 84—ill.]

Sodoma, 1477?–1549. "Apollo and Daphne." Painting, one of a series depicting scenes from Ovid. *c.*1511. Worcester Art Museum, Mass., no. 1925.120. [Hayum 1976, no. 12 / Berenson 1968, p. 409]

Baldassare Peruzzi, 1481–1536, circle (? also attributed to school of Giulio Romano or Raphael). "Apollo and Daphne." Fresco. **1511–12** (or *c.*1517–18). Sala delle Prospettive, Villa Farnesina, Rome. [d'Ancona 1955, pp. 27ff., 93f. / Gerlini 1949, pp. 31ff. / also Frommel 1967–68, no. 51]

Italian School. "Apollo and Daphne." Ceiling fresco. **1508–13**? Sala delle Nozze di Alessandro con Rossana, Villa Farnesina, Rome. [Gerlini 1949, pp. 34ff.]

Jacopo Pontormo, 1494–1556, attributed. "Cupid and Apollo," "Apollo and Daphne." Pendant paintings. **1513.** Kress coll. (K1618), Bucknell University, Lewisburg, Pa., no. BL-K18; Kress coll. (K1619), Walker Art Museum, Bowdoin College, Brunswick, Me. [Shapley 1966–73, 3:10—ill. / also Berenson 1963, p. 221 (as follower of Andrea del Sarto)]

Agostino Veneziano, 1490–1540. "Apollo and Daphne." Engraving (Bartsch 14:238 no. 317), after Baccio Bandinelli? **1515.** [Bartsch 1978, 26:319—ill. / Stechow 1965, pp. 25, 44f.—ill.]

Francesco Bonsignori, *c.*1455–**1519.** "Apollo and Daphne."

Painting. Berenson coll., Settignano, Florence. [Berenson 1968, p. 59]

Bernardino Luini, 1480/85–1532. "Apollo, Daphne, and Peneus" (? or "Adonis, Myrrha, and Cinyras"?). Fresco (detached), part of "Apollo and Pan" cycle, from Villa Pelucca, Sesto San Giovanni. **1520–23.** Pinacoteca di Brera, Milan. [Luino 1975, pp. 35f., 87f., pl. 25]

Dosso Dossi, c.1479–1542. "Apollo" (Daphne in background). Painting. **1520–25.** Galleria Borghese, Rome, no. 1. [Gibbons 1968, no. 55—ill. / Berenson 1968, p. 113 / Pergola 1955–59, 1: no. 35 (as "Apollo and Daphne")—ill.] Copy in Spark coll., New York. [Gibbons]

Hans Vischer the Elder, 1489–1550. "Apollo and Daphne." Drawing. c.1530. Öffentliche Kunstsammlung, Basel. [Giraud 1968, p. 252—ill. (frontispiece)]

Garcilaso de la Vega, 1503–**1536.** (Daphne evoked in) eclogue 3 and sonnet 13 of *Cantos amoras* [Love Songs] (Barcelona: Boscan, 1543). [Giraud 1968, pp. 357–59 / Praz 1925, p. 283]

Giovanni Agostino da Lodi, fl. **1500–40.** "Satyr Playing to a Nymph, with Apollo and Daphne in Background." Painting. Thyssen coll., Lugano. [Berenson 1968, p. 173—ill.]

Andrea Schiavone, c.1522–1563. "Apollo and Daphne." 3 related prints. c.1538–40? [Richardson 1980, nos. 100, 101, 125—ill.]

————, attributed. "Apollo and Cupid," "Apollo and Daphne." Pendant paintings. c.1542–44? Kunsthistorisches Museum, Vienna, nos. 356 (202), 115 (204). [Ibid., no. 323—ill. / Vienna 1973, p. 158—ill.]

————, rejected attribution. "Apollo and Daphne." Painting. A. R. Turner coll., Princeton, N.J. [Richardson, no. 361]

Jacopo Tintoretto, 1518–1594. "Apollo and Daphne." Painting. c.1541. Galleria Estense, Modena. [Rossi 1982, no. 21—ill.]

————, rejected attribution (Venetian school, style of Padovanino). "Apollo and Daphne." Painting. Private coll., Novara. [Ibid., no. A78—ill.]

Marguerite de Navarre, 1492–1549. (Transformation of Daphne in) *L'histoire des satyres et nimphes de Diane.* Poem. Lyon: Saulnier, **1543.** [Giraud 1968, pp. 206–11]

Luca Cambiaso, 1527–1585. "Apollo and Daphne." Fresco. **1544.** Palazzo della Prefettura, Genoa. [Manning & Suida 1958, pp. 74f.]

————. "Apollo and Daphne." Fresco. c.1560. Palazzo Vincenzo Imperiale, Genoa. [Ibid., pp. 87f.—ill.]

Henry Howard, Earl of Surrey, 1517?–**1547.** (Phoebus and Daphne evoked in) "The lover complaineth his harty love not requited." Poem. In Tottel's *Miscellany* (London: 1557). Modern edition by Hyder E. Rollins (Cambridge: Harvard University Press, 1928–29). [Bush 1963, p. 55]

Perino del Vaga, 1501–**1547,** composition (lost painting?). "Apollo and Daphne." Engraving (Bartsch 15:75, no. 18) by Gian Jacopo Caraglio. (Ashmolean Museum, Oxford.) [Stechow 1965, pp. 30 n.2, 31, 34, 41f.—ill]

Matteo Balducci, ?–**1555?** "Apollo and Daphne." Painting. Galerie Van Diemen, Berlin. [Giraud 1968, p. 248 / Stechow 1965, pl. 28]

Girolamo da Santacroce, c.1490–**1556.** "Apollo and

Daphne." Painting. Pinacoteca di Brera, Milan, no. 720. [Berenson 1957, p. 155]

Bacchiacca, 1494/95–**1557.** "Apollo and Daphne." Painting. Cook coll., Richmond, Surrey. [Pigler 1974, p. 27]

Bernard Salomon, 1506/10–c.1561. "Apollo and Daphne." Woodcut, part of a cycle illustrating Ovid. In *Les Metamorphoses d'Ovide figurée* (Lyons: Tivornes, 1557). [Stechow 1965, pp. 42ff., 51f. n.]

Hans Sachs, 1494–1576. *Phöbus und Daphne (Daphne, eine Königstochter)* [Phoebus and Daphne (Daphne, a King's Daughter)]. Tragedy. Published **1558.** In modern edition, *Werke* (Stuttgart: 1870–1908; Hildesheim: Olms, 1964). [McGraw-Hill 1984, 4:301 / Giraud 1968, pp. 328–33]

Girolamo Romanino, c.1484/87–c.1562. "Apollo Chasing Daphne." Painting. Benson coll., London. [Warburg / Stechow 1965, p. 41 n.6]

Arthur Golding, 1536?–1605. (Story of Apollo and Daphne in) *Ovids Metamorphosis* book 1 (London: **1565,** 1567). [Rouse 1961]

Gregorio Silvestre Rodriguez de Mesa, 1520–**1569.** "La fábula de Dafnes y Apolo." Verse tale. In *Obras* (Granada: 1582). [Giraud 1968, pp. 363ff. / Oxford 1978, p. 548]

Tobias Stimmer, 1539–1584. "Apollo and Daphne." Fresco. **1570.** Haus zum Ritter, Schaffhausen. [Pigler 1974, p. 27]

Hans Bol, 1534–1593. "Valley of the Meuse with Apollo and Daphne." Painting. **1574.** Hyde coll., Glens Falls, N.Y. [Warburg]

Paolo Veronese, 1528–1588. "Apollo and Daphne." Painting. c.**1575–78.** Fine Arts Gallery, San Diego. [Pallucchini 1984, no. 146—ill. / Pignatti 1976, no. 191—ill. / also Berenson 1957, p. 135]

Francisco de Aldana, 1537–**1578.** *El laurel de Apolo.* Poem. In *Todas las obras* (Madrid: Sanchez, 1593). [DLE 1972, p. 18]

Hendrik Goltzius, 1558–1617, composition. "Daphne Changed into a Laurel Tree." Engraving, part of a set illustrating Ovid's *Metamorphoses* (1st series, no. 14), executed by assistant(s). c.**1589.** Unique impression in British Museum, London. [Bartsch 1980–82, no. 0302.44—ill.]

————. "Daphne." Drawing. 1595–1600. Staatliche Graphische Sammlung, Munich, inv. 21085. [Reznicek 1961, no. 112—ill.]

Edmund Spenser, 1552?–1599. (Daphne evoked in) *The Faerie Queene* 2.12.52, 3.7.26, 3.11.36, 4.7.22. Romance epic. London: Ponsonbie, **1590,** 1596. [Hamilton 1977 / Giraud 1968, p. 349 / Davies 1986, p. 76]

————. (Story of Apollo and Daphne related in) Sonnet 28 of *Amoretti.* In *Amoretti and Epithalamion* (London: Ponsonbie, 1595). [Oram et al. 1989 / Giraud, pp. 348f.]

Abraham Bloemaert, 1564–1651. "Apollo and Daphne." Painting. **1592.** Formerly Muzeum Narodowe, Wroclaw (Breslau), lost. [de Bosque 1985, pp. 151–53—ill. / Lowenthal 1986, fig. 24 / also Delbanco 1928, no. I.2—ill.]

John Lyly, c.1554–1606. (Story of Apollo and Daphne enacted in) Entertainment for Queen Elizabeth at Sudeley, seat of Lord Chandos, **1592.** Music, John Dowland. [Bond 1902, vol. 1]

Jacopo Peri, 1561–1633, with **Jacopo Corsi,** 1561–1602. *Dafne.* Opera. Libretto, Ottavio Rinuccini. First performed (privately) **1597,** Palazzo Corsi, Florence. First

public performance Carnival 1598, Florence. [Grove 1980, 14:402f. / Bukofzer 1947, p. 56 / Einstein 1947, p. 84]

Friedrich Sustris, *c.*1540–**1599.** "Apollo and Daphne." Drawing. Albertina, Vienna, inv. 7940. [Warburg]

John Dowland, 1563–1626. "Daphne was not so chaste as she was changing," "When Phoebus first did Daphne love." Songs. **1603.** [Grove 1980, 5:596] *See also Lyly, above.*

Francisco Gómez de Quevedo y Villegas, 1580–1645. "De Dafne y Apolo fábula" [Fable of Daphne and Apollo]. Poem. In *Primera parte de las flores de poetas ilustres de España,* edited by Pedro Espinosa (Vallodolid: Sánchez, **1605**). [Giraud 1968, pp. 365f.]

———. "A Apolo, siguendo a Dafne" [To Apollo, Following Daphne], "A Daphne, huyendo de Apolo" [To Daphne, Fleeing Apollo]. Sonnets 25, 26 of *Thalia, musa sexta.* In *Parnaso Español* (Madrid: 1648); reprinted in *Poësias* (Brussels: 1661). [Ibid., pp. 305, 336 *n.*6 / Flynn 1978, p. 154]

Karel van Mander, 1548–**1606.** "Apollo and Daphne." Drawing. Uffizi, Florence, no. 86015. [de Bosque 1985, pp.

Marco da Gagliano, 1582–1643, with **Ferdinando Gonzaga,** ?–1626. *La Dafne.* Opera. Libretto, Rinuccini. First performed Carnival **1608,** Court, Mantua. [Wolff 1971, p. 8 / Einstein 1947, p. 427 / Grove 1980, 7:81, 85 / Bianconi 1987, pp. 170, 174, 177]

Federico Zuccari, 1540/43–**1609,** and assistants. "Apollo and Daphne." Ceiling fresco. Salone d'Ingresso, Villa Farnese, Caprarola. [Warburg]

William Wigthorp, *c.*1579–*c.*1610, attributed. "Daphne." Consort song. [Grove 1980, 20:409]

Bartholomeus Spranger, 1546–**1611.** "Apollo and Daphne." Drawing. Herzog Anton Ulrich-Museum, Braunschweig. [de Bosque 1985, p. 157—ill.]

Thomas Heywood, 1573/74–1641. "Apollo and Daphne." Verse drama. *c.***1612–13**? In *Pleasant Dialogues and Drammas* (London: 1637). [Heywood 1874, vol. 6 / Clark 1931, pp. 157–60, 223]

———. (Daphne as) "Sybilla Delphica." Passage in *Gynaikeion: or, Nine Books of Various History Concerning Women* book 2. Compendium of history and mythology. London: printed by Adam Islip, 1624. [Ipso]

Giovanni Battista Marino, 1569–1625. "Trasformazione di Dafne in Lauro" [Transformation of Daphne into a Laurel]. Sonnet. In *La lira* part 1 (Venice: Ciotti, **1614**). [Giraud 1968, p. 285 / Bush 1963, p. 237 *n.* / Praz 1925, pp. 283, 426]

———. "Parole d'Apollo mentre sequita Dafne" [Apollo's Words while Pursuing Daphne]. Poem. In *La lira* part 2 (1614). [Giraud, p. 284]

———. "Apollo e Dafne, de Guido Reni" [Apollo and Daphne, by Guido Reni]. Sonnet (on Guido's [lost] painting, see below), in *La galleria* (Venice: Ciotti, 1620). [Ibid., p. 289]

———. "Dafne." Eclogue. In *Egloghe boscherecce* (Naples: 1620). [Ibid., pp. 281–84]

———. "Dafne." Idyll. No. 6 in *La sampogna* (Paris: Pacardo, 1620). [Ibid., pp. 286–88]

———. (Daphne avows the power of Venus in) "Nido di colombi in un Lauro." Madrigal. [Ibid., p. 286]

Domenichino, 1581–1641, and assistant(s). "Apollo Pursuing Daphne." Fresco (detached), part of "Life of Apollo" cycle from Villa Aldobrandini (Belevedere), Frascati.

1616–18. National Gallery, London, inv. 6287. [London 1986, p. 161—ill. / Spear 1982, no. 55.v—ill.]

Claudio Monteverdi, 1567–1643. *Lamento di Apollo.* Dramatic cantata. Text, Alessandro Striggio the Younger. *c.***1620.** Music and text lost. [Grove 1980, 12:525 / Redlich 1952, pp. 27, 189]

Guido Reni, 1575–1642. "Apollo and Daphne." Painting, lost, known only from G. B. Marino's sonnet of *c.***1620** (above). [Pepper 1984, p. 305 no. A15]

Gaspar de Aguilar, 1561–**1623.** "Al Sanctissimo Sacramento, siguiendo la metaphora de la fábula de Dafne y Apolo" [To the Most Holy Sacrament, Following the Metaphor of the Fable of Daphne and Apollo]. Allegorical poem. In *Rimas humanas y divinas.* Modern edition, Valencia: 1951. [Giraud 1968, p. 359]

Juan de Arguijo, 1567–**1623.** "Apolo a Dafne," "A Apolo y Dafne." Sonnets, nos. 32, 38 of *Sonetos.* In modern edition by Luis Cernuda, *Sonetos clasicos sevillanos* (Madrid: El Observatorio, 1986). [Giraud 1968, p. 361]

John Milton, 1608–1674. Stanza written in a book under an engraving (by Virgil Solis, 1514–1562), "Apollo and Daphne." **1623.** [Giraud 1968, pp. 35of. (reproduced)]

———. ("As Daphne Was Root Bound," allusion in) *Comus* lines 66of. Masque. Music, Henry Lawes. First performed Michaelmas Day 1634, Ludlow Castle. Published London: Robinson, 1637. [Carey & Fowler 1968]

Pier Francesco Valentini, *c.*1570–1654. *La trasformazione di Dafne.* Opera. Libretto, composer. First performed **1623,** Palazzo Barberini, Rome. [Grove 1980, 19:498]

Miguel de Faría y Sousa, 1590–1649. "Dafne y Apolo." Poem. In *Divinas y humanas flores* (Madrid: **1624**). [Giraud 1968, p. 367]

Gian Lorenzo Bernini, 1598–1680. "Apollo and Daphne." Lifesize marble sculpture. **1622–25.** Galleria Borghese, Rome, inv. 105. [Wittkower 1981, no. 18—ill. / Pope-Hennessy 1985b, 3:107f., 428f.—ill. / also Vermeule 1964, p. 101—ill. / Faldi 1954, no. 35—ill.]

Jan Brueghel the Elder, 1568–1625, attributed. "Apollo and Daphne." Painting. Centraal Museum, Utrecht. [Wright 1980, p. 64]

Nicolas Poussin, 1594–1665. "Apollo and Daphne." Painting. **Mid-1620s.** Alte Pinakothek, Munich, inv. 2334. [Wright 1985, no. 14, pl. 107 / Blunt 1966, no. 130—ill. / Munich 1983, p. 399—ill. / also Thuillier 1974, no. 22—ill.]

———. "Apollo and Daphne." Drawing (similar composition to above). *c.*1630–35. Galleria Corsini, Rome, no. 125570. [Friedlaender & Blunt 1953, no. 173—ill.]

———. "Apollo and Daphne." Painting. *c.*1635–37? Lost or unexecuted. / 2 drawings. Musée Condé, Chantilly, no. 175 (fragmentary); Duke of Devonshire coll., Chatsworth, no. 859. [Ibid., nos. 171–72—ill. / Wright, no. L21 / also Thuillier, no. 105—ill.]

———. "Apollo and Daphne." Painting. Begun 1664–65, unfinished. Louvre, Paris, no. M.I. 776. [Wright, no. 204, pl. 209 / Louvre 1979–86, 4:146—ill. / Blunt, no. 131—ill. / Thuillier, no. 222—ill. / also Vermeule 1964, pp. 115, 174—ill.]

——— (or follower?). "Apollo Sauroctonos" (Apollo killing a lizard; previously known as "Apollo and Daphne"). Drawing, depicting scene from Pliny, *Historia naturalis* 34.70. 1664–65. Louvre, Paris, no. 761. [Friedlaender & Blunt 1953, no. 177—ill.]

Heinrich Schütz, 1585–1672. *Dafne.* Opera (pastoral tragi-

comedy). Libretto, Martin Opitz, after Rinuccini (1608). First performed 13 Apr **1627**, Schloss Hartenfels, Torgau, near Dresden. [Grove 1980, 17:7 / Bianconi 1987, pp. 223f. / Bukofzer 1947, p. 102]

Salvador Jacinto Polo de Medina, 1603–1676. *Fábula de Apolo y Dafne burlesca.* Poem. **1630**. Murcie: 1634; reprinted in *Universidad da amor,* edited by Antolivez de Piedrabuena (Madrid: Widow Martin, 1636). [DLE 1972, p. 728 / Giraud 1968, pp. 306ff.]

Jan Pynas, 1583/84–**1631**. "Apollo and Daphne." Painting. F. Lugt coll., The Hague. [Warburg]

Giovanni Biliverti, 1576–1644. "Apollo and Daphne." Painting. *c.*1633. Staatsgalerie, Stuttgart, inv. 3330. [Florence 1986, no. 2.185 *n.*—ill. (drawing)]

Rembrandt van Rijn, 1606–1669. "Apollo and Daphne." Drawing. *c.*1635. Lost. / Copies in Biblioteca Nacional, Madrid; Mather coll., Princeton, N.J. [Benesch 1973, no. C14—ill.]

Alonso Jerónimo de Salas Barbadillo, 1581–1635. *Laurel de Apolo.* Poem. Madrid: Reino, **1635**. [DLE 1972, p. 815 / Giraud 1968, pp. 309ff., 359]

Lope de Vega, 1562–1635. (Story of Apollo and Daphne, subplot in) *El Amor enamorado* [Cupid in Love]. Pastoral comedy. First performed 29 July **1635**, Buen Retiro, Madrid. Published in *La Vega del Parnaso* (Madrid: Imprenta del Reyno, 1637). [Menendez y Pelayo 1890–1913, vol. 6 / Wooldridge 1978 passim]

Gobbo dei Carracci, *c.*1576–**1636**. "Apollo and Daphne." Painting. Pinacoteca, Turin, inv. 531. [Pigler 1974, p. 27]

Peter Paul Rubens, 1577–1640. "Apollo and Daphne." Painting, for Torre de la Parada, El Pardo, executed by assistant (Jan van Eyck?) from Rubens's design. **1636–38**. Prado, Madrid, no. 1714. [Alpers 1971, no. 1—ill. / Jaffé 1989, no. 1235—ill. / Prado 1985, pp. 765f.] Oil sketch, by Rubens. Musée Bonnat, Bayonne, inv. 1065. [Alpers, no. 1a—ill. / Jaffé, no. 1234—ill. / Held 1980, no. 168—ill. / also Giraud 1968, p. 280—ill.]

———. "Apollo Bested by Cupid" ("Apollo and the Python"). Painting, for Torre de la Parada, executed by Cornelis de Vos from Rubens's design. 1636–38. Prado, Madrid, no. 1861. [Alpers, no. 2—ill. / Jaffé, no. 1233—ill. / Prado 1985, pp. 593, 766] Oil sketch, by Rubens. Prado, no. 2040. [Alpers, no. 2a—ill. / Held, no. 167—ill. / Jaffé, no. 1232—ill.]

———, previously attributed. "Apollo and Daphne." Painting, oil sketch. Städtisches Kunstmuseum, Duisburg. [Held, no. A1—ill.]

Samuel Twardowski, 1600–1660. *Dafnis w drzewem bobkowym* [Daphne into a Laurel Tree]. Collection of poems. Breslau: **1638**. Modern facsimile edition, Breslau: Zaklad im Narodowy Ossolinskich, 1976. [Miłosz 1983, p. 141]

Pier Francesco Cavalli, 1602–1676. *Gli amori d'Apollo e di Dafne* [The Loves of Apollo and Daphne]. Opera. Libretto, Giovanni Francesco Busanello. First performed **1640**, Teatro di San Cassiano, Venice. [Grove 1980, 4:32 / Worsthorne 1954, pp. 58–61, 109, 131 / Glover 1978, pp. 18, 42ff., 158, 187]

Pietro da Cortona, 1596–1569. "Apollo and Daphne." Stucco high-relief, part of series depicting stories of Apollo. Begun **1645–47**, unfinished, completed 1659–61 by Ciro Ferri. Sala di Apollo, Palazzo Pitti. [Campbell 1977, pp. 108ff.—ill. / also Pitti 1966, pp. 79f.—ill.]

Robert Baron, fl. 1630–58. (Story of Apollo and Daphne in) *Erotopaignon, or, The Cyprian Academy.* Romance in prose and verse (plagiary). London: **1647**. [Bush 1963, p. 337]

Richard Crashaw, 1612–1649. "In Apollinem depereuntem Daphnen" [Apollo desperately in love with Daphne]. Latin poem. In *The Delights of the Muses . . .* (London: Moseley, **1648**). [Martin 1966]

William Drummond of Hawthornden, 1585–**1649**. "Now Daphne's armes did grow." Imitation of sonnet by Garcilaso de la Vega (1503–1536). In modern edition by L. E. Kastner, *Poems of William Drummond of Hawthornden* (Edinburgh: Scottish Text Society, 1913). [Ipso, vol. 2 / McDiarmed 1949, p. 18]

Francesco Gessi, 1588–**1649**. "Apollo and Daphne." Painting. Pinacoteca, Turin, inv. 521. [Pigler 1974, p. 27]

Richard Lovelace, 1618–1658. (Apollo and Daphne evoked in) "Princess Louisa Drawing." Poem. In *Lucasta: Epodes, Odes, Sonnets, and Songs* (London: Ewster, **1649**). [Wilkinson 1930]

Charles Dassoucy, 1605–1677. *Les amours d'Apollon et de Daphné.* Musical comedy, dedicated to the king. Libretto, composer. First performed **1650**, Versailles. [Grove 1980, 5:252]

Benedetto Ferrari, 1597/1604–1681. *Dafne in alloro.* Ballet, unfinished, only introduction completed. Libretto, composer. First performed **1651**, Vienna. [Grove 1980, 6:492]

Thomas Stanley, 1625–1678. "Apollo and Daphne." Poem, imitation of Garcilaso de la Vega and of Giovanni Battista Marino. In *Anacreon, Bion, Moschus, etc.* (London: **1651**). [Bush 1963, pp. 247, 337 / Praz 1925, p. 283, 426]

Andrew Marvell, 1621–1678. (Story of Apollo and Daphne evoked in) "The Garden" stanza 4. Poem. *c.*1652. In *Miscellaneous Poems* (London: Boulter, 1681). [Margoliouth 1971 / Craze 1979, pp. 169, 171]

Herman van Swanevelt, *c.*1600–**1655**, attributed (also attributed to Jan Both). "Apollo and Daphne." Painting. Galleria Barberini, Rome, inv. 2230 (as Both). [Warburg]

Pedro Calderón de la Barca, 1600–1681. (Story of Daphne in) *El laurel de Apolo.* Zarzuela. **1657**. First performed 4 Mar 1658, Buen Retiro, Madrid. Published in *Comedias de Calderón,* part 3 (Madrid: 1664). [Valbuena Briones 1960–67, vol. 1 / O'Connor 1988, pp. 119–35]

Francesco Albani, 1578–**1660**. "Apollo and Daphne." Painting. Louvre, Paris, inv. 18. [Louvre 1979–86, 2:141—ill.]

———, attributed. "Apollo and Daphne." Painting. Corporation Galleries, Glasgow, inv. 10. [Pigler 1974, p. 27]

Govaert Flinck, 1615–**1660**. "Apollo and Daphne." Painting. Westfries Museum, Hoorn, inv. A190. [Wright 1980, p. 124]

Edmund Waller, 1606–1687. "The Story of Phoebus and Daphne, Applied." Poem. In *Poems, etc., Written upon Several Occasions* (London: Houry, Herringham, **1664**). [Bush 1963, p. 236]

Jakob Balde, 1604–1668. Latin poem. / Translated into German by Johann Gottfried Herder as "Die Linde" [The Linden] (1795). *See Herder, below.*

Giovanni Benedetto Castiglione, *c.*1616–*c.*1670. "Apollo and Daphne." Drawing. Dyce coll. no. 346, Victoria and Albert Museum, London. [Pigler 1974, p. 28]

Giovanni Andrea Bontempi, *c.*1624–1705, with **Marco**

Gioseppe Peranda, c.1625–1675. *Dafne.* Opera. Libretto, Martin Opitz. First performed 3 Sep **1671,** Dresden. [Grove 1980, 3:37f., 4:362, 14:362]

Jean de La Fontaine, 1621–1695. *Daphné.* Libretto for opera-ballet. **1674.** Commissioned for Jean-Baptiste Lully, but rejected, unperformed. Published in *Poème du quinquina et autres ouvrages en vers* (Paris: Thierry & Barbin, 1682). [Clarac & Marmier 1965 / DLLF 1984, 2:1175 / Girdlestone 1972, p. 125 / MacKay 1973, pp. 145, 148f.]

Isaac de Bensérade, 1613–1691. "Querelle d'Apollon et de l'Amour" [Quarrel of Apollo and Cupid], "Daphné en laurier" [Daphne in the Laurel]. Rondeaux. In *Les Métamorphoses d'Ovide en rondeaux* (Paris: Royal Imprint, **1676,** illustrated with an engraving by François Chauveau). [Giraud 1968, pp. 299f., 513f., fig. 18 / Stechow 1965, pp. 44, 52 *n.*2]

Jan van Neck, 1635–1714. "Daphne Changed into a Laurel Tree." Painting. **1677.** Art Gallery, Montreal. [Warburg]

Cesar Boetius van Everdingen, 1617?–**1678,** follower. "Apollo and Daphne." Painting. Bisschoppelijk Museum, Haarlem, inv. 94. [Wright 1980, p. 119]

Carlo Cignani, 1628–1719. "Apollo and Daphne." Fresco. *c.*1680. Palazzo del Giardino, Parma. [Stechow 1965, pp. 32, 36, 38f., 48—ill.]

Carlo Maratti, 1625–1713. "Apollo Pursuing Daphne." Painting. **1681.** Musées Royaux des Beaux-Arts (Musée d'Art Ancien), Brussels, inv. 269. [Brussels 1984a, p. 183—ill.]

Matthias Rauchmüller, 1645–**1686.** "Apollo and Daphne." Wood sculpture. Kunsthistorisches Museum, Vienna. [Stechow 1965, p. 48]

Philip Ayres, 1638–1712. "Panting for breath, towards her parent brook." Poem, imitation of G. B. Marino's "Apollo e Dafne" (1620). In *Lyric Poems, Made in Imitation of the Italians* (London: **1687**). [Praz 1925, p. 426]

Luca Giordano, 1634–1705. "Apollo and Daphne." Painting. **1689.** Casita del Principe, El Escorial. [Ferrari & Scavezzi 1966, 2:159]

———. "Apollo and Daphne." Drawing. *c.*1689? Louvre, Paris, no. 9631. [Ibid., 2:267—ill.]

Gerard de Lairesse, 1641–1711 (active until *c.*1690), attributed. "Apollo and Daphne." Painting. Centraal Museum, Utrecht. [Wright 1980, p. 230] Another version of the subject, at Dulwich College, London. [Warburg]

John Dryden, 1631–1700. "The Transformation of Daphne into a Laurel," section of "The First Book of Ovid's *Metamorphoses*." Translation. In *Examen poeticum,* part 3 of Tonson's *Miscellany* (London: Tonson, 1693). [Dryden 1956–87, vol. 4]

Filippo Lauri, 1623–**1694,** attributed. "Apollo and Daphne." Drawing. Albertina, Vienna. [Pigler 1974, p. 28]

Henry Purcell, *c.*1658–**1695.** "Yes, Daphne, in your looks I find." Song for solo voice and continuo. Published in *Xansi.* [Grove 1980, 15:473 / Spink 1974, p. 230]

Thomas D'Urfey, 1653–1723, libretto. (Apollo and Daphne in) *Cinthia and Endymion, or, The Loves of the Deities.* Dramatic opera. Incidental music, Daniel Purcell with Jeremiah Clarke? First performed at Court, then late Dec **1696,** Theatre Royal, Drury Lane, London. [Nicoll 1959–66, 1:409 / Le Comte 1944, p. 51f. (as Apr 1697)]

Hendrik Anders, 1657–1714/20. *Apollo en Dafne.* Opera. Libretto, K. Sweerts. **1697.** [Grove 1980, 1:398]

Jean-Baptiste Lully II, 1665–1743, music. *Apollon et Daphné.* Divertissement-ballet. Libretto, Antoine Danchet. First performed 22 Oct **1698,** Fontainebleau. [Girdlestone 1972, pp. 188, 194 / Giraud 1968, pp. 402–05]

Jan Claudius de Cock, *c.*1668–1736. "Apollo Pursuing Daphne." Drawing. **1699.** Koninklijk Museum voor Schone Kunsten, Antwerp, inv. 555. [Düsseldorf 1971, no. 203]

Bernardo Sabadini, ?–1718, music. *Gl'amori d'Apollo e Dafne.* Introduction to ballet. Libretto, G. Tamagni. First performed **1699,** Teatrino di Corte, Parma. [Grove 1980, 16:363]

Sebastián Durón, 1660–1716, with **Juan de Navas,** fl. 1659–1709 (act 2), music. *Apolo y Dafne.* Zarzuela. Libretto, Juan de Benevides. Before **1700.** [EDS 1954–66, 4:1185 / Grove 1980, 5:751, 13:83]

François Girardon, 1628–1715, style. "Apollo and Daphne." Bronze sculpture. *c.*1700. Sold London, 1974. [Warburg]

Alessandro Scarlatti, 1660–1725. *Dafni.* Opera (favola boschereccia). Libretto, Francesco Maria Paglia, after Eustachio Manfredi. First performed **1700,** Casino del Vicere a Posillipo, Naples. [Grove 1980, 16:559]

Italian School. "Apollo and Daphne." Bronze statue. **Early 18th century.** Rudding Park, England, no. 148. [Warburg]

Sebastiano Ricci, 1659–1734. "Apollo and Daphne." Painting, for Palazzo Fulcis-Bertoldi, Belluno. **1703** or later. E. Martini coll., Venice. [Daniels 1976, no. 21—ill.]

———. "Apollo and Daphne." Painting. Early 1720s. Palazzo Taverna, Rome. [Ibid., no. 385—ill.]

Daniel Seiter, 1649–**1705.** "Apollo and Daphne." Painting. Chiswick House, London. [Wright 1976, p. 187]

Philip Tidemann, 1657–**1705.** "Apollo and Daphne." Painting. Hopetown House, Scotland. [Warburg]

André Campra, 1660–1744. *Daphne.* Cantata. In *Cantates françoises,* book 1 (Paris: **1708**). [Grove 1980, 3:665]

George Frideric Handel, 1685–1759. *Die verwandelte Daphne* [Daphne Transformed]. Opera. Libretto, Hinrich Hinsch. First performed Jan **1708,** Theater am Gänsemarkt, Hamburg. [Hogwood 1984, pp. 28f. / Grove 1980, 8:84, 114 / DLL 1968–90, 7:1223]

———. *La terra è liberata: Apollo e Dafne* [The Land Is Liberated: Apollo and Daphne]. Cantata. Completed 1710. [Lang 1966, p. 65 / Grove, 8:122 / Hogwood, pp. 269, 278]

Francesco Trevisani, 1656–1746. "Apollo and Daphne." Painting. **1708–09.** Schönborn coll., Pommersfelden. [DiFederico 1977, no. 43—ill.] Further versions of the subject in Hermitage, Leningrad; private coll., Fermo. [Ibid.]

Emanuele d'Astorga, 1680–1757? *Dafni.* Opera. First performed 21 Apr **1709,** Genoa. [Grove 1980, 1:663]

Andreas Schlüter, 1660/64–1714. "Apollo," "Daphne." Pair of statues. *c.*1711–12. Landhaus Kamecke, Berlin. [McGraw-Hill 1969, 5:126 / Pigler 1974, p. 29]

Nicolas Coustou, 1658–1733, and **Guillaume Coustou the Elder,** 1677–1746. "Daphne," "Apollo Pursuing Daphne." Pair of marble statues, for park at Marly. **1713.** "Daphne" in Louvre, Paris; "Apollo" in Tuileries, Paris. [Giraud 1968, pp. 519ff., pl. 19 / Stechow 1965, p. 48 *n.*4]

Johann Joseph Fux, 1660–1741. *Dafne in Lauro.* Opera (componimento per camera). Libretto, Pietro Pariati. First performed 1 Oct **1715,** Hoftheater, Vienna. [Grove 1980, 7:46]

Charles de La Fosse, 1636–1716. "Apollo and Daphne." Painting. Musée, Orléans. [Pigler 1974, p. 29]

John Hughes, 1677–1720. *Apollo and Daphne.* Masque. Music, Johann Christoph Pepusch. First performed 12 Jan **1716,** Theatre Royal, Drury Lane, London. [Grove 1980, 14:359 / Fiske 1973, pp. 58f., 61]

Thomas Parnell, 1679–1718. "To a Young Lady on Her Translation of the Story of Phoebus and Daphne, from Ovid." Poem. In *Poetical Works* (Edinburgh: Apollo (Martins), 1778). [Ipso]

Antonio Caldara, c.1670–1736. *Dafne.* Opera. Libretto, G. Biave. First performed **1719,** Salzburg. [Grove 1980, 3:615 / Giraud 1968, pp. 445–47]

Antoine Coysevox, 1640–1720. "Apollo and Daphne." Bronze sculpture. Victoria and Albert Museum, London. [Pigler 1974, p. 29]

Matthew Prior, 1664–1721. "Daphne and Apollo." Poem. In *Miscellaneous Works,* edited by J. Bancks (London: 1740). [Oxford 1985, p. 726]

Abraham Genoels, 1640–1723. "Apollo and Daphne." Drawing. Landesmuseum, Darmstadt, no. A.E. 920. [Warburg]

Benedetto Luti, 1666–1724. "Apollo and Daphne." Painting. Muzeum Narodowe, Warsaw, inv. 130867, on display at Lazienki Palace. [Warsaw 1969, no. 703—ill.]

Henry Carey, c.1689–1743. *Apollo and Daphne, or, Harlequin Mercury.* Pantomime. Libretto, John Thurmond. First performed 20 Feb **1725,** Theatre Royal, Drury Lane, London. [Ralph 1985, pp. 153, 166, 729 / Grove 1980, 3:780 / Fiske 1973, pp. 75f.]

François Le Moyne, 1688–1737. "Apollo and Daphne." Painting. **1725.** Hermitage, Leningrad, inv. 1238. [Bordeaux 1984, no. 54—ill. / Hermitage 1986, no. 115—ill.] Replica. Arkhangelskoye Estate Museum, near Moscow. [Hermitage]

——, rejected attribution (attributed to Louis Boulogne). "Apollo and Daphne." Drawing. Musée des Beaux-Arts, Grenoble (as Le Moyne). [Bordeaux, no. X29—ill.]

Johann Ernst Galliard, c.1687–1749. *Apollo and Daphne; or, The Burgo-Master Trick'd.* Pantomime-opera. Libretto, Lewis Theobald. First performed 14 Jan **1726,** Lincoln's Inn Fields, London. [Grove 1980, 7:108 / Ralph 1985, p. 153 / Fiske 1973, p. 75 / Nicoll 1959–66, 2:135–38, 359]

Frédéric-Hubert Paulin, 1678–1761. *Le triomphe de Daphné.* Concert composition. First performed **1728,** at "Concert Spirituel," Paris. [Grove 1980, 14:307]

Jean-François de Troy, 1679–1752, attributed (previously attributed to François Boucher). "Apollo and Daphne." Painting. c.1728. Hermitage, Leningrad, inv. 3739. [Hermitage 1986, no. 263—ill.] Variant ("Apollo, Daphne, River Gods, and Nymphs"). 1728. Sanssouci, Potsdam. [Ibid. / Stechow 1965, pp. 32 n.1, 39 n.1]

——. Series of decorative panels on the Apollo and Daphne theme, for Frederiksdal Castle, Denmark. Lost. [Hermitage]

Bernard Burette, fl. **1702–29.** *Daphné.* Cantata. [Grove 1980, 3:462]

François Verdier, 1651–1730. "Apollo and Daphne." Drawing. Albertina, Vienna, no. 11857. [Warburg]

Giovanni Camillo Sagrestani, 1660–1731. "Apollo and Daphne." Painting. Galleria del Caminetto, Bologna. [Warburg]

Lorenzo Mattielli, 1682/88–1748. "Apollo and Daphne." Stucco sculpture group. **1731.** Schloss Eckartsau, Switzerland. [Pigler 1974, p. 28]

Giovanni Battista Tiepolo, 1696–1770. "Apollo and Daphne." Ceiling fresco, part of "Apollo" cycle. **1731.** Formerly Palazzo Archinto, Milan, destroyed 1943. [Morassi 1962, p. 25]

——. "Apollo and Daphne." Painting. c.1740–44. Louvre, Paris, no. R.F. 2107. [Ibid., p. 38—ill. / Pallucchini 1968, no. 156—ill. / Louvre 1979–86, 2:242—ill.]

—— and **Giovanni Domenico Tiepolo,** 1727–1804. "Apollo and Daphne." Monochrome fresco (detached), part of a series of 22 mythological scenes, from Palazzo Volpato Panigai, Nervesa, Treviso. 1754. Formerly Kaiser Friedrich Museum, Berlin (most of the cycle destroyed in World War II), now in Gemäldegalerie, Berlin, no. B288. [Berlin 1986, p. 74—ill. / Pallucchini, no. 213—ill. / Morassi, p. 4]

—— (Giambattista). "Apollo Pursuing Daphne." Painting. c.1755–60. Kress coll. (K1836), National Gallery, Washington, D.C., no. 1157. [Shapley 1966–73, 3:148f.—ill. / Pallucchini, no. 253—ill. / Morassi, p. 67 / Sienkewicz 1983, p. 17—ill. / also Walker 1984, fig. 475]

Giuseppe Chiari, 1654–1727/33. "Apollo and Daphne." Painting. Galleria Spada, Rome. [Pigler 1974, p. 28 / Stechow 1965, p. 39 n.1]

Gerard Hoet the Elder, 1648–1733. "Apollo and Daphne." Painting. Dulwich College Picture Gallery, London. [Wright 1976, p. 90]

Georg von Reutter the Younger, 1708–1772. *Dafne.* Opera (festa teatrale). Libretto, Pasquini. First performed 19 Nov **1734,** Vienna. [Grove 1980, 15:773]

Giovanni Porta, c.1690–1755. *Dafne.* Serenata. First performed 10 July **1738,** Nymphenburg, Munich. [Grove 1980, 15:133]

Bernard Le Bovier de Fontenelle, 1657–1757. "Je suis, croit jadis Apollon à Daphné." Sonnet. In *Poésies diverses,* vol. 4 of *Oeuvres* (Paris: Brunet, **1742**). [Giraud 1968, p. 495]

Nicholas Lancret, 1690–1743. "Scene in a Comic Opera" (actors portraying Apollo and Daphne). Painting. Sold 1914, unlocated. [Wildenstein 1924, no. 270]

Jean-Baptiste van Loo, 1684–1745. "Apollo and Daphne." Painting. Szépművészeti Múzeum, Budapest, no. 3833. [Budapest 1968, p. 391]

Nicola Conti, fl. 1733–54. *Le Dafne.* Opera. First performed 1747, Naples. [Grove 1980, 4:684]

Jan van Huysum, 1682–1749. "Apollo and Daphne." Painting. Liechtenstein Collection, Vaduz, no. 806. [Pigler 1974, p. 29]

Nicolo Pasquali, c.1718–1757, music. *Apollo and Daphne.* Masque, with pantomime interludes. Libretto, John Hughes (1716). First performed **1749,** Smock Alley Theatre, Dublin. Only overture survives. [Grove 1980, 14:263 / Fiske 1973, p. 203]

Christopher Smart, 1722–1771. "Apollo and Daphne: An Epigram." Poem. In *The Midwife* Dec **1750;** collected in *Poems on Several Occasions* (London: printed for the author by W. Strahan, 1752). In modern edition by K. Williamson, *Poetical Works* (New York: Oxford University Press, 1980). [Ipso]

Franz Anton Hilverding, 1710–1768, choreography. *Apol-*

lon et Daphné, ou, Le retour d'Apollon au Parnasse. Ballet. Music, Joseph Starzer. First performed **1763**, St. Petersburg. [Oxford 1982, p. 18 / Grove 1980, 18:82]

Joseph Friebert, 1724–1799. *Dafne vendicata* [Daphne Vindicated]. Opera. First performed *c.***1764,** Passau. [Grove 1980, 6:848]

Étienne Lauchery, 1732–1820, choreography. *Apollon et Daphné.* Ballet. Music, Jean-Joseph Rodolphe, with Florian Johann Deller. First performed *c.***1764,** Kassel. [Grove 1980, 5:350, 16:92]

Corrado Giaquinto, 1703–**1765.** "Apollo and Daphne." Painting. Villa della Regina, Turin. [Pigler 1974, p. 28]

———. "Apollo and Daphne." Painting. Marchese De Luca coll., Molfetta. [Ibid.]

———. "Apollo and Daphne." Painting. Casita del Principe, El Escorial. [Ibid.]

Pierre Grandjé, fl. 1760–65, choreography. *Apollo and Daphnis.* Ballet. First performed *c.***1765,** St. Petersburg. [Beaumont 1930, p. 28]

James Hook, 1746–1827, music. *Apollo and Daphne.* Serenata. Libretto, John Hughes (1716). First performed 27 Sep **1773,** Marylebone Gardens, London. [Grove 1980, 8:685]

Anton Mayer. *Apollon et Daphné.* Opera. Libretto, Louis-Guillaume Pitra. First performed 24 Sep **1782,** Académie Royale de Musique, Paris. [Giraud 1968, p. 486 / Clément & Larousse 1969, 1:66 / DLF 1951–72, 2:376]

Bernadine Juliane Reichardt, 1752–**1783.** "Daphne am Bach" [Daphne at the Brook]. Vocal composition. [Cohen 1987, 1:576]

Gustav Philip Creutz, 1731–**1785.** "Daphne." Poem. In *Daphne, Atis och Camilla* (Lund: Gleerup, 1934). [Gustafson 1961, p. 127]

Jean-Georges Noverre, 1727–1810, choreography. *Les fêtes de Tempe* [The Festivals of (the Vale of) Tempe (where Daphne was pursued)]. Ballet. Music, Joseph Mazzinghi. First performed 28 Feb **1788,** King's Theatre, London; décor, Marinari; costumes, Lupino. [Grove 1980, 11:868 / Lynham 1950, p. 171]

Antoine Légat de Furcy, *c.*1740–**after 1790.** *Apollon et Daphné.* Opera. Libretto, Saint Marc. Unfinished. Lost. [Grove 1980, 10:610]

Johann Gottfried Herder, 1744–1803. "Die Linde" [The Linden]. Poem, translation from Jakob Balde (1604–1668). In *Terpsichore,* part 1, book 5 (Lübeck: Bohn, **1795**). [Herder 1852–54, vol. 17]

Jacques-Philippe Caresme, 1734–**1796.** "Metamorphosis of Daphne." Painting. Musée des Augustins, Toulouse. [Bénézit 1976, 2:523]

Charles-Louis Didelot, 1767–1837, choreography. *Apollo and Daphne.* Ballet. First performed **1802,** Hermitage Theater, St. Petersburg. [Swift 1974, pp. 93, 195]

Karl Hanke, 1750–**1803,** music. *Phöbus und Daphne.* Ballet. [Grove 1980, 8:145]

William Blake, 1757–1827. "As Daphne Was Root Bound." 3 drawings, after Milton's *Comus* (1634). **1785–1805.** British Library, London. [Butlin 1981, nos. 201.12, 36, 58]

Georg Abraham Schneider, 1770–1839. *Apollo und Daphne.* Opera. First performed **1810,** Berlin? [Hunger 1959, p. 42]

Andrea Appiani the Elder, 1754–1817. "Apollo Pursuing Daphne." Fresco. **1814.** Pinacoteca di Brera, Milan. [Giraud 1968, p. 522 / Stechow 1965, p. 33—ill.]

Esaias Tegnér, 1782–1846. (Apollo's pursuit of Daphne evoked in) *Epilog vid magisterpromotionen.* **1820.** [Algulin 1989, p. 73]

Anne-Louis Girodet, 1767–**1824,** composition. "Apollo and Daphne." Lithograph, part of "Loves of the Gods" cycle. Published Paris: Engelmann, 1825–26. [Boutet-Loyer 1983, no. 87 *n.*]

Pietro Hus, *c.*1770–after 1826, choreography. *Apollo e Dafne.* Ballet. First performed **1825,** Teatro Santa Cecilia, Palermo. [EDS 1954–66, 6:450]

Peter Cornelius, 1783–1867, and studio. "Apollo and Daphne." Ceiling fresco. **1820–26.** Göttersaal, Glyptothek, Munich. [Glyptothek 1980, pp. 214ff., 219f.—ill.]

Gaetano Cignaroli, 1745–**1826.** "Apollo and Daphne." Marble sculpture. Teatro Filarmonico, Verona. [Pigler 1974, p. 28]

Joseph Mallord William Turner, 1775–1851. "The Story of Apollo and Daphne." Painting. Exhibited **1837.** Tate Gallery, London, no. 520. [Butlin & Joll 1977, no. 369—ill.]

———. "Apollo and Daphne." Poem. In *The Sunset Ship* (Lowestoft, Suffolk: Scorpion, 1966). [Boswell 1982, p. 305]

Bertel Thorwaldsen, 1770–1844, design. "Apollo (and Daphne)." Relief, part of "Metamorphoses of Ovid" series, executed by Pietro Galli. **1838.** Formerly Palazzo Torlonia, Rome, destroyed. / Plaster cast. Thorwaldsens Museum, Copenhagen, no. 478. [Thorwaldsen 1985, pp. 5sf. / Hartmann 1979, pl. 43.1]

Augusto Hus the Younger, fl. 1827–53, choreography. *Apollo und Daphne.* Ballet. First performed **1839,** Kärntnerthor Theater, Vienna. [EDS 1954–66, 6:450]

Théodore Chassériau, 1819–1856. "Apollo and Daphne." Painting. Exhibited **1845** (signed "1846"). Louvre, Paris, inv. R.F. 3870. [Louvre 1979–86, 3:132—ill. / Sandoz 1974, no. 99—ill.] Lithograph (after studies). 1844. [Sandoz, no. 269—ill.]

Algernon Charles Swinburne, 1837–1909. "Apollo and Daphne." Poem. *c.***1849–50.** In *Poems and Ballads,* 1st series (London: Moxon, 1866). [Gosse & Wise 1925–27, vol. 1]

George Meredith, 1828–1909. "Daphne." Poem. In *Poems* (London: Parker, **1851**). [Bartlett 1978, vol. 1 / DLB 1985, 35:120]

Harriet Hosmer, 1830–1908. "Daphne." Marble bust. **1853.** Washington University Gallery of Art, St. Louis. [Gerdts 1973, pp. 92f., fig. 79]

Théophile Gautier, 1811–1872. (Allusions to Daphne in) "Le château du souvenir" strophe 19. Poem. In *Le moniteur universel* 30 Dec **1861;** collected in *Emaux et camées* 4th edition (Paris: Charpentier, 1863; reprinted Paris: Gallimard, 1981). [Ipso]

Nicola De Giosa, 1819–1885. *Il bosco di Dafne* [Daphne's Wood]. Opera. First performed **1864,** San Carlo, Naples. [Grove 1980, 5:323 / Clément & Larousse 1969, 1:164]

Emma Lazarus, 1849–1887. "Daphne." Poem. In *Poems and Translations* (Boston: Hurd & Houghton, **1867**). [Boswell 1982, p. 267]

Henry Clarence Kendall, 1839–1882. "Daphne." Poem. In *Leaves from Australian Forests* (Melbourne: Robertson, **1869**). [Bush 1937, p. 558]

George Frederick Watts, 1817–1904. "Apollo and Daphne." Painting. **1870.** Private coll. London. [Hunger 1959, p. 83]
———. "Daphne." Marble bust. 1879–82, unfinished. Tate Gallery, London. [Blunt 1975, p. 191]
———. "Daphne." Painting. 1879–82. [Phythian 1907, pp. 77f.—ill.]

Max Klinger, 1857–1920. "Apollo and Daphne." 3 satirical etchings, nos. 10–12 in "Rescues of Ovidian Sacrifices" cycle, opus 2. **1879.** [Hildesheim 1984, nos. 109–11—ill. / Rotterdam 1978, nos. 67.10–12—ill.]

Simeon Solomon, 1840–1905. "Daphne." Drawing. *c.*1875–90? Victoria and Albert Museum, London. [Seen by author, 1963]

Francis Thompson, 1859–1907. "Daphne." Poem. **1890.** In *Poems* (New York & London: Century, 1932). [Bush 1937, p. 563]

Frederick Tennyson, 1807–1898. "Daphne." Poem. In *Daphne and Other Poems* (London & New York: Macmillan, **1891**). [DLB 1984, 32:285]

John Byrne Leicester Warren, Lord de Tabley, 1835–1895. "Daphne." Poem. In *Poems: Dramatic and Lyrical,* 1st series (London: Mathews & Lane, **1893**). [Boswell 1982, p. 250]

Henri Rabaud, 1873–1949. *Daphne.* Cantata. Prix de Rome, **1894.** [Grove 1980, 15:522]

Arthur Hacker, 1858–1919. "Daphne." Painting. Exhibited **1895.** [Kestner 1989, p. 232, pl. 4.20]

Henrietta Rae, 1859–1928. "Apollo and Daphne." Painting. **1895.** [Kestner 1989, p. 286, pl. 5.15]

Aubrey Beardsley, 1872–1898. "Apollo Pursuing Daphne." Drawing, unfinished. *c.*1896. Unlocated. [Reade 1967, no. 455—ill. / also Weintraub 1976, p. 220—ill.]

Arthur H. Bird, 1856–1923. *Daphne.* Comic opera. First performed 13 Dec **1897,** New York. [Baker 1984, p. 262 / Grove 1980, 2:728]

Gordon Bottomley, 1874–1948. "Daphne." Poem. **1899.** In *The Gate of Smaragdus* (London: At the Sign of the Unicorn, 1904). [Bush 1937, pp. 430, 566]

T. Sturge Moore, 1870–1944. "Daphne." Poem. In *The Vine-Dresser and Other Poems* (London: At the Sign of the Unicorn, **1899**). [Bush 1937, p. 565]

Gabriele D'Annunzio, 1863–1938. (Apollo and Daphne in) "L'oleandro" [The Oleander]. Poem. **1900.** In *Alcyone* (Milan: Treves, 1904). [Roncoroni 1982 / Squarotti 1982, pp. 150f.]

Sara King Wiley, 1871–1909. "Apollo and Daphne." Poem. In *Poems Lyrical and Dramatic* (London: Chapman & Hall, **1900**). [Bush 1937, p. 583]

Rubén Darío, 1867–1916. "Dafne." Sonnet. In *Prosas profanas y otros poemas,* 2d edition (Paris: Bouret, **1901**). [Méndez Plancarte 1967 / Hurtado Chamorro 1967, pp. 147f.]

Gustaf Fröding, 1860–1911. "I Daphne" [In Daphne]. Poem. In *Samlade dikter* (Upsala: **1901**). [Gustafson 1961, p. 323]

Bliss Carman, 1861–1929. "Daphne," "The Lost Dryad" (Daphne). Poems. In *The Pipes of Pan* (Boston: Page, **1904**). [Boswell 1982, p. 66]

Eugène Guillaume, 1822–**1905.** "Apollo and Daphne." Plaster sculpture sketch. Musée d'Orsay, Paris, inv. R.F. 1729. [Orsay 1986, p. 170—ill.]

John William Waterhouse, 1849–1917. "Apollo and Daphne." Painting. **1908.** Lord Lambton coll., Britain. [Hobson 1980, no. 162, pl. 130 / also Wood 1983, pp. 240f—ill. / Kestner 1989, pl. 5.48]

Ezra Pound, 1885–1972. (Daphne evoked in) "A Girl," "Hugh Selwyn Mauberley," "The Tree." Poems. In *Personae* (London: Mathews, **1909;** New York: New Directions; London: Faber & Faber, 1926). [Ruthven 1969, pp. 77, 139ff., 242]
———. ("Dafne" imagined as a sea nymph in) Canto 2, in *A Draft of XXX Cantos* (Paris: Hours, 1930; Norfolk, Conn.: New Directions, 193[3?]). [Flory 1980, p. 110 / Terrell 1980–84, 1:7]

Émile-Antoine Bourdelle, 1861–1929. "Daphne Turning into a Laurel." Bronze sculpture. **1910.** 2 versions. [Jianou & Dufet 1975, no. 506] Bronze study. 4 casts. [Ibid., no. 507]
———. "Daphne." Pair of frescoes. 1912. Théâtre des Champs-Elysées, Paris. [Basdevant 1982, pp. 88f.—ill.] Plaster relief, study. Musée Bourdelle, Paris. [Ibid.—ill. / Jianou & Dufet, no. 478]

Valentin Serov, 1865–1911. "Eros, Apollo, and Daphne." Drawing, sketch for unexecuted mural. **1911.** Tretyakov Gallery, Moscow, inv. 28404. [Sarabyanov & Arbuzov 1982, no. 652—ill.]

Patrick Reginald Chalmers, 1872–1942. "Daphne." Poem. In *Green Days and Blue Days* (Dublin: Maunsel, **1912**). [Bush 1937, p. 569]

Maurice Hewlett, 1861–1923. "Daphne and Leukippos." Poem. In *Gai Saber: Tales and Songs* (London: Mathews, **1916**). [Boswell 1982, p. 131.]

Renée Sintenis, 1888–1965. "(Small) Daphne." Bronze sculpture. **1918.** [Kiel 1956, pp. 28f., 76—ill.] Variant ("Large Daphne"). 1930. Museum of Modern Art, New York; Staatliche Museen, Berlin; Busch-Reisinger Museum, Cambridge, Mass.; elsewhere. [Kiel, pp. 44f.—ill. / Barr 1977, p. 589—ill. / Berlin 1963, no. 82 / Harvard 1985, no. 354—ill. / McGraw-Hill 1969, 5:186—ill.]

John Singer Sargent, 1856–1925. "Apollo and Daphne." Painting. **1916–19.** Corcoran Gallery, Washington, D.C. [Ratcliff 1982, pp. 146f—ill.]

Dionyssios Lavrangas, 1860/64–1941, music. *Apollon ke Dafni.* Ballet. Libretto, A. Doxas. **1920.** First performed 1927, New York. [Grove 1980, 10:555]

Edna St. Vincent Millay, 1892–1950. "Daphne." Poem. In *A Few Figs from Thistles* (New York: Frank Shay Chapbook, **1920;** reprinted New York & London: Harper, 1922). [TCLC 1978–89, 4:306 / Gould 1980, p. 224]

Rainer Maria Rilke, 1875–1926. (Apollo and Daphne evoked in) Sonnet 12 of *Die Sonette an Orpheus* part 2. **1922.** Leipzig: Insel, 1923. [Zinn 1955–66, vol. 1 / Leishman 1960, vol. 2 / Strauss 1971, pp. 198–200]

Rudolf Borchardt, 1877–1945. *Klage der Daphne* [Lament of Daphne]. Poem. Berlin: privately printed, **1924.** [DLB 1988, 66 pt. 1: 50 / DLL 1968–90, 1:784 / Kunisch 1965, p. 117]

Henri de Régnier, 1864–1936. "Apollon et Daphné." Poem. In *Scènes mythologiques* (Paris: Le Livre, **1924**). [Giraud 1968, p. 505]

Sacheverell Sitwell, 1897–1988. "Daphne: An Adaptation from John Milton." Poem, after Milton's 1623 stanza (see above). In *The Thirteenth Caesar and Other Poems* (London: Richards, **1924**). [Ipso]

Philip Connard, 1875–1959. "Apollo and Daphne." Painting. **1925.** Royal Academy, London. [Warburg]

Frank Morgan. "Daphne." Poem. In *The Quest of Beauty* (London: Parsons, **1926**). [Boswell 1982, p. 275]

Siegfried Sassoon, 1886–1967. (Apollo and Daphne evoked in) "Solar Eclipse." Poem. In *Satirical Poems* (New York: Viking, **1926**). [Ipso]

Arthur B. Davies, 1862–**1928.** "Daphne." Painting. Artist's estate in 1931. [Cortissoz 1931, p. 23]

Yvor Winters, 1900–1968. "Apollo and Daphne." Poem. In *Gyroscope* no. 2 (**1929**); collected in *The Proof* (New York: Coward-McCann, 1930). [Isaacs 1981, pp. 87, 158–60]

André Masson, 1896–1987. "Daphne and Apollo." Painting. **1933.** Private coll. [Rubin & Lanchner 1976, pp. 137f.— ill.]

Marya Zaturenska, 1902–1982. "Daphne." Poem. In *Threshold and Hearth* (New York: Macmillan, **1934**). [Ipso]

Pierre Maurice, 1868–**1936.** *Daphné.* Orchestral composition. [Grove 1980, 11:843]

Rudolf Kölling, 1904–1970, choreography. *Apollo und Daphne.* Ballet. First performed **1936,** Staatsoper, Berlin. [Oxford 1982, p. 18 / Clarke & Vaughan 1977, p. 198]

Leo Spies, 1899–1965, music. *Apollo und Daphne.* Ballet. **1936.** [Grove 1980, 17:830]

Richard Strauss, 1864–1949. *Daphne.* Opera. Libretto, Joseph Gregor. First performed 15 Oct **1938,** Staatsoper, Dresden. [Grove 1980, 18:233ff. / Martin 1979, pp. 241–45 / Wilpert 1963, p. 197]

Giorgio de Chirico, 1888–1978. "Apollo and Daphne." Painting. **1939.** Romano Gazzera coll., Turin. [de Chirico 1971–83, 1.2: no. 49—ill.]

César Klein, 1876–1954. "Daphne." Painting. **1945.** [Hannover 1950, no. 40—ill.]

Peter Mieg, 1906–, music. *Daphne.* Ballet. Choreography, M. von Meyenburg? **1945.** [Grove 1980, 12:280]

Ossip Zadkine, 1890–1967. "Daphne." Wood sculpture. **1946.** Van der Wal coll., Amsterdam. [Jianou 1979, no. 340]

———. "Daphne." Bronze sculpture. 1950. Private coll. [Ibid., no. 369]

———. "Daphne." Bronze sculpture. 1960. Private coll. [Ibid., no. 439]

Selden Rodman, 1909–. "Daphne." Poem. Before **1949.** In *The Poetry of the Negro, 1746–1970,* edited by Langston Hughes and Arna Bontemps (New York: Doubleday, 1970). [Ipso]

James Bridie, 1888–1951. *Daphne Laureola.* Drama. First performed 23 Mar **1949,** Wyndham's Theatre, London. [McGraw-Hill 1984, 1:410ff. / Royle 1983, p. 210]

W. R. Rodgers, 1909–1969. "Daphne." Poem. In *Europa and the Bull and Other Poems* (London: Secker & Warburg; New York: Farrar, Straus & Cudahy, **1952**). [DLB 1983, 20:316]

Allen Tate, 1899–1979. (Apollo and the laurel evoked in) "The Maimed Man." Poem. In *The Partisan Review* 19 no. 3 (May-June **1952**). [Squires 1972, pp. 296–99]

Georges van Zevenberghen, 1877–1968. "Apollo Pursuing Daphne." Painting. **1954.** Musées Royaux des Beaux-Arts (Musée d'Art Moderne), Brussels, inv. 9444. [Brussels 1984b, p. 732—ill.]

Jean Arp, 1887–1966. "Daphne." Abstract bronze sculpture. **1955.** 3 casts. [Giedion-Welcker 1957, no. 138—ill. / Arp 1968, p. 104] Marble variant ("Daphne II"). 1960. 3 bronze casts. [Arp, no. 235—ill.]

Stanley Kunitz, 1905–. "A Spark of Laurel." Poem. In *Selected Poems, 1928–1958* (Boston & Toronto: Little, Brown, **1958**). [Ipso]

Rosemary Thomas, 1901–**1961.** "The Complaint of Daphne." Poem. In *Selected Poems* (New York: Twayne, 1968). [Ipso]

Robert Bagg, 1935–. "Apollo and Daphne." Poem. In *Madonna of the Cello* (Middletown, Conn.: Wesleyan University Press, **1961**). [Ipso]

George Garrett, 1929–. "Lament for Daphne." Poem. In *Abraham's Knife and Other Poems* (Chapel Hill: University of North Carolina Press, **1961**). [Ipso]

Guido Jendritzko, 1925–. "Daphne." Bronze sculpture. **1961.** [Gertz 1964, pl. 158a (plaster model)]

Joan Swift, 1926–. "Daphne." Poem. In *The Massachusetts Review* 3 no. 1 (Autumn **1961**). [Ipso]

Helga Fohl, 1935–. "Apollo and Daphne." Iron sculpture. **1963.** Germany. [Clapp 1970, 1:304]

Michael Head, 1900–1976. "Daphne and Apollo." Vocal composition. Text, N. Bush. **1964.** [Grove 1980, 8:419]

Allen Grossman, 1932–. (Apollo and Daphne evoked in) "The Recluse." Poem. In *The Recluse and Other Poems* (Cambridge, Mass.: Pym-Randall Press, **1965**). [Ipso]

Salvador Dalí, 1904–1989. "Daphne." Painting in jeweled setting on petrified wood. **1966.** Owen Cheatham Foundation, New York. [Rotterdam 1970, no. XXXIII—ill.]

———. "Daphne and Apollo." Sculptured gold medal. Cheatham Foundation. [Ibid., no. IX—ill.]

Herbert Read, 1893–1968. "Daphne." Poem. In *Collected Poems* (London: Faber & Faber, **1966**). [Boswell 1982, p. 207]

William Alwyn, 1905–. "Daphne, or, The Pursuit of Beauty." Musical "essay-poem." Published Southwold: **1972.** [Grove 1980, 1:300f.]

A. D. Hope, 1907–. "Apollo and Daphne, I," "Apollo and Daphne, II." Poems. In *A Late Picking: Poems 1965–1974* (Sydney: Angus & Robertson, **1974**). [Hooton 1979, p. 9]

Claudio Parmiggiani, 1943–. "Daphne." Assemblage (olive bough, bronze and iron balls, ribbons, cloth), after description of antique *Daphnephoria.* **1974.** [Reggio Emilia 1985, p. 72—ill.]

C. H. Sisson, 1914–. "Apollo and Daphne." Poem. In *In the Trojan Ditch* (Cheadle: Carcanet, **1974**). [Ipso]

Giulio Paolini, 1940–. "Apollo and Daphne." Assemblage (painting, plaster, paper). **1978.** [Villeurbanne 1983, p. 75—ill.]

Colin Way Reid, 1952–1983. "An Early Daphne." Poem. **1978.** In *Open Secret* (Gerrards Cross, Buckinghamshire: Colin Smythe, 1986). [Ipso]

———. "Daphne After." Poem. 1981. In *Open Secret.* [Ipso]

———. (Apollo with Daphne evoked in) "In Pollaiuolo's Eye." Poem. 1982. In *Open Secret.* [Ipso]

Ruth Zechlin, 1926–. *Apollo und Daphne.* Instrumental composition. **1980.** [Cohen 1987, 2:776]

Sandra Gilbert, 1936–. "Daphne." Poem. In *Emily's Bread* (New York: Norton, **1984**). [Ostriker 1986, pp. 216, 286]

Louise Glück, 1943–. (Apollo and Daphne evoked in) "Mythic Fragment." Poem. In *The Triumph of Achilles* (New York: Ecco, **1985**). [Ipso / CLC 1987, 44:218f.]

Amy Clampitt, 1920–. (Apollo and Daphne evoked in) "Tempe in the Rain." Poem. In *Archaic Figure* (New York: Knopf, **1987**). [Ipso]

DAPHNIS. (1) A shepherd in love with Chloe, the hero of Longus's famous pastoral romance. *See* DAPHNIS AND CHLOE. (2) A Sicilian herdsman celebrated by Theocritus and Virgil. *See* SHEPHERDS AND SHEPHERDESSES.

DAPHNIS AND CHLOE. Foundlings brought up by shepherds on the island of Lesbos, Daphnis and Chloe are the subjects of a pastoral romance by the Greek writer Longus. In the tale, the two fall in love and eventually marry, but not without a series of adventures and surprises, including Chloe's abduction by pirates, from whom she is rescued by Pan. Eros plays his usual willful part in the romance, in which he is known as the Winged Boy.

Longus is credited with creating the pastoral romance, and his *Daphnis and Chloe* was the most admired of all ancient fiction. He himself is, and was even during his lifetime, an elusive, little-known figure; *Daphnis and Chloe* could have been written between the second and fourth centuries CE. A popular story in postclassical art and literature, Longus's tale appealed especially to artists of the eighteenth and nineteenth centuries, when the pastoral style was at its height.

Classical Source. Longus, *Daphnis and Chloe.*

Francesco Bianchi Ferrari, c.1460?–**1510.** "Daphnis and Chloe." Painting. Wallace Collection, London, cat. no. P.2. [Wright 1976, p. 63]

Paris Bordone, 1500–1571. "Daphnis and Chloe." Painting. **1545–50.** National Gallery, London, no. 637. [Canova 1964, p. 105—ill. / Berenson 1957, p. 46 / London 1986, p. 54—ill.]

———. "Mythological Representation of a Couple" (Daphnis and Chloe? previously called "Vertumnus and Pomona," "Angelica and Medoro"). Painting. Louvre, Paris, inv. 125 (1178). [Louvre 1979–86, 2:155—ill. / also Canova, p. 109 (as "Vertumnus and Pomona"?) / Berenson 1957, p. 47 (as "Vertumnus and Pomona")]

Annibale Caro, 1507–**1566.** *Amori pastorali di Dafni e Cloe* [The Pastoral Loves of Daphnis and Chloe]. Poem. [DELI 1966–70, 1:606]

Ambrose Dubois, 1543–1614. "Daphnis and Chloe." Painting cycle, for Château de Fontainebleau. c.**1604–05.** Lost. / Drawing ("Daphnis and Chloe Espied by Lycen-

ion" [a farmer's wife who desired Daphnis]). Private coll., Paris. [Paris 1972, no. 89—ill.]

John Fletcher, 1579–1625. (Daphnis and Chloe in) *The Faithful Shepherdess.* Pastoral tragicomedy. London: Bonian & Walley, c.**1610.** [Levin 1969, pp. 52f.]

Crispyn de Passe the Younger, 1597/98–1670. "Daphnis and Chloe." Series of engravings, illustrations for Marcassus's translation of Longus (Paris: **1628**). [Pigler 1974, p. 311]

John Tatham, fl. 1632–64. *Love Crowns the End.* Pastoral, with interpolated songs. First performed **1632,** Bingham Theatre, Nottingham. [Sharp 1969, 1:242, 2:1186]

Andrew Marvell, 1621–1678. "Daphnis and Chloe." Poem. First published before **1650;** collected in *Miscellaneous Poems* (London: Boulter, 1681). [BW 1979–87, 2:209, 212]

Giovanni Benedetto Castiglione, c.1616–c.**1670.** "Daphnis and Chloe." Painting. Musée Municipal des Beaux-Arts et de la Dentelle, Calais. [Bénézit 1976, 2:589]

Caspar Netscher, 1639–**1684.** "Daphnis and Chloe." Painting. Museum, Braunschweig. [Pigler 1974, p. 311]

Johann Christoph Pepusch, 1667–1752. *Airy Cloe, Proud and Young.* Cantata. Published London: **1710.** [Grove 1980, 14:359]

Pieter van der Werff, 1665–1722. "Daphnis and Chloe." Painting. **1713.** Sanssouci, Potsdam. [Pigler 1974, p. 311]

John Gay, 1685–1732. "Daphnis and Chloe: A Song." Poem. First published as a broadside, 6 Jan **1720;** collected in *Poems on Several Occasions* (London: Tonson & Lintot, 1720). [Dearing & Beckwith 1974, vol. 1]

François Le Moyne, 1688–1737. "Daphnis Standing before the Sleeping Chloe," "The Meeting of Daphnis and Chloe." Paintings. **1721.** Unlocated (U.S.A.). [Bordeaux 1984, nos. 31–32—ill.]

Philippe d'Orléans, 1674–1723. *Daphnis et Chloé.* Illustrations of Longus. [Bénézit 1976]

Joseph Bodin de Boismortier, 1689–1755. *Daphnis et Chloé.* Opera (pastorale), opus 102. Libretto, P. Laujon. First performed 28 Sep **1747,** Académie Royale de Musique, Paris. [Grove 1980, 2:862] Parody, *Les bergers de qualité,* by P. T. Gondot, performed Paris, 1752. [Ibid.]

Pietro Gianotti, ?–1765. *Les petits concerts de Daphnis et Chloé.* Instrumental music, opus 14. c.**1751.** [Grove 1980, 7:350]

Jean-Jacques Rousseau, 1712–1778. *Daphnis et Chloé.* Musical pastorale. Libretto, P. Laujon. c.**1779,** unfinished. Unperformed. [Gagnebin & Raymond 1959–69, vol. 2 / Grove 1980, 16:272]

Leopold Antonin Kozeluch, 1747–1818. *Chloe.* Cantata. **1783.** [Grove 1980, 10:226]

Pierre-Paul Prud'hon, 1758–1823. "The Bath" (Daphnis pulling Chloe into the water). Drawing, illustration for Longus. Engraved by B. Roger, published (Paris: Renouard, **1800**). Drawing in L. Ferté coll. [Guiffrey 1924, no. 1048—ill.]

——— and **François Gérard,** 1770–1837. 9 drawings, illustrations for Amyot's translation of Longus (Paris: Didot, 1800). Drawings in École des Beaux-Arts, Paris, inv. 34572; Château de Chantilly; Musée des Beaux-Arts, Orléans; others unlocated. [Guiffrey, nos. 1049–57, pp. 398f.—ill.]

François Gérard, 1770–1837. "Daphnis and Chloe." Paint-

ing. **1825.** Louvre, Paris, inv. 4740. [Louvre 1979–86, 3:273—ill.] *See also above.*

Jean-Pierre Cortot, 1787–1843. "Daphnis and Chloe." Marble sculpture group. Exhibited Salon of **1827.** Louvre, Paris, inv. 1083. [Pigler 1974, p. 311]

Jean-Baptiste Camille Corot, 1796–1875. "Daphnis and Chloe." Painting. **1845.** [Robaut 1905, no. 465—ill.]

Jean-François Millet, 1814–1875. "Daphnis and Chloe." Painting. **1845.** [Lepoittevin 1973, fig. 46]

———. "Spring: Daphnis and Chloe." Painting, part of a "Seasons" cycle. 1864–65. Matsukata coll., Tokyo. / Study. 1864. Private coll., England. [Herbert 1976, no. 98—ill.]

Charles Gleyre, 1806–1874. "Daphnis and Chloe Passing the Brook." Drawing. Before **1852.** Charles Clément coll., in 1878. [Clément 1878, no. 86]

———. "Daphnis and Chloe Returning from the Mountain." Painting. 1862. De Clercq coll. in 1878. [Clément, no. 84]

Jean-Léon Gérôme, 1824–1904. "The Idyll" ("Daphnis and Chloe"). Painting. **1852.** Musée, Brest. [Ackerman 1986, no. 47—ill.]

———. "Daphnis and Chloe" ("Shepherd and Shepherdess of Corinth"). Painting. 1898. Unlocated. [Ibid., no. 448—ill.]

Jacques Offenbach, 1819–1880. *Daphnis et Chloé.* Opera (travesty). Libretto, Clairville and J. Cordier. First performed 27 Mar **1860,** Bouffes-Parisiens, Paris. [Baker 1984, p. 1677]

Aimé-Jules Dalou, 1838–1902. "Daphnis and Chloe." Plaster sculpture. Exhibited Salon of **1869.** Destroyed. / Copy drawing, from memory. Before 1899. Unlocated. [Hunisak 1977, pp. 51f.—ill. / Caillaux 1935, pp. 125f.]

Pierre Puvis de Chavannes, 1824–1898. "Daphnis and Chloe." Painting. **1872.** Art Museum, University of California, Berkeley. [Wattenmaker 1975, no. 14—ill.]

Antoine Marquet de Vasselot, 1840–1904. "Chloe at the Fountain." Marble statue. Musées Nationaux, inv. RF 219, deposited in Musée, Compiègne, in **1873.** [Orsay 1986, p. 276]

Jean-Baptiste Carpeaux, 1827–**1875.** "Daphnis and Chloe." Plaster statue. Petit Palais, Paris. [Kocks 1981, p. 360—ill.]

Gabriele D'Annunzio, 1863–1938. "A Cloe (da Orazio)." Poem. In "Appendice" of *Primo vere,* 2d edition (Lanciano: Carabba, **1880**). [Palmieri 1953–59, vol. I]

Juan de Valera y Alcalá-Galiano, 1824–1905. *Daphnis y Chloé.* Poem. Madrid: Rivadeneyra, **1880.** [DLE 1972, p. 911 / Sharp 1933, p. 272]

Fernand Leborne, 1862–1929. *Daphnis et Chloé.* Opera. First performed 10 May **1885,** Brussels. [Baker 1984, p. 1319]

Auguste Rodin, 1840–1917. "Daphnis and Chloe." Plaster sculpture (related to "Cupid and Psyche"). **1886.** Musée Rodin, Paris. [Tancock 1976, p. 260—ill.]

———. "Daphnis and Lycenion" (a farmer's wife who desired Daphnis). Bronze sculpture. 1886. Musée Rodin, Paris; Beardsley coll., Elkhart, Ind. [Ibid., p. 260—ill. / Rodin 1944, no. 155—ill.]

Edward John Poynter, 1836–1919. "Chloe." Painting. 2 versions, **1892,** 1893. [Kestner 1989, p. 223]

Charles Ricketts, 1866–1931. Series of monochrome prints illustrating Longus. *c.*1893. Tate Gallery, London, nos. 3997–4000. [Tate 1975, p. 196]

Charles Maréchal, 1842–1924. *Daphnis et Chloé.* Opera. Libretto, J. and P. Barbier. Published Paris: **1895.** First performed 8 Nov 1899, Théâtre Lyrique, Paris. [Grove 1980, 11:666]

Henri Busser, 1872–1973. *Dafnis et Chloe.* Musical pastorale. Libretto, C. Raffali. First performed 14 Dec **1897,** L'Opéra-Comique, Paris. [Baker 1984, p. 388]

Claude Debussy, 1862–1918. *Daphnis et Khloé.* Projected ballet score. Scenario, Pierre Louÿs, based on Longus. **1895–98,** unfinished. [Grove 1980, 5:311]

Pierre Bonnard, 1867–1947. Series of 156 lithographs illustrating Longus. Published Paris: Ambroise Vollard, **1902.** [Bouvet 1981, no. 75—ill.]

Giovanni Bolzoni, 1841–1919. *Dafne e Cloe.* "Bozzetto campestre" for small orchestra, opus 99. Published Milan: **1907.** [Grove 1980, 3:11]

Maurice Ravel, 1875–1937. *Daphnis et Chloé.* Ballet score ("symphonie chorégraphique"). **1909–12.** *See Fokine, below.* / 2 orchestral suites based on ballet score. No. 1, 1911; no. 2, 1913. [Grove 1980, 15:611f., 620]

Mathurin Moreau, 1822–**1912.** "Daphnis and Chloe." Marble sculpture group. Musées Nationaux, inv. Ch. M. 113, deposited at Mobilier National, Paris, in 1959. [Orsay 1986, p. 278]

Michel Fokine, 1880–1942, choreography and libretto. *Daphnis et Chloe.* Ballet. Music, Ravel (see above). First performed 8 June **1912,** Diaghilev's Ballets Russes, Théâtre du Châtelet, Paris; scenery and costumes, Léon Bakst. [Horwitz 1985, pp. 3f. / Simon & Schuster 1979, pp. 173f. / Terry 1976, p. 106 / Fokine 1961, pp. 195–204, 209–14 / Beaumont 1938, pp. 595ff.] Bakst's original designs (for a revival at L'Opéra, Paris, 1922) in Musée des Arts Décoratifs, Paris; Wadsworth Atheneum, Hartford, Conn.; private coll(s). [Spencer 1973, pls. 82–84, XXIX]

Lovis Corinth, 1858–1925. "Daphnis and Chloe." Etching, in "Antique Legends" series. **1919.** [Schwarz 1922, no. 351.V]

Ercole Luigi Morselli, 1882–**1921,** with P. Liuzzi. *Dafni e Cloë.* Favola pastorale. First performed 1923, Rome. [DELI 1966–70, 4:76 / DULC 1959–63, 3:658]

Kas'yan Goleizovsky, 1892–1970, choreography. *Daphnis et Chloé.* Ballet. First performed *c.*1922, Moscow. [EDS 1954–66, 5:374]

George Moore, 1852–1933. *The Pastoral Loves of Daphnis and Chloe.* Poem, imitation of Longus. London: Heinemann, **1924.** [Oxford 1985, p. 254]

W. H. Auden, 1907–1973. "Chloe to Daphnis in Hyde Park." Poem. **1926.** In *Collected Poetry* (New York: Random House, 1945). [Ipso]

Yannis Andreou Papaioannou, 1911–. *Daphnis and Chloe.* Composition for chorus and orchestra. Text, G. Drossinis. **1934.** [Grove 1980, 14:168]

Renée Sintenis, 1888–1965. Series of prints illustrating "Daphnis and Chloe." **1935.** [Hannover 1950, no. 131 / also Kiel 1956, pp. 87f., 112—ill.]

Catherine Littlefield, 1904–1951, choreography and scenario. *Daphnis and Chloe.* Ballet. Music, Ravel (1912).

First performed **1936,** Philadelphia; décor, A. Jarin, costumes, J. Pascal. [Terry 1976, p. 106 / Amberg 1949, p. 208]

Lawrence Durrell, 1912–1990. "Daphnis and Chloe." Poem. **1937.** First published 1941; collected in *A Private Country* (London: Faber & Faber, 1943). [Ipso]

Aristide Maillol, 1861–1944. 45 woodcuts (and 7 unpublished variants), illustrations for an edition of Longus's *Daphnis and Chloe* (Paris: Gonin, **1938**). [Guérin 1965, nos. 76–127—ill. / Guggenheim 1975, no. 168]

Margarethe Wallmann, 1904–, choreography. *Daphnis et Chloe.* Ballet. First performed **1938,** Buenos Aires. [EDS 1954–66, 9:1826]

Ker-Xavier Roussel, 1867–**1944.** "Daphnis and Chloe." Print. [Alain 1968, no. 114—ill.]

Léonide Massine, 1895–1979, choreography. *Daphnis et Chloe.* Ballet. First performed **1944,** Ballet Theatre, New York. [Chujoy & Manchester 1967, p. 612]

Tatjana Gsovsky, 1901–, choreography. *Daphnis und Cloë.* Ballet. Music, Ravel (1912). First performed **1947,** Staatsoper, Berlin; costumes, Paul Strecker. [Cohen-Stratyner 1982, p. 392]

Serge Lifar, 1905–1986, and **Nicholas Zvereff,** 1888–1965, choreography, with elements after Michel Fokine (1912). *Daphnis et Chloe.* Ballet. Music, Ravel (1912). First performed **1948,** Milan. [Oxford 1982, p. 256 / Cohen-Stratyner 1982, p. 970]

Jack Lindsay, 1900–1990. *Daphnis and Chloe.* Translation/ adaptation of Longus. London: Daimon, **1948.** [DLB Yearbook 1984, p. 297]

Conrad Westpfahl, b. 1891. "Daphnis and Chloe." Watercolor. **1949.** [Hannover 1950, no. 136]

Karl Otto Goetz, 1914–. 8 prints, illustrations to Longus. Before **1950.** [Hannover 1950, no. 31—ill.]

Frederick Ashton, 1904–1988, choreography. *Daphnis and Chloe.* Ballet. Music, Ravel (1912). First performed 5 Apr **1951,** Sadler's Wells Ballet, Royal Opera House, London; décor and costumes, John Craxton. [Vaughan 1977, pp. 245–52, 478]

Marc Chagall, 1887–1985. "Daphnis and Chloe." Gouache. **1956.** Ida Chagall coll. [Chagall 1972, no. 64—ill.]

———. Scenery and costume designs for 1959 Paris Opera production of Ravel's *Daphnis et Chloé* (1912) 1958. [San Lazzaro 1973, pp. 38–45—ill.] *See also Skibine, below.*

———. 42 color lithographs illustrating edition of Amyot's translation of Longus's *Daphnis and Chloe* (Paris: Verve, 1961). [Ibid., pp. 113–16—ill.]

———. "Daphnis and Chloe." Painting, illustratig Ravel's ballet. 1964. Ceiling, L'Opéra, Paris. [Ibid., pp. 31–35—ill.]

Paul Kont, 1920–, music. *Daphnis und Chloe.* Chamber dance play. **1957.** [Grove 1980, 10:181]

Georges Skibine, 1920–1981, choreography. *Daphnis et Chloe.* Ballet. Music, Ravel (1912). First performed **1959,** L'Opéra, Paris; décor and costumes, Marc Chagall *(see above).* [Guest 1976, p. 322]

Vaslav Orlikowsky, 1921–, choreography. *Daphnis and Chloe.* Ballet. First performed **1961,** Stadt Theater, Basel. [Cohen-Stratyner 1982, p. 678]

John Cranko, 1927–1973, choreography. *Daphnis and Chloe.* Ballet. Music, Ravel (1912). First performed 15 July **1962,**

Stuttgart Ballet; décor and costumes, Nicolas Georgiadis. [Oxford 1982, pp. 106f., 117 / Terry 1976, p. 106]

A. D. Hope, 1907–. "Six Songs for Chloe." Poem cycle. **1965–69.** In *New Poems: 1965–1969* (New York: Viking, 1970). [CLC 1975, 3:251]

Hans van Manen, 1932–, choreography. *Daphnis and Chloe.* Ballet. Music, Ravel (1912). First performed **1972,** Dutch National Ballet, Amsterdam; décor, Vroom. [Oxford 1982, pp. 117, 271]

John Neumeier, 1942–, choreography. *Daphnis and Chloe.* Ballet. Music, Ravel (1912). First performed **1972,** Frankfurt; design, Jurgen Rose. [Oxford 1982, p. 299]

John Taras, 1919–, choreography. *Daphnis and Chloe.* Ballet. Music, Ravel (1912). First performed 22 May **1975,** New York City Ballet, Lincoln Center; costumes and design, Joe Eula; lighting, Ronald Bates. [Reynolds 1977, p. 323]

Glen Tetley, 1926–, choreography. *Daphnis and Chloe.* Ballet. First performed **1975,** Württemberg State Theater, Stuttgart. [Simon & Schuster 1979, p. 174]

Jean-Paul Comelin, 1939–, choreography. *Daphnis and Chloe.* Ballet. First performed **1976,** Wisconsin Ballet, Milwaukee. [Cohen-Stratyner 1982, p. 198]

Kent Stowell, 1939–, choreography. *Daphnis and Chloe.* Ballet. First performed **1979,** Pacific Northwest Ballet, Seattle. [Cohen-Stratyner 1982, p. 843]

DEIANEIRA. *See* HERACLES, and Deianeira.

DEIDAMIA. *See* ACHILLES, at Scyros.

DEMETER. Daughter of the Titans Cronus and Rhea, Demeter was one of the twelve Olympians, the goddess of corn and of agriculture in general. She was the mother of Plutus by Iasion, of Arion by Poseidon, and most famously, of Persephone by Zeus. Most of Demeter's mythology concerns her devotion to Persephone, who was raped by Hades (Pluto) and carried off to the Underworld. In search of her daughter, Demeter traveled over the whole world, rendering it infertile until Persephone was finally restored to her.

Demeter was identified by the Romans with Ceres. Originally an Italian corn goddess, Ceres was worshiped in the festival called Cerealia and in a cult on the Aventine in conjunction with the fertility deities Liber (who was commonly identified with Bacchus)

and Libera. Demeter was also sometimes connected with the Egyptian Isis and the Phrygian Cybele.

In archaic and classical art, Demeter was shown with her attributes: a scepter, ears of corn, and torches. In postclassical art she is often seen as the personification of summer or of the element Earth.

Classical Sources. Homer, *Iliad* 14.326; *Odyssey* 5.125–28. Hesiod, *Theogony* 453–506, 969–74. *Homeric Hymns,* first and second hymns "To Demeter." *Orphic Hymns* 40, "To Demeter," 41, "To the Ceralian Mother." Virgil, *Georgics* 1.39ff. Pausanias, *Description of Greece* 1.37.2, 8.15.1–4, 8.25.2–7, 8.37.6, 8.42.–1–13.

See also APHRODITE, Venus Frigida; GODS AND GODDESSES; PERSEPHONE; TRIPTOLEMUS.

Giovanni Boccaccio, 1313–1375. "De Cerere, dea frugum et Syculorum regina" [Ceres, Goddess of Fertility and Queen of Sicily]. In *De mulieribus claris* [Concerning Famous Women]. Latin verse compendium of myth and legend. **1361–75.** Ulm: Zainer, 1473. [Branca 1964–83, vol. 10 / Guarino 1963 / Bergin 1981, p. 253]

John Gower, 1330?–1408. (Ceres described in) *Confessio amantis* 5.1221–1244. Poem. *c.***1390.** Westminster: Caxton, 1483. [Macaulay 1899–1902, vol. 2]

Christine de Pizan, *c.*1364–*c.*1431. (Ceres in) *L'epistre d'Othéa à Hector* . . . [The Epistle of Othéa to Hector] chapter 24. Didactic romance in prose. *c.***1400.** MSS in British Library, London; Bibliothèque Nationale, Paris; elsewhere. / Translated by Stephen Scrope (London: *c.*1444–50). [Bühler 1970 / Hindman 1986, pp. 91, 196, pl. 24]

———. (Ceres in) *Le livre de la Cité des Dames* [The Book of the City of Ladies] part 1 no. 35. Didactic compendium in prose, reworking of Boccaccio's *De mulieribus claris.* 1405. [Hicks & Moreau 1986] Translated by Brian Anslay (London: Pepwell, 1521). [Richards 1982]

Michele Pannonio, ?–1464. "Ceres Enthroned." Painting. **1450–60.** Szépművészeti Múzeum, Budapest, no. 44. [Budapest 1968, p. 443—ill. / Berenson 1968, p. 273—ill.]

Francesco del Cossa, *c.*1435–1477, school. "Triumph of Ceres." Fresco, representing the month of August. **1470.** Sala dei Mesi, Palazzo Schifanoia, Ferrara. [Berenson 1968, pp. 94, 131]

Giorgione, *c.*1477–**1510,** attributed (also attributed to Sebastiano del Piombo, *c.*1485–1547). "Ceres (Sitting at the Edge of a Well)." Painting. Early work if by Sebastiano. Gemäldegalerie, Berlin-Dahlem, no. 1/56. [Berlin 1986, p. 61—ill. / Pignatti 1978, no. A5 (as attributed to Sebastiano)—ill.]

Baldassare Peruzzi, 1481–1536. "Ceres." Fresco. **1511–12** (or *c.*1517–18). Sala delle Prospettive, Villa Farnesina, Rome. [d'Ancona 1955, pp. 27ff., 93f. / Gerlini 1949, pp. 31ff. / also Frommel 1967–68, no. 51]

———. "Ceres." Painting. *c.*1521–23. Palazzo Barberini, Rome, inv. FN 19207. [Frommel, no. 84—ill.]

Italian School. "The Triumph of Ceres." Ceiling fresco. **1508–13?** Sala delle Nozze di Alessandro con Rossana, Villa Farnesina, Rome. [Gerlini 1949, pp. 34ff.]

Pinturicchio, 1454–**1513,** and studio. "The Chariot of Ceres." Fresco (detached), from Palazzo Pandolfo Petrucci ("Il Magnifico"), Siena. Metropolitan Museum,

New York, no. 114.8. [Metropolitan 1980, p. 142—ill. / Berenson 1968, p. 345—ill.]

Garofalo, *c.*1481–1559. "Sacrifice to Ceres." Painting. **1526.** National Gallery, London, no. 3928. [Berenson 1968, p. 156]

Dosso Dossi, *c.*1479–1542 (? or follower, after lost original?). "Ceres." Painting. *c.***1525–30.** Dienst Verspreide Rijkskollekties, The Hague, no. NK 1540 (as Dosso). [Gibbons 1968, no. 27—ill.]

Giulio Romano, *c.*1499–1546, assistants, after designs by Giulio. Ceres depicted in frescoes and stuccoes in Sala dei Venti, Sala delle Aquile, Salla delle Stucchi, Grotta, Palazzo del Tè, Mantua. **1527–30.** [Verheyen 1977, pp. 119–130 passim / also Hartt 1958, pp. 115ff.]

———, assistant, after design by Giulio. "Ceres." Fresco. 1536–37. Loggetta, Palazzo Ducale, Mantua. [Hartt, p. 169]

Giorgio Vasari, 1511–1574. "Ceres." Ceiling painting. **1548.** Casa Vasari, Arezzo. [Arezzo 1981, no. 1.3—ill.]

———. "Offering to Ceres." Drawing. Gabinetto Designi e Stampe, Uffizi, Florence. [Pigler 1974, p. 60]

Bonifazio de' Pitati, *c.*1487–**1553.** "Allegory of Harvest" ("Ceres Enthroned"). Painting. Unfinished, completed posthumously, *c.*1554. Ringling Museum of Art, Sarasota, Fla., inv. SN69. [Sarasota 1976, no. 76 / Berenson 1957, p. 44]

Jacopo Tintoretto, 1518–1594, attributed. "Summer" (Ceres). Painting. *c.***1555.** National Gallery, Washington, D.C. [Walker 1975, pl. 298]

Francesco Primaticcio, 1504–1570, design. "Ceres and the Harvest," "Ceres with a Horn of Plenty." Frescoes, for Salle de Bal, Château de Fontainebleau, executed by Niccolò dell' Abbate under Primaticcio's direction. **1551/56.** Repainted 19th century. / Drawing for "Harvest." Château de Chantilly. [Dimier 1900, pp. 160ff., 284ff., no. 124]

Niccolò dell' Abbate, 1509/12–1571? attributed. "Ceres and the Gods" (Bacchus, Neptune, Mercury, Morpheus, others). Drawing. *c.***1552–56.** Musée Pincé, Angers. [Paris 1972, no. 12—ill. / also Lévêque 1984, p. 195—ill.]

———. *See also* Primaticcio, above.

Giambologna, 1529–1608. "Allegory of Prince Francesco de' Medici" ("The Child of Cybele") (Prince led by Mercury to Ceres/Abundance/Cybele). Alabaster relief. *c.***1560–61.** Prado, Madrid, no. 296E. [Avery 1987, no. 145—ill. / Avery & Radcliffe 1978, no. 121—ill.] Bronze and silver versions. Kunsthistorisches Museum, Vienna, nos. 5814, 1195; Museo del Bargello, Florence, no. 128. [Avery & Radcliffe, nos. 118–20—ill. / also Avery, nos. 146–47—ill.]

Paolo Veronese, 1528–1588. "Pluto and Ceres." Fresco, part of cycle celebrating Bacchus and wine. *c.***1560–61.** Stanza di Bacco, Villa Barbaro-Volpi, Maser (Treviso). [Pallucchini 1984, no. 60—ill. / Pignatti 1976, no. 98—ill.]

———. "Venice Receives the Homage of Hercules and Ceres." Painting, for Palazzo Ducale, Venice. 1577–78. Accademia, Venice, inv. 749. [Pallucchini, no. 164—ill. / Pignatti, no. 205—ill.]

Taddeo Zuccari, 1529–1566, and assistants. "Sacrifice to Ceres." Fresco. *c.***1560–61.** Stanza dell' Estate, Caprarola. [Warburg]

Martin Noblet. "Ceres." Painting (copy of an engraving by Hieronymus Cock after Frans Floris?). **1576.** Louvre, Paris, no. R.F. 1938–49. [Louvre 1979–86, 4:122—ill.]

John Lyly, *c.*1554–1606. (Ceres in) *Love's Metamorphosis.*

Comedy. First performed by Children of St. Paul's, London, **1586–88?** / Revised, performed *c.*1599–1600. Published London: 1601. [Bond 1902, vol. 3]

Hendrik Goltzius, 1558–1617. "Ceres in Half-length." Engraving (Bartsch no. 67, Jan Saenredam), part of "Three Deities in Half-length" series (Venus, Bacchus, Ceres). *c.***1596.** [Strauss 1977a, no. 338—ill. / Bartsch 1980–82, no. 160F—ill.]

———. "Ceres." Drawing. After 1600. Musée des Beaux-Arts, Orléans, inv. 1825A. [Reznicek 1961, no. 116—ill.]

———. "Goddess" (so-called "Ceres"). Drawing. 1608. Prentenkabinet, Rijksuniversiteit, Leiden, inv. Welcker 272. [Ibid., no. 126—ill.]

Friedrich Sustris, *c.*1540–**1599.** "Demeter." Cycle of drawings. Albertina, Vienna, inv. nos. 25272, 22398. [Warburg]

Flemish School. "Ceres with Children Personifying the Four Elements." Painting. **1550/1600.** Szépmüvészeti Múzeum, Budapest, no. 888. [Budapest 1968, p. 225]

French School. "Ceres and Vulcan" (as lovers). Painting. **16th century.** Private coll., Basel. [Hofmann 1987, no. 3.9—ill.]

Antonio Mohedano, 1561–1625. "Ceres as an Allegory of the Earth." Ceiling painting. **Early 1600s.** Casa de Pilados, Seville. [López Torrijos 1985, pp. 129, 133, 415 no. 1]

Spanish School. "Ceres." Ceiling painting. **Early 1600s.** Casa de Pilados, Seville. [López Torrijos 1985, pp. 112ff., 405 no. 3, pl. 9]

Samuel Daniel, 1562–1619. (Ceres in) *The Vision of Twelve Goddesses.* Masque. First performed 8 Jan **1604,** Hampton Court. [Sharp 1969, 2:164, 1246]

Bartholomeus Spranger, 1546–**1611.** "Juno, Venus, and Ceres." Drawing. 2 versions. Hessisches Landesmuseum, Darmstadt; Albertina, Vienna. [de Bosque 1985, p. 134—ill.]

William Shakespeare, 1564–1616. (Ceres appears in masque for the betrothal of Miranda and Ferdinand in) *The Tempest* 4.1.60–137. Drama (romance). **1611.** First performed 1 Nov 1611, Whitehall, London. Published London: Jaggard, 1623 (First Folio). [Riverside 1974 / Davies 1986, p. 156 / Brownlow 1977, p. 174]

Peter Paul Rubens, 1577–1640, figures, with **Frans Snyders,** 1579–1657, fruits and flowers, and another (Jan Wildens?), landscape. "Ceres and Pan" (Ceres with cornucopia, Pan with fruit). Painting. *c.***1617** (or *c.*1630?). Prado, Madrid, no. 1672. [Jaffé 1989, no. 439—ill. / Prado 1985, p. 601]

——— and Snyders. "Ceres and Two Nymphs" ("Three Nymphs with Cornucopia"). Painting. *c.*1617 (or 1620–28?). Prado, Madrid, no. 1664. [Jaffé, no. 441—ill. / Prado, p. 601] Oil sketch ("Nymphs Filling the Horn of Plenty"). Dulwich College Picture Gallery, inv. 171. [Held 1980, no. 255—ill. / Jaffé, no. 440—ill.]

Joachim Wtewael, 1566–1638. "Ceres." Painting. **1618.** Muzeul Brukenthal, Sibiu, inv. 1275. [Lowenthal 1986, no. A–74—ill.]

Jacob Jordaens, 1593–1678. "Offering to Ceres." Painting. *c.***1618–20.** Prado, Madrid, no. 1547. [d'Hulst 1982, p. 111, fig. 84 / Rooses 1908, pp. 34ff. (as "Offering to Pomona")—ill. / Prado 1985, p. 342]

Thomas Heywood, 1573/74–1641. "Ceres." Passage in *Gynaikeion: or, Nine Books of Various History Concerning Women* book 1. Compendium of history and mythology. London: printed by Adam Islip, **1624.** [Ipso]

Anthony van Dyck, 1599–1641. "Jupiter and Ceres" (traditional title, now thought to be "Vertumnus and Pomona"). Painting. *c.***1623–25.** Palazzo Bianco, Genoa. [Larsen 1988, no. 477—ill.] Variant copy by Jan de Duyts (1629–76), on Paris art market in 1987. [Ibid., no. A84a]

Girolamo Campagna, 1549/50–**1625?** "Ceres." Bronze statuette. / Copy in Museo di Capodimonte, Naples, no. 10562. [Capodimonte 1964, p. 111]

Pietro da Cortona, 1596–1669. "Triumph of Ceres." Fresco. **1626–29.** Villa Chigi (Sacchetti), Castel Fusano. [Briganti 1962, no. 23—ill.]

Thomas Dekker, 1570?–1632. (Ceres in) *London's Tempe, or, The Field of Happiness.* Pageant with songs. First performed 29 Oct **1629,** for Lord Mayor's inauguration, London. [Sharp 1969, Part 2, A-L, p. 164; M-Z, p. 1185]

Antonio Tempesta, 1555–**1630?** "Offering to Ceres." Fresco. Palazzo Farnese, Caprarola. [Pigler 1974, p. 60]

Simon Vouet, 1590–1649. "Ceres, or, The Harvest" ("Ceres and Harvesting Cupids"). Painting. *c.***1634.** National Gallery, London, inv. 6292. [Crelly 1962, no. 52—ill. / London 1986, p. 672—ill.]

———. "Allegory of Peace" (Neptune and Ceres). Painting. *c.*1640. Musée Henry, Cherbourg (as "Ceres Trampling the Attributes of War"). [Crelly, no. 21—ill. / Lepoittevin 1973, fig. 21]

Michel Anguier, 1612–1686. "Ceres." Bronze sculpture. *c.***1650.** Victoria and Albert Museum, London. [Molesworth 1965, pl. 221]

Nicolas Poussin, 1594–1665. "Ceres." Design for marble term. **1655–56.** Lost. / Marble executed by Jean-Baptiste Théodon (?), 1679–80. Quinconce du Nord, Gardens, Versailles. [Girard 1985, pp. 273f., 276—ill. / also Blunt 1966, no. 231—ill.]

———, formerly attributed. "Festival in Honor of Ceres." Presumed painting, untraced, known from engraving of 1817. [Thuillier 1974, no. R63—ill.]

Frans Snyders, 1579–1657. "Wreath of Fruits around a Bust of Ceres." Painting. Musées Royaux des Beaux-Arts (Musée d'Art Ancien), Brussels, inv. 3375. [Brussels 1984a, p. 279—ill.] *See also Rubens, above.*

Pierre Puget, 1620–1694. "Ceres Crowning Janus with Olive Branches." Sandstone sculpture. **1659–60.** Lost. [Herding 1970, no. 13]

Giovanni Benedetto Castiglione, *c.*1616–*c.*1670. "Sacrifice to Ceres." Drawing. Academy of Fine Arts, Philadelphia. [Pigler 1974, p. 60]

Philippe de Buyster, 1595–1688. "Ceres." Stone statue. **1671.** Façade, Château de Versailles. [Chaleix 1967, pp. 104, 129, pl. 36.1]

Jan Pauwel Gillemans the Younger, 1618–**1675.** "Ceres with Vertumnus and Pomona." Painting. Sold Sotheby's, London 1971. [Warburg]

Luca Giordano, 1634–1705. (Ceres in) "Allegory of Agriculture". Detail in "Allegory of Human Life and the Medici Dynasty." Fresco. **1682–83.** Palazzo Medici Riccardi, Florence. [Ferrari & Scavizzi 1966, 2:112ff.—ill.] Study. D. Mahon coll., London. [Ibid.—ill.]

———. "Ceres." Painting. *c.*1690. Museo del Castelvecchio, Verona, no. 1647. [Ibid., 2:168—ill.]

Pierre Beauchamps, 1631–1705, music. "Ceres." Entrée in *Ballet des arts.* First performed **1685,** Collège Louis-le-Grand, Paris. [Astier 1983, p. 161]

François Girardon, 1628–1715. "Ceres." Design for terminal figure. Executed in marble by Jean Poulletier, **1687–88.** Parterres de Latone, Gardens, Versailles. [Girard 1985, p. 276—ill.]

Johann Philipp Krieger, 1649–1725, music. *Flora, Ceres, und Pomona.* Masquerade. **1688.** [Grove 1980, 10:269]

French School. "Ceres."(?) Painting. **17th century.** Leeds City Art Gallery and Temple Newsam, inv. 18.7.50. [Wright 1976, p. 69]

German School (previously attributed to Johann Karl Loth, 1632–1698). "Ceres." Painting. **17th century.** Herzog Anton Ulrich-Museum, Braunschweig, no. 573. [Braunschweig 1976, p. 18 / also Braunschweig 1969, p. 90]

Antonio Verrio, c.1639–**1707.** "Sacrifice to Ceres." Fresco. King's Great Staircase, Hampton Court Palace. [Warburg]

Antoine Watteau, 1684–1721. "The Triumph of Ceres." Painting. *c.*1710. Lost. / Print by L. Crépy, 1729. [Camesasca 1982, no. 52—ill. / also Posner 1984, fig. 62]

———. "Allegory of Summer" ("Ceres"). Painting. 1711–16. Kress coll. (K2048), National Gallery, Washington, D.C., no. 1413. [Eisler 1977, p. 297—ill. / Walker 1984, p. 328—ill.]

Willem van Mieris, 1662–1747. "The Goddess Ceres." Painting. **1719.** Statens Museum for Kunst, Copenhagen. [Copenhagen 1951, no. 456]

Daniel Gran, 1694–1757. "Evening" (Ceres, or Venus?). Fresco. **1726–30.** Nationalbibliothek, Vienna. [Knab 1977, pp. 50ff., no. F20—ill.]

François Boucher, 1703–1770. "Sleeping Ceres." Painting. *c.*1731. Formerly considered lost, in a sale in Stockholm, Apr 1985. [Ananoff 1976, no. 68 / *Apollo,* Mar 1985] Engraving (by Basan?). [Ananoff—ill.]

Domingo Terradellas, 1713–1751. *Cerere.* Opera (componimento per musica). First performed 20 Jan **1740,** Rome. [Grove 1980 18:697]

Peter Scheemakers, 1691–1781. "Ceres." Stone sculpture. Before **1747.** Gardens, Rousham, Oxfordshire. [Whinney 1964, p. 94]

Jacob de Wit, 1695–1754. "Ceres." Painting. Het Slot, Zeist. [Wright 1980, p. 500]

Simon Carl Stanley, 1703–1761, attributed. "Ceres." Marble statue. **1760.** Park, Fredensborg. [Hartmann 1979, pl. 3.1]

Augustin Pajou, 1730–1809. "Ceres." Marble statuette. *c.*1767. Burat coll., Paris. [Stein 1912, pp. 206f., 400, pl. VIII]

Quirinus van Briemen, 1693–1774. "Ceres." Painting. Stedelijk Museum "De Lakenhal," Leiden, cat. 1949 no. 625. [Wright 1980, p. 61]

Louis-Jean-Jacques Durameau, 1733–1796. "Summer" ("Ceres and Her Companions Imploring the Sun [Apollo]"). Painting. **1774.** Galerie d'Apollon, Louvre, Paris, inv. 4326. [Louvre 1979–86, 3:242—ill. / Rosenberg 1988, p. 225—ill.]

Jean-Antoine Houdon, 1741–1828. "Ceres." Plaster sculpture. *c.*1781. Château, Maisons-Laffitte. [Réau 1964, no. 6—ill.]

———. "Summer." Marble sculpture. 1785. Musée Fabre, Montpellier. / Bronze cast, 1873. Montpellier. [Ibid., no. 9—ill.] Variant, terra-cotta bust. Lost. / Marble and terra-cotta copies in Musée Nisim de Camondo, Paris. [Ibid.]

———. "Ceres and Minerva." Bronze statuette, model for (unexecuted) decorations for Palais-Bourbon. Lost. [Ibid., no. 53]

Andrea Casali, c.1720–**late 18th century.** "Summer" ("Ceres"). Painting. Holburne of Menstrie Museum, Bath, cat. 1936 no. 144 (as Jean-Jacques Lagrenée). [Wright 1976, p. 35]

Johann Wolfgang von Goethe, 1749–1832. (Eleusinian mysteries linked with poet's loves in) *Römische elegien* [Roman Elegies] no. 12. **1788–90.** In Schiller's *Die Horen,* vol. 1 (Stuttgart & Tübingen: Cotta, 1795). [Beutler 1948–71, vol. 1 / Suhrkamp 1983–88, vol. 1 / Oxford 1986, p. 421 / Fairley 1961, pp. 146f.]

North Netherlandish School. "Ceres, Bacchus, and Amor." Painting (simulated statues in a niche). **18th century.** Rijksmuseum, Amsterdam, no. A4179. [Rijksmuseum 1976, p. 669—ill.]

Simeon Skillin, Jr., 1746–1806. "Head of Ceres." Wood sculpture. c.**1800.** New York State Historical Society, Cooperstown. [Clapp 1970, 2 pt. 2: 1004]

Clodion, 1738–**1814.** "Offering to Ceres." Plaster relief. Musée National de Céramique, Sèvres, in 1885. [Thirion 1885, p. 223—ill.]

Pierre-Paul Prud'hon, 1758–**1823,** attributed. "Ceres and Cupids." Painting. Sold 1887, untraced. / Drawing. S. Meyer coll. [Guiffrey 1924, no. 119]

Johann Heinrich Dannecker, 1758–1841. "Ceres Grieving." Marble sculpture, for tomb of Prinz Georg zu Holstein-Oldenburg. **1818–24.** Grossherzogliches Mausoleum, Oldenburg. [Spemann 1958, pl. 54] Plaster cast after original model. Staatsgalerie, Stuttgart. [Ibid.]

Jacques-Antoine Vallin, 1760–after **1831.** "Nymphs Decorating a Term of Ceres with Flowers." Painting. Bowes Museum, Barnard Castle, list 1971 no. 350. [Wright 1976, p. 207]

Eduard Mörike, 1804–1875. "Auf Demeter." Translation of first Homeric Hymn to Demeter. In *Classische Blumenlese* (Stuttgart: Schweizerbart, **1840**). [Hötzer 1967]

Victor de Laprade, 1812–1883. "Éleusis." Poem. In *Revue des deux mondes* **1841.** [DLLF 1984, 2:1219]

Karl-Joseph-Aloys Agricola, 1779–**1852.** "Ceres." Painting. Harrach coll., Vienna. [Bénézit 1976, 1:60]

Eugène Delacroix, 1798–1863. "Ceres Amidst the Harvest." Painting, for Salon de la Paix, Hôtel de Ville, Paris. **1849–53.** Destroyed 1871. [Robaut 1885, no. 1150—ill. (copy drawing)] Study. Fitzwilliam Museum, Cambridge, no. 2034. [Fitzwilliam 1960–77, 1:163—ill.]

John La Farge, 1835–1910. "Ceres." Marble and wood relief, for Vanderbilt mansion, New York. **1881–82.** Destroyed? [Weinberg 1977, pp. 256ff., 261—ill.]

Augustus Saint-Gaudens, 1848–1907. "Ceres." Stone and inlaid wood panel, for dining room of Vanderbilt mansion, New York. **1881–83.** Saint-Gaudens National Historic Site, Cornish, N.H. [Dryfhout 1982, no. 104—ill.]

Christian Griepenkerl, 1839–1916. "Demeter." Painting. **1889.** Akademie der Bildenden Künste, Vienna. [Karlsruhe 1976 p. 103, no. Z47—ill.]

Albert Verwey, 1865–1937. "Demeter." Poem. In *Verzamelde gedichten* (Amsterdam: Versluys, **1889**). [NUC]

Madison Cawein, 1865–1914. "Eleusinian." Poem. In *Intimations of the Beautiful* (New York: Putnam, **1894**). [Boswell 1982, p. 71]

Paul Vidal, 1863–1931, music. *Les mystères d'Éleusis* [The Mysteries of Eleusis]. Five tableaux for marionettes. Text, Maurice Bouchor. First performed 16 Jan **1894**, Galerie Vivienne, Paris. [Grove 1980, 19:710]

Auguste Rodin, 1840–1917. "Ceres." Marble bust. *c.***1896?** Museum of Fine Arts, Boston. [Tancock 1976, pp. 595ff.—ill.]

Arthur B. Davies, 1862–1928. "Demeter." Painting. **1898.** Hollister coll., Corning, N.Y. [Metropolitan 1930, no. 4—ill. / Cortissoz 1931, p. 23]

Victor Rousseau, 1865–1954. "Demeter." Plaster sculpture. *c.***1903.** Musées Royaux des Beaux-Arts, Brussels. [Clapp 1970, 1:772]

Valéry Bryúsov, 1873–1924. "K Demetre" [To Demeter]. Poem, part of cycle "Pravda vechnaia kumirov" [Eternal Truth of Idols]. **1904.** In *Stephanos (Venok)* [Wreath] (Moscow: Skorpion, 1906). [Bryúsov 1982] Translated in Joan Delaney Grossman, *Valery Bryusov and the Riddle of Russian Decadence* (Berkeley & Los Angeles: University of California Press, 1985). [Ipso]

Arthur Davison Ficke, 1883–1945. "Demeter." Poem. In *From the Isles* (Norwich: Samurai, **1907**). [Boswell 1982, p. 254]

Bernard Drew, b. 1885. "Hymn to Demeter." Poem. In *Helen and Other Poems* (London: Fifield, **1912**). [Bush 1937, p. 569]

George Edward Woodberry, 1855–1930. "Demeter," part of "A Day at Castrogiovanni." Poem. In *Flight and Other Poems* (New York: Macmillan, **1914**). [Boswell 1982, p. 237]

Evelyn Beatrice Longman, 1874–1954. "Fountain of Ceres, Court of Four Seasons." Sculpture. **1915.** Exhibited at Panama-Pacific International Exposition, San Francisco. [Clapp 1970, 2 pt. 2: 710]

Karol Szymanowski, 1882–1937. *Demeter.* Cantata for female chorus, alto, and orchestra, opus 37b. Text, Z. Szymanowska, after Euripides' *The Bacchae.* First performed **1917,** Warsaw. / Re-orchestrated 1924, performed 17 Apr 1931. [Grove 1980, 18:503]

Jaroslaw Iwaszkiewicz, 1894–1980. *Legendy i Demeter* [Legends of Demeter]. Collection of stories. **1917–18.** Warsaw: Ignis, 1921. [Miłosz 1983, p. 390]

Ossip Zadkine, 1890–1967. "Demeter." Wood sculpture. **1918.** 2 versions. Stedelijk Van Abbe Museum, Eindhoven; private coll. [Jianou 1979, no. 54—ill.] 3 replicas (1 in bronze). 1958, 1960. Private colls. [Ibid.]

Raoul Dufy, 1877–1953. "Ceres on the Seashore." Watercolor. **1928.** 5 versions. 1 in Perls Galleries, New York; others unlocated (1 sold Hôtel Druout, Paris, 1932; 1 sold Parke Bernet, Los Angeles, 1978). / Variants. "The Triumph of Ceres," Phillips coll., Washington; "Summer, or, Ceres on the Seashore"; "Ceres in the Wheat." [Guillon-Laffaille 1981, nos. 1867–74—ill.]

———. "Ceres" (reclining nude in a landscape). Painting. *c.*1938. Tenoudji coll., Paris. [Laffaille 1977, no. 1642, p. 338—ill.]

William Butler Yeats, 1865–1939. "Colonus' Praise" stanza 3 (called the Demeter stanza). Poem, version of first stasimon of Yeats's *Oedipus at Colonus.* In *The Tower* (London and New York: Macmillan, **1928**). [Finneran 1983 / Clark 1983, pp. 154ff., 160–63]

Maurice Lambert, 1901–. "Ceres" (head). Sandstone sculpture. Before **1931.** [Clapp 1970, 2 pt. 2: 683]

Alice Pike Barney, 1857–**1931.** "Ceres." Pastel sketch. Barney coll. no. 3, National Collection of Fine Arts, Washington, D.C. [Barney 1965, p. 107—ill.]

Gerhard Marcks, 1889–1981. "Demeter." Bronze sculpture. **1935.** Unique (?) cast. Private coll., Hamburg. [Busch & Rudloff 1977, no. 305—ill.]

Gerhart Hauptmann, 1862–1946. *Demeter-Mysterium.* Poetic fragment. **1938.** [Voigt 1965, pp. 133f.]

Roland Oudot, b. 1897. "Ceres." 2 paintings. Before **1939.** Musée National d'Art Moderne, Paris. [Bénézit 1976, 8:60]

Aristide Maillol, 1861–**1944.** "Ceres." Woodcut, illustrating Virgil's *Georgics* (Paris: Phillippe Gonin, 1950). [Guérin 1965, no. 214—ill.]

Eduardo Paolozzi, 1924–. "Head of Demeter." Collage (diagram of engine over book illustration of Knidos "Head of Demeter" [British Museum]). **1946.** British Museum, London. [Konnertz 1984, fig. 42]

Cesare Pavese, 1908–1950. (Demeter, as Mother Earth, speaks with Dionysus in) "Il mistero" [The Mystery]. Dialogue. In *Dialoghi con Leucò* (Turin: Einaudi, **1947**). / Translated by William Arrowsmith and D. S. Carne-Ross in *Dialogues with Leucò,* bilingual edition (Ann Arbor: University of Michigan, 1965). [Ipso / Biasin 1968, pp. 193f., 208f.]

Ezra Pound, 1885–1972. ("Zeus lies in Ceres' bosom," passage in) Canto 81, lines 517ff., in *The Pisan Cantos* (New York: New Directions, **1948**). [Kearns 1980, pp. 159–61 / Flory 1980, p. 214]

John Bradley Storrs, 1885–1956. "Ceres." Sculpture. Before **1954.** Board of Trade Building, Chicago. [Clapp 1970, 2 pt. 2: 1028]

Léonor Fini, 1918–. "Ceres." Painting. **1954.** [Lauter 1984, p. 118]

Albert Ciamberlani, 1864–**1956.** "Demeter" (reclining nude). Painting. Musées Royaux des Beaux-Arts (Musée d'Art Moderne), Brussels, inv. 9729. [Brussels 1984b, p. 105—ill.]

Aurel Milloss, 1906–1988, choreography. *Sei danze per Demetra* [Six Dances for Demeter]. Ballet. Scenario, Milloss and Angelo Musco. Music, Musco. First performed **1958,** Teatro Massimo Palermo. [EDS 1954–66, 7:589, pl. LXI]

Jean Arp, 1887–1966. "Demeter." Abstract marble sculpture. **1960.** / 5 bronze casts. Kolker coll., Scarsdale, N.Y.; elsewhere. [Arp 1968, no. 212—ill. / Read 1968, p. 210—ill.]

———. "Demeter." Abstract marble sculpture. **1961.** / 3 bronze casts. [Arp, no. 212a—ill.]

———. "Demeter's Doll." Abstract marble sculpture. 1961. Staempfli coll., New York. / 5 bronze casts. [Read, p. 210—ill. / Arp, no. 257—ill.]

Kenneth F. Campbell, 1913–. "Ceres." Marble sculpture. *c.***1962.** [Clapp 1970, 2 pt. 1: 168]

Yvonne Georgi, 1903–1975, choreography. *Demeter.* Ballet. First performed **1964,** Hannover. [Cohen-Stratyner 1982, p. 361]

John Fowles, 1926–. (Mme de Seitas, a Demeter-figure, in) *The Magus.* Novel. Begun 1952. Boston: Little, Brown, **1965.** / Revised edition, Boston: Little, Brown; London: Cape, 1977. [DLB 1982, 14:319 / CLC 1975, 3:163]

Lawrence Durrell, 1912–1990. "Eleusis." Poem. In *The Ikons and Other Poems* (London: Faber & Faber, **1966**). [Boswell 1982, p. 97]

Olga Broumas, 1949–, poem, and **Sandra McKee,** painting. "Demeter." Part of 2–media piece "Twelve Aspects of God." Exhibited Sep **1975,** Maude Kerns Gallery, Eugene, Ore. Broumas's poem in *Beginning with O* (New Haven: Yale University Press, 1977). [Ipso]

Jackie Shott, d. **1980.** "Demeter's Throne." Sculpture. [Lauter 1984, p. 139]

Carol Orlock, 1947–. *The Goddess Letters* (exchanged by Demeter and Persephone). Novel. New York: St. Martin, **1987.** [Ipso]

DEMOPHON. A son of Theseus and Phaedra (or Antiope), Demophon is the subject of a complex and contradictory legend. He and his brother Acamas went with the Athenian forces to Troy, where Demophon is said to have joined the embassy to the Trojan court at the outset of the war. At the fall of Troy, Demophon rescued his grandmother, Aethra, who had been taken to Troy with Helen, and began making his way homeward. Stopping in Thrace, he fell in love with Phyllis, a Thracian princess, and vowed to marry her upon his promised return within a year. In Athens, Demophon either wrested the throne from a usurper, Menestheus, or gained it after Menestheus's death. He is also said to have acquired the Palladium, by gift or force, from Diomedes or Odysseus.

According to some accounts, when Demophon departed from Phyllis she gave him a casket that he was not to open unless he decided not to return to her. When he did not appear by the appointed time, Phyllis cursed him and committed suicide; Demophon, meanwhile, opened the casket and was driven to madness and death by the sight of its contents. In another version, when Demophon did not return to Thrace, Phyllis hanged herself and was transformed into an almond tree. When Demophon finally arrived he embraced the tree, which at his touch burst into blossom. Both of these tales are also told of Demophon's brother, Acamas.

Classical Sources. Ovid, *Heroides* 2, "Phyllis to Demophon." Apollodorus, *Biblioteca* 1.5.1, E1.18, E1.23, E5.22, E6.16. Plutarch, *Parallel Lives,* "Theseus" 35. Pausanias, *Description of Greece* 10.25.8. Hyginus, *Fabulae* 59, 263. Quintus of Smyrna, *Sequel to Homer* 13.496ff.

Giovanni Boccaccio, 1313–1375. (Phyllis and Demophon's tale retold in) *Elegia di Madonna Fiammetta.* Prose elegy. **1343–44?** Padua: 1472. [Branca 1964–83, vol. 3 / Bergin 1981, p. 177]

Geoffrey Chaucer, 1340?–1400. "The Legend of Phyllis," part of *The Legende of Goode Women.* Poem. **1385–86.** Westminster: Caxton, c.1495. [Riverside 1987 / Frank 1966, pp. 117, 125, 128, 130]

John Gower, 1330?–1408. (Story of Demophon and Phyllis in) *Confessio amantis* 4.731–878. Poem. c.1390. Westminster: Caxton, 1483. [Macaulay 1899–1902, vol. 2 / Ito 1976, p. 39]

Mariana Pignetelli (16th century). *Demofonte.* Incidental music. [Cohen 1987, 1:550]

Cavaliere d'Arpino, 1568–1640. "Demophon and Phyllis." Fresco. **1594–95.** Loggia Orsini, Palazzo del Sodalizio dei Piceni, Rome. [Röttgen 1969, pp. 279ff.—ill.]

Robert Herrick, 1591–1674. (Story of Demophon and Phyllis told in) "To the Maids to Walke Abroad." Poem. In *Hesperides* (London: Williams & Eglesfield, **1648**). [Martin 1956]

Anonymous composer. *Demofonte.* Opera (dramma per musica). Libretto, Francesco Beverini. First performed 25 Feb **1699,** Cocomero, Florence. [Weaver 1978, p. 184]

Pedro Scotti de Agoiz, ?–**1730,** music. *Filis y Demofonte.* Zarzuela. In *Obras poéticas posthumas* (Madrid: Mojados, 1735). [Barrera 1969, p. 367 / Palau y Dulcet 1948–77, 20:213]

José de Cañizares, 1676–1750. *Templo y monte de Filis y Demofonte* [Temple and Mount of Phyllis and Demophon]. Comedy. Before **1731.** [Barrera 1969, p. 70]

Francesco Corradini, c.1700–after 1749, music. *Templo y monte de Filis y Demofonte.* Zarzuela. Libretto, Cañizares (above). First performed 27 Oct **1731,** Principe, Madrid. [Grove 1980, 4:798]

Pietro Metastasio, 1698–1782. *Il Demofoonte.* Tragedy. Used as opera libretto by Caldara, **1733,** and set by at least 46 further composers to 1794. [Grove 1980, 12:213] Translated by John Hoole in *Works of Metastasio* (London: 1767). [Nicoll 1959–66, 3:272]

Antonio Caldara, c.1670–1736. *Il Demofoonte.* Opera. Libretto, Metastasio. First performed **1733,** Vienna. [Grove 1980, 3:616]

Domenico Sarro, 1679–1744 (Act 1), **Francesco Mancini,** 1672–1737 (Act 2), and **Leonardo Leo,** 1694–1744 (Act 3). *Demofoonte.* Opera seria. Libretto, Metastasio (1733). First performed 20 Jan **1735,** Teatro San Bartolomeo, Naples. [Grove 1980, 10:667, 11:602, 16:501]

Gaetano Maria Schiassi, 1698–1754. *Il Demofoonte.* Opera. Libretto, Metastasio (1733). First performed Carnival, **1735,** Teatro Grimani, Venice. [Grove 1980, 16:638]

Egidio Duni, 1708–1775. *Demofoonte.* Opera seria. Libretto, after Metastasio (1733). First performed 24 May **1737,** King's Theatre, London. [Grove 1980, 5:718]

Giovanni Battista Ferrandini, c.1710–1791. *Demofoonte.* Opera seria. Libretto, Metastasio (1733). First performed 22 Oct **1737,** Munich. [Grove 1980, 6:485]

Giuseppe Ferdinando Brivio, c.1698–c.1758. *Demophoonte.* Opera. Libretto, Metastasio (1733). First performed Carnival, **1738,** Teatro Regio, Turin. [Grove 1980, 3:309]

Giovanni Battista Lampugnani, 1706–c.1786. *Demofoonte.* Opera. Libretto, Metastasio or Vitturi. First performed Carnival, **1738,** Ducale, Piacenza. [Grove 1980, 10:422]

Gaetano Latilla, 1711–1788. *Demofoonte.* Heroic opera. Libretto, Metastasio (1733). First performed Carnival, **1738,** Teatro S. Giovanni Grisostomo, Venice. Music lost. [Grove 1980, 10:504]

Andrea Bernasconi, 1706?–1784. *Demofoonte*. Opera. Libretto, Metastasio (1733). First performed Carnival, **1741**, Rome. [Grove 1980, 2:620]

Anonymous composer. *Demofonte*. Opera (dramma per musica). Libretto, Metastasio? First performed 9 June **1741**. Cocomero, Florence. [Weaver 1978, pp. 287f.]

Giovanni Verocai, *c*.1700–1745. *Demofoonte*. Opera. Libretto, Metastasio (1733). First performed Feb **1742**, Braunschweig. [Grove 1980, 19:674]

Christoph Willibald Gluck, 1714–1787. *Demofoonte*. Opera (dramma per musica). Libretto, Metastasio (1733). First performed 6 Jan **1743**, Teatro Regio Ducal, Milan. [Baker 1984, p. 847 / Grove 1980, 7:472 / Cooper 1935, pp. 44, 58, 284]

Niccolò Jommelli, 1714–1774. *Demofoonte*. Opera seria. Libretto, Metastasio (1733). First performed 13 June **1743**, Teatro Obizzi, Padua. [Grove 1980, 9:692]

———. *Demofoonte* (second setting). Opera seria. Libretto, Metastasio. First performed Carnival, 1753, Teatro Regio Ducal, Milan. [Ibid., 9:693]

———. *Demofoonte* (third setting). Opera seria. Libretto, Metastasio. First performed 11 Feb 1764, Opera House, Stuttgart. [Ibid.]

———. *Demofoonte* (fourth setting). Opera seria. Libretto, Metastasio. First performed 4 Nov 1770, San Carlo, Naples. [Ibid.]

Francesco Maggiore, *c*.1715–*c*.1782. 7 or more arias added to a performance of Gluck's *Demofoonte* (1743). First performed **1743**, Reggio Emilia. [Grove 1980, 11:492]

Carl Heinrich Graun, 1703/04–1759. *Demofoonte, rè di Tracia* [Demophon, King of Thrace]. Opera. Libretto, Metastasio (1733). 1 aria by Frederick II of Prussia. First performed 17 Jan **1746**, Opera, Berlin. [Grove 1980, 7:646, 6:812]

Johann Adolf Hasse, 1699–1783. *Demofoonte*. Opera seria. Libretto, Metastasio (1733). First performed 9 Feb **1748**, at Court, Dresden. [Grove 1980, 8:288]

Baldassare Galuppi, 1706–1785. *Demofoonte*. Opera seria. Libretto, Metastasio (1733). First performed 18 Dec **1749**, Buen Retiro, Madrid. [Grove 1980, 7:137]

Ignazio Fiorillo, 1715–1787. *Demofoonte*. Opera seria. Libretto, Metastasio (1733). First performed **1750**, Braunschweig. [Grove 1980, 6:601]

Francesco Antonio Baldassare Uttini, 1723–1795. *Demofoonte*. Opera. Libretto, Metastasio (1733). First performed *c*.**1750**, Ferrara. [Grove 1980, 19:480]

Davide Perez, 1711–1778. *Demofoonte*. Opera. Libretto, Metastasio (1733). First performed **1752**, Teatro di Corte, Lisbon. [Grove 1980, 14:367]

Gennaro Manna, 1715–1779. *Demofoonte*. Opera seria. Libretto, Metastasio (1733). First performed Carnival, **1754**, Teatro Regio, Turin. [Grove 1980, 11:622]

Gioacchino Cocchi, *c*.1720–after 1788. *Demofoonte*. Opera. Libretto, Metastasio (1733). First performed Ascension Fair, **1754**, San Salvatore, Venice. [Grove 1980, 4:509]

Antonio Mazzoni, 1717–1785. *Il Demofoonte*. Opera. Libretto, Metastasio (1733). First performed **1754**, Teatro Ducale, Parma. [Grove 1980, 11:872]

Antonio Gaetano Pampani, *c*.1705–1775. *Demofoonte*. Opera. Libretto, Metastasio (1733). First performed Carnival **1757**, Teatro della Dame, Rome. [Grove 1980, 14:149]

Tommaso Traetta, 1727–1779. *Demofoonte*. Opera (dramma per musica). Libretto, Metastasio (1733). First performed Autumn **1758**, Accademia Filarmonica, Verona. [Grove 1980, 19:113]

Antonio Ferradini, 1718?–1779. *Demofoonte*. Opera. First performed 26 Dec **1758**, Milan. [Grove 1980, 6:485]

Johann Ernst Eberlin, 1702–1762. *Demofoonte*. Opera. Libretto, Metastasio (1733). First performed **1759**. [Grove 1980, 5:814]

Niccolò Piccinni, 1728–1800. *Demofoonte*. Opera. Libretto, Metastasio (1733). First performed May **1761**, Reggio. [Grove 1980, 14:727]

Antonio Boroni, 1738–1792. *Demofoonte*. Opera. Libretto, Metastasio (1733). First performed Carnival, **1762**, Treviso. [Grove 1980, 3:63]

Gian Francesco de Majo, 1732–1770. *Demofoonte*. Opera seria. Libretto, Metastasio (1733). First performed Carnival, **1764**, Teatro Argentina, Rome. [Grove 1980, 11:544]

Matteo Vento, *c*.1735–1776. *Demofoonte*. Opera. Libretto, Metastasio (1733). First performed 2 Mar **1765**, King's Theatre, London. [Fiske 1973, p. 325 / Grove 1980, 19:622f.]

Brizio Petrucci, 1737–1828. *Demofoonte*. Opera seria. Libretto, Metastasio (1733). First performed 26 Dec **1765**, Teatro Bonacossi, Ferrara. [Grove 1980, 14:595]

Pietro Alessandro Guglielmi, 1728–1804. *Demofoonte*. Opera seria. Libretto, Metastasio (1733). First performed 8 Oct **1766**, Teatro Onigo, Treviso. [Grove 1980, 7:796]

Adrien de La Vieuville d'Orville, Comte de Vignancourt, ?–1774. *Demophon*. Tragedy. **1766**. [Taylor 1893, p. 189]

Josef Mysliveček, 1737–1781. *Il Demofoonte*. Opera. Libretto, Metastasio (1733). First performed Jan **1769**, Teatro San Benedetto, Venice. [Grove 1980, 13:7, 8 / also Pečman 1970, p. 181]

Johann Baptist Vanhal, 1739–1813. *Il Demofoonte*. Opera. Libretto, Metastasio (1733). First performed **1770**, Rome. Music lost. [Grove 1980, 19:524]

Giuseppe Sarti, 1729–1802. *Demofoonte*. Opera (dramma per musica). Libretto, Metastasio (1733). First performed 30 Jan **1771**, Teater on Kongens Nytorv, Copenhagen. [Grove 1980, 16:505]

Johann Antonin Kozeluch, 1738–1814. *Il Demofoonte*. Opera. Libretto, Metastasio (1733). First performed Spring **1771**, Prague. [Grove 1980, 10:225]

Pasquale Anfossi, 1727–1797. *Demofoonte*. Opera (dramma per musica). Libretto, Metastasio (1733). First performed Carnival **1773**, Teatro Argentina, Rome. [Grove 1980, 1:422]

Giovanni Paisiello, 1740–1816. *Demofoonte*. Opera (dramma per musica). Libretto, Metastasio (1733). First performed Carnival **1775**, San Benedetto, Venice. [Grove 1980, 14:100]

Joseph Schuster, 1748–1812. *Demofoonte*. Opera. Libretto, Metastasio (1733). First performed **1776**, Teatro Nuovo, Forlí. [Grove 1980, 16:876]

Gaspare Angiolini, 1731–1803, choreography. *Demofoonte*. Ballet. First performed **1779**, La Scala, Milan. [Clarke & Vaughan 1977, p. 19]

Giacomo Rust, 1741–1786. *Demofoonte*. Opera. Libretto, Metastasio (1733). First performed Autumn **1780**, Teatro della Pergola, Florence. [Grove 1980, 16:349]

Felice Alessandri, 1747–1798. *Demofoonte*. Opera. Libretto, Metastasio (1733). First performed 12 June **1783**, Teatro Nuovo, Padua. [Grove 1980, 1:244]

Alessio Prati, 1750–1788. *Demofonte*. Opera (dramma per

musica). Libretto, Metastasio (1733). First performed 26 Dec **1786**, San Benedetto, Venice. [Grove 1980, 15:203]

Giovan Gualberto Brunetti, 1706–**1787.** *Demofoonte.* Opera. Libretto, Metastasio (1733). First performed 1790. [Clément & Larousse 1969, 1:304]

Luigi Gatti, 1740–1817. *Demofoonte.* Opera seria. Libretto, Metastasio (1733). First performed 12 May **1787,** Teatro Ducal, Mantua. [Grove 1980, 7:185]

Gaetano Pugnani, 1731–1798. *Demofoonte.* Opera (dramma per musica). Libretto, Metastasio (1733). First performed 26 Dec **1787,** Teatro Reggio, Turin. [Grove 1980, 15:447]

Johann Christoph Vogel, 1756–**1788.** *Démophon.* Lyric opera. Libretto, P. Desriaux, after Metastasio (1733). First performed 22 Sep 1789. L'Opéra, Paris. [Grove 1980, 20:55]

Luigi Cherubini, 1760–1842. *Démophon.* Opera. Libretto, Jean-François Marmontel. First performed 2 Dec **1788,** L'Opéra, Paris. [Grove 1980, 4:210]

Vincenzo Federici, 1764–1826. *L'usurpator innocente* [The Innocent Usurper]. Opera. Libretto, after Metastasio's *Demofoonte* (1733). First performed 6 Apr **1790,** Little Haymarket Theatre, London. [Grove 1980, 6:449]

Marcos Antonio Portugal, 1762–1830. *Demofoonte.* Opera. Libretto, Metastasio (1733). First performed **1794,** La Scala, Milan. / Revised, performed 1808, San Carlos. [Grove 1980, 15:148]

Peter Josef von Lindpaintner, 1791–1856. *Demophon.* Opera. First performed **1811,** Munich. [Clément & Larousse 1969, 1:307]

Edward Burne-Jones, 1833–1898. "Phyllis and Demophon." Gouache. **1869–70.** Birmingham City Museum and Art Gallery, England. [Harrison & Waters 1973, pp. 99, 110–13—ill. / Wood 1983, pp. 179, 181—ill. / also Cecil 1969, pl. 72 / Kestner 1989, pl. 2.20] Larger replica, "Tree of Forgiveness." 1881. Lady Lever Art Gallery, Port Sunlight, Cheshire. [Harrison & Waters, pl. 35—ill. / Kestner, pl. 2.21]

Gordon Bottomley, 1874–1948. "Phillis" (waiting for Demophon). Poem. **1902.** In *The Gate of Smaragdus* (London: At the Sign of the Unicorn, 1904). [Bush 1937, pp. 430, 566]

John William Waterhouse, 1849–1917. "Phyllis and Demophon." Painting. **1907.** Formerly H. Henderson coll., Britain. [Hobson 1980, no. 153, pl. 124 / Dijkstra 1986, pp. 96f.—ill. / Kestner 1989, p. 301, pl. 5.47] Replica or variant. *c.*1907. Sold Christie's, London, 1926. [Hobson, no. 154] 3 studies. 2 sold Christie's, London, 1926. [Ibid., nos. 155–57]

DEUCALION AND PYRRHA. When Zeus decided to flood the earth in retribution for the sins of mankind during the mythical Bronze Age, Prometheus advised his son, Deucalion, to build an ark in which to ride out the storm. After nine days the waters receded and the boat came to rest on Parnassus. Deucalion and his wife Pyrrha were then advised by an oracle of Themis to throw the "bones of their mother" behind them. According to Ovid, Deucalion interpreted this to mean that they should toss stones, since these came from the "body" of the earth, the mother of all things. They thus complied

with the oracle, and the stones thrown by Deucalion turned into men, while those thrown by Pyrrha became women; these new people repopulated the world. The couple later bore a son, Hellen, for whom the Greeks named themselves (Hellenes) and their country (Hellas). Because of the similarity of this tale to the biblical account of the flood, Deucalion is often called the Greek Noah.

Classical Sources. Pindar, *Olympian Odes* 9.41–56. Ovid, *Metamorphoses* 1.125ff., 1.260–415. Apollodorus, *Biblioteca* 1.7.1–2. Hyginus, *Fabulae* 153. Lucian, *Of the Syrian Goddess* 12ff.

Jean de Meun, 1250?–1305? (Story of Deucalion and Pyrrha in) *Le roman de la rose* lines 17590–650. Verse romance, completion of unfinished work begun by Guillaume de Lorris (*c.*1230–35). *c.*1275. Lyon: Ortuin & Schenck, *c.*1481. [Dahlberg 1971 / Poirion 1974]

Anonymous French. (Deucalion and Pyrrha allegorized to Noah in) *Ovide moralisé* 1.1945–2364. Poem, allegorized translation/elaboration of Ovid's *Metamorphoses*. *c.*1316–28. [de Boer 1915–86, vol. 1]

Filarete, *c.*1400–1469? "Deucalion and Pyrrha." Relief, on bronze door of St. Peter's, Rome. **1433–45.** In place. [Pope-Hennessy 1985b, 2:318]

Antoine Vérard, fl. 1485–1512. Print, representing Deucalion and Pyrrha throwing stones over their shoulders. In *La Bible des poètes* (Paris: 1493). [Barkan 1986, p. 187, fig. 16]

Baldassare Peruzzi, 1481–1536, circle (? also attributed to school of Giulio Romano or Raphael). "Deucalion and Pyrrha." Fresco. **1511–12** (or *c.*1517–18). Sala delle Prospettive, Villa Farnesina, Rome. [d'Ancona 1955, pp. 27ff., 93f. / Gerlini 1949, pp. 31ff. / also Frommel 1967–68, no. 51]

Domenico Beccafumi, 1486–1551. "Deucalion and Pyrrha." Painting. *c.*1514. Museo Horne, Florence, no. 79. [Sanminiatelli 1967, pl. 5 / Berenson 1968, p. 35]

———. "Deucalion and Pyrrha." Fresco. *c.*1530? Palazzo Bindi Sergardi, Siena. [Sanminiatelli, pp. 93f., pl. 31m]

Niccolò Giolfino, 1476–1555. "The Myth of Deucalion and Pyrrha." Painting. *c.*1520–30. Kress coll. (K1199), Indiana University, Bloomington, no. L62.159. [Shapley 1966–73, 2:94f.—ill.]

Jacopo Tintoretto, 1518–1594. "Deucalion and Pyrrha Praying before the Statue of the God." Painting. *c.*1541. Galleria Estense, Modena. [Rossi 1982, no. 27—ill.]

———. "Deucalion and Pyrrha." Painting. 1543–44. Museo Civico, Padua, no. 2808. [Ibid., no. 71—ill.]

Andrea Schiavone, *c.*1522–**1563.** "Deucalion and Pyrrha." Painting. Galleria Nazionale, Parma, no. 368. [Berenson 1957, p. 161]

———, formerly attributed (attributed to Bonifazio de' Pitati, *c.*1487–1553). "Deucalion and Pyrrha." Painting. Accademia, Venice. [Richardson 1980, no. D371—ill. / also Berenson (as Schiavone)—ill.]

Andrea del Minga, ?–1596. "Deucalion and Pyrrha." Painting. **1570–73.** Studiolo di Francesco I, Palazzo Vecchio, Florence. [Sinibaldi 1950, pp. 11f., 19]

Hendrik Goltzius, 1558–1617, composition. 4 engravings depicting the story of Deucalion and Pyrrha and the

destruction of the world, part of a set illustrating Ovid's *Metamorphoses* (1st series, nos. 8, 10–12), executed by assistant(s). *c.*1589. Unique impressions in British Museum, London. [Bartsch 1980–82, nos. 0302.38, 41, 42—ill.]

Francis Bacon, 1561–1626. "Deucalion, sive restitutio." Chapter 21 of *De sapientia veterum.* Mythological compendium. London: Barker, **1609.** / Translated as "Deucalion, or Restitution" by Arthur Gorges in *The Wisdome of the Ancients* (London: Bill, 1619). Modern facsimile edition (bilingual), New York & London: Garland, 1976. [Ipso]

Peter Paul Rubens, 1577–1640. "Deucalion and Pyrrha." Painting, for Torre de la Parada, El Pardo, executed by assistant (Jan Cossiers?) from Rubens's design. **1636–38.** Formerly Prado, Madrid, lost. [Alpers 1971, no. 17 / Jaffé 1989, no. 1261] Oil sketch. Prado, no. 2041. [Alpers, no. 17a—ill. / Held 1980, no. 184—ill. / Jaffé, no. 1260—ill. / Prado 1985, p. 593] Copy, by Juan Bautista del Mazo (*c.*1612–1667), in Ayuntamiento, Barcelona, on loan from Prado. [Alpers—ill.]

Joachim Wtewael, 1566–**1638.** "The Deluge." Painting. Germanisches Nationalgalerie, Nuremberg, no. 1212. [Lowenthal 1986, no. A–2—ill.]

John Milton, 1608–1674. (Adam and Eve compared to Deucalion and Pyrrha in) *Paradise Lost* 11.8–14. Epic. London: Parker, Boulter & Walker, **1667.** [Carey & Fowler 1968 / Du Rocher 1985, p. 33]

Giulio Carpioni, 1613–**1679.** "Deucalion in the Flood." Painting. At least 4 versions of the subject known. Accademia Carrara, Bergamo; Pinacoteca, Siena; private colls. [Pigler 1974, pp. 66f.]

Luca Giordano, 1634–1705. "Deucalion and Pyrrha." Painting. *c.*1700. Palacio Real, Aranjuez. [Ferrari & Scavizzi 1966, 2:225f.]

Alexis Piron, 1689–1773, libretto. *Arlequin-Deucalion.* Comic opera, or monologue. First performed **1722,** Théâtre de la Foire Saint-Laurent (?), Paris. [Oxford 1959, p. 558 / DLF 1951–72, 2:345, 373]

Germain-François Poullain de Saint-Foix, 1699–1776. *Deucalion et Pirrha.* Comedy. Paris: Prault, **1741.** [Taylor 1893, p. 173]

Denis Ballière de Laisement, 1729–1800. *Deucalion et Pyrrhe.* Parody opera. Libretto, composer. **1751.** [Grove 1980, 2:94]

Pierre-Montan Berton, 1727–1780, with **François-Joseph Giraud,** ?–*c.*1790. *Deucalion et Pyrrha.* Opera-ballet. Libretto, G.-F. Pouillain de Saint-Foix and P. Morand. First performed 30 Sep **1755,** L'Opéra, Paris; choreographer unknown. [Grove 1980, 2:642, 7:406]

Alfonso Verdugo y Castilla, 1706–**1767.** *Deucalión.* Narrative poem. In *Poemas epicos* (Madrid: Revadeneyra, 1851–54). [DLE 1972, p. 931]

Giuseppe Sarti, 1729–1802. *Deucalion oq Pyrrha.* Singspiel. Libretto, C. A. Thielo and Bredal, after Poullain de Saint-Foix (1741). First performed 19 Mar **1772,** Theater on Kongens Nytorv, Copenhagen. [Grove 1980, 16:505]

Paul-César Gibert, 1717–1787. *Deucalion et Pyrrha.* Opera (tragédie lyrique). Libretto, C. H. Watelet. First performed 29 Apr **1772,** Vauxhall de la Foire St. Germain, Paris. [Grove 1980, 7:361]

Johann Michael Demmler, 1748–1785. *Deukalion und Pyr-*

rha. Cantata. First performed **1774,** Augsburg. Lost. [Grove 1980, 5:362]

Heinrich Leopold Wagner, 1747–1779. *Prometheus, Deukalion und seine Recensenten* [Prometheus, Deucalion, and Their Critics]. Verse satire. In *Werke* (**1775**). [Trousson 1976, 1:245f., 2:505]

Ondřej František Holý, *c.*1747–1783. *Deukalion und Pyrrha.* Opera (melodrama). Libretto, K. E. Schubert. First performed *c.***1776,** Berlin. [Grove 1980, 8:668]

Friedrich August Clemens Werthes, 1748–1817. *Deukalion.* Lyric drama. **1777.** [Hunger 1959, p. 89]

Antonio Calegari, 1757–1828. *Deucalion e Pirra.* Opera (festa teatrale). Text, G. Sertor. First performed **1781,** private academy, Padua. [Grove 1980, 3:619]

Ferdinando Bertoni, 1725–1813. *Deucalione e Pirra.* Cantata. Text, Antonio Simeone Sografi. First performed 30 Sep **1786,** Casino d'Orfeo, Venice. [Grove 1980, 2:647 / DELI 1966–70, 5:155]

Franz Anton Maulbertsch, 1724–1796. "Allegory of the Sciences" (Deucalion and Pyrrha, throwing stones). Ceiling painting. **1794.** Strahov Foundation, Prague. [Garas 1960, no. 383, p. 155—ill.] Oil sketches. Národní Galeri, Prague; Stoner coll., London. [Ibid., nos. 381–82—ill.]

Franz Danzi, 1763–1826. *Deucalion et Pirrha.* Opera. First performed *c.***1795.** [Grove 1980, 5:235]

Giacomo Leopardi, 1798–1837. (Story of Deucalion and Pyrrha in) "Storia del genere umano" [History of Mankind]. Tale. **1824.** In *Operette morali* (Milan: Stella, 1827). [Cecchetti 1982]

A. Montfort. *Deucalion et Pyrrha.* Comic opera. Libretto, Michael Carré and Jules Barbier. First performed 8 Oct **1855,** L'Opéra-comique, Paris. [Clément & Larousse 1969, 1:313]

Bayard Taylor, 1825–1878. *Prince Deukalion.* Lyrical drama. Boston: Houghton, Osgood, **1878.** [Bush 1937, p. 580]

Margaret Junkin Preston, 1820–1897. "Prince Deucalion." Poem. In *Colonial Ballads, Sonnets, and Other Verse* (Boston: Houghton, Mifflin, **1887**). [Boswell 1982, p. 206]

Trumbull Stickney, 1874–1904. (Deucalion and Pyrrha evoked in) *Prometheus Pyrphoros* [Prometheus Fire-Bringer]. Verse drama. **1900.** In *Poems,* edited by George Cabot Lodge, William Vaughn Moody, and John Ellerton Lodge (Boston & New York: Houghton, Mifflin, 1905). [Bush 1937, p. 492]

William Vaughn Moody, 1869–1910. (Deucalion and Pyrrha in) *The Fire-Bringer.* Poetic drama. Boston: Houghton, Mifflin, **1904.** [Bush 1937, p. 494]

Hans José Rehfisch, 1891–1960. *Deukalion.* Drama. Berlin: Oesterheld, **1921.** [Kunisch 1965, p. 471]

Pablo Picasso, 1881–1973. "Deucalion and Pyrrha with One of Their Children." Etching, illustration for an edition of Ovid's *Metamorphoses* (Lausanne: Albert Skira, 1931). **1930.** [Goeppert et al. 1983, no. 19—ill. / Bloch 1971–79, no. 100—ill.]

Wilhelm Lehmann, 1882–1968. (Deucalion and Pyrrha evoked in postwar wasteland in) "Nach der Zweiten Sintflut" [After the Second Flood]. Poem. In *Noch Nicht Genug* (Tübingen: Heliopolis, **1950**). [Domandi 1972, 2:101] Translated by Babette Deutsch in *Modern German Poetry, 1910–1960* (New York: Grove, 1962; Evergreen edition, 1964). [Ipso]

DIANA. A Roman goddess of women and of the moon, whose functions and attributes were anciently mingled with those of the Greek goddess Artemis (protectress of the hunt, mistress of animals, and guardian of chastity) and Selene (goddess of the moon). *See* ARTEMIS; SELENE.

DIDO. The founder and queen of Carthage, Dido originally lived in the Phoenician city of Tyre, where she was known as Elissa. When her brother Pygmalion, king of Tyre, murdered her husband (and uncle) Sychaeus, Dido fled with a band of refugees, landing finally on the coast of Libya. There she negotiated with Iarbas, a North African prince, to buy a parcel of land. Offering to purchase as much land as could be encompassed by a bull's hide, she cut the skin into thin strips, which she tied together to encircle enough territory to build a city.

As the city of Carthage grew and prospered, Iarbas became alarmed at its potential strength and demanded marriage with Dido. The queen agreed to the match, but secretly had a pyre built and killed herself. In Virgil's account, Dido dies on the pyre for love of Aeneas.

Dido is most famous for her liaison with Aeneas, but her life before meeting the Trojan prince is also popular in literary, dramatic, and musical works.

Classical Sources. Naevius, *Punic War.* Virgil, *Aeneid* 1.335–69, 6.450–76.

See also AENEAS, and Dido, in the Underworld.

Dante Alighieri, 1265–1321. (Dido among the Lustful in) *Inferno* 5.61f. *c.*1307–*c.*1314? In *The Divine Comedy.* Poem. Foligno: Neumeister & Angelini, 1472. [Singleton 1970–75. vol. 1 / Bono 1984, pp. 52f.]

Francesco Petrarca, 1304–1374. (Dido celebrated in) *Il trionfo della Pudicizia* [The Triumph of Chastity] lines 154ff. Poem. 1340–44. In *Trionfi* (Bologna: Malpiglius, 1475). [Wilkins 1962 / Bezzola 1984]

Giovanni Boccaccio, 1313–1375. "De Didone regina Cartaginensium," "In laudem Didonis" [About Dido, Queen of Carthage; In Praise of Dido]. In *De casibus virorum illustrium* [The Fates of Illustrious Men] 2.10–11. Didactic poem in Latin. 1355–73? [Branca 1964–83, vol. 9 / Hall 1965]

———. "De Didone, seu Elissa, Cartaginensium regine" [Dido, or Elissa, Queen of Carthage]. In *De mulieribus claris* [Concerning Famous Women]. Latin verse compendium of myth and legend. 1361–75. Ulm: Zainer, 1473. [Branca, vol. 10 / Guarino 1963 / Bergin 1981, p. 250]

Geoffrey Chaucer, 1340?–1400. "The Legend of Dido." In *The Legend of Good Women.* Poem. 1385–86. Westminster: Caxton, *c.*1495. [Riverside 1987 / Hieatt 1975, p. 122]

Christine de Pizan, *c.*1364–*c.*1431. (Dido in) *Le livre de la Cité des Dames* [The Book of the City of Ladies] part 1 no. 46, part 2 no. 55. Didactic compendium in prose, reworking of Boccaccio's *De mulieribus claris.* 1405. [Hicks & Moreau 1986] Translated by Brian Anslay (London: Pepwell, 1521). [Richards 1982]

Sienese School. "The Story of Dido." **15th century.** Painting cycle. Musée du Petit Palais, Avignon (on deposit from Louvre, Paris, nos. M.I. 439–42). [Louvre 1979–86, 2:302]

Andrea Mantegna, 1430/31–**1506,** or studio. "Dido." Painting. Late work if autograph. Museum of Fine Arts Montreal, no. 104. [Lightbown 1986, no. 53—ill. / Berenson 1968, p. 240]

Venetian School. "Dido Dividing the Oxhide." Fresco. **16th century.** Villa Giusti, Magnadola de Cessalto (Treviso). [Warburg]

Thomas Heywood, 1573/74–1641. "Of Dido." Passage in *Gynaikeion: or, Nine Books of Various History Concerning Women* book 3. Compendium of history and mythology. London: printed by Adam Islip, **1624.** [Ipso]

Rembrandt van Rijn, 1606–1669. "Dido Has Cut the Oxhide When Founding the City of Carthage" (? or "King Solomon and the Queen of Sheba"?). Drawing. *c.*1640–41. Norton Simon Museum of Art, Fullerton, Calif. [Benesch 1973, no. 490—ill.]

François le Metel de Boisrobert, 1592–1662. *La vraye Didon, ou, La Didon chaste.* Tragedy. First performed late **1641,** Paris. Published Paris: Quinet, 1643. [Barnwell 1982, pp. 44ff., 65, 74, 253 / Lancaster 1929–42, pt. 2, 1:346–48, 2:779]

Jacob Jordaens, 1593–1678. "Dido and Iarbas." Design for "Famous Women" tapestry series. Designs and tapestries lost. [d'Hulst 1982, p. 305]

Gilbert de Sève, 1615–1698. "Dido Building Carthage." Painting, for Chambre de Marie-Thérèse, Versailles. **1671–80.** Louvre, Paris, inv. 7321 and 8769. [Louvre 1979–86, 4:213—ill.] Another version of the subject, for Salon d'Apollon (Chambre de la Reine), Appartement de la Reine, destroyed in renovation, *c.*1678–79. [Berger 1985, pp. 41ff., 70]

Johann Friedrich Fasch, 1688–1758. *Die getreue Dido* [The Faithful Dido]. Opera. First performed 1712, Naumburg. [Grove 1980, 6:414]

Giovanni Battista Pittoni, 1687–1767. "Dido Founding Carthage." Painting. *c.*1720. Hermitage, Leningrad, inv. 241. [Zava Boccazzi 1979, no. 77—ill.]

Victor Honoré Janssens, 1658–1736. "Dido Building Carthage." Painting. Musées Royaux des Beaux-Arts (Musée d'Art Ancien), Brussels, inv. 115. [Brussels 1984a, p. 154—ill.]

Giovanni Paolo Panini, 1691–1765. "Dido Finds the Skull of a Horse." Painting. Galleria Sabauda, Turin. [Bénézit 1976, 8:109]

Francesco Fontebasso, 1709–1768/69. "Dido Dividing the Oxhide." Drawing. Albertina, Vienna, inv. 1877. [Pigler 1974, p. 314 / Warburg]

Angelica Kauffmann, 1741–1807. "Dido." Painting. Exhibited **1777.** [Manners & Williamson, pp. 45, 237] Print by Delattre and Bartollozzi, 1780. [Ibid., p. 224]

Joseph Mallord William Turner, 1775–1851. "Dido Building Carthage" ("The Rise of the Carthaginian Empire"). Painting. **1815.** National Gallery, London, no. 498.

[Butlin & Joll, no. 131—ill. / London 1986, p. 629—ill. / Schulz 1985, pp. 208f.] Copy in Museum of Fine Arts, Boston, no. 17.3252. [Boston 1985, p. 284—ill.]

———. "Dido Directing the Equipment of the Fleet" ("The Morning of the Carthaginian Empire"). Painting. Exhibited 1828. Tate Gallery, London, no. 506. [Butlin & Joll, no. 241—ill.]

August von Platen-Hallermünde, 1796–**1835.** *Gründung Karthagos* [The Founding of Carthage]. Epic. [Hunger 1959, p. 90]

Edward Burne-Jones, 1833–1898. "Dido." 2 decorative tiles, based on Chaucer's *Legend of Good Women* (1385–86). **1861.** Ashmolean Museum, Oxford. [Harrison & Waters 1973, p. 69—ill.]

———. "Dido." Drawing with watercolor. 1861. Tate Gallery, London, no. 4354. [Tate 1975, p. 16]

———. "Dido." Stained-glass panel, part of "Chaucer's Good Women" series. Designed 1864, executed by William Morris & Co. Peterhouse College, Oxford. [Harrison & Waters , p. 187f.]

John Atkinson Grimshaw, 1836–1893. "Dido." Painting. By **early 1870s.** [Kestner 1989, p. 304]

Alois Ausserer, 1876–1950. *Dido, die Gründerin von Karthago* [Dido, Founder of Carthage]. Tragedy. Innsbruck: Wagner, **1912.** [DLL 1968–90, 1:191]

César Klein, 1876–1954. "Dido." Painting. **1947.** [Pfefferkorn 1962, p. 31]

Barry Moser, 1940–. "Dido." Drawing, illustration for edition of Dante's *Inferno* (Berkeley & Los Angeles: University of California Press, **1980**). [Ipso]

DIOMEDES. The son of Tydeus, Diomedes was a warrior who marched on Thebes with the Epigoni (sons of the Seven against Thebes) to avenge their fathers' deaths. He had been a suitor of Helen and led eighty ships to Troy after her abduction by Paris. At Troy, under the protection of Athena (Minerva), Diomedes proved himself second in courage only to Achilles. In one day of fighting, he killed Pandarus, seriously wounded Aeneas, and even injured Aphrodite (Venus) when the goddess interceded to save her son. When Ares, in turn, made for Diomedes, he too was wounded when the hero caught the war god's own spear and turned it against him. Diomedes was later punished for his assault by Aphrodite, who caused his wife to be unfaithful.

Like his ally Odysseus (Ulysses), Diomedes was a man of cunning, but he was also known for his honor. When he and Glaucus, grandson of Bellerophon, met in single combat and discovered that their grandfathers had been friends, the two exchanged armor rather than fight. Diomedes also aided Nestor when his horses were killed on the field. Nestor then joined him in an attack on Hector, which was prevented by a thunderbolt from Zeus.

Among Diomedes' most celebrated adventures in the Trojan War were his two forays into the Trojan camp with Odysseus. On the first raid they killed the Trojan spy Dolon and the Thracian king Rhesus and captured Rhesus's horses. They were later sent to capture the Palladium, the image of Athena that was thought to protect the city of Troy. Disguised as beggars, they stole into the citadel and made off with the small statue, thus setting the stage for the fall of Troy. According to some accounts, Diomedes entered the city alone, but on the way back to the Greek camp Odysseus, wishing to take credit for stealing the Palladium himself, made as if to kill Diomedes and was given a humiliating beating.

According to some sources, Diomedes was one of the few Greek commanders to enjoy an uneventful journey home from Troy; others say that he wandered about the Mediterranean, particularly in Italy, where he founded numerous towns, and was buried on the islands of Diomedes.

Classical Sources. Homer, *Iliad* 2.559–68, 4.365ff., 5 passim, 6.119–236, 10.219–579, and passim; *Odyssey* 3.180ff. Euripides, *Rhesus.* Virgil, *Aeneid* 2.162–94. Ovid, *Metamorphoses* 14.450–519. Apollodorus, *Biblioteca* 1.8.6ff., 3.7.2f., 3.10.8, 3.12.3, E4.2, E5.10–13. Pausanias, *Description of Greece* 1.28.8ff., 2.23.5, 10.31.1. Hyginus, *Fabulae* 97, 98, 102, 108, 113, 175.

See also TROILUS AND CRESSIDA; TROJAN WAR.

Dante Alighieri, 1265–1321. (Diomedes and Ulysses, burned together in a perpetual flame, among the counselors of evil in) *Inferno* 26.55–63. *c.*1307–*c.*1314? In *The Divine Comedy.* Poem. Foligno: Neumeister & Angelini, 1472. [Singleton 1970–75, vol. 1]

Giovanni Boccaccio, 1313–1375. (Diomedes, companion of Ulysses in) *Teseida* 6.44; 7.17, 103, 120; 8.19, 26, 29–30; 9.46. Poem. *c.*1340–42. [Branca 1964–83, vol. 2 / McCoy 1974]

Sandro Botticelli, 1445–1510. Drawing, depicting Diomedes and Ulysses in a flame, illustrating *Inferno* 26, part of series of illustrations to Dante's *Divine Comedy.* **1480s/ early 1490s.** Kupferstichkabinett, Berlin-Dahlem. [Lightbown 1978, 1:147ff., 2:172f., no. E39—ill.]

Franco-Flemish School. "Ulysses and Diomedes Discuss Peace with Priam while Antenor Arranges for the Theft" (of the Palladium). Right side of a tapestry. **Late 15th century.** Duke of Alba coll., Madrid. / Drawing. *c.*1472? Louvre, Paris. [Scherer 1963, p. 242]

Flemish School. "Ulysses and Diomedes Sue for Helen's Return with Priam," "The Theft of the Palladium." Tapestries. *c.*1515–25. Royal Ontario Museum, Toronto. [Scherer 1963, p. 245]

Giulio Romano, *c.*1499–1546, assistants, after designs by Giulio. Frescos depicting the story of Diomedes, part of "Troy" cycle. **1538–39.** Sala di Troia, Palazzo Ducale, Mantua. [Hartt 1958, pp. 179ff.—ill.]

Garofalo, *c.*1481–**1559.** "Venus and Mars before Troy" (Venus begging Mars for help after being wounded by Diomedes?). Painting. Gemäldegalerie, Dresden, no. 135. [Berenson 1968, p. 153]

Venetian School. "Diomedes." Drawing. **Late 16th century.** Musée Bonnat, Bayonne, no. 1277v. [Warburg]

Francis Bacon, 1561–1626. "Diomedes, sive zelus," chapter 18 of *De sapientia veterum*. Mythological compendium. London: Barker, **1609.** / Translated as "Diomedes, or Zeale" by Arthur Gorges in *The Wisdome of the Ancients* (London: Bill, 1619). Modern facsimile edition (bilingual), New York & London: Garland, 1976. [Ipso]

Thomas Heywood, 1573/74–1641. "King Diomed." Episode in *The Iron Age* part 2. Play, fourth in a cycle dramatizing Heywood's *Troia Britanica* (*c*.1609). First performed *c*.1612–13, London. Published London: Okes, 1632. [Heywood 1874, vol. 3 / Clark 1931, p. 64]

Johann Carl Loth, 1632–1698, attributed. "Aphrodite before Zeus" (complaining of Diomedes). Painting. Hermitage, Leningrad, inv. 10117. [Hermitage 1987b, no. 53—ill.]

Thomas Bertin de La Doué, *c*.1680–1745. *Diomède* (ruling in Rutulia after his return from Troy). Opera. Libretto, Jean-Louis-Ignace de La Serre. First performed 28 Apr **1710,** Académie Royale de Musique, Paris. [Girdlestone 1972, pp. 182 *n*., 238 *n*., 240]

Casimir Schweizelsperg, 1668–after 1722. *Diomedes.* Opera. First performed **1717,** Durlach. [Grove 1980, 17:47]

Gottfried Heinrich Stölzel, 1690–1749. *Diomedes.* Opera. First performed **1718,** Bayreuth. [Grove 1980, 18:175]

Lorenzo Gibelli, *c*.1719–1812. *Diomede.* Pasticcio opera. First performed **1741,** S. Giovanni, Persiceto. [Grove 1980, 7:361]

Gabriel-François Doyen, 1726–1806. "Venus Wounded by Diomedes." Painting. *c*.**1761.** Hermitage, Leningrad, inv. 5811. [Hermitage 1986, no. 41—ill.]

Johan Tobias Sergel, 1740–1814. "Diomedes." Marble statue. **1774.** Nationalmuseum, Stockholm. [Cologne 1977, pp. 131, 158—ill. / Hartmann 1979, pl. 13.2 / also 1921, no. 25] Plaster model. 1771. Konstakademien, Stockholm. [Göthe, no. 24—ill.] Terra-cotta sketch and model. Nationalmuseum, Stockholm, nos. 455, 495. [Ibid., nos. 22, 23—ill. / also Janson 1985, pp. 31f.—ill.]

Jacques-Louis David, 1748–1825. "The Battles of Diomedes." Frieze drawing. **1776.** Albertina, Vienna. [Schnapper 1982, p. 40]

———. "Wounded Venus Complaining to Jupiter." Drawing. 1812. Louvre, Paris. [Ibid., p. 260]

John Flaxman, 1755–1826. "Dante and Virgil Arriving at the Valley Where Ulysses and Diomedes Are Punished." Drawing, part of series illustrating Dante's *Inferno*. *c*.**1792.** Houghton Library, Harvard University, Cambridge. / Engraved by Tomasso Piroli, published privately, Rome: 1793; London: Longman & Co., 1807. [Irwin 1979, pp. 94, 226 *n*.41 / Flaxman 1872, 4: pl. 28]

Benjamin West, 1738–1820. "Diomedes and His Horses Stopped [from killing Hector] by the Lightning of Jupiter." Painting. **1793.** Sold New York, 1930. [von Erffa & Staley 1986, no. 168—ill.] Related drawing, 1788. Museum of Fine Arts, Boston. [Ibid.]

Antoine François Callet, 1741–1823. "Venus Wounded by Diomedes." Painting. Exhibited **1795.** Louvre, Paris, inv. 3098. [Louvre 1979–86, 3:94—ill.]

Philipp Otto Runge, 1777–1810. "Diomedes, Ulysses, and Pallas Athena." "Diomedes and Odysseus Surprise Rhesus," "Diomedes and Odysseus [led by Athena] Steal into the Greek [*sic*] Camp." Drawings, part of a cycle illustrating Homer. **1800.** Kunsthalle, Hamburg, nos. 34243–44. [Hamburg 1977, nos. 42–43—ill. / also Bindman 1979, no. 249—ill.]

Jean-Auguste-Dominique Ingres, 1780–1867. "Venus Wounded by Diomedes (Returns to Olympus)." Painting. **1805–06.** Kunstmuseum, Basel (ex-Baron von Hirsch). [Bindman 1979, no. 224—ill. / also Wildenstein 1954, no. 28—ill. / Vermeule 1964, pp. 148, 171]

Walter Savage Landor, 1775–1864. (Diomedes, after his return from Troy, meets Ulysses on his last voyage in) "Ulysses in Argirippa." Latin idyll. In *Idyllia heroica* (Pisa: **1820**). / Translated by the author as "The Last of Ulysses" in *Hellenics* (London: Moxon, 1847). [Wheeler 1937, vol. 2 / Boswell 1982, p. 155]

William Blake, 1757–1827. "Ulysses and Diomed Swathed in the Same Flame." Watercolor, illustrating *Inferno* 26, part of a series of illustrations to Dante's *Divine Comedy.* **1824–27.** National Gallery of Victoria, Melbourne. [Butlin 1981, no. 812.55]

Nicolas Gosse, 1787–1878, and **Auguste Vinchon,** 1789–1855. "Diomedes Wounds Venus." Painting (simulated grisaille bas-relief), part of series of 8 Homeric scenes. Commissioned **1827.** Louvre, Paris, inv. 8475. [Louvre 1979–86, 3:285—ill.]

Maurice Reinhold von Stern, 1860–1938. *Diomed.* Tragedy. Leipzig: Verlag des Literarischen Bülletin, **1899.** [Hunger 1959, p. 92]

Joseph-Paul Blanc, 1846–1904. "The Theft of the Palladium." Painting. Musée, Angers. [Bénézit 1976, 2:65]

Giorgio de Chirico, 1888–1978. "Diomedes." Drawing. **1920.** M. F. coll., Rome. [de Chirico 1971–83, 4.1: no. 268—ill.]

———. "Glaucus Reconciled with Diomedes." Watercolor, part of "Iliad" series. 1967. Galleria Gissi, Turin. [Ibid., 5.3: no. 724—ill.]

T. S. Eliot, 1888–1965. (Ulysses and Diomedes encased in flame, from Dante, evoked in) *The Waste Land.* Poem. **1922.** This passage included in the original manuscript, deleted in revision by Ezra Pound, not in the published version. MS in Berg coll., New York Public Library. [Kenner 1964, pp. 146f., 172f.]

Michael Roberts, 1902–1948. "Diomed, Diomed." Poem. In *Collected Poems* (London: Faber & Faber, 1958). [Boswell 1982, p. 286]

Siegfried Trebitsch, 1869–1956. *Die Heimkehr des Diomedes* [The Homecoming of Diomedes] (on returning from Troy to Argos, Diomedes finds his wife in adultery). Novel. Zurich: Artemis, **1949;** drawings by Hans Erni. [Wilpert 1963, p. 587]

Jan Cox, 1919–1980. "The Spy Dolon Decapitated." Painting, part of "Iliad" series. **1975.** Musées Royaux des Beaux-Arts (Musée d'Art Moderne), Brussels, inv. 8695. [Brussels 1984b, pp. 142f.—ill.]

DIONYSUS. The youngest of the twelve Olympian deities, Dionysus was the son of Zeus (Jupiter) and Theban King Cadmus's daughter Semele. He

was the god of wine and mystic ecstasy. Dionysus appears on Linear B tablets, suggesting that he was worshiped even in Mycenaean times (c. 1580–1120 BCE). The Dionysiac cult was widespread in Thrace and Macedonia and may have been brought to Attica from these northern areas. Some ancient authors, however, attribute its origins to Phrygian roots; the name Bacchus, by which the god was known even to the Greeks, is thought to have come from Lydia.

Among Dionysus's epithets are "bull" and "bull-horned"; the bull mask is a common attribute of the god. He is also recognized as a god of fertility, especially for fruits of the tree and vine (hence his close association with grapes and wine), and thus he is often accompanied by sileni and satyrs with distended phalluses. Dionysus is often described as the god of the irrational, in contrast to the rational Apollo.

On reaching manhood and discovering wine, Dionysus was driven mad by Hera, to roam through Egypt and Syria. When he reached Phrygia, Cybele welcomed him and cured his madness. In Thrace Lycurgus tried to imprison him, along with his women followers (maenads), but Thetis hid him beneath the sea; Lycurgus was finally drawn and quartered by his own subjects.

Dionysus traveled to India, where he conquered as a god driven by panthers and bedecked in ivy. Returning to Greece and Thebes, he introduced the Dionysia (Bacchanalia), rites marked by frenzied dancing and revelry. This ceremony was responsible for the gruesome death of Pentheus at the hands of Agave, his maddened mother.

The Bacchus of Roman mythology is borrowed almost entirely from the Greek tradition. A native Italian wine god, Liber, was worshiped in Republican Rome, with a temple dedicated to him (along with Libera and Ceres, goddesses of agriculture). Bacchus, however, was an almost entirely Hellenized deity whose rites, including the Bacchanalia, owed more to Dionysus than to Liber.

Dionysus is a common figure in ancient Greek vase painting from the sixth century BCE onward. He is shown with grape vines or drinking wine, either alone or with satyrs and maenads (bacchantes). Post-classical representations focus greatly on his role as wine god, with scenes involving barrels of wine and revelers. He is also seen as a personification of autumn (the harvest) and of vice combatted by virtue.

Classical Sources. Homer, *Iliad* 6.130–43. Hesiod, *Theogony* 940–42. *Homeric Hymns,* first, second, and third hymns "To Dionysus." Alkaios of Mytilene, *Hymn to Dionysus* (fragment). Euripides, *The Bacchae. Orphic Hymns*

30, 45–54, "To Dionysus," etc. Aristophanes, *The Frogs.* Diodorus Siculus, *Biblioteca* 3.67–70, 4.2–5, 5.75.4–5. Horace, *Odes* 2.19. Ovid, *Ars amatoria* 1.537ff.; *Metamorphoses* 3.259–315, 3.513–733, 4.1–41, 11.67–84, 11.85–145. Apollodorus, *Biblioteca* 3.4.1–5.3. Hyginus, *Fabulae* 2, 4, 129, 132, 134, 167, 179, 191. Lucian, *Dialogues of the Gods* 3, "Apollo and Dionysus," 6, "Eros and Zeus," 12, "Poseidon and Hermes," 22, "Hera and Zeus." Nonnus, *Dionysiaca.*

Listings are arranged under the following headings:
> General List
> Infancy
> Dionysus and the Pirates
> Dionysus and Ariadne

See also APHRODITE, Venus Frigida; BACCHANALIA; ERIGONE; GODS AND GODDESSES; MIDAS; PAN; PENTHEUS; SATYRS AND FAUNS; SEMELE; SILENUS; TITANS AND GIANTS.

General List

John Gower, 1330?–1408. (Bacchus described in) *Confessio amantis* 5.1043–1058. Poem. *c.*1390. Westminster: Caxton, 1483. [Macaulay 1899–1902, vol. 2]

Christine de Pizan, *c.*1364–*c.*1431. (Bacchus, representing the sin of gluttony, evoked in) *L'epistre d'Othéa à Hector* . . . [The Epistle of Othéa to Hector] chapter 21. Didactic romance in prose. *c.*1400. MSS in British Library, London; Bibliothèque Nationale, Paris; elsewhere. / Translated by Stephen Scrope (London: *c.*1444–50). [Bühler 1970 / Hindman 1986, pp. 90, 196]

Jacopo Bellini, *c.*1400–*c.*1470. "Triumph of Bacchus." Drawing. *c.*1430. Sketchbook, Louvre, Paris. [Wind 1948, p. 33, fig. 50]

———. "Triumph of Bacchus." Pair of drawings. Sketchbook, fols. 92–93, British Museum, London. [Humfrey 1983, fig. IVa]

Michelangelo, 1475–1564. "Bacchus" (and satyr). Marble statue. **1496–97.** Museo del Bargello, Florence. [Baldini 1982, no. 13—ill. / Goldscheider 1964, p. 9—ill. / Pope-Hennessy 1985b, 3:306ff., 452—ill. / Berenson 1963, p. 148 / Vermeule 1964, p. 6]

Alexander Agricola, *c.*1446–**1506.** "Arce sedet Bacchus" [Bacchus Seated on a Barrel]. Motet. [Grove 1980, 1:163]

Andrea Mantegna, 1430/31–**1506,** and **Lorenzo Costa,** *c.*1460–1535 (begun by Mantegna, completed by Costa after Mantegna's death). (Bacchus in) "The Reign of Comus" ("The Gate of Comus"). Painting. Louvre, Paris, inv. 256. [Louvre 1979–86, 2:169—ill. / Lightbown 1986, no. 41—ill. / Louvre 1975, no. 128—ill. / Wind 1948, pp. 46f., fig. 59]

Cima da Conegliano, *c.*1459–1517/18. "Triumph of Bacchus." Painting. *c.*1505–10. Fragments ("Silenus," "A Satyr," "Bacchic Faun") in Philadelphia Museum of Art, nos. 177–78 (Silenus, Satyr); private coll., Paris (Faun). [Humfrey 1983, nos. 117, 123—ill.]

Sandro Botticelli, 1445–1510. "Bacchus Drinking from a Barrel." Painting. Formerly Medici coll., Florence, lost. [Lightbown 1978, no. G6—ill.]

Baldassare Peruzzi, 1481–1536, circle (? also attributed to school of Giulio Romano or Raphael). "Triumph of Bacchus." Fresco. **1511–12** (or *c.*1517–18). Sala delle Prospettive, Villa Farnesina, Rome. [d'Ancona 1955, pp.

27ff., 93f. / Gerlini 1949, pp. 31ff. / Frommel 1967–68, no. 51—ill.; cf. no. 52]

Jacopo Sansovino, 1486–1570. "Bacchus." Marble statue. **1511–12.** Museo del Bargello, Florence. [Pope-Hennessy 1985b, 3:351f.—ill. / Pope-Hennessy 1985a, fig. 84]

———. "Bacchus and a Young Faun." Bronze sculpture group. National Gallery, Washington, D.C., no. A–22. [Sienkewicz 1983, p. 31—ill.]

Italian School. "Bacchus and Pan." Ceiling fresco. **1508–13?** Sala delle Nozze di Alessandro con Rossana, Villa Farnesina, Rome. [Gerlini 1949, pp. 34ff.]

Pinturicchio, 1454–1513. "Bacchus." Ceiling fresco (detached), from Palazzo Pandolfo Petrucci ("Il Magnifico"), Siena. Metropolitan Museum, New York, no. 14.114.16. [Berenson 1968, p. 345—ill.]

Leonardo da Vinci, 1452–1519, studio (formerly attributed to Leonardo). "Bacchus." Painting, after design by Leonardo. *c.*1511–15. (Originally executed as depicting John the Baptist, altered to represent Bacchus, late 17th century.) Louvre, Paris, inv. 780. [Louvre 1979–86, 2:192—ill. / Ottino della Chiesa 1969, no. 36—ill.]

Raphael, 1483–1520. "Triumph of Bacchus." Drawing. By **1517.** Lost. / Painting after, by Garofalo (*c.*1481–1519). / Fresco after, attributed to Girolamo da Carpi (1501–1556). / Print (after drawing by Giulio Romano? after original) by Conrad Martin Metz (1749–1827). [Jones & Penny 1983, pp. 175ff.—ill.] *See also Peruzzi, above.*

Giovanni Francesco Penni, 1488–1528. (Bacchus in) "The Vintage." Drawing. Leo Steinberg coll. / Engraving after (Bartsch no. 306), by Marcantonio Raimondi, *c.*1517–20. [Shoemaker 1981, no. 38—ill. / Bartsch 1978, 26:305—ill.]

Rosso Fiorentino, 1494–1540. "Bacchus in a Niche." Design (lost) for engraving, part of "Gods in Niches" series, executed by Gian Jacopo Caraglio (Bartsch no. 40). **1526.** [Carroll 1987, no. 37—ill. / Paris 1972, no. 202—ill.]

Marco Dente da Ravenna, ?–1527. "Bacchus" (simulated statue in a niche). Engraving (Bartsch 14:232 no. 308). [Bartsch 1978, 26:307—ill.]

Giulio Romano, *c.*1499–1546, and assistant. "Drunken Dionysus [or Silenus] (Put to Bed by Nymphs and Satyrs)." Fresco. **1527–28.** Sala di Ovidio (Metamorfosi), Palazzo del Tè, Mantua. [Verheyen 1977, p. 110 / Hartt 1958, p. 111—ill.] *See also Peruzzi, Raphael above.*

Albrecht Altdorfer, *c.*1480–1538, circle (previously attributed to Altdorfer). "The Rule of Bacchus." Painting, part of triptych "The Fall of Man." *c.*1520s? Kress coll. (K1849A), National Gallery, Washington, D.C., no. 1110. [Eisler 1977, pp. 33–35—ill.]

Lucas Cranach, 1472–1553. "Bacchus at the Wine Tub." Painting. **1530.** Private coll., Switzerland. [Friedländer & Rosenberg 1978, no. 260—ill.]

Dosso Dossi, *c.*1479–1542. "Bacchus." Painting. Galleria Estense, Modena. [McGraw-Hill 1969, 2:278]

Maerten van Heemskerck, 1498–1574. "Triumph of Bacchus." Painting. Before **1543.** Kunsthistorisches Museum, Vienna, inv. 990 (as "Triumph of Silenus"). [Grosshans 1980, no. 24—ill.]

Daniele da Volterra, 1509–1566. Frescoed frieze depicting scenes from the life of Bacchus and other Bacchic scenes. *c.*1548–50. Palazzo Farnese, Rome. [Barolsky 1979, no. 12—ill.]

Léonard Thiry, 1500–1550, composition. "Bacchus." Engraving, executed by René Boyvin. (Musée des Beaux-Arts, Rennes.) [Lévêque 1984, p. 34—ill.]

Agnolo Bronzino, 1503–1572 (or copy after?). "Portrait of Nano Morgante (as Bacchus)." 2 paintings on 1 canvas. Before **1553.** Uffizi, Florence. [Baccheschi 1973, no. 163—ill.]

Giorgio Vasari, 1511–1574. "Bacchus." Decoration for Villa Giulia, Rome. **1553.** Lost. / 3 drawings. Uffizi, Florence, nos. 620F, 641F; Louvre, Paris, no. 2157. [Barocchi 1964, p. 133—ill.]

Pierre de Ronsard, 1524–1585. "L'hinne de Bacus à Jan Brinon" [The Hymn of Bacchus to Jan Brinon]. Poem. **1554.** In *Les meslanges* (Paris: Corrozet, 1555). [Laumonier 1914–75, vol. 6 / Cave 1973, pp. 173 *n.*, 186, 192f. / McFarlane 1973, p. 71]

———. (Triumph of Bacchus in) "L'hymne de l'automne." Poem, hymn. In *Les trois livres du recueil des nouvelles poésies* book 1 (Paris: Buon, 1563). [Laumonier, vol. 12 / McGowan 1985, pp. 148–50, 236f. / Cave, pp. 156–58]

Matteo Balducci, ?–1555? "Triumph of Bacchus." Painting. Palazzo dei Consoli, Gubbio, no. 35. [Berenson 1968, p. 24—ill.]

Camillo Filippi, *c.*1500–1574, attributed. "Triumph of Bacchus." Fresco. *c.*1555. Camerino dei Baccanali, Castello Estense, Ferrara. [Arcangeli 1963, no. 29—ill.]

Francesco Primaticcio, 1504–1570, design. "Bacchanal" (Bacchus, Hebe, fauns, and satyrs), "Bacchus" (2). Frescoes, for Salle de Bal, Château de Fontainebleau, executed by Niccolò dell' Abbate under Primaticcio's direction. **1551–56.** Repainted 19th century. [Dimier 1900, pp. 160ff., 284ff.] / Drawing for "Bacchanal." Château de Chantilly. [Ibid., no. 125]

———. "Bacchus and Thetis" (Bacchus, pursued by Lycurgus, king of Thrace, given refuge by Thetis; previously wrongly called "Bacchus and Naiads"). Fresco, for Salle de Bal, Château de Fontainebleau, executed by Niccolò dell' Abbate under Primaticcio's direction. 1551–56. Repainted 19th century. / Drawing for. British Museum, London, no. 1946–7–13–47. [Paris 1972, no. 166—ill.]

———, design. "Bacchus." Tapestry fragment, part of "The Gods' Arabesques." 1547–59. Musée des Tissues, Lyon. [Dimier 1900, pp. 384ff.]

Niccolò dell' Abbate, 1509/12–1571?, attributed. (Bacchus in) "Ceres and the Gods." Drawing. *c.*1552–56. Musée Pincé, Angers. [Paris 1972, no. 12—ill. / also Lévêque 1984, p. 195—ill.]

———. *See also Primaticcio, above.*

Paolo Veronese, 1528–1588. "Bacchus and Apollo." Fresco. *c.*1557. Palazzo Trevisan, Murano. [Pallucchini 1984, no. 36c—ill. / Pignatti 1976, no. 66—ill.]

———. Fresco cycle, celebrating Bacchus and wine: "Allegory of Bacchus" (with the Lares, Sleep, and Terpsichore, bringing wine to mankind) and others. *c.*1560–61. Stanza di Bacco, Villa Barbaro-Volpi, Maser (Treviso). [Pallucchini, no. 60—ill. / Pignatti, no. 98—ill.]

Giovanni Bernardi, 1496–1553, and **Manno di Bastiano,** design. (Statuette of Bacchus at corner of) "The Farnese Coffer." Silver gilt coffer. **1548–61.** Museo di Capodimonte, Naples, no. 10507. [Capodimonte 1964, p. 129]

Giambologna, 1529–1608, attributed. "Bacchus." Bronze statue. Before **1562.** Borgo San Jacopo, Florence. [Avery 1987, no. 29—ill. / Pope-Hennessy 1985b, 3:381—ill.]

———. "Bacchus." Bronze figurine. 1560s/70s. Herzog Anton Ulrich-Museum, Braunschweig, no. Bro.114; Museum für Kunst und Gewerbe, Hamburg, no. 1950.76. [Avery & Radcliffe 1978, no. 39—ill.]

———. "Morgante [court dwarf to the Medici] as Bacchus." Bronze figurine. c.1580. Museo del Bargello, Florence. [Avery, no. 115—ill.]

Alessandro Vittoria, 1525–1608, studio. Figure of Bacchus atop bronze andiron. **Early 1560s?** Formerly Estensiche Kunstsammlung, Vienna. [Cessi 1960, p. 49, pl. 25]

Paris Bordone, 1500–**1571.** "Venus, Cupid, Bacchus, and Diana." Painting. Formerly Chiesa coll., Milan, sold New York, 1927. [Canova 1964, pp. 119f.—ill.]

Benvenuto Cellini, 1500–**1571.** "Bacchus." Wax statuette. Mezzanine, Palazzo Vecchio, Florence. [Sinibaldi 1950, pp. 28, 61—ill.]

Luís Vaz de Camões, 1524?–1580. (Bacchus, spirit of India and the East, opposes Venus in) *Os Lusíadas* [The Sons of Lusus]. Epic. Lisbon: Gonçalvez, **1572.** / Translated by Sir Richard Fanshawe (Cambridge: Harvard University Press, 1940). [EW 1983–85, 2:761ff.]

Jacopo Bertoia, 1544–**1574.** "Bacchus with a Baby Satyr." Painting. Christ Church, Oxford. [Byam Shaw 1967, no. 170—ill.]

Battista Zelotti, c.1526–**1578.** Cycle of frescoes depicting stories of Bacchus. After 1561. Villa Foscari, Malcontenta, Venice. [Berenson 1957, p. 204]

Andrea Boscoli, c.1560–1607. "Triumph of Bacchus." Drawing. **1582.** Gabinetto Disegni e Stampe, Uffizi, Florence, no. 2251S. [Florence 1986, no. 2.35—ill.]

———. "Triumph of Bacchus." Painting. Late 1590s. Lost. / 2 drawings. Florence, no. 790F; Andrews coll., Edinburgh. [Florence 1986, no. 2.49—ill.]

Luca Cambiaso, 1527–**1585.** "Bacchus." Marble statue. Formerly Casa Battista della Torre, Genoa, lost. / Drawing (for?). Ashmolean Museum, Oxford. [Manning & Suida 1958, p. 99—ill.]

Edmund Spenser, 1552?–1599. (Bacchus evoked in) *The Faerie Queene* 3.1.43, 5.1.2. Romance epic. London: Ponsonbie, **1590,** 1596. [Hamilton 1977]

Annibale Carracci, 1560–1609. "Bacchus." Painting. *c.***1590–91.** Galleria di Capodimonte, Naples, no. 359. [Malafarina 1976, no. 55—ill. / Capodimonte 1964, p. 359]

———. "Youthful Bacchus." Painting. City Art Gallery, Leicester. [Wright 1976, p. 34]

Hendrik Goltzius, 1558–1617. "Bacchus." Engraving, in "Eight Deities" series, after (lost) chiaroscuro frescoes by Polidoro da Caravaggio (c.1498–1543). **1592.** 4 states. [Strauss 1977a, no. 295—ill. / Bartsch 1980–82, no. 255—ill.]

———. "Bacchus." Woodcut. c.1594. 2 states. [Strauss, no. 417—ill. / Bartsch 1980–82, no. 228—ill.]

———. "Bacchus in Half-length." Engraving, part of "Three Deities in Half-length" series (Bartsch no. 65, Jan Saenredam). c.1596. [Strauss 1977a, no. 336—ill. / Bartsch 1980–82, no. 160d—ill.]

———. "Bacchus." Drawing. 1597. Art Museum, Princeton University, N.J. [Reznicek 1961, no. 114—ill.]

———. "Bacchus with a Young Faun." Drawing. c.1600. Albertina, Vienna. [Ibid., no. 115—ill.]

———. "Bacchus." Painting. Bibliotheek, Rijksuniversiteit, Utrecht. [de Bosque 1985, pp. 170, 172—ill.]

———. "Bacchus." Drawing. Bibliothèque Royale, Brussels. [Ibid., p. 174—ill.]

Michelangelo da Caravaggio, 1571–1610. "Self-portrait as Bacchus" ("Bacchino Malato"). Painting. Dated variously *c.***1589–93.** Galleria Borghese, Rome, inv. 534. [Hibbard 1983, fig. 9 / Pergola 1955–59, 2: no. 112—ill.]

———. "Bacchus." Painting. Dated variously c.1589, c.1595–96. Uffizi, Florence, inv. 5312. [Hibbard, fig. 22 / Uffizi 1979, no. P358—ill.]

Bartholomeus Spranger, 1546–1611. "Bacchus and Venus." Painting. **1597?** Niedersächsische Landesgalerie, Hannover. [de Bosque 1985, pp. 169, 171—ill.]

———. "Triumph of Bacchus." Drawing. Louvre, Paris. [Ibid., pp. 170, 172—ill.]

Friedrich Sustris, c.1540–**1599.** "The Procession of Bacchus." Drawing. Louvre, Paris. [de Bosque 1985, pp. 170, 173—ill.]

Hans von Aachen, 1552–1616. "Bacchus, Ceres, and Cupid." Painting. *c.***1600.** Kunsthistorisches Museum, Vienna, inv. 1098 (1509). [Hofmann 1987, no. 3.25—ill. / Vienna 1973, p. 2—ill.]

———. "Bacchus, Venus, and Cupid." Painting. Vienna, inv. 1132 (1512). [Vienna, p. 3—ill.]

Netherlandish or German School. "Bacchus and a Satyr." Painting. *c.***1600.** Szépmüvészeti Múzeum, Budapest, no. 996. [Budapest 1968, p. 489]

Maerten de Vos, 1532–**1603.** "Bacchus on a Barrel." Drawing. Private coll., Paris. [Warburg]

Cornelis Cornelisz van Haarlem, 1562–1638. "Bacchus and a Satyr." Painting. **1608.** Museum Boymans-van Beuningen, Rotterdam, cat. 1962 no. 1268. [de Bosque 1985, pp. 92, 170—ill. / Wright 1980, p. 82]

Francis Bacon, 1561–1626. "Dionysus, sive cupiditas." Chapter 24 of *De sapientia veterum*. Mythological compendium. London: Barker, **1609.** / Translated as "Dionysus, or Passions" by Arthur Gorges in *The Wisdome of the Ancients* (London: Bill, 1619). Modern edition (bilingual), New York & London: Garland, 1976. [Ipso]

Daniel Heinsius, 1580–1655. "Lofsang van Bacchus" [Song in Praise of Bacchus]. Poem. **1614.** Modern edition, in *Bacchus en Christus: Twee lofzangen,* edited by Rank, Warner, and Zwaan (Zwolle: Tjeenk Willink, 1965). [CEWL 1973, 2:645 / Meijer 1971, p. 108]

Joachim Wtewael, 1566–1638. "Bacchus." Painting. *c.***1618.** Muzeul Brukenthal, Sibiu, inv. 1276. [Lowenthal 1986, no. A–75—ill.]

———. "Bacchus." Painting. c.1618–24. Musée de Moulins, inv. 67.1.1. [Lowenthal, no. A–77—ill.]

———. "Bacchus." Painting. c.1628. Belden coll., Washington, D.C. [Lowenthal, no. A–94—ill.]

Hendrik van Balen, 1575–1632, figures, and **Jan Brueghel the Elder,** 1568–1625, landscape. "Triumph of Bacchus." Painting. *c.***1620.** Alte Pinakothek, Munich, inv. 847/173. [Ertz 1979, no. 361]

——— (van Balen). "Bacchus and Diana" (bacchanal, Diana looking on). Painting. Rijksmuseum, Amsterdam, inv. A17. [Rijksmuseum 1976, p. 99—ill.]

———— (van Balen). "Bacchus on a Tiger." Painting. [Bénézit 1976, 1:401]

———— (van Balen). "Bacchus Reclining." Painting. [Ibid.]

———— (van Balen). "Offering to Bacchus and Ceres." Painting. Musée, Cherbourg. [Bénézit 1976, 1:401]

Bartolommeo Manfredi, 1580–1620/21. "Bacchus." Painting. Palazzo Corsini, Rome. [Augsburg 1975, no. E40—ill.]

Juan de Arguijo, 1567–1623. "A Baco." Sonnet. Modern edition by Stanko Vranich, in *Obra poetica* (Madrid: Castalia, 1972). [DLE 1972, p. 58]

Gerrit van Honthorst, 1590–1656. "Bacchus." Painting. *c.*1624. Sold Copenhagen, 1931. [Judson 1959, no. 75] 3 further versions known, unlocated. [Ibid., no. 75a]

Claes Cornelisz Moeyaert, 1590/91–1655. "The Triumphal March of Bacchus." Painting. 1624. Mauritshuis, The Hague, inv. 395. [Mauritshuis 1985, p. 407—ill.]

Frans Francken II, 1581–1642. "Triumph of Bacchus." Painting. *c.*1620–25. Kunsthandel Nijstad, The Hague, in 1953. [Härting 1983, no. A231—ill.] Replica. Private coll., Hamburg. [Ibid., no. A231a]

————, attributed. "Triumph of Amphitrite, with Bacchus." Painting. Nationalmuseum, Stockholm, inv. 609. [Ibid., no. B223 / de Bosque, pp. 275–77—ill.]

Pietro da Cortona, 1596–1669. "Triumph of Bacchus." Painting. Before 1625. Pinacoteca Capitolina, Rome, no. 58. [Briganti 1962, no. 9—ill.]

————. "Triumph of Bacchus." Fresco. 1626–29. Villa Chigi (Sacchetti), Castel Fusano. [Ibid., no. 23—ill.]

Johann Rottenhammer, 1564–1625. "Bacchus on a Barrel." Drawing. Lord Methuen coll., Corsham Court. [Warburg]

Abraham Govaerts, 1589–1626. "Feast of Bacchus." Painting. [Bénézit 1976, 5:138]

Nicolas Poussin, 1594–1665. "Bacchus/Apollo" (originally painted as "Bacchus and Erigone"?). Painting. *c.*1626–27. Nationalmuseum, Stockholm. [Wright 1985, no. 20, pl. 115 / Blunt 1966, no. 135—ill. / also Thuillier 1974, no. 33—ill.]

————. "Triumph of Bacchus." Painting, part of "Bacchanales" series for Château de Richelieu. Mid-1630s. Nelson Gallery, Kansas City, Mo. [Wright, no. 81, pl. 38 / also Blunt, no. 137 (as copy)—ill. / Thuillier, no. 91 (as copy)—ill.] Copies in Musée Fabrégat, Béziers (attributed to Jacques Stella); Victoria and Albert Museum, London, no. 1446–1882; Musée de Poitiers; Musée de Rouen (attributed to Stella); Musée de Tours; private colls.; 5 others known, 2 destroyed. [Blunt / also Kauffmann 1973, no. 286—ill.] Old copy (ruined, effaced, formerly attributed to Poussin), in Louvre, Paris, inv. 7320. [Louvre 1979–86, 4:147—ill.]

————. "The Indian Triumph of Bacchus." Drawing. Mid-1630s? Royal Library, Windsor Castle, no. 11905 recto. [Friedlaender & Blunt 1953, no. 185—ill.]

————. "Bacchus." Design and wax model for marble term. 1655–56. Lost. / Marble executed by Jean-Baptiste Théodon, by 1661. Quinconce du Midi, Gardens, Versailles. [Girard 1985, pp. 273f., 287—ill. / Blunt, no. 230—ill.]

————, rejected attribution. "Bacchus and His Companions." Drawing. Louvre, Paris, no. R.F. 35 (as Poussin). [Friedlaender & Blunt]

————. "Apollo, Diana, Bacchus, and Bacchantes." Painting. Herzog Anton Ulrich-Museum, Braunschweig, no. 514. [Braunschweig 1969, p. 109 / also Blunt, no. R62 / Thuillier, no. R53—ill.]

————. *See also Luca Giordano, below.*

Moyses van Uyttenbroeck, *c.*1590–1648. "Feast of Bacchus." Painting. 1627. Herzog Anton Ulrich-Museum, Braunschweig, no. 216. [Braunschweig 1969, p. 137—ill. / Braunschweig 1976, p. 58—ill.]

Baccio del Bianco, 1604–1656. "Bacchus" (as a youth). Painting. *c.*1628. Galleria Bellini, Florence. [Florence 1986, no. 1.139—ill.]

Diego Velázquez, 1599–1660. "(Triumph of) Bacchus" ("The Topers"). Painting. 1628–29. Prado, Madrid, no. 1170. [López-Rey 1963, no. 57—ill. / López Torrijos 1985, pp. 343ff.—ill. / Prado 1985, p. 727] Replica. *c.*1633–34 or later. Galleria di Capodimonte, Naples, no. 189. [López-Rey, no. 58—ill. / Capodimonte 1964, p. 53] Copy, by José Robles y Martinez (b. 1843), in Victoria and Albert Museum, London, no. 336–1866. [Kauffmann 1973, no. 356—ill.]

Antonio Vassilacchi, 1556–1629. "Triumph of Bacchus." Painting. Szépmüvészeti Múzeum, Budapest, no. 972. [Budapest 1968, p. 727]

David Vinckeboons, 1576–1629. "Dionysus, Metamorphosed into a Lion, Helps Zeus against the Titans." Painting. / Engraved by Jakob Matham (d. 1631). [Warburg]

John Milton, 1608–1674. (Bacchus celebrated as patron of elegies in) "Elegia sexta" [Elegy Six]. Elegy. Dec 1629. In *Poems* (London: Moseley, 1645). [Carey & Fowler 1968 / Woodhouse 1972, p. 36]

————. (Bacchus evoked as an intimate of Comus in) *Comus.* Masque. Music, Henry Lawes. First performed Michaelmas Day 1634, Ludlow Castle. Published (as *A Masque Presented at Ludlow Castle*) London: Robinson, 1637. [Carey & Fowler 1968 / Brown 1985, pp. 68, 76]

Jan Brueghel the Younger, 1601–1678, landscape, and follower of **Abraham Janssens,** *c.*1575–1632, figures (previously attributed to Brueghel the Elder and Hendrik van Balen). "Bacchus in a Wooded Landscape." Painting. Late 1620s. Formerly Residenzschloss, Dessau, lost. [Ertz 1984, no. 216—ill.]

Jusepe de Ribera, *c.*1590/91–1652. "The Fable (Triumph) of Bacchus." Painting. *c.*1629–31. Largely destroyed. Fragments in Prado, Madrid, nos. 1122–23; private colls. [López Torrijos 1985, pp. 345f., 427 no. 16—ill. / Spinosa 1978, no. 90—ill. / also Fort Worth 1982, nos. 9–10—ill. / Prado 1985, p. 558] Copy of entire composition in private coll., France. [López Torrijos, pl. 150 / also Fort Worth, figs. 128, 132]

Simon Vouet, 1590–1649. "Allegory of Love and Abundance" (Bacchus, Venus, and Cupid). Ceiling decoration, for Château de Colombes. Lost. / Engraved by J. Boulanger, 1634. [Crelly 1962, no. 237—ill.]

Peter Paul Rubens, 1577–1640. "Mars, Venus, Bacchus, Cupid, and the Fury." Painting. 1632–35. Palazzo Bianco, Genoa. [Jaffé 1989, no. 1091—ill.]

————. "Triumph of Bacchus." Painting, for Torre de la Parada, El Pardo, executed by Cornelis de Vos from Rubens's design. 1636–38. Prado, Madrid, no. 1860. [Al-

pers 1971, no. 7—ill. / Jaffé, no. 1244—ill. / Prado 1985, p. 766] Oil sketch, by Rubens. Museum Boymans-van Beuningen, Rotterdam, no. St. 31. [Alpers, no. 7a—ill. / Held 1980, no. 175—ill. / Jaffé, no. 1243—ill.]

————. "Bacchus Seated on a Barrel." Painting. c.1636–38. Hermitage, Leningrad. [Jaffé, no. 1342—ill. / also Posner 1984, fig. 73] Free variant ("Drunken Bacchus with Faun and Satyr"), by follower. [Boston 1985, p. 254—ill.]

————, school. "Triumph of Bacchus." Painting. National Gallery of Ireland, Dublin, no. 1064. [Dublin 1981, p. 144—ill.]

Ben Jonson, 1572–1637. "The Dedication of the Kings New Cellar. To Bacchus." Poem. Collected as no. 48 of *The Underwood,* in *Works* (London: 1640). [Herford & Simpson 1932–50, 8]

Jacob Jordaens, 1593–1678. "Triumph of Bacchus." Painting. c.1645. Staatliche Gemäldegalerie, Kassel. [d'Hulst 1982, fig. 181 / also Ottawa 1968, no. 96—ill. / Rooses 1908, pp. 88ff.—ill.] Copies in Musée d'Arras; Wilanów Palace, Warsaw; Musée Crozatier, Le Puy; Musée, Narbonne (?); Metropolitan Museum, New York. [Ottawa]

————. "Triumph of Bacchus." Painting. c.1650. Musées Royaux des Beaux-Arts (Musée d'Art Ancien), Brussels, inv. 3693. [d'Hulst, p. 220 / Rooses, p. 216—ill. / Brussels 1984a, p. 159—ill.] Replica. Private coll., Brussels. [Rooses] Numerous further versions of the subject known, unlocated. [Ibid.]

————. "The Young Bacchus." Painting. c.1651. Max Rooses coll., Antwerp, in 1908. [Rooses, pp. 170f., pl. 173] Numerous other versions of the subject known from 19th-century sales, unlocated. [Ibid., pp. 258f.]

Jan van Dalen, before 1620–after 1653. "Bacchus." Painting. 1648. Kunsthistorisches Museum, Vienna, inv. 1687. [Vienna 1973, p. 53—ill.]

————. "Bacchus." Painting. c.1630–50. Uffizi, Florence, inv. SMeC 101. [Uffizi 1979, no. P1766—ill.]

Robert Herrick, 1591–1674. "To Bacchus, a Canticle," "A Hymne to Bacchus" (two poems with this title), "The Vine." Poems. In *Hesperides* (London: Williams & Eglesfield, 1648). [Martin 1956 / Scott 1974, p. 101]

Anthony van Dyck, 1599–1641, follower (previously attributed to van Dyck). "The Procession of Bacchus." Painting. c.1630s–40s. Unlocated. [Larsen 1988, no. A182—ill.]

Michelina Woutiers, before 1627–? "The Train of Bacchus." Painting. Kunsthistorisches Museum, Vienna, inv. 3548 (1064). [Vienna 1973, p. 204—ill.]

Adriaen van Nieulandt, 1587–1658. "Triumph of Bacchus." Painting. 1652. Statens Museum for Kunst, Copenhagen. [Copenhagen 1951, no. 512]

Alessandro Algardi, 1598–**1654,** previously attributed. "Head of Bacchus." Painted terra-cotta sculpture. Bayerisches Nationalmuseum, Munich, inv. 66/16. [Montagu 1985, no. R.27]

Francesco Francanzano, 1612–*c.*1656. "Triumph of Bacchus." Painting. Galleria di Capodimonte, Naples, no. 1056. [Capodimonte 1964, p. 53]

Jan Thomas van Yperen, 1617–1678. "Bacchanal" ("Triumph of Bacchus"). Painting. 1656. Kunsthistorisches Museum, Vienna, inv. 1727 (1066). [Vienna 1973, p. 175—ill. / Pigler 1974, p. 45]

Abraham van Cuylenburgh, before 1620–**1658.** "Bacchus and Nymphs." Painting. Metropolitan Museum, New York, no. 25.110.37. [Metropolitan 1980, p. 39—ill.]

Charles Le Brun, 1619–1690. "Allegory of Autumn" (Bacchus amid bacchantes). Drawing, design for unexecuted decoration in Château de Vaux-de-Vicomte. **1658–60.** Louvre, Paris, inv. 29.453. [Versailles 1963, no. 95—ill.]

Adriaen van Stalbent, 1580–**1662.** "The Drunkenness of Bacchus." Painting. Count Philippe de Limbourg Stirum coll., Château d'Anzegem, Belgium. [Warburg]

François Girardon, 1628–1715. "Bacchus." Stucco figure, decoration for Galerie d'Apollon, Louvre, Paris. **1663–64.** In place. [Francastel 1928, no. 15—ill.]

Luca Giordano, 1634–1705. "Triumph of Bacchus." Painting. *c.***1665.** Recorded in Cosimo III de' Medici coll., Florence, untraced. [Ferrari & Scavizzi 1966, 2:329]

————. "Triumph of Bacchus." Painting. Recorded in Rosso coll., Florence, before 1677, untraced. [Ibid., 2:330]

————, attributed (previously attributed to Poussin). "Drunken Bacchus." Painting. Prado, Madrid, no. 2321. [Ibid., 2:345]

————. "Bacchus and Silenus." Painting. Ariany y Cenia coll., Palma de Majorca, in 1955. [Ibid., 2:369]

Jean-Baptiste Böesset, 1614–1685, music. *Ballet du triomphe de Bacchus.* Ballet. **1666.** [Grove 1980, 2:844]

Jean-Baptiste Lully, 1632–1687, music. *Ballet de Créquy, ou, Le triomphe de Bacchus dans les Indes* [Ballet of Créquy, or, The Triumph of Bacchus in India]. Ballet. First performed 9 Jan **1666,** Hôtel de Créqui, Paris. [Grove 1980, 11:327]

————. *Les fêtes de l'Amour et de Bacchus.* Pastoral pastiche. Libretto, Philippe Quinault, Molière, and Isaac de Bensérade. First performed 15 Nov **1672,** L'Opéra, Paris. [Grove 1980, 11:315]

Cornelis van Poelenburgh, *c.*1586–**1667.** "Bacchus." Painting. Castle, Schleissheim. [Bénézit 1976, 8:392]

————. "Bacchus." Painting. Staatliches Museum, Schwerin. [Ibid.]

Jakob Balde, 1604–**1668.** (Bacchus visits Olympus in) Neo-Latin poem. Translated by Johann Gottfried Herder as "Die virginische Pflanze" [The Virgin Plant] (1796). *See Herder, below.*

Charles-Alphonse Dufresnoy, 1611–**1668.** "Triumph of Bacchus." Painting. [Bénézit 1976, 3:723]

Philippe de Buyster, 1595–1688. "Bacchus." Stone statue. **1671.** Façade, Château de Versailles. [Chaleix 1967, pp. 104, 129, pl. 36.1]

Balthasar Permoser, 1651–1732. "Bacchus." Sandstone statue. Before **1675.** Unteres Belvedere, Vienna. [Asche 1966, no. P2, pl. 10]

————. "Bacchus with a Satyr Child." Wood sculpture. After 1710. Kunstgewerbemuseum, Cologne, inv. A 1187. [Asche, no. P30, pl. 31]

Petronio Franceschini, *c.*1650–1680, and **G. Partenio** (Act 1 composed by Franceschini, completed by Partenio). *Dionisio, overo, La virtù trionfante del vitio* [Dionysus, or, Virtue Triumphant over Vice]. Opera. First performed 12 Jan **1681,** Teatro SS Giovanni e Paolo, Venice. [Grove 1980, 6:771]

Claude Lorrain, 1600–**1682.** "Landscape with Bacchus at the Palace of the Dead Staphylus." Painting. Pallavi-

cini coll., Rome. [Röthlisberger 1961, no. LV 178—ill.] Drawing after, in the artist's *Liber veritatis*. British Museum, London. [Ibid.]

Pierre Beauchamps, 1631–1705, music. "Bacchus." Entrée in *Ballet des arts*. First performed **1685,** Collège Louis-le-Grand, Paris. [Astier 1983, p. 161]

Francesco Redi, 1626–1698. *Bacco in Toscana*. Dithyrambic poem. Begun 1666. Florence: Matini, **1685.** Translated by Leigh Hunt as *Bacchus in Tuscany* (London: 1825). [Bondanella 1979, p. 435]

Philips de Koninck, 1619–**1688.** "Bacchus Feast." Painting. Museum Bredius, The Hague, inv. 62–1946. [Wright 1980, p. 219]

Jean Raon, 1630–1707. "Bacchus." Marble term, after model by Jean Dugoulon. **1687–93.** Bassin d'Apollon, Gardens, Versailles. [Girard 1985, p. 287—ill.]

[?] Denis. *Les travaux divertissants d'Arlequin Bachus* [The Diverting Labors of Harlequin Bacchus]. Comedy, for the Théâtre Italien, Paris, **1696.** [DLF 1951–72, 3:328 / Lancaster 1929–42, pt. 4, 2: 476, 700–02, 957]

Carlo Agostino Badia, 1672–1738, music. *Bacco, vincitore dell' India* [Bacchus, Conqueror of India]. Opera (festa teatrale). Libretto, D. Cupeda. First performed Carnival **1697,** for Habsburg Court, Vienna. [Grove 1980, 2:9]

Jean-Claude Gillier, 1667–1737. *Les plaisirs de l'Amour et de Bacchus* [The Pleasures of Cupid and Bacchus]. Musical idyll. First performed **1697,** Paris. [Grove 1980, 7:381]

Charles de La Fosse, 1636–1716. "Triumph of Bacchus." Painting, part of series for Château de Meudon. **1700.** Louvre, Paris, inv. 4537. [Louvre 1979–86, 4:24—ill.]

Spanish School. "Bacchus and Cupids." Painting. *c.*1700. Academia de San Fernando, Madrid, no. 413. [López Torrijos 1985, pp. 342, 427 no. 10—ill.]

Venetian School. "Infant Fauns and Bacchus." Painting. *c.*1700. Art Gallery and Museum, Glasgow, cat. 1970 no. 186. [Wright 1976, p. 105]

Guilain (Jean Adam Guillaume), fl. 1702–39. "C'est toy, divin Bacchus" [It Is You, Divine Bacchus]. Air. Published in *Mercure galant* May **1702** (Paris). [Grove 1980, 7:809]

Noël Coypel, 1628–**1707.** "Triumph of Bacchus." Painting (fragments), cartoon for Gobelins tapestry, for "Triumphs of the Gods" series. Louvre, Paris, inv. 3485. [Louvre 1979–86, 3:174—ill.]

Jean-Baptiste Morin, 1677–1754. *Bacchus*. Cantata. Published Paris: **1707.** [Grove 1980, 12:576]

Antoine Watteau, 1684–1721. "The Faun" (Bacchus), "Bacchus" (term). Ceiling paintings, for Hôtel Nointel (Poulpry), Paris. *c.*1707–08. Cailleux coll., Paris. [Camesasca 1982, nos. 30d, 30h—ill. / also Grasselli & Rosenberg 1984, nos. P.2 *n.*, P.3—ill.]

———. "The Gardens of Bacchus." Painting. *c.*1710? Lost. / Print by G. Huquier. [Camesasca no. 61—ill.]

———, rejected attribution. "Little Bacchus." Painting. 1713? Lost. [Camesasca no. 6.b]

———. (Actors portraying Bacchus and Cupid in) "Love in the French Theater." Painting, probably depicting a scene from Lully's *Les fêtes de l'Amour et de Bacchus* (1672). *c.*1712–16? Gemäldegalerie, Berlin-Dahlem. [Grasselli & Rosenberg 1984, no. P.38—ill. / Posner 1984, pp. 258ff., pl. 54 / also Camesasca 1982, no. 187—ill.]

———. "The Grove of Bacchus." Painting. 1716. Lost. / Print by C. Cochin, 1727. [Camesasca, no. 141—ill.]

Louis-Nicolas Clérambault, 1676–1749. *L'Amour et Bacchus*. Cantata. In *Cantates françoises* (Paris: **1710**). [Grove 1980, 4:492]

Paul Heermann, 1673–1732. "Pan," "Satyr," "Bacchus." Sandstone statues. *c.*1710. Grosser Garten, Dresden. [Asche 1966, no. H13]

Juan Conchillos y Falcó, 1641–**1711.** "Seated Bacchus." Drawing. Prado, Madrid, no. F.D. 1946. [López Torrijos 1985, p. 426 no. 3—ill.]

Charles-Hubert Gervais, 1671–1744. *Le triomphe de Bacchus*. Cantata. In [6] *Cantates françoises*, book 1 (Paris: **1712**). [Grove 1980, 7:309]

Anne Finch, Countess of Winchilsea, 1661–1720. "The Bargain: A Song in Dialogue between Bacchus and Cupid." Poem. In *Miscellany Poems on Several Occasions* (London: Taylor & Browne, **1713**). [Fausset 1930, p. 19]

Johann Joachim Kretzschmar, ?–1740. "Bacchus with Satyr Child." Sandstone statue. **1714–15.** Kronentor, Zwinger, Dresden. [Asche 1966, no. K6, pl. 111]

Anonymous English. *Bacchus and Cupid*. Comedy. First performed **1715,** New Theatre, Lincoln's Inn Fields, London. [Nicoll 1959–66, 2:446; cf. p. 366]

Thomas Parnell, 1679–1718. (Bacchus makes sport of Cupid in) "Anacreontick." Poem. In *Poems on Several Occasions* (London: Davies for A. Pope, 1721). Modern edition by H. I. Fausset, in *Minor Poets of the 18th Century* (London: Dent, 1930). [Ipso]

———. "Bacchus; or, The Drunken Metamorphosis." Poem. In *Poetical Works* (Edinburgh: Apollo, 1778). [Boswell 1982, p. 277]

André Campra, 1660–1744. *Silène et Bacchus*. Cantata. First performed Oct **1722,** L'Opéra, Paris. Music lost. [Grove 1980, 3:665]

Noël-Nicolas Coypel, 1690–1734. "Venus, Bacchus, and Cupid." Painting. **1727.** Louvre, Paris, inv. 3527. [Louvre 1979–86, 3:175—ill.]

Bernard Burette, fl. 1702–29. *Bacchus*. Cantata. [Grove 1980, 3:462]

Nicolas-Antoine Bergiron de Briou, 1690–1768. *Bacchus et l'Amour*. Cantata. In *Cantates françoises* (Lyons: **1729**). [Grove 1980, 2:549]

Gabriel Grupello, 1644–1730. "Bacchus." Marble relief. Kunstmuseum, Düsseldorf. [Kultermann 1968, no. 155—ill.]

George Frideric Handel, 1685–1759. "Bacchus One Day Gaily Striding." Song. Text, T. Phillips. Published as no. 8 of *A Choice Collection of English Songs* (London, **1731**). [Grove 1980, 8:126]

Laurent Gervais, fl. 1725–45. *Le triomphe de Bacchus*. Cantata. Published Paris: **1732?** [Grove 1980, 7:309]

François Le Moyne, 1688–1737. "Young Bacchus" (?). Painting. Lost. [Bordeaux 1984, p. 130]

Charles-Joseph Natoire, 1700–1777. "Bacchus Drinking, Surrounded by Fauns and Satyrs." Painting. **1738?** Sold Paris, 1868, untraced. [Boyer 1949, no. 95]

———. "Triumph of Bacchus." Painting. Exhibited 1747. Louvre, Paris, inv. 6854. [Troyes 1977, no. 56—ill. / Louvre 1979–86, 4:120—ill.] Study or replica. Sold Paris, 1914, untraced. [Boyer, no. 97]

Nicholas Lancret, 1690–1743. "Triumph of Bacchus." Painting. Sold 1818, untraced. [Wildenstein 1924, no. 719]

Nicolas de Largillière, 1656–1746. "Portrait of a Man as Bacchus" (formerly mistakenly called "The Regent as Pan"). Painting. Louvre, Paris, no. R.F. 2155. [Louvre 1979–86, 4:32—ill.]

Northern Italian School. "Triumph of Bacchus." Painting. **1700/50.** Museum of Fine Arts, Boston, no. 12.318. [Boston 1985, p. 145—ill.]

French School (previously attributed to Noel Challe, apocryphal signature). "Bacchus." Painting. **Mid-18th century.** Louvre, Paris, no. R.F. 2143. [Louvre 1979–86, 4:313—ill.]

Corrado Giaquinto, 1703–1765. (Bacchus in) "Apotheosis of the Spanish Monarchy" (?). Ceiling painting, for Palazzo Santa Croce, Palermo. Now in Palazzo Rondinini-Sanseverino, Rome. *c.*1751? / Study. National Gallery, London, inv. 6229. [London 1986, p. 232—ill.]

———. "Triumph of the Sun God Apollo and Bacchus" (with Aurora, Ceres, Venus, Diana, Pan, and others). Ceiling painting. Mid-1700s. Salón de Columnas, Palacio Real, Madrid. [Honisch 1965, pp. 39f.]

———. "The Birth of the Sun and the Triumph of Bacchus." Painting. Prado, Madrid, inv. 103. [Prado 1985, p. 243]

Augustin Pajou, 1730–1809. "Bacchus" ("Silenus"). Plaster sculpture. **1758.** Comte Robert de Montesquiou coll., Neuilly-sur-Seine. [Stein 1912, pp. 15–17—ill.]

Henry Fuseli, 1741–1825. "Bacchus." Drawing. **1759.** Kunsthaus, Zürich (*Jugendalbum*). [Schiff 1973, no. 279—ill.]

Antoine Bailleux, *c.*1720–*c.*1798. "L'hime à Bacchus" [Hymn to Bacchus]. Cantatille. Published Paris: **1761?** [Grove 1980, 2:36]

William Hogarth, 1697–1764. "A Procession of Painters to the Shrine of Bacchus." Satirical etching. [Paulson 1965, no. 280—ill.]

Johann Konrad Seekatz, 1719–1768. "Triumph of Bacchus." Painting. Hessisches Landesmuseum, Darmstadt. [Bénézit 1976, 9:496]

Giovanni Battista Tiepolo, 1696–1770. "Youthful Bacchus." Drawing. Sold Sotheby's, London, 1937. [Warburg]

Clodion, 1738–1814. "Intoxication of Wine: Bacchus, Nymph, and Cupid." Terra-cotta statuette. *c.*1775. Metropolitan Museum, New York. [Clapp 1970, 1:176 / Agard 1951, fig. 58] Another version in Petit Palais, Paris. [Frick 1968–70, 4:102]

Johan Henrik Kellgren, 1751–1795. "Till Bacchus och kärleken" [To Bacchus and Lovers]. Poem. **1777.** In *Samlade Skrifter* (Stockholm: [Linde?], 1796). [CEWL 1973, 2:785]

Francisco Goya, 1746–1828. "The Topers." Etching, after Velázquez (Prado). **1778.** [Gassier & Wilson 1981, no. 88—ill.]

———. "Bacchus's Grimaces." Drawing. 1814–23. Prado, Madrid, no. 42. [Ibid., no. 1261—ill.]

Anton Raphael Mengs, 1728–1779. "Bacchus Pressing Grapes." Painting. Schloss, Bückeburg. [Honisch 1965, no. 357]

Francis Ireland, 1721–1780. "Jolly Bacchus." Song. Published Dublin: *c.*1780. [Grove 1980, 9:325]

Francesco de Mura, 1696–1782. "Triumph of Bacchus." Painting. Staatliche Museen, Berlin. [Bénézit 1976, 7:615]

Anna Dorothea Therbusch-Lisiewska, 1721–1782. "Bacchus," "Bacchante." Pendant paintings. Hermitage, Leningrad, inv. 8357. [Hermitage 1987b, nos. 320–21—ill.]

Friedrich von Schiller, 1759–1805. "Bacchus im Triller" [Bacchus Warbling]. Poem. In *Anthologie auf das Jahr 1782* (Stuttgart: Metzler, **1782**). [Petersen & Beissner 1943]

———. (Bacchus leads the procession of gods in) "Der Besuch" [The Visit (of the gods)]. Poem (dithyramb). In *Musenalmanach für das Jahr 1797* (Tübingen: Cotta, 1797). [Ibid.]

Carl Michael Bellmann, 1740–1795. (Homage to Bacchus in) *Bacchi tempel öpnadt vid en hieltes död* [The Temple of Bacchus Opens Wide upon Death]. Collection of poems. Stockholm: **1783.** Reprinted Stockholm: Elmens & Granberg, 1815. [Gustafson 1961, p. 130]

———. (Bacchus celebrated in drinking songs in) *Fredmans sånger* [Fredman's Songs]. Poem cycle. (Stockholm: Zetterberg, 1791). [Algulin 1989, pp. 5ff.]

Jean Dauberval, 1742–1806, choreography. *The Slaves of Conquering Bacchus.* Ballet. Music, François-Hippolyte Barthélemon. First performed 17 Jan **1784,** King's Theatre, London. [Grove 1980, 2:195]

André Chénier, 1762–1794. "Bacchus." Poem, part of *Les bucoliques.* *c.*1778–87. In *Oeuvres complètes* (Paris: Foulon, Baudouin, 1819). [DLLF 1984, 1:447]

Angelica Kauffmann, 1741–1807. "Bacchus Instructing the Nymphs" (to make verses). Painting, after Horace, *Odes* 2.19. **1787.** Captain Spencer Churchill coll., Northwick Park, England. [Manners & Williamson 1924, pp. 72, 153, 181]

Gustav III of Sweden, 1746–1792. *Den bedragne Bachan* [Bacchus Cheated]. Comedy. First performed **1789,** Stockholm; incidental music, Olof Åhlström. [Grove 1980, 1:174]

Asmus Jakob Carstens, 1754–1798. "Bacchus and Cupid." Painting. **1790–95.** Statens Museum for Kunst, Copenhagen. [Cologne 1977, pp. 143, 167—ill.]

Johann Gottfried Herder, 1744–1803. (Bacchus visits Olympus in) "Die virginische Pflanze" [The Virgin Plant]. Poem, translation from Jakob Balde (1604–1668). In *Terpsichore,* part 1, book 5 (Lübeck: Bohn, **1795**). [Herder 1852–54, vol. 17]

Friedrich Hölderlin, 1770–1843. (Bacchus's triumph in India evoked in) "An unsre grossen Dichter" [To Our Great Poets]. Poem. **1798?** In *Musenalmanach für das Jahr 1799.* [Beissner 1943–77, vol. 1 / Hamburger 1980]

———. (Bacchus presides in) "Brot und Wein" [Bread and Wine]. Elegy. 1800–01. In *Musenalmanach für das Jahr 1807.* [Beissner, vol. 2 / Hamburger / Unger 1975, p. 82f.]

———. (Bacchus's triumph in India evoked in) "Dichterberuf" [The Poet's Vocation] strophe 1. Ode. In *Gedichte* (Stuttgart: Cotta, 1843). [Beissner / Hamburger / Unger, pp. 175f.]

Pierre-Paul Prud'hon, 1758–1823. "Bacchus." Painting, part of series of simulated bronze bas-reliefs for Hôtel Lanois, Paris. **1796–99.** Louvre, Paris, no. R.F. 1983-18. [Louvre 1979–86, 4:152—ill. / also Guiffrey 1924, pp. 294ff.]

Italian School. "Herm of Bacchus." Bronze and alabaster

herm. **18th century.** Galleria Borghese, Rome, inv. 145. [Faldi 1954, no. 13—ill.]

North Netherlandish School. "Ceres, Bacchus, and Amor." Painting (simulated statues in a niche). Rijksmuseum, Amsterdam, no. A4179. [Rijksmuseum 1976, p. 669—ill.]

William Hamilton, 1751–**1801.** "Nymphs Adorning the Sleeping Bacchus with Wreaths." Watercolor. Victoria and Albert Museum, London, no. 505–1892. [Lambourne & Hamilton 1980, p. 169]

Bertel Thorwaldsen, 1770–1844. "Bacchus." Marble statue. **1804.** 2 versions, both lost. [Cologne 1977, no. 6] Plaster original. Thorwaldsens Museum, Copenhagen, no. A2. [Thorwaldsen 1985, p. 21 / Hartmann 1979, pp. 57f., pl. 15.2 / Cologne, p. 162—ill.]

———. "Cupid and Bacchus." Marble relief. Modeled *c.*1810. Thorwaldsens Museum, no. A408. Domkirkens Skole, Trondheim, Norway; Hermitage, Leningrad; Kunstmuseum, Randers, Denmark; Thorwaldsens Museum, nos. A407, A797 (executed by R. Anderson and T. Stein, 1889); private coll. Sweden. [Thorwaldsen, pp. 52, 78 / Cologne, no. 54, p. 168—ill. / Hermitage 1984, no. 398—ill. / Hermitage 1975, pl. 59]

———. "Cupid and the Youthful Bacchus Treading Grapes" ("An Allegory of Autumn"). Marble relief. Modeled 1810–11. Thorwaldsens Museum, no. A412. / Plaster original. Thorwaldsens Museum, no. A413. [Thorwaldsen, p. 52]

John Keats, 1795–1821. (Vision of "Bacchus and his crew" in) *Endymion* 4.193–267. Poem. **1817.** (London: Taylor & Hessey, 1818). [Stillinger 1978]

Thomas Love Peacock, 1785–1866. "Hymn to Dionysus." Translation of Homeric Hymn, part of *Rhododaphne: or, The Thessalian Spell*. Poem. **1817.** London: 1818. [Webb 1976, pp. 63, 65 *n.*]

Aleksandr Pushkin, 1799–1837. "Torzhestvo Vakha" [Triumph of Bacchus]. Poem. **1817.** In *Pushkin: Polnoe sobranie sochinenii*, vol. 1, edited by B. V. Tomashevsky (Moscow: Soviet "Academy" edition Akademiya NAUK SSSR, 1962). [Blagoi 1981, pp. 15f.]

———. "Bakx'b" ["Bacchus" ("Bacchic Song")]. Poem. 1825. [Arndt 1984 / EW 1983–85, 5:674]

Patrick MacDowell, 1799–1870. "Bacchus." Marble sculpture. **1829.** [Strickland 1968, 2:62]

Eugène Delacroix, 1798–1863. "Bacchus and a Tiger." Fresco. **1834.** Valmont Abbey, near Fécamp. [Johnson 1981–86, no. 243—ill. / Robaut 1885, no. 547]

———. "Bacchus Lying under a Vine." Painting, for Salon de la Paix, Hôtel de Ville, Paris. 1849–53. Destroyed 1871. [Robaut, no. 1145—ill. (copy drawing)]

———. "Triumph of Bacchus." Painting. *c.*1861–63, unfinished. Bührle Foundation, Zürich. [Johnson, no. 253—ill. / Robaut, no. 1419—ill. (copy drawing); cf. no. 1418]

Tommaso De Vivo, 1787–1884. "Bacchus with a Satyr." Painting. **1834.** Galleria di Capodimonte, Naples, no. 6559. [Capodimonte 1964, p. 63]

Eduard Mörike, 1804–1875. "Auf Bacchus." Translation from Horace. In *Classische Blumenlese* (Stuttgart: Schweizerbart, **1840**). [Hötzer 1967]

———. "Auf Dionysos," Translation of First Homeric Hymn to Dionysus. In *Classische Blumenlese* (1840). [Ibid.]

Alexander Dargomizhsky, 1813–1869. *Torzhestvo Vakha* [Triumph of Bacchus]. Cantata. Text, Pushkin (1817).

1843–46. First performed 1 Apr 1846, St. Petersburg. / Revised as opera-ballet, by 1848. First performed 23 Jan 1867, Bolshoi Ballet, Moscow. [Grove 1980, 5:243f., 15:479]

Heinrich Heine, 1797–1856. (Bacchus in) *Die Göttin Diana* [The Goddess Diana]. "Dance-poem," scenario for ballet/pantomime. **1846.** In *Vermischte Schriften* (Hamburg: Hoffmann & Campe, 1854). [Windfuhr 1975–82, vol. 9 / Butler 1958, p. 287]

———. (Bacchus as Father Superior in a Tyrolean monastery, with Silenus and Priapus, in) *Die Götter im Exil* [The Gods in Exile]. Novella. First published in French, as *Les dieux en exil*, in *Revue des deux mondes* 1 Apr 1853. Unauthorized version, *Die verbannten Götter*, in *Hamburger Nachrichten*, 1853. First book publication, Hamburg: Hoffmann & Campe, 1853. [Windfuhr / Sammons 1979, pp. 289f., 317, 319f. / Sandor 1967, pp. 30f., 42 / Butler, pp. 294, 296, 299f.]

Ralph Waldo Emerson, 1803–1882. "Bacchus." Poem. In *Poems* (London: Chapman, **1847**). [Emerson 1904]

Eberhard Wächter, 1762–**1852.** "Bacchus and Cupid." Grisaille painting. Staatsgalerie, Stuttgart. [Bénézit 1976, 10:596]

———. "Bacchus Singing." Painting. Staatsgalerie, Stuttgart. [Ibid.]

Victor Hugo, 1802–1885. "Éole allait criant: Bacchus m'a pris mon outre" [Aeolus Went Crying: Bacchus Has Taken My Skin-sack]. Poem. 28 Oct **1852.** No. 18 in *Toute la lyre* part 1, in *Oeuvres inédites* (Paris: Hetzel, 1888). [Hugo 1985–86, vol. 7 / Py 1963, p. 85]

———. (Dionysus in) "Le satyre." Poem, prologue to *La légende des siècles* (1st series) part 8, "Renaissance paganisme" (Paris: Hetzel, 1859). [Hugo, vol. 5 / Py, pp. 99ff.]

Samuel Palmer, 1805–1881. "The Vine, or, Plumpy Bacchus." 2 etchings on one plate, after a song in Shakespeare's *Antony and Cleopatra*. In *Songs and Ballads of Shakespeare, Illustrated by the Etching Club* (**1852**). [Alexander 1937, p. 22, no. 5—ill.]

Anonymous English. *Bacchus.* Entertainment. First performed **1855**, London. [Nicoll 1959–66, 5:645]

Richard Westmacott, 1775–**1856.** "The Young Bacchus." Marble sculpture. Duke of Devonshire coll., Chatsworth. [Warburg]

Ludvig Bødtcher, 1793–1874. "Mødet med Bacchus" [Meeting with Bacchus]. Poem. In *Collected Poems*. **1856.** / Translated by S. Foster Damon in *A Book of Danish Verse*, edited by Oluf Friis (New York: American-Scandinavian Foundation, 1922). [Mitchell 1958, p. 165]

Leigh Hunt, 1784–**1859.** "Hymn to Dionysus." Poem, translation of Homeric Hymn. In *Poetical Works* (London: Oxford University Press, 1923). [Webb 1976, p. 65 *n.*]

———. *Bacchus in Tuscany.* Translation of Francesco Redi (1685). London: 1825. [Bondanella 1979, p. 435]

Walter Savage Landor, 1775–1864. "Sophron's Hymn to Bakkos." Poem. In *Hellenics,* revised edition (Edinburgh: Nichol, **1859**). [Wheeler 1937, vol. 2]

Charles Baudelaire, 1821–1867. "Le thyrse" [The Thyrsis (wand of Bacchus)]. Prose poem, dedicated to Franz Liszt. In *Revue nationale et étrangère* 10 Dec **1863**; collected in *Petits poëmes en prose* (later called *Le spleen de Paris*), vol. 4 of *Oeuvres complètes* (Paris: Lévy, 1869). [Pichois 1975]

Carl Rahl, 1812–**1865.** "Bacchus Transforming Water into Wine." Painting. Augusteum, Oldenbourg. [Bénézit 1976, 8:584]

John Gibson, 1790–**1866.** "Bacchus." Marble sculpture. Royal Academy, London. [Read 1982, p. 34]

Simeon Solomon, 1840–1905. "Bacchus." Painting. Exhibited Royal Academy, London, **1868.** [Praz 1956, p. 468 / Pater 1897, p. 37]

Ernest Meissonier, 1815–1891. Painting depicting "Bacchus Seated on a Barrel" seen in the painting "The Sign Painter." *c.*1872. Formerly Lady Wallace coll. / Drawing. Fogg Art Museum, Harvard University, Cambridge, inv. 1943.876. [Houser 1979, no. 69—ill.]

Jules Lefebvre, 1836–1911. "Nymph and Bacchus." Painting. **1874.** Louvre, Paris, deposited in Mairie de Thionville (previously in Musée des Beaux-Arts, Lyons). [Louvre 1979–86, 5:291]

Gustave Moreau, 1826–1898. "Triumph of Bacchus" (in a chariot drawn by panthers). Painting. *c.*1875–76. Daniel Wildenstein coll. [Mathieu 1976, no. 149—ill.]

Edmund Gosse, 1849–1928. "The Praise of Dionysus." Poem. In *New Poems* (London: Kegan Paul, **1879**). [Bush 1937, p. 560]

Gabriele D'Annunzio, 1863–1938. "A Bacco Dionisio" [To Bacchus Dionysus] Poem. In *Primo vere,* 2d edition (Lanciano: Carabba, **1880**). [Palmieri 1953–59, vol. 1]

John La Farge, 1835–1910. "Bacchus." Marble and wood relief, for Vanderbilt mansion, New York. **1881–82.** Destroyed? [Weinberg 1977, pp. 256ff., 261f.—ill.]

Claude Debussy, 1862–1918. *Triomphe de Bacchus.* Orchestral suite, after Théodore de Banville. *c.*1882. Lost. / Allegro arranged for piano (4 hands), 1928. Orchestrated by Gaillard. 1928. [Grove 1980, 5:311]

———. *Dionysos.* Opera (lyric tragedy). Libretto, J. Gasquet. Begun 1904, unfinished. [Ibid.]

Adolf von Hildebrand, 1847–1921. "Bacchus Group." Sculpture. **1878–83.** Destroyed. [Heilmeyer 1922, p. 23]

———. "Bacchus." Plaster sculpture. 1887–88? S. Francesco, Florence. [Ibid., p. 23]

———. "Dionysus" (drunk, supported by a faun, a youth standing by). Stone relief sculpture. 1890. S. Francesco, Florence. [Ibid., p. 31—ill.]

———. "Dionysus." Bas-relief. 1890. 2 versions. Peploe coll., Florence; Hildebrand coll., Munich. [Fiesole 1980, no. 60—ill.]

Hans Thoma, 1839–1924. "The Cortege of Bacchus." Mural. **1886.** Café Bauer coll., Frankfurt. [Thode 1909, pp. 252ff.—ill.]

Walter Pater, 1839–1894. "Denys l'Auxerrois" (as avatar of Dionysus). Story. In *Imaginary Portraits* (London & New York: Macmillan, **1887**). [Jenkyns 1980, pp. 186f., 364]

John Reinhard Weguelin, 1849–1927. "Tribute to the God of Bounty" (woman draping a herm of Dionysus). Painting. **1887.** [Kestner 1989, p. 333]

Auguste Mermet, 1810–**1889.** *Bacchus dans l'Inde* [Bacchus in India]. Opera. Unperformed. [Grove 1980, 12:186]

Joseph Tournois, 1830–**1891.** "Bacchus Inventing Comedy." Bronze statue. Musées Nationaux, inv. R.F. 195, deposited in Jardin du Luxembourg, Paris, after 1891. [Orsay 1986, p. 282]

Richard Garnett, 1835–1906. (Bacchus evoked in) "Wine and Sleep." Poem. In *Poems* (London: Mathews & Lane, **1893**). [Boswell 1982, p. 113]

Frederick William MacMonnies, 1863–1937. "Bacchus and Infant Faun." Bronze statue. **1894.** Metropolitan Museum, New York. / Bronze reduction. Williams College Museum of Art, Williamstown, Mass. [Clapp 1970, 2 pt. 2: 722f.]

Magnus Enckell, 1870–1925. (Bacchus as Orpheus with the lyre in) "La Fantaisie." Painting. **1895.** Musées des Beaux-Arts de Belgique. [Kosinski 1989, pp. 204, 350, fig. 6.37]

Cécile Chaminade, 1857–1944. "Ode to Bacchus." Song. Text, H. Jacquet. London: Enoch, **1899.** [Cohen 1987, 1:144]

Franz von Stuck, 1863–1928. "Dionysus." Painting. *c.***1900.** Private coll. in 1909. [Voss 1973, no. 204—ill.]

———. "The Young Bacchus." Painting. 1901. Von der Mühll coll., Basel, in 1909. [Ibid., no. 222—ill.] Variant ("Young Bacchus Riding on a Panther"). Private coll. [Ibid., no. 223—ill.]

———. "Faun and Young Bacchus." Painting. 1905. Private coll. in 1909. [Ibid., no. 273—ill.] Study. Galerie Dr. Gunzenhauser, Munich. [Ibid., no. 272—ill.]

Edwin Markham, 1852–1940. "The Story of Bacchus." Poem. In *Lincoln and Other Poems* (New York: McClure & Phillips, **1901**). [Boswell 1982, p. 272]

Victor Alphonse Duvernoy, 1842–1907, music. *Bacchus.* Ballet. Scenario, G. Hartmann and J. Hansen, after Mermet's *Bacchus dans l'Inde* (above). First performed 26 Nov **1902,** L'Opéra, Paris. [Guest 1976, p. 312 / Grove 1980, 5:763]

Émile-Antoine Bourdelle, 1861–1929. "Sleeping Bacchus." Bronze sculpture. **1903.** 8 casts. / Ceramic version, edition of 3. Musée Haviland, Limoges; Musée Bourdelle, Paris; elsewhere. [Jianou & Dufet 1975, no. 286]

Constantine Cavafy, 1868–1933. "He synodeia tos Dionysos" [The Retinue of Dionysos]. Poem. **1903.** Published 15 Apr 1907. Collected in *Poiemata* (Athens: Ikaros, 1963). / Translated by Edmund Keeley and Philip Sherrard in *Collected Poems,* bilingual edition (Princeton: Princeton University Press, 1975). [Ipso / Keeley 1976, p. 34]

Henri Fantin-Latour, 1836–1904. Lithograph depicting dancing maenads, illustration to Chénier's "Bacchus" (*c.*1778–87). **1903.** [Hédiard 1906, no. 166—ill. / Fantin-Latour 1911, no. 2019]

———. "Bacchus and Bacchante." Painting. Haviland coll. in 1911. [Fantin-Latour, no. 2263]

Vyachesl\'av Ivánov, 1866–1949. Dionysian cycle of poems, in *Kormchie zyezdy* [Pilot Stars] (St. Petersburg: Survorina, **1903;** Ann Arbor: University Microfilms, 1982). [Poggioli 1960, p. 162]

———. (Dionysus suffers and is resurrected in) *Cor ardens* [Burning Heart]. Poem. Moscow: 1911. [EWL 1981–84, 2:477]

Louis Couperus, 1863–1923. *Dionyzos.* Novel. Amsterdam: Veen, **1904.** [EWL 1981–84, 1:502]

Lidiya Zinovyeva-Anníbal, 1866–1907. (Dionysus in) *Kol'tsa* [The Rings] Drama. Moscow: Skorpion, **1904.** [Pachmuss 1978, pp. 191, 194f.]

Lady Margaret Sackville, 1881–1963. "A Hymn to Dionysus." Poem. In *A Hymn to Dionysus and Other Poems* (London: Mathews, **1905**). [Bush 1937, p. 567]

James Elroy Flecker, 1884–1915. (Bacchus visits London in) "The Ballad of Hampstead Heath." Poem. In *The Bridge of Fire* (London: Mathews, **1907**). [Jenkyns 1980, p. 187]

Frederick William Pomeroy, 1857–1924. "Dionysus." Sculpture. Various versions, **1890–1909**. [Read 1982, p. 317 / Tate 1975, p. 191]

Elihu Vedder, 1836–1923. "Bronze Bacchus." Bronze sculpture. Before **1909**. Unlocated. [Soria 1970, no. S20]

Lovis Corinth, 1858–1925. "Bacchus" (with bacchantes). Painting. **1909**. Formerly Kunstsammlung, Königsberg. [Berend-Corinth 1958, no. 389—ill.] Etching, in "Antique Legends" series, 1919. [Schwarz 1922, no. 351.VI]

Richard Edwin Day, b. 1852. "The Fall of Dionysus." Poem. In *New Poems* (New York: Grafton, **1909**). [Boswell 1982, p. 83]

Jules Massenet, 1842–1912. *Bacchus.* Opera. Libretto, Catulle Mendès. First performed 5 May **1909**, L'Opéra, Paris. [Grove 1980, 11:808]

Leo Staats, 1877–1952, choreography. *Bacchus.* Ballet. First performed **1909**, L'Opéra, Paris. [Beaumont 1938, p. 545]

Yevdokia Apollonovna Nagrodskaya, 1866–1939. *Gnev Dionisa* [The Wrath of Dionysus]. Novel. **1910**. St. Petersburg. 1910. [Pachmuss 1978, p. 9]

Léon Moreau, 1870–1946, music. *Dionysos.* Symphonic poem. First performed **1912**, Paris. [Baker 1984, p. 1582 / Edler 1970, p. 208]

Auguste Rodin, 1840–1917. "Bacchus in the Vat." Marble sculpture. *c.***1912**. Musée Rodin, Paris. [Rodin 1944, no. 427—ill.] Bronze cast. Rodin Museum, Philadelphia. [Tancock 1976, no. 62—ill.]

John Gould Fletcher, 1886–1950. "Dionysus and Apollo." Poem. In *Fire and Wine* (London: Richards, **1913**). [Boswell 1982, p. 106]

Fernand Mazade, 1863–1939. *Dionysos et les nymphes.* Collection of poems. Paris: **1913**. [DULC 1959–63, 3:469]

Rudolf Pannwitz, 1881–1969. *Dionysische Tragödien* [Dionysian Tragedies]. Cycle of tragedies. Nuremberg: Carl, **1913**. [Oxford 1986, p. 692]

———. *Meinungen des Gottes Dionysos* [Belief in the God Dionysus]. Satyr play. In *Trilogie des Lebens* [Trilogy of Life] (Munich-Feldafing: Carl, 1929). [NUC]

Percy MacKaye, 1875–1956. "Dionysus." Poem. In *Poems and Plays* (New York: Macmillan, **1916**). [Boswell 1982, p. 270]

Wyndham Lewis, 1884–1957. "Green Bacchus." Drawing. **1918** (or earlier?). Formerly Sacheverell Sitwell coll., lost. [Michel 1971, no. 261]

Jean-Antoine Carlès, 1851–**1919**. "Bacchus." Marble statue. Musées Nationaux, inv. R.F. 2009, deposited in Musée, Bayonne, in 1953. [Orsay 1986, p. 268] Bronze "Bacchus," Musées Nationaux, inv. R.F. 3910, deposited in Musée, Dijon, in 1929. [Ibid., p. 268]

Edith Södergran, 1892–1923. "Hymn to Dionysus." Poem. In *Rosenaltaret* (Helsingfors: Schildt, **1919**). [EWL 1981–84, 4:266]

Witter Bynner, 1881–1968. "A Canticle of Bacchus." Poem. In *A Canticle of Pan and Other Poems* (New York: Knopf, **1920**). [Boswell 1982, p. 61]

Ivan Khlustin, 1862–1941, choreography. *Dionysis.* Ballet, for Anna Pavlova's touring company. First performed **1921**. [Chujoy & Manchester 1967, p. 212]

Vladislav Khodasevich, 1886–1939. "Bakx'b" [Bacchus]. Poem. In *Tyazhelaya lira* [The Heavy Lyre] (Moscow: Gosudarstvennoe Izdatelstvo, **1922**). [Ipso]

D. H. Lawrence, 1885–1930. (Count Dionys, a Dionysus-figure, in) "The Ladybird." Novella. **1922**. In *The Ladybird, The Fox, The Captain's Doll* (London: Secker, 1923). [DLB 1985, 36:116, 134 / Merivale 1969, pp. 203, 217]

———. (Dionysus invoked in) "Medlars and Sorb Apples." Poem. In *Birds, Beasts, and Flowers* (London: Secker, 1923). [Ipso]

Richard von Schaukal, 1874–1942. "Dionys-bácsi" [Dionysus-Bacchus]. Novella. In *Dionys-bácsi: Drei Novellen* (Braunschweig: Westermann, **1922**). [Domandi 1972, 2:237]

Nicolai Tcherepnin, 1873–1945, music. *Dionysus.* Ballet. First performed **1922**, London. [Grove 1980, 18:636]

Giorgio de Chirico, 1888–1978. "Bacchus." Painting. **1923**. Galleria Farsetti, Prato. [de Chirico 1971–83, 7.1: no. 398—ill.]

———. "Bacchus." Painting, after Rubens. 1953. Private coll., Rome. [Far 1968, no. 158—ill.]

Konstantine Gamsakhurdia, 1891–1975. *Dionisis ghimili* [The Smile of Dionysus]. Novel. **1925**. [GSE 1973–83, 6:80a / Seymour-Smith 1985, p. 1250]

Eugene O'Neill, 1888–1953. (Dion Anthony, a Dionysus-figure, in) *The Great God Brown.* Play. **1925**. First performed 23 Jan 1926, Greenwich Village Theatre, New York. [McGraw-Hill 1984, 4:31, 39]

Edwin Arlington Robinson, 1869–1935. "Demos and Dionysus," "Dionysus in Doubt." Poems. In *Dionysus in Doubt* (New York: Macmillan, **1925**). [DLB 1987, 54 pt. 2:384]

Ettore Romagnoli, 1871–1938. *Il carro di Dioniso* [The Chariot of Dionysus]. Satirical drama. Bologna: Zanichelli, **1927**. [DELI 1966–70, 4:582]

William Butler Yeats, 1865–1939. (Death of Dionysus evoked in 2 songs in) *The Resurrection.* Drama. Dublin: Cuala, **1927**. Songs reprinted as "Two Songs from a Play" in *The Tower* (London & New York: Macmillan, 1928). [Finneran 1983]

———. "Colonus' Praise" stanza 1 (called the Dionysus stanza). Poem, version of first stasimon of Yeats's *Oedipus at Colonus.* In *The Tower* (1928). [Ibid. / Clark 1983, pp. 144, 147]

Arthur B. Davies, 1862–**1928**. "Dionysus." Painting. McVitie coll., Bryn Mawr, Pa. [Cortissoz 1931, p. 23]

Lascelles Abercrombie, 1881–1938. "The Olympians" (Apollo brings the dead Zeus to be buried on Crete as Dionysus reigns). Poem. In *Twelve Idyls and Other Poems* (London: Secker, **1928**). [Bush 1937, p. 431]

Paul Manship, 1885–1966. "Hail to Dionysus Who First Discovered the Magic of Grapes." Bronze medal. **1930**. National Museum of American Art, Washington, D.C.; Yale University Art Gallery, New Haven; elsewhere. [Rand 1989, pp. 135ff.—ill. / Murtha 1957, no. 265—ill.]

Ted Shawn, 1891–1972, with **Margarethe Wallmann,** 1904–, choreography. *Orpheus Dionysus.* Modern dance. First performed **1930**, Berlin. [McDonagh 1976, p. 41 / EDS 1954–66, 9:1826]

Mario Castelnuovo-Tedesco, 1895–1968, music. *Bacco in Toscana.* Dithyramb and ballet with solo voices, chorus, and orchestra, opus 39. Libretto, after Francesco Redi

(1685). First performed 8 May **1931**, La Scala, Milan. [Grove 1980, 3:868 / Baker 1984, p. 427]

Frederick Faust, 1892–1944. *Dionysus in Hades*. Drama. Oxford: Blackwell, **1931**. [Boswell 1982, p. 254]

Oskar Kokoschka, 1886–1980. "Portrait of Bob Gésinus Visser I as Bacchus." Painting. **1933**. Minneapolis Institute of Art. [Bordeaux 1983, no. 29—ill. / also Wingler 1958, no. 274—ill.]

————. (Dionysus in 6 of) 12 etchings illustrating Aristophanes' *The Frogs* (Frankfurt: Ars Librorum, 1969). 1967–68. [Wingler & Welz 1975, nos. 438–39, 441–43, 446—ill.]

Sacheverell Sitwell, 1897–1988. "Bacchus in India." Poem. In *Canons of Giant Art* (London: Faber & Faber, **1933**). [Boswell 1982, p. 294]

Richard Aldington, 1892–1943. "Bromios" (epithet for Dionysus). Poem. In *Poems* (New York: Doubleday, Doran, **1934**). [Boswell 1982, p. 9]

Marino Marini, 1901–1980. "Bacchus." Stone sculpture. **1934**. Kunsthaus, Zürich. [Apollonio 1958, p. 36]

Pablo Picasso, 1881–1973. "Bacchus and Woman in Profile." Etching. **1934**. [Bloch 1971–79, no. 274—ill.]

————. "Bacchus and Reclining Nude." Engraving. 1934. [Ibid., no. 284—ill.]

————. "Bacchus and Nude." Drawing. 1954. [Zervos 1932–78, vol. 16, no. 160—ill.]

William Empson, 1906–1984. "Bacchus." Poem. In *Poems* (London: Chatto & Windus, **1935**). [CLC 1975, 3:147, 19:156, 33:142]

Edward McCartan, 1879–1947. "Dionysus." Gilt bronze sculpture. **1936**. Brookgreen Sculpture Gardens, S.C. [Clapp 1970, 2: Part 2:718]

Guido Guerrini, 1890–1965. "Bacco ubbriaco" [Bacchus Intoxicated]. Vocal composition. **1938**. [Grove 1980, 7:790]

Angelos Sikelianos, 1884–1951. ("Dionysos-Hades" evoked in) "Ellenikos nekrodeipnos" [Greek Supper for the Dead]. Poem. **1941**. [Savidis 1981, vol. 5 / Friar 1973]

————. (Dionysus visits his "Holy Man" in) "The Supreme Lesson" [English title of work written in Greek]. Poem. 1942. [Friar]

Stefan Andres, 1906–1970. *Der gefrohene Dionysus* [Happy Dionysus]. Novel. Berlin: Riemerschmidt, **1942**. Retitled *Die Liebesschaukel* [The Love Swing] (Munich: Piper, 1951). [Oxford 1986, p. 27 / EWL 1981–84, 1:92]

Gerhard Marcks, 1889–1981. "Bacchus." Bronze sculpture. **1942**. At least 3 casts. Gerhard-Marcks-Stiftung, Bremen, inv. 35/71; private colls. [Busch & Rudloff 1977, no. 416—ill.]

Arno Nadel, 1878–**1943**. *Der weissagende Dionysos* [The White Ritual of Dionysus]. Poem. Heidelberg: Schneider, 1959. [Wilpert 1963, p. 427]

Mikhail Mordkin, 1880–**1944**, choreography. *Dionysus*. Ballet. Music, Glazunov. [EDS 1954–66, 7:826]

Ker-Xavier Roussel, 1867–**1944**. "The Procession of Bacchus." Painting. Musée d'Orsay, Paris, no. R.F. 1977–305. [Louvre 1979–86, 4:201—ill.]

Edith Sitwell, 1887–1964. "Song: O Dionysus of the Tree." Poem. In *Green Song* (London: Macmillan, **1944**). [Sitwell 1968]

Cesare Pavese, 1908–1950. (Dionysus speaks with Demeter in) "Il Mistero" [The Mystery]. Dialogue. In *Dialoghi con Leucò* (Turin: Einaudi, **1947**). / Translated by Wil-

liam Arrowsmith and D. S. Carne-Ross in *Dialogues with Leucò,* bilingual edition (Ann Arbor: University of Michigan, 1965). [Ipso / Biasin 1968, pp. 193f., 208f.]

Michael Roberts, 1902–**1948**. "Dionysos." Poem. In *Collected Poems* (London: Faber & Faber, 1958). [Boswell 1982, p. 286]

William Carlos Williams, 1883–1963. "Io Baccho!" Poem. **1950**. [MacGowan 1988]

Jean Cocteau, 1889–1963. *Bacchus*. Drama. First performed 20 Dec **1951**, Théâtre Marigny, Paris, by Renaud/Barrault company. Published Paris: Gallimard, 1952. / Translated by Mary Hoeck in *The Infernal Machine and Other Plays* (New York: New Directions, 1963). [Sprigge & Kihm 1968, pp. 196–201 / Brown 1968, pp. 388–91 / McGraw-Hill 1984, 1:532, 535 / Jones 1962, p. 132]

Salvador Dalí, 1904–1989. "Triumph of Dionysus" ("Bacchus Carriage"). Watercolor. **1953**. Private coll., New York. [New York, no. 215—ill.]

————. "Dionysus Spitting the Complete Image of Cadaques on the Tip of the Tongue of a Three-Storied Gaudinian Woman." Painting. 1958. Private coll. [Ibid., no. 150]

————. "Dionysian Personages Setting Sail." Gouache. 1965. M. Knoedler & Co., New York, in 1965. [Ibid., suppl. p. 6]

————. "Dionysus and Pallas Athena." Silver medallion (face). 1966. Club Français de la Médaille, Paris. [Rotterdam 1970, no. 198—ill.]

Heinz Battke, 1900–1966. "The New Dionysus." Drawing. **1959**. Gerber coll., Heidelberg. [Berlin 1963, no. 66]

Donald Finkel, 1929–. "Dionysus." Poem. In *The Clothing's New Emperor and Other Poems* (New York: Scribner, **1959**). [Ipso]

W. S. Merwin, 1927–. (Dionysus evoked in) "The Drunk in the Furnace." Poem. In *The Drunk in the Furnace* (New York: Macmillan, **1960**). [Feder 1971, p. 413 / Benston 1962, pp. 195f.]

Vassar Miller, 1924–. "Invocation to Bacchus Grown Old." Poem. In *Wage War on Silence* (Middletown: Wesleyan University Press, **1960**). [Ipso]

Frederick Nicklaus, 1936–. (Caravaggio's "Bacchus" described in) "Caravaggio." Poem. In *The Man Who Bit the Sun* (New York: New Directions, **1962**). [Ipso]

Birgit Cullberg, 1908–1982, choreography. *Dionysos*. Ballet. First performed *c.*1967, Riks Theater, Sweden. [Clarke & Vaughan 1977, p. 99]

André Masson, 1896–1987. "Apollo and Dionysus." Etching. **1967**. [Passeron 1973, p. 177]

Roberto García Morillo, 1911–. *Dionysos*. Orchestral composition. **1971**. [Grove 1980, 7:157]

James Cunningham, 1938–, and **Lauren Persichetti**, 1944–, choreography. *Apollo and Dionysus: Cheek to Cheek*. Ballet. First performed **1974**, New York. [McDonagh 1976, p. 358]

Ruth Zechlin, 1926–. *Dionysos und Apollo*. Composition for flute, strings, and percussion. **1976**. [Baker 1984, p. 2558]

Elaine de Kooning, 1920–. "Bacchus." Series of paintings, after Dalou's "Triumph of Silenus" (1884, Paris). **Late 1970s–early 1980s**. National Museum of Women in the Arts, Washington, D.C. [Washington 1987, p. 97—ill. / see also R. Slivka, "Elaine de Kooning: The Bacchus Painting," *Arts Magazine* 57 (Oct 1982): 6–9]

Earl Staley, 1938–. "Bacchus with Maenads and Satyrs." Painting. **1983.** Watson/de Nagy, Houston, in 1984. [Houston 1984, p. 79—ill.]

Erick Hawkins, 1909–, choreography. *God the Reveller.* Modern dance. Music, Alan Hovhaness. First performed Dec **1987,** Erick Hawkins Dance Company, Joyce Theater, New York. [*New York Times,* 20 Dec 1987, Section H, p. 26]

Infancy. When she was pregnant with Dionysus (Bacchus), her child by Zeus (Jupiter), Semele prevailed on the god to show himself to her in his true form. The resulting bolt of lightning reduced the girl to ashes, but Zeus sewed the unborn child in his thigh until gestation was complete. Then, for protection from the jealous wrath of Hera (Juno), Zeus had Hermes (Mercury) spirit the infant away into hiding.

Dionysus was first given to Semele's sister Ino, wife of Athamas, who disguised him as a girl to escape Hera's attention. But the goddess was not deceived and contrived to punish Ino and Athamas by driving them mad. Dionysus was then taken to Mount Nysa, where he was reared as a goat by the mountain nymphs; Zeus later rewarded the nymphs by placing them among a group of stars.

Postclassical representations in the fine arts depict Hermes taking the infant god to the nymphs or Ino caring for him. Some depictions of the infant Dionysus, crowned with vine-leaves and surrounded by bacchantes, prefigure the adult god of wine.

Classical Sources. Homeric Hymns, first and third hymns "To Dionysus." *Orphic Hymns* 51, "To the Nymphs." Diodorus Siculus, *Biblioteca* 4.2.3–4. Ovid, *Metamorphoses* 3.313–15. Apollodorus, *Biblioteca* 3.4.3. Hyginus, *Fabulae* 131, 192. Lucian, *Dialogues of the Gods* 12, "Poseidon and Hermes."

See also SEMELE.

Francesco Colonna, *c.*1433–1527. (Birth and infancy of Bacchus represented in reliefs on triumphal car in) *Hypnerotomachia Poliphili* [The Dream of Poliphilo]. Romance. Venice: **1499;** illustrated with woodcuts by anonymous engraver. [Appell 1893, p. 9, pls. 58, 60]

Giovanni Bellini, *c.*1430–1516 (previously attributed to Basaiti, Giorgione). "The Infant Bacchus." Painting. *c.*1515. Kress coll. (K1659), National Gallery, Washington, D.C., no. 1362. [Sienkewicz 1983, p. 3—ill. / also Shapley 1966–73, 2:43—ill. / Walker 1984, fig. 245] School variant. Palazzo Venezia, Rome. [Sienkewicz / Shapley / cf. Wind 1948, p. 27, fig. 10] Copy (Italian School, 16th century), on marble bas-relief, in North Carolina Museum of Art, Raleigh. [Shapley]

Marcantonio Raimondi, *c.*1480–1527/34. "Pan and the Infant Bacchus" ("Satyr and Child"). Engraving (Bartsch no. 281), after design by Raphael? (or studio?). *c.*1515–16. [Shoemaker 1981, no. 35—ill. / also Bartsch 1978, 26:266]

Antonio da Correggio, *c.*1489/94–1534. "Ino with Infant Bacchus" (? or Vesta with the infant Jupiter?). Fresco. *c.*1519. Camera di San Paolo, Parma. [Gould 1976, pp. 51ff., 243—ill.]

Andrea Schiavone, 1522–1563. "The Infant Bacchus and Nymphs." Painting. *c.*1560. Formerly Italico Brass coll., Venice. [Richardson 1980, no. 306—ill.]

Anthony van Dyck, 1599–1641. "The Triumph of Infant Bacchus." Painting. *c.*1623–25. North Carolina Museum of Art, Raleigh. [Larsen 1988, no. 478—ill.] Replica. Lord Belper coll., Britain. [Ibid., no. 479]

Nicolas Poussin, 1594–1665. "The Nurture of Bacchus" ("Small Bacchanal"). Painting. **Mid-1620s.** National Gallery, London, no. 39. [Wright 1985, no. 16—ill. / Blunt 1966, no. 133—ill. / London 1986, p. 490—ill. / also Thuillier 1974, no. 31—ill.] Variant. Louvre, Paris, no. 7295. [Wright, no. 23, pl. 118 / Louvre 1979–86, 4:144—ill. / Blunt, no. R64 (as school) / Thuillier, no. 37—ill. / Dublin 1985, no. 33—ill.] Copy by Eugène Isabey (1803–1889). Louvre, no. R.F. 1974–13. [Louvre 1979–86, 3:327—ill.]

————. "The Nurture of Bacchus." Painting. 1630–35. Musée Condé, Chantilly, no. 298. [Wright, no. 45, pl. 126 / Blunt, no. 134—ill. / also Thuillier, no. 40 (cf. no. 209)—ill.]

————. "The Birth of Bacchus" (Bacchus delivered to nymphs by Mercury). Painting. 1657. Fogg Art Museum, Harvard University, Cambridge. [Wright, no. 190—ill. / Blunt, no. 132—ill. / Harvard 1985, no. 195—ill. / Vermeule 1964, pp. 112, 174 / also Thuillier, no. 204—ill. / Wildenstein 1968, no. 32—ill.] Copies in Musée Fabre, Montpellier; private colls.; elsewhere. [Blunt]

Hendrik van Balen, 1575–**1632.** "The Birth of Bacchus." Painting. Musée, Moulins. [Bénézit 1976, 1:401]

Thomas Heywood, 1573/74–1641. "Neptune and Mercury" (discuss the birth of Bacchus). Poetic dialogue, translated from Lucian. No. 12 in *Pleasant Dialogues and Dramas* (London: **1637**). [Heywood 1874, vol. 6]

Laurent de La Hyre, 1606–1656. "Mercury Delivers Bacchus to Be Raised by the Nymphs." Painting. **1638.** Hermitage, Leningrad, inv. 1173. [Hermitage 1984, no. 90—ill. / also Hermitage 1974, pl. 39]

Guido Reni, 1575–**1642.** "The Youthful Bacchus Drinking" ("A Putto Drinking Wine"). Painting. Gemäldegalerie, Dresden, no. 327. [Dresden 1976, p. 86 / Pepper 1984, no. 170—ill.]

————, attributed. "(The Boy) Bacchus." Painting. Palazzo Pitti, Florence, no. 47. [Pepper, p. 304 no. C3 (attribution rejected) / also Gnudi & Cavalli 1955, no. 58 (as Guido)—ill. / Pitti 1966, p. 115 (as Guido)—ill.]

————, previously attributed (attributed to Giovanni Andrea Sirani, 1610–1670). "Bacchus as a Child." Painting. Bayerische Staatsgemäldesammlungen, Munich, inv. 1788. [Pepper, p. 304 no. C4]

Alessandro Algardi, 1598–1654. "Infant Bacchus." Marble statue, lost, known only from description in Scipione della Staffa's poem (see below). By 1643. [Montagu 1985, no. L.125]

Scipione della Staffa. "Quest' ebro pargoletti" [This Drunken Child]. Poem, after Algardi's "Infant Bacchus" (above). In *Poesie dedicate alle glorie del Sig. Alessandro Algardi, ottimo degli scultori,* edited by della Staffa (Perugia: **1643**). [Montagu 1985, 2:404]

Nicolaes Berchem, 1620–1683. "The Childhood of Bacchus." Painting. **1648**. Mauritshuis, The Hague, inv. 11. [Mauritshuis 1985, p. 336—ill.]

Jacob Jordaens, 1593–1678. "Young Bacchus" ("Infant Bacchus Seated in a Landscape"). Painting. **Late 1640s**. Muzeum Narodowe, Warsaw, inv. 164265. [Warsaw 1969, no. 539—ill. / Ottawa 1968, no. 95—ill. / also Rooses 1908, p. 257 / d'Hulst 1982, p. 220]

————, attributed. "The Child Bacchus, Asleep" ("Sleeping Bacchus"). Etching. [Rooses 1908, pp. 176, 257]

Jean Lemaire, 1598–**1659** (previously attributed to Poussin, Sustris). "The Childhood of Bacchus" ("The Childhood of Romulus"). Painting. National Gallery of Ireland, Dublin, cat. 800. [Dublin 1985, no. 21—ill.]

Francesco Albani, 1578–**1660**. "Mercury Delivering the Infant Bacchus into the Care of the Nymphs of Nisa." Painting. Bowes Museum, Barnard Castle. [Wright 1976, p. 1]

Ferdinando Tacca, 1619–1686. "Infant Bacchus." Bronze fountain figure. *c.***1660?** Museo, Prato. [Agard 1951, fig. 46]

José Antolínez, 1635–1675. "The Education of Bacchus." Painting. **1665**. Duquesa Viuda de Andría coll., Madrid. [López Torrijos 1985, pp. 340, 426 no. 5—ill.]

————. "The Education of Bacchus in the Art of Love." Painting. 1667. López-Robert coll. [Ibid., no. 6]

Juan Carreño de Miranda, 1614–1685. "Infant Bacchus" ("The Monster," portrait of Eugenia Martinez Vallejo). Painting. *c.***1680**. Prado, Madrid, no. 2800. [López Torrijos 1985, p. 426 no. 1—ill.]

Dutch School? "Young Bacchus." Lead statuette. **1650/ 1700?** Kunstmuseum, Düsseldorf, inv. 1938–27. [Düsseldorf 1971, no. 295—ill.]

Carlo Maratti, 1625–**1713**. "Mercury Delivers the Infant Bacchus to the Nymphs." Drawing. Lugt coll., Institut Neerlandais, Paris. [Warburg]

Jean-François de Troy, 1679–1752. "The Infancy of Bacchus." Painting. **1717**. Staatsmuseum, Berlin, inv. KFMV 240. [Warburg]

Antoine Coypel, 1661–**1722**. "The Infancy of Bacchus." Painting. Musée, Alais. [Bénézit 1976, 3:246]

Pieter van der Werff, 1665–**1722**. "The Infant Bacchus." Painting. Rijksmuseum, Amsterdam, inv. C268. [Rijksmuseum 1976, p. 601—ill.]

Jan Baptist Xavery, 1697–1742. "Young Bacchus." Wooden statuette. **1729**. Victoria and Albert Museum, London, inv. A.18–1948. [Düsseldorf 1971, no. 292—ill.]

Louis Boulogne the Younger, 1654–**1733**. "The Infancy of Bacchus." Painting. City Art Gallery, Dundee. [Wright 1976, p. 24]

François Boucher, 1703–1770. "Mercury Entrusts the Young Bacchus to the Nymphs." Painting. *c.***1734**. Wallace Collection, London, no. P.487. [Ananoff 1976, no. 106—ill.] Grisaille sketch, private coll., New York. [Ibid., no. 105—ill.]

————. "The Birth of Bacchus" (nymphs with infant, Mercury, and cupids above). Painting. 1769. Kimbell Art Museum, Fort Worth, Texas. [Ibid., no. 676—ill.]

Pompeo Batoni, 1708–1787, and **Andrea Locatelli**, 1695–1741. "Mercury Delivering the Infant Bacchus to the

Nymphs of Nysa." Painting. *c.***1738**. Unlocated. [Clark 1985, no. 17—ill.]

French School. "The Education of Bacchus." Painting. **Mid-18th century**. Hermitage, Leningrad, inv. 8423. [Hermitage 1986, no. 134—ill.]

Franz Anton Maulbertsch, 1724–1796. "The Education of Bacchus." Painting (sketch for ceiling decoration?). *c.***1759**. Österreichische Galerie, Vienna. [Garas 1960, no. 117—ill.]

Giovanni Battista Tiepolo, 1696–1770, with **Giovanni Domenico Tiepolo**, 1727–1804. "The Education of Bacchus." Grisaille painting. *c.***1750–60**. Formerly Seusslitz coll., near Grossenhain, Saxony, unlocated. [Morassi 1962, pp. 5, 48]

Joshua Reynolds, 1723–1792. "Ino and the Infant Bacchus." Painting. Exhibited **1771**. Formerly Sir R. Abdy coll., sold 1936. [Waterhouse 1941, p. 61]

————. "Mrs. Hartley as Nymph with Infant Bacchus." Painting. 1773. Tate Gallery, London. [Ibid., p. 63, pl. 141b]

————. "Master Herbert as Bacchus." Painting. Exhibited 1776. Earl of Carnarvon coll., Highclere. [Ibid., p. 67]

Charles-Joseph Natoire, 1700–**1777**. "Mercury Confiding the Infant Bacchus to the Nymphs." Drawing. Fogg Art Museum, Harvard University, Cambridge, inv. 1955.133. [Houser 1979, no. 62—ill.]

John Flaxman, 1755–1826. "The Nurturing of Bacchus." Drawing. *c.***1780**. Hunterian Art Gallery, University of Glasgow. [Irwin 1979, p. 17, fig. 21]

————, design. "Mercury Presenting Bacchus to the Nymphs." Figures on stem of silvergilt candelabrum. Executed by Paul Storr, 1809–10. Royal Collection, England. [Ibid., p. 191, fig. 264 / also Bindman 1979, no. 185b—ill.]

Nicolas Tanche, *c.*1740–? "Infant Bacchus with Putti." Painting. Bowes Museum, Barnard Castle. [Wright 1976, p. 197]

Henry Fuseli, 1741–1825. "Bacchus as a Child" Drawing. *c.***1795**. Kunsthaus, Zürich, inv. 1914/12. [Schiff 1973, no. 998—ill.]

Antonio Canova, 1757–1822. "The Birth of Bacchus" (Hermes giving infant Bacchus to the nymphs). Plaster relief. **1797**. Gipsoteca Canoviana, Possagno, no. 95. [Pavanello 1976, no. 104—ill. / Licht 1983, p. 256—ill.]

Bertel Thorwaldsen, 1770–1844. "Mercury Brings the Infant Bacchus to Ino." Marble relief. 2 versions. Plaster originals, **1809**. Thorwaldsens Museum, Copenhagen, nos. A346, 347. / Marble versions. Thorwaldsens Museum, Copenhagen, no. A796 (executed by P. Andersen and T. Stein, 1889); Biblioteca Ambrosiana, Milan; private colls.; others unlocated. [Cologne 1977, no. 43 / Hartmann 1979, pp. 144ff.—ill. / Thorwaldsen 1985, pp. 47, 78]

Johan Tobias Sergel, 1740–**1814**. "Infant Bacchus Riding on a Ram." Terra-cotta relief. [Göthe 1921, no. 8—ill.]

William Dyce, 1806–1864. "Bacchus Nursed by the Nymphs of Nysa." Painting. Exhibited 1827. Lost. / Oil study and drawing, **1826**. Both in Aberdeen Art Gallery, Scotland. [Pointon 1979, pp. 9f., 197f.—ill.] Watercolor variant. *c.*1827. Beinecke Library, Yale University, New Haven. [Ibid., p. 209—ill.]

Richard James Wyatt, 1795–1850. "Ino and Bacchus." Marble sculpture. Several versions, **1837** and later. For-

merly Grittleton House, Wiltshire; elsewhere. [Read 1982, p. 141]

John Henry Foley, 1818–1874. "Ino and Bacchus." Marble sculpture. Before 1849. [Read 1982, p. 59] Original plaster, **1840.** Royal Dublin Society, Dublin. [Ibid., pl. 56]

William Leman Rede, 1802–1847. *The Boyhood of Bacchus.* Extravaganza. First performed **1845,** London. [Nicoll 1959–66, 4:391]

Heinrich Kümmel, 1810–1855. "The Education of Bacchus." Marble sculpture. **1846.** Niedersächsische Landesgalerie, Hannover. [Cologne 1977, p. 273—ill.]

Jean-Léon Gérôme, 1824–1904. "Anacreon, [Infant] Bacchus, and Amor." Painting. **1848.** Musée des Augustins, Toulouse. [Ackerman 1986, no. 19—ill.]

———. (Children representing) "Drunken Bacchus and Cupid." Painting. 1850. Musée, Bordeaux. [Ibid., no. 31—ill.]

———. "Anacreon with [Infant] Bacchus and Amor." Marble sculpture. 1878–81. Ny Carlsberg Glyptotek, Copenhagen. [Ibid., no. S.10—ill.] At least 20 bronze casts, several sizes. Musée Garret, Vesoul (2); Art Institute of Chicago; Hearst Castle, San Simeon, Calif.; elsewhere. [Ibid.]

Jean-Baptiste Clésinger, 1814–1883. "The Youth of Bacchus" (infant Bacchus on a panther). Marble sculpture. **1869.** Musée d'Orsay, Paris, inv. R.F. 875. [Orsay 1986, p. 99—ill.] Marble reduction. Château de Versailles. / Reduced bronze edition, by Marnyhac. [Ibid.]

Jean-Joseph Perraud, 1819–1876. "The Infancy of Bacchus." Marble sculpture group. Musées Nationaux, inv. R.F. 192, deposited in Musée, Lons-le-Saunier, in 1986. [Orsay 1986, p. 278]

William Bouguereau, 1825–1905. "Return from the Harvest" ("The Donkey Ride") (infant Bacchus on donkey, accompanied by bacchantes). Painting. **1878.** Cummer Gallery of Art, Jacksonville, Fla. [Montreal 1984, no. 71—ill. / also Isaacson 1974, no. 14—ill.] Oil sketch. c.1877. Private coll. [Montreal, p. 119—ill.]

———. "The Education of Bacchus." Painting. 1884. Private coll. [Montreal, no. 100—ill. / also Boime 1971, pl. 64] Oil sketch. Vincens-Bouguereau coll., Paris. [Montreal, no. 105—ill. / Boime, pl. 63]

John La Farge, 1835–1910. "The Infant Bacchus." Stained-glass window, for W. B. Thomas house, Beverly, Mass. **1882–84.** Museum of Fine Arts, Boston. [Adams et al. 1987, no. 106, fig. 25]

Léon Perrault, 1832–1908. "Bacchus as a Child." Painting. **1897.** [Dijkstra 1986, p. 194—ill.]

Eugène Lagare, fl. late **19th-early 20th century.** "The Infancy of Bacchus." Bronze sculpture group. Musées Nationaux, inv. LUX 373, deposited (from Musée du Luxembourg) in Palais du Sénat, Paris, in 1915. [Orsay 1986, p. 274]

Charles Shannon, 1863–1937. "Hermes and the Infant Bacchus." Painting. **1902–06.** Tate Gallery, London, no. 5030. [Tate 1975, p. 204]

Arthur B. Davies, 1862–1928. "Hermes and the Infant Dionysus." Painting. c.**1909.** Cleveland Museum of Art. [Utica 1962, no. 36—ill. / Cortissoz 1931, p. 26]

Émile Aubry, 1880–1964. "Bacchanale" ("The Education

of Bacchus"). Painting. Before **1929.** Musée d'Orsay, Paris, no. RF 1978–41. [Louvre 1979–86, 3:38—ill.]

Karl Begas, b. 1845. "Young Faun and Infant Bacchus." Sculpture. Before **1930?** Staatliche Museen, Berlin. [Bénézit 1976, 1:577]

Angelos Sikelianos, 1884–**1951.** "Dionysos epi likno" [Dionysus Encradled]. Poem. [Savidis 1981, vol. 5 / Keeley & Sherrard 1979]

Jacob Epstein, 1880–1959. "Infant Bacchus" ("Young Bacchus"). Bronze sculpture. **1956.** Schinman coll., Wayne, N.J. [Schinman 1970, p. 76—ill.] Plaster modello (on the back of maquette for "Seated Mother"). [Buckle 1963, p. 305—ill.]

Dionysus and the Pirates. When Dionysus (Bacchus) was kidnapped by Tyrrhenian pirates and held captive on their ship, only Acoetes, the helmsman, recognized that their hostage was a god. Dionysus caused the ship's masts and sails to become overgrown with vines and transformed himself into a lion, thus revealing his divine aspects. All the pirates, except Acoetes, jumped into the sea and were changed into dolphins; the helmsman was put ashore by the god and promised happiness and good fortune.

Perhaps the most famous depiction from antiquity was made by Exekias, whose painting inside a black-figure drinking cup (kylix) from the sixth century BCE shows the god sailing in a garlanded ship.

Classical Sources. *Homeric Hymns,* second hymn "To Dionysus." Ovid, *Metamorphoses* 3.582–692. Apollodorus, *Biblioteca* 3.5.3. Hyginus, *Fabulae* 134; *Poetica astronomica* 2.17. Philostratus, *Imagines* 1.19.

Filarete, c.1400–1469? "Transformation of the Tyrrhenian Pirates into Dolphins." Relief, on bronze door of St. Peter's, Rome. **1433–45.** In place. [Pope-Hennessy 1985b, 2:318]

Daniele da Volterra, 1509–1566. "Bacchus and the Tyrrhenian Pirates." Detail in frescoed frieze. Palazzo Farnese, Rome. c.**1548–50.** [Barolsky 1979, no. 12—ill.]

David Vinckeboons, 1576–**1629.** "Bacchus and the Pirates." Painting. / Engraved by Jacob Matham (d. 1631). [Warburg]

Leigh Hunt, 1784–1859. "Homer's Bacchus, or, The Pirates." Poem. In *The Feast of the Poets* (London: Gale, Curtis & Fenner, **1815**). [NUC]

Alexandros Rizos Rankabes, 1809/10–1892. (Dionysus kidnapped by pirates in) *The Voyage of Dionysos.* Poem. Athens: **1864.** [Trypanis 1981, p. 615]

Gordon Bottomley, 1874–1948. "The Stealing of Dionysos," "An Eclogue to the Stealing of Dionysos: Iacchos Speaking." Poems. In *The Gate of Smaragdus* (London: At the Sign of the Unicorn, **1904**), and in *Poems of Thirty Years* (London: Constable, 1925). [Ipso / Bush 1937, p. 566]

Richard Edwin Day, b. 1852. "The Voyage of Bacchus."

Poem. In *New Poems* (New York: Grafton, **1909**). [Boswell 1982, p. 83]

Alfred Noyes, 1880–1958. "Bacchus and the Pirates." Poem. In *Collected Poems,* vol. 2 (New York: Stokes, **1913**). [Boswell 1982, p. 197]

D. H. Lawrence, 1885–**1930.** (Dolphins playing about Dionysus's ship evoked in) "They Say the Sea Is Loveless." Poem. In *Last Poems* (Florence: Orioli; London: Heinemann, 1932). [Ipso]

Ezra Pound, 1885–1972. (Bacchus and the pirates evoked in) Canto 2, in *A Draft of XXX Cantos* (Paris: Hours, **1930**; Norfolk, Conn.: New Directions, 193[3?]). [Flory 1980, pp. 108f.]

Robert Graves, 1895–1985. (Story of Bacchus and the pirates evoked in) "The Ambrosia of Dionysus and Semele." Poem. In *New Poems* (Garden City, N.Y.: Doubleday, **1963**). [Graves 1975]

Erick Hawkins, 1909–, choreography. (Bacchus and the pirates in) *God the Reveller.* Modern dance. Music, Alan Hovhaness. First performed Dec **1987,** Erick Hawkins Dance Company, Joyce Theater, New York. [New York Times, 20 Dec 1987, Section H, p. 26]

Dionysus and Ariadne. After helping Theseus to kill the Minotaur, Ariadne, daughter of the Cretan king, Minos, and his wife Pasiphaë, sailed from Crete with Theseus. Upon reaching the island of Naxos, Theseus abandoned (or some say forgot) Ariadne and sailed homeward. On Naxos she was discovered, rescued, and wed by Dionysus (Bacchus), to whom she bore many children.

As part of the wedding ceremony, Dionysus crowned Ariadne with a wreath; later (some say upon her death) he threw the crown into the sky, where it became the constellation Corona Borealis. According to Hesiod, Ariadne was made immortal by Zeus because of her marriage to a god. However, Apollodorus suggests that Dionysus kidnapped Ariadne, but did not marry her.

The subject has been very popular in the postclassical period, particularly in the visual arts. Representations center on Dionysus's discovery of Ariadne and especially their wedding ceremony, commonly depicted as a bacchanal.

Classical Sources. Homer, *Odyssey* 11.321–25. Hesiod, *Theogony* 947–49. Bacchylides, "Theseus." Catullus, *Carmina* 64.251ff. Ovid, *Ars amatoria* 1.537ff.; *Heroides* 10; *Metamorphoses* 8.176–83. Apollodorus, *Biblioteca* E1.9. Philostratus, *Imagines* 1.15–25. Hyginus, *Fabulae* 43. Nonnus, *Dionysiaca* 47.

See also ARIADNE.

Donatello, *c.*1386–**1466.** "Bacchus and Ariadne." Marble relief. Palazzo Medici-Riccardi,Florence. [Pigler 1974, p. 46]

Lorenzo de' Medici, 1449–1492. "Canzone di Bacco"

[Song of Bacchus]. Song, composed for Carnival, **1490,** Florence. [Bondanella, 1979, p. 326 / Sturm 1974, pp. 77, 83–5.]

———. "Il trionfo di Bacco e Arianna." Poem. [Pirrotta & Povoledo 1982, pp. 21, 28]

Cima da Conegliano, *c.*1459–1517/18. "Bacchus and Ariadne." Painting. *c.***1505–10.** Museo Poldi Pezzoli, Milan, no. 686. [Humfrey 1983, no. 89—ill. / Berenson 1957, p. 66—ill.]

Baldassare Peruzzi, 1481–1536. "Bacchus and Ariadne." Ceiling fresco, representing the constellation of the Crown. **1510–11.** Sala di Galatea, Villa Farnesina, Rome. [d'Ancona 1955, pp. 25f., 86—ill. / Gerlini 1949, pp. 10ff. / also Frommel 1967–68, no. 18c]

Bartolomeo di Giovanni, fl. *c.*1483–**1511.** "Bacchus and Ariadne." Cassone. Musée de Longchamp, Marseille. [Pigler 1974, p. 46]

Piero di Cosimo, *c.*1462–**1521,** previously attributed. "Bacchus and Ariadne." Painting. Musée des Beaux-Arts, Marseilles. [Bacci 1966, p. 122]

Titian, *c.*1488/90–1576. "Bacchus and Ariadne." Painting. **1520–23.** National Gallery, London, inv. 35. [Wethey 1975, no. 14—ill. / London 1986, p. 617—ill. / also Minneapolis 1978, fig. 7 / Vermeule 1964, p. 87] Copies in Accademia Carrara, Bergamo (by Padovanino); Galleria Pitti, Florence (partial copy, in storage); Accademia di San Luca, Rome, no. 231 (partial); another unlocated. [Wethey]

———. (Sleeping Ariadne in) "The Andrians" ("Bacchanal"). Painting. *c.*1523–25. Prado, Madrid, no. 418. [Wethey, no. 15—ill. / Prado 1985, p. 699] Numerous copies after, *see Bacchanalia.*

Tullio Lombardo, *c.*1455–1532. "Bacchus and Ariadne." Marble relief. Probably before **1525.** Kunsthistorisches Museum, Vienna. [Pope-Hennessy 1985b, 2:341f.—ill.]

Giulio Romano, *c.*1499–1546, and assistant. "Bacchus and Ariadne" ("Venus and Adonis"?). Fresco. **1527–28.** Sala di Ovidio (Metamorfosi), Palazzo del Tè, Mantua. [Verheyen 1977, p. 110 / Hartt 1958, p. 111—ill.]

———, assistant, after design by Giulio. "Bacchus and Ariadne." Fresco. 1528. Sala di Psiche, Palazzo del Tè. [Hartt, p. 132, fig. 262 / Verheyen, p. 117—ill.]

———. 3 further frescoes depicting Bacchus and Ariadne. Grotta, Palazzo del Tè. [Verheyen, p. 130.]

Matteo Balducci, ?–**1555?** "Bacchus and Ariadne." Painting. Pinacoteca, Gubbio. [Pigler 1974, p. 46]

Bastianino, 1532–1602, and **Camillo Filippi,** *c.*1500–1574, attributed. "Triumph of Ariadne." Fresco. *c.***1555.** Camerino dei Baccanali, Castello Estense, Ferrara. [Arcangeli 1963, pp. 9f., no. 27—ill.]

Girolamo da Carpi, 1501–**1556.** "Triumph of Ariadne," "Triumph of Bacchus." 2 frescoes. Castello, Ferrara. [Berenson 1968, p. 189]

Garofalo, *c.*1481–**1559.** "The Marriage of Bacchus and Ariadne." Painting, after a drawing by Raphael. Gemäldegalerie, Dresden, inv. 138. [Pigler 1974, p. 46]

Jan Sanders van Hemessen, *c.*1500–**after 1563.** "Bacchus and Ariadne." Painting. National Gallery of Scotland, Edinburgh, cat. 1970 no. 78. [Wright 1976, p. 89]

Jacopo Tintoretto, 1518–1594. "The Marriage of Bacchus and Ariadne, in the Presence of Venus." Painting. **1577–78.** Sala dell' Anti-Collegio, Palazzo Ducale, Venice.

[Rossi 1982, no. 374—ill. / also de Bosque 1985, p. 45—ill. / Berenson 1957, p. 179] *See also Domenico Tintoretto, below.*

Domenico Tintoretto, 1562–1635 (previously attributed to Jacopo Tintoretto). "Venus, Bacchus, and Ariadne." Painting. **1580s?** Musée des Beaux-Arts, Strasbourg, inv. 177. [Rossi 1982, no. A95—ill.]

Agostino Carracci, 1557–1602, rejected attribution (Bartolomeo Cesi?). "Bacchus and Ariadne." Fresco (detached). **Early 1590s?** Pinacoteca Nazionale, Bologna, inv. 6339. [Ostrow 1966, no. III/2]

Annibale Carracci, 1560–1609. "Triumph of Bacchus and Ariadne" ("Bacchanale"). Fresco. *c.*1597–1600. Galleria, Palazzo Farnese, Rome. [Malafarina 1976, no. 104x—ill. / Martin 1965, pp. 115ff.—ill. / Vermeule 1964, p. 97—ill.]

Flemish School. "Bacchus and Ariadne." Painting. **17th century.** Maidstone Museum and Art Gallery, Kent, inv. 00–1873–84. [Wright 1976, p. 65]

Jan Brueghel the Elder, landscape, 1568–1625, and **Hendrik van Balen**, figures, 1575–1632. "The Marriage Feast of Bacchus." Painting. **1606–07.** Gemäldegalerie, Dresden, inv. 919. [Ertz 1979, no. 147—ill.]

———— and van Balen. "The Marriage of Bacchus and Ariadne." Painting. *c.*1610. Musées Royaux des Beaux-Arts (Musée d'Art Ancien), Brussels, inv. 9736. [Brussels 1984a, p. 40—ill. / also Ertz, no. 230—ill.]

Thomas Heywood, 1573/74–1641. (Bacchus and Ariadne evoked in notes to) *Troia Britanica: or Great Britaines Troy.* Poem. Licensed 5 Dec **1608.** London: Jaggard, 1609. [Clark 1931, pp. 50–54, 63 / also Bush 1963, pp. 194]

Bartolomeo Schidone, c.1570–**1615.** "Bacchus and Ariadne." Painting. [Bénézit 1976, 9:351]

Ludovico Carracci, 1555–**1619.** "Bacchus and Ariadne." Painting. Formerly Manfrin coll., Venice. [Pigler 1974, p. 47]

Guido Reni, 1575–1642. "Bacchus and Ariadne." Painting. **1619–20.** Los Angeles County Museum of Art. [Pepper 1984, no. 66—ill.] Copies in Villa Albani, Rome (attributed to Francesco Gessi); 4 others unlocated. [Ibid.]

————. "Bacchus and Ariadne on the Isle of Naxos." Painting, for Queen Henrietta Maria of England. 1637–40. Destroyed. / Etching by Bolognini. [Pepper, no. 169—ill.] Studio variant (by G. A. Sirani). Accademia di San Luca, Rome. [Ibid. / Gnudi & Cavalli 1955, no. 97—ill.] Copies in Palazzo Montecitorio, Rome; private coll., Rio de Janeiro; 5 others, unlocated. [Pepper / Gnudi & Cavalli, no. 96—ill.]

————, copy after. "Bacchus and Ariadne." Painting. Museum and Art Galleries, Salford. [Wright 1976, p. 171]

Nicolas Poussin, 1594–1665. "Bacchus and Ariadne." Painting. **Mid-1620s.** Prado, Madrid, no. 2312 (as "Bacchanal"). [Wright 1985, no. 15, pl. 108 / Thuillier 1974, no. B8—ill. / Prado 1985, p. 517 / also Blunt 1966, no. R66 (rejected attribution)]

————. "Triumph of Bacchus and Ariadne." Drawing. *c.*1626. Royal Library, Windsor Castle, no. 11990. [Friedlaender & Blunt 1953, no. 183—ill.]

————. "Bacchus and Ariadne." 2 drawings (studies for lost painting?). Early 1630s? Royal Library, Windsor Castle, nos. 11888 verso, 11911. [Ibid., nos. 181–82—ill.]

————, doubtfully attributed. "Bacchus and Ariadne."

Painting. *c.*1630? Hermitage, Leningrad. [Wright, no. A14 / Thuillier 1974, no. R58b—ill. / also Blunt, no. R66]

————, rejected attribution (follower of Dufresnoy). "Bacchus and Ariadne." Painting. Private coll., U.S.A. / Drawing. École des Beaux-Arts, Paris. [Friedlaender & Blunt, no. B23]

————, rejected attribution. "Bacchus and Ariadne." Drawing. British Museum, London, no. 1913–1–11–2 (as Poussin). [Ibid.]

Giovanni da San Giovanni, 1592–1636. "Bacchus and Ariadne." Fresco, detached, one of a series of 6, for Lorenzo de' Medici. *c.*1634. Uffizi, Florence, inv. 5425. [Banti 1977, no. 58 / Uffizi 1979, no. P739—ill.]

————. "Bacchus and Ariadne." Fresco, detached, one of a series of 8, for Lorenzo de' Medici. *c.*1634. Uffizi, Florence, inv. 5428. [Banti, no. 60 / Uffizi, no. P740—ill.]

Peter Paul Rubens, 1577–1640. "Bacchus and Ariadne." Painting, for Torre de la Parada, El Pardo, executed by Erasmus Quellinus from Rubens's design. **1636–38.** Prado, Madrid, no. 1629. [Alpers 1971, no. 8—ill. / Jaffé 1989, no. 1242—ill. / Prado 1985, p. 523] Oil sketch. Museum Boymans-van Beuningen, Rotterdam, no. St. 29. [Alpers, no. 8a—ill. / Held 1980, no. 174—ill. / Jaffé, no. 1241—ill.]

————. Painting, copy after Titian's "The Andrians" (*c.*1523–25, Prado). 1636–38. Nationalmuseum, Stockholm. [Jaffé, no. 1340—ill.]

Simon Vouet, 1590–1649. "Bacchus and Ariadne." Painting. Guy de Chavagnac coll., Paris. / Related tapestry, Château de Châteaudun. [Crelly 1962, no. 116.]

————. "Bacchus and Ariadne." Painting. Lost. / Engraved by Michel Dorigny, **1644.** [Ibid., no. 222—ill.]

————, or studio. "Bacchus and Ariadne." Painting, cartoon for "Loves of the Gods" tapestry series. [Ibid., no. 270u]

Louis Le Nain, *c.*1593–1648. "Bacchus and Ariadne." Painting. Musée des Beaux-Arts, Orléans. [Jacobs & Stirton 1984a, p. 29]

Padovanino, 1588–1648. "Ariadne and Bacchus." Painting. Formerly Dukes of Marlborough coll., Blenheim (as Titian). [Pigler 1974, p. 47] *See also Titian, above.*

Moyses van Uyttenbroeck, *c.*1590–1648, attributed. "Bacchus and Ariadne." Painting. Museum Bredius, The Hague, inv. 195–1946. [Wright 1980, p. 460.]

Alessandro Turchi, 1578–1649. "Bacchus and Ariadne." Painting. Several versions. Hermitage, Leningrad, inv. 123; Pavlovsk Palace, near Leningrad; Paul Ganz coll., New York; elsewhere. [Hermitage 1981, pl. 126]

Jacob Jordaens, 1593–1678. "Bacchus and Ariadne." Painting. *c.*1645–50. Museum of Fine Arts, Boston, no. 54.134. [d'Hulst 1982, fig. 193 / Boston 1985, p. 154—ill.]

————. "Ariadne in the Train of Bacchus" ("Allegory of Fruitfulness"). Painting, variant of "Allegory of Fruitfulness" (*c.*1615–20, Munich, elsewhere). *c.*1650. Gemäldegalerie, Dresden, no. 1009. [Dresden 1976, p. 63 / also Rooses 1908, pp. 92, 98—ill. / d'Hulst, fig. 196]

————. Numerous further versions of the subject known, unlocated. [Rooses, p. 258]

Jacob Backer, 1608–1651. "Bacchus Discovers Ariadne." Painting. Muzeum Narodowe, Warsaw, no. 233180. [Pigler 1974, p. 49]

Richard Fleckno, ?–*c*.1678. *Ariadne Deserted by Theseus and Found and Courted by Bacchus.* Opera. Libretto, composer. Published London: **1654.** [Grove 1980, 6:633 / Greg 1939–59, 2:845, no. 734]

Eustache Le Sueur, 1616–**1655.** "Bacchus Crowning Ariadne with Stars." Painting. Museum of Fine Arts, Boston, no. 68.764. [Boston 1985, p. 167—ill.]

Claude Lorrain, 1600–1682. "Coast View of Naxos with Ariadne and Bacchus." Painting. **1656.** Arnot Art Gallery, Elmira, N.Y. [Röthlisberger 1961, no. LV 139—ill.] Drawing after, in the artist's *Liber veritatis.* British Museum, London. [Ibid.]

Thomas de Keyser, *c*.1597–1667. "Bacchus Discovering Ariadne." Painting. **1657.** Rathaus, Amsterdam. [Pigler 1974, p. 49]

Daniel Vertangen, *c*.1598–1681/84. "Feast of Bacchus and Ariadne." Painting. **1658.** Louvre no. M.N.R. 725. [Louvre 1979–86, 1:146—ill.]

Robert Cambert, *c*.1627–1677. *Ariane, ou, Le mariage de Bacchus.* Opera. Libretto, Pierre Perrin. **1659.** Unperformed. / Music revised by Louis Grabu, 1661. Performed as *Ariane, or, The Marriage of Bacchus* 30 Mar 1674, by Royal Academy of Musick, Theatre Royal, Covent Garden, London. [Grove 1980, 3:638f. / Nicoll 1959–1966, 1:423]

Ferdinand Bol, 1616–1680. "Bacchus and Ariadne on Naxos." Painting. **1664.** Hermitage, Leningrad, cat. 1958 II.760. [Blankert 1982, no. 20—ill.]

Cornelis Willaerts, 1611?–**1666.** "Bacchus and Ariadne." Painting. Hermitage, Leningrad. [Bénézit 1976, 10:738]

Luca Giordano, 1634–1705. "Bacchus and Ariadne." Painting. *c*.**1666.** Untraced. [Ferrari & Scavizzi, 2:389]

———. "Bacchus and Ariadne." Painting. Late 1670s. Museo di Castelvecchio, Verona, no. 2680. [Ibid., 2:87—ill.]

———. "Bacchus and Ariadne." Painting. 1682–83. Gemäldegalerie, Dresden, no. 484. [Ibid., 2:111—ill.] Another version of the subject, mid-1680s, formerly at Dresden, destroyed. [Ibid., 2:272]

———. "Bacchus and Ariadne." Painting. Mid-1680s. Unlocated. [Ibid., 2:394—ill.]

———. "Bacchus and Ariadne." Painting. Walter Chrysler, Jr., coll., New York. [Ferrari & Scavizzi, 2:366]

———, school. "The Meeting of Bacchus and Ariadne." Painting. 18th century. Private coll., Galatina. [Ferrari & Scavizzi, 2:333]

———. "Triumph of Bacchus and Ariadne." Painting. Squerryes Court, Westerham, Kent. [Jacobs & Stirton 1984b, p. 30]

Pier Francesco Mola, 1612–**1666/68.** "Bacchus and Ariadne." Painting. Herzog Anton Ulrich-Museum, Braunschweig, no. 477. [Braunschweig 1976, p. 42—ill.]

Jean Donneau de Visé, 1638–1710. *Le mariage de Bachus et d'Ariane.* Comedy. First performed Dec **1671,** Théâtre Marais, Paris. Published Paris, Le Monnièr: 1672. [Lancaster 1929–42, pt. 3, 2:529–31, 868 / Taylor 1893, p. 139]

Louis de Mollier, *c*.1615–1688. *Le mariage de Baccus et Ariane.* Opera. Libretto, Donneau de Visé (1671). First performed **1672,** Paris. Lost. [Grove 1980, 12:471]

Giulio Carpioni, 1613–1679. "Bacchus Finds Ariadne on the Isle of Naxos." Painting. Szépművészeti Múzeum, Budapest, no. 622. [Budapest 1968, p. 125]

Francesco Redi, 1626–1698. (Bacchus and Ariadne in) *Bacco in Toscana* [Bacchus in Tuscany]. Dithyramb. Florence: Matini, **1685.** [DELI 1966–70, 4:520]

Gérard de Lairesse, 1641–1711 (active until *c*.**1690**). "Bacchus and Ariadne." Painting. Mauritshuis, The Hague, inv. 82. [Mauritshuis 1985, p. 389—ill.]

———. "Bacchus and Ariadne." Painting. Herzog Anton Ulrich-Museum, Braunschweig, no. 1099. [Braunschweig 1969, p. 85]

Johann Georg Conradi, d.1699. *Die schöne und getreue Ariadne* [The Beautiful and True Ariadne]. Opera. Libretto, Christian Heinrich Postel. First performed **1691,** Opera House, Hamburg. [Grove 1980, 4:664f.]

Antoine Coypel, 1661–1722. "Bacchus and Ariadne." Painting. Before **1693.** Hermitage, Leningrad, inv. 3693. [Hermitage 1986, no. 29—ill.] Variants and replicas: for the Duc d'Orléans, and etched by the artist; smaller version, Musée Calvet, Avignon; another sold Paris 1926, unlocated. [Ibid. / cf. Pigler 1974, p. 50]

———. "Bacchus and Ariadne." Painting. Holburne of Menstrie Museum, Bath, cat. 1936 no. 137. [Wright 1976, p. 44]

Marin Marais, 1656–1728. *Ariane et Bacchus.* Opera. Libretto, Saint-Jean. First performed **1696,** Academie Royale de Musique, Paris. [Grove 1980, 11:641 / Girdlestone 1972, p. 126]

Italian School. "Bacchus and Ariadne." Painting. **Late 17th century.** Louvre, Paris, inv. 20411. [Louvre 1979–86, 2:264—ill.]

Willem van Mieris, 1662–1747. "Bacchus and Ariadne." Painting. **1704.** Gemäldegalerie, Dresden, no. 1772. [Pigler 1974, p. 49]

Sebastiano Ricci, 1659–1734. "Bacchus and Ariadne." Painting. *c*.**1705** or later. National Gallery, London, inv. 851. [Daniels 1976, no. 178 / London 1986, p. 531 (as 1700–10 or early 1730s?)—ill.]

———. "Bacchus and Ariadne." Painting. *c*.1705–10. Suida Manning coll., New York. [Daniels, no. 271—ill.]

———. "Bacchus and Ariadne." Painting. *c*.1706–10? Mary Longari Dolci coll., Milan, in 1953. [Ibid., no. 232—ill.]

———. "Bacchus and Ariadne." Painting. *c*.1713. Chiswick House, London. [Ibid., no. 170—ill. / Wright 1976, p. 172]

———. "The Meeting of Bacchus and Ariadne." Painting. 1712–16. Royal Academy, London, no. 541. [Daniels, no. 167—ill.]

———. "Bacchus and Ariadne." Painting. After 1716. Schönborn coll., Pommersfelden, inv. 314. [Ibid., no. 352—ill.]

———. "Bacchus and Ariadne." Painting. Early 1720s. Palazzo Taverna, Rome. [Ibid., no. 386—ill.] Studio variant. Private coll., Italy. [Ibid., no. 123b]

———. "(The Marriage of) Bacchus and Ariadne." Painting. *c*.1717–23? Sir Joseph Weld coll., Lulworth Castle, Dorset, no. 116. [Daniels, no. 214—ill.]

Giacinto Calandrucci, 1646–**1707.** "Bacchus Discovering Ariadne." Painting. Private coll., Berlin. [Voss 1924, p. 358]

Pieter van der Werff, 1665–1722. "Bacchus and Ariadne." Painting. **1712.** Fitzwilliam Museum, Cambridge, no. 376. [Fitzwilliam 1960–77, 1:142—ill. / Wright 1976, p. 220]

Henry Carey, *c*.1689–1743. "The Marriage of Bacchus."

Poem. In *Poems on Several Occasions* (London: **1713**). [Bush 1937, p. 542]

Giovanni Maria Morandi, 1622–**1717.** "Bacchus and Ariadne." Ceiling fresco. Palazzo Salviati, Rome. [Voss 1924, p. 592]

Jean-François de Troy, 1679–1752. "Bacchus and Ariadne." Painting. **1717.** Staatsmuseum, Berlin, inv. no. KFMV 241. [Warburg]

———. "Bacchus and Ariadne." Painting. Marquise d'Escayrac-Lauture, Paris. [Pigler 1974, p. 50] Another version of the subject in private coll., Rome. [Ibid.]

———. "Bacchus and Ariadne." Painting. Musée Fabre, Montpelier. [Bordeaux 1984, no. X23 *n.*]

———. *See also François Le Moyne, below.*

Carlo Cignani, 1628–**1719.** "Bacchus and Ariadne." Fresco. Palazzo del Giardino, Parma. [Pigler 1974, p. 47]

———. "Bacchus and Ariadne." Painting. Schönborn coll., Pommersfelden (as Venus and Adonis). [Ibid.]

Giovanni Gioseffo del Sole, 1654–**1719.** "Bacchus and Ariadne." Painting. Palazzo Giusti, Verona. [Bénézit 1976, 9:688]

Thomas D'Urfey, 1653–1723. *Ariadne, or, The Triumph of Bacchus.* Libretto for opera. In *New Opera's, with Comical Stories and Poems on Several Occasions* (London: **1721**). [Nicoll 1959–66, 2:32, 236, 320]

Giovanni Battista Pittoni, 1687–1767. "Bacchus and Ariadne." Painting. *c.***1720–22.** Private coll., London. [Zava Boccazzi 1979, no. 96—ill.]

———. "Bacchus," "Ariadne." Pendant paintings. *c.***1726–**30. Sorlini coll., Venice. [Zava Boccazzi, nos. 224, 225—ill.]

———. "Bacchus and Ariadne." Painting. *c.***1730–32.** 6 versions. Pinacoteca di Brera, Milan; Národní Galeri, Prague; Museu de Arte, Sao Paolo; Staatsgalerie, Stuttgart; formerly (18th century) Conte Faustino Lechi coll., Brescia; Fogg Art Museum, Harvard University, Cambridge (school of Pittoni). [Zava Boccazzi, nos. 108, 142, 162, 181, 187, 299, S.3—ill. / also Houser 1979, no. 50—ill.]

———, style. "Bacchus and Ariadne." Painting. Mobilier National, on deposit from Louvre, Paris (no. M.N.R. 789). [Louvre 1979–86, 2:295 / also Zava Boccazzi, no. 142 (as Pittoni, *c.*1723)—ill.]

Reinhard Keiser, 1674–1739. *Die betrogene und nochmahls vergötterte Ariadne* [Ariadne Betrayed and Later Deified]. Opera, adaptation of Conradi's *Die schöne und getreue Ariadne* (1691). Libretto, C. H. Postel. First performed **1722,** Hamburg. [Grove 1980, 9:846, 848 / Zelm 1975, p. 73]

Giovanni Porta, *c.*1670–1755. *L'Arianna nell' isola di Nasso* [Ariadne on the Island of Naxos]. Opera seria. Libretto, N. Stampa. First performed 28 Aug **1723,** Teatro Ducale, Milan. [Grove 1980, 15:133]

Giovanni Battista Foggini, 1652–**1725,** attributed. "Bacchus and Ariadne." Bronze statuette. 2 casts known. Private coll., London; sold London, 1899 (as anonymous 18th century). [Montagu 1968, pp. 172f.—ill.] Another version (French, 18th century, possibly Foggini) sold Paris, 1903. [Ibid.—ill.]

Johann Joseph Fux, 1660–1741. *La corona d'Arianna* [The Crown of Ariadne]. Opera (festa teatrale). Libretto, Pietro Pariati. First performed 28 Aug **1726,** Hoftheater, Vienna. [Grove 1980, 7:46]

Jean-Joseph Mouret, 1682–1738, music. "Bacchus et Ari-

adne." Ballet héroïque (opera-ballet), entrée in *Les amours des dieux.* Libretto, Louis Fuzelier. First performed 14 Sep **1727,** L'Opéra, Paris; choreography, Françoise Prévost. [Baker 1984, p. 1595 / Grove 1980, 12:655 / Winter 1974, p. 51]

Marcantonio Franceschini, 1648–**1729.** "Bacchus and Ariadne." Painting. Palazzo Reale, Genoa. [Pigler 1974, p. 47]

———. "Bacchus and Ariadne." Painting. Galleria Davia Bargellini, Bologna. [Ibid.]

François Bouvard, *c.*1683–1760. *Ariane et Bacchus.* Opera. First performed **1729,** at Court, Paris. [Girdlestone 1972, p. 126 *n.*]

François de Troy, 1645–**1730.** "Bacchus and Ariadne." Painting. National Gallery of Ireland, Dublin, no. 723. [Dublin 1981, p. 166—ill.]

Giovanni Battista Tiepolo, 1696–1770. "Bacchus and Ariadne on Clouds, with Putti." Painting, sketch for (unexecuted?) fresco. *c.***1730–31.** Hasson coll., London. [Pallucchini 1968, no. 60—ill. / also Morassi 1962, p. 19—ill.] Sketches/replicas (fragmentary). Broglio coll., Paris; formerly Klienberger coll., Paris. [Morassi, pp. 40f. / Pallucchini]

———. "Bacchus and Ariadne." Painting, representing Earth, part of "Elements" series for Villa Girola, Como. *c.***1740.** Timken coll., New York. [Pallucchini, no. 137—ill. / Morassi, p. 36—ill.; cf. p. 11]

——— (and collaborator?). "Bacchus and Ariadne." Fresco. *c.***1747–50.** Palazzo Labia, Venice. [Pallucchini, no. 187—ill. / also Morassi, p. 59—ill.]

Giuseppe Chiari, 1654–1727/33. "Bacchus and Ariadne." Painting. Galleria Spada, Rome. [Pigler 1974, p. 48]

Nicola Porpora, 1686–1768. *Arianna in Nasso.* Heroic opera. Libretto, Paolo Antonio Rolli. First performed 29 Dec **1733,** Lincoln's Inn Fields, London. [Keates 1985, p. 176 / Hogwood 1984, p. 119 / Grove 1980, 15:126]

Anonymous. *Bacchus and Ariadne.* Ballet. First performed **1734,** London. [Nicoll 1959–66, 2:366]

Marie Sallé, 1707–1756, choreography. *Bacchus et Ariane.* Ballet. First performed 26 Mar **1734,** Covent Garden, London. [Clarke & Vaughan 1977, p. 301]

Ignazio Hugford, 1703–1778. "Triumph of Bacchus and Ariadne." Painting. **1736.** Uffizi, Florence, inv. 6196. [Uffizi 1979, no. P811—ill.]

Pompeo Batoni, 1708–1787, and **Hendrick Frans van Lint,** 1684–1763. "Classical Landscape with Bacchus and Ariadne." Painting. *c.***1735–37.** Unlocated. [Clark 1985, no. 11]

———. "Bacchus and Ariadne." Painting. 1769–73. Private coll., Rome. [Ibid., no. 353—ill.]

François Le Moyne, 1688–**1737,** rejected attribution (Italian school, style of Balestra). "Bacchus and Ariadne." Painting. Muzeum Narodowe, Warsaw, inv. 47098. [Bordeaux 1984, no. XII—ill. / also Warsaw 1969, no. 661 (as Le Moyne)—ill.]

———, rejected attribution (manner of Jean-François de Troy). "Bacchus and Ariadne." Unlocated. [Bordeaux, no. X23—ill.]

Pietro Bianchi, 1694–**1740,** attributed. "Bacchus Discovers Ariadne." Drawing. Kunstmuseum, Düsseldorf. [Pigler 1974, p. 48]

Giovanni Antonio Pellegrini, 1675–**1741.** "Bacchus Dis-

covers Ariadne." Painting. Louvre, Paris, no. R.F. 1964–4. [Louvre 1979–86, 2:215—ill.]

———. "Ariadne and Bacchus." Sartori coll., Bari. [Martini 1964, pl. 39]

———. "Bacchus Discovers Ariadne." Painting. Martini coll., Venice. [Ibid., pl. 45]

Charles-Joseph Natoire, 1700–1777. "Bacchus and Ariadne." Painting. 1743. Présidence de l'Assemblée Nationale, Paris. [Troyes 1977, no. 33—ill.]

———. "Bacchus and Ariadne." Painting. 1740s. Hermitage, Leningrad, inv. 1220. [Hermitage 1986 no. 154—ill. / Boyer 1949, no. 60] Replica, decoration for Château de Marly. 1743. Petit-Trianon, Versailles, no. 193. [Boyer, no. 65] Another painting of the same subject, sold Paris, 1920. [Ibid., no. 96]

François Boucher, 1703–1770. "Ariadne and Bacchus." Painting, model for tapestry in "Loves of the Gods" series. *c.*1749. Lost. / 17 tapestries woven by Beauvais, 1749. Metropolitan Museum, New York, no. 22,16.2; Council Presidency, Budapest; others unlocated. [Ananoff 1976, no. 344—ill.]

Jacopo Amigoni, 1675–1752. "Ariadne and Bacchus." Painting. Pavan coll., Padua. [Martini 1964, fig. 73]

Charles-Antoine Coypel, 1694–1752. "Bacchus and Ariadne." Painting. [Bénézit 1976, 3:248]

Jacob de Wit, 1695–1754. "Bacchus and Ariadne." Painting. City Art Gallery, Manchester. [Wright 1976, p. 222]

Ignaz Holzbauer, 1711–1783. *Le nozze d'Arianna* [The Wedding of Ariadne]. Opera. Libretto, Mattia Verazi. First performed 1756, Mannheim. [Grove 1980, 8:670]

Jean Restout, 1692–1768. "Triumph of Bacchus and Ariadne." Painting. 1757. Neues Palais Sanssouci, Potsdam. [Bénézit 1976, 8:702 / Pigler 1974, p. 50]

Antonio Guardi, 1698–1760. "Bacchus and Ariadne." Drawing. Ashmolean Museum, Oxford. [Morassi 1984, no. D35—ill.] Variant, formerly attributed to Sebastiano Ricci. Louvre, Paris, inv. 5331. [Ibid., no. D36—ill.]

Louis de Silvestre the Younger, 1675–1760. "Bacchus and Ariadne." Painting. Formerly Castle, Dresden. [Pigler 1974, p. 50]

Johann Georg Platzer, 1704–1761. (Bacchus and Ariadne in) "Bacchic Revels." Painting. Art Institute of Chicago. [Lowenthal 1986, fig. 55]

———. "Bacchus and Ariadne." Painting. Louvre, Paris, no. R.F. 1939–20. [Louvre 1979–86, 2:34—ill.] Variant. Staatliche Kunstsammlungen, Kassel, inv. 646. [Ibid.]

———. "Bacchus and Ariadne." Painting. Gemäldegalerie, Dresden, inv. 2100. [Pigler 1974, p. 51]

Louis-Félix de LaRue, 1731–1763. "The Triumph of Bacchus and Ariadne." Drawing. Fogg Art Museum, Harvard University, Cambridge, inv. 1898.22. [Houser 1979, no. 54—ill.]

Angelica Kauffmann, 1741–1807. "Bacchus and Ariadne." Painting. 1764. Amt der Landeshauptstadt, Bregenz. [Hamburg 1977, no. 311—ill.]

———. "Bacchus and Ariadne." Painting. 1794. Attingham Park, Shrewsbury. [Manners & Williamson 1924, pp. 165, 178—ill. / Wright 1976, p. 110]

Johann Gottlieb Willamov, 1736–1777. *Bacchus und Ariadne.* Poem. In *Dithyramben* (Berlin: Bernstiel, 1766 [?]). [Frenzel 1962, p. 51]

Jean-Hugues Taraval, 1729–1785. "Autumn" ("The Triumph of Bacchus and Ariadne"). Painting. 1769. Ceiling, Galerie d'Apollon, Louvre, Paris, inv. 8087. [Louvre 1979–86, 4:229—ill.]

Augustin Pajou, 1730–1809. "Bacchus and Ariadne." Wood bas-relief, part of cycle depicting children as mythological figures. 1769–70. Salle de l'Opéra, Versailles. [Stein 1912, pp. 177–81, 402]

Pasquale Anfossi, 1727–1797. *Il trionfo d'Arianna.* Opera (dramma per musica). Libretto, G. Lanfranchi-Rossi. First performed Ascension 1781, Teatro S. Moisè, Venice. [Grove 1980, 1:422]

Angelo Tarchi, *c.*1760–1814. *Bacco ed Arianna.* Opera or cantata (festa teatrale). Libretto, C. Oliveri. First performed Spring 1784, Teatro Regio, Turin. [Grove 1980, 18:577]

Giuseppe Canziani, fl. 1770–93, choreography. *Arianna e Bacco.* Ballet. Music, Carlo Canobbio. First performed 1789, St. Petersburg. [Grove 1980, 3:689 / Beaumont 1930, p. 29]

Maria Theresia von Paradis, 1759–1824, music. *Ariadne und Bacchus.* Opera (melodrama). Libretto, J. Riedinger. First performed 20 June 1791, Schlosstheater, Laxenburg. [Grove 1980, 14:175 / Cohen 1987, 1:531]

Jean Baptiste Rochefort, 1746–1819, music. *Bacchus et Ariane.* Ballet. First performed 11 Dec 1791, L'Opéra, Paris. [Grove 1980, 16:82]

Alexandre Trippel, 1744–1793. "Bacchus and Ariadne." Sculpture group. Allerheiligen Museum, Schaffhausen. [Cologne 1977, p. 159—ill.]

Vincenzo Righini, 1756–1812. *Il trionfo d'Arianna.* Opera (dramma per musica). Libretto, A. Filistri. First performed 1793, Berlin. [Grove 1980, 16:21]

Johann Gottfried Schadow, 1764–1850. "Bacchus Consoling Ariadne." Marble relief. Modeled 1791, completed 1793. Kunsthalle, Hamburg, inv. 1960/4. [Hamburg 1977, no. 376—ill.] Plaster model. Akademie for de Skone Kunster, Copenhagen. [Cologne 1977, pp. 249, 270—ill.] Marble variant. *c.*1804. Märkisches Museum, Berlin, inv. VII.61/5584. [Berlin 1965, no. 31—ill.]

Jonas Akerström, 1759–1795. "Bacchus and Ariadne." Painting. Exhibited 1794. [Bénézit 1976, 1:73]

Sébastien Gallet, 1753–1807, choreography. *Ariadne et Bacchus.* Ballet. Music, Cesare Bossi. First performed 28 Nov 1797, King's Theatre, London. [Guest 1972, p. 152]

Bertel Thorwaldsen, 1770–1844. "Bacchus and Ariadne." Plaster statuette. 1798. Thorwaldsens Museum, Copenhagen, no. A1. [Thorwaldsen 1985, p. 21 / Cologne 1977, no. 10, p. 156—ill. / Hartmann 1979, p. 127, pl. 73.1]

Johann Gottfried Herder, 1744–1803. *Ariadne libera.* Dramatic poem. In *Adrastea* (journal published by Herder and his wife Caroline), 1802. / Collected in *Dramatische Stücke* in *Sämmtliche Werke* (Tübingen: Cotta, 1805–20). [Herder 1852–54, vol. 15 / Clark 1955, pp. 427]

Philipp Otto Runge, 1777–1810. "The Joy of Wine: Bacchus and Ariadne." Drawing. 1802. Kunsthalle, Hamburg, inv. 34269. [Hamburg 1977, no. 139—ill.]

Franz Sigrist, 1727–1803. "Bacchus and Ariadne." Painting. Národní Galeri, Prague. [Pigler 1974, p. 51]

Johann Heinrich Dannecker, 1758–1841. "Ariadne on a Panther." Terra-cotta sculpture. 1803. Staatsgalerie,

Stuttgart. [Clapp 1970, 1:200] Marble version. 1813–14. Destroyed; fragments in Liebighaus, Frankfurt. [Spemann 1958, pls. 33–34 / also Janson 1985, fig. 55]

August von Kotzebue, 1761–1819. *Ariadne auf Naxos.* Tragicomedy. First performed **1804,** Burgtheater, Vienna. [DLL 1968–90, 9:318]

Thaddäus Weigl, 1776–1844, music. *Bacchus et Ariane.* Ballet. First performed **1799–1805,** Vienna. [Grove 1980, 20:298]

Gottlieb Christian Schick, 1776–1812. "Bacchus and Ariadne." Painting. Staatsgalerie, Stuttgart. [Bénézit 1976, 9:370]

Otto Carl Erdmann von Kospoth, 1753–1817. *Il trionfo d'Arianne.* Singspiel. [Grove 1980, 10:215]

Leigh Hunt, 1784–1859. "Bacchus and Ariadne." Narrative poem. In *Hero and Leander, and Bacchus and Ariadne* (London: Ollier, 1819). / Modern edition, in *Poetical Works* (London: Oxford University Press, 1923). [Boswell 1982, p. 142 / Bush 1937, pp. 173, 179 / Blunden 1930, pp. 140, 259]

Andries Cornelis Lens, 1739–1822. "Ariadne Consoled by Bacchus." Painting. Musées Royaux des Beaux-Arts (Musée d'Art Ancien), Brussels, inv. 590. [Brussels 1984a, p. 174—ill.]

Benjamin Robert Haydon, 1786–1846. "Silenus, Intoxicated and Moral, Reproving Bacchus and Ariadne on Their Lazy and Irregular Lives." Painting. 1824. [Olney 1952, pp. 156f.]

Letitia Elizabeth Landon, 1802–1838. "Bacchus and Ariadne." Poem. In *The Vow of the Peacock* (London: Saunders & Otley, 1835). [Boswell 1982, p. 150]

Joseph Mallord William Turner, 1775–1851. "Bacchus and Ariadne." Painting. Exhibited 1840. Tate Gallery, London, no. 525. [Butlin & Joll 1977, no. 382—ill.]

[?] Leclercq (music or libretto?). *Bacchus and Ariadne.* Ballet. First performed **1841,** Cork. [Nicoll 1959–66, 4:594]

[?] Viotti, choreography. *Nozze di Bacco e Ariana* [Wedding of Bacchus and Ariadne]. Ballet. First performed **1843,** Teatro la Fenice, Venice. [Cohen-Stratyner 1982, p. 112]

Elizabeth Barrett Browning, 1806–1861. "How Bacchus Finds Ariadne Sleeping," "How Bacchus Comforts Ariadne." Paraphrases on Nonnus, *Dionysiaca* 47. 1845. In *Last Poems* (London: Chapman & Hall, 1862). [Browning 1932 / Taplin 1957, p. 154]

———. "Bacchus and Ariadne." Poem, paraphrase from Hesiod. In *Last Poems* (1862). [Browning / Taplin]

Antonio Guerra, 1810–1846, choreography. *Die Hochzeit des Bacchus* [The Wedding of Bacchus]. Divertissement. Music, various hands. First performed 28 Mar **1846,** Hoftheater, Vienna. [EDS 1954–66, 6:21]

James Robinson Planché, 1795–1880. *Theseus and Ariadne; or, the Marriage of Bacchus.* Burlesque. Music, R. Hughes. First performed 24 Apr **1848,** Lyceum, London. [Nicoll 1959–66, 4:383]

Anonymous. *Bacchus and Ariadne.* Ballet. First performed **1861,** London. [Nicoll 1959–66, 5:645]

Eugène Delacroix, 1798–1863. "Autumn: Bacchus and Ariadne." Painting, part of "Four Seasons" cycle. Begun 1856, unfinished. Museu de Arte, Sao Paulo. [Johnson 1981–86, no. 250—ill. / Huyghe 1963, p. 416—ill. / Robaut 1885, no. 1430—ill. (copy drawing)] Oil sketch. Unlocated. [John-

son, no. 246—ill.] Copy (attributed to Pierre Andrieu d. 1892) in Museum of Fine Arts, Boston, no. 21.1453. [Boston 1985, p. 78—ill.]

[?] Magri, choreography. *Bacco ed Arianna.* Ballet. First performed 19 Apr **1864,** Her Majesty's Theatre, London. [Guest 1972, p. 160]

Adolf Müller, 1801–1886. *Bacchus und Ariadne.* Opera. First performed **1867,** Theater an der Wien, Vienna. [Edler 1970, p. 205]

Edward Yardley. "Bacchus and Ariadne." Poem. In *Supplementary Stories and Poems* (London: 1870). [Bush 1937, p. 557]

Henri Fantin-Latour, 1836–1904. "Bacchus" (approaching Ariadne). Painting. 1871. [Fantin-Latour 1911, no. 493]

Hans Makart, 1840–1884. "Bacchus and Ariadne." Painting. 1873–74. Österreichische Galerie, Vienna, inv. 2097. [Frodl 1974, no. 205—ill.] Oil sketch ("Triumph of Ariadne"), sold New York, 1955. [Ibid., no. 204—ill.] First version, 1873. Musée de Picardie, Amiens. [Ibid., no. 202—ill.]

Paul Kuczynski, 1846–1897. *Ariadne.* Oratorio. Text, Herrig, after Herder's *Ariadne libera* (1802). **1880.** [Hunger 1959, p. 50]

John Davidson, 1857–1909. (Bacchus, Ariadne, and Silenus in) *Scaramouch in Naxos.* Pantomime. **1888.** In *Plays* (Greenock: 1889). [Nicoll 1959–66, 5:338 / Bush 1937, pp. 465f., 563]

Cavaliere Mereweather. *Bacchus and Ariadne.* Drama. First performed **1891,** London. Published London: Hayes, 1891. [Nicoll 1959–66, 5:806 / Ellis 1985, p. 179]

Arthur Rimbaud, 1854–1891. (Bacchus's rescue of Ariadne evoked in) "Soleil et chair" [Sun and Flesh] part 4. Poem. Published with *Le reliquaire* (Paris: Genonceaux, 1891). [Adam 1972 / Fowlie 1966]

Aimé-Jules Dalou, 1838–1902. "Bacchus and Ariadne." Marble sculpture. 1894. Private coll., London. [Hunisak 1977, pp. 81ff., figs. 34A-B, H-K] Terra-cotta and plaster models, unique bronze cast. Petit Palais, Paris; private coll(s). [Ibid., figs. 34C-G / Caillaux 1935, pp. 141f.]

Friedrich Nietzsche, 1844–1900. *Ariadne* (Nietzsche as Dionysus and Cosima Wagner as Ariadne). Poem, unfinished. [Highet 1967, p. 689]

Isadora Duncan, 1877–1927, choreography. "Bacchus et Ariadne." Modern dance, part of *Dance Idylls.* First performed **1901–04,** Paris. [McDonagh 1976, p. 18]

Maurice Denis, 1870–1943. "Bacchus and Ariadne." Painting. 1907. Hermitage, Leningrad, inv. 6578. [Hermitage 1987a, pl. 107—ill.]

Hugo von Hofmannsthal, 1874–1929. *Ariadne auf Naxos.* Comedy, libretto for opera. **1910.** Published Berlin: Fürstner, 1912. / Revised, published Berlin: Fürstner, 1916. [Steiner 1946–58, *Lustspiele* vol. 3; *Prosa* vol. 3 / McGraw-Hill 1984, 2:508 / DLL 1968–90, 7:1428]

Maurice Baring, 1874–1945. "Ariadne in Naxos." Drama. In *Diminutive Dramas* (London: Constable, 1911). [Boswell 1982, p. 31]

Maurice Hewlett, 1861–1923. "Ariadne in Naxos." Drama. In *The Agonists: A Trilogy of God and Man* (New York: Scribner, 1911). [Boswell 1982, p. 131]

Eugène Smits, 1826–1912. "Ariadne Consoled." Painting. Musées Royaux des Beaux-Arts (Musée d'Art Moderne), Brussels, inv. 4040. [Brussels 1984b, p. 567—ill.]

Paul Ernst, 1866–1933. *Ariadne auf Naxos.* Drama in verse. Leipzig: Poeschel & Trepte; Weimar: Gesellschaft der Bibliophilen, **1912.** [DLB 1988, 66:106, 110 / DULC 1959–63, 2:66]

Richard Strauss, 1864–1949. *Ariadne auf Naxos.* Opera, opus 60. Libretto, von Hofmannsthal (1910). First performed 25 Oct **1912,** Hoftheater, Stuttgart. [Grove 1980, 18:234 / Martin 1979, pp. 194–203] Second version, performed 4 Oct 1916, Hofoper, Vienna. [Grove / Martin]

Donald Francis Tovey, 1875–1940. *The Bride of Dionysus.* Opera. Libretto, R. C. Trevelyan. First performed 23 Apr 1929, Edinburgh. Published Edinburgh: MacDonald, **1912.** [Grove 1980, 19:103]

Lovis Corinth, 1858–1925. "Ariadne in Naxos" (Theseus and sleeping Ariadne; Bacchus and retinue approaching). Painting. **1913.** Unlocated. [Berend-Corinth 1958, no. 569—ill.]

William Rose Benét, 1886–1950. "Songs of the Satyrs to Ariadne." Poem. In *Merchants from Cathay* (New York: Appleton, Century, **1919**). [Boswell 1982, p. 38]

Alexandre Sakharoff, 1886–1963, and **Clothilde von Derp,** 1892–1974, choreography. Modern dance, in a production of Strauss's *Ariadne auf Naxos* (1912), **1919.** [EDS 1954–66, 8:1409]

Edith Södergran, 1892–1923. "Dionysos." Poem. In *Rosenaltaret* (Helsingfors: Schildt, **1919**). [DSL 1990, p. 567]

Felipe Boero, 1884–1958. *Ariana y Dionysos.* Opera. First performed 5 Aug **1920,** Teatro Colón, Buenos Aires. [Baker 1984, p. 287 / Grove 1980, 2:843]

Renato Brogi, 1873–1924. *Bacco in Toscana* [Bacchus in Tuscany]. Operetta. Libretto, Ferdinando Paolieri and L. Bonelli (originally written for Ruggiero Leoncavallo, but that music never performed). First performed **1923,** Florence. [DELI 1966–70, 4:239 / Baker 1984, p. 352]

Marina Tsvetaeva, 1892–1941. (Bacchus's dialogue with Theseus in) *Tezej* [Theseus]. Verse tragedy. **1923–24.** In *Versty,* book 2 (Paris: 1927). Title changed to *Ariadna* in *Izbrannye proizvedenija* (Leningrad: 1965). / Translated in *Three Plays* (Letchworth: Prideaux, 1978). [Karlinsky 1985, pp. 181–85 / Venclova 1985, pp. 100–04]

Theodor Däubler, 1876–1934. (Ariadne's rescue and union with Bacchus evoked in) *Päan und Dithyrambos: Eine Phantasmagorie* [Paean and Dithyramb: A Phantasmagoria] part 5. Poem. Leipzig: Insel, **1924.** [Ipso / DULC 1959–63, 1:964]

Mario Castelnuovo-Tedesco, 1895–1968, music. *Bacco in Toscana.* Ballet, opus 39. Libretto, Francesco Redi (1685). First performed 8 May **1931,** Milan. [Grove 1980, 3:868 / Baker 1984, p. 427]

Serge Lifar, 1905–1986, choreography. *Bacchus et Ariane.* Ballet. Music, Albert Roussel (opus 43, 1930). Libretto, Abel Hermant. First performed 22 May **1931,** Diaghilev's Ballets Russes, L'Opéra, Paris; décor and costumes, Giorgio de Chirico. [Baker 1984, p. 1944 / Oxford 1982, pp. 28, 93, 255, 354 / Grove 1980, 16:275 / Guest 1976, p. 314] De Chirico's original costume designs in Galleria Blu, Milan. [de Chirico 1971–83, 3.2: nos. 184–95—ill.]

Frank Lucas, 1894–1967. *Ariadne* (found by Bacchus). Poem. Cambridge: Cambridge University Press, **1932.** [Bush 1937, pp. 480, 576]

Lucille Crews, 1888–1972. *Ariadne and Dionysus.* Miniature opera. **1934.** [Cohen 1987, 1:171]

Walter Piston, 1894–1976. "Carnival Song." Choral composition. **1938.** Text, Lorenzo de' Medici's "Canzone di Bacco" (1490). First performed 7 Mar 1940, Harvard Glee Club, Cambridge, Mass. [Grove 1986, 3:573]

André Masson, 1896–1987. "Ariadne's Dream." Drawing. **1941.** Bucholz Gallery, New York. [Hannover 1950, no. 84]

Robert Morse, 1907–1947. "Ariadne: A Poem for Ranting." Poem. In *The Two Persephones* (New York: Creative Age, **1942**). [Merrill 1986, p. 171]

Angelos Sikelianos, 1884–1951. (Bacchus's crowning of Ariadne in) "The Supreme Lesson" [English title of work written in Greek]. Poem. **1942.** [Friar 1973]

Robert Graves, 1895–1985. (Ariadne's life with Bacchus evoked in) "Theseus and Ariadne." Poem. In *Poems, 1938–1945* (London: Cassell, **1945**). [Graves 1975 / DLB 1983, 20:175]

Vittorio Rieti, 1898–. *Il trionfo di Bacco e Arianna.* Opera (dramma per musica). Libretto, Lorenzo de' Medici (1449–1492). **1946–47.** First performed as ballet-cantata, 1948, New York (*see Balanchine below*). [Grove 1980, 16:12 / Baker 1984, p. 1900]

Cesare Pavese, 1908–1950. "La vigna" [The Vineyard] (Leucothea speaks with Ariadne, preparing her for Dionysus's approach). Dialogue. In *Dialoghi con Leucò* (Turin: Einaudi, **1947**). / Translated by William Arrowsmith and D. S. Carne-Ross as *Dialogues with Leucò,* bilingual edition (Ann Arbor: University of Michigan, 1965). [Ipso / Biasin 1968, p. 206]

George Balanchine, 1904–1983, choreography. *The Triumph of Bacchus and Ariadne.* Ballet-cantata. Music, Rieti (1946–47). First performed 9 Feb **1948,** New York City Ballet, City Center, New York; décor and costumes, Corrado Cagli. [Taper 1984, p. 406, pl. 238 / Reynolds 1977, pp. 83f.]

Yvonne Georgi, 1903–1975, choreography. *Bacchus et Ariadne.* Ballet. Music, Roussel (see Lifar, 1931). First performed **1958,** Hannover. [Oxford 1982, p. 44]

George Skibine, 1920–1981, choreography. *Bacchus et Ariadne.* Ballet. Music, Roussel (see Lifar, 1931). First performed **1964,** probably by Harkness Ballet. [Oxford 1982, p. 382 / Grove 1980, 16:275]

Michel Descombey, 1930–, choreography. *Bacchus et Ariane.* Ballet. Music, Roussel (see Lifar, 1931). First performed **1967,** L'Opéra-comique, Paris; décor and costumes, B. Daydé. [Oxford 1982, p. 122 / Guest 1976, p. 324]

Dimitrije Parlić, 1919–, choreography. *Bacchus et Ariadne.* Ballet. First performed **1974,** Helsinki. [Cohen-Stratyner 1982, p. 695]

Eva Noel Harvey, 1900–**1984.** "Marriage of Bacchus and Ariadne." Song, one of "Three Songs from Venus Legends." [Cohen 1987, 1:306]

DIOSCURI. Castor and Polydeuces (Pollux) were the twin sons of Leda and the brothers of Helen and Clytemnestra. Their paternity is uncertain: according to some accounts, both boys were the sons of Leda's mortal husband, King Tyndareus of Sparta, and thus are sometimes called the Tyndaridae; the Homeric Hymns and other sources say their father

was Zeus (Jupiter) in the guise of a swan, and give them the epithet "Dioscuri" ("sons of Zeus"). Most ancient accounts, however, state that Castor was Tyndareus's son, and thus mortal, and that Polydeuces was the son of Zeus, and therefore immortal.

Castor was known for his ability with horses, while his brother's fame lay in his skill as a boxer. The brothers joined Meleager in the Calydonian boar hunt and Jason in the Argonautic expedition, during which Polydeuces distinguished himself in a fist fight with Amycus, son of Poseidon, whom he killed. The twins also went to Attica to recover their sister Helen after Theseus abducted her.

The Dioscuri quarreled with another set of twins, Idas and Lynceus, over Phoebe and Hilaera, the daughters of Leucippus. Castor and Polydeuces abducted the young women (and some sources say raped them) on the day they were to be married to Idas and Lynceus. In a pitched battle, Castor and both of the expectant bridegrooms were killed. Polydeuces begged Zeus to restore his brother to life, or to allow himself to die. When Zeus refused, Polydeuces offered to share his immortality with his brother. According to Pindar (who ascribes the fatal quarrel to a dispute over cattle, not women), the brothers henceforth lived half the time on Olympus, half in Hades (or, according to Homer, they were alive on alternate days).

The Dioscuri were worshiped as protectors of seafarers from the sixth century BCE, taking the form of the twin lights of St. Elmo's fire. In Euripides' *Electra* they appear as protectors of the sailors and champions of just and moral men. When the pair became immortal, they were placed in the heavens as the constellation Gemini. Their cult was worshiped as early as the fifth century BCE in Sparta, but it was during the Roman period that it gained fame. They were said to appear as horsemen on white mounts during the battle of Lake Regillus (496 CE), which led to a great Roman victory. A temple to the twin deities was located in the Forum at Rome, and equestrian statues of them are in the Piazza Quirinale on Monte Cavallo. As horsemen, they were patrons of the Roman order of *equites*.

In the postclassical period, the rape of the Leucippides, also a popular theme in ancient art, is the most commonly treated of all the adventures of the Dioscuri.

Classical Sources. Homer, *Iliad* 3.236–44; *Odyssey* 11.298–305. Alcaeus, "Hymn to Castor and Polydeuces." *Homeric Hymns,* first and second hymns "To the Dioscuri." Pindar, *Olympian Odes* 3.35; *Pythian Odes* 11.61; *Nemean Odes* 10.55–78. Euripides, *Electra*; *Helen* 140f. Apollonius Rhodius, *Argonautica* 2.1–109 and passim. Theocritus, *Idylls* 20, 22.137ff. Ovid, *Metamorphoses* 8.301f., 372–77; *Fasti* 5.699ff. Apollodorus, *Biblioteca* 3.11.2, E1.23. Hyginus, *Fabulae* 80; *Poetica astronomica* 2.22. Lucian, *Dialogues of the Dead* 1,

"Diogenes and Pollux"; *Dialogues of the Gods* 25, "Apollo and Hermes."

See also JASON, and the Argonauts; MELEAGER, Boar Hunt; THESEUS, and Helen; TROJAN WAR, General List.

Guido delle Colonne, *c.*1210–after 1287. (Garbled version of birth of Castor and Pollux and Helen in) *Historia destructionis Troiae* 4.7–17. Latin prose chronicle, adaptation of Benoît de Sainte-Maure's *Roman de Troie* (*c.*1165). **1272–87.** Modern edition by Nathaniel E. Griffin (Cambridge: Harvard University Press, with Mediæval Academy of America, 1936; reprinted New York: Kraus, 1970). / Translated by M. E. Meek (Bloomington: Indiana University Press, 1974). [Benson 1980, p. 50]

Anonymous French. (Deification of Castor and Pollux in) *Ovide moralisé* 12.798–826. Poem, allegorized translation/elaboration of Ovid's *Metamorphoses.* *c.*1316–28. [de Boer 1915–86, vol. 4]

Giovanni Boccaccio, 1313–1375. (Castor [Castore] and Pollux [Polluce] in) *Teseida* 6.25 and gloss; 7.16, 103, 117; 8.18–25 and gloss, 31, 115; 11.59–61, 64. Poem. *c.*1340–42. [Branca 1964–83, vol. 2 / McCoy 1974]

Anonymous English. (Allusion to birth of Castor and Pollux, Helen in) *The Destruction of Troy* lines 1016–20. Alliterative adaptation of Guido delle Colonne. *c.*1385–1400? Modern edition by George A. Panton and David Donaldson, *The "Gest Hystoriale" of the Destruction of Troy* (London: Early English Text Society, 1869, 1874). [Benson 1980, p. 50]

Baldassare Peruzzi, 1481–1536. "Leda and the Swan, with Castor and Pollux." Ceiling fresco, representing the constellation Castor and Pollux. **1510–11.** Sala di Galatea, Villa Farnesina, Rome. [d'Ancona 1955, pp. 25f., 86 / Gerlini 1949, p. 10ff. / also Frommel 1967–68, no. 18c—ill.]

Leonardo da Vinci, 1452–1519. "Leda" (and the swan, with the birth of Helen, Clytemnestra, Dioscuri). Painting. *c.*1510–15? Lost. [Ottino della Chiesa 1969, no. 34] Numerous copies and variant copies: Galleria Borghese, Rome, no. 434 (attributed to Sodoma); Musées Royaux des Beaux-Arts (Musée d'Art Ancien), Brussels, inv. 1402 (Andrea del Sarto, 1486–1530, previously attributed to Francesco Franciabigio); Muzeum Narodowe, Warsaw, inv. 415 (Vincent de Sellaer); Musée des Beaux-Arts, Valenciennes, inv. 131 (de Sellaer); Kress coll. (K426), North Carolina Museum of Art, Raleigh, no. GL.60.17.32; elsewhere. [Ibid.—ill. / also Pergola 1955–59, 1: no. 138—ill. / Brussels 1984a, p. 264—ill. / de Bosque 1985, pp. 60, 202—ill. / Warsaw 1969, no. 1179—ill. / Shapley 1966–73, 2:145f.—ill. / Berenson 1968, p. 169—ill.] Studies (drawings) in Royal Library, Windsor; other related drawings in Windsor; Museum Boymans-van Beuningen, Rotterdam; Duke of Devonshire coll., Chatsworth. [Ottino della Chiesa—ill. / also de Bosque 1985, p. 202—ill.] Copy (drawing), previously attributed to Leonardo, in Louvre, Paris. [Ottino della Chiesa—ill.] Copy (drawing) by Raphael, *c.*1515, in Royal Library, Windsor, no. 12759. [Joannides 1983, no. 98—ill. / Jones & Penny 1983, pp. 28f.—ill.]

———. "Half-kneeling Leda" (with infant Helen, Clytemnestra, and the Dioscuri). Presumed painting, known from variant by Giampetrino in Prince of Wied coll., Neuwied. [Ottino della Chiesa—ill.]

Maerten van Heemskerck, 1498–1574. "Landscape with

[statues of] the Dioscuri." Painting. **1546.** Unlocated. [Grosshans 1980, no. 56—ill.]

Pierre de Ronsard, 1524–1585. "L'hymne de Pollux et de Castor," (Castor and Pollux in) "L'hymne de Calaïs et de Zetes." Poems. In *Le second livre des hymnes* (Paris: Wechel, **1556**). [Laumonier 1914–75, vol. 8 / McGowan 1985, pp. 100f. / Silver 1985, pp. 264–66 / Cave 1973, pp. 19, 172, 226f. / McFarlane 1973, pp. 19, 76]

Giuseppe Porta, called Salviati, c.1520–c.**1575.** "Castor and Pollux Carrying Off the Daughters of Leucippus." Painting. Bowes Museum, Barnard Castle. [Wright 1976, p. 182]

Thomas Heywood, 1573/74–1641. (Castor and Pollux, as participants in the Calydonian hunt and the Argonautic expedition, in) *The Brazen Age.* Drama. First performed c.1610–13, London. Published London: Okes, **1613.** [Heywood 1874, vol. 3 / DLB 62:101, 122ff. / also Boas 1950, pp. 83ff. / Clark 1931, pp. 62ff.]

Peter Paul Rubens, 1577–1640. "The Rape of the Daughters of Leucippus" ("Rape of the Sabines"). Painting. c.**1616–18.** Alte Pinakothek, Munich, inv. 321. [Munich 1983, p. 456—ill. / Jaffé 1989, no. 404—ill. / Baudouin 1977, p. 69]

———. "Castor," "Pollux." Painted cut-outs, part of Arch of Ferdinand, decoration for "Pompa Introitus Fernandi," triumphal entry of Cardinal-Infante Ferdinand of Spain into Antwerp, 17 Apr 1635. Original decoration destroyed. [Martin 1972, no. 36—ill. (print)] Copy (formerly attributed to Theodoor van Thulden), painting, after lost original oil sketch, in Rubenshuis, Antwerp, inv. S.7. [Ibid., no. 36a—ill.]

Jan Boeckhorst, 1605–1668. "The Rape of the Daughters of Leucippus." Painting. **1637–39.** Uffizi, Florence, inv. 3904. [Uffizi 1979, no. P217—ill.]

Pietro da Cortona, 1596–1669. "Castor and Pollux." Fresco. **1642–44.** Sala di Giove, Palazzo Pitti, Florence. [Campbell 1977, pp. 127, 133—ill. / also Briganti 1962, no. 95—ill. / also Pitti 1966, p. 49—ill.]

———. (Dioscuri in) "Triumph of the House of Medici." Ceiling fresco, depicting a Medici prince aided in war by Mars, Hercules, and the Dioscuri. 1645–47. Sala di Marte, Palazzo Pitti, Florence. [Campbell 1977, pp. 121ff.—ill. / also Briganti, no. 96—ill. / Pitti, p. 66—ill.]

Stefano Della Bella, 1610–**1664.** Drawing, project for a fountain of Castor and Pollux. [Bénézit 1976, 1:591]

Claudio Coello, 1642?–**1693,** circle. "Castor and Pollux, with Birds." Painting. Prado, Madrid, no. F.A. 723. [López Torrijos 1985, p. 383, pl. 178]

Antoine Danchet, 1671–1748. *Les Tyndarides* [The Sons of Tyndareus]. Tragedy. First performed **1707,** Paris. [Girdlestone 1972, pp. 200, 203, 212–16, 285]

Pietro Porfirii, fl. 1687–1709. *La Leucippe.* Opera. First performed 20 June **1709,** Senigallia. [Grove 1980, 15:123]

Jean-Philippe Rameau, 1683–1764. *Castor et Pollux.* Opera with ballet. Libretto, Pierre-Joseph Bernard. First performed 24 Oct **1737,** L'Opéra, Paris; choreography, Michel Blondy? [Grove 1980, 15:564, 565f., 570 / Simon & Schuster 1979, p. 65 / Girdlestone 1983, pp. 203–39 / Girdlestone 1972, pp. 285ff.]

Johann Adolf Hasse, 1699–1783. *Leucippo.* Opera (favola pastorale). Libretto, Pasquini. First performed 7 Oct **1747,** at Court, Hubertusburg. [Grove 1980, 8:288]

Tommaso Traetta, 1727–1779. *I Tindaridi, o, Castore e Polluce.* Opera (drama per musica). Libretto, Carlo Innocenzo Frugoni, after Bernard (1737). First performed Apr **1760,** Teatro Ducale, Parma. [Grove 1980, 19:111, 113 / DELI 1966–70, 2:551]

Henry Fuseli, 1741–1825. "Polydeuces Victorious in the Fist-fight with Amycus." Drawing, after Theocritus. **1762–64.** Kunsthaus, Zurich, inv. 1914/41. [Schiff 1973, no. 328—ill.]

Augustin Pajou, 1730–1809. "Castor and Pollux." Wood bas-relief, part of a cycle representing children as mythological figures. **1769–70.** Salle de l'Opéra, Versailles. [Stein 1912, pp. 177–81, 402]

Michel-Jean de Laval, c.1725–1777, choreography. *Castor et Pollux.* Ballet. First performed **1770,** Paris. [Cohen-Stratyner 1982, p. 529]

Gaetano Vestris, 1728–1808, choreography. *Castor et Pollux.* Ballet. Music, Rameau (1737). First performed **1772,** L'Académie Royale de Danse, Paris. [Sharp 1972, p. 257]

Antonio Tozzi, c.1736–after 1812. *Le due gemelli Castore e Polluce.* Opera (dramma per musica). Libretto, G. Tonioli. First performed Summer **1776,** Real Sitio de S. Ildefonso, Madrid. [Grove 1980, 19:105]

Francesco Bianchi, c.1752–1810. *Castore e Polluce.* Opera. Libretto, Frugoni (1760). First performed 8 Sep **1779,** Pergola, Florence. [Grove 1980, 2:674]

Jean-Étienne Despréaux, 1748–1820. *Castor et Pollux.* Parody opera. First performed **1780,** Versailles. [Grove 1980, 5:395]

Antoine Renou, 1731–1806. "Castor" ("The Morning Star"). Ceiling painting. **1781.** Galerie d'Apollon, Louvre, Paris (inv. 7420). [Louvre 1979–86, 4:180—ill.]

Giuseppe Sarti, 1729–1802. *Castore e Polluce.* Opera (dramma per musica). Libretto, Moretti, after Bernard (1737). First performed 3 Oct **1786,** Hermitage Theater, St. Petersburg. [Grove 1980, 16:505]

Georg Joseph Vogler, 1749–1814. *Castore e Polluce.* Opera (tragedia lirica). Libretto, composer, after Frugoni (1760). First performed 12 Jan **1787,** Hoftheater, Munich. [Grove 1980, 20:62 / Hunger 1959, p. 98 (as *Kastor und Pollux*)]

Pietro Angiolini, 1746–1830, choreography. *Castor e Pollux.* Ballet. First performed **1788,** Cremona. [Cohen-Stratyner 1982, p. 26]

Pierre Joseph Candeille, 1744–1827. *Castor et Pollux.* Opera, revision of Rameau (1737). Libretto, Bernard (1737). First performed 14 June **1791,** L'Opéra, Paris. [Grove 1980, 3:683]

Bertel Thorwaldsen, 1770–1844. "Pollux." Statue, after "The Horse Tamers" (Piazza Quirinale, Monte Cavallo, Rome). Plaster original, **1799.** Thorwaldsens Museum, Copenhagen, no. A54. [Thorwaldsen 1985, p. 24]

Friedrich Hölderlin, 1770–1843. "Die Dioskuren." Ode. 3 versions, **after 1800.** In *Gedichte* (Stuttgart: Cotta, 1843). [Beissner 1943–77, vol. 2 / Hamburger 1980]

Vincenzo Federici, 1764–1826. *Castore e Polluce.* Opera. Libretto, Luigi Romanelli. First performed Jan **1803,** La Scala, Milan. [Grove 1980, 6:449]

Charles Le Picq, 1744–1806, choreography. *Castor et Pollux.* Ballet. Music, Carlo Canobbio. First performed **1803,** St. Petersburg. Music lost. [Grove 1980, 3:689]

Peter von Winter, 1754–1825. *Il trionfo dell' amor fraterno* [Triumph of Fraternal Love]. Opera. Libretto, Lorenzo

Da Ponte. First performed 22 Mar **1804,** Theatre Royal, Haymarket, London. / Revised as *Castor et Pollux.* First performed 19 Aug 1806, L'Opéra, Paris. [Grove 1980, 20:456–57]

Felice Alessandro Radicati, 1775–1820. *Castore e Polluce.* Opera. Libretto, L. Romanelli (1803). First performed 27 May **1815,** Teatro del Corso, Bologna. [Grove 1980, 15:531]

Franz Schubert, 1797–1828. "Lied eines Schiffers an die Dioskuren" [Song of a Sailor to the Dioscuri]. Lied, opus (Dürr) 360. **1816.** Text, Mayrhofer. Published 1826, as opus 651. [Grove 1980, 16:793]

Percy Bysshe Shelley, 1792–1822. "Homer's Hymn to Castor and Pollux." Translation of second Homeric Hymn to the Dioscuri. **1818.** In *Poetical Works,* edited by Mary Shelley (London: Moxon, 1824). [Hutchinson 1932 / Webb 1976, pp. 63, 100, 118, 351 / Webb 1977, p. 211]

Salvatore Taglioni, 1789–1868, choreography. *Castore e Polluce.* Ballet. Music, P. Brambilla. First performed Spring **1820,** La Scala, Milan. [EDS 1954–66, 9:630]

Adalbert Gyrowetz, 1763–1850, music. *Castor und Pollux.* Ballet. First performed **1827,** Vienna. [Hunger 1959, p. 98]

Gotthard Oswald Marbach, 1810–1890. *Die Dioskuren.* Novella. Leipzig: Wienbrack, **1840.** [DLL 1968–90, 10:390]

Horatio Greenough, 1805–1852. "Castor and Pollux." Marble bas-relief. **1847–51.** Museum of Fine Arts, Boston. [Gerdts 1973, p. 24, fig. 19]

Ede Szigligeti, 1814–1879. *Castor és Pollux.* Social comedy. First performed 19 Sep **1855,** Magyar Nemzeti Színház, Budapest. [McGraw-Hill 1984, 4:809]

Emile Pessard, 1843–1917. "Castor et Pollux." Fantaisie-bouffonne for 2 voices, orchestra, and pianoforte. Text, Deschamps. Published Paris: **1880.** [Grove 1980, 14:574]

Charles Stuart Calverley, 1831–**1884.** "The Sons of Leda." Poem, based on Theocritus. In *Complete Works* (London: Bell, 1901). [Boswell 1982, p. 647]

José-Maria de Heredia, 1842–1905. 3 poem fragments (invocation to Castor), and another on Castor and Pollux. **1890–93.** [Delaty 1984, vol. 2]

George Santayana, 1863–1952. "The Dioscuri." Poem. In *Harvard Monthly* 34 no. 4 (June **1902**); collected in *Complete Poems* (Lewisburg: Bucknell University Press, 1979). [Boswell 1982, p. 218]

Arthur B. Davies, 1862–1928. "Leda and the Dioscuri." Painting. **1905.** Art Institute of Chicago, no. 26.1028. [Chicago 1961, p. 116 / also Metropolitan 1930, no. 80—ill.]

Aristide Maillol, 1861–1944. "The Dioscuri." Bronze sculpture group, double replica of his "Bicycle Racer." After **1907–08.** Bayerische Staatsgemäldesammlungen, Munich. [Linnenkamp 1960, pp. 92–99, 119—ill.]

Emile Verhaeren, 1855–1916. (Castor kills Menelaus, is killed by Electra, in) *Helenas Heimkehr* [Helen's Homecoming]. Tragedy. Leipzig: Reclam, **1909.** First performed (as *Hélène de Sparte*) 4 May 1912, Théâtre du Chatelet, Paris; incidental music, Déodat de Séverac; choreography, Ida Rubenstein; scenery and costumes by Léon Bakst. [DLLF 1984, 3:2399 / also Grove 1980, 17:202 / Spencer 1973, pp. 144, 324 / Oxford 1982, p. 358 / DMB 1959, p. 19] Bakst's original designs in Galleria del Lavante, Milan; Musée des Arts Décoratifs, Paris; Ashmolean Museum, Oxford; elsewhere. [Spencer, pls. 118–26]

Nicola Guerra, 1865–1942. Ballet choreography for a production of Rameau's *Castor et Pollux* (1737), first performed 21 Mar **1918,** L'Opéra, Paris. [EDS 1954–66, 6:23 / Oxford 1982, p. 189 / Simon & Schuster 1979, p. 66]

Ker-Xavier Roussel, 1867–1944. "The Abduction of the Daughters of Leucippus." Painting. **1922.** Musée d'Orsay, Paris, no. R.F. 1977–303. [Louvre 1979–86, 4:201—ill.]

———. "The Rape of the Daughters of Leucippus." Painting. Private coll., Paris. [Georgel 1968, p. 361, no. 252—ill.]

———. "One of the Daughters of Leucippus Pursued by Two Horsemen." Print. [Alain 1968, no. 73—ill.]

Max Ernst, 1891–1976. "Castor and Pollution." Surrealistic painting. **1923.** Lost. [Spies & Metken 1975–79, no. 623—ill.]

Giorgio de Chirico, 1888–1978. "The Dioscuri." Painting. **1930.** Galleria La Medusa, Rome. [de Chirico 1971–83, 5.1: no. 349—ill.] Variant. *c.*1930. Private coll., Milan. [Ibid., 7.2: no. 543—ill.]

———. "The Dioscuri." Painting. 1934. Sotheby's coll., Italy. [Ibid., 7.2: no. 597—ill.]

———. "Dioscuro" (single figure with 2 horses). Painting. 1935. Nicodemi coll., Marina di Massa. [Ibid., 2.2: no. 109—ill.]

———. "The Dioscuri." Painting. 1936. Private coll., Rome. [Ibid., 1.2: no. 33—ill.]

———. "Dioscuro." Painting. 1936. Guzzinati coll., Ferrara. [Ibid., 1.2: no. 38—ill.]

———. "Castor," "Pollux" (with rearing horses). Paintings. 1954, 1955. Artist's coll., Rome, in 1974. [Ibid., 4.3: nos. 479–80—ill.]

———. "The Dioscuri." Painting. 1967. Galleria L'Approdo, Turin. [Ibid., 4.3: no. 594—ill.]

———. "Castor" (mannequin figure). Silver sculpture. 1970. 9 casts, 2 artist's proofs. [Ibid., 2.3: no. 302—ill.] Bronze variant, 1973. 50 casts in silvered bronze, 50 in gilded bronze. [Ibid., 5.3: no. 816–17—ill.]

William Alexander Percy, 1885–1942. (Castor and Pollux evoked in) "A Legend of Lacedaemon." Poem. In *Selected Poems* (New Haven: Yale University Press, **1930**). [Bush 1937, p. 591]

Antony Tudor, 1908–1987, choreography. *Castor and Pollux.* Ballet. Music, Rameau (1737). First performed **1934,** Oxford University Opera Club. [Beaumont 1938, p. 829 / Sharp 1972, p. 257]

Willa Cather, 1873–1947. (Lucy hears Schubert's "Lied eines Schiffers an die Dioskuren" [1816] in) *Lucy Gayheart.* Novel. New York: Knopf, **1935.** [Ipso, pp. 29f.]

Frederick Ashton, 1904–1988, choreography. (Castor and Pollux, the Gemini, in) *Horoscope.* Ballet. Music and scenario, Constant Lambert. First performed **1938,** London. [Vaughan 1977, pp. 160–63]

Hans Gstettner, 1905–. *Die Dioskuren.* Poem. Berlin: Fischer, **1942.** [DLL 1968–90, 6:983]

Ossip Zadkine, 1890–1967. "Pollux." Bronze sculpture. **1944.** Private coll. [Jianou 1979, no. 330]

———. "Castor." Bronze sculpture. 1967. Private coll. [Ibid., no. 505]

Cesare Pavese, 1908–1950. (Castor and Pollux speak in) "In famiglia" [In the Family]. Dialogue. In *Dialoghi con Leucò* (Turin: Einaudi, **1947**). / Translated by William Arrowsmith and D. S. Carne-Ross in *Dialogues with*

Leucò, bilingual edition (Ann Arbor: University of Michigan, 1965). [Ipso]

Francisco Moncion, 1922–, choreography. *Passepied from Castor and Pollux.* Ballet. First performed **1950,** New York. [Cohen-Stratyner 1982, p. 624]

Alfonso Iannelli, b.1888. "Castor and Pollux." Relief. Before **1951.** Adler Planetarium, Chicago. [Agard 1951, p. 161, fig. 90]

Richmond Lattimore, 1906–1984. "Be with Me Now." Translation of Alcaeus's "Hymn to Castor and Polydeuces." In *The Greek Poets,* edited by Moses Hadas (New York: Random House, **1953**). [Ipso]

Gerhard Marcks, 1889–1981. "Dioscuri." Relief, on prize medals for 1972 Olympic games, Munich. **1971.** Executed in gold (edition of 365), silver (365), and bronze (700). [Busch & Rudloff 1977, no. 979—ill.]

DIRCE. *See* ANTIOPE, and Dirce.

DOLON. *See* DIOMEDES.

DRYADS. *See* NYMPHS, Dryads, Hamadryads, and Oreads.

DRYOPE. *See* APOLLO, Loves.

E

ECHO. *See* NARCISSUS; PAN, Loves.

ELECTRA. (1) The daughter of Agamemnon and sister of Orestes. *See* AGAMEMNON; ORESTES. (2) A Pleiad. *See* PLEIADES.

ELYSIUM. *See* HADES [2]; *also* AENEAS, in the Underworld.

ENCELADUS. *See* TITANS AND GIANTS.

ENDYMION. A young man of great beauty (called by some the king of Elis), Endymion was the son of Calyce and Aëthlius (a son of Zeus) or Zeus himself. He was loved by Selene (Luna) or by Artemis (Diana, also called Phoebe and Cynthia) in her guise as moon-goddess. According to Pausanias, the goddess bore him fifty daughters.

Endymion wished for eternal sleep, some say because he wanted to perpetuate his romance with the goddess, who visited him in his dreams on Mount Latmus; Apollodorus, however, states that Endymion sought immortality and agelessness through everlasting sleep. At Selene's request Zeus granted the wish. Yet another tradition, from the *Great Eoiae* by a follower of Hesiod, recounts that Endymion later fell in love with Hera and was flung by Zeus into Hades.

Classical Sources. Hesiodic poet, *Great Eoiae* 11. Plato, *Phaedo* 72C. Apollonius Rhodius, *Argonautica* 4.57f. Theocritus, *Idylls* 3.50, 20.35–38. Catullus, *Carmina* 66.5ff. Cicero, *De finibus bonorum et malorum* 5.20.25; *Tusculanae disputationes* 1.38.92. Apollodorus, *Bibliotheca* 1.7.5–6. Pausanias, *Description of Greece* 5.1.2, 5.1.3–5, 5.8.1. Hyginus, *Fabulae* 271. Lucian, *Dialogues of the Gods* 19, "Aphrodite and Selene."

Further Reference. Edward S. Le Comte, *Endymion in England: The Literary History of a Greek Myth* (New York: King's Crown Press, 1944).

Master of the Griggs Crucifixion (first half 15th century), circle. "Scenes from a Legend" (of Diana: Callisto, Endymion, others). Painting. *c.*1430. Kress coll. (K275), Walker Art Museum, Bowdoin College, Brunswick, Me., no. 1961.100.1. [Shapley 1966–73, 1:100—ill.]

Benedetto Cariteo, *c.*1450–1514. "Endimione a la luna" [Endymion to the Moon]. Poem. In *Libro de sonetti e canzone* (Naples: **1506**). [Bondanella 1979, p. 103]

Pinturicchio, 1454–1513, and studio. "Diana and Endymion." Fresco. **1503–08.** Piccolomini Library, Cathedral, Siena. [Warburg]

Cima da Conegliano, *c.*1459–1517/18. "Endymion Asleep." Painting. *c.*1505–10. Galleria Nazionale, Parma, no. 370. [Humfrey 1983, no. 120—ill. / Berenson 1957, p. 67—ill.]

Baldassare Peruzzi, 1481–1536, circle (? also attributed to school of Giulio Romano or Raphael). "Selene and Endymion." Fresco. **1511–12** (or *c.*1517–18). Sala delle Prospettive, Villa Farnesina, Rome. [d'Ancona 1955, pp. 27ff., 93f. / Gerlini 1949, pp. 31ff.—ill. / also Frommel 1967–68, no. 51]

———. "Luna and Endymion." Painting. Chigi-Saracini coll., Siena. [Frommel, no. 108—ill.]

Titian, *c.*1488/90–1576, follower. "Landscape with Endymion." Painting. *c.*1520. Barnes coll., Merion, Pa. [Wethey 1975, no. X–18 / Berenson 1957, p. 188—ill.]

Vittore Carpaccio, 1465–1525/26. "Endymion." Painting. Formerly Sulley coll., London. [Berenson 1957, p. 57]

Parmigianino, 1503–**1540.** "Diana and Endymion." Painting. Frick Art Museum, Pittsburgh. [Warburg]

Innocenzo da Imola, 1490/94–1549? "Diana and Endymion." Fresco. **1540–43.** Palazzino della Viola, Bologna. [Warburg]

Francesco Primaticcio, 1504–1570. "Juno in the Land of Sleep." Fresco. **1541–44.** Porte Doré, Château de Fontainebleau. Repainted in the 19th century as "Diana and Endymion." [Dimier 1900, pp. 306f., nos. 100.1, 134]

Giulio Romano, c.1499–1546, studio (Niccolò dell' Abbate? previously attributed to Giulio). "Artemis and Orion" (previously called "Diana and Endymion"). Painting. **1540s.** Szépművészeti Múzeum, Budapest, no. 171 (125). [Budapest 1968, p. 272—ill. / also Berenson 1968, p. 196] *See also Peruzzi, above.*

Benvenuto Tisi, called Garofalo, c.1481–**1559,** studio. "Diana and Endymion." Painting. Gemäldegalerie, Dresden, no. 139. [Berenson 1968, p. 154]

Thomas Howell, fl. 1560–81. (Luna and Endymion evoked in) "An humble sute to his friende, requesting Love for Love." Poem. In *New Sonets, and Pretie Pamphlets* (London: **1567**). / Revised version in *Howell, His Devises* (London: 1581). [Le Comte 1944, pp. 44f.]

Jacopo Zucchi, c.1541–1589/90. "Endymion Sleeping and Diana." Ceiling painting. **c.1572.** Sala delle Carte Geografiche, Uffizi, Florence. [Uffizi 1979, no. S105—ill.]

Jacopo Tintoretto, 1518–1594, attributed (also attributed to Christoph Schwarz, 1545–1592). "Diana and Endymion." Painting. **Early 1580s?** National Gallery of Ireland, Dublin, no. 768 (as Tintoretto). [Rossi 1982, no. A28 (attribution rejected, attributed to Schwarz)—ill. / Dublin 1981, p. 163—ill.]

———. "Venus and Adonis" (formerly called "Diana and Endymion"). Painting. 1543–44. Uffizi, Florence, Contini-Bonacolsi coll. no. 34, on deposit at Palazzo Pitti. [Rossi, no. 66—ill. / also Uffizi 1979, no. P1709—ill.]

Alessandro Tassoni, 1565–1635, writing as "G. Saluiani." "Dormiva Endimion tra l'erbe e i fiori" [Endymion Was Sleeping among the Herbs and Flowers.] Canto 8 of *La secchia rapita* [Rape of the Bucket]. Mock epic. **1585.** Published pseudonymously as *La secchia* (Paris: 1622). / Revised, published Venice: Scaglia, 1630. [DELI 1966–70, 5:248 / Praz 1925, p. 424 / Bondanella 1979, pp. 506ff.]

John Lyly, c.1554–1606. *Endimion, the Man in the Moone.* Comedy. **1584–86.** First performed by Children of St. Paul's, 1586 (?) or 1588. [Bond 1902, vol. 3 / Le Comte 1944, pp. 71–85 / McGraw-Hill 1984, 3:289]

Jean Cousin the Younger, 1522–1594. "Selene and Endymion." Drawing. Graphische Sammlung Albertina, Vienna. [Hermitage 1984, no. 279 *n.*]

George Chapman, c.1559–c.1634. (Endymion evoked in) "Hymnus in Cynthiam." Poem. In *The Shadow of Night* (London: Ponsonbie, **1594**). In modern edition, *Poems,* edited by Phyllis B. Bartlett (New York: 1941). [Le Comte 1944, pp. 86ff. / Bush 1963, pp. 207, 209f.]

Michael Drayton, 1563–1631. *Endimion and Phoebe: Ideas Latmus.* Pastoral poem. London: Busbie, **1595.** / Revised as *The Man in the Moone,* 1606. In *Poemes Lyrical and Pastorall* (London: Ling & Flasket, 1606). [Hebel 1931–32, vols. 1 & 2 / Hulse 1981, pp. 31f., 223 / Bush 1963, pp. 156ff., 164, 196, 300, 327 / Le Comte 1944, pp. 89–106]

Annibale Carracci, 1560–1609. "Diana and Endymion." Fresco. **1597–1600.** Galleria, Palazzo Farnese, Rome. [Malafarina 1976, no. 104b—ill. / Martin 1965, pp. 90f.—ill.]

Bastianino, 1532–**1602,** attributed. "Night" (Diana approaching Endymion). Fresco. Sala dell' Aurora, Castello Estense, Ferrara. [Arcangeli 1963, pp. 29f., 64—ill.]

Lope de Vega, 1562–1635. "De Endimion a Clicie" [From Endymion to Clytie]. Sonnet, no. 16 of *Rimas humanas* part 1. **1602–04.** Madrid: Martin, for Alonso Perez, 1609. [Sainz de Robles 1952–55, vol. 2]

William Alexander, Earl of Stirling, c.1567–1640. (Endymion evoked in) Sonnet, no. 28 of *Aurora.* **1604.** In modern edition, *Poetical Works* (Edinburgh: Blackwood, for Scottish Text Society, 1921–29). [Le Comte 1944, pp. 45f., 59f.]

John Fletcher, 1579–1625. (Phoebe in love with Endymion in) *The Faithful Shepherdess* 1.3.36–43. Pastoral tragicomedy. First performed c.1608–09, Queen's Revels, London. Published London: Bonian & Walley, c.1610. [Le Comte 1944, p. 44 / McGraw-Hill 1984, 2:176f., 179]

Francis Bacon, 1561–1626. "Endymion, sive gratiosus." Chapter 8 of *De sapientia veterum.* Mythological compendium. London: Barker, **1609.** / Translated as "Endymion, or, A Favorite" by Arthur Gorges in *The Wisdome of the Ancients* (London: Bill, 1619). Modern facsimile edition (bilingual), New York & London: Garland, 1976. [Ipso / Bush 1963, p. 252]

Domenichino, 1581–1641, or assistant. "Diana and Endymion." Ceiling fresco, part of "Life of Diana" cycle. **1609.** Palazzo Giustiniani-Odelscalchi, Bassano di Sutri. [Spear 1982, no. 34.iv—ill.]

Scipione Errico, 1592–1670. *Endimione.* Idyll. Messina: **1611.** [DELI 1966–70, 2:382]

William Basse, 1583?–1653. (Endymion evoked in) *Urania, the Woman in the Moone* 1.1–3. Poem. **1606–12.** In modern edition, *Poetical Works,* edited by R. W. Bond (London: 1893). [Le Comte 1944, pp. 88f. / Bush 1963, pp. 196–98]

Lodovico Cardi, called il Cigoli, 1559–**1613.** "Diana and Endymion." 2 drawings. Uffizi, Florence. [Warburg]

William Drummond of Hawthornden, 1585–1649. 2 sonnets on Cynthia and Endymion, nos. 8 and 10 of the first part of *Poems, Amorous, Funerall, Divine, Pastorall* (Edinburgh: Hart, **1616**). [MacDonald 1976, pp. 11–13]

———. (Endymion in) *The Entertainment of the High and Mighty Monarch, Prince Charles.* Entertainment, performed June 1633 (but said to have been written 1629), Edinburgh. [Le Comte 1944, p. 49]

Francesco Ellio, "L'Endimione." Poem. In Bidelli's *Gl'idillij di diversi ingegni illustri* (Milan: **1618**). [Bush 1963, p. 159]

Scarsellino, 1551–1620. "Diana and Endymion" ("Diana Bathing"). Painting. Galleria Borghese, Rome, inv. 214. [Pergola 1955–59, 1: no. 117—ill. / Berenson 1968, p. 391—ill.]

Giovanni Battista Marino, 1569–1625. "Endimione che risguarda la luna, di Carlo Viniziano" [Endymion Looking at the Moon, by Carlo Viniziano]. Sonnet (on a painting), in *La galleria* (Venice: Ciotti, **1620**). [Getto 1962]

Gaspar de Aguilar, 1561–**1623.** *La fábula de Endimeón y*

la luna. Fable. Modern edition, Madrid: Cruz y Raya, 1935. [DLE 1972, p. 12]

Jean Ogier de Gombauld, 1570?–1666. *Endimion*. Heroic romance in prose. Paris: Buon, **1624**, with illustrations by Crispin de Passe the Younger. [DLLF 1984, 2:958 / Bush 1963, p. 335]

Marcelo Díaz Callecerrada. *Endimión*. Narrative poem. Madrid: **1627**. In modern edition by C. Rosell, *Biblioteca de autores españoles*, vol. 29 (Madrid: 1854). [Oxford 1978, p. 158]

[?] La Morelle. *Endymion, ou, Le ravissement* [Endymion, or the Rape]. Pastoral tragicomedy. Paris: Sara, **1627**. [DLF 1951–72, 3:573 / Lancaster 1929–42, pt. 1, 1:270f., 2:761]

Jean Puget de La Serre, 1594–1665. "La lune et Endymion." Poem. In *Les amours des déesses* (Paris: d'Aubin, **1627**). [NUC]

Anthony van Dyck, 1599–1641. "Diana and Endymion (Surprised by a Satyr)." Painting. *c.*1622–28? Prado, Madrid, no. 1492. [Larsen 1988, no. 746—ill. / Prado 1985, p. 200]

———. Sheet of drawings with 2 sets of figures representing Diana and Endymion. *c.*1629? Pierpont Morgan Library, New York. [Wildenstein 1968, no. 56—ill.]

Claudio Monteverdi 1567–1643. *Gli amori di Diana e di Endimione* [The Loves of Diana and Endymion]. Opera. Libretto, A. Pio. First performed **1628**, Parma. Music lost. [Grove 1980, 12:530]

Nicolas Poussin, 1594–1665. "Diana and Endymion." Painting. **Late 1620s/early 1630s**. Detroit Institute of Arts. [Wright 1985, no. 51—ill. / Blunt 1966, no. —ill. / also Thuillier 1974, no. 42—ill. / Vermeule 1964, pp. 112, 174 / Wildenstein 1968, no. 29—ill.]

Peter Paul Rubens, 1577–1640. "Diana and Endymion." Painting, for Torre de la Parada, El Pardo (executed by assistant from Rubens's design?). **1636–38**. Lost. [Alpers 1971, no. 19] Oil sketch. Musée Bonnat, Bayonne. [Ibid., no. 19a—ill. / Held 1980, no. 185—ill. / Jaffé 1989, no. 1262—ill.] Another painting for Torre de la Parada, formerly called "Diana and Endymion" (now identified as "Aurora and Cephalus"), known from an oil sketch in National Gallery, London, no. 2598. [Alpers, no. 6a—ill. / Held, no. 173—ill. / London 1986, p. 547—ill. / Jaffé, no. 1247—ill.]

Richard Hurst. *Endimion: An Excellent Fancy, Interpreted by R. Hurst.* Poem, after Jean Ogier de Gombauld (1624). London: **1639**. [Bush 1963, p. 335]

Agostino Tassi, *c.*1580–**1644**. "Diana and Endymion." Painting. City Art Gallery, York, cat. 1961 no. 921. [Wright 1976, p. 197]

Guercino, 1591–1666. "Endymion." Painting. **1644–47**. Galleria Doria Pamphilj, Rome. [Salerno 1988, no. 247—ill.]

———. "Endymion (Sleeping)." Painting. 1640–50. Uffizi, Florence, inv. 1461. [Uffizi 1979, no. P787—ill. / Salerno, no. 325 (as a copy after a lost original)] Variant. 1657–58. Melega coll., Bologna. [Salerno, no. 324—ill.]

Govaert Flinck, 1615–1660. "Diana and Endymion." Painting. **1640s**. Lichtenstein Collection, Vaduz. [von Moltke 1965, no. 92—ill.]

———. "Endymion Discovers Diana and Her Playmates."

Drawing with wash. *c.*1655. Louvre, Paris, inv. (21.925) 272. [Ibid., no. D28—ill.]

———, attribution rejected (Gerbrandt van den Eeckhout?). "Endymion Discovering Diana and Her Playmates [sleeping]." Drawing. Herzog Anton Ulrich-Museum, Braunschweig (as Flinck). [Ibid., no. W180—ill.]

Jacob Backer, 1608–1651. "Diana and Endymion Embracing." Drawing. Sold Cologne, 1902. [Warburg]

Jean-Baptiste Lully, 1632–1687, music. (Endymion and Diana in) *La nuit*. Ballet. First performed **1653**, Paris. [Grove 1980, 11:327]

Giuseppe Tricarico, 1623–1697. *L'Endimione*. Opera. Libretto, A. Passarelli. First performed **1655**, Ferrara. [Grove 1980, 19:139]

Gabriel Gilbert, before 1620–before 1680. *Les amours de Diane et d'Endimion*. Tragedy ("pastorale héroïque"). First performed Nov/Dec **1656**, Paris. Published Paris: 1657. [Lancaster 1929–42, pt. 3, 2:497f., 864 / Arnott 1977, pp. 36f.]

Françoise Pascal, 1632–after 1657. *Endymion*. Tragicomedy. First performed **1656**, Paris. Published Lyon: Pétit, 1657. [Lancaster 1929–42, pt. 3, 2:497, 500–02, 864]

Giovanni Francesco Romanelli, 1610–1662. "Diana and Endymion." Fresco, part of a cycle depicting scenes from the lives of Apollo and Diana. **1655–58**. Salle des Saisons, Apartement d'Été (Galerie du Bord de l'Eau), Louvre, Paris (inv. 20348). [Louvre 1979–86, 2:228—ill.]

Francesco Albani, 1578–**1660**, attributed. "Diana and Endymion." Painting. Ashmolean Museum, Oxford, cat. 1961 no. A145 (as formerly attributed). [Wright 1976, p. 2]

Jan de Bray, *c.*1627–1697. "Diana and Endymion." Drawing. **1665**. Prentenkabinet, Leyden, no. 121. [Warburg]

Pietro da Cortona, 1596–1669. "Diana and Endymion." Painting. Glynn Vivian Art Gallery, Swansea, cat. 1913 no. 35. [Wright 1976, p. 43]

Giovanni Benedetto Castiglione, *c.*1616–*c.*1670, follower (Andrea di Lione? 1610–1685). "Diana Approaches the Tomb of Endymion." Kincaid-Lennox coll., Downton Castle, sold London, 1975. [Warburg]

Jean Granouilhet Sablières, 1627–*c.*1700. *Les amours de Diane et d'Endymion*. Pastoral opera. Libretto, Henry Guichard. First performed 3 Nov **1671**, Versailles. [Clément & Larousse 1969, 1:56]

Balthasar Permoser, 1651–1732. "Endymion." Ivory relief. Before **1677**. Schöner coll., Munich. [Asche 1966, no. P4]

———. "Endymion and Selene." Ivory sculpture group. *c.*1680. Herzog Anton Ulrich-Museum, Braunschweig. [Ibid., no. P7, pl. 14]

Alessandro Poglietti, ?–1683. *Endimione festeggiante* [Celebration of Endymion]. Opera. Libretto, J. Dizent. First performed 12 Jan **1677**, Göttweig. [Grove 1980, 15:19]

Luca Giordano, 1634–1705. "Diana and Endymion." Painting. **Late 1670s**. Museo di Castelvecchio, Verona, no. 2679. [Ferrari & Scavizzi 1966, 2:87—ill.]

———. "Diana and Endymion." Painting. 1670–80. R. Manning coll., New York. [Ibid., 2:367f.]

———. "Diana and Endymion." Painting. 1675–80? Castle, Gatchina, in 1916. [Ibid., 2:333]

———, attributed. "Diana and Endymion." 2 drawings. Gabinetto dei Disegni, Uffizi, Florence, nos. 6691, 6712. [Ibid., 2:289f.]

Pierre Beauchamps, 1631–1705, and **Louis Pécour,** 1653–1729, choreography. "Endymion." Entrée in *Le triomphe de l'amour.* Ballet. Music, Jean-Baptiste Lully. Libretto, Isaac de Bensérade and Philippe Quinault. First performed 21 Jan **1681**, St. Germain-en-laye, Paris. [Simon & Schuster 1979, pp. 60, 62 / Girdlestone 1972, p. 34]

Marc-Antoine Charpentier, 1645/50–1704. "Endimion." Opera (tragédie mêlée de musique). **1681.** Librettist unknown. [Grove 1980, 4:174]

Alessandro Guidi, 1650–1712, with **Queen Christina of Sweden,** 1626–1689. *Endimione.* Arcadian pastoral in verse. **1681.** Published pseudonymously, as "Erilo Cleoneo," Rome: Komarek, 1692. [DELI 1966–70, 2:160, 3:230 / Herrick 1966, p. 23 / EDS 1954–66, 6:45 (as 1691)]

Bartolomé Esteban Murillo, 1617–**1682,** attributed. "Diana and Endymion." Painting. Paris art market in 1810, untraced. [López Torrijos 1985, pp. 329, 425 no. 18]

Henry Desmarets, 1661–1741. *Endymion.* Opera (tragédie lyrique). First performed 16 Mar **1682**, Versailles. Music lost. [Grove 1980, 5:391]

————, attributed. *Diane et Endymion.* Opera (tragédie lyrique). Libretto, Louise-Geneviève, Mme. Gillot de Sainctonge. First performed Jan 1711, L'Opéra, Nancy. Music lost. [Ibid.]

Alessandro Scarlatti, 1660–1725. *Diana ed Endimione.* Serenata for 2 voices, instruments. First performed *c.*1680–85, Naples? [Grove 1980, 16:559f.]

————. *Endimione e Cintia.* Serenata for 2 voices, instruments. First performed 1705, Rome. [Ibid.]

Philip Ayres, 1638–1712. "Endymion and Diana." Poem, derived from Tassoni's "Dormiva Endimion" (1615). In *Lyric Poems Made in Imitation of the Italians* (London: Knight & Saunders, **1687**). In modern edition by George Saintsbury, *Minor Poets of the Caroline Period,* vol. 2 (Oxford: Clarendon Press, 1905–21). [Le Comte 1944, pp. 541f. / Bush 1963, pp. 249f. / Praz 1925, p. 424]

Giuseppe Antonio Bernabei, 1649?–1732. *Diana amante* [Diana in Love]. Opera. Ballet music, Melchior d'Ardespin. Libretto, Orlandi. First performed **1688**, Munich. [Grove 1980, 2:612, 1:559]

Theodor Schwartzkopff, 1659–1732. *Endymion.* Singspiel with ballets. First performed **1688**, Stuttgart. [Grove 1980, 17:41]

Frans de Neve, 1606–*c.*1689. "Diana and Endymion." Drawing. Kunsthalle, Hamburg, inv. no. 22235. [Warburg]

Gerard de Lairesse, 1641–1711 (active until *c.*1690). "Selene and Endymion." Painting. Rijksmuseum, Amsterdam, inv. A4210. [Rijksmuseum 1976, p. 333—ill.]

————. "Diana and Endymion." Painting. University Kunsthistorisch Instituut, Utrecht. [Wright 1980, p. 230]

Paolo Magni, *c.*1650–1737, with **Giacomo Griffini.** *Endimione.* Opera. Libretto, Francesco de Lemene. First performed 24 Nov **1692**, Lodi. Music lost. [Grove 1980, 11:495]

Giovanni Bononcini, 1670–1747. *Endimione.* Opera. First performed **1693**, Lodi. [EDS 1954–66, 2:790]

Filippo Lauri, 1623–**1694?** "Luna and Endymion." Painting. Liechtenstein Collection, Vaduz, no. 474. [Pigler 1974, p. 162]

Thomas D'Urfey, 1653–1723, libretto. *Cinthia and Endy-* *mion, or, The Loves of the Deities.* Dramatic opera. Incidental music, Daniel Purcell with Jeremiah Clarke? First performed at Court, then late Dec **1696,** Theatre Royal, Drury Lane, London. [Grove 1980, 15:475 / Fiske 1973, pp. 8f. / Nicoll 1959–66, 1:409 / Le Comte 1944, pp. 51ff.]

Anne Danican Philidor, 1681–1728. *Diane et Endymion.* Pastoral. First performed **1698**, Marly. [Grove 1980, 14:627]

Brussels School. "Diana and Endymion." Tapestry. **17th century.** Kunsthistorisches Museum, Vienna. [Warburg]

Florentine School. "Diana and Endymion." Bronze relief sculpture. **17th century.** Heim Gallery, London. [Warburg]

Italian School, (previously attributed to Jacopo Amigoni). "Luna and Endymion." Painting. *c.*1700. Herzog Anton Ulrich-Museum, Braunschweig, no. 1026. [Braunschweig 1976, p. 35 / also Braunschweig 1969, p. 27]

Reinhard Keiser, 1674–1739. *Der gedemütigte Endymion* [Endymion the Courageous]. Opera. Libretto, Nothnagel. First performed **1700**, Hamburg. [Grove 1980, 9:847 / Zelm 1975, p. 47]

————. *Die entdeckte Verstellung, oder, Die geheime Liebe der Diana* [The Removal Discovered, or, The Secret Love of Diana]. Pastoral opera. Libretto, Johann Ulrich von König, after Lemene's *Endymione* (1692). First performed Apr 1712, Hamburg. [Grove, 9:846–48, 10:174] Revised, with 17 new arias, as *Der sich rächende Cupido* [Cupid Avenges Himself]. Libretto, von König. First performed 1724, Hamburg. [Ibid.]

Georg Caspar Schürmann, 1672–1751. *Endimione.* Opera (favola per musica). Libretto, F. de Lemene. First performed **1700**, Salzthal. [Grove 1980, 16:874]

Daniel Seiter, 1649–**1705.** "Luna and Endymion." Painting. Camera da Letto della Regina, Palazzo Reale, Turin. [Pigler 1974, p. 165]

Philip Tidemann, 1657–**1705.** "Diana and Endymion." Painting. Hopetown Estate Development coll., Hopetown House, Scotland. [Warburg]

Antonio Verrio, *c.*1639–**1707.** "Endymion in the Arms of Morpheus." Ceiling painting. After 1699. State bedroom of William III, Hampton Court Palace. [Warburg]

Francesco Trevisani, 1656–1746. "Luna and Endymion." Painting. *c.*1708–09. Schönborn coll., Pommersfelden. [DiFederico 1977, no. 45—ill.]

Barend Graat, 1628–**1709.** "Endymion." Painting. E. van Kovacs-Kanapy coll., Budapest (as by Rubens). [Warburg]

Johannes Voorhout, 1647–1723. "Endymion and Luna." Painting. By **1710.** Herzog Anton Ulrich-Museum, Braunschweig, no. 292. [Braunschweig 1969, p. 144]

Johann Sebastian Bach, 1685–1750. (Diana and Endymion in) "Was mir behagt, ist nur die muntre Jagd!" [What Delights Me Is Only the Merry Chase!]. Cantata. Text, Salomo Franck. Probably performed **1713**, for birthday of Duke Christian of Saxe-Weissenfels. [Grove 1980, 1:807, 824]

Sebastiano Ricci, 1659–1734. "Diana and Endymion." Painting. *c.*1713? Chiswick House, London. [Daniels 1976, no. 174—ill. / Wright 1976, p. 172]

————. "Diana and Endymion." Painting. Early 1700s. Princeton University Art Museum, N.J. [Daniels, no. 363]

Agostino Cornacchini, 1685–1754. "Sleeping Endymion."

Terra-cotta sculpture. **1716.** Museum of Fine Arts, Boston. [Warburg]

———. "Endymion." Marble sculpture. Cleveland Art Museum, Ohio. [Clapp 1970, 1:185]

Leonardo Leo, 1694–1744. "Diana amante" [Diana in Love]. Serenade. First performed 4 Dec **1717,** Royal Palace, Naples. [Grove 1980, 10:668]

Attilio Ariosti, 1666–1729. "Diana on Mount Latmos." Cantata. First performed 28 Feb **1719,** London. [Grove 1980, 1:584]

Pierre François Biancolelli, called Dominique, 1680–1734. *Endymion.* Pastoral comedy. First performed **1721,** Paris. [Grove 1980, 7:381]

Antonio Maria Bononcini, 1677–1726. *Endimione.* Pastoral drama. First performed **1721,** Naples. [EDS 1954–66, 2:788]

Jean-Claude Gillier, 1667–1737, music. *Arlequin Endymion.* Parody of Biancolelli's *Endymion.* Libretto, Alain René Lesage, with Louis Fuzelier and d'Orneval. First performed **1721,** Foire St. Germain, Paris. [Grove 1980, 7:381 / DLF 1951–72, 2:99 / also McGraw-Hill 1984, 3:268]

Luigi Riccoboni, 1676–1753. *Endymion, ou, L'Amour vengé.* Pastorale. First performed **1721,** Paris. [EDS 1954–66, 8:940]

Domenico Sarro, 1679–1744. *Endimione.* Serenata (azione theatrale). Libretto, Pietro Metastasio. First performed 30 May, **1721,** Naples. [Grove 1980, 16:501] Metastasio's libretto was set at least 12 more times to 1783. *See below.* [Ibid., 12:218]

François Collin de Blamont, 1690–1760. *Diane et Endimion.* Cantata. In *Cantates françoises à voix seule, avec simphonie et sans simphonie, livre premier* (Paris: **1723**). [Grove 1980, 4:563]

———. *Endymion.* Pastorale héroïque. Libretto, Fontenelle. First performed 17 May 1731, L'Opéra, Paris. [Ibid.]

Giovanni Battista Pittoni, 1687–1767. "Diana and Endymion." Painting. *c.*1723. Hermitage, Leningrad, inv. 2451. [Zava Boccazzi 1979, no. 78—ill.]

———. "Diana and Endymion." Fresco. 1727. Palazzetto Widman, Bagnoli di Sopra, Padua. [Zava Boccazzi, no. 5—ill.] Modello. Private coll., Rovigo. [Ibid., no. 175—ill.] Another version of the subject in Villa Porto, Trissino, near Vicenza; another sold London, 1972. [Warburg]

Giovanni Antonio Burrini, 1656–1727. "Diana and Endymion." Painting. City Art Gallery, York, Cat. supplement 1974.274. [Wright 1976, p. 28]

Antonio Bioni, 1698–after 1739. *Endimione.* Opera. First performed **1727,** Breslau. [Grove 1980, 2:726]

Jacob de Wit, 1695–1754. "Diana and Endymion" (or "Jupiter and Mnemosyne"?—eagle hovering over shepherd and shepherdess). Painting. **1727.** Rijksmuseum, Amsterdam, inv. A3886. [Rijksmuseum 1976, p. 608—ill. / Staring 1958, p. 146, pl. 92 (as "Jupiter and Mnemosyne"?] Variant, watercolor. 1732. [Staring, pl. 93]

———. "Diana and Endymion." Painting. 1745. Lost. [Staring, p. 153] Drawing for, Cabinet des Dessins, Louvre, Paris. [Ibid.]

———. "Diana and Endymion." Painting. Formerly Kunsthandel Goudstikker, Amsterdam. [Ibid., pl. 97]

Antonio Corradini, 1668–1752. "Diana and Endymion."

Marble sculpture group. *c.*1723–28? Grosser Garten, Dresden. [Hodgkinson 1970, p. 3, fig. 4]

François Boucher, 1703–1770. "Diana and Endymion." Painting. *c.*1729. Formerly Richard Wallace coll., London, lost. [Ananoff 1976, no. 36]

———. "Diana and Endymion." Painting. *c.*1765. National Gallery, Washington, D. C. [Walker 1984, fig. 447]

———. "Venus [sic] and Endymion" (Venus on a cloud above the sleeping youth). Painting. 1769. Getty Museum, Malibu, Calif. [Ananoff, no. 670—ill.]

Giuseppe Maria Buini, *c.*1680–1739. *Endimione.* Opera. Libretto, Metastasio (1721). First performed **1729,** Bologna. [Clément & Larousse 1969, 1:388]

François Le Moyne, 1688–1737. "Diana and Endymion." Painting, for Hôtel Peyrenc de Moras (Hôtel Biron, now Musée Rodin), Paris. **1729–30.** Lost. [Bordeaux 1984, no. 83]

François Verdier, 1651–1730. "Diana and Endymion." Painting, after anonymous engraving. Bibliothèque Nationale, Paris. [Warburg]

Jean-Baptiste van Loo, 1684–1745. "Diana and Endymion." Painting. **1731.** Louvre, Paris, inv. 6249. [Louvre 1979–86, 4:263—ill. / also Bordeaux 1984, fig. 396]

———. "Diana and Endymion." Painting. Musées Royaux des Beaux-Arts (Musée d'Art Ancien), Brussels, inv. 296. [Brussels 1984a, p. 178—ill.]

Balthasar Permoser, 1651–1732. "Diana and Endymion." Marble sculpture. Herzog Anton Ulrich-Museum, Braunschweig. [Warburg]

———. "Endymion" (alone). Ivory sculpture. Weinmüller Auction, Munich 1966. [Warburg]

Daniel Gran, 1694–1757. "Diana and Endymion." Part of fresco "Diana Received into Olympus." **1732.** Schloss Eckartsau, Austria. [Knab 1977, no. F47—ill.]

———. "Diana and Endymion." Fresco. 1755. Schloss Friedau, Obergrafendorf, Austria. [Knab, pp. 137f., no. 94—ill.]

Gerard Hoet the Elder, 1648–**1733.** "Diana and Endymion." Painting. Castle De Slangenburg, Doetinchem. [Warburg]

———. "The Death of Endymion." Painting. Kunsthistorisches Museum, Vienna. [Bénézit 1976, 5:571]

James Thornhill, 1675/76–**1734.** "Diana and Endymion." Painting. Sir W. Worsley coll., Hovingham Hall. [Warburg]

Domenico Alberti, *c.*1710–1740. *Endimione.* Opera. Libretto, Metastasio (1721). First performed **1737,** Venice. [Grove 1980, 1:211]

Giovanni Battista Pescetti, 1704–1766. *Diana e Endimione.* Serenata. First performed 1 Dec **1739,** New Theatre, London. [Grove 1980, 14:570]

Pierre Subleyras, 1699–1749, attributed. "Diana and Endymion." Painting. **1730s.** Brinsley Ford coll. [Royal Academy 1968, no. 643—ill.]

———. previously attributed (Italian School). "Diana and Endymion." Painting. Brinsley Ford coll., London. [Warburg]

Gottfried Heinrich Stölzel, 1690–1749. *Endymion.* Opera. First performed **1740,** Gotha. [Grove 1980, 18:175]

Giovanni Antonio Pellegrini, 1675–**1741.** "Diana and Endymion." Painting. Louvre, Paris, no. R.F. 1964–2. [Louvre 1979–86, 2:215—ill.]

Andrea Bernasconi, 1706?–1784. *Endimione*. Opera. Libretto, Metastasio (1721). First performed 6 Feb **1742**, Venice. [Grove 1980, 2:620]

Johann Adolf Hasse, 1699–1783. *Endimione*. Opera (festa teatrale). Libretto, Metastasio (1721). First performed July **1743**, Court, Naples? [Grove 1980, 8:288]

Thomas-Louis Bourgeois, 1676–1750/51. "Diane et Endimion." Cantata. **1744**. [Grove 1980, 3:113]

Anonymous composer. *Le gare fra gli dei* [The War among the Gods]. Opera (dramma pastorale per musica). Libretto, Ferdinando Caldari, after Metastasio's *Endimione* (1721). First performed 23 June **1746**, Coletti, Florence. [Weaver 1978, p. 311]

Francesco Solimena, 1657–1747. "Diana and Endymion." Painting. Walker Art Gallery, Liverpool, inv. 6366. [Wright 1976, p. 190]

Martin Johann Kremser-Schmidt, 1718–1801. "Luna and Endymion." Painting. **1749**. Barockmuseum, Vienna. [Pigler 1974, p. 165.]

Giovanni Battista Mele, 1701–c.1752. *Endimion y Diana*. Serenata. First performed Spring **1749**. [Grove 1980, 12:103]

Nicola Conti, fl. 1733–54. *L'Endimione*. Opera. First performed **1752**, Naples. [Grove 1980, 4:684]

Joseph Starzer, 1726/27–1787, music. *Diane et Endimione*. Ballet. First performed **1754** (? or 1759), Vienna. [Grove 1980, 18:82]

Giovanni Baldanza, 1708–1789. *Endimione*. Poem. **1755**. [DELI 1966–70, 1:228]

Nicolas-Guy Brenet, 1728–1792. "Sleeping Endymion." Painting. **1756**. Worcester Art Museum, Mass. [Warburg]
———. "Sleeping Endymion." Painting. c.1789. Worcester Art Museum. [Warburg]

Niccolò Jommelli, 1714–1774. *Endimione*. Opera (pastorale). Libretto, after Metastasio (1721). First performed **1756**, Genoa; also 1759, Stuttgart. Lost. [Grove 1980, 9:693, 12:218]

Gaspare Angiolini, 1731–1803, choreography. *Diane ed Endimione*. Ballet. First performed **1757**, Teatro Regio, Torino. [EDS 1954–66, 1:619]

Nicola Sabatino, c.1708–1796. *Endimione*. Serenata. First performed **1758**, Dublin. [Grove 1980, 16:364]

Francesco Fontebasso, 1709–1768/69. "Luna and Endymion." Painting, for Palazzo Bernardi, Venice. **1750s?** Szépmüvészeti Múzeum, Budapest. [Budapest 1968, pp. 237f.]

Giovanni Battista Piazzetta, 1683–1754. "Diana and Endymion." Painting. **1750s?** Lost. [Palluchini 1982, no. 102]

Giovanni Battista Tiepolo, 1696–1770, with **Giovanni Domenico Tiepolo**, 1727–1804. "Diana and Endymion." Grisaille painting. c.**1750–60**. Formerly van Dirksen coll., Berlin, sold London, c.1934, unlocated. [Morassi 1962, pp. 5, 48]

Anton Raphael Mengs, 1728–1779. "Diana and Endymion." Painting. **1758–60**. Villa Albani, Rome. [Honisch 1965, no. 87]

Franz-Christoph Janneck, 1703–1761. "Diana and Endymion." Painting. [Bénézit 1976, 6:34]

Christoph Martin Wieland, 1733–1813. "Diana und Endymion." Verse tale. In *Komische Erzählungen* (Munich: Parcus, **1762**). [Radspieler 1984, vol. 3]

Nicola Conforto, 1718–after 1788. *L'Endimione*. Serenata.

First performed **1763**, Austrian ambassador's palace, Madrid. [Grove 1980, 4:658]

Ignazio Fiorillo, 1715–1787. *Diana ed Endimione*. Serenata. Libretto, Metastasio's *Endimione* (1721). First performed **1763**, Braunschweig. [Grove 1980, 6:601]

Jean-Georges Noverre, 1727–1810, choreography. *Diane et Endimion*. Ballet. First performed **1761–65** (?), Stuttgart or Ludwigsburg. [Grove 1980, 13:443 / EDS 1954–66, 7:1248]

Benjamin West, 1738–1820. "Diana and Endymion." Painting. c.**1766**. Private coll. [von Erffa & Staley 1986, no. 137—ill.] Another version of the same subject. Lost. [Ibid., no. 138]

Giuseppe Sigismondo, 1739–1826, questionably attributed. *Endimione*. Opera. Libretto, Metastasio (1721). First performed **1767**, Vienna. [Clément & Larousse 1969, 1:388]

Jean Restout the Younger, 1692–1768. "Diana and Endymion." Painting. Hôtel de Ville, Versailles. [Bénézit 1976, 8:702]

Louis-Jean-François Lagrenée, 1725–1805. "Luna and Endymion." Painting. **1768**. Nationalmuseum, Stockholm. [Pigler 1974, p. 165] Copy (of this or another work?) in Bowes Museum, Barnard Castle, list 1971 no. 862. [Wright 1976, p. 113]

Mark Akenside, 1721–1770. (Endymion evoked in) "To the Evening Star." Ode, no. 15 in *Poems* (London: Bowyer & Nichols, 1772). [Bush 1937, p. 38]

Johann Christian Bach, 1735–1782. *Endimione*. Serenata for soprano, tenor and orchestra. Libretto, Metastasio (1721). First performed 6 Apr **1772**, King's Theatre, London. / Revised, performed 1774, Hoftheater, Mannheim. [Grove 1980, 1:866, 873] Text reproduced in collected works, New York: Garland, 1985. [DELI 1966–70, 3:590]

Gaetano Vestris, 1728–1808, choreography. *Endymion*. Ballet. First performed March **1773**, Italy. [EDS 1954–66, 9:1625]

Christian Wilhelm Dietrich, 1712–1774. "Endymion and Diana." Painting. Hermitage, Leningrad, inv. 3754. [Hermitage 1987b, no. 163—ill.]

Joseph Aloys Schmittbaur, 1718–1809. *Endymion*. Operetta/serenata. First performed **1774**, Karlsruhe. [Grove 1980, 16:679]

Anonymous choreographer. *Diane et Endymion*. Ballet. First performed 3 Dec **1776**, King's Theatre, London. [Guest 1972, p. 148]

Charles-Joseph Natoire, 1700–1777. "Diana and Endymion." Painting. Sold 1857, untraced. [Boyer 1949, no. 101]

Michael Haydn, 1737–1806. *Endimione*. Serenata. c.**1778**. [Grove 1980, 8:411]

Jean-Baptiste Huet, 1745–1811. "Diana and Endymion." Painting. **1778**. Waddesdon Manor, Buckinghamshire, cat. 1967 no. 111. [Pigler 1974, p. 165 / also Wright 1976, p. 93]

Vicente García de la Huerta, 1734–1787. *Endimión*. Poem. In *Obras poeticas,* edited by Antonio de Sancha (Madrid: **1778–79**). [DLE 1972, p. 369]

Fedosii Shchedrin, 1751–1825. "Sleeping Endymion." Bronze sculpture. **1779**. Tretiakoff Gallery, Moscow. [Warburg / cf. Kennedy 1983, p. 198]

Pietro Alessandro Guglielmi, 1728–1804. *Diana amante* [Diana in Love]. Serenata. Libretto, L. Serio, after Me-

tastasio's *Endimione* (1721). First performed 28 Sep **1781**, Accademia di Dame e Cavalieri, Naples. [Grove 1980, 7:797]

João de Sousa Carvalho, 1745–1798. *L'Endimione*. Opera. Libretto, Metastasio (1721). First performed 25 July **1783**, Palace of Ajuda or Queluz. [Grove 1980, 3:842]

Stefano Torelli, 1712–**1784**. "Diana and Endymion." Painting. Chinese Palace, Lomonosov (Oranienbaum), near Leningrad. / Study. Hermitage, Leningrad. [Hermitage 1981, pl. 241]

Niccolò Piccinni, 1728–1800. *Diane et Endymion*. Opera seria. Libretto, Jean-François Espic de Lirou. First performed 7 Sep **1784**, Académie Royale, Paris. [Grove 1980, 14:728]

Antonio Canova, 1757–1822. "Adonis [or Endymion?] Sleeping." Painting. *c.***1784**–**85**. Formerly Casa Canova, Possagno, destroyed in World War I. [Pavanello 1976, no. D2]

———. "Sleeping Endymion." Marble sculpture. Modeled 1819, completed 1822. Duke of Devonshire coll., Chatsworth. [Ibid., no. 319—ill. / Licht 1983, p. 219—ill.] Plaster models. Gipsoteca Canoviana, Possagno, nos. 275–76. [Pavanello, nos. 320–21—ill.]

Vicente Martín y Soler, 1754–1806. (Endymion in) *L'arbore di Diana* [The Tree of Diana]. Opera. Libretto, Lorenzo Da Ponte. First performed 1 Oct **1787**, Burgtheater, Vienna. [Mann 1977, pp. 447, 453 / Grove 1980, 11:736]

Ludwig August Lebrun, 1752–**1790**. *Diana and Endimion*. Dance music. Lost. [Grove 1980, 10:582]

Anne-Louis Girodet, 1767–1824. "Endymion: Effect of Moonlight" ("The Sleep of Endymion"). Painting. **1791**. Louvre, Paris, inv. 4935. [Bernier 1975, pp. 14ff.—ill. / Montargis 1967, no. 13—ill. / Louvre 1979–86, 3:282—ill.] Oil studies. Musée, Montargis; Louvre, no. R.F. 2152 (by Girodet?). [Montargis, no. 12—ill. / Louvre, 3:283—ill.]

Joseph Weigl the Younger, 1766–1846. *Diana ed Endimione*. Opera. First performed **1792**, Vienna. [Hunger 1959, p. 55]

Gian Battista Innocenzo Colombo, 1717–**1793**. "Diana and Endymion." Painting. Brighton Art Gallery. [Wright 1976, p. 41]

Jonas Akerström, 1759–1795. "Endymion and Diana." Painting. Exhibited **1794**. Private coll. [Bénézit 1976, 1:73]

William Wordsworth, 1770–1850, attributed. (Endymion visited by Diana in) "Written in a Grotto." Poem. In *The Morning Post* 9 Feb **1802**. [De Selincourt 1940–66, vol. 3]

———. (Giordano's "Diana and Endymion" celebrated in) "To Lucca Giordano." Sonnet, no. 14 in *Evening Voluntaries*. 1846. In *Poetical Works* (London: Moxon, 1849–50). [Ibid., vol. 4 / Le Comte 1944, p. 47]

Johann Nepomuk Hummel, 1778–1837. *Diana ed Endimione*. Cantata for the stage. First performed **1807**, Vienna. [EDS 1954–66, 6:437]

Ferdinando Paer, 1771–1839. *Diana e Endimione, ossia, Il ritardo* [Diana and Endymion, or, The Delay]. Opera. First performed **1809**, Tuileries Theater, Paris. [EDS 1954–66. 7:1461]

Henry Fuseli, 1741–1825. "Selene and Endymion." Drawing. **1810**–12. City of Auckland Art Gallery, New Zealand, inv. 1965–76. [Schiff 1973, no. 1793—ill.]

Manuel Garcia, 1775–1832. *Diana ed Endimione*. Opera. First performed **1814**, Naples. [EDS 1954–66, 5:918]

Anonymous choreographer. *Endymion*. Ballet. First performed 13 June **1815**, King's Theatre, London. [Guest 1972, p. 155]

John Keats, 1795–1821. (Endymion evoked in) "I stood tip-toe upon a little hill" lines 181–210. Poem. Dec **1816**. In *Poems* (London: Ollier, 1817). [Stillinger 1978 / Aske 1985, pp. 50–52 / De Selincourt 1951, pp. 414]

———. *Endymion*. Poem. 1817. London: Taylor & Hessey, 1818. [Stillinger / Aske, pp. 53–72 / Gittings 1968, pp. 76–78, 137 / Gradman 1980, pp. 13–37 / Ridley 1933, pp. 66f., 257 / Le Comte 1944, pp. 152–83]

Jean Baptiste Rochefort, 1746–**1819**. *Diane enchaîné par l'Amour* [Diana Chained by Cupid]. Comedy ballet. [Grove 1980, 16:82]

Erik Johan Stagnelius, 1793–1823. "Endymion." Poem. Late 1821–June **1822**. In *Samlade skrifter* (Stockholm: Wiborg, 1824–26). [Algulin 1989, p. 81 / Gustafson 1961, pp. 195f.]

Anne-Louis Girodet, 1767–**1824**, composition. "Diana and Endymion." Lithograph, part of "Loves of the Gods" cycle. Published Paris: Engelmann, 1825–26. [Boutet-Loyer 1983, no. 87 n.—ill.]

Peter Cornelius, 1783–1867, and studio. "Diana and Endymion." Ceiling fresco. **1820**–26. Göttersaal, Glyptothek, Munich. [Glyptothek 1980, pp. 214ff.]

[Petit] Anatole, fl. 1820s, choreography. *Diane et Endymion*. Ballet. Music, Joseph Augustine Wade. First performed 15 July **1828**, King's Theatre, London. [Guest 1972, p. 157]

Jean Bruno Gassies, 1786–**1832**. "Diana and Endymion." Painting, for Château de Saint-Cloud. Louvre, Paris, inv. 8618. [Louvre 1979–86, 3:266—ill.]

Letitia Elizabeth Landon, 1802–**1838**. "The Awakening of Endymion." Poem, no. 7 in "Subjects for Pictures." In *Poetical Works* (London: Longman & Co., 1839). [Le Comte 1944, p. 134]

Bertel Thorwaldsen, 1770–1844. "Cupid Leading Diana to Endymion," "Endymion Sleeping." Marble reliefs, part of "Metamorphoses of Ovid" series. Executed by Pietro Galli from Thorwaldsen's designs. **1838**. Formerly Palazzo Torlonia, Rome, destroyed. / Plaster cast. Thorwaldsens Museum, Copenhagen, no. 465. [Thorwaldsen 1985, p. 55 / also Hartmann 1979, pp. 61, 149—ill.]

William Etty, 1787–1849. "Diana and Endymion." Painting. **1839**. Private coll., London. [Bénézit 1976, 4:211]

Auguste Vestris, 1760–**1842**, choreography. *Diane et Endymion*. Ballet. [EDS 1954–66, 9:1628]

Honoré Daumier, 1808–1879. "Endymion." Comic lithograph, in "Ancient History" series. **1842**. [Delteil 1906–30, 22: no. 969—ill.]

———. "The Sleep of Endymion-Berryer." Satirical lithograph, in "Parliamentary Idylls" series. 1850–51. [Ibid., 25: no. 2075—ill.]

Thomas Hood, 1799–**1845**. "Sonnet: Written in Keats' *Endymion*." Sonnet. In *Complete Poetical Works* (London: Oxford University Press, 1920). [Boswell 1982, p. 264]

Jules Perrot, 1810–1882, choreography. *Diane*. Ballet divertissement. Music, Cesare Pugni. First performed 24

July **1845**, Her Majesty's Theatre, London. [Guest 1984, pp. 153f., 354]

Ernest Hartley Coleridge, 1796–**1849**. "Diana and Endymion." Sonnet. In *Complete Poetical Works,* edited by Ramsay Colles (London: Routledge; New York: Dutton, [1908?]). [Le Comte 1944, p. 146 / Boswell 1982, p. 77]

Thomas Moore, 1779–**1852**. (Endymion evoked in) "Bright Moon." Poem. In *Complete Poems,* edited by W. M. Rossetti (New York: Burt, [191?]). [Le Comte 1944, p. 47]

Matthew Arnold, 1822–**1888**. ("Luna's shame" evoked in) "To Marguerite." Poem. In *Empedocles on Etna, and Other Poems* (London: Fellowes, **1852**). [Allott & Super 1986 / Le Comte 1944, pp. 135f.]

Thomas B. Read, 1822–**1872**. "Endymion." Sonnet. In *Poems* (London: Delf & Trübner, **1852**). [Le Comte 1944, p. 48 / Boswell 1982, p. 284]

Thomas Holley Chivers, 1809–**1858**. "Astarte's Song to Endymion." Poem. In *Viginalia; or, Songs of My Summer Nights* (Philadelphia: Lippincott, **1853**). [Boswell 1982, p. 248]

Louis Ménard, 1822–**1901**. "Endymion." Poem. In *Poèmes* (Paris: Dentu, **1855**). [NUC]

Charles Baudelaire, 1821–**1867**. "La lune offensée" [The Outraged Moon]. Poem. In *Les fleurs du mal* (Paris: Poulet-Malassis & de Broise, **1857**). [Pichois 1975] Translated by Edna St. Vincent Millay in *The Flowers of Evil* (New York: Washington Square Press, 1936; 1962). [Ipso]

William Brough, 1826–**1870**. *Endymion: or, The Naughty Boy Who Cried for the Moon.* Extravaganza. First performed **1860**, London. [Nicoll 1959–66, 5:279]

Benjamin Paul Akers, 1825–**1861**. "Diana and Endymion." Marble sculpture. Lost. [Gerdts 1973, pp. 43f., 79]

Arthur Hugh Clough, 1819–**1861**. "Artemis." Poem. In *Poetical Works* (London: Routledge; New York: Dutton, [1906?]). [Le Comte 1944, pp. 131f. / Bush 1937, p. 555]

Elihu Vedder, 1836–**1923**. "Endymion." Plaster sculpture. 6 examples. *c.*1861–63. Unlocated. [Soria 1970, no. S1]

Robert Williams Buchanan, 1841–**1901**. "Selene the Moon" (in love with Endymion). Poem. In *Undertones* (London: Moxon, **1863**). In modern edition, *Complete Poetical Works,* vol. 1 (London: Chatto & Windus, 1901). [Boswell 1982, p. 59 / Le Comte 1944, pp. 132ff.]

Hans Makart, 1840–**1884**. "Venus and Endymion." Painting. Copy, after Benedetto Caliari? **Early 1860s**. Unlocated. [Frodl 1974, no. 625—ill.]

Walter Savage Landor, 1775–**1864**. "Endymion and Selene." Poetic dialogue. First published in John Forster's *Walter Savage Landor: A Biography* (London: Chapman & Hall, 1869). [Wheeler 1937, vol. 2 / Le Comte 1944, pp. 122f. / Boswell 1982, p. 154]

Alice Mary Smith, 1839–**1884**. Overture to Keats's *Endymion* (1816). **1864**. / Revised 1871. [Cohen 1987, 2:650]

John Wood, 1801–**1870**. "Diana and Endymion." Painting. Dulwich College Picture Gallery, London. [Warburg]

George Frederick Watts, 1817–**1904**. "Endymion." Painting. **1873**. Lord Glenconner coll., Britain. [London 1974, no. 49 *n.*]

———. "Endymion." Painting. 1903. Watts Gallery, Compton, Surrey. [Ibid., no. 49—ill.]

William Henry Rinehart, 1825–**1874**. "Endymion." Mar-

ble sculpture. **1874**. Corcoran Gallery, Washington, D.C. [Gerdts 1973, pp. 56f., fig. 12] Bronze replica, 1881, on Rinehart's grave in Green Mount Cemetery, Baltimore. [Ibid.]

Albert Cahen, 1846–**1903**, music. "Endymion." Ballet entrée ("poème mythologique") in 3 tableaux. Text, Louis Gallet. **1875**. Vocal score published Paris: 1883. [Grove 1980, 3:605]

Anton Romako, 1832–**1889**. "Luna and Endymion." Painting. **1873–76**. Private coll., Vienna. [Hunger 1959, p. 103]

Daniel Chester French, 1850–**1931**. "The Awakening of Endymion." Marble sculpture. **1875–76**. Private coll., Concord, Mass. / Plaster model. Chesterwood, Stockbridge, Mass. [Richman 1976, pp. 4ff.—ill.]

Hans Thoma, 1839–**1924**. "Luna and Endymion." Painting. **1877**. Schulte coll., Berlin. [Thode 1909, p. 100—ill.]

———. "Endymion" (playing a pipe). Painting. 1886. Von Flotow coll., Frankfurt. [Ibid., p. 238—ill.]

———. "Luna and Endymion." Painting. 1898. Thode coll., Heidelberg. [Ibid., p. 410—ill.]

———. "Luna and Endymion." Painting. 1900. Kaiser-Wilhelm-Museum, Krefeld. [Ibid., p. 429—ill.]

———. "Luna and Endymion." Painting. 1905. Herrmann coll., Berlin. [Ibid., p. 462—ill.]

Edmund Gosse, 1849–**1928**. "The New Endymion." Poem. *New Poems* (London: Kegan Paul, **1879**). [Le Comte 1944, pp. 137f. / Boswell 1982, p. 121]

John Atkinson Grimshaw, 1836–**1893**. "Endymion on Mount Latmus." Painting. Exhibited **1880**. [Kestner 1989, p. 304, pl. 5.55]

Anonymous English. *Endymion.* Burlesque. First performed **1881**, Torquay. [Nicoll 1959–66, 5:673]

Oscar Wilde, 1854–**1900**. "Endymion." Poem. In *Poems* (Boston: Roberts; London: Bogue, **1881**). [Ross 1909 / Bush 1937, p. 560]

Ralph Waldo Emerson, 1803–**1882**. (Endymion evoked in) "Manners." Poem. [Emerson 1904 / Le Comte 1944, pp. 124f.]

Henry Wadsworth Longfellow, 1807–**1882**. "Endymion." Poem. In *Complete Poetical Works* (Boston: Houghton, Mifflin, 1886). [Boswell 1982, p. 167 / Le Comte 1944, p. 136]

Walter Crane, 1845–**1915**. "Diana and the Shepherd" (Endymion). Painting. **1883**. Art Galleries and Museums, Dundee. [Kestner 1989, p. 239, pl. 4.32]

Xavier Leroux, 1863–**1919**. *Endymion.* Cantata. Paris: **1885**. [Grove 1980, 10:686]

Stopford Brooke, 1832–**1916**. "Endymion." Poem. In *Poems* (London: Macmillan, **1888**). [Le Comte 1944, p. 57 / Boswell 1982, p. 53]

Madison Cawein, 1865–**1914**. (Story of Endymion in) "Artemis." Poem. In *The Triumph of Music and Other Lyrics* (Louisville, Ky.: Morton, **1888**). [Boswell 1982, p. 70]

James Russell Lowell, 1819–**1891**. "Endymion, A Mystical Comment on Titian's *Sacred and Profane Love.*" Poem. In *Heartsease and Rue* (Boston: Houghton, Mifflin, **1888**). [Bush 1937, pp. 485, 582 / Le Comte 1944, p. 124 / Boswell 1982, p. 168]

Karl Gustaf Verner von Heidenstam, 1859–**1940**. *Endymion.* Novel. Stockholm: Bonnier, **1889**. [CEWL 1973, 3:641 / TCLC 1978–89, 5:248, 250]

Christopher Pearse Cranch, 1813–**1892.** "Luna through a Lorgnette." Poem. In *The Bird and the Bell* (Boston: Osgood). [Le Comte 1944, pp. 148f.]

Harry Bates, 1850–1899. "The Story of Endymion and Selene." Marble relief sculpture. Exhibited Royal Academy, London, **1892.** [Read 1982, p. 317]

Richard Garnett, 1835–1906. "Endymion." Poem. In *Poems* (London: Mathews & Lane, **1893**). [Boswell 1982, p. 110]

Francis Thomé, 1850–1909, music. *Endymion et Phoebé.* Ballet. First performed *c.*1894 (?), L'Opéra-comique, Paris. [Grove 1980, 18:783]

Constantine Cavafy, 1868–1933. "Enopion tou Agalmatos tou Endymionos" [Before the Statue of Endymion]. Poem. **1895.** Published Dec 1916? / Translated by Edmund Keeley and Philip Sherrard in *Collected Poems,* bilingual edition (Princeton: Princeton University Press, 1975). [Ipso]

Frederic H. Cowen, 1852–1935. "The Dream of Endymion." Scena for tenor and orchestra. Libretto, Bennett. First performed **1897,** Philharmonic Society, London. [Grove 1980, 5:13]

Karl August Tavaststjerna, 1860–1898. (Poet as Endymion in) "Diana." Sonnet cycle. In *Laureatus; Epopé i tretton sänger . . .* (Stockholm: Bonnier, **1897**). [DSL 1990, p. 599]

Stephen Phillips, 1868–1915. "Endymion." Poem. In *The Nineteenth Century* 44 (Sep **1898**); collected in *New Poems* (London & New York: John Lane, 1907). [Le Comte 1944, pp. 142ff. / Boswell 1982, p. 202]

Maurice Hewlett, 1861–1923. "Latmos" (Endymion's resting-place). Poem. In *Artemision: Idylls and Songs* (New York: Scribner, **1899**). [Boswell 1982, p. 133]

Laura Sedgwick Collins (**19th century**). "Endymion." Musical dramatic scene. [Cohen 1987, 1:160]

J. Maude Crament (**19th century**). "Endymion." Song. [Cohen 1987, 1:170]

Unknown painter. "Diana and Endymion." Fresco, overpainting of Francesco Primaticcio's "Juno in the Land of Sleep" (1541–44). **19th century.** Porte Doré, Château de Fontainebleau. [Dimier 1900, pp. 306f.]

Sara King Wiley, 1871–1909. "Endymion." Poem. In *Poems Lyrical and Dramatic* (London: Chapman & Hall, **1900**). [Bush 1937, p. 583]

Frederick Converse, 1871–1940. *Endymion's Narrative.* Orchestral composition, after Keats (1817). **1901.** First performed 9 Apr 1903, Boston. [Baker 1984, p. 493 / Grove 1980, 4:706]

Edward John Poynter, 1836–1919. "Diana and Endymion" ("The Vision of Endymion"). Painting. **1901.** 2 versions, both in City Art Gallery, Manchester. [Kestner 1989, pp. 224f., pls. 4.10–11 / Wood 1983, p. 150—ill. (drawing)]

George Wetherbee, 1851–1920. "The Pool of Endymion." Painting. **1901.** [Kestner 1989, p. 331]

Lionel Johnson, 1867–**1902.** (Endymion evoked in) "The Red Moon." Poem. In *Poetical Works* (London: Macmillan, 1915). [Le Comte 1944, pp. 145f.]

Henri Fantin-Latour, 1836–1904. "Diana and Endymion." Painting. **1903.** [Fantin-Latour 1911, no. 1967]
——. "Diana and Endymion." Painting. **1904.** Chouanard coll. in 1911. [Ibid., no. 2054]

Paul Le Flem, 1881–1984. *Endymion et Séléné.* Opera. Libretto, composer. **1903.** [Grove 1980, 10:608]

John Davidson, 1857–1909. (Endymion and Diana in) *The Testament of John Davidson.* Poem. London: Richards, **1908.** [Bush 1937, p. 467]

Rainer Maria Rilke, 1875–1926. "Endymion." Poem. In *Neuen Gedichte: Anderer Teil* (Leipzig: Insel, **1908**). [Zinn 1955–66, vol. 1 / Leishman 1960]

Alice Pike Barney, 1857–1931. "Endymion." Painting. **1910.** Barney coll. no. 186, National Collection of Fine Arts, Washington, D.C. [Barney 1965, p. 133—ill.]

Samuel Coleridge-Taylor, 1875–1912. *Endymion's Dream.* Cantata. First performed **1910,** Brighton. [Grove 1980, 4:529]

Rubén Darío, 1867–1916. (Diana and Endymion evoked in) "Poema del otoño" [Poem of Autumn]. In *Poema del otoño y otros poemas* (Madrid: Bibliotéca "Ateneo," **1910**). [Méndez Plancarte 1967 / Hurtado Chamorro 1967, p. 79]
——. (Endymion evoked in) "Diálogo de una mañana de Año Nuevo" [Dialogue of a New Year's Morning]. Poem. [Méndez Plancarte]

Olive Custance (Lady Alfred Douglas), b.1874. "Endymion." Poem. In *The Inn of Dreams* (London: Lane, **1911**). [Boswell 1982, p. 80]

Bernard Drew, b. 1885. "Endymion and Selene." Poem. In *Helen and Other Poems* (London: Fifield, **1912**). [Bush 1937, p. 569]

Ted Shawn, 1891–1972, with **Norma Gould,** choreography. *Diana and Endymion.* Modern dance. First performed **1912,** New York. [McDonagh 1976, p. 40]

Liza Lehmann, 1862–**1918.** "Endymion." Song. [Cohen 1987, 1:409]

Christian Rohlfs, 1849–1938. "Luna and Endymion." Watercolor. **1919.** Kunsthalle, Kiel. [Vogt 1958, no. 19/21]

John Henry Antill, 1904–1986. *Endymion.* Opera. Text, Keats (1817). **1922.** First performed 22 July 1953, Sydney. [Slonimsky 1986, p. 284 / Grove 1980, 1:470 / EDS 1954–66, 1:690]

Sibilla Aleramo, 1875–1960. *Endimèone.* Dramatic poem. Rome: Stock, **1923.** [DELI 1966–70, 1:62]

Archibald MacLeish, 1892–1982. "Selene Afterwards." Poem. **1924.** In *Streets in the Moon* (Boston: Houghton, Mifflin, 1926). [DLB 1986, 45:242 / Falk 1965, p. 40 / Bush 1937, p. 592]

Countee Cullen, 1903–1946. "To Endymion." Poem. In *Copper Sun* (New York & London: Harper, **1927**). [TCLC 1978–89, 4:53 / Webster 1947, p. 223]

Edna St. Vincent Millay, 1892–1950. Endymion evoked in 2 sonnets, nos. 27 and 52 of *Fatal Interview* (New York: Harper & Row; London: Hamilton, **1931**). [DLB 1986, 45:273 / Boswell 1982, p. 186]

T. Sturge Moore, 1870–1944. "Endymion's Prayer." Poem. In *Poems,* vol. 3 (London: Macmillan, **1932**). [Ipso]

Werner Josten, 1885–1963, music. *Endymion.* Ballet. **1933.** [Grove 1980, 9:738]

Wilhelm Lehmann, 1882–1968. (Diana and Endymion evoked in) "Mond im Januar" [Moon in January]. Poem. In *Antwort des Schweigens* (Berlin: Widerstand, **1935**). [DLB 1987, 56:186]

Mona Inglesby, 1918–, choreography. *Endymion.* Ballet.

Music, Moszkowski. First performed **1938**, London. [Oxford 1982, p. 211]

Marcel Jouhandeau, 1888–1979. *Le jardin de Cordoue, ou, Endymion endormi* [The Garden of Cordoba, or, Endymion Sleeping]. Novel. Paris: Gallimard, **1938**. [DLLF 1984, 2:1129]

John Peale Bishop, 1892–**1944**. "Endymion in a Shack." Poem. In *Collected Poems* (New York: Scribner, 1948). [Boswell 1982, p. 42]

William Rose Benét, 1886–1950. "Endymion in London." Poem, to Keats. In *The Stairway of Surprise* (New York: Knopf, **1947**). [Boswell 1982, p. 36]

Arturo Lòria, 1902–1957. *Endymione*. Satirical drama. Florence: "Letteratura," **1947**. [DELI 1966–70, 3:418]

Cesare Pavese, 1908–1950. (Endymion recalls his encounter with Artemis in) "La belva" [The Beast]. Dialogue. In *Dialoghi con Leucò* (Turin: Einaudi, **1947**). / Translated by William Arrowsmith and D. S. Carne-Ross as "The Lady of Beasts" in *Dialogues with Leucò,* bilingual edition (Ann Arbor: University of Michigan, 1965). [Ipso / Biasin 1968, pp. 195–201, 312]

Richard Church, 1893–1972. "Endymion by Day." Poem. In *Collected Poems* (London: Dent, **1948**). [Boswell 1982, p. 74]

Robert Moevs, 1920–, music. *Endymion*. Ballet. **1948**. [Grove 1980, 12:459]

Eugen Batz, 1905–. "Selene and Endymion." Painting. **1949**. [Hannover 1950, no. 3]

Serge Lifar, 1905–1986, choreography. *Endymion*. Ballet. Music, Jacques Leguerney. Libretto, Doderet. First performed **1949**, L'Opéra, Paris; décor, Dmitri Bouchène. [Grove 1980, 10:619 / Sharp 1972, p. 268 / Guest 1976, p. 320]

Frederick Ashton, 1904–1988, choreography. "Diana and Endymion." Tableau vivant, part of *Sylvia*. Ballet. Music, Léo Delibes. Libretto, Jules Barbier and Baron de Reinach, after Tasso's *Aminta* (1573). First performed 3 Sep **1952**, Sadler's Wells Ballet, Royal Opera House, London. [Vaughan 1977, pp. 267, 480]

Robert Lowell, 1917–1977. "The Injured Moon." Poem, after Baudelaire's "La lune offensée" (*Les fleurs du mal,* 1857). **1958**. In *Imitations* (New York: Farrar, Straus & Giroux, 1961). [Axelrod 1978, p. 265]

Giorgio de Chirico, 1888–1978. "Selene and Endymion." Painting. **1961**. Motta coll., Monza. [de Chirico 1971–83, 2.3: no. 241—ill.]

Allen Grossman, 1932–. "Endymion." Poem. In *A Harlot's Hire* (Cambridge, Mass.: Walker-de Berry, **1961**). [Ipso]

Thomas Kinsella, 1928–. "Endymion." Poem. In *Notes from the Land of the Dead and Other Poems* (New York: Knopf, **1973**). [Ipso / Johnston 1985, pp. 113f.]

Jorge Luis Borges, 1899–1986. "Endimión en Latmos." Poem. In *Historia de la noche* (Buenos Aires: Emecé, **1976**). [Foster 1984, item A60.1]

W. S. Di Piero. "Endymion." Poem. In *Sewanee Review* 89 (Spring **1981**). [Ipso]

Mary Weldon Leahy, 1926–. "Selene on Latmos," part of *Three Little Pieces*. Instrumental composition. **1982**. [Cohen 1987, 1:405]

EOS. The Greek goddess of dawn, Eos was the youngest of the three children of the Titans Hyperion, a god of the sun, and his sister Thea. Eos (Aurora) was an amorous deity, falling in love with a number of handsome youths, whom she carried off by force. The most famous of her liaisons was with Tithonus, a mortal to whom she bore Memnon; Orion, Cleitus, and Cephalus were also objects of her desire. Some legends say that her obsessive pursuit of young men was her punishment for having enticed Ares away from Aphrodite.

Eos is commonly characterized in ancient literature as "rosy-fingered" and "saffron-robed"—epithets derived from colors of the early morning sky. She is often depicted bringing in the day on her chariot, or leading the horses of Phoebus Apollo, the sun god, sometimes accompanied by the Horae (Hours) or Seasons. As Dawn, the bringer of light, Eos symbolizes the defeat of Night, or darkness, and is often seen as an allegory of enlightenment.

A contrasting theme has her mourning for her son, Memnon, who was killed by Achilles at Troy; the morning dew was thought to represent her tears.

Classical Sources. Homer, *Odyssey* 5.121–24, 15.249–51. Hesiod, *Theogony* 371–82, 986ff. *Orphic Hymns* 78, "To Eos." Ovid, *Metamorphoses* 7.690ff., 13.576ff. Apollodorus, *Biblioteca* 1.2.2, 1.4.4, 3.12.4ff. Hyginus, *Fabulae* 160, 189, 270.

Listings are arranged under the following headings:
General List
Eos and Tithonus

See also CEPHALUS; MEMNON; ORION.

General List

Dante Alighieri, 1265–1321. (Aurora routs Night in) *Purgatorio* 2.56; (described as handmaiden of the sun in) *Paradiso* 30.7–8. In *The Divine Comedy*. Poem. *Purgatorio* completed *c.*1314 (?), *Paradiso* completed *c.*1321. Foligno: Neumeister & Angelini, 1472. [Singleton 1970–75, vols. 2–3]

Christine de Pizan, *c.*1364–*c.*1431. (Aurora in) *L'epistre d'Othéa à Hector . . .* [The Epistle of Othéa to Hector] chapter 44. Didactic romance in prose. *c.*1400. MSS in British Library, London; Bibliothèque Nationale, Paris; elsewhere. / Translated by Stephen Scrope (London: *c.*1444–50). [Bühler 1970 / Hindman 1986, p. 198]

Marcantonio Raimondi, *c.*1480–**1527/34**. "Aurora Rising." Engraving (Bartsch no. 293), after a design by Raphael. (Albertina, Vienna.) [Bartsch 1978, 26:281—ill.]

Giorgio Vasari, 1511–1574. "Aurora" (in chariot with Tithonus). Painting, part of scenery for "La talenta." Performed Venice, **1541**. Lost. / Drawing. Istituto Nazionale per la Grafica, Rome, inv. 130.674. [Arezzo 1981, pp. 112ff., no. 5.11—ill.]

Francesco Primaticcio, 1504–1570. "Aurora Chasing away Fatal Dreams." Painting. **1541–44**. Porte Doré, Château de Fontainebleau. Repainted 19th century. / Draw-

ing. Duke of Devonshire coll., Chatsworth. [Dimier 1900, pp. 306f., no. 242]

Battista Dossi, *c.*1474–1548 (with Girolamo da Carpi?). "An Hour [or Aurora?] Leading Forth the Horses of Apollo." Painting. *c.***1540s.** Gemäldegalerie, Dresden, no. 130. [Gibbons 1968, no. 91—ill.]

Jacopo Tintoretto, 1518–1594. "Aurora." Fresco, for Casa Grimani, Venice. **1548–56.** Lost. / Engraved by A. M. Zanetti, 1760. [Rossi 1982, p. 261, fig. 13a] *See also Domenico Tintoretto, below.*

Battista Zelotti, *c.*1526–**1578.** "The Myth of Aurora." Fresco cycle. After 1561. Villa Foscari, Malcontenta, Venice. [Berenson 1957, p. 204]

Domenico Tintoretto, 1562–1635 (previously attributed to Jacopo Tintoretto, 1518–1594). "Allegory of Vigilance" ("Aurora"). Painting. **1580s.** Kress coll. (K166), Birmingham Museum of Art, Ala., no. 61.93. [Rossi 1982, no. A9—ill. / Berenson 1957, p. 170]

Edmund Spenser, 1552?–1599. (Aurora evoked in) "Muiopotmos: or, The Fate of the Butterfly" lines 49–52. Poem. London: Ponsonbie, **1590;** collected in *Complaints* (London: Ponsonbie, 1591). [Oram et al. 1989]

Cavaliere d'Arpino, 1568–1640. "Aurora-Juno." Fresco. **1594–95.** Loggia Orsini, Palazzo del Sodalizio dei Piceni, Rome. [Röttgen 1969, pp. 279ff.—ill.]

Guido Reni, 1575–1642. "Dawn [Aurora] Separating Day from Night." Fresco (detached), for Palazzo Zani. **1598–99.** Bankes coll., Kingston Lacy, Dorset. [Pepper 1984, no. 9—ill.]

——. "Aurora" (leading Apollo's chariot). Fresco. 1614. Casino dell' Aurora, Palazzo Rospigliosi-Pallavicini, Rome. [Ibid., no. 40—ill. / Gnudi & Cavalli 1955, no. 33—ill. / also Vermeule 1964, p. 99—ill.]

Bastianino, 1532–**1602,** attributed. "The Dawn" (Aurora leading Apollo's steeds). Fresco. Sala dell' Aurora, Castello Estense, Ferrara. [Arcangeli 1963, pp. 29f., no. 53]

Annibale Carracci, 1560–1609. "Dawn" (Aurora). Painting. *c.***1602–03.** Musée Condé, Chantilly. [Malafarina 1976, no. 130—ill.]

William Alexander, Earl of Stirling, *c.*1567–1640. *Aurora.* Sonnet cycle. London: Bloient, **1604.** Modern edition, in *Poetical Works* (Edinburgh & London: 1921–24). [Royle 1983, p. 6]

Dilettevole. *Aurora.* Dramatic entertainment (favola boscareccia). First performed Carnival, **1607,** Siena. Published Siena: 1608. [Taylor 1893, p. 329]

Girolamo Giacobbi, 1567–1629. *Dramatodia, overo, Canti rappresentativi sopra l'Aurora ingannata* [Dramatic Ode, or, Songs about Aurora Deceived]. Musical work for the stage. Libretto, R. Campeggi. First performed **1608,** Venice. [Grove 1980, 7:344]

Adam Elsheimer, 1578–**1610.** "Morning Landscape" ("Aurora"). Painting. Herzog Anton Ulrich-Museum, Braunschweig, no. 550. [Andrews 1977, no. 18—ill. / Braunschweig 1976, p. 24—ill.]

Pietro da Cortona, 1596–1669. "Aurora." Painting. *c.***1620.** Palazzo Senatorio, Rome. [Briganti 1962, no. 3—ill.]

Guercino, 1591–1666. "Aurora." Ceiling fresco. **1621.** Casino Ludovisi, Rome. [Salerno 1988, no. 83—ill. / Bologna 1968, 1: pl. III] Copies in National Gallery of Ireland,

Dublin, no. 1686; Powys Castle, Montgomeryshire. [Dublin 1981, p. 67—ill. / Wright 1976, p. 206]

Thomas Heywood, 1573/74–1641. "Aurora, or, The Morning." Passage in *Gynaikeion: or, Nine Books of Various History Concerning Women* book 2. Compendium of history and mythology. London: **1624.** [Ipso]

Peter Paul Rubens, 1577–1640. (Aurora in) "The Flight of Marie de' Medici from Blois." Painting, part of Marie de' Medici cycle. **1622–25.** Louvre, Paris, inv. 1785. [Saward 1982, p. 165—ill. / Jaffé 1989, no. 749—ill. / also Louvre 1979–86, 1:117—ill.] Oil sketch. Alte Pinakothek, Munich, inv. 106. [Munich 1983, pp. 463, 471—ill. / Jaffé, no. 748—ill. / Held 1980, no. 77—ill.]

——. "Aurora." Painted cut-out, part of Arch of Ferdinand, decoration for "Pompa Introitus Fernandi," triumphal entry of Cardinal-Infante Ferdinand of Spain into Antwerp, 17 Apr 1635. Original decoration destroyed. [Martin 1972, no. 36—ill. (print)] Copy, painting after original oil sketch for decoration (lost), in Rubenshuis, Antwerp, inv. S.7. [Ibid., no. 36a—ill.]

——. "Psyche" (? previously called "Aurora" or "Canens"). Painting, for Torre de la Parada (executed by assistant from Rubens's design?). 1636–38. Lost. / Oil sketch, 1636. Formerly Museo Provincial de Bellas Artes, La Coruña, stolen 1986. [Jaffé, no. 1321—ill. / Held, no. 214—ill. / also Alpers 1971, nos. 54, 54a—ill.]

——. (Aurora in) Oil sketch, design for title page of *Pompa Introitus Fernandi,* commemorative book (Antwerp: 1641–42). *c.*1635. Fitzwilliam Museum, Cambridge, inv. F.M. 240. [Held, no. 306—ill. / Baudouin 1977, fig. 139 (print) / also Jaffé, no. 1183—ill.]

Johann Hermann Schein, 1586–**1630.** "Aurora schön mit ihrem Haar . . ." [Fair Aurora with her hair]. Song. [Grove 1980, 16:618]

Giovanni da San Giovanni, 1592–1636. "Aurora and Sleep." Fresco (detached), one of a series of 6 for Lorenzo de' Medici. *c.***1634.** Uffizi, Florence, inv. 5423. [Banti 1977, no. 58 / Uffizi 1979, no. P737—ill.]

——. "Night with Dawn [Aurora]" (and Cupid). Fresco, detached, from Palazzo Pucci, Florence. Museo Bardini, Florence. [Banti, no. 56—ill.]

Vicente Carducho, 1576/78–**1638,** attributed. "A Hunt, with the Goddess Aurora in the Sky." Ceiling painting. After 1604. Palacio del Pardo, Madrid. [López Torrijos 1985, pp. 353, 428 no. 9—ill.]

François Perrier, *c.*1590–**1650.** "Aurora." Ceiling painting, for Hôtel la Trillière, Paris. After 1645. Destroyed, replaced by copy. [Dublin 1985, p. 50]

Marco Marazzoli, *c.*1602/08–1662. *Vaga e lucente, la bionda Aurora* [Wandering and bright, blonde Aurora]. Cantata. **1655–56.** [Grove 1980, 11:645]

Vincenzo Dandini, 1596–**1657.** "Aurora and the Hours." Drawing. Gabinetto Disegni e Stampe, Uffizi, no. 1190 F. / Print by Andrea Scacciati. 1766. [Florence 1986, no. 2.291—ill.]

Cecco Bravo, 1607–**1661.** "Aurora Surrounded by Genii." Painting. Kunsthistorisches Museum, Vienna, inv. 8247. [Vienna 1973, p. 41—ill.]

John Milton, 1608–1674. (Aurora in) *Paradise Lost* 2.175; 5.1ff.; 6.2ff., 13–15. Epic. London: Parker, Boulter & Walker, **1667.** [Carey & Fowler 1968 / Martindale 1986, p. 10]

Gérard de Lairesse, 1641–1711. "Apollo and Aurora."
Painting. **1671.** Metropolitan Museum, New York, no.
43.118. [Metropolitan 1980, p. 103—ill.]

John Jenkins, 1592–1678. "When Fair Aurora." Song.
[Grove 1980, 9:598]

Antonio Giannettini, 1648–1721. *L'Aurora in Atene.* Op-
era. Libretto, G. Frisari. First performed 10 Feb **1678,**
SS. Giovanni e Paolo, Venice. [Grove 1980, 7:348]

Charles Le Brun, 1619–1690. Fresco cycle, for ceiling,
Pavillon d'Aurore, Château de Colbert, Sceaux. **1670s.**
[Knab 1977, figs. 12, 14 (prints)]

Luca Giordano, 1634–1705. "Allegory of Dawn." Painting.
1686–87. Indiana University, Bloomington. [Ferrari &
Scavizzi 1966, 2:151—ill.]

———. "Aurora and Sacrifices to the Sun." Fresco. c.1697.
Formerly Buen Retiro, Madrid, destroyed. [Ibid., 1:155,
2:278]

———, questionably attributed. "Aurora in Her Chariot."
Drawing. Albertina, Vienna, no. 34182. [Ibid., 2:314]

Claudio Coello, 1642?–**1693,** circle. "Aurora, with Cu-
pids, Strewing Flowers." Drawing. Prado, Madrid, no.
F.D. 1352. [López Torrijos 1985, p. 429, no. 11—ill.]

Antonio Draghi, 1634/35–**1700.** *Era l'Aurora.* Cantata for
3 voices. Librettist unknown. [Grove 1980, 5:605]

Reinhard Keiser, 1674–1739. *Der Morgen des europäischen
Glückes, oder, Aurora* [The Morning of Europe's Joy, or,
Aurora]. Pastoral opera. Libretto, Breymann. First per-
formed 16 July **1710,** Hamburg. [Grove 1980, 9:847]

Christian Kirchner, ?–1732. (Eos in) "The Four Winds."
Group of sandstone sculptures. c.1718. Wallpavillon,
Zwinger, Dresden. [Asche 1966, no. K110, pl. 226]

Giovanni Antonio Pellegrini, 1675–1741. "Aurora." Ceil-
ing painting. By **1718.** Mauritshuis, The Hague, inv.
834a. [Mauritshuis 1985, pp. 415f.—ill.]

——— (previously attributed to G. B. Tiepolo). "Aurora
with Angels and Putti." Fresco (detached). Biltmore
House, Ashville, N.C. [Morassi 1962, p. 6]

Giovanni Gioseffo del Sole, 1654–1719. "Aurora." Paint-
ing. Palazzo Jappi, Imola. [Bénézit 1976, 9:688]

Carlo Innocenzo Carlone, 1686–1775. "Allegory of Dawn."
Fresco. **1722.** Oberes Belvedere, Vienna. [Knab 1977,
fig. 3]

Daniel Gran, 1694–1757. "Allegory of Dawn." Fresco.
1723–24. Formerly Gartenpalais Schwarzenberg, Vi-
enna, destroyed. [Knab 1977, pp. 42ff., no. F3—ill.]

———. "Aurora musis benigna," "Aurora" ("Morning").
Frescoes. 1726. Nationalbibliothek, Vienna. [Ibid., nos.
F18, F20—ill.]

———. "Aurora." Fresco. 1747. Schloss Hetzendorf, Vi-
enna. [Ibid., no. F78 *bis*—ill.] 4 oil sketches. Barockmu-
seum, Österreichische Galerie, Vienna, inv. 5285, 5866;
Stiftsgalerie, St. Florian, Austria; Szépmüvészeti Mú-
zeum, Budapest, inv. 2131 (745a). [Ibid., nos. Ö5, Ö6, Ö6a,
Ö77—ill.]

———. "Allegory of Dawn." Fresco. 1755. Schloss Friedau,
Obergrafendorf, Austria. [Ibid., no. F92—ill.]

Jacob de Wit, 1695–1754. "Aurora." Ceiling painting. **1730.**
Herengracht 476, Amsterdam. [Staring 1958, pl. 68] Oil
study. Musée Jacquemart-André, Paris. [Ibid., pl. 67]

———. "Dawn Driving Away the Darkness." Ceiling
painting. c.1735. Ringling Museum, Sarasota, Fla., no.

SN975. [Sarasota 1980, no. 126—ill.] Oil sketch. Musées
Royaux des Beaux-Arts (Musée d'Art Ancien), Brussels,
inv. 4343. [Staring, pl. 43 / Brussels 1984a, p. 331—ill.]

———. "Aurora." Drawing, for lost ceiling painting. c.1743.
Van Eeghen coll., Amsterdam. [Staring, p. 152]

Giovanni Battista Pittoni, 1687–1767. "Aurora." Fresco,
part of "Myth of Phaëthon" series. c.1730–32. Villa
Baglioni (Municipio), Massanzago, Padua. [Zava Boccazzi
1979, no. 104, fig. 214]

Giovanni Battista Tiepolo, 1696–1770. "The Chariot of
Aurora." Painting, sketch for an unknown fresco. c.1730–
35. Clark Art Institute, Williamstown, Mass. [Pallucchini
1968, no. 85—ill. / Morassi 1962, p. 68—ill.]

———. "Zephyr and Aurora" (?). Painting, sketch for a
fresco. c.1730–40. Sold Paris, 1922. [Morassi, p. 41—ill.]

———. "Aurora Dispersing the Clouds of Night." Ceiling
fresco (detached), from Palazzo Mocenigo, Venice. c.1755–
60. Museum of Fine Arts, Boston. [Ibid., p. 6—ill. / Pal-
lucchini, no. 232—ill. / Boston 1985, p. 277—ill.]

——— (or imitator? Francesco Zugno?). "Aurora and
Flying Putti." Fresco (detached), from Palazzo Onigo,
Treviso. c.1750–60. Ringling Museum, Sarasota, Fla.
[Sarasota 1976, no. 110 / Morassi, p. 48—ill. / Pallucchini, no.
231—ill.]

———. *See also Pellegrini, above.*

Laurent Gervais, fl. 1725–45. *L'Aurore.* Cantata. c.1740.
[Grove 1980, 7:309]

Corrado Giaquinto, 1703–1765. (Aurora in) "Triumph of
the Sun God Apollo and Bacchus." Ceiling painting.
Mid-1700s. Salón de Columnas, Palacio Real, Madrid.
[Honisch 1965, pp. 39f.]

Antonio Guardi, 1698–1760. "Aurora." Painting. **1750–
60.** Cini coll., Venice. [Morassi 1984, no. 75—ill.]

Gaspare Diziani, 1689–1767. "Dawn." Ceiling painting,
from Palazzo Sagredo, Venice. Metropolitan Museum,
New York, no. 06.1335.1b. [Metropolitan 1980, pp. 47f.—ill.]

Louis-Jean-Jacques Durameau, 1733–1796. "Aurora."
Ceiling painting, for Chancellerie d'Orléans (Hôtel
d'Argenson, now Banque de France), Paris. c.1767.
Partially destroyed, fragments in place. [Rosenberg 1988,
p. 225—ill.]

François Boucher, 1703–1770, circle. "Aurora." Painting.
Muzeum Narodowe, Warsaw, inv. 127682, on display at
Radziejowice Palace. [Warsaw 1969, no. 138—ill.]

———, style. "Aurora." Ceiling painting (from old studio
of Boucher in Louvre?). Louvre, Paris, inv. 2701. [Louvre
1979–86, 3:83—ill.]

Bartolomeo Altomonte, 1702–1779. "Aurora Rouses
Morpheus from Sleep." Painting (reception piece for
Vienna Academy?). **1770.** Lost. [Heinzl 1964, p. 14]

———. "Aurora Awakens the Day." Detail in fresco "Re-
ligion as Supporter of Science and Art." 1774–76. Li-
brary, Stift, Admont, Austria. [Ibid., pp. 47f.]

Anton Schweitzer, 1735–1787. *Aurora.* Singspiel. Libretto,
Christoph Martin Wieland. First performed 24 Oct **1772,**
Weimar. [Grove 1980, 17:46]

Anton Raphael Mengs, 1728–1779. "Aurora." Ceiling fresco.
c.**1763–75.** Palacio Real, Madrid. [Honisch 1965, no. 6—
ill.] Oil study. Museo Provincial de Bellas Artes, Sara-
gossa, Spain. [Ibid., no. 202]

Gaetano Pugnani, 1731–1798. *Aurora.* Opera (festa per

musica). Libretto, G. D. Boggio. First performed **1775**, Turin. Lost. [Grove 1980, 15:447]

Jean-Baptiste Perronneau, 1715?–**1783**. "Portrait of His Wife as Aurora." Painting. Musée des Beaux-Arts, Orléans. [Jacobs & Stirton 1984a, p. 29]

Johann Gottfried Herder, 1744–1803. "Die Morgenröthe," "Aurora." Prose poems, part of *Paramythien.* In *Zerstreuter Blätter* no. 1 (Gotha: Ettinger, **1785**). [Herder 1852–54, vol. 15 / Clark 1955, pp. 348f.]

———. (Aurora evoked in) "An Olympia." Poem. In *Gedichte* book 6, in *Sämmtliche Werke* (Tübingen: Cotta, 1805–20). [Herder, vol. 13]

Franz Anton Maulbertsch, 1724–1796. "Triumph of Aurora" ("Allegory of Morning"). Painting (study for a ceiling decoration?). *c.***1785**–86. Österreichisches Galerie, Vienna. [Garas 1960, no. 335—ill.]

French School. "Allegory of Aurora and Neptune." Painting. **18th century.** Galleria Palatina, Palazzo Pitti, Florence, no. 594. [Pitti 1966, p. 236—ill.]

Joseph-François Ducq, 1762–1829. "Aurora." Painting, for ceiling of Salon de l'Aurore, Château de Saint-Cloud. **1803**–04. Louvre, Paris, inv. 4275. [Louvre 1979–86, 1:49—ill.]

Jean-Honoré Fragonard, 1732–**1806**. "Dawn." Painting, sketch for a ceiling decoration. Private coll. [Wildenstein 1960, no. 83—ill.]

Angelica Kauffmann, 1741–**1807**, attributed. "Aurora." Ceiling painting, for Ashburton House. Formerly Litchfield Gallery, London. [Manners & Williamson 1924, p. 195]

Philipp Otto Runge, 1777–1810. (Figure of "Venus-Aurora" in) "The Morning" (small version). Painting. **1808.** Kunsthalle, Hamburg, inv. 1016. [Hamburg 1969, p. 284—ill. / Hamburg 1977, pp. 204ff., no. 189—ill. / Hamburg 1985, no. 79—ill.; cf. no. 454] Large version. 1809. Kunsthalle, Hamburg, inv. 1022. [Hamburg 1969, p. 285—ill. / Hamburg 1977, no. 200—ill.]

E. T. A. Hoffmann, 1776–1822. *Aurora.* Heroic opera. **1811**–12. Libretto, F. von Holbein. First performed 5 Nov 1933, Bamberg. [Grove 1980, 8:624]

John Flaxman, 1755–1826. "The Alliance of the Winds, Sealed by the Union of Astraeus and Aurora." Drawing, part of series illustrating Hesiod's *Theogony* (lines 378–80). **1807**–14. Engraved by William Blake. London: Longman, 1817. [Irwin 1979, pp. 90f. / Flaxman 1872, 7: pl. 30]

Anne-Louis Girodet, 1767–1824. "Aurora." Painting. *c.***1814.** Ceiling, Chambre de l'Impératrice, Palais de Compiègne. [Bernier 1975, pp. 167, 171—ill.]

Gioacchino Rossini, 1792–1868. *L'Aurora.* Cantata for alto, tenor, and baritone. First performed Nov **1815,** Rome. [Grove 1980, 16:246]

L. T. Noble, choreography. *Aurora, or, The Flight of Zephyr.* Ballet. First performed 7 Feb **1817,** Covent Garden, London. [Nicoll 1959–66, 4:428, 620]

Francesco Morlacchi, 1784–1841. *Donna Aurora, ossia, Il romanzo all' improviso* [Lady Aurora, or, The Unexpected Romance]. Opera buffa. Libretto, Romani. First performed **1819,** Hoftheater, Dresden. [Grove 1980, 12:578]

Peter Cornelius, 1783–1867, and studio. "Morning" (Aurora strewing flowers from her chariot, driving Lucifer away), with pendants "Aurora and Tithonus Kneeling before Jupiter," "Aurora Rising from Her Couch, Ti-

thonus and Memnon Sleeping." Ceiling frescoes. **1820**–26. Göttersaal, Glyptothek, Munich. [Glyptothek 1980, pp. 214ff., fig. 5]

Franz Gläser, 1798–1861. *Aurora.* Musical work for the stage. **1830**–32. [Grove 1980, 7:425]

George Frederick Watts, 1817–1904. "Aurora." Painting. *c.***1843.** Victoria and Albert Museum, London. [Phythian 1907, pp. 33, 74]

———. "Aurora." Bronze sculpture, study for unexecuted work. *c.***1870**–80. Watts Gallery, Compton, Surrey. [Blunt 1975, p. 190]

———. "Dawn." Painting. *c.***1903.** [Phythian, p. 74—ill.]

William Etty, 1787–1849. "Aurora and Zephyr." Painting. Exhibited **1845.** Lady Lever Art Gallery, Port Sunlight, Cheshire. [Maas 1969, p. 165—ill.]

Charles-Louis Müller, 1815–1892. "Aurora." Ceiling painting, after a design by Charles Le Brun. Commissioned **1850.** Galerie d'Apollon, Louvre, Paris, inv. 6825 (2955). [Louvre 1979–86, 4:118—ill. / also Knab 1977, fig. 11]

Mrs. Henry Roscoe Sandbach, 1812–1852. "Aurora." Poem. In *Aurora and Other Poems* (London: Pickering, **1850**). [Bush 1937, p. 553 / Boswell 1982, p. 288]

George Meredith, 1828–1909. "The Rape of Aurora." Poem. In *Poems* (London: Parker, **1851**). [Bartlett 1978, vol. 1 / DLB 1985, 35:120]

Charles Marie René Leconte de Lisle, 1818–1894. "L'Aurore." Poem. **1855.** In *Poèmes barbares* (Paris: Lemerre, 1862). [Pich 1976–81, vol. 2]

Gaspare Martellini, 1785–**1857.** "Aurora" (riding Pegasus). Ceiling painting. Sala dell' Aurora, Palazzo Pitti, Florence. [Pitti 1966, p. 76]

Alexander Galt, 1827–1863. "Aurora." Marble sculpture. **1859**–60. Kirby coll., on loan to Chrysler Museum, Norfolk, Va. [Gerdts 1973, pp. 84f., fig. 65]

Anonymous choreographer. *Aurora, or, The Goddess of Morning.* Ballet. First performed 9 June **1865,** Grecian Theatre, Hoxton, London. [Nicoll 1959–66, 5:643]

Jules Massenet, 1842–1912. "Aurore." Song, in *Poème pastoral.* Text, F. and A. Silvestre. Paris: **1872.** [Grove 1980, 11:809]

John La Farge, 1835–1910. "Dawn." Painting, for ceiling of reception hall, Vanderbilt mansion, New York. **1881**–82. [Weinberg 1977, pp. 256ff., 265f.—ill.]

———. "Aurora." Stained-glass window. 1897. Administration building, Wells College, Aurora, N.Y. [Adams et al. 1987, p. 249]

Gabriel Fauré, 1845–1924. "Aurore." Song, opus 39.1. Text, A. Silvestre. 20 May **1884.** Published 1885. [Grove 1980, 6:426]

Auguste Rodin, 1840–1917. "Aurora." Marble head. **1885.** Musée Rodin, Paris. [Rodin 1944, no. 125—ill.]

———. "Iris Waking a Nymph [or Aurora]." Bronze sculpture. 1885. Musée Rodin, Paris. [Ibid., no. 145—ill.]

Henri Fantin-Latour, 1836–1904. "Aurora and Night" ("Dawn Chasing Away Night"). Pastel. **1887.** [Fantin-Latour 1911, no. 1293]. Oil replica. 1894. Birmingham City Museum and Art Gallery, England. [Lucie-Smith 1977, pp. 22, 57, pl. 93 / also Fantin-Latour, no. 1536]

———. "The Palace of Aurora." Painting. 1902. Metropolitan Museum, New York, no. 23.280.9. [Metropolitan 1980, p. 56—ill. / Fantin-Latour, no. 1907]

————. Numerous further versions of the subject, 1873–1904, in private colls. or unlocated in 1911. [Fantin-Latour, nos. 670, 1524, 1104, 1525, 1709, 1861, 1879, 2037, 2112, 2126, 2134, 2151]

Eugène Delaplanche, 1836–**1891**. "Aurora." Marble statue. Musées Nationaux, inv. RF 671, deposited in Archives Nationales, Paris, in 1939. [Orsay 1986, p. 270]

William Entriken Baily. "Aurora." Poem. In *Classical Poems* (Cincinnati: Clarke, **1892**). [Boswell 1982, p. 30]

James Maurice Thompson, 1844–1901. "Eos." Poem. In *Poems* (Boston: Houghton Mifflin, **1892**). [Boswell 1982, p. 303]

John Byrne Leicester Warren, Lord de Tabley, 1835–1895. "Aurora." Poem. In *Poems: Dramatic and Lyrical,* 1st series (London: Mathews & Lane, **1893**). [Ipso]

Anonymous English. *Aurora*. Farce. First performed 20 Dec **1893**, Toole's Theatre, London. [Nicoll 1959–66, 5:643]

Émile-Antoine Bourdelle, 1861–1929. "Sad Aurora." Plaster statue. **1894**. Lost. [Jianou & Dufet 1975, no. 204]
————. "Aurora." Bronze bas-relief. 1895. 3 casts. [Ibid., no. 208] Variant (head). 2 casts. Private coll(s). [Ibid.]
————. "Aurora with a Rose." Bronze statue. 1898. 4 casts. [Ibid., no. 221]
————. "Aurora." Bronze head. Before 1904. Private coll(s). [Ibid., no. 297]

Will H. Low, b. 1853. "Aurora." Painting. **1894**. Metropolitan Museum, New York, no. 95.3. [Metropolitan 1965–85, 2:167f.—ill.]

Edward Burne-Jones, 1833–1898. "Aurora." Painting. **1896**. Queensland Art Gallery, Brisbane. / Unfinished version in private coll., England. [Harrison & Waters 1973, p. 160]

George Enescu, 1881–1955. "L'Aurore." Composition for soprano, female chorus, and orchestra. Text, Leconte de Lisle (1855). **1897–98**. [Grove 1980, 6:166]

Ivan Khlustin, 1862–1941, choreography. (Aurora in) *The Stars*. Fantastic ballet. Music, Antoine Simon. First performed 1898, Bolshoi Ballet, Moscow. [Clarke & Vaughan 1977, p. 195]

Irma Baka-Baitz (19th century). *Aurora*. Instrumental composition, opus 6. [Cohen 1987, 1:45]

Herbert James Draper, 1864–1920. "The Gates of Dawn." Painting. **1900**. [Kestner 1989, p. 291, pl. 5.26]

Denys Puech, 1854–1942. "Aurora." Marble statue. **1900**. Musée d'Orsay, Paris, inv. Ch. M. 138. [Orsay 1986, p. 226—ill.] Marble replicas. Collège Technique, Le Raincy (1904); Musée Puech, Rodez (1924). / Edition of porcelain reductions, by Manufacture de Sèvres. / Composition repeated in "Tearful Naiad," 1928. [Ibid.]

Ernst Barlach, 1870–1938. "Aurora" ("Angel Strewing Flowers"). Drawing. **1902–03**. Müller-Oerlinghausen coll., Kressbronn. [Schult 1958–72, 3: no. 198—ill.]

Simeon Solomon, 1840–**1905**. "Aurora." Painting. Birmingham City Museum and Art Gallery, England. [Bénézit 1976, 9:692]

Einar Jonsson, b. 1874. "Aurora." Sculpture. **1907**. [Bénézit 1976, 6:101]

Henri Matisse, 1869–1954. "Reclining Nude I" ("Aurora"). Bronze sculpture. **1907**. Edition of 10. Musée d'Art Moderne, Paris; Museum of Modern Art, New York; Baltimore Museum of Art; elsewhere. [Monod-Fontaine 1984, no. 24—ill. / Schneider 1984, p. 546—ill. / Barr 1951, p. 337—ill.]

Odilon Redon, 1840–1916. "Aurora." Painting. *c.***1910**. Private coll., New York. [Berger 1964, no. 152—ill.]

Lovis Corinth, 1858–1925. "Apollo and the Rosy-fingered Eos." Etching, in "Antique Legends" series. **1919**. [Schwarz 1922, no. 351.II]

Giuseppe Lipparini, 1877–1951. *La fantasie della giovane Aurora* [The Fantasy of the Young Aurora]. Romance. Florence: Vallecchi, **1920**. [DULC 1959–63, 3:177]

Pierre Louÿs, 1870–**1925**. "Aurore." Poem. In *Poësies* (Paris: Crès, 1927). [Ipso]

Arthur B. Davies, 1862–**1928**. "Aurora's Court." Painting. Hollister coll., Corning, N.Y. [Cortissoz 1931, p. 21]

Claude Delvincourt, 1888–1954. "Aurore." Choral composition. **1931**. [Grove 1980, 5:356]

Carl Paul Jennewein, 1890–1978. "Aurora." Polychrome terra-cotta figure. **1932**. Pediment of north wing, Philadelphia Museum of Art. [Agard 1951, p. 159, fig. 86]

Gerhard Marcks, 1889–1981. "Eos." Bronze sculpture. **1934**. At least 5 casts. Wallraf-Richartz-Museum, Cologne, inv. S 83; private colls., Germany and U.S.A. [Busch & Rudloff 1977, no. 299—ill.]
————. "Draped Eos." Bronze sculpture. 1964. Unique (?) cast in Gerhard-Marcks-Stiftung, Bremen, inv. 200/71. [Ibid., no. 833—ill.] Model ("Small Draped Eos"). 1964, revised 1969. At least 10 casts. Unlocated. [Ibid., no. 832—ill.] Study ("Head of Eos"). Unlocated. [Ibid., no. 833a—ill.]

Henriette Hilda Bosmans, 1895–1952. "Aurore." Song. [Cohen 1987, 1:98]

Martha Graham, 1894–1991, choreography. (Aurora in) *Ardent Song*. Modern dance. Music, Alan Hovhaness. First performed 18 Mar **1954**, Saville Theatre, London; costumes, Martha Graham. [Stodelle 1984, p. 312]

Paul Wunderlich, 1927–. "Aurora" ("Homage to Runge"). Painting, after Runge's "Morning" (1808). **1964**. 2 versions. Kunsthalle, Hamburg, inv. 5096; elsewhere. [Jensen 1979–80, 1:39ff.; 2: nos. 133, 134—ill. / Hamburg 1985, no. 373—ill. / Hofmann 1987, no. 16.14—ill.]

Giorgio de Chirico, 1888–1978. "Phaethon and Lampos, Horses of Eos." Painting. **1965**. Private coll., Rome. [Far 1968, no. 79—ill.]

Stein Mehren, 1935–. *Aurora det niende Mørke* [Aurora the Ninth Darkness]. Cycle of 88 poems and texts. Oslo: Aschehoug, **1969**. [Seymour-Smith 1985, p. 1124 / Naess 1973, pp. 68f. / EWL 1981–84, 3:261]

Odaline de la Martinez, 1949–. *Eos*. Instrumental composition. **1976**. [Cohen 1987, 1:456]

Robert Cohan, 1925–, choreography. *Eos*. Ballet. Music, B. Guy. First performed **1978**, London. [Oxford 1982, p. 99]

Reynolds Price, 1933–. "Aurora." Poem. In *Vital Provisions* (New York: Atheneum, **1982**). [Ipso]

Eos and Tithonus. The handsome Tithonus, a brother of Priam, was loved by the goddess Eos (Aurora) and became her consort. According to the

Homeric Hymn to Aphrodite, Eos begged Zeus (Jupiter) to make Tithonus immortal, but forgot to ask that he remain eternally young and beautiful. Zeus granted her stated wish, and Tithonus aged endlessly. When he lost his attractiveness, Eos confined him to a room; only his voice could be heard from within. Some later mythographers say that he eventually turned into a grasshopper.

The union of Eos and Tithonus produced one son, Memnon, who was slain by Achilles at Troy. Depictions of Tithonus in postclassical art most commonly show the old man asleep on their couch as Eos departs to bring in the dawn, or riding with Eos in her dawn-chariot.

Classical Sources. Hesiod, *Theogony* 984–85. *Homeric Hymns,* first hymn "To Aphrodite" 218–38. Ovid, *Metamorphoses* 13.576–622. Apollodorus, *Biblioteca* 3.12.4, 3.14.3.

Dante Alighieri, 1265–1321. (Allusion to Aurora and Tithonus in) *Purgatorio* 9.1. Completed *c.*1314? In *The Divine Comedy.* Poem. Foligno: Neumeister & Angelini, 1472. [Singleton 1970–75, vol. 2 / Toynbee 1968, pp. 74, 611]

Baldassare Peruzzi, 1481–1536, circle (? also attributed to school of Giulio Romano or Raphael). "Aurora and Tithonus" (with the death of Procris). Fresco. **1511–12** (or *c.*1517–18). Sala delle Prospettive, Villa Farnesina, Rome. [d'Ancona 1955, pp. 27ff., 93f. / Gerlini 1949, pp. 31ff.—ill. / also Frommel 1967–68, no. 51—ill. / Lavin 1954, pl. 39e]

Giorgio Vasari, 1511–1574. "Aurora" (in chariot with Tithonus). Painting, part of scenery for "La talenta," performed Venice, **1541.** Lost. / Drawing. Istituto Nazionale per la Grafica, Rome, inv. 130.674. [Arezzo 1981, pp. 112ff., no. 5.11—ill.]

Francesco Primaticcio, 1504–1570. "Tithonus and Aurora" (?). Fresco. **1541–44.** Porte Doré, Château de Fontainebleau. Repainted 19th century. / Drawing. Louvre, Paris, no. 8566. [Dimier 1900, pp. 306f., no. 54] Engraved by Fantuzzi (Bartsch no. 7). [Ibid., no. 48]

Bonifazio de' Pitati, *c.*1487–**1553.** "Allegory of Dawn" (Aurora and Tithonus). Painting. Completed by assistants, *c.*1554. Ringling Museum of Art, Sarasota, Fla., inv. SN70. [Sarasota 1976, no. 77—ill.]

Jacopo Tintoretto, 1518–1594. "Aurora Taking Leave of Tithonus." Fresco, for Casa Marcello, San Trovaso, Venice. *c.***1580–81?** Lost. / Engraving by A. M. Zanetti, 1771. [Rossi 1982, fig. 15a]

Edmund Spenser, 1552?–1599. (Aurora and Tithonus evoked in) *The Faerie Queene* 1.2.7, 1.11.51, 3.3.20. Romance epic. London: Ponsonbie, **1590,** 1596. [Hamilton 1977 / MacCaffrey 1976, p. 308]

————. (Tithonus evoked in) "Epithalamion" lines 74–77. Poem. In *Amoretti and Epithalion* (London: Ponsonbie, 1595). [Oram et al. 1989]

Francis Bacon, 1561–1626. "Tythonus, sive satias." Chapter 15 of *De sapientia veterum.* Mythological compendium. London: Barker, **1609.** / Translated as "Tithonus, or Satiety" by Arthur Gorges in *The Wisdome of the Ancients* (London: Bill, 1619). Modern facsimile edition (bilingual), New York & London: Garland, 1976. [Ipso]

Giovanni da San Giovanni, 1592–1636. "Aurora and Tithonus." Fresco (detached), part of mythological series for Lorenzo de' Medici. *c.*1634. Uffizi, Florence, inv. 5417. [Banti 1977, no. 60—ill. / Uffizi 1979, no. P738—ill.]

————. "Aurora and Tithonus." Fresco, detached, from Palazzo Pucci, Florence. 1634? Museo Bardini, Florence. [Banti, no 56]

Pier Francesco Cavalli, 1602–1676. *Titone.* Opera. Libretto, G. Faustini. First performed **1645,** Teatro San Cassiano, Venice. [Grove 1980, 4:32]

Claude Oudot, ?–1696. *Les amours de Titon et l'Aurore.* Opera. First performed **1677,** Sceaux. [Grove 1980, 14:29]

Volterrano, 1611–**1689.** "Tithonus and Aurora." 2 drawings, studies for an unknown fresco. Biblioteca Marcelliana, Florence; Ashmolean Museum, Oxford. [Florence 1986, no. 2.306—ill.]

Pietro Torri, *c.*1650–1737. *Gli amori di Titone e d'Aurora.* Cantata. First performed July **1691,** Munich? [Grove 1980, 19:82]

Johann Joseph Fux, 1660–1741. *Le nozze di Aurora* [The Wedding Celebrations of Aurora]. Opera (feste teatrale per musica). Libretto, Pietro Pariati. First performed 6 Oct **1722,** Hoftheater, Vienna. [Grove 1980, 7:46]

Daniel Gran, 1694–1757. "Aurora and Tithonus before the Fates." Fresco. **1723–24.** Kuppelsaal, Gartenpalais Schwarzenberg, Vienna. [Knab 1977, pp. 42ff., no. F8—ill.]

Giovanni Battista Pittoni, 1687–1767. "Aurora and Tithonus." Painting. *c.***1727–30.** Sold London, 1932, unlocated. [Zava Boccazzi 1979, no. 260—ill.]

Gregorio Lazzarini, 1655–1730, attributed. "Aurora and Tithonus." Painting. Ferens Art Gallery, Hull. [Wright 1976, p. 115]

Jacob de Wit, 1695–1754. "Aurora and Tithonus Achieve Immortality." Ceiling painting. 1733. N. J. van Aalst coll., Hoevelaken. [Staring 1958, pl. 91]

Bernard de Bury, 1720–1785. *Titon et l'Aurore.* Opera (pastorale héroïque). Libretto, Antoine Houdar de La Motte. First performed 14 Jan **1750,** Théâtre des Petits Appartements, Versailles. [Grove 1980, 3:496]

Jean-Joseph Cassanéa de Mondonville, 1711–1772. *Titon et l'Aurore.* Opera. Libretto, La Marre and Voisenon. First performed 9 Jan **1753,** L'Opéra, Paris. [Baker 1984, p. 1568 / Grove 1980, 12:480f.]

Étienne Lauchery, 1732–1820, choreography. *Titon et l'Aurore.* Ballet. Music, Florian Johann Deller, with Jean-Joseph Rodolphe. First performed 1767, Kassel. [Grove 1980, 5:350, 16:92]

Augustin Pajou, 1730–1809. "Tithonus and Aurora." Wood bas-relief, part of cycle representing children as mythological figures. **1769–70.** Salle de l'Opéra, Versailles. [Stein 1912, pp. 177–81, 402]

Johann Gottfried Herder, 1744–1803. "Tithon und Aurora." Essay. In *Zerstreuter Blätter* no. 4 (Gotha: Ettinger, **1792).** [Herder 1852–54, vol. 27 / Clark 1955, p. 363]

Friedrich Hölderlin, 1770–1843. (Eos and Tithonus evoked in) "Hymne an den Genius der Jugend" [Hymn to the Genius of Youth] lines 89ff. Poem. **1792.** In *Poetische Blumenlese* (Stuttgart: Mäntler, 1793). [Beissner 1943–77, vol. 1]

Peter Cornelius, 1783–1867, and studio. "Aurora and Tithonus Kneeling before Jupiter," "Aurora Rising from

Her Couch, Tithonus and Memnon Sleeping." Ceiling frescoes. **1820–26.** Göttersaal, Glyptothek, Munich. [Glyptothek 1980, pp. 214ff., fig. 5]

William Blake, 1757–**1827.** "Tithonus and Aurora." Painting. Simeon coll. in 1863, untraced. [Butlin 1981, no.846A]

Alfred, Lord Tennyson, 1809–1892. "Tithon." Dramatic monologue. **1833.** / Revised and enlarged as "Tithonus." In *Cornhill Magazine* Feb 1860; collected in *Enoch Arden* (London: Moxon, 1864). [Ricks 1969 / Hughes 1987, pp. 99f., 223–26, 287 / Albright 1986, pp. 106–15, 118–20, 144f., 175f. / Henderson 1978, pp. 30, 33]

Frederik Paludan-Müller, 1809–1876. *Tithon.* Dramatic poem. Copenhagen: Reitzel, **1844.** [CEWL 1973, 3:284]

Elizabeth Barrett Browning, 1806–1861. (Tithonus and Eos evoked in) "Antistrophe." Poem, paraphrase from Euripides' *Trojan Women* lines 853ff. **1845.** In *Last Poems* (London: Chapman & Hall, 1862). [Browning 1932]

Ronald Ross, 1857–1932. *The Judgment of Tithonus.* Drama. Published with *Edgar, or, The New Pygmalion* (Madras: Higginbotham, **1883**). [Ellis 1985, p. 237]

Francis Burdett Thomas Coutts-Nevill, 1852–1923. "Tithonus." Poem. In *Poems* (London: Lane, **1896**). [Boswell 1982, p. 248]

Julia Parker Dabney, b. 1850. "Tithonus." Poem. In *Songs of Destiny and Others* (New York: Dutton, **1898**). [Boswell 1982, p. 82]

Robert Williams Buchanan, 1841–1901. "The Gift of Eos" (to Tithonus). Poem. In *Complete Poetical Works* (London: Chatto & Windus, **1901**). [Boswell 1982, p. 57]

Stephen Henry Thayer, 1839–1919. "Aurora's Gift to Tithonus." Poem. In *Songs from Edgewood* (New York: Putnam, **1902**). [Boswell 1982, p. 301 / Bush 1937, p. 584]

Auguste Rodin, 1840–1917. "Aurora and Tithonus." Marble sculpture. **1906.** Musée Rodin, Paris. [Tancock 1976, pp. 277ff. / Rodin 1944, no. 351—ill.] Plaster study. National Gallery of Art, Washington, D.C. [Tancock, p. 279—ill. / Elsen 1981, no. 78]

Alan Seeger, 1888–1916. "Tithonus." Poem. In *Poems* (New York: Scribner, **1916**). [Boswell 1982, p. 291]

Oliveria Louisa Prescott, 1842–**1919.** "Tithonus." Overture. [Cohen 1987, 1:561]

Conrad Aiken, 1889–1973. (Tithonus, as a grasshopper, sings of Arachne in) "The Wedding." Poem. **1925.** In *The London Mercury* 14 no. 81 (July 1926); collected in *Collected Poems* (New York: Oxford University Press, 1953). [Boswell 1982, p. 6]

John Peale Bishop, 1892–**1944.** (Tithonus evoked in) "Whom the Gods Love." Poem. In *Collected Poems* (New York: Scribner, 1948). [Boswell 1982, p. 43]

James Merrill, 1926–. *The Immortal Husband* (Tithonus). Drama. First performed **1955,** Artists' Theatre, New York. Published In *Playbook* (1956). [Ipso]

George Mackay Brown, 1921–. "Tithonus." Short story. In *Hawkfall and Other Stories* (London: Hogarth Press, **1974**). [CLC 1988, 48:55]

EPHESUS, WIDOW OF. *See* WIDOW OF EPHESUS.

EPIMETHEUS. *See* PANDORA; PROMETHEUS.

ERATO. *See* MUSES, Poetry and Music.

ERICHTHONIUS. The Attic hero Erichthonius was the son of Hephaestus and, according to Apollodorus, either Atthis, daughter of Cranaus, or the chaste goddess Athena (Minerva). When Athena fought off Hephaestus's advances, his seed fell to the ground and from it Erichthonius was born. The goddess reared the child and placed him in a chest, which she left in the care of Pandrosus, daughter of King Cecrops of Athens. She cautioned the girl not to look inside, but Pandrosus's sisters Herse and Aglaurus opened the chest and found the child with a snake coiled around him (or saw that he had the tail of a serpent). The girls were then killed by the serpent (or, driven mad by the sight of the serpent's tail, threw themselves off the Acropolis). Erichthonius subsequently became king of Athens, where he was later worshiped in the form of a serpent.

The details of this tale vary with the sources. In the *Metamorphoses,* for example, Ovid says that Erichthonius was born without a mother and that, of the three sisters, only Aglaurus dared to open the chest in which Athena had placed the child. Erichthonius has sometimes been conflated or confused with his son or grandson, Erechtheus.

Classical Sources. Homer, *Iliad* 2.546–49. Euripides, *Ion* 20–24, 260–74, 1001. Plato, *Timaeus* 23DE. Virgil, *Georgics* 3.274. Ovid, *Metamorphoses* 2.553–63, 9.424. Apollodorus, *Biblioteca* 3.14.6ff. Pliny, *Naturalis historia* 7.197. Pausanias, *Description of Greece* 1.2.6, 1.14.6, 1.18.2, 1.24.7. Hyginus, *Fabulae* 166; *Poetica astronomica* 2.13.

Further Reference. Wolfgang Stechow, "The Finding of Erichthonius," in *Studies in Western Art,* vol. 3 (Princeton: Princeton University Press, 1963), pp. 27–35.

See also HERSE AND AGLAURUS.

Anonymous French. (Erichthonius in) *Ovide moralisé* 2.2221ff. Poem, allegorized translation/elaboration of Ovid's *Metamorphoses* (this passage also derived from Hyginus [*Fabulae* 166] and Fulgentius [2.14]). *c.*1316–**28.** [de Boer 1915–86, vol. 1]

Sebastiano del Piombo, *c.*1485–1547. "The Myth of Aglaurus and Herse" (discovering Erichthonius). Fresco. *c.***1511.** Sala di Galatea, Villa Farnesina, Rome. [d'Ancona 1955, pp. 39ff., 88 / Gerlini 1949, pp. 15f.—ill.]

Raphael, 1483–1520, studio (Luca Penni?), after Raphael's design. "The Birth of Erichthonius." Fresco. **1516.** Stufetta del Cardinal Bibbiena, Vatican, Rome. [Vecchi 1987, no. 125]

Anthonie van Blocklandt, 1532/34–**1583.** "The Daugh-

ters of Cecrops Discovering Erichthonius." Drawing. British Museum, London. [Warburg]

Hendrik Goltzius, 1558–1617, composition. "The Daughters of Cecrops Opening the Casket Entrusted to Them by Minerva." Engraving, part of a set illustrating Ovid's *Metamorphoses* (2d series, no. 12), executed by assistant(s). *c.*1590. (Unique impression in British Museum, London.) [Bartsch 1980–82, no. 0302.62—ill.]

Francis Bacon, 1561–1626. "Erichthonius, sive impostura." Chapter 20 of *De sapientia veterum.* Mythological compendium. London: Barker, 1609. / Translated as "Erycthoneus, or Impostury" by Arthur Gorges in *The Wisdome of the Ancients* (London: Bill, 1619). Modern facsimile edition (bilingual), New York & London: Garland, 1976. [Ipso]

Peter Paul Rubens, 1577–1640. "The Daughters of Cecrops Discovering Erichthonius." Painting. *c.*1615. Liechtenstein Collection, Vaduz. [Jaffé 1989, no. 320—ill. / also d'Hulst 1982, fig. 50] Oil sketch. Courtauld Institute, London. [Jaffé, no. 319—ill. / Held 1980, no. 231—ill.]

————. "The Daughters of Cecrops Discovering Erichthonius." Painting. 1632–33. Cut up in 18th century; fragment in Allen Memorial Art Museum, Ohio. [Jaffé, no. 1077—ill.] Oil sketch, entire composition. Nationalmuseum, Stockholm, inv. 607. [Held, no. 232—ill. / Jaffé, no. 1076—ill.]

————, school. "Erichthonius Found by the Daughters of Cecrops." Painted cabinet panel. Rijksmuseum, Amsterdam, inv. NM11906–1. [Rijksmuseum 1976, p. 484—ill.]

Jacob Jordaens, 1593–1678. "The Daughters of Cecrops Finding the Child Erichthonius." Painting. 1617. Koninklijk Museum voor Schone Kunsten, Antwerp, no. 842. [d'Hulst 1982, p. 76, fig. 49 / Ottawa 1968, no. 14—ill. / Antwerp 1970, p. 117 / Augsburg 1975, no. E17—ill.]

————. "The Daughters of Cecrops Finding the Child Erichthonius." Painting. 1635–40. Kunsthistorisches Museum, Vienna, inv. 6488 (1087A). [Vienna 1973, p. 94—ill. / d'Hulst, fig. 143]

Jan Brueghel the Elder, 1568–1625, and **Johann Rottenhammer,** 1564–1625. "The Finding of Erichthonius." Painting. [Pigler 1974, p. 80]

Bartholomeus Breenbergh, 1599–*c.*1657. "Landscape with the Finding of Erichthonius." Painting. 1636. Formerly Singer coll., London, unlocated. [Röthlisberger 1981, no. 185—ill.]

Rembrandt van Rijn, 1606–1669. "The Daughters of Cecrops Opening the Chest with the Little Erichthonius." Drawings, studies for an unexecuted work. *c.*1637. University, Göttingen; Manley coll., Scarsdale, N.Y. [Benesch 1973, nos. 149–50—ill.]

————. "The Daughters of Cecrops (Opening the Chest with the Little Erichthonius)." Drawing. *c.*1648–49. Museum, Groningen, inv. 186. [Ibid., no. 622—ill.]

Salvator Rosa, 1615–1673. "The Infant Erichthonius Delivered to the Daughters of Cecrops to Be Educated." Painting. *c.*1660? Christ Church, Oxford. [Byam Shaw 1967, no. 223—ill. / Salerno 1975, no. 221]

Hendrick Heerschop, 1620/21–after 1672. "Erichthonius Found by the Daughters of Cecrops." Painting. Rijksmuseum, Amsterdam, inv. A774. [Rijksmuseum 1976, p. 266—ill.]

Jan Lievens, 1607–1674. "The Daughters of Cecrops Discovering Erichthonius." Painting. Ostfriesisches Landesmuseum und Statisches Museum, Ernden. [Warburg]

Johann Wolfgang Franck, 1644–*c.*1710. *Die drei Töchter Cecrops* [The Three Daughters of Cecrops]. Opera. Libretto, Aurora von Königsmarck. First performed 1679, Ansbach? Music lost. [Grove 1980, 6:785]

Nicolaus Adam Strungk, 1640–1700. *Die drei Töchter Cecrops.* Opera. Libretto, von Königsmarck. First performed 1680, Hamburg. [Grove 1980, 18:298]

Gérard de Lairesse, 1641–1711 (active until *c.*1690). "The Daughters of Cecrops Discovering Erichthonius." Painting. National Gallery, Oslo, cat. 1887 no. 49. [Warburg]

Johann Philipp Krieger, 1649–1725. *Cecrops mit seinen drey Töchtern* [Cecrops and His Three Daughters]. Opera. 1698. [Grove 1980, 10:269]

Luca Giordano, 1634–1705. "The Daughters of Cecrops Discovering Erichthonius." Painting. Formerly Duke of Northumberland coll., sold Christies, London, 1958. [Warburg]

Arnold Houbraken, 1660–1719. "The Finding of Erichthonius." Painting. [Pigler 1974, p. 81]

William Taverner, 1703–1772. "Aglaurus Discovers the Infant Erichthonius." Watercolor. British Museum, London. [Pigler 1974, p. 81]

ERIGONE. Erigone was the daughter of Icarius, an Athenian who showed great hospitality to the god Dionysus (Bacchus). In return, the god gave him the gift of wine. Icarius shared the wine with shepherds who, in drunken confusion, killed him. Grief-stricken upon discovering her father's body, Erigone hanged herself. According to some versions of the myth, she was transformed into the constellation Virgo; in others, the people of Attica were subjected to suffering and plague until, on the advice of the god Apollo, they organized a festival honoring Erigone and her father.

Classical Sources. Eratosthenes, *Erigone.* Ovid, *Metamorphoses* 6.125, 10.451. Apollodorus, *Biblioteca* 3.14.7. Hyginus, *Fabulae* 130; *Poetica astronomica* 2.4. Nonnus, *Dionysiaca* 47.34ff.

Baldassare Peruzzi, 1481–1536. (Erigone in) Ceiling fresco, representing the constellation Canus Minor. 1510–11. Sala di Galatea, Villa Farnesina, Rome. [d'Ancona 1955, pp. 25f., 86 / Gerlini 1949, pp. 10ff. / also Frommel 1967–68, no. 18c]

Arthur Golding, 1536?–1605. (Story of Erigone in) *Ovids Metamorphosis* book 6 (London: 1567). [Rouse 1961 / Braden 1978, pp. 21f.]

Edmund Spenser, 1552?–1599. (Story of Bacchus and Erigone [mistakenly called Philyra?] evoked in) *The Faerie Queene* 3.1.43, 5.1.2. Romance epic. London: Ponsonbie, 1590, 1596. [Hamilton 1977; cf. p. 409 *n.*]

Nicolas Poussin, 1594–1665. "Bacchus/Apollo" (originally painted as "Bacchus and Erigone"?). Painting. *c.*1626–

27. Nationalmuseum, Stockholm. [Wright 1985, no. 20, pl. 115 / Blunt 1966, no. 135—ill. / also Thuillier 1974, no. 33—ill.]

Guido Reni, 1575–1642. "Bacchus and Erigone." Painting, lost (known from contemporary documents). [Pepper 1984, p. 307 no. D16]

Jean Desmarets de Saint-Sorlin, 1596–1676. *Erigone.* Tragicomedy in prose. Paris: Le Gras, 1642. [DLLF 1984, 1:627]

François Le Moyne, 1688–1737, tentatively attributed. "Erigone." Painting. Early work (or *c.*1720?) if by Le Moyne. Louvre, Paris, no. R.F.3924, on loan to Maison de l'Amérique Latine. [Bordeaux 1984, p. 130—ill.]

François-Joseph de Lagrange-Chancel, 1677–1758. *Erigone.* Tragedy. 1731. Utrecht: Neaulme, 1732. [DLLF 1984, 2:1184]

François Boucher, 1703–1770. "Erigone [?] Holding a Flageolet" (reclining bacchante with flute and tambourine). Painting. *c.*1735. Pushkin Museum, Moscow, no. 731. [Ananoff 1976, no. 123—ill.]

———. "Erigone Vanquished" (Erigone in deshabille, leaning against a companion). Painting. 1745. Wallace Collection, London, no. P.445. [Ibid., no. 282—ill.]

Étienne-Maurice Falconet, 1716–1791. "Erigone." Sculpture. 1747. [Hunger 1959, p. 162]

Jean-Joseph Cassanéa de Mondonville, 1711–1772. *Bacchus et Erigone.* Opera. Libretto, La Bruyère. First performed 1747, Versailles. [Grove 1980, 12:481]

Jean-Baptiste-François De Hesse, 1705–1779, choreography. *Erigone.* Ballet. First performed 1748, Paris? [Cohen-Stratyner 1982, p. 243]

Jean-Baptiste Lemoyne, 1704–1778. "Erigone." Sculpture. Sold 1795, untraced. [Réau 1927, no. 30]

Pierre Joseph Candeille, 1744–1827. "Bacchus et Erigone." New version of Act 3 of Mondonville's opera, *Fêtes de Paphos.* 1780. Unperformed. [Grove 1980, 3:683]

Nicolas-Guy Brenet, 1728–1792. "Erigone." Painting. 1780s? [Bénézit 1976, 2:297]

Adalbert Gyrowetz, 1763–1850, music. *Erigone.* Ballet. 1817. [Hunger 1959, p. 162]

Anne-Louis Girodet, 1767–1824. "The Sleep of Erigone." Drawing, design for a lithograph. Private coll. [Montargis 1967, no. 91]

Hector Berlioz, 1803–1869. *Erigone.* Choral work for solo voices, orchestra, violin, and piano. Text, Pierre-Simon Ballanche's *Intermède antique.* 1836–41. [Grove 1980, 2:606 / Barzun 1950, 1:292]

Walter Savage Landor, 1775–1864. "Icarius and Erigone." Poem. In *Hellenics* (London: Moxon, 1846). [Wheeler 1937, vol. 2 / Pinsky 1968, pp. 60–62]

Gustave Moreau, 1826–1898. "Erigone." Painting. *c.*1852–55. Musée des Beaux-Arts, Lille. [Mathieu 1976, no. 22—ill.] Watercolor sketch ("Autumn"). Musée Gustave Moreau, Paris. [Mathieu 1985, pl. 7]

Léon Riesener, 1808–1878. "Erigone." Painting. 1855. Louvre, Paris, no. R.F. 394. [Louvre 1979–86, 4:186—ill.]

Henri Fantin-Latour, 1836–1904. "Erigone." Painting. 1882. [Fantin-Latour 1911, no. 1072]

Charles Cunninghame Brend. "Erigone." Poem. In *Freshets of the Hills* (London: Methuen, 1915). [Boswell 1982, p. 49]

Theodor Däubler, 1876–1934. (Story of Erigone and Bac-chus evoked in) *Päan und Dithyrambos: Eine Phantasmagorie* [Paean and Dithyramb: A Phantasmagoria] part 6. Poem. Leipzig: Insel, 1924. [Ipso / DULC 1959–63, 1:964]

Cesare Pavese, 1908–1950. (Dionysus tells the story of Icarius and Erigone in) "Il mistero" [The Mystery]. Dialogue. In *Dialoghi con Leucò* (Turin: Einaudi, 1947). / Translated by William Arrowsmith and D. S. Carne-Ross in *Dialogues with Leucò*, bilingual edition (Ann Arbor: University of Michigan, 1965). [Ipso / Biasin 1968, p. 314 *n.*]

ERINYES. *See* FURIES.

ERIPHYLE. Wife of the seer Amphiaraus, Eriphyle was the sister of Adrastus and mother of Alcmaeon and three other children. When the expedition of the Seven against Thebes was organized to support Polyneices' claim to the Theban throne, Amphiaraus at first refused to join because he could foresee that of the Seven only Adrastus would survive. Polyneices bribed Eriphyle with the magical necklace that Harmonia, first queen of Thebes, had received as a wedding gift. Amphiaraus and Adrastus had previously agreed to let Eriphyle settle any disagreements between them, and she was thus able to persuade her husband to join the fatal campaign. Before he set out, Amphiaraus asked his children to avenge his impending death.

Ten years later, the Epigoni (sons of the Seven against Thebes) proposed to recapture Thebes in retribution for the defeat their fathers had suffered. Eriphyle's son Alcmaeon was chosen as leader. Although he was reluctant, his mother was once again bribed, this time with the robe of Harmonia, and she compelled him to go. Upon returning successfully from Thebes, Alcmaeon learned of the bribes and, obeying his father's injunction, killed Eriphyle. He was subsequently driven mad by the Erinyes (Furies) for the matricide.

Postclassical treatments of the story occur almost exclusively in drama and opera.

Classical Sources. Homer, *Odyssey* 15.248. Diodorus Siculus, *Biblioteca* 4.65ff. Apollodorus, *Biblioteca* 1.9.13, 3.6.2, 3.7.2–5. Pausanias, *Description of Greece* 5.17.4. Hyginus, *Fabulae* 73.

See also SEVEN AGAINST THEBES.

Dante Alighieri, 1265–1321. (Alcmaeon slaying Eriphyle, sculpted on pathway as example of pride defeated, in) *Purgatorio* 12.16–24, 49–51. Completed *c.*1314? In *The Divine Comedy.* Poem. Foligno: Neumeister & Angelini, 1472. [Singleton 1970–75, vol. 2]

George Pettie, 1548–1589. "Amphiaraus and Eriphile."

Tale. In *A Petite Pallace of Pettie His Pleasure* (London: R. W[atkins], **1576**). Modern facsimile edition by Herbert Hartman (London & New York: Oxford University Press). [Ipso]

Alexandre Hardy, c.1570–1632. *Alcméon; ou, La vengeance fêminine.* Tragedy. **1615–25.** In *Théâtre* (Paris: Quesnel, 1625–[28]). [NUC]

Attilio Ariosti, 1666–1729. *Erifile.* Opera (drama per musica). Libretto, G. B. Neri. First performed Carnival **1697,** Teatro San Salvatore, Venice. [Grove 1980, 1:584]

Voltaire, 1694–1778. *Eriphile.* Tragedy. First performed 7 Mar **1732,** Comédie-Française, Paris. [Moland 1877–85, vol. 2 / McGraw-Hill 1984, 5:116 / Besterman 1969, pp. 133 n.164, 173]

Girolamo Abos, 1715–1760. *Erifile.* Opera seria. First performed Spring **1752,** Rome. [Grove 1980, 1:20]

Josef Mysliveček, 1737–1781. *Erifile.* Opera. First performed **1773,** Munich. [Grove 1980, 13:7]

Antonio Sacchini, 1730–1786. *Erifile.* Opera. Libretto, G. de Gamerra. First performed 7 Feb **1778,** King's Theatre, London. [Grove 1980, 16:372]

Francesco Bianchi, 1752–1810. *Erifile.* Opera. Libretto, G. de Gamerra. First performed Jan **1779,** Pergola, Florence. [Grove 1980, 2:673f.]

Felice Alessandri, 1747–1798. *Erifile.* Opera. Libretto, G. B. Neri? First performed 12 June **1780,** Teatro Nuovo, Padua. [Grove 1980, 1:244]

Giuseppe Maria Cambini, 1746–1825. *Alcméon.* Opera (tragédie lyrique). Libretto, A. Dubreuil. First performed 13 July **1782,** Académie Royal, Paris. [Grove 1980, 3:640]

Giuseppe Giordani, c.1753–1798. *Erifile.* Opera. First performed **1783,** Bergamo and Genoa. [Grove 1980, 7:393]

Giuseppe Sarti, 1729–1802. *Erifile.* Opera (dramma per musica). First performed Carnival **1783,** Pavia. [Grove 1980, 16:505]

Carlo Monza, c.1735–1801. *Erifile.* Opera. Libretto, G. de Gamerra. First performed 26 Dec **1785,** Teatro Regio, Turin. [Grove 1980, 12:544]

Pasquale Anfossi, 1727–1797, doubtfully attributed. *Erifile.* First performed **1787,** Lucca. [Grove 1980, 1:423]

Franz Schubert, 1797–1828. "Amphiaraos." Lied. Text, Theodor Körner. **1815.** Published 1894. [Grove 1980, 16:790]

Henry Fuseli, 1741–1825. "The Furies Drive Alcmaeon from the Corpse of His Mother Eriphyle, Whom He Had Killed." Painting. **1821.** Kunsthaus, Zurich, inv. 2441. [Schiff 1973, no. 1489—ill.]

Robert Charles Dallas, 1754–1824. *Adrastus.* Dramatic poem. In *Adrastus, a Tragedy; Amabel, or, The Cornish Lovers; and Other Poems* (London: for James Cawthorn, **1823**). [Stratman 1966, pp. 143f.]

Giovanni Battista Marsuzi, 1791–1849. *Alcmeone (Almeone).* Tragedy in verse. Rome: Florilegio drammatico, **1831.** [DELI 1966–70, 3:527]

Thomas Lovell Beddoes, 1803–1849. "Eriphyle's Love." Dramatic poem. In *Poems Posthumous and Collected* (London: Pickering, **1851**). In modern edition by H. W. Donner, *Works* (Oxford: Oxford University Press, 1935). [Ipso]

Jean Moréas, 1856–1910. *Eriphyle.* Poem. Paris: Bibliothèque Artistique et Littéraire, **1894.** [TCLC 1978–89, 18:283f., 288 / DLLF 1984, 2:1570]

Richard Edwin Day, b. 1852. "The Furies to Alcmaeon." Poem. In *Dante, a Sonnet-Sequence, and Other Poems* (New Haven: Yale University Press, **1924**). [Boswell 1982, p. 83 / Bush 1937, p. 589]

EROS. The Greek god of love, Eros was to Homer only a metaphysical force. He was personified first by Hesiod, who described him as one of the earliest gods, a son of Chaos and a brother of Gaia (Ge; Earth), Tartarus, Erebus, and Nyx (Night). In the *Theogony,* he was characterized as having great beauty and the ability to make men weak by overpowering their minds. He was present at the birth of Aphrodite and became her attendant. A second tradition describes him as the son of Aphrodite (Venus) and Ares (Mars), while a third states that he was the son of Iris, goddess of the rainbow, and Zephyr, god of the west wind. Although most closely associated with Aphrodite, he can be found in the company of almost any other god whenever a myth includes a story of love or seduction. His best-known attributes are the bow and arrow. While his golden arrows inspire love, his leaden ones repel it, setting the stage for a number of tragicomic romances. He is also associated with flowers, especially the rose.

The lyric poets of the seventh and sixth centuries BCE depict Eros as cunning, cruel, beautiful, and unpredictable. To Plato and the philosophers, he was the basis for complex dialogues addressing the manifold meanings of love. In the Classical period, he was youthful, handsome, and athletic, but by the Hellenistic period, his power had been reduced to that of a playful and mischievous boy, who played tricks on both mortals and gods. The Roman Cupid (Amor), son of Venus and Vulcan, devolved into a chubby, winged child, an adaptation of the Hellenistic god whose frivolous actions often had serious consequences.

Eros became the personification of lust, and therefore of vice, as a misdirection of love into selfish and sadistic behavior. As such he is often countered by Chastity or Virtue; "Triumphs" of love and chastity, derived from Petrarch, were popular in the early Renaissance. The literature of chivalry gave rise to themes of courtly love, personified by Cupid, in works of the later Middle Ages and early Renaissance. The idea of Cupid as blind or blindfolded, rare in classical texts, became a popular theme from the early Renaissance onward, illustrating the notion that "Love is blind," striking at random. The alliance of Love and Death (which also strikes arbitrarily) may also arise from this concept. In another popular

allegorical conceit, Time (often depicted as Cronus or Saturn) is seen clipping Cupid's wings: love curbed by the years. A reversal of this theme shows love overcoming time. As the god of love, Cupid is often paired with Hymen, god of marriage.

Classical Sources. Hesiod, *Theogony* 120–23, 201. *Orphic Hymns* 58, "To Eros." Plato, *Symposium* 178B, 199C–212C, and passim. Theocritus, *Idylls* 10.19f. Apollonius Rhodius, *Argonautica* 3.119–66, 3.275–98, 4.445–51. Moschus, *The Runaway Love* 1. Lucretius, *De rerum natura* 4.1050–1279. Propertius, *Elegies* 3.12–24. Virgil, *Eclogues* 8.43–50; *Aeneid* 1.657–722. Horace, *Odes* 2, 8, 14. Ovid, *Metamorphoses* 1.453–566, 3.620, 5.363–84, 9.515, 10.311ff. Pausanias, *Description of Greece* 5.11.8, 9.27.1–4, 9.31.3. Apuleius, *The Golden Ass* 4–6. Lucian, *Dialogues of the Gods* 6, "Eros and Zeus," 20, 23, "Aphrodite and Eros"; *Erotes.* Philostratus, *Imagines* 1.6. *Anacreontea*, "The Rub of Love," "Bargain," "The Test," "Before the Shadows," "The Midnight Guest," "Cupid Wounded," "Cupid Received by Anacreon."

Further Reference. Erwin Panofsky, "Blind Cupid," in *Studies in Iconology: Humanistic Themes in the Art of the Renaissance* (New York: Oxford University Press, 1939). Edgar Wind, *Pagan Mysteries in the Renaissance,* revised edition (New York: Norton, 1968), pp. 53–80.

Listings are arranged under the following headings:

> General List
> Education of Eros
> Punishment of Eros
> Eros and Anteros
> Eros and the Bee
> Eros Triumphant

See also ADONIS; AENEAS, and Dido; APOLLO, Loves; APHRODITE; ARES; DAPHNE; DAPHNIS AND CHLOE; FLORA; GODS AND GODDESSES; GRACES; HEPHAESTUS; JASON, Golden Fleece; PARIS, Judgment; PERSEPHONE; PSYCHE.

General List

Alain de Lille, 1128?–1203. (Cupid in) *Liber de planctu natural* [The Plaint of Nature]. Latin poem. Before 1176, probably **1160–70**. In modern edition by T. Wright (translation and commentary by James J. Sheridan), *Satirical Poets of the Twelfth Century* (Toronto: Pontifical Institute of Mediaeval Studies, 1980). [Fleming 1969, pp. 190–92, 196ff. 205, 208]

Guillaume de Lorris, 1215?–1240? and **Jean de Meun**, 1250?–1305? ("Amors," god of love, active throughout) *Le roman de la rose.* Verse romance. Begun by Guillaume, *c.*1230–35, completed by Jean, *c.*1275. Lyon: Ortuin & Schenck, *c.*1481. [Dahlberg 1971 / Poirion 1974]

Giovanni Boccaccio, 1313–1375. (Cupid in) *Filocolo.* Prose romance. **1336–39?** [Branca 1964–83, vol. 1 / Bergin 1981, pp. 75ff. / Hollander 1977, pp. 31ff.]

Francesco Petrarca, 1304–1374. *Il trionfo dell' Amore* [The Triumph of Love]. Poem. **1340–44**. In *Trionfi* (Bologna: Malpiglius, 1475). [Bezzola 1984 / Wilkins 1962 / Barkan 1986, pp. 225–27]

————. (Laura conquers Love in) *Il trionfo della Pudicizia* [The Triumph of Chastity]. Poem. 1340–44. In *Trionfi* (1475). [Bezzola / Wilkins / Wilkins 1978, p. 253]

Geoffrey Chaucer, 1340?–1400. (Cupid in) *The Romaunt of the Rose.* Poem, fragments, translation of *Roman de la rose.* **1370** and later. London: Thynne, 1532. [Riverside 1987 / Miller 1977, p. 468 / Muscatine 1969, pp. 16–18, 27, 30–41]

————. (Cupid and his daughter Wille [Desire] in) "The Parlement of Foules" lines 211–17. Poem. 1380–82. Westminster: Caxton, 1477. [Riverside]

————. (God of love invoked; strikes Troilus with his arrow, in) *Troilus and Creseyde* 1.15.21, 206–10, 330–50, 421–34, 908ff.; 2.523–39, 827–75; 3.1254–74, 1744–71; 4.288–94; 5.582–602. Poem. 1381–85. Westminster: Caxton, 1475. [Ibid. / Havely 1980, p. 2 / Miller, pp. 311ff. / Minnis 1982, p. 71]

————. (God of love commands poet to write stories of good women as palinode for defamations of women in previous works in) Prologue to *The Legende of Goode Women.* Poem. 1385–86. Westminster: Caxton, *c.*1495. [Riverside / Minnis, p. 69]

John Gower, 1330?–1408. (Cupid in) *Confessio amantis* 8.2745–2898. Poem. *c.*1390. Westminster: Caxton, 1483. [Macaulay 1899–1902, vol. 3]

Francesco Landini, *c.*1325–**1397**, music and lyric. "Questa fanciulla, Amor" [This Girl, Amor]. Madrigal. [Grove 1980, 10:433]

————. "Va' pure, Amor" [Only go, Amor]. Madrigal. [Grove, 10:433]

Christine de Pizan, *c.*1364–*c.*1431. *L'epistre au dieu d'amours* [The Epistle to the God of Love]. Poem. **1399**. MS in British Library, London, Harley MS 4431, fol.51r. [Hindman 1986, p. 26, pl. 85] English translation ("The Letter of Cupyde") by Thomas Hoccleve (London: 1402); in modern edition, Hoccleve's *Works* (London: Oxford University Press, for Early English Text Society, 1925). [Mitchell 1968, pp. 20, 22f., 53–56, 77–84]

————. (Cupid as guide for amorous knights in) *L'epistre d'Othéa à Hector* . . . [The Epistle of Othéa to Hector] chapter 47. *c.*1400. MSS in British Library, London; Bibliothèque Nationale, Paris; elsewhere. / Translated by Stephen Scrope (London: *c.*1444–50). [Bühler 1970 / Hindman 1986, pp. 122f., 198, pl. 38]

John Lydgate, 1370?–1449. (Venus introduces poet to Cupid in her Garden of Roses in) *Reson and Sensuallyte* lines 4818ff. Poem, partial translation of *Les échecs amoureux* [Love's Game of Chess] (1370–80). Probably before **1412**. Modern edition by E. Sieper (London: Early English Text Society, 1901). [Pearsall 1970, p. 116]

————. "The Servant of Cupid Forsaken." Poem. In modern edition by H. N. MacCracken, *Minor Poems,* part 2 (London: Early English Text Society, 1934). [Pearsall 1970, pp. 74, 103]

Jacopo Bellini, *c.*1400–*c.*1470. "Amor and Fauns." Drawing. *c.*1430. Sketchbook, Louvre, Paris. [Wind 1968, p. 33, fig. 50]

Master of the Cassone (studio/circle of Apollonio di Giovanni?). "Triumph of Love," "Triumph of Chastity." Series of thematically related paintings. Louvre, Paris (dated **1448**); Victoria and Albert Museum, London, nos. 144–1869, 398–1890 ("Triumph of Love"), 4639–1858 ("Triumphs of Love, Chastity, and Death"); National Gallery, London, inv. 1196 ("Combat of Love and Chastity"), 3898 ("Triumph of Love"); Galleria Sabauda,

Turin ("Love Bound on the Car of Chastity"). [Kauffmann 1973, nos. 10, 123–24—ill. / London 1986, pp. 199, 366—ill.]

Francesco Pesellino, 1422–**1457.** (Cupid in) "The Triumphs of Love, Chastity and Death." Cassone painting. Gardner Museum, Boston, no. P15e5–s. [Hendy 1974, p. 176—ill.]

Apollonio di Giovanni, c.1415–**1465.** "Triumph of Chastity" (victory over Cupid). Painting. Kress coll. (K491), North Carolina Museum of Art, Raleigh, no. GL.60.17.23. [Shapley 1966–73, 1:98—ill.] *See also "Master of the Cassone," above.*

Donatello, c.1386–**1466.** "Amor-Atys." Bronze statuette. Museo del Bargello, Florence. [Pope-Hennessy 1985b, 2:11, 82—ill.]

————, school. "Amor with Torch." Bronze statuette. Victoria and Albert Museum, London, inv. no. A52–1921. [Warburg]

Sandro Botticelli, 1445–**1510.** (Cupid in the Garden of the Hesperides, in) "The Primavera." Painting. c.1478. Uffizi, Florence, inv. 8360. [Lightbown 1978, 1:73ff., no. B39—ill. / Berenson 1963, p. 34—ill.]

Michelangelo, 1475–**1564.** "Sleeping Cupid." Sculpture. **1496.** Lost, probably destroyed 1698. [Baldini 1982, no. 11 / Vermeule 1964, p. 68] Possible copies in details of paintings by Giulio Romano ("The Infancy of Jupiter," National Gallery, London), and Tintoretto ("Mars, Venus, and Vulcan," Alte Pinakothek, Munich). [Baldini / Goldscheider 1964, p. 223—ill.]

————. "Cupid" (*or* Apollo?). Marble statue. c.1497. Lost. [Baldini, no. 12 / also Goldscheider, pp. 5, 223] Related (?) pair of statues, "God of Love" ("Winged Cupid"). One in private coll., Switzerland; pendant unlocated. [Baldini, nos. 58–59—ill.]

————. *See also Vincenzo Danti, below.*

Francesco Colonna, c.1433–1527. (Cupid in) *Hypnerotomachia Poliphili* [The Dream of Poliphilo]. Romance. Venice: Aldus Manutius, **1499;** illustrated with woodcuts by anonymous engraver. [Appell 1893, passim—ill. / Wind 1968, p. 163 / Barkan 1986, p. 228]

Florentine School. "Allegory of Cupid." Painting. **15th century.** Wallace Collection, London, no. P.556. [Wright 1976, p. 97]

Pseudo-Granacci, fl. 1490s–c.1525 (school of Domenico Ghirlandaio; previously confused with Francesco Granacci). "Triumph of Chastity" (victory over Cupid). Painting. **c.1500.** Walters Art Gallery, Baltimore, inv. 37.458. [Walters 1976, no. 203—ill. / also Berenson 1963 p. 207 (as "Tommaso").]

Andrea Mantegna, 1430/31–1506, follower. "Triumph of Love," "Triumph of Chastity." Paintings (after lost originals of **1501** by Mantegna?), in series of 6 "Triumphs" after Petrarch. Kress coll. (K13, K12), Denver Art Museum. [Shapley 1966–73, 2:27—ill.]

Lorenzo Costa, 1460–1535. (Cupid in) "Allegory of the Court of Isabella d'Este" ("The Garden of Harmony," "The Parnassus of Isabella d'Este"). Painting. **c.1504.** Louvre, Paris, inv. INV 255. [Louvre 1979–86, 2:169—ill. / Wind 1948, p. 49, fig. 61 / Louvre 1975, no. 136—ill.]

Marcantonio Raimondi, c.1480–1527/34. "Cupid and Three Putti (Children)." Engraving (Bartsch no. 320). **1506.**

(British Museum, London.) [Shoemaker 1981, no. 10—ill. / Bartsch 1978, 27:10—ill.]

————. "Young Man and a Nymph Followed by Eros." Engraving (Bartsch no. 252), after a design by Raphael? (Kupferstichkabinett, Berlin.) [Bartsch, 26:250—ill.]

Luca Signorelli, 1441–1523. (Cupid with Petrarch's Laura in) "The Triumph of Chastity: Love Disarmed and Bound." Fresco (detached), after Petrarch's *Triumphs,* from Palazzo del Magnifico, Siena. **c.1509.** National Gallery, London, inv. 910. [London 1986, p. 580—ill.]

Titian, c.1488/90–1576, attributed. "Cupid with a Violin." Drawing. Early work if by Titian. Hermitage, Leningrad, inv. 8207. [Hermitage 1984, no. 273—ill.]

————, formerly attributed (follower of Veronese? Girolamo Romanino? previously attributed to Correggio). "Cupid with the Wheel of Fortune." Painting. Kress coll. (K390), National Gallery, Washington, D.C., no. 324. [Shapley 1966–73, 2:186 (attributed to Titian)—ill. / Wethey 1975, no. X–9 (as follower of Veronese)—ill. / Sienkewicz 1983, p. 6 (attributed to Titian)—ill. / also Walker 1984, fig. 255 / Berenson 1957, p. 192 (as Titian)]

————, circle (formerly attributed to Giorgione). "Cupid." Drawing. Metropolitan Museum, New York, inv. 11.66.5. [Pignatti 1978, no. A37—ill.]

————, previously attributed (circle? also attributed to Veronese). "Cupid with a Tambourine." Painting (possibly a fragment of or copy after a lost work). Kunsthistorisches Museum, Vienna, no. 181. [Ibid., no. X–8—ill. / Pignatti 1976, no. A386—ill. / Berenson 1957, p. 139 (as Veronese)] Copy, by Lambert Sustris, in Kosek coll., Nizza. [Pignatti]

————, follower. "Cupid Holding a Dove" ("Boy with a Bird"). Painting, variant copy after a detail in Titian's "Venus and Adonis" (c.1560–65). 17th century? National Gallery, London, inv. 933. [Ibid., no. X–6 / London 1986, p. 622—ill.]

Jacopo Pontormo, 1494–1556. "Cupid and Apollo." Painting, for a Medici celebration. **1513.** Kress coll. (K1618), Bucknell University, Lewisburg, Pa., no. BL-K18. [Shapley 1966–73, 3:10—ill. / Berenson 1963, p. 221 (as follower of Andrea del Sarto)]

Clément Marot, 1496–1544. "Temple de Cupido." Poem (rondeau). *c.*1514. In *L'adolescence Clémentine* ([Lyons?]: 1532). In modern edition by C. A. Meyer, *Oeuvres lyriques* (London: Athlone, 1964). [DLLF 1984, 2:1424 / Bondanella 1978, p. 367]

Raphael, 1483–**1520,** composition. "Eros Stealing Mars's Shield." Engraving (Bartsch 14:179 no. 298), by Agostino Veneziano (?). [Bartsch 1978, 26:217—ill.]

————, composition. "Eros Escaping by Sea." Engraving (Bartsch 14:179 no. 219), by Marco Dente da Ravenna. [Ibid., p. 218—ill.]

————, composition (presumed attribution). "Eros in the Sea." Engraving (Bartsch 14:188 no. 234), by Agostino Veneziano. [Ibid., p. 231—ill.]

Venetian School. "Cupid in a Loggia." Painting, after detail (now painted over) in Giorgione's "Sleeping Venus." (c.1508, Dresden.) **c.1520.** Akademie der Bildenden Künste, Vienna. [Wethey 1975, no. X–7—ill.]

Bernardino Luini, 1480/85–1532. "Vulcan Forging Cupid's Wing." Fresco (detached), for Casa Rabia, Milan

(?). Painting. *c.*1521? Louvre, Paris, no. M.I. 345. [Louvre 1979–86, 2:197—ill.]

Girolamo di Benvenuto, 1470–**1524.** "Cupid with Bow and Arrow." Painting, on Gherardesca marriage salver. Museo di Castel Sant'Angelo, Rome. [Berenson 1968, p. 187]

Jean Lemaire de Belges, *c.*1473–**1515/25.** *Comptes le second et tiers de Cupido et Atropos* [The Second and Third Accounts of Cupid and Atropos]. Verse. Paris: 1525. [DLLF 1984, 2:1273]

Antico, *c.*1460–**1528.** "Cupid." Bronze statuette. Museo di Capodimonte, Naples, no. 10528. [Capodimonte 1964, p. 130, pl. 142]

———. "Cupid (Shooting an Arrow)." Bronze statuette. Museo del Bargello, Florence. [Pope-Hennessy 1985b, 2:84—ill.]

Giulio Romano, *c.*1499–1546, assistant, after design by Giulio. "The Forging of Cupid's Wings." Stucco relief (pair with "The Education of Cupid"). *c.*1529–30. Sala degli Stucchi, Palazzo del Tè, Mantua. [Verheyen 1977, pp. 123ff.]

———. "Cupid Sharpening His Arrow." Drawing. *c.*1530? Royal Library, Windsor, no. 0295. [Hartt 1958, pp. 225, 305 (no. 296)—ill.]

———. Drawing, depicting Cupid, Diana, Cronus, and Boreas as the Four Elements. Earl of Ellesmere coll., Mertoun House, Roxburghshire, Scotland, no. 123. [Hartt 1958, p. 295 (no. 141)—ill.]

———. *See also Michelangelo, above.*

Lucas Cranach, 1472–1553, attributed. "Cupid." Painting, fragment of a "Venus." *c.*1530. Kunsthistorisches Museum, Vienna, inv. 3530 (1464a). [Vienna 1973, p. 50]

Agnolo Bronzino, 1503–1572, attributed (with others?). "Cupid." Fresco. **1530–32.** Sala dei Semibusti, Villa Imperiale, Pesaro. [Baccheschi 1973, no. 13]

Hans Baldung Grien, 1484/85–1545. "Cupid with Burning Arrow." Painting (fragment). *c.*1533. Städtischen Augustinermuseum, Freiburg, no. 11471. [Osten 1983, no. 78, pl. 165]

———, imitator. "Young Girl, Cupid, and Death." Painting. Mid-16th century? Musées Royaux des Beaux-Arts, Brussels, inv. 8756. [Ibid., no. N109, pl. 199]

Parmigianino, 1503–1540. "Cupid Carving [Bending, Testing] His Bow (Cut with the Arms of Mars from Hercules' Club)." Painting. *c.*1533–34. Kunsthistorisches Museum, Vienna, inv. 275 (62). [Vienna 1973, p. 130—ill. / Saslow 1986, p. 129, fig. 3.24 / also Berenson 1968, p. 320 / cf. Sienkewicz 1983, pp. 38f.—ill.] 3 copies by Joseph Heintz the Elder, *c.*1603. Vienna, inv. 1588; Alte Pinakothek, Munich, inv. 3535; Pyk coll., Stockholm (attributed to Heintz). [Zimmer 1971, no. A42—ill. / also Munich 1983, p. 241—ill.] Copy by Peter Paul Rubens, 1614. Munich, inv. 1304. [Jaffé 1989, no. 235—ill. / Munich, p. 452—ill.] Another copy in Prado, Madrid, no. 281. [Prado 1985, pp. 494f.] Related (?) painting (copy?), "Cupid Mending His Bow." Painting. Saltram Park, Devon, cat. 1967 no. 7. [Wright 1976, p. 156]

Jhan Maistre, *c.*1485–*c.*1545. "Amor vorria maddon'humana." Madrigal. **1537.** [Grove 1980, 11:542]

———. "Amor se tu sei Dio." Madrigal. 1538. [Ibid.]

———. "Amor non vedi." Madrigal. 1541. [Ibid.]

———. "Amor perchè tormenti." Madrigal. 1541. [Ibid.]

Andrea Schiavone, *c.*1522–1563. "Cupid." Etching. *c.*1543–45. [Richardson 1980, no. 107]

———. "Apollo and Cupid." Painting. Kunsthistorisches Museum, Vienna, inv. 115 (204). [Richardson 1980, no. 323—ill. / Vienna 1973, p. 158 / Berenson 1957, p. 162]

———. "Jupiter, Juno [or Venus?], and Cupid." Drawing, sketch for (unexecuted?) work. Several versions. Museo Civico, Bassano, nos. 8.226.531–536. [Richardson, no. 151—ill.]

Bonifazio de' Pitati, *c.*1487–**1553.** "Triumph of Love." Painting. Kunsthistorisches Museum, Vienna, inv. 1521 (201). [Vienna 1973, p. 25—ill.]

Clément Janequìn, *c.*1485–**1558.** "Toy Cupido qui as toute puissance" [Thou, Cupid, Who Hast All Power]. Chanson. [Grove 1980, 9:493] Many other chansons on the same theme. [Ibid.]

Garofalo, *c.*1481–**1559.** (Amor in) "An Allegory of Love." Painting. National Gallery, London, inv. 1362. [London 1986, p. 222—ill.]

Barnaby Googe, 1540–1594. "Cupido Conquered" (by Diana). Poem. In *Eglogs, Epytaphes, and Sonettes* (London: **1563**). Modern edition by Edward Arber (London: Murray, 1871). [Lewis 1958, pp. 257f.]

Luca Cambiaso, 1527–1585. "Satyr Mocked by Cupid (and Derided by Venus and the Graces [?])." Ceiling fresco. *c.*1565. Formerly Palazzo della Meridiana, Genoa, destroyed. / Drawing (for?). Art Museum, Princeton University, N.J. [Manning & Suida 1958, p. 92—ill.]

———. "Sleeping Cupid." Painting. Prado, Madrid, inv. 61. [Ibid., p. 132—ill. / Prado 1985, p. 109]

———. "Cupid Resting." Painting. Galleria Borghese, Rome, inv. 191. [Pergola 1955–59, I: no. 127—ill. / Manning & Suida, p. 147—ill.]

———. "Cupid Making His Bow." Painting. Formerly coll. of Queen Christina of Sweden, lost. / Drawing. Staatsgalerie, Stuttgart. [Manning & Suida, p. 165—ill.]

———. "Venus Blindfolding Cupid." Painting. *c.*1565–70. Private coll., Vienna, in 1930. [Manning & Suida 1958, p. 152—ill.] Variant, drawing. Louvre, Paris. [Ibid.—ill.]

Philippe Desportes, 1546–1606. "Tombeau d'Amour" [Tomb of Love], "Grand Dieu d'Amour, enfant de Cytherè" ("Prière") [Great God of Love, Child of Cytherea (Prayer)]. Poems. **1573.** In *Les amours d'Hippolyte* (Rouen: Petit-Val, 1607). Modern edition by V. E. Graham (Geneva: Droz, 1960). [Ipso]

Vincenzo Danti, 1530–**1576** (formerly attributed to Michelangelo). "Cupid" (*or* Narcissus?). Marble sculpture. Victoria and Albert Museum, London, no. 7560–1861. [Goldscheider 1964, p. 225 / Baldini 1982, no. 12 *n*. / also Berenson 1963, p. 149 (as Michelangelo) / Agard 1951, pp. 74f. (as Michelangelo)—ill.]

Paolo Veronese, 1528–1588. (Cupid in) "Allegories of Love." Cycle of 4 paintings: "Unfaithfulness," "Scorn," "Respect," "Happy Union" ("Conjugal Love"). *c.*1576–78. National Gallery, London, inv. 1318, 1324–26. [Pallucchini 1984, nos. 162a-d—ill. / Pignatti 1976, nos. 233–36—ill. / London 1986, pp. 664f.—ill.]

———. "Cupid with Two Dogs." Painting. *c.*1580–85. Alte Pinakothek, Munich, inv. 29. [Pallucchini, no. 212—ill. / Pignatti, no. 276—ill. / Munich 1983, p. 552—ill.]

———, follower (formerly attributed to Titian). "Cupid

with Wheel of Fortune." Painting. *c.*1560. National Gallery, Washington, D.C. [Wethey 1975, no. X–9—ill.]

———, previously attributed (Titian or circle?). "Cupid with a Tambourine." Painting (possibly a fragment of or copy after a lost work). Kunsthistorisches Museum, Vienna, no. 181. [Pignatti, no. A386—ill. / Berenson 1957, p. 139 (as Veronese)] Copy, by Lambert Sustris, in Kosek coll., Nizza. [Pignatti]

Edmund Spenser, 1552?–1599. (A shepherd describes his vision of Cupid in) "March," in *The Shepheardes Calender.* Cycle of eclogues. London: **1579.** [Oram et al. 1989 / Nohrnberg 1976, pp. 471f., 480f.]

———. (Cupid in) *The Faerie Queene* 2.9.34, 3.6.11ff., 3.11.28–49 (tapestries depicting "Cupid's wars"), 3.12.3–25 ("Masque of Cupid"), 6.7.32–37, 6.8.19–25. Romance epic. London: Ponsonbie, 1590, 1596. [Hamilton 1977 / MacCaffrey 1976, pp. 105–11 / Freeman 1970, pp. 218–23 / Lewis 1958, p. 341 / Hieatt 1975, pp. 126–31]

———. (Cupid's power described in) *Colin Clouts Come Home Againe* lines 803–22. Poem. London: Ponsonbie, 1595. [Oram et al.]

———. "An Hymne in Honour of Love." Poem. In *Fowre Hymnes* (London: Ponsonbie, 1596). [Ibid.]

Philip Sidney, 1554–1586. (Evil Cupid evoked in) *The Countess of Pembroke's Arcadia (The Old Arcadia)* first eclogues, third eclogues. Prose romance with poems, pastoral eclogues. Completed *c.*1580. These passages not included in revision of 1582–84 (London: 1590). [Ringler 1962, nos. 8, 63 / Robertson 1973]

———. (Cupid evoked in) Sonnets, nos. 2, 31 of *Certaine Sonets. c.*1581. Published in *Arcadia . . . with sundry new additions* (London: Ponsonbie, 1598). [Ibid.]

———. (Cupid directs the loves of) *Astrophil and Stella* in sonnets 2, 5, 8, 11, 12, 13, 16, 17, 19, 20, 28, 29, 36, 42, 43, 46, 49, 52, 53, 61, 62, 65, 70, 72, 73, 90, 100, 102. Sonnet sequence. 1581–83. London: Newman, 1591 (pirated). [Ringler 1962]

John Lyly, *c.*1554–1606. (Cupid in) *Sapho and Phao.* Comedy. **1581–82.** First performed at Court, London, Shrove Tuesday 1582. Published London: 1584. [Bond 1902, vol. 2]

———. (Cupid evoked in) "A Warning for Wooers." Poem. In Clement Robinson's *A Handefull of Pleasant Delites* (London: 1584). [Ibid., vol. 3]

———. (Cupid in) *Gallathea.* Comedy. By 1585. First performed 1584–85? or at Court, London, 1 Jan 1588. Published London: 1591. [Ibid., vol. 2]

———. (Cupid in) *Love's Metamorphosis.* Comedy. First performed by Children of St. Paul's, London, 1586–88 (?). / Revised, performed *c.*1599–1600. Published London: 1601. [Ibid., vol. 3]

Walter Ralegh, 1552?–1618. (Cupid addressed in) "A Farewell to False Love." Poem. In William Byrd's *Psalmes, Sonnets, and Songs* (**1588**). [Hammond 1984 (with newly discovered last stanza)]

George Peele, 1558?–1597? *The Huntinge of Cupid.* Pastoral poem (or play?), fragmentary. Stationers' Register, 26 July **1591.** In modern edition by W. W. Greg *Malone Society Collections* I, parts 4–5 (1911). [John P. Cutts, "Peele's Hunting of Cupid," *Studies in the Renaissance* 5 (1958): 121–32]

Jacopo Bassano, *c.*1517/18–**1592,** circle. "Birth of Cupid."

Painting. Early 17th century? Detroit Institute of Arts, no. 28.124. [Arslan 1960, p. 337]

Barnabe Barnes, *c.*1569–1609. "Cupid, Run Away." Poem. version of First Idyll of Moschus. In *Parthenophil and Parthenophe . . .* (London: Wolfe, 1593). [Hebel & Hudson 1947, p. 956]

Christopher Marlowe, 1564–1593. (Cupid in) *Hero and Leander* 1.369–484. Poem, after Musaeus, unfinished. Licensed 1593. London: Blunt, 1598. [Bowers 1973, vol. 2 / Friedenreich et al. 1988, pp. 280, 303, 309f.]

John Davies, 1569–1626. (Cupid evoked in) *Orchestra.* Poem. London: Ling, 1594. [Tillyard 1970, pp. 34, 39, 43ff.]

Agostino Carracci, 1557–1602. "Gold Wins All" (Cupid breaking bow as old man seduces young woman with gold). Engraving, in *"lascivie"* series (Bartsch no. 114). *c.*1590–95. [DeGrazia 1984, no. 190—ill.]

———. "Cupid and Two Amoretti." Fresco, in "Allegories of Love" cycle. 1600–02. Palazzo del Giardino, Parma. [Ostrow 1966, no. I/22–A]

Thomas Morley, 1557/58–1603, music and lyric. "Shoot, false love, I care not." Madrigal. Published London: **1595.** [Grove 1980, 12:584]

William Shakespeare, 1564–1616. (Oberon describes how Cupid imbued a flower with love potion, in) *A Midsummer Night's Dream* 2.1.155–74. Comedy. *c.*1595–96? Published London: 1600; collected in First Folio, London: Jaggard, 1623. [Riverside 1974 / Root 1903, p. 49]

———. (Cupid evoked in) Sonnets 153, 154. 1593–99. In *Shake-speares Sonnets* (London: Thorpe, 1609). [Riverside]

———. (Cupid appears in a masque, in) *Timon of Athens* 1.2.131ff. Tragedy, unfinished. 1607–08? Published London: Jaggard, 1623 (First Folio). [Ibid.]

———. (Iris recounts Miranda and Ferdinand's resistance to the temptations of Venus and Cupid in) *The Tempest* 4.1.86–100. Drama (romance). 1611. First performed 1 Nov 1611, Whitehall, London. Published London: Jaggard, 1623 (First Folio). [Ibid. / Brownlow 1977, p. 177]

Bartholomew Griffin, ?–1602. "Tell me of love, Sweet Love, who is thy Sire?" Sonnet. In *Fidessa, More Chaste Than Kind* (London: Lownes, 1596). In modern edition by Sidney Lee, *Elizabethan Sonnets,* vol. 2 (New York: Cooper Square, 1964). [Ipso]

Luca Marenzio, 1553/54–1599. 33 madrigals addressing Amor. Venice: **1581–99.** [Grove 1980, 11:671–73]

Antoine Caron, 1520/21–**1599,** studio. "Allegory: The Funeral Procession of Love." Painting. Louvre, Paris, no. R.F. 1954–4. [Louvre 1979–86, 3:99—ill. / Paris 1972, no. 49—ill. / also Lévêque 1984, p. 184—ill.]

Flemish School (formerly considered Italian School). "Cupid Asleep." Painting. **16th century?** Mauritshuis, The Hague, inv. 353. [Mauritshuis 1985, p. 476—ill.]

Master of Flora (circle of Primaticcio, School of Fontainebleau, **second half 16th century**). "The Birth of Cupid" (with Venus, attended by nymphs). Painting. Metropolitan Museum, New York, no. 41.48. [Metropolitan 1980, p. 120—ill.]

Venetian School. "Jupiter in the Triumph of Cupid." Painting. **1550/1600.** Szépművészeti Múzeum, Budapest, no. 1042. [Budapest 1968, p. 736]

Hans von Aachen, 1552–1616. "Bacchus, Ceres, and Cupid." Painting. *c.*1600. Kunsthistorisches Museum, Vienna,

inv. 1098 (1509). [Hofmann 1987, no. 3.25—ill. / Vienna 1973, p. 2—ill.]

———. "Bacchus, Venus, and Cupid." Painting. Vienna, inv. 1132 (1512). [Vienna, p. 3—ill.]

———, composition. "Amor fucatus" (Cupid, with Venus with attributes of the arts). Engraving by Raphael Sadeler (c.1560/61–c.1628). [Hofmann, no. 7.36—ill.]

Paulus Moreelse, 1571–1638, composition. "Amor in a Landscape." Engraving (executed by Moreelse?). *c.*1600? (Kupferstichkabinett, Dresden.) [de Jonge 1938, no. 10—ill.]

———, composition. "Dancing Amor with Two Women." Colored woodcut. (Kupferstichkabinett, Berlin.) [Ibid., no. 17—ill.]

Ben Jonson, 1572–1637. (Cupid in) *Cynthia's Revels, or, The Fountaine of Selfe-Love.* Satirical comedy. First performed Blackfriar's Theatre, London, **1600–01.** Published London: 1601. [Herford & Simpson 1932–50, vol. 4 / McGraw-Hill 1984, 3:109, 112]

———. *The Haddington Masque* (*The Hue and Cry after Cupid*). Masque, for the marriage of Lord Haddington. Performed 9 Feb 1608, at Court, London. Published London: 1608. [Herford & Simpson, vol. 7 / McGraw-Hill 1984, 3:111, 113]

———. (Cupid in) *Love Freed from Ignorance and Folly.* Masque. Performed 3 Feb 1611, at Court, London. Published London: 1616. [Herford & Simpson]

———. (Cupid in) *Love Restored.* Masque. Performed 6 Jan 1612, at Court, London. [Ibid.]

———. ("True" and "false" Cupids compete in) *A Challenge at Tilt.* Masque. Performed 1 Jan 1614, at Court, London. Published London: 1616. [Ibid.]

———. (Cupid in) *The Masque of Christmas.* Masque. Performed Christmastime 1616, at Court, London. Published London: 1640. [Ibid.]

———. (Cupid in) *Lovers Made Men* (*The Masque of Lethe*). Masque. Performed 22 Feb 1617, at Court, London. Published London: 1617. [Ibid.]

———. (Cupid in) *Time Vindicated to Himself and to His Honours.* Masque. Performed 19 Jan 1623, at Court, London. Published London: 1623. [Ibid.]

———. (Poet enlists Cupid's aid in) "A Celebration of Charis." Poem. Collected as part of *The Underwood*, in *Works* (London: 1640). [Ibid., vol. 8]

Giovanni Baglione, 1571–1644. "The Heavenly Cupid Conquers the Earthly Cupid." Painting. *c.*1602–03. Gemäldegalerie, Berlin-Dahlem, no. 381. [Berlin 1986, p. 13—ill.]

Joseph Heintz the Elder, 1564–1609. "Cupid Carving His Bow." 3 paintings, copies after Parmigianino (c.1533–34). *c.*1603. Kunsthistorisches Museum, Vienna, inv. 1588; Bayerische Staatsgemäldesammlungen, Munich, inv. 3535; Pyk coll., Stockholm (attributed to Heintz). [Zimmer 1971, no. A42—ill.]

———. "Sleeping Cupid." Painting. c.1605. Schönborn coll., Pommersfelden. [Zimmer, no. A14—ill.] Copy, late 17th century, in Akademie der Bildenden Künste, Vienna, inv. 266. [Ibid., no. 14.0.2—ill.]

Michael East, c.1580–1648. "Young Cupid hath proclaim'd." Madrigal. London: **1604.** [Grove 1980, 5:802]

Guillaume Costeley, c.1530–**1606.** "Dieu Cupido, ce grand villain" [The god Cupid, this great villain]. Chanson, for 4 voices. [Grove 1980, 4:826]

Paolo Farinati, 1524–after **1606.** "Amor with a Torch." Drawing. Duke of Devonshire coll., Chatsworth, no. 7550. [Warburg]

Edward Sharpham, 1576–1608. *Cupid's Whirligig.* Comedy. First performed 29 June **1607,** by the Children of the Kings Majesties Revels, London. Published London: Allde, 1607. Modern edition by Allardyce Nicoll (Waltham Saint Lawrence: Golden Cockerel, 1926). [NUC]

Michelangelo da Caravaggio, 1571–1610. "Sleeping Cupid." Painting. **1608.** Galleria Palatina, Palazzo Pitti, Florence, no. 183. [Pitti 1966, p. 249—ill. / Hibbard 1983, fig. 172] Replica. Clowes Fund Collection, Indianapolis. [Wildenstein 1968, no. 3—ill.]

Francis Bacon, 1561–1626. "Cupido, sive atomus." Chapter 17 of *De sapientia veterum.* Mythological compendium. London: Barker, **1609.** / Translated as "Cupid, or, An Atom" by Arthur Gorges in *The Wisdome of the Ancients* (London: Bill, 1619). Modern facsimile edition (bilingual), New York & London: Garland, 1976. [Ipso]

Sigismondo d'India, c.1582–before c.1629. "Ne Amor si acuti strali" [Not sharper than Love's darts]. Madrigal. **1610.** [Grove 1980, 9:67]

———. "Quale Amor mercede" [What recompense Love]. Madrigal. 1621. [Ibid., 9:67]

Bartholomeus Spranger, 1546–**1611.** "Cupid." Drawing. University Library, Erlangen. [Warburg]

Francis Beaumont, 1584/85–1616, and **John Fletcher,** 1579–1625. *Cupid's Revenge.* Tragic burlesque, based on part of Philip Sidney's *Arcadia* (c.1580, 1590). First performed for Queen's Revels, 5 Jan **1612,** London. London: Harison, 1615. [McGraw-Hill 1984, 1:282]

William Rowley, c.1585–1626 or 1642. *Hymen's Holiday, or, Cupid's Vagaries.* Comedy. First performed *c.*1612, London. [DLB 1987, 58:24]

Luis de Góngora y Argote, 1561–1627. (Cupid evoked in) "Second Solitude" [English title of a work written in Spanish]. Poem. c.1612–13. In *Les soledades* (Madrid: 1627). / Translated by E. M. Wilson in *The Solitudes of Don Luis de Góngora* (Cambridge: Gordon Fraser, 1931). [Ipso]

Thomas Middleton, 1570?–1627. *The Mask of Cupid.* Masque. First performed 4 Jan **1614,** Banquet, Merchant Taylors' Company, London. [DLB 1987, 58:196, 211]

Jacopo Peri, 1561–1633. *Marte e Amore* [Mars and Cupid]. Dramatic music (cantata?). Libretto, F. Saracinelli. First performed 9 Feb **1614,** Salone grande, Palazzo Pitti, Florence. [Grove 1980, 14:404]

Peter Paul Rubens, 1577–1640. "Cupid Carving His Bow." Painting, after Parmigianino (c.1532–33, Vienna). **1614.** Alte Pinakothek, Munich, inv. 1304. [Jaffé 1989, no. 235—ill. / Munich 1983, p. 452—ill.]

———, figures, and **Jan Brueghel the Elder,** 1568–1625. (Cupid in) "Allegory of Sight," "Allegory of Touch," "Allegory of Hearing," "Allegory of Smell." Paintings, in "The Five Senses" cycle. 1617–18. Prado, Madrid, inv. 1394, 1395, 1396, 1398. [Jaffé, nos. 465–67, 469, pp. 28f.—ill. / Ertz 1979, nos. 327–29, 331—ill.] Copies by Jan Brueghel the

Younger and unknown artist in Rubens's circle. *c.*1626. Private coll., U.S.A. [Ertz 1984, nos. 178–81, 182—ill.]

——— (Rubens). (Amor in) "The Presentation of the Portrait of Marie de' Medici to Henri IV," "The Apotheosis of Henri IV and the Assumption of the Regency by Marie de' Medici." Paintings, part of "Life of Marie de' Medici" cycle. 1622–25. Louvre, Paris, inv. 1772, 1779. [Saward 1982, pp. 51ff., 98ff.—ill. / Jaffé, nos. 718, 735, pp. 61f.—ill. / also Louvre 1979–86, 1:116f.—ill. / White 1987, pl. 186] Oil sketches. Alte Pinakothek, Munich, inv. 93, 102 (both); Hermitage, Leningrad ("Apotheosis"). [Jaffé, nos. 717, 733–34—ill. / Held 1980, nos. 60, 69–70—ill. / also Munich, pp. 463f., 467—ill.]

———. "Cupid on a Dolphin." Painting, for Torre de la Parada, El Pardo, executed by Erasmus Quellinus from Rubens's design. 1636–38. Prado, Madrid, no. 1632. [Alpers 1971, no. 12—ill. / Jaffé, no. 1252—ill. / Prado 1985, p. 524] Oil sketch. Musées Royaux des Beaux-Arts (Musée d'Art Ancien), Brussels, inv. 4124 (822). [Alpers, no. 12a—ill. / Held, no. 179—ill. / Jaffé, no. 1251—ill. / Brussels 1984a, p. 252—ill.]

———. "Cupid Beating the Drums of War." Painting. Royal Institution of Cornwall, Truro, cat. 1936 no. 24. [Wright 1976, p. 179]

Bartolomeo Schidone, *c.*1570**–1615,** "Cupid." Painting. Galleria di Capodimonte, Naples, no. 385. [Capodimonte 1964, p. 51]

———, attributed, or circle. "Sleeping Cupid." Painting. Louvre, Paris, inv. 560, on deposit in Musée, Langres. [Louvre 1979–86, 2:299]

———, attributed. "Cupid with an Hourglass." Painting. Art Gallery and Museum, Glasgow. [Bénézit 1976, 9:351]

———. "Cupid." Painting. Hermitage, Leningrad. [Bénézit 9:351]

Girolamo Giacobbi, 1567–1629. *Amor prigionero.* Musical work for the stage. Libretto, S. Branchi. First performed **1615,** Bologna. Music lost. [Grove 1980, 7:344]

Thomas Campion, 1567–1619, music and lyric. "O Love, where are thy Shafts, thy Quiver, and thy Bow?" Song. In *Fourth Booke of Ayres* (London: Snodham, **1617**). [Vivian 1966]

Domenico Fetti, *c.*1589–1624. "Amor." Drawing. *c.*1618. Count Antoine Seilern coll., London. [Augsburg 1975, no. E36—ill.]

Michael Drayton, 1563–1631. "To Cupid." Poem (ode). In *Odes, with Other Lyrick Poesies* (London: Smethwicke, **1619**). [Hebel 1931–32, vol. 2]

———. Sonnet ("Cupid conjured"), no. 36 of *Idea.* Cycle of 63 sonnets. London: Smethwicke, 1619. [Ibid.]

Johann Hermann Schein, 1586–1630. "Cupido blind, das Venuskind" [Blind Cupid, Venus's Child]. Song. Published Leipzig: **1622.** [Grove 1980, 16:619]

———. "Frau Venus und ihr blinder Sohn" [Lady Venus and Her Blind Son]. Song. 1626. [Ibid.]

Giulio Cesare Procaccini, 1574**–1625.** "Cupid." Painting. National Gallery of Scotland, Edinburgh, cat. 1970 no. 63. [Wright 1976, p. 166]

Daniel Seghers, 1590–1661, flowers, and **Domenichino,** 1581–1641, figures. "(Cupid in a Chariot Surrounded by a) Garland of Flowers." Painting. **1625–27,** with figures

added before 1633. Louvre, Paris, inv. 797. [Louvre 1979–86, 1:127—ill. / also Spear 1982, no. 67 (as Domenichino and "Cavaliere Mauro")—ill.] Variant copies in Christ Church, Oxford (studio of Domenichino; Mario de'Fiori?); Musée des Beaux-Arts, Dijon; 1 unlocated. [Spear / Byam Shaw 1967, no. 202]

John Milton, 1608–1674. (Poet acknowledges power of Cupid in) "Elegia septima" [Elegy Seven]. Elegy. Summer **1628.** In *Poems* (London: Moseley, 1645). [Carey & Fowler 1968; cf. p. 553 *n.* / Woodhouse 1972, pp. 26f.]

Johann Liss, *c.*1595**–1629.** "Amor (Vincit)." Painting. Late work. Cleveland Museum of Art, Ohio, no. 71.100. [Cleveland 1982, no. 71—ill. / Augsburg 1975, no. A29—ill.]

Otto van Veen, 1556**–1629.** "Amor Resting." Drawing. Albertina, Vienna, inv. no. 8062. [Warburg]

———. "Time Clipping the Wings of Love." Painting. Musée, Besançon. [Bénézit 1976, 10:419]

Anthony van Dyck, 1599**–1641.** "Amor." Painting. *c.***1628–30.** Kunstmuseum, Düsseldorf, on loan from Bentinck-Thyssen coll. [Larsen 1988, no. 749—ill.]

———. "Time [Saturn] Clipping the Wings of Love [infant Cupid]." Painting. *c.*1628–32. Musée Jacquemart-André, Paris. [Larsen 1988, no. 737—ill.] Copies in Staatliche Kunstsammlung, Kassel; Nationalmuseum, Stockholm. [Ibid., no. A174/1–2—ill.] *See also Flinck, below.*

Alessandro Turchi, 1578–1649. "Cupid." Painting, pendant to "Venus." *c.*1630. Art Institute of Chicago, no. 65. [Chicago 1965]

John Donne, 1572**–1631.** (Cupid's reign bewailed in) "Loves Deitie," "Loves Exchange," "Love's Diet," "Love's Usury," "Love's Alchemie." Poems. In *Poems* (London: Marriot, 1635). [Patrides 1985 / Pinka 1982, pp. 20f., 45–47, 55–62, 158f.]

George Jeffreys, *c.*1610**–1685.** "Cupid blushes to behold." Song. **1631.** Published in Sir Richard Hatton's *Songs Made for Some Comedyes.* [Grove 1980, 9:585]

———. "Cupid, if a God thou art." Song. 1631. Published in Peter Hausted's *The Rivall Friends.* [Ibid.]

Pedro Calderón de la Barca, 1600–1681. (Amor in) "El divino Orfeo." Auto sacramentale. *c.*1634. First published as appendix to Pablo Cabañas's *El mito de Orfeo en la literatura española* (Madrid: Instituto Miguel de Cervantes de Filología Hispánica, 1948). [León 1982, pp. 185ff.]

Rembrandt van Rijn, 1606–1669, school (previously attributed to Rembrandt; false signature). "Cupid Resting." Etching (Bartsch no. 132). **1634?** [White & Boon 1970, no. B132—ill.]

———, school (formerly attributed to Govaert Flinck). "The Boy Amor with Arrow and Bow." Painting. Treuhand-Verwaltung von Kulturgut, Munich, in 1961. [von Moltke 1965, no. W47]

Simon Vouet, 1590–1649. "Allegory of Love and Abundance" (Bacchus, Venus, and Cupid). Ceiling decoration, for Château de Colombes. Lost. / Engraved by J. Boulanger, **1634.** [Crelly 1962, no. 237—ill.]

———. "Love Dispelling Chaos." Decoration for gallery of Hôtel Séguier, Paris. 1633–38. Lost. Engraved by Michel Dorigny, 1651. [Ibid., pp. 112ff., no. 248J—ill.]

———. "Venus Threatened by Cupid," "Venus Testing

the Arrows of Love." Paintings. Musée des Beaux-Arts, Nancy. [Ibid., p. 87, nos. 71a, b—ill.]

———, or studio. "Cupid Making Arrows." Painting, cartoon for "Loves of the Gods" tapestry series. [Ibid., no. 270f]

Lope de Vega, 1562–1635. *El Amor enamorado* [Cupid in Love]. Pastoral comedy. 1625–35. First performed 29 July **1635,** Buen Retiro, Madrid. Published in *La Vega del Parnaso* (Madrid: Imprenta del Reyno, 1637). [Menendez y Pelayo 1890–1913, vol. 6 / Wooldridge 1978 passim]

Giovanni da San Giovanni, 1592–1636. "Cupid Presenting to Mars the Marzocco [heraldic lion], Symbol of the City of Florence." Ceiling fresco. **1635–36.** Salone degli Argenti, Palazzo Pitti, Florence. [Banti 1977, no. 64—ill.]

Thomas Heywood, 1573/74–1641. "Jupiter and Cupid." Poetic dialogue, translation of Lucian. No. 7 in *Pleasant Dialogues and Drammas* (London: **1637**). [Heywood 1874, vol. 6]

Gerrit van Honthorst, 1590–1656. "Amor." Painting. **1637.** Sold 1874, unlocated. [Judson 1959, no. 72]

Guido Reni, 1575–1642. "Cupid (with a Bow)." Painting. **1637–38.** Prado, Madrid, no. 150. [Pepper 1984, no. 171—ill. / Prado 1985, pp. 538f.] Copies in Accademia di San Luca, Rome (attributed to Giovanni Andrea Sirani); Gemäldegalerie, Berlin-Dahlem, inv. 1813 (as anonymous 17th century, formerly attributed to Francesco Albani); Earl of Leicester coll., Holkham Hall. [Pepper / also Berlin 1986, p. 64]

———. "Amor (Lying Near the Sea)." Painting. Late work. Formerly Bishop's palace, Milan, lost. / Copies/ studio variants in Walters Art Gallery, Baltimore, inv. 37.491 (by Elisabetta Sirani?); Museum, Stuttgart; Liechtenstein Collection, Vaduz; 3 more in private colls. or unlocated. [Pepper, p. 299 no. C4—ill. / also Walters 1976, no. 357—ill.]

———, attributed, or circle. "Sleeping Cupid." Painting. Several versions and variants known. Private colls. or unlocated. [Pepper 1984, no. 299f no. C5]

———, follower (Bartolomeo Schidone?). "Cupid with an Hourglass." Painting. Art Gallery and Museum, Glasgow, cat. 1970 no. 130. [Wright 1976, p. 170 / Bénézit 1976, 9:351 (as Schidone)]

Govaert Flinck, 1615–1660. "Cupid Sleeping." Painting. **1639.** Gorissen coll., Cleves, in 1962. [von Moltke 1965, no. 109—ill.]

———. "Cupid Sleeping." Painting. 1655. Glasgow Museum and Art Gallery, on loan from Campbell coll., Carscube, in 1962. [Ibid., no. 110—ill.] At least one further version of the subject known, unlocated. [Ibid., nos. 111–10]

———, formerly attributed (imitator of van Dyck?). "A Boy as Amor." Painting. Sold Vienna 1944. [Ibid., no. W46—ill.]

———. *See also Rembrandt, above.*

Francesco Manelli, 1594–1667, music. (Cupid in) *La Delia, ossia, La sera sposa del sole* [Delia, or, The Evening Bride of the Sun]. Opera. Libretto, G. Strozzi. First performed **1639,** Teatro SS Giovanni e Paolo, Venice. [Grove 1980, 11:612f.]

Nicolas Poussin, 1594–1665. "Cupid on Horseback."

Drawing. Before **1640.** Royal Library, Windsor Castle, no. 11967. [Friedlaender 1949, no. 153—ill.] Studio variant. Windsor, no. 11968. [Ibid.]

———, attributed (or Pier Francesco Mola?). (Cupid in) "Landscape with Nymphs and Satyrs" ("Amor vincit omnia," "Pan with Infant Bacchus"). Painting. Late 1620s? or 1640s? Cleveland Museum of Art, Ohio, no. 26.26. [Wright 1985, no. 37, pl. 122 / Blunt 1966, no. R58 / Thuillier 1974, no. R124—ill. / Cleveland 1982, no. 50—ill.]

———, attributed (formerly attributed to Domenico Podestà). "Cupid and a Sleeping Infant." Painting. Musée de Tessé, Le Mans. [Thuillier, no. R100—ill.]

———, formerly attributed. (Venus, Bacchus, Mercury, and Cupid, representing) "The Four Seasons Dancing to the Music of Apollo's Lute." Presumed painting, known from engraving by J. Avril, 1779. [Blunt, no. R56 / also Thuillier, no. R54—ill.]

Claudio Monteverdi 1567–1643, music. *La vittoria d'Amore* [The Victory of Cupid]. Ballet. Libretto, Morandi. First performed **1641,** Piacenza. [Grove 1980, 12:530 / Redlich 1952, pp. 37, 187]

Pier Francesco Cavalli, 1602–1676. *La virtù de' strali d'Amore* [The Power of Cupid's Arrows]. Opera. Libretto, Giovanni Faustini. First performed **1642,** San Cassiano, Venice. [Rosand 1976, pp. 102–04 / Glover 1978, pp. 18, 47–53, 158]

François Duquesnoy, 1594–1643. "Cupid with a Curling Horn," "Cupid Shaping the Bow." 2 marble sculptures. Bodemuseum, Berlin. [Whinney 1964, pp. 61, 251 *n*.71] *See also Puget, below.*

Marco Marazzoli, *c.*1602/08–1662. *S'è ver che Cupido si pasce.* Cantata. *c.***1637–45.** [Grove 1980, 11:645]

Philippe de Buyster, 1595–1688. "Hymen and Cupid" (infants). Stucco sculptures. *c.***1645.** Château de Maisons, near Paris. [Chaleix 1967, pp. 40, 125, pl. 7.2]

Eustache Le Sueur, 1616–1655. Series of painting cycles, depicting the infancy of Cupid; Cupid with pairs of lovers; Cupid with attributes of gods and heros; Cupid in decorative scenes. For Cabinet de l'Amour, Hôtel Lambert, Paris. **1646–47.** Louvre, Paris, inv. 8050–55; Château de La Grange Montalivet. [Louvre 1972, pp. 9f., 14f., nos. 12–17, 19–48—ill. / also Louvre 1979–86, 4:58f.—ill.] / Saslow 1986, pp. 183f., fig. 5.7] Studies for "Infancy" cycle. Private coll(s)., Paris; 1 ("Birth") unlocated. [Louvre 1972, nos. 12 *bis* - 16 *bis*—ill.]

Robert Herrick, 1591–1674. (Cupid in) "Upon Love," "The Cheat of Cupid: or, The Ungentle Guest," "Upon Cupid" (3 poems with this title); (Cupid invoked in) "An Hymne to Cupid." Poems. In *Hesperides* (London: Williams & Eglesfield, **1648**). [Martin 1956]

Stefano Della Bella, 1610–1664. (Cupid in) "Rebus on Love." Etching. *c.***1648–49.** Gabinetto Disegni e Stampe, Uffizi, no. 2395. [Florence 1986, no. 3.21—ill.]

Richard Lovelace, 1618–1658. (Cupid evoked in) "Princess Louisa Drawing." Poem. In *Lucasta: Epodes, Odes, Sonnets, and Songs* (London: Ewster, **1649**). [Wilkinson 1930]

Henry Purcell, *c.*1658–1695, music. *Cupid Out of His Humor.* Ballet. Performed for Queen Christina of Sweden, **1649.** [Terry 1976, p. 102]

———. (Cupid in "frost scene" of) *King Arthur.* Opera.

Libretto, Dryden (1684). First performed June 1691, Dorset Gardens, London. [Bianconi 1987, pp. 257ff. / Oxford 1972, p. 20]

Filiberto Laurenzi, *c.*1619/20–*c.*1651, with **Andrea Mattioli**, *c.*1620–1679. *L'esiglio d'Amore* [The Banishment of Cupid]. Opera. Libretto, Francesco Berni. First performed **1651**, Teatro di Cortile, Ferrara. [Grove 1980, 10:549]

James Shirley, 1596–1666. *Cupid and Death*. Court masque. First performed 26 Mar **1653**. Set to music by Matthew Locke and Christopher Gibbons. Published London: Crook & Baker, 1653. / Revised 1659, performed Military Ground, Leicester Fields, London. [Grove 1980 11:116; 7:352f. / DLB 1987, 58: 249, 251, 254 / Logan & Smith 1978, p. 160 / Bukofzer 1947, p. 188 / Palisca 1968, p. 185]

Guercino, 1591–1666. "Virtuous (Unselfish) Cupid" (pouring money out of a purse). Painting. **1654**. Prado, Madrid. [Salerno 1988, no. 303—ill.]

Samuel Twardowski, 1600–1660. "Cupid's Suicide" (caused by Lisbon lady's defeat of Venus). Poem, in *Nadobna Paskwalina* [The Comely Pasqualina] part 3. Pastoral romance (based on anonymous Spanish poem?). **1655**. In modern edition, *Five Centuries of Polish Poetry: 1450–1970* by J. Pietrkiewicz & Burns Singer (London: Oxford University Press, 1970). [Ipso]

Jean de La Fontaine, 1621–1695. "Danse de l'amour," part 6 of *Le songe de Vaux* [The Dream of Vaux]. Poetic description (fragments) of Château de Vaux-le-Vicomte, Mainsy, for Nicolas Foucquet. *c.*1659–60? In *Oeuvres diverses* (Paris: Didot, 1729). [Titcomb 1967 / Clarac & Marmier 1965]

———. (Cupid in) *Daphné*. Libretto for opera-ballet. 1674. Commissioned for Jean-Baptiste Lully, but rejected, unperformed. Published in *Poème du quinquina et autres ouvrages en vers* (Paris: Thierry & Barbin, 1682). [Clarac & Marmier]

———. "L'Amour et la Folie" [Love and Folly]. Verse fable (book 12 no. 14). In *Ouvrages de prose et de poésie des sieurs de Maucroix et de La Fontaine* (Paris: Garnier, 1685); reprinted in *Fables choisies* (Paris: 1693). [Ibid. / Spector 1988 / Moore 1954]

Francesco Albani, 1578–1660. "Triumph of Cupid." Painting. Palazzo Bianco, Genoa. [Pigler 1974, p. 20]

———, style. "Triumph of Cupid." Painting. Walters Art Gallery, Baltimore, inv. no. 28.856. [Warburg]

Diego Velázquez, 1599–1660, rejected attribution (Italian school). "Cupid." Painting, copy after figure in Titian's "Education of Cupid" (*c.*1565, Borghese). Contini-Bonacossi coll., Florence. [López-Rey 1963, no. 60—ill.]

Benedetto Ferrari, 1597/1604–1681, music. "Le ali d'Amore" [The Wings of Cupid]. Introduction to a ballet. Scenario, Francesco Berni. First performed **1660**, Parma. [Grove 1980, 6:492]

Elisabetta Sirani, 1638–1665. "Sleeping Cupid." Painting. *c.***1660**? Uffizi, Florence, inv. SMeC 68. [Uffizi 1979, no. P1606—ill.] Another version of the subject, by Elisabetta or Giovanni Andrea Sirani (or old copy?) in Musée, Compiègne (on deposit from Louvre, Paris, inv. 671). [Louvre 1979–86, 2:299]

Joannes Janssens, documented **1665**. "The Power of

Amor." Painting. Provinciaal Overijssels Museum, Zwolle, Netherlands. [Wright 1980, p. 200]

Cornelis van Poelenburgh, *c.*1586–**1667**. "Triumph of Cupid." Painting. Staatliche Kunstsammlungen, Kassel, inv. 191. [Bénézit 1976, 8:392 / Pigler 1974, p. 20]

Sebastián de Herrera Barnuevo, 1619–**1671**. "Cupid Embracing an Eagle." Drawing. Biblioteca Nacional, Madrid. [López Torrijos 1985, p. 430 no. 22—ill.]

Jean-Baptiste Lully, 1632–1687. *Les fêtes de l'Amour et de Bacchus*. Pastoral pastiche. Libretto, Philippe Quinault, Molière, and Isaac de Bensérade. First performed 15 Nov **1672**, L'Opéra, Paris. [Grove 1980, 11:315] *See also Beauchamps and Pécourt, below.*

Pelham Humfrey, 1647–**1674**. "Thus Cupid commences his rapes and vagaries." Song. [Grove 1980, 8:779]

———. "Cupid once when weary grown." Song. [Ibid.]

Marcantonio Franceschini, 1648–1729. "Cupid the Archer." Painting. *c.***1680**. Uffizi, Florence, inv. 750. [Uffizi 1979, no. P619—ill.]

Pierre Mignard, 1612–1695. "Louis, Comte de Toulouse, as Sleeping Cupid." Painting. **1682**. Château de Versailles. [Versailles 1949, pp. 21f.—ill.]

Philip Ayres, 1638–1712. *Cupid's Address to the Ladies*. Poem. London: Bently & Tidmarch, **1683**. [NUC]

John Dryden, 1631–1700. (Cupid awakens Cold Genius in "frost scene" of) *King Arthur* act 3. Drama. **1684**. [Winn 1987, pp. 86, 262, 393f., 448]

Volterrano, 1611–**1689**. "Sleeping Cupid." Fresco. Sala delle Allegorie, Palazzo Pitti, Florence, no. 107. [Pitti 1966, p. 120—ill.]

———. "Venal Love" (Cupid pouring gold into [Venus's?] hand). Fresco. Sala delle Allegorie, Palazzo Pitti, no. 107. [Ibid., p. 122—ill.]

Carlo Agostino Badia, 1672–1738. *Amor chevince lo sdegno, overo, Olimpia placata* [Cupid Conquers Wrath, or, Olympia Placated]. Musical work for the stage. Text, Aurelio Aureli. First performed Carnival **1692**, Capranica Theater, Rome. [Grove 1980, 2:9]

Pierre Puget, 1620–**1694**, attributed (or François Duquesnoy?). "Cupid." Plaster statuette (cast of lost sculpture?). Cézanne studio, Aix-en-Provence. [Chappuis 1973, p. 228—ill. / also Rewald 1983, p. 227—ill.]

Jean-Claude Gillier, 1667–1737. *Les plaisirs de l'Amour et de Bacchus*. Musical idyll. First performed **1697**, Paris. [Grove 1980, 7:381]

Johannes Hannaert, *c.*1650–1709. "Fortuna and Cupid." Marble sculpture. **1697**. Gementemuseum, The Hague, inv. H.Pl.2. [Düsseldorf 1971, no. 223—ill.]

Sebastiano Ricci, 1659–1734. "Cupid Received by Jupiter and Juno." Ceiling fresco (detached), part of "The Olympian Gods" cycle, from Palazzo Mocenigo-Robilant, Venice. **1697–99**. Gemäldegalerie, Berlin-Dahlem, on loan from German government. [Daniels 1976, no. 43—ill. / Berlin 1986, p. 64—ill.]

———. "Cupid with His Quiver, Lying on a Bed." Painting, for Palazzo Fulcis-Bertoldi, Belluno. 1703 or later. Unlocated. [Daniels, no. 23]

———. "Cupid as Artist," "Cupid Extinguishing the Torch of War." Frescoes. *c.*1695–1707? Palazzo Marucelli-Fenzi, Florence. [Ibid., nos. 102a-b]

————. "Cupid before Jupiter" (and Juno, with Paris, Mars [?], Pan, and Neptune). Painting. 1712–16. Royal Academy, London. [Ibid., no. 166—ill.]

Italian School. "Cupid on a Bed." Painting. **17th century.** Dulwich College Picture Gallery, London, cat. 1953 no. 21. [Wright 1976, p. 103]

North Italian School. "Cupid and Monk." Painting. **17th century.** City Art Galleries, Sheffield, cat. 1966 no. 24. [Wright 1976, p. 104]

South Netherlandish School. "Cupid Asleep." Painting. **17th century.** Museum Bredius, The Hague, cat. 1977 no. 353. [Wright 1980, p. 321]

Flemish School. "Cupid with Flowers." Painting. *c.*1700. Szépművészeti Múzeum, Budapest, no. 57.5. [Budapest 1968, p. 232]

John Hughes, 1677–1720. *Cupid and Hymen's Holiday.* Pastoral masque. First performed **1703?** Published in *Works* (London: 1735). [Nicoll 1959–66, 2:338]

Marc-Antoine Charpentier, 1645/50–**1704.** "Cupido perfido dentr'al mio cor" [Faithless Cupid within my heart]. Musical pastorale. In *Pastorelette.* [Grove 1980, 4:174]

John Nost, fl. 1678–1729. "Cupid with a Curling Horn," "Cupid Shaping His Bow." Pair of lead garden sculptures, after François Duquesnoy (1594–1643). *c.*1699–1705. Melbourne Hall, Derbyshire. [Whinney 1964, pp. 61 and 251 *n.*71]

Luca Giordano, 1634–**1705.** "Cupid and the Vices Disarming Justice." Painting. Hermitage, Leningrad, on deposit to Pushkin Museum, Moscow, no. 151, in 1924. [Ferrari & Scavizzi 1966, 2:357]

————, rejected attribution. "Cupid Crowning a Woman." Drawing. Princeton University Art Museum, N.J. [Ferrari & Scavizzi, 2:378]

John Weaver, 1673–1760, attributed, choreography. *Cupid and Bacchus.* Masque. Music, Henry Purcell. First performed 21 Jan **1707,** Theatre Royal, Drury Lane, London. [Ralph 1985, pp. 73, 725 / Nicoll 1959–66, 2:369, 446]

————, choreography. *Bacchus and Cupid.* Entertainment. First performed 1715, Lincoln's Inn Fields, New Theatre, London. [Nicoll]

Matthew Prior, 1664–1721. "Cupid Mistaken," "Cupid and Ganymede," "Mercury and Cupid." Poems. In *Poems on Several Occasions* (London: Tonson, **1709**). Modern edition by A. R. Waller (Cambridge: Cambridge University Press, 1905). [Ipso / Boswell 1982, p. 282]

Louis-Nicolas Clérambault, 1676–1749. *L'Amour et Bacchus.* Cantata. In *Cantates françoises* (Paris: **1710**). [Grove 1980, 4:492]

Jean-Baptiste Morin, 1677–1754. *Le sommeil d'Amour* [The Sleep of Cupid]. Cantata. Published Paris: **1712.** [Grove 1980, 12:576]

————, music. *L'Himen et l'Amour.* Divertissement. Published Paris: 1714. [Ibid.]

————. *Le triomphe de l'Amour et de l'Himen.* Musical parody. Published Paris: 1747. [Ibid.]

Anne Finch, Countess of Winchilsea, 1661–1720. "The Bargain: A Song in Dialogue between Bacchus and Cupid." Poem. In *Miscellany Poems on Several Occasions* (London: Taylor & Browne, **1713**). [Fausset 1930, p. 19]

André Campra, 1660–1744. *La dispute de l'Amour et de*

l'Hymen. Cantata. Published in *Cantates françoises,* book 2 (Paris: **1714**). [Grove 1980, 3:665]

Anonymous English. *Bacchus and Cupid.* Comedy. First performed **1715,** New Theatre, Lincoln's Inn Fields, London. [Nicoll 1959–66, 2:446; cf. p. 366]

Antoine Watteau, 1684–1721. (Actors portraying Bacchus and Cupid in) "Love in the French Theater." Painting, probably depicting a scene from Lully's *Les fêtes de l'Amour et de Bacchus* (1672). *c.*1712–16? Gemäldegalerie, Berlin-Dahlem. [Grasselli & Rosenberg 1984, no. P.38—ill. / Posner 1984, pp. 258ff., pl. 54 / also Camesasca 1982, no. 187—ill.]

Sebastián Durón, 1660–1716. "El picaro de Cupido" [The Rogue of Cupid]. Duet (vocal?). [Grove 1980, 5:751]

Thomas Parnell, 1679–1718. (Bacchus makes sport of Cupid in) "Anacreontick." Poem. In *Poems on Several Occasions* (London: A. Pope, 1721). Modern edition by H. I. Fausset, in *Minor Poets of the 18th Century* (London: Dent, 1930). [Ipso]

John Gay, 1685–1732. "Damon and Cupid: A Song." Poem. In *Poems on Several Occasions* (London: **1720**). [Dearing & Beckwith 1974, vol. 1]

————. "Cupid, Hymen, and Plutus." Fable, no. 12 in *Fables* (London: Tonson, 1727). [Ibid., vol. 2]

————. "Plutus, Cupid, and Time." Fable, no. 13 in *Fables* (London: Tonson, 1738). [Ibid., vol. 2]

Noël-Nicolas Coypel, 1690–1734. "Venus, Bacchus, and Cupid." Painting. **1727.** Louvre, Paris, inv. 3527. [Louvre 1979–86, 3:175—ill.]

Jean-Joseph Mouret, 1682–1738. "Amour, tout l'univers à ton empire" [Amor, all the universe in your empire]. Cantille. Published in *IIIme livre d'airs sérieux et à boire, et de plusiers parodies bachiques* (Paris: **1727**). [Grove 1980, 12:655]

————. "L'Amour et l'Hymen," "L'Amour vainquer," "Hymne a l'Amour." Cantatilles. In *Cantatilles françoises* (Paris: 1718–38). [Ibid.]

Nicolas-Antoine Bergiron de Briou, 1690–1768. *Bacchus et l'Amour.* Cantata. In *Cantates françoises* (Lyons: **1729**). [Grove 1980, 2:549]

Nicolas Renier, ?–*c.*1731. *L'Amour aveuglé par la folie* [Love Blinded by Folly]. Cantata. First performed **1729,** Tuileries, Paris. [Grove 1980, 15:743]

François Le Moyne, 1688–1737. "Venus Showing Cupid the Zeal of Her Arrows." Painting, for Hôtel Peyrenc de Moras (Hôtel Biron, now Musée Rodin), Paris. **1729–30.** Lost. [Bordeaux 1984, no. 81] Drawing. Louvre, Paris. [Ibid., no. D.119—ill.]

————, attributed (also attributed to Fragonard). "Cupid the Bird-catcher." Painting. Mid-1720s? Himmelsbach coll., Bad Schonborn. [Ibid., no. 64—ill.]

————, tentatively attributed (also attributed to Boucher). "Sleeping Cupid." Painting. Pushkin Museum, Moscow, inv. 993. [Ibid., no. 103—ill.]

————. *See also Jean-Baptiste Lemoyne, below.*

François Boucher, 1703–1770. "Cupid the Bird-catcher," "Cupid the Reaper," "Cupid the Bather," "Cupid the Grape-picker." Cycle of paintings. *c.*1731. Private coll(s)., Geneva ("Bird-catcher," "Grape-picker"); Contini-Bonacossi coll. ("Reaper"); Waddesdon Manor, Buckinghamshire ("Bather"). [Ananoff 1976, nos. 62–65—ill.] Tapestries after. Formerly Mme. C. Lelong coll. ("Bird-

catcher," "Grape-picker"), sold 1903; formerly Vicomtesse Vigier coll. ("Reaper," "Grape-picker"), sold 1970. [Ibid., nos. 62–63, 65—ill.] Copies after engravings (by Lépicié) of "Reaper," "Bird-catcher," in Victoria and Albert Museum, London, nos. 494–1882, 495–1882. [Kauffmann 1973, nos. 41–42—ill.]

———. "Sleeping Cupid." Painting. c.1731. Private coll., London. [Ananoff, no. 66—ill.]

———. "Cupid Bathing" (entering a pool, guided by Venus). Painting. 1739. Lost. / Print by Dugy. [Ibid., no. 172—ill.]

———. "Cupid Caresses His Mother." Painting. c.1739. Private coll., New York. [Ibid., no. 242—ill.] Gouache replica, for theater décor. Hermitage, Leningrad, no. 39595. [Ibid., no. 242.1—ill.]

———. "Time Giving His Weapons to Cupid." Painting. c.1742. Reitlinger coll., Paris. [Ibid., no. 206—ill.]

———. "Venus Intoxicating Cupid." Painting. c.1743. Lost. Prints by M. Dupont, F. Basin? ("Cupid Drunk on Nectar"). [Ibid., no. 251—ill.] Drawing. Nationalmuseum, Stockholm, no. 2947/1862. [Ibid.—ill.]

———. "Cupid's Target." Painting, model for tapestry. c.1758. Louvre, Paris, inv. 2715. [Ibid., no. 480—ill. / Louvre 1979–86, 3:80—ill.]

———. "The Three Graces Carrying [torchbearing] Cupid." Painting, sketch. c.1759. Louvre, Paris, no. M.I. 1023. [Ananoff, no. 523—ill. / Louvre 1979–86, 3:81—ill.]

———. "The Confidences of Love" (woman reading a love letter, Cupid beside her holding an arrow). Painting. 1761. Lost. / Engravings by S. C. Miger ("The Harmless Wound," "The Billet-doux"). [Ananoff, no. 551—ill.]

———. "Three Cupids Shooting at a Target" (with a heart bullseye), "Three Cupids: Cupid Asleep," "Three Cupids: The Attributes of Love." Overdoor paintings. 1764. Baroness de Becker coll., Rome. [Ibid., nos. 589–91—ill.]

———. "Young Girl and Cupid." Painting. c.1765. Private coll., Paris. [Ibid., no. 606—ill.]

———. Cycle of paintings depicting Cupid, amorini, and attributes of Venus and Cupid (doves, arrows, torch, quiver), decorations for salon of Gilles Demarteau, Paris. c.1765. Musée Carnavalet, Paris. [Ibid., nos. 620–25—ill.]

———. See also Le Moyne, above.

Charles-Joseph Natoire, 1700–1777. "Mercury and Cupid," "Cupid Strewing Flowers on the Earth," "The Education of Cupid." Paintings, part of "Story of the Gods" cycle, for Château de La Chapelle-Godefroy, Champagne. c.1731. Musée des Beaux-Arts, Troyes, nos. 203, 205 ("Mercury," "Flowers"); Fine Arts Museum, Moscow ("Education"). [Boyer 1949, nos. 35, 37, 40 / Troyes 1977, pp. 54f.]

———. "Cupid Sharpening an Arrow." Painting. 1750. Hermitage, Leningrad, inv. 7653. [Hermitage 1986, no. 155—ill. / cf. Boyer, no. 77]

———. "Cupid's Tricks." Painting. Sold Paris, 1887. [Boyer, no. 84]

Georg Raphael Donner, 1693–1741. "Satyr with Cupid." Bronze bas-relief. c.1733. Museum für Angewandte Kunst, Vienna, inv. 9 (4581). [Schwarz 1968, no. 42—ill.]

Seedo, c.1700–c.1754, music. *Venus, Cupid, and Hymen.* All-sung masque. First performed 21 May 1733, Theatre Royal, Drury Lane, London. [Grove 1980, 17:101 / Fiske 1973, p. 124]

Marie Sallé, 1707–1756, choreography. *Le masque nuptial, ou Les triomphes du Cupidon et d'Hymen.* Ballet. Music, Galliard. First performed 16 March 1734. [EDS 1954–66, 8:1427]

Joseph Bodin de Boismortier, 1689–1755, music. *Les voyages de l'Amour.* Ballet, opus 60. Libretto, C.-A. de La Bruère. First performed 26 Apr 1736, Académie Royale, Paris. [Grove 1980, 2:862]

Jean-Louis Lemoyne, 1665–1755, attributed (formerly attributed to Jean-Baptiste Lemoyne). "Fear of Cupid's Darts" (nymph shying away from Cupid). Marble statue. 1739–40. Metropolitan Museum, New York, no. 67.197. [Réau 1927, no. 19—ill. / Metropolitan 1960, p. 208—ill. / Metropolitan 1983, p. 208—ill.]

Anonymous. *Cupid's Triumph, or, The Fatal Enchantment.* Pantomime. First performed 1740, Punch's Theatre, London. [Nicoll 1959–66, 2:369]

William Hogarth, 1697–1764. "Hymen and Cupid." Engraving, for illustration on ticket for the masque *Alfred.* 1740. [Paulson 1965, no. 157—ill.]

Carl Heinrich Graun, 1703/04–1759. *Venere e Cupido.* Opera. Libretto, G. G. Botarelli. First performed 6 Jan 1742, Schlosstheater, Potsdam. [Grove 1980, 7:646]

Edmé Bouchardon, 1698–1762. "Cupid." Marble statuette, possibly after Parmigianino's "Cupid Testing His Bow" (c.1533–34, Vienna). 1744. National Gallery, Washington, D.C., no. A–1617. [Sienkiewicz 1983, pp. 38f.—ill. / also Walker 1984, fig. 1013]

———. "Cupid Fashioning His Bow from the Club of Hercules." Marble statue. 1747–50. Louvre, Paris. [Clapp 1970, 1:103]

Jean-Baptiste Cardonne, 1730–c.1792. "Etrenne de l'Amour et de Bacchus" [Entrance of Amor and Bacchus]. Air. Published in *Mercure de France* (Paris: Feb 1746). [Grove 1980, 3:776]

Jean-Philippe Rameau, 1683–1764, music. *Les fêtes de l'Hymen et de l'Amour.* Ballet-héroïque. Scenario and choreography, Louis de Cahusac. First performed 15 Mar 1747, Versailles. [Girdlestone 1983, pp. 457–62 / Girdlestone 1972, pp. 302, 311 / Grove 1980, 15:568, 570]

Pompeo Batoni, 1708–1787. "Portrait of a Child [John Damer?] as Cupid." Painting. c.1750. Stopford Sackville coll., Drayton House, Northamptonshire. [Clark 1985, no. 136—ill.]

———. "The Hon. Arthur Saunders Gore with His Wife" (Cupid between them). Painting. 1769. Trustees of the Will of the Sixth Earl of Arran. [Ibid., no. 335—ill.]

French School (previously attributed to Noël Challe; apocryphal signature). "Cupid." Painting. **Mid-18th century.** Louvre, Paris, no. R.F. 2143. [Louvre 1979–86, 4:313—ill.]

Michele Rocca, c.1670/75–1751 or later. "Venus Pulling a Thorn from Cupid's Foot." Painting. Herzog Anton Ulrich-Museum, Brunswick, no. 1123. [Brunswick 1969, p. 115]

Anton Raphael Mengs, 1728–1779. "Cupid Sharpening an Arrow." Pastel. c.1751. Gemäldegalerie, Dresden, no. P177. [Dresden 1976, pp. 114f. / Honisch 1965, no. 41]

Jacopo Amigoni, 1675–1752. "The Birth of Cupid."

Painting. National Gallery of Ireland, Dublin, no. 1688. [Dublin 1981, p. 2—ill.]

Richard Langdon, c.1729–1803. *Cupid and Chloe.* Cantata. London. c.1755. [Grove 1980, 10:445]

Charles-Michel-Ange Challe, 1718–1778. (Cupid in) "Allegory of the Arts." Painting. **1757.** Château de Fontainebleau. [Bordeaux 1984, fig. 403]

Étienne-Maurice Falconet, 1716–1791. "The Menacing Cupid." Marble statue. **1757.** Louvre, Paris. [Levitine 1972, no. 16—ill. / Vermeule 1964, pp. 124, 170—ill. / also Réau 1922, p. 505—ill.] Original plaster model, 1755. Compte de Warren coll., Nancy, in 1922. [Réau, p. 502] Biscuit figurine, 1758. Wallace Collection, London. [Levitine, no. 55—ill.]. Model for figurine. Musée Nationale de Céramique, Sèvres. [Réau, p. 510] Other versions in Hermitage, Leningrad, inv. 1856; Mauritshuis, The Hague, inv. 906, on loan to Rijksmuseum, Amsterdam; elsewhere. [Ibid., p. 502 / also Hermitage 1984, no. 388—ill. / Hermitage 1975, pls. 110–11 / Mauritshuis 1985, p. 492—ill.]

————, attributed. "Venus and Cupid." Series of marble statuettes depicting Venus nursing, chastising, consoling, instructing Cupid, other poses. 1770–80. Wallace Collection, London; private colls. [Levitine 1972, pp. 44f.—ill. / also Réau 1922, pp. 505ff., pls. 15–19 / Agard 1951, fig. 9]

Giovanni Battista Tiepolo, 1696–1770. "Cupid Blindfolded, on a Car Drawn by Putti." Fresco. **1757.** Stanza dell' Orlando Furioso, Villa Valmarana, Vicenza. [Pallucchini 1968, no. 240—ill. / Morassi 1962, pp. 64f.]

————, with **Giovanni Domenico Tiepolo,** 1727–1804. "Amor in the Sky above a Landscape." Fresco. 1757. Stanza dell' Iliade, Villa Valmarana. [Pallucchini—ill. / Morassi]

———— (Giambattista). "Chronos (Time) Entrusting Cupid to Venus." Painting. c.1762–70. Pinto-Basto coll., Lisbon. [Morassi, p. 16—ill. / Pallucchini, no. 297—ill. / also Levey 1986, pp. 268f.—ill.]

Jean-Baptiste Pigalle, 1714–1785. "Cupid Embracing [Mme. de Pompadour as] Friendship." Marble sculpture. **1758.** Louvre, Paris, no. 1445. [Réau 1950, no. 4] Terra-cotta reduction. Musée, Versailles. [Ibid.] Terra-cotta variant ("Mlle. Colombe and Cupid"). Formerly Edouard Kahn coll. [Ibid., pl. 9] Stone replica. 1759. Formerly Dupuy d'Angeac coll., Cognac. [Ibid., pl. 7] Terra-cotta bust, extracted from above. 1759. Musée, Cluny. [Ibid., no. 72, pl. 8]

Louis-Claude Vassé, 1716–1772. "Venus Directing Cupid's Darts." Sculpture group. **1758.** Château de Versailles. [Versailles 1949, p. 84]

Johann Adolf Hasse, 1699–1783. *In van ti scuoti, Amor* (*Amor prigioniero*). Cantata. Libretto, Pietro Metastasio. First performed **1761,** Vienna. [Grove 1980, 8:290]

Carle van Loo, 1705–1765. "Cupid." Painting. Musée des Beaux-Arts, Marseille. [Bénézit 1976, 6:730]

Franz Anton Hilverding, 1710–1768, choreography. *Il trionfo d'Amore.* Court ballet. Music, Florian Gassman. First performed 24 June **1765,** for wedding of Archduke Joseph and Maria Josepha of Bavaria, Schönbrunn, Vienna. [Grove 1980, 8:570 / Clarke & Vaughan 1977, p. 175 (as *Triomphe d'Amour,* 25 Jan 1765)]

Jean-Baptiste Greuze, 1725–1805. "Young Woman Making

Supplication at the Altar of Cupid." Painting. Exhibited Salon of **1769.** Wallace Collection, London, no. P.441. [Brookner 1972, p. 111—ill. / Wright 1976, p. 82]

————. "The Love Letter" (Cupid placing a pen in the hand of a young woman). Drawing. Mid-1770s? Emile E. Wolf coll., New York. [Munhall 1976, no. 78—ill.]

————. "Innocence Carried Off by Cupid (and Followed by Repentance)." Painting. Before 1786. Louvre, Paris, no. R.F. 2154. [Munhall, no. 100—ill. / Brookner, pl. 68 / Louvre 1979–86, 3:289—ill.]

————. "Cupid among the Maidens." Drawing. Early 1790s. Musée des Beaux-Arts, Dijon. [Brookner, p. 130—ill.]

————. "Anacreon in His Old Age Crowned by Love." Drawing. Straus coll., New York. [Munhall, no. 101—ill.]

Augustin Pajou, 1730–1809. "Cupid, Master of the Elements." Lead statue. c.1769. Lost. / 2 drawings. Masson coll., Amiens; Felix Oppenheim coll., Paris. [Stein 1912, pp. 218, 401, pl. IX]

————. "Cupid." Wood bas-relief, part of cycle representing children as mythological figures. 1769–70. Salle de l'Opéra, Versailles. [Ibid., pp. 177–81, 402]

Joshua Reynolds, 1723–1792. "Hope (Miss Morris) Nursing Love." Painting. Exhibited **1769.** Marquess of Lansdown coll., Bowood. [Waterhouse 1941, p. 60—ill.] Replicas. Port Eliot; Morritt coll., Rokeby. [Ibid.]

————. "Venus Chiding Cupid for Learning to Cast Accompts." Painting. Exhibited 1771. Kenwood House, London. [Waterhouse 1941, p. 61 / Pressly 1981, pl. 23] Variant. 1776. Lady Lever Art Gallery, Port Sunlight, Cheshire. [Ibid., p. 67]

————. "Cupid as Link Boy." Painting. 1774. Albright-Knox Art Gallery, Buffalo. [Royal Academy 1986, no. 92—ill.]

————. "Cupid Sleeping in the Clouds." Painting. Exhibited 1777. Earl of Carnarvon coll., Highclere. [Waterhouse, p. 68]

————. "Nymph [or Venus] and Cupid" ("Snake in the Grass"). Painting. Exhibited 1784. Tate Gallery, London, no. 885. [Ibid., p. 75—ill.] Replica ("Cupid Untying the Zone of Venus"). 1788–89. Hermitage, Leningrad, inv. 1320; others in Sir John Soane's Museum, London; private colls. [Hermitage 1984, no. 110—ill. / also Hermitage 1979, pls. 126–27]

Jean-Joseph Cassanéa de Mondonville, 1711–1772, music. *Les projects de l'Amour* [The Projects of Cupid]. Ballet-héroïque. First performed **1771,** Paris. [Grove 1980, 12:481]

Charles Monnet, 1732–after 1808. "Cupid," "Cupid Throwing His Darts," "Cupid Caressing a Dove." Paintings. c.1771. [Bénézit 1976, 7:487]

Jean-Honoré Fragonard, 1732–1806. "The Stolen Shift" (Cupid undressing a girl lying in bed). Painting. **1765–72.** Louvre, Paris. [Wildenstein 1960, no. 230—ill.]

————. "Cupid Sacrificing His Wings for the Delight of the First Kiss." Painting. 1765–72. Private coll. [Ibid., no. 315—ill.]

————. "Cupid in a Rose Bush." Painting (pendant with "Folly"). 1765–72. 12 versions? All lost. [Ibid., nos. 326–27]

————. "Cupid Setting the Universe Ablaze." Painting over door for Pavillion de Louveciennes. 1770. Musée

d'Art et d'Histoire, Toulon, inv. 5572a. [Ibid., no. 298—ill. / Rosenberg 1988, no. 152—ill.]

———. "Love the Sentinel (Conqueror)," "Love the Jester" ("Love as Folly"). Pendant paintings. At least 4 sets executed, c.1772–75. National Gallery of Art, Washington, D.C.; Wildenstein Galleries, New York ("Jester only"); Mrs. Mellon Bruce coll., New York; other(s) lost. [Wildenstein, nos. 317–25—ill. / also Walker 1984, figs. 453–54]

———. "Marie-Catherine Colombe as Cupid." 2 paintings. 1773–76. Messrs. Wildenstein coll., New York. [Wildenstein, nos. 417, 419—ill.]

———. "Young Woman Inspired by Cupid." Painting. 1773–76. Lost. [Ibid., no. 423]

———. "Young Woman Holding Cupid," "Venus Refusing Cupid a Kiss" ("Sappho Entreated by Cupid," "Mlle. Colombe as Cupid"), "Young Woman Entreated by Cupid," "Cupid Preparing His Darts." Paintings. 1773–76. "Venus" in private coll., New York; others lost. [Ibid., nos. 428–31]

———. "The Vow to [a bust of] Cupid." Painting. 1780 or earlier. Private coll., New York. [Rosenberg, no. 280—ill. / Wildenstein, no. 491—ill.] Oil sketch. Louvre, Paris, no. R.F. 1722. [Rosenberg, no. 281—ill. / Wildenstein, no. 493—ill. / Louvre 1979–86, 3:258—ill.]

———. "The Sacrifice of the Rose" ("Offering to Love") (young woman fainting in the arms of Cupid). Painting. 1786–87. 3 finished versions. Private coll., France; Museo Nacional de Arte Decorativo, Buenos Aires; Resnick coll., Los Angeles. [Rosenberg, nos. 284–86—ill. / also Wildenstein, no. 497—ill.]

———. "The Progress of Love." Painting cycle: "Love the Sentinel," "Love the Jester," "Love Reaching for a Dove," "Love Triumphant," "Love the Avenger." Originally intended as overdoor decorations for Pavillion de Louveciennes. c.1790. Frick Collection, New York. [Wildenstein, nos. 527–531—ill. / Rosenberg 1988, pp. 320f.—ill. / Frick 1968–70, 2:100]

———, questionably attributed (also attributed to François Le Moyne). "Cupid the Bird-catcher." Painting. Himmelsbach coll., Bad Schonborn. [Bordeaux 1984, no. 64—ill.]

James Hook, 1746–1827. *Cupid's Revenge.* Arcadian pastorale. Libretto, F. Gentleman. First performed 27 July **1772**, Haymarket, London. [Grove 1980, 8:685]

Étienne-Joseph Floquet, 1748–1785. *L'union de l'Amour et des arts.* Opéra-ballet-héroïque. Libretto, Pierre René Lemonnier. First performed 7 Sep **1773**, L'Opéra, Paris. [Grove 1980, 6:643 and 644]

Niccolò Jommelli, 1714–**1774**. *O come oltre l'osato* (*Venere ed Amore*) [Oh, How Far Beyond the Dared (Venus and Amor)]. Cantata. [Grove 1980, 9:694]

Angelica Kauffmann, 1741–1807. "Cupid, Finding Aglaia Asleep, Binds Her to a Laurel." Painting. Exhibited **1774**. [Manners & Williamson 1924, p. 40] Variant, ceiling painting. Derby House, London. [Ibid., p. 132]

———. "Cupid." Painting. Exhibited 1775. [Manners & Williamson, p. 237]

———. 2 scenes from the story of Cephisa and Cupid: "Cephisa and Her Beloved Discover the Sleeping Cupid in the Forest of Idalia," "Cephisa Cuts Off the Sleeping

Cupid's Wings." Paintings. 1782. Gemäldegalerie, Berlin-Dahlem, Cat. 3/86, 4/86. [Berlin 1986, p. 83]

———. "Ganymede Playing at Dice with Cupid." Painting. 1782. [Manners & Williamson 1924, p. 141]

———. "Cupid." Painting, for Prince Youssoupoff of Russia. 1785. [Manners & Williamson, p. 147]

———. "Venus and Cupid, Who Has Wounded Euphrosyne with an Arrow." Painting, for Lord Barwick. 1793. [Ibid., pp. 164, 173]

———. "Nymph and Cupid." Painting. Capt. Spencer Churchill coll., Northwick Park. [Manners & Williamson, p. 181]

———. "The Marchioness Townsend and Her Son as Cupid." Painting. Marquis of Exeter coll., Burghley House, Stamford. [Manners & Williamson, p. 188] Reduced replica or variant. Countess of Yarborough coll., Brocklesby Park, Lincolnshire. [Ibid., p. 214—ill.]

———. "Cupid Awakened by Two Nymphs (or Virgins)" ("Cupid Asleep"). Painting, design for porcelain group, modeled by J. J. Spängler. Both in F. Hurlbutt coll., Pennyffordd, in 1924. [Manners & Williamson, pp. 5f., pls. 4, 14] Replica, ceiling painting, 20 Queen Anne's Gate, London. [Ibid., p. 133—ill.]

———. "The Temptation of Eros," "The Victory of Eros" (Eros with a nymph). Pendant paintings. Metropolitan Museum, New York, nos. 39.184.18–19. [Metropolitan 1980, pp. 100f.—ill.]

John Flaxman, 1755–1826. (Cupid representing) "The Four Seasons." Designs for Jasper bas-reliefs, executed by Wedgwood studio. **1775**. Wedgwood Museum, Barlaston, Staffs. [Bindman 1979, no. 23—ill.]

———. "Cupid with Night, Erebus, and Chaos," "Venus Presents Cupid to Jupiter." Drawings, part of series illustrating Hesiod's *Theogony.* 1807–14. Engraved by William Blake, published London: Longman & Co., 1817. [Irwin 1979, p. 90 / Flaxman 1872, 7: pls. 24, 27]

Laurent Delvaux, 1696–**1778**. "Cupid the Reaper" Marble sculpture. Musées Royaux des Beaux-Arts, Brussels, inv. 6297. [Brussels 1968, no. 17]

Jean-Baptiste Lemoyne, 1704–1778, attributed (also attributed to François Le Moyne). "A Standing Cupid." Drawing. Rijksmuseum, Amsterdam. [Royal Academy 1968, no. 423—ill.] *See also Jean-Louis Lemoyne, above.*

Joseph Deschamps, 1743–1788. "Cupid." Marble statue, for Temple of Love, Gardens, Versailles. **c.1778**. Original now in the Louvre, Paris, replaced by a replica by Deschamps. [Girard 1985, p. 279—ill.]

Wolfgang Amadeus Mozart, 1756–1791. *Les petits riens.* Ballet score. **1778**. *See Noverre, below.*

Jean-Georges Noverre, 1727–1810, choreography. "Entrée de Cupidon," in *Les petits riens.* Ballet-pantomime. Music, Mozart. First performed 11 June **1778**, Paris. [Oxford 1982, p. 307 / Lynham 1950, p. 170 / Grove 1980, 12:729]

———, choreography. *Les offrandes à l'Amour.* Ballet. Music, Joseph Mazzinghi. First performed 8 Dec 1787, King's Theatre, London; décor, Marionari; costumes, Lupino. [Oxford, p. 306 / Grove, 11:868 / Lynham, p. 106]

Anna Dorothea Therbusch-Lisiewska, 1721–**1782**. "Cupid." Painting. Hermitage, Leningrad, inv. 7392. [Hermitage 1987b, no. 319—ill.]

Nicolai Abildgaard, 1743–1809. "Cupid Playing the Lyre." Painting. *c.*1782. Lost. / Study. Thorwaldsens Museum, Copenhagen, no. B427. [Cologne 1977, pp. 129, 154—ill. / Thorwaldsen 1985, p. 89]

Johann Wolfgang von Goethe, 1749–1832. "Amor, der den schönsten Segen" [Cupid, the fairest blessing]. Poem, for a theater piece. 30 Jan **1782.** [Beutler 1948–71, vol. 3]

———. "Cupido, loser, eigensinniger Knabe!" [Cupid, wicked, capricious boy]. Poem. In *Vermischte Gedichte* (1783). [Ibid., vol. 2]

———. "Amor als Landschaftsmaler" [Amor as Landscape Painter]. Poem. 1787. In *Gedichte der Ausgabe letzter Hand* (Stuttgart: Cotta, 1827–30). [Ibid., vol. 1 / Suhrkamp 1983–88, vol. 1]

Pierre-Paul Prud'hon, 1758–1823. "The Oath of Love" (made by a young woman to Cupid). Watercolor. **1780–83.** Unlocated. [Guiffrey 1924, no. 1]

———. "Love [Cupid] Seducing Innocence, Led by Pleasure, Followed by Repentance." Painting, sketch. *c.*1787. Unlocated. [Ibid., no. 2] Another version of the subject (completion of work begun by Constance Mayer?). Early 1800s. Duchesse de Bisaccia coll. [Ibid., no. 5—ill.] 2 sketches. Unlocated. [Ibid., nos. 6–7]

———. "The Cruel One [Cupid] Laughs at [a young woman shedding] the Tears He Has Caused." Drawing, design for engraving by Copia. *c.*1793. Several versions. Private colls. or unlocated. [Ibid., nos. 19–23] Variant, painting, attributed to Prud'hon, sold 1856, 1869, untraced. [Ibid.]

———. "The Union of Love and Friendship" ("Love and Innocence"). Painting. *c.*1793. Private coll. or unlocated. [Ibid., no. 27]

——— and **Constance Mayer,** 1775–1821. (Cupid in) "Innocence Preferring Love to Wealth." Painting, executed by Mayer under Prud'hon's direction. Exhibited 1804 (as by Mayer). Hermitage, Leningrad, inv. 5673. [Ibid., no. 67 / Hermitage 1983, no. 337—ill. / Hermitage 1984, no. 133—ill.] Study, by Prud'hon. Art Institute of Chicago. [Hermitage 1983]

——— (Prud'hon). "Cupid." Painting, part of series of simulated bronze bas-reliefs for Hôtel Lanois, Paris. 1796–99. Louvre, Paris, no. R.F. 1983-13. [Louvre 1979–86, 4:152—ill. / also Guiffrey, pp. 294ff.]

———. "Hymen, Cupid, and Genius Chaining the Graces and the Muses [of History, Epic Poetry, and Astronomy]." Drawing, design for sculpture decorating Hôtel de Ville for celebration of the marriage of Napoleon to Marie-Louise. 1810. Sculpture executed by Edmé Gaulle, destroyed. Original drawing in Louvre, Paris. [Guiffrey, no. 979, pp. 352f.]

———. "The Cat's Scratch" (Cupid holding a cat that has scratched a little girl). Painting. Baron Edmond de Rothschild coll. [Ibid., no. 36]

———. "Preparations for War" (Cupid surrounded by putti who sharpen his arrows and light his torch). Drawing. L. Ferté coll. [Ibid., no. 41—ill.] Grisaille sketch. Private coll. or unlocated. [Ibid., no. 42]

———. "Venus, Hymen, and Cupid." Painting, grisaille sketch, unfinished. Musée Nationale des Beaux-Arts, Algiers, on deposit in Louvre, Paris (no. D.L. 1970–18).

[Louvre 1979–86, 5:10—ill. / also Guiffrey, no. 190] Another version of the subject known, unlocated. [Guiffrey, no. 190] Another version of the subject known, unlocated. [Guiffrey, no. 189]

———. Numerous further paintings and drawings depicting Cupid, by and attributed to Prud'hon, in private colls. or unlocated. [Ibid., pp. 1–36 passim]

Vincenzo Galeotti, 1733–1816, choreography. *Amors og Balletmesterens Luner* (*Caprices de Cupidon*) [Whims of Cupid and the Ballet-master]. Ballet. Libretto, Galeotti. Music, Jens Lolle. First performed 31 Oct **1786,** Kongelige Danske Ballet, Copenhagen. [Clarke & Vaughan 1977, p. 360]

Gaetano Andreozzi, 1755–1826. *La pace tra Amore e Imeneo* [Peace between Amor and Hymen]. Opera. First performed **1787,** Florence. [Grove 1980, 1:411]

Antonio Canova, 1757–1822. "Prince Henryk Lubomirski as Eros." Marble statue. **1786–88.** Lancut Castle, Poland. [Pavanello 1976, no. 31—ill.] Plaster model (headless). Gipsoteca Canoviana, Possagno, no. 18. [Ibid., no. 32—ill.]

———. "Little Cupid." Marble statuette, variant of above. Several versions, 1787–97. Angelsey Abbey, Cambridgeshire; Hermitage, Leningrad; another unlocated. [Ibid., nos. 33–34, 86—ill.]

———. "Cupid, Having Wounded a Nymph, Flies to Venus." Painting. 1790s. Museo Civico, Bassano del Grappa, no. 107. [Ibid., no. D42—ill.]

Laurent Guyard, 1723–**1788.** "Cupid." Sculpture. Galleria Nazionale, Parma. [Bénézit 1976, 5:320]

Bertel Thorwaldsen, 1770–1844. "Cupid Resting." Relief. Modeled **1789.** / Plaster original. Thorwaldsens Museum, Copenhagen, no. A756. [Thorwaldsen 1985, p. 74 / Cologne 1977, p. 43—ill.]

———. "Mars and Cupid." Marble sculpture group. Modeled *c.*1810. Marble begun 1824–25, completed 1868 by B. L. Bergslien and H. W. Bissen. Thorwaldsens Museum, Copenhagen, no. A6. [Thorwaldsen, p. 21 / Cologne, no. 52, p. 100—ill. / Hartmann 1979, p. 165, pl. 116.2] Plaster original. Thorwaldsens Museum, no. A7. [Thorwaldsen]

———. "(Mars and Cupid in) Vulcan's Forge" ("Cupid's Arrows Forged in Vulcan's Smithy"). Marble relief. Modeled *c.*1810. 2 versions, both unlocated. [Cologne, no. 53, p. 164] Plaster original. Thorwaldsens Museum, Copenhagen, no. A419. [Ibid.—ill. / Thorwaldsen, p. 53 / Hartmann, p. 166, pl. 117.1] Plaster variant ("Venus, Mars, and Cupid in the Smithy of Vulcan"). Thorwaldsens Museum, no. A420. [Thorwaldsen, p. 53]

———. "Cupid and the Graces." Marble sculpture group. 1817–19. Thorwaldsens Museum, Copenhagen, no. A894. [Ibid., p. 85, pl. 17 / Hartmann 1979, p. 115, pls. 55, 57 / Cologne 1977, no. 127—ill.] Plaster model. Thorwaldsens Museum, no. A29. [Thorwaldsen, p. 23] Marble variant ("The Graces with Cupid's Arrow, and Cupid Playing the Lyre"), modeled 1842, executed by C. Freund and H. W. Bissen, 1864. Thorwaldsens Museum, no. A31. / Plaster model. Thorwaldsens Museum, no. A32. [Thorwaldsen, p. 23]

———. "Cupid Playing a Lyre." Marble statue, based on a study for "Cupid and the Graces" (above). At least 4 versions, 1819–*c.*1839. Statens Museum for Kunst, Co-

penhagen; Hermitage, Leningrad; Thorwaldsens Museum, no. A33; private coll(s). [Cologne, no. 128 / Hartmann, pp. 168ff., pls. 58–59 / Thorwaldsen, p. 23] Plaster original. Thorwaldsens Museum, no. A786. [Thorwaldsen, p. 77]

————. "Cupid Standing with His Bow." Marble statue. At least 2 examples. Thorwaldsens Museum, no. A819 (A35); private coll., Norway. [Thorwaldsen, pp. 23, 80 / Cologne, no. 158] Plaster original, c.1819. Thorwaldsens Museum, no. A36. [Thorwaldsen]

————. "The Graces Listening to Cupid's Song." Marble relief, for monument to Andrea Appiani. 1826. Pinacoteca di Brera, Milan. [Hartmann, p. 114—ill.] Studio replica, 1836. Thorwaldsens Museum, no. A601. [Thorwaldsen, p. 65 / Cologne, p. 47—ill.] Cast of original (1821) plaster. Thorwaldsens Museum, no. A602. [Thorwaldsen, p. 65]

————. "A Triumphant Muse and Cupid on a Biga." 2 plaster sketches. 1827. Thorwaldsens Museum, nos. A49–50. [Ibid., p. 24, pl. 46]

————. "Cupid Received by Anacreon" ("An Allegory of Winter"). Marble relief, after *Anacreontea*, Song 3. 1823–28. Thorwaldsens Museum, Copenhagen, no. A827 (A414); National Galerie, Berlin. [Thorwaldsen, p. 81, pl. 29 / Hartmann, pl. 14.3] Plaster model. 1823. Thorwaldsens Museum, no. A415. [Thorwaldsen, p. 52] Marble variant. Thorwaldsens Museum, no. A416. [Ibid.]

————. "Cupid in Heaven, on Jupiter's Eagle, with the Thunderbolt," "Cupid on Earth, as the Lion Tamer, with Hercules' Club," "Cupid at Sea, on a Dolphin, with Neptune's Trident," "Cupid in the Underworld, as the Tamer of Cerberus, with Pluto's Pitchfork." 4 reliefs, representing Cupid's dominion over the Four Elements. Plaster originals. 1828. Thorwaldsens Museum, nos. A381–84 (cf. nos. A385–88, 390). / Marble versions. Thorwaldsens Museum, nos. A377–80, 389, 729. [Thorwaldsen, pp. 49–51, pl. 49 / Hartmann, pp. 178–82, pls. 123.5, 125.3]

————. "Cupid Listening to the Song of Erato." Marble relief. Modeled 1830. Thorwaldsens Museum, no. A343. [Thorwaldsen, p. 47 / Hartmann 1979, p. 167, pl. 115.6 (cf. 115.4)]

————. "Cupid and Hymen Spinning the Thread of Life." Marble relief. 1832–34. Thorwaldsens Museum, Copenhagen, no. A454. / Plaster original, 1831. Thorwaldsens Museum, no. A455. [Thorwaldsen, p. 55]

————. "Cupid Feeding Hygieia's Snake." Marble relief. Thorwaldsens Museum, no. A371. / Plaster original, 1837. Thorwaldsens Museum, no. A372. [Ibid., p. 49]

————. "Cupid and Hymen." Marble relief. 1842–44. Thorwaldsens Museum, no. A451 / Plaster original, 1840. Thorwaldsens Museum, no. A452. [Ibid., pp. 54f.]

————. "Cupid Garlands Hymen's Torches." Relief. Plaster original, 1840. Thorwaldsens Museum, no. A453. [Ibid., p. 55]

————. Numerous reliefs, depicting Cupid in various activities. Plaster and marble versions. 1810, 1831–43. Thorwaldsens Museum, nos. A391–422, 456, 878. [Ibid., pp. 51–53, 55, 84]

Henry Fuseli, 1741–1825. "Sleeping Woman and Cupid." Drawing. **1780–90**. Öffentliche Kunstsammlung, Basel, inv. 1941.291. [Schiff 1973, no. 842—ill.] Etching by Fuseli. [Ibid., no. 842a—ill.]

————. "Eros and Dione." Illustration, engraved by M.

Haughton, in Erasmus Darwin's *The Temple of Nature, or, The Origin of Society* (London: Johnson, 1803). [Ibid., no. 1340—ill.]

Antoine-Frédéric Gresnick, 1755–1799, attributed. *L'Amour exilé de Cythère* [Cupid Exiled from Cythera]. Opera. Libretto, Alexandre Pieyre. First performed **1793**, Lyon. [Grove 1980, 7:704 (rejected attribution) / Baker 1984, p. 888]

Johann Gottfried Schadow, 1764–1850. "The Muses Calliope and Polyhymnia, the Three Graces, Cupid, and Apollo." Drawing, design for title page of *Calendar der Musen und Grazien für das Jahr 1796*. **1794**. Nationalgalerie, Berlin, no. Z.45. [Berlin 1965, no. 103]

————. "The Muses Calliope and Euterpe, with Cupid and the Three Graces." Drawing, companion to above. c.1794. Berlin, no. Z.46. [Ibid., no. 104]

————. "Eros Resting." Marble relief. c.1798. Berlin, inv. B67. [Ibid., no. 21—ill. / Cologne 1977, p. 162—ill.]

————. (Cupid in) "The Power of Music." Façade relief, for C. G. Langhans's theater, Berlin. 1801. Destroyed 1817. / Drawings. Deutsche Akademie der Künste, Berlin, inv. Schadow 165, 797, 798, 800. [Berlin, no. 118—ill.]

William Wordsworth, 1770–1850. "The Birth of Love." Poem. c.1794. In Juvenilia MS, with Vale of Esthwaite. [De Selincourt 1940–66, vol. 1]

Asmus Jakob Carstens, 1754–1798. "Bacchus and Cupid." Painting. **1790–95**. Statens Museum for Kunst, Copenhagen. [Cologne 1977, pp. 143, 167—ill.]

Jean-Antoine Houdon, 1741–1828. "Head of Cupid." Marble sculpture. Sold **1795**, untraced. [Réau 1964, no. 56]

Joseph-Marie Vien, 1716–1809. "Games Established by Cupid." Cycle of 21 drawings depicting Cupid and nymphs: "The Race," "Cupid Mocked and Ridiculed," "Cupid Making the Nymphs Dance," others. **1794–96**. Courtauld Institute, London; British Museum, London; Kupferstichkabinett, Berlin; elsewhere? [Royal Academy 1968, nos. 706–07]

————. "Sacrifice to Cupid." Painting, sketch. Louvre, Paris, no. R.F. 3071. [Louvre 1979–86, 4:272—ill.]

Benjamin West, 1738–1820. "Cupid Releasing Two Doves." Painting. **1798**, retouched 1808. Private coll. [von Erffa & Staley 1986, no. 127—ill.]

————. "Sleeping Cupid" ("Cupid Sleeping on a Bed of Roses"). Painting. c.1802. Painting, after Anacreontic ode "Cupid Wounded." Lost. [von Erffa & Staley, no. 125] Replica or variant. Lost. [Ibid., no. 126]

French School. "Cupid, Blindfolded, Carrying a Sword," "Cupid Watching a Bird." Paintings. **18th century**. Bowes Museum, Barnard Castle, list 1971 nos. 563, 935. [Wright 1976, p. 70]

German School. "Cupid with Shepherd and Shepherdess." Painting. **18th century**. National Museum of Wales, Cardiff, list 1972 no. 265. [Wright 1976, p. 75]

Italian School. "Cupid with an Arrow." Painting. **18th century**. The Binns, West Lothian. [Wright 1976, p. 105]

North Italian School. "Sleeping Cupid." Painting. **18th century**. Szépművészeti Múzeum, Budapest, no. 1024. [Budapest 1968, p. 509]

North Netherlandish School. "Ceres, Bacchus, and Amor."

Painting (simulated statues in a niche). **18th century.** Rijksmuseum, Amsterdam, no. A4179. [Rijksmuseum 1976, p. 669—ill.]

Novalis (Friedrich Leopold von Hardenberg), 1772– **1801.** (Eros and Fable, the poetic imagination, in) *Heinrich von Ofterdingen* part 1. Novel, unfinished. In *Schriften,* edited by F. Schlegel and L. Tieck (Berlin: Buchhandlung der Realschule, 1802). [Strauss 1971, pp. 44f., 51]

Johann Gottfried Herder, 1744–**1803.** *Die Göttergabe* (Poet asks Cupid to wound "Chloë" for him). Poem. In *Gedichte* book 4, in *Sämmtliche Werke* (Tübingen: Cotta, 1805–20). [Herder 1852–54, vol. 13]

Pierre Gardel, 1758–1840, choreography. *Anacréon, ou, L'Amour fugitif.* Ballet. First performed 4 Oct **1803,** Académie Royale, Paris. [EDS 1954–66, 5:938]

Giovanni Domenico Tiepolo, 1727–**1804.** "Homage to Cupid." Fresco (detached). Szépmüvészeti Múzeum, Budapest. [Mariuz 1962, p. 115—ill.] *See also Giambattista Tiepolo, above.*

Washington Allston, 1779–1843. "Cupid Playing with the Helmet of Mars." Painting, after detail in Rubens's "Presentation of the Portrait of Marie de' Medici to Henri IV" (1622–25, Louvre). **1804.** Vassar College Art Gallery, Poughkeepsie, N.Y. [Gerdts & Stebbins 1979, pp. 32–34, 177—ill. / also Richardson 1948, no. 35]

Louis-Jean-François Lagrenée the Elder, 1725–**1805.** "Cupid." Painting. Musées Muncipaux de Toulon. [Bénézit 1976, 6:383]

Alexey Nikolayevich Titov, 1769–1827. *Amur-sud'ya, ili Spor tryokh gratsiy* [Judge Cupid, or, The Argument of the Three Graces]. Opera. Libretto, Knyazhnin. First performed **1805,** St. Petersburg. [Grove 1980, 19:15]

William Blake, 1757–1827. Cupid crouching in the coils of a serpent, drawing, illustrating his *Vala, or, The Four Zoas* Night I. *c.*1797–**1807.** British Library, London, MS 39764. [Butlin 1981, no. 337.4]

——. "Why Was Cupid a Boy." Poem, from the Rossetti MS. First published in *Poetical Works,* edited by John Sampson (London: Oxford University Press, 1913; 1960). [Ipso]

——. *See also John Flaxman, above.*

Philip Reinagle, 1749–1833. "Cupid Inspiring the Plants with Love." Painting, engraved by Thomas Burke, for Thornton's *New Illustration of the Sexual System of Linnaeus* (**1799**–**1807**). Painting in Fitzwilliam Museum, Cambridge, no. PD.65–1974. [Fitzwilliam 1960–77, 3:198]

François-Joseph Bosio, 1769–1845. "Cupid Shooting an Arrow" ("Cupid Bending His Bow"). Marble statue. **1808** or after. Hermitage, Leningrad, inv. 1106. [Hermitage 1984, no. 395—ill. / also Hermitage 1975, pl. 135]

——. "Cupid Seducing Innocence." Marble (?) sculpture. [Bénézit 1976, 2:194]

Christian Faedder Høyer. "Cupid Received by Anacreon." Painting, after *Anacreontea,* song 3. *c.*1808–**11.** Thorwaldsens Museum, Copenhagen, no. B226. [Thorwaldsen 1985, p. 100]

Christoph Martin Wieland, 1733–1813. "Der Verklagte Amor "[Cupid Accused]. Poem. In *Sämmtliche Werke* (Leipzig: Göschen, 1794–**1811**). [Radspieler 1984, vol. 2]

Clodion, 1738–**1814.** "Sacrifice to [a statue of] Eros." Terra-cotta plaque. 3 versions. Louvre, Paris; Georges

Wildenstein estate; Brinsley Ford coll., London. [Royal Academy 1968, no. 798—ill.]

Johan Tobias Sergel, 1740–**1814.** "Cupid with His Bow." Terra-cotta bas-relief. Nationalmuseum, Stockholm, no. 463. [Göthe 1921, no. 66—ill.]

Anonymous. *Cupid and Flora.* Ballet. First performed **1814,** Royalty Theatre, Manchester. [Nicoll 1959–66, 4:447]

Johann Heinrich Dannecker, 1758–1841. "Cupid." Statue. **1810–15.** Staatsgalerie, Stuttgart. [Cologne 1977, p. 162—ill.]

Armand Vestris, 1786–1825, choreography, after Pierre Gardel. *Mars et l'Amour.* Ballet. First performed 29 Apr **1815,** King's Theatre, London. [Guest 1972, pp. 29, 155]

Francesco Hayez, 1791–1882. Frescoed frieze, depicting allegories of love: "Amor, Fierce as a Tiger," "Amor, Light as a Butterfly," "Amor, Strong as a Lion," others. For the study of Count Zanetto, Casa Papadopoli, Santa Maria Formosa, Venice. **1817.** Lost. [Coradeschi 1971, no. 28] Variant after one of these scenes (?) ("Cupid"). 1817–19. On loan to Accademia di Brera, Milan. [Ibid., no. 29—ill.]

Karl Friedrich Ludwig Kannegiesser, 1781–1861. *Amor und Hymen.* Poetic idyl. Prenzlau: Ragocsy, **1818.** [DLL 1968–90, 8:885]

John Gibson, 1790–1866. "Mars and Cupid." Marble sculpture group. **1819.** Duke of Devonshire coll., Chatsworth. [Bénézit 1976, 4:713 / Clapp 1970, 1:405]

——. "Cupid as a Shepherd." Marble statue. 1830s. Hermitage, Leningrad, inv. 251. [Hermitage 1979, pl. 329] 8 replicas. Walker Art Gallery, Liverpool, elsewhere. [Ibid.]

Walter Savage Landor, 1775–1864. *Veneris pueri* [The Boys of Venus] (Eros, bringer of chaos, resigns his power to Cupid). Latin idyll. In *Idyllia heroica* (Pisa: **1820**). / Translated by the author in *Hellenics* (London: Moxon, 1847). / Revised in 1859 edition (Edinburgh: Nichol). [Wheeler 1937, vol. 2 / Boswell 1982, p. 745]

Heinrich Heine, 1797–1856. (Blind Cupid cursed in) "Sie haben dir viel erzählet . . ." [They told you stories so freely]. Suppressed third stanza of poem, no. 24 of "Lyrisches Intermezzo." Cycle of poems. In *Buch der Lieder* (Hamburg: Hoffmann & Campe, **1822**–**23**). [Windfuhr 1975–82, vol. 1 / Draper 1982]

Richard Westmacott, 1775–1856. "Cupid." Marble sculpture. **1823.** Woburn Abbey. [Whinney 1964, p. 215]

——. "Nymph and Cupid." Marble group. 1827. Petworth House, Sussex. [Ibid., pl. 155B]

Edward Fitzball, 1793–1873. *Cupid in Disguise.* Burletta. First performed 31 Oct **1825,** Olympic Theatre, London. [Nicoll 1959–66, 4:313]

Peter Cornelius, 1783–1867, and studio. 4 frescoes, depicting Cupid with symbols of the 4 elements: dolphin (water), eagle of Jupiter (fire and light), peacock of Juno (air), Cerberus (earth). **1820–26.** Ceiling, Göttersaal, Glyptothek, Munich. [Glyptothek 1980, pp. 214ff.—ill.] Cupid also depicted in fresco "The Kingdom of Neptune" ("The World of Water"). Göttersaal, Glyptothek, Munich. [Ibid., no. 265—ill.]

Charles-Gabriel Sauvage, 1747–**1827.** "Cupid." Bronze sculpture. Ashmolean Museum, Oxford. [Royal Academy 1968, no. 819]

Jean-Baptiste Regnault, 1754–**1829.** "Hymen and Cupid

Drinking from the Cup of Friendship." Painting. Louvre, Paris, no. R.F. 2159. [Louvre 1979–86, 4:171—ill.]

Johann Baptist Lampi the Elder, 1751–**1830.** "Cupid." Painting. Szépmüvészeti Múzeum, Budapest, no. 456. [Budapest 1968, p. 370]

Thomas Haynes Bayly, 1797–1839. *Cupid.* Burletta. First performed **1832,** Olympic Theatre, London. [Nicoll 1959–66, 4:262]

Thomas Stothard, 1755–**1834.** "Cupid Preparing for the Hunt." Painting. London. [Bénézit 1976, 9:854]

———. "Cupid Attaching His Shaft." Painting. London. [Ibid.]

Honoré Daumier, 1808–1879. "Étienne-Joconde-Cupidon-Zéphir- *Constitutionnel.*" Satirical lithograph. **1834.** [Delteil 1906–30, 20: no. 203—ill.]

———. "Cupid, Mischievous God, but Full of Vanity." Satirical lithograph, in "Parliamentary Idylls" series. 1850–51. [Ibid., 25: no. 2061—ill.]

———. "Cupid and His Mother." Comic lithograph. 1853. [Delteil 1906–30, 26: no. 2432—ill.]

———. "Two Small Cupids." Painting. Lost. [Maison 1968, p. 440]

Horatio Greenough, 1805–1852. "Love Captive" ("Love Prisoner to Wisdom"). Marble statuette. c.**1834–35.** Museum of Fine Arts, Boston. [Wright 1963, p. 103—ill.]

Paul Taglioni, 1808–1884, choreography. *Amor's Triumph.* Ballet. Music, H. Schmidt. First performed **1835,** Berlin. [Oxford 1982, p. 406]

Joseph Graves. *Cupid.* Burlesque. London: Strange, **1837.** [Ellis 1985, p. 111]

Eduard Mörike, 1804–1875. "Der pflügende Eros" [Eros Ploughing]. Translation from Moschus. In *Classische Blumenlese* (Stuttgart: Schweizerbart, **1840**). [Hötzer 1967]

Victor Hugo, 1802–1885. "L'amour n'est plus l'antique et menteur Cupido" [Love is no longer the old-fashioned and false Cupid]. Sonnet. 29 Dec **1843.** No. 19 in *Toute la lyre* part 6. In *Oeuvres inédites* (Paris: Hetzel, 1888). [Hugo 1985–86, vol. 7]

Patrick MacDowell, 1799–1870 "Cupid." Marble sculpture. **1845.** Royal Academy, London. [Strickland 1968, 2:63]

Jean-François Millet, 1814–1891. "The Counsels of Cupid." Painting. c.**1845.** Unlocated. [Lepoittevin 1973, fig. 45]

———. "Sleeping Amor." Painting. 1848. Singer Museum, Laren, cat. 1962 no. 294. [Wright 1980, p. 279 / Herbert 1976, p. 52]

William Calder Marshall, 1813–1894. "The First Whisper of Love" (Cupid to a young woman). Marble sculpture group. **1846.** Royal Dublin Society, Dublin. [Read 1982, pp. 208f.—ill.]

William Leman Rede, 1802–**1847.** *Cupid in London; or, Some Passages in the Life of Love.* Comedy. [Ellis 1985, p. 228]

Ralph Waldo Emerson, 1803–1882. "Initial, Daemonic, and Celestial Love." Poem. In *Poems* (London: Chapman, **1847**). [Emerson 1904]

———. "Cupido." Poem. In *May-Day and Other Pieces* (Boston: Ticknor & Fields, 1867). [Ibid.]

———. "Eros." Poem. In *The Dial* Jan 1844; collected in *Poems* (London: Chapman: 1847). [Ibid.]

———. "Eros." Poem. [Emerson]

Jean-Léon Gérôme, 1824–1904. "Anacreon, Bacchus, and Amor." Painting. **1848.** Musée des Augustins, Toulouse. [Ackerman 1986, no. 19—ill.]

———. "Drunken Bacchus and Cupid" (children). Painting. 1850. Musée, Bordeaux. [Ibid., no. 31—ill.]

———. "Anacreon with [infant] Bacchus and Amor." Marble sculpture. 1878–81. Ny Carlsberg Glyptotek, Copenhagen. [Ibid., no. S.10—ill.] At least 20 bronze casts, several sizes. Musée Garret, Vesoul (2); Art Institute of Chicago; Hearst Castle, San Simeon, Calif.; elsewhere. [Ibid.]

———. "Cupid at the Door in a Rainstorm" ("Cupid Arrives"), "Young Love's Shivering Limbs the Embers Warm," "Cupid Runs (Out the Door)," "The Poet Dreams of Cupid by the Fire." Paintings, after second ode of Anacreon. 1881–89. Alter coll., Brookline, Mass.; 3 lost. [Ibid., nos. 288–91—ill.] Drawings. Art market in 1977. [Ibid.—ill.]

———. "Cupid and the Vestal." Painting. 1889. Lost. [Ibid., no. 356]

———. (Cupid guiding a woman's hand as she writes) "The Love Letter." Painting. 1889. Unlocated. [Ibid., no. 357—ill.]

———. "Whoever You Are, Here Is Your Master" ("Love, the Conqueror") (Cupid with wild animals). Painting. 1889. Art Institute of Chicago. [Ibid., no. 361—ill.]

William Etty, 1787–**1849.** "A Bivouac of Cupid and His Company." Painting. Museum of Fine Arts, Montreal. [Reynolds 1966, p. 26, pl. 4]

———. "Cupid in a Shell." Painting. Art Gallery, Preston. [Bénézit 1976, 4:210]

Eberhard Wächter, 1762–**1852.** "Bacchus and Cupid." Grisaille painting. Staatsgalerie, Stuttgart. [Bénézit 1976, 10:596]

Dante Gabriel Rossetti, 1828–1882. "Era in pensier d'Amor" (Cupid with lovers). Drawing. c.**1855.** Birmingham City Museum and Art Gallery, England, no. 340'04. [Surtees 1971, no. 700—ill.]

Thomas Crawford, 1813–**1857.** "Cupid." Marble sculpture. Unlocated. [Gerdts 1973, p. 80]

William Bouguereau, 1825–1905. "Wounded Eros." Painting. Exhibited Salon of **1859.** [Montreal 1984, p. 98] Reduction, c.1860. [Ibid., p. 98—ill.]

———. "Eros Testing His Arrows." Painting. 1863. [Ibid., p. 62]

———. "Youth and Eros." Painting. 1877. Exhibited Salon of 1877. [Ibid., p. 64]

———. "Girl Defending Herself against Eros." Painting. 1880. University of North Carolina, Wilmington. [Ibid., pp. 133, 219—ill.] Oil sketch for, c.1879. Private coll. [Ibid., no. 92—ill.] Reduction, Getty Museum, Malibu, Calif. [Isaacson 1974, no. 17—ill. / also Montreal 1984, p. 219]

———. "Eros Shivering in the Rain" ("The Wet Cupid"). Painting. 1891. [Montreal, p. 65 / Dijkstra 1986, pp. 199f.—ill.]

———. "Offering to Eros." Painting. 1893. [Montreal, p. 65] Oil study, private coll. [Ibid., no. 127—ill.]

———. "Admiration" (Cupid surrounded by women). Painting. 1897. San Antonio Museum Association, Texas. [Ibid., no. 135—ill.]

———. "Eros Gliding on the Water." Painting. Exhibited Salon of 1901. [Ibid., pp. 66, 122—ill.]

Johannes Riepenhausen, 1788/89–**1860.** "Cupid Instructing Two Young Girls." Painting. Thorwaldsens Museum, Copenhagen, no. B153. [Thorwaldsen 1985, p. 111]

Thomas Ashe, 1836–1889. "Eros." Poem. In *Dryope and Other Poems* (London: Bell & Doldy, **1861**). [Boswell 1982, p. 21]

———. "Lost Eros." Poem. In *Poems* (London: Bell, 1886). [Ibid., p. 22]

Edward Burne-Jones, 1833–1898. "Cupid's Forge." Watercolor, after Chaucer's "Parlement of Foules" (1380–82). **1861.** [Bell 1901, p. 27—ill. / Harrison & Waters 1973, p. 75] Variant, "Cupid and Delight," wood engraving, by W. H. Hooper. Published London: Kelmscott, 1895. [Harrison & Waters, p. 162—ill.]

———. "Amor." Drawing. c.1865. Henri Dorra coll., Calif. [Ibid., p. 81—ill.]

———. "The Masque of Cupid." Painting. Unfinished. Unlocated. / Drawing. 1872. National Museum of Wales, Cardiff. [Arts Council 1975, no. 205] Related painting. c.1898. Private coll. [Ibid., no. 207]

———. "Cupid's Hunting Fields." Painting. 1880. Victoria and Albert Museum, London. [Delaware 1984, p. 42] Replica, decorative panel, c.1882. Delaware Art Museum, Wilmington. [Ibid., p. 42—ill.] Gouache replica. 1885. Art Institute of Chicago. [Ibid., p. 42]

———. "The Masque of Cupid." Painting. Falmouth Art Gallery, Falmouth, Cornwall. [Jacobs & Stirton 1984b, p. 130]

———. "The Masque of Cupid." Drawings, inspired by Spenser's *The Faerie Queene* (1590–96). [Jenkyns 1980, p. 145]

Jean-Louis Hamon, 1821–1874. "Cupid at the Bathingbeach." Painting. Before **1862.** Musée Ingres, Montauban. [Montauban 1965, no. 141—ill.]

Henri Fantin-Latour, 1836–1904. "Nymph and Cupid." Drawing. **1862.** [Fantin-Latour 1911, no. 197]

———. "Nymph and Cupid." Painting. 1884. Sold 1893 (Ricada coll.). [Ibid., no. 1153]

———. "Nymph Teased by Cupid." Painting. 1901. [Ibid., no. 1880] Drawing (for?). Musée du Luxembourg, Paris. [Ibid., no. 1887]

———. "Nymph Teased" (by Cupid). Painting. 1904, unfinished. [Ibid., no. 2099]

Charles Baudelaire, 1821–1867. "Les tentations, ou, Éros, Plutus, et la Gloire" [The Temptations, or, Eros, Plutus, and Fame]. Prose poem. In *Revue nationale et étrangère* 10 June **1863**; collected in *Petits poëmes en prose* (later called *Le spleen de Paris*), vol. 4 of *Oeuvres complètes* (Paris: Lévy, 1869). [Pichois 1975 / Ruff 1966, p. 188] Translated by Louise Varèse in *Paris Spleen* (New York: New Directions, 1947; 1970). [Ipso]

Jean-Baptiste Camille Corot, 1796–1875. "Cupid's Secret" (Cupid whispering to a reclining nymph). Painting. **1855–65.** Weitzner coll., New York. [Chicago 1960, no. 84 / also Robaut 1905, no. 1335—ill.]

Thomas Love Peacock, 1785–**1866.** "Ode to Love." Poem. In modern edition, *Works,* vol. 7 (London: Constable, 1924–34). [Boswell 1982, p. 279]

Jean-Auguste-Dominique Ingres, 1780–1867. "Eros" Painting. Museum, Basel. [Wildenstein 1954, no. 261—ill.]

Jean-Baptiste Carpeaux, 1827–1875. "Cupid the Jester," figure in "The Dance." High-relief stone sculpture. **1865**–

69. For façade of L'Opéra, Paris (now replaced by a copy). Musée d'Orsay, Paris. [Kocks 1981, pp. 88ff.—ill. / also Beyer 1975, nos. 284–329—ill.] Terra-cotta sketch ("Cupid the Jester"). Musée d'Orsay, inv. RF 2928. [Orsay 1986, p. 86—ill.] Terra-cotta edition, by studio, from 1872. / Bronze edition, by studio. Petit Palais, Paris; elsewhere. [Ibid. / Beyer, nos. 316, 319—ill. / also Kocks, p. 438—ill.] 2 marble versions. Gulbenkian Foundation, Lisbon; another unlocated. [Orsay]

———. "Mocking Cupid." Plaster bozzetto. Musée des Beaux-Arts, Valenciennes. [Kocks, p. 292—ill.]

Pietro Tenerani, 1789–**1869.** "Cupid." Marble high-relief. Pinacoteca Civica, Ascoli Piceno. [Bénézit 1976, 10:110]

Hans Makart, 1840–1884. "Amoretti and Cupid." Painting. **1869–70.** Unlocated. [Frodl 1974, no. 123—ill.]

———. "Cupid." Painting. c.1870. Galerie W. Gurlitt, Munich, in 1954, unlocated. [Ibid., no. 142—ill.]

———. "Cupid." Oil sketch. Sigmund Flesch coll. in 1885. [Ibid., no. 461]

———. "Cupid." Oil sketch. Sold Vienna (Wawra) 1930, unlocated. [Ibid., no. 564]

Gustave Moreau, 1826–1898. "Cupid and the Muses." Watercolor. **c.1870.** Cabinet des Dessins, Louvre, Paris. [Mathieu 1976, no. 122—ill.]

Giovanni Maria Benzoni, 1809–**1873.** "Cupid." Statue. Art Association, Montreal. [Bénézit 1976, 1:637]

Charles Gleyre, 1806–1874. "Young Girl Distracted by Cupid." Drawing. **1874.** Musée, Lausanne, in 1878. [Clément 1878, no. 116]

———. "Cupid Asking the Fates to Have Mercy on a Sick Fiancée." 2 sketches. [Ibid., no. 94–95]

George Frederick Watts, 1817–1904. "Love and Death." Painting. 8 versions, **1875** and later. City Art Gallery, Bristol; Whitworth Art Gallery, Manchester; Watts Gallery, Compton, Surrey; elsewhere. [London 1974, no. 28—ill. / Spalding 1978, pp. 11f., 17—ill. / Minneapolis 1978, no. 20—ill.]

———. (Eros in) "When Poverty Comes in the Door, Love Flies Out the Window." Painting. 1879. Art Market, London, in 1961, untraced. / Study. Carlisle Art Gallery. [London, no. 32—ill.]

———. "Love and Life." Painting. 1882–84. National Collection of Fine Arts, Smithsonian Institution, Washington, D.C. [Minneapolis, no. 30—ill.] Studies and variants. Watts Gallery, Compton; Walker Art Galley, Liverpool; Tate Gallery, London; Louvre, Paris. [Ibid. / Blunt 1975, pp. 154ff., pl. 18a / London, no. 47—ill.] Plaster study. [Blunt, fig. 18b]

———. "Cupid." Painting. Watts Gallery, Compton. [Watts 1970, no. 20]

Auguste Rodin, 1840–1917. "Cupid." Plaster sculpture. **1876.** Musée Rodin, Paris. [Rodin 1944, no. 35—ill.]

Julius Rietz, 1812–**1877.** "Cupido, loser, eigensinniger Knabe" [Cupid, wicked, capricious boy]. Lied, opus 26.2.3. Text, Goethe (1783). [Moser 1949, p. 137]

Austin Dobson, 1840–1921. "Eros Riding a Centaur." Poem, part of "A Case of Cameos." In *Proverbs in Porcelain and Other Verses* (London: King, **1877**); reprinted in *Complete Poetical Works* (London: Oxford University Press, 1923). [Boswell 1982, p. 88]

Coventry Patmore, 1823–1896. "Eros," "The Unknown

Eros." Poems (odes). In *To the Unknown Eros* (London: Bell, **1877**). [Boswell 1982, p. 200f. / Dunn 1969, p. 209]

John Spencer Stanhope, 1829–1908. "Love and the Maiden." Painting. **1877**. Private coll., London. [Spalding 1978, p. 18—ill.]

Hans Thoma, 1839–1924. "Cupid and Death" (with young couple). Painting. *c*.**1877**. Artist's coll., Karlsruhe, in 1909. [Thode 1909, p. 81—ill.] Replica ("Death and Love"). 1879. Kniese coll., Bayreuth. [Ibid., p. 123—ill.]

———. "Cupid as Landscape Painter." Painting. 1886. Solbrig coll., Munich. [Ibid., p. 243—ill.]

———. "Venus on the Dolphin" (with blindfolded Cupid). Painting. 1887. Freiherr von Waldberg coll., Heidelberg. [Ibid., p. 276—ill.] Variant, "Through the Floods." 1889. Thode coll., Heidelberg. [Ibid., p. 307—ill.]

Max Klinger, 1857–1920. "Cupid Shooting." Etching. **1879**. [Hildesheim 1984, no. 340 / also Dückers 1976, 164—ill.]

———. "Cupid." Etching, no. 10 in "A Glove" cycle, opus VI. 1881. [Hildesheim, no. 186—ill. / also Dückers, 165f.—ill.]

———. "Naked Youth Overcome by Cupid," "Maiden Shot by Cupid's Arrow." Paintings, door panels for Villa Albers, Berlin. 1883–85. Museum der Bildenden Künste, Berlin. [Hildesheim, no. 16—ill.]

Oscar Wilde, 1854–1900. "The Garden of Eros." Poem. In *Poems* (London: Bogue; Boston: Roberts, **1881**). [Ross 1909 / Shewan 1977, pp. 8, 10, 50, 54, 95f. / Bush 1937, pp. 420, 560]

Jean-Antoine-Marie Idrac, 1849–1884. "Wounded Eros." Statue. Exhibited Salon of **1882**. École des Beaux-Arts, Paris. [Montreal 1984, 122—ill.] Bronze example in Musée des Beaux-Arts, Lille. [Bénézit 1976, 5:701]

———. "Eros." Plaster sculpture. Musée d'Art Moderne, Paris. [Ibid.]

Laurent-Honoré Marqueste, 1848–1920. "Cupid." Marble statue (with ivory bow). **1882–83**. Musée d'Orsay, Paris, inv. RF 648. [Orsay 1986, p. 194—ill.] Plaster models. Musée de Châlons-sur-Marne; Musée des Augustins, Toulouse. / Marble replica, 1903. Ny Carlsberg Glyptotek, Copenhagen. / Bronze reduction, edition by Siot-Decauville; biscuit reduction, edition by Manufacture de Sèvres. [Ibid.]

Gustave Doré, 1832–**1883**. "The Fate and Cupid." Bronze sculpture. Also plaster and terra-cotta models. [Leblanc 1931, p. 543]

———. "Nymph Pursued by Cupid." Plaster sculpture model. [Ibid., p. 544]

———. "Cupid and Death's Heads." Bronze sculpture. Michel-Doré coll. in 1931. [Ibid., pp. 544f.]

———. "Cupid Shooting an Arrow." Bronze statue. Michel-Doré coll. in 1931. [Ibid., p. 545]

Herbert Gustave Schmalz, 1856–1935. "The Temple of Eros." Painting. **1883**. [Kestner 1989, p. 337]

Algernon Charles Swinburne, 1837–1909. "Eros." Poem. In *A Century of Roundels, and Other Poems* (London: Chatto & Windus, **1883**). [Gosse & Wise 1925–27, vol. 5 / Boswell 1982, p. 224]

Pierre-Alexandre Schoenewerk, 1820–**1885**. "Cupid Saddened by the Sight of a Plucked Rose." Marble statue. Musées Nationaux, inv. RF 1116, deposited in Musée, Grenoble, in 1896. [Orsay 1986, p. 282]

George Grey Barnard, 1863–1938. "Nurse and Cupid."

Terra-cotta sketch. **1885**. Mrs. J. M. Barnard coll. in 1908. [Barnard 1908, no. 14—ill.]

———. "Girl and Cupid." Plaster sketch. 1908. [Ibid., no. 22—ill.]

Gustav Klimt, 1862–1918 (with Franz Matsch and Ernst Klimt?). "Allegory of Music: Eros Hands a Singer the Laurel Wreath" ("Homage to a Singer"). Ceiling painting. **1885**. National Theater, Bucharest. [Novotny & Dobai 1968, p. 276, no. 21—ill. / Strobl 1980, 1:47] Oil sketch, formerly Österreichische Galerie, Vienna, stolen. [Novotny & Dobai, no. 20—ill.] Replica, 1885. Ceiling, City Theater, Rijeka (Fiume), Yugoslavia. [Strobl, 1:47f.—ill. / Novotny & Dobai, no. 24]

Henry Woods, 1846–1921. "Cupid's Spell." Painting. **1885**. Tate Gallery, London, no. 1531. [Tate 1975, p. 96]

Frederic, Lord Leighton, 1830–1896. "Cupid and Dove." Painting. **Mid-1880s?** Unlocated. [Ormond 1975, no. 311] Monochrome cartoon (possibly identical with above), private coll. [Ibid., no. 312]

Émile-Antoine Bourdelle, 1861–1929. "Cupid in Agony." Bronze sculpture. **1886**. 4 casts. Private coll(s). [Jianou & Dufet 1975, no. 45—ill.]

———. "Bacchante Carrying Eros." Bronze sculpture. 1923. 3 versions. Fujikawa Galleries, Osaka; elsewhere. [Ibid., no. 651]

———. "Monsieur Eros." Bronze sculpture. 1929. 4 casts. Fujikawa Galleries, Osaka; private coll(s). [Ibid., no. 701]

Augusta Holmès, 1847–1903. "Hymne à Eros." Song. **1886**. [Cohen 1987, 1:326f.]

Luigi Manzotti, 1835–1905, choreography and libretto. *Amor*. Ballet. Music, Romualdo Marenco. First performed **1886**, La Scala, Milan; scenery and costumes, Alfredo Edel. [Beaumont 1938, p. 529 / Oxford 1982, pp. 13, 271]

Léon Minkus, 1826–1917, music. *L'offrande à l'Amour* [Offering to Cupid]. Ballet. First performed **1886**, St. Petersburg. [Grove 1980, 12:336]

Prosper D'Epinay, 1836–1912. "Cupid Begging Alms." Marble statue. **1887**. Hermitage, Leningrad, inv. 940. [Hermitage 1984, no. 412—ill. / also Hermitage 1975, pls. 146–47]

Elihu Vedder, 1836–1923. "The Cup of Love" (Cupid with a young couple). Painting. **1887**. H. Henderson coll. [Soria 1970, no. 437] Chalk and gouache replica. Richardson coll., Philadelphia. [Ibid., no. D359 / Soria et al. 1979, fig. 175]

———. "Love Ever Present" ("Love Amid Ruins," "Superest invictus Amor," "Amor omnia vincit"). Painting. 1887–99. Ricau coll., Piermont, N.Y. [Soria 1970, no. 440—ill. / Soria et al. 1979, fig. 181 / Dijkstra 1986, pp. 199f.—ill.]

Margaret Ruthven Lang, 1867–1972. "Eros." Song. Published **1889**. [Cohen 1987, 1:397]

Franz von Stuck, 1863–1928. "Cupid the Happy Fisherman." Painting. *c*.**1889**. Unlocated. [Voss 1973, no. 5—ill.]

———. (Cupid riding on) "Love-crazed Centaur." Painting. 1891. Private coll. in 1924. [Voss, no. 36—ill.]

———. "The Secret" (Cupid whispering to a stork). Painting. 1893. 2 versions. Private coll.; unlocated. [Voss, nos. 81, 82—ill.]

———. "The See-saw of Love" (Cupid between man and

woman on a see-saw). Painting. 1902. Mme. de Osa coll., Paris, in 1908. [Voss, no. 247—ill.]

———. "Centaur and Cupid." Painting. 1902. Koch coll., Dresden, in 1912. [Voss, no. 248—ill.]

———. "Cupid Riding on a Dolphin." Painting. c.1912. Unlocated. [Voss, no. 416—ill.]

———. "[Female] Eros with Tambourine," "Eros with Fruitbasket." Paintings. c.1920. Unlocated. [Voss, nos. 529–30—ill.]

———. "Cupid Imperator." Painting. Private coll. [Voss, suppl. no. 1—ill.]

Edmund Gosse, 1849–1928. "Eros" (description of the god sleeping in a forest, bees swarming around him). Poem. In *On Viol and Flute* (London: Kegan Paul, Trench, & Trübner, 1890). [Boswell 1982, p. 119]

Lev Ivanov, 1834–1901, choreography. *Cupid's Pranks.* Ballet. First performed 1890, Maryinsky Theater, St. Petersburg. [Beaumont 1938, p. 514]

Gaston de Meaupou. *L'Amour vengé* [Cupid Revenged (on Jupiter and Antiope)]. Comic opera. Libretto, poem by Lucien Auge de Lassus. First performed 31 Dec 1890, L'Opéra-comique, Paris. [Clément & Larousse 1969, 1:54f.]

Robert Franz, 1815–1892. "Cupido, loser Knabe" [Cupid, wicked boy]. Lied, opus 33. Text, Goethe (1783). Published as no. 4 in Goethe's *6 Lieder.* [Grove 1980, 6:806]

Randolph Rogers, 1825–1892. "Cupid Breaking His Bow." Marble sculpture. Unlocated. [Gerdts 1973, p. 80]

James Maurice Thompson, 1844–1901. "Garden Statues: Eros, Aphrodite, Psyche, and Persephone." Poem. In *Poems* (Boston: Houghton, Mifflin, 1892). [Boswell 1982, p. 303]

Paul Vidal, 1863–1931. *Eros.* Opera (fantaisie lyrique). Libretto, Jules Nariac, Jaime and Maurice Bouchor. First performed 22 Apr 1892, Bouffes-Parisiens, Paris. [Clément & Larousse 1969, 1:402]

Alfred Gilbert, 1854–1934. "Eros." Bronze and aluminum sculpture, monument to 7th Earl of Shaftesbury. 1886–93. Piccadilly Circus, London. [Beattie 1983, pp. 214ff. / Minneapolis 1978, pp. 185ff.—ill. / Read 1982, p. 298, pl. 360] Bronze study. Royal Academy, London. [London 1968, no. 66] Replica. Sefton Park, Liverpool. [Read, p. 365] Bronze model, c.1890–91. Tate Gallery, London, no. 4176. [Tate 1975, p. 138 / Minneapolis, no. 103—ill.]

Niccolò Massa, 1854–1894. *Eros.* Opera. Libretto, Gemma Bellincioni, versified by Enrico Golisciani. First performed 21 May 1895, Teatro Pagliano, Florence. [Clément & Larousse 1969, 1:402 / cf. Cohen 1987, 1:72]

Charles John Allen, 1863–1956. "Love and the Mermaid." Bronze sculpture. 1895. Walker Art Gallery, Liverpool. [Beattie 1983, p. 180, pl. 185]

Paul Cézanne, 1839–1906. "Plaster Cupid." 2 still-life paintings with "Cupid" of Puget (1620–1694). c.1895. Home House Trustees coll., London; Nationalmuseum, Stockholm. [Orienti 1972, nos. 833, 834—ill.]

———. "Cupid of Puget" ("Plaster Cupid"). 4 watercolor studies. 1900–04. Szépmüvészeti Múzeum, Budapest; private colls. [Rewald 1983, nos. 556–58, 560—ill. / also Orienti, nos. 835–38—ill.]

Aubrey Beardsley, 1872–1898. "The Driving of Cupid from the Garden" (old man courting a young woman,

Cupid hurrying away). 1896. National Gallery of South Australia, Adelaide. [Reade 1967, no. 431—ill.]

Arnold Böcklin, 1827–1901. "Cupid with Torches." Wall painting. 1896. Artist's villa, San Domenico. [Andree 1977, no. 450.1—ill.]

Maurice Hewlett, 1861–1923. "Eros-Narcissus." Poem. In *Songs and Meditations* (Westminster: Constable, 1896). [Boswell 1982, p. 132]

Georgie Boyden Saint John, d. 1899. "Cupid at the Bar." Song. [Cohen 1987, 2:609]

Robert Bridges, 1844–1930. "Eros." Poem. In *Poetical Works,* vol. 2 (London: Smith, Elder, 1899). [DLB 1983, 19:44, 46, 55]

Francesco Saverio Citarelli (19th century). "Cupid." Marble statue. Galleria dell' 800 di Capodimonte, Naples, no. 4725. [Capodimonte 1964, p. 62]

George Frampton, 1860–1928. "Love Teaching Harmony to the Arts." Stone spandrel relief. 1897–1900. Glasgow Art Gallery, Scotland. [Beattie 1983, p. 90ff., pl. 76]

Charles Louis Augustin Guérin, 1875–1907. *L'Eros funèbre* [Funereal Eros]. Collection of poetry. [Paris?]: 1900. [DLLF 1984, 2:988]

Charles Ricketts, 1866–1931. "The Flight of Cupid." Woodcut. 1901. [Dijkstra 1986, p. 227]

Sidney Meteyard, 1868–1947. "Eros." Painting. c.1902. [Kestner 1989, p. 111, pl. 2.45]

Ernst Barlach, 1870–1938. "Cupid" (hiding, preparing to shoot his bow). Drawing. 1904. Harmsen coll., Hamburg. [Schult 1958–72, 3: no. 228—ill.]

———. "Cupid's Position on the Trial" (reading a headline—"Moltke-Harden"—and vomiting). Satirical drawing. 1906. Barlach Haus, Hamburg, inv. 1937/45. [Ibid., 3: no. 295—ill.]

Oscar Esplá y Triay, 1886–1976. *El sueño de Eros* [The Dream of Eros]. Symphonic poem. 1904. [Grove 1980, 6:251]

Tor Harald Hedberg, 1862–1931. *Amor och Hymen.* Comedy. Stockholm: Bonnier, 1904. [Sharp 1933, p. 119]

Arthur Rackham, 1867–1939. "The Dance in Cupid's Alley." Drawing with watercolor. 1904. Tate Gallery, London, no. 2479. [Tate 1975, p. 193]

Pierre de Bréville, 1861–1949. *Eros Vainqueur* [Eros the Victor]. Opera (conte lyrique). Libretto, Jean Lorrain. Commissioned 1900, completed 1905. First performed 7 Mar 1910, Brussels. [Baker 1984, p. 343 / Grove 1980, 3:272]

Richard von Schaukal, 1874–1942. "Eros." Novella. In *Eros Thanatos* (Vienna & Leipzig: Wiener Verlag, 1906). [Domandi 1972, 2:237]

Natanael Berg, 1879–1957. *Eros vrede* [Wrath of Eros]. Composition for baritone and orchestra. Text, Gustaf Fröding. 1907. [Grove 1980, 2:541]

Vyacheslàv Ivánov, 1866–1949. *Eros.* Collection of poems. St. Petersburg: 1907. [Poggioli 1960, p. 163 / DULC 1959–63, 2:905]

Lindre [unknown sculptor]. "Young Woman Pulling Cupid's Arrow [from her breast]." Small marble sculpture group. By 1910. Musée d'Orsay, Paris, inv. Ch. M. 119. [Orsay 1986, p. 187—ill.]

Romaine Brooks, 1874–1970. "The Masked Archer"

(Cupid). Painting. **1910–11.** Unlocated. [Breeskin 1971, p. 21—ill.]

Wilhelm Schmidtbonn, 1876–1952. *Der spielende Eros* [Playful Eros]. Comedy. Berlin: Fleischel, **1911.** [Oxford 1986, p. 804]

Runar Schildt, 1888–1925. "Den segrande Eros" [The Victorious Eros]. Short story. **1912.** In *Den segrande Eros och andra berättelser,* vol. 1 of *Skrifter* (Helsingfors: Schildt, 1917). [DSL 1990, p. 545]

Delmira Agustini, 1886–**1914.** *El rosario de Eros* [Eros's Rosary]. Poem. Montevideo: Garcia, 1924. [LAW 1989, 2:653]

Michael Field (**Katherine Harris Bradley,** 1848–**1914,** and **Edith Cooper,** 1862–1943). "Eros," "Eros Does Not Always Smite." Poems. In *A Selection from the Poems of Michael Field* (Boston: Houghton Mifflin, 1925). [Boswell 1982, p. 245]

Michel Fokine, 1880–1942, choreography. *Eros.* Ballet. Scenario, Fokine, after a story by V. I. Svetloff, "A Fiesole Angel." Music, Tchaikovsky's *Serenade for Strings.* First performed 28 Nov **1915,** Maryinsky, St. Petersburg. [Fokine 1961, p. 306 / Chujoy & Manchester 1967, p. 368]

Edith Sitwell, 1887–1964. "The Web of Eros." Poem. In *The Mother and Other Poems* (privately printed, Oxford: Blackwell, **1915).** / Revised in *The Wooden Pegasus* (Oxford: Blackwell, 1920). [Brophy 1968, pp. 100f., 104]

Lovis Corinth, 1858–1925. "Eros." Painting. **1916.** Unlocated. [Berend-Corinth 1958, no. 676—ill.]

———. "Cupid with Bow and Arrow." Etching, illustration to Goethe's *Geschichte Gottfriedens von Berlichingen mit der eisernen Hand* (Berlin: Erich Steinthal, 1921). [Müller 1960, no. 519—ill.]

Edwin Arlington Robinson, 1869–1935. "Eros turannos" [Eros the Tyrant]. Poem. In *Man against the Sky* (New York: Macmillan, **1916).** [DLB 1987, 54 pt. 2: 378]

H. D. (Hilda Doolittle), 1886–1961. "Eros." Poem. **1916–17.** Last five sections, as "Fragment Forty," in *Heliodora and Other Poems* (London: Cape; Boston: Houghton Mifflin, 1924). [Martz 1983 / DLB 1986, 45:131]

Oskar Kokoschka, 1886–1980. "Eros and the Couple at the Table." Lithograph, illustrating the artist's play *Hiob.* **1916–17.** Berlin: Cassirer, 1917. [Wingler & Welz 1975, no. 96—ill.]

Wilfred Owen, 1893–1918. "To Eros." Sonnet. **1917.** In *Complete Poems and Fragments,* vol. 1 (London: Chatto & Windus, 1983). [Ipso]

Liza Lehmann, 1862–1918. "Blind Cupid." Song. [Cohen 1987, 1:409]

Frederic H. Cowen, 1852–1935, music. *Cupid's Conspiracy.* Comedy ballet. **1918.** [Grove 1980, 5:13]

Pablo Picasso, 1881–1973. "Cupid, Woman, Harlequin, Pierrot," "Cupid, Nude Woman, Harlequin, Pierrot Playing the Guitar," "Woman, Cupid, and Harlequin Playing the Guitar." Drawings. **1918.** 2 in Robert de Rothschild coll. in 1949; 1 unlocated. [Zervos 1932–78, 3: pls. 195, 197, 199]

———. Series of drawings, depicting a Minotaur shielding his eyes from his own image in a mirror held by Cupid, or from a dove emblazoned on a shield. 1953. [Ibid., 16: pls. 17–22, 30f; cf. pls. 24f; 9: pls. 96f; 10: pl. 520]

———. "Masked Cupid" ("Woman and Cupid"). Series of drawings. 1954. [Ibid., 16: pls. 124–41 / Penrose & Golding 1973, fig. 414]

———. "Bucolic Scene with Cupid Playing Castanets," "Bucolic Scene with Cupid in Upper Left." Etchings. 1955. [Bloch 1971–79, nos. 772, 776—ill.]

———. "Standing Nude and Cupid." Painting. 1968. [Zervos, 27: pl. 385]

———. "Cupid and Two Nudes," "Cupid, Men, and Reclining Nudes," "Nude and Cupid" (7 versions). Drawings. 1968. [Ibid., pls. 226, 264, 394–99, 401]

———. "Cupid and Bust of Tatooed Man." Drawing. 1969. [Ibid., 31: pl. 223]

Carl Paul Jennewein, 1890–1978. "Cupid and Gazelle." Bronze statuette. **1919.** 16 casts. Metropolitan Museum, New York, no. 33.162; Houston Art Museum, Texas; Brookgreen Gardens, S.C.; Cranbrook Academy of Art, Bloomfield Hills, Mich.; Montclair Art Museum, N.J.; others unlocated. [Metropolitan 1965, pp. 164–65—ill.]

Æ (George William Russell), 1867–1935. "The Grey Eros." Poem. In *Collected Poems* (London: Macmillan, **1920).** [TCLC 1978–89, 10:19 / Boswell 1982, p. 217]

———. "Eros." Poem. In *The House of the Titans and Other Poems* (New York: Macmillan, 1934). [Ipso]

Auguste Léveque, 1864–**1921.** "Hymn to Amour." Painting. Koninklijk Museum voor Schone Kunsten, Antwerp. [Bénézit 1976, 6:628]

Edna St. Vincent Millay, 1892–1950. "Not with Libations" ("worship of Love). Sonnet, no. 3 in an untitled cycle. In *Second April* (New York: Harper, **1921).** [Ipso]

Émile Bernard, 1868–1941. "The Young Woman and Cupid." Painting. **1922.** Private coll., Paris. [Luthi 1982, no. 1053—ill.]

———. "Crouching Nude and Little Cupid." Painting. 1927. Private coll. [Ibid., no. 1200—ill.]

Gabriela Mistral, 1889–1957. "Amo Amor" [Tyrant Love]. Poem. In *Desolación* (New York: Instituto de las Españas en los Estados Unidos, **1922).** [LAW 1989, 2:684]

Edith Södergran, 1892–**1923.** "To Eros" [English title of a work written in Swedish]. Poem. In *Landet som icke är* [The Land Which Is Not] (1925); reprinted in *Samlade dikter* (Stockholm: Wahlström & Widstrand, 1953). / Translated 1980. [DSL 1990, p. 550]

Paul Klee, 1879–1940. "Eros." Abstract watercolor. **1923.** Rosengart coll., Lucerne. [San Lazzaro 1957, p. 291—ill.]

Jan Parandowski, b.1895. *Eros na Olimpie* [Eros on Olympus]. Novel. Lublin: Altenberga, **1923.** [EWL 1981–84, 3:475]

Rainer Maria Rilke, 1875–1926. "Eros." Poem, in French. **1924.** In *Vergers* (Paris: Nouvelle Revue Française, 1926). [Zinn 1955–66, vol. 2 / Leishman 1960 / Leppmann 1984, p. 374 / Prater 1985, p. 369 / Strauss 1971, p. 208]

Babette Deutsch, 1895–1982. "Eros." Poem. In *Honey Out of the Rock* (New York & London: Appleton, **1925).** [DLB 1986, p. 110]

Ernst Krenek, 1900–1974. *Der vertauschte Cupidox* [Cupid Confounded]. Ballet, opus 38. Music after Rameau. First performed 25 Oct **1925,** Kassel. [Baker 1984, p. 1256 / Grove 1980, 10:255]

Denys Puech, 1854–1942. "Cupid and Dolphin." Bronze

sculpture group. Musées Nationaux, deposited in Palais du Sénat, Paris, in **1925**. [Orsay 1986, p. 279]

Léo Staats, 1877–1952, choreography. *Le triomphe de l'Amour.* Ballet. Music, Lully. First performed **1925**, L'Opéra, Paris. [Simon & Schuster 1979, p. 582]

Aristide Maillol, 1861–1944. "Cupid Drawing His Bow." Woodcut, illustration for edition of Virgil's *Eclogues* (Leipzig: Insel, **1926**). [Guérin 1965, no. 48—ill.]

Henry Benrath, 1882–1949. *Eros Anadyomenos.* Tale. Stuttgart: Deutsche Verlags-Anstalt, **1927**. [Kunisch 1965, p. 94]

Eric Gill, 1882–1940. Cupid appears in 9 wood-engravings decorating an edition of Chaucer's *Troilus and Creseyde* (Waltham St. Lawrence: Golden Cockerell, **1927**). (Victoria and Albert Museum, London.) [Physick 1963, nos. 403–46 passim—ill.]

———. "Cupid with Black Wings Cheering." Wood-engraving, decorative border for an edition of Chaucer's *Canterbury Tales* (Golden Cockerell, 1931). 1930. (Victoria and Albert Museum.) [Physick, no. 700]

———. "Cupid." Wood-engraving, for a bookplate. 1935. (Victoria and Albert Museum.) [Physick, no. 887]

William Butler Yeats, 1865–1939. (Eros celebrated in) "From the *Antigone*" (originally titled "Oedipus' Child"). Poem. **1927–28**. In *The Winding Stair* (New York: Fountain Press, 1929). / Revised by Ezra Pound, in *The Winding Stair and Other Poems* (London & New York: Macmillan, 1933). [Finneran 1983 / Clark 1983, pp. 186, 211–42, 250]

Arthur B. Davies, 1862–**1928**, design. "Eros." Tapestry. Artist's estate in 1930. [Metropolitan 1930, no. 179]

Conrad Aiken, 1889–1973. *Costumes by Eros.* Collection of poems. New York: Scribner, **1928**. [DLB 1986, 45:4]

Frederick Ashton, 1904–1988, choreography. "Entrée de Cupidon," in *Nymphs and Shepherds.* Ballet-divertissement. Music, after Mozart's *Les petits riens* (1778). First performed 9 Mar **1928**, by pupils of Marie Rambert, Arts Theatre Club, London. [Vaughan 1977, p. 453]

Henry Oliver Walker, 1843–**1929**. "Cupid and the Muse." Mural. Capitol Building, Washington, D.C. [Bénézit 1976, 10:612]

T. Sturge Moore, 1870–1944. "Suggested by the Representation on a Grecian Amphora of a Winged and Adolescent Eros Seeking to Catch a Hare in a Scarf." Poem. In *Poems,* vol. 3 (London: Macmillan, **1932**).

Luis Cernuda, 1902–1963. (Eros evoked in) "Donde habite el olvido" [Where Oblivion Dwells]. Poem. **1932–33**. In *Donde habite el olvido* (Madrid: Signo, 1934). [Capote 1984 / Jimenez-Fajardo 1978, pp. 38ff. / Schneider & Stern 1988, p. 144]

———. (Eros struggles with Artemis in) "Noche de luna" [Moonlit Night] (first called "Elegia a la luna a de España" [Elegy to the Moon and Spain]). Poem. 1937–40. In *Las nubes* (Buenos Aires: Colección Rama de Oro, 1943). [Capote / Jimenez-Fajardo, pp. 51–54]

Gerhard Marcks, 1889–1981. "Grieving Eros." Bronze sculpture. **1934**. At least 5 casts. Wallraf-Richartz-Museum, Cologne, inv. SK118; private colls., Germany and U.S.A. [Busch & Rudloff 1977, no. 297—ill.]

———. "Venus and Cupid" (Venus teaching Cupid archery). Bronze sculpture. 1952. At least 3 casts. Gerhard-Marcks-Stiftung, Bremen, inv. 95/71; Stadtverwaltung,

Herne; another on art market in 1977. [Ibid., no. 594—ill.] Bronze "Bust of Cupid," derived from above. Unique cast in Gerhard-Marcks-Stiftung, inv. 97/71. [Ibid.]

———. "Cupid." Bronze sculpture. 1960. At least 10 casts. Gerhard-Marcks-Stiftung, inv. 158/71; private colls. [Ibid., no. 740—ill.]

Stanley Bate, 1913–1959, music. *Eros.* Ballet. **1935**. [Grove 1980, 2:283]

Mary Anderson Lucas, 1882–1952, music. *Cupid and Death.* Ballet. **1936**. [Cohen 1987, 1:429]

Jules-Félix Coutan, 1848–**1939**. "Eros." Marble statue. Musées Nationaux, inv. RF 3949, deposited in Musée, Guéret, in 1955. [Orsay 1986, p. 269]

William Carlos Williams, 1883–1963. "Defiance to Cupid." Poem. **1939**. [MacGowan 1988]

David Gascoyne, 1916–. "Eros absconditus." Poem. **1937–42**. In *Poems 1937–1942* (London: Editions Poetry, 1943). [CLC 1987, 45:157]

George Barker, 1913–. *Eros in Dogma.* Collection of poems. London: Faber & Faber, **1944**. [CLC 1988, 48:8, 20 / Feder 1971, p. 380, 382]

Matta, 1912–. "Le vertige d'Éros" [The Giddiness of Eros]. Abstract painting. **1944**. Museum of Modern Art, New York, no. 65.44. [Barr 1977, p. 567—ill.]

Elie Nadelman, 1882–1946. "Eros Standing and Pointing." Bronze statue. *c.***1940–45?** Michael de Lisio coll., New York. [Kirstein 1973, no. 141]

Paul Valéry, 1871–**1945**. (Eros represents Dionysian view in) *Dialogue de l'arbre.* Dialogue. [Hytier 1957–60, vol. 2 / Mathews 1956–71, vol. 4 / Crow 1982, pp. 64, 131]

Finn Høffding, 1899–. *Eros.* Choral composition, opus 42. **1945**. [Grove 1980, 8:615]

Gunther Schuller, 1925–. *Vertige d'Eros* [Giddiness of Eros]. Symphonic poem. **1945**. First performed 15 Oct 1967, Madison, Wis. [Baker 1984, p. 2064]

Ruth Page, 1905–, choreography. (Cupid in) *Les petits riens.* Ballet. Music, Mozart (1778). First performed **1946**, Chicago; décor and costumes, Robert Davison. [Amberg 1949, p. 211]

Rodney Ackland, 1908–, with **Robert G. Newton,** 1903–. *Cupid and Mars.* Comedy. First performed 1 Oct **1947**, Arts Theatre, London. [DLEL 1970–78, 1:1]

Albert Paris Gütersloh, 1887–1973. *Die Fabeln von Eros* [The Fables of Eros]. Collection of stories. Vienna: Luckmann, **1947**. [EWL 1981–84, 2:309]

Cesare Pavese, 1908–1950. (Eros speaks with Thanatos in) "Il fiore" [The Flower]. Dialogue. In *Dialoghi con Leucò* (Turin: Einaudi, **1947**). / Translated by William Arrowsmith and D. S. Carne-Ross in *Dialogues with Leucò,* bilingual edition (Ann Arbor: University of Michigan, 1965). [Ipso]

César Klein, 1876–1954. "Eros." Painting. *c.***1948**. Private coll. [Pfefferkorn 1962, p. 87—ill.]

Gaetano Cecere, b. 1894. "Cupid and Stag." Marble sculpture group. By **1951**. Artist's coll. in 1951. [Agard 1951, p. 165, fig. 93]

Mark Brunswick, 1902–1971. *Eros and Death.* Choral symphony with mezzo-soprano. Text, after Lucretius and other Greek and Roman poetry. **1932–54**. [Grove 1986, 1:315 / Baker 1984, p. 367]

Juan Rulfo, 1918–1986. *Pedro Páramo.* Novel (on the Eros/

Thanatos theme). Mexico: Fonda de Cultura Económica, **1955**. / Translated by Lysander Kemp (New York: 1959). [LAW 1989, 3:1357]

Thomas Blackburn, 1916–. "Eros and Agape" (Eros, sensual love, contrasted with Agape, spiritual love). Poem. In *In the Fire* (London: Putnam, **1956**). [Boswell 1982, p. 44]

Miltos Sahtouris, 1919–. "Eros Slipped" [English title of a work written in Greek]. Poem. **1956**. / Translated by Kimon Friar in *Selected Poems* (Old Chatham, N.Y.: Sachem, 1982). [Ipso]

Mary Skeaping, 1902–, choreography. *Cupido*. Ballet, based on *Cupid Out of His Humor* (see Purcell, 1649). First performed 14 June **1956**, Royal Swedish Ballet, Court Theater, Drottningholm. [Terry 1976, p. 102]

Richard Selig, 1929–1957. "Eros." Poem. In *Poems* (Dublin: Dolmen, 1962). [Ipso]

Delmore Schwartz, 1913–1966. "Cupid's Chant." Poem. **1938–58**. In *Summer Knowledge* (Garden City, N.Y.: Doubleday, 1959). [Knapp 1970, pp. 515f.]

Quincy Porter, 1897–1966. *The God of Love*. Musical settings of 3 Elizabethan lyrics. **1959**. [Grove 1980, 15:137]

Amada Amy Santos-Ocampo de Francesco, 1927–. "Cupid and Death." Choral composition. **1960**. [Cohen 1987, 2:617]

Giorgio de Chirico, 1888–1978. "Cupid and the Minotaur" [*sic*] (Cupid riding on the back of a centaur). Painting. **1961**. M. M. coll., Trani. [de Chirico 1971–83, 3.3: no. 397—ill.]

Alojz Gradnik, 1882–1967. *Eros-Tanatos*. Cycle of poems. Lublin: Drzavna Zalozba Slovenije, **1962**. / Translated in *Selected Poems*, edited by Janko Lavrin (London: Calder, 1964). [Ipso]

André Masson, 1896–1987. "Masquerade on the Theme of Eros and Thanatos." Abstract painting. **1964**. [Clébert 1971, pl. 222]

R. Murray Schafer, 1933–. *The Geography of Eros*. Composition for soprano, pianoforte, harp, 6 percussion instruments, and tape. **1964**. [Grove 1980, 16:589]

R. P. Blackmur, 1904–1965. (Eros the destroyer in) "Scarabs for the Living." Poem. In *Poems* (Princeton: Princeton University Press, 1977). [Ipso]

Lisel Mueller, 1924–. "Eros." Poem. In *Dependencies* (Chapel Hill: University of North Carolina Press, **1965**). [Ostriker 1986, 287]

Isamu Noguchi, 1904–. "Eros." Marble statuette. **1966**. Artist's coll. in 1980. [Grove & Botnick 1980, no. 591—ill.]

Carlo Emilio Gadda, 1893–1973. *Eros e Priapo: Da furore a cenere* [Eros and Priapus: From Frenzy to Ashes]. Novel. Milan: Garzanti, **1967**. [EWL 1981–84, 2:187]

Kathleen Raine, 1908–. "Winged Eros." Poem. In *Collected Poems* (London: Hamilton, **1968**). [Boswell 1982, p. 283]

Denis Roche, 1937–. "Éros, cycle de lymne," "Éros élémentaire toujours a peu près octobre," "Éros énergumène," "Théâtre des agissements d'Éros." Poems. In *Éros énergumène* (Paris: Éditions du Seuil, **1968**). [Ipso]

Stanley Barstow, 1928–. *A Season with Eros*. Collection of short stories. London: Joseph, *c*.**1971**. [DLEL 1970–78, 2:21]

Jonathan Harvey, 1939–, music and text. "Angel/Eros." Song. **1973**. [Grove 1980, 8:271]

James Merrill, 1926–. "Cupid." Poem. In *The Yellow Pages: 59 Poems* (Cambridge, Mass.: Temple Bar Bookshop, **1974**).

C. H. Sisson, 1914–. "Blind Eros." Poem. In *In the Trojan Ditch* (Cheadle: Carcanet, **1974**). [Bedient 1975, p. 123]

Earl Staley, 1938–. "Cupid I." Watercolor. **1977**. Watson/de Nagy Gallery, Houston, in 1984. [Houston 1984, p. 84—ill.]

Judith Reher Martin, 1949–. *Eros Flies into a Tradition*. Electronic composition. **1978**. [Cohen 1987, 1:455]

James Underwood, 1951–. *To Eros*. Composition for soprano, violin, viola, piano, and percussion. **1980**. [Baker 1984, p. 2350]

Clara Janes, 1940–. *Eros*. Collection of poems. Madrid: Hiperion, **1981**. [Galerstein 1986, p. 151]

Ivana Loudova, 1941–. *Amor*. Choral work. **1981**. [Cohen 1987, 1:427]

Colin Way Reid, 1952–1983. "Eros." Poem. **1982**. In *Open Secret* (Gerrards Cross, Buckinghamshire: Colin Smythe, 1986). [Ipso]

Dieter Schnebel, 1930–. *Thanatos Eros*. Symphonic improvisations. First performed 2 Nov **1982**, Festival of International Society for Contemporary Music, Graz. [Slonimsky 1986, pp. 187f.]

Louise Glück, 1943–. (Eros betrays the poet in) "The Reproach." Poem. In *The Triumph of Achilles* (New York: Ecco, **1985**). [Ipso / CLC 1987, 44:218f., 221]

Iris Murdoch, 1919–. "Art and Eros." Dialogue. In *Acastos: Two Platonic Dialogues* (London: Chatto & Windus, **1986**). [CLC 1989, 51:291f.]

Erick Hawkins, 1909–, choreography. "The Birth of Eros from the World Egg," first section of *God the Reveller*. Modern dance. Music, Alan Hovhaness. First performed Dec **1987**, Erick Hawkins Dance Company, Joyce Theater, New York. [*New York Times*, 20 Dec 1987, Section H., p. 26]

Education of Eros. The popular tradition that Eros (Cupid) was the son of Aphrodite is emphasized in scenes depicting the boy-god's education. He is usually seen poring over a book while seated between his mother and Hermes (Mercury). The subject became popular in the Renaissance with the rise of interest in learning. Ares (Mars) is occasionally present as archery instructor. In some works the term "education" is taken to mean the chastisement of Eros for his malicious ways.

Classical Sources. Bion, "Love's Schooling." Lucian, *Dialogues of the Gods* 20, 23, "Aphrodite and Eros."

See also EROS, Punishment.

Antonio da Correggio, *c*.1489/94–1534. "Mercury Instructing Cupid before Venus" ("The School of Love"). Painting. **Mid-1520s.** National Gallery, London, inv. 10. [London 1986, p. 126—ill. / Gould 1976, pp. 124f., 213—ill. /

Berenson 1968, p. 92] Copies in Musée, Chalons-sur-Marne (on deposit from Louvre, Paris, inv. 49); Ham House, Richmond (as "Cupid, Mercury, and Psyche"). [Louvre 1979–86, 2:288 / Wright 1976, p. 43]

Antico, c.1460–**1528.** "Mercury." Bronze statuette (incomplete: presumed figure of Cupid missing; formerly known as "Mercury Teaching Cupid to Read"). Kunsthistorisches Museum, Vienna. [Louvre 1975, no. 60]

Giulio Romano, c.1499–1546, assistant, after design by Giulio. "The Education of Cupid." Stucco relief (pair with "The Forging of Cupid's Wings"). c.**1529–30.** Sala degli Stucchi, Palazzo del Tè, Mantua. [Verheyen 1977, pp. 123ff.]

Titian, 1488/90–1576. "Cupid Blindfolded" ("The Education [or Chastisement] of Cupid," "The Three Graces"). Painting. c.1565. Galleria Borghese, Rome, inv. 170. [Wethey 1975, no. 4—ill. / Pergola 1955–59, 1: no. 235—ill. / Berenson 1957, p. 190] See also EROS, Punishment.

————, studio (Lambert Sustris?). "Venus, Mercury, and Cupid" ("The Education of Cupid"). Painting. Late 1540s or c.1560. Kress coll. (K1694), El Paso Museum of Art, Texas, no. 1961–6/28. [Shapley 1966–73, 2:187—ill. / Wethey, no. X–43—ill.]

Italian School. "Venus Teaching Cupid to Shoot." Bronze statuette. **16th century.** Victoria and Albert Museum, London, inv. 442–1892. [Warburg]

Giovanni Francesco Romanelli, 1610–**1662.** "The Education of Cupid." Painting. / Engraved by Jean-Charles Le Vasseur (1734–1816). [Pigler 1974, p. 12]

Benedetto Luti, 1666–**1724.** "The Education of Cupid." Painting. 1717. Schönborn coll., Pommersfelden. [Voss 1924, p. 610] Further versions of the subject in Schloss, Wilhelmshöhe; Slott Rosenborg, Denmark. [Ibid., p. 362 / Pigler 1974, p. 12]

Charles-Joseph Natoire, 1700–1777. "Mercury and Cupid," "The Education of Cupid." Paintings, part of "Story of the Gods" series, for Château de La Chapelle-Godefroy, Champagne. c.1731. Musée des Beaux-Arts, Troyes, no. 203; Fine Arts Museum, Moscow. [Boyer 1949, nos. 35, 40 / Troyes 1977, pp. 54f.]

————. "The Education of Cupid." Painting. 1765. Musée, Ajaccio, Corsica, no. 552. [Boyer, no. 82]

Georg Raphael Donner, 1693–1741. "Mercury and Cupid." Lead sculpture. c.1736. Stiftsmuseum, Klosterneuberg, inv. KG176. [Schwarz 1968, no. 13—ill.]

François Le Moyne, 1688–**1737,** formerly attributed. "The Education of Amor." Painting. Louvre, Paris, no. M.I. 1087 (as French School, mid-18th century). [Bordeaux 1984, no. X24—ill. / Louvre 1979–86, 4:312—ill.]

François Boucher, 1703–1770. "The Education of Cupid." Painting. 1738. Los Angeles County Museum of Art, no. 47.29.10. [Ananoff 1976, no. 151—ill.]

————. "Mercury Educating Cupid." Painting. 1736–39. Archives Nationales, Paris. [Ibid., no. 164—ill.]

————. "The Education of Cupid" (by Mercury). Painting. c.1739. Lost. / Drawing. Nationalmuseum, Stockholm, no. 2946/1863. [Ibid., no. 166—ill.]

————. "The Education of Cupid." Painting. 1742. Staatliche Schlösser und Gärten, Berlin, no. GKI 4509. [Ibid., no. 204—ill.]

————. "The Drawing Lesson" (Venus teaching Cupid).

Painting. c.1751. Private coll., New York. [Ibid., no. 378—ill.]

Pierre-Charles Trémollière, 1703–**1739.** "The Education of Cupid." Painting. Hôtel de Soubise, Paris. [Bénézit 1976, 10:266]

Carle van Loo, 1705–**1765.** "The Education of Cupid." Painting. Musée, Aix-en-Provence. [Bénézit 1976, 6:729]

Pompeo Batoni, 1708–1787. "Venus Instructing Cupid." Painting. 1785. Archangelskoye Palace, near Leningrad. [Clark 1985, no. 452]

Francesco Zuccarelli, 1702–**1788.** "Venus Teaching Cupid Archery." Painting. Private coll. [Pigler 1974, p. 12]

André Grétry, 1741–**1813.** L'éducation de l'Amour. Musical romance. Libretto, composer. [Grove 1980, 7:711]

Henri Fantin-Latour, 1836–1904. "The Education of Cupid." Lithograph. 1865. [Hédiard 1906, no. 3–ill. / Fantin-Latour 1911, no. 206]

————. "The Education of Cupid" (Nymph giving arrows to Cupid). Painting. 1898. Basily-Callimaki coll. in 1911. [Fantin-Latour, no. 1695]

Narcisse-Virgile Diaz de la Peña, 1808–**1876.** "The Education of Cupid." Painting. Wallace Collection, London, no. P.268. [Walters 1982, no. 42 n.]

Solomon J. Solomon, 1860–1927. "Love's First Lesson" (Venus teaching Cupid archery). Painting. 1885. [Kestner 1989, p. 243]

Gerhard Marcks, 1889–1981. "Venus and Cupid" (Venus teaching Cupid archery). Bronze sculpture. **1952.** At least 3 casts. Gerhard-Marcks-Stiftung, Bremen, inv. 95/71; Stadtverwaltung, Herne; another on art market in 1977. [Busch & Rudloff 1977, no. 594—ill.] Bronze "Bust of Cupid," derived from above. Unique cast in Gerhard-Marcks-Stiftung, inv. 97/71. [Ibid.]

Punishment of Eros. The mischief caused among gods and mortals by the wanton arrows of Eros (Cupid) gave rise in the Hellenistic period to the theme of his punishment at the hands of his mother, Aphrodite (Venus), or others. In postclassical depictions Aphrodite may be seen spanking the boy with a rose branch or confiscating his arrows. The theme is often presented as an allegory of mischief or vice punished by virtue or chastity; here, Athena (Minerva), nymphs of Artemis (Diana), or the Graces are found reprimanding the undisciplined child. These scenes commonly show Eros deprived of his arrows, having his wings clipped, or tied to a tree.

Classical Source. Bion, *Idyllion* 1.

See also EROS, Education.

Girolamo di Benvenuto, 1470–**1524.** "The Punishment of Cupid." Painting, on a salver. Jarves coll., Yale University Art Gallery, New Haven, inv. 1871.65. [Pigler 1974, p. 14]

Andrea Riccio, c.1470–**1532.** "Venus Chastising Cupid." Bronze statuette. Stiftsmuseum, Klosterneuburg, in 1942. [Frick 1968–70, 3:100 / Pigler 1974, p. 13]

————. "Venus Chastising Cupid." Bronze plaquette. Staatliche Museen, Berlin; Henry Harris coll. [Pigler]

Antonio da Correggio, *c*.1489/94–**1534**, attributed. "Venus Disarming Cupid." Painting. Longford Castle, near Salisbury. [Gould 1976, p. 289] *See also Luca Cambiaso, below.*

Rosso Fiorentino, 1494–1540, and assistants. "Venus (Scolding Cupid)" ("Venus Frustrated" [by the departure of Mars?]). Fresco. **1535–40**; repainted/restored 18th, 19th centuries and 1961–66. Galerie François I, Château de Fontainebleau. [Revue de l'Art 1972, p. 126 and passim—ill. / Barocchi 1950, pp. 140f.—ill. / Panofsky 1958, pp. 157f.—ill.]

Titian, 1488/90–1576. "Cupid Blindfolded" ("The Education [or Chastisement] of Cupid," "The Three Graces"). Painting. *c*.1565. Galleria Borghese, Rome, inv. 170. [Wethey 1975, no. 4—ill. / Pergola 1955–59, 1: no. 235—ill. / Berenson 1957, p. 190] Copies in Landsresidenset, Karlstadt (on loan from Nationalmuseum, Stockholm); Museo de Bellas Artes, Seville; Kress coll. (K1804), National Gallery, Washington, D.C., no. 1095 ("Portrait of a Young Lady as Venus Binding the Eyes of Cupid," falsely attributed to Titian; by Lambert Sustris? Damiano Mazza?); another unlocated. [Wethey, nos. 4 *n*., X–5 / also Shapley 1966–73, 2:188—ill. / Sienkewicz 1983, p. 7—ill.] Variant copy ("Allegory of Venus and Cupid"), *c*.1565, incorporating elements from Titian's "Allegory of the Marchese del Vasto," attributed to Damiano Mazza or Lambert Sustris, in Chicago Art Institute. [Wethey, no. X–3] Copy after Washington version, in Ashmolean Museum, Oxford, cat. 1961 no. A226. [Wright 1976, p. 202]

Luca Cambiaso, 1527–1585, attributed. "Venus Disarming Cupid, and Pan." Painting (formerly attributed to Correggio). **1565–68**. Schloss Merkenau, Strasbourg-Müllerhof, in 1912. [Manning & Suida 1958, p. 153—ill.]

————, follower. "Venus Punishing Cupid." Drawing. Albertina, Vienna. [Ibid., p. 175—ill.]

Alessandro Allori, 1535–1607, and assistant. "Venus Disarming Cupid." Painting. **1560s**. 4 versions known. Kress coll. (K224), Los Angeles County Museum, Calif., no. 35.1; Musée, Montpellier; Uffizi, Florence, inv. 1514 (replica of Montpellier?); Hampton Court Palace. [Shapley 1966–73, 3:17f.—ill. / Uffizi 1979, no. P30—ill.]

Paolo Veronese, 1528–1588. "Venus Disarming Cupid." Painting. *c*.1578–82. Private coll., Rome. [Pallucchini 1984, no. 183—ill. / Pignatti 1976, no. 255—ill.]

Agostino Carracci, 1557–1602. "Venus Punishing the Profane Cupid." Engraving, in *"lascivie"* series (Bartsch no. 135). *c*.1590–95. [DeGrazia 1984, no. 182—ill.] Contemporary copy, painting, in Victoria and Albert Museum, London, no. D.48. [Kauffmann 1973, no. 61—ill.]

Tiziano Aspetti, *c*.1565–1607. "Venus Chastising Cupid." Bronze statuette. Museo Nazionale, Trient. [Pigler 1974, p. 13]

Michelangelo da Caravaggio, 1571–1610, circle (Bartolommeo Manfredi? also attributed to Caravaggio). "The Chastisement of Love" (by Mars, Venus trying to restrain him). Painting. *c*.1605–10. Art Institute of Chicago, no. 47.58. [Chicago 1961, p. 273—ill.]

Francesco Albani, 1578–1660. "Cupids Disarmed" (by Diana's nymphs; "Earth"). Painting, part of a cycle of Elements. *c*.1621. Louvre, Paris, inv. 11. [Louvre 1979–86, 2:140—ill.] Anonymous copies in Château de Fontainebleau, Musée, Poitiers (both on deposit from Louvre, Paris, inv. 34, 36). [Louvre 1979–86, 2:283]

Guido Reni, 1575–1642. "Venus with Cupid and Doves" ("Il diamante") (Venus taking away Cupid's bow). Painting. **1626**? Toledo Museum of Art, Ohio, no. 72.86. [Pepper 1984, no. 110—ill.] Copy, formerly in Kaiser Friedrich-Museum, Berlin, destroyed. [Ibid., fig. 43]

————, circle (attributed to Giovanni Andrea Sirani). "Cupid Disarmed by Venus, Juno, and Minerva." Painting. Yale University Art Gallery, New Haven, inv. no. 1871.102. [Pepper 1984, p. 301 no. C12 *n*. / Warburg]

Peter Paul Rubens, 1577–1640. "Venus and Captive Cupid." Drawing. *c*.1633–36? Staatliche Museen, Berlin, inv. 12.222. [Burchard & d'Hulst 1963, no. 198—ill.]

Nicholas Stone, *c*.1587–1647. "Diana Taking Her Repose Having Bereaved Cupid of His Bow and Arrow. . . ." Sculpture, for Gate at Windsor Castle. **1636**. [Whinney 1964, pp. 29f.]

Giovanni Francesco Susini, ?–1646. "Venus Burning the Arrows of Cupid," "Venus Chastising Cupid with Flowers." Pair of bronze statuettes. **1638–39**. 2 sets known. Louvre, Paris, nos. OA8276–77; Liechtenstein coll., Vaduz. [Avery & Radcliffe 1978, nos. 190–91—ill.] Marble version. 1642 (or 1632?). Acton coll., Villa La Pietra, Florence. [Ibid.]

Reynier van der Laeck, ?–*c*.1658. "Venus Scolds Cupid." Painting. 1640. Gemäldegalerie, Berlin-Dahlem, no. 984. [Berlin 1986, p. 42—ill.] Another version of the subject, 1640, in University, Göttingen, no. 99. [Pigler 1974, p. 13]

Georg Stjernhjelm, 1598–1672. *Then fångna Cupido* [Cupid Captured]. Adaptation of a French ballet scenario into Swedish verse. Stockholm: Keyser, **1649**. [DSL 1990, p. 582]

Diego Velázquez, 1599–1660, rejected attribution (Italian school). "Cupid." Painting, copy after figure in Titian's "Education [Chastisement] of Cupid" (*c*.1565, Borghese). Contini-Bonacossi coll., Florence. [López-Rey 1963, no. 60—ill.]

Maurizio Cazzati, *c*.1620–1677. *Le gare d'Amore e di Marte* [The Combat of Cupid and Mars]. Opera. First performed **1662**, Bologna. [Grove 1980, 4:42]

Pietro Antonio Cesti, 1623–1669. *Le disgrazie d'Amore* [Cupid Disgraced]. Opera. Libretto, F. Sbarra. Prologue, Leopold I of Austria. First performed 19 Feb **1667**, Vienna. [Grove 1980, 4:93]

Simon de Vos, 1603–1676. "The Punishment of Cupid." Painting. Gemäldegalerie, Berlin-Dahlem, no. 704. [Berlin 1986, p. 79—ill.]

Pietro Liberi, 1614–1687. "Venus Disarming Cupid." Painting. Bowes Museum, Barnard Castle. [Wright 1976, p. 117]

Willem van Mieris, 1662–1747. "The Punishment of Cupid." Painting. 1692. Szépművészeti Múzeum, Budapest, no. 427.2. [Budapest 1968, p. 446]

Carlo Agostino Badia, 1672–1738. *Cupido fuggitivo da Venere* [Cupid, Fugitive from Venus]. Musical entertainment. Libretto, G. Spedazzi. First performed Carnival, **1700**, Vienna. [Grove 1980, 2:9]

Sebastiano Ricci, 1659–1734. "The Taming of Cupid"

("Love Punished"). Painting. **1703.** Palazzo Marucelli-Fenzi, Florence. [Daniels 1976, no. 108—ill.]

Michel Corneille the Younger, 1642–1708. "Venus Chastising Cupid." Drawing. Louvre, Paris. [Pigler 1974, p. 13]

Matthew Prior, 1664–1721. "Love Disarm'd," "Mercury and Cupid." Poems. In *Poems on Several Occasions* (London: Tonson, **1709**). Modern edition by A. R. Waller (Cambridge: Cambridge University Press, 1905). [Ipso]

Antoine Watteau, 1684–1721. "Cupid Disarmed" (by Venus). Painting. *c.***1715.** Musée Condé, Chantilly. [Camesasca 1982, no. 124—ill. / also Grasselli & Rosenberg 1984, pp. 324—ill. / Posner 1984, p. 79—ill.]

————, attributed. "Cupid Shying away from Venus, Who Holds the Branch of a Rose Bush." Painting. Lost. [Camesasca, no. 6.a]

Nicolas Vleughels, 1668–1737. "The Punishment of Cupid" (tied to a tree, tormented by nymphs). Painting. **1720.** Hermitage, Leningrad, inv. 2520. [Hermitage 1986, no. 331—ill.]

Herman Collenius, 1650–**1720/21.** "Venus Punishing Amor." Painting. Nationaal Rijtuigmuseum, Leek, inv. P3. [Wright 1980, p. 80]

John Gay, 1685–1732. (Cupid's wings clipped in) "The Story of Cephisa." Poem. In *Miscellaneous Works* (London: Tonson?, **1733.** [Dearing & Beckwith 1974, vol. 2; cf. p. 638]

François Boucher, 1703–1770. "The Three Graces Chaining Cupid" (with flowers). Overdoor painting. **1736–38.** Archives Nationales, Paris. [Ananoff 1976, no. 162—ill.] Replica ("The Graces and Cupid"). 1738. Gulbenkian Foundation, Lisbon, inv. 433. [Ibid., no. 154—ill.]

————. "Venus Disarming Cupid," "Venus Punishing Cupid." Paintings. *c.*1740. Rothschild coll., Paris. [Ibid., nos. 178, 179—ill.]

————. "Cupid Chained by the Graces" (with flowers). Painting. *c.*1742. Reitinger coll., Paris. [Ibid., no. 207—ill.]

————. "Venus Disarms Her Son." Painting. Commissioned 1739, completed 1742. Private coll., New York. [Ibid., no. 241—ill.] Gouache replica, for theater décor, Hermitage, Leningrad, no. 39595. [Ibid.—ill.]

————. "Venus Disarming Cupid." Painting. 1749. Louvre, Paris, no. R.F. 289. [Ibid., no. 331—ill. / Louvre 1979–86, 3:81—ill.]

————. "Cupid Disarmed" (by Venus). Painting. 1751. Formerly Hearst coll., New York. [Ibid., no. 375—ill.]

————. "Cupid Imprisoned" (with flowers by the Graces). Painting. 1754. Wallace Collection, London, no. P.432. [Ibid., no. 429—ill.]

————. "Venus Disarming Cupid." Painting. Waddesdon Manor, Buckinghamshire, cat. 1967 no. 100. [Wright 1976, p. 23]

Pompeo Batoni, 1708–1787, and **Andrea Locatelli,** 1695–1741. "The Punishment of Cupid" (Nymphs tying Cupid to a tree). Painting. *c.***1738.** Unlocated. [Clark 1985, no. 16—ill.]

————, attributed. "Diana Breaking Cupid's Bow." Painting. *c.*1750. Unlocated. [Clark, no. 129—ill.]

———— "Diana and Cupid" (Diana taking away Cupid's bow). Painting. 1761. Metropolitan Museum, New York,

inv. 1982.438. [Clark, no. 235—ill. / von Erffa & Staley 1986, p. 35—ill.]

Charles-Joseph Natoire, 1700–1777. "The Three Graces Chaining Cupid." Painting. Exhibited **1738.** Palais du Luxembourg, Paris. [Boyer 1949, no. 56]

Ranieri Calzabigi, 1714–1795. *La gara fra l'Amore e la Virtú* [The Battle of Cupid and Virtue]. Opera (componimento drammatico). First performed 3 Aug **1745,** Naples. [Grove 1980, 3:635f.]

Ignaz Stern, 1680–**1748.** "Cupid Chastised." Painting. National Gallery of Ireland, Dublin, no. 1739. [Dublin 1981, p. 155—ill.]

Jean-Honoré Fragonard, 1732–1806. "Venus Binding Cupid's Wings." Painting. **1748–52.** Major Hugh Rose coll., London. [Wildenstein 1960, no. 52—ill.]

Étienne-Maurice Falconet, 1716–1791. "Little Girl Hiding Cupid's Bow." Sculpture. **1761.** Victoria and Albert Museum, London. [Levitine 1972, p. 42—ill. / also Réau 1922, p. 499]

————, attributed. "Venus Chaining Cupid with a Garland." Sculpture. 1763. Baron Edmund de Rothschild coll., France, in 1922. [Réau, p. 506]

————, attributed. "Venus Chastising Cupid." Marble statuette, part of "Venus and Cupid" series. 1770–80. Wallace Collection, London; elsewhere. [Levitine, pp. 44f.—ill. / also Réau, p. 506, pl. 15]

Joshua Reynolds, 1723–1792. "The Duchess of Manchester and Her Son Lord Mandeville in the Character of Diana Disarming Love." Painting. Exhibited **1769.** Wimpole Hall, Cambridgeshire. [Royal Academy 1986, no. 72—ill. (print) / also Waterhouse 1941, pl. 125]

Augustin Pajou, 1730–1809. "Venus Chaining Cupid" (with flowers) ("Venus Receiving the Apple from Cupid"). Stone sculpture group. **1771.** Sardou family coll., Marly-le-Roi. [Stein 1912, pp. 214–18, 403–4—ill.] Marble replica. Estate of A. de Rothschild, Vienna. [Ibid.]

Angelica Kauffmann, 1741–1807. "Cupid [tied to a tree] Distressed by Three Nymphs (or Virgins)." Painting, design for porcelain group, modeled by J. J. Spängler. By **1777.** F. Hurlbutt coll., Penyffordd. [Manners & Williamson 1924, pp. 5f., 225—ill.]

————. "The Disarming of Cupid." Painting. Kenwood House, London, cat. 1964 no. 75. [Wright 1976, p. 248]

————, attributed. "Euphrosyne Disarming Cupid." Ceiling painting. 39 Berkeley Sq., London. [Manners & Williamson, p. 132] Further versions of the subject known, in private colls. or unlocated in 1924. [Ibid., pp. 199, 201f., 223]

Joseph Nollekens, 1737–1823. "Venus Chiding Cupid." Marble sculpture group. **1778.** Usher Art Gallery, Lincoln. [Whinney 1964, p. 159, pl. 118A]

Jean-Frédéric Edelmann, 1749–1794. *L'Amour enchaîné par Diane* [Cupid Chained by Diana]. Opera. Libretto, Pierre Louis Moline. First performed **1783,** Paris. [Grove 1980, 12:466]

Pierre-Paul Prud'hon, 1758–1823. "Cupid Restrained by Reason" (chained to statue of Minerva, wounded by a nymph). Drawing, design for an engraving by Copia. Exhibited **1793.** Several versions, in private colls. or unlocated in 1924. [Guiffrey 1924, nos. 24–26] Variant,

painting, attributed to Prud'hon, sold 1856, 1869, untraced. [Ibid.]

———, doubtfully attributed. "Venus Disarming Cupid." Painting. Museum, Berlin, no. 540, in 1924. [Ibid., no. 205]

Lady Diana Beauclerk, 1734–1808. "Love in Bondage." Watercolor. *c.*1795. National Museum of Women in the Arts, Washington, D.C. [Washington 1987, p. 156—ill.]

Thomas Stothard, 1755–1834. "Cupid Bound by Nymphs." Painting. Exhibited **1814.** Tate Gallery, London, no. 319. [Tate 1975, p. 76]

———. "Cupid Bound to a Tree." Painting. Tate Gallery, London, no. 1832. [Ibid., p. 76]

Benjamin West, 1738–1820. "Venus Admonishing Cupid." Painting. Lost. [von Erffa & Staley 1986, no. 130]

Jan de Landtsheer, 1750–**1828?** "Venus Clipping Cupid's Wings." Painting. Formerly Musées Royaux des Beaux-Arts (Musée d'Art Moderne), Brussels, inv. 69, on deposit at Ministry of the Interior, lost or destroyed. [Brussels 1984b, p. 357—ill.]

Bertel Thorwaldsen, 1770–1844. "The Graces with Cupid in Chains of Roses." Marble relief. Modeled **1831.** Thorwaldsens Museum, Copenhagen, no. A375. [Thorwaldsen 1985, p. 49] Plaster original. Thorwaldsens Museum, no. A376. [Ibid.]

Horatio Greenough, 1805–1852. "Cupid Bound." Marble sculpture. **1834–35.** Museum of Fine Arts, Boston. [Gerdts 1973, pp. 23, 80, fig. 55]

William Hilton the Younger, 1786–1839. "Cupid Disarmed by Venus." Painting. Oldham Art Gallery, Oldham. [Bénézit 1976, 5:547]

Narcisse-Virgile Diaz de la Peña, 1808–1876. "Cupid Disarmed." Painting. **1850–55.** Walters Art Gallery, Baltimore, inv. 37.114. [Walters 1982, no. 42 *n.*] Further versions of the subject Musée d'Orsay, Paris, no. R.F. 1827 ("Nymph Reprimanding Cupid"); Wallace Collection, London, no. P266; others known from 19th-century sales, unlocated. [Ibid. / Louvre 1979–86, 3:226—ill.]

Jean-Baptiste Camille Corot, 1796–1875. "A Nymph Disarming (Playing with) Cupid." Painting. **1857.** Musée d'Orsay, Paris, no. R.F. 1782. [Louvre 1979–86, 3:153—ill. / Orangerie 1975, no. 76—ill. / also Robaut 1905, no. 1100—ill.] Replica (of figures). 1858. Legentil coll., Arras, in 1905. [Robaut, no. 1103—ill.]

———. "Cupid Disarmed." Painting. *c.*1865–70. Private coll. in 1945. [Schoeller & Dieterle 1948, no. 79—ill.]

———. "Venus Clipping Cupid's Wings." 2 etchings. *c.*1869–70. [Chicago 1960, nos. 179–80 / Delteil 1906–30, 5: nos. 10–11—ill. / Orangerie, no. 177—ill. / Robaut, nos. 3132–33—ill.] Variant, painting. *c.*1870–73. Emile Dekens coll. in 1895. [Robaut, no. 1998—ill.]

Henri Fantin-Latour, 1836–1904. "Cupid Disarmed." Lithograph. **1862.** [Hédiard 1906, no. 2–ill. / also Fantin-Latour 1911, no. 205]. Variant. 1892. [Hédiard, no. 98–ill. / also Fantin-Latour, no. 1490]. Pastel variant. 1893. [Fantin-Latour, no. 1502]. Numerous paintings of this subject, 1872–1904. [Ibid., no. 598, 657, 1437, 1505, 1543, 1836, 1882, 1977, 2049, 2101]

———. "Cupid Scolded" (by Venus). Painting. 1873. [Fantin-Latour, no. 663]. Replica. 1877. [Ibid., no. 832]. Variant, 1900. [Ibid., no. 1807]. Variant, 1903. [Ibid., no. 1962]

Jean-Baptiste Carpeaux, 1827–1875. "Cupid Disarmed." Bronze sculpture. *c.*1872. Clark Art Institute, Williamstown, Mass. [Seen by author] Plaster. Petit Palais, Paris. [Kocks 1981, p. 270—ill.]

———. "Venus Holding Cupid Captive." Terra-cotta sculpture sketch. *c.*1873. Musée d'Orsay, Paris, inv. R.F. 984. [Orsay 1986, p. 72—ill.]

William Bouguereau, 1825–1905. "Cupid Disarmed" ("Woman and Captive Eros"). Painting. **1885.** Exhibited Salon of 1886. [Montreal 1984, pp. 65, 180f–ill.]

Edmonia Lewis, b. 1843/45. "Poor Cupid" ("Love Ensnared"). Marble sculpture. *c.*1885. Private coll., Piermont, N.Y. [Gerdts 1973, p. 80, fig. 56]

Charles Ricketts, 1866–1931. "Captive Cupid." Bronze statuette. Exhibited **1906.** City Art Galleries, Manchester. [London 1968, no. 134]

Émile-Antoine Bourdelle, 1861–1929. "The Graces Disarming Cupid." Fresco. **1912.** Loge, Théâtre des Champs-Élysées, Paris. [Basdevant 1982, pp. 80f.—ill.]

Eros and Anteros. According to some mythographers, Anteros (literally, "answering love") was the son of Ares (Mars) and Aphrodite (Venus) and the younger brother of Eros (Cupid). A minor figure, he is variously and ambiguously described as both an avenger of slighted love and a symbol of reciprocal affection. Similarly, he is sometimes seen as an ally, sometimes an antagonist, of his elder brother. In the Renaissance, Eros and Anteros also came to symbolize sacred and profane love, a theme related to the notion of the "two Venuses," celestial and earthly.

Classical Sources. Cicero, *De natura deorum,* 3.23.59ff. Pausanias, *Description of Greece* 1.30, 6.23.3–5.

Further Reference. R. V. Merrill, "Eros and Anteros," *Speculum* 19 (1944): 265–84.

Andrea Mantegna, 1430/31–**1506,** and **Lorenzo Costa,** 1460–1535 (begun by Mantegna, completed by Costa after Mantegna's death). (Eros and Anteros in) "The Reign of Comus" ("The Gate of Comus"). Painting. Louvre, Paris, inv. 256. [Louvre 1979–86, 2:169—ill. / Lightbown 1986, no. 41—ill. / Louvre 1975, no. 128—ill. / Wind 1948, pp. 46f., fig. 59]

Antoine Héroët, 1492?–1568. (Anteros evoked in) *La parfaicte amye* [The Perfect Friend]. Poetic monologue. Paris: Dolet, **1542.** Modern edition by Christine Hill (Exeter: University of Exeter, 1981). [Merrill 1944, 265f., 280f.]

Maurice Scève, *c.*1510–*c.*1564. (Anteros as shepherd in) *Le saulsaye: Eclogue de la vie solitaire* [The Willow-Plantation: Eclogue of the Solitary Life]. Paris: **1547.** In modern edition by B. Guégan, *Oeuvres poëtiques completes* (Paris: Garnier, 1927). [DLLF 1984, 3:2143 / Merrill 1944, p. 281]

Marguerite de Navarre, 1492–**1549.** (Anteros evoked in) "La distinction du vray amour par dixains." Poem. First

collected by A. Lefranc in *Dernieres poesies* (Paris: Colin, 1896). [Merrill 1944, pp. 281f.]

Sodoma, 1477?–**1549**. "Terrestrial Venus with Eros and Celestial Venus with Anteros" ("Allegory of Love," "Love and Chastity"). Painting. Louvre, Paris, no. R.F. 2106. [Louvre 1979–86, 2:239—ill. / also Hayum 1976, no. 11—ill.]

Garofalo, *c.*1481–**1559**, and studio. "The Myth of Eros and Anteros." Fresco cycle. Palazzo di Ludovico il Moro, Ferrara. [Berenson 1968, p. 154—ill.]

Pierre de Ronsard, 1524–1585. (Anteros evoked in) "Magie, ou, Dèlivrance d'amour" [Wizardry, or, Deliverance from Love]. Poem, added to second (or later?) edition of *Le cinquiesme livre des odes* (Paris: *c.*1560?). [Laumonier 1914–19, vol. 2 / Merrill 1944, p. 282]

Paolo Veronese, 1528–1588. "Venus and Mercury [with an infant—Anteros?] before Jupiter." Painting, thought to be part of a lost cycle depicting the myth of Anteros, recorded in Sanudo coll., Venice, in 1648. *c.*1560–62. Formerly Contini-Bonacossi coll., Florence. [Pallucchini 1984, p. 76, no. 74—ill. / also Pignatti 1976, no. 117—ill.]

Étienne Jodelle, 1532–**1573**. (Anteros evoked in) *Les contr'amours*. Sonnet cycle. [Merrill 1944, p. 283]

———. (Anteros evoked in) *Les amours et autres poèsies* (Paris: 1574). Modern edition by G. Colletet and A. V. Bever (Paris: E. Sansot, 1907). [Ibid.]

Ambrose Dubois, 1543–**1614**. "Letter of Eros and Anteros." Painting. Musèe Granet, Aix-en-Provence. [Bènèzit 1976, 3:685]

Guido Reni, 1575–1642. (Eros and Anteros representing) "Sacred and Profane Love." Painting. **1622–23**. Galleria Spinola, Genoa. [Pepper 1984, no. 88—ill. / Gnudi & Cavalli 1955, no. 12 (as 1605–10)—ill.] Studio variants. Museo Civico, Pisa; Musée des Beaux-Arts, Dijon (by J. P. Naiger); private coll., Bermuda; Shipley Art Gallery, Edinburgh, in 1967–68; National Gallery of Victoria, Melbourne. [Pepper]

———, studio. "The Combat of Sacred and Profane Love." Painting. Christ Church, Oxford, no. 194. [Ibid. / Byam Shaw 1967, no. 194—ill.]

Ben Jonson, 1572–1637. (Eros and Anteros in) "Love's Welcome at Bolsover." Royal entertainment for Charles I. Performed 30 July **1634**, Bolsover Castle. [Herford & Simpson 1932–50, vol. 7]

Pedro Calderón de la Barca, 1600–1681. (Cupido, as unrequited love, and Anteros, as requited love, in) *La fiera, el rayo, y la piedra* [The Beast, the Thunderbolt, and the Stone]. Comedy. First performed May **1652**, Buen Retiro, Madrid; designed by Baccio del Bianco. [Valbuena Briones 1960–67, vol. 1 / O'Connor 1988, pp. 197–209]

Samuel Woodford, 1636–1700. (Anteros, "False Love," evoked in) "Epode." Poem. In *A Paraphrase upon the Canticles with Certain English Rimes* (London: **1679**). [Hieatt 1975, p. 167]

Ercole Bernabei, 1622–1687. *Erote ed Anderote*. Opera. Libretto, V. Terzago. First performed **1686**, Munich. [Grove 1980, 2:612]

Francesco Corradini, *c.*1700–after 1749, music. *Vencer y ser vencido: Anteros y Cupido* [To Conquer and Be Conquered: Anteros and Cupid]. Zarzuela. First performed 14 Feb **1735**, Principe. [Grove 1980, 4:798]

Henry Fuseli, 1741–1825. "Lascivious Old Anteros Approaching the Coquettish God [Cupid]." Drawing. **1790–1800**. Dreyfuss coll., Basel. [Schiff 1973, no. 992—ill.]

Gérard de Nerval, 1808–1855. "Antéros." Sonnet, part of "Les chimères." First published as appendix to *Les filles du feu* (Paris: Giraud, **1854**). [Strauss 1971, pp. 69, 73]

Dante Gabriel Rossetti, 1828–1882. (Anteros evoked in) "Hero's Lamp." Sonnet, no. 88 in "The House of Life" sequence (augmented version). In *Ballads and Sonnets* (London: Ellis, **1881**). [Doughty 1965]

Alfred Gilbert, 1854–1934. "An Offering to Hymen" (woman holding statuette of Anteros and silver goblet). Bronze statuette. **1884–86**. Numerous casts. City Art Galleries, Manchester, England (2 casts); National Museum of Wales, Cardiff; Victoria and Albert Museum, London; Ashmolean Museum, Oxford; elsewhere. [Minneapolis 1978, no. 95—ill. / Beattie 1983, pl. 134]

———. "Anteros." White metal statuette, enlargement of figure in "Offering to Hymen," above. 1893–96. Birmingham City Museum and Art Gallery, England; elsewhere. [Minneapolis 1978, p. 181—ill.] Plaster model. City Museum, Winchester. [Ibid.]

———. (Female figures representing Eros and Anteros, in bronze reliefs, part of) "Mors Janua Vitae." Sculpture, memorial to Edward P. P. Macloghlin. 1905–09. Royal College of Surgeons, London. [Ibid., pp. 43ff.—ill.]

Robert Duncan, 1919–1988. "Anteros." Poem, translation of part of "Les chimères" of Gérard de Nerval (1854). In *Bending the Bow* (New York: New Directions, **1968**). [Ipso / Boswell 1982, p. 253]

Eros and the Bee. In an idyll ascribed to Theocritus (but now rejected), the tale is told of the infant Eros (Cupid) stung by a honeybee as he tried to steal a honeycomb. Running to his mother, Aphrodite (Venus), for comfort, the mischievous god received an object lesson: now he knew what pain his arrows inflicted on others. Although he cried pitifully, the boy-god did not take her moral to heart.

Most postclassical treatments are poetic derivations of the antique idyll or its Anacreontic imitation.

Classical Sources. Theocritus, *Idylls*, no. 19, "Eros and the Bee" (rejected attribution). *Anacreontea* 25 (imitation of Pseudo-Theocritus).

Further Reference. James Hutton, "Cupid and the Bee," *Publications of the Modern Language Association* 56 (1941): 1036–58 [lists more than 130 literary treatments of the theme].

Albrecht Dürer, 1471–1528. Venus and Cupid, the Honey-Thief." Drawing. **1514**. Kunsthistorisches Museum, Vienna. [Strauss 1974, no. 1514/33—ill.]

Philipp Melanchthon, 1497–1560. "E parvo alveolo." Imitation of Pseudo-Theocritus. In Joánnes Soter's *Epigrammata graeca veterum* (Cologne: **1528**). [Hutton 1941, pp. 1040f. / Wind 1968, p. 91]

Lucas Cranach, 1472–1553, and studio. "Venus with Cupid Stealing Honey." Painting. Numerous versions, **1530–**

31 and after 1537. Statens Museum for Kunst, Copenhagen, no. 145; Galleria Borghese, Rome, no. 326; Metropolitan Museum, New York, no. 1975.1.135; Musées Royaux des Beaux-Arts, Brussels, no. 4759 (989); Germanisches Nationalmuseum, Nuremberg (2); Rijksmuseum Kröller-Müller, Otterlo, cat. 1969 no. 48; New York Historical Society, New York, cat. 1915 no. B–196; National Gallery, London, inv. 6344; others in private colls. or unlocated. [Friedländer & Rosenberg, nos. 244–45, 246e-f, 247–48, 395–96, 398, 400—ill.; cf. no. 246R / also Copenhagen 1951, no. 145—ill. / Pergola 1955–59, 1: no. 229—ill. / Metropolitan 1980, p. 36—ill. / Brussels 1984a, p. 76—ill. / London 1986, p. 135—ill.]

Pierre de Ronsard, 1524–1585. "Le petit enfant Amour." Ode. In *Le cinquiesme livre des odes* (Paris: **1553**). [Laumonier 1914–75, vol. 3 / Hutton 1941, pp. 1050, 1053]

Luigi Alamanni, 1495–1556. Imitation of Pseudo-Theocritus, Idyll 19. **1547–55.** In modern edition by Raffaelli, *Opere,* vol. 2 (Florence: 1859). [Hutton 1941, p. 1043]

Rémy Belleau, 1528?–1577. "Amour ne voyoit." Imitation of Anacreontic ode. In *Odes d'Anacréon* (Paris: **1556**). [Doyle 1974, p. 192 / Hutton 1941, p. 1053]

Julius Caesar Scaliger, 1484–1558. "Dum cellas vexat." Ode, imitation of Pseudo-Theocritus. 1594. In *Poemata* (Heidelberg: 1600). [Hutton 1941, p. 1042]

Olivier de Magny, 1529–1561. "Amour, bizet, en pleurant" [Cupid, Stung, Crying]. Ode. In *Odes* (Paris: Wechel, **1559**). [Hutton 1941, p. 1054]

Thomas Watson, 1557?–1592. "Cupid and Bee." Poem. In *Poems, or, Passionate Centurie of Love* (London: Cawood, **1582**). [Hutton 1941, p. 1047]

Torquato Tasso, 1544–1595. "Mentre in grembo a la madre Amore" [While His Mother Held Cupid in Her Lap]. Poem. **1586.** In *Rime* (Ferrara: Vasalini, 1587–90). Modern edition, Bologna: 1898, vol. 2. [Hutton 1941, p. 1043]

Edmund Spenser, 1552?–1599. "Upon a day as Love lay sweetly slumbring." Poem, part of *Amoretti.* In *Amoretti and Epithalamion* (London: Ponsonbie, **1595**). [Oram et al 1989 / Hutton 1941, pp. 1047, 1049ff.]

Gian Battista Guarini, 1538–1612. "Punto da un'ape" [Stung by a Bee]. Poem (madrigal). No. 73 in *Rime* (Venice: Ciotti, **1598**). [Hutton 1941, p. 1044]

Thomas Lodge, 1558?–1625. "In pride of youth" (Cupid and the bee). Poem. In *England's Helicon* (London: Flasket, **1600**). Modern edition by Hyder E. Rollins, *England's Helicon* vol. 1 (Cambridge, Mass.: Harvard University Press, 1935). [Hutton 1941, p. 1055]

Thomas Bateson, c.1570/75–1630, music and lyric. "Cupid in a Bed of Roses." Madrigal. In *Second Set of Madrigals* (London: **1610**). In modern edition by E. H. Fellowes, *English Madrigal Verse* (London: Oxford University Press, 1967). [Grove 1980, 2:285(1618) / Doyle 1974, p. 201 / Hutton 1941, p. 1055]

William Drummond of Hawthornden, 1585–1649. "Ingenious was that Bee." Poem. In *Poems* (Edinburgh: Hart, **1614**). In modern edition by L. E. Kastner, *Poetical Works,* vol. 2 (Edinburgh: Blackwood, 1913). [Hutton 1941, p. 1051]

Robert Herrick, 1591–1674. "The Wounded Cupid," (Cupid bitten by a flea, reflection of bee theme, in) "Upon Cupid," (Venus settles fight of two cupids over some honey in) "The Bag of the Bee." Poems. In *Hesperides* (London: Williams & Eglesfield, **1648**). [Martin 1956 / Hutton 1941, p. 1055]

Thomas Stanley, 1625–1678. "Love, a Bee that lurk'd among roses." Poem, translation of Anacreontic ode. **1649.** In *Anacreon* (London: Moseley, 1651). [Doyle 1974, p. 201 / Hutton 1941, p. 1056]

John Birkenhead, 1616–1679. "Cupid and the Bee." Poem, imitation of Anacreontic ode. [Doyle 1974, pp. 193f., 202] Set to music by Henry Lawes, published in *The Second Book of Ayres and Dialogues* (London: Playford, **1655**). [Ibid., p. 194]

Abraham Cowley, 1618–1667. "Cupid and Bee." Poem. In *Poems* (London: Moseley, **1656**). [Doyle 1974, p. 195]

Francesco de Lemene, 1634–1704. "Amor crudele" [Cruel Cupid]. Lyric poem, imitation of Pseudo-Theocritus. In *Dio, sonetti et immi* (Bologna: **1694.**) [Hutton 1941, p. 1045]

Antoine-Louis Le Brun, 1680–1743. "L'Amour piqué" [Cupid Stung]. Poem. In *Epigrammes, madrigals, et chansons* (Paris: Breton fils, **1714**). [Hutton 1941, p. 1047]

Antoine Coypel, 1661–1722. "Cupid Stung by the Honeybee." Painting. / Engraved by Claude Duflos (1665–1727). [Pigler 1974, p. 253]

John Addison. "As Cupid 'midst the Roses play'd." Poem, translation of Anacreontic ode. In *The Works of Anacreon Translated into English Verse* (London: **1735**). [Hutton 1941, pp. 1037, 1051]

Benjamin West, 1738–1820. "Cupid Stung by a Bee." Painting. **1774.** Corcoran Gallery, Washington, D.C. [von Erffa & Staley 1986, no. 131—ill.]

———. "Cupid Stung by a Bee." Painting. c.1786. Hermitage, Leningrad. [Ibid., no. 132—ill.] Replica. c.1796–1802? Nelson-Atkins Museum of Art, Kansas City, Mo. [Ibid., no. 133—ill. (cf. no. 136)]

———. "Cupid Stung by a Bee." Painting. 1802. Private coll. [Ibid., no. 134—ill.]

———. "Cupid Stung by a Bee." Painting. 1796?–1813. Norwich Castle Museum, England. [Ibid., no. 135—ill.]

Bertel Thorwaldsen, 1770–1844. "Cupid, Stung by a Bee, Complains to Venus." Marble relief. Modeled **1809.** At least 4 marble versions, 1811(?)–28. Thorwaldsens Museum, no. A417; Lord Lucan coll., Laleham House, Middlesex; other private colls.; others lost or destroyed. [Thorwaldsen 1985, pp. 52, 77 / Cologne 1977, no. 42, p. 45—ill.] Variant. Biblioteca Ambrosiana, Milan. [Cologne, no. 42] Plaster original, 1809. Thorwaldsens Museum, no. A780. / Plaster variant. Thorwaldsens Museum, no. A418. [Thorwaldsen, p. 52]

Antoine-Jean Gros, 1771–1835. "Amor, Stung by a Bee, Complains to Venus." Painting. Musée des Augustins, Toulouse. [Bénézit 1976, 5:231]

Reinhold Begas, 1831–1911. "Venus Comforting Cupid." Marble sculpture. **1864.** Nationalgalerie, Berlin. [Janson 1985, p. 173—ill.]

Giosuè Carducci, 1836–1907. "Mentre da dolci favi" [While from the Sweet Honeycomb]. Poem. In *Odi barbare* (Bologna: Zanichelli, **1877**). [Hutton 1941, p. 1043]

Jean-Antoine-Marie Idrac, 1849–1884. "Cupid Stung." Plaster statue. Musées Nationaux, inv. RF 3997, deposited in Musée, Quimper. [Orsay 1986, p. 273]

Eros Triumphant. The triumph of Eros (Cupid) over bestiality and other negative forces derives from the famous line in Virgil's tenth Eclogue, "Omnia vincit Amor" ("Love conquers all"). The theme is often illustrated in postclassical art as Pan (or a satyr) subdued by the boy-god. Other depictions show an exultant young Cupid celebrating either the victory of love over impediments or his capture of another heart.

Classical Source. Virgil, *Eclogues* 10.69.

Filarete, *c.*1400–1469? "Eros and Pan." Relief, on bronze door of St. Peter's, Rome. **1433–45.** In place. [Pope-Hennessy 1985b, 2:318]

Cecchin Salviati, 1510–1563. "Triumph of Cupid." Drawing, design for a tapestry. Uffizi, Florence. [Warburg]

Luca Cambiaso, 1527–1585. "Love Conquers All." Drawing for a lost fresco in the Palazzo della Meridiana, Genoa. Princeton University Art Museum, N.J., inv. no. 48–657. [Warburg]

Agostino Carracci, 1557–1602. "Cupid Overpowering Pan" (allegory of love overcoming nature). Fresco. *c.*1591–92. Palazzo Masetti (now Associazione Commerciante), Bologna. [Ostrow 1966, no. I/10]

———. "Gold Wins All" (Cupid breaking bow as old man seduces young woman with gold). Print, in *"lascivie"* series (Bartsch no. 114). *c.*1590–95. [DeGrazia 1984, no. 190—ill.]

———. "Omnia vincit Amor" (Cupid protecting nymph from satyr). Print. 1599. [Ibid., no. 210—ill.]

Cavaliere d'Arpino, 1568–1640. "Amor vincit omnia" (Cupid conquerer of Pan, crowned by Venus and Juno). Fresco. **1594–95.** Loggia Orsini, Palazzo del Sodalizio dei Picini, Rome. [Kempter 1980, p. 72—ill. / Röttgen 1969, pp. 279ff.—ill.]

Annibale Carracci, 1560–1609. "Cupid Overcoming Pan." Fresco. **1597–1600.** Galleria, Palazzo Farnese, Rome. [Malafarina 1976, no. 104n—ill. / Martin 1965, pp. 95f.—ill.]

Michelangelo da Caravaggio, 1571–1610. "Victorious Cupid" ("Amor vincit omnia"). Painting. **1601–02.** Gemäldegalerie, Berlin-Dahlem, no. 369. [Berlin 1986, p. 21—ill. / Hibbard 1983, fig. 98 / Augsburg 1975, no. E34—ill.]

Johann Liss, *c.*1595–1629. "Amor (Vincit)." Painting. Late work. Cleveland Museum of Art, Ohio, no. 71.100. [Cleveland 1982, no. 71—ill. / Augsburg 1975, no. A29—ill.]

Orazio Riminaldi, 1586–1630/31. "Amor Victorious" ("Love the Artificer"). Painting. Palazzo Pitti, Florence. [Bissell 1981, fig. 184 / Pitti 1966, p. 231—ill.]

———. "Love Triumphant." Painting. National Gallery of Ireland, Dublin, no. 1235. [Dublin 1981, p. 139—ill.]

Giovanni da San Giovanni, 1592–1636. "Cupid and Pan." Fresco, detached, one of a series of 8 for Lorenzo de' Medici. *c.*1634. Uffizi, Florence, inv. 5420. [Uffizi 1979, no. P733—ill. / Banti 1977, no. 60]

Orazio Gentileschi, 1563–1639, circle. "Amor Victorious." Painting. Castle, Prague. [Bissell 1981, no. X–2]

Claudio Monteverdi 1567–1643, music. *La vittoria d'Amore* [The Victory of Cupid]. Ballet. Libretto, Morandi. First performed **1641,** Piacenza. [Grove 1980, 12:530 / Redlich 1952, pp. 37, 187]

Guido Reni, 1575–1642, questionably attributed, design? "Victorious Cupid." / Several versions of composition known: Kunsthistorisches Museum, Vienna, inv. 237; Hermitage, Leningrad (previously attributed to Domenichino, now to Elisabetta Sirani); Louvre, Paris, inv. 559, on deposit in Musée, Vichy; others known, unlocated. [Pepper 1984, p. 300 no. C7 / Louvre 1979–86, 2:298]

Alessandro Turchi, 1578–1649. "Allegory of the Power of Love" ("Omnia vincit Amor"). Painting. Rijksmuseum, Amsterdam, inv. C1372. [Rijksmuseum 1976, p. 549—ill.]

Simon Vouet, 1590–1649, or studio. "Pan and Cupid." Painting, cartoon for "Loves of the Gods" tapestry series. [Crelly 1962, no. 270h]

Paul de Vos, *c.*1596–1678, with **Jan van den Hoecke,** 1611–1651 (figure of Cupid). "Cupid as Victor" ("Amor vincit omnia"). Painting. **1640s.** Kunsthistorisches Museum, Vienna, inv. 3554 (1119). [Vienna 1973, p. 200—ill.]

Jusepe de Ribera, *c.*1590/91–1652, formerly attributed. "Cupid Whipping a Satyr" ("Cupid Conquers Pan"). Etching (Bartsch no. 12). [Brown 1973, no. P.18—ill.]

Nicolas Poussin, 1594–1665, attributed. "Venus, Cupid, and Pan" ("Omnia vincit Amor"). 2 drawings. Royal Library, Windsor Castle, nos. 11980, 11915. [Friedlaender & Blunt 1953, nos. 209–10—ill.]

———, questionably attributed. "Venus and Cupid" ("Amor vincit omnia"). Painting (copy after lost original?). *c.*1630? Hermitage, Leningrad. [Thuillier 1974, no. 38—ill. / Wright 1985, no. A15 / also Blunt 1966, no. R59 (as "Hovingham Master")]

———, attributed (or Pier Francesco Mola?). (Cupid in) "Landscape with Nymphs and Satyrs" ("Amor vincit omnia," "Pan with Infant Bacchus"). Painting. Late 1620s? or 1640s? Cleveland Museum of Art, Ohio, no. 26.26. [Wright, no. 37, pl. 122 / Blunt, no. R58 / Thuillier, no. R124—ill. / Cleveland 1982, no. 50—ill.]

Pier Francesco Mola, 1612–1666/68. "Amor vincit omnia." Drawing. Lugt coll., Institut Neerlandais, Paris. [Warburg]

Filippo Lauri, 1623–1694, style. "Amor vincit omnia." Painting. Shugborough, Staffordshire. [Wright 1976, p. 115]

Marc-Antoine Charpentier, 1645/50–1704. "Amor vince ognicola ('All' armi')" [Love Conquers All (To Arms)]. Musical pastorale. In *Pastorelette.* [Grove 1980, 4:174]

Antonio Verrio, *c.*1639–1707. "Triumph of Cupid." Fresco. Queen Anne's Drawing Room, Hampton Court Palace. [Warburg]

Carlo Cignani, 1628–1719. "Triumph of Love." Fresco. Palazzo del Giardino, Parma. / Copy in Museum of Fine Arts, Boston, no. 28.856. [Boston 1985, p. 51—ill.]

Claudio Francesco Beaumont, 1694–1766. "Triumph of Love." Ceiling painting. *c.*1740. Armory, Royal Palace, Turin. [Llewellyn 1984, p. 121]

Jean-Honoré Fragonard, 1732–1806. "Love Triumphant, Standing on a Pedestal in an Arbor." Painting for Salon of Gilles Demarteau. **1748–52.** Pierre Groult coll. [Wildenstein 1960, no. 63—ill.]

———. "The Triumph of Love." Painting. 1765–72. Lost. [Ibid., no. 312]

———. "Love Triumphant." Painting, part of "Progress of Love" cycle, originally intended as overdoor decora-

tion for Pavillion de Louveciennes. *c.*1790. Frick Collection, New York. [Wildenstein, nos. 530—ill. / Rosenberg 1988, pp. 320f.—ill. / Frick 1968–70, 2:100]

François Boucher, 1703–1770. "Cupid Victorious" (over another amorino). Painting. *c.*1752. Private coll., Paris. [Ibid., no. 416—ill.] Replica, as a detail in "The Chariot of Apollo," 1753. Ceiling, Salle de Conseil, Palais de Fontainebleau. [Ananoff 1976, no. 417—ill.]

Giovanni Domenico Tiepolo, 1727–1804, or **Giovanni Battista Tiepolo,** 1696–1770. "Triumph of Amor." Fresco (detached). *c.*1760–70. Musée Rothschild-Ephrussi, Cap Ferrat. [Mariuz 1979, p. 116 (as Giandomenico) / Morassi 1962, p. 44—ill. (as Giambattista) / Pallucchini 1968, p. 136 (as uncertain attribution)]

Giovanni Battista Cipriani, 1727–1785. "The Triumph of Cupid." Watercolor. By **1781.** Victoria and Albert Museum, London, no. 1737–1871. [Lambourne & Hamilton 1980, p. 64]

Italian School. "Cupid the Conqueror" (seated on Jupiter's eagle). Marble relief. **18th century.** Galleria Borghese, Rome, inv. 74. [Faldi 1954, no. 14—ill.]

Philipp Otto Runge, 1777–1810. "Triumph of Cupid" (first version). Drawing. **1800.** Kunsthalle, Hamburg, inv. 34237. [Hamburg 1977, pp. 150ff., no. 121—ill.] Variant. Private coll., Hamburg. [Ibid., no. 122—ill.]

————. "Triumph of Cupid" (second version). Painting. **1802.** Kunsthalle, Hamburg, inv. 2691. [Ibid., pp. 155ff., no. 127—ill. / Hamburg 1969, p. 275—ill.]

Benjamin West, 1738–1820. "Omnia vincit Amor, or, The Power of Love in Three Elements" (Cupid with Venus and lion, seahorse, eagle, representing the Elements). Painting. **1809–10.** Metropolitan Museum, New York, no. 95.22.1. [Metropolitan 1965–85, 1:35—ill. / von Erffa & Staley 1986, no. 422—ill.]

Bertel Thorwaldsen, 1770–1844. "Cupid Triumphant." Marble statue. Modeled **1814.** At least 2 examples. Rathaus, Vienna; Thorwaldsens Museum, Copenhagen, no. A804 (executed by R. Andersen and T. Stein, 1897–99). [Thorwaldsen 1985, p. 22 / Cologne 1977, no. 68, p. 38—ill.] Original plaster. Thorwaldsens Museum, no. A22. [Thorwaldsen, pl. 15] Plaster variant ("Cupid Triumphant, Examining His Arrow"). 1823. Thorwaldsens Museum, no. A24. [Thorwaldsen, p. 22 / Cologne, p. 160—ill.] Marble version of variant (executed by J. Scholl, 1845–54). Thorwaldsens Museum, no. A23. [Thorwaldsen, p. 38]

Walter Savage Landor, 1775–1864. "Cupid and Pan" [English title of a work written in Latin]. Idyll. In *Idyllia heroica* (Oxford: Munday & Slatter, **1815**). / Translated by the author in *Hellenics* (London: Moxon, 1847). [Wheeler 1937, vol. 2 / Pinsky 1968, pp. 56f., 134–40]

Friedrich Bury, 1763–**1823.** "Amor Triumphant." Painting. Mauritshuis, The Hague, inv. 272. [Mauritshuis 1985, p. 347—ill.]

Paul Taglioni, 1808–1884, choreography. *Amor's Triumph.* Ballet. Music, H. Schmidt. First performed **1835,** Berlin. [Oxford 1982, p. 406]

Holme Cardwell, 1820–**1856.** "Cupid and Pan." Sculpture. Victoria and Albert Museum, London. [Bénézit 1976, 2:522]

William Bouguereau, 1825–1905. "Eros Triumphant."

Painting. **1886.** Exhibited Salon of 1887. [Montreal 1984, p. 65]

Jean-Léon Gérôme, 1824–1904. "Whoever You Are, Here Is Your Master" ("Love, the Conqueror") (Cupid with wild animals). Painting. **1889.** Art Institute of Chicago. [Ackerman 1986, no. 361—ill.]

Arthur B. Davies, 1862–1928. "Amor contra mundam." Painting. **1897.** C. M. Pratt coll., Brooklyn. [Cortissoz 1931, p. 20]

Elihu Vedder, 1836–1923. "Love Ever Present" ("Love Amid Ruins," "Superest Invictus Amor," "Amor omnia vincit"). Painting. **1887–99.** Ricau coll., Piermont, N.Y. [Soria 1970, no. 440—ill. / Soria et al. 1979, fig. 181 / Dijkstra 1986, pp. 199f.—ill.]

Pierre de Bréville, 1861–1949. *Eros vainqueur* [Eros the Victor]. Opera (conte lyrique). Libretto, Jean de Lorrain. Commissioned 1900, completed **1905.** First performed 7 Mar 1910, Brussels. [Baker 1984, p. 343 / Grove 1980, 3:272]

Runar Schildt, 1888–1925. "Den segrande Eros" [The Victorious Eros]. Short story. **1912.** In *Den segrande Eros och andra berättelser,* vol. 1 of *Skrifter* (Helsingfors: Schildt, 1917). [DSL 1990, p. 545]

Michael Field (**Katherine Harris Bradley,** 1848–**1914,** and **Edith Cooper,** 1862–1943). "Onycha: Pan to Eros." Poem. In *A Selection from the Poems of Michael Field* (Boston: Houghton Mifflin, 1925). [Boswell 1982, p. 242]

Isidore Konti, 1862–1938. "Pan and Cupid." Sculpture. By **1918.** [Clapp 1970, 2 pt. 2: 672]

Rudolf Heubner, 1867–1967. *Amor vincit omnia.* Novella. In *Katastrophen* (Leipzig: Staackmann, **1924**). [NUC]

ETEOCLES. *See* OEDIPUS; SEVEN AGAINST THEBES.

EUROPA. Daughter of King Agenor of Tyre and sister of Cadmus, Europa was desired by Zeus (Jupiter). He instructed Hermes (Mercury) to drive a herd of cattle to the seashore, where Europa was playing. There, Zeus disguised himself as a handsome white bull and with feigned gentleness enticed the girl to climb onto his back. He then swam out to sea, carrying Europa away to Crete, where she bore him Minos, Rhadamanthys, and, in some accounts, Sarpedon. Zeus then gave Europa in marriage to the Cretan king, Asterion. She was later worshiped on Crete as a goddess, and the bull became the constellation Taurus. The abduction of Europa was one of the many conquests of Zeus depicted in the tapestry woven by Arachne in her contest with Athena.

Classical Sources. Homer, *Iliad* 14.321ff. Bacchylides, *Odes* 6, "Europa." Herodotus, *History* 4.147.5. Moschus, *Idylls* 2, "Europa." Diodorus Siculus, *Biblioteca* 4.60.2., 5.78.1. Horace, *Odes* 3.27. Ovid, *Metamorphoses* 2.835–77, 6.103–07; *Fasti* 5.605–16. Apollodorus, *Biblioteca* 2.5.7, 3.1.1–2,

3.4.2. Pliny, *Naturalis historia* 12.5. Hyginus, *Fabulae* 178; *Poetica astronomica* 2.35. Lucian, *Dialogues of the Sea Gods* 15, "West Wind and South Wind."

Giovanni Boccaccio, 1313–1375. "De Europa, Cretensium regina" [Concerning Europa, Queen of Crete]. In *De mulieribus claris* [Concerning Famous Women]. Latin verse compendium of myth and legend. **1361–75.** Ulm: Zainer, 1473. [Branca 1964–83, vol. 10 / Guarino 1963 / Bergin 1981, p. 251]

Filarete, c.1400–1469? "Europa." Relief, on bronze door of St. Peter's, Rome. **1433–45.** In place. [Pope-Hennessy 1985b, 2:318]

Giovanni di Paolo, 1399–1482? "The Rape of Europa." Painting. *c.*1460. Musée Jacquemart-André, Paris, no. 1052. [Warburg]

Angelo Poliziano, 1454–1494. (Europa's story in) *Stanze . . . per la giostra di Giuliano de' Medici* stanzas 105–06. Poem. **1475–78.** [Barkan 1986, pp. 8, 291 n.15]

Albrecht Dürer, 1471–1528. Sheet of drawings with a Rape of Europa. **1494–95.** Albertina, Vienna. [Strauss 1974, no. 1494/16—ill.]

———, formerly attributed (now attributed to Hans Baldung Grien). "The Abduction of Europa." Drawing. Schilling coll., Edgeware, Middlesex. [Strauss 1974, no. XW.216—ill.]

Bartolommeo Bellano, c.1440–1496/97, attributed (formerly attributed to Andrea Riccio). "The Rape of Europa." Bronze statuette. Museo del Bargello, Florence; Szepmüvészeti Muzeum, Budapest. [Pigler 1974, p. 81 / also Pope-Hennessy 1985b, 2:85, 331]

Francesco Colonna, c.1433–1527. (Rape of Europa, triumph of Europa, represented on triumphal cars in) *Hypnerotomachia Poliphili* [The Dream of Poliphilo]. Romance. Venice: Aldus Manutius, **1499,** illustrated with woodcuts by anonymous engraver. [Appell 1893, pp. 5, 8, pls. 45, 47–48 / Barkan 1986, p. 227]

Giorgione, c.1477–1510, attributed. "The Rape of Europa." Painting. Formerly Leopold Wilhelm collection, Brussels. / Etching by Theodor van Kessel (c.1620–after 1660) in *Theatrum pictorium.* [Pigler 1974, p. 82] *See also Titian, below.*

Baldassare Peruzzi, 1481–1536. "The Myth of Europa." Ceiling fresco, representing the constellation Taurus. **1510–11.** Sala di Galatea, Villa Farnesina, Rome. [d'Ancona 1955, pp. 25f., 86 / Gerlini 1949, pp. 10ff. / also Frommel 1967–68, no. 18c]

——— (formerly attributed to Giulio Romano). "The Rape of Europa." Fresco, part of a frieze. 1511–12. Sala del Fregio, Villa Farnesina. [d'Ancona, pp. 91f.—ill. / Gerlini, pp. 21ff. / Frommel, no. 18a]

Domenico Beccafumi, 1486–1551. "The Rape of Europa." Painting. *c.*1512. Guarini del Taja coll., Siena. [Sanminiatelli 1967, pl. 3]

Italian School. "The Rape of Europa." Ceiling fresco. **1508–13?** Sala delle Nozze di Alessandro con Rossana, Villa Farnesina, Rome. [Gerlini 1949, pp. 34ff.—ill.]

Pinturicchio, 1454–1513, and studio. "The Rape of Europa." Fresco (detached), from Palazzo Pandolfo Petrucci ("Il Magnifico"), Siena. Metropolitan Museum, New York, no. 114.18. [Metropolitan 1980, p. 142—ill. / Berenson 1968, p. 345—ill.]

Bernardino Luini, 1480/85–1532. "The Myth of Europa." Series of frescoes (detached), from Casa Rabia, Milan. **1520–23.** Staatliche Museen, Berlin, nos. 219a-j. [Luino 1975, pp. 89f., pls. 45–51]

Giulio Romano, c.1499–1546, assistant, after design by Giulio. "The Rape of Europa." Stucco relief. **1527–28.** Sala delle Aquile, Palazzo del Tè, Mantua. [Hartt 1958, p. 125, figs. 222, 224 (drawings) / Verheyen 1977, p. 121—ill.] Variant. 1530s. Hampton Court Palace. [Hartt, p. 218] *See also Peruzzi, above.*

Liberale da Verona, c.1445–1526/29 (previously attributed to Francesco di Giorgio). "The Rape of Europa." Painting. Louvre, Paris, no. M.I. 585 (1640A). [Louvre 1979–86, 2:193—ill. / also Barkan 1986, p. 223, fig. 36 / Berenson 1968, p. 141]

Girolamo Mocetto, c.1458–c.1531. "The Rape of Europa." Grisaille ceiling painting. Musée Jacquemart-André, Paris. [Pigler 1974, p. 82]

Rosso Fiorentino, 1494–1540. "The Rape of Europa." Fresco. **1535–40.** Galerie François I, Château de Fontainebleau. [Barocchi 1950, p. 136—ill. (print) / Carroll 1987, no. 84—ill.]

Lambert Sustris, 1515/20–after 1568, attributed (also attributed to Andrea Schiavone). "The Rape of Europa." Painting. *c.*1541? Rijksmuseum, Amsterdam, inv. A4009 (as Schiavone). [Richardson 1980, no. D340—ill. / Rijksmuseum 1976, pp. 504f.—ill.] Another version of the subject in Principe Castelbarco Albani coll., Milan. [Pigler 1974, p. 82]

Jacopo Tintoretto, 1518–1594. "Jupiter and Europa." Painting. *c.*1541. Galleria Estense, Modena. [Rossi 1982, no. 22—ill.]

Francesco Primaticcio, 1504–1570. "The Rape of Europa." Painting. **1541–44.** Lost, known from drawing in Louvre, Paris, no. 91, and engraving by "Master L. D." (Bartsch no. 29). [Dimier 1900, pp. 327, 525, no. 120, no. 15 / Paris 1972, no. 378—ill. (print) / Lévêque 1984, p. 255—ill. (print)]

Luca Cambiaso, 1527–1585. "The Rape of Europa." Fresco. **1544.** Palazzo della Prefettura, Genoa. [Manning & Suida 1958, pp. 74f.—ill.]

Paris Bordone, 1500–1571, attributed. "The Rape of Europa." Painting. *c.*1550. Zangrando coll., Breda di Piave, Treviso. [Shapley 1966–73, 3:37]

Matthys Cock, 1500/05–1552. "The Rape of Europa." Drawing. Louvre, Paris, no. 20.723. [Warburg]

Jean-Antoine de Baïf, 1532–1589. "L'enlèvement d'Europe." Poem. Paris: Porte, **1552.** [Barkan 1986, p. 203]

Girolamo da Santacroce, c.1490–1556. "The Rape of Europa." Painting. Museo di Palazzo Venezia, Rome. [Shapley 1966–73, 3:37 / Berenson 1957, p. 156]

Titian, c.1488/90–1576. "The Rape of Europa." Painting. **1559–62.** Gardner Museum, Boston. [Wethey 1975, no. 32—ill. / also Hendy 1974, p. 257—ill. / Vermeule 1964, pp. 86, 175f.—ill. / Berenson 1957, p. 184—ill.] Copies in Dulwich College Gallery, London (sketch); Wallace Collection, London; Prado, Madrid, no. 1623 (by Peter Paul Rubens); 2 others in private colls. [Wethey—ill. / also Prado 1985, p. 598] Copy, drawing with wash, by Anthony van

Dyck. *c.*1630–32. Gardner Museum, no. P26E13. [Hendy, p. 86—ill.] Variant copies. Art Institute of Chicago (by David Teniers the Younger, as after a lost original); Ringling Museum of Art, Sarasota, Fla., inv. SN62 (Flemish School, 17th century; previously attributed to Lucas van Leyden and David Teniers the Elder). [Wethey / Chicago 1961, p. 445 / Sarasota 1980, no. 19—ill. / Pigler 1974, p. 82 (Chicago, as after a lost Giorgione)]

Taddeo Zuccari, 1529–**1566.** "The Rape of Europa." Fresco. Salla di Giove, Palazzo Farnese, Caprarola. [de Bosque 1985, p. 42—ill.]

Paolo Veronese, 1528–1588. "The Rape of Europa." Painting. *c.***1568–74.** Rasini coll., Milan. [Pallucchini 1984, no. 117—ill. / Pignatti 1976, no. 151—ill.]

————. "The Rape of Europa." Painting. *c.*1578–80. Anticollegio, Palazzo Ducale, Venice. [Pallucchini, no. 169—ill. / Pignatti, no. 216—ill.] School variants. Pinacoteca Capitolina, Rome (partly autograph); Gemäldegalerie, Dresden, inv. 243; National Gallery, London, inv. 97; National Gallery of Ireland, Dublin; Kunsthistorisches Museum, Vienna. [Pignatti, nos. 217, A68, A160 A243—ill. / also Pallucchini, no. 190—ill. / also London 1986, p. 666—ill. / Dublin 1981, p. 173—ill.] Anonymous copy in Musée, Compiègne (on deposit from Louvre, Paris, inv. 154). [Louvre 1979–86, 2:301] Copy by Giovanni Battista Tiepolo, 1743. *See Tiepolo, below.*

————, studio. "Europa and the Bull." Painting. Art Gallery and Museum, Brighton. [Wright 1976, p. 213]

Giambologna, 1529–1608. "The Rape of Europa." Marble relief, on pedestal of "Fountain of Ocean." **1570–75.** Boboli Gardens, Florence. [Avery 1987, no. 149]

————, follower. "The Rape of Europa." Bronze sculpture (from a model by Giambologna?). *c.*1600. 4 examples known. National Trust coll., Ickworth, Suffolk; Museo Nazionale, Florence, no. 433; Museo di Palazzo Venezia, Rome; private coll., Chicago. [Avery & Radcliffe 1978, no. 68—ill. / also Avery, no. 94—ill.]

Annibale Carracci, 1560–1609, and **Agostino Carracci,** 1557–1602. Fresco cycle: "Jupiter, in the Form of a Bull, Approaching Europa" ("Europa Feeding the Bull"), "Europa Leading the Bull," "Europa Sitting on the Back of the Bull," "The Rape of Europa." *c.*1583–84. Camerina d'Europa, Palazzo Fava (now Hotel Majestic-Baglioni), Bologna. [Malafarina 1976, no. 14—ill. / Ostrow 1966, no. I/6]

———— (Annibale). "Europa and the Bull." Fresco. 1597–1600. Galleria, Palazzo Farnese, Rome. [Malafarina, no. 104h—ill. / Martin 1965, pp. 99f.—ill.]

Andrea Gabrieli, *c.*1510–1586. "Felice Europa." Madrigal. Venice: 1589. [Grove 1980, 7:59]

Karel van Mander, 1548–1606. "The Rape of Europa." Drawing. **1589.** Prentenkabinet, Rijksuniversiteit, Leyden. [de Bosque 1985, pp. 244, 255—ill.] Another version of the theme, by follower, in Szépmüvészeti Muzeum, Budapest. [Pigler 1974, p. 85]

————, composition. "The Rape of Europa." Engraving, by Jacob de Gheyn (1565–1629). / Copy after engraving. University, Göttingen. [Ibid.]

Hendrik Goltzius, 1558–1617. "The Rape of Europa." Engraving, part of a set illustrating Ovid's *Metamorphoses* (2d series, no. 20), executed by assistant(s). *c.*1590.

Unique impression in British Museum, London. [Bartsch 1980–82, no. 0302.70—ill. / also de Bosque 1985, pp. 244, 246—ill.]

————. "Jupiter and Europa." Drawing, composition for a print by Jacob Matham (Bartsch no. 156.) *c.*1590–91. Städelsches Kunstinstitut, Frankfurt, inv. N1793. [Reznicek 1961, no. 135—ill.]

Edmund Spenser, 1552?–1599. (Story of Europa woven into Arachne's tapestry in) "Muiopotmos; or, The Fate of the Butterfly" lines 277–96. Poem. London: Ponsonbie, **1590;** collected in *Complaints* (London: Ponsonbie, 1591). [Oram et al. 1989 / Barkan 1986, pp. 203f., 291 *n.*16]

————. (Europa's story recalled in) *The Faerie Queene* 3.11.30, 5.Proem.5, 7.7.33. Romance epic. London: Ponsonbie, 1590, 1596, 1609. [Hamilton 1977 / Nohrnberg 1976, p. 399]

Francesco Bassano, 1549–1592, attributed. "The Rape of Europa and Mercury with His Flocks." Painting. Uffizi, Florence, inv. 6219. [Uffizi 1979, no. P146—ill. / Arslan 1960, p. 341 (attributed to Leandro Bassano)] Anonymous variant ("Mercury, Argus, and the Rape of Europa"). Roemer-Museum, Hildesheim. [Arslan, p. 346]

Michiel Coxie the Elder, 1499–1592. "The Rape of Europa." Drawing. British Museum, London. [Warburg]

Maerten de Vos, 1532–1603. "Rape of Europa." Painting. Museo de Bellas Artes, Bilbao. [Warburg]

Lope de Vega, 1562–1635. "De Europa y Jupiter." Sonnet, no. 71 of *Rimas humanas* part I. **1602–04.** Madrid: Martin, for Alonso Perez, 1609. [Sainz de Robles 1952–55, vol. 2]

Cavaliere d'Arpino, 1568–1640. "The Rape of Europa." Painting. **1603–06.** Galleria Borghese, Rome, inv. 378. [Rome 1973, no. 34—ill. / Pergola 1955–59, 2: no. 88—ill.]

Jacob Jordaens, 1593–1678. "The Rape of Europa." Painting. *c.***1615–16.** Formerly Zoltan de Boer coll., Malmö, sold London, 1980. [d'Hulst 1982, p. 330 n.15, fig. 20] Replica (also attributed to Gerard Seghers). 1630s. Herzog Anton Ulrich-Museum, Braunschweig, no. 114. [Ibid. / Ottawa 1968, no. 13—ill. / Braunschweig 1969, pp. 79, 123]

————. "The Rape of Europa." Painting. *c.*1615. Gemäldegalerie, Berlin-Dahlem, no. 2/81. [Berlin 1986, p. 41—ill. / also d'Hulst, p. 49, fig. 16]

————. Rape of Europa, representing "April (Taurus)." Ceiling painting, part of "Signs of the Zodiac" cycle for Jordaens's house in Antwerp. Early 1640s. Senate Library, Palais du Luxembourg, Paris. [Rooses 1908, pp. 124f.]

————. "The Rape of Europa." Painting. 1643. Musée des Beaux-Arts, Lille. [d'Hulst, fig. 157]

————. "The Rape of Europa." Drawing, design for an unknown painting. Late 1650s–60s. Hermitage, Leningrad, inv. 4210. [Hermitage 1984, no. 291—ill. / Ottawa, no. 270—ill.]

Giovanni Battista Marino, 1569–1625. "Il rapimento d'Europa." Poem. In *Il tebro festante* (Venice: Ciotti, **1618**). [DELI 1966–70, 3:515 / Praz 1925, p. 287]

————. "Europa." Idyll. No. 3 in *La sampogna* (Paris: Pacardo, 1620). [Getto 1962]

Frans Francken II, 1581–1642, and **Abraham Govaerts,** 1589–1626. "Europa Adorning the Bull." Painting. **1621.** Koninklijk Museum voor Schone Kunsten, Antwerp, no.

903 (as Govaerts). [Härting 1983, no. A234 / Antwerp 1970, p. 96 / de Bosque 1985, pp. 244, 246—ill.]

———— (Francken) and **Jan Tilens**, 1589–1630. "The Rape of Europa." Painting. 1625–30. Alte Pinakothek, Munich, inv. 6330. [Härting, no. A233] Replica (or copy?). Sold Christie's, London, 1978. [Ibid., no. A397]

Johann König, c.1586–1632/35. "The Rape of Europa." Painting. **1621**. Pushkin Museum, Moscow. [Pigler 1974, p. 87]

Hendrik van Balen, 1575–1632, figures, and **Jan Brueghel the Younger**, 1601–1678, landscape (previously attributed to Jan Brueghel the Elder). "The Rape of Europa." Painting. c.**1621–22?** Kunsthistorisches Museum, Vienna, inv. 814 (884). [Ertz 1984, no. 258—ill. / also Bosque de 1985, pp. 242f.—ill. / Vienna 1973, p. 12 (as van Balen and Brueghel the Elder)—ill.]

———— Several further versions of the subject, by van Balen. Musée des Beaux-Arts, Valenciennes; Národní Galerie, Prague; Liechtenstein Collection, Vaduz; Uffizi, Florence (drawing). [de Bosque 1985, pp. 244f.—ill. / Pigler 1974, p. 85]

Leandro Bassano, 1557–**1622**. "The Rape of Europa." Painting. Briganti coll., Rome, in 1931. [Arslan 1960, p. 268] *See also Francesco Bassano, below.*

Ottavio Vernizzi, 1569–1649. Musical intermedi for S. Branchi's *Europa rapita da Giove*. Opera. First performed **1623**, Bologna. [Grove 1980, 19:673]

Giovanni da San Giovanni, 1592–1636. "The Rape of Europa." Ceiling fresco. **1627**. Palazzo Pallavicini Rospigliosi (Bentivoglio), Rome. [Banti 1977, no. 29—ill.]

Anastasio Pantaleón de Ribera, 1600–**1629**. "Fábula de Europa." Poem. In *Obras* (Madrid: Martinez, 1634). [DLE 1972, p. 777]

Aegidius Sadeler, 1570–**1629**. "The Rape of Europa." Drawing. Louvre, Paris, nos. 21, 726. [Warburg]

Antonio Tempesta, 1555–**1630**. "The Rape of Europa." 2 frescoes. Palazzo Farnese, Caprarola. [Pigler 1974, p. 82]

Peter Paul Rubens, 1577–1640. "The Rape of Europa." Painting, copy after Titian (1550, Boston). c.**1630**. Prado, Madrid, no. 1623. [Jaffé 1989, no. 977, p. 81—ill. / Wethy 1975, no. 32 n.—ill. / Prado 1985, p. 598]

———— "The Rape of Europa." Painting, for Torre de la Parada, El Pardo, executed by Erasmus Quellinus from Rubens's design. 1636–38. Prado, Madrid, no. 1628. [Alpers 1971, no. 21—ill. / Jaffé, no. 1266—ill. / Prado, p. 523] Oil sketch. Prado, no. 2457. [Alpers, no. 21a—ill. / Held 1980, no. 187—ill. / Jaffé, no. 1265—ill. / Prado, p. 595]

Rembrandt van Rijn, 1606–1669. "The Abduction of Europa." Painting. **1632**. Klotz coll., New York. [Gerson 1968, no. 62—ill.]

Claude Lorrain, 1600–1682. "Coast View with the Rape of Europa." Etching. **1634**. [Röthlisberger 1961, p. 276] Variant, painting. 1647. Unlocated. [Ibid., no. LV III—ill.]

———— "Coast View with the Rape of Europa." Painting. 1655. Pushkin Museum, Moscow. [Ibid., no. 136—ill.] Drawing after, in the artist's *Liber veritatis*. British Museum, London. [Ibid.] Variant. Royal Collection, U.K. [Ibid.]

———— "Coast View with the Rape of Europa." Painting. 1658. Morrison coll., London. [Ibid., no. LV 144—ill.] Drawing after, in the artist's *Liber veritatis*. British Mu-

seum, London. [Ibid.] Copy, in Marquess of Bute coll., Dumfries. [Ibid.]

————, attributed. "The Rape of Europa." Painting. Schilderijenzaal Prins Willem V., The Hague, on loan from Dienst Verspreide Rijkskollektie, The Hague. [Wright 1980, p. 76]

Guido Reni, 1575–1642. "The Rape of Europa." Painting. **1636–37**. Private coll., Switzerland. [Pepper 1984, no. 164—ill.] Variant. 1638–40. Denis Mahon coll., London. [Ibid., no. 184—ill. / also Gnudi & Cavalli 1955, no. 82—ill.] Studio variants. Musée des Beaux-Arts, Tours, no. 243 (as Giovanni Andrea Sirani); Dulwich College Picture Gallery, London, no. 121; Hermitage, Leningrad, cat. 1958 no. 4051; Museo Capitolino, Rome (as Elisabetta Sirani); formerly Roma di Treviso, Treviso; Ringling Museum of Art, Sarasota, Fla., no. SN44. [Pepper / also Sarasota 1976, no. 207]

————, doubtfully attributed (Francesco Gessi, after Reni?). "The Rape of Europa." Painting. c.1620? Sanssouci, Potsdam. [Pepper, no. 184n, fig. 50] Copy in National Gallery of Ireland, Dublin, no. 1908. [Dublin 1981, p. 136—ill.]

Joachim Wtewael, 1566–**1638**, falsely attributed (false signature). "The Rape of Europa." Drawing. Courtauld Institute, London. [de Bosque 1985, pp. 244, 247—ill.]

Francesco Albani, 1578–1660, attributed. "The Rape of Europa." Painting. **1630–40**. Uffizi, Florence, inv. 1361. [Uffizi 1979, no. P11—ill.] Variant. c.1639. Uffizi, inv. 1366. [Ibid., no. P12—ill.]

————. "The Rape of Europa." Painting. Hermitage, Leningrad. / Copy, fragment, showing only a detail. Louvre, Paris, inv. 20239. [Louvre 1979–86, 2:141—ill.]

————. Numerous further versions of the theme. Galleria Colonna, Rome; Ambrosiana, Milan; Museum of Fine Arts, Boston (by follower); elsewhere? [Pigler 1974, p. 83]

Simon Vouet, 1590–1649. "The Abduction of Europa." Painting. Before **1642**. Private coll., Paris. [Crelly 1962, p. 126, no. 122—ill.]

———— or studio. "The Abduction of Europa." Painting, cartoon for "Loves of the Gods" tapestry series. [Ibid., no. 270k]

Bernardo Cavallino, 1616–1656, "The Rape of Europa." Painting. **Early 1640s**. Walker Art Gallery, Liverpool. [Percy & Lurie 1984, no. 35—ill.]

————. "The Abduction of Europa." Painting. 1640–45. Nelson Gallery-Atkins Museum of Art, Kansas City, Mo. [Ibid., no. 36—ill.]

————, rejected attribution. "The Rape of Europa." Painting. Museo Nazionale Pepoli, Trapani, Sicily, no. 334. [Ibid., no. 72]

Jean Desmarets de Saint-Sorlin, 1595–1676. *Europe*. Comedy. Paris: Legras, **1643**. [DLLF 1984, 1:627]

Bernardo Strozzi, 1581–**1644**. "The Rape of Europa." Painting. Museum, Posnan. [Pigler 1974, p. 83]

Laurent de La Hyre, 1606–1656. "The Rape of Europa." Painting. **1644**. Museum of Fine Arts, Houston. [Dublin 1985, p. 28]

Padovanino, 1588–**1648**. "The Rape of Europa." Painting. Accademia, Siena. [Pigler 1974, p. 83]

Thomas Stanley, 1625–1678. "Europa." Poem, translation of Moschus. In *Europa, Cupid Crucified, and Venus Vigils* (London: Moseley, **1648**). [Bush 1963, pp. 247, 337]

Diego Velázquez, 1599–1660. (Jupiter and Europa, after Titian, depicted in Arachne's tapestry, in) "The Fable of Arachne" ("The Spinners," "The Tapestry Weavers"). Painting. **1648** or earlier. Prado, Madrid, no. 1173. [Barkan 1986, pp. 5–8 / López Torrijos 1985, pp. 319ff.—ill. / also López-Rey 1963, no. 56—ill.] Another version of the subject documented in 1664, lost. [Barkan, p. 290 *n*.6]

Bolognese School. "The Rape of Europa." Painting. **1600/ 50.** Museum of Fine Arts, Boston, no. 10.17. [Boston 1985, p. 140—ill.]

Nicolas Poussin, 1594–1665. "The Rape of Europa." Painting, fragment (copy of a lost original?). **1650.** Despats coll., Cahors. [Wright 1985, no. A5 / Blunt 1966, no. 153—ill.] Drawing (complete composition). Nationalmuseum, Stockholm. [Thuillier 1974, no. 165a—ill.]

Francesco Manelli, 1594–1667. *Il ratto d'Europa.* Opera (dramma per musica). Libretto, "E. Sandri" (P. E. Fantuzzi). First performed **1653,** Teatro Ducale, Piacenza. [Grove 1980, 11:613]

Frans Wouters, 1612–1659. "The Rape of Europa." Painting. Museum, Gotha. [Bénézit 1976, 10:799]

Cornelis van Poelenburgh, *c.*1586–**1667.** "Europa." Staatliches Museum, Schewerin. [Bénézit 1976, 8:392]

———. "Europa." Miniature painting. Musée, Langres. [Ibid.l

———, follower. "The Rape of Europa." Painting. Hofje van Aerden, Leerdam, cat. 1978 no. 10. [Wright 1980, p. 368]

Pier Francesco Mola, 1612–1666/68. "The Rape of Europa." Painting. Galerie, Schleissheim. [Pigler 1974, p. 83]

Filippo Lauri, 1623–1694. "The Rape of Europa." Painting, design for a fan. **1660s.** Christ Church, Oxford. [Byam Shaw 1967, no. 150—ill.]

Sébastien Bourdon, 1616–**1671.** "The Rape of Europa." Painting. Formerly Joshua Reynolds coll., London, untraced. [Pigler 1974, p. 86]

Nicolaes Willing, *c.*1640–**1678.** "Europa and the Bull." Painting. Lord Talbot of Malahide coll., Malahide Castle. [Warburg]

Luca Giordano, 1634–1705. "The Rape of Europa." Painting. *c.***1675–80?** Musée des Beaux-Arts, Douai, no. 1146, in 1919. [Ferrari & Scavizzi 1966, 2:325]

———. "The Rape of Europa." Painting. *c.*1680–83. Lost. / Studio copies in Alte Pinakothek, Munich; Lord Exeter coll., Burghley House, Northamptonshire. [Ibid., 2:117f., 121f., 287]

———. "The Rape of Europa." Painting. Mid-1680s. Borromeo coll., Isola Bella, in 1931. [Ibid., 2:336]

———. "The Rape of Europa." Painting. 1686. Wadsworth Atheneum, Hartford, inv. 1930.3. [Ibid., 2:145—ill. / Pigler 1974, p. 84]

———. "The Rape of Europa." Painting. City Art Gallery and Temple Newsam, Leeds, in 1954. [Ferrari & Scavizzi, 2:336]

———. "The Rape of Europa." Painting. Formerly Hessisches Landesmuseum, Darmstadt, destroyed. [Ibid., 2:272]

———, attributed. "The Rape of Europa." Painting. Mengoni coll., Rome. [Ibid., 2:310]

———. 2 further treatments of the subject, known from 18th-century sales, untraced. [Ibid., 2:374f.]

Gian Lorenzo Bernini, 1598–**1680,** composition. "Europa and the Bull." Engraving, by Nicolas Dorigny (1657–1746). [Pigler 1974, p. 83]

Peter Lely, 1618–**1680.** "Europa and the Bull." Painting. Duke of Devonshire coll., Chatsworth. [Warburg]

Niccolò Berrettoni, 1637–**1682?** "The Rape of Europa." Painting. Ashmolean Museum, Oxford, cat. 1961 no. A919. [Wright 1976, p. 16]

Nicolaes Berchem, 1620–**1683.** "The Rape of Europa." Painting. Hermitage, Leningrad. [Pigler 1974, p. 85]

Charles Le Brun, 1619–**1690.** "The Rape of Europa." Drawing. Louvre, Paris. [Pigler 1974, p. 86]

Peter Motteux, 1660–1718. *The Rape of Europa.* Masque. Music, John Eccles. First performed Oct **1694,** with J. Wilmot's *Valentinian,* Dorset Garden, London. [Grove 1980, 5:820]

Mattia Preti, 1613–**1699.** "The Rape of Europa." Painting. Galleria Pallavicini, Rome. [Cannata 1978, pl. 5]

Pierre Gobert, 1662–1744, attributed. "Europa Carried Off by Jupiter Changed into a Bull." Painting. *c.*1700. Victoria and Albert Museum, London, no. 549–1882. [Kauffmann 1973, no. 153—ill.]

Sebastiano Ricci, 1659–1734 (with Giuseppe Tonelli and Marco Ricci?). "Rape of Europa." Fresco. *c.***1707–08.** Palazzo Pitti, Florence. [Daniels 1976, no. 92e]

———. "The Rape of Europa." Painting. Early 1720s. Palazzo Taverna, Rome. [Ibid., no. 382—ill.]

Michel Corneille the Younger, 1642–**1708.** "The Rape of Europa." 2 drawings. Louvre, Paris. [Pigler 1974, p. 86]

Antoine Watteau, 1684–1721. "The Rape of Europa." Painting. *c.*1710. Lost. / Print by Pierre-Alexandre Aveline, 1730. [Camesasca 1982, no. 56—ill.]

Antoine-Louis Le Brun, 1680–1743. *Europe.* Tragedy. In *Théâtre* (Paris: Ribou, **1712**). [Girdlestone 1972, p. 177]

Carlo Maratti, 1625–1713. "Jupiter and Europa." Painting. National Gallery of Ireland, Dublin, no. 81. [Dublin 1981, p. 102—ill.]

Bartolomeo Altomonte, 1702–1779. "Hermes and Europa as a Cow." Drawing. **1718.** "Albertina Sketchbook" no. 55v, Albertina, Vienna. [Heinzl 1964, p. 70]

Carlo Cignani, 1628–1719. "The Rape of Europa." Fresco. Palazzo del Giardino, Parma. [Pigler 1974, p. 84]

Giovanni Battista Tiepolo, 1696–1770. "The Rape of Europa." Painting. *c.***1720–22.** Accademia, Venice. [Pallucchini 1968, no. 19a—ill. / Levey 1986, pp. 16f.—ill. / also Morassi 1962, p. 53]

———. "The Rape of Europa." Painting, copy after Veronese (*c.*1578–80, Venice). 1743. Runciman coll., London. [Morassi, pp. 18, 20—ill. / also Pallucchini, no. 146—ill.]

Antoine Coypel, 1661–**1722.** "Europa." Painting. Musée des Beaux-Arts, Lyon. [Pigler 1974, p. 87]

———, copy after. "Europa." Painting. Victoria Art Gallery, Bath. [Wright 1976, p. 44]

François Boucher, 1703–1770. "The Rape of Europa." Painting. 1723. Lost. / Engraving, by Pelletier. [Ananoff 1976, no. 11—ill.]

——— (previously attributed to François Le Moyne). "The Rape of Europa." Painting. 1734. Wallace Collection, London, no. P.484. [Ananoff, no. 104—ill. / Pigler 1974, p. 87 (as Le Moyne)] Grisaille sketch. Musée de Picardie, Amiens, no. 103. [Ananoff]

———. "The Rape of Europa." Painting, modello for

tapestry in "Loves of the Gods" series. *c.*1747. Louvre, Paris, inv. 2714. [Ibid., no. 350—ill. / Louvre 1979–86, 3:80—ill.] 13 tapestries woven by Beauvais, from 1750, unlocated. [Ananoff]

Johann Ernst Galliard, *c.*1687–1749, music. *Jupiter and Europa.* Pantomime. Libretto, Lewis Theobald? First performed 23 Mar **1723**, Lincoln's Inn Fields, London. [Grove 1980, 7:108 / Ralph 1985, p. 727 / Fiske 1973, pp. 92, 165]

Richard Leveridge, *c.*1670–1758. *Jupiter and Europa.* Musical work for the stage. First performed 23 Mar **1723**, London. [Grove 1980, 10:702]

Giovanni Battista Foggini, 1652–**1725.** "Rape of Europa." Bronze sculpture. Fitzwilliam Museum, Cambridge. [Warburg]

François Le Moyne, 1688–1737. "The Abduction of Europa." Painting. **1725.** Pushkin Museum, Moscow, inv. 992. [Bordeaux 1984, no. 53—ill.]. *See also Boucher, above.*

Noël-Nicolas Coypel, 1690–1734. "The Rape of Europa." Painting. **1727.** Cadwalader coll., Philadelphia. [Bordeaux 1984, fig. 382]

Michel Pignolet de Montéclair, 1667–1737. *Europe.* Cantata. Paris: **1728.** [Grove 1980, 12:510]

François Collin de Blamont, 1690–1760. *Europe.* Cantata. In *Cantates françoises à voix seule sans symphonie et avec symphonie de différents instrumens* book 2 (Paris: **1729**). [Grove 1980, 4:563]

Charles-Joseph Natoire, 1700–1777. "The Rape of Europa." Painting, part of "Story of the Gods" cycle, for Château de La Chapelle-Godefroy, Champagne. **1731.** Hermitage, Leningrad, inv. 5810. [Boyer 1949, no. 39 / Troyes 1977, pp. 54f. / Hermitage 1986, no. 151—ill.]

Louis de Boulogne the Younger, 1654–**1733.** "The Rape of Europa." Painting. [Pigler 1974, p. 86]

Giovanni Battista Crosato, *c.*1685–1758. "Europa and the Bull." Painting. *c.***1733.** Wadsworth Atheneum, Hartford, inv. 1963.1. [Seen by author, 1986]

———. "The Rape of Europa." Painting. Palazzo Madama, Turin. [Pigler 1974, p. 85]

Antoine Rivalz, 1667–**1735.** "The Rape of Europa." Drawing. Kunstmuseum, Düsseldorf. [Pigler 1974, p. 87]

Giovanni Domenico Ferretti, 1692–1766/69. "The Rape of Europa." Painting. **1728–37.** Uffizi, Florence, inv. 5447. [Uffizi 1979, no. P596—ill.]

Jean Laurent de Béthizy, 1709–1781. *L'enlèvement d'Europe.* Opera. First performed **1739,** Versailles. [Grove 1980, 2:663]

Francesco Trevisani, 1656–1746. "Europa." Painting. Lost. [DiFederico 1977, p. 79]

Jean Baptiste François De Hesse, 1705–1779, choreography. *Jupiter et Europe.* Ballet. First performed **1749,** Paris. [Cohen-Stratyner 1982, p. 243]

[?] Duport, and **[?] Dugué.** *Jupiter et Europe.* Opera. First performed Feb **1749,** Court of Louis XV. [Grove 1980, 5:731]

Jean-Baptiste-Marie Pierre, 1713–1789. "The Abduction of Europa." Painting. **1750.** Private coll. [Bordeaux 1984, fig. 397]

———. "The Abduction of Europa." Painting. Musée, Arras. [Pigler 1974, p. 87]

Johann Jakob Bodmer, 1698–1783. *Die geraubte Europa* [Europa Abducted]. Epyllion, after Moscus. Zürich: **1753.** [DLL 1968–90, 1:65]

Willem Troost, 1685–1759. "The Rape of Europa." Gouache painting. Wenckebach coll., Wassenaar, in 1970. [Warburg]

Antonio Guardi, 1698–1760. "Rape of Europa." Drawing. Sold Christie's, London, 1963. [Warburg]

Corrado Giaquinto, 1703–**1765.** "The Rape of Europa." Painting. After 1752. Milwaukee Art Museum, no. M1970.68.1. [Kilinski 1985, no. 2—ill.]

Benjamin West, 1738–1820. "Europa on the Back of the Bull." Painting. *c.***1765?** Lost. [von Erffa & Staley 1986, no. 140]

———. "Venus and Europa" (Venus and Cupid consoling Europa after her abduction) Painting. *c.*1768–70. North Carolina Museum of Art, Raleigh, no. G.60.13.1. [Ibid., no. 141—ill. / also Kilinski 1985, no. 3—ill.] Variant. 1772. Benton Museum of Art, University of Connecticut, Storrs. [Ibid., no. 142—ill.]

———. "Europa Crowning the Bull with Flowers." Painting (retouched by another?). Exhibited 1816? Sabin Galleries, London. [Ibid., no. 139—ill.]

Gaspare Diziani, 1689–1767. "The Rape of Europa." Painting. Chiomenti coll., Rome. [Pigler 1974, p. 84]

Francesco Fontebasso, 1709–1768/69. "The Rape of Europa." Painting. Elverà-Ceresa coll., Venice. [Pigler 1974, p. 85]

———. "The Rape of Europa." Ceiling fresco. Palazzo Boldu, Venice. [Ibid.]

Jean Baptiste Rochefort, 1746–1819, music. *L'enlèvement d'Europe.* Pantomime héroïque. First performed **1776,** Paris. [Grove 1980, 16:82]

Gottfried August Bürger, 1747–1794. "Europa und Jupiter." Poem. *c.***1777.** In *Gedichte* (Göttingen: Dieterich, 1778). [DLL 1968–90, 2:296f.]

Antonio Salieri, 1750–1825. *L'Europa riconosciuta* [Europa Recognized]. Opera (dramma serio). Libretto, M. Verazi. First performed 3 Aug **1778,** La Scala, Milan. [Grove 1980, 16:418]

André Chénier, 1762–1794. "L'enlèvement d'Europe." Poem. *c.***1781.** In "Bucoliques" section of *Oeuvre complètes* (Paris: Foulon, Baudouin, 1819). [DLLF 1984, 1:442]

Richard Wilson, 1714–**1782,** doubtfully attributed (and Giovanni Battista Cipriani?). "Europa and the Bull." Painting. Dudley Wallis coll., London. [Constable 1953, pp. 118, 124, pl. 136b]

Pierre-Paul Prud'hon, 1758–1823. "The Rape of Europa." Drawing. *c.***1784–87.** Marcille-Jahan-Chévrier coll. [Guiffrey 1924, no. 120]

Francesco Zuccarelli, 1702–1788. "Rape of Europa." Painting. Birmingham Museum and Art Gallery, England. [Jacobs & Stirton 1984b, p. 144]

———. "The Rape of Europa." Painting. Accademia, Venice. [Pigler 1974, p. 85]

Henry Fuseli, 1741–1825. "Zeus, in the Form of a Bull, Carries Europa over the Sea to Crete." Drawing. **1794.** Victoria and Albert Museum, London, inv. E.972–1927. [Schiff 1973, no. 990—ill.]

Bolognese School. "Europa." Painting. **18th century.**

City Art Gallery and Temple Newsam, Leeds, cat. 1954 no. SW.166. [Wright 1976, p. 106]

Joseph Weigl the Younger, 1766–1846. *Il riposo della Europa.* Cantata. Text, L. Prividale. First performed **1806,** Vienna. [Grove 1980, 20:298]

Théodore Géricault, 1791–1824. "Europa and the Bull." Drawing. **1816–17.** Musée des Beaux-Arts, Rouen, inv. 190. [Eitner 1983, p. 335, no. 26]

Alfred, Lord Tennyson, 1809–1892. (Europa evoked in) "The Palace of Art" lines 117–20. Poem. **1832.** In *Poems* (London: Moxon, 1832). / Revised in *Poems* (London: Moxon, 1842). [Ricks 1969 / Buckley 1961, pp. 51, 53]

Johann Heinrich Ramberg, 1763–**1840.** "The Rape of Europa." Painting. Niedersächsische Landesgalerie, Hannover. [Bénézit 1976, 8:591]

Joseph Mallord William Turner, 1775–1851. "Europa and the Bull." Painting. *c.***1835–40.** Taft Museum, Cincinnati. [Butlin & Joll 1977, no. 514—ill.]

Eduard Mörike, 1804–1875. "Europa." Translation of Moschus. In *Classische Blumenlese* (Stuttgart: Schweizerbart, **1840**). [Hötzer 1967]

Victor Hugo, 1802–1885. (Rape of Europa depicted on spinning-wheel in) "Le rouet d'Omphale." Poem. **1843.** No. 3 in *Les contemplations* book 2 (Paris: Hetzel, 1856). [Hugo 1985–86, vol. 5 / Nash 1983, pp. 121, 297f. (reproduced)]

Heinrich Heine, 1797–1856. (Jupiter and Europa in) *Der Doktor Faust.* Ballet scenario. **1847.** Hamburg: Hoffman & Campe, 1851. [Windfuhr 1975–82, vol. 9]

————. (Europa in) "Mythologie." Poem. In *Lamentationen, Romanzero* book 2 (Hamburg: Hoffmann & Campe, 1851). [Atkins & Boeck 1973–78, vol. 2 / Draper 1982]

William Johnson Cory, 1823–1892. "Europa." Poem. In *Ionica* (London: Smith, Elder, **1858**). [Bush 1937, p. 554]

Walter Savage Landor, 1775–1864. "The Ancient Idyll" ("Europa and Her Mother"). Poem. In *Dry Sticks, Fagoted* (Edinburgh: Nichol, **1858**). [Wheeler 1937, vol. 2 / Boswell 1982, p. 152]

Gustave Moreau, 1826–1898. "Jupiter and Europa." Painting. **1868.** Musée Gustave Moreau, Paris. [Mathieu 1976, no. 105—ill.]

————. "The Rape of Europa." Painting. *c.*1869. 3 versions. Musée d'Orsay, Paris, no. R.F. 2704; private coll., Paris; another unlocated. [Ibid., nos. 106–8—ill. / also Louvre 1979–86, 4:113—ill.]

————. "The Rape of Europa." Watercolor. *c.*1869. Wadsworth Atheneum, Hartford, Conn. [Mathieu, no. 109—ill.]

————. "Europa" (in a landscape, with the bull; also called "Pasiphae"). Painting. *c.*1890. Daniel Wildenstein coll. [Ibid., no. 368—ill.]

————. "Europa." 2 drawings, designs for an enamel. 1897. Sold Paris, 1975. [Ibid., nos. 426–427—ill.]

Edward Dowden, 1843–1913. "Europa." Poem. **1873.** In *The Heroines* (London: King, 1876). [Boswell 1982, p. 252]

Adolf von Hildebrand, 1847–1921. "Europa." Stone fountain figure. **1874?** Wittelsbach, Maximilian Platz, Munich. [Clapp 1970, 1:446]

Walter Crane, 1845–1915. "Europa." Painting. **1881.** Lost. [Kestner 1989, p. 239, pl. 4.31]

Aubrey De Vere, 1814–1902. "Europa." Poem. In *Poetical Works* (London: Kegan Paul, Trench, **1884**). [Boswell 1982, p. 84]

Auguste Rodin, 1840–1917. "The Minotaur" ("Jupiter Taurus," "Faun and Nymph"). Painted plaster sculpture. *c.***1886.** Musée Rodin, Paris; Musée, Belfort; Santamarina coll., Buenos Aires; Rodin Museum, Philadelphia. [Tancock 1976, no. 41—ill.] Marble. Museum Folkwang, Essen. [Ibid., p. 273—ill.] Bronze casts in Musée Rodin, Paris; Maryhill Museum of Fine Arts, Wash.; California Palace of the Legion of Honor, San Francisco; Musée d'Orsay, Paris, inv. RF 2242; elsewhere? [Ibid., pp. 272f.—ill. / Rodin 1944, no. 160—ill. / Orsay 1986, p. 235—ill.]

Charles Marie René Leconte de Lisle, 1818–**1894.** "L'enlèvement d'Européia." Poem. In *Oeuvres: Derniers poèmes* (Paris: Lemerre, 1895). [Pich 1976–81, vol. 3]

William Wetmore Story, 1819–**1895.** "Europa." Poem. In *Poems* (Boston: Houghton Mifflin, 1896). [Boswell 1982, p. 297]

George Frederick Watts, 1817–1904. "Europa." Painting. Begun *c.*1865, completed **1898.** Watts Gallery, Compton, Surrey. [Watts 1970, no. 14]

Stephen Henry Thayer, 1839–1919. "Europa." Poem. In *Songs from Edgewood* (New York: Putnam, **1902**). [Ipso]

Rubén Darío, 1867–1916. (Europa and the bull evoked in) "Marina" [Sea]. Poem. In *Cantos de vida y esperanza: Los cisnes y otros poemas* (Madrid: Tipografía de la Revista de Archivos, Bibliotecas y Museos, **1905**). [Méndez Plancarte 1967 / Hurtado Chamorro 1967, p. 220]

Valentin Serov, 1865–1911. "The Rape of Europa." Painting. **1910.** Serov family coll., Moscow. [Sarabyanov & Arbuzov 1982, no. 589—ill.] Sketches. Khmara coll., Moscow; Tretyakov Gallery, Moscow (2); Russian Museum, Moscow (2); another unlocated. [Ibid., nos. 544, 590–93, 616—ill.] Sculpture variant; plaster, bronze, terra-cotta, porcelain versions. Picture Gallery, Novosibirsk; Tretyakov Gallery; Russian Museum; private colls., Moscow. [Ibid., nos. 594–99—ill.]

Georg Kaiser, 1878–1945. *Europa.* Drama. Published Berlin: Fischer, **1915**). First performed 5 Nov 1920, Grosses Schauspielhaus, Berlin. [Kaiser 1971, vol. 1 / EDS 1954–66, 6:863, 866]

Paul Manship, 1885–1966. "Flight of Europa" (carried by the bull). Relief, in bronze ashtray. **1917.** [Murtha 1957, no. 96]

————. "Europa and the Bull." Bronze statuette. 1924. 20 casts, 1924–35. National Museum of American Art, Washington, D.C.; Cranbrook Academy of Art, Bloomfield Hills, Mich.; Minnesota Museum of Art, St. Paul; elsewhere. [Ibid., no. 169—ill. / also Rand 1989, pp. 61ff.—ill. / Minnesota 1985, no. 14—ill. / Minnesota 1972, no. 33—ill.] Bronze sketch, 1922. Washington; St. Paul; elsewhere. [Murtha, no. 154 / Rand, figs. 53–54 / Minnesota 1972, no. 31] Large marble replica, 1926. [Murtha, no. 189] Large bronze version, 1924–35. [Murtha, no. 354] Figurine of Europa, derived from above. Porcelain and terra-cotta versions. St. Paul; elsewhere. [Murtha, no. 190 / Minnesota 1985, no. 16—ill.]

————. "The Flight of Europa" (carried by the bull, with Eros). Bronze statuette. 1925. 20 casts. Washington; St. Paul; elsewhere. [Rand, pp. 67ff.—ill. / also Murtha, nos. 177–

78—ill. / Minnesota 1985, no. 15—ill.] Heroic-size version, cast 1931, for garden of George Washington Hill, Irvington-on-Hudson, N.Y. [Murtha, no. 179] Painted plaster bust of Europa, based on above. [Ibid.] Large marble version, partially destroyed, Eros and head of Europa preserved. [Ibid.]

Gustav Vigeland, 1869–1943. "Europa and the Bull." Clay sculpture sketch. 1919. Vigeland-Museet, Oslo, no. 485. [Oslo 1952, no. 367]

Lovis Corinth, 1858–1925. "Europa with the Bull." Color lithograph, part of "Loves of Zeus" cycle. 1920. [Schwarz 1922, no. L401]

Fritz Behn, 1878–after 1935. "Europa and the Bull." Sculpture. Before 1921. Hearst coll., San Simeon, Calif. [Warburg]

Osip Mandel'shtam, 1891–1939/42. (Europa and the bull evoked in) Untitled poem. 1922. In *Stikhotvoreniia* (Leningrad: Gosudar, 1928). [Raffel & Burago 1973, no. 128 / Terras 1966, p. 262]

Theodor Däubler, 1876–1934. (Europa evoked in) *Päan und Dithyrambos: Eine Phantasmagorie* [Paean and Dithyramb: A Phantasmagoria] part 3. Poem. Leipzig: Insel, 1924. [Ipso / DULC 1959–63, 1:964]

Gustav Heinrich Wolff, 1886–1934. "Woman (or Europa) on a Horse." Bronze sculpture. 1924. Sprengel coll., Hannover. [Clapp 1970, 1:913]

Carl Milles, 1875–1955. "Europa Fountain" (Europa riding the bull, with 4 Tritons). Bronze figures in granite basin. 1923–26. Halmstadt, Sweden. [Rogers 1940, p. 52—ill. / also Cornell 1957, pls. 13–17] Bronze model. Tate Gallery, London, no. 4247. [Alley 1981, p. 518—ill.] Replicas. Cranbrook Academy of Art Museum, Bloomfield Hills, Mich., no. 1934.34; Millesgården, Lidingö, Sweden. [Rogers, p. 52 / Cornell, p. 17, pl. 14 / also Kilinski 1985, p. 30]

———. "Europa Fantasy." Marble sculpture. 1926. Cranbrook; Millesgården; Malmström coll., Malmö. [Rogers, p. 66]

Gerhard Marcks, 1889–1981. "Europa Kneeling" (on bull's head). Bronze sculpture. 1927. Unique (?) cast, formerly private coll., Munich. [Busch & Rudloff 1977, no. 168—ill.]

———. "Europa Seated on the Bull." Bronze sculpture. 1930. Unique (?) cast, formerly private coll., Erfurt. / Plaster model (fragment). [Ibid., no. 206—ill.]

———. "Europa with the Bull." Bronze sculpture. 1930. At least 5 casts. Gerhard-Marcks-Stiftung, Bremen, inv. 251/74; private colls., Germany. [Ibid., no. 221—ill.]

———. "Europa on the Bull." Bronze plaque. 1954. At least 20 casts. Kunsthalle, Hamburg; Deutscher Kunstlerbund, Hamburg; Staatsgalerie, Stuttgart; elsewhere. [Ibid., no. 619a—ill.] Variant. 1954. At least 20 bronze casts. Kunsthalle, Bremen; Busch-Reisinger Museum, Cambridge, Mass.; elsewhere. 150 iron casts. Staatliche Münzsammlung, Munich; Gerhard-Marcks-Stiftung, Bremen; elsewhere. [Ibid., no. 619b—ill.]

———. "Europa on the Bull." Bronze sculpture, model for an unexecuted project. 1959. At least 8 casts. Unlocated. [Ibid., no. 728—ill.]

Darius Milhaud, 1892–1974. *L'enlèvement d'Europe*. Opera-minute, opus 94. Libretto, Henri Hoppenot. First performed 1927, Baden-Baden. [Grove 1980, 12:308]

Rolfe Humphries, 1894–1969. "Europa." Poem. In *Europa and Other Poems and Sonnets* (New York: Gaige, 1928). [Boswell 1982, p. 140]

Henri Matisse, 1869–1954. "The Rape of Europa." Drawing. 1928. [Barr 1951, p. 213 *n*.13]

Émile-Antoine Bourdelle, 1861–1929. "The Rape of Europa." Plaster sculpture. 1929. Musée Ingres, Montauban. / 7 bronze casts. Private colls. [Jianou & Dufet 1975, no. 709] Plaster study/variant (head). Musée Ingres. [Ibid.]

William Plomer, 1903–1973. (Europa in) "The Three Abductions." Poem. In *The Family Tree* (London: Leonard & Virginia Woolf, 1929). [Bush 1937, p. 575]

Max Beckmann, 1884–1950. "The Rape of Europa." Watercolor. 1933. Von Schnitzler-Mallinckrodt coll., Murnau. [Selz 1964, pp. 55, 57—ill.]

William Butler Yeats, 1865–1939. (Europa evoked in) "Crazy Jane Reproved." Poem. In *The Winding Stair and Other Poems* (London & New York: Macmillan, 1933). [Finneran 1983]

Oliver St. John Gogarty, 1878–1957. "Europa and the Bull." Poem. In *Others to Adorn* (London: Rich & Cowan, 1938). [DLB 1983, 19:184]

Gleb Deruyinsky, 1888–1975. "The Rape of Europa." Marble sculpture. 1939. New York. [Warburg]

Jacques Lipchitz, 1891–1973. "The Rape of Europa." Bronze sculpture. 4 versions, 1938–41. Musée National d'Art Moderne, Paris; Museum of Modern Art, New York; Hirshhorn Museum and Sculpture Garden, Washington, D.C.; elsewhere. [Lipchitz 1972, pp. 140f.—ill. / Hammacher 1975, pl. 112 / Barr 1977, p. 561—ill. / Hirshhorn 1974, p. 714, pl. 481] 2 studies for version 2. Museum of Modern Art, New York. [Barr—ill.]

———. "The Rape of Europa" (Europa stabbing the bull; allegory of Europe struggling against Hitler). Bronze sculpture. Edition of 7. [Lipchitz, pp. 151–53—ill. / also Hammacher, pl. 113]

———. "The Rape of Europa." Marble sculpture. 1971. [Lipchitz, p. 222]

Max Aub, 1903–1972. *El rapto de Europa; o, Siempre se puedo hacer algo* [The Rape of Europa; or, Something Can Always Be Done]. Drama. First performed 1943. Published Mexico City: Ediciones Tezontle, 1946. [Schneider & Stern 1988, p. 551 / McGraw-Hill 1984, 1:219]

Alfred-Auguste Janniot, b. 1889. "Europa." Sculpture. By 1946. [Clapp 1970, 1:480]

Roland Petit, 1924–, choreography. (Europa in) *Les amours de Jupiter*. Ballet. Music, Jacques Ibert. Libretto, Boris Kochno, after Ovid's *Metamorphoses*. First performed 1946, Théâtre de Champs-Élysées, Paris. [Oxford 1982, p. 324 / Chujoy & Manchester 1967, p. 727]

Pablo Picasso, 1881–1973. "The Rape of Europa." Painting. 1946. [Boeck & Sabartes 1955, p. 422—ill.]

R. P. Blackmur, 1904–1965. "The Bull," "The Rape of Europa." Poems. In *The Good European and Other Poems* (Cummington, Mass.: Cummington Press, 1947). [Ipso]

James Merrill, 1926–. "Europa." Poem. 1947. In *The Yellow Pages: 59 Poems* (Cambridge, Mass.: Temple Bar Bookshop, 1974). [Ipso]

———. "Three Sketches for Europa." 3 poems. In *The Country of a Thousand Years of Peace* (New York: Knopf,

1959). / Revised, published New York: Atheneum, 1970. [Howard 1969, pp. 335f.]

Robert Laurent, 1890–1970. "Europa." Teakwood sculpture. By **1948.** [Clapp 1970, 2 pt. 2: 689]

Walter Birenheide. "Europa on the Bull." Painting. **1948.** [Hannover 1950, no. 15a]

Marcel Luipart, 1912–, choreography. (Jupiter and Europa in) *Abraxas.* Ballet. Music and libretto, Werner Egk, after Heine's *Der Doktor Faust* (1847). First performed 6 Jun **1948,** Bayerische Staatsoper, Prinzregenten Theater, Munich; décor, Wolfgang Znamenacek. [Oxford 1982, p. 1 / Grove 1980, 6:68 / Krause 1971, p. 190] Further choreographies by Janine Charrat, first performed 1949, Städtische Oper, West Berlin; Helge Pawlinin, first performed 1951, Deutsche Ballett, Hamburg. [Sharp 1972, pp. 1, 247 / Oxford, pp. 1, 91]

Jackson Pollock, 1912–1956. "The Rape of Europa." Abstract painted terra-cotta sculpture. *c.*1949–50. Ileana Sonnabend coll. [O'Connor & Thaw 1978, no. 1052—ill.]

Karel Albert, 1901–. *Europa ontvoerd* [Europa Abducted]. Opera buffa. **1950.** [Grove 1980, 1:210]

Edgar Ende, 1901–1965. "Europa." Painting. **1952.** Michael Ende coll., Munich. [Berlin 1963, no. 49]

W. R. Rodgers, 1909–1969. "Europa and the Bull." Poem. In *Europa and the Bull and Other Poems* (London: Secker & Warburg; New York: Farrar, Straus & Young, **1952**). [DLB 1983, 20:315]

David Smith, 1906–1965. "Europa." Bronze and steel sculpture. **1953.** Iseman coll., New York. [Krauss 1977, no. 295—ill.]

———. "Europa and Calf." Abstract bronze sculpture. 1956–57. Dunkelman coll., Don Mills, Ontario. [Ibid., no. 365—ill.]

Dimitri Hadzi, 1921–. "Europa." Bronze sculpture. **1958.** Galleria Schneider, Rome, in 1958. [Schneider exhibition catalogue 1958, no. 10]

Charles Olson, 1910–1970. (Europa in) *Maximus II.* Poem. New York: Jargon/Corinth, **1960.** [Byrd 1980, pp. 118, 142]

Juan Nickford, 1926–. "Europa with Bull." Welded bronze sculpture. Exhibited **1964.** [Clapp 1970, 2 pt. 2: 828]

Reuben Nakian, 1897–1986. "Europa and the Bull." Sculptures. Numerous versions, bronze and terra-cotta, **1945–65.** Hirshhorn Museum and Sculpture Garden, Washington, D.C.; elsewhere. [O'Hara 1966, nos. 2, 10, 11, 24, 27, 34, 37, 65–66, 99—ill. / also Hirshhorn 1974, p. 728, pl. 731]

———. "Voyage to Crete." Bronze sculptures (at least 2 versions). 1960. Stern coll., Washington, D.C.; Egan Gallery, New York; elsewhere? [O'Hara, p. 16, nos. 55–56—ill.]

———. "Voyage to Crete." Monumental bronze sculpture. 1960–62, cast 1963. Lincoln Center, New York. [Ibid., pp. 16, 46—ill.]

———. "Europa" series. Terra-cotta sculptures and incised terra-cotta plaques. 1948/mid-1960s. Hirshhorn Museum and Sculpture Garden, Washington, D.C.; Egan Gallery; private colls.; elsewhere? [Ibid., nos. 5, 8, 12, 29, 30, 38, 41–45, 49, 50, 57, 59, 68, and addenda—ill. / Hirshhorn 1974, p. 729, pl. 590] Bronzes, 1960–63 (and others?). Egan Gallery; private colls.; elsewhere? [O'Hara, nos. 51, 67, 80–81—ill.]

———. "Europa Series." Drawings. 1959–60. Egan Gallery, on loan to Museum of Modern Art, New York. [Ibid., no. 120—ill.]

———. "Europa and the Bull." Abstract bronze sculpture. 1981. 9 casts. [Marlborough 1982, no. 21—ill.]

———. "Voyage to Crete." Bronze sculpture. 1982. 9 casts. [Ibid., no. 37—ill.]

Edward Dorn, 1929–. "Song: Europa." Poem. In *Geography* (London: Fulcrum, **1965**). [Ipso]

Stein Mehren, 1935–. *Gobelin Europa.* Poem. Oslo: Aschehoug, **1965.** [EWL 1981–84, 3:261]

Gary Snyder, 1930–. (Europa in) "For the West." Poem. **1965.** In *The Back Country* (New York: New Directions, 1968). [Ipso]

Earl Staley, 1938–. "Europa and Zeus." Painting. **1980.** Watson/de Nagy & Co., Houston, in 1984. [Houston 1984, p. 62—ill.]

———. "Europa and Zeus I." Painting. 1980. Burt and Butler coll., Dallas. [Houston 1984, p. 62—ill.]

Derek Walcott, 1930–. "Europa." Poem. In *The Fortunate Traveller* (New York: Farrar, Straus & Giroux, **1981**). [DLB 1987, 42:423]

Douglas Dunn, 1942–. *Europa's Lover* (Europa as Europe). Poem. Newcastle-upon-Tyne: Bloodaxe, **1982.** [DLB 1985, 40:108]

EURYALUS. *See* AENEAS, in Sicily, at Latium.

EURYDICE. *See* ORPHEUS, and Eurydice.

EURYSTHEUS. *See* HERACLES, Birth; HERACLES, LABORS OF.

EURYTION. (1) A centaur (also called Eurytus) who participated in the battle with the Lapiths at the wedding of Pirithous and Hippodamia. *See* CENTAURS; PIRITHOUS, Wedding. (2) The herdsman of Geryon, whose cattle were the object of Heracles' tenth labor. *See* HERACLES, LABORS OF, Cattle of Geryon.

EUTERPE. *See* MUSES, Poetry and Music.

EVADNE. *See* APOLLO, Loves.

EVANDER. *See* AENEAS, in Latium.

F

FATES. To Homer, the Fates (Greek, *Moirai*) spun the thread of a mortal's life at birth and thus determined his destiny. According to Hesiod, they were the daughters of Zeus and the Titan Themis, or of Nyx (Night), and were three in number, each having a specific task: Clotho, "the Spinner," held the distaff; Lachesis, "the Apportioner," pulled out and measured the thread; and Atropos, "the Inflexible," cut it off. They may be conceived as either finishing their task at birth—hence their worship as birth goddesses—or continuing to spin throughout a mortal's life until all the thread is pulled from the distaff, signifying death. Born of Nyx, they were mysterious and inscrutable; born of Zeus, they were all-powerful; born of Themis (goddess of law), they represented order in human lives.

While best known for their spinning, the Fates could also weave and, in some tales, sing. In myth they were present at many of the great beginnings, such as the birth of Aphrodite (Venus) and the marriage of Thetis and Peleus, which prefaced the Trojan War.

In the Roman tradition, the Fates were known as Parcae or Fata. Originally associated only with birth, the Parcae were called Nona, Decuma, and Morta to signify, respectively, birth at nine months (premature to the Romans), birth at ten months (therefore full term), and stillbirth. Because of their nature and number, they were eventually identified with the Greek Fates and therefore as powers of destiny.

Classical Sources. Homer, *Iliad,* 4.517, 5.83, 12.116, 16.433ff.; *Odyssey* 3.269, 7.196ff., 11.292. Hesiod, *Theogony* 217–23, 901–5; *The Shield of Heracles* 249–63. Aeschylus, *Prometheus Bound* 511ff.; *The Eumenides* 956ff. Pindar, *Olympian Odes* 10.52; *Pythian Odes* 4.145; *Nemean Odes* 6, 7. *Orphic Hymns* 59, "To the Fates." Plato, *Republic* 10.616–621A. Catullus, *Carmina* 64, "The Fates." Ovid, *Metamorphoses* 15.808–15. Lucian, *Dialogues of the Dead* 24, "Minos and Sostratus."

Jean de Meun, 1250?–1305? (The Fates, especially Atropos, evoked in) *Le roman de la rose* lines 10371–74, 19763–839, 20359–68. Verse romance, completion of unfinished work begun by Guillaume de Lorris (*c*.1230–35). *c*.**1275.** Lyon: Ortuin & Schenck, *c*.1481. [Dahlberg 1971 / Poirion 1974]

Giovanni Boccaccio, 1313–1375. (Lachesis evoked in opening of) *Elegia di Madonna Fiammetta.* Prose elegy. **1343–44?** Padua: 1472. [Branca 1964–83, vol. 3 / Highet 1967, p. 90]

Geoffrey Chaucer, 1340?–1400. (Allusions to the Fates in) *Troilus and Criseyde* 3.733; 4.1208f., 1546f.; 5.3, 7. Poem. **1381–85.** Westminster: Caxton, 1475. [Riverside 1987]

Christine de Pizan, *c*.1364–*c*.1431. ("Atropos-Mors" in) *L'epistre d'Othéa à Hector* . . . [The Epistle of Othéa to Hector] chapter 34. Didactic romance in prose. *c*.**1400.** MSS in British Library, London; Bibliothèque Nati-

onale, Paris; elsewhere. / Translated by Stephen Scrope (London: *c*.1444–50). [Bühler 1970 / Hindman 1986, pp. 114–16, 140, 196, pls. 30–31]

————. (Atropos guards a gate to the castle of Fortune in) *Le livre de la mutacion de fortune* [The Book of the Change of Fortune]. *c*.1400–03. Modern edition by S. Solente, Paris: Picard, for Société des Anciens Textes Français, 1955. [Hindman, p. 114]

John Lydgate, 1370?–1449. (Atropos in) *The Assemble of Goddes; or, The Accord of Reson and Sensuallyte in the Fear of Death.* Allegorical poem. Probably before **1412.** Westminster: Wynken de Worde, 1498. Modern edition by O. L. Triggs (London: Early English Text Society, with University of Chicago, 1895; reprinted London & New York: Oxford University Press, 1957). [Ipso]

————. (The Parcae, particularly Atropos, evoked in) *Troy Book* 2.873–80. Poem, elaboration of Guido delle Colonne. 1412–20. Modern edition by Henry Bergen (London: Kegan Paul, Trench & Trübner, for Early English Text Society, 1906–35). [Benson 1980, p. 109]

Antico, *c*.1460–1528. "Atropos" ("Venus"). Bronze sculpture. **Late 15th century.** Victoria and Albert Museum, London, no. A.16–1931. [Clapp 1970, 1:39]

Italian School. "The Fates." Ceiling fresco. **1508–13?** Sala delle Nozze di Alessandro con Rossana, Villa Farnesina, Rome. [Gerlini 1949, pp. 34ff.]

Hans Baldung Grien, 1484/85–1545. "The Parcae." Woodcut. **1513.** [Yale 1981, fig. 31]

Albrecht Dürer, 1471–1528. "Kneeling Man Imploring the Three Fates." Drawing. **1515.** Formerly Museum Boymans-van Beuningen, Rotterdam, lost in World War II. [Strauss 1974, no. 1515–63—ill.]

Antonio da Correggio, *c*.1489/94–1534. "The Three Fates Spinning." Fresco. *c*.**1519.** Camera di San Paolo, Parma. [Gould 1976, pp. 51ff., 243]

Jean Lemaire de Belges, *c*.1473–1515/25. *Comptes le second et tiers de Cupido et Atropos* [The Second and Third Accounts of Cupid and Atropos]. Verse. Paris: 1525. [DLLF 1984, 2:1273]

Peter Vischer the Younger, 1487–1528. "The Fates." Drawing. Kupferstichkabinett, Berlin. [Warburg]

————. "The Fates." Painting on glass. Deutsches Museum, Berlin. [Ibid.]

Giulio Romano, *c*.1499–1546, assistant, after design by Giulio. "The Three Fates." Stucco relief. *c*.**1529–30.** Sala degli Stucchi, Palazzo del Tè, Mantua. [Verheyen 1977, pp. 123f.]

Matteo Bandello, 1480?–1562. "Le tre Parche" [The Three Parcae]. Poem. **1531.** In *Canti XI . . . Le tre Parche . . .* (Agenais, Guienne: Reboglio, 1545). [Bondanella 1979, p. 28]

Rosso Fiorentino, 1494–1540. "The Three Fates (Masked)." Design for costumes for a masque. *c*.**1534?** Lost. / Engraved by Pierre Milan, by 1545. [Carroll 1987, nos. 68–69—ill. / also Barocchi 1950, p. 252—ill. / Paris 1972, no. 421 / Lévêque 1984, p. 3—ill.]

————, composition. "The Three Fates, Nude." *c*.1538–

40. Engraving, by Pierre Milan, by 1545. (British Museum, London.) [Carroll, no. 105—ill. / also Barocchi, fig. 232 / Paris, no. 420 / Lévêque, p. 149—ill.] Copy, painted furniture panel, by Marin Le Bourgeoys (fl. 1591–1634?). Musée des Arts Décoratifs, Paris. [Paris, no. 594]

————. *See also Salviati, below.*

Leo Hebraeus, 1460–**1535.** (Fates, the three sisters whom Demogorgon pulls from Chaos, in) *Dialoghi di amore* [Dialogues of Love] (Venice: Aldus Manutius sons, 1545). Modern edition by Santino Caramella Barnes (Bari: 1929). [Nohrnberg 1976, pp. 736, 746 n.]

Francesco Primaticcio, 1504–**1570,** and assistants. "Venus and the Fates." Ceiling fresco, in Galerie d'Ulysse, Château de Fontainebleau. **1541–47.** Destroyed 1738–39. / Drawing. Louvre, Paris, inv. R.F. 1470. [Béguin et al. 1985, pp. 147ff.—ill. / also Dimier 1900, pp. 295ff., no. 115]

Luca Cambiaso, 1527–**1585.** "The Fates." Fresco. *c.*1560. Formerly Palazzo Vincenzo Imperiale, Genoa, destroyed. / Drawing (for?). Kupferstichkabinett, Stuttgart. [Manning & Suida 1958, pp. 87f., 179—ill.]

Cecchin Salviati, 1510–**1563** (previously attributed to Michelangelo, Rosso Fiorentino). "The Three Fates." Painting. Sala di Giove, Palazzo Pitti, Florence, no. 113. [Pitti 1966, p. 53—ill. / Barocchi 1950, p. 94—ill.]

Maerten van Heemskerck, 1498–**1574.** "The Triumph of the Three Fates." Drawing. **1565.** Städelsches Kunstinstitut, Frankfurt. [de Bosque 1985, pp. 192f.—ill.]

Hendrik Goltzius, 1558–**1617.** "The Three Fates." Drawing, composition for print. Prentenkabinet, Rijksuniversiteit, Leyden. [Reznicek 1961, no. 132—ill. / de Bosque 1985, p. 193—ill.] Engraved (by Jacob Matham?) **1587** (Bartsch no. 300, Matham). [Strauss 1977a, no. 251—ill. / Bartsch 1980–82, no. 160i—ill.]

Christopher Marlowe, 1564–**1593.** (The Destinies in) *Hero and Leander* 1.377–450. Poem, after Musaeus, unfinished. (This passage original with Marlowe.) Licensed **1593.** London: Blunt, 1598. [Bowers 1973, vol. 2 / Friedenreich et al. 1988, pp. 280, 303, 309f. / Leech 1986, pp. 180ff.]

Edmund Spenser, 1552?–**1599.** (The Fates in) *The Faerie Queene* 4.2.47–51. Romance epic. London: Ponsonbie, **1596.** [Hamilton 1977 / Maccaffrey 1976, p. 428]

Friedrich Sustris, *c.*1540–**1599.** "The Three Fates." Painting. Schloss, Trausnitz. [de Bosque 1985, p. 102]

Sienese School. "Clotho." Painting. **16th century.** Johnson coll., Philadelphia, inv. 115. [Warburg]

Bastianino, 1532–**1602,** attributed. "Time and the Fates." Fresco. Sala dell' Aurora, Castello Estense, Ferrara. [Arcangeli 1963, pp. 29f., no. 49—ill.]

Andrea Boscoli, *c.*1560–**1607,** attributed. "The Three Fates." Drawing. Gabinetto Nazionale delle Stampe, Rome, no. F.C. 130651. [Florence 1986, no. 2.52—ill.]

————. "The Three Fates." Drawing. Gabinetto Disegni e Stampe, Uffizi, no. 810 F. [Ibid.]

————. "The Three Fates." Drawing. Louvre, Paris, no. 668. [Ibid.]

Ben Jonson, 1572–**1637.** (The Fates in) "An Entertainment of the King and Queen at Theobalds." Royal entertainment for James I and Queen Anne. Performed 22 May **1607,** Theobalds House, London. Published London: 1616. [Herford & Simpson 1932–50, vol. 7]

————. (The Fates in) *Lovers Made Men* (*The Masque of Lethe*). Masque. Performed 22 Feb 1617, at Court, London. Published London: 1617. [Ibid.]

Giovanni Battista Marino, 1569–**1625.** (The Parcae spin the black clothes of Crudeltà in) "Sospetto d'Herode" [The Fear of Herod] stanza 43. Poem. *c.*1610. In *La strage degli innocenti* [The Massacre of the Innocents] (Naples: Beltrano 1632). [Claes Schaar, *Marino and Crashaw: Sospetto d'Herode, a Commentary* (Lund: Gleerup, 1971)]

Thomas Heywood, 1573/74–**1641.** "Of the Parcae." Passage in *Gynaikeion: or, Nine Books of Various History Concerning Women* book 1. Compendium of history and mythology. London: Adam Islip, **1624.** [Ipso]

Peter Paul Rubens, 1577–**1640.** "(The Fates Spinning) The Destiny of Marie de' Medici." Painting, part of "Life of Marie de' Medici" cycle. **1622–25.** Louvre, Paris, inv. 1769. [Saward 1982, pp. 20ff.—ill. / Jaffé 1989, no. 710—ill. / also Louvre 1979–86, 1:115—ill. / Baudouin 1977, pl. 61] Oil sketch ("Fates" and "Triumph of Truth" on 1 canvas). Louvre, inv. M.I. 212. [Jaffé, no. 709—ill. / Held 1980, no. 56—ill. / Louvre, p. 119—ill.]

John Milton, 1608–**1674.** (The Fates evoked in) *Arcades* lines 62–74. Masque. First performed **1632** (?) for Dowager Countess of Derby, Harefield. / Revised, published in *Poems* (London: Moseley, 1645). [Carey & Fowler 1968; cf. p. 159 n.]

————. (Atropos evoked in) "Lycidas" line 75. Pastoral elegy. Nov 1637. In *Justa Eduardo King naufrago . . .* (Cambridge: 1638). [Ibid; cf. p. 232 n.]

Giovanni da San Giovanni, 1592–**1636.** "Juno, Venus, and the Three Fates: Allegory of the Union between the Houses of Medici and della Rovere." Ceiling fresco. **1635–36.** Salone degli Argenti, Palazzo Pitti, Florence. [Banti 1977, no. 64—ill.]

Guido Reni, 1575–**1642,** follower. "A Fate" (Atropos). Painting. *c.*1630–40. Galleria Borghese, Rome, inv. 99. [Pergola 1955–59, 1: no. 111—ill. / Pepper 1984, p. 304 no. C12]

Robert Herrick, 1591–**1674.** "The Parcae; or, Three Dainty Destinies: The Armilet," (The Fates evoked in) "The Dreame." Poems. In *Hesperides* (London: Williams & Eglesfield, **1648.** [Martin 1956]

Angelo Caroselli, 1585–**1653.** "Prophetess and the Fates." Painting. Schilderijenzall Prins Willem V (Dienst Verspreide Rijkskollekties), The Hague, cat. 1977 no. 1. [Wright 1980, p. 72]

Theodoor van Thulden, 1606–**1669,** attributed. "The Three Fates with Cronus." Painting. Musée de Peinture et de Sculpture, Grenoble. [Bénézit 1976, 10:171]

Luca Giordano, 1634–**1705.** (The Fates in) "Allegory of Human Life and the Medici Dynasty." Fresco. **1682–83.** Palazzo Medici Riccardi, Florence. [Ferrari & Scavizzi 1966, 2:112ff.—ill.] Studies. D. Mahon coll., London; D. Barclay coll., London. [Ibid.—ill.]

————. "The Fates." Painting. *c.*1700. Palacio Real, Aranjuez. [Ibid., 2:225f.]

Daniel Gran, 1694–**1757.** "Aurora and Tithonus before the Fates." Fresco. **1723–24.** Kuppelsaal, Gartenpalais Schwarzenberg, Vienna. [Knab 1977, pp. 42ff., no. F8—ill.]

Giuseppe Maria Crespi, 1665–**1747.** "The Parcae." Painting. Palazzo Campogrande, Bologna. [Hunger 1959, p. 225]

Jacob de Wit, 1695–**1754.** "The Fates." Ceiling painting, part of "Apotheosis of Aeneas," for Herengracht 458,

Amsterdam. N. J. van Aalst coll., Hoevelaken. [Staring 1958, pl. 86]

Rosalba Carriera, 1675–**1757.** "The Fate Lachesis." Pastel. Alte Pinakothek, Munich, inv. 14444. [Munich 1983, p. 134—ill.]

————. "Clotho, the Youngest of the Fates." Painting. Gemäldegalerie, Dresden. [Warburg]

Johann Wolfgang von Goethe, 1749–1832. "Parzenlied" [Song of the Fates]. Song, in *Iphigenia auf Tauris* 4.1726–66. Tragedy. First performed 6 Apr **1779,** Weimar. / Revised 1787, performed 1802, Weimar. [Beutler 1948–71, vol. 6 / Suhrkamp 1983–88, vol. 8 / Cox 1987, pp. 86–88, 91 / Hamburger 1969, pp. 76f. / Butler 1958, pp. 99–105 / Viëtor 1949, pp. 63ff.] Set as lieds or choral works by at least 5 composers: Johann Friedrich Reichardt (1752–1814), Ferdinand Hiller (1811–1885), Johannes Brahms (1882), Robert Kahn (1865–1951), Hermann Reutter, 1949. [Moser 1949, pp. 142, 159]

————. (The Fates in) *Faust* Part 2, 1.5305–44. Tragedy. This episode first published 1828 as a continuation of Part 1; incorporated into Part 2, published Heidelberg: 1832. [Beutler, vol. 5 / Suhrkamp, vol. 2]

Henry Fuseli, 1741–1825. "The Three Fates." Drawing. **1781.** Kunsthaus, Zürich, inv. 1938/704. [Schiff 1973, no. 808—ill.]

Friedrich von Schiller, 1759–1805. "An die Parzen" [To the Parcae]. Poem. In *Anthologie auf das Jahr 1782* (Stuttgart: Metzler, **1782**). [Petersen & Beissner 1943]

Johann Gottfried Schadow, 1764–1850. "The Three Fates." Marble relief, tomb of Alexander von der Mark. **1790.** Dorotheenstädtische Kirche, Berlin, damaged or destroyed, 1945. [Janson 1985, pp. 64f.—ill. / also Berlin 1965, no. 6e, p. 97—ill.(dr.)]

Johann Heinrich Dannecker, 1758–1841. "The Three Fates." Clay sculpture group. **1791.** Staatsgalerie, Stuttgart. [Spemann 1958, pl. 4] Variant, for clock-housing. 1793. Stadtarchiv, Stuttgart. [Ibid., pl. 5]

Asmus Jakob Carstens, 1754–1798. "Atropos." Plaster sculpture. **1794.** Städelsches Kunstinstitut und Städtische Galerie, Frankfurt. [Clapp 1970, 1:149]

————. "The Singing Fate" ("Atropos"). Statuette. 1795. Schlossmuseum, Weimar. [Cologne 1977, pp. 144, 168—ill.]

Johann Gottfried Herder, 1744–1803. "Die Parzen: Ein Gemälde von Heinrich Meyer" [The Parcae: A Painting by Heinrich Meyer]. Poem. In *Zerstreuter Blätter* no. 6 (Gotha: Ettinger, **1797**). / Collected in [Herder 1852–54, vol. 13]

Francisco Goya, 1746–1828. "They Spin Finely." Etching. **1797–98.** [Gassier & Wilson 1981, no. 539—ill.]

————. "The Fates" ("Atropos"). Painting. 1820–23. Prado, Madrid, no. 757. [Gassier & Wilson 1981, no. 1615—ill. / also Gudiol 1971, no. 708—ill. / Prado 1985, p. 282]

Friedrich Hölderlin, 1770–1843. "An die Parzen" [To the Parcae]. Alcaic ode. **1798.** In *Gedichte* (Stuttgart & Tübingen: Cotta, 1826). [Beissner 1943–77, vol. 1 / Hamburger 1980]

Pierre-Paul Prud'hon, 1758–1823. "The Three Fates." Painting, part of a series of imitation bronze bas-reliefs for Hôtel Lanois, Paris. **1796–99.** Unlocated. [Guiffrey 1924, pp. 294ff.]

————. Drawings of the Fates, studies for "Aesculapius, Hygeia, the Three Fates, and Charity," unexecuted decoration for façade of Hôtel-Dieu, Paris. 1804. Musée Condé, Chantilly; Musée Baron Martin, Gray; others in private colls. or unlocated. [Ibid., nos. 903–09, pp. 338f.—ill.] Copy, painting, after "Clotho." National Gallery, London, inv. 3587. [London 1986, p. 501—ill.]

Samuel Shelley, 1750–**1808.** "The Three Fates." Watercolor. Victoria and Albert Museum, London, no. E.1362-1948. [Lambourne & Hamilton 1980, p. 345]

Ugo Foscolo, 1778–1827. ("L'invisibile Parca" in) "Inno secondo" [Second Hymn] part 2. Hymn, in *Le Grazie* [The Graces]. Poem, unfinished. **1814.** Florence: 1848. Modern edition by Saverio Orlando as *Le Grazie, carme ad Antonio Canova* (Brescia: Paideia, 1974). [Cambon 1980, pp. 224, 346 / Circeo 1974, pp. 92ff.]

Lord Byron, 1788–1824. (The Destinies in) *Manfred* 2.3–4. Dramatic poem. **1816–17.** London: Murray, 1817. [McGann 1980–86, vol. 4]

John Peter Bologna, 1775–1846, choreography. *The Fates, or, The Harlequin's Holiday.* Harlequinade. First performed **1819,** London. [Nicoll 1959–66, 4:459]

Rudolf Schadow, 1786–1822. "The Spinner" (Clotho). Marble statue. **1820.** Hermitage, Leningrad, inv. 1686. [Hermitage 1984, no. 396—ill.]

William Blake, 1757–1827. Clotho depicted in a design for a visiting card and bookplate, for George Cumberland. **1827.** (Fitzwilliam Museum, Cambridge.) [Bindman 1978, no. 654—ill.]

————. "The Three Fates." Drawing. Unlocated. [Butlin 1981, no. 860]

Charles Tennyson Turner, 1808–1879. "On a Picture of the Fates." Poem. In *Sonnets and Fugitive Pieces* (Cambridge, England: Bridges, **1830**). [Bush 1937, p. 550]

Bertel Thorwaldsen, 1770–1844. "The Fates with the Thread of Life." Marble relief. Plaster original, **1833.** Thorwaldsens Museum, Copenhagen, no. A364. / Marble executed by C. C. Olsen and H. W. Bissen, 1864. Thorwaldsens Museum, no. A365. [Thorwaldsen 1985, p. 49]

Antoine Jean-Baptiste Thomas, 1791–**1834.** "The Three Fates." Painting. Musée, Bourges. [Bénézit 1976, 10:153]

Dante Gabriel Rossetti, 1828–1882. "The Three Fates." Drawing. *c.***1851.** Mrs. Ronald Marshall coll. [Surtees 1971, no. 589]

Owen Meredith (Edward Robert Bulwer Lytton), 1831–1891. *The Parcae; Six Leaves from the Sibyl's Book.* Drama. In *Poems and Dramas,* vol. 1 (London: Chapman & Hall, **1852**). [Ipso]

Heinrich Heine, 1797–1856. (The Fates evoked in) "Zum Lazarus" [Supplement to "Lazarus"] stanza 10. Poem. In *Gedichte 1853–54* (Hamburg: Hoffmann & Campe, **1854**). [Atkins & Boeck 1973–78, vol. 2 / Draper 1982]

Carl Rahl, 1812–**1865.** "The Parcae." Painting. Galerie des 19. Jahrhunderts, Vienna. [Hunger 1959, p. 225]

Frederick Sandys, 1829–1904. "The Tangled Skein." Painting. **1870s.** [Kestner 1989, p. 171]

Johannes Brahms, 1833–1897. "Der Gesang der Parzen" [Song of the Parcae]. Choral composition for 6–part chorus and orchestra, opus 89. Text, Goethe (1779). First performed 10 Dec **1882,** Basel. [Baker 1984, p. 328 / Grove 1980, 3:170, 178]

Gustave Doré, 1832–**1883.** "The Fate and Cupid." Bronze

sculpture. Also plaster and terra-cotta models. [Leblanc 1931, p. 543]

Walter Crane, 1845–1915. (The Fates in) "The Bridge of Life." Painting. **1884.** [Kestner 1989, p. 241]

Elihu Vedder, 1836–1923. "The Fates Gathering in the Stars." Painting (related to illustrations for Edward Fitzgerald's translation of the *Rubáiyát* of Omar Khayyám, 1884). **1887.** Art Institute of Chicago, no. 19.1. [Chicago 1961, p. 459 / Soria 1970, no. 436, pl. 34 / Soria et al. 1979, fig. 172]

Gabriele D'Annunzio, 1863–1938. "Sonetti delle Fate." Sonnet sequence. **1885–88.** In *La Chimera* (Milan: Treves, 1890). [Palmieri 1953–59, vol. 2]

Auguste Rodin, 1840–1917. "Youth Triumphant" ("The Young Girl and the Fate"). Plaster sculpture. **1894.** Musée Rodin, Paris. [Rodin 1944, no. 270—ill.]

Julia Parker Dabney, b. 1850. "The Parcae." Poem. In *Songs of Destiny and Others* (New York: Dutton, **1898**). [Boswell 1982, p. 82]

Odilon Redon, 1840–1916. "The Fates." Painting. **After 1900.** Rijksmuseum Kröller-Müller, Otterlo. [Berger 1964, no. 84]

Jules Massenet, 1842–1912. (Clotho in) *Bacchus.* Opera. Libretto, Catulle Mendès. First performed 5 May **1909,** Paris. [Baker 1984, p. 1478 / Edler 1970, pp. 205f.]

Theodor Däubler, 1876–1934. (Klotho, Lachesis, and Atropos evoked in) "Die Markuskirche" [St. Mark's Church]. Second of 2 poems with the same title, part of *Das Nordlicht.* Epic. Florence: **1910**; Leipzig: 1921. [Ipso] English translation, *The Northern Lights* (Geneva: 1922).

Osip Mandel'shtam, 1891–1939/42. (Parcae evoked in) Untitled poem. **1910.** In *Kamen* [Stone] (Peterburg: Akme, 1913). [Raffel & Burago 1973, no. 12 / Terras 1966, p. 257]

Adolf von Hildebrand, 1847–1921. "The Three Fates." Drawing. **1911.** Hildebrand estate in 1922. [Heilmeyer 1922, p. 45—ill.]

———. "The Three Fates." Stone relief, design based on above. 1916–18. Martius family tomb, Kiel. [Heilmeyer 1922, p. 32—ill.] Terra-cotta sketch. Artist's studio, Munich, in 1922. [Ibid., p. 41]

Paul Valéry, 1871–1945. "La jeune Parque" [The Young Fate]. Poem. **1913–17.** Paris: Éditions de la Nouvelle Revue Française, 1917. [Hytier 1957–60, vol. 1 / Mathews 1956–71, vol. 1 / Crow 1982, pp. 66–102]

Wilfred Owen, 1893–1918. "The Fates." Poem. **1917.** In *Poems* (London: Chatto & Windus, 1920). Collected in *Poems,* edited by Edmund Blunden. [BW 1979–87, 6:459]

Camille Claudel, 1856–**1920.** "Clotho." Sculpture. [Clapp 1970, 1:174]

Frank Lucas, 1894–1967. "The Destinies." Poem. In *Marionettes* (New York: Macmillan, **1930**). [Boswell 1982, p. 269]

George Seferis, 1900–1971. "Nēa Moira" [Young Fate]. Haiku. **c.1932.** In *Tetradio gymnasmaton* [Book of Exercises] (Athens: Ikaros, 1940). [Keeley & Sherrard 1967]

John Peale Bishop, 1892–1944. (The Fates evoked in) "Ode." Poem. In *Now with His Love* (New York & London: Scribners, **1933**). [Ipso]

Léonide Massine, 1895–1979, choreography and book. (Fate and the Destinies dance in) *Les présages.* Choreo-

graphic symphony. Music, Tschaikovsky's 5th Symphony. First performed 13 Apr **1933,** De Basil Company, Théâtre de Monte Carlo; scenery and costumes, André Masson. [Beaumont 1938, pp. 686, 687 *n.,* 746–49]

Miroslav Ponc, 1902–1976, music. *Osudy* [The Fates]. Ballet with speaker. **1934.** First performed 11 May 1935, National Theater, Prague. [Grove 1980, 15:74]

John Melhuish Strudwick, 1849–**1937.** "The Golden Thread" (lower panel: the 3 Fates spinning). Painting. Tate Gallery, London. [Wood 1983, p. 197—ill.]

Émile Bernard, 1868–1941. "The Three Fates." Painting. **1937.** Private coll., Sweden. [Luthi 1982, no. 1462—ill.]

Leo Ornstein, b. 1892. "Dance of the Fates." Orchestral composition. **c.1937.** [Grove 1980, 13:868]

Paul Manship, 1885–1966. "Time and the Fates." Monumental plaster sundial, for New York World's Fair of 1939–40. **1938.** Destroyed. [Murtha 1957, no. 390—ill. / Rand 1989, pp. 155–66—ill. / Minnesota 1985, pp. 121f. figs. 17–19] Bronze reductions. Minnesota Museum of Art, St. Paul; National Museum of American Art, Washington, D.C.; elsewhere. [Rand 1989, figs. 164–65 / Minnesota 1985, no. 80—ill.] Bronze models, 1938. [Murtha, nos. 388–89—ill.]

Laura Riding, 1901–1985. "The Fates and the Mothers." Poem. In *Collected Poems* (New York: Random House, **1938**). [Ipso]

César Klein, 1876–1954. "The Fates." Painting. **1946.** [Hannover 1950, no. 42]

Mary Wigman, 1886–1973, choreography. *Lied der Nornen* [Song of the Fates]. Dance. **Before 1949,** unfinished. [Sorell 1975, pp. 166–68]

David Paltenghi, 1919–1961, choreography. *The Fates' Revenge, or, Rebellion in the Upper Rooms.* Ballet. Music, Peter Tranchell. First performed **1951**; décor, Ronald Ferns. [Sharp 1972, p. 270]

Stephen Spender, 1909–. "The Fates." Poem. By **1953.** In *Collected Poems, 1928–1985* (New York: Random House, 1986). [Ipso]

Doris Humphrey, 1895–1958, choreography. *Ruins and Visions.* Dance, after Spender's "The Fates" (above). Music, Benjamin Britten. First performed **1953,** New London, Conn. [Cohen 1972, p. 205]

Leo Smit, 1921–. *The Parcae.* Overture. First performed 16 Oct **1953,** Boston. [Baker 1984, p. 2151]

Thornton Wilder, 1897–1975. *The Drunken Sisters* (the Fates). Satyr play, to accompany his *Alcestiad.* **1955.** New York: French, 1957. [Hamburger 1969, p. 109]

Bernhard Heiliger, 1915–. "The Fates." Painted stucco sculpture. **1961.** [Berlin 1963, no. 88—ill.] Bronze model. Landesuniversität, Münster. [Ibid.]

Kathleen Raine, 1908–. "Lachesis." Poem. **1960–64.** In *The Hollow Hill and Other Poems* (London: Hamilton, 1965). [DLB 1983, 20:295]

Gian Francesco Malipiero, 1882–1973. *Atropo.* Symphony, no. 10. **1967.** [Baker 1984, p. 1436]

Yannis Ritsos, 1909–1990. ("Aunt Lahó," a Lachesis-figure, in) "Memorial Services" [English title of a work written in Greek]. Poem. 7 Mar **1970.** In *Epanalepseis* (Athens: Kedros, 1972). / Translated by Kimon Friar in *Modern Greek Poetry* (New York: Simon & Schuster, 1973). [Ipso]

Miklós Hubay, 1918–. *Párkák* [The Parcae] (evocative title: the Fates as policewomen in South America]. Drama. In *Szinház a cethal Latán* (Budapest: Szépirsdalmi Könyvkiadó, **1974**). [McGraw-Hill 1984, 2:527f.]

Kathleen Louise Saint John, 1942–. "Clotho, Lachesis, and Atropos." Instrumental composition. **1976.** [Cohen 1987, 2:609]

FAUNS. *See* SATYRS AND FAUNS.

FAUNUS. *See* PAN.

FEAST OF THE GODS. *See* GODS AND GODDESSES.

FLORA. Originally a Sabine fertility deity, Flora was the Roman goddess of flowers, gardens, spring, and love. A temple was dedicated to her in Rome in 238 BCE, and her springtime festival, the Floralia, was instituted after 173 BCE. These rites, which included games and the lascivious practices associated with fertility festivals, perhaps derived from the posthumous cult of a rich prostitute who called herself Flora and who left money to the state for celebrations. Ovid suggests that Flora was a transformation of the Greek nymph Chloris.

In postclassical art, Flora is depicted holding garlands of flowers or leading a procession of spring revelers. She is often seen with her consort, Zephyr (the west wind). Flora is commonly represented in painting as a personification of spring and sometimes of the element Earth.

Classical Sources. Ovid, *Fasti* 5.183–378. Pliny, *Naturalis historia* 18.69, 284ff. Martial, *Epigrams* 8.67.4.

Further Reference. J. S. Held, "Flora, Goddess and Courtesan," in *Essays in Honor of Erwin Panofsky,* edited by M. Meiss (Zürich: Buehler, 1960).

Listings are arranged under the following headings:
General List
Flora and Zephyr

See also GODS AND GODDESSES, as Seasons, as Elements; ZEPHYR.

General List

Giovanni Boccaccio, 1313–1375. "De Flora, meretrice dea florum et Zephyri coniuge" [Flora, Goddess of the Flowers and Wife of Zephyr] (as a Roman prostitute). In *De mulieribus claris* [Concerning Famous Women]. Latin verse compendium of myth and legend. **1361–75.** Ulm: Zainer, 1473. [Branca 1964–83, vol. 10 / Guarino 1963 / Bergin 1981, p. 250]

Angelo Poliziano, 1454–1494. (Chloris and Flora evoked in) *Stanze . . . per la giostra di Giuliano de' Medici* 1.68. Poem. **1475–78.** [Wind 1968, p. 127 *n.*]

Anonymous English. *The Floure and the Leafe* (Flora, "Queen of the Flower," contests with Diana, "Queen of the Leaf"). Allegorical poem. **15th century.** Attributed to Geoffrey Chaucer until end of the 19th century. Modern edition by D. A. Pearsall (London: Nelson, 1962; Manchester: University Press, 1980). [Oxford 1985, pp. 356–57 / Lewis 1958, pp. 247f.]

Albrecht Altdorfer, *c.*1480–1538. "Flora." Engraving. *c.***1506.** [Winzinger 1963, no. 94—ill.]

Palma Vecchio, 1480–1528. "Flora." Painting. *c.***1515**? National Gallery, London, no. 3939. [Mariacher 1968, pl. 50]

———, studio? (previously attributed to Palma). "Head of a Girl" (Flora?). Painting. Fogg Art Museum, Harvard University, Cambridge. [Ibid., p. 96]

Titian, *c.*1488/90–1576. "Flora." Painting. *c.***1520–22.** Uffizi, Florence, inv. 1462. [Wethey 1975, no. 17—ill. / Uffizi 1979, no P1722—ill. / Berenson 1957, p. 186]

Bernardino Luini, 1480/85–**1532,** attributed (also attributed to Leonardo da Vinci, Francesco Melzi). "Vanity" ("Flora"). Painting. Galleria Borghese, Rome, inv. 470 (as Melzi). [Luino 1975, p. 94 / Pergola 1955–59, 1: no. 147—ill.]

Agnolo Bronzino, 1503–1572, design. "Spring" ("Flora"). Tapestry. *c.***1545.** Palazzo Vecchio, Florence. Original design lost. [Baccheschi 1973, no. 58—ill.]

———, design. "Spring" ("Flora"). Tapestry. 1545–46. Palazzo Pitti, Florence. [Ibid., no. 58 / Berenson 1963, p. 42]

Francesco Primaticcio, 1504–1570, and assistants. "Flora, Goddess of Gardens." Ceiling fresco, in Galerie d'Ulysse, Château de Fontainebleau. **1541–47.** Destroyed 1738–39. [Béguin et al. 1985, pp. 195f. / Dimier 1900, pp. 295ff.]

———, design. "Flora." Fresco, for Salle de Bal, Château de Fontainebleau, executed by Niccolò dell' Abbate under Primaticcio's direction. 1551–56. Repainted 19th century. [Dimier 1900, pp. 160ff., 284ff.]

———, design. "Flora." Tapestry fragment, part of "The Gods' Arabesques." 1547–59. Musée des Gobelins. [Dimier, pp. 384ff.]

———, circle ("Master of Flora"). "The Triumph of Flora." Painting, for Fontainebleau. 1550/1600. Private coll. [Paris 1972, no. 130—ill.]

School of Fontainebleau. "Flora." Tapestry, for Château de Fontainebleau. **1551–59.** Mobilier National, Paris. [Paris 1972, no. 450]

Jan Massys, 1509–1575. "Flora." Painting. **1559.** Kunsthalle, Hamburg, inv. 755. [Hamburg 1985, no. 17—ill. / Hamburg 1966, p. 98—ill.] Replica/variant. Nationalmuseum, Stockholm. [Panofsky 1956, p. 64 *n.*15]

Paris Bordone, 1500–1571. "Mars, Venus, Flora, and Cupid." Painting. *c.***1550–60.** Kunsthistorisches Museum, Vienna, inv. 69. [Canova 1964, p. 116—ill. / Vienna 1973, p. 26—ill.]

———. "Flora and Venus, with Mars and Cupid." Painting. Hermitage, Leningrad, no. 1846. [Canova, p. 80—ill. / Berenson 1957, p. 46—ill.]

———. "A Woman as Flora." Painting. Louvre, Paris, no. R.F. 1474 (1180A). [Canova, p. 85—ill. / Louvre 1979–86. 2:156—ill.]

————. "Satyr, Cupid, Flora, and Diana." Painting. Formerly Chiesa coll., Milan, sold New York, 1927. [Canova, pp. 119f.—ill.]

Edmund Spenser, 1552?–1599. (Flora described in gloss for) "March," (Chloris evoked in gloss for) "April," in *The Shepheardes Calender.* Cycle of eclogues. London: **1579.** [Oram et al. 1989]

Andrea Gabrieli, *c.*1510–1586. "Vieni Flora gentil vieni e discaccia." Madrigal. **1580.** [Grove 1980, 7:59]

Leone Leoni, *c.*1560–1627. *Bella Clori* [Beautiful Chloris]. Book of madrigals. Venice: **1591.** [Grove 1980, 10:676]

Luca Marenzio, 1553/54–1599. Chloris addressed in cycle of 10 madrigals. Published Venice: **1581–94.** [Grove 1980, 11:671–73]

Marcello Ferro. *La Chlori.* Pastoral drama (eclogue). Venice: Vincenti, **1598.** [Clubb 1968, p. 111]

Richard Niccols, 1584–1616. (The birth of Flora in) *The Cuckow.* Poem. London: **1607.** [Bush 1963, p. 314]

Giambologna, 1529–**1608**, or circle. "Flora" ("Spring"). Bronze figurine. Bagrit coll., London; Grünes Gewölbe, Dresden. [Avery & Radcliffe 1978, no. 18—ill.]

William Shakespeare, 1564–1616. (Perdita plays Flora, is welcomed as Goddess of Spring, in) *The Winter's Tale* 4.4, 5.1.151f. Drama (romance). **1610–11.** First recorded performance 15 May 1611, Globe Theatre, London. Published London: Jaggard, 1623 (First Folio). [Riverside 1974 / Davies 1986, p. 156 / Muir 1985, p. 72]

Ambrose Dubois, 1543–**1614**, attributed. "Flora." Painting (for Cabinet du Roi, Fontainebleau?). Private coll., Paris. [Paris 1972, no. 85]

Hendrik van Balen, 1575–1632, figures, and **Jan Brueghel the Elder**, 1568–1625, landscape. "Garland of Flowers, with Flora." Painting. **1609–16.** Leger Gallery, London, in 1969. [Ertz 1979, no. 214]

———— (van Balen). "Flora." Painting. Gemäldegalerie, Dresden. [Bénézit 1976, 1:401]

———— (van Balen). "Flora and Pomona." Painting. [Ibid.]

————. *See also Jan Brueghel the Younger and van Balen, below.*

Pietro Bernini, 1562–1629 (with Gian Lorenzo Bernini? previously attributed to Gian Lorenzo). "Flora." Marble herm. *c.*1615–16. Private coll., Morristown, N.J. [Wittkower 1981, no. 82.3]

Giovanni da San Giovanni, 1592–1636. (Flora in) "Allegory of Florence." Fresco, for a house in Piazza della Calza, Florence. **1616.** Detached fragments in possession of Soprintendenza degli Uffizi, Florence. Drawings in Gabinetto Disegni e Stampe, Uffizi, Florence, nos. 1122 F, 2376 S; Kunstmuseum, Dusseldorf, no. F. p. 357; Hermitage, Leningrad, no. 1064. [Banti 1977, no. 1—ill.]

————. "Flora with the Nymphs of the Arno and the God Pan." Ceiling fresco. 1635–36. Salone degli Argenti, Palazzo Pitti, Florence. [Ibid., no. 64—ill.]

Ludovico Carracci, 1555–**1619.** "Flora." Painting. Galleria Estense, Modena. [Malafarina 1976, no. 175—ill.]

Camillo Lenzini. *Clori.* Tragicomedy. Florence: Pignoni, **1626.** [Weaver 1978, p. 109]

Jan Brueghel the Younger, 1601–1678, landscape, and **Hendrik van Balen**, 1575–1632, questionably attributed, figures. (Flora in) "Allegory of Spring." Painting. **1627?** Alte Pinakothek, Munich, inv. 828. [Ertz 1984, no. 188—ill.

/ also Ertz 1979, fig. 461] Reversed copy in Chaucer Gallery, London, in 1984. [Ertz 1984, no. 189—ill.]

———— (Brueghel) and artist in van Balen's circle. "The Domain of Flora." Painting. 1630s? Pelikanwerke, Hannover. [Ertz 1984, no. 190—ill.]

———— (Brueghel) and unidentified collaborator. "Flora with Putto on a Terrace in a Park." Painting. Sold Christie's, London, 1979. [Ibid., no. 192—ill.]

Juan van der Hamen y León, 1596–1631. "Offering to Flora." Painting. 1627. Prado, Madrid, no. 2877. [López Torrijos 1985, p. 432 no. 65—ill. / Prado 1985, p. 325]

Peter Paul Rubens, 1577–1640, studio. "The Goddess Flora." Painting. Before 1628. Prado, Madrid, no. 1675. [Prado 1985, p. 602]

Marco da Gagliano, 1582–1643, with **Jacopo Peri**, 1561–1633. *La Flora, ovvero, Il natal de' Fiori* [Flora, or, The Birth of the Flowers]. Opera (favola per musica). Libretto, Andrea Salvadori. First performed 14 Oct 1628, Teatro del Serenissimo Gran Duca, Uffizi, Florence. [Grove 1980, 7:83, 85; 14:404 / Weaver 1978, p. 111]

Nicolas Poussin, 1594–1665. "The Triumph of Flora." Painting. *c.*1627–30. Louvre, Paris, inv. 7298 (732). [Wright 1985, no. 42, pl. 19 / Blunt 1966, no. 154—ill. / Louvre 1979–86, 4:144—ill. / also Thuillier 1974, no. 48—ill.] Copies in Louvre, Paris, on deposit at Ministry of the Interior; Musée de Tessé, Le Mans; Musée de Marseilles; Princeton University Art Museum, N.J.; Pinacoteca Capitolina, Rome; 2 others unlocated. [Blunt]

————. "The Empire (Realm, Kingdom) of Flora." Painting. 1631. Gemäldegalerie, Dresden, no. 719. [Wright, no. 62, pl. 24 / Blunt, no. 155—ill. / Dresden 1976, p. 82—ill. / also Thuillier, no. 67—ill. / Vermeule 1964, pp. 112, 174]

————. "Flora." Designs and wax models for 2 marble terms (1 also called "Venus"). 1655–56. Lost. / Marbles executed by Jean-Baptiste Théodon, by 1661. Quinconce du Nord, Gardens, Versailles. [Blunt, nos. 224, 227—ill. / also Girard 1985, pp. 273f.]

Ben Jonson, 1572–1637. *Chloridia: Rites to Chloris and Her Nymphs.* Masque. Performed 22 Feb 1630, at Court, London. [Herford & Simpson 1932–50, vol. 7]

Paulus Moreelse, 1571–1638. "Portrait of a Young Woman as Flora." Painting. 1633. Museum of Fine Arts, Boston, no. 46.559. [Boston 1985, p. 212—ill.]

Rembrandt van Rijn, 1606–1669. "Saskia [van Ulenburgh] as Flora." Painting. 1634. Hermitage, Leningrad. [Gerson 1968, no. 92—ill. / Hermitage 1984, no. 69—ill. / Guillaud 1986, fig. 341]

————. "Saskia (as Flora)." Painting. 1635. National Gallery, London. [Gerson, no. 96—ill. / London 1986, p. 515—ill. / Guillaud, fig. 340]

————. "(Hendricke [Stoffels] as) Flora." Painting. *c.*1654. Metropolitan Museum, New York. [Gerson, no. 288—ill. / Guillaud, fig. 388 / Metropolitan 1983, p. 150—ill. / Metropolitan 1980, p. 149—ill.]

————, style (false signature: Rembrandt, 1632). "Saskia as Flora." Painting. Metropolitan Museum, New York, no. 60.71.15. [Metropolitan 1980, p. 151—ill.]

————. *See also Govaert Flinck, below.*

Jan Boeckhorst, 1605–1668. "Flora." Painting. **1630s.** Kunsthistorisches Museum, Vienna, inv. 5763 (879). [Vienna 1873, p. 24—ill.]

Philippe de Buyster, 1595–1688. "Flora" ("Abundance"). Stone sculpture. **1635–40.** Château de Wideville, near Paris. [Chaleix 1967, pp. 35, 124, pl. 4.2]

Jacob Jordaens, 1593–1678. "Flora, Silenus, and [Zephyrus?]." Painting. *c.*1640. Parmentier coll., Knocke. [Rooses 1908, pp. 178, 233—ill.] Variant ("Silenus and the Four Seasons"). Countess de la Gardie coll., Helsingborg. [Ibid., p. 261] 2 further versions known, unlocated. [Ibid.] Copy of Knocke version ("Silenus") in Muzeum Narodowe, Warsaw, inv. 131417, on display at Lazienki Palace. [Warsaw 1969, no. 541—ill.]

Margherita Costa Ronaca, 1600–1682, libretto. *Flora feconda* [Fertile Flora]. Opera (dramma per musica). Composer unknown. Libretto published Florence: Massi e Landi, **1640.** [Weaver 1978, p. 115]

Domenichino, 1581–**1641.** "Flora." Painting. Recorded 1690, untraced. [Spear 1982, p. 311]

Guercino, 1591–1666. "Flora." Painting. **1642.** Palazzo Pallavicini Rospigliosi, Rome. [Salerno 1988, no. 200—ill.]
———, studio (formerly attributed to Guercino). "Flora" ("Spring"). Painting. Galleria Doria Pamphilj, Rome, no. 381. [Salerno 1988, p. 429]

Francisco Gómez de Quevedo y Villegas, 1580–**1645.** "A Flora." Lyric poem. In *El Parnaso español,* edited by J. A. González de Salas (Madrid: González de Salas, 1648). [Oxford 1978, p. 481]

Francesco Furini, 1604–**1646,** studio. "Flora." Painting. Kunsthistorisches Museum, Vienna, inv. 5812. [Vienna 1973, p. 72]

Pieter van Avont, 1600–**1652.** "Flora in the Garden." Painting. Kunsthistorisches Museum, Vienna, inv. 1692 (991). [Vienna 1973, p. 10—ill.]

Thomas Willeboirts, *c.*1614–**1654.** "Flora." Painting. Musée, Dieppe. [Bénézit 1976, 10:740]

Gerrit van Honthorst, 1590–**1656.** "Flora." Painting. Sold 1904, unlocated. [Judson 1959, no. 84]

Pacecco de Rosa, 1607–**1656.** "Flora." Painting. Kunsthistorisches Museum, Vienna, inv. 9679. [Vienna 1973, p. 144—ill.]

Hendrik Gerritsz Pot, *c.*1585–**1657.** "Flora's Mallewagen." Painting. Frans Hals Museum, Haarlem, inv. 240. [Wright 1980, p. 372]

Pedro Calderón de la Barca, 1600–1681. (Flora and Clori in) "La púrpura de la rosa" [The Blush of the Rose]. Zarzuela. Music, Juan Hidalgo. **1659.** First performed 5 Dec 1660, Buen Retiro, Madrid. Libretto published in *Comedias de Calderón,* part 3 (Madrid: 1664). [Valbuena Briones 1960–67, vol. 1 / O'Connor 1988, pp. 304–15]

Govaert Flinck, 1615–**1660,** attributed (traditionally attributed to Rembrandt). "Flora." Painting. Louvre, Paris, no. R.F. 1961–69. [Louvre 1979–86, 1:59—ill.]
———, formerly attributed (also questionably attributed to Jan van Noort or Jan van Loo). "Flora" (also wrongly called "Pomona"). Formerly Hulin de Loo coll., Brussels, sold 1947. [von Moltke 1965, no. W43]

Charles Le Brun, 1619–1690. "Flora." Drawing (part of a ceiling design?). *c.*1660. Musée des Beaux-Arts, Besançon, no. D.1780. [Versailles 1963, no. 100—ill.]
———, design. "Spring" (Flora). Marble statue, executed by Philippe Magnier, 1675–81. Parterre du Nord, Gardens, Versailles. [Girard 1985, p. 272—ill.]

Jean-Baptiste Lully, 1632–1687, music. *Flore.* Ballet. Scenario, Isaac de Bensérade. First performed 13 Feb **1669,** Tuileries, Paris. [Grove 1980, 11:327, 2:508]

Balthasar Permoser, 1651–1732. "Flora." Sandstone sculpture. Before **1675.** Unteres Belvedere, Vienna. [Asche 1966, no. P3, pl. 11]

Antonio Draghi, 1634/35–1700, music. "L'ossequio di Flora" [Homage to Flora]. Vocal composition, introduction to ballet. Text, N. Minato. First performed Carnival **1679,** Vienna. [Grove 1980, 5:605]

Antonio Sartorio, 1630–1680, completed by **Marc' Antonio Ziani,** *c.*1653–1715. *La Flora.* Opera. Libretto, N. Bonis. First performed Dec **1680** (or Carnival 1681), Teatro San Angelo, Venice. [Grove 1980, 16:510, 20:674 / Baker 1984, p. 1993]

Luca Giordano, 1634–1705. (Flora in) "Allegory of Agriculture," detail in "Allegory of Human Life and the Medici Dynasty." Fresco. **1682–83.** Palazzo Medici Riccardi, Florence. [Ferrari & Scavizzi 1966, 2:112ff.—ill.] Study. D. Mahon coll., London. [Ibid.—ill.]
———. "Flora." Painting. *c.*1700. Casita, El Pardo. [Ibid., 2:226]
———. "The Goddess Flora." Painting. Ministerio Asuntos Exterios, Madrid, in 1955. [Ibid., 2:345]
———, studio. "Triumph of Flora." Painting. Castello Sforzesco, Milan. [Ibid., 2:300]

Jean Jouvenet, 1644–1717. "Venus on a Cloud, Visited by Zephyr [or Flora]." Ceiling painting, for Hôtel de Saint-Poulange, Paris. *c.*1681–84. [Schnapper 1974, no. 17] Drawing (for?). Nationalmuseum, Stockholm, no. THC4594. [Ibid., no. 152—ill.]

Johann Philipp Krieger, 1649–1725, music. *Flora, Ceres und Pomona.* Masquerade. **1688.** [Grove 1980, 10:269]

Guillaume Louis Pécour, 1653–1729, choreography. *Le palais de Flore, ou, Le Trianon.* Ballet. Music, Michel-Richard de Lalande and Jean-Baptiste Matho. First performed Jan-Feb **1689,** Trianon, Versailles. [EDS 1954–66, 7:1810 / Grove 1980, 10:384, 11:824]

Claudio Coello, 1642?–**1693.** "Flora." Drawing. Prado, Madrid, no. F.D. 405. [López Torrijos 1985, p. 432 no. 66—ill.]

François Girardon, 1628–1715, design and model. "Flora" ("Spring"). Marble statue. Executed **1688–99** by Marc Arcis (begun and abandoned), completed by Simon Mazière. Bassin d'Apollon, Gardens, Versailles. [Girard 1985, p. 275—ill. / also Francastel 1928, no. 58—ill.]
———, design. "Dawn" (Flora). Marble statue. Executed by Philippe Magnier, 1686–1704. Bosquet des Dômes, Gardens, Versailles. [Girard, p. 282—ill.]
———, attributed. "Flora." Marble bust. Louvre, Paris, in 1798, lost. [Francastel, no. 94]

Venetian School. "Flora." Painting. **17th century.** Attingham Park, Shropshire. [Wright 1976, p. 105]

John Dryden, 1631–1700. (Flora's company competes with Diana's in) "The Flower and the Leaf." Poem, after 15th century poem formerly attributed to Chaucer (see above). In *Fables, Ancient and Modern* (London: Tonson, **1700**). [Dryden 1700 / Van Doren 1946, pp. 56, 227, 244 / Miner 1967, pp. 289, 296ff., 320]

Johann Christoph Pepusch, 1667–1752. *Fragrant Flora,*

hast, appear! Cantata. Published London: **1710**. [Grove 1980, 14:359]

Jean-Baptiste Morin, 1677–1754. *La jeune Flor* [Young Flora]. Cantata. Published Paris: **1712**. [Grove 1980, 12:576]

André Campra, 1660–1744. *La danse de Flore*. Cantata. Published in *Cantates françoises* book 2 (Paris: **1714**). [Grove 1980, 3:665]

Sebastiano Ricci, 1659–1734, with **Antoine Monnoyer**, 1670–1747. "Flora." Painting. **1712–16**. Suida Manning coll., New York. [Daniels 1976, no. 274—ill.] *See also Giovanni Domenico Tiepolo, below.*

Georg Werle, 1668–1727. "The Glorification of Flora" ("Allegory of Spring"). Fresco. **1719**. Formerly Schloss Hirschstetten, Vienna, destroyed. [Knab 1977, p. 212—ill.]

North Netherlandish School. "Flora." Painting. *c.*1670–1720. Stedelijk Museum "De Lakenhal," Leiden, cat. 1949 no. 168. [Wright 1980, p. 315]

Henry Desmarets, 1661–1741. *Le couronnement de la reine par la déesse Flore* [Crowning of the Queen by the Goddess Flora]. Cantata. Text, Marchal. First performed **1724**. Music lost. [Grove 1980, 5:392]

Francesco Trevisani, 1656–1746. "A Lady as Flora." Painting. *c.*1725. Art Gallery and Museum, Perth. [DiFederico 1977, no. P13—ill.]

Daniel Gran, 1694–1757. "Allegory of Flora." Painting. **1728**. Palais Schwarzenberg, Vienna. [Knab 1977, p. 50, no. Ö7—ill.]

Christian Kirchner, ?–1732. "Flora." Sandstone statue. *c.*1728. Gross Sedlitz. [Asche 1966, no. 31, pl. 184—ill.]

Andrea Stefano Fiorè, 1686–1732. *Le retour de Flore* [The Return of Flora]. Cantata. [Grove 1980, 6:599]

Ignazio Hugford, 1703–1778. "Triumph of Flora." Painting. **1736**. Uffizi, Florence, inv. Petraia 272. [Uffizi 1979, no. P810—ill.]

Gottfried Heinrich Stölzel, 1690–1749. *Die gekrönte Flora* [Flora Crowned]. Opera. First performed **1736**. [Hunger 1959, p. 116]

Giovanni Battista Tiepolo, 1696–1770. "Flora." Fresco (detached), from Villa Cornaro, Merlengo. **1736**. Museo Civico, Treviso. [Pallucchini 1968, no. 112 / Morassi 1962, p. 50—ill.]

———. "The Triumph of Flora." Painting. 1743–44. Kress coll. (K1890), M. H. de Young Memorial Museum, San Francisco, no. 61-44-19. [Pallucchini, no. 154—ill. / Morassi, p. 47—ill. / Shapley 1966–73, 3:144f.—ill. / Levey 1986, p. 128]

François Le Moyne, 1688–1737. "Juno, Iris, and Flora." Painting. Louvre, Paris, inv. 6717. [Louvre 1979–86, 4:47—ill. / Bordeaux 1984, no. 34—ill.]

Pompeo Batoni, 1708–1787. "Portrait of a Lady as Flora" (?). Painting. *c.*1738–39. Private coll., London. [Clark 1985, no. 23—ill.]

———. "Flora" (?). Painting. 1744. Private coll., Washington, D.C. [Ibid., no. 88—ill.]

François Boucher, 1703–1770. "Psyche [or Flora] Strewing Flowers over Pomona." Painting. **1739**. Private coll., Paris. [Ananoff 1976, no. 170—ill.]

———. "Flora" (2 women, 1 with an apron full of flowers). Painting. 1745. Private coll., London. [Ibid., no. 287—ill.]

———. "Flora, or, Sweet Leisure." Engraving, after Boucher's painting "The Cupids' Gift" (woman with 2 cupids) of *c.*1758 (lost). 2 versions, engraved by B. L. Henriquez, 1759, and Chéreau. [Ibid., no. 507—ill.]

François Bouvard, *c.*1683–1760. *La feste de Cloris* [The Feast of Chloris]. Cantata. *c.*1740. Paris. [Grove 1980, 3:120]

French School. "Flora." Terra-cotta sculpture. *c.*1740. Brinsley Ford coll. [Royal Academy 1968, no. 822—ill.]

Jean-Marc Nattier, 1685–1766. "Enrichetta of France as Flora." Painting. **1742**. Uffizi, Florence, dep. 23. [Uffizi 1979, no. P1100—ill.]

Jacob de Wit, 1695–1754. "Apotheosis of Flora." Ceiling painting, for Herengracht 609, Amsterdam. **1743–44**. Metropolitan Museum, New York, no. 07.225.301. [Metropolitan 1980, p. 197—ill. / also Staring 1958, p. 152, pl. 75]

François-Gaspard Adam, 1710–1761. "Flora Playing with a Child." Sculpture group. **1749**. Terrace, Sanssouci, Potsdam, in 1885. [Thirion 1885, p. 161]

Étienne-Maurice Falconet, 1716–1791, attributed. "Flora with a Quiver of Roses." Marble statue, probably based on a model by Falconet. *c.*1750. 2 versions. Cognac-Jay Museum, Paris; Walters Art Gallery, Baltimore. [Levitine 1972, nos. 63, 65—ill.]

———. "Flora." Marble statuette. *c.*1770. Hermitage, Leningrad, inv. 1261. [Hermitage 1984, no. 387—ill. / also Hermitage 1975, pls. 108–09]]

———, attributed. "Flora." Marble statuette. Louvre, Paris. [Reau 1922, p. 505]

Franz Anton Maulbertsch, 1724–1796. "Flora." Drawing, sketch for a ceiling painting. *c.*1753–54. Fogg Art Museum, Harvard University, Cambridge. [Garas 1960, no. 47—ill.]

Jean-Baptiste Lemoyne, 1704–1778. "Standing Bather (Flora) about to Enter the Water." Marble statuette. **1755**. Baron Edmond Rothschild coll., Paris. [Réau 1927, p. 55, no. 20—ill.] Further versions in Huntington Library and Art Gallery, San Marino, Calif.; Mauritshuis, The Hague. [Clapp 1970, 1:542 / Bénézit 1976, 6:573]

Rosalba Carriera, 1675–1757. "Flora." Painting. Uffizi, Florence, inv. 3099. [Uffizi 1979, no. P380—ill.]

———. "Portrait of a Woman" ("Flora"). Painting. Uffizi, Florence, inv. 820. [Ibid., no. P381—ill.] Watercolor and gouache miniature copy by Felicita Sartori Hoffmann (?–1760). Gemäldegalerie, Dresden, no. M26. [Dresden 1976, p. 117]

Ferdinand Dietz, ?–*c.*1780. "Triumph of Flora." Sculptural tympanum. **1758**. Formal Electoral Castle, Trier. [Clapp 1970, 1:855]

John Michael Rysbrack, 1694–1770. "Flora." Marble sculpture. Commissioned **1759** for Temple of Hercules, Stourhead, Wiltshire. [Woodbridge 1965, pp. 84, 103]

Antonio Guardi, 1698–1760 (formerly attributed to Jean-Honoré Fragonard). "Flora." Painting. **1750/60**. Bolchini-Bonomi coll., Milan. [Morassi 1984, no. 91—ill.]

Franz Anton Hilverding, 1710–1768, choreography. *La victoire de Flore sur Borée* [The Victory of Flora over Boreas]. Ballet. Music, Joseph Starzer. First performed 29 Apr **1760**, Court Theater, St. Petersburg. [Grove 1980, 8:570 / Winter 1974, p. 94]

William Boyce, *c.*1710–1779. "Go, Flora." Musical ode, composed for the King's birthday, **1762**. [Grove 1980, 3:143]

Louis Antoine Lefebvre, ?–1763. *Le réveil de Flore* [The Awakening of Flora]. Musical divertissement. [Grove 1980, 10:606]

Michel-Jean de Laval, c.1725–1777, choreography. *Le triomphe de Flore, ou, Le retour de Printemps* [The Triumph of Flora, or, The Return of Spring]. Ballet. Music, Antoine Dauvergne. First performed 29 Oct 1765, Fontainebleau. [EDS 1954–66, 6:1288 / Grove 1980, 5:257 (cites "Vallier" as choreographer)]

Jean-Georges Noverre, 1727–1810, choreography. *Flora.* Ballet. Music, Franz Asplmayr. First performed 1766, Vienna. [Grove 1980, 1:658 / Lynham 1950, p. 169]

Baldassare Galuppi, 1706–1785. *Flora, Apollo, Medoaco.* Cantata. 1769. [Grove 1980, 7:137]

Jean-Claude Trial, 1732–1771. *La fête de Flore.* Opera (pastorale héroïque). Libretto, J.-P.-A. Razins de Saint-Marc. First performed 15 Nov 1770, Fontainebleau. [Grove 1980, 19:136]

Johann Gottfied Herder, 1744–1803. (Kingdom of Flora in) "Litteratura," no. 18 of "Bilder und Sprüche" [Pictures and Speech]. cycle of poems. 1762–75. Collected in *Gedichte* book 2, in *Sämmtliche Werke* (Tübingen: Cotta, 1805–20). [Herder 1852–54, vol. 13]

———. "Die Wahl der Flora" [The Choice of Flora]. Prose poem, part of *Paramythien.* In *Zerstreute Blätter* no. 1 (Gotha: Ettinger, 1785). [Ibid., vol. 15 / Clark 1955, pp. 348f.]

———. "Flora und die Blumen." Poem. In *Zerstreute Blätter* no. 3 (Gotha: Ettinger, 1787; revised edition, 1798). [Herder, vol. 13]

Charles-Joseph Natoire, 1700–1777. "Flora." Painting. Château, Compiègne. [Boyer 1949, no. 104]

———. "Goddess with the Attributes of Venus, Flora, and Leda." Painting. Musée, Valenciennes, no. 99. [Ibid., no. 112]

Angelica Kauffmann, 1741–1807. "Flora." Painting. Exhibited 1778. [Manners & Williamson 1924, pp. 46, 238]

———. "Flora." Painting. 1790. [Ibid., p. 158]

Henry Fuseli, 1741–1825. "Flora Attired by the Elements." Drawing, illustration to Erasmus Darwin's *The Botanic Garden.* 1791. Engraved by Anker Smith, published London: Johnson, 1791. [Schiff 1973, no. 973—ill.]

Joseph Weigl the Younger, 1766–1846. *Flora e Minerva.* Cantata. Text, Lorenzo Da Ponte. First performed 1791, Vienna. [Grove 1980, 5:238, 20:298]

Anonymous. "Flora and Cupid." Painting. Before 1800. Dulwich College Picture Gallery, London, cat. 1953 no. 510. [Wright 1976, p. 206]

Didier Boguet, 1755–1839. "Feast of Flora." Painting. c.1803. Galleria di Capodimonte, Naples, no. 114. [Capodimonte 1964, p. 63]

Giovanni Domenico Tiepolo, 1727–1804 (previously attributed to Sebastiano Ricci). "Flora Embracing Cupid." Painting (fragment of a larger composition?). Museo Civico, Padua. [Mariuz 1979, p. 131—ill.]

Eugène Hus, 1758–1823, choreography. *L'apothéose de Flore.* Ballet. First performed 1806, Grand Théâtre, Bordeaux. [EDS 1954–66, 6:450]

James Hervé D'Egville, c.1770–c.1836, choreography. *La naissance de Flore* [Birth of Flora]. Ballet. Music, Puccita.

First performed 27 Apr 1809, King's Theatre, London. [Guest 1972, p. 154]

Clodion, 1738–1814. "Offering to Flora." Plaster relief. Musée National, Sèvres, in 1885. [Thirion 1885, p. 223—ill.]

Anonymous. *Cupid and Flora.* Ballet. First performed 1814, Royalty Theatre, Manchester. [Nicoll 1959–66, 4:447]

Karol Kazimierz Kurpinski, 1785–1857, music. *Mars i Flora.* Ballet. First performed 3 Aug 1820, Warsaw; choreography, L. Thierry. [Grove 1980, 10:319]

Antonio Marini, 1788–1861. "Flora and Amorini." Ceiling painting. c.1820. Sala di Flora, Palazzo Pitti, Florence. [Pitti 1966, p. 209—ill.]

Antoine François Callet, 1741–1823. "The Triumph of Flora." Painting. Louvre, Paris, no. M.I. 1028. [Louvre 1979–86, 3:95—ill.]

François Gérard, 1770–1837. "Flora." Painting. Musée de Peinture et de Sculpture, Grenoble, inv. 1280. [Hamburg 1977, no. 332—ill.]

John Hill Hewitt, 1801–1890. *Flora's Festival.* Cantata for children. Text, composer. First performed 1 May 1838, Baltimore. [Grove 1980, 8:543]

Samuel Colman, fl. 1816–40. "The Temple of Flora." Painting. Tate Gallery, London, no. 6038. [Tate 1975, p. 20]

George Frederick Watts, 1817–1904. "Flora." Fresco, for courtyard of Casa Feroni, Florence. 1843. [Blunt 1975, p. 28]

Giovanni Franceschetti, 1816–1845. "Flora. Statue. Pinacoteca Civica, Brescia. [Hartmann 1979, pl. 76.2]

François-Louis Français, 1814–1897. "Offering to Flora." Painting. c.1847. Hermitage, Leningrad, inv. 6594. [Hermitage 1983, no. 175—ill.] Lithograph after, by Français. Published 1847 in *Les artistes anciens et modernes,* I, vol. 2. [Ibid.]

Pietro Tenerani, 1789–1869. "Flora." Marble statue. 1847. Neue Pinakothek, Munich, inv. L.1857. [Munich 1982, p. 333]

Thomas Crawford, 1813–1857. "Flora." Marble sculpture. 1853. Newark Museum, N.J. [Gerdts 1973, p. 79, fig. 53]

William Bouguereau, 1825–1905. "Triumph of Flora." Oil sketch, copy after Poussin (1627–30). c.1850–54. Private coll. [Montreal 1984, no. 7—ill.]

Pierre Puvis de Chavannes, 1824–1898. "Flora." Painting. c.1857–60. Private coll., France. [Ottawa 1977, no. 26—ill.]

Jean-Baptiste Carpeaux, 1827–1875. "Triumph of Flora," "Crouching Flora." High-reliefs. 1863–65. Pavillon de Flore, Louvre, Paris. [Beyer 1975, nos. 245–83—ill. / Janson 1985, pp. 142f.—ill.] Plaster head of Flora, originally part of relief. Musée des Monuments Français, Paris. [Beyer, no. 277—ill.] Models, sketches, replicas. Musée d'Orsay, Paris; Musée des Arts Décoratifs, Paris; Petit Palais, Paris; Pierre Schommer coll., Paris; Musée des Beaux-Arts, Valenciennes; Staatliche Kunsthalle, Karlsruhe; Musée Chéret, Nice; elsewhere? [Ibid., nos. 261–69—ill. / Orsay 1986, pp. 76–80—ill.] Bronze version. Národní Galeri, Prague. [Orsay, p. 77] Marble statue, variant, "Crouching Flora." Musée des Beaux-Arts, Strasbourg. [Kocks 1981, p. 273—ill.]

Arnold Böcklin, 1827–1901. "Flora." Mural. 1869. Museum an der Augustinergasse, Basel. [Andree 1977, no. 219—ill.]

————. "Flora Strewing Flowers." Painting. 1875. Kruppsche Gemäldesammlung, Essen. [Ibid., no. 306—ill.]

————. "Flora" ("Garlanded Maiden"). Painting. 1875. Museum, Leipzig, inv. 1133. [Ibid., no. 307—ill.]

————. "Flora Awakening the Flowers." Painting. 1876. Von der Heydt-Museum, Wuppertal, inv. 457. [Ibid., no. 308—ill.]

————. "Spring's Awakening" (Pan, Flora, and nymphs). Painting. 1880. Kunsthaus, Zurich, inv. 429. [Ibid., no. 352—ill.]

Auguste Rodin, 1840–1917. "Flora." Painted terra-cotta bust. **1865–70.** 2 casts. Rodin Museum, Philadelphia; Musée Rodin, Paris. [Tancock 1976, no. 105—ill. / Rodin 1944, no. 10—ill.]

John William Waterhouse, 1849–1917, attributed. "Flora." Painting. **1870.** C. Macstravick coll., Britain. [Hobson 1980, no. 1a, pl. 4]

————. "Flora." Painting. *c.*1890. Sold 1912. [Ibid., no. 80, pl. 40]

————. "Flora." Painting. Sold Christie's, London, 1926. [Ibid., no. 211]

Alexandre Cabanel, 1823–1889. "Triumph of Flora." Ceiling painting. **1873.** Salle de consultation, Cabinet des Dessins (Pavillon de Flore), Louvre, Paris (inv. 20339). [Louvre 1979–86, 3:93—ill.]

Hans Thoma, 1839–1924. "Flora of the Black Forest." Painting. **1879.** Von Hansemann coll., Berlin-Grunewald. [Thode 1909, p. 124—ill.]

————. "Flora." Painting. 1881. Friedrich von Schön coll., Munich. [Ibid., p. 176—ill.]

————. "Flora." Painting. 1882. Henry Thode coll., Heidelberg. [Ibid., p. 179—ill.]

————. "Flora." Painting. 1892. Artist's coll., Karlsruhe, in 1909. [Ibid., p. 352—ill.]

————. "Flora." Painting. 1894. Eduard Küchler coll., Frankfurt. [Ibid., p. 378—ill.]

————. "An Allegory of Springtime" (Flora). Painting. 1898. Schwartzenbach-Zeuner coll., Zurich. [Ibid., p. 429—ill.]

Richard Stoddard, 1825–1903. "Arcadian Hymn to Flora." Poem. In *Poems* (New York: Scribner, **1880**). [Boswell 1982, pp. 221f.]

Richard Dadd, 1817–1886. "Flora." Mural. **Early 1880s.** Formerly Broadmoor Hospital, England, effaced. [Allderidge 1974, no. 214]

John La Farge, 1835–1910. "Flora." Painting, for ceiling of reception hall, Vanderbilt mansion, New York. **1881–82.** [Weinberg 1977, pp. 256ff., 265f.—ill.]

Edward Burne-Jones, 1833–1898. "Flora." Painting. **1868–84.** [Bell 1901, pp. 39, 62]

————, design. "Flora." Tapestry. Executed by William Morris & Co., 1885. Exeter College, Oxford. [Harrison & Waters 1973, pp. 137–38—ill. / Bell, p. 91—ill.]

Max Klinger, 1857–1920. "Flora Strewing Flowers over a Landscape." Painting, door panel for Villa Albers, Berlin. **1883–85.** Museum der Bildenden Künste, Berlin. [Hildesheim 1984, no. 16—ill.]

————. "The Spring." Etching, "paraphrase" of Böcklin's "Flora" (1875, Leipzig). 1889. [Andree 1977, p. 390]

William Morris, 1834–1896. "Flora." Poem. In *Poems by the Way* (London: Kelmscott, **1891**). [Morris 1910–15, vol. 9] *See also Burne-Jones, above.*

Charles Rochussen, 1814–**1894.** "Flora." Painting, decorative panel. Museum Willet-Holthuysen, Amsterdam, inv. A 1009. [Wright 1980, p. 389]

Gabriele D'Annunzio, 1863–1938. "Clori." Sonnet, in "Le adultere." In *Intermezzo* (Naples: **1894**). [Palmieri 1953–59, vol. 1]

Lovis Corinth, 1858–1925. "Flora." Painting. **1897.** Formerly Seydlitz coll., Dresden, unlocated. [Berend-Corinth 1958, no. 148—ill.]

————. "Flora" (in modern dress). Painting. 1919. Private coll., Stuttgart. [Ibid., no. 762—ill.]

————. "Flora." Painting. 1923. Kunsthalle, Hamburg, inv. 513. [Hamburg 1985, no. 223—ill. / also Berend-Corinth, p. 168—ill.]

Arthur B. Davies, 1862–1928. "Flora." Painting. **1900.** Macbeth coll., Brooklyn, N.Y. [Cortissoz 1931, p. 25]

Marius Petipa, 1818–1910, choreography. *Probuzhdeniye flori* [The Awakening of Flora]. Ballet. Music, Riccardo Drigo (1894). First performed **1900,** Maryinsky Theater, St. Petersburg. [Clarke and Vaughan 1977, p. 272 / Grove 1980, 5:636]

Rubén Darío, 1867–1916. "Flora." Sonnet. **1901.** [Méndez Plancarte 1967]

Erik Axel Karlfeldt, 1864–1931. *Flora och Pomona.* Collection of poems. Stockholm: Wahlström & Widstrand, **1906.** [Algulin 1989, pp. 150f. / Gustafson 1961, p. 327]

Aristide Maillol, 1861–1944. "Flora (Clothed)." Life-size bronze statue. **1910–12.** Neue Pinakothek, Munich, inv. B.154; elsewhere. [Linnenkamp 1960, p. 117, fig. 67 / Munich 1982, p. 205—ill. / Guggenheim 1975, no. 66—ill. / Waldemar-George, pp. 166, 233—ill.] Bronze study, "Flora (Nude)." 6 casts. [Guggenheim, no. 67—ill. / Waldemar-George 1965, pp. 166, 233—ill.] Variant, "Small Flora, Nude." 6 casts. [Guggenheim, no. 68—ill.] Related study/variant, "Head of Flora." Museum of Modern Art, New York, no. 599.39. [Barr 1977, p. 563]

Franz von Stuck, 1863–**1928,** rejected attribution. "Flora and Faun." Painting. Schäfer coll., Schweinfurt. [Voss 1973, pp. 242, 321—ill.]

Emil Zegadlowicz, 1888–1941. "Flora. Caritas. Sofia." Poem. In *Posagi i poezje* [Statues and Poetry] (Poznan: Fiszer & Majewski, **1928**). [NUC]

Vittorio Giannini, 1903–1966. *Flora.* Opera. **1937.** [Grove 1980, 7:349]

Juan Adsura. "Flora." Plaster sculpture. Before **1939.** [Clapp 1970, 1:16]

Henri Laurens, 1885–1954. "Flora." Marble sculpture. **1939.** [Hoffmann 1970, p. 219—ill.]

Gerhard Marcks, 1889–1981. "Small Flora." Bronze sculpture. **1939.** At least 2 casts. Niedersächsisches Landesmuseum, Hannover, inv. KM1940/21; private coll., Munich. [Busch & Rudloff 1977, no. 369—ill.]

Wolfgang Hutter, 1928–. "Flora I." Drawing. **1946.** Private coll., Vienna. [Hoffmann 1987, no. 16.48—ill.]

David Jones, 1895–1974. "Flora in Calix-light." Painting. **1950.** Kettle's Yard, Cambridge. [Blamires 1972, p. 60]

Jean Françaix, 1912–. "L'horloge de Flore" [Flora's Clock]. Orchestral composition. **1959.** [Grove 1980, 6:741]

Ossip Zadkine, 1890–1967. "Flora." Bronze sculpture. **1966.** Private coll. [Jianou 1979, no. 467]

Giulio Paolini, 1940–. "In the Middle of the Painting Flora Strews Flowers, While Narcissus Looks at Himself in a Water-filled Amphora Held by the Nymph Echo." Painting, after details in Poussin's "Empire of Flora" (1631, Dresden). **1968.** [Villeurbanne 1983, pp. 27f.—ill.]

Ryohei Hirose, 1930–. *Flora 1971.* Instrumental composition. **1971.** [Grove 1980, 8:591]

Flora and Zephyr. The god of the west wind, Zephyr, pursued a wood nymph named Chloris. As he kissed her, flowers issued from her breath and she was transformed into Flora, goddess of flowers. This image is embodied in the line from Ovid's *Fasti,* "Chloris eram quae Flora vocar" ("Chloris I was who am now called Flora"). The subject is an allegory of spring flowers blooming when the cold earth receives the warm touch of the west wind, by which Zephyr became known as Flora's consort. In the postclassical arts the two are commonly depicted as an amorous couple, often seen as personifications of spring.

Classical Sources. Lucretius, *De rerum natura* 5.736–39. Ovid, *Fasti* 5.193–214.

See also FLORA, General List; GODS AND GODDESSES, as Seasons; ZEPHYR.

Jean de Meun, 1250?–1305? (Zephyr and Flora evoked in) *Le roman de la rose* lines 8403–30. Verse romance, completion of unfinished work begun by Guillaume de Lorris (*c.*1230–35). *c.***1275.** Lyon: Ortuin & Schenck, *c.*1481. [Dahlberg 1971 / Poirion 1974]

Angelo Poliziano, 1454–1494. (Chloris, Zephyr, and Flora evoked in) *Stanze . . . per la giostra di Giuliano de' Medici* 1.68. Poem. **1475–78.** [Wind 1968, p. 127 *n.*]

Sandro Botticelli, 1445–1510. (Flora, Chloris, and Zephyr in) "The Primavera." Painting. *c.***1478.** Uffizi, Florence, inv. 8360. [Lightbown 1978, 1:73ff., no. B39—ill. / Wind 1968, pp. 115f.]

Lope de Vega, 1562–1635. "Cefiro blando" [Mild Zephyr]. Sonnet, no. 37 of *Rimas humanas* part 1. **1602–04.** Madrid: Martin, for Alonso Perez, 1609. [Sainz de Robles 1952–55, vol. 2]

Thomas Campion, 1567–1619. (Flora and Zephyr in) *The Lord Hay's Masque.* Masque. First performed 6 Jan **1607,** Whitehall Palace, London. Published London: Brown, 1607. [Vivian 1966 / DLB 1987, 58: 37, 38f.]

Peter Paul Rubens, 1577–1640, and **Jan Brueghel the Elder,** 1568–1625, landscape. "Zephyr and Flora." Painting. *c.***1617.** Schloss Mosigkau, Dessau. [Jaffé 1989, no. 438—ill.]

Abraham Janssens, *c.*1575–1632, figures, and **Jan Brueghel the Younger,** 1601–1678, landscape. "Flora and Zephyr." Painting. **1627?** Schloss Mosigkau, Dessau, inv. 6. [Ertz 1984, no. 187—ill.]

Nicolas Poussin, 1594–1665. "Flora and Zephyr." Painting. *c.***1630.** Lost. [Wright 1985, no. L23 / Blunt 1966, no. L62]

———, follower. "Flora and Zephyr." Drawing, copy after presumed lost original of late 1620s. Louvre, Paris, no. 32503. [Friedlaender & Blunt 1953, no. A60—ill.]

———, follower. "Flora and Zephyr" (? or Psyche brought to Venus by Cupid?). Drawing, copy after presumed lost original of 1650s. Hermitage, Leningrad, no. 5076. [Ibid., no. A61—ill.]

Johann Philipp Krieger, 1649–1725. *Die glückselige Verbindung des Zephyrs mit der Flora* [The Happy Union of Zephyr and Flora]. Singspiel. **1683.** [Grove 1980, 10:269]

Jean Jouvenet, 1644–1717. "Zephyr and Flora." Painting. *c.***1688.** Grand Trianon, Versailles, no. MV8303. [Schnapper 1974, no. 37—ill.; cf. nos. 36, 67–68, 166]

Louis Lully, 1664–1734, and **Jean-Louis Lully,** 1667–1688, music. *Zéphyr et Flora.* Ballet. Libretto, Michel DuBoullay. First performed 22 Mar **1688,** Académie Royale de Musique, Paris. [Grove 1980, 11:329]

Louis Lecomte, 1639–1694. "Zephyr and Flora." Monumental sculpture group. **1680s.** Orangerie, Gardens, Versailles. [Girard 1985, p. 277]

Antoine Coypel, 1661–1722. "Springtime, Represented by Zephyr and Flora." Painting, for Château de Marly. **1699.** Louvre, Paris, inv. 8685. [Louvre 1979–86, 3:171—ill.]

———. "Zephyr and Flora." Painting, copy after presumed lost original. Fitzwilliam Museum, Cambridge, no. 333. [Fitzwilliam 1960–77, 1:158] Another version of the subject, in Musée Municipal des Beaux-Arts, Quimper; 2 others known in old collections, untraced. [Ibid., p. 159 / Wright 1976, p. 44]

Alessandro Scarlatti, 1660–1725. *Clori e Zeffiro.* Serenata for 2 voices, instruments. First performed **1706,** Rome? [Grove 1980, 16:560]

Sebastiano Ricci, 1659–1734. "Zephyr and Flora." Painting. **1700–10.** Gobbi coll., Rome. [Daniels 1976, no. 375—ill.]

———. "Flora and Zephyr with Cupid." Painting. 1700–10. Sold Sotheby's, London, 1969. [Ibid., no. 194—ill.]

———. "Zephyr and Flora." Painting. *c.*1713–14 or earlier. Private coll., Venice. [Ibid., no. 499]

Philippe Courbois, fl. 1705–30. *Zephire et Flore.* Cantata. **1710.** [Grove 1980, 5:1]

Johann David Heinichen, 1683–1729. *Zeffiri e Clori.* Serenata. **1714.** [Grove 1980, 8:439]

Charles de La Fosse, 1636–1716. "Flora and Zephyr." Drawing. Louvre, Paris, inv. 27429. [Royal Academy 1968, no. 362—ill.]

Louis-Nicolas Clérambault, 1676–1749. *Zéphire et Flore.* Cantata. Published in *Cantates françoises à I. et II. voix avec simphonie et sans simphonie,* book 3 (Paris: **1716**). [Grove 1980, 4:492]

Thomas-Louis Bourgeois, 1676–1750/51. *Zéphire et Flore.* Cantata. Paris: **1718.** [Grove 1980, 3:113]

Jacob de Wit, 1695–1754. "Zephyr and Flora." Ceiling painting. **1723.** Lost. [Staring 1958, 145] Drawing. Kupferstichkabinett, Berlin. [Ibid.]

———. "Zephyr and Flora with Attendants and Cherubs in the Clouds." Ceiling painting. 1725. Formerly Delftse Vaart, Rotterdam. [Ibid., pl. 62] Drawing. Museum Boymans-van Beuningen, Rotterdam. [Ibid.]

————. "Zephyr and Flora." Ceiling painting. 1746. Herengracht 468, Amsterdam. [Ibid., pl. 45]

François de Troy, 1645–1730. "Zephyr and Flora." Painting, for Hôtel du Grand Maître (now Hôtel de Ville), Versailles. *c.*1724. In place. [Bordeaux 1984, no. 50 (*n*)—ill.]

Antonio Corradini, 1668–1752. "Zephyr and Flora." Marble sculpture group, for Grosser Garten, Dresden. *c.*1723–28. Victoria and Albert Museum, London, inv. A.5.1967. [Hodgkinson 1970, pp. 10, 12—ill. (frontispiece)]

Giovanni Battista Tiepolo, 1696–1770. "Triumph of Zephyr and Flora." Painting. *c.*1734–35 (or *c.*1746–50). Museo di Ca' Rezzonico, Venice. [Pallucchini 1968, no. 95—ill. / Morassi 1962, p. 55—ill.]

————. "Zephyr and Flora." Fresco. *c.*1747–50. Palazzo Labia, Venice. [Pallucchini, no. 187—ill. / Morassi, p. 59—ill.] Sketch. Birtschanksy coll., Paris. [Morassi, p. 40—ill.]

Jacopo Amigoni, 1675–1752. "Zephyr and Flora." Painting. Museo Correr, Venice. [Levey 1986, pl. 22]

Charles-Antoine Coypel, 1694–1752. "Flora and Zephyr." Painting. [Bénézit 1976, 3:248]

Charles Monnet, 1732–after 1808. "Zephyr and Flora." Painting. 1773. [Bénézit 1976, 7:487]

Joseph Willibald Michl, 1745–1816. *Zephiro et Flora.* Cantata. First performed 1776, Munich. [Grove 1980, 12:269]

Charles-Joseph Natoire, 1700–1777. "Flora and Zephyr." Painting. Sold Paris, 1888, untraced. [Boyer 1949, no. 106]

Antoine François Callet, 1741–1823. "Spring" ("Zephyr and Flora Crowning Cybele with Flowers"). Ceiling painting. 1780. Galerie d'Apollon, Louvre, Paris, inv. 3097. [Louvre 1979–86, 3:94—ill.]

Thomas Stothard, 1755–1834, composition. "Zephyr and Flora." Stipple engraving, executed by William Blake. 1784. [Bindman 1982, no. 26—ill.]

Jean-Baptiste-Marie Pierre, 1713–1789, attributed. "Zephyr and Flora." Painting, study for a ceiling decoration. Louvre, Paris, no. R.F. 2385. [Louvre 1979–86, 4:133—ill.]

Charles-Louis Didelot, 1767–1837, choreography and scenario. *Flore et Zéphire.* Ballet-divertissement. Music, Cesare Bossi. First performed July 7 1796, King's Theatre, London; scenery and machines, Liparotti. [Swift 1974, 130–35, 195 / Simon & Schuster 1979, pp. 78f.]

————, choreography. *Zefir i Flora.* Ballet. Music, Catterino Cavos. First performed Jan 1808, Hermitage Theater, St. Petersburg. [Swift]

————, choreography. *Zéphyr inconstant, puni et fixé, ou, Les noces de Flore* [Unfaithful Zephyr, Punished, and Constrained, or, The Wedding of Flora]. Ballet. Music, Venua. First performed Apr 7 1812, London. [Guest 1972, p. 24 / Swift, p. 196]

————, choreography. *Flore et Zéphyre.* Ballet. Music, Venua. First performed Dec 12 1815, L'Opéra, Paris; décor and costumes, Ciceri and Marches. [Guest 1976, p. 304 / Swift, p. 197]

Clodion, 1738–1814. "Zephyr and Flora" ("The Embrace," formerly called "Cupid and Psyche"). Terra-cotta statuette. 1799. Frick Collection, New York, no. 15.2.76. [Frick 1968–70, 4:102f.—ill.]

German School. "Flora, Zephyr, and Cupid." Painting.

18th century. Herzog Anton Ulrich-Museum, Braunschweig, no. 1298. [Braunschweig 1976, p. 22]

Pierre Chevalier, fl. 1795–1802, choreography. *Les amours de Flore et de Zéphire* [The Loves of Flora and Zephyr]. Ballet anacréontique. Music, Giuseppe Sarti. First performed 19 Sep 1800, Gatchina. [Grove 1980, 16:505]

Charles Mornet, 1732–**1806**. "Zephyr and Flora." Painting. [Bénézit 1976, 7:487]

Louis Antoine Duport, 1781/83–1853, choreography. *L'hymen de Zéphyr, ou, Le volage fixé* [The Wedding of Zephyr, or, Flying Fixed]. Ballet. First performed 1806, Paris. [EDS 1954–66, 4:1154]

Francesco Reina, 1766–1825. *Le nozze di Zefiro e di Clori* [The Wedding of Zephyr and Chloris]. Poem. Milan: **1806**. [DELI 1966–70, 4:528]

Eugène Scribe, 1791–1861, with **Charles-Gaspard Delestre-Poirson** 1790–1859. *Flore et Zéphyre.* Vaudeville. First performed 8 Feb **1816**, Théâtre du Vaudeville, Paris. [McGraw-Hill 1984, 4:353]

Claude Guillet, choreography, after Louis Duport. *Zéphir.* Ballet. Music, Klose. First performed 21 Feb **1818**, King's Theatre, London. [Guest 1972, p. 155]

Jean Coralli, 1779–1854, choreography. *Le nozze di Flora e Zeffiro* [The Wedding of Flora and Zephyr]. Ballet, sequel to Didelot's *Flore et Zéphyr* (1815). First performed **1824**, La Scala, Milan. [Chujoy & Manchester 1967, p. 227 / Beaumont 1938, p. 137]

Filippo Taglioni, 1777–1871, choreography. *Flore et Zéphire.* Ballet. First performed **1830**, L'Opéra, Paris. [Beaumont 1938, p. 233]

William Makepeace Thackeray, 1811–1863, as "Theophile Wagstaffe." *Flore et Zéphyre: Ballet mythologique par Theophile Wagstaffe.* Collection of lithographs, satirizing a production of Didelot's ballet starring Marie Taglioni. London: Mitchell, **1836**. [DLB 1983, 21:265] Originals in Victoria and Albert Museum, London. [Swift 1974, figs. 24, 25 / Oxford 1982, p. 158]

Luigi Astolfi, fl. 1817–51, choreography. *Zeffiro e Flora.* Ballet. First performed **1838**, Rome? [EDS 1954–66, 1:1034]

Carlo Blasis, 1797–1878, choreography. *Flore et Zéphyr.* Ballet. First performed **1847**, Milan. [EDS 1954–66, 2:607]

Augusto Hus the Younger, fl. 1827–53, choreography. *La nozze di Zeffiro et Flora* [The Wedding of Zephyr and Flora]. Ballet. First performed **1847**, Milan. [EDS 1954–66, 6:450]

Honoré Daumier, 1808–1879. "Flora and Zephyr." Satirical lithograph, in "Parliamentary Idylls" series. **1850–51**. [Delteil 1906–30, 25: no. 2053—ill.]

Eugène Gautier, 1822–1878. *Flore et Zéphire.* Opera. Libretto, Leuven and Deslys. First performed **1852**. [Hunger 1959, p. 116]

William Bouguereau, 1825–1905. "Flora and Zephyr." Painting. **1875**. Musée, Mulhouse. [Montreal 1984, pp. 64, 103]

Henrietta Rae, 1859–1928. "Zephyr Wooing Flora." Painting. **1888**. [Kestner 1989, p. 284]

John William Waterhouse, 1849–1917. "Flora and the Zephyrs." Painting. **1898**. Private coll., Britain. [Hobson 1980, no. 120, p. 104—ill.] Replica or variant. *c.*1898. J. Henderson coll., Britain. [Ibid., no. 121]

Léonide Massine, 1895–1979, choreography. *Zéphyre et*

Flore. Ballet. Music, Vladimir Dukelsky. Book, Boris Kochno (1904–). First performed 31 Jan **1925**, Diaghilov and Ballet Russe, Monte Carlo; decor and costumes, Georges Braque; masks, Oliver Messel. [Grove 1980, 5:693 / Percival 1979, 139 / also Cogniat 1980, pp. 36, 120]

Ruth Page, 1905–, choreography. *Zephyr and Flora.* Ballet. First performed **1939**, Chicago. [Cohen-Stratyner 1982, p. 687]

Bentley Stone, 1908–, with **Ruth Page,** 1905–, choreography. *Zephyr and Flora.* Ballet. First performed **1943**, Chicago. [Cohen-Stratyner 1982, p. 842]

FURIES. Known in Greek as the Erinyes and in Latin as the Dirae or Furiae, the Furies were punishing spirits who avenged wrongs, especially murder, within the clan or family. According to Hesiod, they were the daughters of Gaia, conceived from drops of blood that were spilled when Cronus castrated his father, Uranus. Others, such as Ovid, identify them as daughters of Nyx (Night) who dwelled in the Underworld. Usually three in number, they were named Alecto, Megaera, and Tisiphone. In some circumstances, they were called by the propitiatory name Eumenides ("kindly ones"), as in the aftermath of Orestes' acquittal for the murder of his mother, Clytemnestra.

In ancient literature and art, the Furies were depicted as flying hags with serpents in their hands or hair and carrying torches and scourges. Most postclassical representations follow these traditions.

Classical Sources. Homer, *Iliad* 9.571, 19.87. Hesiod, *Theogony* 154ff., 185. Aeschylus, *The Eumenides.* Sophocles, *Oedipus at Colonus.* Euripides, *Orestes. Orphic Hymns* 69, 70, "To the Furies." Cicero, *De natura deorum* 3.18.46. Virgil, *Aeneid* 6.571, 7.323–560, 12.845–69. Ovid, *Metamorphoses* 4.451–511. Apollodorus, *Biblioteca* 1.1.4., 3.7.5, E6.25–26.

See also ATHAMAS AND INO; ERIPHYLE; HADES [2]; IPHIGENIA, at Tauris; OEDIPUS, at Colonus; ORESTES.

Dante Alighieri, 1265–1321. (Furies at gates of the City of Dis in) *Inferno* 9.34–63. c.**1307**–c.**1314?** In *The Divine Comedy.* Poem. Foligno: Neumeister & Angelina, 1472. [Singleton 1970–75, vol. 1 / Schless 1984, pp. 103f.]

Sandro Botticelli, 1445–1510. Furies depicted in a drawing, illustrating *Inferno* 9, part of a series of illustrations to Dante's *Divine Comedy.* **1480s/early 1490s.** Biblioteca Vaticana, Rome. [Lightbown 1978, 1:147ff., 2:172f., no. E24—ill.]

Torquato Tasso, 1544–1595. (Alecto kindles strife in) *Gerusalemme liberata.* Epic. **1575.** Venice: Perchacino, 1581 (authorized edition). [Highet 1967, pp. 149, 604]

Thomas Heywood, 1573/74–1641. "Furiae, or, The Eumenides." Passage in *Gynaikeion: or, Nine Books of Various History Concerning Women* book 1. Compendium of history and mythology. London: Adam Islip, **1624.** [Ipso]

Michael Drayton, 1563–1631. (The Furies in) *The Moon-*

Calfe. Poem. Published with *The Battle of Agincourt* (London: **1627**). [Hebel 1931–32, vol. 3]

Peter Paul Rubens, 1577–1640. "Mars, Venus, Bacchus, Cupid, and the Fury." Painting. **1632–35.** Palazzo Bianco, Genoa. [Jaffé 1989, no. 1091—ill.]

————. (Tisiphone in) "The Temple of Janus." Painted stage, decoration for "Pompa Introitus Fernandi," triumphal entry of Cardinal-Infante Ferdinand of Spain into Antwerp, 17 Apr 1635. Original decoration destroyed. [Martin 1972, no. 44—ill. (print); cf. no. 45] Oil sketch. Hermitage, Leningrad, inv. 500. [Ibid., no. 44a—ill. / Held 1980, no. 161—ill.]

Luca Giordano, 1634–1705. (The Furies in) "Allegory of Human Life and the Medici Dynasty." Fresco. **1682–83.** Palazzo Medici Riccardi, Florence. [Ferrari & Scavizzi 1966, 2:112ff.—ill.] Study. Denis Mahon coll., London. [Ibid.—ill.]

Jean-Philippe Rameau, 1683–1764. (Tisiphone battles Theseus in Hades in) *Hippolyte et Aricié.* Opera (tragédie lyrique). Libretto, Simon-Joseph Pellegrin, after Racine's *Phèdre* (1677). (This passage original with Pellegrin.) First performed 1 Oct **1733,** L'Opéra, Paris. [Grove 1980, 15:564–565 / Girdlestone 1983, chapter 5, pp. 140–202]

Gaspare Angiolini, 1731–1803, choreography. "Dance of the Furies," in *Don Juan, ou, Le festin de pierre* [Don Juan, or, The Stone Guest] act 3. Mime ballet. Scenario, Angiolini, after Molière's play (1665). Music, Christoph Willibald Gluck. First performed 17 Oct **1761,** Burgtheater, Vienna; stage design, Giulio Quaglio. [Simon & Schuster 1979, pp. 67, 69 / Beaumont 1938, pp. 608, 612] Gluck inserted this dance in his opera *Orpheus,* performed Paris 1774. [Simon & Schuster]

John Flaxman, 1755–1826. "The Three Furies." Drawing, illustrating *Inferno* 9.46–8, part of a series of illustrations to Dante's *Divine Comedy.* c.**1792.** Houghton Library, Harvard University, Cambridge. / Engraved by Tomasso Piroli, published privately, Rome: 1793; London: Longman & Co., 1807. [Irwin 1979, pp. 94, 226 n.41 / Flaxman 1872, 4: pl. 10]

Ugo Foscolo, 1778–1827. (The Erinyes evoked in) *Le Grazie* [The Graces], "Inno primo" [First Hymn] part 1. Poem, unfinished. **1814.** Florence: 1848. Modern edition by Saverio Orlando as *Le Grazie, carme ad Antonio Canova* (Brescia: Paideia, 1974). [Cambon 1980, pp. 341, 346]

Henry Fuseli, 1741–1825. "A Fury, Advancing with a Flowing Veil." Drawing. **1810–15.** Grete Ring coll., Ashmolean Museum, Oxford. [Schiff 1973, no. 1525—ill.]

Théodore Géricault, 1791–1824. Series of drawings of Furies and other demons pursuing guilty persons. c.**1818.** Dispersed. [Eitner 1983, pp. 145–47—ill.]

William Blake, 1757–1827. (The Furies threatening Dante in) "The Angel at the Gate of Dis." Watercolor, illustrating *Inferno* 9.36–60, part of a series of illustrations for Dante's *Divine Comedy.* **1824–27.** National Gallery of Victoria, Melbourne. [Butlin 1981, no. 812.20]

Johann Wolfgang von Goethe, 1749–1832. (The Furies in) *Faust* Part 2, 1.5345–92. Tragedy. This episode first published **1828** as a continuation of Part 1; incorporated into Part 2, published Heidelberg: 1832. [Beutler 1948–71, vol. 5 / Suhrkamp 1983–88, vol. 2]

Walter Savage Landor, 1775–1864. "A Greek to the Eumenides." Poem. In *Heroic Idylls* (London: Newby, **1863**). [Wheeler 1937, vol. 3 / Boswell 1982, p. 154]

Arnold Böcklin, 1827–1901. "Murderer Pursued by Furies." Painting. **1870**. Bayerische Staatsgemaldesammlungen, Munich, inv. no, 11–537. [Andree 1977, no. 232—ill.]

Franz von Stuck, 1863–1928. (The Furies lying in wait for) "The Murderer." Painting. **1891**. Private coll. in 1912. [Voss 1973, no. 54—ill.]

Charles Marie René Leconte de Lisle, 1818–**1894**. "Parfum des Erinnyes, l'asphodèle." Poem, no. 9 of "Hymnes orphiques," verse translation from Orphic Hymns. In *Oeuvres: Derniers poèmes* (Paris: Lemerre, 1895). [Pich 1976–81, vol. 4]

Gustav Klimt, 1862–1918. (The Erinyes in) "Jurisprudence." Ceiling painting for Great Hall, University of Vienna. **1903–07**. Destroyed. [Novotny & Dobai 1968, no. 128, p. 78—ill.]

Edith Wharton, 1862–1937. "The Eumenides." Poem. In *Artemis to Actaeon and Other Poems* (New York: Macmillan, **1909**). [Boswell 1982, p. 308]

Wilhelm Berger, 1861–1911. "Gesang der Erynnien" [Song of the Erinyes]. Choral composition with orchestra. Unpublished. [Grove 1980, 2:547]

D. H. Lawrence, 1885–1930. "Erinnyes." Poem. In *Some Imagist Poets* (Boston: Houghton Mifflin, **1916**). [Pinto & Roberts 1964, vol. 2]

Edgar Lee Masters, 1869–1950. "The Furies." Poem. In *The Great Valley* (New York: Macmillan, **1916**). [Ipso / Boswell 1982, p. 179]

Karl Gustaf Verner von Heidenstam, 1859–1940. (The Furies in) *The Soothsayer* [English title of a work written in Swedish]. Drama. Translated by Karoline Knudsen (Boston: Four Seas, **1919**). [TCLC 1978–89, 5:253]

Pío Baroja y Nessi, 1872–1956. *Las Furias*. Novel. Madrid: Caro Raggio, **1921**. [Oxford 1978, p. 50]

Ernst Barlach, 1870–1938. "Three Furies." Drawing. **1922**. Barlach Estate, Güstrow, inv. VIII 2;6. [Schult 1958–72, 3: no. 1570—ill.]

———. "Two Furies." Drawing. 1922. Barlach Estate, inv. VIII 2;2. [Ibid., no. 1623—ill.]

———. "Cursing Fury." Drawing. 1923. Barlach Estate, inv. VIII 2;1. [Ibid., no. 1687—ill.]

———. "Laughing Fury." Drawing. 1926. Barlach Estate, inv. VIII 2;5. [Ibid., no. 1824—ill.]

Richard Aldington, 1892–1943. "Eumenides." Poem. In *Exile and Other Poems* (Boston: Four Seas, **1924**). [Boswell 1982, p. 10]

Basil Bunting, 1900–1985. "Chorus of Furies—Overheard—guarda, mi disse, le feroce Erine." Poem. **1929**. In *Poems* (Galveston: Cleaner's Press, 1950); reprinted in *Collected Poems* (Oxford: Oxford University Press, 1978). [Ipso / CLC 1988, 47:44]

Martha Graham, 1894–1991, choreography. "Chorus for Furies." Modern dance, part of *Three Choric Dances for an Antique Greek Tragedy*. Music, Louis Horst. First performed 20 Feb **1933**, Fuld Hall, Newark, N.J. [McDonagh 1973, p. 313]

Louise Bogan, 1897–1970. "The Sleeping Fury." Poem. **1935–36**. In *The Sleeping Fury and Other Poems* (New York: Scribner, 1937). [Frank 1985, pp. 232, 257–60, 281 / Gould 1980, pp. 280, 289 / Gregory & Zaturenska 1946, pp. 277, 280]

Michel Fokine, 1880–1942, choreography. "Dance of the Furies," in *Don Juan* act 3. Modern dance ("choreographic" tragicomedy), after Angiolini (1761). Music, Gluck (1761). Libretto, Eric Allatini and Fokine, after Molière's *Don Juan, ou, Le festin de pierre* [Don Juan, or, The Stone Guest] (1665). First performed 25 June **1936**, Alhambra Theatre, London, by René Blum Company; décor, Mariano Andre. [Beaumont 1938, pp. 608, 612 / Fokine 1961, p. 272]

George Seferis, 1900–1971. "Arrōstē Erinys" [Sick Fury]. Haiku. In *Tetradio gymnasmaton* [Book of Exercises] (Athens: Ikaros, **1940**). [Keeley & Sherrard 1967 / Seymour-Smith 1985, p. 687]

I. M. Panayotópoulos, 1901–. "Eumenides." Poem. **1944**. In *Alkyone* (Athens: 1950). [Friar 1973; cf. pp. 362, 724f.]

Eugen Batz, 1905–. "Erinyes." Print. **1949**. [Hannover 1950, no. 6]

Louis MacNeice, 1907–1963. (The Furies evoked in) "Areopagus" sections 3, 4. Poem. *c.***1950–51**. [Dodds 1966]

Robert Rauschenberg, 1925–. The Furies depicted in an illustration to Dante's *Inferno* 9. Transfer-drawing. **1959–60**. Museum of Modern Art, New York. [Berlin 1980, p. 152—ill.]

David Pinner, 1940–. *The Furies*. Drama. **1972**. Unpublished. [DLEL 1970–78, 2:244]

Anne Sexton, 1928–**1974**. "The Furies." Poem. In *Complete Poems* (Boston: Houghton Mifflin, 1981). [Ostriker 1986, p. 288]

Donald Justice, 1925–. "The Furies." Poem. In *Selected Poems* (New York: Atheneum, **1979**). [Ipso]

Stephen Spender, 1909–. "The Furies." Poem. **1928–85**. In *Collected Poems, 1928–1985* (New York: Random House, 1986). [Ipso]

G

GAIA. The personification of the Earth and an essential element of early creation myths, Gaia (or Ge) was the daughter of Chaos. The earliest Greek goddess of fertility, she was the mother of Urea (Mountains), Pontus (Sea), and Uranus (Heaven). Mating with Uranus, she produced the Titans, the Cyclopes, and the Hecatoncheires. After Cronus, the youngest of the Titans, castrated his father, she bore the Giants and the Furies from the blood of his wounds. Gaia was also the mother of Typhon

by her son Tartarus, and of Nereus and Phorcys by her son Pontus.

The original guardian of Delphi, Gaia was worshiped as a fertility goddess in early periods of Greek history, although her role was taken over in Classical times by other gods, including Apollo (at Delphi), Hera, Demeter, and Aphrodite.

The Roman earth-goddess Tellus (or Terra), whose origins may predate the Empire, was influenced by the Greek Gaia. Although not accorded her own festival, she was nonetheless worshiped on different occasions throughout the Roman year.

Classical Sources. Hesiod, *Theogony* 116–87, 233–39, 459–97, 820–22, 881–85. *Homeric Hymns*, "To Earth." *Orphic Hymns* 26, "To Earth." Plato, *Republic* 2.377Eff. Lucretius, *De rerum natura* 1.250ff., 2.991ff. Virgil, *Georgics* 2.325ff. Anonymous Roman "Hymn to Tellus, Mother of the Gods." Cicero, *De natura deorum* 2.23.63ff. Apollodorus, *Biblioteca* 1.1.1–4, 1.5.2, 1.6.1–3, 2.12.

Further Reference. Christine R. Downing, "The Mother Goddess Among the Greeks," in *The Book of the Goddess Past and Present: An Introduction to Her Religion,* edited by Carl Olson (New York: Crossroad, 1983: pp. 16–19, 49–59). Pamela Berger, *The Goddess Obscured: Transformation of the Grain Protectress from Goddess to Saint* (Boston: Beacon Hill, 1985: pp. 37–47).

See also URANUS.

Antonio Draghi, 1634/35–1700. *La madre degli dei* [The Mother of the Gods]. Opera. Libretto, N. Minato. First performed 22 July **1693,** Vienna. [Grove 1980, 5:604]

John Flaxman, 1755–1826. "Gaia and the Youthful Zeus" ("The Infancy of Jupiter"). Drawing, part of a series illustrating Hesiod's *Theogony* (lines 479–84). **1807–14.** Engraved by William Blake, published London: Longman & Co., 1817. [Irwin 1979, pp. 90f. / Bindman 1979, no. 157—ill. / Flaxman 1872, 7: pl. 32]

Percy Bysshe Shelley, 1792–1822. "Hymn to the Earth, Mother of All." Translation of Homeric Hymn to Earth. **1818.** In *Poetical Works,* edited by Mary Shelley (London: Moxon, 1839). [Hutchinson 1932 / Webb 1976, pp. 63f., 68f., 118]

Giacomo Leopardi, 1798–1837. "Dialogo della Terra e della Luna" [Dialogue between the Earth and the Moon]. Dialogue. **1824.** In *Operette morali* (Milan: Stella, 1827). [Cecchetti 1982]

Anselm Feuerbach, 1829–1880. "Gaia." Painting. **1875.** Akademie der Bildenden Künste, Vienna. [Hunger 1959, p. 117]

Adalbert von Goldschmidt, 1848–1906. *Gaea.* Opera-oratorio. 1892. First performed **1893,** Berlin. [Grove 1980, 7:505]

Otto Greiner, 1869–1916. "The Earth Goddess" (Gaia). Etching. **1911.** [Dijkstra 1986, p. 85—ill.]

Émile-Antoine Bourdelle, 1861–1929. "Gaia, Mother of the Gods." Fresco. **1913.** Grand Galerie, Théâtre des Champs-Elysées, Paris. [Basdevant 1982, p. 106—ill.]

T. Sturge Moore, 1870–1944. (Nemesis versus Ge in) The

Powers of the Air. Platonic dialogue. London: Richards, **1920.** [Gwynn 1951, pp. 103–128]

Anders Osterling, b. 1884. "Tellus." Idyll. In *Idyllernas Bok* (Stockholm: Bonnier, **1920**). / Translated by C. D. Locock in *A Selection from Modern Swedish Poetry* (New York: Macmillan, 1929). [Ipso]

Richard Aldington, 1892–1943. "An Earth Goddess" (Gaia). Poem. In *Complete Poems* (London: Wingate, 1948). [Boswell 1982, p. 10]

Barnett Newman, 1905–1970. "Gaia." Painting. **1945?** [Marks 1984, p. 610]

Ezra Pound, 1885–1972. (Gaia/Terra evoked in) Canto 82, in *The Pisan Cantos* (New York: New Directions, **1948**). [Surette 1979, pp. 213f. / Flory 1980, p. 221]

W. H. Auden, 1907–1973. "Ode to Gaea." Poem. **1954.** In *The Shield of Achilles and Other Poems* (New York: Random House; London: Faber & Faber, 1955). [Mendelson 1976 / Feder 1971, pp. 174–76]

Robert Duncan, 1919–1988. "A Diary Poem to Day, Gaia," section of "The Continent." Poem. In *Roots and Branches* (New York: Scribner, **1964**). [Ipso]

GALATEA. (1) A sea nymph, enamored of Acis and pursued by Polyphemus. *See* GALATEA. (2) Name given to the statue made by Pygmalion. *See* PYGMALION.

GALATEA. A sea nymph, daughter of Nereus and Doris, Galatea ("milk-white") was in love with Acis, son of Faunus (or Pan). She was ardently pursued by the Cyclops Polyphemus, who sang of his passion for her and offered to make her mistress of his rustic domain. But the nymph rejected him, and when Polyphemus discovered her with Acis he crushed the youth under a rock. According to Ovid, Galatea changed Acis into a river that ever afterward bore his name. In another version of the story, Galatea eventually accepted Polyphemus and bore him a son, Galas (or Galates), the ancestor of the Gauls (Galatians).

In postclassical drama and poetry the sea nymph Galatea has often become a shepherdess or milk-maid, a development deriving from the pastoral settings of her tale in the works of Theocritus, Virgil, and Ovid. In painting, Galatea is a popular subject for elaborate sea-triumphs, in which she is depicted standing in her cockleshell chariot, attended by other Nereids, amoretti, and tritons; these scenes are similar to, and sometimes interchangeably identified as, sea-triumphs of Aphrodite or Amphitrite.

Classical Sources. Homer, *Iliad* 18.45. Hesiod, *Theogony* 250. Theocritus, *Idylls* 11. Bion, "Polyphemus." Propertius,

Elegies 3.2.7. Virgil, *Eclogues* 7.37–40, 9.39–43. Horace, *Satires* 1.5. Ovid, *Metamorphoses* 13.738–897. Apollodorus, *Biblioteca* 1.2.7. Lucian, *Dialogues of the Sea Gods* 1, "Doris and Galatea." Philostratus, *Imagines* 2.18, 2.19.

Further Reference. Heinrich Dörrie, *Die schöne Galatea: Eine Gestalt Rande des griechischen Mythos in antiker und neuzeitlicher Sicht* (Munich: Heimeran, 1968).

See also AMPHITRITE; APHRODITE, Birth; CYCLOPES.

Dante Alighieri, 1265–1321. (Polyphemus's desire for Galatea recalled in) *Eclogae Latinae* eclogue 4. Latin poem. **1319–21.** First printed in *Carmina illustrum poetarum Italorum* (Florence: 1719–26). Modern edition by P. H. Wicksteed and E. O. Gardner, *Dante and Giovanni del Virgilio* (Westminster: Constable 1902). [Toynbee 1968, pp. 240]

Anonymous French. (Story of Galatea, Acis, and Polyphemus in) *Ovide moralisé* 13.3688–4147 (narrative), 4148–4294 (allegory). Poem, allegorized translation/elaboration of Ovid's *Metamorphoses*. c.**1316–28.** [de Boer 1915–86, vol. 4]

John Gower, 1330?–1408. (Story of Acis and Galatea in) *Confessio amantis* 2.97–220. Poem. c.**1390.** Westminster: Caxton, 1483. [Macaulay 1899–1902, vol. 2 / Ito 1976, p. 9]

Christine de Pizan, c.1364–c.1431. (Acis and Galatea in) *L'epistre d'Othéa à Hector* . . . [The Epistle of Othéa to Hector] chapter 59. Didactic romance in prose. c.**1400.** MSS in British Library, London; Bibliothèque Nationale, Paris; elsewhere. / Translated by Stephen Scrope (London: c.1444–50). [Bühler 1970 / Hindman 1986, p. 200]

Angelo Poliziano, 1454–1494. (Polyphemus's love for Galatea evoked in) *Stanze . . . per la giostra di Giuliano de' Medici* 1.115ff. Poem. **1475–78.** [Giamatti 1966, p. 131]

Lorenzo de' Medici, 1449–1492. (Galatea disdains love of the shepherd) *Corinto.* Poem. c.**1486.** [Bondanella 1979, p. 326]

Sandro Botticelli, 1445–1510. "Galatea." Painting. Formerly Medici coll., Florence, lost. [Lightbown 1978, no. G7—ill.]

Raphael, 1483–1520. "Triumph of Galatea." Fresco. **1511.** Sala di Galatea, Villa Farnesina, Rome. [Vecchi 1987, no. 92—ill. / Jones & Penny 1983, pp. 93ff.—ill. / d'Ancona 1955, pp. 45f.—ill. / Gerlini 1949, pp. 18ff.—ill. / also Berenson 1968, p. 353—ill. / Vermeule 1964, p. 60—ill.] Copy, engraving, by Hendrik Goltzius, 1592. 2 states. [Strauss 1977a, no. 288—ill. / Bartsch 1980–82, no. 270—ill.] Copy, painting, by Pietro da Cortona, c.1620. Accademia di San Luca, Rome. [Briganti 1962, no. 2—ill.] Anonymous copies, in Herzog Anton Ulrich-Museum, Braunschweig, no. 1135; Saltram Park, Devon, cat. 1967 no. 81. [Braunschweig 1976, p. 48 / Wright 1976, p. 169] Copy by William Bouguereau, 1852, in Musée, Dijon. [Isaacson 1974, p. 20 / Montreal 1984, p. 61]

Sebastiano del Piombo, c.1485–1547. "Polyphemus." Fresco. **1511.** Sala di Galatea, Villa Farnesina, Rome. [d'Ancona 1955, pp. 45f.—ill. / Gerlini 1949, pp. 20f.—ill.]

Pinturicchio, 1454–**1513,** and studio. "Triumph of Amphitrite" (or Galatea?). Ceiling fresco (detached), from Palazzo Pandolfo Petrucci ("Il Magnifico"), Siena. Metropolitan Museum, New York, no. 114.11 (as Amphitrite). [Metropolitan 1980, p. 142—ill. / Berenson 1968, p. 345 (as Galatea?)—ill.]

Jacopo de' Barbari, 1440/50–**1516,** attributed. "Galatea (Standing on a Dolphin)." Painting. Gemäldegalerie, Dresden, no. 59A. [Dresden 1976, p. 23 / Servolini 1944, p. 122—ill.]

Jacopo Sannazaro, 1458?–1530. *Galatea.* Eclogue. In *Egloghe* (Naples: **1526**). In modern edition by W. P. Mustard, *Piscatory Eclogues* (Baltimore: 1919). [EDS 1954–66, 8:1482]

Giulio Romano, c.1499–1546, and assistants. "Polyphemus." Fresco. **1528.** Sala di Psiche, Palazzo del Tè, Mantua. [Verheyen 1977, p. 117, fig. 39 / Hartt 1958, pp. 129, 132—ill.] Another fresco depicting Polyphemus, in Sala delle Aquile. [Verheyen, p. 121]

Perino del Vaga, 1501–**1547.** "Triumph of Galatea" (? or Venus Anadyomene?). Fresco. Villa Doria-Pamphilj, Rome. [Warburg]

Girolamo Priuli, 1476–**1547.** *La Galatea.* Poem. [Dörrie 1968, p. 89]

Pierre de Ronsard, 1524–1585. "Le Cyclope amoureux." Poem. c.**1553.** In *Le premier livre des poèmes* (Paris: Buon, 1560). [Laumonier 1914–75, vol. 10 / Armstrong 1968, p. 86 n.]

Bernard Salomon, 1506/10–c.1561. "Acis and Galatea." Woodcut, part of a cycle illustrating Ovid. In *Les Metamorphoses d'Ovide figurée* (Lyons: Tivornes, **1557**). [Warburg]

Giambologna, 1529–1608. "Galatea." Marble sculpture. c.**1560.** Lost. [Avery 1987, pp. 97f.]

Alberto Lóllio, 1508–**1568.** *La Galatea.* Dramatic pastorale. Unfinished. [DELI 1966–70, 3:405]

Stoldo di Lorenzi, 1534–1583, attributed. "Marine Nymph" (variously identified as Galatea, Amphitrite, Venus). Bronze statuette. **1573.** Studiolo, Palazzo Vecchio, Florence. [Sinibaldi 1950, pp. 12, 18 / also Pope-Hennessy 1985b, 3:100—ill. / Lensi 1929, pp. 236f., 265 (as Vincenzo de' Rossi)—ill.] Variant copies in Frick Collection, New York, no. 16.2.48 (mid-18th century?); Victoria and Albert Museum, London (stucco, late 18th/19th century). [Frick 1968–70, 3:208f.—ill.]

John Lyly, c.1554–1606. *Gallathea.* Comedy. **1584–85.** London: 1592. [Bond 1902, vol. 2]

Luca Cambiaso, 1527–**1585.** "Triumph of Galatea." Fresco. Formerly Palazzo Sivoli, Genoa, destroyed. / Drawings (for?). Louvre, Paris, inv. 9312; Musée de Besançon, inv. 1476D. [Manning & Suida 1958, p. 95—ill.]

———. "Venus [or Galatea] Carried by a Dolphin." Woodcut. (Uffizi, Florence, no. 6942.) [Ibid., p. 171—ill.]

Miguel de Cervantes Saavedra, 1547–1616. *La Galatea* part 1 (second part never published). Pastoral romance. Alcala de Henares: Juan Gracian, **1585.** [Dörrie 1968, pp. 66, 92 / Oxford 1978, p. 223]

Luca Marenzio, 1553/54–1599. "Stringeami Galatea." Madrigal. Published Venice: **1585.** [Grove 1980, 11:673]

Thomas Lodge, 1558?–1625. (Story of Galatea and Polyphemus in a lyric in) *Rosalynde.* Pastoral romance. London: Gubbin & Busbie, **1590;** reprinted in *England's Helicon* (London: Flasket, 1600). [Bush 1963, p. 85 n.]

Hendrik Goltzius, 1558–1617. "Triumph of Galatea." Engraving, after Raphael (1511, Rome). **1592.** 2 states. [Strauss 1977a, no. 288—ill.]

———. "Venus Marina" (formerly called "Galatea"). Woodcut, in "Children of Demogorgon" series; executed by studio after Goltzius's composition (Bartsch no. 235,

as "Galatea"). *c*.1594. 2 states. [Ibid., no. 422—ill. / Bartsch 1980–82, no. 235—ill.]

Agostino Carracci, 1557–1602. "Venus [or Galatea] Carried by Dolphins." Engraving, in *"lascivie"* series (Bartsch no. 129). *c*.**1590–95**. [DeGrazia 1984, no. 181—ill.]

———. "Glaucus and Scylla" ("Galatea"). Fresco. 1597/1600. Galleria, Palazzo Farnese, Rome. [Malafarina 1976, no. 104r—ill. / Martin 1965, pp. 105ff.—ill.]

Scipione da Manzano, 1560–**1596**. *Aci: Favola marina* [Acis: Marine Fable]. Drama. Venice: Ciotti, 1600. [Dörrie 1968, p. 88]

Annibale Carracci, 1560–1609. "Polyphemus Wooing Galatea," "Polyphemus Slaying Acis." Pair of frescoes. *c*.**1597–1600**. Galleria, Palazzo Farnese, Rome. (Another fresco, formerly known as "Galatea" [now called "Peleus and Thetis" or "Glaucus and Scylla"], is also in the Galleria.) [Malafarina 1976, nos. 104s, 104t—ill. / Martin 1965, pp. 109ff.—ill.] Copy of "Polyphemus Wooing Galatea" (previously considered autograph) in Earl of Leicester coll., Holkham Hall. [Malafarina, no. 218—ill.] *See also Perrier, below.*

Pomponio Torelli, 1539–1608. *La Galatea*. Tragedy. First performed **1603**, Parma. [Dörrie 1968, p. 88 / DELI 1966–70, 5:303]

Guillaume Costeley, *c*.1530–**1606**. "O belle Galathée." 4–voice chanson. Published Paris: 1896–1904. [Grove 1980, 4:826]

Ippolito Andreasi, *c*.1548–**1608**. Drawing of Polyphemus, Galatea, and Acis, sketch for decoration of Sala di Psiche, Palazzo del Tè, Mantua. Kunstmuseum, Düsseldorf, inv. FP 10928. [Hofmann 1987, no. 1.27—ill.]

Luis de Góngora y Argote, 1561–1627. *La fábula de Polifemo y Galatea*. Romance in verse. By **1609**. Madrid: Imprenta Real, 1612. In modern edition by Alexander A. Parker, *Obras* (Madrid: Catedra, 1983). [Oxford 1978, p. 248 / DLE 1972, p. 403]

Palma Giovane, *c*.1548–1628. "Triumph of Galatea." Painting. *c*.**1600–10**. Formerly Sanssouci, Potsdam, inv. G.K.12364, destroyed. [Mason Rinaldi 1984, no. 223—ill.]

Luis de Carrillo y Sotomayor, 1582–**1610**. "Fábula de Acis y Galatea." Poem. In *Obras* (Madrid: Juan de la Cuesta, 1611; revised 1613). [Oxford 1978, p. 198]

Giles Fletcher the Elder, 1549?–**1611**. "Dialogue betwixt Two Sea Nymphs, Doris and Galatea, Concerning Polyphemus." Poem, based on Lucian and on Latin version of Lucian by Johannes Secundus. In modern edition by Sidney Lee, *Elizabethan Sonnets* (Westminster: 1904). [Bush 1963, p. 230]

Bartholomeus Spranger, 1546–**1611**. "Triumph of Galatea." Drawing. Wallraf-Richartz-Museum, Cologne. [de Bosque 1985, p. 281—ill.]

Domenico Fetti, *c*.1589–1624. "Galatea and Polyphemus." Painting. *c*.**1610–12**. Kunsthistorisches Museum, Vienna, inv. 172 (115). [Vienna 1973, p. 65—ill.]

Santi Orlandi, ?–1619. *Gli amori di Aci e Galatea* [The Loves of Acis and Galatea]. Opera. Libretto, Chiabrera. **1612**. First performed Mar 1617, Court, Mantua. [Grove 1980, 13:823]

Gabriello Chiabrera, 1552–1638. *La Galatea: Favola marittima* [Galatea, a Tale of the Sea]. Comedy. First performed **1614**, Mantua. [Dörrie 1968, p. 88]

Cavaliere d'Arpino, 1568–1640, attributed. "Galatea Drawn by Dolphins, with Tritons and Nymphs." Drawing. *c*.1620? Bibliothèque National, Paris, Masson no. 2547. [Rome 1973, no. 138—ill.]

Pietro da Cortona, 1596–1669. "Triumph of Galatea." Painting, copy after Raphael (1511, Rome). *c*.**1620**. Accademia di San Luca, Rome. [Briganti 1962, no. 2—ill.]

Giovanni Lanfranco, 1582–1647. "Polyphemus and Galatea." Painting. *c*.**1620**. Villa Doria-Pamphilj, Rome. [Dublin 1985, p. 52]

Anonymous composer. *Polifemo geloso* [Polyphemus Jealous]. Opera (dramma musicale). Libretto, Gabriello Chiabrera. Published Genoa: Pavoni, **1622**. [Weaver 1978, p. 336 / Dörrie 1968, p. 88]

Nicolas Poussin, 1594–1665. "Acis Transformed into a River God," "Galatea, Acis and Polyphemus." Drawings, illustrating Ovid, for G. B. Marino (for unpublished edition of *Metamorphoses*?). *c*.**1620–23**. Royal Library, Windsor Castle, nos. 11939–40. [Friedlaender & Blunt 1953, no. 158—ill.]

———. "(The Marriage of) Acis and Galatea" (formerly called "The Marriage of Peleus and Thetis"). Painting. *c*.**1628–30**. National Gallery of Ireland, Dublin, no. 814. [Wright 1985, no. 46, pl. 127 / Dublin 1985, no. 34—ill. / Dublin 1981, p. 129—ill. / also Blunt 1966, no. 128—ill. / Thuillier 1974, no. 46—ill. / Loizeaux 1986, fig. 50]

———. "Galatea and Acis." Drawing. Late 1620s. Musée Condé, Chantilly. [Friedlaender & Blunt, no. 215—ill.]

———. "Landscape with Polyphemus." Painting. 1649 (? or later). Hermitage, Leningrad, no. 1186. [Blunt, no. 175—ill. / Thuillier, no. 166—ill. / Wright, no. 166 (as "Ulysses Deriding Polyphemus")—ill. / Hermitage 1984, no. 93—ill. / Hermitage 1974, pl. 28] Copy ("Landscape: Polyphemus and Galatea") in Prado, Madrid, no. 2322. [Prado 1985, p. 519]

———. "Triumph of Galatea." 2 drawings. Nationalmuseum, Stockholm, nos. Wengstrom XIII, XIV. [Friedlaender & Blunt, nos. 216–17—ill.]

Ivan Gundulić, 1589–1638. *Galatea*. Drama in Croatian. **1626**. Unpublished; exists in MSS. [Dörrie 1968, p. 88]

Jacob Cats, 1577–1660. "Galathee." Poem. In *Proteus, ofte Minne-beelden verandert in sinne-beelden* (Rotterdam: Waesberge, **1627**). [CEWL 1973, 2:271]

Thomas Dekker, 1570?–1632. "Song of the Cylops," in *Londons Tempe, or, The Field of Happiness*. Pageant. First performed 29 Oct, London. London: Okes, **1629**. In modern edition by Fredson Bowers, *Dramatic Works* (Cambridge: 1961). [Ipsod]

François Perrier, *c*.1590–1650 (previously attributed to Annibale Carracci). "Polyphemus and the Sea Nymphs." Painting. **Late 1620s** (or early 1640s?). Kress coll. (K1636), Bucknell University, Lewisburg, Pa. [Eisler 1977, p. 264—ill.] Reversed variant, "Acis and Galatea (Hiding from the Gaze of Polyphemus)." Louvre, Paris, inv. 7161. [Louvre 1979–86, 4:129—ill. / Dublin 1985, no. 29—ill.] Replica (previously attributed to Luca Giordano). Louvre, inv. 7162, on deposit in Musée, Carcassonne, since 1892. [Dublin]

——— (previously attributed to Poussin). "Acis and Galatea." Painting. Statens Museum for Kunst, Copenhagen. [Copenhagen 1951, no. 538—ill.]

Cornelis Schut, 1597–1655. "Triumph of Galatea." Painting. *c.*1628–30. Uffizi, Florence, inv. 2145. [Uffizi 1979, no. P1439—ill.]

Francesco Albani, 1578–1660. "Galatea on a Shell-Chariot." Painting. *c.*1630. Gemäldegalerie, Dresden, no. 340. [Dresden 1976, p. 21]

Giovanni da San Giovanni, 1592–1636. "Galatea with Two Dolphins," "Polyphemus and Galatea." Frescoes. *c.*1630. Villa del Pozzino, Castello (Florence). [Banti 1977, no. 39]

Juan Pérez de Montalbán, 1602–1638. *El Polifemo*. Auto sacramentale. 1628–32? [Oxford 1978, p. 458]

Abraham Janssens, *c.*1575–1632. "The Death of Acis." Painting. Alte Pinakothek, Munich. [Bénézit 1976, 6:38]

Pieter Corneliszoon Hooft, 1581–1647. "Galathea." Poem. In *Galathea en andere gedichten* (Amsterdam: Blaev, 1636). Modern edition, Amsterdam: Meulenhoff, 1947. [CEWL 1973, 2:705]

Loreto Vittori, 1580–1670. *La Galatea*. Opera (dramma per musica). Libretto, composer. Published Rome: 1639. First performed 1639 (?), Teatro Barberino (?), Rome. [EDS 1954–66, 9:1737 / Grove 1980, 20:29 / Palisca 1968, p. 119 / Bianconi 1987, p. 170 / Bukofzer 1947, p. 61]

Johann von Rist, 1607–1667. *Galathee*. Pastoral poem. Hamburg: Rebenlein, 1642. In modern edition by E. and H. Mannack *Sämtliche Werke* (Berlin: de Gruyter, 1967–). [Oxford 1986, p. 756]

Agostino Tassi, *c.*1580–1644. Cycle of paintings depicting the story of Galatea and Polyphemus. Palazzo Lancelotti, Rome. [Pigler 1974, p. 9]

Simon Vouet, 1590–1649. "Triumph of Galatea." Painting. Lost. / Engraved by Michel Dorigny, 1644. [Crelly 1962, no. 225]

——, rejected attribution. "Galatea." Painting. P. Cailleux coll., Paris. [Ibid., no. 114]

Padovanino, 1588–1648. "Triumph of Galatea." Painting. Accademia Carrara, Bergamo. [Warburg]

Artemisia Gentileschi, 1593–1652/53, and **Bernardo Cavallino**, 1616–1656, attributed (previously attributed to Cavallino). "Triumph of Galatea" (also called "Triumph of Amphitrite"). Painting. *c.*1645–50. Private coll., New York. [Garrard 1989, pp. 123ff.—ill. / also Percy & Lurie 1984, no. 68—ill.]

Pietro Testa, 1611–1650. "Triumph of Galatea." Painting. Pinacoteca, Lucca. [Warburg]

Abraham Bloemaert, 1564–1651. "Triumph of Galatea." Drawing. Courtauld Institute, London. [de Bosque 1985, pp. 280f.—ill.]

Girolamo Polcastro. *Aci, Galatea, e Polifemo*. Cantata for three voices. First performed *c.*1655 (?), Padua. [Dörrie 1968, p. 89]

Guercino, 1591–1666. "Galatea" (on a barge drawn by tritons). Painting. 1656. Residenzgalerie, Salzburg. [Salerno 1988, no. 318—ill.]

Adriaen van Nieulandt, 1587–1658. "Triumph of the Sea Goddess Galatea" (?). Painting. 1656. Rijksmuseum, Amsterdam, inv. A1582. [Rijksmuseum 1976, p. 417—ill.]

Claude Lorrain, 1600–1682. "Coast View with Acis and Galatea." Painting. 1657. Gemäldegalerie, Dresden, no. 731. [Röthlisberger 1961, no. LV 141—ill. / Dresden 1976, p. 67—ill.] Drawing after, in the artist's *Liber veritatis*. British Museum, London. [Röthlisberger]

Jean-Baptiste Tubi, 1635–1700. "Galatea," "Acis." Stone statues. 1667. Bosquet des Dômes, Gardens, Versailles. [Girard 1985, pp. 198f., 274—ill.]

Pietro Andrea Ziani, 1616–1684. *La Galatea*. Opera. Libretto, Antonio Draghi. First performed 16 Feb 1667, Vienna. [Grove 1980, 20:676 / Dörrie 1968, p. 89]

Theodoor van Thulden, 1606–1669. "Triumph of Galatea." Painting. Sanssouci, Potsdam. [Bénézit 1976, 10:171]

Luca Giordano, 1634–1705. "Galatea." Painting. Early 1670s. Musée des Beaux-Arts, Bordeaux, no. 72. [Ferrari & Scavizzi 1966, 2:83—ill.]

——. "Triumph of Galatea" (Polyphemus looking on). Painting. *c.*1675–76. Galleria Palatina, Palazzo Pitti, Florence, no. 2218. [Pitti 1966, p. 7—ill. / Uffizi 1979, no. P711—ill. / Ferrari & Scavizzi, 2:86—ill.] Replica (or study). Worcester Art Museum, Mass. [Ferrari & Scavizzi—ill.]

——. "Triumph of Galatea (? or of Tethys or Amphitrite). Painting. *c.*1682. Uffizi, Florence, inv. 1381. [Uffizi, no. P715—ill. / also Ferrari & Scavizzi, 2:119—ill.] 2 enlarged replicas known, unlocated. [Uffizi]

——. "Polyphemus with Acis and Galatea." Painting. *c.*1700. Palacio Real, Aranjuez. [Ibid., 2:225f.]

——, attributed. "Galatea." Painting (?). Civico Museo Filangieri, Naples. [Ibid., 2:301]

——, attributed. "Acis and Galatea." Painting. Duke of Devonshire coll., Chatsworth. [Ibid., 2:323]

——, attributed. "Triumph of Galatea." Painting. Mid-1680s? Borromeo coll., Isolabella, in 1931. [Ibid., 2:336]

——, attributed. "Acis and Galatea." Painting. Alte Pinakothek, Munich, no. 1748/1845 (in storage). [Ibid., 2:356]

——, attributed. "Polyphemus and Galatea." Painting. 1675–80? Palazzo Chigi, Rome. [Ferrari & Scavizzi, 2:380—ill.] ——. At least 2 further treatments of the Galatea theme known from contemporary documents, untraced. [Ibid., 2:330f., 381]

——, studio. "Galatea." Painting. Castello Sforzesco, Milan. [Ibid., 2:300]

——, style. "Polyphemus and Galatea." Painting. Hampton Court Palace, inv. 1306. [Warburg]

Jean de La Fontaine, 1621–1695. *Galatée*. Pastoral drama, intended as opera libretto. Begun *c.*1674, unfinished. In *Poème du quinquina et autres ouvrages en vers* (Paris: Thierry & Barbin, 1682). [Clarac & Marmier 1965 / DLLF 1984, 2:1175 / Girdlestone 1972, p. 125 / MacKay 1973, p. 149]

Nicolaes Willing, *c.*1640–1678. "Triumph of Galatea." Painting. Gemäldegalerie, Kassel, inv. 631. [Pigler 1974, p. 93]

Marc-Antoine Charpentier, 1645/50–1704. *Les amours d'Acis et de Galatée*. Opera. 1678. [Grove 1980, 4:174]

François Girardon, 1628–1715. "Triumph of Thetis." Relief on a marble vase, for Versailles. 1683. Louvre, Paris (as "Triumph of Galatea"). [Francastel 1928, no. 55—ill.]

Raymond de La Fage, *c.*1650–1684. "Triumph of Galatea." Drawing. Louvre, Paris. [Bénézit 1976, 6:369]

Edmund Waller, 1606–1687. "Thyrsis, Galatea." Poem. In *Poems Written upon Several Occasions* (London: Herringman, 1684). [Boswell 1982, p. 307]

Jean-Baptiste Lully, 1632–1687. *Acis et Galatée*. Opera (pastorale héroïque). Libretto, Jean Galbert de Campistron. First performed 6 Sep 1686, before the Dauphin, Château d'Anet, near Paris. [Grove 1980, 11:327]

Christian Weise, 1642–1708. *Die betrübte und getröstete Galathée* [Galatea Tried and True]. Drama. First performed *c.*1690, Hamburg. [Dörrie 1968, p. 89]

John Dryden, 1631–1700. "The Fable of Acis, Polyphemus, and Galatea." Poem, translation from Ovid. In *Examen poeticum,* part 3 of Tonson's *Miscellany* (London: Tonson, **1693**). [Dryden 1956–87, vol. 4 / Van Doren 1946, p. 96]

Pietro Antonio Fiocco, *c.*1650–1714. Prologue to Lully's opera *Acis et Galatée* (1686). After **1694**? [Grove 1980, 6:597]

Girolamo Frigimèlica Roberti, 1653–1732. *Il Ciclope* [The Cyclops]. Satirical tragedy. First performed **1695**, Padua. [Dörrie 1968, p. 89]

Charles de La Fosse, 1636–1716. "Polyphemus Throwing a Boulder at Acis." Painting. **1699**. [Pigler 1974, p. 222]
——. "Acis and Galatea." Painting. *c.*1704? Prado, Madrid, no. 2251. [Prado 1985, p. 224]

Bolognese School (?). "Triumph of Galatea." Painting. **17th century.** Fitzwilliam Museum, Cambridge, no. 123. [Fitzwilliam 1960–77, 2:18 / Wright 1976, p. 103]

Bolognese School. "Galatea on Her Team of Dolphins." Painting. **17th century.** Szépmüvészeti Múzeum, Budapest, no. 54.1940. [Budapest 1968, p. 77]

Bolognese School. "Polyphemus Throwing a Boulder at Acis." Painting. **17th century.** Private coll., Madrid. [Pigler 1974, p. 222]

Italian School. "Polyphemus and Galatea." Painting. **17th century.** Gemäldegalerie, Berlin-Dahlem, no. 1809. [Berlin 1986, p. 40]

Peter Motteux, 1660–1718. *Acis and Galatea.* Masque. Music, John Eccles. First performed *c.*Dec **1700** (?) Lincoln's Inn Fields, London, with the opera *The Mad Lover.* [Grove 1980, 5:820 / Fiske 1973, pp. 13f.]

Corneille van Clève, 1644/45–1735. "Polyphemus." Marble statue, traditionally considered the pendant to Le Lorrain's "Galatea" (below). *c.*1700–01? Louvre, Paris. [Beaulieu 1982, p. 51—ill.]

Robert Le Lorrain, 1666–1743. "Galatea." Marble statue, traditionally considered the pendant to van Clève's "Polyphemus" (above). **1701.** National Gallery, Washington, D.C., no. A–1629. [Beaulieu 1982, pp. 50f.—ill. / also Sienkewicz 1983, p. 37—ill. / Walker 1984, fig. 1014]

Giovanni Bononcini, 1670–1747. *Polifemo (Les amours de Polyphème).* Opera. Libretto, Attilio Ariosti. First performed Summer **1702**, Teatro di Litzenbourg, Berlin. [Grove 1980, 1:583, 3:32 / Dörrie 1968, p. 89]

Alexander Pope, 1688–1744. "Polyphemus and Acis." Poem, translation from Ovid. *c.*1702. [Twickenham 1938–68, vol. 1]

Daniel Seiter, 1649–1705. "Triumph of Galatea." Drawing. Louvre, Paris. [Pigler 1974, p. 93]

Girolamo Troppa, *c.*1636–after **1706**. "Triumph of Galatea." Drawing. Kunsthalle, Bremen. [Pigler 1974, p. 92]

Antoine Watteau, 1684–1721. "Acis and Galatea." Painting. *c.*1707? Lost. / Print by Anne-Claude-Phillippe, Comte de Caylus (1692–1765). [Camesasca 1982, no. 17—ill.]

George Frideric Handel, 1685–1759. *Sorge il di* [The Day Is Rising] (*Aci, Galatea, e Polifemo*). Serenata or cantata a tre (azione pastorale per musica). Librettist unknown. First performed July **1708**, Naples, for June wedding of Duke of Alvito and Beatrice, daughter of Prince of Monte Mileto. [Dean & Knapp 1987, pp. 128, 172, 513, 542ff. / Keates 1985, pp. 43f. / Hogwood 1984, pp. 97, 99] Revised as serenata masque, *Acis and Galatea.* Libretto, John Gay, after Theocritus and Ovid, with Alexander Pope (chorus) and John Hughes (1 aria). First performed probably Summer 1718, Cannons (seat of Duke of Chandos), Edgeware, near London. [Keates, pp. 60, 81–85. 158f. / Hogwood, pp. 66, 74 / Fiske 1973, pp. 62, 95 / Dean & Knapp, pp. 166f.] Unauthorized version, pirated by the Arnes. Gay/Pope libretto, with additions by Dr. John Arbuthnot. First performed 10 June 1732, King's Theatre, Haymarket, London. [Baker 1984, p. 940 / Hogwood, pp. 97–99 / Fuller 1983, vol. 1 (Gay's text)]

José de Cañizares, 1676–1750. *Accis y Galatea.* Zarzuela. Music, Antonio Literes. First performed 19 Dec **1708**, Buen Retiro, Madrid. [Barrera 1969, p. 69 / Grove 1980, 11:79]

Francesco Trevisani, 1656–1746. "Seaborne Galatea." Painting. *c.***1714.** Schönborn coll., Pommersfelden. [DiFederico 1977, no. 50] 2 further versions, attributed to Trevisani, in Staatliche Kunstsammlungen, Kassel. [Ibid. (attributions rejected)]
——. "Terrestrial Galatea." Painting. *c.*1715–17. Pommersfelden. [Ibid., no. 51]
——. Another version of the subject ("Galatea"), attributed to Trevisani, in Pommersfelden. [Ibid. (attribution rejected)]

Benedetto Gennari, 1633–**1715**. "Triumph of Galatea." Painting. Hampton Court Palace, inv. 1439. [Bénézit 1976, 4:669]

Gottfried Heinrich Stölzel, 1690–1749. *Acis und Galathea* (also called *Die triumphirende Liebe* [Triumphant Love]). Musical drama. Libretto, composer. First performed **1715**, Prague. / Revised, performed 1729, Gotha. [Baker 1984, p. 2218 / Grove 1980, 18:175 / Dörrie 1968, p. 90]

Sebastiano Ricci, 1659–1734. "Triumph of Galatea." Painting. **1712–16.** Royal Academy, London. [Daniels 1976, no. 168—ill.]

Gabriel Grupello, 1644–1730. "Scylla and Glaucus." (or Galatea and Triton?). Marble sculpture. Before **1716.** Garden, Schloss Schwetzingen. [Düsseldorf 1971, no. 53—ill.; cf. Kultermann 1968, no. 177]

Johann Joachim Kretzschmar, ?–1740. "Nymph with Dolphin" (Galatea?). Sandstone statue. *c.*1716–17. Französischer Pavillon (G), Zwinger, Dresden. [Asche 1966, no. K12, pl. 112]

Bon Boulogne, 1649–1717. "Acis and Galatea on the Water." Painting. Musée des Beaux-Arts, Tours. [Pigler 1974, p. 9]
——. "Triumph of Galatea." Painting. Tours, no. 18. [Ibid., p. 92]

Francesco Bartolomeo Conti, 1681–1732. *Galatea vendicata.* Opera (festa teatrale). Libretto, Pietro Pariati. First performed **1719**, Vienna. / Revised 1724. [Grove 1980, 4:681 / Dörrie 1968, p. 90]

Jean-Baptiste van Loo, 1684–1745. "Triumph of Galatea." Painting. *c.*1720. Hermitage, Leningrad, inv. 1219. [Hermitage 1986, no. 282—ill.]

Pietro Metastasio, 1698–1782. *La Galatea.* Drama (pastorale eroica). First performed **1722**, Naples. Published in *Poesie,* vol. 9 (Paris: 1755). [Dörrie 1968, p. 90] Used as

libretto for operas by at least 7 composers, 1737–87. *See below.*

Gregorio Lazarini, 1655–1730. "Triumph of Galatea." Painting. / Engraved by Alessandro dalla Via (*c.*1688–1724). [Pigler 1974, p. 92]

John Weaver, 1673–1760, attributed, choreography. *Acis and Galatea; or, The Country Wedding.* Masque, after Peter Motteux's *Acis and Galatea* (*c.*1700). First performed 30 Mar **1728,** Theatre Royal, Drury Lane, London. [Ralph 1985, p. 74]

Michel Blondy, 1675–1739, choreography. *Acis et Galathée.* Ballet. First performed 19 Aug **1732,** France. [EDS 1954–66, 2:637]

Nicola Porpora, 1686–1768. *Polifemo* (merging of the 2 Polyphemus stories: Ulysses blinds Polyphemus, thus releasing Acis and Galatea). Opera-pastoral. Libretto, Paolo Antonio Rolli. First performed 1 Feb **1735,** King's Theatre, London. [Hogwood 1984, p. 125 / Grove 1980, 15:126]

Christian Wilhelm Dietrich, 1712–1774. "Triumph of Galatea." Painting. **1736.** Lost. / Drawing. Albertina, Vienna. [Pigler 1974, p. 93]

Domenico Alberti, *c.*1710–1740. *Galatea.* Opera. Libretto, Metastasio (1722). First performed **1737,** Venice. [Grove 1980, 1:211]

Johann Georg Schürer, 1720–1786. *La Galatea.* Opera (pastorale eroica in musica). Libretto, Metastasio (1722). First performed 8 Nov **1746,** Dresden. [Grove 1980, 16:872 / Dörrie 1968, p. 90]

Francesco Corselli, *c.*1702–1778 (act 1), **Francesco Corradini,** *c.*1700–after 1749 (act 2), and **Giovanni Battista Mele,** 1701–*c.*1752. (act 3). *El Polifemo.* Opera seria. Libretto, Rolli (1735). First performed Carnival **1748,** Buen Retiro, Madrid. [Grove 1980, 4:798, 805; 12:103]

Carl Heinrich Graun, 1703/04–1759 (overture, 1 recit, 1 aria). *Galatea ed Acide.* Pasticcio. Libretto, Villati. First performed 11 July **1748,** Schlosstheater, Potsdam. [Grove 1980, 7:646]

Jean-Baptiste-François De Hesse, 1705–1779, choreography. *Acis et Galatée.* Tragedy-pantomime. First performed **1749,** Théâtre-Italien, Paris. [Winter 1974, p. 91]

Giulio Quaglio, 1668–1751. "Polyphemus Throwing a Boulder at Acis." Painting. Palazzo della Porta, Udine. [Pigler 1974, p. 222]

Jean-François de Troy, 1679–1752. "Triumph of Galatea." Painting. Sanssouci, Potsdam. [Pigler 1974, p. 92]

François-Gaspard Adam, 1710–1761. "Triumph of Galatea." Sculpture group, for Great Fountain, Sanssouci, Potsdam. Modeled **1753,** unfinished. [Pigler 1974, p. 93]

Franz Anton Hilverding, 1710–1768, choreography. *Acis und Galathea.* Ballet. First performed 1753, Vienna. [Oxford 1982, p. 2]

————, choreography. *Acis et Galatée.* Ballet. Music, Joseph Starzer. First performed 6 Feb 1764, St. Petersburg. [Grove 1980, 8:570]

John Singleton Copley, 1738–1815. "Galatea." Painting, based on an engraving of Lazarini's "Triumph of Galatea" (above). *c.*1754. Museum of Fine Arts, Boston. [Prown 1966, 1:17, 236–ill.]

Francesco Antonio Baldassare Uttini, 1723–1795. *La Galatea.* Opera. Libretto, Metastasio (1722). First performed **1755,** Drottningholm, Sweden. [Grove 1980, 19:480]

Jean-Georges Noverre, 1727–1810, choreography. *Les caprices de Galathée.* Ballet. Music, François Granier. First performed early **1758,** L'Opéra, Lyons. [Grove 1980, 13:443] Revised, with music by Louis Granier. First performed 30 Sep 1776, L'Opéra, Paris. [Ibid., 7:636f.]

————. *Acis et Galathée.* Ballet. Music, Franz Aspelmayr. First performed 29 Aug 1773, Burgtheater, Vienna. [Ibid., 13:443]

————. *Les caprices de Galathée.* Ballet. Music, Joseph Mazzinghi. First performed 7 May 1789, King's Theatre, London. [Ibid., 11:868]

Johann Heinrich Tischbein the Elder, 1722–1789. "Acis und Galatea." Painting. **1758.** Staatliches Kunstsammlungen, Kassel. [Dörrie 1968, p. 94]

Louis de Silvestre the Younger, 1675–1760. "Acis and Galatea." Painting. Formerly Castle, Dresden. [Pigler 1974, p. 9]

Francesco Zoppis, *c.*1715–after 1781. *La Galatea.* Opera (pastorale eroica in musica). Libretto, Metastasio (1722). First performed **1760,** St. Petersburg. [Dörrie 1968, p. 91]

Pompeo Batoni, 1708–1787. "Polyphemus, Acis, and Galatea." Painting. **1761.** Nationalmuseum, Stockholm, no. NM6662. [Clark 1985, no. 237–ill.]

Anonymous Portuguese. *Fabula de Polifemo e Galatea.* Comedy. First performed **1763,** Lisbon. [Dörrie 1968, p. 91]

Franz Joseph Haydn, 1732–1809. "Acide e Galatea." Cantata for 3 voices (festa teatrale). Libretto, Giovanni Ambrogio Magliavacca. First performed 11 Jan **1763,** Eisenstadt. [Grove 1980, 8:364]

Johann Gottfried Schwanenberger, *c.*1740–1804. *La Galatea.* Opera (favola pastorale). Libretto, Metastasio (1722). First performed Feb **1763,** Braunschweig. [Grove 1980, 17:39f.]

Sebastiano Conca, 1679–1764. "Triumph of Galatea." Painting. Art Gallery and Museum, Glasgow, cat. 1970 no. 195. [Wright 1976, p. 41]

Joseph Friebert, 1724–1799. *La Galatea.* Opera. First performed *c.***1764,** Passau. [Grove 1980, 6:848]

Corrado Giaquinto, 1703–1765. "Acis and Galatea." Painting. DeLuca coll., Molfetta. [Pigler 1974, p. 9]

————. "Triumph of Galatea." Painting. Royal Collection, Aranjuez, Portugal. [Ibid., p. 91]

————. "Triumph of Galatea." Painting. Milwaukee Art Center. [Ibid., p. 92]

Pierre Grandjé, choreography. *Atys and Galatea.* Ballet. First performed **1765,** St. Petersburg. [Beaumont 1930, pp. 27f., 30]

Étienne Lauchery, 1732–1820, choreography. *Acis und Galathea.* Ballet. Music, Christian Cannabich. First performed **1768,** Kassel. [Oxford 1982, p. 2]

Hinrich Philip Johnson, 1717–1779. Choral movements for a performance of Handel's *Acis and Galatea,* **1773,** Stockholm. [Grove 1980, 9:675]

Jean-Baptiste Greuze, 1725–1805. "Triumph of Galatea." Painting. Before **1775?** Musée Granet, Aix-en-Provence. [Brookner 1972, p. 92, pl. 4]

Charles-Joseph Natoire, 1700–1777. "Galatea and Acis." Painting. Musée, Bourges, no. 93. [Boyer 1949, no. 107]

————. "Galatea on the Water." Painting. Sold Paris, 1868, unlocated. [Ibid., no. 108]

Tommaso Giordani, 1730–1806. *Aci e Galatea.* Cantata or opera. First performed **1777**, New Rooms, Tottenham Street, London. [Grove 1980, 7:394 / EDS 1954–66, 5:1311]

Ferdinando Bertoni, 1725–1813. *La Galatea.* Cantata. Libretto, Metastasio? **1781.** [Grove 1980, 2:647]

John Flaxman, 1755–1826. "Acis and Galatea" Sculpture. **1781.** [Irwin 1979, p. 10]

Onorato Viganò, 1739–1811, choreography. *La favola d'Aci e Galatea.* Ballet. Music, Luigi Marescalchi. First performed 27 Dec **1781**, Teatro San Samuele, Venice. [Grove 1980, 11:675 / Oxford 1982, p. 2(1782)]

Jean-Pierre Clovis de Florian, 1755–1794. *Galatée.* Pastoral novel, imitated from Cervantes (1585). Paris: **1784.** [Dörrie 1968, p. 92]

Vicente Martín y Soler, 1754–1806, music. *Aci e Galatea.* Ballet. First performed **1784**, Parma. [Grove 1980, 11:736]

Anonymous French. *Galathée.* Comedy pantomime, based on de Florian's novel (1784). First performed 14 Mar **1785**, Paris. [Dörrie 1968, p. 91]

[?] Giroux, choreography. *Acis and Galatea.* Ballet. First performed 18 Feb **1786**, King's Theatre, London. [Guest 1972, p. 151]

[?] Lépine. *Acis et Galatée.* Comic opera. Libretto, Pierre Louis Moline. First performed 4 Dec **1786**, Théâtre des Beaujolais, Paris. [Clément & Larousse 1969, 1:6]

Bonifazio Asioli, 1769–1832. *Il Ciclope.* Cantata. Libretto, Metastasio's *La Galatea* (1722). First performed **1787**, Turin. [Grove 1980, 1:656 / Dörrie 1968, p. 91]

Tommaso Sogner, 1762–c.1821. *Aci e Galatea.* Cantata for 3 voices. First performed *c.*1789, Court, Naples. [Grove 1980, 17:443]

Francesco Bianchi, 1752–1810. *Aci e Galatea.* Opera (dramma per musica). Libretto, Giuseppe Foppa. First performed 13 Oct **1792**, San Benedetto, Venice. / Revised as *La vendetta di Polifemo,* performed 1793, Palermo. [Grove 1980, 2:674 / Dörrie 1968, p. 91]

Clodion, 1738–1814. "Triumph of Galatea." Terra-cotta relief. **1793.** Musée Jacquemart-André, Paris. [Warburg]

Joseph Anton Koch, 1768–1839. "Polyphemus" (and Galatea). Painting. **1796.** Staatsgalerie Galerie, Stuttgart. [Hunger 1959, p. 296]

Charles-Louis Didelot, 1767–1837, choreography. *Acis et Galathée.* Ballet. Music, Cesare Bossi. First performed 15 June **1797**, King's Theatre, London. [Swift 1974, pp. 66, 195]
———, choreography. *Asis i Galateya.* Anacreontic ballet. Music, Catterino Cavos. First performed 30 Aug 1816, St. Petersburg; scenery, Corsini and Condratiev; machines, Thibeault. [Ibid., pp. 140–43, 197]

Stéphanie-Félicité Ducrest de Saint-Aubin, 1746–1830. *Galathée.* Drama. First performed **1799**, Paris. [EDS 1954–66, 5:1038]

Italian School. "Triumph of Galatea." Painting. **18th century.** Museum of Fine Arts, Boston, no. 94.183. [Boston 1985, p. 139—ill.]

Sébastien Gallet, 1753–1807, choreography. *Acis et Galathée.* Ballet. First performed **1796–1800.** [EDS 1954–66, 5:842]

Johann Gottlieb Naumann, 1741–1801. *Aci e Galatea, ossia, I Ciclopi amanti* [Acis and Galatea, or, The Cyclopes in Love]. Opera buffa. Libretto, Giuseppe Maria Foppa.

First performed 25 Apr **1801**, Kleines Kurfürstliche Theater, Dresden. [Grove 1980, 13:79 / Dörrie 1968, p. 91]

Leopold Antonin Kozeluch, 1747–1818. *La Galatea.* Cantata. **1802.** First performed May 1806, Kärntnertor Theater, Vienna. [Grove 1980, 10:226 / EDS 1954–66, 6:1056]

Christian Friedrich Ruppe, 1753–1826. *Galatée.* Comic opera. Libretto, after Florian (1784). First performed **1804**, Leyden. [Grove 1980, 16:331]

Louis Antoine Duport, 1781/83–1853, choreography. *Acis et Galathée.* Pantomime ballet. Music, Henri Durondeau and Louis Gianella. First performed 10 May **1805**, L'Opéra, Paris. [Grove 1980, 7:347 / Simon & Schuster 1979, p. 83 / Guest 1976, p. 304 / Winter 1974, p. 212]

[?] Favier, choreography. *Acis et Galathée.* Ballet. Music and libretto, anonymous. First performed 31 Jan **1818**, King's Theatre, London. [Guest 1972, pp. 31, 155 / Nicoll 1959–66, 4:423]

Leigh Hunt, 1784–1859. Translation of Theocritus's eleventh Idyll. In *Foliage, or, Poems, Original and Translated* (London: Ollier, **1818**). [Webb 1976, p. 82]

Barry Cornwall (Bryan Waller Procter), 1787–1874. "The Death of Acis." Poem. In *A Sicilian Story* (London: Ollier, **1820**). [Boswell 1982, p. 282]

Jeronymo Francisco de Lima, 1743–**1822.** *La Galatea.* Cantata for 5 voices, instruments. [Grove 1980, 10:863]

Johann Wolfgang von Goethe, 1749–1832. (Triumph of Galatea, climax of the "Classical Walpurgisnight," in) *Faust* Part 2, 2.8346–8485. Tragedy. This episode written **1830.** Heidelberg: 1832. [Beutler 1948–71, vol. 5 / Suhrkamp 1983–88, vol. 2 / Poggioli 1975, pp. 234f. / Viëtor 1949, p. 304]

Anonymous English. *Galathea.* Operetta. First performed 3 Feb **1831**, Queen's Theatre, London. [Nicoll 1959–66, 4:465]

Antoine-Jean Gros, 1771–1835. "Acis and Galatea." Painting. **1833.** Chrysler Museum, Norfolk, Va. [Seen by author, 1986]

Peter Alexander von Ungern-Sternberg, 1806–1868. *Galathée.* Novel. Stuttgart & Tübingen: Cotta, **1836.** [Dörrie 1968, p. 92]

Niccolò Zingarelli, 1752–**1837.** *La Galatea.* Cantata. [Grove 1980, 20:694]

Anonymous English. *Acis and Galatea.* Opera. First performed **1838**, London. [Nicoll 1959–66, 4:423]

Anonymous Spanish. "Loa breve, en metafora de Polifemo e Galatea" [Short Loa, Metaphor of Polyphemus and Galatea]. Dialogue or prologue. Barcelona: **1840.** [Dörrie 1968, p. 91]

Eduard Mörike, 1804–1875. "Der Kyklop." Translation of Theocritus, Idyll 11. In *Classische Blumenlese* (Stuttgart: Schweizerbart, **1840**). [Hötzer 1967]

William Henry Oxberry, 1808–1852. *Acis and Galatea.* Burlesque. First performed 28 Feb **1842**, Adelphi Theatre, London. [Nicoll 1959–66, 4:367]

Francesco Hayez, 1791–1882. "Galatea with Naiads and Tritons." Painting. **1844.** Formerly Marchese A. Busco coll., Milan, unlocated. [Coradeschi 1971, no. 247]

Elizabeth Barrett Browning, 1806–1861. "The Cyclops." Poem, paraphrase on Theocritus. **1845.** In *Last Poems* (London: Chapman & Hall, 1862). [Browning 1932 / Taplin 1957, p. 154]

Gaetano Donizetti, 1797–**1848**. *Aci e Galatea*. Cantata. Mentioned by Albinati, otherwise unknown. [Grove 1980, 5:566]

William Bouguereau, 1825–1905. "Triumph of Galatea." Painting, copy after Raphael (1511, Rome). **1852**. Musée, Dijon. [Isaacson 1974, p. 20 / Montreal 1984, p. 61]

John Stuart Blackie, 1809–1895. "Galatea" (and Polyphemus). Poem. In *Lays and Legends of Ancient Greece with Other Poems* (Edinburgh: Sutherland & Knox, **1857**). [Boswell 1982, p. 45]

Carlo Blasis, 1797–1878, choreography. *Galatea*. Ballet. Music, Ortori. First performed **1857**–58, Lisbon. [EDS 1954–66, 2:610]

Francis Cowley Burnand, 1836–1917, and **M. R. Lacy**. *Acis and Galatea; or, The Nimble Nymph and the Terrible Troglodyte*. Extravaganza. First performed 6 Apr **1863**, Olympic Theatre, London. [Nicoll 1959–66, 5:288, 781]

Thomas Forder Plowman, 1844–1919. *Acis and Galatea, or, The Beau! the Belle!! and the Blacksmith!!!.* Extravaganza. First performed Dec **1869**, Victoria Theatre, Oxford. [Nicoll 1959–66, 5:528]

Austin Dobson, 1840–1921. "A Tale of Polypheme." Poem, part of "A Case of Cameos." In *Proverbs in Porcelain and Other Verses* (London: King, **1877**); reprinted in *Complete Poetical Works* (London: Oxford University Press, 1923). [Boswell 1982, p. 88]

Gustave Moreau, 1826–1898. "Galatea" (sleeping, watched by Polyphemus). Painting. **1880**. Lebel coll., Paris. [Mathieu 1976, pp. 141ff., no. 195—ill.] Watercolor sketch. Unlocated. [Ibid., no. 197—ill. / Mathieu 1985, pl. 16] Variant, watercolor. c.1880–85. Private coll., Paris. [Mathieu 1976, no. 197—ill. / Mathieu 1985, pl. 16] Variant, painting. 1896. Fogg Art Museum, Harvard University, Cambridge. [Mathieu 1976, no. 422—ill.] Variant, painting. c.1896. Kreeger coll., Washington, D.C. [Ibid., no. 423—ill.]

Samuel Palmer, 1805–1881. "Moeris and Galatea." Print, illustrating Virgil's ninth Eclogue (song to Galatea). **1872**–81, unfinished; completed by A. H. Palmer. [Alexander 1937, pp. 28ff., no. 17—ill.]

Richard Watson Dixon, 1833–1900. "Polyphemus" (and Galatea). Poem. In *Odes and Eclogues* (London: Daniel, **1884**). [Boswell 1982, p. 87]

Thomas Ashe, 1836–1889. "Acis." Poem. In *Poems* (London: Bell, **1886**). [Boswell 1982, p. 21]

Auguste Rodin, 1840–1917. "Polyphemus, Acis, and Galatea." Plaster sculpture, originally intended as part of "The Gates of Hell." **1888**. Rodin Museum, Philadelphia. [Tancock 1976, no. 22—ill.] Bronze variant ("Polyphemus and Acis"). Musée Rodin, Paris; Fine Arts Museum of San Francisco. [Rodin 1944, no. 200—ill. / Elsen 1981, no. 272]

————. "Polyphemus." Figure (based on above) in "The Gates of Hell." High-relief sculpture. Numerous versions, 1880–1917; numerous posthumous bronze casts. [Tancock, no. 1—ill. / Rodin, no. 54—ill.] Plaster studies of "Polyphemus." 1888. Musée Rodin, Paris; Philadelphia; Maryhill Museum of Fine Arts, Wash. [Tancock, p. 214 / Rodin, nos. 203–03—ill.] Bronze casts of study. Paris; Koninklijk Museum voor Schone Kunsten, Antwerp; Finlayson coll., Toronto. [Tancock, p. 214 / Rodin, no. 201—ill.]

————. "Galatea." Marble sculpture. Mid-1890s. Musée Rodin, Paris. [Tancock, fig. 25–4]

Auguste-Louis Marie Ottin, 1811–**1890**. "Acis and Galatea." Marble group. Medici Fountain, Luxembourg Gardens, Paris. [Bénézit 1976, 8:55]

Richard Garnett, 1835–1906. "The Cyclop" (and Galatea). Poem. In *Iphigenia in Delphi and Other Poems* (London: Unwin, **1890**). [Boswell 1982, p. 109]

Redento Zardi, music. *Aci e Galatea*. Musical idyll. Libretto, Pompeo Bettini. First performed **1892**, Savona. [Dörrie 1968, p. 92]

Lev Ivanov, 1834–1901, choreography. *Acis et Galathéa*. Ballet. Music, A. Kadletz. First performed **1896**, Maryinsky Theater, St. Petersburg. [Oxford 1982, p. 215]

Théodore Dubois, 1837–1924. "Galatea," part of *Poèmes virgiliens . . . pour piano* [Virgilian Poems . . . for Piano]. Composition for piano. **1898**. Published Paris: Heugel, 1926. [Grove 1980, 5:665]

Albert Samain, 1858–1900. *Polyphème*. Dramatic poem. First performed 10 May 1904, Théâtre de l'Oeuvre, Paris; music, Raymond Bonheur. Published with *Aux flancs du vase* (Paris: Société du Mercure de France, 1902). [Dörrie 1968, p. 92 / Oxford 1959, p. 659]

Robert Williams Buchanan, 1841–**1901**. "Polypheme's Passion." Poem. In *Complete Poetical Works* (London: Chatto & Windus, 1901). [Boswell 1982, p. 58]

Michel Fokine, 1880–1942, choreography. *Acis et Galatée*. Ballet. Music, Andreas Kadletz. First performed **1905**, Imperial Ballet School, St. Petersburg. [Horwitz 1985, pp. 6f. / Oxford 1982, p. 2 / Fokine 1961, p. 300]

Max Klinger, 1857–1920. "Galatea." Sculpture, cast in silver. **1906**. Museum der Bildenden Künste, Leipzig, inv. 413. [Leipzig 1970, no. 16]

Howard Sutherland, b. 1868. "Acis and Galatea." Poem. In *Idylls of Greece*, 1st series (Boston: Sherman & French, **1908**). [Boswell 1982, p. 298]

Emilios Riadis, 1886–1935. *Galateia*. Music drama. Libretto, P. C. Jablonski. **1912**–13. [Grove 1980, 15:826]

Mario Castelnuovo-Tedesco, 1895–1968. "A Galatea." 2 madrigals. Text, Virgil. **1914**. [Grove 1980, 3:869]

Robert Nichols, 1893–1944. "Polyphemus His Passion: A Pastoral." Poem. **1917**. In *Aurelia and Other Poems* (London: Chatto & Windus, 1920). [Bush 1937, p. 571]

Jean Cras, 1879–1932. *Polyphème: Le sommeil de Galatée* [Polyphemus: The Dream of Galathea]. Opera. Libretto, Albert Samain. **1912**–18. First performed Dec 1922, L'Opéra-comique, Paris. [Grove 1980, 5:24]

T. S. Eliot, 1888–1965). (Sweeney compared with Polyphemus in) "Sweeney Erect." Poem. c.**1919**. In *Ara Vos Prec* (London: Ovid, 1920); *Poems* (New York: Knopf, 1920). [Eliot 1964 / Smith 1974, pp. 47f.]

Laurent-Honoré Marqueste, 1848–**1920**. "Galatea." Marble statue. Musées Nationaux, inv. R.F. 854, deposited in Musée, Châteaubriant, in 1931. [Orsay 1986, p. 276]

Aristide Maillol, 1861–1944. 4 woodcuts, illustrating edition of Virgil's *Eclogues* (Leipzig: Insel, **1926**). [Guérin 1965, nos. 43–44, 53–54—ill.]

Genevieve Taggard, 1894–1948. "Galatea Again." Poem. In *Words for the Chisel* (New York: Knopf, **1926**). [Boswell 1982, p. 299]

Raoul Dufy, 1877–1953. "Galatea." Watercolor. *c.***1928.** Virginia Museum of Fine Arts, Richmond. [Guillon-Laffaille 1981, no. 1881—ill.]

Walter Braunfels, 1882–1954. *Galathea*. Opera, opus 40. Libretto, Silvia Baltus. **1924–29.** First performed 26 Jan 1930, Cologne. [Baker 1984, pp. 336f. / Grove 1980, 3:220]

William Rose Benét, 1886–1950. "Riddle for Polyphemus." Poem. In *Golden Fleece* (New York: Dodd, Mead, **1935**). [Boswell 1982, p. 37]

Ker-Xavier Roussel, 1867–1944. "Polyphemus, Acis, and Galatea" ("Polyphemus Surprising Acis and Galatea"). Painting. Musée d'Orsay, Paris, no. R.F. 1977–304. [Louvre 1979–86, 4:201—ill.] Variants. Private coll., Paris; elsewhere. / Study. Private coll., Paris. [Georgel 1968, p. 341, no. 250—ill.]

Octavio Paz, 1914–. (Polyphemus, as symbol of violence, evoked in) "Himno entre ruinas" [Hymn among the Ruins]. Poem. **1948.** In *Libertad bajo palabra* (Mexico City: Tezontle, 1949). [Wilson 1986, pp. 45f.]

Josep Maria de Sagarra i de Castellarnau, 1894–1961. *Galatea*. Drama. First performed **1948,** Victoria Theater, Barcelona. [EDS 1954–66, 8:1387]

Paolo Correnti. *Il Ciclope innamorato, dal mito di Aci e Galatea* [The Cyclops in Love, from the Myth of Acis and Galatea]. Drama. Catania: Conti, **1949.** [Dörrie 1968, p. 92]

Thomas Hugh Eastwood, 1922–, music. *Galatea*. Ballet. First performed **1950.** [Grove 1980, 5:808]

Barbara Hepworth, 1903–1975. "Torso III" ("Galatea"). Abstract bronze sculpture. **1958.** Edition of 7: various private colls. [Hodin 1962, no. 235—ill.]

Robert Finch, 1900–. "Acis in Oxford." Poem cycle. In *Acis in Oxford and Other Poems* (Oxford: privately printed, **1959**); reprinted Toronto: University of Toronto Press, 1961. [CLC 1981, 18:154]

Juan Goytisolo, 1931–. (*Fábula de Polifemo y Galatea* alluded to repeatedly in) *Reivindicación del conde don Julián* [Vindication of Count Julián]. Novel. **1970.** Madrid: Cátedra, 1985. / Translated by Helen R. Lane as *Count Julian* (New York: Viking, 1974). [Labanyi 1989, p. 210]

Lex van Delden, 1919–. "Galathea." Song for voice and pianoforte. **1975.** [Grove 1980, 5:335]

Earl Staley, 1938–. "Triumph of Galatea." Painting. **1982.** Phyllis Kind Gallery, New York, in 1984. [Houston 1984, p. 82—ill.]

GANYMEDE. A beautiful youth, son of the legendary Trojans Tros and Callirrhoë, Ganymede was taken to Olympus to be the cupbearer of Zeus (Jupiter), replacing Hebe. Ancient sources differ on the specifics of the story: Homer in the *Iliad* relates that Ganymede was given to Zeus in exchange for a breed of horses or a golden vine, while in the first Homeric Hymn to Aphrodite it was the wind that carried him off; Virgil, that he was abducted by Jupiter's bird, the eagle; and Ovid, that the eagle was Jupiter himself in disguise. In some accounts, a homosexual relationship between Zeus and Ganymede is suggested; this theme became popular during the medieval period and persisted through the Renaissance. In the fourteenth-century *Ovide moralisé*, Ganymede is seen as prefiguring John the Evangelist. To some Renaissance authors Ganymede personified the soul aspiring to God. A popular theme for artists, Ganymede is most commonly depicted flying off in the grasp of the eagle of Zeus, or pouring wine for the Olympians.

Classical Sources. Homer, *Iliad* 5.265ff., 20.231–35. *Homeric Hymns,* first hymn "To Aphrodite" lines 202–17. *Little Iliad* 7. Pindar, *Olympian Odes* 1.43ff., 10.105. Virgil, *Aeneid* 1.28, 5.253. Ovid, *Metamorphoses* 10.152–61. Apollodorus, *Biblioteca* 2.5.9, 3.12.2. Hyginus, *Fabulae* 224, 271; *Poetica astronomica* 2.16, 2.29. Lucian, *Dialogues of the Gods* 8, "Zeus and Hera," 10, "Zeus and Ganymede."

Further Reference. Gerda Kempter, *Ganymed: Studien zur Typologie, Ikonographie und Ikonologie* (Cologne & Vienna: Böhlau, 1980) [includes a comprehensive catalogue of "Ganymede" representations]. James M. Saslow, *Ganymede in the Renaissance: Homosexuality in Art and Society* (New Haven: Yale University Press, 1986). Penelope Mayo, *Amor spiritualis et carnalis: Aspects of the Myth of Ganymede in Art* (Ann Arbor: University Microfilms, 1967).

Dante Alighieri, 1265–1321. (Rape of Ganymede evoked in) *Purgatorio* 9.19–33. Completed *c.*1314? In *The Divine Comedy*. Poem. Foligno: Neumeister & Angelini, 1472. [Singleton 1970–75, vol. 2]

Anonymous French. (Orpheus sings the story of Ganymede in) *Ovide moralisé* 10.724–52 (narrative), 3362–3424 (allegory). Poem, allegorized translation/elaboration of Ovid's *Metamorphoses*. *c.*1316–28. [de Boer 1915–86, vol. 4 / also Kempter 1980, pp. 29ff., nos H10–12—ill.]

Francesco Petrarca, 1304–1374. (Jupiter's love for Ganymede evoked in) Canzone, no. 23 of *Canzoniere* (*Rime sparse*). Collection of sonnets, madrigals, and *canzoni*. Begun *c.*1336, completed by 1373; no. 23 composed *c.***1341?** [Contini 1974 / Armi 1946 / Sturm-Maddox 1985, pp. 25f., 30f.]

Christine de Pizan, *c.*1364–*c.*1431. (Contest between Apollo and Ganymede, resulting in the youth's death, extrapolation from classical myth, in) *L'epistre d'Othéa à Hector* . . . [The Epistle of Othéa to Hector] chapter 53. Didactic romance in prose. *c.***1400.** MSS in British Library, London; Bibliothèque Nationale, Paris; elsewhere. / Translated by Stephen Scrope (London: *c.*1444–50). [Bühler 1970 / Hindman 1986, p. 198]

Filarete, *c.*1400–1469? "The Rape of Ganymede." Bronze relief on doors of St. Peter's, Rome. *c.***1433–45.** In place. [Saslow 1986, pp. 39f., fig. 1.9 / Kempter 1980, p. 115—ill. / Pope-Hennessy 1985b, 2:318]

Florentine School (circle of Apollonio di Giovanni, *c.*1415–**1465**). Painting. Museum of Fine Arts, Boston, no. 06.2441b. [Boston 1985, p. 142—ill. / Saslow 1986, fig. 1.10 / also Kempter 1980, p. 32, no. 67—ill.]

Baldassare Peruzzi, 1481–1536. "The Abduction of Ganymede." Ceiling fresco, representing the constellation Aquarius. **1510–11.** Sala di Galatea, Villa Farnesina,

Rome. [d'Ancona 1955, pp. 25f., 88—ill. / Gerlini 1949, pp. 10ff.—ill. / also Frommel 1967–68, no. 18c—ill. / Kempter 1980, p. 43, no. 180—ill.]

———, design. "Jupiter and Ganymede." Fresco, part of a cycle representing the Four Elements, for Villa Madama, Rome. 1521–23. Later overpainted. [Frommel 1967–68, no. 58b, p. 102, pl. 50b]

Giovanni Bellini, c.1430–**1516,** attributed (formerly attributed to Andrea Mantegna). "Ganymede on the Eagle." Drawing. Formerly de Hevesy coll., Paris. [Kempter 1980, pp. 64, no. 14—ill.] *See also Campagnola, below.*

Giulio Campagnola, 1481/82–**1516.** "Ganymede (on the Eagle)." Engraving, variant after Bellini (above), with landscape after Dürer. [Kempter 1980, p. 65, no. 14—ill. / Borenius 1923, no. 5—ill.]

———. "Ganymede on the Eagle." Engraving. [Kempter, no. 39]

Raphael, 1483–**1520,** composition. "Jupiter Overcome by Love for Ganymede" ("Ganymede and the Eagle" [with Jupiter, Venus, Mercury, and the Graces]). Engraving, by "Master of the Die," c.1532–33. (Uffizi, Florence, no. 95916.) [Saslow 1986, p. 131, fig. 3.25 / Kempter 1980, p. 66, no. 144—ill.]

Antonio da Correggio, c.1489/94–1534. "(Rape of) Ganymede." Painting. c.**1530.** Kunsthistorisches Museum, Vienna, inv. 276 (59). [Gould 1976, pp. 130f., 274—ill. / Vienna 1973, p. 47—ill. / Kempter 1980, p. 116—ill. / Saslow 1986, pp. 63ff., fig. 2.1 / Berenson 1968, p. 93] Copy, by Eugenio Cajés, in Prado, Madrid, no. 119. [Prado 1985, pp. 166f.]

———, attributed (more recently attributed to Lelio Orsi). "Ganymede, with Jupiter and Two Assistants" ("Rape of Ganymede"). Ceiling fresco (detached), from Rocca di Novellara. 1546–67. Galleria Estense, Modena, no. 51. [Saslow 1986, p. 127, fig. 3.22 (as Orsi) / Kempter 1980, p. 94, no. 170—ill. (as Orsi) / Gould, p. 289 (attributed to Correggio)]

Michelangelo, 1475–1564. "(The Abduction of) Ganymede." Drawing, for Tommaso de'Cavalieri. **1532–33.** Lost. / Preliminary sketch (or copy?). Fogg Art Museum, Harvard University, Cambridge, no. 1955.75. [Saslow 1986, pp. 19–21, fig. 1.1 / Kempter 1980, pp. 45, 85ff., no 146 (as copy) / Harvard 1985, no. 255—ill.] Copy by Giulio Clovio, in Royal Library, Windsor Castle, no. 13036. [Goldscheider 1951, no. 74—ill. / Saslow, fig. 1.2 / Kempter, no. 145—ill. / Barkan 1986, p. 205, fig. 34] Engraving after, attributed to Nicolas Beatrizet, 1533–35. [Kempter, no. 13—ill.] Anonymous variant copies (paintings), in Hampton Court Palace, no. 297; Kunsthistorisches Museum, Vienna; Neues Palais, Potsdam. [Ibid., nos. 150, 152–53]

———, formerly attributed. "The Rape of Ganymede." Drawing (copy after a lost original?). Uffizi, Florence, no. 611E. [Kempter, p. 90, no. 235—ill.]

———, attributed. 2 drawings (studies for a "Ganymede" composition?). Uffizi, Florence, no. 613E. [Ibid., no. 148]

———, attributed. Sketch study for a "Ganymede" composition. Uffizi, Florence, no. 18737F. [Ibid., no. 149]

Giulio Romano, c.1499–1546. (Rape of Ganymede in) "The Young Neptune in His Shell (Taking Possession of the Sea)." Painting, part of "Jupiter" cycle. c.**1533?** Lost. / Drawing. Earl of Ellesmere coll., Mertoun House, Roxburghshire, no. 121. [Hartt 1958, pp. 214, 305 (no. 300)—

ill.] Print by Giulio Bonasone. (British Museum, London.) [Saslow 1986, p. 137, fig. 3.29]

———, and studio. "The Rape of Ganymede." Stucco relief. 1536–37. Ceiling, Camerino dei Falconi, Palazzo Ducale, Mantua. Damaged. / Drawing. Pierpont Morgan Library, New York. [Hartt, p. 170—ill. / Saslow, p. 137, fig. 3.30 (copy drawing)]]

Michiel Coxie the Elder, 1499–1592. "The Rape of Ganymede." Drawing, design for engraving. **After 1533.** British Museum, London. [Kempter 1980, pp. 97f.—ill. / de Bosque 1985, pp. 248f.—ill.] Engraving by Cornelis Bos. [Kempter—ill.]

Parmigianino, 1503–1540. "Ganymede Serving Nectar to the Gods," "Ganymede and Hebe," "Running Ganymede," "Olympus with Ganymede and Saturn." Drawings. c.**1531/32**–40. Private coll., London; Louvre, Paris, no. R.F.580; Huntington Library, San Marino, Calif.; lost, print by G. B. Frulli. [Saslow 1986, pp. 102ff., figs. 3.4, 3.8, 3.9, 3.13]

Polidoro da Caravaggio, 1498–1543. "Jupiter Embracing Ganymede." Drawing, composition for print. British Museum, London. [Kempter 1980, p. 43, no. 184—ill.] Engraving by Cherubino Alberti (Bartsch no. 79). (British Museum, London.) [Saslow 1986, pp. 54f., fig. 1.15 / Kempter, no. 4]

Battista Dossi, c.1474–1548. "The Rape of Ganymede" (?). Drawing. **1530s/40s.** Royal Scottish Academy, Edinburgh, no. 140. [Gibbons 1968, no. 188—ill.]

Niccolò Tribolo, 1500–1550, attributed (previously attributed to Cellini). "Ganymede on the Eagle." Bronze sculpture. **1540–50.** Museo del Bargello, Florence. [Saslow 1986, pp. 164ff., fig. 4.11 / Kempter 1980, pp. 70f., no. 228—ill.]

Benvenuto Cellini, 1500–1571. "Ganymede (and the Eagle)." Marble statue (restoration of head, arms, and feet of antique torso, with added eagle). **1549–50** (or 1546–47). Museo del Bargello, Florence, no. 403. [Pope-Hennessy 1985a, p. 227—ill. / also Saslow 1986, p. 164, fig. 4.1 / Kempter 1980, p. 51, no. 47—ill.] Reduced bronze variant copies, probably 18th century. Frick Collection, New York, no. 16.1.42; Houston Museum of Art, Texas (Ganymede only); Metropolitan Museum, New York, inv. 33.58; elsewhere. [Frick 1968–70, 3:199f.—ill.] Porcelain copies, by Ginori Doccia. Musée Jacquemart-André, Paris, no. 440; Museo Poldi Pezzoli, Milan (c.1770). [Ibid., nos. 61, 63]

———, rejected attribution. "Ganymede" (astride the eagle). Bronze sculpture. c.1570. Museo Nazionale, Florence. [Pope-Hennessy, p. 228f.—ill.]

———. *See also Tribolo, below.*

Battista Franco, c.1498–1561. (Ganymede and the Eagle depicted above) "(Allegory of) The Battle of Montemurlo." Painting. c.**1555.** Sala dell' Iliade, Palazzo Pitti, Florence. [Pitti 1966, p. 11—ill. / Saslow 1986, pp. 166f., fig. 4.12 / also Kempter 1980, p. 94, no. 73—ill.]

Francesco Primaticcio, 1504–1570, design. "The Eagle Abducting Ganymede." Fresco, for Salle de Bal, Château de Fontainebleau, executed by Niccolò dell' Abbate under Primaticcio's direction. **1551–56.** Repainted 19th century. [Dimier 1900, pp. 160ff., 284ff. / Saslow 1986, p. 180—ill.]

Girolamo da Carpi, 1501–**1556**. "The Rape of Ganymede." Painting. Gemäldegalerie, Dresden, no. 145. [Dresden 1976, p. 55 / Kempter 1980, p. 44, no. 87—ill. / Berenson 1968, p. 189]

Bernard Salomon, 1506/10–*c*.1561. "Ganymede on the Eagle." Woodcut, part of a cycle illustrating Ovid. In *Les Metamorphoses d'Ovide figurée* (Lyons: Tivornes, **1557**). [Kempter 1980, p. 69, no. 201—ill.; cf. no. 200]

Pierre de Ronsard, 1524–1585. (Andromache presents Astyanax with Hector's cloak, embroidered with the abduction of Ganymede, in) *La françiade* 1. Epic poem. Paris: Buon, **1572**. [Laumonier 1914–75, vol. 16 / Cave 1973, pp. 160, 172]

Damiano Mazza, fl. *c*.**1573**, attributed (formerly attributed to Titian). "The Rape of Ganymede." Painting. National Gallery, London, no. 32. [London 1986, p. 389—ill. / Saslow 1986, p. 127, fig. 3.23 / Wethey 1975, no. X–16—ill. / also Kempter 1980, pp. 121f., no. 141—ill.] Replica (previously attributed to Tintoretto). H. Kisters coll., Kreuzlingen. [Wethey]

Battista Lorenzi, 1527/28–1594, attributed. "Ganymede Riding the Eagle." Marble sculpture group. **1565–76**. Boboli Gardens, Florence. [Saslow 1986, p. 172, fig. 4.15]

Christopher Marlowe, 1564–1593, and **Thomas Nashe**, 1567–1601. (Jupiter and Ganymede in) *The Tragedie of Dido, Queene of Carthage* 1.1. Tragedy. First performed **1587–88**, by the Children of Her Majestie's Chappell, London. Published London: Woodcocke, 1594. [Bowers 1973, vol. 1 / Bono 1984, pp. 130–36 / Leech 1986, p. 361 / Levin 1952, pp. 141f.]

———— (Marlowe). (Abduction of Ganymede carved in temple of Venus; Neptune abducts Leander, mistaking him for Ganymede, in) *Hero and Leander* 1.141–50, 2.153–225. Poem, after Musaeus, unfinished. Licensed 1593. London: Blunt, 1598. [Bowers, vol. 2 / Leech, pp. 181–83 / Levin, p. 141]

Edmund Spenser, 1552?–1599. (Abduction of Ganymede depicted in tapestry of "Cupid's Wars," in) *The Faerie Queene* 3.11.34. Romance epic. London: Ponsonbie, **1590**, 1596. [Hamilton 1977]

Richard Barnfield, 1574–1627. "Daphnis to Ganymede." Poem. In *The Affectionate Shepheard* (London: Danter, **1594**). [NUC]

George Chapman, *c*.1559–*c*.1634. (Ganymede evoked in) *Hymnus in Cynthiam*. Poem. London: **1594**. [Bush 1963, p. 210]

Cavaliere d'Arpino, 1568–1640. "Ganymede on the Eagle." Fresco. **1594–95**. Loggia Orsini, Palazzo del Sodalizio dei Piceni, Rome. [Röttgen 1969, pp. 279ff.—ill.] Drawing, elaboration of central figures. / Replica, painting, after fresco or drawing. Wessenberg-Gemäldegalerie, Constance. [Kempter 1980, no. 50 / Rome 1973, no. 16—ill. / Röttgen, fig. 26]

Annibale Carracci, 1560–1609. "Ganymede and the Eagle." Fresco. *c*.**1597–1600**. Galleria, Palazzo Farnese, Rome. [Malafarina 1976, p. 104u—ill. / Martin 1965, pp. 112f.—ill. / Saslow 1986, pp. 162f., fig. 4.9]

Spanish School. "Ganymede." Ceiling painting, for Casa de Arguijo, Seville. **1601**. Delegación del Ministerio de Educación y Ciencia, Seville. [López Torrijos 1985, p. 405 no. 1—ill.]

Federico Zuccari, 1540/43–1609. "The Rape of Ganymede." Ceiling fresco. *c*.**1603**. Sala di Ganimede, Biblioteca Hertziana (Palazzo Zuccari), Rome. [Saslow 1986, p. 170, fig. 4.14]

Francisco Pacheco, 1564–1654. "Ganymede on the Eagle." Fresco, ceiling compartment. *c*.**1603–04**. Casa del Pilato, Seville. [López Torrijos 1985, pp. 129ff., 405 no. 1, pl. 17 / Kempter 1980, no. 172]

————. "Ganymede on the Eagle." Fresco, ceiling compartment. Casa de Arguijo, Seville. [Kempter, no. 173]

Alessandro Allori, 1535–1607. "The Rape of Ganymede." Painting. Museo del Bargello, Florence. [Kempter 1980, no. 7]

Abraham Bloemaert, 1564–1651. "The Rape of Ganymede." Painting. Lost. / Engraving (Bartsch no. 26) by Jan Sanraedam, 1565–**1607**. [Kempter 1980, no. 18 / Saslow 1986, p. 240 *n*.15]

Carlo Saraceni, 1579–1620. "(Landscape with) The Rape of Ganymede." Painting. Probably before **1608**. Galleria di Capodimonte, Naples, no. 154. [Ottani Cavina 1968, no. 43—ill. / Capodimonte 1964, p. 51 / Kempter 1980, p. 46, no. 202—ill.]

Joseph Heintz the Elder, 1564–**1609**. (Rape of Ganymede in) "Mythological Feast." Painting. 1609? Kunsthistorisches Museum, Vienna. [Kempter 1980, pp. 123f., no. 92—ill. / also Zimmer 1971, no. 18—ill.]

————. "Ganymede and Jupiter." Painted décor, cornice of bedroom in Hôtel Soubise, Paris. [Mayo 1967, p. 163]

Thomas Heywood, 1573/74–1641. ("Ganimed," son of Tros, defeated by Jupiter, becomes his cup-bearer in) *Troia Britanica: or, Great Britaines Troy* canto 5. Epic poem. London: **1609**. [Heywood 1974]

————. (Ganimed in) *The Golden Age, The Silver Age*. Dramas, derived from *Troia Britanica*. First performed *c*.1610–12, London. Published London: Okes, 1611, 1613. [Heywood 1874, vol. 3 / DLB 1987, 62:101, 122ff. / also Boas 1950, pp. 83ff. / Clark 1931, pp. 62ff.]

————. "Jupiter and Ganymede," "Jupiter and Juno" (Juno jealous of Ganymede). Poetic dialogues, translated from Lucian. Nos. 5, 6 in *Pleasant Dialogues and Drammas* (London: 1637). [Heywood 1874, vol. 6]

Peter Paul Rubens, 1577–1640. "Ganymede Receiving the Cup from Hebe" ("Ganymede [carried by eagle] and Hebe"). Painting. *c*.**1611**. Schwartzenberg coll., Vienna. [Jaffé 1989, no. 169, p. 80—ill. / Saslow 1986, p. 193, fig. 5.13 / also Kempter 1980, p. 73, no. 196—ill.]

————. "(The Rape of) Ganymede." Painting, for Torre de la Parada, El Pardo. 1636–38. Prado, Madrid, no. 1679. [Alpers 1971, no. 24—ill. / Jaffé, no. 1272—ill. / Saslow, pp. 56, 191, fig. 5.14 / Prado 1985, p. 585 / also Kempter, no. 198, fig. 99] Study. Private coll., Switzerland. [Jaffé, no. 1271—ill.]

Giulio Mazzoni, 1525–**1618**. "The Rape of Ganymede." Ceiling fresco. Palazzo Spada, Rome. [Kempter 1980, p. 97, no. 142—ill.]

Paul Bril, 1554–1626. "The Rape of Ganymede." Painting. Koninklijk Museum voor Schone Kunsten, Antwerp, no. 5089. [Antwerp 1970, p. 33 / de Bosque 1985, p. 248—ill.]

Adriaen de Vries, *c*.1550–1626. "Kneeling Ganymede with the Eagle." Bronze sculpture. Lost. / Pictured in the painting "The Painting Gallery of Archduke Leopold

Wilhelm in Brussels" by David Teniers the Younger. 1651. Musées Royaux des Beaux-Arts, Brussels. [Kempter 1980, nos. 215, 245]

Francesco Albani, 1578–1660. "Jupiter and Ganymede." Fresco. **1633.** Villa Corsini, Mezzomonte, near Florence. [Kempter 1980, no. 3]

Thomas Carew, 1594/95–1639/40. (Ganymede and Jupiter in) *Coelum Britannicum.* Satirical masque. First performed **1634,** London; stage designs, Inigo Jones. [Saslow 1986, pp. 159, 194f.]

Giovanni da San Giovanni, 1592–1636. "Ganymede Taken by Jupiter, with the Fall of Hebe." Ceiling fresco. *c.***1634.** Villa Corsini, Mezzomonte, near Florence. [Banti 1977, no. 48—ill. / Kempter 1980, pp. 126f., no. 125—ill. / Saslow 1986, p. 118—ill.]

Kerstiaen de Coninck, *c.*1560–**1635.** "Ganymede on the Eagle." Painting. Wallraf-Richartz-Museum, Cologne. [Kempter 1980, no. 104]

Rembrandt van Rijn, 1606–1669. "The Abduction of Ganymede." Painting. **1635.** Gemäldegalerie, Dresden, no. 1558. [Gerson 1968, no. 73—ill. / Saslow 1986, pp. 185–87, fig. 5.9 / Kempter 1980, pp. 127f., no. 190—ill. / Guillaud 1986, fig. 7 / Dresden 1976, p. 84—ill.]

Stefano Della Bella, 1610–1664. "The Rape of Ganymede." Engraved playing card. Commissioned **1644** as part of mythological game. Uffizi, Florence, no. 7846. [Saslow 1986, pp. 182f., fig. 5.5]

Eustache Le Sueur, 1616–1655. "Ganymede Abducted by Jupiter in the Form of an Eagle," "Ganymede Offering the Cup to Jupiter." Paintings, for Cabinet de l'Amour, Hôtel Lambert, Paris. **1646–47.** "Ganymede Abducted" in Louvre, Paris, inv. 8062. [Saslow 1986, pp. 183f.—ill. / also Louvre 1979–86, p. 60—ill. / Louvre 1972, no. 18, pp. 9f., 44f.—ill.]

Nicolaes van Helt-Stockade, 1614–**1669.** "Jupiter and Ganymede." Painting. National Gallery of Ireland, Dublin, no. 1046. [Dublin 1981, p. 72—ill.]

Nicolaes Maes, 1632–1693. 9 portraits of children posed as Ganymede riding the eagle. **1670s.** 1 in Pushkin Museum, Moscow; others unlocated or in private colls. [Kempter 1980, p. 83, nos. 115–23—ill. / also Saslow 1986, pp. 190f., fig. 5.12]

Johann Philipp Krieger, 1649–1725. *Ganymedes und Juventas.* Tafelmusik (music for dining). **1693.** [Grove 1980, 10:269]

Mattia Preti, 1613–**1699.** "The Rape of Ganymede" ("Ganymede on the Eagle"). Painting. Galleria Pallavicini, Rome. [Cannata 1978, pl. 3 / Kempter 1980, no. 186]

Antonio Verrio, *c.*1639–1707. "The Rape of Ganymede." Painted ceiling of Queen's closet, Ham House, Surrey. *c.***1699?** [Mayo 1967, p. 164 *n.*]

Florentine School. "Ganymede on the Eagle." Marble fountain group. **17th century.** Boboli Gardens, Florence. [Kempter 1980, p. 70, no. 69—ill.]

Anton Domenico Gabbiani, 1652–1726. "Ganymede on the Eagle." Painting. *c.***1700.** Uffizi, Florence, inv. 2176. [Uffizi 1979, no. P651—ill. / Kempter 1980, p. 107, no. 76—ill.]

Vincenzo II De Grandis, 1631–**1708.** *Ganimede alla danza* [Ganymede at the Dance]. Cantata. [Grove 1980, 5:324]

Matthew Prior, 1664–1721. "Cupid and Ganymede." Poem. In *Poems on Several Occasions* (London: Tonson, **1709**).

Modern edition by A. R. Waller (Cambridge: Cambridge University Press, 1905). [Ipso]

Giuseppe Piamontini, 1664–1742. "Standing Ganymede." Bronze statuette. *c.***1690–1710.** Palazzo Corsini, Rome. [Kempter 1980, pp. 52f., no. 183]

Kaspar Waldmann, 1657–1720. Rape of Ganymede, representing "Air." Fresco, part of "Elements" cycle. *c.***1716.** Schloss Grabenstein, Innsbruck-Mühlau. [Kempter 1980, p. 78, no. 246—ill.]

Charles-Joseph Natoire, 1700–1777. "Jupiter Abducting Ganymede." Painting, part of "Story of the Gods" cycle, for Château de La Chapelle-Godefroy, Champagne. *c.***1731.** Musée des Beaux-Arts, Troyes, inv. 835–11. [Troyes 1977, pp. 54f., no. 9—ill.]

José de Cañizares, 1676–1750. *El rapto de Ganimedes.* Drama (melodrama). First performed *c.***1745,** Coliseo del Principe, Madrid. [Palau y Dulcet 1948–77, 3:127]

Claude-Claire Francin, 1702–1773. "(Standing) Ganymede (and the Eagle)." Marble statue. Commissioned Louis XV for Versailles, 1742. Exhibited Salon of **1745.** Walters Art Gallery, Baltimore. [Kempter 1980, p. 53, no. 71—ill. / Mayo 1967, p. 164]. Plaster model, 1744. Musée des Beaux-Arts, Strasbourg. [Kempter, no. 72]

José Nebra, 1702–1768, music. *Cautelas contra cautelas y el rapto de Ganimedes* [Cunning against Cunning and the Rape of Ganymede]. Musical work for the stage. Libretto, Cañizares. First performed 5 June **1745,** Nueva del Principe, Madrid. [Grove 1980, 13:89]

Simon Carl Stanley, 1703–1761. "Ganymede." Marble statue. **1752.** Lost. [Pigler 1974, p. 95] Plaster cast. Statens Museum for Kunst, Copenhagen. [Hartmann 1979, pl. 3.4]

Giovanni Battista Tiepolo, 1696–1770. (Jupiter and Ganymede in) "Olympus." Ceiling fresco. **1753.** Grand Staircase, Residenz, Würzburg. [Kempter 1980, p. 56, no. 224—ill.]

———. "Jupiter and Ganymede." Drawing. Musei Civici di Storia ed Arte, Trieste. [Ibid., no. 225]

———. "Standing Ganymede, with the Eagle." Drawing. Fondazione Cini, Venice, no. 30 089. [Ibid., no. 226]

Jacob de Wit, 1695–**1754.** "Jupiter and Ganymede." Painting. Ferens Art Gallery, Hull. [Wright 1976, p. 222]

———. "The Rape of Ganymede." Drawing, design for (lost? unexecuted?) ceiling decoration. Musées des Beaux-Arts, Brussels. [Brussels 1968, p. 43]

Anton Raphael Mengs, 1728–1779. "Jupiter Kissing Ganymede." Fresco, detached (forgery, presented by Mengs as an original antique painting). **1758–60.** Palazzo Corsini, Rome. [Honisch 1965, no. 86 / Kempter 1980, pp. 56f., no. 143—ill.]

Christoph Martin Wieland, 1733–1813. "Juno und Ganymed." Comic tale. In *Komische Erzählungen* (Munich: Parcus, **1762**). [Radspieler 1984, vol. 3 / Frenzel 1953, p. 116]

Gaetano Gandolfi, 1734–1802. "The Rape of Ganymede." Oil sketch. *c.***1763?** Brinsley Ford coll., London. [Columbia 1967, no. 5—ill.]

———. "The Rape of Ganymede." Design for ceiling fresco. Late 18th century. Bozetto, Pitti Palace, Florence. [Mayo 1967, p. 166, fig. 64]

Carle van Loo, 1705–1765. "The Rape of Ganymede." Painting. Musée, Toulouse. [Kempter 1980, no. 114]

Ferdinand Dietz, ?–*c.*1780. "Ganymede on the Eagle."

Sculpture. *c*.1756–68. Schlosspark, Vietschöchheim. [Kempter 1980, no. 227]

Charles Amédée Philippe van Loo, 1719–1795. "Ganymede Introduced into the Assembly of Gods by Hebe." Ceiling fresco. **1768.** Neues Palais, Potsdam. [Kempter 1980, no. 113]

William Taverner, 1703–1772. "Ganymede Carried Off by the Eagle of Jupiter." Painting. Nottingham Castle Museum and Art Gallery. [Bénézit 1976, 10:92]

Johann Wolfgang von Goethe, 1749–1832. "Ganymed." Poem. Probably **1774.** In *Gedichte der Ausgabe letzter Hand* (Stuttgart: Cotta, 1827–30). [Beutler 1948–71, vol. 1 / Suhrkamp 1983–88, vol. 1 / Reed 1980, pp. 5, 8, 124, 208] Text set to music by at least 12 leider composers, 19th and 20th centuries: Franz Schubert, 1817 (see below); Moritz Hauptmann (1792–1868); Carl Loewe (1796–1869); Karl Graedener,(1812–1883); Hugo Wolf, 1889 (see below); Wilhelm Mauke (1867–1930); Edgar Istel (1880–1948); Martin Grabert (1868–1951); Richard Stöhr (1874–1967); Georg Böttcher; Conrad Kölle. [Moser 1949, p. 158]

Pierre Julien, 1731–1804. "Standing Ganymede" (with eagle marble statue. **1776.** Louvre, Paris. [Kempter 1980, pp. 53f., no. 102—ill.]

Jean Antoine Julien de Parme, 1736–1799. "The Rape of Ganymede." Painting. **1778.** Prado, Madrid, no. 6772. [Prado 1985, p. 351]

Antoni Elliger, 1701–1781. "The Rape of Ganymede." Painting. Stedelijk Museum "De Lakenhal," Leiden, cat. 1949 no. 89. [Wright 1980, p. 115]

Angelica Kauffmann, 1741–1807. "Ganymede Playing at Dice with Cupid." Painting. **1782.** [Manners & Williamson 1924, p. 141]

———. Painting, depicting Ganymede giving Jupiter's eagle a drink out of a bowl, after an ancient cameo. 1793. [Ibid., p. 141]

———. "Venus Chiding Ganymede." Painting. Sold 1879. [Ibid., p. 232]

Johann Michael Demmler, 1748–1785. *Ganymed in Vulkans Schmiede* [Ganymede in Vulcan's Forge]. Musical work for the stage. First performed 30 May 1797, St. Salvator, Augsburg. [Grove 1980, 5:361]

Asmus Jakob Carstens, 1754–1798. "Ganymede." Drawing, sketch for a lost painting. **1793.** Kunstsammlungen, Weimar. [Kempter 1980, p. 47, no. 45—ill. / Mayo 1967, pp. 166f., fig. 65]

Friedrich Hölderlin, 1770–1843. "Ganymed." Ode (originally called "Der gefesselte Strom"). **1802.** In *Nachtgesänge* (Stuttgart: Cotta, 1804). [Beissner 1943–77, vol. 2 / Hamburger 1980 / Reed 1980, p. 208]

Henry Fuseli, 1741–1825. "The Rape of Ganymede." Lithograph. **1800–05.** [Schiff 1973, no. 1346—ill.]

Luigi Pampaloni, 1791–1847. "Ganymede Carried Off by the Eagle." Stucco bas-relief. **Early 19th century.** Saletta da Bagno, Palazzo Pitti, Florence. [Pitti 1966, p. 237—ill.]

Franz Schubert, 1797–1828. "Ganymed." Lied, opus 19/3. Mar **1817.** Text, Goethe (1774). Published 1825. [Grove 1980, 16:756, 796]

William Hilton the Younger, 1786–1839. "The Rape of Ganymede." Painting. **1819.** Royal Academy and City Art Gallery, Leeds. [Bénézit 1976, 5:547]

Bertel Thorwaldsen, 1770–1844. "Ganymede (Offering the Cup)." Marble statue. At least 4 versions, **1804–26.** Thorwaldsens Museum, Copenhagen, no. A854 (A40); Museum Narodowe, Posnan; private coll.; another unlocated. [Cologne 1977, no. 7, p. 97—ill. / Thorwaldsen 1985, pp. 23, 82, pl. 13 / Hartmann 1979, pp. 130ff., pl. 78.1] Plaster cast of original (1804) model. Thorwaldsens Museum, no. A41. [Thorwaldsen, p. 23]

———. "Ganymede with Jupiter's Eagle." Marble statue. 1815. At least 6 versions, 1815–41. Pinacoteca Tosio-Martinengo, Brescia; private coll., Genf; others unlocated. [Cologne, no. 81] Enlarged variant. 1817. 3 versions. Thorwaldsens Museum, no. A44; Minneapolis Institute of Arts; Kennedy Galleries, New York. [Ibid., no. 111, p. 97—ill. / Thorwaldsen, p. 24, pl. 28 / Hartmann, pp. 133f.—ill.] Plaster casts. Thorwaldsens Museum, nos. A45, A733. [Thorwaldsen, pp. 24, 72]

———. "Ganymede (Filling the Cup)". Marble statue. At least 2 versions. Thorwaldsens Museum, no. A42; Hermitage, Leningrad. [Cologne, no. 89, p. 97—ill. / Thorwaldsen, p. 23 / Hartmann, pl. 79.1 / also Hermitage 1975, pl. 57] Plaster cast of original (1816) model. Thorwaldsens Museum, no. A43. [Thorwaldsen, p. 23]

———. "The Abduction of Ganymede." Plaster reliefs (2 versions). 1833. Thorwaldsens Museum, nos. A349, 350. [Thorwaldsen, pp. 47f. / Hartmann, pp. 135f.-ill. / also Cologne, p. 170—ill.]

———. "Hebe Gives Ganymede the Cup and Pitcher." Plaster relief. 1833. Thorwaldsens Museum, no. A351. [Thorwaldsen, p. 48]

———. "Cupid and Ganymede Playing at Dice." Marble relief. Modeled 1831. Thorwaldsens Museum, no. A395. [Thorwaldsen, p. 51]

Joseph Anton Koch, 1768–1839. "The Rape of Ganymede, with Landscape and Mythological Figures." Painting. **1838–39,** unfinished. Niedersächsische Landesgalerie, Hannover. [Kempter 1980, pp. 47f., no. 105—ill.]

Thomas Crawford, 1813–1857. "Hebe and Ganymede." Marble sculpture group. **1842.** Museum of Fine Arts, Boston. [Gerdts 1973, p. 58, fig. 14]

Margaret Fuller, 1810–1850. "Ganymede to His Eagle." Poem. In *At Home and Abroad* (New York: Tribune Association, 1869). [Boswell 1982, p. 257]

Edward Bulwer Lytton, 1803–1873. "Ganymede." Poem. In *Poetical and Dramatic Works,* vol. 3 (London: Chapman & Hall, **1853**). [Bush 1963, p. 293 *n*.]

George Frederick Watts, 1817–1904. "Ganymede." Painting. **1864.** Watts Gallery, Compton, Surrey. [Watts 1970, no. 61]

Richard Evans, *c*.1784–1871. "Ganymede Feeding the Eagle." Watercolor, imitation of antique Roman frescoes. By **1865.** Victoria and Albert Museum, London, no. 159–1865. [Lambourne & Hamilton 1980, p. 124—ill.]

Roden Noel, 1834–1894. "Ganymede." Poem. In *Beatrice and Other Poems* (London: Macmillan, **1868**). [Boswell 1982, p. 276]

Alfred Sacheverell Coke, fl. *c*.1869–93. "Eros and Ganymede." Watercolor. By **1869.** Victoria and Albert Museum, London, no. 519–1869. [Lambourne & Hamilton 1980, p. 68]

Antoine Elwart, 1808–1877. *L'enlèvement de Ganymede* [The Abduction of Ganymede]. Instrumental music for clari-

net, violin, cello, and pianoforte. **1870?** [Grove 1980, 6:148]

Max Klinger, 1857–1920. "Parody of the Rape of Ganymede." Pair of paintings, door panels for Villa Albers, Berlin. **1883–85.** Museum der Bildenden Künste, Berlin. [Hildesheim 1984, no. 16—ill.]

Émile-Antoine Bourdelle, 1861–1929. "Ganymede." Sculpture. **1886.** Plaster and terra-cotta versions. Both in Musée Bourdelle, Paris. [Jianou & Dufet 1975, no. 46]

Gustave Moreau, 1826–1898. "The Rape of Ganymede." Watercolor. **1886.** Formerly Haem coll., Paris, sold London, 1971. [Mathieu 1976, no. 342—ill. / Kempter 1980, p. 49, no. 160—ill.]

————. "Ganymede." Watercolor. *c.*1886. Formerly Edmund Taigny coll., unlocated. [Mathieu, no. 343—ill.]

————. "Ganymede." Watercolor. *c.*1890. Musée Gustave Moreau, Paris. [Mathieu 1985, pl. 41]

————. Several other paintings of the same subject. Musée Gustave Moreau, Paris, cat. 1974 nos. 105, 521, 717, 939; 1 in private coll., Paris. [Kempter, nos. 161–65]

Hans von Marées, 1837–1887. "The Abduction of Ganymede." Painting. **1887.** Neue Pinakothek, Munich, inv. 7865. [Munich 1982, p. 222—ill. / Gerlach-Laxner 1980, no. 164—ill. / Mayo 1967, pp. 167f., fig. 66 / Kempter 1980, pp. 119f., no. 126—ill.; cf. nos. 127–40]

Hugo Wolf, 1860–1903. "Ganymed." Lied, opus 50. Text, Goethe (1774). **1889.** [Grove 1980, 20:496]

Raymond Barthélemy, 1833–1902. "Ganymede." Marble statue. Musées Nationaux, inv. R.F. 850, deposited in Musée, Amboise, in 1968. [Orsay 1986, p. 266]

Lady Margaret Sackville, 1881–1963. "The Return of Ganymede." Poem. In *Bertrud and Other Dramatic Poems* (Edinburgh: Brown, **1911**). [Bush 1963, p. 569]

Lovis Corinth, 1858–1925. "Ganymede and the Eagle." Color lithograph, part of "Loves of Zeus" cycle. **1920.** [Schwarz 1922, no. L401]

Marina Tsvetaeva, 1892–1941. (Ganymede evoked in) *Razluka* [Separation] part 7. Poem. **1921.** In *Kniga stikhov* (Moscow: Gelikon, 1922). [Karlinsky 1985, p. 108]

Stella Stocker, 1858–**1925.** *Ganymede.* Opera. [Cohen 1987, 2:669]

Evan Morgan, 1860–after 1929. "An Incident in the Life of Ganymede." Poem. In *The City of Canals* (London: Routledge, **1929**). [Boswell 1982, p. 275]

William Plomer, 1903–1973. (Ganymede in) "The Three Abductions." Poem. In *The Family Tree* (London: Leonard & Virginia Woolf, **1929**). [Bush 1963, p. 575]

Witter Bynner, 1881–1968. "Ganymede." Poem. In *Guest Book* (New York: Knopf, **1935**). [Boswell 1982, p. 61]

W. H. Auden, 1907–1973. "Ganymede." Poem. In *Common Sense* Apr **1939**; collected in *Collected Shorter Poems, 1927–1957* (London: Faber & Faber, 1966). [Mendelson 1976 / Fuller 1970, p. 145]

Roland Petit, 1924–, choreography. (Ganymede in) *Les amours de Jupiter.* Ballet. Music, Jacques Ibert. Libretto, Boris Kochno, after Ovid's *Metamorphoses.* First performed Mar **1946**, Ballets des Champs-Élysées, Paris. [Oxford 1982, p. 324 / Clarke & Vaughan 1977, p. 274]

William Rose Benét, 1886–1950. "Ganymede." Poem. In *The Stairway of Surprise* (New York: Knopf, **1947**). [Boswell 1982, p. 36]

Hermann Hubacher, b. 1885. "Standing Ganymede." Bronze statue. **1946–52.** Heinrich Wölfflin-Stiftung, Zurich. [Kempter 1980, no. 97]

Jean Arp, 1887–1966. "Ganymede." Abstract terra-cotta sculpture. 2 versions, **1954.** Ströher coll., Darmstadt; artist's coll. in 1957. 5 bronze casts. [Giedion-Welcker 1957, no. 132 / Arp 1968, p. 104]

Robert Rauschenberg, 1925–. "Pail for Ganymede." Assemblage. **1959.** Artist's coll. [Berlin 1980, no. 14—ill. / Smithsonian 1976, no. 72—ill.]

Giorgio de Chirico, 1888–1978. "Ganymede with His Horse." Bronze sculpture. **1970.** 9 casts, 2 artist's proofs. [de Chirico 1971–83, 2.3: no. 306—ill.]

Carlo Maria Mariani. "The Abduction of Ganymede." Painting. **1978?** Sperone Westwater Fischer coll., New York. [Personal communication to author from Mark Thistlethwaite, Texas Christian University, 1984]

————. "The Abduction of Ganymede." Painting. **1981.** Galleria Monti, Rome. [Ibid.]

GE. *See* GAIA.

GIANTS. *See* TITANS AND GIANTS.

GLAUCE. *See* MEDEA.

GLAUCUS. According to Ovid, Glaucus was a Boeotian fisherman who was changed into a sea deity by the gods after he ate a magical weed. He became a merman—half human, half fish. When the nymph Scylla spurned his advances, Glaucus asked the goddess Circe to use her powers to influence Scylla, but Circe herself loved the merman and refused. Glaucus rejected her, and Circe took vengeance on Scylla by poisoning the waters where she bathed with tainted herbs. Scylla was transformed into a monster whose lower body was covered with barking dogs; seeing her thus, Glaucus fled in fright. From her poisoned pool, Scylla waylaid Odysseus's ship and killed six of his men. She was then changed into a rock on which unlucky ships were dashed to pieces.

In the *Odyssey,* Homer describes the monstrous Scylla as having six heads, each with triple rows of teeth. In other tales, Glaucus was considered a patron of sailors and was renowned for his prophecies. He figures in some versions of the legend of the Argonautic expedition.

Classical Sources. Euripides, *Orestes* 362ff. Apollonius Rhodius, *Argonautica* 1.1310–28. Diodorus Siculus, *Biblio-*

teca 4.486. Virgil, *Georgics* 1.427; *Aeneid* 6.36. Ovid, *Metamorphoses* 13.730–14.74. Hyginus, *Fabulae* 199. Philostratus, *Imagines* 2.15.

See also CIRCE; JASON, and the Argonauts.

Anonymous French. (Story of Glaucus and Scylla in) *Ovide moralisé* 13.4295–608. Poem, allegorized translation/elaboration of Ovid's *Metamorphoses. c.*1316–28. [de Boer 1915–86, vol. 4]

Pierre de Ronsard, 1524–1585. "Complainte de Glauce à Scylle nimphe" [Glaucus's Complaint to the Nymph Scylla]. Poem. In *Le troisième livre des odes* (Paris: Cauellat, **1550**). [Laumonier 1914–75, vol. 2 / DLLF 1984, 3:2014]

Bartholomeus Spranger, 1546–1611. "Glaucus and Scylla." Painting. *c.*1581. Kunsthistorisches Museum, Vienna, inv. 2615 (1502B). [Vienna 1973, p. 166—ill.]

Thomas Lodge, 1558?–1625. *Scillaes Metamorphosis, or, Glaucus and Scilla.* Poem. Chiswick: Whittingham, **1589**. [Hulse 1981, pp. 26, 37, 39–46, 48–51, 88–91 / Bush 1963, pp. 83–85]

Agostino Carracci, 1557–1602. "Glaucus and Scylla" ("Peleus and Thetis," "Galatea"). Fresco. **1597–1600**. Galleria, Palazzo Farnese, Rome. [Malafarina 1976, no. 104r—ill. / Martin 1965, pp. 105ff.—ill.]

Peter Paul Rubens, 1577–1640. "Glaucus and Scylla." Painting, for Torre de la Parada, El Pardo, executed by assistant (Erasmus Quellinus?) from Rubens's design. **1636–38**. Lost. [Jaffé 1989, no. 1274 / Alpers 1971, no. 26] Oil sketch. Musée Bonnat, Bayonne. [Alpers, no. 26a—ill. / Held 1980, no. 191—ill. / Jaffé, no. 1273—ill.]

Simon Vouet, 1590–1649, or studio. "Glaucus and Scylla." Painting, cartoon for "Loves of the Gods" tapestry series. [Crelly 1962, no. 270j]

Filippo Lauri, 1623–1694, attributed. "Glaucus and Scylla." Painting. Galleria Pallavicini, Rome. [Warburg]

Flemish School. "Glaucus and Scylla." Drawing. **17th century.** Louvre, Paris, inv. no. 21.132. [Warburg]

William Diaper, 1685–1717. "Glaucus." Poem. In *Nereides: or, Sea-Eclogues* (London: Sanger, **1712**). [Bush 1937, p. 542]

Gabriel Grupello, 1644–1730. "Scylla and Glaucus" (or Galatea and Triton?). Marble sculpture. Before **1716**. Garden, Schloss Schwetzingen. [Düsseldorf 1971, no. 53—ill.; cf. Kultermann 1968, no. 177]

Alessandro Scarlatti, 1660–1725. "Partenope, Nettuno, Proteo, e Glauco" [Parthenope, Neptune, Proteus, and Glaucus]. Serenata. First performed **1716**, Palazzo Reale, Naples. [Grove 1980, 16:561]

Jean-Marie Leclair the Elder, 1697–1764. *Scylla et Glaucus.* Opera (tragédie), opus 11. Libretto, d'Albaret. First performed 4 Oct (or 30 Sep?) **1746**, Académie Royale de Musique, Paris. [Grove 1980, 10:590f. / Girdlestone 1972, pp. 292ff.]

Giuseppe Sarti, 1729–1802. *Doris, Nereus, and Glaucus.* Cantata for 3 solo voices and orchestra. [Grove 1980, 16:505]

James Hervé D'Egville, *c.*1770–*c.*1836, choreography. *Les amours de Glauque et Circe.* Ballet. Music, Venua. Librettist unknown. First performed 6 Jan **1809**, King's Theatre, London. [Guest 1972, p. 154 / Nicoll 1959–66, 4:426]

John Keats, 1795–1821. (Glaucus pines for his lost Scylla in) *Endymion* 3.192ff. Poem. **1817**. London: Taylor & Hessey, 1818. [Stillinger 1978 / Aske 1985, p. 129 / Vendler 1983, pp. 219, 221 / Gradman 1980, pp. 23–28]

John Martin, 1789–1854. "Glaucus and Scylla." Watercolor. **1820**. Vassar College Art Gallery, Poughkeepsie. [Feaver 1975, p. 65, pl. 40—ill.]

Jean-Baptiste Blache, 1765–**1834**, choreography. *Cila et Glaucus.* Ballet. [EDS 1954–66, 2:581]

Maurice de Guérin, 1810–1839. "Glaucus." Poetic fragment. *c.*1835? Published by George Sand in *Revue des deux mondes* 15 May 1840; collected in *Reliquiae,* edited by G. S. Trébutien (Paris: 1861). [DLLF 1984, 2:989–91]

Joseph Mallord William Turner, 1775–1851. "Glaucus and Scylla." Painting. Exhibited **1841**. Kimbell Art Museum, Fort Worth. [Butlin & Joll 1977, no. 395—ill.]

F. T. Traill. *Glaucus, a Fish Tale.* Burlesque. Music, J. H. Tully. First performed 5 July **1865**, Olympic Theatre, London. [Nicoll 1959–66, 5:602, 821]

Paul Hamilton Hayne, 1830–1886. "The Story of Glaucus the Thessalian." Poem. In *Poems* (Boston: Lothrop, **1882**). [Boswell 1982, p. 261]

John Melhuish Strudwick, 1849–1937. "Circe and Scylla." Painting. **1886**. [Kestner 1989, p. 110]

Charles J. Pickering. "Glaukos." Poem. In *Metassai: Scripts and Transcriptions* (Glasgow: Privately printed, **1887**). [Bush 1937, p. 562]

Stopford Brooke, 1832–1916. "Glaucon." Poem. In *Poems* (London: MacMillan, **1888**). [Bush 1937, p. 562 / Boswell 1982, p. 53]

John William Waterhouse, 1849–1917. "Circe Invidiosa" (poisoning the sea). Painting. **1892**. Art Gallery of South Australia, Adelaide. [Hobson 1980, no. 94, pl. 53 / Wood 1983, pp. 230ff.—ill. / Kestner 1989, pp. 298, 303; pl. 5.36]

Gabriele D'Annunzio, 1863–1938. "La corona di Glauco" [The Crown of Glaucus]. Sonnet sequence. **1903**. In *Alcyone* (Milan: Treves, 1904). [Roncoroni 1982 / Mutterle 1982, p. 224]

Ezra Pound, 1885–1972. "An Idyl for Glaucus." Poem. In *Personae* (London: Mathews, **1909**; revised, expanded edition, New York: New Directions; London: Faber & Faber, 1926). [Ruthven 1969, p. 39]

———. (Allusion to Glaucus in) Canto 39, in *Eleven New Cantos, XXXI–XLI* (Norfolk, Conn: New Directions, 1934; London: Faber & Faber, 1935). [Feder 1971, p. 111]

Ercole Luigi Morselli, 1882–1921. *Glauco.* Tragedy. Rome: Rassegna Italiana, **1918**. [McGraw-Hill 1984, 3:441]

Alberto Franchetti, 1860–1942. *Glauco.* Opera. Libretto, Giovacchino Forzano, after Morselli (above). First performed 8 Apr **1922**, Naples. [Baker 1984, p. 755 / Grove 1980, 6:773]

Kenneth Hare, b. 1888. "Glaucus." Poem. In *New Poems* (London: Low, Marston & Co., **1923**). [Bush 1937, p. 573]

Robert Gathorne-Hardy, 1902–. "Glaucus." Poem. In *Village Symphony and Other Poems* (London: Collins, **1931**). [Bush 1937, p. 575]

Paul Klee, 1879–1940. "Scylla." Abstract drawing. **1938**. Klee Foundation, Bern. [San Lazzaro 1957, p. 300—ill.]

Richmond Lattimore, 1906–1984. "Glaukos." Poem. In *Poems, 1957* (Ann Arbor: University of Michigan Press, **1957**). [Boswell 1982, p. 163]

David Wright, 1920–. (Glaucus caught between Circe and Scylla in) "Moral Story III." Poem. In *To the Gods the Shades: New and Collected Poems* (Manchester: Carcanet, **1976**). [Ipso]

GODS AND GODDESSES.

The canonical twelve Olympian deities—Zeus, Hera, Poseidon, Hephaestus, Ares, Apollo, Artemis, Demeter, Aphrodite, Athena, Hermes, and Dionysus—were originally fourteen in number. Hades, whose realm was in the Underworld rather than on earth, and Hestia, whose functions were somewhat limited, were omitted from the Olympian pantheon as the myths surrounding it became more organized.

Many works, both classical and postclassical, present Olympians and other deities in assemblies, feasts, and other scenes, not necessarily focusing on a specific narrative. In the postclassical era, apotheoses of legendary heroes and contemporary luminaries, elevated to the cloud-capped heights of Olympus, have been a favorite subject of ceiling decorations and other paintings on a grand scale. The weddings of Thetis and Peleus and of Eros and Psyche were occasions for feasts of the gods and are also popular subjects for painters.

In the postclassical tradition, the Olympians are often represented by their Roman counterparts: Zeus (Jove, Jupiter), Hera (Juno), Poseidon (Neptune), Hephaestus (Vulcan), Ares (Mars), Artemis (Diana), Demeter (Ceres), Aphrodite (Venus), Athena (Minerva), Hermes (Mercury), Dionysus (Bacchus), Hades (Pluto), and Hestia (Vesta). In the eighteenth and nineteenth centuries, laments for the passing of the pagan divinities were popular among neoclassical poets.

Classical Sources. Hesiod, *Theogony* passim. Homer, *Iliad* 20 and passim. *Homeric Hymns,* first, second, and third hymns "To Aphrodite," first, second, and third hymns "To Apollo," "To Ares," first and second hymns "To Artemis," first and second hymns "To Athena," first and second hymns "To Demeter," first, second, and third hymns "To Dionysus," "To Hephaestus," "To Hera," "To Hermes," first and second hymns "To Hestia," "To Poseidon." *Orphic Hymns,* "To Aphrodite," "To Ares," "To Demeter," "To Apollo," "To Artemis, "To Dionysus," "To Hades," "To Hephaestus," "To Hera," "To Hermes," "To Hestia," "To Pallas," "To Zeus." Lucian, *Dialogues of the Gods, Dialogues of the Sea Gods.* Virgil, *Aeneid* 10.1–117 and passim.

Listings are arranged under the following headings:

> General List
> Gods as Seasons
> Gods as Elements
> Conflict between Vice and Virtue
> Loves of the Gods

See also AENEAS; CRONUS, Birth of Olympians; HERACLES, Apotheosis; PSYCHE; THETIS, and Peleus; TITANS AND GIANTS; TROJAN WAR.

General List

Francesco Petrarca, 1304–1374. (Jove and Pallas replaced by Venus and Bacchus in "Babylonian" Rome, in) Sonnet, no. 137 of *Canzoniere (Rime sparse).* Collection of sonnets, madrigals, and *canzoni.* Begun *c.*1336, completed by 1373; no. 137 composed by **1348.** [Contini 1974 / Armi 1946 / Dünnhaupt 1975, pp. 434f.]

John Lydgate, 1370?–1449. *The Assemble of Goddes; or, The Accord of Reson and Sensuallyte in the Fear of Death.* Allegorical poem. Probably before **1412.** Westminster: Wynken de Worde, 1498. Modern edition by O. L. Triggs (London: Early English Text Society, with University of Chicago, 1895; reprinted London & New York: Oxford University Press, 1957). [Ipso / Lewis 1958, pp. 260f. / Pearsall 1977, p. 240]

Agostino di Duccio, 1418–1481. Series of marble reliefs, depicting planetary gods. **1454–57.** Cappella S. Francesco, Rimini. [Agard 1951, pp. 68f.—ill. / also Clapp 1970, 1:18]

————, or studio (Matteo de' Pasti? *c.*1420–1467/68). Series of marble reliefs, depicting planetary gods in the zodiac. **1450s.** Chapel of the Planets, Tempio Malatestiano, Rimini. [Pope-Hennessy 1985b, 2:311ff., 361—ill.]

Raphael, 1483–1520. "Parnassus" (Homer and the other poets with gods and goddesses). Fresco. **1510–11.** Stanza della Segnatura, Vatican, Rome. [Vecchi 1987, no. 85K—ill. / Jones & Penny 1983, pp. 68ff.—ill / Berenson 1968, p. 354—ill.]

————, assistants (Giulio Romano and/or others), after designs by Raphael. "Council of the Gods," (gods at) "The Wedding Feast of Cupid and Psyche." Frescoes, simulating tapestries, part of "Psyche" cycle. **1517–18.** Loggia di Psiche, Villa Farnesina, Rome. [Vecchi, no. 130—ill. / Jones & Penny, pp. 183ff.—ill. / Hartt 1958, pp. 32f.—ill. / d'Ancona 1955, pp. 55f., 89—ill. / Gerlini 1949, pp. 25ff.—ill.]

Baldassare Peruzzi, 1481–1536. Series of frescoes depicting the Olympians. **1511–12** or *c.*1517–18. Sala delle Prospettive, Villa Farnesina, Rome. [d'Ancona 1955, pp. 27ff., 93f. / Gerlini 1949, pp. 31ff.—ill. / also Frommel 1967–68, no. 51—ill.]

Giovanni Bellini, *c.*1430–1516. "Feast of the Gods." Painting. **1514;** landscape repainted by Titian, *c.*1529. National Gallery, Washington, D.C. [Wethey 1975, no. 12—ill. / also Sienkewicz 1983, p. 4—ill. / Walker 1984, p. 200—ill. / Berenson 1957, p. 36—ill. / Louvre 1975, no. 81—ill. / Wind 1948, fig. 1] Copies in National Gallery of Scotland, Edinburgh (attributed to Poussin); Castel Sant'Angelo, Rome. [Wethy / Thuillier 1974, nos. R105–06—ill. / also Blunt 1966, no. 201—ill.]

Baccio Bandinelli, 1493–1560, composition. "The News Brought to Olympus." Engraving (Bartsch 14:193 no. 241), by Agostino Veneziano, **1516–18.** [Bartsch 1978, 26:238—ill.]

Dosso Dossi, *c.*1479–1542 (and Battista Dossi? *c.*1474–1548). "Bacchanal." Painting, after Bellini's "Feast of the Gods" (1514, Washington). *c.*1519. National Gallery, London, inv. 5279. [London 1986, p. 166—ill. / Wind 1948, p. 62 *n.,* fig. 70 / Gibbons 1968, no. 127 (as Dosso and Battista)—ill.]

Rosso Fiorentino, 1494–1540, composition. "Gods in Niches." 20 engravings (Bartsch nos. 24–43), executed by Gian Jacopo Caraglio. **1526.** Original designs lost. [Carroll 1987, nos. 21–40—ill. / also Barocchi 1950, pp. 62f.—ill. / Paris 1972, nos. 202–03—ill. / Lévêque 1984, p. 165—ill.]

Giulio Romano, *c.*1499–1546, assistants, after designs by

Giulio. Frescoes (simulated statues), depicting Jupiter, Juno, Venus, Minerva, Vulcan. **1527–28**. Sala dei Cavalli, Palazzo del Tè, Mantua. / Ceiling frescoes, depicting deities representing the months of the year. 1527–28. Sala dei Venti, Palazzo del Tè. / Numerous depictions of Mount Olympus (emblem of the Medici) throughout the palace. [Hartt 1958, pp. 112ff., 115ff., 105–60 passim—ill. / Verheyen 1977, pp. 112–130 passim—ill.]

Girolamo Romanino, c.1484/87–c.1562. "Mercury and Other Gods." Fresco. **1531–32**. Castello del Buonconsiglio, Trento. [Berenson 1968, pp. 369f.]

Lorenzo Leonbruno, 1489–c.1537. "Mount Olympus." Ceiling fresco, for Palazzo Ducale, Mantua. Covered and partially destroyed by reconstruction of 1536–37, rediscovered in 1928. [Paccagnini 1974, p. 70]

Benvenuto Cellini, 1500–1571. Series of 12 lifesize silver statues of gods and goddesses: Jupiter, Juno, Apollo, Vulcan, Mars, others. Commissioned **1540**, only "Jupiter" (and "Juno"?) completed. Now lost. / Bronze model of "Juno." Private coll., Paris. [Pope-Hennessy 1985a, pp. 102–6—ill.]

Maerten van Heemskerck, 1498–1574. "Gods and Heroes from Mythology and the Old Testament." Painting cycle (including Neptune, Pluto, Saturn, Zeus, and Momus criticizing the gods' works). c.1545. Dispersed. [Grosshans 1980, no. 30—ill.]

———. "The Assembly of the Gods." Painting. 1556. Museum Boymans-van Beuningen, Rotterdam, inv. 2964. [Grosshans 1980, no. 83—ill.]

———. "Assembly of Gods." Painting. Recorded in private coll., The Hague, 1752, untraced. [Grosshans, no. V28b]

Francesco Primaticcio, 1504–1570, and assistants. Cycle of ceiling frescoes depicting Olympians, in Galerie d'Ulysse, Château de Fontainebleau. 15 compartments, each containing a central motif and 2–8 secondary scenes: "Olympus," "Feast of the Gods," and representations of deities individually and in groups. **1541–47** and later. Destroyed 1738–39. / Original drawings in Louvre, Paris; elsewhere. [Béguin et al. 1985, pp. 119ff.—ill. / Dimier 1900, pp. 295ff.]

———, design. "The Gods' Arabesques." Tapestry. 1547–59. 4 fragments known: Cybele, Flora (Musée des Gobelins); Bacchus, Neptune (Musée des Tissues, Lyon). [Dimier, pp. 384ff.]

Giorgio Vasari, 1511–1574. Painting cycle, depicting the Olympian gods with the signs of the zodiac: "Venus with Libra," "Cupid with Taurus," "Jupiter with Sagittarius and Pisces," "Saturn with Capricorn and Aquarius," "Diana-Luna with Cancer," "Apollo-Sol with Leo," "Mars with Scorpio and Aries," "Mercury with Gemini and Virgo." **1548**. Sala del Trionfo della Virtù, Casa Vasari, Arezzo. [Arezzo 1981, no. 1.4—ill. / also Barocchi 1964, p. 131]

———. "Council of the Gods." Drawing, study for unexecuted decoration in Palazzo Vecchio, Florence. 1555. Musée des Arts Décoratifs, Paris, inv. 946. [Arezzo, no. 5.34a—ill.]

Battista Zelotti, c.1526–1578. Cycle of ceiling paintings for Sala dei Dieci, Palazzo Ducale, Venice. **1553–54**. In place. [Berenson 1957, p. 204—ill.]

———. "Olympus." Ceiling painting. Museo Civico, Vicenza. [Ibid.]

Pierre de Ronsard, 1524–1585. (Court of Olympus compared to Henri II's court in) "Hymne de Henri II de ce nom." Poem, hymn. In *Le second livre des hymnes* (Paris: Buon, **1555**). [Laumonier 1914–75, vol. 8 / McGowan 1985, pp. 47–50]

Olivier de Magny, 1529–1561. (Lesser gods' homage to Jupiter in chant poétique to Henri II in) *Oeuvres poétiques* (Paris: **1557**). [McGowan 1985, pp. 33, 259]

Paolo Veronese, 1528–1588. "The Gods of Olympus." Fresco cycle, for Palazzo Trevisan, Murano. c.**1557**. Partially destroyed, partially detached. 1 section ("Janus and Saturn") in place; 2 sections ("Seven Planetary Gods"—Jupiter, Apollo, Diana and Mars; Venus, Saturn, and Mercury) in Louvre, Paris, no. R.F. 2183, 2183 bis. [Pallucchini 1984, nos. 36b, h, i—ill. / Pignatti 1976, nos. 65, 68—ill. / also Louvre 1979–86, 2:252—ill.] 17th-century copies, paintings, after details depicting Jupiter, Juno, Neptune, Cybele, in Christ Church, Oxford. [Byam Shaw 1967, nos. 107–10—ill.]

———. (Allegorical figure [Eternity? Divine Wisdom? Thalia?] surrounded by Olympian gods, in) Ceiling fresco, for Sala dell' Olimpo, Villa Barbaro-Volpi, Maser (Treviso). c.1560–61. In place. [Pignatti, no. 96—ill. / also Pallucchini, no. 58—ill.]

———. "Olympus." Painting. c.1561–63. Museum of Fine Arts, Boston, inv. 64.2079. [Pallucchini, no. 78—ill. / Pignatti, no. 148—ill. / Boston 1985, p. 292—ill.]

———. "Olympus." Ceiling painting, for Palazzo Pisani, Venice. c.1560–65. Formerly Staatliche Museen, Berlin, destroyed. [Pallucchini, no. 88—ill. / Pignatti, no. 140—ill.]

———. "Jupiter Crowning Germany," "Juno and Apollo," "Minerva and Mars," "Time (Saturn) Helping Religion to Defeat Heresy." Series of paintings glorifying Germany, for Fondaco dei Tedeschi, Venice. c.1578–80. Formerly Kaiser Friedrich Museum, Berlin, destroyed. [Pallucchini, nos. 168a–d—ill. / Pignatti, nos. 209–12—ill.]

Frans Floris, 1516/20–1570. "The Gods of Olympus" ("Feast of the Gods"). Painting. Koninklijk Museum voor Schone Kunsten, Antwerp, no. 956. [Antwerp 1970, p. 82 / de Bosque 1985, pp. 56f.—ill.]

Étienne Delaune, c.1518–1593. Series of engravings depicting pagan divinities. Before **1582**. (Musée des Beaux-Arts, Rennes.) [Lévêque 1984, p. 17—ill.]

Annibale Carracci, 1560–1609, **Ludovico Carracci**, 1555–1619, and **Agostino Carracci**, 1557–1602. 7 termini, depicting Mercury, Venus, Bacchus, Cupid, Vulcan, Saturn, and Rhea, part of "Story of Jason" fresco cycle. c.**1583–84**. Sala di Giasone, Palazzo Fava (now Hotel Majestic-Baglioni), Bologna. [Malafarina 1976, no. 15—ill. / Ostrow 1966, no. I/5]

Luca Cambiaso, 1527–**1585**. Series of frescoes for Palazzo Giovanni Battista Grimaldi, Genoa, representing mythological and historical figures, including Diana, Venus, Mars, Atalanta, Juno, Apollo, Mercury, tritons, fauns. Detached. Some now destroyed. Palazzo Bianco, Genoa. [Manning & Suida 1958, pp. 71f.—ill.]

Jan van der Straet, 1523–1605. "Feast of the Gods." Painting. **1586–87**. Kunsthistorisches Museum, Vienna. [de Bosque 1985, pp. 116f.—ill.]

Jo M. (unknown author). *Philippes Venus: Wherein is pleasantly discoursed sundrye fine and wittie arguments in a senode of the gods and goddesses assembled for the expelling of wanton Venus from among their sacred societie* (London: **1591**). [Bush 1963, p. 320]

Abraham Fraunce, fl. 1587–1633. *The Third Part of the Countess of Pembrokes Yvychurch, Entitled Amintas Dale: The Most Conceited Tales of the Pagan Gods.* Poem. London: **1592**. [Cambridge 1969–77, 1:2053]

Hendrik Goltzius, 1558–1617. "Eight Deities" (Saturn, Neptune, Pluto, Vulcan, Sol, Jupiter, Bacchus, Mercury). Series of engravings, after (lost) chiaroscuro frescoes by Polidoro da Caravaggio (*c.*1498–1543). **1592**. 4 states. [Strauss 1977a, nos. 289–96—ill. / Bartsch 1980–82, nos. 249–56—ill.]

————. Series of drawings, compositions for "Seven Planets" series of prints, depicting Saturn, Jupiter, Mars, Sol (Apollo), Venus, Mercury, and Luna (Diana). 1595–96. 4 drawings (Saturn, Jupiter, Mars, Mercury) survive. Rijksprentenkabinet, Amsterdam (2); Prentenkabinet, Rijksuniversiteit, Leiden (2). (Engraved by Jan Saenredam, Bartsch nos. 73–79.) [Reznicek 1961, nos. 143–46—ill.] Variants, for second ("small") series, 1597. Original drawings unlocated. (Engraved by Jacob Matham, Bartsch nos. 149–155.) [Ibid., nos. 147–153]

John Lyly, *c.*1554–1606. (Saturn, Jupiter, Mars, Sol, Venus, Mercury, Luna, Juno, as the Seven Planets, in) *The Woman in the Moone.* Comedy. *c.*1591–93. Published London: 1597. [Bond 1902, vol. 3]

Paolo Fiammingo, 1540–**1596**. "The Feast of the Gods." Painting. National Gallery of Ireland, Dublin, no. 1834. [Dublin 1981, p. 50—ill.]

Abraham Bloemaert, 1564–1651. "Banquet of the Gods" (formerly called "The Marriage of Peleus and Thetis"). Painting. **1598**. Mauritshuis, The Hague, inv. 1046. [Mauritshuis 1985, p. 340—ill. / de Bosque 1985, p. 214—ill.]

————. "Feast of the Gods." Drawing. 1603. Städelsches Kunstinstitut, Frankfurt. [de Bosque, pp. 216, 219—ill.]

————. "Feast of the Gods." Painting. Schlossmuseum, Aschaffenburg. [Delbanco 1928, no. I.7 / de Bosque, pp. 98f.—ill.] Copy (French School, 18th century). Stadtsgalerie, Stuttgart. [Delbanco]

Antoine Caron, 1520/21–1599. (Janus, Apollo, Mercury, Minerva, Vulcan in) "Triumph of Winter." Painting. Private coll., Paris. [Paris 1972, no. 35—ill.]

Edmund Spenser, 1552?–**1599**. (Mutability attempts to overthrow the gods, debates with Cynthia [Diana], Mercury, Venus, Phoebus, Mars, Saturn, and Jove, in) *The Faerie Queene* 7, cantos 6–7. Romance epic. London: Ponsonbie, 1609. [Hamilton 1977 / MacCaffrey 1976, pp. 427f.]

Hans von Aachen, 1552–1616. (Jupiter abandons Venus and loves Minerva, to) "The Amazement of the Gods." Painting. **1590s?** National Gallery, London, inv. 6475. [London 1986, p. 1—ill.]

French School. "The Court of Henri II as Olympus." Ceiling fresco. **16th century.** Château de Tanlay. [McGowan 1985, p. 34, pls. 11–12]

Spanish School. "Banquet of the Gods." Ceiling painting. **Early 1600s.** Casa de Pilatos, Seville. [López Torrijos 1985, pp. 112ff., 405 no. 3—ill.]

Ben Jonson, 1572–1637. (Julia, daughter of Augustus Cae-

sar, and her friends portray the gods in) *The Poetaster, or, His Arraignment* act 4. Satirical comedy. First performed **1600–01**, Blackfriars Theatre, London. Published London: 1601. [Herford & Simpson 1932–50, vol. 4 / McGraw-Hill 1984, 3:109, 112]

————. (Hercules, Phoebus, Bacchus, Pallas, Mars, Venus, Cupid, Hermes disdained as subjects for poet in) "And must I sing?" Poem. First published in Robert Chester's *Love's Martyr* (London: 1601). / Reprinted as no. 10 of *The Forrest,* in *Works* (London: 1616). [Herford & Simpson, vol. 8]

Spanish School. "Assembly of Gods." Ceiling painting, for Casa de Arguijo, Seville. **1601**. Delegación del Ministerio de Educación y Ciencia, Seville. [López Torrijos 1985, p. 405 no. 1—ill.]

Peter Paul Rubens, 1577–1640. "The Assembly of Gods on Olympus." Painting. **1602**. Hradsin Castle, Prague. [Jaffé 1989, no. 26—ill. / Baudouin 1977, fig. 29]

————. Numerous gods and goddesses depicted in cycle of 21 paintings (including "Council of the Gods"), illustrating the life of Marie de' Medici, for Palais de Luxembourg. 1622–25. Louvre, Paris, inv. 1769–92. [Saward 1982, passim—ill. / Jaffé, nos. 702–55—ill. / also Louvre 1979–86, 1:115–18—ill. / White 1987, pls. 185–90 / Baudouin, pp. 97ff.—ill.] Oil sketches. Alte Pinakothek, Munich, inv. 92–108. [Munich 1983, pp. 463ff.—ill. / Jaffé—ill. / Held 1980, nos. 56–79—ill.]

————. Designs for set of 12 painted cut-outs of the *dii consentes,* part of Portico of the Emperors, decoration for triumphal entry of Cardinal-Infante Ferdinand of Spain into Antwerp, 17 Apr 1635. Original decoration destroyed. / Etchings by Theodoor van Thulden. [Martin 1972, no. 21, figs. 38–43—ill.]

Samuel Daniel, 1562–1619. *The Vision of the Twelve Goddesses.* Masque. First performed 8 Jan **1604**, Hampton Court Palace. Published London: Waterson, 1604. [DLB 1987, 62:30, 34]

Eckbert Wolff. "Portal of the Gods." Sculpture. **1605**. Golden Hall, Buckeburg. [Clapp 1970, 1:913]

Jan Brueghel the Elder, 1568–1625, landscape, and **Hendrik van Balen,** 1575–1632, attributed, figures (figures previously attributed to Johann Rottenhammer). "Feast of the Gods." Painting. **1607–08**. Statens Museum for Kunst, Copenhagen. [Ertz 1979, no. 170—ill. / Copenhagen 1951, no. 24—ill.] Replica, by van Balen and (attributed) Brueghel. Copenhagen. [Copenhagen, no. 23]

———— and van Balen. "Feast of the Gods." Painting. After 1610. Faste Galleri, Tronheim, inv. 554. [Ertz, no. 231—ill.]

———— and van Balen. "Feast of the Gods." Painting. *c.*1618. Musée des Beaux-Arts, Angers, inv. 358. [Ibid., no. 343—ill. / de Bosque 1985, pp. 72, 216, 220 (as van Balen and Jan van Kessel the Elder)]

———— and van Balen. "Feast of the Gods." Painting. *c.*1618. Formerly Kavan coll., Berlin, unlocated. [Ertz, no. 344]

———— and van Balen. "Feast of the Gods." Painting. *c.*1618. J. B. Speed Art Museum, Louisville, inv. 67.24. [Ibid., no. 346—ill.]

———— (or Jan Breughel the Younger) and van Balen. "Feast of the Gods" ("Wedding Banquet of Peleus and

Thetis"). Painting. *c.*1618 or *c.*1625–30. Louvre, Paris, no. D.L. 1973–21, on deposit from Fondation de France. [Louvre 1979–86, 1:164—ill. / also Ertz, no. 345] / Ertz 1984, no. 249 (as Breughel the Younger)—ill.]

——— and van Balen. "Feast of the Gods." Painting. *c.*1620. Alte Pinakothek, Munich, inv. 848. [Ertz, 1979, no. 359—ill.] Replica. Landweer coll., Los Angeles, in 1963 (ex-Gemäldegalerie, Dresden). [Ibid., no. 360]

——— (Breughel, follower) and van Balen. "Feast of the Gods." Painting. Museum der Bildenden Künste, Leipzig. [Ibid., fig. 486]

——— (van Balen). "Feast of the Gods." Painting. Private coll., Brussels. [de Bosque, p. 216—ill.]

——— (van Balen). "Feast of the Gods." Painting. Musée, Aix. [Bénézit 1976, 1:401]

Alessandro Vittoria, 1525–**1608.** "Feast of the Gods." Bronze plaque. Cleveland Art Museum, Ohio, inv. 52.464. [Clapp 1970, 1:895]

Thomas Heywood, 1573/74–**1641.** (Numerous gods and goddesses in) *Troia Britanica: or, Great Britaines Troy.* Epic poem, compendium of mythology and legend. London: **1609.** [Heywood 1974]

———. (Numerous gods and goddesses in) *The Golden Age, The Silver Age, The Brazen Age, The Iron Age* (in 2 parts). Cycle of plays, dramatizations of *Troia Britannica* (and other works?). First performed *c.*1610–13. Published London: Okes, 1611; 1613; 1613; 1632. [Heywood 1874, vol. 3 / DLB 1987, 62:101, 122ff. / also Clark 1931, pp. 62ff. / also Boas 1950, pp. 83ff.]

Bartholomeus Spranger, 1546–**1611.** "Banquet of the Gods." Drawing. Louvre, Paris. [de Bosque 1985, pp. 216, 218—ill.]

Giovanni da San Giovanni, 1592–1636. (Mars, Pallas, Mercury, Apollo, Flora, and the Graces in) "Allegory of Florence." Fresco, for a house in Piazza della Calza, Florence. **1616.** Detached fragments in possession of Soprintendenza degli Uffizi, Florence. Drawings in Gabinetto Disegni e Stampe, Uffizi, Florence, nos. 1122 F, 2376 S; Kunstmuseum, Dusseldorf, no. F. p. 357; Hermitage, Leningrad, no. 1064. [Banti 1977, no. 1—ill.]

Cornelis Cornelisz van Haarlem, 1562–1638. "Feast of the Gods." Painting. **1623.** Neues Palais Potsdam, no. 102. [Fitzwilliam 1960–77, 1:24]

Palma Giovane, 1548–**1628.** (Olympian gods observe) "The Creation of the World." Painting. Palazzo Ducale, Mirandola, Modena, in 1648, untraced. [Mason Rinaldi 1984, p. 178]

Frans Francken II, 1581–1642. "Feast of the Gods." Painting. *c.*1625–30. Alte Pinakothek, Munich, inv. 5967. [Härting 1983, no. A223]

———. "Feast of the Gods." Painting. Before 1630. Private coll., Madrid. [Härting, no. A220—ill.] Variant. Private coll., Mainz. [Ibid., no. A221—ill.] Reverse variant (with Abraham Govaerts?). Muzeum Narodowe, Warsaw, inv. 131491 (as Francken and Govaerts). [Warsaw 1969, no. 425—ill. / also Härting, no. A219]

——— (Francken). "Feast of the Gods." Painting. Museum Bruckenthal, Sibiu, cat. 1901 no. 391. [Härting, no. B220]

——— and **Joos de Momper,** 1564–1635, questionably attributed (or Hendrik van Balen and Lucas van Uden?).

"Feast of the Gods" ("The Banquet of Achelous"?). Painting. Mauritshuis, The Hague, inv. 235 (as Flemish School, previously attributed to de Momper and van Balen). [Härting, no. B222 / Mauritshuis 1985, p. 476—ill. / also de Bosque 1985, pp. 216, 220—ill.]

Cornelis van Poelenburgh, *c.*1586–1667. "Feast of the Gods." Painting. Probably *c.*1630. Mauritshuis, The Hague, inv. 1065. [Mauritshuis 1985, pp. 244, 418f.—ill.]

———. "A Gathering of Gods." Painting. Statens Museum for Kunst, Copenhagen. [Copenhagen 1951, no. 550—ill.]

———. "Feast of the Gods." Painting. Herzog Anton Ulrich-Museum, Braunschweig, no. 786. [Braunschweig 1969, p. 108]

———. "Feast of the Gods." Painting. Wadsworth Atheneum, Hartford. [Lowenthal 1986, p. 65 *n.*19]

———. "The Gods on Olympus." Painting. Staatliche Kunstsammlungen, Kassel. [Bénézit 1976, 8:392]

Abraham Janssens, *c.*1575–**1632.** "Olympus" (Jupiter, Juno, Minerva, Diana, Venus, Cupid, and other gods). Painting. Alte Pinakothek, Munich, inv. 4884. [Munich 1983, p. 262—ill. / de Bosque 1985, pp. 130f.—ill.]

Simon Vouet, 1590–1649. "Assembly of the Gods," "France Asking the Gods for a Minister." Decorations for gallery of Hôtel Séguier, Paris. **1633–38.** Lost. / Engraved by Michel Dorigny, 1651. [Crelly 1962, pp. 112ff., nos. 247, 248A—ill.]

Georges de Scudéry, 1601–1667. *Le cabinet de M. de Scudéry.* Versified guide to an "ideal collection" of poems about pictures of mythological lovers. Paris: Edition de Paris, **1646.** [Borowitz 1985, pp. 49f.]

Gerard Seghers, 1591–**1651.** "Feast of the Gods." Painting. Herzog Anton Ulrich-Museum, Braunschweig, no. 113. [Braunschweig 1969, p. 123—ill.]

Cornelis Schut, 1597–**1655.** (Classical deities in) "Allegory of Peace." Painting. Musées Royaux des Beaux-Arts (Musée d'Art Ancien), Brussels, inv. 4985. [Brussels 1984a, p. 270—ill.]

Nicolas Poussin, 1594–**1665,** attributed. "Feast of the Gods." Painting. National Gallery of Scotland, Edinburgh, cat. 1970 no. 458. [Wright 1976, p. 165]

Jakob Balde, 1604–**1668.** (Death of the classical gods lamented in) Neo-Latin poem. / Translated by Johann Gottfried Herder as *Die Ruinen* [The Ruins] (1796). See *Herder, below.*

Jean Nocret, 1615–1672. (Louis XIV and family as Olympians in) "Allegorical Portrait of the Royal Family." Painting. **1670.** Salle de l'Oeil de Boeuf, Château de Versailles. [Versailles 1949, pp. 12ff.—ill.]

Charles Le Brun, 1619–1690. (Minerva, Mars and other Olympian deities represent the king's virtues in) "The King Governs by Himself." Ceiling painting. **1678–79.** Galerie des Glaces, Château de Versailles. [Berger 1985, p. 54, figs. 94–95]

———. (Mars and Minerva in) "The Decision Taken to Make War on Holland, 1671," (Mars, Vulcan, Ceres, Neptune, Apollo, Mercury, Minerva in) "The King Armed on Land and Sea, 1672," (Louis XIV as Jupiter, with Minerva and Mars, in) "The Taking of the City and Citadel of Ghent in 6 Days, 1678," (Mars, Hercules, Minerva in) "The Conquest of La Franche-Comté, 1674."

Paintings, sketches for decoration of Grand Galerie, Versailles, celebrating the Treaty of Nejmegen in 1678. 1679–84. Musée des Beaux-Arts, Auxerre (2); Musée des Beaux-Arts, Troyes; Musée National de Versailles. [Versailles 1963, nos. 36–38, 40—ill.]

Luca Giordano, 1634–1705. (Gods and goddesses in) "Allegory of Human Life and the Medici Dynasty." Fresco. **1682–83.** Palazzo Medici Riccardi, Florence. [Ferrari & Scavezzi 1966, 2:112ff.—ill.] Study. Denis Mahon coll., London. [Ibid.—ill.]

Claude Oudot, ?–1696. *Le banquet des dieux* [The Banquet of the Gods]. Cantata. First performed **1683,** Paris. [Grove 1980, 14:29]

Sebastiano Ricci, 1659–1734. "The Favor of the Gods" (on the marriage of Odoardo Farnese and Dorothea Sophia Pfalz-Neuburg). Painting, curtain design for musical celebration. **1690.** Destroyed. / Engraved by Carlo Virginio Drago. [Daniels 1976, no. 334—ill.]

———. "The Olympian Gods." Cycle of 9 ceiling frescoes (detached), from Palazzo Mocenigo-Robilant, Venice: "Cupid Received by Jupiter and Juno," "Mercury," "Venus and Cupid," "Saturn," "Pluto," "Minerva," "Diana," "Apollo," and "Mars." 1697–99. Gemäldegalerie, Berlin-Dahlem, on loan from German government. [Daniels, nos. 43–51—ill. / Berlin 1986, p. 64—ill.]

Edward Ward, 1667–1731, *The Revels of the Gods; or, A Ramble Thro' the Heavens.* Burlesque. Published London: **1701.** [Bush 1937, p. 541]

Guillaume Louis Pécour, 1653–1729, choreography. *Les festes des dieux, ou, L'origine des ballets* [The Feasts of the Gods, or, The Origin of Ballets]. Ballet. First performed **1706,** with the tragedy *Adonias,* Collège Louis-le-Grand, Paris. [Astier 1983, p. 155]

Noël Coypel, 1628–1707, design. "Triumphs of the Gods" (Apollo, Athena, Ares, Dionysus). Tapestry series. Woven by Gobelins, 1705–13. Examples in Mobilier National, Paris; Palazzo Pitti, Florence; French Academy, Rome. [Warburg] Cartoons (fragments) in Louvre, Paris, inv. 3482, 3484, 3485, 3489. [Louvre 1979–86, 3:174—ill.]

Antonio Verrio, c.1639–1707. "An Assembly of the Gods." Painting, sketch for a ceiling decoration. Tate Gallery, London, no. T.916. [Tate 1975, p. 88 / Wright 1976, p. 214]

Ignaz Elhafen, 1658–1715, attributed. "Assembly of the Gods." Wood relief. Kunsthistorisches Museum, Vienna, inv. 4172. [Zimmer 1971, no. A21.0.4.4]

François Le Moyne, 1688–1737. "Olympus" (or "Triumph of Venus"?). Painting, sketch for an unexecuted ceiling decoration. c.1718–19. Louvre, Paris, inv. 6718. [Bordeaux 1984, no. 22—ill. / also Louvre 1979–86, 4:47—ill.] Replica. Rochelmayer coll., Mainz. [Bordeaux, fig. 18a]

———. (Jupiter and Juno, Neptune, Mercury, and Aeolus in) "Allegory of Trade and Good Government." Painting, study for unexecuted ceiling decoration for Banque Royale. 1719. Musée des Arts Décoratifs, Paris, inv. 18096. [Bordeaux, no. 21—ill.]

William Hogarth, 1697–1764. 6 etchings, illustrations for King's *Pantheon*: Coelus and Terra, Saturn and Cybele, Jupiter and Juno, Neptune and Amphitrite; Pluto and Proserpina, Apollo and the Muses, Diana and her Nymphs, Vulcan and the Cyclopes; Venus and her attendants, Mercury, Minerva, Mars and his attendants; Bacchus and his attendants, Hercules, Pan and his attendants, Flora; Pomona and Vertumnus, Nereus, Castor and Pollux, Aeolus; Charon and Cerberus, the Parcae, Minos, Radamanthys, and Aeacus, the Eumenides. Published in 2d edition, London: Lintott, **1721**? [Paulson 1965, nos. 12–17—ill.]

———. "Strolling Actresses Dressing in a Barn" (as mythological characters in a fictitious play, *The Devil to Pay in Heaven*). Satirical painting. Lost. / Etching and engraving. 4 states. 1738. [Ibid., no. 156—ill. / also Paulson 1971, 1:395—ill.]

Antoine Coypel, 1661–1722. "The Gods of Olympus." Painting. Szépművészeti Múzeum, Budapest, no. 710. [Budapest 1968, p. 160—ill.] Sketches. Musée des Beaux-Arts, Angers. [Ibid.—ill.]

Louis Chéron, 1660–1725. "The Assembly of the Gods." Painting. Boughton House, Kettering, Northamptonshire. [Bénézit 1976, 1:714]

Jean-Baptiste Maurice Quinault, 1687–1745, music. *Les amours des déesses* [Loves of the Goddesses]. Ballet-héroïque. Libretto, Fuzelier. First performed 9 Aug **1729,** L'Opéra, Paris. [Grove 1980, 15:507]

Jonathan Swift, 1667–1745. (Evocations of Olympians, especially Jupiter, Mars, Apollo, Neptune, and Venus, and other classical allusions satirized in) "Directions for a Birth-day Song." Poem. 1729. In *Works* (London: 1765). [Williams 1958, vol. 2]

———. (Hymen, Venus, Muses, Apollo, Mercury, Hebe, Mars, Juno attend wedding of) "Strephon and Chloë." Poem. 1731. First printed as a pamphlet, 1734; collected in *Works* (Dublin: Faulkner, 1735). [Ibid.]

———. (Olympian gods, especially Jupiter, Mercury, Apollo, Venus, Juno, seen as lower and less mobile than clouds, in) "An Answer to a Scandalous Poem." Poem (reply to Thomas Sheridan's "A New Simile for the Ladies," comparing them to clouds). 1732. First printed as a pamphlet, 1733; collected in *Works*, revised edition (Dublin: Faulkner, 1738). [Ibid.]

Charles-Joseph Natoire, 1700–1777. "Story of the Gods." Painting cycle, for Château de La Chapelle-Godefroy, Champagne. c.1731. [Troyes 1977, pp. 54f. / Boyer 1949, nos. 33–42]

Claudio Francesco Beaumont, 1694–1766. Olympians look down on scenes from the *Aeneid,* in one of "Aeneid" cycle of paintings. c.1740. Armory, Royal Palace, Turin. [Llewellyn 1984, p. 121]

Giovanni Battista Tiepolo, 1696–1770. "The Course of the (Chariot of the) Sun (on Olympus)." Fresco. **1740.** Palazzo Clerici, Milan. [Levey 1986, pp. 91ff.—ill. / Pallucchini 1968, no. 132—ill. / Morassi 1962, p. 25] Related sketch ("Olympus"). Hausammann coll., Zurich. [Morassi, p. 69—ill.]

———. "Apollo and the Continents" ("Olympus, with the Quarters of the Earth," "Allegory of the Planets and Continents"). Fresco. 1753. Grand Staircase, Residenz, Würzburg. [Levey, pp. 191ff.—ill. / Pallucchini, no. 199—ill. / Morassi, p. 68] Oil sketch, 1752. Metropolitan Museum, New York, no. 1977.1.3. [Metropolitan 1983, p. 129—ill. / also Levey, pl. 176 / Pallucchini—ill.]

———. Fresco cycle depicting Olympian gods. 1757. Sala

dell' Olimpo, Villa Valmarana, Vicenza. [Pallucchini, no. 240—ill. / Morassi, p. 65]

————. "The Apotheosis (Triumph) of Spain." Ceiling fresco. 1764. Throne room, Palacio Real, Madrid. [Levey, pp. 261f., pls. 218–20 / Pallucchini, no. 279A—ill. / Morassi, p. 33] Modello. National Gallery, Washington, D.C., no. 540. [Levey, pp. 255ff.—ill. / Morassi, p. 67]

————. "Apotheosis (Glorification) of the Spanish Monarchy." Ceiling fresco. 1762–66. "Saleta," Palacio Real, Madrid. [Pallucchini, no. 279D—ill. / Morassi, p. 33 / Levey, p. 265—ill.] Sketches. Kress coll. (K1281), Metropolitan Museum, New York; Wrightsman coll., New York; Marzotto coll., Portogruaro (by Giandomenico Tiepolo, wrongly attributed to Giambattista). [Morassi, pp. 33, 37, 45—ill. / also Shapley 1966–73, 3:150f.—ill.]

————. "Triumph of Venus" ("Olympus") (Venus in her chariot, surrounded by Jupiter, Juno, Diana, Mercury, Minerva, Saturn). Fresco, for Imperial Court, St. Petersburg. c.1762–70. Lost. / Sketch. Prado, Madrid, no. 365. [Pallucchini, no. 281—ill. / Morassi, p. 21—ill. / Prado 1985, p. 680]

————, rejected attribution. "Olympus." Painting. Musée des Beaux-Arts, Nice. [Morassi, p. 37]

Bartolomeo Altomonte, 1702–1779. (Minerva, Diana, Mars, Venus, and Perseus in) "Apotheosis of Leopold Christoph von Schallenberg." Painting, from design by Daniel Gran. c.1746. Schloss Rosenau, Zwettl, Austria. [Knab 1977, pp. 112f., no. Ö71A—ill.] Oil sketch. Schloss Rosenau. [Ibid., no. Ö71B]

Corrado Giaquinto, 1703–1765. (Jupiter and Juno, Venus and Cupid, Minerva, Bacchus in) "Apotheosis of the Spanish Monarchy" (?). Ceiling painting, for Palazzo Santa Croce, Palermo. Now in Palazzo Rondinini-Sanseverino, Rome. c.1751? / Study. National Gallery, London, inv. 6229. [London 1986, p. 232—ill.]

————. "Triumph of the Sun God Apollo and Bacchus" (with Aurora, Ceres, Venus, Diana, Pan, and others). Ceiling painting. Mid-1700s. Salón de Columnas, Palacio Real, Madrid. [Honisch 1965, pp. 39f.]

————. (Apollo, Bacchus, Juno, Diana, Venus in) "The Birth of the Sun and the Triumph of Bacchus." Painting. Prado, Madrid, inv. 103. [Prado 1985, p. 243]

Daniel Gran, 1694–1757. "Gods on Olympus." Painting, project for a ceiling. Muzeum Narodowe, Warsaw, inv. 182032. [Warsaw 1969, no. 443—ill.]

François-Gaspard Adam, 1710–1761. 12 statues, on pedestals with bas-reliefs, representing Diana bathing, Vulcan forging arms for Venus, Juno with the peacock, Jupiter with a goat, Cybele showing Triptolemus how to plow, Mars in a rage, Minerva armed, Apollo seated on Python, and others. **1755–58**. Gardens, Sanssouci, Potsdam. [Thirion 1885, pp. 161f.—ill.]

Augustin Pajou, 1730–1809. Series of wood bas-reliefs depicting the 12 Olympians. **1769–70**. Salle de l'Opéra, Versailles. [Stein 1912, pp. 177f., 402]

Johann Gottfried Herder, 1744–1803. (Olympian gods and other classical figures evoked in) "An seinen Landsmann Johann Winckelmann" [To His Compatriot Johann Winckelmann]. Poem. **1770**. In *Gedichte* book 3, in *Sämmtliche Werke* (Tübingen: Cotta, 1805–20). [Herder 1852–54, vol. 13]

————. "Paramythien." Poem. 1785. [Ibid., vol. 15]

————. (Death of the classical gods lamented in) *Die Ruinen* [The Ruins]. Poem, translation from Jakob Balde (1604–1668). Part 5 of *Terpsichore* (Lübeck: Bohn, 1796). [Ibid., vol. 17]

Friedrich von Schiller, 1759–1805. (Gods evoked in) "Der Triumf der Liebe, eine Hymne" [The Triumph of Love, a Hymn]. Poem. In *Anthologie auf das Jahr 1782* (Stuttgart: Metzler, **1782**). [Petersen & Beissner 1943]

————. "Die Götter Griechenlands" [The Gods of Greece]. Poem. 1787. In *Der teutsche Merkur* Mar 1788. [Petersen & Beissner / Jenkyns 1980, pp. 175–77 / Butler 1958, pp. 165–68, 294f.]

————. (Gods evoked in) "Das Reich der Schatten" ("Das Reich der Formen") [The Kingdom of the Shades (Forms)]. Poem. 1795. In *Die Horen: Eine Monatsschrift 1795–1796* (Tübingen: Cotta, 1796). [Petersen & Beissner] Revised as "Das Ideal und das Leben" [The Ideal and Life]). In *Sämtliche Werke: Gedichte* (1804). [Oellers 1983]

————. "Der Besuch" [The Visit (of the gods)]. Poem (dithyramb). In *Musenalmanach für das Jahr 1797* (Tübingen: Cotta, 1797). [Petersen & Beissner]

Charles Le Picq, 1744–1806, choreography. *Il convito degli dei* [Assembly of the Gods]. Ballet. Music, François-Hippolyte Barthélemon. First performed 12 Feb **1785**, King's Theatre, London. [Guest 1972, p. 150]

Friedrich Hölderlin, 1770–1843. (Gods evoked in) "Hymne an den Genius Griechenlands" [Hymn to the Genius of Greece]. Poem. Late **1790**. In *Hölderlins gesammelte Dichtungen* (Stuttgart: 1896). [Beissner 1943–77, vol. 1]

————. (Olympians evoked in) *Der Archipelagus* [The Archipelago]. Elegy in classical hexameters. 1800. Stuttgart: 1801. [Beissner 1943–77, vol. 2 / Hamburger 1980 / Butler 1958, pp. 222, 229 / Oxford 1986, p. 34]

————. (Gods in) "Brot und Wein" [Bread and Wine]. Elegy. 1800–01. In *Musenalmanach für das Jahr 1807*. [Beissner, vol. 2 / Hamburger / Oxford, p. 116 / Closs 1957, pp. 131f.]

————. "Die Götter" [The Gods]. Ode. 1798–1803. [Beissner / Hamburger]

————. (Gods evoked in) "Griechenland" [Greece]. Hymn. 3 versions 1800–05? In *Hymnische Bruchstücke aus der Spätzeit* (Hannover: 1920). [Beissner / Hamburger]

Christoph Martin Wieland, 1733–1813. *Neue Göttergespräche* [New Dialogues of the Gods]. Political dialogues. Leipzig: Göschen, **1791**. [Radspieler 1984, vol. 8 / EW 1983–85, 4:600]

Luigi Cherubini, 1760–1842. *Hymne au Panthéon*. Composition for 3 voices and orchestra. Text, J. Chénier. **1794**. [Grove 1980, 4:211]

John O'Keefe, 1747–1833, music. *Olympus in an Uproar; or, The Descent of the Deities*. Burletta. Libretto, Kane O'Hara. First performed 5 Nov **1796**, Covent Garden, London. [Nicoll 1959–66, 3:295]

Evariste-Désiré de Forges Parny, 1753–1814. *La guerre des dieux anciens et modernes* [The War of the Ancient and Modern Gods]. Satire in verse. **1795–99**. Paris: Debray, 1804. [DLLF 1984, 3:1694]

Novalis (Friedrich Leopold von Hardenberg), 1772–1801. Hymn no. 5. Poem, refutation of Schiller's "Götter Griechenlands" (1787). **1799**. In *Schriften*, edited by Lud-

wig Tieck and Friedrich Schlegel (Berlin: 1802). [EW 1983–85, 5:222]

Roman (?) School. "An Assembly of the Gods." Painting. **18th century.** Christ Church, Oxford. [Byam Shaw 1967, no. 155]

German School. "Feast of the Gods." Painting. **18th century.** Herzog Anton Ulrich-Museum, Braunschweig, no. 1654. [Braunschweig 1976, p. 22]

Paul Wranitzky, 1756–1808. *Das Picknick der Götter* [The Picnic of the Gods]. Musical divertissement. First performed 12 Feb **1804,** Schönbrunn, Vienna. [Grove 1980, 20:539]

Lord Byron, 1788–1824. (Passing of the classical gods lamented in) *Childe Harold's Pilgrimage* 2.53, 85–88. Poem. London: Murray, **1812.** [McGann 1980–86, vol. 2 / Jenkyns 1980, p. 177]

William Wordsworth, 1770–1850. (Grecian gods evoked in) *The Excursion* 4.717–62, 847–87. Poem. Begun by 1806. London: Longman & Co., **1814.** [De Selincourt 1940–66, vol. 5 / Bush 1937, p. 60]

Andrea Appiani the Elder, 1754–1817. "The Gods of Olympus." Painting. Château de Compiègne. [Bénézit 1976, 1:236]

Samuel Taylor Coleridge, 1772–1834. "The Visit of the Gods." Poem, after Schiller's "Der Besuch" (1797). In *Sibylline Leaves* (London: Rest Fenner, **1817**). In modern edition by Ernest Hartley Coleridge, *Poems* (London: Oxford University Press, 1924). [Bush 1937, p. 55 *n.*]

Franz Schubert, 1797–1828. "Strophe aus die Götter Griechenlands." Lied. Text, Schiller (1787). 2 versions. Nov **1819.** [Grove 1980, 16:798]

Laurent Pécheux, 1729–**1821.** "Council of the Gods." Painting. Galleria Borghese, Rome. [Bénézit 1976, 8:18]

Peter Cornelius, 1783–1867, and studio. "Olympus" ("Kingdom of Zeus"). Fresco. **1820–26.** Göttersaal, Glyptothek, Munich. [Glyptothek 1980, pp. 214ff., no. 261—ill.]

Heinrich Heine, 1797–1856. (Poet sees Olympians in visions in) *Die Nordsee* [The North Sea] passim. Cycle of poems (including "Die Götter Griechenlands" [The Gods of Greece], answer to Schiller's poem of 1787). **1824–26.** In *Reisebilder,* vols. 1 & 2 (Hamburg: Hoffmann & Campe, 1826–27). [Windfuhr 1975–82, vol. 1, pts. 1 & 2 / Draper 1982 / Sandor 1967, pp. 46, 60f. / Butler 1958, pp. 254–58, 309]

Merry-Joseph Blondel, 1781–1853. Mars and Neptune, Vulcan and Hercules, Silence and Apollo, Mercury and Constance, holding the arms of France, in ceiling decoration, Salle de la Donation Comondo (2e Salle du Conseil d'État), Louvre, Paris (inv. 2628). **1827.** [Louvre 1979–86, 3:65—ill.]

Antonio Fedi, 1771–1843. Ceiling fresco, depicting Justice with Mercury, Jupiter, Juno, and other gods. Sala della Giustizia, Palazzo Pitti, Florence. [Pitti 1966, p. 113]

George Frederick Watts, 1817–1904. "Olympus." Painting. **1849.** Watts Gallery, Compton, Surrey. [Watts 1970, no. 102]

Charles Marie René Leconte de Lisle, 1818–1894. (Zeus, Athena, Aphrodite, Apollo, Artemis, and Leto, evoked as supplanting the earliest gods, Cronos, Uranus, Aether, in) "Niobe" lines 131–267. Poem. In *Oeuvres: Poèmes*

antiques (Paris: Lemerre, **1852**). [Pich 1976–81, vol. 1 / Denommé 1973, p. 83]

———. "La paix des dieux" [The Peace of the Gods]. Poem. In *Oeuvres: Derniers poèmes* (Paris: Lemerre, **1895**). [Pich, vol. 3 / Denommé, pp. 111f.]

Honoré Daumier, 1808–1879. Cycle of 17 drawings, caricatures of mythological figures. **1853.** "Apollo," Suzanne Bollag coll., Zurich. "Hercules," Burrell coll., Glasgow City Corporation. "Jupiter," Hottinger coll., Basel. "Minerva," private coll., Paris (another unlocated). "Cupid," "Apollo," "Bacchus," "Diana," "Juno" (3), "Mars," "Mercury," "Neptune," "Pluto," "Vulcan," all unlocated. [Maison 1968, no. 452–469—ill.]

Eugène Delacroix, 1798–1863. Olympian gods in cycle of ceiling paintings, Salon de la Paix, Hôtel de Ville, Paris. "The Triumph of Peace" (central decoration) and 8 separate coffers. **1852–54.** Destroyed by fire 1871. [Huyghe 1963, pp. 406f., 423 / Robaut 1885, no. 1143—ill. (copy drawing)]

Arnold Böcklin, 1827–1901. "The Gods of Greece." 2 paintings, "free paraphrase" of Schiller's poem (1787). **1859,** 1866. Both lost. [Andree 1977, nos. 123–24—ill.]

Victor Hugo, 1802–1885. (Gods in) "Le satyre." Poem, prologue to *La légende des siècles* (1st series) part 8, "Renaissance Paganisme." Paris: Hetzel, **1859.** [Hugo 1985–86, vol. 5]

Louis Matout, 1811–1888. "The Assembly of the Gods." Ceiling painting. **1868.** Salle du Bas-Empire (Auguste), Louvre, Paris (inv. 20109). [Louvre 1979–86, 4:74—ill.]

William Bouguereau, 1825–1905. "Apollo and the Muses" (Apollo descending from his chariot with his lyre, about to play to the gods). Ceiling painting. **1868–69.** Grand Théâtre, Bourdeaux. [Montreal 1984, pp. 63, 172f.] Oil sketch. 1866–67. Private coll. [Ibid., no. 42—ill.]

Arthur Rimbaud, 1854–1891. (Pagan gods evoked in) "Soleil et chair" [Sun and Flesh]. Poem. May **1870.** Published with *Le reliquaire* (Paris: Genonceaux, 1891). [Adam 1972 / Fowlie 1966]

Arthur Sullivan, 1842–1900. (Jupiter, Apollo, Diana, Mars, Mercury in) *Thespis; or, The Gods Grown Old.* Comic operetta. Libretto, W. S. Gilbert. First performed 26 Dec **1871,** Gaiety Theatre, London. Music lost. [Jefferson 1984, pp. 23ff.]

Edward Calvert, 1799–**1883.** "Olympus." Painting. Whitworth Art Gallery, Manchester. [Bénézit 1976, 2:469]

Aubrey De Vere, 1814–1902. (Passing of the pagan gods lamented in) "Lines Written under Delphi." Poem. In *Poetical Works* (London: Kegan Paul, Trench, **1884**). [Boswell 1982, p. 84 / Bush 1937, p. 273]

Rubén Darío, 1867–1916. (Pagan gods evoked in) "Friso" [Frieze]. Poem. In *Prosas profanas y otros poemas* (Buenos Aires: Coni, **1896**). [Méndez Plancarte 1967]

Gustaf Fröding, 1860–1911. "Gundarna dansa" [The Gods Dance]. Poem. In *Stänk och flikar* [Splashes and Rags] (Stockholm: Bonnier, **1896**). [Algulin 1989, p. 147]

Max Klinger, 1857–1920. "Christ in Olympus" (Christ before Olympian gods). Painting. **1890–97.** Kunsthistorisches Museum, Vienna. [Dückers 1976, pp. 84–93, 164—ill. / also Rotterdam 1978, no. 20—ill.] Oil study. c.1893. Museum der Bildenden Kunste, Leipzig, inv. 1296. [Leipzig 1970, no. 50—ill. / also Hildesheim 1984, no. 27—ill. / Rotterdam, no. 19]

William Ernest Henley, 1849–1903. "The Gods Are Dead." Poem. In *Poems* (London: Nutt, **1898**). [Bush 1937, p. 565]

Edmund Gosse, 1849–1928. (Gods take refuge in a northern island inhabited by Lutherans, but return to Olympus in) *Hypolympia, or, The Gods in the Island.* Poetry and prose fantasy. London: Heinemann; New York: Dodd, Mead, **1901**. [Bush 1937, p. 415 / Boswell 1982, pp. 119f.]

Henri de Régnier, 1864–1936. "L'homme et les dieux" [Man and Gods]. Poem. In *La cité des eaux* (Paris: Mercure de France, **1902**). [NUC]

Valéry Bryúsov, 1873–1924. "K Olimpijtsam" [To the Olympians]. Poem, part of cycle "Pravda vechnaia kumirov" [Eternal Truth of Idols]. **1904.** In *Stephanos (Venok)* [Wreath] (Moscow: Skorpion, 1906). [Bryúsov 1982]

Stanisław Wyspiánski, 1869–1907. *Akropolis* (the gods of Greece come to life in modern Poland). Drama. Cracow: Uniw. Jag. nakladem, **1904.** [Seymour-Smith 1985, p. 1013 / Miłosz 1983, pp. 355, 357f.] First performed 1916. Published with music by B. Raczynski. [Klein et al. 1986, 2:514–17]

Carl Spitteler, 1845–1924. *Olympischer Frühling* [Olympian Spring]. Epic poem. Leipzig: Diedericks, **1900–06.** / Revised, published Jena: Diedericks, 1910. [Bush 1937, pp. 457, 535 / Highet 1967, pp. 529, 703]

Arthur Davison Ficke, 1883–1945. "The Elder Gods." Poem. In *From the Isles: A Series of Songs Out of Greece* (Norwich: Samurai, **1907**). [Boswell 1982, p. 255]

James Elroy Flecker, 1884–1915. "The Bridge of Fire" (vision of all the classical gods). Poem. In *The Bridge of Fire* (London: Mathews, **1907**). [Boswell 1982, pp. 104f.]

―――. "¿Donde estan?" [Where Are They?] (disappearance of the gods). Poem. In *Collected Poems* (London: Secker, 1916). [Jenkyns 1980, p. 174]

Ezra Pound, 1885–1972. (Pagan gods survive as shadows in) "The Return." Poem. In *Personae* (London: Mathews, **1909**; revised, expanded edition, New York: New Directions; London: Faber & Faber, 1926). [Ruthven 1969, pp. 144, 146f.] Set to music by Walter Morse Rummel, 1913. [Ibid.]

Julio Herrera y Reissig, 1875–**1910.** (Olympians evoked in) "El laurel rosa" [The Red Laurel]. Poem. In *Poesías completas* edited by G. de Torre (Buenos Aires: Editorial Losado, 1942). [Schade 1959, pp. 47f.]

Cale Young Rice, 1872–1943. "The Dead Gods." Poem. In *Song-Surf* (New York: Doubleday, Page, **1910**). [Boswell 1982, p. 210]

William Rose Benét, 1886–1950. "The Lost Gods Abiding." Poem. In *Merchants from Cathay* (New York: Appleton-Century, **1913**). [Boswell 1982, p. 37]

Paul Manship, 1885–1966. "Greek Heroes and Deities." 12 terminal figures and busts, of Theseus, Silenus, Odysseus, Hercules, Calypso, Orpheus, Hermes, others, for gardens of Harold McCormick, Lake Forest, Ill. **1914.** Unlocated. [Murtha 1957, no. 61]

Gustav Holst, 1874–1934. *The Planets.* Symphonic suite: "Mars, the Bringer of War," "Venus, the Bringer of Peace," "Mercury, the Winged Messenger," "Jupiter, the Bringer of Jollity," "Saturn, the Bringer of Old Age," "Uranus, the Magician," "Neptune, the Mystic." Opus 32. **1914–16.** First performed 29 Sep 1918, Queen's Hall, London. [Grove 1980, 8:662f., 665 / Baker 1984, p. 1043]

Richard Dehmel, 1863–**1920.** *Die Götterfamilie* [Family of the Gods]. Comedy. Berlin: Fischer, 1921. [Moore 1967, p. 10]

T. Sturge Moore, 1870–1944. *The Powers of the Air* (gods of realms bordering divine and human). Dialogue, between Socrates, Aristocles, and Parrhasios on the subject of Parrhasios's painting. London: Richards, **1920.** [DLB 1983, 19:337f. / Gwynn 1951, pp. 52, 128]

Marguerite Yourcenar, 1903–1987. *Les dieux ne sont pas morts* [The Gods Are Not Dead]. Collection of poems. Paris: Chiberre, **1922.** [Horn 1985, p. 85]

Jan Parandowski, b. 1895. *Eros na Olimpie* [Eros on Olympus]. Novel. Lublin: Altenberga, **1923.** [EWL 1981–84, 3:475]

Charles Tournemire, 1870–1939. *Les dieux sont morts* [The Gods Are Dead]. Opera. First performed **1924**, Paris. [Grove 1980, 19:95]

Dimitrios Levidis, 1885/86–1951, music and libretto. *To fylachto ton theon* [The Talisman of the Gods]. Ballet, with solo voices, chorus, and orchestra. **1925.** [Grove 1980, 10:703]

Rainer Maria Rilke, 1875–1926. "Jetzt wär es Zeit, dass Götter träten aus" [Now It Is Time That the Gods Came Walking Out]. Poem. Oct **1925.** [Zinn 1955–66, vol. 2] Translated by Michael Hamburger in *Rainer Maria Rilke: Poems 1912–1926,* bilingual edition (Redding Ridge, Conn.: Black Swan; London: Anvil, 1981). [Ipso]

Lascelles Abercrombie, 1881–1938. "The Olympians" (Apollo brings the dead Zeus to be buried on Crete as Dionysus reigns). Poem. In *Twelve Idyls and Other Poems* (London: Secker, **1928**). [Bush 1937, p. 431]

Émile-Antoine Bourdelle, 1861–1929. "Battle of the Heroes and the Gods." Bronze sculpture. **1929.** 5 casts. Private colls. [Jianou & Dufet 1975, no. 702—ill.]

Georges Braque, 1882–1963. Series of etched-plaster reliefs of mythological figures, after Hesiod: Helios, Nereids, Heracles (**1931**); Themis and Hera, Hestia, (1941); others. Mme. Félix Bastien coll; elsewhere. [Fumet 1951, introduction, nos. 21–28—ill.]

―――. 16 etchings of mythological figures, illustrating the *Theogony* of Hesiod. 1932. [Braque 1961, p. 76—ill.] 2 lithographs and 2 more etchings for second edition, 1953. [Ibid., p. 80—ill.]

Harald Lander, 1905–1971, choreography. *Gudindernes Strid* [Battle of the Goddesses]. Ballet. Music, Reesen. First performed **1933**, Royal Danish Ballet, Copenhagen. [EDS 1954–66, 6:1196]

Gottfried Benn, 1886–1956. "Olympische Hymne." Poem. **1934.** In *Primäre Tage: Gedichte und Fragmente aus dem Nachlass* (Wiesbaden: Limes, 1958). [Wellershof 1960]

―――. "Olympisch." Poem. In *Apréslude, Gedichte* (Wiesbaden: Limes, 1955). [Ibid.]

―――. "Leid der Götter" [Song of the Gods]. Poem. [Ibid.]

Alexander Lernet-Holenia, 1897–1976. *Olympische Hymne.* Poem. Vienna: **1934.** [DLL 1968–90, 9:1276]

Luis Cernuda, 1902–1963. "A las estatuas de los dioses" [To the Statues of the Gods]. Poem, part of *Invocaciones (a las gracias del mundo)* [Invocations (to the World's Graces)]. **1935.** Included in *La realidad y el deseo,* 3d edition, (Mexico City: 1958). [Flys 1984 / Jimenez-Fajardo

1978, pp. 47f.] Translated by Reginald Gibbons in *Selected Poems of Luis Cernuda*, bilingual edition (Berkeley & Los Angeles: University of California Press, 1977). [Ipso]

—————. (The pagan gods evoked in) "Las edades" [The Ages]. Poem, part of *Vivir sin estar viviendo* [Living without Being Alive]. 1944–49. [Capote 1984 / Jimenez-Fajardo, pp. 111f.]

Catherine Littlefield, 1904–1951, choreography and scenario. *Home Life of the Gods.* Ballet. Music, Erik Satie. First performed **1936**, Philadelphia; décor and costumes, Lazar Galpern. [Amberg 1949, p. 208]

Mark Rothko, 1903–1970. "Olympian Play." Abstract painting. *c.*1944. Mark Rothko Foundation, New York. [Ashton 1983, fig. 19]

Paul Valéry, 1871–**1945**. (Sea gods and goddesses addressed in) "À des divinités cachées" [To Hidden Divinities]. Poem. In *Douze poèmes* (Paris: "Bibliophiles du Palais," 1959). [Mathews 1956–71, vol. 1]

Lawrence Durrell, 1912–1990. *The Parthenon; for T. S. Eliot.* Poem. Privately printed, **1945**. [Vinson 1985, p. 214]

Hermann Buddensieg. *Hymnen an die Götter Griechenlands* [Hymns to the Grecian Gods]. Collection of poems. Hamburg: Saal, **1947**. [DLL 1968–90, 2:247 / Closs 1957, p. 214]

Cesare Pavese, 1908–1950. (The Olympians evoked in) "Le cavalle" [The Mares], "Gli dèi" [The Gods]. Dialogues. In *Dialoghi con Leucò* (Turin: Einaudi, **1947**). / Translated by William Arrowsmith and D. S. Carne-Ross in *Dialogues with Leucò,* bilingual edition (Ann Arbor: University of Michigan, 1965). [Ipso / Biasin 1968, pp. 195, 212]

Max Ernst, 1891–1976. "Feast of the Gods." Abstract painting. **1948**. Museum Moderner Kunst, Vienna, inv. 154/B. [Hofmann 1987, no. 14.30—ill. / Quinn 1977, fig. 302—ill.]

Randall Jarrell, 1914–1965. "1945: The Death of the Gods." Poem. In *Selected Poems* (New York: Knopf, **1955**). [Ipso]

Werner Riemerschmid, 1895–1967. *Zwischen Hades und Olymp: Zwei mythische Komödien* [Between Hades and Olympus: Two Mythic Comedies]. Radio play. Vienna: Bergland, **1955**. [Kürschner 1963, p. 524 / DLL 1968–90, 12:1233]

Zbigniew Herbert, 1924–. (The Gods meet in) "Próba rozwiazania mitologii" [Attempt to Dissolve Mythology]. Prose poem. In *Hermes, pies i gwiazda* [Hermes, Dog, and Star] (Warsaw: Czytelnik, **1957**). / Translated by John and Bogdana Carpenter in *Selected Poems* (Oxford & New York: Oxford University Press, 1977). [CLC 1987, 43:187]

—————. (The Gods evoked in) "Ornamental Yet True" (English language title of a work written in Polish). Prose poem. Translated by the Carpenters in *Selected Poems* (1977). [Ibid.]

—————. "Attempt to Dissolve Mythology" [English title of a work written in Polish] (unsuccessful meeting of the gods). Poem. Collected in *Poezje wybrane* (Warsaw: Spoldzielnia Wydawnicza, 1973). / Translated by John and Bogdana Carpenter in *Zbigniew Herbert: Selected Poems* (London & New York: Oxford University Press, 1977). [Ipso / Pilling 1982, p. 420]

Stanley Kunitz, 1905–. "Among the Gods." Poem. In *Selected Poems, 1928–1958* (Boston: Atlantic Monthly/Little, Brown, **1958**). [Ipso / CLC 1976, 6:287]

Edwin Muir, 1887–**1959**. "The Old Gods." Poem. In *Collected Poems* (New York: Oxford University Press, 1965). [Ipso / Feder 1971, pp. 372–74]

C. Day Lewis, 1904–1972. (Ancient gods evoked in) "The Antique Heroes." Poem. In *The Gate* (London: Cape, **1962**). [Ipso]

Vernon Watkins, 1906–**1967**. "The Parthenon." Poem. In *Fidelities* (London: Faber & Faber, 1968). [Ipso]

Gunnar Ekelöf, 1907–1968. (Gods of the Pantheon above modern Rome evoked in) "Roman Nights" [English title of a work written in Swedish]. Poem. Translated by Muriel Rukeyser and Leif Sjöberg in *Selected Poems of Gunnar Ekelöf* (New York: Twayne, **1967**). [Ipso]

W. S. Merwin, 1927–. "Divinities," "The Gods." Poems. In *The Lice* (New York: Atheneum, **1967**). [Ipso / Feder 1971, pp. 414f.]

Ralph Gustafson, 1909–. "The Philosophy of the Parthenon." Poem. In *Ixion's Wheel* (Toronto & Montreal: McClelland & Stewart, **1969**). [Ipso]

Robert Ruthenfranz, 1905–**1970**, music. *Die olympische Hochzeit* [Olympian Wedding]. Ballet. First performed Witten, Germany. [Grove 1980, 16:350]

István Vas, 1910–. "Gods" [English title of work written in Hungarian]. Poem. In *Mit akar ez az egy ember?* [What Does This Single Man Want?] (Budapest: Szépirodalmi, **1970**). / Translated by Donald Davie in *Collected Poems 1950–1970* (London: Routledge & Kegan Paul; New York: Oxford University Press, 1972). [Vajda 1977, pp. 71f.]

Elizabeth Brewster, 1922–. "Death of the Gods," "For the Unknown Goddess." Poems. In *In Search of Eros* (Toronto & Vancouver: Clarke, Irwin, **1974**). [Ipso]

David Wright, 1920–. *To the Gods the Shades: New and Collected Poems.* Collection of poems. Manchester: Carcanet, **1976**. [Seymour-Smith 1985, p. 1156]

Ivana Loudova, 1941–. *Olympic Overture.* Orchestral composition. **1979**. [Cohen 1987, 1:427]

Reuben Nakian, 1897–1986. "Garden of the Gods I." Abstract bronze sculpture. **1980**. [Marlborough 1982, no. 8] Plaster model, 1979–80. Marlborough Gallery, New York. [Ibid.—ill.] Bronze maquette. 1979. 9 casts. [Ibid., no. 6—ill.]

—————. "Garden of the Gods II." Abstract bronze sculpture. 1982. [Marlborough, no. 32] Plaster model, 1981–82. Marlborough Gallery, New York. [Ibid.—ill.] Bronze maquette. 1980. 9 casts. [Ibid., no. 13—ill.]

Cees Nooteboom, 1933–. "De slapende Goden" [The Sleeping Gods]. Poem. **1955–83**. In *Vuurtijd, ijstijd: Gedichten, 1955–1983* (Amsterdam: Arbeiderspers, 1984). / Translated by Peter Nijmeijer in *Dutch Interior: Postwar Poetry of the Netherlands and Flanders* edited by James S. Holmes and William Jay Smith (New York: Columbia University Press, 1984). [Ipso]

Colin Way Reid, 1952–**1983**. (Gods of the Parthenon celebrated in) "Temenos." Poem. In *Open Secret* (Gerrards Cross, Buckinghamshire: Colin Smythe, 1986). [Ipso]

Gretchen Berg. "The Old Gods." Poem. In *St. John's Review* Summer **1984**. [Ipso]

Gods as Seasons. According to Greek mythology, the Seasons (Greek, *Horae*), daughters of Zeus and Themis and attendants to the greater deities, were closely connected with vegetation. In another ancient tradition, principally Roman, which was revived in Renaissance painting, other gods and goddesses symbolized the four seasons of the year: Flora, goddess of flowers, and her consort Zephyr are often spring, as are the resurrection stories of Adonis and Proserpine (Persephone); the vegetation deities Ceres and Pomona are commonly summer; Bacchus, as god of the vintage, is frequently autumn; Vulcan, god of fire, and Saturn, patron of the midwinter Saturnalia festival, are winter.

Sandro Botticelli, 1445–1510. "The Primavera" (Venus in garden of Hesperides, with Graces, Cupid, Mercury, Flora, Cloris, and Zephyr). Painting. *c.*1478. Uffizi, Florence, inv. 8360. [Lightbown 1978, 1:73ff., no. B39—ill. / Berenson 1963, p. 34—ill.]

————, school. "Spring" (Flora), "Summer" (Ceres, or Juno or Abundantia?). Paintings, part of "Seasons" cycle. 1490s or later. Unlocated. [Lightbown, nos. C57, C58—ill.]

Francesco Colonna, *c.*1433–1527. (Venus, Ceres, Bacchus, and Jupiter Pluvius, representing the Seasons, depicted in reliefs in) *Hypnerotomachia Poliphili* [The Dream of Poliphilo]. Romance. Venice: 1499; illustrated with woodcuts by anonymous engraver. [Appell 1893, pp. 9f., pls. 67–70]

Baldassare Peruzzi, 1481–1536, design. "Proserpine," "Ceres," "Bacchus," "Vulcan." Frescoes, representing the Four Seasons, for Villa Madama, Rome. 1521–23. Later overpainted. [Frommel 1967–68, pp. 101f.]

Taddeo Zuccari, 1529–1566. "Vulcan Chaining Boreas." Ceiling fresco. 1560–61. Stanza dell' Inverno, Caprarola. [Warburg]

Bartholomeus Spranger, 1546–1611, circle. "Allegorical Figures of Summer and Autumn" (Ceres and Bacchus). Painting, based on figures in Spranger's "Ceres and Bacchus Leaving Venus" (1590, Vienna). *c.*1590? Cleveland Museum of Art, Ohio, no. 16.805. [Cleveland 1982, no. 14—ill.] Copy (19th century) in Cleveland Museum of Art. [Ibid.—ill.]

Antoine Caron, 1520/21–**1599.** (Janus, Apollo, Mercury, Minerva, Vulcan in) "Triumph of Winter." Painting. Private coll., Paris. [Paris 1972, no. 35—ill.]

Hans von Aachen, 1552–1616. "Bacchus, Ceres, and Cupid." Painting. *c.*1600. Kunsthistorisches Museum, Vienna, inv. 1098 (1509). [Hofmann 1987, no. 3.25—ill. / Vienna 1973, p. 2—ill.]

Martin Reynbouts, studio. "Allegory of Spring with Flora, Vertumnus, and Pomona." Tapestry. *c.*1600. Hyde coll., Glens Falls, N.Y. [Warburg]

Maerten de Vos, 1532–**1603.** "The Seasons" (represented by Venus and Cupid, Ceres, Bacchus, Aeolus). 4 designs for tapestry series. Unique set woven by Sheldon workshop, Barcheston, *c.*1611. Marquess of Salisbury coll., Hatfield House, Hatfield. [Jackson-Stops 1985, no. 33—ill.]

Hendrik van Balen, 1575–1632, figures, and **Jan Brueghel** the Elder, 1568–1625, landscape. "Allegory of Spring" (Flora), "Allegory of Summer" (Ceres), "Allegory of Autumn" (Bacchus), "Allegory of Winter" (genre scene). Paintings, in "The Four Seasons" cycle. **1616.** Neues Schloss, Bayreuth, inv. 13709–13712. [Ertz 1979, nos. 316–19—ill.]

————— (van Balen, figures, and Brueghel, flowers and background). "Cybele in a Garland of Fruits" (honored by Flora, Ceres, Bacchus, and Hiems as the seasons). Painting. *c.*1617–18. Mauritshuis, The Hague, inv. 233. [Ibid., no. 340—ill. / Mauritshuis 1985, p. 18f.—ill.] Replica. Banque de Paris et des Pays-Bas, Antwerp. [Ertz, no. 341—ill. / also de Bosque 1985, p. 51—ill.] Variant ("Cybele and the Seasons in a Garland of Fruits"). Late 1630s. Prado, Madrid, inv. 1414. [Prado 1985, p. 97 / Ertz 1984, no. 305 (as Jan Brueghel the Younger and follower of van Balen)—ill.]

————— (van Balen), questionably attributed, figures, and **Jan Brueghel the Younger,** 1601–1678, landscape. (Flora in) "Allegory of Spring." Painting. 1627? Alte Pinakothek, Munich, inv. 828. [Ertz 1984, no. 188—ill. / also Ertz 1979, fig. 461] Reversed copy in Chaucer Gallery, London, in 1984. [Ertz 1984, no. 189—ill.]

————— (van Balen). "Offering to Bacchus and Ceres." Painting. Musée, Cherbourg. [Bénézit 1976, 1:401]

Guercino, 1591–1666. "Allegory of Spring" (Flora), "Allegory of Summer" (Ceres). Frescoes, for Casa Pannini, Cento. 1615–17. Detached, unlocated. [Bagni 1984, pp. 171, 187—ill.]

Peter Paul Rubens, 1577–1640, with **Frans Snyders,** 1579–1657 (or Jan Wildens?). "Ceres and Pan" (representing the harvest). Painting. *c.*1630. Prado, Madrid, no. 1672. [Prado 1985, p. 601]

Simon Vouet, 1590–1649. "Allegory of Love and Abundance" (Bacchus, Venus, and Cupid). Ceiling decoration, for Château de Colombes. Lost. / Engraved by J. Boulanger, **1634.** [Crelly 1962, no. 237—ill.]

————. "The Four Seasons" (Ceres and Bacchus as Summer and Autumn, Venus and Adonis as Spring and Winter). Painting. *c.*1635? National Gallery of Ireland, Dublin, no. 1982. [Dublin 1985, no. 41—ill. / also Dublin 1981, p. 175—ill.]

Sebastiano Mazzoni, *c.*1611–1678. "Allegory of Summer" (Ceres). Painting. Before **1638?** Arcivescovado, Florence. [Florence 1986, no. 1.201—ill.]

Bernardo Strozzi, 1581–**1644.** "Spring and Summer" (Flora and Ceres?). Painting. National Gallery of Ireland, Dublin, no. 856. [Dublin 1981, p. 157—ill.]

Charles Le Brun, 1619–1690. "Ceres and Flora." Ceiling painting, for Hôtel Lambert, Paris. **1649.** / Print by Bernard Picard. [Knab 1977, fig. 7]

————, designs. "Fountains of the Seasons." Fountain figures. *c.*1672. "Flora" executed by Jean-Baptiste Tubi, 1672–75; "Ceres" by Thomas Regnaudin, 1672–74; "Bacchus" by Balthazar and Gaspard Marsy, 1673–75; "Saturn" by François Girardon, 1673–75. Gardens, Versailles. [Girard 1985, pp. 274–80—ill.]

————, designs. "Spring" (Flora), "Summer" (Ceres), "Autumn" (Bacchus). Marble statues. Executed by Philippe Magnier ("Flora"), 1675–81; Pierre Hutinot and

son ("Ceres"), 1675–79; Thomas Regnaudin ("Bacchus"), by 1694, (modeled 1680). Parterre du Nord, Gardens, Versailles. [Girard 1985, p. 272—ill.]

———. Chronus, as Winter, Ceres, and other gods, in painted medallions for Cabinet of Hôtel de la Rivière, Paris. / Drawings. Louvre, Paris, inv. 28.659 (Chronus); École des Beaux-Arts, Paris. [Versailles 1963, nos. 82–83—ill.]

Jacob Jordaens, 1593–1678 (or studio?). "Triumph of Bacchus and Ceres." Painting. *c.*1650. Staatsgalerie, Stuttgart, no. 431 (as studio). [Ottawa 1968, no. 230—ill. (drawing)] At least 2 further paintings depicting Bacchus and Ceres, known from 19th-century sales, unlocated. [Rooses 1908, p. 258]

Nicolas Poussin, 1594–1665. (Pan, Bacchus, Ceres, Flora, Pomona, Minerva, and other figures representing "the spirits of the flowers and fruits of the earth," in) Designs and wax models for series of marble terms. **1655–56.** Lost. / Marbles executed by Jean-Baptiste Théodon and others, by 1661. Gardens, Versailles. [Girard 1985, pp. 273f.—ill. / Blunt 1966, nos. 219–31—ill.]

———, formerly attributed. (Venus, Bacchus, Mercury, and Cupid, representing) "The Four Seasons Dancing to the Music of Apollo's Lute." Presumed painting, known from engraving by J. Avril, 1779. [Blunt 1966, no. R56 / also Thuillier 1974, no. R54—ill.]

Sébastien Bourdon, 1616–1671. "Bacchus and Ceres with Nymphs and Satyrs." Painting. Szépművészeti Múzeum, Budapest, no. 691. [Budapest 1968, p. 90]

Jan Erasmus Quellinus, 1634–1715. "The Four Seasons" (with a herm of Pan). Painting. **1676.** Szépművészeti Múzeum, Budapest, no. 586. [Budapest 1968, p. 564]

François Girardon, 1628–1715. "Flora," "Ceres," "Bacchus," "Saturn." Lead fountain figures, representing the Four Seasons. **1672–77.** Only "Saturn" extant. Gardens, Versailles. [Francastel 1928, no. 33—ill. / also Girard 1985, p. 280—ill.]

Ferdinando Tacca, 1619–1686, follower. "Bacchus and Ceres." Bronze statuette, after presumed model by Tacca. Musée Jacquemart-André, Paris. [Florence 1984, no. 4.33—ill.]

Johann Philipp Krieger, 1649–1725, music. *Flora, Ceres, und Pomona.* Masquerade. **1688.** [Grove 1980, 10:269]

Balthasar Permoser, 1651–1732. "The Four Seasons" (Pomona, Ceres, Bacchus, Vulcan). Set of 4 ivory statuettes. *c.*1690. Grünes Gewölbe, Dresden. [Asche 1966, no. P28, pl. 33; cf. nos. P56–7] Variant set. 1695. Herzog Anton Ulrich-Museum, Braunschweig (Flora and Ceres); Harewood House, Yorkshire (Bacchus and Vulcan). [Jackson-Stops 1985, no. 512—ill. / Asche, no. P29, pl. 34]

———. "Ceres," "Vulcan." Sandstone statues. *c.*1714–15. Kronentor, Zwinger, Dresden. [Asche, no. P56–7, pls. 65–66]

———. "Venus Anadyomene and Cupid" ("Spring"). Sandstone statue. 1724. Kronentor, Zwinger, Dresden. [Asche 1966, no. P74, pl. 67]

Antoine Coypel, 1661–1722. "Springtime, Represented by Zephyr and Flora." Painting, for Château de Marly. **1699.** Louvre, Paris, inv. 8685. [Louvre 1979–86, 3:171—ill.]

Antoine Watteau, 1684–1721. "Allegory of Spring" (Venus or Flora, with playing infants). Drawing. *c.*1708–09 or *c.*1713. Art Institute of Chicago. [Grasselli & Rosenberg 1984, no. D.13—ill.]

———. "The Seasons." Painting cycle, for Pierre Crozat. *c.*1715. "Spring" (Zephyr crowning Flora), destroyed. "Summer" (Ceres), National Gallery, Washington, D.C. "Autumn" (Bacchus), lost; print by E. Fessard. [Camesasca 1982, no. 107—ill. / Posner 1984, pp. 79f.—ill. / also Grasselli & Rosenberg 1984, no. P.35—ill.] Related oil sketch ("Autumn"). Louvre, Paris, no. M.I. 1128. [Grasselli & Rosenberg, no. 34—ill. / Camesasca, no. 125—ill. / Louvre 1979–86, 4:286—ill.]

Sebastiano Ricci, 1659–1734. "Bacchus and Ceres." Painting. Before *c.*1710. Fitzwilliam Museum, Cambridge, no. 180. [Daniels 1976, no. 70—ill. / Fitzwilliam 1960–77, 2:137—ill.]

Massimiliano Soldani-Benzi, 1658–1740. 4 bronze reliefs depicting gods as the Seasons. 2 sets, **1708–11,** 1715. Bayerisches Nationalmuseum, Munich; Royal Collection, Windsor Castle. / Replicas of "Ceres" (Summer) and "Bacchus" (Autumn), in University of Kansas Museum of Art. [Wildenstein 1968, no. 51—ill.]

Carlo Maratti, 1625–1713. "Ceres with Bacchus." 2 drawings. Uffizi, Florence, inv. 15667f; Duke of Devonshire coll., Chatsworth, no. 582. [Warburg]

Johann Joachim Kretzschmar, ?–1740. "Spring" (Flora?). Sandstone statue. *c.*1716–17. Kronentor, Zwinger, Dresden. [Asche 1966, no. K10, pl. 113]

French School. "Spring (Flora and Zephyr)," "Summer (Ceres and Triptolemus)." Pair of bronze statues. *c.*1710–20? Victoria and Albert Museum, London, nos. A.16–1955, A.17–1955. [Düsseldorf 1971, no. 365, 366—ill.]

Bartolomeo Altomonte, 1702–1779. Cycle of ceiling frescoes, depicting Flora, Ceres, Pomona, Juno, Bacchus, and Pan representing the Four Seasons. **1732.** Tafelzimmer, Stift, St. Florian. [Heinzl 1964, pp. 22f.]

François Le Moyne, 1688–1737, rejected attribution. "Ceres and Pomona." Drawing. Sold Paris, 1931, untraced. [Bordeaux 1984, no. X52]

Giovanni Antonio Pellegrini, 1675–1741. "Bacchus, Ceres, and Cupid." Painting. Statens Museum for Kunst, Copenhagen, inv. 6661. [Copenhagen 1976, p. 9]

Robert Le Lorrain, 1666–1743. "Flora" ("Spring"), "Ceres" ("Summer"). Marble busts. "Flora" unlocated; "Ceres" in Wallace Collection, London. [Beaulieu 1982, pp. 47f.—ill.]

Anton Kern, 1709–1747. "Spring and Summer" (Flora and Ceres), "Autumn and Winter" (Bacchus and an old man). Pendant paintings. Hermitage, Leningrad, inv. 2177, 2178. [Hermitage 1987b, nos. 231–32—ill.]

Franz Anton Maulbertsch, 1724–1796. "Allegory of the Four Seasons" (Saturn, Flora, Diana, Neptune). 2 variant oil sketches for a ceiling painting. *c.*1750. Städelsches Kunstinstitut, Frankfurt; Österreichische Galerie, Vienna. [Garas 1960, nos. 24–25, p. 14—ill.]

———. "Allegory of the Four Seasons" ("Allegory of Time and Truth," represented by Veritas, Saturn, Flora, Diana, and others). Ceiling painting. *c.*1750. Schloss Suttner, Kirchstetten, Austria. [Ibid., no. 26, pp. 13f.—ill.]

———. Diana and Bacchus, representing Spring, in "Al-

legory of the Seasons and Elements." Painting, study for a ceiling decoration. *c.*1754. Germanisches Nationalmuseum, Nuremberg. [Ibid., no. 61, p. 33—ill.]

Jacob de Wit, 1695–1754. "Bacchus and Ceres in the Clouds." Ceiling painting. **1751.** Huis Boschbeek, Heemstede, Holland. [Staring 1958, p. 156, pl. 60]

Franz Hilverding, 1710–1768, choreography. *La victoire de Flore sur Borée* [The Victory of Flora over Boreas]. Ballet. Music, Joseph Starzer. First performed 29 Apr **1760,** Court Theater, St. Petersburg. [Grove 1980, 8:570 / Winter 1974, p. 94]

Pompeo Batoni, 1708–1787. "Bacchus," "Ceres." Pair of paintings (marriage portraits?). *c.*1763. Private coll., Milan. [Clark 1985, nos. 264–65—ill.]

Jean-Hugues Taraval, 1729–1785. "Autumn" ("The Triumph of Bacchus and Ariadne"). Painting. **1769.** Ceiling, Gálerie d'Apollon. Louvre, Paris, inv. 8087. [Louvre 1979–86, 4:229—ill.]

John Flaxman, 1755–1826. (Cupid representing) "The Four Seasons." Designs for Jasper bas-reliefs, executed by Wedgwood studio. **1775.** Wedgwood Museum, Barlaston, Staffs. [Bindman 1979, no. 23—ill.]

Charles-Joseph Natoire, 1700–1777. "Bacchus and Ceres." Painting. Musée, Bourges, no. 92. [Boyer 1949, no. 94]

Antoine François Callet, 1741–1823. "Spring" ("Zephyr and Flora Crowning Cybele with Flowers"). Ceiling painting. **1780.** Galerie d'Apollon, Louvre, Paris, inv. 3097. [Louvre 1979–86, 3:94—ill.]

————. "Autumn: The Feasts of Bacchus," "Spring: Homage of the Roman Ladies to Juno," "Summer: Feasts of Ceres." Paintings, designs for Gobelins tapestry series "The Four Seasons." 1787. "Autumn" in Louvre, Paris, inv. 3104; "Spring" and "Summer" in Musée, Amiens, on deposit from Louvre, inv. 3102, 3103. [Louvre 1979–86, 3:95, 5:217—ill.]

Johann Gottfried Schadow, 1764–1850. "Bacchus and Pomona." Clay sculpture group. **1789.** Nationalgalerie, Berlin. [Cologne 1977, p. 162—ill.]

Anne-Louis Girodet, 1767–1824. "Apollo" ("Autumn") and "Flora" ("Spring"). Paintings. *c.*1814. Chambre de l'Impératrice, Palais, Compiègne. "Flora" destroyed 1870; "Apollo" in place. [Bernier 1975, pp. 167, 174—ill.]

Peter Cornelius, 1783–1867, and studio. "Autumn" (Bacchus with cupids), "Spring" (Flora with Cupid and Psyche), "Summer" (Ceres, flanked by Pan, Zephyr, and Syrinx). Ceiling frescoes. **1820–26.** Göttersaal, Glyptothek, Munich. [Glyptothek 1980, pp. 214–31—ill.]

Eugène Delacroix, 1798–1863. "The Four Seasons." Painting cycle. "Spring: Orpheus and Eurydice," "Summer: Diana and Actaeon," "Autumn: Bacchus and Ariadne," "Winter: Juno and Aeolus." Begun **1856,** unfinished. Museu de Arte, Sao Paulo. [Johnson 1981–86, nos. 249–51—ill. / Huyghe 1963, pp. 478—ill. / also Robaut 1885, nos. 1428, 1430, 1432, 1434—ill. (copy drawings)] Oil sketches. "Spring," Musée Fabre, Montpellier; "Summer," Mahmoud Khalil Museum, Cairo; "Winter," Reemstsma coll., Hamburg; "Autumn" unlocated. [Johnson, nos. 244–47—ill.] Copies of "Autumn" and "Summer" (attributed to Pierre Andrieu, 1821–1892) in Museum of Fine Arts, Boston, nos. 21.1453–54. [Boston 1985, p. 78—ill.]

Jean-François Millet, 1814–1875. "The Seasons." Painting

cycle, for dining room of Thomas of Colmar, Paris. **1864–65.** "Spring" (Daphnis and Chloë), Matsukata coll., Tokyo; "Summer" (Ceres), Musée, Bordeaux; "Winter," formerly Feuerdent coll., sold 1964; "Autumn," formerly Belgian Royal Collection, destroyed *c.*1900. [Herbert 1976, p. 157—ill. (study for "Spring")]

Arnold Böcklin, 1827–1901. "Bacchus and Ceres on a Cloud Throne." Painting. **1874.** Private coll. [Andree 1977, no. 287—ill.]

————. "Spring's Awakening" (Pan, Flora, and nymphs). Painting. 1880. Kunsthaus, Zurich, inv. 429. [Ibid., no. 352—ill.]

Dante Gabriel Rossetti, 1828–1882. "For 'Spring' by Sandro Botticelli." Sonnet, after Botticelli's "Primavera" (*c.*1478, Florence). **1880.** In *Ballads and Sonnets* (London: Ellis & White, 1881). [Doughty 1965]

Marius Petipa, 1818–1910, choreography and scenario. (Zephyr, the West Wind, in) *Les saisons.* Ballet. Music, Alexander Glazunov (1865–1936). First performed 7 Feb **1900,** Hermitage Theater, St. Petersburg; scenery, Lambini; costumes, Ponomarev. [Sharp 1972, p. 244, 306]

Gods as Elements.

The attributes and domains of classical deities were often used in Renaissance and Baroque art to symbolize the four Elements: Earth, Air, Fire, and Water. Earth is commonly represented by deities such as Ceres (goddess of the harvest), Cybele (goddess of fertility), Flora (goddess of flowers), and Pluto (lord of the Underworld); Air, by Juno in her peacock chariot, Iris (the rainbow goddess), and Jupiter, whose attribute is the eagle; Fire, by Vulcan at his fiery forge, Vesta (keeper of the hearth), and Jupiter with his thunderbolts; Water, by Neptune (the sea-god) and his consort Amphitrite, or Venus's birth and sea-triumph.

Baldassare Peruzzi, 1481–1536, design. "Juno," "Jupiter and Ganymede," "Neptune," "Pluto and Proserpine." Frescoes, representing the Four Elements, for Villa Madama, Rome. **1521–23.** Later overpainted. [Frommel 1967–68, no. 58b, p. 102, pls. 50a-d]

Rosso Fiorentino, 1494–1540. (Pluto with Cerberus, as Earth, Neptune as Water, Jupiter as Air, in) "Elephant *fleurdelysée.*" Fresco. **1535–40;** repainted/restored 18th, 19th centuries and 1961–66. Galerie François I, Château de Fontainebleau. [Carroll 1987, no. 83—ill. / also Panofsky 1958, p. 134—ill. / Revue de l'Art 1972, pp. 136f. and passim—ill. / Barocchi 1950, pp. 146ff.—ill.] Tapestry after, 1541–50. Kunsthistorisches Museum, Vienna. [Revue de l'Art, pp. 106ff.—ill. / Hofmann 1987, no. 1.1—ill. / Barocchi, fig. 140 / also Lévêque 1984, p. 251—ill.]

Benvenuto Cellini, 1500–1571. (Figures representing Ocean [Neptune?] and Earth, seated on) "The Saltcellar of Francis I." Gold and enamel saltcellar. **1540–43.** Kunsthistorisches Museum, Vienna. [Pope-Hennessy 1985a, pp. 106ff., pls. 51, 56–60]

Giulio Romano, *c.*1499–**1546.** Drawing, depicting Cupid, Diana, Cronus, and Boreas as the Four Elements. Earl

of Ellesmere coll., Mertoun House, Roxburghshire, Scotland, no. 123. [Hartt 1958, p. 295 (no. 141)—ill.]

Giorgio Vasari, 1511–1574, with **Cristofano Gherardi,** 1508–1556. Fresco cycle, representing the Four Elements. Air: "The Castration of the Sky [Uranus]," the chariots of the Sun and the Moon; Earth: "The First Fruits of the Earth Being Given to Saturn," "Triptolemus Plowing," "Sacrifice of Cybele"; Fire: "Vulcan [with Venus and Cupid] and the Cyclopes," "Vulcan Surprises Mars and Venus," "Daedalus Forging Weapons for Achilles"; Water: "Venus Born from the Sea." **1555–56.** Sala degli Elementi, Palazzo Vecchio, Florence. [Sinibaldi 1950, pp. 13, 22, 49—ill. / also Lensi 1929, pp. 154ff.—ill. / Barocchi 1964, pp. 38f. / Arezzo 1981, nos. 5.37, 39]

Paolo Veronese, 1528–1588. "Juno, or Air," "Vulcan, or Fire," "Cybele, or Earth," "Neptune, or Water." Frescoes. *c.***1560–61.** Sale dell' Olimpo, Villa Barbaro-Volpi, Maser (Treviso). [Pallucchini 1984, no. 58—ill. / Pignatti 1976, no. 96—ill.]

————. "Pluto and Ceres." Fresco, part of a cycle celebrating Bacchus and wine. *c.*1560–61. Stanza di Bacco, Villa Barbaro-Volpi. [Pallucchini, no. 60—ill. / Pignatti, no. 98—ill.]

Jacopo Bassano, *c.*1517/18–**1592.** Cycle of paintings depicting gods as the Four Elements. Formerly Národní Galeri, Prague. [Pigler 1974, p. 507]

Étienne Delaune, *c.*1518–**1593.** Series of engravings depicting gods as the Four Elements. [Pigler 1974, p. 510]

Jan Brueghel the Elder, 1568–1625, landscape, and **Hendrik van Balen,** 1575–1632, figures. (Ceres, Amphitrite, and Zephyr and Flora, representing earth, water, air, in) "Allegory of the Elements" ("Ceres with the Four Elements"). Painting. **1604.** Kunsthistorisches Museum, Vienna, inv. 815. [Ertz 1979, no. 110—ill. / Vienna 1973, p. 34—ill.] Variant, *c.*1615. Prado, Madrid, inv. 1399. [Ertz, no. 300—ill.]

————— and van Balen. "Allegory of Earth" (Ceres), "Allegory of Air" (Urania), "Allegory of Fire" (forge of Vulcan), "Allegory of Water" (Amphitrite). Painting cycle. *c.*1611. Galleria Doria Pamphilj, Rome, inv. 322, 328, 332, 348. [Ibid., p. 369, nos. 248–51—ill.] Variant of "Earth." Private coll., Scotland. [Ibid., no. 247—ill.] Numerous copies (by Jan Brueghel the Younger, van Balen, others), in Musée des Beaux-Arts, Lyons; elsewhere. [Ibid. / Ertz 1984, nos. 193–94, 196, 198–200, 207b, 208, 208a—ill.]

————— and van Balen ("Water" and "Air"). "Allegory of Water" (river-god and nymph), "Allegory of Fire" (forge of Vulcan), "Allegory of Earth" ("The Earthly Paradise"), "Allegory of Air" (Urania). Painting cycle, for Federico Borromeo. Commissioned 1607, executed 1608, 1621. "Water" and "Fire" in Pinacoteca Ambrosiana, Milan, nos. 65, 68; "Earth" and "Air" in Louvre, Paris, inv. 109293 (1919–20). [Ertz 1979, nos. 190, 302, 342, 372—ill.]

————. See also *Brueghel the Younger and van Balen, below.*

Peter Paul Rubens, 1577–1640. "The Union of Earth and Air" ("Neptune and Cybele"). Painting. *c.***1615.** Hermitage, Leningrad. [Jaffé 1989, no. 304—ill.] Study. Fitzwilliam Museum, Cambridge. [Ibid., no. 303—ill.]

————. "River God with Cybele and Pomona" ("Allegory of Earth, Water, and Air," "Two Nymphs and a River God"). Painting, sketch for unexecuted or lost work.

*c.*1615. Art Museum, Academy of Sciences, Kiev. [Ibid., no. 306—ill. / also Held 1980, no. 256—ill.]

————, school. "Aeolus, or Air," "Vulcan, or Fire." Paintings. Prado, Madrid, nos. 1716–17. [Prado 1985, pp. 603f. / also Alpers 1971, p. 113, fig. 9]

Francesco Albani, 1578–1660. Cycle of paintings depicting the Four Elements. *c.***1621–23.** "The Toilet of Venus" ("Air," variant of part of a cycle depicting the rivalry of Venus and Diana, retouched 1633), "Venus and Vulcan Resting" ("Fire"), "Cupids Disarmed" ("Earth"), "Adonis Led to Venus by Cupids" ("Water"). Louvre, Paris, inv. 9–12. [Louvre 1979–86, 2:140—ill.]

————. Series of paintings depicting gods as the Four Elements. Pinacoteca, Turin. [Pigler 1974, p. 508]

Jan Brueghel the Younger, 1601–1678, landscape, and **Hendrik van Balen,** 1575–1632, figures. "Amphitrite and Ceres." Painting, variant after Jan Brueghel the Elder's "Allegory of the Elements" (1604, Vienna). **Late 1620s.** Sanssouci, Potsdam. [Ertz 1984, no. 203—ill.]

————— and van Balen. (Ceres, Urania, Vesta, and Amphitrite, representing earth, air, fire, and water, in) "Allegory of the Elements." Painting. *c.*1630. Baron de Coppée coll., Brussels. [Ibid., no. 204—ill.]

————— and **Frans Francken II,** 1581–1642 (? or Abraham Govaerts?). "Allegory of the Elements" (Ceres, Urania, Vulcan, and Neptune, representing earth, air, fire, and water). Painting. 1630s. Sold Sotheby's London, 1971. [Ibid., no. 207—ill.]

————— and Frans Francken II? "Allegory of the Elements" (Ceres, Urania, Vesta? and Amphitrite?). Painting. 1630s. Getty Museum, Malibu, Calif., inv. A71.P-8 (as Jan Brueghel the Elder). [Ibid., no. 207a—ill.]

————— and unknown artist in circle of Frans Francken II. "Allegory of Earth and Water" (Flora and Amphitrite), "Allegory of Air and Fire" (Urania and Vesta). Pendant paintings. Late 1630s? Staatsgalerie im Neuen Schloss, Schleissheim, inv. 1997, 1998. [Ibid., nos. 205–06—ill.]

————— and follower of van Balen. "Allegory of the Four Elements" (Ceres, Urania, Vesta? and Amphitrite?). Painting. Late 1630s? Sold Sotheby's, London, 1982. [Ibid., no. 209—ill.]

————— (Brueghel). (Urania in) "Allegory of Air." Painting. *c.*1650. Private coll., Switzerland. [Ibid., no. 210—ill.]

————. See also *Brueghel the Elder and van Balen, above.*

Simon Vouet, 1590–1649. "The Four Elements." Decorations for Vestibule of the Queen, Fontainebleau: "Jupiter and Aeolus" (Fire), "Juno and Iris" (Air), "Neptune and Amphitrite" (Water), "Ceres and Her Children" (Earth), "Phoebus Apollo" (or "Aurora and Tithonus"). Lost. / Engraved by Michel Dorigny, **1644.** [Crelly 1962, no. 251—ill.]

Alessandro Algardi, 1598–**1654.** "Jupiter," "Juno," "Neptune," "Cybele." Bronze andiron figures, representing the Elements. Originals lost and recast, or adapted (by studio) as fountain figures. Jardin de la Isla, Aranjuez (Neptune and Cybele; Jupiter and Juno formerly Aranjuez, unlocated). [Montagu 1985, nos. 126, 129–31—ill.]

Charles Le Brun, 1619–1690. Designs for a set of 4 colossal statues depicting mythological abductions, representing the Four Elements, for Parterre d'Eau, Versailles. *c.***1675.** At least 1 ("Boreas Carrying Off Ori-

thyia") completed, by Gaspard Marsy and Anselme Flamen, c.1675–c.1685. Never installed at Versailles. [Wildenstein 1968, no. 24 *n.*—ill. (bronze reduction of "Boreas and Orithyia")]

Gérard de Lairesse, 1641–1711 (active until *c.*1690). Cycle of etchings depicting nude goddesses as the Four Elements. [Pigler 1974, p. 510]

António Palomino, 1655–1726. "Air" (Juno, with Iris), "Fire" (Vulcan, with Venus and Cupid). Paintings, for Palacio Buen Retiro, Madrid. By **1700**. Prado, Madrid, nos. 3186–87 (original of "Fire" lost; replica in Prado). [López Torrijos 1985, pp. 413 nos. 75–76, 415 no. 6, 419 nos. 26–27—ill. / Prado 1985, pp. 483f.]

Kaspar Waldmann, 1657–1720. "Water" (Neptune), "Fire" (Vulcan), "Earth" (Flora), "Air" (rape of Ganymede). Frescoes. *c.*1716. Schloss Grabenstein, Innsbruck-Mühlau. [Kempter 1980, p. 78, no. 246—ill.]

Giovanni Battista Tiepolo, 1696–1770. "Juno and Luna," "Bacchus and Ariadne," "Triumph of Amphitrite." Painting cycle, representing Air, Earth, and Water (possible fourth work representing Fire, unknown), for Villa Girola, Como. *c.*1740. Timken coll., New York ("Juno and Luna," "Bacchus and Ariadne"); Gemäldegalerie, Dresden, no. 580B ("Amphitrite"). [Pallucchini 1968, nos. 136–38—ill. / Morassi 1962, pp. 11, 36—ill. / also Dresden 1976, p. 102] Studio copies of "Amphitrite" in Pinto-Basto coll., Lisbon; Museo Civico, Trieste. [Morassi, pp. 16, 51]

Charles-Joseph Natoire, 1700–1777. "Fire" ("Venus Asking Vulcan for Arms for Aeneas"), "Air" ("Juno and Iris"), "Water" ("Triumph of Amphitrite"), "Earth" ("Ceres Nursing Triptolemus"). Painting cycle. **1741**. "Fire" and "Air" in Louvre, Paris, inv. 6848, 6850, on loan to Sénat, Assemblée Nationale, Paris; others lost. [Troyes 1977, no. 22 *n.* / also Louvre 1979–86, 5:309]

Gabriel-François Doyen, 1726–1806. "On Juno's Command, Aeolus Releases the Winds from His Cave." Painting, part of a "Four Elements" series. **1753**. Szépmüvészeti Múzeum, Budapest, no. 60.8. [Budapest 1968, p. 196]

Augustin Pajou, 1730–1809. "Cupid, Master of the Elements." Lead statue. *c.*1769. Lost. / 2 drawings. Masson coll., Amiens; Felix Oppenheim coll., Paris. [Stein 1912, pp. 218, 401, pl. IX]

Bernhard Rode, 1725–1797. Series of etchings depicting goddesses as the Four Elements. [Pigler 1974, p. 511]

Benjamin West, 1738–1820. "Omnia vincit Amor, or, The Power of Love in Three Elements" (Cupid with Venus and lion, seahorse, eagle, representing the Elements). Painting. **1809–10**. Metropolitan Museum, New York, no. 95.22.1. [Metropolitan 1965–85, 1:35—ill. / von Erffa & Staley 1986, no. 422—ill.]

Auguste Couder, 1789–1873, and **Merry-Joseph Blondel**, 1781–1853. Ceiling decoration. By Couder: "Earth: Combat of Hercules and Antaeus," "Water: Achilles Nearly Engulfed by the Xanthus and the Simois, Maddened by the Carnage He Has Dealt the Trojans," "Fire: Venus Receives from Vulcan the Arms He Has Forged for Aeneas." By Blondel: "Air: Aeolus Looses the Winds against the Trojan Fleet." **1819**. Vestibule, Galerie d'Apollon, Louvre, Paris (inv. 3378–80, 2625). [Louvre 1979–86, 3:64, 162—ill.]

Peter Cornelius, 1783–1867, and studio. 4 frescoes, depicting Cupid with symbols of the 4 elements: dolphin (water) eagle of Jupiter (fire and light), peacock of Juno (air), Cerberus (earth). **1820–26**. Ceiling, Göttersaal, Glyptothek, Munich. [Glyptothek 1980, pp. 214ff.—ill.]

Bertel Thorwaldsen, 1770–1844. "Cupid in Heaven, on Jupiter's Eagle, with the Thunderbolt," "Cupid on Earth, as the Lion Tamer, with Hercules' Club," "Cupid at Sea, on a Dolphin, with Neptune's Trident," "Cupid in the Underworld, as the Tamer of Cerberus, with Pluto's Pitchfork." 4 reliefs, representing Cupid's dominion over the Four Elements. Plaster originals, **1828**. Thorwaldsens Museum, nos. A381–84 (cf. nos. A385–88, 390). / Marble versions. Thorwaldsens Museum, nos. A377–80, 389, 729. [Thorwaldsen 1985, pp. 49–51, pl. 49 / Hartmann 1979, pp. 178–82, pls. 123.5, 125.3]

Conflict between Vice and Virtue. In the post-classical arts, gods and goddesses (mostly related to the Roman pantheon) and other mythological figures are often represented in allegories of virtue overcoming vice. Deities such as the chaste Diana and the righteous Minerva (or her Greek counterpart, Pallas Athene) are commonly seen in conflict with satyrs, the drunken Bacchus, or lascivious Venus; mischievous Cupid also personifies vice.

Francesco Colonna, *c.*1433–1527. (Vision of the "Triumph of Love," Venus's defeat of Diana, in) *Hypnerotomachia Poliphili* [The Dream of Poliphilo]. Romance. Venice: **1499**; illustrated with woodcuts by anonymous engraver. [Appell 1893, p. 12, pl. 160]

Andrea Mantegna, 1430/31–1506. "Pallas Expelling the Vices (from the Grove of Virtue)." Painting, for studiolo of Isabella d'Este, Corte Vecchia, Mantua. **1502**. Louvre, Paris, inv. 371. [Lightbown 1986, p. 189, no. 40—ill. / Louvre 1979–86, 2:203—ill. / Louvre 1975, no. 110—ill.] Copy by Ernest Rouart, executed 1897 under direction of Edgar Degas. Louvre, Paris, no. R.F. 1975–8. [Louvre 1979–86, 4:196—ill.]

——— and **Lorenzo Costa**, 1460–1535 (begun by Mantegna, completed by Costa after Mantegna's death). "The Reign of Comus" ("The Gate of Comus") (Comus, Janus, and Mercury chasing away the Vices, with other figures representing virtue and vice). Painting. Louvre, inv. 256. [Louvre 1979–86, 2:169—ill. / Lightbown 1986, no. 41—ill. / Louvre 1975, no. 128—ill. / Wind 1948, pp. 46f., fig. 59]

Perugino, 1446/47–1523. (Diana and Minerva battle Venus in) "The Battle of Love and Chastity" (sometimes mistakenly called "Triumph of Chastity"). Painting, for studiolo of Isabella d'Este, Corte Vecchia, Mantua. *c.*1503. Louvre, Paris, inv. 722. [Louvre 1975, no. 121—ill. / Louvre 1979–86, 2:217—ill. / Wind 1948, p. 19, fig. 62]

Marcantonio Raimondi, *c.*1480–1527/34. "The Reconciliation of Minerva with Cupid" ("Peace"). Engraving, probably after (lost) drawing by Raphael, part of "Seven Virtues" series (Bartsch no. 393). *c.*1517–20. [Shoemaker 1981, no. 42—ill. / also Bartsch 1978, 27:85—ill.]

Hans Sachs, 1494–1576. *Die Göttin Pallas mit Venus (wohin*

die Götten Pallas die Tugend und die Göttin Venus die Wollust verficht) [The Goddesses Pallas and Venus (in which Pallas represents virtue and Venus lust)]. Comedy. Published **1530**. Reprinted *Werke* (Stuttgart: 1870–1908; Hildesheim: Olms, 1964). [McGraw-Hill 1984, 4:301]

Lorenzo Leonbruno, 1489–*c.*1537. "Diana and Minerva Chasing Away Satyrs." Drawing. Graphische Sammlung, Munich. [Louvre 1975, no. 119]

Battista Dossi, c.1474–1548, with **Dosso Dossi**, c.1479–1542. "The Reconciliation of Minerva and Cupid." Painting. *c.*1540. Robinson coll., Beverly Hills, Calif. [Gibbons 1968, no. 85—ill. / also Berenson 1968, p. 112 (as " 'Rochdale' Venus in Landscape")—ill.]

Paolo Veronese, 1528–1588. "Jupiter Expelling the Vices." Painting, for Palazzo Ducale, Venice. **1553**. Louvre, Paris, inv. 147. [Pallucchini 1984, no. 20a—ill. / Pignatti 1976, no. 25—ill. / Louvre 1979–86, 2:251—ill.] Copy (style of Delacroix) in Louvre, inv. 20386. [Louvre, 3:208]

Lorenzo Lotto, 1480–**1556**. "The Triumph of Chastity" (over Venus and Cupid). Painting. Pallavicini coll., Palazzo Rospigliosi, Rome. [Berenson 1957, p. 105—ill.]

Luca Cambiaso, 1527–1585. "Diana Fighting a Satyr." Fresco. *c.*1560. Palazzo Pallavicini, Genoa. [Manning & Suida 1958, p. 94—ill.]

Philip Sidney, 1554–1586. (Venus and Diana discuss their rivalry in) *The Countess of Pembroke's Arcadia* (*The Old Arcadia*) fourth eclogues. Prose romance with poems, pastoral eclogues. Completed *c.*1580. This passage not included in revision of 1582–84 (London: 1590). [Ringler 1962, no. 73 / Robertson 1973]

Otto van Veen, 1556–1629. "Youth between Virtue [Minerva] and Vice [Venus]." Painting. **1594–95**. Lost. / Engraving by P. Perret. [Campbell 1977, p. 98—ill.]

Jacopo Tintoretto, 1518–1594, previously attributed (attributed to Domenico Tintoretto). "Virtue Expelling Vice" (previously called "Venus Pursued by Minerva"). Painting. **1590s?** if by Domenico. Prado, Madrid, no. 387. [Rossi 1981, no. A57—ill. / also Berenson 1957, p. 177] Studio variant (also attributed to Jacopo). St. Louis Art Museum, no. 173.55 (as Jacopo). [Rossi, no. A88]

Lope de Vega, 1562–1635. "De Venus y Palas" [On Venus and Pallas]. Sonnet, no. 139 of *Rimas humanas* part 1. **1602–04**. Madrid: Martin, for Alonso Perez, 1609. [Sainz de Robles 1952–55, vol. 2]

William Bosworth, 1607–1650? (Contest between Bacchus [Vice] and Diana [Virtue] in) *The Chast and Lost Lovers, Arcadius and Sepha*. Poem. *c.*1626. London: Blaiklock, 1651. [Bush 1963, p. 199]

Pietro da Cortona, 1596–1669. "Pallas Tears the Youth [Cosimo I de' Medici?] from Venus" (and leads him to Hercules). Ceiling fresco. **1641–42**. Sala di Venere, Palazzo Pitti, Florence. [Campbell 1977, pp. 91ff., 186ff.—ill. / Briganti 1962, no. 85—ill. / Pitti 1966, p. 97—ill.]

Pedro Calderón de la Barca, 1600–1681. (Diana and Venus contest the fates of the royal families of Cyprus and Cnidus in) *Amado y aborrecido* [Loved and Hated]. Comedy. *c.*1650–52. [Valbuena Briones 1960–67, vol. 1 / O'Connor 1988, pp. 213–25 McGraw-Hill 1984, 1:442]

———. (Contest between Diana and Venus in) *Fineza contra fineza* [Favor against Favor]. Comedy. First performed 22 Dec 1671, Vienna, for the birthday of Mariana de Austria, Queen of Spain. [Valbuena Briones / O'Connor, pp. 253–65]

Giovanni Paolo Colonna, 1637–1695. *Le contese di Pallade e Venere* [The Contests of Pallas and Venus]. Dramatic cantata. Text, Bianchini. **1674** or earlier. First performed 1697, Palazzo Pubblico, Bologna. [Grove 1980, 4:583]

T. van Malsen. "Diana and Virtue Punishing Venus and Bacchus." Painting. **1694**. Rijksmuseum, Amsterdam, inv. A2307, on loan to Dienst Vorspreide Rijkskollekties, The Hague. [Rijksmuseum 1976, p. 360—ill.]

Carlo Agostino Badia, 1672–1738. *Diana rappacificata con Venere e con Amore* [Diana Reconciled with Venus and Cupid]. Musical entertainment. First performed 21 Apr **1700**, Vienna. [Grove 1980, 2:9]

Antonio Caldara, *c.*1670–1736. *La gara di Pallade e Venere* [The Quarrel between Pallas and Venus]. Cantata. First performed **1729**, Vienna. [Grove 1980, 3:616]

Bartolomeo Altomonte, 1702–1779. "Pallas Athena Overthrows the Vices." Fresco detail. **1732**. Landhaus, Brünn, Austria. [Heinzl 1964, pp. 23f.—ill.]

John Abraham Fisher, 1744–1806. *Diana and Cupid*. Cantata. Published as *The Favorite Cantata of Diana and Cupid* (**1770**). [Grove 1980, 6:617]

Giuseppe Bonno, 1711–1788. "Dialogo per musica fra Diana e Amore" [Musical Dialogue between Diana and Cupid]. Dramatic duet. Unperformed? [Grove 1980, 3:28]

Bertel Thorwaldsen, 1770–1844. "Minerva Protecting Virtue and Exposing Vice." Marble relief. Modeled **1818**. Landesmuseum, Oldenburg. [Hartmann 1979, p. 153, pl. 99.2]

George Meredith, 1828–1909. (Aphrodite vs. Artemis in) "A Reading of Life." Poem. In *A Reading of Life, with Other Poems* (London: Murray, **1901**). [Bartlett 1978 / Bush 1937, pp. 386f.]

Loves of the Gods. Classical and postclassical images of deities pursuing amorous activities, among themselves and with mortals, are quite common. Artists from the Renaissance onward presented scenes and cycles of pursuits, conquests, and weddings.

See also APOLLO, Loves; PAN, Loves; POSEIDON, Loves; ZEUS, Loves; *also* ADONIS; AMPHITRITE; APHRODITE, and Anchises; ARES AND APHRODITE; CEPHALUS AND PROCRIS; CLYTIE; DIONYSUS, and Ariadne; ENDYMION; EOS, and Tithonus; FLORA, and Zephyr; HERSE AND AGLAURUS; PERSEPHONE; PSYCHE.

Pietro Perugino, 1446/47–1523. (Loves of the gods depicted in the background, in) "The Battle of Love and Chastity." Painting, for studiolo of Isabella d'Este, Corte Vecchia, Mantua. *c.*1503. Louvre, Paris, inv. 722. [Louvre 1975, no. 121—ill. / also Louvre 1979–86, 2:217—ill.]

Perino del Vaga, 1501–1547, and **Rosso Fiorentino**, 1494–1540, compositions. "The Loves of the Gods." Cycle of engravings (Bartsch 15, nos. 9–23, incomplete). 16 or 18 designed by Perino, 2 by Rosso. Executed by Gian Jacopo Caraglio, **1527** or earlier. [Carroll 1987, pp. 132f. nos. 42–43—ill. / also Paris 1972, no. 441—ill.]

Edmund Spenser, 1552?–1599. (Tapestries depicting loves

of the gods in the House of Busyrane, in) *The Faerie Queene* 3.11.29–35. Romance epic. London: Ponsonbie, **1590**, 1596. [Hamilton 1977 / MacCaffrey 1976, pp. 109–12]

Jean Puget de La Serre, 1594–1665. *Les amours des dieux* [The Loves of the Gods]. Poem cycle. Paris: d'Aubin, **1624**. [DLF 1951–72, 3:821 / NUC]

————. *Les amours des déesses* [The Loves of the Goddesses]. Poem cycle. Paris: d'Aubin, 1627. [DLF / NUC]

Giovanni Carlo Coppola, 1599–1652, libretto. *Le nozze degli dei* [The Wedding of the Gods]. Opera (favola in musica). First performed **1637**, Palazzo Pitti, Florence, for wedding of Ferdinand, Duke of Tuscany, and Vittoria of Urbino. Libretto published Florence: Massi & Landi, 1637, with etchings by Stefano Della Bella, after Alfonso Parigi. [Bianconi 1987, p. 172 / Taylor 1893, p. 370]

Padovanino, 1588–**1648** (formerly attributed to Titian). "Loves of the Gods." Cycle of 9 paintings. Formerly Duke of Marlborough coll., Blenheim Castle. / Mezzotints by John Smith (1652–1742). [Pigler 1974, p. 99]

Simon Vouet, 1590–**1649**, and studio. "The Loves of the Gods." Cartoons for a cycle of 24 tapestries. [Crelly 1962, no. 270—ill.]

Matthew Prior, 1664–1721. (Loves of gods, especially Apollo and Jupiter, evoked in) "On Beauty, A Riddle." Poem. In *Poems on Several Occasions* (London: Tonson, **1709**). Modern edition by A. R. Waller (Cambridge: Cambridge University Press, 1905). [Ipso]

Jean-Joseph Mouret, 1682–1738, music. *Les amours des dieux* (including 4 entrées: "Neptune et Amymone," "Jupiter et Niobe," "Apollo et Coronis," "Ariane et Bacchus"). Ballet héroïque (opera-ballet). Libretto, Louis Fuzelier. First performed 14 Sep **1727**, L'Opéra, Paris; choreography, Françoise Prévost. [Baker 1984, p. 1595 / Grove 1980, 12:655 / Winter 1974, p. 51]

Nicolas Blondy, 1677–1747, choreography. *Les amours des déesses*. Ballet héroïque. Music, Jean-Baptiste Maurice Quinault. Scenario, Louis Fuzelier. First performed 9 Aug **1729**, Académie Royale de Musique, Paris. [Baker 1984, p. 1836 / Oxford 1982, p. 62 / Grove 1980, 7:47; 15:507]

Bernard Picart, 1673–**1733**. "The Loves of the Gods." Cycle of 10 engravings. [Pigler 1974, p. 99]

François Boucher, 1703–1770. "The Loves of the Gods" (Ariadne and Bacchus, Abduction of Proserpine, Neptune and Amymone, Jupiter in the Grape, Mars and Venus, abduction of Orithyia, abduction of Europa, Venus at Vulcan's Forge, Apollo and Clytie). Paintings (modellos, cartoons, and studies) for tapestry series. *c.*1750. All but 2 original paintings lost. "Europa" and "Venus" in Louvre, Paris, inv. 2714, M.I. 1025. [Ananoff 1976, nos. 344–52—ill. / Louvre 1979–86, 3:80—ill.] Numerous sets of tapestries woven by Beauvais, from 1750. Metropolitan Museum, New York; Council Presidency, Budapest; private colls.; elsewhere. [Ananoff]

————. Paintings, designs for a "Loves of the Gods" tapestry series. *c.*1764. "The Loves of Neptune and Amyone," "Venus at Vulcan's Forge" in Salon des Nobles de la Reine, Versailles, nos. M.V. 7093; M.V. 7094 inv. 2708; others unlocated. [Ibid., nos. 483–84—ill.] Modellos for tapestries. Louvre, Paris, inv. 2718 (M.R. 1217), 2719. [Louvre, 3:82—ill.] Gobelins tapestries. Formerly Wildenstein coll., Kress coll., unlocated. [Ananoff—ill.]

————. See also French School, *below.*

French School, various artists: François Boucher, 1703–1770, Carle van Loo, 1705–1765, Jean-Baptiste-Marie Pierre, 1713–1789, Joseph-Marie Vien, 1716–1809, and others. "Loves of the Gods." Paintings, cartoons for Gobelins tapestry series. **1757–58**. Original series commissioned included "Vulcan Giving Venus the Weapons for Aeneas" ("The Forge of Vulcan"), by Boucher, Louvre, inv. 2707 *bis*; "Neptune and Amymone," by van Loo, Louvre, inv. 6276 (deposited in Musée Chéret, Nice, in 1927); "Rape of Europa," by Pierre, Louvre, inv. 7227 (deposited in Musée, Arras, in 1872; destroyed or lost in World War I); "Rape of Proserpine," by Vien, Louvre, inv. 8419 (deposited in Musée Grenoble, in 1872). [Louvre 1979–86, 3:79, 5:319, 345, 354—ill. / also Ananoff, no. 478—ill.] Further subjects added 1761–78, including "Mercury and Aglaurus," by Pierre, 1763, Louvre, inv. 7227; "Triumph of Amphitrite," by Hugues Taraval, 1777, Louvre, inv. 8088; "Leda," by Clément Belle, 1778, Louvre, inv. 2491. [Louvre, 3:51, 4:133, 4:229—ill.]

Anne-Louis Girodet, 1767–**1824**, composition. "The Loves of the Gods." Series of 16 lithographs, based on Girodet's drawings: "Thetis and Peleus," "Jupiter and Leda," "Pan Pursuing Syrinx," "Death of Adonis," "Jupiter and Io," "Diana and Endymion," "Clytie Changed into a Sunflower," "Rape of Orythia," "Hermaphrodite and Salmacis," "Jupiter and Callisto," "Cephalus and Aurora," "Jupiter and Semele," "Erebus and Night," "Apollo and Daphne," "Jupiter and Juno," "Mars and Venus." Published Paris: Engelmann, 1825–26. [Boutet-Loyer 1983, no. 87 *n.*—ill.]

Arthur Rimbaud, 1854–1891. (The loves of the Gods evoked in) "Soleil et chair" [Sun and Flesh] part 4. Poem. May **1870**. Published with *Le reliquaire* (Paris: Genonceaux, 1891). [Adam 1972 / Fowlie 1966]

GOLDEN AGE. *See* AGES OF THE WORLD.

GORGON. *See* MEDUSA.

GRACES. According to most mythographers, the Graces (Greek, *Charites*) were daughters of Zeus and the Oceanid Eurynome. Typically three in number, they personified grace, charm, and beauty and were called Aglaia (Splendor), Euphrosyne (Mirth), and Thalia (Abundance). Although they usually accompanied the Muses, Aphrodite (Venus), and Eros (Cupid), they could also be found in association with almost any of the Olympian deities; legends link them to Athena (Minerva), Hephaestus, and others.

In the Classical period, the Graces were depicted as clothed young women, but by the Hellenistic era

they were frequently nude, a tradition continued by Roman artists. During the Roman era, the Graces (Latin, *Gratiae*) were also the symbol of gratitude and were called Castitas (Chastity), Voluptas (Pleasure), and Pulchritudo (Beauty). Postclassical depictions of the Graces—comely figures in a circle—derive directly from the antique model.

Classical Sources. Homer, *Iliad* 5.338, 14.267–70, 18.382ff; *Odyssey* 8.362ff., 18.192ff. Hesiod, *Theogony* 64–65, 907–911, 945–46. Sappho, fragment 65. Pindar, *Olympian Odes* 14.3ff. Theocritus, *Idylls* 16.108. Horace, *Odes* 1, 3. Seneca, *De beneficiis* 1.3. Pausanias, *Description of Greece* 4.24.6–7, 6.24.6–7, 9.35.1–7. Orphic Hymns 60, "To the Graces." Hyginus, *Fabulae* preface.

Further Reference. Edgar Wind, *Pagan Mysteries in the Renaissance,* rev. ed. (New York: Norton, 1968), chapters 2 and 3.

See also APHRODITE; ARES AND APHRODITE; EROS, General List, Punishment; HERMES, General List; PANDORA; PARNASSUS.

Francesco Colonna, *c.*1433–1527. (Figures of Graces adorn fountain in) *Hypnerotomachia Poliphili* [The Dream of Poliphilo]. Romance. Venice: **1499**; illustrated with woodcuts by anonymous engraver. [Appell 1893, p. 7, pl. 23]

Raphael, 1483–1520. "The Three Graces." Painting. **1504–05.** Musée Condé, Chantilly. [Vecchi 1987, no. 38—ill. / Jones & Penny 1983, pp. 7f.—ill.]

————, assistant (probably Giulio Romano), after design by Raphael. "Cupid and the Three Graces." Fresco, part of "Psyche" cycle. 1517–18. Loggia di Psiche, Villa Farnesina, Rome. [Vecchi 1987, no. 10—ill. / Jones & Penny 1983, pp. 183ff.—ill. / Hartt 1958, pp. 32f.—ill. / d'Ancona 1955, pp. 55f., 89—ill. / Gerlini 1949, pp. 25ff.—ill.] Copies in Museum of Fine Arts, Boston, no. 84.561; Bowes Museum, Barnard Castle, cat. 1970 no. 939. [Boston 1985, p. 236—ill. / Wright 1976, p. 77]

————, composition. (Graces in) "Jupiter Overcome by Love for Ganymede" ("Ganymede and the Eagle"). Engraving, by "Master of the Die," *c.*1532–33. (Uffizi, Florence, no. 95916.) [Saslow 1986, p. 131, fig. 3.25 / Kempter 1980, p. 66, no. 144—ill.]

Andrea Mantegna, 1430/31–**1506.** "The Three Graces, with a View of Mantua." Painting. Lost. [Lightbown 1986, no. 103]

Baldassare Peruzzi, 1481–1536. "The Three Graces." Fresco (detached). **1506–09.** Zellerbach coll., San Francisco. [Frommel 1967–68, no. 11—ill. / Berenson 1968, p. 334]

Sandro Botticelli, 1445–1510. (Graces in) "La Primavera." Painting. Uffizi, Florence, no. 8360. [Berenson 1963, p. 34—ill. / Wind 1968, pp. 114, 117f.]

Pinturicchio, 1454–**1513,** and studio. "The Three Graces." Fresco (detached), from Palazzo Pandolfo Petrucci ("Il Magnifico"), Siena. Metropolitan Museum, New York, no. 114.21. [Metropolitan 1980, p. 142—ill.]

Antonio da Correggio, *c.*1489/94–1534. "The Three Graces." Fresco. *c.*1519. Camera di San Paolo, Parma. [Gould 1976, pp. 51ff., 244f.—ill.]

Domenico Beccafumi, 1486–1551. "The Three Graces."

Fresco. *c.***1530?** Palazzo Bindi Sergardi, Siena. [Sanminiatelli 1967, pp. 93f., pl. 31n]

Lucas Cranach, 1472–1553. "The Three Graces." Painting. **1531.** Seligmann coll., Paris, in 1932. [Friedländer & Rosenberg 1978, no. 250—ill.]

————. "The Three Graces." Painting. 1535. 2 versions. William Rockhill Nelson Gallery of Art, Kansas City, Mo., no. 57–1; Law coll., Cambridge, in 1932. [Ibid., no. 251—ill.]

Girolamo Romanino, *c.*1484/87–*c.*1562. "The Three Graces." Fresco. **1531–32.** Castello del Buonconsiglio, Trento. [Berenson 1968, p. 369]

Hans Baldung Grien, 1484/85–1545. "Harmony, or, The Three Graces." Painting. *c.***1541–44.** Prado, Madrid, no. 2219. [Prado 1985, p. 27 / Yale 1981, fig. 33]

Sodoma, 1477?–**1549,** school. "The Three Graces." Painting. Galleria Nazionale, Rome. [Hayum 1976, pp. 275f.]

Germain Pilon, *c.*1531–1590. "The Three Graces" ("Symbols of Three Virtues"). Marble sculpture, tomb of the Heart of Henry IV. **1559–63.** Louvre, Paris, inv. 413.414. [Clapp 1970, 1:705 / Wind 1968, 31 *n.*14]

Cecchin Salviati, 1510–1563. "The Three Graces." Drawing, design for a ewer. Ashmolean Museum, Oxford. [Pope-Hennessy 1985, fig. 30]

Francesco Primaticcio, 1504–**1570,** follower. "The Three Graces." Painting. Bowes Museum, Barnard Castle, cat. 1970 no. 613. [Wright 1976, p. 166]

James Sanford, fl. 1567–73. "Three Graces." Poem. In *The Garden of Pleasure* (London: **1573**). [Bush 1963, p. 315]

Jacopo Tintoretto, 1518–1594. "The Three Graces and Mercury." Painting. **1577–78.** Palazzo Ducale, Venice. [Rossi 1982, no. 373—ill.]

Hendrik Goltzius, 1558–1617. "The Three Graces." Drawing, composition for a print. *c.***1588.** Formerly Kupferstichkabinett, Berlin. (Print by Jacob Matham, 1588, Bartsch no. 285.) [Reznicek 1961, no. 133—ill. / also de Bosque 1985, pp. 226f.—ill.]

Edmund Spenser, 1552?–1599. (The Graces in) *The Faerie Queene* 1.1.48, 1.6.10; (Elizabeth I presented as the fourth Grace) 6.10.11–27. Romance epic. London: Ponsonbie, **1590,** 1596. [Hamilton 1977 / Davies 1986, p. 39ff. / Wind 1968, pp. 28f. / Maccaffrey 1976, pp. 353–56]

————. (The Graces in) *The Teares of the Muses* lines 175–80, 403–06. Poem. London: Ponsonbie, 1591. [Oram et al. 1989 / Nohrnberg 1976, p. 679, 729]

————. (The Graces in) "Epithalamion" lines 103–09, 255ff. Poem. In *Amoretti and Epithalamion* (London: Ponsonbie, 1595). [Oram et al.]

————. (The Graces in) "Hymne in Honour of Beauty" lines 253–61. Poem. In *Fowre Hymnes* (London: Ponsonbie, 1596). [Ibid.]

Giovan Battista Naldini, 1537–1591. "The Three Graces." Painting. Szépművészeti Múzeum, Budapest, no. 173. [Budapest 1968, p. 476—ill.]

Agostino Carracci, 1557–1602. "The Three Graces." Engraving (Bartsch no. 130), in *"lascivie"* series. *c.***1590–95.** [DeGrazia 1984, no. 183—ill.]

Francesco Morandini, called Il Poppi, 1544–1597. "The Three Graces." Painting. Uffizi, Florence, inv. 1471. [Uffizi 1979, no. P1263—ill.]

Andrea Boscoli, *c.*1560–**1607.** "The Three Graces."

Drawing. Gabinetto Disegni e Stampe, Uffizi, no. 812 F. [Florence 1986, no. 2.52 *n.*]

Rutilio Manetti, 1571–1639, attributed. "The Three Graces." Painting. By **1607**? Galleria Borghese, Rome, inv. 527. [Pergola 1955–59, 2: no. 51—ill.]

Ben Jonson, 1572–1637. (The Graces in) *The Haddington Masque* (*The Hue and Cry after Cupid*). Masque, performed for the marriage of Lord Haddington, 9 Feb **1608,** at Court, London. Published London: 1608. [Herford & Simpson 1932–50, vol. 7 / McGraw-Hill 1984, 3:111, 113]

————. (The Graces evoked in a song in) *Pleasure Reconciled to Vertue.* Masque. First performed 1618, at Court, London. [Herford & Simpson / Wind 1968, p. 120]

Cornelis Cornelisz van Haarlem, 1562–1638, falsely attributed? "The Three Graces." Drawing. **1610.** Rijksmuseum, Amsterdam. [de Bosque 1985, pp. 227f.—ill.]

Palma Giovane, *c.*1548–1628. "The Three Graces." Painting. *c.***1611.** Accademia di San Luca, Rome, inv. 229. [Mason Rinaldi 1984, no. 238—ill.]

————. "Mercury and the Three Graces." Painting. 1611. Private coll., Switzerland. [Ibid., no. 300—ill.]

Gabriello Chiabrera, 1552–1638, libretto. *Vegghia delle Gratie* [Vigil of the Graces]. Ballet. Music, recitatives by Jacopo Peri. First performed 16 Feb **1615,** Palazzo Pitti, Florence. [Weaver 1978, p. 98]

Peter Paul Rubens, 1577–1640, figures, and **Jan Brueghel the Elder,** 1568–1625, fruits and flowers. "Nature [Diana of Ephesus] Adorned by the Graces." *c.***1615.** Glasgow Museum and Art Galleries. [Jaffé 1989, no. 322—ill.]

———— (Rubens). "The Three Graces." Monochrome painting, study for unknown (unexecuted?) relief. *c.*1620–23 or *c.*1627–30. Uffizi, Florence, inv. 1165, on display in Palazzo Pitti. [Ibid., no. 896—ill. / Uffizi 1979, no. P1378—ill. / Held 1980, no. 240—ill. / also Pitti 1966, p. 222—ill.]

————. (The Graces in) "The Education of Marie de' Medici." Painting, part of "Life of Marie de' Medici" cycle. 1622–25. Louvre, Paris, inv. 1771. [Saward 1982, pp. 40ff.—ill. / Jaffé, no. 716—ill. / also Louvre 1979–86, 1:115—ill. / also Baudouin 1977, pl. 45] Oil sketches. Alte Pinakothek, Munich, inv. 92; Simson coll., Freiburg. [Jaffé, nos. 714–15—ill. / Munich 1983, pp. 463f.—ill. / Held, nos. 58–59—ill.]

————. (The Graces in) "The Glorification of the Duke of Buckingham" ("Minerva and Mercury Conduct the Duke to the Temple of Virtue"). Ceiling painting, for George Villiers, Duke of Buckingham. *c.*1625–27. Formerly Osterley Park, destroyed 1949. [Jaffé, no. 795—ill.] Oil sketch. National Gallery, London, inv. 187. [Ibid., no. 794—ill. / Held, no. 291—ill. / also London 1986, p. 545—ill.] Copy of lost early sketch, formerly Reyve coll., London, unlocated. [Jaffé, no. 793 / Held, no. 290—ill.]

————. "The Three Graces." Painting. *c.*1635 or 1636–38. Prado, Madrid, no. 1670. [Jaffé, no. 1344—ill. / Prado 1985, pp. 582f. / White 1987, pl. 310 / also Baudouin, pl. 94]

————. "The Three Graces Dancing." Painting, oil sketch for unknown work. *c.*1636 or *c.*1625–28. Dulwich College Picture Gallery, London, no. 264. [Jaffé, no. 1224—ill. / Held, no. 239—ill.]

————. "The Three Graces." Drawing. Count Antoine Seilern coll., London. [Burchard & d'Hulst, no. 204—ill.]

Hans von Aachen, 1552–**1616.** "The Three Graces." Painting. Herzog Anton Ulrich-Museum, Braunschweig, no. 1088. [Braunschweig 1976, p. 7—ill. / de Bosque 1985, p. 119]

Giovanni da San Giovanni, 1592–1636. (The Graces in) "Allegory of Florence." Fresco, for a house in Piazza della Calza, Florence. **1616.** Detached fragments in possession of Soprintendenza degli Uffizi, Florence. Drawings in Gabinetto Disegni e Stampe, Uffizi, Florence, nos. 1122 F, 2376 S; Kunstmuseum, Düsseldorf, no. F. P. 357; Hermitage, Leningrad, no. 1064. [Banti 1977, no. 1—ill.]

Francisco Rodrigues Lobo, 1580–1622. *Comedia Eufrosina.* Comedy. Lisbon: Alvarez, **1616.** [NUC]

Anthony van Dyck, 1599–1641. "The Three Graces." Painting (sketch). *c.***1616–17.** Private coll., England. [Larsen 1988, no. 309—ill.]

Thomas Heywood, 1573/74–1641. "Of the Graces." Passage in *Gynaikeion: or, Nine Books of Various History Concerning Women* book 2. Compendium of history and mythology. London: Adam Islip, **1624.** [Ipso]

Laurent de La Hyre, 1606–1656. "The Three Graces." Drawing. Early work. Musée Fabre, Montpellier. [Metropolitan 1960, no. 52—ill.]

John Milton, 1608–1674. (Euphrosyne, called Mirth, invoked in) "L'allegro" lines 11–16. Poem. Summer **1631**? In *Poems* (London: Moseley, 1645). [Carey & Fowler 1968]

————. ("Universal Pan" leads the Graces and Hours in) *Paradise Lost* 4.266f. Epic. London: Parker, Boulter & Walker, 1667. [Carey & Fowler 1968 / Merivale 1969, pp. 26f.]

Francesco Furini, 1604–1646. "The Three Graces" (previously called "The Parcae"). Painting. **1638.** Hermitage, Leningrad. [Hermitage 1981, pl. 143] Studio copy (reversed). National Gallery, London, inv. 6492. [London 1986, p. 215—ill.]

Simon Vouet, 1590–1649. "Mercury and the Three Graces." Painting. Lost. / Engraved by Michel Dorigny, **1642.** [Crelly 1962, p. 228—ill.]

Robert Herrick, 1591–1674. "A Hymne to the Graces," "A Psalme or Hymne to the Graces," (the Graces attend wedding in) "An Epithalamie to Sir Thomas Southwell and His Ladie" lines 41–50. Poems. In *Hesperides* (London: Williams & Eglesfield, **1648**). [Martin 1956]

Antonio Draghi, 1634/35–1700. *Il pelegrinaggio dell Gratie all' oracolo dodoneo* [The Pilgrimage of the Graces to the Oracle of Dodona]. Opera. Libretto, Nicolò Minato. First performed 23 July **1691,** Vienna. [Grove 1980, 5:604]

Daniel Gran, 1694–1757. "Apollo Surrounded by Virtues and Sciences [or Vices]" (with Minerva and the Graces), "A Youth (Led by Pallas Athena) Receiving the Lamp of Knowledge from the Graces." Frescoes. **1726.** Marmorsaal, Gartenpalais Schwarzenberg, Vienna. [Knab 1977, pp. 48f., nos. F12, F13—ill.]

Jean-Joseph Mouret, 1682–1738. *Les Grâces.* Ballet héroïque. Libretto, Pierre-Charles Roy. First performed 5 May **1735,** L'Opéra, Paris. [Grove 1980, 12:655]

François Boucher, 1703–1770. "The Three Graces Chaining Cupid" (with flowers). Overdoor painting. **1736–38.** Archives Nationales, Paris. [Ananoff 1976, no. 162—ill.] Replica ("The Graces and Cupid"). 1738. Gulbenkian Foundation, Lisbon, inv. 433. [Ibid., no. 154—ill.]

————. "Cupid Chained by the Graces" (with flowers). Painting. *c.*1742. Reitinger coll., Paris. [Ibid., no. 207—ill.]

————. "Cupid Imprisoned" (with flowers by the Graces). Painting. 1754. Wallace Collection, London, no. P.432. [Ibid., no. 429—ill.]

———. "The Three Graces Carrying [torchbearing] Cupid." Painting, sketch. *c*.1759. Louvre, Paris, no. M.I. 1023. [Ibid., no. 523—ill. / Louvre 1979–86, 3:81—ill.]

Pompeo Batoni, 1708–1787. "The Three Graces." Painting. *c*.**1756–58**. Unlocated. [Clark 1985, no. 199—ill.]

Joshua Reynolds, 1723–1792. "Mrs. Hale as Euphrosyne." Painting. **1762–64**. Earl of Harewood coll., Harewood House, Yorkshire. [Royal Academy 1986, no. 61—ill. / Waterhouse 1941, p. 52—ill.]

———. "Lady Sarah Bunbury Sacrificing to [a statue of] the Graces." Painting. 1765. Art Institute of Chicago. [Royal Academy, no. 57—ill. / Waterhouse, p. 56—ill.]

———. "Three Ladies (Graces) Adorning a Term of Hymen." Painting. Exhibited 1774. Tate Gallery, London. [Royal Academy, no. 90—ill. / Waterhouse, p. 64—ill. / Hutchison 1986, p. 40]

Carle van Loo, 1705–1765. "The Three Graces." Painting. Château de Chenonceau, France. [Jacobs & Stirton 1984a, p. 20]

Daniele Florio, 1710–1789. *Le Grazie: Poemetto per le felicissime nozze di Sue Eccellenze* [The Graces: Poem for the Most Happy Nuptials of Their Excellencies] (Venice: Modeste Fenzo, **1766**). [DELI 1966–70, 1:487]

Christoph Martin Wieland, 1733–1813. *Musarion, oder, Die Philosophie der Grazien* [Musarion, or, The Philosophy of the Graces]. Poem. Leipzig: Weidmanns, Erben & Reich, 1768. [Radspieler 1984, vol. 3 / Oxford 1986, pp. 645, 980]

———. "Die Grazien." Poem. In *Sämmtliche Werke* (Leipzig: Göschen, 1794–1811). [Radspieler / Butler 1958, pp. 161f.]

Giovanni Battista Tiepolo, 1696–1770. "Mars and the Graces." Painting. *c*.1762–70. Formerly Oranienbaum Castle, near Leningrad, unlocated. [Morassi 1962, p. 37]

Gian Francesco de Majo, 1732–1770. *Aglaia e Talia*. Oratorio or cantata. [Grove 1980, 11:544]

Jean-Honoré Fragonard, 1732–1806 (formerly attributed to Lagrenée). "The Three Graces." Painting, overdoor for Pavillion de Louveciennes. 1770. Musée Fragonard, Grasse, inv. 5572. [Rosenberg 1988, no. 153—ill.] / also Wildenstein, no. 297—ill.]

———. "The Three Graces." Drawing. Sold 1786, untraced. [Réau 1956, p. 191]

Johann Georg Jacobi, 1740–1814. "Das Lied der Grazien" [The Song of the Graces]. Poem. **1770**. In *Sämmtliche Werke* (Karlsruhe: Schmieder, 1780). [DLL 1968–90, 8:428]

———. "An Aglaia" [To Aglaia]. Poem. 1771. [Ibid.]

Jean-Georges Noverre, 1727–1810, choreography. *Les Grâces*. Ballet. First performed **1768–73** (?), Vienna. [Grove 1980, 13:443]

Angelica Kauffmann, 1741–1807. "Cupid, Finding Aglaia Asleep, Binds Her to a Laurel." Painting. Exhibited **1774**. [Manners & Williamson 1924, p. 40] Variant, ceiling painting. Derby House, London. [Ibid., p. 132]

———. "Venus and Cupid, Who Has Wounded Euphrosyne with an Arrow." Painting, for Lord Barwick. 1793. [Ibid., pp. 164, 173]

Richard Graves, 1715–1804. *Euphrosyne, or, Amusements on the Road of Life*. Entertainment. London: Dodsley, **1776**. [Nicoll 1959–66, 3:265]

Anton Raphael Mengs, 1728–1779. "The Three Graces." Pastel. Formerly Catherine the Great coll., untraced. [Honisch 1965, no. 295]

———, uncertain attribution. "The Three Graces." Painting. Schloss Hohenstadt, Donaueschingen, Germany. [Ibid., no. 407]

———, rejected attribution. "The Three Graces." Painting. Formerly Kolasinski coll., Warsaw. [Ibid., no. 398]

Maximilien Gardel, 1741–1787, choreography. *Les Grâces*. Ballet. First performed **1779**, Paris. [Cohen-Stratyner 1982, p. 353]

[?] Legrand, music. *Les trois roses, ou, Les Grâces*. Comedy with ariettes. Libretto, Rozoi. First performed 10 Dec **1779**, Versailles. [Grove 1980, 10:614]

Benjamin West, 1738–1820. "The Graces Unveiling Nature [Diana of Ephesus]." Ceiling painting. *c*.**1780**. Royal Academy of Arts, London. [Erffa & Staley 1986, no. 426—ill.] Sketch. Private coll. [Ibid., no. 427—ill.]

Charles Dibdin, 1745–1814, music and libretto. *The Graces*. Entertainment. First performed Oct (?) **1782**, Royal Circus, London. [Grove 1980, 5:427 / Fiske 1973, pp. 480, 482]

Heinrich Wilhelm von Gerstenberg, 1737–1823. *Die Grazien*. Poem. / Set to music as a cantata by Friedrich Benda. Cantata published Leipzig: Breitkopf, **1789**. [Grove 1980, 2:465]

Étienne Méhul, 1763–1817. *Euphrosine, ou, Le tyran corrigé* [Euphrosine, or, The Tyrant Corrected]. Opera. Libretto, François-Benoit Hoffman. First performed 4 Sep **1790**, Théâtre Favart, Paris. / Later revised as *Euphrosine et Coradin*. [Grove 1980, 12:65]

Jean-Baptiste Regnault, 1754–1829. "The Three Graces." Painting. 1790. Louvre, Paris, no. M.I. 1101. [Louvre 1979–86, 4:171—ill.]

James Barry, 1741–1806. "Tasso in Prison Crowned by Urania and the Three Graces." Etching. Before **1792**. (Ashmolean Museum, Oxford.) [Pressly 1981, no. P.16]

Johann Gottfried Schadow, 1764–1850. "The Muses Calliope and Polyhymnia, the Three Graces, Cupid, and Apollo." Drawing, design for title page of *Calendar der Musen und Grazien für das Jahr 1796*. **1794**. Nationalgalerie, Berlin, no. Z.45. [Berlin 1965, no. 103]

———. "The Muses Calliope and Euterpe, with Cupid and the Three Graces." Drawing, companion to above. c.1794. Nationalgalerie, no. Z.46. [Ibid., no. 104]

———. (The Graces in) "The Power of Music." Façade relief, for C. G. Langhans's theater, Berlin. 1801. Destroyed 1817. / Drawings. Deutsche Akademie der Künste, Berlin, inv. Schadow 165, 797, 798, 800. [Ibid., nos. 118, 119—ill.]

———. "The Three Graces." Drawing. 1803. Nationalgalerie, Berlin, no. 15. [Ibid., no. 127]

Johann Heinrich Dannecker, 1758–1841. "The Three Graces and Cupid." Plaster sculpture (lamp pedestal). *c*.**1795**. Staatsgalerie, Stuttgart. [Spemann 1958, pls. 12–13]

Johann Gottfried Herder, 1744–1803. "Das Fest der Grazien" [The Festival of the Graces]. Prose poem. **1795**. In *Dichtungen* vol. of *Sämmtliche Werke* (Tübingen: Cotta, 1805–20). [Herder 1852–54, vol. 15]

Antonio Canova, 1757–1822. "The Graces and Two Amorini Dancing before an Image of Venus." Painting. *c*.**1797**. Museo Civico, Bassano del Grappa, no. 7. [Pavanello 1976, no. D75—ill. (cf. nos. 105, D68)] Related relief and painting ("Venus and the Graces Dancing before Mars"). 1797. Gipsoteca Canoviana, Possagno, nos. 98–99. [Ibid., nos. 105, D68—ill. / also Licht 1983, pp. 256–62—ill.]

————. "Dance of the Graces with Cupid." Painting. 1798–99. 2 versions. Gipsoteca Canoviana, Possagno, no. 131; Museo Civico, Bassano del Grappa, no. 13. [Pavanello, nos. D66, D80—ill.]

————. "The Graces." Painting. 1799. Gipsoteca Canoviana, Possagno, no. 132. [Ibid., no. D26—ill.]

————. "Concordia with the Graces." Terra-cotta statuette, variant model for "Maria Luisa d'Asburgo as Concordia." c.1809. Gipsoteca Canoviana, Possagno, no. 202. [Ibid., no. 228—ill.]

————. "The Three Graces." Marble sculpture group. Modeled 1813, completed 1816. Hermitage, Leningrad. [Ibid., no. 270—ill.] Plaster and terra-cotta models. Gipsoteca Canoviana, Possagno, no. 237; Musée des Beaux-Arts, Lyons. [Ibid., no. 271—ill. / also Licht 1983, p. 226—ill.] Marble replica. 1815–17. Duke of Bedford coll., Woburn Abbey, Buckinghamshire. [Pavanello, no. 272—ill. / Licht, pp. 203–11—ill. / Jackson-Stops 1985, no. 480—ill.]

Johann Wolfgang von Goethe, 1749–1832. "Euphrosyne" (descending into Hades). Elegy, for Christiane Neumann. June **1798.** In *Musenalmanach* Sep 1798; collected in *Gedichte* (Tübingen: Cotta, 1812). [Beutler 1948–71, vol. 1 / Suhrkamp 1983–88, vol. 1 / Viëtor 1949, pp. 139, 141 / Butler 1958, pp. 131, 334 / Reed 1980, p. 194]

————. (The Graces in) *Faust* Part 2, l.5299–5304. Tragedy. This episode first published 1828 as a continuation of Part 1; incorporated into Part 2, published Heidelberg: 1832. [Beutler, vol. 5 / Suhrkamp, vol. 2]

Henry Fuseli, 1741–1825. "Fancy and Moderation Hovering over Euphrosyne." Painting, after Milton's "L'allegro" (1631?), for Milton Gallery, no. 45. **1799–1800.** Kurpfälzisches Museum, Heidelberg. [Schiff 1973, no. 907—ill.]

————. "The Three Graces" (3 contemporary women). Drawing. 1810–15. Kunsthaus, Zurich, inv. 1940/61. [Ibid., no. 1606]

————. "Euphrosyne at the Peasant's Dance." Drawing, after Milton's "L'Allegro." c.1820. Meyer coll., Zürich. [Ibid., no. 1813—ill.]

Alexey Nikolayevich Titov, 1769–1827. *Amur-sud'ya, ili, Spor Tryokh Gratsiy* [Judge Cupid, or, The Argument of the Three Graces]. Opera. Libretto, Knyazhnin. First performed **1805,** St. Petersburg. [Grove 1980, 19:15]

Étienne d'Antoine, 1737–**1809.** "Fountain of the Three Graces." Fountain sculpture. Montpellier. [Bénézit 1976, 1:214]

John Flaxman, 1755–1826, design. "The Three Graces Gathering the Apples of the Hesperides." Figures on stem of silvergilt candelabrum. Executed by Paul Storr, **1809–10.** Royal Collection, England. [Irwin 1979, pp. 191f., fig. 263—ill.]

Pierre-Paul Prud'hon, 1758–1823. "Hymen, Cupid, and Genius Chaining the Graces and the Muses [of History, Epic Poetry, and Astronomy]." Drawing, design for sculpture decorating Hôtel de Ville for celebration of the marriage of Napoleon to Marie-Louise. **1810.** Sculpture executed by Edmé Gaulle, destroyed. Original drawing in Louvre, Paris. [Guiffrey 1924, no. 979, pp. 352f.]

Ugo Foscolo, 1778–1827. *Le Grazie.* Poem, unfinished. **1814.** Published, edited by F. S. Orlandini (Florence: 1848). Modern edition by Saverio Orlando as *Le Grazie,*

carme ad Antonio Canova (Brescia: Paideia, 1974). [Circeo 1974 / EW 1983–85, 5:335–39 / Cambon 1980, pp. 207f., 211–19, 346]

John Keats, 1795–1821. "Apollo to the Graces" (Apollo invites the Graces to ride in the sun chariot). Poem. **1818.** First published in *The Times Literary Supplement* 16 Apr 1914. [Stillinger 1978 / De Selincourt 1951, pp. 385, 563 / Vendler, p. 249]

Bertel Thorwaldsen, 1770–1844. "Cupid and the Graces." Marble sculpture group. **1817–19.** Thorwaldsens Museum, Copenhagen, no. A894. [Thorwaldsen 1985, p. 85, pl. 17 / Hartmann 1979, p. 115, pls. 55, 57 / Cologne 1977, no. 127—ill.] Plaster model. Thorwaldsens Museum, no. A29. [Thorwaldsen, p. 23] Plaster sketch ("The Graces"). Thorwaldsens Museum, no. A30. [Ibid. / Cologne, no. 115, p. 24—ill.] Marble variant ("The Graces with Cupid's Arrow, and Cupid Playing the Lyre"), modeled 1842, executed by C. Freund and H. W. Bissen, 1864. Thorwaldsens Museum, no. A31. / Plaster model. Thorwaldsens Museum, no. A32. [Thorwaldsen, p. 23]

————. "The Graces Listening to Cupid's Song." Marble relief, for monument to Andrea Appiani. 1826. Pinacoteca di Brera, Milan. [Hartmann, p. 114—ill.] Studio replica. 1836. Thorwaldsens Museum, no. A601. [Thorwaldsen, p. 65 / Cologne, p. 47—ill.] Cast of original (1821) plaster. Thorwaldsens Museum, no. A602. [Thorwaldsen, p. 65]

————. "The Graces Dancing." Relief. Plaster original, c.1832. Thorwaldsens Museum, no. A374. [Hartmann, p. 116, pl. 52.4 / Thorwaldsen, p. 49]

————. "The Hovering Graces." Relief. Plaster original, c.1836. Thorwaldsens Museum, no. A338. [Thorwaldsen, p. 46]

Karol Kazimierz Kurpinski, 1785–1857, music. *Trzy Gracje* [The Three Graces]. Ballet. First performed 2 June **1822,** Warsaw; choreography, L. Thierry. [Grove 1980, 10:320]

Jean Pierre Aumer, 1776–1833, choreography. *L'offrande aux Grâces* [The Offering to the Graces]. Ballet. First performed 14 Jan **1823,** King's Theatre, London. [Guest 1972, p. 156]

August Bournonville, 1805–1879, choreography. *Gratiernes hyldning* [Celebration of the Graces]. Divertissement. Music, M. E. Caraffa, W. R. V. Gallemberg, and F. Sor. First performed **1829,** Copenhagen. [Terry 1979, pp. 28, 68, 161]

James Pradier, 1792–1852. "The Three Graces." Marble sculpture group. **1831.** [Janson 1985, p. 107]

Antoine Benoît Berbiguier, 1782–1838. "Les Trois Grâces." Rondolettes for flute and piano. **1834.** [Edler 1970, p. 193]

Eduard Mörike, 1804–1875. "Die Chariten" [The Charites]. Translation of Theocritus, Idyll 16. In *Classische Blumenlese* (Stuttgart: Schweizerbart, **1840**). [Hötzer 1967]

François-Joseph Bosio, 1769–**1845.** "The Three Graces." Sculpture group. Musée des Beaux-Arts, Dunkirk. [Bénézit 1976, 2:194]

Antoine-Louis Barye, 1796–1875. (Figures of the Graces on) 9-light candelabrum. c.**1847.** Walters Art Gallery, Baltimore. [Benge 1984, pp. 150f.—ill.] Bronze edition of figures of the Graces, by 1855. [Ibid.] Bronze incense burner, based on candelabrum figures. Metropolitan Museum, New York. [Pivar 1974, no. F17—ill.]

————. "The Three Graces." Figures on bronze 6–light candelabrum. Private coll. [Pivar, no. D25—ill.]

William Etty, 1787–1849. "The Three Graces." Painting, sketch for "Venus Disrobing." Metropolitan Museum, New York, no. 05.31. [Metropolitan 1980, p. 54—ill.]

Edward Hodges Baily, 1788–1867. "The Three Graces." Marble sculpture group. 1849 (after model of early 1800s). Grittleton House, Wiltshire. [Read 1982, pp. 140f.]

Paul Taglioni, 1808–1884, choreography. *Les Grâces.* Divertissement. Music, Cesare Pugni. First performed 2 May 1850, Her Majesty's Theatre, London. [Guest 1972, pp. 140, 159]

Matthew Arnold, 1822–1888. "Euphrosyne" (originally titled "Indifference"). Poem. In *Empedocles on Etna, and Other Poems* (London: Fellowes, 1852). [Allott 1965 / Tinker & Lowry 1940, p. 166]

Samuel Rogers, 1763–1855. "A Temple Dedicated to the Graces." Poem. In *Poetical Works* (London: Routledge, 1867). [Boswell 1982, p. 287]

John Gibson, 1790–1866. "The Graces." Sculpture group. Walker Art Gallery, Liverpool. [Bénézit 1976, 4:714]

Charles Gleyre, 1806–1874. "Minerva and the Graces." Painting. 1866. Musée Cantonal des Beaux-Arts, Lausanne, inv. 1388. [Harding 1979, pp. 43, 132—ill. / Winterthur 1974, no. 74—ill.]

Jean-Baptiste Carpeaux, 1827–1875. (Graces in) "The Dance." High-relief stone sculpture, for façade of L'Opéra, Paris. 1865–69. Original removed 1964, replaced by a copy, by Belmondo; original now in Musée d'Orsay, Paris, inv. R.F. 2884. [Orsay 1986, p. 84—ill. / Wagner 1986, pp. 209ff.—ill. / Beyer 1975, nos. 284–329—ill. / Kocks 1981, pp. 88ff., pl. 382] Plaster models. Musée d'Orsay, Musée de L'Opéra, Paris. [Wagner, fig. 249 / Janson 1985, fig 152] Terracotta version. Ny Carlsberg-Glyptotek, Copenhagen. [Kocks, p. 441—ill.] Painting after. Private coll., Paris. [Beyer, no. 320—ill.]

————. "The Dance of the Graces." Terra-cotta sculpture, after figures in "The Dance." 1874. Petit Palais, Paris, no. P.P.S. 1570. [Beyer 1975, no. 325—ill.] Terra-cotta models: Petit Palais and Fabius coll., Paris. [Beyer, no. 324—ill., no. 326 / Kocks, p. 335—ill.]

Otto Franz Gensichen, 1847–1933. *Euphrosyne.* Drama. Berlin: Grosser, 1878. [DLL 1968–90, 6:198]

Lawrence Alma-Tadema, 1836–1912. "Una Carita: The Three Graces: Laura, Laurence and Anna" (artist's wife and children). Painting. 1883. Unlocated. [Swanson 1977, p. 139]

Edward Burne-Jones, 1833–1898. "The Three Graces." Pastel. c.1885. Carlisle Art Gallery. [Harrison & Waters 1973, pl. 40—ill. / also Arts Council 1975, no. 122]

Arnold Böcklin, 1827–1901. "Hymn to Spring" (the Graces). Painting. 1888. Museum der Bildenden Künste, Leipzig, inv. 775. [Andree 1977, no. 411—ill.]

Émile Bernard, 1868–1941. "The Graces." Painting. 1890. Private coll. [Luthi 1982, no. 261—ill.]

Louis Anquetin, 1861–1932. "The Three Graces." Painting. c.1899. Du Ferron-Anquetin coll., Paris, in 1953. / 2 oil studies. Tate Gallery, London, no. 5252. [Alley 1981, p. 16—ill.]

Odilon Redon, 1840–1916. "The Two Graces." Painting.

1900. Sirak coll., Columbus, Ohio. [Wattenmaker 1975, no. 70—ill.]

Robert Williams Buchanan, 1841–1901. "Euphrosyne: or, The Prospect." Poem. In *Complete Poetical Works* (London: Chatto & Windus, 1901). [Boswell 1982, p. 57]

Frederick Converse, 1871–1940. *Euphrosyne.* Overture. 1903. [Grove 1980, 4:706]

Henri Fantin-Latour, 1836–1904. "To Rossini" (the Graces, Music and Fame decorating a bust of the composer). Lithograph. 1903. [Hédiard 1906, no. 160—ill.]

Lovis Corinth, 1858–1925. "The Graces." Painting. 1902–04. Neue Pinakothek, Munich, inv. 11176. [Berend-Corinth 1958, no. 233—ill. / Munich 1982, p. 376—ill.]

————. "The Three Graces." Letter "G" from "ABC" lithograph series. 1917. [Schwarz 1922, no. 315]

————. "The Three Graces." Etching. 1920. [Ibid., no. 394]

————. "The Three Graces." Etching, illustration for an edition of Arno Holz's *Daphnislieder* (Berlin: Gurlitt, 1923). [Müller 1960, no. 737—ill.]

Demetrios Bernardakes, 1834–1907. *Euphrosyne.* Tragedy. [Trypanis 1981, p. 622]

Arthur B. Davies, 1862–1928. "Gates of Heaven" ("Three Graces"). Painting. 1907. Ryerson coll., Chicago. [Cortissoz 1931, p. 25]

Jules Pascin, 1885–1930. "The Three Graces." Painting. c.1908. Perls Galleries, New York. [Werner 1959, pl. 3]

————. "The Three Graces." Drawing. 1910. Josefowicz coll., New York. [Werner 1959, fig. 18]

Oskar Blumenthal, 1853–1917, with **Rudolf Lothar,** 1865–1943. *Die Drei Grazien.* Comedy. 1910. [Oxford 1986, p. 96]

Émile-Antoine Bourdelle, 1861–1929. "The Graces Playing with the Animals," "Wisdom and the Graces." Frescoes. 1912. Loge, Théâtre des Champs-Elysées, Paris. [Basdevant 1982, pp. 81f., 90—ill.] Plaster studies ("Grace and Ram," "Grace and Kid"). Musée Bourdelle, Paris. [Ibid.—ill. / cf. Jianou & Dufet, no. 480]

Max Ernst, 1891–1976. "The Three Graces." Painting. c.1912–13. Kunstgewerbemuseum, Cologne. [Spies & Metken 1975–79, no. 63—ill. / also Quinn 1977, fig. 23—ill]

Julia Bracken Wendt, 1871–1942. "The Three Graces: History, Science, and Art." Bronze sculpture group. 1914. Rotunda, Los Angeles County Museum of Natural History. [Rubinstein 1982, pp. 97f., fig. 4.3]

Enrico Maria Fusco, b. 1886. *Aglaia.* Collection of poems. Bari: 1917. [DELI 1966–70, 2:557]

Paul Manship, 1885–1966. "Euphrosyne." Reverse of bronze portrait medal of Welles Bosworth. 1920. Minnesota Museum of Art, St. Paul, no. 66.14.223b. [Murtha 1957, no. 125—ill. / Minnesota 1972, no. 24—ill.]

Pablo Picasso, 1881–1973. "The Three Women." Etching. 1922. [Bloch 1971–79, 1: no. 51—ill.] Painting, variant ("The Three Graces"). 1924. [Zervos 1932–78, 5: no. 250—ill.]

————. "The Three Graces II." Etching. 1922–23. [Bloch, no. 59—ill.] Variants ("Group of Three Women," "The Necklace," "The Bathers [I, II & III]"). [Ibid., nos. 57, 58, 60–62—ill.]

————. "The Three Graces on the Beach." Etching. 1932. [Ibid., no. 249—ill.]

Aldous Huxley, 1894–1963. "Two or Three Graces" (ironic evocation of subject in title). Short story. In *Two or Three*

Graces, and Other Stories (London: Chatto & Windus, **1926**). [Ipso]

Francis Picabia, 1878–1953. "The Three Graces." Painting, based on Rubens (1630s, Prado). **1924–27.** Galerie Neuendorf, Hamburg, in 1987. [Hofmann 1987, no. 15.16—ill. / Borràs 1985, no. 474, p. 293—ill. / Camfield 1979, p. 223, fig. 273]

Isadora Duncan, 1877–**1927,** choreography. *Three Graces.* Modern dance. First performed 1928, Paris. [McDonagh 1976, p. 19]

Ossip Zadkine, 1890–1967. "The Three Graces with Coral." Bronze sculpture group. **1927.** Private coll., Japan. [Jianou 1979, no. 148]

———. "Graces Playing." Bronze sculpture group. 1930. 5 casts. Private colls. [Ibid., no. 190, p. 26—ill.]

———. "The Three Graces." Wood sculpture group. 1950. Henriquez coll., Curaçao. [Ibid., no. 365]

Paul Richer, 1849–**1933.** *"Tres in una"* (figures of the Graces, representing the "Ideal of the Female Nude in Art, According to the Renaissance Masters, the Ancients, and the Moderns"). Marble sculpture group. Mairie du 8e arrondissement, Paris. / Plaster sketch. Musée d'Orsay, Paris, inv. RF 2342. [Orsay 1986, p. 228—ill.]

Frederick Ashton, 1904–1988. (3 Graces and Eros in) *Venusberg Scene.* Ballet. First performed 2 Nov **1938,** Vic-Wells Opera, Sadler's Wells, London. [Vaughan 1977, p. 471]

Raoul Dufy, 1877–1953. "The Three Graces." Painting (based on figures representing the Seine, Oise, and Marne in Palais de Chaillot, Paris, bar decoration). **1942.** [Laffaille 1977, no. 1769—ill., cf. nos. 1767, 1770–74]

Marino Marini, 1901–1980. "The Three Graces." Bronze high-relief sculpture. **1943.** Nelson Rockefeller coll., New York. [Apollonio 1958, p. 38—ill.]

Giorgio de Chirico, 1888–1978. "The Three Graces." Painting. **1947.** Artist's coll., Rome, in 1975. [de Chirico 1971–83, 5.2: no. 411—ill.]

———. "The Three Graces." Painting. 1954. Artist's coll., Rome, in 1972. [Ibid., 2.3: no. 172—ill.]

———. "The Three Graces." Painting. 1960–61. Private coll., New York. [Ibid., 7.3: no. 1110—ill.]

Giacomo Manzù, 1908–. "The Three Graces." Etching, illustration for an edition of Virgil's *Georgics* (Milan: Hoepli, **1948**). [Ciranna 1968, no. 78—ill.] Variant. [Ibid., no. 94—ill.]

Benjamin Jarnés Millán, 1888–1949. *Eufrosina; o, La Gracia.* Novel. [Barcelona?]: Janés, **1948.** [EWL 1981–84, 2:500]

William Carlos Williams, 1883–1963. "Three Graces." Poem.

In *Selected Poems* (Norfolk, Conn.: New Directions, **1949**). [MacGowan 1988]

Ruthana Boris, 1918–, choreography. (The Graces in) *Cakewalk.* Ballet. Music, Louis Moreau Gottschalk, adapted by Hershy Kay. First performed 12 June **1951,** City Center, New York; scenery and costumes, Robert Drew. [Sharp 1972, pp. 94, 256]

Gerald Finzi, 1901–1956. *Muses and Graces.* Composition for soprano, chorus, and pianoforte, opus 34. Text, U. Wood. **1951.** [Grove 1980, 6:596]

Jan Frank Fischer, 1921–, music. *Eufrosina.* Ballet. **1951.** First performed 1956, Pilsen; choreography, J. Rey. [Baker 1984, p. 725 / Grove 1980, 6:606]

Gerhard Marcks, 1889–1981. "The Three Graces." Bronze sculpture group. **1957.** 9 (?) casts. Museum of Fine Arts, Boston, no. 88.1971; private colls., Germany and U.S.A.; other(s) on art market. [Busch & Rudloff 1977, no. 664—ill.]

Jean Arp, 1887–1966. "The Three Graces." Abstract dur-aluminium sculpture group. **1961.** Edition of 5: Galerie Denise René, Paris, in 1968; elsewhere. [Read 1968, p. 209—ill. / Arp 1968, no. 263—ill. / also Berlin 1963, no. 75—ill.]

Gustav Seitz, 1908–. "The Three Graces" ("Three Women"). Bronze relief, 1 panel of "Porta d'amore" doors (1963–69). Museum für Kunst und Gewerbe, Hamburg, inv. 1973.183a-b. / 4 casts of "Graces" panel, **1963.** Atelier Gustav Seitz, Hamburg; private colls., Germany. [Grohn 1980, nos. 236, 246—ill.]

Man Ray, 1890–1976. (Figures of Graces in) "Mire universelle" [Universal Aim] ("Target"). Sculpture collage. **1971.** 10 examples. Juliet Man Ray coll., Paris; elsewhere. [Hofmann 1987, no. 14.12—ill. / Schwarz 1977, pl. 287]

John Eaton, 1935–. *The Three Graces.* Vocal composition. Text, D. Anderson. First performed **1972.** [Grove 1980, 5:809]

Lennox Berkeley, 1903–. "The Hill of the Graces." A capella choral composition, with soprano, alto, tenor, and bass, opus 91.2. **1975.** [Grove 1980, 2:563]

Giulio Paolini, 1940–. "The Three Graces." Three sculptures. **1978.** [Villeurbanne 1983, p. 73—ill.]

Kathleen Louise Saint John, 1942–. "The Tender Graces Took Thee Up in Their Bosom, O Lily!" Composition for wind trio. **1978.** [Cohen 1987, 2:610]

GRAIAE. *See* PERSEUS, and Medusa.

H

HADES [1]. Son of Rhea and Cronus (Saturn), Hades (also known as Aides or Aidoneus) was the lord of the Underworld, apportioned to him when the universe was divided among him and his brothers Zeus (Jupiter) and Poseidon (Neptune) after the Olympians' defeat of the Titans. With his wife Persephone (Proserpine), he ruled over the souls of the dead. His name means "unseen," deriving from the cap of invisibility (Greek, *Aidos kyne*) he wore in the battle with the Titans and from his stewardship of the "invisible world."

While classical authors perceived Hades as a grim

and dreaded figure, he was not considered an enemy of mankind. He punished wrongdoers severely, but never actually tormented the dead, leaving this task to the Furies (Greek, *Erinyes*). He had no real cult center in the classical world; the only place of worship known for him was in Elis. His sphere, described as being "underground" or "to the West" by the ancient Greeks, was approached by various natural chasms and bordered by five rivers. Although difficult to enter and almost impossible to leave, it was visited by Odysseus (Ulysses), Heracles (Hercules), and other mythological figures.

The Roman god Dis derived his mythology almost entirely from the Greek Hades. Both the Greeks and the Romans also called him Pluto, a name derived from the Greek *plutos* ("wealth") and alluding to the riches that come from the earth. Postclassical authors and artists have often equated the god with Satan and the classical Underworld with the Judeo-Christian hell. In postclassical art, Hades sometimes appears as a personification of the element Earth.

Classical Sources. Homer, *Iliad* 5.394–400, 15.187–93. 20.61–67. Hesiod, *Theogony* 455f., 765–78, 850. *Homeric Hymns,* first hymn "To Demeter" lines 1–87, 334–433. *Orphic Hymns* 18, "To Hades." Ovid, *Metamorphoses* 5.346–424. Apollodorus, *Bibliotheca* 1.2.1, 1.3.2, 1.5.1–3. Pausanias, *Description of Greece* 4.25.2. Hyginus, *Fabulae* 79, 146. Lucian, *Dialogues of the Dead* passim; *Dialogues of the Gods,* "Hermes and Maia."

See also ALCESTIS; GODS AND GODDESSES; HADES [2]; ORPHEUS, and Eurydice; PERSEPHONE; PLUTUS; TITANS AND GIANTS.

Dante Alighieri, 1265–1321. (Pluto [conflated with Plutus] in) *Inferno* 6.112–15, 7.1ff.; (City of Dis in) *Inferno* 8.115ff., 9.34ff., 11 passim, 34.46–52. *c.*1307–*c.*1314? In *The Divine Comedy.* Poem. Foligno: Neumeister & Angelini, 1472. [Singleton 1970–75, vol. 1 / Samuel 1966, pp. 95f., 100, 109ff., 124]

John Gower, 1330?–1408. (Pluto described in) *Confessio amantis* 5.1103–26. Poem. *c.*1390. Westminster: Caxton, 1483. [Macaulay 1899–1902, vol. 2]

Bartolommeo Bellano, *c.*1440–**1496/97.** (Pluto in) "The Mountain of Hell." Bronze sculpture. Victoria and Albert Museum, London. [Pope-Hennessy 1985b, 2:85—ill.]

Rosso Fiorentino, 1494–1540, composition. "Pluto in a Niche." Engraving, part of "Gods in Niches" series, executed by Gian Jacopo Caraglio (Bartsch no. 30). **1526.** [Carroll 1987, no. 27—ill. / Paris 1972, no. 203—ill. / also Lévêque 1984, p. 165—ill.]

Giulio Romano, *c.*1499–1546. "Young Pluto Entering Hades." Painting, part of "Jupiter" cycle. *c.*1533? Lost. / Engraved by Giulio Bonasone (Bartsch 15.137.95). [Hartt 1958, pp. 215]

————, studio. "Pluto Driving in Orcus." Painting. Kunsthistorisches Museum, Vienna, inv. 157. [Vienna 1973, p. 143]

Maerten van Heemskerck, 1498–1574. "Pluto." Painting, in "Gods and Heroes from Mythology and the Old Testament" cycle. *c.*1545. Peters-Wetzlar coll., Amsterdam. [Grosshans 1980, no. 30f.—ill.]

Paolo Veronese, 1528–1588. "Pluto and Ceres." Fresco, part of cycle celebrating Bacchus and wine. *c.*1560–61. Stanza di Bacco, Villa Barbaro-Volpi, Maser (Treviso). [Pallucchini 1984, no. 60—ill. / Pignatti 1976, no. 98—ill.]

Domenico Poggini, 1520–1590. "Pluto." Bronze statuette. **1572–73.** Studiolo di Francesco I, Palazzo Vecchio, Florence. [Pope-Hennessy 1985b, 3:100, 380—ill. / Lensi 1929, pp. 236f., 263—ill. / Sinibaldi 1950, pp. 12, 19, 38—ill.]

Torquato Tasso, 1544–1595. (Pluto [Satan] in the Council of Demons, in) *Gerusalemme liberata* 4. Epic. **1575.** Venice: Perchacino, 1581 (authorized edition). [Kates 1983, pp. 72f.]

Agostino Carracci, 1557–1602. "Pluto." Ceiling painting, for Palazzo dei Diamanti, Ferrara. **1592.** Galleria Estense, Modena, no. 272. [Ostrow 1966, no. I/11]

Hendrik Goltzius, 1558–1617. "Pluto." Engraving, in "Eight Deities" cycle, after (lost) chiaroscuro frescoes by Polidoro da Caravaggio (*c.*1498–1543). **1592.** 4 states. [Strauss 1977a, no. 291—ill. / Bartsch 1980–82, no. 251—ill.]

————. "Pluto." Chiaroscuro woodcut, in cycle "Children of Demogorgon." *c.*1594. [Strauss, no. 423—ill. / Bartsch 1980–82, no. 233—ill.]

Michelangelo da Caravaggio, 1571–1610, doubtfully attributed. "Jupiter, Neptune, and Pluto" ("The Sons of Chronos"). Ceiling painting. *c.*1597? Casino Ludovisi, Rome. [Hibbard 1983, fig. 187]

John Donne, 1572–1631. (Allusion to Pluto in) "Loves Progress" lines 27–35. Elegy, no. 28. In MS *c.*1590s. In *Wit and Drollery* (London: for Blagrave, 1661). [Patrides 1985]

Francisco Gómez de Quevedo y Villegas, 1580–1645. *Las zahurdas de Plutôn* [The Hogsties of Pluto]. Satirical play. *c.*1608. Published with *El sueño del infierno* (Madrid: 1628). [DLE 1972, p. 753]

Bartholomeus Spranger, 1546–**1611.** "Pluto" (with Cerberus). Drawing. Royal Collection, Windsor Castle. [de Bosque 1985, p. 241—ill.]

Gerard van Opstal, 1597–1668. "Nymph with Faun Children and Pluto." Wood relief. Louvre, Paris, inv. MR 365, N.1060. [Düsseldorf 1971, no. 352—ill.]

William Carr. *Pluto Furens and Vinctus, or, The Raging Devil Bound.* Farce. First performed **1669,** London. [Nicoll 1959–66, 1:395]

Georg Muffat, 1653–1704. *Le fatali felicità di Plutone.* Opera. First performed *c.*1688, Hoftheater, Salzburg. Lost. [Grove 1980, 12:762]

Sebastiano Ricci, 1659–1734. "Pluto." Ceiling fresco (detached), part of "The Olympian Gods" cycle, from Palazzo Mocenigo-Robilant, Venice. **1697–99.** Gemäldegalerie, Berlin-Dahlem, on loan from German government. [Daniels 1976, no. 47—ill. / Berlin 1986, p. 64—ill.]

Jonathan Swift, 1667–1745. (Pluto in) "Death and Daphne." Poem. **1730.** In *Works* (Dublin: Faulkner, 1735). [Williams 1958, vol. 3]

Giuseppe Chiari, 1654–**1727/33.** "The Birth of Pluto." Painting. Palazzo Barberini, Rome. [Warburg]

Augustin Pajou, 1730–1809. "Pluto Holding Cerberus, Chained." Marble sculpture. **1760.** Louvre, Paris. [Stein 1912, pp. 8–10—ill.]

Friedrich von Schiller, 1759–1805. "Der Hypochondrische Pluto: Romanze" [Pluto the Hypochondriac: Romance]. Poem. In *Anthologie auf das Jahr* (Stuttgart: Metzler, **1782**). [Oellers 1983]

John Flaxman, 1755–1826. "Pluto Cursing Dante and Virgil." Drawing, illustrating *Inferno* 7.1–2, part of a series of illustrations to Dante's *Divine Comedy. c.***1792.** Houghton Library, Harvard University, Cambridge. / Engraved by Tomasso Piroli, published privately, Rome: 1793; London: Longman & Co., 1807. [Irwin 1979, pp. 94, 226 n.41 / Flaxman 1872, 4: pl. 8]

———. "Pluto on His Throne" (with Proserpine and Cerberus). Drawing, illustrating Hesiod's *Theogony* lines 767–76. 1807–14. Engraved by William Blake, published London: Longman & Co., 1817. [Irwin, p. 90 / Flaxman, 7: pl. 36]

Luis Paret y Alcazar, 1746–**1799.** "Pluto." Painting. Real Academia di San Fernando, Madrid. [Warburg]

Johann Gottfried Herder, 1744–**1803.** "Jupiter und Pluto" (Jupiter's and Pluto's realms contrasted). Poem. In *Gedichte* book 7, in *Sämmtliche Werke* (Tübingen: Cotta, 1805–20). [Herder 1852–54, vol. 13]

Étienne d'Antoine, 1737–**1809.** "Pluto." Sculpture. Musée des Augustins, Toulouse. [Bénézit 1976, 1:214]

Pierre-Paul Prud'hon, 1758–**1823.** "Pluto among His Counselors." Drawing. Sold 1890, untraced. [Guiffrey 1924, no. 139]

William Blake, 1757–1827. "Plutus" (conflated with Pluto). Drawing with watercolor, illustrating *Inferno* 6.113–15, 7.1–12, part of a series of illustrations for Dante's *Divine Comedy.* **1824–27.** Tate Gallery, London, no. 3355. [Butlin 1981, no. 812.14] *See also John Flaxman, above.*

Charles Meynier, 1768–1832. "Pluto and Vulcan Reject the City of Herculaneum's Sacrifice to Them." Ceiling painting. **1827.** Salle G des Antiquités Égyptiennes, Louvre, Paris, no. 6617 (1279). [Louvre 1979–86, 4:86—ill.]

W. T. Moncrieff, 1794–1857. *Devil's Walk, or, Pluto in London.* Extravaganza. First performed **1830,** London. [Nicoll 1959–66, 4:450, 623]

Henry Singleton, 1766–**1839.** "Pluto" (with Cerberus). Watercolor. Victoria and Albert Museum, London, no. D.1366–1889. [Lambourne & Hamilton 1980, p. 352—ill.]

Robert Williams Buchanan, 1841–1901. "Ades, King of Hell." Poem. In *Undertones* (London: Moxon, **1863**). [Bush 1937, p. 555 / also Boswell 1982, p. 56]

George Augustus Simcox, 1841–1905. "When Nemesis and Aidos Heard None Pray." Poem. In *Poems and Romances* (London: Strahan, **1869**). [Boswell 1982, p. 293]

George Meredith, 1828–1909. (Hades in) "The Day of the Daughter of Hades." Poem (story original with Meredith). **1881.** In *Poems and Lyrics of the Joy of Earth* (London: Macmillan, 1883). [Bartlett 1978, vol. 1 / Boswell 1982, p. 182]

John Davidson, 1857–1909. (Hades conquered in) *The Testament of John Davidson.* Poem. London: Richards, **1908.** [Bush 1937, p. 467]

Franz von Stuck, 1863–1928. "Pluto." Painting. **1909.** Mettler coll., St. Gallen. [Voss 1973, no. 348—ill.]

Michael Field (**Katherine Harris Bradley,** 1848–**1914,** and **Edith Cooper,** 1862–1943). "Hades is Tongueless."

Poem. In *A Selection from the Poems of Michael Field* (Boston: Houghton Mifflin, 1925). [Boswell 1982, p. 245]

Marcel Mihalovici, b. 1898. *L'intransigeant Pluton* [Pluto the Implacable]. Opera. Libretto, Regnard. **1928.** [Grove 1980, 12:286]

Angelos Sikelianos, 1884–1951. (Hades evoked in) "Ellenikos Nekrodeipnos" [Greek Supper for the Dead]. Poem. **1941.** [Savidis 1981, vol. 5 / Friar 1973]

Thomas Merton, 1915–1968. "Pluto King of Hell." Poem, in a letter to Jonathan Williams, 31 Oct **1967.** Cited in Michael Mott, *The Seven Mountains of Thomas Merton* (Boston: Houghton Mifflin 1984), pp. 502, 538.

Edwin Honig, 1919–. "King of Death." Poem. In *Spring Journal* (Middletown: Wesleyan University Press, **1968**). [DLB 1980, 5 pt. 1: 353]

Paul Goodman, 1911–**1972.** (Pluto in) "La Gaya Scienza" section 9. Poem. In *Collected Poems,* edited by Taylor Stoehr (New York: Random House, 1973). [Ipso]

Humberto Costantini, 1924?–**1987.** (Athena, Aphrodite, and Hermes fight Hades on behalf of mortals in) *De dioses, hombrecitos, y policías* [The Gods, the Little Guys, and the Police]. Novel. [Havana?]: Casa de las Américas, **1979.** / Translated by Tony Talbott (New York: Harper & Row, 1984). [Ipso]

HADES [2]. The land of the dead, ruled by the god Hades (Pluto, Dis) and his queen Persephone (Proserpine), was known as the Underworld, Avernus, the Realm or Kingdom of Hades, or simply Hades. Although Homer located this region in the west beyond the stream of Oceanus, later authors placed it underground or at the bottom of great chasms. Descriptions of its geography vary, but typically it was said to contain the Plain of Asphodel (a gray plant), inhabited by ghosts of the dead; Elysium (or the Elysian Fields), where shades of the dead favored by the gods were rewarded with contentment; and Tartarus (or Erebus or Infernal Shades), a place of punishment beneath the Underworld itself. Elysium was also associated with the so-called Islands of the Blessed, and with Leuce (or White Island) in the Black Sea, which was also called the Isle of the Blessed. Other details of Hades' geography were added by Virgil in his description of Aeneas's visit to the Underworld, including a neutral zone for infants, suicides, and persons condemned unjustly, and the Fields of Mourning for victims of unrequited love and warriors who fell in battle.

The Underworld was separated from the land of the living by the river Styx (the river of hate, flowing seven times around the nether world) and the deep, black Acheron (river of woe). Other rivers that ran through the region were Cocytus (river of wailing); Phlegethon (or Pyriphlegethon, river of fire); and,

according to Latin poets, Lethe (river of forgetfulness or oblivion).

The gates of Hades were guarded by the monstrous dog Cerberus. The offspring of Typhon and Echidna, he has been variously described as having three or fifty heads and a mane or tail of snakes. Orpheus, on his visit to Hades to recover his wife, Eurydice, charmed Cerberus with the music of his lyre and song. For his twelfth and most difficult labor, Heracles captured Cerberus and carried him to earth and back again to Hades. According to Ovid, Medea used the saliva of Cerberus in her poisonous concoctions.

The aged ferryman Charon transported dead souls across the Styx or Acheron into the Underworld, charging them one coin (the *obolus,* placed in the mouth at burial) for the journey. Those who had not received proper funeral rites were condemned to wait on the shore for a hundred years before Charon would ferry them across the river. Once across, the dead were assigned an appropriate place in the Underworld by three judges: Minos, Rhadamanthys, and Aeacus.

Classical Sources. Homer, *Odyssey* 4.561–69, 10.513–15, 11. Hesiod, *Theogony* 227, 310–12, 361, 383–403, 769–76, 775–806; *Works and Days* 167–73. Pindar, *Olympian Odes* 2.61–84; *Dirges* 129–30. Herodotus, *History* 6.74. Plato, *Phaedo* 112–14C; *Gorgias* 523–26C. Lucretius, *De rerum natura* 3.978–1023. Virgil, *Aeneid* 6. Ovid, *Metamorphoses* 4.434–64, 7.408–19, 10.15–77. Apollodorus, *Bibliotheca* 1.2.1, 1.2.5, 2.5.12, 3.1.2, 3.12.6, E1.23–42. Pausanias, *Description of Greece* 4.19.11–13, 8.17.5–18.6, 9.39.8, 10.28.1–8. Hyginus, *Fabulae* 151. Lucian, *Dialogues of the Dead* 3, "Shades to Pluto against Menippus," 15, "Pluto and Hermes," 16, "Terpsion and Pluto," and passim; *Dialogues of the Gods* 4, "Hermes and Maia."

See also AENEAS, in the Underworld; ALCESTIS; ATHAMAS AND INO; DANAÏDS; DIOSCURI; FURIES; HADES [1]; HERACLES, LABORS OF, Cerberus; HERMES, General List; IXION; MINOS; ODYSSEUS, in the Underworld; ORPHEUS, and Eurydice; PERSEPHONE; PIRITHOUS; PSYCHE; SISYPHUS; TANTALUS; THESEUS, General List; TITANS AND GIANTS; TITYUS.

Jean de Meun, 1250?–1305? (Classical "Hell" and its denizens described in) *Le roman de la rose* lines 19805–85. Verse romance, completion of unfinished work begun by Guillaume de Lorris (*c.*1230–35). *c.***1275.** Lyon: Ortuin & Schenck, *c.*1481. [Dahlberg 1971 / Poirion 1974]

Dante Alighieri, 1265–1321. (Elements of the classical underworld incorporated in) *Inferno* passim; rivers Styx, Acheron, Phlegethon, and Lethe evoked, 7.100–08, 14.100–20, and passim; Cerberus, guardian of the entrance to Third Circle, 6.1–33; Charon, ferryman of Acheron, 3.70–132. *c.***1307**–*c.***1314?** In *The Divine Comedy.* Poem. Foligno: Neumeister & Angelini, 1472. [Singleton 1970–75. vol. 1]

Giovanni Pontano, 1422/29–1503. *Charon.* Dialogue, in Latin. **1467–91.** In *Pontani opera* (Venice: Aldine, 1513). [DDLI 1977, 2:425]

Sandro Botticelli, 1445–1510. Series of 35 drawings illustrating Dante's *Inferno,* part of *Divine Comedy* series. **1480s/early 1490s.** 8 lost; others in Kupferstichkabinett, Berlin-Dahlem; Biblioteca Vaticana, Rome. [Lightbown 1978, 1:147ff., 2:172f., nos. E21–47—ill.]

John Skelton, 1460?–1529. (Poet prays that the sparrow may be safe from beings of Hades, in) *Phillyp Sparowe* lines 67ff. Poem. *c.***1505?** London: Kele, 1545. [Scattergood 1983]

Andrea Riccio, *c.*1470–1532. "Della Torre Embarking for the Underworld," "Della Torre in Elysium with Great Minds of the Past." Bronze reliefs. *c.***1516–21?** Tomb of Girolamo della Torre, S. Fermo Maggiore, Verona. Originals removed to Louvre, Paris, 1796, replaced by copies. [Pope-Hennessy 1985b, 2:333]

Joachim de Patinier, *c.*1480–**1524.** (Charon's boat) "Plying the Stygian Lake." Painting. Prado, Madrid, inv. 1616. [Prado 1985, p. 497]

Alfonso de Valdés, 1490?–1532. *Diálogo de Mercurio y Carón.* Satirical dialogue in prose. Rome: **1529.** Modern edition by Rosa Novarro Durán (Barcelona: Planeta, Clasicos Universales Planeta, 1987). / Translated by Joseph V. Ricapito as *Dialogue of Mercury and Charon* (Bloomington: Indiana University Press, 1986). [Ipso / Oxford 1978, p. 587 / Bleznick 1972, p. 42]

Hans Sachs, 1494–1576. *Caron mit den abgestorben Seelen* (*Caron mit den Seelen der Verstorbenen*) [Charon with the Souls of the Dead]. Tragedy (also registered as a comedy). **1531.** Modern edition, *Werke* (Stuttgart: 1870–1908; Hildesheim: Olms, 1964). [McGraw-Hill 1984, 4:300]

Pierre de Ronsard, 1524–1585. "Les isles fortunées." Poem. In *Les amours . . . nouvellement augementées* (Paris: La Porte, **1553**). [Laumonier 1914–75, vol. 5 / Armstrong 1968, pp. 14–16]

———. (Description of Hades in) *La franciade* 4.631–718. Epic poem, unfinished. Paris: Buon, 1572. [Laumonier, vol. 16 / McFarlane 1973, p. 60]

Olivier de Magny, 1529–1561. "Hola, Charon!" Poem. In *Oeuvres* (Paris: **1555**). Modern edition, Geneva: Slatkine Reprints, 1969. [Ipso]

Francesco Primaticcio, 1504–1570, design. "Charon and Another Boatman," "Charon and Cerberus." Frescoes, for Salle de Bal, Château de Fontainebleau, executed by Niccolò dell' Abbate. **1551–56.** Repainted 19th century. / Drawing for the first composition. Louvre, Paris, no. 8545. [Dimier 1900, pp. 160ff., 284ff., no. 32 / Paris 1972, no. 167—ill.]

Thomas Sackville, 1536–1608. (The poet descends into Hades, led by Sorrow, in) "Induction." Poem. In *A Myrroure for Magistrates* (London: Marsh, **1563**). Modern edition by Lily B. Campbell, *The Mirror for Magistrates* (Cambridge: Cambridge University Press, 1938). [Bush 1963, pp. 60–63, 313 / DLB 1987, 62:261]

Torquato Tasso, 1544–1595. (Classical conception of Hades medievalized in) *Gerusalemme liberata* 4. Epic. **1575.** Venice: Perchacino, 1581 (authorized edition). [Highet 1967, pp. 148, 150]

Bernardo Buontalenti, 1536–1608. "Hades." Design for entr'acte curtain, for entertainment celebrating the marriage of Ferdinando de' Medici to Christine de Lorraine. **1589.** / Print by Epifanio d'Alfiano, 1589. [Hofmann 1987, no. 9.19—ill.]

Edmund Spenser, 1552?–1599. (Description of Hell and its denizens in) *The Faerie Queene* 1.5.31–36; 2.7.21–25, 56; 6.1.7–8. Romance epic. London: Ponsonbie, **1590,** 1596. [Hamilton 1977]

———. (Gnat descends into Hell and Elysium in) "Virgils Gnat" lines 337ff. Poem. In *Complaints* (London: Ponsonbie, 1591). [Oram et al. 1989]

William Shakespeare, 1564–1616. (Clarence recounts his dream of Hades in) *Richard III* 1.4.43–64. History play. *c.*1592. Published in quarto (corrupt), London: 1597; collected in First Folio, London: Jaggard, 1623. [Riverside 1974]

Francis Bacon, 1561–1626. "Styx, sive foedera." Chapter 5 of *De sapientia veterum.* Mythological compendium. London: Barker, **1609.** / Translated as "Styx, or Leagues" by Arthur Gorges in *The Wisdome of the Ancients* (London: Bill, 1619). Modern facsimile edition (bilingual), New York & London: Garland, 1976. [Ipso]

Bartholomeus Spranger, 1546–**1611.** "Pluto" (with Cerberus). Drawing. Royal Collection, Windsor Castle. [de Bosque 1985, p. 241—ill.]

Ben Jonson, 1572–1637. (Satirical journey through Hades in) "On the Famous Voyage," "The Voyage Itself." Poems. By **1612.** Nos. 133–34 of *Epigrammes,* in *Works* (London: 1616). [Herford & Simpson 1932–50, vol. 7]

———. (Lethe, personified as an old man, in) *Lovers Made Men* (*The Masque of Lethe*). Masque. Performed 22 Feb 1617, at Court, London. Published London: 1617. [Ibid.]

Lorenzo Allegri, *c.*1573–1648, and **Jacopo Peri,** 1561–1633 (recitatives). *I Campi Elisi* [The Elysian Fields]. Ballet with recitatives. Text, Ferdinando Saracinelli. First performed 9 Feb **1614,** Palazzo Pitti, Florence. [Weaver 1978, p. 98 / Grove 1980, 1:267]

Antoine de Boësset, 1586–1643. "Hola, Charon!" Song. Text, Olivier de Magny (1555). In Gabriel Bataille's *Aérs de différents auteurs* 5th book (Paris: Ballard, **1615**). [Grove 1980, 2:282, 843]

Anonymous English. "Charon, O Charon, Row Thy Boat." Musical dialogue. Before **1630.** [Spink 1974, p. 291]

John Hilton the Younger, 1599–1657. "Charon, Come Hither, Charon." Musical dialogue. Before **1631.** Published in *Songs* (*c.*1652–60). [Spink 1974, pp. 49, 291]

Philip Massinger, 1583–1640. (Cerberus, a guard dog in) *The City Madam.* Comedy with interpolated music. First performed 25 May **1632,** King's Company, London. [Sharp 1969, 1:164, 2:1136]

Theodoor van Thulden, 1606–1669. "The Barque of Charon." Drawing (after part of Primaticcio's decoration of Galerie d'Ulysse, Château de Fontainebleau?). **1631–33.** Cabinet des Dessins, Louvre, Paris. [Paris 1972, no. 231—ill.]

Robert Johnson II, *c.*1583–**1633.** "Charon, O Charon." Song for 2 voices. In *Ayres, Songs, and Dialogues* (London: Playford, 1652). [Grove 1980, 9:682 / Spink 1974, p. 291]

Vincenzo Mannozzi, ?–1657. "*Inferno.*" Painting. *c.*1634. Uffizi, Florence, inv. 4973. [Uffizi 1979, no. P991—ill.]

John Milton, 1608–1674. (Elysium evoked in) *Comus* lines 253–59. Masque. Music, Henry Lawes. First performed Michaelmas Day **1634,** Ludlow Castle. Published London: Robinson, 1637. [Carey & Fowler 1968]

———. (Hall of Pandemonium, City of Dis, "infernal rivers," Elysium, described in) *Paradise Lost* 1.710–30; 2.570–628, 871ff.; 3.13–21, 354–64. Epic. London: Parker, Boulter, Walker, 1667. [Carey & Fowler / Samuel 1966, pp. 69–129 passim / Duncan 1972, pp. 22, 31–33, 66]

Thomas Heywood, 1573/74–1641. "Charon, Menippus, and Mercury." Poetic dialogue, translated from Lucian. No. 15 in *Pleasant Dialogues and Drammas* (London: **1637**). [Heywood 1874, vol. 6]

Jacob van Swanenburgh, *c.*1571–**1638.** "Charon's Boat." Painting. Stedelijk Museum "De Lakenhal," Leiden. [Wright 1980, p. 444]

Andrew Marvell, 1621–1678. (Vision of Elysium described in) "A Dialogue between Thyrsis and Dorinda." Poem. Before **1643.** In *Miscellaneous Poems* (London: Robert Boulter, 1681). [Margoliouth 1971 / Craze 1979, pp. 31f.]

———. (Tom May arrives drunk among the Elysian shades in) "Tom May's Death" lines 90–97. Poem. In *Miscellaneous Poems* (London: Boulter, 1681). [Margoliouth]

Anonymous English. "Charon, O Charon (Hear a Wretch Oppressed)." Poetic dialogue. Before **1644.** Set to music by Robert Ramsey (fl. *c.*1612–44) and by William Lawes (*c.*1602–1645). [Grove 1980, 10:562, 564; 15:579 / Spink 1974, p. 291]

Robert Herrick, 1591–1674. "Charon and Phylomel." Poem. Before **1645**? In *Hesperides* (London: Williams & Eglesfield, 1648). [Martin 1956 / Scott 1974, p. 168] Set to music by Henry Lawes and/or William Lawes. Published in *Select Musicall Ayres and Dialogues* (London: John Playford, 1652). [Scott (as Henry) / Grove 1980, 10:562, 564 (as William) / Spink 1974, p. 291 (as William)]

———. "The White Island, or, Place of the Blest," "The Apparition of His Mistresse Calling Him to Elizium." Poems. In *Hesperides* (1648). [Martin / BW 1979–87, 2:113]

———. "The New Charon, upon the Death of Lord Hastings." Poem. 1649. In Richard Brome's *Lachrymae Musarum* (London: Holden, 1649). [Martin] Set to music by Henry Lawes, published in *Select Musicall Ayres and Dialogues* (1652). [Scott, pp. 98, 168]

———. "Charon, O Charon, Draw Thy Boat." Poetic dialogue. 1652. Set to music by Henry Lawes, published in *Select Musical Ayres and Dialogues* (1652). [Martin / Scott, pp. 264, 291]

Richard Crashaw, 1612–1649. (Pluto's realm described, evoked in) "Upon the Gunpowder Treason." 3 poems of the same title. [Martin 1966]

Anonymous English. "The Charon Dialogues." Musical settings. 8 surviving from before **1650,** 3 earlier than 1620. [Spink 1974, pp. 5iff., 291]

Richard Lovelace, 1618–**1658.** "A Mock Charon." Poetic dialogue. In *Lucasta: Posthume Poems* (London: Clement Darby, 1659). [Wilkinson 1930]

Abraham Cowley, 1618–**1667.** "A Dream of Elysium." Poem. In *Sylva: or, Divers Copies of Verses Made upon Sundry Occasions,* vol. 3 of *Works* (London: Harper, 1708). [Levin 1969, p. 115]

Jakob Balde, 1604–**1668.** (Hades evoked in) Neo-Latin

poem. / Translated by Johann Gottfried Herder as "Berwünschungen des Katarrhs" (1796). *See Herder, below.*

Luca Giordano, 1634–1705. (Charon in) "Allegory of Human Life and the Medici Dynasty." Fresco. **1682–83.** Palazzo Medici Riccardi, Florence. [Ferrari & Scavizzi 1966, 2:112ff.—ill.] Study. Denis Mahon coll., London. [Ibid.—ill.]

Henry Purcell, 1658–1695. "Charon, the Peaceful Shade Invites." Song, from *Circe*. c.1685. [Spink 1974, p. 224]

John Dryden, 1631–1700. (Description of Charon in) *Virgil's Aeneis*. Free translation of the *Aeneid*. In *The Works of Virgil* (London: Tonson, 1697). [Dryden 1956–87, vols. 5, 6 / Winn 1987, p. 491]

Thomas Parnell, 1679–1718. "Elysium." Poem. In *Poetical Works* (Edinburgh: 1778). In modern edition, *Minor Poets of the Eighteenth Century* (London: Dent, 1930). [Ipso]

Jonathan Swift, 1667–1745. (Legion Club, Dublin, equated with Hades in) "A Character, Panegyric, and Description of the Legion Club" lines 81–132. Poem. 1736. In *S—t contra omnes: An Irish Miscellany* (London: 1736). [Williams 1958, vol. 3]

Pierre Subleyras, 1699–1749. "Charon Passing the Shades." Painting. Louvre, Paris, inv. 8007. [Louvre 1979–86, 4:227—ill.] Copy ("The Barque of Charon") in National Gallery, London, inv. 4133. [London 1986, p. 602—ill.]

George Frideric Handel, 1685–1759. "Ye fleeting shades I come." Aria, for Charon, from *Alceste,* projected opera of 1750, unperformed. Libretto, Tobias Smollett. [Keates 1985, p. 298]

Augustin Pajou, 1730–1809. "Pluto Holding Cerberus, Chained." Marble sculpture. 1760. Louvre, Paris. [Stein 1912, pp. 8–10—ill.]

Anton Schweitzer, 1735–1787. *Elysium.* Dramatic prologue with songs. Text, Johann Georg Jacobi. First performed 18 Jan 1770, for the Queen's birthday, Schloss Celle, Hannover. [Grove 1980, 17:46 / DLL 1968–90, 8:428]

Friedrich von Schiller, 1759–1805. "Gruppe aus dem Tartarus" [Group from Tartarus], "Elysium, eine Kantate" [Elysium, a Cantata]. Poems. In *Anthologie auf das Jahr 1782* (Stuttgart: Metzler, 1782). [Petersen & Beissner 1943 / Butler 1958, p. 162]

———. (Elysium, setting of) "Die Ideale" [The Ideal]. Poem. 1795. In *Musenalmanach für das Jahr 1796* (Tübingen: Cotta, 1796). [Petersen & Beissner / Butler, p. 162]

John Flaxman, 1755–1826. "A Soul Appearing before the Judges in Hades." Drawing. c.1783. Fitzwilliam Museum, Cambridge. [Bindman 1979, no. 12—ill.]

———. Series of 38 drawings illustrating Dante's *Inferno* 6.13–18. c.1792. Houghton Library, Harvard University, Cambridge. / Engraved by Tomasso Piroli, published privately, Rome: 1793; London: Longman & Co., 1807. [Irwin 1979, p. 94, 226 *n.*41—ill. / Flaxman 1872, 4: pls. 1–38]

———. "Typhon, Echidna, and Geryon," "Furies, Cerberus, Pluto, Proserpine, Harpies, Death," "Pluto on His Throne" (with Cerberus devouring those who try to escape from the Underworld). Drawings, illustrating Hesiod's *Theogony* lines 288–308, 767–69. 1807–14. Engraved by William Blake, published London: Longman & Co., 1817. [Irwin, pp. 90f. / Flaxman, 7: pls. 29, 36]

James Barry, 1741–1806. "Elysium and Tartarus, or, the State of Final Retribution." Mural, part of "Progress of Human Culture" series. 1777–84. Royal Society of Arts, London. [Pressly 1981, no. 27—ill., p. 294]

Carl Michael Bellmann, 1740–1795. (Charon evoked passim, in) *Fredmans sånger* [Fredman's Songs] (Stockholm: Zetterberg, 1791). [Algulin 1989, pp. 58, 60]

Christoph Martin Wieland, 1733–1813. *Die Geheime Geschichte des Philosophen Peregrinus Proteus: Gespräche in Elysium* [The Secret History of the Philosopher Peregrinus Proteus: Dialogues in Elysium]. Philosophical novel. Leipzig: 1791. [Radspieler 1984, vol. 8 / EW 1983–85, 4:589, 602] / Translated by J. B. Elrington as *Confessions in Elysium* (London: Lane, Newman, 1804).

Johann Gottfried Herder, 1744–1803. (Hades evoked in) "Berwünschungen des Katarrhs." Poem, translation from Jakob Balde (1604–1668). In *Nachlese aus Jakob Balde's Gedichten,* part 3 of *Terpsichore* (Lübeck: Bohn, 1796). [Herder 1852–54, vol. 17]

———. "Lethe." Poem. In *Zerstreuter Blätter* no. 6 (Gotha: Ettinger, 1797). [Ibid., vol. 13]

Jean-Joseph Taillasson, 1746–1809. "The Tomb in Elysium." Painting. Musée et Galerie des Beaux-Arts, Bordeaux. [Bénézit 1976, 10:56]

John C. Cross, fl. 1794–1812, libretto. *Lethe.* Ballet. First performed 7 Mar 1812, Theatre Royal, Bath. [Nicoll 1959–66, 4:287]

Vasily Andréevich Zhukóvsky, 1783–1852. "Elisium." Poem. 1812. Modern edition by A. S. Arkhangélskii, *Polnoe sobranie sochenenii* (St. Petersburg: Marksa, 1902). [Terras 1985, p. 532]

William Wordsworth, 1770–1850. (Elysium described in) *Laodamia* lines 90–110. Poem. 1814. In *Poems, Including Lyrical Ballads* (London: Longman & Co., 1815). [De Selincourt 1940–66, vol. 2 / Bush 1937, p. 63]

John Keats, 1795–1821. (Souls in Elysium remember Earth in) *Endymion* 1.371–90. Poem. 1817. London: Taylor & Hessey, 1818. [Stillinger 1978]

Franz Schubert, 1797–1828. "Gruppe aus dem Tartarus." Lied, opus 24/1. Text, Schiller (1782). Sep 1817. Published 1823. [Grove 1980, 16:775, 793, 797] Preliminary version (Mar 1816) published 1975. [Ibid.]

———. "Fahrt zum Hades" [Trip to Hades]. Lied. Jan 1817. Text, Mayrhofer. [Grove, 16:796 / Brown 1958, p. 75]

Percy Bysshe Shelley, 1792–1822. (Description of Hades in) *Prometheus Unbound* 1.195–217. Dramatic poem. 1818–19. London: Ollier, 1820. [Zillman 1968 / Curran 1975, p. 145]

———. (Elysium evoked in) *Epipsychidion* lines 184–89, 422–28, 536–52. Poem. Published anonymously, London: Ollier, 1821; withdrawn. [Hutchinson 1932 / Wasserman 1971, pp. 142 *n.*, 242, 441ff.]

Eugène Delacroix, 1798–1863. "The Barque of Dante" ("Dante and Virgil"). Painting. 1822. Louvre, Paris, no. 3820. [Johnson 1981–86, no. 100—ill. / Robaut 1885, no. 49—ill. (copy drawing) / Louvre 1979–86, 3:199—ill.] Copy, by Edouard Manet, c.1854, Metropolitan Museum, New York. *See Manet, below.*

Johann Wolfgang von Goethe, 1749–1832. "Charon," part 7 of "Neugriechisch-Epirotische Heldenlieder." Poem. 1822. In *Über Kunst und Altertum,* vol. 4 (Stuttgart: Cotta, 1823). [Beutler 1948–71, vols. 1, 15]

Felicia Dorothea Hemans, 1793–1835. "Elysium." Poem.

In *The Siege of Valencia . . . with Other Poems* (London: Murray, **1823**). [Boswell 1982, p. 129 / Bush 1937, pp. 170, 549]

Per Daniel Amadeus Atterbom, 1790–1855. *Lycksalighetens, ö, Hyperboreans* [The Blessed, or, The Hyperboreans]. Fairy-tale play. Upsala: Palmblad, **1824–27**. [Algulin 1989, pp. 76ff.]

William Blake, 1757–1827. Series of watercolors illustrating Dante's *Inferno*. **1824–27**. National Gallery of Victoria, Melbourne; Fogg Art Museum, Harvard University, Cambridge; Tate Gallery, London; British Museum, London. [Butlin 1981, no. 812—ill.] *See also John Flaxman, above.*

William Bell Scott, 1812–1892. *Hades; or, The Transit.* Poem. London: Renshaw, **1838**, illustrated by the author. [NUC]

Henry Singleton, 1766–**1839**. "Pluto" (with Cerberus). Watercolor. Victoria and Albert Museum, London, no. D.1366–1889. [Lambourne & Hamilton 1980, p. 352—ill.]

Eberhard Wächter, 1762–**1852**. "Charon's Barque." Painting. Staatsgalerie, Stuttgart. [Bénézit 1976, 10:596]

Heinrich Heine, 1797–1856. (The Styx, Furies, Cerberus evoked in) "In May." Poem. In *Gedichte 1853–54* (Hamburg: Hoffmann & Campe, **1854**). [Windfuhr 1975–82, vol. 9 / Draper 1982]

Edouard Manet, 1832–1883. "The Barque of Dante." Painting, copy after Delacroix (1822, Louvre). **1854?** Musée des Beaux-Arts, Lyons. [Cachin & Moffett 1983, no. 1—ill.] Another version, later period. Metropolitan Museum, New York, no. 29.100.114. [Ibid.—ill. / Metropolitan 1980, p. 113—ill.]

Charles Baudelaire, 1821–1867. "Le Léthé." Poem. In *Les fleurs du mal* (Paris: Poulet-Malassis & de Broise, **1857**), "condemned" and withdrawn; reprinted in *Les épaves* (Amsterdam & Brussels: Poulet-Malassis, 1866). [Pichois 1975] Translated by George Dillon in *Flowers of Evil* (New York: Washington Square Press, 1936; 1962). [Ipso]

Richard Stoddard, 1825–1903. "The Fisher and Charon." Poem. In *Songs of Summer* (Boston: Ticknor and Fields, **1857**). [Boswell 1982, p. 222]

———. "The Captives of Charon." Poem. In *The Lion's Cub with Other Verse* (New York: Scribner, 1890). [Ibid.]

Henri Fantin-Latour, 1836–1904. "Eugène Delacroix Received in the Elysian Fields" (by Titian, Velázquez, Rembrandt, Rubens, and Veronese). Drawing. **1865**. [Fantin-Latour 1911, no. 2438]

Edward Burne-Jones, 1833–1898. "Souls on the Bank of the River Styx." Painting. **1871–72**. Nahum coll., London. [Kestner 1989, p. 96, pl. 2.24]

Andrew Lang, 1844–1912. "Lost in Hades." Poem. In *Ballades and Lyrics of Old France with Other Poems* (Portland, Me.: Mosher, **1873**). [Boswell 1982, p. 160]

———. "The Fortunate Island." Poem. In *Rhymes à la Mode* (London: Kegan Paul, Trench & Trübner, 1885). [Ibid., p. 158]

———. *Helen of Troy: Her Life and Translation* (Helen translated with Menelaus to Elysium). Poem in 6 books. London: Bell, 1892. [Ibid., p. 159 / Bush 1937, p. 560]

Frederick Sandys, 1829–1904. "Lethe." Painting. c.**1874**. [Kestner 1989, p. 171]

Arnold Böcklin, 1827–1901. "Charon." Painting. **1876**.

Sammlung Georg Schäfer, Obbach über Schweinfurt, inv. 41533524. [Andree 1977, no. 302—ill.]

———. "The Elysian Fields" (with a centaur and nymphs). Painting. 1877–88. Lost. [Ibid., no. 320—ill.] Oil sketch, 1877. Stiftung Oskar Reinhart, Winterthur. [Ibid., no. 319—ill.]

Lewis Morris, 1833–1907. *The Epic of Hades*. Poem. London: King, **1876**. [Bush 1937, pp. 428, 559 / Boswell 1982, p. 189]

Hans Thoma, 1839–1924. "Charon." Painting. **1876**. Trübner coll., Karlsruhe. [Thode 1909, p. 84—ill.]

———. "The Elysian Fields." Painting. 1879. Grunelius coll., Frankfurt. [Ibid., p. 129—ill.]

Emily Dickinson, 1830–1886. "Elysium Is as Far as To." Poem. c.**1882**. In *Boston Transcript* 14 Oct 1890; collected by Thomas H. Johnson in *Poems*, vol. 3 (Cambridge: Harvard University Press, Belknap Press, 1955). [Steven Whicher in *Explicator* 19 (April 1961)]

Alfred, Lord Tennyson, 1809–1892. (Isles of the Blessed evoked in) "Tiresias" lines 161–77. Dramatic monologue. Begun c.1833, completed **1883**. In *Tiresias and Other Poems* (London: Macmillan, 1885). [Ricks 1969 / Ricks 1972, pp. 134–36]

Edmund Gosse, 1849–1928. "The Island of the Blest." Poem. In *Firdausi in Exile and Other Poems* (London: Kegan Paul, Trench, **1885**). [Boswell 1982, p. 120]

Kostas Krystalles, 1868–**1894**. "The Shades of Hades" [English title of a poem written in Greek]. In *Poiimata* (Athens: Nea Melissa, 1952). [Trypanis 1981, p. 667]

Gustaf Fröding, 1860–1911. "Drömmar i Hades" [Dreams in Hades]. Poem. In *Stänk och flikar* [Splashes and Rags] (Stockholm: Bonnier, **1896**). [Algulin 1989, p. 147] Translated by C. W. Stork in *Anthology of Swedish Lyrics from 1750–1915* (New York: American-Scandinavian Foundation; London: Oxford University Press, 1917). [Ipso]

Arthur B. Davies, 1862–1928. "The River Styx." Painting. **1898**. Jenkins coll., Chicago. [Metropolitan 1930, no. 37 / Cortissoz 1931, p. 34]

———. "Elysian Fields." Painting. 1903. Phillips Memorial Gallery, Washington, D.C. [Ibid., p. 24]

———. "Dawn Elysian." Painting. Price coll., New York. [Ibid., p. 23]

Théodore Dubois, 1837–1924. "Le Léthé." Tone poem for piano, in *Poèmes virgiliens . . . pour piano*. **1898**. Published Paris: Hengel, 1926. [Grove 1980, 5:665]

Robert Calverly Trevelyan, 1872–1951. (Hades evoked in poems from) *Mallow and Asphodel*. Collection of poems. London: MacMillan, **1898**. [Bush 1937, p. 565]

José-Maria de Heredia, 1842–1905. "Les fleuves d'ombre" [The Rivers of the Dark]. Sonnet. **1888–99**. In *Revue des deux mondes* 1 Dec 1905. [Delaty 1984, vol. 2]

Ernest Dowson, 1867–1900. "Villanelle of Acheron." Poem. In *Decorations in Verse and Prose* (London: Smithers, **1899**). [Bush 1937, p. 565]

Zinaida Hippius, 1869–1945. (Poet as Charon's oarsman in) "There" [English title of a work written in Russian]. Poem. **1900**. In *Sobranie stikhov: 1889–1903*, bilingual edition (Moscow: Skorpion, 1904). [Pachmuss 1971, pp. 30–32, 417] / Translated in *Modern Russian Poetry* (New York: Bobbs-Merrill, 1967). [Ipso]

Gabriele D'Annunzio, 1863–1938. "L'asfodelo" [The As-

phodel]. Poem. **1902**. In *Alcyone* (Milan: Treves, 1904).
[Roncoroni 1982 / Bàrberi Squarotti 1982, p. 154]

Else Lasker-Schüler, 1869–1945. *Styx*. Collection of poems.
Berlin: Juncker, **1902**. [DLB 1988, 55:285, 300]

Herman Anglada-Camarasa. "The Elysian Fields." Painting. **1905**. [Alloway 1968, pl. 54]

Léon Bakst, 1866–1924. "Elysium." Drawing, design for curtain of Vera Kommisarjevsky Theater, St. Petersburg. **1906**. Tretiakov Gallery, Moscow. [Spencer 1973, pl. 31]

Felix Braun, 1885–1973. *Der Schatten des Todes* [The Shades of the Dead]. Novel. **1910**. [Wilpert 1963, p. 73]

Georg Heym, 1887–1912. "Styx." Poem. In *Gedichte,* edited by C. Meckel (Frankfurt & Hamburg: Fischer-Bucherei, 1968). [TCLC 1978–89, 9:146]

Lorentzos Maviles, 1860–1912. "Lethe." Sonnet. Alexandria: 1915; collected in *Sonnets* (Athens: Klimena, 1982). [Trypanis 1981, p. 648]

Rudolf Alexander Schröder, 1878–1962. *Elysium*. Collection of poems. Leipzig: Insel, 1906; **1912**. [Domandi 1972, 2:261 / Oxford 1986, p. 816]

Wilhelm Lehmbruck, 1881–1919. "Charon in Love." Painting. **1913**. [Hoff 1961, p. 162, fig. 130—ill.]

Percy MacKaye, 1875–1956. "Lethe." Poem. In *Poems and Plays* (New York: MacMillan, **1916**). [Boswell 1982, p. 270]

Wilfred Owen, 1893–1918. (Hades, Lethe, and Styx evoked in) "To a Comrade in Flanders." Poem. **1916**. In *Collected Poems,* edited by C. Day Lewis and E. Blunden (London: Chatto & Windus, 1963). [Ipso]

Edward Thomas, 1878–1917. (Hades, poet's new home, in) "The Sun Used to Shine." Poem. In *Collected Poems* (London: Selwyn & Blount, Ltd., 1920). [Ipso]

Robert Graves, 1895–1985. (The Underworld evoked in) "Escape." Poem. In *Fairies and Fusiliers* (London: Heinemann, **1917**). [DLB 1983, 20:163]

———. "Instructions to the Orphic Adept" (entering the Underworld). Poem. In *Poems, 1938–1945* (London: Cassell, 1945). [Graves 1975]

———. "The Utter Rim" (poet's mind as Cerberus). Poem. By 1975. [Ibid.]

D. H. Lawrence, 1885–1930. "Elysium." Poem. In *Look! We Have Come Through!* (London: Chatto & Windus, **1917**). [Pinto & Roberts 1964, vol. 1]

———. (Hades' "blue light" evoked in) "Bavarian Gentians." Poem. In *Last Poems* (Florence: Orioli; London: Heinemann, 1932). [Pinto & Roberts, vol. 2; cf. pp. 954, 1016 (variants)]

Osip Mandel'shtam, 1891–1939/42. (Charon's boat in) Untitled poem. **1917**. In *Tristia* (Peterburg: 1922). [Raffel & Burago 1973, no. 93]

———. (Elysium evoked in) Untitled poem. 1920. In *Tristia* (1922). [Ibid., no. 123]

Carl Milles, 1875–1955. "Cerberus." 2 granite sculptures. **1917**. Technical High School, Stockholm. [Rogers 1940, pp. 50, 65—ill.]

———. "Cerberus." Granite sculpture. 1917. Liljevachs Gallery, Stockholm. [Ibid., p. 65]

———. (Cerberus in) "Orpheus Fountain." Bronze fountain. 1936. Concert Hall, Stockholm. [Ibid., p. 55f.—ill.]

Adolf von Hildebrand, 1847–1921. "Charon" (carrying two youths in his boat). Stone relief. **1916–18**. Martius family tomb, Kiel. [Heilmeyer 1922, p. 32—ill.]

Maxwell Anderson, 1888–1959. "The Fire Is Out in Acheron." Poem. *c.*1920. In *You Who Have Dreams* (New York: Simon & Schuster, 1925). [Boswell 1982, p. 14]

Franz Werfel, 1890–1945. *Der Besuch aus dem Elysium* [The Visit from Elysium]. Romantic drama. Munich: Wolff, **1920**. [Ungar 1973, p. 277]

H. D. (Hilda Doolittle), 1886–1961. "Asphodel." Novel. **1921–22**. Unpublished. Typescript in Beinecke Library, Yale University. [Robinson 1982, pp. 179f., 252f., 470]

———. "Lethe." Poem. In *Collected Poems* (New York: Boni & Liveright, 1925). [Martz 1983 / Boswell 1982, p. 93]

Edith Södergran, 1892–1923. "Arrival in Hades" [English title of a work written in Swedish]. Poem. In *Landet som icke är* [The Land Which Is Not] (1925); and in *Samlade dikter* (Stockholm: Wahlström & Widstrand, 1953). / Translated into English, 1980. [DSL 1990, P. 568]

Wallace Stevens, 1879–1955. (Isle of the Blessed evoked, mourned, in) "Sunday Morning." Poem. In *Harmonium* (New York: Knopf, **1923**). [Ipso / Buttel 1967, p. 222]

Hilaire Belloc, 1870–1953. "When You to Acheron's Ugly Water Come." Poem. In *Sonnets and Verse* (London: Duckworth, **1924**). [Boswell 1982, p. 34]

Léonide Massine, 1895–1979, choreography and scenario. *Mercure* (Mercury, as the guide of souls to Hades). Ballet. Music, Erik Satie. First performed 15 June **1924**, by Soirées de Paris du Comte Étienne de Beaumont, Théâtre de la Cigale, Paris; drop scene, sets, and costumes, Pablo Picasso. [Simon & Schuster 1979, pp. 199f. / Grove 1980, 16:519 / also Zervos 1932–78, 5: nos. 189–211—ill.]

Marina Tsvetaeva, 1892–1941. "Lety slepotekushchii vskhlip" [The Blindly-Flowing Sob of Lethe]. Excerpt of poem. **1922–25**. In *Posle Rossii 1922–1925* [After Russia] (Paris: [Pouterman] private subscription, 1928). Modern edition, Paris: YMCA Press, 1976. [Karlinsky 1985, pp. 185, 187]

John Drinkwater, 1882–1937. "A Ghost Speaks on the Styx." Poem. In *New Poems* (Boston: Houghton Mifflin, **1925**). [Boswell 1982, p. 253]

Cale Young Rice, 1872–1943. (Charon's boat in) "An Ancient Greek, Dying." Poem. In *Selected Plays and Poems* (London: Hodder & Stoughton, **1926**). [Boswell 1982, p. 210]

Louis MacNeice, 1907–1963. "Charon." Poem. In *Blind Fireworks* (London: Gollancz, **1929**). [Dodds 1966 / Brown 1975, pp. 64, 68, 163]

———. "The Stygian Banks." Poem. 1940–48. In *The Burning Perch* (London: Faber & Faber; New York: Oxford University Press, 1963). [Dodds / Brown, pp. 41f., 102, 116, 135, 205]

———. "Charon." Poem. 1962. [Dodds]

Romaine Brooks, 1874–1970. "Lethe." Drawing. **1930**. National Collection of Fine Arts, Smithsonian Institution, Washington, D.C., no. 1968.90.4. [Breeskin 1971, no. 41—ill.]

Vilhelm Ekelund, 1880–1949. *Lyra och Hades* [Lyre and Hades]. Collection of aphoristic poetry. Stockholm: Bonnier, **1930**. [Algulin 1989, p. 156 / EWL 1981–84, 2:13]

Stanley Kunitz, 1905–. "Prophecy on Lethe." Poem. In *Intellectual Things* (Garden City, N.Y.: Doubleday, Doran, **1930**). [Ipso]

Ezra Pound, 1885–1972. (Image of Hades central to) Can-

tos 14–15, and evoked passim, in *A Draft of XXX Cantos* (Paris: Hours, **1930;** Norfolk, Conn.: New Directions, 193[3?]). [Feder 1971, pp. 105–08]

———. (Poet prays for release from Hades in) Canto 90, in *Section: Rock-Drill, 85–95 De Los Cantares* (New York: New Directions, 1955). [Ibid., p. 119]

Otto Stoessl, 1875–1936. "Griechische Unterwelt" [Greek Underworld]. Poem. In *Arcadia,* vol. 1 of *Gesammelte Werke* (Vienna: Saturn, **1933**). [DULC 1959–63, 4:672]

William Butler Yeats, 1865–1939. (Hades evoked in) "Byzantium." Poem. In *The Winding Stair and Other Poems* (London & New York: Macmillan, **1933**). [Finneran 1983 / DLB 1983, 19:442 / Feder 1971, pp. 85f.]

George Seferis, 1900–1971. (Erebus evoked in) "Hedo teleionoun ta erga tes thalassas" [Here End the Works of the Sea]. Poem. **1933–34.** In *Mythistorema* (Athens: Ikaros, 1935). [Keeley & Sherrard 1967]

Edwin Arlington Robinson, 1869–1935. (The Styx evoked in) *Amaranth.* Poem. New York: Macmillan, **1934.** [Gregory & Zaturenska 1946, pp. 114, 131]

Angelos Sikelianos, 1884–1951. "Meletē Thanatou" [Rehearsing for Death] (preparing to enter Hades). Poem. **1939.** [Savidis 1981, vol. 5 / Keeley & Sherrard 1979]

Ion Pillat, 1891–1942. *Asfodela.* Poem. Bucharest: 1943. [EWL 1981–84, 3:530]

Menelaos Pallandios, 1914–, music. *Pombi ston Aheronta* [Procession toward Acheron]. Ballet. First performed **1942,** Athens? [Grove 1980, 14:140]

Robert Lowell, 1917–1977. (Charon ferries Arthur Winslow across the Acheron in) "Death from Cancer," part 1 of "In Memory of Arthur Winslow." Poem. In *Land of Unlikeness* (Cummington, Mass.: Cummington Press, **1944**). / Revised and enlarged version in *Lord Weary's Castle* (New York: Harcourt Brace, 1946). [Ipso / Mazzaro 1965, pp. 4–16 / Bell 1983, pp. 13–15, 31]

Edith Sitwell, 1887–1964. "Green Flows the River of Lethe-O." Poem. In *Green Song and Other Poems* (London: Macmillan, **1944**). [Sitwell 1968 / Brophy 1968, p. 79]

Salvatore Quasimodo, 1901–1968. "Il traghetto" [The Ferry] (of Charon). Poem. **1943–46.** In *Giorno dopo giorno 1943–46* (Milan: Mondadori, 1947). / Translated by Allen Mandelbaum in *Selected Writings of Salvatore Quasimodo* (New York: Noonday, 1954). [Ipso]

Sándor Weöres, 1913–1989. *Elysium.* Collection of poems. Budapest: "Móricz Zsigmond" Könyvkiado, **1946?** [EWL 1981–84, 4:612]

Eugen Batz, 1905–. "The Shore of the Styx." Painting. **1947.** [Hannover 1950, no. 4]

Werner Gilles, 1894–1961. "Charon." Painting. **1947.** Sprengel coll., Hannover. [Berlin 1962, no. 36]

———. "Hades Landscape." Painting. 1956. [Hentzen 1960, pl. 121]

———. "Gorge with Entrance to the Underworld." Watercolor. 1957. [Ibid., pl. 125.] Another version, 1958, in artist's estate in 1961. [Berlin, no. 169]

Gottfried Benn, 1886–1956. "Acheron." Poem. In *Statische Gedichte* (Zürich: Arche, **1948**). [Wellershof 1960 / Wodtke 1963, p. 78]

Gerhard Marcks, 1889–1981. "Charon's Barque." Sandstone sculpture. **1951.** Hamburg-Ohlsdorf cemetery. [Busch & Rudloff 1977, no. 573—ill.]

Irving Layton, 1912–, **Raymond Souster,** 1921–, and **Louis Dudek,** 1918–. *Cerberus.* Poem. Toronto: Contact, **1952.** [Vinson 1985, pp. 208, 481, 813]

Andrew Young, 1885–1971. *Into Hades.* Poem. London: Hart-Davies, **1952.** [Royle 1983, p. 320]

Harald Kreutzberg, 1902–1968, choreography. *Wächter des Schattenreiches* [Guardian of the Realm of Shades]. Ballet. First performed on **1953** U.S. and European tour with Yvonne Georgi. [EDS 1954–66, 6:1075]

Lawrence Durrell, 1912–1990. "Asphodels: Chalcidice." Poem. In *Tree of Idleness and Other Poems* (London: Faber & Faber, **1955**). [Ipso]

———. (Poet urged to wander Elysium in) "Poem." Poem. In *Collected Poems* (New York: Dutton, 1960). [Ipso]

Daryl Hine, 1936–. (Charon evoked in) *Five Poems* (Toronto: Emblem, **1955**). [Ipso / CLC 1980, 15:280]

———. "Avernus." Poem. In *The Carnal and the Crane* (Toronto: Contact, 1957). [Ipso / CLC]

———. (The afterlife evoked in) "Man's Country." Poem. In *Daylight Saving* (New York: Atheneum, 1978). [Ipso]

William Carlos Williams, 1883–1963). "Asphodel, That Greeny Flower." Poem. In *Journey to Love* (New York: Random House, **1955**). [MacGowan 1988 / DLB 1978–89, 22:465, 467; 54:570, 574 / Mazzaro 1973, pp. 123f., 164f., 176f.]

Alma M. Sanders, 1882–1956. *The Houseboat on the Styx.* Music for theater work. [Cohen 1987, 2:614]

Hans Kox, 1930–. *Little Lethe.* Symphony. **1956.** [Grove 1980, 10:224]

George Garrett, 1929–. "Underworld." Poem. In *The Sleeping Gypsy and Other Poems* (Austin: University of Texas Press, **1958**). [Boswell 1982, p. 257]

Emil Schumacher, 1912–. "Acheron." Painting. **1958.** Bernhard Minetti coll., Berlin. [Berlin 1963, no. 68]

Constantine Trypanis, 1909–. "The Cocks of Hades." Poem. In *The Cocks of Hades* (London: Faber & Faber, **1958**). [Vinson 1985, pp. 869f. / DLEL 1970–78, 2:309]

Vernon Watkins, 1906–1967. "Christ and Charon." Poem. In *Cypress and Acacia* (London: Faber & Faber, **1959**). [Ipso]

Robert Rauschenberg, 1925–. Cerberus depicted in transferdrawing, illustration to Dante's *Inferno.* **1959–60.** Museum of Modern Art, New York. [Berlin 1980, p. 140—ill. / Smithsonian 1976, no. 77—ill.]

Hans Hofmann, 1880–1966. "Elysium." Abstract painting. **1960.** Michener coll., University of Texas, Austin. [Bannard 1976, no. 45—ill. / also Hofmann 1963, no. 120—ill.]

———. "Elysium II." Painting. 1963. Wright coll., Seattle. [Bannard, no. 61—ill.]

Sylvia Plath, 1932–1963. (Lethe and Charon evoked in) "Getting There." Poem. In *Ariel* (New York: Harper & Row, 1966). [Ipso / Feder 1971, p. 411]

W. H. Auden, 1907–1973. (Charon in) "Lost." Poem. **1963?** In *About the House* (New York: Random House, 1965). [Mendelson 1976]

Larry Richardson, 1941–, choreography. *Erebus.* Ballet. First performed **1965,** New York. [Cohen-Stratyner. p. 755]

Richmond Lattimore, 1906–1984. "The Sestina after Dante." Poem. In *The Stride of Time* (Ann Arbor: University of Michigan Press, **1966**). [Ipso]

Juan Benet, 1927–. (The boatwoman, a Charon-figure, in) *Volverás a Región* [Return to Región]. Novel. **1967.**

/ Translated by Gregory Rabassa (New York: Columbia University Press, 1985). [Labanyi 1989, pp. 96f., 115]

Jorge Luis Borges, 1899–1986. "El monstruo Aqueronte" [The Monster Acheron]. Poem. In *El libro de los seres imaginarios* (Buenos Aires: Kier, **1967**). / Translated by N. T. di Giovanni, with Borges, in *The Book of Imaginary Beings* (New York: Dutton, 1969). [Ipso]

Gunnar Ekelöf, 1907–1968. *Vägvisare till underjorden* [Guide to the Underworld]. Collection of poems. Stockholm: Bonnier, **1967**. [Algulin 1989, p. 236]

Anestis Logothetis, 1921–. *Styx.* Instrumental composition. **1968**. [Grove 1980, 11:133]

———. *Styxische flüsse* [Stygian Flood]. Choral composition. 1970. [Ibid.]

Rudolf Komorous, 1931–. *Lethe.* Orchestral composition. **1971**. [Grove 1980, 10:169]

Harry Martinson, 1904–1978. (Hades evoked in) "Plägsamt minne" [Constant Memory], (the Styx overflows in) "Den stora floden" [The Great Flood]. Poems. In *Dikter om ljus och mörker* [Poems about Light and Dark] (Stockholm: Bonnier, **1971**). [Ipso]

———. "Hades och Euklides" [Hades and Euclid]. Poem. / Translated by Robert Bly in *Friends, You Drank Some Darkness: Three Swedish Poets,* bilingual edition (Boston: Beacon Press, 1975). [Ipso]

Janet L. Pfischner McNeil, 1945–. *Asphodel.* Multimedia musical composition. **1974**. [Cohen 1987, 1:470]

Yves Bonnefoy, 1923–. (Charon evoked in) "Le fleuve" [The River]. Poem. In *Dans le leurre du seuil* [The Lure of the Threshold] (Paris: Mercure de France, **1975**). / Translated by Richard Pevear in *Poems, 1959–1975* (New York: Random House, 1985). [Ipso]

Alwin Nikolais, 1912–, choreography. *Styx.* Modern dance. First performed **1976**, New York. [Oxford 1982, p. 303]

Charles Simic, 1938–. "Charon's Cosmology." Poem. In *Charon's Cosmology* (New York: Braziller, **1977**). [Vinson 1985, p. 782 / CLC 1982, 22:380 / Vendler 1980, pp. 357f.]

Miriam Gideon, 1906–. "Voices from Elysium." Song. **1979**. [Cohen 1987, 1:268]

Maura Stanton, 1946–. (Charon evoked in) "At the Landing." Poem. In *Cries of Summer* (Salt Lake City: University of Utah Press, **1984**). [Ipso]

Ivan Lalić, 1931–. (Lethe evoked in) "Roll Call of Mirrors" [English title of a work written in Croation] Poem. / Translated by Charles Simic in *Roll Call of Mirrors: Selected Poems* (Middletown, Conn.: Wesleyan University Press, **1988**). [Ipso]

Anthony Hecht, 1922–. (Charon's cave, Elysian Fields evoked in) "See Naples and Die," section 5. Poem. In *The Transparent Man* (New York: Knopf, **1990**). [Ipso]

HARMONIA. *See* CADMUS.

HARPIES.

Regarded by Homer and Hesiod as the personification of turbulent winds, the Harpies (Greek, *Harpyiae,* "snatchers") were the daughters of the Titan Thaumas and the Oceanid Electra, according to Hesiod, but their parentage varies with the sources. Named Aello, Ocypete, Podarge, and Celaeno, they were often conceived as ministers of divine vengeance and were known principally for carrying off people or objects in their sharp claws. They appear in the *Odyssey* as the storm winds that seize the daughters of Pandareos and deliver them to the Furies. They also figure in the myth of Phineus, whom they plague by stealing most of his food and defiling the rest. In the *Aeneid,* the Harpies make the famous prophecy that the Trojan wanderers will one day eat their tables. They are also described as denizens of Hades. The Harpy Podarge was said by Homer to have coupled with Zephyr, the god of the west wind, and borne Xanthus and Balius, Achilles' divine horses; the horses of Castor and Pollux were also called offspring of the Harpies.

Ancient depictions represented the Harpies as winged women; they later became monsters with the faces of women and bodies of birds.

Classical Sources. Homer, *Iliad* 16.148–51, 19.400; *Odyssey* 20.61–78. Hesiod, *Theogony* 264–69. Apollonius Rhodius, *Argonautica* 2.176–300. Virgil, *Aeneid* 3.209–52, 6.289. Apollodorus, *Bibliotheca* 1.2.6, 1.9.21, 3.15.2. Hyginus, *Fabulae* 14, 19.

See also AENEAS, Wanderings, in the Underworld; HADES [2]; JASON, Phineus and the Harpies; ODYSSEUS, Odyssey.

Dante Alighieri, 1265–1321. (Harpies in the trees of the Suicides in) *Inferno* 13.10–15, 101f. *c.*1307–*c.*1314? In *The Divine Comedy.* Poem. Foligno: Neumeister & Angelini, 1472. [Singleton 1970–75, vol. 1 /]

Sandro Botticelli, 1445–1510. (Harpies in) Drawing, illustrating *Inferno* 12, part of a series of illustrations to Dante's *Divine Comedy.* **1480s/early 1490s.** Biblioteca Vaticana, Rome. [Lightbown 1978, 1:147ff., 2:172f., no. E28—ill.]

Albrecht Dürer, 1471–1528. "Ornament with Harpies and Cornucopiae." Drawing. **1510**. Kestner-Museum, Hannover, no. Z.6. [Strauss 1974, no. XW.718—ill.]

———. (Harpies in) "The Great Column." Drawing. *c.*1510. British Museum, London, no. 5218/87–88. [Ibid., no. 1510.26—ill.] Related woodcut, by studio, 1517 (Bartsch no. 129). [Ibid.]

Florentine School, 1550–**1600**. "Harpy Bestriding a Grotesque Fish." Bronze statuette. 2 versions. Frick Collection, New York, nos. 16.2.51–52. [Frick 1968–70, 3:222ff.—ill.]

Guercino, 1591–1666. "Male Figure with a Harpy." Fresco. **1614**. Casa Provenzale, Cento. [Salerno 1988, no. 7C—ill.]

Peter Paul Rubens, 1577–1640. (Harpies in) "The Temple of Janus." Painted stage, decoration for "Pompa Introitus Fernandi," triumphal entry of Cardinal-Infante Ferdinand of Spain into Antwerp, 17 Apr **1635**. Original decoration destroyed. [Martin 1972, no. 44—ill. (print); cf. no. 45 / Baudouin 1977, fig. 127] Oil sketch. Hermitage, Leningrad, inv. 500. [Martin, no. 44a—ill. / also Held 1980, no. 161—ill.]

Luca Giordano, 1634–1705. (Harpies in) "Allegory of Human Life and the Medici Dynasty." Fresco. **1682–83.** Palazzo Medici Riccardi, Florence. [Ferrari & Scavizzi 1966, 2:112ff.—ill.] Study. Denis Mahon coll., London. [Ibid.—ill.]

John Flaxman, 1755–1826. Drawing, illustrating *Inferno* 13, part of a series of illustrations to Dante's *Divine Comedy*. *c.*1792. Houghton Library, Harvard University, Cambridge. / Engraved by Tomasso Piroli, published privately, Rome: 1793; London: Longman & Co., 1807. [Irwin 1979, pp. 94, 226 *n.*, fig. 124 / Flaxman 1872, 4: pl. 14 / also Bindman 1979, p. 17—ill.]

William Blake, 1757–1827. "The Wood of the Self-Murderers: The Harpies and the Suicides." Watercolor, illustration for *Inferno* 13, part of a series of illustrations to Dante's *Divine Comedy*. **1824–27.** Tate Gallery, London, no. 3356. [Butlin 1981, no. 812.24]

Fernand Khnopff, 1858–1921. "Sleeping Medusa" (as a harpy). Pastel. **1896.** 2 versions. Private colls. [Delevoy et al. 1979, nos. 276, 282—ill. / also Hofmann 1987, no. 13.22—ill.]

Hans Thoma, 1839–1924. "A Harpy." Painting. **1906.** Blum coll., Mannheim. [Thode 1909, p. 473—ill.]

Eric Gill, 1882–1940. 2 woodcuts depicting Harpies, decorations for an edition of Chaucer's *Troilus and Creseyde* (Waltham St. Lawrence, Berkshire: Golden Cockerell Press, **1927**). (Victoria and Albert Museum, London.) [Physick 1963, nos. 451–52]

Francis Picabia, 1878–1953. "Aello." Painting. *c.*1930. Lebel coll., Paris. [Camfield 1979, p. 240, fig. 340 / also Borràs 1985, no. 572—ill.]

———— "Aello." Painting. *c.*1934. [Borràs, no. 616—ill.]

Marc Blitzstein, 1905–1964. *The Harpies*. Opera satire. Libretto, composer. **1931.** First performed 25 May 1953, Manhattan School of Music, New York. [Baker 1984, p. 276 / Grove 1980, 2:795]

Werner Gilles, 1894–1961. "Harpies." Watercolor, in "Arthur Rimbaud Dedication" cycle. **1933–35.** Museum Folkwang, Essen. [Hentzen 1960, pl. 44]

Konrad Weiss, 1880–**1940.** *Harpyie*. Poem. Munich: Kösel, 1953; drawings by Alfred Kubin. [NUC]

Willem Grimm, 3 prints depicting Harpies. **1946** (and later?). [Hannover 1950, nos. 32–34]

Eugen Batz, 1905–. "Harpies." Painting. **1947.** [Hannover 1950, no. 5]

Karl Hofer, 1878–1955. "Harpies." Painting. **1954.** Hofer coll., Berlin. [Rigby 1976, no. 69—ill.]

Robert Rauschenberg, 1925–. Harpies depicted in a transfer-drawing, illustration to Dante's *Inferno* 13. **1959–60.** Museum of Modern Art, New York. [Berlin 1980, p. 168—ill.]

Harry Martinson, 1904–1978. "Harpyorna." Poem. In *Dikter om ljus och mörker* [Poems about Light and Dark] (Stockholm: Bonnier, **1971**). [Ipso]

HEBE. The daughter of Hera (Juno) and Zeus (Jupiter) and the sister of Ares and Eileithyia, Hebe was the cupbearer of the gods and the goddess of youthful beauty. She was married to Heracles after he won immortality. In some early sources this was the reason for her resignation from her serving duties, but later sources say that she was dismissed for her clumsiness and replaced by the Trojan prince Ganymede. However, this report of awkwardness is contradicted by her habit of dancing with the Horae (Seasons) and Muses. In Rome, Hebe was identified with Juventas.

According to Euripides and Ovid, Hebe rewarded Iolaus, king of Thessaly, with restored youth after he had assisted Heracles in conquering the Lernean Hydra. As goddess of youthful beauty, Hebe was a popular subject for portraits of seventeenth- and eighteenth-century gentlewomen.

Classical Sources. Homer, *Iliad* 4.2–3, 5.719–23; *Odyssey* 11.601–04. Hesiod, *Theogony* 922, 950ff. *Homeric Hymns*, "To Apollo" line 195. Epicharmus, *The Marriage of Hebe*. Pindar, *Nemean Odes* 1.71, 10.17ff.; *Isthmian Odes* 4.65. Euripides, *Heracles* 915ff.; *Children of Heracles* 847–58. Ovid, *Metamorphoses* 9.397–403. Apollodorus, *Bibliotheca* 1.3.1, 2.7.7.

See also HERACLES, Apotheosis.

Parmigianino, 1503–1540. "Ganymede and Hebe." Drawing. **1532–40.** Louvre, Paris, no. R.F. 580. [Saslow 1986, pp. 102ff., fig. 3.8]

Francesco Primaticcio, 1504–1570, design. "Hebe." Fresco, for Salle de Bal, Château de Fontainebleau, executed by Niccolò dell' Abbate under Primaticcio's direction. **1551–56.** Repainted 19th century. [Dimier 1900, pp. 160ff., 284ff.]

Cristofano Gherardi, 1508–1556, under direction of **Giorgio Vasari**, 1511–1574. "Hebe." Fresco. **1555–56** (later repainted). Terrazzo di Giunone, Palazzo Vecchio, Florence. [Sinibaldi 1950, pp. 13, 23]

Agnolo Bronzino, 1503–**1572.** "Hebe." Painting. Galleria Nazionale, Rome. [Hunger 1959, p. 126]

Hubert Gerhard, *c.*1540/50–1620. "Hebe." Small bronze sculpture. *c.*1590. Detroit Institute of Arts. [Warburg]

Peter Paul Rubens, 1577–1640. "Ganymede Receiving the Cup from Hebe" ("Ganymede [carried by eagle] and Hebe"). Painting. *c.*1611. Schwartzenberg coll., Vienna. [Jaffé 1989, no. 169, p. 80—ill. / Saslow 1986, p. 193, fig. 5.13 / also Kempter 1980, p. 73, no. 196—ill.]

Adriaen de Vries, *c.*1550–1626. "Hebe." Bronze sculpture. *c.*1620? Detroit Institute of Arts. [Clapp 1970, 1:898]

Johann Rottenhammer, 1564–**1625**, style. "Hebe." Painting. Museum of Fine Arts, Boston, no. 66.854. [Boston 1985, p. 250—ill.]

Giovanni da San Giovanni, 1592–1636. "Ganymede Taken by Jupiter, with the Fall of Hebe." Ceiling fresco. *c.*1634. Villa Corsini, Mezzomonte, near Florence. [Banti 1977, no. 48—ill. / Kempter 1980, pp. 126f., no. 125—ill. / Saslow 1986, p. 118—ill.]

André Campra, 1660–1744. *Hébé*. Cantata. Published in *Cantates françoises* book 1 (Paris: **1708**). [Grove 1980, 3:665]

Charles-Joseph Natoire, 1700–1777. "Jupiter Served by Hebe." Painting, part of "Story of the Gods" cycle, for Château de La Chapelle-Godefroy, Champagne. *c.*1731.

Musée des Beaux-Arts, Troyes, inv. 864.1.14. [Troyes 1977, pp. 54f., no. 8—ill.]

Henri-Charles Guillon, fl. *c.*1700–50. *Le retour d'Hébé.* Cantata. Published Paris: **1736.** [Grove 1980, 7:818]

Jean-Philippe Rameau, 1683–1764. *Les fêtes d'Hébé.* Opera-ballet. Libretto, Antoine Gautier de Montdorge. First performed 25 (or 21) May **1739**, Académie Royale de Musique et de Dance, Paris; choreography, Michel Blondy? [Girdlestone 1983, pp. 361, 411 / Grove 1980, 15:566, 568, 570 / Simon & Schuster 1979, p. 66]

Robert Tournières, 1668–1752 (previously attributed to Pierre-Charles Trémollière). "Portrait of an Unknown Woman as Hebe." Painting. **1742?** Hermitage, Leningrad, inv. 1263. [Hermitage 1986, no. 258—ill.]

Antoine Bandieri de Laval, 1688–1767, and **Michel-Jean de Laval**, *c.*1725–1777, choreography. *Les fêtes d'Hebe.* Ballet. First performed **1744**, Paris. [Cohen-Stratyner 1982, p. 529]

Jean-Marc Nattier, 1685–1766. "The Duchess of Chaulnes as Hebe." Painting. **1744.** Louvre, Paris, no. R.F. 1942-32. [Louvre 1979–86, 4:121—ill.]

———. "Madame de Caumartin as Hebe." Painting. 1753. Kress coll. (K1395), National Gallery, Washington, D.C., no. 785. [Eisler 1977, pp. 310f.—ill.]

Nicolas de Largillière, 1656–**1746**, follower. "A Lady as Hebe." Painting. Bowes Museum, Barnard Castle, list 1971 no. 269. [Wright 1976, p. 114]

Joshua Reynolds, 1723–1792. "Mrs. Pownall as Hebe." Painting. **1762**. Estate of Lord Aldenham. [Waterhouse 1941, p. 51]

———. "Miss (Mary) Meyer as Hebe." Painting. 1772. Rothschild coll., Ascot. [Ibid., p. 62—ill. / Royal Academy 1986, no. 81—ill.]

———. "Mrs. Musters as Hebe." Painting. Exhibited 1785. Kenwood House, London. [Waterhouse, p. 76—ill. / Royal Academy, fig. 35]

Charles Amédée Philippe van Loo, 1719–1795. "Ganymede Introduced into the Assembly of Gods by Hebe." Ceiling fresco. **1768**. Neues Palais, Potsdam. [Kempter 1980, no. 113]

Augustin Pajou, 1730–1809. "Hebe, Goddess of Youth" ("Mme. DuBarry as Hebe"). Marble statue. Lost. / Terracotta sketch. **1771**. François Flameng coll., Paris. [Stein 1912, pp. 129f.—ill.]

Jacques-François-Joseph Saly, 1717–**1776**. "Hebe." Marble statue. Victoria and Albert Museum, London. [Hartmann 1979, pl. 3.2]

George Romney, 1734–1802. "Portrait of Elizabeth Warren as Hebe." Painting. **1776**. [Pressly 1979, p. 127 / also Jaffé 1977, nos. 12–14 (studies)]

———. "Viscountess Bulkeley as Hebe (with the eagle of Zeus)." Painting. *c.*1776. / Drawings. Private colls. [Jaffe, pp. 126f.]

———. "Catherine Vernon as Hebe." Painting. 1777. Earl of Warwick coll. [Ibid., no. 15 *n.*]

Angelica Kauffmann, 1741–1807. "Hebe." Etching. **1780.** [Manners & Williamson 1924, p. 220]

———. "Miss Meyer as Hebe." Painting, after Reynolds (1772). Saltram Park, Devon. [Wright 1976, p. 110]

Paul Ignaz Kürzinger, 1750–*c.*1820, music. *Hebe, Göttin der Jugend* [Hebe, Goddess of Youth]. Ballet. First performed **1780**, Regensburg. [Grove 1980, 10:324]

Bernhard Rode, 1725–1797. "Allegorical Female Figure" (Hebe?). Painting. *c.*1785. Hermitage, Leningrad, inv. 7628. [Hermitage 1987b, no. 294—ill.]

Marie-Louise Elizabeth Vigée-Lebrun, 1755–1842. "Portrait of Anne Pitt as Hebe." Painting. 1792. Private coll., England. / Replica. Hermitage, Leningrad, inv. 4749. [Hermitage 1986, no. 327—ill.]

Antonio Canova, 1757–1822. "Hebe." Marble statue. **1796.** Nationalgalerie, Berlin. [Pavanello 1976, no. 98—ill. / Licht 1983, pp. 175–81—ill.] Variants, **1800–05, 1808–14**. Hermitage, Leningrad, inv. 16; Duke of Devonshire coll., Chatsworth; Pinacoteca Comunale, Forlì. [Pavanello, nos. 100, 213, 215—ill. / also Licht, p. 175—ill. / Vermeule 1964, p. 139—ill. / Hermitage 1984, no. 393—ill.] Plaster models. Galleria Comunale d'Arte Moderna, Milan; Gipsoteca Canoviana, Possagno, no. 83. [Pavanello, nos. 99, 214—ill.]

Thomas Moore, 1779–1852. "The Fall of Hebe." Ode. In *Epistles, Odes, and Other Poems* (London: Carpenter, **1806**); collected in *Poetical Works* (London: Oxford University Press, 1929). [Boswell 1982, p. 188]

Bertel Thorwaldsen, 1770–1844. "Hebe." Marble statue. Modeled **1806.** 2 versions. Thorwaldsens Museum, Copenhagen, no. A875; the other unlocated. [Thorwaldsen 1985, pp. 23, 84, pl. 14 / Cologne 1977, no. 24, p. 99—ill. / Hartmann 1979, pl. 77.1] Plaster models and variants. Thorwaldsens Museum, nos. A37, A870, A874; Staatliche Kunsthalle, Karlsruhe; private colls. [Thorwaldsen / also Cologne, no. 90, p. 164—ill. / Hartmann, pl. 77.3]

———. "Hebe Gives Ganymede the Cup and Pitcher." Plaster relief. 1833. Thorwaldsens Museum, no. A351. [Thorwaldsen, p. 48]

Washington Allston, 1779–1843. "Hebe." Painting. Exhibited **1814.** Lost. [Richardson 1948, no. 78 / also Gerdts & Stebbins 1979, p. 83]

John Keats, 1795–1821. (Hebe in) *Endymion* 4.415ff., 436ff. Poem. **1817**. London: Taylor & Hessey, 1818. [Stillinger 1978]

Nicolas Isouard, 1775–**1818**. *Hébé.* Cantata. Text, Commandeur de St. Priest. Unpublished MS in Paris Conservatory. [Grove 1980, 9:355]

Jean-Jacques Lagrenée, 1739–**1821**. "Hebe Pouring Nectar for Jupiter." Painting. Banque de France, Paris. [Rosenberg 1988, p. 228—ill.]

Adolphe Diez, 1801–1844. "Hebe with Jupiter in the Guise of an Eagle." Painting. Before **1827.** Rijksmuseum, Amsterdam, inv. A1026. [Rijksmuseum 1976, p. 195—ill.]

Letitia Elizabeth Landon, 1802–1838. "Hebe." Poem. In *The Vow of the Peacock* (London: Saunders & Otley, **1835**). [Boswell 1982, p. 150]

William Beechey, 1753–**1839.** "Hebe Feeding Jupiter's Eagle." Painting. Fitzwilliam Museum, Cambridge, no. 628. [Fitzwilliam 1960–77, 3:11—ill.] Several further depictions of Hebe known from contemporary exhibitions, unlocated. [Ibid.]

Thomas Crawford, 1813–1857. "Hebe and Ganymede." Marble sculpture group. **1842.** Museum of Fine Arts, Boston. [Gerdts 1973, p. 58, fig. 14]

James Russell Lowell, 1819–1891. "Hebe" (poet, ena-

mored of youth [as Hebe] frightens her with his earthly pursuit). Poem. **1847**. In *Poems*, 2d series (Boston: Mussey, 1848). [Boswell 1982, p. 168 / Cooke 1906, pp. 26, 104]

Albert-Ernest Carrier-Belleuse, 1824–1887. "Hebe and the Eagle of Jupiter." Silvered bronze statuette. **1858**. Musée d'Orsay, Paris, inv. R.F. 3639. [Orsay 1986, p. 92—ill.]

————. "Hebe Sleeping" (held by the eagle of Jupiter). Marble group. 1869. Musée d'Orsay, inv. R.F. 163. [Ibid., p. 91, pl. 23 / Beattie 1983, pp. 143f., pl. 136]

James Thomson, 1834–1882. "Life's Hebe." Poem. **1866–67**. In *The City of Dreadful Night, and Other Poems* (London: Reeves & Turner, 1880). [Bush 1937, p. 403]

Giosuè Carducci, 1836–1907. (Hebe as cup-bearer in) "Ideale." Ode. In *Odi barbare* (Bologna: Zanichelli, **1877**). [Ipso]

Charles Edouard Lefebvre, 1843–1917. *Divine Hébé*. Choral composition, opus 69. Text, Charles Marie René Leconte de Lisle. **1886**. [Grove 1980, 10:605]

Gabriele D'Annunzio, 1863–1938. "Sonetti d'Ebe" [Sonnets of Hebe]. Sonnet sequence. In *La Chimera*, 2d edition (Milan: Treves, **1895**). [Palmieri 1953–59, vol. 2 / Bàrberi Squarotti 1982, p. 71]

Agathon Léonard, 1841–after 1900. "Hebe." Marble statue. Musées Nationaux, inv. R.F. 1177, deposited in Ministère de l'Intérieur, Paris, in 1900. [Orsay 1986, p. 275]

Adolph Bolm, 1884–1951, choreography. *La fête d'Hébé*. Ballet. Music, Rameau (1739). First performed **1912**, Monte Carlo. [EDS 1954–66, 2:720]

Karel van de Woestijne, 1878–1929. "Hebe." Epic poem. In *Interludiën* (Bussum: Van Dishoeck, **1912–14**). [Meijer 1971, p. 273]

Laurent-Honoré Marqueste, 1848–**1920**. "Hebe." Marble sculpture. Musées Nationaux, inv. R.F. 4021, deposited in Musée, Le Chambon-Feugerolles, in 1967. [Orsay 1986, p. 276]

Antony Tudor, 1908–1987, choreography. *The Descent of Hebe*. Ballet. Music, Ernest Bloch. First performed **1935**, Sadler's Wells, London. [Oxford 1982, p. 423]

HECATE. A daughter of Perses and Asteria, Hecate is often linked with Artemis (Diana) and Selene (Luna) as a triple goddess representing the netherworld, the earth, and the moon. She is particularly confused with Artemis, and their roles do overlap. She was a goddess of fertility, women, and the moon, but she also had powers in courts of law and assemblies and could grant victory in war and athletics. She nurtured children as well, but her main powers lay in the occult and sorcery. Like the Roman Diana, she was known as goddess of the crossroads, with the epithet "trivia" ("three roads"), haunting crossroads and graveyards by night, seen only by barking dogs. Attendant on Persephone (Proserpine), she aided Demeter in the search for her daughter.

In artistic representations, Hecate is usually depicted as one of the triple deities or as goddess of the crossroads.

Classical Sources. Hesiod, *Theogony* 404–52. *Homeric Hymns*, first hymn "To Demeter" lines 24–62, 438–40. Apollonius Rhodius, *Argonautica* 3.477–78, 3.528–30, 3.1035–41, 3.1207–24. *Orphic Hymns* I, "To Hecate." Theocritus, *Idylls* 2.10–16. Diodorus Siculus, *Biblioteca* 4.45ff. Cicero, *De natura deorum* 3.18.46. Virgil, *Aeneid* 4.511, 4.609, 6.247, 6.564. Apollodorus, *Biblioteca* 1.2.4.

Rosso Fiorentino, 1494–1540, and assistants. (Hecate in) "Allegory of Old Age." Fresco. **1535–40**. Galerie François I, Fontainebleau. [Panofsky 1958, p. 150—ill. / Barocchi 1950, pp. 144f.—ill. (copy drawing)]

Maurice Scève, *c.*1510–*c.*1564. (Diana, Luna, and Hecate evoked in) *Délie: objet de plus haute vertue*. Poem. Lyon: Sabou, **1544**. Modern edition, Paris: Gallimard, *c.*1984. [Dellaneva 1988, p. 47]

Pierre de Ronsard, 1524–1585. (Sacrifice to Hecate in) *La franciade* 4, lines 641ff., 695ff. Epic poem, unfinished. Paris: Buon, **1572**. [Laumonier 1914–75, vol. 16 / McFarlane 1973, p. 60 / Cave 1973, p. 60]

George Chapman, *c.*1559–*c.*1634. (Hecate reigns in) *The Shadow of Night*. Poem. London: Ponsonbie, **1594**. [Bush 1963, pp. 207f.]

William Shakespeare, 1564–1616. (Hecate as queen of the Witches in) *Macbeth* 2.1.51, 3.2.40–43, 3.5. Tragedy. *c.***1606**. Possibly first performed 7 Aug 1606, Court, London. Published London: Jaggard, 1623 (First Folio). [Riverside 1974 / Muir 1985, pp. 48f. / Root 1903, pp. 12, 53ff.]

Thomas Middleton, 1570?–1627. (Hecate in) *The Witch*. Tragicomedy. First performed *c.***1610–16** (?) by the King's Men, Blackfriars Theatre, London. Published London: 1778. / Modern edition (London: Oxford University Press, 1950). [Carroll 1985, p. 238 / McGraw-Hill 1984, 3:384 / DLB 1987, 58:196, 212]

Michael Drayton, 1563–1631. (Hecate in) *The Moon-Calfe*. Poem. Published with *The Battle of Agincourt* (London: **1627**). [Hebel 1931–32, vol. 3]

Robert Johnson II, *c.*1583–1633. "Come Away, Hecate." Song for Middleton's *The Witch* (*c.*1610–16). [Grove 1980, 9:682 / Spink 1974, p. 291 / Fiske 1973, p. 26]

John Milton, 1608–1674. (Allusion to Hecate in) *Comus* lines 531–38. Masque. Music, Henry Lawes. First performed Michaelmas Day **1634**, Ludlow Castle. Published London: Robinson, 1637. [Carey & Fowler 1968; cf. p. 606 *n.*]

————. (Hecate as "Triform" in) *Paradise Lost* 2.662–66, 3.725–32. Epic. London: Parker, Boulter & Walker, 1667. [Ibid.]

Robert Herrick, 1591–1674. (Hecate invoked in) "A Conjuration, to Electra," (Hecate evoked in) "The New Charon," lines 31–34. Poems. In *Hesperides* (London: Williams & Eglesfield, **1648**). [Martin 1956]

Jusepe de Ribera, 1590/91–**1652**, attributed (or school?). "Hecate." Painting. Wellington Museum, London. [Spinosa 1978, no. 410—ill.]

Jacques Aubert, 1689–**1753**, music. *La triple Hécate*. Ballet. Libretto, C.-J.-F. Hénault. Libretto published in *Oeuvres inédites* (Paris: 1806). [Grove 1980, 1:683]

William Shirley, fl. 1739–80. "Hecate's Prophecy." Satire.

In *Brief Remarks on the Original and Present State of the Drama* (London: Hooper & Morley, **1758**). [Nicoll 1959–66, 3:331]

Jonathan Battishill, 1738–1801, music, with comic tunes by **John Potter**, *c*.1734–after 1813. *The Rites of Hecate, or, Harlequin from the Moon.* Pantomime. Libretto, James Love. First performed 26 Dec **1763**, Theatre Royal, Drury Lane, London. [Fiske 1973, pp. 298, 407–10, 585–87 / Grove 1980, 2:294]

André Chénier, 1762–1794. "Salut, Trivie, Hécate, Cynthie, ou Lucine" [Greetings, Trivia, Hecate, Cynthia, or Lucina]. Poem. **1778–87**. In *Les bucoliques,* section of *Oeuvre complètes* (Paris: Foulon, Baudouin, 1819). [DLLF 1984, 1:444, 447]

William Blake, 1757–1827. "Hecate." Color print, finished in pen and watercolor. *c*.**1795**. 3 impressions: Tate Gallery, London; National Gallery of Scotland, Edinburgh; Huntington Library and Art Gallery, San Marino, Calif. [Butlin 1981, nos. 316, 317, 318—ill. / Bindman 1978, no. 334—ill. / also Bindman 1982, no. 55—ill.]

Anonymous. *The Cave of Hecate.* Play. First performed 28 Jan **1797**, Bath. [Nicoll 1959–66, 3:399]

Marcos Antonio Portugal, 1762–1830. *Idante, ovvero, I sacrifizi d'Ecate* [Idante, or, The Sacrifices to Hecate]. Opera. Libretto, G. Schmidt. First performed **1800**, La Scala, Milan. [Grove 1980, 15:148f.]

Victor Hugo, 1802–1885. (Hecate evoked in) "L'océan d'en haut" part 4. Poem. **1855**. In *Dieu* (Paris: Hetzel & Quantin, 1891). [Hugo 1985–86, vol. 7]

Gustave Moreau, 1826–1898. (Hecate in) "Jupiter and Semele." Painting. **1894–95**. Musée Gustave Moreau, Paris. [Mathieu 1976, no. 406, pp. 180–82, 207—ill.]

Maurice Hewlett, 1861–1923. "Hecate." Poem. In *Artemision: Idylls and Songs* (New York: Scribner, **1899**). [Boswell 1982, p. 132]

George Meredith, 1828–**1909**. "Hecate." Poem. Unpublished in author's lifetime. [Bartlett 1978, vol. 2 (first publication)]

Yvor Winters, 1900–1968. "Alba for Hecate." Poem. In *The Bare Hills* (Boston: Four Seas, **1927**). [Powell 1980, p. 41]

Pierre-Jean Jouve, 1887–1976. *Hécate.* Novel. Paris: Gallimard, **1928**. [EWL 1981–84, 2:525]

César Klein, 1876–1954. "Hecate." Painting. **1933**. [Hannover 1950, no. 39]

Edmund Wilson, 1895–1972. *Memoirs of Hecate County.* Novel. Garden City, N.Y.: Doubleday, **1946**. [EWL 1981–84, 4:642 / DLB 1988, 63:310f.]

Paul Morand, 1888–1976. *Hécate et ses chiens* [Hecate and Her Dogs]. Novella. Paris: Flammarion, **1954**. [DLLF 1984, 2:1569]

Léonor Fini, 1918–. "Hecate." Painting. **1965**. [Lauter 1984, p. 121]

Jay Macpherson, 1931–. "Hecate Trivia." Poem. In *Welcoming Disaster: Poems 1970–1974* (Toronto: Sannes, **1974**). [Ipso]

Radcliffe Squires, 1917–. "The Garden of Hecate." Poem. In *The Sewanee Review* 83 no. 3 (Summer **1975**); collected in *Gardens of the World* (Baton Rouge: Louisiana State University Press, 1981). [Ipso]

Hugo Claus, 1929–. "Hecate spreckt" [Hecate Speaks].

Poem. In *De wangebeden* (Amsterdam: De Bezige Bij, **1978**). [NUC]

HECATONCHEIRES. *See* TITANS AND GIANTS.

HECTOR. The eldest son of King Priam and Queen Hecuba, Hector was the bravest of all the Trojans, commanding the forces of Troy against the Greek siege in the Trojan War. He owed his position not only to courage, but also to superior judgment and responsibility. He tried first to avert war; when that failed he conducted it, fighting Ajax in single combat, attacking the Greek ships, and killing Patroclus.

One of the most popular episodes from the *Iliad* in postclassical painting, literature, and music is Hector's final farewell to Andromache and their young son, Astyanax.

Classical Sources. Homer, *Iliad* 1.242, 2.416f., 2.802–18, 6.237–529, 13.674–837, 16.816–42, 20.364–454, 22–24, and passim. Sappho, *The Wedding of Andromache.* Euripides, *Rhesus.* Plutarch, *Parallel Lives,* "Marcus Brutus" 46.23.

Listings are arranged under the following headings:
General List
Death of Hector

See also AJAX; ANDROMACHE; PARIS; PATROCLUS; TROILUS AND CRESSIDA; TROJAN WAR, General List.

General List

Benoît de Sainte-Maure, fl. 1150–70. (Hector in) *Le roman de Troie.* Verse romance, after Dares, *De excidio Troiae historia,* and Dictys, *Ephemeris de historia belli Troiani* (late Latin versions of lost Greek poems, pseudoclassical forgeries). *c*.**1165**. [Baumgartner 1987]

Guido delle Colonne, *c*.1210–after 1287. (Hector in) *Historia destructionis Troiae* 6.96–166; 15.539–44, 681–88; 21.40–53, 80ff., 165–79, and passim. Latin prose chronicle, after Benoît de Sainte-Maure. **1272–87**. Modern edition by Nathaniel E. Griffin (Cambridge: Harvard University Press, with Mediæval Academy of America, 1936; reprinted New York: Kraus, 1970). / Translated by M. E. Meek (Bloomington: Indiana University Press, 1974). [Benson 1980, pp. 19–21, 29, 64, 66–69, 105, 125]

Dante Alighieri, 1265–1321. (Hector among the heroes of antiquity in Limbo in) *Inferno* 4.122. *c*.**1307**–*c*.**1314**? In *The Divine Comedy.* Poem. Foligno: Neumeister & Angelini, 1472. [Singleton 1970–75, vol. 1]

Clerc de Troyes (unknown poet). (Andromache's dream, foretelling Hector's death, in) *Le roman de Renart le Contrefait* branch 6, lines 31323–40. Satirical poem. *c*.**1319–22**. Modern edition by G. Raynaud and H. Lemaître (Paris: Champion, 1914). [Pratt 1972, pp. 425ff., 428, 430–33, 648ff.]

Anonymous English. (Hector in) *The Destruction of Troy* lines 6943–51, 8588–8673 and passim. Alliterative adaptation of Guido delle Colonne (1272–87). *c*.**1385–1400**?

Modern edition by George A. Panton and David Donaldson, *The "Gest Hystoriale" of the Destruction of Troy* (London: Early English Text Society, 1869, 1874). [Benson 1980, pp. 64, 87]

Geoffrey Chaucer, 1340?–1400. (Chauntecleer recounts Andromache's dream of Hector's death in) "The Nun's Priest's Tale" lines 3141–47. Poem, part of *The Canterbury Tales.* **1396–1400.** Westminster: Caxton, 1478. [Riverside 1987]

Anonymous English. (Hector in) *The Laud Troy Book.* Metrical romance, after Guido delle Colonne (1272–87). *c.*1400. Modern edition by J. Ernst Wülfing (London: Early English Text Society, 1902, 1903). [Benson 1980, pp. 67f., 82–89]

Christine de Pizan, *c.*1364–*c.*1431. (Hector as the ideal knight, representing Louis of Orléans, in) *L'epistre d'Othéa à Hector* . . . [The Epistle of Othéa to Hector] chapters 1, 88, 90–93. Didactic romance in prose. *c.*1400. MSS in British Library, London; Bibliothèque Nationale, Paris; elsewhere. / Translated by Stephen Scrope (London: *c.*1444–50). [Bühler 1970 / Hindman 1986, pp. 24, 42–44, 194, 56–58, 130–32, 140ff., 202; pls. 2, 6, 8, 47, 48, 87, 93 / Benson 1980, pp. 124–29]

John Lydgate, 1370?–1449. (Hector in) *Troy Book* 3.2078–2121, 5332–99, 5423–502 and passim. Poem, elaboration of Guido delle Colonne (1272–87). **1412–20.** Modern edition by Henry Bergen (London: Kegan Paul, Trench & Trübner, for Early English Text Society, 1906–35). [Benson 1980, pp. 105f., 124–29]

Filarete, *c.*1400–1469? "Hector on Horseback." Bronze statuette. *c.***1458–60.** Museo Arqueologico Nacional, Madrid. [Pope-Hennessy 1985b, 2:317]

Raoul Lefèvre, fl. *c.*1454–67. (Hector in) *Le recueil des hystoires de Troyes* [Collection of the Stories of Troy]. Prose romance. **1464.** / English translation by William Caxton as *The Recuyell of the Historyes of Troye* (Bruges: Mansion, *c.*1474). / Modern edition (of original French) by Marc Aeschbach (Bern & New York: Lang, 1987). [Scherer 1963, pp. 82f.]

Franco-Flemish School. "Meeting of Hector and Achilles in Conference." Tapestry, from Tournai, for Charles the Bold. **After 1474.** Metropolitan Museum, New York. [Scherer 1963, pp. 79—ill.; cf. pp. 242f.]

Jean Lemaire de Belges, *c.*1473–1515/25. *Épistre du roy a Hector de Troye* (Paris: Geoffroy de Marnef, **1513**). [DLLF 1984, 2:1273]

William Shakespeare, 1564–1616. (Hector parodied in Pageant of the Nine Worthies, in) *Love's Labor's Lost* 5.2.632ff. Comedy. *c.***1594–95.** / Revised for Court performance, Christmas 1597, London. Published London: 1598 (and possibly earlier); collected in First Folio, London: Jaggard, 1623. [Riverside 1974]

Antoine de Montchréstien, sieur de Vasteuille, 1575–1621. *Hector.* Tragedy. In *Tragedies* (Rouen: Osmont, **1604**). In modern edition by C. N. Smith, *Two Tragedies* (London: Athlone Press, 1972). [DLLF 1984, 2:1551 / Stone 1974, pp. 105f., 112, 151]

Thomas Heywood, 1573/74–1641. (Hector in) *Troia Britanica: or, Great Britaines Troy* cantos 10–14. Epic poem. London: **1609.** [Heywood 1974]

———. (Hector in) *The Iron Age* part 1. Drama, derived from *Troia Britanica.* First performed *c.*1612–13, London. Published London: Okes, 1632. [Heywood 1874, vol. 3]

Anonymous English (formerly attributed to Thomas Heywood, John Lydgate). *The Life and Death of Hector.* Poem. London: Purfoot, **1614.** [Clark 1931, p. 340]

Adrien Sconin, 1638–? *Hector.* Tragedy. Paris: **1674.** [Lancaster 1929–42, pt. 4, 2:951]

Gérard de Lairesse, 1641–1711 (active until *c.*1690). "Hector and Andromache" (formerly called "Odysseus and Calypso"). Painting. Herzog Anton Ulrich-Museum, Braunschweig, no. 1102. [Braunschweig 1969, p. 85]

John Dryden, 1631–1700. "The Last Parting of Hector and Andromache, from the Sixth Book of Homer's *Iliads.*" Translation. In *Examen poeticum,* part 3 of Tonson's *Miscellany* (London: Tonson, **1693**). [Dryden 1956–87, vol. 4]

Louis de Silvestre the Younger, 1675–1760. "Hector's Farewell to Andromache and Astyanax." Painting. **1708.** Novák coll., Prague. [Pigler 1974, p. 319]

Giovanni Antonio Pellegrini, 1675–1741. "Hector and Andromache." Painting. *c.***1709?** City Art Gallery and Temple Newsam, Leeds. [Wright 1976, p. 158]

Antoine Coypel, 1661–1722. "The Farewell of Hector and Andromache." Painting. Musée, Tours. / Variant, cartoon for Gobelins tapestry, part of "Iliad" series. Louvre, Paris, inv. 3550. [Louvre 1979–86, 3:170—ill.] Another version of the subject in Musée, Troyes. [Pigler 1974, p. 319]

Lucas de Valdés, 1661–1724. "Hector." Drawing. Courtauld Institute, London, no. 250L. [López Torrijos 1985, p. 411 no. 50—ill.]

Gerard Hoet the Elder, 1648–1733. "The Farewell of Hector." Painting. Stedelijk Museum, Zutphen, inv. Br.105. [Wright 1980, p. 177]

Pompeo Batoni, 1708–1787. "Hector's Farewell to Andromache." Painting. **1758–60.** Lost. [Clark 1985, no. 222] Drawing. Musée des Beaux-Arts, Besançon. [Ibid., no. D45—ill.]

Benjamin West, 1738–1820. "The Fright of Astyanax" ("Hector Taking Leave of Andromache"). Painting. *c.***1766.** Lost. [von Erffa & Staley 1986, no. 163—ill. (print)]

———. "The Fright of Astyanax" ("Hector Taking Leave of Andromache"). Drawing with watercolor. 1797. Getty Museum, Malibu, Calif. [Ibid., no. 165—ill.]

———. 3 further versions of this subject recorded, untraced. [Ibid., nos. 164, 166–67]

Jean Restout, 1692–1768. "Hector's Farewell to Andromache and Astyanax." Painting. Museum, Halle. / Oil sketch. Musée, Orléans. [Pigler 1974, p. 319]

Johann Konrad Seekatz, 1719–1768. "Hector's Farewell to Andromache and Astyanax." Painting. Castle Museum, Darmstadt. [Pigler 1974, p. 319] Another version of the subject, Fontmichel House, Grasse, Provence. [Ibid.]

Angelica Kauffmann, 1741–1807. "Hector Taking Leave of Andromache." Painting. Exhibited **1769.** Earl of Morley coll., Saltram Park, Devon. [Manners & Williamson 1924, p. 200 / Wright 1976, p. 110]

———. "Hector Taking Leave of Andromache." Painting. By 1772? Tate Gallery, London, no. T.25. [Tate 1975, p. 46 / Manners & Williamson, p. 227 / Wright]

Richard Shepherd, 1732?–1809. *Hector*. Dramatic poem. London: Flexney, **1770**. [Nicoll 1959–1966, 3:305]

Jacques-Louis David, 1748–1825. "Hector." Painting. **1778**. Musée Fabre, Montpellier. [Cantinelli 1930, no. 16] Replica or studio copy. 1778. Louvre, Paris, inv. 3697. [Ibid., no. 17 / Louvre 1979–86, 3:188—ill.]

———. "Hector's Departure." Drawing. 1812. Louvre, Paris. [Schnapper 1982, p. 260]

William Blake, 1757–1827. "Hector and Andromache" (?). Drawing. *c.*1780? Unlocated. [Butlin 1981, no. 180]

Friedrich von Schiller, 1759–1805. "Hektors Abschied" [Hector's Farewell]. Poem (fragment). **1780**. As "Abschied Andromachas und Hektors," introduced into Schiller's drama *Die Räuber* of 1781. [Oellers 1983 / Hunger 1959, p. 129]

Martin Johann Kremser-Schmidt, 1718–1801. "Hector Leaving Andromache." Painting. **1784**. Schreiner coll., Voitsberg, Steiermark, Austria. / Oil sketch. Szépmüvészeti Múzeum, Budapest, no. 61.7. [Budapest 1968, p. 629]

Joseph-Marie Vien, 1716–1809. "The Farewell of Hector and Andromache." Painting. **1786**. Louvre, Paris, inv. 8427. [Louvre 1979–86, 4:271—ill.]

Jean Antoine Julien de Parme, 1736–**1799**. "The Farewell of Hector and Andromache." Painting. Prado, Madrid, no. 6774. [Prado 1985, p. 352]

Johann August Nahl the Younger, 1752–1825. "Hector's Farewell to Andromache." Painting. **1800**. (Winner of the Goethe Weimar Preisaufgabe for 1800; other entrants included Ferdinand Hartmann, Heinrich Christoph Kolbe, and Friedrich Schnorr von Karolsfeld.) [Rosenblum 1967, p. 25 *n.*]

Jean-Auguste-Dominique Ingres, 1780–1867. "Hector Bidding Farewell to Andromache (Implores Zeus and the Other Gods to Protect His Son)." Painting. **1801**. Unlocated. [Wildenstein 1954, no. 6]

Jean Charles Julien Luce de Lancival, 1764–1810. *Hector*. Tragedy. First performed 1 Feb **1809**, Théâtre Français, Paris. Published Paris: Chaumerot, 1809. [DLF 1951–72, 4 pt. 2: 140f.] Translated by Edward Mangin (Bath: Longman & Co., 1810). [Nicoll 1959–66, 4:353]

Henry Fuseli, 1741–1825. "Hector, Andromache, and Astyanax." Drawing. **1800–10**. Kunsthaus, Zurich, inv. 1914/2 (as "Man and Woman with Reading Child"). [Schiff 1973, no. 1356—ill.]

Francesco Hayez, 1791–1882. "The Departure of Hector." Painting. **1811**. Akademija Likovnih Umjetnosti, Zagreb. [Coradeschi 1971, no. 10—ill.]

———. "The Departure of Hector." Painting. 1821. Private coll., Cremona. [Ibid., no. 48—ill.]

Johann Baptist Seele, 1774–1814. "Hector's Farewell to Andromache and Astyanax." Painting. Castle, Ludwigsburg. [Pigler 1974, p. 319]

John Galt, 1779–1839. *Hector: A Tragic Cento*. Tragedy. Unperformed. Published in *The New British Theatre* (London: Valpy, **1815**). [Stratman 1966, pp. 205, 749 / Nicoll 1959–66, 4:318, 636]

Franz Schubert, 1797–1828. "Hektors Abschied." Lied, opus 58. Text, Schiller (1780). **1815**. [Grove 1980, 16:792]

Christoffer Wilhelm Eckersberg, 1783–1853. "Hector's Farewell to Andromache." Painting. **1813–16**. Thor-

waldsens Museum, Copenhagen, no. B213. [Thorwaldsen 1985, p. 95]

Carl Jonas Love Almqvist, 1793–1866. "Hektors lefnad" [Hector's Leavetaking]. Poem. In *Strödda skrifter* (Stockholm: Bonnier, **1814–16**). [Hunger 1959, p. 129]

Antonio Canova, 1757–1822. "Hector." Marble statue. Modeled 1808, completed **1816**. Palazzo Treves, Venice. [Pavanello 1976, no. 216—ill.] Plaster models. Gipsoteca Canoviana, Possagno, no. 195; Museo Correr, Venice. [Ibid., nos. 217–18—ill.]

Abraham Louis Barbaz, 1770–1833. *Les adieux d'Hector et d'Andromaque*. Dramatic dialogue. In *Théâtre Français* (Amsterdam: Geysbeck, **1817**). [Taylor 1893, p. 219]

Andries Cornelis Lens, 1739–**1822**. "Hector's Farewell." Pastel. Kunsthistorisches Museum, Vienna. [Bénézit 1976, 6:581]

Pierre-Paul Prud'hon, 1758–1823. "The Farewell of Hector and Andromache." Drawing. 2 versions. Musée Baron Martin, Gray; private coll. or unlocated. [Guiffrey 1924, nos. 246–47]

Tommaso Sgricci, 1788–1836. *Ettore*. Tragedy. First performed **1823**, Turin. Published Turin: Chirio & Mina, 1823. [DELI 1966–70, 5:127 / Wasserman 1971, p. 379 *n.*]

Václav Jan Tomášek, 1774–1850. "Hectors Abschied." Lied, for 2 voices and piano, opus 89. Text, Schiller (1780). Before **1825**. [Grove 1980, 19:34]

Johann Heinrich Wilhelm Tischbein, 1751–**1829**. "Hector's Departure from Andromache." Painting. Herzog Anton Ulrich-Museum, Braunschweig, no. 755. [Braunschweig 1969, p. 134]

Thomas Stothard, 1755–**1834**. "Hector Bidding Farewell to Andromache." Watercolor, part of a series illustrating Pope's translation of the *Iliad*. Victoria and Albert Museum, London, no. 94–1892. [Lambourne & Hamilton 1980, p. 368]

Bertel Thorwaldsen, 1770–1844. "Hector's Farewell to Andromache." Marble relief. Modeled **1836–37**. Thorwaldsens Museum, Copenhagen, no. A776. [Thorwaldsen 1985, pp. 57, 76] Plaster original, Thorwaldsens Museum, no. A501. [Ibid.]

Elizabeth Barrett Browning, 1806–1861. "Hector and Andromache." Poem, paraphrase from *Iliad* 6. **1845**. In *Last Poems* (London: Chapman & Hall, 1862). [Browning 1932]

———. "Hector in the Garden." Poem. In *Blackwood's Magazine* Oct 1846; collected in *Poems,* new edition (London: Chapman & Hall, 1850). [Browning / Taplin 1957, p. 233]

Heinrich Heine, 1797–1856. (Hector's ghost conjured up by Faust in) *Der Doktor Faust*. Ballet scenario. **1847**. Hamburg: Hoffman & Campe, 1851. [Windfuhr 1975–82, vol. 9]

George W. Cox, 1827–1902. "The Parting of Hector and Andromache." Poem. In *Poems, Legendary and Historical* (London: Longman & Co., **1850**). [Boswell 1982, p. 108]

The Prix de Rome sculpture competition subject for **1854** was "Hector and His Son Astyanax." First prize, Jean-Baptiste Carpeaux (see below). [Wagner 1986, p. 102]

Jean-Baptiste Carpeaux, 1827–1875. "Hector and His Son Astyanax." Painted plaster sculpture. Prix de Rome, **1854**.

Musée des Beaux-Arts, Valenciennes. [Wagner 1986, pp. 102ff.—ill.] Plaster model in Musée des Beaux-Arts, Laon. [Ibid., fig. 95]

Dante Gabriel Rossetti, 1828–1882. "Cassandra" (prophesying, as Hector departs for battle). Drawing. **1861**. British Museum, London, no. 1910–12–10–4. [Surtees 1971, no. 127—ill.] Study of Hector. Victoria and Albert Museum, London, no. E1466–1925. [Ibid., no. 127a—ill.]
———. "Cassandra." Sonnet, to accompany above drawing. 1869. In *Poems* (London: Ellis, 1870). [Doughty 1965 / Rees 1981, p. 112 / Bush 1937, pp. 410 / also Surtees, p. 80 (reproduced)]

James Harwood Panting, fl. 1881–89. *Hector's Retribution*. Drama. First performed 9 Feb **1881**, Walworth Institute, London. [Nicoll 1959–66, 5:512]

Harry Bates, 1850–1899. "War" ("Hector's Departure from Andromache"). Bronze relief, with predella ("The Body of Hector Dragged behind the Chariot of Achilles"). **1887**. City Art Gallery, Manchester, England. / Original plaster, Tate Gallery, London. [Read 1982, pp. 313, 317]

John Jay Chapman, 1862–1933. "Hector's Farewell." Poem. In *Homeric Scenes* (New York: Gomme, **1914**). [Boswell 1982, p. 248]

Giorgio de Chirico, 1888–1978. "Hector and Andromache" (mannequin figures). Surrealistic painting. **1917**. Private coll., Milan. [de Chirico 1971–83, 6.1: no. 355—ill.] Numerous replicas and variants. 1918 (?), 1935–69. Private colls., Italy, France, U.S.A. [Ibid., 1.1: no. 57; 1.3: no. 73; 2.2: nos. 145, 157; 2.3: nos. 203, 251, 273, 288; 3.2: no. 286; 4.3: nos. 576, 582, 602, 618; 5.1: no. 299; 5.2: nos. 369, 443; 5.3: nos. 69, 741; 6.3: nos. 908, 935, 948, 952, 974; 7.3: nos. 1078, 1083–84—ill.]
———. "Hector and Andromache" (mannequin figure holding weeping Andromache). Terra-cotta sculpture. 1940. Several examples, 1 painted by the artist. [Ibid., 2.2: no. 130—ill.] 6 bronze casts. 1966. [Ibid., no. 129—ill.]
———. "Hector and Andromache" (mannequin busts). Surrealistic painting. 1954. Private coll., Turin. [Ibid., 4.3: no. 473—ill.] 2 variants, 1961. Private colls. [Ibid., 5.3: nos. 706, 707—ill.]
———. "Hector and Andromache." Bronze sculpture (mannequin figures, related to above). 1968. 6 casts, 2 artist's proofs. [Ibid., 2.3: no. 283—ill.] Silvered bronze variant, 1970. 9 casts, 2 artist's proofs. [Ibid., 6.3: no. 1002—ill.]
———. "Hector with One of His Horses." Painting. 1961. Private coll., Rome. [Far 1968, no. 109—ill.]
———. "Hector with His Horse Podargus." Painting. 1966. Private coll., Rome. [Ibid., no. 58—ill.]
———. "Apollo Urges Athena to a Duel between Hector and a Greek." Watercolor, part of "The Iliad" series. 1967. Galleria Gissi, Turin. [de Chirico, 5.3: no. 725—ill.]
———. "Hector and Andromache." Drawing. 1968. Private coll., Rome. [Ibid., 1.3: no. 134—ill.]
———. "Hector and Andromache." Drawing. 1970. Galleria La Medusa, Rome. [Ibid., 2.3: no. 308—ill.]

Edmund Willan. "Hector and Andromache." Poem. In *Mary, Queen of Scots and Other Poems* (London: Oxford University Press, **1919**). [Boswell 1982, p. 309]

Geoffrey Scott, 1884–**1929**. (Hector arranges single com-

bat between Paris and Menelaus at) "The Skaian Gate." Poem. In *Poems* (London: Oxford University Press, 1931). [Ipso]

Willi Baumeister, 1889–1955. "With Hector's Shield." Abstract painting. **1936**. Unlocated. [Grohmann 1965, no. 423]
———. "Hector's Departure." Abstract painting. 1944. Unlocated. [Ibid., no. 748—ill.]

Marcel Luipart, 1912–, choreography. (Hector's ghost conjured up by Faust in) *Abraxas*. Ballet. Music and libretto, Werner Egk, based on scenario by Heinrich Heine's *Der Doktor Faust* (1847). First performed 6 June **1948**, Staatsoper, Munich; décor, Wolfgang Znamenacek. [Sharp 1969, pp. 1, 247]

Janine Charrat, 1924–, choreography. (Hector's ghost appears in) *Abraxas*. Ballet, after Heine. Music, Werner Egk. First performed 8 Oct **1949**, Städtische Oper, Berlin; scenery and costumes, J. Fenneker. [Sharp 1972, p. 247]

Valentin Iremonger, 1918–. "Hector." Poem. In *Reservations* (Dublin: Envoy, **1950**). [Ipso]

Joseph Brodsky, 1940–. (At the moment of death Hector recalls his combat with Ajax in) "Velikii Gektor strelami ubit." Sonnet. *c*.1959–60. / Translated by George Kline as "Great-hearted Hector" in *Selected Poems* (Harmondsworth, Middlesex: Penguin, 1973; Baltimore: Penguin, 1974). [Ipso]

Anne Marianne Lauber, 1943–. "La triade d'Hector" [Hector Trilogy]. Song cycle. **1963**. [Cohen 1987, 1:402]

Andy Warhol, 1928–1987. "Hector and Andromache." Painting, after de Chirico (see above). **1982**. Private coll., New York. [Hofmann 1987, no. 15.31—ill.]

Amy Clampitt, 1920–. (Hector's farewell in) "Homer, A.D. 1982." Poem. In *Poetry* 143 no. 6 (Mar **1984**); collected in *What the Light Was Like* (New York: Knopf, 1985). [Ipso]

Maura Stanton, 1946–. (Hector and Andromache evoked in) "Reading Fitzgerald's *Iliad*." Poem. In *Cries of Swimmers* (Salt Lake City: University of Utah Press, **1984**). [Ipso]

Death of Hector. When Achilles' companion Patroclus entered battle in his friend's stead, he was killed by Hector. Roused to vengeance, Achilles drove the Trojans back into their city, and Hector faced him alone at the Scaean Gate. Athena protected Hector briefly, but then withdrew. The Trojan hero's courage gave way and he ran from Achilles, who chased him three times around the walls of Troy and finally drove a spear into his throat. Dying, Hector begged his conqueror to return his body to his father, Priam, but Achilles refused. Achilles tied a thong through Hector's feet and defiled the body by dragging it behind his chariot around the city walls. Priam brokenheartedly sued for the return of his son's corpse, but only Achilles' mother, Thetis, was finally able to persuade him to allow the Trojans

to bury their hero. Homer's *Iliad* ends with the funeral of Hector.

Classical Sources. Homer, *Iliad* 22–24. Apollodorus, *Biblioteca* E.7. Hyginus, *Fabulae* 106.

See also CASSANDRA.

Utili, fl. 1476–1504 (formerly attributed to Davide Ghirlandaio). "The Siege of Troy: The Death of Hector." Painting. *c.***1490–95.** Fitzwilliam Museum, Cambridge, no. M.44. [Fitzwilliam 1960–77, 2:17—ill.]

Rosso Fiorentino, 1494–1540. "The Funeral of Hector." Drawing (design for unexecuted fresco in Galerie François I, Château de Fontainebleau?). **1535–36.** Lost. / Print by Antonio Fantuzzi. [Carroll 1987, no. 75—ill.] 2 copies after Rosso's drawing, Goethe-Nationalemuseum, Weimar; Musée Fabre, Montpellier. [Ibid.]

Maerten van Heemskerck, 1498–1574. "Mercury Coming to Tell Priam of the Death of His Son Hector." Drawing. **1566.** Städelsches Kunstinstitut, Frankfurt. [de Bosque 1985, pp. 286, 289—ill.]

I. O. (unknown English poet, perhaps John Ogle), 1569–1649. *The Lamentation of Troy, for the Death of Hector.* Poem. London: Mattes, **1594.** [Bush 1963, p. 321]

Peter Paul Rubens, 1577–1640. "Achilles Vanquishing Hector" ("The Death of Hector"). Design for tapestry in "History of Achilles" series. *c.***1630–35.** [Haverkamp Begemann 1975, no. 7] Oil sketches, 1630–32. Museum Boymans-van Beuningen, Rotterdam, no. 1760d. [Held 1980, no. 126—ill. / Jaffé 1989, no. 1040—ill. / also Haverkamp Begemann, pp. 42ff., no. 7a—ill. / White 1987, pl. 280 / Baudouin 1977, fig. 159] Modello, by Rubens and assistant (Erasmus Quellinus? Theodoor van Thulden?). Musée des Beaux-Arts, Pau, inv. 418. [Haverkamp Begemann, pp. 57ff., no. 7b—ill. / Held, no. 127—ill. / Jaffé, no. 1041—ill.] Tapestries, 1640s/60s, in Staatliche Kunstsammlungen, Kassel; Palazzo Reale, Turin. [Haverkamp Begemann—ill.]

Andrew Marvell, 1621–1678. (Hector evoked in) "An Elegy upon the Death of My Lord Francis Villiers" lines 97–104. Elegy. London: Boulter, **1648.** [Margoliouth 1971 / Craze 1979, pp. 60f.]

Cristóbal de Monroy y Silva, 1612–**1649.** *Héctor y Aquiles.* Comedy. [DLE 1972, p. 611 / Barrera 1969, p. 264]

Gerrit van Honthorst, 1590–**1656.** "Priam Looking at the Body of Hector." Painting. Lost. [Judson 1959, no. 9]

Bertholet Flémalle, 1614–**1675,** questionably attributed. "Achilles Drags Hector's Corpse around the Walls of Troy." Painting. Galerie, Kassel, inv. 464. [Pigler 1974, p. 282]

Charles Le Brun, 1619–**1690.** "The Finding of the Body of Hector" (also called "The Finding of the Body of Oedipus"). Painting. Art Gallery and Museum, Bolton (as "Oedipus"). [Wright 1976, p. 115]

Jean Mignon, active at Fontainebleau **16th century.** "Priam Paying the Ransom for Hector." Engraving. [Lévêque 1984, p. 212—ill.]

Giovanni Battista Tiepolo, 1696–1770. "Priam Imploring Achilles to Surrender the Body of Hector." Painting. Early work? Formerly Hoyos-Amerling coll., Vienna, unlocated. [Morassi 1962, p. 66]

William Congreve, 1670–**1729.** "Priam's Lamentation and Petition." Translation from *Iliad* 24. [Dryden 1956–87, 4:703]

Jacopo Amigoni, 1675–**1752.** "Single Combat between Hector and Achilles." Ceiling fresco. Antichamber, Castle, Schleissheim. [Pigler 1974, p. 282]

Gavin Hamilton, 1723–1798. "Andromache Bewailing the Death of Hector." Painting. *c.***1761.** [Rosenblum 1967, pp. 154f.—ill. (print)]

———. "Achilles Drags Hector's Corpse around the Walls of Troy." Painting. By 1766. Formerly Duke of Bedford coll., Arniston. [Warsaw 1969, no. 482 *n.*] Oil sketch. National Gallery of Scotland, Edinburgh, inv. 1829. [Pigler 1974, p. 283]

———. "Hector's Death." Painting. Muzeum Narodowe, Warsaw, inv. 180691. [Warsaw, no. 482—ill.]

———. "Priam Pleading with Achilles for the Body of Hector." Painting. Tate Gallery, London, no. T.864. [Tate 1975, p. 37]

French School. "Achilles Displaying the Body of Hector before Priam and the Body of Patroclus." Painting, sketch for **1769** Prix de Rome competition. Museum of Fine Arts, Boston, no. 77.151. [Boston 1985, p. 105—ill.]

Joseph-Benoît Suvée, 1743–1807. "Achilles Places Hector's Body at the Feet of Patroclus's Corpse." Painting. **1769.** Louvre, Paris, no. R.F. 1969–11. [Louvre 1979–86, 4:229—ill.]

Henry Fuseli, 1741–1825. "Priam Begs Achilles for the Body of Hector." Drawing, after 2 figures in an antique relief (Villa Borghese). **1770–71.** Holland coll., Newcastle-upon-Tyne. [Schiff 1973, no. 384—ill.]

———. "Thetis Appears to Achilles and Commands Him to Give Up the Corpse of Hector." Drawing. 1803–05. Kunsthaus, Zurich, inv. 1938/678. [Ibid., no. 1361—ill.]

Angelica Kauffmann, 1741–1807. "Andromache and Hecuba Weeping over the Ashes of Hector." Painting. Exhibited **1772.** Lady Cicely Goff coll. [Rosenblum 1967, p. 41—ill. / Manners & Williamson 1924, p. 40]

Jacques-Louis David, 1748–1825. "Hector" (dead). Painting, sketch. **1778,** exhibited 1781. Musée Fabre, Montpellier. / Studio (?) copy/replica in Louvre, Paris, inv. 3697. [Louvre 1979–86, 3:188—ill.]

———. "Andromache Mourning Hector." Painting, Academy reception piece. 1783. École des Beaux-Arts, Paris, on loan to Louvre, Paris (no. D.L. 1969–1). [Schnapper 1982, p. 71—ill. / Louvre, 5:7—ill. / also Cantinelli 1930, no. 34] Oil sketch. Pushkin Museum, Moscow. [Schnapper, p. 68 / Rosenblum 1967, pp. 82f.]

———, school? "Hector Dragged through Troy." Painting. Walsall Museum and Art Gallery, England. [Wright 1976, p. 48]

Peter von Winter, 1754–1825, music. *La mort d'Hector.* Ballet. **1779.** Scenario, Legrand. [Grove 1980, 20:457]

Antoine François Callet, 1741–1823. "Achilles Dragging the Body of Hector before the Walls of Troy and under the Eyes of Priam and Hecuba, Who Implore the Conquerer." Painting. **1784–85.** Louvre, Paris, inv. 3099. [Louvre 1979–86, 3:94—ill.]

Pierre-Paul Prud'hon, 1758–1823. "The Death of Hector" ("Andromache's Vigil over the Body of Hector"). Paint-

ing. **1784–87.** Sold 1894, untraced. [Guiffrey 1924, no. 245]

———. "The Corpse of Hector Dragged by Achilles." Painting. Unlocated. [Ibid., no. 248]

Bertel Thorwaldsen, 1770–1844. "Achilles and Priam." Relief. **1791.** Plaster original. Thorwaldsens Museum, Copenhagen, no. A791. [Thorwaldsen 1985, p. 77 / Hartmann 1979, pl. 89.2]

———. "Achilles Dragging the Body of Hector around the Walls of Troy." Drawing. 1804? Thorwaldsens Museum. [Bindman 1979, no. 237b—ill.]

———. "Priam Pleads with Achilles for Hector's Body." Marble relief. Modeled 1815. 4 examples. Woburn Abbey, Bedfordshire; Duke of Devonshire coll., Chatsworth; Palazzo Giraud-Torlonia, Rome; Thorwaldsens Museum, no. A775 (executed by C. Freund and H. W. Bissen, 1868–70). [Cologne 1977, no. 76 / Hartmann, pp. 140ff.—ill. / Thorwaldsen, p. 76] Plaster original. Thorwaldsens Museum, no. A492. [Thorwaldsen, pp. 57, pl. 33 / Cologne 1977, p. 221—ill.]

John Singleton Copley, 1738–1815. "Priam Beseeching Achilles for the Body of Hector." Painting. 1775 or **1797–99.** Lost. / Print by A. Fogg, published 1799. [Prown 1966, 2:445—ill.]

Johann Wolfgang von Goethe, 1749–1832. (Funeral of Hector in) *Achilleis.* Epic, unfinished, fragment of 651 lines. **1797–99.** Published 1808; collected in *Werke* (Stuttgart: Cotta, 1827–42). [Beutler 1948–71, vol. 3 / Butler 1958, pp. 130–34 / Reed 1980, pp. 189, 223]

Jacques Gamelin, 1738–**1803.** "Achilles Drags Hector's Corpse around the Walls of Troy." Painting. Musée des Augustins, Toulouse. [Pigler 1974, p. 283 / Bénézit 1976, 4:602]

Benjamin West, 1738–1820. "Priam Soliciting Achilles for the Body of Hector." Painting. Before **1804.** Lost. / Print by H. Moses. [Ibid., no. 178—ill.]

———. "Iris Delivering Jove's Command to Priam" (that he ask Achilles for Hector's body). Painting. 1808. Westmoreland County Museum of Art, Greensburg, Pa. [Ibid., no. 176—ill.] Another version of the subject known, lost. [Ibid., no. 177]

Ugo Foscolo, 1778–1827. (Hector mourned in) *Dei sepolcri* [On Sepulchres]. Ode, to Ippolito Pindemonte. **1806.** Brescia: 1807. / Translated by Thomas G. Bergin (Bethany, Conn.: Bethany, 1971). [Ipso]

Giacomo Leopardi, 1798–1837. "La morte di Ettore." Sonnet. **1809.** [Origo 1953, p. 38]

Jean Charles Luce de Lancival, 1764–1810. *La mort d'Hector.* Tragedy. First performed 1 Feb **1809,** Théâtre-Français, Paris. Published Paris: Chaumerot, 1809. [DLF 1951–72, 5:140f.]

The Prix de Rome painting competition subject for **1809** was "Priam at the Feet of Achilles." First prize, Jérôme-Martin Langlois. École des Beaux-Arts, Paris. [Grunchec 1984, no. 46—ill. / Harding 1979, p. 92]

William Morris, 1834–1896. (Death of Hector in) *Scenes from the Fall of Troy.* Dramatic poem. Begun *c.*1857, unfinished. Unpublished until 1915. [Morris 1910–15, vol. 24 / Bush 1937, pp. 298–300]

Jules Bastien-Lepage, 1848–1884. "Priam Imploring Achilles." Painting. *c.*1868. Musée des Beaux-Arts, Lille. [Jacobs & Stirton 1984a, p. 60]

Harry Bates, 1850–1899. "The Body of Hector Dragged behind the Chariot of Achilles." Bronze relief, predella to "War" ("Hector's Departure from Andromache"). **1887.** City Art Gallery, Manchester, England. / Original plaster, Tate Gallery, London. [Read 1982, pp. 313, 317]

Briton Riviere, 1840–1920. "Dead Hector." Painting. **1892.** City Art Gallery, Manchester. [Wood 1983, p. 218—ill. / Kestner 1989, pp. 235f., pl. 4.26]

Edwin Muir, 1887–1959. "Ballad of Hector in Hades." Poem. *c.*1921. In *First Poems* (London: Hogarth, 1925). [Huberman 1971, pp. 46–50 / Allen 1967, pp. 34–36 / Blackmur 1959, pp. 34f.]

Hilaire Belloc, 1870–1953. (Hector's death lamented in) "But Oh! Not Lovely Helen." Sonnet. In *Sonnets and Verse* (London: Duckworth, **1923**). [Boswell 1982, p. 34]

Valéry Bryúsov, 1873–**1924.** "Telo Gektora" [Hector's End]. Prose fragment. In *Neizdannaja proza* (Moscow & Leningrad: Gosudastvennoe izdatelstvokhudozhestvenni literatury, 1934). [TCLC 1978–89, 10:85]

Geoffrey Scott, 1884–**1929.** (Hector's death evoked in) "The Skaian Gate." Poem. In *Poems* (London: Oxford University Press, 1931). [Ipso]

Giorgio de Chirico, 1888–1978. "Combat of Hector and Achilles Below the Walls of Troy." Painting. **1947.** Galleria Sianesi, Milan. [de Chirico 1971–83, 2.2: no. 155—ill.]

David Jones, 1895–1974. (Death of Hector evoked in) "Middle-sea and Lear-sea." Poem, part of *The Anathemata-Fragments* (London: Faber & Faber, **1952**). [Blamires 1972, pp. 138, 204]

Mark Van Doren, 1894–1972. "Hector Dead." Poem. In *Spring Birth and Other Poems* (New York: Henry Holt, **1953**). [Boswell 1982, p. 306]

Michael Tippett, 1905–. (Ransom of Hector in) *King Priam.* Opera. First performed **1962,** Coventry. [Grove 1980, 19:10]

Patrick Kavanagh, 1904–1967. (Achilles' killing of Hector evoked in) "On Looking into E. V. Rieu's Homer." Poem. In *Collected Poems* (New York: Devin-Adair, **1964**). [Ipso]

Sidney Nolan, 1917–. "Achilles Dragging Hector around the Walls of Troy." Mural. **1966.** [Marks 1984, p. 624]

Thomas Kinsella, 1928–. "Death in Ilium." Poem. In *Nightwalker and Other Poems* (Dublin: Dolmen Press; London: Oxford University Press; New York: Knopf, **1968**). [Johnston 1985, p. 105]

Carl Dennis. "Hector Dragged around Troy." Poem. In *The Near World* (New York: William Morrow, **1985**). [*New York Times Book Review,* 21 July 1985]

HECUBA. *See* CASSANDRA; HECTOR; PARIS; POLYDORUS; POLYXENA; TROJAN WAR.

HELEN OF TROY. The daughter of Leda and Zeus (or Nemesis), Helen was worshiped as a deity in Sparta, but in literary tradition as early as Homer was given a mortal role. Known for her great beauty,

she was carried off as a girl to Athens by Theseus, but rescued by her brothers Castor and Polydeuces while Theseus was in the Underworld. Back in Sparta, she was courted by all the most eligible noblemen of Greece. Odysseus suggested that Helen be allowed to choose her husband and made all the other suitors vow to defend the successful suitor at need. Helen married Menelaus and bore him a daughter, Hermione.

Sometime later, when Menelaus was away from Sparta, the Trojan prince Paris either abducted Helen or persuaded her to go with him to Troy. Upholding their vow, the former suitors made an armed expedition to Troy, beginning the ten-year Trojan War. After Paris was killed near the end of the war, Helen was wed to his brother Deiphobus, whom she later betrayed to Menelaus. Reclaiming her after the fall of Troy, Menelaus first threatened to kill her for her treachery but then reconciled with her. On the way home from Troy, Menelaus's fleet was battered by a storm. Helen and Menelaus eventually reached Egypt and wandered there for eight years before returning to Sparta.

An alternate tradition suggests that Helen was first taken to King Proteus of Egypt and only her phantom went with Paris to Troy. After the war, Menelaus was reunited with the real Helen on reaching Egypt. According to this version, the Trojan War was a stratagem by the god Zeus to reduce the earth's population.

In the *Iliad* Helen is portrayed as a pitiful figure, hated by Greeks and Trojans alike, forced to be the wife of Paris, and filled with self-reproach. However, in the *Odyssey,* the portrait is gentler; she is pictured living peacefully with Menelaus, although he does recall that she tried to trick the Greeks as they hid in the wooden horse.

After Menelaus died, Helen was driven from Sparta by her stepsons and fled to her friend Polyxo in Rhodes. Polyxo, who had lost her husband in the Trojan War, sought vengeance. Dressing her slaves as Furies (Greek, *Erinyes*), she ordered them to hang Helen, who was thereafter worshiped in Rhodes as "Helen of the Tree."

An auxiliary tradition says that Achilles and Helen met after death on the Isle of Leuce ("White Isle"), where they were eternal lovers. This theme was popularized by Goethe in *Faust* (1827), when the title character summons Helen from the afterlife.

Classical Sources. Homer, *Iliad* 3; *Odyssey* 4, 15 passim. Stasinus, *Cypria* 1.8–11. Hesiod, *Catalogue of Women* 65–68 (fragments). Herodotus, *Histories* 2.112–20. Euripides, *The Trojan Women*; *Helen*; *Orestes*. Theocritus, *Idylls* 18. Virgil, *Aeneid* 2. Ovid, *Metamorphoses* 12.5, 13.200, 14.669, 15.232. Apollodorus, *Biblioteca* 3.10.7–22.1, E1.23, E3.5, E6.29. Pausanias, *Description of Greece* 2.22.6–7, 3.19.9–20.1. Lu-

cian, *Dialogues of the Dead* 5, "Menippus and Hermes," 27, "Aeacus and Protesilaus."

See also ACHILLES, Afterlife; PARIS, General List, and Helen; THESEUS, and Helen; TROILUS AND CRESSIDA; TROJAN WAR.

Benoît de Sainte-Maure, fl. 1150–70. (Helen in) *Le roman de Troie*. Verse romance, after Dares, *De excidio Troiae historia,* and Dictys, *Ephemeris de historia belli Troiani* (late Latin versions of lost Greek poems, pseudo-classical forgeries). *c.*1165. [Baumgartner 1987]

Guido delle Colonne, *c.*1210–after 1287. (Helen in) *Historia destructionis Troiae* [History of the Destruction of Troy] 4.7–17, 29.282ff, and passim. Latin prose chronicle, after Benoît de Sainte-Maure. **1272–87.** Modern edition by Nathaniel E. Griffin (Cambridge, Mass.: Harvard University Press, with Mediæval Academy of America, 1936; reprinted New York: Kraus, 1970). / Translated by M. E. Meek (Bloomington: Indiana University Press, 1974). [Benson 1980, p. 30]

Dante Alighieri, 1265–1321. (Helen among the Lustful in) *Inferno* 5.64. *c.*1307–*c.*1314? In *The Divine Comedy.* Poem. Foligno: Neumeister & Angelini, 1472. [Singleton 1970–75, vol. 1]

Giovanni Boccaccio, 1313–1375. "De Helene, Menelai regis coniuge" [Helen, Wife of King Menelaus]. In *De mulieribus claris* [Concerning Famous Women]. Latin verse compendium of myth and legend. **1361–75.** Ulm: Zainer, 1473. [Branca 1964–83, vol. 10 / Guarino 1963]

Anonymous English. (Helen in) *The Destruction of Troy.* Alliterative adaptation of Guido delle Colonne. *c.*1385–1400? Modern edition by George A. Panton and David Donaldson, *The "Gest Hystoriale" of the Destruction of Troy* (London: Early English Text Society, 1869, 1874). [Benson 1980, p. 50]

John Lydgate, 1370?–1449. (Cassandra's prophecy of Helen's fate, Helen's grief at Paris's death, Achilles advises Menelaus to forget Helen, in) *Troy Book,* 2.4195–239, 4.1049–57, 4.3654–79, and passim. Poem, elaboration of Guido delle Colonne. **1412–20.** Modern edition by Henry Bergen (London: Kegan Paul, Trench & Trübner, for Early English Text Society, 1906–35). [Benson 1980, pp. 101, 108, 110f.]

Raoul Lefèvre, fl. *c.*1454–67. (Helen in) *Le recueil des hystoires de Troyes* [Collection of the Stories of Troy]. Prose romance. **1464.** / English translation by William Caxton as *The Recuyell of the Historyes of Troye* (Bruges: Mansion, *c.*1474). / Modern edition (of original French) by Marc Aeschbach (Bern & New York: Lang, 1987). [Scherer 1963, p. 122]

Florentine School, ?–*c.*1465. "The Story of Helen of Troy." Painting. Allentown Art Museum, Pa., no. K103. [Berenson 1963, p. 217]

Leonardo da Vinci, 1452–1519. "Leda" (and the swan, with the birth of Helen, Clytemnestra, and the Dioscuri). Painting. *c.*1510–15? Lost. [Ottino della Chiesa 1969, no. 34] Numerous copies and variant copies: Galleria Borghese, Rome, no. 434 (attributed to Sodoma); Musées Royaux des Beaux-Arts (Musée d'Art Ancien), Brussels, inv. 1402 (Andrea del Sarto, 1486–1530, previously attributed to Francesco Franciabigio); Muzeum Narodowe, Warsaw,

inv. 415 (Vincent de Sellaer); Musée des Beaux-Arts, Valenciennes, inv. 131 (de Sellaer); Kress coll. (K426), North Carolina Museum of Art, Raleigh, no. GL.60.17.32; elsewhere. [Ibid.—ill. / also Pergola 1955–59, 1: no. 138—ill. / Brussels 1984a, p. 264—ill. / de Bosque 1985, pp. 60, 202—ill. / Warsaw 1969, no. 1179—ill. / Shapley 1966–73, 2:145f.—ill. / Berenson 1968, p. 169—ill.] Studies (drawings) in Royal Library, Windsor; other related drawings in Windsor; Museum Boymans-van Beuningen, Rotterdam; Duke of Devonshire coll., Chatsworth. [Ottino della Chiesa—ill. / also de Bosque 1985, p. 202—ill.] Copy (drawing), previously attributed to Leonardo, in Louvre, Paris. [Ottino della Chiesa—ill.] Copy (drawing) by Raphael, c.1515, in Royal Library, Windsor, no. 12759. [Joannides 1983, no. 98—ill. / Jones & Penny 1983, pp. 28f.—ill.]

————. "Half-Kneeling Leda" (with infant Helen, Clytemnestra, and the Dioscuri). Presumed painting, known from a variant by Giampietrino, in Prince of Wied coll., Neuwied. [Ottino della Chiesa—ill.]

Cima da Conegliano, c.1459–**1517/18.** "Helen." Painting. S. H. Kress Foundation, New York, no. K2001. [Berenson 1957, p. 66]

Girolamo da Santacroce, c.1490–**1556.** "Helen [?] in a Landscape." Painting. Pinacoteca di Brera, Milan, no. 401. [Berenson 1957, p. 155]

Jost Amman, 1539–**1591.** "The Sacrifice of Helen." Painting. [Warburg]

Christopher Marlowe, 1564–**1593.** (Helen with Achilles evoked in) *The Tragicall History of Doctor Faustus* 5.1. Tragedy. Licensed **1592.** First recorded performance 2 Oct 1594, by the Lord Admiral's Men, Rose Theatre. London. Published London: Bushell, 1604. [Bowers 1973, vol. 2 / Levin 1952, pp. 108–35 / Leech 1986, pp. 16–20, 83–121]

William Shakespeare, 1564–**1616.** (Song about Helen performed in) *All's Well That Ends Well* 1.3.70–79. Comedy. c.**1602–03.** Published London: Jaggard, 1623 (First Folio). [Riverside 1974]

Hendrik Goltzius, 1558–**1617.** "Helen of Troy." Painting. **1615.** Carter coll., Montreal. [Augsburg 1975, no. E59—ill.]

Francesco Pona, 1594–**1654.** (Helen among) *La galleria delle donne celebri* [Gallery of Famous Women] part 1. Poetic catalogue. Bologna: Cavalieri, **1633.** [DDLI 1977, 2:425]

Guido Reni, 1575–**1642.** "Head of a Helen." Painting. Cited as in Museo Cospiano, Bologna, in 1677, lost. [Pepper 1984, p. 307 no. E15]

Pier Francesco Cavalli, 1602–**1676.** *Elena.* Opera. Libretto, Nicolò Minato, after Giovanni Faustini. First performed 26 Dec **1660,** San Cassiano, Venice. [Grove 1980, 4:32 / Glover 1978, pp. 23, 71, 77, 92, 94, 107, 111, 113]

John Dryden, 1631–**1700.** "The Epithalamium of Helen and Menelaus." Translation of Theocritus, Idyll 18. In *Sylvae,* part 2 of Tonson's *Miscellany* (London: Tonson, **1685**). [Dryden 1956–87, vol. 3]

William Congreve, 1670–**1729.** "Lamentations of Hecuba, Andromache, and Helen." Poem. In *Poems upon Several Occasions* (London: Tonson, **1710**). [Dryden 1956–87, 4:703]

Andrea Stefano Fiorè, 1686–**1732.** *Elena.* Opera seria. Libretto, C. N. Stampa. First performed Jan **1725,** Ducal, Milan. [Grove 1980, 6:599]

Étienne Méhul, 1763–**1817.** *Hélèna.* Opera. Libretto, J. N.

Bouilly. First performed 1 Mar **1803,** L'Opéra-comique, Paris. [Grove 1980, 12:66]

Jean Charles Luce de Lancival, 1764–**1810.** "Hélène." Scene from a tragedy, suppressed by the author. Printed with *Hector* (Paris: Chaumerot, **1809**). [DLF 1951–72, 4 pt. 2: 140]

Antonio Canova, 1757–**1822.** "Helen." Marble bust. **1811.** Palazzo Albrizzi, Venice. [Pavanello 1976, no. 239—ill.] Plaster model. Gipsoteca Canoviana, Possagno, no. 222. [Ibid., no. 240—ill.] 5 marble replicas, 1816–19. Lord Londonderry coll., London; Hermitage, Leningrad; others unlocated. [Ibid., nos. 239 n., 284, 287–88, 331—ill.]

Lord Byron, 1788–**1824.** "On the Bust of Helen by Canova." Poem. **1816.** In *Letters and Journals of Lord Byron, 1788–1824, with Notices of His Life* (London: Murray, 1830). [McGann 1980–86, vol. 4]

Adalbert Gyrowetz, 1763–**1850.** *Helene.* Opera. First performed 16 Feb **1816,** Hoftheater, Vienna. [Grove 1980, 7:871]

Alfred de Vigny, 1797–**1863.** "Héléna." Poem. In *Poèmes* (Paris: Pélicier, **1822**). [DLLF 1984, 3:2440]

Edgar Allan Poe, 1809–**1849.** "To Helen" (as the epitome of classic beauty). Poem. **1823.** In *Poems* (New York: Bliss, 1831). [Friedman 1981, pp. 233–35 / Tate 1968, pp. 221f.]

Johann Wolfgang von Goethe, 1749–**1832.** (Helen in) *Faust* Part 2, 1.6479ff. and act 3 passim. Tragedy. Act 3 written **1825–27,** first published as "Helena: Klassisch-romantische Phantasmagorie" (1827). Incorporated into *Faust,* published posthumously, Heidelberg: 1832. [Beutler 1948–71, vol. 5 / Suhrkamp 1983–88, vol. 2 / Butler 1958, pp. 139–46 / Fairley 1961, pp. 173, 175, 192f., 224 / Viëtor 1949, pp. 300f., 303, 305 / Reed 1980, pp. 238–42 / Reed 1984, pp. 66–68]

Walter Savage Landor, 1775–**1864.** (Helen evoked in) "Past ruin'd Ilion Helen lives," "When Helen first saw wrinkles in her face." Poems. Published with "Ianthe" group of poems in *Gebir, Count Julian, and Other Poems* (London: Moxon, **1831**). [Wheeler 1937, vol. 3 / Pinsky 1968, pp. 20, 34]

————. "Menelaus and Helen at Troy." Poetic dialogue. In *Works,* vol. 2 (London: Moxon, 1846); reprinted in *Hellenics* (London: Moxon, 1847). [Wheeler, vol. 2 / Boswell 1982, p. 156]

————. "Achilles and Helena on Ida." Poetic dialogue. In *Dry Sticks, Fagoted* (Edinburgh: Nichol, 1858). [Wheeler / Boswell 1982, p. 151]

————. "The Marriage of Helena and Menelaos." Poem. First printed in John Forster, *Walter Savage Landor: A Biography* (London: Chapman & Hall, 1869). [Wheeler]

Alfred, Lord Tennyson, 1809–**1892.** (Helen in) "A Dream of Fair Women" lines 85–98. Poem. **1831–32.** In *Poems* (London: Moxon, 1832). / Revised in *Poems* (London: Moxon, 1842). [Ricks 1969 / Ricks 1972, pp. 92, 95–97, 108 / Buckley 1961, pp. 54f. / Nicolson 1962, pp. 110, 116, 176]

Antoine-Jean Gros, 1771–**1835.** "Helen." Painting. Musée des Beaux-Arts, Arras. [Bénézit 1976, 5:231]

Hippolyte Monpou, 1804–**1841.** "Hélène." Song. Text, Danglemont. **1835–38.** [Grove 1980, 12:499]

————. "Pauvre Hélène." Song. Text, A. Gourdin. 1840–44. [Grove, 12:499]

Eduard Mörike, 1804–**1875.** "Brautlied der Helena" [Helen's Bridal Song] (Menelaus). Translation of Theocritus, Idyll

18. In *Classische Blumenlese* (Stuttgart: Schweizerbart, **1840**). [Hötzer 1967]

Honoré Daumier, 1808–1879. "Menelaus the Conqueror" (reclaiming a fat, defiant Helen). Comic lithograph, in "Ancient History" series. **1841.** [Delteil 1906–30, 22: no. 925—ill.]

Heinrich Heine, 1797–1856. (Helen in) *Der Doktor Faust.* Ballet scenario. **1847.** Hamburg: Hoffman & Campe, 1851. [Windfuhr 1975–82, vol. 9 / Butler 1958, pp. 287f.]

Nikolaus Lenau, 1802–**1850.** *Helena.* Dramatic sketch. In *Dichterischer nachlass,* edited by A. Grün (Stuttgart & Tübingen: Cotta, 1851). [Ungar 1973, p. 170]

William Morris, 1834–1896. (Paris, Helen, and Menelaus in) *Scenes from the Fall of Troy.* Dramatic poem. Begun *c.*1857, unfinished. First published in *Collected Works* (London: Longmans, 1910–1915). [Morris 1910–15, vol. 24 / Bush 1937, pp. 300, 307, 554]

Mihály Mosonyi, 1815–1870. *Szép Ilonka* [Pretty Helen]. Opera. Libretto, M. Fekete, after M. Vörösmarty. First performed 19 Dec **1861,** National Theater, Pest. [Grove 1980, 12:614]

Dante Gabriel Rossetti, 1828–1882. "Helen of Troy." Painting. **1863.** Kunsthalle, Hamburg, no. 2469. [Surtees 1971, no. 163—ill. / Hamburg 1969, p. 270—ill.] Copy ("The Flaming Heart") by Charles Fairfax Murray (1849–1919), with false Rossetti signature. Fitzwilliam Museum, Cambridge, no. 2293. [Fitzwilliam 1960–77, 3:178 / also Surtees, no. 163.R1 (as autograph replica)]

————. "Troy Town" (Helen consecrates a cup to Venus). Ballad. 1869. In *Poems* (London: Ellis, 1870). [Doughty 1965 / Rees 1981, p. 112 / Bush 1937, pp. 410f., 558]

————. "Troy Town." Drawing, illustrating the above poem. *c.*1870. Museum of Fine Arts, Boston, no. 58.734. [Surtees, no. 219—ill.]

————. (Helen as one of) "Death's Songsters." Sonnet, no. 41 in "House of Life" sequence. In *Poems* (London: Ellis, 1870); reprinted as no. 87 in enlarged version, in *Ballads and Sonnets* (London: Ellis & White, 1881). [Doughty]

Jacques Offenbach, 1819–1880. *La belle Hélène.* Opéra bouffe. Libretto, Henri Meilhac and Ludovic Halévy. First performed 17 Dec **1864,** Théâtre des Variétés, Paris. [Grove 1980, 13:510–12]

Frederic, Lord Leighton, 1830–1896. "Helen of Troy" (on the walls of Troy). Painting. *c.***1865.** Private coll., India. [Ormond 1975, no. 118, p. 77 *n.*]

Francis Cowley Burnand, 1836–1917. *Helen; or, Taken from the Greek.* Burlesque, after Offenbach's *La belle Hélène* (1864). First performed 30 June **1866,** Adelphi Theatre, London. [Nicoll 1959–66, 5:289, 781]

Frederick Sandys, 1829–1904. "Helen and Cassandra." Drawing. **1866.** [Kestner 1989, p. 170]

W. A. Rémy, 1831–1898. *Helena.* Symphonic poem. First performed *c.***1862–70** (?), Leipzig. [Grove 1980, 15:735]

Edward Burne-Jones, 1833–1898. "Helen Captive at the Burning of Troy." Unfinished gouache for "Troy" polyptych (unfinished). **1871.** Birmingham Museum and Art Gallery, England. [Harrison & Waters 1973, p. 104—ill. / also Arts Council 1975, no. 127]

————. "Helen." Painting. *c.*1880. Carlisle Museum and Art Gallery, England. [Harrison & Waters, p. 132—ill.]

Andrew Lang, 1844–1912. "The Shade of Helen." Poem. In *Ballads and Lyrics of Old France with Other Poems* (London: Longmans, Green, **1872**). [Bush 1937, p. 558]

————. "Helen on the Walls." Sonnet, part of the cycle "Cameos: Sonnets from the Antique." In *Rhymes à la Mode* (London: Paul, Trench & Trübner, 1890). [Boswell 1982, p. 158]

———— and **H. Rider Haggard,** 1856–1925. *The World's Desire* (Odysseus visits Helen in Egypt). Novel. London: Longmans, Green, 1890. [Boswell, pp. 162f. / Stanford 1974, p. 214]

———— (Lang). *Helen of Troy: Her Life and Translation* (translated with Menelaus to Elysium). Poem in 6 books. London: Bell, 1892. [Bush, p. 560 / Boswell, p. 159]

Gustav Kastropp, 1844–1925. *Helene.* Verse tragedy. Weimar: Kühn, **1875.** [DLL 1968–90, 8:950]

Oscar Wilde, 1854–1900. "The New Helen." Poem. **1879.** In *Poems* (London: Bogue, 1881). [DLB 1983, 19:391 / Shewman 1977, pp. 11f. / Ellmann 1988, pp. 115f.]

Gustave Moreau, 1826–1898. "Helen" (on the walls of Troy). Painting. **1880.** Sold Paris, Georges Petit, 1913, unlocated. [Mathieu 1976, no. 199—ill.]

————. "Helen at the Scaean Gate." Painting. *c.*1880. Musée Gustave Moreau, Paris. [Ibid., pp. 142ff.—ill.]

————. "Helen on the Walls of Troy." Watercolor. *c.*1885. Cabinet des Dessins, Louvre, Paris, no. R.F. 1942–47. [Ibid., no. 332—ill. / Mathieu 1985, pl. 22] Large replica, *c.*1895. Sold Paris, Drouot, 1924. [Mathieu 1976, no. 410]

————. "Helen Glorified." Watercolor. 1896–97. Daniel Wildenstein coll. [Ibid., no. 425—ill.]

Edward John Poynter, 1836–1919. "Helen" (Troy burning in the background). Painting. **1881.** [Wood 1983, p. 143]

J. P. Lavallin, 1859–after 1882. *Helen in Egypt.* Drama, after Euripides. First performed **1882,** Oxford. Published Oxford: Blackwell, 1882. [Nicoll 1959–66, 5:802]

Henry Peterson, 1818–1891. "Helen after Troy." Poem. In *Poems,* 2d series (Philadelphia: Lippincott, **1883**). [Boswell 1982, p. 280]

John Todhunter, 1839–1916. *Helena in Troas* [Helen in Troy]. Tragedy. First performed 17 May **1886,** Hengler's Amphitheatre, Oxford Circus, London. [Nicoll 1959–66, 5:600 / Jenkyns 1980, p. 303]

Jules Laforgue, 1860–**1887.** "Sur l'Hélène de Gustave Moreau" [On the Helen of Gustave Moreau] Poem. First published in *Poésies complètes,* vol. 1 (Paris: Gallimard, 1970). [Nash 1983, p. 142]

Paul Gauguin, 1848–1903. "La belle Hélène." Painting. **1889.** Port Aven, Brittany. [Jacobs & Stirton 1984a, p. 33]

Henri Fantin-Latour, 1836–1904. "Helen" (surrounded by all men captivated by her beauty: soldier, poet, philosopher, etc., and Faust). Lithograph, loosely after Goethe's *Faust* (1825–27). **1890.** [Hédiard 1906, no. 95—ill. / also Fautin-Latour 1911, no. 1423] 2 replicas, paintings. 1892. Petit Palais, Paris; R. Pugno coll. in 1911. [Fantin-Latour, nos. 1460–61 / Lucie-Smith 1977, p. 160]

Paul Valéry, 1871–1945. "Hélène." Sonnet. **1890.** In *Album de vers anciens, 1890–1900* (Paris: Monnier, 1920). [Hytier 1957–60, vol. 1 / Mathews 1956–71, vol. 1 / Nash 1983, pp. 141–49]

Paul Delair, 1842–1894. *Hélène.* Drama. Paris: **1891.** [DLF 1951–72, 5 pt. 1: 298]

André Messager, 1853–1929. Incidental music to P. Delair's *Hélène* (above). First performed 15 Sep **1891**, Vaudeville, Paris. [Grove 1980, 12:203]

Gabriele D'Annunzio, 1863–1938. "Elena." Sonnet, part of "Le adultere" [The Adulteresses] cycle. **1893**. In *Intermezzo* (Naples: 1894). [Palmieri 1953–59, vol. 1]

André Gédalge, 1856–1926. *Hélène*. Opera (drame lyrique). **1893**. [Grove 1980, 7:213]

J. Wilton Jones, d. 1897, libretto. *Helen of Troy Up-to-Date; or, The Statue Shop*. Musical farce. Music, J. Crook. First performed **1893**, Folkestone pier. [Nicoll 1959–66, 5:441]

Aubrey Beardsley, 1872–1898. "The Toilet of Helen" (originally toilet of Venus). Drawing, illustration to the artist's unfinished novel *Under the Hill* (published title of a work originally called *The Story of Venus and Tannhäuser*). In *The Savoy* 1 (**1896**). [Weintraub 1976, pp. 168–73—ill.]

Jules Lemaître, 1853–1914, with **Maurice Donnay**, 1859–1945. *La bonne Hélène*. Drama/verse satire. Paris: Calmann-Lévy, **1896**. [McGraw-Hill 1984, 3:257]

———. *La vieillesse d'Hélène* [Helen in Old Age]. Short story. In *La vieillesse d'Hélène: Nouveaux contes en marge* (Paris: Calmann-Lévy, 1914). [DULC 1959–63, 3:106]

Odilon Redon, 1840–1916. "Helen" ("Ennoia"). Lithograph, illustration to Flaubert's *La tentation de Saint-Antoine*, IV, third series, no. X. Paris: **1896**. [Mellerio 1913, no. 143—ill.]

Adalbert von Goldschmidt, 1848–1906. *Die fromme Helene* [The Innocent Helen]. Comic opera. **1897**. [Grove 1980, 7:505]

Pierre Quillard, 1864–1912. "Les yeux d'Hélène" [Helen's Eyes] (the young Helen foresees her destiny). Poem. In *La lyre héroïque et dolente* (Paris: Société du Mercure de France, **1897**). [Praz 1956, p. 391]

Albert Samain, 1858–1900. (Helen appears to the dying Trojans in) "L'urne penchée" [The Leaning Urn]. Sonnet. In *Le jardin de l'infante* (Paris: Mercure de France, **1897**). [Nash 1983, p. 1427 / Praz 1956, p. 296]

T. Sturge Moore, 1870–1944. "The Home of Helen" (in Sparta after her return from Troy). Poem. In *The Vinedresser and Other Poems* (London: At the Sign of the Unicorn, **1899**); in *Poems: Collected Edition* (London & New York: Macmillan, 1931–33). [Boswell 1982, p. 274]

Anonymous. "Menelaus and Helen." Painting. **19th century**. Uffizi, Florence, inv. SMeC 122. [Uffizi 1979, no. P1520—ill.]

Gordon Bottomley, 1874–1948. "The Last of Helen" (Helen's retirement). Poem. **1902**. In *The Gate of Smaragdus* (London: At the Sign of the Unicorn, 1904). [Bush 1937, pp. 303 *n.*, 566 / Young 1948, p. 80]

Henri de Régnier, 1864–1936. "Hélène au cheval" [Helen with the (Trojan) Horse]. Poem. In *La cité des eaux* (Paris: Mercure de France, **1902**). [Nash 1983, p. 142]

Giovanni Pascoli, 1855–1912. (Helena appears to the dying Trojans in) "Anticlo." Poem. In *Poemi conviviali* (Bologna: Zanichelli, **1904**). [Praz 1956, p. 297]

Franz von Stuck, 1863–1928. "Helen." Bronze statuette. **After 1906**. Neue Pinakothek, Munich, inv. B.365. [Munich 1982, p. 332—ill.]

———. "Helen." Painting. **1925**. Unlocated. [Voss 1973, no. 573—ill.] Variant. Private coll. [Ibid., no. 577—ill.]

Arthur B. Davies, 1862–1928. "Helen, the Dawn Flower." Painting. *c*.**1907**. Art Institute of Chicago, no. 33.1192. [Chicago 1961, p. 116 / also Metropolitan 1930, no. 72—ill.]

James Elroy Flecker, 1884–1915. "Destroyer of Ships, Men, Cities." Poem. In *Bridge of Fire* (London: Mathews, **1907**). [Bush 1937, p. 567 / Young 1948, p. 80]

Maurice Hewlett, 1861–1923. *The Ruinous Face* (Menelaus kills Paris, Helen hangs herself in remorse). Tale. New York: Harper, **1909**. [Boswell 1982, p. 135]

———. "Helen Redeemed." Poem. In *Helen Redeemed and Other Poems* (New York: Scribner, 1913). [Bush 1937, p. 570 / Boswell, p. 132]

Emile Verhaeren, 1855–1916. *Helenas Heimkehr* [Helen's Homecoming] (Helen in retirement; Menelaus killed by Castor, who is killed by Electra). Tragedy. Leipzig: Reclam, **1909**. First performed (as *Hélène de Sparte*) 4 May 1912, Théâtre du Chatelet, Paris; incidental music, Déodat de Séverac; choreography, Ida Rubenstein; scenery and costumes by Léon Bakst. [DLLF 1984, 3:2399 / also Grove 1980, 17:202 / Spencer 1973, pp. 144, 324 / Oxford 1982, p. 358 / DMB 1959, p. 19] Bakst's original designs in Galleria del Lavante, Milan; Musée des Arts Décoratifs, Paris; Ashmolean Museum, Oxford; elsewhere. [Spencer, pls. 118–26]

Theodor Däubler, 1876–1934. (Helen evoked in) "Ob, verliebt in Menelaus, Paris, oder Fausten . . ." [Whether in love with Menelaus, Paris, or Faust]. Passage in "Neapel," part of *Das Nordlicht*. Epic. Florence: **1910**; Leipzig: 1921. [Ipso] English translation, *The Northern Lights* (Geneva: 1922).

William Butler Yeats, 1865–1939. (Helen evoked in) "No Second Troy." Poem. In *The Green Helmet and Other Poems* (London: Macmillan, **1910**). [Finneran 1983 / Feder 1971, pp. 281f. / Ellmann 1964, p. 43]

———. "When Helen Lived." Poem. In *Responsibilities: Poems and a Play* (Dundrum: Cuala, 1914). [Finneran / DLB 1983, 19:417 / Reid 1961, pp. 98f.]

Rupert Brooke, 1887–1915. "Menelaus and Helen." 2 sonnets with the same title. In *Poems* (London: Sidgwick & Jackson, **1911**). [Boswell 1982, p. 53 / Bush 1937, pp. 475f., 569]

Adriaan Roland Holst, 1888–1976. "Helen." Poem. In *Verzen* (Bussum: Dishoeck, **1911**). [EWL 1981–84, 4:73]

Aarre Merikanto, 1893–1958. *Helena*. Opera. First performed *c*.**1911**. Helsinki? [Grove 1980, 12:182]

Wilhelm Schmidtbonn, 1876–1952. *Helena im bade* [Helen in the Bath]. Farce. In *Der spielende Eros* (Berlin: Fleischel, **1911**). [NUC]

Arthur Symons, 1865–1945. "Helen and Faustus." Poem. In *Poems* (New York: Lane, **1911**). [Beckson 1987, p. 298 / Boswell 1982, p. 229]

Sara Teasdale, 1884–1933. "Helen of Troy." Poem. In *Helen of Troy and Other Poems* (New York: Putnam, **1911**). [Ostriker 1986, p. 285 / Gould 1980, pp. 93–95]

Lili Boulanger, 1893–1918. *Faust et Hélène*. Cantata. Libretto, Goethe (1825–27). **1913**. [Cohen 1987, 1:99]

Claude Delvincourt, 1888–1954. *Faust et Hélène*. Cantata. **1913**. [Grove 1980, 5:356]

Karel van de Woestijne, 1878–1929. "Helena." Epic poem. In *Interludiën* (Bussum: Van Dishoeck, **1912–14**). [EWL 1981–84, 4:649 / Meijer 1971, p. 273]

Michel Brusselmans, 1886–1960. *Hélène de Sparte.* Symphonic poem. First performed **1914**, Paris. [Grove 1980, 3:394]

Ettore Romagnoli, 1871–1938. *Elena.* Dramatic satire. Milan: Fratelli Treves, **1914**. [DELI 1966–70, 4:582]

Osip Mandel'shtam, 1891–1939/42. (Helen evoked in) Untitled poem. **1915**. [Raffel & Burago 1973, no. 78 / Terras 1966, p. 258]

Edgar Lee Masters, 1869–1950. "Helen of Troy." Poem. In *Songs and Satires* (New York: Macmillan, **1916**). [Young 1948, p. 81]

Archibald MacLeish, 1892–1982. (Helen with Faust in) "Our Lady of Troy." Dramatic scene in verse. In *Tower of Ivory* (New Haven: Yale University Press, **1917**). [Falk 1965, p. 26]

Charles Williams, 1886–1945. "Troy: Sonnets on Andromache, Helen, Hecuba, and Cassandra." Sonnet cycle. In *Poems of Conformity* (London: Oxford University Press, **1917**). [Bush 1937, p. 571]

Stephen Vincent Benét, 1898–1943. "The Last Vision of Helen" (Helen merges with the Sphinx). Poem. In *Heavens and Earth* (New York: Holt, **1920**). [Bush 1937, p. 588 / Boswell 1982, p. 35 / Young 1948, pp. 82f.]

Rudolf Pannwitz, 1881–1969. *Faustus und Helena.* Poem. Munich-Feldafing: Carl, **1920**. [Kunisch 1965, p. 453]

Cecil Roberts, 1892–1976. "Helen of Troy." Poem. In *Poems* (New York: Stokes, **1920**). [Boswell 1982, p. 285]

Boris Pasternak, 1890–1960. "Elene." Poem. In *Khudozhestvennoe slovo* (Periodical) Moscow: no. 2, **1921**; collected in *Sestra moya zhizn* (Pasternak *Izbrannoe,* Moscow: 1985, 1:106f., 550). / Translated by Mark Rudman with Bohdan Boychuk as "To Helen" in *My Sister-Life and A Sublime Malady* (Ann Arbor, Mich.: Ardis, 1983). [Ipso]

H. D. (Hilda Doolittle), 1886–1961). "Helen." Poem. In *Nation and Anthenaeum* 27 Jan **1923**; collected in *Heliodora and Other Poems* (London: Cape; Boston: Houghton Mifflin, 1924). [Martz 1983 / Ostriker 1986, p. 223 / DLB 1986, 45:130 / Friedman 1981, pp. 232–36, 240–45]

———. *Helen in Egypt.* Epic. 1952–56. New York: New Directions, 1961. [Ipso / Friedman, pp. 59–66, 254 / Peck 1975, pp. 65, 70]

———. (Helen seeks Odysseus in) "Winter Love." Poem. 1959. In *Hermetic Definition* (New York: New Directions, 1961). [DLB 45:143 / Boswell 1982, p. 94 / Robinson 1982, pp. 420–35 / Friedman, pp. 8, 144, 273 / Peck, p. 69]

Bert Kalmar, 1884–1947, and **Harry Ruby,** 1895–1974. *Helen of Troy, New York.* Musical comedy. Libretto, George S. Kaufman and Marc Connelly. First performed 19 June **1923**, Selwyn, New York. [Bordman 1978, p. 379]

John Erskine, 1879–1951. *The Private Life of Helen of Troy* (Helen after the Trojan War). Novel. Indianapolis: Bobbs-Merrill, **1925**. Adapted as a libretto, *Helen Retires,* 1930–32, set as an opera by George Antheil, 1934. (See Antheil, below.) Published New York & Indianapolis: Bobbs-Merrill, 1934. [Boswell 1982, p. 102]

John Gould Fletcher, 1886–1950. "On a Moral Triumph" (Menelaus's recovery of Helen). Poem. In *Parables* (London: Kegan Paul, Trench & Trübner, **1925**). [Boswell 1982, p. 107]

Hugo von Hofmannsthal, 1874–1929. *Die ägyptische Helena* [The Egyptian Helen]. Opera libretto, after Euripides' *Helen.* **1923–26**. Berlin: Furstner, 1927. [Steiner 1946–58, *Dramen* vol. 4 / Hamburger 1969, pp. 96–101 / DLL 1968–90, 7:1428] Translated by Michael Hamburger in *Selected Plays and Libretti* (New York: Pantheon Books, 1963). [Ipso] *See also below.*

Richard Strauss, 1864–1949. *Die ägyptische Helena* [The Egyptian Helen]. Opera. Libretto, Hofmannsthal (above). **1923–27**. First performed 6 June 1928, Staatsoper, Dresden. / Act 2 revised by Strauss, with libretto by L. Wallerstein, performed 14 Aug 1933, Festspielhaus, Salzburg. [Grove 1980, 18:234]

Jack Lindsay, 1900–1990. *Helen Comes of Age.* 3 plays in verse. London: Fanfrolico, **1927**. [DLB Yearbook 1984, p. 294 / Bush 1937, p. 574]

Gérard d'Houville, 1875–1963. *La vie amoureuse de la belle Hélène . . .* [The Amorous Life of the Lovely Helen]. Novel. Paris: Flammarion, **1928**. [DLLF 1984, 2:1042]

George Moore, 1852–1933. (A traveler tells the story of Helen of Troy and Helen of Egypt in) *Aphrodite in Aulis.* Novel. London: Heinemann, **1930**. [EWL 1981–84, 3:308]

Ezra Pound, 1885–1972. (Helen of Troy in) Cantos 7, 8. In *A Draft of XXX Cantos* (Paris: Hours, **1930**; Norfolk, Conn.: New Directions, 193[3?]). [Surette 1979, pp. 31f., 63f.]

Otto Stoessl, 1875–1936. *Die wahre Helena* [The True Helen]. Drama. **1931**. In *Arcadia,* vol. 1 of *Gesammelte Werke* (Vienna: Saturn, 1933). [Ungar 1973, p. 251 / Domandi 1972, 2:289 / EWL 1981–84, 4:343]

George Antheil, 1900–1959. *Helen Retires.* Opera. Libretto, John Erskine, after his novel *The Private Life of Helen of Troy* (1925). **1930–32**. First performed 28 Feb 1934, Juillard School of Music, New York. [Grove 1980, 1:453f.]

Robinson Jeffers, 1887–1962. (Helen hanged by Polyxo in) "At the Fall of an Age." Dramatic poem. In *Give Your Heart to the Hawks and Other Poems* (New York: Random House, **1933**). [DLB 1986, 45:207 / Gregory & Zaturenska 1946, pp. 404, 406, 408]

Otto Brües, 1897–1967. *Der Spiegel der Helena* [The Mirror of Helen]. Drama. **1935–36**. In *Sturm und Stille: Dramen* (Gütersloh: Bertelsmann, 1949). [Kunisch 1965, p. 139]

Pierre-Jean Jouve, 1887–1976. *Hélène.* Poem. Paris: GLM, **1936**; incorporated in *Matière céleste* (Paris: Gallimard, 1937). [EWL 1981–84, 2:525]

Nikos Kazantzakis, 1883–1957. (Ulysses abducts Helen, hoping to gain her help in destroying decadent Crete, in) *Odysseia.* Epic. Athens: Chrestou, **1938**. / Translated by Kimon Friar as *The Odyssey: A Modern Sequel* (New York: Simon & Schuster, London: Secker & Warburg, 1958). [Stanford 1974, p. 228]

Laura Riding, 1901–1985. "Helen's Burning," "Helen's Faces." Poems. In *Collected Poems* (New York: Random House, **1938**). [Ipso]

Marina Tsvetaeva, 1892–**1941**. *Elena.* Unfinished drama, last part of a trilogy. [Venclova 1985, pp. 101f.]

Michel Fokine, 1880–1942, choreography, completed by **David Lichine,** 1910–1972. *Helen of Troy.* Ballet. Music, Offenbach's *La Belle Hélène* (1864), arranged by Antal Dorati. Scenario, Lichine and Dorati. First performed 10 Sep **1942**, Palazio de Bellas Artes, Mexico City; décor and costumes, Marcel Vertès. [Horwitz 1985, pp. 146–50 / Oxford 1982, pp. 199, 254 / Sharp 1972, p. 278 / Fokine 1961, p. 311]

Jean Giono, 1895–1970. "Esquisse d'une mort d'Hélène" [Sketch of a Death of Helen]. Drama. In *Théâtre* (Paris: Gallimard, **1943**). [NUC]

Janet Lewis, b. 1899. "Helen Grown Old." Poem. **1924–44**. In *Poems, 1924–1944* (Denver: Swallow, 1950). [Ipso]

Barbara Pentland, 1912–. *For Helen.* Instrumental composition. **1947**. [Cohen 1987, 1:538]

Albert Camus, 1913–1960. "Helen's Exile" [English title of a work written in French]. Essay. **1948**. / Translated by Justin O'Brien in *The Myth of Sisyphus and Other Essays* (New York: Knopf, 1955). [Ipso]

Horst Lommer, 1904–1969. *Thersites und Helena.* Drama. **1948**. [DLL 1968–90, 9:1646]

Marcel Luipart, 1912–, choreography. (Faust/Achilles theme in) *Abraxas.* Ballet. Music and scenario, Werner Egk, based on Heine's *Der Doktor Faust* (1847). First performed 6 June **1948**, Bayerische Staatsoper, Munich; décor, Wolfgang Znamenacek. [Sharp 1972, pp. 1, 247 / Oxford 1982, p. 264 / DMB 1959, p. 1 / Grove 1980, 6:68]

Janine Charrat, 1924–, choreography. (Faust/Achilles theme in) *Abraxas.* Ballet. Music and scenario, Egk (1948). First performed 21 Oct **1949**, Stadtische Oper, Berlin; décor, Joseph Fenneker. [Oxford 1982, p. 91 / DMB 1959, p. 1]

André Jolivet, 1905–1974. *Hélène et Faust.* Incidental music for Alexandre Arnoux's adaptation of Goethe (1827). First performed **1949**. [Grove 1980, 9:689]

André Suarès, 1868–1948. *Hélène chez Archimède* [Helen with Archimedes] (seeking wisdom). Drama. Paris: Gallimard, **1949**. [CEWL 1973, 1:284]

Angelos Sikelianos, 1884–**1951**. "Hymnos stēn Elene" [Hymn to Helen]. Poem. [Savidis 1981, vol. 4 / Keeley & Sherrard 1979 / Trypanis 1981, p. 674]

I. M. Panayotópoulos, 1901–. "Helene." Poem. **1951**. In *Zodiakós* (Athens: 1952). / Translated by Kimon Friar in *Modern Greek Poetry* (New York: Simon & Schuster, 1973). [Ipso]

Helge Pawlinin, choreography. (Faust/Achilles theme in) *Abraxas.* Ballet. Music and scenario, Egk (1948). First performed **1951**, Deutsche Ballett Theater, Hamburg. [Sharp 1972, pp. 1, 247 / Oxford 1982, p. 1]

André Roussin, 1911–, with **Madeleine Gray.** *Hélène, ou, La joie de vivre.* Comedy, after Erskine's *Private Life of Helen of Troy* (1925). Monaco: du Rocher, **1953**. [McGraw-Hill 1984, 4:261]

George Seferis, 1900–1971. "Elenē" (Helen in Egypt). Dramatic monologue. **1953**. In *Hēmerologio Katastrōmatos G* [Logbook III] (Athens: Ikaros, 1955). [Keeley & Sherrard 1967 / Keeley 1983, p. 98 / Friar 1973, pp. 388, 746]

Seymour Shifrin, 1926–1979. *No Second Troy.* Composition for soprano and pianoforte. Text, Yeats (1910). **1953**. [Grove 1980, 17:256]

Selahattin Batu, 1905–. *Güzel Helena* [Beautiful Helen]. Tragedy. **1954**. / Performed, in a free translation by

Bernt von Heiseler, as *Helen Bleibt in Troja* [Helen Lives in Troy], 1959, Vienna. Published Bayreuth: Baumann, c.1957. [Hunger 1959, p. 131 / Gassner & Quinn 1969, p. 53]

Eva Hemmer Hansen, 1913–. *Skandale i Troja* [Scandal in Troy]. Novel. Copenhagen: Frenad, **1954**. [Hunger 1959, p. 131]

Tákis Sinópoulos, 1917–1979? "Helene," "O Thanatos the Helene" [Death of Helen], "Poiema tia Helene" [Poem of Helen]. Poems. **1949–55**. In *Helene* (Athens: Diphros, 1957). / Translated by Kimon Friar in *Landscape of Death,* bilingual edition (Columbus: Ohio State University Press, 1979). [Ipso]

John Cranko, 1927–1973, choreography. *La belle Hélène.* Ballet. Music, Offenbach (1864). First performed **1955**, L'Opéra, Paris; décor and costumes, Marcel Vertès. [Guest 1976, p. 320]

Louis Simpson, 1923–. (Helen evoked in) "Aegean." Poem. In *Good News of Death and Other Poems* (New York: Scribner, **1955**). [Ipso]

Richard Wilbur, 1921–. "Helen." Sonnet, translation of Valéry's "Hélène" (1980). In *Things of This World* (New York: Harcourt, Brace, **1956**). [Ipso / CLC 1980, 14:577]

Jay Macpherson, 1931–. "Helen" (in Egypt). Poem. In *The Boatman* (Toronto: Oxford University Press, **1957**). [Ipso]

John Heath-Stubbs, 1918–. *Helen in Egypt.* Drama. In *Helen in Egypt and Other Plays* (London: Oxford University Press, **1958**). [DLB 1984, 27:144f. / DLEL 1970–78, 2:138]

Wolfgang Hildesheimer, 1916–. *Das Opfer Helenas* [The Sacrifice of Helen (to Spartan-Trojan politics)]. Comedy for radio. In *Sprich, damit ich dich höre* (Munich: List, **1961**). [Hamburger 1969, p. 172 n. / EWL 1981–84, 2:373]

Robert Lowell, 1917–1977. "Helen." Sonnet, imitation of Valéry's "Hélène" (1890). In *Imitations* (New York: Farrar, Straus & Giroux, **1961**). [Ipso / CLC 1973, 1:182]

C. S. Lewis, 1898–1963. (Helen, aging, in) "Ten Years After." Novel, fragment. In *Of Other Worlds: Essays and Stories,* edited by Walter Hooper (London: Bles, 1966). [Boswell 1982, p. 165]

Peter Hacks, 1928–. *Die schöne Helena* [Beautiful Helen]. Libretto for operetta, after Meilhac and Halévy's libretto for Offenbach's *La belle Hélène* (1864). First performed **1964**, Berlin. [McGraw-Hill 1984, 2:441]

Edwin Muir, 1887–1959. "The Charm." Poem. In *Collected Poems* (London: Oxford University Press, **1965**). [Boswell 1982, p. 195]

Delmore Schwartz, 1913–**1966**. "To Helen." Sonnet, translation of Valéry's "Hélène" (1890). In *Last and Lost Poems* (New York: Vanguard, 1979). [Ipso]

Lawrence Durrell, 1912–1990. "Troy" (Helen's part in the irony of war). Poem. In *The Ikons and Other Poems* (London: Faber & Faber, **1966**). [Ipso]

Yannis Ritsos, 1909–1990. "Hē Helene." Dramatic monologue. **1966**. Athens: Kedros, 1972. / Translated by Yehuda Amichai in *Travels of a Latter Day Benjamin of Tudela* (Toronto: House of Exile, 1976). [Myrsides 1978, p. 451]

Kathleen Spivack, 1938–. (Helen, glad to be delivered to Menelaus, in) "Mythmaking." Poem. In *Poetry* (periodical) **1966**. [Ipso]

Marnix Gijsen, b. 1899. *Helena op Ithaka* [Helen at Ithaca]. Drama. 1967. Amsterdam: Meulenhoff, 1968. [EWL 1981–84, 2:236]

Kurt Klinger, 1928–. *Helen in Ägypten.* Drama. In *Schauplätze* (Vienna: Österreichische-Verlag, **1971**). [DLL 1968–90, 8:1339]

Maurice Béjart, 1924/27–, choreography and scenario. (Faust/Achilles theme in) *Notre Faust,* part 2. Balletic play. Music, J. S. Bach and Argentine tangos. First performed 12 Dec **1975**, Théâtre de la Monnaie, Brussels; sets and costumes, Thierry Bousquet. [Simon & Schuster 1979, pp. 302f.]

C. H. Sisson, 1914–. "Helen," part 2 of "In the Trojan Ditch." Poem. In *In the Trojan Ditch* (Chester Springs, Pa.: Dufour, **1975**). [DLB 1984, 27:325ff.]

Roy Marz, 1911–. "The Humor of Helen." Poem. In *The Island-Maker* (Ithaca, N.Y.: Ithaca House, 1982). [Ipso]

HELENUS. *See* AENEAS, Wanderings; ANDROMACHE; PHILOCTETES.

HELIOS. *See* APOLLO, as Sun God.

HELLE. *See* ATHAMAS AND INO.

HEPHAESTUS. The Greek god of fire and crafts, Hephaestus was the son of Zeus (Jupiter) and Hera (Juno), or of Hera alone. Crippled at birth, he was thrown down from Olympus by his mother, who was ashamed of his deformity. Falling into the ocean, Hephaestus was resuced by the Nereids Thetis and Eurynome. He later took revenge on his mother by trapping her in a throne of his own devising; there she remained imprisoned until Dionysus inebriated him and forced him to release her. In an alternate legend, Hephaestus was hurled to earth by Zeus for siding with Hera in a quarrel about Heracles; he landed on the island of Lemnos, an important center of his cult in the fifth century BCE.

As the fire god and divine blacksmith, Hephaestus labored in a workshop located either in heaven or on Olympus, although Virgil, for example, placed it in a cave on an island near Sicily. A master craftsman, the god forged the armor that Thetis requested for Achilles and the arms that Venus implored him to create for Aeneas. He also fashioned the chains that bound Prometheus to the rock, the necklace of Harmonia, and, with the assistance of the Cyclopes, Zeus's thunderbolts. According to Hesiod, he created Pandora, the first woman, and in some accounts acted as midwife in the birth of Athena (Minerva) by splitting Zeus's head with an axe to release the goddess.

Hephaestus was sometimes said to be the husband of Aglaia, one of the Graces, but in most myths he was married to the ever-unfaithful Aphrodite (Venus). When he discovered her affair with his brother Ares (Mars), he ensnared the lovers in a net and exposed them to the ridicule of the gods. Hephaestus's own pursuit of the virgin Athena failed, but from his spilled semen Erichthonius, legendary king of Athens, was born.

Vulcan, the early Roman god of fire, assumed many of the attributes of Hephaestus, but his importance in the Roman pantheon was far greater than that of his Greek counterpart. To the Romans, Vulcan was also a god of destructive fire, deserving of attention in an era when uncontrollable fires and volcanic eruptions spelled disaster. More than just a fire-god, the Hellenized Vulcan was accorded a creative side, recognized by the epithet "Mulciber" ("he who tempers"). He was said to be the father of Cupid (Amor) by Venus, and was also associated with the goddess Maia, an obscure Italian vegetation deity.

Classical representations of Hephaestus focus on his return to Olympus, his assistance in the birth of Athena, and his delivery of Achilles' armor to Thetis. He also figures prominently in gatherings of Olympians. Postclassical depictions of these themes are also common, as are scenes of Venus visiting Vulcan's forge, either as his wife or as supplicant for Aeneas's armor. Vulcan and his forge are also depicted as symbols of winter and of the element Fire.

Classical Sources. Homer, *Iliad* 1.571–608, 14.338 18.368–617, 21.328–82; *Odyssey* 8.266–366. Hesiod, *Theogony* 570–72, 927–29, 945f. *Homeric Hymns,* "To Hephaestus." Aeschylus, *Prometheus Bound* 1–81, 365–69. *Orphic Hymns* 66, "To Hephaestus." Apollonius Rhodius, *Argonautica* 1.202–05, 1.850–60. Virgil, *Aeneid* 8.416–54. Ovid, *Fasti* 5.229ff. Apollodorus, *Biblioteca* 1.3.5–6, 1.4.3–4, 1.6.2, 3.14.6, 3.16.1. Pausanias, *Description of Greece* 1.20.3, 2.31.3, 8.53.5. Hyginus, *Fabulae* 158, 166; *Poetica astronomica* 2.12–13, 2.15, 2.34. Lucian, *Dialogues of the Gods,* "Hephaestus and Apollo," "Hephaestus and Zeus."

See also ACHILLES, Return to Battle; AENEAS, in Latium; ARES AND APHRODITE; CYCLOPES; GODS AND GODDESSES; PANDORA; PROMETHEUS, Bound.

Andrea Mantegna, 1430/31–1506. (Vulcan at his forge in) "Parnassus" ("Mars and Venus"). Painting, for Studiolo of Isabella d'Este, Corte Vecchia, Mantua. **1497.** Louvre, Paris, inv. INV 370. [Lightbown 1986, p. 189, no. 39—ill. / Louvre 1979–86, 2:203—ill. / Wind 1948, pp. 9ff.—ill. / Louvre 1975, no. 96—ill.]

Piero di Cosimo, c.1462–1521. "The Fall of Vulcan" (or "Hylas and the Nymphs"?). Painting. **c.1495–1500.**

Wadsworth Atheneum, Hartford, no. 32.1. [Bacci 1966, pl. 15 / Berenson 1963, p. 176]

————. "Vulcan and Aeolus" ("Vulcan as Teacher of Mankind"). Painting. National Gallery of Canada, Ottawa, no. 4287. [Bacci, pl. 16 / Berenson, p. 176—ill. / Warburg]

Marcantonio Raimondi, c.1480–1527/34. "Vulcan, Venus, and Cupid." Engraving (Bartsch no. 326). c.1505. [Shoemaker 1981, no. 4—ill. / Bartsch 1978, 27:20—ill.]

————. "Vulcan, Venus, and Three Cupids." Engraving (Bartsch no. 227). [Bartsch, 26:224—ill.]

Giorgione, c.1477–1510. "Vulcan and Cupid." Painting. Lost. / Free copy by follower, c.1530. Pinacoteca Querini-Stampaglia, Venice, no. 84. [Berenson 1957, p. 85]

————, formerly attributed (probably by Palma Vecchio). "The Forge of Vulcan." Painting. Pozzi coll., Novara. [Pignatti 1978, no. V25]

Baldassare Peruzzi, 1481–1536. "Vulcan's Forge." Fresco. **1511–12** (or c.1517–18). Sala delle Prospettive, Villa Farnesina, Rome. [d'Ancona 1955, pp. 27ff., 93f. / Gerlini 1949, pp. 31ff.—ill. / also Frommel 1967–68, no. 51—ill.]

Sodoma, 1477?–1549. "Vulcan's Forge." Fresco. **1508–13**. Sala delle Nozze di Alessandro con Rossana, Villa Farnesina, Rome. [d'Ancona 1955, pp. 69f., 95f.—ill. / Gerlini 1949, pp. 34ff.—ill. / also Hayum 1976, no. 20—ill.]

Antonio Lombardo, c.1458–1516. "Vulcan's Forge." Marble relief. **1507–16**. Hermitage, Leningrad. [Pope-Hennessy 1985b, 2:95—ill. / also Grosshans 1980, p. 121, pl. 174]

Raphael, 1483–1520, design. "Vulcan's Forge." Fresco. Executed by assistants. **1519**. Restored 1943–46. Loggetta, Vatican, Rome. [Vecchi 1987, no. 151]

————, composition. "Venus and Vulcan Surrounded by Cupids." Engraving (Bartsch 14:261 no. 349), by Agostino Veneziano. [Bartsch 1978, 27:46—ill.]

Bernardino Luini, 1480/85–1532. "The Forge of Vulcan." Fresco (detached), from Villa Pelucca, Sesto San Giovanni. **1520–23**. Pinacoteca di Brera, Milan, no. 748. [Luino 1975, pp. 87f., pl. 6 / Berenson 1968, p. 231]

Giovanni Francesco Penni, 1488–1528, attributed. "Venus, Cupid, and Vulcan in the Forge." Drawing. Louvre, Paris, no. 618 (as Perino del Vaga). [Frommel 1967–68, p. 104—ill.]

Giulio Romano, c.1499–1546, assistants, after designs by Giulio. Vulcan depicted in frescoes and stuccoes in Sala dei Venti, Sala delle Aquile, and Salla delle Stucchi, Palazzo del Tè, Mantua. **1527–30**. [Verheyen 1977, pp. 119–124 passim / also Hartt 1958, pp. 115ff.]

————, studio (previously attributed to Giulio). "Venus and Vulcan." Painting. Louvre, Paris, no. 424 (1421). [Louvre 1979–86, 2:183—ill. / Berenson 1968, p. 197 (as Giulio)]

Domenico Beccafumi, 1486–1551, questionably attributed (or Girolamo Genga?). "Venus and Cupid (with Vulcan)." Painting. c.1530. Kress coll. (K1932), Delgado Museum of Art, New Orleans, no. 61.73. [Shapley 1966–73, 3:4—ill. / Sanminiatelli 1967, p. 172]

Maerten van Heemskerck, 1498–1574. "Landscape with Ruins and Vulcan's Forge." Drawing. **1538**. British Museum, London. [Grosshans 1980, p. 44, pl. 171 / de Bosque 1985, p. 164—ill.]

————, composition. "Venus and Cupid in Vulcan's Forge." Engraving. Executed (by D. Coornhert?) 1549. [Grosshans, p. 122, pl. 177]

————. "Mars in the Smithy." Painting. Dienst Verspreide Rijkskollekties, The Hague, inv. NK2869. [Wright 1980, p. 166]

Jacopo Tintoretto, 1518–1594. "Venus, Vulcan, and Cupid." Painting. c.1541. Galleria Estense, Modena. [Rossi 1982, no. 32—ill.]

————. "The Forge of Vulcan." Painting. 1544–45. North Carolina Museum of Art, Raleigh, no. 56.15.2. [Ibid., no. 83—ill.]

————. "Vulcan, Venus, and Cupid." Painting. 1551–52. Galleria Palatina, Palazzo Pitti, Florence, no. 3. [Ibid., no. 157—ill. / Pitti 1966, p. 201—ill.]

————. "The Forge of Vulcan." Painting. 1577–78. Palazzo Ducale, Venice. [Rossi, no. 376—ill. / Berenson 1957, p. 179]

Dosso Dossi, c.1479–1542, and **Battista Dossi**, c.1474–1548. "Vulcan with Two Smiths at a Forge." Painting, from Castello Estense, Ferrara. Lost. [Gibbons 1968, p. 269]

Francesco Primaticcio, 1504–1570. "The Cyclopes in the Forge of Vulcan." Fresco, decoration for Cabinet du Roi, Château de Fontainebleau. **1541–45**. Effaced. / Drawing. Cabinet des Dessins, Louvre, Paris. [Dimier 1900, pp. 262ff., no. 21 / Paris 1972, no. 150—ill. / also Lévêque 1984, p. 168—ill.] Copy, drawing, in Louvre, Paris, inv. 8689. [Paris]

————, design. "Vulcan Forging Arrows for Cupid," "Vulcan." Frescoes, for Salle de Bal, Château de Fontainebleau, executed by Niccolò dell' Abbate under Primaticcio's direction. 1551–56. Repainted 19th century. / Drawing for the latter. Louvre, Paris, no. 8601. [Dimier 1900, pp. 160ff., 284ff., no. 88]

Matteo Balducci, ?–1555? "Vulcan at His Forge." Painting. Bergamo. [Berenson 1968, p. 24]

Cristofano Gherardi, 1508–1556. "Vulcan and the Cyclopes [with Venus and Cupid]" (allegory of Fire). Fresco. **1555–56**. Sala degli Elementi, Palazzo Vecchio, Florence. [Sinibaldi 1950, pp. 13, 22 / Lensi 1929, pp. 154ff., 160—ill.]

Paris Bordone, 1500–1571. "Thetis and Hephaestus" (sometimes called "Minerva [or Venus] at the Forge of Vulcan"). Painting. c.1555–60. Kress coll. (K1112), University of Missouri, Columbia, no. 61.78. [Shapley 1966–73, 3:36—ill. / also [Canova 1964, p. 103—ill. / also Berenson 1957, p. 47 (as "Venus and Vulcan")]

Taddeo Zuccari, 1529–1566. "Vulcan Chaining Boreas." Ceiling fresco. **1560–61**. Stanza dell' Inverno, Caprarola. [Warburg]

Giorgio Vasari, 1511–1574. "The Forge of Vulcan" (with Venus and Cupid). Painting. **1567**. Uffizi, Florence, inv. 1558. [Arezzo 1981, no. 5.50d / Uffizi 1979, no. P1854—ill.]

Lambert Sustris, 1515/20–after 1568. "Venus and Vulcan." Painting. Late work. Schloss, Schleissheim, no. 2408. [Berenson 1957, p. 168—ill.]

Frans Floris, 1516/20–1570. "Vulcan's Forge." Painting. Staatliche Museen, Berlin. [de Bosque 1985, p. 55—ill.]

Vittorio Casini, fl. 1567–72. "Vulcan's Forge." Painting. **1570–73**. Studiolo di Francesco I, Palazzo Vecchio, Florence. [Sinibaldi 1950, pp. 11f., 19]

Vincenzo de' Rossi, 1525–1587. "Vulcan." Bronze statuette. **1570–77**. Studiolo di Francesco I, Palazzo Vecchio, Florence. [Pope-Hennessy 1985b, 3:100, 380 / Lensi 1929, pp. 236f. / also Sinibaldi 1950, pp. 12, 19, 38—ill.]

John Lyly, c.1554–1606. (Vulcan in) *Sapho and Phao.* Comedy. **1581–82.** First performed at Court, London, Shrove Tuesday 1582. Published London: 1584. [Bond 1902, vol. 2]

Luca Cambiaso, 1527–**1585.** "The Forge of Vulcan." Drawing. Courtauld Institute, London. [Manning & Suida 1958, p. 181—ill.]

Edmund Spenser, 1552?–1599. (Vulcan evoked in) *The Faerie Queene* 2.7.36, 3.9.19, 4.5.3–4. Romance epic. London: Ponsonbie, **1590,** 1596. [Hamilton 1977]

———. (Vulcan evoked in) "Muiopotmos; or, The Fate of the Butterfly" lines 63ff. Poem. London: Ponsonbie, 1590; collected in *Complaints,* 1591. [Oram et al. 1989]

Francesco Bassano, 1549–**1592, Leandro Bassano,** 1557–1622, and/or **Jacopo Bassano,** c.1517/18–1592, and/or studio, variously attributed. "The Forge of Vulcan" ("Allegory of Fire," "Venus in Vulcan's Forge"). Painting. Several versions. Louvre, Paris, no. M.N.R. 258 (as studio of Jacopo, questionably Francesco; ex-Sambon coll.); Kunsthistorisches Museum, Vienna (fragments: "Venus and Vulcan," no. 316, and "The Tinkers," no. 317; copy of complete composition, no. 315). [Arslan 1960, pp. 221, 226 (as Francesco) / also Louvre 1979–86, 2:149—ill. / also Berenson 1957, p. 25] Studio (or circle) copies, after Vienna version, in Galleria Capitolina, Rome; Boromeo coll., Isolabella; Galleria Sabauda, Turin, no. 587. [Arslan, pp. 346, 367, 372]

———. "The Forge of Vulcan" ("Allegory of Fire," "Venus in Vulcan's Forge"). Painting. Several versions. Ringling Museum of Art, Sarasota, Fla., inv. SN86 (as Francesco, previously attributed to Jacopo); Muzeum Narodowe, Warsaw, inv. 146 (Francesco); Walker Art Gallery, Liverpool, no. 1218 (also called "The Building of the Ark"). [Arslan, pp. 218, 222f., pl. 216 / Sarasota 1976, no. 68—ill. / also Warsaw 1969, no. 46—ill. / Berenson, p. 18] School copy in Uffizi, Florence, inv. SMeC 134 (as school of Leandro), on display in Cenacolo di Foligno. [Uffizi 1979, no. P161—ill.]

———. "The Forge of Vulcan" ("Venus and Vulcan, with a View of Bassano dal Grappa"). Painting. Museo, Burgos, inv. 354. [Arslan, p. 215 (as Francesco and studio) / Berenson, p. 22 (as Leandro)]

———. "The Forge of Vulcan." Muzeum Narodowe, Posnan, no. MO.3. [Arslan, p. 221 (as Francesco), pl. 250 / Berenson, p. 19 (as Jacopo and Francesco)]

———. "The Forge of Vulcan." Painting. Liechtenstein Collection, Vaduz, no. 232. [Arslan, p. 223 (as Francesco)]

———. "The Forge of Vulcan" ("Allegory of Fire"). Painting. Palazzo Rosso, Genoa, no. 87. [Arslan, p. 223 (as Francesco)]

Hendrik Goltzius, 1558–1617. "Vulcan." Engraving, in "Eight Deities" series, after (lost) chiaroscuro frescoes by Polidoro da Caravaggio (c.1498–1543). **1592.** 4 states. [Strauss 1977a, no. 292—ill. / Bartsch 1980–82, no. 252—ill. / also de Bosque 1985, p. 160—ill. (drawing)]

Palma Giovane, c.1548–1628. "Venus in the Forge of Vulcan." Painting. **c.1590–95.** Private coll., Padua. [Mason Rinaldi 1984, no. 191—ill.]

Antoine Caron, 1520/21–**1599.** (Vulcan and other gods in) "Triumph of Winter." Painting. Private coll., Paris. [Paris 1972, no. 35—ill.]

French School. "Ceres and Vulcan" (as lovers). Painting.

16th century. Private coll., Basel. [Hofmann 1987, no. 3.9—ill.]

Master I. G. "Vulcan's Forge." Bronze plaque. **Late 16th century.** Formerly Schlossmuseum, Berlin. [Grosshans 1980, p. 122, pl. 178]

Tiziano Aspetti, 1565–**1607,** attributed (also attributed to Girolamo Campagna). "Vulcan." Bronze statuette, pendant to "Venus." c.1585–95. Hermitage, Leningrad, inv. 1312; elsewhere. [Hermitage 1984, no. 367—ill. / also Hermitage 1975, pl. 26]

Ben Jonson, 1572–1637. (Vulcan in) *The Haddington Masque* (*The Hue and Cry after Cupid*). Masque, for marriage of Lord Haddington, 9 Feb **1608,** at Court, London. Published London: 1608. [Herford & Simpson 1932–50, vol. 7 / McGraw-Hill 1984, 3:III, 113]

———. (Vulcan and Cyclopes in) *Mercury Vindicated from the Alchemists (at Court).* Masque. Performed 6 Jan 1615, at Court, London. Published London: 1616. [Herford & Simpson / McGraw-Hill, 3:III, 113]

———. "An Execration upon Vulcan" ("Ben Jonson upon the burning of his study and bookes"). Poem. 1623. Published in quarto, London: 1640; collected as no. 43 of *The Underwood,* in *Works* (London: 1640). [Herford & Simpson, vol. 8 / Miles 1986, pp. 223f.]

Thomas Heywood, 1573/74–1641. (Birth and youth of Vulcan in) *Troia Britanica: or, Great Britaines Troy* 5.89–94. Epic poem. London: **1609.** [Heywood 1974]

———. "Vulcan and Apollo" (discuss Cillenius, son of Maia). Poetic dialogue, translation from Lucian. No. 8 in *Pleasant Dialogues and Drammas* (London: 1637). [Heywood 1874, vol. 6]

Bartholomeus Spranger, 1546–**1611.** "Vulcan and Maia." Painting. Kunsthistorisches Museum, Vienna, inv. 1128 (1506). [Vienna 1973, p. 165—ill. / de Bosque 1985, p. 114—ill. / Lowenthal 1986, fig. 53]

———. "Vulcan." Drawing. Royal Collection, Windsor Castle. [de Bosque, pp. 166f.—ill.]

———. "Venus in the Forge of Vulcan." Painting. Late work. Kunsthistorisches Museum, Vienna, inv. 2001. [Vienna 1973, p. 167]

Jan Brueghel the Elder, 1568–1625. "Mars Receiving His Armor" (from Vulcan). Painting. **1613?** Alte Pinakothek, Munich, inv. 1881. [Ertz 1979, no. 276—ill.]

———, landscape, and **Hendrik van Balen,** 1575–1632, figures. "Venus (and Cupid) in Vulcan's Forge" ("Allegory of Fire"). Painting. Several versions of the subject, 1608–23. Higgins Armory, Worcester, Mass.; Galleria Doria Pamphilj, Rome, inv. 332; formerly Kaiser-Friedrich-Museum, Berlin, destroyed; others in private colls. or unlocated. [Ibid., nos. 192, 202, 251–52, 277, 382–83—ill.] Free copies, variants and derivations, by Jan Brueghel the Younger and van Balen. 1620s. Musée des Beaux-Arts, Lyons, inv. A–74; Sanssouci, Potsdam; Alte Pinakothek, Munich, no. 1999 (as "The Prophecy of Jesias" [in Vulcan's forge); others in private colls. or unlocated. [Ertz 1984, nos. 196–97, 202—ill.; cf. Ertz 1979, nos. 254, 260–61 / also Munich 1983, p. 108] Another painting, "Venus in Vulcan's Forge," by Brueghel the Younger and van Balen, incorporating elements of the original, in Sanssouci, Potsdam. [Ertz 1984, no. 202—ill.] Late 17th-century copy in Metro-

politan Museum, New York, no. 29.158.749. [Metropolitan 1980, p. 20—ill.]

————, followers (landscape and metal work by Hieronymous van Kessel). "Venus at the Forge of Vulcan." Painting. Ringling Museum, Sarasota, Fla., no. SN229. [Sarasota 1980, no. 7—ill.] Variant (attributed to Jan van Kessel the Elder and van Balen). Alan Jacobs Gallery, London. [Ibid.]

Pier Francesco Mazzucchelli, called Morazzone, 1573–1626. "Vulcan's Forge." Painting. *c.*1616. Szépmüvészeti Múzeum, Budapest, no. 57.20. [Budapest 1968, p. 464 / Hofmann 1987, no. 1.31—ill.] Replica, fresco. Casa Lattuada, Milan. [Budapest]

Peter Paul Rubens, 1577–1640. "Venus in the Forge of Vulcan." Painting, fragment of an original "Venus Frigida." *c.*1616–17. Cut in half and overpainted in 17th century. Musées Royaux des Beaux-Arts (Musée d'Art Ancien), Brussels, inv. 1372. [Jaffé 1989, no. 429A—ill. / Brussels 1984a, p. 253—ill.] Copy after complete original composition, in Mauritshuis, The Hague, inv. 247. [Mauritshuis 1985, p. 434—ill.]

————. (Vulcan at his forge in) Arch of the Mint, decoration for "Pompa Introitus Fernandi," triumphal entry of Cardinal-Infante Ferdinand of Spain into Antwerp, 17 Apr 1635. Original decoration destroyed. [Martin 1972, no. 51—ill. (print)] Oil sketch. Koninklijk Museum voor Schone Kunsten, Antwerp, no. 317. [Ibid., no. 51a—ill. / Held 1980, no. 164—ill. / Jaffé, no. 1161—ill.]

————. "Vulcan (Forging Jupiter's Thunderbolt)." Painting, for Torre de la Parada, El Pardo. 1636–38. Prado, Madrid, no. 1676. [Alpers 1971, no. 60—ill. / Jaffé, no. 1334—ill.] Oil sketch. Alfred Brod coll., London (ex-Moseley). [Jaffé, no. 1333—ill. / Held 1980, no. 219—ill. / Alpers, no. 60a—ill.] Copy, by Juan Bautista del Mazo (*c.*1612–1667), in Museo Provincial de Bellas Artes, Saragossa, on loan from Prado (no. 1707). [Alpers—ill.]

————, previously attributed. "Vulcan Forging the Thunderbolt." Painting, oil sketch. Private coll., London. [Held, no. A7]

————, school. "Vulcan, or Fire." Painting. Prado, Madrid, no. 1717. [Prado 1985, p. 604 / Alpers, p. 113, fig. 9]

Francesco Albani, 1578–1660. "Venus and Vulcan Resting" ("Fire"). Painting, part of series on the Elements. *c.*1621. Louvre, Paris, inv. 10. [Louvre 1979–86, 2:140—ill.]

————. "Venus in Vulcan's Forge." Painting, part of cycle depicting the rivalry of Venus and Diana. 1622. Galleria Borghese, Rome, inv. 35. [Pergola 1955–59, 1: no. 1—ill.]

————. "Venus Arriving in Vulcan's Workshop." Painting. Musée, Moulins. [Bénézit 1976, 1:78]

————, old copy after. "Venus and Vulcan." Painting. Herzog Anton Ulrich-Museum, Braunschweig, no. 482. [Braunschweig 1969, p. 25]

————, copy after. "Venus and Vulcan." Painting. Musée, Cahors (on deposit from Louvre, Paris, inv. 33). [Louvre 1979–86, 2:283]

Pietro da Cortona, 1596–1669. "The Forge of the Cyclopes." Fresco. **1626–29.** Villa Chigi (Sacchetti), Castel Fusano. [Briganti 1962, no. 23]

————. "Vulcan (Ends the Manufacture of Arms)." Fresco. 1642–44. Sala di Giove, Palazzo Pitti, Florence. [Campbell

1977, pp. 127ff., 133ff.—ill. / also Briganti, no. 95—ill. / Pitti 1966, p. 48—ill.] Copy, by Jacob Ennis (1728–1770), in National Gallery of Ireland, Dublin, no. 4125. [Dublin 1981, p. 204—ill.]

Thomas Dekker, 1570?–1632. (Vulcan in) *London's Tempe, or, The Field of Happiness.* Pageant, with interpolated songs. First performed 29 Oct **1629,** for Lord Mayor's inauguration, London. [Sharp 1969, 2:1071, 1185]

Diego Velázquez, 1599–1660. "The Forge of Vulcan." Painting. **1630.** Prado, Madrid, no. 1171. [López-Rey 1963, no. 68—ill. / López Torrijos 1985, p. 426 no. 2—ill. / Prado 1985, pp. 727f.] Study for head of Apollo. New York art market in 1963. [López-Rey, no. 69—ill.]

Chiarissimi Fancelli, ?–1632. "Vulcan." Statue. Giardino di Boboli, Florence. [Florence 1986, no. 4.23 *n.*—ill.]

Giovanni Carlo Coppola, 1599–1652, libretto. (Marriage of Venus and Vulcan in) *Le nozze degli dei* [The Weddings of the Gods]. Opera (favola in musica). First performed **1637,** Palazzo Pitti, Florence, for wedding of Ferdinand, Duke of Tuscany, and Vittoria of Urbino. Libretto published Florence: Massi & Landi, 1637, with an etching by Stefano Della Bella, after Alfonso Parigi. [Bianconi 1987, p. 172 / Taylor 1893, p. 370 / NUC]

Cornelis Cornelisz van Haarlem, 1562–**1638.** "Vulcan and Venus" (in the forge). Painting. Nationalmuseum, Stockholm. [de Bosque 1985, pp. 161, 164—ill.]

Joachim Wtewael, 1566–**1638.** "Venus in the Forge of Vulcan." Drawing. City Art Museum, St. Louis, inv. 126:66. [Lowenthal 1986, no. A–44 *n.*—ill.] Copy (previously attributed to Wtewael) in Statens Museum for Kunst, Copenhagen. [Ibid.]

Louis Le Nain, *c.*1593–1648, and **Mathieu Le Nain,** *c.*1607–1677. "Venus at the Forge of Vulcan." Painting. **1641.** Musée, Reims. [Metropolitan 1960, no. 29—ill.]

Robert Ramsey, fl. 1616–**44.** "Vulcan and Venus." Musical dialogue. MS in Bodleian Library, Oxford, Ms Don c.57. [Spink 1974, p. 49]

Robert Herrick, 1591–1674. "To Vulcan." Poem. In *Hesperides* (London: Williams & Eglesfield, **1648**). [Martin 1956]

Alessandro Algardi, 1598–**1654.** "Venus and Amor in the Forge of Vulcan." Bas-relief. Original lost. [Montagu 1985, no. L.133] Design reproduced in shell cameo (German, 17th century, British Museum, London); metal dish relief (recorded in Warburg Institute Photographic Collection, London); Wedgwood plaque (*c.*1789? Wedgwood Museum, Barlaston, and elsewhere). [Ibid., pp. 415f.—ill.]

Luca Giordano, 1634–1705. "The Forge of Vulcan." Painting. *c.*1657–60. Hermitage, Leningrad, no. 188. [Ferrari & Scavizzi 1966, 2:337—ill. / Hermitage 1981, pl. 190]

John Milton, 1608–1674. (Mulciber overthrown by Jove, in) *Paradise Lost* 1.731–51. Epic. London: Parker, Boulter, Walker, **1667.** [Carey & Fowler 1968 / Martindale 1986, pp. 72ff.]

David Pohle, 1624–1695. *Das ungereimte Paar Venus und Vulcanus* [The Mismatched Couple, Venus and Vulcan]. Singspiel. Libretto, D. E. Heidenreich. **1679.** [Grove 1980, 15:21]

Pierre Beauchamps, 1631–1705, music. "Vulcain et les Cyclopes." Entrée in *Ballet des arts.* First performed **1685,** Collège Louis-le-Grand, Paris. [Astier 1983, p. 161]

Antonio Draghi, c.1634/35–1700. *La grotta di Vulcano.* Opera. Libretto, N. Minato. First performed 15 Nov **1686,** Vienna. [Grove 1980, 5:604]

Charles Le Brun, 1619–**1690.** "The Forge of Vulcan." Design for tapestry. / Print by S. Le Clerc. [Knab 1977, fig. 26]

Antonio Carneo, 1637–**1692.** "Venus, Vulcan, and Cupid." Painting. Bowes Museum, Barnard Castle, cat. 1970 no. 3. [Wright 1976, p. 33]

Jan de Bray, c.1627–**1697.** "Vulcan and the Cyclopes Forging Arms." Painting. Frans Hals Museum, Haarlem, cat. 1969 no. 44. [Wright 1980, p. 57]

André Campra, 1660–1744. *Vénus.* Divertissement ("feste galante"). Text, Antoine Danchet. First performed 27 Jan **1698,** at the Duchesse de la Ferté's, Paris. [Grove 1980, 3:665 / Girdlestone 1972, p. 194] Revised several times; fourth version, *Les noces de Vénus,* published Paris: 1740. [Grove]

Sebastiano Ricci, 1659–1734. "Venus, Cupid, and Vulcan." Painting. c.**1697–99?** Hermitage, Leningrad, no. 9517. [Daniels 1976, no. 132—ill.]

French School (near circle of Poussin). "Juno, Venus, and Vulcan" (on a cloud). Painting. **17th century.** Muzeum Narodowe, Warsaw, inv. 129741, on display at Belweder Palace. [Warsaw 1969, no. 1545—ill.]

German School (previously attributed to Gérard de Lairesse). "The Forge of Vulcan." Painting. **17th century.** Herzog Anton Ulrich-Museum, Braunschweig, no. 290. [Braunschweig 1976, p. 18 / also Braunschweig 1969, p. 85]

Italian School. "The Forge of Vulcan." Painting. **17th century.** Herzog Anton Ulrich-Museum, Braunschweig, no. 1121. [Braunschweig 1976, p. 35]

Italian School (previously questionably attributed to Jacopo Amigoni, 1675–1752). "Venus and Vulcan." Painting. c.**1700.** Herzog Anton Ulrich-Museum, Braunschweig, no. 471. [Braunschweig 1969, p. 27]

Antoine Houdar de La Motte, 1672–1731. (Vulcan in) *Momus fabuliste, ou, Les noces de Vulcain* [Momus the Fabulist, or, Vulcan's Wedding]. Dramatic fable. In *Fables nouvelles* (Paris: Dupuis, **1719**). [NUC]

Louis Fuzelier, 1674–1752, and **Marc-Antoine Legrand,** 1673–1728. (Vulcan in) *Momus fabuliste, ou, Les noces de Vulcain* [Momus the Fabulist, or, Vulcan's Wedding]. Comedy, parody of La Motte (above). First performed 26 Sep **1719,** Comédie-Française, Paris. Published The Hague: Scheurleer, 1720. [Sharp 1969, 2:1198 / Grove 1980, 7:47 / EDS 1954–66, 5:792]

Francesco Trevisani, 1656–1746. "Venus at the Forge of Vulcan." Painting. **1720–22.** Banco di Roma (Palazzo de Carolis), Rome. [DiFederico 1977, no. 77—ill.]

Louis-Nicolas Clérambault, 1676–1749. *Les forges de Vulcain.* Cantata. Published in *Cantates françoises à I. et II. voix avec simphonie et sans simphonie,* book 5 (Paris: **1726**). [Grove 1980, 4:492]

Laurent Gervais, fl. 1725–45. *Les forges de Lemnos.* Cantata. **1727.** [Grove 1980, 7:309]

Ebeneezer Forrest, fl. 1729–74, attributed, libretto. *Momus Turn'd Fabulist: or, Vulcan's Wedding.* English ballad-opera, after Fuzelier and Legrand (1719). First performed **1729,** Theatre Royal, Lincoln's Inn Fields, London. [EDS 1954–66, 5:792 / Sharp 1969, 2:1071, 1198]

Giovanni Battista Tiepolo, 1696–1770. "Vulcan and Ve-

nus." Painting, sketch for a fresco. c.**1725–30.** Private coll., Zurich. [Morassi 1962, p. 69—ill. / Pallucchini 1968, p. 136 (as uncertain attribution)]

———. "Venus and Vulcan." Painting. c.**1755–60.** Johnson coll., Philadelphia Museum of Art. [Pallucchini, no. 254—ill. / Morassi, p. 44—ill.]

Daniel Gran, 1694–1757. "The Forge of Vulcan." Fresco. **1726–30.** Nationalbibliothek, Vienna. [Knab 1977, pp. 50ff., no. F28—ill.] Oil sketch. Stift Wilten, Innsbruck. [Ibid., no. Ö11—ill.]

Johann Franz Michael Rottmayr, 1654–**1730.** "Venus with Doves and the Anvil (Forge) of Vulcan." Art Institute of Chicago, no. 61.40. [Chicago 1965]

Georg Raphael Donner, 1693–1741. "Venus in Vulcan's Forge." Bronze relief. c.**1732.** Österreichisches Barockmuseum, Vienna, inv. 4199; Szémpmüvészeti Múzeum, Budapest; Münzamtes, Vienna; elsewhere? [Schwarz 1968, no. 38—ill.]

François Le Moyne, 1688–1737, rejected attribution (circle of Pierre-Jacques Cazes). "Venus and Vulcan." Drawing. Musée des Beaux-Arts, Chaumont. [Bordeaux 1984, no. X49]

Matthias Bernard Braun, 1684–**1738,** follower. "Vulcan." Sculpture (head). Národní Galeri, Prague. [Clapp 1970, 1:112]

Pierre Février, 1696–1762/79. *Vulcain dupé par l'amour* [Vulcan Duped by Love]. Cantatille for bass, violin, basso continuo. Paris: **1741.** [Grove 1980, 6:518]

Francesco Solimena, 1657–1747, studio. "Venus in Vulcan's Forge." Painting. Szépmüvészeti Múzeum, Budapest, no. 51.2821. [Budapest 1968, p. 654]

François Boucher, 1703–1770. "The Forge of Vulcan." Painting. **1747.** Louvre, Paris, no. M.I. 1022. [Ananoff 1976, no. 302—ill. / Louvre 1979–86, 3:80—ill.] Replica. 1747. Private coll., New York. [Ananoff 1976, no. 303—ill.]

———. "Venus at Vulcan's Forge." Painting, grisaille sketch for tapestry in "Loves of the Gods" series. c.**1750.** Louvre, Paris, inv. M.I. 1025. [Ibid., no. 352 / Louvre 1979–86, 3:81—ill.] Tapestries woven by Beauvais, 1750. Metropolitan Museum, New York; Council Presidency, Budapest; Wildenstein coll., New York; others unlocated. [Ananoff]

———. "Venus with Vulcan." Painting. 1754. Wallace Collection, London. [Ibid., no. 428—ill.]

———. "Venus at Vulcan's Forge." Painting, model for a "Loves of the Gods" tapestry series. c.**1764.** Salon des Nobles de la Reine, Château de Versailles, no. M.V. 7094, inv. 2708. [Ananoff 1976, no. 484—ill.] Cartoon for tapestry. Louvre, Paris, inv. 2719. [Louvre, 3:82—ill.]

———. "Venus and Vulcan." Painting. Upton House, Banbury, cat. 1964 no. 179. [Wright 1976, p. 23]

Pompeo Batoni, 1708–1787. "Vulcan." Painting. c.**1750.** Musée des Beaux-Arts, Orléans, no. 1111. [Clark 1985, no. 130]

———. "Vulcan in His Forge." Painting. 1750. Private coll. [Clark, no. 131—ill.]

Henry Fuseli, 1741–1825. "Hephaestus." Drawing. **1759.** *Jungendalbum,* Kunsthaus, Zurich. [Schiff 1973, no. 278—ill.]

Antonio Guardi, 1698–1760. "Vulcan." Painting. **1750–60.** V. Cini coll., Venice. [Morassi 1984, no. 77—ill.]

———. "Cupids Making Arrows" (in Vulcan's forge).

Painting, part of "Triumph of Venus" cycle. 1750–60. Italian Embassy, Paris. [Ibid., nos. 79–82—ill.]

Johann Michael Demmler, 1748–**1785.** *Ganymed in Vulkans Schmiede* [Ganymede in Vulcan's Forge]. Musical work for the stage. First performed 30 May 1797, St. Salvator, Augsburg. [Grove 1980, 5:361]

Theodor Schacht, 1748–1823, music. *Vulkan.* Ballet. **1789.** [Hunger 1959, p. 134]

Jean-Baptiste Regnault, 1754–1829. "Venus and Vulcan." Painting. *c.*1796. Hermitage, Leningrad, inv. 5661. [Hermitage 1983, no. 342—ill.]

Friedrich Hölderlin, 1770–1843. "Vulkan." Ode. **1802.** [Beissner 1943–77, vol. 2 / Hamburger 1980]

Bertel Thorwaldsen, 1770–1844. "(Mars and Cupid in) Vulcan's Forge" ("Cupid's Arrows Forged in Vulcan's Smithy"). Marble relief. Modeled *c.*1810. 2 versions, both unlocated. [Cologne 1977, no. 53, p. 164] Plaster original. Thorwaldsens Museum, Copenhagen, no. A419. [Ibid.—ill. / Thorwaldsen 1977, p. 53 / Hartmann, p. 166, pl. 117.1] Plaster variant ("Venus, Mars, and Cupid in the Smithy of Vulcan"). Thorwaldsens Museum, no. A420. [Thorwaldsen, p. 53]

———. "Vulcan." Marble relief. Modeled 1838. Thorwaldsens Museum, no. A8. / Plaster original. Thorwaldsens Museum, no. A9. [Thorwaldsen, p. 21]

Henry R. Bishop, 1786–1855. *Poor Vulcan.* Burletta. Libretto, Charles Dibdin, Jr. First performed 3 Feb **1813,** Covent Garden, London. [Grove 1980, 2:743]

Friedrich Heinrich Füger, 1751–**1818.** "Venus in Vulcan's Forge." Painting. Muzeum Narodowe, Warsaw, inv. 250. [Warsaw 1969, no. 392—ill.]

Pierre Michel de Lovinfosse, 1745–1821. "The Forge of Vulcan." Painting. Bonnefantenmuseum, Maastricht, inv. no. 1257. [Wright 1980, p. 246]

Charles Meynier, 1768–1832. "Pluto and Vulcan Reject the City of Herculaneum's Sacrifice to Them." Ceiling painting. **1827.** Salle G des Antiquités Égyptiennes, Louvre, Paris, inv. 6617 (1279). [Louvre 1979–86, 4:86—ill.]

Johann Nepomuk Haller, 1792–1826. "Vulcan." Design and model for marble statue. Executed by Peter Schöpf, **1841.** Façade, Glyptothek, Munich. [Glyptothek 1980, no. 239—ill.]

Antoine Wiertz, 1806–**1865.** "Vulcan's Forge" (Venus and Vulcan, Cupid, nymphs). Painting. Musées Royaux des Beaux-Arts (Musée d'Art Moderne), Brussels, inv. 1932. [Brussels 1984b, p. 705—ill.]

Arthur W. E. O'Shaughnessy, 1844–1881. "The Wife of Hephaestus." Poem. In *An Epic of Women and Other Poems* (London: Hotten, **1870**). [Bush 1937, p. 558]

Arthur John Arbuthnott Stringer, 1874–1950. "Hephaestus." Poem. In *Hephaestus and Other Poems* (Toronto: Methodist Publishing, **1903**). [Bush 1937, p. 566 / Boswell 1982, p. 298]

Paul Manship, 1885–1966. "Venus and Vulcan." Gilded bronze candelabra figures. **1917.** 12 casts. Cranbrook Academy Galleries, Bloomfield Hills, Mich. (2); Metropolitan Museum, New York; elsewhere. [Murtha 1957, no. 79]

Lovis Corinth, 1858–1925. "The Forge of Vulcan." Etching, in "Antique Legends" series. **1919.** [Schwarz 1922, no. 351]

William Blake Richmond, 1842–**1921.** "Hera and Hephaestus." Painting. Art Gallery, Toronto. [Hunger 1959, p. 136]

Max Ernst, 1891–1976. "Landscape with Vulcan." Abstract painting. **1924?** Unlocated. [Spies & Metken 1975–79, no. 622—ill.]

Louis MacNeice, 1907–1963. (Vulcan evoked in) "Birmingham." Poem. Oct **1933.** [Dodds 1966]

Otto Stoessl, 1875–1936. "Hephaistos und Kypris" [Hephaestus and Cypris [Aphrodite]. Poem. In *Arcadia,* vol. 1 of *Gesammelte Werke* (Vienna: Saturn, **1933**). [DULC 1959–63, 4:672]

André Masson, 1896–1987. "In Honor of Vulcan." Collage-painting. **1942.** Rose Masson coll. [Benincasa 1981, p. 51—ill.]

Giorgio de Chirico, 1888–1978. "The Forge of Vulcan." Painting. **1949.** Pinacoteca, Forlì. [de Chirico 1971–83, 2.2: no. 163—ill.]

John Erskine, 1879–1951. *Venus, the Lonely Goddess* (her life as wife of Hephaestus during the Trojan War). Short novel. New York: Morrow, **1949;** illustrated by Warren Chappell. [Boswell 1982, p. 102]

Arno, 1930–. "Vulcan's Forge." Painting. **1955.** Galerie des 20. Jahrhunderts, Berlin. [Berlin 1963, no. 69]

John Holloway, 1920–. "Hephaistos." Poem. In *The Minute and Longer Poems* (East Yorkshire: Marvell, **1956**). [Boswell 1982, p. 263]

Leonard Baskin, 1922–. "Hephaestus." Wood sculpture. **1963.** Portland Art Museum, Ore. [Jaffe 1980, p. 214]

———. "Hephaestus." Bronze statue. Modeled 1963, cast 1965. Hirschhorn Museum, Washington, D.C.; Ringling Museum, Sarasota, Fla.; Whitney Museum, New York; Armand Erpf coll., New York. [Ibid., pp. 165, 214—ill. / Hirshhorn 1974, p. 662, pl. 909]

———. "Hephaestus." Etching, illustration for an edition of *The Iliad* (New York: Delphic Arts, 1963). [Fern & O'Sullivan 1984, p. 151]

A. D. Hope, 1907–. (Jupiter and Hephaestus in) "Argolis." Poem. In *New Poems, 1965–1969* (Sydney: Angus & Robertson, **1969**). [Hooton 1979, p. 6]

Claudio Parmiggiani, 1943–. "Vulcan and Venus." Assemblage (2 painted canvases, hammer and anvil, wooden stump). **1977.** P. Pagani coll., Bologna. [Munich 1984, p. 61—ill. / also Reggio Emilia 1985, p. 71—ill.]

Franz Fühmann, 1922–1984. (Vulcan at his forge in one of the stories of) *Der Geliebte der Morgenröte* [The Beloved of Aurora]. Story cycle. Rostock: Hinstorff, **1978.** [Oxford 1986, p. 271]

William Oxley, 1939–. "The Notebook of Hephaestus." Poem. In *The Notebook of Hephaestus and Other Poems* (Kinross: Lomond, **1981**). [Vinson 1985, p. 640]

Laurence Josephs. "Hephaestus." Poem. In *St. John's Review* 33 no. 2 (Winter **1982**). [Ipso]

HERA. The daughter of the Titans Cronus and Rhea, Hera was the wife and sister of Zeus (Jupiter) and the mother of Ares (Mars), Eileithyia, Hebe, and Hephaestus (Vulcan). A goddess worshiped in

pre-Hellenic times, she was the deity of marriage and women.

She was perhaps the most jealous goddess in the Greek pantheon: Zeus's innumerable affairs were well known to her, so that she frequently occupied herself with taking vengeance on his mistresses, such as Callisto, Leto, Io, and Semele, and on his off-spring, including Dionysus (Bacchus) and Heracles.

Hera's nature also prompted her hatred of the Trojans after the Judgment of Paris, in which the Trojan prince favored Aphrodite (Venus) over her and Athena (Minerva). Because of his decision, both Hera and Athena sided with the Greeks in the Trojan War. Hera also harried Aeneas at Troy and throughout his travels.

Hera is often equated with the Roman goddess Juno, an old Italian deity whose sphere of responsibility was closely parallel. Juno presided over women and the sexual aspects of their lives, especially marriage and childbirth. The Matronalia, March 1, celebrated Juno as patron of women; June, her month, was the propitious time for weddings. Unlike Hera, however, Juno gained importance as a goddess of the state and in Roman times was worshiped as "Juno Regina" (Queen Juno).

The goddess is often depicted with her husband or with other deities, especially her children. Images of her as a benefactress of women are also popular, particularly in allegorical renderings. She is associated with the peacock (an attribute explained in the myth of Io), and is often depicted riding in a chariot drawn by peacocks, sometimes symbolizing the element Air.

Classical Sources. Homer, *Iliad* 1.536–95, 4.5–67, 5.711–92, 8.198–211, 8.350–484, 14.153–351, 15.12–151, 20.113–131, 20.309–317, 21.377–81, 21.418–22, 24.55–63. *Homeric Hymns,* "To Hera," "To Delian Apollo" lines 92–101, "To Pythian Apollo" lines 300–55. Hesiod, *Theogony* 326–32, 453–506, 921–34. Pindar, *Pythian Odes* 2.21–41; *Nemean Odes* 1.37–40. *Orphic Hymns* 16, "To Hera." Apollonius Rhodius, *Argonautica,* passim. Virgil, *Aeneid* 1.4–80, 4.90–128, 7.286–340, 7.540–71, 9.1–24, 10.1.117, 10.606–632, 12.791–886. Ovid, *Metamorphoses* 1.601–746, 2.466–533, 3.255–338, 3.362–69, 4.416–562, 9.280–323. Apollodorus, *Biblioteca* 1.1.6, 2.1.3–4, 2.4.8, 3.6.7., 3.8.2, E3.2. Seneca, *Hercules furens* 1–124. Pausanias, *Description of Greece* 2.13.3, 2.17.1–7, 8.22.1–2, 9.2.7–3.8. Hyginus, *Fabulae* 5, 13, 22, 52, 102, 150. Lucian, *Dialogues of the Gods* 9, "Hera and Zeus," 18, "Hera and Leto," 22, "Hera and Zeus."

See also AENEAS; APHRODITE, Girdle; ATHAMAS; CALLISTO; GANYMEDE; GODS AND GODDESSES; HERACLES; IO; IXION; PARIS, Judgment; SEMELE; TIRESIAS; TROJAN WAR; ZEUS.

Giovanni Boccaccio, 1313–1375. "De Junone regnorum dea" [Juno, Goddess of the Realms]. In *De mulieribus claris* [Concerning Famous Women]. Latin verse com-pendium of myth and legend. **1361–75.** Ulm: Zainer, 1473. [Branca 1964–83, vol. 10 / Guarino 1963]

Christine de Pizan, *c.*1364–*c.*1431. (Juno as goddess of wealth in) *L'epistre d'Othéa à Hector* . . . [The Epistle of Othéa to Hector] chapter 49. Didactic romance in prose. *c.*1400. MSS in British Library, London; Bibliothèque Nationale, Paris; elsewhere. / Translated by Stephen Scrope (London: *c.*1444–50). [Bühler 1970 / Hindman 1986, p. 198]

———. (Juno in) *Le livre de la Cité des Dames* [The Book of the City of Ladies] part 2 no. 61. Didactic compen-dium in prose, reworking of Boccaccio's *De mulieribus claris.* 1405. [Hicks & Moreau 1986] Translated by Brian Anslay (London: Pepwell, 1521). [Richards 1982]

Sandro Botticelli, 1445–1510, school. (Juno as) "Summer" (? or Ceres or Abundantia?). Painting, part of "Seasons" cycle. **1490s** or later. Unlocated. [Lightbown 1978, no. C58—ill.]

Sebastiano del Piombo, *c.*1485–1547. "Juno" (in peacock chariot). Fresco. *c.*1511. Sala di Galatea, Villa Farnesina, Rome. [d'Ancona 1955, pp. 39ff., 88—ill. / Gerlini 1949, pp. 15f.—ill.]

Baldassare Peruzzi, 1481–1536. "Juno." Fresco. **1511–12** (or *c.*1517–18). Sala delle Prospettive, Villa Farnesina, Rome. [d'Ancona 1955, pp. 27ff., 93f. / Gerlini 1949, pp. 31ff. / also Frommel 1967–68, no. 51]

———, attributed (previously attributed to Perino del Vaga, Raphael). "Juno in the Peacock Chariot." Fresco, for Villa Madama, Rome. 1521–23. Later overpainted. [Frommel, no. 58b—ill. (drawing)]

Antonio da Correggio, *c.*1489/94–1534. "The Punishment of Hera" (by Zeus, for harassing Heracles?). Fresco. *c.*1519. Camera di San Paolo, Parma. [Gould 1976, pp. 51ff., 244]

Raphael, 1483–1520, follower. "Jupiter and Juno Stand-ing in the Clouds." Painting. Christ Church, Oxford. [Byam Shaw 1967, no. 131—ill.]

Giulio Romano, *c.*1499–1546, assistants, after designs by Giulio. Juno depicted in frescoes and stuccoes in Sala dei Cavalli and Sala dei Venti, Palazzo del Tè, Mantua. **1527–30.** [Verheyen 1977, pp. 115, 119f. / also Hartt 1958, pp. 115ff.]

———. "Jupiter and Juno Ascend to Olympus." Painting, part of "Jupiter" cycle. *c.*1533? Hampton Court Palace. [Hartt, pp. 214f.—ill.]

Francesco Primaticcio, 1504–1570. "Juno under a Trellis." Painting. *c.*1543. Grotte du Jardin des Pins, Fontaine-bleau. Badly damaged. / Drawing. Louvre, Paris, no. 8551. [Dimier 1900, pp. 309ff., no. 38]

———, design. "Juno in the Land of Sleep." Fresco. 1541–44. Porte Doré, Château de Fontainebleau. Repainted in the 19th century as "Diana and Endymion." / Draw-ings for. Louvre, Paris, nos. 8613, 8567. [Ibid., pp. 306f., nos. 100.1, 134] Engraved by Monogrammist J. V. [Ibid., no. 85]

———. "Apollo, the Graces, and the Muses, with Jupiter and Juno" ("Parnassus and Jupiter"). Ceiling fresco, in Galerie d'Ulysse, Château de Fontainebleau. 1541–47. Destroyed 1738–39. / Drawing. Uffizi, Florence, inv. 1503E. [Béguin et al. 1985, pp. 190ff.—ill. / Dimier, pp. 295ff., no. 138]

———. "Juno." Fresco, for Salle de Bal, Fontainebleau, executed by Niccolò dell' Abbate under Primaticcio's direction. 1551–56. Repainted 19th century [Dimier, pp. 160ff., 284ff.]

Benvenuto Cellini, 1500–1571. "Juno." Lifesize silver statue, part of series of Olympians. *c.*1540–45. Lost (possibly never completed). / Bronze model. Private coll., Paris. [Pope-Hennessy 1985a, pp. 102ff., pls. 53–54] Drawing. Louvre, Paris. [Ibid., pl. 52 / also Lévêque 1984, p. 6—ill.]

Italian School. "Juno." Painting. 1525/50. Szépművészeti Múzeum, Budapest, no. 1472. [Budapest 1968, p. 329]

Paolo Veronese, 1528–1588. "Juno Pouring Gifts over [a woman representing] Venice." Ceiling painting. 1553. Sala dei Dieci, Palazzo Ducale, Venice. [Pignatti 1976, no. 26—ill. / also Berenson 1957, p. 137] Copies by Adolphe Crespin (1859–1944) and Jean-François Portaels (1818–1895). Musées Royaux des Beaux-Arts (Musée d'Art Moderne), Brussels, inv. 7063, 7005. [Brussels 1984b, pp. 144, 508—ill.]

———. "Juno." Fresco. *c.*1557. Palazzo Trevisan, Murano. [Mariuz 1982, no. 36b—ill. / Pignatti, no. 65—ill. / cf. Byam Shaw 1967, no. 108—ill.]

———. "Hymen between Juno and Venus with a Bride and Groom before Him" ("Tribunal of Love"). Fresco. *c.*1560–61. Stanza dell' Amore Coniugale, Villa Barbaro-Volpi, Maser (Treviso). [Pallucchini 1984, no. 61a—ill. / also Pignatti, no. 99—ill.]

———. "Juno and Apollo." Painting, part of series glorifying Germany, for Fondaco dei Tedeschi, Venice. *c.*1578–80. Formerly Kaiser Friedrich Museum, Berlin, destroyed. [Pallucchini, no. 168b—ill. / Pignatti, no. 210—ill.]

Battista Zelotti, *c.*1526–1578. "Janus and Juno." Painting, ceiling panel. 1553–54. Sala dei Dieci, Palazzo Ducale, Venice. [Berenson 1957, p. 204—ill.]

Giorgio Vasari, 1511–1574, and **Cristofano Gherardi**, 1508–1556. Painting cycle (fresco and canvas), executed by Gherardi under Vasari's direction, for Terrazzo di Giunone, Palazzo Vecchio, Florence. 1555–59 (frescoes later repainted). In place. [Sinibaldi 1950, pp. 13, 23 / Barocchi 1964, pp. 42, 135, 316 / also Lensi 1929, p. 165—ill.]

Bartolommeo Ammannati, 1511–1592. "Fountain of Juno." Fountain, for Sala Grande (Sala dei Cinquecento), Palazzo Vecchio, Florence. Late 1550s. [Pope-Hennessy 1985b, 3:459, 373]

Alessandro Vittoria, 1525–1608. Figures of Jupiter and Juno atop a set of bronze andirons. *c.*1560. Private coll. (?), London. [Cessi 1960, p. 45, pls. 18–19]

———. "Juno." Bronze statuette. 1580s? Museo Civico, Padua; at least one other example known. [Ibid., p. 56, pl. 38]

Andrea Schiavone, 1522–1563. "Jupiter, Juno [or Venus?], and Cupid." Drawing, sketch for (unexecuted?) work. Several versions. Museo Civico, Bassano, nos. 8.226.531–536. [Richardson 1980, no. 151—ill.]

Giovanni Bandini, 1540–1599. "Juno." Bronze statuette. 1572–73. Studiolo di Francesco I, Palazzo Vecchio, Florence. [Pope-Hennessy 1985b, 3:100, 380—ill. / Sinibaldi 1950, pp. 12, 18 / also Lensi 1929, pp. 236f. (as Giambologna)]

Jacopo Tintoretto, 1518–1594. "Juno Conferring Power and Nobility on Venice." Frescoes. 1577. Sala delle Quattro Porte, Palazzo Ducale, Venice. [Rossi 1982, nos. 359–60—ill.]

Christopher Marlowe, 1564–1593, and **Thomas Nashe**, 1567–1601. (Jupiter and Venus complain of Juno in) *The Tragedie of Dido, Queene of Carthage* 1.1, (Juno appears in) 3.2. Tragedy. First performed 1587–88, by Children of Her Majestie's Chappell, London. Published London: Woodcocke, 1594. [Bowers 1973, vol. 1 / Oxford 1983b, p. 526 / Leech 1986, pp. 36, 37]

Edmund Spenser, 1552?–1599. (Juno evoked in) *The Faerie Queene* 1.4.17, 3.11.33, 4.1.22. Romance epic. London: Ponsonbie, 1590, 1596, 1609. [Hamilton 1977 / Nohrnberg 1976, p. 51]

———. (Juno evoked in) "Epithalamion" lines 390–97. Poem. In *Amoretti and Epithalamion* (London: Ponsonbie, 1595). [Oram et al. 1989]

Cavaliere d'Arpino, 1568–1640. "Aurora-Juno." Fresco. 1594–95. Loggia Orsini, Palazzo del Sodalizio dei Piceni, Rome. [Röttgen 1969, pp. 279ff.—ill.]

Hendrik Goltzius, 1558–1617. "Juno." Engraving, in "Four Deities" series (Bartsch no. 64, Jan Saenredam). 1596. [Strauss 1977a, no. 330—ill. / Bartsch 1980–82, no. 160c—ill.] Drawing, variant. Rijksprentenkabinet, Amsterdam, inv. 1899–A4316. [Reznicek 1961, no. 117—ill.]

———. "Juno." Drawing, composition for print. *c.*1596. Staatliche Kunstakademie, Düsseldorf. (Print by Jan Saenredam, Bartsch no. 58.) [Reznicek, no. 139—ill.]

John Lyly, *c.*1554–1606, and/or **John Day**, 1574–1640, questionably attributed. (Juno in) *The Maydes Metamorphosis.* Comedy. 1590s? Published London: 1600. [Bond 1902, vol. 3]

Annibale Carracci, 1560–1609. "Jupiter and Juno." Fresco. 1597–1600. Galleria, Palazzo Farnese, Rome. [Malafarina 1976, no. 104a—ill. / Martin 1965, pp. 89f.—ill.] Variant replica (also attributed to Cavaliere d'Arpino, school of Raphael). *c.*1602. Galleria Borghese, Rome, inv. 515. [Pergola 1955–59, 1: no. 17—ill.]

Emilio de' Cavalieri, *c.*1550–1602, music and choreography. *La contesa fra Giunone e Minerva* [The Contest between Juno and Minerva]. Music pastorale. Libretto, Gian Battista Guarini. First performed 5 Oct 1600, Florence, for the wedding of Henry IV of France and Maria de' Medici. [Grove 1980, 4:21ff., 7:771]

Mathieu Jacquet, 1545?–1611, attributed. "Henry IV as Jupiter," "Marie de' Medici as Juno." Pair of bronze statuettes. *c.*1600. Walters Art Gallery, Baltimore. [Wildenstein 1968, no. 18—ill.]

Samuel Daniel, 1562–1619. (Juno in) *The Vision of the Twelve Goddesses.* Masque with songs. First performed 8 Jan 1604, Hampton Court. [Sharp 1969, 1:538, 2:1246]

Ben Jonson, 1572–1637. (Juno as "Unio" [Union] in) "Hymenaei" ("The Masque of Hymen"). Masque. Performed 5 Jan 1606, at Court, London. Published London: 1606. [Herford & Simpson 1932–50, vol. 7 / Carroll 1985, p. 57]

———. (Juno in) "Chloridia: Rites to Chloris and Her Nymphs." Masque. Performed 22 Feb 1630, at Court, London. [Herford & Simpson]

———. (Juno in) "Love's Triumph through Callipolis." Masque. Performed 6 Jan 1631, at Court, London. [Herford & Simpson]

Adam Elsheimer, 1578–1610. "The Realm of Juno." Painting, part of "Three Realms of the World" series (Venus,

Minerva, Juno). *c.*1607–08. Lost. / Etching by Hollar, 1646. [Andrews 1977, no. 22c—ill.]

Francis Bacon, 1561–1626. "Procus Iunonis, sive dedecus" (Juno courted by Jupiter). Chapter 16 of *De sapientia veterum.* Mythological compendium. London: Barker, **1609.** / Translated as "Juno's Suitor, or Baseness" by Arthur Gorges in *The Wisdome of the Ancients* (London: Bill, 1619). Modern facsimile edition (bilingual), New York & London: Garland, 1976. [Ipso]

Thomas Heywood, 1573/74–1641. (Juno in) *Troia Britanica: or, Great Britaines Troy* cantos 1–5. Epic poem. London: **1609.** [Heywood 1974]

———. (Juno in) *The Golden Age, The Silver Age, The Brazen Age.* Dramas, derived from *Troia Britanica.* First performed *c.*1610–13, London. Published London: Okes, 1611, 1613, 1613. [Heywood 1874, vol. 3 / DLB 1987, 62:101, 122ff. / also Boas 1950, pp. 83ff. / Clark 1931, pp. 62ff.]

———. "Of Juno." Passage in *Gynaikeion: or, Nine Books of Various History Concerning Women* book 1. Compendium of history and mythology. London: printed by Adam Islip, 1624. [Ipso]

Second School of Fontainebleau. "Juno." Marble basrelief. *c.*1594–1610. Musée de Cluny, Paris. [Paris 1972, no. 561]

Bartholomeus Spranger, 1546–1611. "Juno, Venus, and Ceres." Drawing. 2 versions. Hessisches Landesmuseum, Darmstadt; Albertina, Vienna. [de Bosque 1985, p. 134—ill.]

William Shakespeare, 1564–1616. (Juno appears in masque for betrothal of Miranda and Ferdinand in) *The Tempest* 4.1.101–138. Drama (romance). **1611.** First performed 1 Nov 1611, Whitehall, London. Published London: Jaggard, 1623 (First Folio). [Riverside 1974]

Peter Paul Rubens, 1577–1640. (Jupiter and Juno in) "(The Fates Spinning) The Destiny of Marie de' Medici," "The Presentation of the Portrait of Marie de' Medici to Henri IV," "The Apotheosis of Henri IV and the Assumption of the Regency by Marie de' Medici," "The Council of the Gods" ("The Government of the Queen"); (Marie and Henri depicted as Jupiter and Juno in) "The Meeting (of Marie de' Medici and Henri IV) at Lyons." Paintings, part of "Life of Marie de' Medici" cycle. **1622–25.** Louvre, Paris, inv. 1769, 1772, 1775, 1779, 1780. [Saward 1982, pp. 20ff., 51ff., 67ff., 98ff., 114ff.—ill. / Jaffé 1989, nos. 710, 718, 725, 735, 737, pp. 61f.—ill. / also Louvre 1979–86, 1:115ff.—ill. / White 1987, pl. 186 / Baudouin 1977, pl. 61] Oil sketches. Louvre, inv. M.I. 212 ("Destiny"); Alte Pinakothek, Munich, inv. 93, 102, 103 ("Portrait," "Apotheosis," "Council"); Hermitage, Leningrad ("Lyons," "Apotheosis"). [Jaffé, nos. 709, 717, 724, 733, 734, 736—ill. / Held 1980, nos. 56, 60, 64, 69–70, 71—ill. / also Louvre, p. 119—ill. / Munich 1983, pp. 463ff.—ill.]

———. "Jupiter and Juno." Painted cut-out, part of Triumphal Arch of Philip IV, decoration for "Pompa Introitus Fernandi," triumphal entry of Cardinal-Infante Ferdinand of Spain into Antwerp, 17 Apr 1635. Private coll., Antwerp. [Martin 1972, p. 69—ill.] Copy, by Frans Wouters, in Staatsgalerie, Stuttgart. [Ibid., fig. 20] Anonymous copy, after (lost) oil sketch for arch. Rubenshuis, Antwerp, on loan from Oudheidkundige Museum, Antwerp. [Ibid., no. 5a—ill. / Held, no. 148—ill. / Jaffé, no. 1122a—ill.]

Jacob Jordaens, 1593–1678. "The Bath of Diana and Her Nymphs" (traditional title, now considered a bath of Juno and nymphs or other goddesses). Painting. *c.*1630. Prado, Madrid, no. 1548. [Prado 1985, p. 343 / also Rooses 1908, pp. 50, 258]

Giovanni da San Giovanni, 1592–1636. "Juno, Venus, and the Three Fates: Allegory of the Union between the Houses of Medici and della Rovere." Ceiling fresco. **1635–36.** Salone degli Argenti, Palazzo Pitti, Florence. [Banti 1977, no. 64—ill.]

Pietro da Cortona, 1596–1669. "Sacrifice to Juno." Fresco. *c.*1636. Palazzo Barberini, Rome. [Briganti 1962, no. 47—ill.]

Giovanni Carlo Coppola, 1599–1652, libretto. (Marriage of Jupiter and Hera in) *Le nozze degli dei* [The Weddings of the Gods]. Opera (favola in musica). First performed **1637,** Palazzo Pitti, Florence, for wedding of Ferdinand, Duke of Tuscany, and Vittoria of Urbino. Libretto published Florence: Massi & Landi, 1637, with an etching by Stefano Della Bella, after Alfonso Parigi. [Bianconi 1987, p. 172 / Taylor 1893, p. 370 / NUC]

Philippe de Buyster, 1595–1688. "Juno." Stone sculpture. **1635–40.** Château de Wideville, near Paris. [Chaleix 1967, pp. 32ff., pl. 4.1]

James Shirley, 1596–1666. (Juno in) *The Constant Maid.* Comedy with songs. First performed *c.*1636–40, Dublin. [Sharp 1969, 1:538; 2:1138]

Robert Herrick, 1591–1674. "An Hymne to Juno," (Juno as goddess of marriage in) "An Epithalamie to Sir Thomas Southwell and his Ladie" lines 41–50; 108–110. Poems. In *Hesperides* (London: Williams & Eglesfield, **1648**). [Martin 1956]

Andrea Camassei, 1601–1649. "Juno in the Peacock Chariot." Painting. Kunsthistorisches Museum, Vienna, inv. 142 (537). [Vienna 1973, p. 36]

Francesco Manelli, 1594–1667. *La filo, overo, Giunone repacificata con Ercole* [The Thread, or, Juno Reconciled with Hercules]. Opera. Libretto, Francesco Berni. First performed **1660,** Teatro Farnese, Parma. [Grove 1980, 11:613]

Rembrandt van Rijn, 1606–1669. "Juno." Painting. *c.*1660–65. Middendorf coll., on loan to Metropolitan Museum, New York. [Gerson 1968, no. 374—ill. / Wildenstein 1968, no. 34—ill.]

Jan van Noort, 1620–*c.*1676. "Juno." Painting. Herzog Anton Ulrich-Museum, Braunschweig, no. 1373. [Braunschweig 1976, p. 45]

Jan van Kessel the Elder, 1626–1679. "Juno." Painting. Gemeentelijk Museum "Het Prinsessehof," Leeuwarden, inv. OKS 1978/1. [Wright 1980, p. 209]

Luca Giordano, 1634–1705. (Juno in) "Allegory of Agriculture," detail in "Allegory of Human Life and the Medici Dynasty." Fresco. **1682–83.** Palazzo Medici Riccardi, Florence. [Ferrari & Scavizzi 1966, 2:112ff.—ill.] Study. Denis Mahon coll., London. [Ibid.—ill.]

Ferdinando Tacca, 1619–1686. "Mercury and Juno" ("Juno Seated, with Mercury Uncovering a Vase Held in His Left Arm"). Bronze statuette. 3 examples known. Museum, Nuremburg; Walker Art Gallery, Liverpool; Petit-Hory coll., Paris. [Florence 1986, no. 4.35—ill.]

French School (near circle of Poussin). "Juno, Venus,

and Vulcan" (on a cloud). Painting. **17th century.** Muzeum Narodowe, Warsaw, inv. 129741, on display at Belweder Palace. [Warsaw 1969, no. 1545—ill.]

Italian School. "Jupiter and Juno." Painting. **17th century.** Formerly Comendadoras coll., Madrid, unlocated. [López Torrijos 1985, pp. 266, 416 no. 11—ill.]

North Netherlandish School. "Portrait Bust of Juno." Painting. **17th century.** Academic Voor Hoger Bouwkundig Onderwijs, Amsterdam, cat. 1976 no. A25196. [Wright 1980, p. 309]

Balthasar Permoser, 1651–1732. "Juno." Sandstone statue, pair with "Jupiter" (originally part of a group of 4, Mars and Venus destroyed). *c.*1705–06. Museum des Kunsthandwerks, Leipzig. [Asche 1966, no. P38, pls. 41–42]

Benjamin Thomae, 1682–1751. "Juno." Sandstone statue, pair with "Jupiter." *c.*1718. Wallpavillon, Zwinger, Dresden. [Asche 1966, no. T24, pl. 160f.]

Jacob de Wit, 1695–1754. "Juno." Ceiling painting. *c.*1719. Lost. / Drawing. Prentenkabinett, Rijksuniversiteit, Leiden. [Staring 1958, pp. 143f., pl. 83]

———. "Jupiter and Juno." Chimney painting. 1746. Herengracht 468, Amsterdam. [Ibid., p. 153, pl. 48]

François Le Moyne, 1688–1737. "Glorification of Juno." Painting. *c.*1720–24. Unlocated. [Bordeaux 1984, no. 35—ill.]

———. "Juno, Iris, and Flora." Painting. Louvre, Paris, inv. 6717. [Louvre 1979–86, 4:47—ill. / Bordeaux, no. 34—ill.]

Johann Joseph Fux, 1660–1741. *Giunone placata* [Juno Appeased]. Opera (festa teatrale). Libretto, Ippolito Zanelli. First performed 19 Nov **1725,** Hoftheater, Vienna. [Grove 1980, 7:46]

Giovanni Battista Tiepolo, 1696–1770. "Juno with Fortuna and Venus." Fresco. **1731.** Formerly Palazzo Archinto, Milan, destroyed 1943. [Pallucchini 1968, no. 61—ill. / Morassi 1962, p. 25—ill.]

——— (and collaborator?). "Juno and Luna." Painting, representing Air, part of "Elements" series for Villa Girola, Como. *c.*1740. Timken coll., New York. [Pallucchini, no. 136—ill. / Morassi, p. 36—ill.; cf. p. 11]

———. "Juno and the Peacock on Clouds." Grisaille fresco (detached), from Palazzo Sagredo, Venice. *c.*1750. Crespi coll., Milan. [Pallucchini, no. 196—ill. / Morassi, p. 27—ill.]

Gerard Hoet the Elder, 1648–1733. "Juno." Painting. Castle Slagenburg, Doetinchem. [Warburg]

Henry Fielding, 1707–1754. "An Interlude between Jupiter, Juno, Apollo, and Mercury." Comic interlude. *c.*1736–37. In *Miscellanies,* vol. 1 (London: Millar, 1743). Modern edition by H. K. Miller (Middletown, Conn.: Wesleyan University Press, 1972). [Nicoll 1959–66, 2:328]

Benedetto Marcello, 1686–1739. *Le nozze di Giove e Giunone* [The Marriage of Jove and Juno]. Cantata, for a royal wedding. [Grove 1980, 11:649]

Niccola de' Marini, 1704–1790, libretto. *Il natale di Giunone* [The Birth of Juno]. Serenata. First performed **1742,** Palermo. Libretto published in *Rime* (Palermo: Rapetti, 1776). [DELI 1966–70, 3:511]

Charles-Joseph Natoire, 1700–1777. "Jupiter and Juno [or Callisto?]." Painting. **1745.** Nationalmuseum, Stockholm. [Boyer 1949, no. 70]

Jean-Philippe Rameau, 1683–1764. *Platée, ou, Junon jalouse* [Platée, or, Juno Jealous]. Opera (comédie lyrique).

Libretto, J. Autreau and A. J. Le Valois d'Orville. First performed 31 Mar **1745,** Versailles. [Girdlestone 1983, pp. 412–55 / Grove 1980, 15:564, 566, 570]

Corrado Giaquinto, 1703–1765. (Juno in) "Apotheosis of the Spanish Monarchy" (?). Ceiling painting, for Palazzo Santa Croce, Palermo. Now in Palazzo Rondinini-Sanseverino, Rome. *c.*1751? / Study. National Gallery, London, inv. 6229. [London 1986, p. 232—ill.]

———. (Juno in) "The Birth of the Sun and the Triumph of Bacchus." Painting. Prado, Madrid, inv. 103. [Prado 1985, p. 243]

Carle van Loo, 1705–1765. "Juno." Painting. Hermitage, Leningrad. [Bénézit 1976, 6:730]

Christian Joseph Lidarti, 1730–*c.*1793. *La tutela contrastata fra Giunone, Marte e Mercurio, col giudizio di Giove* [The Guardianship Contested among Juno, Mars, and Mercury, with the Judgment of Jove]. Dramatic musical composition. 1767. [Grove 1980, 10:827]

Joshua Reynolds, 1723–1792. "Annabella, Lady Blake, as Juno." Painting. Exhibited 1769. Sold New York, 1915, unlocated. [Waterhouse 1941, p. 60—ill.]

Johan Tobias Sergel, 1740–1814. "Jupiter and Juno." Sculpture. *c.*1769–70. Nationalmuseum, Stockholm, no. 489. [Pressly 1981, pl. 29 / Göthe 1921, no. 12—ill.]

James Barry, 1741–1806. "Jupiter and Juno on Mount Ida." Painting. *c.*1773. Unlocated. [Pressly 1981, no. 11] Etching after. 2 states, 1777, *c.*1790. [Ibid., no. P.11—ill.]

———. "Jupiter and Juno on Mount Ida." Painting. *c.*1804. Sheffield City Art Galleries, England. [Ibid., no. 35—ill.; cf. no. P.39]

Antoine François Callet, 1741–1823. "Spring: Homage of the Roman Ladies to Juno." Painting, design for Gobelins tapestry series "The Four Seasons." 1787. Musée, Amiens, on deposit from Louvre, inv. 3103. [Louvre 1979–86, 3:95, 5:217]

French School. "Juno Receiving Garments from a Young Man." Painting. **18th century.** Galleria Palatina, Palazzo Pitti, Florence. [Pitti 1966, p. 238—ill.]

Italian School. "Juno." Alabaster bust. **18th century.** Galleria Borghese, Rome, inv. 146. [Faldi 1954, no. 12—ill.]

Angelica Kauffmann, 1741–1807, attributed. "Juno." Ceiling painting, from Ashburton House. Formerly Litchfield Gallery, London, unlocated. [Manners & Williamson 1924, p. 195]

Franz Volkert, 1778–1845. *Junon protectrice.* Comic opera. First performed **1816,** Leopoldstadt. [Clément & Larousse 1969, 1:628]

Simon Mayr, 1763–1845. *La figlia dell' aria, ossia, La vendetta di Giunone* [The Daughter of Air, or, The Vendetta of Juno]. Opera (dramma per musica). Libretto, G. Rossi. First performed Lent **1817,** San Carlo, Naples. [Grove 1980, 11:860]

Thomas Wade, 1805–1875. "The Nuptials of Juno." Poem. In *Tasso and the Sisters* (London: Letts Jr., **1825**). [Bush 1937, pp. 171, 550]

Gilbert Abbott À Beckett, 1811–1856. *Caught Courting; or, Juno, by Jove!* Burletta. First performed 2 Aug **1834,** London. [Nicoll 1959–66, 4:249]

William Leman Rede, 1802–1847. *Jupiter and Juno; or, The Roué Reformed.* Farce/burletta. First performed 26 Feb **1835,** Strand Theatre, London. [Nicoll 1959–66, 4:607]

Luigi Catani, 1762–1840. "Juno." Fresco. Sala dell' Educazione di Giove, Palazzo Pitti, Florence. [Pitti 1966, p. 241]

Antoine-Louis Barye, 1796–1875. (Juno, with Minerva and Venus, in) "Candelabrum of Nine Lights." Bronze candlestick. c.1847. Walters Art Gallery, Baltimore. [Benge 1984, pp. 150f.—ill.] Bronze edition of the 3 figures, by 1855. / Bronze edition of separate figures, by 1855. Baltimore; elsewhere. [Ibid., fig. 146 / also Pivar 1974, no. F19—ill.]

Walter Savage Landor, 1775–1864. "Hymn and Offering of Terpander to Juno." Poem. In Hellenics, revised edition (Edinburgh: Nichol, 1859). [Wheeler 1937, vol. 2225]

Jean-Auguste-Dominique Ingres, 1780–1867. "Juno." Painting. Art market, U.S.A., in 1954. [Wildenstein 1954, no. 262—ill.]

Aubrey de Vere, 1814–1902. "A Statue of Juno." Poem. In Poetical Works (London: Kegan Paul, Trench, 1884). [Boswell 1982, p. 85]

Hector Le Roux, 1829–1900. "Juno at Nauplia." Detail (now obscured) of ceiling painting. 1889. Cabinet de Marie Antoinette, Louvre, Paris (inv. 20089). [Louvre 1979–86, 4:53] Sketch after. Louvre, inv. 20535. [Ibid.]

Anonymous. Juno. Musical farce. First performed 7 Sep 1896, Brighton. Title changed to The Gay Goddess, 1908. [Nicoll 1959–66, 5:701]

Carl Spitteler, 1845–1924. Hera die Braut [Hera the Bride] (Hera, in love with Apollo, marries Zeus), part 2 of Olympischer Frühling [Olympian Spring]. Epic poem. 1900–06. / Revised, published Jena: Diedericks, 1910. [Butler 1958, p. 321]

Lovis Corinth, 1858–1925. "Juno, Juno!" Lithograph, letter I/J from "ABC" series. 1917. [Schwarz 1922, no. L315]

W. Blake Richmond, 1842–1921. "Hera and Hephaistos." Painting. Art Gallery, Toronto. [Hunger 1959, p. 136]

Sean O'Casey, 1880–1964. Juno and the Paycock (symbolic evocation of the myth in title). Tragedy. First performed 1924, Abbey Theatre, Dublin. [McGraw-Hill 1984, 4:8f.]

Francis Picabia, 1878–1953. "Hera." Surrealistic painting. c.1929. Private coll., Paris. [Camfield 1979, p. 237, fig. 314 / also Borràs 1985, no. 537—ill.]

Georges Braque, 1882–1963. "Hera and Themis." Etched-plaster relief, after Hesiod. 1931–32. [Braque 1961, p. 76—ill. / Fumet 1951, introduction; cf. nos. 21–28—ill.]

———. "Helios" ("Hera"). Color lithograph. 1946–48. [Braque, no. 29—ill. / Cogniat 1980, fig. 39—ill.]

William Empson, 1906–1984. "Invitation to Juno." Poem. In Poems (London: Chatto & Windus, 1935). [Ipso / CLC 1981, 19:155]

Aristide Maillol, 1861–1944. "Juno." Lithograph. [Guérin 1965, no. 274—ill.]

Paul Valéry, 1871–1945. "L'histoire d'Hera" [The Story of Hera]. Prose poem. In Histoires brisées (Paris: Gallimard, 1950). [Hytier 1957–60, vol. 2 / Mathews 1956–71, vol. 2]

Robert Graves, 1895–1985. (Zeus and Hera complain about) "The Weather of Olympus." Poem. In Poems, 1938–1945 (London: Cassell, 1945). [Graves 1975]

Raoul Dufy, 1877–1953. "Juno." Painting. Sold Hôtel Rameau, Versailles, 1984, unlocated. [Laffaille 1985, no. 2038—ill.]

Jules Olitski, 1922–. "Juno Emanation—5." Abstract painting. 1979. M. Knoedler & Co., New York, in 1981. [Moffett 1981, pl. 135]

Carolyn Kizer, 1925–. "Hera, Hung from the Sky." Poem. In Mermaids in the Basement (Port Townsend, Wash.: Copper Canyon Press, 1984). [Ipso]

HERACLES.

The son of Zeus (Jupiter) and Alcmene, wife of Amphitryon, Heracles (Hercules) became the exemplary Greek hero through the famous twelve labors and other adventures. In youth he was known by the patronym Alcides, after his earthly grandfather Alcaeus, father of Amphitryon. The origin of the name Heracles ("Glory of Hera") is unclear; however, almost all of Heracles' deeds and sufferings grew out of Hera's spite.

A complex figure, Heracles was endowed with near godlike strength, courage, and fortitude, yet showed his humanity in a violent temper, a lack of temperance (particularly in drink), and an insatiable amorousness. These negative traits were easily forgiven in view of his generosity, defense of the threatened or oppressed, and expense of energy for the cause of right, but they caused him many hardships and eventually contributed to his death. According to the sophist Prodicus, as a young man Alcides was given the choice of a life of pleasure or virtue; he chose the latter, with its attendant trials, but did not entirely renounce the former.

The adventures of Heracles cited in Greek and Roman myth are varied and numerous. As a child, he escaped death at the hands of Hera (Juno) by strangling the snakes she placed in his cradle. Educated by the greatest experts in archery, wrestling, and music, he showed his violence and unpredictability when he slew his music tutor, Linus. As a young man he was sent to tend the herds of Amphitryon on Mount Cithaeron, where he killed a marauding lion and thus proved his skill and bravery. When he returned to Thebes, he married Megara, daughter of King Creon, but unwittingly murdered their children in a fit of madness brought on by Hera.

In penance, Heracles was obliged to undertake the famous twelve labors, during which he also performed many other exploits. These included subduing the giant Antaeus and the monster Cacus; setting up the Pillars of Hercules at the limits of the known world; establishing the Olympic Games; engaging in a battle with Pholus and other centaurs that resulted in the wounding and eventual death of the wise centaur Chiron. He also rescued Alcestis from Hades; sailed with the Argonauts; sacked the city of Troy after its king, Laomedon, had refused payment for the rescue of his daughter; and fought

at the side of the Olympians against the insurgent Giants.

After completing the labors, Heracles married Deianeira of Calydon, but later fell in love with Iole, a daughter of King Eurytus of Oechalia. For killing her brother, he was sold into slavery to Queen Omphale of Lydia for a year. His painful death, brought about by his romantic entanglement with both Iole and Deianeira, was followed by his ascension to Olympus, reconciliation with Hera, and marriage to her daughter Hebe.

Heracles has been portrayed as both a hero and a god, a dual role that was debated by scholars as early as the fifth century BCE, when the historian Herodotus identified the divine and mortal Heracles as two different figures. He was worshiped throughout Greece, especially among the Dorians. In Rome he was said to have abolished human sacrifice among the Sabines. Evander, the legendary founder of Rome, was said to have especially revered Hercules as a god.

So complex were the legends surrounding Heracles that Aristotle commented on the difficulty of writing a unified epic or tragedy about him. However, Euripides and Sophocles did produce enduring tragedies centering on his death, and Aristophanes and other comic poets successfully celebrated the hero's human foibles. Moralists and philosophers concentrated on the unselfish fortitude that allowed him to labor for the good of man and achieve immortality through his virtue.

A popular figure in classical art, Heracles was often depicted with a lion-skin cloak, club, and bow. His image was common not only in vase painting and the minor arts, but also in monumental sculpture; the metopes of the Temple of Zeus at Olympia (c.460 BCE) take the twelve labors as their theme. In the postclassical arts Heracles is often an allegorical figure, representing strength and courage against moral evils. Athena (Minerva), as goddess of wisdom and virtue, is his especial protector. In the Middle Ages the hero's rescue of Alcestis and his apotheosis were sometimes interpreted as linking him with Christ.

A sidelight on the theme is that of the "Gallic Heracles." Lucian claimed to have seen in Gaul a picture of Heracles dragging his followers by delicate chains of gold and amber fastened to their ears and to his pierced tongue. This image became an allegory of eloquence, reflecting a French claim to Herculean origins. In Alciati's *Emblemata* (1534) Heracles is depicted as "Typus Eloquentiae."

Classical Sources. Homer, *Iliad* 8.366–69, 19.96–133; *Odyssey* 11.602–27. Hesiod, *Shield of Heracles* 57–480. *Homeric Hymns*, "To Heracles." Epicharmus, *Heracles with Pholus*; *Heracles' Voyage to the Sword-Belt of Hippolyta* (fragment); *The Marriage of Hebe.* Herodotus, *Heracles*; *History* 2.44. Sophocles, *The Women of Trachis*; *Heracles*. Euripides, *Heracles.* Orphic Hymns 12, "To Heracles." Xenophon, *Memorabilia* 1.21ff. Theocritus, *Idylls* 24, 25. Diodorus Siculus, *Biblioteca* 4. Apollodorus, *Biblioteca* 4.8–8.1. Seneca, *Hercules furens, Hercules oetaeus.* Pausanias, *Description of Greece* 5.5.10. Hyginus, *Fabulae* 29–36. Lucian, *Heracles*; *Dialogues of the Dead* 11, "Diogenes and Heracles," 15, "Zeus, Asclepius, and Heracles."

Further Reference. Karl Galinsky, *The Herakles Theme: The Adaptations of the Hero in Literature from Homer to the Twentieth Century* (Totowa, N.J.: Rowman & Littlefield, 1972).

Listings are arranged under the following headings:

General List
Birth of Heracles
Infant Heracles and the Serpents
Choice of Heracles
Madness of Heracles
Pillars of Heracles
Heracles and Cacus
Heracles and Antaeus
Heracles and Deianeira
Heracles and Iole
Heracles and Omphale
Death of Heracles
Apotheosis

See also HERACLES, LABORS OF; *also* ALCESTIS; JASON, and the Argonauts; LAOMEDON; ODYSSEUS, in Hades; PIRITHOUS, Wedding; PROMETHEUS, Freed; THESEUS, and the Amazons; TITANS AND GIANTS.

General List

Anonymous French. (Hercules' career treated in) *L'histoire ancienne jusqu'à César* [Ancient History to Caesar] folios ending with 123c (Paris MS). Prose history. Dictated to Roger de Lille, **1208–30.** MSS in Bibliothèque Nationale, Paris, f. fr. 20125; Morgan Library, New York, MS 212; elsewhere. [Singerman 1986, p. 155]

Anonymous French. (Adventures of Hercules in) *Ovide moralisé* 9.1–1028. Poem, allegorized translation/elaboration of Ovid's *Metamorphoses. c.*1316–28. [de Boer 1915–86, vol. 3]

John Gower, 1330?–1408. (Hercules presented in) *Confessio amantis* 5.1082–1102. Poem. *c.*1390. Westminster: Caxton, 1483. [Macaulay 1899–1902, vol. 2]

Coluccio Salutati, 1331–1406. *De laboribus Herculis* [Of Heracles' Labors] (and other episodes). Poem, with moralizations. *c.*1406. Modern edition by B. L. Ullman (Zürich: Artemis, 1951). [DELI 1966–70, 5:26 / Trousson 1962, p. 86 / Galinksy 1972, pp. 196f., 226]

Raoul Lefèvre, fl. *c.*1454–67. "Les prouesses et vaillances du preux Hercules" [The Deeds and Bravery of Gallant Hercules]. Last 6 chapters of Book 1 and entire Book 2 of *Le recueil des hystoires de Troyes.* Prose romance. **1464.** / English translation by William Caxton as *The Recuyell of the Historyes of Troye* (Bruges: Mansion, *c.*1474). / Modern edition (of original French) by Marc Aeschbach

(Bern & New York: Lang, 1987). [DLF 1951–72, 1:459 / Galinsky 1972, pp. 191–94, 225]

Piero della Francesca, 1410/12–1492. "Hercules." Fresco (detached, fragment). *c.*1464–70. Gardner Museum, Boston, no. P15E17. [Hendy 1974, p. 188—ll.]

Cristoforo Landino, 1424–1504. (Hercules epitomizes the *vita activa* in) *Landini quaestiones camaldulenses. . . .* Dialogues. Florence: *c.*1470. [Goldscheider 1951, p. 43]

Paolo di Stefano Badaloni, 1397–1478. "Labors [Deeds] of Hercules." Painting, depicting Hercules fighting the Ceryneian Hind, Anteaus, and a centaur, in one composition. Metropolitan Museum, New York, no. 1971.115.4. [Metropolitan 1980, p. 139—ill.]

Antonio del Pollaiuolo, 1432/33–1498. "Hercules." Bronze statuette. Before *c.*1475–80? Frick Collection, New York, no. 16.2.5. [Frick 1968–70, 3:22f.—ill. / also Ettlinger 1978, no. 17—ill.]

———, attributed. "Hercules" (with head of Nemean lion). Bronze statuette. Bode Museum, Berlin. [Ettlinger, no. 16—ill.]

Bertoldo di Giovanni, *c.*1420–1491, attributed (executed by studio after Bertoldo's design?). "Hercules." Bronze statuette. Frick Collection, New York, no. 16.2.4. [Frick 1968–70, 3:43f.—ill.]

———, attributed. "Hercules." Bronze statuette. Frederiks coll., The Hague. [Ibid. / Pope-Hennessy 1985b, 2:303]

———, attributed. "Hercules on Horseback." Bronze statuette. Pinacoteca Estense, Modena. [Pope-Hennessy]

Michelangelo, 1475–1564. "Hercules." Marble statue. *c.*1492–93. Lost. [Baldini 1982, no. 6 / Goldscheider 1964, p. 223] Terra-cotta model, attributed to Michelangelo. Casa Buonarroti, Florence. [Baldini, no. 55—ill.]

———. "Hercules" (or Samson?). Clay sketch model, for unexecuted statue. *c.*1525. Casa Buonarroti. [Baldini, no. 39—ill. / cf. Pope-Hennessy 1985b, 3:34, 48—ill.]

Bartolommeo Bellano, *c.*1440–1496/97. (Hercules in) "The Mountain of Hell." Bronze statuette. Victoria and Albert Museum, London. [Pope-Hennessy 1985b, 2:85, 331]

Albrecht Dürer, 1471–1528. "Hercules" (Gallicus?). Engraving (Bartsch no. 73). 1498. [Wind 1938–39, pp. 209ff.—ill. / Hallowell 1962, p. 249 / Strauss 1977b, no. 24 (as "Hercules at the Crossroads" or "Jealousy")—ill. / also Galinsky 1972, pl. 12]

———. "Venus, Cupid, and Hercules." Drawing. 1506? British Museum, no. 5218/130. [Strauss 1974, no. 1506/58—ill.]

———, studio, under Dürer's direction (previously attributed to Lucas van Leiden). Series of drawings, depicting deeds of Hercules, designs for series of medals (unlocated). 1510–11. Formerly Kunsthalle, Bremen, lost. [Ibid., nos. 1511/21–32—ill.]

———, previously attributed (Hans von Kulmbach?). "Hercules Clubbing a Dragon." Drawing. 1495–96. Kupferstichkabinett, Berlin. [Ibid., no. XW.156—ill.]

Antico, *c.*1460–1528. Set of bronze medallions representing deeds of Hercules. 5 known, possibly others? *c.*1500? 2 ("Hercules Strangling the Serpents," "Hercules and the Erymanthian Boar") in Victoria and Albert Museum, London. [Louvre 1975, no. 61]

———. "Hercules with a Club." Bronze sculpture. *c.*1519? Kunsthistorisches Museum, Vienna. [Ibid., no. 53]

Desiderius Erasmus, 1466–1536. (Gallic Hercules evoked in) *Adagia* (*Chiliades adagiorum*). Compendium of adages. First published **1506**; revised and expanded, published Venice: Aldus Manutius, 1508. [Galinsky 1972, p. 223 / Hallowell 1962, p. 247]

Baldassare Peruzzi, 1481–1536. Cycle of grisaille frescoes depicting the deeds of Hercules. **1508–09.** Castello, Ostia Antica. [Frommel 1967–68, no. 17—ill.]

Lazzaro Bastiani, *c.*1425–1512. "Hercules with Flock and Hounds." Painting. Late work. Museo Civico, Padua, no. 1705. [Berenson 1957, p. 26]

Jean Lemaire de Belges, *c.*1473–1515/25. (Gallic Hercules seen as ancestor of Charlemagne in) *Illustrations de Gaule et singularitez de Troye* 2.469, 462. Poem. Paris: Marnef, **1512.** [Hallowell 1962, p. 244]

Guillaume Budé, 1468–1540. (Story of Hercules the Eloquent [Gallic Hercules] in) *Le livre de l'institution du prince* chapter 14. Collection of apothegms, after Lucian. *c.*1519. Paris: Foucher, 1547. [Galinsky 1972, p. 223 / Hallowell 1962, pp. 247]

Florentine School. "Hercules and Triton," "Hercules in Repose." Bronze statuettes. *c.*1500–20. "Triton," Bodemuseum, Berlin, in 1907; "Repose," 2 examples known, Frick Collection, New York, no. 16.2.9; Scheufelen coll., Oberleuningen. [Frick 1968–70, 3:48f.—ill.]

Franciabigio, 1482–1525. "The Temple of Hercules." Painting. *c.*1516–20? Uffizi, Florence, inv. 1600. [Uffizi 1979, no. P629—ill. / Berenson 1963, p. 65]

Raphael, 1483–1520, school. "Gallic Hercules." Drawing. Ashmolean Museum, Oxford. [Pigler 1974, p. 490]

Francesco da Sant'Agata, fl. 1491–1528. "Hercules." Boxwood statuette. 1520. Wallace Collection, London, no. S.273. [Clapp 1970, 1:313]

Rosso Fiorentino, 1494–1540, composition. "The Labors and Adventures of Hercules." 6 engravings, executed by Gian Jacopo Caraglio (Bartsch nos. 44–49). **1524.** Original designs lost. [Carroll 1987, nos. 9–14—ill.; cf. nos. 15–16]

———, and assistants. (Hercules [?] in) "Elephant *fleur-delysée.*" Fresco. 1535–40; repainted/restored 18th, 19th centuries and 1961–66. Galerie François I, Château de Fontainebleau. [Ibid., no. 83—ill.]

———, composition. "Figure Costumed as Hercules." *c.*1539. Anonymous engraving (Bartsch no. 103). (Bibliothèque Nationale, Paris.) [Ibid., no. 107—ill.]

Albrecht Altdorfer, *c.*1480–1538. "Hercules and the Muse." Engraving (Bartsch no. 28). *c.*1520–25. [Winzinger 1963, no. 160—ill.]

Geofroy Tory, *c.*1480–1529. (Gallic Heracles in) *Champfleury* fol. 6. Translation of Lucian's *Heracles.* Paris: 1529. [Galinsky 1972, p. 223 / Hallowell 1962, pp. 244, 247f.]

Giulio Romano, *c.*1499–1546, assistants, after designs by Giulio. Hercules depicted in frescoes and stuccoes in Sala dei Cavalli, Sala delle Aquile and Sala degli Stucchi, Palazzo del Tè, Mantua. **1527–30.** [Verheyen 1977, pp. 115, 121, 123f. / also Hartt 1958, pp. 112ff., figs. 181–86]

Agnolo Bronzino, 1503–1572, attributed (and others?). Fresco decorations for Sala delle Fatiche di Ercole, Villa Imperiale, Pesaro. **1530–32.** In place. [Baccheschi 1973, no. 14—ill.]

Marcantonio Raimondi, *c.*1480–1527/34. "Hercules."

Engraving (Bartsch no. 256), after design by Francesco Francia? [Bartsch 1978, 26:251—ill.]

——. "The Labors of Hercules." Cycle of engravings (Bartsch nos. 289–92). 4 known: "Hercules Killing the Centaur Nessus," "Hercules Killing the Nemean Lion," "Hercules Killing Achelous, Transformed into a Bull," "Hercules Killing Antaeus." [Ibid., 26:277–80—ill.]

Dosso Dossi, c.1479–1542. "Allegory of Hercules" ("Bambocciata") (allegory addressed to Ercole II d'Este, related to choice of Hercules, with references to the story of Hercules and Omphale). Painting. **Mid-1530s.** Uffizi, Florence. [Gibbons 1968, pp. 98ff., no. 22—ill. / also Uffizi 1979, no. P552—ill.]

Camelio, c.1455/60–**1537** (formerly attributed to Francesco da Sant'Agata). "Hercules." Bronze statuette. Ashmolean Museum, Oxford. [Frick 1968–70, 3:164] Variant copy, in wood, by Francesco da Sant'Agata, in Wallace Collection, London. [Ibid.]

Lucas Cranach, 1472–1553, studio. "The Labors of Hercules." Painting cycle, depicting deeds and labors of Hercules. **After 1537.** 7 extant (Choice, Hydra, Stag, Atlas, Hesperides, Geryon, Nessus). Herzog Anton Ulrich-Museum, Braunschweig, nos. 712–718. [Braunschweig 1969, pp. 47f. / Friedländer & Rosenberg 1978, no. 408A]

Lilio Gregorio Giraldi, c.1479–1552. *Vita Herculis.* Prose work. **1539.** In *Opera,* vol. 1 (Leiden: 1696). [Galinsky 1972, pp. 201, 227]

Agostino Veneziano, 1490–**1540.** "Young Hercules." Engraving (Bartsch 14:209 no. 261), after design by Baccio Bandinelli? [Bartsch 1978, 26:254—ill.]

Maerten van Heemskerck, 1498–1574. Hercules and the Hydra, Antaeus, Gadean Pillars, Nessus, in 4 paintings in "Gods and Heroes from Mythology and the Old Testament" series. c.**1545.** Yale University Art Gallery, New Haven, inv. 60.50b-d; Rijksmuseum, Amsterdam, inv. A3513 ("Nessus"). [Grosshans 1980, no. 30h—ill. / also Rijksmuseum 1976, p. 265—ill.]

Francesco Primaticcio, 1504–1570, design. "Hercules, Bacchus, Pan, and Saturn." Ceiling fresco, in Galerie d'Ulysse, Château de Fontainebleau. **1541–47.** Destroyed 1738–39. / Engraved by Giorgio Ghisi. [Béguin et al. 1985, p. 143—ill. / also Dimier 1900, pp. 295ff., no. 63]

——. "Reclining Hercules." Fresco, for Salle de Bal, Château de Fontainebleau, executed by Niccolò dell' Abbate under Primaticcio's direction. 1551–56. Repainted 19th century. [Dimier, pp. 160ff., 284ff.]

Pierre de Ronsard, 1524–1585. "Les bacchanales, ou, Le folastrissime voyage d'Hercueil" [The Bacchanales, or, The Frolicsome Voyage of Hercules]. Ode. **1549.** In *Les amours* (Paris: Buon, 1552). [Laumonier 1914–75, vol. 3 / DLLF 1984, 3:2013 / Cave 1973, p. 77, 347]

——. (Gallic Hercules evoked in) "Ode à Jean D'Orat." Poem. In *Le premier livre des odes* (Paris: Buon, 1550). [Laumonier, vol. 1 / Hallowell 1962, pp. 250f.]

——. (Hercules evoked as putative ancestor of the French in) "La Harangue que fist Monseigneur le Duc de Guise aux soldats de Mets" [The Harangue Delivered by the Duc de Guise to His Soldiers at Metz]. Poem, hymn. In *Le cinquiesme livre des odes* (Paris: 1553). [Laumonier, vol. 5 / Trousson 1962, pp. 80–83]

——. (The King likened to Gallic Hercules in) "Hymn

du treschrestien Roy de France Henri II." Poem. 1555. [Laumonier, vol. 8]

——. "L'hymne de l'Hercule chrestien" [Hymn of the Christian Hercules]. Poem, hymn. In *Le second livre des hymnes* (Paris: Wechel, 1555). [Laumonier / Silver 1985, pp. 269ff. / Cave, pp. 154f., 242f. / Trousson, pp. 86f. / Galinsky 1972, pp. 203ff.]

——. (Gallic Hercules evoked in) "Hymne du tresillustre Prince Charles Cardinal de Lorraine." Poem. 1559. [Laumonier / Hallowell, pp. 252–55]

——. (Gallic Hercules evoked in) "Panégyrique de la renommé." Poem, dedicated to Henri III. Paris: 1579. [Laumonier, vol. 3 / Hallowell, p. 250 / Galinsky, p. 230 n.69]

Bartolommeo Ammannati, 1511–1592. "Hercules." Colossal statue. Before **1550.** Palazzo Mantova Benavides, Padua. [Pope-Hennessy 1985b, 3:372]

——. "Hercules." Drawing. Louvre, Paris. [Warburg]

Giovanni Bernardi, 1496–**1553,** and **Manno di Bastiano,** design. Statuettes representing Hercules resting, Hercules with the apples of the Hesperides, infant Hercules, dying Hercules, on "The Farnese Coffer." Silver gilt coffer. Executed by another, 1548–61. Museo di Capodimonte, Naples, no. 10507. [Capodimonte 1964, p. 129]

Andrea Schiavone, c.1522–1563. "Hercules" (?). Etching. c.**1550–55.** [Richardson 1980, no. 126—ill.]

Frans Floris, 1516/20–1570. "The Labors of Hercules." Cycle of 10 paintings. **1554–55.** All but "Hercules and Antaeus" lost since 1768. [de Bosque 1985, p. 55—ill.]

Giovanni Battista Giraldi Cinthio, 1504–1573. *Ercole.* Epic poem. 26 cantos completed, unfinished. Modena: Gadaldini, **1557.** [DELI 1966–70, 3:133 / Giamatti 1966, p. 180]

Giorgio Vasari, 1511–1574, and assistants. Cycle of ceiling paintings depicting the deeds of Hercules. **1557.** Sala di Ercole, Palazzo Vecchio, Florence. [Sinibaldi 1950, pp. 13, 23 / also Lensi 1929, pp. 154ff., 163f.—ill. / Barocchi 1964, pp. 38ff., 147, 316—ill.]

Jan Swart van Groningen, c.1500?–**1535/60.** Drawing. Printroom, Berlin, cat. 1930 no. 10346. [Warburg]

Baccio Bandinelli, 1493–**1560.** "Hercules." Bronze statuette. Museo del Bargello, Florence. [Pope-Hennessy 1985b, 3:99—ill.]

Vincenzo de' Rossi, 1525–1587. "Labors of Hercules." Series of marble sculpture groups (12 ordered, 7 executed). c.**1568.** 6 (including Hercules and Antaeus, Nessus [or another centaur?], Cacus) in Salone dei Cinquecento, Palazzo Vecchio, Florence; 1 ("Hercules Holding Up the World") on Poggio Imperiale, Florence. [Lensi 1929, pp. 224f. / also Pigler 1974, pp. 112, 113, 128 / Pope-Hennessy 1985b, 3:49, 54—ill.]

Juan de Mal Lara, 1527–**1571.** Moralistic poem, compiling ancient accounts of 17 labors of Hercules. Lost. [Galinsky 1972, pp. 201, 227 n.30]

Jacopo Bertoia, 1544–**1574.** "Hercules." Painting. Christ Church, Oxford. [Byam Shaw 1967, no. 169—ill.]

Paolo Veronese, 1528–1588. "Venice with Hercules and Neptune," "Venice Receives the Homage of Hercules and Ceres." Paintings, for Palazzo Ducale, Venice. **1575–78.** Szépművészeti Múzeum, Budapest, inv. 105; Accademia, Venice, inv. 749. [Pallucchini 1984, nos. 144, 164—ill. / Pignatti 1976, nos. 204–05—ill.]

——. (Hercules as Strength in) "Allegory of Wisdom

and Strength" ("Hercules and Omphale"?). Painting. *c*.1578–80. Frick Collection, New York, no. 12.1.128. [Palluchini, pp. 127ff., no. 174—ill. / Pignatti, no. 243—ill. / Frick 1968–70, 2:272f.—ill.] Study. Draper coll., Miami. [Pignatti, no. 244—ill.] 5 further versions known: Schönborn coll., Pommersfelden; De Young Museum, San Francisco; others unlocated. [Frick] Copy by Carletto Caliari, in Rhode Island School of Design, Providence. [Ibid.]

Derick Gerarde, fl. **1540–80**. *Le forze d'Hercole* [The Powers of Hercules]. Instrumental composition. [Grove 1980, 7:246]

Giambologna, 1529–1608. "Hercules with a Club." Bronze statuette. *c*.1580? Museo del Bargello, Florence, no. 362; Bayerisches Nationalmuseum, Munich, no. R.3240; elsewhere. [Avery 1987, no. 79—ill. / also Avery & Radcliffe 1978, no. 90 (as attributed)—ill. / Florence 1986, p. 65—ill.]

———— with **Pietro Francavilla**, 1546/53–1615. "Hercules Slaying a Centaur." Marble sculpture. 1595–1600. Loggia dei Lanzi, Florence. [Avery, no. 20—ill. / Pope-Hennessy 1985b, 3:388f.—ill.] Wax model. Victoria and Albert Museum, London. [Pope-Hennessy] Bronze replicas/variants, by Giambologna and/or studio. Kunsthistorisches Museum, Vienna, nos. 5834, 6030; Museo del Bargello, Florence; elsewhere. [Avery & Radcliffe, nos. 81–82—ill. (cf. nos. 227–28) / also Avery, nos. 74–75—ill. (cf. nos. 194–95)]

Philip Sidney, 1554–1586. (Gallic Hercules evoked as an orator in) Sonnet 58 of *Astrophil and Stella*. Sonnet sequence. **1581–83**. London: Newman, 1591 (pirated). [Ringler 1962]

Annibale Fontana, ?–1587. "The Labors [deeds] of Hercules." Series of engraved crystals, decorating a casket. Broken up and dispersed. Kunsthistorisches Museum, Vienna ("Hercules with Nessus and Deianeira"); Metropolitan Museum, New York ("Hercules and the Centaur," "Hercules and Cacus[?]"); Walters Art Gallery, Baltimore ("Hercules and the Hydra," "Hercules and Geryon[?]," "Hercules and Cerberus"); others unlocated. [Montagu 1985, pp. 8, 237 *n*.32—ill.]

Hendrik Goltzius, 1558–1617. "The Large Hercules." Engraving. **1589**. 2 states. [Strauss 1977a, no. 283—ill. / Bartsch 1980–82, no. 142—ill.]

Annibale Carracci, 1560–1609, **Ludovico Carracci**, 1555–1619, and **Agostino Carracci**, 1557–1602. Cycle of frescos depicting the deeds of Hercules. *c*.1593–94. Palazzo Sampieri (Talon), Bologna. [Malafarina 1976, p. 103, nos. 73–74—ill. / Ostrow 1966, no. I/15]

———— (Annibale). Fresco cycle, depicting scenes from the life of Hercules: Hercules bearing the globe, resting after his labors, defeating the Nemean Lion, the Hydra, Antaeus, and Cerberus, strangling the serpents, and Hercules' death; also a ceiling canvas depicting Hercules at the crossroads. 1595–97. Camerino, Palazzo Farnese, Rome. ("Crossroads" now in Gallerie Nazionali di Capodimonte, Naples, replaced by a copy.) [Malafarina, nos. 86, 87a–h—ill. / Martin, pp. 24ff., 27ff.—ill.]

————, follower (Pietro Faccini). "Hercules." Painting. Galleria Communale, Bologna. [Malafarina, no. 148—ill.]

Cavaliere d'Arpino, 1568–1640. Cycle of 10 lunette frescoes depicting scenes from the life of Hercules. **1594–95**. Loggia Orsini, Palazzo del Sodalizio dei Piceni, Rome. [Röttgen 1969, pp. 279ff., 285—ill.]

William Shakespeare, 1564–1616. (Hercules represented in Pageant of the Nine Worthies, in) *Love's Labor's Lost* 5.2.587–94. Comedy. *c*.1594–95, revised for Court performance, Christmas 1597, London. Published London: 1598 (and possibly earlier); collected in First Folio, London: Jaggard, 1623. [Riverside 1974]

————. (Antony conceives himself as a Hercules-figure in) *Antony and Cleopatra*, passim and 4.12.43–47 (allusion to shirt of Nessus). Tragedy. 1606–07? Stationers' Register 20 May 1608. No recorded performance in Shakespeare's lifetime. Published London: Jaggard, 1623 (First Folio). [Riverside / Bono 1984, pp. 153ff. / Galinsky 1972, p. 151 *n*.25]

Edmund Spenser, 1552?–1599. (Hercules evoked as a champion of justice in) *The Faerie Queene* 5.1.2–3. Romance epic. London: **1596**. [Hamilton 1977 / Galinsky 1972, pp. 208–12]

Toussaint Dubreuil, *c*.1561–1602, with **Ruggiero de Ruggieri**, ?–1596–97. "History of Hercules." Cycle of paintings, in Pavillon des Poêles, Château de Fontainebleau. Destroyed 1750. [Paris 1972, p. 482, nos. 103–04—ill. (drawings)]

———— (Dubreuil), attributed (or circle of Primaticcio?). "Jupiter Hurling a Thunderbolt between Combatants" (Apollo and Hercules?). Drawing. Private coll., Paris. [Ibid., no. 98—ill.]

Matthäus Greuter, 1564–1638, design. (Gallic Hercules depicted in) "Misticus Tri-Hercules." Decoration on triumphal arch, for entry of Marie de' Medici into Antwerp, **1600**. [Hallowell 1962, p. 249]

Ludwig Munsterman, *c*.1575–1638. "Hercules." Sandstone head. *c*.1600. Focke-Museum, Bremen. [Clapp 1970, 1:654]

Ben Jonson, 1572–1637. (Hercules evoked in) "And must I sing?" Poem. First published in Robert Chester's *Love Martyr* (London: **1601**); reprinted as no. 10 of *The Forrest*, in *Works* (London: 1616). [Herford & Simpson 1932–50, vol. 8]

Agostino Carracci, 1557–1602. "Hercules." Drawing. Fitzwilliam Museum, Cambridge. [Warburg]

Thomas Heywood, 1573/74–1641. (Hercules in) *Troia Britanica: or, Great Britaines Troy* cantos 6–7. Epic poem. London: **1609**. [Heywood 1974]

————. (Hercules in) *The Silver Age*, *The Brazen Age*. Dramas, derived from *Troia Britanica*. First performed *c*.1610–13, London. Published London: Okes, 1613. [Heywood 1874, vol. 3 / DLB 1987, 62:101, 122ff. / also Boas 1950, pp. 83ff. / Clark 1931, pp. 62ff.]

Peter Paul Rubens, 1577–1640. "Head of Hercules." Painting. *c*.1611. Kainde coll., Wrexham. [Jaffé 1989, no. 151—ill.]

————. "Hercules Drunk" ("The Effects of Vice"). Painting. 1613–14. Gemäldegalerie, Dresden, on deposit in Schloss Pillnitz. [Ibid., no. 215—ill. / also White 1987, pl. 81 / Galinsky 1972, pl. 5] Replica. *c*.1615. Gemäldegalerie, Dresden. [Jaffé, no. 308—ill.]

————. "Hercules as Victor over Discord" (formerly called "Hercules Triumphing over Hippolyta," "Hercules Conquering Antaeus"). Painting, oil sketch. *c*.1620. Museum Boymans-van Beuningen, Rotterdam, on loan from Dienst voor 's Rijks Verspreide Kunstvoorwerpen, no. 2673 (2297). [Held 1980, no. 243—ill. / Jaffé, no. 550—ill.] 2 further

versions of the subject known: in ornamental border of painting "Portrait of Charles de Longueval," 1621, Hermitage, Leningrad. Drawing, *c.*1628, British Museum, London, inv. 1900.8.24.138. [Burchard & d'Hulst 1963, no. 188—ill.]

————. (Hercules in) "The Apotheosis of Henri IV and the Assumption of the Regency by Marie de' Medici." Painting, part of "Life of Marie de' Medici" cycle. 1622–25. Louvre, Paris, inv. 1779. [Saward 1982, pp. 98ff.—ill. / Jaffé, no. 735—ill. / also Louvre 1979–86, 1:117—ill. / White, pl. 188] Oil sketches. Hermitage, Leningrad; Alte Pinakothek, Munich, inv. 102. [Jaffé, no. 733–34—ill. / also Munich 1983, pp. 463, 467—ill. / Held, nos. 69–70—ill.]

————. "Heroic Virtue (Hercules) Overcoming Discord [or Envy]." Ceiling painting, for Banqueting House, Whitehall, London. *c.*1632–34. In place. [Jaffé, no. 1018—ill. / White, pl. 276] Oil sketch. Museum of Fine Arts, Boston, inv. 47.1543. [Held, no. 141—ill.; cf. no. 133 / Jaffé, no. 1017—ill. / Boston 1985, p. 253—ill. / Baudouin 1977, fig. 133]

————. "Hercules and Minerva Fighting Mars." 2 oil sketches and a gouache, early pensées for "The Horrors of War" (*c.*1637–38, Pitti, Florence). *c.*1634–35. Speelman & Co., London; Museum Boymans-van Beuningen, Rotterdam, no. 253, on loan to Dienst voor 's Rijks Verspreide Kunstvoorwerpen (without Hercules); Louvre, Paris (gouache). [Held, nos. 244, 253—ill. / Jaffé, nos. 1113–14—ill. / White, pl. 255 / also Baudouin, fig. 121, pl. 62 / Burchard & d'Hulst 1963, no. 169—ill.]

————. Series of paintings depicting episodes from the life of Hercules, part of decoration of Torre de la Parada, El Pardo, executed by assistants after Rubens's designs. 1636–38. Scenes depicted: Infant Hercules suckled by Juno, the labors of the Hydra and Cerberus, the rape of Deianeira, Hercules' apotheosis, and the discovery of Tyrian purple. 2 in Prado, Madrid; others lost. [Alpers 1971, nos. 16, 28–31, 42—ill. / Jaffé, nos. 1258, 1277, 1279, 1281, 1283, 1293—ill.] Oil sketches. Courtauld Institute, London ("Hydra"); Prado ("Cerberus"); Musée Bonnat, Bayonne ("Tyrian purple"); Musées Royaux des Beaux-Arts, Brussels ("Apotheosis," "Juno"). [Alpers—ill. / Held 1980, nos. 183, 192–95, 200—ill. / Jaffé, nos. 1276, 1278, 1280, 1282, 1292—ill.]

————. Series of paintings on deeds of Hercules projected, partially completed (?), cited in 1686 inventory of Palacio Real, Madrid; possibly related to decoration of Torre de la Parada. 1630s. [Alpers, pp. 274ff.]

————. "The Labors of Hercules." Sheet of drawings depicting several of Hercules' exploits, some related to paintings of specific subjects. British Museum, London, inv. 1897.6.15.12. [Burchard & d'Hulst 1963, no. 190—ill.]

Jean Prévost, *c.*1580–1622. *Hercule.* Tragedy. In *Les secondes oeuvres poétiques et tragiques* (Poictiers: Thoreau, 1613). [Daemmrich 1987, p. 134]

Pierre Mainfray, *c.*1580–1630? *Tragédie des forces incomparables et amours du grand Hercule.* Tragedy. Troyes: Girardon, 1616. [DLLF 1984, 2:1360]

Denys Calvaert, 1540–1619. "Hercules." Drawing. Uffizi, Florence, inv. no. 12241. [Warburg]

Guido Reni, 1575–1642. "The Feats of Hercules." Painting cycle, allegorical representation of the "Power and Triumph of the Gonzaga," depicting Hercules and the Hydra, Hercules and Achelous, the rape of Deianeira,

and Hercules on the pyre. 1617–21. Louvre, Paris, nos. 535–38. [Pepper 1984, nos. 68–71—ill. / Louvre 1979–86, 2:226—ill. / Gnudi & Cavalli 1955, nos. 42–45—ill.]

Artemisia Gentileschi, 1593–1652/53. "Hercules." Painting. By *c.*1618–23. Documented in Medici collection, Florence, in 1681, lost. [Garrard 1989, p. 51]

Otto van Veen, 1556–1629, composition. "Alessandro Farnese as Hercules Guided by Religion." Engraving, executed by Ghisbert van Veen. [Martin 1972, p. 211—ill.]

Jusepe de Ribera, *c.*1590/91–1652. "Hercules Resting." Painting. *c.*1630. (Previously considered lost; seen by Prof. Craig Felton, Smith College, in an English private coll. in 1988.) [Personal communication to the author] / Drawing for. Cauchi coll., Rabat, Malta. [López Torrijos 1985, p. 408 nos. 64–65—ill. / also Brown 1973, no. 22—ill. / Fort Worth 1982, fig. 85] / School copy (Francesco Fracanzano?). Louvre, Paris (inv. 940), on loan to Musée Goya, Castres. [Spinosa 1978, no. 229—ill. / Louvre 1979–86, 2:130]

Pieter Lastman, *c.*1583–1633. "Hercules and Minerva." Painting. Dienst Verspreide Rijkskollekties, The Hague, inv. NK1830. [Pigler 1974, p. 118 / Wright 1980, p. 232]

Francisco Zurbarán, 1598–1664. "The Labors of Hercules." Cycle of 10 paintings, for Salón de Reinos, Buen Retiro, Madrid, depicting episodes from the life of Hercules. *c.*1634. Prado, Madrid, nos. 1241–50. [López Torrijos 1985, pp. 141ff., 406 nos. 3–12—ill. / Prado 1985, p. 790]

Pietro da Cortona, 1596–1669. (Hercules, killing a harpy, in) "The Triumph of Divine Providence. . . ." Fresco. 1633–39. Palazzo Barberini, Rome. [Briganti 1962, no. 45—ill.]

————. Hercules as guide to a Medici prince [Cosimo I?], in a cycle of 5 ceiling frescoes. 1641–47 (2 completed 1659–65 by Ciro Ferri). Planetary Rooms, Palazzo Pitti, Florence. [Campbell 1977, pp. 91ff., 111ff., 123ff., 130ff., 144ff., figs. 27, 60, 89, 96, 117 / Pitti 1966, pp. 30–97 passim—ill. / Briganti, nos. 85, 95–97—ill.]

Ottaviano Castelli, ?–1642. (Hercules as Dauphin in) *La sincerità trionfante, overo, L'Erculeo ardire* [Sincerity Triumphant, or, Bold Hercules]. Opera (dramma boscareccio). First performed Jan 1639, Palazzo Farnese, Rome. [Grove 1980, 3:866]

Francisco de Rojas Zorrilla, 1607–1648. *Hércules.* Auto sacramentale. First performed 1639, Madrid. [McGraw-Hill 1984, 4:229]

Domenichino, 1581–1641, doubtfully attributed (actually by P. P. Bonzi?). "Landscape with Hercules Seated." Painting. Pinacoteca Capitolina, Rome. [Spear 1982, p. 318]

Nicolas Poussin, 1594–1665. Series of drawings depicting the labors and other scenes from the life of Hercules, designs for (largely unexecuted, destroyed) decoration of the Long Gallery, Louvre, Paris. 1640–42. Surviving original drawings: Musée Bonnat, Bayonne, no. 48 (6 scenes on single sheet); Louvre, Paris, no. 129 (14 scenes on single sheet); Royal Library, Windsor Castle, no. 11920 (Hercules and Theseus fighting the Amazons). Others known from copies and engravings. Drawings (copies) in Louvre; Windsor; Hermitage, Leningrad; Prado, Madrid; private colls., London and Paris. [Friedlaender & Blunt 1953, p. 11, nos. 241–43, A71–122—ill.]

————. "Hercules." Design and wax model for 2 marble terms (1 also called "Vertumnus"). 1655–56. Marbles executed by Jean-Baptiste Théodon, by 1661. Quinconce

du Nord, Gardens, Versailles. [Girard 1985, pp. 273ff., 287—ill. / Blunt 1966, nos. 220—21—ill.]

————, formerly attributed. "Hercules Conquering Ignorance and Envy" (?). Painting. Lost. [Thuillier 1974, no. R69—ill. (print)]

Luiz Vélez de Guevara y Dueñas, 1579–1644. *El Hércules de Ocaña* [The Hercules of Ocaña]. Comedy. Madrid: 1671. [McGraw-Hill 1984, 5:99]

Jacob van Campen, 1595–1657. "Hercules Hauling Cerberus Out of the Underworld," "Hercules Defeating the Centaurs." Paintings, part of a frieze. *c.*1645. Rijksmuseum, Amsterdam, inv. A4254, on deposit at Museum Flehite, Amersfoort. [Rijksmuseum 1976, pp. 161f.—ill.]

Alessandro Algardi, 1598–1654. Series of stucco reliefs decorating Galleria di Ercole, Villa Belrespiro (now Villa Doria Pamphilj). Executed by R. Bolla and G. M. Sorisi from Algardi's designs (some after Annibale Fontana's crystals, see above). 1646. In place. [Montagu 1985, no. A.198—ill.]

Jacob Jordaens, 1593–1678. "(Hercules and the Nymphs) Filling the Horn of Plenty" ("Hercules and Acheloüs"). Painting. 1649. Statens Museum for Kunst, Copenhagen. [Copenhagen 1951, no. 351—ill. / Rooses 1908, pp. 145ff.—ill.]

Guercino, 1591–1666. "Hercules." Painting. **1640s?** Private coll., Bologna. [Salerno 1988, no. 345—ill.] Further versions of the subject known, lost. [Ibid.]

Charles Le Brun, 1619–1690. Fresco and stucco cycle, depicting the exploits of Hercules, for Hôtel Lambert, Paris. *c.*1650s. / Drawings for. Louvre, Paris, inv. 27.684, 27.970, 27.712, 28.492, 29.479. [Versailles 1963, nos. 73–74, 76–78—ill.]

————. (Hercules in) "The King Governs by Himself." Ceiling painting. 1678–79. Galerie des Glaces, Versailles. [Berger 1985, pp. 52f.—ill.] This painting is part of a cycle originally intended to depict the deeds of Hercules, but adapted to show Louis XIV performing glorious deeds. Drawing of Le Brun's original design, Cabinet des Dessins, Louvre, Paris, inv. 27.067. [Ibid., p. 54, figs. 94–95]

Pierre Puget, 1620–1694. "Standing Hercules" ("Hercules Resting"). Terra-cotta statue. *c.*1660. Skulpturenabteilung, Staatliche Museen, Berlin-Dahlem, inv. M 256. [Herding 1970, no. 15—ill.]

————. "Hercules Resting" ("Gallic Hercules"). Marble statue. 1663–68. Louvre, Paris, no. N 15.345. [Herding, no. 16—ill.] Early versions/variants, *c.*1660–63, in École des Beaux-Arts, Paris, inv. 1248; Musée de Picardie, Amiens, inv. 981/1; another documented in 1694, untraced. [Ibid., nos. 16a-c—ill.]

————, formerly attributed (questionably attributed to Christophe Veyrier). "Hercules Resting." Marble high relief. Musée des Beaux-Arts, Marseilles, inv. S 191. [Ibid., no. 103]

————, formerly attributed (now attributed to Marc Chabry). "Standing Hercules." Bronzed terra-cotta statuette. Musée Bonnat, Bayonne, no. 404. [Ibid., no. 109]

————, formerly attributed. "Hercules." Bronze bust. Late 18th century. London art market in 1969. [Ibid., no. 141]

Pier Francesco Cavalli, 1602–1676. *Ercole amante.* Tragic opera. Libretto, Francesco Buti. 18 ballet entrées by Jean-Baptiste Lully, libretto by Isaac de Bensérade. First performed 7 Feb **1662,** Tuileries, Paris. [Grove 1980, 4:25f.,

29, 32; 11:327 / Baker 1984, p. 433 / Bianconi 1987, p. 239 / Clubb 1968, p. 58 / Palisca 1968, p. 160]

Francesco Baratta, ?–1666. "Hercules." Statue, for Zwinger Palace, Dresden. [Bénézit 1976, 1:425]

Claude-François Vignon, 1633–1703. "Hercules Overcoming Vice and Ignorance in the Presence of Minerva." Painting (largely ruined). 1667. Louvre, Paris, inv. 8442. [Louvre 1979–86, 4:273—ill.]

Antonio del Castillo, 1616–1668, circle. "Two Male Nudes as Hercules." Painting. Museo de Bellas Artes, Cordova. [López Torrijos 1985, p. 408]

Jean de La Fontaine, 1621–1695. (Hercules invoked in) "Le chartier enbourbé" [The Carter Stuck in the Mud]. Verse fable (book 6 no. 18). In *Fables choisies* (Paris: **1668**). [Clarac & Marmier 1965 / Spector 1988 / Moore 1954]

Jürgen Ovens, 1623–1678. "Hercules and Envy." Painting. Statens Museum for Kunst, Copenhagen, inv. 982. [Copenhagen 1951, no. 530—ill.]

François Girardon, 1628–1715. "Mars and Hercules." Sculpture relief. 1680–82. Façade, Château de Versailles. [Vermeule 1964, p. 119]

Antoine Coysevox, 1640–1720. (Hercules in relief on) "The War Vase." Marble vase. 1684–85. Terrasse, Château de Versailles. [Girard 1985, p. 286—ill.]

Jean-Baptiste Tubi, 1635–1700. (Hercules in relief on) "The Peace Vase." Marble vase. 1684–85. Terrasse, Château de Versailles. [Girard 1985, p. 286—ill.]

Louis Lecomte, 1639–1694. "Hercules." Marble term. 1684–86. Gardens, Versailles. [Girard 1985, pp. 171, 286—ill.]

Balthasar Permoser, 1651–1732. "Fighting Hercules." Wood sculpture. *c.*1690–95? Rosenborg Slot, Copenhagen. [Asche 1966, no. P19, pl. 29]

———— "Fighting Hercules." Sandstone statue. *c.*1689–95. Staatliche Museen, Berlin. [Ibid., no. P22, pl. 25]

————, studio (Christian Kurchner?). 4 statues of Hercules. *c.*1689–95. Grosser Garten, Dresden. [Ibid., p. 335]

Luca Giordano, 1634–1705. "The Story of Hercules Related to the Origin of the Order of the Golden Fleece." Ceiling fresco. 1697. Casón del Buen Retiro, Madrid. [López Torrijos 1985, pp. 161ff., 407—ill. / Ferrari & Scavizzi 1966, 2:208f.—ill.]

————. "The History of Hercules." Cycle of 40 frescoes. *c.*1697. Formerly Buen Retiro, Madrid, destroyed. / Engraved by Giuseppe Castillo and Juan Barcelon, 1779. [Ferrari & Scavizzi, 1:155, 2:278—ill. / also López Torrijos, p. 407 nos. 38–54—ill.]

————. "Hercules Fighting with Mars." Painting. Walter Chrysler, Jr., coll., New York. [Ferrari & Scavizzi, 2:367]

————, attributed. "Hercules." Drawing. Museo di Capodimonte, Naples, no. 184. [Ibid., 2:301]

————, questionably attributed. "Story of Hercules." Drawing. Albertina, Vienna, no. 34195. [Ibid., 2:314]

Peter Motteux, 1660–1718. *Hercules.* Masque. Music, John Eccles. First performed May/June **1697,** Lincoln's Inn Fields, London, with Motteux's *The Novelty.* [Fiske 1973, p. 13 / Grove 1980, 5:820 / Nicoll 1959–66, 1:263, 421]

Noël Coypel, 1628–1707. "The Story of Hercules." Painting(s?). **1700.** Trianon, Versailles. [Dublin 1985, p. 17]

Paul Heermann, 1673–1732. "Hercules." Wood statuette. **1700.** Grassimuseum, Leipzig. [Asche 1966, no. H2a, pl. 86]

Attilio Ariosti, 1666–1729. *La più gloriosa fatica d'Ercole* [Hercules' Most Glorious Deed]. Opera (poemetto drammatico). Libretto, P. A. Bernadoni. First performed 15 Nov **1703,** Vienna. [Grove 1980, 1:584]

Sebastiano Ricci, 1659–1734. Series of frescoes depicting the deeds of Hercules. **1706–07.** Sala d'Ercole, Palazzo Marucelli-Fenzi, Florence. [Daniels 1976, no. 110—ill.]
———. Cycle of grisaille frescoes, depicting deeds of Hercules, for ceiling in Portland House, London. 1712–13. Destroyed. [Ibid., no. 208—ill.]

Antonia Bembo, 1670–? *L'Ercole amante.* Tragic opera. Libretto, after Buti's for Cavalli (1662). **1707.** [Cohen 1987, 1:73]

Francesco Gasparini, 1668–1727. *L'Alcide, o, Violenza d'amore* [Alcides, or, The Violence of Love]. Opera. First performed **1709,** Rome. [Clément & Larousse 1969, 1:28]

Johann David Heinichen, 1683–1729. *Hercules.* Opera. First performed *c.***1709,** Leipzig? [Grove 1980, 8:439]

Gérard de Lairesse, 1641–**1711,** follower. Series of 6 grisaille paintings depicting deeds of Hercules: "Hercules in the Garden of the Hesperides," "Hercules Spinning," "Marriage of Hercules and Deianeira," "Hercules Saving Deianeira," "Hercules Strangling Serpents," "Hercules Saving Hesione." Early 18th century. Louvre, Paris, nos. 20769–74. [Louvre 1979–86, 2:378—ill.]

Giacomo Rossi, fl. 1710–31, libretto. *Ercole.* Opera-pasticcio. Music, anonymous. First performed May **1712,** London. [Grove 1980, 16:214 / Nicoll 1959–66, 2:394]

Pier Jacopo Martello, 1665–1727. *Lo starnuto d'Ercole* [The Sneeze of Hercules]. Puppet play. In *Teatro italiano* (Rome: **1715**). [DELI 1966–70, 3:153f., 528]

Johann Philipp Käfer, 1672–*c.*1730. *Der durch sein Siegen bezwungene Hercules* [Hercules, Conqueror through His Victories]. Opera. First performed **1716,** Durlach. [Grove 1980, 9:766]

Alberto Carlieri, 1672–after **1720.** "Sacrifice to Hercules." Painting. Gemäldegalerie, Kassel. [Walters 1976, no. 385 *n.*]

Jean-Louis Lemoyne, 1665–1755. "Hercules." Statue. Garden, Palais-Royal, Paris. **1715–23.** [Réau 1927, 18, no. 15]

Jean-François Millet II, 1666–**1723,** attributed. "Drunken Hercules with Nymphs and Satyrs" ("The Triumph of Silenus"). Painting. Kress coll. (K1913), Portland Art Museum, Oregon, no. 61.60. [Eisler 1977, pp. 295f.—ill.]

François Le Moyne, 1688–1737. "Putti Playing with the Accoutrements of Hercules." Painting. **1721–24.** Unlocated. [Bordeaux 1984, no. 41—ill. (print)]

Gabriel Grupello, 1644–1730, circle. "Hercules." Wood statuette. **1700/25.** Hessisches Landesmuseum, Kassel. [Kultermann 1968, fig. 126 / cf. Düsseldorf 1971, nos. 47–49]

Giovanni Battista Tiepolo, 1696–1770. "Hercules 'Gallicus' Enchains People by His Tongue" ("Hercules and the Chained Cercopes"). Part of "Allegory of Eloquence" ceiling fresco. *c.***1725.** Palazzo Sandi, Venice. [Levey 1986, pp. 23ff.—ill. / Morassi 1962, p. 60 / Pallucchini 1968, no. 32—ill.] Modello. Courtauld Institute, London. [Levey—ill. / Pallucchini, no. 32a—ill.]

Johann Franz Michael Rottmayr, 1654–1730. "Apollo in Laurel Wreath and with Lyre, with the Mares of Admetus, the Muses, and Hercules" (?). Painting. Art Institute of Chicago, no. 61.39. [Chicago 1965]

James Thomson, 1700–1748. "The Farnese Hercules," passage in *Liberty* part 4, lines 141ff. Poem. London: Millar, **1735–36.** [Larrabee 1943, pp. 78–80]

John Michael Rysbrack, 1694–1770. "Hercules." Painted terra-cotta statuette. **1744.** Stourhead, Wiltshire. [Jackson-Stops 1985, no. 156—ill.] Full-size marble version. 1747–56. Stourhead. [Ibid.]

Pedro José Bermúdez de la Torre y Soliér, 1665–? *Hercules aclamado de Minerva* [Hercules Acclaimed by Minerva]. Poem. Lima: Nueva de la Calle de los Mercaderes, **1745.** [Palau y Dulcet 1948–77, 2:186]

Jean-Marc Nattier, 1685–1766. "The Duke of Chaulnes as Hercules." Painting. **1746.** Louvre, Paris, no. R.F. 2157. [Louvre 1979–86, 4:121—ill.]

Francesco Solimena, 1657–**1747.** "Minerva and Hercules." Painting. Museo di Capodimonte, Naples. [Pigler 1974, p. 119]

Daniel Dal Barba, 1715–1801. *Lo starnuto d'Ercole* [The Sneeze of Hercules]. Intermezzo. First performed *c.***1748,** Seminario, Verona. [Grove 1980, 5:151]

Giuseppe Bazzani, 1690/1701–1769. "Hercules" (and Virtue?). Painting. *c.***1750.** Kress coll. (K1271), Howard University, Washington, D.C., no. 61.155.P. [Shapley 1966–73, 3:115—ill.]

Gaetano Casali, ?–1767. *Le azioni d'Ercole, imitate da Truffaldino suo scudiero* [The Deeds of Hercules, Imitated by His Knight Truffaldino]. Comedy. First performed **1753,** Milan. [DELI 1966–70, 1:614]

Franz Anton Maulbertsch, 1724–1796. (Hercules, symbolizing strength, in) "Allegory of Art." Ceiling painting. **1759.** Formerly Akademie der Wissenschaft, Universität, Vienna. [Garas 1960, no. III, p. 51]

Louis François Roubiliac, 1702–1762. "Athena Crowns Hercules." Marble relief, memorial for Major General James Fleming (1682–1751). *c.***1761?** Westminster Abbey, London. [Whinney 1964, p. 108]

Andries Cornelis Lens, 1739–1822. "Hercules Protecting the Muse of the Fine Arts from Jealousy and Ignorance." Painting. **1763.** Koninklijk Museum voor Schone Kunsten, Antwerp, no. 1092. [Antwerp 1970, p. 121]

Giovanni Domenico Tiepolo, 1727–1804. "The Golden Fleece" ("Glorification of Spain") (Hercules, with Cupid and Fama, Jason, and Neptune, presenting Golden Fleece to Spanish monarchy). Ceiling fresco. **1764–66.** Palacio Real, Madrid. [Honisch 1965, p. 41 / Mariuz 1979, p. 123—ill.] Study. Marzotto coll., Portogruaro. [Mariuz 1982, p. 134—ill.]

James Barry, 1741–1806. "Hercules." Drawing. *c.***1767–70.** Ashmolean Museum, Oxford. [Pressly 1981, no. D.2]

Friedrich Maximilian von Klinger, 1752–1831. *Der verbannte Göttersohn* [The Exiled Son of the God] (Hercules, as revolutionary). Dramatic fragment. First part published Gotha: Ettinger, **1777;** second part in *Theater,* vol. 3 (Riga: Hartknoch, 1786–87). [Daemmrich 1987, pp. 133f. / DLL 1968–90, 8:1336]

Laurent Delvaux, 1696–**1778.** "Hercules Resting." Marble statue. Musées Royaux des Beaux-Arts, Brussels, inv. 6296. [Brussels 1968, no. 7]

Johann Samuel Patzke, 1727–1787. *Die Taten des Herkules* [The Deeds of Hercules]. Drama. **1780.** [Hunger 1959, p. 144]

Giuseppe Maria Cambini, 1746–1825. *Alcide.* Opera. Libretto, A. Dubreuil. First performed **1782,** Académie Royal, Paris. [Grove 1980, 3:640]

Luciano Xavier dos Santos, 1734–1808. *Ercole sul Tago* [Hercules at the Tagus (River)]. Opera (dramma per musica). Libretto, V. A. Cigna. First performed **1785,** Queluz or Ajuda. [Grove 1980, 16:485]

Christoph Unterberger, 1732–1798. Cycle of ceiling paintings, 4 scenes from the life of Hercules surrounding a central "Apotheosis of Hercules." **1784–86.** Galleria Borghese, Rome. / Study for "Apotheosis" in Walters Art Gallery, Baltimore, inv. 37.1698. [Walters 1976, no. 427—ill.]

Jan Kamphuijsen, 1760–1841. Ceiling painting with scenes from the life of Hercules, for Brentano house, Herengracht, Amsterdam, probably after a design by G. Maderni (1758–1803). **1790–91.** Rijksmuseum, Amsterdam, inv. A4140–41. [Rijksmuseum 1976, p. 311—ill.]

Friedrich Hölderlin, 1770–1843. (Hercules' struggle against destiny evoked in) "Das Schicksal" [Fate]. Poem. **1793.** In *Neue Thalia,* part 4, edited by Friedrich Schiller (Leipzig: Göschen, 1793). [Beissner 1943–77, vol. 1 / Galinsky 1972, p. 255, 256]

————. (Christ addressed as "Hercules' brother" in) "Der Einzige" [The Only One]. Poem. 1803. [Beissner, vol. 2 / Hamburger 1980 / Unger 1975, pp. 175ff. / Galinsky, p. 256]

————. (Hercules as epitome of the Greek character, in) "Einst hab ich die Muse gefragt" [At One Time I Questioned the Muse]. Hymn, fragment. c.1800–05. [Beissner / Hamburger / Galinsky, p. 258]

Johann Baptist von Alxinger, 1755–1797. "Herkules." Poem. In *Neueste Gedichte* (Vienna: Josef Camesina, **1794**). [Strich 1970, 1:218]

Samuel Rogers, 1763–1855. "On the Torso of Hercules" (Hercules Belvedere). Sonnet. **1802.** In *Poems* (London: Cadell & Davies, 1812). [Larrabee 1943, p. 6]

Francesco Bianchi, 1752–1810. *Le triomphe d'Alcide à Athènes* [The Triumph of Alcides at Athens]. Opera (dramma eroico). Libretto, P. L. Moline and A. F. Pillon. First performed Sep **1806,** Théâtre Molière, Paris. [Grove 1980, 2:674]

August Wilhelm Iffland, 1759–**1814.** *Herkules.* Musical drama. In *Theater* (Vienna: Pichler, 1814–19). [Strich 1970, 1:255n]

Andrea Appiani the Elder, 1754–**1817.** "Hercules and Venus." Painting. Château de Compiègne. [Bénézit 1976, 1:236]

Giuseppe Cacialli, 1770–1828. Cycle of chiaroscuro simulated bas-reliefs depicting scenes from the life of Hercules. **1810–20.** Sala d'Ercole, Palazzo Pitti, Florence. [Pitti 1966, pp. 137ff.—ill.]

François Décombe Albert, 1789–1865, with **André Jean-Jacques Deshayes,** 1777–1846, choreography. *Alcide.* Ballet. First performed 21 July **1821,** for coronation of George IV, King's Theatre, London. [Guest 1972, pp. 35, 156 / Nicoll 1959–66, 4:425]

Giacomo Leopardi, 1798–1837. "Dialogo d'Ercole e di Atlante" [Dialogue between Hercules and Atlas]. Dialogue. **1824.** In *Operette morali* (Milan: Stella, 1827). [Cecchetti 1982 / Casale 1981; cf. p. 16]

William Blake, 1757–1827. "A Vision of Hercules." Drawing. c.1825? Unlocated. [Butlin 1981, no. 802A]

Merry-Joseph Blondel, 1781–1853. Heracles and Olympian gods, holding the arms of France, in ceiling decoration, Salle de la Donation Comondo (2e Salle du Conseil d'État), Louvre, Paris (inv. 2628). **1827.** [Louvre 1979–86, 3:65—ill.]

Pietro Benvenuti, 1769–1844. Cycle of paintings depicting scenes from the life of Hercules: infant Hercules strangling the snakes, Hercules at the crossroads, battling the centaurs, delivering Alcestis, nuptials of Hercules and Hebe. **1828.** Saloncino d'Ercole, Palazzo Pitti, Florence. [Pitti 1966, pp. 137ff.—ill.]

Johann Wolfgang von Goethe, 1749–1832. (Chiron tells Faust of Hercules, "the fairest man," in) *Faust* Part 2, 2.7381–97. Tragedy. This episode written **1830.** Heidelberg: 1832. [Beutler 1948–71, vol. 5 / Suhrkamp 1983–88, vol. 2 / Galinsky 1972, pp. 216f.]

Balthazar-François Tasson-Snel, 1811–1890. "Hercules." Painting. **1830.** Musées Royaux des Beaux-Arts (Musée d'Art Moderne), Brussels, inv. 6111. [Brussels 1984b, p. 607—ill.]

Philippe-Auguste Hennequin, 1763–**1833.** "The French Hercules." Ceiling painting. Commissioned 1800. Salle des Sévères (Antonins), Louvre, Paris (inv. 20097). [Louvre 1979–86, 3:309—ill.]

Frederick Fox Cooper, 1806–1879. *Hercules, King of Clubs.* Farce. First performed 28 July **1836,** Strand Theatre, London. [Nicoll 1959–66, 4:283]

Bertel Thorwaldsen, 1770–1844. "Hercules" ("Allegory of Courage"). Over-lifesize bronze statue. Modeled **1843.** Prinz Jørgens Gaard, Christiansborg Palace, Copenhagen. / Plaster model. Thorwaldsens Museum, no. A14 (cf. A15–16). [Thorwaldsen 1985, p. 22 / Cologne 1977, no. 46]

Antoine-Louis Barye, 1796–1875. Hercules mask, on stone cornice, Pont Neuf, Paris. **1851.** [Benge 1984, pp. 49f., pl. 31]

Eugène Delacroix, 1798–1863. "Episodes from the Life of Hercules." 11 ceiling paintings, for Salon de la Paix, Hôtel de Ville, Paris. **1851–52.** Destroyed by fire, 1871. [Robaut 1885, nos. 1152–62—ill. (copy drawings) / Huyghe 1963, pp. 289, 423, 474]

————. "Hercules Resting from His Labors." Painting. 1858. Wildenstein & Co., New York, in 1978. [Johnson 1981–86, no. 328a—ill. / also Robaut, no. 1351—ill. (copy drawing)]

Thomas Moore, 1779–1852. "Song of Hercules to His Daughter." Poem. In *Poetical Works* (London: Longman & Co., 1853). [Boswell 1982, p. 188]

Charles Marie René Leconte de Lisle, 1818–1894. "Héraklès solaire." Poem. In *Oeuvres: Poèmes antiques* (Paris: Lemerre, **1852**). [Pich 1976–81, vol. 1]

Gaspare Martellini, 1785–**1857.** "Hercules." Painting. Sala di Ulisse, Palazzo Pitti, Florence. [Pitti 1966, p. 131]

Victor Hugo, 1802–1885. (Hercules in) "Le satyre." Poem, prologue to "Renaissance paganisme," part 8 of *La légende des siècles,* 1st series (Paris: Hetzel, **1859**). [Hugo 1985–86, vol. 5]

Carl Spitteler, 1845–1924. *Herakles.* Epic, projected as life's work in **1866,** but unwritten. [Galinsky 1972, p. 279]

————. "Erdenfahrt" [Journey to Earth] (by Heracles).

Poem, epilogue to *Olympischer Frühling* (Leipzig: Diederichs 1900–05). / Revised, published Jena: Diederichs, 1910; Leipzig: Diederichs, 1925. [Ibid., pp. 279–85, 293 / Butler 1958, p. 322]

Louis Moreau Gottschalk, 1829–1869. *Hercule.* Composition for piano. 1869. [Grove 1980, 7:573]

Lawrence Alma-Tadema, 1836–1912. "Hercules." Painting. 1872. Unlocated. [Swanson 1977, p. 137]

Arnold Böcklin, 1827–1901. "The Sanctuary of Heracles." 2 related paintings. *c.*1880. Hessisches Landesmuseum, Darmstadt, inv. GK 657; the other lost. [Andree 1977, nos. 341–42—ill.]

———. "The Sanctuary of Heracles." Painting. 1884. National Gallery, Washington, D.C. [Ibid., no. 378—ill. / Walker 1984, p. 414—ill.]

José-Maria de Heredia, 1842–1905. "Hercule et les centaures." Cycle of 6 sonnets: "Némée," "Stymphale," "Nessus," "La centauresse," "Centaures et lapithes," "Fuite des centaures." "Némée" first published in *La légende du Parnasse contemporain* (Paris: **1884**); complete cycle in *Revue des deux mondes* 15 Jan 1888; collected in *Les trophées* (Paris: Lemerre, 1893). [Delaty 1984, vol. 1; cf. 2:42, 51 / Hill 1962]

Gustav Natorp, 1836–1898? "Hercules." Sculpture. Exhibited **1884.** [Kestner 1989, p. 352]

Gustave Moreau, 1826–1898. "Naked Hercules." Wax models (one full-figure, one head) for unexecuted sculpture. **1875–85.** [Mathieu 1976, p. 189]

Iacob Mureşianu, 1857–1917. *Erculeanul* [Hercules]. Cycle of musical ballads. Text, V. Alecsandri. **1890.** [Grove 1980, 12:791]

Émile-Antoine Bourdelle, 1861–1929. "Head of Hercules." Bronze sculpture. **1905.** 9 casts. Musée Ingres, Montauban; elsewhere. [Jianou & Dufet 1975, no. 185] Variant (mask). *c.*1905. [Ibid.]

———. "Head of Hercules." Bronze sculpture. 1909. 2 versions, 10 casts of each. Musée Bourdelle, Paris; elsewhere. [Ibid., no. 391—ill. / Cannon-Brooks 1983, pp. 63f.—ill.] 3d version, in plaster. Musée Ingres, Montauban; Nouveau Musée des Beaux-Arts, Le Havre; Musée Saint-Pierre, Lyons. / Bronze studies, numerous versions and casts. [Jianou & Dufet, nos. 391–94 / Cannon-Brooks, fig. 89] 2 bronze variants ("Mask of the Large Heracles," "Archer"). 1909. 2 casts of each. Private coll(s). [Jianou & Dufet, nos. 397–98] Variant, based on "Heracles the Archer (Killing the Birds at Lake Stymphalus)." 1909. Bronze, plaster, terra-cotta, and *terre-sèche* versions. Musée Bourdelle, Paris; Ny Carlsberg Glyptotek, Copenhagen; Boymans-van Beuningen Museum, Rotterdam; Dartmouth College Museum, Hanover, N.H.; private colls. [Ibid., no. 396] Variant (mask). 1909. Bronze, terra-cotta, and *terre-sèche* versions. Private colls. [Ibid.]

Rubén Darío, 1867–1916. (Shade of Hercules evoked in) "Salutación del Optimista" [Salutation of the Optimist]. Poem. In *Cantos de vida y esperanza* (Madrid: Tipografía de la Revista de Archivos, Bibliotecas y Museos, **1905**). [Méndez Plancarte 1967 / Hurtado Chamorro 1967, pp. 171, 174f.]

George Cabot Lodge, 1873–1909. *Herakles.* Dramatic poem. **1908.** In *Poems and Dramas,* vol. 2 (Boston: Houghton Mifflin, 1911). [Boswell 1982, p. 268 / Galinsky 1972, pp. 218, 229]

Louis Couperus, 1863–1923. *Herakles.* Novel. Amsterdam: Veen, **1913.** [EWL 1981–84, 1:502 / Meijer 1971, p. 253]

Karel van de Woestijne, 1878–1929. "Hercules." Epic poem. In *Interludiën* (Bussum: Van Dishoeck, **1912–14**). [EWL 1981–84, 4:649 / Meijer 1971, p. 273]

Franz Barwig, 1868–1931. Hercules fountain. Exhibited Cologne, **1914.** [Barwig 1969, no. 15, p. 23]

Paul Manship, 1885–1966. "Hercules." Statue, terminal figure, for gardens of Harold McCormick, Lake Forest, Ill. **1914.** Unlocated. [Murtha 1957, no. 61]

———. "Hercules." Bronze statue, for Hercules Powder Company. 1945. [Ibid., no. 459] 2 bronze sketches. [Ibid., nos. 457–58—ill.]

Edward Field Sanford, Jr., 1886–1951. "Hercules." Bronze statuette. **1916.** Metropolitan Museum, New York, no. 52.108. [Metropolitan 1965, p. 155]

Frank Wedekind, 1864–1918. *Herakles.* Verse drama. Munich: Müller, **1917.** First performed 1 Sep 1919, Prinzregententheater, Munich. [Daemmrich 1987, pp. 133f. / Oxford 1986, p. 961 / McGraw-Hill 1984, 5:130 / Galinsky 1972, pp. 236–40, 297]

Otokar Fischer, 1883–1938. *Herakles.* Tragedy. Prague: Aventinum, **1919.** [Frenzel 1962, p. 262 / EDS 1954–66, 5:401]

Yves de La Casinière, 1897–1971. *Hercule et les centaures.* Symphonic poem, after Heredia. **1920.** [Grove 1980, 10:344]

Felix Braun, 1885–1973. *Die Taten des Herakles* [The Deeds of Heracles]. Novel. **1921.** Leipzig: Speidel, 1927. [Oxford 1986, p. 107]

Aldous Huxley, 1894–1963. (Story of Sir Hercules and Lady Filomenia related in) *Crome Yellow.* Novel. London: Chatto & Windus, **1921.** [Ipso] This episode revised as a short story, "Sir Hercules." In *Twice Seven: Fourteen Selected Stories* (London: Reprint Society, 1944). [Ipso]

Rudolf Borchardt, 1877–1945. *Der ruhende Herakles* [Heracles Resting]. Idyl. Munich: Bremer Presse, **1924.** [DLB 1988, 66:50 / DLL 1968–90, 1:784]

Theodor Däubler, 1876–1934. (Hercules' birth evoked, his exploits celebrated, in) *Päan und Dithyrambos: Eine Phantasmagorie* [Paean and Dithyramb: A Phantasmagoria] part 7. Poem. Leipzig: Insel, **1924.** [Ipso / DULC 1959–63, 1:964]

Sacheverell Sitwell, 1897–1988. "The Farnese Hercules." Poem. In *The Cyder Feast and Other Poems* (London: Duckworth, **1927**). [Boswell 1982, p. 294]

Georges Braque, 1882–1963. "Heracles." Etched-plaster relief, illustrating Hesiod. **1931.** [Fumet 1951, introduction; cf. nos. 21–28—ill.]

Francis Picabia, 1878–1953. "Apollo and his Steeds" ("Hercules and His Coursers"). Painting. **1935.** [Borràs 1985, no. 650—ill. / Camfield 1979, fig. 371]

Yvor Winters, 1900–1968. "Heracles." Poem. In *Rocking Horse* 2 (**1935**); collected in *Twelve Poets of the Pacific* (Norfolk, Conn.: New Directions, 1937); *Collected Poems* (Manchester: Carcanet, 1978). [Ipso / Isaacs 1981, p. 87 / Powell 1980, pp. 38, 116, 129–33, 145, 157]

Gerhart Hauptmann, 1862–1946. "Der Knabe Herakles" [The Boy Heracles]. Poem. **1938.** [Voight 1965, pp. 127f.]

Nikos Kazantzakis, 1883–1957. (Hercules appears at end of) *Odysseia.* Epic poem. Athens: Chrestou, **1938.** / Translated by Kimon Friar as *The Odyssey: A Modern*

Sequel (New York: Simon & Schuster; London: Secker & Warburg, 1958). [Stanford 1974, p. 228]

Janine Charrat, 1924–, choreography. *Héraklès*. Ballet. Scenario, A. Boll. Music, Maurice Thiriet. First performed **1953**, Théâtre des Champs-Elysées, Paris; scenery and costumes, F. Gilst. [Chujoy & Manchester 1967, p. 192 / EDS 1954–66, 3:552 / Grove 1980, 18:773]

Giorgio de Chirico, 1888–1978. "Hercules." Painting. **1953**. Artist's coll., Rome, in 1974. [de Chirico 1971–83, 4.3: no. 459—ill.]

Alan Hovhaness, 1911–. "Hercules." Composition for soprano and violin, opus 56/4. **1956**. [Grove 1986, 2:433]

André Dubois la Chartre. *Journal intime de Hercule* [Intimate Journal of Hercules]. Novel. Paris: Gallimard, **1957**. [Daemmrich 1987, p. 134]

Marijan Matković, 1915–. *Heraklo*. Drama, part 2 of trilogy *I bogovi pati* [Even Gods Suffer]. First performed Zagreb, **1958**. Published Zagreb: Zora, 1962. [McGraw-Hill 1984, 3:35 / EDS 1954–66, suppl. p. 684]

Carl Zuckmayer, 1896–1977. *Der trunkene Herkules* [Drunken Hercules]. Comedy. **1958**. In *Dramen,* vols. 3–4 of *Gesammelte Werke* (Berlin: Fischer, 1960). [Oxford 1986, p. 1015]

John Eaton, 1935–. *Heracles*. Opera. Libretto, M. Fried. **1964**. First performed 15 Apr 1972, Musical Arts Center, Indiana University, Bloomington. [Baker 1984, p. 639]

Jorge Luis Borges, 1899–1986, with **Margarita Guerrero**. "Cronos o Hércules" [Cronus or Hercules]. Prose sketch. In *El libro de los seres imaginarios* (Buenos Aires: Kier, **1967**). / Translated by N. T. di Giovanni, with Borges, in *The Book of Imaginary Beings* (New York: Dutton, 1969). [Ipso]

Archibald MacLeish, 1892–1982. *Herakles*. Verse drama. Boston: Houghton Mifflin, **1967**. [Boswell 1982, p. 175 / Galinsky 1972, pp. 187, 244ff.]

Ján Zimmer, 1926–, music. *Héraklés*. Ballet for television. **1970**. [Grove 1980, 20:686]

———. *Héraklés*. Opera. 1972. [Baker 1984, p. 2567]

Peter Huchel, 1903–. "Unterm Sternbild des Hercules" [Under the Constellation of Hercules]. Poem. Before **1972**. In *Ausgewählte Gedichte*, edited by Peter Wapnewski (Frankfurt: Suhrkamp, 1973). [Ipso]

Salvador Dalí, 1904–1989. "Hercules and Gradiva." Drawing. **1973**. Private coll. [Pompidou 1979, pl. 330]

Pentti Saarikoski, 1937–1983. (Hercules in modern setting in) *Tanssilattia vuorella* [Dance Floor on the Mountain]. Poem. Helsinki: Otava, **1977**. [EWL 1981–84, 4:119]

Birth of Heracles. In Thebes, Alcmene, wife of Amphitryon, was visited by Zeus (Jupiter), who appeared to her in the guise of her husband. She was impregnated by the god on one night and by Amphitryon on the following night. When she went into labor, Zeus boasted that a child who would lead a great dynasty was about to be born. Consumed with jealousy, Hera (Juno) sent Eileithyia, the goddess of childbirth and midwifery, to delay the birth, which she did for seven days and seven nights by sitting outside Alcmene's door with her hands clasped around her knees. In an attempt to break Eileithyia's spell, Alcmene's maid, Galinthias (Galanthis), announced that a son had been born. Startled, Eileithyia jumped up and unclasped her hands. At that moment, Heracles (Hercules), son of Zeus, and his twin brother Iphicles, son of Amphitryon, were born. In anger, Eileithyia changed Galinthias into a weasel. Before Heracles was born, however, Hera had expedited the birth of Eurystheus, later king of Tiryns, and in so doing had thwarted Zeus's prophecy by depriving Heracles of the Tirynthian throne. It was Eurystheus, agent of Hera's spite, who sent Heracles off on his labors.

According to a Hellenistic work ascribed to Eratosthenes (or pseudo-Eratosthenes), the sons of Zeus could be divine only if they were suckled by Hera. Hermes (Mercury) therefore brought the newborn Heracles to Hera, but when she discovered whom she was nursing, she pulled him off her breast. The excess milk that spurted out formed the Milky Way galaxy.

Classical Sources. Homer, *Iliad* 19.96–133. Eratosthenes of Alexandria (ascribed), *Catasterismoi* 44. Plautus, *Amphitruo* 112ff., 760ff., 1123 ff. Diodorus Siculus, *Biblioteca* 4.9.1–4.10.1. Ovid, *Metamorphoses* 9.280–323. Apollodorus, *Biblioteca* 2.4.5, 2.4.8. Hyginus, *Fabulae* 29; *Poetica astronomica* 2.43. Lucian, *Dialogues of the Dead* 11, "Diogenes and Heracles."

See also AMPHITRYON AND ALCMENE.

Albrecht Dürer, 1471–1528, studio, under Dürer's direction. "The Birth of Hercules." Drawing, design for series of medals (unlocated) depicting the adventures of Hercules. **1510–11**. Formerly Kunsthalle, Bremen, lost. [Strauss 1974, no. 1511/21—ill.]

Fernán Pérez de Oliva, 1494?–1533. *El nascimiento de Hércules, ó, Comedia de Anfitrion* [The Birth of Hercules, or, Comedy of Amphitryon]. Comedy, adapted from Plautus. **1525**. Probably unperformed. Published in *Obras,* edited by Ambrosio de Morales (Cordova: Bejarano, 1586). [Oxford 1978, pp. 458f. / Passage & Mantinband 1974, p. 116]

Giulio Romano, c.1499–1546. "The Weaning of Hercules." Painting, part of "Jupiter" cycle. **c.1533?** E. Schapiro coll., London. [Hartt 1958, p. 215—ill.]

Jacopo Tintoretto, 1518–1594. "The Origin of the Milky Way." Painting. **1578–80**. National Gallery, London, no. 1313. [Rossi 1982, no. 390—ill. / London 1986, p. 615—ill. / Berenson 1957, p. 174—ill.]

Michelangelo Buonarroti the Younger, 1568–1646, libretto. *Il natal d'Ercole*. Favola. Text published Florence: Giunti, **1605**. [DELI 1966–70, 1:50]

Jacopo Peri, 1561–1633. *Il natal d'Ercole*. Favola per musica. Libretto, Michelangelo Buonarroti the Younger (above). First performed 22 Oct **1605**, Casino di D. Antonio de' Medici, Florence. [Weaver 1978, p. 92]

Anonymous English. *The Birthe of Hercules*. Comedy,

after Plautus's *Amphitruo* and perhaps Heywood's *The Silver Age*. First performed 4 June **1626**, Court Theater, Dresden? [Passage & Mantinband 1974, p. 117 / Shero 1956, pp. 192ff. / Clark 1931, p. 67 *n*.]

Peter Paul Rubens, 1577–1640. "The Creation of the Milky Way" ("Juno Suckling Hercules"). Painting, for Torre de la Parada, El Pardo. **1636–38**. Prado, Madrid, no. 1668. [Alpers 1971, no. 42 / Jaffé 1989, no. 1292—ill. / White 1987, pl. 301 / Prado 1985, p. 581] Oil sketch. Musées Royaux des Beaux-Arts (Musée d'Art Ancien), Brussels, inv. 4105 (814). [Alpers, no. 42a—ill. / Held 1980, no. 200—ill. / Jaffé, no. 1292a—ill. / Brussels 1984a, p. 251—ill. / White, pl. 300]

John Dryden, 1631–1700. (Prince James Edward's birth compared to Hercules' in) "Britannia Redivia, a Poem on the Prince, Born on the 10th of June, 1688" lines 55–58. Poem. London: Tonson, **1688**. [Dryden 1956–87, vol. 3 / Winn 1987, p. 446 / Miner 1967, p. 106 / Van Doren 1946, p. 112]

William Shirley, fl. 1739–80. *The Birth of Hercules*. Masque, to celebrate the birth of the Prince of Wales. Music, Thomas Arne. In rehearsal for 11 Jan **1763**, Covent Garden, London, unperformed because of Half Price Riots. [Grove 1980, 1:610 / Fiske 1973, p. 316 / Nicoll 1959–66, 3:306]

Henry Fuseli, 1741–1825. "Galinthias Deceives Eileithyia by Announcing the Birth of Heracles." Drawing. *c*.1772. Kunsthaus, Zürich, inv. 1940/188. [Schiff 1973, no. 406—ill.]

Johann Christian Friedrich Haeffner, 1759–1833. *Alcides inträde i världen* [Hercules Enters the World]. Opera. Libretto, Eldencrantz. First performed 11 Nov **1793**, Stockholm. [Grove 1980, 8:20]

Eugène Delacroix, 1798–1863. "Juno and Minerva Holding the Infant Hercules." Ceiling painting, in "Life of Hercules" cycle, for Salon de la Paix, Hôtel de Ville, Paris. **1851–52**. Destroyed by fire, 1871. [Robaut 1885, no. 1153—ill. (copy drawing) / Huyghe 1963, pp. 289, 423, 474]

Aimé-Jules Dalou, 1838–1902. "Juno Nursing Hercules" ("The Milky Way"). Terra-cotta sculpture. **1874**. Destroyed. / Terra-cotta sketch ("Woman Pressing Her Breasts"). Late 1860s. Petit Palais, Paris, no. 202. [Caillaux 1935, p. 127 / Hunisak 1977, p. 124, fig. 44]

Julio Herrera y Reissig, 1875–1910. (Origin of the Milky Way evoked in) "Génesis." Sonnet. **1910**. In *Las clepsidras* (Montevideo: 1910); reprinted in *Los éxtasis de la Montaña* Montevideo: Editoriale elite, [196?]). [Schade 1959, p. 47]

Theodore Däubler, 1876–1934. (Hercules' birth evoked in) *Päan und Dithyrambos: Eine Phantasmagorie* [Paean and Dithyramb: A Phantasmagoria] part 7. Poem. Leipzig: Insel, **1924**. [Ipso / DULC 1959–63, 1:964]

Infant Heracles and the Serpents. Furious at having failed to prevent the birth of Heracles (Hercules), Hera (Juno) attempted to kill the child by placing two serpents in his cradle. When Iphicles, Heracles' mortal twin, screamed, their father Amphitryon came running, sword in hand. When he

saw Heracles strangle the serpents with his bare hands, Amphitryon knew that this was Zeus's son.

Classical Sources. Pindar, *Nemean Odes* 1.41–72. Sophocles, *The Infant Heracles*. Theocritus, *Idylls* 24. Diodorus Siculus, *Biblioteca* 4.10.1–2. Ovid, *Metamorphoses* 9.280–323. Apollodorus, *Biblioteca* 2.4.8–9. Philostratus, *Imagines* 5. Hyginus, *Fabulae* 29.

Filarete, *c*.1400–1469? "The Infant Hercules." Relief, on bronze door of St. Peter's, Rome. **1433–45**. In place. [Pope-Hennessy 1985b, 2:318]

Antico, *c*.1460–1528. "Infant Hercules Strangling the Serpents." Bronze medallion, part of series depicting deeds of Heracles. *c*.**1500**? Victoria and Albert Museum, London. [Louvre 1975, no. 61]

Albrecht Altdorfer, *c*.1480–1538. "Infant Hercules Strangling the Snakes." Print (Bartsch no. 98). *c*.**1520**. [Winzinger 1963, no. 150—ill.]

———. "Lidded Goblet with Infant Hercules." Print (Bartsch no. 98). *c*.**1520–25**. [Ibid., no. 199—ill.]

Giulio Romano, *c*.1499–1546. "Hercules Slaying the Serpents." Painting. Formerly coll. of Leopold of Belgium, lost. [Pigler 1974, p. 107] Engraving (Bartsch no. 315) by Agostino Veneziano, **1533**. [Bartsch 1978, 26:316—ill.]

———. "Hercules Slaying the Serpents." Painting, part of "Jupiter" cycle. *c*.**1533**? Lost. / Drawing in Victoria and Albert Museum, London, no. D.1973–1885. [Hartt 1958, pp. 215, 306 (no. 307a)] Another drawing of the subject, in Szépmúvészeti Múzeum, Budapest. [Ibid., p. 306 (no. 320)]

Giovanni Bernardi, 1496–**1553**, and **Manno di Bastiano**, design. Statuette representing infant Hercules, on "The Farnese Coffer." Silver gilt coffer. Executed by another, 1548–61. Museo di Capodimonte, Naples, no. 10507. [Capodimonte 1964, p. 129]

Giorgio Vasari, 1511–1574, and assistants. Infant Hercules strangling the snakes, depicted in cycle of ceiling paintings on the deeds of Hercules. **1557**. Sala di Ercole, Palazzo Vecchio, Florence. [Sinibaldi 1950, pp. 13, 23 / Lensi 1929, pp. 154ff., 163f.]

Guglielmo della Porta, 1490?–1577. "Infant Hercules Strangling the Serpents." Bronze sculpture. Galleria di Capodimonte, Naples, no. 410. [Capodimonte 1964, p. 31]

Annibale Carracci, 1560–1609. "Infant Hercules Strangling the Serpents." Grisaille fresco, part of "Hercules" cycle. **1595–97**. Camerino, Palazzo Farnese, Rome. [Malafarina 1976, no. 87g—ill. / Martin 1965, pp. 27ff.—ill.]

———. "Infant Hercules Strangling the Serpents." Painting. *c*.**1599–1600**. Louvre, Paris, inv. 206. [Malafarina, no. 113—ill. / Louvre 1979–86, 2:163—ill.]

Aegidius Sadeler, 1570–**1629**. "Infant Hercules" (strangling the serpents). Drawing. Albertina, Vienna. [de Bosque 1985, p. 118—ill.]

Alessandro Algardi, 1598–1654. "Infant Hercules with a Snake." Sculpture group. Original marble and bronze versions lost. [Montagu 1985, no. 127] Bronze casts in Schloss Charlottenburg, Berlin; Louvre, Paris; Palazzo Barberini, Rome; elsewhere. [Ibid., pp. 405ff.—ill.] Marble copy in Charlottenburg (damaged); another unlocated. [Ibid.]

Gerard van Opstal, 1597–**1668**. "Infant Hercules and Serpent." Ivory sculpture. M. H. de Young Memorial Museum, San Francisco. [Clapp 1970, 1:674]

Giovanni Andrea Sirani, 1610–**1670**, attributed (previ-

ously attributed to Guido Reni). "Hercules as a Child." Painting. Bayerisches Staatsgemäldesammlungen, Munich, 1789. [Pepper 1984, p. 304 no. C5]

Luca Giordano, 1634–1705. "Hercules in the Cradle." Fresco, part of "Hercules" cycle, for Buen Retiro, Madrid. *c.***1697.** Destroyed. / Engraved by Giuseppe Castillo and Juan Barcelon, 1779. [López Torrijos 1985, p. 407 no. 39 / Ferrari & Scavizzi 1966, 1:155, 2:278]

Balthasar Permoser, 1651–1732. "Hercules with the Serpents." Marble and bronze statue. *c.***1704–10.** Schloss Charlottenburg, Berlin. [Asche 1966, no. P41, pl. 37]

Gérard de Lairesse, 1641–**1711,** follower. "Infant Hercules Strangling the Two Serpents Sent by Hera." Paintings, part of series of grisailles on deeds of Hercules. Early 18th century. Louvre, Paris, inv. 20773. [Louvre 1979–86, 2:378—ill.]

Sebastiano Ricci, 1659–1734. "The Infant Hercules Strangling the Serpents." Grisaille ceiling fresco, part of "Hercules" cycle, for Portland House, London. **1712–13.** Destroyed. [Daniels 1976, no. 208]

François Girardon, 1628–**1715,** attributed. "Hercules in the Cradle Strangling the Serpents." Sculpture. Documented in 1765, untraced. [Francastel 1928, no. 84]

Pieter van der Werff, 1665–**1722.** "The Infant Hercules with the Snakes." Painting. Rijksmuseum, Amsterdam, inv. C267. [Rijksmuseum 1976, p. 601—ill.]

Richard van Orley, 1663–**1732.** "Hercules as an Infant." Wash drawing. Louvre, Paris. [Warburg]

Pompeo Batoni, 1708–1787. "The Infant Hercules Strangling the Serpents." Painting. **1743.** Uffizi, Florence, inv. 8548 (displayed in Galleria d'Arte Moderna, Palazzo Pitti). [Clark 1985, no. 68—ill. / Uffizi 1979, no. P166—ill.]

Jacob de Wit, 1695–**1754.** "Hercules as an Infant." Painting. Royal Collection, Holyrood House, Edinburgh. [Warburg]

Jean-Hugues Taraval, 1729–1785. "The Infant Hercules (Strangling Serpents in His Cradle)." Painted sketch. Exhibited **1767.** Musée Municipal, Châlons-sur-Marne. [Royal Academy 1986, p. 51, fig. 38] Variant, exhib. 1785. Louvre, Paris, inv. 8089. [Ibid. / Louvre 1979–86, 4:229—ill.]

Joshua Reynolds, 1723–1792. "The Infant Hercules (Strangling the Serpents)." Painting. **1786–88.** Hermitage, Leningrad, inv. 1348. [Hermitage 1979, pl. 125 / Royal Academy 1986, no. 140—ill. / Waterhouse 1941, p. 80]

William Blake, 1757–1827. "The Infant Hercules Throttling the Serpents." Drawing. *c.***1790–93.** National Gallery, Washington, D.C., no. B–11072. [Butlin 1981, no. 253—ill.]

William Dyce, 1806–1864. "The Infant Hercules Strangling the Serpents Sent by Juno to Destroy Him." Painting. **1824.** National Gallery of Scotland, Edinburgh. [Pointon 1979, pp. 6, 197—ill.]

Eduard Mörike, 1804–1875. "Herakles als Kind" [Heracles as a Child]. Translation of Theocritus, Idyll 24. In *Classische Blumenlese* (Stuttgart: Schweizerbart, **1840).** [Hötzer 1967]

Horatio Greenough, 1805–1852. Relief depicting infant Hercules, on side of chair of "Washington." Marble sculpture. **1832–41.** National Collection of Fine Arts, Washington, D.C. [Wright 1963, p. 133]

Charles Marie René Leconte de Lisle, 1818–1894. "L'en-

fance d'Héraklès." Poem. In *Oeuvres: Poèmes antiques* (Paris: Lemerre, **1852).** [Pich 1976–81, vol. 1]

Gustave Moreau, 1826–1898. "Hercules as a Child Strangling the Serpents." Painting. *c.***1856.** Private coll., Vicenza, Italy. [Mathieu 1976, no. 37—ill.]

Jean-Baptiste Clésinger, 1814–1883. (Prince Eugène-Louis-Jean-Joseph Napoléon as) "Infant Hercules" (with serpents). Marble sculpture. **1856–57.** Destroyed? [Wagner 1986, p. 194—ill.]

Dante Gabriel Rossetti, 1828–1882. "Resolution; or, The Infant Hercules" (William Morris under a showerbath, in a rage). Satirical drawing. **1869.** British Museum, London, no. 1939–5–13–I.(8.). [Surtees 1971, no. 604—ill.]

Camille Saint-Saëns, 1835–1921. *La jeunesse d'Hercule.* Symphonic poem, opus 50. First performed 28 Jan **1877,** Paris. [Grove 1980, 16:405 / Baker 1984, p. 1972]

Paul Manship, 1885–1966. "Infant Hercules Fountain." Bronze fountain. **1914.** 2 casts. American Academy, Rome; Anson coll., Bar Harbor, Me. [Murtha 1957, no. 54—ill. / also Rand 1989, pp. 32ff.—ill. / Minnesota 1985, fig. 14]

Choice of Heracles. When Heracles (Hercules) was a young man, he was sent to tend the cattle of his father, Amphitryon, on Mount Cithaeron. On the way, Heracles was met at a crossroads by two women, Pleasure (Vice) and Virtue. The youth chose Virtue, with her accompanying trials, service, and renown.

This allegory, told as a parable by the sophist Prodicus of Ceos in the fifth century BCE, became widespread. In the postclassical tradition the subject is most frequently known as "Hercules (or Alcides) at the Crossroads." Aphrodite (Venus) and Athena (Minerva) often represent pleasure and virtue.

Classical Sources. Hesiod, *Works and Days* 287ff. Prodicus, *The Choice of Heracles.* Xenophon, *Memorabilia* 2.1.21–34.

Further Reference. Erwin Panofsky, *Hercules am Scheidewege, und andere antike Bildstoffe in der neueren Kunst,* Studien der Bibliothek Warburg 18 (Leipzig & Berlin: Teubner, 1930). Karl Galinsky, *The Herakles Theme* (Totowa, N.J.: Rowman & Littlefield, 1972), pp. 101ff., 198ff., 213ff.

Girolamo di Benvenuto, 1470–1524. "Hercules' Choice." Painting, on marriage salver. Early work. Ca' d'Oro, Venice. [Berenson 1968, p. 188—ill. / Panofsky 1930, pp. 111f., 143, pl. 32]

Sebastian Brant, 1458?–1521. (Hercules' choice mentioned in) *Das Narrenschiff.* Satire. Basel: Bergmann, de Olpe, **1494.** / Translated into Latin by Jacob Locker as *Stultifera navis.* Basel: Bergmann, de Olpe, 1497. / Translated into English by Alexander Barclay as *The Shyppe of Fooles* (London: Pynson, 1509). (*Note:* Because of the great success of *Das Narrenschift,* this version of the Hercules story received a great deal of attention and had an influence far outweighing its importance in Brant's work.) [Galinsky 1972, p. 199 / Panofsky 1930, pp. 53f., 155, pl. 18 / Highet

1967, p. 310] A play by Brant on the theme of Hercules at the Crossroads was first performed 1512, Strasburg. [Galinsky]

Albrecht Dürer, 1471–1528. "Hercules (at the Crossroads)" ("Jealousy"). Engraving (Bartsch no. 73). **1498.** [Strauss 1977b, no. 24—ill. / also Kaufmann 1979, pp. 82ff. / Galinsky 1972, pl. 12 / cf. Wind 1938–39, pp. 209ff.—ill.]

Raphael, 1483–1520. "Vision of a Knight" (or "Dream of Scipio"; formerly identified as Choice of Hercules). Painting. **1504–05.** National Gallery, London. [Vecchi 1987, no. 37—ill. / Jones & Penny 1983, pp. 6ff.—ill. / also London 1986, p. 506—ill.]

Domenico Beccafumi, 1486–1551. "Hercules at the Crossroads." Painting. *c.*1512–13. Museo Bardini, Florence, no. 1246. [Sanminiatelli 1967, pl. 4 / also Berenson 1968, p. 35]

———. "Hercules at the Crossroads." Fresco. *c.*1530? Palazzo Bindi Sergardi, Siena. [Sanminiatelli, pp. 93f., pl. 31h]

Piero di Cosimo, *c.*1462–**1521,** rejected attribution. "Hercules at the Crossroads." Painting. Gemäldegalerie, Berlin-Dahlem. [Bacci 1966, p. 115]

Dosso Dossi, *c.*1479–1542. "Allegory of Hercules" ("Bambocciata") (allegory addressed to Ercole II d'Este, related to choice of Hercules; also contains elements related to Hercules and Omphale). Painting. **Mid-1530s.** Uffizi, Florence. [Gibbons 1968, pp. 98ff., no. 22—ill. / also Uffizi 1979, no. P552—ill.]

Rosso Fiorentino, 1494–1540. "The Dream of Hercules" (? Hercules with Virtue?). Drawing. *c.*1537? Louvre, Paris, inv. R.F. 14.685. / Engraved by René Boyvin. (Bibliothèque Nationale, Paris.) [Carroll 1987, no. 108—ill.]

Lucas Cranach, 1472–1553. "Hercules at the Parting of the Ways." Painting. **After 1537.** Julius Böhler Gallery, Munich, in 1932. [Friedländer & Rosenberg 1978, no. 408—ill.]

———, studio. "Hercules at the Crossroads." Painting, part of "Labors of Hercules" cycle. After 1537. Herzog Anton Ulrich-Museum, Braunschweig, no. 712. [Braunschweig 1969, pp. 47f.]

Prospero Fontana, 1512–1597, questionably attributed. "The Choice of Hercules." Ceiling fresco. **1550–55.** Palazzo di Firenze, Rome. [Panofsky 1930, p. 107f., pl. 29]

Adamo Ghisi, *c.*1530–**1574.** "The Choice of Hercules." Engraving (Bartsch no. 26), after a composition by Giulio Romano? [Panofsky 1930, pp. 105f., pl. 30]

Paolo Veronese, 1528–1588. "Allegory of Virtue and Vice" ("The Choice of Hercules," "The Poet between Vice and Virtue"). Painting. *c.*1578–81. Frick Collection, New York, no. 12.1.129. [Frick 1968–70, 2:274f.—ill. / Pallucchini 1984, no. 175—ill. / Pignatti 1976, no. 245—ill.] Variant. Golovin coll., New York. [Pignatti, no. 246—ill.] School copy. Uffizi, Florence, inv. 5929. [Uffizi 1979, no. P1878—ill.] Studio variant. Kunsthistorisches Museum, Vienna. [Pignatti] Numerous further versions, in Fogg Art Museum, Harvard University, Cambridge; others in private colls. or unlocated. [Frick / Pignatti]

———, style. "Youth between Knowledge and Pleasure" (Choice of Hercules? Judgment of Paris?). Painting. National Gallery of Victoria, Melbourne, inv. 1707/4. [Pignatti, no. A179—ill.]

Crispin van den Broeck, 1524–**1591.** "The Choice of Hercules." Painting. / Engraved by Jan Weirix. [Panofsky 1930, pp. 120f., pl. 40]

Thomas Bradshaw. "A Dialogue betwixt Hercules and the Two Ladies, Voluptuous and Vertuous." Poem. In *The Shepherds Starre* (London: **1591**). [Bush 1963, p. 320 / Galinsky 1972, p. 228 *n.*40]

Annibale Carracci, 1560–1609. "Hercules Guided by Virtue." Fresco, part of "Hercules" cycle. *c.*1593–94. Palazzo Sampieri (Talon), Bologna. [Malafarina 1976, no. 73—ill.]

———. "Hercules at the Crossroads." Ceiling painting, for Camerino, Palazzo Farnese, Rome. *c.*1596. Replaced by a copy; original now in Galleria di Capodimonte, Naples, no. 365. [Ibid., no. 86—ill. / Martin 1965, pp. 24ff.—ill. / Capodimonte 1964, p. 49, pl. 60 / also Augsburg 1975, no. E43—ill. / Panofsky 1930, pp. 124ff.] Copy in Gemäldegalerie, Kassel. [Panofsky, pl. 44]

Friedrich Sustris, *c.*1540–1599. "The Choice of Hercules." Painting. 2 versions, 1 engraved *c.*1595 by Johannes Sadeler. [Panofsky 1930, pp. 116ff., 143, pls. 35–36]

Justus Tiel (**16th century**). (Hercules' choice evoked in) "Allegory of the Education of King Philip III." Painting. Prado, Madrid, no. 1846. [Pigler 1974, p. 126 / also Prado 1985, p. 678]

Maerten de Vos, 1532–1603. "Hercules at the Crossroads." Painting. F. Howard coll., London, in 1931. [Warburg]

Jan Jurkowski, ?–1635. (Choice of Hercules in) *Tragedia o polskim Scylurusie i trzech synach koronnych ojczyzny polskiej* [Tragedy of the Polish Scilurus] act 2. Tragedy. **1604.** Modern edition, Cracow: Naki Polskiej Akademii Umiejetności, 1949. [Miłosz 1983, p. 105]

Jan Saenredam, 1565–**1607,** composition. "The Choice of Hercules." Engraving (Bartsch no. 2), anonymous. [Panofsky 1930, p. 119f., pl. 39]

Federico Zuccari, 1540/43–**1609.** "Hercules at the Crossroads." Drawing. Bowdoin College Museum of Art, Brunswick, Me. [Pigler 1974, p. 125]

Ben Jonson, 1572–1637. (Hercules' choice in) "Pleasure Reconciled to Virtue." Masque. Performed 6 Jan **1618,** at Court, London. Published London: 1640. [Herford & Simpson 1932–50, vol. 7 / McGraw-Hill 1984, 3:112f.]

Johann Liss, *c.*1595–**1629.** "Hercules at the Crossroads." Painting. Gemäldegalerie, Dresden, no. 1841A. [Dresden 1976, p. 67 / Augsburg 1975, no. A32—ill. / Panofsky 1930, p. 130, pl. 51]

Peter Paul Rubens, 1577–1640. "The Choice of Hercules." Painting, executed by Jan van Eyck from Rubens's sketch, part of Arch of St. Michael's Abbey, decoration for "Pompa Introitus Fernandi," triumphal entry of Cardinal-Infante Ferdinand of Spain into Antwerp, 17 Apr **1635.** Formerly Palace, Brussels, destroyed 1731. [Martin 1972, pp. 203ff., no. 53—ill. (print) / Jaffé 1989, no. 1163] Oil sketch for entire decoration. Hermitage, Leningrad, inv. 503. [Martin, no. 52a—ill. / Held 1980, no. 165—ill. / Jaffé, no. 1162—ill.] *See also Jan van den Hoecke, below.*

Nicolas Poussin, 1594–1665, attributed. "The Choice of Hercules (between Vice and Virtue)." Painting. **Mid-1630s.** Stourhead, Wiltshire. [Wright 1985, no. 116, pl. 158 / Blunt 1966, no. 159—ill. / also Thuillier 1974, no. B35—ill. / Panofsky 1930, pp. 140ff., pl. 63]

Samuel Columbus, 1642–1679, with **Georg Stjernhjelm,** 1598–1672. *Spel om Hercules Wägewal* [A Play about Hercules' Choice]. **1647.** Drama. Stockholm: 1658. Modern edition, Stockholm: Bonnier, 1955. [Gustafson 1961, p. 97 / CEWL 1973, 3:567]

Georg Stjernhjelm, 1598–1672. (The choice of) *Hercules.* Didactic epic in hexameters, based on Xenophon. **1647.** Stockholm: 1658. Modern edition by Sten Lindroth and Carl Ivar Stahle (Stockholm: Almquist & Wiksell, 1967; includes facsimile of original 1658 edition). [CEWL 1973, 3:567 / Algulin 1989, pp. 35f.]

Pietro Testa, 1611–**1650.** "A Youth between Athena and Venus." Drawing. Albertina, Vienna. [Pigler 1974, p. 126]

Jan van den Hoecke, 1611–1651, attributed (previously attributed to Rubens). "Hercules between Vice and Virtue." Painting. *c.*1647–51. Uffizi, Florence, inv. 1442. [Uffizi 1979, no. P1768—ill. / Panofsky 1930, pp. 113ff., 129, pl. 33]

Pieter Symonsz Potter, 1597/1600–**1652.** "The Choice of Hercules." Painting. Lost. / Engraved by Pieter Nolpe. [Panofsky 1930, pp. 121f., pl. 42]

Michelangelo Cerquozzi, 1602–**1660.** "Hercules at the Crossroads." Painting. Galleria Pallavicini, Rome. [Pigler 1974, p. 125]

Pietro da Cortona, 1596–**1669.** "The Choice of Hercules." Drawing. British Museum, London. [Panofsky 1930, p. 130, pl. 49] Copy in Württembergische Landeskunstsammlunge, Stuttgart. [Ibid.]

Gérard de Lairesse, 1641–1711 (active until *c.*1690). "Hercules between Vice and Virtue." Painting. Louvre, Paris, inv. 1422. [Louvre 1979–86, 1:81—ill.] / Panofsky 1930, p. 132, pl. 61]

———. "Hercules at the Crossroads." Painting. Historisch Museum, Amsterdam, inv. A7359. [Wright 1980, p. 229]

Italian School. "Wisdom and Pleasure Honoring Hercules." Painting. **17th century.** Walters Art Gallery, Baltimore, inv. 37.1840. [Walters 1976, p. 580]

Sebastiano Ricci, 1659–1734. "The Choice of Hercules." Painting. **1703** or later. Palazzo Fulcis-Bertoldi, Belluno. [Daniels 1976, no. 19—ill.]

———. "The Choice of Hercules." Fresco, part of "Hercules" cycle. 1706–07. Sala d'Ercole, Palazzo Marucelli-Fenzi, Florence. [Ibid., no. 110a—ill.] Study. Uffizi, Florence, inv. 1890.9156. [Ibid., no. 96—ill. / Uffizi 1979, no. P1332—ill.]

———. "The Choice of Hercules." Grisaille ceiling fresco, part of "Hercules" cycle, for Portland House, London. 1712–13. Destroyed. [Daniels, no. 208—ill.]

Philip Tidemann, 1657–1705. "Hercules at the Crossroads." Painting. **1703–04?** Hopetown House, Scotland. [Warburg]

Richard Steele, 1672–1729. "The Choice of Hercules." Essay. In *The Tatler* 97 (**1709**). [Ipso]

Anthony Ashley Cooper, Third Earl of Shaftesbury, 1671–1713. Essay on the judgment of Hercules, in *Characteristics of Men, Manners, Opinions, Times* (London: **1711;** revised 1714). [Oxford 1985, p. 888]

Paolo de Matteis, 1662–1728. "The Choice of Hercules." Painting. City Art Gallery & Temple Newsam, Leeds, cat. 1954 no. 22.15/48. [Wright 1976, p. 132] Engraved by S. Gribelin as illustration to Lord Shaftesbury's *Character-*

istics of Men . . . (**1714**). [Paulson 1971, 1:273—ill. / Panofsky 1930, p. 131, pl. 52]

Jacob de Wit, 1695–1754. "Hercules between Minerva and Venus." Painting. **1721.** Sold 1889, unlocated. [Staring 1958, 144]

Adriaen van der Werff, 1659–1722. "Hercules at the Crossroads." Painting. [Warburg]

Gottfried Heinrich Stölzel, 1690–1749. *Hercules Prodicus.* Opera. First performed **1725,** Gotha. [Grove 1980, 18:175]

Johann Sebastian Bach, 1685–1750. *Hercules auf dem Scheidewege* [Hercules at the Crossroads]. Cantata. Libretto, Picander. First performed 5 Sep 1733. [Wolff et al. 1983, 99f., 133f., 191 / Grove 1980, 1:825]

Ottmar Elliger the Younger, 1666–1735. "Hercules at the Crossroads." Painting. [Pigler 1974, p. 126]

John Hoadly, 1711–1776. *The Judgment of Hercules.* Masque. Music, Maurice Greene. Before **1740.** Music lost. [Grove 1980, 7:687 / Fiske 1973, pp. 175, 199]

William Shenstone, 1714–1763. *The Judgment of Hercules.* Masque. **1740.** Published London: Dodsley, 1741? [Fiske 1973, p. 199 / Galinsky 1972, pp. 213ff.]

Pompeo Batoni, 1708–1787. "The Choice of Hercules" ("Hercules at the Crossroads"). Painting. **1742.** Uffizi, Florence, no. 8547 (displayed in Galleria d'Arte Moderna, Palazzo Pitti). [Clark 1985, no. 67—ill. / Uffizi 1979, no. P165—ill.] Copy (17th-century Italian, "Wisdom and Pleasure Honoring Hercules") in Walters Art Gallery, Baltimore, no. 37.1840. [Walters 1976, p. 580]

———. "The Choice of Hercules." Painting. 1748. Liechtenstein Collection, Vaduz, no. 161. [Clark, no. 123—ill.] Variant. Early 1750s. Galleria Sabauda, Turin, no. 471. [Ibid., no. 173—ill.] Variant. 1763–65. Hermitage, Leningrad, no. 4793. [Ibid., no. 288—ill. / Hermitage 1981, pl. 220]

Robert Lowth, 1710–1787. *The Judgment of Hercules.* Poem, based on Prodicus. Glasgow: Foulis, **1743.** [Keates 1985, p. 298]

Giuseppe Bazzani, 1690/1701–1769. "Hercules" (and Virtue?). Painting. *c.*1750. Kress coll. (K1271), Howard University, Washington, D.C., no. 61.155.P. [Shapley 1966–73, 3:115—ill.]

George Frideric Handel, 1685–1759. "The Choice of Hercules." Oratorio, additional "new act" for *Alexander's Feast.* Music adapted from the composer's *Alceste* (projected, unperformed opera). Libretto adapted by Thomas Morell (?) from Robert Lowth (1743). First performed 1 Mar **1751,** Covent Garden, London. [Keates 1985, p. 296?f. / Lang 1966, pp. 502–505 / Hogwood 1984, pp. 222, 291 / Grove 1980, 8:101, 119]

William Cooke, 1711–1797, attributed. *The Tryal of Hercules, an ode on glory, virtue, and pleasure.* Poem. London: printed for M. Cooper, **1752.** [Bush 1937, p. 545]

Anonymous. *The Choice of Hercules.* Dramatic interlude. First performed 14 March **1753,** Covent Garden, London. [Nicoll 1959–66, 3:399]

Pietro Metastasio, 1698–1782. *Alcide al bivio* [Hercules (Alcides) at the Crossroads]. Libretto for opera (festa teatrale). First set by Hasse, 1760, and by at least 7 others to 1809. *See below.* [Grove 1980, 12:218] Published Vienna: **1760,** with an illustration by Gregario Guglielmi. [Panofsky 1930, p. 137, pl. 60]

Johann Adolf Hasse, 1699–1783. *Alcide al bivio.* Opera

(festa teatrale). Libretto, Metastasio (1760). First performed 8 Oct **1760**, for marriage of Crown Prince Joseph to Isabella of Bourbon, Vienna. [Baker 1984, p. 962 / Grove 1980, 8:284, 288; 12:218 / Galinsky 1972, pp. 200, 227]

Edmé Bouchardon, 1698–1762. "Hercules at the Crossroads." Drawing. Louvre, 23857, Paris. [Warburg]

Benjamin West, 1738–1820. "The Choice of Hercules." Painting. **1764.** Victoria and Albert Museum, London. [von Erffa & Staley 1986, no. 143—ill.]

William Dunkin, 1709–1765. "The Judgment of Hercules." Poem. In *Select Poetical Works* (Dublin: Printed Jones etc., 1769–70). [Galinsky 1972, p. 229 / Boswell 1982, p. 253]

Nicola Conforto, 1718–after 1788. *Alcide al bivio.* Opera (festa teatrale). Libretto, Metastasio (1760). First performed **1765,** for marriage of future Charles IV, Palace of Duke of Béjar, Madrid. [Grove 1980, 4:658; 12:218]

Christoph Martin Wieland, 1733–1813. *Die Wahl des Herkules* [The Choice of Hercules]. Drama. **1773.** [Radspieler 1984, vol. 8 / Galinsky 1972, pp. 215f.]

Anton Schweitzer, 1735–1787. *Die Wahl des Herkules* [The Choice of Hercules]. Singspiel (lyric drama), for instruction of 17–year-old prince of Saxe-Weimar. Libretto, Wieland (1773). First performed 4 Sep **1773,** Weimar. [Radspieler 1984, vol. 8 / McGraw-Hill 1984, 5:140 / Grove 1980, 17:46 / Galinsky 1972, pp. 215f., 229]

Dmitry Bortnyansky, 1751–1825. *Alcide.* Opera (dramma per musica). Libretto, Metastasio (1760). First performed **1778,** Venice. [Grove 1980, 3:70]

Luciano Xavier dos Santos, 1734–1808. *Alcide al bivio.* Opera (festa teatrale). Libretto, Metastasio (1760). First performed **1778,** Queluz or Ajuda. [Grove 1980, 16:485]

Giovanni Paisiello, 1740–1816. *Alcide al bivio.* Opera (festa teatrale). Libretto, Metastasio (1760). First performed 6 Dec **1780,** Hermitage, St. Petersburg. [Grove 1980, 12:218; 14:99, 101]

John Stanley, 1712–1786. *The Choice of Hercules.* Cantata. Perhaps unperformed. Unpublished. MS in Rowe Library, King's College, Cambridge. [Keates 1985, p. 298 / Grove 1980, 18:77 / Fiske 1973, pp. 199, 247]

Niccolò Zingarelli, 1752–1837. *Alcide al bivio.* Cantata. Libretto, Metastasio (1760). **1789.** [Grove 1980, 20:694]

Vincenzo Righini, 1756–1812. *Alcide al bivio.* Opera (azione teatrale). Libretto, Metastasio (1760). First performed **1790,** Koblenz. / Revised as cantata. First performed 1804, Vienna. [Grove 1980, 16:21 / see also Hellmut Federhofer, "Vincenzo Righini's Opera *Alcide al Bivio*" (Hercules at the Crossroads), in *Essays Presented to Egon Wellesz* (Oxford: Clarendon Press, 1966)]

Honoré Langlé, 1741–1807. *Le choix d'Alcide* [The Choice of Alcide (Alcides)]. Musical dramatic work. **1800.** Unperformed. [Grove 1980, 10:452]

Ludwig Tieck, 1773–1853. "Der neue Herkules am Scheidewege" [The New Hercules at the Crossroads]. Poem, parody. In *Poetisches Journal* (Jena: Fromann, **1800**). In modern edition, *Satiren und Parodien,* series 17, vol. 9, edited by Andreas Müller (Leipzig: Reclam, 1935). [Ipso]

Simon Mayr, 1763–1845. *Alcide al bivio.* Opera. Libretto, Metastasio (1760). First performed **1809,** Bergamo? [Hunger 1959, p. 145]

Antoine François Le Bailly, 1756–1832. *Le choix d'Alcide* [The Choice of Hercules (Alcides)]. Opera-ballet. Published Paris: Brasseur, **1811.** [Taylor 1893, p. 217]

Friedrich Heinrich Füger, 1751–1818. "Hercules at the Crossroads." Oil sketch. Deutsche Barockgalerie, Augsburg. [Pigler 1974, p. 126]

Mariano Maella, 1739–1819. "Hercules at the Crossroads." Ceiling painting. Royal Palace, Madrid. [Pigler 1974, p. 126]

Pietro Benvenuti, 1769–1844. "Hercules at the Crossroads." Painting, part of "Hercules" cycle. **1828.** Saloncino d'Ercole, Palazzo Pitti, Florence. [Pitti 1966, pp. 137ff.—ill.]

Thomas Stothard, 1755–1834. "The Choice of Hercules." Painting. R. Feigen & Co., New York, in 1981. [*Burlington Magazine,* Dec 1981]

Eberhard Wächter, 1762–1852. "The Choice of Hercules." Painting. **1839.** Württembergische Landeskunstsammlungen, Stuttgart. [Panofsky 1930, p. 142, pl. 64]

Eugène Delacroix, 1798–1863. "Hercules between Vice and Virtue." Ceiling painting, in "Life of Hercules" cycle, for Salon de la Paix, Hôtel de Ville, Paris. **1851–52.** Destroyed by fire, 1871. [Robaut 1885, no. 1154—ill. (copy drawing) / Huyghe 1963, pp. 289, 423, 474]

Daniel Maclise, 1806–1870. "The Choice of Hercules." Painting. Sold Christie's, London, 1965. [Warburg]

Camille Saint-Saëns, 1835–1921. (Choice of Hercules evoked in) *La Jeunesse d'Hercule.* Symphonic poem, opus 50. First performed 28 Jan **1877,** Paris. [Grove 1980, 16:405 / Baker 1984, p. 1972]

William Entriken Baily. "The Choice of Alcides." Poem. In *Classical Poems* (Cincinnati: Clarke, **1892**). [Bush 1937, p. 583]

Arthur Gray Butler, 1832–1909. "The Choice of Hercules." Poem. In *The Choice of Achilles and Other Poems* (London: Frowde, **1900**). [Boswell 1982, p. 60]

Birgit Cullberg, 1908–1982, choreography. *Hercules op de Tweesprong* [Hercules at the Crossroads]. Ballet. First performed **1945,** Royal Swedish Ballet, Stockholm. [Cohen-Stratyner 1982, p. 217]

Richmond Lattimore, 1906–1984. "Hercules at the Crossroads." Poem. In *Poems* (**1957**); reprinted in *Poems from Three Decades* (New York: Scribner, 1972). [Boswell 1982, p. 163]

Madness of Heracles. Returning to Thebes from Mount Cithaeron, Heracles (Hercules) led the Theban citizens in battle against the Minyans of Orchomenus, to whom they had been forced to pay tribute. King Creon rewarded Heracles with the hand of his daughter Megara; the couple married and had three children. Some years later, Hera caused Heracles to suffer a fit of madness, during which he killed his children (and his wife, according to some classical sources). It is said that Heracles also killed two nephews, sons of Iphicles. When he regained his sanity, Heracles went into exile and visited the oracle at Delphi to learn how he might expiate his

crime. He was told to go to Tiryns and serve King Eurystheus for twelve years. According to Euripides' version of the myth, the madness of Heracles and the disastrous results of it occurred after he had performed his twelve labors for Eurystheus.

Classical Sources. Euripides, *Heracles.* Theocritus (or Moschus), *Megara.* Rhinthon of Syracuse, *Heracles.* Diodorus Siculus, *Biblioteca* 4.10.2–4.11.2. Apollodorus, *Biblioteca* 2.4.11–12. Seneca, *Hercules furens.* Hyginus, *Fabulae* 31–32. Philostratus, *Imagines* 2.23.

Further Reference. Karl Galinsky, *The Herakles Theme* (Totowa, N.J.: Rowman & Littlefield, 1972), pp. 192f., 232f.

Jasper Heywood, 1535–1597/98. *Hercules furens.* Translation of Seneca. London: Sutton, **1561** (bilingual edition). [Greg 1939–59, 1:110f., no 34]

Alessandro Turchi, 1578–1649. "The Madness of Hercules." Painting. *c.*1620. Alte Pinakothek, Munich, inv. 490. [Munich 1983, p. 536—ill.]

Nicolas L'Héritier, Seigneur de Nouvelon, *c.*1613–1680. *Hercule furieux.* Tragedy. Paris: Quinet, **1639.** [Daemmrich 1987, p. 134 / Taylor 1893, p. 113]

Jacopo Melani, 1623–1676. *Ercole in Tebe* [Hercules in Thebes]. Opera (festa teatrale), for Medici wedding. Libretto, Giovanni Andrea Moniglia. First performed 8 July (or 8 Dec) **1661,** Pergola, Florence. [Baker 1984, p. 1506 / Grove 1980, 12:96 / Worsthorne 1954, pp. 44, 82 / Weaver 1978, pp. 130f.]

Giovanni Antonio Boretti, *c.*1640–1672, with some arias by Bernardo Sabadini. *Ercole in Tebe.* Opera. Libretto, G. A. Moniglia and Aurelio Aureli. First performed **1670–71,** Teatro San Salvatore, Venice. [Grove 1980, 3:48, 16:363]

Bernardo Sabadini, ?–1718. *L'Ercole trionfante.* Opera. Libretto, Moniglia and Aureli (1670–71). First performed **1688,** Piacenza. / Libretto twice revised by Aureli. [Grove 1980, 16:363]

Antonio Canova, 1757–1822. "Hercules (in His Madness) Killing His Sons." Painting. **1799.** Museo Civico, Bassano del Grappa. [Pavanello 1976, no. D30—ill. / Licht 1983, p. 262—ill.] Wax model, 1790; restored and reconstituted 1971. Museo Correr, Venice. [Pavanello, no. 112—ill. / also Licht, pp. 262–66—ill.] Plaster relief, 1803–04. Gipsoteca Canoviana, Possagno. [Pavanello, no. 133—ill. / Licht—ill.]

Friedrich Hölderlin, 1770–1843. (Heracles in his madness compared to the Rhein in) "Der Rhein." Pindaric ode. **1801–08.** In *Allgemeinen Literatur-Zeitung* 7 July 1808. [Beissner 1943–77, vol. 2 / Hamburger 1980 / Unger 1975, pp. 128f. / Galinsky 1972, pp. 256ff.]

Robert Browning, 1812–1889. (Translation of Euripides' *Heracles,* recited by Balaustion, included in) *Aristophanes' Apology: Including a Transcript from Euripides, Being the Last Adventure of Balaustion.* Dramatic monologue. **1873.** London: Smith, Elder, 1875. [Scudder 1895 / Ryals 1975, pp. 104, 112–17 / Ward 1969, pp. 91, 186 / Bush 1937, pp. 373, 559]

George Cabot Lodge, 1873–1909. *Herakles.* Poetic drama. **1908.** In *Poems and Dramas,* vol. 2 (Boston: Houghton Mifflin, 1911). [Boswell 1982, p. 268 / Bush 1937, pp. 491f.]

Frank Wedekind, 1864–1918. (Madness of Heracles in) *Herakles.* Drama. Munich: Müller, **1917.** First performed 1 Sep 1919, Prinzregenten Theater, Munich. [Galinsky 1972, pp. 236–40]

André-Joseph Allar, 1845–1926. "Hercules Discovering His Dead Son." Sculpture. Musées Municipaux de Toulon. [Bénézit 1976, 1:119]

Yorgos Sicilianos, 1922–1973. *Hercules furens.* Incidental music, opus 20, for performance of Euripides' *Heracles* at Epidaurus. **1960.** [Grove 1980, 17:294]

Archibald MacLeish, 1892–1982. (Madness of Heracles in) *Herakles.* Verse drama. Boston: Houghton Mifflin, **1967.** [DLB 1986, 45:253f. / Galinsky 1972, pp. 66, 244–48]

Pillars of Heracles. The tenth labor of Heracles (Hercules), the theft of the cattle of Geryon, took him to Erytheia, an island on the westernmost edge of the world. On this journey, Heracles erected two pillars—traditionally identified as the rocks of Calpe (Gibraltar) and Abyla (Ceuta)—at the Atlantic entrance to the Mediterranean Sea, so that future travelers could see how far he had come. Some sources call them the Pillars of Gades, referring to the Phoenician colony on the Spanish coast (now Cadiz), northwest of Gibraltar, close to where Erytheia was thought to be located. According to another legend, the rocks were originally one mountain range separating the two seas, which Heracles wrenched apart to create what is known today as the Strait of Gibraltar.

Classical Sources. Herodotus, *History* 4.8. Diodorus Siculus, *Biblioteca* 18.4–5. Strabo, *Geography* 3.5.5, 4.1.7. Apollodorus, *Biblioteca* 2.5.10. Pliny, *Naturalis historia* 2.242. Hyginus, *Poetica astronomica* 2.6.

Albrecht Altdorfer, *c.*1480–1538. "Hercules Carrying the Columns of Gades." Engraving (Bartsch no. 27). *c.*1520–**25.** [Winzinger 1963, no. 143—ill.]

Maerten van Heemskerck, 1498–1574. "Hercules Carrying the Pillars." Painting, in "Gods and Heroes from Mythology and the Old Testament" series. *c.*1545. Yale University Art Gallery, New Haven, inv. 60.50d. [Grosshans 1980, no. 30j—ill.]

Giambologna, 1529–1608. "Hercules and the Pillars." Statuette (medium unknown), presumed part of "Labors of Hercules" cycle for Francesco de' Medici. Before **1581.** Original set lost. / Variants/replicas, by Giambologna (?) and studio. National Gallery of Ireland, Dublin; Palacio de Oriente, Madrid. [Avery & Radcliffe 1978, no. 83—ill. / also Avery 1987, no. 85—ill.]

Francisco Zurbarán, 1598–1664. "Hercules Separating the Mountains Calpe and Abyla" ("Hercules Separating the Strait of Gibraltar"). Painting, part of "Labors of Hercules" cycle, for Salón de Reinos, Buen Retiro, Madrid. *c.*1634. Prado, Madrid, no. 1241. [López Torrijos 1985, pp. 141ff., 406—ill. / Prado 1985, p. 790]

Michel Corneille the Younger, 1642–1708. "Hercules Dragging the Columns of Gades." Drawing. Louvre, Paris. [Pigler 1974, p. 124]

Corrado Giaquinto, 1703–**1765.** "Hercules Dragging the Columns of Gades." Painting. Casita del Principe, El Escorial. [Pigler 1974, p. 124]

Giovanni Battista Tiepolo, 1696–1770. (Hercules, with Pillars, in) "Apotheosis (Glorification) of the Spanish Monarchy." Ceiling fresco. **1762–66.** Saleta, Palacio Real, Madrid. [Pallucchini 1968, no. 279—ill. / Levey 1986, p. 265—ill.] Oil sketches. Kress coll. (K1281), Metropolitan Museum, New York, no. 37.165.3; Wrightsman coll., New York; Marzotto coll., Portogruaro (by Domenico Tiepolo, wrongly attributed to Giambattista). [Pallucchini—ill. / also Metropolitan 1980, p. 183—ill. / Shapley 1966–73, 3:150f.—ill.]

Eugène Delacroix, 1798–1863. "Hercules at the Foot of the Columns." Ceiling painting, in "Life of Hercules" cycle, for Salon de la Paix, Hôtel de Ville, Paris. **1851–52.** Destroyed by fire 1871. [Robaut 1885, no. 1162—ill. (copy drawing) / Huyghe 1963, pp. 289, 423, 474]

Howard Nemerov, 1920–. (Gates of Hercules evoked in) "Seven Macabre Songs" poem no. 6. In *Mirrors and Windows* (Chicago: University of Chicago Press, **1958**). [Ipso]

Dimitri Hadzi, 1921–. "Pillars of Hercules." Bronze sculpture. **1971–72.** Richard Gray Gallery, Chicago, in 1972. [Gray Gallery catalogue]

———. "Pillars of Hercules." Bronze sculpture. 1973–75. Fogg Art Museum, Harvard University, Cambridge, and artist's coll.? [Ibid.]

———. "Pillars of Hercules III." Bronze sculpture, study for a commission by Stanford University. 1977–78. [Ibid.]

Heracles and Cacus. According to a tale related in Virgil's *Aeneid*, Hercules stopped at the future site of Rome while driving the cattle of Geryon homeward to complete his tenth labor. While the hero was entertained by King Evander, some of the cattle were stolen by Cacus, a fire-breathing, three-headed monster who was a son of Vulcan. By dragging the animals backward into his cave on the Aventine hill, Cacus made it impossible to track them. Hercules abandoned his search for them and set out with the rest of the herd, but as he passed the cave he heard lowing from within. Entering the cave, Hercules killed Cacus and recovered the stolen cattle. The site of this encounter is said to be near the Ara Maxima, an altar where Hercules was worshiped by the Romans as the god of victory and commercial enterprise.

Classical Sources. Diodorus Siculus, *Biblioteca* 4.17.1–4.18.5, 4.21. Virgil, *Aeneid* 8.185–270. Livy, *Ab urbe condita* 1.7.3ff. Ovid, *Fasti* 1.543–78, 5.673ff., 6.79ff. Apollodorus, *Biblioteca* 2.5.10.

Further Reference. Karl Galinsky, *The Herakles Theme* (Totowa, N.J.: Rowman & Littlefield, 1972), pp. 130, 133, 136, 153ff.

Dante Alighieri, 1265–1321. (Cacus, as a centaur, among the Thieves in) *Inferno* 25.17–33. *c.*1307–*c.*1314? In *The Divine Comedy*. Poem. Foligno: Neumeister & Angelini, 1472. [Singleton 1970–75, vol. 1]

Baldassare Peruzzi, 1481–1536. "Hercules before Evander." Drawing. **1517–18.** Louvre, Paris, inv. 483. [Frommel 1967–68, no. 63—ill.]

Rosso Fiorentino, 1494–1540, composition. "Hercules Fighting Cacus." Engraving, in "Labors and Adventures of Hercules" cycle, executed by Gian Jacopo Caraglio (Bartsch no. 49). **1524.** Original design lost. [Carroll 1987, no. 14—ill.]

———, composition. "Hercules and Cacus." Etching (Bartsch 16, anon. no. 59, as "Hercules and Antaeus"), by Antonio Fantuzzi. *c.*1543. (Bibliothèque Nationale, Paris.) [Paris 1972, no. 322—ill.]

Michelangelo, 1475–1564. "Hercules and Cacus" (or Samson and a Philistine?). Clay sketch model for unexecuted sculpture. *c.*1525. Casa Buonarroti, Florence. [Pope-Hennessy 1985, 3:34, 48—ill. / cf. Baldini 1982, no. 39—ill.] Related drawing. British Museum, no. BB.1688. [Goldscheider 1964, pl. XXII-f] Bronze statue, after Michelangelo's model, by Pierino da Vinci. Frick Collection, New York. [Ibid., pl. XXIII-a]

Baccio Bandinelli, 1493–1560. "Hercules and Cacus." Marble sculpture. **1527–34.** Piazza della Signoria, Florence. [Pope-Hennessy 1985b, 3:45ff., 363, 457—ill. / Sinibaldi 1950, pp. 6, 32—ill. / Lensi 1929, pp. 119f., 122—ill.] Terra-cotta sketch model. Kaiser Friedrich-Museum, Berlin. [Pope-Hennessy, p. 364]

Hans Sebald Beham, 1500–1550. "Hercules Killing Cacus." Print. 1545. [Augsburg 1975, no. E48—ill.]

Giorgio Vasari, 1511–1574, and assistants. Hercules and Cacus depicted in cycle of ceiling paintings on the deeds of Hercules. 1557. Sala di Ercole, Palazzo Vecchio, Florence. [Sinibaldi 1950, pp. 13, 23]

Antwerp School. "Hercules and Cacus." Marble sculpture. *c.*1555–60. Museum für Kunst und Gewerbe, Hamburg, inv. 1983/30. [Hofmann 1987, no. 2.9—ill.]

Hendrik Goltzius, 1558–1617, composition. "Hercules and Cacus." Woodcut, executed by studio. **1588.** 4 states. [Strauss 1977a, no. 403—ill. / Bartsch 1980–82, no. 231—ill.]

———. "Hercules and Cacus" (allegory of the arts, virtue defeating envy). Painting. 1613. Mauritshuis, The Hague, inv. 43, on loan to Frans Hals Museum, Haarlem. [Mauritshuis 1985, p. 366—ill.]

Annibale Carracci, 1560–1609 (previously attributed to Agostino Carracci). "Hercules and Cacus." Fresco, part of "Hercules" cycle. *c.*1593–94. Palazzo Sampieri (Talon), Bologna. [Malafarina 1976, no. 74—ill.]

Cavaliere d'Arpino, 1568–1640. "Hercules and Cacus." Lunette fresco, part of cycle depicting scenes from the life of Hercules. **1594–95.** Loggia Orsini, Palazzo del Sodalizio dei Piceni, Rome. [Röttgen 1969, pp. 279ff., 285]

———. "Hercules and Cacus." Drawing. 2 versions. Wallraf-Richartz-Museum, Cologne, no. Z2036; Louvre, Paris, inv. 2986. [Rome 1973, no. 101—ill.]

Stefano Maderno, *c.*1576–1636. "Hercules Slays Cacus." Marble sculpture group. **1622.** Formerly Albertinum, Dresden. / Model. Cà d'Oro, Venice. [Pigler 1974, p. 114]

Domenichino, 1581–1641. "Landscape with Hercules Pulling Cacus from His Cave." Painting. *c.*1621–23. Louvre, Paris, inv. 795. [Louvre 1979–86, 2:171—ill. / Spear 1982, no. 83—ill.]

Jacob Jordaens, 1593–1678. "Cacus Stealing the Oxen of Hercules." Etching (based on the composition of "The Master Pulls the Cow Out of the Ditch by Its Tail," tapestry in Jordaens's "Flemish Proverbs" series). **1652.** [Ottawa 1968, no. 291—ill. / also Rooses 1908, pp. 177, 183—ill. (copy)]

Nicolas Poussin, 1594–1665. "Landscape with Hercules and Cacus." Painting. **Early 1660s.** Pushkin Museum, Moscow. [Wright 1985, no. 198, pl. 207 / also Blunt 1966, no. 158—ill. / Thuillier 1974, no. 215—ill.]

————, school. "Hercules and Cacus." Painting. Muzeum Narodowe, Warsaw, inv. 129761, on display at Belweder Palace. [Warsaw 1969, no. 1546 (as French School)—ill.]

Sebastiano Ricci, 1659–1734. "Hercules and Cacus." Painting, part of "Hercules" cycle. **1706–07.** Sala d'Ercole, Palazzo Marucelli-Fenzi, Florence. [Daniels 1976, no. 110—ill.] Study, painting. Uffizi, Florence, inv. 520. [Ibid., no. 96—ill. / Uffizi 1979, no. P1331—ill.]

François Le Moyne, 1688–1737. "Hercules Slaying Cacus." Painting. **1718.** École Nationale des Beaux-Arts, Paris, inv. 2617, on deposit from Louvre, Paris (inv. 6714). [Bordeaux 1984, no. 16—ill.] Modello. 1717. Louvre, inv. 6715. [Ibid., no. 15—ill. / Louvre 1979–86, 4:47—ill.]

John Flaxman, 1755–1826. "Cacus, in the Form of a Centaur, Bitten by Serpents." Drawing, illustrating *Inferno* 25.17–24, part of a series of illustrations to Dante's *Divine Comedy.* *c.*1792. Houghton Library, Harvard University, Cambridge. / Engraved by Tomasso Piroli, published privately, Rome: 1793; London: Longman & Co., 1807. [Irwin 1979, pp. 94, 226 *n.* 41 / Flaxman 1872, 4: pl. 27]

Victor Hugo, 1802–1885, writing as "V. d'Auvernay." "Cacus." Translation of *Aeneid* 8.190–267, extract from an unpublished translation of the *Aeneid.* In *Le conservateur littéraire* 29 Jan **1820.** [Hugo 1985–86, vol. 4]

William Blake, 1757–1827. "The Centaur Cacus." Watercolor, illustrating *Inferno* 25.17–33, part of a series of illustrations for Dante's *Divine Comedy.* **1824–27.** British Museum, London. [Butlin 1981, no. 812.50]

Émile-Antoine Bourdelle, 1861–1929. "Hercules and Cacus." Plaster sculpture study. **1882.** Private coll. [Jianou & Dufet 1975, no. 18] Bronze study, 1889. 4 casts. [Ibid.]

Sir Reed Gooch Baggorre (George Shoobridge Carr), 1837–1912. "Cacus." Poem. In *Mythological Rhymes* (London: Hodgson, **1912**). [Boswell 1982, p. 26]

Heracles and Antaeus. While traveling through Africa before (or after) obtaining the golden apples of the Hesperides, the eleventh of his labors, Heracles (Hercules) encountered the Libyan giant Antaeus, son of Poseidon and Gaia (Earth). The giant challenged all who entered his territory to a wrestling match. He was thought to be invincible because every time he came in contact with the earth, his mother, his strength was renewed. Heracles was

able to overcome Antaeus by holding him aloft and crushing him to death.

Classical Sources. Pindar, *Isthmian Odes* 4.52–55. Diodorus Siculus, *Biblioteca* 4.17.4–5, 4.27.3. Apollodorus, *Biblioteca* 2.5.11. Lucian, *Pharsalia* 4.593–660. Hyginus, *Fabulae* 31. Philostratus, *Imagines* 2.21–22.

Dante Alighieri, 1265–1321. (Antaeus lifts Dante and Virgil into the Ninth Circle in) *Inferno* 31:113–145. *c.*1307–*c.*1314? In *The Divine Comedy.* Poem. Foligno: Neumeister & Angelini, 1472. [Singleton 1970–75, vol. 1 / Samuel 1966, p. 97]

Filarete, *c.*1400–1469? "Hercules and Antaeus." Relief, on bronze door of St. Peter's, Rome. **1433–45.** In place. [Pope-Hennessy 1985b, 2:318]

Antonio del Pollaiuolo, 1432/33–1498. "Hercules Strangling Antaeus." Painting, part of cycle for Palazzo Medici, Florence. *c.*1460. Lost. [Ettlinger 1978, no. 44]

————, attributed. "Hercules and Antaeus." Painting (possibly related to above; see also below). Uffizi, Florence, inv. 10—ill. / Uffizi 1979, no. P1222—ill. / also Berenson 1963, p. 178]

————. "Hercules and Antaeus." Bronze statuette (figures based on Uffizi painting). Before 1492 (*c.*1475–80?). Museo del Bargello, Florence. [Pope-Hennessy 1985b, 2:302—ill. / Ettlinger, no. 18—ill. / also Agard 1951, fig. 39]

Andrea Mantegna, 1430/31–1506. "Hercules and Antaeus." Drawing. *c.*1465–68. Uffizi, Florence, no. 1482F. [Lightbown 1986, no. 183—ill.]

————. "Hercules and Antaeus." Ceiling fresco, part of "Hercules" cycle. 1468–74. Camera Picta (Camera degli Sposi), Palazzo Ducale, Mantua. [Ibid., no. 20, pl. 65]

————, school. "Hercules and Antaeus." Print (Bartsch no. 16), after design by Mantegna. [Ibid., no. 219—ill. / Borenius 1923, no. 11—ill.]

————, school. "Hercules and Antaeus." Print (Bartsch 13:202 no. 1, as Pollaiuolo). [Borenius, no. 12—ill.]

————, school. "Hercules and Antaeus." Print. [Borenius, no. 13—ill.]

Paolo di Stefano Badaloni, 1397–1478. "The Labors of Hercules." Painting, depicting Hercules fighting the Ceryneian Hind, Antaeus, and a centaur, in one composition. Metropolitan Museum, New York, no. 1971.115.4. [Metropolitan 1980, p. 139—ill.]

Sandro Botticelli, 1445–1510. (Antaeus in) Drawing, illustrating *Inferno* 31, part of series of illustrations to Dante's *Divine Comedy.* **1480s/early 1490s.** Kupferstichkabinett, Berlin-Dahlem. [Lightbown 1978, 1:147ff., 2:172f., no. E44—ill.]

Marcantonio Raimondi, *c.*1480–1527/34. "Hercules Killing Antaeus." Engraving (Bartsch no. 292), part of "Labors of Hercules" cycle. Early work. [Bartsch 1978, 26:277—ill.]

————. "Hercules and Antaeus." Engraving (Bartsch no. 346), after (lost) composition by Giulio Romano (previously attributed to Raphael). *c.*1520–22. [Shoemaker 1981, no. 51—ill. / Bartsch, 27:42ff.—ill.]

Albrecht Dürer, 1471–1528, studio, under Dürer's direction. "Hercules Killing Antaeus." Drawing, design for series of medals (unlocated) depicting the adventures of

Hercules. **1510–11.** Formerly Kunsthalle, Bremen, lost. [Strauss 1974, no. 1511/27—ill.]

Antico, *c.*1460–1528. "Hercules and Antaeus." Bronze sculpture. *c.***1519.** Kunsthistorisches Museum, Vienna. [Louvre 1975, no. 52—ill.] Another version in Victoria and Albert Museum, London. [Pope-Hennessy 1985b, 2:85—ill.]

Raphael, 1483–**1520,** composition. "Hercules and Antaeus." Engraved by Agostino Veneziano (Bartsch 14:237 no. 316). [Bartsch 1978, 26:317—ill.] *See also Marcantonio Raimondi, above.*

Francesco da Sant'Agata, fl. 1491–1528, questionably attributed. "Hercules and Antaeus." Bronze statuette. *c.***1520.** National Gallery, Washington, D.C. [Walker 1984, fig. 986 / Clapp 1970, 1:313]

Michelangelo, 1475–1564. "Hercules and Antaeus." Drawing, sketch for a lost sculpture model. *c.***1525.** British Museum, no. BB.1490. [Goldscheider 1964, pl. XXII-g]

———— (authenticity disputed, possible copy or forgery). "Three Labors of Hercules" (Lion, Hydra, Antaeus). Sheet of drawings. *c.*1530. Royal Library, Windsor, no. 12770. [Ibid., no. 68—ill.]

Giulio Romano, *c.*1499–1546, assistants, after designs by Giulio. Fresco (simulated bronze plaque) depicting Hercules and Antaeus. **1527–28.** Sala dei Cavalli, Palazzo del Tè, Mantua. [Hartt 1958, pp. 112ff., fig. 183 / Verheyen 1977, p. 115]

Lucas Cranach, 1472–1553. "Hercules and Antaeus." Painting. *c.***1530.** 2 versions. Private coll., Garmisch-Partenkirchen in 1937; Akademie der Bildenden Künste, Vienna, no. 1148. [Friedländer & Rosenberg 1978, nos. 268–69—ill.]

Hans Baldung Grien, 1484/85–1545. "Hercules and Antaeus." Painting. **1530.** Muzeum Narodowe, Warsaw, inv. 187515. [Osten 1983, no. 70a, pl. 144 / Warsaw 1969, no. 38—ill.]

————. "Hercules and Antaeus." Painting. 1531. Staatliche Gemäldegalerie, Kassel, no. 1125. [Osten, no. 72, color pl. 7, pls. 154–55 / also Yale 1981, p. 252—ill.]

Rosso Fiorentino, 1494–1540, composition. "Hercules and Cacus" ("Hercules and Antaeus"). Etching (Bartsch 16, anon. no. 59, as "Hercules and Antaeus"), by Antonio Fantuzzi. *c.*1543. (Bibliothèque Nationale, Paris.) [Paris 1972, no. 322—ill.]

Maerten van Heemskerck, 1498–1574. "Hercules Conquers Antaeus." Painting, in "Gods and Heroes from Mythology and the Old Testament" series. *c.*1545. Yale University Art Gallery, New Haven, inv. 60.50c. [Grosshans 1980, no. 30i—ill.]

Frans Floris, 1516/20–1570. "Hercules and Antaeus." Painting, one of 10 in "Labors of Hercules" cycle; others lost. **1554–55.** Private coll. [de Bosque 1985, p. 55—ill.]

Giorgio Vasari, 1511–1574, and assistants. Hercules and Antaeus depicted in cycle of ceiling paintings on the deeds of Hercules. **1557.** Sala di Ercole, Palazzo Vecchio, Florence. [Sinibaldi 1950, pp. 13, 23]

Niccolò Tribolo, 1500–1550, and **Bartolommeo Ammannati,** 1511–1592. (Hercules and Antaeus, figures atop) "Fountain of Hercules." Modeled by Tribolo, unfinished; completed **1559** by Ammannati from Tribolo's model. Villa Reale di Castello, near Florence. [Pope-Hennessy 1985b, 3:73f., 359f.—ill.]

Benvenuto Cellini, 1500–1571. "Hercules," "Hercules and Antaeus." Wax models for unexecuted sculptures. In studio inventory, **1571,** lost. [Pope-Hennessy 1985a, p. 284]

Luca Cambiaso, 1527–**1585.** "Hercules Battling Antaeus." Fresco. Formerly Genoa, destroyed. / Drawing. Manning coll., New York. [Manning & Suida 1958, p. 97]

Domenico Tintoretto, 1562–1635 (previously attributed to Jacopo Tintoretto, 1518–1594). "Hercules and Antaeus." Painting. **Late 1580s?** Wadsworth Atheneum, Hartford, no. 1928.2. [Rossi 1982, no. A44—ill. / also Berenson 1957, p. 173 (as Jacopo)]

Cavaliere d'Arpino, 1568–1640. "Hercules and Antaeus." Lunette fresco, part of cycle depicting scenes from the life of Hercules. **1594–95.** Loggia Orsini, Palazzo del Sodalizio dei Piceni, Rome. [Röttgen 1969, pp. 279ff., 285]

Annibale Carracci, 1560–1609. "Hercules and Antaeus." Fresco, part of "Hercules" cycle. **1595–97.** Camerino, Palazzo Farnese, Rome. [Malafarina 1976, no. 87e—ill. / Martin 1965, pp. 27ff.—ill.]

South Netherlandish School. "Hercules Struggling with Antaeus." Painting. **16th century.** Rijksmuseum Twenthe, Enschede, cat. 1976 no. 30. [Wright 1980, p. 305]

Peter Paul Rubens, 1577–1640. "Hercules as Victor over Discord" (formerly called "Hercules Conquering Antaeus"). Painting, oil sketch. *c.***1620.** Museum Boymansvan Beuningen, Rotterdam, on loan from Dienst voor 's Rijks Verspreide Kunstvoorwerpen, no. 2673 (2297). [Held 1980, no. 243—ill. / Jaffé 1989, no. 550—ill.]

————, and **Jacob Jordaens,** 1593–1678. "Hercules and Antaeus." Painting. Designed (and begun?) by Rubens 1638, unfinished, completed by Jordaens after Rubens's death. Formerly Knowsley Hall, sold 1954, with Central Picture Galleries, New York, in 1980s. [Jaffé, no. 1376—ill.] Oil sketch (probably copy after lost original sketch). National Gallery of Victoria, Melbourne, inv. 1720/4. [Ibid., no. 1375—ill. / Held, no. 241A—ill.] Variant sketches, previously attributed to Rubens. Fock-Stenman coll., Stockholm; Musée Granet, Aix-en-Provence, inv. 377. [Held, nos. A3–4—ill.] 2 further painted versions of the subject known: Musée Granet, Aix-en-Provence; another unlocated. [Burchard & d'Hulst 1963, p. 297]

Guercino, 1591–1666. "Hercules Battling Antaeus." Fresco. **1631.** Palazzo Talon (Sampieri), Bologna. [Salerno 1988, no. 134—ill. / also Bologna 1968, 1: pl. XII; 2:124f.]

Francisco Zurbarán, 1598–1664. "Battle of Hercules and Antaeus." Painting, part of "Labors of Hercules" cycle, for Salón de Reinos, Buen Retiro, Madrid. *c.***1634.** Prado, Madrid, no. 1246. [López Torrijos 1985, pp. 141ff., 406—ill. / Prado 1985, p. 790]

Stefano Maderno, *c.*1576–**1636,** after. "Hercules and Antaeus." Bronze statuette. National Gallery, London, inv. 6271. [London 1986, p. 701—ill.]

Pedro Calderón de la Barca, 1600–1681. (Hercules kills Antaeus in) *Fieras afemina Amor* [Love Tames the Wild Beasts]. Comedy (*fiesta de espectáculo*). **1669.** First performed Jan 1670, Vienna? [Valbuena Briones 1960–67, vol. 1 / O'Connor 1988, pp. 159–66]

John Milton, 1608–1674. (Antaeus evoked in) *Paradise Regained* 4.563–68. Epic. London: for Starkey, **1671.** [Carey & Fowler 1968; cf. p. 1164 *n*.]

Francisco Solís, 1629–1684. "Hercules Fighting Antaeus."

Painting, part of "Labors of Hercules" cycle, for Plazuela de la Villa, Madrid. **1680.** Lost. [López Torrijos 1985, p. 406 no. 30]

Sebastiano Ricci, 1659–1734. "Hercules and Antaeus." Fresco, part of "Hercules" cycle. **1706–07.** Sala d'Ercole, Palazzo Marucelli-Fenzi, Florence. [Daniels 1976, no. 110—ill.]

————, attributed. "Hercules and Antaeus (with Gaia)." Painting. Kunsthistorisches Museum, Vienna, inv. 1907. [Ibid., no. 522 / Vienna 1973, p. 143—ill.]

Giovanni Battista Tiepolo, 1696–1770. "Hercules Killing Antaeus." Painting, for Palazzo Sandi, Venice. *c.*1725–26. Da Schio coll., Castelgomberto, Vicenza. [Pallucchini 1968, no. 33c—ill. / Levey 1986, p. 28 / Morassi 1962, p. 8]

John Flaxman, 1755–1826. "Antaeus Taking Dante and Virgil Up and Setting Them Down in the Ninth Circle." Drawing, illustrating *Inferno* 31.139–45, part of series of illustrations to Dante's *Divine Comedy. c.*1792. Engraved by Tomasso Piroli, published privately, Rome: 1793; London: Longman & Co., 1807. Original drawing in Houghton Library, Harvard University, Cambridge. [Irwin 1979, pp. 94, 226 *n.* 41 / Flaxman 1872, 4: pl. 33]

Auguste Couder, 1789–1873. "Earth: Combat of Hercules and Antaeus." Ceiling painting, part of "Elements" cycle. **1819.** Vestibule, Galerie d'Apollon, Louvre, Paris (inv. 3378). [Louvre 1979–86, 3:162—ill.]

Eugène Delacroix, 1798–1863. "Hercules Strangling Antaeus." Ceiling painting, part of "Life of Hercules" cycle for Salon de la Paix, Hôtel de Ville, Paris. **1851–52.** Destroyed by fire, 1871. [Robaut 1885, nos. 1160—ill. (copy drawing) / Huyghe 1963, pp. 289, 423, 474] Replica. 1854? Mahmoud Khalil Museum, Cairo. [Johnson 1981–86, no. 316—ill. / Robaut 1885, no. 1139—ill. (drawing)]

Jean-Baptiste Carpeaux, 1827–**1875.** "Hercules and Antaeus." Drawing. Cabinet des Dessins, Louvre, Paris, no. R.F. 1208. [Beyer 1975, no. 86]

José-Maria de Heredia, 1842–1905. "Hercule et Antée." Sonnet. **1889.** [Delaty 1984, vol. 2]

Wilfred Owen, 1893–1918. "Antaeus" ("The Wrestlers"). Poem. **1917.** In *Poems* (London: Chatto & Windus, 1920); reprinted in *Complete Poems and Fragments,* vol. 2 (London: Chatto & Windus, 1983). [Ipso / BW 1979–87, 6:459]

Gerhard Marcks, 1889–1981. "Kneeling Antaeus." Bronze sculpture. **1926.** Unique (?) cast. Unlocated. [Busch & Rudloff 1977, no. 140—ill.]

Laurence Housman, 1865–1959. "Antaeus." Poem. In *Collected Poems* (London: Sidgwick & Jackson, **1937**). [Boswell 1982, p. 264]

Jacques Lipchitz, 1891–1973. "Hercules and Antaeus." Drawing. *c.*1942. Artist's coll. in 1972. [Lipchitz 1972, p. 160—ill.]

Robert Rauschenberg, 1925–. Transfer-drawing, depicting Antaeus represented as a hand holding Dante and Virgil, illustration to *Inferno* 31. **1959–60.** Museum of Modern Art, New York. [Berlin 1980, p. 240—ill.]

Seamus Heaney, 1939–. "Antaeus," "Hercules and Antaeus." Poems. In *North* (London: Faber & Faber; New York: Oxford University Press, **1975**). [DLB 1985, 40 pt. 1: 189 / Jones & Schmidt 1980, p. 110]

Leonard Baskin, 1922–. "Hercules and Antaeus." Bronze sculpture. **1981.** Kennedy Galleries, New York, in 1982. [Baskin 1982, no. 10—ill.]

Heracles and Deianeira. While in Hades performing his twelfth labor, the abduction of Cerberus, Heracles (Hercules) met the shade of Meleager, who asked the hero to marry his sister Deianeira. To keep his promise, Heracles traveled to Calydon in Aetolia to ask King Oeneus for his daughter's hand. Deianeira, however, had been promised to the river-god Achelous. Heracles challenged Achelous to a wrestling match. During the contest the god transformed himself into a bull; Heracles broke off one of his horns, thus securing the victory. Afterward, Heracles returned the horn to the river-god in exchange for the horn of the goat Amalthea, which could supply its owner with an endless bounty of food and drink; according to an alternate version, the Naiads retrieved Achelous's horn and filled it with fruit and flowers. This *cornu copiae* (horn of plenty) has become a popular device in the visual arts.

After winning Deianeira, Heracles brought her to Tiryns. On the way, they were assisted in crossing the flooded Evenus River by the centaur Nessus, who forded it with Deianeira on his back. When they reached the shore, the centaur tried to rape her, but Heracles killed him with a poisoned arrow. As he lay dying, Nessus told Deianeira to smear some of his blood on a garment, which would win back her husband's love if she should ever lose it. This was the "shirt of Nessus" that later caused Heracles' death.

Deianeira and Heracles lived in Tiryns for a number of years. She bore him several children, including a son, Hyllus. After the murder of Iole's brother Iphitus, Heracles' family was exiled to Trachis.

Classical Sources. Sophocles, *The Women of Trachis.* Diodorus Siculus, *Biblioteca* 4.34.1, 4.36.1–5, 4.38.1–5. Ovid, *Metamorphoses* 8.542–9.133. Apollodorus, *Biblioteca* 1.8.1–3, 2.7.5–7. Seneca, *Hercules oetaeus.* Hyginus, *Fabulae* 31, 33–36, 129, 162, 174, 240, 243. Philostratus, *Imagines* 4.16.

See also HERACLES, Death.

Dante Alighieri, 1265–1321. (Nessus among the centaurs guarding the Murderers in) *Inferno* 12.46–139. *c.*1307–*c.*1314? In *The Divine Comedy.* Poem. Foligno: Neumeister & Angelini, 1472. [Singleton 1970–75, vol. 1]

Anonymous French. (Story of Hercules and Deianeira in) *Ovide moralisé* 9.1–486. Poem, allegorized translation/elaboration of Ovid's *Metamorphoses. c.*1316–28. [de Boer 1915–86, vol. 3]

Giovanni Boccaccio, 1313–1375. "De Deyanira Herculis coniuge" [Deianeira, Wife of Hercules]. In *De mulieribus claris* [Concerning Famous Women]. Latin verse com-

pendium of myth and legend. **1361–75.** Ulm: Zainer, 1473. [Branca 1964–83, vol. 10 / Guarino 1963]

John Gower, 1330?–1408. (Tales of Deianeira, and Nessus, Hercules, and Achelous, in) *Confessio amantis* 2.2145–2308, 4.2045–2134. Poem. *c.*1390. Westminster: Caxton, 1483. [Macaulay 1899–1902, vol. 2 / Beidler 1982, p. 15]

Filarete, *c.*1400–1469? "Hercules, Deianeira, and Nessus." Relief, on bronze door of St. Peter's, Rome. **1433–45.** In place. [Pope-Hennessy 1985b, 2:318]

Apollonio di Giovanni, *c.*1415–1465. "The Rape of Deianeira." Painting. Cincinnati Art Museum, Ohio, no. 1933.9. [Berenson 1963, p. 18]

Antonio del Pollaiuolo, 1432/33–1498 (and Piero Pollaiuolo?). "The Rape of Deianeira." Painting. Before **1467.** Yale University Art Gallery, New Haven, no. 1871.42. [Ettlinger 1978, no. 11—ill. / also Berenson 1963, p. 179—ill.]

Andrea Mantegna, 1430/31–1506. "Hercules Shooting an Arrow," "Nessus Transfixed by Hercules' Arrow." Ceiling frescoes. **1468–74.** Camera Picta (Camera degli Sposi), Palazzo Ducale, Mantua. [Lightbown 1986, no. 20, pls. 67–68]

Michelangelo, 1475–1564. "Battle of the Centaurs" (subject disputed; battle of Hercules and centaurs, with rape of Deianeira? battle of centaurs and lapiths?). Marble relief. **c.1492.** Casa Buonarroti, Florence. [Baldini 1982, no. 4—ill. / Goldscheider 1964, p. 9—ill. / Pope-Hennessy 1985, 3:302—ill.] 2 chalk copies by Peter Paul Rubens, 1600–08. *See below.*

Florentine School. "Deianeira and Nessus." Painting. **15th century.** Blickling Hall, Norfolk. [Wright 1976, p. 97]

Marcantonio Raimondi, *c.*1480–1527/34. "Hercules Killing the Centaur Nessus," "Hercules Killing Achelous, Transformed into a Bull." Engravings (Bartsch nos. 289, 291), part of "Labors of Hercules" cycle. Early work. [Bartsch 1978, 26:277–80—ill.]

Albrecht Dürer, 1471–1528, studio, under Dürer's direction. "Hercules Conquering Achelous," "Hercules Killing Nessus." Drawings, design for series of medals (unlocated) depicting the adventures of Hercules. **1510–11.** Formerly Kunsthalle, Bremen, lost. [Strauss 1974, nos. 1511/28, 31—ill.]

Jan Gossaert, called Mabuse, *c.*1478–1533/36. "Hercules and Deianeira." Painting. **1515.** Barber Institute of Fine Arts, Birmingham, England. [Rotterdam 1965, p. 26—ill. / de Bosque 1985, p. 53—ill.] Related etching. (Museum Boymans-van Beuningen, Rotterdam.) [Rotterdam, no. 76—ill.]

———. "Hercules and Deianeira" (or Omphale?). Woodcut. *c.*1515? (Rijksprentenkabinet, Amsterdam.) [Rotterdam 1965, no. 73—ill.]

Rosso Fiorentino, 1494–1540, composition. "Hercules Shooting Nessus," "Hercules Overpowering the River Achelous." Engravings, in "Labors and Adventures of Hercules" cycle, executed by Gian Jacopo Caraglio (Bartsch nos. 45, 48). **1524.** Original designs lost. [Carroll 1987, nos. 10, 13—ill.]

Giulio Romano, *c.*1499–1546, assistants, after designs by Giulio. Fresco (simulated bronze plaque) depicting Hercules, Deianeira, and Nessus. **1527–28.** Sala dei Cavalli, Palazzo del Tè, Mantua. [Hartt 1958, pp. 112ff., fig. 184 / Verheyen 1977, p. 115]

Parmigianino, 1503–1540. "Hercules, Nessus, and Deianeira." Drawing. Duke of Devonshire coll., Chatsworth, Derbyshire. / Variant print, by Andrea Schiavone, *c.*1540? [Richardson 1980, no. 72—ill.]

Maerten van Heemskerck, 1498–1574. "Hercules Slays the Centaur Nessus." Painting, in "Gods and Heroes from Mythology and the Old Testament" series. *c.*1545. Rijksmuseum, Amsterdam, inv. A3513. [Grosshans 1980, no. 30c—ill. / Rijksmuseum 1976, p. 265—ill.]

Lucas Cranach, 1472–1553, studio. "Hercules and Nessus." Painting, part of "Hercules" cycle. After 1537. Herzog Anton Ulrich-Museum, Braunschweig, nos. 712–718. [Braunschweig 1969, pp. 47f.]

Giorgio Vasari, 1511–1574, and assistants. Hercules and Nessus depicted in cycle of ceiling paintings on the deeds of Hercules. **1557.** Sala di Ercole, Palazzo Vecchio, Florence. [Sinibaldi 1950, pp. 13, 23]

Andrea Schiavone, *c.*1522–1563, attributed. "Nessus and Deianeira." Painting. Rijksmuseum, Amsterdam, inv. A3374. [Rijksmuseum 1976, p. 504—ill.]

Giambologna, 1529–1608. "Nessus and Deianeira." Bronze sculpture group. Examples **1575–80** and later. Louvre, Paris; Huntington Library & Art Gallery, San Marino, Calif.; Staatliche Kunstsammlungen, Dresden; elsewhere. [Avery 1987, nos. 90–92—ill. / Avery & Radcliffe 1978, pp. 109f., nos. 60–65—ill. / also Florence 1986, p. 67—ill.] Marble version. 1591. Private coll., Canada (damaged). [Avery, no. 17 / Avery & Radcliffe, no. 61 *n.*] Bronze variants. Private coll., London; Louvre, Paris, no. OA9480. [Avery & Radcliffe, nos. 66–67—ill. / also Avery, no. 93—ill.] Bronze variant copy, attributed to Adriaen de Vries (*c.*1560–1626), in Frick Collection, New York, no. 15.2.49. [Frick 1968–70, 4:40f.—ill.] Copy, by Pietro Tacca, in Hermitage, Leningrad, inv. 1272. [Hermitage 1984, no. 368—ill.]

——— with **Pietro Francavilla,** 1546/53–1615. "Hercules Slaying a Centaur." Marble sculpture. 1595–1600. Loggia dei Lanzi, Florence. [Avery, no. 20—ill. / Pope-Hennessy 1985b, 3:388f.—ill.] Wax model. Victoria and Albert Museum, London. [Pope-Hennessy] Bronze replicas/variants, by Giambologna and/or studio. Kunsthistorisches Museum, Vienna, nos. 5834, 6030; Museo del Bargello, Florence; elsewhere. [Avery & Radcliffe, nos. 81–82—ill. (cf. nos. 227–28) / also Avery, nos. 74–75—ill. (cf. nos. 194–95)]

Paolo Veronese, 1528–1588. "Hercules, Deianeira, and the Centaur Nessus." Painting. *c.*1582–84. Kunsthistorisches Museum, Vienna, inv. 1525 (398). [Pallucchini 1984, no. 233—ill. / Pignatti 1976, no. 258—ill. / Vienna 1973, p. 197—ill. / Berenson 1957, p. 139]

Luca Cambiaso, 1527–1585. "The Rape of Deianeira" (?). Drawing. Victoria & Albert Museum, London, inv. 342. [Manning & Suida 1958, p. 182—ill.]

Bartholomeus Spranger, 1546–1611. "Hercules, Deianeira, and the Dead Centaur Nessus." Painting. **1580s.** Kunsthistorisches Museum, Vienna, inv. 2613. [Vienna 1973, p. 165—ill. / also Hofmann 1987, no. 3.7—ill. / de Bosque 1985, pp. 67, 204f.—ill.]

——— "Hercules, Deianeira, and Nessus." Drawing. Österreichische Nationalbibliothek, Vienna. [de Bosque, p. 206—ill.]

Hendrik Goltzius, 1558–1617. "Hercules and Deianeira." Drawing, composition for print. *c.*1590–91. Stä-

delsches Kunstinstitut, Frankfurt, inv. N1792. / Print executed by Jacob Matham (Bartsch no. 159). [Reznicek 1961, no. 136—ill. / also de Bosque 1985, p. 204—ill.]

Cavaliere d'Arpino, 1568–1640. "Hercules, Nessus, and Deianeira." Lunette fresco, part of cycle depicting scenes from the life of Hercules. **1594–95.** Loggia Orsini, Palazzo del Sodalizio dei Piceni, Rome. [Röttgen 1969, pp. 279ff., 285]

Peter Paul Rubens, 1577–1640. "Battle of the Centaurs" (Heracles and Nessus?). 2 drawings, copies after Michelangelo (*c.*1492, Florence). **1600–08.** Museum Boymans-van Beuningen, Rotterdam; Fondation Custodia, Paris. [White 1987, pls. 18, 19]

———— and **Frans Snyders**, 1579–1657. "Three Nymphs with Cornucopia" ("Ceres and Two Nymphs"). Painting. *c.*1617 (or 1620–28?). Prado, Madrid, no. 1664. [Jaffé 1989, no. 441—ill. / Prado 1985, p. 601] Oil sketch ("Nymphs Filling the Horn of Plenty"). Dulwich College Picture Gallery, inv. 171. [Held 1980, no. 255—ill. / Jaffé, no. 440—ill.]

————. (Rubens). "Dying Nessus, and Deianeira." Painting. *c.*1635. Unlocated. [Jaffé, no. 1110—ill.]

———— and **Jacob Jordaens**, 1593–1678. "Nessus Abducting Deianeira." Painting. *c.*1635. Niedersächsisches Landesmuseum, Hannover. [Ibid., no. 1112—ill.] Studio copy (also attributed to Rubens). Hermitage, Leningrad. [Ibid. / Rosenberg 1988, no. 217 fig. 2] Watercolor copy, by Jean-Honoré Fragonard, *c.*1777. *See Fragonard, below.*

————. (Rubens). "Deianeira and Nessus." Painting, for Torre de la Parada, El Pardo, executed by assistant (Erasmus Quellinus?) from Rubens's design. 1636–38. Lost. [Prado 1984, pp. 606f. / Alpers 1971, no. 16 / Jaffé, no. 1258; cf. no. 1257] Oil sketch. Private coll., Hannover. [Prado / also Alpers, no. 16a / Held, no. 183—ill.] Copy, by Juan Bautista del Mazo (*c.*1612–1667), in Palacio de Pedralbes, on deposit from Prado, Madrid; copy (18th century) in Prado, no. 2460. [Prado / Alpers—ill.]

————, studio. "Deianeira Abducted by Nessus." Painting, oil sketch, copy after lost original (formerly thought to be connected to Torre de la Parada decoration). *c.*1636–38. Formerly Arnhold coll., New York, unlocated. [Held, no. 234 *n.*—ill. / Jaffé, no. 1345]

————, school. "Hercules Wrestling with Achelous in the Form of a Bull." Painting. Wellington Museum, Apsley House, London. [Wright 1976, p. 178]

Francis Bacon, 1561–1626. "Achelous, sive praelium" (Hercules' battle with Achelous). Chapter 23 of *De sapientia veterum.* Mythological compendium. London: Barker, **1609.** / Translated as "Achelous, or Battell" by Arthur Gorges in *The Wisdome of the Ancients* (London: Bill, 1619). Modern facsimile edition (bilingual), New York & London: Garland, 1976. [Ipso]

Thomas Heywood, 1573/74–1641. (Story of Nessus and Deianeira in) *Troia Britanica: or, Great Britaines Troy* 7.95–96. Epic poem. London: **1609.** [Heywood 1974]

————. (Episode, as above, in) *The Brazen Age.* Drama, partially derived from *Troia Britanica.* First performed *c.*1610–13, London. Published London: Okes, 1613. [Heywood 1874, vol. 3 / DLB 1987, 62:101, 122ff. / also Boas 1950, pp. 83ff. / Clark 1931, pp. 62ff.]

————. (Story of Deianeira in) "Of Women That Have Come by Strange Deaths." Passage in *Gynaikeion: or, Nine Books of Various History Concerning Women* book 4. Compendium of history and mythology. London: Adam Islip, 1624. [Ipso]

David Vinckeboons, 1576–1629. "Nessus, Deianeira, and Hercules." Painting. **1612.** Kunsthistorisches Museum, Vienna, inv. 9101. [Vienna 1973, p. 199—ill.]

Guido Reni, 1575–1642. "Hercules Fighting with Achelous," "Deianeira Abducted by Nessus." Paintings, part of "Feats of Hercules" ("Power and Triumph of the Gonzaga") cycle. **1620–21.** Louvre, Paris, inv. 536. [Pepper 1984, nos. 69, 71—ill. / Louvre 1979–86, 2:226—ill. / Gnudi & Cavalli 1955, nos. 43, 45—ill.] Copy of "Achelous" in Musée des Beaux-Arts, Orléans. / Studio variant of "Deianeira" in Berg Gallery, Prague; copy (attributed to Coypel) in Château de Versailles, on deposit from Louvre (inv. 548). [Pepper / also Louvre, 2:297; cf. nos. 547–48]

Adriaen de Vries, *c.*1550–1626. "Hercules, Nessus, and Deianeira." Bronze statuette. **1622.** Slott, Drottningholm, Sweden. [Frick 1968–70, 4:42]

Domenichino, 1581–1641. "Landscape with Hercules Battling Achelous (in the Form of a Bull)." Painting. *c.*1621–23. Louvre, Paris, inv. 794 (1614). [Spear 1982, no. 82—ill. / Louvre 1979–86, 2:171—ill.]

Johann Rottenhammer, 1564–1625, questionably attributed. "Hercules Freeing Deianeira." Painting. Kunsthistorisches Museum, Vienna, inv. 1147 (1529). [Vienna 1973, p. 145]

Nicolas Poussin, 1594–1665. "Hercules Carrying Off Deianeira." Painting. *c.*1635. Lost. / Drawings. Royal Library, Windsor Castle, no. 11912; Louvre, Paris, no. 32508. [Friedlaender & Blunt 1953, nos. 218–19—ill. / also Thuillier 1974, no. 103—ill. (print) / Wright 1985, no. L24 / Blunt 1966, no. L63]

Pedro Calderón de la Barca, 1600–1681. (Hercules and Deianeira in) *Los tres mayores prodigios* [The Three Greatest Marvels] act 3. Drama. First performed St. John's Night **1636**, Buen Retiro, Madrid. Published in *Comedias de Calderón*, part 2 (Madrid: 1637). [Valbuena Briones 1960–67, vol. 1 / O'Connor 1988, pp. 136, 144–52 / Maraniss 1978, pp. 104f.]

Stefano Della Bella, 1610–1664. "Hercules and Deianeira." Etching, for set of playing cards. **1644.** Gabinetto Disegni e Stampe, Uffizi, no. 102392. [Florence 1986, no. 3.22—ill.]

Padovanino, 1588–1648. "Deianeira and the Centaur Nessus." Painting. Ringling Museum of Art, Sarasota, Fla., inv. SN142. [Sarasota 1976, no. 98—ill.]

Jacob Jordaens, 1593–1678. "(Hercules and the Nymphs) Filling the Horn of Plenty" ("Hercules and Achelous"). Painting. **1649.** Statens Museum for Kunst, Copenhagen. [Copenhagen 1951, no. 351—ill. / Rooses 1908, pp. 145ff.—ill.]

————. Nessus abducting Deianeira, representing "November" ("The Archer"). Ceiling painting, part of "Signs of the Zodiac" cycle, for the artist's house in Antwerp. Early 1640s. Senate Library, Palais du Luxembourg, Paris. [Rooses, pp. 124f.]

————, attributed. "Nessus and Deianeira." Painting. Sold Cologne, 1892. [Rooses, p. 259]

Alessandro Algardi, 1598–1654. "Hercules and Ache-

lous." Drawing. Louvre, Paris, no. 6854. [Montagu 1985, Drawings no. 28—ill.]

Luca Giordano, 1634–1705, attributed (previously attributed to Jusepe de Ribera). "Hercules and Nessus." Painting. **1650s.** Museul de Arta al Republicii, Bucharest, no. 225. [Ferrari & Scavizzi 1966, 2:64—ill.] School variant, 1650–1700. Szépmüvészeti Múzeum, Budapest, no. 524. [Ibid., 2:65 / Budapest 1968, p. 477]

———. "The Rape of Deianeira." Painting. 1650s. Galleria Nazionale, Palermo, on deposit at Museo, Agrigento. [Ferrari & Scavizzi, 2:69—ill.]

———. "Hercules Slaying Nessus." Painting. 1670–80. Manning coll., New York. [Ibid., 2:367f.]

———. "Nessus and Deianeira." Painting. c.1675–80? Musée des Beaux-Arts, Douai, no. 1143, in 1919. [Ibid., 2:325]

———. "The Rape of Deianeira" ("Deianeira and Nessus"). Painting. c.1682. Uffizi, Florence, inv. 1364. [Uffizi 1979, no. P714—ill. / also Ferrari & Scavizzi, 2:119—ill.] 2 enlarged replicas. Formerly Del Rosso coll., unlocated; Burghley House, Northamptonshire. [Uffizi]

———. "The Rape of Deianeira." Drawing. Early 1690s. Museo di San Martino, Naples, no. 20830. [Ferrari & Scavizzi, 2:264—ill.]

———. "The Death of the Centaur Nessus." Painting. 1697–1700. Prado, Madrid, no. 193. [Ferrari & Scavizzi, 2:221—ill. / Prado 1985, p. 253]

———. "Hercules and Nessus." Painting. Palacio Real, Riofrio, in 1884. [Ferrari & Scavizzi, 2:379]

———. 2 further treatments of the subject known: 1 recorded in Rosso coll., Florence, in 1677; 1 sold 1864, untraced. [Ibid., 2:330f., 393]

Pietro Andrea Ziani, 1616–1684. *Le fatiche d'Ercole per Deianira* [The Trials of Hercules for Deianeira]. Opera. Libretto, Aurelio Aureli. First performed **1662,** SS Giovanni e Paolo, Venice. [Grove 1980, 20:675 / Bianconi 1987, p. 188 / Worsthorne 1954, p. 106]

Pier Francesco Mola, 1612–**1666/68,** school. "Deianeira Raped by Nessus." Colonel J. Weld coll., Lulworth Manor, no. 120. [Warburg]

Ulric Robran de la Marche, choreography. *The Loves of Hercules and Dejanira.* Court ballet. First performed **1671,** Naumburg. [Winter 1974, p. 15]

Pietro Liberi, 1614–**1687.** "Heracles and Deianeira." Painting. Herzog Anton Ulrich-Museum, Braunschweig, no. 1055. [Braunschweig 1969, p. 88]

François Girardon, 1628–1715, design. "Achelous." Marble terminal figure, executed by Simon Mazière, **1688.** Parterre de Latone, Gardens, Versailles. [Girard 1985, p. 286—ill.]

Agostino Steffani, 1654–1728. *La lotta d'Hercole con Acheloo* [The Struggle of Hercules with Achelous]. Divertimento drammatico. Libretto, O. Mauro. First performed **1689,** Hannover. [Grove 1980, 18:96]

French School. "Nessus and Deianeira." Bronze sculpture group. **17th century.** Wallace Collection, London. [Warburg]

Italian School. "Deianeira Raped by Nessus." Painting. **17th century.** Princeton University Art Museum, N.J., inv. 39–119. [Warburg]

Sebastiano Ricci, 1659–1734. "Hercules and Deianeira with the Body of Nessus." Painting. **c.1702.** Private coll., Munich. [Daniels 1976, no. 256—ill.]

———. "Hercules Battling with the Centaur Nessus." Fresco, part of "Hercules" cycle. 1706–07. Sala d'Ercole, Palazzo Marucelli-Fenzi, Florence. [Daniels 1976, no. 110—ill.] Study. Palazzo Taverna, Rome. [Ibid., no. 395—ill.]

———. "Hercules and Deianeira with the Body of Nessus." Painting. c.1710? Palazzo Taverna, Rome. [Ibid., no. 389—ill.]

———. "Hercules and Achelous." Grisaille ceiling fresco, part of "Hercules" cycle, for Portland House, London. 1712–13. Destroyed. [Ibid., no. 208]

——— (formerly attributed to Luca Giordano). "The Rape of Deianeira." Painting. 1706–13? Burghley House, Stamford, no. 124. [Ibid., no. 411—ill. / Ferrari & Scavizzi 1966, 2:122] Another version of the subject (based on a presumed modello by Luca Giordano?). Burghley House, no. 478. [Ferrari & Scavizzi]

Gérard de Lairesse, 1641–**1711,** follower. "The Marriage of Hercules and Deianeira," "Hercules Saving Deianeira." Paintings, part of series of grisailles on deeds of Hercules. Early 18th century. Louvre, Paris, inv. 20771–72. [Louvre 1979–86, 2:378—ill.]

François Marot, 1666–**1719.** "The Rape of Deianeira by the Centaur Nessus." Painting. Louvre, Paris, inv. 6444 (555). [Louvre 1979–86, 4:73—ill.]

Antonio Corradini, 1668–1752. "Nessus and Deianeira." Marble sculpture group. **c.1723–28.** Grosser Garten, Dresden. [Hodgkinson 1970, p. 6, figs. 7–8]

François Le Moyne, 1688–1737. "Hercules and Achelous." Painting. Lost. [Bordeaux 1984, p. 130]

———, rejected attribution (manner of Verdot). "Hercules and Achelous." Painting. Private coll., Warsaw, before World War II. [Ibid., no. X22—ill.]

Carle van Loo, 1705–1765. "The Centaur Nessus Assaulting Deianeira." Painting. **1740.** Hermitage, Leningrad, inv. 7553. [Hermitage 1986, no. 278—ill.] Variant. Musée Municipal, Châlons-sur-Marne. / Several copies known. [Ibid.]

Louis-Jean-François Lagrenée, 1725–1805. "The Rape of Deianeira by the Centaur Nessus." Painting. **1755.** Louvre, Paris, inv. 5552. [Louvre 1979–86, 4:25—ill.]

Antonio Guardi, 1698–**1760.** "The Rape of Deianeira." Drawing. Late work. Formerly private coll., Paris, unlocated. [Morassi 1984, no. D37—ill.]

Sebastiano Conca, 1679–**1764.** "Hercules Shooting Nessus." Painting. Sold Christie's, London, 1936. [Warburg]

Pasquale Cafaro, 1716?–1787. *Ercole ed Acheloo.* Cantata. Text, Mattei. First performed 20 Jan **1766,** San Carlo, Naples. [Grove 1980, 3:595]

Stefano Pozzi, c.1707–**1768,** attributed. "The Abduction of Deianeira." Painting. Walters Art Gallery, Baltimore, inv. 37.1836. [Walters 1976, no. 414—ill.]

Jean-Honoré Fragonard, 1732–1806. "Nessus and Deianeira." Watercolor, after Rubens (c.1635, Hannover/Leningrad). **c.1777.** 2 versions. Louvre, Paris; British Museum, London. [Rosenberg 1988, no. 217—ill. / cf. Jaffé 1989, no. 1110]

Gaetano Gandolfi, 1734–1802. "Deianeira Raped by Nessus." Fresco. Palazzo Fiorese-Calzoni (formerly Del Monte), Bologna. **1780–83.** [Warburg]

Franz Anton Maulbertsch, 1724–1796. "Nessus and Deianeira." Painting. *c.*1785–86. Albertina, Vienna. [Garas 1960, no. 341]

Francesco Zuccarelli, 1702–1788. "Hercules Slaying the Centaur Nessus." Painting. Hunterian coll., University of Glasgow. [Wright 1976, p. 226]

Blas de Laserna, 1751–1816. *Hercules y Deyanira.* Melólogo. **1791–97.** [EDS 1954–66, 6:1255]

Pietro Carlo Guglielmi, *c.*1763–1817, music. *Ercole in Caledonia* [Hercules in Calydon]. Pantomime-ballet. First performed 4 Apr **1801,** Turin; choreography by Pietro Angiolini? [EDS 1954–66, 6:37]

Pietro Angiolini, 1746–1830, choreography. *Ercole ed Acheloo.* Ballet. First performed Summer **1807,** Padua. [Grove 1980, 1:427]

James Hervé D'Egville, *c.*1770–*c.*1836, choreography. *L'enlèvement de Déjanire* [The Rape of Deianeira]. Ballet. Music, Venua. First performed 9 Feb **1808,** King's Theatre, London. [Guest 1972, pp. 23, 154]

Francesco Benedetti da Cortona, 1785–1821. *Deianira.* Lyric drama. **1811.** In *Opere,* edited by F. S. Orlandini (Florence: Le Monnier, 1858). [DELI 1966–70, 1:318]

Bertel Thorwaldsen, 1770–1844. "The Centaur Nessus Embracing the Struggling Deianeira." Marble relief. Thorwaldsens Museum, Copenhagen, no. A480; 2 others unlocated. [Thorwaldsen 1985, p. 56, pl. 55 / Cologne 1977, no. 71 / Hartmann 1979, p. 158—ill.] Plaster original. **1814.** Thorwaldsens Museum, no. A481. [Thorwaldsen]

Théodore Géricault, 1791–1824. Several drawings depicting a centaur carrying off a woman (Nessus and Deianeira?). **1816–17.** Louvre, Paris (single drawings, no. 26737–8; sheet of sketches, no. R.F. 5176); private coll., London. [Eitner 1983, figs. 88–90, 335, no. 24.35–6]

François-Joseph Bosio, 1769–1845. "Heracles Fighting Achelous in the Form of a Serpent." Bronze sculpture group. **1824.** Jardin des Tuileries, Paris. [Janson 1985, p. 242]

Eugène Delacroix, 1798–1863. "Hercules Killing the Centaur Nessus." Ceiling painting, in "Life of Hercules" cycle, for Salon de la Paix, Hôtel de Ville, Paris. **1851–52.** Destroyed by fire, 1871. [Robaut 1885, no. 1158—ill. (copy drawing) / Huyghe 1963, pp. 289, 423, 474]

Arthur Rimbaud, 1854–1891. "Combat d'Hercule et du fleuve Achelous" [Battle of Hercules and the River Achelous]. Poem, in Latin, adaptation of the French of Abbé Delisle. **1869.** In *Bulletin de l'Académie de Douai* 11 Apr 1870. [Adam 1972]

Evelyn de Morgan, 1855–1919. "Deianeira." Painting. **1870.** [Wood 1983, p. 199—ill.]

Gustave Moreau, 1826–1898. "Deianeira" ("Autumn," "The Rape of Deianeira by the Centaur Nessus"). Painting. **1872.** Private coll., Paris. [Mathieu 1976, no. 128—ill.]

———. "The Rape of Deianeira." Wax model for unexecuted sculpture, based on above. 1875–85. [Mathieu, no. 189]

Hans Makart, 1840–1884. "Nessus and Deianeira." Painting. *c.*1882–83. Szépművészeti Múzeum, Budapest, inv. 100B. [Frodl 1974, no. 419—ill.]

José-Maria de Heredia, 1842–1905. "Nessus." Sonnet, in "Hercule et les centaures" cycle. In *Revue des deux mondes* 15 Jan **1888;** collected in *Les trophées* (Paris: Lemerre,

1893). [Delaty 1984, vol. 1 / Hill 1962 / Galinsky 1972, pp. 269, 271]

Rubén Darío, 1867–1916. (Nessus recalls Deianeira in) "Coloquio de los centauros" [Colloquy of the Centaurs]. Poem. **1895.** In *Prosas profanas y otros poemas* (Buenos Aires: Coni, 1896). [Méndez Plancarte 1967 / Jrade 1983, pp. 34f.]

Henri de Régnier, 1864–1936. "Déjanire." Poem, part of *Flûtes d'Avril et de Septembre.* In *Aréthuse* (Paris: Librarie de l'Art Indépendant, 1895). [Ipso]

———. "Le centaure blessé" [The Wounded Centaur], section of "Le sang de Marsyas" [The Blood of Marsyas]. Poem. In *La cité des eaux* (Paris: Mercure de France, 1902). [Ipso]

Arnold Böcklin, 1827–1901. "Deianeira and Nessus." Painting. **1898.** Pfalzgalerie, Kaiserslautern, inv. PFG 66/15. [Andree 1977, no. 465—ill.]

Camille Saint-Saëns, 1835–1921. *Déjanire.* Opera (drame lyrique). Libretto, composer, after Louis Gallet. First performed 14 Mar **1911,** Monte Carlo. [Grove 1980, 16:404]

Laurent-Honoré Marqueste, 1848–1920. "The Centaur Nessus Abducting Deianeira." Marble sculpture group. Jardin des Tuileries, Paris. [Orsay 1986, p. 276]

Franz von Stuck, 1863–1928. "Hercules and Nessus" (with Deianeira). Painting. **1927.** Private coll. [Voss 1973, no. 601—ill.] Study. Galerie Raschhofer, Munich-Salzburg. [Ibid., no. 600—ill.] Variant. Unlocated. [Ibid., no. 599—ill.]

Kurt Weill, 1900–1950. *Royal Palace* (Deianeira theme in modern dress). Ballet-opera. Libretto, Yvan Goll. First performed 2 Mar **1927,** Staatsoper, Berlin. [Grove 1980, 20:309]

Pablo Picasso, 1881–1973. "The Centaur Nessus, Desiring to Ravish Deianeira, Is Killed by Hercules." Etching, illustration for edition of Ovid's *Metamorphoses* (Lausanne: Albert Skira, 1931). **1930.** [Goeppert et al. 1983, no. 19—ill. / Bloch 1971–79, no. 116—ill.]

André Masson, 1896–1987. "The Centaur Nessus Abducts Deianeira." Drawing. By **1950.** [Hannover 1950, no. 85a]

Giulio Paolini, 1940–. "Nessus." Assemblage (plaster, photo, cloth). **1977.** Stein coll., Turin. [Munich 1984, pp. 76, 176—ill.]

Heracles and Iole. Sometime after he completed his labors, Heracles (Hercules) fell in love with Iole, daughter of King Eurytus of Oechalia. (The chronology of the myth is confused, and Heracles' intimacy with Iole may have preceded or followed that with Deianeira.) Although Heracles had won Iole in an archery contest, her father and brothers would not let her go. Heracles returned to Tiryns, angry and insulted. When Iole's brother Iphitus, a close friend of Heracles, came to Tiryns in search of some lost cattle, Heracles murdered him in a fit of rage by throwing him from the city's walls. As punishment, the Delphic oracle sent the hero into slavery for a year, during which he was sold to Omphale,

queen of Lydia, and forced to do women's work and to wear women's clothes. Sometime after this servitude, Heracles sacked Oechalia and reclaimed Iole, sending her to Trachis. In some later myths, the story of Iole was conflated with that of Omphale, perhaps because Heracles' servitude to the queen was payment for the crime he had committed in pursuit of Iole.

Classical Sources. Sophocles, *The Women of Trachis*. Diodorus Siculus, *Biblioteca* 4.31.1–3. Ovid, *Heroides* 9.3–6, 9.11–48. Apollodorus, *Biblioteca* 2.6.1, 2.7.7. Seneca, *Hercules oetaeus*. Hyginus, *Fabulae* 31, 35. Plutarch, *Parallel Lives* 13.308f.

Giovanni Boccaccio, 1313–1375. (Hercules describes his humiliation by Iole [conflated with Omphale] in) "Coventus dolentium" [A Gathering of the Mournful]. In *De casibus virorum illustrium* [The Fates of Illustrious Men] 1.12. Didactic poem in Latin. **1355–73?** [Branca 1964–83, vol. 9 / Hall 1965]

———. "De Yole Etholorum regis filia" [Iole, Daughter of the King of Etolia]. In *De mulieribus claris* [Concerning Famous Women]. Latin verse compendium of myth and legend. 1361–75. Ulm: Zainer, 1473. [Branca, vol. 10 / Guarino 1963 / Bergin 1981, p. 250]

Santi di Tito, 1536–1603. "Hercules and Iole." Painting. **1570–73.** Studiolo di Francesco I, Palazzo Vecchio, Florence. [Sinibaldi 1950, pp. 11f., 19]

Torquato Tasso, 1544–1595. (Hercules and Iole evoked in) *La Gerusalemme liberata* 16.3. Epic. **1575.** Venice: Perchacino, 1581 (authorized edition). [Montagu 1968, p. 172 / Highet 1967, p. 152]

Annibale Carracci, 1560–1609. "Hercules and Iole [or Omphale]." Fresco. **1597–1600.** Galleria, Palazzo Farnese, Rome. [Malafarina 1976, no. 104c—ill. / Martin 1965, p. 91—ill.]

Jacopo Peri, 1561–1633. *Iole ed Ercole.* Opera. Libretto, Salvadori. Planned for **1628,** Florence, unperformed, probably unfinished. One aria, "Uccidimi, dolore," extant. [Grove 1980, 14:402, 404]

Luca Giordano, 1634–1705. "Hercules and Iole." Painting. **1663?** Recorded in Andrea d'Avalos coll., Naples, in 1743, untraced. [Ferrari & Scavizzi 1966, 2:361]

———. "Hercules and Iole." Painting. Mid-1670s. Museo di Capodimonte, Naples, no. 1482. [Ibid., 2:85]

———. "Hercules Spinning, with Iole." Painting. Recorded in 1684, untraced. [Ferrari & Scavizzi, 2:381]

———. "Hercules and Iole." Painting. Recorded in Casa Baglioni, Venice, in 1743, untraced. [Ferrari & Scavizzi, 2:388]

Pedro Calderón de la Barca, 1600–1681. (Hercules pursues Iole in) *Fieras afemina Amor* [Love Tames the Wild Beasts]. Comedy (fiesta de espectáculo). **1669.** First performed Jan 1670, Vienna? [Valbuena Briones 1960–67, vol. 1 / O'Connor 1988, pp. 153–70]

Ferdinando Tacca, 1619–1686. "Hercules and Iole" (Hercules as woman). Bronze statuette. 3 examples known. National Gallery of Scotland, Edinburgh; 2 in private colls., London. [Florence 1986, no. 4.34—ill.]

Francesco Trevisani, 1656–1746. "Hercules and Iole."

Painting. **1717.** Formerly Schönborn coll., Pommersfelden, unlocated. [DiFederico 1977, p. 80]

Leonardo Leo, 1694–**1744.** *Le nozze di Iole ed Ercole* [The Marriage of Iole and Hercules]. Serenata or feste teatrali. [Grove 1980, 10:668]

Henry Fuseli, 1741–1825. "Heracles Victorious in Archery; Eurytus Holds His Daughter Iole Back." Drawing. **1811.** Walter A. Brandt coll., London. [Schiff 1973, no. 1528a]

Charles Gleyre, 1806–**1874.** "Hercules and Iphitus" ("Hercules and Theseus"). Drawing. Charles Clément coll., in 1878. [Clément 1878, no. 183]

Ezra Pound, 1885–1972. *The Women of Trachis*. Tragedy, modern version of Sophocles. **1953.** In *Hudson Review* 67.4 (Winter 1954). Broadcast 25 Nov 1954, BBC, London. First book publication London: Spearman, 1956; New York: New Directions, 1957. [Kenner 1971, pp. 522–26 / Galinsky 1972, pp. 236, 240ff. / DLB 1986, 45:338]

Heracles and Omphale. As punishment for his murder of Iole's brother Iphitus, Heracles (Hercules) was sent to serve Queen Omphale of Lydia for a year. There, he was forced to perform women's work, such as spinning, and to dress in women's garb, while the queen took over the hero's lion-skin cloak and club.

The roles of Omphale and Iole have become conflated in this episode, perhaps because Heracles' servitude resulted from his passion for Iole. In the postclassical arts, therefore, Iole is sometimes identified as dominatrix; alternately, Omphale and Heracles are sometimes shown as lovers.

Another story, recounted by Ovid, tells that Heracles found Pan (or Faunus) in Omphale's bed and threw him out.

Classical Sources. Ion, *Omphale*. Cratinus the Younger, *Omphale*. Nicochares, *Heracles as the Bride*. Diodorus Siculus, *Biblioteca* 4.31.5–8. Ovid, *Fasti* 2.303–58; *Ars amatoria* 2.11; *Heroides* 9. Apollodorus, *Biblioteca* 2.6.3. Hyginus, *Fabulae* 32; *Poetica astronomica* 2.14.

Anonymous French. (The story of Hercules, Faunus, and Iole in) *Ovide moralisé* 9.487–599. Poem, allegorized translation/elaboration of Ovid's *Metamorphoses.* c.1316–28. [de Boer 1915–86, vol. 3]

Giovanni Boccaccio, 1313–1375. (Hercules describes his humiliation by Iole, conflated with Omphale, in) "Coventus dolentium" [A Gathering of the Mournful]. In *De casibus virorum illustrium* [The Fates of Illustrious Men] 1.12. Didactic poem in Latin. **1355–73?** [Branca 1964–83, vol. 9 / Hall 1965]

———. (Iole's domination of Hercules, conflated with Omphale's, in) "De Yole Etholorum regis filia" [Iole, Daughter of the King of Etolia]. In *De mulieribus claris* [Concerning Famous Women]. Latin verse compendium of myth and legend. 1361–75. Ulm: Zainer, 1473. [Branca, vol. 10 / Guarino 1963 / Bergin 1981, p. 250]

John Gower, 1330?–1408. (Tale of Hercules and Faunus

in Iole's bed in) *Confessio amantis* 5.6807–6960. Poem. *c.*1390. Westminster: Caxton, 1483. [Macaulay 1899–1902, vol. 3]

Pinturicchio, 1454–**1513**, and studio. "Hercules and Omphale." Fresco (detached), from Palazzo Pandolfo Petrucci ("Il Magnifico"), Siena. Metropolitan Museum, New York, no. 114.17. [Metropolitan 1980, p. 142—ill. / Berenson 1968, p. 345—ill.]

Jan Gossaert, called Mabuse, *c.*1478–1533/36. "Hercules and Deianeira" (or Omphale?). Woodcut. *c.*1515? (Rijksprentenkabinet, Amsterdam.) [Rotterdam 1965, no. 73—ill.]

Hans Baldung Grien, 1484/85–1545. "Hercules and Omphale." Drawing. **1533.** École des Beaux-Arts, Paris. [Yale 1981, fig. 14]

Dosso Dossi, *c.*1479–1542. "Allegory of Hercules" ("Bambocciata") (allegory addressed to Ercole II d'Este, with elements related to the story of Hercules and Omphale). Painting. **Mid-1530s.** Uffizi, Florence. [Gibbons 1968, pp. 98ff, no. 22—ill. / also Uffizi 1979, no. P552—ill.]

Lucas Cranach, 1472–1553, and studio. "Hercules and Omphale." Painting. At least 8 versions, **1531–37.** Minnesota Museum of Art, St. Paul; Xaver Schweidwimmer Gallery, Munich, in 1966; formerly University Gallery, Göttingen, lost; Herzog Anton Ulrich-Museum, Braunschweig, no. 25; Thyssen-Bornemisza coll., Lugano; Statens Museum for Kunst, Copenhagen, cat. 1951 no. 152 (by Lucas Cranach the Younger?); 2 others unlocated. [Friedländer & Rosenberg 1978, nos. 272–75—ill. / Braunschweig 1969, p. 47—ill. / Braunschweig 1976, p. 15—ill. / also [Copenhagen 1951, no. 152—ill.].]

Francesco Primaticcio, 1504–1570. "Hercules Dressed as a Woman by Omphale," "Hercules Awakened (by Omphale)." Pendant paintings. **1535–41.** Portique, Porte Doré, Château de Fontainebleau. Repainted 19th century. [Dimier 1900, pp. 306f.] Drawings in Albertina, Vienna, no. 19; Duke of Devonshire coll., Chatsworth. [Ibid., nos. 151, 238 / also Paris 1972, no. 146—ill. / Lévêque 1984, p. 53—ill.]

Bartholomeus Spranger, 1546–1611. "Hercules and Omphale." Painting. *c.***1575–80.** Kunsthistorisches Museum, Vienna, inv. 1126 (1505). [Vienna 1973, p. 165—ill. / also Hofmann 1987, no. 3.22—ill. / de Bosque 1985, pp. 203f.—ill.]

Paolo Veronese, 1528–1588. (Hercules as Strength in) "Allegory of Wisdom and Strength" ("Hercules and Omphale"?). Painting. *c.***1578–80.** Frick Collection, New York, no. 12.1.128. [Palluchini 1984, pp. 127ff., no. 174—ill. / Pignatti 1076, no. 243—ill. / Frick 1968–70, 2:272f.—ill.] Study. Draper coll., Miami. [Pignatti, no. 244—ill.] 5 further versions known: Schönborn coll., Pommersfelden; De Young Museum, San Francisco; others unlocated. [Frick] Copy by Carletto Caliari, in Rhode Island School of Design, Providence. [Ibid.]

Jacopo Tintoretto, 1518–1594. "Hercules Driving the Faun from Omphale's Bed." Painting. *c.***1585.** Szépművészeti Múzeum, Budapest, no. 6706. [Rossi 1982, no. 447—ill. / Budapest 1968, p. 694—ill. / Berenson 1957, p. 171—ill.]

———. "Hercules and Omphale." Painting. Formerly Contini Bonacossi coll., Florence, unlocated. [Rossi, no. A40 / also Berenson, p. 173]

Francesco Bassano, 1549–1592. "Hercules Spinning" ("Hercules and Omphale"). Painting. *c.*1587. Kunsthistorisches Museum, Vienna, inv. 3575 (280). [Vienna 1973, p. 15—ill. / Arslan 1960, p. 225, pl. 257] Copy in Museo Civico, Padua. [Arslan, p. 360]

——— (School of the Bassano). "Hercules and Omphale." Painting. Musée, Marseilles (on deposit from Louvre, Paris, no. M.I. 1152). [Louvre 1979–86, 2:284]

Annibale Carracci, 1560–1609. "Hercules and Iole [or Omphale]." Fresco. **1597–1600.** Galleria, Palazzo Farnese, Rome. [Malafarina 1976, no. 104c—ill. / Martin 1965, p. 91—ill.]

Peter Paul Rubens, 1577–1640. "Hercules and Omphale." Painting. *c.*1602–05. Louvre, Paris, inv. 854. [Louvre 1979–86, 1:114—ill. / Jaffé 1989, no. 27—ill.]

Abraham Janssens, *c.*1575–1632, questionably attributed (also attributed to Abraham van Bloemaert, 1564–1651). "Jupiter and Antiope" ("Hercules and Omphale"). Painting. 1607. Statens Museum for Kunst, Copenhagen, no. 2435 (as "Jupiter and Antiope"). [Copenhagen 1951, no. 347 / also Delbanco 1928, no. II.8 (as "Hercules and Omphale," unattributed)]

Thomas Heywood, 1573/74–1641. (Hercules and Omphale in) *The Brazen Age*. Drama. First performed *c.*1610–13, London. Published London: Okes, 1613. [Heywood 1874, vol. 3 / DLB 62:101, 122ff. / also Boas 1950, pp. 83ff. / Clark 1931, pp. 62ff.]

Alessandro Turchi, 1578–1649. "Hercules and Omphale." Painting. *c.*1620. Alte Pinakothek, Munich, inv. 496. [Munich 1983, p. 536—ill.]

Palma Giovane, *c.*1548–1628, questionably attributed. "Hercules Adorned with Iole's Finery." Painting. 1620s? Formerly Battistelli coll., Florence. [Mason Rinaldi 1984, no. A23]

———, questionably attributed. "Hercules and Omphale." Painting. Christ Church, Oxford. [Byam Shaw 1967, no. 114]

Grandchamp de Montargis, questionably attributed. *Adventures amoureuses d'Omphalle*. Tragicomedy. Paris: **1630.** [Lancaster 1929–42, pt. 1, 1:331ff., 2:761]

Giovanni da San Giovanni, 1592–1636. "Hercules and Omphale." Fresco (detached), one of a series of 6, for Lorenzo de' Medici. *c.*1634. Uffizi, Florence, inv. 5414. [Uffizi 1979, no. P742—ill. / Banti 1977, no. 58]

Pietro da Cortona, 1596–1669. "Hercules Spinning, with Omphale." Painting. *c.*1635. Formerly Kaiser Friedrich Museum, Berlin. [Briganti 1962, no. 66—ill.] Variant. Schoenbrunn Galerie, Vienna. [Ibid., no. 67]

Bernardo Cavallino, 1616–1656. "Hercules and Omphale." *c.*1640. Private coll., Switzerland. [Percy & Lurie 1984, no. 22—ill.]

Simon Vouet, 1590–1649. "Hercules and Omphale." Painting. Lost. / Engraved by Michel Dorigny, **1643.** [Crelly 1962, p. 83, no. 226—ill.]

——— or studio. "Hercules and Omphale." Painting, cartoon for "Loves of the Gods" tapestry series. [Ibid., no. 270v]

Giovanni Rovetta, *c.*1595–1668. *Ercole in Lidia*. Opera. Libretto, M. Bisaccioni. First performed Ascension Week **1645**, Teatro Novissimo, Venice. [Grove 1980, 16:279 / Worsthorne 1954, pp. 31f.]

Padovanino, 1588–1648. "Hercules and Omphale." Painting. Formerly Milch Galleries, New York. [Sarasota 1976, p. 99]

Volterrano, 1611–1689. "Omphale." Painting, sketch. **1640s**. Private coll., Rome. [Florence 1986, no. 1.225—ill.]

Alessandro Algardi, 1598–**1654**. "Hercules and Omphale." Drawings, 2 versions of subject known. Uffizi, Florence, no. 4571S; Museo di Capodimonte, Naples, no. 0200.9. [Montagu 1985, Drawings nos. 29–30—ill.]

Maurizio Cazzati, c.1620–1677. *Ercole effeminato* [Hercules Become Effeminate]. Opera. First performed **1654**, Bergamo. [Grove 1980, 4:42]

Giovanni Francesco Romanelli, 1610–1662. "Hercules and Omphale." Painting. **1650s?** Hermitage, Leningrad, inv. 1601. [Hermitage 1981, pl. 121] Another version of the subject, in Museo Civico, Viterbo. [Ibid.]

Luca Giordano, 1634–1705. "Hercules and Iole" (Omphale theme?). Painting. **1663?** Recorded in Andrea d'Avalos coll., Naples, in 1743, untraced. [Ferrari & Scavizzi 1966, 2:361]

———. "Hercules and Iole" (Omphale theme?). Painting. Mid-1670s. Museo di Capodimonte, Naples, no. 1482. [Ibid., 2:85]

———. "Hercules Spinning, with Iole." Painting. Recorded in 1684, untraced. [Ibid., 2:381]

———. "Hercules and Iole" (Omphale theme?). Painting. Recorded in Casa Baglioni, Venice, in 1743, untraced. [Ibid., 2:388]

———, attributed. "Hercules and Omphale." Painting. Private coll., Venice. [Ibid., 2:390]

———, attributed. "Hercules and Omphale." Painting. Art Gallery, Brighton. [Wright 1976, p. 76]

Francesco Baratta, ?–1666. "Hercules and Omphale." Marble sculpture group. Formerly Grosser Garten, Zwinger Palace, Dresden. [Pigler 1974, p. 121 / Bénézit 1976, 1:425]

Ferdinando Tacca, 1619–**1686**. "Hercules and Iole" (Hercules as woman). Bronze statuette. 3 examples known. National Gallery of Scotland, Edinburgh; 2 in private colls., London. [Florence 1986, no. 4.34—ill.]

Jean Palaprat, 1650–1721. *Hercule et Omphale*. Comedy. First performed 7 May **1694**, Comédie-Française, Paris. [Lancaster 1929–42, pt. 4, 2:956]

Balthasar Permoser, 1651–1732. "Hercules and Omphale." Ivory sculpture. c.**1690–95**. Grünes Gewölbe, Dresden. [Asche 1966, no. P26, pl. 28—ill.]

André Cardinal Destouches, 1672–1749. *Omphale*. Opera (tragédie lyrique.) Libretto, Antoine Houdar de La Motte. First performed 10 Nov **1701**, Académie Royale de Musique, Paris. [DLLF 1984, 2:1040 / Grove 1980, 5:402 / Girdlestone 1972, pp. 190–92]

Sebastiano Ricci, 1659–1734. "Hercules and Omphale." Painting. c.**1701** or later. Musée de Picardie, Amiens. [Daniels 1976, no. 3 / also Bordeaux 1984, fig. 393]

———. "Hercules and Omphale." Painting. 1703 or later. Palazzo Fulcis-Bertoldi, Belluno. [Daniels, no. 20—ill.]

———. "Hercules and Omphale." Painting. c.1713–14 (or earlier?). Private coll., Bologna. [Ibid., no. 61]

Giovanni Battista Piazzetta, 1683–1754, attributed. "Hercules and Omphale." Painting. **1700–10?** Formerly Heimann coll., New York. [Mariuz 1982, no. A63—ill.]

———, attributed (or Donzelli?). "Hercules and Omphale." Painting. Residenz, Wurzburg. [Ibid., no. A148—ill.]

Gérard de Lairesse, 1641–**1711**, follower. "Hercules Spinning at the Feet of Omphale." Grisaille painting, part of series on deeds of Hercules. Early 18th century. Louvre, Paris, inv. 20770. [Louvre 1979–86, 2:378—ill.]

Daniel Gran, 1694–1757. "Hercules and Omphale." Fresco. **1723–24**. Kuppelsaal, Gartenpalais Schwarzenberg, Vienna. [Knab 1977, pp. 42ff., no. F4]

François Le Moyne, 1688–1737. "Hercules and Omphale." Painting. **1724**. Louvre, Paris, inv. M.I. 1086. [Bordeaux 1984, no. 47—ill. / Louvre 1979–86, 4:47—ill.] Variant. Private coll., New York. [Bordeaux—ill.] Copy in Museum of Fine Arts, Boston, no. 27.153. [Boston 1985, p. 164—ill.]

Georg Philipp Telemann, 1681–1767. *Omphale*. Opera. First performed **1724**, Hofoper, Hamburg. [Baker 1984, p. 2290]

Giovanni Battista Pittoni, 1687–1767. "Hercules and Omphale." Painting. c.**1723–25**. Palazzo Corsini, Rome. [Zava Boccazzi 1979, no. 165—ill.]

———. "Omphale." Painting. c.1725. Pardo coll., Paris. [Ibid., no. 150—ill.]

Giovanni Battista Foggini, 1652–**1725**, attributed (also attributed to Laurent Delvaux, Pierre Puget). "Hercules and Iole" ("Hercules and Omphale"). Bronze statuette. 2 casts known. Victoria and Albert Museum, London, inv. A9–1956 (as Delvaux); the other sold Sotheby's, London, 1967. [Montagu 1968, pp. 171ff.—ill. / also Herding 1970, no. 120—ill. / Düsseldorf 1971, no. 368—ill.] Another bronze version, sold London, 1903. [Montagu, p. 172] Terracotta models (?). City Museum and Art Gallery, Birmingham (as Puget); Heim Gallery, London. [Ibid., p. 175 n.13 / Herding] Related terra-cotta relief. Fogg Art Museum, Harvard University, Cambridge (as after Puget). [Herding]

Jacques Dumont, called Le Romain, 1701–1781. "Hercules and Omphale." Painting. **1728**. Musée des Beaux-Arts, Tours. [Bordeaux 1984, fig. 390]

Charles-Antoine Coypel, 1694–1752. "Hercules and Omphale." Painting. **1731**. Alte Pinakothek, Munich, no. 1168. [Munich 1983, p. 145—ill. / Bordeaux 1984, fig. 392]

François Boucher, 1703–1770. "Hercules and Omphale" (kissing). Painting. c.**1734**. Pushkin Museum, Moscow, inv. 2764. [Ananoff 1976, no. 107—ill. / also Bordeaux 1984, fig. 391] Copy, by Jean-Honoré Fragonard, 1748–52, lost. [Wildenstein 1960, no. 1]

Anonymous English. *Hercules and Omphale*. Entertainment. First performed **1746**, Clerkenwell. [Nicoll 1959–66, 2:374]

Jean-Honoré Fragonard, 1732–1806. "Hercules and Omphale." Painting, copy after Boucher (c.1734, Moscow). **1748–52**. Lost. [Wildenstein 1960, no. 1]

Hélène-Louise Demars, 1736–? *Hercule et Omphale*. Cantatille. Published Paris: c.**1751–52**. [Grove 1980, 5:359]

Francesco Fontebasso, 1709–1768/69. "Hercules and Omphale." Painting, for Palazzo Bernardi, Venice. **1750s?** Szépmüvészeti, Múzeum, Budapest. [Budapest 1968, pp. 237f.]

Carle van Loo, 1705–1765. "Hercules and Omphale." Painting. Musée Municipal, Alençon. [Bénézit 1976, 6:729]

Gaspare Diziani, 1689–1767. "Hercules and Omphale." Painting. Musée, Bordeaux, on deposit from Louvre, Paris (no. M.N.R. 283). [Louvre 1979–86, 2:283]

John Flaxman, 1755–1826. "Hercules" "Omphale." Plaster sculptures. Exhibited 1767 [*sic,* at age 11–12]. [Irwin 1979, p. 10]

Jean-Baptiste Cardonne, 1730–*c.*1792. *Omphale.* Opera (tragédie lyrique). Libretto, Antoine Houdar de La Motte. First performed 2 May 1769, L'Opéra, Paris. [Grove 1980, 3:776]

Gregorio Guglielmi, 1714–1773? attributed. "Hercules and Omphale." Painting. Herzog Anton Ulrich-Museum, Braunschweig, no. 1071. [Braunschweig 1976, p. 30]

Étienne-Joseph Floquet, 1748–1785. *La nouvelle Omphale.* Comic opera. Libretto, "Mme. Beaunoir" (pseudonym of A. L. B. Robineau). 1777. First performed 22 Nov 1782, Versailles; 28 Nov 1782, Comédie-Italienne, Paris. [Grove 1980, 6:644]

Bernard Germain Étienne Médard de la Ville-sur-Illon Lacépède, 1756–1825. *Omphale.* Opera. Libretto, La Motte-Houdar. 1783. Accepted by Opéra but unperformed. Lost. [Grove 1980, 10:345]

Francisco Goya, 1746–1828. "Hercules and Omphale." Painting. 1784. Heirs of Marquesa de Valdeolmos coll., Madrid. [Gassier & Wilson 1981, no. 198—ill. / Gudiol 1971, no. 158—ill.]

Jean Baptiste Rochefort, 1746–1819. *Hercule et Omphale.* Pantomime. First performed 1787, Paris. [Grove 1980, 16:82]

Bertel Thorwaldsen, 1770–1844. "Hercules and Omphale." Relief. 1792. / Plaster cast. Thorwaldsens Museum, Copenhagen, no. A749. [Thorwaldsen 1985, p. 74]

Anonymous English. *Hercules and Omphale.* Pantomime. First performed 1794, London. [Nicoll 1959–66, 3:331]

William Reeve, 1757–1815, with **William Shield,** 1748–1829, music. *Hercules and Omphale.* Pantomime ballet. First performed 17 Nov 1794, Covent Garden, London; choreography, James Byrne. [Grove 1980, 15:669f.]

Italian School. "Hercules and Omphale." Painting. **17th/18th century.** Szépművészeti Múzeum, Budapest, no. 63.5. [Budapest 1968, p. 337]

French School? "Hercules and Omphale." Painting. **18th century.** Louvre, Paris, inv. 20394 (1024). [Louvre 1979–86, 4:315—ill.]

William Hamilton, 1751–1801, attributed. "Portrait of an Actress as Omphale." Painting. Museum of Fine Arts, Boston, no. 22.10. [Boston 1985, p. 129—ill.]

Simon Mayr, 1763–1845. *Ercole in Lidia.* Opera (dramma per musica). Libretto, G. de Gamerra. First performed 29 Jan 1803, Burgtheater, Vienna. [Grove 1980, 11:860]

Joseph Anton Gegenbauer, 1800–1876. "Hercules and Omphale." Fresco (detached). 1826. Thorwaldsens Museum, Copenhagen, no. B314 [Thorwaldsen 1985, p. 97]

Fernando Sor, 1778–1839, music. *Hercule et Omphale.* Ballet. First performed 1826, Moscow. [Grove 1980, 17:534]

Théophile Gautier, 1811–1872. "Omphale, or, The Amorous Tapestry." Painting. 1834. [Py 1963, p. 257 *n.*27]

Victor Hugo, 1802–1885. "Le rouet d'Omphale" [The Spinning-Wheel of Omphale]. Poem. 1843. No. 3 in *Les contemplations* book 2 (Paris: Hetzel, 1856). [Hugo 1985–86, vol. 5 / Py 1963, pp. 146, 158, 257 / Nash 1983, pp. 119–21, 297f.]

Gustave Moreau, 1826–1898. "Hercules and Omphale." Painting. 1856–57? Musée Gustave Moreau, Paris. [Mathieu 1976, pp. 51f.]

Thomas Unwin, 1782–1857. "Hercules with the Distaff." Watercolor. Victoria and Albert Museum, London, no. F.A.461. [Lambourne & Hamilton 1980, p. 390]

Jean-Louis-Adolphe Eude, 1818–1889. "(Hercules Spinning at the Feet of) Omphale." Marble statue. 1859. Musées Nationaux, inv. RF 145, deposited in Musée, Champs-sur-Marne, in 1979. [Orsay 1986, p. 271 / Pigler 1974, p. 124]

Charles Gleyre, 1806–1874. "Hercules at the Feet of Omphale." Painting. 1863. Musée des Beaux-Arts, Neuchâtel, inv. 86. [Winterthur 1974, no. 71—ill. / White 1984, p. 16—ill.]

William Brough, 1826–1870. *Hercules and Omphale; or, The Power of Love.* Burlesque. First performed 1864, London. [Nicoll 1959–66, 5:280]

Léon Roques. *Hercule aux pieds d'Omphale* [Hercules at Omphale's feet]. Musical entertainment. Libretto, Félix Savard. First performed 1869, Paris. [Hunger 1959, p. 145]

Camille Saint-Saëns, 1835–1921. *Le rouet d'Omphale.* Symphonic poem, opus 31. 1869. First performed 9 Jan 1872, Paris. [Baker 1984, p. 1972 / Grove 1980, 16:405]

Hans Makart, 1840–1884. "Hercules and Omphale." Oil sketch. *c.*1870–72. Unlocated. [Frodl 1974, no. 166—ill.]

Alexandre Falguière, 1831–1900. "Omphale." Marble statue. Musées Nationaux, inv. RF 3975, deposited in Ministère des Postes, Paris, in 1879. [Orsay 1986, p. 271]

Rubén Darío, 1867–1916. (Hercules and Omphale in) "A un poeta" [To a Poet]. Poem, part of *Azul.* 1886. In *Excelsior* 30 Jan 1888. [Mendez Plancarte 1967 / Galinsky 1972, pp. 274ff., 292]

Jean-Léon Gérôme, 1824–1904. "Omphale" (leaning on Hercules' club, with Cupid). Marble sculpture. 1887. Musée Garret, Vesoul. [Ackerman 1986, no. S.12—ill. (cf. no. 348)] Plaster model. Lost. [Ibid.—ill.]

Henri de Régnier, 1864–1936. (Hercules addresses Omphale in) "Prélude." Poem, introductory to *Poèmes anciens et romanesques.* 1887–92. In *Poèmes: 1887–1892* (Paris: Mercure de France, 1913). [Nash 1983, pp. 117–20, 282ff. (reproduced)]

John Bell, 1812–1895. "Omphale Farnèse." Marble sculpture. Museum, Salford. [Bénézit 1976, 1:589]

T. Sturge Moore, 1870–1944. *Omphale and Herakles.* Drama. 1895–1909. / Revised in *Poems* (London: Macmillan, 1932–33). [Bush 1937, p. 568 / Gwynn 1951, pp. 29, 31]

Émile Bernard, 1868–1941. "Hercules and Omphale." Painting. 1911. Musée de l'Orangerie, Paris. [Luthi 1982, no. 822]

Claude Adonai Champagne, 1891–1965. *Hercule et Omphale.* Symphonic poem. 1918. [Grove 1980, 4:126]

Peter Hacks, 1928–. *Omphale.* Comedy. First performed **1970,** Frankfurt. Published in *Vier Komödien* (Frankfurt: Suhrkamp, 1971). [Buddecke & Fuhrmann 1981, p. 293 / CEWL 1981–84, 2:315 / DLL 1968–90, 7:44]

Siegfried Matthus, 1934–. *Omphale.* Opera. Libretto, Peter Hacks (1970). First performed 29 Aug **1976,** National Theater, Weimar. [Grove 1980, 11:838]

Death of Heracles. When Heracles (Hercules) had routed Oechalia and gained the princess Iole, he sent his companion Lichas to bring back from Deianeira a white garment to wear for a thanksgiving sacrifice. Deianeira, fearful that Heracles would put her aside in favor of Iole, remembered the dying words of the centaur Nessus: a garment dipped in his blood would win back her husband's love. Deianeira sent the blood-soaked shirt to Heracles, not realizing that Nessus had played a fatal trick on her.

As the hero approached the sacrificial flame, the poisoned shirt caught fire and clung to his flesh. Ravaged by pain, he threw Lichas into the sea and had himself brought back to Mount Oeta in Trachis, where he was placed on a huge funeral pyre. He then instructed his son, Hyllus, to marry Iole when he came of age and gave his bow to the shepherd Peoas (or to Peoas's son, Philoctetes) in exhange for lighting the pyre. Meanwhile, Deianeira, devastated at what she had done, committed suicide.

Classical Sources. Sophocles, *The Women of Trachis*; *Philoctetes* 1407–51. Diodorus Siculus, *Biblioteca* 4.38.1–5. Ovid, *Metamorphoses* 9.134–272; *Heroides* 9.3–6, 11–48. Apollodorus, *Biblioteca* 2.7.7. Seneca, *Hercules oetaeus.* Hyginus, *Fabulae* 36. Lucian, *Dialogues of the Gods* 15, "Zeus, Asclepius, and Heracles."

Jean de Meun, 1250?–1305? (Death of Hercules evoked in) *Le roman de la rose* lines 9184–202. Verse romance, completion of unfinished work begun by Guillaume de Lorris (c.1230–35). c.1275. Lyon: Ortuin & Schenck, c.1481. [Dahlberg 1971 / Poirion 1974]

Anonymous French. (Death of Hercules in) *Ovide moralisé* 9.646–1028. Poem, allegorized translation/elaboration of Ovid's *Metamorphoses.* c.1316–28. [de Boer 1915–86, vol. 3]

Giovanni Boccaccio, 1313–1375. "De Deyanira Herculis coniuge" [Deianeira, Wife of Hercules]. In *De mulieribus claris* [Concerning Famous Women]. Latin verse compendium of myth and legend. **1361–75.** Ulm: Zainer, 1473. [Branca 1964–83, vol. 10 / Guarino 1963]

Sandro Botticelli, 1445–1510. (Hercules and Lichas depicted in relief in setting of) "The Calumny of Apelles." Painting. c.1494–95. Uffizi, Florence, no. 1496. [Lightbown 1978, no. B79—ill.]

Albrecht Dürer, 1471–1528, studio, under Dürer's direction. "The Death of Hercules." Drawing, design for series of medals (unlocated) depicting the adventures of

Hercules. **1510–11.** Formerly Kunsthalle, Bremen, lost. [Strauss 1974, no. 1511/32—ill.]

Jacopo Tintoretto, 1518–1594. "Hercules Killing Lichas." Painting. **1551–52.** Private coll. [Rossi 1982, no. 156—ill.]

Giovanni Bernardi, 1496–**1553,** and **Manno di Bastiano,** design. Statuette representing dying Hercules, on "The Farnese Coffer." Silver gilt coffer. Executed by another, 1548–61. Museo di Capodimonte, Naples, no. 10507. [Capodimonte 1964, p. 129]

Francesco Primaticcio, 1504–1570, design. "Deianeira Holding the Shirt of Nessus." Fresco, for Salle de Bal, Château de Fontainebleau, executed by Niccolò dell' Abbate under Primaticcio's direction. **1551–56.** Repainted 19th century. [Dimier 1900, pp. 160ff., 284ff.]

Robert Garnier, 1545–1590. (Antony's death reflects Hercules' in) *Marc Antoine.* Tragedy. Paris: Patisson, **1578.** / Translated into English by Mary Sidney, Countess of Pembroke, as *The Tragedie of Antonie* (London: Ponsonbie, 1590). [Bono 1984, pp. 116, 119f.]

Edmund Spenser, 1552?–1599. (Allusion to Hercules donning the shirt of Nessus in) *The Faerie Queene* 1.2.27. Romance epic. London: Ponsonbie, **1590,** 1596. [Hamilton 1977 / Galinsky 1972, p. 208]

Pellegrino Tibaldi, 1527–**1596.** "Hercules on the Pyre." Drawing. Louvre, Paris. [Pigler 1974, p. 131]

——— (or Lorenzo Sabatini, c.1530–1576). "Hercules on the Pyre." Painting. Palazzo Lambertini, Bologna. [Ibid.]

Annibale Carracci, 1560–1609. "The Death of Hercules." Fresco, part of "Hercules" cycle. **1595–97.** Camerino, Palazzo Farnese, Rome. [Malafarina 1976, no. 87h—ill. / Martin 1965, pp. 27ff.—ill. / also Martin 1965, fig. 13]

Thomas Heywood, 1573/74–1641. (Death of Hercules in) *Troia Britanica: or, Great Britaines Troy* 7.96–104. Epic poem. **1609.** [Heywood 1974]

———. (Episode, as above, in) *The Brazen Age.* Drama, partially derived from *Troia Britanica.* First performed c.1610–13, London. Published London: Okes, 1613. [Heywood 1874, vol. 3 / DLB 1987, 62:101, 122ff. / also Boas 1950, pp. 83ff. / Clark 1931, pp. 62ff.]

———. (Death of Hercules in) "Of Women That Have Come by Strange Deaths" (Deianeira), "Of Women Strangely Preserved from Death" (Iole). Passages in *Gynaikeion: or, Nine Books of Various History Concerning Women* books 4, 7. Compendium of history and mythology. London: Adam Islip, 1624. [Ipso]

Jean Prévost, c.1580–1622. *Hercule sur le Mont Oeta.* Tragedy, adaptation of Seneca. In *Les tragédies et autres oeuvres poétiques* (Poitiers: Thoreau, **1613**). [DLF 1951–72, 3:817 / Lancaster 1929–42, pt. 1, 1:92f.; 2:760]

Guido Reni, 1575–1642. "Hercules on the Pyre." Painting, part of "Feats of Hercules" ("Power and Triumph of the Gonzaga") cycle. **1617.** Louvre, Paris, no. 538. [Pepper 1984, no. 68—ill. / Gnudi & Cavalli 1955, no. 42—ill. / Louvre 1979–86, 2:226—ill.]

Jean Rotrou, 1609–1650. *Hercule mourant* [Hercules Dying]. Tragedy. First performed **1634,** Paris. Published Paris: Sommaville, 1636. [Girdlestone 1972, pp. 139ff. / DLLF 1984, 3:2019]

Francisco Zurbarán, 1598–1664. "Hercules Burned by the Shirt of Nessus." Painting, part of "Labors of Hercules" cycle, for Salón de Reinos, Buen Retiro, Madrid. c.**1634.**

Prado, Madrid, no. 1250. [López Torrijos 1985, pp. 141ff., 406—ill./ Prado 1985, p. 790]

Peter Paul Rubens, 1577–1640. "Deianeira (Listening to Fama Loquax [advising her to send the shirt of Nessus to Hercules])." Painting. *c.*1638. Galleria Sabauda, Turin. [Jaffé 1989, no. 1203—ill.] Oil sketch. Worsley coll., Hovingham Hall, Yorkshire. [Ibid., no. 1202—ill. / Held 1980, no. 235 *n.* (as copy after lost original sketch)—ill.] Copy in private coll., Switzerland. [Jaffé / Held, no. 235, p. 647—ill.]

———. "Hercules Tearing Off the Shirt of Nessus," "Deianeira and Nymphs." Sheet of drawings. Louvre, Paris, inv. 20.217. [Burchard & d'Hulst 1963, no. 189—ill.]

Joost van den Vondel, 1587–1679. *Trachiniae* [Women of Trachis]. Drama, adaptation of Sophocles. Published **1660**. [McGraw-Hill 1984, 5:119]

Pietro Andrea Ziani, 1616–1684. *Le fatiche d'Ercole per Deianira* [The Trials of Hercules for Deianira]. Opera. Libretto, Aurelio Aureli. First performed **1662**, SS Giovanni e Paolo, Venice. [Grove 1980, 20:675 / Bianconi 1987, p. 188 / Worsthorne 1954, p. 106]

Ciro Ferri, 1634–1689, under direction of **Pietro da Cortona**, 1596–1669. (Hercules on the pyre in) Ceiling fresco, Sala di Saturno, Palazzo Pitti, Florence. Executed **1663–65** (from compositions of 1640s). In place. [Campbell 1977, pp. 134ff., 148—ill. / Pitti 1966, p. 30—ill.]

John Milton, 1608–1674. (Hercules in the shirt of Nessus evoked in) *Paradise Lost* 2.539–46. Epic. London: Parker, Boulter & Walker, **1667**. [Carey & Fowler 1968]

Pierre Puget, 1620–1694. "Hercules Burned by the Shirt of Nessus." Bronze sculpture. **1676–81**. Metropolitan Museum, New York, no. 49.7.61. [Herding 1970, no. 42—ill.]

Jean-François Juvenon La Thuillerie, 1650–1688, attributed (possibly by Abbé Abeille, taking the other's name to escape church censure?). *Hercule.* Tragedy, adaptation of Rotrou's *Hercule mourant* (1634). First performed 7 Nov **1681**, Comédie-Française, Paris. [Girdlestone 1972, pp. 127, 139 / EDS 1954–66, 6:1261 / Lancaster 1929–42, pt. 4, 1:194–200; 2:932]

Florent Dancourt, 1661–1725. *La mort d'Hercule.* Tragedy. First performed **1683**, Paris. Published Paris: 1683. [Lancaster 1929–42, pt. 4, 1:194, 200f., 578; 2:953]

Marin Marais, 1656–1728, and **Louis Lully**, 1664–1734. *Alcide, ou, Le triomphe d'Hercule.* Opera (tragédie lyrique). Libretto, Jean Galbert de Campistron. First performed 3 Feb **1693**, Académie Royale de Musique, Paris. / Revised as *La mort d'Hercule*, 1705. [Grove 1980, 11:329, 641 / Girdlestone 1972, pp. 126, 137–42]

Luca Giordano, 1634–1705. "Hercules Killing Lichas." Fresco, part of "Hercules" cycle, for Buen Retiro, Madrid. *c.***1697.** Destroyed. / Engraved by Giuseppe Castillo and Juan Barcelon, 1779. [López Torrijos 1985, p. 407 no. 54—ill. / Ferrari & Scavizzi 1966, 1:155, 2:278]

———. "Hercules on the Pyre." Painting. *c.*1699–1700. Prado, Madrid, no. 162. [Ferrari & Scavizzi, 2:220—ill.] Variant. Casita del Principe, El Escorial. [Ibid., 2:238/ Prado 1985, p. 248]

François de Salignac De La Mothe-Fénelon, 1651–1715. (Hercules and the shirt of Nessus evoked in) *Les aventures de Télémaque, fils d'Ulysse* (The Hague: Moetiens, **1699**). [Galinsky 1972, p. 229]

Guillaume Coustou the Elder, 1677–1746. "Hercules on the Pyre." Marble sculpture group. **1704.** Louvre, Paris. [Pigler 1974, p. 131 / Clapp 1970, 1:187] Bronze statuette. Löwenburg, Kassel, inv. G.K.III 3433; elsewhere? [Düsseldorf 1971, no. 324—ill.]

Louis-Nicolas Clérambault, 1676–1749. *La mort d'Hercule.* Cantata. Published in *Cantates françaises à I. et II. voix avec simphonie et sans simphonie,* book 3 (Paris: **1716**). [Grove 1980, 4:492]

George Frideric Handel, 1685–1759. *Hercules.* Oratorio ("English opera," or, in advertisements, "musical drama"). Libretto, Thomas Broughton, after Sophocles' *Women of Trachis* and Ovid. First performed 5 Jan **1745**, King's Theatre, London. [Lang 1966, pp. 420–430 / Keates 1985, pp. 118, 256–60 / Hogwood 1984, pp. 190, 196–200, 289 / Fiske 1973, p. 203]

Antoine Dauvergne, 1713–1797. *Hercule mourant* [Hercules Dying]. Opera (tragédie lyrique). Libretto, Jean-François Marmontel. First performed 3 April **1761**, L'Opéra, Paris. [Grove 1980, 5:257 / Girdlestone 1972, p. 325]

Jean-Georges Noverre, 1727–1810, choreography. *La mort d'Hercule.* Ballet-pantomime. Music, Florian Johann Deller (spuriously attributed to Jean-Joseph Rodolphe). First performed 11 Feb **1762**, Hoftheater, Stuttgart; scenery, Innocenzo Colomba and J. J. Servandoni; costumes, Boquet. [Oxford 1982, p. 306 / Winter 1974, pp. 117–19, 153 / Grove 1980, 5:349; 13:443; 16:92 / Lynham 1950, pp. 60, 166f. (music by Rodolphe)]

Étienne Lauchery, 1732–1820, choreography. *La mort d'Hercule.* Ballet. Music, L. Toeschi. First performed **1767**, L'Opéra, Paris. [Grove 1980, 5:349]

Johann Friedrich Gräfe, 1711–1787 (also attributed to Anton Schweitzer, 1735–1787, Joseph Aloys Schmittbaur, 1718–1809). *Herkules auf dem Oeta* [Hercules on Mount Oeta]. Singspiel. Libretto, Johann Benjamin Michaelis. First performed 4 June **1771**, Hannover. [Grove 1980, 7:613, 17:46 / Strich 1970, 1:218]

Francesco Clerico, *c.*1755–after 1838, choreography. *Ercole e Deianeira (La morte di Ercole).* Ballet. Music, Clerico. First performed **1789**, Teatro Nuova, Padua. [EDS 1954–66, 3:967]

Gaetano Vestris, 1728–1808, choreography. *La mort d'Hercule.* Ballet. Music, von Esch. First performed 11 Apr **1791**, King's Theatre, London. [Guest 1972, p. 151]

Charles Le Picq, 1744–1806, choreography, after Noverre. *La mort d'Hercule.* Ballet. **1796.** [EDS 1954–66, 6:1410]

Jean-Baptiste Rochefort, 1746–1819, music. *La mort d'Hercule.* Pantomime. First performed **1796**, Paris. [Grove 1980, 16:82]

Johann Friedrich Reichardt, 1752–1814. *Hercules Tod.* Opera (melodrama). Libretto, after Sophocles. First performed 10 Apr **1802**, National Theater, Berlin. [Grove 1980, 15:706]

Francesco Benedetti da Cortona, 1785–1821. *Deianira.* Lyric drama. **1811.** In *Opere,* edited by F. S. Orlandini (Florence: Le Monnier, 1858). [DELI 1966–70, 1:318]

Samuel F. B. Morse, 1791–1872. "The Dying Hercules." Painting. **1812–13.** Yale University Art Gallery, New Haven. / Study, terra-cotta statuette ("Hercules"). New Haven. [Metropolitan 1965–85, 1:187f.]

Antonio Canova, 1757–1822. "Hercules and Lichas." Mar-

ble sculpture. **1795–1815**. Galleria Nazionale d'Arte Moderna, Rome. [Pavanello 1976, no. 131—ill. / Licht 1983, pp. 188–91—ill. / also Janson 1985, pp. 53f.—ill. / Irwin 1979, fig. 73] Plaster model. 1795–96. Gipsoteca Canoviana, Possagno, no. 87. [Pavanello, no. 132—ill.]

Charles Duquesnoy, 1759–**1822**. *La mort d'Hercule*. Incidental music. [Grove 1980, 5:738]

Friedrich Hölderlin, 1770–**1843**. "Dejanira an Herkules" [Deianeira to Hercules]. Translation of Ovid's *Heroïdes* 9.3–6, 11–48. First published in *Sämtliche Werke und Briefe*, vol. 3 (Leipzig: Insel, 1915). [Beissner 1943–77, vol. 5 / Galinsky 1972, p. 255]

Nadar (Félix Tournachon), 1820–1910. *La robe de Déjanire* [The Cloak of Deianeira]. Novel. New York: Gaillardet, **1846**. [DLLF 1984, 2:1599]

Matthew Arnold, 1822–1888. "Fragment of Chorus of a 'Dejanira.' " Poem. **1847–48?** In *New Poems* (London: Macmillan, 1897). [Allott & Super 1986 / Tinker & Lowry 1940, p. 162f. / Bush 1971, p. 47]

Charles Marie René Leconte de Lisle, 1818–1894. "La robe du centaure" [The Robe of the Centaur]. Poem. In *Oeuvres: Poèmes antiques* (Paris: Lemerre, **1852**). [Pich 1976–81, vol. 1]

August Strindberg, 1849–1912. (Axel Borg muses on Hercules' career and death as he seeks his own death in) *I havsbandet* [On the Seaward Skerries]. Novel. Stockholm: Bonnier, **1890**. Translated by Ellie Schleussner as *By the Open Sea* (London: Palmer, 1913). [Carlson 1982, pp. 158f. / Algulin 1989, p. 124]

John Payne, 1842–1916. "The Last of Hercules." Poem. In *Poetical Works*, vol. 1 (London: Brill-Leyden, for Villon Society, **1902**). [Bush 1937, p. 566]

Emile Verhaeren, 1855–1916. "Hercule." Poem. In *Les rythmes souverains* (Paris: Mercure de France, **1910**). [Galinsky 1972, pp. 276f. and appendix]

Camille Saint-Saëns, 1835–1921. *Déjanire*. Opera (drame lyrique). Libretto, composer, after Louis Gallet. First performed 14 Mar **1911**, Monte Carlo. [Grove 1980, 16:404]

Frank Wedekind, 1864–1918. (Hercules' death in) *Herakles*. Drama. Published **1917**. First performed 1 Sep 1919, Prinzregenten Theater, Munich. [Galinsky 1972, pp. 235–40 / McGraw-Hill 1984, 5:130]

Per Hallström, 1866–1960. *Nessusdräkten* [The Mantle of Nessus]. Comedy. Stockholm: Bonnier, **1919**. [Gustafson 1961, p. 343]

Ricciotto Canudo, 1879–**1923**. *La mort d'Hercule*. Tragedy. [EDS 1954–66, 2:1703]

Richard Edwin Day, b. 1852. "The Gift of Hercules" (Hercules bequeaths his bow and arrows to Philoctetes as he mounts the pyre). Poem. In *Dante and Other Poems* (New Haven: Yale University Press, **1924**). [Boswell 1982, p. 83]

Kurt Weill, 1900–1950. *Royal Palace* (Deianeira theme in modern dress). Ballet-opera. Libretto, Yvan Goll. First performed 2 Mar **1927**, Staatsoper, Berlin. [Grove 1980, 20:309]

Juan José Domenchina, 1898–1959. *La túnica de Neso* [The Tunic of Neso] (symbolic evocation of myth in title). Novella. Madrid: Biblioteca Nueva, **1929**. [Oxford 1978, pp. 167, 271]

Ildebrando Pizzetti, 1880–1968. Incidental music to Soph-

ocles' *Women of Trachis*. First performed 26 Apr **1933**, Teatro Greco, Syracuse. [Grove 1980, 14:797]

T. S. Eliot, 1888–1965. (Allusion to shirt of Nessus, death of Hercules, in) "Little Gidding." Poem, part 4 of *Four Quartets* (London: Faber & Faber, **1943**). [Eliot 1964 / Matthiessen 1958, p. 191 / Smith 1974, p. 294]

Cesare Pavese, 1908–1950. (Prometheus foretells Heracles' death in) "La rupe" [The Mountain]. Dialogue. In *Dialoghi con Leucò* (Turin: Einaudi, **1947**). [Biasin 1968, pp. 203, 312] Translated by William Arrowsmith and D. S. Carne-Ross in *Dialogues with Leucò*, bilingual edition (Ann Arbor: University of Michigan, 1965). [Ipso]

Vyacheslàv Ivànov, 1866–1949. "The chiton that the flame consumes" [English title of work written in Russian]. Sonnet, no. 3 of *De profundis amavi* (**1949**). / Translated in *Modern Russian Poetry* (New York: Bobbs-Merrill, 1967). [Ipso]

Ezra Pound, 1885–1972. *The Women of Trachis*. Tragedy, modern version of Sophocles. **1953**. In *Hudson Review* 67.4 (Winter 1954). Broadcast 25 Nov 1954, BBC, London. First book publication London: Spearman, 1956; New York: New Directions, 1957. [Kenner 1971, pp. 522–26 / Galinsky 1972, pp. 236, 240ff. / DLB 1986, 45:338]

Lucia Dlugoszewski, 1925–. Incidental music to Ezra Pound's *Women of Trachis*. **1960**. [Cohen 1987, 1:200]

James McAuley, 1917–1976. "The Tomb of Heracles." Poem. In *Surprises of the Sun* ([Sydney]: Angus & Robertson, [**1969**–70]). [CLC 1987, 45:249]

Andra Patterson, 1964–. Incidental music for a production of Sophocles' *Women of Trachis*, **1983**, Wellington, New Zealand. [Cohen 1987, 1:534]

Apotheosis. As the body of Heracles (Hercules) was consumed by a flaming pyre, Zeus sent a thunderbolt to extinguish the fire and declared that only the hero's mortal part was consumed, while his immortal part was going in a chariot to Olympus. There he was proclaimed the twelfth Olympian, reconciled with Hera (Juno), and united in marriage with her daughter Hebe, goddess of youthful beauty, who gave him a draught of the gods' immortalizing nectar.

Classical Sources. Homer, *Odyssey* 11.602ff. Hesiod, *Theogony* 950ff. Epicharmus, *The Marriage of Hebe*. Pindar, *Nemean Odes* 1.69ff.; *Isthmian Odes* 4.61–67. Euripides, *Heracles* 915ff. Diodorus Siculus, *Biblioteca* 4.38.5–4.39.4. Ovid, *Metamorphoses* 9.239–273, 400ff. Apollodorus, *Biblioteca* 2.7.7. Hyginus, *Fabulae* 36.

Baldassare Peruzzi, 1481–1536. "The Wedding of Hercules and Hebe." Fresco (detached), from Villa Stati, Rome. **1519–20?** Metropolitan Museum, New York, no. 48.17.13. [Frommel 1967–68, no. 56—ill. / also Metropolitan 1980, p. 141 (subject unidentified)—ill.]

Antonio da Correggio, c.1489/94–1534, attributed. "(Hercules Introduced to) Olympus." Painting, sketch. *c.*1566. Christ Church, Oxford. [Byam Shaw 1967, no. 164 (as imitator)—ill. / Gould 1976, p. 289]

Paolo Veronese, 1528–**1588**, assistant. "The Coronation of Hebe." Ceiling painting, for Palazzo della Torre, Udine. Gardner Museum, Boston, no. P25c26. [Hendy 1974, p. 284—ill.]

Alessandro Allori, 1535–1607. "Hercules Crowned by the Muses." Painting. Before **1589**. Uffizi, Florence, inv. 1544. [Uffizi 1979, no. P29—ill.]

Hans van Coninxloo, c.1540–1595. "Hercules Received into Olympus." Painting. **1592**. Národní Galeri, Prague. [Pigler 1974, p. 132]

Ludovico Carracci, 1555–1619. "Hercules and Jupiter." Fresco, part of "Hercules" cycle. c.**1593**–**94**. Palazzo Sampieri (Talon), Bologna. [Malafarina 1976, p. 103 / Ostrow 1966, no. I/15 n.]

Francisco Pacheco, 1564–1654. "Apotheosis of Hercules." Ceiling painting. **1603**–**04**. Casa de Pilatos, Seville. [López Torrijos 1985, pp. 129ff., 405 no. 1, pl. 12]

Hendrik van Balen, 1575–**1632**. "Repast on Olympus with Hercules and Minerva." Painting. Gemäldegalerie, Dresden. [Bénézit 1976, i:401]

Peter Paul Rubens, 1577–1640. "The Apotheosis of Hercules." Painting, for Torre de la Parada, El Pardo, executed by Jan-Baptist Borrekens from Rubens's design. **1636**–**38**. Prado, Madrid, no. 1368. [Alpers 1971, no. 28—ill. / Prado 1985, pp. 6f.] Oil sketch. Musées Royaux des Beaux-Arts (Musée d'Art Ancien), Brussels, inv. 4103 (812). [Ibid., no. 28a—ill. / Held 1980, no. 195 / Brussels 1984a, p. 251—ill.]

Simon Vouet, 1590–**1649**, rejected attribution. "Hercules Receiving Hebe in Marriage." Painting. Hermitage, Leningrad (as Vouet). [Crelly 1962, no. 51 / Hermitage 1974, pl. 9]

Laurent de la Hyre, 1606–**1656** (formerly attributed to Nicolas Poussin). "Hercules Crowned by Minerva." Painting. Formerly Marquis of Bute coll., Heim Gallery in 1966. [Blunt 1966, no. R78]

Charles Le Brun, 1619–1690. "The Apotheosis of Hercules." Ceiling painting. **1658**. Salon d'Hercule, Château de Vaux. [Titcomb 1967, pl. 4]

———. "The Apotheosis of Hercules." Fresco, part of "Hercules" cycle, for Hôtel Lambert, Paris. c.1650s. / Drawing for. Louvre, Paris, inv. 27.684. [Versailles 1963, no. 73; cf. nos. 74, 76—ill.]

Francesco Berni, 1610–1673. *La filo, overo, Giunone repacificata con Ercole* [The Thread, or, Juno Reconciled with Hercules]. Verse drama. **1660**. In *I drami* (Ferrara: Bolzoni Giglio & Formentini, 1666). [Clubb 1968, p. 43]

Francesco Manelli, 1594–1667. *La filo, overo, Giunone repacificata con Ercole*. Opera. Libretto, Berni (above). First performed **1660**, Teatro Farnese, Parma. [Grove 1980, 11:613]

Antonio Draghi, 1634/35–1700. *Hercole, acquistatore dell' immortalità* [Hercules, Winner of Immortality]. Opera. Libretto, N. Minato. First performed 7 Jan **1677**, Linz. [Grove 1980, 5:604]

Carlo Francesco Pollarolo, c.1653–1723. *Ercole in cielo* [Hercules in Heaven]. Opera. Libretto, Frigimelica Roberti. First performed **1696**, San Giovanni Grisostomo, Venice. [Grove 1980, 15:47 / Worsthorne 1954, p. 174]

Luca Giordano, 1634–1705. "Hercules Receiving Gifts from Minerva, Mercury, and Vulcan." Fresco, part of

"Hercules" cycle, for Buen Retiro, Madrid. c.**1697**. Destroyed. / Engraved by Giuseppe Castillo and Juan Barcelon, 1779. [López Torrijos 1985, p. 407 no. 40 / Ferrari & Scavizzi 1966, 1:155, 2:278—ill.]

Reinhard Keiser, 1674–1739. *Die Verbindung des grossen Hercules mit der schönen Hebe* [The Union of Great Hercules and Fair Hebe]. Singspiel. Libretto, Christian Heinrich Postel. First performed **1699**, for Royal Brunswick wedding, Hamburg. [Zelm 1975, p. 46]

Anton Domenico Gabbiani, 1652–1726. "Hercules Received into Olympus." Ceiling fresco. **1700**. Palazzo Corsini, Florence. [Warburg]

Sebastiano Ricci, 1659–1734. "The Apotheosis of Hercules." Fresco, part of "Hercules" cycle. **1706**–**07**. Sala d'Ercole, Palazzo Marucelli-Fenzi, Florence. [Daniels 1976, no. 110—ill.]

———. "The Apotheosis of Hercules." Grisaille ceiling fresco, part of "Hercules" cycle, for Portland House, London. 1712–13. Destroyed. [Ibid., no. 208]

Andrea Stefano Fiorè, 1686–1732. *Ercole in cielo*. Opera seria. Libretto, P. Pariati. First performed 1 Oct **1710**, Neue Favorita, Vienna. [Grove 1980, 6:599]

Nicolas-Antoine Bergiron de Briou, 1690–1768, music. *L'apotheose d'Hercule*. Divertissement. First performed 15 Apr **1722**, Paris. [Grove 1980, 2:549]

Jacob de Wit, 1695–1754. "Hercules Received into Olympus." Painting. **1725**. Rothschild coll., Waddesdon Manor, Buckinghamshire, cat. 1967 no. 76. [Wright 1976, p. 222 / Pigler 1974, p. 132]

———. "Apotheosis of Hercules." Drawing, for lost ceiling painting. c.1746. Rijksprentenkabinett, Amsterdam. [Staring 1958, p. 154, pl. 58]

Georg von Reutter the Younger, 1708–1772. *Alcide trasformato in dio* [Alcides transformed into a god]. Opera. First performed **1729**, Vienna. [Grove 1980, 15:773]

Carlo Innocenzo Carlone, 1686–1775. "Olympus: Mercury Escorts Hebe [or Psyche?] to Her Wedding on Olympus." Ceiling fresco. **1727**–**30**. Palais Clem-Gallas, Prague. / Study. Gemäldegalerie, Berlin-Dahlem, no. 2003. [Berlin 1986, p. 21—ill.]

François Le Moyne, 1688–1737. "The Apotheosis of Hercules." Fresco. **1733**–**36**. Salon d'Hercule, Château de Versailles. [Bordeaux 1984, pp. 61ff., no. 95—ill. / Girard 1985, p. 282—ill. / Versailles 1949, pp. 30f.—ill.] Modello, in Versailles. [Bordeaux—ill.] Copy in Musée des Augustins, Toulouse. [Ibid.—ill.]

Nicola Porpora, 1686–1768. *Le nozze d'Ercole e d'Ebe*. Cantata or serenata. First performed Carnival **1744**, San Giovanni Grisostomo, Venice. [Grove 1980, 15:126]

Francesco Solimena, 1657–1747. "Hercules Received into Olympus." Painting. Museo di Capodimonte, Naples. [Pigler 1974, p. 132]

Christoph Willibald Gluck, 1714–1787. *Le nozze d'Ercole e d'Ebe* [The Marriage of Hercules and Hebe]. Serenata teatrale, for double wedding of Saxon and Bavarian nobility. First performed 29 June **1747**, Pillnitz Castle, near Dresden. [Grove 1980, 7:456]

Giovanni Battista Tiepolo, 1696–1770. "Apotheosis (Triumph) of Hercules." Fresco. **1761**. Palazzo Canossa, Verona, largely destroyed in World War II. [Levey 1986, pp. 228f.—ill. / Pallucchini 1968, no. 276—ill. / Morassi 1962,

p. 63 / also Galinsky 1972, pl. 16] Study. Currier Gallery of Art, Manchester, N.H. [Pallucchini—ill. / Morassi, p. 23—ill.] *See also Giovanni Domenico Tiepolo, below.*

Giuseppe Antonio Paganelli, 1710–*c*.1763. *Apoteosi di Alcide*. Cantata. Libretto, G. Zangarini. [Grove 1980, 14:85]

Jean-Georges Noverre, 1727–1810, choreography. *L'apothéose d'Hercule*. Ballet. First performed 10 Sep **1767**, for betrothal of Erzherzogin Maria Josefa to the King of Naples, Burg or Kärntnertor Theater, Vienna. [Oxford 1982, p. 306 / Lynham 1950, p. 168]

Giovanni Domenico Tiepolo, 1727–1804 (previously attributed to G. B. Tiepolo). "Triumph (Apotheosis) of Hercules." Fresco, for Imperial Court, St. Petersburg. *c*.**1762–70**. Lost. / Studies. Thyssen-Bornemisza coll., Lugano; another, formerly Strauss coll., Vienna, sold 1926. [Mariuz 1979, pp. 123, 150—ill. / Morassi 1962, p. 21]

Anton Raphael Mengs, 1728–1779. "Apotheosis of Hercules." Ceiling fresco. *c*.**1762–75**. Antecámera de Gasparini, Palacio Real, Madrid. [Honisch 1965, no. 5, pp. 30, 40—ill.]

Giuseppe Pasquale Cirillo, 1709–**1776**. *Le nozze di Ercole ed Ebe*. Dramatic poem. [DELI 1966–70, 2:62–64]

Ferdinando Bertoni, 1725–1813. *Apoteosi di Ercole*. Cantata. *c*.**1781**. Libretto, Butturini. [Grove 1980, 2:647]

Francesco de Mura, 1696–**1782**. "Hercules Received into Olympus." Ceiling fresco. Palazzo Reale, Turin. [Pigler 1974, p. 132]

Jeronymo Francisco de Lima, 1743–1822. *Le nozze d'Ercole e d'Ebe*. Serenata. First performed 13 Apr **1785**, residence of Count F. Nuñez, Lisbon. [Grove 1980, 10:863]

Christoph Unterberger, 1732–1798. "The Apotheosis of Hercules." Ceiling painting, surrounded by 4 scenes from the life of Hercules. **1784–86**. Galleria Borghese, Rome. / Study in Walters Art Gallery, Baltimore, inv. 37.1698. [Walters 1976, no. 427—ill.]

Angelo Tarchi, *c*.1760–1814. *L'apoteosi d'Ercole*. Opera (dramma per musica). Libretto, M. Butturini. First performed 26 Dec **1790**, San Benedetto, Venice. [Grove 1980, 18:577]

Jan Kamphuijsen, 1760–1841. "The Apotheosis of Hercules." Ceiling painting, for Brentano house, Herengracht, Amsterdam, probably after a design by G. Maderni (1758–1803). **1790–91**. Rijksmuseum, Amsterdam, inv. A4140. [Rijksmuseum 1976, p. 311—ill.]

John Flaxman, 1755–1826. "Hercules and Hebe." Plaster sculpture group, full-scale study for unexecuted heroic-size marble. **1792**. University College, London. [Irwin 1979, pp. 58f., fig.74 / Cologne 1977, p. 165—ill.]

Friedrich Hölderlin, 1770–1843. "An Herkules" (Hercules, on Olympus, encourages the poet to aspire to immortality). Poem. *c*.**1796**. First published by Karl Müller-Rastatt in "Aus dem Nachlasse von Friedrich Hölderlin," *Blätter für literarische Unterhaltung* 27 (6 July 1893). [Beissner 1943–77, vol. 1 / Galinsky 1972, pp. 255f.]

Friedrich von Schiller, 1759–1805. "Zeus zu Herkules" [Zeus to Hercules] (welcoming the hero to Olympus). Distich. In *Musenalmanach für das Jahr 1796* (Tübingen: Cotta, **1796**). [Petersen & Beissner 1943]

Bertel Thorwaldsen, 1770–1844. "Hercules Receiving the Draught of Immortality from Hebe" ("An Allegory of Strength"). Marble relief. Modeled **1808**. Several versions, 1821–40. Thorwaldsens Museum, Copenhagen, no. A321; Biblioteca Ambrosiana, Milan; unlocated. [Thorwaldsen 1985, p. 45 / Cologne 1977, no. 33 / Hartmann 1979, pl. 75.3] Plaster original. Thorwaldsens Museum, no. A317. [Thorwaldsen]

Pierre-Paul Prud'hon, 1758–1823. "The Marriage of Hercules and Hebe." Painted frieze, decoration in Hôtel de Ville, for celebration of the marriage of Napoleon to Marie-Louise. **1810**. Destroyed. / Sketch. Louvre, Paris, no. R.F. 363 (757, 1510). [Guiffrey 1924, no. 937, pp. 352f. / also Louvre 1979–86, 4:151—ill.]

Friedrich Heinrich Füger, 1751–**1818**. "Hercules before Jupiter and Juno." Painting, grisaille sketch. Szépmüvészeti Múzeum, Budapest, no. 2129 (751a). [Budapest 1968, p. 252]

————. "Hercules Received into Olympus." Oil sketch. Deutsche Barockgalerie, Augsburg. [Pigler 1974, p. 133]

Saverio Mercadante, 1795–1870. *L'apoteosi d'Ercole*. Opera (dramma per musica). Libretto, G. Schmidt. First performed 19 Aug **1819**, San Carlo, Naples. [Grove 1980, 12:174]

Pietro Benvenuti, 1769–1844. "The Nuptials of Hercules and Hebe." Ceiling painting. **1828**. Saloncino d'Ercole, Palazzo Pitti, Florence. [Pitti 1966, p. 137—ill.]

Sacheverell Sitwell, 1897–1988. "The Hochzeit of Hercules." Poem. In *The Hundred and One Harlequins* (London: Richards, **1922**). [Ipso]

Antony Tudor, 1908–1987, choreography and scenario. Suite of dances for Hercules and Hebe in J. V. Turner's *Jupiter Translated*. Play. Music, Bloch's *Concerto Grosso*. First performed **1933**, Mercury Theatre, London. [Beaumont 1938, p. 830]

————, choreography and scenario. *The Descent of Hebe*. Ballet. Music, Ernest Bloch. First performed 31 Apr **1935**, Mercury Theatre, London; scenery and costumes, Nadia Benois. [Oxford 1982, p. 423 / Beaumont, p. 829]

Robert Graves, 1895–1985. "To Ogmian Hercules." Poem. In *Poems, 1965–68* (Garden City, N.Y.: Doubleday, **1968**). [Graves 1975]

HERACLES, LABORS OF. In a fit of madness caused by Hera, his implacable enemy, Heracles (Hercules) murdered his children and, according to some accounts, his wife, Megara. Horrified by this act, he went into exile and consulted the Delphic oracle to learn how he could expiate his crime. The oracle instructed him to serve King Eurystheus for twelve years. It also said that if he succeeded in performing the labors set for him by the king, he would become immortal.

Eurystheus occupied the throne of Tiryns, which was rightfully Heracles' but for Hera's trickery in delaying his birth, and this exacerbated Heracles' burden. In some versions of the myth, the king is portrayed as a coward who issued orders to Heracles through a messenger and hid whenever the hero

brought back gruesome evidence of the success of his labors.

The number was set at twelve as early as the fifth century BCE. The labors were to (1) kill the Nemean lion and bring back its pelt; (2) slay the Lernean hydra; (3) capture the Erymanthian boar; (4) abduct the sacred Ceryneian hind (or Arcadian stag); (5) kill the Stymphalian birds; (6) clean the stables of Augeas; (7) capture the Cretan bull; (8) bring back the mares of Diomedes; (9) obtain the girdle of the Amazon queen Hippolyta; (10) retrieve the cattle of Geryon; (11) pick the golden apples of the Hesperides; and (12) fetch Cerberus from the Underworld. There is some disagreement about the order in which the labors were performed, but this is the most commonly accepted sequence.

Besides the twelve labors (Greek, *athloi*) some of Heracles' wanderings involved *parerga* (sidelines, sing. *parergon*), in which he performed other deeds or feats of strength. Some of these *parerga,* such as his establishment of the Pillars of Heracles, his battle with Cacus, and his defeat of Antaeus, are often included in cycles that describe or depict the labors themselves.

Classical Sources. Pindar, *Olympian Odes* 10. Sophocles, *The Women of Trachis* 1091ff. Euripides, *Heracles* 15ff. Diodorus Siculus, *Biblioteca* 4.11–27. Virgil, *Aeneid* 8.287–300. Ovid, *Metamorphoses* 9.182–200. Apollodorus, *Biblioteca* 2.4.12, 2.5.1–12. Pausanias, *Description of Greece* 3.17.3, 3.18.13, 5.10.9, 5.25.7. Hyginus, *Fabulae* 14, 20, 30–31, 151. Quintus of Smyrna, *Sequel to Homer* 6.208ff.

Listings are arranged under the following headings:

> General List
> The Nemean Lion
> The Lernean Hydra
> The Erymanthian Boar
> The Ceryneian Hind
> The Stymphalian Birds
> The Stables of Augeas
> The Cretan Bull
> The Mares of Diomedes
> The Girdle of Hippolyta
> The Cattle of Geryon
> The Apples of the Hesperides
> Cerberus

General List

Anicius Manlius Severinus Boethius, *c.*480–524. (Hercules' labors celebrated in) *De consolatione philosophiae* book 4 metrum 7. Dialogue. **524.** [Stewart 1968] Translated into Anglo-Saxon by Alfred the Great (*c.*900), and into Middle English by Geoffrey Chaucer as *Boece* (1381–85). *See Chaucer, below.* [Ibid.]

Anonymous French. (Labors of Hercules in) *Ovide moralisé* 9.600–44. Poem, allegorized translation/elaboration of Ovid's *Metamorphoses. c.*1316–28. [de Boer 1915–86, vol. 3 / Galinsky 1972, pp. 202f.]

Geoffrey Chaucer, 1340?–1400. (Hercules' labors cele-

brated in) *Boece* book 4 metrum 7. Prose translation of Boethius's *De consolatione philosophiae* (524). **1381–85.** Westminster: Caxton, 1478. [Riverside 1987]

————. (Hercules' labors recounted in) "The Monk's Tale" lines 2095–2142. Poem, part of *The Canterbury Tales.* **1388–95.** Westminster: Caxton, 1478. [Riverside / Bryan & Dempster 1958, pp. 629ff.]

Coluccio Salutati, 1331–1406. *De laboribus Herculis* [Of Heracles' Labors] (and other episodes). Poem, with moralizations. *c.*1406. Modern edition by B. L. Ullman (Zürich: Artemis, 1951). [DELI 1966–70, 5:26 / Trousson 1962, p. 86 / Galinksy 1972, pp. 196f., 226]

Enrique de Aragon Villena, 1384–1434. *Los doze trabajos de Ercules* [The Twelve Labors of Hercules]. Allegorical poem. **1417.** First published in Catalan, Burgos: 1499. Modern edition, Madrid: 1876. [DLE 1972, pp. 939f. / Trousson 1962, p. 86 / Galinsky 1972, pp. 197, 226]

Pietro Andrea de Bassi, 1375–*c.*1447. *Le fatiche d'Ercole.* Poem. *c.*1420s. Ferrara: 1475. Modern edition, translated by W. K. Thompson as *The Labors of Hercules* (Barre, Mass.: Imprint Society, 1971). [Galinsky 1972, pp. 194, 225]

Antonio del Pollaiuolo, 1432/33–1498. "Hercules Killing the Hydra," "Hercules Strangling Antaeus," "Hercules Killing the Nemean Lion." Paintings, for Palazzo Medici, Florence. *c.*1460. Lost. [Ettlinger 1978, no. 44] Related drawing, "Hercules and the Hydra." British Museum, London, no. 5210–8. [Ibid., no. 32—ill.]

————, attributed. "Hercules and Antaeus," "Hercules and the Hydra." Paintings (possibly related to above). Dated variously *c.*1465–after 1475. Uffizi, Florence, inv. 1478, 8268 (possible third panel, Hercules and the lion, lost). [Ibid., no. 10—ill. / Uffizi 1979, nos. P1222–23—ill.]

————, imitator (Florentine School). "Labors of Hercules." Fresco frieze. 15th century. Museo di Palazzo Venezia, Rome. [Berenson, p. 221—ill.]

Raoul Lefèvre, fl. *c.*1454–67. "Les prouesses et vaillances du preux Hercules" [The Deeds and Bravery of the Gallant Hercules]. Last 6 chapters of Book 1 and entire Book 2 of *Le recueil des hystoires de Troyes.* Prose romance. **1464.** / English translation by William Caxton, as *The Recuyell of the Historyes of Troye* (Bruges: Mansion, *c.*1474). / Modern edition (of original French) by Marc Aeschbach (Bern & New York: Lang, 1987). [DLF 1951–72, 1:459 / Galinsky 1972, pp. 191–94, 225]

Andrea Mantegna, 1430/31–1506. 4 ceiling frescoes, depicting labors of Hercules (Lion, Hydra, Cerberus, also Antaeus). **1468–74.** Camera Picta (Camera degli Sposi), Palazzo Ducale, Mantua. [Lightbown 1986, no. 20, pls. 63–66]

Italian School. "The Twelve Labors of Hercules." Fresco cycle. **Late 15th century.** Castello di Bracciano, Rome. [Warburg]

Giovan Antonio Amadeo, 1447–1522. "The Twelve Labors of Hercules." Cycle of bas-relief sculptures. *c.*1491–1501. Colleoni Chapel façade, Bergamo. [Clapp 1970, 1:26]

Desiderius Erasmus, 1466–1536. (Hercules' labors evoked in) *Adagia (Chiliades adagiorum).* Compendium of adages. First published **1506;** revised and expanded, published Venice: Aldus Manutius, 1508. [Galinsky 1972, p. 223 / Hallowell 1962, p. 247]

Raphael, 1483–1520. "The Labors of Hercules." Designs

for series (of prints?), known only from 4 extant drawings: "Hercules and a Centaur," "Hercules and the Hydra" (2 versions), "Hercules and the Nemean Lion." *c.*1507–08. British Museum, London; Royal Library, Windsor; Ashmolean Museum, Oxford. [Joannides 1983, nos. 188–90—ill.]

Albrecht Dürer, 1471–1528, studio, under Dürer's direction (previously attributed to Lucas van Leiden). Series of drawings, depicting 12 deeds of Hercules (including Hercules with the Nemean Lion, Lernaean Hydra, Atlas, and Cerberus), designs for series of medals (unlocated). **1510–11.** Formerly Kunsthalle, Bremen, lost. [Strauss 1974, nos. 1511/21–32—ill.]

Baldassare Peruzzi, 1481–1536 (formerly attributed to Giulio Romano). "The Labors of Hercules." Frescoed frieze. **1511–12.** Sala del Fregio, Villa Farnesina, Rome. [d'Ancona 1955, pp. 91f.—ill. / Gerlini 1949, pp. 21ff.—ill. / Frommel 1967–68, no. 18a / also Berenson 1968, p. 334—ill.]

———. "Hercules and the Nemean Lion," "Hercules and the Lernaean Hydra." Ceiling frescos. 1510–11. Sala di Galatea, Villa Farnesina. [d'Ancona, pp. 25f., 86 / Gerlini, pp. 10ff. / also Frommel, no. 18c—ill.]

Rosso Fiorentino, 1494–1540, composition. "The Labors and Adventures of Hercules." 6 engravings (including Hydra, Cerberus), executed by Gian Jacopo Caraglio (Bartsch nos. 44–49). **1524.** Original designs lost. [Carroll 1987, nos. 9–14—ill.; cf. nos. 15–16]

Giulio Romano, *c.*1499–1546, assistants, after designs by Giulio. Cycle of frescoes (imitation bronze plaques) depicting deeds of Hercules (including Hydra, Lion, Bull, Cerberus). **1527–28.** Sala dei Cavalli, Palazzo del Tè, Mantua. [Hartt 1958, pp. 112ff., figs. 181–86 / Verheyen 1977, p. 115]

Michelangelo, 1475–1564 (authenticity disputed, possible copy or forgery). "Three Labors of Hercules" (Lion, Hydra, Antaeus). Sheet of drawings. *c.*1530. Royal Library, Windsor, no. 12770. [Goldscheider 1951, no. 68—ill.]

Austrian School. "The Twelve Labors of Hercules." Sgraffito stucco. **Mid-16th century.** Façade, Riederhaus, Althofen, Karnten. [Warburg]

Lucas Cranach, 1472–1553, studio. "Hercules and Nessus." Painting, part of "Hercules" cycle. After 1537. Herzog Anton Ulrich-Museum, Braunschweig, nos. 712–718. [Braunschweig 1969, pp. 47f.]

Frans Floris, 1516/20–1570. "The Labors of Hercules." Cycle of 10 paintings. **1554–55.** All but "Hercules and Antaeus" lost since 1768. [de Bosque 1985, p. 55—ill.]

Giorgio Vasari, 1511–1574, and assistants. Cycle of ceiling paintings depicting labors (Hydra, Lion, Cerberus, Hesperides, Cacus, Bull) and other deeds of Hercules. **1557.** Sala di Ercole, Palazzo Vecchio, Florence. [Sinibaldi 1950, pp. 13, 23 / also Lensi 1929, pp. 154ff, 163f.—ill. / Barocchi 1964, pp. 38ff., 147, 316—ill.]

Vincenzo de' Rossi, 1525–1587. "Labors of Hercules." Series of marble sculpture groups (12 ordered, 7 executed). *c.*1568. 6 (including Hercules and Antaeus, Nessus [or another centaur?], Cacus) in Salone dei Cinquecento, Palazzo Vecchio, Florence; 1 ("Hercules Holding Up the World") on Poggio Imperiale, Florence. [Lensi 1929, pp. 224f. / also Pigler 1974, pp. 112, 113, 128 / Pope-Hennessy 1985b, 3:49, 54—ill.]

Giambologna, 1529–1608. "The Labors of Hercules." 12 statuettes (medium unknown), for Francesco de' Medici. Before **1581.** Lost. / 6 silver replicas. 1576–89. Tribuna, Uffizi, Florence, in 16th century, now lost. [Avery & Radcliffe 1978, pp. 122f. / Avery 1987, pp. 139ff.] *Bronze replicas and variants by Giambologna (?) and followers:* "Hercules and the Nemean Lion." Bayerisches Nationalmuseum, Munich; National Gallery of Ireland, Dublin; Museo del Bargello, Florence; 1 unlocated. [Avery & Radcliffe, no. 75—ill. / also Avery, no. 77—ill.] "Hercules and the Lernaean Hydra." Dublin; Národní Galeri, Prague; 2 unlocated. [Avery & Radcliffe, no. 76—ill. / also Avery, no. 78—ill.] Wax sculpture (probably original model). Palazzo Vecchio, Florence. [Sinibaldi 1950, p. 28] Bronze variant, French School, mid-17th century. Frick Collection, New York, no. 15.2.53. [Frick 1968–70, 4:62f.—ill.] "Hercules and the Erymanthian Boar." Kunsthistorisches Museum, Vienna, no. 5846; Museo di Capodimonte, Naples, no. 10785; Castello Sforzesco, Milan; Dublin; Bargello; Wallace Collection, London; National Gallery, Washington, D.C., no. A–115. [Avery & Radcliffe, nos. 78–79—ill. / also Avery, no. 81—ill. / Sienkewicz 1983, p. 14—ill.] Variant. 2 examples known. Louvre, Paris, no. 5425; Wallace Collection, no. S126. [Avery & Radcliffe, no. 80—ill.] "Hercules Carrying the Globe." Milan, no. Br. 142. [Avery, no. 80—ill.] *Works not in the Tribuna series, but presumably derived from the original series of 12:* "Hercules and the Arcadian Stag." Bargello; Hermitage, Leningrad, no. 222; Wallace Collection, no. S123; Hovingham Hall, Yorkshire. [Avery & Radcliffe, no. 77—ill. / also Avery, no. 83—ill.] Large variant (studio of Ferdinando Tacca, mid-17th century?). Louvre. [Avery & Radcliffe] "Hercules and the Pillars." Dublin; Palacio de Oriente, Madrid. [Avery & Radcliffe, no. 83—ill. / also Avery, no. 85—ill.] "Hercules and the Dragon (Ladon)." Louvre, no. OA5439 *bis;* Musée Royal d'Art et d'Histoire, Brussels. [Avery & Radcliffe, no. 84—ill.] Bargello; Walters Art Gallery, Baltimore, no. 54.695. [Avery & Radcliffe, nos. 84–85—ill. / also Avery, no. 84—ill.] "Hercules and Cerberus." Baltimore, no. 54.694. [Avery & Radcliffe, no. 86—ill. / Avery, no. 86—ill.]

Cavaliere d'Arpino, 1568–1640. Cycle of lunette frescoes depicting scenes from the life of Hercules (including Lion, Hydra, Bull, Birds, Cerberus). **1594–95.** Loggia Orsini, Palazzo del Sodalizio dei Piceni, Rome. [Röttgen 1969, pp. 279ff., 285—ill.]

Annibale Carracci, 1560–1609. "Hercules Bearing the Globe," "Hercules and the Nemean Lion," "Hercules and the Hydra," "Hercules and Cerberus." Frescoes, part of "Hercules" cycle. **1595–97.** Camerino, Palazzo Farnese, Rome. [Malafarina 1976, nos. 87a, c, d, f—ill. / Martin 1965, pp. 27ff.—ill.]

Francisco Zurbarán, 1598–1664. "The Labors of Hercules." Cycle of 10 paintings, depicting labors (Geryon, Lion, Boar, Bull, Cerberus, Augeas, Hydra) and other deeds of Hercules, for Salón de Reinos, Buen Retiro, Madrid. *c.*1634. Prado, Madrid, nos. 1242–45, 1247–49. [López Torrijos 1985, pp. 141ff., 406—ill. / Prado 1985, p. 790]

José Ximénez Donoso, 1628–1690, and **Claudio Coello,** 1642?–1693. "Labors of Hercules." Series of 6 ceiling paintings. **1673–74.** Salón de Reyes, Casa de la Panadería, Madrid. [López Torrijos 1985, p. 406 nos. 19–24—ill.]

Francisco Solis, 1629–1684. "Hercules and His Twelve Labors." Cycle of 13 paintings, for Plazuela de la Villa, Madrid. **1680.** Lost. [López Torrijos 1985, p. 406 nos. 25–37]

Pierre Beauchamps, 1631–1705, choreography and music. *Les travaux d'Hercule.* Ballet, presented with the tragedy *Clovis.* First performed **1686,** Collège Louis-le-Grand, Paris. [Astier 1983, pp. 153, 161]

Eustache Le Noble, 1643–1711. *Les travaux d'Hercule.* Poem, glorifying Louis XIV. Paris: Claude Mazuel, **1693.** [DLLF 1984, 2:127]

Luca Giordano, 1634–1705. "The History of Hercules." Cycle of 40 frescoes. *c.*1697. Formerly Buen Retiro, Madrid, destroyed. / Engraved by Giuseppe Castillo and Juan Barcelon, 1779. [Ferrari & Scavizzi 1966, 1:155, 2:278—ill. / López Torrijos 1985, p. 407 nos. 39–54]

Sebastiano Ricci, 1659–1734. "Hercules and the Lernaean Hydra," "Hercules and the Nemean Lion," "Hercules and Cerberus." Frescoes, part of "Hercules" cycle. **1706–07.** Sala d'Ercole, Palazzo Marucelli-Fenzi, Florence. [Daniels 1976, no. 110—ill.]

Theodor van der Schuer, 1628–**1707.** "The Labors of Hercules." Paintings. Gemeentemuseum, The Hague, cat. 1935 no. 452, inv. 89–ZJ. [Wright 1980, p. 420]

Bartolomeo Altomonte, 1702–1779. "Labors of Hercules." Fresco detail. **1773.** Cloister, Fürstenzell (Austria?). [Heinzl 1964, pp. 46f.]

Raphael Mengs, 1728–**1779.** "The Twelve Labors of Hercules." Cycle of ceiling frescoes. Galleria Borghese, Rome. [Warburg]

Johann Samuel Patzke, 1727–1787. *Die Taten des Herkules* [The Deeds of Hercules]. Drama. **1780.** [Hunger 1959, p. 144]

Gustave Doré, 1832–1883. "The Labors of Hercules." Lithograph series. Published Paris: Aubert, **1847.** [Leblanc 1931, p. 349]

Robert Barnabas Brough, 1828–1860. *The Twelve Labours of Hercules.* Extravaganza. First performed **1851,** London. [Nicoll 1959–66, 5:278]

Eugène Delacroix, 1798–1863. "Hercules Skinning the Nemean Lion," "Hercules Carrying the Erymanthean Boar on His Shoulders," "Hercules, Conqueror of Hippolyta," "Hercules Chaining Nereus" (part of the Hesperides adventure, q.v.). Ceiling paintings, in "Life of Hercules" cycle, for Salon de la Paix, Hôtel de Ville, Paris. **1851–52.** Destroyed by fire, 1871. [Robaut 1885, nos. 1154–56, 1159—ill. (copy drawings) / Huyghe 1963, pp. 289, 423, 474]

———. "Hercules Rests from His Labors." Painting. 1858. Wildenstein & Co., New York, in 1978. [Johnson 1981–86, no. 328a—ill. / also Robaut, no. 1351—ill. (copy drawing)]

Honoré Daumier, 1808–1879. "Labors of the Prussian Hercules." Satirical lithograph. **1866.** [Delteil 1906–30, 28: no. 3495—ill.]

V. Galleani. *Ercole ed Euristeo* [Hercules and Eurystheus]. Opera. Libretto, V. and G. Gargano. First performed **1888.** [Hunger 1959, p. 145]

George Meredith, 1828–1909. "The Labourer." Poem. In *Westminster Gazette* 6 Feb **1893.** [Bartlett 1978, vol. 2]

Gabriele D'Annunzio, 1863–1938. "La tredicesima fatica" [The Thirteenth Labor]. Epyllion. In *Intermezzo* (Naples: **1894**). [Palmieri 1953–59, vol. 1]

Claude Terrasse, 1867–1923. *Les travaux d'Hercule.* Operetta. Libretto, R. de Flers and G. A. de Caillavet. First performed 7 Mar **1901,** Paris. [Grove 1980, 18:697]

Paul Manship, 1885–1966. "Labors of Hercules." 6 bronze low reliefs on pedestal of "Infant Hercules Fountain." **1914.** [Murtha 1957, no. 54—ill.] 6 bronze casts, 1955. 4 in Minnesota Museum of Art, St. Paul, nos. 66.14.228 a-d. [Minnesota 1972, no. 5—ill. / Minnesota 1985, no. 69—ill.; cf. no. 70]

Marianne Moore, 1887–1972. "The Labors of Hercules." Poem. In *Selected Poems* (New York: Macmillan; London: Faber & Faber, **1935**). [Boswell 1982, p. 187 / Phillips 1982, pp. 159f. / Hadas 1977, pp. 16f., 22, 34, 216]

Yvor Winters, 1900–1968. "Heracles" (as servant of Eurystheus). Poem. In *Rockinghorse* 2 (**1935**); collected in *Poems* (Los Altos, Calif.: Gyroscope, 1940). [Isaacs 1981, p. 87 / Powell 1980, pp. 129–33]

Ossip Zadkine, 1890–1967. "The Labors of Hercules." Series of 28 lithographs. **1941–44.** Published Cologne: 1960. [Jianou 1979, p. 35]

John Fuller, 1937–. *The Labours of Hercules.* Sonnet sequence. Manchester: Manchester Institute of Contemporary Arts, **1969.** [Vinson 1985, p. 281]

Pierrette Mari, 1929–. *Les travaux d'Hercule.* Electronic composition for ondes Martenot, piano, and percussion. **1961–72.** [Cohen 1987, 1:450]

John Heath-Stubbs, 1918–. "The Twelve Labours of Hercules." Poem. In *The Watchman's Flute* (Manchester: Carcanet, **1975**). [DLB 1984, 27:147]

The Nemean Lion. In the first of his labors, Heracles (Hercules) was commanded to bring to King Eurystheus the invulnerable pelt of the Nemean lion, a fierce monster produced by the union of Echidna (or Chimaera) and Orthus (or Typhon). When Heracles found its cave and shot at it, the arrows bounced off. Heracles therefore cornered it in its lair, clubbed it, and strangled it with his bare hands.

As the hero approached Eurystheus with the dead lion slung over his shoulder, the king fled in terror. Heracles flayed the lion by using its own claws, the only objects sharp enough to penetrate its hide. He then donned the pelt as a cloak, with the scalp as a hood. The lion's hide and the club he used against it became Heracles' most common attributes.

In another adventure unrelated to this labor, Heracles also killed the marauding lion of Mount Cithaeron.

Classical Sources. Hesiod, *Theogony* 326ff. Sophocles, *The Women of Trachis* 1091ff. Theocritus, *Idylls* 25.162ff. Diodorus Siculus, *Biblioteca* 4.11.3ff. Virgil, *Georgics* 3.19. Apollodorus, *Biblioteca* 2.5.1. Martial, *Epigrams* 4.64.30, 9.43.13. Statius, *Thebaid* 4.156ff. Hyginus, *Poetica astronomica* 2.24.

Filarete, *c.*1400–1469? "Hercules and the Nemean Lion." Relief, on bronze door of St. Peter's, Rome. **1433–45.** In place. [Pope-Hennessy 1985b, 2:318]

Antonio del Pollaiuolo, 1432/33–1498. "Hercules and the Lion." Painting, part of cycle for Palazzo Medici, Florence. *c.***1460.** Lost. [Ettlinger 1978, no. 44] Conjectural related painting. Lost. [Ibid., no. 10 *n.*]

———, attributed. "Hercules" (with head of Nemean lion). Bronze statuette. Bode Museum, Berlin. [Ettlinger 1978, no. 16—ill.]

Apollonio di Giovanni, *c.*1415–**1465.** "Hercules and the Lion." Painting. Cincinnati Art Museum, Ohio, no. 1933.9. [Berenson 1963, p. 18]

Bertoldo di Giovanni, *c.*1420–**1491,** attributed (probably executed by studio after Bertoldo's design). "Hercules and the Nemean Lion." Bronze statuette. Victoria and Albert Museum, London, no. A.77–1910. [Frick 1968–70, 3:44]

Cosmè Tura, before 1431–**1495.** "Hercules and the Nemean Lion." Drawing. Museum Boymans-van Beuningen, Rotterdam. [Warburg]

Florentine School. "Hercules and the Nemean Lion." Painting. **15th century.** Blickling Hall, Norfolk. [Wright 1976, p. 97]

Antico, *c.*1460–1528. "Hercules Resting after Slaying the Nemean Lion." Bronze plaque. *c.***1500.** Museum of Fine Arts, Houston, no. 44.582. [Kilinski 1985, no. 13—ill.]

Marcantonio Raimondi, *c.*1480–1527/34. "Hercules Killing the Nemean Lion." Engraving (Bartsch no. 290), in "Labors of Hercules" cycle. Early work. [Bartsch 1978, 26:279—ill.]

Baldassare Peruzzi, 1481–1536. "Hercules and the Nemean Lion." Ceiling fresco, representing the constellation Leo. **1510–11.** Sala di Galatea, Villa Farnesina, Rome. [d'Ancona 1955, pp. 25f., 86 / Gerlini 1949, pp. 10ff. / also Frommel 1967–68, no. 18c—ill.] "Hercules Strangling the Nemean Lion." Engraving, by Agostino Veneziano (Bartsch no. 287). [Bartsch 1978, 26:274—ill.]

Raphael, 1483–**1520,** composition. "Hercules Strangling the Nemean Lion." Engraving, by Agostino Veneziano (Bartsch no. 287). [Bartsch 1978, 26:274—ill.]

Albrecht Altdorfer, *c.*1480–1538. "Hercules Overcoming the Nemean Lion." Engraving (Bartsch no. 26). *c.***1520–25.** [Winzinger 1963, no. 144—ill.]

Benvenuto Cellini, 1500–1571. "Hercules and the Lion." Gold medal. *c.***1528.** Lost. [Pope-Hennessy 1985a, p. 46]

Italian School. "Hercules with the Nemean Lion." Bronze statuette. **Mid-16th century.** New Orleans Museum of Art, no. 74.328. [Kilinski 1985, no. 14—ill.]

Andrea Schiavone, *c.*1522–1563. "Hercules and the Nemean Lion." Painting. *c.***1555?** Wellesley College Museum, Mass., no. 65.39. [Richardson 1980, no. 329—ill.]

Peter Paul Rubens, 1577–1640. "Hercules and the Nemean Lion." Painting. *c.***1615.** R. van de Broek, Brussels. [Jaffé 1989, no. 290—ill.] Copy in Sanssouci, Potsdam. [Ibid.]

———. "Hercules and the Nemean Lion." Painting, oil sketch. 1638–39. Kuhn coll., St. Louis. [Ibid., no. 1380—ill. / Held 1980, no. 227] Studio copy (or replica by Rubens?). Musée Jacquemart-André, Paris, inv. I–840. [Jaffé

/ Held, no. 242 (as Rubens)—ill. / also Alpers 1971, p. 277—ill. / cf. Burchard & d'Hulst 1963, no. 190, 192]

———, attributed. "Hercules and the Nemean Lion." Painting, oil sketch. Los Angeles County Museum. [Alpers, p. 277]

Jacob Jordaens, 1593–1678. "July" ("The Lion") (Hercules slaying the Nemean Lion). Ceiling painting, part of "Signs of the Zodiac" cycle for the artist's house in Antwerp. **Early 1640s.** Senate Library, Palais du Luxembourg, Paris. [Rooses 1908, pp. 124f.]

Luca Giordano, 1634–**1705.** "Hercules and the Nemean Lion." Painting. Walter Chrysler, Jr. coll., New York. [Ferrari & Scavezzi 1966, 2:367]

Sebastiano Ricci, 1659–1734. "Hercules and the Nemean Lion." Painting, part of "Hercules" cycle. **1706–07.** Sala d'Ercole, Palazzo Marucelli-Fenzi, Florence. [Daniels 1976, no. 110—ill.]

———. "Hercules and the Nemean Lion." Grisaille ceiling fresco, part of "Hercules" cycle, for Portland House, London. 1712–13. Destroyed. [Ibid., no. 208]

Benjamin Thomae, 1682–1751. "Hercules with the Hide of the Nemean Lion," "Hercules Leaning on a Hide Cartouche." Sandstone statues. *c.***1716–18.** Kronentor, Zwinger, Dresden. [Asche 1966, nos. T20–1, pls. 164–65]

Friedrich Hölderlin, 1770–1843. (Hercules' conquest of the lion evoked in) "Hymne an die Menschheit" [Hymn to Mankind]. Poem. Early draft in *Poetische Blumenlese* (Stuttgart: Mäntler, **1791**). / Revised 1792–93 as "Dem Genius der Kühnheit" [To the Genius of Daring]. In *Musenalmanach* (1793) and *Urania* (1794). [Beissner 1943–77, vol. 1 / Galinsky 1972, pp. 253ff.]

Johann Gottfried Schadow, 1764–1850. "Hercules Battling the Nemean Lion." Sculpture, executed by Conrad Boy. 1792. Friedrichsbrücke, Schloss Monbijou. / Related (?) drawing. *c.*1792. Deutsche Akademie der Künste, Berlin, inv. Schadow 532. [Berlin 1965, no. 73]

French School (?). "Hercules Slaying a Lion." Painting (ruined). **17th/18th century.** Louvre, Paris, inv. 8635. [Louvre 1979–86, 2:360]

Anthony Philip Heinrich, 1781–1861. "The First Labor of Hercules." Composition for piano. Begun *c.*1832, completed **1854.** [Grove 1980, 8:442]

José-Maria de Heredia, 1842–1905. "Némée" [The Nemean Lion]. Sonnet, in "Hercule et les centaures" cycle. In *La légende du Parnasse contemporain* (Paris: **1884**); collected with cycle in *Revue des deux mondes* 15 Jan 1888, and in *Les trophées* (Paris: Lemerre, 1893). [Delaty 1984, vol. 1 / Hill 1962]

Émile-Antoine Bourdelle, 1861–1929. "Herakles Nemean." Drawing. **1913.** [Galinksy 1972, p. 270]

Peter Quennell, 1905–. "The Lion in Nemea." Poem. In *Masques and Poems* (Waltham St. Lawrence, Berkshire: **1922**). [Boswell 1982, p. 283]

Robert Graves, 1895–1985. "Hercules at Nemea." Poem. In *Poems, 1953* (London: Cassell, **1953**). [Graves 1975]

Paul Manship, 1885–1966. "Hercules and the Nemean Lion." Bronze statuette. *c.***1955–57?** National Museum of American Art, Washington, D.C. [Kilinski 1985, no. 15—ill.]

Earl Staley, 1938–. "Hercules and the Nemean Lion."

Painting. **1983.** Watson coll., Houston. [Houston 1984, p. 75—ill.]

Joyce Treiman, 1922–. "Hercules and the Nemean Lion." Painting. **1983.** Tortue Gallery, Los Angeles. [Personal communication to author from Mark Thistlethwaite, Texas Christian University, 1984]

The Lernean Hydra. Offspring of Echidna and Typhon, the hydra was a poisonous water snake that lived in the marshes at Lerna. It had numerous heads, one of which was immortal; if one of the heads was cut off, two new heads grew in its place. As his second labor, Heracles (Hercules) was sent to destroy the hydra, a task made more difficult when Hera sent a giant crab to fight alongside the monster. Heracles killed the crab but required the assistance of his nephew Iolaus to complete his task. Each time the hero cut off one of the hydra's heads, Iolaus cauterized the stump with a hot poker so that no new head would grow. Finally, Heracles severed the immortal head and buried it under a large rock. He then dipped his arrows in the hydra's blood, poisoning them for later use.

Classical Sources. Hesiod, *Theogony* 313ff. Sophocles, *The Women of Trachis* 714ff. Euripides, *Heracles* 419ff. Diodorus Siculus, *Biblioteca* 4.2.5–6, 4.11.5. Virgil, *Aeneid* 6.803, 8.299ff. Ovid, *Metamorphoses* 9.69ff. Apollodorus, *Biblioteca* 2.5.2. Pausanias, *Description of Greece* 2.37.4, 5.10.9, 5.17.11. Hyginus, *Poetica astronomica* 2.11. Quintus of Smyrna, *Sequel to Homer* 6.212ff.

Antonio del Pollaiuolo, 1432/33–1498. "Hercules and the Hydra." Painting, part of cycle for Palazzo Medici, Florence. *c.*1460. Lost. [Ettlinger 1978, no. 44] Related drawing. British Museum, London, no. 5210–8. [Ibid., no. 32—ill.]

————, attributed. "Hercules and the Hydra." Painting, possibly related to above. Dated variously *c.*1465–after 1475. Uffizi, Florence, no. 8268. [Ibid., no. 10—ill. / Uffizi 1979, no. P1223—ill. / Berenson 1963, p. 178—ill.]

————, follower. "Hercules and the Hydra." Grisaille painting. Late 15th century. Ringling Museum of Art, Sarasota, Fla., inv. SN16. [Sarasota 1976, no. 29]

Andrea Mantegna, 1430/31–1506. "Hercules and the Hydra." Ceiling fresco, part of "Labors of Hercules" cycle. **1468–74.** Camera Picta (Camera degli Sposi), Palazzo Ducale, Mantua. [Lightbown 1986, no. 20, pl. 64]

————, composition. "Hercules and the Hydra." Engraving. *c.*1495. [Ibid., no. 229]

————, composition. "Hercules and the Hydra." Engraving (Bartsch no. 15), after presumed drawing by Mantegna, derived from figure of Vulcan in his "Parnassus" (1497, Louvre). *c.*1495–1500. [Ibid., no. 225 / Borenius 1923, no. 23—ill. / Louvre 1975, no. 107]

Baldassare Peruzzi, 1481–1536. "Hercules and the Hydra of Lerna." Ceiling fresco. **1510–11.** Sala di Galatea,

Villa Farnesina, Rome. [d'Ancona 1955, pp. 25f., 86 / Gerlini 1949, pp. 10ff. / also Frommel 1967–68, no. 18c—ill.]

Rosso Fiorentino, 1494–1540, composition. "Hercules Killing the Hydra." Engraving, in "Labors and Adventures of Hercules" cycle, executed by Gian Jacopo Caraglio (Bartsch no. 46). **1524.** Original design lost. [Carroll 1987, no. 11—ill.; cf. no. 15]

Alfonso Lombardi, 1487/97–1537. "Seated Hercules" (with dead Hydra). Sculpture. *c.*1525. Museo Civico, Bologna. [Licht 1983, pp. 160, 162—ill.]

Antico, *c.*1460–1528. "Hercules Slaying the Hydra of Lerna." Bronze relief. Estensiche coll., Vienna. [Pigler 1974, p. 115]

Maerten van Heemskerck, 1498–1574. "Hercules Slaying the Hydra." Painting, in "Gods and Heroes from Mythology and the Old Testament" series. *c.*1545. Yale University Art Gallery, New Haven, inv. 60.50b. [Grosshans 1980, no. 30h—ill.]

Giovanni Bandini, 1540–1599. "Hercules Slaying the Hydra of Lerna." Sculpture group. *c.*1578. Camugliano. [Pope-Hennessy 1985b, 3:458] Another version/example in Palazzo Niccolini, Florence. [Pigler 1974, p. 116]

Giorgio Ghisi, 1520/21–1582. "Hercules Conquers the Hydra." Engraving, after composition by Giovanni Battista Bertani. Kunsthalle, Hamburg, inv. 1/726. [Hofmann 1987, no. 2.13—ill.]

Edmund Spenser, 1552?–1599. (Arthur fighting Orgoglio's beast likened to Hercules fighting the Hydra in) *The Faerie Queene* 1.7.17. Romance epic. London: Ponsonbie, **1590,** 1596. [Hamilton 1977 / Galinsky 1972, pp. 206f.]

Ludovico Carracci, 1555–1619. "Hercules and the Hydra." Fresco (detached). **1594.** Victoria and Albert Museum, London, no. 8368–1863. [Kauffmann 1973, no. 62—ill.]

Tiziano Aspetti, 1565–1607. "Hercules Slaying the Hydra of Lerna." Marble sculpture group. Scala d'Oro, Palazzo Ducale, Venice. [Pigler 1974, p. 116]

Guercino, 1591–1666. "Hercules Slaying the Hydra." Fresco, for Casa Provenzale, Cento. **1614.** [Salerno 1988, no. 7D—ill. / also Bologna 1968, 2: no. 3—ill. (drawing)]

————. "Hercules and the Hydra." Fresco, for Casa Pannini, Cento. 1615–17. Detached, unlocated. [Bagni 1984, p. 117, pl. 113]

Guido Reni, 1575–1642. "Hercules and the Hydra." Painting, part of "Feats of Hercules" ("Power and Triumph of the Gonzaga") cycle. *c.*1620. Louvre, Paris, inv. 537. [Pepper 1984, no. 70—ill. / Gnudi & Cavalli 1955, no. 43—ill. / Louvre 1979–86, 2:226—ill.] Copy in Musée des Beaux-Arts, Lille. [Pepper]

————. "Hercules and Iolaus." Painting, lost. [Ibid., p. 306 no. A31]

Adriaen de Vries, *c.*1550–1626. "Hercules Slaying the Hydra of Lerna." Bronze sculpture group, in Hercules Fountain, Augsburg. [Pigler 1974, p. 117]

Simon Vouet, 1590–1649. "Hercules and Iolaus Slaying the Hydra." Decoration for Gallery of Hôtel Séguier, Paris. **1633–38.** Lost. / Engraved by Michel Dorigny, 1651. [Crelly 1962, pp. 112ff., no. 248G—ill.]

Peter Paul Rubens, 1577–1640. "Hercules and the Hydra." Painting, for Torre de la Parada, El Pardo (executed by assistant from Rubens's design?). **1636–38.** Lost. [Al-

pers 1971, no. 30] Oil sketch. Courtauld Institute, London (ex-Seilern coll.). [Jaffé 1989, no. 1276—ill. / Alpers, no. 30a—ill. / Held 1980, no. 192—ill.] Copy, by Juan Bautista del Mazo (c.1612–1667), in Prado, Madrid, no. 1710. [Alpers—ill. / Prado 1985, p. 402]

Alessandro Algardi, 1598–**1654.** "Hercules and Iolaus with the Hydra." Sculpture group. Lost. [Montagu 1985, no. L.128—ill.] Bronze copies in Szépmüvészeti Múzeum, Budapest, inv. 1358; Wadsworth Atheneum, Hartford, Conn, no. 1926.440; Pope-Hennessy coll., New York. [Ibid., pp. 408f.—ill.] Ivory copy, in Museo degli Argenti, Palazzo Pitti, Florence. [Ibid.] Wax copy, model for untraced porcelain version, in Museo di Doccia, Sesto Fiorentino, inv. 54 (1412). [Ibid.]

Pierre Puget, 1620–1694. "Hercules Conquering the Lernaean Hydra." Sandstone sculpture. **1659–60.** Musée des Beaux-Arts, Rouen, inv. Sc.221. [Herding 1970, no. 12—ill.]

Pietro della Vecchia, 1605–**1678.** "Hercules and the Lernaean Hydra." Painting. Herzog Anton Ulrich-Museum, Braunschweig, no. 489. [Braunschweig 1969, p. 139]

François Girardon, 1628–1715. "Hercules Slaying the Hydra." Stone sculpture. **1679.** Château de Versailles. Restored by Henri Chapu (1833–1891). [Francastel 1928, no. 46]

Gian Lorenzo Bernini, 1598–**1680.** "Hercules Slaying the Hydra of Lerna." Drawing for a fountain group. [Pigler 1974, p. 116]

Jan Claudius de Cock, c.1668–1736. "Hercules Battling the Hydra." Drawing. c.**1700?** Kunsthistorische Musea, Antwerp, inv. 1282. [Düsseldorf 1971, no. 204—ill.]

Lorenzo Mattielli, 1682/88–**1748.** "Hercules Slaying the Hydra of Lerna." Stone sculpture group. Burggarten, Budapest. [Pigler 1974, p. 117]

Corrado Giaquinto, 1703–1765. (Hercules slaying the Hydra in) "Apotheosis of the Spanish Monarchy" (?). Ceiling painting, for Palazzo Santa Croce, Palermo. Now in Palazzo Rondinini-Sanseverino, Rome. c.**1751?** / Study. National Gallery, London, inv. 6229. [London 1986, p. 232—ill.]

Jan Kamphuijsen, 1760–1841. "Hercules Fighting the Hydra." Painting, part of "Hercules" ceiling decoration, for Brentano house, Herengracht, Amsterdam, probably after a design by G. Maderni (1758–1803). **1790–91.** Rijksmuseum, Amsterdam, inv. A4141. [Rijksmuseum 1976, p. 311—ill.]

John Flaxman, 1755–1826, design. Hercules slaying the Hydra, relief on silver "Trafalgar Vase." Executed by Benjamin Smith and Digby Scott, **1805–06.** Numerous examples, Victoria and Albert Museum, London; elsewhere. [Irwin 1979, pp. 190f., fig. 262—ill. / also Bindman 1979, no. 182—ill.]

Victor Hugo, 1802–1885. "L'homme étreint dans ses bras l'obstacle, comme Hercule" [Man Locks His Obstacle in His Arms, Like Hercules]. Poem. 10 Feb **1854.** No. 61 in *Toute la Lyre* part 3. In *Œuvres inédites* (Paris: Hetzel, 1888). [Hugo 1985–86, vol. 7]

Gustave Moreau, 1826–1898. "Hercules and the Hydra of Lerna." Painting. **1876.** Art Institute of Chicago, no.

64.231. [Mathieu 1976, pp. 120f., no. 152—ill. / Chicago 1965] Wash study ("The Hydra"). Daniel Wildenstein coll. [Mathieu, no. 154—ill.]
——— "Hercules and the Lernaean Hydra." Painting. c.1876. Sold Paris, 1914, unlocated. [Ibid., no. 153—ill.]
——— "Hercules and the Hydra." Watercolor. 1876–80. Musée Gustave Moreau, Paris. [Mathieu 1985, pl. 24]

Edward Burne-Jones, 1833–**1898.** "Hercules and the Hydra" Drawing. Victoria and Albert Museum, London (Notebook E.3–1955). [Arts Council 1975, p. 29—ill.]

Franz Barwig, 1868–1931. "Hercules and Hydra." Wood sculpture. **1914.** Private coll. [Barwig 1969, no. 1—ill.]

Franz von Stuck, 1863–1928. "Hercules and the Hydra." Painting. **1915.** Private coll. [Voss 1973, no. 455—ill.]

Paul Valéry, 1871–1945. (Hercules and the Hydra evoked in) "Ode secrète." Poem. In *Charmes* (Paris: Éditions de la Nouvelle Revue Française, **1922**). [Hytier 1957–60, vol. 1 / Mathews 1956–71, vol. 1 / Crow 1982, pp. 217–23 / Bowra 1967, p. 38]

John Singer Sargent, 1856–1925. "Hercules and the Hydra." Painting, part of a mural series. **1921–25.** Museum of Fine Arts, Boston. [Ratcliff 1982, p. 150—ill.]

Marianne Moore, 1887–1972. (Hydra compared to) "Paper Nautilus." Poem. In *What Are Years* (New York: Macmillan, **1941**). [Ipso]

James McAuley, 1917–1976. "The Hero and the Hydra." Poem. In *Under Aldebaron* (Melbourne: Melbourne University Press, **1946**). [CLC 1987, 45:246f., 250f., 254]

Mathias Gasteiger, b. 1872. "Hercules and the Hydra." Sculpture. By **1951.** City Art Museum, St. Louis. [Agard 1951, p. 152, fig. 82]

Sidney Nolan, 1917–. "Hydra." Painting. **1956.** Artist's coll. in 1957. [Whitechapel 1957, no. 139]

Jorge Luis Borges, 1899–1986. "La hidra de Lerna" [The Hydra of Lerna]. Poem. In *El libro de los seres imaginarios* (Buenos Aires: Kier, **1967**). / Translated by N. T. di Giovanni, with Borges, in *The Book of Imaginary Beings* (New York: Dutton, 1969). [Ipso]

Carlos Fuentes, 1928–. *La cabeza de la Hidra* [The Hydra Head] (symbolic evocation of the myth). Novel. Mexico: Mortiz; Barcelona: Liberia Editorial Argos, **1978.** / Translated by Margaret Peden (New York: Farrar, Straus & Giroux, 1978). [EWL 1981–84, 2:179 / LAW 1989, 3:1370–72]

Earl Staley, 1938–. "The Second Labor of Hercules: The Lernaean Hydra." Painting. **1983.** Contemporary Art Museum, Houston. [Personal communication to author from Mark Thistlethwaite, Texas Christian University, 1984 / also Houston 1984, p. 20—ill.]

The Erymanthian Boar. For his third labor, Heracles (Hercules) was charged with catching the boar that lived on Mount Erymanthus in Arcadia and bringing it back to Tiryns alive. He chased it into a field of snow, where it became exhausted, and captured it in a net.

In a *parergon* to this labor, Heracles battled Pholus

and other centaurs and accidentally wounded the immortal centaur Chiron.

Classical Sources. Sophocles, *The Women of Trachis* 1095ff. Apollonius Rhodius, *Argonautica* 1.127. Diodorus Siculus, *Biblioteca* 4.12.1–2. Apollodorus, *Biblioteca* 2.5.4. Statius, *Thebaid* 4.290. Pausanias, *Description of Greece* 8.24.5. Hyginus, *Fabulae* 30.

Antico, c.1460–1528. "Hercules and the Erymanthian Boar." Bronze medallion, part of series depicting deeds of Heracles. **c.1500?** Victoria and Albert Museum, London. [Louvre 1975, no. 61]
Lucas Cranach, 1472–1553. "Hercules with the Boar of Erymanthus." Painting. **After 1537.** Private coll., Lyon, in 1924. [Friedländer & Rosenberg 1978, no. 408B / also Warburg (as sold London, 1969)]
Francesco Primaticcio, 1504–1570, design. "Hercules and the Erymanthian Boar." Fresco, for Salle de Bal, Château de Fontainebleau, executed by Niccolò dell' Abbate under Primaticcio's direction. **1551–56.** Repainted 19th century. [Dimier 1900, pp. 160ff., 284ff.]
Francesco Manelli, 1594–1667, music. *L'Ercole nell'Erimanto.* Ballet. Libretto, Bernardo Morando. First performed Carnival **1651,** Teatro Ducale, Piacenza. [Grove 1980, 11:613 / DELI 1966–70, 4:60]
Antoine-Louis Barye, 1796–1875. "Hercules with the Erymanthian Boar." Bronze statuette. **c.1820.** Walters Art Gallery, Baltimore, no. 27.105; elsewhere. [Benge 1984, pp. 16f., pl. 3 / also Pivar 1974, no. F30—ill.] Variant. [Pivar, no. F31—ill.]

The Ceryneian Hind. The fourth labor of Heracles (Hercules) was to capture the Ceryneian hind (also known as the Arcadian stag). A deer with golden horns and bronze feet, the animal was sacred to Artemis (Diana) and could not be harmed without incurring the goddess's wrath. Heracles tracked the hind for a year, finally catching up with it by the bank of the river Ladon. There, he grazed it with an arrow and slung it on his back, preparing to carry it back to Tiryns. On his way he met Artemis, who demanded the return of her sacred beast. Her wrath was appeased, however, when Heracles put the blame for his misdeeds on Eurystheus and promised to release the hind after showing it in Tiryns.

Pindar set his version of this tale in the land of the Hyperboreans and said that the deer's golden horn was stamped with the name of Artemis. This story is often linked to that of Heracles' eleventh labor, obtaining the apples of the Hesperides, and in some classical vase paintings the hind is depicted beside the tree of the Hesperides.

Classical Sources. Pindar, *Olympian Odes* 3.29ff. Euripides, *Heracles* 375ff. Callimachus, *Hymns,* 3, "To Artemis"

lines 89ff. Diodorus Siculus, *Biblioteca* 4.13.1. Apollodorus, *Biblioteca* 2.5.3.

Paolo di Stefano Badaloni, 1397–1478. "The Labors of Hercules." Painting, depicting Hercules fighting the Ceryneian Hind, Antaeus, and a centaur, in one composition. Metropolitan Museum, New York, no. 1971.115.4. [Metropolitan 1980, p. 139—ill.]
Étienne-Barthélemy Garnier, 1759–1849. "Hercules Receiving from Diana the Hind with Golden Horns." Ceiling painting. **c.1802.** Salle d'Olympie, Louvre, Paris (inv. 20310). [Louvre 1979–86, 3:265—ill.]
Gustave Moreau, 1826–1898. "Hercules and the Hind with Brazen Feet." Watercolor. **c.1872.** Daniel Wildenstein coll. [Mathieu 1976, no. 131—ill.] Related (?) painting. Unlocated. [Ibid., no. 135]
Émile-Antoine Bourdelle, 1861–1929. "Heracles with the Hind." Bronze sculpture. **1910.** 9 casts. Private colls.; elsewhere? [Jianou & Dufet 1975, no. 508]
Paul Manship, 1885–1966. "Hercules and the Ceryneian Hind." Gilded bronze sculpture, sketch. **1955.** Unique cast. [Murtha 1957, no. 570—ill.]
Joyce Treiman, 1922–. "Hercules and the Arcadian Stag." Painting. **1983.** Tortue Gallery, Los Angeles. [Personal communication to author from Mark Thistlethwaite, Texas Christian University, 1984]

The Stymphalian Birds. For his fifth labor (sometimes called the sixth), Heracles (Hercules) was to kill the birds that infested the woods by Lake Stymphalus in Arcadia. Some sources say that the birds were man-eating creatures with brazen claws and feathers that could be shot like arrows. Heracles flushed out the birds by making a great noise with a rattle—made by Hephaestus and given to him by Athena—and then shot them with his bow.

Classical Sources. Apollonius Rhodius, *Argonautica* 2.382ff., 1036ff. Diodorus Siculus, *Biblioteca* 4.13.2. Strabo, *Geography* 8.6.8. Apollodorus, *Biblioteca* 2.5.6. Pliny, *Naturalis Historia* 6.32. Pausanias, *Description of Greece* 8.22.4. Hyginus, *Fabulae* 20, 30. Quintus of Smyrna, *Sequel to Homer* 6.227ff.

Albrecht Dürer, 1471–1528. "Hercules and the Stymphalian Birds" (as Harpies). Painting. **1501–02.** Germanisches Nationalmuseum, Nuremberg, no. Gm 166. [Strauss 1977b, p. 99 / Strauss 1980, p. 612—ill. (drawing) / Strauss 1974, no. 1500/8—ill. (drawing) / also Anzelewsky 1971, no. 67—ill.]
Gustave Moreau, 1826–1898. "Hercules and the Stymphalian Birds." Painting. **1865.** Sold Paris, 1922, unlocated. [Mathieu 1976, no. 70—ill.]
———. "Hercules at the Lake of Stymphalus." Painting. c.1872. Private coll., Paris. [Ibid., no. 132—ill.]
———. "Hercules and the Stymphalian Birds." Watercolor. c.1872. Musée des Beaux-Arts, Dijon. [Ibid., no. 133—ill.]
José-Maria de Heredia, 1842–1905. "Stymphale." Sonnet,

in "Hercule et les centaures" cycle. In *Revue des deux mondes* 15 Jan **1888;** collected in *Les trophées* (Paris: Lemerre, 1893). [Delaty 1984, vol. 1 / Hill 1962 / Galinsky 1972, pp. 270f.]

Émile-Antoine Bourdelle, 1861–1929. "Heracles the Archer" ("Heracles Killing the Birds at Lake Stymphalus"). Bronze sculpture. **1909.** 2 versions, 10 casts of each. Musée Bourdelle, Paris; Musée d'Orsay, Paris, inv. RF 3174; Galleria Nazionale d'Arte Moderna, Rome; Metropolitan Museum, New York; elsewhere. [Jianou & Dufet 1975, no. 391—ill. / Cannon-Brookes 1983, pp. 63f.—ill. / also Orsay 1986, p. 55—ill. / Agard 1951, p. 149 / / Clapp 1970, 1:104] 3d version, in plaster. Musée Ingres, Montauban; Nouveau Musée des Beaux-Arts, Le Havre; Musée Saint-Pierre, Lyons. / Bronze studies, numerous versions and casts. [Jianou & Dufet, nos. 391–94 / Cannon-Brookes, fig. 89] 2 bronze variants ("Mask of the Large Heracles," "Archer"). 1909. 2 casts of each. Private coll(s). [Jianou & Dufet, nos. 397–98] Variant ("Head of Heracles"). 1909. Bronze, plaster, terra-cotta, and *terre-sèche* versions. Musée Bourdelle, Paris; Ny Carlsberg Glyptotek, Copenhagen; Museum Boymans-van Beuningen, Rotterdam; Dartmouth College Museum, Hanover, N.H.; private colls. [Jianou & Dufet, no. 396] Variant (mask). 1909. Bronze, terra-cotta, and *terre-sèche* versions. Private colls. [Ibid.]

Paul Manship, 1885–1966. "Hercules and the Stymphalian Birds." Gilded bronze sculpture (sketch). **1955.** Unique cast. [Murtha 1957, no. 571—ill.]

The Stables of Augeas. A son of Helios, King Augeas of Elis in the Peloponnese owned vast herds of cattle, which he kept in stables that had never been cleaned. For his sixth labor (sometimes called the fifth), Eurystheus commanded Heracles (Hercules) to clean the stables, which were bringing sterility to the land. Heracles agreed with Augeas to cleanse the stables in exchange for one-tenth of the herd. He accomplished the task by diverting water from the Alpheus and Peneus rivers so that they flowed through the outbuildings. Augeas then reneged on his part of the bargain and expelled Heracles and his own son Phyleus, who had sided with the hero. After Heracles had completed the rest of his labors, he returned to Elis and killed Augeas, putting Phyleus on the throne in his place.

In a *parergon* to this labor, Heracles established the Olympic games, to be held at Olympia in honor of Zeus every four years. This distinction, however, has been alternately given to Heracles the Dactyl, of Mount Ida.

Classical Sources. Pindar, *Olympian Odes* 10.26ff. Theocritus, *Idylls* 25.7ff. Diodorus Siculus, *Bibliotheca* 4.13.3. Apollodorus, *Bibliotheca* 1.9.16, 2.5.5. Pausanias, *Description of Greece* 5.1.9ff., 5.2.2, 5.3.1ff.

Samuel Butler, 1612–1680. (Hercules cleaning the Augean stables in) *Hudibras* 1.2.457ff., 3.139–44. Satirical mock-

heroic poem. London: Marriott, **1663.** Modern edition by John Wilders (Oxford University Press, 1967.) [Ipso]

René François Armand Sully-Prudhomme, 1839–1907. "Les écuries d'Augias" [The Stables of Augeas]. Poem. In *Poésies, 1865–67* (Paris: Lemerre, **1867**). [DLLF 1984, 3:2244 / Galinsky 1972, pp. 272ff.]

August Strindberg, 1849–1912. (Hercules-figure in) *Et drömspel* [A Dream Play]. Drama. **1902.** First performed 17 Apr 1907, Swedish Theater, Stockholm. [Carlson 1982, p. 157]

————. "Hercules." Short story. / Translated by H. Carlson in *Scandinavian Review* 64 (September 1976). [Ibid., pp. 157, 229]

Friedrich Dürrenmatt, 1921–1990. *Herkules und der Stall des Augias* [Hercules and the Stable of Augeas]. Radio play, comedy. Zurich: Verlag der Arche, **1954.** Produced 20 Mar 1963, Radio Zurich. [McGraw-Hill 1984, 2:60, 62 / Moore 1967, p. 152 / Galinsky 1972, pp. 249, 279, 286ff., 293]

Heiner Müller, 1929–. *Herakles 5.* Drama. **1964–65.** First performed 1968, Munich. Published with *Philoktet* (Frankfurt: Suhrkamp, 1966). [Demetz 1986, pp. 259f., 266 / McGraw-Hill 1984, 3:451 / EWL 1981–84, 3:31]

The Cretan Bull. For his seventh labor, Heracles (Hercules) was ordered to capture the Cretan bull (probably the bull sent from the sea by Poseidon, which had fathered the Minotaur on Pasiphaë). The bull was now wandering through Crete, where Heracles subdued it and brought it back to Tiryns (some say riding across the sea on its back). He showed it to Eurystheus and then set it free. The bull roamed to Marathon, where it was eventually captured and sacrificed by Theseus.

Classical Sources. Diodorus Siculus, *Bibliotheca* 4.13.4. Virgil, *Aeneid* 8.294ff. Apollodorus, *Bibliotheca* 2.5.7. Pausanias, *Description of Greece* 1.27.9–10, 5.1.9–2.2, 8.22.4.

Pierre Puget, 1620–1694. "Hercules and the Cretan Bull." Anonymous print, after presumed original drawing of *c.*1660. (Musée des Beaux-Arts, Marseilles.) [Herding 1970, p. 148, pl. 34]

Charles-Joseph Natoire, 1700–1777. "Hercules Battling the Bull of Crete." Overdoor painting. Sold Paris, 1888, untraced. [Boyer 1949, no. 109]

Jan Kamphuijsen, 1760–1841. "Hercules Fighting the Bull." Painting, part of "Hercules" ceiling decoration, for Brentano house, Herengracht, Amsterdam, probably after a design by G. Maderni (1758–1803). **1790–91.** Rijksmuseum, Amsterdam, inv. A4141. [Rijksmuseum 1976, p. 311—ill.]

Henry Fuseli, 1741–1825. "Heracles Subdues the Cretan Bull." Drawing. **1798–1800.** Huntington Library and Art Gallery, San Marino, Calif. [Schiff 1973, no. 988—ill.]

Théodore Géricault, 1791–1824. "Bull Tamer" (Hercules and the Cretan Bull?). Drawing. **1816–17.** Louvre, Paris, no. R.F. 795. [Eitner 1983, fig. 93, p. 336 *n.*44]

Charles Marie René Leconte de Lisle, 1818–1894. "Hé-

raklès au Taureau." Poem. In *Oeuvres: Poèmes antiques* (Paris: Lemerre, **1852**). [Pich 1976–81, vol. 1]

Paul Manship, 1885–1966. "Hercules and the Cretan Bull." Bronze statuette. **1956.** National Museum of American Art, Washington, D.C. [Rand 1989, fig. 181]

The Mares of Diomedes. The Thracian king Diomedes, son of Ares and the nymph Cyrene, fed his four mares on the flesh of men. Heracles (Hercules) was required for his eighth labor to bring these horses to Eurystheus. After overpowering the grooms, Heracles drove the mares to the sea, where he was overtaken by Diomedes. He killed the king, whose body was then devoured by his own horses. Having eaten their master's flesh, the mares went tamely with Heracles. Eurystheus dedicated them to Hera and set them free, but they were eaten by wild animals on Mount Olympus.

Classical Sources. Diodorus Siculus, *Biblioteca* 4.15.3–4. Ovid, *Metamorphoses* 9.194ff. Strabo, *Geography* 7 fragments 44, 47. Apollodorus, *Biblioteca* 2.5.8. Philostratus, *Imagines* 25. Quintus of Smyrna, *Sequel to Homer* 6.245ff.

John Gower, 1330?–1408. (Story of Hercules and the horses of "Dionys, tyrant" in) *Confessio amantis* 7.3341–54. Poem. *c.*1390. Westminster: Caxton, 1483. [Macaulay 1899–1902, vol. 3 / Ito 1976, p. 7]

Sandro Botticelli, 1445–1510. (Hercules capturing the horses of Diomedes [?] depicted in frieze in setting of) "The Calumny of Apelles." Painting. *c.*1494–95. Uffizi, Florence, no. 1496. [Lightbown 1978, no. B79—ill.]

Baldassare Peruzzi, 1481–1536. "Hercules and the Man-eating Mares." Grisaille fresco, part of "Hercules" cycle. **1508–09.** Castello, Ostia Antica. [Frommel 1967–68, no. 17—ill.]

Charles Le Brun, 1619–1690. "Hercules Slays Diomedes." Painting. *c.*1639–41. Castle Museum and Art Gallery, Nottingham, inv. 93.52. [Versailles 1963, no. 2—ill. / also Jacobs & Stirton 1984b, p. 156] Study. Private coll., Paris. [Versailles—ill.]

Luca Giordano, 1634–1705. "Hercules and the Mares of Diomedes." Painting. *c.*1685. G. Simonotti Manacorda coll., Villabella, Alessandria. [Ferrari & Scavezzi 1966, 2:140—ill.] Related drawing. Museo di San Martino, Naples, no. 20841. [Ibid., 2:265—ill.]

Bernardo Sabadini, ?–1718. *Diomede punito da Alcide* [Diomedes Punished by Alcides]. Opera. Libretto, Aurelio Aureli. First performed **1691**, Piacenza. [Grove 1980, 16:363]

Tomaso Giovanni Albinoni, 1671–1751. *Diomede punito da Alcide.* Opera. Libretto, Aureli. First performed **1700,** Venice. [Grove 1980, 1:219]

Henry Fuseli, 1741–1825. "Heracles Slays the Horses of Diomedes" (confusion of two versions of the legend). Drawing. **1798.** Ulrich coll., Zürich. [Schiff 1973, no. 989—ill.] Another version of the subject, 1800–05. Art Institute, Chicago, inv. 2221/52. [Ibid., no. 1372—ill.]

William Theed the Elder, 1764–1817. "Hercules Taming the Thracian Horses." Sculpture. *c.*1816. Buckingham Palace, London. [Whinney 1964, pl. 166A]

Eugène Delacroix, 1798–1863. "Hercules Feeds Diomedes to His Mares." Painting, unused study for "Life of Hercules" cycle (Hôtel de Ville, Paris, **1851–52**). Ny Carlsberg Glyptotek, Copenhagen. [Johnson 1981–86, no. 312—ill. / Robaut 1885, no. 1274—ill. (copy drawing)]

Gustave Moreau, 1826–1898. "Diomedes Devoured by His Horses." Painting. **1865.** Musée des Beaux-Arts, Rouen. [Mathieu 1976, p. 96, no. 78—ill.] Smaller version. *c.*1865. Unlocated. [Ibid., no. 79] Watercolor variant. *c.*1885. Unlocated. [Ibid., no. 331]

Remy de Gourmont, 1858–1915. *Les chevaux de Diomède* [The Horses of Diomedes] Novel. Paris: Mercure de France, **1897.** [DLLF 1984, 2:969]

Gutzon Borglum, 1867–1941. "The Mares of Diomedes." Bronze sculpture group. **1904.** Metropolitan Museum, New York, no. 06.1318. [Metropolitan 1965, pp. 101f.—ill. / also Rand 1989, fig. 8] Reductions. Rhode Island School of Design, Providence; Newark Museum, N.J. / Fragments. Brookgreen Gardens, S.C.; Musée du Luxembourg, Paris. [Metropolitan]

André Masson, 1896–1987. "The Horses of Diomedes." Painting. **1934.** [Rubin & Lanchner 1976, p. 137 / Clébert 1971, p. 11] Etching ("Diomedes"). 1934. [Clébert, pl. 79]

The Girdle of Hippolyta. The Amazon queen Hippolyta possessed a girdle (belt) given to her by her father, Ares. It was desired by Admete, the daughter of Eurystheus, who sent Heracles (Hercules) on his ninth labor to retrieve it for her. Hippolyta welcomed Heracles, boarding his ship at the mouth of the Thermodon River, and readily promised him the girdle. But Hera, disguised as an Amazon, instigated a battle between Heracles and the Amazons in which Hippolyta was killed. Heracles then removed the girdle from her body and brought it to Tiryns.

Many variants of this tale exist. In some, the Athenian hero Theseus joined Heracles in the expedition and was given Hippolyta's sister Antiope as a reward. In others, Heracles captured Hippolyta's second-in-command, Melanippe, who obtained the girdle for him as the price of her freedom. In differing accounts Antiope is sometimes confused or conflated with Hippolyta.

Classical Sources. Epicharmus, *Heracles' Voyage to the Sword-Belt of Hippolyta* (fragment). Euripides, *Heracles* 408ff. Diodorus Siculus, *Biblioteca* 4.16.1–4. Ovid, *Metamorphoses* 9.189f. Apollodorus, *Biblioteca* 2.5.8–9.

See also THESEUS, and the Amazons.

Raoul Lefèvre, fl. *c.*1454–67. (Hercules and Theseus fight the Amazons in) "Damosels of Scythie," part of *Le recueil des hystoires de Troyes* [Collection of the Stories of Troy].

Prose romance. **1464.** / English translation by William Caxton as *The Recuyell of the Historyes of Troye* (Bruges: Mansion, c.**1474**). / Modern edition (of original French) by Marc Aeschbach (Bern & New York: Lang, **1987**). [Kleinbaum 1983, pp. 62f.]

Franco-Flemish School. "Amazon Queens" (Orthia, Melanippe, and Hippolyta, preparing to fight Hercules and Theseus). Tapestry. **Late 15th century.** Isabella Stewart Gardner Museum, Boston. [Warburg]

Luca Cambiaso, 1527–1585. "Hercules Battling the Amazons." Fresco. **1544.** Palazzo della Prefettura, Genoa. [Manning & Suida 1958, pp. 74f.—ill.]

Nicolas Poussin, 1594–1665. "Hercules and Theseus Fighting the Amazons." Drawing, study for (unexecuted or destroyed) decoration for the Long Gallery, Louvre, Paris. **1640–42.** Royal Library, Windsor Castle, no. 11920. [Friedlaender & Blunt 1953, p. 11, no. 243]

Pietro Andrea Ziani, 1616–1684, with **Lodovico Busca,** fl. 1670–88, and **Pietro Simone Agostini,** c.1635–1680. *L'Ippolita reina delle Amazzoni* [Hippolyta, Queen of the Amazons]. Opera. Libretto, Carlo Maria Maggi. First performed **1670,** Teatro Ducale, Milan. [Grove 1980, 20:676]

Antonio Sartorio, 1630–1680. *Ercole su'l Termodonte* [Hercules at the Thermodon]. Opera. Libretto, Giacomo Francesco Bussani. Jan/Feb **1678,** San Salvatore, Venice. [Grove 1980, 16:508, 510]

Johann Philipp Krieger, 1649–1725. *Hercules unter denen Amazonen* [Hercules among the Amazons]. Opera. Libretto, Friedrich Christian Bressand. **1693–94.** Probably composed for performance at Court, Weissenfels. [Grove 1980, 10:269 / DLL 1968–90, 2:38]

Johann Christoph Graupner, 1683–1760. *Il fido amico, oder, Der getreue Freund Hercules und Theseus* [The Faithful Friend, or, The Faithful Friend Hercules and Theseus]. Opera. Libretto, Breymann. First performed **1708,** Hamburg. [Grove 1908, 7:648 / McCredie 1966, p. 79]

Giuseppe Maria Orlandini, 1675–1760. *Amazzoni vinte da Ercole* [Amazons Conquered by Hercules]. Opera (dramma per musica). Libretto, Antonio Salvi. First performed Apr **1715,** Florence. [Weaver 1978, p. 228 / Grove 1980, 13:824(Apr 1718, Emilia)]

Giacomo Rampini, 1680–1760. *Ercole su'l Termodonte* [Hercules at the Thermodon]. Opera. Libretto, G. F. Bussani. First performed June **1715,** Teatro Obizzi, Padua. [Grove 1980, 15:578]

Antonio Vivaldi, 1678–1741. *Ercole su'l Termodonte.* Opera. Libretto, G. F. Bussani. First performed 23 Jan **1723,** Teatro Capranica, Rome. [Grove 1980, 20:34, 44]

Nicola Conti, fl. 1733–54. *L'Ippolita* [Hippolyta]. Comic opera. Libretto, G. A. Federico. First performed Spring **1733,** Fiorentini, Naples. [Grove 1980, 4:684]

Sebastiano Nasolini, c.1768–1806/16. *Ercole al Termodonte, ossia, Ippolita Regina delle Amazzoni* [Hercules at the Thermodon, or, Hippolyta Queen of the Amazons]. Opera (dramma/tragedia). Libretto, A. S. Sografi. First performed Spring **1791,** San Pietro, Trieste. [Grove 1980, 13:43]

Niccolò Piccinni, 1728–1800. *Ercole al Termodonte (La disfatta delle Amazzoni)* [Hercules at the Thermodon (The Defeat of the Amazons)]. Opera seria. First per-

formed 12 Jan **1793,** San Carlo, Naples. [Grove 1980, 14:728]

Anonymous. *Hypolita, Queen of the Amazons.* Melodrama. First performed **1819,** Royal Amphitheatre, London. [Nicoll 1959–66, 4:481]

Théophile Gautier, 1811–1872. "Le Thermodon." Poem. In *Emaux et camées* (Paris: **1852**). [Bush 1937, p. 447]

Gustave Doré, 1832–1883. "The Combat of Hercules and the Amazons." Drawing. Sold 1885, unlocated. [Leblanc 1931, p. 494]

Julian F. Thompson, d. 1939. *The Warrior's Husband.* Comedy. First performed 11 Mar **1932,** Morosco Theatre, New York. [Kleinbaum 1983, pp. 202–05]

Richard Rodgers, 1902–1979. *By Jupiter!* Musical comedy. Lyrics, Lorenz Hart. Libretto, Rodgers and Hart, after Thompson's *The Warrior's Husband* (1932). First performed 11 May **1942,** Shubert Theater, Boston. [Oxford 1984, p. 116]

Paul Manship, 1885–1966. "Hercules Gets the Belt of Hippolyta, Queen of the Amazons." Drawing. National Museum of American Art, Washington, D.C. [Rand 1989, p. 13—ill.]

The Cattle of Geryon. The three-headed monster Geryon, son of Callirhoë and Chrysaor, lived on the island of Erytheia, located at the western edge of the world. He possessed a large herd of red cattle, which were tended by his herdsman, Eurytion, and a two-headed dog, Orthus. The tenth labor of Heracles (Hercules) was to bring the cattle back to Tiryns. When he reached northern Africa, Helios gave him a great golden cup in which to sail to the distant island. Once there, Heracles killed Eurytion and Orthus, then slew Geryon and took the cattle. He loaded the cattle into the cup, sailed with them back to the mainland, and herded them overland to Greece.

On the journey to and from Erytheia, Heracles was involved in a number of *parerga,* among them the establishment of the Pillars of Heracles at the Strait of Gibraltar and the killing of the monster Cacus in Italy. When at last he reached the court of Eurystheus, the king sacrificed the cattle to Hera.

Classical Sources. Hesiod, *Theogony* 287–94, 979. Stesichorus, *Geryoneis.* Herodotus, *History* 4.8. Euripides, *Heracles* 423ff. Diodorus Siculus, *Biblioteca* 4.17.1–18.6. Horace, *Odes* 2.14.7ff. Ovid, *Metamorphoses* 9.184ff. Apollodorus, *Biblioteca* 2.5.10. Hyginus, *Fabulae* 30, 151.

Dante Alighieri, 1265–1321. (Geryon, symbol of deceit, carries Dante and Virgil to Malebolge in) *Inferno* 16.124ff., 17.1ff. c.**1307**–c.**1314**? In *The Divine Comedy.* Poem. Foligno: Neumeister & Angelini, 1472. [Singleton 1970–75, vol. 1 / Samuel 1966, pp. 100f., 106f., 128]

Sandro Botticelli, 1445–1510. Geryon depicted in drawings illustrating *Inferno* 16, 17, 18 [*sic*], part of a series of

illustrations to Dante's *Divine Comedy*. **1480s/early 1490s.** Kupferstichkabinett, Berlin-Dahlem; Biblioteca Vaticana, Rome. [Lightbown 1978, 1:147ff., 2:172f., nos. E29–31, E38—ill.]

Jan Gossaert, called Mabuse, *c.*1478–1533/36. "Hercules Slays Eurytion." Drawing. 1508–09 or **1517–19?** Rijksprentenkabinet, Amsterdam. [Rotterdam 1965, no. 67—ill.]

Francesco Primaticcio, 1504–1570 (previously attributed to Rosso Fiorentino). "Hercules and Geryon." Painting. **1541–45.** Porte Doré, Château de Fontainebleau. Repainted 19th century. [Dimier 1900, pp. 306ff. (as "Hercules on the Argo")] Drawing for. Albertina, Vienna. [Ibid., no. 161] Engraved by "Master L. D." (Bartsch no. 44) and by Hendrik Goltzius, *c.*1577 (Bartsch no. 267). [Ibid., no. 3 / Strauss 1977a, no. 5—ill. / Bartsch 1980–82, no. 267—ill.]

Edmund Spenser, 1552?–1599. (Geryon evoked in) *The Faerie Queene* 5.10.9–10. Romance epic. London: Ponsonbie, **1596.** [Hamilton 1977 / Nohrnberg 1976, p. 369]

Joos de Momper, 1564–**1635.** "Hercules Stealing Geryon's Cattle." Painting. Rijksmuseum, Amsterdam, inv. A3894. [Rijksmuseum 1976, p. 392—ill.]

Giovanni Battista Langetti, 1625–**1676.** "Hercules Stealing the Cattle of Geryon." Painting. Kunsthistorisches Museum, Vienna, inv. 1878 (430B). [Vienna 1973, p. 97—ill.]

Carlo Agostino Badia, 1672–1738. *Ercole, vincitore di Gerione* [Hercules, Conqueror of Geryon]. Opera (poemetto dramatico). Libretto, Bernadoni. First performed 4 Nov **1708,** Vienna. [Grove 1980, 2:9]

John Flaxman, 1755–1826. "Geryon Carrying Dante and Virgil." Drawing, illustrating *Inferno* 17.100–20, part of series of illustrations to Dante's *Divine Comedy*. *c.*1792. Houghton Library, Harvard University, Cambridge. / Engraved by Tomasso Piroli, published privately, Rome: 1793; London: Longman & Co., 1807. [Irwin 1979, pp. 94, 226 *n.* 41 / Flaxman 1872, 4: pl. 18 / also Bindman 1979, p. 179—ill.]

Joseph Anton Koch, 1768–1839. "Dante and Virgil on the Back of Geryon." Drawing, illustrating *Inferno* 17. *c.*1802. Private coll. [Bindman 1979, no. 255—ill.]

Robert Rauschenberg, 1925–. Transfer-drawing, depicting Geryon carrying Dante and Virgil, illustrating Dante's *Inferno* 17. **1959–60.** Museum of Modern Art, New York. [Berlin 1980, p. 184—ill.]

The Apples of the Hesperides. The tree of golden apples that Gaia gave to Hera as a wedding present grew in a garden at the edge of the world. It was guarded by the Hesperides and by the dragon Ladon, who was coiled around the tree. For his eleventh labor, Heracles (Hercules) was ordered to bring the apples to Eurystheus. To do so he first had to find the garden. In some versions of the myth, he forced the information from the sea-god Nereus, who transformed himself into many shapes in a vain attempt to escape the hero's grasp.

Upon reaching the garden, Heracles killed Ladon

and, according to Euripides, plucked the apples himself. According to other authors, the Titan Atlas obtained the apples while Heracles assumed his burden of shouldering the sky; Heracles then had to trick Atlas into resuming the irksome load. In some early tales, Heracles kept the apples, symbols of immortality, for himself instead of handing them to Eurystheus, but in later versions Athena eventually returned the sacred apples to the garden because it was forbidden for a mortal to possess them.

The *parergon* in which Heracles killed the Libyan giant Antaeus is associated with this labor.

Classical Sources. Hesiod, *Theogony* 215ff. Euripides, *Heracles* 395ff. Diodorus Siculus, *Biblioteca* 4.26–27. Ovid, *Metamorphoses* 4.637ff., 9.190. Apollodorus, *Biblioteca* 2.5.11. Pausanias, *Description of Greece* 5.11.6, 5.18.4, 6.19.8. Hyginus, *Poetica astronomica* 2.3, 2.6. Philostratus, *Imagines* 2.2.

Bertoldo di Giovanni, *c.*1420–**1491.** "Hercules" (with the Apples of the Hesperides). Bronze statuette. Victoria and Albert Museum, London. [Pope-Hennessy 1985b, 3:4f.—ill.]

Bernardino Luini, 1480/85–**1532,** attributed. "Hercules and Atlas" (?). Fresco (detached), from Palazzo Landriani, Milan. Civico Museo d'Arte Antica, Castello Sforzesco, Milan. [Luino 1975, p. 92, pl. 59 / also Berenson 1968, 9:232]

Giovanni Bernardi, 1496–**1553,** and **Manno di Bastiano,** design. Statuette representing Hercules with the apples of the Hesperides, on "The Farnese Coffer." Silver gilt coffer. Executed by another, 1548–61. Museo di Capodimonte, Naples, no. 10507. [Capodimonte 1964, p. 129]

Vincenzo de' Rossi, 1525–1587. "Hercules Holding Up the World." Marble statue, part of "Labors of Hercules" cycle for Palazzo Vecchio, Florence. *c.*1568. Poggio Imperiale, Florence. [Lensi 1929, pp. 224f.]

Lorenzo dello Sciorina, *c.*1535–1598. "Hercules Killing the Dragon of the Hesperides." Painting. **1570–73.** Studiolo di Francesco I, Palazzo Vecchio, Florence. [Sinibaldi 1950, pp. 11f., 19]

Ludovico Carracci, 1555–1619. "Hercules and Atlas." Fresco, part of "Hercules" cycle. *c.*1593–94. Palazzo Sampieri (Talon), Bologna. [Ostrow 1966, no. I/15 / Malafarina 1976, p. 103]

Annibale Carracci, 1560–1609. "Hercules Bearing the Globe." Fresco, part of "Hercules" cycle. **1595–97.** Camerino, Palazzo Farnese, Rome. [Malafarina 1976, no. 87a—ill. / Martin 1965, pp. 27ff.—ill.]

——. "Hercules and the Dragon." Design for fresco, executed by studio under direction of Domenichino. *c.*1603–04 (or *c.*1608?). Galleria, Palazzo Farnese, Rome. [Malafarina 1976, no. 105j—ill. / Martin 1965, p. 140—ill.]

Alessandro Allori, 1535–**1607.** "Hercules in the Garden of the Hesperides." Fresco. Villa Poggio, Caiano. [Pigler 1974, p. 115]

Peter Paul Rubens, 1577–1640. "Hercules and the Golden Apples of the Hesperides" (Hercules about to slay Ladon). Painted cut-out, part of Arch of the Mint, decoration for "Pompa Introitus Fernandi," triumphal entry

of Cardinal-Infante Ferdinand of Spain into Antwerp, 17 Apr **1635**. Original decoration destroyed. [Martin 1972, no. 51—ill. (print)] Oil sketch. Koninklijk Museum voor Schone Kunsten, Antwerp, no. 316. [Ibid., no. 50a—ill. / Held 1980, no. 163—ill. / Jaffé 1989, no. 1163—ill.]

———. "Hercules (Slaying the Dragon) in the Garden of the Hesperides." Painting. Lost. / Copy by Juan Bautista del Mazo (*c.*1612–1667). Prado, Madrid, no. 1711. [Prado 1985, pp. 402f. / cf. Alpers 1971, pp. 274ff., fig. 199]

———. "Hercules in the Garden of the Hesperides" (with dead dragon). Painting. *c.*1638. Galleria Sabauda, Turin. [Jaffé, no. 1362—ill.] Oil sketch. Louvre, Paris. [Ibid., no. 1361—ill.]

Pietro da Cortona, 1596–1669. "Hercules in the Garden of the Hesperides." Drawing. / 2 engravings by Johann Friedrich Greuter (1590/93–**1662**). [Pigler 1974, p. 115] Another version of the subject, painting, engraved by Albertus Clouwet (1636–1679). [Ibid.]

Francisco de Herrera, 1612/22–1685. "Hercules Supporting the Globe." Drawing. **1668**. Albertina, Vienna. [López Torrijos 1985, p. 409 no. 79—ill.]

Michel Anguier, 1612–1686. "Hercules Takes the World from Atlas." Terra-cotta sculpture group. **1669**. Louvre, Paris, inv. 900. [Pigler 1974, p. 113]

Pedro Calderón de la Barca, 1600–1681. (Hercules seeks the apples of the Hesperides in) *Fieras afemina Amor* [Love Tames the Wild Beasts]. Comedy (*fiesta de espectáculo*). **1669**. First performed Jan 1670, Vienna? [Valbuena Briones 1960–67, vol. 1 / O'Connor 1988, pp. 153–70]

Balthasar Permoser, 1651–1732. "Hercules and the Hesperidean Dragon." Sandstone sculpture. *c.***1689–95**. Grosser Garten, Dresden. [Asche 1966, no. P21, pl. 27]

———. "Hercules with the Globe." Sandstone statue. *c.*1715–16. Elstra. [Ibid., no. P64, pl. 53]

———. "Hercules with the Globe" ("Hercules Saxonicus"). Sandstone statue. *c.*1716–18. Wallpavillon, Zwinger, Dresden. [Ibid., no. P65, pl. 52]

———. "Standing Hercules with the Globe." Sandstone statue. *c.*1723–28? Stadtpavillon, Zwinger, Dresden. [Ibid., no. P81b]

Gérard de Lairesse, 1641–**1711**, follower. "Hercules in the Garden of the Hesperides after the Battle with the Monster." Paintings, part of series of grisailles on deeds of Hercules. Early 18th century. Louvre, Paris, inv. 20769. [Louvre 1979–86, 2:378—ill.]

Giovanni Antonio Pellegrini, 1675–1741. "Hercules in the Garden of the Hesperides." Painting. **1724**. Schloss Schönborn, Pommersfelden. [Pigler 1974, p. 115]

Jean-Baptiste Lemoyne, 1704–1778. "Hercules Reclining, Holding the Apples of the Hesperides." Sculpture. Exhibited **1738**. Lost. [Réau 1927, no. 13]

Gian Francesco de Majo, 1732–1770. *Alcide negli orti Esperide* [Hercules in the Garden of the Hesperides]. Opera. Libretto, M. Coltellini. First performed 7 June **1764**, Burgtheater, Vienna. [Grove 1980, 11:543f.]

Carlo Giuseppe Ratti, 1737–1795. "Hercules Takes the Globe from Atlas." Painting. **1787**. Palazzo Rosso, Genoa. [Pigler 1974, p. 113]

Henry Fuseli, 1741–1825. "Heracles Kills the Dragon Ladon, as the Terrified Hesperides Huddle Together at the Foot of the Tree." Drawing. **1814**. Öffentliche Kunst-

sammlung, Basel, inv. 1914.132.22. [Schiff 1973, no. 1528—ill.]

Théodore Géricault, 1791–1824. "Hercules Killing the Dragon in the Garden of the Hesperides." Drawing. **1816–17**. Ecole des Beaux-Arts, Paris, inv. 2896. [Eitner 1983, p. 335 *n.* 26]

William Morris, 1834–1896. "The Golden Apples." Poem. In *The Earthly Paradise*, vol. 4 (London: Ellis, **1870**). [Morris 1910–15, vol. 6 / Calhoun 1975, pp. 203–06]

Henri Büsser, 1872–1973. *Hercule au jardin des Hespérides* [Hercules in the Garden of the Hesperides]. Symphonic poem. **1900**. [Grove 1980, 3:512]

Georges Desvallières, 1861–1950. "Hercules in the Garden of the Hesperides." Painting. **1914**. Musée d'Orsay, Paris, no. R.F. 1977–152. [Louvre 1979–86, 3:221—ill.]

Paul Manship, 1885–1966. "Hercules Upholding the World—Armillary Sphere." Bronze sculpture. **1918**. Museum of Fine Arts, Houston, Texas. [Murtha 1957, no. 107—ill.]

Marianne Moore, 1887–1972. (Allusion to Hercules' search for the garden of the Hesperides in) "Marriage." Poem. In *Selected Poems* (New York: Macmillan, **1935**). [Ipso]

Cerberus. In his final and most difficult labor, Heracles (Hercules) was sent to fetch Cerberus, the three-headed hound who guarded the entrance to the Underworld. Guided by Hermes and Athena, Heracles descended and received permission from Hades, lord of the Underworld, to capture Cerberus as long as he did not use weapons. Heracles wrestled the hound into submission and carried him to Eurystheus, then returned him to Hades.

While in the Underworld, Heracles released Ascalaphus, who was trapped under a stone for betraying Persephone, and found Theseus and Pirithous attached to their chairs after their attempt to carry off Persephone. He delivered Theseus but was unable to free Pirithous. Heracles also spoke with the shade of Meleager and agreed to marry Meleager's sister, Deianeira, a promise which eventually led to his death.

Classical Sources. Homer, *Iliad* 8.366–69; *Odyssey* 11.623ff. Stesichorus, *Cerberus.* Euripides, *Heracles* 23ff., 1277ff. Diodorus Siculus, *Biblioteca* 4.25.1, 4.26.1. Virgil, *Aeneid* 8.294ff. Ovid, *Metamorphoses* 7.408–19. Apollodorus, *Biblioteca* 2.5.12.

Christine de Pizan, *c.*1364–*c.*1431. (Hercules and Cerberus in) *L'epistre d'Othéa à Hector* . . . [The Epistle of Othéa to Hector] chapters 3, 27. Didactic romance in prose. *c.***1400**. MSS in British Library, London; Bibliothèque Nationale, Paris; elsewhere. / Translated by Stephen Scrope (London: *c.*1444–50). [Bühler 1970 / Hindman 1986, p. 53, pl. 3]

Baldassare Peruzzi, 1481–1536. "Hercules and Cerberus." Drawing. *c.*1521–23. Ashmolean Museum, Oxford. [Frommel 1967–68, no. 97]

Rosso Fiorentino, 1494–1540, composition. "Hercules

Fighting Cerberus." Engraving, in "Labors and Adventures of Hercules" cycle, executed by Gian Jacopo Caraglio (Bartsch no. 44). **1524**. Original design lost. [Carroll 1987, no. 9—ill.]

Parmigianino, 1503–**1540**. "Hercules with Cerberus." Drawing. Duke of Devonshire coll., Chatsworth. [Warburg]

Andrea Schiavone, c.1522–**1563**. "Hercules Carries Cerberus from the Underworld." Painting. I. Brass coll., Venice. [Pigler 1974, p. 114]

Lorenzo Sabatini, c.1530–**1576**. "Hercules Carries Cerberus from the Underworld." Ceiling painting. Sala Ducale, Vatican, Rome. [Pigler 1974, p. 114]

Francesco da Sangallo, 1493–**1576**. "Hercules and Cerberus." Bronze sculpture. North Carolina Museum of Art, Raleigh. [Valentiner 1959, p. 42, pl. 13]

Paolo Farinati, 1524–**after 1606**. "Hercules Carries Cerberus from the Underworld." Drawing. Royal Library, Windsor Castle. [Pigler 1974, p. 114]

Peter Paul Rubens, 1577–**1640**. "Hercules and Cerberus." Painting, for Torre de la Parada, El Pardo, executed by Jan Boeckhorst (?) from Rubens's design. **1636–38**. Lost. [Alpers 1971, no. 29 / Jaffé 1989, no. 1279—ill.] Oil sketch. Prado, Madrid, no. 2043. [Alpers, no. 29a—ill. / Held 1980, no. 193—ill. / Jaffé, no. 1278—ill. / Prado 1985, pp. 593f.]

Jacob van Campen, 1595–1657. "Hercules Hauling Cerberus Out of the Underworld." Painting. c.1645. Rijksmuseum, Amsterdam, inv. A4254, on deposit at Museum Flehite, Amersfoort. [Rijksmuseum 1976, pp. 161f.—ill.]

Pierre Puget, 1620–1694. "Hercules Abducting Cerberus." Bronze sculpture. Modeled **1659–60**. Badisches Landesmuseum, Karlsruhe, inv. 64/161. [Herding 1970, no. 14—ill.]

Luca Giordano, 1634–1705. (Hercules and Cerberus in) "Allegory of Human Life and the Medici Dynasty." Fresco. **1682–83**. Palazzo Medici Riccardi, Florence. [Ferrari & Scavezzi 1966, 2:112ff.—ill.] Study. Denis Mahon coll., London. [Ibid.—ill.]

Max Beckmann, 1884–1950. "Perseus's [? or Hercules'?] Last Duty" (Perseus [or Hercules] wielding a sword, decapitated female figures, Cerberus [?] to one side). Painting. **1949**. Stanley J. Seeger, Jr. coll., Frenchtown, N.J. [Göpel 1976, no. 798—ill. / also Lackner 1977, 42—ill.]

Joyce Treiman, 1922–. "Cerberus." Painting. **1983**. Tortue Gallery, Los Angeles. [Personal communication to author from Mark Thistlethwaite, Texas Christian University, 1984]

HERMAPHRODITUS.

A handsome youth born from the union of Hermes and Aphrodite, Hermaphroditus attracted the attention of the beautiful spring-nymph Salmacis. The youth rejected her advances, but one day as Hermaphroditus bathed in her pool the nymph threw herself at him, clinging to him passionately. As Hermaphroditus struggled against her embraces, Salmacis begged the gods to keep them joined for all time. The gods acceded, and as the two bodies twisted in the water they became one, both male and female.

The hermaphrodite, or androgyne—a generic theme deriving indirectly from the myth of Hermaphroditus and Salmacis—was a popular theme in ancient art, especially in the Hellenistic period, and in the postclassical era particularly so among nineteenth-century *fin de siècle* poets and artists.

Classical Sources. Diodorus Siculus, *Biblioteca* 4.6.5. Ovid, *Metamorphoses* 4.285–388. Strabo, *Geography* 14.2.16. Martial, *Epigrams* 14.174.

Anonymous French. (Story of Hermaphroditus and Salmacis in) *Ovide moralisé* 4.1997–2389. Poem, allegorized translation/elaboration of Ovid's *Metamorphoses*. *c.*1316–28. [de Boer 1915–86, vol. 2]

Christine de Pizan, c.1364–c.1431. (Hermaphroditus and Salmacis in) *L'epistre d'Othéa à Hector* . . . [The Epistle of Othéa to Hector] chapter 82. Didactic romance in prose. *c.*1400. MSS in British Library, London; Bibliothèque Nationale, Paris; elsewhere. / Translated by Stephen Scrope (London: c.1444–50). [Bühler 1970 / Hindman 1986, p. 200]

Antonio Beccadelli, 1394–1471. *L'Hermafroditus.* Latin poem, dedicated to Cosimo de' Medici. Bologna: **1424**. [DELI 1966–70, 1:292f.]

Jan Gossaert, called Mabuse, c.1478–1533/36. "The Metamorphosis of Hermaphroditus and the Spring-nymph Salmacis." Painting. *c.*1516–17 or *c.*1521? Museum Boymans-van Beuningen, Rotterdam. [Rotterdam 1965, no. 16—ill. / de Bosque 1985, p. 270—ill.]

Baldassare Peruzzi, 1481–1536, design. "Salmacis and Hermaphroditus" (?). Fresco, for Villa Madama, Rome. **1521–23**. Later overpainted. [Frommel 1967–68, no. 58c.4—ill. (drawing)]

Girolamo Parabosco, c.1524–1557. *L'hermafrodito.* Comedy. Vinegia: Giolito de Ferrari, **1549**. [DELI 1966–70, 4:249]

Arthur Golding, 1536?–1605. (Story of Salmacis and Hermaphroditus in) *Ovids Metamorphosis* book 4 (London: **1565**, 1567). [Rouse 1961 / Logan & Smith 1978, p. 21 / Cambridge 1969–77, 1:1107]

Thomas Peend. *The Pleasant Fable of Hermaphroditus and Salmacis.* Narrative poem, after Ovid's *Metamorphoses.* London: Colwell, **1565**. [Bush 1963, pp. 299, 313f. / Logan & Smith 1978, p. 21 / Smith 1952, pp. 68f.]

Bartholomeus Spranger, 1546–1611. "Hermaphroditus and the Nymph Salmacis." Painting. *c.*1581. Kunsthistorisches Museum, Vienna, inv. 2614 (1502A). [Vienna 1973, p. 166—ill. / de Bosque 1985, pp. 266f.—ill.]

Christopher Marlowe, 1564–1593. (Salmacis evoked in) *Hero and Leander* 2.45–49. Poem, after Musaeus, unfinished. Licensed 1593. London: Blunt, 1598. [Bowers 1973, vol. 2]

Annibale Carracci, 1560–1609. "Salmacis and Hermaphroditus." Fresco. **1597–1600**. Galleria, Palazzo Farnese, Rome. [Malafarina 1976, no. 104m—ill. / Martin 1965, pp. 97f.—ill.]

Francis Beaumont, 1584/85–1616, attributed. *Salmacis and Hermaphroditus.* Poem. Published anonymously, London: Hodgets, **1602**. Modern edition by Gwyn Jones (London: Golden Cockerel, 1951, with engravings by

John Buckland-Wright). [Martindale 1986, p. 192 / Bush 1963, pp. 184–87 / DLB 1987, 58:5, 8 / Logan & Smith 1978, p. 21 / Smith 1952, pp. 69–74]

Carlo Saraceni, 1579–1620. "(Landscape with) Salmacis and Hermaphroditus." Painting. Probably before **1608.** Galleria di Capodimonte, Naples. [Ottani Cavina 1968, no. 44—ill. / Capodimonte 1964, p. 51]

Girolamo Preti, 1582–1626. "La Salmace." Idyll. In *Poesie* (Rome: Facciotti, **1614**). [DELI 1966–70, 4:452 / Praz 1925, p. 290]

Hendrik Goltzius, 1558–1617, composition. "Salmacis and Hermaphroditus Transformed into a Single Person." Engraving, part of a set illustrating Ovid's *Metamorphoses* (3d series, no. 12), executed by assistant(s). *c.*1615. Unique impression in British Museum, London. [Bartsch 1980–82, no. 0302.82—ill. / also de Bosque 1985, p. 267—ill.]

Scarsellino, 1551–1620. "Venus and Endymion" ("Salmacis and Hermaphroditus"). Painting. Galleria Borghese, Rome, no. 214. [Berenson 1968, p. 391—ill.]

Domenichino, 1581–1641. "Salmacis in a Landscape." Painting. Lost. / Copy by Carlo Maratti (1625–1713), recorded in 1712, unlocated. [Spear 1982, p. 311]

Giovanni Francesco Susini, ?–1646. "Hermaphroditus." Bronze sculpture. **1640–46.** Kunsthistorisches Museum, Vienna, inv. P.5672. [Hofmann 1987, no. 8.35—ill.]

Edward Sherburne, 1618–1702. "Salmacis." Poem. In *Salmacis, Lyrian and Silvia, Forsaken Lydia, The Rape of Helen* (London: Dring, **1651**). [Praz 1925, p. 290]

John Cleveland, 1613–1658. "Upon a Hermaphrodite." Poem. In *Poems, with additions never before printed* (London: for W. Shears, 1662). [Smith 1984, p. 272]

Francesco Albani, 1578–1660. "Salmacis and Hermaphroditus." Painting. Louvre, Paris, inv. 19. [Louvre 1979–86, 2:141—ill.]

———. "Salmacis and Hermaphroditus." Painting. Louvre, inv. 37, deposited in Musée, Saint-Quentin, in 1872, probably destroyed in World War II. [Louvre 1979–86, 2:283]

———. Further versions of the subject in Liechtenstein Collection, Vaduz; Galleria Borghese, Rome; Pinacoteca, Turin. [Pigler 1974, p. 235] Studio variant (after Rome or Turin). Kunsthalle, Hamburg, inv. 192. [Hamburg 1966, p. 17—ill.] Copy in Dulwich College Picture Gallery, London, cat. 1953 no. 458. [Wright 1976, p. 2]

Nicolas Poussin, 1594–1665, formerly attributed. "Salmacis and Hermaphroditus." Painting. Lost. / Engraving by Bernard Picart (1673–1733). [Thuillier 1974, no. R89]

Johannes Glauber, 1646–1726. "Arcadian Landscape with Salmacis and Hermaphroditus." Painting. Rijksmuseum, Amsterdam, inv. A1217. [Rijksmuseum 1976, p. 244—ill.]

Jean-François de Troy, 1679–1752. "Salmacis and Hermaphroditus." Painting. *c.*1730. Private coll., Paris. [Cleveland 1982, p. 145]

François Le Moyne, 1688–1737. "Salmacis and Hermaphroditus." Painting. Lost. [Bordeaux 1984, p. 130]

Henry Fuseli, 1741–1825. "Hermaphroditus." Drawing. **1795–1800.** Duke coll., London. [Schiff 1973, no. 1076—ill.]

Benjamin West, 1738–1820. "Salmacis and Hermaphroditus." Painting (possibly identical to a lost "Arethusa" of *c.*1802). Exhibited 1804. Lost. [von Erffa & Staley 1986, no. 154]

John Martin, 1789–1854. "Salmacis and Hermaphroditus." Painting. Exhibited **1814.** Unlocated. Mead Art Museum, Amherst College, Mass. [Seen by author 1986 / also Feaver 1975, pp. 23, 218 *n.*34] Another version of the subject, *c.*1822, unlocated. [Feaver, pl. 9]

François Dominique Aimé Milhomme, 1758–**1823.** "Hermaphroditus." Sculpture. Musée, Lille. [Bénézit 1976, 7:415]

Anne-Louis Girodet, 1767–**1824,** composition. "Hermaphroditus and Salmacis." Lithograph, part of "Loves of the Gods" cycle. Published Paris: Engelmann, 1825–26. [Boutet-Loyer 1983, no. 87 *n.*]

François-Joseph Bosio, 1769–**1845.** "Salmacis." Marble sculpture. Louvre, Paris. [Clapp 1970, 1:102]

Algernon Charles Swinburne, 1837–1909. "Hermaphroditus." Poem. **1862.** In *Poems and Ballads,* 1st series (London: Moxon, 1866). [Gosse & Wise 1925–27, vol. 1 / McGann 1972, pp. 150f., 204f. / Hyder 1970, pp. 24, 64]

Gabriele D'Annunzio, 1863–1938. (Hermaphroditus addressed in) "L'andrògine." Idyl. **1885–88.** In *La Chimera* (Milan: Treves, 1890). [Palmieri 1953–59, vol. 2]

———. (Hermaphroditus evoked in) *Il piacere* [The Child of Pleasure]. Novel. Milan: Treves, 1889. [Jullian 1973, pp. 61f. / Mutterle 1982, p. 126]

Joris-Karl Huysmans, 1848–1907. (Hermaphrodite theme in) *Là-bas.* Novel. Paris: Plon-Nourrit, **1891.** [Symons 1958, p. 77]

Joséphin Péladan, 1858–1918. *L'androgyne.* Novel. Paris: Plon-Nourrit, **1891**; frontispiece by Alexandre Séon. [DLLF 1984, 3:1728 / Praz 1956, pp. 325f.]

Aubrey Beardsley, 1872–1898. (Hermaphroditic figure in) Drawing for *Bon Mots of Smith and Sheridan* (London: Dent, **1893**). R. A. Harari coll., London. [Reade 1967, no. 200—ill.]

———. (Hermaphroditic figure in) Title-page drawing for edition of Oscar Wilde's *Salome* (London: Mathews & Lane; Boston, Copeland & Day, **1894**). Fogg Art Museum, Harvard University, Cambridge. [Ibid., no. 274—ill.]

———. (Hermaphroditic figure in) "The Mirror of Love." Drawing. *c.*1895. Victoria and Albert Museum, London. [Ibid., no. 386—ill.]

———. "Hermaphroditus." Drawing. Julian Sampson coll. in 1899. [Beardsley 1967, pl. 40]

Hugh McCulloch, 1869–1902. "Hermaphroditus." Poem. In *The Quest of Heracles* (Cambridge & Chicago: Stone & Kimball, **1894**). [Boswell 1982, p. 270]

Albert Samain, 1858–1900. "L'hermaphrodite." Poem. In *Au jardin de l'infante, augmenté de plusieurs poèmes* (Paris: Société du Mercure de France, **1900**). [Praz 1956, p. 372]

Stefan George, 1868–1933. (Hermaphrodite theme throughout) *Maximin.* Collection of poems. Berlin: Blätter für die Kunst, **1907.** [Butler 1958, pp. 323, 328–31]

———. (Hermaphrodite theme throughout) *Der siebente Ring* [The Seventh Ring]. Collection of poems. Berlin: Bondi, 1909. [Ibid., pp. 323, 328–31]

Elie Nadelman, 1882–1946. "Hermaphrodite." Bronze statuette. *c.*1906–08. Robert Schoelkopf Gallery, New York, in 1973. [Kirstein 1973, no. 75—ill.]

Dino Campana, 1885–1932. "Hermaphrodite." Poem. **1913.** In *Canti orfici* (Marradi: Ravagli, 1914). [Ipso]

Alberto Savinio, 1891–1952. *Hermaphrodito.* Novel. Flor-

ence: Libreria della Voce, **1918**. [DELI 1966–70, 5:59 / DULC 1959–63, 4:370]

Ossip Zadkine, 1890–1967. "Hermaphroditus." Bronze sculpture. **1920**. Private coll., Brussels. [Jianou 1979, no. 77]

————. "Hermaphroditus." Wood sculpture. 1936. [Ibid., no. 238]

Kenneth Hare, b. 1888. "Salmacis." Poem. In *New Poems* (London: Benn, **1923**). [Bush 1963, p. 573]

Max Ernst, 1891–1976. "Hermaphrodite." Surrealistic painting. c.**1934**. Private coll. [Spies & Metken 1975–79, no. 2130—ill.]

David Gascoyne, 1916–. "Venus Androgyne." Poem. In *Collected Poems* (London: Oxford University Press, **1965**). [Boswell 1982, p. 257]

Olav Anton Thommessen, 1946–. *Hermaphroditen* [The Hermaphrodite]. Chamber opera. First performed 28 July **1975**, Vadstena, Sweden [Baker 1992, p. 1876]

Giulio Paolini, 1940–. "Hermaphroditus." Photomontage with antique statue of Hermaphroditus. **1982**. [Villeurbanne 1983, p. 118—ill. / Bandini et al. 1985, pl. 36]

HERMES. One of the most complex of the Olympian deities, Hermes was the god of travelers, commerce, manual skill, eloquence, thieves, and the wind. He was the son of Zeus (Jupiter) and Maia, one of the Pleiades, and many of the traits by which he is known—from his oratorical skills to his cunning and thievery—are vividly illustrated in the summary of his early life, given in the Homeric Hymn to Hermes. The hymn also highlights the similarities between him and his half-brother and rival Apollo: both are pastoral deities with interests in flocks, music, and fertility.

Hermes' most important role is that of divine messenger, usually for Zeus. In this guise, he wears a winged hat and sandals (*talaria*) and carries a caduceus (herald's wand), which sometimes bears entwined snakes. According to differing accounts, Hermes invented the caduceus or received it from Apollo in exchange for his lyre or a shepherd's pipe, both of which he also invented. As the divine messenger he guides souls to the Underworld (with the epithet "psychopomp") and serves as emissary from the gods to mortals. He led the goddesses Athena (Minerva), Hera (Juno), and Aphrodite (Venus) to the Judgment of Paris, escorted Pandora to earth and Psyche to Olympus, helped Odysseus (Ulysses) on the islands of Calypso and Circe, commanded Aeneas to forsake Dido, and accompanied Zeus on his visit to Baucis and Philemon, among many other duties. He is also known as leader of the Graces.

Hermes united with Aphrodite, who bore him the child Hermaphroditus, and with Herse, daughter of King Cecrops of Athens, who bore him Cephalus (sometimes confused with the huntsman loved by

Eos). He is generally thought to be the father of Pan and of the Argonauts Autolycus (with Chione) and Eurytus. As a fertility god, he was often represented in antiquity by stone pillars with protruding phalluses.

Hermes may be among the earliest of the Greek gods; his name appears on a Linear B tablet from Pylos and his cult center was in the Peloponnesian province of Arcadia. He seems to have been absorbed directly into the Roman pantheon as Mercury (or Mercurius); no Italianate or pre-Roman cult to such a god has been discovered. His main function in the Roman context is as a god of commerce, and a festival of merchants was celebrated on 15 May at his temple on the Aventine.

Classical Sources. Homer, *Iliad* 24.334–469, 679–94; *Odyssey* 5.28–148, 10.275–308, 24.1–10. *Homeric Hymns,* "To Hermes," first hymn "To Demeter" lines 334–84. Aesop, *Fables,* "Hermes and the Dishonest Woodsman." Aeschylus, *Prometheus Bound* 1–1079. Sophocles, *Ichneutai* [*Searching Satyrs*] (lost satyr play, fragments). Euripides, *Ion* 1–18. *Orphic Hymns* 28, 57, "To Hermes." Eratosthenes, *Hermes.* Diodorus Siculus, *Biblioteca* 5.75.1–3. Virgil, *Aeneid* 4.219–78. Horace, *Odes* 1.10. Ovid, *Metamorphoses* 2.685–835, 8.618–724, 11.303–17. Apollodorus, *Biblioteca* 1.6.2–3, 2.1.3, 2.4.2–3, 3.2.1, 3.10.2, E3.5. Hyginus, *Fabulae* 195; *Poetica astronomica* 2.7, 2.16, 2.42. Lucian, *Dialogues of the Dead* 5, "Menippus and Hermes," 20, "Charon and Hermes"; *Dialogues of the Sea Gods* 11, "South Wind and West Wind"; *Dialogues of the Gods* 1, "Ares and Hermes," 2, "Pan and Hermes," 4, "Hermes and Maia," 7, "Zeus and Hermes," 11, "Hephaestus and Apollo," 12, "Poseidon and Hermes," 14, "Hermes and Helios," 16, "Hermes and Apollo," 17, "Hermes and Apollo," 21, "Apollo and Hermes," 25, "Apollo and Hermes." Philostratus, *Imagines* 1.26.

Further Reference. Norman Oliver Brown, *Hermes the Thief: The Evolution of a Myth* (Madison: University of Wisconsin Press, 1947).

Listings are arranged under the following headings:
General List
Infancy

See also AENEAS, and Dido; AMPHITRYON; BAUCIS AND PHILEMON; CREUSA; DIONYSUS, Infancy; EROS, Education; GODS AND GODDESSES; GRACES; HERSE AND AGLAURUS; IO; ODYSSEUS, Circe, Calypso; PANDORA; PARIS, Judgment; PERSEPHONE; PERSEUS, and Medusa; PROMETHEUS, Bound; PSYCHE; ZEUS.

General List

Christine de Pizan, c.1364–c.1431. (Mercury in) *L'epistre d'Othéa à Hector . . .* [The Epistle of Othéa to Hector] chapter 12. Didactic romance in prose. c.**1400**. MSS in British Library, London; Bibliothèque Nationale, Paris; elsewhere. / Translated by Stephen Scrope (London: c.1444–50). [Bühler 1970 / Hindman 1986, pp. 80, 85, 87, 89, 94, 130, 194, pls. 16, 26, 75, 79]

Francesco del Cossa, c.1435–1477, school. "Triumph of Mercury." Fresco, representing month of June. **1470**. Sala dei Mesi, Palazzo Schifanoia, Ferrara. [Berenson 1968, pp. 94, 131]

Sandro Botticelli, 1445–1510. (Mercury in) "The Prima-vera." Painting. *c.***1478.** Uffizi, Florence, inv. 8360. [Lightbown 1978, 1:73ff., no. B39—ill.]

Albrecht Dürer, 1471–1528. "Mercury." Drawing, copy after engraving for a set of Tarot cards (known as the "Tarocchi," attributed to Parrasio Michele da Ferrara, *c.*1470s). *c.***1494–95.** Louvre, Paris, no. 18.959. [Strauss 1974, no. 1494/22—ill.]

———. (Mercury as) "An Allegory on Eloquence." Draw-ing. 1514. Ambras Album, Kunsthistorisches Museum, Vienna. [Ibid., no. 1514/35—ill. / Wind 1938–39, pp. 211ff.]

Andrea Mantegna, 1430/31–1506. (Mercury in) "Parnas-sus" ("Mars and Venus"). Painting, for Studiolo of Isa-bella d'Este, Corte Vecchia, Mantua. **1497.** Louvre, Paris, inv. INV 370. [Lightbown 1986, p. 189, no. 39—ill. / Louvre 1979–86, 2:203—ill. / Wind 1948, pp. 9ff.—ill. / Paris 1975, no. 96—ill.]

———, composition. (Mercury, personifying the Arts and Sciences, redeems fallen Man, in) "Virtus combusta/ Virtus deserta." Pair of engravings. (Bibliothèque Na-tional, Paris.) [Paris, no. 115—ill. / also Borenius 1923, nos. 16–17—ill. / Panofsky 1956, p. 44—ill.]

——— and **Lorenzo Costa,** 1460–1535 (begun by Man-tegna, completed by Costa after Mantegna's death). (Mercury in) "The Reign of Comus" ("The Gate of Comus"). Painting. Louvre, Paris, inv. 256. [Louvre, 2:169—ill. / Lightbown 1986, no. 41—ill. / Paris, no. 128—ill. / Wind, pp. 46f., fig. 59]

Jacopo de' Barbari, *c.*1440/50–1516. (Mercury in) "View of Venice." Woodcut. **1500.** [Servolini 1944, pls. 87–89]

Baldassare Peruzzi, 1481–1536. "Mercury." Ceiling fresco, representing the planet and the constellation Scorpio. **1510–11.** Sala di Galatea, Villa Farnesina, Rome. [d'Ancona 1955, pp. 25f., 86 / Gerlini 1949, pp. 10ff. / also Frommel 1967–68, no. 18c]

———. "Mercury." Fresco. 1511–12 (or *c.*1517–18). Sala delle Prospettive, Villa Farnesina, Rome. [d'Ancona 1955, pp. 27ff., 93f. / Gerlini 1949, pp. 31ff. / also Frommel 1967–68, no. 51] Copy by Jean-Auguste-Dominique Ingres (1780–1867) in École des Beaux-Arts, Paris. [Wildenstein 1954, no. 68]

———. "Allegory of Mercury." Drawing. Louvre, Paris, inv. 1419. [Frommel, no. 125—ill.]

Giovanni Francesco Rustici, 1474–1554. "Mercury." Bronze fountain figure, for Palazzo Medici. *c.***1515.** Private coll., London. [Pope-Hennessy 1985b, 3:342—ill.]

Hans Sachs, 1494–1576. *Merkur, ein Gott der Kaufleut* [Mercury, a God of the Merchants]. Schwank. First performed **1526,** Nuremberg. [Hunger 1959, p. 150]

Giulio Romano, *c.*1499–1546, assistant, after design by Giulio. "Mercury before Jupiter, Juno, and Neptune." Stucco relief. **1527–28.** Sala delle Aquile, Palazzo del Tè, Mantua. [Verheyen 1977, p. 121 / Hartt 1958, p. 125, fig. 57] Mercury also depicted in Sala dei Venti, Sala delle Stuc-chi. [Verheyen, pp. 119f., 123f. / Hartt, pp. 115ff.]

———. "Mercury." Fresco (simulated statue). 1540–44. Casa Giulio Romano, Milan. [Hartt, p. 240, fig. 493]

———. "Mercury." Drawing (modello for unknown or unexecuted fresco?). British Museum, London, no. Ff. 1–40. [Hartt, p. 308 (no. 356)—ill.]

Antico, *c.*1460–**1528.** "Mercury." Bronze statuette (in-complete: presumed figure of Cupid missing; formerly

known as "Mercury Teaching Cupid to Read"). Kunst-historisches Museum, Vienna. [Paris 1975, no. 60]

Alfonso de Valdés, 1490?–1532 (formerly attributed to Juan de Valdées). *Diálogo de Mercurio y Carón.* Satirical prose dialogue. Rome: **1529.** Modern edition by Rosa Novarro Durán (Barcelona: Planeta, Clasicos Univer-sales Planeta, 1987). / Translated by Joseph V. Ricapito as *Dialogue of Mercury and Charon* (Bloomington: Indi-ana University Press, 1986). [Ipso / Oxford 1978, p. 587 / Bleznick 1972, p. 42]

Dosso Dossi, *c.*1479–1542. "Jupiter, Mercury, and 'Virtue' [or the Virgin]." Painting, after a dialogue of Lucian (or interpolation by L. B. Alberti?). **Late 1520s?** Kunsthis-torisches Museum, Vienna, no. 9110. [Gibbons 1968, no. 78—ill. / Vienna 1973, p. 56—ill. / also Berenson 1968, p. 114—ill.] Variant copy, by Luca da Reggio (1605–1654), in Bonfadini coll., Venice. [Gibbons]

Agnolo Bronzino, 1503–1572, attributed (with others?). "Mercury." Fresco. **1530–32.** Sala dei Semibusti, Villa Imperiale, Pesaro. [Baccheschi 1973, no. 13]

Girolamo Romanino, *c.*1484/87–*c.*1562. "Mercury and Other Gods." Fresco. **1531–32.** Castello del Buonconsiglio, Trento. [Berenson 1968, pp. 369f.]

Hans Baldung Grien, 1484/85–1545. "Mercury as God of the Planets, and a Lioness." Painting, panel from astro-nomical clock. *c.***1533.** Nationalmuseum, Stockholm, inv. 1073. [Osten 1983, no. 77a, pl. 163]

Francesco Primaticcio, 1504–1570. "Mercury Conducting the Shades to Hades." Fresco, for Chambre du Roi, Château de Fontainebleau. **1533–35.** Destroyed. [Di-mier 1900, pp. 256ff.]

Andrea Schiavone, *c.*1522–1563. "Mercury." Etching. *c.***1538?** [Richardson 1980, no. 71]

———. "Mercury." Etching. *c.*1536–40. [Ibid., no. 99]

Jacopo Sansovino, 1486–1570. "Mercury." Bronze statu-ette. **1540–45.** Loggetta, Piazza San Marco, Venice. [Pope-Hennessy 1985b, 3:79f., 404f.]

Benvenuto Cellini, 1500–1571. "Mercury." Bronze statu-ette. **1546–53.** Formerly in base of "Perseus" statue, Loggia dei Lanzi, Florence, now in Museo Nazionale, Florence. [Pope-Hennessy 1985a, pp. 174f.—ill. / also Pope-Hennessy 1985b, 3:99, 371—ill.]

Niccolò dell' Abbate, 1509/12–1571? attributed. (Mercury in) "Ceres and the Gods." Drawing. *c.***1552–56.** Musée Pincé, Angers. [Paris 1972, no. 12—ill. / also Lévêque 1984, p. 195—ill.]

Paris Bordone, 1500–1571. "A Young Hero Armed by Bellona [or Minerva?] and Mercury." Painting. **1550s.** Kress coll. (K1631), Birmingham Museum of Art, Ala., no. 61.117. [Shapley 1966–73, 3:36—ill.]

Giambologna, 1529–1608. "Allegory of Prince Francesco de' Medici" ("The Child of Cybele") (Prince led by Mercury to Ceres/Abundance/Cybele). Alabaster relief. *c.***1560–61.** Prado, Madrid, no. 296E. [Avery 1987, no. 145—ill. / Avery & Radcliffe 1978, no. 121—ill.] Bronze and silver versions. Kunsthistorisches Museum, Vienna, nos. 5814, 1195; Museo del Bargello, Florence, no. 128. [Avery & Radcliffe, nos. 118–20—ill. / also Avery, nos. 146–47—ill.]

———. "Mercury." Bronze statue, for Emperor Maximil-lian II. *c.*1564–65. Presumed lost, but possibly identical with a work in a Swedish private coll. (or in Kunsthis-

torisches Museum, Vienna, no. 5898). [Avery, no. 30—ill. (cf. no. 73)] Bronze model (?). Museo Civico, Bologna. [Ibid., no. 68—ill. / Avery & Radcliffe, no. 33—ill.] Replicas and variants, by Giambologna and studio. *c.*1575?–80. Kunsthistorisches Museum, Vienna (2, cf. above); Museo di Capodimonte, Naples, no. 10784; Grünes Gewölbe, Dresden; Museo del Bargello, Florence. [Avery & Radcliffe, nos. 34–35—ill. / also Avery, nos. 34, 44, 72–73—ill. / Hofmann 1987, no. 1.34—ill. / Capodimonte 1964, p. 110, pl. 144 / Agard 1951, fig. 44] At least 4 further versions, by Giambologna (?), Giovanni Francesco Susini, others? [Avery & Radcliffe, no. 35 *n.* / Wildenstein 1968, no. 52—ill.]

Paolo Veronese, 1528–1588. "Venus and Mercury before Jupiter" (with an infant—Cupid? Aeneas?). Painting. *c.***1560–62.** Formerly Contini-Bonacossi coll., Florence. [Pallucchini 1984, no. 74—ill. / Pignatti 1976, no. 117—ill.]

Taddeo Zuccari, 1529–**1566.** "Mercury Attending a Concert with Dancing Nymphs, Led by Diana, at Sunrise." Fresco. Villa Giulia, Rome. [de Bosque 1985, p. 41—ill.]

——. "Life of Mercury." Fresco cycle, on façade of Casa Mattiuolo, Rome. Destroyed. [Stechow 1940, p. 105]

Jacopo Zucchi, *c.*1541–1589/90. "Mercury." Ceiling painting. *c.***1572.** Sala delle Carte Geografiche, Uffizi, Florence. [Uffizi 1979, no. S106—ill.]

Jacopo Tintoretto, 1518–1594. "The Three Graces and Mercury." Painting. **1577–78.** Sala dell' Anti-Collegio, Palazzo Ducale, Venice. [Rossi 1982, no. 373—ill. / Berenson 1957, p. 179]

Balthasar de Beaujoyeulx, ?–*c.*1587, choreography. (Mercury in) *Ballet comique de la reine* act 3. Ballet. Music, Lambert de Beaulieu, Jacques Salmon, Beaujoyeulx, et al. Libretto, La Chesnaye. First performed 15 Oct **1581,** Palais Bourbon, Paris; scenery and costumes, Jacques Patin. [Simon & Schuster 1979, p. 43 / Arnott 1977, p. 105 / Clarke & Vaughan 1977, p. 42 / Terry 1976, p. 4]

Pierre de Ronsard, 1524–1585. "Hymne de Mercure." Poem. **1585.** In *Hymnes* (Paris: Buon, 1587). [Laumonier 1914–75, vol. 18, pt. 1 / Cave 1973, p. 195 / McFarlane 1973, p. 71]

Hendrik Goltzius, 1558–1617. "Head of Mercury." Drawing. **1587.** Ashmolean Museum, Oxford. [Reznicek 1961, no. 119—ill. / de Bosque 1985, pp. 87, 90—ill.]

——. "Mercury and Minerva." Drawing, composition for print. 1588. Landolt coll., Chur. (Print by Jacob Matham, Bartsch no. 281.) [Reznicek, no. 134—ill.]

——. "Mercury." Engraving, in "Eight Deities" series, after (lost) chiaroscuro frescoes by Polidoro da Caravaggio (*c.*1498–1543). 1592. 4 states. [Strauss 1977a, no. 296—ill. / Bartsch 1980–82, no. 254—ill.]

——. "[Statue of] Mercury as Protector of Rhetoric, Fine Arts, and Commerce." Drawing, composition for print in "Seven Planets" series. 1595–96. Prentenkabinet, Rijksuniversiteit, Leiden, inv. Welcker 257. (Engraved by Jan Saenredam, Bartsch no. 74.) [Reznicek, no. 146—ill.] Variant, for second ("small") series, 1597. Unlocated. (Engraved by Jacob Matham, Bartsch no. 154.) [Ibid., no. 152]

——. "Mercury (the Artist)." Painting. 1611. Mauritshuis, The Hague, inv. 44, on loan to Frans Hals Museum, Haarlem. [Mauritshuis 1985, p. 366—ill. / de Bosque, p. 140—ill.]

——. "Mercury." Painting. Hermitage, Leningrad. [Bénézit 1976, 5:96]

Bartholomeus Spranger, 1546–1611. "Venus and Mercury." Painting. *c.***1580s.** Kunsthistorisches Museum, Vienna, inv. 1100 (1501). [Vienna 1973, p. 166]

——. "Mercury and Minerva." Painting. Národní Galeri, Prague. [de Bosque 1985, p. 115—ill.]

William Vallans, fl. 1578–90. (Mercury in) *A Tale of Two Swannes.* Poem with prose. London: for J. Sheldrake, **1590.** [Bush 1963, p. 320]

Edmund Spenser, 1552?–1599. (Mercury brings ark with prince's ashes to heaven in) "The Ruines of Time" lines 666ff. Poem. In *Complaints* (London: Ponsonbie, **1591**). [Oram et al. 1989]

——. (Mercury sent by Jove to warn the lion of the usurping ape in) "Prosopopoia; or, Mother Hubberds Tale" lines 1225–70. Poem. In *Complaints* (1591). [Ibid.]

Christopher Marlowe, 1564–1593. (Mercury in) *Hero and Leander* 1.386–484. Poem, after Musaeus, unfinished. Licensed **1593.** London: Blunt, 1598. [Bowers 1973, vol. 2 / Hulse 1981, pp. 31, 99, 115–19, 131 / Leech 1986, pp. 180f. / Levin 1952, p. 143]

Adam Elsheimer, 1578–1610. "A Painter Presented to Mercury" (as patron of the visual arts). Painting. **1595.** Herzog Anton Ulrich-Museum, Braunschweig, inv. 070. [Andrews 1977, no. 30—ill.]

Antoine Caron, 1520/21–**1599.** (Mercury and other gods in) "The Triumph of Winter." Painting. Private coll., Paris. [Paris 1972, no. 35—ill.]

Italian School. "Mercury." Bronze statue. **16th century.** National Gallery. Washington, D.C., no. A–1699. [Sienkewicz 1983, p. 34—ill.]

Ben Jonson, 1572–1637. (Mercury in) *Cynthia's Revels, or, The Fountaine of Selfe-Love.* Satirical comedy. First performed Blackfriar's Theatre, London, **1600–01.** Published London: 1601. [Herford & Simpson 1932–50, vol. 4 / McGraw-Hill 1984, 3:109, 112]

——. (Mercury in) "The Entertainment at Highgate" ("The Penates"). Royal entertainment for James I and Queen Anne. Performed 1 May 1604 at house of Sir William Cornwallis, Highgate, London. Published London: 1616. [Herford & Simpson, vol. 7]

——. (Mercury in) "An Entertainment of the King and Queen at Theobalds." Royal entertainment for James I and Queen Anne. Performed 22 May 1607, Theobalds House, London. Published London: 1616. [Ibid.]

——. *Mercury Vindicated from the Alchemists (at Court).* Masque. Performed 6 Jan 1615, at Court, London. Published London: 1616. [Ibid. / McGraw-Hill 1984, 3:111, 113 / Barton 1984, pp. 136f., 239]

——. (Mercury in) *Lovers Made Men (The Masque of Lethe).* Masque. Performed 22 Feb 1617, at Court, London. Published London: 1617. [Herford & Simpson]

——. (Mercury in) *Pleasure Reconciled to Virtue.* Masque. Performed 6 Jan 1618, at Court, London. Published London: 1640. [Ibid. / McGraw-Hill 1984, 3:112f.]

Alessandro Vittoria, 1525–**1608.** "Mercury." Bronze statuette, surmounting andiron. Metropolitan Museum, New York. [Clapp 1970, p. 895]

Federico Zuccari, 1540/43–**1609.** "Self-Portrait as Mer-

cury." Fresco. Villa d'Este, Tivoli. [de Bosque 1985, p. 42—ill.]

William Shakespeare, 1564–1616. (Autolycus compares himself to Mercury in) *The Winter's Tale* 4.3.24–26. Drama (romance). **1610–11.** First recorded performance 15 May 1611, Globe Theatre, London. Published London: Jaggard, 1623 (First Folio). [Riverside 1974 / Davies 1986, p. 157]

Palma Giovane, *c.*1548–1628. "Mercury and the Three Graces." Painting. **1611.** Private coll., Switzerland. [Mason Rinaldi 1984, no. 300—ill.]

Thomas Heywood, 1573/74–1641. (Mercury in) *The Silver Age.* Drama, partially derived from Heywood's *Troia Britanica* of 1609. First performed *c.*1610–12, London. Published London: Okes, 1613. [Heywood 1874, vol. 3 / DLB 1987, 62:101, 122ff. / also Boas 1950, pp. 83ff. / Clark 1931, pp. 62ff.]

———. (Mercury, with Jupiter and Plutus, in) "The Manhater." Poetic dialogue, translation of Lucian's "Misanthropos." No. 4 in *Pleasant Dialogues and Drammas* (London: 1637). [Heywood 1874, vol. 6]

———. (Mercury complains that he is overtaxed by Jupiter's demands, in) "Mercury and Maia." Poetic dialogue, translated from Lucian. No. 10 in *Pleasant Dialogues and Drammas* (1637). [Ibid.]

Adriaen de Vries, *c.*1550–1626. "Mercury." Bronze statue. **1603–13.** National Gallery, Washington, D.C., no. A–20. [Sienkiewicz 1983, pp. 29f.—ill. / also Walker 1984, fig. 954]

Lodovico Cardi, called il Cigoli, 1559–**1613,** attributed. "Figure of Mercury." Painting. City Museum and Art Gallery, Plymouth. [Wright 1976, p. 37]

Jacopo Peri, 1561–1633. "La speranza guidata da Mercurio" [Hope Guided by Mercury]. Intermedio, for Gabriello Chiabrera's *Veglia delle grazie.* First performed 16 Feb **1615,** Palazzo Pitti, Florence. [Grove 1980, 14:404]

Giovanni Battista Marino, 1569–1625. (Mercury in) *L'Adone.* Poem. Paris: Varano, **1623.** [Bondanella 1979, p. 320 / Vinge 1967, pp. 207–11]

Peter Paul Rubens, 1577–1640. (Mercury in) "The Education of Marie de' Medici," "The Apotheosis of Henri IV and the Assumption of the Regency by Marie de' Medici," "The Council of the Gods" ("The Government of the Queen"), "The Meeting of the Queen with Louis XIII at Angoulême" ("The Treaty of Angoulême"), "Temple of Peace" ("Conclusion of the Peace"); (Marie with Mercury's caduceus in) "Peace Is Confirmed in Heaven" ("The (Final) Reconciliation (of the Queen and Her Son)"). Paintings, part of "Life of Marie de' Medici" cycle. **1622–25.** Louvre, Paris, inv. 1771, 1779, 1780, 1786–88. [Saward 1982, pp. 40ff., 98ff., 114ff., 166ff., 168f., 174f.—ill. / Jaffé 1989, no. 716, 735, 750, 752, 754—ill. / also Louvre 1979–86, 1:115–18—ill. / White 1987, pl. 186 / Baudouin 1977, pl. 45] Oil sketches. Alte Pinakothek, Munich, inv. 92, 102, 103, 107, 108 (all); Simson coll., Freiburg ("Education"); Hermitage, Leningrad ("Apotheosis"). [Jaffé, nos. 714, 715, 733, 734, 736, 751, 753—ill. / Munich 1983, pp. 463ff.—ill. / Held 1980, nos. 58–59, 69–60, 71, 79—ill.]

———. "The Glorification of the Duke of Buckingham" ("Minerva and Mercury Conduct the Duke to the Temple of Virtue"). Ceiling painting, for George Villiers, Duke of Buckingham. *c.*1625–27. Formerly Osterley Park,

destroyed 1949. [Jaffé, no. 795—ill.] Oil sketch. National Gallery, London, inv. 187. [Ibid., no. 794—ill. / Held 1980, no. 291—ill. / also London 1986, p. 545—ill.] Copy of lost early sketch, formerly Reyve coll., London, unlocated. [Jaffé, no. 793 / Held, no. 290—ill.]

———. "Mercury." 2 drawings, designs for statuette (lost). Before 1628. Fogg Art Museum, Harvard University, Cambridge; Print Room, Copenhagen. [Alpers 1971, p. 234]

———. (Mercury in) "The Peaceful Reign of King James I." Ceiling painting, for Banqueting House, Whitehall, London. 1633–34. In place. [Jaffé, no. 1010, p. 71—ill.] Oil sketch. Akademie der Bildenden Künste, Vienna, inv. 628. [Ibid., no. 1007—ill. / Held 1980, no. 130—ill. / White, pl. 275 / Baudouin, fig. 124] Oil sketch, study for Mercury and another figure ("Mercury and a Sleeping Herdsman"). Museum of Fine Arts, Boston, inv. 42.179. [Held, no. 139—ill. / Jaffé, no. 1014—ill. / Boston 1985, p. 253—ill.]

———. (Mercury in) "Philip IV Appoints Prince Ferdinand Governor of the Netherlands" ("The Apotheosis of Isabella Clara Eugenia"). Painting, executed by Gerard Seghers from Rubens's design, part of Stage of Isabella, for "Pompa Introitus Fernandi," 1634. Largely destroyed; fragment (not including Mercury) in Rubenshuis, Antwerp. [Martin 1972, no. 35, fig. 66 (print) / Jaffé, no. 1142—ill.] Oil sketch, by Rubens. Pushkin Museum, Moscow, inv. 2626. [Martin, no. 34a—ill. / also Held 1980, no. 158—ill. / Jaffé, no. 1141—ill.]

———. "Mercury Departing from Antwerp." Painting, executed by Theodoor van Thulden from Rubens's design, part of Stage of Mercury, decoration for "Pompa Introitus Fernandi," triumphal entry of Cardinal-Infante Ferdinand of Spain into Antwerp, 17 Apr 1635. Original decoration destroyed; painting formerly Royal Palace, Brussels, destroyed 1731. [Martin, pp. 178ff.—ill. (print) / Jaffé, no. 1157] Copy in Nationalmuseum, Stockholm, no. 597. [Martin, no. 47—ill.] Oil sketch of entire decoration. Hermitage, Leningrad, inv. 501 (565). [Ibid., no. 46a—ill. / Held 1980, no. 162—ill. / Jaffé, no. 1156—ill.]

———. (Herm of Mercury in) Oil sketch, design for title page of *Pompa Introitus Fernandi,* commemorative book (Antwerp: 1641–42). *c.*1635. Fitzwilliam Museum, Cambridge, inv. F.M. 240. [Held 1980, no. 306—ill. / Baudouin 1977, fig. 139 (print) / also Jaffé, no. 1183—ill.]

———, composition. (Mercury in) Frontispiece for *Justus Lipsius, opera omnia* (Antwerp: 1637). Engraved by Cornelis Galle. [Baudouin, fig. 160]

———. "Mercury." Painting, for Torre de la Parada, El Pardo. 1636–38. Prado, Madrid, no. 1677. [Alpers 1971, no. 39—ill. / Jaffé, no. 1299—ill.] Copy, by Juan Bautista del Mazo (*c.*1612–1667), in Prado, no. 1708. [Alpers]

Nicolas Poussin, 1594–1665. "Venus and Mercury." Painting (allegory of the sovereignty of beauty and spiritual love in the arts?). **Mid-1620s.** Dulwich College Picture Gallery, London, no. 481. [Thuillier 1974, no. 32—ill. / Blunt 1966, no. 184—ill. / Wright 1985, no. 12, pl. 6] A fragment ("Concert of Love" [cupids playing music]) in the Louvre, Paris, inv. 7299. [Thuillier—ill. / Blunt—ill. / Wright—ill. / Louvre 1979–86, 4:145—ill.] Copies in Musée de Lille; Museo Communale, Prato; 2 others known. [Blunt]

———, formerly attributed. (Venus, Bacchus, Mercury,

and Cupid, representing) "The Four Seasons Dancing to the Music of Apollo's Lute." Presumed painting, known from an engraving by J. Avril, 1779. [Blunt, no. R56 / also Thuillier, no. R54—ill.]

Claudio Monteverdi, 1567–1643. *Mercurio e Marte* [Mercury and Mars]. Musical "torneo" [tournament]. Text, C. Achillini. First performed **1628**, Parma. Music lost. [Grove 1980, 12:530 / Redlich 1952, p. 105]

John Donne, 1572–**1631**. "Mercurius Gallo-Belgicus." Epigram. In *Poems* (London: Marriot, 1633). [Patrides 1985]

Thomas Carew, 1594/95–1639/40. (Mercury in) *Coelum Britannicum*. Satirical masque. First performed 18 Feb **1634**, Inns of Court, London; settings, Inigo Jones. [Altieri 1989, pp. 339f., 342f.]

Jacob Jordaens, 1593–1678. "Mercury." Drawing. *c.*1630–35. Stedelijk Prentenkabinet, Antwerp. [d'Hulst 1982, fig. 117]

———. 8 cartoons for "The Riding School" tapestry series: "Levade Performed under the Auspices of Mars and in the Presence of Mercury," "Levade Performed under the Auspices of Mars and in the Presence of Mercury, Venus, and a Riding-Master," "Mars and Mercury Leading Horses to Venus," 5 others (4 lost). *c.*1645. National Gallery of Canada, Ottawa; Marquess of Bath coll., Longleat, Wiltshire (2). [d'Hulst, pp. 232, 303, fig. 184] Tapestries woven by Leyniers & Rydams, Brussels, 1651. Kunsthistorisches Museum, Vienna. [Ibid., pp. 303f., fig. 185 / Ottawa 1968, no. 281—ill.]

———. "Commerce [Mercury] and Industry Protecting Art." Painting. *c.*1665. Koninklijk Museum voor Schone Kunsten, Antwerp, no. 219. [d'Hulst, p. 263, pl. 228 (drawing) / Antwerp 1970, p. 114]

———, attributed. "Mercury and the Daughters of Dryops." Painting. G. Falck coll., Copenhagen. [Rooses 1908, p. 259]

———, attributed. "Bust of Mercury." Painting. Sold Brussels 1901, unlocated. [Ibid.]

Cornelis Cornelisz van Haarlem, 1562–**1638**. "Mercury." Drawing. University Art Museum, Gottingen. [Warburg]

Simon Vouet, 1590–1649. "Mercury and the Three Graces." Painting. Lost. / Engraved by Michel Dorigny, **1642**. [Crelly 1962, p. 228—ill.]

Pietro da Cortona, 1596–1669. "Mercury (Announces Peace to Mankind)." Fresco. **1642–44**. Sala di Giove, Palazzo Pitti, Florence. [Campbell 1977, pp. 127, 133—ill. / Briganti 1962, no. 95—ill. / also Pitti 1966, p. 48—ill.] Copy by Jacob Ennis (1728–1770), in National Gallery of Ireland, Dublin, no. 4127. [Dublin 1981, p. 204—ill.]

Jan Brueghel the Younger, 1601–1678. (Mercury in Venus's chariot in) "Allegory of the Topsy-Turvy World." Painting. **Late 1640s?** 3 versions known, unlocated. [Ertz 1984, nos. 224–26—ill.]

Antoine Furetière, 1619–1688. *Le voyage de Mercure*. Satire in verse. Paris: Chamhoudry, **1653**. [DLLF 1984, 1:857]

Gerrit van Honthorst, 1590–**1656**. "Mercury and a Nymph." Painting. Sold Cologne, 1920, unlocated. [Judson 1959, no. 88]

Salvator Rosa, 1615–1673. "(Landscape with) Mercury and the (Dishonest) Woodman." Painting, after Aesop. *c.***1655–60**. National Gallery, London, no. 84. [Salerno

1975, no. 145—ill. / London 1986, p. 536—ill.] 2 other versions known, unlocated. [Salerno]

———, attributed (previously attributed to J. F. van Bloemen). "Mercury and the Woodman." Painting. National Museum of Wales, Cardiff, cat. 1972 no. 616. [Wright 1976, p. 175]

Nicolaus Knupfer, *c.*1603–*c.*1660. "Mercury Conducting Happiness from the Earth." Painting. Statens Museum for Kunst, Copenhagen. [Copenhagen 1951, no. 266—ill.]

Giovanni Felice Sances, *c.*1600–1679. *Mercurio esploratore* [Mercury the Explorer]. Opera. Prologue and intermezzos, G. A. Cicognini. Libretto, Amalteo. First performed 21 Feb **1662**, Vienna. [Grove 1980, 16:462]

Jean de La Fontaine, 1621–1695. "Le Bûcheron et Mercure" [The Woodman and Mercury]. Verse fable (book 5 no. 1), after Aesop. In *Fables choisies* (Paris: **1668**). [Clarac & Marmier 1965 / Spector 1988 / Moore 1954]

Jean-Baptiste de Champaigne, 1631–1681. "Mercury in a Chariot Pulled by Cocks." Ceiling painting. **Early 1670s.** Salon de Mercure, Appartement du Roi, Château de Versailles. [Berger 1985, pp. 41ff., 69, fig. 73]

Michel Corneille the Younger, 1642–1708. "Mercury Bestowing His Influence on the Arts and Sciences." Ceiling painting. **Early 1670s.** Salon de Mercure (Salon de la Reine), Appartement de la Reine, Château de Versailles. [Berger 1985, pp. 41ff., 70, fig. 80]

Francesco Antonio Arezzo, ?–**1672**. *Mercurio*. Comedy. First performed Palermo? [EDS 1954–66, 1:810]

Jacob van der Ulft, 1627?–1689. "Mercury." Drawing. **1680**. Musée Royal de Beaux-Arts, Brussels, cat. 1913 no. 3688. [Warburg]

Anne Mauduit de Fatouville. *Arlequin Mercure galant*. Comedy. First performed Jan **1681**, Hôtel Bourgogne-Italien, Paris. Published Paris: 1694. [Lancaster 1929–42, pt. 4, 2:523f., 605–08, 649f., 952]

Pierre Beauchamps, 1631–1705, music. "Mercure." Entrée in *Ballet des arts*. First performed **1685**, Collège Louis-le-Grand, Paris. [Astier 1983, p. 161]

Antonio Draghi, 1634/35–1700. Prologue to *Le nozze di Mercurio* [The Marriage of Mercury]. Opera. **1685**. [Grove 1980, 5:604]

Ferdinando Tacca, 1619–1686. "Mercury and Juno" ("Juno Seated, with Mercury Uncovering a Vase Held in His Left Arm"). Bronze statuette. 3 examples known. Museum, Nuremburg; Walker Art Gallery, Liverpool; Petit-Hory coll., Paris. [Florence 1986, no. 4.35—ill.]

Albert Meyeringh, 1645–1714. "Ideal Landscape with Flying Mercury" ("Mercury and Herse"). Painting. **1686**. Herzog Anton Ulrich-Museum, Braunschweig, no. 398. [Braunschweig 1976, p. 41 / Braunschweig 1969, p. 95]

Ignaz Bendl, ?–*c.*1730. "Mercury." Fountain figure. **1693**. Brno, Czechoslovakia. [Clapp 1970, 1:78]

Corneille van Clève, 1644/45–1735. "Mercury." Marble term. **1684–97**. Parterre de Latone, Gardens, Versailles. [Girard 1985, p. 283—ill.]

Vicente Salvador Gómez, 1645?–**1698?** "Mercury" with other figures. Drawing. Biblioteca Nacional, Madrid. [López Torrijos 1985, p. 423 no. 12—ill.]

Johann Karl Loth, 1632–**1698**. "Mercury." Painting. Herzog Anton Ulrich-Museum, Braunschweig, no. 1117. [Braunschweig 1969, p. 91]

Sebastiano Ricci, 1659–1734. "Mercury." Ceiling fresco (detached), part of "Olympian Gods" cycle, from Palazzo Mocenigo-Robilant, Venice. **1697–99.** Gemäldegalerie, Berlin-Dahlem, on loan from German government. [Daniels 1976, no. 44—ill. / Berlin 1986, p. 64—ill.]

Antoine Coysevox, 1640–1720. "Mercury." Equestrian marble sculpture. **1690s.** Jardins des Tuileries, Paris. [Agard 1951, fig. 56 / Molesworth 1965, p. 235]

John Nost, fl. 1678–1729. "Mercury." Garden sculpture, after Giambologna (c.1564–65). **c.1699–1705.** Melbourne Hall, Derbyshire. [Whinney 1964, p. 61]

Gabriel Grupello, 1644–1730. "Mercury." Life-size marble statue. **1700–09.** Park, Schloss Schwetzingen. [Kultermann 1968, no. 138—ill.]

————. "Mercury." Marble relief. Kunstmuseum, Düsseldorf. [Ibid., no. 155—ill.]

Matthew Prior, 1664–1721. "Mercury and Cupid." Poem. In *Poems on Several Occasions* (London: Tonson, **1709**). Modern edition by A. R. Waller (Cambridge: Cambridge University Press, 1905). [Ipso]

François Girardon, 1628–1715, attributed. "Mercury." Marble bust. Formerly (1798) Louvre, Paris, lost. [Francastel 1928, no. 94]

Paul Egell, 1691–1752. "Hermes." Sandstone statue. *c.*1717. Mathematischer Pavillon, Zwinger, Dresden. [Asche 1966, no. E3, pl. 300]

Benjamin Thomae, 1682–1751. "Mercury." Sandstone statue. *c.*1716–18. Kronentor, Zwinger, Dresden. [Asche 1966, no. T19, pl. 158]

Jacob de Wit, 1695–1754. "Mercury Steals Venus's Girdle." Ceiling painting, for N. Keizersgracht 58, Amsterdam. **1726.** Sold 1897. [Staring 1958, p. 146] Drawing. Rijksprentenkabinet, Amsterdam. [Ibid., pl. 72]

————. "Mercury Bringing a Hero before Venus." Painting. Rijksmuseum, Amsterdam, inv. A4659. [Rijksmuseum 1976, p. 609—ill.]

Jean-Philippe Rameau, 1683–1764. *Mercure.* Cantata. First performed 22 Nov **1728,** L'Opéra, Paris. [Girdlestone 1983, p. 78]

————. (Mercury in) *Platée, ou, Junon jalouse* [Platée, or, Juno Jealous]. Opera (comédie lyrique). Libretto, J. Autreau and A. J. Le Valois d'Orville. First performed 31 Mar 1745, Versailles. [Ibid., pp. 412–55 / Grove 1980, 15:564, 566, 570]

Paul Heermann, 1673–1732. "Mercury and Apollo." Marble sculpture. **1729.** Museum für Geschichte, Leipzig. [Asche 1966, no. H30]

Matthias Bernard Braun, 1684–1738. "Mercury." Sculpture. *c.*1730. Libechov, Czechoslovakia. [Clapp 1970, 1:112]

Corneille van Clève, 1644/45–1735. "Mercury." Sculpture. Trianon, Versailles. [Bénézit 1976, 3:68]

Henry Fielding, 1707–1754. "An Interlude between Jupiter, Juno, Apollo, and Mercury." Comic interlude. *c.*1736–37. In *Miscellanies,* vol. 1 (London: Millar, 1743). Modern edition by H. K. Miller (Middletown, Conn.: Wesleyan University Press, 1972). [Nicoll 1959–66, 2:328]

Pompeo Batoni, 1708–1787. (Mercury in) "The Triumph of Venice." Painting. **1737.** North Carolina Museum of Art, Raleigh. [Clark 1985, no. 13—ill.]

————. "Mercury Crowning Philosophy, Mother of the Arts." Painting. 1745–47. Hermitage, Leningrad, no. 3734. [Ibid., no. 110—ill.]

Karel de Moor, 1656–1738. "Mercury and Abundance" ("Portrait of a Merchant as Mercury, with His Family"). Painting. Louvre, Paris, inv. 1581. [Louvre 1979–86, 1:94—ill.]

Georg Raphael Donner, 1693–1741. "Mercury." Lead statuette. **1730s.** Numerous examples. Hermitage, Leningrad, inv. 1896; elsewhere. [Hermitage 1984, no. 377—ill.]

Andrea Locatelli, 1695–1741. "Landscape with Mercury and the Woodsman." Painting. Staatliche Kunstsammlungen, Kassel. [Bénézit 1976, 6:709]

Jean-Baptiste Pigalle, 1714–1785. "Mercury Fastening His Talaria." Marble statue. **1744.** Louvre, Paris, no. 1442. [Réau 1950, no. 1, pl. 3] Original plaster. Dr. Dagencourt coll., Paris. [Ibid.] Terra-cotta replica. Metropolitan Museum, New York. [Ibid., pl. 1] Replicas: plaster, Academia de San Fernando; marble, Kaiser-Friedrich Museum, Berlin, in 1940; stone, Château de Millemont, Seine-et-Oise; lead, Louvre, no. 1443. [Ibid.] Pendant (no Mercury figure), "Venus (Giving a Message to Mercury)." 1748. Kaiser Friedrich Museum, Berlin. [Ibid., no. 2, pl. 5] Stone replica. Paul Gouvert coll., Paris. [Ibid., pl. 4]

Franz Anton Maulbertsch, 1724–1796. "Allegory of Time and Truth" (chariot of Apollo, led by Hermes and Veritas, driving away night-demons). Painting, sketch for a ceiling. *c.*1750. Wallraf-Richartz-Museum, Cologne. [Garas 1960, no. 23, p. 13—ill.]

————. "Diana and Mercury." Drawing, sketch for a ceiling painting. *c.*1754. Hermann coll., Karlsruhe. [Ibid., no. 59—ill.]

Thomas Augustine Arne, 1710–1778. *Mercury Harlequin.* Pantomime. Libretto, Henry Woodward. First performed 27 Dec **1756,** Theatre Royal, Drury Lane, London. [Grove 1980, 10:610 / Nicoll 1959–66, 3:209, 317]

Giovanni Battista Tiepolo, 1696–1770. "Mercury." Fresco. **1757.** Sala dell' Olimpo, Villa Valmarana, Vicenza. [Pallucchini 1968, no. 240—ill. / Morassi 1962, p. 65]

Giovanni Domenico Tiepolo, 1727–1804. "Mercury and Commerce." Fresco. *c.*1761–62. Villa Pisani, Stra. [Mariuz 1979, pp. 136f.—ill.]

Christian Joseph Lidarti, 1730–c.1793. *La tutela contrastata fra Giunone, Marte, e Mercurio, col giudizio di Giove* [The Guardianship Contested between Juno, Mars, and Mercury, with the Judgment of Jove]. Dramatic musical composition. **1767.** [Grove 1980, 10:827]

Henry Fuseli, 1741–1825. "Unidentified Scene with the Figure of Hermes." Drawing. **1764–68.** Christopher Lennox-Boyd coll., London. [Schiff 1973, no. 1732—ill.]

Anton Cajetan Adlgasser, 1729–1777. *Mercurius, oder, Pietas in Deum* [Mercury, or, Piety to the Gods]. Oratorio. First performed **1772,** Salzburg. [Grove 1980, 1:110]

Johann Wolfgang von Goethe, 1749–1832. (Mercury in) *Prometheus.* Drama, unfinished, 2-act fragment completed. **1773.** [Beutler 1948–71, vol. 1 / Suhrkamp 1983–88, vol. 7 / Mackworth-Young 1952–53, pp. 55f. / Viëtor 1949, pp. 25–27]

Joshua Reynolds, 1723–1792. "Mercury as Cutpurse." Painting. **1774.** Faringdon coll., Buscot. [Royal Academy 1986, no. 93—ill.]

Augustin Pajou, 1730–1809. "Mercury, God of Commerce." Marble statue. **1777–79.** Baron de Schlichting coll., Paris. [Stein 1912, pp. 212–15—ill.]

Ferdinand Dietz, ?–c.1780. "Mercury." Sculpture, from

Schloss Veitschochheim Park. After 1763. Mainfranisches Museum, Wurttemberg. [Clapp 1970, 1:855]

André Chénier, 1762–1794. *Hermes.* Didactic philosophical poem. **1781–82,** unfinished. [DLLF 1984, 1:446 / Highet 1967, p. 402]

Pierre-Antoine-Auguste de Piis, 1755–1832, and **Pierre-Yves Barré,** 1749–1832. *Les étrennes de Mercure.* Comedy. By **1783.** In *Théâtre de Piis et Barré* (Paris: 1784). [NUC]

Gaetano (Kajetan), ?–c.1792. *Zólta szlafmyca albo Koleda na Nowy Rok* [The Yellow Nightcap, or, A Carol for the New Year]. Opera. Libretto, F. Zablocki, after Piis and Barré's *Les étrennes de Mercure.* First performed 1783, Warsaw. [Grove 1980, 7:76]

Philip Hayes, 1738–1797. *The Judgment of Hermes.* Oratorio. **1783.** [Grove 1980, 8:414]

Giovanni Battista Cipriani, 1727–1785. "Apollo with His Lyre, with Mercury and a Muse." Watercolor, design for a benefit ticket. Victoria and Albert Museum, London, no. 97b–1892. [Lambourne & Hamilton 1980, p. 64]

John Flaxman, 1755–1826. "Mercury Uniting the Hands of Britain and France." Jasper relief, commemorative plaque, designed for Wedgwood. Designed **1786,** produced 1787. F. Joseph coll., Nottingham. / Wax and biscuit models. Wedgwood Museum, Barlaston, Staffs. [Irwin 1979, p. 26 / also Bindman 1979, no. 52—ill.]

———, attributed. "Mercury." Basalt bust. After 1789. [Bindman, no. 31—ill.]

———, design. Jugate heads of Minerva and Mercury depicted on obverse of gold medal for Royal Society of Arts. 1805. [Irwin, p. 203—ill. / also Bindman, no. 186—ill.]

Francesco Guardi, 1712–1793. "Mercury." Drawing. Late work. Schmidt coll., Vienna. [Morassi 1984, no. D185—ill.]

Paul Wranitzky, 1756–1808. *Merkur der Heiratsstifter, oder, Der Geiz im Geldkasten* [Mercury the Matchmaker, or, Greed in the Money-box]. Singspiel. First performed 21 Feb **1793,** Leopoldstadt, Vienna. [Grove 1980, 20:539]

Pierre-Paul Prud'hon, 1758–1823. "Mercury." Painting, part of series of simulated bronze bas-reliefs for Hôtel Lanois, Paris. **1796–99.** Louvre, Paris, no. R.F. 1983–17. [Louvre 1979–86, 4:152—ill. / also Guiffrey 1924, pp. 294ff.]

Franz Anton Zauner, 1746–1822. Bronze relief, on base of monument to Emperor Joseph II, depicting the Emperor commanding Mercury to untie the hands of Trade. **1795–1806.** Vienna. [Janson 1985, pp. 60f.—ill.]

Percy Bysshe Shelley, 1792–1822. "Hymn to Mercury." Translation of first Homeric Hymn to Hermes. **1818–22.** In *Posthumous Poems,* edited by Mary Shelley (London: Hunt, 1824). [Hutchinson 1932 / Webb 1976, pp. 64, 70–79, 95, 121 / Chernaik 1972, p. 179 *n.*]

———. (Mercury befriends Prometheus—a reversal of Aeschylus's version—in) *Prometheus Unbound* 1.358–429. Dramatic poem. London: Ollier, 1820. [Zillman 1968 / Wasserman 1971, pp. 287ff., 297]

François-Vincent Latil, 1798–1890. "Mercury." Painting. Commissioned **1825.** Louvre, Paris, inv. 5716. [Louvre 1979–86, 4:33—ill.]

François Rude, 1784–1855. "Mercury Attaching His Wings." Bronze sculpture. **1827.** Louvre, Paris. [Wagner 1986, fig. 53 / also Janson 1985, p. 111]

———. "Mercury." Sculpture. Musée des Beaux-Arts, Dijon. [Bénézit 1976, 9:166]

Eduard Mörike, 1804–1875. "An Mercurius." Ode, trans-

lation of Horace. In *Classische Blumenlese* (Stuttgart: Schweizerbart, **1840**). [Hötzer 1967]

Bertel Thorwaldsen, 1770–1844. "Mercury Putting Mars to Sleep with His Pipes." Sculpture. Museo Nacional de Arte Moderno, Madrid. [Clapp 1970, 1:853]

Eugène Delacroix, 1798–1863. "Mercury, God of Commerce." Painting, for Salon de la Paix, Hôtel de Ville, Paris. **1849–53.** Destroyed 1871. [Robaut 1885, no. 1147—ill. (copy drawing)]

Henri Chapu, 1833–1891. "Mercury Inventing the Caduceus." Marble sculpture. *c.*1862. Musée d'Orsay, Paris, inv. R.F. 165. [Orsay 1986, p. 95—ill.]

Jean-Auguste-Dominique Ingres, 1780–1867. "Mercury." Painting, copy after Peruzzi (1511–12, Farnesina). École des Beaux-Arts, Paris. [Wildenstein 1954, no. 68]

Reinhold Begas, 1831–1911. "Mercury." Sculpture. **1870.** Stock Exchange, Berlin. [Bénézit 1976, 1:577]

Arthur Sullivan, 1842–1900. (Mercury in) *Thespis; or, The Gods Grown Old.* Comic operetta. Libretto, W. S. Gilbert. First performed 26 Dec **1871,** Gaiety Theatre, London. Music lost. [Jefferson 1984, pp. 23ff.]

Charles Gleyre, 1806–1874. "Mercury." Drawing. Charles Clément coll. in 1878. [Clément 1878, no. 214]

Julien-Hippolyte Moulin, 1832–1884. "Secret from Above" (Mercury whispering to a term of Pan). Marble sculpture group. **1873–76** (but dated 1879). 2 examples. Musée d'Orsay, Paris, inv. R.F. 259; Château, Chantilly. [Orsay 1986, p. 202—ill.]

Jean-Antoine-Marie Idrac, 1849–1884. "Mercury Inventing the Caduceus." Marble statue. **1877–78.** Musée d'Orsay, Paris, inv. R.F. 301. [Orsay 1986, p. 178—ill. / also Agard 1951, fig. 68] Bronzed plaster replica. 1886. Musée des Augustins, Toulouse. [Orsay]

Amédée-René Ménard, 1806–1879. "Mercury Inventing the Caduceus." Sculpture. Musée, Nantes. [Bénézit 1976, 7:327]

Marcel Schwob, 1867–1905. "Hermes." Prose poem. In *Mimes* (Paris: Mercure de France, **1884**). [TCLC 1978–89, 20:320]

Ernest Myers, 1844–1921. "The Olympic Hermes." Poem. In *The Judgement of Prometheus and Other Poems* (London: Macmillan, **1886**). [Bush 1937, p. 562]

William Blake Richmond, 1842–1921. "Hermes." Painting. 1886. [Kestner 1989, p. 174, pl. 3.32]

Adolf von Hildebrand, 1847–1921. "Mercury." Bronze statue. **1885–87.** Museum, Weimar. [Fiesole 1980, p. 135—ill. / also Heilmeyer 1922, p. 23—ill.] Plaster modello. Peploe coll., Florence. [Fiesole, no. 57—ill.]

Hans von Marées, 1837–1887. "Seated Mercury." Painting. Mesirca family coll., Schloss Elmau, Oberbayern. [Gerlach-Laxner 1980, no. 128—ill.]

Auguste Rodin, 1840–1917. "Standing Mercury." Plaster sculpture, based on a figure in "The Gates of Hell." **1888.** Musée Rodin, Paris. [Rodin 1944, no. 204—ill.] Bronze cast. Jay S. Cantor coll. [Elsen 1981, no. 271]

Francis Thompson, 1859–1907. "Hermes." Sonnet. In *New Poems* (London: Century, **1897**). [Boswell 1982, p. 303 / Bush 1937, p. 563]

Edward Burne-Jones, 1833–1898. "Love Praying to Mercury for Eloquence." Painting, unfinished. Sold from artist's estate, 1898. [Bell 1901, pp. 138f.]

John Cowper Powys, 1872–1963. "The Hermes of Praxi-

teles" (as guide of souls). Poem. In *Poems* (London: Rider, **1899**). [Boswell 1982, p. 204]

Henry Scott Tuke, 1858–1929. "Hermes at the Pool." Painting. **1900.** [Kestner 1989, pp. 340f., pl. C.18]

Gabriele D'Annunzio, 1863–1938. (Hymn to Hermes in) *Laus vitae* [Praise of Life]. Poem. Published with *Maia*, first book of *Laudi* cycle (Milan: Treves, **1903**). [Mutterle 1982, pp. 125f. / Bàrberi Squarotti 1982, p. 130]

Gustave-Frédéric Michel, 1851–1924. "Mercury on the Prow of a Boat." Terra-cotta high-relief (early pensée for decoration of Pont de Bir Hakeim, Paris?). *c.*1906? Musée d'Orsay, Paris, inv. R.F. 3767B. [Orsay 1986, p. 198—ill.]

Attillo Parelli, 1874–1944. *Hermes.* Opera. First performed 8 Nov **1906**, Geneva. [Baker 1984, p. 1720]

Luigi Pirandello, 1867–1936. *Erma bifronte* [Two-faced Hermes]. Novella. Milan: Treves, **1906**. [DULC 1959–63, 3:1072 / see also Isotta Cesari, "The Two-Headed Hermes," *Italica* 30 no. 3 (1953): 144–52]

Hans Thoma, 1839–1924. "Mercury." Painting. **1907.** Kunsthalle, Karlsruhe. [Thode 1909, p. 492—ill.]

Maxfield Parrish, 1870–1966. "Hermes." Painting, for *Collier's* magazine "Mythology" series (unpublished). **1907–08.** Published in *Hearst's Magazine* Sep 1912. Original painting formerly Austin Purves coll., Philadelphia, unlocated. [Ludwig 1973, pp. 21, 35, 210]

Robert Ingersoll Aitken, 1878–1949. "The Tired Mercury." Plaster sculpture study. **1910.** [Clapp 1970, 2 pt. 1: 51]

Elie Nadelman, 1882–1946. "Mercury Petassos." Marble head. *c.*1911. Unlocated. [Kirstein 1973, no. 64—ill.] Bronze version. [Ibid., no. 66]

———. "Head of Mercury." Drawing. *c.*1913. Nadelman Estate. [Ibid., no. D32—ill.]

H. D. (Hilda Doolittle), 1886–1961. "Hermes of the Ways." Poem, inspired by epigram by Phanias in *The Greek Anthology.* **1912.** In *Poetry* Jan 1913; collected in *Des imagistes: An Anthology,* edited by Ezra Pound (London: Poetry Workshop; New York: Boni, 1914). [Martz 1983 / DLB 1986, 45:117 / Robinson 1982, pp. 29, 32–37, 102, 105 / Gregory & Zaturenska 1946, p. 193]

Wyndham Lewis, 1884–1957. "Head of Mercury." Drawing. **1912.** White Museum of Art, Cornell University, Ithaca. [Michel 1971, no. 68]

August Gaul, 1869–1921. "Mercury." Bronze statue. **1913.** Kunsthalle, Hamburg. [Clapp 1970, 1:371]

Paul Manship, 1885–1966. "Hermes." Statue, terminal figure, for gardens of Harold McCormick, Lake Forest, Ill. **1914.** Unlocated. [Murtha 1957, no. 61]

———. Mercury, surmounting a locomotive on Southern Railways System, depicted on Centennial bronze medal. 1930. [Ibid., no. 271]

Richard Aldington, 1892–1943. "Hermes, Leader of the Dead." Poem. In *Images, 1910–15* (London: Wingate, **1915**). [Boswell 1982, pp. 10–11 / Bush 1937, p. 570]

Grace Hazard Conkling, 1878–1958. "To Hermes." Poem. In *Afternoons of April* (Boston: Houghton Mifflin, **1915**). [Boswell 1982, p. 248 / Bush 1937, p. 587]

Giorgio de Chirico, 1888–1978. "Roman Villa with Mercury" (flying overhead). Painting. *c.*1921. Private coll., Florence. [de Chirico 1971–83, 7.1: no. 394—ill.]

———. "Self-portrait with Head of Mercury." Painting. 1924. Private coll., Biella. [Ibid., 1.1: no. 59—ill.]

———. "Mercury." Drawing. 1933. Private coll., Rome. [Ibid., 6.3: no. 572—ill.]

———. "The God Mercury." Drawing. 1967. Formerly Galleria La Vetrina, Rome. [Ibid., 2.3: no. 275—ill.]

———. "Metaphysical Interior with Head of Mercury." Surrealistic painting. Begun 1960, finished 1969. Artist's coll., Rome, in 1974. [Ibid., 4.3: no. 623—ill.]

———. "View of Athens" (Mercury flying overhead). Painting. 1970. Artist's coll., Rome, in 1975. [Ibid., 5.3: no. 746—ill.]

Léonide Massine, 1895–1979, choreography and scenario. *Mercure.* Ballet. Music, Erik Satie. First performed 15 June **1924**, by Soirées de Paris du Comte Etienne de Beaumont, Théâtre de la Cigale, Paris; drop scene, sets, and costumes, Pablo Picasso. [Simon & Schuster 1979, pp. 199f. / Grove 1980, 16:519 / also Zervos 1932–78, 5: nos. 189–211—ill.]

———, choreography. *Mercure.* Ballet, revision of above. Libretto, Jean Cocteau. First performed 1927, Théâtre de Champs-Elysées or L'Opéra, Paris. [Percival 1979, pp. 140f.]

D. H. Lawrence, 1885–1930. "London Mercury." Poem. In *Nettles* (London: Faber & Faber, **1930**). [Pinto & Roberts 1964, vol. 2]

———. (Sacrifice of living things to Venus and Hermes scorned in) "Self-Sacrifice" (I). Poem. In *Last Poems* (Florence: Orioli; London: Heinemann, 1932). [Ibid.]

———. (Poet visited by Hermes in) "Maximus." Poem. In *Last Poems* (1932). [Ibid.]

Frederick Ashton, 1904–1988, choreography. *Mercury.* Ballet. Music, Satie (1924). First performed 22 June **1931**, Marie Lambert Dancers, Lyric Theatre, Hammersmith; scenery, W. Chappell. [Vaughan 1977, pp. 59f., 79, 458]

Elisabeth Langgässer, 1899–1950. "Merkur" (personified by bankers and innkeeper) Story. In *Triptychon des Teufels: Ein Buch von dem Hass, den Börsenspiel und der Unzucht* (Dresden: Jess, **1932**). [DLB 1988, 69:220]

Edwin Markham, 1852–1940. "A Prayer at the Altar of Hermes." Poem. In *New Poems: Eighty Songs at Eighty* (Garden City, N.Y.: Doubleday, Doran, **1932**). [Boswell 1982, p. 272 / Bush 1837, p. 591]

Sacheverell Sitwell, 1897–1988. "The Hermes of Praxiteles." Poem. In *Canons of Giant Art: Twenty Torsos in Heroic Landscapes* (London: Faber & Faber, **1933**). [Boswell 1982, p. 294]

Antonio de Obregón, 1910–. *Hermes en la vía pública* [Hermes in the Public Street]. Novel. Madrid: Espasa-Calpe, **1934**. [DLE 1972, p. 653]

Bentley Stone, 1908–, choreography. *Mercure.* Ballet. Music, Satie (1924). First performed **1936**, Chicago Opera Ballet, Chicago. [Chujoy & Manchester 1967, p. 865]

Alexander Calder, 1898–1976. "Mercury." Steel fountain figure, for Spanish Pavilion, Paris World's Fair. **1937.** Destroyed. [Whitney 1976, p. 193—ill.]

Mirko, 1910–1969. "Mercury." Bronze bust. **1939.** [Trieste 1976, no. 85, p. 150—ill.]

Fritz Usinger, 1895–1982. *Hermes.* Collection of poems. Darmstadt: Darmstädter Verlag, **1942**. [Oxford 1986, p. 922]

Cesare Pavese, 1908–1950. (Hermes speaks in) "Le ca-

valle" [The Mares], "La madre" [The Mother]. Dialogues. In *Dialoghi con Leucò* (Turin: Einaudi, **1947**). / Translated by William Arrowsmith and D. S. Carne-Ross in *Dialogues with Leucò*, bilingual edition (Ann Arbor: University of Michigan, 1965). [Ipso / Biasin 1968, pp. 193, 195, 201f., 309]

William John, 1860–**1952.** "Hermes Making His Caduceus." Bronze statuette. Fine Art Society, London. [London 1968, no. 87]

Herbert Ferber, 1906–. "Mercure." Copper sculpture. **1955.** Riesenfeld coll., New York. [Clapp 1970, 2: pt. 1:373]

Zbigniew Herbert, 1924–. "Hermes, pies i gwiazda" [Hermes, Dog, and Star]. Poem. In *Hermes, pies i gwiazda* (Warsaw: Czytelnik, **1957**). Translated by John and Bogdana Carpenter in *Zbigniew Herbert, Selected Poems* (London & New York: Oxford University Press, 1977). [Ipso / Pilling 1982, p. 421 / Miłosz 1983, p. 470]

Xavier Corbero, 1935–. "Death of Mercury." Sculpture. **1960.** [Clapp 1970, 1:185]

Radcliffe Squires, 1917–. *Fingers of Hermes.* Collection of poems. Ann Arbor: University of Michigan Press, **1965.** [Boswell 1982, p. 220]

Oskar Kokoschka, 1886–1980. "Mercury." Lithograph. **1967.** [Wingler & Welz 1975–81, no. 389—ill.]

István Vas, 1910–. (Hermes as wayfarer in) "Gods" [English title of work written in Hungarian]. Poem. In *Mit akar ez az egy ember?* [What Does This Single Man Want?] (Budapest: Szépirodalmi, **1970**). / Translated by Donald Davie in *Collected Poems 1950–1970* (London: Routledge & Kegan Paul; New York: Oxford University Press, 1972). [Vajda 1977, p. 72]

Alan Hovhaness, 1911–. "Hermes Stella." Work for piano and tam tam, opus 247. **1971.** [Grove 1980, 8:742]

Leonard Baskin, 1922–. "Hermes." Bronze sculpture. **1973.** Virginia Museum of Fine Arts, Richmond. [Jaffe 1980, p. 217]

Jay Macpherson, 1931–. "Messenger" (Hermes conducting souls to Hades). Poem. In *Welcoming Disaster: Poems 1970–74* (Toronto: Sannes, **1974**). [Ipso]

Robert Graves, 1895–1985. "The Accomplice" (of Mercury). Poem. By **1975.** [Graves 1975]

Thomas Kinsella, 1928–. (Mercury as) "The Messenger." Poem. In *Peppercanister Chapbook* (Dublin: Dolmen, **1978**). [Johnston 1985, pp. 115, 118]

Humberto Costantini, 1924?–1987. (Athena, Aphrodite, and Hermes fight Hades on behalf of mortals in) *De dioses, hombrecitos, y policías* [The Gods, the Little Guys, and the Police]. Novel. [Havana?]: Casa de las Américas, **1979.** / Translated by Tony Talbott (New York: Harper & Row, 1984). [Ipso]

Claudio Parmiggiani, 1943–. "Mercury Passing before the Sun." Assemblage (plaster head on painted canvas, 2 palettes). **1982.** [Reggio Emilia 1985, p. 126—ill.]

Ronald Bottrall, 1906–. "Hermes" (as guide of dead souls in the modern world). Poem. In *Against a Setting Sun* (London & New York: Alison & Busby, **1984**). [Ipso]

Seamus Heaney, 1939–. (Hermes in) "The Stone Verdict." Poem. In *The Haw Lantern* (New York: Farrar, Straus & Giroux, **1987**). [Ipso]

Infancy of Hermes.

Infancy of Hermes. Probably the most precocious child in mythology, Hermes (Mercury) accomplished an array of feats in his first day of life. The most comprehensive account is given in the Homeric Hymn to Hermes.

Soon after his birth, he emerged from the cave of his mother, Maia, killed a tortoise, and transformed its shell into the first lyre. He then ventured out into the world and stole fifty head of cattle from his half-brother Apollo's herd, teaching the animals to walk backward and wearing sandals to mask his own steps in order to confound the herdsman-god. An old man, Battus, witnessed the event, but was bribed by Hermes to keep silent; Battus later told Apollo and, according to Ovid, was changed into a stone for his betrayal. Apollo confronted Hermes, who steadfastly pleaded his innocence. The two eventually agreed to appeal for judgment to Zeus, who arranged a truce. Reconciling their differences, Apollo presented Hermes with the caduceus (herald's staff) and made him keeper of herds, and Hermes gave Apollo the lyre.

In many postclassical treatments, Hermes is cited as stealing the herds of King Admetus of Pherae while Apollo, who served as the king's mortal herdsman for a year, was guarding them. This appears to be a conflation of two different stories that were not originally related.

Classical Sources. *Homeric Hymns,* first and second hymns "To Hermes." Sophocles, *Ichneutai* [Searching Satyrs] (lost satyr play, fragments). Diodorus Siculus, *Biblioteca* 3.59.2, 5.75.3. Ovid, *Metamorphoses* 2.685–713. Apollodorus, *Biblioteca* 3.10.2. Lucian, *Dialogues of the Gods* 11, "Hephaestus and Apollo." Philostratus, *Imagines* 1.26.

Baldassare Peruzzi, 1481–1536 (formerly attributed to Giulio Romano). "Mercury (Driving the Heifers Stolen from Apollo)." Fresco, part of a frieze. **1511–12.** Sala del Fregio, Villa Farnesina, Rome. [d'Ancona 1955, pp. 91f. / Gerlini 1949, pp. 21ff.—ill. / Frommel 1967–68, no. 18a]

Pierre de Ronsard, 1524–1585. (Invention of the lyre evoked in) "Ode à Michel de l'Hospital." Ode. In *Le cinquiesme livre des odes* (Paris: **1553**). [Laumonier 1914–75, vol. 2 / Cave 1973, p. 220]

———. "La lyre." Poem. In *Le sixième livre des poèmes* (Paris: Buon, 1569). [Laumonier, vol. 15 / McGowan 1985, pp. 114–19 / Cave, p. 71 / McFarlane 1973, p. 71]

Girolamo da Santacroce, *c.*1490–**1556,** attributed (formerly attributed to circle of Domenico Campagnola). "The Young Mercury Stealing Cattle from the Herd of Apollo." Painting. Rijksmuseum, Amsterdam, inv. A3966. [Rijksmuseum 1976, p. 243—ill.]

James Sanford. (Mercury and Battus story retold in) *The Garden of Pleasure.* Collection of narratives. London: **1573.** [Bush 1963, p. 315]

Hendrik Goltzius, 1558–1617, composition. "Battus Changed into a Stone." Engraving, part of set illustrating Ovid's *Metamorphoses* (2d series, no. 16), executed by assistant(s).

*c.*1590. (Unique impression in British Museum, London.) [Bartsch 1980–82, no. 0302.66—ill.]

Jean Cousin the Younger, 1522–**1594.** "Mercury Stealing Admetus's Herds." Drawing. Bibliothèque, Nationale, Paris. [Hermitage 1984, no. 279 *n.*]

Annibale Carracci, 1560–1609, design. "Mercury and Apollo" (Mercury giving the lyre to Apollo). Fresco, executed by studio under direction of Domenichino. *c.*1603–04 (or *c.*1608?). Galleria, Palazzo Farnese, Rome. [Malafarina 1976, no. 105g—ill. / Martin 1965, p. 138—ill.]

Domenichino, 1581–1641. "Mercury Stealing the Herds of Admetus." Fresco (detached), part of "Life of Apollo" cycle from Villa Aldobrandini (Belvedere), Frascati. **1616–18.** National Gallery, London, no. 6291. [Spear 1982, no. 55.ix—ill. / London 1986, p. 163—ill.]

Cornelis van Poelenburgh, *c.*1586–1667. "Mercury and Battus." Painting. *c.*1621. Uffizi, Florence, inv. 1231. [Uffizi 1979, no. P1208—ill. / also Röthlisberger 1981, no. 23—ill.]

Moyses van Uyttenbroeck, *c.*1590–1648. "Mercury and Battus." Painting. **1626.** Gemäldegalerie, Berlin-Dahlem, no. 1963. [Berlin 1986, p. 76—ill.]

Claude Lorrain, 1600–1682. "Landscape with Apollo Guarding the Herds of Admetus and Mercury Stealing Them." Painting. *c.*1645–46. Galleria Doria-Pamphilj, Rome. [Röthlisberger 1961, no. LV 92—ill.] Drawing after, in the artist's *Liber veritatis.* British Museum, London. [Ibid.] Copy in Tiroler Landesmuseum Ferdinandeum, Innsbruck. [Ibid.]

———. "Landscape with Apollo Guarding the Herds of Admetus and Mercury Stealing Them," "Landscape with Mercury and Battus." Pendant paintings. 1654. Formerly Holker Hall, England, destroyed; private coll., Switzerland. [Ibid., nos. LV 128, 131—ill.] Drawings after, in *Liber veritatis.* [Ibid.—ill.] Variant drawing ("Landscape with Mercury and Apollo as Shepherd," similar to no. LV 128. 1673. Kunsthalle, Hamburg, inv. 24007. [Hamburg 1985, no. 425—ill.]

———. "Landscape with Apollo Guarding the Herds of Admetus and Mercury Stealing Them." Painting. 1654. Earl of Leicester coll., Holkham Hall. [Röthlisberger, no. LV 135—ill.] Drawing after, in *Liber veritatis.* [Ibid.] Copy in Pallavicini coll., Rome. [Ibid.]

———. "Landscape with Apollo Guarding the Herds of Admetus and Mercury Stealing Them," "Landscape with Mercury and Battus." Pendant paintings. 1660. Wallace Collection, London; Duke of Devonshire coll., Chatsworth. [Ibid., nos. LV 152, 159—ill.] Drawings after, in *Liber veritatis.* [Ibid.] Copies in Lacueva coll., Nice; Musée d'Art et d'Histoire, Geneva. [Ibid.]

———. "Landscape with Apollo Guarding the Herds of Admetus and Mercury Stealing Them." Painting. *c.*1666. Private coll., New York. [Ibid., no. 230—ill.] Related (?) drawing, in *Liber veritatis,* no. 170. [Ibid., p. 402—ill.]

———. "Landscape with Apollo and Mercury." Painting. 1679. Unlocated. / Drawing after, in *Liber veritatis.* [Ibid., no. LV 192—ill.]

Diego Velázquez, 1599–1660. "Mercury and Apollo." Painting. *c.*1659. Destroyed by fire in 1734. [Prado 1985, p. 731]

Francesco Albani, 1578–**1660.** "Apollo Guarding the Herds of Admetus and Mercury Stealing Them." Painting. Galleria Nazionale, Rome. [Pigler 1974, p. 34] Another version of the subject ("Apollo Guarding the Herds of Admetus") in Château de Fontainebleau (on deposit from Louvre, Paris, inv. 13). [Louvre 1979–86, 2:283]

———. "Mercury Gives the Lyre to Apollo." Painting. Earl of Wemyss, Gosford House, inv. no. 164. [Warburg]

Francisque Millet, 1642–**1679/80.** "Mercury and Battus." Painting. Metropolitan Museum, New York, no. 29.100.21. [Metropolitan 1980, p. 127—ill.]

Filippo Lauri, 1623–**1694.** "Apollo Guarding the Herds of Admetus and Mercury Stealing Them." Painting. Brinsley Ford coll., London, no. 96. [Pigler 1974, p. 34]

Luca Giordano, 1634–**1705.** "Mercury Educating Apollo." Painting (?). Sold 1777, untraced. [Ferrari & Scavizzi 1966, 2:372]

Johann Franz Michael Rottmayr, 1654–**1730.** "Hermes with the Headless Body of Argus and the Cattle of Apollo." Painting. Art Institute of Chicago, no. 61.37. [Chicago 1965]

James Barry, 1741–1806. "Mercury Inventing the Lyre." Painting. *c.*1774. Lord Egremont coll., Petworth. [Pressly 1981, no. 15—ill.]

Percy Bysshe Shelley, 1792–1822. "Hymn to Mercury." Translation of first Homeric Hymn to Hermes. **1818–22.** In *Posthumous Poems,* edited by Mary Shelley (London: Hunt, 1824). [Hutchinson 1932 / Webb 1976, pp. 64, 70–79, 95, 121]

Johann Wolfgang von Goethe, 1749–1832. "Phöbus und Hermes." Poem. In *Gedichte der Ausgabe letzter Hand* (Stuttgart: Cotta, **1827–30**). [Beutler 1948–71, vol. 1]

Francisque-Joseph Duret, 1804–1865. "Mercury Inventing the Lyre." Plaster statue. **1828–31.** Musée des Beaux-Arts, Valenciennes. [Wagner 1986, fig. 51]

James Russell Lowell, 1819–1891. "The Finding of the Lyre." Poem. In *Under the Willows and Other Poems* (Boston: Fields, Osgood, **1868**). [Boswell 1982, p. 168 / Cooke 1906, p. 115]

Albert Roussel, 1869–1937. "La naissance de la lyre." Incidental music (conte lyrique), opus 24, for Théodore Reinach's translation of Sophocles' *Ichneutai.* First performed 1 July **1925,** L'Opéra, Paris. [Grove 1980, 16:275 / Slonimsky 1971, p. 416]

W. H. Auden, 1907–1973. "Under Which Lyre: A Reactionary Tract for the Times" (Hermes vs. Apollo). Poem. **1946.** In *Harper's Magazine* June 1947; collected in *Nones* (New York: Random House, 1951). [Mendelson 1976 / Carpenter 1981, p. 341 / Fuller 1970, pp. 184f., 237 / Spears 1963, pp. 186f.]

Tony Harrison, 1937–. *The Trackers of Oxyrhynchus.* Play, based partly on Sophocles' *Ichneutai.* First performed 12 July **1988,** stadium at Delphi. / Revised, performed 27 Mar 1990, National Theatre, London; music, Stephen Edwards; design, Jocelyn Herbert. Published London: Faber & Faber, 1990. [National Theatre program notes]

HERMIONE. *See* ANDROMACHE; ORESTES.

HERO AND LEANDER.

HERO AND LEANDER. The ill-fated lovers Hero and Leander lived on opposite sides of the Hellespont in Asia Minor. Hero was a priestess of Aphrodite (Venus) in Sestos, a city on the European shore. Every night she lit a torch in a tower to guide Leander as he swam across from Abydos, on the Asian shore, to visit her. During a violent storm, the torch was extinguished and Leander drowned. Finding his body, the grieving Hero threw herself into the sea.

The story is best known from Musaeus's Greek poem of the late fourth or early fifth century CE. Treatments of this theme in the postclassical fine arts most commonly depict Leander braving the Hellespont as Hero watches for him, and the dead Leander borne by Nereids.

Classical Sources. Virgil, *Georgics* 3.258–64. Ovid, *Heroides* 18, 19; *Ars amatoria* 2.249f. Martial, *The Book of Public Entertainment and Book of Party Favors* 14.174–81. Musaeus, *Hero and Leander.*

Dante Alighieri, 1265–1321. (Leander evoked in) *Purgatorio* 27.2, 28.73–75. Completed *c.*1314? In *The Divine Comedy.* Poem. Foligno: Neumeister & Angelini, 1472. [Singleton 1970–75, vol. 2 / Toynbee 1968, p. 250, 385]

Anonymous French. (Story of Hero and Leander in) *Ovide moralisé* 4.3150–3731. Poem, allegorized translation/elaboration of Ovid's *Metamorphoses* and other Ovid works. *c.*1316–28. [de Boer 1915–86, vol. 2]

Francesco Petrarca, 1304–1374. (Hero and Leander led captive in) *Il trionfo dell' Amore* [The Triumph of Love] part 3. Poem. 1340–44. In *Trionfi* (Bologna: Malpiglius, 1475). [Bezzola 1984 / Wilkins 1962 / Wilkins 1978, p. 248]

Christine de Pizan, *c.*1364–*c.*1431. (Hero and Leander in) *L'epistre d'Othéa à Hector* . . . [The Epistle of Othéa to Hector] chapter 42. Didactic romance in prose. *c.*1400. MSS in British Library, London; Bibliothèque Nationale, Paris; elsewhere. / Translated by Stephen Scrope (London: *c.*1444–50). [Bühler 1970 / Hindman 1986, pp. 94, 198, 214]

———. (Hero in) *Le livre de la Cité des Dames* [The Book of the City of Ladies] part 2 no. 58. Didactic compendium in prose, reworking of Boccaccio's *De mulieribus claris.* 1405. [Hicks & Moreau 1986] Translated by Brian Anslay (London: Pepwell, 1521). [Richards 1982]

Garcilaso de la Vega, 1503–1536. "Pasando el mar Leandro el animoso" [Brave Leandro Swimming the Sea]. Poem, imitation of Martial. In *Obras* (Madrid: Garcia, 1570). [Praz 1925, p. 429]

Bernardo Tasso, 1493–1569. "Favola di Leandro e d'Hero." Poem. In *Gli amori di Bernardo Tasso* (Vinegia: Stagnino, 1534–37). [DELI 1966–70, 5:233]

Tiziano Minio, 1517–1552/53, under direction of **Jacopo Sansovino,** 1486–1570. "Thetis Succouring Leander." Marble relief. 1537–39. Loggetta, Piazza San Marco, Venice. [Pope-Hennessy 1985b, 3:404f.]

Clément Marot, 1496–1544. *Histoire de Léandre et Héro.* Poem. Paris: 1541. [DLLF 1984, 2:1425]

Hans Sachs, 1494–1576. *Historia die unglückhafft Lieb* *Leandri mit Frau Ehron* [Story of the Unfortunate Love of Leander and Hero]. Poem (lied). 1541. In modern edition, *Werke* (Stuttgart: 1870–1908; Hildesheim: Olms, 1964). [Frenzel 1962, p. 267]

Juan Boscán de Almogáver, 1493–1542. *Hero y Leandro.* Poem. In *Obras de Boscán y algunas de Garcilaso de la Vega* (Barcelona: 1543). [Oxford 1978, p. 74 / DLE 1972, p. 119]

Hendrik Goltzius, 1558–1617. "Leander." Engraving. *c.*1580. [Strauss 1977a, no. 140—ill. / Bartsch 1980–82, no. 159—ill.]

Jehan Baptista Houwaert, 1533–1599. "Leander and Hero." Drama, part of *Den Handel der amoreusheyt* [The Commerce of Amorosity]. 1583. [Gosse 1910, p. 721]

Christopher Marlowe, 1564–1593. *Hero and Leander.* Poem, after Musaeus, unfinished. Licensed 1593. London: Blunt, 1598. [Bowers 1973, vol. 2 / Hulse 1981, pp. 104–24, 116–19, 124–27 / Leech 1986, pp. 13ff., 175–98 / Friedenreich et al. 1988, pp. 279–92 / Levin 1952, pp. 18ff., 138–46 / Bush 1963, pp. 121–37] *See also George Chapman, below.*

Thomas Nashe, 1567–1601. (Hero and Leander in) *Prayse of the Red Herring.* Prose burlesque. London: 1599. In modern edition by R. B. McKerrow, *Works,* vol. 3 (London: Sidgwick & Jackson, 1920). [Bush 1963, p. 300]

William Shakespeare, 1564–1616. (Rosalind ridicules the notion that Leander died for love, in) *As You Like It* 4.1.100–08. Comedy. *c.*1599. Stationers' Register, 4 Aug 1600. First recorded performance 2 Dec 1603, by King's Men, Wilton House, Wiltshire. Published London: Jaggard, 1623 (First Folio). [Riverside 1974 / also McGraw-Hill 1984, 4:404]

Annibale Carracci, 1560–1609. "Hero and Leander." Fresco. 1597–1600. Galleria, Palazzo Farnese, Rome. [Malafarina 1976, no. 104k—ill. / Martin 1965, pp. 100f.—ill.]

Luis de Góngora y Argote, 1561–1627. "La fábula de Leandro y Hero." Poem. *c.*1600. In *Obras completas* (Lisbon: Craesbeck, 1646). Modern edition by Juan and Isabel Millé y Jiménez, *Obras completas* (Madrid: Aguilar, 1932 and later). [Frenzel 1962, p. 267]

Thomas Campion, 1567–1619, music and lyric. "Shall I come, if I swim?" (Leander to Hero). Song. Published in Rosseter's *A Booke of Ayres* (London: Morley, 1601). [Vivian 1966] Modern edition, New York: Scolar Press, 1977.

Peter Paul Rubens, 1577–1640. "Hero and Leander" (Leander drowned). Painting. *c.*1605. Yale University Art Gallery, New Haven. [Jaffé 1989, no. 51, pl. 779] Another version of the subject (or possibly identical) formerly in possession of Rembrandt, untraced. [Ibid.] Copy in Gemäldegalerie, Dresden, inv. 1002. [Pigler 1974, p. 323]

Domenico Fetti, *c.*1589–1624. "Hero and Leander." Painting. *c.*1610–12. Kunsthistorisches Museum, Vienna, inv. 160 (120). [Vienna 1973, p. 65—ill.]

Ben Jonson, 1572–1637. (Hero and Leander parodied in puppet play in) *Bartholomew Fair* 5.4. Comedy. First performed Oct 1614, London. Published London: 1631. [Herford & Simpson 1932–50, vol. 6 / Barton 1984, pp. 213ff.]

George Chapman, *c.*1559–*c.*1634. *The Divine Poem of Musaeus.* Poem, completion of Marlowe's unfinished *Hero and Leander* (1593). London: Hawkins, 1616. [Hulse 1981, pp. 124–27, 130–33, 125, 137 / Bush 1937, pp. 211–14, 216–18 / Leech 1986, pp. 197f. / Levin 1952, pp. 139–44]

Anthony van Dyck, 1599–1641, attributed. "Hero and Leander." Painting. *c.*1618–20. Sold New York, 1978 (as by Thomas Willeboirts). [Larsen 1988, no. 300—ill.]

Gabriel Bocángel y Unzueta, 1603–1658. "La fabula de Leandro y Hero." Poem. In *Rimas y prosas, junto con la fábula de Leandro y Ero* (Madrid: **1627**). Modern edition, *Rimas y prosas* (Barcelona: Montaner y Simon, 1948). [Oxford 1978, p. 69 / DLE 1972, p. 116]

Nicholas Lanier, 1588–1666. "Hero and Leander." Musical recitative. *c.***1625–28?** [Baker 1984, p. 1304 / Grove 1980, 10:455 / Bukofzer 1947, pp. 183f.]

Francesco Bracciolini dall' Api, 1566–1645. *Ero e Leandro.* Fable (favola maratima). Rome: Facciotti, **1630**. [DELI 1966–70, 1:463f.]

Le sieur de La Selve. *Les amours infortunées de Léandre et d'Héron.* Tragicomedy. Montpellier: Puech, **1633**. [Taylor 1893, p. 101]

Jan van den Hoecke, 1611–1651. "Hero Mourns the Dead Leander." Painting. *c.*1635–37. Kunsthistorisches Museum, Vienna, inv. 727 (1063). [Vienna 1973, p. 87—ill. / Warburg (as by Cornelis Schut, 1597–1655)]

Giacinto Gimignani, 1611–1681. "Hero and Leander." Painting. **1637?** Uffizi, Florence, inv. 2131. [Uffizi 1979, no. P708—ill.]

Antonio Mira de Amescua, 1574?–**1644**. *Hero y Leandro.* Drama. 17th century. Lost. [Oxford 1978, p. 389]

Francisco Gómez de Quevedo y Villegas, 1580–**1645**. *Ero y Leandro.* Romance. Collected in *Obras menores* (Brussels: Foppens, 1660–61). [Flynn 1978, pp. 146, 335]

Robert Baron, fl. 1630–58. (Story of Hero and Leander in) *Erotopaignion, or, The Cyprian Academy.* Romance in prose and verse (plagiary). London: **1647**. [Bush 1963, p. 337]

Robert Stapylton, *c.*1605–1669. *Musaeus, on the loves of Hero and Leander.* Verse translation of Musaeus and Ovid. London: Mosley, **1647**. [Bush 1963, p. 336]

———. *The Tragedie of Hero and Leander.* Tragedy. Imprimatur 25 Aug 1668. Unperformed. London: printed for Thomas Dring the Younger, 1669. [Nicoll 1959–66, 1:101, 433]

Robert Herrick, 1591–1674. "Leander's Obsequies." Poem. In *Hesperides* (London: Williams & Eglesfield, **1648**). [Martin 1956]

Gillis Backereel, 1572–1662. "Hero Lamenting the Dead Leander." Painting. **1640s.** Kunsthistorisches Museum, Vienna, inv. 1711 (1090). [Vienna 1973, p. 11—ill.]

Nicolo Renieri, 1590–1667. "Hero and Leander." Painting. *c.*1650. National Gallery of Victoria, Melbourne. [Warburg]

Anonymous. *The Loves of Hero and Leander.* Burlesque poem. London: **1651**. [Bush 1963, p. 302]

Francisco de Trillo y Figueroa, 1615?–1665? "Fábula de Leandro." Poem. In *Poesías varias, heroicas, satíricas y amorosas* (Granada: **1652**). [DLE 1972, p. 890]

Paul Scarron, 1610–1660. "Léandre et Héro." Burlesque ode. Paris: de Sommaville, **1656**. [Bush 1963, p. 302]

Gabriel Gilbert, before 1620–before 1680. *Léandre et Héro.* Tragedy. Paris: **1667**. [Frenzel 1962, p. 268]

William Wycherley, 1640–1716, attributed. *Hero and Leander.* Travesty burlesque. London: **1669**. In modern edition by Montague Summers, *Complete Works,* book 4 (London: Nonesuch, 1924). [Bush 1963, p. 304]

Jacob Jordaens, 1593–1678, attributed. "Hero and Leander." Painting. Recorded in 1768, untraced. [Rooses 1908, p. 259]

———, questionably attributed (also attributed to Isaac Isaacsz, 1599–1665). "A Goddess Carrying a Drowned Man toward Heaven" (Venus allowing nymphs to save Leander?). Statens Museum for Kunst, Copenhagen, inv. 1310a (attributed to Isaacsz). [Copenhagen 1951, no. 344—ill.]

Giulio Carpioni, 1613–1679. "The Corpse of Leander Pulled from the Sea." Painting. Szépművészeti Múzeum, Budapest, no. 600. [Budapest 1968, p. 125] At least 4 other versions. P. Ganz coll., New York; Musée Magnin, Dijon; Donzelli coll., Florence; Museo Civico, Padua; elsewhere. [Ibid.]

Francesco Antonio Pistocchi, 1659–1726. *Il Leandro.* Opera (lyrical drama). Libretto, C. Badovero. First performed 15 May **1679**, Riva delle Zattere, Venice. / Another version, *Gli amori fatali,* performed Jan 1682, San Moisé, Venice. [Grove 1980, 14:777]

Philip Ayres, 1638–1712. "Leander Drowned." Poem, imitation of Garcilaso de la Vega's "Pasando el mar Leandro el animoso" (above). In *Lyric Poems Made in Imitation of the Italians.* . . (London: for Knight & Saunders, **1687**). [Praz 1925, p. 429]

Vincenzo II De Grandis, 1631–1708. "Le lagrime d'Ero" [The Tears of Hero]. Cantata. [Grove 1980, 5:324]

Louis-Nicolas Clérambault, 1676–1749. *Léandre et Héro.* Cantata. Published in *Cantates françoises à I. et II. voix avec simphonie et sans simphonie,* book 2 (Paris: **1713**). [Grove 1980, 4:492]

Alessandro Scarlatti, 1660–1725. *Ero e Leandro.* Cantata. [Grove 1980, 16:561]

d'Albaret. *Léandre et Héro.* Tragedy. First performed **1750**, Paris. [Girdlestone 1972, pp. 296ff.]

Pierre de La Garde, 1717–*c.*1792, music. "Léandre et Héro." Act 3 of *La journée galante.* Opera-ballet. Libretto, P. Laujon. First performed 25 Feb **1750**, Versailles. [Grove 1980, 10:359f.]

René de Béarn, Marquis de Brassac. *Léandre et Héro.* Opera (tragédie lyrique). Libretto, Jean-Jacques Le Franc de Pompignan. First performed 5 May **1750**, L'Opéra, Paris. [Clément & Larousse 1969, 2:642 / Girdlestone 1972, pp. 296ff.]

Nicolas Racot de Grandval, 1676–1753. *Léandre et Héro.* Cantata. *c.*1755. [Grove 1980, 7:636]

Daniel Schiebeler, 1741–1771. "Hero." Ballad. *c.*1767? Published in *Musikalische Gedichte* (Hamburg: Bock, 1770). [Frenzel 1962, p. 167]

Thomas Horde, attributed. *Leander and Hero.* Tragedy. London: **1769**. [Nicoll 1959–66, 3:272, 333]

Jean François de La Harpe, 1739–1803. "Hero." Poem. *c.*1783? In *Oeuvres diverses* (Paris: Dupont, 1826). [DLLF 1984, 2:1185]

Johann Baptist von Alxinger, 1755–1797. *Hero.* Tragedy. **1785**. In *Sämmtliche Werke* (Vienna: Haas, 1812). [Frenzel 1962, p. 267]

Jean-Pierre Clovis de Florian, 1755–1794. "Héro et

Léandre." Dramatic monologue. In *Théâtre* (Paris: Didot l'Aîné, **1786**). [Frenzel 1962, p. 268]

Niccolò Zingarelli, 1752–1837. *Ero.* Oratorio. First performed **1786**, Milan. [Baker 1984, p. 2570 / Grove 1980, 20:694]

William Reeve, 1757–1815, music. *Hero and Leander.* Burletta. Libretto, Isaac Jackman. First performed **1787**, Royalty Theatre, London. Published London: Hughes & Bysh, 1787. [Nicoll 1959–66, 3:276 / Grove 1980, 15:670 / Fiske 1973, p. 484]

Friedrich Hölderlin, 1770–1843. "Hero." Poem. **1788**. First published in August Sauer, "Ungedruckte Dichtungen Hölderlins," *Archiv für Litteraturgeschichte,* vol. 13 (1885). [Beissner 1943–77, vol. 1 / Unger 1975, pp. 206–20, 257–60].

Angelica Kauffmann, 1741–1807. "Hero and Leander" (meeting in the Temple of Venus). Painting, for Prince of Waldeck. **1791**. [Manners & Williamson 1924, pp. 160, 170]

Simon Mayr, 1763–1845. *Ero.* Cantata for voice and orchestra. Libretto, G. Foppa. First performed **1793**, Teatro Mendicanti, Venice. [Grove 1980, 11:860]

———. *La aventura di Leandro.* Cantata. Libretto, Countess Velo. First performed 1797, for Count Carcano, Vicenza. [Ibid.]

Gottlob Bachmann, 1763–1840. *Hero und Leander.* Musical romance. Text, Samuel Gottlieb Bürde. Published Vienna: **1798**? [NUC]

Louis-Jacques Milon, 1766–1845, choreography. *Héro et Léandre.* Ballet. Music, Lefebvre. First performed **1799**, L'Opéra, Paris. [Guest 1976, p. 302 / Beaumont 1938, p. 6]

Friedrich von Schiller, 1759–1805. "Hero und Leander." Ballad. **1801**. In *Gedichte* (Leipzig: Crusius, 1800–03). [Oellers 1983]

Fortunata Fantàstici Sulgher, 1755–1824. *Ero e Leandro.* Poem. Parma: Bodoniani, **1802**. [DELI 1966–70, 2:419]

John Flaxman, 1755–1826. Series of drawings illustrating Musaeus's *Hero and Leander.* **1805**. [Irwin 1979, p. 91]

Désiré Beaulieu, 1791–1863. *Hero.* Cantata. Libretto, J. M. B. B. de Saint-Victor. Grand Prix de Rome, **1810**. [Grove 1980, 2:325]

Lord Byron, 1788–1824. (Story of Hero and Leander evoked in) "Written after Swimming from Sestos to Abydos." Poem. 9 May **1810**. In *Poems* (London: Murray, 1812). [McGann 1980–86, vol. 1]

———. (Story of Hero and Leander evoked in) *The Bride of Abydos: A Turkish Tale* 2.1. Poem. London: Murray, 1813. [McGann, vol. 3 / Bush 1937, p. 73]

John Keats, 1795–1821. "On a Leander Which Miss Reynolds, My Kind Friend, Gave Me." Sonnet. **1816–17**. In *The Gem* (edited by Thomas Hood) 1829. [Stillinger 1978 / De Selincourt 1951, pp. 540f.]

Leigh Hunt, 1784–1859. "Hero and Leander." Narrative poem. In *Hero and Leander, and Bacchus and Ariadne* (London: Ollier, **1819**). Modern edition by H. S. Milford, *Poetical Works* (London: Oxford University Press, 1923). [Boswell 1982, p. 142 / Bush 1963, pp. 179, 548]

Andries Cornelis Lens, 1739–**1822**. "Jupiter and Hero Asleep on Mount Ida." Painting. Kunsthistorisches Museum, Vienna. [Bénézit 1976, 6:581]

A. J. Brüssel. *Hero.* Lyric epic. **1822**. [Frenzel 1962, p. 268]

John Gibson, 1790–1866. "The Meeting of Hero and Leander." Marble relief. Duke of Devonshire coll., Chatsworth. *c.***1822**. [Hunger 1959, p. 152 / Bénézit 1976, 4:713]

William Etty, 1787–1849. "The Parting of Hero and Leander." Painting. **1827**. Tate Gallery, London, no. 5614. [Tate 1975, p. 29]

———. "Hero and the Drowned Leander." Painting. 1829. Private coll., on loan to York City Art Gallery. [Kestner 1989, p. 70, pl. 2.7]

Thomas Hood, 1799–1845. "Hero and Leander." Poem. In *The Plea of the Midsummer Fairies* (London: Longman & Co., **1827**). [Bush 1963, pp. 190f.]

Thomas Moore, 1779–1852. "Hero and Leander." Poem. In *Legendary Ballads* (London: Power, **1828**). [Boswell 1982, p. 188]

Franz Grillparzer, 1791–1872. *Des Meeres und der Liebe Wellen* [Waves of the Sea and of Love]. Verse tragedy. **1820–29**. First performed 5 Apr 1831, Burgtheater, Vienna. [DLL 1968–90, 6:801 / McGraw-Hill 1984, 2:418]

Alfred, Lord Tennyson, 1809–1892. "Hero to Leander." Dramatic monologue. In *Poems, Chiefly Lyrical* (London: Wilson, **1830**). [Ricks 1969 / Hughes 1987, pp. 46, 261, 262 n. / Nicolson 1962, p. 94]

Fanny Caecilia Hensel, 1805–1847. "Hero und Leander." Song. **1832**. [Cohen 1987, 1:315]

Robert Schumann, 1810–1856. (Stormy night of Leander's death evoked in) "In der Nacht." Composition for piano. In *Phantasiestuche* opus 12. **1837**. [Grove 1980, 16:865]

Joseph Mallord William Turner, 1775–1851. "The Parting of Hero and Leander—from the Greek of Musaeus." Painting. **1837**. National Gallery, London, inv. 521. [Butlin & Joll 1977, no. 370—ill. / London 1986, p. 630—ill.]

William Leman Rede, 1802–1847, libretto. *Hero and Leander.* Burletta. First performed 16 Apr **1838**, St. James Theatre, London. [Nicoll 1959–66, 4:478, 628]

Honoré Daumier, 1808–1879. "Leander." Comic lithograph, in "Ancient History" series. **1842**. [Delteil 1906–30, 22: no. 963—ill.]

Théodore Chassériau, 1819–**1856**. "(The Last Meeting of) Hero and Leander" ("The Poet and the Siren"). Grisaille sketch. Louvre, Paris, no. R.F. 3873. [Sandoz 1974, no. 185 / Louvre 1979–86, 3:132—ill.]

Louis Gustave Ratisbonne, 1827–1900. *Héro et Léandre.* Verse tragedy. Paris: Levy, **1859**. [Frenzel 1962, p. 268]

William Henry Rinehart, 1825–1874. "Leander." Marble statuette. Begun by 1859, completed **1865**. 2 examples. Unlocated. [Ross & Rutledge 1948, no. 26b] Replica. Baillière coll., Baltimore. [Ibid., no. 26a—ill.]

———. "Hero." Marble statuette. 1866–67. Peabody Institute, Baltimore. [Ibid., no. 17—ill.] 8 replicas, 1867–71. Peabody Institute; Pennsylvania Academy of Fine Arts, Philadelphia; elsewhere. [Ibid. / Gerdts 1973, pp. 20, 38, 57, fig. 11]

John La Farge, 1835–1910. "Swimmer" ("Leander, Study of a Man Swimming, Twilight"). Watercolor. **1866**. Yale University Art Gallery, New Haven. [Adams et al. 1987, fig. 93 / Weinberg 1977, p. 53, fig. 28]

Edward Armitage, 1817–1896. "Hero Lighting the Beacon." Painting. **1869**. [Kestner 1989, p. 246]

Francis Reginald Statham. "Hero." Poem. In *Glaphyra and Other Poems* (London: **1870**). [Bush 1937, p. 558]

Henry Hugh Armstead, 1828–1905. "Hero and Leander." Stone relief. *c.***1875.** Tate Gallery, London, no. 2054. [Tate 1975, p. 1]

Augusta Holmès, 1847–1903. *Héro et Léandre.* Opera. Libretto, composer. **1875.** Unperformed. [Cohen 1987, 1:326f. / Grove 1980, 8:656]

Ödön Péter József de Mihalovich, 1842–1929. "Hero und Leander." Orchestral ballade. **1875.** [Grove 1980, 12:286]

Giovanni Bottesini, 1821–1889. *Ero e Leandro.* Opera. Libretto, Arrigo Boito. First performed 11 Jan **1879,** Milan. [Grove 1980, 3:92] Text published 1897, and in *Tutti gli scritti* (Milan: 1942). [DELI 1966–70, 1:415f.]

Arthur Goring Thomas, 1850–1892. "Hero and Leander." Musical scene. Text, G. Macfarre. First performed **1880,** London. [Grove 1980, 18:777]

Arthur Coquard, 1846–1910. "Héro et Léandre." Lyric scenes. **1881.** [Grove 1980, 4:760]

Dante Gabriel Rossetti, 1828–1882. "Hero's Lamp." Sonnet, no. 88 in "The House of Life" sequence (augmented version). In *Ballads and Sonnets* (London: Ellis & White, **1881**). [Doughty 1965]

Ernst Frank, 1847–1889. *Hero.* Opera. Libretto, F. Vetter, after Grillparzer's *Des Meeres und der Liebe Wellen* (1820–29). First performed 26 Nov **1884,** Royal Opera, Berlin. [Grove 1980, 6:798f.]

Charles Harford Lloyd, 1849–1919. *Hero and Leander.* Cantata. First performed **1884,** Worcester Festival. [Grove 1980, 11:98]

Evelyn Pickering de Morgan, 1855–1919. "Hero Awaiting the Return of Leander." Painting. **1885.** [Kestner 1989, p. 111]

Alfredo Catalani, 1854–1893. *Ero e Leandro.* Symphonic poem, based on Boito's libretto (1879). First performed 9 May **1885,** La Scala, Milan. [Grove 1980, 4:2]

Arthur Hill, fl. 1858–93. "The Signal" (of Hero?). Painting. **1887.** [Kestner 1989, p. 248]

Frederic, Lord Leighton, 1830–1896. "The Last Watch of Hero" and (predella) "Leander Drowned." Paintings. *c.***1887.** City Art Gallery, Manchester, no. 1887–89. [Ormond 1975, nos. 330, 331—ill. / Minneapolis 1978, no. 54—ill. / Wood 1983, pp. 62, 72 / Kestner 1989, pl. 3.12]

Madison Cawein, 1865–1914. "Leander to Hero." Poem. In *Accolon of Gaul with Other Poems* (Louisville, Ky.: Morton, **1889**). [Boswell 1982, pp. 71f.]

Eugène-Antoine Aizelin, 1821–1902. "Leander." Marble statue. **1890.** Louvre, Paris, inv. R.F. 158, on deposit in Musée, Lyons. [Louvre 1979–86, 5:265]

Henry Scott Tuke, 1858–1929. "Leander." Painting. **1890.** [Kestner 1989, p. 340]

Gaston-Victor-Edouard Gaston-Guitton, 1825–**1891.** "Leander." Marble statue. Musées Nationaux, inv. R.F. 51, deposited in Musée, Sainte-Maxime, in 1952. [Orsay 1986, p. 272]

Anonymous. *Hero and Leander.* Drama. First performed 17 Jan **1891,** Gaiety Theatre, Hastings. [Nicoll 1959–66, 5:692]

Harold Kyrle Bellew, 1855–1911. *Hero and Leander.* Poetic drama. First performed 9 May **1892,** Prince's Theatre, Manchester; 2 June 1892, Shaftesbury Theatre, London. [Nicoll 1959–66, 5:256, 692]

Edmond Haraucourt, 1856–1942. *Héro et Léandre.* Dramatic poem. Performed 24 Nov **1893,** Chat-Noir, Paris; incidental music, "Paul-Lucien Hillemacher" (collaboration of Paul and Lucien Hillemacher). Published Paris: Charpentier & Fasquelle, 1902. [Grove 1980, 8:562]

Aristide Maillol, 1861–1944. "Hero and Leander." Woodcut. **1893.** [Guérin 1965, no. 4—ill.]

Luigi Mancinelli, 1848–1921. *Ero e Leandro.* Opera (tragedia lirica). Libretto, A. Boito. First performed 8 Oct **1896,** Norwich Festival; first staged performance 1897, Madrid. [Grove 1980, 11:601]

Ludvig Schytte, 1848–1909. *Hero.* Opera. Libretto, P. Levin. First performed 25 Sep **1898,** Copenhagen. [Baker 1984, p. 2085 / Hunger 1959, p. 153]

Victor Herbert, 1859–1924. *Hero and Leander.* Symphonic poem. First performed **1901,** Pittsburgh. [Grove 1980, 8:501]

Havergal Brian, 1876–1972. *Hero and Leander.* Symphonic poem, opus 8. **1904–05.** First performed 3 Dec 1908, London. Lost. [Baker 1984, p. 344 / Grove 1980, 3:275]

John Drinkwater, 1882–1937. "The Death of Leander." Poem. In *The Death of Leander and Other Poems* (Birmingham: Cornish, **1906**). [DLB 1983, 19:161]

Charles Edward Perugini, 1839–1918. "Hero." Painting. **1914.** [Kestner 1989, p. 303, pl. 5.52]

Wolfgang von Waltershausen, 1882–1954. *Hero und Leander.* Symphonic poem, opus 22. First performed **1925,** Munich. [Baker 1984, p. 2447]

Brookes More, b. 1859. *Hero and Leander.* Poem. Boston: Cornhill, **1926.** [Bush 1937, p. 590]

Frank Morgan. "Hero and Leander." Poem. In *The Quest of Beauty* (London: Parsons, **1926**). [Boswell 1982, p. 275]

James Urquhart. "Hero and Leander." Poem. In *Athens o' the North* (Edinburgh: Darien, **1928**). [Bush 1937, p. 574]

Malcolm Cowley, 1898–1989. "Leander." Poem. In *Blue Juniata: Collected Poems* (New York: Cape & Smith, **1929**). [Bush 1937, p. 490 n.]

A. E. Housman, 1859–**1936.** (Hero and Leander evoked in) "Tarry delight, so seldom met." Poem. No. 15 in *More Poems* (London: Cape; New York: Knopf, **1936**). [Housman 1940]

Berthe di Vito-Delvaux, 1915–. *Héro et Léandre.* Cantata, opus 11. Text, Felix Bodson. **1940.** [Cohen 1987, 2:728]

———. *Les amants de Sestos* [The Lovers of Sestos]. Opera, opus 37. Libretto, Bodson. 1949. [Ibid.]

Paul Gasq, 1860–**1944.** "Hero and Leander." Marble high-relief. Musées Nationaux, inv. R.F. 1151, deposited in Musée, Bandol, in 1955. [Orsay 1986, p. 272]

Hermann Schroeder, 1904–. *Hero und Leander.* Opera. **1950.** [Grove 1980, 16:745]

Paul Manship, 1885–1966. "Leander." Bronze statuette. **1955.** Unique cast. Minnesota Museum of Art, St. Paul, no. 66.14.83. [Minnesota 1972, no. 136 / also Murtha 1957, no. 573]

Juan Corelli, 1934–, choreography. *Héro et Léandre.* Ballet. First performed *c.***1961,** Radio-Télévision Française. [Cohen-Stratyner 1982, p. 206]

Marjorie Eastwood Dudley, 1891–**1963.** "Hero to Leander." Song. [Cohen 1987, 1:207]

Gerhard Wimberger, 1923–, music. *Hero und Leander.* Dance drama. **1963.** [Grove 1980, 20:446]

Andreas Nezeritis, b. 1897. *Hero and Leander.* Opera.

Libretto, R. Nezeritis's translation of Grillparzer's *Des Meeres und der Liebe Wellen* (1820–29). Before **1964**. [Grove 1980, 13:197]

Stein Mehren, 1935–. "Hero og Leander." Poem. In *Dikt for enhver som vaager* [Poetry for Whoever Dares] (Oslo: Aschehoug, **1973**). / Translated by Nadia Christensen in *Lines Review* 55–56 (Jan 1976). [Ipso]

Robert Heger, 1886–**1978**. *Hero and Leander*. Symphonic poem. [Baker 1984, p. 984]

HERSE AND AGLAURUS. Circling above the temple of Athena (Minerva), the winged god Hermes (Mercury) espied the beautiful Herse, daughter of King Cecrops of Athens. He fell in love with her and asked her sister Aglaurus (or Agraulus) for assistance, but she demanded a fortune of gold in return. Athena, angry with Aglaurus for opening the chest in which the goddess had hidden the child Erichthonius, afflicted the girl with jealousy for Herse's happiness. When Hermes approached Herse's door, Aglaurus sat outside and refused the god entrance. With his wand, Hermes opened the door and turned Aglaurus into a black stone. According to Apollodorus, Herse bore Hermes a son called Cephalus, who is sometimes confused with the huntsman loved by Eos.

Classical Sources. Euripides, *Ion* 23ff., 270ff. Ovid, *Metamorphoses* 2.552–834. Apollodorus, *Biblioteca* 3.14.2–3. Pausanias, *Description of Greece* 1.18.2–3, 1.26. Hyginus, *Fabulae* 166.

See also ERICHTHONIUS.

Dante Alighieri, 1265–1321. (Voice of Aglaurus, representing envy, heard in) *Purgatorio* 14.136–39. Completed *c.*1314? In *The Divine Comedy*. Poem. Foligno: Neumeister & Angelini, 1472. [Singleton 1970–75, vols. 2–3]

Christine de Pizan, *c.*1364–*c.*1431. (Mercury, Herse, and Aglaurus in) *L'epistre d'Othéa à Hector* . . . [The Epistle of Othéa to Hector] chapter 18. Didactic romance in prose. *c.*1400. MSS in British Library, London; Bibliothèque Nationale, Paris; elsewhere. / Translated by Stephen Scrope (London: *c.*1444–50). [Bühler 1970 / Hindman 1986, p. 196]

Flemish School. Series of 8 tapestries depicting the story of Mercury and Herse. Woven by Willem de Pannemaker for Brabant, Brussels, *c.*1550. 2 panels in Metropolitan Museum, New York; 2 in Prado, Madrid. [Metropolitan 1983, p. 223—ill.]

Francesco Primaticcio, 1504–**1570**. "Mercury in Love with Herse." Drawing. Duke of Devonshire coll., Chatsworth, 184. [Warburg]

Jacob Jordaens, 1593–1678. "Mercury and Herse," "Mercury Discovering Herse and Her Companions." Drawings (for lost tapestry series?). *c.*1570? Museum of Art, Rhode Island School of Design, Providence; Stedelijk Prentenkabinet, Antwerp (copy). [d'Hulst 1982, p. 307]

Paolo Veronese, 1528–1588. "Mercury (Hermes), Herse, and Aglaurus." Painting. *c.*1576–80. Fitzwilliam Museum, Cambridge, no. 143. [Pallucchini 1984, no. 177—ill. / Pignatti 1976, no. 247—ill. / Fitzwilliam 1960–77, 2:125—ill.]

Hendrik Goltzius, 1558–1617, composition. 3 engravings, depicting the story of Herse and Aglaurus, part of a set illustrating Ovid's *Metamorphoses* (2d series, nos. 17–19), executed by assistant(s). *c.*1590. (Unique impressions in British Museum, London.) [Bartsch 1980–82, nos. 0302.67–69—ill.]

Maerten de Vos, 1532–1603. "Mercury in Love with Herse." Drawing. Printroom, Antwerp. [Warburg]

Jacob Pynas, *c.*1585–after 1648, attributed (also attributed to Adam Elsheimer). "(Landscape with) Mercury and Herse." Painting. *c.*1605–08. Uffizi, Florence, inv. 1116. [Uffizi 1979, no. P1289—ill. / Röthlisberger 1981, no. 3—ill.] Variant ("Landscape with Herse"). Unlocated. [Röthlisberger, no. 4—ill.]

Paul Bril, 1554–1626, and **Adam Elsheimer**, 1578–**1610**. "Mercury in Love with Herse." Painting. Duke of Devonshire coll., Chatsworth. [Warburg] *For Elsheimer, see also Jacob Pynas, above.*

Denys Calvaert, 1540–**1619**. "Mercury in Love with Herse." Drawing. Uffizi, Florence, inv. 2352. [Warburg]

Claes Cornelisz Moeyaert, 1590/91–1655. "Mercury and Herse." Painting. **1624**. Mauritshuis, The Hague, inv. 394. [Mauritshuis 1985, pp. 234, 403—ill.]

Cornelis van Poelenburgh, *c.*1586–1667 (formerly attributed to Bartholomeus Breenbergh). "Landscape with Mercury and Herse" ("Mercury Struck by the Beauty of Herse"). Painting. *c.*1624. Mauritshuis, The Hague, inv. 134. [Röthlisberger 1981, no. 50—ill. / Mauritshuis 1985, p. 418—ill.] Another version of the subject in Staatliche Kunstsammlungen, Kassel, inv. 194. [Bénézit 1976, 8:392]

———, circle? (also attributed to Breenbergh). "Landscape with Mercury and Herse." Painting. Unlocated. [Röthlisberger, no. 329 (Breenbergh attribution rejected)—ill.]

Nicolas Poussin, 1594–1665, attributed. "Mercury, Herse, and Aglaurus." Painting. **Mid-late 1620s.** École des Beaux-Arts, Paris, no. 69. [Wright 1985, no. A26, pl. 214 / Blunt 1966, no. 164—ill. / also Thuillier 1974, no. B13—ill.]

———, formerly attributed. "Mercury, Herse, and Aglaurus." Painting. Sir Francis Cook coll., London. [Blunt, no. R87]

Hendrik van Balen, 1575–**1632**, and **Jan Brueghel the Elder**, 1568–1625 (foliage). "Herse with Her Servants." Painting. Gemäldegalerie, Kassel. [Bénézit 1976, 1:401]

——— (van Balen). "Mercury Watching Herse and Aglaurus at the Temple of Minerva." Painting. Musée, Valenciennes. [Ibid.]

Frans Francken II, 1581–1642, figures, and **Jan Wildens**, landscape. "Mercury and Herse." Painting. **1630s.** Prado, Madrid, inv. 2733. [Härting 1983, no. A253]

Govaert Flinck, 1615–1660. "Hermes (Mercury) and Aglaurus." Painting (false signature: "Rembran 1652"). *c.*1639–40? Museum of Fine Arts, Boston, inv. 03.1143. [von Moltke 1965, no. 85—ill. / Boston 1985, p. 100—ill.]

Claude Lorrain, 1600–1682. "Coast View with Mercury and Aglaurus." Painting. **1643**. Pallavicini coll., Rome. [Röthlisberger 1961, no. LV 70—ill.] Drawing after, in the artist's *Liber veritatis*. British Museum, London. [Ibid.] Copy in Earl of Leicester coll., Holkham Hall. [Ibid.]

Laurent de La Hyre, 1606–1656. "Mercury and Herse." Painting. **1649**. Musée, Épinal. [Dublin 1985, p. 28]

Bartholomeus Breenbergh, 1599–*c.*1657. "Mercury, Aglaurus, and Herse." Painting. Lost. [Röthlisberger 1981, no. 262] *See also van Poelenburgh, above.*

Juan Bautista del Mazo, *c.*1612–1667, attributed (formerly attributed to Diego Velázquez). "(Landscape with) Mercury and Herse." Painting. Prado, Madrid, no. 1217. [Prado 1985, p. 400 / López Torrijos 1985, pp. 311, 423 no. 6—ill.]

Jan Boeckhorst, 1605–1668. "Herse and Mercury." Painting. Kunsthistorisches Museum, Vienna, inv. 379 (1073). [Vienna 1973, p. 25—ill.] 17th-century copy in Metropolitan Museum, New York, no. 29.97. [Metropolitan 1980, p. 57—ill.]

Theodoor van Thulden, 1606–1669. "Mercury and Herse." Painting. Herzog Anton Ulrich-Museum, Braunschweig, no. 1036. [Braunschweig 1969, p. 133]

Valentin Lefebvre, *c.*1642–*c.*1680/82, questionably attributed. "Mercury in Love with Herse." Drawing. Szépművészeti Muzéum, Budapest, inv. E.35.14. [Pigler 1974, p. 179]

Albert Meyeringh, 1645–1714. "Mercury and Herse" ("Ideal Landscape with Flying Mercury"). Painting. 1686. Herzog Anton Ulrich-Museum, Braunschweig, no. 398. [Braunschweig 1976, p. 41 / also Braunschweig 1969, p. 95]

Gérard de Lairesse, 1641–1711 (active until *c.*1690). "Mercury in Love with Herse." Painting. [Pigler 1974, p. 178]

Jan Verkolje, 1650–1693, attributed (also attributed to Nicolaes Verkolje, 1653–1746). "Herse Preparing to Receive Mercury." Painting. Statens Museum for Kunst, Copenhagen. [Copenhagen 1951, no. 751—ill.]

Jan Erasmus Quellinus, 1634–1715. "Hermes Falls in Love with Herse." Painting. 1696. Musées Royaux des Beaux-Arts (Musée d'Art Ancien), Brussels, inv. 6510. [Brussels 1984a, p. 237—ill.]

——— (or Erasmus Quellinus, 1607–1678). "Mercury Slays Aglaurus." Painting. Musée des Beaux-Arts, Nantes. [Bénézit 1976, 8:550 (as Jan Erasmus) / Pigler 1974, p. 179 (as Erasmus)]

Flemish School. "Herse and Mercury." Painting. **17th century.** Herzog Anton Ulrich-Museum, Braunschweig, no. 1084. [Braunschweig 1976, p. 26]

Johann van Boekhorst, 1661–1724. "Mercury in Love with Herse." Painting. Galleria Doria, Rome, cat. 1942 no. 81 (as Jan Both). [Warburg]

Sebastiano Ricci, 1659–1734, questionably attributed (or William Kent?). "Mercury, Herse, and Aglaurus." Painting. City Art Gallery, Manchester. [Daniels 1976, no. 221]

Ottmar Elliger the Younger, 1666–1735. "Mercury in Love with Herse." Painting. [Pigler 1974, p. 178]

Daniel Gran, 1694–1757. "Mercury and Herse." Fresco. **1755.** Schloss Friedau, Obergrafendorf, Austria. [Knab 1977, no. F93—ill.]

Johann Georg Platzer, 1704–1761. "Mercury in Love with Herse." Painting. Gemäldegalerie, Dresden, inv. 2099. [Bénézit 1976, 8:379]

Jean-Baptiste-Marie Pierre, 1713–1789. "Mercury, in Love with Herse, Changes Aglaurus to Stone." Painting, model for part of "Loves of the Gods" Gobelins tapestry series. **1763.** Louvre, Paris, inv. 7227. [Louvre 1979–86, 4:133—ill.]

Louis-Jean-François Lagrenée, 1725–1805. "Aglaurus Tries to Hinder Mercury's Suit of Herse." Painting. **1767.** Nationalmuseum, Stockholm, inv. 839. [Pigler 1974, p. 179]

Joseph Mallord William Turner, 1775–1851. "Mercury and Herse." Painting. Exhibited **1811.** Private coll., England. [Butlin & Joll 1977, no. 114—ill.]

Anne-Louis Girodet, 1767–1824. "The Dream of Aglaurus" (seeing Mercury in the arms of Herse). Drawing. Musée, Montargis. [Boutet-Loyer 1983, no. 95—ill.]

HESIONE. *See* LAOMEDON.

HESPERIDES. Daughters of Nyx (Night) and Erebus (Darkness), the Hesperides were the guardians of a tree that produced golden apples. The tree grew in a garden located in the far west of the world, on the border of Oceanus; the Hesperides were thus called "Nymphs of the Setting Sun." The tree, a wedding gift from Gaia to Hera, was protected by the dragon Ladon.

Later versions of the myth name Hesperis and Atlas or Ceto and Phorcys as the parents of the Hesperides and identify between three and seven sisters. Among the names given to them are Aigle, Erytheia, Arethusa, Hespere, and Hesperethusa.

The golden apples figure in several myths, among them the eleventh labor of Heracles and the race of Hippomenes (or Melanion) and Atalanta.

Classical Sources. Hesiod, *Theogony* 215ff. Euripides, *Heracles* 394ff. Diodorus Siculus, *Biblioteca* 4.26ff. Ovid, *Metamorphoses* 4.637ff. Apollodorus, *Biblioteca* 2.5.11. Pausanias, *Description of Greece* 5.11.6, 5.18.4, 6.19.8. Hyginus, *Poetica astronomica* 2.3, 2.6.

See also ATALANTA; HERACLES, LABORS OF, Apples of the Hesperides.

Sandro Botticelli, 1445–1510. (Venus, Graces, Cupid, Mercury, Flora, Cloris, and Zephyr in the garden of the Hesperides in) "The Primavera." Painting. *c.*1478. Uffizi, Florence, inv. 8360. [Lightbown 1978, 1:73ff., no. B39—ill. / Berenson 1963, p. 34—ill.]

Edmund Spenser, 1552?–1599. (Tree of golden apples in Garden of Proserpina, progenitor of the apples associated with the Hesperides in) *The Faerie Queene* 2.7.53–55. Romance epic. London: Ponsonbie, **1590,** 1596. [Hamilton 1977 / Freeman 1970, pp. 150ff. / Hieatt 1975, p. 204 / Nohrnberg 1976, pp. 335f.]

Thomas Heywood, 1573/74–1641. "The Hesperides." Passage in *Gynaikeion: or, Nine Books of Various History Concerning Women* book 2. Compendium of history and mythology. London: Adam Islip, **1624.** [Ipso]

John Milton, 1608–1674. (The Attendant Spirit retires to the Garden of the Hesperides in) *Comus* lines 975–98. Masque. Music by Henry Lawes. First performed Michaelmas Day **1634,** Ludlow Castle. Published London:

Robinson, 1637. [Carey & Fowler 1968; cf. p. 225 *n.* / Duncan 1972, pp. 32f. / Brown 1985, pp. 142f., 146f.]

———. (Allusions to the Hesperides in) *Paradise Lost* 3.563–73, 4.245–51. Epic. London: Parker, Boulter & Walker, 1667. [Carey & Fowler; cf. pp. 596 *n.*, 626 *n.* / Brown, p. 144]

Nicola Porpora, 1686–1768. *Gli orti esperidi* [The Hesperidean Gardens]. Opera (azione teatrale). First performed 28 Aug **1721**, Palazzo Reale, Naples. [Grove 1980, 12:218]

François Collin de Blamont, 1690–1760, music. *Le jardin des Hesperides* [The Garden of the Hesperides]. Divertissement. **1739**. [Grove 1980, 4:563]

Nicola Conforto, 1718–after 1788. *Gli orti esperidi* [The Hesperidean Gardens]. Opera. First performed **1751**, Naples. [Grove 1980, 12:218]

Italian School. "Venus Gathering Apples in the Gardens of Hesperides." Painting. Before **1800**. Dulwich College Picture Gallery, cat. 1953 no. 260. [Wright 1976, p. 107]

John Flaxman, 1755–1826, design. "The Three Graces Gathering the Apples of the Hesperides." Figures on stem of silvergilt candelabrum. Executed by Paul Storr, **1809–10**. Royal Collection, England. [Irwin 1979, pp. 191f., fig. 263—ill.]

———, design. "The Serpent Ladon and Three Hesperides." Figures on stem of silvergilt candelabrum. Executed by Phillip Rundell, 1820–21. [Bindman 1979, no. 185a—ill.]

Alfred, Lord Tennyson, 1809–1892. "The Hesperides." Poem. **1830**. In *Poems* (London: Moxon, 1832). [Ricks 1969 / Hughes 1987, pp. 83–88, 242, 246, 269, 290 / Buckley 1961, pp. 46–48 / Schulz 1985, pp. 225f.]

Edward Burne-Jones, 1833–1898. "The Garden of the Hesperides." Painting. At least 2 versions, *c.*1869–73. Kunsthalle, Hamburg, inv. 5205; other(s?) cited as on loan to Birmingham City Museum and Art Gallery, England, and/or private coll. [Hamburg 1985, no. 170—ill. / Cecil 1969, pl. 71 / Harrison & Waters 1973, pp. 98, 101, pl. 17]

———, design. "Feeding the Dragon in the Garden of the Hesperides." Painting, cassone panel, executed by T. M. Rooke? 1882. Wightwick Manor, near Wolverhampton, on loan from Birmingham City Museum and Art Gallery, England. [Harrison & Waters, p. 128—ill.]

Hans von Marées, 1837–1887. "The Hesperides." Painting triptych. **1878–79**. Destroyed. [Gerlach-Laxner 1980, no. 170] 2d version, *c.*1884–87. Neue Pinakothek, Munich, inv. 7854 (8004). [Ibid., no. 143—ill. / Munich 1982, p. 218—ill.]

Edward Calvert, 1799–**1883**. "Garden of the Hesperides." Painting. Sir Geoffrey Keynes coll., England. [Lister 1962, pp. 41f.—ill. / also Maas 1969, p. 42—ill.]

Gabriele D'Annunzio, 1863–1938. "L'Esperidi e le Górgoni" [The Hesperides and the Gorgons]. Sonnet. **1885–88**. In *La Chimera* (Milan: Treves, 1890). [Palmieri 1953–59, vol. 2]

Frederic, Lord Leighton, 1830–1896. "The Garden of the Hesperides." Painting. *c.*1892. Lady Lever Art Gallery, Port Sunlight, Cheshire, no. 29. [Ormond 1975, no. 364—ill. / also Wood 1983, pp. 33, 76—ill. / Maas 1969, p. 178—ill. / Kestner 1989, pl. 3.17] Bronze model. Royal Academy, London. [Ormond] Color sketch. private coll. [Ibid., no. 365—ill.]

William Holman Hunt, 1827–1910. "The Garden of the Hesperides." Painted plaster relief, study for background of his painting "The Lady of Shalott." Exhibited **1906**. City Art Galleries, Manchester, England. [London 1968, no. 83]

Amy Lowell, 1874–1925. "Apples of the Hesperides." Poem. In *A Dome of Many-Coloured Glass* (Boston: Houghton Mifflin, **1912**). [TCLC 1978–89, 1:372]

John Singer Sargent, 1856–1925. "Atlas and the Hesperides." Painting, part of mural series. **1921–25**. Museum of Fine Arts, Boston. [Ratcliff 1982, p. 155—ill.] Study. Boston. [Ibid.—ill.]

Ridgely Torrence, 1875–1950. *Hesperides*. Collection of poems. New York: Macmillan, **1925**. [Gregory & Zaturenska 1946, p. 38]

John Lehmann, 1907–1987. *Hesperides*. Collection of poems. 10 broadsheets, privately printed, **1928**. [Vinson 1985, p. 487]

Max Ernst, 1891–1976. "The Garden of the Hesperides." Surrealistic painting. **1935**. 2 versions. Galerie André François Petit, Paris; the other unlocated. [Spies & Metken 1975–79, nos. 2200, 2201—ill. / also Quinn 1977, fig. 226]

———. "The Garden of the Hesperides." Surrealistic painting. *c.*1935. Jimmy Ernst coll. [Spies & Metken, no. 2203—ill. / also Quinn, fig. 224]

———. "The Garden of the Hesperides." Surrealistic painting. 1935–36. Unlocated. [Spies & Metken, no. 2253—ill.]

Ker-Xavier Roussel, 1867–**1944**. "The Garden of the Hesperides." Painting, part of a triptych. Private coll., Paris. [Georgel 1968, p. 367, no. 257—ill.]

César Klein, 1876–1954. "Apples of the Hesperides." Painting. **1945**. Kunsthalle, Hamburg. [Pfefferkorn 1962, p. 78—ill.]

———. "Garden of the Hesperides." Painting. 1947. [Hannover 1950, no. 43]

André Masson, 1896–1987. "Hesperides." Abstract lithograph. **1947**. [Passeron 1973, no. 11—ill.]

Eudora Welty, 1909–. *The Golden Apples* (symbolic evocation of myth in title). Collection of short stories. New York: Harcourt, Brace, **1949**. [DLB 1978, 2:529f.]

Max Ackermann, 1887–1975. "Garden of the Hesperides." Abstract painting. **1968**. [Ackermann exhibition catalog, University of Chicago, 1969, no. 28—ill.]

Jules Olitski, 1922–. "Hesperides." Abstract painting. **1973**. Felizitas Liemersdorf, Ratingen. [Moffett 1981, pl. 113]

C. H. Sisson, 1914–. "The Garden of the Hesperides." Poem. In *Exactions* (Manchester: Carcanet, **1980**). [Ipso]

HESPERUS. The personification of the evening star, in early myth Hesperus was the son of Eos (Aurora) and Astraeus or Cephalus. A later myth, identifying him as the son or brother of Atlas, relates that he disappeared in a whirlwind while climbing up Mount Atlas to observe the stars. In the postclassical arts Hesperus is sometimes associated with wedding songs (epithalamia) or with the marriage god Hymen (Hymenaeus).

Classical Sources. Bion, "Hesperus." Diodorus Siculus, *Biblioteca* 3.60.2–3, 4.27.1–2. Hyginus, *Fabulae* 65; *Poetica astronomica* 2.42.

Ben Jonson, 1572–1637. (Hesperus in) *Cynthia's Revels, or, The Fountaine of Selfe-Love.* Satirical comedy. First performed Blackfriar's Theatre, London, **1600–01.** Published London: 1601. [Herford & Simpson 1932–50, vol. 4 / McGraw-Hill 1984, 3:109, 112]

————. (Hesperus invoked in) "Epithalamion." Poem, part of *The Haddington Masque* (*The Hue and Cry after Cupid*). Masque, for marriage of Lord Haddington, 9 Feb 1608, at Court, London. Published London: 1608. [Herford & Simpson, vol. 7]

Thomas Campion, 1567–1619. (Hesperus in) *The Lord Hay's Masque.* Masque. First performed 6 Jan **1607,** Whitehall Palace, London. Published London: Brown, 1607. [Vivian 1966 / DLB 1987, 58: 37, 38f.]

Mark Akenside, 1721–1770. "To the Evening Star." Ode. No. 15 in *The Pleasures of Imagination* (London: Dodsley, **1744**). [Bush 1937, p. 38 / Boswell 1982, p. 8]

Jean Paul, 1763–1825. *Hesperus.* Novel. **1792–94.** Berlin: Matzdorff, 1795. Modern edition by Norbert Miller (Munich: Hanser, 1959). [Ipso]

Peter Cornelius, 1783–1867, and studio. "Evening" (Luna, with Hesperus and a maiden as Twilight). Ceiling fresco. **1820–26.** Göttersaal, Glyptothek, Munich. [Glyptothek 1980, pp. 214ff., fig. 5]

William Etty, 1787–**1849.** "Hesperus." Painting. Lady Lever Art Gallery, Port Sunlight, Cheshire. [Lister 1962, p. 41—ill.]

Harriet Hosmer, 1830–1908. "Hesper." Marble sculpture bust. **1852.** Watertown Free Public Library, Mass. [Gerdts 1973, pp. 47, 85, fig. 63]

Gaspare Martellini, 1785–**1857.** (Hesperus in) "Aurora." Ceiling painting. Sala dell' Aurora, Palazzo Pitti, Florence. [Pitti 1966, p. 76]

Edward Burne-Jones, 1833–1898. "Hesperus, the Evening Star" (female figure). Gouache. **1870.** Private coll., England. [Harrison & Waters 1973, pl. 28—ill.]

John Addington Symonds, 1840–1893. "Hesperus and Hymenaeus." Poem. In *New and Old: A Volume of Verse* (London: Smith, Elder, **1880**). [Boswell 1982, p. 227]

John Linnell, 1792–**1882.** "Hesperus." Painting. Museum and Art Gallery, Blackburn. [Jacobs & Stirton 1984b, p. 190]

Catulle Mendès, 1841–1909. *Hesperus.* Poem. In *Poésies* new edition, vol. 5 (Paris: Ollendorff, **1885**). [DLLF 1984, 2:1468]

Clara Angela Macironi, 1821–**1895.** "Hesperus." Song. [Cohen 1987, 1:437]

Arthur B. Davies, 1862–1928. "To Hesperus." Painting. **1909.** Hardon coll., New York. [Cortissoz 1931, p. 34]

————. "Shine, Hesperus." Painting. Exhibited 1918. Los Angeles County Museum of Art. [Davies 1975, no. 21—ill.]

A. E. Housman, 1859–1936. ("Hesper" leads bridegroom to bride in) "Epithalamium." Poem. In *Last Poems* (London: Richards; New York: Holt, **1922**). [Housman 1940]

H. D. (Hilda Doolittle), 1886–1961. (Hesperus central) "Hesperia." Short story. **1924.** In *Seven Stories* (unpublished, typescript in Beinecke Library, Yale University). [Robinson 1982, pp. 319, 471]

Frederic Prokosch, 1908–1989. "Hesperus, the Gentlest Star." Poem. In *Chosen Poems* (Garden City, N.Y.: Doubleday, **1947**). [Ipso]

Fritz Usinger, 1895–1982. *Hesperische Hymnen* [Hesperian Hymns]. Collection of poems. Stuttgart: Müller, **1948.** [Oxford 1986, p. 922]

Gerhard Marcks, 1889–1981. "Hesperus" (child). Bronze sculpture. **1971.** At least 8 casts. [Busch & Rudloff 1977, no. 975—ill.]

HESTIA. Daughter of the Titans Cronus and Rhea, the virgin goddess Hestia was guardian of the hearth and keeper of the home and family. A deity with limited roles and functions, she was rarely humanized and had little mythology. Hestia spurned the advances of Poseidon (Neptune) and Apollo, preferring to remain chaste. She was revered as the oldest of Cronus's children and was usually given precedence at banquets and in sacrificial rituals.

The traits and powers of the Roman goddess Vesta were equivalent to those of Hestia, but her role in Roman religion was more significant. She was worshiped at the hearth not only in every Roman home, but also in a temple in the Roman forum, in which was kept the sacred hearth of the state. Vesta was celebrated in a yearly festival and her temple was attended by "vestal virgins," pure young women who were said to represent the daughters of the early Roman kings and who were charged with keeping Vesta's sacred fire burning.

Because of her connection to the hearth, Vesta/Hestia is sometimes depicted in postclassical allegories as a personification of the element Fire.

Classical Sources. Hesiod, *Theogony* 453–506. *Homeric Hymns,* first and second hymn "To Hestia," first hymn "To Aphrodite" lines 21–32. Pindar, *Nemean Odes* 11.1ff. *Orphic Hymns* 84, "To Hestia." Virgil, *Georgics* 1.408; *Aeneid,* 1.292, 2.296. Ovid, *Fasti* 6.240–468. Pausanias, *Description of Greece* 5.14.4.

Antonio da Correggio, c.1489/94–1534. "Vesta" (?). Fresco. *c.*1519. Camera di San Paolo, Parma. [Gould 1976, pp. 51ff., 244]

Giulio Romano, c.1499–1546. "Vesta." Ceiling fresco. **1527–28.** Sala dei Venti, Palazzo del Tè, Mantua. [Hartt 1958, pp. 115ff.—ill.]

Domenico Beccafumi, 1486–**1551.** "Temple of Vesta." Painting. Contesse Martelli coll., Florence. [Berenson 1968, p. 35]

Thomas Heywood, 1573/74–1641. (Vesta, as mother of Saturn, in) *Troia Britanica: or, Great Britaines Troy* canto 1. Epic poem. London: **1609.** [Heywood 1974]

————. (Vesta in) *The Golden Age.* Drama, based on *Troia*

Britanica. First performed *c.*1609–11, London. Published London: Okes, 1611. [Heywood 1874, vol. 3 / DLB 1987, 62:101, 122ff. / also Boas 1950, pp. 83ff. / Clark 1931, pp. 62ff.]

Michael Drayton, 1563–1631. (Vesta evoked in) Sonnet 30 of *Idea.* Cycle of 63 sonnets. London: Smethwicke, **1619.** [Hebel 1931–32, vol. 2]

Jan Brueghel the Younger, 1601–1678, landscape, and **Hendrik van Balen,** 1575–1632, figures. (Vesta, representing fire, in) "Allegory of the Elements." Painting. *c.***1630.** Baron de Coppée coll., Brussels. [Ertz 1984, no. 204—ill.]

Thomas Middleton, 1570?–1627. "To Vesta." Poem. In modern edition, *Moonstruck: An Anthology of Lunar Poetry,* edited by R. Phillips (New York: Vanguard, 1974). [Ipso]

Antonio Draghi, 1634/35–1700. *Il fuoco eterno custodito delle Vestali* [The Eternal Fire in the Custody of the Vestal Virgins]. Opera. Libretto, Minato. First performed **1674.** [Hunger 1959, p. 370]

Sebastiano Ricci, 1659–1734. "Sacrifice to Vesta" (a priestess at the altar). Painting. **1723.** Gemäldegalerie Alte Meister, Dresden. [Daniels 1976, no. 83a—ill. / Dresden 1976, p. 87]

Francisco Goya, 1746–1828. "Sacrifice to Vesta." Painting. **1771.** J. Gudiol Ricart coll., Barcelona. [Gassier & Wilson 1981, no. 22—ill. / Gudiol 1971, no. 14—ill.]

Johann Adam Braun, 1753–after 1804. *Vesta.* Drama. **1783.** [DLL 1968–90, 1:916]

Ludwig van Beethoven, 1770–1827. *Vestas Feuer* [Flame of Vesta]. Opera, fragment. Libretto, Emanuel Schikaneder. **1803.** Published Wiesbaden: 1953. [Kerman & Tyson 1983, pp. 37, 38, 174]

Joseph Weigl the Younger, 1766–1846. *Vestas Feuer.* Opera. Libretto, Schikaneder, begun for Beethoven (above). First performed **1805.** [Oxford 1972, p. 359]

Ugo Foscolo, 1778–1827. (Vesta evoked in) *Le Grazie,* "Inno secondo" (part 2). Poem, unfinished. **1814.** Florence: 1848. Modern edition by Saverio Orlando, as *Le Grazie, carme ad Antonio Canova* (Brescia: Paideia, 1974). [Cambon 1980, pp. 85, 227ff., 346 / Circeo 1974, pp. 71ff.]

Percy Bysshe Shelley, 1792–1822. (Vesta evoked in) "Lines Written on Hearing the News of the Death of Napoleon." Published as a coda to *Hellas* (London: Ollier, **1822**). [Wassermann 1971, pp. 412, 451]

Pietro Tenerani, 1789–1869. "Vesta." Statue. Residenz, Munich; Galleria Nazionale d'Arte Antica, Rome. [Bénézit 1976, 10:110]

Henry Brougham Farnie, 1836–1889. *Vesta.* Burlesque. First performed 2 Sep **1871,** St. James Theatre, London. [Nicoll 1959–66, 5:361]

Anonymous. *Vesta's Temple.* Farce. First performed 14 Nov **1872,** Court Theatre, London. [Nicoll 1959–66, 5:763]

Edgar Fawcett, 1847–1904. "Vesta." Poem. In *Fantasy and Passion* (Boston: Roberts, **1878**). [Boswell 1982, p. 104]

Albert Kellner, b. 1857. *Das Feuer der Vesta* [The Fire of Vesta]. Comedy. **1885.** [DLL 1968–90, 8:1049]

Margaret Junkin Preston, 1820–1897. "Hestia." Poem. In *Colonial Ballads, Sonnets, and Other Verse* (Boston: Houghton Mifflin, **1887**). [Boswell 1982, p. 205]

John Greenleaf Whittier, 1807–1892. "Vesta." Poem. In *Complete Poetical Works* (Boston: Houghton Mifflin, 1863–94). [Ipso]

HIPPODAMIA. *See* PIRITHOUS.

HIPPOLYTA. *See* AMAZONS; HERACLES, LABORS OF, Girdle of Hippolyta; PENTHESILEA; THESEUS, and the Amazons.

HIPPOLYTUS. *See* PHAEDRA AND HIPPOLYTUS.

HIPPOMENES. *See* ATALANTA.

HYACINTH.

A handsome young man from Amyclae, Hyacinth (or Hyacinthus) was loved by Apollo, the bard Thamyris, and Zephyr, the west wind. According to Ovid, Apollo was so taken with the young man that he neglected his other duties. While teaching Hyacinth to throw the discus, Apollo accidentally struck and killed him; in another version, it was Zephyr who blew the discus off course out of jealousy. Where Hyacinth's blood spilled, Apollo caused a hyacinth flower to grow. Hyacinth was honored every year in the Laconian festival Hyacinthia, a ceremony of regeneration.

Classical Sources. Euripides, *Helen* 1465–78. Ovid, *Metamorphoses* 10.162–219. Apollodorus, *Biblioteca* 1.3.3; 3.10.3. Pausanias, *Description of Greece* 4.19.3–5. Lucian, *Dialogues of the Gods* 16, "Hermes and Apollo." Philostratus, *Imagines* 1.24. Philostratus the Younger, *Imagines* 14.

Anonymous French. (Story of Hyacinth in) *Ovide moralisé* 10.753–882 (narrative), 3425–3519 (allegory). Poem, allegorized translation/elaboration of Ovid's *Metamorphoses.* *c.***1316–28.** [de Boer 1915–86, vol. 4]

Marcantonio Raimondi, *c.*1480–1527/34. "Apollo, Hyacinth, and Amor." Engraving (Bartsch no. 348). **1505.** [Shoemaker 1981, no. 2—ill. / Bartsch 1978, 27:45—ill.]

Benvenuto Cellini, 1500–1571. "Apollo and Hyacinth." Marble sculpture group. Begun **1546,** unfinished. Museo Nazionale del Bargello, Florence. [Pope-Hennessy 1985a, pp. 229f.—ill. / also Saslow 1986, pp. 152f., fig. 4.6]

Gian Jacopo Caraglio, 1498/1500–1570. "Apollo and Hyacinth." Engraving. (Bibliothèque Nationale, Paris.) [Saslow 1986, pp. 112f., fig. 3.16]

Edmund Spenser, 1552?–1599. (Story of Apollo and Hyacinth depicted in tapestry of "Cupid's Wars," in) *The*

Faerie Queene 3.11.337. Romance epic. London: Ponsonbie, **1590,** 1596. [Hamilton 1977]

Annibale Carracci, 1560–1609. "Apollo and Hyacinth." Fresco. *c*.**1597–1600.** Galleria, Palazzo Farnese, Rome. [Malafarina 1976, no. 104v—ill. / Martin 1965, p. 113—ill. / also Saslow 1986, p. 163, fig. 4.10]

Domenichino, 1581–1641. "Apollo and Hyacinth." Fresco. **1603–04.** Loggia del Giardino, Palazzo Farnese, Rome. [Spear 1982, no. 10.ii—ill.] Copy by William Hamilton (1751–1801), Wedlesdon Hall, U.K. [Warburg]

John Milton, 1608–1674. (Death of Hyacinth evoked in) "On the Death of a Fair Infant Dying of a Cough" stanza 4. Poem. Winter **1625–26.** In *Poems, etc. upon Several Occasions* (London: Dring, 1673). [Carey & Fowler 1968]

Nicolas Poussin, 1594–1665. "Apollo Carrying the Dead Hyacinth." Drawing. Late **1620s.** Lost, known only from a copy by follower, in British Museum, London, no. 1946–7–13–1147. [Friedlaender & Blunt 1953, no. A47—ill.]

Peter Paul Rubens, 1577–1640. "The Death of Hyacinth." Painting, for Torre de la Parada, El Pardo, executed by Jan Cossiers from Rubens's design. **1636–38.** Palacio Real, Madrid. [Prado 1985, p. 596 / Jaffé 1989, no. 1287—ill. / also Alpers 1971, no. 32 (as lost)—ill.] Oil sketch. Prado, Madrid, no. 2461. [Alpers, no. 32a—ill. / Held 1980, no. 197—ill. / Jaffé, no. 1286—ill.]

Pietro da Cortona, 1596–1669. "Apollo and Hyacinth." High-relief stucco, part of a series depicting stories of Apollo. Begun **1645–47,** unfinished, completed 1659–61 by Ciro Ferri. Sala di Apollo, Palazzo Pitti. [Campbell 1977, pp. 108ff.—ill. / also Pitti 1966, pp. 79f.—ill.]

Louis Boulogne the Younger, 1654–**1733.** "Apollo and Hyacinth." Painting. Château de Fontainebleau. [Bènèzit 1976, 2:229]

Jacob de Wit, 1695–1754. "Apollo and Hyacinth." Mural. **1746.** Herengracht 468, Amsterdam. [Warburg]

Giovanni Battista Tiepolo, 1696–1770. "The Death of Hyacinth." Painting. *c*.**1752–53.** Thyssen-Bornemisza coll., Lugano. [Levey 1986, pp. 206f.—ill. / Pallucchini 1968, no. 209—ill. / Morassi 1962, p. 20]

Wolfgang Amadeus Mozart, 1756–1791. *Apollo et Hyacinthus.* Latin intermezzo. Libretto after Pausanias and Ovid. First performed 13 May **1767,** Salzburg University. [Baker 1984, p. 1600 / Grove 1980, 12:682, 728 / Mann 1977, pp. 27–34]

Benjamin West, 1738–1820. "The Death of Hyacinth." Painting. **1771.** Swarthmore College, Pa. [von Erffa & Staley 1986, no. 145—ill.]

Novalis (Friedrich Leopold von Hardenberg), 1772–1801. (Story of Hyacinth evoked in) *Die Lehrlinge zu Sais* [The Novices at Sais]. Novel, fragment. **1789.** In *Schriften,* edited by F. Schlegel and L. Tieck (Berlin: Buchhandlung der Realschule, 1802). [DLL 1968–90, 11:474]

Andrea Appiani the Elder, 1754–1817. "Apollo and the Dying Hyacinth." Fresco. **1811.** Villa Reale, Milan. [Bénézit 1976, 1:236]

John Keats, 1795–1821. (Death of Hyacinth evoked in) *Endymion* 1.327–31, 4.68–72. Poem. **1817.** London: Taylor & Hessey, 1818. [Stillinger 1978 / De Selincourt 1951, p. 422]

Peter Cornelius, 1783–1867, and studio. "Hyacinth." Ceiling fresco. **1820–26.** Göttersaal, Glyptothek, Munich. [Glyptothek 1980, pp. 214ff., 219f.—ill.]

François-Joseph Bosio, 1769–**1845.** "The Young Hyacinth." Marble sculpture. Musée des Beaux-Arts, Dunkerque. [Borowitz 1985, pp. 91f.—ill.]

Charles Marie René Leconte de Lisle, 1818–1894. "Fultus Hyacintho" [Hyacinth Supported]. Poem. In *Oeuvres: Poèmes antiques* (Paris: Lemerre, **1852**). [Pich 1976–81, vol. 1]

Lawrence Macdonald, 1799–1878. "Hyacinth." Marble statue. **1852.** Royal Collection, Buckingham Palace, London. [Read 1982, p. 132, pl. 160]

Merry-Joseph Blondel, 1781–**1853.** "The Death of Hyacinth." Painting. Artist's estate in 1853, untraced. [Bénézit 1976, 2:91]

Alexander Alexeevich Kisielev, 1855–**1895?** "Death of Hyacinth." Painting. / Copy (by Marchenko?) in Muzeum Narodowe, Warsaw, inv. 130277. [Warsaw 1969, no. 558—ill.]

Olive Custance (Lady Alfred Douglas), b. 1874. "Hyacinthus." Poem. In *The Inn of Dreams* (London: Lane, **1911**). [Boswell 1982, p. 81]

Siegfried Sassoon, 1886–1967. *Hyacinth, an Idyll.* Poem. London: Chiswick Press, **1912.** [Ipso]

Georg Trakl, 1887–**1914.** "Apollo und Hyazinthus." Poem. In *Gesammelte Werke: Dichtungen,* vol. 1 (Salzburg: Müller, 1938). [Ipso]

Constantine Cavafy, 1868–1933. (Hyacinth evoked in) "Lanes Taphos" [Tomb of Lanis]. Poem. Dec **1916.** Alexandria: privately printed, 1918? / Translated by Edmund Keeley and Philip Sherrard in *Collected Poems,* bilingual edition (Princeton: Princeton University Press, 1975). [Ipso / Keeley 1976, p. 82]

H. D. (Hilda Doolittle), 1886–1961. "Hyacinth." Poem. In *Heliodora and Other Poems* (London: Cape; Boston: Houghton Mifflin, **1924**). [Martz 1983]

D. H. Lawrence, 1885–1930. (Tram-conductor reminds the poet of Hyacinth in) "For a Moment." Poem. In *Last Poems* (Florence: Orioli; London: Heinemann, 1932). [Pinto & Roberts 1964, vol. 2]

Robert Duncan, 1919–1988. "An Apollonian Elegy" (Apollo mourning Hyacinth). Elegy. **1946.** In *The Years as Catches: First Poems, 1939–46* (Berkeley, Calif.: Oyez, 1966). [Boswell 1982, p. 253 / CLC 1977, 7:88]

Kathleen Raine, 1908–. (Hyacinth evoked in) "The Hyacinth." Poem. In *Living in Time* (London: Editions Poetry London, **1946**). [Ipso / CLC 1987, 45:330]

Cesare Pavese, 1908–1950. (Thanatos and Eros speak of Hyacinth as) "Il fiore" [The Flower]. Dialogue. In *Dialoghi con Leucò* (Turin: Einaudi, **1947**). / Translated by William Arrowsmith and D. S. Carne-Ross in *Dialogues with Leucò,* bilingual edition (Ann Arbor: University of Michigan, 1965). [Ipso / Biasin 1968, pp. 195, 311]

Hans Werner Henze, 1926–. "Apollo und Hyazinthus." Lied, for contralto and harpsichord. Text, Georg Trakl (see above). **1948.** [Grove 1980, 8:491, 496]

Ralph Gustafson, 1909–. (Hyacinth evoked in) "Hyacinths with Brevity." Poem. In *Fire on Stone* (Toronto: McClelland & Stewart, **1974**). [Ipso / CLC 1986, 36:218]

Louise Glück, 1943–. "Hyacinth." Poem. In *The Triumph of Achilles* (New York: Ecco, **1985**). [Ipso / CLC 1987, 44:217, 222]

HYGIEIA. *See* ASCLEPIUS AND HYGIEIA.

HYLAS. *See* JASON, Hylas.

HYMEN. The god of marriage, Hymen (Hymenaeus) was the son of Aphrodite (Venus) and Dionysus (Bacchus) or of Apollo and one of the Muses. Sometimes described as the personification of the wedding feast or as the leader of the nuptial chorus, he presided with his torch over the wedding of numerous mythological couples, including Perseus and Andromeda, Iphis and Ianthe, and Orpheus and Eurydice.

In the postclassical arts, Hymen is frequently associated with Eros (Cupid), god of love. Entertainments performed at wedding celebrations often invoke Hymen's name in their titles, even if the god does not actually make an appearance.

Classical Sources. Virgil, *Eclogues* 8.30; *Aeneid* 1.651, 4.99, 4.127. Ovid, *Metamorphoses* 4.758–64, 9.762–97f. 10.1–7. Nonnus, *Dionysiaca* 4.88ff., 29.24–178, 37.723–49, 38.137.

Francesco Colonna, *c.*1433–1527. (Hymen evoked in) *Hypnerotomachia Poliphili* [The Dream of Poliphilo]. Romance. Venice: **1499**; illustrated with woodcuts by anonymous engraver. [Wind 1968, p. 158 *n.*]

Giulio Romano, *c.*1499–1546. "Hymen" (?). Fresco (simulated statue). **1540–44**. Casa Giulio Romano, Milan. [Hartt 1958, p. 240—ill.]

Paolo Veronese, 1528–1588. "Hymen between Juno and Venus with a Bride and Groom before Him" ("Tribunal of Love"). Fresco. *c.*1560–61. Stanza dell' Amore Coniugale, Villa Barbaro-Volpi, Maser (Treviso). [Pallucchini 1984, no. 61a—ill. / also Pignatti 1976, no. 99—ill.]

Agnolo Bronzino, 1503–1572. "Stories of Hymen." 3 decorations for wedding festival of Francesco I de' Medici and Joanna of Austria. **1565**. Lost. / 2 drawings ("Virtues of Love Chasing the Vices," "Allegory of Hymen with Venus Crowned by the Muses"). Louvre, Paris; Christ Church Gallery, Oxford. [McCorquodale 1981, p. 149, figs. 104–05]

Philip Sidney, 1554–1586. (Apostrophe to Hymen in) *The Countess of Pembroke's Arcadia* (*The Old Arcadia*) third eclogues. Prose romance with poems, pastoral eclogues. Completed *c.*1580. This passage not included in revision of 1582–84 (London: 1590). [Ringler 1962, no. 63 / Robertson 1973]

Andrea Gabrieli, *c.*1510–1586. "Vieni Himeneo" [Come, Hymen]. 2 madrigals (with the same title). Published Venice: 1589, 1590. [Grove 1980, 7:59]

Edmund Spenser, 1552?–1599. (Hymen evoked and celebrated on marriage day of the poet in) "Epithalamion" lines 25–29, 140–147, 256, 405. Poem. In *Amoretti and Epithalamion* (London: Ponsonbie, **1595**). [Oram et al. 1989]

William Shakespeare, 1564–1616. (Hymen presides at the wedding of Orlando and Rosalind, Oliver and Celia, in) *As You Like It* 5.4.107ff. Comedy. *c.*1599. Stationers' Register 4 Aug 1600. First recorded performance, by King's Men, 2 Dec 1603, Wilton House, Wiltshire. Published London: Jaggard, 1623 (First Folio). [Riverside 1974 / Edwards 1986, p. 94]

———— and **John Fletcher,** 1579–1625. (Hymen presides at the wedding of Theseus and Hippolyta in) *The Two Noble Kinsmen* 1.1 (this passage attributed to Shakespeare). Drama (romance), adaptation of Chaucer's "The Knight's Tale." *c.*1613. No recorded performance in Shakespeare's lifetime. Published London: Waterson, 1634. [Riverside / Brownlow 1977, pp. 212, 219 / Muir 1985, p. 74 / Thompson 1978, pp. 213ff.]

Ben Jonson, 1572–1637. *Hymenaei (The Masque of Hymen)*. Masque. Performed 5 Jan **1606**, at Court, London. Published London: 1606. [Herford & Simpson 1932–50, vol. 7 / Miles 1986, pp. 105f., 159., 165 / Barton 1984, pp. 265, 314]

————. (Hymen in) *The Haddington Masque (The Hue and Cry after Cupid)*. Masque, for wedding of Lord Haddington, 9 Feb 1608, at Court, London. Published London: 1608. [Herford & Simpson]

————. (Hymen in) *A Challenge at Tilt*. Masque. Performed 1 Jan 1614, at Court, London. Published London: 1616. [Ibid.]

————. (Hymen in) *Love's Triumph through Callipolis*. Masque. Performed 9 Jan 1631, at Court, London. [Ibid.]

William Rowley, *c.*1585–1626/42. *Hymen's Holiday, or, Cupid's Vagaries*. Comedy. First performed *c.*1612, London. [DLB 1987, 58:24]

Samuel Daniel, 1562–1619. *Hymens Triumph*. Pastoral tragicomedy. First performed 2 Feb **1614**, Somerset House, London. Published London: Constable, 1615. [DLB 1987, 62:30, 38]

Hendrik Goltzius, 1558–**1617**, attributed, composition. "Hymen." Engraving, in "Four Deities" series, executed by Claes Jansz Visscher (Bartsch no. 28). Unique impression in British Museum, London. [Bartsch 1980–82, no. 0302.28—ill.]

Peter Paul Rubens, 1577–1640. (Hymen in) "The Presentation of the Portrait of Marie de' Medici to Henri IV," "The Marriage of Marie de' Medici to Henri IV by Proxy," "The Exchange of the Princesses (of France and Spain) at Andaye." Paintings, part of "Life of Marie de' Medici" cycle. **1622–25**. Louvre, Paris, inv. 1772, 1773, 1782. [Saward 1982, pp. 51ff., 58, 137ff.—ill. / Jaffé 1989, nos. 718, 721, 741, pp. 61f.—ill. / also Louvre 1979–86, 1:116f.—ill. / Baudouin 1977, pl. 43] Oil sketches. Alte Pinakothek, Munich, inv. 93, 94, 101. [Munich 1983, pp. 463ff.—ill. / Jaffé, nos. 717, 720, 740—ill. / Held 1980, nos. 60, 62, 73—ill.] Monochrome modello for "Marriage." Cholmondeley coll., Holkham Hall, Norfolk. [Jaffé, no. 719—ill. / also Baudouin, fig. 97]

—————. (Hymen in) "Minerva Protects Pax from Mars" ("Peace and War"). Painting. 1629–30. National Gallery, London, inv. 46. [White 1987, pp. 228f.—ill. / London 1986, p. 543—ill. / Baudouin, pl. 63]

—————. "Hymenaeus." Design for pair of stone statues, part of Triumphal Arch of Philip IV, decoration for "Pompa Introitus Fernandi," triumphal entry of Cardinal-Infante Ferdinand of Spain into Antwerp, 17 Apr 1635. Originals (executed by Hans van Mildert?) destroyed. [Martin 1972, pp. 70f., 89] Copies, after (lost) oil sketches for arch. Rubenshuis, Antwerp (1 on loan from Oudheidkundige Museum, Antwerp). [Ibid., nos. 5a, 13a—ill. / Held, nos. 148–49—ill.]

George Jeffreys, c.1610–1685. "Hymen hath together tyed." Song. **1631.** Published in Sir Richard Hatton's *Songs Made for Some Comedyes.* [Grove 1980, 9:585]

John Milton, 1608–1674. (Hymen described in) "L'allegro" lines 125–30. Poem. Summer **1631?** In *Poems* (London: Moseley, 1645). [Carey & Fowler 1968]

Prospero Bonarelli Della Rovere, 1582–1659. *L'Imeneo* [Hymen]. Dramatic pastorale in verse. Bologna: Tebaldini, **1641.** [Herrick 1966, p. 13]

Philippe de Buyster, 1595–1688. "Hymen and Cupid" (infants). Stucco sculptures. **c.1645.** Château de Maisons, near Paris. [Chaleix 1967, pp. 40, 125, pl. 7.2]

James Shirley, 1596–1666. (Hymen in) *The Triumph of Beauty.* Comedy with songs. London: **1646.** [Sharp 1969, p. 1242]

Robert Herrick, 1591–1674. (Hymen summoned to attend the bride in) "An Epithalamie to Sir Thomas Southwell and His Ladie." In *Hesperides* (London: Williams & Eglesfield, **1648**). [Martin 1956]

Gerrit van Honthorst, 1590–1656. (Hymen in) "Allegory of the Marriage of Fredrick Hendrick and Amalia van Solis." Painting. **1650.** Oranjezaal, Huis ten Bosch, The Hague. [Judson 1959, no. 124—ill.]

—————. (Hymen in) "The Landing of William II and Mary Stuart." Painting. After 1650. Huis ten Bosch. [Ibid., no. 127]

Giuseppe Antonio Bernabei, 1649?–1732. *Trionfo d'Imeneo* [Triumph of Hymen]. Opera. Libretto, Orlandi. First performed **1688,** Munich. [Grove 1980, 2:612]

Carlo Agostino Badia, 1672–1738. *Imeneo trionfonte* [Hymen Triumphant]. Serenata. First performed 28 Feb **1699,** Hoftheater, Vienna. [Grove 1980, 2:9]

John Hughes, 1677–1720. *Cupid and Hymen's Holiday.* Pastoral masque. First performed **1703?** Published in *Works* (London: 1735). [Nicoll 1959–66, 2:338]

André Campra, 1660–1744. *La dispute de l'Amour et de l'Hymen.* Cantata. Published in *Cantates françoises,* book 2 (Paris: **1714**). [Grove 1980, 3:665]

Jean-Baptiste Morin, 1677–1754, music. *L'Himen et l'Amour.* Divertissement. Published Paris: **1714.** [Grove 1980, 12:576]

—————, music. *Le triomphe de l'Amour et de l'Himen.* Parody. Published Paris: 1747. [Ibid.]

Nicola Porpora, 1686–1768. *Imeneo.* Cantata. Libretto, Silvio Stampiglia. First performed **1723,** for wedding of Prince of Montemilletto, Naples. [Grove 1980, 15:126]

—————. *Imeneo in Atene* [Hymen in Athens]. Heroic opera. Libretto, Silvio Stampiglia. First performed 1726, San Samuele, Venice. [Ibid.]

—————. *La festa d'Imeneo* [The Festival of Hymen]. Cantata. Libretto, Paolo Antonio Rolli. First performed 4 May 1736, King's Theatre, Haymarket, London. [Ibid. / Keates 1985, p. 200]

John Gay, 1685–1732. "Cupid, Hymen, and Plutus." Fable, no. 12 in *Fables* (London: Tonson, **1727**). [Dearing & Beckwith 1974, vol. 2]

Jonathan Swift, 1667–1745. (Hymen presides at the wedding of) "Strephon and Chloë." Poem. **1731.** First printed as a pamphlet, 1734; collected in *Works* (Dublin: Faulkner, 1735). [Williams 1958, vol. 2]

Seedo, c.1700–c.1754, music. *Venus, Cupid, and Hymen.* All-sung masque. First performed 21 May **1733,** Theatre Royal, Drury Lane, London. [Grove 1980, 17:101 / Fiske 1973, p. 124]

Marie Sallé, 1707–1756, choreography. *Le masque nuptial, ou, Les triomphes du Cupidon et d'Hymen.* Ballet. Music, Galliard. First performed 16 March **1734.** [EDS 1954–66, 8:1427]

Richard Jones, ?–1744, music. *Hymen's Triumph.* Pantomime. Libretto, anonymous. First performed by Gifford's company, 1 Feb **1737,** Lincoln's Inn Fields, London. [Fiske 1973, p. 91 / Nicoll 1959–66, 2:375]

Jean-Joseph Mouret, 1682–**1738.** *L'Amour et l'Hymen.* Cantatille. Published in *Cantatilles françoises* (Paris: 1718–38). [Grove 1980, 12:655]

George Frideric Handel, 1685–1759. *Imeneo.* Operetta. Libretto, Silvio Stampiglia (1723). First performed 22 Nov **1740,** Theatre Royal, Lincoln's Inn Fields, London. [Lang 1966, p.322 / Hogwood 1984, pp. 153, 164 / Keates 1985, pp. 235f. / Grove 1980, 8:116] Revised as concert version. First performed as *A New Serenata Called Hymen,* 1742, New Music Hall, London. [Hogwood, pp. 174, 287 / Keates, p. 241]

William Hogarth, 1697–1764. "Hymen and Cupid." Engraving, for illustration on ticket for the masque *Alfred.* **1740.** [Paulson 1965, no. 157—ill.]

Jean-Philippe Rameau, 1683–1764. *Les fêtes de l'Hymen et de l'Amour.* Ballet-héroïque. Scenario and choreography, Louis de Cahusac. First performed 15 Mar **1747,** Versailles. [Girdlestone 1983, p. 457–62 / Girdlestone 1972, pp. 302, 311 / Grove 1980, 15:568, 570]

Elizabeth Ryves, 1750–1797. "Triumph of Hymen." Poem. In *Poems on Several Occasions* (London: Wignell, **1762**). [Nicoll 1959–66, 3:304]

Michael Arne, c.1740–1786, songs. *Hymen.* Interlude. Text by Allen. First performed 23 Jan **1764,** Theatre Royal, Drury Lane, London. [Grove 1980, 1:604 / Fiske 1973, p. 310 / Nicoll 1959–66, 3:232]

Niccolò Jommelli, 1714–1774. *Imeneo in Atene.* Pastorale. Libretto, after Stampiglia (1726). First performed 4 Nov **1765,** Ducal Palace, Ludwigsburg. [Grove 1980, 9:693]

Jean-Georges Noverre, 1727–1810, choreography. *Das Fest des Hymenaüs* [The Festival of Hymen]. Ballet. First performed 11 Feb **1766,** New Opera House, Ludwigsburg. [Lynham 1950, pp. 63, 168]

Joshua Reynolds, 1723–1792. "Three Ladies (Graces) Adorning a Term of Hymen." Painting. Exhibited **1774.** Tate Gallery, London. [Royal Academy 1986, no. 90—ill. / Waterhouse 1941, p. 64—ill. / Hutchison 1986, p. 40]

Benjamin West, 1738–1820. (Hymen in) "Mr. and Mrs.

John Custance." Portrait painting. **1778.** Nelson-Atkins Museum of Art, Kansas City, Mo. [von Erffa & Staley 1986, no. 607—ill.]

————. "Hymen Leading and Dancing with the Hours before Peace and Plenty." Painting, for Marble Gallery, Windsor Castle. 1789. Lost, probably destroyed. [Ibid., no. 432—ill.]

Angelica Kauffmann, 1741–1807. "Hymen." Painting, for Prince Yousoupoff of Russia. **1785.** [Manners & Williamson 1924, p. 149]

Gaetano Andreozzi, 1755–1826. *La pace tra Amore e Imeneo* [The Peace between Amor and Hymen]. Opera. First performed **1787,** Florence. [Grove 1980, 1:411]

Johann Gottlieb Naumann, 1741–1801. *La reggia d'Imeneo* [The Court of Hymen]. Opera (festa teatrale). Libretto, Migliavacca. First performed 21 Oct **1787,** Kleines Kurfürstliches Theater, Dresden. [Grove 1980, 13:79]

Anton Eberl, 1765–1807. *La gloria d'Imeneo* [The Glory of Hymen]. Cantata, opus 11. Libretto, C. Gattechi. **1799.** [Grove 1980, 5:813]

Jean-Baptiste Greuze, 1725–**1805.** "Innocence Led by Cupid" ("The Triumph of Hymen"). Painting. Louvre, Paris, no. R.F. 2154. [Louvre 1979–86, 3:289—ill. / also Munhall 1976, no. 100—ill. / Brookner 1972, pl. 68]

Luigi Cherubini, 1760–1842. "Ode à l'Hymen." Music for Napoleon's marriage. **1810.** [Grove 1980, 4:211]

Pierre-Paul Prud'hon, 1758–1823. "Hymen, Cupid, and Genius Chaining the Graces and the Muses [of History, Epic Poetry, and Astronomy]." Drawing, design for sculpture decorating Hôtel de Ville for celebration of the marriage of Napoleon to Marie-Louise. **1810.** Sculpture executed by Edme Gaulle, destroyed. Original drawing in Louvre, Paris. [Guiffrey 1924, no. 979, pp. 352f.]

————. "Hymen Uniting Mars and Minerva" (representing Napoleon and Marie-Louise). Drawing, design for entablature above "Psyche," sculpture decoration for apartments of Empress Marie-Louise, Paris. c.1810. Marcille-Jahan-Chévrier coll. [Ibid., no. 980, pp. 365f.—ill.]

————. "Venus, Hymen, and Cupid." Painting, grisaille sketch, unfinished. Musée National des Beaux-Arts, Algiers, on deposit in Louvre, Paris (no. D.L. 1970–18). [Louvre 1979–86, 5:10—ill. / also Guiffrey, no. 190] Another version of the subject known, unlocated. [Guiffrey, no. 189]

Karl Friedrich Ludwig Kannegiesser, 1781–1861. *Amor und Hymen.* Poetic idyl. Prenzlau: Ragocsy, 1818. [DLL 1968–90, 8:885]

Jean-Baptiste Regnault, 1754–**1829.** "Hymen and Cupid Drinking from the Cup of Friendship." Painting. Louvre, Paris, no. R.F. 2159. [Louvre 1979–86, 4:171—ill.]

Manuel Bretón de los Herreros, 1796–1873. *El templo de Himeneo* [The Temple of Hymen]. Comedy in verse. First performed 12 Dec **1829,** Teatro del Principe, Madrid. [McGraw Hill 1984, 1:408]

Bertel Thorwaldsen, 1770–1844. "Cupid and Hymen Spinning the Thread of Life." Marble relief. **1832–34.** Thorwaldsens Museum, Copenhagen, no. A454. / Plaster original, 1831. Thorwaldsens Museum, no. A455. [Thorwaldsen 1985, p. 55]

————. "Cupid and Hymen." Marble relief. 1842–44. Thorwaldsens Museum, no. A451. / Plaster original, 1840. Thorwaldsens Museum, no. A452. [Ibid., pp. 54f.]

————. "Cupid Garlands Hymen's Torches." Relief. Plaster original, 1840. Thorwaldsens Museum, no. A453. [Ibid., p. 55]

————. "Hymen." Relief. Plaster original, 1843. Thorwaldsens Museum, no. A731. / Plaster cast. Thorwaldsens Museum, no. A457. [Ibid., pp. 72, 55]

C. Long. *Hymen's Muster Roll.* Extravaganza. First performed 3 June **1847,** Grecian Theatre, London. [Nicoll 1959–66, 4:347]

Anonymous. *Hymen's Muster Roll.* Extravaganza. First performed **1860,** London. [Nicoll 1959–66, 5:695]

Victor Hugo, 1802–1885. "O Hyménée." Poem, no. 5 in *Les chansons des rues et des bois* (Paris: Hetzel, **1865**). [Hugo 1985–86, vol. 5]

Edward Burne-Jones, 1833–1898. "Hymenaeus." Painting. **1868.** Delaware Art Museum, Wilmington. [Delaware 1984, p. 38—ill.]

————. "The Altar of Hymen" (Pygmalion and Galatea embracing, Hymen looking on). Gouache, based on an illustration to William Morris's "Pygmalion and the Image" (1868). 1874. Private coll. [Harrison & Waters 1973, p. 116—ill.]

————. "Hymen" (with a man and woman). Painting. 1875. [Bell 1901, p. 52]

John Addington Symonds, 1840–1893. "Hesperus and Hymenaeus." Poem. In *New and Old: A Volume of Verse* (London: Smith, Elder, **1880**). [Boswell 1982, p. 227]

Alfred Gilbert, 1854–1934. "An Offering to Hymen" (woman holding a statuette of Anteros and a silver goblet). Bronze statuette. **1884–86.** Numerous casts. City Art Galleries, Manchester, England (2 casts); National Museum of Wales, Cardiff; Victoria and Albert Museum, London; Ashmolean Museum, Oxford; elsewhere. [Minneapolis 1978, no. 95—ill. / Beattie 1983, pl. 134]

Tor Harald Hedberg, 1862–1931. *Amor och Hymen.* Comedy. Stockholm: Bonnier, **1904.** [Sharp 1933, p. 119]

H. D. (Hilda Doolittle), 1886–1961. "Hymen." Poem. In *Hymen* (London: Egoist; New York: Holt, **1921**). [Martz 1983 / Friedman 1981, p. 7]

A. E. Housman, 1859–1936. (Hymen joins the groom and bride in) "Epithalamium." Poem. In *Last Poems* (London: Richards; New York: Holt, **1922**). [Housman 1940]

Marianne Moore, 1887–1972. (Hymen evoked in) "Marriage." Poem. In *Marriage* (New York: Wheeler [Manikin no. 3], **1923**); collected in *Selected Poems* (New York: Macmillan; London: Faber & Faber, 1935). [Hadas 1977, pp. 148, 151]

Doris Humphrey, 1895–1958, choreography. "Les fêtes de l'Hymen et Terpsichore." Dance interlude in *Les romanesques.* Music, Rameau, arranged by Griffes. First performed **1930,** The Glen, Newport, R.I.; production, Gerald Cornell. [Cohen 1972, pp. 94, 287]

Georges Braque, 1882–1963. "Hymen." Stone sculpture. **1939.** Galerie Maeght, Paris. [Cogniat 1980, pp. 45, 50—ill. / Fumet 1951, no. 35—ill. / Clapp 1970, 1:111] Bronze. Galerie Maeght. [Berlin 1963, no. 77—ill.]

Edvin Kallstenius, 1881–1967. *Hymen, o Hymenaios.* Cantata, opus 45. **1955.** [Grove 1980, 9:781]

Maura Stanton, 1946–. (Hyman evoked in) "The Boy Next Door: A Pastoral." Poem. In *Snow on Snow* (New Haven: Yale University Press, **1975**).

HYPERION. A sun-god and the last of the twelve Titans, offspring of Uranus and Gaia, Hyperion was the brother and spouse of Thea. They had three children: Helios, Selene, and Eos, deities of the sun, moon, and dawn, respectively. Hyperion's power and attributes as a sun-god, along with those of Helios, were later assumed by Apollo.

Classical Sources. **Homeric Hymns,** "To Helios." Hesiod, *Theogony* 371–74.

See also TITANS AND GIANTS.

William Shakespeare, 1564–1616. (Hamlet compares his dead father to Claudius as "Hyperion to a satyr" in) *Hamlet* 1.2.139f. Tragedy. *c.*1600–01. Published London: 1603 (inferior text); collected in First Folio, London: Jaggard, 1623. [Riverside 1974]
Thomas Gray, 1716–1771. (Hyperion in) "The Progress of Poesy." Ode. **1754**. London: Horace Walpole, 1757. [Ipso]
William Blake, 1757–1827. Hyperion driving out the forces of Night, depicted in illustration for Gray's "The Progress of Poesy" (1754). Drawing with watercolor. *c.*1797–98. Mellon coll., Upperville, Va. [Butlin 1981, no. 335.46—ill.]
Friedrich Hölderlin, 1770–1843. *Hyperion, oder, Der Eremit in Griechenland* [Hyperion, or, The Hermit in Greece] (symbolic use of myth in title). Novel. **1794–99.** Tübingen: Cotta, 1797 (vol. 1), 1799 (vol. 2). [Beissner 1943–77, vol. 3 / Strich 1970, 1:358ff. / Butler 1958, pp. 214–21 / Closs 1957, pp. 114f., 121f., 124, 130]
John Keats, 1795–1821. *Hyperion: A Fragment.* Poem. Oct 1818–April **1819** (London: Taylor & Hessey, 1820). [Stillinger 1978 / Aske 1985, pp. 73, 82–100, 136 / Gradman 1980, pp. 22f., 38–63 / Ridley 1933, pp. 57–95]
————. *The Fall of Hyperion: A Dream.* Poem. Begun July/Sep 1819, as a revision of *Hyperion,* unfinished. First published by Richard Monckton Milnes (without 1.187–210) as *Another Version of Keats' Hyperion* in *Miscellanies of the Philobiblon Society* 3 (1856–57). [Stillinger 1978 / Vendler 1983, pp. 196–226 / Gradman 1980, pp. 119–36 / Ridley 1933, 266–80] Omitted lines first published in *Hyperion: A Facsimile,* edited by De Selincourt (Oxford: Clarendon Press, 1905). [Stillinger]

Henry Wadsworth Longfellow, 1807–1882. *Hyperion.* Semi-autobiographical prose romance. New York: Colman, **1839.** [Oxford 1983a, p. 443]
Algernon Charles Swinburne, 1837–1909. "Hyperion." Poem. **1859**. In *Swinburne's Hyperion and Other Poems,* edited by Georges Lafourcade (London: Faber & Gwyer, 1927). [Bush 1937, p. 330]
Johannes Brahms, 1833–1897. "Schicksalslied" [Song of Fate]. Composition for 4 voices and orchestra, opus 54, setting of the poem "Hyperions Schicksalslied" from Hölderlin's *Hyperion* (1794–99). **1868–71.** First performed 1871, Karlsruhe. [Grove 1980, 3:170, 178 / Closs 1957, p. 127]
George Frederick Watts, 1817–**1904.** "Hyperion." Painting. [Phythian 1907, pp. 75f.]
Georg Kaiser, 1878–1945. *Hyperion: Die Gabe an die Freunde* [Hyperion: The Gift to the Friends]. Drama. Weimar: Wagner, **1911;** 1913. [McGraw-Hill 1984, 3:122 / Paulsen 1960, p. 144]
Stefan George, 1868–1933. "Hyperion." 3 poems (I–III). In *Das neue Reich* (Berlin: Bondi, **1928**). [Oxford 1986, p. 285 / Closs 1957, pp. 125, 190]
Richard Wetz, 1875–**1935.** "Hyperion." Composition for baritone solo, chorus, and orchestra, opus 32. [Baker 1984, p. 2486]
Ernst Toch, 1887–1964. *Hyperion.* Symphonic poem, opus 71, after Keats (1819). First performed 8 Jan **1948,** Cleveland. [Baker 1984, p. 2318 / Grove 1980, 19:21 (1947)]
Mihail Andricu, 1894–1974, music. *Luceafărul* [Hyperion]. Ballet (score, opus 60). **1951.** Choreography, A. Jar. [Grove 1980, 1:413]
Peter Richard Tahourdin, 1928–. *Hyperion.* Overture. **1952.** [Grove 1980, 18:526]
Bruno Maderna, 1920–1973, music. *Hyperion.* Lyric spectacle. Libretto, Maderna and V. Puecher, after Hölderlin (1794–99). First performed 6 Sep **1964,** Venice Festival. [Slonimsky 1986, p. 305 / Baker 1984, p. 1423 / Grove 1980, 11:455]
Ole Buck, 1945–. *Hyperion.* Composition for string quartet. **1969–70.** [Grove 1980, 3:409]
Tudor Jarda, 1922–, music. *Hyperion.* Ballet. **1974.** Choreography, I. Rîpa and I. Capuseanu. [Grove 1980, 9:555]
Fanny Rubio Gamez, 1948–. *Hiperión.* Poem. Madrid: **1977.** [Galerstein 1986, p. 281]

HYPERMNESTRA. See DANAÏDS.

HYPSIPYLE. See JASON, Hypsipyle.

I

IARBAS. *See* DIDO.

ICARIUS. *See* ERIGONE.

ICARUS AND DAEDALUS. A master craftsman from Athens, Daedalus was forced to flee the city after murdering his nephew, an artist of even greater skill. Settling in Crete, Daedalus created the

wooden cow in which Pasiphaë, wife of King Minos, was impregnated by the Cretan bull. To contain her monstrous offspring, the Minotaur, Daedalus built the labyrinth. Furious at the assistance Daedalus had given to Pasiphaë, Minos imprisoned him and his son, Icarus, in the labyrinth. They managed to escape by flying away on wings that Daedalus fashioned from feathers and wax. Daedalus counseled his son to fly a middle course, neither too close to the water nor too near the sun, but Icarus soared so high that the heat of the sun melted the wax in his wings. He fell into the Aegean Sea and drowned. After burying his son on the island now called Ikaria, Daedalus flew on safely to Sicily.

Classical Sources. Xenophon, *Memorabilia* 4.2.33. Virgil, *Aeneid* 6.14–33. Horace, *Odes* 2.20, 3.7, 4.2. Ovid, *Tristia* 1.163–64; *Metamorphoses* 8.155–262; *Fasti* 4.284. Strabo, *Geography* 14.1.19. Apollodorus, *Bibliotheca* E1.12–14. Pliny, *Naturalis historia* 7.56.168. Pausanias, *Description of Greece* 9.11.4ff. Hyginus, *Fabulae* 40, 190. Lucian, *Icaromenippus.*

Further Reference. John H. Turner, *The Myth of Icarus in Spanish Renaissance Poetry* (London: Tamesis, 1976).

See also PASIPHAË.

Anonymous French. (Icarus's flight and death in) *Ovide moralisé* 8.1579–1708, 1767–1928. Poem, allegorized translation/elaboration of Ovid's *Metamorphoses*. *c.*1316–28. [de Boer 1915–86, vol. 3 / Turner 1976, p. 22]

Giovanni Boccaccio, 1313?–1375. (Fortiene recites Icarus's story in) *L'amorosa visione* cantos 35, 37–45. Poem, allegorical dream-vision. *c.*1340. First published Venice: Zoppinol, 1531. [Branca 1964–83, vol. 3]

Geoffrey Chaucer, 1340–1400. (Icarus evoked in) "The Hous of Fame" lines 919–24. Poem. **1378–80.** Westminster: Caxton, *c.*1483. [Riverside 1987]

John Gower, 1330?–1408. (Story of Icarus in) *Confessio amantis* 4.1035–71. Poem. *c.*1390. Westminster: Caxton, 1483. [Macaulay 1899–1902, vol. 2 / Beidler 1982, p. 37]

John Lydgate, 1370?–1449. (Icarus evoked in) *Reson and Sensuallyte* lines 4162ff. Poem, partial translation of *Les échecs amoureux* [Love's Game of Chess] (1370–80). Probably before **1412.** In modern edition by E. Sieper (London: Early English Text Society, 1901). [Pearsall 1970, p. 117 / Ebin 1985, p. 37]

Juan de Mena, 1411–1456. (Icarus evoked in) *El laberinto de Fortuna.* Poem. **1444.** [Salamanca?]: 1481–88. Modern edition by J. C. Cummins (Salamanca: 1968). [Turner 1976, pp. 47f.]

Filarete, *c.*1400–1469? "Daedalus," "Icarus." Reliefs, on bronze door of St. Peter's, Rome. **1433–45.** In place. [Pope-Hennessy 1985b, 2:318]

Albrecht Dürer, 1471–1528, previously attributed. "The Fall of Icarus." Woodcut. **1493.** [Strauss 1980, no. X–4—ill.]

Sebastiano del Piombo, *c.*1485–1547. "Daedalus and Icarus." Fresco. *c.*1511. Sala di Galatea, Villa Farnesina, Rome. [d'Ancona 1955, pp. 39ff., 88 / Gerlini 1949, pp. 15f.]

Jacopo Sannazaro, 1458?–1530. Sonnet beginning "Icaro

cadde qui" In modern edition by A. Mauso, *Opere volgari* (Bari: 1961). [Turner 1976, pp. 50, 59]

Lodovico Ariosto, 1474–1533. (Icarus evoked in) Sonnet beginning "Nel mio pensier . . . " and another passage beginning "Tacer debbo e vorrei. . . ." In modern edition, *Rime* (Bari: 1924). [Turner 1976, pp. 50ff.]

Garcilaso de la Vega, 1503–1536. (Icarus evoked in) Sonnet, no. 12, beginning "Se para refrenar este desseo loco. . . ." In modern edition by E. Rivers, *Obras* (Madrid: 1964). [Turner 1976, pp. 58f.]

Jacopo Tintoretto, 1518–1594. "The Fall of Icarus" (?). Painting. *c.*1541. Galleria Estense, Modena. [Rossi 1982, no. 33—ill.]

Giulio Romano, *c.*1499–1546. "Daedalus and Icarus" ("Daedalus Teaching Icarus to Fly"). Painting. Lost. / 2 drawings (for?). Earl of Ellesmere coll., Mertoun House, Roxburghshire, Scotland; Uffizi, Florence, no. 145E. [Hartt 1958, pp. 168, 278, 305 (no. 297)—ill.]

———, circle (after design by Giulio?). "The Fall of Icarus." Painting. Sala dei Cavalli, Palazzo Ducale, Mantua. [Hartt, p. 168]

Giovanni Angelo Montorsoli, 1507?–1563. "The Fall of Icarus." Bas-relief, on Orion Fountain, Messina. **1548.** [Warburg]

Pierre de Ronsard, 1524–1585. (Icarus evoked in) Sonnets, nos. 167 (a translation of Ariosto) and 168 of *Les amours* (Paris: Buon, **1552**). [Laumonier 1914–75, vol. 3 / Turner 1976, pp. 70f.]

Annibale Caro, 1507–1566. Icarus linked to the Phoenix in a poem (sestina). In *Rime* (Venice: 1757). [Turner 1976, p. 53]

Luigi Tansillo, 1510–1568. (Icarus evoked in) Sonnet, beginning "Amor m'impenna e'ale . . . " and madrigal, beginning "S'un Icaro. . . ." In modern edition, *Canzoniere*, vol. 1 (Naples: 1926). [Turner 1976, pp. 53ff., 59f.] Numerous other treatments of the subject. [Ibid.]

Pieter Brueghel the Elder, 1527/28?–1569. "The Fall of Icarus." Painting. Musées Royaux des Beaux-Arts (Musée d'Art Ancien), Brussels, inv. 4030 (800). [Brussels 1984a, p. 39—ill.]

Maso da San Friano, 1536–1571. "The Fall of Icarus." Painting. **1570–71.** Studiolo di Francesco I, Palazzo Vecchio, Florence. [Sinibaldi 1950, pp. 11f., 19] Study. Uffizi, Florence, inv. 6233. [Uffizi 1979, no. P1027—ill.]

Philippe Desportes, 1546–1606. "Icare est cheut" [Icarus Has Fallen]. Sonnet. **1573.** In *Premières oeuvres* (Paris: 1573). In modern edition by V. E. Graham (Geneva: Droz, 1960). [Ipso / Pichois 1975, pp. 1116f.] Translated by Maurice Baring in *Collected Poems of Maurice Baring* (London: Heinemann, 1925).

Diego Hurtado de Mendoza, 1503–1575. (Icarus evoked in) Poem beginning "Pensamiento mío. . . ." In modern edition by P. Bohigas, *Epístolas y otras poesías* (Barcelona: 1944). [Turner 1976, pp. 66f.]

Luca Cambiaso, 1527–1585. "The Fall of Icarus." Fresco, part of cycle illustrating the gods' punishment of presumptuous mortals. Palazzo Marchese Ambrogio Doria, Genoa. [Manning & Suida 1958, pp. 82f.—ill.]

Giordano Bruno, 1548–1600. (Icarus evoked in) "Poi che spiegate ho l'ale." Sonnet, part of *Gl'eroici furori* [The Heroic Enthusiasts]. Poem. Paris: **1585.** Modern trans-

lation by Paul Memmo (Chapel Hill: University of North Carolina Press, 1964). [Turner 1976, pp. 54f.]

Miguel de Cervantes Saavedra, 1547–1616. (Icarus evoked in a passage of) *La Galatea* part 1. Novel. Alcala: **1585.** In modern edition by J. B. Avalle-Arce (Madrid: 1961). [Turner 1976, p. 84]

———. (Icarus evoked in a sonnet recited by Cardenio, in) *La entretenida* act 1. Comedy. Madrid: 1615. In modern edition, *Obras completas* (Madrid: 1918). [Ibid., pp. 83f.]

Cornelis Cornelisz van Haarlem, 1562–1638. "The Fall of Icarus." Painting. *c.*1588. Lost. / Engraved by Hendrik Goltzius, 1588. *See Goltzius, below.*

Hendrik Goltzius, 1558–1617. "The Fall of Icarus." Engraving, after Cornelis van Haarlem (above). **1588.** (Rijksmuseum, Amsterdam.) [Strauss 1977a, no. 258 / Bartsch 1980–82, no. 259—ill. / also de Bosque 1985, pp. 262f.—ill. / Hofmann 1987, no. 4.23—ill.]

Hans Bol, 1534–**1593.** "The Fall of Icarus." Painting. Mayer van den Bergh Museum, Antwerp. [de Bosque 1985, p. 61—ill.] Variant replica, drawing. Kunsthalle, Hamburg, inv. 1920/176. [Hofmann 1987, no. 8.21—ill.] Another version of the theme in Nationalmuseum, Stockholm, inv. no. 731. [Warburg]

Torquato Tasso, 1544–**1595.** (Icarus and Phaethon evoked in) Sonnet beginning "Se d'Icaro. . . ." In modern edition, *Rime* (Bologna: 1900). [Turner 1976, pp. 56f.]

Fernando de Herrera, 1534–**1597.** (Icarus evoked in) Sonnet beginning "Dichoso fue el ardor" In modern edition by J. M. Blecua, *Poesías* (Madrid: 1975). [Turner 1976, pp. 76ff.]

———. (Icarus evoked in) Sonnet beginning "O cómo buela en alto mi desseo. . . ." In modern edition by J. M. Blecua, *Poesías* (Madrid: 1975). [Ibid.]

Gian Battista Guarini, 1538–1612. (Icarus evoked in) Poem beginning "A voi, Donna, volando. . . ." In *Rime* (Venice: **1598**). [Turner 1976, pp. 57f.]

Cavaliere d'Arpino, 1568–1640, composition. "The Fall of Icarus." Engraving, executed by Raphael Giudi, **1600.** [Rome 1973, no. V—ill.]

Annibale Carracci, 1560–1609. "Daedalus and Icarus" ("Fall of Icarus"). Fresco, designed by Carracci (or Domenichino?), executed by studio under direction of Domenichino. *c.*1603–04 (or *c.*1608?). Galleria, Palazzo Farnese, Rome. [Malafarina 1976, no. 105d—ill. / Martin 1965, pp. 136f.—ill. / cf. Spear 1982, no. 12]

Francisco Pacheco, 1564–1654. "Daedalus and Icarus." Ceiling painting. **1603–04.** Casa de Pilatos, Seville. [López Torrijos 1985, pp. 129ff., 405 no. 1]

Carlo Saraceni, 1579–1620. "(Landscape with) The Flight of Icarus (and Daedalus)," "(Landscape with) The Fall of Icarus," "(Landscape with) The Burial of Icarus." Pendant paintings. Probably before **1608.** Galleria di Capodimonte, Naples, nos. 151–53. [Ottani Cavina 1968, nos. 40–42—ill. / Capodimonte 1964, p. 51]

Francis Bacon, 1561–1626. "Daedalus, sive Mechanicus," "Scylla, et Icarus, sive viamedia." Chapters 19, 27 of *De sapientia veterum.* Mythological compendium. London: Barker, **1609.** / Translated as "Daedalus, or Mechanique," "Scylla and Icarus, or the Middle Way" by Arthur Gorges in *The Wisdom of the Ancients* (London: Bill,

1619). Modern facsimile edition (bilingual), New York & London: Garland, 1976. [Ipso].

Thomas Heywood, 1573/74–1641. (Story of Daedalus and Icarus in) *Troia Britanica: or, Great Britaines Troy* canto 7. Epic poem. London: **1609.** [Heywood 1974]

Ben Jonson, 1572–1637. (Daedalus in) "Pleasure Reconciled to Virtue." Masque. Performed 6 Jan **1618,** at Court, London. Published London: 1640. [Herford & Simpson 1932–50, vol. 7 / McGraw-Hill 1984, 3:112f.]

Lope de Vega, 1562–1635. (Icarus evoked in) Sonnet dedicated to Leonora Pimental, introducing *La Filomena.* Novel. Madrid: Viuda de Alonzo Martín, **1621.** [Turner 1976, pp. 103ff.]

———. (Icarus evoked in) Sonnet beginning "Cayó la torre. . . ." [Ibid., pp. 105f.]

Juan de Tassis y Peralta, 1582–**1622.** (Icarus evoked in) "De cera son las alas," "Si con mayor peligro." Sonnets. In modern edition by Juan Manuel Rozas, *Obras completas* (Madrid: 1969). [Turner 1976, pp. 118–22]

Juan de Arguijo, 1567–**1623.** (Icarus evoked in) Sonnet beginning "Osaste alzar el temerario vuelo. . . ." In modern edition by R. Benítez Claros, *Obras completas* (Santa Cruz de Tenerife: 1968). [Turner 1976, pp. 110f.]

Giovanni Battista Marino, 1569–**1625.** "Icarus in cera" [Icarus in Wax]. Poem. In *Le sculture* (Venice: Ciotti, 1636). [Praz 1925, p. 293]

Paul Bril, 1554–**1626,** style. "A Bay with the Fall of Icarus." Painting. Museum Boymans-van Beuningen, Rotterdam, cat. 1962 no. 2176. [Wright 1980, p. 62]

Luis de Góngora y Argote, 1561–**1627.** (Icarus evoked in) Sonnet, mourning the death of Margaret, wife of Philip III, beginning "Icaro de bayeta. . . ." In modern edition, *Obras completas,* 6th edition (Madrid: 1967). [Turner 1976, pp. 92f.]

———. (Icarus evoked in) Sonnet beginning "No enfrene tu gallardo. . . ." Modern edition, as above. [Ibid.]

———. (Icarus evoked in) Poem beginning "Por más daños. . . ." Modern edition, as above. [Ibid. pp. 86ff.]

———. (Icarus evoked in) *Soledades,* 1.129–33, 1002–11; 2.74–80, 137–50. Poem. Modern edition, as above. [Ibid., pp. 93f., 99]

Anthony van Dyck, 1599–1641. "Daedalus and Icarus." Painting. *c.*1630. Art Gallery of Ontario, Toronto. [Larsen 1988, no. 738—ill.] Another version known, lost. [Ibid]

———, circle? (formerly attributed to Govaert Flinck). "Daedalus and Icarus." Painting. Städisches Museum, Wiesbaden, cat. 1959 no. 188 (as Jan Lievens). [von Moltke 1965, no. 37]

Orazio Riminaldi, 1586–**1630/31,** attributed (formerly attributed to Bernardo Cavallino). "Daedalus and Icarus." Painting. Wadsworth Atheneum, Hartford, no. 44.38. [Percy & Lurie 1984, no. 68]

Tobias Verhaecht, 1561–**1631.** "Fall of Icarus." Painting. Städelsches Kunstinstitut, Frankfurt, cat. 1971 no. 1689. [Warburg]

Martin de Saavedra y Guzmán, ?–1654. (Icarus evoked in) Sonnet beginning "Veloz camina con osado vuelo. . . ." In *Ocios de Aganipe* (Trani: **1634**). [Turner 1976, p. 129]

Peter Paul Rubens, 1577–1640. "The Fall of Icarus." Painting, for Torre de la Parada, El Pardo, executed by

Jacob Peter Gowy from Rubens's design. **1636–38.** Prado, Madrid, no. 1540. [Alpers 1971, no. 33—ill. / Jaffé 1989, no. 1289—ill. / Prado 1985, p. 263] Oil sketch. Musées Royaux des Beaux-Arts (Musée d'Art Ancien), Brussels, inv. 4127 (825). [Alpers, no. 33a—ill. / Held 1980, no. 198—ill. / Jaffé, no. 1288—ill. / Brussels 1984a, p. 252—ill.]

Francisco Gomez de Quevedo y Villegas, 1580–**1645.** (Icarus evoked in) "Canción a la muerte de don Luis Carrillo." Poem. In modern edition by J. M. Blecua, *Obras completas* (Barcelona: 1963). [Turner 1976, pp. 112f.]

Miguel de Faría y Sousa, 1590–**1649.** (Daedalus and Icarus evoked in) Sonnets beginning "Obligada dos veces . . ." and "En gentil elegancia. . . ." In *Fuente de Aganipe* (Madrid: **1646**). [Turner 1976, pp. 136f.]

William Drummond of Hawthornden, 1585–**1649.** "Icarus." Poem, madrigal. Published in *Poems* (London: Tomlins, 1656). [MacDonald 1976, p. 74]

Abraham Bloemaert, 1564–**1651.** "The Fall of Icarus." Drawing. Uffizi, Florence. [de Bosque 1985, pp. 262f.—ill.]

Edward Sherburne, 1618–1702. "On the Picture of Icarus in Wax." Poem, translation of G. B. Marino's "Icarus in cera" (1636). In *Poems and Translations: Amorous, Lusory, Morall, Divine* (London: Dring, **1651**). [Praz 1925, p. 293]

Gerrit van Honthorst, 1590–**1656.** "Daedalus and Icarus." Painting. Sold 1743, untraced. [Judson 1959, no. 80]

Francesco Allegrini, 1587–**1663.** "Fall of Icarus." Painting. Fitzwilliam Museum, Cambridge. [Wright 1976, p. 2]

Jan de Momper, fl. **1661–65** (previously attributed to Hans Bols). "Fall of Icarus." Painting. Nationalmuseum, Stockholm, cat. 1928 no. 731. [Warburg]

Miguel de Barrios, 1625?–1701. (Icarus evoked in) Sonnet beginning "Esta que fue de amor. . . ." In *Flor de Apolo* (Brussels: **1665**). [Turner 1976, pp. 135f.]

Hierónimo Barrionuevo y Peralta, 1587–**1671.** "Fábula de Icaro." Narrative poem. [Turner 1976, pp. 144ff.]

Pieter Thijs the Elder, 1624–**1677.** "Icarus and Daedalus." Painting. Koninklijk Museum voor Schone Kunsten, Antwerp, no. 353. [Antwerp 1970, p. 216]

———. "Daedalus and Icarus." Painting. Bayerische Staatsgemaldesammlungen, Munich, inv. no. 1965. [Warburg]

Jacob Jordaens, 1593–**1678,** attributed. "Daedalus and Icarus." Painting. Staatsgalerie, Stuttgart, no 324. [Rooses 1908, p. 258]

Sister Juana Inés de la Cruz, 1648/51–1695. (Icarus evoked in) "Primero sueño" [First Dream]. Poem. **1680–81.** In modern edition by Méndez-Plancarte, *Obras completas* (Mexico City: 1951). [Turner 1976, pp. 137ff.]

Nicolaes Berchem, 1620–**1683.** "Fall of Icarus." Drawing. Groninger Museum, The Hague. [Warburg]

Charles Le Brun, 1619–**1690.** "Daedalus and Icarus." Painting. Hermitage, Leningrad. [Hermitage 1974, pl. 59]

Daniel Seiter, 1649–1705. "Daedalus and Icarus." Painting. By **1697.** Herzog Anton Ulrich-Museum, Braunschweig, no. 1024. [Braunschweig 1969, p. 124]

Johann Carl Loth, 1632–**1698.** "Daedalus Mourning Icarus." Painting. Kunstmuseum, Düsseldorf. [Warburg]

Manoel da Veiga Tagarro (17th century). "Laura de Anfriso" (story of Icarus). Poem. [Turner 1976, pp. 139ff.]

Luca Giordano, 1634–**1705,** attributed. "Fall of Icarus."

Painting (?). Marquès de Huetor coll., Madrid, in 1954. [Ferrari & Scavizzi 1966, 2:298—ill.]

Paul Ambroise Slodtz, 1702–1758. "Fall of Icarus." Sculpture. **1743.** Louvre, Paris, inv. no. MR 2092. [Waruburg]

Antonio Canova, 1757–1822. "Icarus and Daedalus" (Daedalus fixing wings to Icarus). Marble statue. **1777–79.** Museo Correr, Venice. [Pavanello 1976, no. 14—ill. / Licht 1983, pp. 157f.—ill. / also Janson 1985, fig. 39]

Charles Paul Landon, 1760–1826. "Daedalus and Icarus." Painting. **1799.** Musée Municipal, Alençon. [Bénézit 1976, 6:419]

Italian School. "Daedalus Fastening Wings on Icarus." Painting. Before **1800.** Glynn Vivian Art Gallery, Swansea, cat. 1913 no. 68. [Wright 1976, p. 107]

James Gillray, 1757–1815. "The Fall of Icarus." Satirical etching. **1807.** Hermitage, Leningrad, inv. 300260. [Hermitage 1979, pl. 174]

Franz Volkert, 1778–1845. *La chute d'Icare* [The Fall of Icarus]. Opera. First performed **1817,** Leopoldstadt. [Clément & Larousse 1969, 1:236]

Salvatore Viganò, 1769–1821, choreography. *Dedalo.* Ballet. Music, Peter Lichtenthal, Haydn, Mozart, Umlang, Rossini. First performed 6 Apr **1818,** La Scala, Milan; scenery, Alessandro Sanquirico; costumes, Giacomo Pregliasco. [EDS 1954–66, 9:1679 / Winter 1974, pp. 191, 193, pl. 130]

Merry-Joseph Blondel, 1781–1853. "The Sun: The Fall of Icarus." Ceiling painting. **1819.** Vestibule, Galerie d'Apollon, Louvre, Paris (inv. 2624). [Louvre 1979–86, 3:64—ill.]

Johann Nepomuk Haller, 1792–1826. "Daedalus" (with wings, now missing). Marble statue. Modeled **1819–20.** Executed by Joseph Lassarini, 1841. Façade, Glyptothek, Munich. [Glyptothek 1980, no. 235—ill.]

Francisco Goya, 1746–1828. "Daedelus Seeing Icarus Fall" (?). Drawing. **1824–28.** Prado, Madrid, no. 395. [Gassier & Wilson 1981, no. 1811—ill.]

John Sterling, 1806–1844. "Daedalus." Poem. In *Poems* (London: Moxon, **1839**). [Bush 1937, p. 552]

Honoré Daumier, 1808–1879. "The Fall of Icarus" (Daedalus watching through a telescope). Comic lithograph, part of "Ancient History" series. **1842.** [Delteil 1906–30, 22: no. 955—ill.]

———. "Tne New Icaruses," "The New Icarus." Satirical lithographs. 1850, 1855. [Ibid., 26: nos. 2546, 2013—ill.]

Henry David Thoreau, 1817–1862. (Icarus evoked in) "Smoke." Poem. **1843.** In *Poems of Nature* (Boston: Houghton Mifflin, 1854). [Ipso]

Charles Baudelaire, 1821–1867. "Les plaintes d'un Icare" [The Complaints of an Icarus]. Poem. In *Le boulevard* 28 Dec **1862.** Collected in *Les fleurs du mal,* 3d edition (*Oeuvres complètes,* vol. 1, Paris: Lévy, 1868). [Pichois 1975 / Fowlie 1965, p. 249 / Ruff 1966, p. 187]

Stéphane Mallarmé, 1842–1898. (Poet longs to fly like Icarus in) "Les fenêtres" [The Windows]. Poem. In *Le Parnasse contemporain* **1863;** collected in *Poésies* (Paris: Éditions de la Revue Indépendante, 1887). [Mondor & Jean-Aubry 1974 / Caws 1982 / Strauss 1971, pp. 94f. / Fowlie 1970, pp. 32f.]

Bayard Taylor, 1825–1878. "Icarus." Poem. In *The Poet's*

Journal (Boston: Ticknor & Fields, **1863**). [Bush 1937, p. 579]

Frederic, Lord Leighton, 1830–1896. "Daedalus and Icarus" (preparing for the flight). Painting. *c.*1869. Buscot Park, Oxfordshire. [Ormond 1975, no. 186—ill. / Minneapolis 1978, no. 50—ill. / Wood 1983, pp. 50f.—ill. / Jackson-Stops 1985, no. 554—ill. / Kestner 1989, pl. 189] Color sketch. Leighton House, London. [Ormond, no. 187]

Maria del Pilar Sinues y Navarro, 1835–1893. *Las alas de Icaro* [The Wings of Icarus]. Novella. Valencia: Piles, **1872**. [Galerstein 1986, p. 299]

Auguste Rodin, 1840–1917. "Ugolino/Icarus." Drawing. *c.*1880–82. Musée Rodin, Paris, no. 1993. [Elsen 1981, p. 197—ill.]

———. "The Fall of Icarus." Marble sculpture. *c.*1895. Unlocated. [Ibid., fig. 4.23 / Tancock 1976, p. 192] Plaster model. Musée Rodin, Paris. [Tancock, fig. 18–2]

Alfred Gilbert, 1854–1934. "Icarus." Bronze statue. **1884**. National Museum of Wales, Cardiff. [Read 1982, pp. 290, 294, 299—ill. / Minneapolis 1978, no. 94—ill. / Beattie 1983, pl. 133] Numerous bronze reductions. Tate Gallery, London; Birmingham City Museum and Art Gallery, England; Ashmolean Museum, Oxford; Royal Collection, Sandringham; National Gallery of Victoria, Melbourne; private colls. [Minneapolis / also Jackson-Stops 1985, no. 59—ill. / London 1968, no. 59—ill. / Ormond 1975, p. 117, pl. 128—ill.]

Émile-Antoine Bourdelle, 1861–1929. "Icarus." Bronze sculpture. *c.*1887. 4 casts. / Terre-sèche version. Musée Bourdelle, Paris. [Jianou & Dufet 1975, no. 63]

———. "The Fall of Icarus." Fresco. 1912. Grand Galerie, Théâtre des Champs-Elysées, Paris. [Basdevant 1982, pp. 104f.—ill.] Gouache study. Musée Bourdelle, Paris. [Ibid.—ill.]

William Blake Richmond, 1842–1921. "Icarus." Painting. **1887**. [Kestner 1989, p. 175]

John Byrne Leicester Warren, Lord de Tabley, 1835–**1895**. "Daedalus." Poem. In *Collected Poems* (New York: Macmillan, 1903). [Boswell 1982, p. 250]

Gaetano Leonello Patuzzi, 1841–1909. *Volo d'Icaro* [Flight of Icarus]. Romance. Milan: **1895**. [DELI 1966–70, 4:297]

Herbert James Draper, 1864–1920. "The Lament for Icarus." Painting. Exhibited **1898**. Tate Gallery, London. [Maas 1969, p. 233—ill. / Wood 1983, p. 215—ill. / Kestner 1989, p. 290, pl. 5.22]

Daniel Chester French, 1850–1931. "Daedalus Fixing Wings to His Son, Icarus." Sculpture. **19th century**. Minneapolis Institute of Fine Arts, Minnesota. [Licht 1983, p. 157—ill.]

Sydney Meteyard, 1868–1947. "Icarus." Painting. *c.*1900. Piccadilly Gallery, London. [Harrison & Waters 1973, p. 184—ill.]

Aimé-Jules Dalou, 1838–**1902**. Study of a man for "The Fall of Icarus" (?). Bronze statuette, gilded. Musée d'Orsay, Paris, inv. RF 3666. [Orsay 1986, p. 113—ill.] Terra-cotta. Petit Palais, Paris. / Five bronzes cast by A. A. Hébrard, 1906; one in Petit Palais. [Ibid.]

Gabriele D'Annunzio, 1863–1938. (Icarus's flight evoked in) "L'ala sul mare" [Wing over the Sea], "Altius egit iter" [Take the Higher Course], "Ditirambo 4." Poems. In *Alcyone* (Milan: Treves, **1904**). [Roncoroni 1982 / Bàrberi Squarotti 1982, pp. 155f.]

Arthur Knowles Sabin, 1879–1959. "The Death of Icarus." Poem. In *The Death of Icarus and Other Poems* (Glasgow: MacLehose, **1906**). [Boswell 1982, p. 288]

Valéry Bryúsov, 1873–1924. "Dedal i Ikar" [Daedalus and Icarus]. Poem. **1908**. In *Vse napevy* [All Melodies] (Moscow: [Skorpion?], 1909). [Bryúsov 1982]

Clarice Tartùfari, 1868–1933. *Il volo d'Icaro* [The Flight of Icarus]. Novel. Rome: **1908**. [DELI 1966–70, 5:233]

Gottfried Benn, 1886–1956. "Da fiel uns Ikarus vor die Füsse" [There Fell Icarus at Our Feet]. Poem. In *Die Aktion* 3 (26 Feb **1913**); collected in *Fleisch: Gesammelte Lyrik* (Berlin: Aktion, 1917). [Wellershof 1960]

———. "Ikarus." Poem. In *Die weissen Blätter* II.5 (May **1915**); collected in *Die Gesammelte Schriften* (Berlin: Reiss, 1922). [Ibid. / Wodtke 1963, pp. 14, 16f. / Hamburger 1957, pp. 289–92] Translated by Michael Hamburger in *Modern German Poetry, 1910–1960* (New York: Grove, 1962). [Ipso]

Julio Camba, 1882–1962. *Las alas de Icaro* [The Wings of Icarus]. Poetic sketches. **1913**. In *Obras completas* (Madrid: Editiones Plus-Ultra, 1948). [HLE 1981–83, 5:367 / Oxford 1978, p. 88]

James Joyce, 1882–1941. (Story of Icarus and Daedalus, central metaphor of) *A Portrait of the Artist as a Young Man*. Novel. Serialized in the *Egoist* beginning 2 Feb **1914**; first book publication London: Egoist Press; New York: Huebsch, 1916. [Ipso / Davies 1975, pp. 29–34, 83f., 91f.]

———. (Daedalus and Icarus evoked in) *Ulysses*. Novel. Paris: Shakespeare & Co., **1922**. [Scholes & Kain 1965, pp. 40f., 264–70]

Wilhelm Lehmbruck, 1881–1919. "Icarus I," "Icarus II." Etchings. **1917**. [Hoff 1961, p. 164]

Stephen Vincent Benét, 1898–1943. "Winged Man" (Icarus). Poem. In *Young Adventure* (New Haven: Yale University Press, **1918**). [Boswell 1982, p. 35]

Johannes Robert Becher, 1891–1958. *Ikaros*. Drama, unfinished. In the yearbook *Die Erhebung* (Berlin: **1919**). [Ritchie 1976, pp. 119f.]

Marguerite Yourcenar, 1903–1987. (Icarus tames the Chimaera and takes her wings to fly to Helios in) *Le jardin des Chimères* [The Garden of the Chimeras]. Verse drama. Paris: Perrin, **1921**. [Horn 1985, pp. 84f.]

Lauro De Bosis, 1901–1931. *Icaro*. Verse tragedy. **1927**. 1928 Olympic Prize for Poetry. Milan: Alpes, 1930. / Translated by Ruth Draper, *Icaro* (London: Oxford University Press, 1933). [Bush 1963, p. 531 *n.* / Highet 1967, pp. 527, 703 / DDLI 1977, 1:158]

Gerhard Marcks, 1889–1981. "Icarus." Stone relief. **1930**. Staatliche Gallerie Moritzburg, Halle. [Busch & Rudloff 1977, no. 223—ill.]

Léopold Survage, 1879–1968. "The Fall of Icarus." Painting. **1927–32**. [Hermitage 1987a, pl. 314 *n.*]

John Redwood Anderson, b. 1883. "Icarus." Poem. In *Transvaluations* (London: Oxford University Press, **1932**). [Bush 1937, p. 576]

Juan José Domenchina, 1898–1959. *Dédalo*. Collection of poems. Madrid: Biblioteca Nueva, **1932**. [HLE 1981–83, 5:439f. / Oxford 1978, p. 167]

Marino Marini, 1901–1980. "Icarus" (?). Wood sculpture. **1933**. Battiato coll., Milan. [Apollonio 1958, p. 36]

Igor Markevich, 1912–1983, music. *L'envol d'Icare* [Icarus

Taking Wing]. Ballet. First performed 6 June **1933**, Paris. [Grove 1980, 11:691]

Stephen Spender, 1909–. "Icarus." Poem. **1933**. In *Selected Poems* (New York: Random House, 1964). [Ipso. / Boswell 1982, p. 296]

———. "Discovered in Mid-Ocean." Poem. In *Modern British Poetry,* 7th edition, revised by Louis Untermeyer (New York: Harcourt, Brace, 1962). [Ipso]

Arturo Martini, 1889–1947. "Daedalus and Icarus." Bronze statuette. **1934–35**. Museum of Modern Art, New York, no. 345.49. [Barr 1977, p. 566—ill.]

George Barker, 1913–. "Daedalus" (grieving for Icarus). Poem. In *Poems* (London: Faber & Faber, **1935**). [CLC 1988, 48:9, 12 / Boswell 1982, p. 33]

Serge Lifar, 1905–1986, choreography. *Icare.* Ballet. Libretto and rhythms, Lifar. Percussion arranged by J. E. Szyfer. First performed 9 July **1935**, L'Opéra, Paris; set and costumes, Paul Larthe; backcloth, Pablo Picasso. [Anderson 1986, p. 189 / Simon & Schuster 1979, p. 222]

Pablo Picasso, 1881–1973. Backcloth design for Serge Lifar's ballet *Icarus.* **1935**. *See Lifar, above.*

———. "The Fall of Icarus." Mural. 1957. UNESCO Building, Paris. [Penrose & Golding 1973, p. 214, fig. 354] Print (3 faces above a reclining nude), published in Jean Leymarie's *La Chute d'Icare,* illustrated study of Picasso's UNESCO project (Geneva: Albert Skira, 1972). [Bloch 1971–79, no. 2016, 197—ill.]

———. Drawings, studies for sets for ballet *Icarus.* 1962. [Zervos 1932–78, 20: nos. 351–54—ill.]

Eleanor King, 1906–, choreography. *Icaro.* Modern dance. Music, David Diamond and Franczeska Boas. Scenario, Lauro de Bosis First performed **1937**, Brooklyn Museum Dance Center, New York. [Grove 1980, 5:421 / Chujoy & Manchester, 1967, p. 527]

Eugene Berman, 1899–1972. Set designs for production of Lifar's *Icare* (*see 1935, above*) by Ballets Russe de Monte Carlo (London, **1938**). 3 gouache designs in Museum of Modern Art, New York, nos. 61.42.1–3. [Barr 1977, pp. 524f.]

Angelos Sikelianos, 1884–1951. "Daidalos." Poem. 15 June **1938**. [Savidis 1981, vol. 5 / Keeley & Sherrard 1979 / Keeley 1983, pp. 36f., 48–51]

———. *O Dhedhalos stin Kriti* [Daedalus in Crete]. Poetic drama. Athens: Ikaros, 1943. [Keeley, p. 49 *n.* / Friar 1973, p. 748 / Trypanis 1981, p. 676]

Sidney Nolan, 1917– . Stage and costume designs for production of Lifar's *Icare* (Sydney, 1940). **1939–40**. Original designs in private coll. [Clark 1987, p. 34—ill.]

———. "Icarus." Painting. 1943. Heide Park Art Gallery, Melbourne. [Clark, p. 48—ill.]

———. "Icarus and Daedalus." Painting. 1956. Artist's coll. in 1957. [Whitechapel 1957, no. 129]

Fritz Diettrich, 1902–. *Die Flügel des Daidalos* [The Wings of Daedalus]. Tragedy. Kassel: Bärenreiter, **1941**. [DLL 1968–90, 3:246]

Elio Talarico, 1907–. *Dedalo e fuga* [Daedalus Has Fled]. Drama. In *Dramma* (periodical, Turin) **1942**. [DELI 1966–70, 5:224]

Giuseppe Lipparini, 1877–1951. *Daedalus.* Collection of poems. Bologna: Zanichelli, **1943**. [DULC 1959–63, 3:177]

Henri Matisse, 1869–1954. "Icarus." Painted paper cut-out. **1943**. Tériade coll., Paris. Published in *Jazz* (Paris: Tériade, 1947). [St. Louis 1977, no. 24, pp. 101f.—ill. / Barr 1951, pp. 500, 560—ill. / also Schneider 1984, pp. 175, 661—ill.] Preliminary version, "The Fall of Icarus." Tériade coll. [St. Louis, no. 14—ill.]

W. H. Auden, 1907–1973. (Fall of Icarus evoked in) "Musée des Beaux-Arts." Poem. By **1944**. In *Collected Shorter Poems, 1930–44* (London: Faber & Faber, 1950). [Mendelson 1976 / Johnson 1973, pp. 39–42 / Replogle 1969, p. 180]

Muriel Rukeyser, 1913–1980. "Waiting for Icarus." Poem. In *Breaking Open* (New York: Random House, **1944**). [Kertesz 1980, p. 347]

Ronald Bottrall, 1906–. "Icarus." Poem. In *Farewell and Welcome* (London: Editions Poetry, **1945**). [DLB 1983, 20:83]

Jackson Pollock, 1912–1956. "Icarus." Painting. *c.***1945**. Lost. [O'Connor & Thaw 1978, no. 996—ill.]

Ivan Meštrović, 1883–1962. "Icarus" (winged, about to take flight). Wood sculpture. **1947**. Artist's coll. in 1959. [Schmeckebier 1959, pl. 156]

———. "The Fall of Icarus." Plaster study. 1954. Artist's coll. in 1959. [Ibid., pl. 157—ill.]

Marcel Poot, 1901–. *Icare.* Oratorio. **1947**. [Grove 1980, 15:84]

Gerhard C. Schulz. "Icarus." Drawing with watercolor. **1947**. [Hannover 1950, no. 128]

Herwig Hensen, 1917–. *Daidalos.* Collection of poems. Brussels: Manteau, **1948**. [DULC 1959–63, 2:706]

Peter Viereck, 1916–. (Icarus paints the sky as) "Kilroy." Poem. In *Terror and Decorum: Poems 1940–1948* (New York: Scribners, **1948**). [Ipso / DLB 1980, 5 pt. 2:343]

Valentin Iremonger, 1918–. "Icarus." Poem. In *Contemporary Irish Poetry,* edited by Greacen and Iremonger (London: Faber & Faber, **1949**). [Ipso]

Eduardo Paolozzi, 1924–. "Icarus." Abstract bronze sculpture. **1949**. M. Richmond coll., London. [Konnertz 1984, fig. 102]

———. "Icarus II." Bronze sculpture. 1957. Betty Parsons Gallery, New York. [Clapp 1970, 1:681]

Kurt Roesch, 1905–. "Icarus" (falling). Drawing. By **1950**. [Hannover 1950, no. 113]

Goffredo Petrassi, 1904–. (Icarus story paralleled in) *La morte dell' aria* [Death in the Air]. Opera. First performed 24 Oct **1950**, Rome. [Grove 1980, 14:585 / Baker 1984, p. 1759]

Louis MacNeice, 1907–1963. (Icarus evoked in) "The Island" section 1. Poem. *c.***1950–51**. [Dodds 1966]

Juan Carlos Paz, 1901–1972. *Dédalus 1950.* Chamber composition for flute, clarinet, and pianoforte. **1950–51**. [Grove 1980, 14:317]

Michael Hamburger, 1924–. "Lines on Brueghel's Icarus." Poem. In *Poems 1941–1951* (Aldington Kent: Hand & Flower Press, **1952**). [Ipso]

W. R. Rodgers, 1909–1969. (Fall of Icarus in) "Spring." Poem. In *Europa and the Bull and Other Poems* (London: Secker & Warburg, **1952**). [Ipso]

Wander Bertoni, 1925–. "Icarus." Aluminum sculpture. **1953**. Open Air Museum, Middelheim, Antwerp. [Clapp 1970, 1:86]

Gene Derwood, *c.*1913–**1954**. "Bird, Bird." Poem. In *Poems* (New York: Clarke & Way, 1955). [Ipso]

Erik Lindegren, 1910–1968. "Ikaros." Poem. In *Vinteroffer* [Winter Rites] (Stockholm: Bonnier, **1954**). [Algulin 1989, p. 240]

Giorgio de Chirico, 1888–1978. "Icarus." Painting, after Rubens (1636–38, Prado). **1955.** Muzzi coll., Rome. [de Chirico 1971–83, 5.3: no. 677—ill.]

Richard Hunt, 1935–. "Icarus." Steel sculpture. **1956.** Albright Knox Art Gallery, Buffalo, N.Y. [Clapp 1970, 2: pt. 2: 552]

Joseph Thomas Langland, 1917–. "Fall of Icarus: Brueghel." Poem. In *The Green Town* (New York: Scribner, **1956**). [Ipso / Boswell 1982, p. 266]

Marcello Mascherini, 1906–. "Icarus." Bronze sculpture. Exhibited Venice Biennale, **1956.** [Clapp 1970, 1:596]

———. "Icarus." Bronze sculpture. 1959. [Ibid.]

Vassar Miller, 1924–. "The New Icarus." Poem. In *Wage War on Silence* (Middletown, Conn.: Wesleyan University Press, **1957**). [Boswell 1982, p. 273]

Constantin Andreou, 1917–. "Icarus." Metal sculpture. **1958.** [Clapp 1970, 1:29]

Jean Atlan, 1913–1960. "Icarus." Painting. **1958.** Wallraf-Richartz-Museum, Cologne, no. 3065. [Cologne 1965, p. 23]

John Hollander, 1929–. "Icarus before Knossos." Poem. In *A Crackling of Thorns* (New Haven: Yale University Press, **1958**). [Ipso / DLB 1980, 5 pt. 1: 346 / Howard 1969, pp. 206f.]

Richard Lytle, 1935–. "Icarus Descended." Painting. **1958.** Museum of Modern Art, New York, no. 130.58. [Barr 1977, p. 562]

Ernst Schnabel, 1913–. *Ich und die Könige: Projekte, Zwischenfälle, und Résümes aus dem Leben des Ingenieurs D* [I and the King: Projects, Incidents, and Conclusions from the Life of Engineer D(aedalus)]. Novel. Frankfurt: Fischer, **1958.** / Performed as a radio play, 1960. / Translated by J. J. Dunbar (New York: Harcourt, Brace, 1961). [Oxford 1986, p. 805 / Ziolkowski 1962, p. 235 *n*.]

Peter Rühmkorf, 1929–. "Anti-Ikarus." Poem. In *Irdisches Vergnügen in g* [Earthly Delights in g]. (Hamburg: Rowohlt, **1959**). [Ipso]

Tauno Pylkkäner, 1918–. *Ikaros.* Opera, opus 43. Libretto, P. Knudsen. **1956–60.** [Grove 1980, 15:484]

Josephine Miles, 1911–. (Icarus evoked in) "Wings." Poem. In *Poems, 1930–1960* (Bloomington: Indiana University Press, **1960**). [Ipso]

Jap Mooy, 1915–. "Icarus." Iron sculpture. *c.*1960? Stadtische Kunsthalle, Recklinghausen. [Clapp 1970, 1:648]

Hans Otte, 1926–. *Daidalos.* Composition for 2 pianos, guitar, harp, and 2 percussion. **1960.** [Grove 1980, 14:25]

Rosemary Thomas, 1901–1961. "Icarus." Poem. In *Selected Poems* (New York: Twayne, 1968). [Ipso]

Michael Ayrton, 1921–. "Icarus Transformed I." Bronze sculpture. **1961.** Tate Gallery, London, no. T.460. [Tate 1975]

———. *The Testament of Daedalus.* Prose-poetry narrative. 1962. London: Methuen, 1962, illustrated with 27 drawings (1955–62). [Ipso]

Čestmír Gregor, 1926–. *The Children of Daidalos.* Symphonic poem. **1961.** [Baker 1984, p. 886]

Hans Helms, 1932–. *Daidalos.* Composition for 4 solo voices. **1961.** [Grove 1980, 8:468]

Bruce Beasley, 1939–. "Icarus." Cast aluminum sculpture. **1962.** [Clapp 1970, 2 pt. 1: 121]

Anne Sexton, 1928–1974. (Icarus evoked in) "To a Friend Whose Work Has Come to Triumph." Poem. In *All My Pretty Ones* (Boston: Houghton Mifflin, **1962**). [Boswell 1982, p. 291]

William Carlos Williams, 1883–1963. "Landscape with the Fall of Icarus." Poem. In *Pictures from Brueghel* (New York: New Directions, **1962**). [MacGowan 1988]

Birgit Aakesson, 1908–, choreography. *Ikaros.* Ballet for solo dancer (Bjorn Holmgren). Music, Sven Erik Bäck, with Kaarl Gundersen. First performed 24 May **1963**, Royal Swedish Ballet, Stockholm; décor, Lage Lindell. [Oxford 1982, p. 6 / Chujoy & Manchester 1967, p. 1]

Salvador Dalí, 1904–1989. "The Fall of Icarus." Print, in "Mythology" series. **1963.** [Rotterdam 1970, no. 171]

Nino Franchina, 1912–. "Icaro." Sheet metal sculpture. **1963.** Private coll. [Clapp 1970, 1:314]

Eugène Ionescu, 1912–. (Icarus in) *Le piéton de l'air.* Drama. **1963.** In *Théâtre* (Paris: Gallimard, 1954–66). / Translated by Donald Watson as *A Stroll in the Air* (New York: Grove Press, 1968). [Ipso]

Hans Jaenisch, 1907–. "Icarus." Drawing. **1963.** [Berlin 1963, no. 43]

Charles Umlauf, 1911–. "Icarus." Bronze sculpture. Exhibited Illinois University, Urbana, **1963.** [Clapp 1970, 2 pt. 2: 1084]

Lucas Hoving, *c.*1920–, choreography. *Icarus.* Modern dance. Music, Chin-Ichi Matsuhita. First performed 5 Apr **1964**, Lucas Hoving Company, New York. [Sorell 1986, pp. 55–57 / Terry 1976, p. 182]

Günter Kunert, 1929–. "Ikarus 1964." Poem. **1964.** In *Der ungebetene Gast* [The Unbidden Guest] (Berlin & Weimar: Auf-Bau Verlag, 1965). [Flores 1971, p. 288]

Leonid Nikolaevich Martý, 1905–. "Daedalus." Poem. In *Stikhi* (Moscow: Pravda, **1964**). [Terras 1985, p. 275]

Paul Manship, 1885–1966. "Icarus Falling." Bronze statuette. **1965.** Unique cast. Minnesota Museum of Art, St. Paul, no. 66.14.30. [Minnesota 1972, no. 150—ill. / Minnesota 1985, no. 24—ill.]

Anne Elizabeth Boyd, 1946–. *The Fall of Icarus.* Instrumental composition. **1966.** [Cohen 1987, 1:102]

Robert Hayden, 1913–1980. "O Daedalus, Fly Away Home." Poem. In *Selected Poems* (New York: October House, **1966**). [Boswell 1982, p. 260]

Sam Shepard, 1943–. "Icarus' Mother" (symbolic evocation of myth in title). One-act play. *c.***1966.** [McGraw-Hill 1984, 4:455]

Leonard Baskin, 1922–. "Daedalus." Bronze sculpture. **1967.** At least 5 casts. Private colls. [Jaffe 1980, pp. 170, 215—ill.]

———. "Icarus." Color woodcut. 1967. [Fern & O'Sullivan 1984, no. 500—ill.] Variant, "Icarus in Black and White." 1967. [Ibid., no. 500a]

———. "Birdman/Icarus." Etching. 1968. [Ibid., no. 505—ill.]

———. "Icarus." Bronze relief. Modeled 1969. 4 casts, 1978: Virginia Museum of Fine Arts, Richmond; 3 private colls. [Ibid., p. 216]

Ib Nørholm, 1931–. *After Icarus.* Orchestral suite, opus 39. **1967.** [Grove 1980, 13:281]

Zbigniew Herbert, 1924–. "The Fathers of a Star" (Daedalus and Icarus). Poem. In *Selected Poems* (New York: Ecco, **1968**). [Ipso]

Raymond Queneau, 1903–1976. *Le vol d'Icare* [The Flight of Icarus]. Novel, chiefly in dialogue. Paris: Gallimard, **1968.** / Translated by Barbara Wright (New York: New Directions; London: Calder & Boyars, 1973). [Shorley 1985, pp. 32, 84f., 117, 163 / EWL 1981–84, 3:617 / Popkin 1977, pp. 239f.]

Radcliffe Squires, 1917–. *Daedalus*. Verse. Ann Arbor, Mich.: Generation, **1968.** [Vinson 1985, p. 823]

Alastair Reid, 1926–. "Daedalus." Poem. Before **1969.** In *Weathering: Poems and Translations* (Edinburgh: Canongate; New York: Dutton, 1978). [Ipso]

Pauls Dambis, 1936–. *Ikars* [Icarus]. Opera. **1970.** Libretto, J. Peters. First performed 1976, Riga. [Grove 1980, 5:170]

Henri Pousseur, 1929–. *Les éphémerides d'Icare II*. Composition for piano and 18 instruments. First performed 20 Apr **1970,** Madrid. [Grove 1980, 15:171]

———. *Icare apprenti* [Icarus Apprenticed]. Composition for any instruments. First performed Oct 1971, Paris. [Ibid.]

———. *Les noces d'Icare et Mnémosyne* [The Marriage of Icarus and Mnemosyne]. Chamber music. First performed 1 Oct 1981, festival of International Society for Contemporary Music, Brussels. [Slonimsky 1986, p. 173]

Vladimir Vasiliev, 1940–, choreography. *Icarus*. Ballet in 7 tableaux. Music, Sergei Slonimsky. Scenario, Yuri Slonimsky. First performed 29 May **1971,** Bolshoi Ballet, Moscow. [Slonimsky 1986, pp. 25f. / Oxford 1982, p. 433]

Aurel Milloss, 1906–1988, with **G. Zacharias,** choreography. *Dedalo*. Ballet. Music, Guido Turchi. First performed **1972,** Florence. [Grove 1980, 19:259]

Igor Dmitrievich Belsky, 1925–, choreography. *Icarus*. Ballet. First performed **1973,** Leningrad. [Clarke & Vaughan 1977, p. 61]

Gerald Arpino, 1928–, choreography. *The Relativity of Icarus*. Ballet. Music, Gerhard Samuel. Scenario, John Larson. First performed 30 Aug **1974,** Lewiston, N.Y.; setting and costumes, Rouben Ter-Arutunian. [Terry 1976, p. 270]

Barbara Lekberg, 1925–. "Icarus." Bronze sculpture. **1975.** Exhibited 1978, Mount Holyoke College, South Hadley, Mass. [Seen by author]

Hans Tentije, 1944–. "Ikaries is de zee" [Icarian Is the Sea]. Poem. In *Alles is er* (Amsterdam: De Harmonie, **1975**). / Translated by Scott Rollins in *Dutch Interior: Postwar Poetry of the Netherlands and Flanders,* edited by James S. Holmes and William Jay Smith (New York: Columbia University Press, 1984). [Ipso]

David Wagoner, 1926–. "The Return of Icarus." Poem. c.**1976.** In *Collected Poems, 1956–1976* (Bloomington: Indiana University Press, 1976). [Ipso]

Roy Shifrin, 1938–. "Icarus." Bronze sculpture. **1972–77.** Manhattan Community College, N.Y. [*Art News* 82 (Nov 1983): 11f.—ill.]

Marc Chagall, 1887–1985. "The Fall of Icarus." Painting. **1974–77.** Musée National d'Art Moderne, Paris, no. AM 1978–733. [Pompidou 1987, p. 126—ill.]

John Butler, 1920–, choreography. *Icarus*. Ice ballet. Music, Gordon Crosse. First performed **1977,** John Curry Theatre of Skating, London. [*Dance and Dancers* Oct 1977, p. 20]

Olga Morano, 1935–. "The Fall of Icarus." Abstract painting-collage. **1977.** Musées Royaux des Beaux-Arts (Musée d'Art Moderne), Brussels, inv. 9790. [Brussels 1984b, p. 460—ill.]

Gale Ormiston, 1944–, choreography. *Icarus*. Modern dance. First performed **1977,** New York. [Cohen-Stratyner 1982, p. 678]

Wolf Biermann, 1936–. *Preussischer Ikarus* [Prussian Icarus]. Collection of prose and poems. Cologne: Kiepenheuer & Witsch, **1978.** [EWL 1981–84, 1:265]

Joanne Forman, 1934–. *Ikarus*. Opera. First performed **1981,** Southwest Chamber Opera, Albuquerque. [Cohen 1987, 1:243]

Giulio Paolini, 1940–. "The Fall of Icarus." Assemblage (9 canvases suspended over 9 chairs). **1981.** Von Abbemuseum, Eindhoven. [Bandini et al. 1985, pl. 34 / Villeurbanne 1983, pp. 104f.—ill. / also Munich 1984, pp. 77, 91—ill.]

Earl Staley, 1938–. "Fall of Icarus I." Painting. **1982.** Comeaux coll., Houston. [Houston 1984, p. 81—ill.]

Alfred Corn, 1943–. "Stephen Dedalus: Self-Portrait as a Young Man." Poem, reflection on Joyce's novella. In *The West Door* (New York: Viking Penguin, **1988**). [Ipso]

Richard Wilbur, 1921–. "Icarium Mare" [Icarian Sea]. Poem. In *New and Collected Poems* (New York: Harcourt Brace Jovanovich, **1988**). [Ipso]

IDAS. *See* APOLLO, Loves; JASON, and the Argonauts; MELEAGER, Boar Hunt.

IDOMENEUS. Grandson of Minos and son of Deucalion, Idomeneus was the leader of the eighty-ship Cretan contingent in the Trojan War. He had been one of Helen's suitors and was one of the Greeks hidden inside the wooden horse at the fall of Troy. Caught in a storm on his homeward journey, Idomeneus vowed to Poseidon that if he could reach Crete safely he would sacrifice the first thing he met there. When he disembarked, the first to greet him was his son. Idomeneus dutifully prepared the sacrifice but was interrupted when a plague broke out on the island. The Cretans saw it as divine retribution for his actions and exiled him. He settled in Calabria in southern Italy.

Classical Sources. Homer, *Iliad* 2.645–52, 13.210–519; *Odyssey* 3.191, 9.178, 13.259ff. Virgil, *Aeneid* 3.121ff., 3.400ff., 11.264f. Apollodorus, *Biblioteca* 3.5.1, E.3.13, E.6.10–11. Pausanias, *Description of Greece* 5.25.9. Hyginus, *Fabulae* 81, 97, 270. Quintus of Smyrna, *Sequel to Homer* 1.247, 4.284, 5.134, 12.320.

See also TROJAN WAR, General List.

Prosper Jolyot de Crébillon, 1674–1762. *Idoménée*. Tragedy. First performed 29 Dec **1705,** Théâtre-Français, Paris. [Girdlestone 1972, p. 201]

André Campra, 1660–1744. *Idoménée*. Opera. Libretto, Antoine Danchet. First performed **1712,** Paris. [Grove 1980, 3:665]

Franz Anton Hilverding, 1710–1768, choreography. *Idoménée.* Dance drama, based on Crébillon (1705). First performed before **1740,** Theater am Karntnerthor, Vienna. [Winter 1974, p. 92]

Baldassare Galuppi, 1706–1785. *Idomeneo.* Opera seria. First performed 7 Jan **1756,** Teatro Argentina, Rome. [Grove 1980, 7:137]

Antoine-Marin Lemierre, 1723–1793. *Idoménée.* Tragedy. First performed **1764,** Paris. [DLLF 1984, 2:1276 / Girdlestone 1972, p. 202]

Wolfgang Amadeus Mozart, 1756–1791. *Idomeneo, re di Creta.* Opera (dramma per musica). Libretto, Giambattista Varesco, after Danchet's text for Campra (1712). First performed 29 Jan **1781,** Hoftheater, Munich. [Einstein 1945, pp. 370, 387, 403–07 / Grove 1980, 12:700, 729 / Mann 1977, pp. 252–88 / Kerman 1988, pp. 80–85, 223 / Tovey 1934, p. 94f.]

Giuseppe Gazzaniga, 1743–1818. *Idomeneo.* Opera. Libretto, G. de Sertor. First performed 12 June **1790,** Teatro Nuovo, Padua. [Grove 1980, 7:206]

Ferdinando Paer, 1771–1839. *Idomeneo, re di Creta.* Opera. Libretto, G. de Sertor. First performed **1794.** [Hunger 1959, p. 161]

Nicasio Alvarez de Cienfuegos, 1764–1809. *Idomeneo.* Tragedy. In *Poesías* (Madrid: Imprenta Real, **1798**). [DLE 1972, p. 31]

Jacques Gamelin, 1738–**1803.** "The Return of Idomeneus." Painting. Musée des Augustins, Toulouse. [Bénézit 1976, 4:602]

Vincenzo Federici, 1764–1826. *Idomeneo.* Opera. Libretto, Luigi Romanelli. First performed 31 Jan **1806,** La Scala, Milan. [Grove 1980, 6:449]

Giuseppe Farinelli, 1769–1836. *Idomeneo, re di Creta.* Opera. Libretto, Giacomo Rossi. First performed **1811.** [Hunger 1959, p. 161]

Abraham Louis Barbaz, 1770–1833. *Idoménée, roi de Crete.* Tragedy. In *Théâtre français* (Amsterdam: Geysbeck, **1817**). [Taylor 1893, p. 219]

Tommaso Sgricci, 1788–1836. *L'Idomeneo.* Improvised tragic poem. First performed **1828,** Florence. Published in *Poésie* (Florence: Pagni, 1827–28). [DELI 1966–70, 5:127]

George Meredith, 1828–1909. "The Shipwreck of Idomeneus." Poem. In *Poems* (London: Parker, **1851**). [Bartlett 1978, vol. 1 / Boswell 1982, pp. 183f.]

Richard Strauss, 1864–1949. Orchestral interlude, for Mozart's *Idomeneo* (1781). First performed 16 April **1931,** Staatsoper, Vienna. [Grove 1980, 18:234, 236]

INO. *See* ATHAMAS AND INO; DIONYSUS, Infancy.

IO. Daughter of Inachus, the mythical first king of Argos, Io was a priestess of Hera (Juno). She was seduced by Zeus (Jupiter), who changed her into a beautiful white heifer at the approach of his wife. Hera, suspicious, asked for the heifer as a gift and Zeus was forced to oblige. (In some accounts, Hera herself changed Io into a heifer.) Hera then ordered the many-eyed herdsman, Argus, to watch the animal. He guarded her day and night, closing only two of his eyes at a time to rest. At length, Hermes (Mercury) was summoned by Zeus to kill Argus; he lulled the herdsman to sleep with music and beheaded him. Hera retrieved the eyes of Argus and placed them on the tailfeathers of her sacred bird, the peacock. Io was haunted by Argus's spirit and plagued to madness with a gadfly sent by Hera. Still in animal form, she wandered throughout Europe, swam across the sea (now called the Ionian) to Thrace, where she came upon Prometheus chained to his rock. When she reached Egypt, Zeus changed her back to human form and, by the touch of his hand, produced their son, Epaphus. According to Apollodorus, Io was later identified by the Egyptians with the goddess Isis (or the cow-shaped goddess Hathor).

Classical Sources: Aeschylus, *The Suppliants* 41ff., 291ff., 540ff.; *Prometheus Bound* 561–886. Herodotus, *History* 1.1, 2.41, 2.153. Ovid, *Metamorphoses* 1.568–746. Apollodorus, *Biblioteca* 2.1.3ff. Pliny, *Naturalis historia* 16.239. Pausanias, *Description of Greece* 1.25.1, 2.16.1, 3.18.3. Hyginus, *Fabulae* 145, 149, 155. Lucian, *Dialogues of the Sea Gods* 11, "South Wind and West Wind"; *Dialogues of the Gods* 7, "Zeus and Hermes."

See also PROMETHEUS, Bound.

Jean de Meun, 1250?–1305? (Argus's watch over Io evoked in) *Le roman de la rose* lines 14381–94. Verse romance, completion of unfinished work begun by Guillaume de Lorris (c.1230–35). **c.1275.** Lyon: Ortuin & Schenck, c.1481. [Dahlberg 1971 / Poirion 1974]

Anonymous French. (Story of Jupiter and Io in) *Ovide moralisé* 1.3408–4012. Poem, allegorized translation/elaboration of Ovid's *Metamorphoses.* **c.1316–28.** [de Boer 1915–86, vol. 1 / also Hindman 1986, p. 94, pl. 79]

John Gower, 1330?–1408. (Tale of Argus and Mercury in) *Confessio amantis* 4.3317–61. Poem. **c.1390.** Westminster: Caxton, 1483. [Macaulay 1899–1902, vol. 2 / Beidler 1982, p. 45]

Christine de Pizan, c.1364–c.1431. (Story of Io in) *L'epistre d'Othéa à Hector* . . . [The Epistle of Othéa to Hector] chapters 29–30. Didactic romance in prose. **c.1400.** MSS in British Library, London; Bibliothèque Nationale, Paris; elsewhere. / Translated by Stephen Scrope (London: c.1444–50). [Bühler 1970 / Hindman 1986, pp. 94, 196, pls. 25–26]

Filarete, c.1400–1469? Series of small reliefs depicting Argus, Hermes, Io, the death of Argus, and Hera with the eyes of Argus, on bronze door of St. Peter's, Rome. **1433–45** In place. [Pope-Hennessy 1985b, 2:318]

Apollonio di Giovanni, c.1415–**1465,** circle. "Io and Argus." Painting. Museum of Fine Arts, Boston, no. 06.2441c. [Boston 1985, p. 142—ill.]

Bartolomeo di Giovanni, fl. c.1483–1511 (formerly attributed to Pinturicchio). "The Myth of Io." Pendant paintings, each incorporating several scenes. **c.1488.** Walters Art Gallery, Baltimore, inv. 37.421; Wittelsbacher Ausgleichsfond, Schloss Berchtesgaden. [Walters 1976, no. 64—ill. / Berenson 1963, pp. 24f.—ill.]

Garofalo, *c.*1481–1559. "Jupiter and Io." Painting. Early work. Muzeum Narodowe, Poznan, inv. MO15. [Berenson 1968, p. 157]

Pinturicchio, 1454–**1513**. "The Myth of Io." 5 ceiling frescoes. Sala dei Santi, Vatican, Rome. [Berenson 1968, p. 346—ill.] *See also Bartolomeo di Giovanni, above.*

Antonio da Correggio, *c.*1489/94–1534. "(Jupiter and) Io." Painting, for Federico II Gonzaga. *c.***1530?** Kunsthistorisches Museum, Vienna, no. 274 (64). [Gould 1976, pp. 130f., 275 / Vienna 1973, p. 47—ill. / Berenson 1968, p. 93 / Saslow 1986, pp. 63f., fig. 2.2 / Kempter 1980, p. 16, no. 57—ill.] Copy in Galleria Borghese, Rome, inv. 128. [Pergola 1955–59, 1: no. 27—ill.] Another copy (anonymous, restored by Antoine Coypel; head of Io repainted by Pierre-Paul Prud'hon, 1813–14) in Museum, Berlin, no. 216, in 1924. [Guiffrey 1924, no. 121]

Bramantino, 1450/55–**1536**. "Mercury Plays Music to Argus," "Mercury Kills Argus." Frescoes. Sala del Tesoro, Castello, Milan. [Berenson 1968, p. 61]

Jacopo Tintoretto, 1518–1594. "Mercury Lulling Argus to Sleep." Painting. *c.*1541. Galleria Estense, Modena. [Rossi 1982, no. 28—ill.]

———. "Argus and Mercury." Painting. 1543–44. Suida Manning coll., New York. [Rossi, no. 62—ill.]

Luca Cambiaso, 1527–1585. 5 frescoes depicting the story of Io. **1544**. Palazzo della Prefettura, Genoa. [Manning & Suida 1958, pp. 74f.—ill.]

———. "Mercury and Argus." Painting. *c.*1563. Costa coll., Genoa. [Ibid., p. 100—ill.]

Battista Dossi, *c.*1474–1548. "At the Fall of Phaethon, Io, Transformed into a Cow, Is Watched by Argus in the Shape of Juno's Peacock, the Heliades Are Turned into Poplars, and Cycnus into a Swan." Cartoon for a tapestry in "Metamorphoses" cycle. **1543–45**. Louvre, Paris. [Gibbons 1968, no. 196—ill.] Tapestry woven by Hans Karcher, 1545. Salle de la Colonnade, Louvre, Paris. [Ibid. / Berenson 1968, p. 115]

Giorgio Vasari, 1511–1574, and **Cristofano Gherardi**, 1508–1556. "Io." Painting (executed by Gherardi under Vasari's direction?). **1555–59**. Terrazzo di Giunone, Palazzo Vecchio, Florence. [Barocchi 1964, p. 135—ill.]

Paris Bordone, 1500–1571. "Jupiter and Io." Painting. *c.***1559?** Konstmuseum, Göteborg. [Canova 1964, pp. 78f.—ill.]

Lambert Sustris, 1515/20–after **1568** (previously attributed to Andrea Schiavone). "(Landscape with) Jupiter and Io." Painting. Hermitage, Leningrad, no. 121. [Richardson 1980, no. D350—ill. / Hermitage 1981, pls. 78–79]

Jacopo Sansovino, 1486–**1570**. "Mercury and Argus." Bronze sculpture group. Loggetta, Piazza San Marco, Venice. [Warburg]

Florentine School (formerly attributed to Elia Candido). "Mercury with the Head of Argus." Bronze statuette. **1550/75**. Frick Collection, New York, no. 16.2.45; Museo Nazionale, Florence. [Frick 1968–70, 3:217f.—ill.] Variants/studies in Staatliche Museen, Berlin (3); Rijksmuseum, Amsterdam; Louvre, Paris. [Ibid.]

Hendrik Goltzius, 1558–1617. "Argus and Mercury." Engraving. *c.*1583. [Strauss 1977a, no. 172—ill. / Bartsch 1980–82, no. 157—ill.]

———, composition. "Jupiter and Io," "Mercury Putting Argus to Sleep," "Mercury Killing Argus." Engravings,

part of set illustrating Ovid's *Metamorphoses* (first series, nos. 16, 17, 19), executed by assistant(s). *c.*1589. Unique impressions in British Museum, London. [Bartsch 1980–82, nos. 0302.46, 47, 49—ill.] Original drawings in Museum Boymans-van Beuningen, Rotterdam ("Jupiter and Io"); Musée des Beaux-Arts, Besançon, inv. D267 ("Mercury Killing"). [Reznicek 1961, no. 99—ill. / also de Bosque, p. 137—ill.]

———. (Mercury with Argus's head, Juno placing eyes in the peacock's tail, in background of) "Juno." Engraving, in "Four Deities" series (Bartsch no. 64, Jan Saenredam). 1596. [Strauss, no. 330—ill. / Bartsch, no. 160c—ill.] Drawing, variant. Rijksprentenkabinet, Amsterdam, inv. 1899–A4316. [Reznicek, no. 117—ill.]

———. "Mercury Giving the Eyes of Argus to Juno." Painting. Boymans-van Beuningen Museum, Rotterdam. [de Bosque, pp. 89, 135, 138—ill.]

Edmund Spenser, 1552?–1599. (Argus evoked in) "Muiopotmos: or, The Fate of the Butterfly" lines 88–96. Poem. London: Ponsonbie, **1590**; collected in *Complaints* (London: Ponsonbie, 1591). [Oram et al. 1989]

Anonymous. "Mercury, Argus, and the Rape of Europa." Painting, variant after "Rape of Europa and Mercury with His Flocks" (Uffizi) by Francesco Bassano (1549–**1592**; also attributed to Leandro Bassano). Roemer-Museum, Hildesheim. [Arslan 1960, p. 346 / cf. Uffizi 1979, no. P146—ill.]

Samuel Daniel, 1562–1619. (Io's story on gift casket fails to warn Rosamond of her fate in) *The Complaint of Rosamond* lines 409–13. Poem. London: Waterson, **1592**. [Smith 1952, p. 107]

Friedrich Sustris, *c.*1540–**1599**. "Mercury and Argus." Drawing. Albertina, Vienna, no. 7941 (42963). [Warburg]

Hans Bol, 1534–1593. "Mercury and Argus." Drawing. **1601**. Albertina, Vienna, inv. 7910. [Warburg]

Adam Elsheimer, 1578–**1610**. "Mercury Lulls Argus to Sleep," "Mercury Beheads Argus as He Sleeps." Paintings. Staatliche Museen, Berlin, nos. inv. 664D, 664E. [Pigler 1974, pp. 177f.]

Peter Paul Rubens, 1577–1640. "Juno [and the peacock] and Argus" ("The Death of Argus"). Painting. *c.*1611. Wallraf-Richartz-Museum, Cologne, no. 1040. [Cologne 1965, p. 149—ill. / Jaffé 1989, no. 142—ill.]

———. "Mercury and Argus." Painting, for Torre de la Parada, El Pardo. 1636–38. Prado, Madrid, no. 1673. [Alpers 1971, no. 40—ill. / Jaffé, no. 1301—ill. / Prado 1985, pp. 583f.] Oil sketch. Musées Royaux des Beaux-Arts (Musée d'Art Ancien), Brussels, inv. 2897 (394). [Alpers, no. 40a—ill. / Held 1980, no. 203—ill. / Brussels 1984a, p. 250—ill. / Jaffé, no. 1300—ill.]

———. "Mercury and Argus." Painting. Gemäldegalerie, Dresden. [Jaffé, no. 1216—ill.] Copy, sketch (formerly attributed to Rubens), in private coll. England. [Held, no. A6]

Paul Bril, 1554–1626. "Mountain Landscape with Mercury and Argus." Painting. *c.*1612. Kunsthistorisches Museum, Vienna, no. 3583 (902). [Vienna 1973, p. 29]

Thomas Heywood, 1573/74–1641. "Jupiter and Io." Verse drama. *c.***1612–13?** In *Pleasant Dialogues and Drammas* (London: 1637). [Heywood 1874, vol. 6 / Clark 1931, pp. 157–60]

———. "Isis, or Io." Passage in *Gynaikeion: or, Nine Books*

of Various History Concerning Women book 1. Compendium of history and mythology. London: Adam Islip, 1624. [Ipso]

Pieter Lastman, *c.*1583–1633. "Juno Discovering Jupiter with Io." Painting. **1618.** National Gallery, London, inv. 6272. [London 1986, p. 309—ill.]

Hans Bock the Elder, 1550–1624. "Jupiter and Io." Painting. **1619.** Szépmüvészeti Múzeum, Budapest, no. 57.22. [Budapest 1968, p. 73]

David Teniers the Elder, 1582–1649. "Landscape with Jupiter and Io." Painting. Before **1620.** Lost. [Duverger & Vlieghe 1971, p. 79]

————. "Jupiter Entrusts Io, Transformed into a Cow, to Juno," "Mercury, Argus, and Io." Paintings, part of a series illustrating Ovid. 1638. Kunsthistorisches Museum, Vienna, nos. 743 (1138), 745 (1137). [Vienna 1973, p. 172—ill. / Duverger & Vlieghe, pl. 41]

Nicolas Poussin, 1594–1665. "Io, Mercury, and Argus." Drawing, illustrating Ovid, for G. B. Marino (for unpublished edition of Ovid's *Metamorphoses?*). *c.*1620–23. Royal Library, Windsor Castle, no. 11945. [Friedlaender & Blunt 1953, no. 164—ill.]

————, attributed. "Landscape with Juno and Argus (and Io)." Painting. 1635–40. Bode Museum, Berlin. [Wright 1985, no. 91, pl. 42 / Blunt 1966, no. 160—ill. / also Thuillier 1974, no. 81—ill.]

————, formerly attributed (actually by Gaspard Dughet?). "Landscape with Mercury and Argus." Presumed painting, known only from an engraving by J. Volpate. [Blunt, no. R88 / Thuillier, no. R116—ill.]

————, attribution rejected. "Mercury and Argus." 3 drawings, all attributed to Poussin by their owners. Musée Bonnat, Bayonne, no. 1689 (probably 17th-century French); Musée des Beaux-Arts, Lyons (2, one attributable to Jean Lemaire). [Friedlaender & Blunt, pp. 28f.]

Jean Puget de La Serre, 1594–1665. "Jupiter and Io." Poem. In *Les amours des dieux* (Paris: d'Aubin, **1624**). [DLF 1951–72, 3:821]

Jacob Jordaens, 1593–1678. "Mercury and Argus." Painting. **Early 1620s.** Musée des Beaux-Arts, Lyons. [d'Hulst 1982, fig. 74] Enlarged variant. *c.*1646. Private coll., Belgium. [Ibid., fig. 188] Replica. Wouters coll., Antwerp. [Rooses 1908, pp. 142f.—ill.]

————. "Mercury and Argus" (Mercury about to decapitate Argus). Painting. *c.*1650. Dulière coll., Brussels. [d'Hulst, fig. 195 / also Rooses, pp. 144, 146—ill.] Variant. Hermitage, Leningrad. [Rooses, p. 144]

———— (and collaborator?). "Jupiter and Io Observed by Juno," "Mercury Decapitates Argus." Etchings. 1652. [Ottawa 1968, nos. 289–90—ill. / d'Hulst, p. 237]

————. "Jupiter and Io." Painting. Musée des Beaux-Arts, Besançon, inv. 896.1.115. [d'Hulst, p. 237]

————. Numerous further versions of the subject known, in private colls. or unlocated in 1908. [Rooses, pp. 143f., 257]

Moyses van Uyttenbroeck, *c.*1590–1648. "Juno, Argus, and Io." Painting. **1625.** Alte Pinakothek, Munich, inv. 5074. [Munich 1983, p. 538—ill. / Augsburg 1975, no. E46—ill.]

Bartholomeus Breenbergh, 1599–*c.*1657, questionably attributed. "Landscape with Mercury and Argus." Paint-

ing. **Mid-1620s?** Musée Calvet, Avignon. [Röthlisberger 1981, no. 81—ill.] Another version of the subject by Breenbergh known, lost. [Ibid., no. 244—ill.]

Willem Ossenbeck. "Mercury and Io." Painting. **1632.** Rijksmuseum, Amsterdam, inv. A297. [Rijksmuseum 1976, p. 429—ill.]

Joachim Wtewael, 1566–**1638.** "Jupiter and Io, Juno and Argus." Drawing. 3 versions. Herzog Anton Ulrich-Museum, Braunschweig; Staatliche Kunstsammlungen, Dresden; Kunstmuseum, Düsseldorf. [de Bosque 1985, p. 135—ill.]

————. "Mercury and Argus." 2 drawings. Uffizi, Florence; Rijksuniversiteit, Leyden. [Ibid., p. 139—ill.]

Rembrandt van Rijn, 1606–1669, attributed. "The Metamorphosis of Io into a Cow." Drawing. *c.*1642–43? Victoria and Albert Museum, London. [Benesch 1973, no. A39—ill.]

————. "Mercury, Argus, and Io." Drawing. *c.*1645. Norton Simon coll., Los Angeles. [Ibid., no. 567a—ill.]

————. "Mercury, Argus, and Io." Drawing. *c.*1647–48. Ince Blundell Hall, Lancashire. [Ibid., no. 598—ill.]

————. "Mercury, Argus, and Io." Drawing. *c.*1648–50. University Library, Warsaw. [Ibid., no. 627—ill.] School variant (after lost autograph variant?), formerly in de Burlet coll., Basel. [Ibid.—ill.]

————. "Mercury and Argus." Drawing. *c.*1651–52. Louvre, Paris. [Ibid., no. 884—ill.]

————, attributed. "Mercury Killing Argus." Drawing. *c.*1648–49. Kupferstichkabinett, Berlin. [Ibid., no. A27a—ill.]

————, school. "Io Led to Juno by Argus." Drawing. Kupferstichkabinett, Berlin. [Ibid., no. A39 *n.*]

————. *See also Govaert Flinck, below.*

Claude Lorrain, 1600–1682. "Landscape with Argus Guarding Io." Painting. *c.*1644–45. Earl of Leicester coll., Holkham Hall. [Röthlisberger 1961, no. LV 86—ill.] Drawing after, in the artist's *Liber veritatis.* British Museum, London. [Ibid.]

————. "Landscape with Argus Guarding Io." Painting. *c.*1646. Lost. [Röthlisberger, no. LV 98—ill.] Drawing after, in *Liber veritatis.* [Ibid.]

————. "Landscape with Juno Confiding Io to the Care of Argus." Painting. 1660. National Gallery of Ireland, Dublin, no. 763 (813). [Röthlisberger 1961, no. LV 149—ill. / Dublin 1981, p. 24—ill. / Dublin 1985, no. 15—ill.] Drawing after, in *Liber veritatis.* [Röthlisberger]

————. "Landscape with Mercury and Argus." Painting. *c.*1660. G. Harwood coll., South Africa. [Röthlisberger, no. LV 150—ill.] Drawing after, in *Liber veritatis.* [Ibid.]

————. "Landscape with Juno Confiding Io to the Care of Argus." Painting. 1668. Formerly Earl of Jersey coll., destroyed. [Röthlisberger, no. 209—ill.]

————, school. "Mercury and Argus." Painting. Dulwich College Picture Gallery, London, cat. 1953 no. 336. [Wright 1976, p. 39]

Abraham Bloemaert, 1564–1651. "Mercury Putting Argus to Sleep with His Flute." Painting. **1645.** Galerie Liechtenstein, Vienna. [Delbanco 1928, no. I.50—ill.]

————. "Mercury Striking Argus." Drawing. British Museum, London. [de Bosque 1985, pp. 135, 137—ill.]

Giovanni Lanfranco, 1582–**1647,** follower. "Mercury Lulls

Argus to Sleep with His Flute." Painting. Louvre, no. R.F. 1978–31. [Louvre 1979–86, 2:262—ill.]

Jan Both, c.1618–1652, landscape, and **Nicolaus Knupfer,** c.1603–c.1660, figures. "Landscape with Mercury and Argus." Painting. c.1647–48. Kunsthistorisches Museum, Vienna, inv. 9031. [Vienna 1973, pp. 27f.—ill.]

Richard Lovelace, 1618–1658. (Europa and Io in) "Amarantha, a Pastorall" lines 90–118. Poem. In *Lucasta: Epodes, Odes, Sonnets, and Songs* (London: Ewster, 1649). [Wilkinson 1930]

Pier Francesco Mola, 1612–1666/68. "Mercury Putting Argus to Sleep." Painting. **1640s.** Kress coll. (K1706), Allen Art Museum, Oberlin College, Ohio, no. 61.85. [Shapley 1966–73, 3:69—ill.] Variant. c.1660–65. Staatliche Museen, Berlin, no. 383. [Ibid.] Copy, Brown University, Providence (as Carracci school). [Ibid.]

Jacob van Campen, 1595–1657. "Argus, Mercury, and Io." Painting. c.1650. Mauritshuis, The Hague, inv. 1062. [Mauritshuis 1985, pp. 160, 348—ill.]

Carel Fabritius, 1622–1654. "Mercury and Argus." Painting. Art market, New York, in 1988. [Rosenberg 1988, p. 249—ill.] Copy by Jean-Honoré Fragonard. *See Fragonard, below.*

Diego Velázquez, 1599–1660. "Mercury and Argus." Painting. c.1659. Prado, Madrid, no. 1175. [López-Rey 1963, no. 62—ill. / López Torrijos 1985, pp. 309ff.—ill. / Prado 1985, p. 730]

Johann Carl Loth, 1632–1698. "Mercury Piping to Argus." Painting. **Late 1650s.** National Gallery, London, inv. 3571. [London 1986, p. 335—ill.]

Govaert Flinck, 1615–1660 (previously attributed to Rembrandt). "Mercury, Argus, and Io." Painting. Rijksmuseum, Amsterdam, inv. A3133. [Rijksmuseum 1976, p. 229—ill. / also von Moltke 1965, no. 98] Variant. Städtisches Museum, Kleve, cat. 1960.16. [von Moltke, no. 99]

———. "Juno Appears to Jupiter and Io." Painting. Sold London, 1923, unlocated. [von Moltke, no. 96—ill.]

Jan Gerritsz van Bronckhorst, 1603–1661. "Juno with Argus and Io," "Juno Giving Mercury into the Care of the Shepherd Argus." Paintings. Centraal Museum, Utrecht, cat. 1952 nos. 48–49. [Wright 1980, p. 63]

Bernard Fabritius, 1624–1673. "Mercury and Argus." Painting. 1662. Gemäldegalerie, Kassel, cat. 1929 no. 262. [Warburg]

Ferdinand Bol, 1616–1680. "Argus and Mercury." Painting. c.1661–63. Neues Palais, Potsdam, inv. G.K.I.5026. [Blankert 1982, no. 19—ill.]

Adriaen van de Velde, 1636–1672. "Mercury Beheads Argus as He Sleeps." Painting. 1663. Liechtenstein coll., Vaduz, inv. 689. [Pigler 1974, p. 177]

———. "Mercury and Argus." Painting. 1671. Národní Galeri, Prague. [Ibid.]

Antonio Maria Abbatini, 1609/10–1677/79. *Ione.* Opera. Libretto, Antonio Draghi. First performed 1664, Hoftheater, Vienna. [Grove 1980, 1:5].

Jean de La Fontaine, 1621–1695. "La Paon se plaignant à Junon" [The Peacock Complaining to Juno]. Verse fable (book 2 no. 17). In *Fables choisies* (Paris: 1668). [Clarac & Marmier 1965 / Spector 1988]

Dirck van der Lisse, ?–1669. "Landscape with Mercury,

Argus, and Io." Painting. Art Gallery and Museum, Glasgow, cat. 1961 no. 595. [Wright 1976, p. 119]

Benito Manuel de Agüero, 1626?–1670. "Landscape with Mercury and Argus." Painting. Prado, Madrid, no. 899. [López Torrijos 1985, p. 423 no. 4—ill. / Prado 1985, p. 4]

Hendrik Bloemaert, c.1601–1672. "Mercury and Argus." Painting. Centraal Museum, Utrecht, cat. 1952 no. 34. [Wright 1980, p. 40]

Salvator Rosa, 1615–1673. "Romantic Landscape with Mercury and Argus." Painting. Late work. National Gallery of Victoria, Melbourne. [Salerno 1975, no. 142—ill.]

———. "Mercury and Argus." Painting. Nelson Gallery of Art, Kansas City. [Salerno, no. 143—ill.] Replica. L. Harris coll., London. [Ibid., no. 144—ill.] Variant, attributed to Rosa. Mount Holyoke College Art Museum, South Hadley, Mass. [Personal communication to the author from the museum]

———. "Mercury and Argus." Painting. Private coll., Rome. [Ibid., no. 204—ill.]

———, attributed. "Landscape with Mercury and Argus." Painting. Tatton Park, Cheshire. [Wright 1976, p. 176]

Marco Gioseppe Peranda, c.1625–1675, with **Giovanni Andrea Bontempi,** c.1624–1705. *Giove e Io.* Opera. Libretto, Bontempi or C. C. Dedekind, after Abbatini and Draghi's *Ione* (1664). First performed 16 Jan 1673, Dresden. [Baker 1984, p. 301 / Grove 1980, 3:37f., 14:362]

Cornelis Bisschop, 1630–1674. "Mercury and Argus." Painting. Dordrechts Museum, Dordrecht, inv. DM/954/115. [Wright 1980, p. 36]

Giovanni Battista Langetti, 1625–1676, attributed. "Mercury Piping to Argus." Painting. Allen Memorial Art Museum, Oberlin College, Ohio, inv. 04.402. [Warburg]

Jan van Noort, 1620–c.1676. "Juno Consigning Io to Argus." Painting. Louvre, Paris, no. R.F. 1973–3. [Louvre 1979–86, 1:98—ill.]

Nicolaes Berchem, 1620–1683. "Juno Commanding Argus to Keep Watch on Io." Painting. Rijksmuseum, Amsterdam, inv. A1936. [Rijksmuseum 1976, p. 110—ill.]

John Dryden, 1631–1700. "The Transformation of Io into a Heyfar," "The Eyes of Argus Transform'd into a Peacock's Train." Sections of "The First Book of Ovid's *Metamorphoses.*" Translation. In *Examen poeticum,* part 3 of Tonson's *Miscellany* (London: Tonson, 1693). [Dryden 1956–87, vol. 4]

Sebastián Durón, 1660–1716. *Jupiter y Yoo.* Opera (comedia). First performed 1699. [Grove 1980, 5:751]

Monogrammist "M. B." (Netherlandish School, previously attributed to Filippo Lauri, 1623–1694). "Juno and Argus." Painting. 17th century. Holburne of Menstrie Museum, Bath. [Wright 1976, p. 140]

Luca Giordano, 1634–1705. "Mercury and Argus." Painting (?). Sold 1864, untraced. [Ferrari & Scavizzi 1966, 2:393]

Girolamo Troppa, c.1636–after 1706. "Mercury and Argus" (2 scenes: Mercury about to slay Argus, Mercury leading Io away). Painting. Statens Museum for Kunst, Copenhagen. [Copenhagen 1951, no. 719]

Bartolomeo Altomonte, 1702–1779. "Hermes and Europa [sic] as a Cow." Drawing. 1718. "Albertina Sketchbook" no. 55v, Albertina, Vienna. [Heinzl 1964, p. 70]

Giovanni Battista Pittoni, 1687–1767. "Juno and Argus." Painting. c.1723. Private coll., Milan. [Zava Boccazzi 1979, no. 113—ill.]

Giovanni Battista Foggini, 1652–1725. "Mercury Beheads Argus as He Sleeps." Bronze sculpture group. Museo Nazionale del Bargello, Florence. [Pigler 1974, p. 177]

Gregorio de Ferrari, 1644–1726. "Juno and Argus" Painting. Louvre, Paris, no. R.F. 1981–9. [Louvre 1979–86; 2:174—ill.]

Johannes Glauber, 1646–1726. "Arcadian Landscape with Jupiter and Io." Painting. 2 versions. Rijksmuseum, Amsterdam, inv. A118, A1200. [Rijksmuseum 1976, pp. 243f.—ill.]

François Le Moyne, 1688–1737. "Io and Jupiter." Painting, free copy after Correggio (c.1530, Vienna). c.1725–27. Hermitage, Leningrad, inv. 1221. [Bordeaux 1984, no. 56—ill. / Hermitage 1986, no. 114—ill.]

———. "Mercury, Argus, and Io." Painting, for Hôtel Peyrenc de Moras (Hôtel Biron, now Musée Rodin), Paris. 1729–30. Lost. [Bordeaux, no. 86]

———, rejected attribution. "Mercury and Argus." Painting. Central Picture Galleries, New York, in early 1970s. [Ibid., no. X3—ill.]

Johann Franz Michael Rottmayr, 1654–1730. "Hermes with the Headless Body of Argus and the Cattle of Apollo." Painting. Art Institute of Chicago, no. 61.37. [Chicago 1965]

François Verdier, 1651–1730. "Mercury Lulls Argus to Sleep with His Flute." Painting. Louvre, Paris, inv. 910. [Pigler 1974, p. 177]

Charles-Joseph Natoire, 1700–1777. "Jupiter Abducting Io." Painting, part of "Story of the Gods" series, for Château de La Chapelle-Godefroy, Champagne. c.1731. Musée des Beaux-Arts, Troyes, no. 202. [Troyes 1977, pp. 54f.—ill. / Boyer 1949, no. 33] Replica. R. Sibilat coll. in 1935. [Boyer, no. 46]

Jacopo Amigoni, 1675–1752. "Jupiter and Io," "Argus Lulled to Sleep by the Flute of Mercury," "Mercury about to Slay Argus," "Juno Receiving the Head of Argus from Mercury." Paintings. c.1732. Moor Park, Rickmansworth. [Wright 1976, p. 3 / Jacobs & Stirton 1984b, p. 99—ill.]

———. "Mercury about to Slay Argus." Painting. Tate Gallery, London, no. T1299. [Wright]

Sebastiano Ricci, 1659–1734, attributed. "Mercury Putting Argus to Sleep." Painting. Private coll., Como. [Daniels 1976, no. 75]

Peter Prelleur, fl. c.1728–55, music. Jupiter and Io. Pantomime-masque. First performed 24 Jan 1735, Goodman's Fields, London. [Fiske 1973, p. 125]

Georg Raphael Donner, 1693–1741. "Mercury" (with the head of Argus). Lead statue. c.1739. Österreichisches Barockmuseum, Vienna; Szépmüvészeti Múzeum, Budapest; Kunsthistorisches Museum, Vienna; Hermitage, Leningrad; Germanischen Nationalmuseum, Nuremberg; Herzog Anton Ulrich-Museum, Braunschweig. [Schwarz 1968, no. 16—ill.]

Andrea Locatelli, 1695–1741. "Landscape with Mercury and Argus." Painting. Hermitage, Leningrad, inv. 3559. [Hermitage 1981, pl. 212]

Henry Fielding, 1707–1754. "An Interlude Between Jupiter, Juno, and Mercury." Dramatic interlude (sketch). In Miscellanies, vol. 1 (London: Strand, 1743). [Nicoll 1959–66, 2:328]

Jean-Honoré Fragonard, 1732–1806. "Jupiter and Io." Painting. 1748–52. Musée des Beaux-Arts, Angers. [Wildenstein 1960, no. 86—ill.]

———. "Mercury and Argus." Painting, copy after Carel Fabritius. c.1764? Louvre, Paris, no. R.F. 1981–17. [Rosenberg 1988, no. 121—ill. / Louvre 1979–86, 3:260—ill.]

Giovanni Battista Tiepolo, 1696–1770. "Juno and the Peacock." Fresco. c.1754. Formerly Villa Soderini, Nervesa, destroyed. [Morassi 1962, p. 32]

François-Gaspard Adam, 1710–1761. "Juno with the Peacock." Statue, part of mythological cycle. 1755–58. Gardens, Sanssouci, Potsdam. [Thirion 1885, pp. 161f.—ill.]

Jean-Philippe Rameau, 1683–1764, music. Io. Ballet in one act. Unperformed. [Girdlestone 1983, p. 623 / Grove 1980, 15:571]

Angelica Kauffmann, 1741–1807. "Juno with the Peacock." Etching. 1770. [Manners & Williamson 1924, p. 220]

Pierre-Henri de Valenciennes, 1750–1819. "(Landscape with) Mercury and Argus." Painting. 1793? Bowes Museum, Barnard Castle, list 1971 no. 437. [Royal Academy 1968, no. 688 / Wright 1976, p. 207]

Charles Monnet, 1732–after 1808. "Jupiter and Io as Lovers." Drawing, design for an engraving, executed by G. Vidal (1742–1801). [Pigler 1974, p. 145]

John Keats, 1795–1821. "As Hermes once took to his feathers light" ("On a Dream"). Sonnet. 16 Apr 1819. In The Indicator 28 June 1820; reprinted in Life, Letters, and Literary Remains of John Keats, edited by Richard Monckton Milnes (London: Moxon, 1848). [Stillinger 1978 / Bate 1963, pp. 471f. / De Selincourt 1951, pp. 549ff.]

Anonymous. Argus and His Hundred Eyes. Ballet. First performed 1821, London. [Nicoll 1959–66, 4:427]

Carl von Steuben, 1788–1856. "Mercury Putting Argus to Sleep." Painting. Commissioned 1817, exhibited 1822. Louvre, Paris, inv. 7972. [Louvre 1979–86, 4:226—ill.]

Bertel Thorwaldsen, 1770–1844. "Mercury (about to Kill Argus)." Marble statue. 4 versions, 1819–28. Thorwaldsens Museum, no. A873 (A4); Prado, Madrid; Chatsworth House, Derbyshire; Potocki coll., Cracow, in 1829. [Cologne 1977, no. 132, p. 105—ill. / Thorwaldsen 1985, pp. 22, 83, pl. 12] Plaster original, 1818. Thorwaldsens Museum, no. A5 (cf. no. A868). [Thorwaldsen, p. 22]

Benjamin Robert Haydon, 1786–1846. "Mercury in the Disguise of a Clown, Playing Argus Asleep." Painting. 1830. [Olney 1952, p. 187]

Joseph Mallord William Turner, 1775–1851. "Mercury and Argus." Painting. Exhibited 1836. National Gallery of Canada, Ottawa. [Butlin & Joll 1977, no. 367—ill.]

Victor-François-Eloi Biennourry, 1823–1893. "Mercury and Argus." Painting (sketch). 1842. École des Beaux-Arts, Paris. [Grunchec 1984, no. 27—ill.]

François-Joseph Bosio, 1769–1845. "The Nymph Io." Sculpture. [Bénézit 1976, 2:194]

Richard Garnett, 1835–1906. "Io in Egypt." Poem. In Io in Egypt and Other Poems (London: Bell & Daldy, 1859). [Heilbrun 1961, p. 202]

Gustave Moreau, 1826–1898. "The Peacock Complaining to Juno." Watercolor, illustration to La Fontaine's fable

(1668). **1881.** Musée Gustave Moreau, Paris. [Mathieu 1976, no. 226—ill. / Mathieu 1985, pl. 35]

Gerard Manley Hopkins, 1844–1889. "Io." Poem. First published in *The Poems of Gerard Manley Hopkins,* edited by Robert Bridges (London: Oxford University Press, 1918). [Phillips 1986 / Boswell 1982, p. 137]

Dudley Beresford. "Io and Jupiter." Poem. In *Lyrics and Legends* (London: Allen, **1908**). [Boswell 1982, p. 243 / Bush 1937, p. 568]

Lovis Corinth, 1858–1925. "Io with the Cloud." Color lithograph, part of "Loves of Zeus" cycle. 2 versions. **1920.** [Schwarz 1922, no. L401]

Sean O'Casey, 1880–1964. *Juno and the Paycock* (ironic use of myth in title and theme: characters provide an allusion to the mythological figures). Tragedy. First performed **1924,** Abbey Theatre, Dublin. [Oxford 1983b, p. 603]

Marc Chagall, 1887–1985. "The Peacock Complaining to Juno." Painting. **1926–27.** List family coll., New York. [Chagall 1975, no. 21—ill.]

Georges Braque, 1882–1963. "Io" ("The Chariot of the Sun"). Plaster relief. **1935.** [Cogniat 1980, fig. 32 / also Fumet 1951, no. 9—ill.]

Max Beckmann, 1884–1950. "Jupiter and Io." Painting. **1946.** [Hannover 1950, no. 12]

Arman, 1928–1974. "Small Argus." *Accumulation* (dolls' eyes in a wooden box). **1961.** F. A. Becht coll., Holland. [Martin 1973, p. 74—ill.]

———. "Argusmyope." *Accumulation* (old spectacles in polyester form). 1963. Private coll., Brussels. [Ibid., p. 103—ill.]

Salvador Dalí, 1904–1989. "Argus" (Juno giving Argus's eyes to the peacock). Etching, in "Mythology" series. **1963.** [Rotterdam 1970, no. 170—ill.]

Lawrence Durrell, 1912–1990. "Io." Poem. In *The Ikons, and Other Poems* (London: Faber & Faber; New York: Dutton, **1966**). [Ipso]

Olga Broumas, 1949–, poem, and **Sandra McKee,** painting. "Io." Part of 2–media piece "Twelve Aspects of God." Exhibited Sep **1975,** Maude Kerns Gallery, Eugene, Ore. Broumas's poem in *Beginning with O* (New Haven: Yale University Press, 1977). [Ipso]

Laurence Josephs. "Io." Poem. In *St. John's Review* 33 no. 2 (Winter **1982**). [Ipso]

Laurie Sheck. "Io at Night." Poem. In *Io at Night* (New York: Knopf, **1990**). [Ipso]

IOLE. *See* HERACLES, and Iole.

ION. *See* CREUSA.

IPHIGENIA. Daughter of Agamemnon, king of Mycenae, and Clytemnestra, Iphigenia was a central figure in two episodes from the prologue and the epilogue to the Trojan War. She was sacrificed by her father at Aulis in order to gain favorable winds for the Greek fleet sailing to Troy. According to one tradition, she was saved from sacrifice by Artemis and became her priestess at Tauris. She was eventually reunited with her brother, Orestes, after his vengeful murder of their mother, Clytemnestra. An auxiliary legend holds that, after leaving Tauris with Orestes, Iphigenia became a priestess at Delphi.

Listings are arranged under the following headings:
> Iphigenia at Aulis
> Iphigenia at Tauris
> Iphigenia at Delphi

Iphigenia at Aulis. On his way to join in the Trojan War, Agamemnon killed a deer in a grove sacred to Artemis (Diana). In retribution, the goddess sent adverse winds that kept the Greek fleet in port at Aulis. The soothsayer Calchas decreed that the sacrifice of Agamemnon's daughter, Iphigenia, was needed in order to turn the winds in the Greeks' favor. On the pretext that she was to marry Achilles, Iphigenia was brought from Mycenae with her mother, Clytemnestra. According to one version of the story, the sacrifice took place; another says that at the moment of sacrifice Artemis snatched Iphigenia from the altar and replaced her with a deer.

In the postclassical era, especially the Baroque, the story has been a recurrent subject for opera and for drama. It has been less commonly treated in the visual arts.

Classical Sources. Homer, *Iliad* 9.145; *Odyssey* 1.40–44, 3.193ff., 306–10, 4.546ff. Euripides, *Iphigenia in Aulis.* Pacuvius, *Chryses.* Lucretius, *De rerum natura* 1.84–103. Cicero, *De officiis* 3.25. Ovid, *Metamorphoses* 12.1–38, 13.182–95. Apollodorus, *Biblioteca* E3.21–22. Pausanias, *Description of Greece* 1.33.1, 1.41.1, 1.43.1, 2.22.7, 2.35.1, 3.16.7, 7.26.5, 9.19.6. Hyginus, *Fabulae* 98.

Anicius Manlius Severinus Boethius, *c.*480–524. (Sacrifice of Iphigenia evoked in) *De consolatione philosophiae* book 4 metrum 7. Dialogue. **524.** [Stewart 1968] Translated into Anglo-Saxon by Alfred the Great (*c.*900), and into Middle English by Geoffrey Chaucer as *Boece* (1381–85). *See Chaucer, below.* [Ibid.]

Dante Alighieri, 1265–1321. (Sacrifice of Iphigenia recalled in) *Paradiso* 5.68–72. Completed *c.***1321.** In *The Divine Comedy.* Poem. Foligno: Neumeister & Angelini, 1472. [Singleton 1970–75, vol. 3]

Anonymous French. (Sacrifice of Iphigenia in) *Ovide moralisé* 12.1320–1494. Poem, allegorized translation/elaboration of Ovid's *Metamorphoses.* *c.***1316–28.** [de Boer 1915–86, vol. 4]

Geoffrey Chaucer, 1340?–1400. (Sacrifice of Iphigenia evoked in) *Boece* book 4 metrum 7. Prose translation of Boethius's *De consolatione philosophiae* (524). **1381–85.** Westminster: Caxton, 1478. [Riverside 1987]

Anonymous English. (Story of Iphigenia in) *The Destruction of Troy.* Alliterative adaptation of Guido delle Co-

lonne's *Historia destructionis Troiae* of 1272–87 (this passage not in Guido). *c.*1385–1400? Modern edition by George A. Panton and David Donaldson, *The "Gest Hystoriale" of the Destruction of Troy* (London: Early English Text Society, 1869, 1874). [Pearsall 1977, pp. 166f., 188, 297 / Benson 1980, p. 35]

John Lydgate, 1370?–1449. (Story of Iphigenia in) *Troy Book* 2.6215–34. Poem, elaboration of Guido delle Colonne (this passage not in Guido). **1412–20.** Modern edition by Henry Bergen (London: Kegan Paul, Trench & Trübner, for Early English Text Society, 1906–35). [Benson 1980, pp. 97–129]

Raoul Lefèvre, fl. *c.*1454–67. (Sacrifice of Iphigenia in) *Le recueil des hystoires de Troyes* [Collection of the Stories of Troy]. Prose romance. **1464.** / English translation by William Caxton as *The Recuyell of the Historyes of Troye* (Bruges: Mansion, *c.*1474). / Modern edition (of original French) by Marc Aeschbach (Bern & New York: Lang, 1987). [Scherer 1963, p. 46]

Desiderius Erasmus, 1466–1536. *Iphigenia in Aulide*. Latin translation of Euripides. **1506.** In *Euripides tragediae duae: Hecuba et Iphigenia in Aulide* (Basel: Frobenius, 1524). [Stone 1974, p. 68]

Floriano Ferramola, *c.*1480–1528. "Sacrifice of Iphigenia." Fresco (detached), from Casa Borgondio della Corte, Brescia. *c.*1511. Formerly Sir Humphrey Noble coll., sold Christie's, London, 1960, to J. Weitzner. [Kauffmann 1973, pp. 102f.]

Lodovico Dolce, 1508–1568. *Iphigenie in Aulide*. Tragedy. **1543–47.** In *Tragedie* (Venice: 1566). [Frenzel 1962, p. 297]

Thomas Sébillet, 1512–1589. *Iphigénie à Aulis*. Tragedy, after Erasmus (1506). Paris: Corrozet, **1549.** [Stone 1974, p. 68]

School of Fontainebleau. "Diana Saves Iphigenia." Tapestry, in "History of Diana" series for Château d'Anet (designs attributed to Jean Cousin the Elder or Luca Penni). **1549–52.** Château d'Anet. [Paris 1972, no. 459]

Niccolò Giolfino, 1476–1555. "Sacrifice of Iphigenia." Painting. Fogg Art Museum, Harvard University, Cambridge, no. 1943.1841. [Berenson 1968, p. 171]

Jane, Lady Lumley, *c.*1537–1577. *The Tragedie of Euripides Called Iphigeneia*. Drama, after Euripides and Erasmus. **1558.** Modern edition, London: Chiswick Press, for Malone Society, 1909. [Ipso]

Lambert Sustris, 1515/20–**after 1568** (previously attributed to Andrea Schiavone). "The Sacrifice of Iphigenia." Painting, part of a series of scenes associated with the Trojan War. Galleria Sabauda, Turin, no. 561. [Berenson 1957, p. 161 (as Schiavone) / Richardson 1980, no. D366 (as Sustris)—ill.]

Domenichino, 1581–1641, and assistant? "The Sacrifice of Iphigenia." Ceiling fresco, part of "Life of Diana" cycle. **1609.** Palazzo Giustiniani-Odelscalchi, Bassano di Sutri. [Spear 1982, no. 34.ii—ill.]

Philippe Millereau, *c.*1570–**1610**, attributed. "The Sacrifice of Iphigenia." Painting. Musée du Château, Fontainebleau. [Paris 1972, no. 135—ill. / also Lévêque 1984, p. 51—ill.]

Vicente Carducho, 1576/78–1638. "Achilles at the Port of Aulis." Fresco, in "History of Achilles" series, Palacio del Pardo, Madrid. **1609–12.** Lost. / Drawing. Alcu-

bierre coll., Madrid. [López Torrijos 1985, pp. 203ff., 409 nos. 1, 3—ill.]

Samuel Coster, 1579–1665. *Iphigeneia*. Tragedy in verse, political satire. Amstelredam: Biestkens, **1617.** [CEWL 1973, 2:337 / Meijer 1971, p. 110]

Jean Rotrou, 1609–1650. *Iphygénie*. Tragedy. First performed **1640**, Paris. Published Paris: de Sommaville, 1641. [DLLF 1984, 3:2018 / Barnwell 1982, p. 112]

Bertholet Flémalle, 1614–1675 (previously attributed to Bernardo Campi). "The Sacrifice of Iphigenia." Painting, for Cabinet de l'Amour, Hôtel Lambert, Paris. **1646–47.** Louvre, Paris, inv. 161. [Louvre 1979–86, 1:58—ill. / Louvre 1972, pp. 29ff., no. 52—ill.]

Giovanni Francesco Romanelli, 1610–**1662.** "The Sacrifice of Polyxena" ("The Sacrifice of Iphigenia"). Painting. Metropolitan Museum, New York, inv. 54.166. [Metropolitan 1980, p. 158—ill. / Scherer 1963, p. 247 (as "Iphigenia")]

Jan Steen, 1626–1679. "The Sacrifice of Iphigenia." Painting. **1671.** Rijksmuseum, Amsterdam, inv. A3984. [Rijksmuseum 1976, p. 521—ill.]

Jean Racine, 1639–1699. *Iphigénie en Aulide*. Tragedy. First performed 18 Aug **1674**, Versailles; late 1674, Hôtel de Bourgogne, Paris. Published Paris: 1675 (with illustrations by François Chauveau). [Rat 1974 / Pocock 1973, pp. 216–23 / Turnell 1972, pp. 209–35 / Vinaver 1963, pp. 70–74, 112f., 217 / Allen 1982, pp. 95f., 99ff. / Barnwell 1982, pp. 111ff., 213ff. and passim]

Michel Le Clerc, 1622–1691, and **Jacques de Coras**, 1630–1677. *Iphigénie*. Tragedy. First performed 24 May **1675**, Théâtre Guénégaud, Paris. Published Paris: 1678. [Lancaster 1929–42, pt. 4, 2:951 / Girdlestone 1972, p. 126]

Jean Jouvenet, 1644–1717. "The Sacrifice of Iphigenia." Ceiling painting, for Hôtel de Saint-Poulange, Paris. *c.*1681–84. Musée des Beaux-Arts, Troyes. [Schnapper 1974, no. 21—ill.]

Abel Boyer, 1667–1729. *Achilles; or, Iphigenia in Aulis* (later called *The Victim*). Tragedy. By **1699.** First performed 1700, Theatre Royal, Drury Lane, London. London: 1714. [Stratman 1966, p. 54 / Nicoll 1959–66, 1:393, 2:299, 3:86]

Reinhard Keiser, 1674–1739. *Die Wunderbar errettete Iphigenia* [The Miraculously Rescued Iphigenia] (unconfirmed subject; possibly Iphigenia at Tauris?). Opera. Libretto, Christian Heinrich Postel. First performed **1699**, Hamburg. [Zelm 1975, p. 46]

Italian School. "The Sacrifice of Iphigenia." Painting. **Late 17th century.** Ferens Art Gallery, Hull. [Wright 1976, p. 103]

José de Cañizares, 1676–1750. *El sacrificio de Efigenia*. Drama. Barcelona: Piferrer, **1700.** [Barrera 1969, p. 70 / Cook 1959, p. 151]

Carlo Maria Maggi, 1630–1699. *Ifigenia*. Tragedy. In *Opere*, edited by L. A. Muratori (Milan: **1700**). [DELI 1966–70, 3:454]

Aurelio Aureli, *c.*1630–1708. *L'Ifigenia*. Opera (dramma per musica). First performed **1707**, Venice? [DELI 1966–70, 1:208f.]

Agostino Bonaventura Coletti, *c.*1675–1752. *Ifiginia*. Opera. Libretto, P. Riva. First performed Carnival **1707**, S. Cassiano, Venice. [Grove 1980, 4:530]

Domenico Scarlatti, 1685–1757. *Iphigenia in Aulide*. Opera (dramma per musica). Libretto, Carlo Sigismundo Ca-

pece, after Euripides. First performed 11 Jan **1713**, Teatro Domestico della Regina Maria Casimira di Pollonia, Rome. [Kirkpatrick 1953, pp. 50, 53, 415f. / Grove 1980, 16:574]

Charles Johnson, 1679–1748. *The Victim, or, Achilles and Iphigenia in Aulis.* Tragedy (probable plagiary of Abel Boyer, 1699). First performed 5 Jan **1714**, Theatre Royal, Drury Lane, London. [Stratman 1966, p. 289 / Nicoll 1959–66, 2:72, 339]

Pier Jacopo Martello, 1665–1727. *Ifigenia.* Tragedy. In *Teatro italiano* (Rome: Gonzaga, **1715**). [DELI 1966–70, 3:530]

Jean-Joseph Mouret, 1682–1738, music. (Iphigenia in) "La ceinture de Vénus." Ballet-opera, first interlude for *Les grandes nuits de sceaux.* Libretto, Antoine Houdar de La Motte. First performed **1715**, for Duc and Duchesse du Maine, Château de Sceaux. [Winter 1974, p. 48]

Johann Philipp Käfer, 1672–c.1730. *Iphigenia.* Opera. First performed **1716**, Durlach. Lost. [Grove 1980, 9:766]

Giovanni Paolo Panini, 1691–1765. "Iphigenia in Aulis." Painting. **1716–18.** Holburne of Menstrie Museum, Bath, no. 1353. [Arisi 1961, no. 23, pl. 47]

Apostolo Zeno, 1668–1750. *Ifigenia in Aulide.* Libretto for opera. First set by Caldara, **1718,** and by at least 7 further composers to 1807. *See below.*

Antonio Caldara, c.1670–1736. *Ifigenia in Aulide.* Opera. Libretto, Apostolo Zeno. First performed **1718,** Vienna. [Zinar 1971, p. 91 / Grove 1980, 3:615]

Petros Katsaitis, fl. 1715–20. *Iphigenia.* Tragedy. **1720.** Modern edition by Emmanuel Kriaras (Athens: 1950). [Trypanis 1981, p. 575]

Herman Collenius, 1650–**1720/21.** "Agamemnon and Iphigenia" (?). Painting. Groninger Museum, Groningen, inv. 1970/47. [Wright 1980, p. 79]

Giovanni Battista Tiepolo, 1696–1770. "The Sacrifice of Iphigenia." Painting. *c.***1720–25.** Bonomi coll., Milan. [Morassi 1962, p. 26 / also Pallucchini 1968, p. 136 (as uncertain attribution)]

———. "The Sacrifice of Iphigenia." Painting. *c.*1725–30. Giustianti-Recanati coll., Venice. [Pallucchini, no. 53—ill. / Morassi, p. 62—ill.]

———. "The Sacrifice of Iphigenia," "Diana Flying to Tauris with Iphigenia," "Triumph of Diana." Fresco cycle. 1736. Palazzo Cornaro di S. Maurizio, Merlengo. [Pallucchini, no. 112 / Morassi, p. 23] Studies/replicas of "Sacrifice." Kress coll., University of Arizona, Tucson; Kunsthalle, Hamburg; Patino coll., Paris (formerly Rothschild coll.). [Morassi, pp. 13, 42, 51—ill. / also Pallucchini, no. 217—ill.] Study for "Triumph of Diana." Dulwich College Picture Gallery, London. [Morassi, p. 17—ill.]

———. "The Sacrifice of Iphigenia," "Diana and Aeolus," "The Greek Fleet in Aulis." Fresco cycle. 1757. Sala d'Ifigenia, Villa Valmarana, Vicenza. [Pallucchini, no. 240—ill. / Morassi, pp. 64f.—ill. / Levey 1986, pp. 231f.—ill.]

———. *See also* Giovanni Battista Crosato, Giovanni Domenico Tiepolo, Francesco Zugno, *below.*

Carl Heinrich Graun, 1703/04–1759. *Iphigenia in Aulis.* Opera. Libretto, Postel (1699), revised by Frederick II of Prussia. MS dated **1728.** First performed Winter 1731, Braunschweig. [Grove 1980, 7:645, 646]

———. *Iphigenia in Aulide.* Opera. Libretto, Villati, with Frederick II, after Racine (1674). First performed 13 Dec 1748, Opera, Berlin. [Grove, 7:646]

François Le Moyne, 1688–1737. "The Sacrifice of Iphigenia." Painting. **1728.** Private coll., Lisbon (?). [Bordeaux 1984, no. 71—ill.] Oil sketch. Louvre, Paris, no. M.N.R. 74. [Ibid.—ill. / Louvre 1979–86, 4:48—ill.]

Giuseppe Maria Orlandini, 1675–1760. *Ifigenia in Aulide.* Opera (dramma per musica). Libretto, Zeno (1718). First performed 4 Feb **1732,** Teatro della Pergola, Florence. [Grove 1980, 13:824 / Weaver 1978, pp. 266f.]

Carlo Innocenzo Carlone, 1686–1775. "The Sacrifice of Iphigenia." Oil sketch (for part of a ceiling decoration in Schloss Ludwigsburg, near Stuttgart?). *c.***1731–33?** Rust coll., Washington D.C. [Columbia 1967, no. 33—ill.]

Giovanni Battista Crosato, *c.*1685–1758, attributed (or Bernardino Galliari? previously attributed to G. B. Tiepolo, Sebastiano Ricci). "The Sacrifice of Iphigenia." Painting (study). *c.***1733?** Uffizi, Florence, inv. 923. [Uffizi 1979, no. P483—ill.]

Paolo Antonio Rolli, 1687–1765. *Ifigenia in Aulide.* Tragedy. Before **1735.** In *Componimenti poetici in vario genere di Paolo Antonio Rolli* (Verona: Tumermani, 1744). [NUC]

Nicola Porpora, 1686–1768. *Ifigenia in Aulide.* Heroic opera. Libretto, Paolo Antonio Rolli. First performed 3 May **1735,** King's Theatre, London. [Grove 1980, 15:126 / Zinar 1971, p. 91]

Georg von Reutter the Younger, 1708–1772. *Il sacrifizio in Aulide.* Opera (festa teatrale). Libretto, P. Pariati. First performed 19 Nov **1735,** Vienna. [Grove 1980, 15:773]

Charles-Antoine Coypel, 1694–1752. "The Sacrifice of Iphigenia." Painting. 1730 or **1737.** Musée Municipal, Brest. [Bénézit 1976, 3:247 / Pigler 1974, p. 327] A tapestry depicting this subject, designed by Charles and Antoine Coypel and manufactured by Gobelins, 1717–30, is owned by Musées Nationaux, Paris. [Scherer 1963, pp. 249f.]

Giovanni Porta, *c.*1690–1755, attributed (sometimes attributed to Bernardo Aliprandi). *Ifigenia in Aulide.* Opera seria. Libretto, Zeno (1718). First performed **1738,** Court, Munich. [Grove 1980, 15:133]

Geminiano Giacomelli, *c.*1692–1740. *Achille in Aulide.* Opera. First performed **1739,** Teatro Argentina, Rome. Music lost. [Grove 1980, 7:344]

Pompeo Batoni, 1708–1787. "The Sacrifice of Iphigenia." Painting. **1741–42.** Earl of Wemyss and March coll., Gosford House, Longniddry, Scotland. [Clark 1985, no. 59—ill.] Oil sketch. Earl of Yarborough coll., Brocklesby Park, Lincolnshire. [Ibid., no. 58—ill.]

Girolamo Abos, 1715–1760. *Ifigenia in Aulide.* Opera. First performed **1744–45,** Naples. [Grove 1980, 1:20 / Zinar 1971, p. 91]

Franz Anton Maulbertsch, 1724–1796. "The Sacrifice of Iphigenia." Painting. *c.***1750.** Muzeum Narodowe, Warsaw, inv. 127708. [Garas 1960, no. 27—ill. / Warsaw 1969, no. 768—ill.]

Giovanni Battista Piazzetta, 1683–1754. "The Sacrifice of Iphigenia." Painting. **1750.** Pinacoteca Civica, Cesena. [Mariuz 1982, no. 154—ill.]

Niccolò Jommelli, 1714–1774. *Ifigenia in Aulide.* Opera. Libretto, M. Verazi, after Zeno (1718). First performed 9 Feb **1751,** Teatro Argentina, Rome. [Grove 1980, 9:693]

Tommaso Traetta, 1727–1779. 4 arias for a revision of Jommelli's *Ifigenia in Aulide* (above). First performed 18 Dec **1753**, San Carlo, Naples. [Grove 1980, 19:114]

Francesco Algarotti, 1712–1764. *Iphigénie en Aulide.* Model libretto for opera (in French), after Euripides and Racine (1674), in the essay "Saggio sopra l'opera in musica." **1755.** Livorno: Coltellini, 1763. [DELI 1966–70, 1:82 / Nicoll 1959–66, 3:332 / Grove 1980, 1:256]

Denis Diderot, 1713–1784. "Entretiens sur *Le Fils Naturel.*" Essay (on Iphigenia at Aulis as ideal subject for opera). Amsterdam: **1757.** [Ipso]

Francesco Fontebasso, 1709–1768/69. "The Sacrifice of Iphigenia." Painting, for Palazzo Bernardi, Venice. **1750s?** Szépmüvészeti Múzeum, Budapest. [Budapest 1968, pp. 237f.]

Corrado Giaquinto, 1703–1765. "The Sacrifice of Iphigenia." Painting. *c.*1759–60. Prado, Madrid, no. 105. [Prado 1985, p. 243]

Ferdinando Bertoni, 1725–1813. *Iphigenia in Aulide.* Opera seria. Libretto, Vittorio Amedeo Cigna-Santi. First performed **1762**, Teatro Regio, Turin. [Grove 1980, 2:647]

Gian Francesco de Majo, 1732–1770, doubtfully attributed. *Ifigenia in Aulide.* Opera. First performed **1762,** Naples. [Grove 1980, 11:544]

Giovanni Domenico Tiepolo, 1727–1804 (previously attributed to G. B. Tiepolo). "The Sacrifice of Iphigenia." Painting. **1760–65.** Schlossmuseum, Weimar. [Mariuz 1979, p. 151—ill.]

———. "The Sacrifice of Iphigenia." Fresco (detached), from Palazzo Labia, Venice. Sold Sotheby's, London, 1968, unlocated. [Ibid., p. 122]

Jean-Baptiste Deshayes, 1729–1765, design. "Calchas Demanding the Sacrifice of Iphigenia," "Agamemnon Consenting to the Sacrifice of Iphigenia." Beauvais tapestries, woven *c.*1766. Spanish Royal Collection, Casa del Rey, Madrid. [Scherer 1963, p. 250]

Carle van Loo, 1705–**1765.** "The Sacrifice of Iphigenia." Painting. Neues Palais, Sanssouci, Potsdam. [Bénézit 1976, 6:73]

Anton Cajetan Adlgasser, 1729–1777. *Iphigenia mactata, oder, Chalcis expugnata* [Iphigenia Sacrificed, or, Chalchis (port of Euboea) Captured]. Oratorio. First performed **1765,** Salzburg. [Grove 1980, 1:110]

Christoph Willibald Gluck, 1714–1787, music. *Iphigénie.* Ballet. Scenario and choreography, Gaspare Angiolini. First performed 19 May **1765,** Laxenburg, Vienna. [Grove 1980, 1:426; 7:461f., 464]

———. *Iphigénie en Aulide.* Opera. Libretto, F. L. G. Le Blanc du Roullet, after Racine (1674). First performed 19 Apr 1774, Académie Royale, Paris. [Grove 1980, 7:464f., 472; 16:268 / Cooper 1935, pp. 177ff. / Tovey 1934, pp. 83, 104–07, 115 / Sternfeld 1966, p. 129]

James Hook, 1746–1827, music. *The Sacrifice of Iphigenia.* Pantomime. First performed 12 July **1766,** Richmond Theatre, London. Only the overture published. [Grove 1980, 8:685]

Jean Restout, 1692–**1768,** attributed. "The Sacrifice of Iphigenia." Painting. Musée des Beaux-Arts, Troyes. [Bénézit 1976, 8:702]

Pietro Alessandro Guglielmi, 1728–1804. *Ifigenia in Au-lide.* Opera seria. Libretto, Giovanni Gualberta Bottarelli. First performed 16 Jan **1768,** King's Theatre, Haymarket, London. [Grove 1980, 7:796]

Charles Le Picq, 1744–1806, choreography. *Il sacrificio di Efigenia.* Ballet. First performed **1772,** Venice. [EDS 1954–66, 6:1409]

Francesco Salari, 1751–1828. *Ifigenia in Aulide.* Opera. First performed **1776,** Casal Monferrato. Music lost. [Grove 1980, 16:410]

Charles-Joseph Natoire, 1700–1777. "The Sacrifice of Iphigenia" (Iphigenia carried off by Diana). Painting. Sold Paris, 1910. [Boyer 1949, no. 176]

Giuseppe Sarti, 1729–1802. *Ifigenia.* Opera (dramma per musica). First performed Carnival **1777,** Teatro Argentina, Rome. [Grove 1980, 16:505]

Francesco Antonio Baldassare Uttini, 1723–1795. Choruses to Racine's *Iphigénie en Aulide* (1674). First performed **1777,** Stockholm. [Grove 1980, 19:480]

———. *Iphigénie i Auliden.* Libretto, Johan Henrik Kellgren, after Le Blanc du Roullet (1774). First performed 29 Dec 1778, Stockholm. [Ibid.]

Jean-Étienne Despréaux, 1748–1820, music. *Iphigénie en Aulide.* Musical parody. Libretto, composer. First performed Aug **1778,** Choisy. [Grove 1980, 5:395]

Thomas Hull, 1728–1808. *Iphigenia; or, The Victim.* Tragedy, after Boyer's *Achilles* (*c.*1699). First performed 23 Mar **1778,** Covent Garden, London; incidental music, John Abraham Fisher. [Nicoll 1959–66, 3:274 / Grove 1980, 6:617]

Georg Christoph Lichtenberg, 1742–1799. *Iphigenie.* Musical drama. First performed before **1779,** Germany. [Strich 1970, 1:225 *n.*]

Vicente Martín y Soler, 1754–1806. *Iphigenia in Aulide.* Opera seria. Libretto, L. Serio. First performed 12 Jan **1779,** Teatro San Carlo, Naples. [Grove 1980, 11:736]

Francisco Goya, 1746–1828. "The Sacrifice of Iphigenia" (?). Painting. *c.*1775–80. Lost. / Print. [Gassier & Wilson 1981, no. 167—ill. / Gudiol 1971, no. 107—ill.]

———. "The Sacrifice of Iphigenia" (?). Painting. *c.*1775–80. José Várez coll., San Sebastian. [Gassier & Wilson, no. 169—ill. / Gudiol, no. 109—ill.]

Tommaso Giordani, 1730–1806. *Ifigenia in Aulide.* Opera. First performed *c.***1780** (?), Dublin or London? [Zinar 1971, p. 91]

Francesco de Mura, 1696–1782. "The Sacrifice of Iphigenia." Painting. Rhode Island School of Design Museum, Providence, no. 55.113. [Warburg]

Luigi Cherubini, 1760–1842. *Iphigenia in Aulide.* Opera-ballet. Libretto, F. Moretti. First performed 25 May **1782,** King's Theatre, London; choreography, Jean-Georges Noverre. [Lynham 1950, p. 172] Revived 12 Jan 1788, Teatro Regio, Turin; 24 Jan 1789, London, with dances by Noverre and Coindre. [Ibid. / Grove 1980, 4:204]

Jean-Georges Noverre, 1727–1810, choreography. *Iphigenia en Aulide.* Opera-ballet. **1782,** 1789. *See Cherubini, above.*

———, choreography. *Iphigenia in Aulide.* Ballet. Music, Miller. First performed 23 April 1793, King's Theatre, London. [Oxford 1982, p. 307 / Guest 1972, pp. 22, 151]

Alessio Prati, 1750–1788. *L'Ifigenia in Aulide.* Opera

(dramma per musica). Libretto, Luigi Serio. First performed **1784**, Pergola, Florence. [Grove 1980, 15:203 / also Zinar 1971, p. 91]

Franz Joseph Leonti Meyer von Schauensee, 1720–1789. *Iphigenie.* Singspiel. **1785.** [Grove 1980, 12:257]

Ignaz Joseph Pleyel, 1757–1831. *Ifigenia in Aulide.* Opera. Libretto, Zeno (1718). First performed 30 May **1785,** San Carlo, Naples. [Grove 1980, 15:10]

Angelo Tarchi, c.1760–1814. *Ifigenia in Aulide.* Opera. Libretto, Zeno (1718). First performed **1785,** Teatro Nuovo, Padua. [Grove 1980, 18:577 / also Zinar 1971, p. 91]

Giuseppe Giordani, c.1753–1798. *Ifigenia in Aulide.* Opera. First performed **1786,** Rome. [Grove 1980, 7:393 / also Zinar 1971, p. 91]

Michael Wodhull, 1740–1816. *Iphigenia in Aulis.* Tragedy, after Euripides. Oxford: Payne, **1786.** [Nicoll 1959–66, 3:316]

Francesco Zugno, 1709–1787 (previously attributed to G. B. Tiepolo). "The Sacrifice of Iphigenia." Painting. Alte Pinakothek, Munich. [Morassi 1962, p. 31]

Niccolò Zingarelli, 1752–1837. *Ifigenia in Aulide.* Opera. Libretto, Moretti (1782). First performed 27 Jan **1787,** La Scala, Milan. [Grove 1980, 20:694]

Giuseppe Luigi Biamonti, 1772–1824. *Ifigenia.* Tragedy. **1789.** In *Opere* (Parma: Fiaccadori, 1841). [DELI 1966–70, 1:363]

Friedrich von Schiller, 1759–1805. *Iphigenie in Aulis.* Verse drama, after Euripides. **1790.** In *Theater* vol. 4 (Tübingen: Cotta, 1805–07). In modern edition, *Schillers Werke in zehn Bändern* (Basel: Birkhäuser, 1946). [Ipso / Butler 1958, pp. 169f.]

Vincenzo Ferrari. "The Sacrifice of Iphigenia." Painting. **1794.** Galleria Nazionale, Parma. [Scherer 1963, p. 250]

Josiah Wedgwood, 1730–1795. "The Sacrifice of Iphigenia." Plaque. c.**1795.** Metropolitan Museum, New York. [Scherer 1963, p. 250]

Giuseppe Mosca, 1772–1839. *Ifigenia in Aulide.* Opera. Libretto, Zeno (1718). First performed **1799,** Rome. [Grove 1980, 12:597f.]

Nicolai Abildgaard, 1743–1809. "The Flight of Clytemnestra." Painting, illustrating act 5, scene 4 of Racine's *Iphigénie en Aulide* (1674). **1800.** Statens Museum for Kunst, Copenhagen. [Pressly 1979, p. 70]

Vittorio Trento, c.1761–1833. *Ifigenia in Aulide.* Opera. First performed 4 Nov **1804,** Naples. [Baker 1984, p. 2334 / Zinar 1971, p. 91]

Jean-Honoré Fragonard, 1732–1806. "The Sacrifice of Iphigenia" (? or "Sacrifice to the Minotaur"?). Painting, sketch. Unlocated. [Rosenberg 1988, p. 220—ill. / also Wildenstein 1960, no. 218—ill.]

Johann Coelestin Mayer. *Ifigenia in Aulide.* Opera. **1806?** [Zinar 1971, p. 91]

Franz Danzi, 1763–1826. *Iphigenie in Aulis.* Opera. Libretto, Zeno (1718). First performed 27 Jan **1807,** Hoftheater, Munich. [Grove 1980, 5:235]

Vincenzo Federici, 1764–1826. *Ifigenia in Aulide.* Opera. Libretto, Luigi Romanelli. First performed 28 Jan **1809,** La Scala, Milan. [Grove 1980, 6:449]

Ferdinand Ries, 1784–1838. "Iphigenie aus Aulis." Scena for soprano and orchestra. **1810.** [Grove 1980, 16:10]

Simon Mayr, 1763–1845. *Il sacrifizio d'Ifigenia.* Opera (azione seria drammatica per musica). Libretto, G. Arici, after Le Blanc du Roullet (1774). First performed Carnival **1811,** Teatro Grande, Brescia. [Grove 1980, 11:860 / Zinar 1971, p. 91]

Cesare Della Valle, 1777–1860. *Ifigenia in Aulide.* Tragedy. Naples: **1818.** [EDS 1954–66, 4:408]

Giuseppe Marco Calvino, 1785–1833. *Ifigenia in Aulide.* Tragedy. Catania: **1819.** [DELI 1966–70, 1:533]

Jacques-Louis David, 1748–1825. "The Wrath of Achilles (at the Sacrifice of Iphigenia)." Painting. **1819.** Private coll. [Schnapper 1982, p. 297—ill. / also Cantinelli 1930, no. 149] Replica. 1825. Private coll. [Schnapper / also Cantinelli, no. 162]

Louis Moritz, 1773–1850. "The Actresses Joanna Zieseuis-Walter and Gertruida Grevelink-Hilverdink in the Play *Iphigenia*" (of Racine, 1674). Painting. Before **1827.** Rijksmuseum, Amsterdam, inv. A2201, on loan to Toneelmuseum, Amsterdam. [Rijksmuseum 1976, p. 398—ill.]

Alfred, Lord Tennyson, 1809–1892. (Iphigenia in) "A Dream of Fair Women" lines 100–16. Poem. **1831–32.** In *Poems* (London: Moxon, 1832). / Revised in *Poems* (London: Moxon, 1842). [Ricks 1969 / Nicolson 1962, pp. 110, 116, 176 / Ricks 1972, pp. 445f.]

Walter Savage Landor, 1775–1864. "The Shades of Agamemnon and of Iphigineia." Poetic dialogue. Incorporated into *Pericles and Aspasia* (London: Saunders & Otley, **1836**); reprinted as a separate piece, 1847. [Wheeler 1937, vol. 2 / Boswell 1982, p. 55 / Pinsky 1968, pp. 44, 63, 76, 144–45, 151–61]

———. "Iphigeneia." Poem. 1845. In *Hellenics* (London: Moxon, 1846). [Wheeler / Pinsky, pp. 76, 145, 152]

Nicolas-André Monsiau, 1754–1837. "A Scene from Act 4 of *Iphigenia in Aulis.*" Painting. Musée des Beaux-Arts, Marseille. [Bénézit 1976, 7:492]

Antonio Galatti, 1807–1870. *Ifigenia in Aulide.* Tragedy. In *Tragedie* (Messina: **1830–40**). [DELI 1966–70, 3:6]

Honoré Daumier, 1808–1879. "Yes, it is Agamemnon, it is your father who wakes you." Lithograph, caricature from Racine's *Iphigénie en Aulide* (1674), part of "Physionomies tragico-classiques" series. **1841.** [Delteil 1906–30, 22: no. 902—ill.]

John William Calcraft, 1793?–1870. *Iphigenia in Aulis.* Tragedy, adaptation of Euripides. First performed 28 Nov **1846,** Dublin. [Nicoll 1959–66, 4:575]

Edwin Arnold, 1832–1904. "Iphigenia." Poem. In *Poems: Narrative and Lyrical* (Oxford: MacPherson, **1853**). [Bush 1937, p. 554]

William Bell Scott, 1812–1892. "Iphigenia at Aulis." Poem. In *Poems* (London: Smith, Elder, **1854**). [Boswell 1982, p. 290]

John Stuart Blackie, 1809–1895. "Iphigenia." Poem. In *Lays and Legends of Ancient Greece and Other Poems* (Edinburgh: Sutherland & Knox, **1857**). [Boswell 1982, p. 45]

Adolphe Dennery (D'Ennery), 1811–1899. *Le sacrifice d'Iphigénie.* Comedy. Paris: **1861.** [DLLF 1984, 1:613]

William James Linton, 1812–1898. "Iphigenia at Aulis." Poem. In *Claribel and Other Poems* (London: Simpkin & Marshall, **1865**). [DLB 1984, 32:210]

Erastus Dow Palmer, 1817–1904. "Iphigenia." Plaster intaglio. **1878.** Frothingham coll., Hattiesburg, Miss. [Webster 1983, p. 154, pl. 138]

Théodore de Banville, 1823–1891. "La prophetie de Calchas" [The Prophecy of Calchas]. Poem, part of *Le sang de la coupe.* In *Oeuvres* vol. 3 (Paris: Lemerre, 1846–79). [Ipso]

William E. Baily. "The Sacrifice of Iphigenia." Poem. In *Dramatic Poems* (Philadelphia: privately printed, **1894**). [Boswell 1982, p. 31]

Siegfried Anger, 1837–1911. *Iphigenie in Mycene.* Drama, companion piece for Anger's *Iphigenie in Delphi.* Neisse: Graveur, [**1901**]. [DLL 1968–90, 1:118]

Félix Soulès, 1857–**1904.** "Iphigenia Carried Off by Diana." Marble sculpture. Musées Nationaux, Paris, inv. LUX 110, deposited (from Musée du Luxembourg) in Musée, Bordeaux, in 1905. [Orsay 1986, p. 282]

Isadora Duncan, 1877–1927, choreography. *Iphigenia in Aulis.* Modern dance. Music, Gluck. First performed 24 Nov **1905,** Krystall-Palast, Berlin. [Blair 1986, p. 197 / McDonagh 1976, pp. 15f.]

Sara King Wiley, 1871–1909. "Iphigenia." Poem. In *Alcestis and Other Poems* (New York: Macmillan, **1905**). [Bush 1937, p. 584] Set to music by W. H. Humiston as "Iphigenia before the Sacrifice at Aulis." Published New York: Breitkopf & Hartel, 1912. [Ibid.]

Maurice Baring, 1874–1945. "The Aulis Difficulty." Play. In *Diminutive Dramas* (London: Constable, **1911**). [Boswell 1982, p. 31]

Émile-Antoine Bourdelle, 1861–1929. "Tragedy" ("Calchas and Iphigenia"). Marble high-relief. **1912.** Façade, Théâtre des Champs-Elysées, Paris. [Jianou & Dufet 1975, no. 454—ill. / Basdevant 1982, p. 60f.—ill.] Plaster and bronze studies and variants. Musée Bourdelle, Paris; elsewhere. [Jianou & Dufet, nos. 454–60]

Walter Damrosch, 1862–1950. Incidental music for Euripides' *Iphigenia in Aulis.* First performed **1915,** Berkeley, Calif. [Grove 1980, 5:175]

H. D. (Hilda Doolittle), 1886–1961. "Choruses from *Iphigeneia in Aulis.*" Poem/adaptation. In *Egoist* 2 (Nov **1915**), and in *Choruses from the Iphigeneia in Aulis and the Hippolytus of Euripides, Egoist* 3 (1919). [Martz 1983 / Robinson 1982, pp. 99–106]

————. (Iphigenia's fate recalled in) "Pallinode" 5.5–8; 6.2, 4, 6. Part 1 of *Helen in Egypt.* Epic. 1952–56. New York: New Directions, 1961. [Ipso / Friedman 1981, pp. 262f. / DLB 1986, 45:139–41]

Peter Quennell, 1905–. "In Aulis." Poem. In *Masques and Poems* (Waltham St. Lawrence, Berkshire: Golden Cockerel, **1922**). [Boswell 1982, p. 283]

Teresa de la Parra, 1895–1936. *Ifigenia* (modern recasting of the myth: sacrifice to social custom). Novel. Paris: Casa Editorial Franco-Ibero-Americana, **1924.** [LAW 1989, 2:717]

Irma Duncan, 1897–1977, choreography. *Iphigenia in Aulis.* Dances for concert works. First performed **1928,** New York. [Cohen-Stratyner 1982, p. 281]

David R. Williamson. "The Sacrifice of Iphigenia." Poem. In *Collected Poems* (London: Mitre, **1928**). [Boswell 1982, p. 310]

Doris Humphrey, 1895–1958, and **Charles Weidman,** 1901–

1975, choreography. 9 modern dances for Herbert Graf's production of Gluck's *Iphigenia in Aulis* (1774), 23 Feb **1935,** Academy of Music, Philadelphia. [Siegel 1987, pp. 15f. / Cohen 1972, p. 288]

John Masefield, 1878–1967. "Klytaimnestra" (lamenting Iphigenia's sacrifice). Poem, part of "A Tale of Troy." In *Poems* (New York: Macmillan, **1935**). [Boswell 1982, p. 177]

Francis Picabia, 1878–1953. "Iphigenia" ("Resignation"). Painting, after a figure in the Pompeiian fresco "Sacrifice of Iphigenia." *c.***1935.** Formerly M. Waismann coll., Paris, unlocated. [Camfield 1979, fig. 363]

Otto Brües, 1897–1967. (Sacrifice of Iphigenia in) *Der Spiegel der Helena* [The Mirror of Helen]. Drama. **1935–36.** In *Sturm und Stille: Dramen* (Gütersloh: Bertelsmann, 1949). [Kunisch 1965, p. 139]

Federico García Lorca, 1898–**1936.** *El sacrificio de Ifigenia.* Sketch for a tragedy, unfinished. [EDS 1954–66, 5:929]

Ossip Zadkine, 1890–1967. "Iphigenia." Bronze sculpture. **1940.** 8 casts. Private colls. [Jianou 1979, no. 277]

David Jones, 1895–1974. "Aphrodite [as Iphigenia] in Aulis." Painting. **1941.** Private coll. [Blamires 1972, pp. 4, 67–69]

Mark Rothko, 1903–1970. "The Sacrifice of Iphigenia." Painting. **1942.** [Waldman 1978, no. 29—ill.]

Gladys Schmitt, 1909–1972. *The Gates of Aulis.* Novel. New York: Dial, **1942.** [Boswell 1982, p. 289]

Gerhart Hauptmann, 1862–1946. *Iphigenie in Aulis.* Tragedy, part 1 of *Die Atriden* tetralogy. First performed 15 Nov **1943,** Burgtheater, Vienna. Published Berlin: Suhrkamp, 1943. Tetralogy first performed 10 Sep 1947, Max Reinhardts Deutsches Theater, Berlin. [McGraw-Hill 1984, 2:462 / Seidlin 1961, pp. 238, 241 / Closs 1957, p. 211 / Voight 1965, pp. 146–58 / Daemmrich 1987, p. 147]

Hans Schwarz, 1890–1967. *Iphigeneia in Aulis.* Tragedy. Hamburg: Strom, **1947.** [Kürschner 1963, p. 600]

Herwig Hensen, 1917–. (Sacrifice of Iphigenia in) *Agamemnoon.* Tragedy. Brussels: Manteau, **1948.** [McGraw-Hill 1984, 1:313 / DULC 1959–63, 2:706]

André Jolivet, 1905–1974. Incidental music to Racine's *Iphigénie en Aulide* (1674). **1949.** [Grove 1980, 9:689]

Ildebrando Pizzetti, 1880–1968. *Ifigenia.* Opera for radio. Libretto, composer, with A. Perrini. First performed 3 Oct **1950,** Radio Audizioni Italiane, Turin. First stage performance, 9 or 19 May 1951, Teatro Comunale, Florence. [Grove 1980, 14:797 / Baker 1984, p. 1784]

Hermann Reutter, 1900–. "Monolog der Iphigenie." Vocal solo with orchestra, opus 74. *c.***1950.** [Grove 1980, 15:774]

Edgard Tytgat, 1879–1957. "The Embarkation of Iphigenia for the Island of Sacrifice." Painting. **1950.** Musées Royaux des Beaux-Arts (Musée d'Art Moderne), Brussels, inv. 6541. [Brussels 1984b, p. 619—ill. / also Berlin 1963, no. 46]

Kenneth Rexroth, 1905–1982. *Iphigenia.* Drama, part 2 of *Beyond the Mountains.* First performed **1951,** New York. Published New York: New Directions; London: Routledge, 1951. [Vinson 1982, p. 671]

André Obey, 1892–1975. *Une fille pour du vent* [A Girl [exchanged] for the Wind]. Drama, antiwar satire. First

performed 15 Apr **1953**, Comédie-Française, Paris. [McGraw-Hill 1984, 4:5f.]

Karol Rathaus, 1895–**1954**. Chorus from Euripides' *Iphigenia in Aulis,* composition for voices, horn, opus 61. [Grove 1980, 15:597]

Zbigniew Herbert, 1924–. "Ofiara Iphigenia" [Sacrifice of Iphigenia]. Poem. In *Hermes, pies i gwiazda* (Warsaw: **1957**). / Translated by John and Bogdana Carpenter in *Selected Poems* (Oxford, London, and New York: Oxford University Press, 1977). [Ipso / Pilling 1982, p. 420]

Ruggero Jacobbi, 1920–. *Ifigenia.* Tragedy. Unperformed. First published in *Anhembi* Sep/Dec **1960**. [EDS 1954–66, suppl. p. 516]

Peter Russell, 1921–. (Iphigenia meets) "Agamemnon in Hades." Poem. Easter **1962**. Aylesford, Maidstone: Saint Albert's Press, 1965. [Vinson 1985, p. 733]

Hilding Hallnäs, 1903–, music. *Iphigenia.* Ballet. **1961–63**. [Baker 1984, p. 932]

Betty Jolas, 1926–. *Iphigénie.* Incidental music to Racine's *Iphigénie en Aulide* (1674). **1964**. [Cohen 1987, 1:353]

Chryssa, 1933–. "Flock of Morning Birds from *Ipigenia in Aulis* by Euripides." Abstract mixed-media sculpture, study for "The Gates #15." **1967**. Hirshhorn Museum and Sculpture Garden, Washington, D.C. [Hirshhorn 1974, p. 674, pl. 931]

Jack Lindsay, 1900–1990. *Iphigeneia in Aulis.* Play, after Euripides. First performed **1967**, Mermaid Theatre, London. [DLB Yearbook 1984, p. 296]

Thomas Merton, 1915–**1968**. "Iphigenia: Politics." Poem. In *Collected Poems* (New York: New Directions, 1977). [Boswell 1982, p. 185]

Pascal Bentoiu, 1927–. *Jertfirea Iphigeniei* [Sacrifice of Iphigenia]. Opera for radio, opus 17. First performed **1968**, Bucharest. [Grove 1980, 2:509]

Paul Delvaux, b. 1897. "The Sacrifice of Iphigenia." Surrealist painting. **1968**. Galerie Le Bateau Lavoir, Paris, in 1975. [Delvaux 1975, no. 306—ill.]

Michael Adamis, 1929–. "Iphigenia in Aulis." Composition for tape. **1970**. [Grove 1980, 1:100]

Francis Routh, 1927–. "The Death of Iphigenia." Song, opus 25. Text, from Gilbert Murray's translation of Aeschylus. First performed **1972**, Mez. [Grove 1980, 16:278]

Dannie Abse, 1923–. "The Victim of Aulis." Poem. **1948–76**. In *Collected Poems, 1948–76* (Pittsburgh: University of Pittsburgh Press, 1977). [Boswell 1982, p. 5]

Peter Schickele, 1935–, as "P. D. Q. Bach." *Iphigenia in Brooklyn.* Satirical cantata. *c.***1970s**. [Grove 1980, 16:640]

Eleanor Wilner, 1937–. "Iphigenia, Setting the Record Straight." Poem. In *Maya* (Amherst: University of Massachusetts Press, **1979**). [Ostriker 1986, p. 328]

Leonard Baskin, 1922–. "Iphigenia and Jephtha's Daughter." Bronze relief. **1980**. Kennedy Galleries, New York in 1982. [Baskin 1982, no. 8—ill.] Bronze study. Kennedy Galleries, New York in 1982. [Ibid., no. 15—ill.]

Iphigenia at Tauris. After saving Iphigenia from the sacrificial altar at Aulis, Artemis made her a priestess in her temple at Tauris (the Crimea). Tauris was occupied by a race of savages who insisted on the sacrifice of all strangers entering their land. It was Iphigenia's task to consecrate the victims.

Upon his return from the Trojan War, Iphigenia's father, Agamemnon, was murdered by his wife, Clytemnestra, who was in turn slain by their son, Orestes. Pursued by the Furies for the matricide, Orestes was ordered, as an act of absolution, to steal Artemis's statue from Tauris and bring it to Attica. Having been separated since childhood, Iphigenia and Orestes each thought the other was dead. However, when Orestes and his friend Pylades were captured by the Taurians and brought to the temple for sacrifice, Iphigenia recognized her brother. Together, the three deceived King Thoas and escaped, taking with them the statue of the goddess, which was later placed in a temple in Attica.

Classical Sources. Aeschylus, *The Eumenides.* Herodotus, *History* 4.103. Euripides, *Iphigenia in Tauris.* Hyginus, *Fabulae* 120, 261.

Dante Alighieri, 1265–1321. (Voice of Pylades, claiming to be Orestes, an example of charity in) *Purgatorio* 13.32. Completed *c.***1314?** In *The Divine Comedy.* Poem. Foligno: Neumeister & Angelini, 1472. [Singleton 1970–75, vol. 2 / Toynbee 1968, p. 510]

Giovanni Rucellai, 1475–**1525**. *L'Oreste.* Tragedy, after Euripides' *Iphigenia in Tauris.* In *Opere* (Padua: Comino, 1772). [DELI 1966–70, 4:620 / Brunel 1971, p. 117]

Agostino Veneziano, 1490–**1540**. "Iphigenia" (with Orestes and Pylades). Engraving (Bartsch 14:158 no. 194), after Baccio Bandinelli? [Bartsch 1978, 26:191—ill.]

Giulio Romano, *c.*1499–**1546**. "Iphigenia Escaping with Orestes and Pylades" (?). Drawing. Duke of Devonshire coll., Chatsworth. [Hartt 1958, p. 289 (no. 42)—ill.]

Pieter Lastman, *c.*1583–1633. "Orestes and Pylades Disputing at the Altar." Painting. **1614**. Rijksmuseum, Amsterdam, inv. A2354. [Rijksmuseum 1976, p. 338—ill.]

Jean Racine, 1639–1699. *Iphigénie en Tauride.* Projected tragedy. First act outlined *c.***1673–76** (?), unwritten. [Pocock 1973, pp. 234–36, 280, 306]

Antonio Draghi, 1634/35–1700. *Il tempio di Diana in Taurica* [The Temple of Diana in Tauris]. Opera. Libretto, Nicolò Minato. First performed 1 Sep **1678**, Vienna. [Grove 1980, 5:604]

François-Joseph de Lagrange-Chancel, 1677–1758. *Oreste et Pylade, ou, Iphigénie en Thauride.* Tragedy. First performed 11 Dec **1697**, Paris. Published Paris: 1699. [Lancaster 1929–42, pt. 4, 2:958 / DLLF 1984, 2:1184]

John Dennis, 1657–1734. *Iphigenia.* Tragedy, after Euripides' *Iphigenia in Tauris.* First performed Dec **1699**, Lincoln's Inn Fields, London; incidental music, Daniel Purcell. [Stratman 1966, p. 158 / Nicoll 1959–66, 1:402; 2:18, 63, 85, 317 / Grove 1980, 15:475 / Paul 1966, pp. 25–27, 214]

Henry Desmarets, 1661–1741, with additions by **André Campra**, 1660–1744. *Iphigénie en Tauride.* Opera (tragédie lyrique). Libretto, Joseph-François Duché de Vancy and Antoine Danchet. First performed 6 May **1704**,

L'Opéra, Paris. [Grove 1980, 5:391 / Girdlestone 1972, p. 126 n.]

Domenico Scarlatti, 1685–1757. *Ifigenia in Tauri.* Opera (dramma per musica). Libretto, Carlo Sigismundo Capece, after Euripides. First performed 15 Feb **1713,** Teatro Domestico della Regina Maria Casimira di Pollonia, Rome. [Kirkpatrick 1953, p. 50, 53, 416]

Arnold Houbraken, 1660–**1719.** "Orestes and Pylades at the Altar of Tauris." Painting. Formerly van Heemskerk coll., The Hague. [Pigler 1974, p. 336]

Giuseppe Maria Orlandini, 1675–1760. *Ifigenia in Tauride.* Opera. Libretto, Benedetto Pasqualigo. First performed Carnival **1719,** San Giovanni Grisostomo, Venice. [Grove 1980, 13:824]

Leonardo Vinci, c.1690–1730. *Ifigenia in Tauride.* Opera. Libretto, Pasqualigo (1719). First performed Carnival **1725,** San Giovanni Grisostomo, Venice. [Grove 1980, 19:787]

Antonio Caldara, c.1670–1736, with **Georg von Reutter the Younger,** 1708–1772 (act 1). *La forza dell' amicizia, ossia, Pilade ed Oreste* [The Strength of Friendship, or, Pylades and Orestes]. Opera. Libretto, Pasquini. First performed 17 Aug **1728,** Graz. [Grove 1980, 3:615, 5:773]

Giovanni Battista Tiepolo, 1696–1770. "The Flight of Iphigenia and Orestes." Fresco. **1736.** Palazzo Cornaro di S. Maurizio, Merlengo. [Pallucchini 1968, no. 112 / Morassi 1962, p. 23]

Johann Elias Schlegel, 1719–1749. *Die Geschwister in Taurien* [Brother and Sister in Tauris]. Tragedy, adaptation of Euripides. **1739.** Retitled *Orest und Pylades,* 1742. In *Theatralische Werke* (Copenhagen: Mumme, 1747). [Gassner & Quinn 1969, p. 329 / McGraw-Hill 1984, 4:342]

Nicolaes Verkolje, 1653–**1746.** "Orestes and Pylades." Painting. Historisch Museum, Amsterdam, inv. A28673. [Wright 1980, p. 469]

Johann Ernst Galliard, c.1687–**1749.** *Oreste e Pilade.* Opera. Unfinished, lost. [Grove 1980, 7:108]

Antonio Mazzoni, 1717–1785. *Ifigenia in Tauride.* Opera. Libretto, Marco Coltellini. First performed **1756,** Teatro Dolfin, Treviso. [Grove 1980, 11:872]

Claude Guimond de La Touche, 1723–1760. *Iphigénie en Tauride.* Tragedy, after Euripides. First performed 4 June **1757,** Comédie-Française, Paris. Published Paris: Duchesne, 1758. [Viëtor 1949, p. 67 / DLF 1951–72, 5 pt. 1: 539]

Jean-Baptiste-Claude Vaubertrand. *Iphigenie en Tauride.* Tragedy. Paris: **1757.** [Frenzel 1962, p. 299]

Tommaso Traetta, 1727–1779. *Ifigenia in Tauride.* Opera (dramma per musica). Libretto, Coltellini (1756). First performed 4 Oct **1763,** Schloss Schönbrunn, Vienna. / Revised by Franz Joseph Haydn as *Orestes,* 1786. [Baker 1984, p. 2331 / Grove 1980, 19:112f.]

Henry Fuseli, 1741–1825. "Orestes Pursued by the Furies." Drawing. **1762–64.** Staatliche Kunstsammlungen, Dresden. [Schiff 1973, no. 332—ill.]

———. "Orestes' Vision." 2 drawings, after Euripides' *Iphigenia in Tauris,* lines 285–91. c.1800. Colin Anderson coll., London; Kurt Meissner coll., Zurich. [Ibid., nos. 1425–26—ill.]

———. "Orestes Carries Iphigenia onto the Ship, as Pylades Battles the Tauri." Drawing. 1810–20. Museum and Art Gallery, Belfast, inv. 3539 (I). [Ibid., no. 1522—ill.]

Gian Francesco de Majo, 1732–1770. *Ifigenia in Tauride.* Opera seria. Libretto, M. Verazi. First performed 4 Nov **1764,** Mannheim. [Grove 1980, 11:543f.]

Benjamin West, 1738–1820. "Pylades and Orestes (Brought as Victims before Iphigenia)." Painting. **1766.** Tate Gallery, London, no. 126. [von Erffa & Staley 1986, no. 186—ill. (cf. no. 187) / also Tate 1975, p. 92]

Baldassare Galuppi, 1706–1785. *Ifigenia in Tauride.* Opera seria. Libretto, Coltellini 1756). First performed 2 May **1768,** Court, St. Petersburg. [Grove 1980, 7:137]

Niccolò Jommelli, 1714–1774. *Ifigenia in Tauride.* Opera seria. Libretto, M. Verazi. First performed 30 May **1771,** S. Carlo, Naples. [Grove 1980, 9:693]

Johann Friedrich Agricola, 1720–1774. *Oreste e Pilade.* Opera. Libretto, Landi. First performed early **1772.** / Revised as *I Greci in Tauride* [The Greeks in Tauris]. Performed Mar 1772, Potsdam. [Grove 1980, 1:165]

Jean-Georges Noverre, 1727–1810, choreography. *Iphigénie en Tauride.* Ballet, sequel to *Agamemnon.* Music, Franz Asplmayr. First performed **1772–73,** Kärntnerthor, Vienna. [Lynham 1950, pp. 74, 169 / Grove 1980, 1:658, 13:443] *See also Gluck, below.*

André Grétry, 1741–1813. *Iphigénie en Tauride.* Opera, fragment. **1778.** [Grove 1980, 7:711 / EDS 1954–66, 5:1733]

Johann Wolfgang von Goethe, 1749–1832. *Iphigenie auf Tauris.* Prose drama, written for Duchess Anna Amalia. First performed 6 Apr **1779,** Ettersburg (with Goethe as Orestes). / Adapted as a verse play, 1787. First performed 7 Jan 1800, Vienna. / Revised by Friedrich von Schiller, performed 15 May 1802, Weimar. [Beutler 1948–71, vol. 6 / Suhrkamp 1983–88, vol. 8 / Cox 1987, pp. 84–93, 269, 271 n. / Steiner 1984, pp. 46–51 / Fairley 1961, pp. 110–17, 179–83, 217–20 / Viëtor 1949, pp. 63–69, 77ff. / Reed 1984, pp. 57–60]

Christoph Willibald Gluck, 1714–1787. *Iphigénie en Tauride.* Opera (tragédie lyrique). Libretto, N. F. Guillard and Du Roullet, after Euripides. Ballet music perhaps by P. Gossec. First performed 18 May **1779,** Académie Royale, Paris; choreography, Jean-Georges Noverre? [Baker 1984, p. 848 / Lynham 1950, pp. 74, 147, 169 / Tovey 1934, pp. 108ff., 236ff. / Grove 1980, 7:464ff., 472] German version, *Iphigenie in Tauride,* libretto translated by Johann Baptist von Alxinger and Gluck. First performed 23 October 1781, Burgtheater, Vienna. [Grove, 7:464, 472]

Charles-Simon Favart, 1710–1792. *Les rêveries renouvelées des Grecs* [The Greeks' Dreams Renewed]. Drama, parody of Gluck's *Iphigénie en Tauride* (above). First performed **1779,** Paris. [Grove 1980, 6:439]

Franz Linder, 1736–1802. "Orestes and Pylades in Tauris." Painting. **1779.** Formerly Castle Hédervár, Hungary. [Pigler 1974, p. 336]

Niccolò Piccinni, 1728–1800. *Iphigénie en Tauride.* Opera (tragédie lyrique). Libretto, Alphonse Du Congé Dubreuil. First performed 23 Jan **1781,** Académie Royale, Paris. [Grove 1980, 14:728]

Carlo Monza, c.1735–1801. *Ifigenia in Tauride.* Opera seria. Libretto, Pasqualigo (1719). First performed Jan **1784,** La Scala, Milan. [Grove 1980, 12:544]

Jean-Baptiste Regnault, 1754–1829. "Orestes and Pylades in Tauris." Design for a tapestry. **1787.** Musée des Beaux-Arts, Marseille. [Pigler 1974, p. 336]

Francesco Clerico, c.1755–after 1838, choreography. *I sac-*

rifizi di Tauride [The Sacrifices of Tauris]. Ballet. First performed **1789**, La Scala, Milan. [EDS 1954–66, 3:968]

Johann Friedrich Reichardt, 1752–1814. Incidental music to Goethe's *Iphigenia auf Tauris* (1779). **c.1798**. [Grove 1980, 15:706]

Vincenzo Federici, 1764–1826. *Oreste in Tauride*. Opera. First performed 27 Jan **1804**, La Scala, Milan. [Grove 1980, 6:449]

Johann Baptist Seele, 1774–1814. "Orestes and Pylades in Tauris, Recognized by Iphigenia." Painting. **1806**. Scholz, Ludwigsburg. [Pigler 1974, p. 336]

Franz Schubert, 1797–1828. "Orest auf Tauris." Lied. Text, Johann Mayrhofer. Mar **1817**. Published 1831. [Grove 1980, 16:796]

———. "Iphigenia" (in Tauris). Lied, opus 98/3. Text, Mayrhofer. July 1817. Published 1829. [Ibid., 16:797]

Michele Carafa di Colobrano, 1787–1872. *Ifigenia in Tauride*. Opera (melodramma seria). First performed 19 June **1817**, Teatro San Carlo, Naples. [Grove 1980, 3:769]

Simon Mayr, 1763–1845. *Ifigenia in Tauride*. Opera (azione sacra drammatica per musica). Libretto, after Apostolo Zeno. First performed Spring **1817**, Pergola, Florence. [Grove 1980, 11:860]

Tommaso Sgricci, 1788–1836. *Ifigenia auf Tauris*. Poetic "improvisation." Performed **1820**. [Wassermann 1971, p. 379 n.]

Cesare Della Valle, 1777–1860. *Ifigenia in Tauride*. Tragedy. Milan: **1821**. [EDS 1954–66, 4:408]

The Prix de Rome painting competition subject for **1822** was "Orestes and Pylades." First prize not awarded; second prize shared by Auguste-Hyacinthe Debay and François Bouchot. [Harding 1979, p. 93]

Ippolito Pindemonte, 1753–**1828**. *Iphigenia in Tauri*. Tragedy. Unpublished. [DELI 1966–70, 4:375]

Antonio Galatti, 1807–1850. *Ifigenia in Tauride*. Tragedy. In *Tragedie* (Messina: **1830–40**). [DELI 1966–70, 3:6]

Anonymous English. *Iphigenia in Tauris*. Opera. Libretto based on Goethe (1779). First performed **1840**, Princes Theatre, London. [Nicoll 1959–66, 4:482]

Eugène Scribe, 1791–1861, with **Dupin**, libretto. *Oreste et Pylade*. Comic opera. Music, Thys. First performed 28 Feb **1844**, L'Opéra-comique, Paris. [McGraw-Hill 1984, 4:357]

Nicholas Ivanovich Khmelnitsky, 1789–**1846**. *Greek Ravings, or, Iphigenia in Tauris*. Parody, vaudeville. [Varneke 1951, p. 193]

Anselm Feuerbach, 1829–1880. "Iphigenia" (in Tauris). Painting. **1862**. Hessisches Landesmuseum, Darmstadt. [Karlsruhe 1976, no. 39–ill.] Variant. 1871. Staatsgalerie, Stuttgart. [Ibid., no. 55–ill.]

Louis Théodore Gouvy, 1819–1898. *Iphigenie in Tauris*. Cantata. **1885**. [Grove 1980, 7:592]

Valentin Serov, 1865–1911. "Iphigenia in Tauris" (on the seashore). Painting. **1893**, unfinished. Art Gallery, Kazan. [Sarabyanov & Arbuzov 1982, no. 209] Studies. Brodsky Memorial Museum, Leningrad; Museum of Local Lore, Vladimir; History Museum, Moscow (3 studies); Tretyakov Gallery, Moscow; another unlocated. [Ibid., nos. 210–14, 230–31–ill.]

Arthur Foote, 1853–1937. "O fear the immortals, ye children of men." Vocal composition. Text from Goethe's *Iphigenia in Tauris* (1779). **1900**. [Grove 1980, 6:702]

Jean Moréas, 1856–1910. *Iphigénie*. Tragedy. First performed Aug **1903**, Open-Air Theater of Orange; Dec 1903, Théâtre de l'Odéon, Paris. Published Paris: Société du Mercure de France, 1904. [DLLF 1984, 2:1570 / TCLC 1978–89, 18:280, 284]

Margaret Morris, 1891–1980, choreography. Incidental dances for Granville Barker's production of *Iphigenia in Tauris*, **1914**, London. [Cohen-Stratyner 1982, p. 635]

Isadora Duncan, 1877–1927, choreography. *Iphigenia in Tauris*. Modern dance. First performed **1916**. / Produced 1934, Croton-on-Hudson, N.Y., as a drama with opera score by Irma Duncan and incidental music. [McDonagh 1976, p. 19]

Albert A. Stanley, 1851–1932. Incidental music for Euripides' *Iphigenia in Tauris*. First performed 29 Mar **1917**, Classical Club, University of Michigan, Ann Arbor. [Stanley 1924, pp. 123ff.]

Witter Bynner, 1881–1968. *Iphigenia in Tauris*. Drama. based on Euripides. In *A Book of Plays* (New York: Knopf, **1922**). [Boswell 1982, p. 62]

Alfonso Reyes, 1889–1959. *Iphigenia cruel*. Dramatic poem with prose commentary. **1923**. Madrid: Editorial "Saturnina Calleja," 1924. First performed Mexico City 1934. [Paz 1976, pp. 116–19 / LAW 1989, 2:694, 699]

Randall Jarrell, 1914–1965. "Orestes at Tauris." Poem. **1936**. In *Kenyon Review* 5 no. 1 (Winter 1943); collected in *Losses* (New York: Harcourt Brace, 1948). [Ipso / DLB 1986, 48:255 / Wright 1986, p. 16 / CLC 1980, 13:300]

Philip James, 1890–1975. Incidental music to Euripides' *Iphigenia in Tauris*. **1937**. [Grove 1980, 9:472]

Hilding Rosenberg, b. 1892. Incidental music to Goethe's *Iphigenie auf Tauris* (1779). First performed (as *Iphigenie in Tauride*) **1940**, Stockholm. [Grove 1980, 16:200]

Petros Petridis, 1892–1978. Incidental music to Euripides' *Iphigenia in Tauris*. First performed 15 Oct **1941**, Greek National Theater, Athens. [Grove 1980, 14:590]

Egon Fritz, 1903–. *Iphigenie in Amerika*. Drama. Hamburg: Toth, **1948**. [Hunger 1959, p. 167]

Hermann Rossmann, 1902–. *König Thoas*. Drama, sequel to Goethe's *Iphigenie auf Tauride* (1779). In *Titanen, drei Einakter* (Vienna: Desch, **1955**). [Wilpert 1963, p. 492]

Gottfried Benn, 1886–1956. (Goethe's *Iphigenie auf Tauride* evoked in) "Kleiner Kulturspiegel." Poem. [Wellershof 1960]

Aurel Milloss, 1906–1988. Dance choreography for a production of Euripides' *Iphigenia in Tauris*. Music, R. Vlad. First performed **1957**, Taormina. [EDS 1954–66, 7:593]

Richmond Lattimore, 1906–1984. *Iphigeneia in Tauris*. Translation of Euripides. New York: Oxford University Press, **1973**. [Ipso]

Pina Bausch, 1940–. Choreography for a production of Gluck's *Iphigenia in Tauris* (1779), **1974**, Wuppertal. [Oxford 1982, p. 48]

Iphigenia at Delphi. After escaping from Tauris, Iphigenia, her brother Orestes, and his friend Pylades went to Delphi. There, Iphigenia was mistaken for a Taurian by her long-lost sister, Electra. Thinking that Orestes had been murdered in Tauris, Elec-

tra tried to kill (or blind) Iphigenia, who was saved only by Orestes' last-minute intercession. Iphigenia then became a priestess at Delphi and Electra married Pylades.

Classical Sources. Herodotus, *History* 4.103–04. Hyginus, *Fabulae* 122.

Johann Wolfgang von Goethe, 1749–1832. *Iphigenie in Delphi.* Plan for a drama. **1786,** never completed. [Frenzel 1962, pp. 300f. / Butler 1958, p. 114]

Karl Friedrich Ludwig Kannegiesser, 1781–1861. *Iphigenia in Delphi.* Tragedy. Prenzlau: Ragocsy, **1843.** [DLL 1968–90, 8:885]

Archer Thompson Gurney, 1820–1887. *Iphigenia at Delphi.* Tragedy in verse. London: Longman, **1855.** [Stratman 1966, p. 229 / Nicoll 1959–66, 5:397]

Friedrich von Halm, 1806–1871. *Iphigenie in Delphi.* Tragedy. First performed **1856,** Burgtheater, Vienna. [Oxford 1986, p. 345 / DLL 1968–90, 7:203]

Joseph Viktor Widmann, 1842–1911. *Iphigenie in Delphi.* Tragedy. **1865.** Frauenfeld: Huber, 1865. [Wilpert 1963, p. 629]

Richard Garnett, 1835–1906. "Iphigenia in Delphi." Dramatic poem. In *Iphigenia in Delphi and Other Poems* (London: Unwin, **1890**). [Boswell 1982, pp. 110f.]

Siegfried Anger, 1837–1911. *Iphigenie in Delphi.* Drama. Grandenz: Röthe's Buchdruckerei, **1898.** [DLL 1968–90, 1:118]

Rudolf Pannwitz, 1881–1969. *Iphigenia mit dem Gotte* [Iphigenia among the Gods]. Tragedy. In *Dionysische Tragödien* (Nuremberg: Carl, **1913**). [Frenzel 1962, p. 301 / Hunger 1959, p. 167 / Kunisch 1965, p. 453]

Gerhart Hauptmann, 1862–1946. *Iphigenia in Delphi.* Tragedy, part 4 of *Die Atriden* tetralogy. **1941.** First performed 15 Nov 1941, Staatliches Schauspielhaus, Berlin. Published Berlin: Suhrkamp, 1942. Full tetralogy first performed 10 Sep 1947, Max Reinhardts Deutsches Theater, Berlin. [McGraw-Hill 1984, 2:462 / Hamburger 1969, pp. 78ff. / Seidlin 1961, p. 238f. / Closs 1957, p. 211 / Voigt 1965, pp. 164–74 / Daemmrich 1987, p. 147]

Ilse Langner, b. 1899. *Iphigenie kehrt heim* [Iphigenia Turns Home]. Dramatic poem. Berlin: Aufbau-Verlag, **1948.** [DLL 1968–90, 9:939]

Yannis Ritsos, 1909–1990. "Hē epistrophe tes Iphigeneias" [The Return of Iphigenia]. Dramatic monologue. Athens: Kedros, **1972.** [EWL 1981–84, 4:55 / Myrsiades 1978, p. 451]

IPHIMEDIA. *See* POSEIDON, Loves.

IRIS. Daughter of the Titan Thaumas and the Oceanid Electra, Iris was the personification of the rainbow. Her main function was as messenger of the gods, especially Hera (Juno) and Zeus (Jupiter). According to Alcaeus, she and Zephyr, god of the west wind, were the parents of Eros (Cupid).

In archaic and Classical art Iris is depicted holding the herald's staff. Although wingless in earlier representations, by the Classical era she is always shown with wings, an attribute that persists in the postclassical era. She is occasionally pictured as bringing sleep, and sometimes represents Air in allegories of the four Elements.

Classical Sources. Homer, *Iliad* 3.121, 8.397ff., 15.143ff., 18.166, 24.77ff. Hesiod, *Theogony* 265ff., 780–87. *Homeric Hymns,* "To Delian Apollo" line 102. Alcaeus, fragment 13 Bergk. Euripides, *Heracles* 822ff. Aristophanes, *The Birds.* Apollonius Rhodius, *Argonautica* 2.283–300, 4.753–779. Callimachus, *Hymns* 4, "To Delos" lines 22f., 66f., 228f. Virgil, *Aeneid* 4.693ff., 5.605ff., 9.1ff. Ovid, *Metamorphoses* 1.207f., 271; 4.480; 11.585ff., 682; 14.85, 839. Lucian, *Dialogues of the Sea Gods* 9, "Iris and Poseidon."

See also AENEAS, in Latium; GODS AND GODDESSES, as Elements; JASON, Phineus and the Harpies; TROJAN WAR.

Dante Alighieri, 1265–1321. (Iris evoked in) *Purgatorio* 21.50f., *Paradiso* 12.10–12, 28.32f. In *The Divine Comedy.* Poem. *Purgatorio* completed *c.*1314 (?), *Paradiso* completed *c.*1321. Foligno: Neumeister & Angelini, 1472. [Singleton 1970–75, vols. 2–3 / Toynbee 1968, p. 372]

Cristofano Gherardi, 1508–1556, under direction of **Giorgio Vasari,** 1511–1574. "Iris." Fresco. **1555–56** (later repainted). Terrazzo di Giunone, Palazzo Vecchio, Florence. [Sinibaldi 1950, pp. 13, 23]

Samuel Daniel, 1562–1619. (Iris in) *The Vision of the Twelve Goddesses.* Masque. First performed 8 Jan **1604,** Hampton Court. [Sharp 1969, 2:498, 1246]

William Shakespeare, 1564–1616. (Iris appears in a masque for the betrothal of Miranda and Ferdinand in) *The Tempest* 4.1.60–138. Drama (romance). **1611.** First performed 1 Nov 1611, Whitehall, London. Published London: Jaggard, 1623 (First Folio). [Riverside 1974]

Thomas Heywood, 1573/74–1641. (Iris in) *The Silver Age.* Drama. First performed *c.*1610–12, London. Published London: Okes, 1613. [Heywood 1874, vol. 3 / DLB 1978–89, 62:101, 122ff. / also Boas 1950, pp. 83ff. / Clark 1931, pp. 62ff.]

Francis Beaumont, 1584/85–1616. (Iris in) *Masque of the Inner Temple and Gray's Inn.* Masque. First performed 20 Feb **1612,** Whitehall, London. [Sharp 1969, 1:498, 2:1193]

Giulio Carpioni, 1613–1679. "Iris, Messenger in the Realm of Hypnos." Painting. **1655–60.** Kunsthistorisches Museum, Vienna, inv. 1608 (442). [Vienna 1973, p. 39—ill.] Numerous other treatments of the subject. Szépművészeti Múzeum, Budapest, no. 599; Galleria Nazionale d'Arte Antica, Rome; Museo Correr, Venice; elsewhere. [Budapest 1968, p. 124—ill.]

Christian Kirchner, ?–1732. (Iris and Auster [Notus] in) "The Four Winds." Group of sandstone sculptures. *c.*1718. Wallpavillon, Zwinger, Dresden. [Asche 1966, no. K110, pl. 225]

Karl Gustav Klingstedt, 1657–1734. "The Sleep of Iris." Miniature painting. [Bénézit 1976, 6:246]

Charles Noblet, *c.*1715–1769. *L'etrenne d'Iris* [Iris's New Year's Gift]. Cantata. Paris: **1736.** [Grove 1980, 13:257]

François Le Moyne, 1688–1737. "Juno, Iris, and Flora."

Painting. Louvre, Paris, inv. 6717. [Louvre 1979–86, 4:47—ill. / Bordeaux 1984, no. 34—ill.]

Clodion, 1738–1814. "Iris." Sculpture. **1780.** Park, Château de Versailles. [Hirshhorn 1974, p. 674]

Anne-Louis Girodet, 1767–1824. "Iris." Painting. **1798?** Private coll. [Montargis 1967, no. 22]

Pierre-Narcisse Guérin, 1774–1833. "Morpheus and Iris." Painting. **1811.** Hermitage, Leningrad, inv. 5675. [Hermitage 1983, no. 226—ill.]

John Flaxman, 1755–1826. "Iris [filling a pitcher with water] about to Spill Abundance onto the Earth." Drawing, illustrating Hesiod's *Theogony.* **1807–14.** / Engraved by William Blake, published London: Longman & Co., 1817. [Irwin 1979, p. 90 / Flaxman 1872, 7: pl. 37]

Domenico Podestà, ?–1862. "Jupiter Sending Iris and Minerva to the Arts." Ceiling fresco. **1817.** Sala delle Belle Arti, Palazzo Pitti, Florence. [Pitti 1966, p. 131—ill.]

Percy Bysshe Shelley, 1792–1822. (Iris in) "The Triumph of Life" lines 337–460. Narrative poem. **1822,** unfinished. In *Posthumous Poems,* edited by Mary Shelley (London: Hunt, 1824). [Hutchinson 1932 / Cameron 1974, pp. 448f.]

Auguste Rodin, 1840–1917. "Iris Waking a Nymph" ("Iris Waking Aurora," "Venus and Cupid"). Bronze sculpture. **1885.** Musée Rodin, Paris. [Rodin 1944, no. 145—ill.]

———. "Iris, Messenger of the Gods" (headless). Bronze sculpture. 1890–91. Cast in 3 sizes. Musée Rodin, Paris (all 3 versions); Národní Galeri, Prague; Kunsthaus, Zurich; Los Angeles County Museum of Art, Calif.; Hirshhorn Museum and Sculpture Garden, Washington, D.C.; private colls. [Tancock 1976, pp. 288ff.—ill. / Rodin, no. 248—ill. / also Elsen 1981, fig. 5.13 / Hirshhorn 1974, p. 740, pl. 90 / Janson 1985, fig. 253] Plaster. Musée Rodin. [Elsen, fig. 6.47] Variant, with head. Bronzes: Paris; Stanford University Art Gallery and Museum, Calif. Plaster: Musée Rodin. [Elsen, figs. 6.48–49 / Tancock, pp. 291f.]

———. "Head of Iris." Bronze sculpture, derived from a study for above. 1890–91. 2 sizes. Musée Rodin (small bronze and large terra-cotta); Des Moines Art Center, Iowa; Stanford University Art Gallery and Museum, Calif. (both versions); Bethnal Green Museum, London; private colls. [Tancock, p. 292—ill. / Elsen, no. 354 / Rodin, no. 255—ill. / Alley 1981, pp. 641f.—ill.]

George Frederick Watts, 1817–1904. "Iris." Painting. **1891–94.** Black Sun Books coll. [Minneapolis 1978, no. 33—ill.] Another version in Watts Gallery, Compton, Surrey. [Watts 1970, no. 23]

Robert Williams Buchanan, 1841–1901. "Iris the Rainbow." Poem. In *Complete Poetical Works* (London: Chatto & Windus, **1901**). [Boswell 1982, p. 57]

Mihály Babits, 1883–1941. "Himnusz Iriszhez" [A Hymn to Iris]. Poem. In *Levelek Irisz koszórujából* [Leaves from Iris's Wreath] (Budapest: Athenaeum, **1909**). [Reményi 1964, p. 311]

———. "Balada Irisz fátyoláról" [Ballad of the Veil of Iris]. Poem. In *Herceg, hátha megjön a tél is* [But, Prince, If Winter Should Come] (Budapest: Nyugat Kiadasa, c.1911). [Ibid., p. 312]

Constantin Nottara, 1890–1951. *Iris.* Musical work for the stage. **1926.** [Grove 1980, 13:429]

Arthur B. Davies, 1862–**1928.** "Iris and Aeolus Bandying

Showers." Painting. Artist's estate in 1931. [Cortissoz 1931, p. 27]

Hans Hofmann, 1880–1966. "Iris." Abstract painting. **1964.** Unlocated. [Bannard 1976, p. 98—ill.]

ISMENE. *See* ANTIGONE; OEDIPUS.

ISSE. *See* APOLLO, Loves.

IXION. A king of Thessaly and ruler of the Lapiths, Ixion was the father by Dia of Pirithous. Rather than pay bridal-gifts, Ixion murdered his father-in-law, Eioneus, but was purified by Zeus (Jupiter). Then, ignoring the debt he owed to Zeus as well as the custom of hospitality, Ixion began to court the god's wife, Hera (Juno). Zeus intervened, creating a phantom Hera out of a cloud (later called Nephele), to whom Ixion made love; from this union Centaurus, progenitor of the race of centaurs, was born. For his impiety, Zeus struck Ixion with a thunderbolt and ordered Hermes (Mercury) to chain him to a perpetually revolving wheel in Hades.

Treatments of Ixion in the fine arts commonly depict him with the phantom Hera on a cloud, thrown into Hades, or bound to the wheel. He is sometimes grouped with Sisyphus, Tantalus, and Tityus as the Four Deceivers (or Disgracers, Blasphemers, Condemned).

Classical Sources. Aeschylus, *The Eumenides* lines 440, 718. Pindar, *Pythian Odes* 2.21–48. Sophocles, *Philoctetes* 679ff. Diodorus Siculus, *Biblioteca* 4.69.3–5. Virgil, *Georgics* 4.484. Ovid, *Metamorphoses* 4.461, 9.124, 10.42, 12.504–06. Strabo, *Geography* 9.5.19. Apollodorus, *Biblioteca* E1.20. Hyginus, *Fabulae* 14, 62. Lucian, *Dialogues of the Gods* 9, "Hera and Zeus."

Titian, c.1488/90–1576. "Ixion." Painting, part of "The Four Condemned" series. **1548–49.** Lost. [Wethey 1975, no. 19D]

Cornelis Cornelisz van Haarlem, 1562–1638. "Ixion." Painting, part of "The Four Disgracers" series. **1588.** Museum Boymans-van Beuningen, Rotterdam, inv. 3006. [de Bosque 1985, pp. 261–65—ill.] Engraved by Hendrik Goltzius, 1588. [Strauss 1977a, no. 260—ill. / Bartsch 1980–82, no. 261—ill. / Hofmann 1987, no. 4.25—ill.]

Karel van Mander, 1548–1606. "The Deception of Ixion." Drawing. 1605. Louvre, Paris, no. 5574 (20.047). [Warburg]

Sands Penven. *Ambitions Scourge, Described in the Morall Fiction of Ixyon.* Poem. London: Helme, **1611.** [Bush 1963, p. 329]

Peter Paul Rubens, 1577–1640. "Ixion, King of the Lapiths, Tricked by Juno" ("Jupiter and Ixion"). Painting.

*c.*1615. Louvre, Paris, inv. RF 2121. [Jaffé 1989, no. 299—ill. / Louvre 1979–86, 1:120—ill.]

William Drummond of Hawthornden, 1585–1649. "Ixion." Sonnet. In *Poems: Amorous, Funerall, Divine, Pastorall* (Edinburgh: Andro Hart, **1616**). [MacDonald 1976, p. 35]

Michael Drayton, 1563–1631. (Ixion evoked in) Sonnet 40 of *Idea.* Cycle of 63 sonnets. London: Smethwicke, **1619.** [Hebel 1931–32, vol. 2]

Henry Hutton. "History of Ixion's Wheele." Verse travesty. In *Follie's Anatomie: or, Satyres and Satyricall Epigrams* (London: for M. Walbankes, **1619**). Modern edition, London: Percy Society, 1842. [Bush 1963, p. 332]

Jusepe de Ribera, *c.*1590/91–1652. "Ixion." Painting. **1632.** Prado, Madrid, no. 1114. [López Torrijos 1985, pp. 400f., pl. 183 / Spinosa 1978, no. 76—ill. / also Fort Worth 1982, fig. 34]

————. "Ixion." Painting. Lost. / Copy on deposit in Prado, Madrid. [López Torrijos, pl. 187 / Spinosa 1978, no. 72a—ill.]

Christiaen van Couwenbergh, 1604–1667. "Ixion Tricked by Juno." Painting. **1640.** Louvre, Paris, no. R.F. 3776. [Louvre 1979–86, 1:42—ill.]

Richard Lovelace, 1618–1658. (Ixion evoked in) "Against the Love of Great Ones" stanza 1. In *Lucasta, Epodes, Odes, Sonnets, and Songs* (London: Ewster, **1649**). [Wilkinson 1930]

Giovanni Battista Langetti, 1625–1676. "The Torture of Ixion." Painting. Museo de Arte, Ponce, Puerto Rico, inv. no. 64.0455. [*Art Quarterly* 27 no. 1 (1964): 36]

John Eccles, *c.*1668–1735. music. *Ixion.* Masque, interpolated into *The Italian Husband* by Ravenscroft. First performed Nov **1697,** Lincoln's Inn Fields, London. [Grove 1980, 5:820 / Nicoll 1959–66, 1:426 / Fiske 1973, pp. 13, 24]

Nicolaus Adam Strungk, 1640–1700. *Ixion.* Opera. Libretto, C. L. Boxberg, after Perisetti's *L'Isione.* First performed **1697,** Leipzig. [Grove 1980, 18:299]

Luca Giordano, 1634–**1705.** "Ixion." Painting, after Ribera (1632, Prado no. 1114). Prado, Madrid, inv. 1649, on deposit at Instituto, Badajoz. [Ferrari & Scavizzi 1966, 2:319]

————, formerly attributed. "Ixion Chained to the Burning Wheel." Painting. Národní Galeri, Prague. [Ibid., 2:378]

Johann Philipp Käfer, 1672–*c.*1730. *Ixion.* Opera. First performed **1718,** Durlach. [Grove 1980, 9:766]

Jonathan Swift, 1667–1745. (Ixion's tale recalled in) "An Answer to a Scandalous Poem." Poem (reply to Thomas Sheridan's "A New Simile for the Ladies," comparing them to clouds). **1732.** First printed as a pamphlet, 1733; collected in *Works,* revised edition (Dublin: Faulkner, 1738. [Williams 1958, vol. 2]

Laurent Gervais, fl. 1725–45. *Ixion.* Cantata. **1741.** Published Paris: *c.*1755. [Grove 1980, 7:309]

Nicolas Racot de Grandval, 1676–**1753.** *Ixion.* Cantata. [Grove 1980, 7:636]

Henry Fuseli, 1741–1825. "As Zeus and Hera Look on, Ixion Embraces the Cloud." 3 drawings. **1809.** Huntington Library and Art Gallery, San Marino, Calif. (2); City of Auckland Art Gallery, New Zealand. [Schiff 1973, nos. 1366, 1367, 1792—ill.]

Benjamin Disraeli, 1804–1881. *Ixion in Heaven.* Prose burlesque. In Bulwer-Lytton's *New Monthly Magazine* 35 (**1832**); collected in *Ixion in Heaven, The Infernal Marriage,* etc. (London: Warne, 1833). [Bush 1937, p. 551]

Francis Cowley Burnand, 1836–1917. *Ixion; or, The Man at the Wheel.* Extravaganza. First performed **1863,** London. [Nicoll 1959–66, 5:69, 288]

————. *Ixion Rewheeled.* Extravaganza. First performed 1874, London. [Ibid., 5:290]

Lydia Thompson, 1836–1908. *Ixion; or, The Man at the Wheel.* Burlesque. First performed 21 Sep **1868,** Wood's Museum, New York. [Sharp 1969, 1:538, 2:1173 / Oxford 1984, p. 665]

Hermann von Lingg, 1820–1905. *Ixion.* Verse drama. **1882.** In *Ausgewählte Gedichte* (Stuttgart: Cotta, 1905). [Trousson 1976, 2:400]

Robert Browning, 1812–1889. "Ixion." Poem. In *Jocoseria* (London: Smith, Elder, **1883**). [Scudder 1895 / Ryals 1975, pp. 183–85 / Bush 1937, p. 378]

Rubén Darío, 1867–1916. (Ixion and the cloud evoked as parents of centaurs in) "Coloquio de los centauros" [Colloquy of the Centaurs]. Poem. **1895.** In *Prosas profanas y otros poemas* (Buenos Aires: Coni, 1896). [Méndez Plancarte 1967 / Jrade 1983, pp. 28f.]

Innokénty Ánnensky, 1856–1909. *Car' Iksion* [King Ixion]. Tragedy. St. Petersburg: Frolovoi, **1902.** [Terras 1985, p. 22 / Setschkareff 1963, pp. 173–83, 261]

Vyacheslav Ivánov, 1866–1949. (Ixion's story reported in) *Tantal.* Tragedy. **1905.** St. Petersburg: Alkonost, 1905. [Venclova 1985, pp. 90, 94f.]

Joseph Auslander, 1897–1965. "Ixion." Poem. In *Cyclops' Eye* (New York & London: Harper, **1926**). [Boswell 1982, p. 25]

William Empson, 1906–1984. (Ixion evoked in) "Invitation to Juno." Poem. In *Poems* (London: Chatto & Windus, **1935**). [Ipso]

Rued Langgard, 1893–1952. *Ixion.* Symphony, no. 11. **1944.** [Grove 1980, 10:450]

Cesare Pavese, 1908–1950. (The cloud and Ixion speak in) "La nube" [The Cloud]. Dialogue. In *Dialoghi con Leucò* (Turin: Einaudi, **1947**). / Translated by William Arrowsmith and D. S. Carne-Ross, in *Dialogues with Leucò,* bilingual edition (Ann Arbor: University of Michigan Press, 1965). [Ipso / Thompson 1982, p. 122]

Morton Feldman, 1926–. *Ixion.* Composition for 10 instruments. **1965.** / Revised for 2 pianos, 1965. [Grove 1980, 6:456]

Thomas Merton, 1915–**1968.** "Gloss on the Sin of Ixion." Poem. In *Collected Poems* (New York: New Directions, 1977). [Ipso / Labrie 1979, p. 131]

Ezra Pound, 1885–1972. (Torture of Ixion evoked in) Canto 113, in *Drafts and Fragments of Cantos CX–CXVII* (New York: New Directions, **1968**). [Ipso / Feder 1971, p. 121 / Flory 1980, p. 280 / Surette 1979, p. 261]

Ralph Gustafson, 1909–. *Ixion's Wheel.* Collection of poetry. Toronto: McClelland & Stewart, **1969.** [Vinson 1985, p. 335]

Budd Hopkins, 1931–. "Ixion No. 2." Painting. **1978.** Artist's coll. [DCAA 1982, p. 284—ill.]

J

JANUS. One of the earliest of native Italian gods, Janus has no equivalent in Greek mythology. To the Romans, he was the god of gates and doorways and of the New Year and beginnings in general. He was the first to be named in any list of gods invoked in prayer, superseding even Jupiter, and the first to receive a portion of the sacrifice. His name was given to the first of the Roman months. His symbol, common in sculpture and coinage, was a double-faced head, looking both ahead and behind. His temple on the Janiculum in Rome was famous for its two sets of doors—situated at the western and eastern ends of an arched passageway—that were kept closed in times of peace and opened in times of war.

Janus did not figure strongly in myth. One story describes him as an early king of Latium and the father of Tiberinus, who drowned in a river that from then on bore his name, the Tiber. Janus was believed to have received Saturn (Cronus) when he was driven from Greece by Zeus.

Classical Sources. Virgil, *Aeneid* 7.180, 7.610, 8.357, 12.198. Livy, *Ab urbe condita* 1.19.2. Ovid, *Metamorphoses* 14.785ff.; *Fasti* 1.63–299.

Andrea Mantegna, 1430/31–**1506,** and **Lorenzo Costa,** 1460–1535 (begun by Mantegna, completed by Costa after Mantegna's death). (Janus in) "The Reign of Comus" ("The Gate of Comus"). Painting. Louvre, Paris, inv. 256. [Louvre 1979–86, 2:169—ill. / Lightbown 1986, no. 41—ill. / Louvre 1975, no. 128—ill. / Wind 1948, pp. 46f., fig. 59]

Battista Zelotti, c.1526–1578. "Janus and Juno." Painting, ceiling panel, part of a cycle of gods and goddesses. **1553–54.** Sala dei Dieci, Palazzo Ducale, Venice. [Berenson 1957, p. 204—ill.]

Francesco Primaticcio, 1504–1570, design. "Janus." Fresco, for Salle de Bal, Château de Fontainebleau, executed by Niccolò dell' Abbate under Primaticcio's direction. **1551–56.** Repainted 19th century. [Dimier 1900, pp. 160ff., 284ff.]

Paolo Veronese, 1528–1588. "Janus." Fresco detail, part of "Gods of Olympus" cycle. *c.*1557. Palazzo Trevisan, Murano. [Pallucchini 1984, no. 36b—ill. / Pignatti 1976, no. 65—ill.]

Giorgio Vasari, 1511–1574, and assistants. "Saturn Landing in Italy, Recieved by Janus," "Saturn and Janus Building Saturnia." Ceiling frescos, part of "Saturn" cycle. **1558.** Damaged by fire in 1600. Terrazzo di Saturno, Palazzo Vecchio, Florence. [Sinibaldi 1950, pp. 13, 22]

Edmund Spenser, 1552?–1599. (Janus evoked in) Sonnet 4 of *Amoretti.* In *Amoretti and Epithalamion* (London: Ponsonbie, **1595**). [Oram et al. 1989]

Antoine Caron, 1520/21–1599. (Janus closing the doors of war in) "The Triumph of Winter." Painting. Ehrmann coll., Paris. [McGowan 1985, p. 150, pl. 40 / Paris 1972, no. 35—ill.]

Peter Paul Rubens, 1577–1640. "The Temple of Janus." Painted stage, decoration for "Pompa Introitus Fernandi," triumphal entry of Cardinal-Infante Ferdinand of Spain into Antwerp, 17 Apr **1635.** Original decoration destroyed 1731. [Martin 1972, no. 44—ill. (print) / Jaffé 1989, no. 1152 / Baudouin 1977, fig. 127 (print)] Oil sketch. Hermitage, Leningrad, inv. 500. [Martin, no. 44a—ill. / Held 1980, no. 161—ill. / Jaffé, no. 1151—ill. / White 1987, pl. 286]

Andrew Marvell, 1621–1678. (Janus evoked in) "Upon the Death of the Lord Protector" lines 232–37. Ode. **1658.** In *Miscellaneous Poems* (London: Boulter, 1681). [Margoliouth 1971]

Pierre Puget, 1620–1694. "Ceres Crowning Janus with Olive Branches." Sandstone sculpture. **1659–60.** Lost. [Herding 1970, no. 13]

Jakob Balde, 1604–**1668.** Neo-Latin poem. / Translated by Johann Gottfried Herder as "Der Janustempel" [The Temple of Janus] (1795–96). *See Herder, below.*

Claude Ballin, 1615–**1678.** Janus heads, incorporated in bronze vases, North and South Parterres, Gardens, Versailles. Cast 1765–69, 1865. In place. [Girard 1985, p. 270—ill.]

John Blow, 1649–1708. "Great Janus, New Year's Day." Musical ode. First performed **1679,** Court, London. [Grove 1980, 2:810]

———. "Dread Sir, Father Janus." Musical ode. First performed 1683, Court, London. [Ibid.]

Luca Giordano, 1634–1705. (Janus in) "Allegory of Human Life and the Medici Dynasty." Fresco. **1682–83.** Palazzo Medici Riccardi, Florence. [Ferrari & Scavizzi 1966, 2:112ff.—ill.] Studies. Denis Mahon coll., London; D. Barclay coll., London. [Ibid.—ill.]

John Dryden, 1631–1700. (Janus in) "The Secular Masque." Masque. Music, Daniel Purcell. First performed as part of Vanbrugh's *The Pilgrim,* 29 Apr **1700,** Drury Lane, London. [Kinsley 1958, vol. 4 / Winn 1987, pp. 510–12 / Van Doren 1946, pp. 188f. / Grove 1980, 15:475]

John Eccles, c.1668–1735. "Janus, did ever thy wand'ring eyes." Musical ode. Text, E. Smith. First performed late **1704.** [Grove 1980, 5:820]

———. "Janus! The shining round survey." Musical ode, composed for New Year's Day, 1730. Text, L. Eusden. [Ibid., 5:821]

Carlo Maratti, 1625–**1713,** attributed (or **Charles Le Brun,** 1619–1690), composition. "Janus and the Four Seasons" ("Janus Opens the Door to the Year"). Print, executed by R. V. Audenaerd. (Albertina, Vienna.) [Knab 1977, fig. 16]

Jonathan Swift, 1667–1745. "To Janus on New Year's Day." Poem. **1729.** In *Works* (Dublin: Faulkner, 1735). [Williams 1958, vol. 3]

French (or German?) School. "Mars, Janus, and Minerva—Allegory of War and Peace." Bronze sculpture. **1700–30.** Museum für Kunst und Gewerbe, Hamburg, inv. 1961.207. [Düsseldorf 1971, no. 187—ill.]

William Boyce, c.1710–1779. "Forward, Janus." Musical ode. **1770.** [Grove 1980, 3:143]

Anton Raphael Mengs, 1728–1779. (Janus in) "Allegory of History." Fresco. **1772–73.** Camera dei Papiri, Vatican, Rome. [Honisch 1965, no. 3—ill.]

John Flaxman, 1755–1826. "Peace Preventing Mars from Opening the Gates of (the Temple of) Janus." Relief, commemorative plaque, designed for Wedgwood. Designed 1786, produced **1787.** / Wax and biscuit models. Wedgwood Museum, Barlaston, Staffs. [Irwin 1979, p. 26 / also Bindman 1979, no. 51—ill.]

Johann Gottfried Herder, 1744–1803. "Der Janustempel" [The Temple of Janus]. Poem, translation from Jakob Balde (1604–1668). In *Terpsichore* book 4 (Lübeck: Bohn, **1795–96**). [Herder 1852–54, vol. 17]

Algernon Charles Swinburne, 1837–1909. "The Temple of Janus." Poem, winner of **1857** Oxford Newdigate Prize. Lost. [Bush 1937, p. 329]

Gregor Csiky, 1842–1891. *Janus.* Tragedy in verse. First performed **1877.** [Sharp 1933, p. 61]

Karel van de Woestijne, 1878–1929. *Janus met het dubbele voorhoofd* [Janus of the Double Countenance]. Collection of short stories. Bussum: Van Dishoeck, **1908.** [EWL 1981–84, 4:649f.]

Æ (George William Russell), 1867–1935. "Janus." Poem. In *Collected Poems by A. E.* (London: Macmillan, **1920**). [Boswell 1982, p. 217]

George Barker, 1913–. *Janus.* Prose. London: Faber & Faber, **1935.** [CLC 1988, 48:10]

Paul Valéry, 1871–**1945.** (Janus evoked in) "À des divinités cachées" [To Hidden Divinities]. Poem. In *Douze poèmes* (Paris: "Bibliophiles du Palais," 1959). [Mathews 1956–71, vol. 1]

Barbara Hepworth, 1903–1975. "Two Heads" ("Janus"). Abstract wood sculpture. **1948.** Joseph Hirschhorn coll., New York. [Hodin 1962, no. 151]

W. S. Merwin, 1927–. "A Mask for Janus." Poem. In *A Mask for Janus* (New Haven: Yale University Press, **1952**). [Seymour-Smith 1985, p. 168 / CLC 1974, 2:277]

John Holloway, 1920–. "The Gates of Janus." Poem. In *The Fugue and Shorter Pieces* (London: Routledge & Kegan Paul, **1960**). [DLB 1984, 27:158]

Beverly Grigsby, 1928–. *The Two Faces of Janus.* Instrumental composition. **1963.** [Cohen 1987, 1:287]

Max Ernst, 1891–1976. "The Janus Bird." Sculpture. **1974.** [Quinn 1977, pp. 22f.—ill.]

William O. Smith, 1926–. *Janus.* Composition for trombone and jazz orchestra. **1977.** [Baker 1984, p. 2155]

Paul Mills, 1948–. "Janus." Poem. In *Third Person* (Manchester: Carcanet, **1978**). [Ipso]

Cecilie Ore, 1954–. "Janus." Instrumental composition. **1985.** [Cohen 1987, 1:523]

JASON. The son of Aeson, the Thessalian hero Jason was the leader of the Argonauts, the band of heroes who took part in the quest for the Golden Fleece. Jason was by right to become the king of Iolchus, but the throne was usurped by Pelias, his father's half-brother. In one version of the myth, Jason's mother staged a mock funeral and convinced Pelias that the boy was dead in order to get him safely out of Iolchus. Then, she arranged for him to be sent to the centaur Chiron, who reared and educated him.

When he reached adulthood, Jason returned to claim his throne. Approaching Iolchus, he lost one of his sandals while helping an old woman to cross a river. (According to one version, the old woman was the goddess Hera in disguise, and she thereafter placed Jason under her protection.) Pelias, who had been warned by an oracle to beware a descendant of Aeson wearing one sandal, equivocated when Jason confronted him. He assured the youth that he would be happy to relinquish his throne if only Jason could recapture the Golden Fleece, believing such a task would be impossible. The fleece of the golden ram on which Phryxus and Helle had escaped the wrath of Athamas now hung in Colchis, and Jason was charged with restoring it to its rightful home in Greece.

For this epic quest, Jason gathered together fifty of the bravest heroes in Greece. They put in at a number of ports and took part in numerous adventures before arriving at Colchis to claim the Golden Fleece. They were aided by the king's daughter, Medea, a sorceress who fell in love with Jason and helped him to steal the fleece and escape. During a return journey filled with perils and adventures, Jason married Medea. When they reached Iolchus, Medea killed Pelias with her magic. Jason was thus avenged for the mistreatment of his family, but because he was responsible for the murder of his uncle, he and Medea were banished by Pelias's son, Acastus.

Jason placed the fleece in the temple of Zeus at Orchomenus, then went with Medea in exile to Corinth, where he dedicated his ship, the *Argo,* to Poseidon. After ten years he divorced Medea in order to marry King Creon's daughter Glauce (Creusa). In a rage, Medea killed her two children by Jason, then escaped to Athens. Jason remained in Corinth, or, according to other accounts, was exiled and wandered about Greece for many years before returning to Corinth. There, resting beneath the hull of the *Argo,* he was struck and killed by a piece of timber that fell from the ship's stern.

Classical Sources. Hesiod, *Theogony* 992ff. Pindar, *Pythian Odes* 4. Euripides, *Medea.* Apollonius Rhodius, *Argonautica.* Diodorus Siculus, *Biblioteca* 4.40–53. Ovid, *Heroides* 6, 12; *Metamorphoses* 7.1–400. Apollodorus, *Biblioteca* 1.8.2, 1.9.16–28, 3.13.7. Valerius Flaccus, *Argonautica.* Statius, *Thebaid* 516ff. Pausanias, *Description of Greece* 2.3.6–11, 5.17.9–10. Hyginus, *Fabulae* 12–14, 24–26.

Listings are arranged under the following headings:
 General List
 Jason and the Argonauts

Hypsipyle
Hylas
Phineus and the Harpies
Jason and the Golden Fleece

See also ATHAMAS; CHIRON; MEDEA; MELEAGER, Boar Hunt.

General List

Dante Alighieri, 1265–1321. (Jason among the Seducers in) *Inferno* 18.83–97. *c.***1307**–*c.***1314?** In *The Divine Comedy.* Poem. Foligno: Neumeister & Angelini, 1472. [Singleton 1970–75, vol. 2 / Schless 1984, pp. 160ff.]

Anonymous French. (Story of Jason in) *Ovide moralisé* 7. Poem, allegorized translation/elaboration of Ovid's *Metamorphoses. c.***1316–28.** [de Boer 1915–86, vol. 3]

Giovanni Boccaccio, 1313–1375. "Medea, regina Colcorum" [Medea, Queen of Colchis]. In *De mulieribus claris* [Concerning Famous Women]. Latin verse compendium of myth and legend. **1361–75.** Ulm: Zainer, 1473. [Branca 1964–83, vol. 10 / Guarino 1963]

Filarete, *c.*1400–1469? "Jason." Relief, on bronze door of St. Peter's, Rome. **1433–45.** In place. [Pope-Hennessy 1985b, 2:318]

Bernardo Parentino, 1437–**1531.** 2 paintings with scenes from the story of Jason: battle scene and marriage to Medea (?). Brooklyn Museum, N.Y., nos. 26.517–18. [Berenson 1968, p. 318]

———. "The Story of Jason" (?). Painting. Formerly Emile Weinberger coll., Vienna. [Ibid., p. 319—ill.]

Baccio Bandinelli, 1493–1560. "Jason" (with the golden fleece). Bronze statue. **1545–55.** Museo Nazionale, Florence. [Pope-Hennessy 1985a, pp. 177f.—ill.]

Joachim Du Bellay, 1522–1560. (Jason evoked in) "Les regrets." Poem. *Les regrets et autres oeuvres poétiques* (Paris: **1559**). [DLLF 1984, 1:228f.]

Annibale Carracci, 1560–1609, **Ludovico Carracci,** 1555–1619, and **Agostino Carracci,** 1557–1602. "The Story of Jason." Cycle of 18 frescoes. *c.***1583–84.** Sala di Giasone, Palazzo Fava (now Hotel Majestic-Baglioni), Bologna. [Malafarina 1976, no. 15—ill. / Ostrow 1966, no. I/5]

Lope de Vega, 1562–1635. "De Jason." Sonnet, no. 68 of *Rimas humanas* part 1. **1602–04.** Madrid: Martin, for Alonso Perez, 1609. [Sainz de Robles 1952–55, vol. 2]

Pedro Calderón de la Barca, 1600–1681. "El divino Jasón." Auto sacramentale. Before **1630.** In *Autos sacramentales,* part 1 (Madrid: de Buendia, 1677). [Oxford 1978, p. 87]

Pier Francesco Cavalli, 1602–1676. *Il Giasone.* Opera (dramma per musica). Libretto, Giacinto Andrea Cicognini. First performed 5 Jan **1648–49,** Teatro San Cassiano, Venice. [Grove 1980, 4:25, 32 / Bianconi 1987, pp. 186, 188, 196 / Glover 1978, pp. 55, 158 / Pirrotta & Povoledo 1982, p. 278 / Wolff 1971, p. 10 / Worsthorne 1954, p. 150]

Anne Maudit de Fatouville. *Arlequin Jason.* Comedy. First performed 9 Sep **1684,** Hôtel Bourgoyne-Italien, Paris. [Lancaster 1929–42, Pt. 4, 2:605, 607, 617f., 655, 953]

Johann Sigismund Küsser, *c.*1660–1727. *Jason.* Singspiel. Libretto, FriedrichChristian Bressand. First performed 1 Sep **1692,** Braunschweig. [Baker 1984, p. 1279 / Grove 1980, 10:325 / DLL 1968–90, 2:38]

Georg Caspar Schürmann, 1672–1751. *Giasone, overo, Il conquisto del Vello d'Oro* [Jason, or, The Conquest of the Golden Fleece]. Opera (dramma per musica). Libretto, F. Parisetti. First performed **1707,** Brunswick. [Grove 1980, 16:874]

Nicola Porpora, 1686–1768. *Giasone.* Opera. First performed **1742,** Naples. [Grove 1980, 15:126 / EDS 1954–66, 8:343]

Jean-François de Troy, 1679–1752, designs. "The History of Jason." Tapestry series. "The Capture of the Golden Fleece," "Jason Taming the Bulls," "Jason Swearing Eternal Affection to Medea," "Medea Flying Off on Her Chariot after Slaying Her Children," others. At least two sets of cartoons/studies executed, **1742–46.** One set in French national collections, inv. 8220–26 (1 painting in Louvre, Paris, 3 on deposit in Musées de Puy and Clermont-Ferrand; 3 others lost). Other set(s?) dispersed. Hodgkin coll., London; Barber Institute, Birmingham, England; National Gallery, London, inv. 6330; elsewhere. [Louvre 1979–86, 4:240—ill. / Royal Academy 1968, nos. 680–81—ill. / Columbia 1967, no. 64—ill. / London 1966, p. 155—ill.] 7 sets of tapestries, executed by Gobelins, 1746 and later. Victoria and Albert Museum, London; elsewhere? [Royal Academy / Columbia, no. 89]

Giovanni Domenico Tiepolo, 1727–1804. "The Golden Fleece" ("Glorification of Spain") (Hercules, with Cupid and Fama, Jason and Neptune, presenting the Golden Fleece to the Spanish monarchy). Ceiling fresco. **1764–66.** Palacio Real, Madrid. [Honisch 1965, p. 41 / Mariuz 1979, p. 123—ill.] Study. Marzotto coll., Portogruaro. [Mariuz 1982, p. 134—ill.]

Richard Glover, 1712–**1785.** *Jason.* Tragedy. First performed 1799, London. [Nicoll 1959–66, 3:26]

Franz Grillparzer, 1791–1872. *Das Goldene Vlies* [The Golden Fleece]. Trilogy of tragedies: *Der Gastfreund* [The Intimate Friend] (Phrixos), *Die Argonauten* (Jason in Colchis), and *Medea.* **1820.** First performed 26 Mar 1821, Burgtheater, Vienna. Published Vienna: Wallishausser, 1822. [DLL 1968–90, 6:800–802 / EW 1983–85, 5:429ff. / McGraw-Hill 1984, 2:413ff.]

Bertel Thorwaldsen, 1770–1844. "Jason (with the Golden Fleece)." Marble statue. 2 versions, **1803–28,** 1846–62 (executed by B.L. Bergslien and H. W. Bissen). Thorwaldsens Museum, Copenhagen, nos. A822, A51 (in City Hall, Copenhagen). [Thorwaldsen 1985, pp. 24, 80, pl. 11 / Hartmann 1979, pp. 48ff.—ill. / Cologne 1977, no. 1, pp. 35ff., 95, 116—ill. / Licht 1983, p. 203—ill.] Plaster original. 1802–03. Thorwaldsens Museum, no. A52. [Thorwaldsen]

William Morris, 1834–1896. *The Life and Death of Jason.* Epic poem. London: Bell & Daldy, **1867.** / Revised 1882. [Morris 1910–15, vol. 2 / Marshall 1979, pp. 74ff., 89ff. / Henderson 1967, pp. 88f.]

Alexander Mackenzie, 1847–1935. *Jason.* Cantata, opus 26. Libretto, William E. Grist. First performed **1882,** Bristol Festival. [Grove 1980, 11:442]

Edward Burne-Jones, 1833–1898. 2 illustrations for 4th edition of William Morris's *The Life and Death of Jason* (London: Kelmscott Press, **1895**). [Arts Council 1975, no. 286]

Rubén Darío, 1867–1916. (Poet listens to Jason in) "Caracol" [Seashell]. Poem. **1903.** In *Cantos de vida y espe-*

ranza: Los Cisnes y otros poemas (Madrid: Tipografía de la Revista de Archivos, Bibliotecas y Museos, 1905). [Méndez Plancarte 1967 / Jrade 1983, pp. 32, 52, 68, 69]

Maxfield Parrish, 1870–1966. 3 paintings, for *Collier's* magazine "Mythology" series. **1908.** "Jason and the Talking Oak," unpublished; "Quest of the Golden Fleece," published 5 Mar 1910; "Jason and His Teacher," published 23 July 1910. Originals in Vose Galleries, Boston. [Ludwig 1973, pp. 35, 209, pl. 3, 5]

Michael Field (**Katherine Harris Bradley,** 1848–**1914,** and **Edith Cooper,** 1862–1943). "Jason." Poem. In *A Selection from the Poems of Michael Field* (Boston: Houghton Mifflin, 1925). [Boswell 1982, p. 245]

Archibald MacLeish, 1892–1982. "Iason." Poem. In *Tower of Ivory* (New Haven: Yale University Press, **1917**). [Boswell 1982, p. 175]

Robert Graves, 1895–1985. *Hercules, My Shipmate.* Novel. First published as *The Golden Fleece* (London: Cassell, **1944**). Retitled, published New York: Creative Age Press, 1945. [Ipso / DLB 1983, 20:155 / Seymour-Smith 1982, pp. 283–86, 389]

Eduardo Paolozzi, 1924–. "Jason." Abstract bronze sculpture. **1956.** Unique cast. Museum of Modern Art, New York, no. 661.59. [Kirkpatrick 1970, fig. 20 / Barr 1977, p. 575—ill. / Konnertz 1984, fig. 178]

Henry Treece, 1912–1966. *Jason.* Novel. London: Bodley Head; New York: Random House, **1961.** [Richardson 1971, p. 610]

Jason and the Argonauts. When Jason set out to recapture the Golden Fleece, he took with him fifty of the greatest Greek heroes, including Heracles (Hercules), Orpheus, Peleus, Telamon, Zetes and Calais (the winged sons of Boreas), and the Dioscuri, Castor and Polydeuces (Pollux). They sailed on the *Argo,* named for its shipwright, Argus; it was the first ship built for forty oarsmen, a marvel of its time.

The Argonauts first landed at Lemnos, an island populated only by women and ruled by Queen Hypsipyle. She fell in love with Jason and prevailed on the Argonauts to stay for a year. They then put in at various ports throughout the Aegean and beyond. At Samothrace, they were initiated into the local mysteries; at Cyzicus, Heracles killed the giants who were menacing the local citizens. At Cius, the youth Hylas, beloved of Heracles, was taken by water nymphs. Heracles remained behind to look for the boy, and the voyage continued without him. The *Argo* then passed into the Black Sea, to the land of the Bebryces; there Polydeuces inadvertently killed their king, Amycus, which led to a battle in which the Argonauts triumphed.

The next port was Salmydessus, in Thrace, where they met the blind prophet and king, Phineus, whom they helped by sending Zetes and Calais to chase away the Harpies who were tormenting him. In return, Phineus foretold the remainder of the Argonauts' journey and warned them of impending dangers.

At Colchis, Jason, with the help of the princess Medea, secured the Golden Fleece and escaped the Colchian king's wrath, taking Medea with him as his intended bride. On the homeward journey the Argonauts sailed successfully past the Sirens' rocks, the perils of Scylla and Charybdis, and the Clashing Rocks. In Phaeacia, they were overtaken by the Colchians, but the Phaeacian king, Alcinous, agreed to give Medea over to her father's emissaries only if she were still an unmarried virgin; upon learning this, Jason and Medea were immediately married. After several more adventures the *Argo* returned safely home, where Jason dedicated the Golden Fleece in the temple of Zeus at Orchomenus.

Classical Sources. Anonymous Orphic *Argonautica.* Pindar, *Pythian Odes* 4. Apollonius Rhodius, *Argonautica.* Theocritus, *Idylls* 22.45–136. Diodorus Siculus, *Biblioteca* 4.41–53. Apollodorus, *Biblioteca* 1.9.17–26. Valerius Flaccus, *Argonautica.* Hyginus, *Fabulae* 14.

Filarete, c.1400–1469? "Jason and the Argonauts." Relief, on bronze door of St. Peter's, Rome. **1433–45.** In place. [Pope-Hennessy 1985b, 2:318]

Ercole da Ferrara, 1450/56–**1496,** studio. Cycle of paintings on the Argonautic expedition. Dispersed. "Hercules and the Argonauts in a Boat," Museo Civico, Padua, no. 67 (inv. 424); "Jason Kills the Dragon before Medea," Lady Houstoun Boswall coll., London; "Banquet of the Argonauts" (fragment), Musée des Arts Décoratifs, Paris; "Battle of Argonauts" (fragment), Conte Rucellai coll., Florence; "Return of the Argonauts with Medea," Thyssen coll., Lugano. [Berenson 1968, pp. 121f.]

Paduan School. "Battle of the Argonauts." Painting. **15th century.** Brooklyn Museum, N.Y., inv. 26.517. [Warburg]

Utili, fl. 1476–1504. "Story of the Argonauts." 2 paintings. Metropolitan Museum, New York, nos. 09.136.1–2. [Berenson 1963, p. 211—ill. / Metropolitan 1980, p. 11—ill.]

Baldassare Peruzzi, 1481–1536. The Argo depicted in a ceiling fresco representing the constellation Argo. **1510–11.** Sala di Galatea, Villa Farnesina, Rome. [d'Ancona 1955, pp. 25f., 86 / Gerlini 1949, pp. 10ff. / also Frommel 1967–68, no. 18c]

Dosso Dossi, c.1479–1542. "Scene from a Legend" (traditionally called "Departure of the Argonauts," now tentatively identified as "The Building of the Argo" or "Aeneas and Achates on the Libyan Coast"). Painting. **Mid-1520s?** Kress coll. (K448), National Gallery, Washington, D.C., no. 361. [Gibbons 1968, no. 79—ill. / Shapley 1966–73, 2:73f. (as "Aeneas and Achates")—ill. / also Berenson 1968, p. 114]

Francesco Primaticcio, 1504–1570 (previously attributed to Rosso Fiorentino). "Hercules on the Argo" (?). Painting. **1541–45.** Porte Doré, Château de Fontainebleau. Repainted 19th century. [Dimier 1900, pp. 306ff.] Drawing. Albertina, Vienna. [Ibid., no. 161] Engraving (Bartsch no.

267) by Hendrik Goltzius, c.1577. [Ibid., no. 3 / Strauss 1977a, no. 5—ill. ("Hercules and Geryon") / Bartsch 1980–82, no. 267—ill. (as "Hercules and Geryon")] *See also Domenico del Barbiere, below.*

Léonard Thiry, 1500–**1550.** "The Conquest of the Golden Fleece." Cycle of 26 drawings. Engraved by René Boyvin, published in French and Latin editions, with text by Jacques Gohory, dedicated to Charles IX of France, 1563. 2 drawings extant: "Phryxus Received by King Aeëtes," "Medea Telling Jason How to Steal the Golden Fleece." Rijksuniversiteit, Leiden. [Paris 1972, nos. 225–26, 283–84—ill.]

Coriolano Martirano, c.1503–1558. *Argonautica.* Comedy. Naples: Simonetta, **1556.** [Taylor 1893, p. 16]

Pierre de Ronsard, 1524–1585. (Orpheus on the Argonautic expedition in) "L'Orphée." Poem. In *Les trois livres du recueil des nouvelles poésies* book 1 (Paris: Buon, **1563**). [Laumonier 1914–75, vol. 12]

Edmund Spenser, 1552?–1599. (The Argo celebrated in) *The Faerie Queene* 2.12.44–45. Romance epic. London: Ponsonbie, **1590,** 1596. [Hamilton 1977 / MacCaffrey 1976, pp. 244f. / Hieatt 1975, pp. 192f.]

———. (The Argonauts evoked in) Sonnet 44 of *Amoretti.* In *Amoretti and Epithalamion* (London: Ponsonbie, 1595). [Oram et al. 1989]

———. (Strife among the Argonauts, calmed by Orpheus's music, evoked in) *The Faerie Queene* 4.2.1. Romance epic. London: Ponsonbie, 1596. [Hamilton 1977]

Agostino Carracci, 1557–1602. "Galatea and the Argonauts" (?). Fresco, in "Allegories of Love" cycle, representing the love of gold. *c.***1600–02.** Palazzo del Giardino, Parma. [Ostrow 1966, no. I/22]

Francisco Gómez de Quevedo y Villegas, 1580–1645. (Jason as Argonaut in) "Mi madre Tuvo." Sonnet. **1603.** In Pedro Espinoza's *Flores de poetas ilustres de España* (Valladolid: 1605). In modern edition, *Obra poética* (1963–72). [Crosby 1967, p. 157]

Francesco Cini. *L'Argonautica.* Verse drama. First performed 2 Nov **1608,** Arno, for wedding of Cosimo II de' Medici and Maria Maddalena of Austria. [Weaver 1978, p. 94 / Clubb 1968, p. 79]

Thomas Heywood, 1573/74–1641. (Story of the Argonautic expedition in) *Troia Britanica: or, Great Britaines Troy* canto 7. Epic poem. London: **1609.** [Heywood 1974 / also Boas 1950, pp. 62ff.]

———. (Argonauts in) *The Brazen Age.* Drama, partially derived from *Troia Britanica.* First performed c.1610–13, London. Published London: Okes, 1613. [Heywood, vol. 3 / DLB 1987, 62:101, 122ff. / also Boas, pp. 83ff. / Clark 1931, pp. 62ff.]

Pierre Guédron, c.1570/75–1619/20, music. *Ballet des Argonautes.* Ballet. First performed **1614,** Paris. [Grove 1980, 7:784]

Pierre Corneille, 1606–1684. *La conquête de la Toison d'Or* [Conquest of the Golden Fleece]. Tragedy (spectacle play, with machines by Giacomo Torelli). First performed Nov **1660,** Théâtre du Marais, Paris. Published Paris: Courbé et de Luyne, 1661. [Couton & Rat 1971, vol. 3 / Pocock 1973, pp. 16, 121, 167 / Girdlestone 1972, p. 146 / Arnott 1977, p. 55 / McGraw-Hill 1984, 1:552f., 554]

Jacob Jordaens, 1593–1678, attributed. "Zetes and Ca-

lais." Painting, sketch. Sold Paris, 1785, untraced. [Rooses 1908, p. 261]

Giuseppe Passeri, 1654–1714. "Jason Returning from Colchis with the Golden Fleece." Ceiling fresco, for Palazzo Barberini, Rome. **1678.** In place; restored 1960s. [Montagu 1971, pp. 366ff.—ill.]

Pierre Toutain, 1645–1686. "Jason Presenting the Golden Fleece in the Temple of Jupiter." Painting. **1681.** Louvre, Paris, inv. 8199. [Louvre 1979–86, 4:238—ill.]

Antonio Draghi, 1634/35–1700. *Gli Argonauti in viaggio* [The Argonauts' Voyage]. Vocal chamber work. Libretto, Nicolò Minato. First performed 9 June **1682,** Laxenburg. [Grove 1980, 5:605]

Pascal Collasse, 1649–1709. *Jason, ou, La Toison d'Or* [Jason, or, The Golden Fleece]. Opera (tragédie lyrique). Libretto, Jean-Baptiste Rousseau, after Pierre Corneille. First performed 6 Jan **1696,** L'Opéra, Paris. [Grove 1980, 4:535 / Girdlestone 1972, pp. 126 n., 127f., 146–49]

Jonathan Swift, 1667–1745. (Jason's return with the fleece recalled in) "Mr. Jason Hassard, a Woolen-Drapier in Dublin, Put Up the Sign of the Golden Fleece, and Desired a Motto in Verse." Poem. c.1720? In *Works* (Dublin: Faulkner, 1746). [Williams 1958, vol. 3]

Pasquale Cafaro, 1716?–1787. *Peleo, Giasone, e Pallade* [Peleus, Jason, and Pallas]. Cantata. **1766.** Probably performed San Carlo, Naples. [Grove 1980, 3:595]

Johann Heinrich Voss, 1751–1826. *Orfeus der Argonaut* [Orpheus the Argonaut]. Poem. In *Gedichte* (Königsberg: Nicolovius, **1795**). [NUC]

Asmus Jakob Carstens, 1754–**1798.** "The Voyage of the Argonauts." Series of 24 drawings. Unfinished; completed and engraved by Joseph Anton Koch. In *Les Argonauts selon Pindare, Orphée, et Apollonius de Rhodes* (Rome: 1799). Original drawings in Royal Print Room, Copenhagen. [Bindman 1979, no. 254—ill./ Irwin 1979, p. 83, fig. 104]

Washington Allston, 1779–1843. "Jason Returning to Demand His Father's Kingdom." Painting. **1807–08.** Lowe Art Museum, University of Miami, Fla. [Gerdts & Stebbins 1979, pp. 52–53—ill. / also Richardson 1948, no. 41—ill.] Sketch for. Fogg Art Museum, Harvard University, Cambridge. [Gerdts & Stebbins, p. 181—ill. / also Richardson, no. 42—ill.]

Victor de Laprade, 1812–1883. "Les Argonautes." Poem. In *Odes et poèmes* (Paris: Labitte, **1843**). [DLLF 1984, 2:1219]

Josef Engel, 1815–1891. "The Amazons and the Argonaut." Marble sculpture group. c.**1851.** Royal Collection, Osborne House, Isle of Wight. [Read 1982, p. 132, pl. 161]

Nathaniel Hawthorne, 1804–1864. (Argonauts in) *Tanglewood Tales.* Prose tales. Boston: Ticknor, Reed & Fields, **1851.** [Ipso]

Charles Kingsley, 1819–1875. "The Argonauts." Poem. In *Heroes* (Cambridge: Cambridge University Press, **1856**). [Bush 1937, p. 305]

Bayard Taylor, 1825–1878. (Orpheus evoked in) "Passing the Sirens." Poem. In *The Poet's Journal* (Boston: Ticknor & Fields, **1863**). [Boswell 1982, p. 230 / Bush 1937, p. 579]

William Morris, 1834–1896. (Story of Argonautic expedition in) *The Life and Death of Jason* books 2–16 (London: Bell & Daldy, **1867**). [Morris 1910–15, vol. 2]

José-Maria de Heredia, 1842–1905. "The Argonauts."

Outline for a sonnet cycle, with fragments. **1860s?** [Delaty 1984, vol. 2]

Otto Bach, 1833–1893. *Die Argonauten.* Opera. *c.*1870. [EDS 1954–66, 1:1220]

Vilhelm Kristian Sigurd Topske, 1840–1884. *Jason med det gyldne skind* [Jason with the Golden Fleece]. Novel, published anonymously. Copenhagen: Gyldendal, **1875.** [Mitchell 1958, p. 188]

Alexander Lindsay, Earl of Crawford and Balcarres, 1812–1880. "Argo: or, The Quest of the Golden Fleece." Poem, after Apollonius Rhodius. London: Murray, **1876.** [Bush 1937, p. 559]

Alice Mary Smith, 1839–1884. *Overture to Jason, or, The Argonauts and Sirens.* Orchestral composition. **1879.** [Cohen 1987, 2:650]

Augusta Holmès, 1847–1903. *Les Argonautes.* Dramatic symphonic work. **1880.** First performed 1881, Paris. [Cohen 1987, 1:326f. / Grove 1980, 8:656]

Madison Cawein, 1865–1914. "Argonauts." Poem. In *Intimations of the Beautiful* (New York: Putnam, **1894**). [Boswell 1982, p. 70]

Gustave Moreau, 1826–1898. "The Return of the Argonauts." Painting. Begun **1897,** unfinished. Musée Gustave Moreau, Paris, no. 20. [Mathieu 1976, p. 165 *n.*582]

Eliza Pawlowska Orzeszkowa, 1842–1910. *Argonauci* [The Argonauts]. Novel. Warsaw: **1899.** / Translated by Jeremiah Curtin (New York: Scribner, 1901). [DULC 1959–63, 3:909]

Andrew Lang, 1844–1912. *The Story of the Golden Fleece.* Story for children. Philadelphia: Altemus, **1903,** with illustrations by Mills Thompson. [Boswell 1982, p. 161]

Aleksandr Blok, 1880–1921. "Our Argo" [English title of a work written in Russian]. Poem, dedicated to Andrei Bely. *c.*1904? [Mochulsky 1977, p. 54]

Valéry Bryúsov, 1873–1924. "Orfej i Argonauty" [Orpheus and the Argonauts]. Poem, part of the cycle "Pravda vechnaia kumirov" [Eternal Truth of Idols]. **1904.** In *Stephanos* (*Venok*) [Wreath] (Moscow: Skorpion, 1906). [Bryúsov 1982]

Aleister Crowley, 1875–1947. "The Argonauts." Poem. In *The Work of Aleister Crowley* (Foyers: Society for Propagation of Religious Truth, **1905–07**). [Boswell 1982, p. 249]

Rubén Darío, 1867–1916. (The poet as Argonaut in) "Retorno" [Return]. Poem. **1907.** In *Poema del Otoño y Otros Poemas* (Madrid: Bibliotéca "Ateneo," 1910). [Méndez Plancarte 1967 / Jrade 1983, p. 30]

Giorgio de Chirico, 1888–1978. "The Departure of the Argonauts." Painting. **1909.** Sakraischik coll., Rome. [de Chirico 1971–83, 7.1: no. 384—ill.]

———. "The Departure of the Argonauts." Painting. 1922. Private coll., Milan. [Ibid., 3.2: no. 191—ill.]

Sir Reed Gooch Baggorre (**George Shoobridge Carr**), 1837–1912. "The Argonauts." Poem. In *Mythological Rhymes* (London: Hodgson, **1912**). [Boswell 1982, p. 27]

William Rose Benét, 1886–1950. "The Argo's Chanty." Poem. **1913.** In *Merchants from Cathay* (New York: Appleton-Century, 1919). [Boswell 1982, p. 35]

Vincente Blasco Ibáñez, 1867–1928. *Los Argonautas* (symbolic use of myth in title: immigrants as Argonauts). Novel. Valencia: Prometeo, **1914.** [DLE 1972, p. 114]

Adolf Schafheitlin, 1852–**1917.** *Hellenika: Argonauten-*

fahrt durch Grossgriechenland und Hellas [The Voyage of the Argonauts through Greece and Hellas], part 1. Poem. Wiesbaden: Weiser, [n.d.]. [NUC]

Osbert Sitwell, 1892–1969. *Argonaut and Juggernaut.* Verse narrative. London: Chatto & Windus, **1919;** 1928. [DULC 1959–63, 4:525]

Max Ernst, 1891–1976. "The Argonauts." Abstract painting. **1933.** Jacques Tronche coll., Paris. [Spies & Metken 1975–79, no. 1891—ill.] 778

Antonius Johannes Derkinderen, 1859–**1935.** "The Building of the *Argo.*" Painting, study for an unexecuted decoration for Amsterdam Stock Exchange. Rijksmuseum, Amsterdam, inv. 3470. [Rijksmuseum 1976, p. 192—ill.]

George Seferis, 1900–1971. "Argonautes." Poem. In *Mythistorema* (Athens: Ikaros, **1935**). [Keeley & Sherrard 1967 / CLC 1979, 11:495]

Slavko Batušić, 1902–. *Argonauti.* Novel. Zagreb: Matice Hrvatske, **1936.** [DULC 1959–63, 1:316]

Jorgos Theotokàs, 1906–1966. *Argo; mythistorema* [Argo; Mythic Story]. Novel. Athens: **1936.** / Translated by Margaret Brooke and Ares Tsatsopoulos (London: Methuen, 1951). [DULC 1959–63, 4:824]

Nikos Kazantzakis, 1883–1957. (Argonautic voyage, with Odysseus as an Argonaut, in) *Odysseia.* Modern Greek epic. Athens: Chrestou, **1938.** / Translated by Kimon Friar as *The Odyssey: A Modern Sequel* (New York: Simon & Schuster, 1958; London: Secker & Warburg, 1958). [Strauss 1971, pp. 248f.]

Sheila Wingfield, 1906–. "Young Argonauts." Poem. In *Poems* (London: Cresset Press, **1938**). [Vinson 1985, p. 943]

Robert Graves, 1895–1985. *Hercules, My Shipmate.* Novel. First published as *The Golden Fleece* (London: Cassell, **1944**). Retitled, published New York: Creative Age Press, 1945. [Ipso]

Cesare Pavese, 1908–1950. "Gli Argonauti" [The Argonauts]. Dialogue. In *Dialoghi con Leucò* (Turin: Einaudi, **1947**). / Translated by William Arrowsmith and D. S. Carne-Ross in *Dialogues with Leucò,* bilingual edition (Ann Arbor: University of Michigan, 1965). [Ipso / Biasin 1968, pp. 205f., 313]

Max Beckmann, 1884–1950. "The Argonauts." Painting, triptych. **1949–50.** Private coll., New York. [Göpel 1976, no. 832—ill. / also Lackner 1977, p. 166—ill. / Selz 1964, no. 78—ill.]

Elisabeth Langgässer, 1899–1950. *Die märkische Argonautenfahrt* [Argonauts of the Mark Brandenburg] (refugees from ruined Berlin traveling to a monastery, the Golden Fleece symbolic of an unattainable spiritual good). Novel. Hamburg: Claassen, **1950.** / Translated by Jane Bannard Greene as *The Quest* (New York: Knopf, 1953). [Columbia 1980, p. 460 / DLB 1988, 69:222f.]

Vassilis Vassilikos, 1933–. *He diegese tou Iasona* [The Narrations of Jason] (his childhood departure on the Argo). Novella. Athens: **1953.** [EWL 1981–84, 4:540]

W. S. Merwin, 1927–. "When I Came from Colchis." Poem. In *The Dancing Bears* (New Haven: Yale University Press, **1954**). [Boswell 1982, p. 273]

Frank O'Hara, 1926–1966. "The Argonauts." Poem. In *A City Winter and Other Poems* (New York: Tibor de Nagy, **1954**). [Howard 1969, pp. 402, 592]

Rosemary Thomas, 1901–1961. "Those Argonauts." Poem. In *Selected Poems* (New York: Twayne, 1968). [Ipso]

Rocio Sanz, 1934–. Incidental music to Sergio Magaña's *Los Argonautas* (1965). **1967.** [Cohen 1987, 2:617]

Yannis Ritsos, 1909–1990. "Hē parakme tes Argos" [The Decay of the Argo]. Poem. 7 May **1968.** In *Epanalepseis* (Athens: Kedros, 1972). / Translated by Edmund Keeley in *Yannis Ritsos, Exile and Return: Selected Poems 1967–1974* (New York: Ecco Press, 1985). [Ipso]

Hypsipyle. The first port the Argonauts visited was the island of Lemnos, where they found a population of women ruled by Hypsipyle, daughter of King Thoas. Aphrodite had punished the women for neglecting her rites by making them unattractive to their husbands, who turned instead to the Thracian concubines they had captured in war. In revenge the women killed all the men, except for Thoas, who escaped either with the help of his father, Dionysus, or by floating across the sea in a chest.

When the Argonauts arrived, the women of Lemnos were so happy to see men that they persuaded the travelers to stay. Many children were born, including the twins Euneus and Thoas (Nebrophonus) to Jason and Hypsipyle. At the end of a year Jason and the Argonauts departed.

Some time after the Argonauts' departure, Hypsipyle was captured by pirates and sold into slavery under King Lycurgus of Nemea. In another tale, she was banished from Lemnos by the other women for saving her father. In both stories she was eventually rescued by her sons and returned to the island.

Representations are rare in postclassical painting, but recur in poetry, drama, and opera.

Classical Sources. Homer, *Iliad* 7.467f. Pindar, *Olympian Odes* 4.32c; *Pythian Odes* 4.251ff. Herodotus, *History* 6.138. Euripides, *Hypsipyle* (fragments). Apollonius Rhodius, *Argonautica* 1.607–909. Propertius, *Elegies* 1.15.17ff. Ovid, *Heroides* 6; *Metamorphoses* 13.399ff. Apollodorus, *Biblioteca* 1.9.17, 3.6.4. Valerius Flaccus, *Argonautica* 2.242ff. Statius, *Thebaid* 4.740–770, 5.29, 5.494ff. Hyginus, *Fabulae* 15, 74, 254.

Dante Alighieri, 1265–1321. (Story of Hypsipyle evoked in image of Jason among the Seducers in) *Inferno* 18.83–97. *c.*1307–*c.*1314? In *The Divine Comedy*. Poem. Foligno: Neumeister & Angelini, 1472. [Singleton 1970–75, vol. 2 / Schless 1984, pp. 160ff.]

Anonymous French. (Story of Jason and Hypsipyle in) *Ovide moralisé* 7.250–72. Poem, allegorized translation/elaboration of Ovid's *Metamorphoses* and other works. *c.*1316–28. [de Boer 1915–86, vol. 3]

Giovanni Boccaccio, 1313–1375. "De Ysiphil, regina Lemni" [Hypsipyle, Queen of Lemnos]. In *De mulieribus claris* [Concerning Famous Women]. Latin verse compendium of myth and legend. **1361–75.** Ulm: Zainer, 1473. [Branca 1964–83, vol. 10 / Guarino 1963]

Geoffrey Chaucer, 1340?–1400. (Hypsipyle evoked in) "The Hous of Fame" lines 397–404. Poem. **1378–80.** Westminster: Caxton, *c.*1483. [Riverside 1987]

———. "The Legend of Hypsipyle and Medea," part of *The Legende of Goode Women.* Poem. 1385–86. Westminster: Caxton, *c.*1495. [Riverside / Schless 1984, pp. 160–66 / Frank 1966, pp. 123f.]

Christine de Pizan, *c.*1364–*c.*1431. (Hypsypyle in) *Le livre de la Cité des Dames* [The Book of the City of Ladies] part 2 no. 9. Didactic compendium in prose, reworking of Boccaccio's *De mulieribus claris.* **1405.** [Hicks & Moreau 1986] Translated by Brian Anslay (London: Pepwell, 1521). [Richards 1982]

Francesco Mondella. *Isifile.* Tragedy in verse. Verona: Donne, **1582.** [Herrick 1966, p. 46]

Marco Marazzoli, *c.*1602/08–1662. *Gli amori di Giasone e di Issifile* [The Loves of Jason and Hypsipyle]. Opera (festa teatrale). Libretto, Orazio Persiani. First performed **1642,** SS Giovanni e Paolo, Venice. [Pirotta & Povoledo 1982, p. 272 / Grove 1980, 11:643]

Pier Francesco Cavalli, 1602–1676. (Hypsipyle in) *Il Giasone.* Opera (dramma per musica). Libretto, Giacinto Andrea Cicognini. First performed 5 Jan **1648–49,** Teatro San Cassiano, Venice. [Bianconi 1987, pp. 186, 188, 196 / Grove 1980, 4:25, 32 / Glover 1978, pp. 55, 158 / Pirrotta & Povoledo 1982, p. 278 / Wolff 1971, p. 10 / Worsthorne 1954, p. 150]

Pierre Corneille, 1606–1684. (Hypsipyle's story in) *La conquête de la Toison d'Or* [Conquest of the Golden Fleece]. Tragedy (spectacle play, with machines by Giacomo Torelli). First performed Nov **1660,** Théâtre du Marais, Paris. Published Paris: Courbé et de Luyne, 1661. [Couton & Rat 1971, vol. 3 / McGraw-Hill 1984, 1:552f., 554]

Pietro Metastasio, 1698–1782. *Issipile.* Libretto for opera. Set by Bioni, Conti, Hasse, and Porta in 1732 (below), and by at least 21 further composers to 1810. [Grove 1980, 12:217]

Antonio Bioni, 1698–after 1739. *Issipile.* Opera. Libretto, Metastasio. **1732.** [Grove 1980, 2:726]

Francesco Bartolomeo Conti, 1681–1732. *Issipile.* Opera (dramma per musica). Libretto, Metastasio. First performed **1732,** Vienna. [Grove 1980, 4:681 / Weaver 1978, p. 303]

Johann Adolf Hasse, 1699–1783. *L'Issipile.* Opera seria. Libretto, Metastasio. First performed 1 Oct **1732,** San Bartolomeo, Naples. [Grove 1980, 8:288]

———, with arias by Leonardo Leo. *L'Issipile.* Opera. First performed 19 Dec 1742, Teatro San Carlo, Naples. [Grove, 10:668]

Giovanni Porta, *c.*1690–1755. *L'Issipile.* Opera seria. Libretto, Lalli (?), after Metastasio. First performed Autumn **1732,** San Giovanni Grisostomo, Venice. [Grove 1980, 15:133 / Weaver 1978, p. 303]

Francesco Feo, 1691–1761. *L'Issipile.* Opera seria. Libretto, Metastasio (1732). First performed **1733,** Regio, Turin (? also allegedly not performed). [Grove 1980, 6:466]

Nicola Porpora, 1686–1768. *Issipile.* Heroic opera. Libretto, Metastasio (1732). First performed Carnival **1733,** Rucellai, Rome. [Grove 1980, 15:126]

Pietro Giuseppe Sandoni, 1685–1748. *Issipile.* Opera. Libretto, Metastasio (1732). First performed 8 Apr **1735,** London. [Grove 1980, 16:467]

Baldassare Galuppi, 1706–1785. *Issipile.* Opera seria. Libretto, Metastasio (1732). First performed 26 Dec **1737,** Regio, Turin. [Grove 1980, 7:136]

John Christopher Smith, 1712–1795. *Issipile.* Opera. Libretto, Metastasio (1732). First performed **1743,** London. [Fiske 1973, p. 588]

Giovanni Verocai, c.1700–1745. *Hissifile.* Opera. Libretto, Metastasio (1732). First performed **1743,** Braunschweig. [Grove 1980, 19:674]

Domingo Terradellas, 1713–1751, attributed. *Issipile.* Opera (dramma per musica). Libretto, Metastasio (1732). First performed 23 Jan **1744** (or 1741–42), Cocomero, Florence. [Weaver 1978, pp. 288, 303 / Grove 1980, 18:697 (as 1741–42)]

Antonio Mazzoni, 1717–1785. *L'Issipile.* Opera. Libretto, Metastasio (1732). First performed **1747,** Teatro Comunale, Macerata. [Grove 1980, 11:872]

Christoph Willibald Gluck, 1714–1787. *Issipile.* Opera (dramma per musica). Libretto, Metastasio (1732). First performed Carnival **1752,** Prague. 4 arias extant. [Grove 1980, 7:457, 472 / Cooper 1935, pp. 51, 284]

Ignaz Holzbauer, 1711–1783. *L'Issipile.* Opera. Libretto, Metastasio (1732). First performed 4 Nov **1754,** Mannheim. [Grove 1980, 8:670]

Pasquale Errichelli, 1730–after 1775. *Issipile.* Opera. Libretto, after Metastasio (1732). First performed 18 Dec **1754,** Teatro San Carlo, Naples. [Grove 1980, 6:239]

Florian Leopold Gassmann, 1729–1774. *Issipile.* Opera. Libretto, Metastasio (1732). First performed Carnival **1758,** San Moisè, Venice. [Grove 1980, 7:179]

Giuseppe Scarlatti, c.1718/23–1777. *L'Issipile.* Opera. Libretto, Metastasio (1732). First performed Autumn **1760,** Burgtheater, Vienna. [Grove 1980, 16:579]

Giuseppe Sarti, 1729–1802. *Issipile.* Opera (dramma per musica). Libretto, Metastasio (1732). First performed Autumn **1760–61,** Theater on Kongens Nytorv, Copenhagen. [Grove 1980, 16:504]

Johann Christian Bach, 1735–1782. *Issipile.* Opera. Libretto, Metastasio (1732). First performed 26 Dec **1763,** Teatro San Carlo, Naples. [Grove 1980, 1:872]

Johann Gottfried Schwanenberger, c.1740–1804. *L'Issipile.* Opera. Libretto, Metastasio (1732). First performed **1766.** / Revised with 3 new ballets, performed 10 Feb 1767, Braunschweig. [Grove 1980, 17:40]

Pasquale Anfossi, 1727–1797. *Issipile.* Opera. Libretto, Metastasio (1732). First performed **1784,** London. [Grove 1980, 1:422f.]

L'Abbé Du Four. *Issipile.* Lyric drama. In *Poésies diverses* (Rennes: Montenay, **1785**). [Taylor 1893, p. 201]

Étienne Méhul, 1763–1817. *Hypsipyle.* Opera. Libretto, Valadier. **1787,** unperformed. [EDS 1954–66, 7:364]

Francisco Mariano Nifo, 1719–**1803.** *Hipsipile, Princesa de Lemnos.* Comedy, adapted from Metastasio's *Issipile* (1732). [Cook 1959, pp. 206f.]

[?] Lefebre, choreography. *Issipéle.* Ballet. First performed **1808,** La Scala, Milan. [Winter 1974, p. 222]

Johann Nepomuk Poissl, 1783–1865. *Issipile.* Opera. Libretto, composer, after Metastasio (1732). **1818.** Unperformed. [Grove 1980, 15:23]

Edward Burne-Jones, 1833–1898. "Hypsiphile and Medea." Stained-glass panel, part of a series illustrating Chaucer's *Legend of Good Women* (1385–86). Designed **1864,** executed by Morris and Co., later. Peterhouse College, Cambridge. [Harrison & Waters 1973, pp. 76, 188—ill.] Cartoon. Birmingham Museum and Art Gallery, England. [Harrison & Waters, p. 76]

George Augustus Simcox, 1841–1905. "Hypsipyle," "Thoas." Poems. In *Poems and Romances* (London: Strahan, **1869**). [Boswell 1982, p. 292]

Thomas Ashe, 1836–1889. "The Sorrows of Hypsipyle." 1-act play. In *Poems* (London: Bell, **1886**). [Boswell 1982, p. 23]

Hylas. The young son of Theiodamas, king of the Dryopes, Hylas was a favorite of Heracles and accompanied him on the Argonautic expedition. When the ship put in at Mysia, Hylas went to a spring to bring fresh water to Heracles and Telamon. The spring's nymphs were so taken with the youth that they pulled him into the water to remain with them forever. Heracles searched the island, calling for Hylas. According to Theocritus, Hylas answered these calls three times but sank before Heracles could find him. When the *Argo* set sail at nightfall, Heracles remained behind to continue the search, but to no avail. Before returning to Argos he established a cult of Hylas at Cius.

Classical Sources. Anonymous Orphic *Argonautica* 634ff. Apollonius Rhodius, *Argonautica* 1.1207–1362. Theocritus, *Idylls* 13.38–75. Propertius, *Elegies* 1.20. Virgil, *Eclogues* 6.43ff. Apollodorus, *Biblioteca* 1.9.19. Strabo, *Geography* 12.4.3. Valerius Flaccus, *Argonautica* 3.521ff. Hyginus, *Fabulae* 14.

Angelo Poliziano, 1454–1494. (Hylas stolen by naiads in) *Sylvae* [Woods] nos. 5, 12. Latin eclogues. / Translated as *Selve d'amore* [The Woods of Love] (Florence: **1483**). [Levin 1969, p. 42]

Lorenzo de' Medici, 1449–1492. (Hylas evoked in) *Sonetti e canzoni,* passim. In modern edition by Giosuè Carducci, *Poesie* (Bologna: 1859; reissued Florence: 1932). [Bondanella 1979, p. 327]

Piero di Cosimo, c.1462–1521. "Hylas and the Nymphs" (? traditional title; more probably "The Fall of Vulcan"). Painting. c.**1495–1500.** Wadsworth Atheneum, Hartford. [Bacci 1966, pl. 15]

Giulio Romano, c.1499–1546. "Hylas and the Nymphs." Drawing (for a lost or unexecuted painting?). c.**1530?** Lost. / Copies in Louvre, Paris, inv. 3665; private coll., London. [Hartt 1958, p. 225]

Francesco Primaticcio, 1504–1570, and assistants. "Hylas Held by the Nymphs." Ceiling fresco, in Galerie d'Ulysse, Château de Fontainebleau. **1541–47.** Destroyed 1738–39. / Drawing. Louvre, Paris, inv. 8523. [Béguin et al. 1985, pp. 188f.—ill. / also Dimier 1900, pp. 295ff., no. 13]

Pierre de Ronsard, 1524–1585. "Hylas." Poem. In *Le septiesme livre des poëmes* (Paris: Dallier, 1569). [Laumonier 1914–75, vol. 15 / Armstrong 1968, pp. 182f., 192 / Cave 1973, pp. 166f., 289]

Christopher Marlowe, 1564–1593. (Hylas and Hercules likened to Piers Gaveston and Edward in) *Edward II* lines 143–45, 689–94. Historical drama. First performed 1593. Published London: 1594. [Bowers 1973, vol. 2 / Leech 1986, pp. 127, 133]

Giovanni Battista Marino, 1569–1625. (Mercury relates the story of Hylas in) *L'Adone.* Poem. Paris: Varano, 1623. [Bondanella 1979, p. 320]

N. de Rayssiguier, ?–1660. *Les inconstances d'Hilas.* Drama. In *Théâtre* (Paris: David, 1632). [Taylor 1893, p. 94]

Francesco Furini, 1604–1646. "Hylas and the Nymphs." Painting. Galleria Palatina, Palazzo Pitti, Florence, no. 3562. [Pitti 1966, p. 170—ill.] Replica. National Gallery of Ireland, Dublin, no. 1658. [Dublin 1981, p. 57—ill.]

Lorenzo Mattielli, 1682/88–1748. "Nymph and Hylas." Stone sculpture group. 1716. Schwarzenbergpark, Vienna. [Pigler 1974, p. 135]

François Lupien Grenet, c.1700–1753, music. "Hylas." Entrée in *Le triomphe de l'harmonie.* Ballet-héroïque. Libretto, Jean-Jacques Le Franc de Pompignan. First performed 9 May 1737, L'Opéra, Paris. [Grove 1980, 7:702]

Bernard de Bury, 1720–1785. *Hylas et Zelie.* New entree in *Les caractères de la folie.* Opera-ballet. First performed 6 July 1762, Paris. [Grove 1980, 3:496]

François-Joseph Gossec, 1734–1829. *Les agréments d'Hylas et Silvie.* Pastorale. Libretto, M.-R.-J. Rochon de Chabannes. First performed 10 Dec 1768, Comédie-Française, Paris. [Grove 1980, 7:562]

Étienne Lauchery, 1732–1820, choreography. *Hylas et Eglée, ou, La fête d'amour.* Ballet. Music, Florian Johann Deller. First performed 1769, Kassel. [Grove 1980, 5:350]

Léopold-Bastien Desormery, c.1740–c.1810, with Joseph Le Gros, 1739–1793, music. *Hylas et Eglé.* Ballet-héroïque, revision of Grenet and Le Franc de Pompignan's *Hylas* (1737). First performed 16 Feb 1775, L'Opéra, Paris. [Grove 1980, 5:393]

James Hervé D'Egville, c.1770–c.1836, choreography. *Hylas et Témire.* Ballet. Music, Bossi. First performed 18 Apr 1799, King's Theatre, London. [Guest 1972, p. 152]

John Gibson, 1790–1866. "Hylas and the Water-Nymphs." Marble sculpture. 1826. Tate Gallery, London, no. 1746. [Tate 1975, p. 34 / Agard 1951, fig. 64]

Bertel Thorwaldsen, 1770–1844. "Hylas Stolen by the Water Nymphs." Marble relief. Thorwaldsens Museum, Copenhagen, no. A482. [Thorwaldsen 1985, p. 56 / Hartmann 1979, pp. 156f., pl. 102.5] Plaster original, 1831. Thorwaldsens Museum, no. A483. [Thorwaldsen]

———. "Hylas Stolen by the Water Nymphs." Marble relief. Thorwaldsens Museum, no. A484. [Ibid.—ill.] Plaster original, 1833. Thorwaldsens Museum, no. A485. [Ibid.]

William Etty, 1787–1849. "Hylas and the Nymphs." Painting. 1833. [Hunger 1959, p. 157]

Joseph Anton Koch, 1768–1839. "Hylas and the Nymphs." Painting. Städelsches Kunstinstitut, Frankfurt. [Bénézit 1976, 6:263]

Eduard Mörike, 1804–1875. "Hylas." Translation of Theocritus, Idyll 13. In *Classische Blumenlese* (Stuttgart: Schweizerbart, 1840). [Hötzer 1967]

Charles Marie René Leconte de Lisle, 1818–1894. "Hylas." Poem. In *Oeuvres: Poèmes antiques* (Paris: Lemerre, 1852). [Pich 1976–81, vol. 1]

Bayard Taylor, 1825–1878. "Hylas." Poem. In *A Book of Romances, Lyrics, and Songs* (Boston: Ticknor, Reed & Fields, 1852). [Bush 1937, p. 579]

William Morris, 1834–1896. (Story of Hylas in) *The Life and Death of Jason* book 4 (London: Bell & Daldy, 1867). [Morris 1910–15, vol. 2 / Calhoun 1975, p. 148 / Bush 1937, p. 310]

Jean-François Millet, 1814–1875. "Hylas and the Nymphs." Painting. Rijksmuseum Kröller-Müller, Otterlo, cat. 1969 no. 508. [Wright 1980, p. 279]

Gabriele D'Annunzio, 1863–1938. "Hyla! Hyla!" Idyll. 1885–88. In *La Chimera* (Milan: Treves, 1890). [Palmieri 1953–59, vol. 2]

Stopford Brooke, 1832–1916. "Hylas." Poem. In *Poems* (London: Macmillan, 1888). [Bush 1937, p. 562 / Boswell 1982, p. 54]

Théodore Dubois, 1837–1924. "Hylas." Lyric scene for soprano, baritone, chorus, and orchestra. Text, after a poem by Edward Guinand. Published Paris: Heugel, 1893? [Grove 1980, 5:665]

Francis Burdett Thomas Coutts-Nevill, 1852–1923. "Hercules and Hylas." Poem. In *Poems* (London: Lane, 1896). [Bush 1937, p. 569]

John William Waterhouse, 1849–1917. "Hylas and the Nymphs." Painting. 1896–97. City Art Gallery, Manchester. [Hobson 1980, no. 116, pl. 86 / Kestner 1989, pp. 298f., pl. 5.39 / Wood 1983, p. 235—ill. / Reynolds 1966, p. 93, pl. 56]

Bliss Carman, 1861–1929. "Hylas." Poem. In *The Pipes of Pan* (Boston: Page, 1904). [Boswell 1982, p. 66]

John Erskine, 1879–1951. (Story of Hylas related in) "A Song to Friends." Poem. In *Actaeon and Other Poems* (New York & London: Lane, 1907). [Ipso]

Harriet Hosmer, 1830–1908. "Fountain of Hylas." Marble sculpture group. Artist's studio. [Gerdts 1973, p. 64]

Edmund Clarence Stedman, 1833–1908. "Hylas." Poem. In *Poems* (Boston: Houghton Mifflin, 1908). [Boswell 1982, p. 296]

George Wetherbee, 1851–1920. "Stray'd Hylas." Painting. 1908. [Kestner 1989, p. 331]

Madison Cawein, 1865–1914. "Hylas." Poem. In *New Poems* (London: Richards, 1909). [Boswell 1982, p. 71]

Arthur B. Davies, 1862–1928. "Hylas and the Nymphs." Painting. 1910. Stephen C. Clark coll., New York. [Metropolitan 1930, no. 94—ill. / Cortissoz 1931, p. 27]

Henrietta Rae, 1859–1928. "Hylas and the Water-Nymphs." Painting. 1910. [Kestner 1989, p. 285]

Richard Barham Middleton, 1882–1911. "Hylas." Poem. In *Poems and Songs,* 2d series (London: Unwin, 1912). [Bush 1937, p. 570]

Olive Custance (Lady Alfred Douglas), b. 1874. "Hylas." Poem. In *The Inn of Dreams* (London: Lane, 1911). [Boswell 1982, p. 81]

Cecil Roberts, 1892–1976. "Strayed Hylas." Poem. Published 1914; reprinted in *Poems* (New York: Stokes, 1920). [Bush 1937, p. 572]

Maxwell Anderson, 1888–1959. "Hylas." Poem. In *Contemporary Verse* 9 (Apr 1920). [Shivers 1985, item 85]

Hervey Allen, 1889–1949. "Hylas." Poem. In *Wampum and Old Gold* (New Haven: Yale University Press, 1921). [Boswell 1982, p. 13]

Aristide Maillol, 1861–1944. "Hylas Disappearing into a Fountain." Woodcut, illustrating Virgil's sixth Eclogue. Published Leipzig: Insel, 1926. [Guérin 1965, no. 40—ill.]

Peggy Glanville-Hicks, 1912–, music. *Hylas and the Nymphs*. Ballet. 1937. [Cohen 1987, 1:272 / Baker 1984, p. 839]

Carl Milles, 1875–1955. "Hylas and the Nymphs." Marble sculpture group. Before 1940. Västerås, Sweden. [Rogers 1940, p. 63]

Stanley Glasser, 1926–. "Hylas." Musical canzone. 1972. [Grove 1980, 7:427]

Phineus and the Harpies. When the Argonauts landed at the Thracian port of Salmydessus they were met by the blind king, Phineus, a noted soothsayer. He was the son of Agenor (or Poseidon), the brother of Cadmus and Europa, and the husband of Cleopatra, daughter of Boreas, the north wind. He had been blinded by Zeus (Jupiter) because his prophetic gift trespassed on the gods' prerogative of knowing the future, or by Zeus or Boreas in retribution for blinding his own sons. Zeus then sent Harpies to torment Phineus; they stole most of the food that was set before him and defiled the rest. In another version, Phineus chose blindness in return for a long life, whereupon Helios sent the Harpies to plague him for choosing never to see the sun.

In answer to Phineus's plea for help, the Argonauts Zetes and Calais, the winged sons of Boreas, chased the Harpies to the Strophades Islands. They would have killed the creatures, but Iris, Zeus's messenger, interceded and promised that they would desist from tormenting the king. In return, Phineus forewarned the Argonauts of the dangers awaiting them on the remainder of their journey to Colchis.

Classical Sources. Hesiod, fragments 138, 151, 157 (Merkelbach-West). Sophocles, *Antigone* 969–81. Apollonius Rhodius, *Argonautica* 1.211ff., 2.178–489. Diodorus Siculus, *Biblioteca* 4.43.3–4. Virgil, *Aeneid* 3.209–19. Ovid, *Metamorphoses* 7.2–4. Apollodorus, *Biblioteca* 1.9.21, 3.15.2ff. Pausanias, *Description of Greece* 3.18.15, 5.17.11. Hyginus, *Fabulae* 19.

Anonymous French. (Story of Phineus and the Harpies in) *Ovide moralisé* 6.3946–4068. Poem, allegorized translation/elaboration of Ovid's *Metamorphoses* and other works. *c.*1316–28. [de Boer 1915–86, vol. 2]

Pierre de Ronsard, 1524–1585. "L'hymne de Calaïs et de Zetes." Poem, hymn. In *Le second livre des hymnes* (Paris: Wechel, 1556). [Laumonier 1914–75, vol. 8 / Cave 1973, pp. 27, 185 / McFarlane 1973, pp. 18, 27, 76]

Lodovico Pozzoserrato, fl. *c.*1581–1603/05, attributed. "The Sons of Boreas Pursuing the Harpies." Painting. National Gallery, inv. 5467. [London 1986, p. 496—ill.]

Simon Vouet, 1590–1649. "Calais and Zetes Driving the Harpies away from King Phineus." Decoration for Gallery of Hôtel Séguier, Paris. 1633–38. Lost. / Engraved by Michel Dorigny, 1651. [Crelly 1962, pp. 112ff., no. 248H—ill.]

Peter Paul Rubens, 1577–1640. "The Harpies Driven Away by Zetes and Calais." Painting, for Torre de la Parada, El Pardo, executed by assistant from Rubens's design. 1636–38. Prado, Madrid, no. 1633 (as Erasmus Quellinus). [Alpers 1971, no. 27—ill. / Jaffé 1989, no. 1336—ill. / Prado 1985, p. 524] Oil sketch. Prado, no. 2458. [Held 1980, no. 220—ill. / Alpers, no. 27a—ill. / Jaffé, no. 1335—ill. / Prado, p. 596]

Sebastiano Ricci, 1659–1734. "Phineus and the Sons of Boreas." Painting. Museum of Fine Arts, Boston, no. 1980.275. [Boston 1985, p. 245—ill.]

William Rose Benét, 1886–1950. "The Guests of Phineus" (Harpies). Poem. In *Merchants from Cathay* (New York: Appleton-Century, 1919). [Gregory & Zaturenska 1947, p. 442]

Jason and the Golden Fleece. When the *Argo* arrived at Colchis, Hera and Aphrodite caused the king's daughter, Medea, a priestess of Hecate, to fall in love with Jason. When Jason explained his quest, King Aeëtes refused to hand over the Golden Fleece until the Argonauts had performed an impossible task: to yoke a pair of fire-breathing bronze bulls, use them to plow a large field, sow it with dragon's teeth, and fight the armed men who sprang from these seeds. By the use of her magical powers Medea enabled the Argonauts to accomplish the task.

However, the king was still not prepared to relinquish his treasure and planned to kill the Argonauts. Medea revealed his intentions to Jason and helped him to find the fleece, drug the serpent that guarded it, and steal it away. After a battle with Aeëtes' men, the Argonauts escaped from Colchis, accompanied by Medea. According to Apollodorus, they also took along Medea's brother Apsyrtus; when Aeëtes pursued them, they killed the child and cut him up, throwing his body into the sea piece by piece to delay Aeëtes as he stopped to retrieve the limbs. The Argonauts subsequently went to Aeaea to be purified by Circe.

In the postclassical era most treatments of the Argonautic expedition have focused on the episode at Colchis: the taking of the Golden Fleece and the love of Jason and Medea. Some narrative works also include other passages of the story.

Classical Sources. Pindar, *Pythian Odes* 4. Apollonius Rhodius, *Argonautica* 4.92–211. Diodorus Siculus, *Biblio-*

teca 48.1–5. Ovid, *Metamorphoses* 7.1–159. Apollodorus, *Biblioteca* 1.9.1, 1.9.23–24. Hyginus, *Fabulae* 3, 22, 188.

See also ATHAMAS AND INO; MEDEA.

Benoît de Sainte-Maure, fl. 1150–70. (Story of the capture of the Golden Fleece in) *Le roman de Troie* lines 715–2078. Verse romance, after Dares, *De excidio Troiae historia,* and Dictys, *Ephemeris de historia belli Troiani* (late Latin versions of lost Greek poems, pseudo-classical forgeries). *c.*1165. [Baumgartner 1987]

Guido delle Colonne, *c.*1210–after 1287. (Story of the Golden Fleece in) *Historia destructionis Troiae* [History of the Destruction of Troy] 1.88–93 (debunked), 3.112–26, 3.360ff. Latin prose chronicle, after Benoît de Sainte-Maure. 1272–87. Modern edition by Nathaniel E. Griffin (Cambridge: Harvard University Press, with Mediæval Academy of America, 1936; reprinted New York: Kraus, 1970). / Translated by M. E. Meek (Bloomington: Indiana University Press, 1974). [Benson 1980, p. 15, 45ff., 80]

Giovanni Boccaccio, 1313–1375. (Aeëtes, and the seizure of the fleece, evoked in) "Concursus infelicium" [Gathering of Unhappy Souls]. In *De casibus virorum illustrium* [The Fates of Illustrious Men] 1.7. Didactic poem in Latin. 1355–73? [Branca 1964–83, vol. 9 / Hall 1965]

John Gower, 1330?–1408. (Story of Jason and Medea at Colchis recounted in) *Confessio amantis* 5.3241–3570, 4020–4229. Poem. *c.*1390. Westminister: Caxton, 1483. [Macaulay 1899–1902, vol. 3 / Ito 1976, p. 81]

Anonymous English. (Jason's return to the city of Colchis with the fleece in) *The Destruction of Troy* lines 973ff. Alliterative adaptation of Guido delle Colonne. *c.*1385–1400? Modern edition by George A. Panton and David Donaldson, *The "Gest Hystoriale" of the Destruction of Troy* (London: Early English Text Society, 1869, 1874). [Benson 1980, p. 46]

Christine de Pizan, *c.*1364–*c.*1431. (Story of Jason and the Golden Fleece in) *L'epistre d'Othéa à Hector* . . . [The Epistle of Othéa to Hector] chapter 54. Didactic romance in prose. *c.*1400. MSS in British Library, London; Bibliothèque Nationale, Paris; elsewhere. / Translated by Stephen Scrope (London: *c.*1444–50). [Bühler 1970 / Hindman 1986, pp. 95, 192, 198, pls. 39, 82]

Anonymous English. (Jason and Medea in love in) *The Laud Troy Book* lines 870–86. Metrical romance, after Guido delle Colonne. *c.*1400. Modern edition by J. Ernst Wülfing (London: Early English Text Society, 1902, 1903). [Benson 1980, p. 80]

John Lydgate, 1370?–1449. (Jason's quest for the Golden Fleece evoked in) *Reson and Sensuallyte* lines 3524. Poem, partial translation of *Les échecs amoureux* [Love's Game of Chess] (1370–80). Probably before 1412. Modern edition by E. Sieper (London: Early English Text Society, 1901). [Pearsall 1970, p. 118]

————. (Jason's capture of the Golden Fleece recounted in) *Troy Book* 1.1951–67, 2160–2248, 2868ff., 3545–81. Poem, elaboration of Guido delle Colonne. 1412–20. Modern edition by Henry Bergen (London: Kegan Paul, Trench & Trübner, for Early English Text Society, 1906–35). [Benson 1980, p. 104 / Pearsall, p. 128 / BW 1979–87, 1:63ff.]

Raoul Lefèvre, fl. *c.*1454–67. *Le roman de Jason et Medée.*

Prose romance. Bruges: Mansion, *c.*1460. / Translated by William Caxton as *The History of Jason* (Westminster: Caxton, *c.*1477). Modern edition, London: Kegan Paul, Trench & Trübner, Oxford University Press, for Early English Text Society, 1976. [Wilson 1972, pp. 779f. / DMA 1982–89, 7:534]

Utili, fl. 1476–1504 "The Meeting of Jason and Medea." Painting. 1486–87. Musée des Arts Décoratifs, Paris. [Berenson 1963, p. 211]

Bartolomeo di Giovanni, fl. *c.*1483–1511 (formerly attributed to Piero di Cosimo). "The Story of Jason and the Golden Fleece," "Jason Received by the King of Colchis." Paintings. *c.*1487. Robinson coll., Capetown ("Story of Jason" formerly Robinson coll.). [Berenson 1963, pp. 25, 175—ill. (figures in "Jason Received" attributed to Piero) / Bacci 1966, p. 116]

Ercole da Ferrara, 1450/56–1496, studio. "Jason Kills the Dragon before Medea," "Banquet of the Argonauts" (fragment), "Battle of Argonauts." Paintings, part of a cycle on the Argonautic expedition. Dispersed. Lady Houstoun Boswall coll., London; Musée des Arts Décoratifs, Paris; Conte Rucellai coll., Florence. [Berenson 1968, pp. 121f.]

Ferrarese School? "Mythological Scene" (Aeëtes finding the pieces of Apsyrtus's body?). Painting. Late 15th century. Szépművészeti Múzeum, Budapest, no. 1325. [Budapest 1968, p. 220]

Léonard Thiry, 1500–1550. "Medea Telling Jason How to Steal the Golden Fleece." Drawing, 1 of 2 extant from "Conquest of the Golden Fleece" cycle. / Engraved by René Boyvin, published in French and Latin editions, with text by Jacques Gohory, dedicated to Charles IX of France, 1563. [Paris 1972, no. 225–26, 283–84—ill.]

Baccio Bandinelli, 1493–1560. "Jason" (with the fleece). Bronze statue. 1545–55. Museo Nazionale, Florence. [Pope-Hennessy 1985a, pp. 177f.—ill.]

Cavaliere d'Arpino, 1568–1640. "Jason and Medea." Fresco. 1594–95. Loggia Orsini, Palazzo del Sodalizio dei Piceni, Rome. [Röttgen 1969, pp. 279ff.—ill.]

Annibale Carracci, 1560–1609. "Jason and the Golden Fleece." Fresco. 1597–1600. Galleria, Palazzo Farnese, Rome. [Malafarina 1976, no. 104j—ill. / Martin 1965, p. 101—ill.]

Richard Brathwaite, 1588?–1673. "The Golden Fleece." Didactic poem. London: Pursett, 1611. [Vinge 1967, p. 385 n. / Bush 1963, p. 328]

Pietro Francavilla, 1546/53–1615. "Jason with the Golden Fleece." Statue. Palazzo Ricasoli, Florence. [Pope-Hennessy 1985b, 3: 391]

Lope da Vega, 1562–1635. *El Vellocino de Oro* [The Golden Fleece]. Drama. 1622. First performed 15 May 1622, Aranjuez. Published 1623. [Menéndez y Pelayo 1890–1913, vol. 6 / McGraw-Hill 1984, 5:98]

Anthony Munday, 1553/60–1633. *The Triumphs of the Golden Fleece.* Pageant. First performed 29 Oct 1623, Streets of London. Published London: Snodham, 1623. [DLB 1987, 62:232f.]

Peter Paul Rubens, 1577–1640. "Jason and the Golden Fleece." Painted cut-out, part of Arch of the Mint, decoration for "Pompa Introitus Fernandi," triumphal

entry of Cardinal-Infante Ferdinand of Spain into Antwerp, 17 Apr **1635**. Original decoration destroyed. [Martin 1972, no. 50—ill. (print)] Oil sketch. Koninklijk Museum voor Schone Kunsten, Antwerp, no. 317. [Ibid., no. 51a—ill. / Held 1980, no. 164—ill. / Jaffé 1989, no. 1161—ill.]

———. "Jason and the Golden Fleece." Painting, for Torre de la Parada, El Pardo, executed by Erasmus Quellinus from Rubens's design. 1636–38. Prado, Madrid, no. 1631. [Alpers 1971, no. 34—ill. / Jaffé, no. 1291—ill. / Prado 1985, pp. 523f.] Oil sketch. Musées Royaux des Beaux-Arts (Musée d'Art Ancien), Brussels, inv. 4104 (813). [Alpers, no. 34a—ill. / Held 1980, no. 199—ill. / Jaffé, no. 1290—ill. / Brussels 1984a, p. 251—ill.]

Pedro Calderón de la Barca, 1600–1681. (Jason's search for the Golden Fleece in) *Los tres mayores prodigios* [The Three Greatest Marvels] act 1. Comedy. **1636**. First performed St. John's Night, 1636, Buen Retiro, Madrid. Published in *Comedias de Calderón*, part 2 (Madrid: 1637). [Valbuena Briones 1960–67, vol. 1 / Maraniss 1978, p. 104 / O'Connor 1988, pp. 186f.]

Pierre Corneille, 1606–1684. *La conquête de la Toison d'Or* [Conquest of the Golden Fleece]. Tragedy (spectacle play, with machines by Giacomo Torelli). First performed Nov **1660**, Théâtre du Marais, Paris. Published Paris: Courbé et de Luyne, 1661. [Couton & Rat 1971, vol. 3 / Pocock 1973, pp. 16, 121, 167 / Arnott 1977, p. 55 / McGraw-Hill 1984, 1:552f., 554]

Salvator Rosa, 1615–1673. "Jason and the Dragon." Etching (Bartsch no. 18). **1663**. [Wallace 1979, no. 118—ill. / Salerno 1975, no. 218a—ill.] Variant, painting. c.1668. Museum of Fine Arts, Montreal. [Wallace, no. 118a—ill. / Salerno, no. 218—ill. / Wildenstein 1968, no. 40—ill.] Replica. Earl of Harrowby coll., England. [Wallace, no. 118b—ill. / Salerno, no. 253] 2 further versions known. Lord Bute coll., Mont Stuart, Scotland; the other sold Christie's, London, 1925 (copy?). [Salerno, no. 218 *n*.] Variant copy, "Jason Stupefies the Dragon," by Frans de Jong (previously attributed Salvator Rosa), in Statens Museum for Kunst, Copenhagen. [Copenhagen 1951, no. 348—ill.]

Charles de La Fosse, 1636–1716. "Jason Debarking at Colchis." Ceiling painting. Early **1670s**. Salon de Diane, Appartement du Roi, Château de Versailles. [Berger 1985, pp. 41ff., 69]

Antonio Draghi, 1634/35–1700. *La conquista del Vello d'Oro* [The Conquest of the Golden Fleece]. Opera. Libretto, Nicolò Minato. first performed **1678**, Wiener Neustadt. [Grove 1980, 5:605]

Pascal Collasse, 1649–1709. *Jason, ou, La Toison d'Or* [Jason, or, The Golden Fleece]. Opera (tragédie lyrique). Libretto, Jean-Baptiste Rousseau, after Corneille (1660). First performed 6 Jan **1696**, L'Opéra, Paris. [Grove 1980, 4:535 / Girdlestone 1972, pp. 126 *n*., 127f., 146–49]

Guillaume Louis Pécour, 1653–1729, choreography. *Jason, ou, La conquête de la Toison d'Or*. Ballet. First performed **1701**, Collège Louis-le-Grand, Paris. [Astier 1983, p. 154]

Alain René Lesage, 1668–1747, with **D'Orneval**, c.1698?–1766. *La conquête de la Toison d'Or*. Opéra-comique. First performed **1724**, Théâtre de la Foire, Saint-Laurent, Paris. [McGraw-Hill 1984, 3:268]

Giuseppe Scolari, c.1720–after 1774. *Il Vello d'Oro* [The Golden Fleece]. Opera (dramma per musica). Libretto, G. Palazzi. First performed Carnival **1748–49**, S. Cassiano, Venice. [Grove 1980, 17:55]

Johann Christoph Vogel, 1756–1788. *La Toison d'Or*. Opera (tragédie lyrique). Libretto, Philippe Desriaux. First performed 5 Sep **1786**, Paris. Performed as *Médée de Colchos*, 1788, Paris. [Girdlestone 1972, p. 329 / Grove 1980, 20:55]

Johann Gottlieb Naumann, 1741–1801. *Medea* (also called *La partenza di Giasone da Colco* [Jason's Departure from Colchis] and *Il ritorno di Giasone in Grecia* [Jason's Return to Greece]). Opera. Libretto, A. Filistri. First performed 16 Oct **1788**, Königliche Oper, Berlin. [EDS 1954–66, 7:1054] Revised as *Medea in Colchide*. First performed 11 Feb 1805, Königliche Oper, Berlin. [Grove 1980, 13:78f.]

Giuseppe Gazzaniga, 1743–1818. *Gli Argonauti in Colco, o, La conquista del Vello d'Oro* [The Argonauts in Colchis, or, The Conquest of the Golden Fleece]. Opera. Libretto, Antonio Sografi. **1789**. First performed 1790, San Samuele, Venice. [Grove 1980, 7:206]

Joseph Mallord William Turner, 1775–1851. "Jason" (confronting the dragon). Painting. Exhibited **1802**. Tate Gallery, London, no. 471. [Butlin & Joll 1977, no. 19—ill.]

Henry Fuseli, 1741–1825. "Circe Absolves Medea and Jason of the Murder of Apsyrtus." Drawing. c.**1805**. City of Auckland Art Gallery, New Zealand, inv. 1965–70. [Schiff 1973, no. 1794—ill.] [J&M]

———. "The Theft of the Golden Fleece." Painting, after Joel Barlow's *Columbiad*. 1806. British Museum, London, inv. 1907–11–6–2. [Schiff, no. 1239—ill.]

Christian Daniel Rauch, 1777–1857. "Jason" (seizing the fleece). Relief. / Plaster model, **1805–09**. Rauch-Museum, Berlin. [Cologne 1977, p. 270—ill.]

Franz Grillparzer, 1791–1872. *Die Argonauten* (Jason in Colchis). Tragedy, part 2 of the trilogy *Das goldene Vlies*. **1820**. First performed 26 Mar 1821, Burgtheater, Vienna. Published Vienna: Wallishausser, 1822. [DLL 1968–90, 6:800–802 / EW 1983–85, 5:429ff. / McGraw-Hill 1984, 2:413ff.]

Bertel Thorwaldsen, 1770–1844. "Jason (with the Golden Fleece)." Marble statue. 2 versions, **1803–28**, 1846–62 (executed by B. L. Bergslien and H. W. Bissen). Thorwaldsens Museum, Copenhagen nos. A822, A51 (in City Hall, Copenhagen). [Thorwaldsen 1985, pp. 24, 80, pl. 11 / Hartmann 1979, pp. 48ff.—ill. / Cologne 1977, no. 1, pp. 35ff., 95, 116—ill. / Licht 1983, p. 203—ill.] Plaster original. 1802–03. Thorwaldsens Museum, no. A52. [Thorwaldsen]

James Robinson Planché, 1795–1880. *The Golden Fleece; or, Jason in Colchis, and Medea in Corinth*. Extravaganza. First performed 24 Mar **1845**, Theatre Royal, Haymarket, London. [Planché 1986, p. 145 / Nicoll 1959–66, 4:382, 605]

Richard Dadd, 1817–1886. "The Flight of Medea with Jason." Watercolor. **1855**. Victoria and Albert Museum, London. [Alldderidge 1974, no. 153—ill.]

Francis Oliver Finch, 1802–1862. "Jason in Search of the Golden Fleece." Watercolor. Victoria and Albert Museum, London, no. P.13–1958. [Lambourne & Hamilton 1980, p. 132—ill.]

Gustave Moreau, 1826–1898. "Jason" (seizing the fleece, with Medea). Painting. **1865**. Musée d'Orsay, Paris, no.

R.F. 2780. [Louvre 1979–86, 4:114—ill. / Mathieu 1976, no. 69—ill.]

———. "Jason and Cupid" (Jason holding Cupid, the expiring dragon at his feet). Painting. c.1890. Formerly Willy Blumenthal coll., unlocated. [Mathieu, no. 377—ill.]

José-Maria de Heredia, 1842–1905. (Theft of the fleece depicted on ivory vase in) "Le vase." Sonnet. In *L'artiste* 1 Feb **1868**; collected in *Les trophées* (Paris: Lemerre, 1893). [Delaty 1984, vol. 1; cf. 2:42 / Hill 1962]

John William Waterhouse, 1849–1917, attributed. "Jason and the Argonauts with Medea." Painting. c.**1872.** Sold Christie's, London, 1973. [Hobson 1980, no. 1]

Théodore de Banville, 1823–1891. "La Toison d'Or" [The Golden Fleece]. Poem. In *Le sang de la coupe* (Paris: Lemerre, **1874**). [Ipso]

Vilhelm Kristian Sigurd Topske, 1840–1884. *Jason med det Gyldne Skind* [Jason with the Golden Fleece]. Novel. Published anonymously, Copenhagen: Gyldendal, **1875.** [Mitchell 1958, p. 188]

Gustav Mahler, 1860–1911. *Die Argonauten.* Opera. Libretto after Grillparzer (1820). **1880,** unfinished, MS later destroyed by the composer. [Baker 1984, p. 114]

Amina Boschetti, 1836–**1881,** choreography. *Il Vello d'Oro* [The Golden Fleece]. Ballet. Music, G. Giaquinto. First performed 1882, Teatro San Carlo, Naples. [EDS 1954–66, 2:866]

Calixa Lavallée, 1842–1891. *Golden Fleece.* Overture. Published Boston: **1885–88.** [Grove 1980, 10:552]

Stanislaw Przybyszewski, 1868–1927. *Zlote runo* [The Golden Fleece]. Drama. First performed 27 Mar **1901,** Lvov, Poland. [McGraw-Hill 1984, 4:171ff.]

Andrei Bely, 1880–1934. "The Golden Fleece" [English title of a work written in Russian]. Poem. In *Zoloto v lazuri* [Gold in Azure] (Moscow: Skorpion, **1904**). [Mochulsky 1977, pp. 47, 54]

Herbert James Draper, 1864–1920. "The Golden Fleece" (Apsyrtus being thrown into the sea). Painting. **1904.** Bradford Art Galleries. [Kestner 1989, p. 290, pl. 5.24 / Wood 1983, p. 216—ill.]

Maxfield Parrish, 1870–1966. "Jason and the Talking Oak" (the sacred oak of Didona, in the Argo's hull, warns the Argonauts they will be punished for the murder of Apsyrtus unless they are purified), unpublished; "Quest of the Golden Fleece," published 5 Mar 1910. Paintings, 2 or 3 on the story of Jason made for *Collier's* magazine "Mythology" series. **1908.** Originals in Vose Galleries, Boston. [Ludwig 1973, pp. 35, 209—ill.]

Robert P. Tristram Coffin, 1892–1955. "The House of Jason" (symbolic use of myth: ram's head as metaphor for crisis). Poem. In *Dew and Bronze* (New York: Boni, **1927**). [Boswell 1982, p. 77]

Tom Roberts, 1856–**1931.** "The Golden Fleece." Painting. Art Gallery of New South Wales, Sydney, Australia. [Bénézit 1976, 9:12]

William Rose Benét, 1886–1950. *The Golden Fleece.* Collection of poems. New York: Dodd, Mead, **1935.** [Gregory & Zaturenska 1946, p. 442]

Alexandre Tansman, b. 1897. *La Toison d'Or* [The Golden Fleece]. Opéra bouffe. Libretto, S. de Madariaga. **1938.** [Grove 1980, 18:566]

Hanya Holm, b. 1898, choreography. "The Golden Fleece." Modern dance. First performed **1941,** New York; costumes, Kurt Seligmann. [McDonagh 1976, p. 79 / Sorell 1979, pp. 84–87]

J. B. Priestley, 1894–1987. *The Golden Fleece.* Comedy. First performed as *The Bull Market,* **1944,** Civic Theatre, Bradford. Published in *Three Comedies* (London: Heinemann, 1945). [Vinson 1982, p. 654 / McGraw-Hill 1984, 4:170]

Sulkhan Tsintsadze, 1925–. *Okros verdzi* [The Golden Fleece]. Opera. **1952.** [Grove 1980, 19:232]

Robert Duncan, 1919–1988. *Medea at Kolchis: The Maiden Head.* Play. First performed **1956,** Black Mountain, N.C. Published Berkeley: Oyez, 1965. [Vinson 1985, p. 211]

Robert Motherwell, 1915–1991. "The Golden Fleece." Abstract painting. **1961.** Chrysler Museum, Norfolk, Va. [Arnason 1982, pp. 11, 144—ill.]

Claire Polin, 1926–. *The Golden Fleece.* Orchestral composition. **1979.** [Cohen 1987, 1:554]

JOCASTA. *See* OEDIPUS, General List; SEVEN AGAINST THEBES.

JUNO. An Italian (Roman) goddess of childbirth, goddess of the life of women in general, and, for the Romans, a great goddess of the state. Because of functional similarities, Juno was identified with the Greek goddess Hera. *See* HERA.

JUPITER. An Italian (Roman) sky-god, honored in Rome as the supreme god of the pantheon. As god of heaven, Jupiter shared most of his powers and mythology with the Greek sky-god, Zeus. *See* ZEUS.

L

LAMIA. Daughter of Belus and Libya, Lamia was one of Zeus's conquests. When her children by Zeus were murdered by his jealous wife Hera, Lamia went mad with grief. Unable to revenge herself on Hera, she took to snatching and killing the children of others. Her face eventually turned into a hideous

mask. Associated with her were the Lamiae, amorous fiends who lured young men to bed, then drank their blood and ate their flesh.

Classical Sources. Aristophanes, *Knights* 693; *Wasps* 1035; *Peace* 758. Diodorus Siculus, *Biblioteca* 20.41.3–6. Strabo, *Geography* 1.2.8. Plutarch, *Moralia* 516. Philostratus, *Life of Apollonius of Tyana* 4.25.

Angelo Poliziano, 1454–1494. *Lamia.* Poem. Florence: Antonius Miscominus, **1492.** [DELI 1966–70, 4:416]
Lilio Gregorio Giraldi, *c.*1479–1552. (Lamia described in) *De deis gentium.* Compendium of history and mythology. Basel: Oporinus, **1548.** [Rachewiltz 1987, pp. 174, 186]
William Painter, *c.*1540–1594. "Lamia." Novel 12, in *The Palace of Pleasure* part 2 (London: Tottell & Jones, **1566**). [Bush 1963, p. 34 *n.*]
John Keats, 1795–1821. *Lamia.* Narrative poem. **1819.** London: Taylor & Hessey, 1820. [Stillinger 1978 / Aske 1985, pp. 127–42 / Bate 1963, pp. 543–61 / Gradman 1980, pp. 99–118 / Ridley 1933, pp. 241–65]
Thomas Hood, 1799–1845. *Lamia.* Dramatic romance. *c.***1827.** In *Autobiography of William Jerdan,* vol. 1 (1852). [Bush 1937, pp. 189, 549]
Edward MacDowell, 1860–1908. *Lamia.* Symphonic poem, opus 29. **1887–88.** Published Boston & Leipzig: 1908. [Grove 1980, 11:420]
August Enna, 1859–1939. *Lamia.* Opera. First performed 3 Oct **1899,** Antwerp. [Grove 1980, 6:207]
George Frampton, 1860–1928. "Lamia." Bronze, ivory, and opal sculpture. **1899–1900.** Royal Academy, London. [Beattie 1983, p. 150f., 160f.—ill.]
Helge Rode, 1870–1937. *Lamia.* Drama. Copenhagen: Gyldendal, **1901.** [CEWL 1973, 3:417]
John William Waterhouse, 1849–1917. "Lamia." Painting, after William Keats. **1905.** T. Rowe coll., Britain. [Hobson 1980, no. 148, p. 122—ill. / Kestner 1989, p. 301] 2 replicas ("Lamia—Keats"), *c.*1905. Sold Christie's, London, 1926 and 1930. [Hobson, nos. 149–50]
———. "Lamia." Painting. 1909. Private coll., Italy. [Hobson, no. 173, pl. 80]
Herbert James Draper, 1864–1920. "Lamia." Painting. **1909.** [Kestner 1989, p. 291, pl. 5.28]
Arthur Symons, 1865–1945. "Lamia." Poem. In *Lesbia and Other Poems* (New York: Dutton, **1920**). [Beckson 1987, p. 298]
Frederick Zech, 1858–**1926.** *Lamia.* Symphonic poem. [Baker 1984, p. 2557]
Francis W. Sargant. "Lamia." Marble relief. Before **1931.** [Clapp 1970, 1:788]
Robert Graves, 1895–1985. "Lamia in Love." Poem. In *Man Does; Woman Is* (London: Cassell, **1964**). [Graves 1975]
Jacob Druckman, 1928–. "Lamia." Composition for soprano and orchestra. First performed 20 Apr **1974,** Albany Symphony, Albany, N.Y. [Burbank 1984, p. 393]
Peter Davison, 1928–. "Lamia." Poem. In *A Voice in the Mountain* (New York: Atheneum, **1977**). [Ipso]

LAOCOÖN. A prince of Troy and brother of Anchises, Laocoön was a priest of Apollo (or of Poseidon). During the Trojan War, he warned the Trojans of the dangers of the wooden horse—left by the Greeks outside the city—and flung his spear into its side. As he was sacrificing to Poseidon, he and his two sons were attacked by sea serpents and crushed to death. This was taken by the Trojans as a sign of the gods' punishment and confirmed their decision to pull the horse within the city walls.

The subject is best known through the statuary group depicting Laocoön and his sons strangled by the serpents, carved in Rhodes *c.*25 BCE and now in the Vatican Museum. Most postclassical representations of Laocoön are derived from this sculpture.

Classical Sources. Sophocles, *Laocoön* (fragments). Virgil, *Aeneid* 2.40–56, 190–240. Apollodorus, *Biblioteca* E5.17–18. Petronius, *Satyricon* 89.23ff. Hyginus, *Fabulae* 14, 135. Quintus of Smyrna, *Sequel to Homer* 12.449ff.

Further Reference. Margarete Bieber, *Laocoön: The Influence of the Group Since Its Rediscovery,* rev. ed. (Detroit: Wayne State University Press, 1942).

See also TROJAN WAR, General List, Wooden Horse.

Filippino Lippi, *c.*1457–**1504.** "The Story of Laocoön." Drawing. Koenigs coll., Haarlem. [Pigler 1974, p. 330]
Baccio Bandinelli, 1493–1560. "Laocoön." Marble sculpture, after the antique statue. **1520–25.** Uffizi, Florence, inv. 1914 no. 284. [Uffizi 1979, no. Sc5—ill.]
Giulio Romano, *c.*1499–1546, design. "(The Death of) Laocoön." Fresco, executed by Rinaldo Montovano. Sala di Troia, Palazzo Ducale, Mantua. **1536–39.** [Hartt 1958, pp. 179ff.—ill. / Eisler 1977, pp. 196, 199]
Iacopo Sadoleto, 1477–**1547.** *De Laocoontis statua* [Of the Statue of Laocoön]. Latin poem. Leipzig: Papa, 1549. [DELI 1966–70, 5:9]
Anonymous. "Laocoön." Relief, formerly considered antique. **16th century?** Sala Italiana, Prado, Madrid. [Eisler 1977, p. 196]
El Greco, 1541–1614. "Laocoön." Painting. Dating disputed, **1600–14?** Kress coll. (K1413), National Gallery, Washington, D.C., no. 885. [Eisler 1977, pp. 195–201—ill. / Sienkewicz 1983, p. 18—ill. / Walker 1984, p. 240—ill. / López Torrijos 1985, p. 412 no. 53—ill.] 2 further treatments of the subject known (in inventory at artist's death), untraced. [Eisler]
Adriaen de Vries, 1550–1626. "Laocoön." Bronze sculpture group. **1623.** Museum, Drottningholm. [Pigler 1974, p. 330]
Jusepe de Ribera, *c.*1590/91–1652. "Laocoön and His Sons Entwined with Serpents." Painting. Lost. / Drawing (for?). *c.***1630.** Gabinetto delle Stampe, Rome, no. 125594. [López Torrijos 1985, p. 412 nos. 58–59, pl. 85 / Brown 1973, no. D.21—ill.]
Anonymous. "Caricature of Laocoön" (Laocoön and his sons as apes). Engraving, after a lost original woodcut said to be by Titian. **1640s?** [Hofmann 1987, no. 7.13—ill.]
Leonhard Kern, 1588–1662. "Laocoön." Ivory sculpture

group. Formerly C. Mayer de Rothschild coll., Paris. [Pigler 1974, p. 331]

Pietro da Cortona, 1596–**1669**. "Laocoön." Drawing. / Etching by F. Bartolozzi, 1765. [Pigler 1974, p. 330]

Raymond de La Fage, *c.*1650–**1684**. "Laocoön." Drawing. Nationalmuseum, Stockholm. [Pigler 1974, p. 330] Another drawing of the subject, in Albertina, Vienna. [Ibid.]

Giuseppe Piamontini, 1664–1742. "The Downfall of Laocoön." Bronze relief. *c.*1700? Bayerisches Nationalmuseum, Munich, inv. R.3928. [Düsseldorf 1971, no. 377—ill.]

James Thomson, 1700–1748. "The Laocoön," in *Liberty* part 4. Poem. London: Millar, **1735–36**. [Larrabee 1943, 81]

Gotthold Ephraim Lessing, 1729–1781. *Laokoön; oder, Über die Grenzen der Mahlerei und Poesie* [Laocoön, or, On the Limits of Painting and Poetry]. Essay. Berlin: Voss, **1766**. [Highet 1967, pp. 371–74]

Johann Gottfried Herder, 1744–1803. "Laokoons Haupte" [Laocoön's Heads]. Poem. *c.*1770–72? In *Gedichte* book 2, in *Sämmtliche Werke* (Tübingen: Cotta, 1805–20). [Herder 1852–54, vol. 13]

Pietro Alessandro Guglielmi, 1728–1804. *Laocoonte*. Opera. Libretto, G. Pagliuca. First performed 30 May **1787**, San Carlo, Naples. [Grove 1980, 7:796]

Johann Wolfgang von Goethe, 1749–1832. "Ueber Laokoon" [On Laocoön]. Essay. In *Propyläen* 1 (**1798**). [Beutler 1948–71, vol. 13 / Suhrkamp 1983–88, vol. 3]

Henry Fuseli, 1741–1825. "A Woman before the Laocoön." 2 drawings. **1801–05**. Kunsthaus, Zurich, inv. 1913/9. [Schiff 1973, nos. 1072, 1072a—ill.]

Francesco Hayez, 1791–1882. "Laocoön." Painting. **1812**. Accademia di Brera, Milan, on deposit at L'Intendenza di Finanza. [Coradeschi 1971, no. 11a—ill.] Replica. On deposit at Galleria d'Arte Moderna, Milan. [Coradeschi 1971, no. 11b]

William Blake, 1757–1827. "Laocoön." Engraving, after the antique sculpture, surrounded by inscriptions. *c.*1820–22. [Bindman 1982, no. 110—ill. / also Bindman 1978, no. 623—ill.]

———. "Free Version of the Laocoön." Watercolor, after the antique statue. *c.*1825. Sir Geoffrey Keynes coll., Newmarket, Suffolk. [Butlin 1981, no. 681—ill.]

Théodore Géricault, 1791–**1824**. "Laocoön and the Serpents." Painting. Musée des Beaux-Arts, Rouen. [Bénézit 1976, 4:685]

Georg Christian Braun, 1785–1834. *Laokoön*. Tragedy. **1824**. [DLL 1968–90, 1:910]

Paolo Costa, 1771–1836. *Il Laocoonte*. Poem. In *Opere* (Bologna: **1825**). [DELI 1966–70, 2:145]

Giuseppe Bernardino Bison, 1762–**1844**, attributed. "Laocoön." Drawing. Galleria del Caminetto, Bologna. [Pigler 1974, p. 330]

Karl Pavlovic Brüllov, 1799–**1852**. "The Death of Laocoön." Painting. Hermitage, Leningrad. [Bénézit 1976, 2:355]

Matthew Arnold, 1822–1888. "Epilogue to Lessing's Laocoön." Poem. **Early 1860s**. In *New Poems* (London: Macmillan, 1867). [Allott & Super 1986 / Tinker & Lowry 1940, pp. 184–86 / Bush 1971, pp. 37f.]

Honoré Daumier, 1808–1879. "Imitation of the Laocoön Group." Satirical lithograph. **1868**. [Delteil 1906–30, 28: no. 3632—ill.]

Constantin Brancusi, 1876–1957. "Laocoön Study." Clay sculpture sketch. **1898**. Unlocated. [Geist 1975, no. 2—ill.]

Domenico Milelli, 1841–1905. *Laocoonte*. Poem. Aquila: **1899**. [DELI 1966–70, 4:9f.]

Charles Ricketts, 1866–1931. "Laocoön (and His Sons)." Bronze statuette. Exhibited **1906**. Ivor Newton coll. [London 1968, no. 132—ill.]

Max Ernst, 1891–1976, and **Jean Arp**, 1887–1966. "Laocoön." Collage-sculpture. **1919**. [Clapp 1970, 1:281f.]

——— (Ernst). "Laocoön and Sons" ("The Poulpe") ("Octopus"). Painting. 1927. De Menil coll., Houston. [Spies & Metken 1975–79, no. 1083—ill.]

E. Proschek. *Laocoön*. Tragedy. **1919**. [Hunger 1959, p. 198]

Eduard Maydolf, b. 1843. *Laokoön*. Tragedy. Tübingen: **1925**. [DLL 1968–90, 10:632]

Sacheverell Sitwell, 1897–1988. "The Laocoön of El Greco." Poem. In *The Cyder Feast* (London: **1927**). [Boswell 1982, p. 294 / Bush 1937, p. 574]

Ossip Zadkine, 1890–1967. "Laocoön." Bronze sculpture. **1931**. Private coll. [Jianou 1979, no. 198]

Eric Gill, 1882–1940. "Laocoön." Wood-engraving, jacket design for *XX Century Library* (London: John Lane, **1934**). (Victoria and Albert Museum, London.) [Physick 1963, no. 854—ill.]

Karl Hofer, 1878–1955. "Laocoön." Painting. **1935**. Augustiner Museum, Freiburg. [Rigby 1976, pp. 208, 291]

Giorgio de Chirico, 1888–1978. "Head of Laocoön." Painting. **1939**. Raffaele Valentini coll., Milan. [de Chirico 1971–83, 1.2:no. 45—ill.]

Werner Gilles, 1894–1961. "Laocoön." Painting. **1948**. Knauer coll., Berlin. [Berlin 1962, no. 36]

Erik Lindegren, 1910–1968. (Laocoön evoked in) "Gipsavgjutning." Poem. In *Vinteroffer* (Stockholm: Bonnier, **1954**). [Ipso]

Donald Hall, 1928–. "Laocoön." Poem. Before **1957**. In *New Poems by American Poets, #2*, edited by Rolfe Humphries (New York: Ballantine, 1957). [Ipso]

Alexander Calder, 1898–1976. "Laocoön." Aluminum and steel sculpture. **1958**. Weiss coll., Chicago. [Clapp 1970, 2:pt.2:162]

Robert Goodnough, 1917–. "Laocoön." Abstract painting. **1958**. Museum of Modern Art, New York, no. 9.59. [Barr 1977, p. 545—ill.]

Robert Rosenwald, 1920–. "Laocoön." Oak sculpture. Exhibited New York, **1958**. [Clapp 1970, 2 pt. 2: 957]

Eduardo Paolozzi, 1924–. "Laocoön." Collage (automobile interior, a drawing of the antique "Laocoön" seen through the windshield). **1961**. Unlocated. [Konnertz 1984, fig. 259; cf. n. 106]

———. "Towards a New Laocoön." Abstract aluminum sculpture. 1963. Vanthournout-T'Kint coll., Belgium. [Ibid., fig. 258 / Kirkpatrick 1970, fig. 44]

Tadeusz Rózewicz, 1921–. *Grupa Laokoona* [Laocoön Group]. Drama. First performed 4 Apr **1962**, Teatr Dramatycyncy, Sala Prób, Warsaw. [McGraw-Hill 1984, 4:264, 266 / Mihailovich et al. 1972–76, 2:303, 386]

Ernst Fuchs, 1930–. "The Antilaocoön." Drawing. **1965.** Artist's coll. [Hofmann 1987, no. 16.7—ill.]

Rudolf Hausner, 1914–. "Large Laocoön." Painting. **1963–67.** Private coll., Vienna. [Hofmann 1987, no. 16.6—ill.]

Stefan Augustin Doinas, 1922–. *Semintia lui Laokoon* [Laocoön's Stock]. Collection of poetry. Bucharest: Tineretului, **1967.** [EWL 1981–84, 1:574]

Gunnar Ekelöf, 1907–1968. "Laocoön." Prose poem. / Translated by Muriel Rukeyser and Leif Sjöberg in *Selected Poems* (New York: Twayne, **1967**). [Ipso]

Siegfried Anzinger, 1953–. "Laocoön II." Clay sculpture. **1986.** Galerie Krinzinger, Vienna. [Hofmann 1987, no. 16.24—ill.]

LAODAMIA. *See* PROTESILAUS AND LAODAMIA.

LAOMEDON. A legendary king of Troy, Laomedon employed Apollo and Poseidon (Neptune) to build a wall around his city. When the work was completed, Laomedon refused to pay for it. In retaliation, Apollo sent a pestilence upon the Trojans and Poseidon called up a sea monster to attack the city; the monster would be appeased only by the sacrifice of Laomedon's daughter, Hesione.

Returning from his ninth labor, Heracles (Hercules) arrived at Troy in time to destroy the beast and rescue Hesione, asking in return for the king's famous horses. Laomedon reneged, and in anger Heracles attacked and captured the city, giving Hesione to his friend Telamon as a reward for his valor in the battle. In this fray Laomedon and all but one of his sons were killed. The survivor, Priam, became the ruler of Troy.

Classical Sources. Homer, *Iliad* 5.638–51, 20.236ff., 21.441–57. Pindar, *Olympian Odes* 8.31–41; *Isthmian Odes* 6.26ff. Ovid, *Metamorphoses* 11.196–215. Strabo, *Geography* 13.1.32. Apollodorus, *Biblioteca* 2.5.9, 2.6.4, 3.12.3–8, E3.24. Hyginus, *Fabulae* 89.

Benoît de Sainte-Maure, fl. 1150–70. (Story of Laomedon in) *Le roman de Troie* lines 915–1090, 2079–3650. Verse romance, after Dares, *De excidio Troiae historia,* and Dictys, *Ephemeris de historia belli Troiani* (late Latin versions of lost Greek poems, pseudo-classical forgeries). *c.*1165. [Baumgartner 1987]

Guido delle Colonne, *c.*1210–after 1287. (Laomedon's story retold in) *Historia destructionis Troiae* 2.7–22, 56–62; 3.406ff.; 4.120–48, 273–81, 291–300. Latin prose chronicle, after Benoît de Sainte-Maure. **1272–87.** Modern edition by Nathaniel E. Griffin (Cambridge, Mass.: Harvard University Press, with Mediæval Academy of America, 1936; reprinted New York: Kraus, 1970). / Translated

by M. E. Meek (Bloomington: Indiana University Press, 1974). [Benson 1980, pp. 17, 20, 24f., 28f., 62f.]

Anonymous French. (Building of Troy, story of Hercules and Hesione, in) *Ovide moralisé* 11.969–1041. Poem, allegorized translation/elaboration of Ovid's *Metamorphoses.* *c.*1316–28. [de Boer 1915–86, vol. 4]

Anonymous English. (Story of Laomedon told in) *The Destruction of Troy* lines 1313ff. Alliterative adaptation of Guido delle Colonne. *c.*1385–1400? Modern edition by George A. Panton and David Donaldson, *The "Gest Hystoriale" of the Destruction of Troy* (London: Early English Text Society, 1869, 1874). [Benson 1980, pp. 62f.]

John Gower, 1330?–1408. (Story of Laomedon and Hesione in) *Confessio amantis* 5.7194–7288. Poem. *c.*1390. Westminster: Caxton, 1483. [Macaulay 1899–1902, vol. 3 / Ito 1976, p. 99]

Christine de Pizan, *c.*1364–*c.*1431. (Laomedon in) *L'epistre d'Othéa à Hector* . . . [The Epistle of Othéa to Hector] chapters 37, 61, 66. Didactic romance in prose. *c.*1400. MSS in British Library, London; Bibliothèque Nationale, Paris; elsewhere. / Translated by Stephen Scrope (London: *c.*1444–50). [Bühler 1970 / Hindman 1986, pp. 196, 200]

John Lydgate, 1370?–1449. (Laomedon expels the Argonauts in) *Troy Book* 1.957ff. Poem, elaboration of Guido delle Colonne. **1412–20.** Modern edition by Henry Bergen (London: Kegan Paul, Trench & Trübner, for Early English Text Society, 1906–35). [Benson 1980, p. 125]

Raoul Lefèvre, fl. *c.*1454–67. (Hercules destroys Troy twice and rescues Hesione in) *Le recueil des hystoires de Troyes* [Collection of the Stories of Troy]. Prose romance. **1464.** / English translation by William Caxton as *The Recuyell of the Historyes of Troye* (Bruges: Mansion, *c.*1474). / Modern edition (of original French) by Marc Aeschbach (Bern & New York: Lang, 1987). [Scherer 1963, pp. 24, 26]

Michele da Verona, *c.*1470–**1536/44** (also attributed to Bernardo Parentino, *c.*1437–1531). "Laomedon and the Building of Troy." Series of paintings. 2 ("Apollo and Poseidon Come to Assist Laomedon," "Laomedon Refuses Apollo and Poseidon Their Reward") in Fitzwilliam Museum, Cambridge, nos. M.69–70; another ("Apollo and Poseidon Building") with Knoedler and Co., New York, in 1962. [Fitzwilliam 1960–77, 2:105 / also Berenson 1968, 1:317f. (as Parentino)]

Cavaliere d'Arpino, 1568–1640. "Hercules and Hesione." Lunette fresco, part of a cycle depicting scenes from the life of Hercules. **1594–95.** Loggia Orsini, Palazzo del Sodalizio dei Piceni, Rome. [Röttgen 1969, pp. 279ff., 285]

William Shakespeare, 1564–1616. (Hercules' rescue of Hesione evoked in) *The Merchant of Venice* 3.2.53–62. Comedy. **1596–97?** Stationers' Register 22 July 1598. Published London: 1600; collected in First Folio, London: Jaggard, 1623. [Riverside 1974 / Carroll 1985, pp. 119f. / Root 1903, p. 21]

Thomas Heywood, 1573/74–1641. (Story of Laomedon and Hesione in) *Troia Britanica: or, Great Britaines Troy* canto 6.89–101. Epic poem. London: **1609.** [Heywood 1974]

————. (Sea-monster slain by Hercules and Argonauts in) *The Brazen Age*. Drama, partially derived from *Troia Britanica*. First performed *c.*1610–13, London. Published London: Okes, 1613. [Heywood 1874, vol. 3 / DLB 1987, 62:101, 122ff. / also Boas 1950, pp. 83ff. / Clark 1931, pp. 62ff.]

Domenichino, 1581–1641, and assistant(s). "Apollo and Neptune Advising Laomedon on the Building of Troy." Fresco (detached), part of "Life of Apollo" cycle, from Villa Aldobrandini, Frascati. **1616–18.** National Gallery, London, inv. 6289. [London 1986, p. 162—ill. / Spear 1982, no. 55.viii—ill.]

Charles Le Brun, 1619–1690. "Hercules Delivers Hesione (from the Monster Sent by Neptune)." Fresco, part of "Hercules" cycle, for Hôtel Lambert, Paris. *c.*1650s. / Drawing. Louvre, Paris, inv. 29.479. [Versailles 1963, no. 77—ill.]

Salvator Rosa, 1615–1673. "Laomedon Refusing Payment to Poseidon and Apollo." Painting. Hunterian coll., University of Glasgow. [Wright 1976, p. 175]

Francesco Ballarotti, *c.*1660–1712. *Esione.* Opera. First performed **1699**, Turin. [Grove 1980, 2:86]

André Campra, 1660–1744. *Hésione.* Opera (tragédie lyrique). Libretto, Antoine Danchet. First performed 20 Dec **1700**, L'Opéra, Paris. [Grove 1980, 3:664f.]

Gérard de Lairesse, 1641–1711, follower. "Hercules Saving Hesione from the Attacks of a Sea Monster." Grisaille painting, part of a series on deeds of Hercules. Early 18th century. Louvre, Paris, inv. 20774. [Louvre 1979–86, 2:378—ill.]

Lorenzo Baseggio, *c.*1660–*c.*1715. *Laomedonte.* Opera. Libretto, G. B. Guizzardi or G. B. Ruperti. First performed **1715**, Teatro San Moisè, Venice. [Grove 1980, 2:235]

Gaspard Abeille, 1648–1718, libretto. *Hesione.* Opera. [EDS 1954–66, 1:25]

François Le Moyne, 1688–1737. "Hercules Freeing Hesione." Painting, for Hôtel Peyrenc de Moras (Hôtel Biron, now Musée Rodin), Paris. **1729–30.** Musée des Beaux-Arts, Nancy, inv. 925. [Bordeaux 1984, no. 85]

Pierre François Biancolelli, called Dominique, 1680–**1734**, and **Jean Antoine Romagnesi**, 1690–1742. *Hésione.* Comedy. In *Les parodies du nouveau théâtre italien* (Paris: 1738). [Hunger 1959, p. 198]

Angelo Maria Benincori, 1779–1821. *Hésione.* Opera. **1807.** [EDS 1954–66, 2:247]

Thomas Earle, 1810–1876. "Hercules Delivering Hesione from the Sea Monster." Sculpture group. **1840.** Royal Academy, London. [Bénézit 1976, 4:92]

Eugène Delacroix, 1798–1863. "Hercules Rescuing Hesione." Ceiling painting, in "Life of Hercules" cycle, for Salon de la Paix, Hôtel de Ville, Paris. **1851–52.** Destroyed by fire, 1871. [Robaut 1885, no. 1157—ill. (copy drawing) / Huyghe 1963, pp. 289, 423, 474]

Hans Thoma, 1839–1924. "Hercules Delivering the King's Daughter." Painting. **1880.** Hans Thoma Collection, Basel. [Thode 1909, p. 143—ill.]

LATINUS. *See* AENEAS, in Latium.

LATONA. *See* LETO.

LAVINIA. *See* AENEAS, in Latium.

LEANDER. *See* HERO AND LEANDER.